DICTIONARY OF IRISH ARTISTS

To my wife Betty and children Alan, Sheila, Michael, Stephen and Paul

DICTIONARY OF IRISH ARTISTS

20th Century

Theo Snoddy

MERLIN
PUBLISHING

This second edition published in 2002 by
Merlin Publishing
16 Upper Pembroke Street
Dublin 2, Ireland
Tel: +353 1 676 4373
Fax: +353 1 6764368
publishing@merlin.ie
www.merlinwolfhound.com

First edition 1996
Second edition 2002
Reprinted 2006

A CIP catalogue record for this book is available from the British Library.

ISBN: 1-903582-17-2

Cover painting: *The Rehearsal*, 1950, by John Luke, RUA (1906-75) by kind permission of Mrs Sadie McKee and the trustees of the Ulster Muesum

Cover design: Joe Gervin, first edition, and Slick Fish Design, second edition.

Typesetting: Teresa Kane

Printed by: The Bath Press

CONTENTS

Acknowledgements

Since the inaugural publication, research for this second volume has been continuous, involving not only journeys in Ireland but also to London. Once again the author is deeply indebted to various institutions and individuals who have supported the project financially from three cities: Belfast, Dublin and London; also a special word of thanks to an American subscriber; The Arts Council, Dublin; Christie's, auctioneers, London; de Veres Art Auctions, Dublin; Marie Donnelly, Dublin; The Esme Mitchell Trust, Belfast; The Irish Antique Dealers' Association, Dublin; Jorgensen Fine Art, Dublin; Peter Lamb and Sean O'Criadain, Dublin; Molesworth Gallery, Dublin; James Mullin Fine Art, Belfast; Pyms Gallery, London; Lochlann and Brenda Quinn, Dublin; William M. Roth, Princeton, USA; Ulster Television plc., Belfast; and Whyte's, auctioneers, Dublin.

Introduction

'Research is the life blood of any subject – without it, the subject remains static' – Irish professor of archaeology quoted recently. There have been radical changes since the inaugural edition, with more than one hundred new entries, again all deceased. How this revolutionary leap forward came about in five years requires explanation. The 1996 edition continued where Walter G. Strickland's *A Dictionary of Irish Artists* left off in 1913. Now, that is no longer the case. The twentieth century artists in that publication have been incorporated here with enhanced information: for example, Edwin Hayes, RHA, RI, ROI (1819-1904), Richard T. Moynan, RHA (1856-1906), Walter F. Osborne, RHA (1859-1903), Edward M. Synge, ARE (1860-1913), Richard W. West (1848-1905) and almost a score of others.

The definition of 'Irish' remains debatable. Being born in Ireland and departing in childhood, never to return, was not conducive to inclusion, unless perhaps the artist made the distinct effort of retaining the link by exhibiting in Ireland. But artists who were born outside Ireland and who settled here, at least for some years, have not been neglected. In the introduction to the *Dictionary of American Biography*, 1928 edition, New York, the confession was made that the very term 'American' was not free from ambiguities. They had agreed to include those individuals of foreign birth 'who have identified themselves with the country and contributed notably to its history', a policy repeated in this publication.

The second group of interpolated artists is rather a mixed bag. These new names are generally of artists for whom not sufficient information had been obtained for the first edition. Thus, John Day (1854-1931) the etcher is now included, and a surprise to many, the revolutionary, Maud Gonne (1866-1953). Tortuous was the research on Kathleen Mac Causland (1859-1928) who lived in France. The brave ceramic painter, Eugene Sheerin (1856-1915), confined to a bath-chair at Belleek, also made the grade.

The third group of new names, the largest, those who died in the period 1 January 1991-31 December 1999, include for example: Arthur Armstrong, RHA (1924-96), Tom Carr, HRHA, RUA, RWS (1909-99), Patrick Collins, HRHA (1910-94), Nevill Johnson (1911-99), F.E. McWilliam, RA, HRUA (1909-92), Domhnall Ó Murchadha, RHA (1914-91) and Alexandra Wejchert, RHA (1921-95).

As the recipient of some 2,500 letters over many years, a list of acknowledgements is not feasible. I am most grateful of course to those who supplied information and replied to queries. Many of their names appear in the Literature lists at the end of artists' entries. A special word of indebtedness is again due to the National Library of Ireland, Dublin; the Central Public Library and Linen Hall Library in Belfast. The innovation of the National Irish Visual Arts Library in Dublin has been appreciated. In London, the National Art Library at the Victoria and Albert Museum and the Family Records Centre have again proved valuable in researching. The list of artists now numbers 600.

Theo Snoddy
Belfast, January 2002

Abbreviations

The following abbreviations have been used in the dictionary:

AAI	Associazione Artistica Internazionale	Chas	Charles	FRSAI	Fellow of the Royal Society of Antiquaries of Ireland
AAI	Association of Art Institutions	Cist	Cistercian		
AB	Able-bodied seaman	cm	centimetre(s)	FSA	Fellow of Society of Antiquaries
ACNI	Arts Council of Northern Ireland	CMG	Companion of the Order of St Michael and St George	FTCD	Fellow of Trinity College, Dublin
ADC	Aide-de-Camp	Co.	County		
ALS	Associate of Linnean Society	c/o	care of	GAA	Gaelic Athletic Association
AM	Alpes-Maritimes	CP	Congregation of the Passion (Passionists)	GCMG	Grand Cross of the Order of St Michael and St George
ANA	Associate of National Academy of Design (New York)	CVO	Commander of the Royal Victorian Order	GDR	German Democratic Republic
				GHQ	General Head Quarters
ANCA	Associate of National College of Art	DAC	Dublin Art Club		
		DC	District of Columbia	Hants	Hampshire
AOH	Ancient Order of Hibernians	DCL	Doctor of Civil Law	HE	His Eminence
ARA	Associate of Royal Academy	DD	Doctor of Divinity	Herts	Hertfordshire
ARBA	Associate of Royal Society of British Artists	DFC	Distinguished Flying Cross	HLMGMA	Hugh Lane Municipal Gallery of Modern Art
		DL	Deputy Lieutenant		
ARCA	Associate of Royal College of Art	Dr	Doctor	HM	His (or Her) Majesty
		DSC	Dublin Sketching Club	HML	His (or Her) Majesty's Lieutenant
ARE	Associate of Royal Society of Painter-Etchers and Engravers	DSO	Distinguished Service Order		
				HMS	His (or Her) Majesty's Ship
ARMS	Associate of Royal Society of Miniature Painters	ed.	editor	Hon.	Honourable
		eg	*exempli gratia*, for example	HRH	His (or Her) Royal Highness
ARUA	Associate of Royal Ulster Academy of Arts	ENT	Ear, Nose and Throat	HRHA	Honorary Royal Hibernian Academician
		ESB	Electricity Supply Board		
Aus	Australia	et al	and others	HRSA	Honorary Royal Scottish Academician
BA	Bachelor of Arts	FBSE	Fellow of Botanical Society, Edinburgh	IAOS	Irish Agricultural Organisation Society
Bart.	Baronet				
BAS	Belfast Art Society	FCA	Fellow of Institute of Chartered Accountants	IBM	International Business Machines
BBC	British Broadcasting Company				
BC	British Columbia	fl.	flourished	ICA	Institute of Contemporary Arts
B Ch	Bachelor of Surgery	FNCI	Friends of the National Collections of Ireland		Irish Countrywomen's Association
Berks	Berkshire				
BI	British Institution	Fr	Father	ICE	Institution of Civil Engineers
BL	Bachelor of Law; Barrister-at-Law	FRAI	Fellow of the Royal Anthropological Institute	ICEI	Institution of Civil Engineers in Ireland
BMAG	Belfast Museum and Art Gallery	FRBS	Fellow of Royal Society of British Sculptors	IELA	Irish Exhibition of Living Art
Bt.	Baronet	FRCP	Fellow of the Royal College of Physicians	IFAS	Irish Fine Art Society
Bucks	Buckinghamshire			Ill	Illinois
BWS	British Water-colour Society	FRCPI	Fellow of Royal College of Physicians in Ireland	INRI	Iesus Nazarenus Rex Iudaeorum (Jesus of Nazareth, King of the Jews)
c	*circa*, about	FRCS	Fellow of Royal College of Surgeons		
Cap	Capuchin			IRA	Irish Republican Army
CAS	Contemporary Art Society	FRCSI	Fellow of Royal College of Surgeons in Ireland	ITGWU	Irish Transport and General Workers' Union
CB	Companion of the Order of the Bath	FRHS	Fellow of Royal Horticultural Society		
CBE	Commander of the Order of the British Empire			jnr; jr	junior
		FRIAM	Fellow of Royal Irish Academy of Music	JP	Justice of the Peace
CC	Catholic Curate				
CE	Civil Engineer	FRIBA	Fellow of Royal Institute of British Architects	KBE	Knight Commander of the Order of the British Empire
CEMA	Council for the Encouragement of Music and the Arts				
		FRS	Fellow of Royal Society	KC	King's Counsel

KCB	Knight Commander of the Royal Victorian Order	OBE	Officer of the Order of the British Empire	RSMA	Royal Society of Marine Artists
KCMG	Knight Commander of the Order of St Michael and St George	OFM	Order of Friars Minor	RSPP	Royal Society of Portrait Painters
		OMI	Oblate of Mary Immaculate	RTÉ	Radio Telefís Éireann
KCVO	Knight Commander of the Royal Victorian Order	OP	Order of Preachers (Dominicans)	Rt Hon.	Right Honourable
				RUA	Royal Ulster Academy of Arts or Academician
KG	Knight of the Order of the Garter	OSA	Order of Saint Augustine		
		OSB	Order of Saint Benedict	RUC	Royal Ulster Constabulary
		Oxon	Oxoniensis (of Oxford)	RWS	Royal Society of Painters in Water-Colours
LAA	Liverpool Academy of Arts	PAFA	Pennsylvania Academy of the Fine Arts		
Lancs	Lancashire				
LCC	London County Council	PC	Privy Councillor	S	Saint
LDS	Licentiate in Dental Surgery	PEN	Poets, Playwrights, Editors, and Novelists' Club	SA	South Africa
Litt D	Doctor of Letters			SC	Senior Counsel
LL D	Doctor of Laws	PhD	Doctor of Philosophy	senr	senior
LMS	London, Midland and Scottish (Railway)	PLC	Public Limited Company	SJ	Society of Jesus
		PM	Prime Minister	SPCK	Society for Promoting Christian Knowledge
LRAM	Licentiate of the Royal Academy of Music	PP	Parish Priest		
		PRA	President of the Royal Academy	Sr	Sister
Ltd	limited liability			SS	Steamship
				St	Saint
m	metre(s)	QC	Queen's Counsel	SWA	Society of Women Artists
MA	Master of Arts	q.v.	*quod vide*, which see		
M Arch	Master of Architecture	qq.v.	*quod vide*, which see (plural)	TCD	Trinity College, Dublin
Mass	Massachusetts			TD	Teachta Dála
MB	Bachelor of Medicine	RA	Royal Academy or Academician	trs	translator
MBE	Member of the Order of the British Empire			UAA	Ulster Academy of Arts
		RAF	Royal Air Force	UCC	University College, Cork
MC	Military Cross	RAM	Royal Academy of Music	UCD	University College, Dublin
MCC	Marylebone Cricket Club	RAMC	Royal Army Medical Corps	UK	United Kingdom
MD	Doctor of Medicine	RBA	Royal Society of British Artists	UM	Ulster Museum
MFH	Master of Foxhounds			USPCA	Ulster Society for the Prevention of Cruelty to Animals
Mgr	Monsignor	RBAI	Royal Belfast Academical Institution		
MH	Mention Honorable			USSR	Union of Soviet Socialist Republics
MICE	Member of the Institution of Civil Engineers	RBS	Royal Society of British Sculptors		
				US/USA	United States / United States of America
Miss	Mississippi	RCA	Royal College of Art		
MJI	Member of the Institute of Journalists	RCSI	Royal College of Surgeons in Ireland	USS	United States Ship
				UWS	Ulster Watercolour Society
Mlle	Mademoiselle	RDS	Royal Dublin Society		
mm	millimetre(s)	RE	Royal Society of Painter-Etchers and Engravers	V&A	Victoria and Albert Museum
Mme	Madame				
MP	Member of Parliament	Regt	Regiment	VAD	Voluntary Aid Detachment
MRIA	Member of Royal Irish Academy	Rev.	Reverend	VC	Victoria Cross
		RFA	Royal Fleet Auxiliary	Ven.	Venerable
mss	manuscripts	RHA	Royal Hibernian Academy or Academician	VS	Vocational School
NA	National Academy of Design (New York)	RI	Royal Institute of Painters in Water Colours	WCSI	Water Colour Society of Ireland
NATS	National Art Training School	RIA	Royal Irish Academy	Wilts	Wiltshire
NCA	National College of Art	RIAM	Royal Irish Academy of Music	WRNS	Woman's Royal Naval Service
nd	no date, not dated				
NEAC	New English Art Club	RIC	Royal Irish Constabulary		
NGI	National Gallery of Ireland	RM	Resident Magistrate	Yorks	Yorkshire
NGS	National Gallery of Scotland	RN	Royal Navy		
NLI	National Library of Ireland	ROI	Royal Institute of Oil Painters		
Notts	Nottinghamshire	RSA	Royal Scottish Academy or Academician		
nr	near				
NZ	New Zealand	RSAI	Royal Society of Antiquaries of Ireland		

ACHESON, ANNE, FRBS, RUA (1882-1962), sculptor. Born in Portadown, Co. Armagh, daughter of John Acheson. Anne Crawford Acheson entered Victoria College, Belfast, in 1897. Specialising in modern literature, she took her BA degree at the then Queen's College and began a short career in teaching at her old school, but abandoned the profession for the study of art and the serious development of her hobbies, drawing and modelling.

After attending the Belfast School of Art, she moved to London. At the Royal College of Art under Professor Edouard Lanteri (1848-1917) she obtained a diploma in sculpture in 1910 and settled down in a Chelsea studio. She was soon exhibiting at the Royal Academy, the Paris Salon and elsewhere on the Continent; also at exhibitions of the Society of Women Artists – she later became secretary – and the Royal Society of British Artists. The exhibits were not confined to sculpture; her name appeared in the catalogues of the Royal Society of Portrait Painters and the Royal Institute of Painters in Watercolours.

In modelling, her favourite material being lead, she specialised in child studies. She also modelled figurines for the Royal Worcester Potteries. The fashion of having one's own child modelled as a garden ornament in lead or bronze may have originated in her London studio. She exhibited *The Leprechaun* in Dublin at the Royal Hibernian Academy in 1914. Her work appeared at fairly regular intervals at the Royal Academy from 1911 until 1949, when she exhibited a head, *Virginia Ironside*, but the great majority of her works shown at the RA were garden or fountain figures with such titles as *The Imp*; *Water Baby*; and *Boy with Puppy*.

Working from photographs, she was responsible for a bronze portrait bust of 'the uncrowned Queen of Arabia', Gertrude Bell, for the National Museum, Baghdad. During the First World War she worked at the Surgical Requisites Association's headquarters at Mulberry Walk, Chelsea. This service and her demonstrations in British and French hospitals earned her the CBE in 1919. By 1924 she was exhibiting in a garden setting at the British Empire Exhibition at Wembley.

At the British Artists' exhibition in 1927 at the Belfast Museum and Art Gallery, the address of her studios was given as King's Road, London. In 1930, the year she was made an academician of the Ulster Academy of Arts, she was represented in the exhibition of Irish art at Brussels, and in 1932 at the less influential United Society of Artists exhibition, London. In Scotland, *Harriet Emily* appeared in bronze at the 1938 Empire exhibition. In that year, too, she became the first woman to be elected a Fellow of the Royal Society of British Sculptors. Also in 1938, she was the recipient of the Gleichen memorial award for her work *Thief*, exhibited at the RA.

She showed a fountain figure, from 9 Sydney Close, London, at the 1944 exhibition of the Royal Scottish Academy. Contributions to the Institute of the Sculptors of Ireland exhibitions were: 1954, *River Nymph*, wood; 1957, *Mischief*, lead; *Harriet Glasgow Acheson*, her mother, bronze. In 1951 she moved from London to live with her sisters at Glebe House, Glenavy, Co. Antrim. She died there on 13 March 1962.

Works signed: Anne Acheson or A. Acheson.
Examples: Belfast: Ulster Museum; Victoria College. London: Royal Geographical Society.
Literature: *Belfast Telegraph*, 9 December 1940; *Northern Whig*, 15 March 1962; *The Times*, 16 March 1962; Mercy Hunter, *The Victorian*, 1962; *Dictionary of British Artists 1880-1940*, Woodbridge 1976; *Royal Academy Exhibitors 1905-1970*, Calne 1985; *The Royal Scottish Academy Exhibitors 1826-1990*, Calne 1991.

ADAM – see SANTRY, DENIS

ADDEY, JOSEPH POOLE (1852-1922), landscape and portrait painter. Born in Dublin but regarded as 'of Cork'. Joseph Poole Addey was the son of a draper, George Addey, who sent him to Newtown School, Waterford, 1862-7, and then to the Royal Dublin Society School of Design. In 1869 he was at the Cork School

of Art and in 1872 was admitted to the training school at South Kensington. In 1875 he was appointed the first headmaster of the Londonderry School of Art. Two years later he showed at the Royal Hibernian Academy, from then until 1914 being a regular contributor, missing only two years and showing 134 works. Paintings by his wife, Maria Louisa Addey (née Dixon) were also hung for some years.

At the Irish Arts and Manufactures exhibition, Rotunda, Dublin, 1882, he was represented, and also at the Cork Industrial and Fine Art Exhibition of 1883. In 1887, the year after his Quaker mother, Eliza Poole, a poet, died in Cork, he resigned his Derry post. As a teacher, he could not comprehend how anyone would be unable to copy accurately, with pencil, a simple object. Writing in the *Cork Historical and Archaeological Society Journal* in 1943, Michael Holland stated that Addey painted in the 1880s 'admirable pictures of rustic life farm-yard scenes with their adjuncts of fowl and fodder'. When he exhibited at the Belfast Art Society exhibition of 1895, after a period living in Dublin and Co. Wicklow, his address was 1 Park Villas, Victoria Road, Cork.

Addey returned to Dublin and a circular dated 1 May 1898 produced for the summer season by the Dublin Sketching Club stated: 'Mr Joseph P. Addey has kindly promised to attend as many of the excursions as possible, and to give hints and advice on sketching to any of the members who may wish for such assistance.' His *Killiney Bay, Co. Dublin*, was dated 1898. A watercolour of Scotch fir in the Dublin hills, near Stepaside, signed and dated 1899, appeared in the 1980s in an exhibition at the Cynthia O'Connor Gallery, Dublin. *Kinsale, County Cork*, another watercolour, was painted in 1899.

It was not unusual for Addey to have five or six works in an RHA show. In 1899, then at 21 Oakley Road, Ranelagh, Dublin, he exhibited a portrait of the Rt. Hon. Lord Castlemaine. At the 1902 exhibition, *'Is it Sound, or Fragrance, or Vision?'* was presented, and it appeared again in the 1980s in an exhibition at the Gorry Gallery, Dublin. This is a watercolour of a woman with a guitar, seated on a chaise-longue in front of a Chinese screen. It was one of the first examples in Ireland of the then fashionable chinoiserie, according to Anne Crookshank and the Knight of Glin in their 1994 book on Irish watercolours – and they considered that Addey should be better known. His 1900 watercolour, *View of Haulbowline*, is at the Crawford Municipal Art Gallery, Cork.

When Hugh Lane's show of works by Irish painters was held at the Guildhall, London, in 1904, *A Kerry Belle* was in the watercolour section. In 1905, 1906, 1907 and 1909, Addey was tutor to a Dublin Metropolitan School of Art sketching class. In 1906 at the RHA, six out of seven works were portraits, including those of Miss Amy Gage and Lady Ashbourne. According to the Dublin catalogues, he was residing at Surbiton, Surrey, in 1911, and at Kingston-on-Thames in 1914, when he contributed to the RHA: *Springtime*; *Dawn – Colwyn Bay*; and *An Unwilling Model*. Prior to his death, he renewed his association with Dublin and the Metropolitan School of Art by tutoring outdoor sketching classes in the summer term at Rathfarnham Castle. He died on 18 October 1922 at Stanborough's Sanatorium, London.

Works signed: J. Poole Addey or J.P. Addey.
Examples: Cork: Crawford Municipal Art Gallery; Waterford: City Hall, Municipal Art Collection.
Literature: *Dublin Sketching Club Minute Book*, 1898; Walter G. Strickland, *A Dictionary of Irish Artists*, Dublin 1913; *Cork Historical and Archaeological Society Journal*, January-June 1943; W. Hubert Poole, *Letters to the editor*, 1968; John Turpin, 'The Metropolitan School of Art, 1900-1923', *Dublin Historical Record*, June 1985; Ann M. Stewart, *Royal Hibernian Academy of Arts: Index of Exhibitors 1826-1979*, Dublin 1986; Peter Murray, compiler, *Illustrated Summary Catalogue of The Crawford Municipal Art Gallery*, Cork 1991 (also illustration); Anne Crookshank and the Knight of Glin, *The Watercolours of Ireland*, London 1994 (also illustrations); John Turpin, *A School of Art in Dublin since the Eighteenth Century*, Dublin 1995.

ALEXANDER, DOUGLAS (1871-1945), landscape painter. Born in Limerick, son of James Alexander of 'Beechlawn'. He was from a Quaker family who owned a grocery and ship's chandlery business at the corner of William Street and O'Connell Street. Apprenticed to J. & G. Boyd, Ltd, wholesale merchants, William Street, he was said to have caused not a little irritation by drawing caricatures of some of the staff on the walls. His tenure there was not long and he headed for Dublin where he was employed for a time as a

lithographic artist by James Walker & Co., printers, Rathmines Road. In due course he married a travelling artist, Mabel Vane.

Alexander painted scenes of the West of Ireland, particularly Connemara, both in oils and watercolour. Ranks, the flour millers in Limerick , purchased a number of his works, including *On Lough Corrib, Connemara*, and reproduced these in colour for calendars. Goodwin Galleries, Limerick, and Victor Waddington Galleries, Dublin, handled his work. He showed only two pictures at the Royal Hibernian Academy: 1935, *At Roundstone, Connemara*; 1938, *Bog Road*.

As a member of the Dublin Sketching Club, he exhibited six pictures in both the 1937 and 1938 exhibitions, including *Near Lough Alton, Co. Donegal*; *On the Antrim Coast*; and *Near Dooks*, *Co. Kerry*. Although for several generations members of the Alexander family were prominent in Limerick in both business and philanthropic pursuits, Douglas, of 5 Upper Gardiner Street, Dublin, ended his days in poverty.

Works signed: Douglas Alexander.
Examples: Limerick: City Gallery of Art.
Literature: P.H.D. Jackson, *Letters to the author*, 1981; Ann M. Stewart, *Royal Hibernian Academy of Arts: Index of Exhibitors 1826-1979*, Dublin 1986.

ALLAN, HENRY, RHA (1865-1912), landscape, figure and portrait painter. Born on 18 June 1865 at Retreat House, Dundalk, Co. Louth, Henry Allan was the youngest son of William Allan. In the year 1882-3 he studied at the Dublin Metropolitan School of Art with Roderic O'Conor (q.v.). In May 1884 along with O'Conor and Richard T. Moynan (q.v.) he enrolled in the summer course at the Académie Royal in Antwerp, not yet nineteen years of age. The Irish students shared lodgings, and Moynan was one of those who boarded with the Dundalk youth in a house in Mutsaartstraat, near the Académie. Allan studied first in the Antique class, being awarded fifth prize in drawing from the Antique Figure.

Allan studied at the Antwerp school of art the same time as Vincent van Gogh (1853-90), who was there for some weeks early in 1886. Life classes were under Charles Verlat (1824-90), and Allan won fourth prize in painting from the model in 1887. Another Irish student was Dermod O'Brien (q.v.), eight days older than Allan; they were in the Life class together 1887-8.

Van Gogh rented a little room in Antwerp for twenty-five francs a month. A letter to his brother Theo conveyed that he liked the Academy 'pretty well; especially because there are all kinds of painters there, something I never before experienced — to see others work. The models are good, and being there will avoid a great deal of expense.' Writing in English from Paris to the English painter H. M. Livens (1862-1936), he dated his letter 1887 instead of 1886, called the recipient 'Levens' and asked that he be remembered to 'Allen,' and others named. The index to *The Complete Letters of Vincent van Gogh* states 'H. Allan.'

Allan, at 10 Loos Street, completed his studies at Antwerp in 1888 and probably returned directly to Ireland. A £20 Taylor prize from the Royal Dublin Society was won in 1888, and a £25 prize in 1889. At the Royal Hibernian Academy, he first exhibited in 1889 and continued each year until 1912, a total of 113 works, beginning with *Country Road near Antwerp* and *Dutch Interior*. For some four years his address was Blackcanneway House, Downpatrick, Co. Down.

At the RHA in 1890 he showed a Flemish interior, a Flemish cow stall, and *Berchem-near Antwerp*. In 1893 his address was 20 Lincoln Place, Dublin, and it was then that he exhibited *The Little Match-Seller*, awarded the Albert Prize by the Academy. In the 1894 exhibition catalogue he gave his address as Brighton Villa, Upper Rathmines, Dublin; among his three pictures was *The Rue de Steen, Antwerp*. In 1895 he was elected ARHA.

Allan had a high opinion of the centenary picture which he showed in 1898: *Martial Law — an episode of the Irish Rebellion in 1798,* at £250 the highest price for any of his Academy exhibits. Next year saw *The Holy Women and St John with the Body of our Lord,* and so in 1901 he was elected a full member of the Academy. A portrait appeared in 1903; another in 1904. Among his eight works presented in 1905 were landscapes of Counties Down and Dublin.

By 1908 his address was 45 Leinster Road, Rathmines, and he was represented by eight pictures, including *Mrs Kidney and Maureen*; *The Yellow Blouse*; and *Dublin Ragpickers*. After the death of Patrick V. Duffy

(q.v.) in November 1909, Allan became RHA treasurer, serving until 1911. In 1909, from 5 Leinster Street, Dublin, he showed three portraits among eight works; in 1910 the subject was Hubert Frankenstein.

In his *A Dictionary of Irish Artists,* Walter G. Strickland stated that Allan's early works were full of promise, showing an artistic sense and painter-like qualities; 'but his later pictures, weak imitations of French landscape painters, were poor and without vigour. He essayed portraiture, but with little success.'

Allan did not exhibit at the Royal Academy but showed a few works at the Walker Art Gallery, Liverpool. His *A Dutch Interior* on board was on a small scale, 26 cm x 36 cm. Following his death, this work was presented by his friend, Joseph M. Kavanagh (q.v.), another Antwerp student, to the National Gallery of Ireland. The painting depicted an old man, wearing an apron, in his workshop. Allan died on 2 September 1912 at 29 Leinster Road, Rathmines.

Works signed: H. Allan.
Examples: Dublin: National Gallery of Ireland.
Literature: Walter G. Strickland, *A Dictionary of Irish Artists*, Dublin 1913; *The Complete Letters of Vincent van Gogh*, London 1958; *Dictionary of British Artists 1880-1940*, Woodbridge 1976; Julian Campbell, *The Irish Impressionists: Irish Artists in France and Belgium*, catalogue, Dublin 1984 (also illustration); Ann M. Stewart, *Royal Hibernian Academy of Arts: Index of Exhibitors 1826-1979*, Dublin 1986.

ALLEN, JOSHUA (1850-1921), topographical artist. Joshua Allen's sole claim to recognition is a book containing thirty sketches, mainly of buildings in and near Dublin, with sixty-four pages of manuscript text, ink on paper, presented by his brother, W.N. Allen, in year of the artist's death. Among the drawings in the album at the National Gallery of Ireland are: *Old House, Newmarket*; *The Brass Castle, Stirling Street*; *Gate of Old Military Hospital, James's Street*; *Lisle House, Crumlin*; *Drimnagh Castle*.

The drawings, which are detailed, were made in the years 1887-91 and the artist, whose home at the time of his death was at 11 North Circular Road, Dublin, stated at the back of the album: 'I had originally intended including in this collection many other places of interest but many circumstances have prevented the carrying out of this idea... – J. Allen, 1899.'

Works signed: J. Allen.
Examples: Dublin: National Gallery of Ireland.

ALLEN, MARGARET, HRHA (1830-1914), portrait and genre painter. Although she became the first woman appointed an honorary academician of the Royal Hibernian Academy, information on her family and art training is sadly lacking. In the period 1853-94 inclusive she contributed more than fifty works to the Academy exhibitions, initially with two unnamed portraits. Nine years elapsed before she showed again.

In 1864 at the RHA she gave 12 Westland Row, Dublin, as her address, which remained for the next twenty years. *The Village Humorist* was exhibited in 1864, the *Art-Journal* describing it as a picture 'of very great ability...it is full of life and pleasant character. A group of cottagers are enjoying the humour of a 'raconteur'; the fun is obvious, but it can be by no means coarse; it is certainly such as the pretty maid may hear and her parents sanction. The work is conceived with matured thought, and executed with considerable power.'

At the Dublin exhibition in 1872 she showed a series of portraits, some in pastel; works included *Willy and Lilly, Children of William Hunter, Esq.,* but she returned to genre the following year with *Great Grandmother's Old Brocade*; *The Pet of the Family*; and *The Bridesmaid.* In 1873 she painted *Listening to the Birds*.

At the Manchester City Art Gallery, according to the catalogue, a Miss M. Allen of 28 Ardwick Green, Manchester, exhibited in 1876 an oil painting, *The Last Hour in the Old Country*, no doubt the work which was hung at the RHA in 1877 as *The Last Hour in the Old Land*, an emigration scene which poignantly portrayed the sadness of leaving Ireland. The painting appeared at an exhibition in the Gorry Gallery in Dublin in 1989, and the catalogue referred to the wall poster denoting a free passage to New York, and added: 'The Artist also adds a touch of irony to the picture by her depiction of the advertisement for Hubert O'Grady's

play *The Eviction* then in production at the old Theatre Royal.' Possibly it was this work which led to the artist being appointed an honorary member of the Academy in 1878, ahead of a similar honour for Sarah Purser (q.v.) by twelve years.

Margaret Allen moved to Manchester, possibly to stay with a friend or relative. In any event, she showed *The Sick Doll*, oil, 1887 RHA, at the Manchester exhibition in 1889 from Surrey Terrace, 428 Stockport Road, Manchester, an address listed in the 1890 Dublin catalogue. The three works hung at the RHA in 1892 included *Hide and Seek*, and her final contribution was *Mother's Darling* in 1894.

According to the Manchester Street directories, in 1878 Edward H. Williams, dentist, was listed at 28 Ardwick Green; and in 1881 he was recorded at 428 Stockport Road. In 1883 there was a joint entry for Williams and Allen for that address. She later returned to Ireland.

In addition to Manchester, she showed a few pictures at the Walker Art Gallery, Liverpool, and with the Royal Society of Artists, Birmingham. Some of her last years were believed to have been spent in Newtown Mountkennedy, Co. Wicklow, but she died at Brookville, Balleen, Co. Kilkenny on 26 March 1914.

Works signed: Margaret Allen or M. Allen.
Literature: *Art-Journal 1864*; *Thieme-Becker*, Leipzig 1907; General Register Office, Dublin, *Register of Deaths, Urlingford, 1914*; *Dictionary of British Artists 1880-1940*, Woodbridge 1976; Ann M. Stewart, *Royal Hibernian Academy of Arts : Index of Exhibitors 1826-1979*, Dublin 1986; Gorry Gallery, A*n exhibition of 18th, 19th and 20th Century Irish Paintings*, catalogue, Dublin 1989 (also illustration); catalogue, Dublin 1990 (also illustration); Manchester Central Library, *Letter to the author*, 1997; also, Manchester City Art Galleries, 1997.

ALMENT, MARY M. (1834-1908), landscape painter. Born at home, St Mary's Abbey, Dublin, on 9 April 1834, Mary Martha Alment was the daughter of William F. Alment. A Huguenot grandfather, John Alment, manufactured scientific instruments, such as telescopes and sundials.

Mary Alment was a pupil of Henry M. Macmanus, RHA (c. 1810-78), the first headmaster of the School of Design created by the Board of Trade out of the Dublin Society Schools in 1849. Macmanus organised evening classes for women, and he reported that they exceeded his expectations. Most of the students entered at a very young age, girls from aged fifteen. Macmanus was said to have the faculty of developing the talents of his pupils and inspiring them with interest and enthusiasm.

In 1858 Mary Alment exhibited at the Royal Hibernian Academy, from 71 Harold's Cross, Dublin, and from then until 1908 she contributed close on 100 works. In 1859 she gave a Rathmines address, showing *Rathfarnham Park*, and *On the Dodder*. In 1860 she was at 39 Williamstown Avenue, Blackrock, Co. Dublin.

Although credited with some portraits, few appeared at the RHA; indeed there were five landscapes at the 1861 exhibition. Oil paintings of her nephews and nieces were unsigned. Contributions to the Academy in 1863 included *Enniskerry, Co. Wicklow* and *June on the Dodder*. The Dodder river was a favourite painting haunt. By 1871 she had settled at 47 Carysfort Avenue, Blackrock.

The first of a number of North Wales scenes appeared in 1873, and four years later at the Academy she portrayed a mill at Bettws-y-Coed. In the exhibiting years 1882-5 inclusive she presented at least seven works based on the North Wales area. She also painted on the river Derwent. By 1886 she had a studio at 29 Dawson Street, Dublin, and exhibits that year included a Clovelly, North Devon, scene and a Hampshire farmyard. Visits to Wales continued for several years.

For the 1889 RHA, her studio was at 54 Dawson Street. Among her later local views she depicted showery weather in the Rocky Valley, Co. Wicklow; a midsummer's day on the Liffey; cliffs at Howth; and in 1898, *The Kilbroney River, Rostrevor*. Two pictures with Warwick subject matter were exhibited in 1900, and one in 1905.

Mary Alment also exhibited with the Dublin Sketching Club and Water Colour Society of Ireland, and favoured watercolour as a medium. She was the aunt of Elizabeth Alment (1868-1962), an exhibitor of watercolours — landscapes and flowerpieces — at the Academy between 1873 and 1916, and who taught art at the French School, Bray. Only one descendant of the Alment family (the author discovered) lived in Ireland in 1997. Mary died on 11 April 1908.

Works signed: M. M. Alment (if signed at all).
Literature: *Thom's Directory 1855, 1905*; Walter G. Strickland, *A Dictionary of Irish Artists,* Dublin 1913; Ann M. Stewart, *Royal Hibernian Academy of Arts: Index of Exhibitors 1826-1979,* Dublin 1986; National Gallery of Ireland and Douglas Hyde Gallery, *Irish Women Artists: From the Eighteenth Century to the Present Day*, catalogue, Dublin 1987; John Turpin, *A School of Art in Dublin since the Eighteenth Century*, Dublin 1995; Mrs Gladys M. Ellaway, *Letters to the author*, 1997.

ALTENDORF, GEORGE (1904-66), illustrator. Born in Dublin, his father Harry, from Dresden, was in the hotel business. The family moved to England and then returned to Dublin, from Carlisle, after the end of the First World War. Living at the Emerald Hotel, 94 Marlborough Street, George attended the Dublin Metropolitan School of Art and during his stay there kept a diary with abbreviated entries, for example: 'Mr Keating said my stuff was very good. Eureka!' On 6 December, 1922 he recorded: 'Went to S. Art but at 7 o'clock the military cleared us all out!' His brother Albert Altendorf (1911-73) also attended the School of Art and later worked as a designer in stained glass at the Harry Clarke Studios.

At the inception of the *Irish Press* in 1929 he was appointed assistant art editor, later becoming art editor. He exhibited with the short-lived 'rebel' association, Associated Irish Artists, in 1934. In 1938 he began contributing illustrations to the *Capuchin Annual*. He also drew for the *Father Mathew Record* in the 1930s and 1940s, produced cartoons for *Our Boys* and supplied cover illustrations for a number of booklets issued by Veritas Co. Ltd. Illustrations were also incorporated in a history, printed in Hull, for Senior Primary Nigerian Schools under the Holy Ghost Fathers, Onitsha Archdiocese. He died in Dublin on 19 August 1966.

Works signed: G. Altendorf or G.A.
Literature: *George Altendorf Diary*, 1922; Patricia Lynch, *The Turf-Cutter's Donkey Goes Visiting,* London 1935 (illustrations); as *The Donkey Goes Visiting*, New York 1936 (illustrations); *Capuchin Annual*, 1940; Aodh de Blacam, *Golden Priest*, Dublin 1943 (illustrations); Mrs Mary Altendorf, *Notes on the Altendorf Family*, 1981; *Irish Press, Letter to the author*, 1981.

ANNESLEY, MABEL M. (1881-1959), wood engraver and watercolourist. Daughter of Hugh, fifth Earl Annesley, of Castlewellan, Co. Down. Lady Mabel Marguerite Annesley's maternal great-grandfather was Sir Francis Grant, PRA (1803-78). In 1895 she studied art at the Frank Calderon School of Animal Painting.

She became an active member of the Belfast Art Society and in later years was appointed an honorary member of the Royal Ulster Academy. In the early 1920s she studied wood engraving at the Central School of Arts and Crafts, London, under Noel Rooke (1881-1953). She was elected a member of the Society of Wood Engravers in 1924. The Society exhibited in 1932 at Daniel Egan's Gallery, Dublin, and she was represented. When living at Rathfriland, Co. Down, her work was included in the exhibition of Irish art in Brussels, 1930.

Her book illustrations made her name more familiar to the public than her exhibitions, which were limited. She supplied eighteen wood engravings for *Songs from Robert Burns*, published in 1925 by the Golden Cockerel Press, then run by Robert Gibbings (q.v.). Costumes for the 1500th anniversary of the landing of St Patrick at Saul, Co. Down were designed by William Conor (q.v.) and Lady Mabel for the pageant, written by Richard Rowley, at Castle Ward, Strangford, 1932. In 1933 she had a one-person show of watercolours, wood engravings and silverpoints at the Batsford Gallery, London. She travelled to Egypt in 1935 and visited Cyprus the following year. The Dublin Painters welcomed her as an exhibitor in 1938.

In 1939, the Belfast Museum and Art Gallery received a gift from Lady Mabel Annesley of a hundred wood engravings, including work by E.M. O'Rorke Dickey (q.v.) and Gibbings, and consisting of examples by foremost English artists and the ablest French exponents, as well as a set of nineteen by herself. 'Her prints range from the isolated still-life *Buddha*, through the domesticated peace of flax dam and towstack, over park and pasture to the friendly clachan among the little hills, from the broad road with homecoming horse and labour-weary man, to the high tracks in the broken peaks with jolting turf cart ...', recorded the recipients.

After being bombed out in Belfast during the Second World War, she settled down near Nelson, New Zealand, returning to England about 1953. *The Times* said that she had 'an incorruptible sense of duty and

tradition, most strikingly combined with a passionate grasp of all that was most vital in the world of modern art. She distained publicity, yet her engravings were exhibited and prized throughout the world'. She died at Clare, Sudbury, Suffolk, on 19 June 1959.

A memorial exhibition of the work of three of the earliest members of the Society of Wood Engravers – Mabel Annesley, Robert Gibbings and Gwen Raverat – took place at the Whitworth Art Gallery, Manchester, 1960.

Works signed: M.A.
Examples: Belfast: Ulster Museum. London: British Museum. Wanganui, New Zealand: Sargeant Gallery.
Literature: Campbell Dodgson, *Contemporary English Woodcuts*, London 1922 (illustration); Richard Rowley, *Co. Down Songs*, London 1924 (illustrations); A.E. Coppard, compiler, *Songs from Robert Burns*, Waltham St Lawrence 1925 (illustrations); Richard Rowley, *Apollo in Mourne*, London 1926 (illustrations); J. Crampton Walker, *Irish Life and Landscape*, Dublin 1927 (illustration); *Belfast Museum and Art Gallery Quarterly Notes*, June 1939; Lynn Doyle, *Yesterday Morning*, London 1943 (illustration); *The Times*, 26 June 1959; Mabel M. Annesley, Constance Malleson, editor, *As the Sight is Bent*, London 1964 (also illustrations); John Hewitt and Theo Snoddy, *Art in Ulster-1*, Belfast 1977 (also illustration).

ANTRIM, ANGELA, RUA (1911-84), sculptor, cartoonist and illustrator. The third daughter of Sir Mark Sykes, MP, Angela Christina Sykes was born on 6 September 1911 at Sledmere, Malton, Yorkshire. Educated privately, she studied sculpture in Brussels, 1927-32, under Professor Marnix d'Haveloose (1885-1973), and for six months at the British School in Rome, returning to London to set up her own studio in Chelsea. In 1929, aged seventeen, she had two works accepted by the Royal Academy, *Mother and Child* and *Woman and Child*, and in 1932 a bronze head, *The Comtesse Beatrice de Liedekerke*.

In 1934 she married the 13th Earl of Antrim, and in 1937 she held her first one-person show, at the Beaux Arts Gallery, London, where she exhibited eighteen pieces of sculpture with a number of cartoons, five in collaboration with the artist's brother, Christopher Sykes. The sculpture included *The Seven Deadly Sins*, statuettes in bronze; also a mask in bronze of Cyril Connolly. Among her cartoons was *The Fall of the House of Lords*. At the Whitechapel Art Gallery in 1939, she showed a sculptured group, untitled in catalogue.

The Countess of Antrim's first solo show in Ireland was held at the CEMA Gallery, Belfast, in 1950. It included sculpture in bronze, stone and terracotta; oil paintings and watercolours. Religious art formed a significant part of the display, but *Belsen Mother and Child*, a sculpture, sprang directly from her experiences as a worker with Catholic Relief Services.

Angela Antrim exhibited occasionally at the Royal Hibernian Academy and the Irish Exhibition of Living Art. She participated in all the annual exhibitions, 1953-7, of the Institute of the Sculptors of Ireland, and also in their international exhibition of 1959 at the Municipal Gallery of Modern Art, Dublin. She was president of the Institute in 1956. In 1957 her work included *Patrick Morris (1789-1849)*, reformer, a bronze head 'commissioned by the Newfoundland Government for Parliament House'. However, the only work since traced at St John's, Newfoundland, is a bronze bust, *John Kent*, 1939.

Her first stained glass window, 1961 is in the Church of the Immaculate Conception at Glenarm, Co. Antrim. The artist used a number of village children as models in the nativity scene. A statue by her is in the church grounds. There are three memorial windows at the ancestral home, Sledmere. Architectural sculptures are in the entrance hall at Glenarm Castle, and murals in the dining-room, drawing-room and a bedroom. A painting representing the Apocalypse is on the ceiling of the chancel at Holy Trinity Church, Mark Beech, Edenbridge, Kent.

The Countess of Antrim was chairperson of the committee which organised an exhibition of post-war church building and works of art, Art in Worship Today, shown in Belfast, 1968 and Dublin, 1969.

In 1969 a sculpture, about 3½ metres in height, mounted on Mourne granite and cast in bronze, was unveiled at the Broadway multi-storey block of flats at the Royal Victoria Hospital, Belfast. It depicts a hand surrounded by twining branches and surmounted by a cross and flame. *St Patrick*, as a youth, posed by her son Hector, is on the gable wall of St Mary's Church, Feystown, Co. Antrim.

Queen's University of Belfast awarded her the honorary degree of Doctor of Laws in 1971. An exhibition at the Hamet Gallery, London, was held in 1972. Outside of her work as an artist, she had spent much time promoting amateur drama in Ulster. A member of the board of the Arts Council of Northern Ireland, she was also a trustee of the Ulster Museum. She illustrated six books.

More than sixty of her illustrations, including maps, appeared in her history of her husband's family, *The Antrim McDonnells*, 1977, with a foreword by John Betjeman, who wrote that the Sykes family were 'a talented lot with a natural gift for drawing and originality of verbal expression. Lady Antrim has an inherent comic line so that her drawings are slightly risible, particularly on solemn occasions ...'. The Earl of Antrim died five days after his wife wrote the introduction to the book. An exhibition of drawings used in the publication was held at the Bell Gallery, Belfast, 1977. Lady Antrim died on 27 August 1984 at Glenarm Castle.

Works signed: A.A.
Examples: Belfast: Royal Victoria Hospital, Broadway. Ballygally, Co. Antrim: St Joseph's Church. Edenbridge, Kent: Holy Trinity Church, Mark Beech. Feystown, Co. Antrim: St Mary's Church. Glenarm, Co. Antrim: Church of the Immaculate Conception. St John's, Newfoundland: Confederation Building.
Literature: *Belfast Telegraph*, 5 July 1944, 28 November 1957, 3 October 1961, 9 June 1969, 7 July 1971. *Irish News*, 26 September 1950; *Irish Times*, 28 January 1956; *Who's Who in Art*, 1960: *Irish Independent*, 31 December 1965; Angela Antrim, *The Antrim McDonnells*, Belfast 1977 (illustrations); Sir Basil Bartlett, *Jam Tomorrow*, London 1978 (illustrations); Christopher Simon Sykes, *The Visitors' Book*, London 1978 (illustrations); Alice Morland, *The Story of the Little Round Man*, London 1979 (illustrations); Angela Antrim, *The Yorkshire Wold Rangers*, Tayport, Fife 1981 (illustrations); John Rickatson-Hatt, *A Tropical Traveller*, London 1982 (illustrations); Hector McDonnell, *Letter to the author*, 1985; also, Rev. William McKeever, 1985; T.G. Talbot, QC, 1985; P.J. McNicholas, 1988.

ARMSTRONG, ARTHUR, RHA (1924-96), landscape and still life painter. Born on 12 January 1924 at Carrickfergus, Co. Antrim, Arthur Charlton Armstrong was the son of a housepainter, Charlton Armstrong, and remembered his father painting pictures with paint remnants from various jobs. The family left Carrickfergus for Belfast. Arthur attended Strandtown Primary School, but devoted a lot of his time to painting pictures.

At Queen's University, 'not through my own choice but from family pressure,' he studied first Political Science and then switched to Architecture. After two years, he departed and spent six months at Belfast College of Art evening classes, meeting Gerard Dillon (q.v.) and then becoming acquainted with George Campbell and Daniel O'Neill (qq.v.), contemporaries in Belfast. All four were then virtually unknown as artists.

Belfast in the 1940s was 'a dead city' for artists, said Armstrong, although a considerable number of paintings were being created. When he started painting seriously he began with 'portraits of people, social scenes, commenting on life inside a city. Then I had a spell of almost action painting...'

In 1946 he became a 'professional painter' but only survived for some years with clerical jobs. Indeed his fellow artist, James MacIntyre, has recalled that in 1947 Armstrong left his job at the Belfast Gas Office with enough savings to last nine months. Without telling his widowed mother, he spent the time painting at MacIntyre's home. He approached the proprietor, Tom Nisbet, and an exhibition was arranged for the Grafton Gallery in Dublin in 1950, and included *Boat on a Pier, Kilkeel*. His work was presented in Belfast in Ulster group shows in 1951 at Council for the Encouragement of Music and the Arts gallery, 55a Donegall Place, and there he held a solo exhibition in 1956.

Involved with the Irish Exhibition of Living Art in Dublin, in the three years 1955-7 he showed seven works, including three still life, *Bar, West of Ireland* and two Roundstone scenes. About 1957, his commercial work having included designing for a firm of handkerchief manufacturers, he left Belfast for London where he stayed for a time with Dillon and obtained employment in a Labour Exchange. In 1957 he won a CEMA travel scholarship, hence a visit to Spain.

Commenting on Armstong's exhibition in 1961 at the CEMA gallery, now in Chichester Street, Frederick Allen in the *Belfast News -Letter* noted that it revealed 'a development towards a type of abstraction which

is more concerned with a play of textures and an interlocking of quantities and areas of colour...' Moving from London to Dublin in 1962, he shared a house with Dillon in Ranelagh. He also showed at the Oireachtas.

Armstrong first exhibited at the Royal Hibernian Academy in 1962, giving the Ritchie Hendriks Gallery, Dublin, as his address. He provided thirty-five oil paintings at Hendriks in 1964, first of several exhibitions. Up until 1995 he contributed a total of seventy-four works at the RHA. In 1965 he exhibited *Landscape with Old Buildings* and *Still Life with Lamp*.

In 1965 he designed a stained glass window for the 'Covent Chapel, Bedford, Beds.,' but this work has not been traced. Paintings and drawings were on view in 1966 at the Arts Council Gallery in Belfast; among the oils were: *Beach near Palo*; *African Town;* and *Red Still Life*. In 1966 too he was represented in the 'Eight North of Ireland Painters' gathering at New Cross Gallery, Glasgow. A prizewinner in the Gibraltar International Art Exhibition of 1967, he was the winner in 1968 of the Douglas Hyde Gold Medal at the Oireachtas exhibition with *Gleann dá Loch*.

Armstrong designed the poster for the Abbey Theatre's *Long Day's Journey into Night*, 1967. In that year, also in Dublin, the Walsh Studio published *Eight Reproductions by two Irish Artists George Campbell RHA and Arthur Armstrong*. The Armstrong reproductions were: *Hornbill*; *Twin Bays, Connemara; My Studio: Still Life with Mandolin*. Associate membership of the RHA came in 1969, and that year he worked with Campbell and Dillon on settings for *Juno and the Paycock*, Abbey Theatre. Part-time, he taught painting at the National College of Art. Carey Clarke, president of the Academy, wrote: 'His capacity for communicating and his ability to empathise with the students' problems won him great respect as a teacher.'

At the RHA in 1970, his contributions included *Landscape in Blues and Greens* and *Blue Landscape with Figures*. As well as exhibiting with the David Hendrik Gallery, the 1970s also saw displays at the Tom Caldwell Gallery, Belfast, and the Cork Arts Society Gallery. He became an RHA in 1972, and was included among the external assessors for the National College of Art summer examinations. His address was 28 Chelmsford Avenue.

In an interview in 1972 with Harriet Cooke of the *Irish Times*, he said: 'I keep painting all the time. I paint about three hundred pictures a year — it's probably prolific in the generation I belong to... I like working very large. The way I'm working at the moment, I'm using plaster and there's a strict time limit. There's about an hour you have to work before your plaster sets hard...' In 1972 he painted *Landscape in Clew Bay*.

In 1973 he was a prizewinner in the Arts Council of Northern Ireland 'Art in Context' scheme, producing a play sculpture in concrete and fibreglass for Belmont House School, Londonderry. In the same year, he joined with Roy McFadden in a poster-poem commission from ACNI. Galeria Avignon, Madrid, and Watergate Gallery, Washington DC, both hosted exhibitions in 1974, and in 1976 he showed at Kenny Art Gallery, Galway, and returned in 1977 and 1980.

Galeria Kreisler, Madrid, hung his work in 1977, and Gallery 22, Dublin, arranged a 1979 exhibition. *Near Spiddal* was painted in 1980. ACNI organised a retrospective exhibition for 1981, covering the years 1950-80, made up of fifty-eight oils, seven collages, and one of watercolour, monoprint, and mixed media.

In 1988 he showed six works at the RHA, including *Light on Rocks*. His three pictures in 1990 were: *My Studio*; *Brown Landscape*; *Looking West*. In his final year at the Academy, 1995, he contributed *Autumn Landscape*; *Studio Still Life*; and *Low Tide*. He once said that he considered himself 'an abstract painter completely,' and painted in despair 'an awful lot of the time.'

Membership of Aosdána he cherished. Carey Clarke found him 'a quiet, reflective, humorous man...' A bachelor, he died in a Dublin hospital on 13 January 1996. An 'In Memoriam' tribute followed at the Academy exhibition. A studio sale of his work took place in Dublin in 1988.

Works signed: Armstrong.
Examples: Beijing: Irish Embassy. Belfast: Arts Council of Northern Ireland; Department of the Environment for Northern Ireland; Ulster Museum. Cork: Crawford Municipal Art Gallery. Dublin: Aer Lingus; Arts Council; Córas Iompair Éireann; Office of Public Works; Radio Telefís Éireann; Trinity College Gallery. Limerick: City Gallery of Art. Londonderry: Belmont House School. Longford: County Library. Malaga, Spain: Museum of Fine Arts. Moscow: Irish Embassy. Vienna: Irish Embassy. Waterford: City Hall, Municipal Art Collection.

Literature: Grafton Gallery, *Arthur Armstrong*, catalogue, Dublin 1950; *Northern Whig*, 4 April 1951, 6 November 1956; *Irish News*, 20 November 1951; *Belfast News-Letter*, 28 February 1961, 10 September 1964; *Belfast Telegraph*, 25 March 1963; *Irish Times*, 27 April 1965, 19 September 1969, 2 May 1972, 16 and 22 January 1996; Arts Council Gallery, *Arthur Armstrong*, catalogue, Belfast 1966; Walsh Studio, *Eight Reproductions by two Irish Artists George Campbell, RHA and Arthur Armstrong*, Dublin 1967; *Arts Council of Northern Ireland report April 1, 1972-March 31, 1973*, Belfast; John Hewitt and Theo Snoddy, *Art in Ulster: I*, Belfast 1977; Mike Catto, *Art in Ulster:2*, Belfast 1977; National Gallery of Ireland, *The Abbey Theatre 1904-1979*, catalogue, Dublin 1979; Arts Council of Northern Ireland, *Arthur Armstrong Paintings 1950-80*, catalogue, Belfast 1981 (also illustration); Ann M. Stewart, *Royal Hibernian Academy of Arts: Index of Exhibitors 1826-1979*, Dublin 1986; *Royal Hibernian Academy of Arts 1980*, also *1981-86, 1988-96*, catalogues, Dublin; Arthur Armstrong, 'Amongst Friends', *Martello*, Dublin 1990 (also illustration); John Turpin, *A School of Art in Dublin since the Eighteenth Century*, Dublin 1995; Howard Greenaway, *Letter to the author*, 1997.

ARMSTRONG, WILLIAM (1822-1914), landscape and marine painter. Born in Dublin on 28 July 1822, William Armstrong was the seventh son of Major-General Alexander Armstrong, and received tuition at the Royal Dublin Society's School of Architecture, winning a prize for architectural drawing. In addition, he and his sisters were given the opportunity of attending art lessons in Dublin under the tutorship of Edward Newman. W.G. Strickland in his *A Dictionary of Irish Artists* referred to a nineteenth-century draughtsman, J.E. Newman, who executed 'careful perspective studies in water-colour, examples of clever ingenuity . ..'.

When William Armstrong reached the age of sixteen, his father recognised his talent for draughtsmanship. At the considerable cost of six hundred pounds sterling, he arranged for his son to serve as apprentice for a three-year term to T.J. Woodhouse of Leicester, chief engineer of the Midland Counties Railway. The training led to eventual employment as a designer and draughtsman in England, which included preparing plans for bridges and railway stations. In 1842 he returned to Ireland to marry Lucy Kirby Daniell of Co. Wicklow. In 1848 he and his family moved from Accrington to Liverpool but in 1851, after trying to settle in Dublin, the Armstrongs with their young family emigrated to Canada at a time of railway expansion there.

Now settled, in 1851, Armstrong entered the Toronto Mechanics Institute competition for the best view of the city and was awarded a diploma. He continued his previous engineering association with railways, working for the Northern Railway Co., the Grand Trunk, and the Toronto, Guelph, and Sarnia Railways. Two watercolours of Toronto were sent to the 1855 Universal Exposition in Paris, and by now he was exhibiting at the Upper Canada Provincial Exhibition.

In 1856 he undertook a commission from Toronto City Council to paint a Toronto view which was hand-lithographed and coloured and distributed to other municipalities. His drawings often appeared in local maps and magazines. By 1857 he was a partner in the firm of Armstrong, Beere and Hime, civil engineers, draughtsmen and photographers. In 1860 he and other Canadian artists painted views of the various receptions given for the Prince of Wales (later Edward VII) on the first royal state tour of Canada. His *Arrival of the Prince of Wales at Toronto, September 1860*, watercolour, is in the National Gallery of Canada. Another version is in the Art Gallery of Ontario.

Armstrong won first prize for the best collection of photographed landscapes at the Provincial Exhibition in Toronto in 1862. From the 1860s onwards, he carried out his western travels on the steamers of the Northern Steamship Company. As a lover of the sea and sailing, marine subjects were noticeable in his work. He was particularly impressed with the picturesque and nomadic life of the Indians. One of his most dramatic pictures was *Blackfoot Indian Encampment, Foothills of the Rocky Mountains* (Royal Ontario Museum). In 1865 he sent a collection of watercolour drawings to Ireland, composed of twenty-eight views of the country extending from Canada West to Vancouver Island, portraits of twenty-seven Indian chiefs and forty-one 'stereoscopic views' of Lake Superior for display in the Dublin Exhibition. In that year he exhibited with the Art Association of Montreal.

About 1864 he began a period as drawing instructor in the Toronto Normal School. He also taught at the School of Practical Science, the Collegiate Institute and other institutions, becoming totally involved in his teaching and art and eventually abandoning his business as a civil engineer. His *Thunder Cape, Lake Superior, Ontario* (National Archives of Canada) was painted in 1867. In his views of Toronto in the 1860s he was

particularly concerned with engineering feats. The National Archives also possess two of his watercolours showing opening functions for two railways, views crowded with hundreds of figures.

In 1870 he joined the military expedition under Colonel Garnet Wolseley that was sent to subdue the French Canadian Louis Riel and his followers, then in open rebellion at Fort Garry. His engineering skills enabled the troops to negotiate the rivers and lakes of northwestern Ontario. He was given, it was said, the rank of captain in the 63rd Regiment and was made chief engineer. The *Canadian Illustrated News* published his drawings and sketches of the Red River Expedition, as well as a series of Nipigon Bay views. A watercolour, *Garnet Wolseley's Camp*, 1870, is in the Royal Ontario Museum, where there is a large collection of Ontario landscapes. A woodcut, *Red River Expedition*, 1870, is in the National Archives of Canada. Despite all this apparent evidence, some of which is from an obituary in the *Toronto Evening Telegram*, it has been stated that no contemporary records have been found to support the expedition story. Armstrong was not mentioned in *The Story of a Soldier's Life*, Wolseley's autobiography, which includes an account of the 600-mile trek – only to find that the rebels had bolted!

Among the works at the Art Gallery of Hamilton is *Interior of a Wigwam, St William*, 1874. An associate of the Royal Canadian Academy from 1880 until his resignation in 1887 in response to what he regarded as unfair picture-hanging practices, he also exhibited with the Ontario Society of Artists. His role as a teacher in the public school system came to an end with his retirement in 1897 but he continued to give lessons at a private girls' school for several years as well as at his home.

Still active, although known to have copied or reworked earlier compositions, his *Wash Day*, 1907, and *Call to Dinner*, 1908, are both in the Art Gallery of Ontario collection, and *Bad Boy, Qui-we-sain-shis, a Cree Indian*, 1908, is in the National Archives of Canada, where there are sixty-six works. In the Market Gallery, Toronto, is *Stone Boater off Toronto Island*, 1909.

Toronto Evening Telegram reported that Armstrong was playing whist and painting on the night of his death, and 'twenty unfinished Turner sketches are scattered here and there on the walls'. He died at 'The Priory', 15 Augusta Avenue, his residence in Toronto since 1853, on 8 June 1914, survived by his wife and large family. In 1981 the Market Gallery, administrator of Toronto city's art collection, mounted the exhibition 'William Armstrong's Toronto'.

Works signed: Armstrong, W. Armstrong, Wm. Armstrong or W.A., monogram.
Examples: all Canada: Calgary: Glenbow-Alberta Institute. Hamilton: Art Gallery. Montreal: McCord Museum. Ottawa: National Archives of Canada; National Gallery of Canada. Toronto: Archives, Market Gallery; Art Gallery of Ontario; Central Library; Government of Ontario Art Collection; Marine Museum of Upper Canada; Royal Canadian Yacht Club; Royal Ontario Museum. Winnipeg: Art Gallery; Provincial Archives of Manitoba.
Literature: Field-Marshal Viscount Wolseley, *The Story of a Soldier's Life*, London 1903; Walter G. Strickland, *A Dictionary of Irish Artists*, London 1913; *Toronto Evening Telegram*, 10 June 1914; Glenbow Art Gallery, *William Armstrong Historical Watercolours 1822 to 1914*, catalogue, Calgary 1968; Henry C. Campbell, *Early Days on the Great Lakes: The Art of William Armstrong*, Toronto [1971]; H.C. Campbell, 'William Armstrong, Great Lakes Artist', typescript, Winnipeg Art Gallery, n.d.; *Canadian Consulting Engineer*, October 1973; Public Archives Canada, *W.H. Coverdale collection of Canadiana: paintings, water-colours and drawings*, Ottawa 1983; National Gallery of Canada, *Canadian Art*, Ottawa 1988; Anne Crookshank and the Knight of Glin, *The Watercolours of Ireland*, London 1994 (also illustrations); Art Gallery of Hamilton, *Letter to the author*, 1995; also, Art Gallery of Ontario; Canadian Pacific Archives; Market Gallery, City of Toronto Archives, all 1995; Market Gallery, *A Century Ago: Art in Toronto 1890-1910*, catalogue, 1995; Metropolitan Toronto Reference Library, *Letter to the author*, 1995; also, National Archives of Canada; Royal Ontario Museum, both 1995.

ATKINSON, GEORGE, RHA (1880-1941), etcher, painter and designer. Born in Cobh, Co. Cork, on 18 September 1880, the son of Thomas W.R. Atkinson, timber merchant, he was educated at Collegiate School, Cork, and was inspired to become an artist by reading about fellow Cork artist, James Barry (1741-1806), son of a builder. George was at the Crawford School of Art in 1897 and subsequently won a scholarship to the National Art Training School at South Kensington. His introduction to the Dublin Metropolitan School of Art came in the summer schools of 1902, 1903 and 1904 when his qualities as a teacher were noted. In

his student days he also visited Paris and Munich; later, he etched in Florence. He contributed *Piazza San Marco, Venice*, to the 1912 Royal Hibernian Academy.

By 1912 he was an inspector, Department of Technical Instruction, with 97 St Stephen's Green, Dublin, as his residence. Appointed to the Metropolitan School of Art as assistant to the headmaster in 1914, he became headmaster in 1918. Art educationalist and an energetic organiser, he had a close association with the Royal Hibernian Academy since he first exhibited in 1911, showing nearly forty works. Elected an associate in 1912, he became a full member in 1916 when he showed three portraits, including one of Donald L. Fletcher of the Leinster Regiment.

Among his several activities was membership of the Black and White Artists' Society of Ireland. At the second exhibition in 1914, he showed *Building of the Royal College of Science, Dublin*, an etching, and in the same medium two years later, *The Church of St Andrew, Dublin*. An illustration of a war memorial for Grangegorman Church, Dublin, 'writing' by George Atkinson, RHA, appeared in *The Studio*, December 1921, and in the same issue he was credited with arranging the Irish Arts and Crafts Society exhibition. He was the designer for the cenotaph erected in Dublin in 1923 to the memory of Arthur Griffith and Michael Collins, a temporary structure on Leinster Lawn subsequently dismantled. He also designed the Lyster Memorial in bronze at the National Library of Ireland.

In 1924, the scroll bearing the sixty-four signatures of the members of the first Irish Senate was prepared by Atkinson for inclusion in the casket presented by Senator Alice Stopford Green. In the same year, he carried the burden of organising the exhibition of Irish art in connection with Aonach Tailteann; 1592 items, divided into fifty classes, ranging from oil paintings to violins. He was also associated with the organisation of the 1928 and 1932 Tailteann Games, and it was he who designed the statue of Queen Tailte. He was RHA treasurer 1929-38 and secretary 1939-40.

In his spare time, Atkinson worked at sculpture, furniture design, mezzotinting, metalwork, bookplates and book decoration. According to J. Crampton Walker in 1927, he was the first to produce a mezzotint in Ireland after a lapse of a hundred years. In his principal works he listed a portrait of Rt. Hon. Gerald Fitzgibbon (mezzotint). In the 1920s and '30s he played a prominent part on the committee appointed, through the Gibson Bequest, to purchase works for the Crawford Municipal Art Gallery, Cork. His relationship with his superiors in the Department of Education was far from smooth.

This versatile man, who also designed masks for a Japanese 'Noh' play at the Abbey Theatre in 1935, was the designer of a stamp commemorating the 200th anniversary of the Royal Dublin Society in 1931, also a stamp in 1932 commemorating the International Eucharistic Congress, and in 1939 the stamp celebrating the 150th anniversary of the US Constitution. He acted as treasurer of the organising committee for the 1930 Irish exhibition at the Royal Museum of Art in Brussels. He showed three works at the Walker Art Gallery, Liverpool, and two in London at the Royal Academy. In later life he became a governor of the National Gallery of Ireland.

Writing about the 1920s, Tim Mulhall recalled the headmaster '...a stocky handsome man who walked with an imperious air and looked through rimless spectacles seemingly seldom pleased by what he saw ...Despite his stern exterior he was a kindly man who seldom refused the request of a student or member of staff.'

Between 1925 and 1929, he had been responsible for a series of studies etched during the construction of the hydro-electric scheme at Shannon. One of these etchings is in the Crawford Municipal Art Gallery, Cork, where there is also an anatomical study in pencil and watercolour. During the 1930s, he taught etching in his own private studio at the Dublin college.

Atkinson designed the monumental lettering on the front of the Barber Institute of Fine Arts, The University, Birmingham, a commission arrived at through the director, Thomas Bodkin, who, in a letter dated 3 March 1936 to the architect of the building, recommended Atkinson as a master in the design of lettering, adding that, in his (Bodkin's) opinion, 'he would be better even than Eric Gill for the particular job'. Atkinson, however, did not do the carving himself. He provided the template and the cutting was done by a local sculptor. In 1937 he became the first director of the newly constituted National College of Art, Dublin. Melancholic by temperament, on 24 March 1941 he was found at lunchtime gassed in his office at the college.

Works signed: George Atkinson, Geo. Atkinson or G. Atkinson.
Examples: Cork: Crawford Municipal Art Gallery. Dublin: Hugh Lane Municipal Gallery of Modern Art; Royal Dublin Society.
Literature: *Thom's Official Directory*, 1913; Daniel Corkery, *A Munster Twilight*, Dublin 1916 (illustration); L.G. Remond-Howard, *Sir Roger Casement*, Dublin 1916 (illustration); J. Crampton Walker, *Irish Life and Landscape*, Dublin 1927 (also illustration); *Irish Times*, 25 March 1941; Hilary Pyle: Cork Rosc, *Irish Art 1900-1950*, catalogue, 1975; *Dictionary of British Artists 1880-1940*, Woodbridge 1976; *A Dictionary of Contemporary British Artists, 1929*, Woodbridge 1981; Royal Irish Academy, *Letter to the author*, 1984; Ann M. Stewart, *Royal Hibernian Academy of Arts: Index of Exhibitors 1826-1979*, Dublin 1985; Peter Murray, compiler, *Illustrated Summary Catalogue of The Crawford Municipal Art Gallery*, Cork 1991 (also illustrations); John Turpin, *A School of Art in Dublin since the Eighteenth Century*, Dublin 1995 (also illustrations).

AUGER, YVONNE – see JAMMET, YVONNE

AUGUSTINE, EDWARD – see McGUIRE, EDWARD, jnr

B

BAGWELL, LILLA – see PERRY, LILLA

BAKER, ALFRED R. (1865-1939), portrait and landscape painter. Born on 24 November 1865 in Southampton. Alfred Rawlings Baker was the son of Major H. Baker, onetime secretary of Southampton Art Society. Alfred received his first lessons in art at Hartley College, Southampton, where he won several medals. In 1889, with a Southampton address, he exhibited at the Royal Academy. *An Autumn Moonrise* and *A Hampshire Homestead*, both watercolours, appeared in the 1900 exhibition of the RA. Early in life he had gone to Paris and studied at Académie Julian. Returning to London, he entered the Central School of Practical Art, and in 1890 he joined the staff of the Government School of Art, Belfast.

A member of the Ulster Arts Club, Baker closely associated himself with art activities in the city. By 1892 he was vice-president of the Belfast Art Society and seven years later became president. On the 1905 exhibition, *The Nationalist* found a fine mastery of technique, 'and his work is all of it distinctive'. During the First World War he had another two-year spell as president. As second master in the School of Art, he was called on for lectures, speaking on 'Ornament in Nature' and 'The Human Figure in Relation to Decorative Design'. In 1915 he was present at the Dublin Metropolitan School of Art when F. Ernest Jackson (1872-1945) gave a series of lectures in practical lithography.

A daughter, Ethelwyn M. Baker, attended the Belfast School of Art, winning the Royal Dublin Society's Taylor Scholarship for modelling in both 1919 and 1920. She subsequently studied in London at the Slade School of Fine Art and the Royal Academy Schools, and had a studio in Hampstead.

Between 1916 and 1923, Alfred Baker showed fifteen works at the Royal Hibernian Academy. At the 1920 event, he exhibited *An Irish Harvest*. At the 1923 RA, he contributed a lithograph, *Howth Pier*. In the early 1920s he founded and was elected first president of the Ulster Society of Painters, established for purely professional artists. In 1927 when the Belfast Museum and Art Gallery held a loan exhibition of Irish portraits by Ulster artists, Baker was represented by: *Dr John W. Renshaw* (Queen's University); *Viscount Massereene and Ferrard, HML, DSO*; and *Mr C.H. Crookshank, KC*.

Also in 1927, he held one-person shows in London at Walker's Gallery, New Bond Street, and Caxton Gallery, Westminster. At this period he had studios at 22 Garfield Chambers, Royal Avenue, Belfast. Among four works at the 1931 RHA was *A Cornish Farmyard*. He retired from the Belfast College of Art in 1934, and he died in London on 21 September 1939.

Works signed: A.R. Baker.
Examples: Belfast: Queen's University; Ulster Museum. Dublin: Royal College of Physicians of Ireland. Lisburn, Co. Antrim: Friends' School.
Literature: *The Nationalist,* 2 November 1905; *Northern Whig*, 5 May 1925, 23 September 1939; *A Dictionary of Contemporary British Artists, 1929*, Woodbridge 1981; Ann M. Stewart, *Royal Hibernian Academy of Arts: Index of Exhibitors 1826-1979*, Dublin 1986; Eileen Black, *A Sesquicentennial Celebration: Art from the Queen's University Collection*, Belfast 1995 (also illustration).

BALL, ETHEL (1886-1959), sculptor. One of the five children of Valentine Ball, CB, LL D, FRS, latterly of 23 Waterloo Road, Dublin. Ethel Gresley Ball was born on 24 November 1886 and was a sister of Maude Ball (q.v.). She studied under Oliver Sheppard (q.v.) and her sculptures were often based on animal studies she made at Dublin zoo. A photograph taken in the modelling room of the Metropolitan School of Art showed her with a caryatid. At the Royal Hibernian Academy, she showed for the first time in 1917, a statuette. A portrait of Miss Florence Gifford was exhibited in 1920, and one of Miss May Crosbie in 1921.

An exhibition of paintings, miniatures, lithographs and sculpture by Maude Ball, Dorothy FitzGerald (q.v.) and Ethel Ball was staged at Mills' Hall, Merrion Row, Dublin, in 1922. She exhibited at the same hall with her sister Maude in 1930 where there was a replica of her *Conjectural Reconstruction of the Great Irish Deer* which had been bought by the Friends of the National Collections and presented by them in bronze to the National Museum of Ireland.

In 1928 she had exhibited a statuette group in bronze, *Chimpanzee Companions*, at the Royal Academy. She also showed at the Grosvenor Galleries, London, and contributed one work to the Royal Scottish Academy. She showed more than fifty pieces at the RHA, and among her exhibits in 1928 was *The Old Macaw*. In 1938 she contributed *Golden Cat sharpening her Claws* and *Chimpanzee and her Baby*, which she also showed at the RSA in 1940 from 28 Waterloo Road, Dublin. Her only exhibit in 1940 – and her last – was *Zoo Babies at Play*.

At the Royal Zoological Society of Ireland (her death broke a link there with the Ball family going back to 1842) are three pieces: five lion cubs in bronze; a lioness, marble relief; and an orang-utan, bronze. She died on 3 July 1959.

Works signed: E.B.
Examples: Dublin: National Museum of Ireland; Royal Zoological Society of Ireland.
Literature: *Irish Times*, 21 February 1930; Sir Nigel Ball, Bt, *Letter to the author*, 1969; Ann M. Stewart, *Royal Hibernian Academy of Arts: Index of Exhibitors 1826-1979*, Dublin 1986; *The Royal Scottish Academy Exhibitors 1826-1990*, Calne 1991; John Turpin, *A School of Art in Dublin since the Eighteenth Century*, Dublin 1995 (illustrations).

BALL, MAUDE (1883-1969), landscape painter and miniaturist. A sister of Ethel Ball (q.v.), Maude Mary Ball was born in Dublin on 5 April 1883 and educated privately. She studied art at the Royal Hibernian Academy Schools, winning prizes in the 1909-10 year, as well as at the Dublin Metropolitan School of Art. She first exhibited at the RHA in 1910, and between then and 1935 showed more than fifty works.

In 1969, Dorothy FitzGerald (q.v.) told the author that she went to France with Maude Ball to sketch for several years running and that Maude painted landscapes and portraits in oils 'but never got very far with these and took to miniatures and obtained some commissions'. Among her works at the 1914 exhibition of the RHA were: *Sardine Boat, Brittany*; *Drying the Nets*; and *An Old Breton Fisherman*. At Mills' Hall, Merrion Row, Dublin, Maude exhibited miniatures and paintings in a 1922 exhibition with her sister Ethel and D. FitzGerald. In 1930 she showed at Mills' Hall with Ethel.

Maude Ball was a friend of the Belgian painter, Marie Howet of Brussels. In a letter to the author in 1981, she stated that she first met Maude on Achill Island in 1929 when both were painting there. She also recalled that her friend, whose miniatures she regarded as '*grande valeur*', exhibited at Libramont, Belgium, in 1949, two small flowerpieces which she had painted in the Ardennes. A '*Point de Vue*' in the Belgian Ardennes was exhibited at the 1933 RHA. She also exhibited at the Salon des Artistes Français in 1938 and 1939.

Maude Ball was an old friend of Mainie Jellett (q.v.), another Achill visitor, and had supported Mainie since the first great abstract art controversy in Dublin. She also helped in hanging Mainie's shows. But for the 1939 Jellett exhibition, 'Maw Baw', as Maude was known in the Jellett family, 'was so submerged in new pipes in her house and a new maid', that she could not assist. She died on 7 April 1969 in a nursing home.

Works signed: M. Ball.
Literature: *Irish Times*, 21 February 1930; Sir Nigel G. Ball, Bt, *Letters to the author*, 1969; Marie Howet, *Letter to the author*, 1981; Ann M. Stewart, *Royal Hibernian Academy of Arts: Index of Exhibitors 1826-1979*, Dublin 1986; Bruce Arnold, *Mainie Jellett and the Modern Movement in Ireland*, New Haven and London 1991.

BARNES, EILEEN (fl. 1921-32), illustrator. Eileen Barnes was employed as an occasional temporary assistant in the National Museum of Ireland. As part of her duties, she made drawings of objects in three departments: natural history, art and antiquities. A colleague who worked with her at the museum wrote in 1981: 'She is justly famous for having made an accurate detailed drawing of both faces of the Tara Brooch.'

For two monographs by R.L. Praeger, published in 1921 and 1932 by the Royal Horticultural Society, Eileen Barnes made numerous drawings. In an acknowledgement of her work for the later paper, *An account of the Sempervivum group*, Praeger wrote: 'I owe special obligation to Miss Eileen Barnes, the artist to whom the figures are due. Her patience and skill in portraying the plants and making analysis of the flowers have resulted in drawings which add greatly to whatever value the present account possesses.' The treatises are still the standard reference texts, essential for the study of succulents.

Literature: R.L. Praeger, *An account of the genus Sedum*, London 1921 (illustrations); R.L. Praeger, *An account of the Sempervivum group*, London 1932 (illustrations); Maura Scannell, *The Capuchin Annual*, 1976; Ellen Prendergast, *Letter to the author*, 1981.

BARRY, MATTHEW (1892-1976), landscape painter. Born in Midleton, Co. Cork, Matthew Barry trained at the Crawford Municipal School of Art, Cork, and the Dublin Metropolitan School of Art. Before the outbreak of the First World War, he studied at Goldsmiths' College, London, for a year. Most of his working life was spent as a teacher at Ballsbridge Technical School, Dublin. But he never felt happy in this profession and in later years expressed the view that his life had been a failure and that he wished he had followed a boyhood inclination to be a cabinetmaker.

A regular exhibitor at the Royal Hibernian Academy from 1923, he showed some two score works. He worked mainly in watercolour, with occasional drawings in pencil and crayon. He also etched. When living at 2 Auburn Villas, Rathgar, he showed the following in the 1928 exhibition: *Malahide Strand*; *View near Howth*; *The Pigeon House*; and *View near Blanchardstown*. He also exhibited at the Oireachtas but never had a one-person show. At the 1935 RHA, he showed seven works, including *The Abbey, Baltinglass* and *Balscadden and Howth Harbour*.

The National Museum of Ireland has a pen and wash sketch of Tom Kent's cell in Cork Military Prison, as well as a pencil sketch of his grave, both dated 1922. Barry resided for the last twenty-eight years of his life at 24 Morehampton Terrace, Donnybrook. Desmond, his eldest son, exhibited sculpture at the RHA in 1950 and 1951.

Works signed: Matthew Barry or M. Barry, rare.
Examples: Dublin: National Museum of Ireland; Navan: Meath County Library.
Literature: J. Crampton Walker, *Irish Life and Landscape*, Dublin 1927 (illustration); Francis Barry, *Letter to the author*, 1981; Ann M. Stewart, *Royal Hibernian Academy of Arts: Index of Exhibitors 1826-1979*. Dublin 1986.

BARRY, MOYRA (1885-1960), flowerpiece and landscape painter. Born in Dublin, Moyra A. Barry was educated at the Loreto Convent, George's Street. At the Royal Hibernian Academy Schools in the year 1908-9, she won the prize for the best drawing from the antique and for the best composition from a given subject. At the Slade School of Fine Art, London, 1911-14, she won a first prize for painting from the cast.

As early as 1908, she exhibited at the RHA and continued regularly until 1952, with paintings in oil and watercolour, averaging about two works per year in that period. She lived most of her life at 29 Palmerston Road, Dublin, apart from a spell in the late 1920s when she was a private tutor of painting and English at Quito, Ecuador. When an exhibition of her work was held in 1982 at the Gorry Gallery, Dublin, it contained some watercolours from Ecuador, dated 1926 and 1927. A 1920 self-portrait in that exhibition was purchased by the National Gallery of Ireland.

Having returned to Dublin, she had her first exhibition in 1932 at the Angus Gallery, St Stephen's Green. She also showed in London and Amsterdam. In 1936, the Thomas Haverty Trust, Dublin, presented an oil, *Rhododendrons*, to the Belfast Museum and Art Gallery. Several one-person shows were also held at the Victor Waddington Galleries, Dublin, in the period 1936-52. Flowerpieces predominated, with the occasional landscape: Howth, Phoenix Park and Clonskea all figured in her compositions. The Goodwin Galleries, Limerick, showed her work in 1949. She was represented in the Contemporary Irish Painting North American tour in 1950, and in the Contemporary Irish Art exhibition at Aberystwyth, in 1953.

As a member of the Dublin Sketching Club, she was a regular exhibitor in the 1930s. In the period 1938-59, she showed almost sixty works at the Water Colour Society of Ireland exhibitions. Her work also appeared in the exhibitions of the Dublin Painters and the Oireachtas. It was from the 1953 Oireachtas exhibition that the Crawford Municipal Art Gallery, Cork, purchased a watercolour, *Dahlias*. Her death occurred on 2 February 1960.

Works signed: Moyra Barry, M.A. Barry or M.A.B.
Examples: Belfast: Ulster Museum. Clonmel: South Tipperary County Museum and Art Gallery. Cork: City Library; Crawford Municipal Art Gallery. Dublin: National Gallery of Ireland. Limerick: City Gallery of Art; University, National Self-Portrait Collection.
Literature: Ulster Museum, *Flower Paintings*, catalogue, 1975: Gorry Gallery, *Moyra A. Barry*, catalogue, Dublin 1982; Ann M. Stewart, *Royal Hibernian Academy of Arts: Index of Exhibitors 1826-1979*, Dublin 1986; *Water Colour Society of Ireland Exhibition List 1872-1994*, Dublin 1995.

BARRY, W.G. (1864-1941), landscape and portrait painter. William Gerard Barry was born at Ballyadam, Carrigtwohill, Co. Cork. His father, Patrick Barry, was a local magistrate. On leaving school, where he showed little aptitude for anything except drawing and painting, he attended the Cork School of Art and studied under Henry Thaddeus Jones (q.v. Thaddeus) who advised him to continue his studies in Paris.

According to Barry's niece, Edith Bourke of Cobh, he was in Paris in 1886 when he jumped into the Seine and rescued a man and a boy from drowning, for which he received a medal. In 1887, he was at Étaples, seventeen miles from Boulogne, where there was a small artists' colony. That year he sent a painting to the Royal Dublin Society and won a prize in the Taylor Art Competition.

In 1888 he exhibited *Time Flies*, 1887, as W. Gerard Barry, at the Royal Academy, the catalogue showing his Co. Cork address. This work was later presented to the Crawford Municipal Art Gallery. In the Cork area in 1981, according to a letter to the author, there was a large oil painting of an interior, and the people in it were the same as those in *Time Flies*: an old woman (this time seated in a chair by the fire) and two little girls.

On returning to Ireland for a holiday, he fell out with his father, who in consequence turned him away with only a few pounds in his pocket. Subsequently, his visits home were rare. Barry set sail for Montreal, working as a deckhand during the journey to pay for his passage. On arriving in Canada, he met a bunch of ranchers who took him along with them to help break in horses. As soon as he had earned sufficient money, he bought a supply of paints and brushes, and wandered through the land painting name-signs for ranchers. Eventually he moved to the USA, where he received many picture commissions and became, according to the news in Cork, 'a most successful portrait painter ...'.

After a few years he returned to Paris. Most of his life from then on was spent between France and America. According to M. Fielding's *Dictionary of American Painters, Sculptors and Engravers*, 1926, he was then active in New York. He also travelled to other countries and spent some years in the South Sea Islands, painting pictures as he went, meeting and travelling with Frederick O'Brien, author of *White Shadows in the South Seas*, 1919. His personal needs were few and he journeyed with almost all he possessed in a couple of cases.

As he grew old, he devoted his time to drawing heads of well-known people in charcoal in a small studio which he rented on the French Riviera. In 1981, a charcoal at a private house in Co. Cork was of a thatched cottage surrounded by trees and inscribed on the back: 'To my Friend Dr Healy from Gerard Barry, Brittany, 1930'.

Prior to Barry's death, his niece received an undated letter from an English civil servant who worked for the Foreign Office's Prisoners of War Department and who knew Barry and his circumstances. He stated that the artist was a difficult man to get on with and 'though willing to buy a house in Ireland feared his family would shut him up and that this way he would lose control of his money, his greatest love in life... His income last year was I think over £2,000, part of which, it is true, is derived from an annuity ... He likes looking at his sketches and thinking of the past. It keeps his mind off regretting what he could have done with his money and didn't ...'.

Barry, unmarried, ended his days at St Jean-de-Luz, south-west France. During the German occupation, he met with a fatal accident. According to information received in Ireland by his niece, Mrs Bourke, from an occupant of the *pension* in which Barry stayed, a bomb went off and shook the house. A heavy wardrobe fell on top of the artist and killed him on 9 September 1941.

Works signed: Gerard Barry or W.G. Barry.
Examples: Cork: Crawford Municipal Art Gallery.
Literature: *Journal of the Cork Historical and Archaeological Society*, 1913; Mrs Edith M. Bourke, *W.G. Barry memorandum*, typescript, Cobh 1973; Mrs Edith M. Bourke, *Letter to the author*, 1981; Mrs Mary O'Neill, *Letter to the author*, 1981; Peter Murray, compiler, *Illustrated Summary Catalogue of The Crawford Municipal Art Gallery*, Cork 1991 (also illustration).

BARTON, MARY (1861-1949), landscape painter. Mary Georgina Barton was born on 3 April 1861 at Dundalk, daughter of James Barton, civil engineer, and from 1863 lived at Farndreg House, Dundalk. On her second birthday, her mother died, leaving seven children, of whom Mary was the youngest. In 1878 her only sister married, and Molly, as Mary Barton was known, was asked to help with the children of her father's second marriage – nine were born between 1871 and 1885.

In 1895 she set up house in London at 2 Spencer Street, Victoria Street, and studied at Westminster School of Art. In 1898, she studied in Rome where she also gave art classes. In that year she painted at Walberswick, Suffolk. *'After Sunset'*, exhibited in 1900, was the first of only four works which she showed at the Royal Hibernian Academy.

A regular exhibitor at the Water Colour Society of Ireland exhibitions, she showed eighty-seven works in the period 1897-1922. She opened her account with three: *St Peter's Church, Oxford*; *A Quiet Corner*; *A Wild Day*.

During summers she taught small groups of women at the homes of the landed gentry around the country. In 1900, for example, she taught at least forty-three individuals at five different venues. She became a member of the Women's International Art Club. Specialising in watercolour, her subjects ranged from harvesting at Farndreg, to lake and trees near Dundalk, to the snow-capped peaks of the Himalayas. In 1902 she accepted an invitation to exhibit with the Belfast Art Society.

In 1904, two of her pictures, *A Cypress Avenue* and *Autumn in Muckross,* were included in the exhibition of works by Irish painters organised by Hugh P. Lane and held at the Guildhall, London. She exhibited three times at the Fine Art Society. In 1902, the exhibition was called 'Irish Life and Scenery' and was held jointly with watercolours by Ina Clogstoun. The second show was in 1905, the year during which she travelled to India to visit her brother Edward. The 1909 exhibition bore the title 'Mexico, Watercolours'.

The 1909 expedition in Mexico involved travelling many hundreds of miles and she painted in eleven different centres. In a subsequent article in *The Studio*, she wrote: '... my first experience of a Mexican crowd, which came round me so closely that, in spite of my elbowings and appeals for more space, I could hardly move ... Artists are rare in Mexico, only a few from the States coming thither, so that one had that very delightful experience of seeing things freshly, untrammelled by other painters' visions...'.

At the WCSI exhibition of 1908, she contributed eight works including *A Wet Day, Lough Eske, Co. Donegal*; *The Lake, Darbhanga, Bengal*; *Howth's June Glory*.

Also in 1909, she was appointed an associate of the Society of Women Artists and two years later became a full member. She exhibited extensively with that society until the year of her death. In 1914 she visited Canada and in 1929, France and Portugal. At the Ridley Art Club exhibition in 1938, three pictures were of Carew Castle, South Wales; the catalogue for 1949 listed her as a member.

Mary Barton also exhibited at the Paris Salon, as well as in Venice, Vienna and Durban. *Fountain in the Cathedral Patio, Seville* was regarded as a principal work. In 1981, the Gorry Gallery, Dublin, exhibited a watercolour study of geese. Three watercolours, formerly owned by her sister, Isabel, Lady Carlyle, were in 1982 in private possession in Essex. One was of a group of cottages with washing hanging out, and a label on the back read 'Reading Guild of Artists'. For some considerable time she had a London address, latterly

a flat at 3b Carlisle Place, SW1, as well as Thatched Cottage, Bracknell, Berkshire, where she died on 8 November 1949.

Works signed: Mary Barton.
Examples: Dublin: Hugh Lane Municipal Gallery of Modern Art.
Literature: *Mary Barton Photograph Album*, 1895-c.1909; Mary Barton, 'Painting in Mexico', *The Studio*, July 1910; Mary Barton, *Impressions of Mexico*, London 1911 (also illustrations); *A Dictionary of Contemporary British Artists, 1929*, Woodbridge 1981; Michael MccGwire, *Letters to the author*, 1993, 1994, 1995; *Water Colour Society of Ireland Exhibition List 1872-1994,* Dublin 1995.

BARTON, ROSE, RWS (1856-1929), townscape painter. Born at Rochestown, Co. Tipperary, 21 April 1856, Rose Mary Barton was the daughter of a solicitor, Augustine Barton, and the cousin of Edith Somerville (q.v.). Educated privately, she was presented at Dublin Castle in 1872, the year she first began exhibiting with the Water Colour Society of Ireland, from 16 Merrion Square. In 1874, her father died and the next year her mother took Rose and her sister Emily Alma on a visit to Brussels where they had drawing and painting lessons. Three years later, Rose exhibited *Dead Game,* the first of a dozen works at the Royal Hibernian Academy.

In 1879 she was on the local committee of the Irish Fine Art Society which arranged their exhibition at the Theatre Royal, Cork. In the early 1880s she decided to become a professional artist and, accompanied by Mildred Anne Butler (q.v.) who became a lifelong friend, she studied at the studio of the French artist, Henri Gervex (1852-1929). Both women also worked in London under Paul Jacob Naftel (1817-91).

Exhibiting at the 1883 Cork Industrial Exhibition, Rose Barton gave her address as 44 Merrion Square, Dublin, and the following year she was represented at the Royal Academy. Also in 1884 her painting, *Hard Times*, at the Irish Fine Art Society exhibition in Cork, produced the *Cork Examiner* comment: '... that promising young artist'. Her first important show was in 1893 at the Japanese Gallery, London, where her *Cloth Alley, Smithfield, London* was one of sixty views of the city. The Dudley Gallery and the Grosvenor Gallery also showed her work.

In some of her watercolours, there was a noted interest in atmospheric effects; *The Last Lamp* was dated 1892. *On Yarmouth Sands* was dated 1893. She was elected an associate of the Royal Society of Painters in Water-Colours in 1893 but did not reach full membership until 1911. In the National Gallery of Ireland is *Hop Pickers in Kent Returning Home*, 1894. Her next major London exhibition was at the Clifford Gallery in 1898.

In the first decade of the century, her watercolours were well known in Dublin and London, particularly as she had illustrated books about both cities. Frances Gerard, the author of *Picturesque Dublin Old and New*, 1898, was a pseudonym for Geraldine Fitzgerald, a sister of Percy Fitzgerald (q.v.). As well as portraying children in cities, she occasionally placed them in rustic settings. In their book on Irish watercolours published in 1994, Anne Crookshank and the Knight of Glin noted that she had a real feeling for weather, especially the foggy atmosphere of London with its glimmering street lamps, rain-washed streets and busy thoroughfares. The Royal Society of Painters in Water-Colours presented pictures to King Edward VII, and Miss Barton's gift was of a child constructing a daisy chain.

Altogether at the WCSI exhibitions she showed more than 100 works, no fewer than nine in 1899, including *Old Wall at Chelsea*; *A Day Out*; *Bed Time.*

In her London book, 1904, she wrote that the city 'has ever been to me a most enthralling place, not only on account of its intense attractions from an artistic point of view, but also from what it has always taught me to feel so strongly – how little and feeble each one of us is, and that therefore there comes the stronger necessity to try and work aright'. She also referred to travelling on the Underground with her easel and stool, mentioning a studio in South Kensington as well as one which she rented for a winter in Glebe Place. The publication had sixty-one colour illustrations from her watercolours; Lord Iveagh owned sixteen of the originals, including *In the Strand: Waiting for Election News*; *Gordon's Statue*; and *The Thames, Charing Cross.*

Early in the century, she was a committee member of the Water Colour Society of Ireland. In 1904, *Lord Ardilaun's Garden* and *The Art Student* appeared at the Guildhall, London, in the exhibition of works by Irish painters organised by Hugh P. Lane. In the same year, she exhibited *Richard, son of Plunket Greene, Esq.* at the Royal Academy. She exhibited with more than a dozen different societies, but principally with the Royal Society of Painters in Water-Colours and the Society of Women Artists. At the RHA in 1904, she showed *Ring o'Bells Inn, Wells, Somerset* and *Cowslips*.

A broadminded social observer, she had a fondness for betting and horseracing. The United Arts Club, Dublin, arranged an exhibition in 1910, and she was listed as a member in the Black and White Artists' Society of Ireland catalogue, 1914.

The Garden of Lindsey House, London, pencil and watercolour on paper, was executed in 1917 and is in the NGI collection. Because of ill health in 1924, and probably later, she was unable to paint. However, she contributed two pictures to the 1928 WCSI exhibition: *Water Babies* and *St Martin's Church, Trafalgar Square, London*.

Among her works at the Dublin Civic Museum are: *Huguenot House in the Liberties*; *St Michan's Church, Church Street*; and *Chapel Royal, Dublin Castle*. She divided her time between Dublin and London, but her most permanent residence was 79 Park Mansions, Knightsbridge, where she died on 10 October 1929.

Works signed: Rose Barton.
Examples: Belfast: Ulster Museum. Dublin: Civic Museum; Hugh Lane Municipal Gallery of Modern Art; National Gallery of Ireland. Preston, Lancashire: Harris Museum and Art Gallery.
Literature: Frances Gerard, *Picturesque Dublin, Old and New*, London 1898 (illustrations); Marcus B. Huish, *British Water-Colour Art*, London 1904; Rose Barton, *Familiar London*, London 1904 (also illustrations); W. Shaw Sparrow, *Women Painters of the World*, London 1905 (illustration); *Irish Book Lover*, April and May 1917; J. Crampton Walker, *Irish Life and Landscape*, Dublin 1927 (illustration); Anne Crookshank and the Knight of Glin, *The Painters of Ireland c.1660-1920*, London 1978 (also illustrations); Christie's, *Elvedan Hall Sale*, catalogue, London 1984 (also illustrations); Ann M. Stewart, *Royal Hibernian Academy of Arts: Index of Exhibitors 1826-1979*, Dublin 1986; Crawford Municipal Art Gallery, *Rose Barton RWS (1856-1929)*, catalogue, Cork 1987 (also illustrations); Peter Murray, compiler, *Illustrated Summary Catalogue of The Crawford Municipal Art Gallery*, Cork 1991; Anne Crookshank and the Knight of Glin, *The Watercolours of Ireland*, London 1994 (also illustrations); *Water Colour Society of Ireland Exhibition List 1872-1994*, Dublin 1995; National Gallery of Ireland, *Gallery News*, March-May 2001.

BAYLY, LANCELOT (1869-1952), landscape painter. Lancelot Francis Sanderson Bayly was born at Bayly Farm, Nenagh, Co. Tipperary, where he lived as a child, and again after his marriage from about 1912 until 1920. After his father, L.G.A. Bayly, died in 1871, the family moved to Dresden. He stayed at school there until about fourteen years of age and then moved to Rugby School for only four or five terms before returning to Dresden to finish his education. When he was about twenty, the family went to Paris where they lived until his mother died about 1899. Until this time, he had moved in musical and artistic circles in both Dresden and Paris. As for his own painting, he favoured watercolour.

A strong supporter of the Water Colour Society of Ireland from 1910, he showed more than 100 works. His first two contributions were: *Bridge at Pont Aven, Brittany* and *Molini Grassi, Vareve, Italy*.

Around the end of the century, he went on a world tour which lasted about three years, spending some months in Tahiti. He returned there in 1912 on his honeymoon. During this period of travel he wrote three books; two of science fiction brought him a letter of congratulation from Jules Verne. The third publication, *The Log of an Island Wanderer* (the South Pacific), was written under the pen name of Edwin Pallender.

In 1914, he exhibited *Elders in Blossom, near Nenagh* at the Royal Hibernian Academy. His catalogue address was Bayly Farm, Nenagh, as it was in 1915 when *On the Beach, Tahiti* was among his works. He also painted in Switzerland. At the WCSI exhibition of 1919, pictures included *On the Kerry Coast* and *The Old Mill*.

The newly established *Dublin Art Monthly*, commenting on the 1927 Dublin Sketching Club exhibition, referred to his 'characteristic studies of streets and houses' as 'always subtly interesting'.In 1928 when living at Killarney Hill, Bray, *In Rathnew* and *Ireland's Eye* were hung at the RHA. In 1929 he held an exhibition at Cambridge's Galleries, Dublin. After leaving Ireland in 1930 to reside at Swindon, Wiltshire, he exhibited

a view of Rathnew village, Co. Wicklow, in London at the 1935 show of the United Society of Artists, followed in 1938 by a Kerry coastal scene. In the National Gallery of Ireland, he is represented by a watercolour, *Sunnybank, Chapelizod, Co. Dublin, Birthplace of Viscount Northcliffe*. He also painted in Gloucestershire and in Berkshire, where he died in 1952.

Works signed: Lancelot Bayly.
Examples: Bray: Public Library. Dublin: National Gallery of Ireland.
Literature: *Dublin Art Monthly*, December 1927; J. Crampton Walker, *Irish Life and Landscape,* Dublin 1927 (illustration); L.D. Bayly, *Letter to the author*, 1981; *Water Colour Society of Ireland Exhibition List 1872-1994,* Dublin 1995.

BEAMISH, JANIE E. (1856-1930), landscape painter. Born 26 July 1856 at Bandon, Co. Cork, Jane Eliza Beamish was the daughter of Henry Beamish. At her home, Ballymodan House, she taught music and painting, and was also organist of Bandon Methodist Church.

A regular exhibitor of watercolours at the Royal Hibernian Academy from 1905, she showed more than fifty works in a period of some twenty years. At the 1906 exhibition, her subjects were a street scene in Omagh, Co. Tyrone, where she had relatives; the sands of Bundoran, Co. Donegal; and an old bridge near Bandon. She visited Rouen in France. At the 1913 RHA, she presented: *The Bluebell Wood – Morning,* as well as another for the Afternoon; *When the dead leaves flutter idly down*; and *The Year's at the Spring.*

In the period 1908-30, she showed ninety pictures at the Water Colour Society of Ireland exhibitions. *Old Cottages at Ennis, Co. Clare* and *Lough Eske, Donegal* were both hung in 1910 and among the 1912 contributions was *The Bread Shop.*

In 1913 she was represented in a loan exhibition of 'modern paintings' at the Belfast Museum and Art Gallery. *Corner of a Rickyard* was shown there, which is now in the Cork municipal collection. Janie Beamish showed some pictures with the Royal Society of Painter-Etchers and Engravers, London. In 1927 at the WCSI show, titles included *The Old Forge at Kircubbin, Co. Down* and *Opposite the Copeland Islands, Co. Down.* She had moved from Co. Cork to Co. Down. Of 21 Waverley Drive, Bangor, she died on 26 November 1930.

Works signed: J.E. Beamish.
Examples: Cork: Crawford Municipal Art Gallery.
Literature: Mrs R. Beare, *Letter to the author*, 1981; also, Mrs I.A. Bradshaw, 1981; Ms Doris Kingston, 1981; Ann M. Stewart, *Royal Hibernian Academy of Arts: Index of Exhibitors 1826-1979,* Dublin 1986; *Water Colour Society of Ireland Exhibition List 1872-1994*, Dublin 1995.

BECKETT, FRANCES (1880-1951), portrait painter. Daughter of William Frank Beckett, a Dublin building contractor, she had four brothers, one of whom was William Frank Jr, the father of Samuel Beckett who was thought to have portrayed her as Hamm in *Endgame.* But answering an enquiry from the author in 1981, he replied that he' had not heard before of this ludicrous theory'.

As a young girl, Frances was called 'Fannie' to distinguish her from her mother. Her brothers nicknamed her 'Cissie', a name by which she was known most of her life. She received her art training at the Dublin Metropolitan School of Art. In 1903, she exhibited with a Young Irish Artists, Dublin, group which also included Beatrice Elvery, Dorothy Elvery, Count Markievicz, Frieda Perrott, Estella Solomons and Lily Williams (qq.v.). At about this time, she painted a portrait, now in the Model and Niland Centre, Sligo , of Estella Solomons, a close friend with whom she and the Elvery sisters visited Paris, spending some time drawing from life at Colarossi's in 1904.

Fannie Beckett exhibited at the Royal Hibernian Academy in the period 1897-1908. In 1897, from Glenburn, Palmerston Road, Dublin, she had only one exhibit, *Study*; in 1901, '*Estelle*', the address being Earlsfield, Ballsbridge. Her portrait of Rev. Israel Leventon, superintendent reader at the Jewish Synagogue, Adelaide Road, is at the Irish Jewish Museum. Other portraits were exhibited at the RHA, all without names, with the exception of *Miss Sophie Solomons* in 1905. In 1908 she gave her address as 21 Herbert Park.

About 1908 she married William Sinclair, an antique dealer known as 'The Boss' and a friend of William Orpen (q.v.). The Sinclairs had a cottage on the Hill of Howth where they kept open house for the poets, writers and painters of Dublin. A landscape of Howth exists, signed 'F. Sinclair' and dated 1909. Also in family possession in 1981 were three portraits of the artist's father, two of which were unsigned; one of William Sinclair's grandfather, Morris Harris, who died in 1909; an oil still life and a watercolour street scene of a German town, both painted in the 1930s.

In 1922 the family (there were five children) moved to Kassel, Germany, as William Sinclair hoped to inject a new vitality into the business of shipping German antiques and paintings to the shop in Dublin. His friend, Cecil ffrench Salkeld (q.v.), had gone to Kassel sometime earlier to study art, and the Sinclair family was to see a lot of him. After her husband died, 'Cissie' slowly became crippled with arthritis. She died in Dublin in 1951.

Works signed: F. Beckett or F. Sinclair (if signed at all).
Examples: Dublin: Irish Jewish Museum. Sligo: Model and Niland Centre.
Literature: *Thom's Directory*, 1898; Beatrice, Lady Glenavy, *Today we will only Gossip*, London 1964; Deidre Bair, *Samuel Beckett*, London 1978; Samuel Beckett, *Letter to the author*, 1981; Morris Sinclair, *Letter to the author*, 1981; Ann M. Stewart, *Royal Hibernian Academy of Arts: Index of Exhibitors 1826-1979*, Dublin 1986.

BECKETT, WILLIAM (1903-56), cartoonist. William Victor Oliver Beckett was born on 20 December 1903, son of Staff Sergeant J. Beckett of the Army Pay Corps. He attended Peter Symonds School, Winchester, Hampshire, from 1916 until 1922 and was editor of the school magazine in 1920. He became a teacher of art at a Bromley primary school but never taught at an art school. In 1982 a teacher who knew him in Bromley advised the author that he would have 'laughed at the idea. He could only do this comic drawing and was constantly trying out his jokes on friends and strangers. I would say he was thoroughly professional about his work.'

Beckett gave up teaching art for full-time cartooning when he left London in 1946 for Dublin. He had been contributing to the *Dublin Opinion* from London; also thirty-one cartoons between 1939 and 1948 to *Punch*; *London Opinion* and other publications. He produced an enormous output of highly topical drawings in a style which was all his own, and his horrible children were a feature of his work.

In Dublin, he co-edited *Passing Variety* for some years with Niel O'Kennedy. For a year and a half before his death, he contributed a daily topical cartoon to the *Evening Press*. In an appreciation in that newspaper on the day after his death O'Kennedy wrote: 'In his work he was a genuine original. When he first began to draw, he was influenced by the Continental cartoonists but he soon evolved a very personal style which was a reflection of his own personality ... He was indeed a brilliant draughtsman ... His fine talent would have brought him success wherever he chose to work, but he lived in Ireland and decided to settle down here' He died on 27 April 1956 at his home in Dollymount Park, Dublin.

Works signed: Maskee.
Literature: *Evening Press*, 28 April 1956; Mrs Anna Beckett, *Letter to the author*, 1982; also, Peter Bogan, 1982.

BEE – see BROWN, VICTOR

BEHAN, BEATRICE – see SALKELD, BEATRICE

BENSON, MARY K. (1842-1921), landscape and figure painter. Mary Kate Benson was the daughter of a leading Dublin surgeon, Professor Charles Benson of 42 Fitzwilliam Square. Her sister, Charlotte E. Benson (1846-93) also painted. Both studied in the Dublin Society's School where each won prizes. In later life, Mary studied under Sir Hubert von Herkomer (1849-1914) and P.-H. Calderon (1833-98). From her studies outside Ireland, especially in Paris, she acknowledged that she had come to 'see and feel colour more vividly, and more brightly, and that she had come to a fuller comprehension of the inexhaustible study of values'.

Both sisters began exhibiting at the Royal Hibernian Academy in 1873, and more than a hundred of Mary's works were regularly hung there over the next thirty years. In 1872, the Ladies' Sketching Club had been founded, the first of its kind in Dublin. The following year, gentlemen were admitted and the name changed to the Dublin Amateur Artists' Society, although the management remained in the hands of the ladies. In 1874, Mary K. Benson took over the secretaryship and acted with great zeal until 1887 when the club amalgamated with the Dublin Sketching Club. She also exhibited with the Nineteenth Century Art Society. In 1878, she exhibited at the Irish Fine Art Society's first exhibition in Cork. The *Cork Examiner* considered her *Evening on Caragh Lake, Co. Kerry* to be the finest painting there.

Contributions to the RHA exhibitions indicated that, while in Ireland, she painted in Connemara as well as in counties Carlow, Cork, Donegal and Dublin. In Great Britain, Cornwall, Cumberland, London and North Wales were favoured for her forays. At the RHA in 1882, she exhibited charcoal portraits of Arthur H. Benson, FRCSI, and J. Hawtrey Benson, MD. After several trips abroad, she showed *Eisboden Pastures, near Grundelwald* and *At Oeschenen See, Kandersteg* in 1887. She contributed three works at the Royal Scottish Academy in 1888. Works at the 1890 RHA included a Belgian interior; *Old Houses, La Roche, Belgium*; and *Bullock Cart*, a sketch in the Ardennes. Having painted at Quimperle, Brittany, her pictures in the 1896 RHA included *Old Mills, Montreuil, Normandy* and *A Normandy Shrimper*.

In 1897, she exhibited at the Water Colour Society of Ireland for the first time, and works included: *A Little Quimperle Maiden* and *Evening Impression – St Ives*.

By 1897, she was in her new house, Eskeragh, Howth, Co. Dublin, with its indoor and outdoor studios. Here she looked forward to years of work but she became a victim of arthritis and did not exhibit at the RHA after 1906. At the WCSI, 1906 was her last exhibiting year. One of her works depicted a girl seated at a window and holding an earthenware bowl; tonality described as 'silvery'. In 1916, she organised an exhibition of her pictures for the benefit of the Dublin Fusiliers' Prisoners of War Fund. After years of suffering, she died on 21 March 1921 at her home.

Works signed: M.K. Benson.
Literature: *Cork Examiner*, 5 October 1878; W.G. Strickland, *A Dictionary of Irish Artists*, Dublin 1913; *Irish Times*, 23 March 1921, 15 June 1921; Crawford Municipal Art Gallery, *Beatrice Gubbins of Dunkathel, Co. Cork (1874-1948)*, catalogue, Cork, 1986; Ms Elizabeth Guinness, *Letter to the author*, 1986; Ann M. Stewart, *Royal Hibernian Academy of Arts: Index of Exhibitors 1826-1979*, Dublin 1986; *The Royal Scottish Academy Exhibitors 1826-1990*, Calne 1991; *Water Colour Society of Ireland Exhibition List 1872-1994*, Dublin 1995.

BERGER, ALICE – see HAMMERSCHLAG, ALICE BERGER

BIGGS, MICHAEL (1928-93), sculptor and illustrator. Born on 26 August 1928 at Stockport, Cheshire, he was brought to Dublin at the age of two when his father, Claud Biggs, became Professor of Pianoforte at the Royal Irish Academy of Music. Michael attended Aravon School, Bray, Co. Wicklow, and from 1941-5, St Columba's College, Dublin, where he met William Trevor. His linocuts in the school magazine were noted. At Trinity College, Dublin, he studied languages for a year and a half.

Biggs returned in 1948 to England where he was a National Service recruit, and after serving he headed for Ditchling in Sussex where the legacy of Eric Gill (1882-1940) was kept alive. Apprenticeship there led to a personal calligraphy and later an alphabet. He returned to Dublin in 1952 and attended the National College of Art but only for six weeks.

According to Liam Miller, Biggs had 'an appreciation of lettering for print while developing his work in stone...' Miller's first commission for the Dolmen Press produced linocuts in 1953 for *The Midnight Court*, and in the same year he supplied a wood engraving for the frontispiece of a book on The Nativity from St Luke. As well as hand-lettering for Dolmen, his cuts were in Gudrun Tempel's *The Bird that Flew Away*, 1958. He supplied fourteen unsigned woodcuts for Romano Guardini's *The Way of the Cross*, 1959. In 1960 his *A Gaelic Alphabet* appeared.

The Arts Council in Dublin commissioned him to prepare an illustrated handbook for publication under the Council's auspices by the Dolmen Press, on the general principals of cemeteries, the proper use of material and design in memorial stones, the technique of letter-cutting and the proper arrangement of inscriptions. Publication has not been traced by this author.

The John F. Kennedy Aboretum in Co. Wexford, opened in 1968, has a commemorative fountain by Biggs, hewn from a single block of granite and weighing more than ten tons. The fountain bears the words 'ask not what your country can do for you...ask what you can do for your country' with the Irish translation. The memorial plaque was also by Biggs.

In a casket-like cube attached on the diagonal to the old Victorian Convent of Mercy building, Cookstown, Co. Tyrone, the architect Lawrence McConville assembled together in 1965 two five metre stained glass windows by Patrick Pye, an altar and ambo by Michael Biggs, and tabernacle and candles by Patrick McElroy. In that year Biggs completed the granite foundation stone for the Lyric Theatre in Belfast. Foundation stones were also executed for the new Abbey Theatre and Liberty Hall in Dublin.

Writing in 1964, Liam Miller was of the opinion that whilst Biggs had produced an impressive body of work in other media, 'his achievement in incised lettering in stone and wood is the greatest in this field that any artist working in Ireland for centuries past has produced...Parallel too with the precise heraldic language of signs and symbols is his use of pictorial subjects which are sometimes called for to accompany the lettering...' He was responsible for the lettering of a poem at the Garden of Remembrance in Dublin, opened in 1966, and at the Arbour Hill Cemetery he lettered the Proclamation in Irish and English as well as the signatories names. The lettering for Europa 1968 stamp was executed by Biggs. The baptismal font was his at the new Church of the Redeemer, Ardeasmuin, Dundalk, 1969. He was responsible for the sanctuary and altar at Church of St Oliver Plunkett, Galway.

At Holy Cross Abbey, Thurles, Co. Tipperary he was credited with the altar, ambo, sedilia, and for St Conal's Church, Glenties, Co Donegal, the altar, ambo and sedilia together with fretted steel crucifix. He designed the sanctuary stonework, ambo, altar and chair, at the new Church of the Nativity of Our Lady opened in 1975 at Newtown, Co. Kildare, giving each element 'an elegant, strong curved form.' A notable commission was for St Michael's Church, Dun Laoghaire, Co. Dublin: altar, ambo, sedilia, baptismal font. His last work — regarded by his fellow artist Patrick Pye as his masterpiece — was at St Macartan's Cathedral, Monaghan, where he redesigned the sanctuary; carved the altar and ambo, also the bishop's chair.

When St Columba's College held their 150th anniversary exhibition in 1993, he lent a mahogany panel 61 cm x 122 cm, the model for a bronze commissioned by the Office of Public Works for Fishamble Street, in connection with the commemorative for Handel's *Messiah*. Although he executed some paintings in oils, he did not exhibit at the Royal Hibernian Academy. He was a member of Aosdána.

In an appreciation in the *Irish Times*, the writer, William Trevor, wrote: 'The monuments he left behind reflect a talent that was never permitted to run away with itself, a skill in which flamboyance was forbidden, as were flourishes for their own sake, and decoration that disguised a vacuum.' After a long and rare illness, he died at St James's Hospital on 26 November 1993.

Examples: Dublin: Gonzaga College; St Patrick's College, Drumcondra. Dun Laoghaire, Co. Dublin: St Michael's Church. Dundalk, Co. Louth: Church of the Redeemer, Ardeasmuin. Galway: Church of St Oliver Plunkett. Glenties, Co. Donegal: St Conal's Church. Monaghan: St Macartan's Cathedral. New Ross, Co. Wexford: John F. Kennedy Aboretum, Slievecolta. Newtown, Co. Kildare: Church of the Nativity of Our Lady. Thurles, Co. Tipperary: Holy Cross Abbey.

Literature: Brian Merriman, trs. by David Marcus, *The Midnight Court,* Dublin 1953 (illustrations); *The Nativity from the Holy Gospel according to St Luke,* Dublin 1953 (illustration); Gudrun Temple, *The Bird that Flew Away,* Dublin 1958 (illustrations); Romani Guardini, *The Way of the Cross,* Dublin 1959 (illustrations); Liam Miller, *Arena,* Summer 1964; *Belfast Telegraph,* 7 June 1965; Department of Posts and Telegraphs, *Letter to the author,* 1968; Liam Miller, *Dolmen XXV,* Dublin 1976 (also illustrations); *Irish Times,* 29 November 1993, 14 June 1994; *St Columba's College 150th Anniversary Exhibition,* catalogue, Dublin 1993; *Letter from author to Frances Biggs,* confirmation of telephone call, 1997; Patrick Pye, RHA, *Letter to the author,* 1997; also, Royal Irish Academy of Music, 1997; Wexford County Council, 1997; Rev. Paul O'Boyle, 1998; Church of St Oliver Plunkett, Galway, 1998.

BION, C.W. (1889-1976), landscape and seascape painter. Cyril Walter Bion was born on 31 August 1889 at Simla, India, where his English parents were civil servants. Educated at Taunton School, Devon, he returned to Simla for holidays and spent some time painting the Indian scenery. At Durham University, he qualified as a naval architect. He became a lecturer at Hong Kong University and continued his painting and sketching. He was a teacher of mathematics at Campbell College, Belfast and Portrush, for twenty-five years from 1924.

In 1924 and 1925, he exhibited at the Royal Academy, and at the Paris Salon in 1926, 1928 and 1939. His first exhibition in Belfast was in 1933 at the Locksley Hall and this included flowerpieces in watercolour. He exhibited *A Yellow Moon* and *The Voice of Spring* at the Royal Hibernian Academy in 1941 when living in Portrush, Campbell College having been evacuated, and altogether showed a dozen works with the Academy.

In 1935 *The Studio* reproduced *Winter Sunshine* from an exhibition of landscapes of Northern Ireland, the West Highlands and Dorset held that year at Walker's Galleries, New Bond Street, London. Among the nineteen oil paintings was one entitled *Evening in the Himalayan Foothills*. The twelve watercolours included subjects such as an old mill at Millisle, Co. Down, and old cottages in Dorset and Surrey. In 1935, he also exhibited seascapes and landscapes at the Rodman Galleries, Belfast. In 1948, he contributed *Purdy's Farm* at the RHA, and *A Frosty Morning* at the 1949 exhibition, his last.

The Council for the Encouragement of Music and the Arts provided their gallery in Belfast for two shows in 1951 and 1954. On the 1951 exhibition, the *Belfast News-Letter* commented: 'All have that clarity yet softness of outline, that absence of harshness, which characterises Bion's work and makes it a harmonious whole.' He returned to England in 1954. In 1963 he held an exhibition at the Magee Gallery, returning to Belfast for the opening; *The Dying Giant* indicated his continued interest in trees. He died at Fleet, Hampshire, on 22 February 1976.

Works signed: C.W.B.
Examples: Belfast: Ulster Museum. Limerick: City Gallery of Art.
Literature: *The Studio*, May 1935 (also illustration); *Belfast Telegraph,* 24 October 1935; *Belfast News-Letter*, 16 October 1951; Magee Gallery, *C.W. Bion*, catalogue, Belfast 1963; *Northern Whig*, 19 March 1963; Mrs B. Roe, *Letter to the author*, 1981; Ann M. Stewart, *Royal Hibernian Academy of Arts: Index of Exhibitors 1826-1979*, Dublin 1986.

BIRD, W. – see YEATS, JACK B.

BLACKHAM, DOROTHY (1896-1975), landscape and townscape painter; linocut artist. Born in Dublin on 1 March 1896, Dorothy Isabel Blackham was the daughter of Charles H. Blackham, whose three cousins, the Whartons, were professional painters. Her grandfather, T.K. Lowry, LL D, edited *The Hamilton Manuscripts*, Belfast 1867.

During the First World War, she entered the Royal Hibernian Academy Schools and later studied at Goldsmiths' College, London. She was a regular exhibitor at the RHA for thirty years from 1916. Her work, which included bookplates, was also hung at the Royal Ulster Academy, the Water Colour Society of Ireland and the Ulster Society of Women Artists. Among her early contributions to the RHA were: 1916, *A Moor-Queen's County*; 1923, *Castle Poggio, near Florence*; 1929, *The Old Market, Boulogne*, linocut.

In Dublin she knew the Yeats sisters, Elizabeth (q.v.) and Lily (1866-1949), and produced woodcuts for the Cuala Press Christmas and greeting cards, and also worked for the Cluna Studio. The Irish Tourist Association commissioned some folder covers. In 1929, her address was 16 Harcourt Street, Dublin. In 1936 she held an exhibition at the Stephen's Green Gallery.

Between 1934 and 1971, she contributed no fewer than 135 works to the WCSI exhibitions, and among her six works in 1935 were: *Gulliver in the Studio*; *The Old Viaduct, Drogheda*; *Liscannor, Co. Clare*. As from 1937, Achill Island subjects featured frequently in her exhibitions.

Dorothy Stewart, her married name, also taught art in several schools, notably Alexandra College, 1936-43, and The Hall School, Monkstown. In 1943, she held an exhibition at 7 St Stephen's Green. In 1944, she was

an assistant warden at the Gibraltarian Evacuation Camp, Londonderry. *The Harbour, Portstewart* and *Spring in Antrim* were exhibited at the RHA in 1946.

In 1941, an article by Anna Sheehy in *The Bell* stated: 'Her name, of recent years, has come to be especially associated with the linocut, in which she has done a great deal of interesting work. She works on a large scale, producing prints three or four times the average size... one of the few linocut artists here to experiment seriously and effectively with the colour print.'

In 1947, she and her husband moved to London where she resumed teaching art. She visited Portugal and subsequently exhibited at the Royal West of England Academy and the United Society of Artists, London. At the South London Art Gallery are watercolours of Coronet Theatre and an eighteenth-century house in High Street, Peckham. In the collection of Queen's University, Belfast, is an oil, *Keele, Achill, Co. Mayo*.

After returning to Northern Ireland in 1964, the Stewarts resided at Moat Street, Donaghadee. In 1970 at the WCSI show, *The Pink Pavilion* and *Evening Porto Venere* were both hung. She died on 4 September 1975. Exhibitions of her work were held at the Queen's University, Belfast, in 1976, and at the Neptune Gallery, Dublin, in 1977.

Works signed: Dorothy Blackham, D. Blackham or D.B.
Examples: Belfast, Queen's University. Dublin: Voluntary Health Insurance Board. London: South London Art Gallery.
Literature: Bulmer Hobson, editor, *Saorstát Eireann Official Handbook*, Dublin 1932 (illustrations); *Irish Independent*, 10 June 1936; Anna Sheehy, 'Dorothy Blackham', *The Bell*, July 1941; The British Council, *Britain To-Day*, February 1950 (illustration); Ann M. Stewart, *Royal Hibernian Academy of Arts: Index of Exhibitors 1826-1979*, Dublin 1986; *Water Colour Society of Ireland Exhibition List 1872-1994*, Dublin 1995.

BLAKE, LADY EDITH (1845-1926), botanical illustrator. Edith Osborne, born at Newtown Anner, Clonmel, Co. Tipperary in 1845, was the elder daughter of Ralph Bernal Osborne. Edith's sister, Grace Osborne (1848-1926) also painted and became the Duchess of St Albans. Ralph Bernal, an outspoken and witty member of the House of Commons, had married Catherine Isabella Osborne, the only child of Sir Thomas Osborne of Newtown Anner, and had then assumed the surname Osborne by royal licence. A close friend of both sisters was Fanny Currey (q.v.).

Edith Osborne grew up in a lively and educated household where she developed an interest in many different subjects. Edith's mother produced a series of sketchbooks used at country house visits in England and Ireland. Edith's interest in painting developed early in life. Thomas Shotter Boys (1803-74) stayed at Newtown Anner and his only known Irish watercolour was painted there about 1866.

Early in 1872, Edith Osborne began a tour of Europe, visiting Austria, Germany, Greece, Italy, Sicily and Turkey. In addition to sketching, she studied customs, social conditions, architecture and art galleries. She kept a diary of her travels and observations and published these in *Twelve Months in Southern Europe*, 1876, with four drawings by the author, all apparently unsigned, including *In the vaults of the Cappuccini Convent, Rome* and *Doorway of San Gregorio, Grand Canal, Venice*.

In 1874, Edith married a widower, Captain Henry Arthur Blake, head of the Clonmel police, the Royal Irish Constabulary. The marriage was not approved by Edith's parents, so the pair eloped, with Edith escaping down a ladder from her bedroom window. She was disinherited and after their wedding the Blakes moved to Belfast. Her husband achieved rapid promotion in the police force, and in 1876 he was appointed a Resident Magistrate. In 1879, his wife, who had other writings to her credit, published her second book, *The Realities of Freemasonry* by 'Mrs Blake'. In 1880 there followed *Pictures from Ireland* by Terence McGrath, a pseudonym for Henry Blake. Appointed a 'Special Magistrate' at the time of the land agitation, he was threatened by assassination and his wife, armed, insisted on accompanying him wherever he went. Her interest in politics extended to a close friendship with Anna Parnell, sister of Charles Stewart Parnell.

Henry Blake applied for a colonial post, and in 1884 he was appointed Governor of the Bahamas, the first of a series of governorships which were to take the couple to many parts: Bahamas, 1884-7; Newfoundland, 1887-8; Jamaica, 1889-97; Hong Kong, 1897-1903; and Ceylon, 1903-07. Everywhere the Blakes went they took a deep interest in the development and conditions of the country. More than a hundred Native American

artefacts which Edith collected in the Bahamas are at the National Museum of the American Indian, New York. In the Bahamas, she appears to have worked with a pet snake entwined round her waist. A large watercolour at Myrtle Grove, Youghal, Co. Cork, depicts the opening of the Placentia Railway in Newfoundland in 1888.

A collection of 196 of her watercolours, all unsigned, depicting the *Lepidoptera* and plants of Jamaica, were painted from nature and are now in the Entomology Library, Natural History Museum, London. In their catalogue of the collection, C.V. Ellwood and J.M.V. Harvey stated: 'Many of the drawings show the various stages in the life cycle of a moth or butterfly and the foodplant of the larval stage. The result of her work in Jamaica is a collection of drawings which have scientific and artistic interest.' Many drawings were annotated by the artist, for example: 'Chrysalis formed 25th Sept. Moth emerged 6th Oct. 1893.' Arranged by its director, Dr Valentine Ball, some of her works were exhibited at the Museum of Science and Art, Dublin, in 1894.

A Jamaican publication, *Natural Science*, found her collection in 1898 'a treat to the artist as well as to the entomologist. She has also painted many of the beautifully coloured fish which abound in the Caribbean Sea, and she has contributed to scientific journals in America and England, articles on the "Aborigines of the West Indies" and kindred topics'. She also painted some landscapes. In Hong Kong, Henry and Edith continued to show an interest in botany, and two species of oak were separately named after them.

Sir Henry Blake retired from the colonial service in 1907 and returned to Ireland, settling at Myrtle Grove, once the residence of Sir Walter Raleigh. His book, *China*, appeared in 1909. Other works and sketchbooks of his wife's are at Myrtle Grove, where the staircase is framed with her botanical illustrations. According to Edith's granddaughter, Patricia Cockburn, Lady Blake could speak nine languages, including Chinese and Russian. She described Edith as being 'a strong character who had a good sense of humour'. Lady Blake died at Myrtle Grove on 18 April 1926.

Examples: London: Natural History Museum. Youghal, Co. Cork: Myrtle Grove.
Literature: Edith Osborne (Mrs Blake), *Twelve Months in Southern Europe*, London 1876 (also illustrations); *Natural Science*, Jamaica, September 1898; Patricia Cockburn, *Figure of Eight*, London 1985; National Gallery of Ireland and Douglas Hyde Gallery, *Irish Women Artists: From the Eighteenth Century to the Present Day*, Dublin 1987 (illustrations); Patricia Butler, *Three Hundred Years of Irish Watercolours and Drawings*, London 1990 (illustration); C.V. Ellwood and J.M.V. Harvey: Natural History Museum, *The Lady Blake Collection: Catalogue of Lady Edith Blake's Collection of Drawings of Jamaican Lepidoptera and Plants*, London 1990; Anne Crookshank and the Knight of Glin, *The Watercolours of Ireland*, London 1994 (also illustrations); National Museum of the American Indian, *Letter to the author*, 1995.

BOAK, R. CRESSWELL (1875-1949), landscape, portrait painter and etcher. Robert Cresswell Boak was born on 31 May 1875 at Letterkenny, Co. Donegal, the son of Alexander Boak. He studied at the Londonderry School of Art, and the Royal College of Art, as well as in Paris and Rome. *The Derry Almanac and Directory*, 1898, listed R.C. Boak as an assistant in the evening school of the Government School of Science and Art. Later he taught art at schools in Portsmouth and Southsea, Hampshire, as well as in London, before deciding to devote all his time to his own work.

Boak painted *Battleships in the Solent*, 1900. A portrait of Alderman John Corke, 1910, Mayor of Portsmouth, was probably destroyed when the Guildhall was burnt out in 1941. He exhibited twenty-seven works at the Royal Cambrian Academy, as well as showing at the Royal Hibernian Academy. In 1927, he became a member of the Belfast Art Society. In the following year, with studios at 26 Garfield Chambers, Royal Avenue, Belfast, his work at the RHA included: *Rathlin Island from White Park Bay, Co. Antrim;* and *On the Yorkshire Moors*. In 1936, he held a one-person show of watercolours in the James A. Pollock Art Gallery, Donegall Place, Belfast.

Boak married the artist and writer, Margaret Cooper, who was educated in Belfast. During his stay in the city, he did a notable series of etchings of the beauty spots of the Province and of historic and other buildings, such as Queen's University, and, in 1932, the Royal Belfast Academical Institution. He left Belfast some years before the Second World War and ultimately settled in London, where he died in 1949.

Works signed: R. Cresswell Boak.
Examples: Belfast: Department of the Environment for Northern Ireland; Royal Belfast Academical Institution. Downpatrick: Down County Museum.
Literature: *The Tree*, Belfast 1936 (illustration); *Northern Whig*, 17 June 1936, 3 August 1949; *Dictionary of British Artists 1880-1940*, Woodbridge 1976; *A Dictionary of Contemporary British Artists, 1929*, Woodbridge 1981.

BOLTON, JOHN N. (1869-1909), landscape and portrait painter. Born in Dublin on 25 July 1869, John Nunn Bolton was the son of Henry Edward Bolton (1839-1917), whom Walter G. Strickland in his Dictionary described as 'a clever amateur landscape painter.' The father exhibited regularly at the Royal Hibernian Academy between 1889 and 1915. According to a relative in 1997, the lineage of the family could be traced back clearly to Richard Bolton of Beaumaris in Anglesea, who was born before 1595. John N. Bolton attended Dublin Metropolitan School of Art and the RHA Schools, and won a Taylor Scholarship in 1892 with his *Old Leinster Market, Dublin*.

Bolton first exhibited at the RHA in 1890 from his home address, Sylvan House, Donnybrook, Dublin, and from then until 1907 he showed a total of forty-seven works. At first he appeared to concentrate on marine subjects, for example in 1890, *Collier Unloading on the Liffey*, and in 1891: *The Port of Dublin* and *Shipping on the Liffey*, but titles in the next three years indicated visits to North Wales, for example the Lleddr River area. The first sign of portraits came in the 1897 Academy exhibition with those of two unnamed women. His *Study of Trees at Rathfarnham, Co. Dublin* was accompanied in 1898 by *Mill Street, Warwick*.

As to why Bolton left Dublin to reside in Warwick is unclear. Between 1899 and 1902 at the Royal Birmingham Society of Artists' exhibitions, he showed seven paintings — portraits, figure studies and one genre subject. Between 1899 and 1907 he contributed at least six other portraits, judging by titles, to the Dublin exhibition. In 1900 he showed: *Kathleen*; *Leicester Hospital, Warwick*; *Old Bridge at Warwick*. His *Mother's Darling*, 1907, lent by his father.

Bolton was heavily involved with Louis N. Parker in the Warwick Pageant of 1906. He designed the costumes, prepared the artistic posters and arranged the colour effects. The souvenir booklet was illustrated with colour reproductions of six watercolours by him. A number of watercolour drawings were reproduced and widely sold as colour postcards. Warwickshire Museum holds four 1906 cards: *Queen Elizabeth and the boy Shakespeare*; *The Visit of Warwick, the King-Maker, to the Court of Lewis*; *Guy's Trophy*; *Origin of the Bear and Ragged Staff*.

In 1906 his miniature portrait of Viscountess Helmsley appeared at the Royal Academy. In 1907 he visited the majority of English counties by request of London publishers in order to make watercolour sketches for colour reproduction. Later in the year a selection of these sketches was exhibited in Leamington.

According to a record at the Hugh Lane Municipal Gallery of Modern Art, Dublin, where he is represented by an oil, *Lleydn River Valley*, he was a friend of Walter Osborne (q.v.). In September 1908, he took up an appointment as visiting art teacher at Leamington Municipal School of Art but had to resign in November because of ill health. He died at his home, 39 High Street, Warwick, on 11 February 1909, leaving a widow and four small children.

Works signed: J. N. Bolton.
Examples: Dublin: Hugh Lane Municipal Gallery of Modern Art.
Literature: *Leamington Spa Courier,* 12 February 1909; Walter G. Strickland, *A Dictionary of Irish Artists,* Dublin 1913; *Royal Academy Exhibitors 1905-1970*, Calne 1985; Ann M. Stewart, *Royal Hibernian Academy of Arts: Index of Exhibitors 1826-1979*, Dublin 1986; Daphne Foskett, *Miniatures Dictionary and Guide*, Woodbridge 1987; Leamington Art Gallery and Museum, *Letter to the author*, 1997; also, Robert Lidwell, 1997; Warwickshire County Record Office, *Letters to the author*, 1997; also, Warwickshire Museum, 1997.

BOOTH, ARTHUR (1892-1926), cartoonist. Arthur James Conrey Booth was born in Dublin and educated at the Catholic University School. There was an interest in art, although not professional, on both sides of his family. His father, James Booth, was awarded a medal in 1861 from the Department of Science and Art.

Arthur himself drew from a very early age and had 'trunks' of drawings, according to an aunt with whom he lived as a boy.

Booth became friendly with Charles E. Kelly (q.v.) by offering to paint scenery for an amateur dramatic society. Following that, he, Kelly and later Tom Collins, a writer, discussed the possibility of starting a humorous journal. Booth resigned his post in the Dublin United Tramway Company and became the first editor of *Dublin Opinion* in 1922, working full time on the journal until his unexpected death on 8 October 1926 at 46 Casimir Road, Dublin.

Works signed: Booth or A. Booth.
Literature: Robert A. Booth, *Letter to the author*, 1982.

BOURKE, JOHN D. (1918-80), sculptor. John Damian Bourke was born on 23 April 1918 at Kilmacthomas, Co. Waterford. He received a scholarship from the Waterford School of Art to attend the National College of Art, Dublin, where he worked under Laurence Campbell (q.v.). He married Ann Clarke, a daughter of Harry Clarke (q.v.).

In the 1940s he painted scenery at the Abbey Theatre, and modelled the new proscenium arch at the Olympia Theatre, from photographs and pieces which had survived the collapse of the old arch. His work was in the 1944 – *Connemara Girl* – and the 1945 – *Scattering Day* – exhibitions of the Royal Hibernian Academy. Making models for films in England and at Ardmore Studios, near Bray, Co. Wicklow, followed in the 1950s. He contributed *The Herring Fisher* to the 1953 RHA, giving his address as c/o The Grafton Gallery, 2 Harry Street, Dublin. Altogether, he showed eight works at the Academy.

He played a part in the affairs of the Institute of the Sculptors of Ireland, being a member of the first council and honorary secretary in 1954. His work appeared in the Institute's exhibitions 1953-6 inclusive, and in their international exhibition, also in Dublin, at the Municipal Gallery of Modern Art, 1959. *One-eyed King*, plaster, was shown at that last display, a work which found its way to the Belvedere School, Liverpool, but which cannot now be traced.

Bourke exhibited *Jesuit*, a bust in plaster, at the Society of Portrait Sculptors exhibition at the Imperial Institute, South Kensington, 1957. *The Unknown Political Prisoner* is in the Hugh Lane Municipal Gallery of Modern Art. Of Putland Road, Bray, he died in hospital on Christmas Day, 1980.

Works signed: John D. Bourke or John Damian Bourke.
Examples: Dublin: Hugh Lane Municipal Gallery of Modern Art. London: St. George's Cathedral.
Literature: *Irish Times*, 27 December 1980; Mrs Ann Bourke, *Letter to the author*, 1982; Ann M. Stewart, *Royal Hibernian Academy of Arts: Index of Exhibitors 1826-1979*, Dublin 1986.

BOURKE, MICHAEL J. – see de BURCA, MICHEÁL

BOWEN, GRETTA (1880-1981), primitive painter. Margretta Bowen was born in Dublin on New Year's Day, 1880, the daughter of Samuel Arthur Bowen, a Midland Great Western Railway official. She married Matthew Campbell, who moved north in 1921 to start a catering business. He died four years later and she took in boarders to support herself and her three sons, Arthur, George (qq.v.) and Stanley, all of whom later painted.

A few weeks before her seventieth birthday, in her home in Magdala Street, Belfast, she came across some gouache material left over by her son Arthur, and began to paint herself. She decided to sign the pictures with her maiden name to avoid trading on her sons' reputations. Her first one-person show was in Belfast in 1955, at the gallery run by the Council for the Encouragement of Music and the Arts. In the following year, she exhibited at the Victor Waddington Galleries, Dublin, with proceeds in aid of the Central Remedial Clinic; all thirty-six paintings were sold.

In 1955, *The Times* stated: 'Rhythm and movement are the characteristics of her work. There is nothing static in it. She will paint children at play, a fun fair, nuns in procession, children on their way to confirmation,

a Twelfth of July Orange procession, a military band or a dockside scene – and whatever she paints conveys a feeling of happiness, of brightness, of delight in life.'

Other solo shows followed: David Hendriks Gallery, Dublin, 1961; Bell Gallery, Belfast, 1965; Tom Caldwell Gallery, Belfast, 1970, 1976, 1980; Tom Caldwell Gallery, Dublin, 1977, 1980. She also exhibited at the Oireachtas, the Royal Hibernian Academy – eight works – and the Ulster Society of Women Artists, showing in oil, gouache and wax crayon. At the Oireachtas in 1966, her sons, George and Arthur, were also represented. She concluded exhibiting at the RHA: 1971, *Games by the River*; *Fun Fair*; 1972, *Lounge Bar*.

At the Ulster Museum are two oils, *A Night at Home* and *Library*. She was represented at the International Naives exhibition, Hamiltons Galleries, London, 1979. She died in her sleep on 8 April 1981.

Works signed: Gretta Bowen or G. Bowen, rare.
Examples: Belfast: Department of the Environment for Northern Ireland; Ulster Museum.
Literature: *The Times*, 29 December 1955; John Hewitt and Theo Snoddy, *Art in Ulster: 1*, Belfast 1977; Ann M. Stewart, *Royal Hibernian Academy of Arts: Index of Exhibitors 1826-1979*, Dublin 1986.

BOWEN, HOWARD (1916-84), landscape, figure and portrait painter. Born on 22 February 1916 in St Louis, Missouri, USA, he was the son of Sherman Worcester Bowen, civil engineer. Howard Bowen studied at Washington University School of Fine Arts in St Louis and was awarded the Weyman Crow Medal in 1936. Later he attended Barnes Hospital, the medical school of Washington University, and furthered his knowledge of anatomy. Showing an interest in graphical work, he was employed by a New York agency, obtaining commissions for book illustrations. A watercolour, *Minsky's Vaudeville, New York*, may date from this time. He subsequently returned to St Louis and opened a studio.

In 1942, he was conscripted into the army and sent to Europe the following year. During the three years he spent there he made many drawings and paintings of his surroundings in Belgium, Holland and Germany. Although conditions were far from normal and pleasant, this experience instilled in Bowen a love of travel and provided the inspiration for many of his paintings.

Returning to America in 1946, he furthered his studies in Cape Cod, Maine, concentrating on portraiture. He took up a teaching post in 1950 in one of the John Burroughs schools in St Louis county before opening his own studio where he conducted art classes and painted still life and portraits. One of his oil paintings was of American Indians washing clothes. He exhibited regularly in Missouri as well as making frequent painting trips abroad, especially to the Mediterranean area, where he worked almost exclusively in watercolour, thus *Market Scene, Cyprus*. However, his *Street Scene, Tunis*, was in oil. In 1957 he moved to London.

After spending a year in Spain, he held his first London exhibition at the Cooling Galleries, New Bond Street, in 1959, showing Spanish watercolours. He later set up a studio at Fulham. He exhibited again at the Cooling Galleries in 1964 when an oil, *Fiesta, Segovia, Spain* was included. *Trafalgar Square, London*, watercolour, is probably of this period. The Greek Centre in Regent Street showed his work from the Greek Islands, where he had gone at the invitation of a shipping company. Another of his watercolours was of the *SS Romantica*'s swimming pool. Richmond Hill Gallery also presented his work.

In 1967, he moved to Ireland with his wife Mary, a London dress designer. At Killaloe, Co. Clare, he continued to paint portraits and landscapes, including *Fishermen at Brian Boru's Fort, Killaloe*. An exhibition of his work was held in 1968 at the Goodwin Galleries, Limerick, featuring the historic churches along Lough Derg's shoreline, and the Georgian houses of Limerick. His work in oil in the National Self-Portrait Collection of Ireland is described thus: '... possesses the clarity and brightness of his watercolours ... As an experienced and skilled portraitist, Bowen here displays his ability to convey a sense of character in a direct and informal manner.' He died on 21 January 1984 at Milford Hospice, Limerick. In 1986, a studio sale of fifty-one works was held at the Gorry Gallery, Dublin. In 1994, an exhibition was hosted by the University of Limerick. Two years later, an auction sale of works from his studio was held at Sixmilebridge, Co. Clare.

Works signed: Howard Bowen.
Examples: Killaloe, Co. Clare: St Flannan's Cathedral. Kraków, Poland: Modlnica Palace. Limerick: University, National Self-Portrait Collection.

Literature: Cooling Galleries, *Recent Watercolours of Spain by Howard Bowen*, catalogue, London 1959; *Limerick Leader*, 4 September 1971; Gorry Gallery, *The Studio of Howard Bowen 1916-1984*, catalogue, Dublin 1986 (also illustrations); Sarah Finlay: University of Limerick Press, *The National Self-Portrait Collection of Ireland*, catalogue, Limerick 1989 (also illustration); Mrs Mary Bowen, *Letter to the author*, 1995; also, Polish Cultural Institute, London, 1995; *Irish Times*, 23 November 1996.

BOYLE, ALICIA , RBA (1908-97), landscape and figure painter. Alice Louisa Letitia Boyle, daughter of B. P. Boyle, MIEE, was born in Bangkok, Siam, on 1 August 1908. Her father, the son of Major Alexander Boyle of Bridge Hill, Limavady, Co. Derry, had to relinquish his post with the British Dock Company in Siam because of the climate, and the family returned to Limavady in 1909.

In 1920 the Boyles moved to London where Alicia attended Clapham High School, subsequently moving to an art training college for teachers which she considered 'a backwater,' but at the Byam Shaw School of Art, run by 'a genius,' F. Ernest Jackson (1872-1945), she won two scholarships during her stay, 1929-34. While still a student, she received in 1934 her first commission, executing a mural decoration for the nurses' home lounge (now the hospital restaurant) at the Great Ormond Street Hospital for Sick Children. Two other Byam Shaw students were involved with murals, also of London scenes. Alas, the room in which the murals were situated was redecorated in the 1970s and the decorations were removed or painted over.

Commercial designs for posters and wrappers augmented her income. At the Royal Academy in 1932, from 19 Patten Road, Wandsworth Common, SW, she had exhibited *Lot's Wife*, and in 1936 from 57 Hereford Road, W, she showed *The Spell*, tempera. In 1938 she spent some time in Northern Ireland hoping to find a sale for her paintings. Disappointed, she returned to London. In 1939 she received an invitation from the Greek Government to be guest artist at the School of Fine Art, Mykonos. During the Greek visit she had an exhibition in Athens, making enough money to sail to Naples and visit other Italian places. On the eve of the outbreak of war, she arrived back in London.

In 1940 she was appointed an assistant mistress at Northampton High School for Girls, remained there until 1946 and then became a part-time teacher of painting and drawing at Northampton School of Art until 1951. Meanwhile, the Peter Jones' Gallery, London, had hosted her first one-person exhibition in 1945. *The Studio* described it as a 'gay little show, full of movement. Her sense of calligraphic technique and her expressive design conveyed the joy of living and also the feeling that painting is 'grand fun.' This was refreshing as a foil to the grim, ultra-serious attitude adopted by so many artists.' A painting shown was *Fishermen and Trees*.

The artist still retained her Irish links, painting in Counties Derry and Donegal in 1947. In 1949 she exhibited at the Leger Galleries, London, and this time *The Studio* recorded that she had made 'great strides' since her last show in London, and : 'Her technical experience and a sense of order allow her to use just as much realism as she needs to express the very strong emotion shown in some of her work while the pictures indicative of her lighter veins are full of fun and blazing with colour.' Also in 1949, she had a solo show with Midland Group of Artists, Nottingham.

In 1950 and 1952 Council for the Encouragement of Music and the Arts organised exhibitions in Belfast, and in 1951 she presented ninety works at Northampton Art Gallery. In 1951, too, many Irish landscapes were on view at her exhibition of drawings and watercolours at the Leger Galleries. *The Studio* was represented again and noted that there was 'a lively sweeping line that performs arabesques among the Connemara hills and harbours containing blues and greens of an un-English lushness...'

In 1952 she resumed exhibiting at the RA: *The Sea's Edge, Connemara* from 21 Battersea High Street, SWII. In the early 1950s she sent works to the Irish Exhibition of Living Art, Dublin, for example in 1953: *Girl in the Rain, Carna* and *Le Bar Bonal, Rue de Seine*. New paintings exhibition at the Leger Galleries in 1953 was followed by one sponsored in 1954 by Midland Group of Artists. By the middle of the decade she had resumed part-time teaching, at the Medway College of Art, Rochester, Kent. In 1955 she went to Spain and lived for some weeks in a Mallorcan peasant's home.

In 1956 Alicia Boyle was in Catalonia, living in a mountain village above Gerona. She returned to the RA in 1957, and in 1960 with *Slatty Strand, towards Sherkin*. She studied lithography in London at the Central

School of Arts and Crafts; in 1958 she was one of three artists whose works were chosen for reproduction by the Senefelder Colour Prints Club. That year she had an exhibition of watercolours at Walker's Galleries, London, and in 1958 too she was appointed a member of the Royal Society of British Artists. Under CEMA auspices, she showed recent oil paintings in 1959 at the Belfast Museum and Art Gallery, the thirty-five works including *Gathering Kelp Near Finistèrre*; *Sunday in Mallorca*; *Benweed and Docken, Shanveagh*.

In 1960, from 81d Eccleston Square, SWI, she contributed three oils at the RBA winter exhibition: *Plum Orchard, Higham*; *Sherkin Abbey — The Edge of Ireland*; *Girl with Goat, Shanveagh*. Finances were augmented by the major award of £200 for *The Red Weaver, Ardara* in the 1962 CEMA open painting competition. Other travels abroad included visits to Galicia — *The Boy with the Hawks*, the Basque country and Andalusia In 1963 the Arts Council of Northern Ireland arranged an exhibition of watercolours, and that year she moved to Farnham, Surrey, becoming visiting teacher at West Sussex College of Art and Farnham College of Art.

The main event in 1967 was her exhibition in Londonderry for the North-West Arts Festival, followed by the Arts Council Gallery, Belfast. In 1971 she moved from Farnham to her new studio dwelling at Reenacappul, Durrus, near Bantry, Co. Cork. From this Irish base, exhibitions soon followed: 1972, Barrenhill Gallery, Baily, Co. Dublin; 1973, 1976, Cork Arts Society Gallery; 1975, 1978, Tom Caldwell Galleries, Dublin; 1979, United Arts Club, Dublin. In 1977 she provided illustrations for Hilary Pyle's *You Can Say That Again*, Common Prayer in the Church of Ireland. In 1979 the Arts Council, Dublin, awarded a bursary for two years.

Under the title of 'Sweeny the Madman', twenty oils and six watercolours appeared in 1981 at Taylor Galleries, Dublin. In 1983 ACNI presented a retrospective exhibition of paintings completed since 1938. Taylor Galleries in 1986 featured trees in her exhibition. In 1988 Crawford Municipal Art Gallery, Cork, held an exhibition of paintings, drawings and prints 1932-88. Also in 1988 paintings and drawings were shown at Trinity Gallery, London, and also at the Irish Museum of Modern Art in Dublin in 1989.

Although she exhibited at the Oireachtas exhibition in Dublin she never patronised the Royal Hibernian Academy. In London, she also showed some works with Cooling and Sons Gallery and the New English Art Club. She had one abiding principal, it was said, that good drawing was the basis of good art, and beyond that she was quite undogmatic. Through the Friends of the National Collections of Ireland, she bequeathed to the National Gallery of Ireland six oil paintings and 105 sketchbooks, 1931-96. She died in Dublin on 11 January 1997. A studio sale took place in Dublin in 1998.

Works signed: AB, monogram; Alicia Boyle or Boyle.

Examples: Belfast: Arts Council of Northern Ireland; Ulster Museum. Churchill, Letterkenny, Co. Donegal: Glebe Gallery, Derek Hill's Collection. Coleraine, Co. Derry: North West Art Trust, University of Ulster. Cork: Crawford Municipal Art Gallery. Coventry: Herbert Art Gallery and Museum. Derby: Derbyshire County Council School Library Service. Dublin: National Gallery of Ireland. Kendal, Cumbria: Abbot Hall Art Gallery and Museum. Limerick: University, National Self-Portrait Collection. London: Imperial War Museum. Northampton: Central Museum and Art Gallery; High School. Nottingham: Castle Museum and Art Gallery; Midland Group of Artists. Wakefield, Yorks. : Art Gallery.

Literature: *The Studio*, December 1945, March 1946 (also illustration), June 1949, July 1949, April 1951; *Belfast Telegraph*, 9 January 1951, 15 April 1958; Belfast Museum and Art Gallery, *Recent Paintings by Alicia Boyle*, catalogue, Belfast 1959; *Belfast News-Letter*, 24 February 1959; Arts Council of Northern Ireland, *Alicia Boyle watercolour drawings*, catalogue, Belfast 1963; *Dictionary of British Artists 1880-1940*, Woodbridge 1976; John Hewitt and Theo Snoddy, *Art in Ulster: I*, Belfast 1977 (also illustration); Hilary Pyle, *You can Say That Again*, Dublin 1977 (illustrations); Arts Council of Northern Ireland, *Alicia Boyle*, catalogue, Belfast 1983 (also illustrations); *Royal Academy Exhibitors 1905-1970*, Calne 1985; Crawford Municipal Art Gallery, *Alicia Boyle*, catalogue, Cork 1988 (also illustrations); Liam Kelly, interview with Alicia Boyle, *The GPA Irish Arts Review Yearbook 1988*; Great Ormond Street Hospital for Children, *Letter to the author,* 1997; also, Wandworth Borough Council, 1997; *Irish Times*, 15 January 1997, 12 September 1998; de Veres Art Auctions, *The Studio Works of Alicia Boyle 1908-1997*, catalogue, Dublin 1998 (also illustrations).

BRACKEN, JOSEPH K. (1852-1904), sculptor. Joseph Bracken was born on 29 February 1852 at Templemore, Co. Tipperary. The baptismal record stated his name to be 'Joseph John'. A Fenian and one of

the co-founders of the Gaelic Athletic Association, Joseph Kyran ('J.K.') was the father (by his second wife) of Brendan Bracken, who became Winston Churchill's Minister of Information. He had inherited his father's stonecutting and monumental business which expanded as he moved into building and road contract work.

Bracken, who might also have been described as a stonemason, was responsible for the carving for the 1798 memorial at Clonmel, as well as for other memorials of an historical nature. In a letter dated 11 November 1902, he wrote to W. Murphy, one of the honorary secretaries of the ''98 Memorial Committee' in Clonmel: 'The model of the figures is ready. I will send it to you by the end of the week. We have been declared contractors for the Martyrs' Monument in County Clare: estimate £305; and also for a Public Monument for the County Meath: £500, within the past week.'

In her *Irish Public Sculpture: A History*,1998, Judith Hill wrote on the pikeman at Clonmel: 'Bracken seems to have taken the image of the aristocratic Lord Edward Fitzgerald rather than the generic pikeman at Liberty Square as his model, for the figure is dressed in waistcoat and cravat and his features resemble those of the young lord.'

In 1903, a report of the laying of the foundation stone for the Manchester Martyrs Irish limestone monument at Kilrush, Co. Clare, occupied almost two columns in the *Clare Journal*. A special steamer from Limerick brought the mayor of that city and others to the event. The report stated: 'The monument is to be erected on the Market Square, and will be the work of Messrs Bracken & Co., Templemore. The style is Hiberno-Romanesque as regards plinth and pedestal ... Surmounting the pedestal will stand the allegorical figure of Erin, conventional, no doubt, but done in a very spirited and effective way ... Crouching at the feet of this excellently modelled figure is the ever faithful wolf dog sentinel. On the lower panels the inscriptions are in Gaelic on two panels, and in French and English on the others. The upper panel contains the portraits of Allen, Larkin and O'Brien ...' Bracken is also credited with the Maid of Erin, the Manchester Martyrs' memorial in Tipperary town, as well as Celtic crosses and other tombstones.

'The curious can still inspect in Clonmel and elsewhere,' wrote Andrew Boyle in *Poor, Dear Brendan*, 'these products of the dying man's patriotism and rough artistry. They deserve to be better known for their blend of the plain and gently impressionistic.' But it was the realist who spoke in the last letter Joseph Bracken wrote to his patrons in Tipperary:

'I hope you and the other gentlemen are pleased with the Monument. I am deeply grateful for having been entrusted with the designing and working of your National Memorial, although in a pecuniary sense it was by no means a profitable transaction for me. I beg to enclose my bill and shall be much obliged for cheque, as I am leaving home for a change.' His bills, which included laying foundations and completing the lettering on the pedestal, came to £131.

In 1902, the Bracken family had moved from Templemore, where they had a quarry, to Kilmallock, Co. Limerick. 'J.K.' died there at Ardvullen on 2 May 1904.

Works signed: Bracken.
Examples: Clonmel, Co. Tipperary. Kilrush, Co. Clare. Tipperary town.
Literature: *Clare Journal*, 31 August 1903; Andrew Boyle, *Poor, Dear Brendan*, London 1974; Miss Molly Bracken, *Letter to the author*, 1978; Charles Edward Lysaght, *Brendan Bracken*, London 1979; Rev. William Noonan, P.P., *Letter to the author*, 1982; James McGuane, *Kilrush from Olden Times*, 1984; Judith Hill, *Irish Public Sculpture: A History*, Dublin 1998.

BRADY, CHARLES, HRHA (1926-97), still life and landscape painter. Born in Manhattan, New York, on 27 July 1926, the son of Arthur Brady, industrial hardware merchant, of Irish extraction, Charles received his art training at the Art Students' League, 1948-51, where his teachers included Reginald Marsh (1898-1954). He was one of the many young, aspiring artists who entered the Cedar Street Tavern to see the leading figures of abstract expressionism. He met Willem de Kooning there, and he became friendly with Franz Kline (1910-62), the 'daddy' of young painters like himself. In 1950 his work appeared in a group exhibition at the Metropolitan Museum of Art, New York.

When he finished art school, he worked for a year and a half as a guard at the Metropolitan Museum of Art, followed by a short spell in the US Navy. The Urban Gallery, New York, hosted in 1955 his first one-person show. In 1956 he travelled to Ireland and lived for a year in a cottage overlooking Lismore, Co. Waterford; his actress wife to be, Eelagh, came from the area. He returned to the United States in 1958. Back in Ireland in 1959 he married, and they then spent a year in Spain at Malaga. On returning to Ireland, he played a leading role in the founding of the Independent Artists group, and for the inaugural exhibition in 1960 at the Building Centre, Dublin, he was a member of the committee and showed four works: *Wicklow Landscape*; *Thinking of Ashbourne*; *Hill at Ballyduff; Rathfarnham*.

Brady's first Irish show was in 1964 at the Molesworth Gallery, Dublin. In the Babcock Gallery, New York, where his work had been seen in group presentations, he was one of three artists who exhibited there in 1967. As well as showing with Independent Artists, he also contributed to the Irish Exhibition of Living Art and also the Oireachtas. At IELA in 1966, he exhibited *The Sculptor's Table*. A member of the United Arts Club, he was active on the artists' group formed in 1969, and Patricia Boylan wrote in her history of the club: 'Charlie Brady was always an encouraging, discerning presence whose judgement of duds was witty and merciless.' He held a solo show there in 1972.

Brady's work did not appear at the Royal Hibernian Academy until 1969 and from then until the year of his death he showed a total of twenty-nine pictures. His first exhibit, *Ball of Blue Wool*, was despatched from 1 Royal Terrace West, Dun Laoghaire, Co. Dublin, premises he had converted into flats. He held a show at the Brown Thomas Gallery in 1970. Also in Dublin was his exhibition at the Davis Gallery in 1971, when the *Irish Times* stated that he had won himself 'a quiet but firmly based reputation...It is private rather than public painting, neatly marrying the most traditional and even trite subject matter to a thoroughly modern treatment...'

In an interview in 1972 with Harriet Cooke for the *Irish Times*, he remarked: 'As long as I paint every day, something is bound to happen...' Most observers, not least himself, were surprised when he won the Douglas Hyde Gold Medal in the 1973 Oireachtas with *Wolfe Tone's Military Hat Box*, after translation. In 1975 his pictures were at the Tom Caldwell Gallery, Dublin, and from 1976-83 he lectured in painting at the National College of Art and Design in Dublin. At the RHA in 1977 he exhibited *My New Wallet* (Arts Council, Dublin) and *Facecloth*. In 1979 he painted *The Wallet*, oil (Hugh Lane Municipal Gallery of Modern Art). In the period 1979-95 inclusive he staged eleven exhibitions at the Taylor Galleries, Dublin.

In 1981 at the RHA he contributed *Used herbal teabag* and *Box of salt*, both oils, but in 1983 his *Clothes Peg* was a lithograph. In 1983 he became a founder member of Aosdána. In his joint exhibition with Brian Ballard in 1984 at the Tom Caldwell Gallery in Belfast, his subject matter included an RHA rejection slip. However, in 1990 he was elected an honorary member of the Academy. Grant Fine Art, Newcastle, Co. Down, hosted in 1994 a joint exhibition with Edward Delaney, RHA. A TV documentary film *An American in Ireland* produced by Sean Ó Mórdha, was viewed in 1995 on RTÉ. He won again the Douglas Hyde Gold Medal in 1995. In a final Academy flourish in 1997, both oils being 25.4 cm x 33 cm, he offered: *Sliced pan with mould* and *Home-made Pistachio Ice-cream*. In her *Modern Art in Ireland*, 1997, Dorothy Walker wrote that he had hollowed a distinct groove in the Irish scene with his small-scale still lifes. She found his work often quite humorous 'like his small painted bronze sculptures of thrown-away bus tickets or other detritus'.

Throughout his life he had empathy with a wide range of people, and through correspondence he kept in touch with past friends in the Art Students' League. In his finesse as a painter, and the small scale of his work, Brady's style reminded some observers of the Italian, Giorgio Morandi (1890-1964), of whom it was said: 'More than most contemporary artists he went his own way and worked in isolation from current movements.' He died at St Vincent's Hospital on 1 August 1997.

Works signed: Brady or CB monogram, rare.
Examples: Athens: Irish Embassy. Beijing: Irish Embassy. Belfast: Arts Council of Northern Ireland; Ulster Museum. Churchill, Letterkenny, Co. Donegal: Glebe Gallery, Derek Hill's Collection. Cork: Crawford Municipal Art Gallery. Dublin: Arts Council; Hugh Lane Municipal Gallery of Modern Art. Enniskillen: Fermanagh County Museum. Kildare: County Council. London: Irish Embassy.

Literature: Brown Thomas, The Gallery, *Charles Brady Exhibition of paintings*, catalogue, Dublin 1970; *Irish Times*, 4 May 1971, 19 July 1972, 3 August 1972, 4 and 5 August 1997, 9 October 1997; *Irish Art 1943-73*, catalogue, Cork 1980; Tom Caldwell Gallery, *Brian Ballard, Charles Brady*, catalogue, Belfast 1984; Ann M. Stewart, *Royal Hibernian Academy of Arts: Index of Exhibitors 1826-1979*, Dublin 1985; *Royal Hibernian Academy of Arts 1980-1986, 1988-1997*, catalogues; Patricia Boylan, *All Cultivated People : A History of The United Arts Club, Dublin,* Gerrards Cross 1988; Aileen C. Connor, *Aosdána*, Dublin 1996; Taylor Galleries, *Letter to the author*, 1997; Dorothy Walker, *Modern Art in Ireland,* Dublin 1997 (also illustrations).

BRADY, R.N. (1901-73), portrait painter. Richard Noel Brady was born on 12 January 1901 and was a member of the Dublin medical profession. He received lessons in painting from his friend, George Collie (q.v.), and at the age of forty, painted the Lord Mayor of Dublin, Alderman P.S. Doyle. A portrait of Professor J.B. Butler is at University College, Dublin. He also portrayed Thomas Bouchier-Hayes, a surgeon in Mercer's Hospital, Dublin.

At the 1939 exhibition of the Royal Hibernian Academy, when he was living at 4 Tower Avenue, Rathgar, he exhibited *E. McCabe, Esq;* and in 1944, *John Gordon Hanna, Esq,* as well as a flowerpiece. He died in Dublin on 26 August 1973.

Works signed: R.N. Brady.
Examples: Dublin: Mansion House; University College (Earlsfort).
Literature: Miss Sheila Brady, *Letter to the author*, 1981.

BRAITHWAITE, CHARLES, ARHA (1876-1941), landscape painter and craftsman. Born in Lisburn, Co. Antrim, on 25 February 1876, he attended the Government School of Art, Belfast, and was awarded a scholarship to South Kensington where he studied under Professor W.R. Lethaby (1851-1931). His main areas of study were in the applied arts of illumination, jewellery and leatherwork, examples of which he later displayed in such centres as Paris, Berlin and Weimar. In 1907, he was the illuminator for an address presented to Sir Josslyn Gore-Booth, Bart. by Sligo United YMCA. A memorial board illuminated by Braithwaite in 1908 is in All Souls Non-Subscribing Presbyterian Church, Belfast.

In 1909, he entered Methodist College, Belfast, as a part-time drawing master and remained at the school until his death, by which time he had become head of the art department. Taking an active part in the affairs of the Belfast Art Society, he was one of its representatives on the Corporation's art advisory committee. Between 1912 and 1929, he showed twenty-one works at the Royal Hibernian Academy, becoming an ARHA in 1914.

At the RHA in 1929, he showed: *'Summer suns are glowing'* and *The Blue Hills of Antrim*. An issue of *La Revue Moderne* stated that he specialised 'particularly in the effects of the sun, clouds and transparencies of atmosphere and he is an excellent designer'. He was responsible for Methodist College's first war memorial, 1923, an example of his skills in lettering and Celtic ornament.

In later life, he tended not to participate in artistic activities outside of his scholastic duties. In the Ulster Museum are two bequeathed works: *The Village Street*, an oil painting, and an illumination of W.B. Yeats' poem, 'The Lake Isle of Innisfree'. He died on his birthday in 1941 at his home in Belfast, 165 Cliftonpark Avenue.

Works signed: C.B.
Examples: Belfast: All Souls Non-Subscribing Presbyterian Church; Methodist College; Ulster Museum.
Literature: *La Revue Moderne*, 15 October 1925; *Belfast News-Letter*, 16 March 1942; John Hewitt and Theo Snoddy, *Art in Ulster: 1*, Belfast 1977; Sligo Art Gallery, *The Illuminated Address 19th-20th Century*, catalogue, 1983; Ann M. Stewart, *Royal Hibernian Academy of Arts: Index of Exhibitors 1826-1979*, Dublin 1986; Paul Larmour, *Belfast: An Illustrated Architectural Guide*, Belfast 1987.

BRANDT, MURIEL, RHA (1909-81), portrait, mural and landscape painter. Born in Belfast on 16 January 1909, daughter of Hugh McKinley. She studied at the Belfast College of Art, winning a scholarship to the Royal College of Art, London, where she entered the mural decoration department. She was at the college

1934-7. In 1935, she had married Frank Brandt and their first child, Ruth (q.v.), was born a few months before Muriel took her final examinations for the ARCA diploma.

In 1938, she began a forty-year association with the Royal Hibernian Academy. During this time, she showed 145 works, with portraits at nearly all exhibitions. Meanwhile, her first major commission was for seven paintings at the Church of the Franciscan Friars, Merchants' Quay, Dublin, depicting scenes from the life and miracles of St Anthony. A sketch design in pencil is in the National Gallery of Ireland. The largest painting, about eleven square metres, formed the background for a wooden statue of the saint, although the painting was destroyed by fire a few months before the artist's death. At the Adam and Eve Church, also on hardboard panels, is one large painting of the death of St Francis, as well as a group of five paintings describing the efficacy of the Prayer of the Church for the Dead.

In 1943, she first exhibited with the Water Colour Society of Ireland and from then until 1980 contributed a total of forty-one works. In 1948, she showed: *Salmon Leap, Clady River, Co. Donegal* and *'Prizewinners'*.

In 1954, Stations of the Cross on canvas were erected at the Franciscan Friary, Rossnowlagh, Co. Donegal. At the Franciscan Friary in Athlone is a replica, with adaptations, of the San Damiano Crucifix. Completed in 1975 and standing just over two metres high, it is a fair copy, except that the Athlone friary and some famous friars of the community were added at the base. Muriel had discovered that the medieval tradition was for the artist to put in his or her own portrait on these crucifixes. Thus she not only signed 'Muriel Brandt' but also included her own head, just under Christ's left elbow, and looking over the left shoulder of the centurion. A number of the artist's letters at the friary show that she was very careless in dating her own correspondence, however. Other work is at the Church of the Holy Cross, Sacramento, California, at a church in Leeds, and in a Ballymun public house, *Seven Signatories*.

In 1948, Muriel Brandt had been appointed an associate of the RHA, and in 1961 she became a full member. Studies of children appeared often in these exhibitions, including *Master Sheridan Kenny* in 1943, when she also exhibited an etching, *Trees in Battersea Park*. She also exhibited at the Oireachtas and in 1953, *An Samhradh Samh* was purchased for the Crawford Municipal Art Gallery, Cork. In 1949, she had designed a postage stamp to commemorate the international recognition of the Republic of Ireland. She was an occasional contributor of drawings to *Dublin Opinion, Ireland of the Welcomes* and various newspapers.

In addition to her child studies, portraits of theatrical personalities were a part of her oeuvre. A group portrait of Micheál MacLiammóir, Hilton Edwards and Christine Longford is at the Gate Theatre, Dublin. Among her more formal portraiture is *Major-General W. Egan, Chief of Staff*, at McKee Barracks, Dublin. A 1954 self-portrait is in the National Self-Portrait Collection of Ireland, Limerick. *Portrait of George O'Brien* is at the National Gallery of Ireland. *Sun Hat*, oil, is in the Office of Public Works collection.

When the W.B. Yeats Centenary Exhibition was held at the National Gallery of Ireland in 1965, three drawings of his home at Thoor Ballylee were by Muriel Brandt: one chalk and wash; another black ink and watercolour; a third black ink and wash. In 1967, she won the Douglas Hyde Gold Medal at the Oireachtas for her historical painting, *Carrick Fergus*. In that year, *Kitten* and *Celbridge Abbey* were hung at the WCSI show.

During the 1972 Christmas holidays, she coached children in portrait painting at the NGI. In the period 1975-81, she was on the board of the National College of Art and Design. A fellow painter, James Nolan, RHA, wrote: 'She had an impish sense of humour coupled with a passionate concern for the arts and the environment ... She was a compulsive draughtsman and sketched like lightning, achieving in minutes those likenesses of her contemporaries ... ' A member of the United Arts Club, Dublin, and a governor of the National Gallery of Ireland, she lived for many years at Sutton, Co. Dublin, and died in Dublin on 10 June 1981.

Works signed: Muriel Brandt or M. Brandt, rare.
Examples: Armagh: County Museum. Athlone: Franciscan Friary. Cork: Crawford Municipal Art Gallery; University College. Drogheda: Library, Municipal Centre. Dublin: Adam and Eve Church; Arts Council; Gate Theatre; McKee Barracks; National Gallery of Ireland; National Museum of Ireland; Office of Public Works; Royal Dublin Society. Kilkenny: Art Gallery Society. Limerick: University, National Self-Portrait Collection. Rossnowlagh, Co. Donegal:

Franciscan Friary. Sacramento, California: Church of the Holy Cross. Termonfeckin, Co. Louth: An Grianán. Waterford: City Hall, Municipal Art Collection.

Literature: Donal O'Sullivan, *Irish Folk Music and Song*, Dublin, 1952 (illustrations); Department of Posts and Telegraphs, *Letter to the author*, 1968; Terence de Vere White, *Leinster*, London 1968 (illustrations); *Irish Times*, 28 December 1972; 11, 13 and 16 June 1981; *Who's Who, What's What and Where in Ireland,* Dublin 1973; Rev. Patrick Conlan, ofm, *Letters to the author*, 1982; National Gallery of Ireland, *Exhibition of Acquisitions 1981-82*, catalogue, Dublin 1982; Ann M. Stewart, *Royal Hibernian Academy of Arts: Index of Exhibitors 1826-1979*, Dublin 1986; John Turpin, *A School of Art in Dublin since the Eighteenth Century*, Dublin 1995; *Water Colour Society of Ireland Exhibition List 1872-1994*, Dublin 1995.

BRANDT, RUTH (1936-89), illustrator and etcher. Daughter of Frank Brandt, a designer in the Electricity Supply Board, she was born on 22 June 1936 in Dublin. Her mother was Muriel Brandt (q.v.). Ruth taught for short time in a Paris convent and later attended the National College of Art in Dublin where she studied painting and was awarded a three-year scholarship. Subsequently, she spent a year in Florence on an Italian government grant. At the Royal Hibernian Academy exhibition in 1958, she showed *At the Jazz-Band Ball*. Early in her career she also exhibited with the Irish Exhibition of Living Art, and in 1961 she showed *Head of a Woman*; *Girl*; and *Flowers* from an address at 7 Waterloo Road, Dublin.

In 1961 she married a Dublin artist, Michael Kane. During the summer months they augmented their income by giving classes for children. Ruth also did some part-time work in the College of Art. As a book illustrator, her work came to the fore with Sheelah Kirby's *The Yeats Country*, 1962, and John Irvine's *A Treasury of Irish Saints* in 1964, both published by the Dolmen Press for whom she also contributed title lettering and devices. Her drawings, after the manner of early woodcuts, were regarded as perfect accompaniments to Irvine's verses and the book on Irish saints proved popular, both the Irish and New York editions. She was responsible for the device for *Poetry Ireland*, 1962-8. The W.B. Yeats Centenary Exhibition, held in the National Gallery of Ireland in 1965, included ten black ink drawings on loan which featured five of the poet's London homes.

Freelance illustration and lettering as well as part-time teaching divided her career. She designed a decorative panel for St Michael's Church, Creeslough, Co. Donegal. At St Brigid's Church, Blanchardstown, Co. Dublin, is a plaque celebrating all the priests of the parish. In 1972, her husband founded the magazine, *Structure*; Ruth Brandt was among the illustrators for the first issue.

She rejoined Graphic Studio Dublin in 1973. She was a member from then until her death, producing dozens of etchings and taking a keen interest in the running of the associated gallery. In 1974, she exhibited at the Setanta Gallery in Dublin with her husband and Berenice Cleeve, as well as with her mother at the United Arts Club, Dublin. In 1975, she held two one-person shows, at the United Arts Club and the Kenny Art Gallery, Galway. Full-time teaching at the National College of Art and Design began in 1976. In that year, she exhibited solo at the Emmet Gallery, Dublin, and in 1978 at the Setanta Gallery.

In 1976, her work was seen in a group show in Nottingham and in the Creative Women exhibition in Belfast. She became a member of the Independent Artists group, Dublin. Because of a deep interest in Buddhism, she travelled to Scotland in 1979 where she attended a Buddhist retreat at Samye Ling, near Lockerbie. Her linear sculpture at the new Meteorological Service building at Glasnevin, Dublin, depicted an ancient Gaelic weather saying in the foyer. In 1981, with Barbara Warren and Anita Shelbourne, she exhibited at the United Arts Club, and in the Five Contemporary Irish Artists presentation at Tara Galerie, Zurich. Her work was also seen at the Listowel Graphics exhibition.

She held one-person shows at the Lincoln Gallery, Dublin, 1982, and at the James Gallery, Dalkey, Co. Dublin, 1985. She exhibited a watercolour, *Bell Rock*, *Avoca*, at the 1985 exhibition of Independent Artists. In the period 1984-8, she showed ten works at Water Colour Society of Ireland exhibitions. In 1986 at the RHA, she won the graphic prize, and three years later the watercolour prize. A stained glass piece is in the Artane Oratory, Dublin. Subjects for her painting and etching (she also worked in pastel) were largely domestic including her garden. She received various commercial commissions for her etching. *Begonias*, an etching, is at the Hugh Lane Municipal Gallery of Modern Art.

A colleague, Mary Farl Powers, wrote that Ruth Brandt was 'vibrant, colourful, stylish, and discriminating. She was also highly strung, and needed familiarity, continuity, and a sense of place to produce her art'. She retired as a lecturer at the National College of Art and Design in 1988 because of illness and died at her residence, Sherrard Avenue, Dublin, on 13 August 1989.

Works signed: R. Brandt (if signed at all).

Examples: Athens: Irish Embassy. Dublin: Artane Oratory; Arts Council; Hugh Lane Municipal Gallery of Modern Art; Mount Temple Comprehensive School; Meteorological Service, Glasnevin Hill; Voluntary Health Insurance Board. New Delhi: Irish Embassy. Ottawa: Irish Embassy. Rome: Irish Embassy.

Literature: Richard Murphy, *The Last Galway Hooker*, Dublin 1961 (illustrations); Constance Powell-Anderson, *Barren*, Dublin 1962 (illustration, dust cover); Austin Clarke, *Forget-me-not*, Dublin 1962 (illustration); Sheelah Kirby, *The Yeats Country*, Dublin 1962 (illustrations); John Irvine, *A Treasury of Irish Saints*, Dublin 1964 (illustrations); Austin Clarke, *The Bright Temptation*, Dublin 1965 (illustration); National Gallery of Ireland, *W.B. Yeats: A Centenary Exhibition*, catalogue, 1965; *Irish Times*, 1 January 1971, 14 August 1989, 27 September 1989; *Irish Press*, 31 March 1971; Liam Miller, *Dolmen XXV*, Dublin 1976 (also illustration; and reproductions from other books); Mary Hanley and Liam Miller, *Thoor Ballylee: home of William Butler Yeats*, Dublin 1977 (illustration); *Oibre*, 14 June 1980; Henry Sharpe, *Michael Kane: His Life and Art*, Dublin 1983; *Irish Arts Review*, Autumn 1986; Graphic Studio Dublin Gallery, *Ruth Brandt Biographical Notes* and *Letters to the author*, 1989; *Water Colour Society of Ireland Exhibition List 1872-1994*, Dublin 1995.

BRENAN, JAMES,RHA(1837-1907), figure and landscape painter. Born in Dublin in 1837, he is not to be confused with the Cork portrait painter, James Butler Brenan, RHA (1825-89). In 1852 he won the prize medal at the Government School of Design, Royal Dublin Society; he also attended the Royal Hibernian Academy Schools.

If the year of birth generally given for Brenan is correct, then at the age of fourteen or thereabouts he was in London studying decorative art under Owen Jones (1809-74) and Sir Matthew Digby Wyatt (1820-77), assisting them in the decoration of the Pompeian and Roman Courts of the Crystal Palace. Wyatt was one of the English family of artists, an artistic dynasty; in 1844 he had travelled to the Continent, spending two years making nearly a thousand ink and watercolour drawings of monuments.

Brenan won the Department of Science and Art's 1853 students' prize medal. Returning to Ireland, he worked for a time in the Royal Dublin Society School of Art. In 1855 he was admitted to the National Art Training School in Marlborough House, London, where he completed his art education. In 1857 he became an assistant at Birmingham School of Art; but the following year he returned to the Training School, which had moved to South Kensington, and then for a month or two at a time he took charge at the Liverpool, Taunton and Yarmouth schools.

In 1860 Brenan became headmaster of the Cork School of Art, after a succession of 'short-lived and occasionally disastrous appointments.' His profile as an artist came to the fore in 1861 with work at the Royal Hibernian Academy, giving the School of Art as his address. He contributed to the Dublin exhibition until 1906, and more than 100 of his works were presented.

At the RHA in 1863 he exhibited *'Bad News'* with *The Prayer of the Penitent* (Crawford Municipal Art Gallery). The 1868 exhibition titles indicated a visit to Scotland. At the annual exhibition of students' work at the Cork School of Art in 1872, he was presented with an illuminated address and 'a costly set of knives and forks.' In 1876 he was elected an associate of the RHA, and in 1878 a full member. According to Walter G. Strickland, by his 'commonsense, shrewdness and tact, became one of the Academy's most useful and influential members.'

Cottage interiors were among his contributions to the RHA in four exhibitions, 1876-9. A review of the 1882 exhibition in the *Freeman's Journal* gave particular attention to *The Village Scribe* and *Left Behind*, both depicting the interiors of Irish cottages, and were described by the *Cork Examiner* as 'faithful views of the homes of the peasantry.'

For his landscape painting, he travelled to Co. Donegal, the river Blackwater near Kenmare, Co. Kerry, and to Ballycotton, Co. Cork. Judging by titles, each of the five works at the Royal Scottish Academy 1881-5 inclusive were genre works, for example: 1882, *The spinning lesson*: 1884, *Watching and waiting*. His

address was now Buxton Hill, Sunday's Well, Cork. He was in charge of the fine art section of the Cork Exhibition of 1883.

With his knowledge of the Great Exhibition of 1851 and its association of art and industry, Brenan set out to revive the lace industry. In 1884 he supervised the setting up of art and design classes initially in the convents of Kenmare, Killarney and Kinsale. By means of a grant from the Cork Exhibition committee, supplemented by one from the Department of Science and Art, a collection of old lace was purchased for use as examples for classes.

In 1889 he was appointed headmaster of the Dublin Metropolitan School of Art. In the next year he established a lace class. By 1893 he resided at 8 Palmerston Road, Rathmines, Dublin. Day and evening classes in design were on a firm foundation by 1897. From time to time he to returned to South Kensington to inspect the results of the National Competition. To compare the school with its European counterparts, Brenan, the art educationalist, and Valentine Ball of Dublin visited Hamburg, Stockholm, Berlin and Vienna in 1894.

Brenan did not exhibit at the Royal Academy but showed a few pictures at the Walker Art Gallery, Liverpool. There are three other oil paintings in the Crawford Municipal Art Gallery collection: *News from America*, 1875; *A Committee of Inspection*, 1877; *Patchwork*, 1891.

Strickland wrote that Brenan's 'personal qualities, his kindness of heart and upright character, made him popular not only with his pupils but with all who knew him.' Following retirement in 1904, friends and pupils presented him with an illuminated address and a purse of sovereigns. The four roundels on the cover of the address represented Painting, Sculpture, Design and Handicraft, reflecting Brenan's interests. He died at his residence, 140 Leinster Road, Rathmines, on 7 August 1907.

Works signed: J. B. or monogram.
Examples: Cork: Crawford Municipal Art Gallery.
Literature: Walter G. Strickland, *A Dictionary of Irish Artists*, Dublin 1913; *Dictionary of British Artists 1880-1940*, Woodbridge 1976; Ann M. Stewart, *Royal Hibernian Academy of Arts: Index of Exhibitors 1826-1979*, Dublin 1986; Peter Murray, compiler, *Illustrated Summary Catalogue of The Crawford Municipal Art Gallery,* Cork 1991 (also illustrations); *The Royal Scottish Academy Exhibitors 1826-1990*, Calne 1991; John Turpin, *A School of Art in Dublin since the Eighteenth Century,* Dublin 1995; *The Dictionary of Art,* London 1996.

BRENNAN, PETER J. (1916-95), sculptor. Peter Joseph Brennan was born on 4 December 1916 at Sandycove, Co. Dublin, the son of Joseph Brennan, a bricklayer who worked for Peter's grandfather, Weaver's house designing and building business. After attending Presentation College, Bray, Co. Wicklow, he enrolled at the Dublin Metropolitan School of Art and in 1936 won the Taylor Scholarship for modelling. When Friedrich Herkner (q.v.) arrived in 1938 at the National College of Art to take up his appointment, he found that the classes in sculpture were being maintained by two Oliver Sheppard (q.v.) senior students Peter Brennan and Peter Grant, as part-time instructors. Herkner in due course asked Brennan to cast his first head executed in Ireland, which followed a tradition in the Viennese academy whereby leading students did such work.

Brennan executed a number of heads whilst still a student, including one of Steve O'Hanlon, an attendant at the college. In 1938 he exhibited at the Royal Hibernian Academy for the first time, giving the National College of Art as his address, showing *Peter Redmond, Esq.* and *'Steve'*. A portrait of Miss Nora Kearney in 1940 was in limestone. In 1941 he won the Taylor Scholarship for a second time, again for modelling, and that year he obtained a post to teach art on a time share basis between Kilkenny and Carlow Technical Schools. According to John Turpin in his history of the School of Art in Dublin: 'This marked the beginnings of special art and design activity at Kilkenny, a forerunner of the later establishment of Kilkenny Design Workshops.'

Altogether, Brennan provided thirteen works for the RHA, concluding in 1943 with *Jane* and in alabaster, *Deidre*, the latter drawing special mention by Albert Power (q.v.) in his review in *The Bell*. Brennan's contributions in 1942 were a fountain piece and *Kasperle*. At the inaugural show of the Irish Exhibition of

Living Art in 1943 he contributed the sculpture, *Judas*. In the three years 1943-5 he exhibited nine works at the Water Colour Society of Ireland gatherings, including four Carraroe studies.

In Kilkenny, he found that there was an interest in the arts, but little to satisfy it. He arranged a visiting exhibition by painters from the RHA, and this encouraged the Kilkenny Art Gallery Society, founded in 1943, to purchase pictures for a permanent collection. The founder of the Society, George Pennefather (q.v.), left the city in 1946 and Brennan then took a leading part in caring for the collection.

Brennan could not see a living for his students in the fine art world, so he decided to broaden his teaching to include pottery. He saw an advertisement for a pottery wheel, kiln and accessories for £100 and this was bought by the Kilkenny Vocational Education Committee. As well, he now concentrated his own interests on making pottery and for a time worked at the Carrigaline pottery in Co. Cork, making a limited range of sculptures. He also arranged for some of his students to receive tuition in pottery throwing at Carrigaline.

In 1950 he opened the Ring Ceramic Studios in Kilkenny with the Dublin dealer, Victor Waddington. At first, he worked for half a week at 'the Ring' but as it developed he gave up his teaching job and devoted himself fulltime to the making of pottery. He was joined by another former NCA student, John ffrench, who had been studying and working in ceramics in Italy. During these years Brennan did not do any sculpture. He visited Bernard Leach (1887-1979), the leading British studio potter, at St Ives, Cornwall, staying for ten days, but declined Leach's offer of an apprenticeship in view of his Irish commitments.

In 1954 Victor Waddington Galleries in Dublin held a ceramics exhibition by 'Pouchal (France), Gamboni (Italy), Peter Brennan and John ffrench (Ireland)'. Herkner at the College of Art was assisted in his ceramic classes by Brennan who was responsible for introducing the concept of studio pottery. Dun Laoghaire VEC set up a pottery class in Blackrock with Brennan and ffrench as teachers. The two potters made a short film, 'Clay Play', and this was shown to prospective students.

In 1963 he joined the National College of Art staff and taught sculpture and pottery, establishing the ceramics department when the design school was inaugurated in 1971. In 1965 he had married Helena Ennis (daughter of Helen Yates, q.v.) who had been a student at NCA. They set up a pottery studio at their home, 37 Northumberland Avenue, Dun Laoghaire, Co. Dublin, and in 1968 they visited the Congress of World Crafts in Peru and showed work. The business became a full-time occupation when he retired from the National College of Art and Design in 1982. He died on 15 July 1995, having swum a length at his beloved Dun Laoghaire Baths.

Works signed: P. J. B., sculpture.
Literature: *Royal Dublin Society Report of the Council 1936, 1941*; *The Bell*, June 1943; *Ireland of the Welcomes*, November-December 1954; Little Theatre, Brown Thomas, *Peter and Helena Brennan: Exhibition of handthrown stoneware*, catalogue, Dublin 1969; Ann M. Stewart, *Royal Hibernian Academy of Arts: Index of Exhibitors 1826-1979*, Dublin 1986; S. B. Kennedy, *Irish Art & Modernism 1880-1950*, Belfast 1991; John Turpin, *A School of Art in Dublin since the Eighteenth Century*, Dublin 1995 (also illustration); *Water Colour Society of Ireland Exhibition List 1872-1994*, Dublin 1995; Helena Brennan, *Letter to the author*, 1997; also, John ffrench, 1997; Kilkenny Art Gallery Society, 1997.

BREWSTER, GORDON (1889-1946), cartoonist. Born 26 September 1889, Gordon W. Brewster attended the Dublin Metropolitan School of Art and was a member of a family which had close associations with Independent Newspapers. His father, W.T. Brewster, was general manager, while his brother, T. Brewster, was manager of the Cork office. Gordon joined the company as an artist in 1906.

In 1916, he exhibited *The Tavern Fire* and *The Wayfarer* at the Royal Hibernian Academy. *The Dead Rebel* was part of the 1917 exhibition. He contributed to the *Irish Cyclist and Motor Cyclist* in 1918. His drawings, frequently on money matters, appeared in the Independent Group's newspapers for many years. The cartoons for the *Sunday Independent* feature were titled 'This, that and the other'. His services were also in demand by commercial firms. A series of newspaper cartoons is in the National Library of Ireland, along with cover illustrations for religious booklets. His home was at Sutton, Co. Dublin, when he died on 16 June 1946.

Works signed: Gordon Brewster or Brewster.

Examples: Dublin: Hugh Lane Municipal Gallery of Modern Art; National Library of Ireland.
Literature: *Irish Cyclist and Motor Cyclist*, 22 May 1918 (illustrations); *Irish Independent*, 17 June 1946; Independent Newspapers, Ltd, *Letter to the author*, 1981.

BRIDLE, KATHLEEN, RUA (1897-1989), landscape painter. Daughter of a coastguard officer, Lieutanant James Bridle, who was reared in Ireland, Kathleen Mabel Bridle was born at Swalecliff, Kent, on 19 November 1897 and spent her childhood at various coastguard stations. She lived for about a year at Holyhead, Wales, in her father's last coastguard station. 'I never went to school for any length of time,' she recalled. 'The only thing I really liked doing was drawing.' As she had relatives living in Dublin, in 1915 she enrolled at the Metropolitan School of Art. There she won two silver medals and, from the Royal Dublin Society, the Taylor Scholarship in her final year, 1921. Under her tutor, George Atkinson (q.v.), she showed a natural ability in the watercolour medium. One of her medals was for modelling under Oliver Sheppard (q.v.).

At the Arts and Crafts Society of Ireland's exhibition at the School of Art in 1921, she showed enamel plaques. *The Mermaid* was awarded first prize for enamels at the 1924 Aonach Tailteann. She continued her studies from 1921-5 at the Royal College of Art, London, where she became friendly with the sculptor, Henry Moore (1898-1986). She was awarded a continuation scholarship and the George Clausen Prize for portraiture. Thomas Derrick (1885-1954) taught her most about painting during her time in London. After a period of part-time teaching in England, she returned to Dublin in 1925 to work for six months in the stained glass studio of J. Clarke & Sons.

She resumed her teaching career in Fermanagh in 1926, joining the staff of Enniskillen Technical School. She taught part-time at Portora Royal School, the Convent Grammar School, Mount Lourdes, and the Collegiate School. In 1955 she became a full-time member of the Collegiate School staff where she taught until her retirement. At the school are two portraits by her of former principals.

Between 1921 and 1939, she exhibited more than thirty works at the Royal Hibernian Academy, including portraits of Miss Kitty Curling and G.B. Phibbs in 1926; in 1927 of J.F. Hunter (q.v.) and her grandmother. An exhibition at the Town Hall, Enniskillen, in 1928 was said to be the first ever held by an artist in Co. Fermanagh. In that year, she also exhibited at Holyhead. She visited Nice in 1930 with Norah McGuinness (q.v.), a friend from art college days, and showed again in Enniskillen. The Irish Exhibition of Living Art and the Oireachtas both presented her work in Dublin. In 1934, she was represented in the Ulster Unit exhibition in Belfast. In 1935, she was appointed an associate of the Ulster Academy of Arts. She held her first one-person show in the city in 1936 at Magee's Gallery where her works included *The Child in the Bath* and *A Girl Sewing*. In 1947, she showed forty watercolours at 55a Donegall Place, Belfast.

Lough Erne from Rossfad, watercolour, dated 1945, is in the Ulster Museum. Fermanagh County Museum's five works include an oil, *Hydrangeas*, 1936. A portrait of Bridle by T.P. Flanagan is at the museum. The Belfast Museum and Art Gallery gave her a one-person show in 1950 where she exhibited twenty-eight watercolours and four oils. John Hewitt described her in the catalogue's foreword as one of the foremost exponents of watercolour with '... very special qualities: economy of means, directness, spontaneity ...'. At Stranmillis, she was one of the artists included in the Festival 1951 exhibition, Contemporary Ulster Art. At the Royal Ulster Academy that year, she showed three Italian scenes; but she also painted in Austria, France, French Guiana, Greece, New Zealand, Switzerland and Wales, accompanied by friends.

In 1953, she was one of the Irish artists represented in the exhibition of watercolours arranged in Belfast by the Council for the Encouragement of Music and the Arts. In 1958, she held an exhibition at the Piccolo Gallery, Belfast. In 1962, she was made an honorary academician of the RUA, and in 1963, she showed again at the Town Hall, Enniskillen. In 1968, she exhibited solo at the Queen's University staff common room. She taught T.P. Flanagan and William Scott (q.v.) and in 1973, under the auspices of the Arts Council of Northern Ireland, a 'teacher and two pupils' exhibition of watercolours was presented in Belfast and subsequently at Enniskillen Collegiate School. She continued to sketch and paint right into her nineties.

Bridle taught William Scott while he was still attending Enniskillen Model School and special arrangements were made for him to have lessons at the Technical School, 1926-28. Scott said of his teacher:

'Her teaching influence on me was profound... We learn from her work a new way of looking, the familiar is transformed and she invites us to share a new vision.'

In association with Denise Ferran, she showed Fermanagh landscapes at Fermanagh County Museum in 1978. An exhibition of her paintings since 1930 was held at the Ardhowen Centre, Enniskillen, in 1986. An ACNI funded film on her work, 'Reminiscence by Kathleen Bridle,' directed by David Hammond, interviewer T. P. Flanagan, was completed in 1989. She died in a nursing home on 25 May 1989. A retrospective exhibition took place at Fermanagh County Museum in 1998, followed by the Ulster Museum; and Armagh County Museum in 1999.

Works signed: Kathleen Bridle or K. Bridle, rare (if signed at all).
Examples: Belfast: Arts Council of Northern Ireland; Education and Library Board; St Mary's College; Ulster Museum. Enniskillen, Co. Fermanagh: Collegiate Grammar School; Convent of Mercy; Erne Hospital; Fermanagh County Museum; Library; Mount Lourdes Grammar School; St Fanchea's Secondary School; Technical School; Town Hall.
Literature: *The Studio,* December 1921 (also illustration), October 1924; *Belfast News-Letter,* 2 July 1936, 26 May 1989; *C.E.M.A. Annual Report 1944-45,* Belfast 1945; Belfast Museum and Art Gallery, *Kathleen Bridle,* catalogue, 1950; *Northern Whig,* 3 November 1953; *Belfast Telegraph,* 25 October 1968; Arts Council of Northern Ireland, *Kathleen Bridle, William Scott, T.P. Flanagan,* catalogue, 1973; John Hewitt and Theo Snoddy, *Art in Ulster: 1,* Belfast 1977; *Impartial Reporter,* 31 October 1985, 1 June 1989; Fermanagh District Council, *Kathleen Bridle: Paintings since 1930,* catalogue, Enniskillen 1986; Ann M. Stewart, *Royal Hibernian Academy of Arts: Index of Exhibitors 1826-1979,* Dublin 1986; Collegiate Grammar School, *Letter to the author,* 1989; Fermanagh County Museum, *Letter to the author,* 1989; Ms Carole Durix, *Letters to the author,* 1989, 1990; Convent of Mercy, Enniskillen, *Letter to the author,* 1990; Carole Froude-Durix, *The Life and Art of Kathleen Bridle,* Dublin 1998 (also illustrations).

BRINE, SALLY– see de MONTFORT, SALLY

BROE, DESMOND (1921-68), sculptor. Son of Leo Broe (q.v.) and brother of Irene Broe, (q.v.). Desmond and his brother took over the business founded by their father at 94 Harold's Cross Road, Dublin. When studying at the National College of Art, he won the Taylor Scholarship for modelling in 1943. In 1948, at the Olympic Games art exhibition in London, he was awarded a bronze medal for *Over the Obstacle.*

In his book, *Stone Mad,* 1950, Seamus Murphy (q.v.) listed Desmond Broe among the figure carvers. Closely associated with the founding of the Institute of the Sculptors of Ireland, Broe exhibited at all their annual exhibitions, 1953-7, and at the international exhibition in 1959 when he was honorary treasurer. In the Institute's inaugural he showed works in bronze, limestone and red sandstone, including a bust, *Alderman Senator Andrew S. Clarkin, Lord Mayor of Dublin.* In 1956 he also exhibited a bust, *Lt.-Gen. Sean MacEoin, TD.*

In 1958, the *Dublin Magazine* referred to Broe's *Killarney Rock'n'Roll,* exhibited at the Institute the previous year, as a 'most moving and impressive work, with its suggestion of some chthonic god of prehistory, part woman and part animal ... Whether or not this astonishing creation was really inspired by "rock-an'-rolling", it is clear that its plastic implications go far beyond its nominal subject'. This work was displayed at the Cork Sculpture Park, 1969.

Broe had first exhibited at the Royal Hibernian Academy in 1946 and showed a total of twenty-five works over the years. *Malachi Horan* (Dublin Civic Museum) appeared in 1947; *Brendan Behan* in 1954; and *Peta Cunningham* in 1955. A head of Professor Thomas T. O'Farrell is at St Vincent's Hospital, Dublin. A head of Maurice Elliman, a plaque which once hung in the Metropole Cinema, Dublin, is in the Irish Jewish Museum.

Much of the artist's time was spent in working on public monuments; there are IRA memorials at Athlone, Banagher, Longford and Rathvilly. Brow carved the monument at Naas to Jack Higgins of the GAA; the Lourdes memorial at Kildysart, Co. Clare; the Parnell relief at Creggs, Co. Roscommon; and *The Fifteen Mysteries of the Rosary,* designed by Soirle M. MacCana (q.v.) at Lee Road, Cork. His final contribution to the RHA was '*Whistling Boy*' in 1964.

When he died on 16 September 1968, he was working at the Curragh on a 4-metre-high monument to St Brigid. His home was at Belgrave Road, Rathmines, Dublin. Irene Broe exhibited a head of her brother at the 1969 RHA. A selection of his work was assembled at an Independent Artists' exhibition at the Project Arts Centre, Dublin 1975.

Works signed: Desmond Broe.
Examples: Cork: Lee Road; Public Museum. Dublin: Civic Museum; Irish Jewish Museum; Mansion House; St Vincent's Hospital. Naas.
Literature: *Dublin Magazine*, January-March 1958; Mrs Patricia Reid Broe, *Letters to the author*, 1975, 1982; Ann M. Stewart, *Royal Hibernian Academy of Arts: Index of Exhibitors 1826-1979*, Dublin 1986.

BROE, IRENE (1923-92), sculptor. Born at Nassau Street, Dublin, on 19 February 1923, she was the daughter of Leo Broe (q.v.). Although born into a family of sculptors, her first career choice was otherwise. However, encouraged by the family she entered the National College of Art in 1947, her brother, Desmond Broe (q.v.) having already studied there. According to Professor Friedrich Herkner (q.v.) she was a very serious student and made 'numerous studies from life and imagination and carried out her works in various materials. She was a very ambitious and conscientious student and attended all classes very regularly.' She took her diploma in 1951.

R. M. Fox has recounted her setting to work in a tenement studio, at least for a few years, in the York Street area of the city: 'This was really a cellar that one reached through the crumbling passages and decayed brickwork of a dilapidated building. It was bitterly cold, for the heating facilities were to be so primitive as to be almost non-existent…Always I felt it an eerie sensation to go down the dark passage, push a rotting wooden door and see, gleaming at me from shelves around the cellar, the heads of figures at which she had worked…'

In 1952 she visited Paris. On her return to Dublin she became a member of the first council of the Institute of the Sculptors of Ireland, and participated in their annual exhibitions 1953-7 inclusive, also in the international exhibition in 1959 at the Municipal Gallery of Modern Art. For the inaugural exhibition she gave the address of the family firm, 94 Harold's Cross Road, and showed three pieces: *Leo Broe*; *The Winner*; and *Uda*. Three of the four exhibits in 1954 were portraits, with *Siesta*. In 1955 she showed *Urania*. In 1956, from 30 Lower Kimmage Road, Terenure, Dublin, she contributed a portrait of Michael P. Sullivan; also, *L'Amorata*, plaster, and *Ave Maria,* relief panel. Exhibits in 1957 from 19a Pembroke Road included *Motherhood*, and in 1959, a plaster for bronze, *Fishes*.

At the Royal Hibernian Academy, in the period 1953-92, she exhibited a total of twenty-nine works. *The Thoughtful One* and *The Hypnotist* at the 1955 exhibition inspired Fox : 'a dream-like idealistic face' on the former, and 'a head and face of vibrant intensity, of almost electrical energy, modelled from life.' Her first ecclesiastical work came in 1956, a bronze plaque with the figure of Our Lady in the centre, with St Joseph on one side representing Industry, and St Christopher on the other for Travel and Exploration. *Madonna of May Day* was destined for the Adam and Eve Church, Dublin. *Bird 1*, *Bird 2* and *Organic Form* were all executed 1957-8. She was not, however, entirely satisfied with her work.

In 1958-9 she lived in London for periods, and in 1959 she showed *Pierre* at the RHA, listing 28 Cranley Gardens, South Kensington, as her address, accommodation which was shared with fellow sculptors Hilary Heron and Frank Morris (qq.v.) She also met in London sculptors F. E. McWilliam (q.v.) and Lynn Chadwick. Jim McDonnell, a research biochemist from Dublin who had moved to work in London in 1959, married Irene Broe that year and within a few months they flew to Malaysia where he was employed by the Malaysian Rubber Research Institute.

In her seven years in Malaysia she was a regular participant in the National Art Gallery's annual exhibition in Kuala Lumpur. At least fourteen works were executed in the years 1960-4 inclusive. The figure, *St Clare*, for Adam and Eve Church, Dublin, was shipped in 1961 for casting; the plaster found its way to the Exhibition of Irish Sacred Art in Dublin, 1962. The National Union of Plantation Workers gave the Irish artist her most important commission: a head of the first Prime Minister of Malaysia, Tenku Abdul Rahman, which had a

place of honour in the Malaysian pavilion at the 1964 New York World's Fair and is now in the House of Parliament, Kuala Lumpur.

The National Art Gallery purchased *Plunder Bird,* cement and metal, at their 1963 exhibition, which also included the head of the Prime Minister. At that gathering she showed two oils, *Storm Bird* and *Wild Bird,* but she also painted other works as a form of relaxation from sculpting. A head of a girl is also in the National Art Gallery collection. In 1964 she was responsible for a head of Ralph Deraniyagala, Speaker, House of Representatives, Sri Lanka, and *St John Baptist de la Salle,* bronze, for St John's Institution, Kuala Lumpur.

In 1966 she returned to Ireland, taking up residence at 68 Carysfort Avenue, Blackrock, Co. Dublin, and showing a bust of Roger Casement at the RHA. A head of Donogh O'Malley, Minister for Education, was completed in 1968, a few days before his death. Eight bronze castings were made from the original, and presumably it was one of these which appeared at the Contemporary Irish Artists exhibition at Cork Sculpture Park in 1969; also there is representation of O'Malley at Trinity College, Dublin; National University of Ireland, Galway; and University of Limerick. At the 1970 RHA she showed a bronze bust of Brendan Behan.

A portrait head of author Patricia Lynch appeared at the 1971 Dun Laoghaire Arts Week exhibition, and a head of James Le Jeune (q.v.) in a group show at the United Arts Club, Dublin, in 1972. A 1978 bust, 34.5 cms. high, of Arland Ussher is in the National Gallery of Ireland. There is also a 1980 bronze bust of Ussher at Trinity College, Dublin, but this one has a hand!

Altogether, she executed more than ninety pieces. A figure, *St Valentine,* is in Our Lady of Mount Carmel Church, Aungier Street. Later works at the RHA were: *Gina,* in 1986; *Portrait of Samuel Beckett,* 1988; *Simon* and *Lived in Time,* 1991; *Shane,* 1992. Irene Broe died at St Vincent's Hospital, Dublin, on 27 August 1992. Her son, Shane McDonnell (q.v.), lost his life in a car accident in 1994.

Works signed: Irene Broe or I. Broe (if signed at all).
Examples: Dublin: Adam and Eve Church; National Gallery of Ireland; Office of Public Works; Our Lady of Mount Carmel Church, Aungier Street; Trinity College. Galway: National University of Ireland. Kuala Lumpur, Malaysia: House of Parliament; St John's Institution. Limerick: University.
Literature: *Dublin Evening Mail,* 4 August 1950, R. M. Fox, 'Irene Broe: Sculptor of Ireland,' *Assisi,* May 1956; Prof. F. Herkner, National College of Art, *Irene Broe Reference,* 1959; National Art Gallery, *Sixth National Art Exhibition,* catalogue, Kuala Lumpur 1963; *Irish Independent,* 10 March 1969, 23 August 1971; *Irish Times,* 7 September 1972, 28 August 1992; Ann M. Stewart, *Royal Hibernian Academy of Arts: Index of Exhibitors 1826-1979,* Dublin 1986; *Royal Hibernian Academy of Arts 1980-1986, 1988-1992,* catalogues; National Gallery of Ireland, *Acquisitions 1986-88,* catalogue, Dublin 1988 (also illustration); Anne Crookshank and David Webb, *Paintings and Sculptures in Trinity College Dublin,* Dublin 1990; Jim McDonnell, *Letters to the author,* 1997, 1998.

BROE, LEO (1899-1966), sculptor. Born Stillorgan, Co. Dublin, he was baptised Bernard Joseph on 16 April 1899, the son of a stonecarver, Bernard Broe (1876-1918). According to family tradition, his mother, who died very young and had a great devotion to Pope Leo, insisted on her death-bed that he be called Leo. The father of Desmond Broe and Irene Broe (qq.v.), he studied under Oliver Sheppard (q.v.) at the Dublin Metropolitan School of Art. He was the owner of the firm, Leo Broe and Sons, sculptors, which operated from 94 Harold's Cross Road, Dublin.

In his book *Stone Mad,* 1950, Seamus Murphy (q.v.) listed him among the names of figure carvers. Much of Broe's time was taken up with ecclesiastical work for Dublin churches, along with IRA memorials in provincial districts.

In the early 1950s Broe carved the Bruff memorial. According to Judith Hill in her *Irish Public Sculpture: A History,* 1998, the Volunteer was depicted 'in a belted trench coat and gaiters, carrying a revolver and wearing a cap with the peak turned to the back. Standing with one leg resting on a rock he points purposefully northwards. Broe based his carving (executed in Portland stone) on a photograph of the building contractor for the project, who had dressed in the uniform and taken up the required pose...'

He exhibited in all the annual exhibitions of the Institute of the Sculptors of Ireland, 1953-57, and in the international exhibition at the Dublin Municipal Gallery of Modern Art in 1959, when he was the Institute's president. *Countess Markievicz* in limestone was exhibited in 1953 and is now in Kilmainham Jail Historical

Museum. He was said to be a personal friend of the Countess. Commissions for the Newfoundland government were also included in the Institute's exhibitions: in 1957, *Dr William Carson*, physician and reformer; 1959, *Charles Fox Bennett*, both bronze busts.

Dublin Magazine described *The Kiss*, shown in 1957 at the Institute, in Portland stone as an 'original and dramatic conception'. A head of Broe by his daughter, Irene Broe, appeared in the 1953 exhibition. *Patrick Pearse*, a marble bas relief of 1932, from the Dublin Municipal Gallery of Modern Art, was included in the Golden Jubilee of the Easter Rising exhibition at the National Gallery of Ireland, 1966.

Other sculptures of IRA Volunteers may be found at Emly, Co. Tipperary; Cavan town; Thomastown, Co. Kilkenny; Pettigoe, Co. Donegal; and in Dublin at Phibsboro' Bridge. Figures of Our Lady are at the Oblate Church, Inchicore; Priory Road, Harold's Cross; and at Drumcondra Bridge. *St Augustine* is at John's Lane Church; *St Francis and St Clare* is at Church Street Church. *Madonna and Child*, a carving, is at Adam and Eve Church, Dublin.

Works signed: Leo Broe.
Examples: Dublin: Adam and Eve Church; Augustinian Friary Church, John Street; Franciscan Capuchin Friary, Church Street; Hugh Lane Municipal Gallery of Modern Art; Kilmainham Jail Historical Museum. St John's, Newfoundland: Confederation Building.
Literature: Registry Office, Dublin, *Register of Deaths 1918*; *Dublin Evening Mail*, 4 August 1950; *Dublin Magazine*, January-March 1955; Mrs Patricia Reid Broe, *Letters to the author*, 1975, 1982; P.J. McNicholas, *Letter to the author*, 1988; also, Jim McDonnell, 1998; Judith Hill, *Irish Public Sculpture: A History*, Dublin 1998.

BROPHY, N.A. (fl. 1860-1911), landscape artist. Nicholas A. Brophy trained at South Kensington and was headmaster of the Limerick School of Art from 1860 until his retirement in 1911. In that year, one of his most promising pupils, Sean Keating (q.v.), transferred under scholarship to the Dublin Metropolitan School of Art. Prior to taking up the headmastership, Brophy's brother, J.J. Brophy, emigrated to Australia. Another brother, H.F. Brophy, a Fenian, was transported there in 1867. They were the sons of Thomas Brophy, a Dublin builder.

During his stay in Limerick, he also gave instruction in art at the Crescent College. Brophy exhibited at the Royal Hibernian Academy in the period 1865-83; of fourteen works in all, at least five were executed in the Glengarriff area. Others included *View on the Dodder, near Rathgar* and a Scottish evening scene, of the area near Arrochar.

In an article entitled 'Technical Instruction in Limerick', which appeared in 1912, the principal of the Municipal Technical Institute, Limerick, J. Comerton, wrote in the Department's *Journal*: 'For several decades the control of the School of Art remained rested in the capable hands of Mr N.A. Brophy, ARCA, who, with practically no assistance from public or corporate funds, succeeded in maintaining a lively interest in Art for its own sake amongst successive generations of the people of Limerick ... His name is synonymous with Art and artistic culture in Limerick; and what he accomplished in the face of innumerable difficulties, towards the cultivation of the artistic sense amongst all who had the pleasure of working under him, will not soon be forgotten.'

Four of Brophy's watercolours were known to be in private possession in 1982. These included a panoramic view, dated 1903, of old Limerick, taking in King John's Castle, the County Courthouse and the river; St Munchin's Church and Thomond Bridge with Cathedral tower in background; a seascape of Lahinch, Co. Clare, with village and Golf Links Hotel; and St Flannan's Cathedral, Killaloe, with river in the foreground. The date and place of his death have not been traced.

Works signed: N.A. Brophy (if at all).
Literature: J. Comerton, BA, *Department of Agriculture and Technical Instruction for Ireland Journal*, April 1912; Limerick Municipal Art Gallery, *Civic Week '78 Exhibition of Paintings*, information sheet, 1978; Bernard F. Brophy, *Letters to the author*, 1982, 1983; Canon J.L. Enright, *Letter to the author*, 1982; Ann M. Stewart, *Royal Hibernian Academy of Arts: Index of Exhibitors 1826-1979*, Dublin 1986.

BROSNAN, MEREDITH (1905-74), cartoonist. Born 17 August 1905 in Tralee, Co. Kerry. His father, Patrick Brosnan, was an officer in the British Army and a riding instructor attached to the Curragh. Meredith's

work later in life was under the pen name 'Warner'. Early in his career, he attended the Slade School of Fine Art in London on a scholarship in 1924 but left after a year.

As an illustrator and cartoonist, he worked in Edinburgh for *The Scotsman* between 1926 and 1938. Returning to Dublin on the outbreak of war, he contributed to *Dublin Opinion, Irish Farmers' Journal, Irish Tatler and Sketch,* the *Irish Times* and *Sunday Independent*.

'Warner' was the creator of the cartoons and limericks (on a trial period of twelve weeks) advertising Odearest mattresses which appeared weekly in the *Irish Times* for about twenty-five years, commenting on contemporary Irish life. Some of these cartoons formed a public exhibition and there were two shows in the Mansion House. Caricatures of contemporaries, as well as pen and ink sketches of Dublin and its people, were included in other exhibitions.

In the late 1950s he and his son David Brosnan completed a mural for the Green Goose public house at Fairview, Co. Dublin. He was personally responsible for a series of cartoon etchings for the Red Bank Restaurant, D'Olier Street, Dublin. His home was at Eglinton Road, Donnybrook, and he died in hospital on 29 September 1974.

Works signed: Warner.
Examples: Dublin: King's Inns.
Literature: *The Kerryman*, 11 December 1954; Meredith Brosnan, *Letters to the author*, 1974, 1983; *Irish Times*, 30 September 1974.

BROWN, CHRISTY (1932-81), primitive painter. Born on 5 June 1932, his father was a bricklayer of Stannaway Road, Dublin, whose wife bore twenty-one other children. Christy Brown began life almost completely paralysed with cerebral palsy, having control over only his left foot. For many years, he could only grunt rather than speak.

At the age of five, he was watching his sister doing sums on a piece of slate and, much to her surprise, he managed to take the chalk out of her hand with his left foot. This event prompted his mother to try to teach him the alphabet as he manipulated the chalk between his first and second toes. Using the same method, he began to paint at the age of ten and in time became a writer, learning to type with his little toe.

When he began to paint, his parents would pin the drawing paper to the floor with tacks, and this was his easel. In his autobiography, *My Left Foot*, which sold 14,000 copies, he wrote: 'Slowly I began to lose my early depression. I had a feeling of pure joy while I painted, a feeling I had never experienced before and which seemed almost to lift me above myself ... Painting became the one great love in my life, the main pivot of my concentration. I lived within the orbit of my paints and brushes ...' He came under contract to a disabled artists' association in Liechtenstein, sending off about eight paintings a year. Most of these were reproduced on charity cards. He was a founder-member of the Disabled Artists' Association, Cork.

Some of the works exhibited at the Agnew Somerville Gallery, Dublin, in 1970 had been painted as early as 1957. The preface in the catalogue stated: 'Talking to Christy Brown, one realises that here is a man who both writes and paints because he has to. His ambition is to develop and grow both as a painter and as a writer. Trees, he feels, are sad and are painted so. Portraits, painted from memory, show an insight into the person – as in the two faces of Brendan Behan. His landscapes are gloomy, perhaps because as he himself says, he sees with a melancholy gaze – the inner man.' The thirty works in this, his first one-person show, included *Jugs and Bottles* and *Canal at Mount Street*. The proceeds of the exhibition were handed to the Disabled Artists' Association.

After his marriage, he lived with his wife Mary in Rathcoole, Co. Dublin. He died on 6 September 1981 at Glastonbury, Somerset, and was buried at Glasnevin Cemetery in the presence of the Lord Mayor of Dublin. The President and Taoiseach were both represented. Christie's of London in their auction of Irish paintings and drawings at the RHA Gallagher Gallery in 1990 included seventeen works by Brown.

Works signed: Brown (if signed at all).
Examples: Cork: Disabled Artists' Association. Dublin: Sandymount School and Clinic.

Literature: Christy Brown, *My Left Foot*, London 1954; Hunter Davies, *The Sunday Times*, 25 January 1970, 18 February 1973; Agnew Somerville Gallery, *Christy Brown Exhibition*, catalogue, Dublin 1970; *Irish Independent*, 3 December, 1970; *Irish Times*, 15 September 1981; Disabled Artists' Association, Cork, *Letter to the author*, 1983; *Sunday Press*, 2 December 1990.

BROWN, VICTOR (1900-53), illustrator and cartoonist. Born on 21 April 1900 in Nuneaton, Warwickshire. His family had lived in Ireland for some years where his father was in the British Army. Arriving in Dublin in the middle 1920s, he established himself as a leading freelance commercial artist, his work appearing in books and magazines. He also designed calendars, some with Irish historical figures, and Christmas cards.

The theme of Gaelic mythology was in much of his work. He took a keen interest in literature, numbering among his friends the poet, F.R. Higgins, who was joint editor with W.B. Yeats of a series of twelve monthly broadsides published in 1935; of twenty-four illustrations, Brown contributed six. Some drawings for the 1937 series of broadsides, also published by Cuala Press, were contributed by Brown.

In the early days of the *Irish Press*, his political cartoons appeared under the name 'Bee'. The Easter Rising twenty-fifth anniversary 2½d postage stamp was issued in 1941 and designed by Brown. In the following year, he was responsible for the setting of *The Kiss* by Austin Clarke, performed at the Peacock Theatre by the Dublin Verse Speaking Society. His home was at Carysfort Avenue, Blackrock, and he died in hospital on 16 August 1953.

Works signed: V.B. or Bee.
Literature: F.R. Higgins, *Salt Air*, Dublin 1923 (illustrations); M.J. MacManus, *Dublin Diversions*, Dublin 1928 (illustrations); Michael Walsh, *Red on the Holly*, Dublin 1934 (illustrations); *A Broadside*, Dublin 1935 and 1937 (illustrations); *Irish Times*, 17 August 1953; Tony Brown, *Letter to the author*, 1983.

BROWNE, NASSAU BLAIR, RHA (1867-1940), landscape and animal painter. A native of Co. Kilkenny, he was the son of John Blair Browne and his education was mainly private. He studied art at the Slade School of Fine Art, London, and at a school of animal painting in Midhurst, Sussex, directed by W.F. Calderon (1865-1943).

Exhibiting only occasionally at the Royal Academy, he was closely connected with the Royal Hibernian Academy for many years. In 1901, he was appointed an associate, becoming a full member in 1903. The following year, *White Horses* appeared at the exhibition of works by Irish artists held at the Guildhall of the Corporation of London and organised by Hugh P. Lane. He painted *Orby*, which won the Derby in 1907.

Browne was secretary of the RHA 1911-24, and had an additional administrative burden when the building was destroyed by fire in 1916. He was a governor of the National Gallery of Ireland from 1918 until 1924. The minutes of the RHA annual meeting, 1916, recorded him as one the visitors appointed to the living model school.

In the period 1894-1940, he was a constant exhibitor at the RHA, averaging more than two works per annum. In 1897, he was at Brownstown House, Kilkenny, when he exhibited *Dark December*; *On the Yorkshire Coast*; and *Atlantic Breakers*. In the 1914 exhibition, his address was 31 Victoria Road, Rathgar; *Seaside Pasture* was included in that show. An address in Farnham, Hampshire, appeared in the 1925 catalogue when he showed *Cattle Drinking*, and he was still in England in 1930. In 1933, from 86 Marlborough Road, Dublin, he contributed *Gipsy Ponies*.

In the last ten years of his life, although in failing health, he showed a score of works at the Academy, including *Porchester Castle* in 1940. The RHA council recorded 'with deep regret' his death on 7 August 1940 at Marlborough Road.

Works signed: N. Blair Browne.
Literature: *Irish Independent*, 8 August 1940; Royal Hibernian Academy, *Letter to the author*, 1975; *Dictionary of British Artists 1880-1940*, Woodbridge 1976; *A Dictionary of Contemporary British Artists, 1929*, Woodbridge 1981; Ann M. Stewart, *Royal Hibernian Academy of Arts: Index of Exhibitors 1826-1979*, Dublin 1986.

BRUCE-JOY, ALBERT, RHA (1842-1924), sculptor. Son of Dr W. Bruce Joy, he was born in Dublin and was a brother of George William Joy (q.v.). The Joys were descended from an old Huguenot family which had settled in Antrim in 1612. Educated at Becker's School, Offenbach; in Paris, and at King's College, London, Albert became a student at South Kensington and the Royal Academy Schools of Art. He was a pupil of the Dublin-born J. H. Foley (1818-74) for four years and studied in Rome for a further three.

Before he was twenty-five, he had exhibited at the Royal Academy, and before long at the Paris Salon. At the Paris International Exhibition of 1878, he won one of the three medals for sculpture awarded to Great Britain with his bronze group, *The Forsaken*. The news of his Paris success probably influenced the committee responsible for commissioning the W.E. Gladstone statue.

Thousands were present when the Gladstone work was unveiled in 1881 in front of Bow Church, London. Other colossal statues included one of Lord Frederick Cavendish, which is in front of the Town Hall, Barrow-in-Furness; and John Bright, in front of the Town Hall, Manchester. As *The Times* stated: '... he had a remarkably good understanding of the official requirements in public monuments, particularly in portrait statues on the grand scale; and he was able to fulfil them in a dignified manner with some originality in the conception and unfailing thoroughness in the workmanship. He had, in fact – to take an illustration from literature – the capacities which go to make a successful Poet Laureate.'

Meanwhile in 1870, Bruce-Joy had begun a long association with the Royal Hibernian Academy and went on to exhibit more than fifty works in the next forty years, including many portraits, several in medallion form which were generally untitled. In 1882, he exhibited at the Irish Arts and Manufactures exhibition in Dublin, giving his address as Fulham Road, London. By 1888, he had a studio at Beaumont Road, West Kensington. In 1890, the year of completion of the Bishop Berkeley statue in Cloyne Cathedral, he was appointed an associate of the RHA and a full member in 1893. His bust of Robert McDonnell at the Royal College of Surgeons in Ireland is dated 1892.

For the next twenty years, Bruce-Joy's output was prolific. He was said to have looked the part of the sculptor: a sturdy figure of a man, bearded, bearing a resemblance to Rodin. A list, date uncertain, which he sent to the Walker Art Gallery, Liverpool, was shown to the author in 1972. It contained no fewer than 120 items covering private and public commissions – in or outside town halls and universities, also in churches and the House of Commons. Also listed were medallions, for which he was especially noted. At the Natural History Museum, London, is a medallion in plaster of Alfred Russel Wallace.

In 1907, A.L. Baldry contributed a special article to *The Studio* on medallions by Bruce-Joy: '... his effort has always been to unite freedom of imagination with realistic precision.' Among works mentioned were *W. Bruce Joy, MD* and *Sir G. Gabriel Stokes, FRS*. The artist is represented in this medium at the Hugh Lane Municipal Gallery of Modern Art. The Stokes medallion was one of seven pieces on view at the Irish International Exhibition at Herbert Park, Dublin, 1907, which also included a bronze bust, *Field-Marshal Earl Roberts, KG*.

Due to lack of encouragement for his 'ideal' sculpture, he was led to concentrate on portrait busts and public commissions. His imaginative composition, *The Lark's First Flight*, is at Aberdeen Art Gallery; the subject is of a girl holding a nest of young larks. Bruce-Joy also travelled in America where, among other works, he executed the colossal Ayer Lion at Lowell, near Boston, Massachusetts. In the 1914 exhibition of the RHA he exhibited *Andrew Sterett, US Navy, 1st August, 1801*, classified as 'miniature'.

The sculptor is represented at the British Museum and the National Portrait Gallery, London. He had some working associations with Belfast, the birthplace of his father. A statue of Lord Kelvin was unveiled in the Botanic Gardens, Belfast in 1913, at which time he was engaged on a colossal statue of Queen Victoria commissioned by the government of British Columbia. At the loan exhibition of Irish Portraits by Ulster Artists held at the Belfast Museum and Art Gallery in 1927, Bruce-Joy was represented by a marble bust, *Sir Edward Harland, Bart., MP*, lent by the Belfast Harbour Commissioners. At this exhibition Miss Grace Eleanor Bruce-Joy exhibited a portrait of Captain T.C. Bruce-Joy.

In his *A Dictionary of British Sculptors,* M.H. Grant wrote: 'Bruce-Joy, an Academician of the Royal Hibernian Academy, never received, or never sought the honours of the English RA. He was, and remained an Irishman, and in his art will ever be the pride of his native country.' In Dublin, the seated

figure of Lord Chief Justice James Whiteside is in St Patrick's Cathedral; also statues of Lord Justice Fitzgibbon and Dr George Salmon. A marble bust of Humphrey Lloyd, DD, is at Trinity College. At the Royal College of Physicians of Ireland is a bust of the sculptor's father, William Bruce Joy, and a full figure in marble of Robert James Graves. Albert Bruce-Joy died on 22 July 1924 at Bramshott Chase, near Hindhead, Surrey.

Works signed: A. Bruce-Joy or A. Bruce Joy.
Examples: Aberdeen: Art Gallery. Barrow-in-Furness: Town Hall, outdoor. Belfast: Botanic Gardens; Harbour Office; Ulster Museum. Birkenhead: Hamilton Square. Cambridge: Jesus College; St John's College. Canterbury: Cathedral. Cloyne, Co. Cork: St Colman's Cathedral. Dublin: Hugh Lane Municipal Gallery of Modern Art; Royal College of Physicians of Ireland; Royal College of Surgeons in Ireland; St Patrick's Cathedral; Trinity College. Dundee: City Art Gallery. Folkestone: The Leas. Liverpool: St John's Gardens; Walker Art Gallery. London: Bow Road; Lincoln's Inn; Mansion House; National Portrait Gallery; Palace of Westminster; St Paul's Cathedral; Westminster Abbey. Manchester: Albert Square. Rochdale: Town Hall.
Literature: A.L. Baldry, 'Some Medallions by Mr A. Bruce-Joy, RHA', *The Studio*, April 1907; R.M. Young, *Belfast and the Province of Ulster in the 20th Century*, Brighton 1909; *The Times*, 23 July 1924; Albert Bruce-Joy, *List of some of Mr Bruce-Joy's Public Works*, typescript, n.d.; M.H. Grant, *A Dictionary of British Sculptors*, London 1953; John Hewitt and Theo Snoddy, *Art in Ulster-1*, Belfast 1977; Ann M. Stewart, *Royal Hibernian Academy of Arts: Index of Exhibitors 1826-1979*, Dublin 1986.

BUCKLEY, AENGUS (1913-78), mural and portrait painter. Born in Cork on 4 July 1913, son of John Buckley. He was baptised James Buckley and became a pupil of the Christian Brothers at the North Monastery School. In his early education, he also studied at the Crawford Municipal School of Art. He joined the Dominican Order in 1932 and spent some time at the Dominican House of Studies, Tallaght, Co. Dublin, receiving the religious name Aengus. In 1938 he left for Rome to continue his studies at the Dominican University, the Angelicum, where he was ordained in the following year, being assigned to the Dominican Priory of San Clemente throughout the war.

After studying art at the Academia delle Belle Arti, he received a diploma. He taught for three years, 1944-7, at the then Pontifical Institute, the Angelicum; his subjects were English and the History of Art. His portrait of Monsignor John Kyne is in the Irish College.

While in Italy, he learnt the art of fresco painting from Angelo Landi (1879-1944) who gave him the use of his studio in the Via Margutta. There are five frescoes in the Angelicum, now the University of St Thomas Aquinas at Rome, and these are to be found around the main entrance. On entering, in an arch overhead, is one of St Thomas Aquinas; high up on the left, also in an arch, is *Sedes Sapientiae*, featuring Our Lady seated on throne. Two frescoes over doors are of Plato and Aristotle; in a room is *St Catherine of Alexandria*, together with portraits in oils of Fr Emmanuel Suarez, O.P., and Fr Michael Brown, O.P.

After returning to Ireland in 1948, he spent five years in Waterford before moving to Limerick where he lived for the rest of his life. Through his association with St Saviour's and his other interests (from 1971 he was a teacher of aesthetics and art appreciation at the local school of art) he became a familiar figure in the city where he gave lectures and opened many exhibitions.

Father Buckley painted a large canvas in oils, *The Last Supper*, exceeding seven metres in width, for the Irish embassy in Rome. It was too large and was given to the Irish Franciscans. The heads of the Apostles were actual portraits of people he knew and the painting was undertaken in Dublin. The head of St Matthew was that of Fr Tyndall Atkinson, O.P., assistant general of the Dominican Order.

Apart from his portraits in oils, most of his work was done in fresco and may be found in Dominican and diocesan churches in Ireland. He also completed some murals in the United States and Britain. The mural *Into Europe*, 3 metres by 5½ metres, is at the University of Limerick where he also has a self-portrait, 1965. *Into Europe* depicts the various times at which Ireland entered Europe with a significant impact. According to information held by the university, the mural's message 'is symbolised with a "Fresco secco" technique that steers a middle course between forceful realism and pure abstraction'. The artist gave the cartoon for this fresco to the community centre in Bruff. The mural was completed in 1976, and the National Institute for Higher Education, as it was then, is represented by three students in the foreground.

Also in Limerick are *The Triumph of the Cross* and *Stations of the Cross*, both at St Saviour's, the Dominican church, as well as a statue of St Martin in bronze. Frescoes are in St Colman's Chapel, Galway Cathedral, and in the mortuary chapel of Mullingar Cathedral on the theme of the Resurrection of Christ and the new hope among those detained in Limbo. The *Stations* in Our Lady and St Michael Church at Ennistymon, Co. Clare, are in a continuous series along the full length of the wall. There are also *Stations* at Kilmacow and at St Mary's Church, Newry.

Portraits by Aengus Buckley include those of Archbishop Jeremiah Kinane, the Rt. Rev. Monsignor Edward Kissane and Bishop Jeremiah Newman at St Patrick's College, Maynooth; of the Bishop of Dromore, Dr Eugene O'Doherty; Bishop of Ferns, Dr James Staunton; Bishop of Galway, Dr Michael Browne; Archbishop of Tuam, Dr Joseph Walshe. Among his other portraits was one of Robert Briscoe, 1958, of Dublin, and of Walter Sheehan, the then headmaster of Canterbury School, New Milford, Connecticut, USA. *Mayoral Portrait* is in the Municipal Art Collection, City Hall, Waterford.

The Rev. Louis Coffey, O.P., wrote: 'He was a most erudite man, something in the way of a throw-back to the outstanding figures of the Renaissance ... Easily and without strain he could discuss theology, and more particularly philosophy, with men of international renown who happened to be passing through our priories. I have heard it said by Italians that his Italian accent was the most perfect they had ever heard from a non-native of Italy. Nothing seemed to be beyond him, for as well as being a musician, he was president of the Society of Magicians in Munster.' He died on 30 August 1978 in Dublin, and was buried at Mount St Lawrence Cemetery, Limerick.

Works signed: A. Buckley, Aengus Buckley or Fr. Ae. Buckley, O.P.
Examples: Dublin: Pharmaceutical Society of Ireland; St Saviour's Priory. Ennistymon, Co. Clare: Our Lady and St Michael Church. Galway: Cathedral. Limerick: St Saviour's Church; University; also National Self-Portrait Collection. London: Manor Park Church. Maynooth, Co. Kildare: St Patrick's College. Mullingar, Co. Westmeath: Cathedral of Christ the King. Newry, Co. Down: St Brigid's Church; St. Mary's Church. Philadelphia, USA: St Joseph's Church. Rome: Collegio San Clemente; Irish College; University of St Thomas Aquinas. Sligo: Holy Cross Church. Waterford: City Hall, Municipal Art Collection; Kilmacow Church; St Saviour's Church.
Literature: Aengus Buckley, *Fra Angelico the Master Painter*, Tralee 1952; National Institute for Higher Education, *Bulletin*, September-October 1976; Rev. Louis Coffey, O.P., *Letter to the author*, 1978; *Limerick Leader*, 30 August 1978; *Irish Times*, 31 August 1978; Rev. Fintan J. Campbell, O.P., *Cork Examiner*, 5 September 1978; Rev. Fintan J. Campbell, O.P., *Letter to the author*, 1982; also, Rev. Joseph Moran, O.P., 1982; Pharmaceutical Society of Ireland, 1988; St Patrick's College, Maynooth, 1999.

BURCH, LAWSON, RUA (1937-99), landscape and figure painter. Born in Belfast on 26 July 1937, James Lawson Burch was the son of James Burch, a clerk. After attending Grosvenor High School, Belfast, he entered Stranmillis College in 1955 to train as a teacher. He first taught art at Holywood Intermediate School, Co. Down, then Castlederg Intermediate School, Co. Tyrone.

In 1965, from 16 Ballymaconnell road, Bangor, Co. Down, he showed *Low Tide, Annalong* at the Royal Ulster Academy. John Luke (q.v.) was much appreciated as a mentor. Festival '69, Queen's University, hosted his first one-person show; another followed at the Arts Council Gallery in 1974, coinciding unfortunately with the Ulster Workers' Council strike and power cuts. However, a Swedish television crew, over in Northern Ireland to film the strike, used some of the 'troubles' paintings to illustrate parts of their documentary, so some people saw the works — in Sweden.

In 1975 he showed at the Tom Caldwell Gallery, Belfast. Misfortune dogged him again when he had fourteen paintings stolen from his car, sitting outside the Ulster Arts Club, after his exhibition there in 1975. He was a regular exhibitor at the Club. Attracted by a German abstract painter who used to pour different coloured oil paints on to a canvas and then set fire to it, Burch emulated with petrol out in the garden, just avoiding a serious accident.

Northern Ireland Tourist Board published in 1976 *Discover Northern Ireland* by Ernest Sandford with drawings by Lawson Burch. The 200-page publication averaged about a drawing per page. *Belfast Telegraph* reported that year on the Ulster artist who hoped to give away his personal protest about violence in the

province: 'He is Lawson Burch, an art teacher at Friends' School, Lisburn, and his protest takes the form of a charcoal drawing of a gunman against the background of a rolling landscape.' The work, *Monument for Ireland, 1976*, was displayed at the Royal Ulster Academy's annual exhibition at the Ulster Museum. The artist did not wish to make any profit from the work.

Burch was a regular exhibitor with the RUA during the 1970s. In his 1977 exhibition at the Bell Gallery, Belfast, he depicted people in the city caught up in the tension; also he showed Donegal landscapes. After four years teaching in Lisburn, he became a full-time painter in 1978. The first of his three exhibitions at the Image Gallery, Dublin, took place in 1978. Solo shows were also held at the Keys Gallery, Londonderry, in 1978 and 1981. Work was also hung in Dublin with Independent Artists in 1978 and 1979. Individual events in 1980 were: Platform I Gallery, Manchester; Queen's University Festival; and Grendor Gallery, Holywood, Co. Down.

In 1981 the George Campbell Memorial Award enabled him to spend some months painting in Spain, and he exhibited work in Galeria Malacce, Malaga. In 1981 he showed at Lynne Park Centre, Cheshire, and in 1982 at Grant Fine Art, Newcastle, Co. Down. At the RUA in 1981 he was listed as an associate. In 1983 he contributed *Spanish Gypsy Woman*. He had been represented in 1982 at the Irish Contemporary Art exhibition, Boston, USA. In 1984, the year he became an academician, he held an exhibition at the Gordon Gallery, Londonderry. In 1986 he showed at Harmony Hill Arts Centre, Lisburn, and the Bank of Ireland, Manchester, in 1987, also again at the Gordon Gallery.

In 1988 he showed thirty-one works at the Cavehill Gallery, Belfast: nineteen acrylic, including *Silent Studio* and *Girl Washing*; six gouache, including *Lake at Annaghmakerrig*; five mixed media, for example *Moonlight at Dawros*; and one watercolour. At the end of the year he made his home at Ardara, Co. Donegal. In his small studio, he occasionally spent time writing. In the 1992-8 period he showed a dozen pictures at the RUA, his final contributions being *Tory Icon* and *Rock Pool Atlantis*.

At the Royal Hibernian Academy, he first exhibited in 1993; a total of six works, all acrylic, up until the year of his death. In 1993 he contributed *Grey Light,* and in 1994, *Beach Relic* and *Wet September*. His final presentation was *Atlantis Winter*. In 1994 he returned to the Bell Gallery, and that year he also exhibited solo at the Willow Island Gallery, Enniskillen, Co. Fermanagh.

Burch was involved in the planning of the 'Crossings' exhibition at Higgins Gallery, Malone House, Belfast, in 1996 when three Northern and three Southern artists participated. In 1997 the Thomas Haverty Trust purchased *Solitary Bogman* for Donegal County Museum. He contributed to group shows at the Kenny Gallery, Galway; the Model Arts Centre, Sligo; and the Sligo Art Gallery. He died suddenly in Co. Donegal on 12 June 1999 and was buried at Inniskeel Parish Church graveyard, Portnoo. A studio sale was held at the Bell Gallery, Belfast, in 2000.

Works signed: Burch or Lawson Burch.
Examples: Belfast: Arts Council of Northern Ireland; Department of the Environment for Northern Ireland; Ulster Arts Club. Dublin: Voluntary Health Insurance Board. Hillsborough, Co. Down: Lisburn Borough Council. Letterkenny: Donegal County Museum. Limerick: University, National Self-Portrait Collection. Mossley, Co. Antrim: Newtownabbey Borough Council.
Literature: *Irish News*, 13 June 1974; *Belfast Telegraph*, 30 December 1975, 15 June 1976, 17 November 1977; Lisburn Borough Council, *Lisburn Borough Guide,* Lisburn c. 1975 (illustrations); Ernest Sandford, *Discover Northern Ireland*, Belfast 1976 (illustrations); Mike Catto, *Art in Ulster: 2*, Belfast 1977 (illustration); *Sunday News,* 30 August 1987; Cavehill Gallery, *Lawson Burch,* catalogue, Belfast 1988; *Irish Times,* 14 June 1999, 5 July 1999; Mrs Jean Burch, *Letter to the author*, 1999; Theo Snoddy, *UTV Art Collection: Catalogue of Works and Artists' Biographies,* Belfast 1999.

BURKE, ROBERT (1909-91), landscape and figure painter. Born in Dundee, Scotland, on 16 August 1909, the son of William Burke, Robert Burke was educated at Lawside Secondary School. He then entered Dundee College of Art in 1926 and was awarded the diploma in design and applied art in 1930, having specialised in metalwork and enamelling. A year was spent at Dundee Training College for a course in teaching methods and practice.

In the period 1931-6 he was art master at the Boys' Central School and the Technical Institute, Grantham, Lincolnshire, residing at 24 Redcross Street. At the Royal Academy he exhibited *The Balladmonger,* a decoration, in 1932 and *Coming of the Shee* in 1933. At the Royal Scottish Academy in 1933 he showed the head of a man. A course in typography and woodengraving was taken in the summer of 1934 at the Central School of Arts and Crafts, London. In 1934 too he exhibited at the Paris Salon. He married Elizabeth Kinross, the art teacher at the Girls' Central School, Grantham.

Burke was appointed headmaster of the Waterford School of Art in 1936 and remained there until retirement in 1974. He first exhibited at the Royal Hibernian Academy in 1937 with *Early Spring — Co. Waterford,* from 20 John's Hill, Waterford. Altogether he showed ten works up until 1963. His wife contributed to the 1937 and 1938 exhibitions. Now at Summerville Avenue, Passage Road, Waterford, he exhibited *Evening in the Dublin Hills* and *Early Sorrow* at the 1938 Academy. In that year he was elected Fellow of the National Society of Art Masters for his thesis, 'The Future Development of Art Education as a Cultural Force in Rural Areas.'

In 1937 he had joined the committee which organised the exhibitions, inaugurated in 1934, at Newtown School, Waterford. When the headmaster, Arnold Marsh, who was married to Hilda Roberts (q.v.), left, Burke became chairman of the committee. Later, he commented: 'We had no financial assistance and work was collected and sent down from Dublin by Victor Waddington, who was always helpful...' The Department of Education asked him to organise and conduct a short course in drawing and design for art teachers and manual instructors in July 1938.

On *'Two by Two'* which was hung at the 1944 RHA, *The Bell* described it as 'a vigorous, satirical line-and-wash drawing.' *Behold the Hebrides* and *Autumn in the Park* were hung in 1945. A member of the Society of Dublin Painters, he showed *Beside the Sea* at the 1948 Oireachtas, the *Dublin Magazine* referring to its 'gaiety.' He was represented in the exhibition of pictures by Irish artists held in Technical Schools in 1949.

In 1957 he exhibited *Wandering Friar*, terracotta, in the Institute of the Sculptors of Ireland exhibition in Dublin. After an interval of seventeen years, he returned to the RHA in 1962. In the Waterford Municipal Collection is a work of local interest, *Unloading at Custom House*; at South Tipperary County Museum and Art Gallery is a Tramore scene.

The Chief Education Officer for Lincolnshire regarded Burke's work, both as a teacher and as an artist, of high quality, and a man of 'agreeable personality,' who stimulated his pupils effectively and 'maintained their enthusiasm even while correcting their errors.' Among his other interests was Celtic art and mythology, and he had work published on the subject. Of Dunmore East, Co. Waterford, he died on 24 October 1991 at St Columcille's Hospital, Loughlinstown, Co. Dublin.

Works signed: R. Burke.
Examples: Clonmel: South Tipperary County Museum and Art Gallery. Waterford: City Hall, Municipal Art Collection.
Literature: Francis Cooper, DA, ARCA, *Robert Burke Reference*, typescript, 1938; *The Bell*, May 1944; *Report of Training and Qualifications of Robert Burke, DA*, typescript, 1946; *Dublin Magazine*, January-March 1949; *Letter from Robert Burke to Liam Glynn*, 1983; *Royal Academy Exhibitors 1905-1970*, Calne 1985; Ann M. Stewart, *Royal Hibernian Academy of Arts: Index of Exhibitors 1826-1979*, Dublin 1986; *Irish Times*, 25 October 1991; S. B. Kennedy, *Irish Art & Modernism 1880-1950*, Belfast 1991; *The Royal Scottish Academy Exhibitors 1826-1990,* Calne 1991; Dr Kinross Burke, *Letters to the author,* 1997.

BURKE, THOMAS (1906-45), portrait and figure painter. Born in Liverpool in June 1906, Thomas Aloysius Burke, the son of Irish parents, trained at Liverpool College of Art and in London at the Royal College of Art. He was credited with also studying in 'Chelsea, Paris and Ireland.' His home was at 450 Aigburth Road, Liverpool, where his mother and sister lived.

In 1938 he painted *The Student,* exhibited at the autumn exhibition of the Walker Art Gallery, Liverpool. If one is to judge by the title, it was shown in Dublin the following year at the Royal Hibernian Academy, and in 1940 at the Royal Academy. Subsequently, this work found its way to the Walker Art Gallery

collection, where there is also another oil, *An Old Kitchen,* with the figure of a woman. Both works were presented by members of the artist's family.

As Tom Burke, he showed a racecourse scene, *The Green Umbrella,* at the 1938 RA, from 2 Stanley Studios, Park Walk, SW 10. One critic wrote later that this work showed how far he had 'progressed technically, and the alertness of his pictorial sense…'. At the RHA in 1939 the interior which he contributed might possibly have been *The Studio Window.* In 1940, from 11 Edith Grove, Chelsea, London, he showed two works in the Dublin exhibition, *Hyde Park* and *Miss Derval Healy.* At the Royal Society of Portrait Painters he contributed one picture.

The *Liverpool Post* was of the opinion that 'as a young painter, had already shown a natural bent for portraiture and genre painting when the war claimed him…'. As a portrait painter 'his choice of subject seemed sometimes a bit sensational…'. But, he possessed 'well-defined and diverse gifts.' Among his portraits was one of Len Harvey. An occasional flowerpiece was painted. His *Still life with wine bottle,* oil, is at Williamson Art Gallery and Museum.

In 1940 he was a radio officer on the *SS Dalesman,* only to be taken prisoner at Crete on 1 June 1941; he became a prisoner-of-war at Merlag and Milag Nord, Germany. The artist's sister bequeathed to the Walker Art Gallery seven drawings made in prison camp. They show scenes of everyday life. One was a costume and set design for a performance of *The Mikado,* and an inscription on the back noted : 'The men used to make the wigs out of Red Cross parcels string and the dresses out of cretonne bags…'. He drew posters for the camp theatre. Four of the other drawings donated were in pencil, including *England v. Australia (2nd Test).* Until shortly before the liberation of the camp, he had been assisting with settings for a production of *The Plough and the Stars.*

Burke painted in Ireland, judging by titles of works, for example *Caragh River, Co. Kerry* and *West of Ireland Landscape.* The National Gallery of Ireland received in 1981 from his sister, Catherine Burke, of Glenageary, Co. Dublin, two oils : *Landscape with a bog* and *Portrait of a model.*

After his return from imprisonment, he died in Northern Hospital, Liverpool, and was buried at Ford Roman Catholic Cemetery on 19 July 1945. A memorial exhibition of eighteen works took place in 1946 at Bluecoat Chambers, Liverpool.

Works signed: Thomas Burke or Tom Burke.
Examples: Birkenhead, Merseyside: Williamson Art Gallery and Museum. Dublin: National Gallery of Ireland. Liverpool: Walker Art Gallery.
Literature: *Liverpool Post,* 27 July 1945, 7 May 1946; City of Liverpool Art Gallery Bluecoat Chambers, *Memorial Exhibition Thomas Burke, Michael Coonan,* catalogue, Liverpool 1946; *Dictionary of British Artists 1880-1940,* Woodbridge 1976; Walker Art Gallery, *Merseyside Painters, People & Places,* Liverpool 1978; National Gallery of Ireland, *Exhibition of Acquisitions 1981-82,* catalogue, Dublin 1982 (also illustration); *Royal Academy Exhibitors 1905-1970,* Calne 1985; Ann M. Stewart, *Royal Hibernian Academy of Arts: Index of Exhibitors 1826-1979,* Dublin 1986; *Concise Illustrated Catalogue of British Paintings in the Walker Art Gallery and at Sudley,* Liverpool n.d. (also illustrations); Liverpool Central Library, *Letter to the author,* 1997; also Walker Art Gallery, 1997.

BUTLER, LADY ELIZABETH – see THOMPSON, ELIZABETH

BUTLER, MILDRED A., RWS (1858-1941), landscape painter.

Mildred Anne Butler was born on 11 January 1858. She lived for most of her life at the family home, Kilmurry, outside Thomastown, Co. Kilkenny. Her father was Captain Henry Butler, a grandson of the 11th Viscount Mountgarret, and died in 1881. He had been in the army and in 1841 published *South African Sketches: Illustrative of the Wildlife of a Hunter on the Frontier of Cape Colony.*

Mildred was one of a family of six, outliving them all and inheriting Kilmurry. It was the chief source of inspiration throughout her career, with flower gardens and, her forte, landscapes with animals and birds figuring prominently in her watercolours. Her sketchbooks date from about 1878. She showed two watercolours at the 1884 exhibition of the Irish Fine Art Society exhibition in Cork.

In 1885 she visited France, Switzerland and Italy – *Sailing Boats on Lake Como* – with her sketchbook. The following year she was in London where she worked under Paul Jacob Naftel (1817-91), saying that it was from him that her first real understanding came. In correspondence, he analysed sample landscapes which she offered for criticism.

The Dudley Gallery, London, showed her work in 1888, and she began to exhibit with the Water Colour Society of Ireland in 1892. "*And Straight Against that Great Array Went Forth the Valiant Three*" (National Gallery of Itreland), 1893, depicted three crows sitting on a bush. In that year too, her work was included in the book of watercolours given by the Society of Lady Artists to Princess May, later Queen Mary, on her marriage to the Duke of York. Queen Mary later bought a watercolour by her and in 1922 she painted a tiny picture of crows for the Queen's doll's house at Windsor. She was regularly represented at WCSI exhibitions and contributed more than 200 works.

Mildred Butler showed only five works at the Royal Hibernian Academy, the first in 1891, *A Smoking Concert*, and the last in 1904, *By the Shed*. In 1891, she exhibited at the first exhibition of the Belfast Art Society. *A Sheltered Corner* of the same year was regarded as one of her principal works. It is in the Ulster Museum. She was invited to exhibit at the 1896 BAS event and was one of the first nine academicians elected by the Ulster Academy of Arts in 1930. By the annual meeting in January 1933, she was the only academician who had presented her diploma work which fully adhered to the rules.

In 1894, she was in Paris. In that year she corresponded with Luke Fildes (1844-1927) and the Dublin-born Stanhope Forbes (1857-1947) over suitable lodgings in Newlyn. She travelled with May Guinness (q.v.) to study under Norman Garstin (q.v.), who had been painting in Ireland before settling in Cornwall in 1886 and who, like Walter Osborne (q.v.), had been a pupil of Charles Verlat (1824-90) in Antwerp. She spent two summers in succession at Newlyn,1894 and 1895.

In 1896, the purchase by the Chantrey Bequest of *The Morning Bath*, a picture of pigeons bathing in a fountain, exhibited at the Royal Academy in the same year, was a major success and a rare honour for a woman. Also in 1896, she became an associate of the Royal Society of Painters in Water Colours, but had to wait forty-one years before being granted full membership. In 1897, Lady Cadogan, the Vicereine in Dublin, gave the Princess of Wales a Butler watercolour. In the same year, the art critic of the *Athenaeum* said she could make good pictures out of 'simple and indeed trivial material'; the American periodical, *Hearth and Home*, described how she worked out of doors and stressed that it was this method which 'gives ... an actuality and a freshness that can be acquired in no other way. Miss Butler's landscape bears always the impress of truth...'.

As early as 1898, she was a committee member of the WCSI, and her *Raiders from the Rookery* of that year was regarded as another principal work. A study, black chalk on paper for *A Preliminary Investigation* is at NGI. In 1904, she was represented in the exhibition of works by Irish painters held at the Guildhall of the Corporation of London and organised by Hugh P. Lane. *Green-eyed Jealousy* appeared in the watercolour section. Her surviving diaries, which began in 1891 and ended in 1938, indicated her friendship with Rose Barton (q.v.).

In the period 1900-6, *The Studio* recognised her as '... an Irishwoman whose work is familiar to the habitués of London galleries'; 'Drawings of animal life and birds alternate with records of pretty garden subjects'; '... among the best contributors to the exhibition of Society of Women Artists'. From 1905 she travelled regularly for some years to Aix les Bains where she took the waters and had treatment for arthritis. *Twilight, the first lamp, Aix les Bains* dates from this period. At the 1906 WCSI show she contributed ten works including *A Group of Peafowl* and *Poppies and Corn*.

Tramore was a favourite place for a sketching holiday at home. *A seaside holiday, Tramore Strand* was exhibited in Belfast in 1919. In 1907, in London, she showed at the New Dudley Gallery with Percy French, Claude Hayes and Bingham McGuinness (qq.v.). As well as attending the Westminster School of Art, she studied animal painting for one term under William Frank Calderon (1865-1943). In 1909, she was among those who participated at the first exhibition of the Calderon Art Society, composed of past and present students of the school.

An exhibition of British artists was staged in Darmstadt in 1911, where the Grand Duke of Hesse bought two of her pictures. Although she rarely painted in England, she exhibited continuously there. A portrait of Dermod O'Brien (q.v.) was shown at the 1914 Royal Academy. Through the RWS, she exhibited in Japan in 1921. Studies of the gardens and trees at Kilmurry were favourite subjects. Another principal work was *A Sunshine Holiday*, also at the Ulster Museum.

She avoided all social comment and political upheavals, remaining a quiet country gentlewoman. Remembered as an artist in watercolours, she also worked in oils and NGI hold *A Bowl of Flowers* as well as several watercolours. In the last ten years of her life, she painted little. As for her 'recreations', she replied that she took 'a great pleasure and interest in the music of the parish church of Thomastown'. She died on 11 October 1941.

In 1978, some works from her private collection were sold at Christie's in London. Subsequently, as a prelude to a second sale in London, an exhibition was held in Kilkenny and then Dublin in 1981. All the watercolours in the exhibition were from Kilmurry. Many of her sketchbooks, notebooks and catalogues only came to light when the property was sold.

Works signed: Mildred A. Butler, M.A. Butler, rare: M.A.B. or M.B., rare (if signed at all).
Examples: Belfast: Ulster Museum. Dublin: Hugh Lane Municipal Gallery of Modern Art; National Gallery of Ireland. Kilkenny: Art Gallery Society. London: Tate Gallery. Termonfeckin, Co. Louth: An Grianán. Waterford: City Hall, Municipal Art Collection.
Literature: *Cork Examiner*, 27 November 1884; *Hearth and Home*, 15 April 1897; Marcus B. Huish, *British Water-Colour Art*, London 1904 (also illustration); J. Crampton Walker, *Irish Life and Landscape*, Dublin 1927 (illustration); *Who Was Who 1941-1950*, London 1952; Martyn Anglesea, *The Royal Ulster Academy of Arts,* Belfast 1981; Anne Crookshank and the Knight of Glin, *Mildred Anne Butler 1858-1941*, catalogue, Kilkenny 1981 (also illustrations); Christie, Manson and Woods, Ltd, *Watercolours by Mildred Anne Butler*, catalogue, London 1981 (also illustrations); National Gallery of Ireland, *Exhibition of Acquisitions 1981-82*, catalogue, Dublin 1982 (also illustrations); Ann M. Stewart, *Royal Hibernian Academy of Arts: Index of Exhibitors 1826-1979*, Dublin 1986; Anne Crookshank, *Mildred A. Butler*, Dublin 1992 (also illustrations); Anne Crookshank and the Knight of Glin, *The Watercolours of Ireland*, London 1994 (also illustrations); *Water Colour Society of Ireland Exhibition List 1872-1994*, Dublin 1995.

BYRNE, MICHAEL (1923-89), abstract painter and printmaker. Son of Michael Byrne, baker, he was born in Dublin, one of a family of ten. He first worked with a photographer, then as a dental technician. His friend, Dan Treston O'Connell, allowed him to use his flat on the Dublin quays, and he went to the National College of Art and worked as an assistant to Fergus O'Ryan (q.v.), who taught lithography. He also studied at King Alfred's University College, Winchester.

In 1952, he travelled to Spain with O'Connell, and they subsequently visited other countries, including France, Greece, Turkey, Israel and Morocco. While away, he visited galleries and attended concerts, but his main interest was painting, although he was not concerned with promoting his career and was a rare exhibitor at the Royal Hibernian Academy. He exhibited at the Irish Exhibition of Living Art, and in 1953 showed *Poverty*. In 1958 commenting on a mixed exhibition at the Cavendish Gallery, Dublin, the *Dublin Magazine* referred to his *Alone* as 'a very haunting, imaginative picture', and his *Spanish Boy* as showing 'bold portraiture and colour'.

Byrne played an active role in the foundation of Independent Artists in 1960. At the second exhibition in 1961, his works included *Death of a King*. His first one-person show was held in 1966 at Inglewood Library Gallery, Los Angeles, USA. At the Irish-Dutch exhibition in Dublin at the Municipal Gallery of Modern Art in 1968, he showed three abstracts. The *Irish Times* referred to 'a small dark one rather turgid in texture dating from 1965, while his present works are large, clear, beautifully organised in a delicate complexity and look very poised and finished'.

In 1969, his abstractions appeared in the Independent Artists' exhibition, as well as at the opening exhibition of the Project Gallery's new premises. The *Irish Times* critic said the works were akin to the 'chromatic symphonies of Albers and others of that kind ...'. He was a member of the Project committee. In 1971, he became a part-time lecturer at the National College of Art and Design where he served until 1979.

A large-scale exhibition of his work was held at the Project Arts Centre in 1971. Most of the works were oils, and titles generally concerned squares – *Yellow Square*, *Orange Square*, for example.

Byrne continued to exhibit with Independent Artists but unexpectedly showed *Age*, a watercolour, at the 1973 RHA. He exhibited prints at the Setanta Gallery, Dublin, in 1974, 1976 and 1981. He had another solo show in 1981 at the Tara Gallery, Zurich, where he displayed silkscreens and watercolours; the latter included *Blue with Fireworks* and *Green Horizon*. He was by then working full-time in his Dublin studio and had a show in the Davis Gallery, Dublin, in 1982.

In the Arts Council collection in Dublin, he is represented by two works in acrylic, *Yellow Square* and *Blue and Violet Squares*, and by seven screenprints. A member of Aosdána, he was a founder-director of the Black Church Print Studio where he taught screenprinting. Younger artists found him approachable, encouraging and helpful. Unmarried, he died suddenly at his home, 9 Offaly Road, Cabra, Dublin, on 25 January 1989. An exhibition of his work was held in 1990 at the Davis Gallery, Dublin. In 1994, the Arts Council agreed to administer a fund established to commemorate the life and work of Michael Byrne.

Works signed: Michael Byrne or M. Byrne.
Examples: Berne, Switzerland: Irish Embassy. Dublin: Arts Council; Córas Iompair Éireann. Limerick: University, National Self-Portrait Collection. Oregon, USA: Gallery of Modern Art.
Literature: *Dublin Magazine*, April-June 1958; *Irish Times*, 10 December 1968, 8 May 1969, 5 September 1969, 6 December 1969, 8 November 1972, 26 and 28 January 1989, 14 April 1989; Project Arts Centre, *Michael Byrne*, catalogue, Dublin 1971; Tara Gallery, *Michael Byrne*, catalogue, Zurich 1981; *Black Church Print Studio*, brochure, Dublin 1989; Dan Treston O'Connell, *Letters to the author*, 1989; *An Chomhairle Ealaíon Information System*, 1995; Aileen C. Connor, *Aosdána*, Dublin 1996; Arts Council, *Awards and opportunities for individuals*, Dublin 1997.

C

CAFFREY, GERRY (1947-97), abstract expressionist painter. Gerard Joseph Caffrey was born on 13 September 1947 in Dublin. His father, Thomas Caffrey, of a musical family, was a violinist who decided that accountancy paid more money, so he took a degree at night. In addition, he produced some pictures composed of inlaid woodcuts. His wife, Elizabeth, was a furniture restorer before her marriage, and her father, Thomas Lawler, a bookbinder whose work is at King's Inns. Gerard, the artist, also played the guitar, and his brother Thomas: a goldsmith and an accomplished musician.

Gerard Caffrey attended De La Salle College, Churchtown, Dublin; the curriculum did not neglect art. He emigrated to Canada in 1971, and reckoned 1978 was when he began to paint seriously, with a view to earning money. He held an exhibition in Halifax before leaving Canada in 1979, having visited the United States on several occasions, and from London his brother, Raymond McCaffrey, the first son, brought him to Denmark.

On one of his visits to Denmark, he was much taken with a yellow-brown colour that is used in a distemper for fishermen's houses in Elsinore. He returned to Dublin and painted a series using the forms and colours he had seen there. He was attracted by the work of the Danish painter, Edvard Weie (1879-1943), who, it was said, 'became absorbed in the abstract qualities of colours that were rich and glowing'. Some of Weie's pictures were characterised by 'broad, rhythmical brush strokes and harmoniously modulated, light-drenched colours.'

In 1982 and 1983 Caffrey was credited as participating with watercolours in group exhibitions in Chicago, USA, and Ontario, Canada. In Dublin, his work was hung with Independents Artists in 1985 and 1986. In 1986 in the Irish Visual Arts Foundation 'Art Works' exhibition he was represented. His pictures were in the 1987 and 1989 Oireachtas exhibitions. Arts Council bursaries were awarded in 1988 and 1990. In 1988 he had become a member of the Temple Bar Gallery and Studios, Dublin.

Golden Icon and *Red Rain*, both oils, were painted in 1990. He had a one-person show at Temple Bar and also Berkeley Gallery, Thomastown, Co. Kilkenny, in 1990. Solo exhibitions in 1991 were: Droichead Arts Centre, Co. Louth, and Westbury Gallery, Dublin. At the Drogheda centre he showed seventeen works, nearly all oils, including *Forest and Garden*; *Self Portrait*; *An Ancient Place*. In the 1991 Arnotts National Portrait Awards competition, he won a subsidiary prize of £150, for a self-portrait.

As well as with other group shows, for example Temple Bar artists in 1992 at Riverrun Gallery, Limerick, he was involved with 'Best Medicine', artists in children's hospitals project, 1992. He painted a series of works in Co. Leitrim. He was one of seventeen artists invited in 1996 to a work-in-residence scheme at the National Botanic Gardens, Dublin, as a focus of inspiration for their artistic talents, and organised by Artcore of Kilkenny. His brother Raymond wrote: 'He had a great feeling for nature, for its beauty, its intensity: but also, for its absence of beauty, its mundane bareness.'

Aidan Dunne, *Irish Times*, described him as a 'bold colourist who relished the wallop of pure reds and yellows, but he also had a feeling for a much more muted, earthy palette, which came out in his later work, and for texture. Almost invariably he structured his pictures in terms of a single, central motif against a ground...From first to last his output is characterised by its honesty and directness.' On his life, his wife said that his 'distain for mundane work and love of freedom left him more than often penniless.' He died in Dublin on 26 January 1997. The exhibition of work by the Botanic Gardens artists, held that year at the Hugh Lane Municipal Gallery of Modern Art, was dedicated to Gerry Caffrey. A memorial exhibition at the Temple Bar Gallery and Studios took place in 1998-9.

Works signed: Caffrey (if signed at all).
Literature: *The Dictionary of Art,* London 1996; Hugh Lane Municipal Gallery of Modern Art, *Ramus,* catalogue, Dublin 1997; Arnotts plc, *Letter to the author,* 1998; Raymond McCaffrey, *Letters to the author,* 1998; Royal Danish

Embassy, London, *Letter to the author*, 1998; Temple Bar Gallery and Studios, *Gerry Caffrey 1947-1997*, catalogue, Dublin 1998 (also illustrations); also, *Letters to the author*, 1998; *Irish Times*, 12 January 1999.

CAMPBELL, ARTHUR M., ARUA (1909-94), landscape painter, designer and illustrator. Born in Belfast on 9 November 1909, Arthur Matthew Campbell was a brother of George Campbell (q.v.) and a son of Gretta Bowen (q.v.). He spent his first nine years in Dublin and Arklow, Co. Wicklow. As he had regular commercial employment for most of his working life with photography as an enthusiastic hobby, he had not all the time he would have wished for painting. However, he went to night classes at Belfast College of Art. In 1925-45 he was a printing and advertisement designer with W. & G. Baird Ltd., Belfast.

In 1939 he exhibited for the first time at the Royal Hibernian Academy: *Pollan Bay, Inishowen*, and his last contribution was in 1967, a total of only eight works in almost three decades. In 1942-3 he made seventy-three landscape drawings for *Belfast Telegraph*. A good organiser, he was to the fore in the 1943 publication, *Ulster in Black and White*, featuring the work of the Campbell brothers, Maurice C. Wilks (q.v.) and Patricia Webb.

In spite of wartime restrictions, the year 1944 was unusually busy. At three shillings and sixpence, Arthur and George Campbell produced *Now in Ulster*, containing short stories, articles, verse and illustrations. Arthur contributed an article, his painting *Caravans* was reproduced, and he assisted with thumbnail sketches as well as providing two photographs.

Also 1944 saw an exhibition of paintings and drawings by the Campbell brothers at the Mol Gallery, 54 Upper Queen Street, Belfast. A Northern Ireland branch of Artists International Association was formed in 1944, but the only 'official' exhibition to be held was 'Belfast Commentary', in association with Council for the Encouragement of Music and the Arts at the Belfast Museum and Art Gallery in 1945. Arthur Campbell was an exhibitor. In 1946 he was appointed publicity manager for Harry Ferguson (Motors) Ltd.

Some of Campbell's photographs 'fleshed out five-minute sketches and colour notes which I painted at home...The camera was a surrogate drawing pad, which explains why some photographs have affinities with certain paintings...'

Regular articles, personally illustrated, were contributed to the Ford Motor Company's publication, *Ford Times*, and photographs appeared regularly in photographic journals and as illustrations for other articles. In Dublin, at the 1947 RHA, he showed two watercolours, giving the address 42 Oakley Road, Ranelagh, Dublin. At about this time his brother George took him on walkabouts to places in Dublin that had caught his fancy, and they sketched. In 1949 he spent nine months with a Manchester advertising agency as a visualiser; and took night classes at Stockport Art School. In 1953 he returned to Harry Ferguson's.

Campbell, sponsored by CEMA, had his first one-person show in 1950, at 55a Donegall Place, Belfast. Five of the works were in oil, including *Flower Sellers*, with twenty-seven in watercolour or gouache, for example *Yellow Door, Stephen's Green*; *Bramhall Cascade, Cheshire; Sunday in Manchester*; *Salmon Port, Cushendall*. John Hewitt wrote in the foreword: 'In the stonework of old bridges, the shapes of twisted metal, in weathered and battered brick surfaces rather more emphatically than in the more conventional play of foliage and whitewash he has found his deepest interest...'

The Donegall Place gallery in Belfast was used for two group shows by Ulster artists in 1951, Campbell among them. Early in the 1950s the Belfast Museum and Art Gallery purchased four works, including *Red Mill, Whitehouse*. Three pictures went into the local history department and included *Pond in Botanic Gardens*, in charcoal and gouache. A prize of £50 was won for second place in the poster design competition of the Society of Motor Manufacturers and Traders for the 1959 Motor Show at Earl's Court.

After a long interval, giving the address c/o Ritchie Hendriks Gallery, Dublin, he contributed to the RHA in 1966: *Tinker Encampment*; *On Lough Erne*; *Boatyard, Carnlough*. The Arts Council of Northern Ireland hosted in 1984 an exhibition of watercolours and photographs since 1935. In 1986 he was appointed an associate of the Royal Ulster Academy, and that year he showed at their exhibition *Interior at Slievenaman Mournes* and *Glenveagh, Donegal*.

Campbell will be remembered for his two books of old photographs. *Return Journey* contained seventy-two photographs of 'Belfast and beyond' in the years 1936-9. This publication was followed two years later, in

1989, by *Looking Back,* covering the period 1939-60 with sections dealing with Dublin, Belfast, and his artist friends numbering more than a dozen. Meticulous in his records, he was able to publish, almost without exception, the exact date on which a photograph was taken. Thus we know that on 8 June 1950 Oskar Kokoschka (1886-1980) attended the opening of a Dublin exhibition with his fellow Austrian, the Belfast collector, Zoltan Lewinter-Frankl. Arthur Campbell died peacefully at his home, 133 Malone Avenue, Belfast, on 20 March 1994.

Works signed: Arthur M. Campbell or Arthur Campbell.
Examples: Belfast: Arts Council of Northern Ireland; Ulster Museum.
Literature: *Ulster in Black and White,* Belfast 1943 (illustrations); Arthur and George Campbell, compilers, *Now in Ulster,* Belfast 1944 (also illustrations); Council for the Encouragement of Music and the Arts, *An Exhibition of Paintings by Arthur Campbell,* catalogue, Belfast 1950; *Northern Whig,* 4 April 1951; *Irish News,* 20 November 1951; *Belfast Telegraph,* 8 December 1958, 21 and 22 March 1994; Arts Council of Northern Ireland, *Arthur Campbell Watercolours and Photographs since 1935,* Belfast 1984 (also illustration); Ann M. Stewart, *Royal Hibernian Academy of Arts: Index of Exhibitors 1826-1979,* Dublin 1986; Arthur Campbell, *Return Journal,* Belfast 1987; Arthur Campbell, *Looking Back,* Belfast 1989; S. B. Kennedy, *Irish Art & Modernism 1880-1950,* Belfast 1991; Mrs Margaret Campbell, *Letter to the author,* Belfast 1997.

CAMPBELL, BEATRICE – see GLENAVY, LADY

CAMPBELL, CHRISTOPHER (1908-73), portrait and figure painter and stained glass artist. Born in Dublin on 9 December 1908, he was one of a family of eight children and lived for many years at 17 Brian Road, Clontarf. His father, a carpenter, died when he was still a child. His mother acted as model for a number of his paintings. Educated by the Christian Brothers at Saint Mary's Place, he chose painting as a career and had Patrick Tuohy (q.v.) as a teacher at the Dublin Metropolitan School of Art. His brother, Laurence Campbell (q.v.) the sculptor, also studied there.

In the period 1927-71, Campbell showed more than seventy works at the Royal Hibernian Academy. After studying stained glass in various studios, he worked for a period at Harry Clarke Stained Glass, Ltd. *Christopher of Stained Glass,* a self-portrait of the artist at Clarke's, appeared at the RHA in 1937. A stained glass window is at Tiraun Church, Belmullet, Co. Mayo, and a three-light is at Our Lady of Mercy Church, Coolock, Dublin.

In 1932 he painted a portrait of Maud Gonne (q.v.). Two of his 1933 watercolours, not exhibited at the Academy, were *Figure in a Forest* and *Beggarman.* At the 1936 RHA, *Brothers* appeared. A charcoal drawing of the artist and his brother Laurence, it was apparently a joint effort as the latter signed it too. In that year, Christopher also exhibited *The Sculptor Critic,* his brother, as well as five other works, including *The Child of Prague,* a cartoon for stained glass. Also in Dublin, he showed at the Academy of Christian Art exhibition in 1941. At the Munster Fine Art Club exhibition in 1942, he exhibited *The Letter,* oil.

Campbell became an art teacher and was at Kilkenny Technical School 1947-51. Between 1953 and 1969, he contributed a number of illustrations for the *Capuchin Annual.* According to a biographical note in the 1956-7 issue, his work had been exhibited, in addition to the RHA, 'in Chicago, Belgium and Australia', and that his masterpiece to date was *Conversation Piece,* portraying the Waddington family of Beaulieu, Drogheda. This work was painted at a time when he was suffering from a severe duodenal ulcer.

In the period 1958-71, he showed mainly stained glass designs at the RHA. The St Catherine Labouré triptych, in bright blue and soft gold, formerly at the Vincentian College, Blackrock, is now at Celbridge, Co. Kildare. *Stations of the Cross* are at Our Lady of Lourdes Hospital, Drogheda, and County Hospital, Kilkenny. A crayon drawing of Michael Shortall (q.v.) is in the Hugh Lane Municipal Gallery of Modern Art collection. *Self-portrait: the Artist and his sister,* oil, is at the Ulster Museum.

In 1976, the Neptune Gallery, Dublin, presented what was probably the first one-person show ever arranged for this artist. Works were in oils, crayon, red chalk, watercolour, pastel, pencil and charcoal. In the introduction to the catalogue, Bruce Arnold wrote: 'Introverted, self-conscious, shy, dominated by his mother, overshadowed by his brother, unsuccessful in selling his work, increasingly bewildered about the direction

in which he was going, yet with a firm and lasting belief in his basic skills and his vision, Christopher Campbell presents himself an enigmatic figure in Irish art.' He died at Mater Misericordiae Hospital on 17 June 1973.

Works signed: Christopher Campbell (if signed at all).
Examples: Belfast: Ulster Museum. Belmullet, Co. Mayo: Tiraun Church. Celbridge, Co. Kildare: Vincentian House of Studies, St Wolstan's. Drogheda, Co Louth: Our Lady of Lourdes Hospital; St Mary Chapel of Ease. Dublin: Hugh Lane Municipal Gallery of Modern Art; Masonic Hall, Molesworth Street; Our Lady of Mercy Church, Coolock. Kilkenny: County Hospital. Limerick: University, National Self-Portrait Collection.
Literature: *Capuchin Annual*, 1956-57; *Who's Who in Art*, 1972; General Register Office, Dublin, *Register of Deaths*, 1973; Bruce Arnold: Neptune Gallery, *Christopher Campbell*, catalogue, Dublin 1976; Nesbit Waddington, *Letter to the author*, 1984; Ann M. Stewart, *Royal Hibernian Academy of Arts: Index of Exhibitors 1826-1979*, Dublin 1986; Gorry Gallery, *An exhibition of 18th, 19th and 20th century paintings*, catalogue, Dublin 1995.

CAMPBELL, GEORGE, RHA (1917-79), painter of landscape, still life and figure subjects; stained glass artist. George Frederick Campbell was born on 29 July 1917 in Arklow, Co. Wicklow, son of Gretta Bowen (q.v.). His father, Matthew, died in Belfast when he was eight years of age, and in 1929 he was sent to the Masonic Orphan Boys' School at Clonskeagh, Dublin, where he was a boarder six years.

Virtually self-taught, he began painting after the air raids on Belfast in 1941. Restless in commercial life, he eventually decided on painting as a profession. In 1944 he held a joint exhibition at the Mol Gallery, Belfast, with his brother, Arthur Campbell (q.v.). He also exhibited that year with Gerard Dillon (q.v.) in John Lamb's gallery in Portadown. After six months' experience in London, he exhibited successfully in Dublin at the Victor Waddington Galleries in 1946, the first of several shows at that venue. In 1948 he showed at Heal's Mansard Gallery, London, with Dillon, Daniel O'Neill and Nevill Johnson (qq.v.). In these early years, he painted with Dillon in Connemara.

Campbell first exhibited at the Royal Hibernian Academy in 1947. He was a regular contributor for the next thirty years, showing close on one hundred works. His first Spanish pictures were presented in 1952 when he showed *Spanish Market*; *Net Menders, Catalonia*; and *Harbour, Catalonia*. Among his works at the Ulster Museum are two Alicante subjects.

In 1949 the Council for the Encouragement of Music and the Arts had arranged a one-person exhibition in Belfast and subsequently in 1952 and 1960. CEMA's successor, the Arts Council of Northern Ireland, hosted shows in 1966 and 1972. In 1962, Campbell was the winner of a £500 prize in an open painting competition sponsored by CEMA. In the same year, he won an award in an exhibition of modern church art held by An Chomhairle Ealáion. In 1966, he won the Douglas Hyde Gold Medal for the best historical painting at the Oireachtas, and three years later the £100 prize for landscape.

On a tour to France, Italy and Switzerland in 1950, he became friendly with the Russian sculptor, Ossip Zadkine (1890-1967), who then lived in Paris. During the summer of 1951, he spent a month painting and sketching on Inishlacken Island off Roundstone in Connemara, staying in Dillon's cottage with James MacIntyre making up the trio. Campbell first visited Spain in 1951, returning nearly every year. For half of the year, the reeds and rocks of Co. Mayo, the stones and ruins of Co. Galway or Dun Aengus, Inishmor, would be replaced by picadors, gypsies moving camp, the beach at Palo, a street corner in Cordova, or perhaps blind street musicians. He also painted Irish musicians. In 1954 he moved to London.

As well as painting, he mastered the guitar and was accepted in Malaga as a player of flamenco. In 1955, he held an exhibition in Torremolinos. In 1957, after working for six months in the tiny fishing village of Pedrejalejos, Malaga, the British Council arranged for a show in Gibraltar. Arland Ussher's book *Spanish Mercy*, 1959, contained a chapter, 'Flamenco', which was largely a conversation with Campbell, who once said that 'the great pleasure in painting was doing the thing, not finishing it'.

In Ireland, he exhibited at the Irish Exhibition of Living Art, the Ritchie Hendriks Gallery, Dublin, and the Tom Caldwell Gallery, Belfast and Dublin. He was appointed an associate of the RHA in 1954 and a full member in 1964. He showed a still life in the 1960, 1961 and 1962 RHA exhibitions.

The Water Colour Society of Ireland elected him a member in 1954 but he showed only three works in 1955. In 1969, Campbell, Dillon and Arthur Armstrong (q.v.) designed the settings for *Juno and the Paycock* at the Abbey Theatre. Appointed in 1972, he was on the first board of the National College of Art and Design. Among his contributions to the 1972 RHA were *Still Life Shapes* and *Diverse Forms*.

Galeria CAA in Malaga arranged an exhibition in 1973, and with Armstrong, he showed at Galeria Kreisler, Madrid, in 1977. A fluent Spanish speaker, he was made a Knight Commander of Spain by the Spanish government.

Campbell's first attempt at stained glass was *The Sower Sowing the Seed*, approximately 3 metres by .75 metres, for the reconstructed church of St Colman, Tierneevan, Gort, Co. Galway. Other commissions were to follow: for St Dominic's, Athy; Galway Cathedral; and St Mary's, Tallaght, Co. Dublin. Extremely versatile, he wrote a series of articles on art for *Artists International*. He also broadcast several times, encouraged younger artists, illustrated occasionally for *Ireland of the Welcomes* and studied animals at Dublin Zoo. He executed an etching of his fellow artist Patrick Collins (q.v.) who reciprocated.

In 1971 and 1972, he was the subject of BBC programmes, and in 1973 of an RTÉ film, *Things Within Things*. In the 1970s Campbell had returned to Belfast to paint a series of the city torn by self-destruction. In 1973, among fifty works in mixed media at the David Hendriks Gallery, Dublin, were *Lottery Ticket Sellers, Avila* and *Golden Bird Legend*. In 1975, the Tom Caldwell Gallery showed 'Friends and Acquaintances 1944-1974', which included among the painters: Armstrong, Dillon, O'Neill; William Conor and Jack B. Yeats (qq.v.). Four paintings from his Belfast series were shown at the 1975 RHA. In 1977 'Mostly Connemara' was the title of a show at the Kenny Art Gallery, Galway.

In the Sligo Model and Niland Centre there is a Campbell crayon drawing of Yeats. *City Episode (Belfast Series)* and *Confrontation*, two oils, are in the Students' Union at Queen's University, Belfast. In the year of his death, he exhibited with Armstrong and Eric Patton at Gallery 22, Dublin, and then at the Joyce Gallery, Dusseldorf. He died on 18 May 1979 in Dublin and was buried at Laragh, Glendalough, Co. Wicklow. The George Campbell Memorial Travel Award, instituted to celebrate the strong cultural links which he developed with Spain, is funded by the Arts Councils in Belfast and Dublin and the Instituto Cervantes.

Works signed: Campbell or G. Campbell, rare.
Examples: Antequera, Spain: Museum of Fine Arts. Athens: Irish Embassy. Athlone, Co. Westmeath: Institute of Technology. Ballinasloe, Co. Galway: St Joseph's College. Belfast: Arts Council of Northern Ireland; Queen's University; Ulster Museum. Berne: International Post Office. Cork: City Library; Crawford Municipal Art Gallery. Downpatrick: Down County Museum. Dublin: Arts Council; Hugh Lane Municipal Gallery of Modern Art; Institute of Public Administration; Irish Museum of Modern Art; Radio Telefís Éireann; Trinity College Gallery; University Hall, Lower Hatch Street. Galway: Cathedral. London: Irish Embassy; St Mary's College, Twickenham. Malaga, Spain: Museum of Fine Arts. Mossley, Co. Antrim: Newtownabbey Borough Council. Navan: Meath County Library. New Brunswick, Canada: Beaverbrook Art Gallery. Oxford: Trinity College. Sligo: Model and Niland Centre. Waterford: City Hall, Municipal Art Collection. Wexford: Arts Centre.
Literature: Arthur and George Campbell, *Ulster in Black and White*, Belfast 1943; Arthur and George Campbell, *Now in Ulster*, Belfast 1944; Patrick Collins, *Envoy*, January 1950; *Irish Times*, 30 September 1964, 22 May 1979; James White and Eric Newton, *George Campbell, RHA*, Dublin 1966; *Eight Reproductions by two Irish Artists, George Campbell, RHA, and Arthur Armstrong*, Dublin 1967; Peter Harbison, *Guide to the National Monuments in the Republic of Ireland*, Dublin 1970 (illustrations); *George Campbell, An Eyeful of Ireland*, Dublin 1974 (also illustrations); John Hewitt and Theo Snoddy, *Art in Ulster: 1*, Belfast 1977 (also illustration); William J. Hogan, *Out of Season*, Galway 1978 (illustrations); Ann M. Stewart, *Royal Hibernian Academy of Arts: Index of Exhibitors 1826-1979*, Dublin 1986; Michelle Baily: Droichead Arts Centre, *George Campbell 1917-1979*, catalogue, Drogheda 1992 (also illustrations); James MacIntyre, *Three Men on an Island*, Belfast 1996 (also illustrations); *Irish Art at the Frederick Gallery*, catalogue, Dublin 1998.

CAMPBELL, JOHN P. (1883-1962), illustrator and designer. John Patrick Campbell was born in Belfast on 7 March 1883, son of William Henry Campbell, a road contractor of Loreto, Castlereagh Road. John was a brother of the poet, Joseph Campbell, who illustrated some of his own books, notably *Mearing Stones*, 1911. After their father died unexpectedly in 1900, they had to shoulder the burden of family affairs. John had shown artistic gifts and when he and his brother visited London in the summer of 1901, he had already been

to classes in design and life at the local School of Art. He designed a bookplate for the Belfast antiquary, Francis Joseph Bigger.

From the recollections of the poet, Padraic Colum, the Campbell brothers attended the Féis of the Nine Glens in 1904. Indeed the Belfast Central Public Library has a pen and ink drawing by John Campbell of the procession at Red Bay, and he designed and drew the cover for the Féis syllabus. *Songs of Uladh*, published in 1904, was a work of collaboration. The airs were collected and arranged by Herbert Hughes; Joseph Campbell wrote the lyrics and brother John provided the illustrations. The illustrator wrote to Francis Joseph Bigger on his lack of success promoting the book with the musicsellers of Belfast, and decorated his letter with a cartoon: skull and crossbones, red hand, musicsellers suspended from crossbar. In 1905 Bulmer Hobson's Dungannon Club was founded and Campbell was one of the artists who produced political postcards. He also contributed to *The Republic*.

In an article on John Campbell in *The Studio*, R.A. Dawson, ARCA, wrote that the signature 'Seaghan MacCathmhaoil' was becoming familiar on illustrations, principally of ancient Celtic romance, and suggested that Campbell might be called one of the products of the 'recent literary revival'. He was, in fact, associated with the Ulster Literary Theatre, acting as well as designing some of the costumes. Two other artists, W.R. Gordon and Jack Morrow (qq.v.), were with the company at this time. When the play, *Suzanne and the Sovereigns*, was revived in 1909, the programmes were printed as broadsheets with a drawing by Campbell of King William astride a rocking horse.

Dawson also wrote in his 1909 article in *The Studio*: 'He is a young artist with only a few years' professional practice, having no experience in other lands, no London or Paris training. From the time when, as a schoolboy, he was called on to draw posters advertising school events, up to the present, it is sheer hard study and some experience in the local school of art that have produced the powerful individual work we see in his latest productions.'

Notable among his illustrations were the six for the second edition of *The Táin* by Mary A. Hutton. Reproductions of the original drawings, lent by Lord Dunsany, were reproduced in *The Studio* two years later, 1909. Some of Campbell's earlier illustrations had appeared in the Irish text publications of the Gaelic League: for example, *Fréamaca na-h-Éireann*. His work was also published in *Uladh*, 1904-05, a literary quarterly, and as the frontispiece for *The Shanachie*, 1906. Twelve illustrated pages appeared in the *Calendar of the Saints: 1 Patric*, published in 1907 for 1908.

Campbell showed five works at the 1910 Royal Hibernian Academy, including *Balor is told of the Slaughter of his People* and *The Meeting of Midir and Étaín*. In 1910, at the centenary exhibition of Sir Samuel Ferguson, held in the Central Public Library, Belfast, a portrait by Campbell, a study from an earlier portrait of the poet, was published as a souvenir: 'Print. Entered at Stationers' Hall. All rights reserved.' Copies were available from print-sellers or the artist himself at 43 Chichester Street, Belfast. The Belfast Directory, 1911, described him at that address as a 'rent agent'.

In 1912, the brothers Campbell travelled to America with *The Drone* company. John stayed in New York and opened his studio. When Joseph returned to New York in 1935, his brother was at the pier to meet him. Joseph stayed some weeks at John's apartment on 65th Street. According to Padraic Colum, 'he illustrated many books when he came to New York, but his main interest was the stage and the pageant field ...'. However, Colum's illustrating claim for 'many books' has not been substantiated by New York Public Library.

Campbell was described as 'Director' for an Irish pageant, two episodes from *An dhord Fhiann* by Anne Abbot Craig, 'under the auspices of the American committee of the Gaelic League of Ireland in conjunction with the Gaelic League of New York', held at the 69th Regiment Amory, Lexington Avenue and 25th Street, New York, 7 and 8 May 1913. Apart from his other duties, Campbell supplied twelve drawings for the programme, including: *A King of Ireland and his retinue on their way to the Hill of Tara*; *The burial of Cumhall, father of Finn*; *St Patrick's first landing on the Shores of Ireland*; *Balor of the Evil Eye*.

According to R.A. Dawson, Campbell also produced when in Belfast 'a fine series of caricature portrait studies ... with a great sense of humour and a distinct character, marked by a decorative feeling and strong drawing'. Cathal O'Byrne in his *As I Roved Out*, 1946, which he dedicated to Francis Joseph Bigger, stated

that the latter bought Jordan's Tower, Ardglass, and changed its name to Castle Seaghan. In the retiring room of the third floor was written: 'Here was John Campbell's "Signs of the Zodiac", than which anything more beautiful has ever been done in Ireland since the matchless book of Kells'. He died in New York on 19 August 1962.

Works signed: John P. Campbell, Seağan Mac Cat m̃aoil, or S. Mac C.
Examples: Belfast: Central Public Library
Literature: Joseph Campbell and Herbert Hughes, *Songs of Uladh*, Belfast 1904 (illustrations); *Journal of the Irish Folk Song Society*, July and October 1904 (illustrations); *Uladh*, November 1904, February and September 1905 (illustrations); Belfast Central Public Library, *F.J. Bigger Collection*; Cathal O'Byrne and Cahir Healy, *The Lane of the Thrushes*, Dublin 1905 (illustration); *The Shanachie*, No. 1, 1906 (illustration); Ethna Carbery and C. Milligan Fox, *Songs from 'The Four Winds of Eirinn'*, Belfast 1906 (illustrations); Aodmain Mac Griógón, *Fréamaca na-h-Eíreann*, Belfast and Dublin 1906 (illustrations); *Calendar of the Saints: 1 Patric*, Dublin 1907 (illustrations); Mary A. Hutton, *The Táin*, Dublin 1907 (illustrations); R.A. Dawson, 'An illustrator of Celtic romance', *The Studio*, October 1909 (also illustrations); C. Milligan Fox, *Four Irish Songs*, Dublin 1909 (illustrations); Anne Abbot Craig, *An dhord Fhiann : an Irish historic pageant*, New York 1913 (illustrations); Eleanor Rodgers Cox, *Singing Fires of Erin*, New York 1916 (illustrations); Padriac Colum, 'I remember Joseph Campbell,' *Rann*, Autumn 1962; Sam Hanna Bell, *The Theatre in Ulster*, Dublin 1972; John Hewitt and Theo Snoddy, *Art in Ulster: I*, Belfast 1977 (also illustrations); Sr Assumpta Saunders, *The Journal of Irish Literature*, September 1979; *Irish Times*, 28 December 1985; John Killen, *John Bull's Famous Circus*, Dublin 1985; New York Public Library, *Letter to the author*, 1997.

CAMPBELL, LAURENCE, RHA (1911-64), sculptor. Born in Dublin, one of a family of eight children, Laurence T. Campbell was educated by the Christian Brothers at St Mary's Place. His grandfather was a woodcarver. An uncle, and his father too, carried on the family interest in the craft.

Laurence studied at the Dublin Metropolitan School of Art, initially at night classes, winning the Taylor Scholarship in 1935. His brother, Christopher Campbell (q.v.), also studied at the School of Art. While still attending classes, Laurence, an intensely reserved person, began stonecarving with a firm of commercial sculptors. His 1933 bust of Maud Gonne MacBride (q.v., Maud Gonne) is at the Hugh Lane Municipal Gallery of Modern Art.

Winner of the Henry Higgins travelling scholarship in 1936 and again in 1939, he was able to pursue his studies outside Ireland. In Stockholm, 1937, he worked under Nils Sjögren (1894-1952) and returned to Dublin after two years' study more confident and relaxed, having continued his interest in painting. At the Academie Ranson in Paris, 1939, his work was said to have won golden opinions from the sculptor, Aristide Maillol (1861-1944), who was also a painter. In that year, he also travelled through the Black Forest mountains in Germany.

A fellow student at the Metropolitan School of Art, Peter Brennan (q.v.), recalled to the author in 1983: 'I was almost at the end of my training and only worked with Campbell for a short time. I admired his work a great deal and he got on well with the students but not so well with the director ... I found him considerate and sensitive, and although he had a slight frame, his technique with stone was excellent. I believe in his early years he had worked as a monumental sculptor. I had great faith in Campbell's talent and was disappointed in later years that I did not learn of any success or distinction.'

From 1930 until 1955, Campbell showed more than one hundred works at the Royal Hibernian Academy. *The Happy Satyr* and *Mermaid*, both in wood, were in the 1939 exhibition, at a time when his address was Hôtel de l'Odéon, No. 3 rue de l'Odéon, Paris. An oil painting, *Port de l'Alma, Paris*, is in the Waterford municipal collection. He was appointed ARHA in 1938 and a full member in 1939. He also became Keeper of the Academy and Acting Professor of Sculpture at the National College of Art when Professor Friedrich Herkner (q.v.) left to join the German Army. He also succeeded Oliver Sheppard (q.v.) at the RHA Schools. In 1946, however, he severed his connection with the College of Art after a disagreement with the Department of Education about low rates of payment.

His style attracted attention in the field of religious statuary. *Madonna and Child*, 1933, was in sandstone. Two statues at Knockbridge, Dundalk, are both dated 1936. An elongated draped figure, *St Luke*, 1943, is at the county hospital, Kilkenny. *Saint Christopher*, carved out of Irish sycamore, appeared at the 1944 RHA.

One of his earliest commissioned works, *St Anthony and Child*, marble, is at the Adam and Eve Church, Dublin. In his 1995 history of the Dublin art school, John Turpin wrote: "Clay modelling had predominated in the school up to the 1930s, but subsequently there was a significant amount of stone-carving done under the influence of Laurence Campbell and Domhnall Ó Murchadha."

The painter James Sleator (q.v.) showed a portrait of Campbell at the 1942 RHA. In 1943, the sculptor was on the executive committee of the Irish Exhibition of Living Art. In the same year, the *Irish Art Handbook* appeared, and Arthur Power (q.v.) wrote: 'Of the younger sculptors, there is Mr Campbell, of outstanding precision and ability ... (he) has been through a number of phases in search of true personality, but at least he seems to be approaching it. There is his pleasant head of Miss Le Brocquy; and the dynamic realisation of his head of Mr Michael Scott, the architect. At present he is doing a three-quarter figure of Seán Heuston, the Sinn Féin commandant, which is to be erected in the Phoenix Park ...' A reported 2,000 people were present at the Heuston unveiling.

On the 1943 RHA, Máirín Allen in the *Father Mathew Record* found his *Mary Magdalene* 'so dramatic that it must belong to an earlier stage in his art, but his woodcarving of *Christ Healing the Sick*, on the other hand, is subdued, based on an unusual placing of perpendiculars and horizontals, just the combination of new but unstartling design and technical excellence that is typical of this sculptor's work'.

Campbell was responsible for the medallion heads on the Cenotaph at Leinster Lawn: Kevin O'Higgins, Michael Collins and Art O'Griffin. Two limestone panels symbolising Industry and Commerce are exterior at Marino Vocational School; also the torch. The Thomas Davis plaque, 1945, profile bust in low relief, at 67 Lower Baggot Street is also by his hand. In the same year, he exhibited a head of fellow academician, Jack B. Yeats (q.v.) at the RHA, now cast in bronze and at the National Gallery of Ireland. A bust of Yeats is at the Ulster Museum. Four Provinces ballroom, Harcourt Street, was designed in 1946 and on the front of the premises, Campbell carved a series of panels illustrating the history of the bakery and milling trades. The building was the headquarters for the Irish Bakers, Confectioners and Allied Workers' Union and was demolished in 1988.

Writing in the *Father Mathew Record*, Thomas MacGreevy said of Campbell's bust of the Most Rev. Dr William MacNeely, Bishop of Raphoe, exhibited at the 1946 RHA: '... It is a fully elaborated statement and the sculptor has made it with a subtle mastery of his medium that could not be surpassed anywhere, and equalled only by a very few living Parisian masters of the art.' Both dated 1948 are *Blessed Virgin and Child* and *St Joseph the Workman,* two of his three woodcarvings at the Jesuit Retreat House, Tullamore.

An informal 1950 portrait, head and shoulders, of General McKee is in McKee Barracks, Dublin. In the 1950s, Campbell had a studio at 30 Baggot Lane, Ballsbridge, Dublin. Little is known about his subsequent sojourn in the USA. A claim in *Martello*, the 1991 special edition on the RHA, that in the early 1950s 'when Ivan Mestrovic, the great Yugoslav sculptor, retired from his professorship of the University of Notre Dame, Indiana, one of the applicants for the position was Laurence Campbell of Dublin... His application was accepted' cannot be substantiated. Mestrovic in fact never 'retired' from Notre Dame but rather died in 1961 while still an active member of the faculty. He had joined the staff at Notre Dame in 1955 from Syracuse University, New York, where there is also no evidence that Campbell was employed there. In 1967, the Irish Embassy in Washington gave as his last known address the Deprato Statuary, Chicago.

Works signed: Laurence Campbell or Laurence T. Campbell.
Examples: Belfast: Ulster Museum. Benburb, Co. Tyrone: Priory. Dublin: Adam and Eve Church; Áras an Uachtaráin; Hugh Lane Municipal Gallery of Modern Art; Leinster Lawn; McKee Barracks; Marino Vocational School; National Gallery of Ireland; Phoenix Park. Kilkenny: St Luke's Hospital. Knockbridge, Co. Louth: St Mary's Church. Tullamore, Co. Offaly: Jesuit Retreat House. Waterford: City Hall, Municipal Art Collection
Literature: *Father Mathew Record*, September 1941, June 1943, May 1946; *Irish Art Handbook*, Dublin 1943; *Capuchin Annual*, 1945-6; Peter Brennan, *Letter to the author*, 1983; Rev. F. J. Hand, *Letter to the author*, 1983; Ann M. Stewart, *Royal Hibernian Academy of Arts: Index of Exhibitors 1826-1979*, Dublin 1986; *Irish Times*, 4 April 1988; *Martello*, 1991; University of Notre Dame, *Letter to the author*, 1991; also, Syracuse University, 1991; John Turpin, *A School of Art in Dublin since the Eighteenth Century*, Dublin 1995; Judith Hill, *Irish Public Sculpture: A History*, Dublin 1998 (also illustration).

CARACCIOLO, NICCOLO, RHA (1941-89), portrait and landscape painter. Born in Dublin on 18 September 1941, Niccolo d'Ardia Caracciolo was the only son of Ferdinando Caracciolo, Prince of Cursi. His mother was a FitzGerald of The Island, near Waterford, where he was reared. Educated at the Oratory School, 1955-9, Woodcote, near Reading, he showed no particular artistic leanings but one day he was bored and started to paint. The artist Pietro Annigoni (1910-88) saw a sample of his work in London and suggested that his talent be developed.

At Annigoni's recommendation, at the age of nineteen he began to study art in Florence under Nera Simi. He also had the critical advice of Annigoni from whom he learnt tempera, and virtually kept a base in Florence for the rest of his life, travelling back and forth to Ireland. Initially he worked on portraits in oil and tempera. When he painted landscapes, whether in Italy or Ireland, the scene was, according to one critic, often bathed in a soft, almost benign light familiar from nineteenth-century painting.

In 1964, Caracciolo was one of the painters chosen to paint a replica of the Sistine Chapel for the scenery of the film on the life of Michelangelo, *The Agony and the Ecstasy*. He arrived back at his Rathfarnham home for a well-deserved holiday: a seventeen-hour day on the project was not unusual. By the early 1970s he also had a studio in London, and from 1975-8 he lived at Rosemount House, Moate, Co. Westmeath. The scenes in his exhibition at the Lad Lane Gallery in Dublin, 1978, were devoted almost entirely to a study of the countryside near his home. Works included *Graveyard at Horseleap*; *Barn door, Rosemount*. The *Irish Times* said the pictures conveyed 'a very particular sense of things past, decaying, somewhat over-lush in their palette'.

While living in Italy, he worked closely with his friend and fellow painter, Anthony Bream. In 1979, he held his first one-person show in London, at the King Street Galleries in St James's. This featured scenes of Dublin and Florence, including *Factory Site in Coombe* and *Ponte Vecchio*. He exhibited occasionally at the Royal Academy summer exhibition and the Royal Portrait Society. In 1980, he held his second Dublin exhibition, again at the Lad Lane Gallery. In addition to the landscapes, there were nine still lifes.

A new departure was an exhibition of landscapes and still lifes in 1981 at the Ashley Gallery, Palm Beach, Florida, owned by an Irishman, Anthony McCarthy. The artist now divided his time between Ireland, England, France and Italy, the last two countries being the main inspirations for this American show of ninety works. He often made and gilded his own frames. Another show followed at the King Street Galleries in 1981, and when he exhibited at the Royal Hibernian Academy in 1982, it was from an address at Castletown, Celbridge, Co. Kildare. His 1982 exhibition at the Solomon Gallery, Dublin, included the oils, *Road to Clifden* and *Montpelier Market*, as well as a watercolour of Regent's Park. That year also saw shows at the King Street Galleries; Tuscaloosa Gallery, Alabama; G. S. McKenna Gallery, North Carolina.

In 1983, he was elected an associate of the RHA and held solo shows at the Solomon Gallery, Tuscaloosa Gallery and Grant Fine Art Gallery, Newcastle, Co. Down. In 1984, he became a full member of the RHA and arranged another display at King Street in London. At the Water Colour Society of Ireland 1984 show, he contributed *North Wall, Dublin* and *Grand Canal, Venice*, and two works in 1985.

Caracciolo, Antonio Ciccone and Annigoni were among the contemporary artists represented in a group exhibition at Comune Di Tuscania, Tuscany, in 1986. His last exhibition was at the Solomon Gallery in 1989, and a month later, his tragic death occurred on 16 December 1989 following a car accident near Siena, Italy. Burial was at Bunclody, Co. Wexford. The 1990 RHA contained a memorial section. Friends initiated an art scholarship in his name, and this was awarded for the first time in 1993 at the annual exhibition, for representational work to an Irish artist for a period of study in Italy.

Works signed: N. d'Ardia Caracciolo, N. d'A. Caracciolo, N. Caracciolo or N. d'A.C. (if signed at all).
Examples: Beijïng: Irish Embassy. Dublin: Office of Public Works. Limerick: University, National Self-Portrait Collection. Washington: Irish Embassy.
Literature: *Irish Press*, 13 September 1964; *Irish Times*, 13 February 1978, 27 February 1980, 19 and 22 December 1989, 5 February 1990, 25 April 1990; Lad Lane Gallery, *Niccolo Caracciolo*, catalogue, Dublin 1978; King Street Galleries, *Recent Paintings by Niccolo Caracciolo*, catalogue, London 1979; Ashley Gallery, *Niccolo D'Ardia Caracciolo*, catalogue, Palm Beach 1981; *The Post*, Palm Beach, 22 March 1981; Solomon Gallery, *Niccolo Caracciolo*,

ARHA, catalogue, Dublin 1983; Mrs Shirly Caracciolo, *Letters to the author,* 1990; Oratory School, *Letter to the author,* 1991; *Water Colour Society of Ireland Exhibition List 1872-1994*, Dublin 1995.

CAREY, JOHN (1861-1943), illustrator, animal and figure painter. Son of the Rev. J.W. Carey, Moravian minister in Kilwarlin, Co. Down, he was the brother of Joseph W. Carey (q.v.). He resided for nearly forty years at 12 Cyprus Park, Belfast, and took an active part in the affairs of the Moravian Church, University Road.

After working as an illustrator with Marcus Ward & Co., Belfast, he went into business with his brother and Ernest Hanford at Rea's Buildings, 142 Royal Avenue, Belfast, eventually working on his own behalf. He designed the well-known label for Camp coffee, depicting a Scottish Highlander.

A member of the Belfast Ramblers' Sketching Club, he designed the cover for the exhibition catalogue for 1888, at which time he was living with his brother at 11 Claremont Street. At this exhibition, John and Joseph Carey showed illustrations to *In Southern Seas*, a trip to the Antipodes by 'Petrel', a pen name used by the Belfast banker, Robert Cromie, who later wrote *The Crack of Doom*. 'Twain' was credited in the book for the illustrations. Among John's contributions was one on donkey rides, *Ashore at Ismailia*.

In 1898 the *Shan Van Vocht* reported that, with Miss Rosamond S. Praeger (q.v.), also of the Belfast Art Society, he helped to organise a Gaelic tableaux at a Feis Ceoil under the auspices of the Gaelic League in Belfast. Minute books of the Belfast Art Society showed his name on the committee, 1901, and his black and white sketches at a 1903 monthly meeting were regarded as very attractive: 'Most of them have been reproduced in the illustrations of a serial melodramatic story.' He also contributed to the political postcard. When Thomas H. Sloan retained his seat in 1906 the 'horsey' card read: 'Triumphant Return of Mr Sloan, M.P., and his Backers after winning the Parliamentary Handicap with Independent Unionism (by Integrity out of Protestantism)'.

Suprised, watercolour and pencil, 1890, of cavalrymen and their two horses, is in the Ulster Museum collection, and *The Long Car* in watercolour and pen is at the Ulster Folk and Transport Museum. He travelled by train and bicycle when he sketched in Connemara, describing his experiences at a Belfast Art Society meeting in 1912. He was credited with a series of twelve watercolours illustrating characters from the works of William Shakespeare.

Carey was responsible for at least two works depicting eighteenth-century Volunteers; both were probably from designs by Francis Joseph Bigger, Belfast, and one subsequently became the property of Robert Day, FSA, Cork. Carey contributed to Thomas McGowan's Old Belfast collection, Ulster Museum. Towards the end of his life, he became partially blind and his hearing was poor. He was knocked down by a bus on 26 April 1943 and died on the same day at the Royal Victoria Hospital.

Works signed: John Carey or J.C., rare.
Examples: Belfast: Ulster Museum. Cultra: Ulster Folk and Transport Museum.
Literature: 'Petrel', *In Southern Seas*, Edinburgh 1888 (illustrations); *The Shan Van Vocht*, 6 June 1898; *Gem Selection Songs of Ireland,* Dublin 1900 (illustrations); *The Lady of the House*, Christmas 1907, 1914 (illustrations); A.H. Mumford, *Our Church's Story: being a history of the Moravian Church for Young People*, London 1911 (illustrations); Ulster Society for the Prevention of Cruelty to Animals, *The Tree*, Belfast 1936 (illustration); Honor Rudnitzky, *The Careys*, Belfast 1978; Martyn Anglesea, *The Royal Ulster Academy of Arts*, Belfast 1981 (also illustration); Brian Kennedy: Ulster Museum, *British Art 1900-1937, Robert Lloyd Patterson Collection*, catalogue, Belfast 1982; John Killen, *John Bull's Famous Circus*, Dublin 1985; Molesworth Gallery, *Irish Watercolours and Drawings*, catalogue, Dublin 2000 (also illustrations).

CAREY, JOSEPH W. (1859-1937), seascape and landscape painter and illustrator. Son of the Rev. J.W. Carey, Moravian minister of Kilwarlin, Co. Down, Joseph W. Carey was a brother of John Carey (q.v.) and trained as an illustrator with Marcus Ward & Co., Belfast. A contemporary and a lifelong friend of Hugh Thomson (q.v.) who also worked at the firm, Carey was one of the original members of Belfast Ramblers' Sketching Club. At the club's exhibition in 1888 illustrations by Joseph and John Carey for *In Southern Seas*, an account of a trip to the Antipodes, were displayed. At least two of J.W. Carey's drawings were dated 1886

but it has not been established that the brothers were actually on the New Zealand Shipping Company's *Aorangi*, which left Tilbury for Tenerife. Among Joe Carey's contributions to the book was *Milford Sound, New Zealand*.

In 1893, he showed his first work, *Bravo Toro*, at the Water Colour Society of Ireland exhibition; in total he contributed seventy pictures. His initial address was 4 Wellington Crescent, Belfast. Eight years elapsed before he showed again in Dublin.

Following the failure of Marcus Ward's in 1899, he went into business with his brother John and Ernest Hanford. Later at the same address, 142 Royal Avenue, Belfast, he was in partnership with Richard Thomson (1862-1932), brother of Hugh Thomson. Early in the century, he supplied illustrations for Dungannon Club postcards, for example *The Battle of Antrim, 7th June, 1798*. In his younger days, he had been a balloonist and a chess player of some note.

The most prestigious commission of his career was for the Ulster Hall: thirteen scenes from Belfast history, on canvas, completed in 1903. These included: *Origin of Shipbuilding in Belfast: Ritchie's Dock*; *The White Linen Hall 1898*; *Old Turnpike and Dublin Coach Road c. 1830*; *The Blockade of Belfast by Thurot 1760*. Restoration of all the oil paintings, each measuring 1.1m. by 2.4m., began in 1989 and took a year to complete.

Unlike his brother John, Joseph Carey showed twenty-six works at the Royal Hibernian Academy in the period 1915-35. Among five contributions in 1917 were *Achill Head, Co. Mayo* and *A Fair Day, Galway City*. Among his WCSI contributions that year were: *The Poolbeg Lighthouse, Dublin*; *Glencar, near Sligo*.

Carey and Thomson specialised in illuminated addresses; miniature scenes in watercolour by Carey. A presentation album produced by them in 1915 is in Armagh County Museum. A 1924 volume containing loyal addresses from Ulster Unionists in Northern Ireland to the Rt. Hon. Lord Carson of Duncairn, each preceded by a composite page of views by Carey and known as 'The Carson Testimonial', was sold at Sotheby's, London, for £3,520 in 1982. In 1995 the Linen Hall Library in Belfast obtained a 1906 illuminated address by Carey and Thomson to James Wood, the last independent/liberal MP for East Down.

Percy French (q.v.) was a close friend and visited the Careys at their Belfast home, Brugh, Knockdene Park. Joseph also designed bookplates, including one for Robert John Welsh, MRIA. A Concarneau market day scene in watercolour was painted in 1922. In Co. Kerry, *The Gap of Dunloe*, watercolour, was dated in 1928. When the Ulster Academy of Arts, of which he became an academician, was founded in 1930, J.W. Carey was the only surviving member there of the original group which formed the Belfast Art Society.

The Ulster Museum has in its collection *Old House, Howth*, 1887, and *Rothesay*, 1890. He contributed sepia drawings to Thomas McGowan's Old Belfast collection for the Belfast Museum and Art Gallery. He is represented by five watercolours, including *The East Light, Rathlin*, and *The Wreck of the Girand*, at Ballycastle Museum, Co. Antrim. *The Canal, Lisburn*, 1919, watercolour, is at Lisburn Museum. He died in Belfast on 28 May 1937. An exhibition of his watercolours took place at the Malone Gallery, Belfast, in 1980. In an exhibition on the Kelly fleet at the Linen Hall Library, Belfast, in 2000, seven of the named ships portrayed were painted by Carey.

Works signed: J.W. Carey, Joe Carey, Jos. Carey or J.W.C., rare.
Examples: Armagh: County Museum. Ballycastle, Co. Antrim: Museum. Bangor, Co. Down: Town Hall. Belfast: Harbour Office; Linen Hall Library; Ulster Hall; Ulster Medical Society; Ulster Museum. Cultra, Co. Down: Ulster Folk and Transport Museum. Downpatrick: Down County Museum. Giant's Causeway, Co. Antrim: Visitors' Centre. Lisburn, Co. Antrim: Museum.
Literature: 'Petrel' (Robert Cromie), *In Southern Seas*, Edinburgh 1888 (illustrations); Francis Joseph Bigger, *The Ancient Friary of Bun-na-Mairge,* Belfast 1898 (illustration); and *Sir Arthur Chichester and the Plantation of Ulster*, Belfast 1904 (illustrations); and *The Northern Leaders of '98: William Orr*, Dublin 1906 (illustrations); David E. Lowry, *Norsemen and Danes of Strangford Lough*, Belfast 1927 (illustration); *Belfast News-Letter*, 15 February 1932; Ulster Society for the Prevention of Cruelty to Animals, *The Tree*, Belfast 1936 (illustration); John Hewitt and Theo Snoddy, *Art in Ulster: 1*, Belfast 1977; Honor Rudnitzky, *The Careys*, Belfast 1978 (also illustrations); Martyn Anglesea, *The Royal Ulster Academy of Arts*, Belfast 1981; Brian Kennedy: Ulster Museum, *British Art 1900-1937, Robert Lloyd Patterson Collection*, catalogue, Belfast 1982; John Killen, *John Bull's Famous Circus*, Dublin 1985; Ann M. Stewart, *Royal Hibernian Academy of Arts: Index of Exhibitors 1826-1979*, Dublin 1986; *Irish Times,* 29 January 1990; Lisburn Museum, *Letter to the author*, 1993; Anne Crookshank and the Knight of Glin, *The Watercolours of Ireland*, London

1994 (illustration); Moyle District Council, *Letter to the author*, 1994; *Water Colour Society of Ireland Exhibition List 1872-1994*, Dublin 1995.

CARNEY, MINA (1892-1974), sculptor. Mina Schoeneman was born in Chicago, Illinois, and received part of her training in Rome and Vienna. She was in Rome in 1936 when she corresponded with a Dublin friend. In her youth, she often made visits to Mexico where she worked in sculptors' studios. She met Jack Carney, her future husband, in Chicago through the American Communist movement prior to the First World War. Her husband was a friend of Jim Larkin and they were both deported from the USA during the so-called 'Palmer raids' following the war.

After the deportation, the Carneys were a much-travelled pair. They were in Russia to see the new experiment in socialism, as well as in Vienna, Rome, London, Dublin, and even back to the United States. They left Dublin for London about 1930, where Jack went to work as a journalist in Fleet Street. In 1947, Mina donated two works to the Municipal Gallery of Modern Art in Dublin: a bronze head of Jim Larkin, subsequently displayed at the Golden Jubilee of the Easter Rising exhibition at the National Gallery of Ireland in 1966; and a bronze head of a German boy. In 1983 in Dublin, the author inspected two plaster heads of Larkin in private possession and one of the boy. A small statuette of Eve holding the apple has not been traced.

Julius H. Kuney, whose wife was a niece of the Carneys, wrote to the author from New York: 'I really cannot answer your question about how committed Mina was to her sculpture. When we met her again after World War II, and lived with them, she already had given up as a practising artist. She had so many commitments, both political and emotional, that it really was a little hard for her to settle on anything. I know of no (public) work that exists outside the Dublin gallery. We have a small piece ourselves, and some postal cards of an old man and a Russian woman, but nothing of the magnitude of the Larkin work. She was an exceedingly bright and very complex woman.'

During the Second World War in London, Mina Carney ran a kind of salon in which many left-wing artists and writers participated. The Carneys were very friendly with the playwright Sean O'Casey and the painter Oskar Kokoschka (1886-1980), whose formative years had been spent in Vienna. When Mina died, there were no sculptures in her flat at Clifford's Inn, only pictures by Kokoschka, who had settled in England in 1938.

Works signed: Carney.
Examples: Dublin: Hugh Lane Municipal Gallery of Modern Art.
Literature: Dublin Municipal Gallery of Modern Art, *Letter to the author*, 1973; Julius H. Kuney, *Letter to the author*, 1983; also, Dr Viktor Matejka; Chris O'Sullivan, both 1983.

CARR, TOM, HRHA, RUA, RWS (1909-99), landscape and figure painter. Born at 14 Deramore Drive, Belfast, on 21 September 1909, Thomas James Carr was the son of a stockbroker similarly named. An early interest in art was encouraged by his grandfather, John Workman (1834-1922), a watercolourist, who took young Tom on sketching expeditions.

At the age of thirteen he entered Oundle School, Northants., and there he received his first serious instruction in art, from E.M. O' Rorke Dickey (q.v.). Another member of the Oundle staff, for a short period, Christopher Perkins (1891-1968), took Carr in 1926 on a family painting holiday to the South of France, where the youth from Ulster was delighted to sell a painting for £10.00.

In 1927 he enrolled at the Slade School of Fine Art, London, leaving after two years for a six-month stay in Italy, Professor Henry Tonks (1862-1937) having arranged accommodation for him at Settignano, outside Florence, in the medieval castle owned by the artist, Aubrey Waterfield (1874-1944). Carr visited 1 Tatti, home of the Renaissance expert Bernard Berenson. The great man was away but his niece enlivened proceedings. During his Italian stay, Carr had a period of study at the British School in Rome.

In 1933 he participated in the 'Objective Abstractions' exhibition at the Zwemmer Gallery, London. Among the group were Ivon Hitchens (1893-1979), Victor Pasmore (1908-98) and Ceri Richards (1903-71).

In 1935, at Canterbury, Carr held his first one-person exhibition, venue unknown but probably Beazley's Gallery.

The Euston Road School established itself in 1937 with William Coldstream (1908-87), Claude Rogers (1907-79) and Pasmore; Carr too was associated with the return to sober naturalism or muted realism. In 1937 he combined with Pasmore and Rogers at the Storran Gallery. At the London Group in 1938 he contributed *River Lagan; Edenderry House*.

In the company of the South African, Graham Bell (1910-43) he journeyed to Dublin on a painting expedition. They showed at Contemporary Pictures, Dublin, in 1939, and at the same venue that year Carr's work was in the 'Loan and Cross-Section Exhibition of Contemporary paintings.' Bell was later to lose his life on an RAF training flight.

Queen Elizabeth The Queen Mother acquired in 1939 the oil painting, *Dover Beach*, from the exhibition of contemporary English paintings at the Wildenstein Gallery, London. On the outbreak of War, Carr returned to Northern Ireland and settled with his family at Newcastle, Co. Down. His first solo show in London was at the Wildenstein Gallery in 1940 when he presented paintings. In Dublin, his inauguration at the Royal Hibernian Academy was with *Storm at Newcastle, Co. Down* in 1940.

On his London exhibition of thirty works at the Redfern Gallery in 1941, *The Studio* referred to him using 'what photographers call "the soft focus," a kind of artificial or almost arty short sight...' In Dublin, Contemporary Pictures held an exhibition in 1941. Occasional commissions for the War Artists' Advisory Committee included *Making Coloured Parachutes*, 1941.

In 1942 he shared space with Bell and two others at Leicester Galleries, London; in 1943 he showed forty-seven watercolours there, including *House with a pigeon loft*; *The Priests' Bridge*. In 1945 he exhibited oil paintings at the Leicester. In 1945 too from 'Elsinore,' Bryansford Road, Newcastle, he contributed to the Royal Academy: *Gray's Shop*; *The Bonfire*; *The Card Game*. At Burlington House he showed a total of ten pictures. Also he participated with the New English Art Club. Work appeared in the short-lived Northern Ireland branch, Artists International Association exhibition at Belfast Museum and Art Gallery, 1945. Forty-seven watercolours, including *Smithfield Market, Belfast* and *Capel Street Bridge, Dublin*, were hung at the Leicester in 1946.

Newcastle Beach, oil, 1947, portrayed a dozen figures on sand and in sea. In 1947 the Contemporary Art Society presented a watercolour, *The Farm Street,* to Leicestershire Museum and Art Gallery, and in 1947 he became an associate member of the Royal Watercolour Society. CEMA in Belfast, 1948, and the Redfern in London, 1949, organised exhibitions.

Festival 1951 produced the Contemporary Ulster Art exhibition at BMAG, and his work was included. Bournemouth Arts Club hosted an exhibition in 1952, the year of his watercolour, *Isaac Taylor's Farm*. CEMA sponsored another show in 1953, attendance 1,687. Other exhibitions followed at the Royal Albert Memorial Museum and Art Gallery, Exeter, 1955; Worthing Museum and Art Gallery, 1957. The Carr family left Newcastle in 1955 and moved to Beechill Park Avenue, Belfast, settling at 5a Malone Hill Park within a few years.

Carr with architect Robert McKinstry opened the Piccolo Gallery in Belfast in 1957 for showing local modern paintings and sculpture. On his two examples at the Irish Exhibition of Living Art in 1957, the *Dublin Magazine* commented: 'His *Nuns on the Beach* was a small masterpiece, reminding us of some coast-scenes of the English or the Normandy painters; only that this, and the more grandiose *Steps to the Shore*, lie a little outside the field of experimental art — they are in the best sense traditional.' It was in 1957 that he made his final contribution to the RA, *Winter Promenade*. During the late 1950s he taught part-time at the Belfast College of Art. Full membership of the RWS came in 1959.

CEMA staged another exhibition, this time at 7 Chichester Street, in 1960, twenty-two oils and eight watercolours. Another solo show took place at the Magee Gallery, Belfast, 1962. On his exhibition with Robert Buhler (1916-89) and Lawrence Gowing (1918-91) at the Leicester in 1965, *The Studio* noted: 'Thomas Carr has long been noticeable for his choice of unusual subjects and his unconventional treatment of design — *Children in Bed*, *Washing up*, and *The Clothes Line* are good examples, while the handling of paint in *Self-Portrait* is full of vigour.'

At the Leicester Galleries, 1966, he joined forces with John Piper (1903-92) and Kenneth Rowntree (1915-97). In 1967 he painted *The Oil Lamp*, oil. The Tom Carr and George Campbell (q.v.) exhibition in 1969 was displayed at the Arts Council Gallery, Belfast, and Brooke Park Gallery, Londonderry.

On his 1970 exhibition of watercolours at the David Hendriks Gallery, Dublin, the *Irish Times* critic wrote: '…big pictures as watercolour goes, but there is no suggestion of them being blown up beyond their style and content. They are also courageously and unfashionably traditional in theme. Almost all are landscapes, with a few studies of flowers or reeds…there is freshness, brilliance, lyricism and superb technique…On the strength of this exhibition he is, quite definitely, the outstanding watercolourist in this country.'

Deer's Meadow by Carr was one of the three paintings by Northern Ireland artists reproduced for special postage stamps, marking the Ulster '71 festival. In that year he held a joint exhibition with Charles Oakley at Tom Caldwell Gallery, Belfast. After an absence of thirty-one years, he returned to the RHA in 1971, showing *Lagan, Evening* and *Dog Rose, Summer*, both watercolours, and participated in only two other exhibitions, 1972 and 1979.

In 1971 and 1972 his work attracted attention in the Oireachtas exhibitions, Dublin. In 1973 he won the Gold Medal at the Royal Ulster Academy, the year he was elected an associate. Three solo exhibitions followed: George McClelland Gallery, Belfast, 1973; Caldwell, Belfast, 1974, and Dublin, 1975.

In 1974 he was awarded the MBE. The Arts Council of Northern Ireland commissioned in 1975 a portrait of Hilda Hawnt. There is a portrait of Professor K. G. Emeleus at Queen's University, Belfast. In 1976 Carr won the Conor Award at the RUA and the Oireachtas award in Dublin for landscape. Exhibitions in 1980 were: Grant Fine Art, Newcastle; Ulster Office, London.

A major retrospective, organised by the Arts Councils in Belfast and Dublin, took place in 1983 at the Ulster Museum and then Douglas Hyde Gallery, Dublin. The exhibition, covering more than fifty years, consisted of 162 works. The appreciation in the catalogue was written by T. P. Flanagan. In 1983 he showed two works at the Water Colour Society of Ireland exhibition: *Nine Crows* and *Tractor Tracks*.

Exhibitions celebrating his 80th birthday were arranged in 1989 in Belfast by the Caldwell Gallery and Eakin Gallery. 'Three Generations' followed in 1990 at the Eakin: Carr with his son-in-law, Martin MacKeown, and his grandson, James MacKeown. These three also showed in 1990 at the Phoenix Gallery, Highgate, London: Phoenix Gallery, Lavenham, Suffolk; Mistral Gallery, London. He received a Doctorate of Literature at Queen's University in 1991. Two years later works by Carr were exhibited at the European Parliament, Strasbourg, and that year he was made an honorary member of the RHA and was awarded the OBE.

In 1995 he left Belfast to live with his daughter at Itteringham, Norfolk. The BBC film on the artist, 'Sunshine in a Room', was transmitted in 1996. In London, he is represented by a lithograph, *Bedtime*, at the Tate Gallery, and by an oil, *High Tide*, in the Arts Council of Great Britain collection. The artist died at West Norfolk Hospital, Norwich, on 17 February 1999. Later in the year, Eakin Gallery hosted an exhibition of oils and watercolours.

Works signed: T. Carr.
Examples: Armagh: County Museum. Athlone, Co. Westmeath: Institute of Technology. Belfast: Arts Council of Northern Ireland; Education and Library Board; Malone Golf Club; Queen's University; St Joseph's College; Ulster Arts Club; Ulster Museum. Bristol, Avon: Art Gallery. Coleraine, Co. Derry: New University of Ulster. Coventry: Herbert Art Gallery and Museum. Downpatrick: Down County Museum. Leicester: Leicestershire Museum and Art Gallery. London: Arts Council of Great Britain; Clarence House; Tate Gallery; Victoria and Albert Museum. Manchester: City Art Gallery. Southampton: Art Gallery. Washington DC: Phillips Collection. Waterford: City Hall, Municipal Art Collection.
Literature: *Belfast Directory*, 1910; *The Studio*, January 1942, June 1965, January 1967; *Belfast Telegraph*, 7 September 1948; *C.E.M.A. annual report 1953-54, 1957-58*, Belfast; *Northern Whig*, 1 August 1957; *Dublin Magazine*, October-December 1957; *Irish News*, 12 July 1960; *Irish Times*, 19 September 1970, 8 May 1971, 22 September 1971, 14 October 1972; John Hewitt and Theo Snoddy, *Art In Ulster: I*, Belfast 1977 (also illustration); Martyn Anglesea, *The Royal Ulster Academy of Arts*, Belfast 1981 (also illustration); Arts Council of Northern Ireland, *Tom Carr Retrospective*, catalogue, Belfast 1983 (also illustrations); *Royal Academy Exhibitors 1905-1970*, Calne 1985; Ann M. Stewart, *Royal Hibernian Academy of Arts: Index of Exhibitors 1826-1979*, Dublin 1986; Eamonn Mallie, *Tom Carr*, Belfast 1989

(illustrations); S. B. Kennedy, *Irish Art & Modernism*, Belfast 1991 (also illustration); *The Oxford Dictionary of Art*, Oxford 1997; Clarence House, *Letter to the author*, 1999; also, Leicester City Council; Martin MacKeown; Oundle School; Royal Watercolour Society, all 1999; *News Letter*, 20 February 1999; *The Times*, 20 March 1999; Theo Snoddy, *UTV Art Collection: Catalogue of Works and Artists' Biographies*, Belfast 1999.

CARRÉ, J. S. M. (fl. 1900-14), sculptor. Joseph S. M. Carré exhibited a bronze bust, *The Very Rev. Canon Joseph McGrath*, at the 1900 exhibition of the Royal Academy, London, giving an address at 66 Glebe Place, Chelsea. Within a few years, he was sculpting as well as acting in Dublin, appearing in *The Dilettante*, a play by Casimir Markievicz (q.v.) at the Gaiety Theatre, and also in Sligo, 1908. He first showed at the Royal Hibernian Academy in 1909: *Athlete Resting* and a portrait bust of Canon McGrath.

Carré was associated with the Irish Art Companions of 28 Clare Street, Dublin. He exhibited, all pieces in plaster, at the Irish International Exhibition at Herbert Park, Dublin, 1907: *Bust of a Lady*; *June*; *Crepuscule* and, described as 'group, relief', *David Senex*. A member of the United Arts Club, Dublin, he held an exhibition there in 1910.

A contributor to the *Irish Review* in 1914 mentioned Carré in a production of Ibsen's *Rosmersholm* at the Theatrical Club: 'I cannot imagine anyone better in the character of the scholar bohemian ...'

At National Museum of Ireland there are plaster busts of Dr Douglas Hyde and Countess Markievicz (q.v.), both dated 1907, and a bust of Dr Hyde is also at the Model and Niland Centre, Sligo. At the National Gallery of Ireland is a standing male nude in bronze. The Royal Irish Academy has a bas-relief of the Rev. Sir John Pentland Mahaffy, and also in Dublin, at Richmond Hospital, are bronze busts of Sir W. Thornley Stoker and Sir William Thompson.

In the 1913 RHA exhibition, he contributed a portrait statuette in bronze and marble, *John Robert O'Connell*, and a bronze bust, *Edward H. Taylor, Esq., Surgeon*. He exhibited a statuette of a lady at the 1914 RHA, giving his address as Clonmel Street, off Harcourt Street, but that may have been his last showing in Dublin as he is believed to have returned to London. Altogether, he showed thirteen works at the Academy.

Works signed: Carré or J. S .M. Carré, rare.
Examples: Dublin: National Gallery of Ireland; National Museum of Ireland; Richmond Hospital; Royal Irish Academy. Sligo: Model and Niland Centre.
Literature: *The Studio*, October 1910; *Irish Review*, February 1914; Seán O'Faoláin, *Constance Markievicz*, London 1934; *Irish Times*, 3 September 1982; Eoin T. O'Brien, *Letter to the author,* 1982; Ann M. Stewart, *Royal Hibernian Academy of Arts: Index of Exhibitors 1826-1979*, Dublin 1986.

CARROLL, RAY (1930-94), liturgical sculptor. Born in Dublin on 21 November 1930, son of a businessman, Thomas Carroll, Raymond Patrick Carroll attended Blackrock College. At University College, Dublin, he dropped out of the civil engineering course and in 1951 travelled to Paris, where he studied at the studio of Fernand Léger (1881-1955), 'the primitive of a machine age.'

In his biography of Cardinal Cahal B. Daly, a student in Paris the same time as Carroll, Billy FitzGerald wrote: 'Those were the days of the flourishing of Existentialism. If the black soutanes of the clergy were to be seen in the colleges and the cafés of the student quarter, they were not the only ones in black. The black shirts of those who would have thought themselves followers of Jean-Paul Sartre and others of the new enlightenment were there too. One such was a young Irish artist and sculptor...Ray Carroll...' Leger, 'despite his appearance (he always dressed in dark suit with shirt and necktie, having the appearance of nothing other than a minor French civil servant) the perfect Man of the Left. His students, including Carroll, often remarked how little sense of humour he displayed...'

On leaving Paris and his Socialist colleagues, Carroll had sworn that he would never more have anything to do with the Roman Catholic Church, despite the advice of the great Jewish sculptor, Jacob Epstein (1880-1959), with whom he had also studied: 'Go back to Ireland and offer your talents to the Catholic Church. Work for the nuns; they are great people to work for.' At this time, one of Epstein's principal sculptures was *Madonna and Child*, 1950-2.

Carroll opened the Pine Forest Art Centre at Glencullen, Co. Dublin, for exhibiting his and other artists' works. At the beginning of his career as an artist he painted portraits and landscapes as well as religious subjects, but discontinued this activity when he started working to commission for churches and covents. His wife, Mary Carroll, later ran the Centre for art education. Overall, he worked in a variety of media: oil and tempera painting, sculpture in stone, wood, resins, metal and enamel.

Carroll's exhibition at the Pine Forest Art Centre in 1961 attracted Father Cahal Daly. Much to his surprise, the artist soon afterwards found himself in receipt of an invitation to visit Belfast with the aim of discussing the design of a set of *Stations of the Cross* for the Good Shepherd Sisters chapel. Thus began a friendship of collaboration. The *Stations* were later transferred to Ara Coeli, Armagh. Also at the Archbishop's residence is the Oratory designed by Carroll, whose window *The Disciples going to Emmaus* is at the Good Shepherd Centre in Belfast.

At the Exhibition of Irish Sacred Art held in Dublin in 1962, Carroll contributed *Mother of God* in wood. He was a member of the advisory committee on Sacred Art and Architecture set up in 1964 to help co-ordinate liturgical and artistic activities throughout the Irish Church. *Stations of the Cross* in brass, on a silver plaque, were sent in 1965 to the Liverpool diocese. He was responsible in 1966 for the baptistery and the *Stations* for the new St Mary's Church, Tamnaherin, Co. Derry. Monsignor Austin Duffy recalled to the author in 1998 seeing the Stations as a visitor to the church after it was opened: 'My memory is that they were moulded in polystyrene or some similar material. I am told that they did not appeal to the devotional taste of the parishioners and that they were subsequently removed and replaced by a more traditional set.' According to an architect associated with the scheme, the original Stations are stored in the church.

At the Independent Artists' exhibition in Dublin in 1968 he showed a crozier. For the new church, the Church of the Redeemer at Ardeasmuin, Dundalk, he was responsible in 1969 for the ambo, altar, chair, tabernacle and sanctuary decor. Sanctuary furnishings all in wood were provided for the extension to St Mary's Church, Tallaght, Co. Dublin; he was also responsible for the tabernacle. Also in 1969 he executed the enamelled tabernacle standing on a podium of Wicklow granite for the renovated chapel at St Patrick's College, Carlow.

Stations of the Cross were designed in 1971 for the Church of St Teresa, Sion Mills, Co. Tyrone, and also for the renovated church of St Saviour's, Dublin; also at Dominick Street, the pillar under the tabernacle and the screen behind the tabernacle were both the work of Carroll. In Knock, Co. Mayo, he was responsible for the tapestry in the Basilica of Our Lady Queen of Ireland.

Carroll's major work was at St Mel's Cathedral, Longford, where he re-ordered the sanctuary, the biggest task that he had ever undertaken. Crucial to the whole design was an enormous tapestry, *The Second Coming of Christ*, 8.5 m. in height, stretching up from floor level and carrying the colour scheme of the carpet up into the cathedral apse. He also painted *The Road to Emmaus,* in tempera, and designed and sculpted the altar, ambo and chair. Bishop Daly, who had given the commission, considered that these works for the cathedral were perhaps the best he had ever done. The project was completed in 1974.

Carroll was appointed artist consultant for the 1979 visits to Clonmacnois and to Knock by Pope John Paul II. A 1990 painting at St Mary's Church, Carrick-on-Shannon, Co. Leitrim, attracts the interest of the many tourists who visit the church, but it is not appreciated by many of the regular worshippers who still pine for the old arrangement of the sanctuary. The work is fitted into an 'egg-shaped' niche in an elaborate timber back-drop to the sanctuary, and to add to the controversy it is open to a variety of interpretations. The subject, in the opinion of some, is *Christ the Good Shepherd.*

Carroll designed and supervised the total refurbishment of the interior of Tuam Cathedral in 1991. Archbishop Joseph Cassidy was one of his noted patrons as regards church refurbishment, and as a result he was involved in several churches in the archdiocese. Carroll was a direct descendant of the original architect of the Cathedral, Dominick Madden.

The Church of Mary of the Immaculate Conception at Tír an Fhia, Co. Galway, was re-opened after renovation in 1992. Carroll, on his last commission, was responsible for the altar and cross, both stolen four years later but replaced with replicas by Ursula Klinger, a German artist living at Clifden, Co. Galway. His painting in the church was untouched. He once said in an interview: '...poetry is art. And art is for telling

things in the deepest possible way, even down to the sub-conscious level.' In Northern Ireland, and having been discharged from Antrim General Hospital prior to travelling home, he suffered a fatal heart attack in the town and died on 27 June 1994.

Works signed: Ray Carroll (if signed at all).
Examples: Armagh: Ara Coeli. Athlone, Co. Westmeath: Church of Our Lady Queen of Peace, Coosan. Belfast: Dominican Convent, Falls Road; Good Shepherd Centre. Blackrock, Co. Dublin: St Joseph's Church. Carlow, Co. Carlow: St Patrick's College. Carrick-on-Shannon, Co. Leitrim: St Mary's Church. Drumshambo, Co. Leitrim: Convent of Perpetual Adoration. Dublin: St Saviour's Church. Dundalk, Co. Louth: Church of the Redeemer, Ardeasmuin. Ennis, Co. Clare: St Flannan's College. Kildare, Co. Kildare: St Brigid's Church. Knock, Co. Mayo: Basilica of Our Lady Queen of Ireland. Longford, Co. Longford: St Mel's Cathedral. Maynooth, Co. Kildare: St Patrick's College. Newbridge, Co. Kildare: Newbridge College. Portstewart, Co. Derry: Dominican Convent. Sion Mills, Co. Tyrone: Church of St Teresa. Tallaght, Co. Dublin: St Mary's Church. Tamnaherin, Co. Derry: St Mary's Church. Tír an Fhia, Co. Galway: Church of Mary of the Immaculate Conception. Tuam, Co. Galway: Cathedral.
Literature: *Newbridge College Annual*, 1966; *Irish Times*, 29 November 1969, 28 June 1994; *Nationalist and Leinster Times*, 12 December 1969; *Irish Press*, 8 April 1971, 25 May 1971; Billy FitzGerald, *Primate: A Portrait of Cardinal Cahal B. Daly*, London 1992; Wilfrid Cantwell, *New Liturgy*, Autumn 1994; Mrs Mary Carroll, *Letters to the author*, 1997; also, Cardinal Cahal B. Daly, 1997; Church of the Redeemer, *Letter to the author*, 1998; also, Rev. Ciarán de Bláca, 1998; Monsignor Austin Duffy, 1998; Sister Maureen Flanagan, OP, 1998, 1999; Charles Hegarty; St Mary's Church, Carrick-on-Shannon; St Mary's Dominican Priory, Tallaght, all 1998; Rev. Joseph Quinn, 1999.

CASHEN, A. J. (1896-1972), primitive painter. Born in Nicholas Place, The Liberties, Dublin, Aloysius J. Cashen became a master tailor with a flourishing business at 17 South Anne Street. In addition to painting as a hobby, he wrote poetry, broadcast and acted. A brother, James F. Cashen (1893-1958), tailor and short-story writer, painted the human figure and tended not to exhibit publicly. However, his *Joseph Robinson*, from the National Museum of Ireland, was exhibited in 1966 at the Golden Jubilee of the Easter Rising exhibition, National Gallery of Ireland. He designed the badge and flag for Na Fianna, Countess Markievicz's organisation for boys.

According to a relative familiar with the work of both men, there was 'the same quality of intensity which owes nothing to technique, but rather to a naked feeling – an indefinable something that often surmounts bad draughtsmanship'. A.J. Cashen's best work was recollected from his youth. *Jack Carroll's Public House*, 1909, was at the corner of Nicholas Street and Christchurch Place. His best known work, *The Ship that Never Sails*, 1937, is of an old-fashioned tailor's workshop and so called because of the nautical terms which were employed in tailors' workplaces, the foreman being the skipper, and his men the crew, who would come on board at six bells in the morning.

During the period 1957-66, he exhibited nine works at the Oireachtas, his last being *Carnabhal faoin nGealach*. He showed *The Ruby Light* at the 1957 Royal Hibernian Academy. According to an undated and untitled magazine cutting which came into the author's possession, Cashen's paintings were displayed at the Cafe Royal, Piccadilly, sent from Dublin, for a silver jubilee dinner related to 'Friends of Don Orione'. The artist was quoted: 'My doctor has given me strict orders not to attend ... I feel sure you are starting something new, and that it will be the first exhibition of paintings for guests at a dinner'.

The oil painting, *Cill Mhaighneann*, appeared at the 1962 Oireachtas. It depicted a volunteer on his knees in Kilmainham Jail. A breach in the wall of the gaol showed the fires in O'Connell Street then recently bombarded.

In an article in *The Harp*, Bryan Guinness, wrote: 'By his art he has been able to make us not only see what he used to see, but feel what he used to feel, and live what he used to live.' Among the score of paintings in his flat before he died were: *Beach at Portsalon*; *Nocturne: Moonlight Sonata*; *The Lady on the Bog: Ballinakill, Co. Galway*; *The Famine, 1847*; *Dublin Newsboy*; *Carnival: Dun Laoghaire*. Cashen had previously resided at 59 Glandore Road. He died on 23 August 1972 at 107 Hollybank Road, Drumcondra.

Works signed: A.J. Cashen.
Literature: Bryan Guinness, *The Harp*, July 1959; Lord Moyne, *Letter to the author*, 1972; also, Mrs M. Beaton, 1973; J.E. Cashen, 1983; An tOireachtas, 1983; Frederick Gallery, *Irish Art*, catalogue, Dublin 2000 (also illustration).

CASSIDY, JOHN, RBS (1860-1939), sculptor. Son of a farmer, he was born on 1 January 1860 at Littlewood, Slane, Co. Meath. Five of his six brothers emigrated. He also left the small farm and served his apprenticeship as a bar assistant in the White Horse Hotel, Drogheda, and was said to have spent his spare time etching.

Two oil paintings by Cassidy of 1880 vintage are in Drogheda. One is a street scene with notable characters of the town; the other is a copy of an earlier watercolour, *The Wooden House, Shop Street, Drogheda, 1830*. Both these works were presented to Drogheda Corporation in 1949 by R.B. Davis, who advised that the picture of the wooden house was copied for his late father, who was said to have encouraged Cassidy to attend art school.

At the age of twenty-two, Cassidy travelled to England to study at the Manchester School of Art, then under the direction of a newly appointed headmaster, R.H.A. Willis (q.v.), a talented painter and sculptor and an excellent teacher who was born at Dingle, Co. Kerry. Cassidy himself had intended to become an art teacher, but he afterwards specialised in modelling, winning several medals and prizes.

Cassidy's first commission, gained through Willis's recommendation, was for decorative modelling at the new Harris Institute building at Preston, for which Roscoe Mullins (1849-1907) was carving the figure sculpture. There followed an engagement to give demonstrations in modelling from life at the Manchester Jubilee Exhibition of 1887, during which time he was said to have modelled more than 200 heads. It was through commissions that arose from this assignment that he was able to set up as a professional sculptor.

In his first appearance at the Royal Academy in 1897, he showed a bust of Sir Charles Hallé. Two years later, again from Lincoln Grove Studio, Manchester, he exhibited at the Royal Hibernian Academy a sketch model for a colossal group in bronze: *John and Sebastian Cabot, the discoverers of North America, and pioneers of British maritime enterprise*. He gave the same Manchester address when he exhibited two portrait busts at the Royal Academy in 1904. His sixth and last exhibit at the RHA was an equestrian statuette of Miss O. Walker. In 1914, he was appointed a member of the Royal Society of British Sculptors, and two years later he was patronised by the Queen. Many other commissions, public and private, followed.

Cassidy showed extensively in exhibitions at the Manchester City Art Gallery, and to a lesser degree at the Royal Cambrian Academy, becoming a member in 1928, and the New Gallery, London. In the 1925 British Empire Exhibition, he was represented by a bust, *Annie Besant*. His statue, *King Edward VII*, is in Whitworth Park, Manchester. The commission for the bronze statue, *Edward Colston*, at Bristol, was gained in competition. Public war memorials are in several English towns, including Skipton, Clayton-le-Moors, Stourbridge and Heaton Moor, now Greater Manchester. The commission for Skipton was to execute and erect the memorial at a cost not exceeding £3,000.

There are several examples of his work in the Manchester City Art Gallery. These include a bronze bust of the painter, William Powell Frith, RA (1819-1909), modelled from life in his ninetieth year; and a bronze bust of the Manchester painter, H. Clarence Whaite (1828-1912). A bust of Edward John Broadfield is in marble, and a bronze figure is *The Ship Canal Digger*. There are also four bronze plaques and a bronze medallion, *Alcock and Brown*, 1919.

A full-length figure of Queen Victoria, signed and dated 'John Cassidy fecit 1897', was situated at Queen Victoria Memorial School, Durham Street, Belfast, but was subsequently rescued from the bulldozer and is now in the stableyard of the National Trust premises, Rowallane House, Saintfield, Co. Down.

For many years, Cassidy, a keen ornithologist, was treasurer of the Manchester Academy of Fine Arts, a member of the art section of the Manchester Education Committee, and a governor of the Whitworth Institute. A bachelor, his last known address was at Ashton-on-Mersey, Cheshire, and he died on 19 July 1939.

Works signed: John Cassidy or J.C., rare.
Examples: Bolton: Victoria Park; Victoria Square. Bristol: Museum and Art Gallery; St Augustine's Parade. Bury: Spring Street. Cardiff: National Museum of Wales. Drogheda, Co. Louth: Corporation Council Chamber. Manchester: City Art Gallery; Piccadilly Gardens; Queen's Park; John Rylands Library; Whitworth Park. Saintfield, Co. Down: Rowallane House. Skipton, Yorkshire: High Street.
Literature: W.G. Strickland, *A Dictionary of Irish Artists*, Dublin 1913; *Manchester Guardian*, 20 July 1939; Patrick L. Cooney, *Irish Independent*, 15 August 1967; *Dictionary of British Artists 1880-1940*, Woodbridge 1976; *A Dictionary of Contemporary British Artists, 1929*, Woodbridge 1981; Skipton Town Council, *Letter to the author*, 1983; National

Trust, Saintfield, *Letter to the author*, 1985; Ann M. Stewart, *Royal Hibernian Academy of Arts: Index of Exhibitors 1826-1979*, Dublin 1986.

CASSON, KAY (1915-92), stage designer and landscape fantasy painter. Kathleen O'Connell was born in Dublin on 1 October 1915, daughter of Michael O'Connell, a tram inspector. She attended Sion Hill Convent, Blackrock, Co. Dublin, and 1933-5 studied at the Dublin Metropolitan School of Art. In 1935 she joined the Gate Theatre as assistant scenepainter and designer to Molly MacEwen, working on the Edwards –Mac Liammóir productions. The actor, Christopher Casson (1912-96), son of Sir Lewis Casson and Dame Sybil Thorndike, arrived at the Gate in 1938. Three years later he married Kay O'Connell. Subsequently they joined Lord Longford's company as actor and designer respectively.

In 1932 Christopher Casson had toured with his mother and father in Australia, taking up painting and sketching — 'always searching for abstractions in the theatre and everywhere — from Gertrude Stein to Picasso and Braque...,' he said. In 1943 he and his wife had their first joint exhibition, at The Country Shop, St Stephen's Green, Dublin.

In her theatre work, in the 1940s for example, Kay Casson supplied the settings for *The Magistrate*; *The Watcher; The Lady from the Sea*; *A Midsummer Night's Dream* (also costumes); *The Doctor's Dilemma*; *Yahoo*; *John Donne*; and *The Time of your Life*. She designed *The Taming of the Shrew* at the Gaiety Theatre in 1954; and *The Tempest* in 1958 for the reopening of the Gate Theatre after renovation. In the 'Irish Art 1900-1950' exhibition at Cork in 1975 three of her designs, all in gouache, were exhibited: front cloth for *Twelfth Night*; tapestry for *The School for Scandal*; front cloth for *A Midsummer Night's Dream*.

The titles of her works at the Royal Hibernian Academy exhibitions did not indicate a fantasy element. One observer wrote: 'Hers was a land of personal make-believe, be it Dublin, Amalfi, Venice or the Alhambra.' She used clear, bright colours, blue and green figuring largely. Hers was a trained eye, so one could hardly describe her work as "naive."' Bronwen Casson, her daughter, wrote to the author: 'The distortion of perspective was deliberate. Size was relative to importance in the overall view. I am looking at one picture in which an angel is larger than the oratory beside which it is standing.'

In 1977, from 83 Strand Road, Sandymount, Dublin, she opened her account at the RHA, and thereafter showed annually up to the year of her death, a total of thirty-one pictures. With the exception of her initial exhibit, *Powerscourt*, a watercolour, all were in gouache. In 1979 she contributed *Dublin Gate Theatre* and *Lower Lake, Killarney*. A visit abroad was indicated in 1983 by *Venice*. She tended not to paint people.

' I just love drawing and painting and I do it for the love of it; if people like it and buy, that's fine,' she once remarked. 'But I'd do it anyway whatever people thought...' In her exhibition at the Grafton Gallery, Dublin, in 1985 she showed forty works, including *Cobh Harbour* and *Glendalough*.

For the first time, in 1986, she was represented by four works at the Academy: *St Stephen's Church*; *Croagh Patrick*; *Customs House*; *Dingle, Co. Kerry*. By one of those odd coincidences, her final exhibit bore her maiden name, *O'Connell Street*, but the last curtain had already fallen. She died at St Vincent's Hospital on 1 April 1992.

Fifty years after their first show in Dublin, Christopher Casson and the late Kay Casson held an exhibition at the Peacock Theatre Gallery in 1993. He described his pencil and felt pen drawings as 'an expression of my neurosis' : religious and abstract themes with their own sense of humour. In 1994 at the Peacock he exhibited with Bronwen Casson, a stage designer who showed costume designs in ink and acrylic. A second joint exhibition of father and daughter took place at the United Arts Club in 1996. He was credited with a drawing a day for about four years.

Works signed: Kay Casson.
Examples: Dublin: Gate Theatre.
Literature: Grafton Gallery, *Kay Casson*, catalogue, Dublin 1985; Ann M. Stewart, *Royal Hibernian Academy of Arts: Index of Exhibitors 1826-1979*, Dublin 1986; *Royal Hibernian Academy of Arts 1980-1986, 1988-1992*, catalogues; *Irish Times*, 2 April 1992, 2 May 1992; Peacock Theatre Gallery, *Press Release*, Dublin 1993; *Exhibition of Paintings by Bronwen and Christopher Casson at The Peacock Theatre Gallery*, catalogue, Dublin 1994; Bronwen Casson, *Letters to the author*, 1997.

CHARDE, HUGH C.(1858-1946), landscape and portrait painter. Born in Queenstown, Co. Cork, Hugh Coleman Charde was the son of John P. Charde, master painter. Receiving his early tuition in the drawing school of the North Monastery, Cork, he then studied at Cork School of Art under James Brenan, RHA. (q.v.), and won prizes in 1879 and 1881. In an extended continental studentship, he attended the École des Beaux Arts at Antwerp under Charles Verlat (1824-90), and also studied at Paris studios. *A Corner of old Antwerp* was on view at the Cork Industrial and Fine Art Exhibition, 1883, as well as *Study of an Italian*. An Antwerp address was given.

Charde's *Market Women*, 1886, oil, is in Crawford Municipal Art Gallery, Cork. In 1889 he apparently joined the staff of Cork School of Art, although he did not receive his teaching certificate from South Kensington until 1893. He continued to win prizes as a 'student' right up until 1897, which was at least eighteen years after admission. In 1904, he completed a commission for the Cork Operative Society of Masons and Bricklayers; this was a banner measuring 3.6m by 2.7m.

A regular contributor to the Royal Hibernian Academy exhibitions in Dublin from 1886 until 1938, he exhibited forty-five works in all including: 1916, *Marshes near Kenmare*; 1928, *The Upper Reaches, Dingle Bay*. In 1920 he was instrumental in forming the Muster Fine Art Club, and was appointed chairman. At the 1925 exhibition he showed a watercolour, *Dingle Peninsula*. His portraits were in demand locally; Denny Lane was a sitter.

In 1919, he became headmaster of the Crawford School of Art and remained in that post until 1937. His *'Feeding Time'* of 1900 was hung at the RHA, and is now in the Cork Municipal collection. As principal of the School of Art, he was appointed in 1920 to advise on the selection and purchase of works for the gallery as stipulated in the Gibson Bequest. His popularity and ability to teach ensured the success of his classes and when he was second master the then Department of Technical Instruction had engaged him to take charge of summer courses at Dalkey, Rathfarnham and Wexford.

Charde's 1920 oil portrait of Terence MacSwiney, Lord Mayor of Cork, is also at Crawford Municipal Art Gallery. Imbued with a love of the Irish countryside and coastline, Charde was a keen walker. Kinsale and Garrettstown Strand were favourite places for painting. The final contribution at the RHA was *The Sand Boat* in 1938. His works could often be seen hanging in the Palace Theatre, Cork. A fellow Cork artist told the author in 1973 that Charde was 'like a character from Dickens and well liked'. His studio was at 52 Grand Parade, Cork. In latter years, he specialised in watercolours. He died at South Informary, Cork, on 15 July 1946.

Works signed: H. Charde, Hugh Charde or H.C. Charde.
Examples: Cork: Crawford Municipal Art Gallery. Killarney: Town Hall.
Literature: Cork Examiner, 17 July 1946; *Dictionary of British Artists 1880-1940*, Woodbridge 1976; Belinda Loftus, *Marching Workers*, catalogue, Belfast 1978; *A Dictionary of Contemporary British Artists, 1929*, Woodbridge 1981; M.C. Hutson, *Letter to the author*, 1983; Ann M. Stewart, *Royal Hibernian Academy of Arts: Index of Exhibitors 1826-1979*, Dublin 1986; Peter Murray, compiler, *Illustrated Summary Catalogue of The Crawford Municipal Art Gallery*, Cork 1991 (also illustrations).

CHESTER, EILEEN – see MURRAY, EILEEN

CHILD, A.E. (1875-1939), stained glass artist. Alfred Ernest Child was born on 11 February 1875 at 192 Malpas Road, Deptford, London, son of Henry Child, dock clerk. When he left school, it was to work in an accountant's office, but after a year it was suggested that his talents would be better utilised in an artistic career. He won a scholarship and began studying stained glass. Child attended the Central School of Arts and Crafts, founded 1896, where Christopher Whall (1849-1924) taught. Whall was a follower of William Morris (1834-96). In the late 1890s Child started working in Whall's studio as an assistant glass-painter and designer. He was one of the team who helped Whall with his most important commission, the Lady Chapel windows at Gloucester Cathedral, begun in 1898.

In his book, *Edward Martyn and the Irish Revival*, Denis Gwynn quoted Martyn: 'I succeeded in persuading Mr T.P. Gill to settle in the School of Art Mr Child, a pupil of the celebrated Christopher Whall and a most efficient teacher ... I also at the same time suggested to Miss Purser the advisability of opening a studio where he should be the chief artist ...' Sarah Purser (q.v.) agreed and *An Túr Gloine* was founded.

Child, who was highly regarded by Whall as both designer and craftsman, entered the Dublin Metropolitan School of Art in September 1901 and two months later formed a class in stained glass. The Tower of Glass studio was opened officially in January 1903, although it is likely that work had been going on in late 1902. Child was the manager. When the Guild of Irish Art-Workers was formed in 1910, he was a member.

Child's elder daughter was to marry the father of Keith Dungan, who wrote to the author in 1999:'...as was not uncommon, he "became more Irish than the Irish themselves": he had Gaelic lessons from Padraic Pearse and learned bridge from Thomas Clarke, according to my grandmother.'

Edward Martyn was a generous benefactor of the new Loughrea Cathedral, and in 1903 he had placed commissions for windows with *An Túr Gloine*. It is the opinion of Dr Michael Wynne, an authority on Irish stained glass, that these early windows were designed by Child. No doubt appears to exist about the other Loughrea windows credited to Child: *Saints Clare and Francesca*, two-light, 1929; *The Centurion*, 1934; *Saint Patrick*, 1937. The window of St Finnian of Moville and St Mobhi for St Eunan's Cathedral, Letterkenny, was completed in 1911.

When *An Túr Gloine* celebrated its twenty-fifth anniversary, T.P. Gill said in a speech: 'The best piece of Mr Child's popular and charming work is, perhaps, the big East window in Castletownbere, but he is well represented nearer at hand in the Unitarian Church in Stephen's Green, and the war window in St Philip's, Temple Road.' The booklet issued in connection with the celebration also quoted from the *Christian Science Monitor*, which referred to the Unitarian Church window as a 'memorial to Thomas Wilson, Ship Owner, and Consul for USA. His father was the first Consul in Dublin for USA, after serving as ADC to General Washington.'

In the chancel of the Honan Chapel at University College, Cork, is Child's *Our Lord*; and in the nave: *St Ailbe*, *St Colman* and *St Fachtna*. The five-light window, dated 1918, in the Unitarian Church, Dublin, has representations of Christopher Columbus, Martin Luther, Christ in the Temple, Florence Nightingale and William Caxton. On the most miniature of scales, he contributed a window to Titania's Palace, now in Denmark. St Andrew's College, Dublin, commissioned a five-light window as a war memorial, with St Andrew as a central figure. It was installed in St Stephen's Green in 1921 and moved to Clyde Road with the school. As a suitable place had not been found in the new Booterstown school, it was in storage there in 1994.

Student numbers at the stained glass course had been in decline for some years and in 1938 it was suspended. Child's main contribution to stained glass in Ireland was the teaching of technique and practical approach to the making of a window. He trained two students who were to become famous in the medium, Harry Clarke and Michael Healy (qq.v.). *The Agony in the Garden*, charcoal, is at the National Gallery of Ireland. Despite failing eyesight, he worked at *An Túr Gloine* until his death in 1939.

Works signed: A.E. Child or A.E.C., monogram.
Examples: Billund, Denmark: Legoland. Blackrock, Co. Dublin: St Andrew's College, Booterstown Avenue. Castletownbere, Co. Cork: Sacred Heart Church. Cork: Honan Chapel, University College. Dublin: Methodist Church, Sandymount; National Gallery of Ireland; St Philip's Church, Temple Road; Unitarian Church, St Stephen's Green. Emly, Co. Tipperary: St Ailbe's Church. Kilkenny: St Canice's Cathedral. Letterkenny, Co. Donegal: St Eunan's Cathedral. Loughrea, Co. Galway: St Brendan's Cathedral. Magheralin, Co. Down: Holy Trinity Church. Randalstown, Co. Antrim: St Brigid's Church. Tulsk, Co. Roscommon: Church of St Fidelma and Ethna.
Literature: *Register of Births, Grennwich*, 1875; *Titania's Palace*, Dublin 1926; *An Túr Gloine: Twenty-Fifth Anniversary Celebration*, Dublin 1928; Denis Gwynn, *Edward Martyn and the Irish Revival*, London 1930; Michael J. O'Kelly, *The Collegiate Chapel, Cork*, Cork 1955; James White and Michael Wynne, *Irish Stained Glass*, Dublin 1963; William J. Dowling, *Letter to the author*, 1969; Peter Cormack, *Letters to the author*, 1983; Dr Michael Wynne, *Letter to the author*, 1983; Graham Harrison, *Saint Eunan's Cathedral, Letterkenny, Co. Donegal*, Dublin 1988; Ms Georgina Fitzpatrick, *Letter to the author*, 1994; also, Royal Danish Embassy, London, 1994; John Turpin, *A School of Art in*

Dublin since the Eighteenth Century, Dublin 1995; Keith Dungan, *Letter to the author*, 1999; also, William Morris Gallery, 2000.

CHRISTEN, MADAME (1847-1923), landscape and portrait painter. Sydney Mary Thompson was born in Belfast, the daughter of a linen merchant, James Thompson. She was a niece of the celebrated naturalist, William Thompson (1805-52), also of Macedon on the shores of Belfast Lough. She was perhaps better known as a naturalist and geologist than as a painter, and was for many years an active member of the Belfast Naturalists' Field Club. Geology was then a popular science for women to study.

After attending the Government School of Art in Belfast where she won a number of prizes, she later served on the board. In 1886 she was elected a member of the Ramblers' Sketching Club, Belfast, when she exhibited five landscapes at the club rooms, 55 Donegall Place. In 1888, her contribution included two Giant's Causeway subjects. She was represented in that year in the Irish Exhibition in London. When the club became the Belfast Art Society, she had a period as honorary secretary. In 1893, she was presented with an album containing fifty-eight original sketches by members of the Society as a token of their appreciation for her services.

In 1888, this time in Paris, she renewed acquaintance with Rodolfe Christen (1859-1906), a Swiss artist, and for the best part of two years they made many sketching excursions together. Both attended life classes at the Académie Délécluse in the Rue Notre Dame des Champs.

As a teacher, Christen later organised sketching classes in various towns in Great Britain and Ireland. He arrived in Belfast via Dublin on his first visit in 1893, and was made an honorary member of the Belfast Art Society. He must have known Sarah Purser (q.v.) from his Dublin visits, because in July 1899 they went to a London theatre, 'where we laughed to split our sides'.

Sydney Mary Thompson married Rodolfe Christen in 1900, the year she was elected an honorary member of the Belfast Art Society. Then for two years they toured the continent, sketching and painting. In 1902 they spent a month in Donegal, and some of his work, for example *Peat Carrying in Donegal*, was reproduced in the biography which she wrote after his death at their Scottish home, St Imier, Brig O'Gairn, Ballater. The book also included several Co. Antrim landscape reproductions.

In 1921, she was made a patron of the Belfast Art Society. At the Belfast Museum and Art Gallery in 1927, she was represented in a loan exhibition, Irish Portraits by Ulster Artists, by *Samuel Alexander Stewart, ALS, FBSE*, 1896. This found its way into the Belfast Natural History and Philosophical Society collection which is now in the Ulster Museum. In the geology department, there are two watercolours by her of Co. Donegal terrain. Madame Christen died at Llandudno on 16 July 1923.

Works signed: S.M.T.
Examples: Belfast: Ulster Museum.
Literature: Belfast Art Society, *Minute book*, 1900; Sydney Mary Christen, *Rodolfe Christen: The story of an artist's life*, London 1910; Martyn Anglesea, *The Royal Ulster Academy of Arts*, Belfast 1981.

CHRISTIAN, CLARA (1868-1906), landscape, interior and still life painter. Born on 27 September 1868 at Holly Cottage, Willow Walk, Tottenham, Co. Middlesex, Clara Christian was the daughter of James Christian, jewels casemaker. She attended the Slade School of Fine Art and contributed regularly to the New English Art Club shows from 1897 until her death. She exhibited *Poppies* at the Royal Academy in 1898 when living at 33 Tite Street, Chelsea, where she shared accommodation with Ethel Walker (1861-1951), who was later to be created Dame Commander, Order of the British Empire, for her services to painting. They also shared lodgings at 38 Cheyne Walk and travelled together in Italy and Spain.

In 1901, she accompanied George Moore of literary fame to Dublin, where she lived in relative seclusion at Tymon Lodge, Tallaght, Co. Dublin, as related by Moore in *Hail and Farewell*, in which he used the pseudonym 'Stella'. Evidence would also suggest that 'Florence' was Ethel Walker, Clara's contemporary at the Slade where they studied under Professor Frederick Brown (1851-1941). After the exhibiting of *The Orchard* at the Royal Hibernian Academy in 1902, *The Studio* considered it 'worthy of favourable notice'.

Clara Christian was an enigmatic figure in Moore's life. Mary Swanzy (q.v.) described her as 'an Englishwoman who came over to Dublin when Moore moved from London and was known as "George Moore's friend"'. In 1904, she spent several months in Italy at Rapallo, from where she sent *Milking Time* and *July* to the RHA. In the following year, she donated a genre interior *Meditation*, oil, to the Municipal Gallery of Modern Art, Dublin.

In *Hail and Farewell*, Moore stated that, prior to her 1901 arrival, she had never been in Dublin before. In another passage, he wrote that she had spoken of Sligo 'to go there and stay with friends'. In Rathfarnham she found suitable motives for painting. Several examples of her watercolours graced the drawing-room of Moore's house in Ely Place. *The Cherry Tree* is at Model and Niland Centre, Sligo.

Clara Christian married Charles MacCarthy, the city architect of Dublin, at the Church of Our Most Holy Redeemer, Chelsea, on 11 January 1905. *The Studio* considered her '... one of the most gifted and promising of young Dublin artists'. In her landscape work, she had 'much in common with Mr Mark Fisher. Her landscapes have a sincerity, a sense of beauty and a feeling for composition but rarely found in the work of women artists ...'. She showed, under her married name, *Lady writing* and *Midsummer* at the 1906 RHA. She died in childbirth at Tymon Lodge, 7 June 1906.

Examples: Dublin: Hugh Lane Municipal Gallery of Modern Art. Sligo: Model and Niland Centre.
Literature: *Register of Births, Tottenham*, 1868; *The Studio*, April 1902, July 1906; *Irish Times*, 8 June 1906; George Moore, *Hail and Farewell*, London 1976 (edition with introduction and notes by Richard Cave); *Dictionary of British Artists 1880-1940*, Woodbridge 1976.

CLARKE, HARRY, RHA (1889-1931), stained glass artist and illustrator. Born in Dublin on 17 March 1889, Henry Patrick was the second son of Joshua Clarke and Brigid MacGonigal, aunt of Maurice MacGonigal (q.v.). Other members of Harry's family were his elder brother, Walter, who died in 1930, and his two sisters, Kathleen and Florence.

Joshua Clarke, born on 1 June 1858, had arrived in Dublin from Leeds. After a short period of gaining experience, he had established a church decorating business and stained glass studio in 1886 at 33 North Frederick Street, where the family also resided. In 1898, Joshua was responsible for painting a banner for the Amalgamated Society of Tailors, Dublin.

Walter and Harry Clarke were educated at the Marlborough Street Model Schools and Belvedere College. Both were destined for their father's business, at which William Nagle (q.v.), a Dublin man, was to teach Harry the art of producing stained glass. In 1903 his mother died. In 1906, he began night classes at the Dublin Metropolitan School of Art under A.E. Child (q.v.), interrupted by a short period of study at the National Art Training School, South Kensington. During his student days, he visited Inisheer, the Aran Islands, with Austin Molloy(q.v.), a fellow art school student, filling sketchbooks with drawings and also painting.

A landscape by the coast, in oils and dated 1910, is at the National Gallery of Ireland. A scholarship in stained glass was awarded by the Metropolitan School of Art in 1910, thus enabling him to attend full-time daily classes. One of his teachers there was (Sir) William Orpen (q.v.). He showed stained glass at the 1910 exhibition of Arts and Crafts Society of Ireland. From the Metropolitan, he sent entries to the National Competition under the Board of Education in 1911, 1912 and 1913. In each year, he was awarded the only gold medal given for work in stained glass. The judges' citation in 1911 found his work 'full of vigour and character, earnest feeling, richness of conception and great resource in design and detail', presumably referring to *The Consecration of St Mel, Bishop of Longford, by St Patrick* (Crawford Municipal Art Gallery).

Other pieces of 1911 stained glass are in the Cork Municipal Gallery: *St Brendan and the unhappy Judas* and *The Godhead Enthroned*. Among Clarke's contemporaries at the Metropolitan School of Art was Margaret Crilley (q.v. Margaret Clarke) whom he married in 1914. Also in attendance were Sean Keating, Albert Power, James Sleator, Kathleen Fox and Leo Whelan (qq.v.). In his student days, he was keen on book illustration and he persuaded his father in 1913 to let him rent a studio in London and stay with cousins. While there, he worked on his black and white illustrations. In November, the Department of Agriculture and Technical Instruction in Dublin informed him that he had been awarded a special travelling scholarship

for the following year, thus enabling him to see stained glass in France. His sole contribution to the Water Colour Society of Ireland was *The Lady of the Decoration* in 1915.

Before returning to Dublin from London, Clarke had approached several London publishers for illustrating work. In his book, *Some Memories 1901-1935*, the publisher George G. Harrap wrote: 'He had come from Dublin ... for only a brief stay, bringing the addresses of a dozen publishers who might give him work. He called upon them all in turn, but not one appreciated that here was an artist indeed. When he had reached the limit of his stay and was making the last call on his list the publisher suggested he should "see Harraps". Clarke had never before heard of us, but he promptly set out on this final voyage of discovery. He came into my room late in the afternoon, slim, pale, and youthful, with the air of one who has had rebuffs. He opened his portfolio very shyly and with delicate fingers drew out his lovely drawings ...'

The result of the visit to Harraps was a commission to illustrate Hans Christian Andersen's *Fairy Tales* which, on publication, *The Studio* review stated: 'Aubrey Beardsley has left behind many disciples, and that Mr Harry Clarke must be ranked as one of them is the conviction which is immediately driven home on glancing at the numerous line drawings he has contributed to the volume, and also, though not to the same extent, at the colour drawings ...' Harraps produced, in addition to the twenty-shillings edition, a limited edition of three guineas.

Harraps commissioned four other works for illustration by Clarke. *Tales of Mystery and Imagination* appeared in 1919. On this occasion *The Studio* commented: 'Among the twenty-four illustrations he contributes to this edition of Poe's weirdly fascinating tales, most if not all of them reveal his predilection for weaving, as it were, an intricate, almost lace-like fabric of lines, which in some cases is carried to the extent of obscuring the meaning of the drawing...' However, the book was so popular that it was reprinted a number of times. George G. Harrap thought it was Clarke's greatest work.

An early commission in Dublin was given by the Rt. Hon. Laurence A. Waldron, PC. This was for six illustrations for Alexander Pope's *The Rape of the Lock* and were not for publication. All the blocks for the illustrations for Coleridge's *The Rime of the Ancient Mariner* were burnt in Middle Abbey Street, Dublin in the 1916 Rising. The original illustrations were preserved. His initial showing at the Royal Hibernian Academy was in 1914 when he contributed ten decorative illustrations. Between 1915 and 1929, he exhibited twenty-five works, which included stained glass and designs.

In 1925, St George's Gallery in London held an exhibition of the work of three book illustrators: John Austen (1886-1948), Harry Clarke and Alan Odle (1888-1948). *The Studio* critique said of Clarke: 'His drawings for book illustration are distinguished by great technical mastery and are pre-eminent examples of the minute style of decorative composition. When he uses colour, he does so with a rare delicacy of feeling; and his work as a whole is remarkable for the depth and truth of its imaginative penetration.'

An active committee member of the Arts and Crafts Society of Ireland, he first exhibited in 1917. Clarke, who for about five years from 1918 had a weekly class of graphic design and book illustration at the Metropolitan School of Art. Nano Reid (q.v.), a student of Clarke's recalled: 'He taught in the Design Room and came and went without much talk or fuss. But it was wonderful to watch him draw when giving instruction. The ideas seemed to flow from the pencil like magic...'. He also found time to design book wrappers, supply designs for handkerchiefs, decorative schemes, bookplates, advertising booklets, certificates and the occasional Christmas and memorial card. Four designs for textiles, dating from 1919, are at NGI.

Clarke received his first big commission in stained glass in 1915 when Sir John O'Connell gave him the first order for the Honan Hostel Chapel windows at Cork. The commission established Clarke, the illustrator, as a stained glass artist of distinction. The eleven windows were completed in 1917. They depicted Saints Fin Barre, Albert, Declan, Ita, Brendan, Gobnait and Joseph; Our Lady; and a three-light of Saints Columcille, Patrick and Brigid. Thomas Bodkin, later to be appointed director of the National Gallery of Ireland, commented that nothing like the windows had been produced before in Ireland. 'The sustained magnificence of colour,' he wrote, 'the beautiful and most intricate drawing, the lavish and mysterious symbolism, combine to produce an effect of splendour which is overpowering...' Clarke later regarded these windows as some of the best he had ever done.

Nine panels, illustrating J.M. Synge's poem, *Queens,* were made in 1917 for Laurence Waldron and were sold eighty years later at Christie's, London, for £331,500.

Clarke, who had mastered the process of aciding glass, made a number of other miniature secular panels. A series illustrating *The Eve of St Agnes* by John Keats won for him the gold medal in the applied art group of the *Aanoch Tailteann*, 1924. In another section, a pen and ink illustration, *Mad Mulrannies*, won a silver medal. Eighteen preparatory drawings for *The Eve of St Agnes* are in the Crawford Municipal Art Gallery, Cork. At the 1921 exhibition of the Arts and Crafts Society, he contributed twenty-two works, 'exemplifying every phase of his great versatility', as *The Studio* commented. He was also a supporter of the Guild of Irish Art- Workers. He also exhibited in London and showed a few works with the Fine Art Society and the International Society. Among his 1926 contributions to the RHA were: *Tavern Scene* and *Faust and Mephistopheles.*

Following the acclaim for the Cork windows, there was no shortage of other commissions. He was greatly encouraged by patrons of discriminating taste. The Very Rev. Dr John Healy, parish priest of St Joseph's, Terenure, Dublin, gave him the task of making a window for that church which was to become famous. This was *The Adoration of the Cross*, 1920, three-light and about 18½ square metres in area.

On 13 September 1921, Joshua Clarke died. Walter Clarke and his brother were determined to carry on the studios. Despite increased administrative duties, Harry was working in 1923 on various commissions. These included: a three-light window for Dowanhill, Glasgow; and a three-light for Brisbane, Australia. Later three windows at Dowanhill were moved to the Notre Dame College of Education, Bearsden, Glasgow. In 1924, the firm moved to larger premises at Nos. 6 and 7 North Frederick Street, by which time he had received another important order for the Convent of Notre Dame chapel at Ashdown Park, Sussex, now a hotel; a pencil and wash study *The Presentation in the Temple* is at NGI.

In 1924 he was elected as associate of the RHA and a member in 1925, when *The Studio* reported that he was working on twelve windows for St Mary's Church, Belcamp, Raheny. In that year, he organised with his wife an exhibition of recent work by J. Clarke & Sons. Early in 1926, he had a bad bicycle accident. By the end of the year, he was working at The Glasshouse, Lettice Street, Fulham, where Wilhelmina Geddes (q.v.) rented a studio. By 1928 the battle was on against deteriorating health. At his doctor's insistence he left the following year for Davos, Switzerland, in the hope of a cure for his tuberculosis. Windows for the Jesuit Retreat House at Rathfarnham, 1928, were designed by Clarke but carried out by assistant artists; five were transferred to the Church of the Assumption at Tullamore, Co. Offaly, and three to Our Lady's Hospice, Harold's Cross, Dublin. The last exhibition of his lifetime, of drawings, was held in 1929 at Mills' Hall, Dublin. An oil portrait of him by his wife Margaret is at the NGI.

Meanwhile, Clarke had begun working on *The Geneva Window* in 1927. It had been commissioned in 1926 by the Irish government for the International Labour Building of the League of Nations, and Clarke had travelled to Geneva to view the site. When it was finished, the panels formed a rectangular window 190.5cm by 104cm and showed fifteen incidents from works of twentieth-century Irish literature: *St Joan* by G.B. Shaw; *The Playboy of the Western World* by J.M. Synge; *Juno and the Paycock* by Sean O'Casey; *The Dreamers* by Lennox Robinson; *The Others* by Seamus O'Sullivan; *The Demi-gods* by James Stephens; *The Countess Cathleen* by W.B. Yeats; *Mr Gilhooley* by Liam O'Flaherty; *Deidre* by George Russell; *A Cradle Song* by Padraic Colum; *The Magic Glasses* by George Fitzmaurice; *The Weaver's Grave* by Seamus O'Kelly; *On Music* by James Joyce; *The Wayfarer* by Patrick Pearse; *The Story Brought by Brigid* by Lady Gregory.

The Geneva Window was ready for viewing by September 1930 but was rejected by the government, which had banned some of the authors and works represented, although they paid the artist the agreed sum. In 1933, Clarke's widow bought the window back. It was on exhibit for some time at the Hugh Lane Municipal Gallery of Modern Art, where the *Eve of St Agnes* window is located. The window remained in the Clarke family until 1988 when it was sold to the collector Mitchell Wolfson, Jr, for permanent exhibition in the Miami, Florida, headquarters of the Wolfsonian Foundation. In an article in *Stained Glass*, the quarterly of the Stained Glass Association of America, Mary Clerkin Higgins, who conserved the window in 1992, wrote: '*The Geneva Window* is the work of a mature artist, accomplished in his technique and sure of his vision. In pushing

the limits of his craft, as well as the limits of his society's cultural mores, he left us an invaluable legacy and example in his window for the League of Nations.'

In an article in *Studies*, C.P. Curran wrote: 'Harry Clarke's windows shine with an incomparable jewelled splendour. An artist of great virtuosity, he created a world of his own, through which passed strange figures, unsubstantial and disquieting, figures whose frailty bear with difficulty the almost insupportable burden of their glittering ornament.' In her *Modern Art in Ireland*, 1997, Dorothy Walker wrote:'...The traditionally homely Saint Patrick might well have been astonished at the exquisite and luxurious raiment designed for him by Clarke, but since the biblical scenes and all of the early saints belonged to the Near and Middle East, his Levantine elegance is perfectly justifiable, if somewhat theatrical...'.

Clarke's last work, *The Last Judgment*, at Newport, Co. Mayo, is regarded as a masterpiece; two sketch designs are at NGI. In July 1930, his brother Walter died, and in October his friend, Lennox Robinson, accompanied him to Davos. On 6 January 1931 on his way home from Davos, he died at Coire, where he was buried. His home was at 48 North Circular Road, Dublin.

The studios which had borne his name since 1930, Harry Clarke Stained Glass Ltd, closed down in 1973. A retrospective exhibition of his work, the most important ever, was held at the Douglas Hyde Gallery, Trinity College, in 1979, and then at the Ulster Museum, Belfast, and Crawford Municipal Art Gallery. The comprehensive monograph-catalogue was written and compiled by Nicola Gordon Bowe. Restoration of the fourteen *Stations of the Cross* windows for the pilgrim church of Lough Derg was completed in Dublin in 1990.

Works signed: Harry Clarke, H. Clarke, H.C. (also monogram) or C.
Examples: Aston-in-Makerfield, Lancashire: Church of St Oswald and St Edmund. Balbriggan, Co. Dublin: St Peter and Paul's Church. Ballinrobe, Co. Mayo: Church of St. Mary. Belfast: Dominican Convent, Falls Road. Brisbane, Australia: St Stephen's Cathedral. Carnalway, Co. Kildare: St Patrick's Church. Carrickmacross, Co. Monaghan: St Joseph's Church. Castletownshend, Co. Cork: St Barrahane's Church. Colwyn Bay, N. Wales: St Joseph's Church. Cork: Crawford Municipal Art Gallery; Honan Hostel Chapel, University College. Dublin: Belcamp College, Malahide Road; Church of Ireland Church, Sandford Road; Clontarf Presbyterian Church, Howth Road; Hugh Lane Municipal Gallery of Modern Art; National College of Art and Design; National Gallery of Ireland; Our Lady's Hospice, Harold's Cross; St Brigid's Church, Castleknock Road; St Joseph's Church, Terenure; St Peter's Church, Phibsborough; Sandford Parish Church, Sandford Road. Glasgow:Notre Dame College of Education, Bearsden. Gorey, Co. Wexford: Christ Church. Killiney, Co. Dublin: Holy Trinity Church. London: Victoria and Albert Museum. Lough Derg, Co. Donegal: St Patrick's Basilica. Lusk, Co. Dublin: St. Maculind's Church. Miami, Florida: Wolfsonian Foundation. Nantwich, Cheshire: St Mary's Church. Newport, Co. Mayo: St Patrick's Church. Penarth, South Wales: All Saints' Church. Sturminister Newton, Dorset: St Mary's Church. Tullamore, Co. Offaly: Church of the Assumption. Tullycross, Co. Galway: Church of Christ the King. Wexford: Church of the Assumption.
Literature: *Irish Review*, July 1913 (illustration); Hans Christian Andersen, *Fairy Tales*, London 1916 (illustrations); John R. O'Connell, *The Honan Chapel, Cork*, Cork 1916; *The Studio*, November 1916, October 1917, November and December 1919, December 1921, March and May 1925; *The Arts and Crafts Society of Ireland*, cover, catalogue, Dublin 1917 (illustration); *The Dublin Drama League*, cover, 1918 (illustration); Edgar Allan Poe, *Tales of Mystery and Imagination*, London 1919 (illustrations); *Stained Glass Memorial Window, St Joseph's, Terenure, Souvenir of Dedication*, Dublin 1920; L.D'O. Walters, compiler, *The Years at the Spring*, London 1920 (illustrations); *The Fairy Tales of Charles Perrault*, London 1922 (illustrations); *The Dublin Magazine*, cover, 1923 (illustration); *Ireland's Memorial Records*, Dublin 1923 (illustrations); *The History of a Great House: The Origins of John Jameson Whiskey*, Dublin 1924 (illustrations); Goethe, *Faust*, London 1925 (illustrations); J. Crampton Walker, *Irish Life and Landscape*, Dublin 1927 (also illustration); *Selected Poems of Swinburne*, London 1928 (illustrations); Alice Curtayne, *The Fourteen Stations of the Cross in St Patrick's Basilica, Lough Derg*, n.d.; George G. Harrap, *Some Memories 1901-1935*, London 1935; C.P. Curran, *Studies*, March 1942; William J. Dowling, 'Harry Clarke: Dublin Stained Glass Artist', *Dublin Historical Record*, March 1962; James White and Michael Wynne, *Irish Stained Glass*, Dublin 1963 (also illustration); M.J. O'Kelly, *The Honan Chapel, University College, Cork*, Cork 1966; John Delieu, *Letter to the author*, 1970; David Larkin, editor, *The Fantastic Kingdom: a collection of illustrations from the golden days of storytelling*, London 1974 (also illustrations); Michael Wynne, *Irish Stained Glass*, Dublin 1977 (also illustrations); Belinda Loftus, *Marching Workers*, Belfast 1978; Nicola Gordon Bowe, *Harry Clarke*, monograph-catalogue, Dublin 1979 (also illustrations); National Gallery of Ireland, *Exhibition of Acquisitions 1981-82*, catalogue, Dublin 1982; David Clarke, *Letter to the author*, 1983; Ann M. Stewart, *Royal Hibernian Academy of Arts: Index of Exhibitors, 1826-1979*, Dublin 1986; Nicola Gordon Bowe, *The Life and work of Harry Clarke*, Blackrock 1989 (also illustrations); *Irish Times*, 14 December 1989, 2 February 1990, 22 May 1997; Peter Murray, compiler, *Illustrated Summary Catalogue of The Crawford Municipal*

Art Gallery, Cork 1991 (also illustrations); *Stained Glass*, Spring 1993; Anne Crookshank and the Knight of Glin, *The Watercolours of Ireland*, London 1994 (illustration); John Turpin, *A School of Art in Dublin since the Eighteenth Century*, Dublin 1995 (also illustrations); The Abbey Stained Glass Studios, *Letter to the author*, 1997; Dorothy Walker, *Modern Art in Ireland*, Dublin 1997 (also illustrations).

CLARKE, MARGARET, RHA (1888-1961), portrait, figure and landscape painter. Born 29 July 1888 in Newry, Co. Down, daughter of Patrick Crilley. She attended Newry Technical School and in 1905 won a scholarship to Dublin where she studied under (Sir) William Orpen (q.v.) at the Metropolitan School of Art. He regarded her as one of his most promising pupils. At the School of Art, a fellow student was Harry Clarke (q.v.) who became her husband in 1914. She spent several summers on the Aran Islands with Clarke and John Keating (q.v.).

In the National Competition under the British Board of Education, she won silver and bronze medals for painting from the nude in 1911, and in 1913, the bronze for a figure from the nude. Awarded a scholarship for teachers in training, she later taught painting and drawing from life in the School of Art and the Royal Hibernian Academy Schools. She showed under her married name at the 1915 RHA exhibition and from then until 1953 was a regular exhibitor, contributing more than sixty works, many of them portraits. A portrait of Minnie Clarke is at the Hugh Lane Municipal Gallery of Modern Art.

Work exhibited at the 1915 RHA received mention in the May edition of *The Studio*. In 1926, she was appointed ARHA and in 1927 became a full member. The Irish correspondent of *The Studio* had commented in 1924: 'Before her marriage Mrs Clarke was well known in Ireland as one of the most brilliant of that remarkable group of students which Sir William Orpen fostered during the few years in which he acted as a teacher at the Dublin Metropolitan School of Art. Since her marriage the cares of a growing household restricted Mrs. Clarke's artistic production, but she has lately found leisure to return again to her studio. The result of her brilliant exhibition has been to remind Dublin people of what an accomplished painter she is, and to make them hope that this, her first individual show, will prove to be the first of an annual series.'

In 1924, she won the Tailteann gold, silver and bronze medals; another Tailteann bronze medal came in 1928; and a Tailteann bronze trophy in 1932. Painted c. 1925, *Bath Time at the Crèche* (National Gallery of Ireland), a special painting of the Clarke family, is curiously signed 'Maggie Cr...'. At the RHA in 1927, she showed *Strindbergian* and *Salutation*; in 1929, *The Nuns' Hour* and *Christmas Gifts*. The newly-established *Dublin Art Monthly* chose to reproduce *The Ostracised* in 1927.

A portrait of Lennox Robinson, presumably the oil now at Crawford Municipal Art Gallery, Cork, was exhibited in 1927 at the Belfast Museum and Art Gallery in an exhibition 'Irish Portraits by Ulster Artists'. Also at the Crawford is a charcoal portrait of Dolly Robinson (q.v.). Among her other sitters were: Dermod O'Brien (q.v.), the Most Rev. John C. McQuaid, General Sean McMahon, the Rt. Rev. Dom Justin McCarthy, Professor Mary Macken, Dr Edward Sheridan, the Rt. Rev. Monsignor V. Curran, Mrs Josephine McNeill. A portrait of Joshua Clarke, her father-in-law, is at NGI, along with one of her husband, the latter painted from photographs, and her daughter Ann. A recent acquisition for Merrion Square was *Ophelia*.

In 1930 her work was hung in an exhibition of Irish art held in Brussels, and in the same year she received a commission for a poster from the Empire Marketing Board, England. Her husband died in 1931. She was a director of Harry Clarke Stained Glass Ltd until her death. In 1932, the Thomas Haverty Trust commissioned the painting, *St Patrick Climbs Croagh Patrick*, which was for some years in the Mansion House, Dublin, later removed to the Municipal Gallery. *Robin Redbreast* and *Strindbergian*, both oils, are at the Ulster Museum.

In 1938, she exhibited with the Dublin Painters, and in the following year had an exhibition at 7 St Stephen's Green which included *Autumn at Davos* and other landscapes, flowerpieces and drawings of children. Four works at the 1940 RHA were all flowerpieces. When the Irish Exhibition of Living Art began in 1943, she was on the executive committee. The catalogue for the Contemporary Irish Painting exhibition which toured North America, 1950, stated: 'At present working at genre and portrait painting.' She was on the committee which organised the Evie Hone (q.v.) exhibition at University College, Dublin, 1958. She died on 31 October

1961. An exhibition of oils and drawings, a few executed before her marriage, was held in 1979 at the Taylor Galleries, Dublin.

Works signed: Margaret Clarke, Margaret C. Clarke, M. Clarke; Margaret Crilley or Crilley, both rare.
Examples: Belfast: Ulster Museum. Cork: Crawford Municipal Art Gallery. Dublin: Government Buildings; Hugh Lane Municipal Gallery of Modern Art; McKee Barracks; National Gallery of Ireland; University College (Earlsfort Terrace). Lagos: Irish Embassy. Limerick: City Gallery of Art. London: General Dental Council. Rome: Irish College. Roscrea, Co. Tipperary: Mount St Joseph Abbey.
Literature: Sir William Orpen, RA, *Stories of Old Ireland and Myself*, London 1924; *The Studio*, May 1924; *Dublin Art Monthly*, November 1927 (also illustration); J. Crampton Walker, *Irish Life and Landscape*, Dublin 1927 (also illustration); *Irish Times*, 1 November 1961; Hilary Pyle: Cork Rosc, *Irish Art 1900-1950*, catalogue, 1975; Taylor Galleries, *Margaret Clarke*, catalogue, Dublin 1979 (also illustrations); National Gallery of Ireland, *Exhibition of Acquisitions 1981-82*, catalogue, Dublin 1982 (also illustration); National Gallery of Ireland, *Acquisitions 1982-83*, catalogue, Dublin 1984 (also illustration); Ann M. Stewart, *Royal Hibernian Academy of Arts: Index of Exhibitors 1826-1979*, Dublin 1986; Peter Murray, compiler, *Illustrated Summary Catalogue of The Crawford Municipal Art Gallery*, Cork 1991 (also illustrations); Anne Crookshank and the Knight of Glin, *The Watercolours of Ireland*, London 1994 (illustration); National Gallery of Ireland, *Gallery News*, September-November 2000.

CLARKE, TERENCE (1917-68), stained glass artist. Born on 28 September 1917 at 33 North Frederick Street, Dublin, he was a son of Walter Clarke and a grandson of Joshua Clarke, founder of the church decorating business and stained glass studios of J. Clarke and Sons in 1886. Educated at Belvedere College, Dublin, where his father and his famous uncle Harry Clarke (q.v.) preceded him, Terence began work with Harry Clarke Stained Glass Ltd in 1934. He also attended the Dublin Metropolitan School of Art.

In the course of his career, he designed many windows for churches in Ireland and abroad. He painted still life and landscape but did not exhibit. In 1953, in the stained glass section of the Irish Exhibition of Living Art, he showed *Dead Christ*, and in 1954, *Pietá*. In 1983, these two works were donated by the Clarke family to the Royal College of Surgeons in Ireland for the interdenominational chapel.

Clarke had great powers of concentration, particularly evident in designs of intricate Celtic ornament executed by him for Donegal Carpets, Ltd, 1955-6. A brochure published by the firm illustrated 'an exquisite design from Harry Clarke Studios, Dublin, world famous designers of stained glass windows, for an altar carpet in the Celtic taste'. It was said that the Gaelic atmosphere of the west of Ireland 'enchanted him and he returned there each summer, finding artistic friendship and freedom'.

In 1957 he was associated with William J. Dowling (q.v.) in the design-making of a set of *Stations of the Cross* in *opus sectile* medium for the Church of the Immaculate Conception, Clonskea. The fourth station, *Jesus meets his Mother*, was by Clarke alone; there may have been others. His partner referred to him as 'a gifted artist and a man of deep spirituality'. A stained glass cartoon by Clarke is in the Hugh Lane Municipal Gallery of Modern Art.

The records of St Mary's Church, Westport, Co. Mayo show that the cost of designing, making and installing the *St Patrick* window in 1959 for St Mary's was £500. Their *St Brigid* window in 1960, also by Clarke, was £550. He first visited Andalucia about this time, developing an all-absorbing interest in things Spanish, visiting many galleries and quickly acquiring fluency in the language. He died in Dublin on 14 February 1968.

Works signed: Terence Clarke; T. Clarke (designs only) or T.C., rare.
Examples: Brisbane, Australia: Christian Brothers' College, Albion Heights. Drogheda, Co. Louth: St Magdalen's Church. Dublin: Church of the Immaculate Conception, Bird Avenue, Clonskeagh; Holy Ghost Missionary College, Kimmage Manor; Hugh Lane Municipal Gallery of Modern Art; Our Lady of the Wayside Church, Bluebell; Royal College of Surgeons in Ireland. Hollywood, California: St Ambrose Church. Lusk, Co. Dublin: St MacCullin's Church. Rochfort Bridge, Co. Westmeath: Church of the Immaculate Conception. San Francisco, California: St Brigid's Church. San Pedro, California: Mary Star of the Sea Church. Waco, Texas: Church of St Louis. Westport, Co. Mayo: St Mary's Church.
Literature: W.J.D., Terence Clarke: Appreciation, *Irish Times*, 15 March 1968; William J. Dowling, *Letter to the author*, 1969; John Clarke, *Letters to the author*, 1983.

CLAUSEN, KATHARINE F., ARWS (1886-1936), landscape and flower painter. Born on 15 March 1886 in New York, Katharine Frances Clausen, the younger daughter of Sir George Clausen, RA (1852-1944), first studied painting at the Royal Academy Schools and gained the Landseer Scholarship and other prizes. She soon broke away from the academic tradition and developed a freer and more individual style. A break in artistic work was enforced by the First World War, when she worked as a nurse. She changed her nationality when, in 1928, she married Conor O'Brien, architect, writer, master mariner and the half-brother of Dermod O'Brien (q.v.). With her husband, she lived on the little yacht *Saoirse*, in which he had sailed round the world, 1923-5.

When exhibiting at the Royal Academy in 1921 she had given the address 51 Ordnance Road, NW8, and oil paintings included *Magda Agafonova* and *Flowers in a lustre jug*. Her *Path to the Forest*, hung at a New English Art Club exhibition in 1924, was noted by *The Studio*. The following year, the magazine found her exhibition of watercolours at the Goupil Gallery of 'more than average merit'. However, it went on to say: 'Miss Clausen's work was not as consistent as it should have been, but the best things she showed were drawn with much decision and were distinguished by much intelligence of observation.'

In the exhibition of works by 'living British artists' at the Belfast Museum and Art Gallery in 1927, she was represented by a flowerpiece with a studio address at 6 Ladbroke Terrace, London. In the autumn of 1931, she sailed to the Mediterranean with her husband. They spent four winters in Ibiza and visited Spain, Italy and the Greek Islands. When in Ibiza, she also painted on the neighbouring island of Formentera.

In 1929, she exhibited for the first time at the Royal Hibernian Academy with a portrait of Conor O'Brien. In 1930, she contributed four works from Barneen, Foynes, Co. Limerick, including three portraits, and between 1931 and 1936, she exhibited nineteen pictures. In the 1936 show, her contributions included *Sunset – Ibiza* and *The Island of Santorin*. Meanwhile, she had contributed more than fifty illustrations for her husband's *Voyage and Discovery*, published in 1933.

In addition to sending several pictures to the Royal Academy and the New English Art Club, she showed extensively with the Royal Society of Painters in Water-Colours, becoming an associate in 1931, and the Beaux Arts Gallery. Outside of London, she had twenty-nine works hung at the Walker Art Gallery, Liverpool. Some of her pictures were sent abroad, and in the Exhibition of Contemporary British Watercolours at the Art Gallery of Toronto in 1939, *The Banks of the Shannon* and *Calm Waters, the Shannon* were both displayed.

If Mrs Kitty O'Brien, of 'great personal charm and high sense of humour', had been normally resident on land, she might have been known as a portrait painter. The portrait of her husband was shown in 1966 at the Easter Rising Golden Jubilee exhibition at the National Gallery of Ireland. After only two days' illness, her death occurred in the hospital at Truro on 27 July 1936. A memorial exhibition was held at the Beaux Arts Gallery in 1936, and a small tribute in works displayed was paid at the RHA in 1937.

Works signed: K. Clausen or K.F. Clausen.
Examples: Cardiff: National Museum of Wales. Cork: Crawford Municipal Art Gallery. Kilkenny: Art Gallery Society. Limerick: City Gallery of Art. London: British Museum.
Literature: Marion Bryce, *Nancy in the Wood*, London 1914 (illustrations); *The Studio*, February 1924, March 1925, February 1936 (illustration), February 1937; Conor O Brien, *Voyage and Discovery*, Edinburgh 1933 (illustrations); *Who's Who in Art*, 1934; Beaux Arts Gallery, *Memorial exhibition of Paintings and Water-Colours by the late Katharine F. Clausen 1886-1936*, catalogue, London 1936; *Irish Times*, 31 July 1936, 3 March 1969; E. Bénézit, *Dictionnaire des Peintres, Sculpteurs, Dessinateurs et Graveurs*, Paris 1976; Henry Boylan, *A Dictionary of Irish Biography*, Dublin 1978; Ann M. Stewart, *Royal Hibernian Academy of Arts: Index of Exhibitors 1826-1979*, Dublin 1986; Royal Society of Painters in Water-Colours, *Letter to the author*, 1990.

COFFEY, LILLA M. – see VANSTON, LILLA M.

COGHILL, SIR EGERTON (1853-1921), landscape painter. Egerton Bushe Coghill was the second son of Sir Joscelyn Coghill, Bt, born on 7 February 1853 in Castletownshend, Co. Cork. He was educated at Haileybury School, Hertfordshire, and first studied engineering, forsaking the profession to become a painter.

His initial studies were at Dusseldorf, where his family spent some months in 1880, but it was not until the following year when he went to Paris that he was able to concentrate on his work. Between 1882 and 1919, he showed twenty-three works in Dublin at the Royal Hibernian Academy.

In Paris, he attended the Académie Julian. The visiting critic and teacher was W.-A. Bouguereau (1825-1905). Coghill studied there for four years, occasionally painting at Barbizon, a small village on the outskirts of the Forest of Fontainebleu which had already given its name to the 'Barbizon School'. The subject of his painting in the Ashmolean Museum, Oxford, is a female figure going through a field of rye near Barbizon, 1883-4.

After leaving Paris in 1884, he became a member of the New English Art Club in London and showed *A Back Kitchen* in 1888. Most of the rest of his life was spent in Castletownshend where, in 1893, he married his cousin, Hildegarde Somerville, sister of Edith Somerville (q.v.). He painted a series of oils near Étaples, France, in 1898. In 1905, he contributed *Early Morning, Lac Champex, Switzerland* to the RHA.

Coghill was quite lacking in any competitive spirit or desire for publicity and showed once only at the Paris Salon, in 1886, and never at the Royal Academy. A 1903 view of Castletownshend, oil, is in the National Gallery of Ireland. At the 1913 exhibition of the RHA there were four landscape 'colour sketches', two each of his home town and Lahinch. The Walker Art Gallery, Liverpool, hung three of his works.

At the 1918 Dublin exhibition, he showed *Rhododendrons and Reflections*, oil, now in the Crawford Municipal Art Gallery, Cork, but generally he favoured Castletownshend and West Cork scenes, concentrating on atmospheric effects. He died on 9 October 1921 on a visit to England and was buried at Twickenham. In 1923, his body was exhumed, brought to Ireland and buried in St Barrahane's churchyard, Castletownshend. In 1964, his heirs arranged an exhibition of seventy-three works at the Ashmolean, Oxford. A smaller exhibition took place in 1965 at the gallery of the Alpine Club, London.

Works signed: E.B. Coghill.
Examples: Cork: City Library; Crawford Municipal Art Gallery. Dublin: National Gallery of Ireland. Oxford: Ashmolean Museum.
Literature: Ashmolean Museum, *Egerton Bushe Coghill*, catalogue, Oxford 1964; Maurice Collis, *Somerville and Ross*, London 1968; Sir Patrick Coghill, *Letter to the author*, 1973; *Dictionary of British Artists 1880-1940*, Woodbridge 1976; Ann M. Stewart, *Royal Hibernian Academy of Arts: Index of Exhibitors 1826-1979*, Dublin 1986; Peter Murray, compiler, *Illustrated Summary Catalogue of The Crawford Municipal Art Gallery*, Cork 1991 (also illustration).

COGHLAN, BRIAN (1903-78), etcher and topographical artist. Born on 12 May 1903 into a landowning family near Dublin, his father, Henry, was Irish and his mother English. In the 1930s he resided at Hatch End, Middlesex, but returned to Ireland, joining the Royal Society of Antiquaries of Ireland in 1938 and becoming a life member in 1951. He had addresses in Glenageary, Co. Dublin, and Delgany, Co. Wicklow. Between 1941 and 1948, he showed eleven works at the Royal Hibernian Academy, including the watercolours: 1943, *St George's Church, Dublin* and in 1947, *Towers at Waterford*.

More than eighty drawings, the vast majority of Dublin streets and buildings, are in the possession of the Royal Society of Antiquaries of Ireland, ranging over the years from 1942 until 1959. These include: *Old Stable Buildings in St Mary's Place*, 1946; *Moore Street Market*, 1952; and in pencil and crayon, *Courthouse, Dunlavin, Co. Wicklow*, 1952. Other drawings, together with etchings, are at the Royal Dublin Society premises.

A brother, H.H. Coghlan, FSA, FRAI, was honorary curator of the borough museum at Newbury, Berkshire. While living there, Brian recorded its changing face in a series of six notebooks, from about 1965 for a period of ten years, showing his concern with insensitive planning, architecture, and intrusive roadworks. These loose-leaf books, *Newbury Streets and Buildings*, include newspaper cuttings and photographs, as well as a number of drawings, mainly in ballpoint pen.

Two months before his death, while living at 13 Wilson Court, Speen, Newbury, he sent additional drawings of Dublin to the Royal Society of Antiquaries of Ireland, to add to the collection he had already presented. A rather shy and retiring bachelor, with a lively sense of humour, he died on 7 August 1978 at

Speen. Frederick Gallery, Dublin, in association with the Neptune Gallery, issued in 1998 a second edition of etchings, nine views of Dublin.

Works signed: Brian Coghlan (if signed at all).
Examples: Cork: Crawford Municipal Art Gallery. Dublin: Civic Museum; Hugh Lane Municipal Gallery of Modern Art;National Library of Ireland; Royal Dublin Society; Royal Society of Antiquaries of Ireland. Reading: Berkshire Record Office. Waterford: City Hall, Municipal Art Collection.
Literature: Brian Coghlan, *Letter to Royal Society of Antiquaries of Ireland*, 1978; H.H. Coghlan, *Letter to RSAI*, 1978; A.R. Higgott, Newbury District Museum, *Letter to the author*, 1983; Ann M. Stewart, *Royal Hibernian Academy of Arts: Index of Exhibitors 1826-1979*, Dublin 1986; Frederick Gallery, *Drawings, Etchings & Engravings*, catalogue, Dublin 1998 (also illustrations).

COGHLAN, EILEEN (1909-90), illustrator. Born on 18 May 1909 at Kilbeggan, Co. Westmeath, the daughter of William Coghlan, merchant tailor. She attended the Dublin Metropolitan School of Art for a short period. Early employment was devoted to commercial art, but later she concentrated almost exclusively on book illustration, with special reference to children's books, and schoolbooks for the Dublin-based Browne and Nolan, Ltd, the Educational Company of Ireland and, prior to her retirement, Folens Publishers.

In 1946, *The Bell*, referring to the Educational Readers, found that the artist made an 'excellent job' of the Preparatory book but had not been so 'uniformly good' in the other three. Some years later, she illustrated the Fact and Fancy readers. Illustrations for Mary Flynn's *Cornelius Rabbit of Tang*, 1944, was followed by work for other books, including John D. Sheridan's *Paradise Alley*, Maura Laverty's *The Cottage in the Bog*, and Patricia Lynch's *Strangers at the Fair*. The last-named also appeared in 1949 in Puffin Story Books. Other illustrated publications followed, including three by Sinéad de Valera.

Residence in Dublin found her contributing the odd cartoon to the *Dublin Opinion*. In the 1960s she had a spell supplying a weekly illustrated topical article in light-hearted vein to the *Irish Press*. Illustrations also appeared in the *Irish Digest*. Three of her watercolours are in Athlone Public Library. She died at Midland General Hospital, Tullamore, Co. Offaly, on 13 April 1990.

Works signed: Eileen Coghlan, E. Coghlan or E.C.
Examples:Athlone, Co. Westmeath: Public Library.
Literature: Mary Flynn, *Cornelius Rabbit of Tang*, Dublin 1944 (illustrations); Irish Junior Red Cross, *Iris na Nodlag*, Dublin 1944 (illustrations); Mary Flynn, *Cornelius on holidays*, Dublin 1945 (illustrations); Maura Laverty, *The Cottage in the Bog*, Dublin 1945 (illustrations); Patricia Lynch, *Strangers at the Fair, and other stories*, Dublin 1945 (illustrations); John D. Sheridan, *Paradise Alley*, Dublin 1945 (illustrations); *The Bell*, October 1946; Kathleen Eagar, *The Adventures of Jum*, Dublin 1946 (illustrations); Mary Flynn, *Cornelius in charge*, Dublin 1946 (illustrations); Patricia Lynch, *The Turfcutter's donkey kicks up his heels*, Dublin 1946 (illustrations); Mary Flynn, *Danny Puffin*, Dublin 1947 (illustrations); Sinéad de Valera, *Fairy Tales*, Dublin 1948 (illustrations); John D. Sheridan, *Stirabout Lane*, London 1955 (illustrations); Sinéad de Valera, *The Emerald Ring*, Dublin 1960 (illustrations); Sinéad de Valera, *The four-leaved shamrock, and other stories*, Dublin 1964 (illustrations); Longford-Westmeath County Library, *Letter to the author*, 1982; *Irish Times*, 18 April 1990; Col. G.V. Coghlan, *Letter to the author*, 1991; also, Westmeath County Library, 1991.

COLEMAN, JAMES – see Ó COLMÁIN, SÉAMUS

COLEMAN, SIMON, RHA (1916-95), landscape and portrait painter. Born in Duleek, Co. Meath, on 22 June 1916, he was the son of a postman, Peter Coleman. Educated at Duleek National School and the Christian Brothers' School, Drogheda, Co. Louth, he entered the Dublin Metropolitan School of Art in 1933, on the understanding that he was to follow fashion-designing. He found Maurice MacGonigal (q.v.) 'an extraordinarily conscientious teacher...he was warm, friendly, personal and always generous in his assessment of my early efforts...' wrote Coleman. By the end of the second year all thoughts of becoming a fashion artist had completely faded. Maintenance money from a teacher-in-training scholarship allowed him to live in Dublin.

Seán Keating, head of painting at the National College of Art, employed four artists to assist him with his mural for the 1939 World's Fair in New York, Coleman serving at £3 per week. At the beginning of the War, George and Jack Laffan, who were Australians, inherited an antique shop in Liffey Street. George had seen some of Coleman's work and decided that having a resident artist working on the premises, who not only painted but played the fiddle, would be a great attraction.

Coleman first exhibited at the Royal Hibernian Academy in 1940, and from then for the next fifty years showed 200 works. In 1941 he gave his address as c/o Laffans' Galleries and showed four pictures: *Paddy Joe*; *The Black Hat*; *The Ploughman*; *Miss Margaret Laffan*. He showed only two works — in 1942 — at the Water Colour Society of Ireland exhibitions.

Of his four portraits at the 1943 Academy, the one that received most attention was that of Sir James Nelson, Bart. *The Bell* considered it the best portrait in the show and said it was 'well-conceived, and finely painted in a hard and honest manner. It renders character excellently, is original, and the subject is presented in a background which is pleasant and revealing.' Through Lady Nelson, Coleman was commissioned to paint Molly O'Rourke, about to retire as master of Galway Blazers Hunt. Molly chose to be painted in her hunting attire in an Athenry public house, among the customers.

Coleman's most important commission came early in his career: President Douglas Hyde's gift to the nation on his retirement from office. Coleman has recorded the trials and tribulations over *The Council of State, 1940*, 1.7m x 2.3m, covering fifteen men, of whom Eamon de Valera, who thought the wrong painter had been chosen, and Seán T. O' Kelly proved the least co-operative. The artist had to meet and sketch each member personally, and he said that he grew 'heartily sick of the Council of State,' which was completed in 1945.

In 1944 he had been appointed an associate of the RHA and in 1949 a full member. During these years he had a number of addresses. In 1948 he held an exhibition at the Victor Waddington Galleries, Dublin. His work was included in the exhibition of pictures by Irish artists in Technical Schools, 1949; his address then was Farranboley House, Clonskeagh, Dublin, and the catalogue noted that he also worked as a designer and publicity agent. At St Laurence's School, Drogheda, he taught art for some years.

Coleman spent short periods in the field with two of the Irish Folklore Commission's full-time collectors, Seán Ó hEochaidh in Donegal, 1949, and Ciarán Bairéad in Galway and Clare, 1959. Guided by them in the respective localities, he undertook the task of drawing and sketching artefacts, crafts, dwellings, agricultural practices and other scenes from rural life. He also painted some watercolours and completed one portrait in oils, *Anna Nic a' Luain* (Irish Folklore Commission), 1949; she lived at the foot of the Blue Stack mountains. A number of pen and ink drawings were also executed. He became involved in the Irish language and the fourteen pictures which he showed at the RHA 1960-2 all bore Irish titles.

In 1956 he exhibited six works at the RHA, including *The Slaney at Enniscorthy*. His depiction of a hurling scene at Croke Park, Dublin, on 23 September 1956 when Wexford defeated Cork for All Ireland honours is at the County Museum, Enniscorthy. He contributed occasionally at the Munster Fine Art Club exhibitions. In 1965 at the RHA his contributions included *Crucifixion in Blue and Blue-Green* and *Snow on the Wicklow Hills*, and in 1967 his pictures included *Christ in Space* and *Tinkers by the Sea*.

On presenting prizes in 1969 for a child art competition, which he had judged in Enniscorthy, organised by Co. Wexford's Strawberry Fair Committee, he took the opportunity in his speech to say: 'Irish artists are totally neglected and have been so for the past fifty years.' Later, he elaborated on that view in a letter to the *Irish Times* and added: 'To embellish our letters with stamps designed by foreigners shows the slave mentality of a beaten people.'

'I have photographic vision which compels me to be accurate in drawing always,' he once said. He believed that 'portraiture is always suspect as a likeness' in that it could not represent someone as accurately as a photograph. Two of five works at the 1979 RHA were portraits, and in 1984 he showed a portrait of his friend, Dr T. K. Whitaker, with whom he corresponded in Irish.

In his last ten years of exhibiting he produced two interiors. Among his contributions in 1989 were *The Horse* and *Coursing*. In 1993 his work was included in the Irish Folklore Commission exhibition at Newman House, Dublin. Droichead Arts Centre presented a retrospective exhibition in 1994 consisting of forty-nine

works. *Winter Landscape* was presented to the Hugh Lane Municipal Gallery of Modern Art by the Thomas Haverty Trust. The Drogheda municipal collection has a self-portrait and *A Man of the West*. A bachelor, of Station Road, Duleek, Co. Meath, he died on 17 February 1995 at St Clares Nursing Home, Stamullen, Co. Meath. He was commemorated at that year's Academy exhibition.

Works signed: Coleman, S. Coleman or Simon Coleman.
Examples: Armagh: County Museum. Athy, Co. Kildare: Cuan Mhuire, Cardington. Belfast: Ulster Museum. Bray, Co. Wicklow: Public Library. Drogheda, Co. Louth: Library, Municipal Centre. Dublin: Áras an Uachtaráin; County Dublin Vocational Education Committee; Hugh Lane Municipal Gallery of Modern Art; Irish Folklore Commission, University College (Belfield). Enniscorthy, Co. Wexford: County Museum. Kilkenny: Art Gallery Society. Limerick: City Gallery of Art; University, National Self-Portrait Collection. Longford, Co. Longford: County Library. Wexford: County Council.
Literature: *The Bell*, June 1943; *Collection of Historical Pictures, etc., established at Áras an Uachtaráin by Dr Douglas Hyde*, catalogue, Dublin 1944; *Exhibition of Pictures by Irish Artists in Technical Schools*, catalogue, Dublin 1949; *Irish Times*, 8 and 24 July 1969; *Who's Who in Art*, Havant 1972; Ann M. Stewart, *Royal Hibernian Academy of Arts: Index of Exhibitors 1826-1979*, Dublin 1986; *Royal Hibernian Academy of Arts 1980-1986, 1988-1993*, catalogues; Sarah Finlay, editor, *The National Self-Portrait Collection of Ireland*, Limerick 1989; Department of Irish Folklore, University College, Dublin, *Amharc Oidhreacht Éireann*, catalogue, Dublin 1993 (also illustrations); Droichead Arts Centre, *Simon Coleman RHA*, catalogue, Drogheda 1994; Kevin M. Coleman, *Letter to the author,* 1997.

COLLES, ALEXANDER (1850-1945), landscape painter. Born in Kilkenny, son of Alexander Colles, landowner, he received his art education at the Royal Hibernian Academy Schools. On becoming an official at Dublin Castle, there was a time when he did most of his painting while on county court inspections. He first exhibited at the Royal Hibernian Academy in 1879 and went on to show more than eighty works in sixty years. A Lillie Colles of Kilkenny exhibited two works at the 1880 RHA. Alexander Colles also painted Kilkenny scenes.

Blanche and *On the Nore, Co. Kilkenny* appeared in the 1882 RHA. In 1883, he was admitted as a member of the Dublin Sketching Club, with an address at 72 Pembroke Road. From 1901 until 1945, he contributed close on seventy works to the Water Colour Society of Ireland exhibitions. In 1903, he was appointed president and served for many years – indeed at the 1926 exhibition at Mills' Hall, Merrion Row, he was still president and exhibited *On the Barrow, Carlow*. He showed twelve works at the London Salon.

At the 1905 RHA he contributed *The Old Quay, Wicklow* and *A Mountain Road, Achill*. Other exhibits were: 1919, *Sand Dunes, Tralee Bay*; *A Dream of Peace*; 1922, *A Fisherman's Home, Galway*; *A Wicklow Farmyard*; and at the 1925 show, *Old Bridge, Castlegregory*; *Above the Harbour, Howth*.

At the 1933 WCSI exhibition, his contributions were: *Ballinahinch, Connemara* and *Clones, Co. Monaghan*. St Bartholomew's Church parish magazine described him as 'that grand old man of the parish ... Everybody loved him for his gentle Christian character ...'. His final appearance at the RHA in 1938 was represented by *An Island Home – Lettermullen, Connemara*. Of 3 Elgin Road, Dublin, he died there, five years short of his century, on 30 October 1945.

Works signed: A. Colles.
Literature: *Irish Independent*, 23 October 1926; *Who's Who in Art*, 1934; *Irish Times*, 1 November 1945; *St Bartholemew's Parish Church Magazine*, December 1945; *Dictionary of British Artists 1880-1940*, Woodbridge 1976; Dr G.O. Simms, *Letter to the author*, 1982; Ann M. Stewart, *Royal Hibernian Academy of Arts: Index of Exhibitors 1826-1979*, Dublin 1986; *Water Colour Society of Ireland Exhibition List 1872-1994*, Dublin 1995.

COLLIE, GEORGE, RHA (1904-75), portrait painter. Born on 14 April 1904 at Greaghdrummit, Carrickmacross, Co. Monaghan, he was educated at St Kevin's School, Blackpitts, Dublin. His interest in art was early evident as he showed two pictures at the Royal Hibernian Academy at the age of eighteen.

When receiving his art training at the Dublin Metropolitan School of Art, he won the 1927 Taylor Scholarship. The judges stated: '... and as this work displays exceptional merit, they further recommend that the trustees make a special grant to this student to enable him to study abroad'. In the following year he again

won the Taylor award. He continued his studies at the Royal College of Art in London and later in Paris at the Académie la Grande Chaumière and Académie Colarossi.

After his return to Dublin he taught at the Metropolitan School of Art until he opened his own school in Schoolhouse Lane, off Molesworth Street. There he gave 'individual instruction for beginners and advanced pupils in drawing, painting and pastel, still life, draped life model, etc.,' and he ran the school for more than thirty years. His Schoolhouse studio was first mentioned in the 1938 RHA catalogue.

At the 1933 RHA, giving his address as the Metropolitan School of Art, he exhibited six works, including *Officer of 1840*; *J. J. Robinson, Esq., M. Arch.*; and *Miss Gwendoline Lloyd.* Appointed an associate of the RHA in 1933, he waited nine years until he became a full member. The number of his contributions was exceptional. In the period 1930-75 he never missed a single exhibition, averaging more than five pictures per annum. The year 1935 was unusual in that it did not produce a single formal portrait, and among the six works were: *In Cossack Attire*; *Meditation*; and *Sunset and Dawn.*

The catalogue of a touring exhibition to Technical Schools of pictures by Irish artists in 1949 and 1950 described him as 'portrait painter and ecclesiastical artist'. However, when he showed *St Brigid receiving the veil from St Mel* at the RHA, 1952, for centre section of an altar piece for a church in a Dublin suburb, the *Dublin Magazine* was caustic in its comments: 'a formless concoction based on stock studio poses, crude in colour and completely without feeling. This is really the *reductio ad absurdum* of academic painting.' The artist was included in the Contemporary Irish Art exhibition at Aberystwyth in 1953; Los Angeles was mentioned in the catalogue as one of his exhibition venues. At the Ritchie Hendriks Gallery, Dublin, he was one of ten artists involved in 1957 in an exhibition of flower paintings.

George Collie painted portraits of many leading figures in Irish life: Cardinal D'Alton, President de Valera, Liam Cosgrave, Taoiseach. There are two Lord Mayors of Dublin, Ald. Senator Andrew S. Clarkin and Councillor Philip Brady, works hanging at the Mansion House; at McKee Barracks, Lt-Gen. D. Hogan; at University College, Professor J. F. Cunningham; at the National Gallery of Ireland: Thomas MacGreevy, Miss Iris Kellett. A self-portrait is at the University of Limerick. In Cavan Cathedral there are a number of works: *Stations of the Cross*, some portraits of bishops, and a Resurrection in the apse, from a set of panels. At Carlow, *Stations of the Cross*, formerly in St Patrick's College, are now in the Cathedral.

Many of the portraits he exhibited at the RHA were not for sale, particularly from 1955 onwards, so he could not have been relying for a steady income on purchases at the annual exhibitions. In 1967, Sutton Golf Club commissioned a portrait of Joe Carr. For reasons of health, Collie resigned in 1974 as a member of the council of the Arts Council. He died on 1 July 1975 at the Mater Hospital, Dublin; his home was at 23 Oaklands Terrace, Terenure.

Works signed: George Collie or G. Collie.
Examples: Belfast: Ulster Museum. Carlow: Cathedral of the Assumption. Cavan: Cathedral. Dublin: Church of St Brigid, Killester; Hugh Lane Municipal Gallery of Modern Art; Irish Writers' Centre; Mansion House; McKee Barracks; National Gallery of Ireland; Pharmaceutical Society of Ireland; Sutton Golf Club; University College (Newman House and Earlsfort Terrace). Limerick: City Gallery of Art; University, National Self-Portrait Collection. Maynooth: St Patrick's College.
Literature: *Royal Dublin Society Report of the Council*, 1927; Ulster Museum, *Biographical record*, Belfast 1936; *Irish Art Handbook*, Dublin 1943; *Dublin Magazine*, July-September 1952; *Irish Times*, 27 November 1967, 2 July 1975; Ann M. Stewart, *Royal Hibernian Academy of Arts: Index of Exhibitors 1826-1979*, Dublin 1986.

COLLINS, MAUREEN – see RYAN, MAUREEN COLLINS

COLLINS, PATRICK, HRHA (1910-94), landscape and figure painter. Born in Dromore West, Co. Sligo, on 6 November 1910, Patrick Collins was the son of William Collins, an RIC man who died of tuberculosis at an early age. The family moved to Riverstown, then to Sligo, where his mother ran a small grocery and confectionery shop. Patrick had developed an absorbing interest in wildlife, exploring fields and woodlands. Birds were a subject that were to appear in his paintings. He attended the model school attached to Summerhill

College, and then was sent to St Vincent's Orphanage, Glasnevin, Co. Dublin, as a boarder. Suffering from ill-health himself, much time was spent in hospital.

Collins obtained employment with a Dublin insurance company where he worked for about twenty years. In his spare time he read modern Irish literature and had intentions of becoming a writer himself; on Saturdays he played for Clontarf Rugby Club. He did not begin painting until his late twenties, formal training being limited to a couple of evening terms at the National College of Art; he also worked in the life class of George Collie (q.v.).

In the mid-1940s he forsook commercial life. Soon after, he went to live in a tower in Howth Castle, Lord Talbot de Malahide allowing him to use dead timber in the grounds. Aidan Higgins resided there too, and recorded that Collins could spend six months or more on a painting. *Ulysses* was his Bible, Higgins also noted. In 1950 Collins painted *Stephen Hero*, the figure of James Joyce's Stephen Daedulus. Meanwhile the tower had become a gathering place for a small literary and artistic circle.

Three works were accepted for the Irish Exhibition of Living Art in 1950; he exhibited there for some twenty years. Brian O'Doherty described his early canvases as 'usually predominantly of one tone or colour, grey as if misted, or brownly aqueous, as if steeped in peat water…' Art critics were attracted by his contributions to the 1951 IELA. The *Dublin Magazine* described him as 'a painter of quiet individuality. *Landscape with Round Tower* and *Children in a Legend* are romantic pictures in the best sense. They have colour and quality as well as an unemphasised rightness of form.' *The Bell* stated: '…an exponent of the misty scene in which one gradually begins to enter and slowly to perceive legendary figures and historic buildings…'

Represented in the Contemporary Irish Art exhibition at Aberystwyth in 1953, he gave as his address: 'The Turret, Howth Demesne, Howth, Co. Dublin.' His first solo show came in 1956 at the Ritchie Hendriks Gallery, Dublin, thirty works painted over six years. The catalogue foreword stated: '…When he has produced a picture it contains the essence of his subject with much of the original data excluded, yet overlaid with the vital sensory facts: He likes appearances which are stimulating in terms of character and atmosphere and rejects those which merely state the cold shape…' He exhibited at the same gallery in 1959.

Travelling Women (Ulster Museum), the first Tinker theme picture, was particularly noted at the 1957 IELA. In 1958 he received the first prize of 1,000 dollars for *Liffey Quaysides* in the Irish section of the Guggenheim International, New York; this work was purchased in 2001 by the National Gallery of Ireland. Other large companion pieces were *Moorland Water* and *Spring Morning*. In the late 1950s he travelled to Brittany for megalithic study at Carnac.

At his Ritchie Hendriks Gallery exhibition in 1961, the first of the Menhir pictures appeared, inspired by the Brittany trip. He initially exhibited at the Royal Hibernain Academy in 1962 with *Menhirs with Sun*, and from then until 1990 he contributed nineteen works. In 1963 he was one of twelve Irish painters chosen for a New York exhibition sponsored by the Arts Council, Dublin. In 1964 he completed a series of paintings of the Stations of the Cross. In that year he participated at the Oireachtas for the first time. In an interview in 1965 he said: 'You are absolutely alone in painting. You must be if you are trying to do something.'

Julian Campbell wrote that during the 1960s 'his painting matured, its style becoming more refined and simplified. Two pictures, both painted in 1963, show a surprising simplicity of composition: *Country Road* and *Hy Brazil*.' The last-named is at the Hugh Lane Municipal Gallery of Modern Art with four other oils.

In the period 1961-72 he showed nine times at the Hendriks Gallery. Twenty-eight works were hung in 1968 at the Arts Council Gallery in Belfast. Mercury Gallery, London, also held a show that year. *A Memory of W. B. Yeats* was hung at the 1969 RHA; *Harbour Scene* was painted that year. In 1969 on his exhibition at David Hendriks Gallery, Brian Fallon wrote in the *Irish Times*: '…A man with an original vision, he has still been content too often to repeat himself and smother his originality…too many of his pictures remain in a state of embryo, only half realised…he is Romantic with a capital R, evocative, imaginative and poetic…Collins can be a master of subtly mixed tones, but this continual urge towards half-statement leads him too often into an inchoate no-man's land of blue-grey mists…'

Collins' work was included in other group exhibitions, notably the Arts Council's modern Irish painting selection which began its European tour in 1969. The 1970s saw solo shows at the Tom Caldwell Gallery in

Belfast and Dublin. His work was in 'The Irish Imagination' Rosc '71 exhibition in Dublin. Along with Cecil King (q.v.) and Robert Ballagh he showed in 1971 at the Compass Gallery, Glasgow. In 1971 he won the Irish landscape prize at the Oireachtas exhibition in Dublin. He executed an etching of his fellow artist George Campbell (q.v.) who reciprocated.

In 1971 he moved to France with almost disastrous consequences. Soon after arriving in Paris, he stayed with the South American artist Leopoldo Novoa, who gave him a studio in which to work. But he did not stay very long. After two years in the city, where he sometimes lived at a point of near starvation, he had nine addresses, he said. At the Braun Gallery in 1972 an exhibition of Irish delineation took place, Collins being represented by a series of drawings of Paris bridges and some Irish landscapes. The David Hendriks Gallery in 1972 presented his first show entirely painted outside Ireland. At the RHA in 1972 he showed *Cottage in the Country* and *Rain on the Bog*. Cork Arts Society hosted a show in 1973. The human presence was rare in his pictures.

In 1973 he moved to Orne, Normandy, and lived in a farmhouse until 1976 with a stable nearby for painting. In 1976 he was residing at a village near Nice. The Irish American Cultural Institute Award for £2,250 was presented to him in 1976. After six years in France, he returned to Ireland and obtained the steward's cottage at Kindlestown House, Delgany, Co. Wicklow. He returned to France in 1979 and was delayed there by months of illness.

After a barren painting period, he was assisted financially by an Arts Council bursary in 1980, the year he was elected an honorary member of the RHA. His work was still included in important Irish group exhibitions, including 'The Delighted Eye', which travelled to London in 1980 before its Irish tour. Additional financial assistance came in 1981 on appointment as a member of Aosdána.

In the period 1980-93 he contributed only five works at the RHA. In 1981, from 11 Hume Street, Dublin, he showed *Countryside after rain* and *Stones in the high field*. Frances Ruane selected the retrospective exhibition for the Douglas Hyde Gallery, Dublin, in 1982. The comprehensive catalogue contained valuable information on his life and work. Dr Ruane noted that his art sprang from memory, and he thrived on it. The exhibition, which consisted of 104 works, including sixteen drawings, was also seen in Belfast and Cork.

Edward McGuire (q.v.) completed his portrait of Collins in 1983. Early in 1985 came the announcement that the 'Patrick Collins Portfolio will be published in Dublin and will be available to subscribers at IR£300 per copy.' The portfolio was to consist of seven original colour photographic prints of paintings chosen by Collins, and spanning a period of thirty-five years of his career, with the artist's comments opposite each plate.

A retrospective exhibition was held at Sligo Art Gallery in 1985. Elected Saoi by Aosdána members in 1987, he was made an Honorary D Litt in 1988 at Trinity College, Dublin. In London, Clifford Street Fine Art presented his work in 1990. His final exhibition at the Tom Caldwell Gallery in Dublin was in 1992. 'Originally a maverick, Collins became one of the grand old men of Irish art,' wrote Brian Fallon. 'Bohemian, impulsive, unmercenary, he could still be a disciplined worker when he chose...'

Another critic, Brian O'Doherty, described his art as 'perilous and strange, the product of a rare imagination.' Dorothy Walker in her *Modern Art in Ireland*, 1997, wrote: 'He had an almost mythological artist's temperament: loveable, hopeless at organising himself, floundering about from one country to another with picturesque passions and traditional vices, alternating between poverty and the generosity of patrons.' He died on 2 March 1994 at his home in Monkstown, Co. Dublin.

Works signed: Patrick Collins; P. Collins or Collins, both rare.
Examples: Athens: Irish Embassy. Belfast: Arts Council of Northern Ireland; Ulster Museum. Berlin: Irish Embassy. Brussels: Irish Embassy. Coleraine, Co. Derry: University of Ulster. Cork: Crawford Municipal Art Gallery; University College. Dublin: Arts Council; Hugh Lane Municipal Gallery of Modern Art; Institute of Public Administration; National Gallery of Ireland; National Roads Authority; Trinity College; Trinity College Gallery; United Arts Club. Kilkenny: Art Gallery Society. Leeds: City Art Gallery. Limerick: City Gallery of Art. London: Irish Embassy. Naas: Kildare County Council. New York: State University. Newbridge: Kildare County Library. Sligo: Model and Niland Centre. Vienna: Irish Embassy. Waterford: City Hall, Municipal Art Collection.

Literature: *The Bell*, September 1951; *Dublin Magazine*, October-December 1951, October-December 1957; Ritchie Hendriks Gallery, *Patrick Collins*, catalogue, Dublin 1956; Brian O'Doherty, 'Ambiguities: The Art of Patrick Collins,' *Studies*, Spring 1961; Marion FitzGerald, 'The Artist Talks: Patrick Collins,' *Irish Times*, 27 February 1965; 21 July 1969, 28 January 1972, 28 June 1972, 1 July 1972, 14 March 1987, 3 March 1994, 29 March 2001; Tom Caldwell Galleries, *Patrick Collins*, catalogue, Belfast 1976; Frances Ruane, *Patrick Collins*, catalogue, Dublin 1982 (also illustrations);Gordon Lambert and Seán McCrum, *Living with Art: David Hendriks*, Dublin 1985; *Magill*, February 1985; Ann M. Stewart, *Royal Hibernian Academy of Arts: Index of Exhibitors 1826-1979*, Dublin 1986; *Royal Hibernian Academy of Arts 1980-1986, 1988-1993*, catalogues; Julian Campbell, 'Patrick Collins and "The sense of place,"' *Irish Arts Review*, Autumn 1987; Tom Caldwell Galleries, *Patrick Collins*, catalogue, Dublin 1989 (also illustrations); *The Guardian*, 16 March 1994; Dorothy Walker, *Modern Art in Ireland,* Dublin 1997 (also illustrations); *Irish Art at the Frederick Gallery*, catalogue, Dublin 1998.

COLTHURST, ANNIE (1855-1930), landscape, portrait and still life painter. Anne Cape Colthurst was born in Ireland, daughter of Sir George Colthurst, Bt. She studied at Pau, Paris and London, where she lived for many years, and was a pupil of Eugene Carrière (1849-1906). In 1902 she showed for the first time at the Royal Hibernian Academy, contributing *Haystacks* and *London in Winter* from 47 Hill Street, London.

An *Irish Wake*, now in the Hugh Lane Municipal Gallery of Modern Art, appeared in the 1904 exhibition of works by Irish painters held at the Guildhall of the Corporation of London and organised by Hugh Lane. *Watching the dead in Ireland* was in the 1906 exhibition of the Royal Academy.

Altogether at the RHA she showed some forty works. In 1908, as well as a portrait, she exhibited *Au Parc Monceau, Paris* and *Kitty O'Callaghan the Flowerseller*. Works which impressed *The Studio* contributor who saw her exhibition in 1910, 'Impressions of Ireland, etc.' at the Baillie Gallery, London, included: *Before Mr Justice D*; *Ross Carbery*; *In the Stackyard*; and *Little Mary Casey*. She showed seventeen works at the London Salon.

An even more popular London venue than the Baillie Gallery was Walker's Galleries as a place for exhibiting. Among her contributions to the 1925 Dublin exhibition were: *Mimosa*; *Indian China and Irish Flowers*; and *The Market Place, Galway*. In 1929, when she showed pastels at the Paris Salon, she was living at 23 Cromwell Road, London, where she and her sister Julia were known for their musical evenings. She died in London.

Works signed: A. C. Colthurst.
Examples: Dublin: Hugh Lane Municipal Gallery of Modern Art.
Literature: *The Studio*, March 1910; *Dictionary of British Artists 1880-1940*, Woodbridge 1976; *A Dictionary of Contemporary British Artists, 1929*, Woodbridge 1981; Mrs S. Combe, *Letter to the author*, 1983; Ann M. Stewart, *Royal Hibernian Academy of Arts: Index of Exhibitors 1826-1979*, Dublin 1986.

COLVILL, HELEN (1856-1953), landscape artist. Youngest daughter of James Chaigneau Colvill, she was born on 11 December 1856 at the family home, Coolock House, Co. Dublin. She studied privately and stated that Bingham McGuinness (q.v.) went out sketching with her a good deal and that the studio of May Manning (q.v.) in Dublin 'provided models later on. I also had lessons from Mr Soper in London'.

An early member of the Water Colour Society of Ireland, her membership constituted something of a record, for she exhibited regularly in the exhibitions for more than sixty years, from 1892 until the year of her death, 1953, averaging at least four pictures per show. She was a committee member of the Society for several years.

In 1900 she was in Italy, hence *Arch of Titus, Rome*. The United Arts Club, Dublin, gave her an exhibition in 1910. She painted in Venice in 1912. A few pictures were sent to the exhibitions of the Royal Society of Artists, Birmingham, and the Society of Women Artists, London.

In the period 1920-47 she showed twenty-nine works at the Royal Hibernian Academy. Among her four contributions to the 1929 exhibition were: *Dublin Bay from Howth* and *The Cherwell at Oxford*. In 1934 she showed *Buttercup Time* and *Royat Auvergne*. Contributions to the 1935 WCSI exhibition included *Market Square, Shrewsbury* and *Sunshine and Showers over Cushendall*.

In the Drogheda collection is a watercolour, *A March Snowfall*, painted from a window of Coolock House, where she had returned to live 1927-37. *The Mall, Armagh, Springtime* is at the Hugh Lane Municipal Gallery

of Modern Art. She resided for many years at 'Cloghereen', Baily, Co. Dublin, until her death at the age of ninety-seven. An exhibition of her watercolours was held at the Gorry Gallery, Dublin, in 1994.

Works signed: H. Colvill or H. C., rare.
Examples: Drogheda: Library, Municipal Centre. Dublin: Hugh Lane Municipal Gallery of Modern Art. Limerick: City Gallery of Art.
Literature: Jane Barlow, *Letter to Sarah Purser*, 1900; J. Crampton Walker, *Irish Life and Landscape*, Dublin 1927 (illustration); C. E. F. Trench, *Letter to the author*, 1967; *Dictionary of British Artists 1880-1940*, Woodbridge 1976; *Allied Irish Banks Calendar*, Dublin 1981 (also illustration); Ann M. Stewart, *Royal Hibernian Academy of Arts: Index of Exhibitors 1826-1979*, Dublin 1986; *Irish Arts Review*, Summer 1987; Gorry Gallery, *Helen Colvill 1856-1953*, catalogue, Dublin 1994 (also illustrations); *Water Colour Society of Ireland Exhibition List 1872-1994*, Dublin 1995.

CONDON, MARGARET (1884-1969), still life, landscape and portrait painter. Daughter of Patrick Condon, she was familiarly known as Mog and was a niece of Alderman Tom Condon, for many years Nationalist MP for East Tipperary and Mayor of Clonmel. A grand opera singer and a participant when young in the 'penny readings' at the Clonmel Town Hall – her diction was excellent – she was the last surviving member of a family which had made a signal contribution to the cultural life of the town.

When the family victualling establishment at 81 O'Connell Street closed down in the early 1930s this allowed her more time for painting – and space to hang her oils, watercolours and pastels. Represented in the South Tipperary County Museum and Art Gallery by *Knitting* and *At Prayer*, she had knowledge of the London galleries as she once advised a friend who was going there what to see.

The *Clonmel Nationalist* stated that 'in landscape she celebrated the scenic beauties of her native heath in evocative paintings of old Clonmel and its environs. In portraiture ... she captured with uncanny accuracy so many of the colourful characters of her day'. With her jet-black hair (which she rarely washed but used castor oil on instead), strong and handsome face, she would have looked a real gypsy had she worn earrings. Her death was on 26 April 1969.

Works signed: M. Condon.
Examples: Clonmel: South Tipperary County Museum and Art Gallery.
Literature: *Clonmel Nationalist*, 3 May 1969; Ms Fanny Feehan, *Letter to the author*, 1983.

CONN, W. H. (1895-1973), black and white artist and cartoonist. Son of William Conn, a Belfast lithographer, William H. Conn received his education at Ulster Provincial School (now Friends' School, Lisburn) and Royal Belfast Academical Institution. His ability in figure drawing was early evident at Lisburn, where he was in keen demand as a contributor to autograph albums.

In 1921 he began as a commercial artist with W. and G. Baird, Ltd, Belfast, and in 1936 he was appointed staff artist on the *Belfast Telegraph* and *Ireland's Saturday Night*, a position he held until his retirement in 1962. As a newspaper contributor, his best known work was his regular cartoon 'The Doings of Larry OHooligan' in *Ireland's Saturday Night*. In Dublin circles his name was also familiar through his contributions of a monthly page drawing in pen for several years to *Dublin Opinion*; double spread at Christmas. Subjects included a Georgian tenement; sunlight in St Stephens Green; moonlight in College Green.

C. E. Kelly, who edited *Dublin Opinion*, said that he worked 'in what could only be described as tones of pen and ink, almost distaining resort to outline, so that everything was set off by its surroundings. His sentimental, nostalgic drawings had a worldwide public and requests for the originals were many and frequent'.

In 1943 the Three Candles Press in Dublin produced a broadsheet with a reproduction of a pen and ink drawing by Conn of a skeleton with chain mail rotting on its bones, seated amid ruined columns and drifts of sand, with a great sword across its knees. For this broadsheet, the Ulster poet John Irvine provided verse.

In 1933 Conn held an exhibition at the Ulster Arts Club, of which he was a member. He showed only four works at the Royal Hibernian Academy, 1934-5; in 1934, *The Wandering Jew* and *Venus and Tannhauser*.

In association with another black and white artist, A. Erwin, he exhibited in 1936 at the Pollock Gallery, Belfast. He was a member of the Royal Ulster Academy, and in 1958 the RUA held a retrospective exhibition of his work. A bachelor and somewhat lonely figure, he spent three years in hospital and died there on 25 August 1973. A memorial exhibition was held at the Ulster Arts Club shortly after his death.

Works signed: W. H. Conn.
Examples: Belfast: Ulster Museum.
Literature: John Irvine, *Sic Transit Gloria Mundi*, Dublin 1943 (illustration); *Dublin Magazine*, October-December 1943; Tom Collins and Charles E. Kelly, *Forty Years of Dublin Opinion*, Dublin 1961; *Belfast Telegraph*, 25 August 1973; *Irish Times*, 19 June 1974; John Hewitt and Theo Snoddy, *Art in Ulster: 1*, Belfast 1977.

CONNOR, JEROME (1874-1943), sculptor. Jerome Connor was born on 23 February 1874 at Coumduff, Annascaul, Co. Kerry. He was registered as Jeremias. His father Patrick, a stonemason, had married as his second wife, Margaret Currane; Jerome was the fourth son of that marriage. The eldest brother, Timothy, was already in the USA when his father decided to emigrate in 1888 with the rest of the family to Holyoke, Massachusetts. After only a short period in the USA, Patrick Connor died. His siblings made census returns — of a kind.

Later in life Jerome, as he was known in the family, claimed to have run away from home, and to have learnt before he was twenty-one the trades of signpainter, machinist and stonecutter. As well as learning the techniques of stonecarving, he also became familiar with bronzecasting. He was also a professional boxer, known as Patrick J. O'Connor. In this period he worked for a Springfield, Mass., monument company. In later years he was responsible for the Spanish American War Memorial at Springfield.

Lorado Taft in his *History of American Sculpture* referred to an exhibition at Philadelphia Academy of Fine Arts in 1893 of a number of studies by Jerome Connor: 'His special field is the interpretation of the life of the working man ... an office that he performs with remarkable directness and sympathy.' In 1896 Connor was responsible for the Civil War Memorial at South Hadley, Mass.

Between 1898 and 1903 he was with the Roycroft colony of craftsmen at East Aurora, near Buffalo City in New York State, directed by Elbert Hubbard. During his time there he married Anne Donohue and in 1903 they settled in Syracuse, New York State, where he set up a studio. As well as learning the techniques of stonecarving, he also became familiar with bronzecasting. A sculpture of Thomas Moore, believed to be a bust, was in the Corcoran Gallery of Art, Washington DC, from 1911, gift of a local poetry group, until 1955 when it was sold to a local art dealer.

In 1912 he completed the Archbishop John Carroll monument for the campus at Georgetown University, Washington DC. Over the years the Carroll sculpture has been the victim of student pranks, one of which involved painting the figure red; in 1934 the space beneath the chair was filled in with bronze books to discourage students from placing commodes there.

Connor was commissioned in 1912 for the *Robert Emmet* standing portrait for the Smithsonian Institution, Washington DC, but not unveiled until 1917. It is now at Massachusetts Avenue. For that work he made a copy of the death mask of Emmet and an actor, Brandon Tynan, was selected as the model. Tynan once played Emmet in a theatrical production. A small copy of the work is at Woodrow Wilson House. Another full length statue of Emmet of the same period is at Emmetsburg, Iowa. An Emmet plaque is at the National Museum of Ireland. A second cast of *Robert Emmet* for San Francisco was unveiled in 1919 by President Éamon de Valera before an estimated 80,000 people.

The gravestone memorial at Oak Hill Cemetery, Washington DC, for John A. Joyce, poet, soldier, philosopher, included inscriptions for other members of the Joyce family and quotations from Joyce's poems. The bust of Joyce depicted him wearing a suit with a small bow tie. He had full wavy hair and a moustache. Joyce died in 1915 but apparently the sculpture was installed before his death.

When he exhibited a study for the *Bishop Huntington Tablet* at the Pennsylvania Academy of Fine Arts, 1920, his address was 322 North Carolina Avenue, Washington DC. Four years later he completed one of his most important works, *Nuns of the Battlefields*, commemorating the nuns who gave their services as

nurses during the Civil War. The sculpture, 1.8 m x 2.7 m, for Rhode Island Avenue, Washington DC, depicted twelve nuns dressed in various ecclesiastical robes and hats together with two winged figures, angels of Patriotism and Peace. The work was erected by the ladies auxiliary of the Ancient Order of Hibernians. National Park Service files noted that the artist ended up suing AOH for non-payment.

At this period he was engaged on a war memorial for the Bronx, New York, dedicated in 1925; the cost was 6,000 dollars. He was also responsible for *The Supreme Sacrifice* in Washington and was a member of the Society of Washington Artists.

Kentucky Historical Society has a portrait bust of Anne Baker, architect, wearing a high collared dress and centre-parted hair with headband; and also a bust of William O. Bradley. *Cain*, marble bust, is at the Metropolitan Museum of Art, New York.

There were two distinct periods in Connor's working life. The second, the Irish one, began in 1925 when he arrived in Ireland to make the *Lusitania* peace memorial. Many wealthy Americans had gone down with the ship and the commission came from a distinguished American committee, which included William H. Vanderbilt, chairman, and Franklin Delano Roosevelt. The monument at Cobh was to commemorate the dead. A site was made available in 1927.

Connor rented and converted two stables near the Park Gate, at the rear of 2 North Circular Road, Dublin, to serve as a studio. His wife Anne and daughter Peggy had joined him in the city. The address on a letter which he wrote in 1926 expressing his interest in submitting designs for the new Free State coinage was 'Parkside Hotel, Dublin'.

Connor was not long in establishing himself in the cultural life of Dublin, and with the important *Lusitania* commission settled in his name, he made a series of relief portraits of the 1926 Cabinet. He also found time to produce designs for the proposed new coinage. The studio was soon to be recognised by some as one of the centres of Dublin's bohemian life.

In 1926, too, he was responsible for the first piece of bronze statuary ever completed in Ireland, cast at the Bell Foundry, James's Street, Dublin: a bust of George Russell (q.v.). Thus he became the first Irish artist to cast, chase and patinate his own bronze sculptures. A bronze bust of George Russell is now at the Limerick City Gallery of Art. A plaque in plaster, *Walt Whitman, Poet* is at the National Gallery of Ireland – inscribed in pencil on the reverse: 'To A. E. as a token of our mutual regard for 'The Leaves of Grass' from Jerome Connor, April, 1926'.

All this Dublin activity was punctuated by visits to the USA in connection with the *Lusitania* project. He was there in 1927. Máirín Allen pointed out in one of her important contributions on Connor for the *Capuchin Annual*, that he was in London in 1928 when he and his wife attended a ball at Burlington House, the Royal Academy premises; Jerome wore an Indian headdress of feathers. He was said to have been an honorary chief of the Cherokee Indians. In any event, he showed at the Royal Academy in 1929, 1930, 1931, and 1932; a bust, *Colonel Joyce*, appeared in the 1930 exhibition.

In the meantime, work progressed on the heroic, almost twice life size, statue of his old friend and patron, Elbert Hubbard of the Roycroft company, a victim of the *Lusitania* disaster. Connor, with County Cork well out of mind, made a model in Ireland which had to be brought to the USA for criticism and approval. The work was completed in 1929, the year he was on the Continent twice, and the model was cast in bronze at Mount Vernon, New York. Connor was at East Aurora in June 1930 for the dedication. According to Elbert Hubbard II, the total cost of the statue was slightly over 30,000 dollars, paid for by Hubbard's friends. Connor returned to the States later in the year. He also visited Mexico twice in 1930, the year he showed *Mary* and *Peggy* at the British Empire Academy second exhibition, New Burlington Galleries, London.

The model for the Tralee '98 Pikeman was ready in 1931 but did not satisfy its creator. The Tralee committee took the sculptor to court for failure to complete the work. About this time his wife and daughter returned to the States, but came back to Ireland on visits. However, by 1932 Connor was off again to the USA with amended models of the *Lusitania* project. Two years later he took back with him to Ireland, from the USA, the approved photographs of his latest models, assuring the Cobh Urban Council that the monument would be erected the following year. In 1934 too he was quoted as saying: 'We hope to start a world-wide movement for peace from this memorial. I do not intend to have it commemorate anything to do with war or

the horrors of war.' Connor was on the Continent again in 1935. In November he declined the request of the Council to have a Gaelic inscription on the monument, commenting that 'the group of two Irish fishermen on the work is enough Gaelic'.

The *Mother Éire* figure for the Kerry Poets' Memorial Committee was not yet ready and this produced a letter from the solicitor for the committee stating that legal proceedings would be taken. In reply, the sculptor sent a telegram: 'Delighted with letter. Magnificent. Will reply – Jerome Connor'. In cross-examination in court, the sculptor indicated a cost of £20,000 for the *Lusitania* monument, of which he had received £12,000. The judgement against Connor in 1936 precipitated his bankruptcy proceedings.

In 1935 and 1936 he had been occupied making the full-size models for his new *Lusitania* inspiration of two mourning fishermen, and he personally cast the great figures into bronze. *The Fishermen* was displayed outside the doors of the Royal Hibernian Academy exhibition in 1941 but did not reach Cobh until 1952. *The Angel of Peace* for the same monument had been ready for casting in bronze when the Second World War intervened. It was not until 1968, after the Arts Council had appointed Domhnall Ó Murchadha (q.v.) to complete the *Lusitania* peace memorial, that *The Angel of Peace*, cast in Florence, completed its long journey. In her *Irish Public Sculpture: A History*, 1998, Judith Hill wrote:'Whereas it is the angel which gives the memorial its distinctive and memorable outline, it is the fishermen who demand a response from the viewer.'

In the years immediately preceding his death, Connor produced a series of small bronzes which found their way into private collections. Eight pieces appeared at the 1937 exhibition of the Royal Hibernian Academy, including *The Labourer*; *Irish Peasant Girl*; and *Man of the Soil*. The Dawson Gallery, Dublin, held an exhibition in 1950 of pictures and sculpture from the collection of the late Senator Joseph Brennan, one of his patrons; the Connor sculptures included: *The Bellman*; *The Workman*; and *The Boxer*. Nearly all the pieces which he displayed at the RHA 1938-43 were on loan.

The last few years were sad ones, only relieved by the help of friends. In 1938 he was evicted from his studio with consequent moves. Crampton Court was his last studio, and his address when he exhibited at the 1943 RHA. He was included in Alan Reeve's famous Palace Bar *Dublin Culture* cartoon of personalities, 1940. A portrait of Connor by Gaetano de Gennaro (q.v.) is in the Hugh Lane Municipal Gallery of Modern Art, where there is a bronze head, *Street Singer*, 1939. Bronzes at the National Gallery of Ireland include *Miss Brenda Charles* and *The Patriot, 1916 Memorial*. The plaster for the latter is also in the gallery together with six other plasters and a study in red wax, all presented by the Jerome Connor Trust, Annascaul.

Richard Hayward, in his *Munster and the City of Cork*, wrote: 'He was one of the most powerful and immensely vital men I have ever met and he had a rich speaking voice than made you listen to him whether you wanted to or not. He had a soft cat-like walk and the feeling about him of all the pent-up live muscular power of a tiger. His hands were enormous and I could never imagine them caressing anything but cut stone or cast bronze. He died a desperately poor man and no one will ever know what went on within his turbulent wayward mind.' His death was on 21 August 1943 at the Adelaide Hospital, and he was buried at Mount Jerome cemetery. A small memorial exhibition of his works took place at the 1943 Irish Exhibition of Living Art.

In 1966 the Robert Emmet Statue Committee of the USA decided to present a cast of Connor's famous Washington statue to Dublin, and this was unveiled in St Stephen's Green in 1968, opposite Emmet's birthplace. A bronze of a kinsman, Dr Thomas Addis Emmet, is at Áras an Uachtaráin. Also in 1968, NGI decided on a bronze casting from an original plaster of an early portrait of Éamon de Valera. In 1978 Connor's *Éire*, bronze, a tall female figure leaning on a harp, was sited in Merrion Square, Dublin, where in 1985 a bust of George Russell was unveiled; a replica went to Lurgan Town Hall in the same year. A commemorative weekend of events was held at Annascaul in 1988. Eight works owned by the Jerome Connor Trust formed the core of a Connor exhibition at the National Gallery of Ireland in 1993, and these sculptures will be housed at The Jerome Connor/Tom Crean Centre, when built, at Annascaul.

Works signed: Jerome Connor or Connor.
Examples: Cobh, Co. Cork: Casement Square. Dublin: Áras an Uachtaráin; Hugh Lane Municipal Gallery of Modern Art; Merrion Square; National Gallery of Ireland; National Museum of Ireland; St Stephen's Green. Emmetsburg, Iowa: Courthouse. Frankfort, Kentucky: Kentucky Historical Society. Limerick: City Gallery of Art. Lurgan, Co. Armagh:

Town Hall. New York: Bronx, Mosholu Parkway; Metropolitan Museum of Art. San Francisco: Golden Gate Park. Springfield, Mass.: Monument Square. Syracuse, New York: Union Park. Washington DC: District Building; Georgetown University; Massachusetts Avenue; Oak Hill Cemetery; Rhode Island Avenue; Woodrow Wilson House. Waterford: City Hall, Municipal Art Collection.

Literature: Lorado Taft, *History of American Sculpture*, New York 1924; *Irish Independent*, 5 October 1926; J. Crampton Walker, *Irish Life and Landscape*, Dublin 1927 (illustration); *Irish Builder*, 30 November 1935; *Irish Times*, 9 July 1936, 23 August 1943, 11 May 1968; *The Bell*, May 1943; Mantle Fielding, *Dictionary of American Painters, Sculptors and Engravers*, New York 1945; Máirín Allen, *Capuchin Annual*, 1963, 1964, 1965 (all: also illustrations); Richard Hayward, *Munster and the City of Cork*, London 1964; National Gallery of Ireland, *Jerome Connor 1874-1943, Irish American Sculptor*, catalogue, Dublin 1993; Jerome Connor Trust, *Letter to the author*, 1995; also, Corcoran Gallery of Art, 1997; *Smithsonian Institution Art Inventories Catalogue*, Washington DC 1997; Judith Hill, *Irish Public Sculpture: A History*, Dublin 1998 (also illustrations); Giollamuire Ó Murchú, *Letter to the author*, 1999.

CONOR, WILLIAM, RHA, RUA, ROI (1881-1968), figure and portrait painter. Born on 9 May 1881 in Fortingale Street, Belfast, he was the son of William Connor, a sheetmetal worker. Later with artistic licence the artist dropped an 'n' out of his name. Following Cliftonpark Central National School, he entered the Government School of Design in 1894. He had been 'discovered' by a friendly music teacher, Louis Mantell, who found him sketching on a wall as he waited for the end of a friend's music lesson.

In 1904 he joined David Allen & Sons Ltd, lithographers, at 4s. 6d. per week as an apprentice poster designer, and remained for about five years. He exhibited at the Belfast Art Society in 1910. At about this time he stayed for some months on the Blasket Islands, Dingle Bay, Co. Kerry. Later in life he recalled to a friend, Dr Jim Ryan, being in Paris 'in 1912 and 1913'; probably his visit did not exceed six months.

During the First World War Conor was appointed by the Government to produce official records of soldiers and munition workers. In 1916, an exhibition of his war drawings was auctioned for the Ulster Volunteer Force Patriotic Fund. He went to London 'in 1920 to settle down there', he told Dr Ryan, and stayed at 32 Percy Street, off Tottenham Court Road, exhibiting for the first time at the Royal Academy in 1921. In London he became acquainted with Sir John Lavery (q.v.), Augustus John (1878-1961) and the Café Royal circle.

Meanwhile, Conor had begun exhibiting at the Royal Hibernian Academy in 1918 and from then until 1967 he showed nearly 200 works. His initial contribution of six pictures included *'The Darlin'*; *Balloon Man*; and a portrait of Lieut.-Col. Sir James Craig, MP. He rarely exhibited at the Oireachtas. A portrait of R. V. Williams (Richard Rowley) appeared in the 1921 exhibition of the Royal Society of Portrait Painters, London, and he also showed at the Paris Salon. In the following year, again in London, he was represented at the Goupil Gallery and the Grosvenor Galleries. In 1923 at the Goupil he showed more than forty works, and he also held an exhibition at Magee Gallery, Belfast.

Conor had returned to Belfast in 1921, the year he showed for the first time at the Glasgow Institute of the Fine Arts. He now had a studio at 7 Chichester Street, mainly for the purpose of painting the official opening of the Northern Ireland Parliament by the King and Queen, a commission which had been suggested by Sir John Lavery. The work was completed in 1922, and that year, among several contributions to the Belfast Art Society, he showed: *Study for the painting of the Opening of the Northern Parliament*, priced at £150.

When Conor wrote in 1923 to Lawrence Haward, director of Manchester City Art Galleries, he explained to him that it had long been his custom to carry a sketchbook in his pocket, 'and to note down any little happening which strikes me as interesting and significant. With my sketching block held under cover of a newspaper, I have been able to garner many happy impressions, which I have afterwards worked up into drawings and paintings'.

By 1925 the Belfast artist's work was well known in Dublin. Exhibitions were held at the Dawson Gallery, 1921, and at 7 St Stephen's Green in 1924 and 1925. The display of his work in London produced in 1925 an article by Holbrook Jackson in *The Studio*. He wrote in part: 'Belfast has ... produced a painter. This event is of twofold importance. In the first place William Conor is a painter of genius, and in the second place he is a painter of Belfast. There are notes in his work that suggest he could not have painted anywhere else, and this despite the fact that he had looked upon the French impressionists with affection and understanding ... If a modern manufacturing town could have folk-songs and if those folk-songs could be translated into

pictures, or if the feelings which inspired them could be pictorially represented, they would take the form of the art of William Conor.'

A 1926 portrait of the Marquess of Londonderry, Chancellor of Queen's University, was a useful recommendation in the USA for Conor as a portrait painter when he left for Philadelphia in June 1926. He received many commissions before his return nine months later. During his visit, he showed the Londonderry portrait in his exhibition at the Babcock Galleries, New York, 1926, and Sir John Lavery bought an oil painting, *At the Pump*, and presented it to the Brooklyn Museum, New York. An attractive child-study in this show found the artist besieged by parents who wished to have their children drawn or painted – in the hottest of summers. On his return to Belfast, Conor obtained new studio premises at 1 Wellington Place. In 1929 he showed forty-five crayon drawings at the Godfrey Phillips Gallery, Duke Street, London, including *The Melodeon Player*; *The Jaunting Car*; *The Potato Gatherers*; and *Colette O'Neil*.

Conor was elected one of the first nine academicians when the Belfast Art Society became the Ulster Academy of Arts in 1930, in which year he was also elected a foundation member of the National Society of Painters, Sculptors and Gravers. Sir Robert Baird commissioned in 1931 for the Belfast Museum and Art Gallery a mural decoration which was unveiled in 1932: *Ulster Past and Present*, 2.8m. by 7.4m, consisted of ancient Irish warriors, mill girls and shipyard workers. It was then the largest mural in Ireland; the cartoon is at the Royal School, Armagh. Also in 1932 he made costume designs for some of the principals in a pageant of St Patrick at Castleward, Co. Down; the designs are now at Church House, Armagh. And in 1932 he became the first Irish member of the Royal Institute of Oil Painters. The following year he showed at the New English Art Club, London.

Appointed an associate of the RHA in 1938, he became a full member in 1946. A portrait of the Rev. William Anderson, commissioned by Mountjoy School Old Boys' Association, is now at Mount Temple Comprehensive School, Dublin. He also exhibited in Dublin at Combridge's Galleries, 1938, 1939. He last exhibited at the RA in 1939. In the Second World War he was again commissioned, this time by the Ministry of Information, to record aspects of Northern Ireland's participation in the war effort. The Belfast Museum and Art Gallery purchased *Building an Air Raid Shelter*; *The Warden*; and twenty-seven sketches. Some of his work appeared at the exhibition of war artists at the National Gallery, London, 1941. He was also represented in the United Artists' charity exhibition at the Royal Academy, 1943.

The Irish Scene appeared in 1944 with coloured reproductions of his work and a tribute from Richard Rowley: '... he is a serious and important painter, endowed with a very personal vision, practised in many branches of his profession, and above all, that his work is based on the surest foundations, an innate capacity of draughtsmanship, a seeing and remembering eye, and a mental rectitude which scorns sham and pretence He has devoted all his manhood's years to the praise and glory of the city which gave him birth; he has immortalised her beauty, and the steadfastness of her people, in works which will last to carry her fame to remote generations ...'

Conor exhibited at the Victor Waddington Galleries, Dublin, in 1944 and 1948. In an issue of the *Belfast Telegraph* in 1945 St John Ervine wrote: 'It is plain from his portraits that he likes people, but I fancy that even when he encounters a person he dislikes, he remains interested in him. It is this fact which makes his portraits extraordinarily vivid.' His contributions to the 1949 RHA included *The Flax Gatherers* and *Churning Butter*. Among the six works at the 1957 Dublin exhibition were *Gathering Potatoes* and *Going to Mass, Co. Kerry*.

Among the other notable people who sat for him were Dr Douglas Hyde, Sir William Moore, Lord Chief Justice of Northern Ireland; Professor Andrew Fullerton, president, Royal College of Surgeons in Ireland; the Most Rev. Dr Charles F. D'Arcy, St John Ervine and the Rev. J. B. Armour. A self-portrait and a portrait of his mother Mary, née Wallace, are in the Ulster Museum collection. Another self-portrait is in the National Self-Portrait Collection at the University of Limerick. A pencil sketch of William Conor by Raymond Piper is at the Ulster Museum.

Council for the Encouragement of Music and the Arts honoured him in 1945 with a one-person show at Tyrone House, Belfast, and it became the first solo show to tour the Province. Lynn Doyle (Leslie A.

Montgomery), for whom he had illustrated books, opened another CEMA exhibition in 1950. Two years later he received the OBE. When another CEMA show was held in 1954 the attendance exceeded 2,800.

CEMA organised a retrospective exhibition of more than 160 works, the largest individual show ever presented in the Province, at the Belfast Museum and Art Gallery in 1957, the year he was elected president of the Royal Ulster Academy, and held office until 1964. In 1957 he received an honorary Master of Arts degree from Queen's University, Belfast. A Civil Pension was granted in 1959. He now decided to close his studio at 11A Stranmillis Road, Belfast, which he had opened in 1944. The Bell Gallery, Belfast, hosted exhibitions in 1964, 1966 and 1967.

As well as a collection of more than fifty works, crayon with watercolour predominating, at the Ulster Museum, there is an equally impressive array in size and content at the Ulster Folk and Transport Museum, Cultra. At the Victoria and Albert Museum, London, are three costume designs which were reproduced in *Robes of Thespis*. At the Ashmolean Museum, Oxford, is a crayon drawing of a street scene with sand, air raid shelters and children, presented by HM Government (War Artists' Advisory Committee). One of his First World War works is at the Imperial War Museum, London, depicting Bren gun practice at Ballykinlar Camp, Co. Down.

Conor died on 5 February 1968 at his home, 107 Salisbury Avenue, Belfast, and was buried at Carnmoney churchyard. At the service at Townsend Street Presbyterian Church, Capt. Terence O'Neill, Prime Minister of Northern Ireland, read the lesson. As a memorial tribute, the Arts Council of Northern Ireland held an exhibition which then toured the Province. There is a Conor Room at the Ulster Folk and Transport Museum, and a Conor Hall at the University of Ulster, Belfast.

Other exhibitions in Belfast followed his death: 'William Conor 1881-1968', Wm Rodman and Co. Ltd incl. L. A. Kaitcer (Antiques) Ltd, 1969; 'Children of Ulster', McClelland Galleries, 1969; 'The Belfast Blitz of 30 years ago', McClelland Galleries, 1971. A centenary exhibition, with works covering the period 1905-57, was held at the Ulster Folk and Transport Museum in 1981, and of the 158 pictures on view, nearly a third were from the museum's collection. Nearly fifty works were exhibited in 'The People's Painter' exhibition which opened at the Ulster Museum in December 1998 in association with W. & G. Baird Ltd.

Works signed: Conor, W. Conor or William Conor.
Examples: Armagh: Church House; County Museum; Royal School. Athlone, Co. Westmeath: Public Library. Ballymoney, Co. Antrim: Trinity Presbyterian Church. Bangor, Co. Down: Town Hall. Belfast: City Hall; Department of the Environment for Northern Ireland; Linen Hall Library; Queen's University; Royal Ulster Rifles Museum, Waring Street; Ulster Museum. Bray, Co. Wicklow: Public Library. Clonmel: South Tipperary County Museum and Art Gallery. Coleraine, Co. Derry: University of Ulster. Cork: Crawford Municipal Art Gallery. Cultra, Co. Down: Ulster Folk and Transport Museum. Downpatrick: Down County Museum. Dublin: Hugh Lane Municipal Gallery of Modern Art; Masonic Hall, Molesworth Street; Mount Temple Comprehensive School; Office of Public Works; University College (Belfield). Galway: County Council. Kilkenny: Art Gallery Society. Leamington Spa, Warwick.: Art Gallery and Museum. Limerick: City Gallery of Art; University, National Self-Portrait Collection. Lisburn, Co. Antrim: Museum. London: Imperial War Museum; Overseas House; Victoria and Albert Museum. Londonderry: Foyle and Londonderry College. Manchester: City Art Gallery; Whitworth Art Gallery. New York: American Irish Historical Society; Brooklyn Museum. Oxford: Ashmolean Museum. Sligo: Model and Niland Centre. Waterford: City Hall, Municipal Art Collection.
Literature: *Ulster Volunteer Force Hospital Book*, Belfast 1916 (illustration); *La Revue Moderne*, 30 October 1921 (illustration); *The Studio*, October 1925; J. Crampton Walker, *Irish Life and Landscape*, Dublin 1927 (also illustration); George Sheringham and R. Boyd Morrison, *Robes of Thespis: Costume Designs by Modern Artists*, London 1928 (illustrations); Lynn Doyle, *Ballygullion Ballads and other Verses*, London 1936 (illustrations); Society for the Prevention of Cruelty to Animals, *The Tree*, Belfast 1936 (illustration); Thomas Bodkin, introduction, *Twelve Irish Artists*, Dublin 1940 (also illustration); *Father Mathew Record*, October 1942; Richard Rowley, appreciation, *The Irish Scene*, Belfast 1944 (also illustrations); *Belfast Telegraph*, 23 February 1945; Lynn Doyle, *A Bowl of Broth*, London 1945 (illustration); John Irvine, *By Winding Roads*, Belfast 1950 (illustrations); *Brave Crack*, Belfast 1950 (illustrations); Lynn Doyle, *The Ballygullion Bus*, London 1957 (illustrations); British Broadcasting Corporation, *To-day and Yesterday in Northern Ireland*, 1968 (illustrations); Arts Council of Northern Ireland, *Causeway*, Belfast 1971 (also illustration); Judith C. Wilson, *Conor 1881-1968: The Life and Work of an Ulster Artist*, Belfast 1981 (also illustrations); Ulster Folk and Transport Museum, *1881-1968 William Conor*, catalogue, Cultra 1981; Ann M. Stewart, *Royal Hibernian Academy of Arts: Index of Exhibitors 1826-1979*, Dublin 1986; Brooklyn Museum, *Letter to the author*, 1991; Lisburn Museum, *Letter to the author*, 1993; Anne Crookshank and the Knight of Glin, *The Watercolours of Ireland*, London 1994

(illustration); Eileen Black, *A Sesquicentennial Celebration: Art from the Queen's University Collection*, Belfast 1995 (also illustrations); Martyn Anglesea, *William Conor -The People's Painter*, Belfast 1998 (illustrations).

CONWAY, JAMES (1891-1968), portrait and figure painter. Born Kingstown, Co. Dublin, now Dún Laoghaire, on 2 November 1891, he spent several years at sea as a young man before joining Dublin Fire Brigade in 1918. He did most of his painting from about 1923 onwards, consisting in the main of portraits of himself, relatives and friends.

During the years 1927-31 he studied at Dublin Metropolitan School of Art, and when he exhibited *The Newsvendor* at the Royal Hibernian Academy in 1928 he gave his address as the School of Art. Altogether at the RHA, in the period 1927-41, he showed seventeen works, and from 1932 his address was Fire Station, Dorset Street, Dublin. '*A Knight of the Road'* was hung in 1934.

Patience: the Card Player is in the Hugh Lane Municipal Gallery of Modern Art collection, presented by Joseph Holloway in 1944. *The Burning of the old Gresham Hotel* is at Áras an Uachtaráin. At the Central Fire Station, Tara Street, is a self-portrait, *A Dublin Fireman*, presented to the Corporation of Dublin by Aonác na Nodlag, 1932, and presumably the work of that title exhibited at the 1931 RHA. In 1936 the Thomas Haverty Trust, Dublin, presented *Sez You* to the Belfast Museum and Art Gallery. The artist died on 2 May 1968.

Works signed: J. Conway or Conway (if signed at all).
Examples: Belfast: Ulster Museum. Dublin: Áras an Uachtaráin; Central Fire Station; Hugh Lane Municipal Gallery of Modern Art.
Literature: Miss Margaret Conway, *Letters to the author*, 1983; Ann M. Stewart, *Royal Hibernian Academy of Arts: Index of Exhibitors 1826-1979*, Dublin 1986.

COOKE, KATHLEEN (1908-78), sculptor and figure painter. Daughter of Edward and Elizabeth Holmes, she was born in Belfast on 30 September 1908. In the early 1920s the family moved to Winnipeg, Canada. Her brother Lambert sought film work in Hollywood, finding limited success with small parts. Kathleen also moved to the USA where her development as an artist came relatively late.

Partially self-taught, she attended at least three drawing classes, including a night school in New York. She taught drawing herself, bringing her pupils to the zoo. In an article in *The Arts in Ireland* in 1975 she wrote: 'Goya drew when he wanted to show the cruelty of his age. Perhaps I use drawing to show that the human race is trapped and in bondage. We accept the bondage as the animals accept theirs. Each human has his own bars. But the dignity of the animals is so great, even in their boredom, they are magnificent. I do my best to convey that with one line.'

In 'The World of the Zoo' exhibition at Betty Parsons Gallery, New York, 1969, her work was included, and Grace Glueck, writing that year in the *New York Times*, said that the artist made 'sensitive charcoal and pastel drawings of polar bears, elephants, bison and yak that show Lascaux and Japanese influence ...'. In the following year she held her first solo show at the Betty Parsons Gallery. About this time she returned to Ireland, the first of several visits, to seek out any relatives in Belfast and to secure an exhibition of her work in Dublin. On these visits home she sketched on occasions in Co. Donegal.

A Danish critic wrote in the 1970s: 'The animals remind you of things you have been dreaming. Prehistoric beings, hovering in a universe of their own, but all of them with recognisable features ... I imagined the animals as soundless. There is a strange poetry in those pictures.' Winning the Mark Rothko Foundation Award in 1971, she also exhibited that year with the Society for Contemporary Art at the Art Institute of Chicago: 'Works on Paper'.

In 1971 and 1973 she held one-person exhibitions at the David Hendriks Gallery, Dublin, and also in 1973 at the Arts Council of Northern Ireland gallery in Belfast, when, in addition to her drawings, she also showed lithographs. At the Irish Museum of Modern Art she is represented by *Paris Zoo: Afternoon of a Faun*, pencil and charcoal. In 1973 she also had solo exhibitions at Kunstmuseum, Odense, Denmark; Galerie Carstens, Copenhagen; Galerie Rivolta, Lausanne, Switzerland; and the Compass Gallery, Glasgow, where among the

twenty works were *Monkey Shines*; *Camel*; and *Llamas Feeding*. In 1975 the Parsons-Truman Gallery, New York, showed her exhibition titled 'Animals and Nudes'. The Truman Gallery was holding an exhibition of her sculpture and drawings when she died in New York, attending a Democratic Party conference, on 7 February 1978.

Works signed: K. Cooke.

Examples: Dublin: Irish Museum of Modern Art; Trinity College Gallery. Ithaca, USA: Cornell University. New York: Whitney Museum of American Art. Utah, USA: University.

Literature: Grace Glueck, *New York Times*, 25 January 1969; David Hendriks Gallery, *Kathleen Cooke*, catalogue, Dublin 1971; Compass Gallery, *Kathleen Cooke Drawings*, catalogue, Glasgow 1973; Kathleen Cooke, *The Arts in Ireland*, June 1975; Truman Gallery, *Kathleen Cooke*, catalogue and curriculum vitae, New York 1978; Mrs M. T. Collett, *Letter to the author*, 1984.

COOKE-COLLIS, SYLVIA (1900-73), painter of landscape and figure subjects. Born Glanmire, Co. Cork, Sylvia Margaret Phillips was the daughter of Hilda and Cecil Phillips. She studied at the Crawford Municipal School of Art and later under Mainie Jellett (q.v.) at 36 Fitzwilliam Square, Dublin. The Dublin artist spent some of her summer holidays working with her Cork friend at the latter's studio, and also in the open. Sylvia had grown up largely at Annes Grove, Castletownroche; her mother, widowed early, had remarried R. A. Grove Annesley.

As well as painting in Co. Cork and Co. Kerry, she also visited Connemara, working mostly in oils and gouache. Horses and fairs attracted her, also fishing port scenes. In the period 1936-57, she contributed sixty works to the exhibitions of the Water Colour Society of Ireland. Since 1937 she was a member of the Society of Dublin Painters. Fantasies and decorative compositions were also in her oeuvre and in the exhibition at the Dublin Painters' gallery in 1944 the catalogue included: *Elizabeth's Dream – Is the War over?* and *Murder in the Rhubarb*.

At the WCSI show in 1944, *Little Fish* and *Clock Tower, Youghal* were both on display, and in 1945: *Garden Lake, Annes Grove* and *Castletownroche Village*.

At the Royal Hibernian Academy she showed only three works. At the 1946 exhibition of the Dublin Painters, she showed *Cathedral Square, Waterford*, which the *Dublin Magazine* described as 'cool and original colour, and a harmonic interplay of line in the trees against the static masonry in the background ...'. *Mill House, Killavullen* appeared in 1947 at the Grafton Gallery. She also exhibited at the Grafton in 1949 and 1952. In Cork, pictures were hung at the Imperial Hotel and in the exhibitions of the Munster Fine Art Club. *A Rain Ballet* was her final contribution to WCSI in 1957.

Among the seven Cooke-Collis works at the Crawford Municipal Art Gallery in Cork are: *Festival Scene*, oil; *Cahirmee Fair*, acrylic; and *Donkeys in County Clare*, oil. In the Waterford municipal collection is *A Rain Ballet*. At the Irish Exhibition of Living Art in 1954, *A Cork Teashop Interior* was exhibited. *A Tribute to Evie Hone and Mainie Jellett*, published in 1957 in Dublin and edited by Stella Frost, contained a contribution, 'Mainie Jellett as Teacher' by Sylvia Cooke-Collis, who died on 7 February 1973 at Mallow Hospital; her home was at Ballymacmoy House, Killavullen, Co. Cork.

Works signed: Sylvia Cooke-Collis, S. Cooke-Collis or S. C.-C. (if signed at all).

Examples: Armagh: County Museum. Belfast: Ulster Museum. Cork: Crawford Municipal Art Gallery. Drogheda: Library, Municipal Centre. Enniscorthy: Wexford County Museum. Kilkenny: Art Gallery Society. Limerick: City Gallery of Art. Sligo: Model and Niland Centre. Waterford: City Hall, Municipal Art Collection.

Literature: *Dublin Magazine*, October-December 1946; Stella Frost, ed., *A Tribute to Evie Hone and Mainie Jellett*, Dublin 1957; F. P. Grove Annesley, *Letter to the author*, 1984; Mrs Diana Hill, *Letter to the author*, 1984; Peter Murray, compiler, *Illustrated Summary Catalogue of The Crawford Municipal Art Gallery*, Cork 1991 (also illustrations); *Water Colour Society of Ireland Exhibition List 1872-1994*, Dublin 1995.

CORKERY, DANIEL (1878-1964), landscape painter. Born on 14 February 1878 in Cork, son of William Corkery, carpenter, he was educated at the Presentation Brothers' South Monastery School. After training as a national teacher in Dublin, he returned to teach in Cork at St Francis's and St Patrick's Schools. At St

Patrick's, he taught Seamus Murphy (q.v.) and, noticing that he drew well, suggested that he should go to art school. After Murphy opened his work yard in Blackpool, Corkery gave him an early commission. They became close friends and for several years went out sketching together.

Corkery studied at night at the Crawford School of Art and from 1922 until 1925 was an art teacher in the North Cork area for Cork County Technical Education Committee. Author of *The Hidden Ireland* and *Threshold of Quiet*, it was as a writer that he made his name. He was Professor of English at University College, Cork, 1931-48. In 1935 he lectured on 'Modern Sculpture' at an exhibition under the auspices of the Cork University Art Society. In 1951 he was co-opted as a member of An Chomhairle Ealaíon.

Corkery, who enjoyed carpentry and made furniture for his own use, was a prolific painter of watercolours and usually spent his summers painting in the country; Youghal, Ardmore and around Ballygroman were favourite haunts. A founder member of the Munster Fine Art Club, he was a regular exhibitor; he showed *Beal an Chuain* at the 1933 exhibition. At the Royal Hibernian Academy he exhibited eight works in the period 1917-22. In 1920 he had been appointed to the subcommittee for advising on the purchase of works as stipulated in the Gibson Bequest to the Crawford Municipal School of Art.

The author, Francis MacManus, who stayed at Corkery's home in 1935, recollected seeing a pen-portrait of J. M. Synge as well as many watercolours on the walls. In 1954 Corkery held an exhibition at the Victor Waddington Galleries, Dublin. *Dublin Magazine* commented: 'his pictures are rarely more than pleasantly painted transcriptions of appearance'.Another one-person show followed in 1958 at the North Mall, Cork, where titles included *Parliament Bridge, Cork*; *Kilmore Quay*; and *On Sherkin Island*.

In the Crawford Municipal Art Gallery is a watercolour, *Seandun*. Although in the last three or four years of his life his eyesight failed considerably, he kept on painting long after he had stopped writing and left an attic full of sketches. Most of his work was bought by or given to people who admired him as a writer. A pencil sketch of Corkery by William Sheehan (q.v.) is at the National Library of Ireland. He died on 31 December 1964 at 6 Victoria Terrace, Glenbrook. A commemorative exhibition, arranged by the Cork Arts Society and opened by Seamus Murphy, was held in 1971.

Works signed: D. Ó Corcora (if signed at all).
Examples: Belfast: Ulster Museum. Cork: Crawford Municipal Art Gallery.
Literature: *Father Mathew Record*, April 1935; *Capuchin Annual*, 1940 (illustration), 1959; *Dublin Magazine*, January-March 1955; *Cork Holly Bough*, Cork 1971; *Irish Times*, 21 October 1971, 9 August 1977; Seamus de Roiste, *Daniel Corkery 1878-1964*, catalogue, Cork 1971; Hilary Pyle: Cork Rosc, *Irish Art 1900-1950*, catalogue, 1975; Mrs M. Murphy, *Letter to the author*, 1984.

CORRY, EMILY D. (1873-1942), still life and portrait painter. Born in Belfast, Emily Davis Workman was the daughter of the Rev. Robert Workman, DD, and was educated by a governess in Belfast before going to boarding school in Germany. Her father had a practical interest in painting.

A regular exhibitor for some twenty years, she showed with the Belfast Art Society in 1919 and subsequently with its successor, the Ulster Academy of Arts, becoming an academician in 1936.

In Dublin, she exhibited six works at the Royal Hibernian Academy in the period 1920-37, including *Up the Rocky Mountains* in 1920 and two Torquay scenes in 1924. In 1923 she had shown for the first time at the Water Colour Society of Ireland — for example, *In the Green and Silent Valley* — and from then until 1935 contributed a total of thirty-one works. In 1926, also in Dublin, Daniel Egan presented his Exhibition of Modern Art, which featured 100 works from Paris, and Emily Corry was represented by four pictures, including *Spearing Fish*. In 1927 at the WCSI, she exhibited three Co. Antrim scenes, one an impression of Ballycastle Fair. In the late 1920s she was associated with the short-lived Ulster Society of Painters, holding presidential office.

In 1935 with *To remind you of spring* and in 1937 with *Roses*, she exhibited at the Royal Scottish Academy. *Elderberries*, an oil, was exhibited at the 1938 Ulster Academy and was later presented by her husband, J. W. Corry, to the Belfast Museum and Art Gallery. In 1940, at the Ulster Academy, she contributed *Tobacco flowers*; *Lilies*; and *September, Co. Antrim*.

Outside of Ireland, she exhibited in 1926 and 1933 at the Paris Salon. A self-portrait and two portraits of young girls were reproduced in *La Revue Moderne*; works also appeared in *L'Art Contemporain*. A dozen pictures were shown at the Royal Cambrian Academy, and a group of fruit and flowers at the 1931 Royal Academy.

Works were also seen at the Royal Institute of Oil Painters and the Society of Women Artists' exhibitions. She was a member of the United Society of Artists, London, and exhibited *Wistaria and Laburnum* in 1941, the year before her death. A musician of some standing, late in life she learnt to play the harp. Her home was at Redroofs, Newtownbreda, Belfast.

Works signed: E. D. Corry.
Examples: Belfast: Ulster Museum.
Literature: Daniel Egan, *Exhibition of Modern Art*, catalogue, Dublin 1926; Margaret A. K. Garner, *Robert Workman of Newtownbreda*, Belfast 1969; *Dictionary of British Artists 1880-1940*, Woodbridge 1976; *A Dictionary of Contemporary British Artists, 1929*, Woodbridge 1981; Mrs G. M. Corry, *Letter to the author*, 1984; Ann M. Stewart, *Royal Hibernian Academy of Arts: Index of Exhibitors 1826-1979*, Dublin 1986; *The Royal Scottish Academy Exhibitors 1826-1990*, Calne 1991; *Water Colour Society of Ireland Exhibition List 1872-1994*, Dublin 1995.

COSTELLOE, EILEEN (1911-76), painter of landscape, flower and marine subjects. Born in Dublin 2 March 1911, daughter of a silversmith, John Costelloe, she attended Presentation Convent, George's Hill, Dublin, entering the Civil Service in 1928. Several years elapsed before she attended the National College of Art, Dublin, but she also received considerable guidance from George Campbell (q.v.). She visited France, Italy, Spain and Greece and studied paintings in the major galleries.

Eileen Costelloe had rather a late start as an artist and first exhibited in 1949. She showed at the Irish Exhibition of Living Art, the Royal Hibernian Academy, the Oireachtas exhibition and the Water Colour Society of Ireland from 1953 until 1975, a total of sixty-two works, opening with *Fog in the City* and *Study of a Boy*. A combination of gouache and pastel was used for *After Rain, Malin Head*, displayed in 1956.

A one-person show came in 1959 at the Dublin Painters' Gallery, and three years later she held an exhibition of gouaches at the David Hendriks Gallery, Dublin. In 1961 she exhibited at the RHA for the first time, from 16 De Courcy Square, Dublin, and showed a total of twenty-one works; *Island Ruin* in 1962.

Particularly attracted to Connemara and the Wicklow coastline for subject matter, in 1964 her work was chosen, with other Irish artists, for an exhibition in Montreal arranged by the Irish Tourist Board. A solo show was held in 1966 at the David Hendriks Gallery, and, in the same year, at Queen's University, Belfast, where eighteen oils were hung, including *Ruined Abbey, Inishbofin*; *Folk Dancers*; and *Greek Gorge*, also seven gouaches were on view.

On her work in a group expedition at the David Hendriks Gallery in 1971, the *Irish Times* critic wrote: 'Though she still owes something to Chagall, she is strikingly original, and also quite strikingly "Celtic".' Not only did she show *Blue Landscape, Wicklow* at the 1972 RHA but *Green Landscape, Wicklow* as well. Her final contribution to the Academy was in 1975: *Lighthouse*. That year another exhibition was held at the David Hendriks Gallery and a critique in the *Irish Times* stated: 'She is always interesting, sometimes genuinely exciting, rarely entirely convincing.'

As a new member, her work also appeared in group shows at the United Arts Club. Six weeks prior to her official retirement date in the Civil Service, she retired, having made arrangements to travel to a Penzance school of painting, but ill-health intervened. She died on 11 September 1976 in hospital. An exhibition was held in 1977 at the David Hendriks Gallery, and the United Arts Club also held a show.

Works signed: Eileen Costelloe.
Examples: Athens: Irish Embassy. Belfast: Arts Council of Northern Ireland. Dublin: Co. Dublin Vocational Education Committee; Institute of Public Administration; Irish Museum of Modern Art. Naas: Kildare County Council. New York: Irish Embassy. Newbridge: Kildare County Library. Waterford: City Hall, Municipal Art Collection.
Literature: Queen's University, *Eileen Costelloe*, catalogue, Belfast 1966; David Hendriks Gallery, *Eileen Costelloe*, catalogue, Dublin 1971; *Irish Times*, 22 October 1971, 21 February 1975, 28 September 1976, 5 April 1977; Miss Lily

Costelloe, *Letter to the author*, 1984; Ann M. Stewart, *Royal Hibernian Academy of Arts: Index of Exhibitors 1826-1979*, Dublin 1986; *Water Colour Society of Ireland Exhibition List 1872-1994*, Dublin 1995.

COSTELLOE, ROBERT E. (1943-74), abstract and figure sculptor and painter. Born in Dublin, a blue baby, Robert Emmet (Robin) Costelloe was the son of an American mother and an Irish father, William J. Costelloe. He was eleven years of age when he knew that he wanted to be an artist, and later in life spoke gratefully of the encouragement he had received at Blackrock College and its preparatory school, Willow Park. He won first prize in a national art competition for children.

After studying successfully at the National College of Art, Dublin, he moved on to the Central School of Arts and Crafts, London, and when there was given a year's leave of absence to study at the Accademia di Belle Arti, Rome, where he was awarded a gold medal for landscape painting. In Dublin, he showed two watercolours at the Royal Hibernian Academy: 1962, *Running Horse*; 1963, *Dancing Man*. At the Central School he had become rather tired with the proliferation of attitudes on contemporary painting, so he experimented with ceramics, graduating with distinction in 1964.

In 1966 he held his first show, ceramic sculpture, together with paintings, at the Alwin Gallery, Brook Street, London, sharing with Cyril Mann and Roger Warrren who exhibited oil paintings. In an introduction to the catalogue, Gilbert Harding-Green wrote: 'Robert Costelloe has recently turned his attention to ceramics, producing in the round some remarkable pieces of direct modelling. He works at incredible speed, resulting in forms that have a lively virility in a style very much his own' Among his sculpture works were: *St Peter* and *Agony in the Garden*, both about 90cm high.

On returning to his home, Booterstown House, Co. Dublin, he was commissioned to execute in 1967 a concrete wall sculpture at Lansdowne House, 1.8m by 9m. The architect, Brian Hogan, was aware of Costelloe's achievements in exploring the sculptural possibilities of poured concrete: 'He had developed a particular skill in making highly decorative and complex relief patterns in concrete wall faces by utilising standard metal industrial objects (cog wheels, large nuts and bolts, angle irons) which he heated with a blow lamp to a temperature sufficient to melt expanded polystyrene. The red hot metal burnt a true imprint of each object in the polystyrene which then became the mould lining'. The Dublin wall was in nine panels.

Costelloe was also responsible for a concrete mural at Dublin Airport. Each of the three panels was more than a square metre in area and weighed about 100 kgs. The work was in poured concrete and pieces of coloured glass were incorporated in the design. During the time when the North terminal was being converted into offices, the mural was taken from the wall and in the process of dismantling was fractured. Subsequently, it was destroyed.

In 1968 at the Irish Exhibition of Living Art he won the £50 Carrolls prize, confined to artists under 25, for his painting *E Pluribus Rex 3*. Earlier in that year he was the youngest artist ever to exhibit at the Ritchie Hendriks Gallery, Dublin, a total of forty paintings of which eleven were small gouache on paper. Another exhibition was held at this gallery in 1971. He also exhibited in Dublin at the Oireachtas.

In 1970 Costelloe, holding dual citizenship, became artist in residence at the North Carolina School of the Arts in Winston-Salem, where he helped to organise and teach a new visual arts programme and was also commissioned to design a large sculpture complex in concrete for the campus in 1971. During his American stay he won a citation for excellence in the fine arts category of the 1972-3 Design in Steel award for his work titled *Mayo*, now at the corporate headquarters of Burlington Industries in North Carolina. The award was sponsored by the American Iron and Steel Institute of Design to give recognition to designers, architects, engineers and artists for their imaginative uses of steel.

Three massive aluminium plate sculptures were featured in the Young Artists' 1973 exhibition at the Union Carbide Building, Park Avenue, New York. The show had a wide variety of paintings, graphics, tapestries and sculpture by young artists from fifty-six countries. The Costelloe sculptures were erected on the plaza at Park Avenue. *Kanturk* measured ten metres long. The artist returned to Ireland in 1973 and in November joined the staff of the Regional Technical College at Letterkenny as a lecturer in art. He was killed on 28 February 1974 in a motor accident in Dublin. The Irish Exhibition of Living Art that year included a small memorial section of his work.

Works signed: R. E. Costelloe or R. E. C. (if signed at all).
Examples: Dublin: Arts Council; Lansdowne House, Ballsbridge. Greensboro, North Carolina: Burlington Industries Inc. Letterkenny, Co. Donegal: Regional Technical College. Newmarket-on-Fergus, Co. Clare: Church of the Blessed Virgin Mary of the Rosary. Winston-Salem, USA: North Carolina School of the Arts.
Literature: Alwin Gallery, *Cyril Mann and Roger Warren oil paintings*; *Robert Costelloe ceramic sculpture*, catalogue, London, 1966 (also illustrations); *Irish Times*, 20 June 1968, 8 December 1970; Ritchie Hendriks Gallery, *Robert E. Costelloe*, catalogues, Dublin 1968, 1971; *Irish Press*, 23 April 1973, 25 May 1973; Aer Rianta, *Letter to the author*, 1984; also, County Donegal Vocational Education Committee, 1984; Brian Hogan, 1984.

COULTER, WILLIAM A. (1849-1936), marine painter. The son of James Coulter, a coastguard, William Alexander Coulter was born in Glenariff, Co. Antrim, on 7 March 1849. His first seven years were spent at Islandmagee in the same county, before the family moved to Glenarm, Co. Antrim, where the harbour provided him with his first opportunity to sketch sailing ships. Later he was to become known among shipping men throughout the world for his accuracy in oil paintings of sailing vessels, and the sea.

At the age of thirteen he began his seagoing life of seven years aboard a square-rigger as a 'boy', performing the menial tasks, but at seventeen he was an AB. In his spare time he acquired the skills of a marine artist by studying the working details of ships. In 1869 he arrived in San Francisco but broke his ankle in a land accident and had to give up sailing. His official entry into the art world was in 1874 when he exhibited at the San Francisco Art Association's exhibition. By this time he had become a recognised marine artist in the city.

Beginning a pilgrimage to the European art centres in 1876, he was absent from San Francisco for about two years. In a survey of California artists published in 1906 he listed his places of study as Antwerp, Brussels, Copenhagen, London and Paris; in Copenhagen under Vilhelm Melbye (1824-82) and in Paris under François Musin (1820-88), both sea painters. Among more than fifty works in the National Maritime Museum, San Francisco, is a painting of a San Francisco scene looking west toward Golden Gate and depicting the arrival of ex-President Grant aboard the steamer *City of Tokyo* during a world tour. This work was dated 1878. The museum collection includes several drawings in ink and pencil on stipple board.

Titles of works included in a one-person exhibition in San Francisco in 1881 were: *Under London Bridge* and *Dublin Bay*. In 1882 he spent seven months in Hawaii, returned to California and for about a year painted thirty panels 4½ x 6 metres for an extravagant presentation called 'Palette and Pen in King Kalakaua's Kingdom'. The panels were first exhibited, then presented as panoramic entertainment. By 1890 he was living in Sausalito, travelling by ferry to San Francisco.

Coulter was represented in 1893 in the 'Best of Californian Art' exhibition at the World's Columbian Exposition in Chicago. In the monograph by Elizabeth Muir Robinson published by James V. Coulter in memory of his father, there is a reproduction of an oil painting dated 1894 of *The Maidens*, dangerous rocks with double lighthouses off the coast at Larne, Co. Antrim. There is no known record of Coulter having returned to Ireland at this time. Another reproduction is of waterfalls in Co. Antrim, an oil untitled and undated. Coulter, incidentally, often repeated the same titles, for example *Homeward Bound* and *After a Storm*.

From 1896 to 1906 he worked as an illustrator on the *San Francisco Call*, producing as waterfront artist pen and ink drawings of vessels or maritime news events. He sketched the devastation from fire which followed the earthquake in 1906. During the reconstruction, he received commissions for a group of paintings for a room created especially for the marine department, Chamber of Commerce, in the Merchants Exchange Building. In 1909 he began work from a scaffolding on the first and most famous of the panels, measuring about 5 by 5½ metres. The fifth and last was not commissioned until 1920.

In 1928, by which time he had painted more than 3,000 seascapes, Coulter sold his famous *Burning of the Light*, held an exhibition and then he and his wife Harriet left to spend ten months in Ireland and Europe, making a five-week journey by freighter from San Francisco to Belfast. They resided most of the winter in Glenarm, at the home of Mary and Michael Coulter, his sister and brother, and also travelled to different parts of Ireland. When they returned to the USA he took up his brush once again and in 1934 he held an exhibition

of seventy-five marine canvases, all painted after his 80th birthday. He died in Sausalito on 13 March 1936. In 1943 the Liberty ship *SS William A. Coulter* was launched at Richmond, California.

Works signed: W. A. Coulter or W. A. C.
Examples: New York: US Merchant Marine Academy, King's Point. San Francisco: Commerical Club; National Maritime Museum; Union Bank. Sausalito, California: Public Library.
Literature: *New York Herald Tribune*, 15 March 1936; *Dictionary of Sea Painters*, Woodbridge 1980; Elizabeth Muir Robinson, *W. A. Coulter: Marine Artist*, Sausalito 1981; United Stated Department of the Interior, *Letters to the author*, 1984.

COX, KATHLEEN (1904-72), sculptor and illustrator. Born on 2 July 1904 in Woosung, China, both her parents being Irish, Christina Mary Kathleen Cox was the daughter of Dr R. H. Cox, from Dundalk, who worked for the Customs as a medical officer in Shanghai. The family moved to Ireland in 1910, first to Listowel, Co. Kerry, and then to Howth, Co. Dublin.

When modelling at the Dublin Metropolitan School of Art under Oliver Sheppard (q.v.), she won the Taylor Scholarship in 1925, 1926 and 1927 with statuettes: *Adam*; *An Excavator*; and *A Dancer* respectively. She was one of only three students to win the scholarship three years in succession and was enabled to visit Paris.

In Dublin she held several exhibitions, mostly at her studio at 7 Schoolhouse Lane, and was known as a painter as well as a potter. In a difficult period for artists financially, without her parents' help she could not have carried on. She experimented with Irish clays and produced pottery and glazed figures, mostly of Dublin characters.

In the period 1930-3 she exhibited seventeen works at the Royal Hibernian Academy. In the sculpture section, 1933, she showed a holy water font and: *'Dedication'*; *Pottery Statuette*; and *Nigel*. About this time she became dissatisfied with certain limitations in her work and soon after broke up all her moulds and sold her electric kiln, the first in Dublin. She had the experience of working at the potteries in Burslem, Staffordshire.

In the National Museum of Ireland there are four pieces, ranging in height from about 27cm to 33cm: plaster model of a young Nigel Beamish, inscribed at back 'Nigel 1933'; portrait head of a young woman, glazed in blue; mask, boy's head, white glazed pottery; plaque, glazed and painted female figure with blue cloak, holding a bunch of flowers.

Not by nature a writer, 'she had a burning conviction that religious tolerance was worth a big-scale creation', as her husband Alan Palmer wrote in a letter to the author, and she spent three years writing and illustrating a book for children, *A Story of Stories* on the major religions of the world, under the name C. M. Kay. She died in St George's Hospital, London.

Works signed: KC, possibly; monogram.
Examples: Dublin: National Museum of Ireland.
Literature: C. M. Kay, *A Story of Stories*, Pitlochry and Portlaw 1970 (illustrations); *Irish Times*, 6 September 1972; Alan Palmer, *Letter to the author*, 1972; *Dictionary of British Artists 1880-1940*, Woodbridge 1976; Miss Moira Cox, *Letters to the author*, 1984; National Museum of Ireland, *Letter to the author,* 1984.

CRAIG, H. ROBERTSON, RHA (1916-84), portrait and landscape painter. Henry Robertson Craig, son of a grocer, George Craig, was born on 7 May 1916 in Dumfries, Scotland. James McIntosh Patrick, RSA, taught Craig and Patrick Hennessy (q.v.) from Cork when they were students at Dundee College of Art, which Craig had entered in 1934. In 1938 he was awarded a year of post diploma study which was followed by a travelling scholarship, held over until the termination of the War and subsequently declined.

In 1940 Craig joined the British Army, spending most of his service in London working in the Royal Army Service Corps on maps, camouflage, and various tasks for the underground forces of occupied Europe. In his spare time he painted portraits and did some book illustration. After being demobilised in Berlin in 1946, he painted in London.

In 1947, with landscape painting in view, he travelled to Ireland and renewed acquaintance with Hennessy. They took a house in Crosshaven, Co. Cork, then moved to Cobh, a few miles away, remaining there until they departed for Dublin in 1950. Landscapes were painted in the West and South of Ireland with long visits to Clifden, Co. Galway. Craig first exhibited at the Royal Hibernian Academy in 1948: *Cork Bay* and *Primroses*.

The art critic of the *Dublin Magazine* noted favourably in 1950 his portrait at the RHA, *Mr F. Christian, UCD Boxing Team*. Both he and Hennessy were also associated with the Dublin Painters. *Coming of Age* appeared at the 1951 RHA, and in that year he added ARHA after his name and painted a portrait of Patrick, 9th Viscount Powerscourt. The Dublin Painters' annual exhibition in 1955, the year he became an RHA, produced *The Painter – Reginald Grey* which had 'something of the stuffy warmth and clubland intimacy one associates with English painting of the Edwardian period', according to the *Dublin Magazine*.

At the Ritchie Hendriks Gallery, Dublin, in 1956 a 'Paintings of Paris' exhibition was the outcome of several visits to that city. Works included *On the Steps, Versailles*; *Lunch under the Trees*; and *Paris from the Sacré-Coeur*. By this time he had also painted in Italy and Germany. In 1966 he had a one-person show at the Guildhall Galleries, Chicago. At this time he made a documentary film of his work. Both Craig and Hennessy had visited Paris in 1947, and in subsequent years the coast of Normandy, Côte d'Azur and the Dordogne. They also travelled in Belgium, Holland, Spain, and a complete trip round Italy included Sicily.

In 1968 both painters left Dublin for Tangier, from where they sent works to the Guildhall Galleries, and from this North African base they continued to travel extensively. David Hendriks, the dealer, a close friend of both, presented a joint exhibition at the Cork Arts Society Gallery in 1974. In 1980 they went to live in the Algarve, Portugal. In twenty-five years of exhibiting at the RHA, Craig had shown some fifty works.

The Regatta, which Craig completed in 1959, is in the collection of the National Gallery of Ireland. In the foreground is the art collector, C. Gordon Lambert, who found 'Harry' exuded charm. Among others depicted in the background of this work are the artist himself, Patrick Hennessy, David Hendriks and the curator of the Municipal Gallery of Modern Art, Patrick O'Connor (q.v.).

A flowerpiece by Craig is in the United Arts Club, Dublin. He also painted seascapes. A self-portrait is in the collection at the University of Limerick. *Aperitif*, oil, is at the Irish Museum of Modern Art. In his last year of exhibiting at the RHA, 1983, he showed three oils, *Cafe at Portimao*; *Beach near Tangier*; and *Fisherman's Child*. He died on 5 December at Portimao, Portugal; cremated at Golder's Green Crematorium, London. A studio sale of his and Patrick Hennessy's work was held at Christie's, London, in 1986.

Works signed: H. Roberston Craig.
Examples: Dublin: Hugh Lane Municipal Gallery of Modern Art; Irish Museum of Modern Art; National Gallery of Ireland; Office of Public Works; Pharmaceutical Society of Ireland; United Arts Club. Limerick: University, National Self-Portrait Collection.
Literature: *Dublin Magazine*, July-September 1950, 1952, 1955, January-March 1957; Ritchie Hendriks Gallery, *Robertson Craig, RHA, Paintings of Paris*, catalogue, Dublin 1956; *Irish Independent*, 7 May 1971; H. Robertson Craig, *Letter to the author*, 1981; *Irish Times*, 11 December 1984; C. Gordon Lambert, *Letters to the author*, 1985; Duncan of Jordanstown College of Art, *Letter to the author*, 1985; also, Mrs Isobel M. Wright, 1985; Ann M. Stewart, *Royal Hibernian Academy of Arts: Index of Exhibitors 1826-1979*, Dublin 1986.

CRAIG, J. HUMBERT, RHA (1877-1944), landscape painter. Born on 12 July 1877 at 16 Brougham Street, Belfast, his father was Alexander Craig, a wholesale tea merchant who had married in Castlereagh Presbyterian Church, Co. Down, Marie Metzenen, a native of Lausanne, Switzerland, with a painting tradition in her family. 'Jimmy' the son spent his youth at Ballyholme, Bangor, Co. Down. In his boyhood he had always drawn and painted. Practically a self-taught artist, he failed to see a term through at the Belfast College of Art.

After spending some time in his father's business, he was engaged on his own account and then emigrated to the USA but stayed only a short time. On one occasion when slung aloft in a cradle working at Brooklyn Bridge, New York, he saw a man in the act of committing suicide by jumping towards the Hudson river, only to fall short and hit the roof-tops of Brooklyn instead; that episode finished Craig with bridge painting.

A hankering to depict landscape, above all Irish landscape, persisted and Craig returned home to paint out of doors – and to fish. He had a great affection for the Glens of Antrim and their people, and stayed at Tornamona Cottage, Cushendun, where he had a studio; his home was at Dunedin, Antrim Road, Belfast. As well as expeditions to Donegal, he also painted in Connemara.

Craig's pictures first appeared at the Royal Hibernian Academy in 1915, and he was a constant exhibitor until his death, showing 130 works. In the years 1920, 1921 and 1922 he contributed twenty pictures, scenes of Counties Antrim and Donegal being prominent. In 1925 he was appointed an associate of the RHA and in 1928 a full member. He was also an academician of the Ulster Academy of Arts. An article in *The Studio* in 1923 stated: 'In the North the best men are, almost without exception, engrossed in landscape. They form a very distinct group whose work is characterised by typical racial traits. Their landscapes, though by no means emotional, are always most obviously sincere, closely observed, firmly and cleanly handled' The writer, who mentioned Paul Henry and Frank McKelvey (qq.v.) among others in this growing school, went on to describe Craig: 'the most typical Northern of them all, has, curiously enough, a large circle of admirers in Dublin'

An oil painting with the oddly named title, *Blacksod Bay, County Mayo , on "The All Red Route"*, is at St Patrick's College, Maynooth, in the Philbin Collection. According to information from the College: 'The reference was to a scheme to have a chain of transport all around the earth, keeping all land travel within the British Empire. Blacksod Bay, with it's great depth, was to be the port of disembarkation — onto a projected train service — of a liner coming from Canada. The First World War put an end to that plan.'

In Belfast, as well as showing at the Belfast Art Society's exhibitions, he also exhibited at the Magee Gallery. Normally associated with oils, he showed two watercolours at a Belfast Museum and Art Gallery exhibition in 1920. In the 1928 Royal Scottish Academy exhibition he showed *On the Kerry Coast*. The Empire Marketing Board commissioned a poster, *Northern Ireland: Flax Growing*, for sixty-five guineas; it first appeared on hoardings in 1932. In his exhibition of Irish landscapes at the Fine Art Society, New Bond Street, London, in 1933 his five highest-priced works were: *Sunlight Valley –The Rosses, Co. Donegal*; *Connemara*; *Muckish, Co. Donegal*; *Dungloe, Co. Donegal*; and *The Lower Bann*.

Craig showed few pictures at the Royal Academy, but these included *Cloud Shadows on the Rosses* in 1935, and *The Road to Dungloe* in 1937. The Fine Art Society presented more than 200 of his works, and in a group exhibition in 1928 of Irish artists' work he exhibited along with Paul Henry, E. L. Lawrenson and Crampton Walker (qq.v.). When he had an exhibition of paintings of Ireland at the Fine Art Society in 1935 he showed fifty-eight works, mainly Co. Antrim, Co. Down and particularly Co. Donegal scenes. He also showed with the Fine Art Society in 1937. He exhibited in London with the Royal Institute of Oil Painters; in 1933 with fellow Ulster artists William Conor and G. Moutray Kyle (qq.v.).

Represented in an exhibition of Irish Art at Brussels, 1930, at Los Angeles in 1932 his work was included in the Olympic art exhibition, and in that year too he was president of the short-lived Ulster Society of Painters and he also held an exhibition at Locksley Hall, Belfast. Several visits were made to the Continent: he painted in Switzerland, South of France and Northern Spain. He illustrated *In Praise of Ulster*, 1938, by his lifelong friend, Richard Hayward. His work was reproduced widely in prints, calendars and other forms. Frost and Reed, London, published an engraved colour print, *Cottages at Dungloe, Co. Donegal*. Combridge Galleries, Dublin, also published prints.

Among works at the National Gallery of Ireland are the oils *Cushendun in June* and *The End of the Glen*. A seascape and two landscapes, *Leenane* and *Windy Day, Donegal* are in the Queen's University collection. He presented *Cloud Shadows, Connemara* to the Municipal Gallery of Modern Art, Dublin. The Craig Room at the Town Hall, Bangor, has thirteen landscapes, all Irish scenes with the exception of one Swiss. The works were bequeathed by the artist's widow, Mrs Annie S. L. Craig, provided that a suitable room would be set aside in the Town Hall for their display. Also hanging in the room is a portrait of Craig by Maurice Wilks (q.v.). Another portrait by Paul Nietsche (q.v.) is in the Ulster Museum, where there is also his last picture, *A Good Catch, Donegal*, and five other oils including *Cushendun* and *A Summer Day on the Thames*.

Working up to the time of his death, on 12 June 1944 at Cushendun, he was buried at Cushendall, Co. Antrim. A few months later an exhibition of his work took place at the Municipal Technical College,

Londonderry. A memorial exhibition was held at the Belfast Museum and Art Gallery in 1945. Combridge Galleries held an exhibition in 1946. Another Dublin exhibition was held at the Oriel Gallery, 1978. A retrospective was presented at the Ulster Museum in 2000.

Works signed: J. H. Craig; J. Humbert Craig, J. H. C. or J. C., all rare.

Examples: Armagh: County Museum. Bangor, Co. Down: Town Hall. Belfast: Department of the Environment for Northern Ireland; Queen's University; Ulster Museum. Bray, Co. Wicklow: Public Library. Cork: Crawford Municipal Art Gallery. Drogheda, Co. Louth: Library, Municipal Centre. Dublin: Hugh Lane Municipal Gallery of Modern Art; National Gallery of Ireland; National Library of Ireland. Limerick: City Gallery of Art. Maynooth, Co. Kildare: St Patrick's College. Waterford: City Hall, Municipal Art Collection.

Literature: *The Studio*, December 1923, January 1947 (illustration); J. Crampton Walker, *Irish Life and Landscape*, Dublin 1927 (also illustration); J. H. Pollock, *The Valley of the Wild Swans*, Dublin 1932 (illustration, jacket); Anthony Liddell, *The Ulsterman*, July 1933; Ulster Society for the Prevention of Cruelty to Animals, *The Tree*, Belfast 1936 (illustration); Michael Floyd, *The Face of Ireland*, London 1937 (illustrations); Richard Hayward, *In Praise of Ulster*, London 1938 (illustrations); Victor Waddington Publications, Ltd, *Twelve Irish Artists*, Dublin 1940 (also illustration); Richard Hayward, *The Corrib Country*, Dundalk 1943 (illustrations); Bangor Borough Council, *Letter to the author*, 1972; *Dictionary of British Artists 1880-1940*, Woodbridge 1976; Mrs M. M. Broughton-Mills, *Letter to the author*, 1978; Oriel Gallery, *James Humbert Craig, RHA*, catalogue, Dublin 1978 (also illustrations); Martyn Anglesea, *The Royal Ulster Academy of Arts*, Belfast 1981 (also illustration); Stephen Constantine, *Buy & Build: The Advertising Posters of the Empire Marketing Board*, London 1986 (also illustration); Ann M. Stewart, *Royal Hibernian Academy of Arts: Index of Exhibitors 1826-1979*, Dublin 1986; George A. Connell, *James Humbert Craig, RHA (1877-1944)*, Belfast 1988 (also illustrations); *The Royal Scottish Academy Exhibitors 1826-1990*, Calne 1991; Henry P. Stinson, *Letter to the author*, 1993; Eileen Black, *A Sesquicentennial Celebration: Art from the Queen's University Collection*, Belfast 1995 (also illustrations); St Patrick's College, Maynooth, *Letter to the author*, 1999.

CRANWILL, MIA (1880-1972), designer and artist in metal. Born in Dublin, her father, Arthur Cranwill, an analytical chemist, was a strong supporter of Charles Stewart Parnell. The Cranwells came from Cranwell, Lincolnshire, and settled in Wexford about the time of Elizabeth I of England, the name later changing to Cranwill.

Education for Mia Cranwill was fragmentary, private school and home teaching, owing to delicate health in childhood and youth. The family moved to England when she was fifteen and two years later she persuaded her parents to allow her to attend evening art classes two nights per week at Salford Art School. Two scholarships followed, the first for attendance every evening and the second for day classes. She had no difficulty in qualifying in Manchester as an art teacher.

In 1907, after teaching in a temporary post, she became art mistress at Whalley Range High School, Manchester, but after some years her health broke down and she eventually resigned in 1915, joining up with the mathematics mistress to open a poultry and fruit farm at Emsworth, near Portsmouth. After eighteen months her friend's health broke down; they decided to close with a small credit balance.

'I used to experiment with metal, silver brooches, boxes and spoons though I never had any teaching in that art – I studied Geo. Coffey's handbook and became familiar with the Irish style; so took my courage in hand and came back to Dublin in May 1917. I rented one room in 14 Suffolk Street over a cycle shop ...' she wrote in her personal memorandum.

An early commission was for a pectoral cross to be presented by Count John McCormack as a gift to the see of Baltimore, USA. She was firmly established when in 1920 she was asked to undertake for £1,500, including materials, a monstrance for St Patrick's Church, San Francisco. The receptacle was about a metre in height, in platinum, gold and silver ornaments, and enamels, the stem resembling the Cross of Cong. This work was shown in the National Museum of Ireland before being despatched abroad. She also made a sanctuary lamp, tabernacle and frames for altar cards for the same church.

Certain parts of the monstrance for San Francisco were too heavy for her and these were made by Frederick Newland Smith, ARCA, teacher of goldsmiths' and silversmiths' work at Manchester School of Art. He came over with his family and stayed with her at her Killiney cottage. In an article in the *Dublin Magazine* in 1924 he wrote: 'Her work is not only inspired, poetical, and traditional, but of excellent technique – a combination often dreamed of but by no means often realised in these days of haste'.

In the early 1920s she also received a commission from Senator Mrs Alice Stopford Green for a casket for the Irish Senate. In the shape of the ancient Gallarus church in Co. Kerry, the casket was in gold, silver and enamel on a copper foundation, and was presented to the Senate in 1924. A resolution was passed in 1936 offering the casket as a gift for preservation in the Royal Irish Academy and this was accepted.

Smith also assisted with the sanctuary lamp, about 2¼ metres in height, for St Patrick's Church, San Francisco. Made entirely of silver, it took three and a half years to complete and was 'unveiled' at Daniel Egan's Gallery, Dublin, in 1932.

Mia Cranwill made only two pieces for Irish churches, a hymn board, 1932 for Holy Trinity Church in Killiney, Co. Dublin, and, through the good offices of the sculptor, Albert Power (q.v.), a close personal friend of the administrator, a tabernacle door for St Michael's Church, Ballinasloe, Co. Galway, a fine example of her metalwork in gold, silver, and enamels, the subject being Christ at Emmaus. The artist also made the episcopal ring for the bishop, the Most Rev. Dr Dignan, on his consecration in 1924; gold sovereigns which had been left by Rory O'Connor for incorporating in an ecclesiastical object were used in the manufacture of the ring. The Army commissioned her to design flags for the different battalions, and these were executed by Cuala Industries and borne for the first time on St Patrick's Day, 1937.

In 1920 she had exhibited at the Royal Miniature Society. A friend of Sir Nevile Wilkinson (q.v.), she executed in miniature for his famed Titania's Palace reproductions of the Ardagh Chalice and the Cross of Cong. Her commissions were therefore varied and unique. She designed a trophy in 1933 for the Catholic Boy Scouts of Ireland. She made rings for Compton Mackenzie, Mícheál Mac Liammóir (q.v.) and Mrs G. B. Shaw. George Bernard Shaw in an article in *Time and Tide* described her as 'the Irish Benvenuto Cellini'. Brooches, pendants and earrings were also executed for special orders.

An issue of *Father Mathew Record* described four panels on the Catholic Boy Scouts' trophy which had been presented by Sir Martin J. Melvin: 'The first panel illustrates the arrival of the boy, Fionn Mac Cumhaill, with his Sunburst banner at Teamhair; the second, a Fenian of the '67 with his pike; the third, a Fianna scout of 1916 in front of a radiant Cross; and the last, a modern Catholic Boy Scout with the pediment of the Pro-Cathedral behind him.'

Once interviewed by Hilda Tweedy, the artist showed her a 'beautiful silver ring, almost an inch deep, designed on AE's poem 'Babylon'. It is decorated with five enamel panels symbolising the five great civilisations of Ireland, Egypt, Greece, Syria and India. AE chose the inscription engraved inside in middle Irish'.

At the age of seventy-four she was still looking after her own small house, making her clothes and mending her shoes. When over seventy, she illustrated books for the Dolmen Press, Dublin. The last ten years of her life were spent at Alexandra Guild House, Dublin, where she died on 20 October 1972.

Works signed: Mia Cranwill or Mia Cranuill.
Examples: Ballinasloe, Co. Galway: St Michael's Church. Dublin: Catholic Boy Scouts of Ireland; Royal Irish Academy. Killiney, Co. Dublin: Holy Trinity Church. San Francisco, USA: St Patrick's Church.
Literature: *Dublin Magazine*, January 1924; *The Studio*, February 1925; *Titania's Palace*, Dublin 1926; *A Book of Dublin*, Dublin 1929; *Irish Times,* 21 March 1932, 27 October 1972; *Father Mathew Record*, April 1934; Ewart Milne, *Galion*, Dublin 1953 (illustrations); *Irish Independent*, 20 November 1954; Thomas Kinsella, trs, *The Sons of Usnech*, Dublin 1954 (illustrations); Hilda Tweedy, *Irish Housewife Annual*, 1958; Rev. Patrick K. Egan, *The Parish of Ballinasloe*, 1960; Mia Cranwill, *Notes re work etc.*, typescript, 22 May 1965; Rev. Patrick K. Egan, *Letter to the author*, 1979; also, Mrs Ina Conlan, 1984.

CRILLEY, MARGARET – see CLARKE, MARGARET

CUFFE, CHARLOTTE – see WHEELER-CUFFE, LADY

CUNINGHAM, OSWALD H. (1883-c.1935), painter and etcher, black and white artist. Born in Newry, Co. Down, on 16 June 1883, Oswald Hamilton Cuningham was the son of James Cuningham, and attended the

Merchant Taylors' Endowed School, Dublin. His art education was at the Dublin Metropolitan School of Art and the Slade School of Fine Art, London. In 1907 he contributed an illustration for *The Shanachie*.

In 1911 he became a member of the London Sketch Club. His illustrations appeared occasionally in the *Irish Cyclist and Motor Cyclist* in 1918. When he exhibited at the Royal Hibernian Academy in 1920 his address was Hill Crest, Upper Drumcondra, Dublin, and he showed *The Conflict*; *Paddy*; and *Bacchanale*.

In 1920 he painted *Slainte*, watercolour, a ploughing scene, with a label verso bearing the address 15 Golders Way, Golders Green, London N.W. In 1924 he had a studio at 22 Avonmore Road, Kensington, exhibiting at the Royal Academy, *The Two Queens*, etching and aquatint. He contributed three cartoons to *Punch* between 1916 and 1923. Between 1922 and 1933 he showed four works at the Royal Academy. At the Walker Art Gallery, Liverpool, he exhibited two pictures.

Altogether he contributed thirteen works to the RHA, including *The Breeze – Belgium* and *Paddington Station* to the 1929 exhibition. He also showed at the Paris Salon and was responsible for 'interior decorations at Fernbank, Hampstead', believed to be 5 East Heath Road. *A Lonely Road* was named as his principal etching, presumably the same as *A Lonely Road, Norfolk* exhibited at the 1922 RA. In 1981 the Gorry Gallery, Dublin, offered for sale a watercolour, *To Work at Dawn*. The date of his death could not be traced in the Registry Office, London.

Works signed: Cuningham or Oswald H. Cuningham.
Literature: *The Shanachie*, Autumn 1907 (illustration); *Punch*, 14 June 1916, 27 August 1919, 24 October 1923 (each illustration); *Irish Cyclist and Motor Cyclist*, 22 May 1918, 25 December 1918 (both illustration); *Dictionary of British Artists 1880-1940*, Woodbridge 1976; *A Dictionary of Contemporary British Artists, 1929*, Woodbridge 1981; *Punch, Letter to the author*, 1984; also, Greater London Council, 1984; London Sketch Club, 1984; Fredrick Gallery, *Important Irsh Art*, catalogue, Dublin 1998.

CURREY, FANNY (1848-1917), landscape and flower painter. Frances Wilmot Currey was born on 30 May 1848, daughter of Francis Edmund Currey, agent to the 6th and 7th Dukes of Devonshire 1840-80, and during that time resident in Lismore Castle, Co. Waterford. Fanny was probably educated privately. A friend of Edith and Grace Osborne – Lady Blake (q.v.) and the Duchess of St Albans respectively – she stayed with them at Newtown Anner when she was a girl and assisted in illustrating envelopes for letters sent to Mrs Osborne.

Fanny was represented in the exhibition of drawings and watercolours at Lismore Courthouse in 1871, and organised by a society formed the previous year by six ladies whose object was the 'mutual improvement in painting and drawing and the cultivation of a taste for art'. A second exhibition followed at Clonmel, and in 1872 under the title of the Irish Amateur Drawing Society the third exhibition moved to Carlow. In 1878 the title was Irish Fine Art Society. Dublin exhibitions became a regular feature.

A fairy tale book, *Prince Ritto; or, the Four-leaved shamrock,* 1877, was written by Fanny Currey and illustrated by her friend, Helen O'Hara (q.v.). At the Royal Hibernian Academy in 1877 she exhibited for the first time, and from then until 1896 contributed twenty-one pictures, including several flowerpieces; her first exhibit was *View near Ischl, Austria*. She continued to take a lead in the Irish Fine Art Society's activities, and was active in the hanging of the Society's first exhibition in Cork, at the Athenaeum, in 1878.

In 1878 at the RHA she showed *An Autumn Day on the Conwy River, North Wales*, and in 1879, giving the Lismore Castle address, she contributed *Gloire de Dijon Roses*. In the period 1881-97 inclusive nineteen works were hung at the Royal Academy. In London she exhibited more than one hundred pictures in other exhibitions, including the Royal Institute of Oil Painters, Royal Institute of Painters in Water Colours and the Society of Women Artists. Work was also hung at the Dudley Gallery, Grosvenor Gallery and New Gallery. Outside of London, she had outlets in the Walker Art Gallery, Liverpool, and Manchester City Art Gallery.

A Stile in Brittany at the 1882 RHA denoted another visit abroad. The title 'Water Colour Society of Ireland' came into existence at its Belfast exhibition of 1887-8. Evidence from a presentation teapot establishes that she was secretary of the group for the ten years preceding 1890. She was appointed a member of the Society

of Women Artists in 1886. The published letters sent between Edith Somerville (q.v.) and Violet Martin show that Edith and Fanny were close friends.

Somerville wrote to Martin on 15 July 1887 from Drishane, Castletownshend, describing the new people, the Lloyds, as a very dull lot. Apparently Mr Lloyd's two sisters were 'more stupid than you could believe to be possible'. One told Edith of her dogs, pugs, and said: 'Miss Currey tells me that if pugs run among bushes their eyes drop out, but they are attached to a bit of white string and you can generally put them in again!' This, added Edith, 'with a gentle seriousness'.

Among the Currey contributions to the 1888 RA was *A Bazaar in Tangier*. By now her work was considered of such a high standard that it was said she 'could not be considered an Amateur in any sense of the word save one, that she is not dependent upon the pursuit of Art for a livelihood'. An 1889 watercolour of Clonmel, found in the collection of her friend, Lady Blake, depicted the West Gate on market day. According to Anne Crookshank and the Knight of Glin in their book, *The Watercolours of Ireland*, it is a 'freely worked picture, demonstrating that she knew about the recent developments in painting'.

Taking into account the old titles of the Society, she showed more than fifty works at WCSI exhibitions, and judging by its price, she had a high opinion of an 1892 exhibit, *Erin, the Tear and the Smile in Thine Eye*.

In 1892 the WCSI committee of twelve included seven women, among whom was Fanny Currey, whose *The Old Hospital, Rye, Sussex* was one of nine works exhibited in 1895. A final exhibit at the RA in 1897 was *Rhododendrons*. She appears to have abandoned in the later years of her life some interests in order to become a gardener, and, more especially, a professional bulb-grower. She was elected a member of the Royal Horticultural Society of Ireland in 1901. The Royal Horticultural Society holds in London a number of her Warren Gardens catalogues, the oldest dated 1900, and in 1909 they awarded her the silver-gilt Banksian medal for her daffodils.

According to Edith Somerville in her reminiscences, *Wheel-Tracks*, a project was started in connection with the drainage of Lismore, and the powers that be decided to run a drain through the centre of her walled-in garden, bringing destruction to the daffodil plots. A notice was served on her, and she entered a protest without success. She brought out her gun and shot rooks on the wing before seating herself on the garden wall, still with her gun. The plan never materialised.

Somerville, who occasionally stayed with Fanny and painted with her, also wrote: 'There was something very attractive and impressive in her curious, plain face, full of intellect, and devilry, and good fellowship too ...'. A Suffrage speaker, she was an organist at Lismore Cathedral, and as well as country pursuits such as fishing and shooting, had a practical interest in mosaics, woodwork and sculpture. A small marquetry table has survived in the possession of a relative. She died on 30 March 1917 after a prolonged illness.

Works signed: Fanny Currey or C.
Literature: *Waterford News*, 3 May 1901; *The Royal Academy of Arts 1769 to 1904*, London 1905; *Munster Express*, 7 April 1917; E. OE. Somerville and Martin Ross, *Wheel-Tracks*, London 1923; *Water Colour Society of Ireland, Centenary Exhibition 1870-1970*, catalogue, Dublin 1970; *Dictionary of British Artists 1880-1940*, Woodbridge 1976; Ann M. Stewart, *Royal Hibernian Academy: Index of Exhibitors 1826-1979*, Dublin 1986; National Gallery of Ireland and Douglas Hyde Gallery, *Irish Women Artists: From the Eighteenth Century to the Present Day*, Dublin 1987; Gifford Lewis, ed., *The Selected Letters of Somerville and Ross*, London 1989; Peter Murray, compiler, *Illustrated Summary Catalogue of The Crawford Municipal Art Gallery*, Cork 1991; Anne Crookshank and the Knight of Glin, *The Watercolours of Ireland*, London 1994 (also illustration); Dermot Edwards, *Letter to the author*, 1995; also, Royal Horticultural Society, 1995; *Water Colour Society of Ireland Exhibition List 1872-1994*, Dublin 1995.

CURTIS, LESLIE (1918-74), figure painter and etcher. Born in Dublin on 30 April 1918, he was the son of John F. Curtis, who was closely involved with the National Literary Society of Ireland. Educated at St Andrew's College, Dublin, he attended evening classes at the National College of Art in the early 1940s. After serving briefly with the Irish Army, during which time he became friendly with Cecil ffrench Salkeld (q.v.) who guided him in his painting, he worked in wartime at Aldergrove, Co. Antrim, becoming acquainted with George Campbell (q.v.) and his painter friends in Belfast.

In 1946 he held an exhibition at the Grafton Gallery, Dublin, during which he was invited to go to London to teach at the Anglo-French Art Centre, St John's Wood, where he met and became a close friend of the Polish artist, Jankel Adler (1895-1949). Shortly after the Dublin exhibition, he visited Paris. When the Anglo-French Art Centre closed, he moved to Regent Street Polytechnic and from there to Hammersmith College of Art, where he worked from 1959 until he retired in 1970. The demand on his time as a lecturer meant that his output as a painter was small.

At the Irish Exhibition of Living Art in 1958 he showed three works: *Bonjour Tristesse*; *David and Bathsheba*, aquatint; and *Salomé*, aquatint. In the 1966 'Rising' exhibition at the Municipal Gallery of Modern Art, his work, *The Watering of the Rose*, depicting the execution of James Connolly in Kilmainham Jail, was 'highly commended' in the senior painting competition. He left London in 1972 and exhibited at the 1973 exhibition of the Royal Hibernian Academy: *Golden Delicious* and *Wilhelmina O'Doherty*; also a nude in 1974.

According to a friend, 'the content of his work was often a strange amalgam of faery, compassion, and penetrating insight; built up with an impeccable regard for fine draughtsmanship and loving respect for his medium ...'. Of Bridge End, Newcastle, Co. Wicklow, he died in a shooting accident on 23 May 1974.

Works signed: Curtis.
Literature: *Irish Times*, 8 June 1974; Mrs Marcella Curtis, *Letters to the author*, 1984; J. McGill, *Letters to the author*, 1984.

CUSACK, JOSEPH (1906-83), landscape and portrait painter. Born on 26 May 1906 in Tramore, Co. Waterford, son of John Cusack, Royal Navy, Patrick Joseph Cusack was educated at the Christian Brothers' School, after which he attended the Waterford School of Art and the Dublin Metropolitan School of Art. At an early age he was a pupil-teacher at Waterford School of Art and from 1928 until he retired in 1971 an established art teacher. Skilful in several ways, he won awards for his tooled leatherwork, and he was also a woodcarver, weaver, caneworker and designer.

Much of his painting was sold overseas. In 1949 his work was included in an exhibition by Irish artists in Technical Schools. *Tramore Farmhouse* is at South Tipperary County Museum and Art Gallery. In private possession in Waterford was a watercolour of four trawlers at anchor beside Waterford quay. Suffering from Parkinson's disease, he was unable to paint during the latter part of his illness and was confined to a wheelchair. He resided in Waterford for twenty-five years, but the rest of his life was spent in Tramore, where he died on 25 February 1983.

Works signed: J. Cusack or Joseph Cusack.
Examples: Clonmel: South Tipperary County Museum and Art Gallery. Waterford: City Hall.
Literature: Noel Cusack, *Letter to the author*, 1984; also, William M. Glynn, 1984.

CUSACK, RALPH (1912-65), painter and stage designer. Born at Portmarnock, Co. Dublin, on 28 October 1912, Ralph Desmond Athanasius Cusack was the son of Major Roy J. R. Cusack, banker and later Dublin stockbroker. Educated at Charterhouse and Cambridge University, he took a degree in economics in 1934.

In 1935 he went to live in a Menton villa, South of France, left to him by his mother. A first cousin of Mainie Jellett (q.v.), he was largely self-taught as a painter and studied art on his own in France and Germany. He showed at the Salon de Monaco in 1937. In four successive years, from 1938, he exhibited at the Exposition Annuel de la Société des Amis des Arts, Menton. Interested in a wide range of subjects, he acted with the Menton Players in 1938 and 1939, also designed and executed scenery.

Before the outbreak of war, he returned to Ireland. Shortly after hostilities began, his villa, precariously placed near the Italian border, was destroyed. His first one-person show was held at the Dublin Painters' Gallery, 7 St Stephen's Green, in 1940, and the works included *Place du Pont* (Menton) and *Midi, Place du Marché*. Commenting in *The Leader*, Stephen Rynne said that clear statements, clever technique, and versatility characterised his art. Other shows were held at the same gallery in 1941 and 1943. In the years

1941,1942 and 1943, he showed ten works at the Water Colour Society of Ireland exhibitions, including *Nostalgia,1937-43* and *The Seed*.

In 1942 he designed settings for *The Strings are False* at the Olympic Theatre, Dublin, assisted by Anne Yeats, and for *The House of Cards*, at the same theatre, sets painted by R. Cusack, Anne Yeats and Thurloe Conolly. In 1943 he designed scenery for *Saint Joan* at the Gaiety Theatre, Dublin, and painted it with Robert Heade. In the same year, for the Olympia Theatre, he and Anne Yeats designed and painted sets for the premiére of *Red Roses for Me*.

Cusack was on the first executive committee in 1943 of the Irish Exhibition of Living Art, with which he was associated for several years, and his work was included in an exhibition, 'Subjective Art', held in 1944 at 6 Lower Baggot Street, Dublin; and later displayed at the Arcade Gallery, London, in 1945. A writer in the *Dublin Magazine*, a critique on a Dublin Painters' exhibition in 1945, described his pictures as 'ultra-revolutonary'.

On his solo show at the Dublin Painters' gallery in 1945, the *Dublin Magazine* said that he had 'a fine sense of design, a good sense of colour; but his draughtsmanship is weak, hesitating and ineffective'. When the Cultural Relations Committee of Ireland included his work in an exhibition of contemporary Irish painters which toured North America in 1950, at which time he was living at Roundwood, Co. Wicklow, the catalogue stated that he had, among other places, shown in Paris, Nice and Monte Carlo. At Roundwood he managed with his wife Nancy a nursery for rare and uncommon bulbs.

Cusack, who suffered from tuberculosis but succeeded in curing himself, settled in France in 1954, mainly because he liked the country, and his pictures were included in the 'Artistes Etrangers en France' exhibition at the Petit Palais, Paris, 1955. Living at Spéracèdes, Alpes Maritimes, he wrote between 1955 and 1957, *Cadenza*, an absorbing unconventional autobiography 'almost from the borderline of consciousness'. He died in the Grasse hospital on 20 July 1965.

Works signed: Cusack or R. Cusack, rare (if signed at all).
Examples: Kilkenny: Art Gallery Society.
Literature: *Ralph Cusack Scrapbook*. 1937-55; *Irish Independent*, 4 October 1940; *The Leader*, 12 October 1940; *Dublin Magazine*, April-June 1945, January-March 1946; *Who's Who in Art*, 1950; *Times Pictorial*, 3 May 1952; Ralph Cusack, *Cadenza*, London 1958; Roy Cusack, *Letter to the author*, 1984; *Water Colour Society of Ireland Exhibition List 1872-1994*, Dublin 1995.

D

DANFORD, JOHN A. (1913-70), sculptor and designer. John Alexander Danford was born in Dublin on 12 July 1913, son of George Danford. Educated in England, he attended Sutton County School. A student of drawing, painting and architecture, he specialised in sculpture and the history of art. After Wimbledon School of Art, he won a gold medal for sculpture, and also a silver medal, in 1935 at the Royal Academy.

Danford's choice in the use of a British Institution scholarship was distinctly original. Instead of conventional studies, he purchased a small van, equipped it as a temporary home and made a complete circuit of the Mediterranean, 17,000 miles in all, an experience which produced a series of travel lectures complete with brochure issued from his home in Sutton, Surrey. The lectures were illustrated by 'slides, drawings and reconstructions'.

In 1938 he was awarded the Proxime Accessit, Prix de Rome, for sculpture. As a reserve officer of the Royal Artillery, his art career was interrupted in 1939 on the outbreak of the Second World War. When peace returned, he joined the British Council in 1946 and spent more than a year in Lagos lecturing on art before moving to Ibadan, Western Nigeria. When there, he exhibited *West African Jungle Village* at the 1947 Royal Hibernian Academy, also another watercolour, *Desecration*. In the 1949 Royal Academy, he showed *African Jungle Village*, and that year, from Nigeria, he contributed three watercolours to the RHA, two of Yugoslav scenes.

Danford's next posting was in 1958 as the Council's representative in Trinidad. When he retired in 1969, he was representative in Sierra Leone. Awarded the MBE in 1952, his *Nigeria in Costume* was published in 1961; in the following year he was awarded the OBE.

According to the British Council, he gained a reputation as a talented artist. A statue of Emotan, a local heroine revered in Benin, was executed by him after a tree which was dedicated to her was accidentally knocked down by a contractor. At the Royal Academy in 1956 he showed a statue, *Emotan of Benin*, presumably a model for the larger work. He also designed the mace for the Western Nigeria Legislature.

During his leave periods he spent time in artistic and creative work. Particularly notable is the ceiling of the ballroom at his old home, Ballinacurra House, Kinsale, Co. Cork, on which he painted the changing phases and shades of the four seasons. There is also at Ballinacurra work done on silk/cotton fabric and used as wall coverings/tapestry. He died there on 12 October 1970.

Works signed: J.A. Danford, John Danford or J.D.
Examples: Abeokuta, Nigeria. Benin, Nigeria: Oba Market Road. Ibadan, Nigeria: Oyo State House of Assembly. Kinsale, Co. Cork: Ballinacurra House.
Literature: *Who's Who in Art*, 1962; *Irish Times*, 13 October 1970; British Council, *Letters to the author*, 1973, 1984.

DARWIN, ELINOR M. (1879-1954), book illustrator and portrait painter. Born in Limerick, Elinor Mary was the daughter of W.T. Monsell, resident magistrate, who died young. The family was brought up by an uncle, the poet Aubrey de Vere, of Curragh Chase, Adare, Co. Limerick. Elinor's teenage drawings were admired by the painter, Charles W. Furse (1868-1904) who coached her with many letters.

Elinor Mary Monsell entered, in 1897, the Slade School of Fine Art, and in 1898 she illustrated her first book. Later at the Slade she gave some instruction in wood engraving to Gwen Darwin, later Raverat (1885-1957), who was to make her name in the medium. In 1899 Elinor showed two studies at the Royal Scottish Academy. When attending the Slade, she became much too friendly – for her mother's liking – with the artist Charles Conder (1868-1909). In 1905 she shared exhibition space at Baillie's Gallery, London, with J.H. Donaldson, Mrs Norman and Jack B. Yeats (q.v.). In 1906 she married Gwen Darwin's brother, Bernard Darwin, who was for many years golfing correspondent of *The Times*, and a grandson of the scientist, Charles Darwin.

Nearly all her life was spent in England, exhibiting principally in London at the New English Art Club and to a lesser extent at the Alpine Club Gallery. In addition to being a woodcut artist, she was also a painter on silk and fans. As for Ireland, she contributed to the short-lived *The Shanachie*. The Dun Emer Press's pressmark, Lady Emer and tree, by Elinor Monsell, was first used in 1907. She had met W.B. Yeats in 1899 when staying at Lady Gregory's home, Coole Park, Gort, Co. Galway, and later she received letters from him relating to her work. In one dated 6 January 1903, following a suggestion by him of a book of woodcuts by her, he wrote: 'Beside wanting to talk to you about the woodcuts practically, I want to tell you how beautiful I think your work – it is full of abundance and severity, a rare mixture'.

In 1924 the *Dublin Magazine* published two of her illustrations, after woodcuts, and in 1926 when Daniel Egan arranged an exhibition at his new premises in Merrion Row, she contributed a decorative panel, *Dancers*. Referring to the exhibition, *The Studio* stated that her name would 'always be remembered in connection with the famous poster of the Abbey Theatre'. The Queen Maeve with Irish wolfhound design, a woodcut of 1904 for W.B. Yeats, had originated on the programme cover.

At the Royal Hibernian Academy she exhibited ten works in all, 1924-5, including two silk paintings and *Dancers*; *The Old Villa, Venice*. An oil painting, *Two Nuns*, is in the municipal collection at Waterford. At the Brygos Gallery, New Bond Street, London, in 1938 she showed terracottas with John Smith. Among her twelve works were: *Child Crying*; *Model Resting*; and *Woman and Baby*.

Elinor Darwin, according to her daughter Ursula, wanted to be a sculptor but the medium was frowned on at the Slade. When she was seventy and ill her daughter, a potter, gave her some clay to make her happier and she immediately did interesting work, but found that she wanted to carve rather than build up. She used all her remaining strength in carving during her last years. She died on 2 May 1954 at her home at Downe, Kent.

Works signed: ED, monogram; E.M.D., E. Darwin, Elinor M. Darwin or Elinor Monsell (if signed at all).
Examples: Waterford: City Hall, Municipal Art Collection.
Literature: Alice M. Dew-Smith, *Tom Tug and others*, London 1898 (illustrations); *The Shanachie*, No. 1, 1906 (illustration), Summer 1907 (illustrations); *Dublin Magazine*, January 1924, March 1924 (illustrations); *The Studio*, March 1926; Eva Eckersley, *Stories Barry Told Me*, London 1927 (illustrations); *Who's Who in Art*, 1934; Roger E. Ingpen, *Nursery Rhymes for Certain Times*, London 1946 (illustrations); Bernard Darwin, *Every Idle Dream*, London 1948 (illustrations); Thomas Balston, *English Wood-Engraving 1900-1950*, London 1951; Gwen Raverat, *Period Piece: A Cambridge Childhood*, London 1952; *The Times*, 3 May 1954; Liam Miller, *The Dun Emer Press, later The Cuala Press*, Dublin 1973; *Dictionary of British Artists 1880-1940*, Woodbridge 1976; Mrs Ursula Mommens (née Darwin), *Letter to the author*, 1985; Hilary Pyle, *Jack B. Yeats: A biography*, London 1989; *The Royal Scottish Academy Exhibitors 1826-1990*, Calne 1991.

DAVIDSON, LILIAN, ARHA (1893-1954), landscape, portrait and genre painter. Born Bray, Co. Wicklow, Lilian Lucy Davidson was the daughter of Edward Ellice Davidson, sub-sheriff of Co. Wicklow. Prior to attending the Dublin Metropolitan School of Art, she was educated privately. She began exhibiting with the Water Colour Society of Ireland in 1912 and from then until 1953 never missed a year.

Closely associated with the Royal Hibernian Academy, she exhibited 135 works in forty years, beginning in 1914. When living at 13 Gulistan Terrace, Rathmines, she exhibited in 1916 a sketch of Lily Williams' (q.v.). In 1920, she held a joint exhibition with Mainie Jellett (q.v.) at Mills' Hall, Dublin. In the 1920s she gave art lessons on Saturday mornings at her studio in Earlsfort Terrace, Dublin. Among her pupils were Bea Orpen and Kitty Wilmer O'Brien (qq.v.). She also taught in several Dublin schools, including Belgrave School, Rathmines, and was a dedicated teacher.

Among her contributions to the 1925 WCSI exhibition were: *Barque at Montreux*; *Old House, Lucerne*; *The Glencar*. Altogether, she contributed 188 works to the Society exhibitions.

Low Tide, Wicklow, exhibited at the 1934 RHA, was purchased by the Thomas Haverty Trust and subsequently presented to the Belfast Museum and Art Gallery. In 1940 she added ARHA after her name. The 1946 RHA catalogue listed four oils: *A Warm Hearth; No More to Sea; Snow on the Canal;* and *Half Mast*.

In addition to exhibiting with the RHA, she also showed at exhibitions of the Dublin Painters and the Munster Fine Art Club. According to biographical information supplied by her to the Belfast Museum and Art Gallery in 1936, she had by then also exhibited in Paris, London, Amsterdam and Chicago. In that year too a one-person exhibition was held in Dublin at the Stephen's Green gallery, sixty-three pictures in oils and watercolours included Wicklow, Donegal and Western Ireland scenes as well as portraits of 'A.E.' (George Russell, q.v.) and the Countess of Longford. In a critique, *The Studio* described her as a 'competent and decorative painter'.

In the W.B. Yeats centenary exhibition held at the National Gallery of Ireland in 1965, three of her portraits were hung. The National Gallery itself provided a drawing in brown chalk of Sarah Purser (q.v.) which the artist had bequeathed to the gallery. The Municipal Gallery of Modern Art lent an oil of the poet and dramatist, Austin Clarke, and the Abbey Theatre provided an oil of the playgoer and diarist, Joseph Holloway. The artist herself was greatly interested in drama, wrote a play, painted scenery and designed for the Torch Theatre, which operated in the 1930s.

A portrait of Jack B. Yeats (q.v.) was also bequeathed to the NGI. Her work was included in an exhibition of pictures by Irish artists held in the Technical Schools, 1949 and 1950. The catalogue for the exhibition of Contemporary Irish Art held at Aberystwyth in 1953 stated that she had worked in France, Belgium and Switzerland. *Fish Market, Bruges* was regarded by her as one of her principal works. She died on 29 March 1954 at 4 Wilton Terrace, Dublin.

Works signed: L.D., monogram.
Examples: Belfast: Ulster Museum. Cork: Crawford Municipal Art Gallery. Dublin: Abbey Theatre; Hugh Lane Municipal Gallery of Modern Art; National Gallery of Ireland. Galway: Art Gallery Committee. Limerick: City Gallery of Art.
Literature: C.H. Bretherton, *A Zoovenir,* Dublin 1919 (illustrations); Bulmer Hobson, ed., *A Book of Dublin*, Dublin 1929 (illustrations); Ulster Museum, *Lilian Davidson Biographical memo.*, 1936; *The Studio*, March 1937; *Irish Times*, 30 March 1954; *Irish Independent*, 31 March 1954; Hilary Pyle: Cork Rosc, *Irish Art 1900-50*, catalogue, 1975; *A Dictionary of British Artists 1880-1940*, Woodbridge 1976; *A Dictionary of Contemporary British Artists, 1929,* Woodbridge 1981; Lillias Mitchell, *Some Memories of Lilian Davidson*, ARHA, typescript, 1986; Ann M. Stewart, *Royal Hibernian Academy of Arts: Index of Exhibitors 1826-1979*, Dublin 1986; Irish Museum of Modern Art, *Mainie Jellett Exhibition Guide*, Dublin 1991; *Water Colour Society of Ireland Exhibition List 1872-1994*, Dublin 1995.

DAY, JOHN (1854-1931), etcher. John George Day was born at Tralee, Co. Kerry, on 29 July 1854. His grandfather was the subject of a book by his, the artist's, wife, Ella B. Day, *Mr Justice Day of Kerry (1745-1841)*, Exeter 1938. A relationship to the artist John Day who was active in Cork city in the 1860s has not been established.

Educated at Cheltenham College, he entered Woolwich at the age of sixteen, relinquishing a university scholarship to join the Army. In 1873 he obtained his commission into the Royal Engineers, and from 1878 to 1880 he served in the Afghan campaign under Lord Roberts. Always a keen draughtsman, his pen drawing with wash of a bazaar was dated 1880. A wood engraving was executed in 1885 and signed 'John Day'.

After his retirement in 1905 from active service — he had also been in China — he began etching seriously, and, according to *The Times*, worked for two years in his native country 'at the Dublin Museum and wrote several of their handbooks, having a great knowledge and love of all artistic antiquities.' The Science and Art Museum in Dublin published in 1906 a general guide to the art collections, and *Glass,* part IX, price one penny, was written by Colonel Day, 'late R.E.'

In 1907, from 85 Lower Leeson Street, Dublin, Day contributed three works to the Royal Hibernian Academy exhibition, including *After Ingres* and a portrait of his elder daughter, Kathleen Day. An 1913 etching, *Le Grand Escalier, Blois,* indicated a French connection. At the Royal Academy in 1914 he was described in the catalogue as a painter, of Byron House, Aylesbury, Bucks., and showed *Grace's Cottage, Stoke Mandeville* and *Pulteney Bridge, Bath*. However, the latter subject was also etched.

Meanwhile, he was responsible for two important portrait etchings, both signed with a distinctive sunrise symbol. These works were to find their way into the National Portrait Gallery, London: *John Edward*

Redmond, 1913, 235 mm x 184 mm; *Edward Carson, 1st Baron Carson,* 1914, 229 mm x 178 mm. Both portraits were reproduced in the *Illustrated London News* in 1914. That of Sir Edward Carson is also at the British Museum. Another 1914 etching was *St James's Park, Winter from Simpson's Bridge.*

Called up to serve in the First World War, he was sent as commandant to Belfast. When he showed five works at the 1920 RHA, the familiar titles indicating etchings, he gave as his address the Kildare Street Club, Dublin. At his friend's request, he travelled to Bath in 1921 for a portrait etching of Field Marshal Sir Henry Wilson. Dated 1923 was *The Outlook Étaples,* etching. According to his widow, in 1924 he was made an 'associé' of the Salon des Beaux-Arts and exhibited there several times.

Crawford Municipal Art Gallery hold twelve works, including ten etchings, of which three are signed by the sunrise symbol 'which is almost invisible and could be mistaken for a clump of grass,' according to the Gallery. All these works at the Crawford had been owned by John Westby who died in 1995. The auction sale of the contents of his home, The Glebe House, Timoleague, Co. Cork, took place in 1996. He was a grandson of the artist and the etching plates were last in his possession, but had so deteriorated that he scrapped them.

Deputy Lieutenant for the County of Kerry, Colonel Day died at Trépied, Etaples, France, on 15 November 1931. He was buried in the cemetery of Le Touquet-Paris-Plage.

Works signed: John Day or sunrise symbol.
Examples: Cork: Crawford Municipal Art Gallery. London: British Museum; National Portrait Gallery. Marlborough, Wilts. : Marlborough College.
Literature: Science and Art Museum, *Glass,* Dublin 1906; *The Times,* 24 November 1931; *Folkestone Herald,* 5 December 1931; *Royal Academy Exhibitors 1905-1970,* Calne 1985; Ann M. Stewart, *Royal Hibernian Academy of Arts: Index of Exhibitors 1826-1979,* Dublin 1986; Peter Murray, compiler, *Illustrated Summary Catalogue of The Crawford Municipal Art Gallery,* Cork 1991; Hamilton Osborne King, *The Old Glebe,* auction catalogue, contents, Cork 1996; Crawford Municipal Art Gallery, *Letters to the author,* 1998, 1999; British Museum, *Letter to the author,* 1999; also, National Museum of Ireland, 1999; National Portrait Gallery, 1999; Royal Engineers Association, 1999; Major David F. Westby, *Letters to the author,* 1999.

de BURCA, MICHEÁL, RHA (1913-85), landscape, figure and portrait painter. Born in Castlebar, Co. Mayo, on 25 September 1913, Michael J. Bourke was the son of Thomas Bourke, motor and cycle dealer, cinema owner, and supplier of electricity to Castlebar. Michael was educated at St. Gerald's College, Castlebar, and the Dublin Metropolitan School of Art. He furthered his art education in the 1930s by short visits to Germany. Among his early contributions to the Royal Hibernian Academy were *A Captured Thought* in 1933, and *A Mayo Market* in 1934.

In 1940, by which time he was already well known as a painter, he became an art inspector with the Department of Education, working in close contact with Cork, Limerick and Waterford Schools of Art. In 1942 he was appointed Acting Director of the National College of Art, a daunting task as shortages caused by the war restricted development. Although he had no experience of managing a teaching department, he met the Irish language requirements and was appointed to the directorship in 1943. His innovations eventually included the re-establishment of the crafts of stained glass, metalwork and weaving, which had been neglected for many years. In 1970 he resigned as Director in protest at the lack of funding for the institution, but by then the student revolution was in full swing and he was the subject of severe criticism. Offered the post of senior art inspector, he accepted and acted until he retired on health grounds in August 1973.

In spite of his administrative duties, de Burca was a regular exhibitor at the RHA, from 1933 until 1976, missing only the odd year. In 1943 he was appointed an associate of the RHA and a constituent member in 1948, when, at the general meeting, he was elected secretary of the Academy, a position he retained until 1971. His works were also exhibited in Holland and the USA, included in the exhibition of pictures by Irish artists in the Technical Schools, 1949, and also in the Irish art exhibition at Aberystwyth, 1953.

One of his colleagues found that his preoccupation with light in his early Dublin scenes was to 'find expression in the paintings of his native West. There was a sparkle and lightness about these works ...'. Landscapes and seascapes were painted on Achill Island, for example *Curraghs, Achill* and *Turf Stack, Achill;*

Connemara, Clew Bay, Kerry and the Dublin environs were to the fore. A limited number of Dun Laoghaire harbour watercolours were signed 'Mairtin Maughan', a well-known name among travelling folk in the West of Ireland. De Burca spoke the Irish language fluently, and died where he was born, Castlebar, on 9 December 1985. An exhibition of his watercolours and oil paintings was held in 1988 in Cork; attendance 1,100.

Works signed: Michael Bourke, Micheál De Burca, De Burca or Mairtin Maughan, rare (if signed at all).
Examples: Armagh: County Museum. Belfast: Ulster Museum. Cork: Crawford Municipal Art Gallery. Dublin: Co. Dublin Vocational Education Committee; Hugh Lane Municipal Gallery of Modern Art; National College of Art and Design; United Arts Club. Killarney: Town Hall. Navan: Meath County Library. Waterford: City Hall, Municipal Art Collection.
Literature: *Contemporary Irish Art*, catalogue, Aberystwyth 1953; *Irish Times*, 12 November 1970, 6 January 1986. Aodh J. Bourke, *Letters to the author*, 1986, 1988; Ann M. Stewart, *Royal Hibernian Academy of Arts: Index of Exhibitors 1826-1979*, Dublin 1986; Marketing Centre, *Exhibition of Watercolours and Oil Paintings by Micheal de Burca, RHA*, catalogue, Cork 1988; John Turpin, *A School of Art in Dublin since the Eighteenth Century*, Dublin 1995.

de GENNARO, GAETANO (1890-1959), portrait painter. Born in Naples on 1 March 1890, his parents died early and he lived with friends of the family in Grenoble, France. His grandfather was a designer and engraver of banknotes; his maternal uncle was Luigi Barone, who had painted what was once a tourist attraction: a decorative panel in the Naples Central Station.

At the age of fifteen, de Gennaro proceeded to Nice and studied for four years under Professor Alexis Mossa at the College of Decorative Arts. Later he settled in Paris, where he was a friend of the painter, Albert Besnard (1849-1934). In 1923 he painted Pope Piux XI. At the Salon des Indépendants in 1929 two of his portraits were praised in the Paris *Le Matin*: 'the renaissance of the beautiful pastel'.

Before his arrival in Ireland about 1940, holding pro-Mussolini views, he had been painting portraits in London. In 1942 and 1943 he showed a total of five portraits at the Royal Hibernian Academy. Soon he was recognised in Dublin for his work in the pastel medium, executing many portraits of prominent people in the city over a period of some five years. A pastel, 1943, of Dr Douglas Hyde hangs at Áras an Uachtaráin; at the National Gallery of Ireland is a portrait of the actor Anew McMaster as Othello; and at the Hugh Lane Municipal Gallery of Modern Art is a portrait of Jerome Connor (q.v.), probably the one exhibited at the 1943 RHA. Other portraits in Ireland included fellow artists Robert Gibbings, John Keating, Albert Power and Jack B. Yeats (qq.v.).

In 1943 de Gennaro travelled to the island of Inisheer, Co. Galway, where he portrayed old and young. An exhibition in the same year, at the Shelbourne Hotel, Dublin, included two sculptures and two miniatures. In the catalogue he listed his prices for portrait commissions. Pastels ranged from head, 30 guineas, to full length, 200 guineas. Miniatures on ivory were 50 guineas.

The publication in 1945 of *Pastels and Paintings* prompted *The Studio* to describe it as a 'large and handsome monograph devoted to the work of a Neapolitan artist now living and working in Ireland ... His work is academic but never dull'. There were thirty-six reproductions, five in colour. The number of copies printed was 1,000, of which the de luxe edition numbered 100.

An unexpected tribute to the artist emanated from Londonderry in early 1945 when Dr R.E.G. Armattoe, who had, admittedly, his portrait painted by him, contributed three articles to *The Londonderry Sentinel*, subsequently reprinted, *Homage to Three Great Men*. De Gennaro was one of them and Armattoe stated that the most remarkable thing about the Italian was his 'immense application, his supreme modesty and his total unawareness of a sense of mission ... he is neither voluble nor temperamental. Gifted with consummate skill and facility, he is, nevertheless, most exacting and would destroy works which others admire, but which have failed to come up to his own standard ...'.

De Gennaro painted in 1946 portraits of the singer, Margaret Burke-Sheridan, now in the Gaiety Theatre, Dublin, and the actress Ria Mooney, hung in the Abbey Theatre. In the same year his own portrait by John Keating (q.v.) appeared in the RHA exhibition.

The Italian-born artist left Dublin for Brazil, settling in Sao Paulo, where he was a professor of painting, exhibiting his works in the I Sao Paulo Fine Arts Exhibition where he won a silver medal. He also received

a bronze medal in the X Parana Fine Arts Exhibition in 1953. When in Dublin the Golden Jubilee of the Easter Rising exhibition was held at the National Gallery of Ireland in 1966 there were pastel portraits of Liam S. Gogan, 1942, and Eamonn Martin, 1946.

Works signed: G. De Gennaro.
Examples: Cardiff: National Museum of Wales. Cork: Crawford Municipal Art Gallery. Dublin: Abbey Theatre; Áras an Uachtaráin; Gaiety Theatre; Hugh Lane Municipal Gallery of Modern Art; National Gallery of Ireland; National Museum of Ireland. Honfleur, France: Musée Eugène Boudin. Sao Paulo, Brazil: Fine Arts Museum.
Literature: *Gaetano de Gennaro*, catalogue, Dublin 1943; Gaetano de Gennaro, *Pastels and Paintings*, Dublin 1945 (also illustrations); R.E.G. Armattoe, *Homage to Three Great Men*, Londonderry 1945; *The Studio*, November 1945; *Capuchin Annual*, 1959 (illustration); John Ryan, *Letter to the author*, 1984; also, Brazilian Embassy, London 1985.

de GERNON, VINCENT (1856-fl.1909), landscape and figure painter. Born in Dublin, the son of William de Gernon, BL, MA (TCD), he was probably the first Dublin student to study at the Royal Academy, Antwerp, and was there from 1877 until 1880. At first he was in the antique class, under the director of the Academy, Nicaise de Keyser (1813-87); he won third prize in historical composition, 1878. In the life class he studied under Charles Verlat (1824-90). In 1877 he sent two marine pictures – one of Morecame Bay – to the Royal Hibernian Academy, giving an address 84 Grosvenor Road, South Kensington, London. His three works at the 1878 exhibition were all Antwerp subjects.

De Gernon, registered as Gernon at the Antwerp academy, stayed at 1 Longe Neue Straat, where Roderic O'Conor (q.v.) resided later. During his Antwerp studies he won the Royal Dublin Society's Taylor Scholarship in 1879 and 1880. An oil painting, *Scene from Corneille's tragedy, 'Cinna'* secured the initial award. These scholarships enabled him to continue his studies abroad. He moved to Paris about 1880 and studied under Carolus-Duran (1838-1917), whose Irish students were to include Norman Garstin (q.v.) and O'Conor. In 1881, when he was named de Gernon at the RHA, 53 Lansdowne Road (Dublin) appeared as his address; the five works displayed included *A Pompeian Serenade* and *Out of Tune, Flemish Style*.

In 1883 at the RHA he exhibited a portrait of his stepmother and father. De Gernon moved to the United States. St Paul, Minnesota, city directories listed him for 1886-90 and he was described as 'artist'. The Minnesota State Agricultural Society sponsored the Minnesota State Fair and in 1888 he was superintendent of the art gallery, which housed a loan exhibition. He was paid 150 dollars for this service. The fair lasted six days.

After a ten-year interval, this elusive Irishman showed at the RHA in 1893 a portrait of Thomas Butler of Priestown, Co. Meath. His studio address in Kensington, London, was the same as for Mrs Emma de Gernon who showed at the 1894 exhibition a scene near San Diego Bay, California. Vincent was presumably there too as in the following year in Dublin he contributed *A Camp of Pueblo Indians, San Diego, California* together with a view of Priestown House, his address being c/o Miss Butler at that house.

Judging by the titles of exhibits in 1907, 1908 and 1909 he had travelled in Italy, for example: *The Baptistry, St. Mark's Venice*, and a work depicting the place where Daniel O'Connell died in Genoa, 1847. In these three exhibiting years at the RHA his address was given as 19 Clarinda Park West, Kingstown, Co. Dublin. A watercolour purporting to show Charles Stewart Parnell's bathing place on the Aghavannagh River, hanging in the Kilmainham Jail Historical Museum, was dated 1909. The date and place of de Gernon's death have not been discovered.

Works signed: Vincent de Gernon.
Examples: Dublin: Kilmainham Jail Historical Museum.
Literature: *Royal Dublin Society Report of the Council*, 1879, 1880; *Minnesota State Agricultural Society Annual Report*, St Paul 1888; *Dictionary of British Artists 1880-1940*, Woodbridge 1976; Julian Campbell: National Gallery of Ireland, *The Irish Impressionists: Irish Artists in France and Belgium 1850-1914*, catalogue, Dublin 1984; Minnesota Historical Society, *Letter to the author*, 1985; Ann M. Stewart, *Royal Hibernian Academy of Arts: Index of Exhibitors 1826-1979*, Dublin 1986.

de MONTFORT, SALLY (1929-96), landscape painter. Born in Aldershot, Hampshire, on 23 November 1929, Sally Brine's father was an army officer who abandoned the family soon after her birth. She studied Fine Art 1948-51 at Bath Academy of Art, Corsham, where she relished tuition under the senior painting master, William Scott (q.v.). In addition to painting, she studied music — a strong interest — drama and stagecraft. The post graduate teaching qualification was gained in 1952 at the Institute of Education, London University. After teaching art for four years, first in Horsham, Sussex, and then in Fulham, London, she moved to Ireland in 1956, having married William Louis Bolton de Montfort, a Cork stockbroker.

In the 1960s she became closely involved with Cork Arts Society, founded in 1963, and was a member of the Wednesday Painters Group, amateur and professional women artists who met to paint, criticise and occasionally exhibit together. Represented in the winter exhibitions at the Limerick Municipal Art Gallery, works there included: *The Pint*, 1963; *Still Life with Chair*, 1965; *Ill Met by Moonlight*, 1967. She also exhibited with Munster Fine Art Club.

An event of some standing was the exhibition in 1966 at Cork Arts Society, 'Recent Drawings, Gouaches, Monotones', the work of six Cork artists, including Seamus Murphy (q.v.). The *Irish Times* stated that the exhibition was 'a fine display of ability and technique. Each artist has a highly individual style and each is fully capable of getting the utmost from his materials.' The critic referred to de Montfort's *Dream River*, a combination of etching and line drawing on a gouache background as delightful and having 'a mysterious fairylike quality. The subtle colours and first-class composition of her etchings *Lir like* and *Golden End* continue the magical effect.'

In the period 1970-95 she taught at the Crawford College of Art and Design, Cork. In the 1970s she began painting lush landscapes, woods, gateways and openings; also she made a series of intricate largescale still life studies. Gouache was a favourite medium. In 1978, when she exhibited with Mary Scaife at the Cork Arts Society gallery, she featured a Gateway series. At the same venue in 1984 she showed twenty-eight works, the majority gouaches and these included *Cyclamen in Window*; *West Cork Washing*; *Yellow Road*.

In 1985 she was represented in the 'Cork Art Now' exhibition, first at the Crawford Municipal Art Gallery and then in Amsterdam. In 1986 with five other women artists she showed again at Cork Arts Society. After the death of her husband in 1987, she moved from Cork city to Baltimore and became an active member of the West Cork Arts Centre. In her exhibition with Ann Chambers, an American and former reportorial artist, at The Gallery, Ballydehob, in 1994, her acrylics included *Atlantic with Yellow Lichen* and *Field Pattern with Cows*. Patricia de Montfort, her daughter, noted that she was 'fascinated by the effects of time and human intervention on the landscape and made many studies of field patterns.' Still in Co. Cork, she showed with four friends at the Boat House Gallery, Castletownshend, in 1995.

Towards the end of her career she confessed that she had become 'hooked' on the sea and shore, 'in all their diversity: and where the natural phenomenon of tidal ebb and flow, dramatically displayed in the Rapids at Lough Hyne fill me with wonder.' The final exhibition was a major show of her own work and of pictures by artists chosen by her, at West Cork Arts Centre in 1996 entitled 'Sally de Montfort and Guests.' She attended the opening, just a few weeks before her death on 11 June 1996.

Works signed: de M.
Examples: Cork: Crawford Municipal Art Gallery.
Literature: *Irish Times*, 25 January 1966, 13 June 1996; The Gallery, *Sally de Montfort and Ann Martin Chambers : Exhibition of Recent Paintings*, catalogue, Ballydehob 1994; Triskel Arts Centre, *The Cork Review 1994-95*; Ms Patricia de Montfort, *Letters to the author*, 1998; Ms Orla Murphy, *Letter to the author*, 1998; also, Crawford Municipal Art Gallery, 2001.

de PADILLA, DOREEN – see VANSTON, DOREEN

DEANE, THOMAS MANLY, RHA (1851-1933), draughtsman and designer. The eldest son of Sir Thomas Newenham Deane, RHA (1830-99), Thomas Manly Deane was born on 8 June 1851 at Ferney, Co. Cork, and was educated at private schools before entering Trinity College, Dublin. Whilst attending Trinity, he also

studied architecture as his father's pupil. A regular exhibitor at the Royal Hibernian Academy since 1863, his father showed designs, landscapes and townscapes until the year before his death. However, his appointment as an RHA and that of his son was on architectural merit. T.M. Deane's great grandfather, Robert O'Callaghan Newenham, of Cork, was the illustrator of *Picturesque views of the Antiquities of Ireland*, 1830.

On graduating from Trinity in 1872, Thomas Manly Deane was apprenticed to William Burges, ARA (1827-81), an architect who also designed jewellery, furniture, and other objects. The designs made by Burges for original buildings were characterised, it was said, 'by force and massiveness of general style and composition, combined with great picturesqueness of detail'. Deane said he owed more to Burges than he could express for having put him 'on the right road to the knowledge of his profession and its allied arts'. After leaving Burges's office he studied life drawing in the studio of Frederick Weekes, a Royal Academy exhibitor and son of the sculptor, Henry Weekes, RA (1807-77). Next, in London, he attended the Slade School of Fine Art, then made a six-month architectural study tour in France, returning home at the end of 1875 to spend a year in his father's office.

In 1876 he won the Royal Academy Travelling Scholarship for an architectural project with the title 'The Assize Courts of a Large Provincial Town', and as a result he spent nearly a year and a half in Italy in 1877-8. According to the biographical information in the Irish Architectural Archive, the breadth of Deane's education reflected his father's view of how the aspiring architect should prepare himself for his profession: 'He must see what is good, and learn to draw it; he must study what has been done by others who have gone before him; he must, as it were, dissect ancient art, and when he has done so draw it honestly and faithfully. The figure must be his study, and he must read so as to become a man of letters'. On his return to Dublin from Italy, he began practice as an architect in partnership in his father's firm at 3 Upper Merrion Street.

Hundreds of drawings, mainly pencil on paper, are in nine sketchbooks, two albums, one jotting book and a diary of a trip to France in 1880, all at the National Gallery of Ireland. For example, one sketchbook has fifty-one leaves of animal, architectural and figure studies, including *A Lady Playing Tennis*. Another sketchbook has twenty leaves of architectural and figure studies including *Portrait of a Gentleman and Two Mice*. A third sketchbook has fifty-three leaves of figure, flower and sculptural studies, including a Palermo fountain drawn in 1878. Deane married in 1888 Florence Mary Wright, whose mother, Marianne Bunting, was the daughter of the celebrated musician and collector of ancient Irish music, Edward Bunting.

Deane showed only five works at the RHA, and in 1897 from his home, 15 Ely Place, Dublin, he contributed a medallion in plaster, *My Little Daughter*. Generally his exhibits were designs; he showed four items at the Royal Academy and three at the Glasgow Institute of the Fine Arts. The Irish Pavilion at the 1901 Glasgow International Exhibition, dedicated to art, industry and science, was designed by him; the attendance at the event exceeded eleven million. He also designed the mural decoration and elaborate mosaic pavements at St Bartholomew's Church, Dublin, and, as well as the drawings to a large scale of all the figure work and ornament, painted himself the cherubim in the roof of the sacrarium.

In 1901 he designed an octagonal raised baptismal font for All Saints' Church, Cootehill, Co. Cavan, and a memorial cross to his father for Dean's Grange Cemetery, Dublin. He was on the executive committee of the Queen Victoria Statue Fund and National Memorial to her late Majesty. In 1904 he was appointed co-architect with Aston Webb for the new Royal College of Science and Government Buildings, Upper Merrion Street. Elected an RHA in 1910, he was knighted in 1911 when the College of Science was officially opened. In that year he designed a temporary arch for Leeson Street Bridge for the visit of King George V. In 1912, from Ailesbury Park, he showed at the RHA exhibition a medallion portrait of his father.

After his only son was killed at Gallipoli in 1915, he resigned from the Royal Institute of the Architects of Ireland and undertook little further architectural work. His friend, R.M. Butler, wrote that he was 'a brilliant draftsman, and as a designer was foremost in his day and generation in this country. Of a retiring disposition, he took no part in the affairs of the Institute, and none in public life, his interests being wholly centered in artistic matters'. In the mid-1920s he retired to Wales and resided at Erw-Lydan, Penmaenmawr. He died on 3 February 1933.

Works signed: Thomas Manly Deane or Thomas M. Deane, both architectural drawings.

Examples: Dublin: Dean's Grange Cemetery; Irish Architectural Archive; National Gallery of Ireland; St. Bartholomew's Church.

Literature: *Dictionary of National Biography*, London 1886; *Irish Builder*, 13 and 27 February 1901; *The Royal Academy of Arts 1769-1904*, London 1905; *Who Was Who 1897-1915*, London 1920; *Dictionary of British Artists 1880-1940*, Woodbridge 1976; *National Gallery of Ireland: Illustrated Summary Catalogue of Drawings, Watercolours and Miniatures*, Dublin 1983; Ann M. Stewart, *Royal Hibernian Academy of Arts: Index of Exhibitors 1826-1979*, Dublin 1986; Allan Massie, *Glasgow: Portraits of a City*, London 1989; Irish Architectural Archive, *Index of Architects: Biography*, Dublin [1995]; Royal Academy of Arts, *Letter to the author*, 1995.

DELMONTE, KOERT (1913-82), landscape and portrait painter. A Sephardic Portuguese Jew, born in Amsterdam on 15 April 1913, his real name was Simeon Delmonte; he adopted Koert as a youngster. His father, Solomon Delmonte, was a banker in Amsterdam who lost his fortune. Koert attended the Académie voor Beeldende Kunsten and won a scholarship to Académie des Beaux Arts in Brussels where he studied under Alfred Bastien (1873-1947).

In 1936 he held his first one-person show, in the Gallery De Ronde Brug, Amsterdam. During the war in the Netherlands, he refused to become a member of the German-organised Confederation of Artists, and consequently he went underground and became involved in the Resistance Movement, making, for example, false passports and ration cards. After the War, he was awarded the Gerrit van der Veen Penning for this work. France, Germany, Italy, Spain and Switzerland were all visited, for studying and painting. After his journeys, he joined his mother at Purley, Surrey, painting landscapes, townscapes and portraits.

In 1950 he was one of six little-known artists who exhibited at the Wildenstein Gallery, New Bond Street, London. The *Manchester Guardian* critic noted that Delmonte found London 'a much brighter town than most artists do: his St Paul's has a rather Continental look but is nevertheless unmistakably St Paul's. He is an artist of great promise'.

At Wildenstein's in 1951 he was represented in the 'Some Contemporary Painters' exhibition, all his seven works having Dublin subjects, for example: *Dublin Harbour*; *Clare Street, Dublin;* and *Dublin Quay. The Studio* commented that he painted Dublin scenes 'with a broad colour scheme that gives warmth and character to cold stone and brick...'. The Redfern Gallery in London also showed his work, and it was hung at the Royal Academy 1953-5 and 1957-8. A painting was bought by London Transport for a poster.

On his visit to Ireland, he had stayed at the United Arts Club, Dublin, and exhibited there in 1951, receiving several portrait commissions. Fewer than a dozen pictures were shown at the Royal Hibernian Academy, the first in 1952 by Koert S. Delmonte de Soto; two years later he settled in Dublin. In his exhibition at Brown Thomas's Little Theatre in 1956 he showed portraits in oils of Eoin ('The Pope') O'Mahony and the Dean of St Patrick's Cathedral, the Very Rev. W.C. de Pauley. For his drawings, using a variety of tinted and surfaced papers, he worked mainly with felt and wood nibs.

Drawings of Cork, Dublin, Galway, little towns and harbours along the coast, were reproduced in newspapers and magazines and were on sale as post-cards and Christmas cards. A series of his Dublin illustrations was published in the *Irish Times*. In 1957 he was represented in the Wildenstein Gallery, along with Jack Hanlon (q.v.) in a group exhibition. The Ritchie Hendriks Gallery in Dublin gave him a one-person show in 1961, and in the 1967 RHA he showed views of Cobh and Drogheda. Chief organiser of the Dutch Contemporary Art in Ireland exhibition at the Municipal Gallery of Modern Art, Dublin, in 1967 he was one of nine artists involved.

In 1969 he returned to the Netherlands for a solo show at The Hague; Mullingar followed in 1971. In that year he became a part-time lecturer, until his death, in the College of Marketing and Design in Dublin. He was represented in the Dutch Exhibition of artists living in Ireland, at the Bank of Ireland, 1975. He held an exhibition at the Molesworth Gallery, Dublin, and in his retrospective exhibition of 'paintings' at the the Lad Lane Gallery, Dublin, in 1979, he displayed *Harbour Scene*, burnt with blow-lamp on old door.

An unusual commission came from Powers Royal Hotel in Dublin to reproduce on glass a copy of *Un Garde-manger* by Frans Snyders (1579-1657) to adorn an area about 3.6 metres long. In a note by the artist on 'Glass Tapestry', Delmonte stated: 'This is a technique in which the painted side of the glass is sealed in. The richness of the antique glass which is used, the depth of its colours and its beautiful lustre guarantee a

magnificent way of decorating walls giving them lasting splendour ... For in this technique glass is not used for windows but on walls ...'. His 1981 presidential portrait of Frank Eustace was for the Friendly Brothers of St Patrick. He died at his home, Ballylusk, Ashford, Co. Wicklow, on 11 August 1982.

Works signed: Delmonte or Del Monte (if signed at all).
Examples: Amsterdam: Rijksmuseum, Prentenkabinet. Dublin: United Arts Club.
Literature: *Manchester Guardian*, 5 December 1950; *The Studio*, January 1952; Little Theatre, *Drawings and Some Portraits by Koert Delmonte*, catalogue, Dublin 1956; *Irish Times*, 25 July 1956, 19 September 1969, 3 September 1982; *Irish Press*, 26 September 1957; Ritchie Hendriks Gallery, *Koert Delmonte*, catalogue, Dublin 1961; *Irish Independent*, 22 February 1967; *Who's Who in Art*, 1970; Lad Lane Gallery, *Koert Delmonte*, catalogue, Dublin 1979; Ann M. Stewart, *Royal Hibernian Academy of Arts: Index of Exhibitors 1826-1979*, Dublin 1986; Mrs N.C. Horsman-Delmonte, *Letters to the author*, 1989; College of Marketing and Design, *Letter to the author*, 1989; also, Friendly Brothers of St Patrick, 1997.

DENNIS, KATHLEEN – see MARESCAUX, KATHLEEN

DICKEY, E.M. O'RORKE (1894-1977), painter and wood engraver. Edward Montgomery O'Rorke Dickey was born on 1 July 1894, son of a Belfast solicitor, Edward O'Rorke Dickey. Educated at Wellington College and Trinity College, Cambridge, he studied art at Westminster School of Art, London. In 1920 he was elected a member of the London Group, and was one of the eleven artists who formed the Society of Wood Engravers, the inaugural exhibition being held at the Chenil Gallery, Chelsea. Among the other members were Robert Gibbings (q.v.), Eric Gill (1882-1940) and Lucien Pissarro (1863-1944). Also in 1920 he was elected one of the first 'Members' of the Belfast Art Society, later becoming an honorary academician of the Ulster Academy of Arts.

Dickey exhibited extensively in London at the Beaux Arts Gallery and the Leicester Galleries, also at the New English Art Club. He illustrated with a dozen woodcuts a book of poems *Workers*, by his friend R.V. Williams ('Richard Rowley'), published in 1923. In that year *The Studio*, London, reported: 'Mr. Dickey has had the honour of favourable notice in England from Sir Charles Holmes and Professor A.M. Hind'. *The Volscian Mountains from the Sabines*, a 1923 oil, is in the Crawford Municipal Art Gallery, Cork. Another 1923 oil, *San Vito Romano*, is at the Ulster Museum; it was a Royal Academy picture. In Dublin in 1924 his work was hung in the 'New Irish Salon' organised by J. Crampton Walker (q.v.).

Further commendation of an unexpected nature appeared in another issue of *The Studio*, January 1924. Some drawings and paintings by Vincent van Gogh (1853-90) and a number of pictures by Dickey had been on view at the Leicester Galleries. 'Among the works by van Gogh', the critique read, 'there were a few which gave some hint of the power with which he has been credited by his followers, but as a whole the show was certainly unconvincing. Mr Dickey, however, made an excellent impression as an artist with correct aims and an unaffected manner of expressing himself ...'

In 1924 he was residing at Burgess Hill, Sussex. As well as painting in Italy he had also worked in Co. Donegal. *The Studio* continued to keep a close eye on his progress, finding that the development of his talent had been both 'rapid and uninterrupted. His admirers look for great things from him in the near future and are not likely to be disappointed'. But the unexpected happened. Deciding to take up art teaching, he became a master at Oundle School, Peterborough.

At the London Group exhibition of 1926 his *Budleigh Salterton from Jubilee Park* attracted favourable notice. In 1926, too, he was appointed Professor of Fine Art and Director of King Edward VII School of Art at Armstrong College in the Newcastle division of the University of Durham, a post which he held until 1931. During that period his work appeared at the annual exhibitions in the Laing Gallery, Newcastle-upon-Tyne. In 1928 he held an exhibition of watercolours at the Redfern Gallery, London, and his work was included in the exhibition of Irish art at Brussels, 1930.

Dickey's *A Picture Book of British Art* appeared in 1931. At the Beaux Arts Gallery, Bruton Place, London, in 1935 he showed forty-one works in an exhibition of drawings and watercolours, including *Piazza del Re*,

Alassio; *Tantallon Castle*; and *The Twisted Tree, Mimizan*. His next post was staff inspector of art, Ministry of Education, and he served for twenty-six years, being awarded the CBE. During this time his appointment in 1939 as secretary of the War Artists' Advisory Committee made him responsible for drawing up a list of artists qualified to record the war at home and abroad, and making the arrangements for them to do so.

In 1951 he became an honorary fellow of the Royal College of Art, London. At the Victoria and Albert Museum there is a pen and wash drawing by him of a Northumberland farm, and in a similar medium is a study of Alassio at the Ashmolean Museum, Oxford. There are woodcuts at the British Museum. His last home address was Turvey, Bedford, and he died on 12 August 1977.

Works signed: E.M. O'R. Dickey or Dickey.
Examples: Belfast: Ulster Museum. Cork: Crawford Municipal Art Gallery. Dublin: Hugh Lane Municipal Gallery of Modern Art. Glasgow: Museum and Art Gallery. Limerick: City Gallery of Art. London: British Museum; Victoria and Albert Museum. Manchester: City Art Gallery. Oxford: Ashmolean Museum.
Literature: Campbell Dodgson, *Contemporary English Woodcuts*, London 1922 (illustration); *The Studio*, December 1923, January 1924, March 1924 (also illustration), April 1924 (also illustration), March 1926 (also illustration), March 1927 (also illustration), October 1928; Richard Rowley, *Workers*, London 1923 (illustrations); E.M.O'R. Dickey, *The Isle of Pheasants*, London 1926 (illustration, wrapper); J. Crampton Walker, *Irish Life and Landscape*, Dublin 1927 (also illustration); E.M. O'R. Dickey, *A Picture Book of British Art*, London 1931; *Dictionary of British Artists 1880-1940*, Woodbridge 1976; John Hewitt and Theo Snoddy, *Art in Ulster-1*, Belfast 1977; Martyn Anglesea, *The Royal Ulster Academy of Arts*, Belfast 1981; University of Durham, *Letter to the author*, 1984.

DIGNAM, MICHAEL (c. 1874-1934), painter of portraits and townscapes. Little is known about this artist and it is assumed that he is the same Michael Dignam who studied in Paris in the 1890s, painted London and Paris street scenes and also worked later in Dublin.

In an article in *The Studio*, August 1893, entitled 'The Sketch-Book in the Street', George Thomson stated that the young artist had been for some years in Paris – at Julian's and the Beaux-Arts – and was now working out his future in his own way. The illustrations to the article included four pencil sketches: a landscape study near Paris, a street scene in London, half a dozen figures, and a group of vehicles. 'He has made hundreds of such sketches in his walks abroad ... With a decided prepossession for grace, they show much daintiness and skill in rendering action.'

A portrait of E. MacDowel Cosgrave, dated 1916, is in the Royal College of Physicians of Ireland, and as Michael J. H. Dignam he exhibited nine works at the Royal Hibernian Academy between 1912 and 1916. In 1912, giving his address as 59 Cabra Road, Dublin, he showed *Miss Winifred A. Sweeney*, and in 1913, now at 21 ½ Mary Street, his works included portraits of Dr Cosgrave and Dr O'Keeffe Wilson. By 1915 he had moved again: 'c/o Messrs Morrow, 20 Nassau Street', and in the 1916 RHA he concluded with *Westmoreland Street, Dublin*.

Dignam contributed three illustrations, all dated 1915, to the magazine, *The Lady of the House*, published at Christmas. One of College Green, Dublin, showed many figures and occupied a full page. The other two were headed 'Dublin Streets in War Time' and bore the titles: *At Westmoreland Street Corner* and *The Recruiting Post at Grattan's Statue, Dublin, on the Royal Dublin Fusiliers' Flag Day*.

The name of Michael Dignam cropped up in the 1930s in Co. Waterford. According to the *Waterford News*, he 'specialised in church work, also carried out several important contracts in many mansions on this and the other side of the Channel. He was engaged for a period by the Marquis of Waterford at Curraghmore. He was also responsible for the renovation of the beautiful statue of Our Lady of Waterford, which has since been enshrined in St Saviour's Dominican Church, Bridge Street'.

Lady Irene Congreve gave him accommodation at Mount Congreve, where he restored some of the pictures, amusing his benefactress by passing on odd bits of information on restoring this and that, saying each time such was 'worth half-a-crown'. He was responsible for painting the six angels in the church at Butlerstown. The local tradition is that he died while this work was in progress. The Waterford Infirmary records gave his address as 11 The Mall. Admitted there on 27 August 1934, he died of lead poisoning six days later, 'aged 60', and was buried in an unmarked grave in the Butlerstown churchyard.

Works signed: Michael Dignam.
Examples: Dublin: Royal College of Physicians of Ireland. Butlerstown, Co. Waterford: St. Mary's Church.
Literature: *The Studio*, August 1893 (also illustrations); *Thieme-Becker Lexicon*, Leipzig 1907; *The Lady of the House*, Dublin 1915 (illustrations); *Waterford News*, 7 September 1934; Ambrose Congreve, *Letter to the author*, 1984; Rev. John Callanan, *Letter to the author*, 1984; Ann M. Stewart, *Royal Hibernian Academy of Arts: Index of Exhibitors 1826-1979*, Dublin 1986.

DILLON, GERARD (1916-71), landscape and figure painter. Born on 20 April 1916 at 26 Lower Clonard Street, Belfast, Francis Gerard Dillon was the youngest of eight children, whose father, Joseph Henry Dillon, was a Post Office night sorter and had served in the British Army. Educated at Raglan Street Public Elementary School and the Christian Brothers' School, Hardinge Street, Gerry left school at fourteen and was apprenticed to the painting and decorating firm of Maurice Sullivan, 41 Falls Road.

The illustrations of Sean Keating (q.v.) for the book, *The Playboy of the Western World* and the pictures of the Russian-born Marc Chagall (1887-1985) were the first images that made him want to paint, but he was so independent that his stay at the Belfast College of Art was short-lived. In 1934 he left Belfast for London, much to the regret of his nationalist mother, and in the two periods he was to reside there, his employment varied from painter and decorator to labourer, boilerman, night porter and art teacher, using his earnings to buy art materials and visit galleries – 'The old masters ... so much craft, so little joy', he once commented. Later in his career he said: 'I am always trying to see with a child's innocence and sincerity'. *A Child's World, Belfast*, is in Hugh Lane Municipal Gallery of Modern Art Dublin.

Connemara, where he was to spend much time with his friend, George Campbell (q.v.), was first visited in 1939 and provided inspiration for his painting. In 1941, the year of the air raids on Belfast, he decided to live in Dublin. In the following year Mainie Jellett (q.v.), from whom he received encouragement, opened his first exhibition at the Country Shop, St Stephen's Green. Along with fellow Belfastman Daniel O'Neill (q.v.) he exhibited at the Contemporary Picture Galleries, Dublin, in 1943. One of his works was *Blitzed Landscape*. Dillon and O'Neill participated in the Golden Jubilee Exhibition of the Gaelic League in Belfast in 1943.

In 1943 he showed his first work at the Royal Hibernian Academy, *Disused Brickfield*, and in the same year he began exhibiting at the Irish Exhibition of Living Art, Dublin, becoming a regular contributor and a valued member of the committee for twenty years. Altogether at the IELA in the period 1943-70 he showed eighty-seven pictures. In the three years 1943-5, he showed ten works with the Water Colour Society of Ireland. He was also a member of the Dublin Painters. Staying with Nano Reid (q.v.) at Drogheda, he painted with her in the area. In 1944 he exhibited with Campbell in the gallery of John Lamb in Portadown.

Once Dillon returned to London in 1945, helping in emergency repairs to bombed sites, taking up residence at 102 Abbey Road, he became involved in a constant surge of exhibition and other activity which continued for the rest of his life. In Ireland alone, Council for the Encouragement of Music and the Arts, the predecessor of the Arts Council of Northern Ireland, gave him a one-person show in Belfast in 1946 and 1950. He was among the group of Irish artists who showed in 1947 at the Associated American Artists' galleries, New York.

In 1949 the Thomas Haverty Trust purchased his *Medical Students*, oil, and presented it to the Belfast Museum and Art Gallery. In Dublin, he had two solo shows at the Victor Waddington Galleries, first in 1950, when he exhibited *Aran Islanders in their Sunday Best*, and then in 1953 his oil, *Island People*, was bought by the Crawford Municipal Art Gallery, Cork. At the Dawson Gallery, Dublin, there were ten openings between 1957 and the year of his death, 1971, when the 'Early Paintings of the West' exhibition included *Before the Races, Omey Island*. In addition, his work appeared in most of the Oireachtas exhibitions between 1949 and 1970. After a lapse of nine years, he showed his second picture at the RHA, *Connemara Child*, in 1952, and between 1958 and 1971 he contributed twenty-one pictures.

Meanwhile in London, his original primitive-type style had not gone unnoticed. After being included in a group show at the Leicester Gallery, 1946, he left for Italy and spent several months there. His work appeared in a group exhibition of four Ulster painters at Heal's Mansard Gallery, London, in 1948, and in 1951 he was

represented by six works, including *Saint Francis*, in the 'Five Irish Artists' show at the Tooth Galleries, after which he left for a tour of Spain, spending some weeks in Malaga. The work of the five artists, sponsored by the Institute of Contemporary Art, Boston, was exhibited in 1950 in various public galleries in the USA.

Self-Contained Flat (Ulster Museum) was painted about 1953. *The Yellow Bungalow*, purchased by the Thomas Haverty Trust in 1954, is also at the Belfast museum, a work which was painted at Roundstone in Connemara. Dillon had a cottage for a year as part payment for a painting, on Inishlackan island off Roundstone. In the summer of 1951, Campbell and James MacIntyre shared the accommodation and the novelist, Kate O'Brien, entertained on two occasions the three artists at her home in Roundstone. Dillon estimated beforehand that £15 would cover MacIntyre's expenses for his six weeks stay. Dillon's *Seaweed Gatherers – Inishlackan* is in the Newtownabbey Borough Council collection.

In 1953 and 1954 his paintings were hung at the Piccadilly Gallery, London. Some of his work in the late 1950s stemmed from the collapse of a garden wall, and planning to rebuild it he ordered too much sand and then used the surplus in devising new textures. In Belfast, he exhibited at Queen's University in 1958.

Dillon, then teaching painting at evening classes for the LCC, was one of the five artists who formed 'The First Group' and showed at the South London Art Gallery in 1961. The artists came together 'to push and work for a wider public and patronage for art ... We are sending this exhibition on tour round some of the municipal art galleries of England. In each town we hope to meet and talk with people about the need for greater municipal patronage ...' stated an introduction in the catalogue. In this exhibition he showed twenty-three works, including *Forms – standing, lying, floating*; *Surface, black, surface*. In 1963 he exhibited at the Whitechapel Gallery. The Arts Council of Northern Ireland hosted an exhibition in 1966. In London again the Mercury Gallery presented twenty-seven oils in 1967, including *The Past Keeps Behind* and *Frightened Kite*; among seven collages was *Blue Mood*.

Further afield, and in connection with the 1952 St. Patrick's Day celebrations, he had supervised for Macy's store, New York, a large design, contributing a panel, 2.1 X 1.2 metres. Two years later the Maxwell Galleries, San Francisco, arranged an exhibition. In 1958 he was one of the artists chosen to represent Britain in the Pittsburgh International Exhibition of Contemporary Art, and in the same year he was represented in the Guggenheim International, USA, and again in 1960. He attended in Paris in 1960 the opening of his exhibition at the Raymond Duncan Gallery. In 1961 and 1963 he exhibited at the Marzotto International, Rome, and in 1962 at the Festival of Modern Art, Boston, Massachussetts, and the Obelisk Gallery, Washington, DC.

In the period 1962-6 three of his brothers died, each as a result of heart defects. In his show in the Dawson Gallery in 1965 he exhibited *The Brothers*. In October 1963 Dillon travelled to the USA with an Irish Trade and Culture delegation, contributing to an exhibition of twelve Irish artists at the New School Gallery and at the well-known store, Lord and Taylor's, New York. The 1960s saw him using 'found objects' in his works. In 1966 he had work included in an Irish Cultural Relations exhibition which toured Wales, Holland, Sweden, Germany and the USA; and his pictures were in the 'Eight North of Ireland Painters' show at the New Charing Cross Gallery, Glasgow. He wrote and illustrated several articles for the magazine, *Ireland of the Welcomes*.

Always willing to experiment, his *String Life*, oil and collage, is at the Institute of Public Administration in Dublin. He designed the poster for *Red Roses for Me* by Sean O'Casey, presented at the Abbey Theatre in 1967. Moving back to Dublin in 1968, he and fellow artist Arthur Armstrong (q.v.) shared 28 Chelmsford Avenue. His work was included in the 'Ulster Painting '68' exhibition at the Arts Council of Northern Ireland gallery, and that body also commissioned him for a poster design. In Dublin, the set for the *Juno and the Paycock* production at the Abbey Theatre was designed by Armstrong, Dillon and Campbell, signed 'A.D.C. 1969'. In that year Dublin Regional Tourism commissioned a wall hanging, 3m by 1.2m approximately, for their head office in O'Connell Street, and in the same year, the beginning of the 'Troubles' in Belfast, he withdrew his work from the Living Art show bound for Belfast.

At the 1968 RHA, he exhibited: *Artist's Dilemma*; *Couple on the Rocks*; *Dreaming*; and *His Two Selves*. In 1969, he lectured at the Municipal Gallery of Modern Art and at the National College of Art. In the last year of his life he took up etching at the Graphic Studio, Dublin. In his book on Dillon, James White wrote: 'It is hard to imagine that any other artist ever got more out of his art than Gerard did. Through it he discovered the full joy of creativity'. A self-portrait is at the National Gallery of Ireland, also, *West of Ireland landscape*.

A recent addition at NGI was *Mellifont Abbey*, oil. He suffered a stroke on a visit to Belfast in February 1971, and died at the Adelaide Hospital, Dublin, on 14 June 1971, and was buried in Belfast.

The two Arts Councils, Belfast and Dublin, organised a retrospective exhibition, consisting of 104 works in oil, watercolour, collage, tapestry, mixed media and etching. The exhibition was held at the Ulster Museum in 1972 and then at the Municipal Gallery of Modern Art, Dublin. In 1972 the Irish Post Office issued their fourth stamp in the series on Contemporary Irish Art, featuring the painting *Black Lake* by Dillon. A sale of paintings from the artist's estate was not held until 1976, at the Dawson Gallery; an exhibition of his work took place at the Tom Caldwell Gallery, Dublin, 1977.

Works signed: Gerard Dillon, G. Dillon, Dillon, rare, or G.D., mainly illustrations.
Examples: Beijing: Irish Embassy. Belfast: Queen's University; Ulster Museum. Coleraine: University of Ulster. Cork: Crawford Municipal Art Gallery. Drogheda: Library, Municipal Centre. Dublin: Arts Council; Bord Failte Éireann; Hugh Lane Municipal Gallery of Modern Art; Institute of Public Administration; Irish Museum of Modern Art; Irish Writers' Centre; National Gallery of Ireland; Office of Public Works; Radio Telefís Éireann; Trinity College Gallery. Kilkenny: Art Gallery Society. Limerick: City Gallery of Art. Maynooth, Co. Kildare: St Patrick's College. Mossley, Co. Antrim: Newtownabbey Borough Council. Sligo: Model and Niland Centre. Waterford: City Hall, Municipal Art Collection. Wexford: Arts Centre. Wigston, Leicester: Abington High School.
Literature: *Envoy*, February 1951 (also illustrations); Arthur Tooth & Sons, Ltd., *Five Irish Painters*, catalogue, London 1951 (also illustration); *An Tostal Handbook*, Dublin 1953 (illustrations); *Ireland of the Welcomes*, May-June 1955 (also illustrations), September-October 1962 (illustration), July-August 1964 (also illustrations), November-December 1964 (illustration), November-December 1965 (illustration), May-June 1968 (illustrations), November-December 1968 (illustrations), September-October 1970 (illustrations); *Belfast Telegraph*, 27 October 1956, 11 November 1960; South London Art Gallery, *The First Group*, catalogue, 1961; Arts Council of Northern Ireland, *Gerard Dillon*, catalogue, 1966; *Irish Times*, 11 November 1960, 2 September 1969, 8 July 1971; Arts Council of Northern Ireland and An Chomhairle Ealaion, *Gerard Dillon*, catalogue, 1972 (also illustrations); John Hewitt and Theo Snoddy, *Art in Ulster-1*, Belfast 1977; Mike Catto and Theo Snoddy, *Art in Ulster-2*, Belfast 1977; Abbey Theatre, *Letter to the author*, 1984; Ann M. Stewart, *Royal Hibernian Academy of Arts: Index of Exhibitors 1826-1979*, Dublin 1986; James White, *Gerard Dillon*, Dublin 1994 (also illustrations); Leicestershire County Council, *Letter to the author*, 1995; James MacIntyre, *Three Men on an Island*, Belfast 1996 (also illustrations); Dorothy Walker, *Modern Art in Ireland*, Dublin 1997 (also illustrations); *Water Colour Society of Ireland Exhibition List 1872-1994*, Dublin 1995; National Gallery of Ireland, *Gallery News*, March-May 2000.

DIXON, JAMES (1887-1970), primitive painter. Born on Tory Island, Co. Donegal, on 2 June 1887, his father came from Meenlaragh on the Donegal mainland. Apart from one short period as instructor on a fishing course, and an occasional visit to the mainland, James Dixon remained on the island, his life being devoted to fishing and small farming, on the odd occasion painting perhaps a bird or a flower.

About 1959 Dixon watched Derek Hill, of Churchill, Co. Donegal, painting a large landscape of West End village and remarked: 'I think I could do better'. Hill immediately encouraged him and promised to forward paints, size and paper (he preferred paper to canvas), but Dixon refused brushes, saying he could make his own out of donkey hair. Apart from the occasional glimpse at paintings that some visitors to the island may have done, he was completely untutored. In the Arts Council, Dublin, collection is Dixon's *Mary Driving the Cattle Home*.

Dixon's first one-person show was held at the New Gallery, Belfast, in 1966 when the twenty-one works, all oils, included: *Yacht passing Tory Island going to America*; *The famous Cutty Shark, 11th March, 1966*; and three portraits. *Famous Yacht Wild Goose*, which was also catalogued, found its way into the Scottish National Gallery of Modern Art. A painting by Dixon at the Bournemouth public gallery was allocated by the Contemporary Art Society. Some works were of historic interest, for example the landing of the first helicopter on Tory, and to this category belongs *The first Air Ship that ever passed over Tory Island on her way to America*.

In 1967 there was an exhibition of his work at the Dawson Gallery, Dublin, followed by one in Vienna at the Autodidakt Gallery in 1968 and another at the Portal Gallery, London. Paintings appeared at Sotheby's auctions in London during the period 1968-73, if not on other occasions. He was represented in the 'Aspects of Landscape' exhibition organised by the Arts Council, Dublin, in 1970; 'Irish Primitive Painters' exhibition

at Queen's University, Belfast, 1971; 'Elements of Landscape', Municipal Gallery of Modern Art, Dublin, 1976; and 'Irish Art 1943-1973', Cork Rosc, 1980.

John Dixon (1895-1970), a brother of James Dixon, also became interested in painting and was joined by other islanders. John died six months after his brother James; he too is represented in the Ulster Museum and in Derek Hill's Collection. His work also appeared in the 'Irish Primitive Painters' exhibition, 1971. The first Tory Island painters exhibition was in 1968 at the New Gallery, Belfast, and four years later there was a show at Grange House, Ballyragget, near Freshford, Kilkenny. In 1983, arranged by the Arts Councils, there was the first exhibition of the Tory Island painters to tour Ireland. Homage was paid to James Dixon and another primitive, Alfred Wallis (1855-1942) of St Ives, with a joint exhibition at the Irish Museum of Modern Art in 1999. Tate St Ives held a joint show in 2000.

Works signed: James Dixon.
Examples: Belfast: Ulster Museum. Bournemouth, England: Russell-Cotes Art Gallery and Museum. Churchill, Letterkenny: Glebe Gallery, Derek Hill's Collection. Dublin: Arts Council; Hugh Lane Municipal Gallery of Modern Art. Edinburgh: Scottish National Gallery of Modern Art.
Literature: New Gallery, *James Dixon*, catalogue, Belfast 1966; *Ireland of the Welcomes*, May-June 1968; Sotheby's catalogues, London 1968-73; Arts Councils, *Tory Island Painters*, catalogue, Belfast and Dublin 1983; *Irish Times*, 28 August 1999; *Sunday Telegraph*, 28 May 2000.

DIXON, JOHN – see DIXON, JAMES

DIXON, SEÁN (1905-46), landscape and portrait painter. John Laurence Dixon was born in Dublin on 13 April 1905, son of Joseph Dixon, labourer, and he attended the Model School, Inchicore. When serving his time with a firm of provision merchants, he studied at night under Seán Keating and Patrick Tuohy (qq.v.) at the Dublin Metropolitan School of Art. At the age of about sixteen he gave up his job to paint full time, much to the annoyance of his mother.

Dixon, despite suffering from asthma, never lost his sense of humour. He was keen on music and in the 1920s, favouring knickerbockers, he played the violin at the Father Mathew Hall. Encouragement in his painting pursuits came when *Snow in Dublin* was accepted for the 1933 exhibition of the Royal Hibernian Academy. He exhibited with the short-lived 'rebel' association, Associated Irish Artists, in 1932. He accepted the daunting commission of a posthumous portrait of Matt Talbot, who died in 1925, composed from personal descriptions as a photograph was not available. According to a report in the *Irish Times*: 'Evidence of the painter's industry and thoroughness is forthcoming from the fact that he had over one thousand interviews and made five hundred drawings before getting the finished work'.

In the period 1934-43 he showed seven pictures at the RHA. Some of the Talbot commission pencil sketches and paintings appeared at an exhibition of his work at the Angus Gallery, 38 St Stephen's Green, in 1935. A series of exhibitions was held at the Country Shop, 23 St Stephen's Green. The 1936 show, opened by Keating, indicated that he had been dabbling in sculpture: a head of Matt Talbot and a miniature full length clay model, which may have helped towards the promotion of a one-person show at the Academy of Christian Art, 42 Upper Mount Street, in 1937.

An exhibition held at the Country Shop, 1941, included portraits of F.R. Higgins, poet; Professor M. Hayes, UCD; P.S. Doyle, TD; Cardinal Lauri. There were also a number of Dublin townscapes in addition to *The Gave, Lourdes, France; Dunlaoghaire Pier*; and *The Reeks, Co. Kerry*. At the 1941 RHA, *The Letter Study* was exhibited and *Turf Carriers* in 1942; from 12 Glenmalure Park, Rialto, Dublin. He painted a number of Galway subjects.

Other portraits were of Alderman Alfie Byrne and the playwright, T.C. Murray, each of whom opened an exhibition; also portraits of Arthur Griffith; Pádraic Ó Conaire, writer; Jimmy O'Dea, comedian; and a commissioned portrait of the Rev. Patrick Barrett, SJ. The artist died on 2 March 1946, and later in the year an exhibition of paintings, watercolours and black and white drawings was held at The Country Shop.
Works signed: Seán Dixon or S. Dixon.

Examples: Clonmel: South Tipperary County Museum and Art Gallery. Dublin: Civic Museum. Limerick: City Gallery of Art.
Literature: *Father Mathew Record*, January 1934 (illustration), June 1934; *Irish Times*, 6 August 1935; *Evening Herald*, 1 August 1936; Mrs Anne Hunter (née Dixon), *Letters to the author*, 1984; Hugh Quinn, *Letter to the author*, 1984; Ann M. Stewart, *Royal Hibernian Academy of Arts: Index of Exhibitors 1826-1979*, Dublin 1986.

DOBBIN, ALFRED W. – see DOBBIN, LADY KATE

DOBBIN, LADY KATE (1868-1955), flower and landscape painter. Born in Bristol, England, she was the daughter of William Wise, solicitor, of Clifton, Bristol. In 1887 she married Alfred Graham Dobbin of Cork who was knighted in 1900 and was High Sheriff of Cork in that year. Sir Alfred owned the Imperial Hotel, Cork, and when, in the 1920s, their home was burnt down, they lived in the hotel.

Lady Dobbin studied at the Crawford Municipal School of Art 1891-95, taking her certificates and winning a prize for 'a beautiful monochrome from the cast'. In 1894 she exhibited at the Royal Hibernian Academy for the first time, and from then until 1947 she was a regular contributor, showing more than one hundred works, Co. Cork and Connemara landscapes to the fore, also flowerpieces, with the occasional portrait.

In 1899 she showed for the first time with the Water Colour Society of Ireland and was a regular exhibitor for fifty years, despite living in Cork, and showed 138 works. In 1908 she contributed *Winter Flowers*; *Turf-Cutters in Connemara*; *Old Bessie*.

When she presented *'When the long, dark autumn evenings come'* at the 1904 RHA, her address was Frankfort, Cork. In 1913 a loan exhibition of modern paintings was held at the Belfast Museum and Art Gallery and she contributed River Lee and Connemara market day scenes. She was particularly noted for her flowerpieces in watercolour, and although suffering from arthritis she painted most of her life. *Chrysanthemums; Portrait of woman with white shawl; View of Clarke's Bridge and the Glasshouse Chimney;* with two other watercolours, are in the Cork municipal collection.

Lady Dobbin's pictures were also familiar in exhibitions of the Munster Fine Art Club, and she showed *The Last Day in Port* in the 1925 exhibition. In 1927 at the RHA, she showed two views of Bath, and that year she was represented in the exhibition of Irish artists at the Fine Art Society, London. *Anemones* was her final contribution to the RHA show. Alfred W. Dobbin (1911-42), Lady Kate's son, also painted and is represented in the Crawford Municipal Art Gallery and at Killarney Town Hall. His mother died on 26 February 1955 in Victoria Hospital, Cork, where she had been a patient for some years.

Works signed: K. Dobbin.
Examples: Clonmel: South Tipperary County Museum and Art Gallery. Cork: Crawford Municipal Art Gallery. Limerick: City Gallery of Art.
Literature: J. Crampton Walker, *Irish Life and Landscape*, Dublin 1927 (illustration); *Irish Independent*, 28 February 1955; *Irish Times*, 28 February 1955; *Dictionary of British Artists 1880-1940*, Woodbridge 1976; Ann M. Stewart, *Royal Hibernian Academy of Arts: Index of Exhibitors 1826-1979*, Dublin 1986; Peter Murray, compiler, *Illustrated Summary Catalogue of The Crawford Municipal Art Gallery*, Cork 1991 (also illustrations); Anne Crookshank and the Knight of Glin, *The Watercolours of Ireland*, London 1994 (illustration); *Water Colour Society of Ireland Exhibition List 1872-1994*, Dublin 1995.

DONNELLY, GERALD (1911-75), landscape painter. Born in the Liberties, Dublin, on 12 October 1911, he attended the Dublin Metropolitan School of Art for evening classes. He was general manager of a timber sawmill at the East Wall, Dublin. He first exhibited at the Royal Hibernian Academy in 1936 and from then until 1974 he showed thirty-five pictures, principally watercolours. He was a close friend of Tom Nisbet, proprietor of the Grafton Gallery, Dublin.

Donnelly first exhibited with the Water Colour Society of Ireland in 1948 and was a regular contributor for the rest of his life, showing seventy-five works. *On the Dodder* and *Near Tallaght* were presented in his initial year.

When an exhibition of Irish pictures by Irish artists was arranged for Technical Schools, touring in 1949, his work was included. The County Wicklow mountains was a favourite area for painting, but he also painted in Scotland, France, Canada and the USA. At the 1954 RHA he showed *Bridge at Manor Kilbride,* and at WCSI in 1962, *Bridge near Cresslough, Co. Donegal* and *River near Annamoe, Co. Wicklow.*

He is represented at the Meath County Library by an oil, *Regatta.* A watercolour of the Liffey at Straffan, Co. Kildare, is with the Dublin Vocational Education Committee. Among his RHA contributions in the 1960s were: *Cockle Pickers, Shellybanks, Dublin* and *The Boyne at Beauparc.*

In his last few years he produced pottery, using the kiln at the College of Art, and he also turned more to oil painting. His only one-person show was in 1975 at the Kilakee Art Gallery, Kilakee, Co. Dublin. He died on 13 July 1975 at his home, 99 Mourne Road, Drimnagh, Co. Dublin.

Works signed: G. Donnelly.
Examples: Dublin: County Dublin Vocational Educational Committee. Neath: Meath County Library.
Literature: *Irish Times,* 17 September 1976; Tom Nisbet, *Letter to the author,* 1984; Peter Donnelly, *Letter to the author,* 1985; Ann M. Stewart, *Royal Hibernian Academy of Arts: Index of Exhibitors 1826-1979,* Dublin 1986; *Water Colour Society of Ireland Exhibition List 1872-1994,* Dublin 1995.

DONOVAN, PHOEBE (1902-98), flower, landscape and portrait painter. Born at Ballymore, Camolin, Co. Wexford, on 23 February 1902, she was the youngest daughter of Richard Donovan, who died when she was only fourteen. Farming activities became her daily companions, and she became an accomplished horsewoman. Initially, she was educated privately and later attended the French School in Bray, Co. Wicklow. A painting career began by joining a local art group in Gorey, Co. Wexford. On a visit to Rome in 1926, she spent time working in a studio there; a term at Regent Street Polytechnic in London followed.

In 1927 she enrolled at the Dublin Metropolitan School of Art and also attended, when in Dublin, the Royal Hibernian Academy Schools. During her stay she received instruction in portraiture from Sean Keating (q.v.). In 1931, from Ballymore, she exhibited at the Royal Hibernian Academy for the first time, showing *The Contemptuous Cat,* followed in 1932 by *Country Gold* and *The Rat-catcher's Daughter.* An interest in craft might be judged by three of the six works in 1933: *Loom Loft, Avoca Woollen Mills,* also the subjects of basketmaking and brushmaking at Richmond Institute.

In 1932 she was represented in a Dublin Sketching Club exhibition. In 1933 her work entered the Water Colour Society of Ireland exhibition for the first time; altogether, up until 1997, she contributed more than 150 pictures. In 1936 she exhibited with the Pastel Society, London. *A Potter at Work* was her sole rendering at the 1938 RHA exhibition. When visiting Carley's Bridge Potteries on a commission from Miss Muriel Gahan to do drawings of country craftworkers, she heard that it was to close down owing to the death of the owner. She took a lease of the operation and kept it going from 1938 to 1945, when the late owner's son took over.

In 1945 she moved to Dublin, and that year she held an exhibition at The Country Shop, opened by Keating. In 1948 she was elected a member of WCSI. At the Munster Fine Art exhibition in 1949 she showed *The Sickle or Stacking before the Rain,* oil. In 1950, represented in the Contemporary Irish Painting exhibition which toured North America, she was residing at Summerfield, Dalkey, Co. Dublin. A child study in pastel, *Gabriel,* at the 1950 WCSI, attracted favourable comment from the *Dublin Magazine.* She had one-person exhibitions at the Dublin Painters' Gallery in 1951 and 1967. This loyal supporter of the WCSI served on the committee from 1954 until 1987, when she was appointed an honorary member. *The Black Raincoat* was offered at the 1954 exhibition for four guineas; *The Black Glove,* for ten.

One of the ten artists represented in the exhibition of flower paintings at the Ritchie Hendriks Gallery, Dublin, in 1957, her work prompted this comment from the *Dublin Magazine* : '...if she is a less consummate craftsman, has a greater freshness. Her brushwork is more rough and vigorous; her flowers, one feels, are things that have *grown,* and some real air plays around them...' All three pictures at the 1960 WCSI exhibition were flowerpieces.

After an interval of twenty-eight years, she resumed showing at the RHA in 1969, from 'An Tigh Thuas', Torca Hill, Dalkey, a house which she shared with Elizabeth Rivers (q.v.). An interest in lithography was evident in the 1969, 1971 and 1972 WCSI exhibitions. She had joined the Graphic Studio in Dublin soon after its foundation in 1961. Unfortunately, making lithographs involved carrying the heavy stones about in quite confined studio space; on one occasion she dropped a stone and broke a toe. During the Wexford Festival of 1970 she held her fourth exhibition at Corish's Picture Gallery: twenty-one oils, including *Old Bergerie in Provence*; six pastels; and eleven lithographs.

Another visit to France: *Ochre Fields in the Vaucluse* at the 1977 WCSI. She had a cousin living in Provence and she used to visit in February and paint. In 1982 she showed at the RHA for the last time; twenty-seven works in all. In 1983, 1984 and 1987 she exhibited at WCSI, Annaghmakerrig landscapes dominating as a consequence of her visits to the Tyrone Guthrie Centre in Co. Monaghan. Her solo show, all oil paintings and spanning fifty years, took place in 1990, hosted by Stephen O'Mara at 21 Sandycove Road, Sandycove, Co. Dublin.

Katie Donovan's first collection of poems, *Watermelon Man*, 1997, included a poem, 'Magic Brushes,' devoted to her great-aunt, and said in part: 'your brush-strewn studio remains, with its paints and potion bottles, charms of driftwood and dried flowers, canvases of copper brambles, cow parsley and crab apples, charcoal men in shirtsleeves at the threshing.' She moved back to Ballymore in 1991.

In the Corporation building in Wexford town is an oil portrait of the founder member of the Old Wexford Society, Dr George Hadden of the long beard. She did a number of presentation portraits of men, also some of women — and individual horses and dogs. At the County Council offices there are two landscapes, including *Vinegar Hill from Enniscorthy*, oil. The artist once said that she always painted better when lonely. 'Not just alone. Lonely. I put more into it.' A restored Stables Gallery at her childhood home, Ballymore, contains forty of her works. She died on 11 May 1998 at Valencia Nursing Home, Camolin. A memorial panel with six works was displayed at the 1998 WCSI exhibition. The Wexford Arts Centre hosted an exhibition of lithographs in 2001.

Works signed: P. Donovan or P.D.
Examples: Dublin: Arts Council; Voluntary Health Insurance Board. Wexford: Corporation; County Council.
Literature: *Contemporary Irish Painting Exhibition, North America,* catalogue, Dublin 1950; *Dublin Magazine,* July-September 1950, April-June 1957; Corish's Picture Gallery, *Paintings and Lithographs Phoebe Donovan,* catalogue, Wexford 1970; Ann M. Stewart, *Royal Hibernian Academy of Arts: Index of Exhibitors 1826-1979,* Dublin 1986; *Royal Hibernian Academy of Arts,* catalogues, 1980-98; *Water Colour Society of Ireland Exhibition List 1872-1994.* Dublin 1995; catalogues, 1995-98; *Irish Times,* 29 November 1997, 13 May 1998, 2 July 1998, 24 March 2001; Graphic Studio Dublin, *Letter to the author,* 1998; also, Tyrone Guthrie Centre, 1998; Richard Donovan, 1999.

DORAN, C.M. (1900-81), landscape and townscape painter. Born in Adare, Co. Limerick, Christopher Doran was a son of Daniel Doran, a cooper by trade who had secured employment on the Dunraven Estate, Adare. When his father changed employment, the family moved to Garryowen, Limerick. After leaving school, Christy worked for some years before entering Limerick School of Art under Richard Butcher, who had taken up the headmastership in 1922.

In the 1920s Doran left for Buffalo, New York State, where he worked for some years in commercial art before returning to Ireland in the 1930s depression, setting up a studio in William Street, Limerick. He was described as 'a very private, refined person, of a reticent turn ...'. He was a founder member of the Limerick Arts Club in 1942. His work at the University of Limerick includes an oil, *Little Newenham Street*, and a watercolour, *The Spanish Arch, Galway*. Old Limerick was a favourite theme but he did not confine his painting to the city. He exhibited for many years at the Goodwin Galleries, Limerick.

Victor Waddington Galleries in Dublin had an interest in his work, and he used their address when he exhibited sixteen works, 1937-47, at the Royal Hibernian Academy. He also exhibited with the Munster Fine Art Club. In the period 1937-43, he showed thirty works at the exhibitions of the Water Colour Society of Ireland, and in 1943 contributed four pictures associated with Cork city, including *Hop Houses, Wise's Quay, Cork*.

A 'Dublin Old and Modern' exhibition of watercolours was held in 1945 at Arts Ltd in O'Connell Street, including *Market Day in Smithfield*; *Christ Church from near Rosemary Lane*; and *Corner of Moore Street*. His final contribution in 1947 to the RHA was *Dunmore Head, Dunquin, Co. Kerry*. He also painted in counties Clare, Donegal, Mayo and Tipperary.

In the early 1950s he was to be seen occasionally at the College of Sacred Heart, Limerick, painting backdrops for school operas. About 1955 he went to London, stayed three years and painted murals, some in Irish ballrooms. As a consequence of the disastrous fire in 1959 at Todd's store, Limerick, he lost most of his possessions, and the following year he opened a studio at 47 Cecil Street which he occupied until his death on 23 August 1981 at his Limerick residence in St Mary's Court. In 1984 the Limerick Art Society presented a commemorative exhibition of his paintings and drawings at the Municipal Art Gallery.

Works signed: C.M. Doran.
Examples: Limerick: City Gallery of Art; University, also National Self-Portrait Collection.
Literature: *C.M. Doran: Dublin Old and Modern*, catalogue, Dublin 1945; Thomas Ryan, RHA, *Letter to the author*, 1983; Tom Geaney, *Letter to the author*, 1984; Limerick Art Society, *C.M. Doran Commemorative Exhibition*, catalogue, 1984; Ann M. Stewart, *Royal Hibernian Academy of Arts: Index of Exhibitors 1826-1979*, Dublin 1986; *Water Colour Society of Ireland Exhibition List 1872-1994*, Dublin 1995.

DOUGLAS, HARRY R. (1862-1934), portrait painter. Born in Edinburgh, he studied art under Sir Noel Paton (1821-1901), leaving Scotland to begin business as a professional portrait painter in Belfast. By 1888 he was a member of the committee of the Belfast Ramblers' Sketching Club, graduating to the honorary secretaryship of the Belfast Art Society with the occasional request for lectures, such as 'The Perception of the Beautiful in Nature and in Art'.

Royal Chambers, 35 Royal Avenue, Belfast, was the address of his studio; his notepaper also stated: 'Portrait Painter'. That address was given when he exhibited in 1900, at the Royal Hibernian Academy , a portrait of the Right Rev. William Packenham Walsh, DD, late Bishop of Ossory, Ferns and Leighlin. This portrait hangs in The Palace, Kilkenny.

In an article on the Belfast Art Society exhibition of 1927, the *Dublin Art Monthly* noted that what was most peculiar to the artist was 'the fidelity of his painting, albeit that it is a photographic fidelity, every vein and bone stands out clearly defined...'.

In one of a series of reminiscent articles in the *Belfast Telegraph* on Ulster artists, John Hewitt wrote about Douglas: 'A full-time professional, a stoutish little man in knickerbockers with a red face and a snow white moustache. His attitude to his craft was thoroughly Victorian; he set out to beat the camera. In his enormous portrait of Sir Robert Meyer in the City Hall you can read the very address on the stationery on the Town Clerk's desk; you could almost lift the old style telephone. I have seen, in a friend's house, his painting of a fish, with every gill and fin and scale meticulously defined ...'

The Meyer portrait from the City Hall appeared in the 'Loan exhibition of Irish Portraits by Ulster Artists' at the Belfast Museum and Art Gallery, 1927, together with portraits of Lavens M. Ewart (Linen Hall Library) and Alderman George A. Doran (City Hall). A meeting in 1920 of the Belfast Art Gallery Libraries, Museums and Art Committee recorded a gift from Miss Doran of a large pencil sketch by Harry Douglas showing Alderman Doran pleading the cause of the King's Crimean and Indian Mutiny Veterans with Viscount French on the occasion of His Excellency's visit to Orangefield, 17 July 1917.

At the City Hall, Belfast, is also a portrait of Sir Robert J. McConnell. The Ulster Museum has in its collection eight portraits, including those of James A. Henderson, Sir William Turner and Isaac W. Ward; also a River Lagan scene. At Queen's University, Dept Of Medicine, is a portrait of Professor James Cuming, 1900, and in the Library is a portrait of the Rev. George Hill, 1897. In the Armagh County Museum are portraits of Judith Paul, 1897; Herriett McCrum, 1899; R.G. McCrum, 1909; and Joseph Atkinson.

Outside of the Belfast exhibitions, with which he was associated for forty years, Douglas exhibited little. He showed one work at the Walker Art Gallery, Liverpool. As he was deeply interested in angling, he travelled

outside the city and was the author of an Ulster Tourist Development Association guide to the sport in Ulster, published in 1926, as well as a general guide book to the Province. He died in Belfast on 27 February 1934.

Works signed: Harry R. Douglas.
Examples: Armagh: County Museum. Belfast: City Hall; Linen Hall Library; Queen's University; Ulster Museum. Kilkenny: The Palace.
Literature: *Belfast Ramblers' Sketching Club*, catalogue, 1888; *Belfast Museum and Art Gallery Report*, 1917-21; *Belfast Art Society Minute Book*, 1926; *Dublin Art Monthly*, November 1927; *Belfast Telegraph*, 1 March 1934, 15 June 1957; *Dictionary of British Artists 1880-1940*, Woodbridge 1976; Belfast City Council, *Letter to the author*, 1984; Eileen Black, *A Sesquicentennial Celebration: Art from the Queen's University Collection*, Belfast 1995 (also illustration); Church of Ireland, Representative Church Body Library, *Letter to the author*, 1996.

DOUGLAS, JESSIE (fl. 1892-1925), figure and landscape painter. Little is known about the family background and art training of Jessie Ogston Douglas of 1 Windsor Park Terrace, Belfast. She occupied a studio in the city centre. The Belfast Art Society catalogues indicated one at 6 Chichester Street in 1893, then 1 Donegall Square East, 1895, and then at 24 Garfield Chambers, 44 Royal Avenue, possibly until the 1920s for art classes.

Beginning in 1892, she was a regular exhibitor with the Water Colour Society of Ireland for thirty years, contributing seventy-two works. *A Flemish Lacemaker* was hung in 1893, and *By the Firelight* in 1895.

Judging by the titles of other works, painting on the Continent was not uncommon: *A Chapel in St Mark's, Venice*, a pastel study, 1892; *Calvaire, Rue de l'Oie, Brittany*, 1896, the year she was elected a BAS vice-president; *A Zeeland Interior*, 1910. According to an 1898 issue of *Fáinne an Lae*, reporting on the Gaelic Festival and Tableaux in Belfast in which she had assisted, Miss Douglas had studied in Paris and Italy.

Strong support for English and Scottish exhibitions of some standing make it additionally difficult to understand why so little is known about her, at least in Ireland. A score of works were accepted by the Glasgow Institute of the Fine Arts as well as the Walker Art Gallery, Liverpool, and the London Salon. Among the other exhibitions to which she contributed in England were: Royal Society of Artists, Birmingham; Royal Institute of Painters in Water Colours; Society of Women Artists.

Exhibiting at the Royal Academy in 1903 she showed *The Pink Satin Gown*; and in 1908, *The Time O'Day*, a watercolour, exhibited four years later at the Belfast Art Society exhibition, priced at £60, one of the most expensive pictures in the show. By comparison, in that same exhibition a work by Jack B. Yeats (q.v.) might have been acquired for ten guineas. In Dublin, she exhibited eight works at the Royal Hibernian Academy, 1906-20. At the Royal Scottish Academy exhibition of 1913 she contributed '*The sea hath its pearls*', shown at the RHA in 1910. Contributions at the 1913 WCSI included *Grandmother's Dress* and *Bretonnes*.

When she exhibited in 1905 at the Belfast Art Society her work came under the critical Celtic revival eye of the local art critic for the Dublin-based *The Nationalist*: '*The Silk Weaver* is a nice little drawing of a cottage interior, discovering a white-bearded weaver at work on his loom of cherry silk. The grey interior and the white-bearded man are Irish, without a doubt; but the cerise-hued fabric (which 'makes' the picture) is foreign. Is this sort of thing legitimate? I very much question it. And I fail to see that any good is to be attained by artists "forcing" their subjects. *The Choir* as a bit of colouring has the same defect. The picture is bright and catchy, but there is no motif underlying it ...'

Elected an honorary member of the Belfast Art Society in 1918, her last exhibit was in 1920, *Love in a Mist*. In that year she showed in Dublin: *The Grandmother* and *Spider's Web*. She also painted views of the South of England, Connemara and Co. Donegal. According to the Society's membership list, she was still associated with Garfield Chambers in 1928. Her name does not appear in the catalogues of the Ulster Academy of Arts, instituted in 1930. Attention has been drawn to her by the watercolour in the Ulster Museum, *Cherry Ripe*, head and shoulders of a girl and inscribed on verso: 'painted/by Miss Jessie Douglas/ Belfast/A Real Artist!/The portrait of a niece of hers/ a daughter of Dean Seaver'. In their 1999 Irish sale in London, Sotheby's included a watercolour, 48 cm x 65.5 cm, of a seated girl with rabbits in an orchard.

Works signed: J. Douglas (if signed at all).
Examples: Belfast: Ulster Museum.
Literature: *Fáinne an Lae*, 14 May 1898; *The Nationalist*, 2 November 1905; *Dictionary of British Artists 1880-1940*, Woodbridge 1976; Martyn Anglesea, *Royal Ulster Academy of Arts*, Belfast 1981 (also illustration); Ann M. Stewart, *Royal Hibernian Academy of Arts: Index of Exhibitors 1826-1979*, Dublin 1986; National Gallery of Ireland and Douglas Hyde Gallery, *Irish Women Artists: From the Eighteenth Century to the Present Day*, Dublin 1987 (also illustration); *The Royal Scottish Academy Exhibitors 1826-1990*, Calne 1991; *Water Colour Society of Ireland Exhibition List 1872-1994*, Dublin 1995.

DOWLING, WILLIAM J. (1907-80), stained glass artist. Born in Dublin on 12 July 1907, his father was Joseph Dowling, who worked in a printer suppliers' firm. After attending the O'Connell Schools, Christian Brothers, North Richmond Street, William John became a student of Harry Clarke (q.v.) at the Dublin Metropolitan School of Art.

On the staff of J. Clarke & Sons from 1928, he became manager of Harry Clarke Stained Glass Ltd in 1940 and remained in that capacity until the studios closed down in 1973. His unique knowledge of that famous firm was apparent in his paper, 'Harry Clarke, Dublin Stained Glass Artist', which he read in 1956 to the Old Dublin Society. He also enjoyed membership of the Royal Society of Antiquaries of Ireland. In the three years 1940-2, when residing at 99 St Declan's Road, Dublin, he showed eight works at the Royal Hibernian Academy, mainly landscapes, but also *Owen Roe O'Neill* in 1942.

Dowling designed windows for churches in more than a dozen Irish counties. There is *Christ the King* in St Joseph's Church, Rathmullan, Co. Donegal; *St Anthony and the Horse* and *St Philomena* in Mount Melleray Abbey, Cappoquin, Co. Waterford; *St Patrick* in Mount St Joseph's Abbey, Roscrea, Co. Tipperary; and *The Crucifixion* in St Michael's Church, Kildysart, Co. Clare. A number of windows were also designed for churches abroad. In the design and making of the *Stations of the Cross* at the Church of the Immaculate Conception, Clonskeagh, Dublin, he had the assistance of Terence Clarke (q.v.) in this *opus sectile* work.

The closure of the Clarke Studios did not end Dowling's practice of the art which had become so much a part of his life. He became a self-employed freelance artist and was allowed the use of the kiln owned by Stanley Tomlin (q.v.) in the latter's glassworks in Dublin. Eighteen of his stained glass cartoons are at the Hugh Lane Municipal Gallery of Modern Art.

In 1975 Dowling designed and made nine figure windows for a Brisbane church, followed later by a memorial window for the Church of Ireland church at Shillelagh, Co. Wicklow. An outstanding stained glass commission was completed in 1977 for the church on Inishbofin, Co. Galway, erected to commemorate the tragic drowning of two young men students of Kansas University. The three windows were: *Christ Calming the Storm*; *Madonna, Queen of Heaven*; and *The Miraculous Draught of Fish*.

Patrick Heney, a stained glass studio colleague, wrote that Willie endeared himself to his colleagues for his kindly personality, good humour and valued advice, when sought, by his fellow artists. 'Throughout his long career the quality of his stained glass work was well known. He had built up a reputation in Ireland, Great Britain, USA and Australia such that he received commissions in his own right ...' Of 49 Copeland Avenue, Dublin, he died there on 19 April 1980.

Examples: Blackrock, Co. Dublin: Blackrock College. Cork: St Mary's Cathedral. Dublin: Church of the Immaculate Conception, Bird Avenue; Holy Ghost Missionary College, Kimmage Manor; Hugh Lane Municipal Gallery of Modern Art; Our Lady of the Wayside Church, Bluebell, Naas Road; St Joseph's Church, Terenure Road East. Inishbofin, Co. Galway: St Colman's Church. La Habra, California: Parish Church. London: St George's Cathedral. Newport, Co. Mayo: St Patrick's Church. Saul, Co. Down: Presbyterian Church. Shillelagh, Co. Wicklow: Parish Church.
Literature: *Dublin Historical Record*, 1961-62; *Irish Times*, 28 January, 19 April and 17 May 1980; Jones and Kelly, *Letter to the author*, 1983; Miss Frances Dowling, *Letter to the author*, 1984; Ann M. Stewart, *Royal Hibernian Academy of Arts: Index of Exhibitors 1826-1979*, Dublin 1986.

DOYLE-JONES, F.W. (1873-1938), sculptor. Born in West Hartlepool of Irish parents, Francis William Doyle-Jones studied sculpture in London under Edouard Lanteri (1848-1917), a Frenchman who for many

years was Professor of Sculpture at South Kensington. Doyle Jones, apparently hyphenless at that time, first exhibited at the Royal Academy in 1905.

A statue of John Mandeville in Michelstown, Co. Cork, was unveiled in 1906. According to Judith Hill in her *Irish Public Sculpture: A History*, 1998, Doyle-Jones produced 'a very convincing and appealing figure, and an heroic portrait... Mandeville stands at the edge of the vast expanse which is New Market Square and, addressing the main street, points behind him to the square, making reference to the events of 1887..'

Responsible for a number of public memorials, he showed at the Irish International Exhibition in 1907 at Herbert Park, Dublin, models associated with monuments to soldiers for Middlesbrough and West Hartlepool. Three years later he modelled from life a bust of John Redmond, now in the House of Commons, Westminster. A casting, bronze, is in the National Gallery of Ireland. In 1912 he completed the Burns memorial at Galashiels, Scotland. He became a member of the Royal Society of British Sculptors in 1919.

The monument to Dr Thomas W. Croke at Thurles, Co. Tipperary, was unveiled in 1922 and the artist was presented with a Gaelic Athletic Association championship medal. The pedestal of the monument is in limestone, about 5 ½ metres high and standing on a shamrock base, surmounted by the statue in bronze of Dr Croke which is almost 2 ½ metres high. On the sides of the pedestal in two niches are statuettes in bronze, one of St Patrick and the other of an Irish bard holding a broken harp in his hand. Croke, in his archbishop's robes, has a breviary in one hand.

Doyle-Jones, or Jones, first exhibited at the Royal Hibernian Academy in 1923 with a bust in bronze of Michael Collins on an Irish marble plinth, now in the NGI. Altogether at the Dublin exhibition he contributed fourteen works, but his main outlet was the Royal Academy.

In 1924 Doyle-Jones was among the prizewinners in an exhibition of Irish art held in connection with Aonach Tailteann. His statue of the Very Rev. P.A. Canon Sheehan, pen in hand, was unveiled in 1925 at Doneraile, Co. Cork, twelve years after the novelist's death there. Owing to the rival claim of Mallow, Sheehan's birthplace, there had been considerable delay about the proposed monument. As for the actual pedestal, this was procured, on the advice of the sculptor, nearer home in Cork. The life-size bronze statue had to be brought by the local Doneraile carrier, in its large crate, on a one-horse cart from Mallow railway station.

In 1926 a writer in *The Studio*, referring to a bust by Doyle-Jones, ARBS, stated: 'Illustrates adequately the tendency in modern sculpture towards an uncompromising realism, which marks the present day revolt against the classic convention by which British sculpture was dominated in the past'. The following year the Reform Club in London was presented with a bronze bust of Lord Oxford and Asquith, and the donor also donated a cast to Balliol, Asquith's college.

In 1927 at the RHA he exhibited *Sonia*, a head study, and *Knighton Hammond*, a head study in 'toned plaster'. The 1929 statue of Cardinal Patrick O'Donnell is at St Eunan's Cathedral, Letterkenny, Co. Donegal. In 1936, giving his usual address, 2 Wentworth Studios, Manresa Road, Chelsea, London, he showed for the last time at the RHA, bronze busts of R.J. Duggan, Joseph McGrath and Dan MacCarthy. A bronze of Joseph Devlin, executed in 1932, is in the Hugh Lane Municipal Gallery of Modern Art. He was also responsible for the bust of T.P. O'Connor, unveiled in Fleet Street, London, in 1936. He resigned from the Royal Society of British Sculptors in 1937.

A tablet to Edgar Wallace is in Ludgate Circus, London, and a memorial to Capt. Matthew Webb, the first person to swim the Channel, is at Dover. His most important Irish work is the colossal statue in local granite of St Patrick at Saul, Co. Down, some 6 metres in height and more than 11 metres taking the plinth into account. The sculptor was occupied on the work for three years and it was unveiled in 1938. He was assisted by Frank J. McAleenan (q.v.). On the four bronze panels of the plinth are depicted incidents in the life of St Patrick on his mission to Ireland. Doyle-Jones died on 10 May 1938 in St Luke's Hospital, Chelsea.

Works signed: Francis Doyle, F. Doyle Jones, Francis Doyle Jones or Doyle Jones.
Examples: Doneraile, Co. Cork: Church of the Nativity. Dover: East Cliff Promenade. Dublin: Hugh Lane Municipal Gallery of Modern Art; National Gallery of Ireland. Galashiels, Scotland: Corn Mill Square. Letterkenny, Co. Donegal: St Eunan's Cathedral. Limerick: City Gallery of Art. Liverpool: North Crosby Road. London: Fleet Street; House of

Commons, Westminster; Ludgate Circus; Reform Club. Mitchelstown, Co. Cork: The Square. Oxford: Balliol College. Saul, Co. Down. Thurles, Co. Tipperary: Liberty Square.

Literature: *Tipperary Star*, 10 June 1922; *The Studio*, October 1924, August 1926 (also illustration), December 1937; *Capuchin Annual*, 1931 (illustration), 1945-1946 (illustration), 1952 (also illustration); Denis Gwynn, *The Life of John Redmond*, London 1932 (illustration); *Daily Telegraph*, 11 May 1938; *The Times*, 11 May 1938; *The Connoisseur*, May 1942 (illustration); *Irish Times*, 5 December 1966; *National Gallery of Ireland Catalogue of the Sculptures*, Dublin 1975; Reform Club, *Letter to the author*, 1984; Ann M. Stewart, *Royal Hibernian Academy of Arts: Index of Exhibitors 1826-1979*, Dublin 1986; Graham Harrison, *Saint Eunan's Cathedral, Letterkenny, Co. Donegal*, Dublin 1988 (illustration); Royal Society of British Sculptors, *Letter to the author*, 1996; Judith Hill, *Irish Public Sculpture: A History*, Dublin 1998 (also illustration).

DREW, PAMELA, RSMA (1910-89), marine and aviation painter. Eldest daughter of John M. Drew, calico printer, she was born in Burnley, Lancs., on 11 September 1910, and began to paint at an early age. In London, at the Grosvenor School of Art, she studied under Iain MacNab (1890-1967), and in 1928 she was in Paris. When she exhibited at the Royal Institute of Oil Painters in 1936, *The Bleach, Lowerhouse Printworks, Lancashire*, her address was Eversley, Milnthorpe, Westmorland.

After her marriage to the 4th Baron Rathdonnell in 1937, she lived at Lisnavagh, Rathvilly, Co. Carlow, served during the Second World War and towards the end of hostilities was stationed in Belfast as 3rd Officer WRNS. Represented in the inaugural exhibition of the Society of Marine Artists in 1946, she subsequently became a member. The RSMA diploma work, *The Fitting-out Basin, Harland & Wolff*, oil, is in the National Maritime Museum. She was also associated with the Guild of Aviation Artists.

In 1953 the Ulster Museum acquired a Harland and Wolff painting, *Tanker 'British Explorer', Basin Trials*, 1950. In 1953 she became airborne as the RAF needed an artist for their Coronation Review, and the following year she travelled to Belfast and painted the launching ceremony of the *Southern Cross*, and was by then a member of the newly-formed Society of Aviation Artists. At the Society of Marine Artists' exhibition in 1955 she showed *Belfast Lough from Carrickfergus*, and an oil sketch of the launch of *Southern Cross* by HM Queen Elizabeth II.

In 1955 too she was with the Middle East Air Forces as Air Ministry accredited artist, and at Port Said and Suez as a war artist in 1956. The Imperial War Museum bought three oils of Royal Air Force operations against the Mau Mau; five other works are in their collection. At the Royal Air Force Museum at Hendon there are sixteen pictures, mainly oils but with some pastels, covering a period, judging by those dated, 1953-58; three are of Cyprus flying activities in 1955. A one-person show in London in 1956 was followed by two in Nairobi, 1957 and 1958.

Lord Rathdonnell died in 1959. In 1961 his widow married Major H.C. Massy. An oil painting, 71 cm by 91.5 cm, of the arrival of Sir Francis Chichester in *Gipsy Moth IV* through Tower Bridge, 7 July 1967, is in the Port of London Authority collection. In 1970 her home became The Studio, Ballinatray, Youghal, Co. Cork; she also had a London address. Although she did not exhibit at the Royal Hibernian Academy, she knew and was encouraged by Sean O'Sullivan and Norah McGuinness (qq.v.).

Before she left Co. Cork in 1980, she held two exhibitions at the Cork Arts Society's gallery. The first, opened by Sir Alfred Beit in 1975, was of East African drawings and a few paintings, including a head of Tom Mboya. The 1978 show concentrated on aviation paintings. She was something of a pioneer in painting on aluminium, which she found damaged less easily when travelling on active location abroad. In 1982 she held a show in Malaga, Spain, and the following year at Kendal, England. In 1983 she had four pictures hung at the Paris Salon. She died in Cumbria on 11 June 1989.

Works signed: Pamela Drew.

Examples: Belfast: Ulster Museum. Dublin: Airport. London: Imperial War Museum; National Maritime Museum, Greenwich; Port of London Authority, Tilbury; Royal Air Force Museum, Hendon.

Literature: *Belfast News-Letter*, 19 August 1954; *Who's Who in Art*, 1972; *Debrett's Peerage and Baronetage*, London 1979; Meirion and Susie Harries, *The War Artists*, London 1983; Pamela Drew, *Letter to the author*, 1984; *Irish Times*, 15 June 1989; Cork Arts Society, *Letter to the author*, 1989; also, Imperial War Museum; Museum of London; Lord Rathdonnell; Royal Air Force Museum; all 1989.

DRUMMOND-FISH, G. – see FISH, G. DRUMMOND

DUFFY, P. VINCENT, RHA (1836-1909), landscape painter. Patrick Vincent Duffy was the son of James Duffy, a jeweller and dealer in works of art at 28 Nassau Street, Dublin. Strickland in his *A Dictionary of Irish Artists*, stated that the artist was born in Nassau Street in 1832, 'and was baptised on the 4th March of that year in Westland Row Church. He was christened "Patrick"; his second name "Vincent" was taken at his confirmation, and he always used it.' A note that appears quite acceptable until one reads in the *Dictionary of National Biography* that Duffy was 'born on 17 March 1836 at Cullenswood, near Dublin,' which was indeed once the Duffy family home. He was buried at Glasnevin and the record there shows 'aged 73 years,' hence the birth date in this entry. The National Gallery of Ireland catalogue of paintings lists his year of birth as 1822.

After his schooldays at Stapleton's in Wicklow Street, he began his art education in the Royal Dublin Society schools, Kildare Street, in which he won prizes and medals. His first aspirations were towards sculpture rather than painting. At this time his family lived at Cullenswood and it was said that he 'jealously guarded the privacy of his own room, which was studio and bedroom and all. In order that no profane eyes might rest on his drawings and modellings and sketches in the various stages of their progress, he dispensed with all attendance, and kept his little kingdom in order for himself.'

When still a pupil, he began to exhibit at the Royal Hibernian Academy in 1851, *Exterior of St Patrick's Cathedral, Dublin*, giving 28 Nassau Street as his address, and from then until 1909 he showed the remarkable total of 456 works over nearly sixty years. Titles in 1859 indicated a Connemara expedition. By 1860 he was well into his stride when he contributed fourteen pictures to the Academy, and, as in the future, moonlight scenes were included, for example *Moonlight from Bray Strand* and *Autumnal Moonrise*. Hence the later appellation, 'Moonlight' Duffy. However, he and a brother-artist once spent the night on the summit of the Sugar Loaf to see the sun rise from the mountain-top.

Elected an associate of the RHA in 1860, his name was included a few months later in the new charter as a full member. He took rooms at 7 Henrietta Street. In 1861 John Faulkner (fl. 1853-87) was academically honoured and shared rooms with Duffy, giving the Henrietta Street address at the RHA in 1865. Apparently, Faulkner's life and habits were irregular, in contrast to Duffy's, and in 1870 he left Dublin in circumstances which brought about his removal from membership of the Academy.

From 1861 until 1866, Killarney subjects figured prominently in Duffy's pictures at the 'annual,' for example *Old Weir Bridge, Killarney*; *Eagle's Nest, Killarney*; and *Oak Island, Killarney*. He continued his visits there for several years. In 1870 he was appointed Keeper of the RHA, and took up residence in Academy House in Abbey Street, holding the post until his death.

No fewer than sixteen Duffy works appeared at the 1871 show, and *Upper Lake, Glendalough — by Moonlight* was top price. He had also been painting on the Dargle river, Co. Wicklow, and in Rossmore Park, Co. Monaghan. Later travels included the Antrim Coast and Connemara again. His sole contribution to the Royal Academy came in 1876: *Flood in the Dargle, County Wicklow*. In Dublin that year, an evening scene on the Rhine denoted a visit abroad. He showed some pictures at the Walker Art Gallery, Liverpool, and with the Royal Society of British Artists.

According to a writer in *The Irish Monthly*, Duffy was 'deeply religious and truly charitable in word and work.' The writer recalled that one summer, when living twelve or fourteen miles out in the country, near Glencree, he more than once walked in all the way in order to discharge his duties in the St Vincent de Paul Society, of which he was an active member.

In 1880 it was reported that more than 35,000 people attended the RHA exhibition. Of his sixteen works hung in 1881, at least seven had Lancashire subjects, including *My Home in Formby, Lancashire*. At the 1885 Academy, Charles Russell, RHA (q.v.) showed a portrait of Duffy. In 1886 works included a twilight study at Multyfarnham, Co. Westmeath; in 1888, *The Drachenfels on the Rhine*; in 1892, *The Black Castle of the Naul*.

Two of his highest priced works were *The Old Castle of Dunluce, Co. Antrim*, exhibited 1895, and *Dublin Bay and Wicklow Hills, from Howth,* 1896. In the last ten years of his exhibiting life, 1900-9, he showed fifty-seven pictures, including *Moonlight on Rathfarnham Castle Demesne,* 1901. Most of his life was tied up with the RHA and in 1902 he accepted the additional office of treasurer. He is represented in the National Gallery of Ireland by *A Wicklow Common*.

Sir Thomas Drew, RHA president, said that Duffy preserved the enthusiasm of youth till the end. Another commentator noted that from a method technically called 'tight', accurately executed in every detail, the artist gradually evolved 'a style flowing, strong, broad, and vigorous.' Walter G. Strickland wrote: 'His pictures show much artistic feeling, but he lacked the power to fully express his conceptions…' John Butler Yeats (q.v.) wrote that he was 'a thorough artist — an artist to the finger-tips. He was also an infallible judge of Art. Whether I agreed or not with him, I always found his conversation full of instruction…' After a long illness, during which he was removed to Richmond Hospital, he died on 22 November 1909.

Works signed: P. Vincent Duffy (if signed at all).
Examples: Dublin: National Gallery of Ireland.
Literature: *The Royal Academy of Arts,* London 1905; *The Irish Monthly,* January 1910; *Dictionary of National Biography,* London 1912; Walter G. Strickland, *A Dictionary of Irish Artists,* Dublin 1913; *Dictionary of British Artists 1880-1940,* Woodbridge 1976; Ann M. Stewart, *Royal Hibernian Academy of Arts: Index of Exhibitors 1826-1979,* Dublin 1986; Glasnevin Cemeteries Group, *Letter to the author,* 1997.

DUNCAN, MARY (1885-1964), painter and etcher. Born in England, daughter of John Kinmont Duncan, she studied at Bromley School of Art, Slade School of Fine Art and in Paris. At the 1907 Royal Scottish Academy she exhibited *Notre Dame de Paris*, and used the accommodation address of 93 Hope Street, Glasgow, until 1925. Altogether at the RSA she contributed fifteen works in the period 1907-48.

Flower Sellers, Piccadilly Circus, sold at a Sotheby, London, auction in 1971 was dated 1909. The artist probably arrived in Dublin about 1910, when she renewed acquaintance with one of her old friends at the Slade. She formed a friendship with Estella Solomons (q.v.), and a portrait of her is in Trinity College, Dublin. Lithographs were executed of Seamus O'Sullivan (J.S. Starkey), who married Stella Solomons; George Russell (q.v.) and James Stephens. In the period 1910-53 she showed seventy-five pictures at the Royal Hibernian Academy.

In the company of her friends, she adopted an Irish version of her name. At Donnybrook, she painted the work which is now in the Model and Niland Centre, Sligo, *Stephen and Marie MacKenna at Seaview Terrace in 1912*. When she exhibited at the RHA in 1913 her studio address was 7 North Great George's Street, Dublin; works included *Hayfield at Portmarnock* and *On the Dart at Low Tide*. In 1919, her studio now at 26 Great Brunswick Street, she held an exhibition with Estella Solomons at Mills' Hall, Merrion Row, Dublin. She showed seven works that year at the RHA, including *Dartmouth by Night* and *Old House at Waterford*.

On returning to England, she opened a studio at Bushey, Hertfordshire, in 1922, and in addition to sending works to Dublin and Edinburgh she contributed to exhibitions of the Royal Academy. When her work was included in the 'Works of Living British Artists' exhibition at the Belfast Museum and Art Gallery in 1927 she was living at Paul, near Penzance. An oil painting of this period and entitled *Todncoath Corner* is in Plymouth City Museum and Art Gallery.

Etchings were reproduced in the *Saorstát Eireann Official Handbook,* 1932, in which year she exhibited with the London-based United Society of Artists and was later appointed a member. In 1935 in London her work appeared in a joint exhibition and *The Studio* commented: 'At the Arlington Gallery three Irish women painters, well-known in their own country – Mary Duncan, Louise Jacobs, ARCA, and Estella Solomons, ARHA, recently showed their work for the first time in London. All three are painters of great accomplishment.' In Cornwall, accommodation was cheap and she stayed there for the rest of her life, settling in Mousehole, near Penzance. She died there in Lynwood Nursing Home on 24 June 1964.

Works signed: M. Duncan.

Examples: Armagh: County Museum. Dublin: Hugh Lane Municipal Gallery of Modern Art; Trinity College. Leamington Spa, Warwicks.: Art Gallery and Museum. London: National Portrait Gallery. Plymouth, Devon: City Museum and Art Gallery. Sligo: Model and Niland Centre.

Literature: *Irish Review*, January 1913 (illustration); *The Book of St. Ultan*, Dublin 1920 (illustration); *Dublin Magazine*, October 1923 (illustration), November 1923 (illustration); J. Crampton Walker, *Irish Life and Landscape*, Dublin 1927 (also illustration); Bulmer Hobson, ed., *Saorstát Eireann Official Handbook*, Dublin 1932 (illustrations); *The Studio*, May 1935; Hilary Pyle, *Portraits of Patriots*, Dublin 1966; *Who's Who in Art*, 1966; Hilary Pyle: Cork Rosc, *Irish Art 1900-1950*, catalogue, 1975; *Dictionary of British Artists 1880-1940*, Woodbridge 1976; Mrs Berta Murphy, *Letter to the author*, 1984; Ann M. Stewart, *Royal Hibernian Academy of Arts: Index of Exhibitors 1826-1979*, Dublin 1986; Anne Crookshank and David Webb, *Paintings and Sculptures in Trinity College Dublin*, Dublin 1990; *The Royal Scottish Academy Exhibitors 1826-1990*, Calne 1991.

DUNIN MARKIEVICZ, CASIMIR – see MARKIEVICZ, CASIMIR

DUNN, MARY – see REDMOND, MARY

E

EARLEY, WILLIAM (1872-1956), stained glass artist. The death of Thomas Earley, surviving partner in the late firm of Earley and Powells, ecclesiastical sculptors, church decorators, and stained glass manufacturers, Upper Camden Street, Dublin, where he resided, was reported by the *Irish Builder* in 1893. Thomas was born of Irish parents in Birmingham in 1819. His father was James Earley (1788-1845) and he, Thomas, established himself in Dublin as an agent for John Hardman and Company, an ecclesiastical firm which executed church work and stained glass designed by A.W.N. Pugin (1812-52).

A nephew of Thomas Earley, William Earley, born in Dublin on 11 September 1872, was the son of John Earley (1831-73), a stained glass artist for John Hardman and Company. William attended the Dublin Metropolitan School of Art, and first exhibited at the Royal Hibernian Academy in 1903, when he showed cartoons for stained glass and he also contributed in 1904, again giving his address as 56 South Richmond Street, Dublin, where he was to reside most of his life. An elder brother, John Bishop Earley, also designed stained glass and was responsible for the Father O'Coigley memorial windows at St Francis Church, Maidstone, Kent.

William Earley showed *The Annunciation* at the 1944 RHA, and *The Assumption* in 1945. He was a director of Earley and Co. for many years. The firm closed down in 1975. Windows were not personally credited but a former member of the firm, Leo Earley, a grandson of John Bishop Earley, told the author in 1976 that there were two outstanding commissions by William Earley in Dublin: a five-light window at St Patrick's Church, Ringsend, featuring St Patrick and St Brigid, and a rose window at St Mary's Church, Haddington Road, *Our Lady and the Four Evangelists*. His last window, 1949, is a memorial in the convent chapel, Mater Misericordiae Hospital, Dublin. A stained glass cartoon, *The Resurrected Christ*, is at the Hugh Lane Municipal Gallery of Modern Art. He died on 23 September 1956.

Examples: Dublin: Hugh Lane Municipal Gallery of Modern Art; Mater Misericordiae Hospital, Eccles Street; St Mary's Church, Haddington Road; St Patrick's Church, Ringsend. Listowel, Co. Kerry: St Mary's Church. Woodford Bridge, Essex: Chigwell Convent.
Literature: *Irish Builder*, 1 July 1893; *Denvir's Irish Library*, November 1902; *Dictionary of British Artists 1880-1940*, Woodbridge 1976; Canon J.H. Morris, *Letters to the author*, 1984; Michael Earley, *Letters to the author*, 1984, 1985.

EASON, PHYLLIS (1896-1974), landscape and townscape painter. Born in Dublin, daughter of William Waugh Eason, bookseller, Hertha Phyllis Eason was educated at Beverley High School, East Yorkshire. During the Second World War she attended life classes at the National College of Art, Dublin, but confessed that she never enjoyed life drawing and her art was chiefly self-taught.

In the 1940s she was closely acquainted in Dublin with the White Stag Group of artists and followers, and exhibited occasionally. She opened the Group's exhibition in 1941 at 30 Upper Mount Street, Dublin. A review of her one-person show at the White Stag Gallery, Merrion Row, in 1946 stated that she excelled in Dublin street scenes. She showed *Hadrian's Wall* at the 1947 Royal Hibernian Academy.

At the RHA in 1950, when living at 3 Herbert Street, she exhibited *Merrion Square, North* and *Wilton Terrace, Dublin*. She also painted many pictures of the Burren, Co. Clare, capturing the 'limestone fields' atmosphere. Some colourful fantasies were painted on greaseproof paper as well as on board. Interested in psychology and its relation to art and religion, she was a friend of the Dutch opera singer, Gré Brouwenstijn, visiting her in Holland. She died in Dublin on 5 June 1974.

Works signed: H.P. Eason or H.P.E.
Examples: Limerick: City Gallery of Art.

Literature: Ms Rhoda Coghill, *Letters to the author*, 1984; Mrs Barbara Eason, *Letter to the author*, 1984; also, Mrs Olive McKinley; Patrick Pye; Mrs Molly Walmsley, all 1984; S.B. Kennedy, *Irish Art & Modernism 1880-1950*, Belfast 1991.

EGESTORFF, PAUL (1906-95), landscape and abstract painter. Born in London of a German father and an Irish mother, he moved after the First World War to Berlin, where at one period he played the piano in a cinema. In Dublin, he had a spell on the organ at the Carlton Cinema. Privately, he played the flute.

In a Dublin advertising agency he earned his living as an artist. In his spare time he attended night classes in the Dublin Metropolitan School of Art under Sean Keating and Maurice MacGonigal (qq.v.). Lessons were also taken from Mainie Jellett (q.v.) and she became an influence on his painting.

In 1938 he first exhibited at the Royal Hibernian Academy, from Clarkeville, Baldolye, Co. Dublin, and his last contribution was in 1943 from 44 Morehampton Road, Dublin, a total of nine works. Beginning with a tree study and *Kenagh*, he followed in 1939 with *Winter Scene* and *Near Enniskerry*. In 1940 he showed a still life; in 1942, *Rhododendrons*. His 1943 contributions were *Drogheda* and *Trees*.

Egestorff had become associated in Dublin with Basil Rákóczi and Kenneth Hall (qq.v), leading lights in the White Stag Group, and he exhibited in the second group show in 1940. Opening the exhibition, Mainie Jellett said that those participating aimed 'to interpret the times in which they live,' without being 'hidebound to any particular school or cramped by academic conventionality.' Egestorff also participated in the large group show in 1941. The most important event organised by the White Stage Group was the 'Exhibition of Subjective Art' held at 6 Lower Baggot Street in 1944. He was among the thirteen artists who participated, and that year he also showed at the Irish Exhibition of Living Art.

In his *Irish Art & Modernism 1880-1950*, S. B. Kennedy wrote: 'Like Jellett, Egestorff emphasised the structural element in composition, concerning himself with tone and prismatic colour progression to produce what he calls "adequate provision of *passage*" to enable the eye to move freely around the picture. Egestorff was more interested in formal structures and theories of composition than any of the other White Stag artists for whom such things approached anathema.' His *Stranded Boiler* in gouache is in Office of Public Works collection, Dublin. *Fusion*, oil, is at the Ulster Museum.

Egestorff had also been exhibiting with the Water Colour Society of Ireland, beginning in 1939 and showing every year until 1950, a total of forty works. From such pictures as *Wayside Cottages* in 1939 and *Trees in Co. Longford* in 1940, he must have caused, in this context, something of a stir in 1942 with *Construction based upon an accidentally discovered form*. However, in the period 1943-9, five pictures were titled *Composition* and one other, *Study for a Composition*. His wife Edith was a regular contributor to the Society's exhibitions in the years 1944-51 inclusive.

Egestorff was described as 'a man of varied and remarkable attainments.' Partnered by his wife, they assembled an important collection of historic scientific instruments and mechanical antiquities, including some of Irish manufacture. By his skill as a craftsman, he was able to restore instruments to first-rate condition and where necessary to make parts to a standard at least equal to the original. The collection is in the National Museum of Ireland. A retrospective exhibition of his pictures took place at European Modern Art, Dublin, in 1990. Of Wellington Place, Dublin, he died at the Royal Hospital, Donnybrook, on 14 March 1995.

Works signed: P. Egestorff.
Examples: Belfast: Ulster Museum. Dublin: Office of Public Works.
Literature: Ann M. Stewart, *Royal Hibernian Academy of Arts: Index of Exhibitors 1826-1979*, Dublin 1986; S. B. Kennedy, *Irish Art & Modernism 1880-1950*, Belfast 1991 (also illustration); *Irish Times*, 16 March 1995, 21 April 1995; *Water Colour Society of Ireland Exhibition List 1872-1994*, Dublin 1995.

EGGINTON, FRANK (1908-90), landscape painter. Son of Wycliffe Egginton, RI (1875-1951), Francis John Egginton was born in Wallasey, Cheshire, on 10 November 1908. When he was a baby, the family moved to Newton Abbot in Devon, his father having been appointed head master of the College of Art there.

Educated at Newton College and then Newton Abbot College of Art, he then spent some time in an architect's office perfecting his drawing. In 1921 the family moved to Teignmouth, Devon.

In 1930 he visited Co. Donegal and painted some pictures for a businessman, a friend of his father's. As the years went by, he stayed longer and longer in Ireland each year. He exhibited *The Calabber River, Co. Donegal* at the 1936 Royal Scottish Academy. In 1938 he visited the USA and spent several months travelling and painting the landscape, also American Indians in their villages. During the Second World War he worked in a Belfast factory, and in 1946 he moved with his wife to Cookstown, Co. Tyrone. A keen ornithologist, in his younger days he had painted on bird-watching trips in Iceland and Switzerland.

Egginton, caravanning for most of his Irish travels – he also painted in Scotland – first exhibited at the Royal Hibernian Academy in 1932 with a Dunfanaghy, Co. Donegal, address, showing three Donegal landscapes and the interior of a Donegal cottage. Between 1933 and 1938 inclusive he contributed fifteen works, the majority having Donegal connections. He showed two watercolours in 1947 from Lissan House, Cookstown: *Peter the Fiddler, Co. Sligo* and *The Old Bridge, Coolaney, Co. Sligo*.

In 1952 Victor Waddington Galleries, Dublin, held a joint exhibition for Howard Knee (q.v.) and Frank Egginton. Edward Sheehy in the *Dublin Magazine* referred to them as belonging to the 'school of drawing-room painters', but found Egginton more interesting as a watercolourist 'in so far as many of his pictures achieve some depth and atmosphere. His wash is more free and lucent than that of Knee. *A Cottage near Tralee, Co. Kerry* and *Connor Pass, Co. Kerry* are among the best of their kind'.

At the age of about fifty, Egginton began painting some oils during the winter months; watercolours, however, were always his first choice. A regular exhibitor with the Fine Art Society in London, he showed well over one hundred works. His other main exhibiting venue was the Royal Cambrian Academy exhibitions at Conwy. A few pictures were sent to the Royal Institute of Painters in Water Colours, London, and the Walker Art Gallery, Liverpool.

In Belfast, his work was seen occasionally at Rodman's Art Gallery, Belfast. His two watercolours in the Queen's University collection are *Mahee, Co. Down* and *Near Ventry, Co. Kerry*. Among four works at Waterford City Hall are: *Erriff Wood, Connemara* and *Soft Day near Castlecove*. Of The Mill, Dunfanaghy, he died on 7 April 1990. In that year a nephew, Robert Egginton from Scotland, held an exhibition at the Magee Gallery, Belfast.

Works signed: Frank Egginton or F.J. Egginton.
Examples: Belfast: Queen's University. Limerick: City Gallery of Art. Waterford: City Hall, Municipal Art Collection.
Literature: *Dublin Magazine*, January-March 1953; *Who's Who in Art*, 1970; *Dictionary of British Artists 1880-1940*, Woodbridge 1976; Ann M. Stewart, *Royal Hibernian Academy of Arts: Index of Exhibitors 1826-1979*, Dublin 1986; Mrs Hilary Egginton, *Letter to the author*, 1990; *Irish Times*, 9 April 1990; John Magee, Ltd, *Letter to the author*, 1990; Mrs Moira Harley (née Egginton), *Letter to the author*, 1991; *The Royal Scottish Academy Exhibitors 1826-1990*, Calne 1991; Eileen Black, *A Sesquicentennial Celebration: Art from the Queen's University Collection*, Belfast 1995 (also illustration).

ELLIOTT, ROBERT (1863-1910), landscape painter. Born in 1863, Robert M. J. Elliott went to sea as a cabin boy at fourteen years of age, devoting himself to study and only allowing himself four hours sleep per night, according to one source, 'thus becoming master of many tongues, and deeply read in all art literature, he turned his talents to etching and painting…' Elliott recorded later that at South Kensington he worked to please himself under Edouard Lanteri (1848-1917), the sculptor, and Frank Short (1857-1945), the etcher. In 1900 he exhibited at the Royal Hibernian Academy for the first time, from 12 Margravine Studios, West Kensington, showing five works, including *A Bit of Old Greenwich*; *The Chimneys of Eblana*; *A Ringsend Boathouse*.

Tiring of London, according to the *Irish Book Lover*, he went to Ireland 'and there settled down to a patient cultivation of Art and Letters — spreading the light.' Elliott stated that he attended the Dublin Metropolitan School of Art as a 'free student.' He found more liberty of action there than many of the students did at South Kensington. In 1901 his address was Ormonde Villa, Vernon Avenue, Clontarf, Dublin, and he had seven pictures hung that year at the RHA, including two etchings and three works in a *Celtic Homes* series.

An article by him in the *Irish Rosary*, in 1903, on 'Sculpture in Catholic Dublin', prompted correspondence in the *Irish Builder and Engineer*. His object was to discredit all that was feeble in modern ecclesiastical sculpture. Probably his writing took up more of his time than his practical art, and 1906 was a particularly busy year. *Hi-You*, published by Sealy, Bryers and Walker of Dublin, at 2s 6d, contained tales of the sea, and no doubt featured autobiographical material. *The Scotsman* said that it drew a 'pathetic picture of the hard life and gentle self-sacrificing character of a ship's boy on an old tea-clipper.' In eleven pages – fourteen paragraphs – 'A discussion in art' occupied space in *New Ireland Review*, and an article of thirteen pages on the value of taste appeared in the *Irish Ecclesiastical Record*.

However, the big literary event of 1906 was the publication of *Art and Ireland*, a book that contained, wrote Elliott, 'only a small selected *quantum* of what I have written on art...' It contained essays selected in major part from the *Irish Rosary* and *The Leader* with some amendments. The preface was by Edward Martyn. The book, from the same Dublin publishers, contained a photograph of the altar relief for Loughrea Cathedral, which Elliott had visited, taken from the clay model in the studio of the sculptor, John Hughes (q.v.). Elliott had journeyed in France and Italy and may have seen Hughes in Paris. The sculptor inscribed the photograph: 'To my friend Robert Elliott. Paris 1907 (sic)'. Thomas Bodkin, reviewing the book for *New Ireland Review*, was of the opinion that the author had somewhat spoilt his case 'by denunciation and diffusiveness...'

In 1908 Elliott presented an etching *Boathouse* to the Municipal Art Gallery, Dublin. An oil painting, a woodland scene, is at Limerick City Gallery of Art. After an interval of seven years, he showed at the 1909 exhibition of the RHA, from 30 Upper Dominick Street, Dublin, five works, all associated with the county, for example *County Dublin: The Runnel*. Altogether, he contributed nineteen pictures to the local Academy, and three at the London Salon.

A novel, *The Immortal Charlatan*, ran into a quarter of a million words, according to one reviewer, and was published posthumously. The scene was set in Dublin, here called Huddlefort, and its subject was briefly classed by the critic as 'low life and high art.' Described on the death registration as 'Artist', Robert Elliott died at the Midland Hotel on 24 March 1910.

Works signed: Robert Elliott (if signed at all).
Examples: Dublin: Hugh Lane Municipal Gallery of Modern Art. Limerick: City Gallery of Art.
Literature: *Irish Builder and Engineer*, 4 and 18 June 1903; Robert Elliott, *Art and Ireland*, Dublin [1906]; Robert Elliott, *Hi-You*, Dublin 1906; *Irish Ecclesiastical Record*, November 1906; *New Ireland Review*, April 1906, February 1907; General Register Office, Dublin, *Register of Deaths*, 1910; *Irish Book Lover,* October 1910, December 1910; *Dictionary of British Artists 1880-1940*, Woodbridge 1976; Ann M. Stewart, *Royal Hibernian Academy of Arts: Index of Exhibitors 1826-1979*, Dublin 1986; Hugh Lane Municipal Gallery of Modern Art, *Letter to the author,* 1997; also, Limerick City Gallery of Art, 1997.

ELVERY, BEATRICE – see GLENAVY, LADY

ELVERY, DOROTHY – see KAY, DOROTHY

ENNIS, HELEN – see YATES, HELEN

ENRAGHT-MOONY, R.J. – see MOONY, R. J. ENRAGHT

EVANS, GWEN – see TAYLOUR, GWEN

F

FARRELL, MICHAEL (1893-1948), still life and mural painter. Born in Sligo on 13 March 1893, his father was Patrick Farrell, a baker, and his early art classes were taken at the Sligo Municipal Technical School, from which he obtained a scholarship to Dublin Metropolitan School of Art. He showed a still life at the Royal Hibernian Academy in 1921, a portrait in 1922; both from the School of Art. His next exhibit, a still life, was in 1926 when his address was 225 rue d'Alessia, Paris, and he was already acquainted with John Hughes (q.v.).

Farrell, devoted to art, had a stringent life in Paris for several years. In 1926 he was represented at the Dublin 'Autumn Salon', 38 St Stephen's Green, favouring still life – two still life oils are in the Hugh Lane Municipal Gallery of Modern Art. The Mexican artist, Angel Zarraga (1886-1946) eased the financial burden in Paris by employing the Sligo artist in the production of murals. A 1929 dictionary of artists stated that Farrell had exhibited in 'Paris, Dublin, Munich, Salon d'Autumne, RHA'. In the early 1930s he received a visit from Seamus Murphy and Sean O'Sullivan (qq.v.), both of whom were directed to him by the Metropolitan School of Art authorities. About 1932 he returned to Sligo, holding an exhibition there.

Farrell had married a French girl, the daughter of a restaurant owner. Prior to the outbreak of the Second World War, he and his family went to live in his wife's old homestead in Brittany. Here he had a preference for seascapes and the area was encouraging for the sale of paintings, at least until hostilities began. In the early years of the German occupation the Farrells managed to live reasonably well as some German officers and their families came from Paris and elsewhere to spend holidays and even purchase paintings. But the time arrived when keeping alive from day to day was the Farrells' main preoccupation, scouring the country for food.

Farrell used to go out sketching although it was against the regulations. He changed his name to O'Farrell. He was constantly harassed by the occupying force. When the Normandy landings took place, the Germans evacuated the whole area. Later, Brittany had a worse enemy, for free of Germans the French now wreaked their vengeance on those who had collaborated.

In a poverty-stricken condition, the Farrell family arrived in Sligo from France in 1946, when they were maintained mainly by relatives. A few friends also rallied round and in the following year an exhibition of his work was held at the Grand Hotel, Sligo, consisting mostly of watercolours executed since his arrival. His papers included half a dozen coloured drawings of European national costumes, with his eldest daughter as model. This 'most engaging conversationalist and the gentlest and least selfish of persons' also wrote poetry. He died in hospital on 14 August 1948. In 1959 the Sligo Art Society's 'Sligo and its Painters' exhibition included works by Farrell, for example *Apples in Straw*; *Tureen and Spoon*; and *Billiard Balls*. His work also appeared in the 'Sligo Painters of the Past' exhibition in 1981, including *Boule de Neige*, oil, and *Lough Gill*, watercolour. A retrospective exhibition of paintings by Farrell, John M. MacCarthy (q.v.) and Bernard McDonagh was held at Sligo Art Gallery in 2000.

Works signed: Michael Farrell or Michael O'Farrell (if signed at all).
Examples: Dublin: Hugh Lane Municipal Gallery of Modern Art.
Literature: *Irish Independent*, 16 October 1926; Bernard McDonagh, ANCA, *Michael Farrell: Recollections of a Sligo Artist*, typescript, c.1960; R.B. Anderson, *Letter to the author*, 1969; Alan Denson, *John Hughes Sculptor 1865-1941*, Kendal 1969; Tomás Mac Evilly, *Letters to the author*, 1969; Mrs P. O'Farrell, *Letter to the author*, 1969; Bernard Dolman, editor, *A Dictionary of Contemporary British Artists, 1929*, Woodbridge 1981; Sligo Art Gallery, *Letter to the author*, 2000.

FAULKNER, RICHARD, RUA (1917-88), landscape painter. Born in Belfast on 21 February 1917, son of Richard Faulkner, accountant, he attended evening classes at the Belfast College of Art when working in the

art department of the printers, Wm Strain & Sons (1934) Ltd. During the war years, he was a display artist in a Belfast fashion store.

Although he also painted in oils, he was principally known as a watercolourist and exhibited *Evening Donegal* and *The Old Mill* at the 1938 Ulster Academy of Arts, sending in from Denorrton Park, Belfast. In 1937 works had been hung at the Royal Hibernian Academy for the first time and from then until 1954 he showed more than thirty. In the first five years of exhibiting in Dublin, Co. Donegal scenes figured prominently but he also painted on Achill Island, Co. Mayo, and in Co. Kerry.

In 1946, a move which allowed him greater opportunity to paint on the North Antrim coast, he left Belfast and set up business at 37 Ann Street, Ballycastle, where he sold his pictures, provided a framing service and supplied art materials. Sixteen of his works were exhibited in 1947 at the Courtfield Road, London, music studio of Miss Margaret Montgomery, also of Ballycastle. Several commissions were received from Head Line Shipping in Belfast for paintings of their ships, the first for *Ramore Head.*

An exhibition, 'Irish Pictures by Irish Artists', in Technical Schools in the Republic included his work in 1949 when he was then an associate of the Ulster Academy of Arts. In 1950 at the RHA exhibition he showed two watercolours, *Achill Head, Co. Mayo* and *On the River Dun, Cushendun.* Later he was appointed an academician of the Royal Ulster Academy followed by honorary membership.

A fellow artist wrote: 'His watercolours depicted the North coast of Antrim in simple liquid washes which showed much selective planning and a sensitive direct technique'. In 1975 he left Ballycastle to live in Portrush, Co. Antrim and died there on 1 July 1988. A small memorial tribute was paid at that year's RUA show.

Works signed: R. Faulkner.
Literature: *Belfast Telegraph*, 5 December 1947; *Ulster Tourist Development Association Guide*, 1948 (illustrations); *Who's Who in Art*, 1972; Ann M. Stewart, *Royal Hibernian Academy of Arts: Index of Exhibitors 1826-1979*, Dublin 1986; *Royal Ulster Academy of Arts 107th Annual Exhibition*, catalogue, Belfast 1988; Mrs Dorothy Faulkner, *Letter to the author*, 1988.

FISH, G. DRUMMOND (1876-fl.1938), landscape and portrait painter. Born on 22 February 1876, he studied at Liverpool School of Art and won a travelling scholarship to Paris, Brussels and Antwerp. In 1906 his address was in Hoylake, Cheshire. An artist in civilian life, he was commissioned into the 6th Battalion, the Royal Irish Rifles, in December 1914, and joined at Belfast. He saw active service at Gallipoli in 1915 as part of the 29th Brigade of the 10th (Irish) Division, and went through the campaign sketching for military purposes until wounded. He was admired for the manner in which he managed to include a paint-box and a sketch book in the very scanty kit allowed to officers.

The National Army Museum collection in London contains two watercolours by Fish of the Gallipoli terrain. There are also two watercolours at Army Headquarters, Ballymena, Co. Antrim: *Communication trench from Anzac to Fisherman's Hut on way to Suvla plain*; *The landing stage at Anzac Cove.* Eight watercolour sketches in colour – one was *Salt Lake, Chocolate Hill, and Ismail Oglu Tepe* – were used to illustrate *The Pals at Suvla Bay*, 1916, being the record of 'D' Company of the 7th Royal Dublin Fusiliers, by Henry Hanna. Illustrations in *The Tenth (Irish) Division in Gallipoli*, 1918, by Major Bryan Cooper, included three from Fish's watercolours.

Captain Fish first exhibited at the Royal Hibernian Academy in 1918, giving his address as Embarkation Office, North Wall, Dublin; according to the local directory he appeared to be residing then at 125 Anglesea Road, Dublin. In the 1919-25 period he showed eight pictures at the RHA. *Spring Morning on the Lledr* and *The Valley of Maentwrog*, exhibited in 1918, both indicated a sojourn in North Wales. But his inaugural contributions to the Water Colour Society of Ireland in the same year showed travels elsewhere: *Mrs Grey of Meelick*, presumably Co. Mayo; *Coire Lagan, Isle of Skye.*

In 1919 at the RHA, *The Morar River*, West Inverness, was included, and in 1920 he was back in Wales with two river scenes at Bettwys-y-Coed, his address being Milano, Vico Road, Dalkey, Co. Dublin. A later title indicated activity at Glen Falloch, Perthshire. There were also local scenes: at the Water Colour Society

in 1919 he exhibited *Merrion Strand* and *A Moonlight Night, Killiney Bay*. A portrait of Miss Sybil Harvey was also shown at the WCSI.

Fish's last year for exhibiting at the two main Dublin exhibitions was 1925, and at about this time he left Dalkey and probably Ireland. In 1926 he showed sixty-five watercolours of the Isle of Skye and Western Highlands at Walker's Galleries, New Bond Street, London, and at intervals of two years 1928-38 inclusive more watercolours at the same venue, almost entirely Scottish subject matter, for example: 1932 title of exhibition, 'Scottish fishing lochs and rivers and the rivers Test and Wye'; 1938, 'Highlands of Scotland'. In all, including some views of the Dolomites, he exhibited 468 works at Walker's. All the firm's catalogues gave his surname as Drummond-Fish. The date of his death has not been found.

Works signed: G. Drummond Fish or, possibly, G. Drummond-Fish.
Examples: Ballymena, Co. Antrim: Army Headquarters 107 (Ulster) Brigade. London: National Army Museum.
Literature: Henry Hanna, *The Pals at Suvla Bay*, Dublin 1916 (illustrations); Major Bryan Cooper, *The Tenth (Irish) Division in Gallipoli*, London 1918 (illustrations); *Thom's Directory*, 1918, 1926; *Dictionary of British Artists 1880-1940*, Woodbridge 1976; Ann M. Stewart, *Royal Hibernian Academy of Arts: Index of Exhibitors 1826-1979*, Dublin 1986; I.B. Gailey, *Letter to the author*, 1993; also, National Army Museum, 1993; Royal Ulster Rifles Association, 1993; Victoria and Albert Museum, National Art Library, 1993; Water Colour Society of Ireland, 1993.

FITZGERALD, DOROTHY (1888-1979), portrait painter and lithographer. Born on 10 April 1888 and christened Dorothea Charlotte Jellett FitzGerald, she was always known as Dorothy. Her father was Professor G.F. FitzGerald of Trinity College, Dublin, who died when she was thirteen, leaving her mother with eight children to rear. Provost Jellett of TCD was her grandfather. She was educated at Alexandra College, Dublin, 1905-7, and it was in 1905 that she exhibited for the first time at the Royal Hibernian Academy .

In the class of Oliver Sheppard (q.v.) at the Dublin Metropolitan School of Art she studied modelling, winning a prize for a head of a woman. When aged sixteen she entered the Royal Hibernian Academy Schools. Mainie Jellett (q.v.) was her first cousin and both studied under Sarah Cecilia Harrison (q.v.) who accepted a few private pupils at her home in Harcourt Street. They found Miss Harrison a very strict teacher.

After winning the Taylor Scholarship in 1911, Dorothy FitzGerald left Dublin for London where she studied lithography. On exhibiting a lithograph at the RHA in 1913 her address was Stratford Road, Kensington. In 1914 she showed with the Black and White Artists' Society of Ireland. Over the years in London she exhibited half a dozen works with the Royal Society of Portrait Painters, three with the Fine Art Society and one at the Royal Academy, but she did not neglect the RHA, contributing a total of sixteen works.

After the First World War she tried to work on her own, painting and lithography, but found the latter too expensive. In 1921 she travelled to Italy and painted there, Florence and Venice being on the itinerary, and she also worked in the Tyrol. A joint exhibition with Ethel Ball and Maude Ball (qq.v.) was held at Mills' Hall, Merrion Row, Dublin, in 1922, and she exhibited lithographs as well as paintings. In later years she was to sketch with Maude Ball in France. In 1927 at the RHA she showed *Portrait in Spanish Dress*, and in 1930, her final contribution, *The Black Hat*.

Trips abroad were no doubt supported financially by her work in arts and crafts studios in London where she designed and printed by linocut. Two of her lithographs were included in the exhibition of Irish art at Brussels, 1930. Her two most important portraits were *Dean Ovenden*, Dean of St Patrick's Cathedral, Dublin, in private possession in England, and *G.B. Abbott, Esq.*, the latter being painted in London, where she died in a nursing home on 5 November 1979.

Works signed: Dorothy FitzGerald.
Examples: Dublin: Hugh Lane Municipal Gallery of Modern Art.
Literature: *The Studio*, January 1915; J. Crampton Walker, *Irish Life and Landscape*, Dublin 1927 (also illustration); Miss Maude Ball, *Letter to the author*, 1968; Miss Dorothy FitzGerald, *Letters to the author*, 1968, 1969; *Dictionary of British Artists 1880-1940*, Woodbridge 1976; *A Dictionary of Contemporary British Artists, 1929*, Woodbridge 1981; Ann M. Stewart, *Royal Hibernian Academy of Arts: Index of Exhibitors 1826-1979*, Dublin 1986.

FITZGERALD, JOHN (1825-1910), topographical artist and woodcarver. He was born in Hanover Street, Cork, and his father died young. He went to Father Mathew's School on Sullivan's Quay, and then, after attending the Christian Brothers' establishment, the North Monastery, he was apprenticed at the age of fifteen to his brother-in-law, Michael Murphy, a cabinetmaker in London. After a year he returned to his beloved Cork, where he was to resume work at cabinetmaking. After some six years he turned his attention to woodcarving, at which occupation he continued for most of his life and was for a time master at the Cork School of Art.

FitzGerald was superintendent in the wood-carving department at the Dublin Exhibition in 1853. Better known as a poet, John FitzGerald was titled the 'Bard of the Lee'. A collection of his writings, *Legends, Ballads and Songs of the Lee* was published in his native city in 1862. Much of his painting at the time of execution was of antiquarian interest, and he probably copied from other work. Cork Public Museum has three FitzGerald 'pen and wash sketches', including: *The South Gate and Bridge, Cork, 1797, from Elizabeth Fort* (a work of similar title is in the Crawford Municipal Art Gallery collection) and *Attacking Shandon Castle, Cork, 1603.* Two other watercolours are at the Crawford, including *Elizabeth Fort and old St. Finbarr's, Cork 1796.*

On 20 June 1882 the *Cork Examiner* reported on a piece of wood-carving which he had just completed. 'The carving, an ornamental top for a glass case, measuring over four feet in length, was embellished with the Cork coat of arms and national emblems such as a wolfhound, a round tower and a ruined abbey'. The glass case was intended for the display of items in the 'Irish Exhibition', presumably the Cork Industrial Exhibition of 1883, in which FitzGerald exhibited two wood-carvings of shields, and was awarded a prize.

In 1898, on the centenary of the 1798 rebellion, he published a booklet, *Echoes of Ninety Eight.* A devoted antiquary, he was a council member of the Cork Historical and Archaeological Society and contributed many articles of antiquarian lore to their *Journal*, which stated in an appreciation: '... in his monochrome drawings he visualised for us Cork as it was in bygone days ... He was of gentle and unassuming manner, and his work in literature and art was ever a labour of love'. He was, according to another tribute, 'unblest with much of the world's goods', and he died on 14 May 1910.

Works signed: John FitzGerald or J. FitzGerald.
Examples: Cork: Crawford Municipal Art Gallery; Public Museum.
Literature: *Cork Examiner*, 20 June 1882; *Irish Book Lover*, October 1910; *Cork Historical and Archaeological Society Journal*, 1913; *Cork Holly Bough*, 1936; Peter Murray, compiler, *Illustrated Summary Catalogue of The Crawford Municipal Art Gallery*, Cork 1991 (also illustrations); Cork Public Museum, *Letter to the author*, 1996.

FITZGERALD, PERCY (1830-1925), sculptor. Son of Thomas Fitzgerald, who was MP for Louth at the time of his death in 1834, Percy Hetherington Fitzgerald was born on 26 April 1830 at Fane Valley, Co. Louth, and was educated at Stonyhurst College, 1843-49, Lancashire, and Trinity College, Dublin, studying for the legal profession. He was High Sheriff for Co. Louth and Crown Prosecutor on the North East Circuit. As a writer of books, on a variety of subjects, he was prodigious.

In 1870 he married the Hon. Dorcas Olivia Skeffington, eldest daughter of Viscount Massereene and Ferrard of Antrim Castle. Most of his life was spent in London, but in his *Recollections of Dublin Castle and of Dublin Society*, published in 1902, he stated that he was 'a denizen of Dublin for 40 years and more'. He had a long and intimate association with Charles Dickens and accompanied him to both Belfast and Dublin for his readings. Fitzgerald, for most of his career, was a writer and sculptor more for love of his art than as a means of livelihood. His wife died after only six years of marriage.

In 1910 *The Times* was informed by Fitzgerald that he intended to have unveiled his bronze statue of Dr Samuel Johnson at St Clement Danes Church, London, which Johnson used to attend. The staffman from the newspaper, Michael Macdonagh, made Fitzgerald's acquaintance at his home in St George's Square, Pimlico, for background information. The statue had been in position wrapped in canvas for four months. The original intention was to have it unveiled early in May by Princess Louise but the death of her brother, King Edward VII, upset the arrangement. Then it was arranged that the ceremony would be performed by the rector, the

Rev. J.J.H. Septimus Pennington. He died a few days before the date arranged. In accordance with his wishes, however, it had been decided that the statue should be unveiled. As it happened, the unveiling took place on the same date as the service for the dead before the funeral.

The unveiling of the Johnson statue, close on midnight, in the St Clement Danes enclosure, was an odd and weird scene. The sculptor and donor, Fitzgerald, was of course there, but the only other person present was Macdonagh. Both had attended the church prayers. They then went outside and unveiled the statue, nearly two metres high on a pedestal of black granite, and moved to the front porch where Fitzgerald delivered a brief eulogy of Johnson. Macdonagh earlier had found his voice 'resonantly pompous' and 'a saturnine glint in his still piercing eyes, suggested to me the old-time actor of the melodramatic school'. In daylight, viewers would have seen more clearly on the pedestal three bas-reliefs: a medallion of Boswell; Johnson and Mrs Thrall; Boswell introduced to The Club by Johnson. Air raids in 1941 destroyed the church, since rebuilt, but the statue survived.

In his preface to *Picturesque London*, 1890, he gave his address as the Athenaeum Club. He was also a member of the Garrick Club. Percy Fitzgerald, MA, FSA, of 'Fane Valley, Co. Louth; Ashleigh, Clapham; and 37 St. George's Road' published privately in 1912 *An Output*: 'A list of writings on many diverse subjects; of sculptures; dramas; music; lectures; tours; collections; clubs; and public donations. Being a record of work done during a long and busy life. 1850-1912'.

In the sculptures section of his book more than fifty items were listed including a statue of James Boswell in bronze with Portland stone pedestal and three tablets of scenes in his life, at Market Place, Lichfield. Also recorded was a bust of Sir Henry Irving at the Lyceum Theatre, Strand, with three figures of him in character. The author also mentioned busts of Charles Dickens and Jane Austen in the Pump Room at Bath, and another of Dickens in Eastgate House Museum, Rochester. A bust of Dickens which he described as situated Furnival's Inn is at Holborn Bars, London. A bust of his friend, Charles Reade, DCL, is in Magdalen College, Oxford, and another is at the National Portrait Gallery where there is also an ink drawing by Fitzgerald, dated 1860, of Charles Waterton, naturalist.

Statues and busts were probably all presented by the sculptor. Another of his activities was that of collector and room after room in his house was filled with a miscellany of acquisitions. Macdonagh also stated years later that he 'showed no false modesty. He regarded himself with the utmost satisfaction. He had a rage for fame ...' He died on 24 November 1925 at 37 St George's Square, London, with not a single relative surviving, and he was buried in Glasnevin Cemetery, Dublin.

Works signed: P. Fitzgerald (if signed at all).
Examples: Lichfield, Staffordshire: Market Place. London: National Portrait Gallery; Prudential Assurance Co. Ltd., Holborn Bars; St Clement Danes Church, Strand. Oxford: Magdalene College. York: Minster Library, Dean's Park.
Literature: Percy Fitzgerald, *The Life of Laurence Sterne*, London 1864 (illustration); Percy Fitzgerald, *Chronicles of Bow Street Police-Office*, vol. 1, London 1888 (illustration); Percy Fitzgerald, *Memoirs of an Author*, London 1894 (illustrations); 'A Native', *Recollections of Dublin Castle and Dublin Society*, London 1902; Percy Fitzgerald, *Boswell's Autobiography*, London 1912 (illustrations); Percy Fitzgerald, *An Output*, London 1912 (and illustrations); *Irish Book Lover*, May 1913; Michael Macdonagh, *Irish Independent*, 17 February 1938; Stonyhurst College, *Letter to the author*, 1985; also, Glasnevin Cemetery, 1985; Dickens House Museum, 1985.

FITZPATRICK (or FitzPatrick), THOMAS (1860-1912), cartoonist and illustrator. Born in Cork on 27 March 1860, as a schoolboy he was forever making caricatures of his schoolmates. Once he ventured to portray the master, but with such unpleasant result that he did not repeat the experiment. He was probably the Thomas Fitzpatrick who won a prize at the Cork School of Art in 1872. He began his art career with Guy Brothers, letterpress printers at 26 Academy Street. On the expiration of his apprenticeship, after what he called 'seven long, weary years,' he found employment as a lithographic artist in Dublin with Hugh and Michael Woods, wholesale stationers, lithographic and letterpress printers and engravers, of 38-43 High Street.

In his early days in Dublin he described himself as a 'litho. and illuminating artist,' of 6 Upper Sackville Street. A resuscitated weekly periodical, *Pat*, which had titled itself as 'artistic, literary, humorous, satirical,'

appeared in January 1881, produced by William P. Swan, Carlton Steam Printing Works. Fitzpatrick contributed cartoons but the publication collapsed financially after just over two years. In the hope of improving his career, he left for London but several years of mixed fortune saw him return to Dublin.

Fitzpatrick contributed to the *Weekly Freeman Journal*, and then was appointed chief cartoonist for the *National Press*. He continued to draw the weekly supplement after they merged in 1892, for example *Tyrant and Toady*, in which he reversed the English stereotyping process with images of the Irish made by an Irishman, in *The Weekly Freeman and National Press*, 17 September 1892. *The Frankenstein of Hatfield and His Handwork* appeared on 6 May 1893, Lord Salisbury being cast as Dr Frankenstein.

In the 1890s he contributed to the *Irish Figaro*. 'Fitz', as he was often called, also worked for the *Irish Emerald* and the *Weekly Nation*. He also produced illuminated addresses with his daughter Mary incorporating Celtic designs. In 1905 he realised his cherished ambition by launching his own humorous review, *The Lepracaun*, a monthly magazine of topical comment and satire which lasted almost ten years. Until his health failed in 1911, when his daughter Mary took over the editorship, he drew most of the black-and-white feature cartoons and illustrated advertisements for the review. His cover design for *The Lepracaun* was regarded as characteristic, almost rivalling the famous *Punch* cover by Richard Doyle (1824-83).

The May 1907 issue of *The Lepracaun*, price one penny, contained six cartoons by Fitzpatrick. 'Thomas FitzPatrick' was named as the proprietor. The issue also contained a 'report' on 'the second annual meeting of The Lepracaun, Unlimited,' which was held, 'as on last year, in "The Fifteen Acres," kindly lent for the occasion by the Board of Works…From an early hour thousands of horses, cars, automobiles, aeroplanes, balloons, etc., could be seen travelling in the direction of the Phoenix Park…' The June 1907 issue gave 6 Upper Sackville Street as the office; cheques and postal orders payable to Thomas FitzPatrick.

Fitzpatrick had a dislike of Paddy jokes. His cartoons in this monthly often contained a John Bull with bulging eyes and paunch and heavy jowls. He also depicted the failings of John Redmond as a national leader. Walter G. Strickland in his *Dictionary* wrote: 'He showed much fertility of invention and happy humour and had a keen eye for social abuses and hypocrisy in public life, which he never hesitated to expose with keen satire; but though he dealt unsparingly with public men, there was a humour and kindly spirit underlying his work which never left a sting behind it.' One of the causes of his death was recorded as 'neurasthenia (overwork)'. He died at 10 Cabra Road, Dublin, on 16 July 1912.

In 1913 his cartoons and sketches which had appeared in *The Lepracaun* during the first year of publication, May 1905 to April 1906, were published in book form, 'the various issues of the year in question being long since out of print, the present publication has been undertaken in order to meet the continuous demand for the pictures of that period.' A photograph of 'The late Thomas FitzPatrick, MJI' appeared as a frontispiece.

Works signed: Fitz, Fitzpatrick or FitzPatrick.
Literature: *Slater's Directory Ireland*, 1870; *Thom's Directory*, 1890; General Registry Office, Dublin, *Register of Deaths*, 1912; *Journal of the Cork Historical and Archaeological Society 1913; Leprachaun Cartoons and Sketches by the late T. Fitzpatrick*, Dublin [1913]; Walter G. Strickland, *A Dictionary of Irish Artists*, Dublin 1913; L. Perry Curtis, Jr., *Apes and Angels: The Irishman in Victorian Caricature*, Newton Abbot 1971(also illustrations); Peter Murray, compiler, *Illustrated summary catalogue of The Crawford Municipal Art Gallery*, Cork 1991.

FLANAGAN, HENRY (1918-92), sculptor. Born on 2 September 1918 in Dublin, Patrick Joseph Flanagan was the son of Henry Flanagan, a builder's foreman in the firm of J. & R. Thompson Ltd. The son attended the Christian Brothers' School, North Richmond Street. Gothic architecture influenced him, and his parents encouraged his interests in music and art. When he was aged fifteen, he began sculpting.

In 1936 he entered the Dominican Order and was ordained in 1943, contributing on the way illustrations for the students' *The Watchman*. Henry was his name in religion. In 1945 he joined Newbridge College, Co. Kildare, where he remained for the rest of his life, teaching English, History, Art and Music. He played the organ and had an extensive knowledge of the instrument; trained the choir, produced plays, and operettas. He supplied some artwork for the Dominicans' *Far & Near*.

An interest in sculpture had been encouraged at summer courses under Professor Domhnall Ó Murchadha (q.v.) but for the most part he was self-taught, fortunately having at his disposal school facilities and equipment for working in many media, for example clay and plaster, then wood, stone, concrete, plastics, copper and enamels. In 1952 he exhibited at the Oireachtas exhibition, and that year he completed *St Vincent Ferrer,* mahogany, for the Dominican Convent, Cabra, Dublin. Another early work, *Aisling,* elm, 1955, is one of many pieces in the Newbridge College collection. At the 1955 Oireachtas he was again represented. In the theatre at Newbridge, one of four pieces is *Artist's Father when Dying,* Portland stone.

In 1957 he contributed again to the Oireachtas, and in 1959: *Báireoir.* Other works at the Oireachtas included: 1963, *Éabha mé, a bhain Parthas de mo chlainn;* 1965, *Teanghbháil Íosa lena Mháthair.* The *St Martin de Porres* group at St Saviour's Church, Dublin, 1960, is in Austrian oak but was later painted to resemble plaster (!) , according to Stephen Rynne in his valuable 1979 book on the artist.

Also at Newbridge College is *St Martin and the Beggar,* bog yew, 1964. At the Gordon March Gallery in Boston, USA, he exhibited in 1965. In Dublin, he showed *Pieta* in 1965 and *The Wave* in 1966 at the Royal Hibernian Academy. In the period 1966-72 his work was also seen in Cork, Limerick and Waterford. All the sculpture in the church at Newbridge is by him, works of 1966 including *Madonna and Child* and the Crucifixion group, both in cast concrete, also *Stations of the Cross* in bog yew.

At the Cork Sculpture Park in 1969 he showed *The Two Marys,* concrete. His 1971 *Children of Lir,* cold cast metal brass, was a choral trophy for University College, Galway, commissioned by the College Choir for an intervarsity choral festival. Another counterbalance to his religious work at this time was *The Jivers* (Newbridge College) in modelled concrete. *Cross of Sion* (St Dominic's School, Sion Hill), cold cast copper, saw completion in 1971.

Another limestone work of special interest was the 1973 St Martin de Porres statue in St Dominic's Church, Athy, Co. Kildare. The side chapel contains six beaten cooper panels illustrating incidents in the saint's life. At St Mary's Priory, Tallaght, is a tabernacle, decorated in enamels, about 25 cm high, suggested by Cormac's Chapel. The panels portray various Eucharistic symbols. Also silver-plated with enamels is an unusual crucifix of five panels with the centre one the crucifix proper; the others show incidents in the passion of Our Lord. Later, at the Retreat House at the Priory, he provided *Stations of the Cross* and *St Joseph.*

The year 1975 also produced a *Madonna and Child* in glazed earthenware. A copper-enamel front piece, representing the Sacraments, designed to make the altar at St Magdalen's Church, Drogheda, look less severe, is now in the prayer room. Two 1976 pieces were considered by Stephen Rynne as a pair: *Our Lady and the Little Girl* (Scoil Muire, Newbridge), Portland stone, on a high pedestal in a green plot; and *Madonna and Child* (Newbridge College), polished limestone.

Another facet of his oeuvre appeared in 1977 with the *Stations of the Cross* in enamel for Kildangan Church in Co. Kildare; similar work is at Littleton, Co. Tipperary; Holy Cross Priory, Tralee, Co. Kerry. An unusual feature of the *Stations* in enamel at the convent of the Sisters of Our Lady of Charity in High Park in Dublin is that these are not the traditional fourteen separate pieces but hang in four panels, and there is a *Resurrection.* There are also *Stations* at St Dominic's Church, Tallaght, Dublin, where there is also a *Madonna and Child.* Other 1977 works were: *St Catherine of Siena* (Dominican Convent, Blackrock), polished limestone, and a crucifix in resin and bronze for Holy Cross Church, Sligo, which has an over life-size figure of Christ.

In limestone at St Clare's Church, Graiguecullen, Co. Carlow, is the two-figure *Mary, Joyful Mother of Children,* 1978. The parish outdoor cross devised a few years later for Graiguecullen, 2.6 metres high without pedestal and 300 hours work, enclosed within its arms the activities of the parishioners from birth to school to work to play. Another major commission was a 2 ½ metres figure in resin and bronze of St Columban for the Basilica of Our Lady, Knock, Co. Mayo.

Stations in ash, 1979, were placed at Black Abbey, Kilkenny, but were moved to Siena Monastery at Drogheda, Co. Louth. At this time the collection at Newbridge was enlarged by: *The Girl with the Flaxen Hair,* sycamore, and *Deidre and the Sons of Uisneach,* resin and bronze. At the Carmelite Church, Loughrea, Co. Galway, there are four works: *Stations,* cast concrete; *St Joseph,* teak statue; *Our Lord and Two Disciples at Emmaus,* plaque; *Crucifix,* bog oak. At the Carmelite Monastery of St Joseph, Malahide, Co. Dublin, are *Stations* in ash.

In 1982, his second exhibition there, the Kilcock Art Gallery in Co. Kildare showed seventeen works, of which eight were in elm, including *Miss Cortez* and *Meditation*. Among five in polished limestone were *The Wave of Cliona* and *Deidre*. Among the three in mahogany was *The Seeker*. *Sleeping Child* was in marble. In 1982 *Stations* were installed at Gormanston College, Co. Meath, and *St Francis and the Wolf* outdoors in 1984. The 'medallions' surrounding the 1983 *Crucifix* at the Chapel of Ease, Grange, Co. Carlow, depict the vocations or avocations of the people. His 1985 *St Catherine* in four panels went to Scoil Chaitríona in Dublin. A Saint Brigid group in low relief is over a well in Kilcullen, Co. Kildare.

Cill Mhuire Church, Newbridge, has two limestone pieces, *Madonna,* 1983, and *St Anthony and Child*, 1986. At the Kilcock Art Gallery in 1984 his twelve exhibits included five ceramics, four representing the seasons, and *The Human Condition*. Among sculpture was *The Prima Donna*, lime. In 'The Religious Spirit in Contemporary Art' exhibition at Westminster Cathedral in 1985 he was represented by *The Good Samaritan*. In 1986 at Kilcock he showed twelve works on the themes of music, dance, relationships. *Pas de Deux* and *Three Dancing Ladies*, both elm, represented dance. The two highest priced works were both under relationships : *Consolation* and *'Our New Baby'*.

The pieces or groups for the sixteen niches in a wooden structure in the St Dominic's Church reredos in Dublin are all in elm; the last completed in 1990, *Angels for Dormition*. A life-size statue, *Fr Peter O Higgin*, the seventeenth century martyr, with a rope around his neck, is outside the Newbridge College church, also *St Dominic* is similarly placed.

A statue of Saint Colman, the limestone quarried outside Kilkenny, with a small deer at his feet, was unveiled by the sculptor in 1991 at St Colman's Cathedral, Newry, Co. Down. Cost of the limestone alone for *St Kilian* with long cloak and cowl, at Mullagh, Co. Cavan, was £900. In 1991 he returned to exhibiting at the RHA : *War Widows,* polished limestone, and in the same material he showed *Stone Hen* in 1992. The Nativity scene at the Newbridge College church was done year by year, shepherds, then kings, angels and so on. Commissioned by his own community, he executed a work for a new plot in the local Kilbelin cemetery. The *Pieta*, as he liked to call it, 'had to be' placed in the best position regarding light, so it faces outwards, rather than towards the graves. He was the first to be buried there.

'A self-satisfied artist is to my mind an impossibility...' wrote Father Flanagan. 'On the other hand, to debase oneself, to deny one's worth or talents is only false humility. It's difficult to strike a balance. But it's very important not to take oneself too seriously. A healthy sense of humour is very necessary in order to see the idiot lurking in the foreground.' Altogether, he produced some 400 pieces, many going to private collections. 'I do it for the agony and the ecstasy,' he said in a studio interview a few weeks before his death. He died on 26 April 1992 at the Meath Hospital, Dublin.

Works signed: HF monogram or H . Flanagan.
Examples: Athy, Co. Kildare : St Dominic's Church. Ballincollig, Co. Cork: Church of Christ Our Light. Blackrock, Co. Dublin: St Dominic's School, Sion Hill. Curragh, Co. Kildare: Golf Club. Drogheda, Co. Louth: Monastery of St Catherine of Siena; St Magdalene's Church. Dublin: Dominican Convent, Cabra; Office of Public Works; St Dominic's Church, Tallaght; St Dominic's Secondary School, Cabra; St Mary's Priory, Tallaght, also Retreat House; St Saviour's Church; Scoil Chaitríona, Mobhi Road; Sisters of Our Lady of Charity Convent, Grace Park Road. Ennis, Co. Clare; Coláiste Mhuire Secondary School. Gormanston, Co. Meath: Gormanston College. Graiguecullen, Co. Carlow: St Clare's Church. Grange, Co. Carlow: Chapel of Ease. Kilcullen, Co. Kildare: Riverside Park. Kildangan, Co. Kildare: Our Lady of Victories Church. Knock, Co. Mayo: Basilica of Our Lady. Littleton, Co. Tipperary: Church of Our Lady and St Kevin. Loughrea, Co. Galway: Carmelite Church. Malahide, Co. Dublin: Carmelite Monastery of St Joseph, Seapark. Mullagh, Co. Cavan: St Kilian's Church. Mullingar: Longford-Westmeath County Library. Newbridge, Co. Kildare: Cill Mhuire Church; Newbridge College; St Conleth's Cemetery, Kilbelin; Scoil Muire. Newry, Co. Down: St Colman's Cathedral. Sligo: Holy Cross Church. Tralee, Co. Kerry: Holy Cross Priory.
Literature: Stephen Rynne, intro., *The Sculpture of Henry Flanagan O.P.*, The Curragh 1979 (also illustrations); Kilcock Art Gallery, *Sculpture by Henry Flanagan O.P.*, catalogue, Kilcock 1982; also, *George W. Walsh, Fr. Henry Flanagan,* catalogue, Kilcock 1984; *Fr. Henry Flanagan, O.P., Sculptures*, catalogue, Kilcock 1986; Ann M. Stewart, *Royal Hibernian Academy of Arts: Index of Exhibitors 1826-1979*, Dublin 1986; *Royal Hibernian Academy of Arts 1991, 1992,* catalogues; *Irish Times*, 28 April 1992; *Irish Catholic*, 7 May 1992; James Downey, 'A View from Dublin', *The Universe*, 10 May 1992; *Newbridge College Annual*, 1992; Catholic Press and Information Office, *Letter to the author,* 1997; also,

St Magdalene's Priory, 1997; Sister Maureen Flanagan, OP, *Letters to the author,* 1997, 1998; University College Galway, *Letter to the author*, 1998.

FLANNAGAN, JOHN B. (1895-1942), sculptor. Of Irish descent, he was born at Fargo, North Dakota, USA, on 7 April 1895. In the introduction to the catalogue issued for the exhibition at the University of Notre Dame, Indiana 1963, Robert J. Forsyth wrote: 'He seemed destined to attract the tragic to himself: a father's premature death, separation from his mother and placement in an orphanage for five years, poverty, alcoholism, his desertion of a dependant mother and brother for an art career, a broken marriage, two crippling injuries (twice struck by cars), and attempts at suicide. In spite of these tragedies, however, he displayed his brilliant intelligence and natural Irish charm and humour both in his writings and his works'.

Flannagan studied painting for three years at the Minneapolis Institute and School of Arts. When he left in 1917 he became an able-bodied seaman and spent five years in the merchant marine. He then worked on a farm where he painted at night and also started carving in wood. His attempt to carve large wooden planks in low relief as supports for his strange wax paintings drew him to sculpture. By 1926 he had abandoned wood for stone and was self-taught.

Forsyth in his introduction to the Notre Dame catalogue also wrote: 'He had a natural, intuitive feeling for and attraction to stone, as did his ancient ancestors ... He accomplished his work by a most careful search for exactly the right stone ... From this stone, with seemingly little effort ... he released the human figure or animal which he visualised as providentially having been hidden there ...'

A dream made possible through a grant of money from his dealer enabled Flannagan to visit Ireland in 1930 and he remained a year in Connemara. The stone *Donkey* and drawings *Ibex* and *Tired Irishman* are from this period, and he also visited Paris. Another period, from 1932 to 1933, encompassed a second trip to Ireland, this one financed by a Guggenheim Fellowship and producing work in granite of mythological or primeval animals as well as the repetitious theme of mother-and-child. At the Hugh Lane Municipal Gallery of Modern Art, Dublin, is *Mother and Child* in limestone.

In a letter dated 22 June 1930 from Clifden, Ireland, to his dealer, Carl Zigrosser, he wrote: 'This comes from the rocky wilds of Connemara and these hills are a sculptor's dream – or nightmare – I still don't know which. Stone-stone-green-white-black marble – granites including my black. None of it being quarried – you just find it in the fields and fences. Ireland is the most beautiful country I've ever seen and that's said with no sentiment. I'm tempted to paint again – so don't be surprised if I fall.' In the same letter he said he did not feel the need for drink any more.

Flannagan's letters, in which he frequently mentioned his allowance and other money matters, revealed that his wife Grace was expecting a child. They had to pay a year's rent for the house, reduced from £30 to £25 after he had done some repairs. If anywhere was an animal's country, Ireland was surely it; his agent was bound to receive at least one Connemara Ram. 'The goat has such a decorative quality, and then there's the thoughtful sadness of the ass,' he wrote.

After relishing the country's loneliness and its wildness, some disillusionment set in. The people had charm and humanity of a sort that was 'sometimes lovable – and sometimes in their very casualness – maddening. They will do most anything for you, but rarely do it well'. The place was not practical for a sculptor. He had painted a lot of watercolours for the most part at night when too tired to carve. They never saw anyone except the tradespeople. However, 'old' Augustus John (1878-1961) passed by 'in a very sporty roadster that hardly became his beard'.

In September 1930 Flannagan wrote to Zigrosser that he would have '37 things' for him before December; he felt it was the finest work he had ever done. The mere matter of tools was heart-breaking; he had to send them to Galway to get them properly sharpened at a shilling apiece, perhaps at the rate of forty per week when busy. '... I've got one great thing since I've come and that is a certain sort of assurance as to the future. I mean by that I'm dead sure of the things I do now. In short I feel capable, and I think, touched a sculptural secret that is real ...' In a letter dated 17 November 1930 he said he would very much like to stay on for a while. He was a little more at peace with himself, if not with the rest of the world. In another letter dated 23

January 1931 he reckoned he could move his family to Paris for not more than fifty dollars. The most logical thing about Ireland was 'the presence of the Blarney stone'.

After his return in June 1933 from his second visit to Ireland, Flannagan went through a period of strain which resulted in a breakdown and confinement in Bloomingdale Hospital, New York, for six months, leaving in March 1935. In that year his first monumental sculpture, *Design for a Skyscraper Court*, was completed. Several exhibitions of his work were held at the Weyhe Gallery, New York, where there was a large showing in 1938. The following year he had a near-fatal accident. In two decades he had carved more than 200 sculptural works in wood, stone, and metal.

Jonah and the Whale, bronze; *Elephant*, bluestone; *Frog*, sandstone; *Monkey*, granite, are all in American galleries. *Kitten on its Back*, field stone, and *The Rag Doll*, bronze, are in the Ulster Museum. Flannagan did not sign his sculptures. His death was by suicide on 6 January 1942; a mask is in Minneapolis. In that year, memorial exhibitions were held at Buchholz Gallery, New York, and the Museum of Modern Art. A memorial exhibition was also held at the Institute of Arts, Detroit, 1943. The 1963 exhibition held at the University of Notre Dame contained drawings, paintings, woodcuts as well as sculpture.

Works signed: John B. Flannagan, drawings.
Examples: Ann Arbor, Michigan: University of Michigan Museum of Art. Baltimore, Maryland: Museum of Art. Belfast: Ulster Museum. Detroit, Michigan: Detroit Institute of Arts. Dublin: Hugh Lane Municipal Gallery of Modern Art. Lincoln, Nebraska: University of Nebraska. Minneapolis, Minnesota: Minneapolis Institute of Arts. New York: Metropolitan Museum of Art; Whitney Museum of American Art. Philadelphia, Pennsylvania: Museum of Art. St. Louis, Missouri: Art Museum.
Literature: *The Studio*, April 1934 (also illustrations), October 1936 (also illustration), April 1938 (also illustration), July 1938 (illustration), August 1943 (also illustrations), June 1944 (illustration); W.R. Valentiner, intro., *Letters of John B. Flannagan*, New York 1942; Corporation of Dublin, *Municipal Art Gallery, Dublin*, catalogue, 1958; University of Notre Dame, *John B. Flannagan*, catalogue, Notre Dame, Indiana 1963; Minneapolis Institute of Arts, *Letter to the author*, 1985.

FLYNN, GERTRUDE – see O'FLYNN, GERTRUDE

FOX, KATHLEEN (1880-1963), portrait, flowerpiece and historical painter. Born in Dublin on 12 September 1880, her father was Captain Henry Charles Fox, King's Dragoon Guards. She studied under William Orpen (q.v.) at the Dublin Metropolitan School of Art and for a period acted as his assistant. In the National Competition of 1908 she won a gold medal for a cup of beaten copper and 'basse-taille' enamel, with design of processional draped figures. The cup was displayed in London at the Victoria and Albert Museum. Again under Oswald Reeves (q.v.) she was responsible for *A Shaving Mirror with Pendant on Copper Stained in Zodiacal Design of Sagittarius.*

In 1910 the School of Art students organised a 'past and present' exhibition at 35 Dawson Street, and her watercolours, oil paintings, enamels and stained-glass also won admiration. Among the stained glass panels, *The Healing of St Tobias* attracted attention and was erected that year in St Joseph's Church, Glenageary, Co. Dublin. At the Arts and Crafts Society of Ireland exhibition in 1910 she displayed enamels. She showed *Science and Power* and a portrait at the 1911 Royal Hibernian Academy .

As a continuation of her training, she had a studio in London, and also worked in Paris. At the RHA in 1913 her address was given as 20 Rue Chalgrin, Avenue de Bois de Boulogne, Paris, and she contributed: '*All Alive, O*' and *The Tiger*. Post-war, she had a studio in Bruges, Belgium, and travelling widely, she spent time in Germany and France. Throughout her life, more than eighty works were exhibited at the RHA in the period 1911-57.

In 1916 she went openly and in a spirit of curiosity into some of the most dangerous centres in Dublin to capture in her paintings, from an artistic viewpoint, the scenes of The Rising. She portrayed Countess Markievicz (q.v.) surrendering outside the College of Surgeons. A painting entitled *The Fishwife* is of her active Republican friend, Grace Gifford (q.v.). In 1917 she married Lieutenant Cyril Pym, British Army, who was killed the following year. In 1920 the RHA catalogue listed her address as 2 Harcourt Place, Westland Road,

and she showed several works, including *Bruges-Pont du Cheval Snow*; *Fish Market, Bruges*; *T.P. Wall, Esq., B.L.*; and *Major C.V. Fox, D.S.O., Scots Guards*, her brother.

Kathleen Fox, Sir John Lavery (q.v.) and Orpen were all represented at the National Portrait Society's 1921 exhibition in London. A portrait of Mervyn, 8th Viscount Powerscourt, in the uniform of an Irish Deputy Lieutenant and with the sash, star and cloak of the Order of Saint Patrick was painted in 1922. She showed occasionally at the Walker Art Gallery, Liverpool, and in London at the New English Art Club, Royal Society of Portrait Painters, Royal Academy and the Society of Women Artists.

At the Royal Scottish Academy in 1921 she showed *Oxeye Daisies*, and at the Royal Academy that year, giving an address 3 Scarsdale Studios, Earl's Court, London, she exhibited *Archbishop Mannix*, an oil which she had painted in London at Nazareth House, Hammersmith, sharing the sitting with the sculptor Albert Power(q.v.). She presented this work in 1937 to the Municipal Gallery of Modern Art, Dublin. When the exhibition of Irish art was held at Brussels in 1930 she was represented by an enamel plaque. She also showed at the Oireachtas exhibitions in Dublin.

An exhibition at the Dawson Gallery, Dublin, in 1946 included: *Entrance Hall, College of Surgeons*; *Violets*; and *The Blue Jug*. In 1953 she was represented in the Contemporary Irish Art exhibition at Aberystwyth. The Thomas Haverty Trust had presented to the Municipal Gallery of Modern Art, *Those of Yesterday*, an interior of her studio in Paris. She also presented to the gallery *Science and Power*. A portrait of Albert Power was also donated to the Municipal by the artist. At the RHA in 1953 she exhibited: *The Lilies of the Field*; *Rhododendrons*; and *Christmas Day*.

In the Model and Niland Centre, Sligo is *The Arrest 1916 (College of Surgeons)*. *The Four Courts* is in the possession of University College, Dublin. *The Entombment* is in the Church of the Assumption, Milltown, Dublin. *Stations of the Cross*, oil on canvas specially designed to fit into marble niches, are at the Jesuit House of Studies, Milltown Park, Dublin. After considerable preparation, she began the work there when she was in her middle seventies, taking two years to complete. Mrs Fox Pym lived at Brookfield, Milltown, where she died on 17 August 1963.

Works signed: K. Fox.
Examples: Cork: Crawford Municipal Art Gallery. Dublin: Church of the Assumption, Milltown; Jesuit House of Studies, Milltown Park; Hugh Lane Municipal Gallery of Modern Art; University College (Newman House). Glenageary, Co. Dublin: St Joseph's Church. Limerick: City Gallery of Art. Longford: County Library. Neath: Meath County Library. Sligo: Model and Niland Centre. Waterford: City Hall, Municipal Art Collection.
Literature: *The Studio*, September 1908, March 1910, January 1915; *The Builder*, 31 October 1908; *Sinn Fein*, 11 January 1910; *Irish Independent,* 27 October 1921; *Contemporary Irish Art*, catalogue, Aberystwyth 1953; *Irish Press*, 29 August 1963; National Gallery of Ireland, *Golden Jubilee of the Easter Rising*, catalogue, Dublin 1966; *Dictionary of British Artists 1880-1940*, Woodbridge 1976; Rev. Cyril Barrett, SJ, *Letter to the author*, 1984; Christie, Manson & Woods, Ltd, *Powerscourt Auction*, catalogue, London 1984; Miss Susanna Pym, *Letters to the author*, 1985; Ann M. Stewart, *Royal Hibernian Academy of Arts: Index of Exhibitors 1826-1979*, Dublin 1986; *The Royal Scottish Academy Exhibitors 1826-1990*, Calne 1991; John Turpin, *A School of Art in Dublin since the Eighteenth Century*, Dublin 1995 (also illustrations).

FRENCH, PERCY (1854-1920), landscape painter and illustrator. William French was born on 1 May 1854 at Cloonyquin House between Elphin and Tulsk in Co. Roscommon. The French family had lived in the area since the eighteenth century. His father, Christopher French, was a Doctor of Law; his mother was the daughter of the Rev. William Percy. When his professional days on the stage arrived, Willie became known as Percy French.

During Willie's boyhood, his father lived for a time in Derby, and he was sent to an English preparatory school at Kirk Langley. He then moved, when aged thirteen, to Windermere College. In order to prepare for the Trinity College, Dublin, entrance examination, he was sent to Foyle College, Londonderry, for special coaching. At Foyle he became a friend of John Ross, later Lord Chancellor of Ireland. Sir John wrote of French: 'His rapid sketches and drawings were a source of wonder and delight to us all'. It seems likely that

he contributed to the school magazine, *The Birch*. In 1872 he entered Trinity, but did not complete his engineering degree until eight years later, he and his banjo being popular.

In 1872 he exhibited with the Water Colour Society of Ireland for the first time and from then until 1910 showed a total of sixty-four works.

In 1881 he took up an appointment with the Board of Works in Cavan as an engineer on a drainage scheme. In his seven years there, he painted watercolours in his spare time, started a sketching club and wrote songs. He lived at 16 Farnham Street, Cavan. On returning to Dublin he became associated with the Dublin Sketching Club, sang his songs in smoking concerts, and was appointed a 'working member' in 1890; his address was St John's Road, Sydney Parade. Minutes of the club dated 1 July 1891 referred to his 'recent bereavement', his wife having died after a year's marriage.

The Percy French Society collection includes a door taken from a house in Baldoyle, Co. Dublin, where he lived for a short time after his wife's death. French painted local seascape scenes on the panels of the door. The short-lived *The Jarvey*, the Irish *Punch*, of which he was editor, had ceased publication at the end of 1890. *St Cast, Brittany* was painted in 1893.

In the period 1891-1901, French showed two dozen works at the Royal Hibernian Academy. His four pictures at the 1894 exhibition included *Peat Burning, Co. Mayo* and *Morning, Nassau Street*. He also wrote stories and verse as well as the libretti of a musical comedy, a comic opera, and an opera, all produced in Dublin. Prior to his second marriage early in 1894, he painted in Devon and Hampshire. In a Belfast Art Society catalogue, 1895, he was listed as a member, at 38 Mespil Road, Dublin. He gave sketching classes, and his entertainment in 1899 at the Molesworth Hall, Dublin, attracted a large gathering. Throughout his life he never had a lesson in singing, acting, drawing or painting.

Richard Orpen (q.v.), an architect by profession, had contributed a number of drawings to *The Jarvey*. French and Orpen now produced 'Dublin-up-to-date' at the Antient Concert Rooms with sketches, recitations and a comic lecture. Richard could not travel far and Percy took over his sketching act and decided to go it alone with 'the orchestra', Dr W.A. Houston Collison. French sketched with coloured chalks on large sheets of paper but when these were turned upside down they had become something else. 'Chuckles in Chalk' he described them. Another of his artistic acts was to create a picture on the back of a china plate, having blackened it by candle-smoke and then 'etched' it with a matchstick or the wrong end of his brush.

Sadly lacking in business sense, his generally atmospheric watercolours, many of Irish bogland or heather-clad mountains, were either sold for a song or given to friends. His contributions to the 1896 RHA included *Bogland near Omagh*. His name, however, was a household word in most Irish towns, both as entertainer and artist. Contributions at the 1897 WCSI exhibition included *Sketches at Stanstead, Hampshire* and *In Galway Bay, an eligible building site*.

In 1900 *The Studio* mentioned in the March issue that this 'well known painter of Irish skies and bogs' was about to take up his residence in London; then, in the July number reported that he had just spent a few weeks in Dublin, after a tour in the West of Ireland; and in December described his *The Queen's Entry into Dublin* as a 'bright bit of colour' at the Dublin Sketching Club exhibition. This work is now in the National Gallery of Ireland. In the Royal Library at Windsor Castle is a drawing of the Queen Victoria procession entering Phoenix Park.

Galway Bay was his final exhibit at the RHA, sent from 21 Clifton Hall, St John's Wood, London, and now his headquarters, but he still sang his amusing, popular songs and painted in Ireland. In 1901 he appeared at Kingstown Town Hall. *Morning, Dublin Bay* was painted in 1905. His appearances at Steinway Hall, London, were run in conjunction with painting exhibitions at the New Dudley Gallery, 169 Piccadilly. His one full-scale West End production was a children's play, *Noah's Ark*, which ran during the Christmas season 1905-6. In 1907 at the New Dudley he held a joint exhibition with Mildred Butler, Claude Hayes and Bingham McGuinness (qq.v.). He also exhibited in London at the Modern Gallery.

French and his musical director, Dr Collisson, received a farewell dinner at the Savage Club, London, on 27 September 1910, prior to their tour in Canada – opening at Montreal – and the USA. French was said to have borne a distinct resemblance to the American humorist, Mark Twain. 'Humours of Art and Music' was also presented at Bermuda, the West Indies and Panama. As French once said, 'We unite brains, beauty,

brushwork and banjos in one harmonious whole'. *New York from the Hudson* and *The Jetty, Quebec* are both in the Percy French Society collection.

Towards the end of 1913 on behalf of 'Waifs and Strays' he visited Switzerland, performed in the hotels and sketched the snow-clad mountains; an exhibition of some of these scenes was held in 1914 at the United Arts Club, Dublin, where he occasionally stayed. During the First World War, he and his partner travelled in Ireland, England and France entertaining the troops and raising money for war charities. In the month that hostilities began their itinerary included: August 5, Gweedore, Co. Donegal; 12, Ballycastle, Co. Antrim; 19, Kilkee, Co. Clare; 26, Wicklow. When he appeared with Miss May Laffan at the Molesworth Hall in Dublin in April 1918, 'Will Wagtail' was another name for 'the inimitable Percy French'. A portrait of French by Sir Robert Ponsonby Staples (q.v.) is in the Ulster Museum.

Early in 1920, when travelling home from an engagement in Glasgow, he was taken ill and, breaking his journey, made his way to the home of his cousin and friend, Canon J.B. Richardson at Formby, Lancashire, where he died on 24 January. Such were the circumstances of his wife and three daughters, that a Percy French Memorial Fund was established.

In 1951 a memorial was unveiled at Newcastle, Co. Down, erected by the Urban Council in memory of French and his song, 'The Mountains of Mourne'. Fifty years after his death a plinth of Mayo granite was unveiled at St Luke's Church cemetery, Formby, organised by the Liverpool Irish Centre. In 1974, 1979 and 1982 exhibitions of his works were held at the Oriel Gallery, Dublin. In 1978 there was a French exhibition at the Ulster Museum. A bust of French by Jim Joe McKiernan was unveiled in 1984 at Cloonyquin by his daughters, Ettie and Joan, who had travelled from England. In 1983 the Percy French Society had been formed, and by 1999 their collection included eighty watercolours, some 70% signed, at the North Down Heritage Centre.

Works signed: Percy French, P.F. , W. Percy French, W.P. French, W.P.F.; or P. French, rare (if signed at all).
Examples: Armagh: County Museum. Bangor, Co. Down: North Down Heritage Centre. Belfast: Ulster Museum. Dublin: Hugh Lane Municipal Gallery of Modern Art; National Gallery of Ireland. Limerick: City Gallery of Art. Lissadell, Co. Sligo: Lissadell House. Sligo: Model and Niland Centre. Windsor, Berkshire: Windsor Castle, Royal Library.
Literature: *Irish Times*, 24 August 1899, 12 August 1901, 10 April 1974, 17 May 1977; *The Studio*, March 1900, July 1900, December 1900, May 1903; *The Lady of the House*, 1915, 1916 (illustrations); *Irish Cyclist and Motor Cylist*, 3 April 1918; *Irish Book Lover*, March 1920, October-November 1920; Mrs De Burgh Daly, *Chronicles and Poems of Percy French*, Dublin 1922; Mrs De Burgh Daly, ed., *Prose, Poems and Parodies of Percy French*, Dublin 1925; J. Crampton Walker, *Irish Life and Landscape*, Dublin 1927 (also illustration); *Capuchin Annual*, 1945-46; *Belfast News-Letter*, 1 November 1951; James N. Healy, *Percy French and his Songs*, Cork 1966; *Ireland of the Welcomes*, July-August 1974 (illustrations); *Dictionary of British Artists 1880-1940*, Woodbridge 1976; Honor Rudnitzky, *The Careys*, Belfast 1978; Christie's, *Mildred Anne Butler*, catalogue, London 1981; Brendan O'Dowda, *The World of Percy French*, Belfast 1981; D.A.E. Roberts, *Letter to the author*, 1985; Ann M. Stewart, *Royal Hibernian Academy of Arts: Index of Exhibitors 1826-1979*, Dublin 1986; Anne Crookshank and the Knight of Glin, *The Watercolours of Ireland*, London 1994 (illustration); Ettie French, *Willie*, Belfast 1994 (also illustrations); *Water Colour Society of Ireland Exhibition List 1872-1994*, Dublin 1995: Percy French Society, *Letter to the author*, 1999.

FREWEN, CLARE – see SHERIDAN, CLARE

FRIERS, IAN, RUA (1909-75), sculptor. Born on 28 February 1909 in Belfast, Thomas Ian Friers was the son of William Friers, cashier, and a brother of the cartoonist, Rowel Friers (q.v.). Educated at Belfast Model School, he then studied fine art at the Belfast School of Art, but never embarked on a professional career as an artist.

A member of the Royal Naval Volunteer Reserve, he was called up in 1939 and served throughout the War. In the Navy he became interested in wood sculpture. He used to do drawings of imaginary branches and knots in trees, using their forms to create living images. Soon after, he found most of his early carving inspiration in pieces of wood already shaped by nature, turning them into bird and animal carvings. He claimed he achieved his results through 'erosion' rather than through carving.

At the 1950 Royal Hibernian Academy he showed *Regency*, a woman's head in ash; and in 1951, *The Spartan*. In 1954 the *Dublin Magazine* found his wood carving *Today and Yesterday* had 'something of a Chinese perfection in form and surface'. In the following year, again at an Institute of the Sculptors of Ireland exhibition, the element of satire in *Oh My Papa* was noted in the magazine. He also exhibited at the Institute in 1953 and 1956. When living at Dundonald, Co. Down, his work was included in an exhibition, Contemporary Irish Art, at Aberystwyth, 1953. That year he showed his fourth and final piece at the RHA, *Mother and Child*.

An academician of the Royal Ulster Academy, he was a regular exhibitor. A friend of Sir Gerald Kelly, PRA (1879-1972), it was through his and his brother's efforts that Kelly participated in RUA exhibitions. When the new CEMA gallery was opened in Belfast in 1960 with a show by Ulster artists, Ian Friers's work was included. He is represented by *Woman* in the Arts Council of Northern Ireland collection. After a long illness, he died in hospital on 14 November 1975. An exhibition of his works was held at the Grendor Art Gallery, Holywood, in 1976.

Works signed: TIF, monogram inside triangle.
Examples: Belfast: Arts Council of Northern Ireland.
Literature: *Dublin Magazine*, July-September 1954, July-September 1955; Grendor Art Gallery, *A Tribute: Exhibition of Works of the late T. Ian Friers, R.U.A.*, catalogue, Holywood 1976 (also illustrations); Martyn Anglesea, *The Royal Ulster Academy of Arts*, Belfast 1981 (also illustration); Rowel Friers, *Letter to the author*, 1985.

FRIERS, ROWEL, RUA (1920-98), cartoonist and illustrator. Born in Belfast on 13 April 1920, Rowel Boyd Friers, brother of Ian Friers (q.v.), was the son of William Friers, cashier, from Co. Monaghan and a Huguenot background. Educated at Park Parade Intermediate School, Belfast, in 1935 he began his apprenticeship as a designer and lithographer with S.C. Allen and Co. Ltd., being released for study at the Belfast College of Art. Eventually he was awarded a full-time scholarship after Allen's went into liquidation in 1939.

Belfast was subject to heavy German aerial bombardment in 1941, and a portfolio of lithographs, published by the Ulster Academy of Arts to raise money for the Ulster Hospital for Children and Women, included work by Friers. In 1942, from Keelong, Ballybeen, Dundonald, Co. Down, he exhibited at the Royal Hibernian Academy, and up until 1953 showed a total of twelve works. In 1945 he contributed two Co. Donegal landscapes, and in 1946: *Killinchy Farmstead* and *The Haunted House*.

Meanwhile his drawings had appeared in *London Opinion* and Queen's University students' magazine, *Pro Tanto Quid*. From 1943 he contributed to *Dublin Opinion* and the editors wrote later that he drew 'with great fluency and speed and skill, contributed drawings of every kind, from pirates with a sense of humour to lovelorn and guitar-strumming Mexicans.' He also drew for the *Radio Times*. The first book was *Wholly Friers* in 1948, and thereafter he averaged a publication per year containing his illustrations, either his own book or for another.

Friers designed sets and acted for Fisherwick Dramatic Society, Belfast. Duty officer at the wartime American Officers' Club, Union Hotel, he painted a mural in the club's billiards room. In exhibitions by Ulster artists at Ulster House, London, in 1947, and Grafton Gallery, Dublin, in 1948, he was represented. In the period 1948-53, ten of his cartoons appeared in *Punch*. In 1950 when the Royal Ulster Academy of Arts came into existence, his name was among the associates.

The famous Stanley Spencer (1891-1959), whose brother Harold lived in Belfast, knew Friers and called on occasions to see him at his Dundonald home. Spencer invited Friers to Cookham in Berkshire; the Ulster artist regretted later that he had not travelled. The Englishman wrote him a most flattering tribute to his draughtsmanship. In London, Friers met the cartoonists Leslie Illingworth (1902-79) and Ronald Searle.

In 1952 he showed *Variety Market* at the RHA, and in 1953, *Temptation in the Wilderness* (Royal Ulster Academy). His first one-person exhibition came in 1953 at the CEMA gallery, 55a Donegall Place, Belfast, 'one visitor per minute throughout its run,' October 19-31. The *Belfast News-Letter* commented: 'His draughtsmanship was of superb quality, the lines drawn with assurance and incisiveness. He had also

astonishing fertility of invention and richness of imagination.' Elected a full academician in 1953, he was represented in the Contemporary Irish Art exhibition at Aberystwyth.

From the single column top cartoon for the *Belfast Telegraph*, grew the large feature cartoon. Invited to do a series of illustrations for the *Irish Times*, he later contributed to the *Irish Press* and *Irish Independent*. The *Daily Express* published his work. He also designed for the Lyric Theatre, Belfast. An exhibition of his American cartoons opened at the Belfast Museum and Art Gallery in 1956. At the same venue, only thirty-seven works graced the Royal Ulster Academy annual show in 1958, the year of artistic controversy in Belfast. Being aware of the Irish Exhibition of Living Art in Dublin, Friers produced a cartoon for the *Belfast Telegraph* entitled *R.U.A. 'Exhibition of Livid Irish Art, 1958.'* The scene depicted outside the Museum at Stranmilllis showed protesters with placards. One read: 'We want a hanging committee not a lynching party!'

Friers showed with William Conor and Padraic Woods (qq.v.) at the Academy's rooms in College Square in 1960. A mural, *An Arabesque of Wild Horses*, 9.5 m x 6.5 m., was completed at his old school, Park Parade, in 1961. When the author enquired about the work in 1998, he was advised by an official of the Belfast Institute of Further and Higher Education that the bottom of the mural had been painted over! Friers supplied cartoons for *A State of Chassis* at the Peacock Theatre, Dublin, in 1970, and settings for grand opera in Belfast in 1971.

Riotous Living, one of several books of his cartoons, appeared in 1971. Illustrated with coloured insets, *Irish Folk Tales*, edited by W. B. Yeats, was issued in 1973 by the Limited Editions Club, Avon, Connecticut. In 1976 he held the first of his exhibitions at the Grendor Gallery, Holywood, Co. Down. TV graphics were produced for BBC and UTV. In 1977 he was awarded the MBE for contributions to journalism and art, and that year he was represented in the 'Cartoons of the World' exhibition at Berlin.

An honorary MA from the Open University was conferred in 1981. He supplied the illustrations for a religious education pack issued in 1988 by the South Eastern Education and Library Board, Belfast. In 1990 he won the Conor Award at the RUA exhibition, and switched regular cartooning from the *Belfast Telegraph* to the *News letter*.

Appointed RUA president in 1993, he served for four years. *Drawn from Life*, an autobiography, was published in 1994. At the National Portrait Gallery, London, he is represented by caricatures of Lord Fitt, Ian Paisley and Enoch Powell. At the Ulster Museum are two large pencil drawings, notably *The Old Masters*, 1992, with the artist depicted in a mirror; the other artists are: William Conor, John Luke, Frank McKelvey, Colin Middleton, Maurice Wilks and Padraic Woods (qq.v.). He died at his home, 33 Victoria Road, Holywood, on 21 September 1998.

Works signed: Rowel Friers, Rowel F. or R.F. (if signed at all).
Examples: Armagh: County Museum. Belfast: Arts Council of Northern Ireland; Mater Hospital; Royal Ulster Academy; Ulster Museum. Cultra, Co. Down: Ulster Folk and Transport Museum. Limerick: University, National Self-Portrait Collection. London: National Portrait Gallery.
Literature: Books illustrated, Belfast published unless otherwise stated; L. =London: Rowel Friers, *Wholly Friers,* Lisburn 1948; Jeanne Cooper Foster, *Ulster Folklore,* 1951; Rowel Friers, *Mainly Spanish,* 1951; S. K. Girvan, *Peter and His Tales of The Wee People,* L. 1951; Seán Mac Giollarnáth, *Conamara,* Dublin 1954; Janet McNeill, *My Friend Specs McCann,* L. 1955; also, *A Pinch of Salt,* L. 1956; *A Light Dozen,* L. 1957; *Specs Fortissimo,* L. 1958; *This Happy Morning,* L. 1959; *Special Occasions,* L. 1960; *Various Specs,* L. 1961; *Try These For Size,* L. 1963; Geoffrey Palmer and Noel Lloyd, *A Brew of Witchcraft,* L. 1964; Wendy White, *The Beedy Book,* L. 1965; Florence Mary McDowell, *Other Days Around Me,* 1966; Mary E. Beck, *Food, Fact & Figure,* Edinburgh 1967; Ida Moore, *Yandoon,* Langley 1967; Geoffrey Palmer and Noel Lloyd, *Moonshine and Magic,* L. 1967; also, *The Obstinate Ghost,* L. 1968; Benjamin Patrick, *Exploring Coins,* Feltham 1968; Geoffrey Palmer and Noel Lloyd, *Starlight and Spells,* L. 1969; John Barry, *Doonigan's Day,* Limerick 1970 (with C. E. Kelly); *Children Everywhere: The 1970 Childcraft Annual,* Chicago 1970 (Ireland section); Janet McNeill, *Best Specs,* L. 1970; Rowel Friers, *Riotous Living,* 1971; also, *Pig in the Parlour,* 1972; Florence Mary McDowell, *Roses and Rainbows,* 1972; Rowel Friers, *The Book of Friers,* 1973; W. B. Yeats, editor, *Irish Folk Tales,* Avon, Connecticut 1973; Ted Bonner, *Don't Shoot — I'm not Well,* Dublin 1974; Rowel Friers, *The Revolting Irish,* 1974: Tony McAuley, ed., *Today and Yesterday in Northern Ireland,* L. 1975; John Pepper, *What a thing to say,* 1977; also, *See me, see her?,* 1978; *A Quare Geg,* 1979; Billy Simpson, *The Best of Billy Simpson,* 1979; Cyril Cusack, *The Humour Is On Me,* 1980; Arthur Fowweather, *One Small Head,* Downpatrick 1980; John Pepper,

Ulster-English Dictionary, 1981; *The Royal Belfast Golf Club 1881-1981,* 1981; Rowel Friers, *On the Borderline,* 1982; Bill Nesbitt, *The only place for me,* 1982; Royal Victoria Hospital, Diabetic Clinic Staff, *Good Health and Diabetes: Non Insulin;* also, *Insulin Dependent,* 1985; John Pepper, *Ulster Haunbook,* 1986; Rowel Friers, *Trouble Free!,* 1988; Harry McCaw and Brum Henderson, *The Royal County Down Golf Club: The First Century,* 1988; Rowel Friers, *Friers Country,* 1991; also, *Drawn from Life,* 1994; Jonathan Swift, *Gulliver in Lilliput,* Oxford 1997; Rev. Frank Sellar, compiler, *Frankly Speaking,* Dublin 1998.
Literature: General: *Belfast News-Letter,* 7 September 1944, 28 September 1951, 20 October 1953, 13 December 1956; *The Studio,* July 1947; *Dublin Magazine,* July-September 1948; *Belfast Telegraph,* 4 April 1961, 22 September 1998; Tom Collins and Charles E. Kelly, editors, *Forty Years of Dublin Opinion,* Dublin 1961 (also illustrations); *Irish Times,* 17 September 1970, 4 May 1971; *Cartoons of the World,* catalogue, Berlin 1977; John Hewitt and Theo Snoddy, *Art in Ulster:1,* Belfast 1977 (also illustration); *Who's Who in Art,* Havant 1980; Martyn Anglesea, *The Royal Ulster Academy of Arts,* Belfast 1981 (also illustration); *Dictionary of British Book Illustrators: The Twentieth Century,* London 1983; Ann M. Stewart, *Royal Hibernian Academy of Arts: Index of Exhibitors 1826-1979,* Dublin 1986; David Savage and John Ferguson: South Eastern Education and Library Board, *Jesus the Man,* religious education pack, Belfast 1988 (illustrations); Theo Snoddy, *UTV Art Collection,* catalogue, Belfast 1996 (also illustration); R. Taylor Carson, *Letter to the author,* 1998.

FRÖMEL, GERDA J. (1931-75), sculptor. Born in Schönberg, Czechoslovakia, the eldest of four sisters of German parents, she moved with her family to Vienna in 1945. Between 1948 and 1952 she studied sculpture, first at Stuttgart, where she won a scholarship, and then at Darmstadt and Munich. In 1953 she travelled to Ireland, lived for a year in Dublin and then returned to Munich where she married a German sculptor, Werner Schurmann. In 1956 they settled at Woodtown, Rathfarnham, Dublin. A decade later her husband returned to Germany, leaving her the sole support of her four children.

The Irish Exhibition of Living Art first showed her work in 1956 and she continued to exhibit until 1975. In 1962, she showed with Independent Artists, and that year won the sculpture prize in the Irish Church Art exhibition. In 1963 she was the recipient of the Arts Council's scholarship in sculpture, value £600. In 1960 and 1962 she was represented in the Salzburg Biennale, and in 1964 her work was included in an Arts Council exhibition of graphic art and she had her first one-person show in Dublin, at the Dawson Gallery.

At an exhibition of contemporary Irish artists at the Cork Sculpture Park in 1969, she was represented by *Moon and Antimoon,* granite, and *Animal,* bronze. A joint exhibition with Michael Scott had been held at the Dawson Gallery in 1967. Three years later in a one-person show she exhibited sculptures and drawings at the same gallery. She did not exhibit at the Royal Hibernian Academy until 1972, and showed only six works; *Kilian and his Dog* appeared in 1974.

In 1970 a major commission for the Carroll factory in Dundalk had been completed. The pool fronting the factory was dominated by a polished stainless steel sculpture, *Sails,* a triple aircraft wing construction 8 ½ metres high mounted on pivots and capable of moving with the wind. In the IELA exhibiton two years later *Mobile Shape* was exhibited. The Oireachtas exhibitions in Dublin also attracted her submissions and, having been a prizewinner in 1970, she won the gold medal for sculpture in 1973. In 1972, she was an external assessor for the National College of Art and Design summer examinations.

At the Agricultural Credit Corporation in Hatch Street, Dublin, the setting for her work was a pool in the entrance hall of the building. The motif was a wheat grain composed of several interlocking pieces on a thin central spine, based on her moving wind sculptures and she had hoped to create an artificial draught to make them rotate. As this was not practicable in an entrance hall, an electric motor was used instead. This was highly complex as she wanted the individual pieces to move in different directions and at different speeds. The system, alas, gave up after a brief period.

The pink marble sculpture for Galway Regional Technical College has an archaic circular or oval form with a hollow dish carved out of the centre. There is also stainless steel sculpture outside the Setanta Building, Dublin. A versatile artist, she executed a number of portrait heads and also worked in alabaster, slate, onyx and zinc. *Interlocking Shapes,* alabaster on a marble stand, is in the Bank of Ireland collection. Stained glass is in Kildare Cathedral and in two German churches, at Cologne and Wuppertal. *Mobile,* aluminium, is at the Irish Museum of Modern Art; and there are four drawings and a collage in the Arts Council, Dublin, collection. A portrait of the artist by Hilda Roberts (q.v.) is in the National Gallery of Ireland.

In *Modern Art in Ireland*, 1997, Dorthy Walker noted: 'Her early work was a form of romantic figuration ...as she became involved in Ireland her work became increasingly abstracted; in the end, she had moved from bronze figures of girls and small children to stainless-steel abstractions and beautiful translucent alabaster works...' Professor George Dawson wrote: 'The charm and vivacity of Gerda Frömel was combined with a contrasting decisiveness. In her sculptures she knew exactly what she wanted and achieved it. Like all fine sculptors she was a craftsman ... She enhanced sculpture and the quality of life in Ireland ...'

The artist died tragically on 4 August 1975 after she had gone to the rescue of one of her sons who was in difficulties when swimming near Belmullet, Co. Mayo, the family being on holiday. She was buried at Whitechurch Cemetery, Rathfarnham. A retrospective exhibition, organised by the Arts Council and the Goethe Institute, was held at the Hugh Lane Municipal Gallery of Modern Art in 1976.

Works signed: G.J.F. (if signed at all).
Examples: Bray: Public Library. Cologne, Germany: Church of St. Clement, Mühlheim. Dublin: Arts Council; Hugh Lane Municipal Gallery of Modern Art; Irish Museum of Modern Art; Setanta Centre. Dundalk: P.J. Carroll & Co. Ltd. Galway: Regional Technical College. Kildare: Cathedral. Limerick: City Gallery of Art. Wuppertal, Germany: Church of Christ the King.
Literature: *Arts Council, Dublin, Report*, 1963-1964; Dublin Municipal Gallery of Modern Art, *Paintings and Sculpture (1945-65) from Private Collections in Ireland*, catalogue, Dublin 1965; *Irish Times*, 7,12,14 October 1970, 16 November 1972, 4, 7 August 1975; Michael Morrow, *Introspect*, 1975; Arts Council and the Goethe Institute, *The Sculpture of Gerda Frömel*, catalogue, Dublin 1976; Michael Scott, *Introspect*, 1976; Campbell Conroy Hickey Associates, *Letter to the author*, 1985; John Turpin, *A School of Art in Dublin since the Eighteenth Century*, Dublin 1995; Dorthy Walker, *Modern Art in Ireland*, Dublin 1997 (also illustration).

FROST, STELLA (1890-1962), landscape painter. Stella Noel Frost was born on 6 January 1890 at 23 Francis Road, Edgbaston, Birmingham, the daughter of the Rev. Charles H. Frost, Rector of Foulsham, Norfolk.

Stella Frost kept up a connection with the American poet, Robert Frost, who died in 1963. When living in Dublin at Hazelbrook, Terenure Road West, where she ran schools for girl gardeners, she was perhaps better known as a close friend of Evie Hone and Mainie Jellett (qq.v.) than as an artist.

In the period 1932-54 inclusive she showed thirty-seven works at the Water Colour Society of Ireland exhibitions. Her initial contributions included *On the coast of Dalmatia* and *The Big Mosque, Sarajevo*. In 1934, *In Mallorca* was her sole contribution.

At the Royal Hibernian Academy in 1935, she showed two Ibiza scenes, and she exhibited occasionally at the Irish Exhibition of Living Art: in 1953, *Achill Turf House*; and in 1958, *Atlantic Sculpture*. Some of her work appeared at the Victor Waddington Galleries, Dublin; *Villeneuve*, a gouache, was sold there. As well as her interest in gardening, she was also a water diviner.

Staying in a house at Keel West, Doagh, Achill Island, she spent many holidays painting with Mainie Jellett, and indeed on her own; she was there, for example, in 1956. *Achill Rocks* is in the collection of the Voluntary Health Insurance Board, Dublin, and *Bog Hill, Achill Island* is at the Crawford Municipal Art Gallery, Cork.

Performing the offices of friendship, she compiled and edited *A Tribute to Evie Hone and Mainie Jellett*, in which she wrote: 'Few people have been fortunate enough, as I have, to make pilgrimages with Evie Hone to the great cathedrals of Chartres, Le Mans and Bourges, and to spend intensive weeks with her in Paris visiting the modern stained glass workers, and exhibitions of painting, tapestry and sculpture.' She was on the committee which arranged the Hone retrospective exhibition at University College, Dublin, 1958. She died four years later, and is buried in the Church of Ireland graveyard at Tallaght, Co. Dublin.

Works signed: Stella Frost.
Examples: Cork: Crawford Municipal Art Gallery. Dublin: Voluntary Health Insurance Board. Kilkenny: Art Gallery Society. Limerick: City Gallery of Art. Sligo: Model and Niland Centre. Wexford: Arts Centre.
Literature: *Register of Births, Edgbaston*, 1890; Stella Frost, *Letter to Thomas MacGreevy*, 1956, TCD Papers; Stella Frost, ed., *A Tribute to Evie Hone and Mainie Jellett*, Dublin 1957; *Irish Times*, 7 July 1979; Miss Wilhelmina Wilson, *Letters to the author*, 1984; *Water Colour Society of Ireland Exhibition List 1872-1994*, Dublin 1995.

FRY, ARTHUR (1865-1936), landscape, marine and portrait painter. Born Otley, Yorkshire, on 25 September 1865, son of William Fry, secretary and librarian, William Arthur Fry was educated at Salt Schools, Shipley, Yorks. One of the original members of the Belfast Art Society, he acted for some years as secretary. In 1909, with a Holywood, Co. Down, address he showed *September Sea at Portrush* at the Yorkshire Union of Artists' exhibition at Cartwright Hall, Bradford.

After serving for about fifteen years as an artist with the Belfast printing firm of McCaw, Stevenson and Orr Ltd, he left in the early 1920s to work on his own, soon producing illuminated addresses, some for the Urban District Councils and these were presented to King George V when he visited Belfast to open the first Northern Parliament in 1921.

Fry showed two works, *Spring in the Woods* and *Ardglass* at the 1920 Water Colour Society of Ireland exhibition. Representing the Belfast Art Society, he was co-opted on to the city's Libraries, Museums and Art Committee in 1921 and rendered 'valuable assistance' as a member of the art sub-committee. He was also a lecturer, and addressed the Belfast Natural History and Philosophical Society.

When a loan exhibition of oil paintings and early British watercolours was held at the Belfast Museum and Art Gallery in 1920, one of his watercolours was *Awaiting the Chieftain, Sean O'Neill's Castle*, which he regarded as one of his principal works; he showed it at the Royal Hibernian Academy in 1919. In another loan exhibition, held at the museum in 1927 and entitled 'Irish Portraits by Ulster Artists,' he was represented by four works, including a portrait of Alderman Sir William G. Turner, Lord Mayor of Belfast.

Fry was represented at the British Empire Exhibition, 1924. At the RHA he showed a total of eleven works, contributions in 1925 including: *A Girl of Mozambique* and *The last days of H.M.S. Hindustan*; in 1926 he exhibited *The Hayfield* and *Pastorale*. He was one of the first eight associates elected in 1930 to the Ulster Academy of Arts. His pictures are in the 'Old Belfast' collection at the Ulster Museum, for example *Cranmore House, Malone*, watercolour, and *Macedon, Whitehouse*, sepia. A portrait in watercolour of John Renshaw is at Queen's University. He died on 24 February 1936 at his residence, High Street, Holywood.

Works signed: W.A. Fry.
Examples: Belfast: Queen's University; Ulster Museum.
Literature: *Who's Who in Art*, 1927; *Belfast Telegraph*, 24 February 1936; *Belfast Museum and Art Gallery Annual Report*, 1 April 1935-31 March 1936; Martyn Anglesea, *The Royal Ulster Academy of Arts*, Belfast 1981 (also illustration); City of Bradford Metropolitan Council, *Letter to the author*, 1985; Ann M. Stewart, *Royal Hibernian Academy of Arts: Index of Exhibitors 1826-1979*, Dublin 1986; Eileen Black, A Sesquicentennial Celebration: Art from the Queen's University Collection, Belfast 1995; *Water Colour Society of Ireland Exhibition List 1872-1994*, Dublin 1995.

FRY, WILLIAM H. (1883-1962), painter and designer. Eldest son of William Fry, a regular soldier, he was born in Belfast but educated at the Irish Society Schools, Coleraine, Co. Derry. Entering the Government School of Art in Belfast in 1896, he won numerous certificates, the National bronze medal for damask design and the Dunville Scholarship, which, unfortunately, he was unable to accept.

At the age of seventeen he began a career in damask designing, working for Mather's, later for William Adams and Co. Ltd, and for another Belfast linen firm, J.N. Richardson, Sons and Owden Ltd he designed the 'Shakespeare Cloth', which bore scenes from eight plays. His ability at plant drawing was well known in the linen houses of Ireland. In 1932 he was the designer of the altar cloth used at the Eucharistic Congress, Dublin.

A member of the Ulster Arts Club, he was a friend of Paul Nietsche (q.v.), F.L. Green, the novelist, and John Irvine, the poet. In his youth he had shown an interest in oil painting, but his work in this medium mainly circulated at home and overseas in the form of prints, produced by the London firm of A. and C. Bell. Three 'collotypes in colour' were: *An Irish Holiday*, depicting early morning near Strangford Lough, where, as a lover of sailing, he kept a boat; *An Irish Farmstead* and *Going to the Meet*. He used the palette knife in his painting. An exhibition of landscape oil paintings was held at Robinson and Cleaver's, Belfast, 1937.

Fry continued damask designing right up until the time of his death. In 1937 he hinted that he was going to forsake landscape painting for portrait and historical work. In that year his *Rose and Bowl* appeared at the

Royal Hibernian Academy and was mentioned in *Revue Moderne*. He showed six other works at the Dublin exhibition, including *A Full House* in 1946, his last appearance.

Major historical paintings, of whatever excellence, were something of a rarity in twentieth-century Irish art and so there was a stir when his *Martyrdom of Oliver Plunkett*, size 1.9m x 2m, was unveiled in Belfast in 1938. This work was purchased the following year by the Thomas Haverty Trust, Dublin, and is now in St Peter's Church, Drogheda.

In 1940 he held an exhibition of oil paintings at the Eve Salon, 47a Donegall Place, Belfast. The show comprised portraits, fruit and flower studies and landscapes. Portraits were painted of Most Rev. Dr Mageean, Bishop of Down and Connor, 1941, now at St MacNissi's College, and of Rt. Rev. Monsignor A.H. Ryan, now at the Catholic Chaplaincy, Queen's University. The artist died in Belfast on 13 September 1962 at his residence, 94 Lisburn Road.

Works signed: W. Fry, W.H. Fry or William H. Fry.
Examples: Belfast: Catholic Chaplaincy, Queen's University, 28 Elmwood Avenue. Carnlough, Co. Antrim: St MacNissi's College. Drogheda, Co. Louth: St Peter's Church.
Literature: *Irish News*, 26 January, 2 February 1937, 17 January 1940, 14 September 1962. *Northern Whig*, 12 May 1939; *Belfast Telegraph*, 7 November 1958; Ann M. Stewart, *Royal Hibernian Academy of Arts: Index of Exhibitors 1826-1979*, Dublin 1986; St Brigid's Presbytery, *Letter to the author*, 1996.

FURLONG, SEAMUS (1920-98), sculptor. Born in New Ross, Co. Wexford, on 21 September 1920, he was the son of a barber, Michael Furlong. At one period he studied painting and sculpture under Robert Burke (q.v.) at Waterford School of Art.

Back in the 1950s fashionable ladies in Wexford town and Enniscorthy travelled to New Ross to have their hair arranged by Seamus Furlong. The man noted for his tonsorial artistry turned out later to be a sculptor as well as the actor godfather of local theatre. He believed that his ability as a sculptor was drawn from his years of hairdressing, a family tradition at 53 South Street. He had trained in the profession at his brother Pierce's business in London.

In 1972, with a portrait of Stephen Jordan of Galway, Furlong exhibited at the Royal Hibernian Academy for the first time. In all, he presented six works at the Dublin show up until 1979, including those of Brendan Corish in 1973; Dr Herlihy, Bishop of Ferns, 1974; Dr T. J. Walsh, 1975.

Nicky Rackard was portrayed as a hurler in action; portraits were also executed of Dr T. K. Whitaker, Cardinal Tomás Ó Fiaich and Tomás MacAnna. Dr Whitaker told the author that Furlong visited his Dublin home on three or four occasions for the modelling, and he found him 'a modest man'. The signature on his bust appears on the back of the collar.

The bespectacled Walsh work is at the Theatre Royal, Wexford, and here the signature is on the side of the bust on the shirt collar. An exhibition of portrait sculpture was staged at the Bank of Ireland, Wexford, in 1981, and he showed no fewer than thirty-seven pieces, including *Child of Africa*; *Snooker Player*; *Tribute to Hairdressing*. At the Garter Lane Arts Centre, Waterford, in 1985, the works were all designated as in editions of five. Garter Lane also hosted an exhibition in 1992.

At the Abbey Theatre in Dublin there is the head of MacAnna, who knew the provincial drama scene and had twice directed Furlong in plays at the Wexford Opera Festival. Furlong played comic and serious roles and was a key player in getting the New Ross Drama Festival off the ground. On one occasion at the West Gate Heritage Tower in Wexford he gave a recital of W. B. Yeats' poems 'spoken and acted.'

During the Wexford Festival of 1989 he exhibited with a student of his, Imogen Stafford, at the Ferrycarrig Hotel, and of his ten works, three were listed as unique: *Chess Set*; *Meditation on the last straw*; *Sailing*. The Festival exhibition of 1992 was also a joint affair, Ruth Walsh showing paintings, and among his twenty-six works were *Weight Watching* and *Lydia and the Swan*.

In his Festival exhibition of 1994 he again combined with Ruth Walsh and presented twenty works, for example *Hopscotch* and *Gym Exercise*. In that show, *Comedy* and *Dance* were among the five sculptures listed under 'Theatrical Trophies'. There was also a portrait of Billy Roche. At the 1995 Festival, Walsh

exhibited watercolours of Irish and French waterways, and for Furlong it was the initial exhibition of his 'original and unique plastic compound sculpture...'

For his exhibition at the Loft Gallery in New Ross in 1995, he described some of the works as 'abstracts', and the catalogue note stated: 'Cast in bronze, with black patination, these represent the dark images and silhouettes in my mind...Images are always dark, but there is always line and shape which I try to interpret.' Cast in solid bronze, his *Chalice to Freedom* incorporated the symbols: Stem: The Proclamation. Cup: Padraig Pearse; Religious Sufferance; The Country; Surrender; Execution.

Furlong remained for his entire life in the town. Late in his career he built a studio at Barrack Lane, the New Ross Art and Craft Studio, Ltd. Feâchtas Ealoin commissioned sculpture, *The Gathering,* for St Michael's Theatre, New Ross. Nominated as a director of the board, he was too ill to take up the post. His death took place at Wexford General Hospital on 29 October 1998.

Works signed: Seamus Furlong or S. Furlong.
Examples: Dublin: Abbey Theatre. New Ross, Co. Wexford: St Michael's Theatre. Wexford: Bishop's House; Theatre Royal.
Literature: T. J. Walsh, *Second Empire Opera: The Théâtre Lyrique, Paris 1851-1870,* London 1981 (illustration); Ann M. Stewart, *Royal Hibernian Academy of Arts: Index of Exhibitors 1826-1979,* Dublin 1986; *New Ross Standard,* 4 November 1998; Nicky Furlong, 'The New Ross Master,' *The Echo,* 5 November 1998; Wexford County Library, *Letter to the author,* 1998; Mrs Phyllis Corish, *Letter to the author,* 1999; also, Bishop of Ferns, 1999; Mrs Monica Furlong, *Letters to the author,* 1999; St Michael's Theatre, *Official opening,* programme, New Ross 1999; Wexford Festival Opera, *Letter to the author,* 1999.

FURNISS, HARRY (1854-1925), caricaturist and illustrator. Born in Wexford town on 26 March 1854, his father was a civil engineer of Yorkshire origin; his mother was Scottish. The family moved to Dublin when he was aged ten, but even at that early age he had already been drawing humorous characters and scenes. He attended 'the Wesleyan Connexional School, St Stephen's Green', and produced a periodical, in manuscript, called *The Schoolboys' 'Punch'.* Drawing came to him naturally and intuitively and in a few years he was regularly contributing cartoons to public journals.

Early in his teens he was invited to join the life school of the Royal Hibernian Academy, but as with the South Kensington system later, he was never happy with the institutional approach. In Dublin he was asked by A.M. Sullivan, founder and editor, to supply some illustrations for *Zozimus,* the Irish *Punch.* Furniss was then aged sixteen. He obtained employment with George Hanlon, engraver, Grafton Street, Dublin, and worked on commercial illustrations. He visited Galway and sketches made there appeared in the *Illustrated London News,* and after he moved to London in 1873 he contributed regularly to that publication. As for *Punch,* he was parliamentary caricaturist for twelve years.

Gainsborough Gallery, Old Bond Street, London, was assured throughout the summer of 1887 of high attendances when in April they showed Harry Furniss's 'Joke Academy'. The *Daily Telegraph* reported: 'He has taken eighty-seven of our leading painters, mastered their style, school, and habitual subject, and in black and white brilliantly imitated their method'. *The Times* commented: 'That the public will be amused, there can be no question, but whether the Academicians will see the fun of the thing is not quite so clear'. The exhibition was the result of three years patient work behind locked studio doors. A Scottish artist whose style exasperated Furniss was the genre painter, Thomas Faed (1826-1900), who had to his credit *Cold little Tootsies* and *My Ain Fireside.* He was parodied in *Scottish Cottage Comfort Redolent of true Scottish sentiment and Spirit.* Alongside this sketch, Furniss wrote: 'So long as this popular artist furnishes the Royal Academy with such pictures as this, the reputation of Scotch Art and Scotch drink will never faed'.

As a lecturer he travelled to the USA, Australia and Canada. In Dublin in 1891 during Horse Show week he gave his lecture, 'The Humours of Parliament', and he also spoke in Belfast. After a row with *Punch,* he founded a new periodical, *Lika Joko* and Jack B. Yeats (q.v.) contributed to the first number; George Morrow (q.v.) was also to contribute. Furniss illustrated some fifty books, several of which were autobiographical humorous reminiscences, and a friendship with Charles Dodgson ('Lewis Carroll') led to his illustrating

Sylvie and Bruno, 1889, price 'three half-crowns'. For the works of Charles Dickens, 1910, he produced 1,200 illustrations, followed a year later by an edition of Thackeray.

In 1912 he turned his attention briefly to the cinematograph, working for Thomas Edison in New York variously as actor, writer and producer. Many of his drawings were exhibited at the Fine Art Society, London. At the National Portrait Gallery, London, there are more than sixty drawings, including portraits of Lord Randolph Churchill, Charles Dickens, Benjamin Disraeli, Alexander Dumas, Sir Henry Irving, Rudyard Kipling and Thomas Power O'Connor. At the Victoria and Albert Museum there are almost forty drawings. Regarded as argumentative and egotistical, he recorded in one of his manuals of instruction in art: 'I have often, and do still, whilst conversing with my "subject", draw his face with pencil and paper in my pocket'. He died at Hastings on 14 January 1925.

Works signed: Harry Furniss, Hy. Furniss, Hy.F. or H.F.
Examples: Bournemouth: Russell-Cotes Art Gallery and Museum. London: National Portrait Gallery; Victoria and Albert Museum.
Literature: Harry Furniss, *Parliamentary Views*, London [1885] (illustrations); Gainsborough Gallery, *Harry Furniss's Royal Academy: An Artistic Joke*, catalogue, London 1887 (illustrations); Two Art-Critics, *Pictures at Play or Dialogues of the Galleries*, London 1888 (illustrations); Lewis Carroll, *Sylvie and Bruno*, 1889 (illustrations); Harry Furniss, *Royal Academy Antics*, London 1890 (illustrations); Fine Art Society, *Catalogue of a Collection of Drawings Political and Pictorial by Harry Furniss*, London 1894; Harry Furniss, *The Confessions of a Caricaturist*, London 1901 (also illustrations); Harry Furniss, *How to Draw in Pen and Ink*, London 1905 (illustrations); Harry Furniss, *How & Why I Illustrated Thackeray*, London 1912 (illustrations); *Irish Book Lover*, March 1912, August-September 1917 (illustration); Harry Furniss, *More about How to Draw in Pen and Ink*, London 1915 (also illustrations); Harry Furniss, *My Bohemian Days*, London [1919] (illustrations); *Northern Whig*, 19 January 1925; *The Connoisseur*, May-August 1973; *Dictionary of British Artists 1880-1940*, Woodbridge 1976; *Dictionary of British Book Illustrators and Caricaturists 1800-1914*, Woodbridge 1981.

G

GAFFNEY, WILLIAM (1853-1922), sculptor. Born in 1853 in Waterford, he was the son of William Gaffney and the family lived on the Waterside. The monumental works which the son ran was in Beresford Street, later renamed Parnell Street, and by 1998 the site of the business was a funeral parlour, not entirely inappropriate as three generations of the Gaffney family had produced headstones there.

Gaffney was responsible for the design and execution of the Lourdes Irish Cross, which was not, according to a contemporary account, made for 'profit or human praise.' Apparently for some years of his life, as he humbly confessed, he was 'addicted to the vice of intemperance...but having once taken a pledge he promised, if Mary would help him to keep it, he would put forth the best effort of his intellect and his hands on a work that should live to show his gratitude to God and to Mary and make some amend for misspent years.' That promise was made in 1901, and he conceived the idea of making a cross after the model of the Great Cross of Monasterboice. This was the gift, erected in 1913, which the Irish Pilgrims and Associates sent to Lourdes.

The sculptor depicted the mysteries of the Rosary in carved scenes over the surface of the cross, and carved the cap to represent the Judgment Day. Altogether, there were twenty-one panels. The height was 4.6 m from base to apex, carved out of Kilkenny limestone. On the centre of the back, for example, the sculptor carved the figure of the Lamb standing on the Book and Seals (from the Apocalypse) surrounded by the four Evangelists. According to a booklet published in 1913, and written by an unnamed author: 'The figures of Mary Magdalen and St John the Evangelist are carved at the foot of the Crucifix, while Our Blessed Lady, crushing the head of the Serpent with the Apple in its mouth (Genesis) is a work of which any Sculptor might be justly proud.'

Judith Hill in her *Irish Public Sculpture*, 1998, found Gaffney's Independence memorial cross erected in Murroe, Co. Limerick, as 'one of the more impressive monuments of the period. It is also primarily Catholic in inspiration.' A figure of the crucified Christ was carved on the front. Also depicted were scenes from the life of Christ, the Stations of the Cross, the Assumption of Our Lady, and Christ praying for souls in purgatory.

The expulsion of Adam and Eve, situated on the base at the back, produced a complex scene: the weeping figures of Adam and Eve were balanced by an angel brandishing a sword; God appears from the clouds next to Mary, who holds baby Jesus; a lion and a unicorn run over a writhing snake.

Gaffney's Celtic Cross, erected to the men of the East Limerick and Mid-Limerick Brigades, IRA, who lost their lives in 1920 and 1921, was unveiled by the Most Rev. Dr Harty, Archbishop of Cashel. Thousands of people were present at the ceremony from Counties Limerick and Tipperary. Members of the Limerick Corporation were attended by the Sword and Mace Bearers. Several bands were present. The *Limerick Chronicle* also included in its extensive report a list of clergy present, also members of the Corporation. The sculptor, who was in his grave, was not even mentioned. He had died on 5 February 1922 in Waterford.

Works signed: Gaffney.
Examples: Lourdes, France: Shrine. Murroe, Co. Limerick.
Literature: *The Lourdes Irish Cross,* Waterford 1913 (also illustrations); *Limerick Chronicle*, 29 May 1923; Judith Hill, *Irish Public Sculpture*, Dublin 1998 (also illustration); Mrs Ida Kennedy (née Gaffney), *Letter to the author*, 1998; also, Monsieur L'Économe de L'Oeuvre de la Grotte, 1998.

GALBALLY, CECIL, RHA (1911-95), landscape, portrait and figure painter. William Cecil Galbally was born in Dublin on 31 January 1911, the son of a civil servant, Lawrence Galbally. Since a child, he had always been interested in drawing and painting. He became a clerk in the Hibernian Bank, and he was said to have brought the same thoroughness to the study of painting 'and soon acquired a very impressive technique and grasp of form.' At evening life classes in the Dublin Metropolitan School of Art he would 'spend an hour

studying the model, meticulously prepare his palette, then deftly create a fine, solid portrait.' A student exhibition at the Victor Waddington Galleries in Dublin contained two of his landscape oils, and both were sold. Waddington urged him to work for a solo show.

Despite the classes at the School of Art, Galbally was always of the opinion that art could not be taught; it was something you had to develop yourself. He first exhibited at the Royal Hibernian Academy in 1940, from 73 Sandford Road, Dublin, and up until 1954 showed a total of twenty-five pictures. *La femme au nez casse* was one of three works shown in his initial year. In 1941, now at 51 Dollymount Avenue, he contributed a portrait of P.A. Noonan. Another four works were hung in 1942 and all were portraits. His *Sixpence a Stone* (Galway Art Gallery Committee) at the 1943 RHA was described in *The Bell* as a richly painted picture with the artist having 'a remarkable feeling for paint, and who understands quality.' In 1944 he exhibited a portrait of Sir Francis Brooke, Bart., and *Bus Queue*.

An 1944 show at the Victor Waddington Galleries attracted 'sold-out' publicity, but it did not appear to alter the views of the *Dublin Magazine* critic: 'While willing to admit that his local-colour, in say, *Church Door, Oranges in Moore Street,* or *Pavement Artist,* was observed carefully and on the spot, his presentation is grossly sentimentalised. It is a kind of perverted though unconscious social commentary which gives some kind of meaning to the plea for social realism. The painter sees life through a kind of literary-romantic haze; and the result is a perversion of reality and an abuse of his medium; hence its appeal to the drawingrooms who see the frozen pavement-artist warmed by his own goodness of heart like a character in a Dickensian moral tale…' *Blue and Gold, Kinsale* and *Sunday Morning, Kinsale* were, however, three singled out as in 'refreshing contrast, even if they were a bit garish.'

In 1945 he was appointed an associate of the RHA, and among his four works exhibited that year were *Curtain Up* and *The Green Jacket.* He also participated in the 1945 Irish Exhibition of Living Art. In 1946 he was appointed a full member of the Academy; served on the Oireachtas selection committee; and showed at the RHA: *High Mass at the Church of the Annunciation, Blackpool, Cork* and *Evening at Baggot Street.* Tom Nisbet, RHA, wrote later: 'From respected bank official to eminence as an artist in a few years was a considerable achievement, yet Cecil remained a modest, unpretentious and very amiable character.'

The *Dublin Magazine* returned to the scene for Galbally's 1947 exhibition at the Waddington Galleries. In this show 'there seemed to be two painters at work. One is an obvious and deeply influenced disciple of Maurice MacGonigal, in whom a contemplative realism expresses itself in quiet-toned landscapes. He is a careful observer and recorder of subtle colour-harmonies as can be seen in his painting of the warm cornfield in *Harvesting, Innishmore,* or again in his treatment of the cold, wrack-strewn shingle of *Drying Weed, Innishmore…* To this painter of the Irish countryside the other, and urban, painter, bears hardly any recognisable resemblance. There is scarcely one of these urban pictures but betrays some chromatic solecism; the blatant mauves and magentas of *Sandwich-boards and Winter Sunshine…*the salmon-pink road in *On North Gate Bridge, Cork…*'

In 1950 he exhibited again at the Waddington Galleries, 8 South Anne Street. He then left for Spain, where he painted and held several one-person exhibitions and sold almost all the pictures, but with no regular income he decided to start private teaching of English. He taught for a short period in Madrid, then he moved to Reinosa, a small town in Cantabria, in the north of Spain where he taught and painted.

After an interval of seven years, his final showing at the RHA in 1954 was: *Fisherman in Alicante* and *Spanish Burro.* The former picture was presented to Bangor Borough Council by the Thomas Haverty Trust. Over in Spain he had acquired the reputation of being a very successful English language teacher. About 1958 he stopped painting until 1990, when he retired from teaching and started painting again, changing to completely abstract work. In Dublin, however, he is represented by *Winter Evening near Killester* at the Hugh Lane Municipal Gallery of Modern Art, and at the National Gallery of Ireland by a portrait of the art dealer, Victor Waddington. The artist died in Santander on 25 January 1995.

Works signed: Cecil Galbally or Galbally.
Examples: Bangor, Co. Down: Town Hall. Dublin: Hugh Lane Municipal Gallery of Modern Art; National Gallery of Ireland. Galway: Art Gallery Committee. Limerick: City Gallery of Art.

Literature: *The Bell*, June 1943; *Dublin Magazine*, January-March 1945, April-June 1947; Ann M. Stewart, *Royal Hibernian Academy of Arts: Index of Exhibitors 1826-1979*, Dublin 1986; S. B. Kennedy, *Irish Art & Modernism 1880-1950*, Belfast 1991; *Irish Times,* 27 January 1995, 16 February 1995; Juan Galbally, *Letter to the author*, 1998.

GARSTIN, NORMAN (1847-1926), landscape and figure painter. Born on 28 August 1847 at Cahirconlish, Co. Limerick, he was the only child of an Anglo-Irish soldier, Colonel William Garstin of the 83rd Regiment of Foot, and an Irishwoman, Mary Hastings Moore, who was related to George Moore. The son's early years were marked by a double tragedy. His mother developed a form of muscular paralysis that also deprived her of speech, and his father committed suicide. Norman was brought up initially by his grandparents in a country parsonage near Limerick, and was later placed in the care of guardians.

Because of delicate health, he was sent to the Channel Islands in 1858. In Jersey he stayed with a relative, the Rev. Dr Norman Garstin, having entered Victoria College, St Helier. During his holidays back in Ireland he divided his time between hunting and painting. On leaving school he was encouraged by his guardians to study a 'useful' profession and he enrolled at Queen's College, Cork. The professor with whom he stayed observed his drawing and suggested that he should study architecture rather than engineering. Garstin therefore went to London, where he spent two years in an architect's office, a period of his life that he subsequently regarded as a waste of time

Seeking his fortune abroad, for four years he lived in Kimberley in the early 1870s, part of the time digging for diamonds, sometimes camping out with Cecil Rhodes, whom he knew well. Subsequently he and Cecil St Leger founded the *Cape Times* newspaper, Garstin establishing a reputation as a journalist. On returning to Ireland, misfortune again struck, when he was blinded in one eye by a thorn bush in a riding accident. Ironically, he now decided that art was to be his profession.

In 1880 Garstin travelled to Antwerp, where he studied under Charles Verlat (1824-90) for about two years. In the last six months of his stay in Belgium he painted in the country with Theodor Verstraete (1850-1907). On moving to Paris, where he met Edgar Degas (1834-1917), he studied under Carolus-Duran (1838-1917) for three years, one of a group of young painters who made their headquarters at the Hôtel St Malo. Roderic O'Conor (q.v.) and some other Irish students also studied at the same atelier.

Garstin first exhibited at the Royal Hibernian Academy in 1883 with *Birds Nesting*, sent from Paris. *Church and square, Brittany* was painted about this time; *Artichokes* in 1883 at Hyères, South of France; *Arabs* in 1885 at Tangier. He was also in Italy in 1885 and Spain the following year. On his return he married, settled in Newlyn, Cornwall – he was there in 1888 when he exhibited at the RHA – and became an eloquent spokesperson for the Newlyn School. Stanhope Forbes (1857-1947) recalled his arrival in Newlyn: 'a certain distinguished looking Irishman whose delightful wit and fine artistic insight soon began to charm us'. In 1886 he showed *The Day After* at the Royal Scottish Academy, and *Other People's Dinners* in 1891.

An 1888 catalogue of the New English Art Club listed him as a member. *The Rain it Raineth every Day*, one of his most impressive paintings, was painted in 1889. The following year the Garstin family moved from Newlyn to Penzance, home was at 4 Wellington Terrace for the rest of his life. In 1892 he recorded the opening of the Canadian Pacific Railway, sending back an illustrated account to the *Art Journal*.

An artist in her own right, Alethea Garstin (1894-1978) was taught to paint by her father and accompanied him on many of the summer schools of painting he annually conducted, from 1899, in northern France and Brittany, thus supplementing his income along with remuneration for articles in, for example, *The Studio*, lecturing and one novel. Harold Harvey (1874-1941), Cornish painter, had his first lessons as a boy from Garstin. An exhibition of paintings and drawings from the studio of Alethea Garstin was presented in 2001 at the Molesworth Gallery, Dublin.

Altogether to the RHA he contributed thirty-four pictures, two in 1904: '*The Cotillon*' and *The Old Bridge of Livenon*. He was included in Hugh P. Lane's exhibition of Irish art at the Guildhall, London, 1904. In that year too an exhibition in London at the Fine Art Society, 'In Border Lands', presented watercolours executed in Normandy, Brittany and Holland. Many of his pictures were exhibited at Walker's Galleries. He also showed in London at the Royal Academy, and the Ridley Art Club, of which his daughter was also a member. He sent more than thirty works to the Walker Art Gallery, Liverpool. *The Studio* said of his paintings: 'One

of the greater merits of his work is its freedom from insistence upon trivial details which do not help the general effect ...'.

A final contribution to the RHA was *The Sarine* in 1916. The National Gallery of Ireland has in its collection, *The Last of the Fair*, presented by his widow. A portrait of his wife bequeathed by his daughter, *A Woman Reading a Newspaper*, painted in Canada in 1891, is in the Tate Gallery. *The Kermesse, Diest* is a watercolour in the Victoria and Albert Museum.

The Times said he was a man 'of general artistic and intellectual ability rather than a powerful artist, though his work, in several mediums, was remarkable for sensitive feeling and decorative charm ...'. He died on 22 June 1926 at Penzance. In 1978, sponsored by Penwith Society of Arts, a touring exhibition of the works of Norman and Alethea Garstin included the National Gallery of Ireland in its itinerary.

Works signed: Norman Garstin.
Examples: Cork: Crawford Municipal Art Gallery. Dublin: Hugh Lane Municipal Gallery of Modern Art; National Gallery of Ireland. Glasgow: Art Gallery and Museum. Huddersfield: Art Gallery. Limerick: University, National Self-Portrait Collection. London: Tate Gallery; Victoria and Albert Museum. Luxembourg: Musée. Manchester: City Art Gallery. Penzance, Cornwall: Library; Penlee House Museum. Plymouth: City Museum and Art Gallery. Sheffield: Graves Art Gallery. Truro, Cornwall: County Museum and Art Gallery.
Literature: *The Studio*, February 1904, April 1909 (also illustrations), March 1942; *The Times*, 26 June 1926; *Dictionary of British Artists 1880-1940*, Woodbridge 1976; Penrith Society of Arts, *Norman and Alethea Garstin: Two Impressionists – Father and Daughter*, catalogue, 1978 (also illustrations); Newlyn Orion Galleries, *Artists of the Newlyn School (1880-1990)*, catalogue, Penzance 1979; Julian Campbell: National Gallery of Ireland, *The Irish Impressionists: Irish Artists in France and Belgium 1850-1914*, catalogue, 1984; Ann M. Stewart, *Royal Hibernian Academy of Arts: Index of Exhibitors 1826-1979*, Dublin 1986; *The Royal Scottish Academy Exhibitors 1826-1990*, Calne 1991.

GAY, EDWARD, NA (1837-1928), landscape painter. Born on 23 April 1837 near Mullingar, Co. Westmeath, he was the son of Richard Gay, a mason and stonecutter, who emigrated with his family in 1848 and settled in Albany, New York, where he became a successful builder. As a youth, Edward held various jobs, and in one appointment the proprietor of a wine cellar found him making charcoal drawings, recognised his talent and introduced him to some local artists. Gay was befriended by the Scottish-born painter, James M. Hart (1828-1901) and accompanied him and other painters on a sketching trip to Lake George. In order to support himself, he taught at the Albany Female Academy. In 1858 he began to exhibit at the National Academy of Design and became a regular contributor.

In 1862, feeling the need of a freer, fuller technique, he went abroad to study art in Germany, under J.W. Schirmer (1807-63) in the art academy at Karlsruhe and K.-F. Lessing (1808-80) in the academy at Dusseldorf. In the spring of 1864, when Gay had completed his studies, he made a brief visit to Ireland. On his return to Albany, he married Martha Fearey, whom he had met at the Albany Female Academy. In 1870 they moved their growing family out of the city to the then-rural Mount Vernon, New York.

Elected an associate of the National Academy of Design in 1869, he became a full member in 1907, and *The Wind Among the Grain* was presented upon election. During that period he won a medal in San Francisco in 1885, and then the Metropolitan prize of 2,000 dollars, 1887, for the painting, *Broad Acres*, presented to the Metropolitan Museum of Art, New York. Other notable canvases were: *Late Afternoon near Albany*, 1876; *Last Load – Harvest Time*, 1878; and *Gathering the Leaves*, 1880.

Following two exhibitions in 1881, he and his wife visited Europe. *Banks of the Thames* was painted in 1882, and Gay visited his old artist friend, George Boughton (1833-1905), then living in London. In England he became enthusiastic about the work of John Constable (1776-1837). Norway and France were also on the itinerary. In 1883 he visited Europe again and stopped in Ireland on his way home. In 1890, for a proposed magazine article, he was in Egypt with the American artist, M. de Forest Bolmer (1854-1910).

In 1903 Gay won the Shaw prize from the Society of American Artists, which had been founded in 1878, and in 1905 he secured the Inness gold medal from the National Academy of Design for the outstanding landscape in the exhibition; *The Valley, Near Stamford, Conn.* and *In the South Wind* were both hung. Gay often went to Florida during the winter, sometimes stopping in South Carolina. One of his most striking

characteristics as an artist was that he saw nature under sunny aspects. As a man he was said to be simple and unaffected, and these qualities were reflected in his work. In later life he lived at 434 Second Avenue, Mount Vernon, New York, and died there on 22 March 1928.

After a lawyer from South Carolina, Richard Gay, had written to the Cathedral House in Mullingar inquiring about the area in which his grandfather, Edward Gay, was born, an oil painting entitled *The Clam Diggers* was received in 1967 for the ecclesiastical museum attached to the Cathedral of Christ the King, donated by the descendants of the artist. In 1973 an appreciative biography of the artist, *Portrait of an American Painter: Edward Gay 1837-1928*, by his grandson, Richard G. Coker, was published in New York.

Works signed: Edward Gay.
Examples: Albany, New York: Institute of History of Art. Mullingar, Co. Westmeath: Cathedral of Christ the King, museum. New York: Metropolitan Museum of Art; National Academy of Design.
Literature: J.D. Champlin, *Cyclopaedia of Painters and Paintings*, New York 1888; *Dictionary of American Painters, Sculptors and Engravers*, New York 1945; *Dictionary of Artists in America 1564-1860*, New Haven 1957; *Who was Who in America*, Chicago 1960; James Seery, *Letter to the author*, 1969; also, National Academy of Design, 1985.

GEDDES, WILHELMINA M. (1887-1955), stained glass artist. Daughter of William Geddis, of Tandragee, Co. Armagh, where his father, who spelt his name Gaddis, farmed, Wilhelmina Margaret Geddis was born on 25 May 1887 at her grandfather's home, Drumreilly, Co. Leitrim. When she was still a baby, the family moved to Belfast where her father, who had emigrated to the USA as a young man, established himself as a building contractor. Wilhelmina, who had several severe illnesses as a child, was educated at Methodist College, 1898-1902, and after some delay – she had thought of studying English – she entered Belfast School of Art. In 1907 she became a member of the Belfast Art Society. A first venture towards stained glass emerged at the School of Art in 1911 when a cartoon, *Sir Walter Raleigh*, won a prize in the National Competition, and a travelling scholarship enabled her to visit the British Museum and the Victoria and Albert Museum.

On moving to the Dublin Metropolitan School of Art, she worked in the summer classes under (Sir) William Orpen (q.v.). In 1910 she had exhibited an illustration at the Arts and Crafts Society of Ireland exhibition in Dublin. She executed her first work in stained glass, the three-light window, *Saint Colman*, representing episodes from his life, the panels of which are now in the Hugh Lane Municipal Gallery of Modern Art and were formerly owned by Sarah Purser (q.v.), whose attention to the young Belfastwoman had been drawn by seeing her watercolours on exhibit in Dublin. The Ulster sculptor, Rosamond Praeger (q.v.) had also recognised Wilhelmina's talent early on and had persuaded her father to send her to art school. A portrait of Praeger, by Geddes, is in the Ulster Museum.

In July 1912 she joined Miss Purser's An Túr Gloine ('The Tower of Glass') and was to remain there for twelve years, apart from those periods when she was absent through illness – among her ailments was curvature of the spine – or was working in London. In 1913 she showed three works at the Royal Hibernian Academy including *Jacob and the Angel*. One of her principal creations in stained glass, executed in London and completed in 1919, was a three-light window for St Bartholomew's Church, Ottawa, commissioned by the Duke of Connaught, Governor-General of Canada, as a memorial to members of his Canadian staff who fell in the First World War.

Other early An Túr Gloine windows were: *The Good Shepherd with two angels at the tomb*, 1913, at St Molaise's Church, Monea, Co. Fermanagh; *Faith, Hope and Charity*, 1914, two-light, at Townsend Street Presbyterian Church, Belfast. Her first windows for location outside Great Britain and Ireland were *Faith* and *Hope* for the chapel of Karori Crematorium, Wellington, New Zealand, installed in 1914. *Hope* depicted the Angel of Hope carrying flowers waiting for a small girl in a boat to reach the shore, commemorating a child who died. *Faith* included the Angel of Faith with a sword and lantern walking through a dark forest inhabited by wild beasts and a raven.

Submissions to the Royal Hibernian Academy were few – seven in all – but she was represented by drawings and stained-glass cartoons at the Arts and Crafts Society of Ireland fifth exhibition in 1917, and by needlework pictures and panels at the 1921 exhibition, for which she collaborated with her sister, Ethel May

Geddes. Woodcuts were displayed at an exhibition at the Horse Show, Ballsbridge, 1922, also stained glass and embroidered panels, designed as blazonry for banners.

Stephen Gwynn, writing in *The Studio*, October 1922, on 'The Art of Miss W.M. Geddes', referred to the five lancet windows in the apse of St Luke's Church, Wallsend-on-Tyneside: '... her latest and her principal achievement. Physically alone, the advance in the scale of the work is surprising; and in all senses this window group is a big thing for a woman to have done'. He also wrote: '... the power of simplifying without loss of meaning which remains her chief characteristic And however good her colour, design and drawing will be with her the master gift'. In his book on the Buildings of Northumberland, Sir Nikolaus Pevsner described the St Luke's window as being of exceptional high quality.

When An Túr Gloine, which was founded in 1903, celebrated its twenty-fifth anniversary, T.P. Gill said of Miss Geddes: 'Many critics hold that she is the most gifted of all modern stained glass artists, her modern resembling old glass, while being original at the same time ... Her finest work is the great *Crucifixion* in Wallsend, but the *St Michael* window in St Ann's, Dawson Street, Dublin, is all the admiration of all connoisseurs of stained glass'. The *St Michael* window, one of three at the church, was executed in 1918.

Among the prizewinners at the exhibition of Irish art held in connection with Aonach Tailteann, 1924, she held a show in Belfast in the same year with Rosamond Praeger, contributing thirty-five items, including drawings, linocuts and designs for stained glass. She was an admirer of the work of Arthur Rackham (1867-1939), the book illustrator. In her last four years in Dublin, during which she had spells of illness and returned to Belfast, she executed: *The Leaves of the Trees were for the Healing of the Nations*, 1920, St John's Church, Malone Road, Belfast; *St Patrick and St Columcille*, two-light, 1923, All Saints' Church, Inver, near Larne, Co. Antrim; *Saint Brendan*, 1924, Our Lady Queen of the Universe Church, Currane, Achill, Co. Mayo. *Saint Brendan* was painted by Ethel Rhind (q.v.) and exhibited at the Basilica of Stained Glass, British Empire Exhibition, Wembley, 1924.

When still in Ireland, letters from Wilhelmina Geddes (more often than not signed 'Geddis' and undated) to Sarah Purser indicated almost a love-hate relationship. An undated letter from 43 Wellington Park, Belfast: 'With regard to Wallsend which you say I take so cavalierly what am I to do? You always accuse me of taking things calmly but what else can one do, in writing anyhow? One can't cry all over the paper and what would be the good if one did? You have often seen me weeping profusely in the shop and what good was that? I don't take things calmly at any time. I only wish I could.'

In response to a letter of complaint from Sarah about her time-keeping, she replied – undated letter – from 33 Upper Baggot Street, Dublin: 'I've been really late this last fortnight (about 12 o'clock) because I'm not well and not fit for anything in the mornings. Miss Rhind has turned over a new leaf since you talked to her last week. I don't think we could absolutely put in an eight-hour day as they do in offices; the work is too hard. It would only lead to dawdling. Teachers in schools knock off about 3 o'clock. As for the morning being the best part of the day, it isn't for me ...' But from a letter dated 19 August 1924, from Ulsterville House, Lisburn Road, Belfast: 'I am very, very sorry to leave you after all your kindness. Nobody ever saw nearly so much in my work or brought me forward as you did and few have put up with my personality so well.' After she left An Túr Gloine she had a nervous breakdown.

In 1925 she departed Belfast for London where she took a studio in the Fulham stained glass co-operative, the Glasshouse, in Lettice Street, and it was there that she was later to instruct Evie Hone (q.v.) on how to convert her designs for the first time into glass. Wilhelmina had a flat at 22 Crompton Court, Brompton Road, exhibited with Fulham Artists, continued her correspondence with Sarah Purser, and was represented with woodcuts in the exhibition of Irish art at Brussels, 1930.

One of the first windows which she undertook at Fulham was the *St Christopher* window for All Saints' Church, Laleham, near Staines, Middlesex. Another two-light window for the Church of Ireland church at Inver, near Larne, is also dated 1927. In *A Dictionary of Contemporary British Artists, 1929*, the four principal works mentioned are given as at Ottawa, Wallsend-on-Tyneside, Laleham and the Presbyterian Church House, Belfast, for the four-light 'parable' window, 1916.

In the period 1929-34 she was occupied mainly with windows for Belfast: *Pilgrim's Progress* and *Go ye forth, teach ye all Nations*, both 1929, for Rosemary Street Presbyterian Church but removed to Presbyterian

Church House after 1941 air raids; *Christ blessing the little children* and *Moses with the Tablets of the Law*, both 1929, Rosemary Street Presbyterian Church, destroyed in 1941 air raids; *The Sorrowful Fate of the Children of Lir*, with eight small scenes, 1930, Ulster Museum; *Rhoda opens the door to Saint Peter*, 1934, Ulster Museum. In 1934 she was appointed an academician of the Ulster Academy of Arts. 'Geddes's robust depiction of saints was refreshingly different from the limp piety often demanded by clerics,' wrote Dorothy Walker in *Modern Art in Ireland*, 1997.

A prestigious commission of the London period was the rose window in memory of King Albert of the Belgians at St Martin's Cathedral, Ypres, unveiled in 1938 by King Leopold. The artist was present at the unveiling. The window consists of two circles. The inner one shows a figure of Christ blessing two kneeling soldiers surrounded by apostles. The outer circle is composed of thirty-two smaller windows with faces of sixteen prophets and sixteen martyrs. The latter include early English evangelists who preached in Flanders.

At the Victoria and Albert Museum, London, are designs for the rose window at Ypres Cathedral, also three cartoons, in black chalk, crayon and wash for the three-light window in All Saints' Church, Laleham, 1926; the largest is approximately 230cm x 44.5cm. All designs and cartoons were presented by the artist's sister. More than thirty designs for stained glass windows are in the National Gallery of Ireland. Wilhelmina Geddes, after a life of indifferent health, died in London on 10 August 1955.

Works signed: Graphics: W.M. Geddes; W.M. Geddis, Geddis or W.M.G., all rare.
Examples: Achill, Co. Mayo: Our Lady Queen of the Universe Church, Currane. Belfast: Presbyterian Church House; St John's Church, Malone Road; Townsend Street Presbyterian Church; Ulster Museum. Blackrock, Co. Dublin: All Saints' Church. Derrygonnelly, Co. Fermanagh: St Ninidh's Church. Dublin: Hugh Lane Municipal Gallery of Modern Art; Rathgar Presbyterian Church, Rathgar Road; St Ann's Church, Dawson Street. Inver, near Larne, Co. Antrim: All Saints' Church. Laleham, near Staines, Middlesex: All Saints' Church. Lee, Kent: St Mildred's Church. Monea, Co. Fermanagh: St Molaise's Church. Ottawa, Canada: St Bartholomew's Church. Pepworth, Sussex: North Chapel Parish Church. Southport, Lancs.: Holy Trinity Church. Wallsend-on-Tyneside: St Luke's Church. Wellington, New Zealand: Karori Crematorium. Ypres, Belgium: St Martin's Cathedral.
Literature: *Irish Review*, February 1913 (illustration); *The Studio*, October 1917 (also illustrations), December 1921, October 1922 (also illustrations), October 1924, December 1924 (also illustration), March 1927 (also illustration), October 1927 (illustration), January 1938; *Arts and Crafts Society of Ireland 6th Annual Exhibition*, catalogue, Dublin 1921 (illustration); Harrap, *Essays of To-day*, London 1923 (illustration); *Irish Times*, 14 July 1923; *Dublin Magazine*, October 1923 (illustration), December 1923 (illustration), July 1924 (illustration), August 1924 (illustration), November 1924 (illustration); Harrap, *One Act Plays for To-Day*, London 1924 (illustration); *Letters to Sarah H. Purser*, mss, Natinal Library of Ireland; Bruce Graeme, *The Return of Blackshirt*, London 1927 (illustration, book jacket); *An Túr Gloine: Twenty-Fifth Anniversary Celebration*, Dublin [1928] (also illustration); *Northern Whig*, 21 May 1938; *Irish Press*, 27 May 1938; *Belfast Telegraph*, 13 August 1955; *Belfast News-Letter*, 31 May 1962, 5 August 1965; *A Dictionary of Contemporary British Artists, 1929*, Woodbridge 1981; Martyn Anglesea, *The Royal Ulster Academy of Arts*, Belfast 1981; Rev. C. Wilcock, *Letter to the author*, 1985; Mrs E.M.F. Kerr, *Letters to the author*, 1986, 1987; *Linen Hall Review*, Summer 1986; Ms Fiona Ciarán, *Letters to the author*, 1987; Townsend Street Presbyterian Church, *Letter to the author*, 1996; Dorothy Walker, *Modern Art in Ireland*, Dublin 1997 (also illustration).

GERALD, REV. FATHER (1910-58), illustrator. A native of Belfast, Joseph MacCann was born on 2 February 1910. He was a brother of Soirle MacCann (q.v.) and their father was John MacCann, a funeral undertaker. Joseph was educated at the Christian Brothers' School, Oxford Street, Belfast; Capuchin College, Rochestown, Co. Cork; and University College, Cork.

In 1929 he joined the Capuchin Order and from his ordination in 1937 he was attached to the *Capuchin Annual* office until June 1950 when he was transferred to Rochestown College, where he taught art. His contribution to the work of Irish illustrators was unique. Never in good health, he still managed to cherish the Franciscan tradition of happiness, and his 'black and whites' of friars at prayer, at work and at play, for fourteen years a feature of the *Capuchin Annual*, reflected that spirit. He also supplied tailpieces for the publication.

A note in an *Annual* read: 'His little friars won the plaudits of renowned critics in many lands and were accorded by them the leading place in the world in this form of art'. A friend of Richard King and Sean

O'Sullivan (qq.v.), he died in Dublin when conducting a retreat. The blocks for some of his illustrations, which were unsigned, continued to be used in the Capuchin publications.

Literature: *Capuchin Annual*, 1939, 1958, 1959; illustrations, 1932-46; Father Cuthbert (MacCann), *Letter to the author*, 1986.

GERNON, VINCENT – see de GERNON, VINCENT

GETHIN, PERCY F. (1874-1916), landscape painter and etcher. Born on 25 July 1874, Percy Francis Gethin was the second son of Capt. George Gethin of Holywell, Sligo. At an early age he made it clear that he wanted to become an artist. After studying at South Kensington, he became a pupil of Mouat Loudan (1868-1925) at Westminster School of Art and then moved on to the Atelier Colarossi, Paris.

On returning from France, he worked with Gerald Moira (1867-1959) on decorative schemes for the Unitarian Hall, Liverpool, the council chamber at Lloyd's Registry, and the P & O pavilion at the Paris International Exhibition, 1900. He gave a Chelsea address when he exhibited *Evening off the Essex Coast* at the 1900 Royal Hibernian Academy. He then became a master at Plymouth School of Art. In 1904 his *View near Lough Gill* was included in the exhibition by Irish painters held at the London Guildhall and organised by Hugh P. Lane. In the following year he joined the staff of the Liverpool School of Art, where his friend, F.V. Burridge (1869-1945) was in charge, and there he took the subject of etching more seriously.

Gethin still retained Irish connections. In group exhibitions in 1907 and 1910 at the Leinster Lecture Hall, Dublin, his fellow exhibitors on both occasions included W.J. Leech and G.W. Russell (qq.v.). He was also involved in designs for four panels of embroidery illustrating W.B. Yeats' 'Lake Isle of Inisfree' and worked by the Hon. Maude Wynne, who lived at Lough Gill, Co Sligo. All panels are in the National Museum of Ireland; the largest is 39.2cm. x 186.5cm. In 1913 from 4 Colquith Street, Liverpool, he sent to the Royal Hibernian Academy: *Bending the Jibs*; *The Terrace, Compiègne*; *Interior of a Burgundian Church*. In the same year his work appeared at a loan exhibition of modern paintings at the Belfast Museum and Art Gallery. Among his drawings were *Blacksod Bay* and *Custom House, Dublin*.

Gethin also exhibited at the Walker Art Gallery, Liverpool, and in London at the New English Art Club and Colnaghi's Gallery. His work was in the 1912 exhibition of the Senefelder Club (founded for the advancement of artistic lithography) held at the Goupil Gallery. During the summers of 1911 and 1912 he travelled in Burgundy and made a series of drawings, twelve of which were later reproduced in the book, *Burgundy and Morvan*.

Burridge became principal of the Central School of Arts and Crafts in 1913, and Gethin also joined the staff. He gave a London address when he showed *Auxerre* and *Westport* at the 1914 RHA. In 1914 he sold a drawing in black ink and wash entitled *The Porch* to the Bradford gallery, allowing 'a discount of 25 per cent on the catalogue price'. From 50 Rochester Row, Westminster, London, he showed in 1914 three works at the Royal Scottish Academy, including, *Market day in County Mayo town*. The Burgundy book was not published until 1925, and in a review *The Studio* commented: 'Gethin's work has a delightful luminous quality which is well displayed in these illustrations. It is the work of a charming and sensitive personality rather than that of a robust genius.'

At the Tate Gallery, London, the three Gethin works include a pen and wash drawing, *Athlone*. The artist is generously represented at the British Museum in drawings and etchings; among the former are: *Near Lisdoonvarna, Co. Clare*; *The City of Cashel*; and *Ballyvaughan at Evening*. Among the etchings is *The Travelling Circus, County Clare*. At the Ulster Museum is *A Sonata of Daicellos*, oil. An *Ascension* painting, 91.5cm x 244cm, is in St John's Cathedral, Sligo. After joining the Devonshire Regiment, he was killed at the Battle of the Somme, on 28 June 1916. Following publication of the book with his illustrations, his name came to the fore again in 1926 with a retrospective exhibition of drawings and etchings at Colnaghi's Gallery, Bond Street.

Works signed: P.F. Gethin or P.F.G. (if signed at all).

Examples: Belfast: Ulster Museum. Bradford: Cartwright Hall. Dublin: Hugh Lane Municipal Gallery of Modern Art; National Gallery of Ireland; National Museum of Ireland. Kilkenny: Art Gallery Society. Lissadell, Co. Sligo: Lissadell House. Liverpool: Walker Art Gallery. London: British Museum; Tate Gallery. Manchester: Whitworth Art Gallery. Perth, Scotland: Art Gallery and Museum. Sligo: St John's Cathedral. Waterford: City Hall, Municipal Art Collection.
Literature: *The Studio*, February 1912, November 1916, March 1917 (illustration); W.M. Crowdy, *Burgundy and Morvan*, London 1925 (also illustrations); Colnaghi's Gallery, *Percy F. Gethin*, catalogue, London 1926; *Tate Gallery Modern British Paintings, Drawings and Sculpture*, London 1964; Alan Denson, *An Irish Artist, W.J. Leech, RHA (1881-1968)*, Kendal 1968; Col. Wagstaff, *Letters to the author*, 1969; *Dictionary of British Artists 1880-1940*, Woodbridge 1976; City of Bradford Metropolitan Council, *Letter to the author*, 1985; National Museum of Ireland, *Letter to the author*, 1991; *The Royal Scottish Academy Exhibitors 1826-1990*, Calne 1991.

GIBBINGS, ROBERT, ARHA (1889-1958), wood engraver and illustrator. Born in Co. Cork on 23 March 1889, his father, the Rev. Edward Gibbings, was rector of Garrettstown and later Canon of St Fin Barre's Cathedral, Cork. The Gibbings family had settled in Co. Cork in Elizabethan times. Robert John Gibbings attended 'boarding school at Fermoy' at the age of eleven, by which time he had already been out sketching. After his father moved to Carrigrohane, he attended day school in Cork city.

Gibbings entered University College, Cork, in 1906 as a medical student. In his spare time he studied art under Harry Scully (q.v.). In the academic year 1909-10 he was registered for both Arts and Medicine. After abandoning his university studies, he went to London in 1911 and spent two years in the drawing classes at the Slade School of Fine Art. He then attended the Central School of Arts and Crafts and began etching, but at the suggestion of Noel Rooke (1881-1953) and under his direction there he concentrated on wood engraving. Rooke was then involved in bringing about a revival of the art to which Gibbings was to make a significant contribution. In 1913 he exhibited a bookplate at the Royal Hibernian Academy .

An early commission as an artist was executed in Co. Cork on behalf of the Southern Railway company in England. On the outbreak of the First World War he enlisted in the 4th Battalion, Royal Munster Fusiliers, and was wounded at Gallipoli in 1915. He later served in Salonika, and *City Walls, Salonika* is at the Crawford Municipal Art Gallery, Cork. At the Black and White Artists' Society of Ireland exhibition in 1916 he showed a woodcut, *The Retreat from Serbia*. At the Royal Hibernian Academy , 1917, the work of Lieut. Robert Gibbings of Carrigrohane, Co. Cork, included two Gallipoli scenes. During his active service in the Army he made numerous drawings.

In 1917 he was stationed on Bear Island, Co. Cork. He designed a library bookplate for University College, Cork, and for their Old Corkonian Club a golden wedding address, with Celtic ornament, for their president. Robert Gibbings was one of the signatories. Out of the army, he returned to London and the Imperial War Museum commissioned an oil painting, *Gallipoli: Sunset over Lemnos, HMS Triumph and HMS Swiftsure, 1919.*

Gibbings played an active role in the formation in 1920 of the Society of Wood Engravers, acting as honorary secretary. The inaugural exhibition was held at the Chenil Gallery, Chelsea. Among the other ten artists forming the new society were E.M.O'R. Dickey (q.v.), Eric Gill (1882-1940), Gwendolen Raverat (1885-1957) and Noel Rooke. Gibbings was also associated with the Decorative Art Group in London. In 1921 twelve of his wood engravings were published privately. Portraits were rare, but in the early 1920s he produced a woodcut of William Walcot, RE, FRIBA (1874-1943).

Four ink drawings including *Dublin under Snow*, 1918, are in the Hunterian Art Gallery, University of Glasgow. A first commission to decorate a book came with Samuel Butler's *Erewhon*, 1923, proving a turning point in his career. In 1924 he took over the Golden Cockerel Press. This gave him a unique opportunity to explore the relationship of illustration and text and to treat the book as a whole. During the nine years of his proprietorship he was responsible for the design and production of seventy-two books, forty-eight of them decorated with wood engravings; other artists were also involved. The first book published, at Waltham St Lawrence, near Reading, was *Lives of Gallant Ladies*, 1924, by Pierre de Bourdeille, with ten Gibbings' wood engravings, followed by Henry Carey's *Songs and Poems*, 1924, with twenty-four wood engravings by Gibbings.

In the mid-1920s his work was displayed at the Redfern Gallery, London. He also showed with the International Society of Sculptors, Painters, and Gravers. In 1929 he sailed to Tahiti on a commission. His *The 7th Man*, 1930, he described as 'a true cannibal tale of the South Sea Islands told in fifteen wood-engravings and precisely one hundred and eighty-nine words.' In 1930 he was represented in an exhibition of Irish art at Brussels. The Society of Wood Engravers exhibited at Daniel Egan's Gallery, Dublin, in 1932 and Gibbings was represented. As for the famous Press, the most prolific artist working for it was Gill, with whom Gibbings had close contact. The Irishman illustrated *Rummy*, 1932, by A.E. Coppard.

Iorana, A Tahitian Journal, with illustrations, was published in 1932. A wood engraving, *Noontime in Italy,* 1932, is in the Art Gallery of Western Australia. Wherever he travelled when collecting material for his books, he made pencil sketches. In 1934, after he had sold his interest, he illustrated for Golden Cockerel Press, *Beasts and Saints*, translated by Helen Waddell, and *Glory of Life* by his friend, Llewelyn Powys. Looking back twenty years later, he wrote: 'My engravings for these two books were the best I had so far accomplished.' He described his *A True Tale of Love in Tonga*, 1935, as 'told in 23 engravings and 337 words'.

Gibbings taught in the University of Reading School of Art from 1936 to 1942. In his first year of part-time teaching he was a sessional lecturer in topography, book production and engraving. In the next year he was full-time lecturer in typography and book production. He thus had opportunity to undertake several major projects in the vacations. The University has a Gibbings Collection which includes books, prints, blocks, manuscripts and letters.

In 1937, the year he was represented at the Paris International Exhibition, he visited Bermuda and, using special diving apparatus, spent a great deal of time underwater making pencil sketches on xylonite of the marine life among the reefs. The drawings were incorporated into *Blue Angels and Whales*, 1938, 'a record of personal experiences below and above water'. One of the drawings is in the Victoria and Albert Museum collection. 'Under Sea Drawings' was the title of an exhibition at the Stafford Gallery, London, in 1939. He worked for Penguin Books as art editor for the series 'Illustrated Classics', published in 1938.

The National University of Ireland conferred an MA honorary degree in 1938, recommended by University College, Cork. In the early summer of 1939 the *Willow*, a flat-bottomed boat, was built to his design in the woodwork room of the school of art at the university, and for the rest of the summer Gibbings, who had already travelled more than 50,000 miles over salt water and visited the five continents, made his memorable exploration of the Thames. The result was the first of his river books, *Sweet Thames Run Softly*, 1940. The great success of the book encouraged him to write further river books, including *Coming Down the Wye*, 1942, and *Lovely is the Lee*, 1945. Five other river books were to follow. A total of almost 500 wood engravings appeared in the series. He gave a lecture, 'An Artist Under the Sea' in 1943, before the Royal Dublin Society.

Gibbings returned to the South Seas and following a sojourn in the Polynesian Islands, *Over the Reefs*, 1948, was the outcome. In 1950 at the RHA, under 'Watercolours and Drawings', and giving an address Whitehall Towers, Rathfarnham, Co. Dublin, he exhibited *Bermudian Fish; Grand Swell on the Reef;* and *Blue Angels and Gorgonias*. A return visit to Co. Cork resulted in *Sweet Cork of Thee*, 1951, the year he was elected ARHA. His final contribution to the Academy was in 1953 when he showed two Seine watercolours. As well as wood engravings, *Trumpets from Montparnasse*, 1955, included eight colour plates of oil paintings. In 1955 he left London and moved to Long Wittenham, Berkshire, where he wrote and illustrated *Till I End My Song*, 1957.

Of the fourteen wood engravings at the Museum of New Zealand, Wellington, all save one were donated in 1951 by Rex Nan Kivell of the Redfern Gallery, London, and he also gave five to the Auckland City Art Gallery. As well as ten wood engravings, the Hawke's Bay Art Gallery and Museum at Napier, New Zealand, has an untitled oil painting of a green elephant. In the USA, Harvard University Art Museums own thirty-two wood engravings including *Saint Brendan and the Sea Monsters* and *Hezekia Brown, Esq.*

The largest collection of his wood engravings is in Reading Museum and Art Gallery. The Scottish National Gallery of Modern Art has eleven, including two in colour: *The Retreat from Serbia*, 1916, and *Evening at Gaza*, 1918. In Oxford, there are forty-three wood engravings of which twenty-seven are from the Thomas

Balston Gift of 1954, at the Ashmolean Museum. Among the four at Manchester City Art Gallery is *Love is Birds among Fruit over Running Water*. The Crawford Municipal Art Gallery in Cork has sixty wood engravings, including one of the coat of arms of University College, Cork. Gibbings, once described as 'an immense man, a patriarchal figure; tall, bearded and burly', died on 19 January 1958 at the Churchill Hospital, Headington, Oxford. He was buried in Long Wittenham churchyard. A memorial exhibition was held at the Victoria and Albert Museum in 1960.

Works signed: Robert Gibbings, R. Gibbings, Gibbings or R.G.
Examples: Adelaide: Art Gallery of South Australia. Auckland, New Zealand: Art Gallery. Belfast: Ulster Museum. Cambridge: Fitzwilliam Museum. Cambridge, Mass., USA: Harvard University Art Museums. Cardiff: National Museum of Wales. Cork: Crawford Municipal Art Gallery; University College. Dublin: Hugh Lane Municipal Gallery of Modern Art. Edinburgh: Scottish National Gallery of Modern Art. Glasgow: Hunterian Art Gallery, University. Limerick: City Gallery of Art. London: British Council; British Museum; Imperial War Museum; Victoria and Albert Museum. Manchester: City Art Gallery. Napier, New Zealand: Hawke's Bay Art Gallery and Museum. New York: Metropolitan Museum of Art. Newport, Gwent: Museum and Art Gallery. Oxford: Ashmolean Museum. Perth: Art Gallery of Western Australia. Reading: Museum and Art Gallery; University. Wellington: Museum of New Zealand.
Literature: (excluding books already mentioned): *The Studio*, June 1916, December 1918, February 1919 (also illustrations), September 1919, July 1920, November 1920, February 1921 (also illustration), August 1922, March 1930 (illustration), March 1931 (illustration), September 1934 (illustration), December 1937 (illustration), February 1939 (illustration), December 1940, April-May 1943 (illustration), July 1943, August 1943 (illustration), June 1945, July 1949, February 1950 (also illustration), May 1951; Robert Gibbings, *Twelve Wood Engravings*, published privately, 1921; Campbell Dodgson, *Contemporary English Woodcuts*, London 1922 (illustrations); J. Crampton Walker, *Irish Life and Landscape*, Dublin 1927 (also illustration); Robert Gibbings, *Fourteen Wood Engravings*, London 1932; Robert Gibbings, *Coconut Island; or, the adventures of two children in the South Seas*, London 1936 (illustrations); *Belfast Museum and Art Gallery Quarterly Notes*, June 1939; *Irish Times*, 6 November 1943; Thomas Balston, *The Wood-Engravings of Robert Gibbings*, London 1949 (also illustrations); Richard Bennett, *The Story of Bovril*, London 1953 (illustrations); Robert Gibbings, *The Perfect Wife*, Dublin 1955 (illustrations); Patience Empson, ed., *The Wood Engravings of Robert Gibbings*, London 1959; A. Mary Kirkus, ed. by Patience Empson and John Harris, *Robert Gibbings: A Bibliography*, London 1962; *Ireland of the Welcomes*, January-February 1963; Eric Cross, *The Tailor and Ansty*, New York 1964 (illustrations); *Cork Examiner*, 10 March 1969; University of Reading, *4 aspects of the work of Robert Gibbings*, catalogue, Reading 1975; Ms Patience Empson, *Letter to the author*, 1985; University College, Cork, *Letters to the author*, 1985, 1996; Ann M. Stewart, *Royal Hibernian Acdemy of Arts: Index of Exhibitors 1826-1979*, Dublin 1986; Peter Murray, compiler, *Illustrated Summary Catalogue of The Crawford Municipal Art Gallery,* Cork 1991 (also illustrations); Art Gallery of Western Australia, *Letter to the author*, 1995; also, all 1995, Ashmolean Museum; Auckland City Art Gallery; Harvard University Art Museums; Hawke's Bay Cultural Trust; Hunterian Art Gallery; Imperial War Museum; Manchester City Art Galleries; Museum of New Zealand; National Galleries of Scotland.

GIBSON, JOSEPH S. (1837-1919), topographical artist. Born on 9 October 1837 in the parish of Kilmurry, near Macroom, Co. Cork, Joseph Stafford Gibson spent his early youth in Kilmurry. Later he lived at Grand Parade, Cork, and at Glenbrook, Co. Cork. He attended Farrington's School, Cork, and Brown's School, Bandon. The Crawford Municipal Art Gallery has five portrait miniatures by Frederick Buck (1771-c.1840) of members of the Gibson family.

On his coming of age in 1858, he inherited from his father, William Gibson, some money and an income which he proceeded to increase by means of mortgages, loans and investments. He had two absorbing passions, first to learn painting and become an artist; and second to travel. His diary began when he was twenty-four years of age. Apparently he did not receive much tuition in art. He went to London in 1861 and in the following years visited France, Switzerland and Italy. London was his base for frequent visits to Paris, and he returned to Glenbrook on occasions, mainly for business purposes.

In addition to art and travel, he was interested in music and architecture. After studying Spanish in London for four years, he left for Spain, reaching Madrid in 1878 where he resided until his death, a stay of just over forty years. His lodgings were at 31 and 33 Calle de la Aduana and from that base he visited art centres and churches, sketching most of the time. Among the places which he visited were San Sebastian, Valladolid, Tarragona, Barcelona, Oviedo, Zaragoza, Montalban and many other centres. Albarracin, 120 miles east of Madrid, appeared to have a special attraction in the period 1884-1907, judging by titles and dates of works.

In his diary for 10 August 1883, he wrote: 'Passages, Guipurseoa. The second picture I am doing here has as often occurs caused me a good deal of trouble in the sky, I wanted to get a clear blue one. The sky of Spain is often a most transparent one, at the same time a very intense blue colour, two things very difficult to get in watercolour. I don't remember ever to have seen anyone able to do it, though I have often seen the thing tried. This month is finer than the last but there are often wet and cloudy days.'

From his diary at Elche, 12 June 1884: 'Have made two paintings ¼ imperial. The first is done in Chinese Ink and came out pretty well, the second in watercolours. It looks a failure, the sky is thick. They are both to the south of Elche, close to one another. They are date trees. The difficulty I had in finding a sketch is that they are planted in squares and in small groves with a wall round them. This wall forms a line along the picture which is very ugly ...' On his occasional return visits to Cork, Gibson would seek advice and encouragement from James Brenan, RHA (q.v.), who was headmaster of the Cork School of Art, 1860-89.

Painting occupied Gibson's bachelor thoughts from his youth to the end of his life, an abiding passion. His name is remembered by the Gibson Bequest. In his will dated 24 June 1916 he bequeathed to the School of Art, Cork, the sum of £14,790. The income was to purchase works of art and in cases of Munster-born students 'of unusual talent and good habits' for travel on the Continent of Europe 'for a period not exceeding one year to study oil painting or sculpture...The money should be sent him or her once each month or each two months as it is not advisable for young people to have too large a sum of money at one time – they squander it'.

Gibson also presented to the Municipal Art Gallery portfolios of watercolours, 280 works in all. Since he never exhibited, the works were totally unknown to Irish eyes during his lifetime. Anne Crookshank and the Knight of Glin in their book on Irish watercolours published in 1994 wrote: 'The watercolours themselves are truly remarkable and vary from the delicacy of his foliage in pictures of the Forest of Compiègne, 1869, or Nogent sur Maine, 1872, to the abstract Glacier de Bossons, Charmonix, 1876, and the extraordinary verve of his series of alleyways with their overhanging roofs, shadows, and searching light, which he did in towns in Spain later in his career, from 1898 to 1907'. His bequest also allowed for the binding of his loose leaf diary and the provision of cabinets for his coins and other souvenirs together with his sketches. He also donated pictures by other artists. He died in Madrid on 3 February 1919.

Works signed: J.S. Gibson; Joseph S. Gibson or J.S.G., both rare (if signed at all).
Examples: Cork: Crawford Municipal Art Gallery.
Literature: W.G. Strickland, *A Dictionary of Irish Artists*, Dublin 1913; Gibson Bequest and City of Cork Vocational Education Committee, *Cork Art Galleries*, Cork 1953; Crawford Municipal Art Gallery, *Letters to the author*, 1985, 1986; Peter Murray, compiler, *Illustrated Summary Catalogue of The Crawford Municipal Art Gallery*, Cork 1991 (also illustrations); Anne Crookshank and the Knight of Glin, *The Watercolours of Ireland*, London 1994.

GIFFORD, GRACE (1888-1955), cartoonist and caricaturist. One of a family of twelve children, Grace Vandeleur Gifford was born in Dublin, daughter of a solicitor, Frederick Gifford, a Catholic, and a Protestant mother. Her parents were Unionist. The family was not a happy one and the children soon separated. Grace and her brother, Gabriel Paul Gifford, attended the Dublin Metropolitan School of Art, and after studying there under (Sir) William Orpen (q.v.), she moved to the Slade School of Fine Art, London.

One of her earliest cartoons was dated '07: *The Mad-Tea Party (celebrating the erection of the Molesworth Street Statues)*. This work was formerly at the Abbey Theatre but is now in the National Library of Ireland. In 1907 she had drawings published in *The Shanachie*. Also at NLI is a 1912 caricature of John McCormack, tenor, and *William Orpen 'Seeing Life'*. She also contributed to the *Irish Review*, the editorship of which was taken over in 1913 by Joseph M. Plunkett, whom she later married. An issue of *Irish Life* in 1913 contained her *Design for a Greek Vase*, depicting Professor Mahaffy of TCD on the utensil.

A number of the drawings in the Abbey Theatre collection at NLI were presented by Joseph Holloway, the Dublin theatre-goer who kept a diary and accumulated material relating to the theatre. Among the Abbey works are drawings of Miss Maureen Delany in *Meadowsweet*, 1919, and the six figures in W.B. Yeats's *The Words upon the Window Pane*, 1930, include May Craig, Eileen Crowe, F.J. McCormick and Arthur

Shields. Taking into account all the Gifford/Plunkett works at NLI, theatre and non-theatre, some uncatalogued, at least thirty-six are established.

Writing from 8 Temple Villas, Palmerstown Road, on 19 June 1915 to Holloway, she sent two drawings 'of the Abbey people' for assessment, having confessed: 'I can't make a halfpenny!' In another letter, undated from the same address, she sent to Holloway 'a water colour and ink sketch made of Geo. Moore when he was last over. One reason I send it is that everyone who knows anything about drawing who has seen it, says that it is the best thing ever done of Moore. I think so myself, but it may not appeal to you ...'

In another letter, incompletely dated from 49 Philipsburgh Avenue, she told Holloway that she was emigrating, 'not being able to make a living – however humble – in Dublin. It is a terrible tragedy – I would rather be a servant in Ireland than a millionaire elsewhere ...' Although some other members of the family left Ireland – and some were said to have changed their names – Grace remained in Dublin.

Grace joined Sinn Féin, took a part in the Republican struggle, and married against her parents' wishes the 1916 leader, Joseph Plunkett, late on the evening before his execution at Kilmainham Jail. At Áras an Uachtaráin are two posthumous sketches of her husband: a pencil sketch, whole length seated, dated June 1916; pen and ink, head and shoulders, dated 1938. Both sketches were presented by the artist. Her sister Muriel was married to Thomas MacDonagh, another of the executed signatories to the declaration of the Irish Republic.

A member of the Provisional Republican Government in 1917, Grace did much artistic work in cartoons, posters and banners to aid the cause of nationalism. There were other commissions. On May Day 1919 members of the Irish Women Workers' Union were active, holding a general holiday and distributing handbills with a caricature by Grace Plunkett. She was later imprisoned in Kilmainham, where she painted during the Civil War a mural on the wall of her cell, the 'Kilmainham Madonna', restored nearly half a century later.

Her name was particularly associated with pen and ink caricatures of leading literary and theatrical people in the Dublin of her period. Among her drawings were: John MacDonagh, writer; Harry Clarke (q.v.), stained glass; F.J. McCormick, actor; Francis O'Higgins, poet; Jimmy O'Dea, actor; Harold White, musician; Seamus O'Sullivan, writer and editor; Arthur Darley (National Gallery of Ireland), violinist. A caricature of Lady Gregory at NLI, bore the caption: 'Sighing for new worlds to Kiltartanise'. She also designed some costumes for the Abbey Theatre.

An occasional contributor to *Dublin Opinion* and *Irish Tatler and Sketch*, she had one cartoon published in *Punch* in 1934. Three books of pen and ink drawings of Irish celebrities and theatrical people were published: *To hold as 'twere*, 1919, contained seventeen drawings; Sir Edward Carson, Countess Markievicz (q.v.), T.M. Healy, Eamon de Valera, Joseph Devlin were the first five. *Twelve Nights at the Abbey Theatre* appeared in 1929; 200 copies only for subscribers. *Doctors recommend it!*, 1930, sub-titled 'An Abbey Theatre tonic in 12 doses', contained drawings depicting scenes from that number of plays; all the players were named. By the time the last two were published she resided at 11 Nassau Street, Dublin, and still sent drawings to Holloway for possible sale.

The proposal in 1955 to commission portraits and busts of 1916 leaders and members of the first and second Dáil for Leinster House produced some problems over a bust of Joseph Plunkett. Asked by the Government to give co-operation and assistance to the project, his widow replied that as far as she was aware no sculptor existed who had known any of the 1916 leaders personally and a bust made from a photograph would be deplorable, historically and artistically. The bust by Albert Power (q.v.) of Madam Markiewicz (q.v.) had been described, she said, 'as looking like a fireman'.

In a later letter to Mr de Valera, Mrs Plunkett asked what co-operation she could give to an artist – was she to stand by and tell him to remove some clay from the cheekbone and more from the nose and eyelids? 'I cannot conceive any artists tolerating such interference', she said. The execution of the proposed bust of her late husband was put in hand, despite indications that 'her co-operation and assistance may not be forthcoming'.

In a letter to the author written in 1982 by Mrs Geraldine Plunkett Dillon, sister of the executed J.M. Plunkett, she wrote: 'I did see Grace and her sister Sydney (who wrote under the name of John Brennan) now

and then but Grace was a loner and often very difficult. She was to a great extent an undeveloped artist and her best work was Joe Holloway's cartoons. I heard that only a portion of them reached the National Library. It was Sydney who emigrated. Grace was never serious about it. She had a good pension as Joe's widow and could have made plenty more but she did not care about money and threw it or gave it away. She changed a lot after her sister Muriel MacDonagh was drowned. She died alone in a flat and was not found for a week ...'

Works signed: Grace Gifford, Grace Plunkett or Grace Vandeleur Plunkett, rare.
Examples: Belfast: Linen Hall Library. Dublin: Abbey Theatre; Áras an Uachtaráin; Kilmainham Jail Historical Museum; Hugh Lane Municipal Gallery of Modern Art; National Gallery of Ireland; National Library of Ireland.
Literature: *The Shanachie*, Autumn 1907 (illustration), Winter 1907 (illustration); *Irish Review*, July 1911 (illustration), September-November 1914 (illustration); *An Bhearna Bhaoghail*, Dublin 1912 (illustration); *Irish Life*, 25 April 1913 (illustration); Grace Gifford, *Letters to Joseph Holloway*, 1915 and n.d., mss., National Library of Ireland; *The Poems of Joseph Mary Plunkett*, Dublin 1916 (illustration); Mrs Joseph Plunkett, *To hold as 'twere*, Dundalk 1919 (illustrations); J.B. Dollard, *Clontarf*, Dublin 1920 (illustration); *Dublin Magazine*, January 1924 (illustration), May 1924 (illustration); Grace Plunkett, *Twelve Nights at the Abbey Theatre*, Dublin 1929 (illustrations); Grace Plunkett, *Doctors recommend it!*, Dublin 1930 (illustrations); *Irish Tatler and Sketch*, Christmas 1931 (illustration); R.M. Fox, *Rebel Irishwomen*, Dublin 1935; Dr Douglas Hyde, *Collections of Historical Pictures, etc. established at Áras an Uachtaráin*, catalogue, Dublin 1944; Tom Collins and Charles E. Kelly, *Forty Years of Dublin Opinion*, Dublin 1961; *Capuchin Annual*, 1974; Sydney Gifford Czira, *The Years Flew By*, Dublin 1974; Cork Rosc, *Irish Art 1900-1950*, catalogue, 1975; Belinda Loftus, *Marching Workers*, catalogue, Belfast 1978; National Gallery of Ireland, *The Abbey Theatre 1904-1979*, catalogue, 1979; Mrs Geraldine Plunkett Dillon, *Letters to the author*, 1982, 1985; *Irish Times*, 19 January 1985; John Turpin, *A School of Art in Dublin since the Eighteenth Century*, Dublin 1995 (illustrations).

GILBERT, JOHN (1834-1915), topographical artist and illuminator. Born in England, he settled in Cork city as a landscape and portrait painter but specialised in illuminated addresses, and for many years was the proprietor of an art shop at 120 Patrick Street. A trade label on the back of one of his own pictures read: 'Printseller and Frame Maker. Illuminator. Artists' Colourman. Optician to the Faculty and Eye Hospital. Art and Fancy Goods'.

Gilbert organised a ceramic exhibition, said to be the first ever held in Cork, in 1880, and another in 1881 included examples of Meissen ware as well as works 'by local enthusiasts of this fashionable art form of painting on porcelain'. At the Cork Industrial Exhibition, 1883, art section, he showed watercolours together with two 'illuminations' and four 'addresses'. At Kinsale Regional Museum is an illuminated address to Most Rev. Dr O'Callaghan, Bishop of Cork, on the opening of St John's Secondary School, Kinsale, c. 1896.

As well as painting in Cork city, he made excursions; a watercolour exists of Youghal, 1879. Some of his watercolours were executed in pairs: also in private possession are: *The Marina – Looking East* and *The Marina – Looking West*, approximately 10cm x 12.5cm. *Timoleague Castle* is also privately owned. Painted in 1913, a watercolour, *The Pigeon House, Dublin*, is in Crawford Municipal Art Gallery, Cork, where there is also *Patrick's Quay, Cork, 1886* and *Globe Lane, Cork, 1887*, both watercolours.

In 1914, giving his address as 9 Glenville Villas, Cork, he exhibited at the Royal Hibernian Academy: *South Coast Cliffs – Crosshaven* and *Evening on the Lee*. At the sale in 1915 of the collection of the late Robert Day, FSA, Cork, antiquarian and connoisseur, there were fourteen Gilbert watercolours of local views, framed together. In that year of his death he showed *Her Last Anchorage* at the RHA. He died at home in Cork on 8 August 1915. The business was carried on for many years by a son.

Works signed: John Gilbert or J. Gilbert.
Examples: Cork: Crawford Municipal Art Gallery. Kilkenny: Art Gallery Society. Kinsale: Regional Museum.
Literature: *Robert Day Collection Sale*, catalogue, Cork 1915; *Irish Art in the 19th century*, catalogue, Cork 1971; J.F. Hegarty, *Letters to the author*, 1985; Peter Murray, compiler, *Illustrated Summary Catalogue of The Crawford Municipal Art Gallery*, Cork 1991 (also illustration).

GILLESPIE, FLORENCE – see PIELOU, FLORENCE

GILLESPIE, GEORGE K.(1924-95), landscape painter. George Kennedy Gillespie was born in Belfast on 29 September 1924, the son of a breadserver, George W. Gillespie. Educated at Belfast High School, from 1941 until 1945 he attended the evening classes at Belfast College of Art, studying jewellery, silversmithing as well as painting. Interest in fine art was encouraged in the late 1950s when he attended painting classes in the studio of R. Boyd Morrison (q.v.) in Holywood, Co. Down.

In 1977, due to a coronary attack, he retired from his bakery business and took up art professionally, working from his studio at home in Newtownards, Co. Down. In 1980 at the Oriel Gallery, Dublin, he showed forty-one paintings, about a quarter Co. Donegal scenes, also included were: *Near Ardee, Co. Louth*; *At Cushendun, Co. Antrim*; *Near Slane, Co. Meath*; *Near Drumahare, Co. Sligo*. Exhibitions were also held at the Kenny Gallery, Galway, and the James Gallery, Dalkey, Co. Dublin.

Gillespie admired the academic work of such Ulster practitioners as J. Humbert Craig and Frank McKelvey (qq.v.). Co. Donegal was his first love, for example Horn Head and Lough Finn, followed by the rugged scenery of Connemara and the west coast. As he had to avoid prolonged exposure to the elements, the camera assisted him in his compositions.

In the collection of the Department of the Environment for Northern Ireland there are twenty-three works. At the Office of Public Works in Dublin are nine landscapes, including the oils *In the Ballinahinch Lake District, Connemara*, a second similarly titled, and *On the Road to Gweedore*. He died on 20 August 1995 in Newtownards Hospital.

Works signed: G. K. Gillespie.
Examples: Belfast: Department of the Environment for Northern Ireland. Dublin: Office of Public Works.
Literature: Oriel Gallery, *Exhibition of Paintings by George Gillespie*, catalogue, Dublin 1980 (also illustrations); *Irish Times*, 2 October 1995; Office of Public Works, *Art of the State*, catalogue, Dublin 1995 (illustrations); Office of Public Works, *Landscapes North and South,* catalogue, Dublin 1997 (also illustrations); Stephen Gillespie, *Letter to the author*, 1998.

GILMER, ARTHUR (1882-1929), landscape and topographical artist. 'Artie' was the son of James Gilmer, Malone Avenue, Belfast. Before the First World War he had a studio at the rear of the upstairs premises of Irish Decorative Art Assocation Ltd, 35 Wellington Place, Belfast. One of the original members of the Ulster Literary Theatre, founded in 1902, he was also a member of the Ulster Arts Club where his works were exhibited in 1911. In 1914, for the first and only time, he showed at the Royal Hibernian Academy: '*Nocturne*', *Ballycastle*, coloured etching, and *A Breton Village Forge*.

In 1921 Gilmer married Madge Lilburn in Belfast. Her sister Annie married an artist, J. Humbert Craig (q.v.), and another sister, Edie, also married an Ulster artist, J. Stanley Prosser (q.v.). After his marriage 'Artie' lived in Dublin, where he was in business associated with a musical firm.

The Ulster Museum, provenance unknown, has fifty-one unsigned drawings, more than half either in charcoal and chalk or charcoal and watercolour. These include such Dublin landmarks as the City Hall, St Patrick's Cathedral, The Coombe and Dublin Castle. He also painted outside the city, for example *Donegal, Looking towards Tory Island* and *An Irish Clachan*. He died at his residence, 75 Lower Beechwood Avenue, Ranelagh, Dublin on 25 February 1929, and was buried at Dundonald Cemetery, Belfast.

Examples: Belfast: Ulster Museum.
Literature: Mrs E.K. Archer, *Letter to the author*, 1977; Mrs R.K. Walsh, *Letter to the author*, 1977; *A Concise Catalogue of the Drawings, Paintings & Sculptures in the Ulster Museum*, Belfast 1986.

GIRLING, MILLICENT (1900-93), illustrator and designer. Millicent Grace Girling was born in Waterford on 23 June 1900, the daughter of a solicitor, George Philip Girling. In his book on Irish stamps, James A. Mackay described her as a ceramic and stained glass artist and book illustrator, who trained as an art teacher at the Dublin Metropolitan School of Art. Commenting on the school in general in the 1920s, Hilda van Stockum wrote: 'At that time it was very informal. I don't remember any examinations, I just paid the fee

and went…We used to go and visit the night school's students who had special studios.' She recalled that Millicent Girling and Seán O'Sullivan (q.v.) both had studios. Among the students cited by the headmaster, George Atkinson (q.v.), as exemplars of high attainment was Millicent Girling.

At that period in the School of Art, Harry Clarke (q.v.) held a weekly class in graphic design and book illustration. He had contacts with George Russell (q.v.), editor of the *Irish Statesman*, and Seamus O'Sullivan, editor of the *Dublin Magazine*, and managed to promote black-and-white work by his students in these periodicals. Among those whose works were published was Millicent Girling, who provided an illustration of three men in a public house for a story by Brinsley MacNamara in the *Dublin Magazine*, August 1923, and in the following month she had two illustrations: a drawing for a story by Michael Gillacrist and a full page for herself, *A Fantasy*, bearing a resemblance to work by Clarke.

In 1922 she had exhibited at the Royal Hibernian Academy three watercolours, illustrations for R. L. Stevenson's *A Child's Garden of Verses,* giving her address as 4 Garville Road, Rathgar, Dublin, but there is no evidence that these illustrations appeared in an edition of the book. At this time her father's office was at 10 Nassau Street, Dublin.

A permanent issue postage stamp designed by her appeared in 1923. The armorial bearings of the Four Provinces were depicted on a shield surrounded by a border of shamrocks. The arms for Leinster showed a golden harp with silver strings on a green field. Connaught: Half an eagle on a white field from the side of which sprang an arm bearing a sword on a blue field. Ulster: A red cross on a gold field in the centre of which was a red hand on a white shield. Munster: Three golden crowns on a blue field. According to Mackay in his book: 'The design of the shield is interesting since some attempt was made by Miss Girling to show the various lines and dots used by heraldic artists to denote colours in monochrome.'

In a conversation with the author in 1978, Maurice MacGonigal (q.v.) remembered Millicent Girling at the School of Art, finishing about 1924. In 1926, from 29 Kenilworth Square, Dublin, she resumed exhibiting at the RHA, showing four works, including *'Once, Once upon a Time'* and *The Snow Giant.* In the next three years, from Burn Brae, Portadown, Co. Armagh, she showed four pictures. Contributions in 1928 were: *Manannan and Lugh, the Sun God* and *'From Ghosties and Ghoulies and Long-legged Beasties…'* At her last Academy exhibition she showed an illustration for 'The Pink Frock,' a poem by Thomas Hardy, but again publication has not been traced. She travelled to England and taught art for a couple of years at Spalding Girls' School, Lincs. Her death was on 2 November 1993 at Glebe House, Mill End, Northleach, Glos., the widow of K. C. Mann, civil engineer.

Works signed: Millicent Girling.
Literature: *Dublin Magazine*, August 1923 (illustration), September 1923 (illustrations); *Thom's Directory*, 1923; Department of Posts and Telegraphs, *Letter to the author*, 1968; James A. Mackay, *'Eire': the story of Eire and her stamps*, London 1968; Ann M. Stewart, *Royal Hibernian Academy of Arts: Index of Exhibitors 1826-1979*, Dublin 1986; *Register of Deaths*, Cheltenham 1993; John Turpin, *A School of Art in Dublin since the Eighteenth Century*, Dublin 1995; Mrs J. M. Auchinleck (née Mann), *Letter to the author*, 1999.

GLEESON, EVELYN (1855-1944), designer. Evelyn Gertrude Mary Gleeson was the daughter of an Irish doctor, Edward Moloney Gleeson, from Kilcolman near Nenagh, Co. Tipperary, who was practising at Knutsford, Cheshire, at the time of her birth, 15 May 1855. Later he gave up his medical practice and returned to Ireland in 1863, to Benown, Athlone, having founded woollen mills in the town in 1859. She was a cousin of T.P. Gill, who became permanent secretary of the Department of Agriculture and Technical Institution in 1900.

Evelyn Gleeson studied at the Atelier Ludovici in Charlotte Street, off Fitzroy Square, London, 1890-92. She had earlier trained as a teacher. Some portraits by her are still in the possession of her family. More significantly, as it turned out, she spent six months under Alexander Miller at South Kensington learning the arts of design. There she showed 'great skill in choosing and blending colours' as Miller acknowledged. Several of her designs were purchased by Templeton's of Glasgow, the carpet manufacturers, through their London branch.

In London she became associated with the Irish Literary Society, founded by W.B. Yeats in 1891, and also the Gaelic League. The ideals of William Morris (1834-96) were prevalent among artists and craft workers at the time, and she soon became friendly with the Yeats sisters, Elizabeth (q.v.) and Lily (1866-1949), with whom she shared an interest in craft work, and a desire to contribute in some practical way to an Irish revival.

After an operation in 1900, Dr Augustine Henry, an old friend of the Gleeson family, considered that the London smog was a danger to her. He wanted to get her back into purer air and saw in an Irish craft centre a happy solution. It was mainly his capital and advice that resulted in the establishment of the Dun Emer Industries. The house in Dundrum, Co. Dublin, was secured in 1902, the name being changed from 'Runnymede' to 'Dun Emer'.

Evelyn Gleeson superintended the hand-weaving of carpets, rugs and tapestries, which she herself designed, with Celtic ornament to the fore, and having arranged for the Yeats sisters to come over from London they undertook embroidery and printing under Dun Emer Industries. There was a separation in 1908, Miss Gleeson carrying on the weaving under the name of Dun Emer Guild and the Misses Yeats continuing their work as the Cuala Industries in Churchtown, Co. Dublin.

In the article in *The Celt*, 1903, Evelyn Gleeson named some of the leading Irish painters of that time. She then wrote: 'Coming back to Ireland after some years one returns with a fresh eye to which everything appears with startling clearness'. In the same article she noted that unrest was everywhere with the craving for life and excitement. 'The Gaelic League is changing all this; wherever a branch is established the young men are no longer listless and intemperate, the young women do not go to America'. Interest in Irish artistry or handicrafts was not high, and she went around the country judging at shows and encouraging people to keep alive the art industries.

Tapestry was woven to fit panels of screens, for mantels, as wall hangings, and to cover chairs, stools, and sofas, whilst hand-tufted carpets were made for both domestic and church purposes. Banners, vestments and altar cloths were made for ecclesiastical use. In 1910 she became a founder member of the Guild of Irish Art-Workers. Two years later her workrooms moved to Mangan Hall, Hardwicke Street, Dublin. Under her own name, she exhibited in the 1910 and 1917 exhibitions of the Arts and Crafts Society of Ireland.

For the Honan Chapel, Cork, she collaborated in 1917 with her niece in the design of the tapestries of the symbols of the Four Evangelists. In 1923, at 7 St Stephen's Green, Dublin, she displayed the vestments made for St Patrick's Church, San Francisco, but these were designed by her niece, Katherine MacCormack (q.v.). The banner of the Irish Women Workers' Union, 183cm x 112cm c. 1919, was designed by Gleeson. There is a ship banner by her in the National Museum of Ireland. She continued to live at Dun Emer and, despite early anxiety about her health, died there in old age, on 20 February 1944.

Works signed: EG, monogram, watercolours.
Examples: Cork: Honan Chapel, University College. Dublin: Irish Women Workers' Branch, Federated Workers' Union of Ireland, Fleet Street; National Museum of Ireland.
Literature: *The Celt,* September 1903; Katherine MacCormack, *The Book of St Ultan*, Dublin 1920 (illustration); *Irish Times*, 19 July 1923, 21 and 22 February 1944, 16 September 1953; Liam Miller, *The Dun Emer Press, Later the Cuala Press*, Dublin 1973; Belinda Loftus, *Marching Workers*, catalogue, Belfast 1978; *Irish Arts Review*, Winter 1984, Summer 1985; St Patrick's Church, San Francisco, *Letter to the author*, 1986; also, Dr Patrick Kelly, 1988; John Turpin, *A School of Art in Dublin since the Eighteenth Century*, Dublin 1995.

GLENAVY, LADY, RHA (1881-1970), painter, stained glass artist and sculptor. Beatrice Moss Elvery was the second of seven children of William Elvery, of Rothbury, Foxrock, Co Dublin, a Dublin businessman whose ancestors had originated in Spain. They were silk merchants called Alvarez who had first settled in England, later changing the name to Elvery. Beatrice's mother, Theresa Moss, had attended the Dublin Metropolitan School of Art along with her sister, Annie Moss (Traquair q.v.).

Beatrice, in 1896, and her sister, Dorothy Elvery (Kay q.v.), followed in their mother's footsteps and entered the School of Art. In the painting class William Orpen (q.v.) was the star attraction. In later years he was to paint several portraits of Beatrice and use her as a model. When she was taken to the sculpture room

in the School of Art, John Hughes (q.v.) saw her effort and suggested that she should join his class. At the age of sixteen she was awarded a three-week scholarship to South Kensington.

In 1900 in the National Competition, a Queen's Prize for drawing from life was awarded, and she also gained a bronze medal for a design for a modelled tobacco jar. In 1901 she won the Taylor Scholarship with a statuette entitled, *A Bather*. In awarding the scholarship the judges required evidence that the work submitted by her was her own unaided work. Accordingly, she was required to model a head from life in the presence of the judges, who subsequently expressed themselves satisfied.

In 1902 she exhibited for the first time at the Royal Hibernian Academy, statuette of a boy. In 1902 and 1903 she again won the Taylor Scholarship with her modelling, thus over the three years her monetary award totalled £150. Her head in 1903 was of Francis Valerio, model at the School of Art. She is only one of three students to win the Scholarship three years in succession. Some forty years later she herself acted as an adjudicator of the same competition.

'Sculpture in Dublin was almost negligible,' wrote P.L. Dickinson in *The Dublin of Yesterday* (1904-14). 'Miss Beatrice Elvery turned out a good deal of small work which was very clever and sympathetic; indeed, her subjects were invariably spirited and attractive. She had a great talent, and had she really worked seriously, in my opinion, would have achieved almost any success...' William Orpen in *Stories of Old Ireland and Myself*, published in 1924, said much the same thing. He described her as having 'many gifts, much temperament, and great ability. Her only fault was that the transmission of her thoughts from her brain to paper or canvas, clay or stained glass, became so easy to her that all was said in a few hours. Nothing on earth could make her go on and try to improve on her first translation of her thought...'

About 1904 Beatrice and Dorothy Elvery, together with Estella Solomons and 'Cissie' Beckett (Frances) (qq.v.) visited Paris where they studied drawing from life at Colarossi's. In 1904 Beatrice showed some small statuettes and a panel in relief at the Arts and Crafts Exhibition, Dublin. In 1905 she exhibited in the 'Young Irish Artists' exhibition at the Leinster Hall, Molesworth Street, Dublin. Among others who participated were her sister Dorothy and Lily Williams (q.v.). Cissie Beckett also showed. Beatrice was among the sculptors and painters whose work was exhibited at the Oireachtas Art Exhibition in 1906. In 1906 too she contributed '*The Big Hat*' at the RHA, and in the exceptionally lengthy period 1902-69 she showed two hundred works.

In her early days she also illustrated some children's books, made drawings for doctors, taught, and became an active member of the United Arts Club; some of her cartoons still hang on the walls. Later in life she was to contribute occasionally to the humorous journal, *Dublin Opinion*.

In 1903 Sarah Purser (q.v.) had inaugurated the glassworks, An Túr Gloine, and suggested to her that she should design for stained glass, beginning at nine pence per hour, and having accepted she and another girl were taken on a tour of the cathedrals and churches of England to study the subject. Her first windows were installed in 1905 at the Convent of Mercy chapel, Enniskillen, Co. Fermanagh, where there are six in all. *Christ among the Doctors*, 1907, is at St Stephen's Church, Mount Street, Dublin; and at St Nicholas's Church, Carrickfergus, is a three-light, *Good Shepherd*; *Good Samaritan*; and *The Prodigal Son*. A war memorial is at the Church of Ireland Church, Carrickmines, Co. Dublin. Some of her sketch designs, in ink and watercolour, for stained glass are in the National Gallery of Ireland.

In 1910 she exhibited with five others in the Leinster Lecture Hall, Dublin; works by P.F. Gethin, W.J. Leech and G.W. Russell (qq.v.) were also hung. In the same year, when she was included in an exhibition of past and present students' work at the Metropolitan School of Art, she also exhibited at the Arts and Crafts Society of Ireland exhibition and travelled to London to spend about a year at the Slade School of Fine Art. On her return to Dublin she taught for a time at the Metropolitan School of Art. In 1912 she married Gordon Campbell, later 2nd Baron Glenavy, and settled in London until after the War. In London, the circle in which they lived was frequented by literary and artistic personalities, including the painter, Mark Gertler (1891-1939), who attended her 'Sunday evenings' at 24 Norfolk Road.

Among the Campbells' literary friends were D.H. and Frieda Lawrence, Middleton Murry and Katherine Mansfield. The latter described Beatrice in one of her letters as 'a queer mixture for she is really loving and affectionate, and yet she is malicious'. When she exhibited *The Tramp's Child*, among other works, at the RHA in 1914 her address was 9 Selwood Terrace, South Kensington. On returning to Ireland after the War,

she concentrated more on her painting. Appointed an associate in 1932 and in 1934 a full member, she became a faithful attender at Academy meetings. Her painting, often still life compositions, was individual, variously described as 'a charming fantasy-world of her own'; and by the sculptor, Albert Power (q.v.): '... romantic, absurd, theatrical and exhilarating ...' However, a writer in 1936 in *Ireland To-Day* thought that her world was 'made of wool and that everything solid is cylindrical'.

In 1933 she showed *The Intruder* at the Royal Academy, and in the same year, when living at Clonard, Kimmage Road, Terenure, Co. Dublin, her works in the RHA included *Poet and Shepherdess* and *The Music Makers*. In 1935 she had a one-person show at 7 St Stephen's Green, Dublin. When the Cuala Industries were operating from 133 Lower Baggot Street, Dublin, she provided illustrations for two prints, poems by W.M. Letts and Monk Gibbon. The Leinster Galleries, London, showed her work in 1936. She assisted Shelah Richards in the production of two plays for the Dublin Drama League in 1936, and designed for one of these, *The Housetop Madman* by Kwan Kikuchi. A plaster relief, *Mermaid*, 1947, is one of her works at the Crawford Municipal Art Gallery, Cork.

At the 1948 exhibition of the Royal Scottish Academy, she exhibited *Driftwood*, from Rockbrook House, Rathfarnham, Co. Dublin; and *Madonna* was among her exhibits at the RHA. By way of a change, she actually dated an oil, *Primula*, as 1953; part of a dead tree in the immediate background to the flower in a pot, also a landscape with miniature figures. Associated with An Tostal, an exhibition of contemporary Irish art was held in 1954 at the International Hotel, Bray, and her work was included. A one-person show followed at the Victor Waddington Galleries, Dublin, in 1955, and *Madonna with Angel* appeared with *Shells and Things*. Her work was included in an exhibition of flower paintings at Ritchie Hendriks Gallery, Dublin, 1957. She was still to the fore in artistic circles and her home welcomed many for 'Sunday evenings'. In the Arts Council's 1964-65 year the council contributed to the cost of plaques designed by Lady Glenavy for erection on the houses once occupied by George Russell and George Moore.

Monk Gibbon found her 'an unique mixture; of talent and diffidence; of gregariousness and contempt for the herd; of gentle consideration and a savage determination to wound. Only those who knew her well knew her at all; and even to them she remained something of a mystery ...' Of Rockall, Sandycove, Co. Dublin, she died on 21 May 1970.

Works signed: B.C., rare; BE, monogram; B.M.E., Elvery, rare; or BG, monogram.
Examples: Armagh: County Museum. Belfast: Ulster Museum. Carrickfergus, Co. Antrim: St Nicholas's Church. Carrickmines, Co. Dublin: Tullow Church. Cork: Crawford Municipal Art Gallery. Drogheda: Library, Municipal Centre. Dublin: Dominican Convent Chapel, Griffith Avenue; Hugh Lane Municipal Gallery of Modern Art; National Gallery of Ireland; Office of Public Works; Pearse Museum; St Mary's Church, Haddington Road; St Stephen's Church, Mount Street; United Arts Club. Enniskillen, Co. Fermanagh: Convent of Mercy Chapel. Killarney: Town Hall. Limerick: City Gallery of Art. Magheralin, Co. Down: Holy Trinity Church. Tory Island, Co. Donegal: St Colmcille's Church.
Literature: *Royal Dublin Society Report of the Council*, 1901, 1902, 1903;*The Studio*, February 1901, January 1905, March 1910; *The Shanachie*, No. 1, 1906 (illustration); Padraic Mac Piarais, *Íosagán agus Scéalta Eile*, Dublin 1907 (illustrations); Susan Mitchell, *Aids to the Immortality of Certain Persons in Ireland*, Dublin 1908 (illustration); Scoil Éanna, *An Macaomh*, Midsummer 1909 (illustration); *The Irish Review*, May 1912 (illustration); Violet Russell, *Heroes of the Dawn*, Dublin 1913 (illustrations); Stephen Gwynn, *The Famous Cities of Ireland*, Dublin 1915; K.F. Purdon, *Candle and Crib*, Dublin 1920 (illustrations); Katherine MacCormack, *The Book of St Ultan*, Dublin 1920 (illustration); *Dublin Magazine*, August 1923 (illustration), October 1923 (illustration), December 1923 (illustration); Sir William Orpen, RA, *Stories of Old Ireland and Myself*, London 1924; Katharine S. O'Brien, *A First Irish Book*, London 1924 (illustrations); P.L. Dickinson, *The Dublin of Yesterday*, London 1929; *Ireland To-Day*, September 1936; *The Bell*, May 1942; Tom Collins and Charles E. Kelly, *Forty Years of Dublin Opinion*, Dublin 1961; J. White and M. Wynne, *Irish Stained Glass*, Dublin 1963; Beatrice, Lady Glenavy, *Today we will only gossip*, London 1964; *Arts Council, Dublin, Report*, 1964-1965; Noel Carrington, ed., *Mark Gertler Selected Letters*, London 1965; Alan Denson, *An Irish Artist W.J. Leech, RHA (1881-1968)*, Kendal 1968; *Irish Times*, 25 May 1970, 2 December 1980; Hilary Pyle: Cork Rosc, *Irish Art 1900-1950*, catalogue, 1975; Jeffrey Meyers, *Katherine Mansfield: A Biography*, London 1978; Brenna Katz Clarke and Harold Ferrar, *The Dublin Drama League 1918-1941*, Dublin 1979; Pearse Museum, *Letters to the author*, 1985; Mrs Marjorie Reynolds, *Letter to the author*, 1985; Ann M. Stewart, *Royal Hibernian Academy of Arts: Index of Exhibitors 1826-1979*, Dublin 1986; *The Royal Scottish Academy Exhibitors 1826-1990*, Calne 1991; John Turpin, *A School of Art in Dublin since the Eighteenth Century*, Dublin 1995; Gorry Gallery, *An Exhibition of 18th, 19th and 20th century Irish Paintings*, catalogue, Dublin 1999 (also illustration).

GLENN, WILLIAM ST JOHN, RUA (1904-74), cartoonist. Born in Belfast on 22 October 1904, he was the son of Jonathan Carlisle Glenn who worked in the Belfast shipyards. Billy gained some drawing experience at the Belfast School of Art, and his first illustration was published, in *Ireland's Saturday Night*, at the age of sixteen.

After supplying book illustrations and commercial work for Graham and Heslip Ltd, Belfast, printers and lithographers, from 1919 until 1926, he joined the staff of the *Belfast Telegraph*, starting the 'Oscar' strip which was syndicated to *The Friend* in South Africa. Oscar's beautiful dark-haired wife was modelled on the artist's own wife, Dorothea, a relation of the famous Brontë family.

By travelling with the landscape artist, J. Humbert Craig (q.v.), he learnt something of the countryside, and he was also friendly with Rosamond Praeger and Frank McKelvey(qq.v.), who painted a large portrait of his wife. His address was 6 Chilworth Buildings, Stranmillis Road, Belfast. Glenn's talent was spotted by the *Daily Mail*, and here he starred his wife in 1936 in the strip he called 'Dorothea', joining the editorial staff in London in the following year and remaining there until 1961, apart from a break during the war when he was at the the the Ministry of Information. In 1951 after a brain operation, he returned to the *Mail* to draw 'Teddy Tail' daily. Many other newspapers and magazines were involved in his London career, but he contributed only two cartoons to *Punch*, in 1939 and 1941. He illustrated short stories for the *Evening News* and had his own strip, 'Ginger', in *Everywoman*, a monthly magazine.

When living in London he contributed to *Dublin Opinion* for more than thirty years, a series of scraperboard drawings on the imaginary Ballyscunnion, a subtle commentary on village life. One hundred of these drawings were exhibited at the Irish Club, London, in 1970. Returning occasionally to Ireland, he once toured in an old London taxi with his family. He rarely contributed to the Royal Hibernian Academy, but he exhibited in 1936 *Gajoes* and *The Symptons*.

In 1968 he was elected an honorary academician of the Royal Ulster Academy. Late in life he lived at 15 Bolton Gardens, London SW5. The fellow cartoonist, Rowel Friers, wrote that he was 'greatly loved and respected by all who enjoyed a good crack and appreciated a sharp sardonic wit. His verbal shafts were enormously enhanced by a voice of compelling charm ... Undoubtedly one of the finest line artists in these islands ...' After a long illness, he died in hospital, on 2 June 1974.

Works signed: W. St. J. Glenn or Glenn.
Literature: W. St J. Glenn, *Letter to the author*, 1969; *Irish Times*, 17 March 1970, 12 June 1974; *Belfast Telegraph*, 11 June 1974; Martyn Anglesea, *The Royal Ulster Academy of Arts*, Belfast 1981; C. B. Glenn, *Letter to the author*, 1986.

GOFF, ROBERT, RE (1837-1922), landscape painter and etcher. Born on 28 July 1837, son of George Goff, Robert Charles Goff was Irish on both sides of the family. His grandfather was Joseph Fade Goff of Mountjoy Square, Dublin, and Newtown Park, near Dublin, a successful Dublin businessman originally from England. In 1855 R.C. Goff received a commission in the Army; he fought in the Crimea, moving on to Ceylon and Malta.

Goff first exhibited at the Royal Academy in 1870 with *Bazaar Scene, Damascus*, and in 1871, *Windsor* and *Muckross Abbey*, all from 5 Charles Street, London. Between 1870 and 1890 he contributed twenty works to Burlington House exhibitions. In the period 1871-75 he exhibited at the Society of British Artists in Suffolk Street. In the seventies he learnt from a brother officer the process of etching. Having exchanged into the Coldstream Guards, he retired in 1878 after his marriage to Beatrice, daughter of Baron Testaferrata of Malta.

As Colonel Goff generally dated his work, the titles indicated the 'where and when' of his travels. By 1882, from 1 Courtfield Road, South Kensington, he showed *Approach to Shrine, Yenoshima, Japan*. The only year he exhibited at the Royal Hibernian Academy was in 1883 when he sent over six works, including *Kentish Sheep Farm* and *Venice, Evening*. The oldest etching in the Victoria and Albert Museum collection is *Old Putney Bridge*, 1883, drypoint.

The RA catalogues, mediums uncertain, listed Dordrecht views in 1884 and 1887, and *San Giorgio, Venice* in 1889. In 1889 he left London and took up residence at Hove, building a studio at Holland Road. In 1887

he had been elected a Fellow of the Society of Painter-Etchers. What was probably a rare visit to Ireland produced *Kingstown Pier*, 1890, drypoint. Again, judging by his etchings, he was in Paris in 1890, Venice in 1891. The French painter and engraver, Alphonse Legros (1837-1911) drew a pencil portrait of Goff in 1889.

'... the two etchers now exhibiting at Mr Dunthorne's Gallery are careless of popular applause, and work out their own ideas in their own manner ...' wrote *The Studio* critic on the exhibition of works with Charles J. Watson (1846-1927) at Rembrandt Head Gallery in 1893. In Bristol, the Museum and Art Gallery holds a score of drawings, the oldest dated work being *Street in Aix-les-Bains*, 1891, pen and ink; also there are two pencil studies of peacocks, 1894; *Street in Ghent*, 1894, pencil and watercolour; two watercolour marine scenes at Amalfi, 1896. He exhibited again at the Rembrandt Head Gallery in London in 1896. Prices ranged from fifteen shillings to three guineas. In 1903 he moved to a villa overlooking Florence.

In a 1904 issue of *Magazine of Art*, a member of the Royal Society of Painter-Etchers wrote: '... in the happy circumstances in which he is placed he has the rare opportunity of ignoring the commercial side of art altogether, and of roaming through the beautiful places of the earth, unfettered by anything but his own discretion, and he generally restricts his output to watercolours and etchings...His 150 plates show the range of his travels, as well as the extent of his powers ...' The writer singled out three plates for special mention: *Summer Storm in the Itchen Valley*; *Work at New Kew Bridge*; and *Cannon Street Station*.

Etchings of 1901 and 1904 indicated work in Lausanne and Tuscany respectively. Goff illustrated two books by his second wife, Clarissa Goff: *Florence and some Tuscan Villas*, 1905; *Assisi of St Francis*, 1908. He contributed fifty illustrations to the second publication, of which thirty-two were in coloured plates.

The Victoria and Albert Museum has a collection of etchings formed by Colonel Goff as a complete record of his work at the time of presentation. Contained in eight portfolios, each portfolio (or volume) contains a special etched plate, used as an index sheet, with the catalogue number and title of each etching and year of exhibition at the Royal Society of Painter-Etchers, as it became. Of a total of 201, thirty-two are drypoints. The collection of etchings, arranged in ten portfolios, made by himself and presented to the British Museum total 249. There are also many examples of his etchings at Hove Museum and Art Gallery together with some watercolours and studies.

Titles and dates of etchings in the period 1905-10 indicated visits to Boulogne, Cairo, Rome and Japan. An exhibition of the works of Leandro Ramon Garrido (1868-1909), Aubrey Vincent Beardsley (1872-98) and Goff was held in Brighton in 1914, when he gave an address at 63 Preston Street, Brighton. He remained in Florence until the war and then moved to Switzerland. He was an honorary member of the Florence and Milan Academies of Arts. His *Fair at Vesey* (Bristol Museum and Art Gallery), pencil and watercolour, was dated 1915. A view of Fribourg, 1918, watercolour, is among six drawings at the Ashmolean Museum, Oxford. In private collection in Dublin is a watercolour of North Dublin, the only Irish view the owner has seen.

In addition to the many works shown at the Royal Society of Painter-Etchers and Engravers, more than 300 were shown at the Fine Art Society, where there was a memorial exhibition in 1923. He contributed to other exhibitions, for example the Royal Institute of Painters in Water Colours and the Royal Institute of Oil Painters. Outside of London, his favourite venue was the Walker Art Gallery, Liverpool. Late in life he also gave as an address Wick Studio, Holland Road, Hove, Sussex.

The Times noted that his plates were 'marked by originality of style, good composition, an instinct for picture-making, and a special talent for drawing buildings and landscape figures. He thoroughly understood the technical side to his art, but was not a slave to it ... His line was vigorous and well bitten, and his use of drypoint skilful. His plates vary in size, some small ones being specially remarkable. The note of his life was incessant energy and productive enthusiasm ...' He died on 1 July 1922 at La Tour de Peitz, Vevey. A memorial exhibition was held at Brighton in 1923 with Douglas Fox-Pitt (1864-1922). An exhibition of his work took place at Walker's Galleries, London, 1934.

Works signed: R. Goff or R.G.

Examples: Bristol: Museum and Art Gallery. Glasgow: University, Hunterian Art Gallery. Hove: Museum and Art Gallery. London: British Museum; Victoria and Albert Museum. Oxford: Ashmolean Museum.

Literature: Rembrandt Head Gallery, *The Etched Work of Charles J. Watson and Colonel R. Goff,* catalogue, London 1893; *The Studio*, November 1893 (also illustrations); *Magazine of Art*, May 1904 (also illustrations); Mrs Robert Goff, *Florence and some Tuscan Villas,* London 1905 (illustrations); *The Royal Academy of Arts Exhibitors 1769-1904,* London 1905; Mrs Robert Goff, *Assisi of St Francis*, London 1908 (illustrations); County Borough of Brighton Public Art Galleries, *Beardsley-Garrido-Goff Exhibition*, catalogue, 1914; *The Times*, 3 July 1922; *Who Was Who 1916-1928*, London 1929; Walker's Galleries, *An Exhibition of Water-Colours and Etchings by Colonel Robert Charles Goff (1837-1922)*, catalogue, London 1934; *Burke's Landed Gentry*, London 1969; *Dictionary of British Artists 1880-1940*, Woodbridge 1976; *Dictionary of British Watercolour Artists up to 1920*, Woodbridge 1976; Ann M. Stewart, *Royal Hibernian Academy of Arts: Index of Exhibitors 1826-1979*, Dublin 1986; Anne Crookshank and the Knight of Glin, *The Watercolours of Ireland*, London 1994 (illustration); Ashmolean Museum, *Letter to the author*, 1995; also, Bristol Museum and Art Gallery; British Museum; Sir Robert Goff, Bt.; Hove Museum and Art Gallery; Hunterian Art Gallery; Royal Society of Painter-Printmakers; Victoria and Albert Museum; all 1995.

GONNE, MAUD (1866-1953), illustrator and portrait painter. Born on 21 December 1866 at Tongham, near Aldershot, Hampshire, Maud Gonne was the daughter of Colonel Thomas Gonne, 17th Lancers, of Mayo descent. Her English mother died in 1871. Maud received part of her education from a governess in France. Col. Gunne was appointed Assistant Adjutant General in 1882 and for a time his daughter figured in Dublin Castle society. Further tragedy struck the family when her father died in Dublin of typhoid fever.

Because of the threat of tuberculosis, Maud's doctor advised her to take the cure at the French inland watering place, Royat. Again, for health reasons, she stayed at St Raphael on the Riviera, sketching in the woods. Between 1890 and 1894 she bore two children to her secret lover, Lucien Millevoye: a son, who died young, and Iseult in 1894. As witnessed in her autobiography, *A Servant of the Queen*, in which, incidentally, chronology is difficult to follow, and in biographies, her art was a minor part of an exciting life, which combined frequent nationalist activities, for example lecturing at home and abroad, with a courageous social concern, notably at the 1899 Mayo evictions.

Sarah Purser (q.v.) evidently introduced the Swiss artist, Louise Breslau (1856-1927) to Maud Gonne in Paris. In an 1889 letter to Sarah, Breslau asked: 'What has become of your nice tall friend from Avenue Wagram?'; Maud lived there at No. 61. In 1890 Maud posed for the painting, *The New Pet*, later re-titled *Lady with a Monkey: a Portrait* (Hugh Lane Municipal Gallery of Modern Art). Under its original title, this oil painting by Sarah Purser was hung at the 1891 Royal Hibernian Academy. Maud wrote from St Raphael prior to the exhibition asking if the work had been sent in 'and if anyone wanted to buy me.'

Maud Gonne fractured an arm in Dublin in June 1898, and began convalescence while staying with Sarah Purser, who executed a pastel head and shoulders, also now located at HLMGMA. John O'Grady, in his biography of Sarah Purser, wrote: 'Though less than life size, it conveys Gonne's larger-than-life aura in the regal carriage of the head, well proportioned features, brilliant eyes, full throat, and mass of auburn hair...Alone among representations of Gonne, this portrait gives an inkling of what it was about her which so struck beholders. Purser rose to the challenge, and made a work of art.' It was Sarah who took Maud and the poet, W. B. Yeats, to visit John Hughes (q.v.).

In a life that also included some experimental occult experiences; conversion to Catholicism; a Jubilee anti-Queen Victoria children's procession in Dublin; a touch of gambling at Aix-les-Bains; and the founding of Inghinidhe na hEireann in 1900, she had completed her third money-raising lecture tour to the USA by 1901. Meanwhile W. B. Yeats, whom she had first met at the London home of his father, John Butler Yeats (q.v.) in 1889, continued to show his passionate devotion, which found its way into verse. The artist, George Russell (q.v.) designed the dresses for his own play, *Deirdre*, produced by the Daughters of Ireland. In 1902 Maud herself took the title role in W. B. Yeats' *Cathleen ni Houlihan*. In 1903 she married John MacBride in Paris; a son Seán was born in 1904. First steps were taken in 1905 for a legal separation. Her printed memoirs ended with the marriage.

In her house at 13 Rue de Passy, Paris, she practised her painting and embroidery, sending off to W. B. Yeats a 1906 pastel of Iseult: 'Tell me if you like it. She had her hair twisted up for her bath which makes her look too old but otherwise it is like her.' Two years or so later Ella Young stayed at the Passy house,

'green-shuttered and demure beyond a stone-flagged courtyard...' She remembered Maud painting Iseult with an iris blossom.

The hostess at Passy must have had some acquaintance with Auguste Rodin (1840-1917) because she took her friends Ella and the poet to visit him at his studio. They found Rodin, widely regarded then as the greatest living sculptor, chiselling at a block of marble without a model of any kind. Ella Young described him in her memoirs as 'broad-shouldered, bronzed, bearded, and had the air of a man who spent a good deal of time in the open country. He received us graciously...' The room was full of sculptures and he led his visitors from one to the other, gesticulating as he talked. Then he showed them his sketches in the other room. Ella said later to Maud: '...He is mad, brutally and sensually mad. Perhaps it will never brake out, but it shows in those sketches.' Maud replied that there were times when he had to be shut away. Regular visits to the Louvre for Ella, with Iseult and her mother, were probably less exciting.

In New York, the prosperous lawyer John Quinn indulged his tastes in art, literature and Ireland. According to Samuel Levenson in his 1977 Gonne biography, Maud had dabbled in watercolours, woodcuts, and pencil drawings (eventually it would be gold leaf on parchment), and was now trying oils. In answer to Quinn's offer to buy one of her paintings, she said that she wanted to wait until her work had improved. Later, she forwarded a painting of St Brigid.

In July 1908 she wrote to Quinn from 'Les Mouettes,' above the seashore at Colleville-sur-mer, in Calvados, Normandy, and said she was working very hard at her painting and had just sent off three pictures to an exhibition at the Albert Hall, London. She had been told, she added, that Georges Rouault (1871-1958) was sending some of his work there. The London Salon of the Allied Artists' Association patronised the Royal Albert Hall in the two years that Maud Gonne exhibited, 1908 and 1909. In fact in the first year she showed five works, all in the watercolour and black and white section: *Graveyard by the Sea, Colleville, Normandy*; *Portrait of Mlle. Iseult Gonne*; *Portrait of Seagan Gonne*; *Study of Girl's Head*; *Fand and Liban*. Classified as black and white drawings in 1909, she showed: *Portrait of Mrs Bertie Clay*; *Study of a Head (10)*; *Partholam (10)*. A record has not been found of her participating in any other exhibition, anywhere.

The year 1909 saw the publication of Ella Young's *The Coming of Lugh*, Irish fairy stories retold, with Gonne illustrations, described by one writer as 'black-and-white renderings of Celtic iconography, serpents coiled, peacocks and embracing swans.' Quinn considered her illustrations were splendid and would make good designs for tapestries. In 1910 the same artist-illustrator collaboration resulted in *Celtic Wonder Tales*, retold.

In correspondence with Quinn she wrote that much of her time had been spent at her painting. 'My master Granié and Hughes the sculptor who I think you know say I am improving in spite of my inconsequent interest in things outside art.' No doubt the reference is to Joseph Granié (1866-1915) who was based in Paris. On one of his stops in Paris between South America and England she met Sir Roger Casement — he took charge of the Rio de Janeiro consulate in 1909 — and painted a portrait of him which, wrote Levenson, 'revealed the intensity of a Spanish fanatic in the swarthy Ulsterman.' In 1912 she had a new visitor to Passy, Gwen John (1876-1939), who had gone to live in Meudon on the outskirts of the city, and had modelled for Rodin.

Connections with Dublin continued; she was involved for example in a school meals campaign. In wartime France she assisted in nursing the wounded. After the Easter Rising in Dublin, John MacBride was executed. In 1917 she returned to Ireland in disguise and bought a house at 73 St Stephen's Green; it became a Republican meeting place. That year she was in Holloway Prison. A book of poetry by Ella Young, *The Rose of Heaven*, 1920, had Gonne illustrations. In 1922 she and Mrs Despard moved to Roebuck House, Clonskeagh, Co. Dublin.

Elizabeth Coxhead, author of *Daughters of Erin*, described her as 'a gifted amateur artist, and I have seen examples of her shell-flower work which suggest that she could have made a living that way had it been necessary.' Ella Young described her as 'tall and like a queen out of saga. Her hair is burnished gold and her eyes are gold, really gold.' A plaster head, completed in 1932, by Laurence Campbell (q.v.) is at HLMGMA. She died on 27 April 1953 and was buried at Glasnevin Cemetery.

Works signed: M.G.

Literature: *The London Salon*, catalogue, 1908, 1909; Ella Young, *The Coming of Lugh*, Dublin 1909 (illustrations); also, *Celtic Wonder Tales*, Dublin 1910 (illustrations); Katherine MacCormack, *The Book of St Ultan*, Dublin 1920 (illustration); Ella Young, *The Rose of Heaven*, Dublin 1920 (illustrations); Maude Gonne MacBride, *A Servant of the Queen*, London 1938; also, edited by A. Norman Jeffares and Anna MacBride White, Gerrards Cross 1994; Joseph Hone, *W. B. Yeats 1865-1939*, London 1942 (also illustration); Ella Young, *Flowering Dusk*, New York 1945; Elizabeth Coxhead, *Daughters of Erin*, London 1965; *Dictionary of British Artists 1880-1940*, Woodbridge 1976; Samuel Levenson, *Maud Gonne*, London 1977; William M. Murphy, *Prodigal Father*, Ithaca 1978; John O' Grady, *The Life and Work of Sarah Purser*, Blackrock 1996; Hugh Lane Municipal Gallery of Modern Art, *Letter to the author*, 1997.

GORDON, W.R., RUA (1872-1955), landscape, portrait and banner painter. Born at Moira, Co. Down, on 18 August 1872, William Robert Gordon attended the Blue Coat Schools, Downpatrick, before venturing to England aged fourteen to work in the Port Sunlight Soap Factory. In his spare time he studied at the Laird School of Art, Birkenhead; in 1898 his design was regarded as 'distinguished' in the National Competition. He qualified as an art teacher.

Obliged to labour at the shipyards on his return to Belfast, he studied at the School of Design under George Trobridge (q.v.) and became a textile designer, but commercial work did not suit him. In 1901 he was appointed art master at the Royal Belfast Academical Institution and remained there for forty-four years, acquiring the nickname of 'Daddy'.

Gordon made countless friends but no enemies. In addition to his teaching activities – for many years he took evening classes at Newtownards Technical School – he was a founder member and joint honorary secretary of the Ulster Arts Club in 1902; in 1914 and 1915 he was president. Keenly interested in drama, he was an original member of the Ulster Literary Theatre, becoming involved with John Campbell and Jack Morrow (qq.v.). He played the viola, was a singer of traditional ballads, lectured and demonstrated occasionally on art, served on the Council for the Encouragement of Music and the Arts art committee, was a member of the Belfast Libraries, Museums and Art Committee, and also broadcast.

As a means of augmenting his income, he painted banners for both Orange and Hibernian lodges. In 1904 he charged £18 for a 9ft x 8ft banner complete with poles and fittings. About 1920 he was responsible for the banner, now in the Ulster Museum, of the Belfast District of the Amalgamated Society of Woodworkers, signed on front 'W.R. Gordon, 17 Bridge Street, Belfast.' That was the address he gave when he showed three Antrim Coast landscapes at the 1921 Royal Hibernian Academy .

During the 1920s he executed a series of lithograph portraits of local characters. He was the designer of the official standard of the Governor of Northern Ireland. At the Belfast Museum and Art Gallery's loan exhibition in 1920 he was represented by two watercolours, *A Cottage in the Glens* and *The Lake, Belvoir Park*. Four years later he painted the decorated friezes of the Ulster Pavilion at the Wembley Exhibition. In 1927 at the Belfast Museum and Art Gallery in the 'Irish Portraits by Ulster Artists' exhibition he was represented by three works, including *Hill Sinclair, MA, Mathematical Master, RBAI, 1887-1926*, location now untraced.

In 1933 he began work with his friend John F. Hunter (q.v.) on a mural for the Belfast Museum and Art Gallery. On three panels, the work was presented by the Thomas Haverty Trust and unveiled on 14 June 1934. The right-hand mural, measuring 2.9m x 4.6m, depicting barter between the Phoenicians and the Early Irish, is by Gordon; the left-hand, a scene at the conclusion of a boar-hunt, is by Hunter. The small section above the door is a joint production. The Museum held an exhibition of Gordon's work in 1947, demonstrating that he found inspiration in the Glens of Antrim. Two years later he was appointed an academician of the Ulster Academy of Arts.

Altogether at the RHA, he showed a total of ten works, including *The Lagan Canal* and *Harvest* in 1942. In his 80s, popular as ever, he held an exhibition at 55A Donegall Place, Belfast, 1952, and he was one of six Ulster watercolourists whose work was shown by CEMA at the same address in 1953. The following year he exhibited there oils and watercolours. A self-portrait is in the Ulster Arts Club.

Professor Hugh Meredith, a friend for more than forty years, wrote that he had 'the financially fatal accomplishment of never appearing to need. He cut his coat so superbly to his cloth that it might easily escape notice how thin the coat was. He lived, perhaps, in a vicious circle of asking too little and giving too much.

What he had was given unsparingly in response to any flicker anywhere that suggested interest in arts ...'. He died on 25 February 1955 at his home, 9 Sicily Park, Belfast.

Works signed: W.R.G. or W.R. Gordon.
Examples: Belfast: Ulster Arts Club; Ulster Museum. Armagh: County Museum.
Literature: *The Studio*, September 1898; *Northern Whig*, 11 December 1933, 24 May 1952, 3 November 1953; Ulster Society for the Prevention of Cruelty to Animals, *The Tree*, Belfast 1936 (illustration); Belfast Museum and Art Gallery, *Exhibition of work by W.R. Gordon (painter) and Morris Harding, RHA (sculptor)*, catalogue, 1947; *Belfast News-Letter*, 11 September 1947, 30 March 1954, 26 February 1955, 2 January 1967, 28 August 1972; *Belfast Telegraph*, 25 February 1955, 6 July 1957; Royal Belfast Academical Institution, *School News*, Easter 1955; Patrick Shea, *A History of the Ulster Arts Club*, Belfast 1971; *Dictionary of British Artists 1880-1940*, Woodbridge 1976; John Hewitt and Theo Snoddy, *Art in Ulster-1*, Belfast 1977; Belinda Loftus, *Marching Workers*, catalogue, Belfast 1978; Martyn Anglesea, *The Royal Ulster Academy of Arts*, Belfast 1981; Ann M. Stewart, *Royal Hibernian Academy of Arts: Index of Exhibitors 1826-1979*, Dublin 1986.

GORE, W. CRAMPTON, RHA (1871-1946), landscape, interior, portrait and still life painter. The only son of Captain William Gore, 13th Hussars, of Innismore Hall, Enniskillen, Co. Fermanagh, William Crampton Crawford Gore was born on 24 October 1871. He studied medicine at Trinity College, Dublin, qualifying in 1897. A charming and versatile man, he practised medicine until 1901 when he virtually relinquished it for painting, having already spent four months in 1898 under Henry Tonks (1862-1937) at the Slade School of Fine Art, London, and travelled abroad as a ship's surgeon to New York, India and Italy, painting and sketching when the opportunity arose.

In 1900 he returned to the Slade and spent five years there, travelling between times. Subsequently he took lessons in Paris. In his London student days he was friendly with William Orpen (q.v.) and for a short while both lived at 21 Fitzroy Street; Gore posed as the doctor in Orpen's *A Mere Fracture*. He moved to a studio at 76 Charlotte Street. In the summer of 1901 when abroad, he met the Norwegian painter, Fritz Thaulow (1847-1906), and travelled back to Paris with him. Gore recorded in his diary: 'I saw him frequently and learned more from him (by seeing him paint) than anyone else.' In 1902 he returned to 21 Fitzroy Street. *'The Happy Valley'* at the 1904 Water Colour Society of Ireland exhibition depicted an October evening in Brittany.

In 1905 Gore shared a studio with Augustus John (1878-1961) in his lodgings, 1 Fitzroy Street. John, who spent a considerable time drinking, never could pay the rent and Gore constantly offered to pay for him. Finally, there came an outburst from John when the Irishman refused to continue paying the landlady: he became violent and smashed up furniture around him in a drunken rage.

Gore first exhibited at the Royal Hibernian Academy in 1905, and from then until 1939 he contributed more than one hundred works. He painted in 1911, *Petite Promenade sur les Ramparts de Montreuil-sur-Mer, Pas de Calais*. When he exhibited in 1913, a year in which he also showed at the Royal Academy, his address was Rue St Genoch, Paris, and he presented *Rose Peonies*; *Petit Appartement à Paris*; and *On the Ramparts*, which the *Irish Review* described as 'a crisp breezy landscape'. However, Gore established a reputation for the painting of interiors, and in an article on the subject in *The Studio* in 1919 A.L. Baldry stated that his pictures were 'definitely instructive'. Many years later a writer in the *Dublin Magazine* found him 'a delightfully urbane painter, with a rich sense of colour somewhat reminiscent of Pissarro, and at times of Osborne, especially in his interiors. There is a rightness and absence of strain in his composition ...'.

Gore, who also exhibited at the Paris Salon, kept up his Irish associations throughout his life. In 1914, giving an address 61 Rue de la Tournelle, Paris, his works at the RHA included *A Grey Day at Dugort*; *Achill Interior*; and *The Road to Dugort, Achill Island*. He served as a captain in the Royal Army Medical Corps in the First World War. In 1915 he returned to Ireland for a holiday and painted in Co. Donegal with George W. Russell and Dermod O'Brien (qq.v.), a relative. In 1916 he was elected an associate member of the RHA and in 1918 a full member.

On his marriage in France in 1923, after spending a year travelling in China and Japan, he settled in Montreuil-sur-Mer. *The Green Shutters*, featuring his wife and daughter, was painted at 44 Rue du Général

Potez. Dermod O'Brien went to stay with the Gores on several occasions and painted. Under the auspices of the British Artists' Exhibitions, Gore was represented in an exhibition at the Belfast Museum and Art Gallery in 1927; *Zinnias in a Blue Bowl* and *Interior: Le Petit Salon* were hung. In that year at the Royal Institute of Oil Painters he showed *Souvenir of India – Moonlight in the Gardens of the Taj Mahal*, a painting which, judging by its title, appeared at the RHA in 1928. He was also represented in the exhibition of Irish art at Brussels, 1930, and that year he completed work on his scene in an Irish cottage, *The Boiling Pot*, begun in 1912.

From France he moved in 1932 to Colchester, Essex, and served at the Military Hospital until 1940, when he was injured in a road accident and was on crutches until he died. At the RHA in 1933 his address was given as 1A The Avenue, Colchester, and the works included a Co. Wicklow landscape and *In a French Farmyard*.

Gore also showed in London at the Goupil Gallery, the Fine Art Society and the New English Art Club, but only two works were hung at the Royal Academy. A keen traveller, he also painted in Spain. An accomplished musician and composer, he set to music verses written by his ancestor, Captain Josiah Crampton. He had too many interests to worry very much about pushing himself as an artist.

Of 72 Winnock Road, Colchester, Gore died on 10 January 1946 at Essex County Hospital. A small memorial show was held at the RHA exhibition. Later in the year an exhibition of his work took place at the Victor Waddington Galleries, Dublin.

Works signed: William Gore, W. Crampton Gore or W. Gore (if signed at all).
Examples: Dublin: Hugh Lane Municipal Gallery of Modern Art. Limerick: City Gallery of Art.
Literature: *Irish Review*, April 1913; *The Studio*, January 1919 (also illustrations); J Crampton Walker, *Irish Life and Landscape*, Dublin 1927 (illustration); *Irish Times*, 12, 14 January 1946; *Essex County Standard,* 18 January 1946; *Dublin Magazine*, October-December 1946; Royal Hibernian Academy, *Letter to the author,* 1975; *Dictionary of British Artists 1880-1940*, Woodbridge, 1976; *A Dictionary of Contemporary British Artists, 1929*, Woodbridge 1981; Mrs R. Brigid Ganly, *Letters to the author*, 1981, 1986; Colchester Art Society, *Letter to the author*, 1986; Ann M. Stewart, *Royal Hibernian Academy of Arts: Index of Exhibitors 1826-1979*, Dublin 1986; Mrs E. Parry-Crooke (née Gore), *Letters to the author*, 1987, 1998, and extracts from artist's diary.

GORE-BOOTH, CONSTANCE (1868-1927), landscape and portrait painter. Constance Georgine Gore-Booth was born at Buckingham Gate, London, on 4 February 1868, the eldest child of Sir Henry Gore-Booth, of Lissadell, Co. Sligo. She had two brothers and two sisters, one of whom, Eva, wrote poetry and became interested in women's suffrage. When Constance was twelve her mother invited Sarah Purser (q.v.) to paint her and Eva; in the double portrait the two girls were shown in Lissadell woods. Miss Purser may have inspired Constance, who was already showing a great interest in painting and drawing. In 1886 she spent six months in Florence, taking private drawing lessons. After her return home, drawing and hunting helped to occupy the idle hours. In 1889 she was presented at Court in London.

An impatient character, she persuaded her family that she wanted to take up art seriously. In 1893 she enrolled in the Slade School of Fine Art under Alphonse Legros (1837-1911), having spent some 'season' time in London working under her friend Anna Nordgren (1847-1916), whose portrait in pastel dated 1899 of Constance in Paris is in the National Gallery of Ireland. Later the Swedish artist stayed at Lissadell where they painted *en plein air*. Constance moved to Paris, studied in Julian's from 1898-1900 and there met Paul Henry (q.v.). In January 1899 at a students' ball she became acquainted with Count Casimir Dunin de Markievicz (q.v.), a Polish nobleman whose family owned an estate in the Ukraine. That spring his wife died and, soon after, his second son.

In May 1900 Casimir stayed at Lissadell, and on 29 September 1900 they were married at Saint Marylebone's Parish Church, London. After their honeymoon bicycling in Normandy, and a winter in Kiev with the Count's family, they returned to Paris and painting. Through their friend the portrait painter, Boleslaw von Szankowski (1873-1953), who had attended Julian's when Constance was there, they were able to rent from him a studio and four rooms at 17 Rue Compagne Premiére, off the Boulevard Montparnasse.

In 1901 Szankowski painted Constance, dressed in black; this work is now in Dublin at the Hugh Lane Municipal Gallery of Modern Art.

On 13 November 1901 their only child, Maeve Alys, was born at Lissadell. Before returning to Paris in 1902, they left the baby with Lady Gore-Booth who was to bring the child up virtually unaided. In due course Maeve also painted, in the Sligo district and in England; landscapes are in Sligo at the Model and Niland Centre and at Lissadell House, signed M. de M. She died on 8 June 1962.

In 1902 the Markieviczes spent the summer painting in the Ukraine, repeated the visit in 1903 and settled that year in Dublin at St Mary's, Frankfort Avenue, Rathgar. She exhibited with her husband and George Russell (q.v.) at the Leinster Lecture Hall, Molesworth Street, and showed twenty-seven pictures, including *Study of an Apple Tree; A Lonely Cottage;* and *A Misty Garden.* In 1904 at the Leinster Lecture Hall the same three exhibited again, Constance providing seventy-six works, some painted in Poland, in an exhibition entitled 'Pictures of Two Countries'.

In 1905 she assisted her husband and others in the founding of the United Arts Club, Dublin, and on the institution of life classes, the Markieviczes both attended. P.L. Dickinson in his *The Dublin of Yesterday* wrote: 'Madame was the soul of good-nature, and was always ready to help and advise others with less knowledge. As a matter of fact they were both painters of considerable merit, and could have been really first-rate had they worked. They never did, however; their energies were too diffuse to concentrate on painting ...' Nevertheless, they took a cottage at Balally, Rathdown, in 1906 and painted in the district.

Constance Gore-Booth exhibited only five works at the Royal Hibernian Academy, from 1904 until 1907. *Maternite* in 1904 and *Bed Time* in 1905 were each priced at £50, far higher than the prices then asked for by Jack B. Yeats (q.v.). For the Municipal Gallery, she helped to organise a ladies' committee to raise a sum for the purchase of a picture. In 1907 with Russell, Percy Gethin and W.J. Leech (qq.v.) she and her husband exhibited again at 'the Leinster'; another exhibition followed in 1908, Dermod O'Brien (q.v.) replacing Gethin. In 1909 it was a joint show with Frances Baker, Leech and Russell.

By 1908 Casimir was involved in the theatre and Constance, who took leading roles in plays written by him, plunged into nationalist politics, joined Inghinidhe na hÉireann, the Daughters of Ireland, and founded the Fianna boy scouts. In the first issue of *Bean na hÉireann*, Women of Ireland, a penny monthly which first appeared in February 1909, the heading, a drawing of a peasant woman against a round tower and a rising sun, was contributed by Constance.

Throughout the vicissitudes of her life she drew and painted, wood-carved, and also did fretwork and poker work but she had difficulties with her eyesight. In the winter of 1913-14 she organised soup kitchens during the great strike. Kathleen Fox (q.v.) remembered her coming in at night to the classes at the Dublin Metropolitan School of Art: 'She was a jolly sort of happy character. She used to come and amuse herself ... She wasn't seriously an artist...'. She fought in 1916 with the Irish Citizen Army and, after surrender, was imprisoned in Aylesbury Jail. Eva persuaded the Home Office to allow prison facilities for drawing. Eva wrote a play in verse, *The Death of Fionavar*, for which Constance drew the decorations in prison.

In 1918, having been released from the first, she began her second prison term, this time at Holloway, where she painted a series of watercolours; oils were unsuitable because of the smell. One work in private possession bears the title, *How the English rule in Ireland*, signed C. de M., inscribed 'Holloway Jail 1919'. The Daniel Egan Gallery at 38 St Stephen's Green, Dublin, opened in 1925 and during his tenure he showed forty-one Holloway watercolours including *James Connolly's Declaration; An English Fairy Story; Bringing Home Potatoes.* In 1922 she produced a paper in the Republican interest. She wrote most of the 'copy', drew the political cartoons, printed and circulated the publication. When elected an MP in 1918 she had not taken her seat.

At Lissadell House there were once portraits of Sir Henry Gore-Booth and Sir Josslyn Gore-Booth but the latter is now in an English house. There are also by Constance, drawings of Sarah Purser, Eva Gore-Booth and Mabel Gore-Booth together with oil paintings of Irish scenery. In the National Museum of Ireland are some thirty watercolour landscapes which she painted in prison. At the Dublin Civic Museum are two watercolours, *Women working in a field* and *Old man seated by a fire-side*; a pencil sketch of her by George Russell is also there. Representation in Kilmainham Jail Historical Museum includes an oil, *Shepherd and*

Sheep. Wexford County Museum has bellows 38 cm long, including the brass nozzle, and 15 cm wide. The timber used appears to be oak. The whole top including the handle is extensively decorated with an oakleaf motif. The reverse side is left uncarved, and bears a brass plaque with the following inscription: 'Woodcarving by Constance Countess Markievicz . Property of Miss Helena Molony 1927.'

Constance's death on 15 July 1927 took place in St Patrick Dun's Hospital, Dublin, with her husband and his son Stanilaus present. In 1991 an exhibition of her Holloway watercolours was held at the Irish Labour History Museum, Dublin.

Works signed: Con. Gore-Booth, C. Gore-Booth, C.G.B., Constance de Markievicz or C .de M.
Examples: Dublin: Civic Museum; Hugh Lane Municipal Gallery of Modern Art; Kilmainham Jail Historical Museum; National Museum of Ireland. Lissadell, Co. Sligo: Lissadell House. Sligo: Model and Niland Centre. Wexford: County Museum.
.**Literature:** Eva Gore-Booth, *The Death of Fionavar*, London 1916 (decorations); P.L. Dickinson, *The Dublin of Yesterday*, London 1929; Daniel Egan Gallery, *Exhibition of Water Colours done in Holloway Jail 1918 by the late Countess de Markievicz*, catalogue, Dublin n.d.; Sean O'Faoláin, *Constance Markievicz*, London 1934; Thomas Bodkin, *Hugh Lane and His Pictures*, Dublin 1934; Anne Marreco, *The Rebel Countess*, London 1967; Alan Denson, *An Irish Artist W.J. Leech RHA*, Kendal 1968; *Ireland*, 24 September 1968; Miss Aideen Gore-Booth, *Letters to the author*, 1969, 1970, 1989; Paul Henry, *Further Reminiscences*, Belfast 1973; Hilary Pyle: Cork Rosc, *Irish Art 1900-1950*, catalogue, 1975; Nancy Cardozo, *Maude Gonne: Lucky Eyes and a High Heart*, London 1979; Ann M. Stewart, *Royal Hibernian Academy of Arts: Index of Exhibitors 1826-1979*, Dublin 1986; National Museum, Warsaw, *Letter to the author*, 1990; also, National Museum of Ireland, 1991; John Turpin, *A School of Art in Dublin since the Eighteenth Century*, Dublin 1995; Wexford County Museum, *Letter to the authour*, 1988; *Irish Times*, 5 June 1999.

GOULD, DAVID (1871-1952), landscape painter. Born in Kinross, Tayside, Scotland, he travelled to Belfast in 1891 to learn damask designing, but qualified as an art teacher after attending the Government School of Art. There must be some doubt that the David Gould, giving a Westmoreland address, who showed three local scenes at the 1894 Royal Hibernian Academy, is the same person. In addition to the Belfast College of Art, he taught at Victoria College, Belfast; Friends' School, Lisburn; and Bangor Technical School.

The Ulster Arts Club was founded in 1902 and Gould was on the committee; in 1916 and 1917 he was president. A member of the Belfast Art Society, he convinced the committee in 1905 that it would by a good idea to hold an 'Art Union' or lottery in connection with the Society's next exhibition. In that year his work attracted the art critic of *The Nationalist* at the twenty-fourth 'annual': 'His watercolours all breathe an atmosphere. They are symbolic of some idea ... In *A Frosty Evening on the Lagan* we have expressed for us the whole poetry of our northern winter twilight ...'.

The only picture which he submitted to the Royal Academy in London was *Lilac and Hawthorne*, hung 'on the line' in 1903, when he gave his address as 20 Rosemary Street, Belfast. *The Studio Cleaner*, portrait, oil 1904, is in Lisburn Museum, Co. Antrim. He lived at Lisburn from 1909 until 1926, then he moved back to Belfast. Also at Lisburn Museum is *The Square, Lisburn*, 1919, watercolour. In that year his five contributions to the RHA included *In the Wallace Park, Lisburn*, and *Willows and Poplars, Early Summer*.

In the three years, 1928, 1929 and 1930, he showed eight pictures at the Dublin exhibition, from 133 University Street, Belfast. Some of his watercolours were exceptionally large; one hangs at Friends' School, Lisburn. At his Belfast exhibition in 1936 at the Ulster Arts Club's new premises, 122 Great Victoria Street, there were some oils. Islandmagee, Co. Antrim, where he had a cottage, provided inspiration for many of his subjects, for example: *Morning at Portmuck* and *North End of the Gobbins*. He died on 3 December 1952 at his home, Cranmore Gardens, Belfast.

Works signed: D. Gould or David Gould.
Examples: Belfast: Royal Belfast Academical Institution – Inchmarlo, Cranmore Park; Ulster Arts Club; Ulster Museum. Lisburn, Co. Antrim: Friends' School; Museum.
Literature: *The Nationalist*, 2 November 1905; *Belfast Telegraph*, 9 May 1936; *Northern Whig*, 4 December 1952; Patrick Shea, *A History of the Ulster Arts Club*, Belfast 1971; Theo Snoddy, *Exhibition of Irish Art at Friends' School, Lisburn*, catalogue, 1976; Martyn Anglesea, *The Royal Ulster Academy of Arts*, Belfast 1981; Lisburn Museum, *Letter to the author*, 1993.

GOULET, YANN RENARD – see RENARD-GOULET, YANN

GRACEY, THEO. J., RUA (1895-1959), landscape painter and illustrator. Theodore James Gracey was born in Belfast on 17 September 1895, son of a tailor, James Gracey. He began his career in 1909 as an apprentice lithographic artist with the Belfast firm, McGowan and Ingram. He attended Belfast School of Art in 1915. In the mid-1920s he set up in partnership with Donald McPherson (q.v.) the firm of McPherson and Gracey, commercial artists, 50 Upper Queen Street, Belfast. About this time he received the first of several commissions from Thomas McGowan for the latter's Old Belfast collection at the Belfast Museum and Art Gallery, chiefly copies from engravings and photographs.

In the period 1924-51 he showed seventy works at the Royal Hibernian Academy, Co. Antrim and Co. Donegal scenes being well to the fore. Recognised mainly as a watercolourist, Gracey sent a few pictures to the Fine Art Society, London, and, with the RHA, exhibited mainly with the Belfast Art Society, later the Royal Ulster Academy, of which he was an academician. He showed in 1925 at the New Irish Salon, Merrion Row, Dublin.

In 1930 he was represented in an exhibition of Irish art at Brussels. In 1933 at the RHA he showed *A Glimpse of Rosapenna* and *Muckish, Co. Donegal*. The Glens of Antrim provided subject matter for much of his work. Co. Down and Co. Mayo also attracted his brush. One of his rare one-person shows was held in 1935 at the Locksley Hall, Fountain Street, Belfast. In 1937, and again in 1954, he showed in Canada at Eaton's Fine Art Gallery, Toronto.

At the 1941 RHA he provided, unusually, variety in his subject matter: *Lower Lake, Killarney*; *Atlantic Drive, Co. Galway*; *In the Mournes, Co. Down*; *Cottages, Glendun*. Following on the death of McPherson, he went into partnership with Andrew Long. On the passing of J. Humbert Craig (q.v.), the author Richard Hayward asked Gracey to fill the breach as an illustrator for his next book, *In the Kingdom of Kerry*, which was published in 1946. In a review in *The Bell*, Bryan MacMahon wrote: 'Theo. J. Gracey's drawings mate admirably with the text. There are three types, the purely diagrammatic, the land or seascapes that are subservient to the text and, finally, the independent or whimsical. The whimsical have won my heart'. In this publication, and quite untypical of his work, is the crowded scene in the drawing, *A Glimpse of 'Puck Fair' – Before 'His Majesty' is raised aloft to his throne*.

A popular figure among his fellow Ulster artists, he enlivened sketching excursions with Frank McKelvey and Rowel Friers (qq. v.). In Dublin, Maurice MacGonigal (q.v.) regarded him as a 'businesslike type', but possibly his appearance belied an undying passion for playing poker into the small hours. Gracey, who lived at 7 Ferguson Drive, Belfast, died on 29 January 1959. A small memorial show in February was held in the Belfast Room of the Stranmillis museum. In June, an exhibition was held at the Magee Gallery, Belfast; another show took place there in 1963. In 1980, at Oakland Antiques, Belfast, his works were again on display.

Works signed: Theo. J. Gracey or T.J.G., rare.
Examples: Belfast: Ulster Museum.
Literature: *Ulster Review*, April 1925; J Crampton Walker, *Irish Life and Landscape*, Dublin 1927 (illustration); *Belfast News-Letter*, 4 December 1935, 13 January 1959; Richard Hayward, *In the Kingdom of Kerry*, Dundalk 1946 (also illustrations); *The Bell*, October 1946; *Belfast Telegraph*, 13 February 1959; *Irish News*, 9 June 1959; *Irish Times*, 29 February 1980; Martyn Anglesea, *The Royal Ulster Academy of Arts*, Belfast 1981 (also illustration); Ann M. Stewart, *Royal Hibernian Academy of Arts: Index of Exhibitors 1826-1979*, Dublin 1986; Mrs Esther Thomas (née Gracey), *Letter to the author*, 1986.

GRAY, EILEEN (1878-1976), designer and painter. Born on 9 August 1878 at Brownswood, Enniscorthy, Co. Wexford, Kathleen Eileen Moray Smith was the youngest of five children of James Maclaren Smith and his wife Evelyn, who was born at Dresden. Brownswood House had been purchased by Captain J.L. Pounden MD, early in the nineteenth century; he had married Lady Jane Stewart and was the father of Eileen Gray's mother, who, on the death of her uncle, became Baroness Gray in 1896 in the peerage of Scotland. The following year, by royal licence, her husband assumed the surname and arms of Gray. As James Maclaren

Smith he had exhibited in the 1870s, from London addresses, at the Royal Academy and Society of British Artists. At the RA in 1876 he showed fifteen illustrations for *The Pearl Fountain and other fairy tales,* by Bridget and Julia Kavanagh.

Eileen Gray was privately educated, 'governess after governess', and her earliest years were divided between Brownswood and London until she was sent to Dresden to study music and German. In 1898 she entered the Slade School of Fine Art, London, and studied painting for two years. At this time she first became involved with lacquer work. Instead of bothering about lunch, she spent time wandering around London and on one occasion discovered Charles' workshop in Dean Street, where screens and other items were repaired. She had remembered seeing old lacquer screens and had been fascinated by that matière. The outcome was that she was allowed to work there. In 1900 her father, who had spent much of his life in Italy, died in Switzerland. She visited Paris for a weekend in 1902.

After the Slade, she studied at Colarossi's in Paris and then the Académie Julian, finding a studio in the rue Joseph Barras. She continued travelling between London and Paris. However, in 1907 she finally settled in a large flat at 21 rue Bonaparte, where she was to live, with the exception of a period during the Second World War, until her death sixty-nine years later. She was friendly with the French aviator, Hubert Latham. In 1912 she visited the USA. She drove an ambulance in Paris for the French Army in the First World War.

Dissatisfied with her drawings – always refusing to sign any of her work – she began to make furniture, feeling she wanted to do something 'more useful'. She began with relief screens and panels and in partnership with a Japanese craftsman, Sugawara, became a master in lacquer work, an art which united her skill as a painter with her increasing interest in furniture and interiors. They also worked in London and set up a studio in Cheyne Walk. The works of her figurative period are well characterised by the screen *Le Magician*, a naked young magician holding a lotus flower.

The *New York Times* commented in 1922 that her 'designs adhere neither to the rules established by the creators of classic periods, nor do they attempt to achieve sensational novelty by imitation of the primitive'. In 1922, too, when she exhibited at the Salon d'Automne, Paris, her own establishment, the Gallerie Jean-Désert was opened at 217 Rue Faubourg Saint Honoré, displaying furniture, lacquer, rugs and some painting and sculpture. Artists sometimes exhibited at the gallery, the most prominent being the Russian-born sculptor, Ossip Zadkine (1890-1967). In 1923 she exhibited at the Exposition des Artistes Decorateurs, Paris. A black lacquered wood screen made about this time and measuring 195.5 cm x 212 cm was sold at Christie's, New York, sixty years later. In 1926 she abandoned lacquer, which was highly fashionable in France during the 1920s.

Encouraged and assisted by the Romanian-born architect Jean Badovici, and without any real training in architecture, she designed in 1927 her first house at Roquebrune and then a second some years later at Castellar, where she moved during the Second World War. This house became the home of Graham Sutherland (1903-80). The architect Le Corbusier (1887-1965) had done murals for the house at Roquebrune, and it was with Le Corbusier she had worked for the 1937 pavilion of L'Esprit Nouveau in Paris.

Although living practically all her life in France, and something of a recluse, she still thought of herself as Irish. Her designs for furniture, rugs, interiors and architecture were in her time considered outrageously *avant-garde*. She was a friend of the dress designer, Paul Poiret, also Jean Cocteau and Guillaume Apollinaire (1880-1918), and took a passionate interest in what her younger friends were up to: always ideas, never gossip. The exhibition of her work as a designer, held in Dublin in 1973, was lent by the Royal Institute of British Architects. In that year too she was elected honorary fellow of the Royal Institute of the Architects of Ireland. She went on working, toying with new materials and ideas until a few months before her death in a Paris hospital on 31 October 1976, after a fall in her flat. In 1991, Sotheby's auctioned at Monaco thirty pieces of her work. In 2000, the National Museum of Ireland acquired her collection from the apartment, including furniture, models and personal effects.

Examples: Dublin: National Museum of Ireland. London: Victoria and Albert Museum.
Literature: Bridget and Julia Kavanagh, *The Pearl Fountain and other fairy tales*, London 1896; Sir John Balfour Paul, *The Scots Peerage*, Edinburgh 1907; Phillippe Garner, 'The lacquer work of Eileen Gray and Jean Dunand', *Connoisseur*,

May 1973; Royal Institute of the Architects of Ireland, *Eileen Gray, Pioneer of Design*, catalogue, Dublin 1973; *Dictionary of Victorian Painters*, Woodbridge 1976; *Irish Times*, 16 February 1976, 4 November 1976, 26 January 1979, 19 December 1987, 12 October 1991, 29 June 2000; Elizabeth Lynch: Polytechnic of North London, *Eileen Gray: Her Life and Work*, London 1976; *The Times*, 3 November 1976; Victoria and Albert Museum, *Eileen Gray*, catalogue, London 1979; Peter Adam, *Eileen Gray: Architect/Designer*, London 1987 (also illustrations).

GREENE, HILARY – see HERON, HILARY

GREGORY, ROBERT (1881-1918), landscape, portrait painter and stage designer. Born on 20 May 1881, William Robert Gregory was an only child. His father, the Rt. Hon. Sir William Gregory, PC, KCMG, was a Member of Parliament, first for Dublin City and then Galway County. Sir William was also Governor of Ceylon, where his first wife died, and in 1880 he married the daughter of one of his Co. Galway neighbours, Isabella Augusta Persse, later renowned as a folklorist, dramatist, director of the Abbey Theatre, 'godmother of the Irish Literary Revival' and hostess to literary figures at Coole Park, Co. Galway.

After Harrow, Robert attended New College, Oxford, 1899-1903, but expressed a wish to become a painter and so entered the Slade School of Fine Art, London, in 1903, studying later in Paris under J.-E. Blanche (1861-1942). He met G.F. Watts (1817-1904) a few weeks before the English artist's death when he accompanied his mother on a visit to Limnerslease. As his work at the Slade drew to a close, he came increasingly under the influence of Augustus John (1878-1961). Before he left Oxford, he had begun to design for the Abbey Theatre: in collaboration with Sturge Moore (1870-1944) settings for W.B. Yeats's *The Hour Glass* in 1903.

When still at the Slade, he designed in Dublin special scenery and costumes for Lady Gregory's *Kincora*, a major undertaking; the play was presented at the Abbey Theatre in 1905, and that year too he collaborated in *The White Cockade*. He was responsible for the scenery for Yeats's *On Baile's Strand* and *The Shadowy Waters* in 1906. His oil painting of the actor Arthur Sinclair as King James II in *The White Cockade* is in the Abbey Theatre. He was also involved occasionally in stage lighting.

A different contribution for the theatre was the translation of *The Antigone of Sophocles*, performed in 1907. In the sets for Lady Gregory's *The Image*, 1909, and Douglas Hyde's *The Nativity*, 1911, both for the Abbey, he faced the problem of a stylised open-air setting. The wood scene for J.M. Synge's *Deirdre of the Sorrows*, 1910, was also painted by Gregory, and he designed costumes for Lady Gregory's *The Deliverer*, 1911. Sean O'Casey described him as 'a fine and sensitive designer for the theatre'.

In the period 1905-07 he contributed three illustrations for the Dun Emer Press. In 1907 he married a fellow Slade student, Margaret Parry. The best man was Augustus John. After his marriage he continued to paint, living mostly at Coole. His painting was principally in south Galway and north Clare. At this period he studied at Blanche's atelier. Henry Lamb (1883-1960), who had met Gregory in Paris, remembered his personality more than his paintings, and was puzzled that this sportsman, in appearance and bearing the soldier, should be an artist. He called him 'an uneasy man'. A drawing by Jack B. Yeats (q.v.) showed Gregory on his horse clearing a jump at the Gort Show, 1906. *Kiltartan History Book* by Lady Gregory was published in 1909 with four Gregory illustrations in colour. Athlete as well as horseman, he played cricket for Ireland in 1912.

In London, apart from showing a few works at the New English Art Club, he held two exhibitions, first at the Baillie Gallery in 1912 and then at the Chenil Gallery in 1914. Commenting on the second exhibition, in Chelsea, *The Studio* said: 'This artist's drawing lacks assurance even in its own vein, but all his pictures are composed with a rare art of expressing design in nature while at the same time retaining the sense of atmosphere which is so essential to the poetry of the moods of nature. The latter is perhaps a gift which no imaginative interpreter of Irish landscape could be without, but it is rare indeed that it finds expression side by side with so conscious a concern with pattern as Mr Gregory exhibits.' The *Illustrated London News* found his Ireland 'green after a fashion, but the chief note of his work at the Chenil Gallery is one of storm-coloured hills, dun earth and purple rocks'.

On the Chenil exhibition, *The Observer* wrote: 'Volumes of printed books could not reveal more of the character of the land and people than these invariably well-arranged designs, which have a quiet charm of

colour, in their restriction to slate-grey, greyish purple and green, of which Mr Gregory alone holds the secret ...'. *Coole Lake*, exhibited at the Chenil, was bought by (Sir) Hugh Lane and is now at the Municipal Gallery in Dublin. Also at the Municipal is a portrait of Gregory, 1906, painted by his friend, Charles Shannon (1863-1937), who was commissioned by Lady Gregory.

Among Gregory portraits are three in the National Gallery of Ireland, all purchased at the sale in 1932 of Lady Gregory's collection: Sara Allgood, who acted in many productions of Yeats's and Lady Gregory's plays, pencil with ink; Padraic Colum, poet, black crayon; J.M. Synge, playwright, red chalk. In the Berg Collection, New York Public Library, is a rough sketch in ink of novelist George Moore and playwright Edward Martyn entitled 'The Peasant Sinner, the Peasant Saint'.

In 1915, when he exhibited *The Island* at the New English Art Club, he joined the 4th Connaught Rangers, transferring to the Royal Flying Corps in 1916 and being awarded the Legion d'Honneur and the Military Cross before being shot down in error by an Italian pilot on the North Italian front, on 23 January 1918. He was buried at Padua. W.B. Yeats wrote four poems connected with the artist, including 'In Memory of Major Robert Gregory'.

Works signed: R. Gregory (if signed at all).
Examples: Dublin: Abbey Theatre; Hugh Lane Municipal Gallery of Modern Art; National Gallery of Ireland. Galway: University College. New York: Public Library.
Literature: W.B. Yeats, *Stories of Red Hanrahan*, Dublin 1905 (illustration); Lady Gregory, *A Book of Saints and Wonders*, Dublin 1906 (illustration); W.B. Yeats, *Discoveries,* Dublin 1907 (illustration); Lady Gregory, *The Kiltartan History Book*, Dublin 1909 (illustrations); *The Studio*, July 1914; *The Observer*, 17 February 1918; Lady Gregory, *Hugh Lane's Life and Achievement*, London 1921; Lennox Robinson, *Pictures in a Theatre*, Dublin 1947; National Gallery of Ireland, *W.B. Yeats Centenary Exhibition*, catalogue, Dublin 1965; Liam Miller, *The Dun Emer Press, Later the Cuala Press*, Dublin 1973; Lady Gregory, *Seventy Years*, Gerrards Cross 1974 (also illustrations); Cork Rosc, *Irish Art 1900-1950*, catalogue, 1975; E.H. Mikhail, ed., *Lady Gregory: Interviews and Recollections*, London 1977; National Gallery of Ireland, *The Abbey Theatre 1904-1979*, catalogue, Dublin 1979; *Irish Times*, 16 May 1981; Colin Smythe, ed., *Robert Gregory 1881-1918*, Gerrards Cross 1981 (also illustrations); Galway Arts Festival, *Robert Gregory, Painter*, catalogue, 1982; Colin Smythe, *A Guide to Coole Park*, Gerrards Cross, 1983; *Irish Arts Review*, Winter 1985; Ann Saddlemyer and Colin Smythe, editors, *Lady Gregory, Fifty Years After*, Gerrards Cross 1987.

GREY, ALFRED, RHA (1845-1926), landscape and cattle painter. Son of Charles Grey, RHA (1808-92), portrait and landscape painter who was born in Greenock, Scotland. Alfred, born in Dublin, was a member of a large family; he had fourteen brothers and one sister. Among his artistic brothers were Edwin Landseer, Gregor, Charles Malcolm(q.v.) and James, who died during the lifetime of his father.

During the early part of Alfred Grey's career he and his father visited the Scottish Highlands as guests of Viscount Powerscourt and the Marquis of Londonderry, his father's patrons. He thus acquired the opportunity of studying and representing highland cattle in their natural surroundings. As he only exhibited three pictures at the Royal Academy, between 1873 and 1886, giving an address at 4 Lower Gardiner Street, Dublin, it is rather difficult to understand how his paintings 'of cattle and of Highland landscapes created a stir in London'. Nevertheless, Queen Victoria was said to have so much admired his work that she had him taken specially to the Scottish Highlands to paint a number of her favourite views around Mar Lodge. The Prince of Wales (afterwards King Edward VII) also admired Grey's landscapes and wrote to him in congratulatory fashion. The Royal Library at Windsor Castle contains one oil sketch dated 1873 by Grey which is mounted into one of the Victorian Scottish Souvenir Albums.

Meanwhile, in Dublin, Michael J.F. McCarthy was mischievously keeping a close eye on Grey's works at the Royal Hibernian Academy. In his *Five Years in Ireland 1895-1900* he wrote: 'Mr Grey's bulls, cows, and sheep look plaintively at us in March, April and May every year from the walls of the RHA in Abbey Street. They are capital cattle, on misty braeside, or knee-deep in the placid Tolka. I personally know them all, as if they were old friends, quiet, healthy, contented-looking animals. Mr Grey is as keen a cattle artist as Sidney Cooper, I think; but why does he go in for Scotch cattle so much?'

Grey had first exhibited at the RHA in 1864, and continued for another sixty years, averaging at least six works per exhibition, and missing exceptionally few. No exhibition was considered complete without his

work. One commentator described a typical canvas as showing 'a delightful pastoral of mountain, vale, and river, a herd driving cattle homewards, while the lengthening, spreading shadows and fading sunlight divide the scene'.

Grey was appointed ARHA in 1869 and a full member in 1870, the year he supplied twenty-one 'studies from nature'. One of his highest priced pictures appeared in 1875: *The Hill Side, West Highland Cattle*. Nineteen of his works, engraved by his brother Charles M. Grey (q.v.), appeared in the monthly, *The Monitor*, in 1879.

Elected president of the Dublin Sketching Club at the inaugural meeting in 1874, he became an honorary member in 1886. At the club's exhibition in 1900 his contributions were all studies of trees; he was still exhibiting in 1914. In the Cork Industrial Exhibition catalogue of 1883 his address was 1 Lower Sherrard Street, Dublin. Although he achieved recognition as an oil painter of landscape, he was a watercolourist for some years and a portrait painter. He showed four pictures at the Royal Scottish Academy: in 1884, *A stalk in the Mar Lodge Woods, Braemar*.

Compared with his extensive exhibiting in Dublin, comparatively few pictures were hung in England, but he showed some at the Walker Art Gallery, Liverpool; Royal Society of Artists, Birmingham; and the Royal Institute of Oil Painters. In Dublin, his work was in the Oireachtas exhibition, 1907, and he took a kindly and personal interest in the RHA Schools, particularly in the life school, of which from year to year he was appointed visitor. Between 1909 and 1917 he showed twenty-five works at Water Colour Society of Ireland exhibitions concluding with *A Hillside Shelter* and *Study of a Dead Stag's Head*.

In the National Gallery of Ireland are two works, an oil painting, *The River Bank*, 1884, and an 1873 charcoal sketch of Augustus Nicholas Burke, RHA (1839-91). His artistic gifts brought him 'admirers, rather than fortune, but to the end he bore himself with fortitude and cheerfulness'. He died on 17 January 1926 in his rooms, Gardiner's Place, Dublin, the last survivor of a family of Irish artists.

Works signed: A. Grey.
Examples: Dublin: Irish Museum of Modern Art; National Gallery of Ireland; Royal Hibernian Academy. Limerick: City Gallery of Art. Windsor, Berks.: Royal Library, Windsor Castle.
Literature: *The Monitor*, Dublin 1879 (illustrations); Dublin Sketching Club, *Notes on the origin and early history*, n.d., typescript; minute books. *The Studio*, December 1900, January 1915; Michael J.F. McCarthy, *Five Years in Ireland 1895-1900*, Dublin 1901; W.G. Strickland, *A Dictionary of Irish Artists*, Dublin 1913; *Irish Times*, 19 January 1926; *Irish Independent*, 20 January 1926; Royal Hibernian Academy Minute Book, 1926; J. Crampton Walker, *Irish Life and Landscape*, Dublin 1927 (also illustration); *Dictionary of British Artists 1880-1940*, Woodbridge 1976; Ann M. Stewart, *Royal Hibernian Academy of Arts: Index of Exhibitors 1826-1979*, Dublin 1986; *The Royal Scottish Academy Exhibitors 1826-1990*, Calne 1991; *Water Colour Society of Ireland Exhibition List 1872-1994*, Dublin 1995.

GREY, CHARLES M. (1841-1911), wood engraver. Charles Malcolm Grey was a son of the Dublin portrait and landscape painter, Charles Grey, RHA (1808-92). He had fourteen brothers and one sister. An engraver on wood, he worked in Dublin for some time, where he was employed on *Zozimus*, the first Dublin periodical to make a serious bid for the title of the Irish *Punch*. A one-penny weekly, it was launched in May 1970 and lasted until August 1872.

Other papers and periodicals employed him, including *The Monitor*, which presented in its first year, 1879, almost a score of illustrations after landscape and figure drawings by his brother Alfred Grey (q.v.) The monthly was published by Joseph Dollard, James Street.

Giving his address as 1 Lower Sherrard Street, Mountjoy Square, Dublin, Grey showed wood engravings at the 1880 Royal Hibernian Academy. His father, brothers Alfred, Gregor and James, also participated in that exhibition, surely a family record. In 1882 he moved to London where he worked for the *Illustrated London News* and *The Graphic*. Of 44 New Street, Newington, he died on 23 June 1911 at St George's Workhouse, Southwark.

Works signed: C. M. Grey or C.M.G., rare.
Literature: *The Monitor*, Dublin 1879; *Register of Deaths*, Southwark, 1911; Walter G. Strickland, *A Dictionary of Irish Artists*, Dublin 1913; L. Perry Curtis, Jr., *Apes and Angels: The Irishman in Victorian Caricature*, Newton Abbot 1971; Ann M. Stewart, *Royal Hibernian Academy of Arts: Index of Exhibitors 1826-1979*, Dublin 1986.

GRIBBON, C. EDWARD (1898-1939), landscape and still life painter. Charles Edward Gribbon was the son of Robert W. Gribbon, handkerchief manufacturer. Born in Belfast on 27 June 1898, he was educated at Campbell College, Belfast, 1909-14. Never in good health, he was at various sanatoria in Switzerland in the early 1920s before residing in France.

Without any formal art training, he began to paint in the mid 1920s in France and spent the rest of his life struggling financially, a willing slave to his art. His upbringing in a strict Plymouth Brethren atmosphere was something he had escaped from, but he had some financial support from his family in Belfast, and he exhibited at Magee's Gallery there. His marriage to a Frenchwoman ended in tragedy when she died following the birth of their son in Cannes, 1929.

Intellectually versatile with interests in the world of literature and art, he is said to have met well-known artists of many nationalities in the South of France. In Paris, Louis Vauxcelles, a French art critic, admired his work and helped him with words of encouragement and, which was even more important, money. 'A man paints', said Gribbon, 'because he had a strong feeling that he had something to say, not because he wants to make money or a name.'

In 1931 he held his first exhibition in London, paintings and drawings at the Twenty One Gallery. One critic wrote that he was 'original enough to excite curiosity ... He is a very subtle colourist, coaxing strange harmonies out of what looks at a glance a naturalistic representation'. *The Observer* critic wrote: 'Whether Mr Gribbon's work is still life or landscape or portrait, the comparison with Van Gogh is almost inevitable – and this comparison is bound adversely to affect the appreciation of the talented Irish painter's work'.

The London exhibition may have prompted Sir John Lavery (q.v.) to write to the Belfast Museum and Art Gallery on 23 December 1931 from 5 Cromwell Place, London: 'There is a very good Belfast artist practically starving on the Riviera. He is C. Edward Gribbon and his address is Chez Madame Cortése, St Laurent du Var, France, AM. He has some pictures here in London good and cheap. I bought one during the summer because of its colour quality and I would offer it to the Museum but that I think it might prevent someone else doing the same. If you know of anyone who would spend £20 or £30 and have his name handed down as a patron of the best art by a Belfast man that I can remember of – now is the time.'

In 1932 Gribbon began showing in Dublin, *St Laurent-du-Var*; *Cap d'Antibes*; *Yellow Carnations*; and *Cagnes from West* were included in seventeen works at Daniel Egan's Gallery, 38 St Stephen's Green, and it was noted by a critic that he made great use of his palette knife for flower paintings. In 1932, at the Angus Gallery, St Stephen's Green, he showed twenty-eight pictures of Rome. *St Peter's from the Gardens of the Citta del Vaticano* was lent by the Hon. Evan Morgan, and *La Casa del Sole* by La Duchessa Brady, Rome. *The Altar of S. Giovanni d'Fiorentini* was 'for sale only by special request'. At the Crawford Municipal Art Gallery, Cork, is a watercolour, *St Peter's, Rome*. He was in Dublin again in 1933, visited his son in Belfast, and painted in Co. Wicklow.

In 1935 he participated in a joint exhibition at Daniel Egan's Gallery. The two highest-priced paintings were forty guineas each: *St Peter's during the Holy Year* and *Penitents at Cospicua, Malta*. He had become a Catholic. In 1936 he and his second wife were spending a holiday in Spain when the Civil War intervened and they escaped to Portugal where he spent some months painting. He was associated with the organisation of the Salon d'Automne Cagnes-sur-Mer. He died at St Paul-de-Vence on 14 April 1939.

Works signed: Gribbon or C.E. Gribbon.
Examples: Dublin: Hugh Lane Municipal Gallery of Modern Art.
Literature: *The Observer*, 5 July 1931; Angus Gallery, *Edward Gribbon,* catalogue, Dublin 1932; *Northern Whig*, 26 January 1932, 30 July 1936; *Irish Times*, 31 March 1933; Daniel Egan's Gallery, *C.E. Gribbon*, catalogue, Dublin 1935; Herbert A. Gribbon, *Letter to the author*, 1986; Dr P.W.F. Gribbon, son, *Letter to the author*, 1986.

GRIERSON, C MacIVER (1864-1939), painter of literary and genre subjects. Charles MacIver Grierson was born in Queenstown, now Cobh, Co. Cork, on 8 December 1864. His father, Charles Grierson, was manager of the Cunard Steamship Company, Queenstown, and he was educated in Plymouth. A pupil of the Cork architect, William Henry Hill, 'not loving the profession, he devoted himself to pictorial art'.

After attending the Cork School of Art, where he was active in 1881, he settled for a time in London, studying at Westminster School of Art. In 1886, from 183 Belsize Road, St John's Wood, London, he exhibited *A Reverie* and *Mephistopheles* at the Royal Hibernian Academy. In 1892 he became a member, but resigned some years later, of the Royal Institute of Painters in Water Colours, with whom he exhibited some eighty works. In 1893 he showed these two of his three works at Water Colour Society of Ireland exhibitions: *'The Latest Scandal'* and *'Sweet Seventeen'*.

Grierson, who was there in 1899 if not before, painted in Co. Sligo for some years, and when he exhibited *'Natives of the West'* at the RHA in 1903 his address was Cartron, Sligo. He was appointed a member of the Pastel Society in 1904. The Royal Academy catalogue address in 1904 was John Street, Sligo; he exhibited *Potato-Digging in the West*. The John Street address appears on a label at the back of a large watercolour, *Joint Labour*, which was exhibited at the Royal Institute in 1904, price £63. This picture was bought by the present owner's father, residing in Co. Sligo, from the artist, who at the time expressed annoyance that it had not been sold in London; he disposed of it for £20. The subject is a woman, modelled by the artist's wife, and boy tilling the soil beside the seaside in Co. Sligo.

In the Sligo area, also in private possession, are portraits, *Annie L'Estrange* and *John Corcoran*. Grierson also held art classes at Beltra. His wife Ethel was the daugher of Cochran Davys, Clerk of the Crown and Peace, Sligo. Several of his paintings were reproduced, including *Comfort Ye Them*; *An Old Man's Dream*; and *Somewhere in France*, a watercolour of 1915. *Barges at Hammersmith, Evening*, watercolour, was painted in 1921.

Altogether at the RHA he showed seven pictures, the last in 1925: *Palm Beach*. Among the other centres where he exhibited were: the Royal Society of Artists, Birmingham; Walker Art Gallery, Liverpool; Abbey Gallery, London; Royal Institute of Oil Painters. He also showed at Adelaide and Sydney, Australia. The Art Gallery of South Australia has a watercolour, *The Poacher*, a bequest from Sir Samuel Way, Chief Justice of South Australia from 1876 to 1914, and exhibited at the 'Victorian Social Conscience' exhibition at the Art Gallery of New South Wales in 1976. Grierson last resided at Eastcote, Ruislip, Middlesex, and died on 25 September 1939.

Works signed: C. MacIver Grierson, MacIver Grierson, C.M.I. Grierson or C.M.I..
Examples: Adelaide, Australia: Art Gallery of South Australia.
Literature: *Journal of the Cork Historical and Archaeological Society, 1913; Who Was Who 1941-1950*, London 1967; *Dictionary of British Artists 1880-1940*, Woodbridge 1976; *A Dictionary of Contemporary British Artists, 1929*, Woodbridge 1981; Sligo Art Gallery, *Sligo Painters of the Past*, catalogue, 1981; Mrs Audrey Irwin, *Letter to the author*, 1983; Ms Lynette Brown, *Letters to the author*, 1985; Art Gallery of South Australia, *Letter to the author*, 1986; Ann M. Stewart, *Royal Hibernian Academy of Arts: Index of Exhibitors 1826-1979*, Dublin 1986; *Water Colour Society of Ireland Exhibition List 1872-1994*, Dublin 1995; Frederick Gallery, *Irish Art*, catalogue, Dublin 2000 (also illustrations).

GRIFFITH, PAT (1912-73), landscape and portrait painter. Born on 26 January 1913 in Dublin, Patricia Mary Wallace was the daughter of William Wallace, who became secretary to the directors, Arthur Guinness, Son and Co. Ltd. She studied at Howell's School, Denbigh, North Wales; and pursued her art studies at the Royal Hibernian Academy Schools and, in 1935, the year her father died, at the Slade School of Fine Art, London, where she began a lifelong friendship with Bea Orpen (q.v.). Another close friend, Jennifer Davidson, opened the small Torch Theatre in Dublin in the mid-1930s, and Pat became the scene painter.

Working mainly in gouache, she began exhibiting at the RHA under Patricia Wallace in 1934 from 23 Palmerston Gardens, Dublin and in 1942 she held her first one-person show at 7 St Stephen's Green, the premises of the Dublin Painters, in which there was a strong representation of women painters with individual characteristics, so she was associated with Mainie Jellett and Nano Reid (qq.v.). She also exhibited with the Irish Exhibition of Living Art and from 1938 until 1966 she contributed almost fifty works to the Water Colour Society of Ireland exhibitions.

During the Second World War she was a member of the White Stag Group in Dublin, and when her husband, William A. Griffith, opened the Unicorn Restaurant in the city, by which some employment was found for European refugees, her murals there attracted attention. A flair for designing interiors was

demonstrated at the Old Head Hotel, Louisburgh, Co. Mayo, run by the Wallace family. Many of her paintings, and her large tweed pictures, were hung there. Giving the hotel address, she showed at the RHA: 1941, *Ruins by the Sea*; *Old Head, Co. Mayo*; 1942, *Melting Snow*.

Altogether at the RHA, under Wallace and Griffith, she showed a total of twenty-seven works. In 1943, from Priorswood, Raheny, Co. Dublin, she exhibited under her married name two watercolours: *Head of a Girl; Croagh Patrick*. Her final exhibit, *Yard Buildings*, was in 1948. Contributions to the WCSI exhibitions included: 1952, *Charcoal Burners*; 1955, *The Mask*; 1966, *Boy with Cats*.

Portraits of children showed a particular facility for capturing the essence of their characters, and she sometimes incorporated scenes from their lives, or favourite pursuits, into the background. She had farmed with her husband at Belcamp Park, Raheny, Co. Dublin, then in Co. Limerick, and at her last home, a small farm near Nenagh, Co. Tipperary, she died on 13 March 1973.

Works signed: Pat Griffith or Pat Wallace.
Examples: Belfast: Ulster Museum. Drogheda: Library, Municipal Centre.
Literature: *Irish Art Handbook*, Dublin 1943; Professor Brian Boydell, *Letter to the author*, 1985; Ms Yvonne Boydell, *Letter to the author*, 1985; C.E.F. Trench, *Letter to the author*, 1985; Tom Nisbet, *Letter to the author*, 1986; Ann M. Stewart, *Royal Hibernian Academy of Arts: Index of Exhibitors 1826-1979*, Dublin 1986; Donald G. Wallace, *Letter to the author*, 1986; *Water Colour Society of Ireland Exhibition List 1872-1994*, Dublin 1995.

GRUBB, ALEXANDER (1842-1925), landscape painter. Born at Cahir, Co. Tipperary, Alexander Grubb was the second son of Richard Grubb. Educated in Co. Dublin, he attended Kingstown School under the Rev. William Stackpoole at York Road. In 1859 he passed into the Royal Military Academy at Woolwich, and in 1862 with the Royal Artillery he was posted to Melbourne, Australia.

On the outbreak of the Maori wars he was desptched at the age of twenty-one to New Zealand, North Island. While in camp, he filled many idle moments painting watercolours but, contrary to report, some of these were not bought by the New Zealand Government. However, the National Library of Australia's pictorial collection has eleven watercolours which appear to have been removed from an album or sketchbook. The dates range over two years, 1864 and 1865, and the works include: *The Mission Church, Te Papa*; *Durham Redoubt Camp, Te Papa*; *The Cemetery Ground, Tauranga*. It is incorrect to credit these to Alexander Henry Watkins Grubb (1873-1933), a son of Alexander who also painted.

In 1870, now back in Australia, he won the New Zealand Cross; as only twenty-two other soldiers were similarly honoured, it is now regarded as one of the rarest decorations in the world. Other postings abroad were to Gibraltar, Ceylon and Malta. His *Trincomalee, Ceylon, 1872*, is reproduced in *The Grubbs of Tipperary*, 1972. He returned to Ireland, and in 1877 was Adjutant to the Wicklow Artillery Militia.

The author of the book on the Grubb family, G.W. Grubb, wrote that Alexander was 'neat and tidy, an artist and diarist, methodical with all the inherited Grubb organising ability and a love of "knocking things together"'. He produced 'illustrated diaries and beautifully mounted large photographs or watercolours in leather albums were religiously prepared and kept.'

According to the Alexander Turnbull Library of the National Library of New Zealand, their artists' biographies file states that a diary/album is held in private hands in Dublin and contains views of Auckland and, for example, Waikato, Tauranga, Whangarei and Rotorua 'as well as Asian views'. With the rank of Lieutenant-Colonel, Grubb retired in 1884, his last residence in England being Elsfield House, Hollingbourne, Kent, where he died.

Works signed: A. G.
Examples: Canberra: National Library of Australia.
Literature: *Slater's Directory of Ireland*, 1856; General Register Office, London, *Registration of Deaths*, 1925; Geoffrey Watkins Grubb, *The Grubbs of Tipperary*, Cork 1972 (also illustration); National Library of Australia, *Letter to the author*, 1995; also, National Library of New Zealand; New Zealand High Commission, London; both 1995.

GUBBINS, BEATRICE (1878-1944), landscape and figure painter. Beatrice Edith Gubbins was born on 19 September 1878, the youngest of two brothers and five sisters, living for most of her life at Dunkathel House,

overlooking the river Lee at Glanmire, just outside Cork city. The Gubbins family hailed from Co. Limerick. Thomas Wise Gubbins, Beatrice's father, ran Wise's distillery, North Gate, Cork. His five daughters were all deaf. Beatrice, the youngest, took a keen interest in the running of the estate, and many of her watercolours depicted the woodlands and fields around her home, for example *River Lee from Dunkathel* and *Labourers Cutting Hay*.

For many years she was a member of the Queenstown Sketch Club and acted as honorary secretary. Comments and observations were invited on members' work. Rule 5 stated that sketches 'were to reach the Hon. Sec. before the 1st of the month for which they are intended. When no sketch is sent a fine of 6d to be paid.' Rule 7 stated that members 'may criticise and give a maximum of 3 votes to each sketch (their own excepted). Votes and criticisms to be signed with pseudonym.' Some of her works still have attached to them slips of paper with the club heading on them and criticisms marked beneath. For the purpose of anonymity, Beatrice called herself, at various stages, 'Greyhound', 'Jessamine' and 'Benjamin', and some of her watercolours were thus inscribed.

A life-long friend of Edith Somerville and friendly with Lady Kate Dobbin (qq.v.), she exhibited at the Royal Hibernian Academy from 1897 for forty years, also she showed at the exhibitions of the Munster Fine Art Club. Altogether at the RHA she showed thirty-nine works in the period 1897-1937. The first four pictures which she presented had a price tag of £5.0.0 each; four of the five in the 1937 exhibition were £5.5.0 each.

As a young woman she visited many of the Irish scenic beauty spots, but the meticulous recording of her diaries indicated a passion for travelling abroad. In 1899 she had visited Italy, returning there in 1905 which resulted in many of her finest watercolours; *Sunny Italy* at the 1907 RHA. In her youth she became an ardent motorist. She also travelled in France – Barbizon in 1902 – Holland, Spain and Switzerland.

In 1912 and 1913 she made several visits to London where she underwent treatment for her hearing. As a nurse during the First World War, she cycled in the Devon countryside sketching and painting. At the RHA in 1913 she showed *Alcala, Spain*; *Dooagh Bay*; and *In Connemara*. In 1913 she exhibited with the Water Colour Society of Ireland for the first time and from then until 1931 showed a total of twenty-one pictures. Contributions in 1914 at WCSI included *A Passing Shower* and *The Yellow Bow*.

In 1922 she sketched in Corsica, and in 1924 it was the turn of Sicily and Italy. *Sorrento*, 1924 is in Crawford Municipal Art Gallery along with four other watercolours. A trip to Morocco in 1929 provided many examples of the street life of the towns and villages, for example *Arabs under Archway*. In 1930 she was in the West Indies; 1931, Algeria and Tunisia; and in 1934, Portugal, where she sketched churches and interiors of buildings. Domestic scenes were prominent in her figure work, and her subject matter also included still lifes. On 12 August 1944 she died at Dunkathel. In 1986 an exhibition of her work was held at the Crawford Municipal Art Gallery.

Works signed: B.G. or B.E.G., 'Benjamin', 'Greyhound' or 'Jessamine' (if signed at all).
Examples: Cork: Crawford Municipal Art Gallery. Glanmire, Co. Cork: Dunkathel House.
Literature: Francis Russell: Crawford Municipal Art Gallery, *Beatrice Gubbins of Dunkathel, Co. Cork (1878-1944)*, catalogue, Cork 1986 (also illustrations); Ann M. Stewart, *Royal Hibernian Academy of Arts: Index of Exhibitors 1826-1979*, Dublin 1986; Anne Crookshank and the Knight of Glin, *The Watercolours of Ireland*, London 1994 (also illustration); *Dunkathel House*, brochure, Glanmire [1995]; *Water Colour Society of Ireland Exhibition List 1872-1994*, Dublin 1995.

GUINNESS, MAY (1863-1955), landscape, genre and imaginative painter. Mary Catherine Guinness was born on 11 March 1863, daughter of Thomas Hosea Guinness, solicitor and landed proprietor, and Mary Davis, only daughter of Charles Davis of Coolmanna, Co. Carlow, and Tibradden, Rathfarnham, Co. Dublin. May's five brothers and sisters were to pre-decease her at comparatively early ages.

In 1892 she began a long association with the Water Colour Society of Ireland, lasting until 1951 and exhibiting no fewer than 129 pictures but in the years 1912-30 inclusive, she did not contribute at all.

In 1894 she travelled with Mildred Butler (q.v.) to study painting under Norman Garstin (q.v.) at Newlyn, Cornwall. She sketched in Florence in 1902 and 1903. Six works were hung at the Royal Hibernian Academy

between 1897 – *Turkeys* that year – and 1911; subsequently she refused to exhibit again. One French critic stated that she began by painting in the tradition of Corot: 'those melancholy scenes in the neighbourhood of Dublin recall the sites of Ville-d'Avray ...'. Associated with the press appeal in 1912 for the provision of a suitable building for the Lane pictures, she was by this time spending a few months in France each year. Dr Olive Purser, reminiscing to the author in 1968, recalled: 'After two sisters had died of consumption, she said to me: "I determined I would not die!"'

About 1910 she made the first of her painting trips to France, and in 1911 she showed *A Breton Pardon* at the RHA. Scenes of life in Brittany included fairs and weddings. The First World War brought the greatest moments in the life of this independent and formidable woman. At the age of fifty-one she left Dublin in 1914 to join the French Army as a military nurse. Her experiences were enough to have daunted anyone less courageous. She was awarded the Croix de Guerre and, at the end of hostilities, the Medáille de la Reconnaissance Française.

An exhibition of 'Decorative Paintings and Drawings' was held at the Eldar Gallery, London, in 1920. A note in the catalogue stated: 'Miss May Guinness paints not to represent but to decorate ... Her achievement – she has preserved her own individuality, and that through years spent in the Paris studios. More, she has fought for it. Her genius is for colour and design. Under Edwin Scott, the Paris-American, she found her colour being firmly subdued. She broke away. At the old Vitti studio Hermen Anglada, the Spaniard, taught her to pile broken paint on thickly. She broke away from him. She broke away from them all albeit learning all the time, until she found a leader and not a driver – van Dongen.' Matisse was said to have impressed her too.

Drawings, woodcuts, embroideries (she gave some local girls embroidery classes) and other pieces of decorative work were exhibited in 1921 at the Crock of Gold, South Anne Street, Dublin. An undated cutting from the *Christian Science Monitor* referred to needlework pictures – 'flowers worked in various silks glow richly from a frame of many colours. A joyous fancy is expressed in the painted boxes and glass bottles, and the large pots are admirably decorative in designs of black and white and scarlet. No less interesting is the screen, where zebras, elephants and giraffes are figured in silver and black ... It is considered that Miss Guinness' most important work lies in the decoration of mural frescoes.'

Murals were painted at Tibradden and Cloragh, a house in the Tibradden demesne, where there were scenes from the Apocalypse in ultramarine blue and vermilion, a war memorial executed in the early 1920s. Both murals are no longer in existence. An exhibition of her paintings was held at the Stephen's Green Gallery, Dublin, in 1922. Continuing to spend her winters in Paris, she had studied under André Lhote (1885-1962) for three years before holding an exhibition at the Galerie Visconti in Paris, January 1925. Lhote wrote the introduction for the catalogue. Among the works exhibited were: *Quai de Saint-Servan*; *La fille aux cheveux d'or*; *La bouteille verte*; and *La tasse de thé*. This exhibition was hosted later in the year by the Mayor Gallery, London. She also exhibited at the Salon d'Automne. According to a writer from *The Sphere*, who met her at the Mayor Gallery, the artist admitted that she had been through all the phases, and had now settled down to 'stylisation', the flat and rhythmic arrangement of line and colour.

On her mother's death in 1925 she left Tibradden House for the annexe at Marlay House, Rathfarnham. An exhibition took place in 1926 at Daniel Egan's Gallery, 38 St Stephen's Green, which included twelve woodcuts, for example *Pelicans* and *White Horses*. The *Irish Independent* singled out *Golden Wedding in Belgium*, ' a natural grouping of a large number of figures round the table and, in the treatment of colour, clever manipulation of white, of which there is a good deal.'

In 1933 she moved to St Thomas's, the dower house to Tibradden, where she entertained fellow-artists at tea-parties, and lived there until her death. She was closely associated with Evie Hone and Mainie Jellett (qq.v.) who had both studied under Lhote. Her house was full of paintings, not only her own as she was a collector of acumen: works, for example, by Bonnard, Rouault, Picasso, Matisse and Dufy. The Friends of the National Collections of Ireland saw an exhibition of modern French painting at St Thomas's in 1936. In that year at WCSI she showed *Cards*; *Byzantine Church, Greece*; *Vesuvius from Naples*.

Mills' Hall, Merrion Row, Dublin, was the venue in 1932 of an exhibition which included sketches in Italy. Several canvases were from her Paris exhibition in 1930. An exhibition of pictures of Palestine and

elsewhere (she also visited Spain) was held at the Stephen's Green Gallery, 1935, and three years later she exhibited at Combridge's Gallery, Dublin. In that year she was represented at the Dublin Painters' exhibition in London at the Office of the High Commissioner for Ireland.

In her 80s she was still active and exhibiting. *The Bell* found 'jollity' in *Wedding in Brittany* at the Irish Exhibition of Living Art in 1945. *A Religious Procession in Brittany*, an oil painting, is in the National Gallery of Ireland collection. *Mediterranean Morning* is at Alexandra College, Dublin. In her exhibition of pastels and oils at the Victor Waddington Galleries, Dublin, 1946, works included *Russian Princess*; *Place de Vosges, Paris; Autumn Flowers*. She was represented in the Leicester Galleries, London, exhibition 'Artists of Fame and Promise' in 1949. This indomitable woman, who had faced so much family bereavement and the tragedy of war, died on 16 July 1955 at the age of ninety-two. A memorial exhibition was held in 1956 at Dawson Hall, Dawson Street, Dublin. The Agnew Somerville Gallery, Dublin, arranged an exhibition of her work in 1969.

Works signed: M. Guinness, May Guinness or M.G., monogram (if signed at all).
Examples: Churchill, Letterkenny, Co. Donegal: Glebe Gallery, Derek Hill's Collection. Cork: Crawford Municipal Art Gallery. Drogheda: Library, Municipal Centre. Dublin: Alexandra College; Church of Ireland Theological College, Braemor Park; Hugh Lane Municipal Gallery of Modern Art; National Gallery of Ireland. Kilkenny: Art Gallery Society. Limerick: City Gallery of Art. Sligo: Model and Niland Centre. Termonfeckin, Co. Louth: An Grianán. Waterford: City Hall, Municipal Art Collection.
Literature: Eldar Gallery, *May Guinness*, catalogue, London 1920; *Irish Times*, 9 August 1921, 11 February 1932, 1 March 1938; Galerie Visconti, *May Guinness*, catalogue, Paris 1925; *The Sphere*, 17 October 1925; *Irish Independent*, 16 June, 1926, 1 June 1936; *The Studio*, September 1938; *The Bell*, May 1942, October 1945; *Capuchin Annual*, 1949; *May Guinness Memorial Exhibition*, catalogue, Dublin 1956; Charles S. Guinness, *Letter to Agnew Somerville Gallery, Ltd*, 1968; Dr Olive Purser, *Letter to the author*, 1968; Major Owen Guinness, *Letter to the author*, 1969; Christie's, *Mildred Anne Butler 1858-1941*, catalogue, London 1981; Ms Elizabeth Guinness, *Letter to the author*, 1986; also, Lord Moyne, 1986; *Water Colour Society of Ireland Exhibition List 1872-1994*, Dublin 1995; Dorthy Walker, *Modern Art in Ireland*, Dublin 1997 (illustration).

H

HALL, KENNETH (1913-46), landscape and figure painter. Born in Surrey on 15 April 1913, Charles Kenneth Hall had an Irish mother who came from Cork. His father, A. H. Hall, was Chief Superindent at the Royal Aircraft Establishment. Educated at Lancing College, Sussex, 1927-31, he then studied furniture design with a London interior decorating firm, and began to draw and paint in his spare time. Apart from a few lessons, he was self-taught as an artist.

In the mid-1930s he met the painter Basil Rákóczi (q.v.) and they became close friends. Rákóczi had formed the Society for Creative Psychology at 8 Fitzroy Street, London, where Hall attended meetings and by 1936 had a studio there. As well as experimenting with psycho-analytic techniques, he and Rákóczi began to make paintings which drew upon the results of these experiments. The works were exhibited in Fitzroy Street under the name of the White Stag Group.

In 1936 Hall visited Spain with Rákóczi and decided to paint full-time. They travelled and painted in a number of European countries. Hall showed twelve watercolours, including *Fair, Hampstead Heath*, at the Wertheim Gallery, London, in 1936. He painted in 1937 at San Feliu de Guixois, North-East Spain. In the same year his *Scuola di Ballo*, watercolour on paper, indicated a visit to Italy. *Trafalgar Square IV: 8th October 1937* is in the Ulster Museum. In 1938 he painted in Greece and stayed at Glyphada, a seaside resort near Athens. Apparently it was an unhappy time for Hall, who wrote a journal filled with despair about his life. His oil, *View from Bathroom, Villa les Fauvettes*, was of the house in which Rákóczi stayed in Greece with Herbrand Ingouville-Williams, who later moved to Dublin as part of the White Stag Group.

Hall returned to Burlington Gardens in 1938 for a second exhibition at the Wertheim Gallery, paintings of Cap d'Ail. He was represented by *The Circus* in the Exhibition of British Contemporary Art at Perth, Scotland, in 1939. In July he and Rákóczi travelled to Dublin and to the West of Ireland, taking a cottage at Delphi, Co. Mayo overlooking Killary Harbour. Hall wrote to the London art dealer, Lucy Wertheim: 'Life is very primitive but also nice and homely, oil lamps, peat fire, and water from a stream'. Two oils from the Wertheim collection, *Trafalgar Square* and *Cap d'Ail*, are in the Tower Art Gallery, Eastbourne.

Missing city life, the two friends moved in March 1940 to Dublin, where they resurrected the Society for Creative Psychology and the White Stag Group. In his *A Fretful Midge*, Terence de Vere White described the visitors to Dublin as a 'corduroy pantzer division'. Their commissariat was The Country Shop in St Stephen's Green 'where at midday their multi-coloured uniforms provided a bright contrast to the meek tweeds and sober suits of the regular customers ...'

In 1940 the White Stag Group, at 6 Lower Baggot Street, held its first Dublin exhibition of twentieth century art. Among the artists represented of international fame were Picasso and Rouault; the pictures were borrowed from collections in Ireland. This was the era of what the Group called 'Subjective Art', but prior to this period Hall was mainly a landscape painter. Birds and fishes now began to dominate his work, although in his exhibition at the White Stag Gallery in 1942 he showed abstract studies. Mainie Jellett (q.v.) took a keen interest in the Group's activities and, with Evie Hone (q.v.) and other Irish artists, exhibited with them. A few other artists from England and abroad also showed but just happened to be living in Dublin. In fact the White Stag Group consisted only of Hall, Rákóczi and a non-painter, Dr Ingouville-Williams, a psychiatrist by profession.

Commenting on Hall's work in a group exhibition at the Contemporary Picture Galleries in 1943, the *Dublin Magazine* referred to his 'private experiments and childish humours'. From 18 Upper Fitzwilliam Street, Dublin, he exhibited only three works at the Royal Hibernian Academy, in 1944 and 1945. In the Subjective Art Exhibition, 1944, *Bird with Worm* was included. Referring to his exhibition at the White Stag Gallery in 1945, the *Dublin Magazine* said that he seemed content with 'a kind of animated geometry as the vehicle for a childish symbolism, and which, moreover, involves a technique so over-simplified as to be practically non-existent'. *Head Looking 1* and *Head Looking 2*, both oil on canvas, were included in the

Young Irish Painters' exhibition at Arcade Gallery, London, 1945. A self-portrait is in the National Self-Portrait Collection, University of Limerick. *Study for a Drake Resting* is with the Office of Public Works, Dublin.

Three Painters, with an introduction by Hall's friend, Ingouville-Williams, was published in Dublin in 1945. All his six illustrated works were either birds or fishes. The other two painters were Rákóczi and the Dubliner, Patrick Scott. The book was concerned with Subjective Art. In September 1945, the war having ended, Hall and Rákóczi left Ireland. Hall, who had been unwell in Dublin and had spent some time in the Adelaide Hospital, returned to London where he showed at the Redfern Gallery. Suffering acute depression with his illness, he died in London on 26 July 1946. A retrospective exhibition was held in 1991 at European Modern Art, Dublin.

Works signed: Hall (if signed at all).
Examples: Belfast: Ulster Museum. Dublin: Office of Public Works. Eastbourne: Towner Art Gallery. Kilkenny: Art Gallery Society. Limerick: University, National Self-Portrait Collection. Tehran, Iran: Irish Embassy.
Literature: *Irish Art Handbook*, Dublin 1943; *Dublin Magazine*, October-December 1943, April-June 1945; Herbrand Ingouville-Williams, intro., *Three Painters*, Dublin 1945 (also illustrations); Terence de Vere White, *A Fretful Midge*, London 1957; Brian Kennedy: European Modern Art, *Kenneth Hall 1913-1946*, catalogue, Dublin 1991; Lancing College, *Letter to the author*, 1991; also, Patrick Scott, 1991; European Modern Art, 1992.

HAMILTON, EVA H. (1876-1960), portrait and landscape painter. Eldest daughter of Charles R. Hamilton, MRIA, of Hamwood, Dunboyne, Co. Meath, Eva Henrietta Hamilton was a sister of Letitia Hamilton (q.v.) and of Amy, who was secretary of the Yorkshire County Federation of Women's Institutes for twenty years.

After attending Alexandra College, Dublin, she was a student at the Dublin Metropolitan School of Art, and also studied at the Slade School of Fine Art, London. She earned a living, for a period, copying portraits, some of them by Sir William Orpen (q.v.). At Áras an Uachtaráin is a half-length oil painting of Bartholomew Teeling, United Irishman, 'copy painted by Miss Eva Hamilton, Chapelizod, based on a miniature in the possession of Teeling's father'. At University College, Galway, is a copy portrait of Sir Thomas Moffett. Among her original portraits were those of James Macmanaway, Bishop of Clogher; Lady Gregory, Lord Frederick Fitzgerald and Sir William Mahon. A portrait of Oliver Fry is in the Masonic Hall, Dublin, where there is also her painting of the bicentenary thanksgiving service in St Patrick's Cathedral, Dublin, 1925. *Supper at Emmaus*, a copy, is at Trinity College, Dublin.

In the period 1898-1950, she showed more than ninety works at the Water Colour Society of Ireland exhibitions and at one period served on the committee. A substantial number of works were portraits, some of children.

When Hugh P. Lane organised the exhibition of works by Irish painters held at the Guildhall, London, in 1904 she was represented by *A Lady in Pink* – the 'ladies in black' work by Sir John Lavery (q.v.) had already emerged – and in that year she showed portraits of her two sisters at the Royal Hibernian Academy. She continued to exhibit for some forty years and showed a total of 121 works at the Academy. In 1912, reviewing the RHA exhibition, *The Studio* stated that she had 'gained in breadth and fineness of vision' and was particularly successful in her interior, *A Bright Morning*, with a mother and child looking out across a Dublin street. A 1913 portrait of her cousin, Rose Dorothy Brooke, is at the National Gallery of Ireland. Her catalogue address at the 1915 RHA was 40 Lower Dominick Street, her father's city offices, and among her six contributions were *Milking Time* and *Amsterdam*. During the First World War she was actively engaged in philanthropic work.

In 1924 *The Studio* commented on an exhibition in Dublin of paintings by Eva and Letitia Hamilton: 'These Venetian pictures were the first works of the kind which either of them has produced, and were warmly and deservedly admired.' The Kilkenny Art Gallery Society has in its collection a night scene of Venice. Once described to the author by Mary Swanzy (q.v.) as having 'red hair and a temper to match', Eva continued to exhibit with Letitia, the dominant personality. As to why Eva was represented in a loan exhibition of Irish portraits 'by Ulster artists' at the Belfast Museum and Art Gallery in 1927 is not clear. She was then living at Font Hill, Palmerston Road, Dublin.

In 1930 she was represented in the exhibition of Irish art at Brussels, and in 1933 at the RHA she showed *Miss Veronica Colley* and *An Autumn Bouquet*. A joint exhibition was held with Letitia in 1937. Two years later, covering the New Burlington Galleries (Goupil Gallery Salon) in London, *The Studio* found *Evening in Connemara* having 'true feeling for the poetry of landscape and revealed the artist as particularly sensitive to effects of light and atmosphere'. As well as Connemara, she also painted in Counties Clare, Cork, Kerry and Mayo, also North County Dublin. Among her works at the 1935 RHA were *The Road to Glenties* and *Haymaking in Achill.*

At the 1941 WCSI exhibition she showed *Malahide*; *Roundstone Harbour*; *Group of Children*. In 1943 her contributions were *Bay in Connemara*; *The Concertina Player*; *Beech Trees*.

Closely associated with the Dublin Painters and holding the office of president, many of her exhibitions with Letitia were held at 7 St Stephen's Green, and the sisters were exhibiting there as late as 1951. A portrait of Letitia by Eva was hung at the 1946 RHA. She had brief encounters exhibiting with the Irish Exhibition of Living Art, Fine Art Society, London, and the Walker Art Gallery, Liverpool. Eva Hamilton died on 14 March 1960 at Woodville House, Lucan, Co. Dublin, a few weeks after the death there of Amy.

Works signed: Eva H. Hamilton, E.H.H. or E.H., rare (if signed at all).
Examples: Belfast: Ulster Museum. Clogher, Co. Tyrone: Cathedral. Clonmel: South Tipperary County Museum and Art Gallery. Cork: Crawford Municipal Art Gallery. Dublin: Áras an Uachtaráin; Masonic Hall, Molesworth Street; National Gallery of Ireland; Trinity College. Galway: National University of Ireland. Kilkenny: Art Gallery Society. Limerick: City Gallery of Art. Sligo: Model and Niland Centre.
Literature: *Thom's Directory*, 1876, 1916; *The Studio*, September 1912, March 1924, October 1939; J. Crampton Walker, *Irish Life and Landscape*, Dublin 1927 (illustration); *Ireland To-Day*, April 1937; *Dublin Magazine*, April-June 1951; *Irish Times*, 15 and 25 March 1960; Cork Rosc, *Irish Art 1910-1950*, catalogue, 1975; *Dictionary of British Artists 1880-1940*, Woodbridge 1976; *A Dictionary of Contemporary British Artists, 1929*, Woodbridge 1981; Major C.R.F. Hamilton, *Letter to the author*, 1986; Ann M. Stewart, *Royal Hibernian Academy of Arts: Index of Exhibitors 1826-1979*, Dublin 1986; *Water Colour Society of Ireland Exhibition List 1872-1994*, Dublin 1995.

HAMILTON, LETITIA M., RHA (1878-1964), landscape painter. Daughter of Charles R. Hamilton, MRIA, of Hamwood, Dunboyne, Co. Meath, Letitia Marion Hamilton was a younger sister of Eva H. Hamilton (q.v.) and a cousin of Rose Barton (q.v.). Educated at Alexandra College, Dublin, she studied under (Sir) William Orpen (q.v.) at the Dublin Metropolitan School of Art, under Frank Brangwyn (1867-1956) in Belgium, and at the Slade School of Fine Art, London. In the period 1902-64, she exhibited at the Water Colour Society of Ireland exhibitions, averaging almost four works per exhibition. In 1909 she exhibited at the Royal Hibernian Academy for the first time: *Dunboyne Village* and *The Cafe*, from the Hamwood address.

Early in her painting career she exhibited occasionally under 'May Hamilton', for example at the WCSI show in 1915, later becoming a member of the committee. Among the oil paintings at the Hugh Lane Municipal Gallery of Modern Art, Dublin, is one of the May Hamilton period. In 1914 she had a Dublin address, 40 Lower Dominick Street, but moved to Monasterevin, Co. Kildare, during the War. A founder member of the Dublin Painters in 1920, two years later, when living in Sligo, she contributed a painting of the Bog of Allen to the Irish Exhibition in Paris. After showing one work at the Royal Academy in 1922, she exhibited three paintings in 1924: *The Ca d'Oro, Venice*; *View of Florence*; and *The Bridge of Sighs*, sent from Font Hill, Palmerston, Co. Dublin. Eleven years elapsed before she again showed at Burlington House, and by then she was living at Dunsinea House, Castleknock, Co. Dublin.

An exhibition of paintings executed in Venice with her sister Eva – a Venetian scene of Letitia's is in the Limerick City Gallery of Art – was held in Dublin in 1924, and in due course she was to have her own studio in Venice. Hitherto she had been known 'as a sincere and able painter of somewhat sombre scenes in the Irish Midlands'. An exhibition entitled 'The Bogs of Queen's County' was held in Dublin in 1925. At the RHA the same year, however, she contributed *Autumn Flowers*; *Olive Trees near Florence*; and *The Kitchen Passage.*

Altogether at the RHA she exhibited more than 200 works, rarely missing an exhibition and being represented in the year of her death. The Italian connection was again evident with three Siena pictures at the

1926 Academy. In the period 1925-28 she participated at the Paris Salon, and by now her work was on view at the Goupil Gallery and Walker's Gallery, her main outlets in London where she showed more than fifty works in each gallery. She also exhibited with the International Society of Sculptors, Painters, and Gravers, and in a minor role with the Fine Art Society and the Royal Society of British Artists, also with the Scottish Society of Women Artists, Edinburgh.

At the age of fifty she described her recreations as 'tennis and all outdoor games'. Represented in the exhibition of Irish art at Brussels in 1930, her works at the 1933 RHA included a scene depicting poplars in the Jura Valley and an interior, *Palazzo Ducale*. The following year she was appointed ARHA and in 1944 a full member.

In 1934, too, she showed forty-five works, including York and Venice subjects, at the French Gallery, Berkeley Square, London. In August 1936 she wrote to the Belfast Museum and Art Gallery from Gravedona, Lago di Como, Italy, and when she exhibited with the Dublin Painters at the office of the High Commissioner for Ireland in London in 1938 her Italian scenes were specially noted by *The Studio*. *The Harbour, Malcesine, Lake Garda*, oil, is at Wesley College, Dublin. By this time her work was appearing in the New Burlington Galleries (Goupil Gallery Salon). In addition to Italy, she travelled extensively in France and also visited Yugoslavia and Spain.

At the 1943 WCSI gathering she contributed *Perseus and the Flowers*; *Richmond, Yorkshire*; *Beech Trees*; *Chrysanthemums*.

Among her pictures at the 1943 RHA were: *Spraying Potatoes near Mulranny* and *Marble Hill, Donegal*. Whilst acknowledging her technical accomplishment, the art critic of the *Dublin Magazine* felt disposed to say in 1944: 'Her excessive use of the palette knife, a predeliction for the most sugary tones and a super-abundance of white inevitably suggest the confectioner's.' In her exhibition at the Victor Waddington Galleries, Dublin, in 1945 the works included a flowerpiece and *The Harbour, Roundstone*. She showed there again in 1948, the year she won the bronze medal at the Olympic Games art section in London with *Meath Hunt Point-to-Point Races*.

Against her home background, it was suggested, she really belonged to the world of Somerville and Ross, but preferred to swop the hunting crop for palette knife and easel. She exhibited frequently with her sister Eva, and in 1951 at the Dublin Painters' Gallery she exhibited *The Calary Hunt Races* and *The North Kildare Harriers*. In 1952 she showed forty-two works including *The Chicken Market, Co. Cork* and *The Storm, Achill Island*, at Beaux Arts Gallery, Bruton Place, London.

The Dawson Gallery, Dublin, hung her work in 1956, and at the same gallery two years later she showed paintings of Ireland and Majorca, including *The Cathedral, Palma* and *The Lemon Tree, Valdemosa*. At the Dawson Gallery in 1960 there were paintings of Ireland, Portugal and Italy. She had a typically successful show at the same gallery in 1963, every picture being sold. *A View of Bantry Bay, County Cork*, oil, is at the National Gallery of Ireland. As enthusiastic as ever, she was painting ten days before her death on 10 August 1964. Goldolphin Gallery, Dublin, held an exhibition in 1982.

Works signed: L.M.H. or M.H., rare (if signed at all).
Examples: Athlone, Co. Westmeath: Public Library. Belfast: Ulster Museum. Clonmel: South Tipperary County Museum and Art Gallery. Cork: Crawford Municipal Art Gallery. Drogheda, Co. Louth: Library, Municipal Centre. Dublin: Hugh Lane Municipal Gallery of Modern Art; National Gallery of Ireland; Office of Public Works; Voluntary Health Insurance Board; Wesley College. Kilkenny: Art Gallery Society. Limerick: City Gallery of Art. Mullingar: Westmeath County Library. Sligo: Model and Niland Centre. Waterford: City Hall, Municipal Art Collection.
Literature: *The Studio*, September 1912, March 1924, July 1925, February 1926, September 1937, February 1938, September 1938; J. Crampton Walker, *Irish Life and Landscape*, Dublin 1927 (illustration); E.H. Walpole, compiler, *Mount Usher 1868-1928*, Ashford 1928 (illustrations); *Dublin Magazine*, January-March 1944, April-June 1951; *Contemporary Irish Art*, catalogue, Aberystwyth 1953; *Irish Independent*, 12 August 1964; Cork Rosc, *Irish Art 1910-1950*, catalogue, 1975; *Dictionary of British Artists 1880-1940*, Woodbridge 1976; *A Dictionary of Contemporary British Artists, 1929*, Woodbridge 1981; Godolphin Gallery, *Letitia Mary Hamilton*, catalogue, Dublin 1982; Major C.R.F. Hamilton, *Letter to the author*, 1986; Ann M. Stewart, *Royal Hibernian Academy of Arts: Index of Exhibitors 1826-1979*, Dublin 1986; *Water Colour Society of Ireland Exhibition List 1872-1994*, Dublin 1995.

HAMMERSCHLAG, ALICE BERGER (1917-69), symbolic and abstract painter; designer. Born on 18 February 1917 in Vienna, Alice Berger attended a grammar school for eight years. At the age of ten she was asked by her teacher to paint a poster on the theme 'Drink More Milk', for an international exhibition at Geneva. Hers was an enormous milkbottle in a meadow with life-size children dancing around it. She was one of very few Austrian children who received a diploma. When still at school she had lessons in the afternoons with the well-known Professor Franz Cizek (1865-1946). She graduated from Vienna School of Arts and Crafts under Professor Bertold Löffler (1874-1960).

In the tragic circumstances in Austria in 1938, she left her native land and travelled to Northern Ireland, where she met her husband-to-be, Heinz Hammerschlag. She worked as a freelance artist, receiving commercial art commissions and executing several stage-set designs in Belfast and Dublin, joining the permanent staff of the Belfast Lyric Players' Theatre as a scene designer. After the Ulster Hospital for Children and Women had suffered aerial bombardment in 1941, a portfolio of lithographs was published by the Ulster Academy of Arts to raise money for the hospital and her work was included.

Queen's University, Belfast, organised a one-person show in 1956, and subsequently four more exhibitions were held there, the last in 1968 when she showed a new series based on rhythmic patterns. It was now that her 'Streams of Light' series appeared. Her work attracted attention in England. In 1959 she had a solo show at the New Vision Centre Gallery, London, another in 1960 at the Avgarde Gallery, Manchester, and in 1962 at the Arnolfini Gallery, Bristol, where she showed forty works, oils and gouaches, including *Earth Emanations*, gouache.

After exhibiting at the Royal Ulster Academy in 1957, she served on a very controversial selection committee the following year. In 1959, Council for the Encouragement of Music and the Arts sponsored her show at the Piccolo Gallery, followed by a second exhibition in 1962 at their own gallery in Chichester Street, where her works included *The Seven Parallelograms* (from Yeats's *The Death of Cuchulain*) and *Appeal for Amnesty, 1961*. She had a spell as joint secretary of the Ulster Society of Women Artists, and she was a member of the Women's International Art Club, and also of the Free Painters and Sculptors, London.

The decade which concluded with her death was one of continual activity. In addition to her painting, she gave help, encouragement and advice to young artists, and she ran the New Gallery in Belfast, which was associated with the Lyric Theatre. As well as showing the work of Irish artists there, she used her cosmopolitan contacts to bring to the city a cross-section of European *émigré* art.

Alice Berger Hammerschlag's work was first seen in Dublin in 1961 at the Irish Exhibition of Living Art, and also 1964-7 inclusive. The Dawson Gallery ran two shows, 1965 and 1968. Her work frequently appeared in Arts Council of Northern Ireland group exhibitions. In 1963 it was on view at the United Nations Building, Rome; in 1966 in a solo show at the Ulster Office, London; in 1967 at the Galerie Creuze, Paris; and in 1968 and 1969 at Salon International Cannes, France. At her exhibition in the Arts Council Gallery in Belfast in 1966, the works included *Dissolving Barriers; Point of Release*; and *Transcending Spheres*. At Monaghan County Museum is *Concordant Rhythms*, 1967. At the Institute of Technology, Athlone, is *Silent Emergency*. In the Austrian Gallery, Vienna, is an oil painting, *Receding Light-waves*. *Spiralling Light Structure* is in the Arts Council, Dublin, collection, and *Emergence*, oil, in the Office of Public Works.

In 1969 she was invited to exhibit with the Scottish Society of Women Artists, and a painting by her in poster form was displayed on hoardings in Northern Ireland towns as part of the Arts Council's series. The country of her adoption did not appear to have any influence on her work. She died in Belfast on 14 July 1969. The Alice Berger Hammerschlag Trust was set up in her memory in 1970 to make awards to Irish artists, and in that year ACNI held a retrospective exhibition which attracted 2,445 people to their Belfast gallery. In 1998 the artist's sister Dr. Trudie Berger, York, bequeathed twelve oil paintings to the Ulster Museum. In 2000 an exhibition of the artist's work was held there.

Works signed: A. Berger or A.B.H. (if signed at all, but probably inscribed in full on back).
Examples: Athlone, Co. Westmeath: Institute of Technology. Belfast: Arts Council of Northern Ireland; Department of the Environment for Northern Ireland; Queen's University; Ulster Museum. Coleraine: North West Art Trust, University of Ulster. Downpatrick: Down County Museum. Dublin: Arts Council; Hugh Lane Municipal Gallery of Modern Art; Office of Public Works. Monaghan: County Museum. Oxford: Oxfam Building. Vienna: Austrian Gallery.

Literature: CEMA Gallery, *Alice Berger Hammerschlag*, catalogue, Belfast 1962; Dawson Gallery, *Alice Berger Hammerschlag*, catalogue, Dublin 1968; Dr Trudie Berger, *Letter to the author*, 1969; Arts Council of Northern Ireland, *Alice Berger Hammerschlag Retrospective Exhibition*, catalogue, 1970 (also illustrations); Arts Council of Northern Ireland, *Causeway, The Arts in Ulster*, Belfast 1971; *Arts Council of Northern Ireland Annual Report*, 1970-71; Mike Catto and Theo Snoddy, *Art in Ulster:2*, Belfast 1977; Martyn Anglesea, *The Royal Ulster Academy of Arts*, Belfast 1981; Heinz Hammerschlag, *Letter to the author*, 1986; also, Osterreichische Galerie, 1986.

HANLON, REV. JACK P. (1913-68), painter of figure compositions, flowerpiece and religious subjects. Born in Dublin on 6 May 1913, John Thomas Hanlon was the son of James Hanlon, proprietor of J. and R. Hanlon, butchers. Jack was educated at Belvedere College and University College, Dublin; and at Holy Cross College, Clonliffe and Maynooth College in his studies for the priesthood. As a boy in Templeogue, his mother had inspired him with a love of flowers, out of which he may have developed his vivid yet fragile form of painting; from his earliest years he was an enthusiastic gardener and painter. He first exhibited at the Royal Hibernian Academy at the age of twenty-one; in all, he showed only eight works.

During his stay at Maynooth, where he was ordained in 1939, the discipline of life was interrupted by holidays in Belgium, France and Spain with visits to galleries and cathedrals. He had spells in the studios of several artists, including that of André Lhote (1885-1962) in Paris. Advice was also given by the famous Henri Matisse (1869-1954). According to his brother Desmond Hanlon, in a letter to the author: 'He never studied with Mainie Jellett, I was the member of the family fortunate enough to do that. He worked in the late twenties with Henrietta Healy, who had her studio on Molesworth Street in Dublin. He was not fluent in Italian, but had a passable knowledge of French.' In London he studied at the Ablett Studios and passed the examination of the Royal Drawing Society.

In 1939 he was an exhibitor at the New York World Fair. In the period 1940-68 he showed thirty-seven works at Water Colour Society of Ireland exhibitions. The first one-person show was at the Victor Waddington Galleries, Dublin, in 1941, where his works included *Luxembourg Gardens-Winter* and *Belgium Farm*. Exhibitions followed at the same gallery in 1946, 1948 and 1953. In the last two he showed a total of forty-two watercolours and thirty-three oil paintings. On the 1948 show, the *Father Mathew Record* commented that the strength of the exhibition lay 'in its invention, inspiration and taste rather than in manual skill'.

During wartime, Hanlon had designed Christmas cards for Victor Waddington Publications Ltd. In the 1940s too his work was in group shows with the Dublin Painters. In 1943 this priest-painter was a member of the first executive committee of the Irish Exhibition of Living Art and became a regular exhibitor. In 1943 he held an exhibition of watercolours and stained glass at the Contemporary Picture Galleries, Dublin. In 1948 he won a bronze medal at the Olympic Games art section in London. At this time he resided at The Presbytery, Donard, Co. Wicklow.

'An airy delicacy in his work suggestive of Marie Laurencin', and 'an echo of the calligraphy of Raoul Dufy' were two comments on his painting. In 1950 he executed a mural for the Irish Pavilion in the Chicago World Fair. He showed six works, including *Boats at Nice* and *Recreation at the Convent*, in London at Wildenstein's 'Some Contemporary Painters' exhibition in 1951, and *The Studio* referred to him as a 'decorative interpreter who uses colour with emotional purpose.' A mural is at Our Lady Star of the Sea Church, Cobh, Co. Cork.

Hanlon's work appeared in an exhibition of contemporary Irish art at Aberystwyth in 1953. Works included in his exhibition at the Waterford Books gallery in 1955 were: *The Cathedral, Barcelona*; *The Walls of Avila*; *Madonna in Red*. He was represented in the exhibition of flower paintings in 1957 at the Ritchie Hendriks Gallery, Dublin. In Wexford town, seven nuns, Sisters of the Convent of Perpetual Adoration, made five vestments and a cope which were presented by the Irish Government to Pope Pius XII. The work was completed in 1957 from designs by Father Hanlon, who supervised the colour of all the materials and threads used. Next he was involved in five oil paintings of St Patrick, St Pius X, St Brigid, the Holy Family and St Oliver Plunkett for an aisle in Our Lady of the Rosary Church, Limerick.

Solo shows were at the Dawson Gallery, Dublin, in 1958, 1962 and 1965. At the 1960 RHA he contributed *The Beech Avenue* and *The Bamboo Chair*. In 1961 he painted *Stations of the Cross* for Holy Cross Church, Seaview, Isle of Wight, and that year he showed again at Wildenstein's; several Mentone scenes were on view. In 1962 he won the President Hyde Gold Medal award at the Oireachtas exhibition for *Cormac's Chapel*. Also in 1962 he was represented at the Irish Sacred Art exhibition in Dublin, and he exhibited *Altar Boys in a Meadow*, his final RHA offering.

Outside of Ireland, one-person shows were staged in Paris, Brussels and Curacao, Venezuela. In Co. Limerick, at St Patrick's Church, Ardpatrick, are two paintings, one of St Patrick and the other of The Baptism of Christ. The latter work has a local background. There are *Stations of the Cross* at Stella Maris Church, Downings, Co. Donegal. The Rev. Jack Hanlon, CC, Churchtown, Dublin, died on 12 August 1968.

All his own pictures were bequeathed to friends and institutions, which mainly accounts for the lengthy 'Examples' list in this entry. More than fifty sketchbooks are in the National Gallery of Ireland. From the beginning of his career he collected contemporary works of art, and some three score Continental and Irish pictures were sold at the Dawson Gallery, Dublin, in 1968. Works by Lhote, Ivon Hitchens (1893-1979) and Maurice de Vlaminck (1876-1958) were in the sale. In 1975 the Neptune Gallery, Dublin, held an exhibition of his drawings and watercolours, taken from two sketchbooks, one of scenes of Venice, Florence and Northern Italy, the other of landscape and urban subjects in France.

Works signed: Jack P. Hanlon, Jack Hanlon, J.P. Hanlon, J. Hanlon, J.P.H. (if signed at all).
Examples: Ardpatrick, Kilmallock, Co. Limerick: St Patrick's Church. Armagh: County Museum. Ballinasloe, Co. Galway: St Joseph's College. Beijing: Irish Embassy. Belfast: Ulster Museum. Chudleigh, South Devon: Redemptoristine Convent. Churchill, Letterkenny, Co. Donegal: Glebe Gallery, Derek Hill's Collection. Clonmel: South Tipperary County Museum and Art Gallery. Cobh, Co. Cork: Our Lady Star of the Sea Church. Cork: African Missions House; City Library; Crawford Municipal Art Gallery. Downings, Co. Donegal: Stella Maris Church. Drogheda, Co. Louth: Library, Municipal Centre. Dublin: Belvedere College; Holycross College, Clonliffe; Hugh Lane Municipal Gallery of Modern Art; National Gallery of Ireland; Office of Public Works; Trinity College Gallery; University College (Belfield). Galway: National University of Ireland. Isle of Wight: Holy Cross Church, Seaview. Killarney: Town Hall. Limerick: City Gallery of Art; Our Lady of the Rosary Church. Maynooth: St Patrick's College. Sligo: Model and Niland Centre. Waterford: City Hall, Municipal Art Collection. Wicklow: Dominican Convent.
Literature: *The Bell*, December 1943; *Dublin Magazine*, October-December 1943, July-September 1950, April-June 1958; *The Studio*, June 1947, March 1949, March 1950 (illustration), January 1952; Rev. Fr Augustine, OFM Cap, *Some Irish Heroes of the Mass*, Dublin 1946 (illustrations); *Father Mathew Record*, November 1948; *Capuchin Annual*, 1950-51 (also illustration); Waterford Books, *Rev. Fr Hanlon, CC*, catalogue, 1955; *Sunday Dispatch*, 16 December 1956; Wildenstein, *Some Contemporary British Painters XVIII*, catalogue, London 1961; *Kilkenny Magazine*, Autumn-Winter 1962; *Irish Times*, 13 and 20 August 1968, 7 August 1969, 11 February 1975; Cork Rosc, *Irish Art 1900-1950*, catalogue, 1975; Very Rev. Patrick O'Regan, *Letter to the author*, 1978; also, Rev. R.Q. Hind, 1987; Department of Industry and Commerce, 1987; Rev. Liam O'Sullivan, 1987; John Coleman, 'A Painter of Living Art: Jack P. Hanlon 1913-1968', *GPA Irish Arts Review Yearbook*, 1988; Desmond Hanlon, *Letter to the author*, 1998.

HARDING, MORRIS, RBS, RHA (1874-1964), sculptor. Born at Stevenage, Herts., on 29 April 1874, Morris Harding was trained in the studio of his uncle, Harry Bates, ARA (1850-99) and also worked under J.M. Swan, RA (1847-1910). Four of Swan's animal sketches were presented by Harding to the Belfast Museum and Art Gallery, and a sculpture in plaster, *Angel*, is also at the Ulster Museum. Harding taught sculpture and life drawing at the London County Council Technical Institute. A life-size figure of G.K. Vansittart-Neale, who died at Eton, aged fourteen, in 1904 is in the Church of All Saints, Bisham, Bucks; the subject's dog, Norman, was taken from life. A marble, *Polar Bears at Play*, 1909, is at Queen's University, Belfast, presented by the artist.

Harding exhibited at the Royal Academy, the London Salon, Walker Art Gallery, Liverpool; Glasgow Institute of the Fine Arts; and also showed at Milan. Elected a member of the Royal Society of British Sculptors in 1912, he became a member of the Society of Animal Painters in 1921. His war memorial for Eastergate village, Sussex, which was erected in 1921, is surmounted by a lion. In a search for work four years later he called to see Sir Charles Nicholson who, as consulting architect, asked if he would like to take

on St Anne's Cathedral in Belfast. Harding, with a family to consider, did not hesitate. A fortnight later he was in Belfast, standing on scaffolding as snow fell on his head.

In 1927 he joined the Belfast Art Society. The sculptor Rosamond Praeger (q.v.) guided him to Holywood, Co. Down, and they shared St Brigid's Studios, occasionally issuing invitation cards for 'At Homes'. Harding rented a flat on the ground floor, and that was the address he gave when he exhibited *Leopard and Cub* at the 1929 Royal Hibernian Academy. Altogether at the Dublin exhibition, up until 1953, he contributed nearly fifty works, showing the occasional tiger, wild boar, polar bear, lion, and greyhounds for good measure.

The Belfast Cathedral commission was to become the major work of his career, spending some twelve years working on seven nave columns, also groups in the portals of the West Front, which he completed first. Miss Rita Harding, his daughter, advised the author in 1977 that the capitals her father was responsible for were: Agriculture, Arts, Linen, Music, Science, Shipbuilding, and Motherhood. He also did a series of portraits of dignitaries of the Irish Church, and when he could not find photographs or illustrations of some of the clerics he had been asked to include, he used, sometimes without their knowledge, some Church dignitaries with whom he was familiar. The model for his recording angel was a well-known local journalist, not of the Protestant faith. Another model, unknown to her, was a girl who passed by the Cathedral every morning; he made a clay model and later she appeared on the Music pillar.

When working on the Motherhood pillar his model was a woman 'drawn to the Cathedral like a magnet'. Poor and working-class, she always carried a child in her arms and often commented on the work in progress. With more glee than pride, he introduced his own figure into the Arts pillar and, characteristically, he holds a hammer. High up on the West Front are four unusual little groups – *The Four Aces*. Industry is represented by a man digging with a spade; Strife by two men fighting with clubs; Hearts by a man and a girl holding hands; and Diamonds by a miser with his money bag.

Closely involved in the artistic life of Northern Ireland, he became an academician of the Ulster Academy of Arts in 1931. In 1947 he assumed the presidency of the Ulster Academy, holding office until he retired in 1957 as president of the Royal Ulster Academy.

In 1933 he was appointed ARHA and in the same year a full member. In 1933 he exhibited at the RHA, *The late Dean of Belfast and Canon of St Patrick's Cathedral, Dublin, the Very Rev. Henry R. Brett, MA, and Mrs Brett*. Among other works at that exhibition was *Polar Bear and Seals* in alabaster.

At the Belfast exhibitions, busts of local personalities would appear, for example: *Jimmy Warnock*, 1937; *Alderman Thomas Henderson, MP*, 1950; and in 1947 at the Belfast Museum and Art Gallery, where he had a joint exhibition with W.R. Gordon (q.v.), *Field-Marshal Lord Montgomery*, a head. Other commissions in Belfast included: Font and side chapel reredos for St Peter's Church, Antrim Road; the Royal Coat of Arms at Telephone House; lioness with cubs over doorway at the Masonic Hall, Crumlin Road; the Civil Service War Memorial in the Old Parliament Buildings. Coats of Arms at the old Government House, Hillsborough, Co. Down, for the Duke of Abercorn and Earl Granville, were carved by him. His last big work was the tomb for the seventh Lord Londonderry at Mount Stewart, Co. Down, and he was also responsible for Lady Londonderry's tomb, commissioned in advance of her death.

In 1938 Harding had been responsible for a frieze 45.7 metres long, 1.2 metres deep with fifteen panels, for the Northern Ireland Government's pavilion at the Glasgow Empire Exhibition, and was assisted by Poppy Mollan and John Luke (q.v.), who did the sketches full size in crayon and then boldly outlined them in charcoal. Harding, using a gouge, incised the wood fibre board up to half an inch in depth. All the major industries of Northern Ireland were portrayed in the main series of panels, and there was a tourist and sporting section of three panels.

In 1951 he was one of eleven artists invited to exhibit in the Contemporary Ulster Art exhibition held for Festival 1951 at the Belfast Museum and Art Gallery, and two years later at the same venue he was represented in an exhibition of sculpture, organised by Council for the Encouragement of Music and the Arts. Awarded the OBE in 1950, and holder of a Civil pension, he received an honorary Master of Arts degree from Queen's University in 1958. He was too frail to attend the ceremony and was robed in his Holywood home, Church Road. He died there on 15 January 1964.

Works signed: Morris Harding.
Examples: Belfast: Masonic Hall, Crumlin Road; Parliamentary Buildings; Queen's University; St Anne's Cathedral; St Peter's Church, Antrim Road; Telephone House, Cromac Street; Ulster Museum. Bisham, Bucks: Church of All Saints. Eastergate, Chichester, West Sussex. Hillsborough, Co. Down: Government House. Holywood, Co. Down: Sullivan Upper School. Mount Stewart, Co. Down.
Literature: *Belfast Telegraph*, 20 October 1937, 18 October 1950, 18 May 1957, 9 July 1958; *Belfast News-Letter*, 27 January 1938, 11 September 1947, 21 May 1951, 2 July 1959, 16 January 1964; Belfast Museum and Art Gallery, *Morris Harding*, catalogue, 1947; *The Guardian*, 15 May 1957; *The Story of All Saints the Parish Church of Bisham*, Bisham 1967; John Hewitt and Theo Snoddy, *Art in Ulster: 1*, Belfast 1977; Martyn Anglesea, *The Royal Ulster Academy of Arts*, Belfast 1981 (also illustration); Pallant House Gallery Trust, *Letter to the author*, 1986; Ann M. Stewart, *Royal Hibernian Academy of Arts: Index of Exhibitors 1826-1979*, Dublin 1986; National Trust, Northern Ireland Region, *Letters to the author*, 1988, 1989; Eileen Black, *A Sesquicentennial Celebration: Art from the Queen's University Collection*, Belfast 1995 (also illustration).

HARE, ST GEORGE, RI, ROI (1857-1933), historical, genre and portrait painter. Born in Limerick on 5 July 1857, he was the eldest son of George Frederick Hare. His father was born in Ipswich, Suffolk, and had travelled as a young man to be an assistant dentist in Limerick to St George Freeman, LDS, of Waterford, and spent the rest of his life in Limerick. He married Ella, daughter of his senior partner.

St George Hare was a nephew of Jabez Hare, who died in 1837 aged seventeen and who is commemorated in St Matthew's Church, Ipswich: 'This tablet is erected by the subscription of his affectionate friends as a record of early talent and worth.' In 1956 Ipswich Corporation Museum Committee, empowered by an Act of 1948, sold a St George Hare self-portrait together with a portrait by Jabez Hare for £1. The self-portrait had been presented by the artist's only child, Sidney.

St George Hare entered the Limerick School of Art and for three years studied under N.A. Brophy (q.v.) before moving in 1875 to South Kensington, where he remained for seven years, distinguishing himself by acquiring all three art masters' certificates. For a time he held an appointment as a master, but he wished to be an artist. He first exhibited at the Royal Hibernian Academy in 1881 when he showed Limerick and Waterford scenes, and a third work, *Parental Admonition.*

A watercolour, *Ladies' Cove, Tramore, Co. Waterford*, signed, inscribed and dated 1881 on reverse, appeared in a Gorry Gallery, Dublin, sale in 1985. Some watercolours were hung at the Dudley Gallery, London, in 1882 and 1883. He showed for the first time at the Royal Academy in 1884 with *A Little Mother*, and in the following year a study of a child before a looking glass, *Natural Instincts*, achieved immediate popularity.

Death of William the Conqueror, hung at the 1886 RA, won a gold medal when it was exhibited later at the Crystal Palace. In Dublin, he exhibited a portrait of his father at the 1888 show; a total of twenty-seven pictures were displayed at the RHA. The two highest priced by far were '*Many waters cannot quench Love*', exhibited in 1903 at £300, and '*Misere Domine*' exhibited in 1906 at £400.

'It is extremely rare in Ireland till the twentieth century to find the nude used as a subject. We have no Ettys, we have no Leightons with the startling exception of one academic painter from Limerick...' wrote Anne Crookshank and the Knight of Glin in *The Watercolours of Ireland*, 1994. They found *The Slave Girl* an 'outstanding example in the Leighton manner'. Elsewhere, he was said to have 'exploited the nude', but he also painted 'fluffy Edwardian "keepsake beauties"'.

In 1890 he had exhibited his first important painting of the nude, *The Victory of Faith* ('*Misere Domine*'). A work of this title was presented by an anonymous donor to the National Gallery of Victoria, Australia, in 1905. St George Hare lived most of his life in Chelsea, and was one of the original founders of the Chelsea Arts Club in 1891. The following year he was elected a member of the Royal Institute of Painters in Water Colours and the Royal Institute of Oil Painters. He exhibited extensively at their exhibitions.

In the period 18 November - 23 December, 1893, *The Graphic* published Hare drawings for a story by W. Outram Tristram. The illustrations are in the Victoria and Albert Museum. Also in their collection is the original drawing for *The Graphic* of 2 December 1899, *The first to scan the casualty lists in the 'Times'* – *the girl he left behind him*. At the Society of Oil Painters' exhibition in 1903 he showed a portrait of Lady

Nash, and in 1904, from Netherton Grove, Fulham Road, London, his work was included in the exhibition by Irish painters held at the Guildhall of the Corporation of London and arranged by Hugh P. Lane. When in 1906 *The Studio* published a special number on the Royal Institute of Painters in Water Colours, the St George Hare reproduction was: *This – all this was in the olden time long ago.*

The Witt Library in London has reproductions of portraits of Sir Henry Hoare, 6th Baronet, of Stourhead, his wife and son. Outside of London his work was frequently seen at the Walker Art Gallery, Liverpool, and he also showed at the Manchester City Art Gallery and the Royal Society of Artists, Birmingham. In the RHA collection there are two portraits, one of B. Barrington and the other of the artist's mother, inscribed 'St George Hare, 1911, Limerick, for Ethel Wynne-Palmer'. The National Gallery of Ireland has an oil self-portrait of a bearded man. He died in hospital on 30 January 1933.

Works signed: St George Hare or Hare.
Examples: Dublin: National Gallery of Ireland; Royal Hibernian Academy. Limerick: City Gallery of Art . London: Victoria and Albert Museum. Melbourne: National Gallery of Victoria.
Literature: *The Magazine of Art*, June 1900; *The Art Journal*, November 1908; *Dictionary of British Artists 1880-1940*, Woodbridge 1976; *Dictionary of British Watercolour Artists up to 1920*, Woodbridge 1976; Mrs Norah Odell, *Letter to Christchurch Museum*, 1977; *Dictionary of Victorian Painters*, Woodbridge 1978; Anne Crookshank and the Knight of Glin, *The Painters of Ireland c. 1660-1920*, London 1978 (also illustration); National Gallery of Victoria, *Letter to the author*, 1986; Mrs Norah Odell, *Letters to the author*, 1986; Ann M. Stewart, *Royal Hibernian Academy of Arts: Index of Exhibitors 1826-1979*, Dublin 1986; Anne Crookshank and the Knight of Glin, *The Watercolours of Ireland*, London 1994 (also illustration).

HARRISON, CHARLES L. (1858-1913), architectural sculptor. Charles Lloyd Harrison had three brothers in the same profession. He was the eldest son of Yorkshire-born Charles W. Harrison (1834-1903), a monumental sculptor in Great Brunswick Street, Dublin, the first employer of James Pearse, the father of Patrick Pearse. Charles senior was responsible for many carvings, notably the monkeys on Kildare Street Club, a marble chimneypiece at Kilkenny Castle and the Lord Carbery memorial Celtic cross at Castlefreke, Clonakilty, Co. Cork.

In addition to headstones, mantelpieces, carvings of angels and other embellishments on churches and buildings, including his father's tombstone in Mount Jerome cemetery, Charles L. Harrison was responsible for the ornamental stone carving of the old Royal College of Science building in Merrion Street. Panels of the high altar pulpit of St Colman's Cathedral, Newry, rank highly as an example of this type of work.

Harrison also carved in 1906 the 5 ½ metres high Celtic cross, made of Ballinasloe limestone, over the grave of the poet, Thomas Moore, in Wiltshire. He was also responsible for a statue of the French General Humbert. He executed portrait medallions of Sir Henry Page Turner Barron, Bart; The Dowager Lady Bantry; Bishop Hanson and others. He was for many years a member of the Architectural Association of Ireland and a member of the Royal Dublin Society. He died at his residence in Great Brunswick Street, on 14 June 1913.

Examples: Bromham, Wiltshire: Churchyard. Cobh, Co. Cork: St Colman's Cathedral. Dublin: Government Buildings, Merrion Street. Mullingar, Co. Westmeath: St Finian's College. Newry, Co. Down: St Colman's Cathedral.
Literature: *Irish Builder*, 18 June 1903, 21 June 1913; *Devizes and Wiltshire Gazette*, 22 November 1906; *Irish Times*, 16 May 1967, 9 June 1976; Mrs Violette Sparrow (née Harrison), *Letters to the author*, 1976, 1977.

HARRISON, CHARLES W. — see HARRISON, CHARLES L.

HARRISON, SARAH CECILIA (1863-1941), portrait painter. Born on 21 June 1863 at Holywood, Co. Down, she was the third child of Henry Harrison, JP, of Holywood House and Ardkeen, Co. Down, and his second wife, Letitia Tennent. Related to Henry Joy McCracken, Sarah Cecilia Harrison's portrait of him, which she donated, is in the Ulster Museum. Her brother, Henry Harrison, was known as the vindicator of Parnell. On her father's death, the family moved to London, where she attended Queen's College; in session 1881-82 she was awarded a silver medal by University College, London, for a painting from the antique.

Under Professor Alphonse Legros (1837-1911) she trained at the Slade School of Fine Art, and won the Slade Scholarship. She continued her artistic education by studying the masters in Italy, the treasures at the Louvre and at other galleries at Amsterdam, Haarlem and The Hague. In 1889, from 16 Fitzwilliam Place, Dublin, she exhibited at the Royal Hibernian Academy for the first time. In 1890 she painted at Étaples, North France. In 1895 she exhibited at the Belfast Art Society exhibition with a London address. *The Studio* noted in 1898 her portrait at the New English Art Club's winter exhibition of Mrs Hugh Chisholm: 'minutely detailed...is remarkable for its delicate realism'.

Altogether at the RHA, between 1889 and 1933, she showed sixty works, the vast majority portraits. Indeed the opening of the century saw her settling down as a portrait painter but at the same time being actively engaged in Dublin with Hugh Lane in his work for spreading in Ireland a knowledge of the best modern art, and also in campaigning for a modern Dublin gallery. Indeed it was said she had fallen in love with Lane, who was responsible for an exhibition of modern paintings held at the Belfast Corporation Art Gallery in 1906, and Celia (as the artist was sometimes called) was represented by a portrait of Mrs Walter Ford.

At the Belfast Art Society exhibition in 1906 she was represented by portraits, *George MacDonald, LL D*, now in the Scottish National Portrait Gallery, and *Monsignor O'Laverty, MRIA*, which she presented to the Belfast gallery. The portrait of the Scottish writer was painted in 1897 at his house, Bordighera, Italy, when the artist was on a visit.

The descriptive and critical notes for the first Municipal Gallery, Dublin, catalogue, 1908, were compiled by Miss S.C. Harrison, and in that year she was represented in the exhibition of pictures by Irish artists at the Franco-British Exhibition by her portrait of Thomas and Anna Haslam, pioneers of the Irish Women's Suffrage Movement. The painting was presented by Lane to the Municipal Gallery.

A disciple of John Butler Yeats (q.v.), she joined him as one of the leading portrait painters in Dublin. Mary Swanzy (q.v.) told the author in 1968: 'I first met her when as a young painter she did a pastel portrait of my younger sister. She studied hard after that and became a careful, polished portrait painter.' In 1979 Dorothy FitzGerald (q.v.) commented to the author: 'Miss Harrison held private classes in her house. She was a very strict teacher. She would not allow painting, only drawing.' A portrait of Gerald FitzGibbon was commissioned by the Hon. Society of King's Inns, 1909. A presidential portrait of John H. Chapman, MD, was for the Friendly Brothers of St. Patrick.

An early fighter for women's rights, in 1912 she created history when elected a member of Dublin Corporation, the first woman to achieve that distinction. She earnestly campaigned for the cause of Dublin's poor. A room of her home at 7 St Stephen's Green, above Robert Smyth and Sons Ltd, grocers, was used as an office where she heard the grievances and wants of hundreds of poor every week.

In 1912 too hers was one of the signatures in a letter to the press regarding the provision of a gallery for Lane's pictures. At a public meeting a committee was elected for the purposes of acquiring a suitable site and of raising more funds; she was elected secretary. The list of subscriptions for 1905-8 showed that she had already given £5.0.0.

In 1915 at the Royal Hibernian Academy, listing 16 Upper Mount Street, Dublin, as her address, she showed four portraits. *The Studio* commented that the most notable was *Father Stafford* and that her work was distinguished by its sincerity and high technical achievement. Apart from the RHA, a dozen works were hung at the Royal Academy, but appearance at other English exhibitions was limited. As a tribute to the man whom some thought she had hoped to marry, she copied *St Francis in Ecstacy* by El Greco (1541-1614), a work presented by Lane in 1914 to the National Gallery of Ireland; the copy is now at St Patrick's College, Maynooth. After the death of Sir Hugh Lane in 1915, she strongly supported the claim for the return of the thirty-nine Lane bequest pictures.

Belfast Museum and Art Gallery displayed seven of her works, including *Lieut. J. Tennent Harrison* and *Commendatore Michelo Esposito*, in a loan exhibition of Irish portraits by Ulster artists in 1927. The portrait of the pianist and composer is in the NGI collection. In 1931 she was appointed an honorary academician of the Ulster Academy of Arts, and in that year's Belfast exhibition portraits of Robert Lloyd Praeger and Senator Colonel Maurice Moore were particularly noted.

Self-portraits are in the Hugh Lane Municipal Gallery of Modern Art and the NGI, where there are, among others, portraits of Hugh Lane and Henry Harrison. A portrait of S.C. Harrison by Antonio Mancini (1852-1930) is also at the Merrion Square gallery. A portrait of Senator Thomas Johnson hangs in Leinster House. An etching of a man's head is in the Crawford Municipal Art Gallery collection, Cork. Among the 'official purchases' which she listed in 1929 were: Copy of Holbein's portrait of Anne of Cleves (Princess Louise); Prince of Wales (gift for Queen Victoria), but neither can now be traced in the Royal Collection. Celia Harrison died on 23 July 1941.

Works signed: S.C. Harrison or SCH., monogram (if signed at all).
Examples: Austin, Texas, U.S.A: University of Texas, Humanities Research Center. Belfast: Ulster Museum. Cork: Crawford Municipal Art Gallery. Dublin: Hugh Lane Municipal Gallery of Modern Art; King's Inns; Leinster House; Masonic Hall, Molesworth Street; National Gallery of Ireland; Office of Public Works; Royal College of Physicians of Ireland. Edinburgh: Scottish National Portrait Gallery. Limerick: University, National Self-Portrait Collection. Maynooth, Co. Kildare: St Patrick's College.
Literature: *The Studio*, December 1898, May 1915; *Exhibition of Modern Paintings at Belfast Corporation Art Gallery*, catalogue, 1906; *Irish Review*, June 1913; *Belfast Museum Quarterly Notes*, Christmas 1915; J. Crampton Walker, *Irish Life and Landscape*, Dublin 1927 (also illustration); P.L. Dickinson, *The Dublin of Yesterday*, London 1929; *Belfast Telegraph*, 22 October 1931; *Capuchin Annual*, 1949; Thomas Bodkin, *Hugh Lane and His Pictures*, Dublin 1956; Cork Rosc, *Irish Art 1900-1950*, catalogue, 1975; *Irish Times*, 28 October 1975; Anne Crookshank and The Knight of Glin, *The Painters of Ireland* c.1660-1920, London 1978; *A Dictionary of Contemporary British Artists, 1929*, Woodbridge 1981; Martyn Anglesea, *The Royal Ulster Academy of Arts*, Belfast 1981; *Irish Arts Review*, Winter 1985; Ann M. Stewart, *Royal Hibernian Academy of Arts: Index of Exhibitors 1826-1979*, Dublin 1986; Wanda Ryan-Smolin, *King's Inns Portraits*, Dublin 1992; Friendly Brothers of St Patrick, *Letter to the author*, 1997.

HARRISON, THEODORA L. (1890-1969), illuminating and heraldic artist. Theodora Lawrenson was born on 23 July 1890 at Ballinakill, Glenealy, Co. Wicklow, the daughter of Robert Lawrenson, 'gentleman farmer'. She served a four-year apprenticeship under James McConnell, illuminating and heraldic artist, 48 Lower Sackville Street, Dublin. His three daughters, Frances, Ruby and Mabel were also actively engaged in the studio, and Theodora's connection with them and the firm was long-lasting. Following her apprenticeship, she attended the Dublin Metropolitan School of Art.

After her studies, she established herself independently as an illuminating and heraldic artist in Dublin, receiving commissions for royalty and also from the Vatican. In 1929 she left Ireland to join her husband, William C. Harrison, a violinist, in the USA. On the occasion of the coronation of King George VI and Queen Elizabeth she executed a 'loyal address' from the members of the Washington State branch of the English-Speaking Union, composing the wording as well as illuminating.

In Seattle, she re-established her studio and, over the years, developed a wide artistic connection. In the recession her husband resorted to cabinet-making. The arts of illumination and heraldry were at the time almost wholly unknown there, and she gave innumerable lectures, which included some at the University of Washington. Professor Walter Isaacs, head of the Department of Painting, Sculpture and Design, wrote of her work: '... for pure expression of the best traditions of illuminating, I believe to be unparalleled in this country'.

Active in the affairs of the Seattle Art Museum from the time of its foundation, she was also involved in a weekly radio broadcast on artistic matters, and was a director for a time of a local commercial gallery. A watercolour painter, she was for several years president of the Women Painters of Washington. Illuminated manuscripts and heraldic work were exhibited at the Rockefeller Plaza, New York; Grant Galleries, Brooklyn; San Francisco's Crock of Gold and the Seattle Art Museum. Returning to Ireland in 1951, she was elected a member of the Water Colour Society of Ireland in the following year, and she showed eleven works; in 1953, *4a.m., San Juan Islands*; *Old Chinese Theatre, Vancouver*; *En Deshabille*. One of her later commissions was a memorial album for the Dowager Countess of Meath. Theodora Lawrenson Harrison died in Dublin on 28 July 1969.

Works signed: Theodora Harrison, Theodora Lawrenson Harrison or Theodora, watercolours.

Examples: Seattle, USA: Art Museum.

Literature: *Thom's Directory,* 1905; Stationery Office, Dublin, *Handbook of the Ulster Question*, Dublin 1923 (illustration); *Seattle Times*, 6 November 1949, 19 August 1969; Prof. Walter F. Isaacs, *Theodora Lawrenson Harrison*, pamphlet, Washington, n.d.; General Register Office, Dublin, *Register of Deaths*, 1969; Mrs Elizabeth Bell, daughter, *Letter to the author*, 1986; also, Charles and Emma Fry Art Museum, 1987; *Water Colour Society of Ireland Exhibition List 1872-1994*, Dublin 1995.

HARTLAND, GERTRUDE (1865-1954), botanical illustrator. Born in Co. Waterford, Mary Gertrude Galway Hartland was the daughter of Richard Hartland, whose younger brother, William Baylor Hartland, the second, became a prominent Cork nurseryman who exported bulbs all over the world. He was the third generation of his family to be involved in the nursery and seed business in Co. Cork, and he set up his own business in Cork city in 1878.

In the Hartland history, William Baylor Hartland generated more note and comment than all the rest of the family and never missed an opportunity to publicise his business. For example, while acting as a judge he could not compete at major Cork flower shows, but he would put on a dazzling non-competing display of flowers, which would in every respect 'steal the show'. Like his brother, Henry Albert Hartland (1840-93), the landscape painter who moved on to Liverpool, he had an artistic temperament and followed his projects 'with buoyant enthusiasm'. When Queen Victoria visited Cork in 1885 the cluster of flowers which she carried had been 'gratuitously placed in the Royal Carriage at Ballyhooly Railway station'.

Gertrude Hartland drew and painted flowers, principally daffodils, for W. B. Hartland's nursery between 1887 and 1897 and possibly later. Her artwork was used as the basis for illustrations published in a variety of different places including Hartland's idiosyncratic bulb and seed catalogues. In 1887 he had an article on Christmas roses in the *Gardeners' Chronicle* and the engraved illustration was from an original watercolour by his niece. In 1897 he published his special edition of *Hartland's Conference Daffodils* with forty-six illustrations by Gertrude, reproduced as engravings. The ordinary issue was available for a few pence but a limited number of hand-coloured copies sold at one guinea each. The engraving was done by W. J. Welch, who was the principal engraver for *Gardeners' Chronicle*. Hartland was among the pioneers in the promotion of daffodils as a popular flower.

The Royal Horticultural Society holds two Hartland catalogues in their library but the illustrations are unsigned. He was a member of the RHS daffodil committee. Gertrude Hartland did not show at the Royal Hibernian Academy or the Water Colour Society of Ireland nor does she appear to have exhibited outside Ireland. She married Stephen Jackson and died in Dublin in 1954.

Works signed: Gertrude Hartland (if signed at all).

Literature: General Register Office, Dublin, *Register of Births,* 1865; *Gardeners' Chronicle*, 8 October 1887 (illustration); Mallow Archaeological and Historical Society, Seamus Crowley, 'The Hartland Nursery Family of Mallow and Cork', *Mallow Field Club Journal*, No. 3, 1985; Megan Morris, 'Irradiating the present: restoring the past', *Moorea*, volume 4, Dublin 1985; National Gallery of Ireland and Douglas Hyde Gallery, *Irish Women Artists: From the Eighteenth Century to the Present Day*, catalogue, Dublin 1987; Royal Horticultural Society, *Letter to the author*, 1998.

HARVEY, CHARLES W. (1895-1970), landscape, still life and flower painter. Born in London, his father was a map-maker in Ordnance Survey. The Harvey family arrived in Belfast in 1906. His father travelled Ireland surveying, sometimes taking young Charles and his sister along. Charles learnt Irish on the way, and later spoke French and Italian.

Charles Harvey studied at the Belfast School of Art with John McAllister (q.v.), subsequently sharing a studio with him in North Street. He won a gold medal in the National Competition for design. In 1914 he attended the summer term at the Dublin Metropolitan School of Art, and he is believed to have taken a summer course in etching at Glasgow School of Art. Training as a damask designer, he became friendly with Hans Iten (q.v.).

A man of wide interests, he was knowledgeable about antique furniture. He began teaching in a part-time capacity at St Mary's Training College, Belfast, from 1932 to 1936, but for the next twenty-four years he

was a full-time lecturer, retiring as head of the art department. He exhibited at the Ulster Arts Club, and assisted with life classes there. He rarely exhibited elsewhere because he did not approve of academies and felt they were only the stamp of technical skill, not artistic worth.

Paintings by Harvey were included in 'The Ulster Unit: Exhibition of Contemporary Art' in the Locksley Hall, Belfast, 1934, and the following year he painted in Brittany with Padraic Woods (q.v.). In 1937 he visited Paris with fellow artists John Luke and Nevill Johnson (qq.v.). Landscapes were also painted in Connemara as well as Counties Antrim, Donegal, Down and Wicklow. About 1942 Henry P. Stinson, a teacher of art at Londonderry Technical School, persuaded him to join in an exhibition in the city; they sold all their work. He died on 26 June 1970 at his home, 124 Somerton Road, Belfast. A retrospective exhibition was held at the Arts Council of Northern Ireland Gallery in 1976; attendance 1,200.

Works signed: C. W. Harvey or C. Harvey (if signed at all).
Examples: Belfast: St Joseph's College of Education; St Mary's College.
Literature: Arts Council of Northern Ireland, *Charles Harvey*, catalogue, Belfast 1976; *Arts Council of Northern Ireland Report*, 1976-77; John Hewitt and Theo Snoddy, *Art in Ulster: I*, Belfast 1977; H.P. Stinson, *Letters to the author*, 1986.

HASLETT, HENRY P. (1906-68), monumental sculptor. Born in Londonderry on 10 November 1906, Henry Poston Haslett was the son of Alexander Haslett (1874-1959) who had worked in Glasgow in his youth and had founded the firm of Haslett Bros, monumental sculptors, in Londonderry early in the century. Harry, as the artist was called, attended the Belfast College of Art and passed with distinction in the years 1932 and 1933, in industrial design; object and memory drawing; drawing from casts.

Haslett was described as 'a stonemason particularly gifted in that he could make up his own designs either for surface carving, ornamental lettering or figure carving'. In the Londonderry area at St Mary's Church, Ardmore chapel, is a tablet, *The Immaculate Conception*, over the entrance, and *The Madonna*. A statue of St Bernadette at St Eugene's Cathedral was re-designed and carved by him.

In the chapel of St Columb's College, Londonderry, he carved the front of the altar table and the reredos, involving many months' work. At the Limavady Post Office he was responsible for the Royal Coat of Arms in the same Portland stone as used in the building. Under the Commonwealth War Graves Commission he was involved in headstones bearing regimental badges, often of intricate design. Local architects and builders consulted him on the use of stone as he could tell at a glance the type and probable origin of any piece. He died on 3 December 1968 at 'The Grove', Bridgend, Co. Donegal.

Examples: Limavady, Co. Derry: Post Office. Londonderry: St Columb's College; St Eugene's Cathedral; St Mary's Church.
Literature: *News Letter*, 9 December 1968; Alexander Haslett, *Letter to the author*, 1968; Mrs. W.M. Haslett, *Letter to the author*, 1969.

HAUGHTON, WILFRED J., RUA (1921-99), landscape painter. Born at Hillmount, Cullybackey, Co. Antrim, on 14 December 1921, Wilfred James Haughton was the son of J. Wilfred Haughton of Frazer and Haughton, Ltd., linen manufacturers. As a child he was always interested in painting and drawing. Educated in England at Terra Nova School, Birkdale, Southport, and Worksop College, Notts., he served during the War with the Royal Air Force and this prevented him from attending art school on any sort of regular basis, so he was largely a self-taught artist. Whilst serving overseas, he did some painting although restricted by lack of time and conditions.

In 1946 he became connected with the Ulster Academy of Arts and was a prime mover in obtaining the prefix 'Royal'. In 1948 he introduced his work to Dublin and from then until 1965 he showed thirteen pictures at the Royal Hibernian Academy from Cullybackey, at least four being snow scenes, for example in 1952, *Snowbound Lane*, and in 1957, *Haystacks in Snow*.

Haughton's main exhibiting outlet in Dublin was the Water Colour Society of Ireland exhibitions. In 1949 he showed for the first time, and from then until 1999 he presented sixty-five works. In 1949 he was represented by *The Docks* and *Ramsey Harbour, Isle of Man*. On his 1957 exhibition of thirty-eight landscapes

in Rodman's Art Gallery, Belfast, one commentator wrote: 'The vast mirror of the Norfolk Broads has provided many of the best themes...' He returned to this gallery in 1959, when his snow scenes were specially commended.

Elected a full academician of the RUA in 1959, he held another exhibition at Rodman's Art Gallery in 1961, and that year he showed *Boat Miscellany-Moville* at the RHA and *Ancient Windmill, Essex* at the WCSI. His portrait of J. Wilfred Haughton, a past chairman, was received by the Northern Ireland Tourist Board in 1963.

In 1964 he succeeded William Conor (q.v.) as RUA president and served until 1970. *The Artist* arranged for two articles in 1965 on the subject of 'Problems and incentives of a self-taught landscape artist'. In the second of these, Haughton wrote: 'One of the great problems when working on your own is to assess the quality of your painting. It is so easy to accept praise from relations or close friends, which may or may not mean anything at all. So often they seem to regard one's efforts as "a hobby" and something to be praised whether or not the standard is good, and in many cases they are not qualified to judge.'

The articles in *The Artist* — he also contributed to *The Leisure Painter* — produced an invitation from the Gordon Gallery in Wimbledon Village for an exhibition in 1966, his first one-person show in England. The editor of the magazine, Frederick Parkinson, attended the event and spent a considerable time viewing the paintings. He said that as a self-trained artist Haughton 'displayed a staggering technical ability and a great sympathy with the general countryside.' Later in the year the Gordon Gallery organised an exhibition by seven artists, Haughton included, calling themselves the 'Ulster Artists Club'.

As president, he presented in 1967 to the RUA a gold medal — awarded annually for the most outstanding work selected from a member of the academic body. In 1969, the year he staged an exhibition at the Aer Lingus terminal, London, he forfeited business life for full-time painting. At the Magee Gallery in Belfast thirty-two of his forty works were oils. In 1971 he was in Galway for an exhibition, mainly watercolours, at the Kenny Art Gallery. At the Magee Gallery in 1972 the exhibition included *River Corrib, Galway; Aghadowey Fields* and *Thames Barges*.

President of the Coleraine Art Society for several years, over in Co. Antrim in 1974 he showed in Ballymena at a new gallery, The Master's Hand. When he exhibited for a second time with Walker & Co. in Coleraine in 1976, his activities then included a private instruction class at Antrim Forum, a day class at Larne Technical College and tutoring the Antrim Coast School of Painting in the Ballycastle area during summer months.

Haughton's work was also hung at the Royal Scottish Society of Painters in Watercolours, and in London at the Royal Institute of Painters in Watercolours and the Pastel Society. In 1977 he was instrumental in the formation of the Ulster Watercolour Society. At the Oriel Gallery, Dublin, he exhibited in 1978, the Malone Gallery in Belfast in 1979, and he returned to the Malone in 1981 with pastels.

As well as his tutoring, he was the author of two books on art, *Brush Aside,* 1982, and *Purely Watercolour,* 1987. In his last four years, he contributed twelve works to WCSI exhibitions; eight were pastels. At his final exhibition in 1999, he presented *Sunlight Field*, pastel; *Ancient Cattle Barn,* watercolour; *Water Meadows,* pastel. He died at his home, 17 Dromona Lane, Cullybackey, on 17 December 1999.

Works signed: Haughton.
Examples: Belfast: Ulster Museum. Navan: Meath County Library.
Literature: *Belfast Telegraph*, 24 September 1957, 1 September 1959, 11 April 1963, 23 January 1966, 13 February 1974, 3 May 1979; *News Letter,* 18 September 1961, 11 February 1966, 18 December 1999; *The Artist*, August 1965; *Who's Who in Art,* Havant 1966; *Irish News,* 6 February 1969, 14 October 1972; *Irish Times*, 15 April 1971; E. Walker & Co., *Exhibition of Oil and Watercolour Paintings by Wilfred J. Haughton, PPRUA, WCSI,* catalogue, Coleraine 1976; Martyn Anglesea, *The Royal Ulster Academy of Arts,* Belfast 1981 (also illustration); Wilfred J. Haughton, *Brush Aside,* Cullybackey 1982 (also illustrations); Ann M. Stewart, *Royal Hibernian Academy of Arts: Index of Exhibitors 1826-1979,* Dublin 1986; Wilfred Haughton, *Purely Watercolour,* Coleraine 1987 (also illustrations); *Water Colour Society of Ireland Exhibition List 1872-1994,* Dublin 1995; WCSI catalogues, 1995-1999; Theo Snoddy, *UTV Art Collection: Catalogue of Works and Artists' Biographies,* Belfast 1999; Mrs Priscilla Haughton, *Letter to the author,* 2000.

HAYDEN, ADRIAN MURRAY – see MURRAY-HAYDEN, ADRIAN

HAYDN, J.A. (1881-1957), architectural and landscape painter. John Armour Haydn was the only son of the Venerable J.A. Haydn, rector of Nantenan, near Rathkeale, Co. Limerick, and sometime Archdeacon of Limerick. Jack was in the employment of Guinness's for some years in Dublin and later in Limerick. Living in the capital, he was a regular worshipper at St Patrick's Cathedral, and was a member of the belfry from 1906 to 1915.

In the period 1933-46 he exhibited nine works at the Royal Hibernian Academy, all Limerick subjects, four connected with St Mary's Cathedral. In the 1946 exhibition he showed *The Yard Gate (Strand House, Limerick)*. The great interests of his life were the Cathedral in Limerick – in his time he held most of the offices open to a layman – his painting, in watercolours and oils, and music. He executed many pictures of St Mary's interior and exterior, and also made a fine model of the building. Interiors were also painted of St Patrick's Cathedral, Dublin.

For many years in the latter part of his life he and his unmarried sister lived at 26 Barrington Street, Limerick. He travelled on a bicycle with a large bag on the bar for his painting equipment. As well as in Co. Limerick, he painted in Co. Clare, Kilkee being favourite terrain. In private possession is an oil painting of Arthur's Quay, Limerick, and one of the West Door of St Mary's Cathedral; also two black and white pen drawings of the South Door of the Cathedral. He died on Christmas Day, 1957, and was buried in the grounds of the Cathedral.

Works signed: J.A. Haydn, J. Haydn or J.A.H.
Examples: Limerick: City Gallery of Art; St Mary's Cathedral.
Literature: *Limerick Chronicle,* 28 December 1957; Tom Greaney, *Letter to the author,* 1985; Ann M. Stewart, *Royal Hibernian Academy of Arts: Index of Exhibitors 1826-1979,* Dublin 1986; Canon J.L. Enright, *Letter to the author,* 1987; also, Mrs P.M. Masterson, 1987; Paul Rowlandson, 1987; St Patrick's Cathedral, 1996.

HAYES, CLAUDE, RI, ROI (1852-1922), landscape and portrait painter. Born in Dublin the year his father moved to London, he was the son of Edwin Hayes (q.v.), who, despite his ability as a marine painter, did not encourage his son to take up painting. Claude was, however, continually drawing for his own amusement. After a disagreement, he ran away to sea, serving on *The Golden Fleece*, one of the transports used in the Abyssinian Expedition of 1867-8. He then spent a year in America. He first showed at the Royal Hibernian Academy in 1874, and presented a total of twenty-one works.

On his return to England, he studied at Heatherley's Academy and then for three years at the Royal Academy Schools, where he was much influenced by the so-called Romanticists, examples of whose work continually came before his notice at Christie's, where the Saturday sales of pictures were, to him, an education in themselves. Later he studied under Charles Verlat (1824-90) at Antwerp. From 1876 he exhibited at the Royal Academy, a connection which was to last more than forty years. At the RHA in 1879 he contributed eight works, including *Driving Cattle Home – Evening* and *An Eastern Girl*.

At first he practised as a portrait painter in oils, but eventually devoted himself to landscape, first in oils and then in watercolour as his favourite medium. In 1884 he first exhibited at the Royal Institute of Painters in Water Colours, where he was to show more than 200 works, and was elected RI in 1886. Three years previously he had been elected a member of the Royal Institute of Oil Painters, with whom he also exhibited regularly.

Also in London he showed extensively at Brook Street Art Gallery and Walker's Galleries, and his name was familiar at the Royal Society of British Artists' exhibitions. East Anglia was a favourite sketching ground. Thomas Collier, RI (1840-91) was a friend. In 1884 he showed at the RHA for the last time: *In the Orchard* and *The Old Home*. In the period 1901-08 he showed five works at Water Colour Society of Ireland exhibitions, including *A Surrey Pastoral* and *Scanty Pasturage*.

The Studio published in 1906 a colour supplement in connection with the Royal Institute of Painters in Water Colours, and Hayes advertised an art correspondence class, prospectus on application from

Whitehouse, Shamley Green, Guildford. In 1907 at the New Dudley Gallery, London, he exhibited with Mildred A. Butler, Percy French and Bingham McGuinness (qq.v.). Two years later he contributed to an exhibition of the Belfast Art Society. In 1911 the Society successfully recommended to the Belfast Corporation the purchase of his large watercolour, *Across the Common*. Also in the Ulster Museum collection is *A Windmill in Sussex*.

When he exhibited in 1920 at a loan exhibition at the Belfast Museum and Art Gallery, he was described as an 'Irish painter' and represented by a watercolour, *Near Wells, Norfolk*, and an oil *Near Dordrecht* – a work of that name appeared in an exhibition held by the Gorry Gallery, Dublin, in 1985.

A landscape with sheep, a rural scene with haystacks, landscape with bridge and cattle, church across fields, a shepherd and his flock, an extensive landscape with haymakers, were some of his subjects. He had several addresses in Surrey and worked there with his close friend, William Charles Estall (1857-97), whose sister-in-law he had married. In Hampshire he met James Aumonier (1832-1911). In his lifetime he never quite received the recognition some thought he deserved. He was a very rapid worker but this, combined with ill-health and loss of money towards the end of his career, was said to have led to slipshod productions. He died at Brockenhurst, Hampshire, on 25 January 1922.

Works signed: Claude Hayes.
Examples: Belfast: Ulster Museum. Bournemouth: Russell-Cotes Art Gallery and Museum. Brighton: Art Gallery. Eastbourne: Towner Art Gallery. Harrow: Harrow School. Ipswich: Christchurch Mansion. Leeds: City Art Gallery. London: Victoria and Albert Museum. Newcastle-upon-Tyne: Laing Art Gallery. Newport, Monmouthshire: Museum and Art Gallery. Wanganui, New Zealand: Sargeant Gallery.
Literature: *The Studio*, January 1905; *The Studio: Royal Institute of Painters in Water Colours*, supplement, 1906 (also illustration); W.G. Strickland, *A Dictionary of Irish Artists*, Dublin 1913; *Dictionary of British Artists 1880-1940*, Woodbridge 1976; *Dictionary of British Watercolour Artists up to 1920*, Woodbridge 1976; *Dictionary of Victorian Painters*, Woodbridge 1978; Martyn Anglesea, *The Royal Ulster Academy of Arts*, Belfast 1981; Christie's, *Mildred Anne Butler*, catalogue, London 1981; Ann M. Stewart, *Royal Hibernian Academy of Arts; Index of Exhibitors 1826-1979*, Dublin 1986; *Water Colour Society of Ireland Exhibition List 1872-1994*, Dublin 1995.

HAYES, EDWIN, RHA, RI, ROI (1819-1904), marine painter. Born in Bristol on 7 June 1819, he spent most of his youth and early life in Dublin where his father, Charles Hayes, who had left Bristol about 1832, kept an hotel and tavern in Marlborough Street. His father and mother were both English. Edwin was a student at the Royal Dublin Society School of Art, and his ambition was to be a marine painter. Resolved to see something of a sailor's life and learn more about nautical matters, he shipped as a steward's boy on board a vessel bound for America, and on his outward and return voyages had testing experiences. 'Thoroughly in earnest in his work,' wrote Walter G. Strickland in his *Dictionary*, 'he made the sea his studio, and in a little ten-ton yacht he spent his time sailing about Dublin Bay...'

Hayes began exhibiting at the Royal Hibernian Academy in 1842, from 109 Marlborough Street, and for the next ten years resided in Dublin practising his art. In the mid 1840s his name was associated with the running of the Shakspear Tavern at 9 Hawkins Street. Altogether at the RHA, until the year of his death, he showed just over 250 works, marine views to the fore. Among his eight contributions at the 1847 Academy were: *Dutch Boats in a fresh breeze* and *Castletownshend, County of Cork, as seen from the Sea*, possibly from his yacht. In 1848, from 21 Lombard Street, Dublin, contributions included: *Ringsend Bridge* and *A Balbriggan Smack entering Dublin Harbour*, both watercolours.

Hayes' work was known in Scotland, and from 1851 until 1881 he showed thirty works at the Royal Scottish Academy. In 1851, one of four pictures, he contributed *Departure of the Queen from Kingstown harbour, August 10th, 1849*. In 1852, the year he was elected ARHA and his son Claude Hayes (q.v.) was born, he removed to London where he apprenticed himself to the scene painter, William Telbin (1815-73). Under him he worked at the scenery of the new Adelphi and other theatres. His first venture as an exhibitor in London came in 1854 with the British Institution, also patronised by Telbin. He continued to exhibit at the BI until 1867.

In 1855 from 10 Lambton Terrace, Greenwich, he showed at the Royal Academy for the first time — *Sandymount Strand, Bay of Dublin* — and from then until 1904 he contributed more than eighty works, invariably marine subjects. Telbin, incidentally, showed at the RA in 1857. In the years 1856, 1857 and 1858 at the RA, Hayes presented works associated with the French coast; Kingstown Harbour; Antwerp; Dover; The Thames; Ostend. Something different, however, emerged at the 1856 RHA: *Barry going over his Studio with Visitors* and *The Italian Boy*, both watercolours.

At the RA in 1862 he probably provided one of the longest-ever titles for a picture there: *Momentous incident in the first voyage of HMS 'Shannon' under Captain W. Peel, VC. During the 'Shannon's' voyage to the Cape, Mr. J. Coaker, master's assistant, a most promising young Greenwich scholar, fell off the fore-yard, but his head struck the fore-chains, and he was killed before reaching the water.*

Hayes obviously returned to Ireland on visits. In 1861 he showed at the RHA: *On the River Suir, at Longfield, Co. Tipperary* and *Killiney Bay, from the Hill*. An associate three years earlier, he became a member in 1863 of the Institute of Painters in Water-Colours, later the Royal Institute of Painters in Water Colours, hence RI. He also exhibited with the Society of British Artists. Often he changed his address. In 1868 he named 76 Newman Street, and *Stormy sunset: port of Dublin* appeared that year at the RSA.

Elected a member of the RHA in 1871, he was then at 53 King Henry Road, Hampstead. In that year in Dublin his works included a harbour scene at Genoa and another at St Ives, Cornwall. *Dutch Boats off Dordrecht, Holland* and *Entrance to Calais Harbour*, both exhibited at Burlington House in 1874, were described in the *Dublin Magazine* as having 'life, truth to nature, and conscientiousness.' Prior to this date he was known to have exhibited in Paris.

Leicester City Council purchased from him in 1881 *Trawling off Gorleston Harbour*, oil. In 1883 he became a member of the Royal Institute of Oil Painters, and in that year he showed *Calm off Dordrecht* at the RHA. An exhibition of one hundred and fifty of his works including sketches, the result of work done in many places during twenty years, was hosted in the Dowdeswill Galleries in Bond Street in 1888.

In Australia, the National Gallery of Victoria acquired the watercolour *Fishing Vessels off Granton* in 1891 from the Royal Anglo-Australian Society of Artists exhibition in Melbourne for £65. This work, however, is no longer in the collection as it was de-accessioned and sold at auction in Melbourne in 1950 with other works from the collection. However, the Art Gallery of South Australia hold a Granton fishing boats scene bought at the same exhibition.

Judging by exhibited titles, he returned to Ireland in the 1890s and at the RHA the Bailey Lighthouse, Dublin Bay, was subject matter for two works. His *Sunset at sea, from Harlyn Bay, Cornwall*, exhibited at the RA in 1894, was bought by the Chantrey Bequest trustees for £175; it is now in the Tate Gallery. Exhibited in the 1902 RHA was the highly priced *Stormy Sunset, Dutch Boats returning from Sea, Katwyke Beach, Holland*. Prestigious artists were sought by the Belfast Art Society for their annual exhibition in 1903. Hayes was one of the few who complied.

In many of the other leading exhibitions and galleries in England his work was familiar, for example the Royal Society of Artists, Birmingham; Manchester City Art Gallery; Walker Art Gallery, Liverpool; and in London at the New Gallery. In Scotland, he also showed at the Glasgow Institute of the Fine Arts.

Surprisingly, he was not represented at the National Gallery of Ireland until 1932. There are four oil paintings there, including *An Emigrant Ship, Dublin Bay, Sunset*, regarded by Anne Crookshank and the Knight of Glin in *The Painters of Ireland c. 1660-1920* as his best-known picture 'and its quietness belies its tragic subject. The smooth finished surface is not altogether typical and works like *The Shipping Making for Harbour in Rough Sea* in the Graves Art Gallery, Sheffield, has an understanding of the motion of the water and its contrast with the sky is extremely lifelike. His figures are well drawn and characterised'.

Among the works at the Ulster Museum are *Fishing Boats, Holland*, oil, and *Towing a Vessel into Harbour*, watercolour. Four pictures at the National Museum of Wales include *Brigantine off Yarmouth*, oil, and *Gathering lobster pots*, watercolour. The only oil painting at the National Maritime Museum at Greenwich is *Action between USS Wasp and HMS Reindeer, 28 June 1814*.

As well as the shores and harbours of the Irish and English coasts, and his visits abroad, particularly to the coasts of Belgium, France and Holland, Hayes had many subjects for his marine interest. According to

Strickland, he had expressed a wish to die with his brush in his hand; and so it happened, for on 7 November 1904, as he stood before the easel in his house, 20 Aldridge Road Villas, Bayswater, he was seized with heart failure, and in a few hours passed away. In 1905 a studio sale took place at Christie's.

Works signed: E. Hayes.
Examples: Adelaide: Art Gallery of South Australia. Belfast: Ulster Museum. Bristol: Museum and Art Gallery. Cape Town: South African National Gallery. Cardiff: National Museum of Wales. Dublin: Hugh Lane Municipal Gallery of Modern Art: National Gallery of Ireland. Gateshead, Tyne and Wear: Shipley Art Gallery. Kilkenny: Art Gallery Society. Leicester: Leicestershire Museum and Art Gallery. London: National Maritime Museum; Tate Gallery. Salford, Manchester: Museum and Art Gallery. Sheffield: Graves Art Gallery.
Literature: Slater's Directory of Ireland, Manchester 1846; *Dublin University Magazine,* August 1874; National Art Library, Victoria and Albert Museum, *Letter from Edwin Hayes to H. M. Cundall,* c. 1878; *The Royal Academy of Arts 1769-1904,* London 1905; Walter G. Strickland, *A Dictionary of Irish Artists,* Dublin 1913; *Dictionary of British Artists 1880-1940,* Woodbridge 1976; Anne Crookshank and the Knight of Glin, *The Painters of Ireland c. 1660-1920,* London 1978 (also illustration); *Dictionary of Victorian Painters,* Woodbridge 1978; *Dictionary of Sea Painters,* Woodbridge 1980 (also illustrations); Martyn Anglesea, *The Royal Ulster Academy of Arts,* Belfast 1981; Ann M. Stewart, *Royal Hibernian Academy of Arts: Index of Exhibitors 1826-1979.* Dublin 1986; *The Royal Scottish Academy Exhibitors 1826-1990,* Calne 1991; Art Gallery of South Australia, *Letter to the author,* 1998; also, National Gallery of Victoria, 1998; National Maritime Museum, 1998; National Museum of Wales, 1998.

HAYES, ERNEST C., RHA (1914-78), portrait and landscape painter. Born in Dublin on 26 October 1914, the eldest son of Ernest Robert Hayes, an ophthalmic optician, Ernest Columba Hayes entered Terenure College, Dublin, in 1929, remaining a boarder for only a short time; twice he escaped school by jumping over the boundary wall. Prior to studying under Sean Keating (q.v.) at the Dublin Metropolitan School of Art, 1931-4, he took his first art classes there during the evenings.

Hayes's first painting for the Royal Hibernian Academy, *The Corridor*, was accepted when he was still at the Metropolitan. In the following year, 1933, he had six works hung, including a self-portrait and *The Old Homestead*, and from then on he contributed regularly up to the year of his death, averaging about four works annually.

In 1935 he became a member of the Dublin Sketching Club and three years later he was appointed secretary, a post he held for seven years. He exhibited for the first time with the Munster Fine Art Club in 1937, and with the Water Colour Society of Ireland in four years, 1937-40, he showed sixteen works.

In 1937 his first one-person show was held at the Victor Waddington Galleries, Dublin; the catalogue contained one of his poems. Hopes of publishing a collection of his verse, some of which related to his painting, were not realised. Among his pictures at the 1938 RHA was *Before the Games*. The studio which Hayes used in the National College of Art is depicted in *The Studio*, 1938, now in the College.

In 1940 his painting, *The Coliseum*, with a scattered group of lions in the foreground (he made numerous sketching trips to the Dublin Zoo), was shown at the winter exhibition at Burlington House, London, his work having been specially invited for this charity show. At this period he had been devoting much time to the study of classical architecture and had painted several works with classical subjects. Another large companion work, *Slaves in the Forum*, was exhibited at Combridge's Galleries, Dublin.

In 1942 he was elected ARHA, and in 1945 a full member. Giving a studio address for the first time, at 64 Dawson Street, Dublin, all six works which he showed at the 1946 exhibition were portraits, including those of Baroness Livonius and John McMahon. Presidency of the Dublin Sketching Club lasted from 1946 until 1956. His work was included in the exhibition of Irish Contemporary Art at Aberystwyth in 1953; the catalogue stated that he had made a special study of marine painting. He was a great admirer and friend of the marine painter Julius Olsson (1864-1942), an RA with other honours, who moved to Dalkey, Co Dublin, after his house was bombed in the Second World War.

In the period 1956-9 Hayes worked in London. He lived at 92 Carlton Hill, St John's Wood, in a sculptor's studio. Among his commissions was a two metre high portrait of the Duchess of Gloucester for the Worshipful Company of Fan Makers. Unveiled in 1958, it is now in St Botolph's Hall. According to the *Daily Mirror*, he was given six sittings of an hour each and the Duchess's public engagements kept getting in the way.

'During the sittings,' the artist was quoted, 'the Duchess would stand still for ten minutes. She would have a five-minute break walking round the room, and then stand still for another ten minutes.' This portrait was exhibited in 1958 in the Royal Society of Portrait Painters' exhibition at the Royal Institute Galleries and was shown again in 1963 in the exhibition of paintings from the Halls of the City Guilds at the Guildhall Art Gallery, London.

In 1959 he contributed to the Society of Marine Artists' exhibition at the Guildhall, London, and at the RHA his works included *The Old Coast Road* and *Malahide Hill*. From 1960 until 1977 he made frequent visits to the Continent, painting portraits and landscapes in Germany, France, Holland, Denmark and Italy. A painting of outbuildings, *Sunlit Roofs*, 1961, is regarded as his masterpiece for the period.From 1961 until 1965 his home was a Coastguard Station at Ballymacaw, Co. Waterford. In 1963 he painted *Storm Seas, Irish Coast*, oil (Ulster Museum).

Hayes first visit to Italy was in 1963, working in Rome during the winter. In 1966 he settled in Co. Wicklow. He made a brief visit to Venice in 1968, and returned to Italy in 1969,1971 and 1972. *Village in Tuscany* and *Nettuno* were both painted in 1971.

In 1972 he exhibited with his friend, the watercolour painter Otto Ehrich in Schloss Lembeck, Westphalia, and later that year he had a one-person show in Bielefeld, Germany, where he had patrons. In 1975 he worked in Alsace, France, and two years later painted his last portrait in Germany.

The Co. Wicklow cottage, garden, the fields and other houses nearby formed the core of his work in the last ten years of his life. A keen model engineer, he was working on the model of a horizontal steam engine the day before he died, on 21 October 1978, in Dublin. A memorial section at the RHA commemorated him the following year. In 1981, European Fine Arts, Dublin, presented an exhibition of his work. *Ernest Hayes: The Wild Garden*, containing seventeen colour plates, was published in 1984 by his widow, Hildegard Hayes. A memorial exhibition took place at the Hugh Lane Municipal Gallery of Modern Art in 1992.

Works signed: Ernest Hayes or Ernest C. Hayes.
Examples: Belfast: Ulster Museum.Clonmel: South Tipperary County Museum and Art Gallery. Cork: City Hall. Dublin: Hugh Lane Municipal Gallery of Modern Art; National College of Art and Design; National Museum of Ireland. Limerick: University, National Self-Portrait Collection. London: St Botolph's Hall, Bishopsgate. Waterford: City Hall, Municipal Art Collection.
Literature: *Dublin Evening Mail*, 9 October 1937, 1 February 1940; *Irish Contemporary Art*, catalogue, Aberystwyth 1953; *News Chronicle*, 28 February 1958; *Daily Mail*, 3 March 1958; *Irish Times*, 25 October 1978; European Fine Arts, *Ernest Hayes*, catalogue, Dublin 1981; Mary Lavin, *Selected Stories*, Harmondsworth 1981 (illustration); Barbara Nolan, *The Life and Works of Ernest Hayes, RHA (1914-1978)*, BA thesis, 1982; *Ernest Hayes: The Wild Garden*, Dublin 1984 (also illustrations); *Irish Arts Review*, Autumn 1985; Mrs. Hildegard Hayes, *Letters to the author*, 1986; Ann M. Stewart, *Royal Hibernian Academy of Arts: Index of Exhibitors 1826-1979*, Dublin 1986; Hugh Lane Municipal Gallery of Modern Art, *Ernest Hayes R.H.A. 1914-1978*, catalogue, Dublin 1992 (also illustrations); *Water Colour Society of Ireland Exhibition List 1872-1994*, Dublin 1995.

HAYES, GABRIEL (1909-78), sculptor. Born at Bridgehouse, Monasterevan, Co. Kildare, on 25 August 1909, she was the daughter of J.J. Hayes, an architect with the Board of Works. A student at the Dominican College, Eccles Street, Dublin, she wanted to be a painter. After a period in the USA, she spent three years studying French in a school near Montpellier, attended art classes and also studied in the art galleries, thence to Paris.

Back home, she entered the Dublin Metropolitan School of Art, spending her summer holidays in France or Italy, studying, sketching and painting. In her second year at college she won the teachers-in-training scholarship, and in 1933 she had five works exhibited at the Royal Hibernian Academy, including three linocuts. The following year she won the Royal Dublin Society's Taylor Scholarship for sculpture, not painting, with *Prodigal Son*. All courses were completed in 1936. She was responsible for *The Three Graces* on a corner of the Dublin College of Catering, which was opened in 1941. Stations of the Cross at Our Lady's Hospice, Harold's Cross, Dublin, are painted plaques.

The wife of Professor Séan P. O'Riordain of University College, Cork, mother of two infants and living in Monkstown, near Cork, she travelled to Dublin for work in 1942 on the new Department of Industry and

Commerce building in Kildare Street. Among the other sculptors who had submitted designs for this commission were Laurence Campbell and Seamus Murphy (qq.v.).

For the sum of £930 she agreed to design and carve two main keystones (23 metres from ground level), two courtyard keystones, panel over entrance door, panel over staircase window; Minister's balcony – three large and four small panels on front and two small panels on each end. She worked in Kildare Street from a wooden cage raised by a steel derrick. The sculptures are generally symbolic, representing themes connected with industry and commerce in general, but there are also some heads, one representing St Brendan as personifying navigation and another 'Eire' over the main entrance.

Altogether, at the RHA, she showed thirty-three works. In 1942 she exhibited *Jill* and *The Three Kings*. When living in Cork, Gabriel Hayes painted four portraits and executed two large reliefs in bronze for the side altars of Holy Cross Church, Glanworth, *Madonna and Child* and *Christ*, 1945. A life-size statue in carved limestone, *Ascension*, is in the Church of the Ascension, Cork. Over the Adam and Eve Church, Merchants' Quay, Dublin, is a figure about two metres high of the Madonna in gilt bronze. Her final contribution to the RHA was *Madonna of the Flowers* in 1947.

On the quay near Reginald's Tower is a bronze over-life-size figure of Luke Wadding, 1958, for the Franciscans of Waterford city. A statue about 2.7 metres high of the Madonna and Child in limestone was carved for the Servite Fathers of Benburb, Co. Tyrone. In Portland stone is a life-size group of the Holy Family, 1967, at Holy Family Post Primary School, Newbridge, Co. Kildare. In Co. Kerry is a two-metre high bronze figure of the Madonna, 1954, for the front of the church in the Black Valley, and a life-size low relief in Portland stone, *Christ Carrying His Cross*, 1959, for St John's Church in Tralee, also a life-size of St Brendan in Bath stone.

In 1953 she exhibited in the inaugural exhibition of the Institute of the Sculptors of Ireland. Most of her commissions were completed before starting on the life-size Stations of the Cross for Galway Cathedral. Work began in 1957 and took twelve years to complete. However, a life-size Madonna was carved for St Mary's Church, Westport, 1960, and is situated over the main door. A few other commissions were accepted 'to get a break from "Station" work and so not to get too stale. I also, for the same reason, did not carve the Stations in sequence, or according to number and so was able to concentrate on each individual group with its special problems of figure composition and construction', she wrote. Work on the Stations had also been interrupted by a fall which broke her collar bone.

Another commission during the Galway period was designs for the new decimal coins: the halfpenny based on a manuscript in Cologne Cathedral; the penny from the Book of Kells; and the twopence from a Bible in the Bibliotheque Nationale, Paris.

A series of seven medals, in silver, depicting incidents in the life of Saint Patrick were designed for the Franklin Mint, Pennsylvania, USA. A commemorative medal, made from Irish silver, depicting Saint Patrick landing in Ireland was also designed by her for presentation in 1972 to Rt. Rev. Mgr. Jeremiah Newman, president of St Patrick's College, Maynooth. A portrait in oils of Ven. Archdeacon Begley is in Limerick City Gallery of Art. In 1977 she won the Oireachtas gold medal for sculpture with *Grainne*. Now resident at Newbridge Lodge, Celbridge, Co. Kildare, Gabriel Hayes died in Dublin on 28 October 1978.

Works signed: Gabriel Hayes, G. Hayes, G.H. or G. O Riordain.
Examples: Benburb, Co. Tyrone: Priory. Black Valley, Killarney: Church of Our Lady of the Valley. Chisekei, Zambia: Canicous College. Cork: Church of the Ascension. Dublin: Adam and Eve Church; Department of Industry and Commerce, Kildare Street; Dublin College of Catering, Cathal Brugha Street; Our Lady's Hospice, Harold's Cross; Our Lady's Hospital for Sick Children, Crumlin; St Vincent's Hospital. Galway: Cathedral of Our Lady Assumed into Heaven and St Nicholas. Glanworth, Co. Cork: Holy Cross Church. Killarney: St Brendan's College. Limerick: City Gallery of Art; Crescent College. Naas, Co. Kildare: Clongowes Wood College. Newbridge, Co. Kildare: Holy Family Post Primary School. Tralee, Co. Kerry: St John's Church. Waterford: Near Reginald's Tower. Westport, Co. Mayo: St Mary's Church.
Literature: Ethel Boyce Parsons, *Tales of Tara*, Dublin 1934 (illustrations); *Royal Dublin Society Report of the Council*, 1934; *Irish Press,* 13 March 1942; *Irish Independent,* 22 April 1942; *Father Mathew Record*, September 1942; *Irish Times*, 24 April 1968, 20 May 1972, 30 October 1978, 7 April 1979; *Guide to St John's Church, Tralee*, Tralee 1981; Fionbharr O'Riordain, *Letters to the author*, 1983, 1986, 1990, and *Gabriel Hayes Curriculum Vitae*; Office of Public

Works, *Letter to the author*, 1986; Ann M. Stewart, *Royal Hibernian Academy of Arts: Index of Exhibitors 1826-1979*, Dublin 1986.

HAYWARD, PHYLLIS (1903-85), still life and flower painter. Born at 34 Pretoria Road, Southsea, Portsmouth, on 15 November 1903, Phyllis Mildred May Hayward was the daughter of a skilled labourer, William Hayward. She studied briefly at Portsmouth School of Art and part-time at the Central School of Arts and Crafts, London. Interested in the practice of psychology, she became a member of the Society of Creative Psychology in Bloomsbury and met Basil Rákóczi (q.v.) and other White Stag artists.

In 1940 she travelled from England to Dublin in the wake of the White Stag painters, first exhibiting her work in the Three Dublin Painters exhibition, a mixed show with Robert Dawson, who later became a professional photographer, and Cicely Peel, at Contemporary Picture Galleries in 1941. In the same month, November, she showed in the White Stag Group's second event of the year, the largest of all their exhibitions, including work by her husband, Donald Teale, and son Martin Teale. Her *Still Life with Guitar* dated from the early 1940s.

In 1943 with Kenneth Hall (q.v.), Patrick Scott and Rákóczi she participated in a joint exhibition of watercolours, and in 1943 too she contributed to the White Stag Group's first show — they held two — of the year. In 1944 she was represented in the only White Stag show that year, and writing of her flowerpiece at the Irish Exhibition of Living Art, Stephen Rynne said it was '…so lacy, graceful, and vivacious.' Represented in the Exhibition of Subjective Art arranged by White Stag Group in 1944, she tended to be more representational in manner than any of her colleagues.

In 1945 she was again represented at the Living Art exhibition and showed a flowerpiece. Although one might have imagined her age would disqualify her, she was represented in the Young Irish Painters exhibition in 1945 at Arcade Gallery, London. *Flowers in a Pot*, 1947, was regarded as one of her major works. In 1948 she joined the Society of Dublin Painters, holding a one-person exhibition at their gallery in 1949.

In his book on Irish art and modernism, S. B. Kennedy referred to her experimental use of mixed media 'whereby she often combined gouache, ink, crayon, pastel and occasionally monotype in one work.' He considered that French Impressionism, Fauvism and Cubism were the early influences. She also painted some portraits. In 1950 at the IELA she contributed *Roof Tops, Dublin* and *Still Life with Cactus*. Soon after, she returned to England and later went to France where she remained until about the early sixties before settling permanently in London where she died in 1985.

Works signed: Hayward.
Literature: National Gallery of Ireland and Douglas Hyde Gallery, *Irish Women Artists: From the Eighteenth Century to the Present Day*, catalogue, Dublin 1987; S. B. Kennedy, *Irish Art & Modernism 1880-1950*, Belfast 1991 (also illustration); Portsmouth City Council, *Copy of Birth entry 1903*, 1998.

HEALY, CHRISTOPHER (1898-1970), stone modeller. Born in Dublin, he lived in the city all his life. He did not like his work as a butcher, his daughter told the author, and became a labourer. He had no formal art training and was called on to make a grotto each year which was placed inside railings in Luke Street, where he lived.

Healy, who also carved in wood, never had any proper tools. After the demolition of Newgate Prison, he obtained stone and worked with a penknife on three models, which he then presented to Dublin Civic Museum: *Weavers' Hall, The Coombe, Dublin*; *Newgate Prison 1773-1893, Green Street, Dublin; St Kevin's early Christian Church, Camden Row, Dublin*. He died on 24 May 1970, unknown to the artistic fraternity.

Works signed: C. Healy.
Examples: Dublin Civic Museum.

HEALY, HENRY, RHA (1909-82), landscape and townscape painter. Born in Dublin on 2 April 1909, son of James Healy, confectioner, Henry Healy was educated at Synge Street Christian Brothers. He attended the Dublin Metropolitan School of Art, graduating in 1934, and he also studied in London and Paris. In 1938 he

showed his first picture at the Royal Hibernian Academy, *Pearse's cottage at Rosmuck*. After the Second World War, he made many visits to the Continent, indulging in his painting and architectural interests. He showed three Parisian scenes at the 1950 RHA; others in the next two years.

In 1953 he was represented in the Irish Contemporary Art exhibition at Aberystwyth. The *Dublin Magazine* made several references to his work, finding Whistleresque handling of greys in *Cuan Binn Eadair* at the 1949 Oireachtas exhibition; at his exhibition at the Dublin Painters' gallery in 1954 *Spanish Peasants* was 'a new departure into vigorous and colourful decoration ...'; a well-composed *Winetavern Street Bridge* in the 1955 Dublin Painters' annual exhibition; and in 1956 his exhibition at the Dublin Painters' gallery indicated that visits to Spain and Holland 'seem to be responsible for some startling changes in recent work ...'

Among his contributions to the 1957 RHA were *Evora, Portugal* and *Capel Street Bridge*. In 1958 Arland Ussher wrote about his exhibition at the Dublin Painters' gallery: 'This artist has always had a gift for patterns, for blocking out his pictures, for clever angles and perspectives; but he has used it chiefly to capture the charm of Georgian squares or Spanish villages – things we do not need the aid of pictures to enjoy ... Mr Healy's pictures of Algarve, Evora and Connemara are pleasant enough in the picturesque tradition; but he is more interesting when he strips his patterns of their too facile evocative associations ...' He singled out *Rue St Vincent, Montmartre* as a 'very satisfying, well-designed and sensitive picture'.

In 1962 he showed two works in the painting section of the Exhibition of Irish Sacred Art in Dublin. Altogether at the RHA, up until 1979, he exhibited more than 130 works, and in 1960 he was appointed an associate. In 1966 he became a full member as well as treasurer, still holding that post at the time of his death.

As president of the Dublin Painters he wrote to the press in 1969, from 37 Sutton Downs, Co. Dublin, regarding the plight of the artist in having no gallery for the RHA annual exhibitions. Subsequently he took an active interest in the development of the Gallagher Gallery for the Academy, of which he was one of its most familiar figures. He also showed at several other venues, including the United Arts Club, Dublin.

Over a period of thirty-five years he also painted in Lapland, Italy, the islands of the Aegean and Turkey. At the Davis Gallery, Dublin, in 1970 he showed watercolours on the theme of eighth to twelfth century church sculpture. The works spanned a period of about three years during which the artist visited old churches in Aran, many other sites in Ireland and famous cathedrals in France. In his second one-person show in 1972 at the Barrenhill Gallery, Baily, Howth, works included: *Howth Harbour*; *Old Gables Rossaviel*; and *Roundstone*. In 1973 he was appointed to the board of the National College of Art and Design but resigned in 1974. In 1981 he was elected to the Board of Governors of the National Gallery of Ireland. He also served as a member of the Oireachtas arts council.

The Gondoliers, an oil, is in the Arts Council, Dublin, collection. Three oils are at St Patrick's College, Drumcondra, Dublin, including *Faro, on the Algarve*. For the last years of his life Healy painted and ran art classes in Dooega, Achill Island, and prior to that he had established classes in Dublin during the winter: 'they became more clubs than classes.' A vintage Dubliner, he was excellent company, rich in anecdotes. Twelve hours before the heart attack which killed him he was running a class. He died in a Dublin hospital, on 4 February 1982. In the following month the Taylor Galleries, Dublin, staged an exhibition of his works.

Works signed: Henry Healy.
Examples: Beijing: Irish Embassy. Canberra: Irish Embassy. Dublin: Arts Council; Institute of Public Administration; Office of Public Works; St Patrick's College, Drumcondra; Voluntary Health Insurance Board. Limerick: University, National Self-Portrait Collection. Mullingar: Westmeath County Library. Navan: Meath County Library.
Literature: *Dublin Magazine*, January-March 1950, July-September 1954, July-September 1955, April-June 1956, April-June 1958; *Irish Times*, 6 May 1969, 20 May 1970, 7 March 1972, 8 and 12 February 1982, 16 March 1982; Davis Gallery, *Watercolours by Henry Healy*, catalogue, Dublin 1970; Taylor Galleries, *Henry Healy*, catalogue, Dublin, 1982; Ann M. Stewart, *Royal Hibernian Academy of Arts: Index of Exhibitors 1826-1979*, Dublin 1986; Mrs Doreen Healy, *Letter to the author*, 1987; also, St Patrick's College, 1995; John Turpin, *A School of Art in Dublin since the Eighteenth Century*, Dublin 1995.

HEALY, MICHAEL (1873-1941), stained glass artist. Born in modest circumstances at 40 Bishop Street, Dublin, on 14 November 1873, Michael Healy was the son of Andrew Healy, who died when Michael was

a child. At the age of fourteen, by which time drawing was no stranger to him, he worked in a sugarboiler's and subsequently moved to a firm of wholesale spirit bonders, Haig and Haig Ltd. He left in 1897 to enter the Dublin Metropolitan School of Art, where he had no difficulty in passing the usual examinations in drawing and won some distinction in the National Competition. Before leaving the School of Art he ventured to London with a few drawings in a brief search for work as a book illustrator.

In 1898 Healy joined the Royal Hibernian Academy Schools. Its secretary, S. Catterson Smith (q.v.) testified to his 'marked ability and utmost industry' and continued: 'Last session (1899) he obtained the Academy first prize for drawing from the life, on which occasion there was an unusually severe competition for that honour.' In 1898 the Rev. H.S. Glendon, editor of the *Irish Rosary*, had given him the post of illustrator. He was then living at 61 Bride Street. The issues of the magazine between September 1898 and the end of 1899 have fifty-nine Healy drawings. Other illustrations were supplied for the *Rosary* series of lives of Dominican Saints. Father Glendon urged him to go to Florence to continue his studies and, finding Healy more than willing, took the necessary steps to introduce him to the studio of the Florentine painter, de Bacci-Venuti. Commissions for further illustrations made the visit possible.

Healy, who earlier had thoughts of becoming a Dominican friar, left for Florence in 1899 and studied in the art school of the R. Istituto di Belle Arte. He spent one holiday with his friend and professor, Cav. de Bacci-Venuti at his villa at Arezzo. Back in Ireland in 1901, he contributed again to the *Rosary* but only on an occasional basis. He also began painting in oils, a spare time occupation which took him into the country on Sundays. He illustrated Canon Sheehan's *The Triumph of Failure* and *A Spoiled Priest*, and he contributed cartoons to *The Leader*.

In his solitary lodgings in Heytesbury Street or Pleasants Street he accumulated hundreds of drawings, having made rapid sketches in the Dublin streets, and his evening's task was to translate many of these notes into lightly washed-in watercolour. His subjects included perambulators with children (or vegetables), street hawkers, bank messengers, basket women, elder sisters with children, men in betting shops, pensioners in parks and so on. In the 1913 RHA exhibition his contributions included *Travellers* and a portrait; he was then lodging at 41 Heytesbury Street.

On his return from Florence, Healy had taken up a post as art teacher in the Dominican College at Newbridge, Co. Kildare, but he resigned the post. His friend, the sculptor John Hughes, had told Sarah Purser (qq.v.) about his ability, and he welcomed her invitation to join the new stained glass firm, An Túr Gloine, founded in 1903. Here he studied his new craft under A.E. Child (q.v.), who had been enabled to set up a class in the school of art. His first window was *St Simeon*, 1904, one-light, for Loughrea Cathedral, which was eventually to hold his work of every period, ten windows in all, culminating in his two three-light windows: *The Ascension*, 1936, and *The Last Judgment*, 1940.

In the matter of plating and aciding he was an innovator of this elaborate process. Of outstanding interest in the period before the First World War is the five-light window at St Eunan's Cathedral, Letterkenny, 1910, the subject being St Columcille at the Convention of Drum Ceat. In that year he was invited to join a Pittsburgh firm of glassmakers, and three years later the Union Internationale des Beaux Arts et des Lettres invited him to join their society. At the Arts and Crafts Society of Ireland exhibition in 1917, at Belfast, Dublin and Cork, he showed stained glass.

The window, *St Patrick at Slane*, was exhibited at the Exposition d'Art Irlandais in Paris, 1922. In the chapel of Mercersburg Academy, Pittsburgh, Pennsylvania, is his *St Michael*, installed 1926. He was represented in the exhibition of Irish art at Brussels, 1930. The four-light *St Augustine* window in the Augustinian Church in John Street West, Dublin, executed in the mid-1930s, is regarded as representing the maturity in his art. His work was not exclusively ecclesiastical and there is an heraldic panel on behalf of the Incorporated Law Society at the Four Courts, Dublin. In 1938 he completed *The Annunciation* and *The Visitation*, both two-light, for the Blackrock College Chapel.

His last illness cut short the completion of the Clongowes Wood College series – he had already two windows there – designed to illustrate the Seven Dolours. According to his friend, C.P. Curran, he was beginning to regard these as his *magnum opus* but he lived to complete only three. The work was finished

by his friend and colleague, Evie Hone (q.v.). Healy's *St Joseph*, 1916, at Clongowes ranks high among Irish stained glass achievements.

More than seventy of his windows are to be seen in a score and more of Irish counties. His work was also sent to England, New Zealand, Newfoundland and the USA. Three windows, *Charity*, 1931; *Love*, 1931; and *Wisdom*, 1937, were installed in the chapel of Karori Crematorium, Wellington, New Zealand. *Love,* a memorial, depicted in a paradisal garden two angels strolling, one carrying a flaming torch and sceptre and the other strewing golden dust.

The National Gallery of Ireland has the design for the window in the Church of the Sacred Heart, Donnybrook, Dublin, 1914, and many other designs; also a landscape oil painting and more than 150 miscellaneous studies. *Outside the Courts*, a blue glass panel framed in wood is at the Hugh Lane Municipal Gallery of Modern Art. In the Model and Niland Centre, Sligo, is a stained glass panel, *É Finito*, 1929. Six sketches of Dubliners are in the Limerick City Gallery of Art; another four drawings are at Mary Immaculate College. Six figure studies in watercolour at Crawford Municipal Art Gallery, Cork, were presented by Evie Hone.

C.P. Curran wrote of this pioneer artist of the modern stained glass movement: 'His life was almost that of a recluse, passed amongst a very limited, rarely extended circle of friends; he exhibited seldom, belonged to no academy, and dropped silently out of life.' Of 21 Pleasants Street, he died in Mercer's Hospital, Dublin, on 22 September 1941, and was buried at Mount Jerome.

Works signed: Stained glass – Miceal O'H-Ealaigh, Míceál ohéaluidé or M. ohE. (if signed at all). Illustrations – Michael Healy, M. Healy, Healy, M.H., M. h. or m. ohé.

Examples: Ballinderry, nr Ballyronan, Co. Derry: Church of Ireland Church. Ballyhaunis, Co. Mayo: Convent of Mercy. Ballyporeen, Co. Tipperary: Assumption of Our Lady Church. Belfast: St Mark's Church, Strandtown. Billy, near Bushmills, Co. Antrim: Church of Ireland Church. Blackrock, Co. Dublin: Blackrock College. Bloomfield Hills, Michigan, USA: Cranford Academy of Art Museum. Boston, Mass., USA: Sacred Heart Convent, Newton. Bridge-a-Crin, Co. Louth: Holy Rosary Church. Castlecomer, Co. Kilkenny: St Mary's Church. Castlerock, Co. Derry: Christ Church. Churchill, Letterkenny, Co. Donegal: Glebe Gallery, Derek Hill's Collection. Clarecastle, Co. Clare: Clare Abbey. Conception Harbour, Newfoundland: St Anne's Church. Cork: Crawford Municipal Art Gallery; St Joseph's Church. Drogheda, Co. Louth: Library, Municipal Centre. Dublin: Church of the Sacred Heart, Donnybrook; Civic Museum; Holy Trinity Church, Rathmines; Hugh Lane Municipal Gallery of Modern Art; Incorporated Law Society, Four Courts; Mount Jerome Cemetery; National Gallery of Ireland; St Catherine's Church, Donore Avenue; Church of St John the Baptist and St Augustine, John Street West. Dundalk: St Malachy's Church. Dundrum, Co. Dublin: Holy Cross Church. Dysart, Co. Westmeath: St Patrick's Church. Enniskillen, Co. Fermanagh: Convent of Mercy Chapel. Fairymount, Co. Roscommon: Christ the King Church. Galway: Art Gallery Committee; St Mary's of the Claddagh Church. Glenariff, Co. Antrim: St Patrick and St Brigid Church. Gowran, Co. Kilkenny: St Mary's Church (closed). Julianstown, Co. Meath: St Mary's Church. Kilmore, Co. Monaghan: St Aidan's Church. Kilsallaghan, Co. Dublin: Church of Ireland Church. Layde, near Cushendall, Co. Antrim: Church of Ireland Church. Letterkenny, Co. Donegal: St Eunan's Cathedral. Limerick: City Gallery of Art; Mary Immaculate College. Litter, Co. Wexford: Christ Church. Lorrha, Co. Offaly: Church of Ireland Church. Loughrea, Co. Galway: St Brendan's Cathedral. Magheralin, Co. Down: Holy Trinity Church. Mercersburg, Pennsylvania, USA: Mercersburg Academy. Naas, Co. Kildare: Clongowes Wood College. Phoenix, Arizona, USA: Brophy College Chapel. Rochestown, Co. Cork: St Francis' Church. St John's, Newfoundland: St John's Church. Sligo: Holy Cross Church; Model and Niland Centre. Tralee, Co. Kerry: Holy Cross Church. Wallsend, Tyne and Wear: St Peter's Church. Warrenpoint, Co. Down: St Peter's Church. Waterford: City Hall, Municipal Art Collection. Wellington, New Zealand: Karori Crematorium.

Literature: Canon Sheehan, *The Triumph of Failure*, London 1904 (illustrations); Canon Sheehan, *A Spoiled Priest*, London 1905 (illustrations); Robert Elliott, *Art and Ireland,* Dublin [1906] (illustration); *Canon Sheehan's Short Stories*, London 1908 (illustrations); *The Studio*, October 1917; J. Crampton Walker, *Irish Life and Landscape,* Dublin 1927 (illustration); *Studies,* March 1942, Summer 1955, Winter 1965; C.P. Curran, 'A Note on Michael Healy', *Capuchin Annual*, 1944 (also illustrations); Thomas MacGreevy, 'St Brendan's Cathedral, Loughrea', *Capuchin Annual*, 1946-47; James White and Michael Wynne, *Irish Stained Glass*, Dublin 1963; Cork Rosc, *Irish Art 1900-1950*, catalogue, 1975; *Irish Times*, 30 May 1985, 17 September 1986; Ms Fiona Ciaran, *Letter to the author*, 1987; Rev. H.J.W. Moore, *Letter to the author*, 1987; Nicola Gordon Bowe, David Caron, Michael Wynne, *Gazetteer of Irish Stained Glass*, Dublin 1988; Graham Harrison, *Saint Eunan's Cathedral, Letterkenny, Co. Donegal*, Dublin 1988 (illustrations); Dorothy Walker, *Modern Art in Ireland*, Dublin 1997 (illustration).

HEATHER, NAOMI (1911-89), figure painter and children's illustrator. Born on 22 May 1911 at Smethwick, Birmingham, Naomi Hersée Heather was the daughter of the Rev. Charles Herbert Heather. She attended for a brief period Birmingham School of Art. Relatives offered Naomi and her sister Nancy a home in Co. Waterford.

In 1939 she supplied the illustration for the cover of *Fisherman's Wake*, poems by Temple Lane, and in 1940 the drawings for *The Wild Garden* by Francis MacManus. Other books illustrated in the 1940s included *The Wind Fairies* by Elizabeth Brennan; *Keepers of the Wishing Well* by Ida Moore; and her own *Fairy Tales*.

In 1940, from Lisduggan Lodge, Waterford, she exhibited for the first time at the Royal Hibernian Academy and from then until 1959 showed a total of thirteen works. In 1941 she contributed *The Little People's Market* and *Pixie Lad*, then in 1943 came *Fairy Dance*; *Bog Fairies*; and *The Big Wind*, all watercolours.

Considering it was limited to a mere four pages, the *Irish Times*, possibly spellbound, was not ungenerous in its critique in 1944 of Naomi's exhibition of watercolour drawings titled 'The World of Little People', at Arts Ltd., 19a Upper O'Connell Street, Dublin, a business which the street directory described as 'artistic objects'. The newspaper considered the artist as 'a clever draughtswoman, particularly in the delineation of children, fairies, leprechauns, witches and hobgoblins generally. The figures, frequently attired in costumes reminiscent of the eighteenth century, have character, as well as elegance. The artist also shows a developed capacity to suggest movement...' Where the exhibition disappointed, the reviewer continued, was in the 'relatively dull neutrality of the colours. In this matter, as in the concentration of interest in the figures, the artistic descent would seem to be from Arthur Rackham...'

In the years 1945-59 inclusive she contributed twenty-two works to Water Colour Society of Ireland exhibitions, and these included: *The Wicked Grandfather* in 1945; *Bridget and the Little Elves*, 1952; *The Witch*, 1959. In Cork, she showed *Celia* and *The Duet* in the pastels section of the 1949 Munster Fine Art Club exhibition. After an interval of thirteen years, her final offering at the RHA in 1959 was *Gypsies*, sent from Rose Cottage, Annestown, Co. Waterford. According to a niece, she did not exhibit in England and painted two murals in Ireland, one at a hotel and the other in the children's ward of a hospital, 'probably long since gone'.

William M. Glynn, for long associated with the city and its art collection, wrote to the author in 1985 of a visit to a Waterford home where there was a portrait by Naomi Heather, 'and I was shown a watercolour, some 5" x 12", a typical representation of gnomes and fairies disporting themselves on mushrooms and suchlike. The picture is well done and displays a good deal of humorous observation.' At the time of his visit the artist was living in sheltered accommodation in Martley, Worcestershire, and it was there she died on 10 February 1989.

Works signed: Naomi Heather.
Examples: Waterford: City Hall, Municipal Art Collection.
Literature: Temple Lane, *Fisherman's Wake*, Dublin [1939] (illustration); Francis MacManus, *The Wild Garden*, Dublin 1940 (illustrations); *Irish Times*, 5 April 1944; Mary King, *Moppets the Magpie*, Dublin [1944] (illustrations); T*hom's Directory*, 1945; Elizabeth Brennan, *The Wind Fairies*, Dublin [1946] (illustrations); Naomi Heather, *Fairy Tales*, London [1946] (illustrations); Ida Moore, *Keepers of the Wishing Well*, London [1946] (illustrations); Elizabeth Brennan, *The Wind Fairies Again*, Dublin 1948 (illustrations); Freda Dee, *Pinky goes to town*, Dublin n.d.; William M. Glynn, *Letter to the author*, 1985; Ann M. Stewart, *Royal Hibernian Academy Exhibitors 1826-1979*, Dublin 1986; *Register of Deaths*, Malvern, 1989; *Water Colour Society of Ireland Exhibition List 1872-1944*, Dublin 1995; Ms Judy Heather Vincent, *Letter to the author*, 1999.

HEMMINGWAY, D.L. (1894-1968), landscape painter. Born in Bitaghstown House, Co. Kildare, Douglas Louis Hemmingway was educated at King's Hospital School, Dublin, and entered Trinity College in 1913 to study divinity. On the outbreak of the First World War, he joined up, returning to civilian life in 1919 when he entered the Medical School at Trinity. He was president of the Philosophical Society, 1921-2, and was a holder of the Society's gold medal for oratory.

In 1925 he opened medical practice in the village of Richhill, Co. Armagh, where he was to remain a loved and respected figure for the rest of his life, taking a keen and active interest in local events. In an amateur capacity he had always been interested in painting and sketching, and his new life and love of the countryside was ideal to pursue his hobby. He was a member of the Armagh and Lurgan Art Clubs. Hemmingway painted too in the Isle of Man and the West of Ireland. In the 1920s he executed a number of pen and ink sketches of the Ulster countryside which were published as the frontispiece of the *Irish Cyclist and Motor Cyclist* magazine. At the 1938 Ulster Academy of Arts he exhibited *The Gate Lodge, Portavo* and *Cottages at Glen Mora, Isle of Man*. There are four watercolours in the Armagh County Museum collection. He died on 29 May 1968. Part of his art collection – as well as his own work – was sold at a charity sale in Richhill in 1976.

Works signed: D.L. Hemmingway.
Examples: Armagh: County Museum.
Literature: *Irish Cyclist and Motor Cyclist*, 3 October 1928 (illustration), 4 January 1929 (illustration), 10 July 1929 (illustration); *Ulster Gazette*, 30 May 1968; *Belfast Telegraph*, 12 August 1976; Trinity College Library, *Letter to the author*, 1986; also, Mrs Margaret Browett, 1987.

HENNESSY, PATRICK, RHA (1915-80), still life, landscape and *trompe l'œil* painter. Born in Cork on 28 August 1915, the son of an officer, he was taken as a child in a troubled period to Arbroath in Angus, Scotland, where he had relatives. Winning a scholarship to Dundee College of Art, he met H. Robertson Craig (q.v.) there in 1933. Both were taught by James McIntosh Patrick, RSA (1907-98). Hennessy was an outstanding student, gaining his diploma in art, his post-diploma and then a travelling scholarship which enabled him to study in Paris and Rome. After his return, he was accepted to the advanced art college, Hospitalfield near Arbroath.

In 1939 he had a still life and a self-portrait hung at the Royal Scottish Academy, giving his address as 9 Bridge Street, Arbroath. On the outbreak of the Second World War he returned to Ireland, where he began a career as a professional painter. In 1941 he exhibited for the first time at the Royal Hibernian Academy. In the war years he divided his time between Dublin, where he joined the Dublin Painters' group, and Co. Cork. His technical finesse immediately attracted attention. *Exiles* at the 1943 RHA exhibition was bought by the Thomas Haverty Trust, and is now in the Hugh Lane Municipal Gallery of Modern Art. A self-portrait is in the National Gallery of Ireland.

Hennessy's work had a compelling fascination for the critics. On a 1944 exhibition at the Dublin Painters' gallery, the *Dublin Magazine* commented: '... combines a not-too-exciting realism, a low-keyed and consistent palette with a morbid pessimism which sees flesh as something very much less healthy than grass. Even the flowers, in his beautifully painted still-lifes, such as *Minerva and the Lilies*, imply the same consciousness of doom explicit in the ruined façade of Trinity College in *De Profundis* or the mouldering classical statues against an infinitely dreary stretch of marshland in *Miserere* ...'

A regular exhibitor at the RHA, he showed almost 100 works. He and Craig met again in 1946 in Dublin, took a house in Co. Cork at Crosshaven, moving on to Cobh. Hennessy exhibited at the Munster Fine Art Club. In 1948 he was appointed an associate of the RHA; in 1949, a full member. He turned to the recording of Georgian buildings and painted some portraits, but *The Voice in the Wilderness* at the 1951 RHA was described as having a Surrealist-flavoured atmosphere.

A retrospective exhibition, covering 1941-51, was held at the Dublin Painters' gallery. In its review of the 1952 RHA, the *Dublin Magazine* stated that he had achieved 'the remarkable feat of producing a forbiddingly Gothic atmosphere in a pseudo-classical setting in his practically monochromatic *Two Monsignori walking on the roof of St Peter's*'. In 1953, his contributions included *The Bronze Horses of St Mark's* and *The Moon in the Tangled Branches*.

As well as painting in the Co. Cork area, Hennessy and Craig travelled extensively in South and West Ireland, particularly in Co. Kerry and Connemara with long visits to Clifden, Co. Galway. He was represented at the exhibition of Irish contemporary art at Aberystwyth in 1953; address, 28 Herbert Place, Dublin.

Thomas Agnew & Sons Ltd in Old Bond Street gave him his first one-person show in London in 1956; thirty-eight recent paintings were hung, including portraits of Elizabeth Bowen, Mrs Charles Hambro, Lady Ursula Vernon and Caroline Jobling-Purser. At the Ritchie Hendriks Gallery, Dublin, he was represented in an exhibition of flower paintings in 1957, and *The Flight of the Wild White Horses* and *The Sacred Mountain* were among the twenty-one works at his show there in 1963. Some of his paintings were reproduced in print form and sold by Combridge's Galleries, Dublin.

At the 1966 RHA he exhibited *The Sunset Ponies* and *The Lost Headland*. He held an exhibition at the Guildhall Galleries, Chicago, in 1966. Two years later when he showed at the Ritchie Hendriks Gallery the *Irish Times* critic thought that his nearest parallel would be to the 'equally *outré* American, Andrew Wyeth'. He exhibited at the David Hendriks Gallery in 1969 and 1972, and two years later, presented by David Hendriks, the Cork Arts Society held a joint exhibition for Hennessy and Craig. At the Crawford Municipal Art Gallery, Cork, are five oils, including *Portrait of Elizabeth Bowen at Bowenscourt*. There are four oil paintings at the Irish Museum of Modern Art, Dublin, including *Boy and Seagull* and *Yellow Ribbon*. In the Office of Public Works collection is *St Christopher in landscape*. At the Ulster Museum is *The Old Tree,* oil. *The Oracle* is another work at NGI.

Regular visits were made to the Continent, first to Paris in 1947, and in subsequent years, until 1968, to the coast of Normandy, the Côte d'Azur and the Dordogne. Belgium and Holland were also on the itinerary. A complete trip round Italy included Sicily, where Hennessy first made contact with the ruins of Greek civilisation and this influenced his subsequent work. After a visit to Spain, where they took a house near Malaga, Hennessy and Craig left Dublin for Tangier in 1968. Hennessy had almost died of pneumonia in a Dublin winter.

On to Morocco, living there until 1980, when they transferred to Portugal. Hennessy became ill in Portimao and was taken by ambulance to the British Hospital in Lisbon, but they did not have the proper facilities. Craig flew with him to the Royal Free Hospital, London. He died there on 30 December 1980, and his ashes were scattered in Golders Green Crematorium. Cork Arts Society displayed thirty-four works in their 'Tribute to Patrick Hennessy', 1981. Christie's, London, held a joint studio sale with the work of H. Robertson Craig in 1986.

Works signed: Hennessy.
Examples: Belfast: Ulster Museum. Bray, Co. Wicklow: Public Library. Cork: Collins Barracks; Crawford Municipal Art Gallery; University College. Dublin: Arts Council; Hugh Lane Municipal Gallery of Modern Art; Irish Museum of Modern Art; Irish Writers' Centre; National Gallery of Ireland; Office of Public Works; University College (Newman House). Galway: Art Gallery Committee. Limerick: City Gallery of Art; County Library; University, National Self-Portrait Collection. Waterford: City Hall, Municipal Art Collection.
Literature: *Irish Independent*, 23 November 1940; *Dublin Magazine*, January-March 1945, January-March 1951, July-September 1951, January-March 1952; *Irish Contemporary Art*, catalogue, Aberystwyth 1953; *Capuchin Annual*, 1959; *Irish Times*, 2 November 1968, 31 October 1969, 10 November 1972, 25 January 1986, 28 June 1986; *Dictionary of British Artists 1880-1940*, Woodbridge 1976; H. Robertson Craig, *Letter to the author*, 1981; Cork Art Society, *Tribute to Patrick Hennessy*, catalogue, 1981; Ann M. Stewart, *Royal Hibernian Academy of Arts: Index of Exhibitors 1826-1979*, Dublin 1986; *The Royal Scottish Academy Exhibitors 1826-1990*, Calne 1991.

HENNESSY, WILLIAM J., NA, ROI (1839-1917), landscape, genre painter and illustrator. Born at Thomastown, Co. Kilkenny, on 11 July 1839, William John Hennessy was the son of John Hennessy, who escaped from Ireland after the unsuccessful rising of the Young Ireland movement in 1848, made his way to Canada, thence to New York city. His wife Catherine and two sons joined him in 1849. He was a native of Knocktopher, Co. Kilkenny.

William's education was for the most part derived from private tutors. He began to make drawings from life at the age of fifteen, and in 1854 he entered the school of the National Academy of Design. He began exhibiting at the National Academy in 1857, from 87 Franklin Street, but by 1860 and for some years afterwards the catalogue address was New York University. In 1861 he was elected an associate and he

became an academician two years later. The 'representative example of work' which he presented on election is entitled *The Wood Gleaner*, a tiny oil sketch painted on paper.

In his city studio he produced a large number of paintings and illustrations which were well received. His genre works had a sentimental appeal. His landscapes were described as luminous; he was noted particularly for his interpretation of skies. As an illustrator, he made his mark during this New York period, illustrating the works of Longfellow, Tennyson, Whittier and other poets. Wood engraved illustration was his media speciality.

Hennessy regularly sent his pictures to the National Academy exhibitions. He was one of the founders of the Artists' Fund Society, and an honorary member of the American Society of Painters in Water Colors. *Mon Brave*, at the Brooklyn Museum, New York, was painted in 1870 during the Franco-Prussian War for a fund for the distressed French peasantry.

In 1870 he worked on several if not all of the drawings for *Edwin Booth in Twelve Dramatic Characters,* published in Boston in 1872. He married a second time and moved to London in 1870, and there he became a member in 1902 of the Royal Institute of Oil Painters, and also showed at the Grosvenor Gallery, the New Gallery and at the Royal Academy 1871-82, except 1874, all London addresses in catalogue. Also hung were works at the Walker Art Gallery, Liverpool; Manchester City Art Gallery; and Glasgow Institute of the Fine Arts. He showed eight pictures at the Royal Hibernian Academy between 1879 and 1907, opening with *An Evening on the Thames.*

When living in England, he tended to spend his summers in Normandy and he became so fond of that province that in 1875 he had moved to France and leased a manor on the coast near Honfleur. Three 1875 drawings, black and white chalk on buff paper, were of Normandy peasant women gathering faggots and picking fruit (sold at an auction at Sotheby's, London, 1985). In 1878 he painted *Fête Day in a Cider Orchard, Normandy* (Ulster Museum). In 1886 he moved to Saint-Germain-en-Laye, and five years later he made a tour of Italy. In 1893 he moved to Sussex. His *Relic of the Old Chain Pier, 1897*, Brighton, was painted some time after the disastrous storm of 6 October 1896.

At the Society of Oil Painters, London, exhibition in 1903, his works were: *Waiting for the Boats – Coast of Calvados*; *Feeding Pigeons – Mareil, Marly*; and a sketch study near Bordighera, Italy. His address was given as Hollybank, Lindfield, Hayward's Heath.

Represented by *'Twixt Day and Night, Calvados* at the 1904 exhibition of works by Irish painters held at the Guildhall of the Corporation of London and organised by Hugh P. Lane, the following year he painted *The Glimpses of the Moon – Dryburgh Abbey, the burial place of Sir Walter Scott* (Sotheby's auction, 1985). At the RHA in 1906 he contributed *Indian Summer* and *Gossips at the Gate*. He died at Rudgwick, Sussex, on 27 December 1917.

Works signed: W.J. Hennessy.
Examples: Amherst, Massachusetts: Amherst College. Belfast: Ulster Museum. Brighton: Museum and Art Gallery. New Haven, Connecticut: Yale University. New York: Brooklyn Museum; National Academy of Design; New York Historical Society; Public Library; Vassar College, Poughkeepsie.
Literature: William Winter, *Edwin Booth in Twelve Dramatic Characters,* Boston 1872 (illustrations); *Dictionary of American Biography*, New York 1932; E. Bénézit, *Dictionnaire des Peintres, Sculpteurs, Dessinateurs et Graveurs*, Paris 1966; *Dictionary of British Artists 1880-1940*, Woodbridge 1976; Witt Library, London, illustrative records; National Academy of Design, *Letter to the author*, 1986, also, *Exhibition Record*; Ann M. Stewart, *Royal Hibernian Academy of Arts: Index of Exhibitors 1826-1979*, Dublin 1986; John Kirwan, Kilkenny Archaelogical Society, *Letter to the author*, 2000; also, Brighton Museum and Art Gallery, 2001.

HENRY, GRACE, HRHA (1868-1953), landscape, portrait and flower painter. The second youngest of ten children of the Rev. John Mitchell, a Church of Scotland minister, Emily Grace Mitchell was born at Peterhead, near Aberdeen. Her grandmother was cousin to the poet, Lord Byron. She studied at Brussels, where she worked at the Blanc Garrins Academy, and then went to Paris, attending the Delecluse Academy. Later she studied under François Quelvée (1884-1967) and André Lhote (1885-1962). She first met Paul Henry (q.v.) in Paris, and in 1903 they were married at St Peter's Church, Bayswater, London.

In 1904, giving the address Beaufort Cottage, Knapp Hill, Surrey, she exhibited at the Royal Academy a miniature, *Lord Macnaghten*. In 1910 she and Paul first exhibited at the Royal Hibernian Academy, from 13 Pembridge Crescent, London, and two years later they made the rather extraordinary move to Achill Island, Co. Mayo, which brought to the fore her work as a colourist. About seven years were spent on Achill and during that time they held some exhibitions in Belfast. *Evening Achill*, oil, is in the Hugh Lane Municipal Gallery of Modern Art.

In 1920 she showed at Cooling and Sons Gallery, London, and most of her work which appeared in London was hung there. Paintings were also exhibited at the Leicester Galleries, the London Salon and the Fine Art Society. She also showed occasionally at the Walker Art Gallery, Liverpool.

A studio was rented in Merrion Row, Dublin, and she was represented by five Connemara paintings in the Irish exhibition in Paris in 1922. As well as exhibiting with the Society of Dublin Painters, Paul and Grace Henry, who were founder members, showed at the Stephen's Green Gallery in 1921, 1922 and 1923. In 1923 she exhibited in Belfast with her husband at the Magee Gallery, but her talent was somewhat overshadowed by the name of Paul Henry. She was represented in the New Irish Salon Exhibition in Dublin in 1924. In the mid-1920s she lived in Paris, but in 1926 at The Studio, Merrion Row, she exhibited with her husband Irish landscapes.

The name of Grace Henry appeared in a catalogue for a loan exhibition of Irish portraits 'by Ulster artists' at the Belfast Museum and Art Gallery in 1927 when she was represented by *Miss Kitty Hearne*; *Mr Stephen Gwynn*; and *The Girl in White*. The last-named is in the HLMGMA., having been presented by the Thomas Haverty Trust. A portrait of Stephen Gwynn is in the Limerick City Gallery of Art. She was represented in the Brussels exhibition of Irish art in 1930; her address was 13a Merrion Row, Dublin.

A High Court notice dated 20 April 1934 indicated a separation with £3.0.0 per week alimony. In the 1930s she spent much time abroad, travelling in France, Spain and Italy, and in her exhibition at 7 St Stephen's Green, Dublin, in 1930 her works included *Almond Blossom, Lake Como*; *Portrait Study of James Joyce*; *Bridge over the Seine*. In a four-artist exhibition at Daniel Egan's Gallery, 38 St Stephen's Green, in 1935 her titles included *Sails at Chioggia* and from South-East France, *Cannes-sur-mer* and *Arve River*.

The Storran Gallery, London, presented an exhibition in 1938 of English and French paintings which included works by Matthew Smith (1879-1959), Duncan Grant (1885-1978), Maurice Utrillo (1883-1955), Georges Rouault (1871-1958) and Grace Henry. Work was hung again in London in the Dublin Painters' exhibition at the Office of the High Commissioner for Ireland in 1938.

In 1939 she showed at the Calmann Gallery, London. *The Studio* commented: 'There is no doubt about the effect Grace Henry strives to achieve. As surely as Verlaine wanted his poetry to be all music, she wants her painting to be all poetry ... Her drawing is sensitive, her colour is invariably harmonious and she has the rare gift of being able to make portraiture as poetic as any other branch of art...' A portrait of Helen Waddell was exhibited. Among works at the National Gallery of Ireland is a portrait, *Master Conor Padilla*, presented by the sitter, and *Still Life with Marble Torso*.

In her show at the Victor Waddington Galleries, Dublin, in 1939, were *The Fair at Joigny* and *The Creek, Cushendun*. Another exhibition followed in 1941. Writing in the *Father Mathew Record* in 1942, Máirín Allen said that in Grace Henry's pictures 'there is reflected the character, the mood of the artist herself: vivacity; at times a youthful, irresponsible gaiety; more often the tender reminiscence of a mood evoked by flowers in a bowl, or sails at Chioggia, or shadowy trees on the banks of the Seine...'

At the Waddington Galleries in 1943, *The Whits Mountain, Corofin* was listed, and two years later subject matter involved Dun Laoghaire, Howth and the Wicklow Mountains. Her last exhibition was at the Dawson Gallery, Dublin, in 1946 when she showed *Old Limerick* and *The Garden U.C.G.* At the RHA, 1946, she presented *Mountain Sheep* and *Wexford Garden*.

Altogether at the RHA she showed thirty works. Although never appointed even an associate, in 1949 she was elected Honorary RHA. At the annual exhibition in 1950 her address was Summerhill Hotel, Enniskerry, Co. Wicklow. Her final contribution was in 1952: *Quiet Waters*. On 11 August 1953 she died in a Dublin nursing home. Mrs Creed Meredith, then living in Cyprus, presented in 1954 to the Belfast Museum and Art Gallery portraits of Paul Henry and his brother, Professor R.M. Henry, both painted by Grace Henry. A joint

exhibition of works by Paul and Grace Henry was held in 1991 at the Hugh Lane Municipal Gallery of Modern Art.

Works signed: G. Henry, G.H. or Grace Henry.
Examples: Ballinasloe, Co. Galway: St Joseph's College. Belfast: Ulster Museum. Churchill, Letterkenny, Co. Donegal: Glebe Gallery, Derek Hill's Collection. Clonmel: South Tipperary County Museum and Art Gallery. Cork: Crawford Municipal Art Gallery. Drogheda, Co. Louth: Library, Municipal Centre. Dublin: Hugh Lane Municipal Gallery of Modern Art; National Gallery of Ireland; Trinity College Gallery; University College (Belfield); Voluntary Health Insurance Board. Galway: Art Gallery Committee. Kilkenny: Art Gallery Society. Limerick: City Gallery of Art. Waterford: City Hall, Municipal Art Collection.
Literature: Katherine MacCormack, *The Book of St Ultan*, Dublin 1920 (illustration); J. Crampton Walker, *Irish Life and Landscape*, Dublin 1927 (illustration); *Capuchin Annual*, 1935 (illustrations); *The Studio*, August 1936 (illustration), May 1938, September 1938, August 1939 (illustration), September 1939; *Father Mathew Record*, November-December 1937 (illustration), November 1942; Victor Waddington Publications, *Twelve Irish Artists*, Dublin 1940 (also illustration); *Irish Times*, 14 August 1953, 12 February 1954, 16 December 1978, 2 December 1991; Trinity College, Dublin, *Paul Henry*, catalogue, 1973; Cork Rosc, *Irish Art 1900-1950*, 1975; *Dictionary of British Artists 1880-1940*, Woodbridge 1976; Ann M. Stewart, *Royal Hibernian Academy of Arts: Index of Exhibitors 1826-1979*, Dublin 1986; S.B. Kennedy, *Irish Art & Modernism 1880-1950*, Belfast 1991 (also illustrations); Dorothy Walker, *Modern Art in Ireland*, Dublin 1997 (illustration).

HENRY, MABEL – see YOUNG, MABEL

HENRY, OLIVE, RUA (1902-89), stained glass artist and genre painter. Born in Belfast on 15 January 1902, Olive Henry was the daughter of a tea merchant, George Adams Henry. Educated at Victoria College, Belfast, she attended evening classes at the Belfast School of Art where she was attracted to the stained glass medium. When her teacher heard that the Belfast firm of W.F. Clokey & Co. Ltd was looking for an apprentice, he recommended her and she obtained the post, remaining there for more than half a century, probably the only woman stained glass artist ever to work in Northern Ireland. Her sister Marjorie Henry (1900-74) also painted; Marjorie's work is in the Crawford Municipal Art Gallery, Cork, and with the County Dublin Vocational Education Committee.

An avid photographer from her youth, Olive Henry won awards in photography, and in the 1930s wrote a regular column in *Amateur Photographer*. An active member of the Belfast Art Society, she became an associate, with her sister Marjorie, of its successor, the Ulster Academy of Arts, in 1936. In 1940 she painted in gouache, *Road Block, Belfast*, now in the Ulster Museum, where there are also four watercolour designs for stained glass. After the bombing of the Ulster Hospital for Children and Women in 1941, the Academy, as a means of raising money, published her work in a portfolio of lithographs.

In 1941 she first exhibited at the Royal Hibernian Academy with *Nice Day for a Sail* and *Mountain Farm, Downings, Co. Donegal*, sending from Glen Lodge, Belmont, Belfast. Between 1942 and 1950 she contributed seven other works to the Dublin exhibition; in her last year with *Shell and Sail* and *Tréboul, Brittany*. An inveterate traveller, she visited almost a score of countries, often taking her painting gear and sometimes her bicycle. A fluent French speaker, she was particularly fond of Brittany.

The name of Olive Henry was familiar at the Water Colour Society of Ireland exhibitions and in the period 1943-86 she showed more than 100 works, opening with *River Pool* and *In Donegal*.

In Dublin, she also exhibited with the Irish Exhibition of Living Art – in 1948 and 1977 for example. In 1944 in Belfast she exhibited watercolours with Violet McAdoo (q.v.) at the Belfast Museum and Art Gallery, and in 1948 she was appointed an academician of the Ulster Academy of Arts. In 1950 she exhibited in London – *Chimney Corner* at the National Society – and in Dublin at the Oireachtas. A still life appeared in the 1951 exhibition of the United Society of Artists in London, where she also showed with the Royal Society of British Artists and the Society of Women Artists. In 1953 she was represented in the Contemporary Irish Art exhibition at Aberystwyth.

At the Royal Ulster Academy in 1956 she contributed three oils, *Pillar Box*; *City Lunch Hour*; and *Harbour Maze*. Council for the Encouragement of Music and the Arts held in Belfast in 1957 a one-person show of

oils and watercolours. In that year she visited the USA and studied American techniques in stained glass. In 1957 too she was a founder member of the Ulster Society of Women Artists and became president, 1979-81.

An international scholarship awarded in 1958 by the Soroptomists of Belgium enabled her to visit that country and study stained glass. In 1959 at the WCSI show she contributed *Cafe-Montmartre*; *Trees in Spring*; *Seafront*. Among her 1961 exhibits was an abstract.

On behalf of the Sullivan Association of Former Pupils, she designed in 1965 a window for Sullivan Upper School, Holywood, Co. Down. Her training in stained glass showed in her paintings which often had strongly marked patterns; some bore such titles as *Lough Shapes* and *Barrack Shapes*. In 1987, thirty years after her last solo show, she held another at the Shambles Gallery, Hillsborough, Co. Down. She last exhibited at the Royal Ulster Academy in 1987, and died on 8 November 1989 at Crawfordsburn, Co. Down.

Works signed: O. Henry, pictures.
Examples: Beijing: Irish Embassy. Belfast: Bloomfield Presbyterian Church, Beersbridge Road; Department of the Environment for Northern Ireland; Donegall Square Methodist Church (closed); St Columba's Church, King's Road; St Donard's Church, Beersbridge Road; Ulster Museum. Holywood, Co. Down: Sullivan Upper School. Lisburn, Co. Antrim: Museum.
Literature: *Contemporary Irish Art*, catalogue, Aberystwyth 1953; *Northern Whig*, 5 November 1957; *Belfast Telegraph*, 12 March 1959; John Hewitt and Theo Snoddy, *Art in Ulster: I*, Belfast 1977; Martyn Anglesea, *The Royal Ulster Academy of Arts*, Belfast 1981 (also illustration); Ann M. Stewart, *Royal Hibernian Academy of Arts: Index of Exhibitors 1826-1979*, Dublin 1986; *Royal Ulster Academy of Arts 109th Annual Exhibition*, catalogue, Belfast 1990; Mrs Audrey H. Rebbeck, *Letter to the author*, 1990; also, Lisburn Museum, 1993; *Water Colour Society of Ireland Exhibition List 1872-1994*, Dublin 1995.

HENRY, PAUL, RHA (1876-1958), landscape and portrait painter. Born in Belfast on 11 April 1876, he was one of four sons of the Rev. R.M. Henry, University Road, minister of Great Victoria Street Baptist Church and who later joined the Plymouth Brethern. His mother was Kate Berry of Athlone, daughter of Rev. Thomas Berry. He recounted that throughout his childhood he found the atmosphere at home restrictive. When he entered Methodist College, Belfast, in 1882 he was drawing regularly, and by the time he transferred to the Royal Belfast Academical Institution at the age of fifteen – his father died a few months later – he had decided to be an artist. At 'Inst.' he made the acquaintance of Robert Lynd, who became a lifelong friend.

Outside of school, Thomas Bond Walker, a man with a 'genuine enthusiasm for teaching', tendered his help shortly after his father's death and offered to give free drawing lessons. Edwin Morrow (q.v.), also at 'Inst.,' was a pupil of Walker's. On leaving school, Henry entered the Broadway Damask Co. as an apprentice designer but stayed only a year, moving to the Government School of Design where he met William Conor (q.v.). The turning point in his prospects came, however, when a bachelor cousin, a past pupil of RBAI who was later to become Sir John MacFarland, Chancellor of Melbourne University, offered to pay for his training abroad as an artist.

Henry rarely dated anything, hence an absence of dates from his written reminiscences. About 1898 he left Belfast for the Académie Julian in Paris where he studied under Jean-Paul Laurens (1838-1921) in the rue de Dragon. Constance Gore-Booth (q.v.), later Countess Markievicz, was a fellow student. Later he changed to a studio which J.A. McN. Whistler (1834-1903) had opened; a teacher there was the poster designer, the Czech Alphonse Mucha (1860-1939). Tuition was also given by the portraitist, Benjamin Constant (1845-1902).

In Paris he first met Grace Mitchell (q.v., Henry) whom he married in London in 1903. It was mainly a commercial career he saw ahead of him. He stayed in Paris about two years, and began to appreciate charcoal. From Paris, where he was influenced by Whistler, he moved to London where he lived with Robert Lynd, now a journalist, first in the Vauxhall Bridge Road area and then at 72 Pembroke Walk.

Henry attempted to organise evening classes for the study of drawing. 'Trained models will pose two nights weekly from eight o'clock till ten. Terms: £2.2s. for course of ten weeks or 2s.6d. for a single night.' He also produced a pamphlet for art correspondence classes. Initially he met with little success either with his classes or in selling his black and white work. He and Eddie Morrow, now in London, together with Lynd, George

Morrow and Norman Morrow (qq.v.) were all among the first members in 1901 of a literary club which met in the Napier Tavern, High Holborn.

Henry paid frequent visits to the Fitzroy Street studio of Walter Sickert (1860-1942), finding him an enthusiastic supporter of young artists. Frank Rutter was editor of a weekly paper called *Today* and Henry supplied drawings, mostly of notable persons of the time such as G.K. Chesterton, Ellen Terry, Henry Irving, and some criticism. According to his friend, Arthur Power (q.v.), he did a portrait of the Empress Eugenie who was living in England.

As for illustration, he also worked for *The Graphic*; *The Lady*; *The Woman at Home*; and *Black and White*. He drew sets of illustrations for Edward Garnett, and book jackets and illustrations for John Lane of the Bodley Head. His first show, all charcoals, was held at the Goupil Gallery. Most of his work in London now and later was hung at the Leicester Galleries, and he also showed at the Fine Art Society and the London Salon but contributed little to the Royal Academy.

In 1907 the Ulster Arts Club in Belfast granted the use of rooms to Professor R.M. Henry, a member and brother of Paul Henry, for an exhibition by Paul and Grace. In March 1908 there were exhibitions of the work of Hugh Thomson (q.v.) and Paul Henry at the Ulster Arts Club. At the September meeting of the Belfast Art Society, by which time the Henrys were living near Guildford, Surrey, they were elected members.

In 1910 he showed for the first time at the Royal Hibernian Academy: *The West Wind* and *The Flock*. He became a member of the Allied Artists' Association, and he exhibited five pictures in the exhibition held at the Albert Hall in 1910 and was a member of the hanging committee. Here he met Hugh Lane, the collector and dealer, and Dermod O'Brien (q.v.) and they discussed with him the possibility of showing his work in Dublin. In 1911 he exhibited at the Leinster Lecture Hall, Dublin. In 1910 he had shown at the Royal Academy for the first time, a portrait of James Wilder.

Another turning point in Henry's life came in 1910, when, prompted by Lynd and his wife who had just returned from a honeymoon on Achill island, the Henrys went to Co. Mayo to see for themselves and stayed about a year. In 1912 they settled on Achill, having shown Irish landscapes in Belfast in 1911. At that time he was one of the few Irish painters to bring Parisian influences to Ireland. Living on the island he deliberately held aloof from visitors and tourists, fishing with the local men at week-ends. Genre scenes with older peasant folk were among his early works in the West of Ireland.

After some months in Keel he was asked to take on the post of paymaster for the Erris peninsula by the Congested Districts Board, so enabling him to move around and do many drawings. He became known locally as 'the sketcher'. Stephen Gwynn in his book, *Ireland*, 1927, stated that Paul and Grace Henry were on Achill most of seven years, and when they were not on Achill they were at Leenane or Salrock or Mallaranny. However, Arthur Power (q.v.) told the author in 1972 that he was with Henry in Dublin when the latter executed charcoal drawings of buildings burning in Easter Week, 1916.

Altogether, at the RHA, he showed twenty-eight works. *The Watcher* in 1913 was sent from 61 University Road, Belfast. During most of his time on Achill, Henry held exhibitions in Belfast, usually with his wife. Some of these were held at the premises of the Irish Decorative Art Association Ltd, 35 Wellington Place. In 1913 the Henrys exhibited at Pollock's Gallery, 47 Donegall Place, and that year Paul had three pictures in the exhibition of Irish art at Whitechapel Art Gallery, London. His 1916 charcoal portrait of Arthur O'Gorman Lawlor is in the Ulster Museum. In 1917, 1918 and 1919 he and his wife showed paintings of the West of Ireland at Mills' Hall, 8 Merrion Row, Dublin. Henry assisted Arthur Power to organise, for Dublin, an exhibition in 1919 of modern paintings.

After the move to Dublin in 1920 he and his wife helped to found that year the Society of Dublin Painters with eight other artists. Paul was the secretary. The memorandum of agreement for the tenancy at 7 St Stephen's Green was signed on behalf of the Society by Clare Marsh, Jack B. Yeats (qq.v.) and Paul Henry. The first exhibition was held in August.

The studio which Henry used at 13a Merrion Row had formerly been occupied by Nathaniel Hone and Walter Osborne (qq.v.). About this time he became, unfortunately, red-green colour blind. Paintings appeared in a group show in 1922 at the Galeries Barbazanges, Paris. Henry was by now the Irish artist most widely known outside Ireland, and the French Government secured in 1922 *A West of Ireland Village*, now in the

National Museum of Modern Art. He is not however represented in the Metropolitan Museum of Art, New York, as stated in some dictionaries.

The Henrys showed at the Stephen's Green Gallery in 1921, 1922 and 1923, and at the Magee Gallery, Belfast, in 1923. When Arthur Griffith died in 1922 a portrait was executed by Henry and presented to the Free State by the English signatories to the Treaty. The New Irish Salon was also an outlet and he showed there four years, 1923-26. A 'Pictures of Beautiful Ireland' exhibition was held at his studio, Merrion Row, in 1925, and in 1926 there was a similarly titled exhibition with Grace participating.

In 1925 Henry had designed for the London, Midland and Scottish Railway the poster, *Connemara*, which became the best selling LMS poster. A poster which he designed for the dairy industry aroused some controversy in 1927, the Free State Government expressing a wish that it should not be exhibited by the Empire Marketing Board.

Henry was appointed an associate of the Royal Hibernian Academy in 1926; in 1928, a full member. At a loan exhibition of Irish portraits by Ulster artists, at the Belfast Museum and Art Gallery in 1927, he exhibited *William Cosgrave, President of the Irish Free State*, and in the same year at the Imperial Gallery of Art, South Kensington, London, he was represented in an exhibition by artists 'resident in Great Britain and the Dominions', and again in 1928. In 1928 too he showed at the Fine Art Society, London, with J.H. Craig, E.L. Lawrenson and Crampton Walker (qq.v.).

Participation in group exhibitions in Sheffield, 1929, when the Corporation bought *The Village by the Lake*, and Brussels, 1930, was followed by the Contemporary Irish Artists exhibition travelling in 1930 to Boston, Massachusetts, and then Toronto, Canada. Relations with Grace were now considerably strained and her establishment at the studio was against his wishes. In 1930 a deed of separation was made providing for a separation for two years and payment of £4.0.0. per week by Henry, later amended by the High Court in 1934 to £3.0.0. per week. In 1930, the year that he became one of the first twelve academicians of the Ulster Academy of Arts, he took up residence at Carrigoona Cottage, Kilmacanogue, Co. Wicklow, where he had a studio provided by an artist whom he later married, Mabel Young (q.v.), who ran the guest house.

In an interview, Mabel Henry said that when he was inspired he could not stop working. He would lock himself up in the studio and never painted out of doors. In 1931 a friend in New York, James A. Healy, helped in selling Henry's work. In 1931 he held his first exhibition at Combridge's Galleries, Dublin; eight others followed until 1945. In 1934 his 'In Connemara' exhibition of forty-four works was hung at the Fine Art Society, London, and despite the title he included *Spring in Co. Down*; *Belfast*; and some Wicklow scenes. The 1935 Combridge show was of Co. Kerry landscapes. The Hackett Galleries, New York, hosted an exhibition in 1938. In a talk on the BBC in 1940, he said: 'I count myself unusually fortunate in having three hobbies or habits or vices if you will: getting up early in the morning, painting and fishing.'

Henry was represented in the Oireachtas exhibitions of 1942 and 1944. In 1942 he had obtained a permit from the Department of Defence for sketching and painting in Counties Mayo and Galway. A poster of the West of Ireland for Bord Fáilte in 1943 ran to 10,000 copies. A series of Irish landscapes was published in 1943 as Christmas cards by A. Armstrong & Co. Ltd, Dublin, attaining wide distribution. The War greatly depressed Henry, sales of his pictures slumped, and in 1945 he had a nervous breakdown. His sight was seriously affected and he was almost blind for the rest of his life.

Heal's Gallery, London, staged an exhibition in 1946 and four years later he moved to 1 Sidmonton Square, Bray, Co. Wicklow. In that year his works were exhibited in Providence and Boston, USA. By this time Henry had taken to writing and his autobiography, *An Irish Portrait*, was published in 1951 after at least two years' work. Writing and the occasional broadcast were now the only means of making a living. The novelist John Broderick donated *Eel Weirs at Athlone*, oil, to Athlone Publc Library.

A retrospective exhibition held at the Victor Waddington Galleries in 1952 included *Winter Trees*; *Glencormac*; and *Chrysanthemums*, and at Combridge's Galleries, Dublin, the print *Blue Hills of Connemara* retained its popularity. In 1953 he married Mabel Young, and in that year *Further Reminiscences* was dictated but published posthumously. In his writings, references to his first wife, who died in 1953, are conspicuous by their absence. His final exhibit at the RHA, *The Maam Valley*, appeared in the 1953 show.

The collection of Mrs Kathleen Henry, widow of the artist's brother, Professor Henry, was displayed at the Belfast Museum and Art Gallery in 1956. In commemoration of his eightieth birthday, Bord Fáilte Éireann sponsored the promotion of a retrospective exhibition in 1957 at the Ritchie Hendriks Gallery, Dublin, later hung at the Belfast Museum and Art Gallery, and in part at Shannon Free Airport. Prior to this exhibition Bord Fáilte issued a poster of an Achill landscape which was widely distributed in Britain, the Continent and the United States.

The Road to Coomasharn, Co. Kerry is at Queen's University, Belfast. *Lakeside Cottages*, at the Hugh Lane Municipal Gallery of Modern Art, was presented by the Thomas Haverty Trust. At the Limerick City Gallery of Art is a portrait of A.O'G. Lalor. Sheffield City Art Galleries possess *The Village by the Lake*. In the Victoria and Albert Museum, London, there is a charcoal portrait of a little girl wearing a sash. Museum of Fine Arts, Boston, USA, possess *Mountain Village*. A portrait of his brother, Professor Henry, was destroyed by fire at Queen's University. At the Irish Museum of Modern Art is *Turf Stacks in the Bog*, oil. Representation at the Ulster Museum also includes *The Potato Digger* and *The Blacksmith*, both oils. On 24 August 1958 Paul Henry died at his home in Bray. He was buried at St Patrick's Church, Enniskerry, Co. Wicklow.

Organised jointly by Trinity College, Dublin, and the Ulster Museum, a retrospective exhibition was held in 1973, first in Dublin and then in Belfast, and in that year *Further Reminiscences* was published in Belfast. In 1974 the National Gallery of Ireland received a bequest from the estate of Mabel F. Henry, a collection of his paintings, drawings, sketch-books and the easel from his studio. This donation included a charcoal portrait of Henry by Edwin Morrow (q.v.). Celebrating the centenary of his birth, the Post Office featured the painting, *The Lobster Pots, West of Ireland*. An hour long programme, *Clouds of the Irish Sky*, about the life and work of Henry was transmitted by Radio Telefís Éireann in 1979. A joint exhibition of works by Paul and Grace Henry was held in 1991 at the Hugh Lane Municipal Gallery of Modern Art. More than forty works by Paul Henry were featured in 'An Irish Portrait' exhibition at the Ulster Museum in 1997. *Paul Henry* by S.B. Kennedy was published in 2000.

Works signed: Paul Henry; some drawings, Pal Hny, Paul Hny, Paul Hy, Paul H...y, Pa...Hy (if signed at all).
Examples: Athlone, Co. Westmeath: Public Library. Belfast: Northern Ireland Tourist Board; Queen's University; Ulster Museum. Boston, USA: College Library; Museum of Fine Arts. Churchill, Letterkenny, Co. Donegal: Glebe Gallery, Derek Hill's Collection. Cork: Crawford Municipal Art Gallery. Cultra, Co. Down: Ulster Folk and Transport Museum. Dublin: Government Buildings; Hugh Lane Municipal Gallery of Modern Art; Irish Museum of Modern Art; National Gallery of Ireland; Trinity College Gallery; University Hall, Lower Hatch Street; Voluntary Health Insurance Board. Kilkenny: Art Gallery Society. Limerick: City Gallery of Art. London: Victoria and Albert Museum. Paris: National Museum of Modern Art. Sheffield: City Art Galleries. Sligo: Model and Niland Centre. Waterford: City Hall, Municipal Art Collection.
Literature: Jane Barlow, *By Beach and Bog-Land,* London 1905 (illustration); John Davidson, *The Ballad of a Nun*, London 1905 (illustrations); Robert Lynd and Ladbroke Black, *The Mantle of the Emperor*, London 1906 (illustrations); John Keats, *Isabella; or, The Pot of Basil*, London 1906 (illustrations); *Northern Whig*, 19 March 1908, 13 March 1911; Katherine MacCormack, *The Book of St Ultan*, Dublin 1920 (illustration); *The Studio*, December 1923, June 1927, June 1928; *Dublin Magazine*, January 1925 (illustration), January - March 1957; Stephen Gwynn, *Ireland*, London 1927 (also illustration); J. Crampton Walker, *Irish Life and Landscape*, Dublin 1927 (also illustration); Daniel Corkery, *The Stormy Hills*, Dublin 1929 (illustration, jacket); Bulmer Hobson, ed., *A Book of Dublin*, Dublin 1929 (illustrations); Bulmer Hobson, ed., *Saorstát Éireann Official Handbook*, Dublin 1932 (illustrations); *Irish Times* 1 February 1933, 22 February 1952, 17, 23 and 30 October 1973, 2 December 1991; *Capuchin Annual*, 1935 (also illustrations), 1940 (illustration), 1953-54; Thomas H. Mason, *The Islands of Ireland* , London 1936 (illustration); Michael Floyd, *The Face of Ireland*, London 1937 (illustrations); *Liverpool Post*, 24 February 1938; Sean O'Faolain, *An Irish Journey*, London 1940 (illustrations); Victor Waddington Publications Ltd, *Twelve Irish Artists*, Dublin 1940 (also illustration); *The Bell*, August 1951; Paul Henry, *An Irish Portrait*, London 1951 (also illustrations); *Belfast Telegraph*, 1 November 1956, 26 August 1958; Ritchie Hendriks Gallery and Belfast Museum and Art Gallery, *Paul Henry Retrospective Exhibition*, catalogue, Dublin 1957; Brian O'Doherty, *The University Review*, 7 November 1960; Patrick Shea, *A History of the Ulster Arts Club*, Belfast 1971; Paul Henry, *Further Reminiscences*, Belfast 1973 (also illustrations); Trinity College, Dublin, and Queen's University, *Paul Henry 1876-1958*, catalogue, Dublin 1973; John Hewitt and Theo Snoddy, *Art in Ulster: I*, Belfast 1977; *Bulletin of the Dept of Foreign Affairs*, 15 October 1978; Martyn Anglesea, *The Royal Ulster Academy of Arts,* Belfast 1981; *National Gallery of Ireland: Illustrated Summary Catalogue of Drawings, Watercolours and Miniatures*, Dublin 1983; Ann M. Stewart, *Royal Hibernian Academy of Arts: Index of Exhibitors 1826-1979*, Dublin

1986; Bord Fáilte, *Letter to the author*, 1987; Metropolitan Museum of Art, New York, *Letter to the author*, 1987; Eileen Black, *A Sesquicentennial Celebration: Art from the Queen's University Collection*, Belfast 1995 (also illustration); Ulster Museum, *An Irish Portrait Paul Henry*, news release, Belfast 1997; Athlone Public Library, *Letter to the author*, 1999.

HERBERT, GWENDOLEN (1878-1966), sculptor. Gwendolen Egerton Herbert was born in 1878 at Cahirnane House, Killarney, Co. Kerry, the daughter of Henry Herbert, also of Dunkerron Castle, Kenmare, who died in 1898, by which time the family fortunes had reached a point where the family seat had to be sold and Gwendolen moved to Dublin with her mother. They resided at 7 Clyde road.

In 1899 she began attending classes at the Dublin Metropolitan School of Art, won a studentship in 1900 and studied modelling, but from 1904 she concentrated on metalwork and enamelling under P. Oswald Reeves (q.v.) and was represented that year at the Arts and Crafts Society of Ireland exhibition by two painted panels, one for a book cover and the other for a box. Modelling ability attracted her to the Irish Art Companions, an Irish revival industry at 27-28 Clare Street, described as 'a guild for the improvement of taste and the revivifying of Irish art', in an attempt to turn back the tide of imported statuary in Ireland.

The Companions manufactured plaster from native gypsum and produced Irish art products in the form of plaster figures and statues both secular and ecclesiastical, firing the plaster in their own kilns. Other sculptors included Joseph S. M. Carré, Mervyn Lawrence and Lilla M. Vanston (qq.v). Gwenda Herbert was credited with studies of Irish peasantry — old women, itinerant fiddlers and workmen with their staves — much admired at the time. As one commentator put it: 'It is a source of consolation to intelligent tourists to be able to buy some dignified and respectful representative figures of Irish peasants, in place of the monstrous bog-oak Paddies with pigs of which the public are as tired as they are of the typical stage Irishman.'

In 1907 she moved to London and supported herself by teaching and making garden statues, although books on garden ornament appear to have passed her by. In 1907 she exhibited at the Irish International Exhibition at Herbert Park, Dublin, her contributions including a box with a bronze top and mother-of-pearl sides. In her only appearance in 1907 at the Royal Academy she showed from 141 Church Street, Chelsea, a case of three plaquettes, bronze and silver: a portrait, a medal for a physical training college, and *Goats at Glendalough*. She exhibited one work at the Walker Art Gallery, Liverpool. In 1908 she contributed two pieces to the Royal Hibernian Academy: *Andromeda* and *Reflections*.

The attribution to Herbert of the plaster statuette, *An Old Irish Woman*, 27 cms in height, at the National Gallery of Ireland was based on the illustration of a very similar work in *The World's Work*, May 1907. Gwendolen Herbert died on 26 May 1966 at Rockville Home, Military Hill, Cork.

Examples: Dublin: National Gallery of Ireland.
Literature: *Thom's Directory*, 1901; Bernard Burke, *Landed Gentry of Ireland*, London 1912; Register Office, Dublin, *Register of Deaths*, 1966; *Dictionary of British Artists 1880-1940*, Woodbridge 1976; *Royal Academy Exhibitors 1905-1970*, Calne 1985; *National Gallery of Ireland Acquisitions 1984-86*, Dublin 1986 (also illustration); National Gallery of Ireland and Douglas Hyde Gallery, *Irish Women Artists: From the Eighteenth Century to the Present Day*, catalogue, Dublin 1987 (also illustration); Paul Larmour, *The Arts & Crafts Movement in Ireland*, Belfast 1992 (also illustration).

HERKNER, FRIEDRICH, RHA (1902-86), sculptor. Born in Brüx, Bohemia, now Czechoslovakia, on 25 October 1902, son of Anton Herkner, Fritz studied in the art school at Teplitz-Schonau and from 1921 to 1929 he attended the Academy of Fine Arts in Vienna under Professor Josef Müllner. In his last four years there he had his own studio and gave master classes. In 1929 he received the State Rome Prize for sculpture and spent some months in Rome and Florence. In 1931 he was called to Czechoslovakia to work in co-operation with Herman Zettlitzer on a number of statues and reliefs. He founded a school of fine and applied art in Aussig/Elbe.

Interviewed in Dublin in late 1937 for a vacancy at the National College of Art, he did not speak English; in 1938 he was appointed Professor of Sculpture. His first major commission in Ireland aroused some controversy in that a local sculptor had not been employed. His 5.5-metre-high statue, *Mother Eire* for the

Ireland Pavilion at the 1939 New York World's Fair was carved with assistance at the College of Art. On the outbreak of War he was ordered home by the German Government. He was given an appointment as professor of sculpture but a year later was drafted into the army and sent to the Russian Front. He ended the war as a prisoner in Berlin.

After hostilities he stayed six months in Heidelberg and went back to Vienna in 1946 and worked with a group of sculptors engaged in the restoration of war-damaged monuments. In 1945 he had contacted the Department of Education in Dublin and was invited back but did not resume his position at the National College of Art until 1947 because of travel restrictions. One of his immediate innovations was the establishment of a pottery class, where the ceramic process was used for fine art purposes. A former student, Brian King, recalled Herkner spending most of his day in his own studio in college, 'where he worked away but he came out on lightning visits to see and comment on the students' work. He could be secretive and did not let students into his studio to inspect his own work.'

Between 1948 and 1979 Herkner, who became its Professor of Sculpture in 1982, was a regular exhibitor at the Royal Hibernian Academy, showing more than sixty works. *The Tragic Age* in 1951, and *Ecce Homo* in 1953 were the first of several life-size statues, and in 1951 there was a statuette of John Keating (q.v.). Other portraits included: Sean McDermott, ciment fondu, 1957; the Most Rev. John Charles McQuaid, 1962; Sean F. Lemass, 1963. When living on his own in Palmerston Road, Dublin, portrait busts of Garret FitzGerald and Charles Haughey were reported as sitting at the window.

Herkner's was one of the two prize-winning entries from Ireland in the international sculpture competition, 'The Unknown Political Prisoner', and this work was exhibited at the Tate Gallery, London, 1953. In that year his sculpture was included in the Contemporary Irish Art exhibition at Aberystwyth, and in the Institute of the Sculptors of Ireland exhibition in Dublin, also in the latter in 1954, 1955 and 1957. In 1955 the critic of the *Dublin Magazine* had this to say: 'I find it difficult to decide which I dislike the more: the empty rhetoric of Frederick Herkner's *Moonlight*, formally obtuse in its attempt to convey an abstract idea that has nothing to do with sculpture; or the uninspired and almost clinical realism of his *Standing Figure*.' Herkner was also represented in the Institute's international exhibition in Dublin in 1959 at the Municipal Gallery of Modern Art. A bust of the Honourable Philip Francis Little in the Confederation Building, St John's, Newfoundland, was cast in Dublin in 1957.

Represented by a drawing in the self-portrait collection in the Uffizi Gallery, Florence, Herkner exhibited in Prague, Vienna, Aussig and Leipzig. He retired from his Dublin post in 1967. In an exhibition by contemporary Irish artists at the Cork Sculpture Park in 1969, he was represented by *The Proud Horse*, 86 cms high, cast stone; *W.B. Yeats*, about 74 cms high, cast stone, now in the Yeats Society Building, Sligo. In 1972 he was appointed ARHA and in 1979 a full member.

The statue of Our Lady and the Child overlooking Ballintubber Abbey, Co. Mayo, and the bust of Sean McDermott at McDermott Barracks in the Curragh Camp are by Herkner. Described as 'modest and meticulous, good humoured and energetic', he worked up until near the end of his life, and attended the 1986 RHA exhibition. In his *'Notes on Sculpture'*, which he left to the RHA along with a number of casts, he gave this advice: 'Clear your mental fluoroscope of anger, hate, fear, jealousy and selfishness, and put love, knowledge of the truth, service, cheerfulness, kindliness and appreciation in their place.' He died at St Vincent's Hospital, Dublin, on 27 June 1986.

Works signed: Herkner.
Examples: Ballintubber, Co. Mayo: Abbey. Curragh, Co. Kildare: Camp. Dublin: Royal Hibernian Academy. Florence: Uffizi Gallery. Limerick: University, National Self-Portrait Collection. Prague: Museum. St John's, Newfoundland: Confederation Building. Sligo: Yeats Society Building.
Literature: *Academy of Fine Arts, Vienna, List of Classification*, 1921-29; *Who's Who in Art*, 1966; *Notes of a conversation between Professor F. Herkner and Professor J. Turpin*, Dublin 1984; *Irish Times*, 1 and 11 July 1986; Ann M. Stewart, *Royal Hibernian Academy of Arts: Index of Exhibitors 1826-1979*, Dublin 1986; House of Assembly, Province of Newfoundland and Labrador, *Letter to the author*, 1987; also, Uffizi Gallery, 1987; John Turpin, *A School of Art in Dublin since the Eighteenth Century*, Dublin 1995 (also illustration).

HERON, HILARY (1923-77), sculptor. Born in Dublin on 27 March 1923, daughter of James Heron, bank official, Hilary Mary Heron spent most of her childhood in Coleraine, Co. Derry, and New Ross, Co. Wexford, where she attended John Ivory's School, a one-teacher establishment. At the National College of Art she won the Taylor Scholarship three years in succession, 1944-46, one of only three students to do so since its inception. In 1943 she had exhibited at the first Irish Exhibition of Living Art, and in 1944 her set of chessmen in walnut was admired for its humorous originality and excellent craftsmanship.

When she left the College of Art she was regarded as a rebel, and had some knowledge of the work of Henry Moore (1898-1986) and Barbara Hepworth (1903-75). In 1945 she first exhibited at the Royal Hibernian Academy: *Horse*. One of her early portraits was *James Connolly*, 1946. She showed only three other works at the RHA: 1946, *Dawn*; 1947, *Comedy*; *Tragedy*. In 1948 she won the Mainie Jellett Memorial Scholarship awarded by the Living Art Exhibition Committee. This enabled her to spend the greater part of that year in France and Italy, where she admired Romanesque carvings. Although barely out of her student days she was regarded as a mature and original sculptor.

Edward de Courcy, writing in *Envoy*, thought that her 1948 *Limestone Lady* was the nearest she had approached to the abstract: 'In fact it can be called abstract at all only because insistence on the sculptural elements, the self-contained solidity of form, the extraordinarily subtle yet inevitable modality of the polished planes seem, at first, to have eliminated the human element until one realises that the form as a whole is organically human.'

At the 1949 IELA her *Danaan Woman* in Australian Blackwood, grown in Kerry, was regarded by some as outstanding. The *Dublin Magazine* commented: 'Detail is conceived, not realistically, but subordinated to the formal unity of the whole. This work shows a fusion of her qualities as a sculptor: acute observation, an imaginative sense of form and a sensitive feeling for the character of her medium.'

The first one-person show was at the Victor Waddington Galleries, Dublin, in 1950, and among the works were: *Flight into Egypt*, walnut; *Figure for a Garden*, limestone; *Virgo*, Isoko-wood; *Black Mask*, Kilkenny marble; *Flesh of my Flesh*, yew. She continued to exhibit at the IELA and in 1952 contributed three low reliefs in lead. A second solo show followed at the Victor Waddington Galleries in 1953, the year in which her work was included in the Contemporary Irish Art exhibition at Aberystwyth – her address was then Mounteagle, Sandyford, Co. Dublin – and at the Institute of the Sculptors of Ireland show.

When *Crazy Jane in Steel* appeared at the 1956 IELA, the *Dublin Magazine* critic found it an 'over-laboured literary fantasy'. In that year she represented Ireland with Louis le Brocquy at the Venice Biennale and also visited China as a member of an Irish delegation. She was sent to New York in 1958 by the Irish Government who had commissioned her to do work for the Irish Exhibition there. Although energetic and innovative, she shared a lack of enthusiasm for individual shows with her friend and fellow sculptor, Oisin Kelly (q.v.).

In 1960 she held her first exhibition in England, at the Waddington Galleries, London, where more than thirty works were on view, including *Bird Barking*, steel, 2 metres long; reliefs *Square Eye* and *Squares in Different Places*, both brass. A friend of Elizabeth Frink (1930-93) since they met in Dublin in the 1950s, Hilary saw a great deal of her when she went to live in London in 1959, sharing accommodation at 28 Cranley Gardens, South Kensington, with fellow sculptors Irene Broe and Frank Morris (qq.v.). Elizabeth Frink lent her a studio, and later visited her in Ireland on several occasions.

The English critic, Nevile Wallis, wrote about the London exhibition: 'This youngish Irish sculptor has roamed widely overseas, assimilating exotic styles for her own individual, at times almost surrealist, purposes, as was seen when she represented Ireland at the Venice Biennale ... Whether she works in metal or walnut, her capricious spirit is controlled always by a very feminine sensibility and feeling for the nature of her material ... (she) brings something fresh, diverting, and also very genuine to our inbred world of sculpture.'

Married to Professor David Greene, in 1961 they moved to 2 Vico Terrace, Dalkey, Co. Dublin. A bronze relief, *The Clonfinloch*, went to Bord Fáilte Éireann in 1962. The catalogue for her exhibition in 1963 at Queen's University, Belfast, mentioned that she had visited the USSR as well as most European countries. She was in correspondence with the Ulster Museum in 1972 from Boston, Mass., USA. *Torso* is located in the downtown Dallas store of Neiman-Marcus. In private possession are two lead plaques, *Icarus II* and *Woman taking Wine*. In the South Mall branch of the Bank of Ireland, Cork, are hanging four bronze panels,

Mac con glinne and the King. At the Irish Museum of Modern Art in Dublin there is a portfolio of pencil sketches.

Dorothy Walker in her *Modern Art in Ireland*, 1997, considered her 'the leading modernist sculptor. Although she had been influenced by Henry Moore, and perhaps more so by Barbara Hepworth, she had developed her own quirky, witty view of the world...'.

Always an artist with a sense of humour, she had a constant flair for exploring unusual combinations of technique and materials like her stone and metal 'Lithodendrons'. She lived beside the sea and was in the habit of collecting stones and other objects from the shore, some of which she incorporated in her sculpture. A collection of bottles, some old, most chosen for their colour and shape formed a wall decoration in the sculptor's dining-room. She was an integral part of Dalkey, 'a lively, accessible, dependable friend', helping with enthusiasm the aged and the ill. Gardener and botanist, she held membership of the RTE Authority. She died on 28 April 1977.

Works signed: HH, monogram.
Examples: Belfast: Ulster Museum. Dublin: Arts Council; Bord Fáilte Éireann; Irish Museum of Modern Art.
Literature: *Royal Dublin Society Report of the Council*, 1944, 1945, 1946; *Dublin Magazine*, January-March 1945, April-June 1948, October-December 1949, January-March 1951, October-December 1952, October-December 1956; *Envoy*, June 1950; Waddington Galleries, *Hilary Heron,* catalogue, London 1960; Queen's University Visual Arts Group, *Hilary Heron*, catalogue, Belfast 1963; *Who's Who in Art,* 1970; Rosc, *The Irish Imagination,* catalogue, Dublin 1971; *Irish Times*, 30 April 1977, 12 August 1977, 12 December 1981; Cork Rosc, *Irish Art 1943-73*, catalogue, 1980; Mrs Eily Bresnihan, *Letter to the author*, 1987; also, Elizabeth Frink, 1987; Roddy Heron, 1987; Neiman-Marcus, 1987; National Gallery of Ireland and Douglas Hyde Gallery, *Irish Women Artists: From the Eighteenth Century to the Present Day*, catalogue, 1987;Dorothy Walker, *Modern Art in Ireland*, Dublin 1997 (also illustrations); Jim McDonnell, *Letter to the author*, 1998.

HICKEY, EPHREM (1872-1955), portrait painter. Born at Kilmacow, Co. Limerick, on 1 November 1872, George Hickey was the son of James Hickey and became Ephrem on entering religion, in which he had a number of personal difficulties with Superiors. However, he was given permission to go to Munich and Florence to study art. Apparently a difficult student, he had his own very determined ideas about mixing colours.

He became a member of the English province of the Franciscan Order. Ordained in 1895, he was appointed guardian of the Franciscan house in Killarney in 1896 and was removed from office the following year. After being in the Glasgow friary, he was transferred to London, serving at Forest Gate and Stratford. In 1909 he exhibited at the London Salon. He showed only six works at the Royal Hibernian Academy, the first in 1912, a portrait of the Most Rev. Dr O'Dwyer, Bishop of Limerick. A portrait of the Bishop is in private possession at Croom, Co. Limerick.

In 1913 Dermod O'Brien (q.v.), president of the RHA, invited him over for varnishing day but he was unable to travel to Ireland until the summer. In his letter he enclosed a photograph of his *Last Supper*, 'modelled on Ghirlandaio's *Last Supper* in the Franciscan Friary of Ognissanti in Florence. The authorities have asked me to fix it in its place as soon as ever I can'. This painting hung for many years in the Franciscan Church in Chilworth, Guildford, Surrey, from which a report emanated that 'the paint had started to run down the Apostolic leg'. The work was transferred to the Forest Gate Friary, where it had been painted years before, various members of the parish standing in for the Apostles.

For the 1913 RHA, he sent three portraits: *The Very Rev. Fr Jackman, OFM, Adam and Eve's, Merchants' Quay, Dublin* (now at Dún Mhuire, Killiney); *The Most Rev. Dr Mannix, Archbishop of Pharsolus and Coadjutor Archbishop of Melbourne*; *Portrait of the Right Honourable the Lord Major of Dublin (Lorcan Sherlock, LL D)*, at the Mansion House. Portraits of Archbishops Thomas Fennelly and Daniel Mannix, the latter 1912, are at St Patrick's College, Maynooth.

After London, he was stationed at St Bernardine's College in Buckinghamshire, and from there he sought in 1917 incardination into the diocese of Limerick; he was not successful. However, he did receive the requisite permission to leave the Order and he became a secular priest in 1917. He went to the USA and

served in Iowa, but the records of the Sioux City diocese do not indicate any artistic activity. He returned to England in 1926, entered the diocese of Nottingham and was parish priest of Corby Glen, Lincolnshire, from 1932 until his death on 28 February 1955 at St Francis Nursing Home, Leicester.

Works signed: Ua h-Iceada.
Examples: Dublin: Mansion House. Killiney, Co. Dublin: Franciscan Institute, Dún Mhuire. London: Franciscan Friary, Forest Gate. Maynooth: St Patrick's College.
Literature: Trinity College, Dublin, *Dermod O'Brien Papers*; *Dictionary of British Artists 1880-1940*, Woodbridge 1976; Rev. Patrick Conlan, OFM, *Letter to the author*, 1978; also, Rev. John Fleming, 1978; Rev. Benignus Millett, OFM, 1978; Thomas Ryan, RHA, 1978; Garrett Sweeney, 1978; Rev. Mgr L.M. Ziegmann, 1979; Ann M. Stewart, *Royal Hibernian Academy of Arts: Index of Exhibitors 1826-1979*, Dublin 1986; Rev. Justin McLoughlin, OFM, *Letter to the author*, 1987.

HICKEY, PATRICK (1927-98), etcher and landscape painter. Patrick William Hickey was born on 22 April 1927 in Bannu, India, now Pakistan. His father was a Colonel in the Indian Army, 1st Punjab Regiment. After attending Ampleforth College, Yorkshire, he moved to Dublin in 1948 to study architecture at University College, Dublin, qualifying in 1954, the year he executed his first painting — in Wicklow.

On his work at the 1956 Irish Exhibition of Living Art, the *Dublin Magazine* found 'nice placing and fastidious sense of design,' but his colour was 'coarsely applied.' However, at the 1957 gathering his three pictures showed a 'very fresh and interesting style'. From 1956 to 1963 he worked for the architect, Michael Scott, interrupting this occupation for a year when in 1957 he won an Italian State Scholarship and studied etching and lithography at the Scuola del Libro, Urbino.

In 1961 he was much to the fore in the founding in Dublin of the Graphic Studio in an Upper Mount Street basement. Writing in *Studies*, Summer 1961, Elizabeth Rivers (q.v.) noted signs of individual and talented young artists turning to figurative painting, and 'foremost among these in Ireland is Patrick Hickey who has a range of colour that is original and convincing, with a grasp of natural forms which take up a new identity in his paintings.'

In 1965 the Italian Government held a competition to illustrate Dante's *Divine Comedy*, marking his 700th anniversary, and Hickey's eighteen Inferno etchings won second prize. These etchings were included in his graphics exhibition of sixty works at the Dawson Gallery, Dublin, 1965. Among the other etchings exhibited were: *Toucans* and *Monal Pheasant*, both on silk. Also at the Dawson were fourteen drawings of the Camargue, Provence. His etchings *Stations of the Cross* were displayed in book form, but a set was purchased by the National Archives in Paris and the Crawford Municipal Art Gallery, Cork.

In 1967 he showed twenty-six works, including *Rain at Annacurra* and *The Liffey at Palmerston* in a paintings exhibition at the Dawson. In 1967 too he visited Norway on a Norwegian Government scholarship and painted watercolours. He showed twenty works, including sixteen watercolours, at the New Gallery, Belfast, *Lough Bray, Wicklow* and *Birch Woods, Norway* being among the watercolours.

In 1967, then of 27 Crosthwaite Park West, Dun Laoghaire, Co. Dublin, he designed the 5d and Is.5d. stamps, both multi-colour, issued by the Department of Posts and Telegraphs in connection with the Centenary of Canadian Confederation. From 1968 until 1985 he taught part-time at the School of Architecture at UCD. In 1969 he was one of the artists sponsored by the Cultural Relations Committee to represent Ireland at the first International Biennale of Engravings in Liege, Belgium. He was represented in several other biennales of graphics, for example Cracow and Sao Paulo.

An authority on Irish delftware, he organised the exhibition of eighteenth century pieces in Castletown House, Co. Kilkenny, part of the 1971 Rosc programme. *Bogland, Wicklow* was his first exhibit, in 1972, at the Royal Hibernian Academy. The *Irish Times* critic now considered that he was far more convincing as a graphic artist and watercolourist than as a painter in oils. In 1972 he was appointed a board member of the National College of Art and Design.

Critics made him 'quite angry'. On his exhibition at the Dawson Gallery in 1972, the *Irish Times* stated that originality was not his 'strongest point,' yet his show was 'shining with professional efficiency, there is scarcely a weak work in the lot.' The Wicklow landscapes, birds, Oriental calligraphy were 'all grist to his

glittering mill, and all are ground down to the same level of polished, rather impersonal assurance.' He could be guaranteed, the writer went on, to 'hold his own in any exhibition or cross-section of contemporary Irish art; he can also be guaranteed not to stand out.' Other exhibitions were held at the Dawson in 1974 and 1976.

On his show at the Tom Caldwell Gallery, Belfast, in 1972, the *Irish Times* critic found 'particularly satisfying his etching of Two Hippos who manage to be endearing and repellent at the same time — all his animal series is keenly observed and skilfully executed.' In contrast, he was appointed to design the new Irish banknote.

Sadly, in 1973 Parkinson's disease was diagnosed. The only exhibition held outside Ireland was at the Prudhoe Gallery, London, in 1974. In a catalogue note, the gallery stated that all his etchings were 'now produced in editions of no more than 20; and all are printed by the artist.' The Taylor Galleries, Dublin, hosted an exhibition in 1978.

The three etchings, all signed 'Patrick Hickey', at the Cork Rosc exhibition of 1980 were: *Escarpment*; *Barren Landscape with Rain Cloud*; *Sea Birds IV*. From 1980 until 1984 he took a degree in Italian and Art History at UCD. He showed again at the Taylor Galleries in 1981, 1983, 1986 and 1989. After an interval of fourteen years, he exhibited at the RHA in 1986: *Pomegranates & Pine Cones*; *Apples*; both oils. From 1986 until 1990 he was Head of Painting at NCAD.

In 1990 he showed two more oils at the Academy: *Virginia Creeper and Garden Wall*; *Morning Wicklow Hillside*. His remaining exhibits were two etchings, sent from 6 Mulgrave Terrace, Dun Laoghaire, Co. Dublin: 1992, *Still Life with Pears and Apples*; 1993, *The Fourth Tree*. A retrospective exhibition in Dublin in 1994 at the Royal Institute of the Architects of Ireland was followed in 1995 by a show at the Graphic Studio Gallery, all the work — twenty-seven items —having been produced over the previous two and a half years. *Gold and Paeonies* was a colour etching with gold leaf.

In 1996 RTÉ paid tribute with 'Patrick Hickey Artist'. Despite the debilitating effects of his illness, he held another exhibition at the Taylor Galleries in 1997; seventeen oil paintings, including *Huguenot Cemetery* and *Cat with Aubergines*. A member of Aosdána, he acted on the Cultural Relations Committee of the Department of Foreign Affairs and also served on the Kilkenny Design Workshops board. When painting, he liked to be alone. Among the painters who had influenced him was Ben Nicholson (1894-1982), 'with his cool greys and absolute tranquillity.' He died at home, 65 Clearwater Cove, Monkstown, Co. Dublin, on 16 October 1998. An exhibition of landscape prints from the 1970s was held at the Graphic Studio Gallery in 2000.

Works signed: Patrick Hickey, Pat Hickey, Hickey or H.
Examples: Athlone, Co. Westmeath: Institute of Technology. Belfast: Arts Council of Northern Ireland; Ulster Museum. Coleraine, Co. Derry: University of Ulster. Cork: Crawford Municipal Art Gallery. Dublin: Arts Council; Hugh Lane Municipal Gallery of Modern Art; National College of Art and Design; Office of Public Works; Voluntary Health Insurance Board. Limerick: City Gallery of Art; University, National Self-Portrait Collection. Paris: National Archives. Sligo: Model and Niland Centre.
Literature: *Dublin Magazine*, October-December 1956, October-December 1957; *Studies,* Summer 1961; *Arts Council, Dublin, 1964-65 Report;* Dawson Gallery, *Graphics Patrick Hickey,* catalogue, Dublin 1965; also, *Patrick Hickey Recent Paintings*, catalogue, Dublin 1967; New Gallery, *Patrick Hickey Recent Paintings,* Belfast 1967; Department of Posts and Telegraphs, *Letter to the author,* 1968; *Irish Times,* 6 February 1969, 7 May 1970, 22 April 1972, 20 May 1972, 1 November 1972, 17 October 1998, 6 November 1998; Prudhoe Gallery, *Patrick Hickey Etchings,* catalogue, London 1974; Rosc, *Irish Art 1943-1973,* catalogue, Cork 1980; Marianne Hartigan, interview, *Irish Arts Review,* Spring 1986; Graphic Studio Gallery, *Patrick Hickey New Prints,* Dublin 1995 (also illustrations); Taylor Galleries, *Patrick Hickey,* catalogue, Dublin 1997; Ms Twink Hickey, *Letter to the author,* 1999; Graphic Studio Gallery, *Press Release,* Dublin 2000.

HIGGINS, JOSEPH (1885-1925), sculptor. Born on 22 April 1885 at Ballincollig, Co. Cork, son of William Higgins, historian and teacher but at the time of Joseph's birth a cooper at the local powder mills. A member of the Fenian brotherhood, the father had served a term of imprisonment in Cork gaol after the rising of 1867. Joseph attended Ballincollig National School but by the age of fourteen the family had moved to Cork city,

where he obtained employment as a clerk with the tea merchants, Newsom and Sons, inheriting the stool of Terence MacSwiney, later Lord Mayor of Cork.

At the Crawford School of Art, Higgins was a night student, specialising in modelling and woodcarving, and there he met Katherine Turnbull, whom he later married. A head of Daniel Corkery (q.v.), a friend throughout his life, was modelled in 1909 and is now in University College, Cork. In 1910 he was given the highest award in the National Competition for a study from life of a child, in clay. This piece, *Charlie,* was exhibited at the 1913 Royal Hibernian Academy. The model was Charles Higgins, the artist's nephew, later an Inspector of Taxes. The work, which has a crab 'climbing' on rock towards the boy's bare toes, was cast in bronze in 1965 and placed in its present position in Fitzgerald Park, Cork, and is known as *Boy with a Boat.* A plaster cast is in the National Gallery of Ireland.

At a practical, timed examination the board awarded him a bronze medal for construction and modelling of the human head. In the following years he had other academic successes. He also won a number of first prizes for woodcarving at exhibitions held by the Royal Dublin Society. Despite these awards, he never had an opportunity to travel or study abroad. The first time he exhibited at the Royal Hibernian Academy was in 1912. Referring to his portrait bust of a child, the *Irish Review* commented: '... it is full of humour and vitality, and ought to have been given a good place instead of being put in the "kitchen".'

In 1913 he gave up travelling in tea for travelling as an art teacher to Youghal, Fermoy, Midleton and neighbouring villages. Two years later when he accepted the job of art and crafts teacher at Youghal Technical School he married, left 70 Dominick Street, Cork, and went to live permanently in Youghal. He enjoyed teaching, built boats, sailed and spent hours talking to the local fishermen. As well as continuing to sculpt, he also painted: *Blessing of the Boats in Youghal* and *Corpus Christi,* both 1916.

A Toiler of the Sea and *An Strachaire Fir,* two heads of Youghal fishermen, were executed about this time and are in the Crawford Municipal Art Gallery. Andrew O'Connor (q.v.) commented on the works: 'Grand, grand. Rodin would wish to have done them. Any sculptor would feel sure of himself if he could say "They're mine".' A limewood head of Joseph's brother, Patrick Higgins, was carved in 1916. Among works on children was *Maighread and Liam,* twin heads carved from one block of marble. Some other sculptures are in limewood. Of his *Madonna and Child,* Seamus Murphy (q.v.) commented: 'It is a grand conception, full of reverence and feeling, and very reminiscent of things done in medieval Europe.'

Higgins, who suffered from tuberculosis, never had a single commission for a portrait bust and never saw the casting of his own work. He enjoyed teaching, and his innate kindliness enabled him to make friends with his students and give help and advice outside of class. In 1922, in limewood, he carved a head in the form of a mask of Michael Collins from sketches done during a pro-Treaty meeting in Cork.

At the Táilteann Games, in 1924, he won the bronze medal for sculpture and in the same year began his portrait bust of Professor W.F.P. Stockley, now in University College, Cork, and regarded as his masterpiece. This was his last work. He exhibited his fifteenth work – some non-sculpture – at the RHA in 1925, and died on 25 November. His widow succeeded him as teacher of arts and crafts at Youghal Technical School. Katherine died in 1975, the year in which, as a tribute in commemoration of the 50th anniversary of her husband's death, fifteen examples of his work were included in the Cork Rosc, Irish Art 1900-1950 exhibition. A Cork Arts Society exhibition of sculpture and paintings in 1982 devoted one room to the work of Higgins and his son-in-law, Seamus Murphy.

Works signed: Joseph Higgins, J. Higgins or J.H., monogram (if signed at all).
Examples: Cork: Crawford Municipal Art Gallery; Fitzgerald Park; University College. Dublin: National Gallery of Ireland.
Literature: *Irish Review,* April 1912; Joseph Ethelston, *Capuchin Annual,* 1952; *Irish Times,* 26 August 1972, 4 March 1975, 8 October 1975, 24 March 1982, 17 April 1985; Cork Rosc, *Irish Art 1900-1950,* catalogue, 1975; *Dictionary of British Artists 1880-1940,* Woodbridge 1976; Ann M. Stewart, *Royal Hibernian Academy of Arts: Index of Exhibitors 1826-1979,* Dublin 1986; Mrs Maigread Murphy, *Letter to the author,* 1987.

HILL, NATHANIEL, RHA (1860-1930), genre painter. Born in Drogheda, Co. Louth, his father being Richard R. Hill, a miller, he expressed a wish to become a painter rather than join the family business. In

1877 he entered the Dublin Metropolitan School of Art and studied there for three years. J.M. Kavanagh and Roderic O'Conor (qq.v.) were contemporaries; Hill had lodgings at 88 Pembroke Road with the O'Conor family. In 1880 he exhibited for the first time at the Royal Hibernian Academy, a head of a dog, giving the address Cowslip Lodge, Drogheda. He was a contemporary of Kavanagh and W.F. Osborne (q.v.) at the RHA Schools.

The 1880s saw a concentration of Irish artists in Paris and Antwerp. In 1881 with other Irish students, J.J.A. Greene, Kavanagh and Osborne, Hill enrolled at the Académie Royale, Antwerp, and shared lodgings at 49 Kloosterstraat (Rue du Couvent). One of his tutors was Charles Verlat (1824-90) who ran a life class. In May 1883 he was awarded second prize for painting from nature, and then at the RHA he showed *Feeding time in a Flemish Farm yard* and *A Reminiscence of the Spaniards, Antwerp*, from 45 Rue du Couvent, Kavanagh's former address. The year 1883 was an encouraging one for Hill as he won the Royal Dublin Society's Taylor Scholarship with *Convalescence*, and he received a silver medal from the Metropolitan School of Art.

Hill headed south to Brittany with Kavanagh and Osborne, stayed at the Maison Gloanec in Pont-Aven and from there won the 1884 Taylor Scholarship for the second time with his *Breton Beggars*. He showed Breton scenes at the RHA that year, and in October was with Osborne and the English painter Edward Stott (1858-1918) as companions at North Littleton, near Evesham, in Worcestershire, where he painted a cottage interior with an old woman winding a skein of wool; this work is in private hands.

Hill and Osborne worked at Walberswick, and it was there that he met Philip Wilson Steer (1860-1942), who described him years later as 'a good painter'. Steer's *Children Paddling, Walberswick* (Fitzwilliam Museum, Cambridge) was dated 1894. Osborne did a small painting of Hill at Walberswick which he gave to J.B.S. McIlwaine (q.v.).

In 1885, when he exhibited *Sunshine, Brittany* at the RHA, Hill gave his address as Balmerino, Drogheda, and the critic of the *Dublin University Review* wrote: 'This picture shows a very considerable advance on Mr. Hill's previous work, especially as regards colour. The textures of the various surfaces, the slates, stone steps are well rendered and the warm quality of sunshine not unsuccessfully painted. The figures also deserve notice.' In 1885 too he was allowed to attend the RHA Schools for free study.

Hill exhibited at the Dublin Art Club in 1886. Altogether, up until 1893, he showed three works at the Walker Art Gallery, Liverpool, and seven at the Royal Institute of Oil Painters. Osborne also had paintings hung at these exhibitions. Hill painted several small sketches of village scenes on wood panels.

In 1892 he was appointed ARHA and in 1894 a full member. His portraits were mainly of his family but in 1895 at the RHA, the last year he exhibited there, he showed *The late Alderman Branigan, J.P.*, his twenty-seventh contribution. Branigan was a Drogheda man. A charcoal portrait of Walter Osborne by Hill is in the National Gallery of Ireland. His portrait of Thomas Plunkett Cairnes of Stameen, Drogheda, is on loan to the Municipal Art Collection.

Hill's mother died in 1897. A relation had this to say ninety years later: 'It seems that shortly after he had won the grand prize in Paris, something in his life went wrong. My mother used to persuade herself that it was an unhappy love affair but it could have been a nervous breakdown. Whatever it was, the family never found out and Nathaniel returned from France to the family home and it appears never painted a stroke for the rest of his life. He just lived with the family and did nothing. He and two unmarried sisters eventually went to live at Betws-y-coed. I can remember seeing him there when I was a small boy. He was a very tall, thin old man, very deaf, and seemed to be a solitary figure.' He died at Snowdon Villa, Betws-y-coed, Wales, on 17 February 1930.

Works signed: NH, monogram (if signed at all).
Examples: Drogheda, Co. Louth: Library, Municipal Centre; St Peter's National School. Dublin: National Gallery of Ireland.
Literature: *Royal Dublin Society Report of the Council*, 1883, 1884; Algernon Graves, *A Dictionary of Artists*, London 1901; *Irish Times*, 19 February 1930; Jeanne Sheehy, *Walter Osborne*, Ballycotton 1974; *Dictionary of British Artists 1880-1940*, Woodbridge 1976; Mrs Rhona Hill, *Letters to the author*, 1983, 1987; Julian Campbell: National Gallery of Ireland, *The Irish Impressionists: Irish Artists in France and Belgium 1850-1914*, catalogue, 1984; Ann M. Stewart,

Royal Hibernian Academy of Arts: Index of Exhibitors 1826-1979, Dublin 1986; Rochdale Art Gallery, *Letter to the author*, 1989.

HILL, ROWLAND, ARUA (1915-79), landscape and marine painter. Born in Belfast on 18 July 1915, son of Thomas Hill, grocer, Rowland Buckley Hill attended Hillman Street Public Elementary School, sometimes killing the monotony of lessons by surreptitious sketching of teachers and classmates. As a boy he wandered about the port and shipyards sketching, and his love of the sea remained throughout his life. At the age of sixteen, after serving uncertainly as an apprentice grocer, he decided to become a painter and attended evening classes at the Belfast College of Art. He also received encouragement and guidance from J. Humbert Craig (q.v.).

In addition to exhibiting at the Ulster Academy of Arts at an early age, becoming ARUA in 1964, he showed seventeen landscapes at the Royal Hibernian Academy between 1935 and 1966, including: 1935, *Trees on the Lagan*; 1939, *Ducks near the Blackwater*; 1944, *Dunfanaghy, Co. Donegal*; 1948, *Passing Shower, Mourne Mountains*; and 1964, *Rain on the Roofs*.

Cooling Galleries, Albermarle Street, London, handled his work, mainly Irish landscapes but also some marine scenes including yachting on the Solent. Many of his paintings were sent by Cooling to their gallery in Toronto, Canada; others to the USA. Smaller works were generally sold in London at the Deighton Gallery.

A member of the Ulster Arts Club, Hill participated in their shows. He was represented when the club held an exhibition at the Ulster Government Office, London, in 1962. In Belfast, he also exhibited at the Magee Gallery, 1965, and the 1960s saw a series of exhibitions at the Anderson & McAuley store.

On some of his painting expeditions to Donegal he was accompanied by Theo. Gracey and Padraic Woods (qq.v.). He also painted in Connemara and the counties of Antrim, Down and Galway. Seascapes with boats often featured Belfast Lough. He died in Belfast on 13 March 1979.

Works signed: Rowland Hill.
Examples: Department of the Environment for Northern Ireland.
Literature: *Belfast Telegraph*, 1 August 1964; Magee Gallery, *Rowland Hill*, catalogue, Belfast 1965; *News Letter,* 20 January 1966; Anderson & McAuley Ltd, *Rowland Hill*, catalogues, 1966, 1968, 1969, 1970; *Who's Who in Art*, Havant 1980; Ann M. Stewart, *Royal Hibernian Academy of Arts: Index of Exhibitors 1826-1979*, Dublin 1986; Newman & Cooling Ltd, *Letter to the author,* 1987.

HOAD, JEREMIAH (1924-99), landscape painter. Born on 13 September 1924 at Fife in Scotland, Jeremiah Philip Edward Hoad was the son of an Irish father, Philip George Hoad, an RAF quartermaster. In 1939 the family moved to England. Jeremiah obtained in 1941 a county scholarship to Winchester School of Art, where he qualified as a teacher.

At Camberwell School of Art he taught full-time 1947-57 but resigned because he was 'browned off' by the constant controversies over what constituted Fine Art. He then taught drawing and painting for nine years at the Frank Hooker Secondary Modern School, Canterbury.

In 1967 he moved to rural Wales so that he could paint and his wife Judith write. In 1971 they created a business, Lluniau Cymreig — literally, Welsh Pictures — to market postcards and prints from black and white drawings by Jeremiah. There were almost 150 postcards alone, probably the first bi-lingual ones to be offered in Wales. In 1981 he held a one-person show at Oxford Playhouse Theatre, and that year he and his wife settled in Donegal with their three children.

Judith Hoad's second book, *This is Donegal Tweed*, appeared in 1987 with line drawings by her husband and a painting for the cover. In 1988 he exhibited West of Ireland paintings at The Gallery, Ascot, Berkshire, including *Inver Herrings; Sunlit Snowscape in Donegal*; *Thorn Tree in The West of Ireland*; *Moonlight and Child on a Beach*. In Ireland, his first show was held in 1991 at the Gorry Gallery, Dublin, where fifty-seven works were hung, all oils with the exception of three pastels. Among the oils were: *The Wee House-Gweedore*; *Dusk at Teelin*; *After a Rain Storm*; *North Mayo*; *Honeysuckle and Fuchsia*; *View of Muckish*.

James Gorry wrote in the 1991 catalogue: 'Immersing himself in the countryside, he conveys to the viewer his own very personal experience at a given time — with rainbows, 'moonbows', sunlight and shade, rainstorms, indeed every facet of nature carefully observed and celebrated in paint. His powerful yet sensitive expression of the phenomenon of light has a mystical, almost magical quality.'

In 1991 a Welsh film company, commentary in Welsh, produced 'The Hoad Family on St Patrick's Day', and two years later came Radio Telefis Éireann's radio programme, 'Judith, Jeremiah and Jens in the Rainbow'. In his second exhibition at the Gorry Gallery in 1994 he provided fifty-two oil paintings, including *Storm at Achill*; *Camille's Studio*; *Cherries on a Dish*; *Seals on the Strand of the Great Blasket*; *Clare Island*.

Swirling shapes and bird's eye views were often a feature of his work. His isolation and almost hermit life style in Donegal was by choice. Hoad maintained that throughout the twentieth century man had alienated himself from his organic environment. This disharmony, he claimed, was 'reflected in the Arts of the period. It is time for us all to reconstruct our relationships with the Natural World.' Painting excursions were facilitated by his old bicycle. He died on his 75th birthday, 13 September 1999, at his Inver home, and was buried in the orchard. A memorial celebration of his life was held in October at the Royal Hibernian Academy.

Works signed: J. Hoad or Hoad.
Literature: Judith Hoad, *This is Donegal Tweed*, Inver 1987 (illustrations); The Gallery, *Jerry Hoad*, catalogue, Ascot 1988 (also illustrations); Gorry Gallery, *Jeremiah Hoad*, catalogue, Dublin 1991 (also illustrations), also 1994; Mrs Judith Hoad, *Letter to the author,* 1999; *Irish Times,* 15 September 1999.

HOGAN, JOHN V. (1841-1920), sculptor. John Valentine Hogan was the eldest son of a sculptor, John Hogan (1800-58) who was born at Tallow, Co. Waterford, and was sent for training to Rome in 1824. John Valentine was born there on 14 February 1841. His father had married Cornelia Bevignani, who bore eight daughters and three other sons. As a consequence of the Italian revolutionary movements, John Hogan and his large family left Rome for Ireland in 1849. In Dublin, John Valentine entered St Francis Xavier's College (later Belvedere College) in 1856 along with his brother Richard who was a year younger.

In his last days John Hogan was said to have looked in sorrow at a work in his studio for St Saviour's Church, Dominick Street, and remarked to his son and his assistant: 'Finish it well boys; I shall never handle the chisel more!' At his death in 1858 he left one major commission unfinished, the gigantic panel for the Wellington Memorial, an enormous obelisk situated in Phoenix Park. Hogan's was on *Catholic Emancipation* or *Civil and Religious Liberty*. John Valentine, aged seventeen, wrote to Lord Carlisle, the Viceroy: 'I respectfully solicit from your Excellency the completion of this work, as it is my intention to proceed to Rome, where I can have it executed for your extreme satisfaction.'

Accompanied by his mother, in October 1858 he left Ireland for Rome where he was to execute the full size work from his father's sketch model under Giovanni Benzoni (1809-73), his father's special friend among Roman sculptors.

Some time before John Hogan's fatal seizure he completed a design for a Father Mathew statue for Cork, for which he was to receive one thousand pounds. This work was not undertaken by him because of poor health but John Valentine hopefully submitted a model from his father's design; alas, the committee rejected it and the work was given to J.H. Foley (1818-74).

So far as the Royal Hibernian Academy was concerned, John Valentine never exhibited there. *Shepherd Boy*, contributed by his father to the 1850 exhibition was described in the catalogue as 'unfinished' and may have been completed by the son. Marble, it is in Iveagh House, Dublin. *The Transfiguration* at the 1878 RHA was 'finished by his son John V. Hogan'. *Portrait of John Hogan*, plaster low relief in the National Museum of Ireland, is probably by him.

On a more positive note, John Valentine is the sculptor of the *Mary Immaculate* in the Pro-Cathedral, Dublin, and the *Spring Memorial* in Glasnevin cemetery. He is credited as the model for the angel on the memorial by his father to Peter Purcell in the Pro-Cathedral. In St Andrew's Church, Westland Row, there is a bust of Dean Walter Meyler, who died in 1864, in an attitude of prayer. At Loreto Abbey, Rathfarnham, is *The Saviour*. His sister, Mother Clement Hogan, taught art at the school.

The memorial to Carolan, 1874, executed in Rome, a bequest made in her will by Sydney Lady Morgan, is in St Patrick's Cathedral, Dublin, and unsigned. The work is in white marble bas relief and the bard is represented seated, and touching the Irish harp. According to the *Irish Builder*, quoting from 'a daily contemporary', his costume is that of the period of his death. 'The figure and harp are raised on a tondo or circular base, and are nearly five foot high. The features of the bard have been reproduced from an engraving by Rogers and an old picture in the possession of the Royal Irish Academy, which from the likeness of the face in the engraving is manifestly a portrait of Carolan ...' According to 'Benmore' (John Clarke) in his *Memorials of John Hogan, the Great Irish Sculptor*, John Valentine had a long period in poor health. He died in Rome on 20 March 1920.

Examples: Dublin: Glasnevin Cemetery; Loreto Abbey, Rathfarnham; St Andrew's Church, Westland Row; St Mary's Pro-Cathedral; St Patrick's Cathedral.

Literature: *Irish Builder*, 15 August 1874; 'Benmore' (John Clarke), *Memorials of John Hogan, the Great Irish Sculptor*, Glenarm 1927; Homan Potterton, *Irish Church Monuments 1570-1880*, Belfast 1975; John Turpin, *John Hogan: Irish Neoclassical Sculptor in Rome 1800-1858*, Dublin 1982; Ann M. Stewart, *Royal Hibernian Academy of Arts: Index of Exhibitors 1826-1979*, Dublin 1986.

HOGAN, KATHLEEN – see VERSCHOYLE, KATHLEEN

HOLLAND, MICHAEL (1855-1950), topographical artist and illustrator. Born in Clonakilty, Co. Cork, his parents moved to Cork city when he was very young and he spent most of his life there, residing for many years at 8 North Mall. He was a student at Cork School of Art and while there won some distinction. In 1875 he was a twenty-year-old boardroom clerk with James Dwyer's concern. Alderman Dwyer was connected with the reception and entertainment of John Mitchel, who arrived unwell in the city. Holland made a small drawing of him when he was confined to bed. An admired example of Holland's work was the illuminated address presented to Charles Stewart Parnell on one of his visits to Cork in the heyday of his popularity.

Before long Holland utilised his artistic knowledge when he started a hand-made lace industry. The Cork Historical and Archaelogical Society was founded in 1891, and he enrolled as a member the following year, for the rest of his life taking an intense interest in the affairs of the Society, filling in turn almost every official position, including editor of the Society's *Journal*, to which he contributed more than forty articles. It was his custom for many years with a chosen companion or two to go tramping during week-ends to places of historic or antiquarian interest. He was also devoted to the study of natual history.

During his trips he made much use of pen and pencil. As a result, most parts of the county were familiar to him. He was an authority on the life and growth of Cork city. During the latter years of his life he took pride in the illustrated historical strips which appeared regularly in the *Cork Examiner* and *Cork Weekly Examiner*. The Cork Public Library holds more than 200 of the originals. The strips, written and illustrated by himself, were based on some event, place, incident in local history or in the lives of well-known Corkmen. In Kinsale Regional Museum is a pencil and wash drawing of the wreck of the *City of Chicago* off the Old Head of Kinsale, July 1892.

Portrait of a Gentleman in the Crawford Municipal Art Gallery, Cork, is by Henry Jones Thaddeus (q.v.) and is inscribed Michael Holland, 1920. In his later life he was described as a 'slender, white-haired figure ... walking with short, nimble steps, alert, keen, kind and learned'. He was the father of Catherine Holland, an heraldic artist who worked in England and who was a friend of Robert Gibbings (q.v.). Michael Holland died on 6 November 1950 at the South Infirmary, Cork.

Works signed: MH, monogram.

Examples: Cork: City Library. Kinsale: Regional Museum.

Literature: *Cork Examiner*, 7 November 1950; *Journal of the Cork Historical and Archaelogical Society*, 1950; Richard J. Hayes, *Sources of Irish Civilisation:Articles in Irish Periodicals*, Boston 1970; *Evening Echo*, 30 December 1985; C.J.F. MacCarthy, *Letters to the author*, 1987.

HOLMES, SOPHIA – see MILLER, P.H.

HONE, EVIE, HRHA(1894-1955), stained glass artist. Evie Sydney Hone was the youngest of four daughters of Joseph Hone, maltster, of M. Minch & Son Ltd, and was born on 22 April 1894 at Roebuck Grove, Donnybrook, Co. Dublin. Her mother, Eva, was the daughter of Sir Henry Robinson, and she died two days after Evie's birth. The Hone family was long settled in the Dublin area. Evie was a great-great-great granddaughter of Joseph Hone, a brother of the portrait painter, Nathaniel Hone, RA (1718-84), and father of Horace Hone (1756-1825) and John Camillus Hone (1759-1836), both portait painters. Early members of the family had trade relations with Flanders; family tradition is of a Flemish origin. Remarkably, Galyon Hone was the pupil of another Flemish glass-worker who had emigrated from Flanders to England and had succeeded him as King's Glazier in 1517.

Within weeks of her twelfth birthday, Evie Hone became a victim of infantile paralysis and was thereafter lame; a hand was also affected. Mary Swanzy (q.v.) told the author in 1968: 'Evie was sent abroad with her governess to see a specialist at Ouchy, Switzerland, where she stayed about six months, returning to London with her mind directed to art and her body subject to more medical treatment ... she had heaps of courage and never mentioned her disabilities.'

Education from a governess continued. Having regained some mobility, she visited Italy in May and June of 1914 and included Assisi, Venice and Florence where the work of Giotto of the fourteenth century left a lasting impression. Some years later she visited Spain and El Greco (1541-1614) was admired. Throughout most of her life she had a constant companion.

In London before the First World War she studied at the Byam Shaw School of Art, moving in wartime to the Central School of Arts and Crafts, where she found a stimulating teacher in Bernard Meninsky (1891-1950). She attended some classes at Westminster Art School under Walter Sickert (1860-1942). Mainie Jellett (q.v.), who was to become her lifelong friend, also studied under Sickert at Westminster. They first met in 1917 in London. Meninsky advised Evie Hone to continue her studies in Paris, and in 1920 she departed, being followed some months later by her friend. For the next ten years they pursued their studies together in France, spending some months there nearly every year.

Hone and Jellett became students of André Lhote (1885-1962), painting landscapes, portraits and other work with a Cubist tendency. Before long they persuaded Albert Gleizes (1881-1953) to give them lessons. He has recorded 1921 as the year of their first meeting at his atelier at Puteaux, where they received instruction in what he called 'translation and rotation'. Sometimes they travelled to Gleizes' studio at Serviéres in the Ardèche. A watercolour of Gleizes' home, *St Rémy de Provence*, by Evie Hone is in the Crawford Municipal Art Gallery, Cork.

In 1924 Evie Hone and Mainie Jellett held a joint exhibition at the Dublin Painters' Gallery. Evie also exhibited with the group from time to time. Mild wonder was expressed that the works at the joint show could be taken seriously. *The Studio* commented: '... excited vehement controversy ... None of the works bore a title, and the vast majority of them were as far removed from any effort at representation as they could possibly be... The few essays in representational art which these two ladies exhibited, when judged by ordinary standards, seemed no better and no worse than the productions of the average uninspired art student in her teens.'

Unexpectedly, she joined in 1925 a community of Anglican nuns in Truro, Cornwall, and it seemed that she had broken completely with art. This intermission lasted more than a year. She resumed her studies with Gleizes, who accepted drawings by post for critical examination. Both Irish artists were elected to the group Abstraction-Creation and their pictures were reproduced in journals published by that society in Paris. Their work was also accepted in the exhibitions of the Salon des Indépendants, Salon des Surindépendants and the Salon d'Automne. Between 1926 and 1931 Evie Hone was a member of the 7 & 5 Society in London. In the period 1931-46 she showed forty-three works at Water Colour Society of Ireland exhibitions; about one-third were designs for stained glass.

Apparently tiring of abstract art, she began to study the problems of stained glass, visiting Chartres and Le Mans. The work of the French painter, Georges Rouault (1871-1958) also influenced her. She made three designs for small panels, showed them to Sarah Purser (q.v.) of An Túr Gloine who suggested she should join the class run by A.E. Child (q.v.) in the School of Art. After a short spell there, she went to London

where the illustrator, Arthur Rackham (1867-1939) advised her to seek out a craftworker. Accordingly, she consulted Wilhelmina Geddes (q.v.) and in the latter's kiln converted her designs for the first time into glass. Roland Holst (1868-1938) was a noted Dutch teacher and stained glass artist and through the good offices of her fellow-artist, Hilda van Stockum, she took her 1933 panels to him in Amsterdam – presumably accompanied by Mainie Jellett as in that year they also visited Antwerp – and he insisted that stained glass was her calling. From these panels *The Annuciation* and two abstracts were arranged in 1934 into one window for St Nathi's Church, Dundrum, Co. Dublin.

In 1933 she entered An Túr Gloine and was to remain there until Miss Purser's death in 1943. Working beside the helpful Michael Healy (q.v.), she increased her technical knowledge. In Blackrock College in 1937 she was received into the Catholic Church by the Most Rev. John Charles McQuaid, DD. At this time, she was responsible for armorial and decorative windows in the College Chapel. In the College Castle Chapel is a three-light, *Pentecost*.

Despite her physical handicaps, she worked continuously, and showed stained glass at the Glasgow Empire Exhibition in 1938. At the Salon d'Automne in 1938 she and Mainie Jellett were represented in an exhibition of works by students of Albert Gleizes. In her *Modern Art in Ireland*, 1997, Dorothy Walker suggested that Hone may have been inspired by the untimely death of Harry Clarke (q.v.) to carry on his religious work 'although her style was very different from his, much less fantastical and theatrical, more humble, imbued with an almost Franciscan spirit of compassion and mercy...'.

In the first five years of her stained glass commitment, the most important commission was that given by the Department of Industry and Commerce for the Irish Pavilion at the New York World Fair, 1939. *My Four Green Fields*, 6.4 metres by 2.4 metres, was to win first prize for a work in stained glass. The arms of the Irish provinces were freely translated in an otherwise purely abstract design. This window is probably the sole example of a secular window of its size created in Ireland. It was on loan to Córas Iompair Éireann at 59 Upper O'Connell Street, Dublin, but is now installed in Government Buildings, Merrion Street.

In 1941, after a serious operation and following on the death of Michael Healy, she undertook to continue for Clongowes Wood College the series of *The Seven Dolours*. Healy had finished three subjects and she completed three more. A noteworthy contribution for St Brendan's Cathedral, Loughrea, Co. Galway, was *Saint Brigid*, completed in 1942. In the early 1940s she was responsible for three windows, all crests, at Rockwell College, Cashel, Co. Tipperary. Her friendship with the Rev. Donal O'Sullivan resulted in the appearance of many of her works in churches throughout Ireland. The Jesuits were her main patrons and it was he who commissioned the five striking windows for the chapel at St Stanislaus College, Tullabeg, Co. Offaly; *The Nativity* and *The Beatitudes* there were high in the artist's affection. The college became a retreat house but the Jesuits left in 1991. Eventually, the five windows were transferred to a new building designed as a prayer room at Manresa House, Dollymount, Dublin, thus the windows were kept in the possession of the Society of Jesus.

In 1944 An Túr Gloine was formally dissolved as a co-operative and Evie Hone opened a studio of her own at Marlay Grange, Rathfarnham, Co. Dublin. In 1947 for the chapel at University Hall, Lower Hatch Street, Dublin, she supplied five windows and employed symbols. Her 1947 window at Lanercost Priory in Cumbria depicted Saint Cecilia in a local background. At St Anne's Hospital, Northbrook Road, Dublin, is a window, *St Anne and Our Lady*, over the front door. The artist herself suggested the background of broken green glass.

Some of her finest work, 1947-48, is in the Church of the Immaculate Conception (formerly St Mary's Church) at Kingscourt, Co. Cavan, where there are three two-light and one three-light windows. *Ascension*, two-light, she regarded highly and C.P. Curran wrote of it: 'I do not think there is in Ireland a lovelier window or one of more original design or of more tender colour or that moves one more by its imaginative beauty...'

The windows at Tullabeg and Kingscourt influenced Lord Crawford and Sir Jasper Ridley, particularly the latter, to put forward Evie Hone's name in 1949 for the replacement for one of the great windows in Eton College chapel destroyed in 1940 by a bomb. After some hesitation, she accepted the commission. The equipment of her studio at Dower House, Marlay, Rathfarnham, had to be enlarged and some additional help

engaged. Her studio was close to St Columba's College and she used the gymnasium there to inspect her cartoons.

This East window was placed in position in 1952, an admired masterpiece 10.4 metres in height by 8.8 metres wide but not, as sometimes claimed, the largest church window in the country. She was also responsible for two side windows at Eton. In detailed notes provided by the artist, she divided the large window into three sections, the Tracery Lights, The Crucifixion and The Last Supper, with the apex of the arch, The Dove of the Holy Spirit. The Crucifixion has nine lights with the central one Christ on the Cross. In The Last Supper the central light is Christ; and, for example, first and second lights, Melchizedek; eighth and ninth lights, The Sacrifice of Isaac.

Of her other work in England, the five-light window at St Michael's Church, Highgate, London, 1954, ranks high. Altogether, she received more than fifty commissions for stained glass in Ireland and abroad. Stained glass apart, she was represented at the Irish exhibition at Brussels, 1930. She showed eleven works, including four stained glass designs, at the Royal Hibernian Academy between 1931 and 1937. When the Dublin Painters exhibited in 1938 at the London Office of the High Commissioner for Ireland, she showed a design for stained glass.

The Contemporary Picture Galleries, Dublin, also hung her work, and subsequently the Dawson Gallery, Dublin. At the Contemporary in 1941 she presented a group of drawings based on the tombs at St Canice's Cathedral, Kilkenny. A founder member with Mainie Jellett in 1943 of the Irish Exhibition of Living Art, she exhibited in that year at St Michael's Workshop, Oxford. The White Stag Group in Dublin also displayed her work. After her exhibition at the Dawson Gallery in 1945, the *Dublin Magazine* stated: '... her inspiration is largely derived from the sculpture on the Irish medieval crosses. In fact there is little difference in spirit between her original work and her drawings from stone carvings at Cashel, Kells and Kildare.'

At the Church of St Peter and Paul, Kiltulla, Athenry, Co. Galway, are framed oil paintings of the Stations of the Cross, 1946. In 1948 she embarked on an extended tour in Central Italy, ending with a visit to Ravenna. At the Irish Exhibition of Living Art that year she showed *Village near Assisi* and *Square, Arezzo*. Our Lady of the Rosary Church was built in Limerick in 1949. Her *Baptism of Christ* was originally in the main porch but it was transferred to the baptistry where it now has two side panels, *Nativity* and *Resurrection of Christ* by John and Roisin Murphy.In 1953 she was represented at the Contemporary Irish Art exhibition at Aberystwyth. Her activities also included the designing of Christmas cards for the Cuala Press.

The Tate Gallery, London, holds a design in gouache, *The Crucifixion and Last Supper*, for the East window of Eton College chapel, bequeathed by the artist's sister, Mrs Nancy Connell. A scale drawing, from which the window was made, belongs to the National Gallery of Ireland. A cartoon is at St Patrick's College, Maynooth, but also there are two pieces of stained glass, *O Death, where is thy Victory?* and *The Deposition*. *The Cock*, stained glass, was presented by the Friends of the National Collections of Ireland to the Hugh Lane Municipal Gallery of Modern Art. *The Deposition* is also in the gallery's collection. *St. Hubert*, stained glass, is in the Crawford Municipal Art Gallery, Cork, where there are also unsigned gouaches and watercolours. An untitled gouache is in Wexford Arts Centre. *Saint Veronica* is in St Mel's Diocesan Museum, Longford. *Ardmore, Co. Waterford*, gouache, is at the Ulster Museum, and *In the Woods at Marlay*, watercolour, is in the Kilkenny Art Gallery Society collection.

Evie Hone and *Evie Hone at Work in her Studio*, paintings by Hilda van Stockum, are in the National Gallery of Ireland, where the collection also includes Evie Hone's *Snow at Marlay*. In 1953 the degree of LL D *honoris causa* was conferred by Trinity College, Dublin. In that year the artist suffered a stroke. Early in 1955 the Royal Hibernian Academy elected her an honorary member. After a lifelong struggle against polio and arthritis, Evie Hone died on 13 March 1955 as she was entering her parish church, St Joseph's, Rathfarnham. She was buried in the graveyard of St Maelruain's Church, Tallaght, Dublin.

A small memorial exhibition was held in 1955 at the Irish Exhibition of Living Art. Her valuable bequest to the National Gallery of Ireland included a collage by Pablo Picasso (1881-1973), another by Juan Gris (1887-1927), a 1923 painting by Gleizes and a work by Jean Marchand (1883-1940). In 1957 the Dawson Gallery hosted an exhibition of her abstract paintings as well as one for religious and secular works.

The memorial exhibition of drawings, paintings and stained glass was held in 1958 at University College, Earlsfort Terrace, Dublin; attendance exceeded 22,000. An outstanding feature was the inclusion of four large stained glass windows: *The Beatitudes* and *The Last Supper* from St Stansilaus College, Tullabeg; *The Ascension* from St Mary's Church, Kingscourt; and *My Four Green Fields*. These were erected in a specially designed pavilion with lighting. Expenditure then was the highest ever for an Irish art exhibition. In 1959 the exhibition moved to London at the Arts Council Gallery and Tate Gallery. *My Four Green Fields* had to be omitted as too large. In 1968, in connection with the Queen's University Festival, an exhibition was held in Belfast. In 1969 the Eton College chapel window was featured on an Irish postage stamp.

Works signed: E. Hone or Evie Hone (if signed at all).
Examples: Windows only: Ardara, Co. Donegal: Church of the Holy Family. Belfast: Dominican Convent, Falls Road; St John's Church, Malone Road. Blackrock, Co. Dublin: Blackrock College; Church of St John the Baptist. Bournemouth, Dorset: Catholic Church. Boyle, Co. Roscommon: Church of Ireland Church. Cashel, Co. Tipperary: Rockwell College. Clonsilla, Co. Dublin: St Mary's Church. Cloughjordan, Co. Tipperary: Church of Saints Michael and John. Cork: Collins Barracks; Crawford Municipal Art Gallery. Dolgellan, Wales: Church of Our Lady of Sorrows. Downe, Kent: St Mary the Virgin Church. Dublin: All Hallows College, Gracepark; Cathal Brugha Barracks; Government Buildings, Merrion Street; Holy Ghost Fathers: Kimmage Manor, Whitehall Road; Hugh Lane Municipal Gallery of Modern Art; Incorporated Law Society of Ireland, Blackhall Place; Irish Museum of Modern Art; Jesuit Order: Cherryfield Lodge, Milltown Park; Manresa House, Dollymount; Taber House, Milltown Park; University Hall, Lower Hatch Street; National Gallery of Ireland; St Anne's Hospital, Northbrook Road; St Thomas's Church, Foster Avenue; Sandymount Methodist Church; Terenure College, Templeogue Road. Dundrum, Co. Dublin: St Nathi's Church. Eton, Berks.: Eton College. Ettington, Warwickshire: Ettington Park Private Mortuary Chapel. Fahan, Co. Donegal: St Mura's Church. Galway: Magdalen Convent. Greystones, Co. Wicklow: Church of the Holy Rosary. Howth, Co. Dublin: St Mary's Church. Kilmilkin, Co. Galway: Church of the Nativity. Kingscourt, Co. Cavan: Church of the Immaculate Conception. Lanercost, near Brampton, Cumbria: Priory. Limerick: Our Lady of the Rosary Church. London: Jesuit Church, Farm Street; St Michael's Church, Highgate; Tate Gallery; Victoria and Albert Museum. Loughrea, Co. Galway: St Brendan's Cathedral. Lusk, Co. Dublin: St MacCullin's Church. Maynooth, Co. Kildare: St Patrick's College. Naas, Co. Kildare: Clongowes Wood College. Newbridge, Co. Kildare: County Library. Peterswell, Co. Galway: Church of St Thomas the Apostle. Pittsburgh, Pennsylvania: University. Tara, Co. Meath: The Hill of Tara (formally St Patrick's Church). Washington, USA: Cathedral. Wellingborough, Northampton: All Hallows Church.
Literature: *The Studio*, September 1924, September 1938; *Academy of Christian Art Journal*, Vol. 1, Part 2, 1938; *Irish Times,* 27 November 1941, 1 and 2 August 1969, 6 and 29 March 1973, 21 and 23 November 1977, 16 February 1982, 12 March 1986, 9 June 1986; *Dermod O'Brien Papers,* Trinity College, Dublin; *Dublin Magazine*, January-March 1946, October-December 1955; Thomas MacGreevy, *Capuchin Annual*, 1949; *Belfast Telegraph,* 4 May 1953; *The Tablet,* 26 March 1955; C.P. Curran, *Studies,* Summer 1955, Winter 1965; Stella Frost, ed., *A Tribute to Evie Hone and Mainie Jellett,* Dublin 1957 (also illustrations); James White, *Evie Hone,* memorial exhibition, catalogue, Dublin 1958 (also illustrations); Eileen MacCarvill, *Mainie Jellett, The Artist's Vision,* Dundalk 1958; *Eire/Ireland,* 1 October 1958; *Arts Council Report, 1958-59,* Dublin; James White and Michael Wynne, *Irish Stained Glass,* Dublin 1963 (also illustrations); *Tate Gallery Modern British Paintings, Drawings and Sculpture,* London 1964; Michael Wynne, *Irish Stained Glass,* Dublin 1977 (also illustrations); G.K. White, *Letter to the author,* 1979; also, Our Lady of the Rosary Church, 1980; Eton College, 1982; Ann M. Stewart, *Royal Hibernian Academy of Arts: Index of Exhibitors 1826-1979,* Dublin 1986; Oliver Hone, *Letters to the author,* 1987; Catholic Press and Information Office, *Letter to the author,* 1987; also, Jesuit Order, 1987; Lanercost Priory, 1987; Rockwell College, 1987; St Anne's Hospital, 1987; G.V. Walsh, 1991; Anthony Symondson, 'A New Setting for Evie Hone's Rahan windows', *Irish Arts Review Yearbook,* 1995; *Water Colour Society of Ireland Exhibition List 1872-1994,* Dublin 1995; Dorothy Walker, *Modern Art in Ireland,* Dublin 1997(also illustrations).

HONE, NATHANIEL, RHA (1831-1917), landscape painter. Born on 26 October 1831 at Fitzwilliam Place, Dublin, Nathaniel Hone, who had four sisters and eight brothers, was the son of Brindley Hone, lawyer and company director. Nathaniel was a great-grandson of another Brindley Hone, pin manufacturer, a brother of the portrait painter, Nathaniel Hone, RA (1718-84). The Hone family was Flemish, according to family tradition, but the branch in Ireland is some three centuries old.

Nathaniel Hone, entering shortly before his fifteenth birthday, studied Engineering and Science at Trinity College, Dublin, and graduated in 1850. He worked as an engineer on the making of the Midland Great Western Railway of Ireland. He was interested in painting, and the outdoor life suited him. Members of the

family were keen yachtsmen, too. Later in life he presented one of his beach scenes, a pony and cart collecting seaweed, to the Royal Irish Yacht Club, Dun Laoghaire, Co. Dublin.

On deciding to become a painter, a family friend, William Armitage, put him in touch with Adolphe Yvon (1817-93), the French battle painter, and in 1853 he went to Paris, one of the earliest of the Irish painters to study abroad. During his spell with Yvon, he registered as a copyist in the Louvre; and there became friendly with Henri Fantin-Latour (1836-1904). He then worked in the atelier of another historical painter, Thomas Couture (1815-79), and met Edouard Manet (1832-83). He worked hard for three or four years drawing and painting from the model. He visited Fontainebleu in 1855 and painted the old church at Bourron-Marlotte, where there was a colony of artists. The English artist, G.F. Watts (1817-1904), was in Paris in 1856 and met Hone, their studios being in the same house.

About 1857 he moved to the village of Barbizon, some seven miles from Fontainebleu. Unlike many of the painters there, Hone was financially independent. He knew Jean Francois Millet (1814-75) and Charles Jacque (1813-94), and recounted how the former was glad to sell a picture for forty francs in the early days of their acquaintanceship. He remembered Millet as 'charming'. In 1862 a Hone landscape was hung at the Royal Hibernian Academy. By 1865 Hone had moved from Barbizon across the Forest to Bourron-Marlotte. Here he met Henry Joseph Harpignies (1819-1916), who became his closest friend in France. Both exhibited at the 1881 RHA.

Hone also met Theodore Rousseau (1812-67) and of Gustave Courbet (1819-77) he said: 'I met him often, he was a very impetuous, foolish fellow, but a fine painter.' Another friend was J.-B.C. Corot (1796-1875) with whom he dined, thirty-five years the master's junior and a great admirer of his work. *The Boundary Fence, Forest of Fontainebleau* is small, 39 by 60 cm, but is considered one of Hone's finest paintings under Barbizon School 'truth to nature' influence.

Hone stayed in France for seventeen years – he visited home regularly – and lived for the most part at Barbizon or Fontainebleu yet he was one of the least-known Barbizon painters. He exhibited at the Paris Salon in 1865, 1867, 1868 – including *Le Port de Roscoff, Finistère* – and 1869, sending from 44 Rue Notre Dame de Lorette; seven paintings accepted by the Salon in four years.

As well as the Fontainebleu landscapes, he also painted at Trouville, Normandy. *Study from Nature* appeared at the Royal Academy in 1869. He spent considerable time travelling. Landscapes were painted in the Alpes Maritimes, and he also worked at many villages along the Mediterranean coast, for example Cannes, Villefranche, Antibes and Menton.

In Normandy, he painted *A View of the Cliffs at Étretat* which is in the National Gallery of Ireland collection. In Paris he was friendly with J.E.E. Brandon (1831-97) and stayed at his apartment in Rue Notre Dame de Lorette. In 1870 Brandon painted a portrait of a bearded Hone, wearing a dark coat, light trousers, and high-heeled French boots. This work is also at NGI. The portrait may have been painted just before Hone left for Italy, where he spent eighteen months or so. Also at NGI is a portrait of Hone by Walter Osborne (q.v.). After the end of the Franco-German War in 1871, he returned to France. The German soldiers had used his house at Bourron-Marlotte. Many of his things had either disappeared or been damaged, a discovery that may have prompted him to leave the country.

Hone returned to Ireland and in 1872 married Magdalen, daughter of John Jameson of the wealthy distilling family. The couple went on an extended honeymoon to the Continent. Hone painted a number of scenes at the Bay of Nice, including *Petite Afrique*, from Saint Jean, one of his finest works. At home, the Dublin Sketching Club was inaugurated in 1874 and he was an early member; later, he was made an honorary one. In 1876 at the RHA he exhibited *Coast near Bordighera* and *Stone Pines, near Cannes*. With the exception of a few odd years, he exhibited regularly in Dublin until his death, averaging about four works per RHA exhibition. He was made an associate of the RHA in 1879 and a full member in 1880. His work was in the Water Colour Society of Ireland's exhibition of 1882. When he showed at the Cork Industrial Exhibition of 1883 his address was Seafield, Malahide, Dublin. About this time he painted *Evening, Malahide Sands,* which he later presented to the Municipal Gallery of Modern Art, Dublin.

As well as the South and East Anglian coasts of England, he visited Scheveningen on the Dutch coast and a painting so titled was hung at the RHA in 1886. The following year he was in Paris, visiting a sick friend,

and he painted in Corfu, Greece and Constantinople. At the Irish exhibition in London in 1888 he showed *The Pont de Garde*, and that year he visited Germany. Between 1886 and 1894 he contributed to the short-lived Dublin Art Club. At that club's exhibition of 1889 he showed his painting of Saint Patrick, 2.4 metres by 6 metres, executed for the Kyrle Society, and when erected in a ward in Sir Patrick Dun's Hospital bore the title: *Saint Patrick with Seven Missionaries take the form of Deer to pass through a Hostile Country. Off Lowestoft*, c. 1891, he presented to the Municipal Gallery of Modern Art.

In 1892 he visited Holland, Turkey, Greece, Egypt – *The Sphinx* (NGI) – and from Cairo he corresponded with Sarah Purser (q.v.). When living at Moldowney, Malahide, he was elected in 1894 Professor of Painting at the RHA and held the post until his death. St Dolough's Park, Raheny, was inherited from his uncle in 1895 and he continued to paint and farm for the rest of his life. Many of his finest pictures are from scenes in the neighbourhood, for example *The Pasture at Malahide* (NGI), 82cm by 124 cm.

In his book on five years in Ireland, published in 1901, Michael J. F. McCarthy wrote: 'Mr. Hone is freely criticised every year for his well-known pasturages in the broadest style; but I think his drawing is marvellously good, and his effects wonderful. I know those cattle of his, particularly the Hereford heifer at Malahide in his picture of this year [1900]; in my opinion, the best picture in the Academy.'

Sarah Purser organised an exhibition of his pictures – twenty-one – and those of John Butler Yeats (q.v.) at 6 St Stephen's Green, Dublin, in 1901, and Hugh Lane's interest in Irish contemporary art was fired. His aunt, Lady Gregory, wrote that he was much excited – 'ran about Dublin talking of them and wanted to buy the whole collection'. George Moore wrote a preface for the catalogue and said of Hone: '... the influence of France is not apparent in his work. His painting is somewhat abstract. It is not so vivacious as a Frenchman's. It is, perhaps, a little apathetic, the painting of a man who lives in a flat country where life is easy and indolent. Therefore, his painting reminds me of the modern Hollanders, whom I don't admire, but I do admire Mr Hone ... but we should like a little more intimate and personal life in his canvases than he cares to put into them ...' The sculptor, John Hughes (q.v.), then living in Dublin, wrote to Miss Purser: 'George Moore was here ... He says Hone just missed being a great artist. That a man may struggle against poverty but no man can struggle against wealth.'

Late in his career, Walter Osborne (q.v.) had become friendly with Hone, whom he visited at Malahide. Hone was shocked by the death of Osborne, whose portrait of him was the last he ever painted. According to Paul Henry (q.v.) in *Further Reminiscences*, his studio in Merrion Row had been used by both Hone and Osborne. When Hugh Lane organised the exhibition of Irish artists at the London Guildhall in 1904, Hone was represented. In 1905 he joined a committee to work for a Gallery of Modern Art in Dublin. No fewer than sixteen of his works were in the Franco-British exhibition of 1908. *The Pasture at Malahide* had been shown at the Guildhall in 1904 and again in the Irish International Exhibition, Dublin, 1907, a year in which he exhibited at the Oireachtas and (Sir) William Orpen (q.v.) painted his portrait. Another fellow artist, J. Crampton Walker (q.v.) described Hone's work as being painted in 'low and restrained tones, but with great dignity, a grace of freedom, a subtlety of tone and poetic beauty ...'

Julian Campbell said he was a 'painter of cows and sheep, but not strictly an animal painter. He was a painter of sailing vessels and seascapes, but not a conventional maritime artist. He was interested in archaelogical subjects, but not a topographical artist ... Hone is a great painter of the elements: land, sea, and sky, light and weather, and the "mood" of nature.'

Hone showed four works at the Walker Art Gallery, Liverpool. His work was also presented in the Whitechapel Art Gallery, London, in 1910, at the International exhibition in Rome, 1911, at a Belfast loan exhibition in the same year, and at the Oireachtas exhibition in Dublin. The exhibition of Irish art at the Whitechapel Art Gallery in 1913 produced fourteen paintings.

Hone painted and exhibited so many pictures with similar titles, particularly for the Malahide area, that identification is difficult. He rarely exhibited watercolours, which were mostly small and unsigned, using these as studies for his paintings. Of six watercolours at the Crawford Municipal Art Gallery, Cork, only one is signed. Seven watercolours in the British Museum are all unsigned. He rarely dated his work. Two of his paintings were exhibited at the famous Armory Show in New York in 1913.

Painting in Ireland was not confined to North Dublin as he worked in counties Clare, particularly near Kilkee; Donegal and Wicklow. He was a man who courted neither fame nor money and was genuinely modest about his work. Almost unknown beyond the circle of his acquaintances, he died on 14 October 1917 at St Dolough's. Soon after his death, Dermod O'Brien (q.v.) commissioned Oliver Sheppard (q.v.) to do a posthumous portrait, in the form of a bronze medallion about 46 centimetres in diameter.

The National Gallery of Ireland benefited from Mrs Hone's will. The collection comprised no fewer than 550 works in oils, 887 watercolours, nearly 100 of which had separate scenes painted on the reverse; and 17 sheets of miscellaneous studies. The sum of £1,500 was provided for additional accommodation. However, the terms of the will were somewhat ambiguous, giving rise to doubts as to whether she intended that all the pictures, or only a selection of them, should pass to the nation. A compromise was reached. The Governors of the National Gallery, with the assent of her executors, decided many years later to accept a selection of some hundreds of the most noteworthy and sell the residue with a view to providing additional funds for building. An exhibition from the Hone Bequest was held at the Gallery in 1921. In 1925 a loan exhibition of Hone's works took place at the Belfast Museum and Art Gallery. The Fine Art Society in London held an exhibition of oils and watercolours in 1937.

Works signed: N.H., a few monogrammed; N. Hone or Nathl. Hone, rare (if signed at all).
Examples: Belfast: Ulster Museum. Churchill, Letterkenny, Co. Donegal: Glebe Gallery, Derek Hill's Collection. Clonmel, Co. Tipperary: South Tipperary County Museum and Art Gallery. Cork: Crawford Municipal Art Gallery. Dublin: Hugh Lane Municipal Gallery of Modern Art; National Gallery of Ireland; Office of Public Works; University Hall, Lower Hatch Street. Dun Laoghaire, Co. Dublin: Royal Irish Yacht Club. Edinburgh: City Art Centre. Galway: National University of Ireland. Johannesburg, South Africa: Municipal Art Gallery. Kilkenny: Art Gallery Society. Killarney: Town Hall. Limerick: City Gallery of Art. London: British Museum; Tate Gallery. Maynooth, Co. Kildare: St Patrick's College. Waterford: City Hall, Municipal Art Collection.
Literature: *Dublin Sketching Club Minute Book*, 1883; *Notes on the Origin and early History of the Dublin Sketching Club*, n.d.; Michael J. F. McCarthy, *Five Years in Ireland 1895-1900*, Dublin 1901; *Irish Review*, January 1912 (illustration); Thomas Bodkin, *Four Irish Landscape Painters*, Dublin 1920; Lady Gregory, *Hugh Lane's Life and Achievement*, London 1921; *Irish Statesman*, 27 September 1924; *The Studio*, November 1924; J. Crampton Walker, *Irish Life and Landscape*, Dublin 1927 (also illustration); *Sarah Purser Papers*, National Library of Ireland; *Studies*, Winter 1965; *Thomas MacGreevy Papers*, Trinity College, Dublin; Jeanne Sheehy, *Walter Osborne*, Ballycotton 1974; Anne Crookshank and the Knight of Glin, *The Painters of Ireland c.1660-1920*, London 1978 (also illustrations); Julian Campbell: National Gallery of Ireland, *The Irish Impressionists: Irish Artists in France and Belgium, 1850-1914*, catalogue, Dublin 1984 (also illustrations); Oliver Hone, *Letter to the author*, 1987; Julian Campbell: National Gallery of Ireland, *Nathaniel Hone the Younger*, catalogue, 1991 (also illustrations); Peter Murray, compiler, *Illustrated Summary Catalogue of The Crawford Municipal Art Gallery*, Cork 1991 (also illustrations); Anne Crookshank and the Knight of Glin, *The Watercolours of Ireland*, London 1994 (illustrations).

HOOKE, RICHARD (1820-1908), portrait painter. Born in Banbridge, Co. Down, in 1820, he trained as a carpenter at the flax and tow spinners at Sion Mills, Co. Tyrone, Herdmans, which had been established in 1835. Hooke showed artistic ability, and a member of staff, Andrew Ferguson, encouraged him to pursue portraiture as a career. He went to Belfast and apparently received some artistic training at the Royal Belfast Academical Institution drawing school in 1843-4, under its master, the artist Joseph Molloy (1798-1877).

Hooke became successor to Samuel Hawksett (1776-1851) as the leading portraitist in the city. John Hewitt noted: 'Not nearly so interesting as a painter, but a far more representative of the newly emergent clientele, the new industrialists, self-made men with no sort of cultural tradition, admiring themselves, who sought to have their features perpetuated in a no-nonsense style. So photography was extensively used by Hooke as a basis and support for his pedestrian productions, exactly to the simple taste of his patrons.'

In the period 1850-81 inclusive he showed nineteen portraits at the Royal Hibernian Academy, some anonymous, 'Portrait of a Gentleman' or 'Portrait of a Lady'. His inaugural offering was of Sir William G. Johnson, Mayor of Belfast in 1849. He exhibited a self-portrait at the 1851 gathering. Among his portraits at the 1853 exhibition, sent from 17 Chichester Street, Belfast, were those of Dr James F. Duncan and J. C. Ferguson, MD

In 1857 his address in Belfast was 73 Upper Arthur Street, and soon after he settled in Manchester, becoming a regular exhibitor at the Royal Manchester Institution from 1858. A member of the 2nd Manchester Volunteers, he travelled by special train to London in 1860 for the march past Queen Victoria and Prince Albert at Hyde Park. He became a member of the Manchester Academy of Fine Arts in 1861, and as in Belfast he established himself as a painter of the city's leading figures. In 1863, for example, he executed three-quarter length portraits of Aldermen Benjamin Nicholls and Ivie Mackie, ex-Mayors of the city, which were presented by subscribers to Manchester Corporation and are at the Town Hall. However, he still retained an extensive practice in Belfast, through regular visits, Rodman's Gallery at 41 Donegall Place hosting exhibitions of finished portraits of local citizens.

Elected a Fellow of the Royal Astronomical Society in 1867, he became a member of the Manchester Academy of Arts on its formation about three years later. He showed a portrait of his patron, the Marquess of Downshire, at the 1872 Royal Academy, sent from 18 Exchange Street, Manchester, and his only contribution to that institution. In 1873, after an absence of seventeen years from exhibiting in Dublin, he showed the Downshire portrait at the RHA, his address being given as 'Manchester, and 5 Great Denmark Street, Dublin'. In 1879 at the RHA he showed from 24 Clare Street, *Portrait of Miss Chadwick* and *His Grace the Lord Primate.*

In the period 1878-89 approximately Hooke painted six Professors of Queen's University, Belfast, all works unsigned and designated for the University. On the retirement of Professor Thomas Andrews in 1879, Queen's commissioned a portrait by Hooke, which was placed in the Common Hall; a replica was given to the sitter for his residence.

Hooke joined the Manchester Literary Club in 1883, later appointed a vice-president. The *Manchester City News* stated that he wrote many papers 'which were generally distinguished by a peculiar vein of Hibernian humour. A favourite subject with him was that of the folk tales of Ireland. He was also a frequent and ready speaker, and knew how to enliven a debate with flashes of Irish wit.' Early in the century, a portrait of Dr John Watts by Hooke was presented to Manchester Libraries by his son but this work can no longer be traced. There are no Hooke portraits at Manchester City Art Gallery. Manchester Literary Club ceased to exist after the First World War.

Leaving aside the curious 'oil on a photograph on board' of Edward Jones Smith, donated in 1922, and the portrait of Dr T. Henry Purdon, 'accidentally destroyed 1945', there are seven portraits at the Ulster Museum including those of the Belfast historian, George Benn; James MacAdam and James Patterson, MA, MD. At the City Hall in Belfast the years of office for five portraits of Mayors indicate Hooke's popularity over thirty-five years: Sir William Johnson (Mayor, 1849) to Sir David Taylor (1883-4). At the Belfast Harbour Commissioners office is a portrait of William Herdman; an identical version of this portrait, likewise by Hooke, is in the Ulster Museum. There is also at the Harbour Office portraits of Charles Duffin and, attributed to Hooke, Alexander Mitchell.

Hooke collaborated with the animal painters Charles Ward (fl. 1826-70) and Henry Calvert (1798-c. 1869) by executing the portraits in their paintings. In old age, when his eyesight was failing, he was assisted in his practice by his friend William Worthington Jolley (1849-1915). Some pictures largely painted by Jolley were signed by Hooke.

An obituary described him as 'a boon companion — hospitable, generous, kindly, and always ready with a good story. His outlook on life was wide and tolerant, and even in his most advanced years he retained much of the buoyancy and freshness of youth.' He died at this home, Kersal Dale, Radford Street, Higher Broughton, on 17 October 1908.

Works signed: Hooke (if signed at all).
Examples: Belfast: City Hall; Harbour Office; Queen's University; Ulster Museum. Manchester: Town Hall.
Literature: *Slater's Dictionary of Ireland,* Manchester 1846; *Belfast and Province of Ulster Directory for 1858-9,* Belfast 1858; *Manchester Libraries Annual Report,* 1902-3; *Manchester City News,* 20 and 21 October 1908, 7 November 1908; Walter G. Strickland, *A Dictionary of Irish Artists,* Dublin 1913; *1835 to 1935 at the Works of Herdmans Limited Sion Mills Co. Tyrone,* Sion Mills 1935; John Hewitt and Theo Snoddy, *Art in Ulster: I,* Belfast 1977; M. Patry, Eccles and District History Society, *Some Lancashire Artists,* 1977; Eileen Black, 'Of Art and Artists', J. C. Beckett et al, *Belfast*

The Making of The City 1800-1914, Belfast 1982 (also illustration); Eileen Black, *Paintings, Sculptures and Bronzes in the Collection of The Belfast Harbour Commissioners*, Belfast 1983; Ann M. Stewart, *Royal Hibernian Academy of Arts: Index of Exhibitors 1826-1979*, Dublin 1986; Eileen Black, *A Sesquicentennial Celebration: Art from the Queen's University Collection*, catalogue, Belfast 1995; Belfast City Council, *Letter to the author*, 1998; also, Belfast Harbour Commissioners, 1998; Manchester City Art Galleries, 1998; Manchester City Library, 1998; Manchester Literary and Philosophical Society, 1998.

HORSBRUGH-PORTER, W.E. (1905-85), landscape and portrait painter. Born in Dalkey, Co. Dublin, son of A.H. Horsbrugh-Porter, stockbroker, William Eric Horsbrugh-Porter was a first cousin of Sir Andrew Horsbrugh-Porter and was educated at Bedales School, Petersfield, 1917-20.

After attending the Dublin Metropolitan School of Art, he went to the Slade School of Fine Art, London, where he held the Slade Scholarship and the Robert Ross Scholarship.

Horsbrugh-Porter collaborated with Stephen Bone (1904-58), another past pupil of Bedales, on the Piccadilly Circus Underground station murals, painted in 1928, and shared a flat in Knightsbridge owned by Stephen's father, Muirhead Bone (1876-1953). The murals were removed in the early 1930s and replaced by commercial advertising.

Between 1926 and 1974 he showed more than forty works at the Royal Hibernian Academy, initially with a Gloucester Road, London address. In 1928 from Knightsbridge he was represented by a portrait of Lord Ashbourne. In 1932 from 29 Fitzwilliam Square, Dublin, he exhibited *The Lime Tree* and *Hell Fire Club*. Judging by other titles, Cumberland, Connemara and counties Cork, Donegal and Kerry were all painting venues.

In London, he exhibited with the United Society of Artists in 1932. In 1933 he showed *The Beach, Roundstone*, oil, at the Munster Fine Art Club, and *Pines, Co. Limerick* appeared at the Royal Academy, and he was also represented there in 1936. A view of Glenveagh Castle was hung at the 1936 exhibition of the Royal Institute of Oil Painters when he was living at Glenhest, Carrickmines, Co. Dublin. He showed one work only at the New English Art Club. He also exhibited at the Paris Salon. In 1935 he exhibited fifty-seven works at the Cooling Galleries, New Bond Street, London, where the highest-priced was *After the Resurrection* at £52.10.0.

In 1932 membership of the Society of Dublin Painters was confined to twelve persons, and Horsbrugh-Porter was one of them. An exhibiton at the Combridge Galleries, Dublin, in 1937 prompted a review in *The Studio*, which stated that he possessed a quality which always made his work interesting 'in that he is excited to paint by almost anything – he sees beauty in the most odd things and what is more important he makes the spectator do so as well. That he has the spirit of adventure – in painting I mean – was apparent in this exhibition, for his subjects are legion and his approaches numerous. He is not an imitator of nature, but he tells us nature's effect upon himself. He varies his handling and technique for the purpose of emphasising his reactions to each particular subject.'

The writer in *The Studio* particularly mentioned *Ellischau Castle; Portrait of Countess Taaffe;* and *Merrion Sands.* 'The latter is treated as a two dimensional pattern and is an impish and slightly satirical revelation of the artist's observations of the doings of a motley summer beach crowd.' Prior to the Second World War, he visited Czechoslovakia. His last two exhibits at the RHA were: 1972, *Wild Roses*; 1974, *The Grasshopper.* In the Limerick City Gallery of Art is *Fishing Shelter, Dunlewy.* On 14 December 1985 he died in a private nursing home.

Works signed: W.E. Horsbrugh-Porter or H.P.
Examples: Dublin: Hugh Lane Municipal Gallery of Modern Art. Limerick: City Gallery of Art. Waterford: City Hall, Municipal Art Collection.
Literature: *Who's Who in Art,* 1934; *The Studio,* October 1937, December 1937 (illustration); *Eric Horsbrugh-Porter,* catalogue, no venue stated, 1951; *Dictionary of British Artists 1880-1940,* Woodbridge 1976; *Irish Times,* 16 December 1985; Bedales School, *Letter to the author,* 1987; London Transport Museum, *Letter to the author,* 1987; Ann M. Stewart, *Royal Hibernian Academy of Arts: Index of Exhibitors 1826-1979,* Dublin 1987; Ms. Mary Adshead, *Letter to the author,* 1988; Lady Mary Horsbrugh-Porter, *Letter to the author,* 1988; S.B. Kennedy, *Irish Art & Modernism 1880-1950,* Belfast 1991.

HOUCHEN, HARRY (1870-1914), landscape and flower painter. Born on 23 July 1870 at Great Ellingham, Norfolk, Harry Houchen was the son of James Houchen, draper. His father came of yeoman stock in Norfolk, and his mother was a grandniece of the great landscape painter, John Constable (1776-1837). Despite the artistic link with the past, his parents objected to a career in art. At school he distinguished himself by his drawing, and during a three-year studentship at South Kensington, he gained distinctions and prizes. His study of chrysanthemums won first prize in the National Competition.

In 1903 he was appointed art master under the Cork County Council for their schools at Fermoy, Midleton and Youghal. Here he at once made his mark as an inspired and inspiring teacher, and the schools were said to have grown tenfold in attendance during his direction. Practically all crafts and all materials came easy to his hand.

In 1909 from 'Bellavista', Highfield Avenue, Cork, he showed at the Royal Hibernian Academy for the first time, and in 1911 *Rouen*; *Near Dieppe*; *Evening, Cork*; and *The Lee, near Cork* were all hung in the Dublin show. His address for the 1912 exhibition was The Studio, College Road, Cork. Altogether, he showed twenty-two works in five exhibitions in Dublin, concluding in 1914. He had three pictures accepted at the London Salon. Paris and Dieppe both provided sunset scenes as subjects. He also painted in Rouen. When he had the time available, he was untiring as an artist, and fifteen hours a day was not unusual.

In 1913 he was appointed headmaster of the Londonderry School of Art, and he continued his painting in the North-West. The school had been languishing, but immediately after Houchen took charge the numbers rose as they had done in Cork. When he arrived in February there were thirty-five students but by December 1914 there were about 200. He himself took up enamelling and jewellery, and also made designs for cabinetmakers and laceworkers. An old clothes-wringer was used to print his etchings. He died at his residence, 'St Lurach's', Northland Road, Londonderry, on 23 December 1914. In 1915 there was a two-day sale at the Crawford School of Art of his paintings and drawings, about 300 works. Lady Mary Aldworth opened the exhibition.

Works signed: H.H.
Literature: *Register of Births, Attleborough*, 1870; *Irish Times*, 26 December 1914; *The Studio*, March 1915 (also illustration); *Cork Free Press*, 22 May 1915; *Dictionary of British Artists 1880-1940*, Woodbridge 1976; Ann M.Stewart, *Royal Hibernian Academy of Arts: Index of Exhibitors 1826-1979*, Dublin 1986.

HUGHES, JOHN, RHA (1865-1941), sculptor. Born at 21 Portland Place, Dublin, on 27 January 1865, son of Patrick Hughes, carpenter, John J. Hughes was educated by the Christian Brothers at their O'Connell School, North Richmond Street, Dublin. When still in attendance, he enrolled in 1878 as a part-time student at the Dublin Metropolitan School of Art. In 1880 he became full-time and remained there for six years. Following an absence of more than a year, he returned to the Metropolitan School in December 1888 and studied until April 1890. At the School of Art he formed friendships with George Russell, Oliver Sheppard (qq.v.) and W.B. Yeats, executing a bust of the then beardless Russell which is now in the Hugh Lane Municipal Gallery of Modern Art.

In October 1890 he was enrolled as a scholarship student at South Kensington, where his sculpture master was the French-born Edouard Lanteri (1848-1917). He formed friendships with David McGill (1864-1947), a Scotsman, and Frederick Shelley (1865-1929), who was to become principal of Plymouth School of Art. During the summer of 1892, having left the South Kensington school earlier in the year, Hughes visited Paris and studied at the Académie Julian, and at Colarossi's. He also visited Italy. These journeys were financed by a travelling scholarship from the National Art Training School.

Hughes's first teaching appointment was second art master at Plymouth School of Art, beginning in October 1893 and staying only for the school year. He became the new Instructor in Modelling at the Dublin Metropolitan School of Art in 1894. Beatrice Elvery, later Lady Glenavy (q.v.), recalled him as a most amusing and inspiring teacher. 'He looked more like a Frenchman or an Italian than an Irishman; perhaps that was due to his great love of those countries. He talked to us about everything ... In the modelling room he used to read aloud to the students. Sometimes it was Dante's *Inferno* in Italian; we liked the sound of it

but none of us understood a word. Another time it was *The Hound of the Baskervilles* and we were so thrilled we forgot to model and the model forgot to pose,' she recorded in her autobiography.

In 1895 Hughes exhibited for the first time at the Royal Hibernian Academy and was appointed ARHA in that year, gaining full membership in 1900, the year he exhibited *Hermes*, a statuette, at the Royal Academy. He had built himself a studio at 28 Lennox Street, Dublin. In 1898 he exhibited *The Finding of Eurydice,* marble, at the RHA; it had been exhibited at the RA the previous year. This work was referred to as *Orpheus and Eurydice* in an article which Russell wrote in 1898: 'The sculptor ... may smile a little if he hears that I claim him as representing, more than any of his contemporaries in art, the movement known as the Celtic renaissance; and that I place him in that position, not on account of any interpretation of Celtic tradition, history, or character, but because of his most tender and beautiful treatment of the world-famous myth of ancient Greece ... The precision and delicacy of the modelling is something quite new in Ireland ...' This work is now at HLMGMA. It was displayed, under *Orpheus and Eurydice*, at the 1907 Irish Industrial Exhibition in Dublin. Also in the Municipal Gallery collection is a plaster study of a boy with a drinking cup.

In the Ulster Museum collection is a bronze, *Thérèse*, 1896. The artist's first life-size bronze was the *Charles J. Kickham* monument, erected in Tipperary town in 1898. Sarah Purser (q.v.), with whom he had a lifelong friendship, forcefully suggested his name for this commission as Hughes was reticent and modest about his own claims. In her *Irish Public Sculpture: A History*, 1998, Judith Hill described the work: '...depicts an elderly, seated writer, paper on knee and quill in hand, a dreamy abstracted expression on his face, the paper about to slip from his knee...'.

Two bronzes, *L'Ame du Vin*, exhibited at the 1899 RHA (1898, RA) and *Napoli* at the 1900 show, were later presented by the seventh Viscount Powerscourt to the National Museum of Ireland. The last-named work is also known as *The Mandolin Player*. Also in the National Museum are busts in marble of William Edward Steele and Valentine Ball. For the bust of Dr Ball, the treasurer's statement showed '£118 paid to Mr Hughes for bust and pedestal'.

A small memorial high-relief in marble to the celebrated Victorian actress, Helena Faucit, was completed in 1899. A marble relief head of Sir Frederick William Burton, RHA (1816-1900), and a bronze bust of Sir Thomas Newenham Deane (1830-99), were among his commissions. Both are in the National Gallery of Ireland. His eighth and last exhibit at the RHA, *The Springtime of Life*, appeared in 1901.

Hughes had two pieces shown at the Walker Art Gallery, Liverpool, but increasing commissions forced him to resign from the Dublin Metropolitan School of Art in 1901, when in a letter to Sarah Purser he mentioned three small models which he had to make 'of the decaying statues on Bank of Ireland'. About this time he began work on two of his most important and successful commissions, the bronze relief over the High Altar, *The Man of Sorrows*, and *Madonna and Child* in the Lady Chapel, both for St Brendan's Cathedral, Loughrea, Co. Galway. A religious theme was unusual in his work. Besides these two major works, Hughes was involved with Michael Shortall (q.v.) in other work at Loughrea. The tabernacle and reredos are attributed to Hughes.

About 1902 he received one of his largest commissions, the Irish national monument to Queen Victoria, and he went to live in Paris as that city afforded greater facilities for carrying out such a big task; it was also the city he had longed to live in. In his biography of John Hughes, Alan Denson described the work: 'The central figure of the Queen was cast in bronze. Immediately below her are Lunel marble carvings of three putti representing Science, Literature and Art. The three bronze supporting allegorical groups represented: Erin presenting a laurel wreath to an Irish soldier; Peace; and Fame. The elaborate pedestal is worked in the very hard Lunel marble.'

The statue, in front of Leinster House, was unveiled by the Lord Lieutenant in 1907. The total cost was £7,320. Not surprisingly, the monument was later to become an object of public protest and, unfortunately, it was by this work that he was best known to his own countrymen. The faithful Sarah Purser visited him in Paris in 1908.

On the Queen Victoria monument, Judith Hill wrote about the figures around the monuments: '...a figure of Erin laying a laurel wreath on the head of the dying soldier; a beautiful grouping. Peace was also represented, by two muscular figures; another gesture to nationalist sensibilities. Victory, a winged figure

carrying a trumpet, had a stately quality, perhaps derived from Hughes' study of Renaissance sculpture. All these figures can now be seen in the gardens of Dublin Castle where their over-large limbs hanging over low supports look incongruous. But, set within the elaborate pedimented niches decorated with cascading fruit, shells and putti which formed the three sides of the pedestal of the original monument, their trailing limbs complemented its Baroque character. It was exotic for Dublin and not inappropriate as a gesture to Queen Victoria's long reign and considerable empire...'

In a letter dated 17 September 1909, Sir Walter Armstrong wrote in part from London to Miss Purser: 'Hughes went back to Paris on Thursday last, having had quite a triumphal career in London, ending up with a dinner at Brooks's among all sorts of political bigwigs – and your humble servant.' What the 'triumphal career' was is not clear, unless the members had prior knowledge that Hughes had won the commission for a large monument for Dublin to commemorate William Ewart Gladstone. In any event, a contract was entered into by the Gladstone Memorial Trustees and Hughes in 1910.

A statue of Provost George Salmon, in Galway marble, was unveiled in 1911 at Trinity College, Dublin. Later, it was removed outside to the quadrangle. Judith Hill suggested that Hughes demonstrated something of the developing use of stone as exemplified by the Romanian artist, Constantin Brancusi (1876-1957). 'Hughes was nowhere near abstracting the forms of the figure,' she added, 'but there is a boxiness about the Salmon figure seated in his simple chair which suggests the original block of stone. An elderly Salmon is presented in his academic robes, leaning forward to engage; status and character are both depicted...'

By 6 August 1914 all five full-size models for the Gladstone monument had been completed and were ready for casting, but the War had intervened. Sir Walter Armstrong wrote to Sarah Purser on 25 May 1915; 'I hear fairly regularly from Hughes, making things to please himself now that he has practically finished the Gladstone monument ...' In 1915 Hughes resigned his membership of the Royal Society of British Sculptors. In 1919 he despatched the figures to his bronze caster at Brussels. The monument had an overall height of 8.5 metres. Dublin Corporation, however, refused to display it in the city; nor were they willing to receive it. A site for the work was eventually found in Gladstone's home village, Hawarden, North Wales, and it was set up in 1925. Below the central figure of the statesman are bronze allegorical figures representing: Erin, with harp; Classical Learning; Finance; Eloquence.

A portrait of Hughes by Walter Osborne (q.v.) is in the National Gallery of Ireland. Sadly, his artistic efforts from 1920 onwards declined severely. He resided in Florence for about six years. He wrote to Oliver Sheppard (q.v.) from Firenze, Italy, in 1922; in that year he was represented in the Irish exhibition in Paris. He was also represented in the Irish exhibition at Brussels in 1930. Lady Glenavy met him in Paris in the 1930s and he told her he had almost given up sculpture for the flute. Apparently he played in Paris cinemas. She felt he was in poor circumstances. He shared accommodation with two of his sisters.

In August 1939 he left Paris and settled in Cagnes-sur-Mer. On 9 April 1941 from a hotel there he wrote to Sarah Purser in Ireland: 'I am a wandering waif now, and have been so ever since I lost Mary – always lonesome! Jane died too, alas! I wonder if I shall ever see Drumcondra again! or Italy?' He died at Nice on 6 June 1941 and was buried in the communal Caucade Cemetery.

In 1948 the 4.6 metres high Queen Victoria statue was removed from the Leinster House lawn for storage. It is now in Sydney, Australia, displayed in front of the Queen Victoria Building. The work had been requested by the Lord Mayor of Sydney and was sent on permanent loan by the Government. In 1971 the first Christmas stamp issued by the Irish Post Office illustrated Hughes's *Mother and Child*; there was no indication of the sculptor's identity.

Works signed: John Hughes, Jn. Hughes or J. Hughes (if signed at all).
Examples: Belfast: Ulster Museum. Dublin: Castle; Hugh Lane Municipal Gallery of Modern Art; National Gallery of Ireland; National Museum of Ireland; Trinity College. Hawarden, North Wales: Gladstone Way. Loughrea, Co. Galway: St Brendan's Cathedral. Sydney, Australia: Queen Victoria Building. Tipperary: Main Street.
Literature: George Russell ('A.E.'), *Journal and proceedings of the Arts and Crafts Society of Ireland*, 1898; Robert Elliott, *Art and Ireland*, Dublin [1906] (illustration);*Dublin Magazine*, January-March 1938; *Sarah Purser Papers*, National Library of Ireland; Alan Denson, ed., *Letters from A.E.*, London 1961 (also illustration); Beatrice, Lady Glenavy, *Today we will only Gossip*, London 1964 (also illustrations); Alan Denson, *John Hughes, Sculptor 1865-1941: a*

documentary biography, Kendal 1969; *Irish Times*, 10 November 1971, 2 October 1986; Frederick O'Dwyer, *Lost Dublin*, Dublin 1981; Ann M. Stewart, *Royal Hibernian Academy of Arts: Index of Exhibitors 1826-1979*, Dublin 1986; Council of the City of Sydney, *Letter to the author*, 1987; Judith Hill, *Irish Public Sculpture: A History*, Dublin 1998 (also illustrations).

HUGHES, MYRA K., ARE (1877-1918), etcher. Myra Kathleen Hughes was born at Polehore, Wexford, on 9 September 1877, daughter of Sir Frederic Hughes, who served in the 7th Madras Light Cavalry. She had four sisters and two brothers. In 1898 she was at the Slade School of Fine Art, and in that year she exhibited at the Royal Hibernian Academy for the first time, from Alexandra House, Kensington Gore. In London, she studied under the etcher and engraver, Sir Frank Short (1857-1945).

Between 1898 and 1918 she contributed twenty-two works at Water Colour Society of Ireland exhibitions. In 1899 at the RHA she showed a miniature of Miss Winifred Hughes, giving the family home address, Barntown House, Wexford. She was a member of the Dublin Sketching Club.

Some of her best etchings were of the old city of London. When she exhibited at the Royal Academy for the first time, 1906, the theme was old houses in 'Vanishing London'. Her address then was The White Studio, 22a Pembridge Villas, W, and she may have known Paul Henry (q.v.) in that area. With the exception of three years, she continued to exhibit at the RA until 1918. In 1915 at WCSI she exhibited *The Mill on the Hill* and *Lincolnshire Fens*. A graphic arts exhibition at Burlington House in 1917 included her work.

P.L. Dickinson, writing about the period 1904-14 in his *The Dublin of Yesterday*, regarded Myra Hughes as probably the best etcher of that period and added: 'Indeed, much of her work takes a very high place; her draughtsmanship was adequate and decided, and her choice of subject always satisfactory for her medium...She never went too far with her work and knew exactly how to get her effect with a minimum amount of line.'

Etchings were hung in the exhibitions of the Royal Society of Painter-Etchers and Engravers. She was appointed an associate member in 1911 and also served as president. She also exhibited with the Society of Women Artists. The Walker Art Gallery, Liverpool, showed her work. In 1910 she exhibited six pictures at the RHA, including *Milton's Cottage; A Corner of Leinster Market, Dublin; The Four Courts, Dublin.* She visited Norway, judging by *Old Norwegian Bridge* at the RHA in 1911. She travelled to Iceland and there were two Icelandic scenes at the RA of 1913, giving the address 13 Gloucester Road, SW.

In 1914 and 1916 her work was in the exhibitions of the Black and White Artists' Society of Ireland. At the RHA she showed in 1914 a portrait of the Rt. Hon. A.H.D. Acland. She executed a set of five etchings of Trinity College, Dublin. One, of the Examination Hall from the Provost's Gardens, was reproduced in J. Crampton Walker's *Irish Life and Landscape*, 1927.

In 1917 Myra Hughes visited Palestine and was the author of 'Impressions of Palestine' for an article in *The Studio* with illustrations. On Jerusalem she commented: 'Permission to sketch in the Temple area could only be obtained through our Foreign Office, and this caused great delay. Owing to the curiosity of the people, it is not pleasant sketching in the streets, though no objection is made to you doing so. I usually hired a boy to keep the children from crowding too closely round me ...' She found the donkeys very useful for sketching trips. Alas, she contracted tuberculosis there and died at Hindhead, Surrey, on 21 August 1918.

Works signed: M.K. Hughes.
Examples: Dublin: Civic Museum; National Library of Ireland.
Literature: *Dublin Sketching Club Minute Book*, 1898; *The Studio*, January 1915, June 1916, March 1917, February 1918 (also illustrations); *The Field*, 16 February 1918 (illustrations); J. Crampton Walker, *Irish Life and Landscape*, Dublin 1927 (also illustration); P.L. Dickinson, *The Dublin of Yesterday*, London 1929; E. Bénézit, *Dictionnaire des Peintres, Sculpteurs, Dessinateurs et Graveurs*, Paris 1966; *Dictionary of British Artists 1880-1940*, Woodbridge 1976; Miss Mary Hughes, *Letters to the author*, 1986; Ann M. Stewart, *Royal Hibernian Academy of Arts: Index of Exhibitors 1826-1979*, Dublin 1986; *Water Colour Society of Ireland Exhibition List 1872-1994*, Dublin 1995.

HULL, F.W. (1867-1953), landscape painter. Born at Drogheda, Co. Louth, Frederick W. Hull was a Belfast businessman who lived at 8 Ireton Street for more than half a century. When about thirty years of age he took up painting as a hobby, attending evening classes at the Government School of Art under George Trobridge

(q.v.), and having lessons in outdoor sketching with David Gould (q.v.). In 1902 he became a member of the Belfast Art Society and thence played an active part in its affairs. He also exhibited in the city at the Ulster Arts Club, of which he was a foundation member in 1902, also served on the committee and was president in 1918 and 1919.

In the period 1903-30 Hull exhibited thirty-five works at the Royal Hibernian Academy, so knowledge of his painting was by no means confined to the Belfast area. Of the first nine pictures hung in Dublin, the word 'sunshine' appeared in three of the titles. In 1920 at the Belfast Museum and Art Gallery his work was included in a loan exhibition of oil paintings and early British watercolours, and in 1924 he was represented at the British Empire Exhibition, London. He also exhibited at one of the annual exhibitions at the Walker Art Gallery, Liverpool.

The highlight of his painting career came in 1949 when the Belfast Museum and Art Gallery showed more than seventy works, mainly oil paintings and watercolours, including *Cornfield, Edenderry; Winter, Barnett's Park; The Gobbins, Islandmagee.* The Lagan Valley on his half-day was a favourite painting area. Firmly rooted in Impressionism, he worked outdoors, painting on little wooden panels which were made to fit inside the lid of his painting box. A portrait of him by Paul Nietsche (q.v.) is in the Ulster Museum. He died on 21 April 1953 at the Royal Victoria Hospital, Belfast.

Works signed: F.W. Hull.
Examples: Belfast: Department of the Environment for Nothern Ireland; Ulster Museum.
Literature: Belfast Museum and Art Gallery, *The work of F.W. Hull,* catalogue, 1949; *Belfast Telegraph,* 22 June 1957; Patrick Shea, *A History of the Ulster Arts Club,* Belfast 1971; John Hewitt and Theo Snoddy, *Art in Ulster: I,* Belfast 1977; Ann M. Stewart, *Royal Hibernian Academy of Arts: Index of Exhibitors 1826-1979,* Dublin 1986.

HUNTER, JOHN F., RUA (1893-1951), landscape painter and wood engraver. Born on 5 June 1893 at Chin-Chow, Manchuria, where his father, Rev. William Hunter of Doagh, Co. Antrim, was an Irish Presbyterian Church missionary, John Frederick Hunter, a brother of the Ulster artist and teacher, Mercy Hunter (q.v.), was educated at Larne Grammar School, 1906-08, Royal Belfast Academical Institution and Trinity College, Dublin, which he left during the First World War to serve in the Royal Inniskilling Fusiliers.

As Lieut. J.F. Hunter he exhibited at the 1918 Royal Hibernian Academy; his five works included two etchings. He gave the Dublin Metropolitan School of Art as an address in 1920 when he exhibited at the RHA an illustration to *The Twilight of the Gods.* A fellow art student in Dublin was Frank Wiles (q.v.), another artist with Larne connections.

Hunter may not have been happy in the changed political climate in Dublin following the Easter Rising and he transferred to the Royal College of Art to follow the diploma course in 1920-21. In 1921 he was responsible for the metalwork with James Wallace for a triptych designed by P. Oswald Reeves, ARCA (q.v.) of ebony, gold, silver, etc. for a war memorial in All Saints' Church, Grangegorman, Dublin. James Hicks, woodwork; George Atkinson (q.v.), writing; Reeves, enamelling, were the other contributors. Hunter graduated at the Royal College in 1922.

In 1923 he became the first Inspector of Art to the Ministry of Education, Northern Ireland, and thereafter was closely connected with the schemes to promote greater interest in art in the schools. His new approach to teaching methods and his encouragement of children's own form of self-expression were regarded as showing distinctive results.

In 1934 he completed with his friend W.R. Gordon (q.v.) the mural *The Bronze Age in Ireland* at the Belfast Museum and Art Gallery, presented by the Thomas Haverty Trust. Hunter's contribution on the left was the conclusion of a bear-hunt, 2.9 metres by 4.6 metres. The small section above the door was a joint production. The unveiling was by Dr Thomas Bodkin, MRIA.

Academician of the Royal Ulster Academy, he was president 1943-7 of the Ulster Academy of Arts, as it then was. A member of the Ulster Arts Club, he was one of the original members in 1943 of the Council for the Encouragement of Music and the Arts in Northern Ireland, and was chairman of the art committee, 1944-9.

His work was included in the exhibition by Ulster painters, sponsored by CEMA, at Ulster House, Regent Street, London in 1947.

An exhibition at the Victor Waddington Galleries, Dublin, in 1949 prompted the art critic of the *Dublin Magazine* to write: 'John Hunter belongs to the category of gifted amateurs, which does not mean that he is not technically superior to many professionals I could name; but his approach is different. With an eye that owes something to Cezanne and Pissarro he takes an obvious pleasure in translating the familiar scenes into paint, sometimes a little sentimentally, sometimes a little obviously, but always with genuine feeling. His chief fault lies in not paying sufficient attention to quality. *The Pleasure Boat*, good in colour and consistently lively in quality, is his best picture here. *Village Corner*, smoother in style, is particularly interesting in composition.'

In connection with Festival 1951, he was one of eleven artists chosen for an exhibition, Contemporary Ulster Art, at the Belfast Museum and Art Gallery, and in that year he was awarded the OBE. He died at his home in Merville Garden Village, Whitehouse, Co. Antrim, on 23 October 1951. CEMA organised a memorial exhibition of oil paintings in 1952 at 55a Donegall Place, Belfast; attendance was 1233.

Works signed: John F. Hunter, John Hunter, rare, or J.H., monogram.
Examples: Armagh: County Museum. Belfast: Arts Council of Northern Ireland; Ulster Museum. Dublin: All Saints' Church, Grangegorman.
Literature: *The Studio*, December 1921, July 1947; Francis Joseph Bigger, *Crossing the Bar*, Belfast 1926 (illustrations); *The Ulsterman*, May 1933 (illustrations); Ulster Society for the Prevention of Cruelty to Animals, *The Tree*, Belfast 1936 (illustration); *Dublin Magazine*, July-September 1949; *CEMA Annual Report*, 1951-52; *The Grammarian*, June 1952; *Belfast Telegraph*, 6 July 1957; *Dictionary of British Artists 1880-1940*, Woodbridge 1976; John Hewitt and Theo Snoddy, *Art in Ulster: I*, Belfast 1977; *A Dictionary of Contemporary British Artists, 1929*, Woodbridge 1981; Ann M. Stewart, *Royal Hibernian Academy of Arts: Index of Exhibitors 1826-1979*, Dublin 1986; Larne Grammar School, *Letter to the author*, 1987; John Turpin, *A School of Art in Dublin since the Eighteenth Century*, Dublin 1995.

HUNTER, MERCY, RUA (1910-89), calligraphist and designer. Martha Saie Kathleen Hunter was born in Belfast on 22 January 1910. Her mother was Russian. At the age of four, Mercy, as she was known in the family, travelled to China by the Trans-Siberian Railway and spent her childhood in Manchuria, where her father, the Rev. William Hunter of Doagh, Co. Antrim, was an Irish Presbyterian Church missionary. She was a sister of John F. Hunter (q.v.), and her secondary education was provided in Toronto and at the Belfast Royal Academy.

After studying at the Belfast College of Art 1927-29, she won a scholarship to the Royal College of Art, 1930-3. In London she formed one of a colony of Ulster art students, including F.E. McWilliam and William Scott (qq.v.), later international names in the art world. Her special subject at the Royal College of Art was calligraphy under Edward Johnston (1872-1944).

In 1937 she returned to Northern Ireland and married fellow student George MacCann (q.v.), a sculptor whose head of his wife is in Armagh County Museum. Her career was devoted to grammar school teaching, concluding with Victoria College, Belfast, where she was head of the art department from 1947 until her retirement in 1970, the year she was awarded the MBE for services to education and art. Later she became a trustee of the Ulster Museum; in its collection is her 1953 drawing in pencil of Friar's Bush Graveyard, Belfast.

In addition to illuminated addresses and other lettering and calligraphic commissions, she lectured and broadcast on art, and designed costumes for the theatre, grand opera and the Patricia Mulholland Irish Ballet, the latter for several years. Some of her ballet designs are in the Grand Opera House, Belfast. When the Grand Opera Society of Northern Ireland performed *Carmen* in 1958 almost all the costumes had been designed by Mercy Hunter, and by that time, overall, it was estimated that 200 dresses and uniforms had been based on her coloured sketches.

Another activity was book illustration, including *Sparrows Round My Brow*, 1942, by George Galway, her husband. In 1975 an honorary degree of Master of Arts was conferred by Queen's University, Belfast. Academician of the Royal Ulster Academy, she was appointed president in 1975, and served for two years.

She was a founder member and past president of the Ulster Society of Women Artists. Of Northland Place, Dungannon, Co. Tyrone, she died in hospital on 20 July 1989.

Works signed: Mercy Hunter.
Examples: Belfast: Grand Opera House; Ulster Museum. Downpatrick: Down County Musuem.
Literature: George Galway, *Sparrows Round My Brow*, Newcastle 1942 (illustrations); *Belfast Telegraph*, 26 April 1958; W. Haughton Crowe, *More Verses from Mourne*, Dundalk 1970 (illustration, dust jacket); John Hewitt and Theo Snoddy, *Art in Ulster: I*, Belfast 1977; *News Letter*, 22 and 31 July 1989; Mrs. Mercy Little, *Letter to the author*, 1989.

INGLES, DAVID N.,ARHA(1889-1933), portrait painter. Scottish born, he was the younger son of Alexander Ingles, Forest View, Selkirk. In the 1891 Census Returns the father was described as a 'letter carrier.' From his home address, David showed a portrait study at the Royal Scottish Academy in 1913, and from an Edinburgh address, *A study in blue and gold* in 1914. His only other contributions to the RSA were in 1915, from Selkirk, one work being the study of a gipsy, and he himself travelled to Dublin.

Ingles first exhibited at the Royal Hibernian Academy in 1917 from the Studio, Irish Times Buildings, Westmoreland Street, and from then until 1932 he showed twenty-five works. Two portraits and *Horses in Action* were exhibited at the initial show. In 1918 he had eight works on view, three of which were portraits, including one of Right Rev. Maurice Day, DD, Lord Bishop of Clogher, and this work would appear to be the one hanging in St Macartan's Cathedral, Clogher but the artist's signature has not been discovered in Co. Tyrone.

In the year that he exhibited six works at the RHA, 1919, he was appointed an associate. One of the four portraits which he showed at the gathering was of W.H. Lauder but there was no trace of this work in 1998 with the Lauder family in Dublin, nor was the sitter known. *Spring* in 1918 and *Grafton St-Armistice Day* in 1919 were displayed at Water Colour Society of Ireland exhibitions. *Glendalough* was among his works at the 1920 RHA. He now departed to London and there was a gap of ten years before he exhibited again in Dublin, for which he expressed his regret to the Academy.

In 1930, from 58 Erskine Hill, Golder's Green, he sent a portrait of Sir Arthur du Cros to the RHA; the du Cros family on the Isle of Man had no knowledge in 1998 of its whereabouts. Ingles showed *Panther Lady* in 1931. He never exhibited at the Royal Academy and showed only one work each at the Grosvenor Gallery, London, and the Walker Art Gallery, Liverpool. He died on 23 May 1933 at North Middlesex Hospital, London.

Examples: Clogher, Co. Tyrone: St Macartan's Cathedral.
Literature: *Royal Hibernian Academy Council Minutes*, 1933; Southern Reporter, 1 June 1933; *Dictionary of British Artists 1880-1940*, Woodbridge 1976; Ann M. Stewart, *Royal Hibernian Academy of Arts: Index of Exhibitors 1826-1979*, Dublin 1986; *Royal Scottish Academy Exhibitors 1826-1990*, Calne 1991; *Water Colour Society of Ireland Exhibition List 1872-1994*, Dublin 1995; Sir Claude du Cros, *Letter to the author*, 1998; also, Huntly St John Lauder, 1998; Dean Thomas R. Moore, 1998; Selkirk Library Headquarters, 1998.

INGLIS, J. JOHNSTON, RHA (fl. 1885-1903), landscape painter. He was one of the six sons of Sir Malcolm Inglis, a prominent Scottish-born Dublin businessman who had arrived in the city in 1859 at the age of twenty-two. Sir Malcolm's portrait by Walter F. Osborne (q.v.) was exhibited at the 1902 Royal Hibernian Academy, the year of his death.

Inglis exhibited at the Royal Hibernian Academy from 1885 until 1903, missing only two years, almost seventy works, his first address being 3 Brighton Terrace, Monkstown, Co. Dublin. In 1887 he was at Trenton House, Ballsbridge, Dublin, and ten years later the RHA catalogue showed Montrose, Donnybrook, Dublin. He was represented in the Irish exhibition in London in 1888 by *Early Spring, Fontainebleu*. In 1892 he was appointed ARHA, and in the same year, a full member.

Judging by titles, he must have spent considerable time painting in Britain, for example a shore scene at Buckhaven, 1886, the year he became a member of the Dublin Sketching Club; *Sunny Day, Glencoe,* 1889; he was near Milford, Surrey, in 1895; *Benvenue and the Trossachs from Loch Achray,* 1895; an Essex farmyard, 1897; *On the Conway River, North Wales,* 1899; and in 1902, when he showed two works associated with Howth, Co. Dublin, *Thirlmere, Cumberland.* At the 1903 RHA, subject matter included a Scottish moor and an Essex backwater.

Almost running parallel with his exhibiting in Dublin was the appearance of his works in London at the Royal Academy, where paintings were hung at nine exhibitions between 1890 and 1902. In 1890 he gave 88 Fellowes Road, NW, in the catalogue, and the next year he showed two pictures from Bolton Grange, Hampstead; one was titled, *'Spring's first flood, born of the winter's snow'*. In 1904 he was represented in the exhibition of Irish painters held at the Guildhall of the Corporation of London and organised by Hugh P. Lane.

Inglis's work appeared at a number of other English venues – a dozen works at the Grosvenor Gallery, London; he also showed at the Royal Society of Artists, Birmingham and the Walker Art Gallery, Liverpool, where his *Llyn Idwal* in 1896 was priced at £200. He also had works exhibited at the Manchester City Art Gallery. According to W.G. Strickland's *A Dictionary of Irish Artists*, his name was removed from the RHA's list in 1912. The date and place of his death have not been found.

Works signed: J.J. Inglis.
Literature: *Dublin Sketching Club Minute Book*, 1886; *Thom's Directory*, 1900; *Irish Times*, 25 and 29 April 1902; W.G. Strickland, *A Dictionary of Irish Artists*, Dublin 1913; *Thomas MacGreevy Papers*, Trinity College, Dublin; *Dictionary of British Artists 1880-1940*, Woodbridge 1976; Ann M. Stewart, *Royal Hibernian Academy of Arts: Index of Exhibitors 1826-1979*, Dublin 1986; National Museums and Galleries on Merseyside, *Letter to the author*, 1988; also, Tessa K. Malcolm, 1988.

IRWIN, CLARA (1853-1921), landscape and townscape artist. Born in 1853, Alice A. Clara Irwin was the youngest daughter of John Robert Irwin of Carnagh House, Castleblayney, Co. Monaghan. At the Irish exhibition in London in 1888 she was represented by a watercolour, *In the Woods*, and in the following year she became a corresponding member of the Dublin Sketching Club.

In 1890 she began exhibiting at the Royal Hibernian Academy and showed thirty-one pictures until 1916, almost all landscapes, first from 19 Lower Pembroke Street, Dublin, and, later, regularly from the Carnagh address. She first exhibited with the Water Colour Society of Ireland in 1892 and from then until 1921 contributed 170 works; she was a member of the committee.

At the RHA in 1890 she showed a Scottish scene, *On the River Orchy, Dalmally* but generally her landscapes were Irish and she painted in counties Antrim, Donegal, Down, Mayo, Tyrone and Wicklow. In 1894 she became a member of the Belfast Art Society with an address Mountain View, Rostrevor, and she exhibited *Walberswick, Suffolk*. When she exhibited *Corner of Fitzwilliam Square, Dublin* in 1904, this picture corresponded with the type of work her name is associated with for Armagh city, and her importance to the Armagh County Museum is in her topographical record. There are five watercolours in their collection; *Ballinahone, Armagh* is dated 1900, and *College Street, Armagh*, 1920. Clara Irwin had shown a Venentian scene at the RHA in 1908 and again in 1911.

Among her contributions to the 1913 WCSI were: *A Bit of D.D.D.*; *St Patrick's Cathedral, Armagh*; *Clock Tower, Westminster*; *A congested district, Donegal*. Among her 1918 works were *The Grandmother* and *Boats of our Allies*. She died on 13 June 1921.

Works signed: Clara Irwin or C. Irwin.
Examples: Armagh: County Museum.
Literature: *Dublin Sketching Club Minute Book*, 1889; *Belfast Ramblers' Sketching Club Minute Book*, 1894; *The Studio*, September 1912; *Thom's Directory*, 1913; *Belfast News-Letter*, 15 June 1921; *Thomas MacGreevy Papers*, Trinity College, Dublin; Armagh County Museum, *Letter to the author*, 1967; Ann M. Stewart, *Royal Hibernian Academy of Arts: Index of Exhibitors 1826-1979*, Dublin 1986; *Water Colour Society of Ireland Exhibition List 1872-1994*, Dublin 1995.

ITEN, HANS (1874-1930), landscape and flower painter. Born in Zurich on 10 March 1874, he studied at the School of Art, St Gall, Switzerland, and then worked some years in Paris where he became friendly with Pierre Montezin (1874-1946), who was influenced by the Impressionists. An oil painting of Iten by Montezin, inscribed *'à mon ami'*, is in the Ulster Museum together with a sketch for same.

In 1904 Iten travelled to Belfast to take up an appointment as a damask designer with McCrum, Watson and Mercer Ltd, linen manufacturers, Linen Hall Street. He soon became closely associated with the Belfast Art Society and was elected a vice-president in 1906; 'Jean Iten' appeared in their catalogue for that year. On obtaining a house at 18 South Parade, he resided there for the rest of his life. A studio at 20 Rosemary Street was shared. The artist was known as John Iten to his contemporaries in Ulster.

Attracted by the Irish landscape motifs as well as the people, Iten was not hesitant in venturing into the Dublin art scene. His pictures were hung in the Royal Hibernian Academy of 1908 – the Belfast Art Society showed eight that year – and from then until the year of his death he exhibited nearly fifty works at the RHA, including a number of flowerpieces. His landscapes were mainly scenes of County Antrim, Cushendall and Cushendun to the fore, and to a lesser extent County Down, St John's Point for example and *In the Barony of Lecale*. Nearer home the Lagan Valley, particularly Belvoir Park, was a source of inspiration. In the Armagh County Museum collection is an oil painting, *Sunset, Belvoir Park,* 13 cm by 20 cm, and a charcoal drawing, *Belvoir Park,* 35 cm by 43 cm.

Iten was represented by three works, including *Fleurs de Campagne*, in the Belfast Museum and Art Gallery's 1920 exhibition of oil paintings and early British watercolours. He experimented successfully, it is believed only twice, in lithography. The Society of French Artists showed his work. In 1926 he had an 'honourable mention' in the Paris Salon, and in that year Rodman's Art Gallery in Belfast advertised an exhibition for 'Hans Iten, MH'. Many years later Alfred McGuigan of that gallery, with an extensive knowledge of Irish art, recalled to the author Iten's work and the show: 'There was no one to touch him anywhere in Ireland as a flowerpainter.' In 1927 Iten was represented in a loan exhibition, Irish Portraits by Ulster Artists, at the Belfast Museum and Art Gallery with *Mr F.A.C. Mills, FRSAI.*

Iten endeavoured to return regularly to Switzerland for holidays. At the Belfast Art Society exhibition in 1927 he showed *The End of a Swiss Cattle Fair.* One of the three pictures which he exhibited at the Royal Academy in 1927 and 1928 bore the title *Corner of a Swiss farmyard.* He showed six works at the Fine Art Society, London, and four at the Walker Art Gallery, Liverpool. Eight works were hung in Scotland at the Glasgow Institute of the Fine Arts.

Forrest Reid, the novelist, described Iten as a 'realist who is not afraid at times to be brutal and strident, if that happens to be the way his subject strikes him. The more delicate side of his talent is revealed chiefly in his still-life pieces, in which all is harmonious, and the tone, at its best, has a delightfully satisfying quality.' The author, Denis Ireland, commented: 'To my mind his small studies are more valuable than many of his finished paintings, his smaller canvases better than his larger finished pictures. When it came to the large, highly-finished oleographs formerly demanded by museums and academies, something of freshness and spontaneity is lacking. It is as if he had painted out whatever had been originally in his mind ...'

A next-door neighbour to the Itens advised the author in 1967 that Mrs Iten had told him: 'Hans never signed his pictures but I would sign them if asked to do so.' A letter from her to the Ulster Museum reinforces her statement, judging by the handwriting. She presented *The Peonies* to the Municipal Gallery of Modern Art in Dublin. A charcoal portrait of the artist by George McDowell Kane (q.v.) is in the Ulster Museum, which holds *Les Capucines* and *Still Life with Oysters.* The two oils in the Queen's University collection are *On the Lagan, Winter* and *Old Thatched Cottage.*

In 1930 Iten was one of the first nine academicians elected to the Ulster Academy of Arts. In the same year he had a joint exhibition with the sculptor, Rosamond Praeger (q.v.) at Mills' Hall, Dublin, and was represented in the Irish exhibition at Brussels. He had not been in good health and went to Switzerland in the hope that the visit might have a beneficial effect, but died in August at Bulach. In 1971 the Arts Council of Northern Ireland in collaboration with Ulster Arts Club, of which Iten was an active member and former vice-president, presented a retrospective show at the Arts Council Gallery; the attendance was 1445. The Ulster Museum, which at the time had nineteen paintings and one lithograph, presented in 1999 in association with W. & G. Baird Ltd. forty-five of his works, 'A Continental Touch'.

Works signed: H. Iten, Hans Iten or John Iten, rare (if signed at all).

Examples: Armagh: County Museum. Belfast: Queen's University; Ulster Museum. Dublin: Hugh Lane Municipal Gallery of Modern Art.

Literature: J. Crampton Walker, *Irish Life and Landscape,* Dublin 1927 (also illustration); *Northern Whig,* 26 August 1930; *The Ulsterman,* April 1933; *Belfast News-Letter,* 4 March 1963, 21 February 1964; E. Bénézit, *Dictionnaire des Peintres, Sculpteurs, Dessinateurs et Graveurs,* Paris 1966; A.T.S. Scarisbrick, *Letter to the author,* 1967; *Arts Council of Northern Ireland Annual Report,* 1971-72, Belfast; *Dictionary of British Artists 1880-1940,* Woodbridge 1976; John Hewitt and Theo Snoddy, *Art in Ulster: I,* Belfast 1977; *A Dictionary of Contemporary British Artists, 1929,* Woodbridge 1981; Martyn Anglesea, *The Royal Ulster Academy of Arts,* Belfast 1981; *A Concise Catalogue of the Drawings, Paintings & Sculptures in the Ulster Museum,* Belfast 1986; Ann M. Stewart, *Royal Hibernian Academy of Arts: Index of Exhibitors 1826-1979,* Dublin 1986; Eileen Black, *A Sesquicentennial Celebration: Art from the Queen's University Collection,* Belfast 1995 (also illustration); Martyn Anglesea, *A Continental Touch — Hans Iten 1874-1930,* Belfast 1999 (also illustrations).

J

JACKSON, GERTRUDE– see HARTLAND, GERTRUDE

JACKSON, ROBERT WYSE (1908-76), landscape painter and illustrator. Born on 12 July 1908 in Co. Offaly, Robert Wyse Jackson was the only son of Richard Jackson. Educated at the Abbey School, Tipperary; Drogheda Grammar School and Bishop Foy School, Waterford, he graduated from Trinity College, Dublin, as a senior moderator in legal and political science. Early artistic efforts were his Indian ink drawings in issues of *The College Pen*, a Trinity magazine of which he was an editor and a frequent contributor from 1929-31.

Following graduation in 1931, he despatched political cartoons to a London Socialist newspaper. The original of his 1932 caricature of Eamon de Valera is still in the Wyse Jackson family. In that year he became a barrister in the Middle Temple. In England, he decided to enter the Church and was ordained in 1935, returning to Ireland in 1936. In 1942 with friends he founded the Limerick Arts Club when he was rector of St Michael's Church, but the club lapsed in 1946 after his appointment as Dean of Cashel, being re-established in 1950 as Limerick Art Society.

Always interested in painting, he became a member of the Water Colour Society of Ireland and between 1947 and 1974 showed forty-three works. Among his early contributions were: 1948, *Cashel Mausoleum;* 1952, *Mayo Moorland;* 1958, *Waterford Harbour*. It was said that wherever he went he joined (or founded) the local art club, historical society, drama group or musical circle!

In 1961 he was consecrated Lord Bishop of Limerick, Ardfert and Aghadoe. Contributions to WCSI continued, for example: 1961, *St Kevin's Kitchen*; 1964, *Augustinian Abbey, Adare*; 1967, *Youghal Clock Tower*. In 1963 he had painted in Toronto, Canada. A sole exhibit at the Royal Hibernian Academy was *Limerick City* in 1970, the year he was made a Freeman of Limerick, the first Protestant to hold the honour since Dermod O'Brien (q.v.) in 1936. The Primate, Most Rev. G. O. Simms, wrote that often as Bishop of Limerick 'he would speak out for the whole community at a time when such a thing was rather unusual...'

A humorist, he won the competition in 1970 for Limericks, run in conjunction with the Festival of the Maigue Poets. He took an active part in the Limerick Art Society and was president until 1970 when he retired as Bishop for health reasons and moved to Greystones, Co. Wicklow, by then an established writer in the fields of law, local and Church of Ireland history, and on literary figures, particularly as an authority on Jonathan Swift. A collection of Cork and Limerick silver graced his home, and his book, *Irish Silver*, appeared in 1972. Dr Wyse Jackson also wrote two novels and three plays. Some of his books were illustrated with his Indian ink line drawings. Occasional drawings accompanied his articles in the *Church of Ireland Gazette*.

In 1973 he held three one-person exhibitions: Molesworth Hall, Dublin; Thomond Antiques Gallery, Limerick; and Cashel Palace Hotel. His books were also displayed in the Dublin exhibition as well as sketches executed early in the morning at Drumcliffe, Co. Sligo, at the W. B. Yeats Centenary in 1965. A conservationist, he was also represented at that Dublin show by perhaps the last painting ever made of Stella's Cottage at Laracor, and by some 'acid cartoons against the despoilers'. At the 1973 Limerick exhibition, portraits of President de Valera and Bean de Valera were presented.

At the silver jubilee exhibition of the Limerick Art Society in 1974 and opened by President Erskine Childers, he was represented by *Across the Shannon* and *Limerick*. In his final year, 1974, at WCSI he showed *Brandon, Co. Kerry*; *Yeats' Tor Ballylee*; *Dingle Farm on Tralee Bay*. He also painted on Achill Island and in counties Kilkenny, Wexford and Wicklow. In England, he also pursued his hobby in the Cotswolds. At South Tipperary County Museum and Art Gallery he is represented by *The Rock from the Palace Garden*.

Tom Ryan, RHA, recalled to the author that Dr Wyse Jackson opened his, Tom's, first exhibition in Limerick in 1962, during which event came news that the Bishop had become the father of twins. 'He was

a very popular man in all his postings. As Dean, Bishop he wore the leggings, apron and tied-down hat of a Church of Ireland senior ecclesiastic and rode a powerful motor-bike in that outfit! He was known as "Boney",' added the former RHA president.

Wyse Jackson gave his recreations as 'painting, Swiftiana, exploring, church silver'. A member of the Society of Antiquaries of Ireland and the Royal Irish Academy, a former president and an honorary life member of the Thomond Archaeological Society, he died at the Royal City of Dublin Hospital on 21 October 1976.

Works signed: Robert Jackson, Robt. Jackson, R. J., R. W. Jackson, R.W.J., Robert Limerick or R.L. (if signed at all). Occasionally +(signifying Bishop) placed before signature.
Examples: Clonmel: South Tipperary County Museum and Art Gallery.
Literature: R. Wyse Jackson, *Swift and His Circle*, Dublin 1945 (illustration); R. Wyse Jackson, *The Bible and Ireland*, Dublin 1950 (illustration); R. Wyse Jackson, *Oliver Goldsmith : Essays Towards an Interpretation*, Dublin 1951 (illustration);T. J. Johnston, J. L. Robinson and R. Wyse Jackson, *A History of the Church of Ireland*, Dublin 1953 (illustrations); *Irish Times*, 10 June 1970, 22 October 1976; R. Wyse Jackson, *Adare Church*, Adare [1970] (illustration); Robert Wyse Jackson, *Irish Silver*, Cork 1972; *Irish Tatler and Sketch*, June 1973; *Church of Ireland Gazette*, 29 October 1976, 5 and 12 November 1976; *North Munster Antiquarian Journal*, vol. XVIII, 1976; *Who Was Who*, London 1981; Limerick Art Society, *Golden Jubilee Exhibitions,* catalogue, 1992; *Water Colour Society of Ireland Exhibition List 1872-1994,* Dublin 1995; John Wyse Jackson, *Phenolphthalein : A Fictional Quest for the Eighth Plot*, London 1996 (illustrations); Dr Michael Wyse Jackson, *Letters to the author*, 1998; also, Tom Ryan, RHA, 1998.

JACOB, ALICE (1862-1921), designer and botanical illustrator. Brought up in a Quaker family who had emigrated from Dublin to New Zealand, as her birth was not registered in Ireland it is assumed she was born abroad. The family returned home and settled at 88 Thomas Street, Dublin. Anthony Pim Jacob, her father, established dining rooms and a temperance hotel.

After entering the Dublin Metropolitan School of Art, she won the Gilchrist Trust Scholarship in the year 1882-83, and in 1888 was offered a free studentship. At the Art Industries competition at the Royal Dublin Society Horse Show in 1890 she was foremost among the prizewinners. In 1891 the Kyrle Society, London, awarded her a prize for a painted frieze; Walter Crane (1845-1915) made the award. Commenting on the embroidery designs at the National Competition of 1891, the *Art Journal* noted: 'The most striking of these is by Alice Jacob of Dublin, for a curtain with cut liners and embroidered fitting. The cut portion of the design representing Celtic interlaced draperies is handsome and shows considerable power, but the foliage is weak ...' In that year she attended the summer course at South Kensington.

In the period 1891-93 her designs were represented at the Paris exhibition, Arts de la femme, and she designed a tea service for Dr E. Percival Wright, Dublin, manufactured by the Belleek company. In the 1894 Art Industries competition at the Horse Show, she won nine first prizes. Three years later she received a silver medal for lace design in the National Competition. In 1898 her work was selected for a Hungarian Government exhibition in the new Museum of Industrial Art in Budapest.

In 1898 Alice Jacob accepted the post of teacher of design and ornament at the Dublin Metropolitan School of Art, which inaugurated in 1900 the first summer course in lace and embroidery-making for National School teachers, and with Frederick Luke she gave instruction in drawing and design. A skirt front of Carrickmacross guipure and appliqué, c. 1900, was designed by her. At the Dublin Horse Show in 1901 she exhibited one of her designs for Carrickmacross lace, worked at Glencolumbkille Lace Class in Co. Donegal where she also gave instruction. An interest in botanical illustration may have been encouraged by her illustrations for *A Handy Book of Horticulture* by the Rev. F.C. Hayes, published in London, 1900.

In 1905 she was among The Gaelic Society members photographed at the Metropolitan School of Art. In 1908 she succeeded Lydia Shackleton (q.v.) in the task of painting the orchid collection at the National Botanic Gardens, Dublin. Frederick Moore, the Keeper, was permitted to spend not more than three pounds each year commissioning her work but she had to do the paintings in her own time. She painted, until 1920, more than 100 orchids. Her work was in the fifth exhibition of the Arts and Crafts Society of Ireland in 1917

but she did not show at the Royal Hibernian Academy. Some of her lace designs are in the National Museum of Ireland. Of 14 Belmont Park, Donnybrook, she died in hospital on 31 July 1921.

Works signed: A.J. (if signed at all).

Examples: Dublin: National Botanic Gardens; National Museum of Ireland.

Literature: *Thom's Directory,* 1882; Rev. F.C. Hayes, *A Handy Book of Horticulture,* London 1900 (illustrations); *Irish Times,* 2 August 1921; Ada Longfield, *Irish Lace,* Dublin 1978 (also illustration); Prof. John Turpin, 'The South Kensington System and the Dublin Metropolitan School of Art 1877-1900' and '1900-1923', *Dublin Historical Record,* December 1982 and March 1984 respectively; E. Charles Nelson and Eileen M. McCracken, *The Brightest Jewel: A History of the National Botanic Gardens, Glasnevin, Dublin,* Kilkenny 1987 (also illustration); National Gallery of Ireland and Douglas Hyde Gallery, *Irish Women Artists: From the Eighteenth Century to the Present Day,* Dublin 1987 (also illustration); Pat Earnshaw, *Youghal and other Irish Laces,* Guildford 1988; Friends' Historical Library, Dublin, *Letter to the author,* 1991; John Turpin, *A School of Art in Dublin since the Eighteenth Century,* Dublin 1995 (also illustrations).

JAMESON, FLORA H. – see MITCHELL, FLORA H.

JAMESON, HARRIET – see KIRKWOOD, HARRIET

JAMESON, JOAN (1892-1953), figure, flower and landscape painter. Born on 4 October 1892, Joan Moira Maud Musgrave was the eldest daughter of Sir Richard and Lady Musgrave of Tourin, Cappoquin, Co. Waterford. She was educated in the fashion of the day, at home, but spent two years at the Sorbonne in Paris, and she also studied art at the Académie Julian. In 1916 she exhibited three works at the Water Colour Society of Ireland exhibition, including *Venice* and *The Boatcove, Derrynane.* In 1920 she married Capt. T.O. Jameson, and they lived in London until 1929 when they returned to Tourin.

London became an important outlet for exhibiting and she had two one-person shows at the Leicester Galleries, in 1933 and 1937, a total of more than sixty works. The Wertheim Gallery and the Goupil Gallery also displayed her work in London. At the Royal Hibernian Academy, however, she exhibited only three pictures: 1933, *'The Nigger'* and *Moll;* and 1934, *The Lake.*

A member of the Dublin Painters, she held a solo show at their gallery in 1934, and she also exhibited at the Victor Waddington Galleries. In 1936 she painted in Connemara. *The Studio* reproduced her portrait, *The Lady Charles Cavendish,* in 1937. Contributions to the Irish Exhibition of Living Art, to which she contributed from the first exhibition in 1943, attracted the critics.

In 1945 in the *Dublin Magazine* her *Making the Bed* was described as having 'incisiveness and a well-spaced composition'. Again, three years later, the same publication found her *Nude* 'forceful and dramatic' and *Red Lilies* showed her to be a painter of 'courage and distinction', but a still life where the emphasis was on colour rather than form was not so successful.

In 1947 she moved to Rock House, Ardmore, Co. Waterford. In 1949 at the IELA the *Dublin Magazine* stated that most of her pictures showed a freshness of approach, and *The Bell* in 1951 noted *Mother and Child* at the same venue. In 1953 she was represented in the Contemporary Irish Art exhibition at Aberystwyth, and that year she showed only one work at the Living Art, *Fisherman's Family.*

Norah McGuinness (q.v.) was one of her closest friends and was frequently a visitor. Another friend was the novelist, Molly Keane, also a keen poker player, who considered that she had 'found her way into painting against the time-consuming social life in which she was born and brought up ... No one in my life has ever matched her infinite variety. And, when she died, magic certainly fell from the air, to live on in her pictures. In them, I can still feel the strength of her great understanding and acceptance of everything in life.'

Buried at Ardmore, Co. Waterford, where she died on 25 September 1953, her headstone, carved by Seamus Murphy (q.v.), bears a palette and brushes. At the IELA in 1954 six of her works were shown 'in her memory, with affection'. In 1989, the Crawford Municipal Art Gallery, with Sotheby's sponsorship, arranged an exhibition of her paintings for Cork and the RHA Gallagher Gallery, Dublin.

Works signed: Joan Jameson, J. Jameson, J.M.J. or Joan Musgrave, rare (if signed at all).

Examples: Bray, Co. Wicklow: Public Library.
Literature: *The Studio*, June 1937 (illustration); *Dublin Magazine,* October-December 1945, October-December 1948, October-December 1949; *The Bell,* September 1951; Registry Office, Dublin, *Register of Deaths*, 1953; *Irish Exhibition of Living Art*, catalogue, Dublin 1954; *Dictionary of British Artists 1880-1940,* Woodbridge 1976; Bebhinn Marten, *Seamus Murphy 1907-1975,* Cork 1982; Shane Jameson, *Letters to the author,* 1987; Crawford Municipal Art Gallery, *Joan Jameson 1892-1953,* catalogue, Cork 1989; *Water Colour Society of Ireland Exhibition List 1872-1994*, Dublin 1995; *Burke's Peerage & Baronetage*, Crans 1999.

JAMM – see MIDDLETON, JOHN

JAMMET, YVONNE (1900-67), sculptor and landscape painter. Born in Paris in 1900, Yvonne Auger studied at the Académie Julian and at the atelier of Jean-Paul Laurens (1838-1921). In the year of her birth, the Restaurant Jammet opened in Dublin, and it was to close the year of her death. In 1928 she arrived in Dublin with her husband, Louis Jammet, restaurateur. Both were interested in the arts and became close friends of Mícheál Mac Liammóir (q.v.) of the Gate Theatre.

The restaurant – in Nassau Street in 1928 – was a meeting place for writers, actors, painters and critics. Among those who patronised it were Peter Ustinov, Barry Fitzgerald, Walt Disney, Paulette Goddard, Ingrid Bergmann, Ronald Regan and a host of others. Although Yvonne played only a minor role in the running of the establishment, she was part of the scene.

In an interview in 1974, the veteran art dealer, Victor Waddington, commented: 'She contributed to the vibrancy of the Dublin that mattered, enormously so ... One never hears her talked of but she took under her wing without any of the worst aspects of patronage all sorts of people and the encouragement was absolutely terrific.' Among the artists who patronised the restaurant were Harry Kernoff and Sean O'Sullivan (qq.v.). She encouraged painters; O'Sullivan was a close friend.

A member of the avant garde, the White Stag Group, she held an exhibition of paintings, including portraits, still life and landscapes, at the Victor Waddington Galleries, Dublin, in 1943. West of Ireland and County Wicklow scenes were included. She also exhibited at the Irish Exhibition of Living Art. In 1944 she again showed at the Victor Waddington Galleries and subjects included a bridge at Poulaphuca, Co. Clare; Martello Tower, Seapoint; and architectural forms in the Dordogne. In normal times she endeavoured to return to the Continent every year, and among the paintings which she exhibited at Waddington's were *La rue St Vincent* and *Cernay la Ville.* Carvings, generally worked in wood, included *Descente de Croix* and *L'enfer Notre Dame.* She also exhibited appliqué in tweed.

A person with a great sense of humour, and remaining a Parisienne to the end of her days, her art developed when she was in Ireland. She carved the sanctuary figures of the Sacred Heart and Our Lady for Our Lady of the Rosary Church, Limerick. *The Twelve Tribes* was a commission for Terenure Synagogue, Dublin. In 1951 she held two exhibitions at the Victor Waddington Galleries. When she exhibited at the Contemporary Irish Art exhibition at Aberystwyth in 1953 her address was Kill Abbey, Kill-o-the-Grange, Co. Dublin, where she had a specially built studio. In 1953 in a mixed summer exhibition at the Victor Waddington Galleries, *Notre Dame du Rosaire* was among the sculpture.

In 1954 she was represented in the An Tostal exhibition of contemporary Irish art at Bray, Co. Wicklow, and two years later she showed Stations of the Cross in mahogany with the Institute of the Sculptors of Ireland at their exhibition in Dublin. After St Michael's Church, Dun Laoghaire, Co. Dublin, had been destroyed by fire in 1965, she presented carved Stations of the Cross for the new church. She died on 30 August 1967 at Lowell, Mass., on a visit to the USA, and was interred at Dean's Grange, Blackrock, Co. Dublin.

Works signed: Y. Jammet.
Examples: Dublin: Terenure Synagogue. Dun Laoghaire, Co. Dublin: St Michael's Church. Limerick: Our Lady of the Rosary Church.
Literature: *Irish Times,* 9 September 1944, 4 September 1967, 23 August 1973, 26 June 1974, 11 April 1987; *The Bell,* January 1951, September 1951; *Contemporary Irish Art,* catalogue, Aberystwyth 1953; *Contacts,* Spring 1980; Dean's Grange Joint Burial Board, *Letter to the author,* 1988; Rev. M.V. Quilter, *Letters to the author,* 1988.

JELLETT, MAINIE (1897-1944), abstract and figure painter. Mary Harriet Jellett was born on 29 April 1897 at 36 Fitzwilliam Square, Dublin, eldest of four daughters of William Morgan Jellett, KC. Her mother, Janet Stokes, a musician of note, was a granddaughter of Sir William Stokes, MD. Mary acquired the 'pet' name of Mainie. Educated by governesses at home, it was there, at about the age of eleven, she had lessons in watercolour painting as one of a class taken by Elizabeth Yeats (q.v.). She then worked under Sarah Cecilia Harrison (q.v.) but as she found her too stern she moved to the Merrion Row studio of May Manning (q.v.). Already painting in watercolour, she had her first visit to France, Wimereux, aged fourteen and two years later in 1913 she was with a sketching class to Brittany.

In 1914 she entered the Dublin Metropolitan School of Art; William Orpen (q.v.) was still teaching there. In January 1917 she left for London and studied under Walter Sickert (1860-1942) at the Westminster Art School. Prior to her departure she had completed a group of paintings of nude figures. Under Sickert 'drawing and composition came alive to me'. She exhibited at the Royal Hibernian Academy 1918-21 inclusive; a gap of nine years followed before she resumed. In 1919 she had returned to Dublin and resumed her studies at the School of Art for a year. *The Blue Girl,* 1919, was hung at the 1920 RHA; 34 Norfolk Square, W2 on reverse. In 1920 she visited Avila, Spain, with Evie Hone (q.v.). A drawing *In Sickert's Studio* was dated 1918, the year he left Westminster and was succeeded by Walter Bayes (1869-1956), of whom she did a portrait. In London, she also seriously studied the piano but finally decided on painting as a career.

It was at Westminster Art School she met Evie Hone, who became a lifelong friend and fellow-worker. Her last year in London was 1919, and she painted in County Donegal in holiday-time, as in the previous year. The Taylor Scholarship was won in 1920 and in that year and the following she painted in Scotland when on family holiday. *Loch Carron from Plockton, Rosshire* was dated 1921. At Mills' Hall, Dublin, in 1920 she held a joint exhibition with Lilian Davidson (q.v.)

In February 1921 Jellett and Hone travelled to Paris, where they worked in André Lhote's studio. Jellett later recorded: 'With Lhote I learnt how to use natural forms as a starting point towards the creation of form for its own sake; to use colour with the knowledge of its great potential force, and to produce work based on a knowledge of rhythmical form and organic colour ...' The class consisted almost entirely of Scandinavians. 'He did not use the purely abstract theories of Cubism, his form was always derived from natural objects, though often much distorted,' she wrote. She worked with Lhote for two periods of several months during two years, and then with Evie decided that she wanted to go further into the extreme abstraction of Cubism.

Albert Gleizes (1881-1953) has recorded that it was in 1921 when the two Irish artists called to his Puteaux studio, close to Paris, seeking tuition. After some hesitancy, he accepted. He was engaged in research and they became his companion workers, travelling over once or twice a year for the next ten years or so, either to Paris or to Serriéres in the Ardêche. The new technique Translation and Rotation endowed painting-without-subject with a mobile rhythm. Jellett now felt she had 'come to essentials, and though the type of work I had embarked upon would mean years of misunderstanding and walls of prejudice to break through, yet I felt I was on the right track'. In 1922 she produced a substantial body of pure Cubist canvases.

In the intervals when she returned to Dublin she worked out the abstract ideas she had gleaned in France and continued her enthusiastic teaching at Fitzwilliam Square of private students, among whom were Jack Hanlon and Sylvia Cooke-Collis (qq.v.), with whom she occasionally painted at her County Cork studio. Many of Jellett's pupils were children and she instructed each one individually. On occasions she returned herself to representational painting.

In 1923 she exhibited two Cubist paintings in a Dublin Painters' exhibition at 7 St Stephen's Green. George Russell (q.v.) in the *Irish Statesman* described her as 'a late victim to cubism in some sub-section of this artistic malaria'. Cubism had arrived in Ireland. When the two students of Gleizes held their first exhibition in Dublin in 1924 at the same gallery, criticism was again hostile. *The Studio* noted that the exhibition 'excited vehement controversy ... None of these works bore a title, and the vast majority of them were as far removed from any effort at representation as they could possibly be.'

W.B. Yeats opened a Jellett exhibition at the Dublin Radical Club in 1926, and in 1926, 1927, 1928 and 1929 she again exhibited at the Dublin Painters' Gallery. In the 1920s she was active exhibiting outside Ireland, particularly in Paris, where she had three works at the Salon des Vrais Indépendants in 1923, and

two years later she showed with the London Group in Pall Mall. She also exhibited at the London Salon. In 1925 she was represented at Versailles in an exhibition entitled 'L'Art d'aujourd'hui'. In 1925, 1926 and 1928 her work was in the Salon des Indépendants exhibitions. She was represented in the Irish section of the exhibition of art at the Olympic Games at Amsterdam in 1928.

Perhaps less committed to the French connection, she resumed exhibiting at the RHA in 1930, continuing each year until 1937. In 1930 she was represented by two paintings at the exhibition of Irish art, Brussels, and her work was in the Salon des Surindépendants in Paris. In 1931 she exhibited with the Water Colour Society of Ireland for the first time, showing nearly fifty works up until 1943. The Gate Theatre at this time was something of a rallying place for *avant garde* ideas. She exhibited her pictures in the foyer, became involved in stage sets for plays, and designed a drop curtain.

Mainie Jellett also designed rugs, which were sold at some of her exhibitions. A carpet design is at the Crawford Municipal Art Gallery, Cork. In 1931 she visited Lithuania, staying in Antwerp on her way back; staged another exhibition of her Cubist paintings at the Dublin Painters' Gallery, and lectured there during the show. Towards the end of the year she became associated with the Abstraction – Création group of artists, contributed to their manifesto and the exhibition in 1932. In 1932 in the arts and crafts section of Aonach Tailteann she won the silver gilt medal for *Decorative Painting*, and also in 1932 she lectured at the Dublin Metropolitan School of Art on 'Rhythm in Art.' In the next ten years her commitments may have overtaxed her strength.

Another Cubist exhibition was held at 7 St Stephen's Green in 1933; she visited Amsterdam and Antwerp with Evie Hone; broadcast twice for Radio Éireann with special talks; and won a £10 prize in a competition of industrial designs at the Imperial Institute: Royal Society for the Encouragement of Arts, Manufacturers and Commerce. As well as broadcasting, she wrote articles and opened exhibitions of the younger painters. In a lecture in 1934 to the Architects' Association of Ireland she advocated the setting up by the local authority of a Committee of Beauty (as in Amsterdam). In the same year she exhibited at the Salon des Surindépendants at Versailles, and at the RHA, *Bridge, Co. Cork* was among three works. *The Blackwater, Co. Cork* appeared at the 1934 WCSI show.

Mainie Jellett and her friend Stella Frost (q.v.) spent several holidays on Achill Island. She was involved in a Radio Éireann discussion in 1935 with the RHA president, Dermod O'Brien (q.v.) on 'The Academic Tradition and the Modern Movement in Painting'. Oriental art was an influence on her work after attending the Chinese Art exhibition at Burlington House, London, which opened in 1935.

At the Salon d'Automne in 1938 Jellett and Hone were represented in an exhibition of works by students of Gleizes. She designed for the ballet, *Puck Fair*, produced by the Gaiety Theatre in 1939, and in that year she began lecturing at the Contemporary Picture Galleries, 134 Lower Baggot Street, Dublin, and in war-time she also lectured in Cork.

The Irish Government commissioned her to decorate the Irish Pavilions for the Glasgow Exhibition in 1938 and the New York World's Fair in 1939. For Glasgow, there were ten sets, each consisting of four panels, designed to cover the two sides of the wall-space reserved for the murals. Among the subjects were: Mountain sheep and donkeys; Turf-cutting; Creamery and butter-making. The total space was 3 metres by 58.5 metres. One of the designs is in Limerick City Gallery of Art. In 1939, the year of her last visit to France, she exhibited again at the Dublin Painters' Gallery, showing studies for the Glasgow murals as well as gouaches: *Horses; Donkeys; Cylamens;* for example.

In 1940 she began the first of her lectures to the White Stag Group and she was a regular participant at their group shows. She used her influence to help artists from abroad who had arrived in Ireland since the outbreak of war. In 1940 she exhibited with five other Irish artists who had studied at L'Academie Lhote. At 7 St Stephen's Green she exhibited mainly gouaches in 1941, and she again used the catalogue to advertise her drawing and painting classes; she had a group of more than thirty students in 1942. She was represented in an exhibition of designs for the theatre at the Contemporary Picture Galleries in 1942, following her set for the ballet *Puck Fair*.

Many of the semi-abstract pictures painted in the last three or four years of her life were religious in subject, for example *The Ninth Hour*, 1941, now in the Hugh Lane Municipal Gallery of Modern Art, and *The*

Madonna of Eire, 1943. In addition to their relatively small holding of oil paintings, which include *Achill Horses,* exhibited 1941, the National Gallery of Ireland has more than 200 drawings, some in gouache on board, others pencil on paper; included are abstracts, figure studies and a range of other subjects, for example a watercolour, *Under the Big Top at a Circus;* a poster design for an ice rink; and a sign for The Country Shop. An oil painting, *Pietá,* is at the Irish Museum of Modern Art in Dublin.

In a 1942 issue of the *Father Mathew Record,* Máirín Allen wrote: 'Miss Jellett has some of the qualities of an ascetic and an idealist. She has followed her own path despite opposition and misunderstanding. She has worked very quietly. But I cannot help thinking that her influence may be one of the most important in bringing our painters back into contact with European thought and European painting.'

However, Charles Sidney commented in *The Bell:* 'While it is easy to detect in her canvases some sound draughtsmanship and a nice sense of colour harmony, her work was so clearly a mere adaptation of that of her master Gleizes, that even her most realistic horses' heads were borrowed directly from that artist's woodcut illustrations of the early twenties...'

The artist, Louis le Brocquy, recalled in 1990 that Mainie Jellett's image remained clear in his mind: 'Tall, slightly stooped perhaps, a wisp falling free of her severely arranged hair, a seemingly eternal cigarette hanging casually from her thin lips; her kindness, her guidance and her intense passion for painting. But what was memorable above all in the person of Mainie Jellett was her quiet, even modest *authority* – an authority born of deep spiritual conviction, an authority which gave weight to her occasional outbursts of indignation against myopic academism, punctuating her usual calm and deep human concern.'

The last picture which this versatile artist finished was *Western Procession* in 1943 and it appeared in the inaugural exhibition of the Irish Exhibition of Living Art. She had been appointed chairman but became seriously ill and was removed to St Vincent's Hospital, missing the first exhibition. Her death in the private nursing home was on 16 February 1944 and she was buried at St Fintan's, Howth, Co. Dublin.

The IELA inaugurated a Mainie Jellett Memorial Scholarship Fund, and *Homage to Fra Angelico* took the place of honour at the 1944 show. A memorial exhibition was held that year at the Dublin Painters' Gallery and also at the Victor Waddington Galleries. A retrospective exhibition consisting of 127 works was held at the Municipal Gallery of Modern Art, Dublin, in 1962, and subsequently was hung at the Crawford Municipal Art Gallery, Cork.

A detail from her painting, *Madonna of Eire,* appeared on a special postage stamp issued in 1970. In 1974 there was an exhibition of more than ninety works at the Neptune Gallery, Dublin, and two years later that gallery arranged the first Jellett exhibition in Belfast, at the Octagon Gallery. In 1976 too UNICEF reproduced *The Nativity* on a Christmas card. A large and comprehensive retrospective exhibition took place at the Irish Museum of Modern Art, Dublin, 1991-92. One Oxford Street, the Belfast gallery, hosted an exhibition in 1997, celebrating the centenary of her birth.

Works signed: M. Jellett, Mainie H. Jellett, Mainie Jellett, M.H. Jellett, M. Jellett, Jellett or M.J. (if signed at all).
Examples: Armagh: County Museum. Belfast: Ulster Museum. Cork: Crawford Municipal Art Gallery. Drogheda, Co. Louth: Library, Municipal Centre. Dublin: Hugh Lane Municipal Gallery of Modern Art; Irish Museum of Modern Art; Irish Writers' Centre; National Gallery of Ireland; Office of Public Works; Trinity College Gallery. Galway: Art Gallery Committee. Kilkenny: Art Gallery Society. Limerick: City Gallery of Art. Sligo: Model and Niland Centre. Waterford: City Hall, Municipal Art Collection.
Literature: *The Studio,* September 1924; *Father Mathew Record,* April 1942; *Dublin Magazine,* October-December 1942 (illustration), January-March 1944; *Irish Times,* 17 February 1944, 14 September 1944, 13 September 1974; Charles Sidney, *The Bell,* November 1944; Elizabeth Bowen, *The Bell,* December 1944; Stella Frost, ed., *A Tribute to Evie Hone and Mainie Jellett,* Dublin 1957 (also illustrations); Eileen MacCarvill, ed., *Mainie Jellett: The Artist's Vision,* Dundalk 1958 (also illustrations); Elizabeth Rivers, *Studies,* Summer 1961; Dublin Municipal Gallery of Modern Art, *Mainie Jellett,* catalogue, 1962; Department of External Affairs, *Ireland,* 5 November 1962; Trinity College, Dublin, *Thomas MacGreevy Papers;* Harold Osborne, *The Oxford Companion to Art,* Oxford 1970; Bruce Arnold: Neptune Gallery, *Mainie Jellett,* catalogue, Dublin 1974 (also illustrations); Hilary Pyle, Cork Rosc, *Irish Art 1900-1950,* catalogue, 1975 (also illustration); Octagon Gallery and Neptune Gallery, *Mainie Jellett,* catalogue, Belfast and Dublin 1976 (also illustrations); Ann M. Stewart, *Royal Hibernian Academy of Arts: Index of Exhibitors 1826-1979,* Dublin 1986; Irish Museum of Modern Art, *Mainie Jellett Exhibition Guide,* Dublin 1991; Anne Madden le Brocquy, *Seeing his way,* Dublin

1994; John Turpin, *A School of Art in Dublin since the Eighteenth Century*, Dublin 1995; *Water Colour Society of Ireland Exhibition List 1872-1994,* Dublin 1995; Dorothy Walker, *Modern Art in Ireland*, Dublin 1997(illustrations).

JOHNSON, NEVILL (1911-99), landscape and figure painter. Born in Buxton, Derbyshire, in July 1911, the son of a cotton merchant, he attended the preparatory school, St Chad's, Prestatyn, North Wales, moving on to Sedbergh School, Cumbria. As he declined to go into his father's business, he became an industrial trainee, painting only at week-ends. In 1934 he was posted to Belfast, where he met John Luke (q.v.), who gave him painting lessons for two years in technique, earning his keep by day.

In 1937 he visited Paris with Luke and they saw Cubist and Surrealist pictures. He married in Belfast, and after the bombing raid on the city in 1941, Major Paul Terris provided accommodation at his farm, Knappagh House, Killylea, Co. Armagh. Johnson persuaded the Major to take in Luke and his mother.

Johnson returned to Belfast and in 1946 participated in a group show with Olive Henry (q.v.), Gladys and Max Maccabe and Aaron McAfee at the short-lived MacGaffin Gallery. In Dublin, he showed at the Victor Waddington Galleries in 1946 and the Dublin dealer encouraged him to paint full time, offering a regular allowance. He left his job and Dublin became his home in 1947.

In 1947 he joined with George Campbell, Gerard Dillon and Dan O'Neill (qq.v.) in the exhibition Four Ulster Painters at Waddington Galleries, and they showed at Heal's Mansard Gallery in London in 1948, *The Studio* commenting that they were 'linked by one strong characteristic — imaginative power.' Johnson had adopted a more Cubist manner, for example in *The Family*, which was hung at Heal's. He showed at the Irish Exhibition of Living Art in 1947 and became a regular exhibitor, also at the Waddington Galleries from 1948. A sole contribution to the Royal Hibernian Academy was *The Wall* in 1949, when he also participated at the Oireachtas.

Johnson exhibited in London in the Five Irish Painters exhibition organised in 1951 by Arthur Tooth and Sons, Ltd. Among his seven works were *Toi et Moi* and *The Plantation. The Studio* found his landscapes of 'surrealist atmosphere'. Back in Dublin he occupied a mews house in Convent Place lane. During 1952-3 he took a series of photographs of the city which were later published in book form. He was represented in a touring exhibition of six Irish painters in America in 1953. He designed textiles. During the early 1950s he gathered a group of younger painters about him, including Cecil King (q.v.), instructing them in his studio.

In the mid 1950s 'circumstances demanded my return to Belfast.' He stayed for some months at the home of George MacCann and his wife, Mercy Hunter (qq.v.) in Botanic Avenue, sleeping and working in an attic room. In an adjoining room, also seeking temporary refuge, lived Stanley Spencer (1891-1959), one of the most original figures in twentieth century British art. 'I found Stanley a cocky little man,' wrote Johnson in his autobiography, 'not shy of talking. At once pragmatic and poetic, his vision was intensely assured; no hang-ups, no biting of the nails...' Business completed, Johnson returned to Dublin.

Johnson was one of the artists represented in the Irish exhibition during 1950 sponsored by the Institute of Contemporary Art, Boston, in various public galleries in the USA. In the same year examples were also included in the Contemporary Irish Painting exhibition, organised by the Cultural Relations Committee of Ireland, touring USA and Canada.

The *Dublin Magazine* critic kept a close eye on the artist: 'In spite of the fact that he shows himself capable of considerable finesse in the chosen idiom of the moment, for me a great deal of his work has a disconcerting air of studied contrivance, or over-elaborate simplification. In short I have a feeling that his preoccupations are still too much with manner and technique; that he has yet to come to grips with life.' On the IELA show that year, 1950: 'Nevill Johnson continues to exploit his rather surrealist idiom in his smoothly painted and almost monochromatic *Sisters,* a picture inspired by rather obvious symbolism, but nevertheless coldly effective in its clarity.'

On his *Mother and Child* at the 1951 IELA, the *Dublin Magazine* found it 'rigid, cubistic, cold in colour and unemotional in the quality of its paint, is obviously a picture of power and sincerity. I must confess, however, that I found myself somewhat repelled by its uncompromising austerity.' But his exhibition at the Victor Waddington Galleries in 1952 showed 'phenomenal development since his one man show last year...

I feel that Johnson can be numbered among the first half-dozen important modern painters in the country at the moment…'.

At the IELA in 1954, from rere 20 Lower Leeson Street, Dublin, he presented four works: *Mini; The Witnesses; The Barrier between Us and Them; Aegean Shore*. In 1955 he moved to London and 'drifted for two years', then returned to Dublin. He showed at the 1957 IELA. He set off again and took any old job in London, worked continuously at his painting — and destroyed all he made; a period of self-doubt given as 1958-63. He was represented at the IELA 1966-9. From 1970 he wrote a number of articles and reviews and appeared on English television speaking about art, design and living.

At the Collectors' Gallery, Portobello Road, London, acrylics and drawings were exhibited in 1970. He had chosen the medium of acrylics because it was possible to paint very fast. Another London exhibition followed in 1972, at the Archer Gallery, Grafton Street. In Ireland, he showed paintings at the Listowel Graphics event in 1975 and at a loan exhibition in Drogheda, 1976. He was represented by *The Third Day* in the 1975 Rosc exhibition, 'Irish art 1900-1950', at the Crawford Municipal Art Gallery, Cork. He exhibited at the Tom Caldwell Gallery, Belfast, in 1978, the year he won the Silver Medal at the Royal Ulster Academy. Among the works purchased by the Arts Council of Northern Ireland at this time were: *Landscape with Pond*, collage; *Fiesta*, acrylic and charcoal.

Beginning in 1979 he had a succession of shows at the Tom Caldwell Gallery, Dublin. His book of photographs, *Dublin: The People's City*, 1981, won an award at the Leipzig International Book Art Fair. *The Other Side of Six*, autobiography, appeared in 1983. At the Tom Caldwell Gallery in Belfast in 1984 he exhibited thirty-one acrylic paintings, including *Landscape with Birds* and *My Father's House*.

The Solomon Gallery in Dublin presented Johnson's work in 1995; the Caldwell Gallery, Belfast, in 1999. An oil, *Howth Interior*, is at the Crawford Municipal Art Gallery. In acrylic, *Summer Soltice* is in the Ulster Museum collection.

A writer in the *Irish Times* considered that he had 'a rather retiring lifestyle and personality, but his cool, precise, elegant, sometimes cerebral style did not appeal to art-lovers as immediately as the work of some of his contemporaries did. He was a fastidious technician, a fine draughtsman and a skilful, muted colourist, but to the end there was something almost hermetic in his mentality.' He died in London.

Works signed: Johnson, Nevill Johnson or NJ, monogram, rare (if signed at all).
Examples: Belfast: Ulster Museum. Cork: Crawford Municipal Art Gallery. Dublin: Hugh Lane Municipal Gallery of Modern Art; Trinity College Gallery.
Literature: *The Studio*, October 1948, August 1951; *Dublin Magazine*, July-September 1950, October-December 1950, October-December 1951, April-June 1952, October-December 1952; Arthur Tooth & Sons, Ltd., *Five Irish Painters*, catalogue, London 1951; *Irish Times*, 10 December 1970, 14 August 1999; Cork Rosc, *Irish Art 1900-1950*, catalogue, 1975; *Arts Council of Northern Ireland annual report 1977-78*, Belfast; Tom Caldwell Gallery, *Nevill Johnson*, catalogue, Belfast 1978; Nevill Johnson, *Dublin: The People's City*, Dublin 1981; Nevill Johnson, *The Other Side of Six*, Dublin 1983 (also illustrations); S. B. Kennedy, *Irish Art & Modernism 1880-1950*, Belfast 1991 (also illustration).

JONES, F.W. DOYLE – see DOYLE-JONES, F.W.

JONES, HENRY THADDEUS – see THADDEUS, HENRY J.

JOY, ALBERT BRUCE – see BRUCE-JOY, ALBERT

JOY, GEORGE W., ROI (1844-1925), painter of historical subjects, genre and portraits. George William Joy was the son of William Bruce Joy, MD, and brother of Albert Bruce-Joy (q.v.), known in his youth as 'Ardent Albert'. Born in Dublin on 7 July 1844, 'Gentle Georgie' was descended from an old Huguenot family which settled in Antrim in 1612. His grand-uncle, Chief Baron Joy, was famous both as a lawyer and as a judge.

Joy was educated at Harrow School, 1858-63, his father being domiciled in the town, and 'mitigated the severity of his studies by dangerous excursions into the field of caricature'. Intended for the army, he was sent to Jeffrey's School of Shooter's Hill, but the idea of the army had to be abandoned owing to an accident to one of his feet. At the age of nineteen he became an art student at South Kensington. There he took every prize he competed for, and had Hubert von Herkomer (1849-1914) as one of his fellow students. He had a short period at the Royal Academy Schools, being the only student passing the test for the life school from the antique.

In 1868 he went to Paris where he studied under the portrait and genre painter, Charles François Jalabert (1819-1901), a pupil of Paul Delaroche (1797-1856), and under Léon Bonnat (1833-1922), portrait and history painter. When the two-year apprenticeship was ended, Jalabert begged his pupil to remain longer but he returned to England. In 1878 his first serious picture, *Laodamia*, was hung at the Royal Academy. Three years later *Joan of Arc* was sold on the day the exhibition opened. He was by now a member of the Artists' Corps of the Volunteers, and was one of their crack shots at Wimbledon and Bisley, representing Ireland some half-dozen times.

Patriotic subjects found favour. *The Young Nelson,* 1883, was succeeded by *The Young Wellington,* 1885. Other subjects, harping on patriotic themes, followed. *The Little Drummer Boy* just about ended the series. His portrait of HRH the Princess Alice of Albany was exhibited by command at the 1886 RA. According to the *Art Journal,* at the 1888 Royal Academy, *The Danaids* was 'one of the earliest wholly undraped figures allowed on the line'. This picture was sent to the Paris Salon where it was awarded a medal, and from France it went to Munich where it received the same distinction. Chicago and St Petersburg also extended a welcome, and he won a medal at Chicago. At the RA in 1892, *The King's drum shall not be played for rebels, 1798* found a home in the Russell-Cotes Art Gallery and Museum, Bournemouth.

The Maid of Orléans had not been forgotten and he returned to her at the 1895 RA. The work was admired at the Paris Salon the following year. By one of those odd coincidences, two letters arrived at the painter's home the same day – one from the Corporation of Leeds, giving the artist his own terms; the other from the French Government offering two-thirds less; the great honour supplementing the lower price! Joy decided on France as the destination, and the work went to the Museum at Rouen. Leeds, however, is strongly represented by *Cordelia comforting her father, King Lear, in Prison* and *The Death of General Gordon, Khartoum, 26th January, 1885.*

Joy is perhaps best known for *The Bayswater Omnibus,* 1.2 metres by 1.7 metres, exhibited at the RA in 1895 and at the Paris Salon in 1896, the year he was appointed a member of the Royal Institute of Oil Painters. Described as a 'delightful genre painting which shows an attempt at social realism in the way the different social types of passenger are contrasted on the bus', the picture also produced the comment from a French critic: 'M. Joy est le Pickwick de la palette.' The sitters included the artist's wife (the young mother), and their daughter Rosalind (the small girl). Rosalind donated the picture in 1966, after it had been lent by her mother, to the London Museum. Joy himself also recorded that he borrowed an omnibus from the London General Omnibus Company during his work on the painting. In 1900 his Bayswater address was: The Red Lodge, 51 Palace Court.

In 1903 in the Society of Painters' exhibition Joy exhibited *Kathleen, Daughter of the Rev. W.A. Wilson, Rector of Swanage.* In 1904 his autobiographical sketch, *The Work of George W. Joy* was published, dedicated 'To Present and Old Harrovians' by 'one of themselves'. In 1905 Oldham purchased for their permanent collection *A Dinner of Herbs.* In addition to exhibiting at the Royal Academy, until 1914, when he showed *The Countess Ferrers,* more than a score of works were hung at the Royal Institute of Oil Painters' exhibitions as well as the Walker Art Gallery, Liverpool. He also had pictures exhibited at the Royal Society of Artists, Birmingham; Manchester City Art Gallery; Glasgow Institute of the Fine Arts; and the New Gallery, London.

At the Royal Hibernian Academy he had eleven works on view between 1876 and 1905 inclusive; portraits in the inaugural year were of Miss Margery May and J.G. Swift McNeill.

As a worker, he was regarded as industrious rather than prolific. He also painted a number of portraits of young girls; and as an example of genre: a woodland path, children picking bluebells. His *Christ and a Little Child* was in the 1901 RHA with *Guardian Elves. Truth,* exhibited at the Royal Academy in 1893, went to

the National Gallery in Berlin but reappeared in London in 1980 when it was sold by Christie's on behalf of the German Democratic Republic. The theme concerned a little child who lowered her bucket into an old and disused well and was surprised to see the very goddess of Truth herself.

Joy, who lost both his sons in 1915 in the First World War, died at his home, Purbrook, Hants, on 28 October 1925. His brother had died the previous year. At the funeral of G.W. Joy at Christ Church, Portsdown, the Rev. F. Flynn, DD, said: 'He lived among us in his simple retirement, and perhaps only few were aware that we had in our midst a man, famous not only in England, and on the Continent of Europe, but in that great western Continent of America, where his works are well known and prized ...'.

Works signed: George W. Joy, George Joy, or G. Joy; G.W. Joy, G.J., monogram, both rare (if signed at all).
Examples: Bournemouth: Russell-Cotes Art Gallery and Museum. Coventry: Herbert Art Gallery and Museum. Leeds: City Art Gallery. London: Museum of London. Oldham: Art Gallery and Museum. Rouen, France: Museum.
Literature: W. L. Woodroffe, *Art Journal*, January 1900 (also illustrations); Rev. F. Flynn, DD, *Mss of Sermon,* 31 October 1925; *The Field*, 24 December 1925; *Catalogue of the Oil Paintings in the London Museum,* London 1970; *Dictionary of British Artists 1880-1940,* Woodbridge 1976; John Hewitt and Theo Snoddy, *Art in Ulster: I,* Belfast 1977; *Dictionary of Victorian Painters,* Woodbridge 1978; Witt Library, London, illustrative records; Ann M. Stewart, *Royal Hibernian Academy of Arts: Index of Exhibitors 1826-1979,* Dublin 1986; Harrow School, *Letter to the author,* 1988; also, Rev. J.K. Hewitt, 1988; Oldham Metropolitan Borough, 1988.

JURY, ANNE P.,RUA (1907-95), flower, landscape and animal painter. Anne Primrose Jury was the daughter of Percy Morgan Jury (1875-1945), architect, Blackwood and Jury, Belfast. Born on 30 January 1907 at Dunmurry, Co. Antrim, she lived there for many years at 'Brooklands' and then 'Brooklands Cottage'. Her father, a keen watercolourist who encouraged her painting career, was the grandson of the man who gave Dublin the Shelbourne Hotel as well as the hotel that still bears his name.

'Nancy' Jury, as she was familiarly known, studied at Belfast School of Art and in England, France and Switzerland. In 1929 she exhibited for the first time at the Royal Hibernian Academy, showing a total of thirteen works from then until 1945, of which ten were flowerpieces. The first picture which she sold was at the RHA. At her exhibition in 1929 at Rodman's Gallery, 41 Donegall Place, Belfast, *Bowl of Nasturtiums,* oil, was regarded by one observer as 'among distinguished company'.

In 1933 she was appointed an associate of the Ulster Academy of Arts. At a second exhibition at Rodman's Gallery, in 1935, she showed sixty-one oils; just over a quarter were flowerpieces. Most of her landscapes were Counties Antrim and Down scenes but there was also *Cottage, Keel, Achill.* There were four dog portraits, singled out by the *Belfast Telegraph*, in particular the group of five Cairn terriers, *The Good Companions.*

What was to be a sixty-year association with Co. Donegal had already begun: she showed *Near Lackagh, Donegal* at the 1935 Munster Fine Art Club exhibition. Sixty-three works were presented at Rodman's in 1936, Donegal landscapes to the fore, for example *Errigal: On the Road to Dunlewy*, but the three Belfast morning newspapers were all in agreement on her flower paintings, for example in the *Belfast News-Letter*: 'Miss Jury's paintings of flowers are on as high a plane as one will find in Irish art to-day.'

A 1937 exhibition at Rodman's Gallery produced fifty-four oils, principally flower paintings and landscapes. The *Belfast Telegraph* said that she perpetuated the late Hans Iten (q.v.) as a still life painter. In 1938 the Victor Waddington Galleries hosted her first exhibition in Dublin, most of the scenic material being the result of a long visit to Connemara that year. The *Irish Times* critic wrote: 'Her paintings show her to be a young artist of considerable skill. She has a great sense of composition, her draughtsmanship is sound, and she indicates her atmospheres with nice judgement.' Among the forty-two paintings, *Wallflowers* received special notice in the *Irish Press,* and in the *Evening Mail* her dog studies were considered so 'alive' that they 'might answer a call at any moment.'

In February 1939 Victor Waddington sailed for America with some 270 works. Among the artists represented were William Conor, Paul Henry and Jack B. Yeats (qq.v.), and Anne Jury. Three months later in Dublin she exhibited at the Spring Show in the Irish Industries Hall. At the RHA in 1943 she showed *In*

Connemara, and *Donegal Rocks, near Downings* in 1944. After the War, her exhibiting was principally confined to the Ulster Academy of Arts and its successor, the Royal Ulster Academy.

In the four years 1951-4 at the RUA, all twelve works shown were flowerpieces, excepting *Gipsies Near Bryansford, Co. Down*. In 1966 she was one of seven artists, the 'Ulster Artists Group', who showed at the Gordon Gallery in Wimbledon. All four works contributed at the 1967 RUA were County Donegal landscapes, and at the 1969 exhibition she won the Conor Award with *Fellow Labourers*, donkeys.

After a gap of forty-four years since she was appointed an associate of the Ulster Academy of Arts, she became an academician in 1976. In 1977 she sold her cottage and went to live at 'The Wee Field', Dunfanaghy, Co. Donegal, where she now had a studio. *Autumn Flowers* was her final contribution to the RUA in 1987. *Primroses*, oil, is at Limerick City Gallery of Art.

'Nancy' Jury was a tireless worker all her life for the Ulster Society for the Prevention of Cruelty to Animals, and bequeathed *Donkeys* to the Society. Stocky and of a ruddy complexion, she was a formidable enemy of the neglectful farmer or animal owner. Outspoken, boundlessly energetic, she was a distinctive figure in Dunfanaghy. She died at hospital in Letterkenny on 10 August 1995. A studio sale took place that year in Belfast, and the USPCA benefitted.

Works signed*:* A. P. Jury.
Examples: Belfast: Department of the Environment for Northern Ireland; Ulster Museum; Ulster Society for the Prevention of Cruelty to Animals. Limerick: City Gallery of Art.
Literature: *Belfast News-Letter*, 23 October 1929, 25 February 1936, 11 August 1995; *Belfast Telegraph*, 4 February 1935, 3 July 1937, 30 August 1977; *Cork Evening Echo*, 29 November 1935; Rodman's Gallery, *Exhibition of Oil-Paintings by Miss A. P. Jury*, catalogue, Belfast 1935, 1936, 1937; *Northern Whig*, 25 February 1936; *Irish News*, 27 February 1936; Ulster Society for the Prevention of Cruelty to Animals, *The Tree*, Belfast 1936 (illustration); *Evening Mail*, 19 September 1938; *Irish Press*, 22 September 1938; *Irish Times*, 22 September 1938, 13 February 1939, 5 May 1939, 25 October 1995; John Hewitt and Theo Snoddy, *Art in Ulster:I*, Belfast 1977; Anne P. Jury, *Letter to the author*, 1977; Martyn Anglesea, *The Royal Ulster Academy of Arts*, Belfast 1981 (also illustration); Ann M. Stewart, *Royal Hibernian Academy of Arts: Index of Exhibitors 1826-1979*, Dublin 1986; *Derry People and Donegal News*, 18 August 1995; Mrs Ada Arnold, *Letter to the author*, 1998; also, Ulster Society for the Prevention of Cruelty to Animals, 1998.

K

KAIN, THOMAS (1886-1948), portrait and banner painter. Born in Glasgow on 5 June 1886, he was the son of Thomas Kain, army tailor, and attended in Dublin the Royal Hibernian Military School. In an edition of *Who's Who in Art,* he described himself also as a lacquer worker and the winner of two first prize medals for painted furniture, at the Royal Dublin Society and Aonac Tailteann.

In the 1920s he contributed cartoons to the *Voice of Labour.* He showed only four works at the Royal Hibernian Academy – in 1925 a portrait of T. Magee, TD, and in the same year he painted from a photograph a portrait of James Connolly which had an unexpected elevation as it was lent by the Irish Transport and General Workers' Union for the Golden Jubilee of the Easter Rising exhibition held at the National Gallery of Ireland in 1966. Other portraits by Kain at Liberty Hall are: Tom Foran, 1926; Tom Kennedy, 1942. Thomas Nagle, TD, and Alderman W. O'Brien also sat for him.

In a reminiscence, Senator Fintan Kennedy wrote to the author in 1983: 'The artist Tom Kain lived at 15 Old Camden Street, Dublin with his brother Christopher, who was a housepainter. Both of them were Bohemian in their approach to life and socialistic in their politics. They were regarded as great "characters" in the Dublin of the 1920s. I well remember visiting their studio, as they were pleased to call it, when my father was sitting for his portrait. Actually, I always had to stay outside as the studio was so cluttered up with paraphernalia that only two people could occupy it at the same time. And there were pieces of carpet and linoleum everywhere, Tom being a carpet-layer by trade ...'

In 1926 at the Daniel Egan gallery, 38 St Stephen's Green, Dublin, an exhibition of modern art included 100 works from Paris. Thomas Kain was represented by two paintings, including, *The Fortuneteller.*

As a banner painter, Kain had a high standard and delighted in floral delicacy. In 1920 he executed the banner of the Carters' section No. 1 branch of the ITGWU, Dublin, 2.5 metres by 1.9 metres, now at Liberty Hall. In 1930 he was responsible for the shield-shaped banner for the Electrical Trades Union, Dublin, showing a figure running with a torch, and also in that year he painted the first banner of the Transport and General Workers' Union in Belfast, also at Liberty Hall. On 9 October 1948, late of 368 Kildare Road, Dublin, he died in hospital.

Works signed: T. Kain.
Examples: Dublin: Liberty Hall.
Literature: Daniel Egan, *Exhibition of Modern Art*, catalogue, Dublin 1926; *Who's Who in Art*, 1934; General Register Office, *Registration of Death*; Belinda Loftus, *Marching Workers*, catalogue, Belfast 1978 (also illustrations); Senator Fintan Kennedy, *Letter to the author*, 1983; Ann M. Stewart, *Royal Hibernian Academy of Arts: Index of Exhibitors 1826-1979*, Dublin 1986.

KANE, GEORGE MacD. (1889-1954), sculptor and portrait painter. Born in Belfast on 29 October 1889 and baptised George Kane, he was the son of William Kane, plasterwork designer and contractor, and took the name 'MacDowell' from his maternal grandfather. He attended Belfast Mercantile College, and was later associated with the Ulster Arts Club and the Ulster Literary Theatre. A small head and shoulders pencil portrait of a relative was dated 1908. He had been attending art classes at the Belfast School of Art since he was aged sixteen, occupation then given as railway clerk of 115 Dunluce Avenue; for the session 1907-08 he was an 'architect's apprentice'. He took these classes for five years, winning the Dunville Scholarship to the Dublin Metropolitan School of Art.

Prior to 1914, Kane would have met Roger Casement, a distant relation – hence his life-size head of Casement, regarded as one of his finest works. Having decided on architecture as a profession, he was articled with the Belfast firm, Blackwood and Jury, and by 1913 was a qualified architect. However, the previous year in the studio of his friend W.R. Gordon (q.v.), he had modelled a head of John Whaley, a Queen's

University student from Waringstown, Co. Down. A cast in bronze is now in the Ulster Museum. At the time of the modelling, some colleagues decided to measure it against the head of the sitter. Although the artist – or architect – had made no measurements, working 'by eye', the head was 'true' to an unbelievable degree.

Francis Joseph Bigger, the Belfast antiquarian, commissioned Kane to do a series of drawings of Irish buildings to illustrate a book, which was never published. The drawings were sold at auction after Bigger's death.

In 1913 he executed his striking charcoal portrit of Hans Iten (q.v.), now in the Ulster Museum. A portrait, in private hands, of Alfred Percival Graves (1846-1931), sketched during a lecture, was undated. He also executed a portrait of the novelist Forrest Reid. The artist's sister, Eleanor Kane Archer, told the author in 1973: 'He was to go under the patronage of Hugh Lane but Lane went down in the Lusitania.'

Kane left Belfast for Edinburgh to assist James Pittendrigh Macgillivray, RSA (1856-1938) with work on the Gladstone Memorial, sculpting minor figures. In 1915, giving an address 'c/o Rodman & Co., 41 Donegall Place, Belfast', he exhibited two works at the Royal Scottish Academy: *Head of a boy* and *Father*. A pen and ink drawing of the façade of the gate-tower of S. Gregorio, Valladolid, was dated 1916. This was not more, according to a relative, than 15 centimetres high and the detail required a magnifying glass to examine. At this time his whereabouts were for a period unknown (nor were they ever ascertained). The Edinburgh monument was unveiled in 1917 and is now located in Coates Crescent.

On returning to Belfast, he worked for a spell with Seamus Stoupe (q.v.) but devoted much of his time to portrait drawings, often in pencil or conté crayon, and many of these were of family and relatives. He could not resist using his pencil on any scrap of paper that came to hand, and undoubtedly pleased many of his friends by making them presents of such work. Studies in red conté of actors and actresses preparing for performance can be dated 1925 and these are described by a relative as 'very mature, bold, assured work'.

Kane, who was a brother-in-law of a Town Clerk of Belfast, John Archer, was not really interested in publicly exhibiting his work. He is believed to have done only one lithograph, a self-portrait life-size head, astonishing his fellow-artists by using a stone belonging to one of them although he had not practised the craft. Also extant are a few small landscapes in pen and ink. He was something of an eccentric and was said at one period to have allowed his hair to grow for years, plaited it and wound it round his head like a Sikh. His last portraits were drawn about 1950. He died in Purdyburn Hospital, Belfast, on 5 March 1954.

Works signed: Geo. MacD. Kane.
Examples: Belfast: Ulster Museum.
Literature: Miss Georgina Whaley, *Letter to the Ulster Museum*, 1957; John Hewitt, *Letter to the Ulster Museum*, 1973; *Country Life*, 9 August 1973; Kane Archer, *Letters to the author*, 1977; John Hewitt and Theo Snoddy, *Art in Ulster: I*, Belfast 1977; Martyn Anglesea, *The Royal Ulster Academy of Arts*, Belfast 1981 (illustration); College of Technology, *Letter to the author*, 1988; Brian Kennedy, compiler, *Ulster Museum Twentieth Century Sculpture*, catalogue, Belfast 1988.

KANGLEY, EDWARD – see MARK, BROTHER

KAVANAGH, JOHN F., RBS (1903-84), sculptor. John Francis Kavanagh was born on 24 September 1903 at Birr, Co. Offaly. Early education was at the Christian Brothers' School in Cork. At the age of sixteen, a serious accident changed his life. As the result of a fall in a quarry, he received severe spinal injuries which kept him in bed for three years and lamed him for life. To pass the time, he took up modelling in clay and made hundreds of small figures, mostly of a religious nature. Discovering that he had a special aptitude for modelling, he determined to take up sculpture as a career.

Kavanagh studied at the Crawford School of Art and, in 1920-21, at the Liverpool School of Art. Four years living with his family followed and then, in 1925, he won a scholarship to the Royal College of Art, London, and studied sculpture under Gilbert Ledward (1888-1960) and Henry Moore (1898-1986). His great interest in coins was stimulated by his years under Ledward. In his third year at the Royal College he was appointed an assistant to Charles Sargeant Jagger (1885-1934). Apparently it was Kavanagh, not Jagger, who

in 1930 modelled the elephants outside the New Residence at New Delhi. Jagger was responsible for the overall sculptural design.

In 1929 Kavanagh won an RCA travelling scholarship, with which he studied in Berlin, Munich, Vienna and Paris. In 1930 he entered the competition set by the British School at Rome and won the Rome Prize in Sculpture for two years of study. A third year was paid for by the Royal Academy. During this time he exhibited in Rome and Venice. In Italy he found subjects for his sculpture that particularly suited his style and temperament. *Wanda Tiburzzi* (Royal Academy, 1933) was an Italian woman he glimpsed in the streets and searched for with great difficulty until he located and persuaded her to model for him. This work won the bronze medal at the Paris Salon in 1935 and was exhibited at the Royal Hibernian Academy in 1936 when he gave his address as 5 St Oswald's Studios, Sedlescombe Road, Fulham, London.

Tanith, also of Italian inspiration and a nude, appeared at the RA in 1933 and won an honourable mention at the Paris Salon in 1934. After his return from Italy in 1934, he was appointed head of the department of sculpture and modelling at the Leeds College of Art. He held this position for six years. In 1935 he was made a Fellow of the Royal Society of British Sculptors. With the successes at exhibitions, and his appointment at Leeds, came a series of public commissions. For example, *Christ Triumphant on the Cross* for the Church of our Lady, Leeds, was carved in limewood and was said to be the largest wooden figure made in England at that time since the Renaissance. It was designed to be hung on chains above the nave of the church, high above the heads of the worshippers.

During his period at Leeds, he maintained a studio in London. His *Madonna and Child* for the Catholic Hospital, Lambeth Road, London is now in the Holy Family Convent, Frimley, Surrey. In 1936 he won an international competition to design the medal presented by the Royal Institute of British Architects to winners of the Rome Scholarship in Architecture. Dated 1936, and placed on top of a granite plinth some 140 cm high, is a bronze 76 cm high of a classical female athlete carrying a torch and set on a diamond shaped base at Roundhay School, Leeds.

In 1937 at the Royal Academy he exhibited portraits of J.W. Dulanty and Sir Francis Joseph. He was represented at the British Empire Exhibition in Glasgow in 1938, and in 1939 at the RA he contributed a portrait bust of Cardinal Hinsley, now in Westminster Cathedral Clergy House Library. Altogether, eighteen works were exhibited at Burlington House.

Kavanagh's most important commission was in 1940 to carve all the sculpture for the new Walthamstow Civic Centre. This included sixteen panels of relief, symbolising themes of work. There were also five statues, each about 2.3 metres high, on social themes; one work, *Fellowship*, incorporated a portrait of William Morris (1834-96), who was born in Walthamstow.

In 1941, he won a competition for a monument in Galway to Father Tom Burke. His tender, from Rodney Walk, Chelsea, London, for the execution of the 3.4 metre-high memorial to his design was £750. In 1943 at the Royal Academy he showed *Head of a Russian Peasant*, which was bought under the terms of the Chantrey Bequest and is now housed in the Tate Gallery, London. In 1944 his *Lady Jane* toured America with other British sculpture, presumably the work of that name at the 1936 RHA. The 1950 competition for the Custom House Memorial in Dublin was won by Kavanagh who could not begin the work because of an appointment abroad.

In 1951 Kavanagh travelled to New Zealand to take up a post as senior lecturer in sculpture at the Elam School of Fine Art in the University of Auckland, and there he remained until his retirement. In his first year in Auckland, he won a competition to design the seal for the Medical Research Council of New Zealand. In his first twenty years in New Zealand, however, he received only one other commission, for a portrait head. In 1978 he won the Grand Prix de Lyons with a bronze taken from the marble head of Georgia Leprohon, a four-year-old child. *Crouching Figure* in sandstone, height 35 cm, is in Aigantighe Art Gallery, Timaru.

At the University of Auckland is a bronze head of Sir Douglas Robb, 1956, and an oil on canvas, 1961, of the same sitter. In 1979 an exhibition of sculpture and models from the collection of John F. Kavanagh was held at Auckland City Art Gallery with important information about the artist's life recorded in the catalogue. He died on 18 June 1984.

Works signed: J.F. Kavanagh or Kavanagh (if signed at all).
Examples: Auckland, New Zealand: Mount Albert War Memorial; University. Delhi, India: New Residence. Frimley, Surrey: Holy Family Convent. Galway: Grattan Road and Father Griffin Road junction. Leeds: Church of our Lady; Roundhay School. London: Walthamstow Civic Centre, Waltham Forest; Westminster Cathedral. Timaru, New Zealand: Aigantighe Art Gallery.
Literature: *Apollo*, June 1933 (illustration); *The Universe*, 7 February 1941; *The Studio*, May 1944 (illustration); *Tate Gallery: The Modern British Paintings, Drawings and Sculpture*, catalogue, London 1964; Auckland City Art Gallery, *John F. Kavanagh, Sculptor*, catalogue, 1979; Mrs Margaret Kavanagh, *Letter to the author*, 1987; also, Aigantighe Art Gallery, 1988; Roundhay School, 1988; University of Auckland, 1988; *Irish Times*, 8 September 1999.

KAVANAGH, JOSEPH M., RHA (1856-1918), landscape and seascape painter. Born in Dublin, he was encouraged in an art career by having a work accepted for the 1875 Royal Hibernian Academy and also by winning the silver medal at the Royal Dublin Society Christmas competition in the same year. He was then living at 101 Great Britain Street. A free student at the Dublin Metropolitan School of Art 1877-78, in the following year he was awarded first prize for a drawing from the antique, and he also won the Grundy Prize. He also studied at the RHA Schools, where his friend Walter Osborne (q.v.) received tuition.

In 1881 Kavanagh won the Albert Scholarship with a picture of Franciscan monks of the Middle Ages (RHA, 1881), and that September he travelled with Osborne and Nathaniel Hone (q.v.) to Antwerp for study at the Académie Royale. The three shared lodgings at 49 Kloosterstraat. Kavanagh gave the French name of the street 'Rue du Couvent' when he exhibited at the RHA in 1882. In that year he was represented at the Exhibition of Irish Arts and Manufactures, Dublin, and from The Bungalow, Castle Avenue, Clontarf, he exhibited half-a-dozen Flemish scenes, in and around Bruges, at the 1883 RHA, and these included *An Old Flemish Draw-Well, Merxem* and *Under the Shadow of St Jacques, Antwerp*. He had an interest in architectural detail. The three students spent most of their time in the life class of Charles Verlat (1824-90), and it was through the influence of his teacher that Kavanagh studied etching; his first work in this medium at the RHA was in the 1883 exhibition.

In 1883-84 he worked in Brittany and Normandy. *The Old Convent Gate, Dinan* was painted in 1883 (RHA, 1884) and is now in the National Gallery of Ireland with other works. Osborne may also have visited Dinan with Kavanagh. Other Continental works were *The Little Chapel of St Aubert, Mont St Michel, Normandy* (RHA, 1885) and *A Sunny Corner, Quimperle* (RHA, 1886). About this time he painted *Village street in Normandy* (NGI).In 1885 he was proposed and seconded as a 'working member' of the Dublin Sketching Club but he resigned about a year later.

In 1886 Kavanagh exhibited *A Hallowed Spot* at the Royal Academy, and *Soul-soothing Act* two years later. In 1887 he returned to Ireland and *Pursuing his Gentle Calling* of that year showed the painter himself at work in the snow in a Dublin street scene. In 1889 he was made an associate of the RHA and three years later a full member. He was to show more than 200 works at the Dublin exhibition. In 1890 the Dublin Art Club issued a portfolio of nine etchings, five of which were Kavanagh's, including *Port du Baudets, Bruges* and *On the Ramparts, Mont St Michel*. There is a set in the British Museum. There are three etchings, including *The Palin Brug, Antwerp*, at NGI.

Appointed a visitor at the RHA living model school in 1892, he acted until 1911. In his *Five Years in Ireland – 1895-1900,* Michael J.F. McCarthy wrote that Kavanagh's pictures of 'level strand and tide are excellent'. *Carting Seaweed on Sutton Sands*, 1895, is at NGI. He drew some of the illustrations for *Medical Practice in Dentistry* by W.B. Pearsall (q.v.), 1898. At the RHA in 1899 the first two of several plaques appeared, one in embossed silver, the other in embossed brass.

Killenshine Ponds and *Woodland Pastures* were exhibited at the 1902 RHA and are now in the Crawford Municipal Art Gallery, Cork, having been presented by Friends of the National Collections of Ireland. Writing about that exhibition, *The Studio* commented that the artist had 'at least the virtue of individuality'. Kavanagh was represented by *Irish Cabins* in the exhibition of 1904 of works by Irish painters held at the Guildhall of the Corporation of London and organised by Hugh P. Lane. *A November Evening*, 1904 RHA, is in NGI. In 1906 he was represented in the Oireachtas exhibition in Dublin.

Kavanagh, a bachelor, resided at 10 Mount Merrion Avenue, Blackrock, Co. Dublin, when he was appointed Keeper of the RHA in 1910 and so moved to their premises in Lower Abbey Street. He took a deep interest in the affairs of the Academy, accepting the treasurership the following year, after which he worked hard to improve the financial position. On the death of his friend, Henry Allan (q.v.), he presented the latter's *A Dutch Interior* to the NGI.

One of Kavanagh's best known pictures is described *The Cockle Pickers* and is dated 1890. It may be *Cockle Pickers on the North Bull Sands,* RHA 1893. In the 1896 RHA he showed *Dublin Cockle Pickers.* Among the places and rivers mentioned in titles of his works are: Dollymount, Donnycarney, Feltrim, Killester, Liffey, Portmarnock, Portrane, Raheny, Rathfarnham, Rush, Shannon, Stillorgan and Tolka. *Gypsy Encampment on the Curragh* is in the Ulster Museum collection, and *Rathlin Light House* is with the Royal Irish Yacht Club, Dun Laoghaire, Co. Dublin.

Kavanagh's name is associated with the traumatic experience of the burning of the Academy building in the Rebellion of 1916, and he was probably unfairly criticised for not saving more of the Academy's treasure. A very conscientious official, he was devoted to the affairs of the RHA. The president, Dermod O'Brien (q.v.), recounted how Kavanagh, who had apartments in the building, was working in the Council room, painting, when all at once there was a tremendous crash and every pane of glass was shivered by the explosion of a shell outside the window, a fragment of the shell going up through the ceiling and floor above him. Kavanagh had remained on the premises from Easter Monday until the Wednesday when he was forced to flee for his life. He and others were interned for a week by the military in the Custom House and were not allowed to communicate with the outside world, so he had 'disappeared'. The only items he was able to save were the two Royal Charters, the President's chain and badge of office, bank book, policies of insurance, and an account book.

According to a newspaper report, he left the Academy when all around him was ablaze. 'I had to go into the street,' he said. 'I could not face the barricade that was in flames, and I had to face the artillery stationed under Butt Bridge that was firing up Abbey Street at the barricade...' He lost all his belongings, including many of his pictures, in the fire. He was a kindly, popular and respected teacher, and his pupils contributed towards a money gift. He took up residency at Moran's Hotel. It was said that he never recovered from his nerve-racking experience and he died at Fitzwilliam Nursing Home in Upper Pembroke Street on 2 April 1918.

Works signed: J.M. Kavanagh, Kavanagh or JMK, monogram.
Examples: Belfast: Ulster Museum. Cork: Crawford Municipal Art Gallery. Dublin: National Gallery of Ireland; Royal Hibernian Academy. Dun Laoghaire, Co. Dublin: Royal Irish Yacht Club. Limerick: City Gallery of Art. London: British Museum.
Literature: *Dublin Sketching Club Minute Book,* 1885-87; William Booth Pearsall, *Medical Practice in Dentistry,* London 1898 (illustrations); Michael J.F. McCarthy, *Five Years in Ireland – 1895-1900,* Dublin 1901; *The Studio,* April 1902; *Irish News,* 8 May 1916; *Thom's Directory,* 1919; J. Crampton Walker, *Irish Life and Landscape,* Dublin 1927 (illustration); *Capuchin Annual,* 1932 (illustration), 1933 (illustration), 1934 (illustration); Lennox Robinson, *Palette and Plough,* Dublin 1948; Ethna Waldron, 'Joseph Malachy Kavanagh', *Capuchin Annual,* 1968; Alan Denson, *John Hughes Sculptor 1865-1941,* Kendal 1969; *Irish Times,* 12 December 1969, 11 November 1975; Julian Campbell: National Gallery of Ireland, *The Irish Impressionists: Irish Artists in France and Belgium 1850-1914,* catalogue, Dublin 1984 (also illustrations); Ann M. Stewart, *Royal Hibernian Academy of Arts: Index of Exhibitors 1826-1979,* Dublin 1986; National Gallery of Ireland, *Gallery News,* September-November 2000.

KAY, DOROTHY (1886-1964), portrait, figure painter and illustrator. Born on 3 December 1886 at Greystones, Co. Wicklow, Dorothy Moss Elvery was the fourth child in the family of John William and Theresa Elvery, and a sister of Beatrice Elvery (q.v. Lady Glenavy). Her father sold sporting goods. Dorothy studied at the Dublin Metropolitan School of Art and also at the Royal Hibernian Academy Schools where she won prizes in the 1902-03 session. *The Breadwinner* of 1902 appeared in a retrospective exhibition in 1966. In 1904 she won the Taylor Scholarship. Along with her sister Beatrice and others she visited Paris for

a few weeks study. In 1905 she exhibited with the Young Irish Artists at the Leinster Hall, Molesworth Street, Dublin, and by 1906 three pictures had been hung at the RHA.

When she showed in 1910 at the first 'past and present' exhibition organised by the students of the Metropolitan School of Art, *The Studio* referred to her 'excellent watercolours'. In that year she emigrated to South Africa, where she married Dr H.W.A. Kay, who later became district surgeon in Port Elizabeth. The couple settled there in 1917 and became active in artistic affairs, being founder members in 1918 of the Eastern Province Society of Arts and Crafts, later known as the Eastern Province Society of Fine Arts. In 1919 she became a member of the South African Society of Artists.

Family life interrupted her painting but when the children began to grow up she took up her brushes again. In 1921 she sent *The Passing Train* to the RHA. In 1922 she held a one-person exhibition at St George's Hall, Grahamstown. In 1923 she contributed three works to the Water Colour Society of Ireland exhibition, including *A Veld Fire*. She was represented in the British Empire Exhibition in London in 1924 and exhibited five paintings, including *Old Oyster Woman*.

In 1924 she showed again in London, at the Royal Society of British Artists, and also in Jamaica, Canada and Australia; and that year she was elected a member of the Royal British and Colonial Society of Artists. She returned to the WCSI show in 1926 with four works, including *The Basuto Blanket* and *Zulu Baby*.

In 1926 from Port Elizabeth she sent no fewer than eight pictures to the RHA. Under Elvery and Kay she showed more than a score of works at the Dublin exhibition. When the British Empire Academy exhibition was held in London in 1930 at the New Burlington Galleries, Dorothy Kay of Mill Park, Port Elizabeth showed *Painting the Mast* and *Portrait 'Margery'*. At the Dominion Artists' Exhibition in London in 1926, Queen Mary had purchased an etching, *Romance*. She began illustrating stories for the weekly family magazine, *Outspan*, and over the years 1927-45 she produced about 2,000 black and white illustrations. *The Elvery Family (A Memory)* was painted in 1938.

In 1940 the Union Government commissioned her to paint war subjects. Several other commissions followed: two large mural panels, at Port Elizabeth Technikon, commissioned by General Motors South Africa; a mural for the South African Broadcasting Corporation in Grahamstown and in 1943 murals for the Reserve Bank, Port Elizabeth. *St. George's Park Cricket Ground, Port Elizabeth* (Marylebone Cricket Club) was dated 1950. A portrait of General Smuts was executed in 1951 and is in King George VI Art Gallery, Port Elizabeth, where there are twenty-three other works, including a self-portrait, *The eye of the beholder*. Her work continued to be hung outside South Africa: Sao Paulo Bienal, 1952; South African Graphics Exhibition, Yugoslavia and Munich, 1961; Venice Biennale, 1964.

A monotype, *Doorway, Dame Street, Dublin*, was dated 1954. She ceased to exhibit in 1955. Eastern Province Society of Arts and Crafts held a retrospective exhibition of her works, 1902-55. She was in Ireland again in 1959. Throughout her career she was commissioned to paint numerous portraits of dignitaries and private citizens. She painted twenty-four mayoral portraits: all but one were destroyed in the disastrous 1977 fire at City Hall, Port Elizabeth. A writer in the *Eastern Province Herald* said she was 'not only a painter of portraits but was an artist of vivid imagination and widely ranging skills...' It was also said that 'vitality, a power of absorption and a passion for investigation were her possessions to the very end...' She died in Port Elizabeth on 13 May 1964.

A retrospective exhibition took place at Port Elizabeth in 1965; in 1966 at the Pretoria Art Gallery and the Durban Art Gallery. The large retrospective held at the South African National Gallery, Cape Town, in 1982 contained 133 works, including thirteen monotypes, eight etchings, six ceramics and a wooden panel of marquetry inlay designed by her.

Works signed: Dorothy Kay, D. Kay; Dorothy Elvery or D. Elvery, both rare (if signed at all).
Examples: Cape Town: South African National Gallery; University, Medical School. Grahamstown, SA: Albany Museum; Rhodes University; South African Broadcasting Corporation. Johannesburg: Africana Museum; South African National Museum for War History, Saxonwold. Kwazulu, Natal, SA: Hilton College. London: Marylebone Cricket Club. Port Elizabeth, SA: City Hall; Collegiate School for Girls; Grey Hill School; King George VI Art Gallery; Museum; Reserve Bank; St Augustine's Cathedral; Technikon. Pretoria, SA: Arts Gallery; Kunsmuseum; University.

Literature: *Royal Dublin Society Report of the Council*, 1904; *The Studio*, March 1910; Beatrice, Lady Glenavy, *Today we will only Gossip*, London 1964; Durban Art Gallery, *Dorothy Kay Retrospective exhibition*, catalogue, 1966; *Dictionary of British Artists 1880-1940*, Woodbridge 1976; South African National Gallery, *Dorothy Kay Retrospective Exhibition*, Cape Town 1982 (also illustrations); Mrs Marjorie Reynolds, *Letter to the author*, 1985; Ann M. Stewart, *Royal Hibernian Academy of Arts: Index of Exhibitors 1826-1979*, Dublin 1986; Marjorie Reynolds, '*Everything you do is a portrait of yourself*': *Dorothy Kay, a biography*, Rosebank 1989; King George VI Art Gallery, *Letter to the author*, 1995; also, Marylebone Cricket Club, 1995; South African Reserve Bank, 1995; *Water Colour Society of Ireland Exhibition List 1872-1994*, Dublin 1995.

KEATING, JOHN (SEAN), RHA (1889-1977), portrait and figure painter. John Keating was born in Limerick on 28 September 1889. His father, Joseph Keating, was a bookkeeper at a bakery company. John, who had three brothers and three sisters, was educated at St Munchin's College but was not a good attender, spending hours playing truant on the city's docks. 'I was always drawing and scribbling. At the age of sixteen I had proved myself incapable of doing anything else. I was a dreamer and idler. My mother decided to send me to the Technical School in Limerick for drawing,' he told the author in 1965.

In 1911 he won a scholarship to the Dublin Metropolitan School of Art where he came under the influence of the life school of (Sir) William Orpen (q.v.) and became something of a protégé. In 1914 he won the Taylor Scholarship with *Appeal for Mercy*. He had three works hung at the 1915 Royal Hibernian Academy, *The Studio* commenting that *Annushka*, a seated portrait of a lady in a black dress, was 'a vivid piece of painting', and in another large canvas, *Pipes and Porter*, he displayed 'a clear vision and brilliant incisiveness of touch which promise well for his future work'.

In 1914 he discovered the Aran Islands and this visit became a turning-point in his life. He had been overworking at the School of Art and his friend Harry Clarke (q.v.) had suggested a visit to the Aran Islands. Keating demurred as he had only five pounds in his pocket, but Clarke assured him that so much money would go a long way in Inisheer.

Orpen asked Keating to assist him in his studio, and in 1915 he left for London. When he had to return to Ireland the following year, he tried to persuade Orpen to go back with him, saying that he was going to Aran, 'there is endless painting to be done', but Orpen remained to become a War artist. Orpen occasionally used him as a model and his portrait may be seen in *The Pattern; The Western Wedding;* and the *Holy Well*.

A charcoal study of John Daly is at Áras an Uachtaráin. Keating, from 10 Lower Gardiner Street, Dublin, resumed exhibiting at the RHA in 1917 and *The Studio* found his work 'strong and decorative. He has made a study of West of Ireland types, and his figures, painted in flat tones, have a vivid sense of personality.' *The Men of the West* appeared in that exhibition and the artist later presented it to the Municipal Gallery of Modern Art. *An Allegory* and *Homage to Frans Hals* are in the National Gallery of Ireland collection. The latter, in 1988, was on loan to the Irish Embassy in Washington.

In 1919 Keating was appointed an assistant teacher at the Dublin Metropolitan School of Art. In 1919 he was elected an associate of the RHA and in 1923 a full member. In 1921 he had his first one-person exhibition – at The Hall, Leinster Street – and was commissioned to paint Stations of the Cross for the chapel of Clongowes Wood College. In that year too he painted *An IRA Column*, 1.5 metres by 1.9 metres. This work is at McKee Barracks in Dublin and includes the leader of a North Cork Column, Sean Moylan; it is the earlier of a similar picture painted by the artist, *Men of the South* (RHA, 1922), now in the Crawford Municipal Art Gallery, Cork and regarded by the artist as one of his principal works. It was painted in the School of Art, where he had a studio which was also used for private commissions – mainly portraits.

In the exhibition of Irish art held in 1924 in connection with Aonach Tailteann, Keating won the gold medal for his large oil painting, *Homage to Hugh Lane*, now in the Hugh Lane Municipal Gallery of Modern Art. The persons arranged about the portrait of Lane comprise most of those who were prominently associated with him in his efforts to establish a gallery of modern art in Dublin: W.B. Yeats, Thomas Bodkin, Dermod O'Brien (q.v.), George W. Russell (q.v.), W. Hutcheson Poë, Thomas Kelly and R.C. Orpen (q.v.).

The year 1924 saw Keating represented at the Royal Academy, where he was to exhibit fairly regularly over the next thirty years. He also showed in 1924 at the New Salon, Paris, and in the exhibition organised

by the French Committee of the Olympic Games. In her *Modern Art in Ireland*, 1997, Dorothy Walker wrote: 'Keating's paintings of guerrilla fighters in heroic attitudes look like posters for Wild West movies...'.

Recalling some sixty years later the Dublin Metropolitan School of Art in the 1920s, Hilda van Stockum wrote: 'I admired Sean Keating for looking just as I thought Michelangelo must have looked. He wore rough clothes, a sweeping brown beard and his short hair stood up.' As someone else said, his life-style had a vaguely frugal touch about it. He was said to be the first man seen in Dublin wearing the crios and báinin. He mastered the Aran dialect of Irish and said the Islands were a revelation: 'There was a wonderful background of barren landscape with very agile, handsome men.'

Republican Court 1921, oil, is in Collins Barracks, Cork. Keating was commissioned by the Electricity Supply Board in 1926 to execute a series of pictures illustrating the development of the hydro-electric scheme on the river Shannon. He lived with the workmen on the building site at Ardnacrusha. The series encompassed a group of drawings and paintings, twenty-six in all, showing the progress of the work until completion in 1929. Among the titles were: *Excavations for Headrace with Steam Shovel* and *Building site from top of Barrage*.

In an exhibition of British Art at Brussels in 1927, *The Mountainy Man* (1926 RA) was purchased by the Belgian Government. In 1927 too he provided ten illustrations in colour for a de luxe edition of *The Playboy of the Western World*. An allegorical work, *Night's Candles are Burnt Out*, was exhibited at the 1929 Royal Academy. In England, the Empire Marketing Board issued in 1929 the poster, *Irish Free State Pigs* by Keating. Further afield, he was represented in the exhibition of Irish art at Brussels, 1930, the year he had a solo show at Hackett Galleries, New York. In the period 1928-58 he exhibited eight works at the Royal Scottish Academy.

In 1931 his one-person exhibition was held at the Victor Waddington Galleries, Dublin. The National Gallery of Canada, Ottawa, hosted *The Overman* in a touring exhibition, Contemporary British Painting, in 1932. In that year he held a one-person show at the Waddington Galleries. He was represented in the Associated Irish Artists' exhibition in the Angus Gallery, St Stephen's Green, Dublin, in 1934. In 1937 he was appointed Professor of Painting at the Metropolitan School of Art. He was not selective about commissions and he carried out designs for Hospitals Trust Ltd for the settings of sweepstake draws. He also designed a recruiting poster for the formation of the Volunteer Force.

An exhibition at the Victor Waddington Galleries in 1937 attracted considerable attention. About half of the twenty-eight works were heads in crayon, and one commentator in *Ireland To-Day* considered the artist at the height of his powers. 'No artistic godfathers, if there are any, are in evidence. These paintings are almost aggressively independent ...'. He was the designer of the stamp issued in 1938 commemorating the Centenary of Temperance Crusade which depicted Father Theobald Mathew after the bust by Hogan. He was also responsible for a mural at the Irish College, Rome: *St Patrick lighting the Paschal Fire at Slane*.

Keating's decorative capacity showed itself in a great mural of fifty-four panels for Ireland's Pavilion at the New York World's Fair in 1939, a total area of 7.3 metres by 22 metres. At the same fair he won first prize for *The Race of the Gael* in an IBM competition from seventy-nine countries. As for *Irish Romanesque* at the 1943 RHA, the *Dublin Magazine* considered it was 'not just a successful grouping of an old couple against an architectural background but an exploration into the soul of the people'.

Republican Court, 1921 (Crawford Municipal Art Gallery) was hung in the 1946 exhibition in Dublin celebrating the Davis and Young Ireland Centenary. Keating was also involved with the theatre and designed set and costumes for *The Playboy of the Western World*. Another exhibition was held at the Waddington Galleries in 1947.

In 1948 Keating was admitted an Honorary Freeman of the City of Limerick, an appointment that was in danger some years later when on an RTÉ programme he said that in his day his native city was 'a medieval dung heap'. In 1949 he was elected president of the RHA, and in that year he executed a mural, *The Scapular Vision* for the Carmelite Fathers at Gort Muire, Dundrum, Co. Dublin.

In 1951 he painted Stations of the Cross for St Eunan's Cathedral, Letterkenny. He showed *Ulysses in Connemara* in the Royal Scottish Academy exhibition of 1952, and he was represented in the Contemporary Irish Art exhibition at Aberystwyth, 1953. He also showed at the Glasgow Institute of the Fine Arts and the

Walker Art Gallery, Liverpool, but his work in Britain was mainly hung in London at Burlington House. He retired from teaching in 1954.

Still actively involved in church commissions, he executed a mural in 1955, *St Therese of the Child Jesus,* for the Church of St Therese, Mount Merrion, Dublin, and in 1956 in conjunction with the sculptor, Gabriel Hayes (q.v.), he contributed thirteen Stations of the Cross for St John's Church, Tralee. An exhibition of pastels and drawings was held at the Ritchie Hendriks Gallery, Dublin, in 1956. Another important mural was commissioned in 1959, on behalf of the Government, for the International Labour Office, Geneva. It was of irregular shape, and measured 3.7 metres by 7.3 metres and took two years to complete.

Keating exhibited nearly 300 works at the RHA – he resigned from the presidency in 1962 – and he also showed at the Oireachtas. In 1963 a retrospective exhibition was held at the Municipal Gallery of Modern Art, opened by President de Valera. Among the works exhibited were: *An Aran Fisherman and his Wife*, 1916 (HLMGMA), *Night's Candles are Burnt Out* (Oldham Art Gallery and Museum) and *May Dawn* (National Museum of Ireland). In his introduction to the catalogue, James White wrote: 'Again and again his pictures have made apparent his contempt for compromise and his conviction that principles can never be sacrificed. His *Allegory* (National Gallery of Ireland) makes clear to the young people of today the conflict of loyalties which followed the 1922 period.' Keating regarded this painting as one of his principal works.

An exhibition in Belfast at the Bell Gallery was held in 1965. In the Golden Jubilee of the Easter Rising Exhibition in 1966 at the National Gallery of Ireland, he was represented by no fewer than six portraits: John Devoy, Erskine Childers, Terence MacSwiney, Thomas MacCurtain, General Michael Brennan and Dr Ella Webb. Portraits of Brennan and General Duffy are at McKee Barracks. In his lifetime he painted about one hundred portraits. A self-portrait is at the NGI, Limerick City Gallery of Art and also at the University of Limerick. At NGI there is a portrait of Keating by Gaetano de Gennaro (q.v.).

Still remarkably active, he combined with the younger generation, Carolyn Mulholland, sculptor, in an exhibition at the Kenny Art Gallery, Galway, in 1968; three years later he returned there for a solo show. Commemorating the silver jubilee of the opening of the Municipal Art Gallery, Limerick, he joined with Fergus O'Ryan, RHA (q.v.), and Thomas Ryan, RHA, in a 1973 exhibition.

Throughout his life Keating, who lived in the Rathfarnham district of Dublin for half a century, took a firm stand on the side of traditional art. Disliking the modern movement, he feared it would bring back a decline in standards. Despite his outspoken views, his students regarded him as an honest and lovable man, perhaps admired more as an artist and as a personality than as a teacher. Anything that could be labelled 'Modernism', so far as he was concerned, was a hoax.

His death was at the Adelaide Hospital, on 21 December 1977, and he was buried at Cruagh Cemetery, Rockbrook, Rathfarnham. A small memorial exhibition was held at the 1978 RHA. The Grafton Gallery, Dublin, arranged an exhibition of works on paper in 1986, and in 1987 there was an Irish tour of his works commissioned by the Electricity Supply Board for the Shannon scheme. Justin Keating's documentary of his father, Sean Keating, was shown on RTÉ in 1996.

Works signed: Keating, Céitinn; Seán Céitinn, S. Céitinn or K., all three rare.
Examples: Armagh: County Museum. Ballinasloe, Co. Galway: St Joseph's College. Beijing: Irish Embassy. Belfast: Ulster Museum. Bray, Co. Wicklow: Public Library. Brussels: Museé Moderne. Cork: Collins Barracks; Crawford Municipal Art Gallery. Dublin: Áras an Uachtaráin; Church of Ireland See House, Temple Road, Milltown; Church of St Therese, Mount Merrrion; Church of the Holy Spirit, Ballyroan; Co. Dublin Vocational Education Committee; Dublin Institute for Advanced Studies; Electricity Supply Board; Federated Workers' Union of Ireland; Hugh Lane Municipal Gallery of Modern Art; Institution of Engineers of Ireland; McKee Barracks; Mansion House; National Gallery of Ireland; National Museum of Ireland; Office of Public Works; Pharmaceutical Society of Ireland; University College (Newman House; Earlsfort Terrace). Dundrum, Co. Dublin: Carmelite Fathers, Gort Muire. Enniskillen, Co. Fermanagh: Passionist Retreat, The Graan. Galway: National University of Ireland. Glasgow: Art Gallery and Museum. Kilkenny: Art Gallery Society. Letterkenny, Co. Donegal: St Eunan's Cathedral. Limerick: City Gallery of Art; County Library; University, National Self-Portrait Collection. Naas, Co. Kildare: Clongowes Wood College. Oldham, Lancs: Art Gallery and Museum. Rome: Irish College. Sligo: Model and Niland Centre. Tralee, Co. Kerry: St John's Church. Waterford: City Hall, Municipal Art Collection.

Literature: *Royal Dublin Society Report of Council*, 1914; *The Studio*, May 1915, July 1917, September 1923 (also illustration), July 1924, October 1924, November 1951; Seumas O'Brien, *The Whale and the Grasshopper*, Dublin 1920 (illustration); *Dublin Magazine*, December 1923 (illustration), October 1924 (illustration), July- September 1943, October-December 1946; John M. Synge, *The Playboy of the Western World*, London 1927 (illustrations); J. Crampton Walker, *Irish Life and Landscape*, Dublin 1927 (also illustration); Mary MacCarvill, *Rhymer's Wake*, London 1931 (illustration); Bulmer Hobson, ed., *Saorstát Éireann Official Handbook*, Dublin 1932 (illustrations); *Father Mathew Record*, June 1934, October 1941 (also illustration); *Ireland To-Day*, August 1937, December 1937; Patricial Lynch, *The Grey Goose of Kilnevin*, London 1939 (illustrations); Thomas Bodkin, intro., *Twelve Irish Artists*, Dublin 1940 (also illustration); *The Bell*, June 1942; Municipal Gallery of Modern Art, *John Keating Paintings-Drawings*, catalogue, Dublin, 1963; *The Word*, April 1965; *Irish Independent*, 26 January 1967; Kenny Art Gallery, *Exhibition of paintings by Sean Keating, RHA and sculptures by Carolyn Mulholland*, catalogue, Galway 1968; *Ireland of the Welcomes*, May-June 1968 (illustration); *Limerick Official Guide*, n.d.; *Irish Times*, 4 and 10 December 1971, 22 and 23 December 1977, 21 February 1984, 16 March 1985, 30 November 1996; *Dictionary of British Artists 1880-1940, Woodbridge* 1976; Liam Miller, *Dolmen XXV*, Dublin 1976 (illustration); Rev. John Hanly, *Letter to the author*, 1978; *A Dictionary of Contemporary British Artists, 1929*, Woodbridge 1981; *Guide to St John's Church, Tralee*, Tralee 1981; Stephen Constantine, *Buy and Build: The Advertising Posters of the Empire Marketing Board*, London 1986 (also illustration); Ann M. Stewart, *Royal Hibernian Academy of Arts: Index of Exhibitors 1826-1979*, Dublin 1986; Touring Exhibitions Service, *Sean Keating and the ESB*, catalogue, Dublin 1987 (also illustrations); Department of Foreign Affairs, *Letter to the author*, 1988; Michael Keating, *Letter to the author*, 1988; *The Royal Scottish Academy Exhibitors 1826-1990*, Calne 1991; John Turpin, *A School of Art in Dublin since the Eighteenth Century*, Dublin 1995 (also illustrations); Dorothy Walker, *Modern Art in Ireland*, Dublin 1997 (also illustration); National Gallery of Ireland, *Gallery News*, September - November 1999.

KEIR, HARRY (1902-77), genre painter and illustrator. Henry Keir was born in Sligo, his father having left Scotland to be gamekeeper on the estates of the Earl of Arran in Co. Mayo. Harry spent his childhood and early youth in Ireland. In his late teens he went to live in Glasgow, and was first a woodcarver, then a housepainter.

Interested in art, he took evening classes at the Glasgow School of Art and became one of the few artists to depict working class life in the city. Dozens of works were produced of the old Glasgow tenements, bustling with life, and he also portrayed chipshops, pubs, street musicians, and was fascinated by tinkers and tramps. He was not keen on selling his work, sometimes giving it away, and he thought that the Glasgow Art Club had 'too many business men and not enough artists'.

Although he left Ireland before he had turned to the largely self-taught field of art, he never forgot his early attachment to, and affection for, the Mayo-Sligo countryside. A retrospective exhibition included a pen and ink drawing of farm workers riding in a cart and inscribed by the artist 'Road to Ballina'. He is believed to have only re-visited the country of his birth on one rather short trip after he had settled in Glasgow, where he married.

Keir had a wry sense of humour. Some Glasgow newspapers, notably *The Bulletin*, commissioned him to do cartoons in the 1930s. In the period 1933-40 from 161 Shamrock Street, Glasgow, he showed six works at the Glasgow Institute of the Fine Arts and two at the Royal Scottish Academy: *Sanctions*, 1936, and *The Adoration*, 1937. At one period during the Second World War his address was Corrie, Arran island. In 1947 at the Royal Scottish Academy, from 68 Baldwin Avenue, Glasgow, he contributed *Woman at the Bar*.

In 1947 he illustrated Dickens's *Oliver Twist* for Collins, including colour plates. He also illustrated some of Burns's poems. Among the ten works in the collection of the People's Palace, Glasgow, are: *Job exhorting the masses*, crayon on paper; *Italian Ice Cream Shop*, pen and wash; *Rue de la Paix*, a man and woman at the barrows, watercolour. His last exhibit at the RSA was *The Visionaries* in 1954. At the Ulster Museum are two oil paintings, *The Bagpiper* and *Tam O'Shanter*, both dated 1959. At the Glasgow Art Gallery and Museum are four drawings, three in pen and wash – *The Fish Supper* included – and one in pen, watercolour and chalk.

For some of his life he was an alcoholic, and this coloured his work. A self-portrait of 1970, entitled *One for the Road*, showed him sitting bolt upright in his coffin, having a last, long drink. A pen and ink drawing, c. 1940, and entitled *Time Gentlemen, Please!* depicted a crowded bar, beneath, with a vision of Old Father Time and a death's head above.

Keir and his wife, who predeceased him by only a few months, latterly lived in the Knightswood district of the city and in the last few years of their lives became friendly with a Dublin pair, Harold Davis and his wife, who visited them on a number of occasions, finding the artist 'a man of genuine humility, friendship and human understanding'. He died in a Glasgow hospital, his great ambition unrealised, to illustrate the Book of Job. A memorial exhibition was held in 1978 at the John D. Kelly Gallery, Glasgow, and was then transferred to the People's Palace.

Works signed: Harry Keir, H. Keir or Keir.
Examples: Belfast: Ulster Museum. Glasgow: Art Gallery and Museum; People's Palace.
Literature: Charles Dickens, *Oliver Twist*, London 1947 (illustrations); Clifford Hanley, *Dancing in the Streets*, London 1958 (illustration, dust jacket); *Dictionary of British Artists 1880-1940*, Woodbridge 1976; *Glasgow Herald*, 22 November 1977; Harold Davis, *Letter to the author*, 1978; Glasgow Art Gallery and Museum, *Letters to the author*, 1978, 1988; National Library of Scotland, *Letters to the author*, 1988; Royal Scottish Academy, *Letter to the author*, 1988; *The Royal Scottish Academy Exhibitors 1826-1990*, Calne 1991.

KELLY, CHARLES E. (1902-81), cartoonist. Charles Edward Kelly was born in Dublin on 15 June 1902, son of David Kelly, Corporation official. He was educated at the Christian Brothers' School in Synge Street. While following a career as a civil servant, he was one of three who founded the humorous magazine, *Dublin Opinion*, in 1922 before he had reached his twentieth birthday. The first editor was Arthur Booth (q.v.); Thomas J. Collins and Kelly were his collaborators. Booth died in 1926; the other two founders carried on as joint editors until the magazine was voluntarily wound up by them in 1968.

Kelly, without formal art training, had no work published before the magazine began. He told the author in 1974: 'I had a baptism of fire and learned my cartoon technique the hard way, studying the great cartoonists to see how they got over problems and eventually developing a style of my own.' There were some who claimed that the publication, with its critical, acerbic commentary, was as important as anything else in taking the bitterness out of the Civil War's aftermath.

Although Kelly produced a phenomenal number of cartoons, the two most associated with his name were: *The Night the Treaty was Signed*, with the Cork graveyard emptying itself on the road to Dublin, and *Céilidhe in the Kildare Street Club*, both of national appeal. A number of his cartoons also appeared in the *Capuchin Annual* in the period 1942-55.

Side by side with his cartoon work, he began watercolour painting about 1930 and some years later became a member of the Dublin Sketching Club and the Water Colour Society of Ireland. At the latter exhibitions he showed more than sixty works in the period 1941-80, concluding with *The Bridge below the Town* and *After Mass*.

Kelly was Director of Broadcasting in Radio Éireann from 1948-52, followed by Director of Savings, Post Office Savings Bank. An exhibition of his watercolours took place in 1972 at 3 St Stephen's Green, Dublin. He received an honorary doctorate in Literature from the National University in 1979. President and chairman of PEN, he died on 20 January 1981 at his residence, 9 Seafield Road, Booterstown, Dublin.

Works signed: C.E.K., cartoons, or C.E. Kelly.
Literature: Thomas J. Collins and Charles E. Kelly, *Fifteen Years of Dublin Opinion*, Dublin 1937 (also illustrations); *Capuchin Annual*, 1942 (also illustration), 1943 (illustration), 1944 (illustration), 1946-47 (illustration), 1948 (illustration), 1955 (illustration); Thomas J. Collins and Charles E. Kelly, editors, *Thirty Years of Dublin Opinion*, Dublin 1952 (illustrations); Thomas J. Collins and Charles E. Kelly, editors, *Forty Years of Dublin Opinion*, Dublin 1962 (illustrations); *Who's Who in Art*, Havant 1966; *Irish Times*, 4 and 11 April 1972, 21 January 1981, 10 February 1981, 22 July 1981; *Water Colour Society of Ireland Exhibition List 1872-1994*, Dublin 1995.

KELLY, JOHN F.,RHA (1921-95), portrait and still life painter. Born in Ballinagore, Co. Westmeath, on 22 May 1921, John Francis Kelly was the son of a publican, John Kelly, and grew up in Mullingar where he attended the Christian Brothers School. In 1939 he won a scholarship to the National College of Art, Dublin,

spending one year studying design with Professor Bernardus Romein before switching to painting. He received his diploma in 1942.

When Kelly studied at NCA he found John Keating (q.v.) 'very encouraging; if he saw any spark in your work, he helped you to develop.' Keating and Maurice MacGonigal (q.v.) had their own studios, in which they painted when they were not teaching. In Kelly's recollection, 'a student was welcome there at any time and it was a fascinating experience for a young trainee artist to watch a master at work, while enjoying the discussion that inevitably developed.'

Kelly was assistant teacher in the NCA school of painting from 1942-6. A feature of the college when he was first a teacher was admission to the classes of German airmen who were interned in the Republic but permitted a limited range of activity. Then on an Italian government scholarship he departed Dublin for Florence, where he spent 1946-7 studying fresco painting and lithography at the Academia di Belle Arti. He studied etching at St Luke's Academy, Rome, working in that city on a further scholarship. In 1947 he returned to teaching at NCA until 1953.

In the years 1944-94, Kelly exhibited at the Royal Hibernian Academy, contributing almost six score works, portraits predominating. In 1945 he submitted from 41 Northumberland Road, Dublin, but in 1949 he designated Austin Friars Street, Mullingar, the family home, and at this time he had a commission for the Cathedral. In 1950 the Academy hung: *The Pint; The Fiddler; The Cure.* Two years later he exhibited *St Brendan the Navigator* and a lithograph, *Willie.* When he showed in the Contemporary Irish Art exhibition at Aberystwyth in 1953, his address was 34 Elgin Road, Dublin.

On a Spanish government scholarship, he studied for six months in Madrid in 1954. Appointed an associate of the RHA in 1954, he became a full member in 1957. A portrait of Harry Kernoff (q.v.) appeared in the 1955 exhibition. Another trip abroad saw him in New York for a year, from October 1958, returning home on the retirement of Keating to become assistant Professor of Painting to MacGonigal. He had a studio at 7 Lower Baggot Street but on his appointment as Keeper of the RHA in 1961 he moved to Academy House, 15 Ely Place, and that year his exhibition pictures included *Commandant Eamon de Valera, Boland's Mills, 1916* and '*Congo '61*'; the latter is now at the United Nations Training School, Curragh Camp, Co. Kildare, and Commandant Patrick Liddy was the subject. Academy House provided accommodation to the artist and his family for twenty years, having married in 1961 Anna Kennedy, ANCA, who had taken Professor Romein's class in the design studio for two years when he retired at NCA in 1959.

The Thomas Haverty Trust presented to Drogheda municipal collection in 1962, *Pierrot /John Molloy,* oil, signed 'John F. O' Kelly', a portrait of his friend and neighbour in Ely Place. Molloy, who was dressed up for the sitting, was a graduate of the Marcel Marceau school of mime in Paris. Some years later the artist, in response to an enquiry from Drogheda, stated that he used to sign 'O'Kelly' but preferred to be known as Kelly. His *Cathal Brugha* at Leinster House was painted in 1963, signed 'John F. Kelly'. In the period 1964-81 he served on the Board of Governors of the National Gallery of Ireland.

In 1964 he painted a portrait of Dom Camillus Claffey, Abbot of Mount St Joseph, Roscrea, Co. Tipperary, a commission that had been awarded to Sean O'Sullivan (q.v.) but his work had scarcely begun when he suffered a fatal stroke. In 1969 Kelly was appointed Professor of Painting at NCA, succeeding MacGonigal and finding himself in the middle of the student revolution. According to John Turpin in his *A School of Art in Dublin since the Eighteenth Century,* Kelly was the last professor of painting in the Orpen tradition, gaining credit for attempting to establish a more 'liberal' course than his predecessor.

In the 1970s and 1980s he was kept busy with portrait commissions, reflected in his listings at the RHA, from Grianan, Church Road, Ballybrack, Co. Dublin. His 1976 portrait of Harold Quinlan, MD, is at St Vincent's Hospital, Dublin. He enjoyed, however, working on abstract and figurative compositions favouring subjects of Irish mythology. In 1980 he was elected Professor of Painting to the Academy.

In 1980 he painted the portrait of Dr M. I. Drury for the Royal Academy of Medicine in Ireland. His 1981 *St Francis Xavier* is at Our Lady of Good Counsel Church, Johnstown, Killiney, Co. Dublin. *Dr Patrick Hillery* (Arás an Uachtaráin) was one of three portraits at the 1982 RHA. In 1984 he retired from teaching. In 1985 he exhibited *Mr Jack Lynch* (Leinster House) and in 1989, *An Taoiseach, Charles J. Haughey* (Leinster House). Thomas Aloysius Finlay, for King's Inns, sat for him in 1989.

At the 1990 Academy he contributed four still life, *Blown Roses*, a self-portrait, and a portrait of Mervyn Wall. A portrait of Ambassador Margaret Heckler is in Washington. Four of the six works hung at the 1993 RHA were portraits, and in 1994, the year before his death, he showed seven pictures, including *Still Life with Skull*; *The Three Graces*; and *The Wicker Chair*.

A still life is in the collection of the Office of Public Works, Dublin, and the Ulster Museum. A portrait of Maureen Hurley is at Sutton Park School, Dublin. *St Colman meets Our Lord at the Ford of Mullingar* is at the Cathedral of Christ the King, Mullingar. A colleague, John Coyle, RHA, found him 'unassuming and considerate', of 'wise counsel, skilful brush and erudition'. After a cardiac arrest in December 1992, he never regained full health and died at his home on 16 December 1995.

Works signed: John F. Kelly; Kelly, J. F. K. or John F. O' Kelly, all three rare.
Examples: Belfast: Ulster Museum. Curragh Camp, Co. Kildare: United Nations Training School. Drogheda, Co. Louth: Library, Municipal Centre. Dublin: Arás an Uachtaráin; Irish Municipal, Public and Civil Trade Union; King's Inns; Leinster House; Office of Public Works; Royal Academy of Medicine in Ireland; St Vincent's Hospital; Sutton Park School; Wesley College. Killiney, Co. Dublin: Our Lady of Good Counsel Church, Johnstown. Limerick: University, National Self-Portrait Collection. Mullingar, Co. Westmeath: Cathedral of Christ the King. Roscrea, Co. Tipperary: Abbey Mount St Joseph. Washington, DC: Department of Health and Human Services, Independence Avenue.
Literature: *Cathedral of Christ the King*, Mullingar n.d. (illustrations); John F. Kelly, *Letter to the author*, 1968; Ann M. Stewart, *Royal Hibernian Academy of Arts: Index of Exhibitors 1826-1979*, Dublin 1986; and catalogues, 1980-1986, 1988-1994, 1996; Wanda Ryan-Smolin, *King's Inns Portraits*, Dublin 1992 (also illustration); *Irish Times*, 18 December 1995; Chalmers Trench, *Drogheda Municipal Art Collection*, catalogue, 1995; John Turpin, *A School of Art in Dublin since the Eighteenth Century*, Dublin 1995; Cathedral of Christ the King, *Letters to the author*, 1998; Mrs Anna Kelly, *Letters to the author*, 1998; St Vincent's Hospital, *Letter to the author*, 1998; also, Sutton Park School, 1998; United Nations Training School, 1998.

KELLY, OISÍN, RHA (1915-81), sculptor. Austin Ernest William Kelly was born on 17 May 1915 in Dublin, son of William S. Kelly, a schoolmaster who taught at St James's National School. He did not acquire the name 'Oisín' until his schooldays. He entered Mountjoy School in 1926 and left aged eighteen for Trinity College, where he studied French and Irish, and began night classes at the Dublin Metropolitan School of Art. In 1937 he was awarded a travelling scholarship to study in Frankfurt am Main University, an exchange lectureship, and he took the opportunity to attend the art school in Frankfurt. His sister Doreen was the wife of the painter, Henry Healy (q.v.).

Kelly became a schoolmaster in 1937 and his first post was at Clones High School in Co. Monaghan. He then moved on to Galway Grammar School. In 1942 he married Ruth Gwynn, daughter of the Provost of Trinity College, and in 1944 he took up a post at Bishop Foy School, Waterford. He stayed there until 1946 and during this time attended classes in woodcarving under the principal of the School of Art, Robert Burke (q.v.). *Mrs Peabody*, wood; *Zarathustra*, marble; *Céilí Dancers*, wood; and *Reclining Figure*, wood, were all carved in the 1944-46 period.

In 1946 he joined the staff of St Columba's College, Dublin, and taught there until 1964, first French and Irish, and later Art. He had not been long at the Rathfarnham school when he wrote to the sculptor, Henry Moore (1898-1986), asking if he could go and work with him, even doing menial jobs. Moore replied that there were several people doing that but offered him a place in his class at Chelsea Polytechnic. St Columba's gave him two terms off and he spent the winter of 1947-8 in London. His *Step Dancer* of 1947 in wood was one of the first works which he sold. *Torso* at the 1948 Oireachtas was in cement.

In 1949 he received the first of many church commissions: *Our Lady of Fatima* for the Church of Our Lady of the Rosary, Limerick. At the Irish Exhibition of Living Art in the same year appeared his humorous *Masters in Chapel*, terracotta. In 1949 too he showed his first works at the Royal Hibernian Academy, and at about this time he attended evening classes at the National College of Art and won a medal for sculpture.

In 1950 the *Dublin Magazine* commented that his *Le Jongleur de Dieu* at the Irish Exhibition of Living Art, 'though a piece of conscious mediaevalism, had a nice humour'. A curious three-in-one composition, *Eire, Banba and Fodhla* at the 1951 Living Art attracted and puzzled many. In 1951 he became a committee

member. In the early 1950s he completed a group of religious statuettes as prize trophies for the Catholic Stage Guild.

Although not keen on the one-person exhibition, he had no hesitation about the group shows and exhibited in all the exhibitions of the Institute of the Sculptors of Ireland –1953- 7 inclusive – and at their international exhibition in 1959 in the Municipal Gallery of Modern Art, Dublin. The materials used in these exhibitions included beech, bog oak, copper, elm and limestone, and for the concluding event the Government lent his *Thomas MacDonagh*, bronze. His *St Brigid* which was shown in the 1957 exhibition was for the Church of St Brigid, Curragh Camp, Co. Kildare.

In 1958 he was appointed an associate of the RHA; in 1965, a full member. In his 1954 exhibition he had shown a head of Professor David Greene and *Mask of Evie Hone* in papier maché. He was a close friend and neighbour of the stained glass artist. As she was a religious artist herself, he may have received from her encouragement in his work. 'I don't distinguish, when on the job, between the sacred and the profane, but I prefer church work because one enters a world where everybody speaks the same language...' he wrote in *Hibernia Review*. 'I prefer working to commissions, because I feel a desire should precede its fulfilment, that an object should be made because somebody needs it rather than in the hope that somebody may need it...'

Further important church commissions were: *St Peter*, 1961, St Peter's Church, Milford, Co. Donegal; *St Christopher*, 1963, Church of Our Lady Queen of Heaven, Dublin Airport; and *St Patrick*, 1964, St Patrick's Church, Murlog, Lifford, Co. Donegal. An external feature of the new St Teresa's Church, 1963, at Sion Mills, Co. Tyrone, was the 4 metres by 14 metres engraving on the slate depicting *The Last Supper* over the main entrance door.

In 1964, the year he gave up his teaching post at St Columba's, he became artist-in-residence for two days weekly at the Kilkenny Design Workshops, where his designs included the silver statuette, *Saint Patrick's Breastplate*, presented to Pope John Paul II in 1979. A work, similarly titled but in bronze, is at Down County Museum. In 1964 he showed *The Good Shepherd*, mosaic of pebbles, at the RHA. His *Girl Dancer* at the Cork Sculpture Park was dated 1966. In the National Gallery of Ireland is a terracotta head of Dr C.S. Andrews, and a cast of the maquette or original study for the monumental bronze sculpture, *The Children of Lir*.

Birds in Flight is at the Irish Museum of Modern Art. In the Bray Public Library is *Translation from the Kilcorban Madonna*. Figures of the Sacred Heart and the Blessed Virgin are in Church of Christ the King, Salthill, Galway. Two churchwardens' wands, each one topped by an angel in bronze about 13 cm high, are in St Fin Barre's Cathedral, Cork. At Corpus Christi Church, Knockanure, Moyvane, Co. Kerry, is a teak carving, *The Last Supper*. Described as a terracotta cast, *The Last Supper* is at St Patrick's College, Drumcondra, Dublin, also a cartoon of the same title and a statue, *Mother and Child*, terracotta.

At the 1969 Oireachtas, Kelly won the Gold Medal and £100 prize for *Faoileáin* (Seagulls). A major commission *Working Men*, 1969, from the Irish Transport and General Workers' Union, is outside Cork County Hall, the union having been forced to scrap plans to erect the work outside headquarters at Liberty Hall, Dublin. Planning permission was refused. In 1971 Kelly represented Ireland in an international congress of designers at Minsk, Belorussia.

The largest public work, *Children of Lir,* was commissioned in 1966 and having been cast by a foundry in Florence, eight pieces in all, arrived in Dublin by ship from Italy in December 1970. The 7.6 metres high statue weighing eleven tonnes approximately was unveiled in July 1971 in the Garden of Remembrance, Parnell Square, Dublin, bringing more publicity in its wake than almost any other piece of public statuary in the country. The total cost was about £40,000. On the *Children of Lir* work, which depicts the moment when they become swans, Kelly initially explained that he wished to illustrate the moment of transformation in a nation. 'This theme,' he wrote, 'is, I think, of sufficient grandeur to illustrate the function of this park. It is both national and universal and it would be easily comprehensible while being of a nature to permit the use of modern idioms, as this sculpture must be contemporary because there is no alternative...I should like a memorial which does not attempt to bully my countrymen into having splendid thoughts and noble feelings, but rather one whose message was implicit, a hint rather than a shout.' He also felt that the magical theme

related to the perception that the Irish are imaginative, with a mythology which had the monstrous and extravagant at its heart.

In 1971 he was commissioned by the Government for a statue of Sir Roger Casement. The unveiling at Ballyheigue, Co. Kerry was not until 1984, thus bringing to an end a controversy on the best location.

In 1972 he was appointed to the board of the National College of Art and Design, serving for six years. He was commissioned by the Arts Council of Northern Ireland for a three-metre high grasshopper in scrap metal for St Mary's Girls' Primary School, Strabane. In 1975 he was appointed Professor of Sculpture at the Royal Hibernian Academy, an honorary post, and he was commissioned by St Andrew's Church in Dublin for a crucifix. His secular work included as well as birds in flight, sports people in action. His last year for exhibiting at the RHA was 1979; *Hurdles*, bronze, was included.

Another major commission had been given in 1977 for a statue of Jim Larkin for O'Connell Street, Dublin, a work 3.7 metres high, cast by the Dublin Art Foundry. In 1978 he was commissioned by Irish Life for a sculpture for the plaza of the Irish Life Centre. The Dublin Art Foundry cast sixty-four separate sections over a two-year period and *Charity of Fire*, which weighed approximately seven tonnes, was unveiled in 1982 after the artist's death. His statue to Carolan, the harpist, which he was working on at the time of his death, was unveiled in 1986 at Mohill, Co. Leitrim.

A remarkable aspect of the artist's career was that he never had a one-person exhibition until the Arts Councils of Ireland arranged the retrospective in 1978, for Belfast, Dublin and Cork venues, with a special essay in the catalogue by Dorothy Walker. The artist with the 'druidic beard, fastidious mind and gentle, rather diffident manner' died suddenly at the Kilkenny Design Workshops on 12 October 1981. An exhibition of his smaller works took place in 1997 at the Linenhall Arts Centre, Castlebar, Co. Mayo.

Works signed: O. Kelly.
Examples: Ballyheigue, Co. Kerry. Belfast: Mater Hospital. Bray: Public Library. Carlow: Irish Institute of Pastoral Liturgy. Claremorris, Co. Mayo: Ballintubber Abbey. Cork: County Hall; Fitzgerald Park; St Fin Barre's Cathedral. Curragh Camp, Co. Kildare: Church of St Brigid. Downpatrick: Down County Museum. Dublin: Abbey Theatre; Arts Council; Church of Our Lady Queen of Heaven, Airport; Garden of Remembrance; Hugh Lane Municipal Gallery of Modern Art; Irish Life Centre; Irish Museum of Modern Art; Leinster House; Liberty Hall; National Gallery of Ireland; O'Connell Street; Royal Hibernian Academy; St Andrew's Church, Westland Row; St Francis Xavier Church, Gardiner Street; St Patrick's College, Drumcondra. Dundalk, Co. Louth: Church of the Redeemer, Ardeasmuin. Galway: Church of Christ the King, Salthill. Kildare: St Brigid's Church. Knockanure, Moyvane, Co. Kerry: Corpus Christi Church. Lifford, Co. Donegal: St Patrick's Church. Limerick: Church of Our Lady of the Rosary; University, National Self-Portrait Collection. Londonderry: Our Lady of Lourdes Church, Steelstown. Milford, Co. Donegal: St Peter's Church. Mohill, Co. Leitrim: Bridge Street. Sion Mills, Co. Tyrone: St Teresa's Church. Strabane, Co. Tyrone: St Mary's Church, Melmount; St Mary's Girls' Primary School. Waterford: City Hall, Municipal Art Collection.
Literature: *Dublin Magazine*, January-March 1949, October-December 1949, October-December 1950; *Belfast Telegraph*, 31 August 1963; *Ireland of the Welcomes*, September-October 1966; *Hibernia Review*, August 1967 (also illustration); *Irish Times*, 26 June 1969, 19 July 1969, 21 December 1970, 22 February 1971, 17 May 1971, 25 June 1971, 12 and 16 July 1971, 22 April 1972, 14, 15 and 16 October 1981, 11 December 1981, 8 July 1982, 29 December 1982, 19 September 1984, 1 October 1984, 31 January 1985, 20 June 1985, 11 August 1986, 20 May 1997; Arts Councils of Ireland, *The Work of Oisín Kelly, Sculptor*, catalogue, Dublin 1978 (also illustrations); Ann M. Stewart, *Royal Hibernian Academy of Arts: Index of Exhibitors 1826-1979*, Dublin 1986; Bishop Edward Daly, *Letter to the author*, 1987; Rev. Maurice Carey, *Letter to the author*, 1988; also, Dublin Art Foundry Ltd, 1988; Fergus Kelly, 1988; Office of Public Works, 1988; Rev. Michael O'Leary, 1988; Fergus Kelly, 'The Life and Work of Oisín Kelly', *The GPA Irish Arts Review Yearbook*, 1989-90; St Patrick's College, Dublin, *Letter to the author*, 1991; John Turpin, *A School of Art in Dublin since the Eighteenth Century*, Dublin 1995; Judith Hill, *Irish Public Sculpture: A History*, Dublin 1998 (also illustration); Sister Maureen Flanagan, OP, *Letter to the author*, 1999.

KELLY, ROBERT GEORGE (1822-1910), portrait and landscape painter. Born in Dublin on 22 January 1822, the second son of Commander Richard Nugent Kelly, RN, as a boy 'he evinced a decided bent for art'. Educated at a private school at Stranraer, this was not his only connection with Scotland as his wife, Mary Walker, came from that town. The second of their four sons, Robert Talbot Kelly, RBA, RI (1861-1934), born in Birkenhead, became known as a painter of Egyptian subjects in watercolour.

In Dublin, Robert George Kelly made his art studies in the schools of the Royal Dublin Society and Royal Hibernian Academy, and he first exhibited at the RHA in 1842 and from then until 1899 showed almost sixty works. In his initial year, from Hampstead, Glasnevin, Dublin, he contributed two watercolours, of Carrickfergus Castle, Co. Antrim, and Glasnevin Bridge. In 1845, from 14 Westland Row, Dublin, one of his two portraits was that of the late Joseph Stringer of Glasnevin, possibly the work of that title presented five years later at the Royal Scottish Academy.

Portrait of his Mother at the 1847 RHA attracted attention as the work of a young artist of promise, and that year he also showed portraits of the family of Sir James Dalrymple Hay, Bt., of Park, Wigtownshire, also of the children of General Sir J. A. Agnew Wallace, Bt., KCB., Lochryan, Wigtownshire. The same area crops up again at the 1848 Dublin exhibition with a Bay of Luce scene.

In 1847 Kelly had painted *Inspiration: Portrait of the Artist in the Chamber of the Hibernian Academy*, now in the Williamson Art Gallery and Museum, Birkenhead. The painting was included in an exhibition of self-portraits at the Walker Art Gallery, Liverpool, in 1995 and according to Xanthe Brooke in the catalogue: 'The light streaming through the window, spot-lighting the artist, enhances the daydream-like quality of Kelly's self-portrait, as he stands holding a book, as if in reverie, overwhelmed by the grand surroundings of the Academy, and seemingly inspired by the art of his predecessors and contemporaries. In the background one can dimly see examples of his own student work, large history paintings on religious themes such as *The Last Man* and *Christ helping the drowning St Peter.*'

In addition to the Stringer portrait at the 1850 Royal Scottish Academy, there was also a portrait of the Town Clerk of Stranraer, William Black; two portraits of ladies, and, rather surprisingly, *Indian mountaineer on guard*. The sixth work, *A Tear and a Prayer for Erin — an ejectment,* has all the appearance title-wise of the work which was shown at the British Institution in 1853, priced at £80, and was, according to Strickland: 'much criticised as a political picture, which the artist never intended it to be, and was actually discussed in the House of Commons.' The *Illustrated London News* commented: 'R. G. Kelly paints the horrors of 'An Ejectment in Ireland' in a manner to move the sympathies of the sternest political economist, if not to gratify the sense of the critical observer. Ruthless policemen swaggering over kneeling and imploring females; whilst old men and infants are scattered helplessly in the mêlée. In a word, the subject is vulgarly treated, and, artistically, is of very little merit.'

In 1853 he left Dublin for London and settled at first at 3 St Peter's Terrace, Islington, and later in Birkenhead where most of his active life was spent, largely occupied in teaching, and he was art master and one of the managers of the School of Art. He exhibited again at the BI in 1856, from 36 Howland Street, London, and in 1859.

Glen Truill, Kirkcudbright was his initial contribution, in 1856, to the Royal Academy. When he showed a Wigtownshire scene in 1860 his address was 19 Brunswick Terrace, Birkenhead, and in 1862, for *The Garden Seat*, he was at Glasnevin, Ball's Road, Birkenhead. Altogether, he showed five pictures at the RA. After an interval of sixteen years he resumed exhibiting in Dublin and in that year, 1864, also in 1865 and 1869, he showed Connemara subjects. *Connemara Market Scene* was highly rated. A large canvas, *The Last Man,* hung in 1878, also attracted praise.

A staunch constitutionalist, he acted for many years as churchwarden at Christ Church, Birkenhead, and as manager of the Higher Grade School. In painting, he continued to visit Ireland and at the 1879 RHA all three works had Killarney subject matter, e.g. *Muckross Abbey, with Peasant's Funeral,* and in 1884: *View from Roche's Hotel, Glengarriff.* North Wales also attracted his brush. *London Bridge in 1856*, which he showed at the RA in 1888, reappeared at the RHA in 1891. By this time he had a commodious studio in Dale Street in the centre of Liverpool and shared it with his son Talbot. Killarney scenes continued to the fore in his Dublin exhibitions.

Elijah running before the Chariot of Ahab was designated an important work. He continued to exhibit in England until 1907, living at Hollywell House, Parkgate, Chester. A portrait of Clarke Aspinall, Coroner of Liverpool, was transferred from the Magistrates Court in 1979 to the Walker Art Gallery, where, during his lifetime, Kelly showed more than fifty works in their exhibitions. His wife, Mary, blamed much of his lack of success on his being married and having to keep his large family of eleven children. A few years after his

death she wrote to her son Talbot: 'Dear old Father had to work for bread and butter, not for fame or for important exhibition pictures...' He died on 9 May 1910.

Works signed : R. G. Kelly.
Examples: Birkenhead, Merseyside: Williamson Art Gallery and Museum. Liverpool: Walker Art Gallery.
Literature: *Illustrated London News*, 26 February 1853, *The British Institution 1806-1867*, London 1875; Walter G. Strickland, *A Dictionary of Irish Artists,* Dublin 1913; *A Dictionary of Contemporary British Artists, 1929*, London 1929; *Dictionary of British Artists 1880-1940,* Woodbridge 1976; Alpine Club Gallery, *Talbot Kelly: Three generations of artists*, catalogue, London 1981; Ann M. Stewart, *Royal Hibernian Academy of Arts: Index of Exhibitors 1826-1979*, Dublin 1986; *The Royal Scottish Academy Exhibitors 1826-1990,* Calne 1991; Walker Art Gallery, *Face to face,* catalogue, Liverpool 1995; Liverpool Central Library, *Letter to the author*, 1998; also, Walker Art Gallery, 1998.

KEMP, JOHN (1833-1923), landscape and genre painter. At the National Arts Exhibition held in Cork in 1852, John Kemp was among the students representing the Cork School of Design. The following year he was training as an art master at the Royal Academy. He settled in Gloucester and in 1860 assumed control of the School of Art, which had been founded in a very small way the previous year. It continued under his direction for thirty-two years, flourishing under his guidance, with annual exhibitions of work in which his own paintings, as well as those of his pupils, were displayed.

A watercolour, *Rouen Cathedral,* 1860, is in Gloucester City Museum and Art Gallery, and *Street View, St Malo*, a gouache of 1861, is in the Victoria and Albert Museum. Anne Crookshank and the Knight of Glin in their 1994 book, *The Watercolours of Ireland*, considered him at this time 'to have been a highly proficient practitioner in the Samuel Prout manner'. A watercolour exhibited at the Society of British Artists in Suffolk Street, London, indicated a return to Ireland although he never showed at the Royal Hibernian Academy: *The Mourne Mountains from Greenore.* In oil, there was also *Killaha Castle near Killarney.* His *A Woody Bit, North Wales* was dated 1867.

Kemp exhibited at the Royal Scottish Academy in 1872, 1873 and 1874, a total of five works including *Kilchurn Castle* and *The Lednock, Comrie.* A new School of Art, opened in 1872, catered for an increasing number of pupils. Kemp was paid two-thirds of their fees, plus a share of the government grant, and by 1880-81, with 262 students on the register, he was earning £350 a year. He also taught drawing in other schools in the city. One of his pupils was Philip Wilson Steer (1860-1942), who painted his portrait in 1880 and it is now at Gloucester City Museum and Art Gallery.

At the Gloucester school named Sir Thomas Rich's are two oil paintings: *Buttons*, 1882, depicting a master sewing a button onto a pupil's trousers, and the other is of a class of Bluecoat pupils at work with slates. Prior to his retirement in 1893, when he went to live at Clevedon, Avon, Kemp had another pupil who became eminent in art, George Belcher, RA (1875-1947), whose charcoal drawings were a feature in *Punch.*

Goodrich, 1896, and *St Mark's, Venice*, 1904, are two other watercolours at the Gloucester gallery; another four are unsigned and undated. He painted up to about five years before his death on 9 June 1923 at Rockleigh House, Walton Park, Long Ashton, Avon. The Gloucester Society of Artists and the School of Art arranged a memorial exhibition in his honour in 1924 with some 100 works on view.

Works signed: John Kemp, J. Kemp or J.K. (if signed at all).
Examples: Gloucester: City Museum and Art Gallery. London: Victoria and Albert Museum.
Literature: Avon County Council, *Death Certificate John Kemp*, 1923; Gloucester Journal, 30 June 1924; *Dictionary of British Book Illustrators and Caricaturists 1800-1914*, Woodbridge, 1978; *Dictionary of Victorian Painters*, Woodbridge 1978; *The Royal Scottish Academy Exhibitors 1826-1990,* Calne 1991; Peter Murray, compiler, *Illustrated Summary Catalogue of The Crawford Municipal Art Gallery*, Cork 1992; Anne Crookshank and the Knight of Glin, *The Watercolours of Ireland*, London 1994 (also illustration); Gloucester City Museum and Art Gallery, *Letter to the author*, 1995; also, Sir Thomas Rich's, 1995; Victoria and Albert Museum, 1995.

KERNOFF, HARRY, RHA (1900-74), portrait, landscape and decorative painter. Harry Aaron Kernoff was born on 9 January 1900 in London to Jewish parents of mixed Russian and Spanish descent. He began his education at an elementary school. His father, Isaac Kernoff, was a cabinetmaker who decided to set up

business in Dublin. Harry was apprenticed to the trade and recalled being rebuked for painting a picture on the window pane with a butter-tipped finger, and also for attempting a portrait on the floorboards under one of his father's Viennese chairs.

Always anxious to draw, he attended night classes at the Dublin Metropolitan School of Art. After winning the Taylor Scholarship in 1923, he became a full-time day student, influenced and encouraged by Sean Keating and Patrick Tuohy (qq.v.). Maurice MacGonigal (q.v.), a fellow pupil, told the author in 1976 that he 'walked the city with Kernoff, who wandered'. Another student, Hilda van Stockum, remembered him as 'a silent gnome' who 'worked away quietly and did lovely watercolours'.

Kernoff was one of the few artists to depict Dublin and its people, showing a sympathy and understanding, not least for the unemployed. His *Dublin Kitchen* was dated 1923.In 1925 he showed illustrations at the Arts and Crafts Society of Ireland exhibition. In 1926 there began his remarkable exhibiting association with the Royal Hibernian Academy and, with the exception of the years 1930 and 1931, he showed each year until 1974, averaging about six works per show, from 13 Stamer Street, Dublin. His studio was in the attic.

According to the *Irish Times*, the autumn of 1926 was the great day of Mrs Bannard Cogler's Studio Cabaret, which had moved to 40 Harcourt Street from Daniel Egan's picture gallery in St Stephen's Green: 'There was nothing quite like it in Dublin before or since ...Round the walls were pinned cut-out heads – nearly all of them done by Harry Kernoff, of prominent Dubliners and habitués of the cabaret. Artists, poets, playwrights, "characters" of every degree had their likenesses there...'.

Kernoff became involved with many theatre and literary figures, including Liam O'Flaherty and his brother Tom who founded the Radical Club and through it Kernoff became a member of the Studio Art Club. The painters' group associated with the Radical Club held an exhibition at Egan's in 1926 and Kernoff was well represented. He was responsible for the unique decorative scheme at the Little Theatre, South William Street, and had an exhibition there in 1927. He designed for the Dublin Drama League's *Hoppla!* by Ernst Toller in 1929.

Among his early portraits were: Coralie Carmichael and Hilton Edwards, both Gate Theatre, 1928; Gabriel Fallon, author and critic, 1928; F.R. Higgins, poet, 1928; Sydney Gifford (John Brennan), 1929; Lyle Donaghy, poet, 1930. In 1926 – 'Catalogue of the Impressions and Landscape Paintings' – there began a series of one-person shows at 7 St Stephen's Green, Dublin. In 1930 he held an exhibition at the Civic Theatre, Dun Laoghaire, and was also responsible for stage settings in the pageant, Erin through the Ages, at the People's Park. In the period 1930-33 he showed each year with the Water Colour Society of Ireland.

A member of the Friends of Soviet Russia, he was one of a delegation of four to visit Leningrad, Moscow and Tiflis in 1930. The masthead of the *Irish Workers' Voice*, circulating as the Communist weekly, was designed by him, and a number of pen sketches of the leading political personalities of the time were used to illustrate the paper. In 1931 he was in Paris: *Metro, Paris* and *Place de Tertre, Paris* are so dated; *Place de Combat, Paris*, 1932.

Kernoff's sole contribution to the Royal Academy was in 1931 when he showed *Jupiter and the Muses*, decoration, but that year he had a solo show at Gieves Gallery, Old Bond Street, London, and in a foreword to the catalogue stated: 'I prefer doing a portrait in one sitting, and retain freshness of vision thereby, and avoid a laboured work.' His works included: *A Pope, Ukraine* and *Ukraine Peasant*. His only other exhibition in London was at the White Gallery, New Burlington Street, in 1938, and Frederick Carter wrote in the *Dublin Magazine*: 'The impression given by the whole group of pictures exhibited is of lightness and movement; there seems to be no heavy concentration to attain emphasis ... The use of line is his talisman ...'. Works included *Farm, County Limerick*; *Painting a Bridge, Kew, London*; *Connemara Man*.

On Boxing Day, 1934, Kernoff wrote to the standing committee at the School of Art and advocated financial support 'to ameliorate the artists position in Ireland, and to give certain artists of undoubted ability an income from the state, sufficient to allay their fears of starvation, to allow them to marry, so that they can work unhampered and produce their best works thereby'. In practical terms a subsistence wage for a guaranteed number of works.

Exhibitions at 7 St Stephen's Green continued and he also showed with the Dublin Painters. As well as his portraits, the 1930s found him portraying Leeson Street Bridge, Dublin; gantries on a Belfast Sunday;

yachts on the hard at Dun Laoghaire; and an interior of Davy Byrne's public house in Dublin. In 1936, John Dowling wrote in *Ireland To-Day*: 'Kernoff is not only a Dubliner, but he is a convinced "towny". Shapes are what interest him, such as the mass of a building against the sky or a pattern of roofs and chimney pots, and his feeling for the city with its jumble of houses and shops and quays, its bridges and ships and machinery, is emphasised by a difference between his handling of these subjects and his more pastoral themes ...'. Kernoff's diary recorded that he designed the settings for the Dublin productions of *The Shadow of a Gunman* and *The Glittering Gate*.

In 1933 the Medici Press reproduced his watercolour, *Birches, Phoenix Park*. An exhibition at Daniel Egan's Gallery, 38 St Stephen's Green, followed in 1934, and he was represented among the illustrators when the Cuala Press published a second and third series of *A Broadside* in 1935 and 1937 respectively. In 1935 he was elected an associate of the RHA and in the same year to full membership. In 1936 and 1937 he held exhibitions at the Victor Waddington Galleries, Dublin, returning in 1940, and in 1937 at Mills' Hall, Dublin. He was represented at the Glasgow Empire Exhibition in 1938. Although not keen on teaching, he assisted in a summer course of instruction for teachers of drawing in Secondary Schools, held at the National College of Art in 1939. His 1941 *Davy Byrne's Pub, Duke Street, from the Bailey* is at the National Gallery of Ireland.

In 1942 appeared the first of his three books of woodcuts. *Woodcuts* at 21s. net was a limited edition of 220 copies. That year he also exhibited at the Studio Arts Club, 13 Harcourt Street, and at this time the Gayfield Press used his woodcuts in the Dublin Poets and Artists series. His exhibition in oil, watercolour and pastel at the Grafton Gallery, Harry Street, in 1944 was a record of his visit to Killarney. Raymond McGrath in *The Bell* felt that he had missed his vocation: 'He should be painting stage-sets and murals, not easel-pictures.' The Oireachtas exhibitions also carried his work. In 1947 he had a show at Castlebar, Co. Mayo, and his *Bend in the Road, Richmond, Surrey* (Ulster Museum), oil, was painted that year. He was represented at the Contemporary Irish Art exhibition at Aberystwyth in 1953. *Wisemen of the East* was shown at the 1955 RHA.

In 1957 he visited Nova Scotia, a friend extending hospitality, and had ten works in the Arts Festival. His account book showed expenses of £35 for June to October. An exhibition of Nova Scotia pictures was held at the Ritchie Hendriks Gallery, Dublin, in 1958. He began painting some oils on smaller than usual canvases and at the RHA in 1961 and 1962 he exhibited 'Ten small oils each £10'. An exhibition in Lugano in 1964 was followed by one in Toronto in 1965. His account book for 5 April 1965-5 April 1966 showed a profit of £326.18s. 'less £42.00 for non-payment'. However, two years later there was a loss.

When the W.B. Yeats Centenary Exhibition was held in the National Gallery of Ireland in 1965 he was represented by four portraits: James Connolly, woodcut in colour; and pastels of Sean O'Casey, Liam O'Flaherty and Denis Johnston. An exhibition of portraits was held at Robertstown, Co. Kildare, in 1968. The Godolphin Gallery in Dublin hosted an exhibition in 1973. He was made a life member in 1974 of the United Arts Club, Dublin. He was for many years a member of the art advisory committee of the Municipal Gallery of Modern Art.

The critic Edward Sheehy wrote: 'Clarity of vision, the refusal to poeticise, a sanity expressed through a careful and untemperamental craftsmanship, these are to me the predominant qualities of Kernoff's best work...'. During a busy career, he also found time for book illustration.

In his studio he had painted a generation of Dubliners. In the National Gallery of Ireland are many of his portraits, including Sean O'Casey, 1930; Peig Sayers, 1932; Brendan Behan, 1964; and fellow artists MacGonigal, 1925, and Jerome Connor (q.v.), 1943. In the Waterford Municipal collection there is a portrait in oils of W.B. Yeats. In the Crawford Municipal Art Gallery, Cork, is a 1928 pastel of F.R. Higgins. Athlone Public Library has a 1967 portrait of John Broderick. A self-portrait is in the University of Limerick collection. In addition to the prints at the Irish Jewish Museum, Dublin, there is a decorated ash-tray. Five portraits are in the Dublin Writers' Museum: Austin Clarke, Maurice Craig, Oliver St J. Gogarty, James Joyce and Sean O'Casey.

After a lifetime of artistic activity, Harry Kernoff died on 25 December 1974 in the Meath Hospital, Dublin, and was buried at Dolphin's Barn. In 1975 his sister, Miss Lena Kernoff, presented a collection of sketches, portraits and other memorabilia to the National Gallery of Ireland. At the National Library of Ireland, as well

as account books and other material, are more than 200 verses, many satirical, on scraps of paper and card. In 1975 the Godolphin Gallery held an exhibition of portraits, and in 1976 a memorial exhibition was presented at the Hugh Lane Municipal Gallery of Modern Art.

Works signed: H.A. Kernoff, Kernoff, H.A.K. or K.
Examples: Athlone, Co. Westmeath: Public Library. Beijing: Irish Embassy. Belfast: Ulster Museum. Cork: Crawford Municipal Art Gallery. Dublin: Áras an Uachtaráin; Dublin Writers' Museum; Hugh Lane Municipal Gallery of Modern Art; Irish Jewish Museum; Liberty Hall; National Gallery of Ireland; Office of Public Works. Galway: National University of Ireland. Killarney: Town Hall. Limerick: City Gallery of Art; County Library; University, National Self-Portrait Collection. Luxembourg: Irish Embassy. Waterford: City Hall, Municipal Art Collection.
Literature: *Dublin Magazine*, August 1923 (illustration), November 1923 (illustration), October-December 1938, October-December 1942 (illustration), January-March 1944; J. Crampton Walker, *Irish Life and Landscape*, Dublin 1927 (illustration); Bulmer Hobson, ed., *A Book of Dublin*, Dublin 1929 (illustrations); E.M. Stephens, ed., *Dublin Civic Week 1929 Official Handbook*, Dublin 1929 (illustrations); *The Watchword*, 6 December 1930; *La Revue Moderne*, 15 September 1931 (illustration); Bulmer Hobson, ed., *Saorstát Éireann Official Handbook*, Dublin 1932 (illustrations); *Model Housekeeping*, September 1933; W.B. Yeats and F.R. Higgins, eds, *A Broadside*, Dublin 1935 (illustrations); Leslie Daiken, ed., *Good-Bye, Twilight*, London 1936 (illustrations); N.L. Lees, *Bogs and Blarney*, Dublin 1936 (illustration); Kenneth Sarr, *Somewhere to the Sea*, London 1936 (illustration, dust jacket); *Ireland To-Day*, October 1936; *The Studio*, March 1937 (also illustration); W.B. Yeats and Dorothy Wellesley, eds, *A Broadside*, Dublin 1937 (illustrations); Thomas Bodkin, intro., *Twelve Irish Artists*, Dublin 1940 (also illustration); Harry Kernoff, *Woodcuts*, Dublin 1942; *Times Literary Supplement*, 25 July 1942 (illustration); *The Bell*, May 1944; Harry Kernoff, *12 Woodcuts*, Dublin 1944; Patricia Lynch, *A Storyteller's Childhood*, London 1947 (illustrations); *Irish Tatler and Sketch*, November 1948; Devin A. Garritty, ed., *New Irish Poets*, New York 1949 (illustrations); Harry Kernoff, *36 Woodcuts*, Dublin 1951; *Ireland of the Welcomes*, July-August 1955 (illustrations); Patricia Lynch, *Tinker Boy*, London 1955 (illustrations); Cathal O'Shannon, *Fifty Years of Liberty Hall 1909-1959*, Dublin 1959 (illustration, dust jacket); *Irish Times*, 10 January 1938, 6 February 1968, 25-27 and 30 December 1974, 8 February 1975, 11 April 1975, 23 May 1975, 10 March 1979; *Who's Who*, London 1970; *Capuchin Annual*, 1973 (illustration); Liam Miller, *The Dun Emer Press, Later the Cuala Press*, Dublin 1973; Godolphin Gallery, *Harry Kernoff: a selection of Dublin paintings*, catalogue, Dublin 1974; *Harry Kernoff Papers*, National Library of Ireland; Hilary Pyle: Cork Rosc, *Irish Art 1900-1950*, catalogue, 1975; National Gallery of Ireland, *Press release*, 10 October 1975; Hugh Lane Municipal Gallery of Modern Art, *Kernoff*, catalogue, 1976; *A Dictionary of Contemporary British Artists, 1929*, Woodbridge 1981; Ann M. Stewart, *Royal Hibernian Academy of Arts: Index of Exhibitors 1826-1979*, Dublin 1986; Crawford Municipal Art Gallery, *Letter to the author*, 1988; John Turpin, *A School of Art in Dublin since the Eighteenth Century*, Dublin 1995 (also illustrations); *Water Colour Society of Ireland Exhibition List 1872-1994*, Dublin 1995; Athlone Public Library, *Letter to the author*, 1999; National Gallery of Ireland, *Gallery News*, September-November 2000.

KERR, ALFRED E. (1901-80), illustrator. Alfred Edward Laws Kerr was born at Wollston, Hants, son of Alfred E. Kerr. His parents returned to Belfast when he was a small boy. After joining an engineering firm as a draughtsman, he resigned to become a commercial artist with an office at 36 Waring Street and then 3 Adelaide Street. Among his commissions was handkerchief design.

A member of the Belfast Art Society, he was associated with their Dramatic Club. In 1925 he won a £5.5s. prize from the Royal Society of Arts in a competition for book illustration in colour. He was then living at 12 Deramore Avenue, Belfast, and listed as his recreations research into Celtic mythology, Gaelic culture and traditions; the theatre. A number of his illustrations, general and for advertisements, appeared in 1930 issues of the local *Macs' Magazine*.

Book illustrations for the Quota Press, Belfast, brought his name into prominence. A number of undated pamphlets were issued by this firm, quoting book reviews, for example Florence Davidson's *Loan-Ends* was published in 1933 with original linocuts, and the *Irish Times* was quoted: 'Illustrated with remarkable feeling by an artist whose pen is almost worthy of Mr Jack Yeats.' In 1936 and 1937 Kerr designed two posters 'See Northern Ireland by Train and Motor Coach' for LMS Northern Counties Committee/Northern Ireland Road Transport Board.

In a Quota Press pamphlet c. 1936, headed 'The Art of Alfred Kerr' and signed by Gilbert H. Fabes, New Bond Street, London, the writer stated that it was a notable event in his literary life when he received a copy of Kit Cavanagh's *A Dunleary Legend and other tales*, which had been published in 1934 (price 7s.6p.; deluxe

edition of 100 copies on hand-made paper, £1.1s.). The book had brought to Fabes' notice the art of Alfred Kerr. He made enquiries about him from the publishers ... 'When I learned that he had moved quietly and naturally from commercial art to book illustrating and that, until a few months ago, when he visited London, he had never seen a Beardsley drawing, I was amazed. I then discovered that he was also ignorant of the technique and style of other artists who are famous in the book-world ...' When Fabes saw the drawings in *Whisht: Listen a Minute*, 1935, he 'resolved to introduce the art of this Irishman to London's West End and in this new world it has been received with admiration ...'.

On *A Dunleary Legend and other tales*, the Quota Press quoted the *Weekly Scotsman*: 'He has caught the spirit of the stories, and imagination and art have been combined in the production of some of the finest-finished and most elaborately detailed drawings ever conceived for a volume of this description. The detail of the drawings is almost microscopic yet every line is full of delicacy, beauty, or strength; and there is an element of weird fantasy throughout ...'.

In 1936, the year that Kerr, the 'Ulster Beardsley', moved to London, he supplied the illustrations for *The Beast* by Claude Houghton. 'Only 250 copies will be offered for sale at one guinea each ...' Quota announced per pamphlet. The book preceded *This Ireland*, a portfolio of drawings 'limited to 200 signed copies'. Fabes felt it would be interesting for admirers of Kerr's work to know that when the manuscript of *The Beast* came into the artist's hands he began to work at once on the drawings before any contracts were arranged.

During the Second World War, Kerr was involved in the writing and illustrating of half a dozen military handbooks, mainly associated with the Home Guard. After hostilities, he began to write and illustrate children's books under the pseudonym of Patrick Sinclair, but generally did not sign the illustrations. He was a member of the Society of Graphic Artists, London. In the Chenil Gallery in King's Road the 'Artists of Chelsea' held their third exhibition in 1951 and *The Studio* commented: 'Alfred Kerr in *The Turf Bog* suggests the mists of Ireland in the haze-rimmed silhouettes of receding ridges filled with lovely blues and greens.'

In 1950 his Chelsea address when he exhibited *Ombres et Lumieres, Seine* at the Royal Institute of Oil Painters was 25d Whiteheads Grove; in 1954 he showed *Spring Morning, Paris*. In the period 1956-70 under the auspices of the Carnegie United Kingdom Trust's visual arts policy, he gave professional guidance to members of a number of amateur art clubs in England and the Isle of Wight. These included the Derby and North Midland Group of Art Clubs and the Weymouth and South Dorset Art Group.

In 1959 he moved permanently to the Isle of Wight where he founded at Thornton Cross, Ryde, the Seaview School of Painting, jointly with a pupil, Comtesse Georgette de Malet Roquefort. The school attracted most of the best artists on the island. Some aspirants travelled from the mainland for classes. His *Anyone Can Paint Pictures*, 1960, was followed by a second book, *Colour – and the Artist*, 1969. In 1972 he held an exhibition at the Ryde Public Library art gallery which included landscapes, oils and watercolours with some Surrealist studies, and among the nudes, *Tristesse*.

President of St Lawrence Art Society, Ventnor, since its inauguration in 1969, Alfred ('Paddy') Kerr died at his home in Ryde, on 10 January 1980. His name is incorporated in the title of a painting group of former pupils. In 1981, with memorabilia, a memorial exhibition of his work was held at the Ryde Library.

Works signed: Alfred E. Kerr, Alfred Kerr, Kerr, A.E.K. or A.K. (if signed at all).
Literature: Books illustrated, published London unless otherwise stated: Florence Davidson, *Loan-Ends*, Belfast 1933; Lydia M. Foster, *Tyrone among the Bushes*, Belfast 1933; Kit Cavanagh, *A Dunleary Legend and other tales*, Belfast 1934; Lydia M. Foster, *The Bush that Burned*, Belfast 1934; D.M. Large, *An Irish Medley*, Belfast 1934; Jean Waddell, *Sing a Song of Children*, Belfast 1934; Avril Anderson, *Whisht: Listen a Minute*, Belfast 1935; Claude Houghton, *The Beast*, Belfast 1936;Alfred E. Kerr and Ruddick Millar, *Four Irish Pictures*, Belfast 1938; Abbie P. Walker, *Christmas at the Four-Paws Club*, 1938; Alfred E. Kerr, *The Art of Guerilla Fighting and Patrol*, 1941; Alfred E. Kerr, *The Home Guard Handbook*, 1941; Alfred E. Kerr, *Air Cadet*, 1943; Alfred E. Kerr, *Guerilla*, 1943; Alfred E. Kerr, *The Art of Night Fighting*, 1943; Alfred E. Kerr, *Home Guard Field First Aid*, 1944; Patricia Lynch, *Knights of God*, 1945; Patrick Sinclair, *Lambkin*, 1945; A. Kerr, *Roddy the Rooster*, 1946; Margaret Meredith, *The Swan Prince*, 1946; Margaret Meredith, *Writer of Tales*, 1946; Patrick Sinclair, *Cottonwood Tales*, 1946; Patricia Lynch, *Brogeen of the Stepping Stones*, 1947; Patricia Lynch, *The Cobbler's Apprentice*, 1947; Margaret Meredith, *The Wishing Imp*, 1947; Christina Murray, *The Little Yellow Horse*, 1947; D.J. O'Sullivan, *Light-Keeper's Lyrics*, Dundalk 1947; Patrick Sinclair, *The Calf that Lost its Moo*, 1949; Patrick Sinclair, *The Duck that lost its Quack*, 1949; Patrick Sinclair, *Quack Takes a Holiday*,

1952; Patrick Sinclair, *Dilly Duck Stories*, 1953; Alfred E. Kerr, *Anyone Can Paint Pictures*,1960; Alfred (Paddy) Kerr, *Colour - and the Artist*, Ryde 1969.
Literature: General: *Belfast and Province of Ulster Directory*, 1928; *Macs' Magazine*, monthly, August-December 1930 (illustrations); Alfred E. Kerr, *This Ireland*, portfolio of drawings, Belfast 1936; Quota Press pamphlet, Belfast [1936]; *Who's Who in Northern Ireland*, Belfast 1937; *The Studio*, October 1951; *Isle of Wight Mercury,* 18 January 1980; *Isle of Wight County Press*, 19 January 1980; Carnegie United Kingdom Trust, *Letter to the author*, 1988; also, Mrs Esther Rose, 1988; Royal Society for the encouragement of Arts, Manufactures and Commerce, 1988; Bethnal Green Museum of Childhood, 1996.

KEYES, CECILIA (1873-1941), portrait painter and lace designer. Born in Skibbereen, Co. Cork, on 9 August 1873, Cecilia Mary Keyes' parents died when she was about eight years of age, and she was sent as a boarder to the Convent of Mercy, Kinsale, Co. Cork. At the age of nineteen, she was a pupil-teacher of art.

In 1895 she obtained the benefit of the vacation course at South Kensington, and in 1897 she won the two-year National Scholarship. On the completion of her studies in London, she returned to Kinsale where she taught art and lace design at the Convent of Mercy until her death. In the art studio in the Convent she executed designs for the workers as well as assisting them in the workrooms.

Handicapped by being lame, she was described as 'an absolute genius and could depict any flower she saw'. There was a tradition in Kinsale that she had drawn every flower in the area.

In 1927 and 1929 she executed two large paintings of Mother Catherine McAuley. She also painted a portrait of Mother Patricia Murphy, foundress of Mercy Convent, Passage West, Co. Cork.

Cecilia Keyes is represented by three works at Kinsale Regional Museum: a pencil study of Rev. Lawrence Cummins, vice-president of the League of the Cross, Kinsale, who died in 1900; and two oil paintings, *Arrival of James II and Patrick Sarsfield in Kinsale* and *Departure of King James II from Kinsale,* both painted in 1939. She died at Kinsale on 22 January 1941.

Works signed: Cecilia Keyes or C. Keyes.
Examples: Kinsale, Co. Cork: Convent of Mercy; Regional Museum.
Literature: *Register of Deaths, Kinsale*, 1941; Michael Mulcahy, *Letter to the author*, 1973; Kinsale and District Local History Society, *The Kinsale Record*, 1991; Sister Patricia Quinlan, *Letters to the author*, 1999.

KING, CECIL (1921-86), abstract painter. Born in Rathdrum, Co. Wicklow, he was educated in the Church of Ireland Ranelagh School in Athlone, Co. Westmeath, and later at Mountjoy School 1936-9, in Dublin. He joined the printing firm of W. and S. Magowan in Dundalk, Co. Louth, and became a director. Involved in amateur dramatics, he attended the Gaiety School of Acting in Dublin. An early enthusiasm for cycling and walking saw him actively involved in An Óige, the Irish Youth Hostel Association, and he served as honorary national secretary and honorary treasurer.

An ardent collector, King took up painting in 1954 in his spare time, and it was in the studio of Barbara Warren that he painted his first picture. Under the influence of Derbyshire-born Nevill Johnson (q.v.) in Dublin, he painted semi-abstract pictures, depicting water and its reflection as seen at Ringsend and the Dublin quays. He also painted still life and religious pictures.

In 1956 his work was selected for the Irish Exhibition of Living Art, and he continued to show until 1979, missing only a few years. In 1956 too his work was exhibited for the first time at the Oireachtas, and in 1957 at the Munster Fine Art Club. In 1958 he was represented in the Dublin Painters' exhibition. An association with the Ritchie Hendriks Gallery, Dublin, began in 1959 with one-person shows and ended in 1980 at the David Hendriks Gallery, a total of nine exhibitions. In his introduction to the 1959 catalogue, James White wrote: 'He is reticent in subject, preferring landscapes almost lost in moonlight or figures in arabesque appearing from the city gloom.'

In 1961 he was responsible for the decor for a production of *Les Sylphides* by the Irish National Ballet Company at the Abbey Theatre, Dublin, and the following year his work was included in the Exhibition of Sacred Art, Dublin. In 1964 he left business to paint full time, and that year he had his first one-person show outside Ireland, at the Charing Cross Gallery, Glasgow. In 1964 he won an award at the Arts Council of

Northern Ireland's Open Painting Exhibition. A founder member of the Contemporary Irish Art Society, he organised the exhibition, Paintings and Sculptures from Private Collections, at the Municipal Gallery of Modern Art in Dublin, 1965. *Yellow and Turquoise*, pastel, was dated 1965.

In 1967 he held three one-person shows: Howard Roberts Gallery, Cardiff; Richard Demarco Gallery, Edinburgh; Arts Council Gallery, Belfast. At the latter show, some of the paintings – there were also pastels – were described as in 'Acrylic Vinyl Copolymer on canvas'. Kenneth Jamison wrote in the catalogue: 'His creative activity is a natural extension of the educated eye that enjoys hanging in the same Georgian room, sensibilities as different as Herman and Hartung. These pictures of Cecil King's reflect a taste that embraces the surrealism of Nevill Johnson (an early influence on his own work), the sophisticated images of Patrick Scott and the more robust work of Léon Zack... Although untitled, these pictures are inspired by the circus ...'.

London began to take notice as early as 1961 when he exhibited at the Leicester Galleries' Artists of Fame and Promise. The first year for his work to appear in Festival gallery exhibitions in Edinburgh was in 1966. He was a founder member of the Rosc Committee of 1966 and was closely involved in the presentation of the Dublin exhibitions. In 1968 he exhibited at the Queen Square Gallery, Leeds, and at Nottingham University the same year he showed with a Welsh painter, Tom Nash, contributing fifteen oils and ten pastels.

In the late 1960s he developed his own version of the 'hard-edge' school; the surface quality of the paint and his use of colour was particularly noticeable. On his exhibition in 1969 at the Ritchie Hendriks Gallery, the *Irish Times* commented: 'Cecil King continues his involvement with Hard Edge, and even if the result lacks real originality, his current prepossessions have certainly tautened up his painting and made it stronger formally.' Dorothy Walker in her *Modern Art in Ireland*, 1997, noted that once he had found his new mode of expression in the *Baggot Street* series, 1967, 'his painting developed with conviction and a particular taut elegance that made it distinctive from the bulk of the abstract work produced at this time'. When the Arts Council's Modern Irish Painting European tour set off in 1969, his work was included. A one-person show was held in Dundalk the same year.

Editions Alecto Ltd, London, published in 1970 the Berlin Suite of screenprints in an edition of seventy-five, exhibited at Galerie Monika Beck, Schwarzenacker Saar, France. In the introduction to the catalogue, Ethna Waldron, Dublin, wrote: 'A recent visit to Berlin made a deep and lasting impression on the artist. Man living under tensions and the claustrophobic pressures of a divided city are reflected in the window-onto-life effects of this new set of six prints. The colour variations introduce the city's subtle changes of mood and emphasis while the basic tensions remain taut and keyed-up to fever pitch ...'. Two oil paintings from his Berlin series are with the Irish Management Institute, Dublin. *Berlin Painting 21* is in the Arts Council, Dublin, collection.

King had three shows in 1971: Compass Gallery, Glasgow, with Patrick Collins (q.v.) and Robert Ballagh; Cork Arts Society Gallery; Queen's University Gallery, Belfast. In that year he won an award in the open section of the Irish Exhibition of Living Art. In 1972 and 1977 his works occupied the Octagon Gallery, Belfast, also at the Oxford Gallery, Oxford. Referring to the 1972 Belfast show, the *Irish Times* found him 'soothing, reassuring. He is the only one of his generation of Irish painters who is not caught up in the narrative tradition. His work is cool, refined, intellectual.' In 1974 Editions Alecto published *Red Intrusion*, a silk screenprint in an edition of 100 which won the gold medal at the 4th International Graphic Biennale, Frechen, West Germany, 1976.

Represented in Rosc, The Irish Imagination 1959-71 show in Dublin in 1971, he was also involved in the Third Biennale of Graphic Art, Florence, 1972, and in 1973 a solo show was held at the Park Square Gallery, Leeds. He was also a designer of tapestries, and the Arts Council of Northern Ireland for their Art in Context project commissioned in 1973 a 1.5 metres by 3 metres tapestry for the Ulster Hospital, Dundonald. There is also a tapestry of this period at the National University of Ireland, Galway.

King's work, some of which was untitled, was seen extensively on the Continent. In 1974 he represented Ireland at the Festival of Cagnes-sur-Mer, France. Also in 1974 he held his first show at Galerie Monika Beck; two more followed in 1978 and 1980. The Brussels art critic, Sven-Claude Bettinger, wrote of the 1974 display: 'One may be deceived by the coldness and austerity of the works but on closer examination one

discerns, behind the thrust of the geometric lines and the forms, the colour integration achieved by the technique in the use of pastel medium. The colours overflow into each other in a most subtle way ...'

A retrospective exhibition was held as part of the Kilkenny Arts Week in 1975. William Packer of the *Financial Times* commented on the pictures: 'We look at them for what they are, not for how they are made. Their very completeness belies the skill and judgement of the artist.' King's business background must have assisted him in organising a bewildering number of exhibitions.

An exhibition at the Angela Flowers Gallery, London, in 1975, was followed by: Galeria Maestre Mateo, Corunna, Spain, 1976, 1978; Galeria Atalayo, Gijon, Spain, 1976; Leane Gallery, Listowel, Co. Kerry, 1976; Jordan Gallery, London, 1977; Keys Gallery, Londonderry, 1978, 1981; Baldwin Gallery, Dundalk, 1978; Triskel Arts Centre, Cork, 1979; Galeria Pepe Rebollo, Saragossa, Spain, 1979; Galerie Ressle, Stockholm, 1980; Tulfarris Art Gallery, Blessington, Co. Wicklow, 1980; A.D.C.A., Longjumeau, Paris, 1981; Galerie Klothen, München Gladbach, West Germany, 1981; Galerie Gamblebyen, Fredrikstad, Norway, 1981.

In his catalogue introduction to a portfolio of four screenprints, published by Edition Monika Beck in 1975, edition of 300, James Johnson Sweeney of New York wrote: 'Elegance, meticulousness, conviction are the essence of Cecil King's art. These qualities combined with a knowledgeable and scrupulous craftsmanship have steadily brought him the widening international recognition he has come to enjoy today ...'. In 1975 a screenprint was published by Claire Turyn, Paris, edition seventy-five, and one by Editions Alecto, edition 100.

Edition Monika Beck published in 1979 four sonnets by Seamus Heaney and four paintings by Cecil King, edition fifty. Publications in 1981 were: Screenprint, *Idrone*, Ward River Press Ltd, edition 100; four screenprints, text by Thomas Kinsella, Edition Monika Beck, edition 125; three screenprints, text by Ludwig Harig, Kinvara Press, edition forty. In 1984 a portfolio of four of his paintings and four poems by Micheál O Siadhail was published, edition sixty, by Edition Monika Beck.

In 1974 he had been represented in the fifth International Exhibition of Original Drawings at Rijeka, Yugoslavia, also at the Norwegian International Print Biennale at Fredrikstad in 1974 and 1978. In 1978 he had work in Poland at the Cracow Biennale Prizewinners' Exhibition, and in France at the Biennale Europeane de la Gravure de Mulhouse. Indeed the 1970s and 1980s saw him represented in several other group exhibitions – in Ireland, at the Oireachtas in 1974 and 1977; England and abroad: Italy, West Germany and Switzerland all showed his work, which was included in the Irish Directions USA tour in 1974.

A retrospective exhibition held at the Hugh Lane Municipal Gallery of Modern Art in 1981 was the artist's twenty-ninth one-person show in a quarter of a century. In addition to more than four score works in oil or pastel, three tapestries and various prints were on view. The two oldest pictures exhibited were: *Ringsend Morning* and *Evening Ringsend*, both 1957. A selection of pictures from his personal collection was displayed in separate rooms. At the Irish Museum of Modern Art in Dublin he is represented by six works, all from the Gordon Lambert collection, including *Disintegration*, oil, and *Circus Series*, pastel.

A member of Aosdána, King lived in Blackrock, Co. Dublin, for many years. Noted for his support of young artists, he acted as an assessor of final-year students in art colleges around the country. Three days prior to the opening of his exhibition at the Oliver Dowling Gallery, Dublin, he died of a heart attack at St Michael's Hospital, Dun Laoghaire, on 7 April 1986, and was buried at Rathdrum. At a memorial service held on 10 May in Christ Church Cathedral, Dublin, the Very Rev. Maurice Carey, Dean of Cork, said in his address: 'Giving help and advice and encouragement to others was a characteristic, for which many have expressed cause to be thankful ... He was universally liked, and the warmth and living concern of his personality will be widely missed.'

Works signed: Cecil King or C. King, rare; signature probably on reverse.
Examples: Athens: Irish Embassy. Belfast: Arts Council of Northern Ireland; Education Committee; Ulster Museum. Coleraine: North West Art Trust; University of Ulster. Cork: Crawford Municipal Art Gallery. Dublin: Arts Council; City University; Hugh Lane Municipal Gallery of Modern Art; Institute of Public Administration; Irish Management Institute; Irish Museum of Modern Art; Irish Writers' Centre; Office of Public Works; Radio Teleffs Éireann; St Patrick's Hospital; Trinity College Gallery; University College (Belfield). Galway: National University of Ireland. Leeds: University. Limerick: City Gallery of Art; Mary Immaculate College; University, National Self-Portrait Collection. Lodz,

Poland: Museum Sztuki. London: Tate Gallery; Victoria and Albert Museum. New York: Cultural Centre; Irish Embassy; Museum of Modern Art. Oxford: Wadham College. Paris: Irish Embassy. Riyadth, Saudi Arabia: Irish Embassy. Saarbrücken, Germany: Museum. Stirling, Scotland: University. Waterford: City Hall, Municipal Art Collection.
Literature: Arts Council of Northern Ireland, *Cecil King*, catalogue, 1967; *Irish Times*, 10 January 1969, 11 August 1972, 29 September 1972, 10 November 1972, 9 and 10 April 1986, 9 May 1986, 27 May 1987; Hugh Lane Municipal Gallery of Modern Art, *Cecil King*, catalogue, Dublin 1981 (also illustrations); Sean McCrum and Gordon Lambert, editors, *Living with Art: David Hendriks*, Dublin 1985; *An Address by the Very Reverend Maurice Carey, Dean of Cork*, pamphlet, Dundalk 1986; James Adam and Sons, *Irish art sale*, catalogue, Dublin 1987; Dorothy Walker, *Modern Art in Ireland*, Dublin 1997 (also illustration).

KING, MARION (1897-1963), cartoonist, illustrator and painter on glass. Born in Trim, Co. Meath, she was one of eleven children and spent much of her early life in Leeds, her father, Thomas King, a Customs and Excise officer, having been transferred there. After studying at Leeds College of Art, she returned to Ireland in 1922, supplementing her income by commercial art, and working from her home at 3 Eaton Square, Monkstown, Co. Dublin.

Something of an inventor, her technique of painting on glass created a surprise in artistic circles, meriting notice in Paris and New York. She was said to have written a book teaching her startling new methods. Some of her work on glass appeared in the exhibition of the Associated Irish Artists, regarded as a 'rebel' group, at the Angus Gallery, St Stephen's Green, Dublin, in 1934.

The method of making glass pictures was patented in the United Kingdom and the Irish Free State. According to the UK specification, 1932, 'this invention concerns a method of working pictures on glass or the like, its object being to provide in a simple manner pictures of striking and novel appearance and artistic and highly decorative effect'. The method consisted in working a picture essentially in outline with raised lines of a distinctive colour, preferably gold, upon the front surface of a sheet of glass or the like and applying the body of the picture in colours to the back of the sheet.

'In carrying out the invention according to the preferred procedure, the picture to be produced is first sketched upon a sheet of paper in the ordinary way, a sheet of glass is placed over the paper and the outline of the picture is traced upon the glass with gold paint or equivalent material mainly in the form of lines as hereinafter explained. The lines of gold paint in general delineate the various parts of the picture which it is intended to represent in different colours on the back of the glass, but they also represent matter, notably ornamentation, which is not intended to appear in colour on the back of the glass. The paper bearing the sketch is then removed, the glass reversed, and the body of the picture is painted thereon in the desired colours...'

In 1936 Marion King exhibited at the Salon des Femmes Peintres and the Salon des Artistes Français. She was an associate of the Women Painters and Sculptors' Union in Paris. In an interview in 1974 with the artist, Matthew Moss, who had received assistance from Marion King with his painting, he told the author that she knew James Joyce and had shown him the new Irish coins (presumably in 1939 in Paris). Moss also recalled seeing her glass paintings displayed in a creamery shop in O'Connell Street, Dublin.

A member of the Academy of Christian Art, she exhibited at its premises, 42 Upper Mount Street, Dublin, in 1937. As her work did not appear at the Royal Hibernian Academy, this exhibition gave an indication to the Dublin public as to her *oeuvre*. Works were classified under various headings; for example, under 'Irish Subjects' she listed *Balor of the Evil Eye*, exhibited in France the previous year, and *Dermot and Grania*. Under 'Persian Subjects': *There was a Door to which I found no key*. Under 'Chinese Subjects': *Hsi Wang Mu*. 'Moonlight Pictures' produced *The Fairy Ring* and *The Water Lily*. The exhibition also included a portrait of the late Dr Gaughran, Bishop of Meath.

Having a great love for children, she wrote and illustrated a number of children's story books with Irish texts, published in Dublin 1937-39. The Radio Éireann programme, 'Drawing and Painting with Marion King', which began in 1943, became an attractive one for children, with the involvement of characters from her children's books. She eventually found herself teaching blind children to model her little characters in plasticine.

Sean Bunny, her cartoon-and-story strip in the *Irish Times*, began in 1953 and continued until her death. For the first few years the feature ran three days a week, after which it appeared daily. Despite a long illness, she continued to broadcast up to the year before her death. She died at the Mater Nursing Home on 13 July 1963.

Works signed: M. King or M.K.

Examples: Mullingar, Co. Westmeath: The Palace.

Literature: Patent Office, London, *Patent Specification 384245*, 1932; *Father Mathew Record*, June 1934; Academy of Christian Art, *Marion King*, catalogue, Dublin 1937; *Academy of Christian Art Journal*, 1937, 1938 (illustration); Marion King, *Cáit agus Cól*, Dublin 1937 (illustrations); Marion King, *Nodlaig*, Dublin 1937 (illustrations); Marion King, *Séan*, Dublin 1937 (illustrations); Marion King, *Clann Coinín*, Dublin 1939 (illustrations); Marion King, *Taimín*, Dublin 1939 (illustrations); Marion King, *A b c na Gaedhilge*, Dublin 1942 (illustrations); Marion King, *It's Fun to Draw*, series, Dublin 1952 (illustrations); *Irish Press*, 15 July 1963; *Irish Times*, 15 July 1963; *Irish Times, Letter to the author*, 1988.

KING, RICHARD ENDA(1943-95), sculptor and liturgical artist. Born in Dalkey, Co. Dublin, on 1 February 1943, he was the son of Richard J. King (q.v.). Educated at the Christian Brothers' School in Dun Laoghaire, Co. Dublin, he then attended St Conleth's Private School, Ballsbridge, Dublin.

In 1960-5 he was a student at the National College of Art, Dublin, specialising in sculpture, architecture and craftwork. In 1960 he showed a stained glass panel, *St Enda*, at the Arts and Crafts Society of Ireland Exhibition. In the Irish Sacred Art exhibition in Dublin, 1962, his work, *St Gall*, beaten copper, was in the metalwork section. He was represented in stained glass at the New York World's Fair, 1964.

In the period 1965-7 he was an architectural student with the firm, Peppard and Duffy. During 1966 he completed in his spare time his first liturgical art commission. For the next six years he was a full-time director of a liturgical art studio in Dublin, Gill- Gunning. He was chairman 1968-70 of the Irish Society for Arts and Crafts. A part-time designer for the Focus Theatre, Dublin, he was also a lecturer at Dun Laoghaire School of Art.

A work in metal and ceramic of the Virgin Mary was the central foyer piece of the newly constructed building, Gort Muire Conference Centre, Dublin, and has become the institution's symbol. *Stations of the Cross* were installed in 1966 at St Mary's Church, Dingle, Co. Kerry.

Stations of the Cross followed in 1968 at Manresa Retreat House, Dollymount, Dublin. Stuttgart International Exhibition for metal/enamel sculpture had been requesting Stations for several months so he had made another set for Manresa. A low relief 1970 sculpture, *'Out of Darkness and Imagination Towards Truth'*, 4.3 m x 3.2 m, is at St Laurence College, Loughlinstown, Co. Dublin; the outline of the work and title used for school crest. The crucifix in the private chapel of St Patrick's College, Drumcondra, Dublin, was designed for the main chapel but was considered by the then Archbishop of Dublin, John Charles McQuaid, as too 'modern', so it was hung in the private chapel.

In 1971 he was chosen to represent Ireland at the International Exhibition of Enamels, Cologne, West Germany, and he executed an enamelled copper piece based on a theme from the Cuchulain cycle in, he said, 'the frivolous — heroic mood.' Among his contributions in 1971-2 to St Fintan's Church, Sutton, Dublin, were *Stations of the Cross* sandblasted in bronze tinted glass, inlaid with gold leaf and placed in the windows around the church. A memorial plaque of 1973 in Fermoy, Co. Cork, consisted of short lengths of wire, depicted in semi-abstract form a group of cows, in memory of three Moorepark dairy scientists who died in the 1968 Aer Lingus crash. For the rebuilt St Michael's Church in Dun Laoghaire, 1973, King executed the tabernacle and crucifix.

The Cathedral of Saints Peter and Paul, Ennis, Co. Clare, saw refurbishment in 1975. King was responsible for altar, ambo, and celebrant's chair in granite. At Holy Cross Abbey, Thurles, Co. Tipperary, he executed the new tabernacle with Twelve Apostles and two stained glass windows. In 1975-6 his work at the Convent of Mercy, Templemore, Co. Tipperary, included thirteen granite panels depicting Christ and the twelve Apostles, sandblasted and inlaid with gold leaf. In 1977-8 he was at St Oliver Plunkett's Church, Kilcloon, Co. Meath, where, among other contributions, he created a tabernacle in hand repoussé copper, vitreous enamelled.

An information sheet was supplied to Dominican Convent, Wicklow, in 1978. As well as describing the images, he stated that the tabernacle door was composed of 'solid etched bronze glazed with kiln fired vitreous enamels,' and the crucifix was composed of 'polychromed solid cast aluminium.' The front of the tabernacle, 1979, for the community chapel in Belvedere House, Belvedere College, Dublin, was enamelled on a theme from Teilhard de Chardin.

Among contributions to St Raphael's, Celbridge, Co. Kildare, in 1980-1, were: sheet granite altar and bronze tabernacle with vitreous enamelled exterior panels for the chapel, and carved solid granite sanctuary elements for the oratory. Completed in 1981 was the total reconstruction of the Carmelite Monastery chapel at Newry, Co. Down, where he also provided a stained glass window. *Mother and Child* in stained glass is at Our Lady of Wayside Church, Kiltiernan, Co. Dublin. Brownswood Hospital, Enniscorthy, Co. Wexford, where he also had work, ceased to operate in 1987. By 1998 the Tau Cross made for St Aidan's Cathedral, Enniscorthy, Co. Wexford, had 'disappeared'. In 1988 and 1989 material grants were awarded by the Arts Council, Dublin.

The first of four major public sculptures awarded under the Government 1% for Art Scheme was that for the Navan Inner Relief Road entitled *The Fifth Province*, 1989, height ten metres and constructed in 10 mm mild steel plate using the acetylene welding technique. The artist described the work as a 'sculptural metaphor for the aspirational ideal of the cultural integration of all the people of Ireland. It is a growth form, in which the central stem, supporting four branches, elevates in an upward-thrusting column culminating in a final accented form, symbolic of the flowering of the spirit of peace...'.

King's next major commission, at the Athlone Relief Road, *Evocation*, 1990, was in 10 mm mild steel plate, height of six metres. 'The sculpture expresses in an abstract visual manner the ancient Irish "Fe-Fiada" or "Incantation of Presence" ... The concern is not to illustrate swans *per se*, but to express and evoke the spirit of the Children of Lir,' stated the artist.

Spirit of the Air, 1991, entrance to Dublin Airport on a landscaped roundabout, is seventeen metres in height and illuminated at night. The work won an £80,000 competition and was one of ninety-seven entries. According to the artist, the sculpture was symbolic of the vision of the Tuatha de Danann and took the form of 'a white analogical bird or aeronautical form, aspiring upwards, towards a condition of universal harmony'. The work, constructed in reinforced concrete and stainless steel, was the Irish entry, endorsed by the Arts Council, for the Joan Miro International Plastic Arts Prize, held in Barcelona as Olympiada Cultural, in conjunction with the 1992 Olympic Games.

The theme of *Vigil*, 1991, monochromed plate steel, for Dun Laoghaire Fire Station, was based on the mythological bird, the Phoenix. 'The sculpture is conceived as an analogical bird and flame form,' stated the artist.

King had many liturgical commissions. The last was completed just weeks before his death, for the newly-built St Colmcille's Church in Holywood, Co. Down. Among the several items there is the circular altar, composed of two hand-carved blocks of Portuguese limestone. The mensa block rests on a pedestal base which is composed of three hand-carved figurative relief panels. The *Stations of the Cross* are in copper panels inlaid by hand, with polychromed resin enamel. Of 45 South Park, Foxrock, Dublin, he died in St Vincent's Hospital on 12 October 1995.

Works signed: R. Enda King or R.E.K. (if signed at all).
Examples*:* Athlone, Co. Westmeath: Relief Road roundabout. Bagenalstown, Co. Carlow: St Laserian's Church. Ballyshannon, Co. Donegal: St Joseph's on the Rock Church. Belfast: St James' Church, Shore Road; St Mary's College. Bennettsbridge, Co. Kilkenny: St Bennet's Church. Callan, Co. Kilkenny : Christian Brothers, Edmund Rice House. Carlow, Co. Carlow: St Leo's, Convent of Mercy. Castlebar, Co. Mayo : Sacred Heart Home. Celbridge, Co. Kildare: St Raphael's. Crumlin, Co. Antrim: Mater Dei Church. Dingle, Co. Kerry: St Mary's Church. Donaghpatrick, Co. Meath: St Catherine's Church. Drogheda, Co. Louth: St Mary's Church. Dublin: Airport entrance; Belvedere College; Blessed Sacrament Chapel, Bachelor's Walk; Bord Iascaigh Mhara; Carmelite Centre, Marlborough Road; Gort Muire Conference Centre, Ballinteer Road; Manresa Retreat House, Dollymount; Nazareth House, Malahide Road; Sacred Heart Convent, Mount Anville; Sacred Heart School, Mount Anville; St Fintan's Church, Sutton; St John of God Hospital, Stillorgan; St Joseph's Church, Berkeley Road; St Mary's Priory, Tallaght; St Patrick's College, Drumcondra; St Vincent's Hospital. Dun Laoghaire, Co. Dublin: Fire Station; St Michael's Church; St Michael's Hospital. Edinburgh :

Society of the Sacred Heart. Ennis, Co. Clare: Cathedral of Saints Peter and Paul. Fermoy, Co. Cork: Teagasc, Moorepark. Finglas, Co. Dublin: Children's Centre, Department of Justice. Galway: St Patrick's Church, Forster Street. Glasgow: St Joseph's Church, Clarkston. Greencastle, Co. Antrim: St Mary's Church. Holywood, Co. Down: St Colmcille's Church. Howth, Co. Dublin: St Fintan's Church. Kilcloon, Co. Meath: St Oliver Plunkett's Church. Kilkenny, Co. Kilkenny: Loreto Convent; St Canice's Church. Kilnaleck, Co. Cavan: St Joseph's Church. Kiltiernan, Co. Dublin: Our Lady of the Wayside Church. Kircubbin, Co. Down: St Mary's Church. Loughlinstown, Co. Dublin: St Laurence College. Maam, Co. Galway: Kilmeelicken Church. Manchester: St Augustine's School, Wythenshawe. Maynooth, Co. Kildare: Presentation Primary School; St Patrick's College. Monaghan, Co. Monaghan: St Macartan's Cathedral. Navan, Co. Meath: Inner Relief Road; Our Lady's Hospital. Newry, Co. Down: Carmelite Monastery. Nottingham, Notts. : Little Company of Mercy Convent. Salisbury, Wilts. : St Gregory's Church. Templemore, Co. Tipperary: Convent of Mercy. Thurles, Co. Tipperary: Holy Cross Abbey. Tuam, Co. Galway: Convent of Mercy. Wicklow, Co. Wicklow: Dominican Convent.

Literature : Mary MacGoris, *Irish Independent*, 7 March 1973; *Irish Independent*, 16 August 1973, 16 August 1989; Rev. Paul Andrews, SJ, *Letter to the author*, 1982; Peter Harbison *et al*, *Shell Guide to Ireland*, London 1989; *Irish Times*, 4 October 1989, 18 October 1995; *Dublin Tribune*, 22 November 1990; Richard Enda King, *Curriculum Vitae*, typescript, 1992; *Parish of St Colmcille Holywood 1995*, Holywood (also illustrations); Mrs Mary King, *Letters to the author*, 1997, 1998, 1999; Gort Muire Conference Centre, *Letter to the author*, 1998; Judith Hill, *Irish Public Sculpture: A History*, Dublin 1998 (illustration); Manresa House, *Letter to the author*, 1998; also, St Laurence College, 1998; Teagasc, 1998; Wexford General Hospital, 1998; Athlone Public Library, 1999.

KING, RICHARD J. (1907-74), stained glass artist and illustrator. Born on 7 July 1907 in Castlebar, Co. Mayo, Richard Joseph King was the son of John J. King, a sergeant in the Royal Irish Constabulary, and the uncle of Brian King, the sculptor. After receiving his early education from the De La Salle Brothers, he moved with his family to Westport in 1922 and his education was completed by the Christian Brothers. Showing great skill with his hands, his home was full of toys, gadgets and a violin which he also made, for his own use.

The King family moved to Dublin in 1926. Richard entered the Dublin Metropolitan School of Art and studied illustration and design under Austin Molloy (q.v.), planning architecture as a profession. However, Molloy told Harry Clarke (q.v.) of his accomplished pupil, and the outcome was that King entered the firm of J. Clarke and Sons in 1928. So from an early age he dedicated himself to liturgical art, becoming steeped in its symbolism. His mark, the initial 'K', appeared on some of the works from the firm.

Clarke died in 1931 and King became manager of Harry Clarke Stained Glass Ltd in 1935 and was succeeded by his lifelong friend, William J. Dowling (q.v.) in 1940 when he resigned to carry out commissions at his own studio at Hawkcliff, Vico Terrace, Dalkey, and to launch out into graphic art. Dowling was a frequent companion on his fishing and sketching expeditions in the West of Ireland. Devoted to his native county, King seldom travelled abroad.

King, who was represented at the Chicago World's Fair of 1933, designed twelve postage stamps, issued during the period 1933-49. The first commission was for Holy Year, followed in 1934 by the 'hurling' stamp, commemorating the Golden Jubilee of the Gaelic Athletic Association. Next came the Constitution of Ireland stamp of 1937, repeated for the 21st anniversary issue of 1958. The St Patrick stamp of 1937 was a high value one. The Four Masters design of 1944 commemorated the tercentenary of the death of the Rev. Michael O'Cleary. Young Ireland, for the Thomas Davis centenary, appeared in 1945, and in 1946 there was an issue commemorating the centenary of the birth of Charles Stewart Parnell and Michael Davitt. The four designs for airmail issues, two in 1948 and two in 1949, had for their basic theme the Flight of the Angel Victor – Messenger to St Patrick – carrying the Voice of the Irish over the world; a historical landmark was depicted in each of the four Provinces. Finally, for 1949, he designed the James Clarence Mangan stamp, the centenary of his death.

From 1940, when he joined the staff, King supplied a constant flow of illustrations for the *Capuchin Annual*. In colour for the 1942 *Annual* frontispiece was *St Francis of Assisi*, a foretaste of what was to come, although *The Dancing Stage at Carna Show*, a striking oil painting also in colour, in the 1943 issue could not have been anticipated. The 1945-6 *Annual* began a series on Irish Saints, all in colour, five in that issue. In 1952 the publication presented a colour supplement, *The Way of the Cross*, fourteen plates, specially

painted for the *Annual*. Some of his work in colour was published separately and enjoyed popularity in the USA. There were, however, cheap reproductions printed without his authorisation. He resigned from the *Capuchin Annual* staff in 1953.

Some of his black and white drawings in the *Father Mathew Record* were also the work of a tiny brush, not of a pen, but the vast majority of his black and white illustrations were drawn on white or black scraper-board. His first illustration in the *Record* appeared in 1936 but from the second half of 1940 his drawings were a distinct feature with the occasional black and white inset page, for example in September 1941: *Saint Michael, Archangel*. In August and September 1950 his work was on the front cover of the *Record*. In addition to his graphic work, he designed active service medals. He was a member of the Irish Society for Design and Craftwork.

King, who is represented by a landscape at the Crawford Municipal Art Gallery, Cork, exhibited only three works – two in 1945, one in 1949: *Anniversary Bouquet* – at the Royal Hibernian Academy. In 1948 at the Victor Waddington Galleries, Dublin, he held a one-person show of 'oils, pastels, drawings, inks and other media'. His oil paintings included: *Mouth of the Killary; Madonna and Child; Reflections - Roundstone*. He continued his association with this gallery for some years.

The 1948 exhibition at Waddington's did not please the art critic of the *Dublin Magazine*: 'Richard King is a painter of religious pictures in styles which range from a softened pastiche of Rouault, as in *Yet He Opened Not His Mouth*, to that sickly and sweetly decorative style which appears to be the occupational disease of modern religious art ... the inclusion in this exhibition of so much that is merely meretricious makes it difficult to devote any serious consideration to a small residue of landscapes and still lifes in which might be detected the approach to an individual if not highly original style.' In 1949 his work was included in the exhibition of pictures by Irish artists held in Technical Schools. In 1949 and 1950, December issues, Irish Art Publications advertised his Christmas cards in the *Father Mathew Record*.

R. Enda King (q.v.), a son of the artist, recalled to the author in 1988 his father's enthusiasm for the windows in the Dominican Convent chapel in Wicklow, also 'the carved, polychromed timber crucifix – a particularly good example in the modern liturgical idiom'. In the 1950s there was a commission for five paintings 3 metres by 1.8 metres each of Our Lady for the Marian Centre at the Church of Our Lady of the Scapular, Manhattan, New York. King's last window for Ireland, *I am the Resurrection and the Life*, 1973, was for St Patrick's Church, Newport, Co. Mayo.

On the occasion in 1952 of the first private viewing of a two-light and a single light window for Boston College Library, Mass., an exhibition of other work was also on view. A note in the catalogue stated: '... we have sought to show the various facets of his unusually diversified talents and interests. The items on view ... display both realistic and stylized treatments of religious and secular themes. It is interesting to observe, for example, the decisive contrast between the two sets of Stations of the Cross exhibited, and to see, also, how successfully the artist can turn from religious themes and capture the flavor of everyday Irish life in his genre paintings. Again, versatility in talent and in use of media is shown in his stamp designs, his black and white illustrations on a wide variety of themes, and his distinctive Christmas cards.' In 1945 Victor Waddington Publications Ltd had issued a set of twenty-six original designs for Christmas cards, ranging from two-colour to six-colour.

In his work for churches in Ireland, England, Wales, Australia, Canada, New Zealand and the USA, King was responsible for more than sixty stained glass windows; also for Stations of the Cross in oils as well as in enamels and stained glass; crucifixes in enamels; murals; oil paintings. Over the years, he built up an immense knowledge of the history of stained glass.

One of his most important stained glass creations was the wall of glass, 4 metres by 18 metres, comprising seven windows and Stations of the Cross, for the St Thomas More Jesuit Chapel, University of West Australia, twenty-one windows in all. In the year before his death, the artist singled out this outstanding work. Seven studies for *Seek Wisdom* are at the National Gallery of Ireland, all in charcoal, watercolour and gouache on board.

Completed in 1970 was his largest window in Ireland, triangular in form, 26 metres by 24 metres (base), on the theme of the Holy Spirit for the Church of the Holy Spirit at Upper Walkinstown, Dublin, and involved

the virtual translation of a wall. As an example of one of his symbolic abstract creations in glass – in fact unpainted – the artist nominated that at Nazareth Home, Malahide Road, Dublin. At the Capuchin Friary in Church Street, Dublin, there are fifteen paintings depicting the Glorious, Joyful and Sorrowful Mysteries.

In Co. Mayo, Stations of the Cross in oils and stained glass windows at St Mary's Church, Swinford, are regarded as representative examples of King's talent in both media. In England are notable examples of work in vitreous enamel at the Church of the Holy Family, Holbrooks, Coventry, where there is a great crucifix about 3.8 metres high and Stations of the Cross in the same medium. However, for St Macartan's Seminary, Monaghan, his *Stations of the Cross* are in opal glass.

In the *Capuchin Annual*, 1943, Máirín Allen had written: 'The mark of the stained-glass training can be seen in King's art: in his tendency to reduce arrangements of figures or masses to simple abstractions of line or mass; in his avoidance (and this is notable even in his illustrations) of any effort to be three-dimensional or plastic ... Perhaps it is to the influence of Clarke that Mr King owes one notable characteristic: I mean the striving after and the expression of the powerfully imaginative quality in his work. But it is the more remarkable that he is, in the end, so personal, so little the product of any "school", or the pupil of any one master ...'. Of an unassuming disposition, he invariably shunned publicity, working long hours and devoting his life to religious art. He died at his home, Howth Road, Raheny, on St Patrick's Day, 1974.

Works signed: Risteárd Ó Cionga, Ó Cionga, King, K or ÓC, monogram, rare.
Examples: Aberaeron, Dyfed, Wales: Church of the Holy Cross. Adelaide, Australia: St John's Church, Kurralta Park; St Joseph's Convent, Kensington. Athlone, Co. Westmeath: Convent of Mercy; Sts Peter and Paul's Church. Ballinskelligs, Co. Kerry: St Michael's Church, Dungeagan. Belfast: Convent of the Good Shepherd; St Malachy's College; St Mary's College. Birr, Co. Offaly: St Brendan's Church. Boston, Mass., USA: College Library. Carrickmacross, Co. Monaghan: St Joseph's Church. Celbridge, Co. Kildare: St John of God House, St Raphael's. Clara, Co. Offaly: St Brigid's Church. Corduff, Co. Monaghan: St Michael's Church. Coventry, West Midlands: Church of the Holy Family, Holbrooks. Crawley, Western Australia: St Thomas More Jesuit Chapel, University of West Australia. Doncaster, Yorks.: St Paul's Church. Donegal: Church of the Four Masters. Dublin: Capuchin Friary, Church Street; Church of Our Lady, Mother of Divine Grace, Howth Road, Raheny; Church of the Holy Spirit, Greenhills, Upper Walkinstown; Daughters of Charity of St Vincent de Paul, Mount Prospect Avenue; National Gallery of Ireland; Nazareth Home, Malahide Road; Sacred Heart School, Mount Anville; St Agnes's Church, Crumlin; St Conleth's College, Clyde Road; University College (Earlsfort Terrace). Dunleer, Co. Louth: St John of God Brothers, St Mary's. Dunmore, Co. Galway: Our Lady and St Nicholas Church. Faversham, Kent: St Jude's Carmelite Shrine. Ferbane, Co. Offaly: Church of the Immaculate Conception. Fruitland, Ontario, Canada: St Francis Xavier Church. Fylemore, Co. Kerry: Church of the Immaculate Conception. Gosnells, Western Australia: Church of Our Lady of the Blessed Sacrament. Hawthorn, Victoria, Australia: Jesuit Church. Killeshandra, Co. Cavan: Convent of Sisters of the Most Holy Rosary. Kiltulla, Co. Galway: Sts Peter and Paul's Church. Letterkenny, Co. Donegal: St Eunan's Cathedral. Manchester: Church of Our Lady of the Assumption, Langley. Melbourne, Australia: Dominican Church. Monaghan: St Macartan's Seminary. Navan, Co. Meath: St Mary's Church; Sisters of Charity of St Vincent de Paul, Johnstown. New York: Church of Our Lady of the Scapular, Manhattan. Newport, Co. Mayo: St Patrick's Church. Newry, Co. Down: St Colman's College. Perth, Australia: St Columba's Church. Port Pirie, Australia: St Mark's Cathedral. Raferagh, Co. Monaghan: Church of St John the Evangelist. Salisbury,Wilts.: St Gregory's Church. Sutton-in-Ashfield, Notts: St Joseph's Church. Swinford, Co. Mayo: St Mary's Church. Tralee, Co. Kerry: St John's Church. Tuam, Co. Galway: Cathedral of the Assumption. Wicklow: Dominican Convent.
Literature: *Mayo News*, 6 September 1933; *Capuchin Annual*, 1939, 1940-69 (also illustrations), 1971-75 (also illustrations); *Father Mathew Record*, December 1945, and in 1940's regular illustrations, some repeated; *Dublin Magazine*, April-June 1948; Boston College Library, *Richard King Exhibition*, catalogue, 1952; *The Bell*, March 1954; J. White and M. Wynne, *Irish Stained Glass*, Dublin 1963; Department of Posts and Telegraphs, *Letter to the author*, 1968; *Irish Times*, 5 June 1974; Catholic Press and Information Office, *Letter to the author*, 1988; Richard Enda King, *Letters to the author*, 1988; Rev. J.F. Sweeney, *Letter to the author*, 1988; also, Rev. Alfred Tabone, 1988.

KING-HARMAN, ANNE S. (1919-79), landscape painter. Daughter of Sir Cecil and Lady Stafford-King-Harman, Anne King-Harman was born in England on 31 July 1919 and was brought up in Rockingham, near Boyle, Co. Roscommon. She worked in the Foreign Office in England from 1940 to 1943. During a long illness there in a sanatorium, she met Adrian Hill (1895-1977), the well-known artist, author

– *Art versus Illness*, 1945 – and television personality. In 1945 he encouraged her to start painting as occupational therapy, and aroused in her a deep interest in modern art and artists.

Hill's influence she regarded as one of the most fortunate and enlightened periods of her life, and without his enthusiasm she would never have taken an interest in art, or aspired to become a painter. She was sent to Switzerland in 1947, and her father brought her out a box of oil paints when he went to visit her. Returning to Ireland in 1949, she entered the National College of Art in 1950 for a year, which resulted in a violent aversion to plaster cast heads, and a great admiration for the teaching of Maurice MacGonigal (q.v.).

Initially, her experience of landscape painting was under Charles Lamb (q.v.) at Carraroe, Co. Galway. There she met Barbara Warren, and in Dublin for a time they shared the studio of the late Dermod O'Brien (q.v.) at the rear of Fitzwilliam Square. In company with Kitty Wilmer O'Brien (q.v.), from whom she received much encouragement, she went to Paris and worked for a short time in André Lhote's studio, and they also painted together in Co. Mayo.

In 1953 she began seriously to exhibit with the Water Colour Society of Ireland and from then until 1978 showed sixty-seven works. In 1954 she contributed *Lonely Shore*; *Cactus and Prickly Pears*; *The Writing Table*.

Paintings were also exhibited at the Irish Exhibition of Living Art and the Oireachtas. At the IELA for example, in 1954 she showed *In a Barren Land* and *Cry Unto The Hills*; and in 1968, *Light in Darkness*. The Royal Hibernian Academy first showed her work in 1957 with *Westport*; followed by *Yellow Landscape* in 1966 with only three other pictures thereafter. At the Grafton Gallery, Dublin, she had a one-person show in 1955, and at the Dawson Gallery, Dublin in 1957. She also exhibited with the Dublin Painters. In London, her pictures were hung at the New Vision Centre, 1956, and in the Artists of Chelsea exhibition, 1960.

In the Kilkenny Art Gallery Society collection is a gouache, *Lough-na-Tulaigh*. Among her works at the Hugh Lane Municipal Gallery of Modern Art, Dublin is *Ruined House*. Ritchie Hendriks Gallery, Dublin, hosted shows in 1962 and 1966. In 1969, 1971, 1973 and 1975 she exhibited at the Kenny Art Gallery, Galway. Some works were also shown in the USA. Most of her landscapes were of the West of Ireland, and she particularly liked the handling of mountains and lakes, thus Mweelrea Mountains and Doughruagh Mountain, also Kylemore Lough, Connemara, all figured as subject matter. In 1976 she showed *Maamturk Mountains* at the WCSI event. In 1977 she exhibited at the Wellesley Ashe Gallery, Dublin.

After a lifelong struggle against indifferent health, Anne King-Harman of St Catherine's Park, Leixlip, Co. Kildare, died in a Dublin hospital, on 31 January 1979. She left forty-three paintings and drawings by various artists to the Friends of the National Collections of Ireland, having at one period served as joint honorary secretary. An exhibition of some fifty of her works, the vast majority landscapes but including *Race Horses* and *Soccer Match*, was held at the Kenny Art Gallery in 1979.

Works signed: A. S.-King-Harman or Anne S. King-Harman.
Examples: Cork: Crawford Municipal Art Gallery. Dublin: Hugh Lane Municipal Gallery of Modern Art. Kilkenny: Art Gallery Society. Sligo: Model and Niland Centre. Wexford: Arts Centre.
Literature: Kenny Art Gallery, *Anne S. King-Harman*, catalogue, Galway 1969, 1979; *Irish Times*, 12 May 1979, 26 June 1979; Sir Cecil Stafford-King-Harman, *Letter to the author*, 1979; Ann M. Stewart, *Royal Hibernian Academy of Arts: Index of Exhibitors 1826-1979*, Dublin 1986; Friends of the National Collections of Ireland, *Letter to the author*, 1988; also, Kenny Art Gallery, 1988; Mrs R. Tindal, 1988; Ms Barbara Warren, 1988; *Water Colour Society of Ireland Exhibition List 1872-1994*, Dublin 1995.

KINGSLEY, LUCAS– see WADE, JONATHAN

KINKEAD, ALICE S.(1871-1926), portrait and landscape painter. Born in Tuam, Co. Galway, Alice Sarah Kinkead was the daughter of Richard Kinkead, MD. She was listed in 1895 among the members of the Belfast Art Society, of Forster House, Galway, the address given when she exhibited in 1897 at the Royal Hibernian Academy, a portrait study in pastel. Forster House was the home of Professor Richard J. Kinkead of Queen's College, Galway.

In 1897 she exhibited in Paris at the Salon de la Nationale, a society formed in 1890. Among its founder members were Eugène Carrière (1849-1906) and Pierre Puvis de Chavannes (1824-98). By 1898 she resided in London and at the RHA that year she showed *Portrait of Miss Kinkead*, sent from Pomona Studios, 111 New King's Road, Fulham, and possibly the same work as *Portrait of my Sister*, miniature on ivory, which she showed that year at the autumn exhibition of the Walker Art Gallery, Liverpool. In that exhibition she was also credited with *A Brittany Fisherman*, oil. In 1899 at Liverpool she again showed two works: *Reading*, oil; *Portrait of Mrs J. Leared*, pastel.

The BAS minute book for April 1899 recorded that she intended holding sketching classes at Newcastle, Co. Down, and Portrush, Co. Antrim, in the summer. At the 1901 Walker exhibition her bookplates were described as 'chromo-Xylographs', but she returned to painting in the following year with *Chelsea Embankment*, oil.

Bookplates were exhibited at the 1901 exhibition of the Society of Women Artists in London, also a Christmas and greeting card, and in other exhibitions she displayed craftware. In 1902 at the Cork International Exhibition, *Portrait of W. B. Yeats, Esq.* and *Fishermen at Howth, Co. Dublin*, watercolour, were both on view, 'lent by Alice S. Kinkead'. 'Annie' appears to derive from the exhibition of works by Irish painters held at the Guildhall of the Corporation of London, 1904, and organised by Hugh P. Lane, *The Fairy's Wood at Coole* in watercolour being lent by 'Miss Annie Kinkead'. All other catalogue references refer to 'Alice S. Kinkead'. Perhaps the Yeats portrait and the Coole landscape indicate an acquaintance with Lady Augusta Gregory.

Mainly her exhibiting area was England, particularly at the Walker Gallery, where in 1904 she showed four pieces of jewellery: an oxidised silver brooch, two pendants and chains, and a gold pendant ('matrix, opal and seed pearl') at two guineas. In 1905 she supplied two watercolours, *Old Trees* and *Beatrice*. The most expensive jewellery item came in 1908: gold and opal necklace at eighteen guineas.

At the Irish International Exhibition in Dublin in 1907 she was represented by *A September Evening*. The only work hung at the Royal Academy, *Kellswater, Co. Antrim*, appeared in 1915; she was then at 23 Clareville Grove, Onslow Gardens, S.W. In 1920 she contributed her seventh and final work to the RHA, a portrait of Lieut. A. Haslam, MC, DFC, RFA, RAF.

In 1922 Alice Kinkead exhibited again at the Salon de la Nationale. According to *The Studio* in 1924 : 'A particular interest attaches to Miss A. S. Kinkead's portrait of Joseph Conrad at the present moment, since it is but a few weeks since the world of English letters was saddened by the news of the death of one of its most distinguished sons. The painting succeeds admirably in showing not only the subtle psychologist we landsmen know, but also the clear-eyed resolute ship-master.' The work, which was illustrated in *The Studio*, was exhibited in the 1925 exhibition of the Royal Society of Portrait Painters. Twenty-five years later it was 'offered' to the National Portrait Gallery in London but was not accepted.

The artist showed three pictures at the London Salon, and one other at RSPP. In the SWA exhibitions, *The Village of Piana, Corsica* was presented in 1923, and from 81 Bedford Gardens, London W8, *The Prunelli River, Campo-del-Ora, Corsica* in 1924. She died on 1 November 1926 at Vicars Hill, High Street, Fareham, Southampton.

Works signed: A. S. Kinkead.
Literature: *Belfast Art Society Exhibition*, catalogue, 1895; *Belfast Art Society Minute Book*, 1899; *Census of Ireland, 1901, Return, Forster Street, Galway*; *The Studio*, September 1924 (also illustration); *Register of Deaths, Fareham, 1926*; E. Bénézit, *Dictionnaire des Peintres, Sculpteurs, Dessinateurs et Graveurs*, Paris 1976; *Dictionary of British Artists 1880-1940*, Woodbridge 1976; *Royal Academy Exhibitors 1905-1970*, Calne 1985; Ann M. Stewart, *Royal Hibernian Academy of Arts: Index of Exhibitors 1826-1979*, Dublin 1986; Ann M. Stewart, *Irish Art Loan Exhibitions 1765-1927*, Dublin 1990; *The Society of Women Artists Exhibitors 1855-1996*, Calne 1996; Galway County Libraries, *Letter to the author*, 1998; also, Very Rev. Dr R. B. MacCarthy, 1998; National Portrait Gallery, 1998; Walker Art Gallery, 1998.

KIRKWOOD, HARRIET (1882-1953), landscape and still life painter. Born at Sutton House, Sutton, Co. Dublin, Grace Harriet Sara Jameson was the daughter of the Rt. Hon. Andrew Jameson, PC. She studied at the Slade School of Fine Art, London. In 1910 she married Major T.W. Kirkwood, who hailed from Co.

Roscommon, and they settled in Co. Dublin. Major Kirkwood had a talent for languages, and in 1913 he was sent to Moscow to learn Russian. In a letter to the author in 1969 he said that his wife had studied 'under Mashkoff in Moscow', presumably I.I. Mashkov (1881-1944).

Between 1920 and 1937 Harriet Kirkwood showed only nine works at the Royal Hibernian Academy. *Harbour, St Jean* in 1923 was from Sutton House, Baily, Co. Dublin, and *The Yellow House* in 1936 from Collinstown Park, Clondalkin, Co. Dublin, where she and her husband welcomed many of the leading Irish artists of the day.

In the 1930s she studied in Paris with the Cubist painter, André Lhote, who had been sought out by Evie Hone and Mainie Jellett (qq.v.) a decade earlier. She was a close friend of both artists, and with her husband was instrumental in giving the former her first commission for a stained glass window. In 1937 her work was included in an exhibition of modern Irish art held at Newtown School, Waterford.

Writing about the Dublin Painters, of which she was president for some years, James White in the *Irish Art Handbook*, 1943, said that they represented some twenty painters who were collectively the most competent group in the country. 'The large preponderance of female painters,' he continued, 'is unaccountable in view of the fact that in England the leaders in such groups are men. Mainie Jellett, Harriet Kirkwood, Frances Kelly, Nano Reid, Pat Wallace and Jack P. Hanlon come to mind as painters possessive of individual characteristics and exciting techniques ... Harriet Kirkwood expresses a deep satisfaction in the subtle colour of farm scenes and woodland places. One feels she sits in deep contemplation of the scene until the morning light has cast a faint grey mist over the whole ...'.

In addition to her interest in the Dublin Painters, she showed regularly in the Irish Exhibition of Living Art from its inception in 1943. In the two years 1944 and 1945 she showed six works at the Water Colour Society of Ireland exhibitions; *The Garden* and *At the Window* in 1945.

A niece of her husband, Phoebe Kirkwood, also exhibited with the Dublin Painters but died young in 1945. In 1950 Harriet was represented in the Contemporary Irish Painting exhibition which toured North America. The Thomas Haverty Trust presented *Tea in the Studio* to the Armagh County Museum. The National Gallery of Ireland has an oil painting of Dr George Furlong and *Still Life with Fruit and Flowers*, painted at the artist's own home, Collinstown Park, where she had her studio, and died there on 20 June 1953. Four of her paintings were displayed that year in the Living Art exhibition 'in her memory with gratitude and affection'.

Works signed: Harriet Kirkwood (if signed at all).
Examples: Armagh: County Museum. Dublin: National Gallery of Ireland; Trinity College Gallery.
Literature: *The Studio*, December 1937; *Irish Art Handbook*, Dublin 1943; *Dublin Magazine*, April-June 1945; *Irish Times*, 22 June 1953, 18 January 1972, 9 August 1982; *Irish Exhibition of Living Art*, catalogue, 1953; Armagh County Museum, *Letter to the author*, 1967; Major T.W. Kirkwood, *Letters to the author,* 1969; *National Gallery of Ireland Acquisitions 1982-83*, catalogue, 1984; Ann M.Stewart, *Royal Hibernian Academy of Arts: Index of Exhibitors 1826-1979*, Dublin 1986; Dr David Scott, *Letter to the author*, 1988; *Water Colour Society of Ireland Exhibition List 1872-1994*, Dublin 1995.

KNEE, HOWARD (1889-1971), landscape painter. Born in London and educated at Manchester Grammar School, 1903-06, where he won the art prize in his final year, Frederick Howard Knee, a businessman with an interest in astrology, arrived in Ireland in 1912 and lived, worked and painted there for the rest of his life. Entirely self-taught, outside of some early attendances at Dublin Metropolitan School of Art classes, he joined the Dublin Sketching Club during the First World War, switching at that time from oils to watercolours.

In 1916 he exhibited at the Royal Hibernian Academy with *Among the Dublin Mountains* and *Menawn Cliffs, Achill Island*, and between then and 1967 he was to show another sixty works. In 1917 he exhibited with the Water Colour Society of Ireland and continued right up to and including the year of his death, 1971, never missing a single exhibition and showing an average of three works per annum.

In 1924 he held a joint exhibition with Edward J. Rogers (q.v.) at Mills' Hall, Merrion Row, Dublin. At the Royal Academy, London, he contributed only one work, *After the shower*, in 1935. In 1942 he showed at the Victor Waddington Galleries, Dublin, where his watercolours were eagerly sought. Belfast, Dublin

and Glasgow firms reproduced his work. At the WCSI event in 1943 he showed *Howth from Portmarnock*; *Spring at Tallaght*; *The Dodder*.

Knee had another one-person show at the Waddington Galleries in 1948, and following a pattern of every two years he returned in 1950. Writing about the 1952 exhibition, the *Dublin Magazine* referred to him as a 'drawing-room' painter whose work, 'however competent and however true to the carefully named landscape, is almost invariably pedestrian and dull. His forty-one canvases, which cover the country from Kerry to Mayo, point to an astonishing industry and a most catholic impartiality in the celebration of local pieties.' His 1954 show included *The Four Courts* and *The Poisoned Glen, Donegal*. He was now secretary of the Dublin Sketching Club. In 1956 at WCSI, he contributed *Spring* and *The Custom House*.

At the Little Theatre, Brown Thomas, Dublin, in 1957 there were works on Dublin and Counties Cork, Donegal, Galway, Kerry, Limerick, Wexford and Wicklow subjects. Of the few interiors, there was one of St Patrick's Cathedral. He also exhibited at this gallery in 1962, and the exhibition there in 1968 of 'Inland Waterways of Ireland and other Scenery' included *Between Husband Bridge and Baggot Street Bridge*; *Robertstown House*; *Knockvicar Bridge*. The *Irish Independent*, on that 1968 show, thought he was 'technically perfect in a limited medium'.

When the Limerick Art Gallery held its 21st annual exhibition in 1970 Knee contributed to the lectures and demonstrations. His realistic landscape scenes, painted with patient skill and accuracy direct from the subject, commanded a following throughout his long life, and his last exhibition at Combridge's Galleries, a few weeks before his death, was no exception. Of Clovelly, Mount Tallant Avenue, Dublin, he died on 12 November 1971 in a Dublin hospital. President of the Dublin Sketching Club at the time of his death, there was a small memorial display at the 1972 exhibition.

Works signed: Howard Knee.
Examples: Belfast: Department of the Environment for Northern Ireland. Limerick: City Gallery of Art.
Literature: *Irish Statesman*, 20 September 1924; *Irish Times*, 20 October 1942, 16 October 1968, 13 and 17 November 1971, 12 September 1972; *Dublin Magazine*, January-March 1953; Victor Waddington Galleries, *Howard Knee: Recent Watercolours*, catalogue, Dublin 1954; Little Theatre, *Howard Knee*, catalogue, Dublin 1957, 1968; *Who's Who in Art*, 1966; *Irish Independent*, 7 October 1968; *Limerick Art Society 21st Annual Exhibition*, catalogue, 1970; Ann M. Stewart, *Royal Hibernian Academy of Arts: Index of Exhibitors 1826-1979*, Dublin 1986; Manchester Grammar School, *Letter to the author*, 1988; *Water Colour Society of Ireland Exhibition List 1872-1994*, Dublin 1995.

KNOWLES, MARGARET(1869-1933), archaeological illustrator and landscape painter. The daughter of William James Knowles, the 'Father of Ulster Antiquaries', of Ballymena, Co. Antrim, and the younger sister of Matilda C. Knowles, an authority on lichens and a noted botanist at the National Museum of Ireland, Dublin. The Knowles family had settled in the time of Cromwell at Cullybackey, near Ballymena.

In the Francis J. Bigger collection in the Belfast Central Public Library there are Margaret Knowles drawings of a number of objects of archaeological interest found in Ulster 1894-1908. First exhibiting at the Royal Hibernian Academy in 1906, from then until 1931 she showed a total of twenty-four works. Her address was Flixton Place South, Ballymena. In 1907, *The Garden, Glendun* and *Le Jardin du Luxembourg*, were both hung.

Among five pictures at the 1910 Academy were *On the Maine* and *Old Kitty's Garden*. In 1911, in addition to a portrait of her father, she contributed *Corner of a Gloucestershire Garden* and *Crumkill bog, near Ballymena*. Probably there were two portraits of her father in circulation at this time; he appeared again in 1913 and 1923. She showed *The Girl at the Window* in 1919. At the 1922 exhibition of the Belfast Art Society she exhibited *W. J. Knowles, FRAI, MRIA,* now in the Ulster Museum.

W. J. Knowles' huge collection of local Stone Age implements and other relics of the past was sold at Sotheby's in 1924, the more important items being purchased by the Dublin and Belfast Museums. He died in 1927 at the age of ninety-six at his recently acquired home at Glenalla, Ballycastle, Co. Antrim, and in an appreciation in the *Irish Naturalists' Journal*, the writer concluded: 'The value of his writings on archaeology is much enhanced by the beautiful black-and-white illustrations contributed thereto by his daughter, Miss M. Knowles.'

Wallflowers, sent from Glenalla, was hung in 1931 at the RHA, and she showed flowerpieces at the 1932 Water Colour Society of Ireland event, her only appearance. At the Ulster Museum there is also an 1881 chalk drawing of the head of a girl; and another oil portrait of the artist's father.

Tragedy struck the family. Matilda planned to retire from her post in the Museum and live at Ballycastle but within a few weeks of her retirement she contracted pneumonia and died at 11 Nassau Street, Dublin, on 27 April 1933, her sister having been summoned from Ballycastle. Margaret, in her turn, caught the infection and died three days later, 30 April, at the same address. The sisters were buried at Dean's Grange Cemetery, Dublin, in the same grave.

Works signed: M. Knowles or M.K.

Examples : Belfast: Central Public Library; Ulster Museum.

Literature: *Irish Naturalists' Journal,* September 1927, May 1933, July 1933; Ann M. Stewart, *Royal Hibernian Academy of Arts: Index of Exhibitors 1826-1979,* Dublin 1986; *Water Colour Society of Ireland Exhibition List 1872-1994,* Dublin 1995; Dean's Grange Cemetery, *Letter to the author,* 1998.

KYLE, G. MOUTRAY (1865-1950), landscape and figure painter. Georgina Moutray Kyle was the daughter of George Wilson Kyle, a Scotsman with an extensive business in Belfast. She was born at Craigavad, Co. Down, and educated at home by governess and tutors. After attending the Colarossi studio in Paris, she exhibited at the Paris Salon, and one of her works, *Le Marché dans la rue* was reproduced in a catalogue.

As she had travelled widely, she must have brought a breath of Continental air to the Belfast Art Society. In 1893 she became ladies' life class secretary, gave a lecture on Impressionism in 1908, and in 1920 was elected an honorary member in recognition of her long service to the Society.

The Belfast Museum and Art Gallery bought *The Market, Concarneau,* exhibited at the Paris Salon in 1924, and *A Busy Day at Smithfield, Belfast,* exhibited at the Ulster Pavilion in the Wembley Exhibition of 1924. In 1926 she showed at the Royal Hibernian Academy for the first time; the last occasion was in 1939, a total of sixteen works, and of these, Concarneau figured in at least two, and Belfast market scenes in three. *The Lifting of the Fog at the Gasworks, Belfast,* also in the Ulster Museum, appeared in the 1934 RHA.

In 1928 she and the Swiss-born Hans Iten (q.v.) had attempted to demolish the reputation of J.-B.-C. Corot (1796-1875) at a Belfast Art Society discussion asking 'Is Corot the great artist he is reputed to be?' Miss Kyle 'questioned whether Corot felt deeply the subjects he painted, for he never showed intense feeling'.

In 1930 she was represented in the Irish exhibition at Brussels, and that year became one of the first nine academicians of the Ulster Academy of Arts. She also exhibited at the Royal Institute of Oil Painters, London, and in 1933 showed three works, including *A Market in France.* As well as brush, she also painted by palette knife and her work was seen too at the Walker Art Gallery, Liverpool, the Royal Scottish Academy in 1931 and 1937, also the Glasgow Institute of the Fine Arts, with which she was more closely identified.

At the Armagh County Museum is *The Dyke at Volendam.* In the 1945 retrospective exhibition at the Belfast Museum and Art Gallery nearly seventy works were on view, including *The Approach of Twilight, Notre Dame, Paris* (Queen's University); *Approach of Evening at Newlyn; The Pink Sails at Honfleur; The Herring Fishery, Isle of Man.* The artist died at her home, 5 West Elmwood, Lisburn Road, Belfast, on 25 February 1950. Eight oil paintings were bequeathed to the Belfast Museum and Art Gallery.

Works signed: G. Moutray Kyle (if signed at all).

Examples: Armagh: County Museum. Bangor: Town Hall. Belfast: Department of the Environment for Northern Ireland; Queen's University; Ulster Museum. Cultra, Co. Down: Ulster Folk and Transport Museum. Dublin: Hugh Lane Municipal Gallery of Modern Art.

Literature: Belfast Museum and Art Gallery, *The Work of Miss G. Moutray Kyle,* catalogue, 1945; *Belfast News-Letter,* 27 and 28 February 1950; *Belfast Museum and Art Gallery Annual Report ,*1950-1951; John Hewitt and Theo Snoddy, *Art in Ulster: I,* Belfast 1977; *A Dictionary of Contemporary British Artists, 1929,* Woodbridge 1981; Martyn Anglesea, *The Royal Ulster Academy of Arts,* Belfast 1981; Ann M. Stewart, *Royal Hibernian Academy of Arts: Index of Exhibitors 1826-1979,* Dublin 1986; Eileen Black, *A Sesquicentennial Celebration: Art from the Queen's University Collection,* Belfast 1995 (also illustrations).

L

LAFFAN, GEORGE B. (1918-88), sculptor. George Barry Laffan was born in 1918 of Irish parents in Queensland, Australia. His father, H. W. Laffan, who was from Limerick, worked on the railway in Brisbane. The family moved to Dublin in 1933, and as a young man George assisted in their antique shop, attending night classes at the National College of Art 1939-45 and specialising in sculpture under Laurence Campbell (q.v.). During his training he exhibited three works at the Royal Hibernian Academy, including *Peter* in 1943. In 1948 he showed at the Oireachtas.

A sculptor of the human figure, he worked in a great variety of materials: wax, clay, bronze, stone, wood, and plaster. As for painting, portraits were of his family and to commission, also he executed still lifes of house plants and landscapes of the West of Ireland. Woodcuts included *The Hurler*; *Head of Christ*; and *Sea Goddess*. Among the themes in his early sculptural work was a female figure, holding out a mirror.

In 1955-6 he exhibited in the exhibitions of the Institute of the Sculptors of Ireland, a crucifix in wood in the first, from 1 Herbert Park, Dublin, and two bronzes in the second, *Venus* and *Young Man*. Prominent in the next ten years were dancing female figures, perhaps arms overhead, and female figures practising yoga. In the late 1960s his work was regarded as more fluid.

In 1972 he showed sculpture with his son Justin Laffan, and with John Behan and Stepinac McNamee at the Kenny Art Gallery, Galway, and in the same year at the Irish Exhibition of Living Art the *Irish Times* found his small ballerinas 'highly competent but have a flavour of the old-fashioned salon about them'. Much involved with Independent Artists, he was their first treasurer, and showed with them in 1973 at Trinity College Library, Dublin, where the sculpture section was regarded as 'solid'. A male torso in beechwood attracted attention at the 1975 Independent Artists' show at the Project Arts Centre, and that year he was personally involved in their sculpture workshop at Rothe House, Kilkenny.

In the period 1974-84 he executed a number of heads, some in limestone and sandstone, also *Sea Goddess* both in limestone and red marble. According to an Independent Artists' Sculpture Group brochure in 1978 he was 'currently concerned with the development and extension of the human figure in stone. He has worked extensively in bronze and wood as well. George sees people as rocks – carved water-polished rocks. There is no one else working in Ireland who has his particular original sensual command of stone.'

In 1978 he exhibited *Maighdean Dubh* in bog oak, 2.4m high, at the Oireachtas. After a gap of more than half a century, he returned to Australia in 1984 and executed a number of portrait sketches and landscapes. Female torsos in walnut and bog oak were a feature of his work in the 1980s. In Dublin, at Our Lady's Hospice, are two crucifixes, one in bronze and the other in walnut. Of 44 Heytesbury Lane, Dublin, he died on 13 May 1988.

Works signed: George B. Laffan.
Examples: Dublin: Carmelite Fathers, Morehampton Road; Our Lady's Hospice, Harold's Cross.
Literature: *Dublin Magazine*, January-March 1949; *Irish Times*, 19 September 1972, 8 November 1972, 15 November 1973, 26 September 1975, 14 May 1988; *Independent Artists' Sculpture Group*, brochure, Dublin 1978; Mrs Frances Laffan, *Letters to the author*, 1988.

LAMB, CHARLES, RHA, RUA (1893-1964), landscape, portrait and figure painter. Born in Portadown, Co. Armagh, on 30 August 1893, Charles Vincent Lamb was the eldest of seven children of a painter and decorator in Bridge Street, John Lamb, to whom he became apprenticed. He attended Portadown Technical School, and in 1913 won a gold medal as best apprentice housepainter of the year. At Belfast School of Art he studied in the evenings, arriving back home at midnight, and in 1917 he won a scholarship to the Dublin Metropolitan School of Art, where he studied for four years and came under the influence of Sean Keating (q.v.). During his art college days Lamb mixed in a group which included Pádraic Ó

Conaire from Connemara. They became firm friends and it was the writer who encouraged the artist to go and paint the unspoilt landscape and simple lifestyle of Connacht.

In 1919 he had four works, including a portrait of W. Crampton Gore (q.v.), selected for the Royal Hibernian Academy, and he continued to exhibit there regularly, missing only a few years, until his death, averaging more than four works per show. *Country People at Prayer*, presented by the artist to the then Limerick Municipal Art Gallery, was dated 1919. His *A Lough Neagh Fisherman*, now in the Ulster Museum, was painted in 1920 (exhibited at Belfast Art Society, 1921) and what is now regarded as his masterpiece, *Dancing at a Northern Crossroads* was also 1920 vintage. For a few months that year he assisted in giving instruction in drawing and painting at the School of Art.

In 1921 a portrait of his fellow Ulsterman, John Hunter (q.v.) was hung at the RHA, and the following year, after the end of the school term, he set out for Connemara, 'settled' in Carraroe, a remote Irish-speaking distinct in Co. Galway, and thereafter painted landscapes and many figure subjects connected with life in the West of Ireland. Very much at home in the Gaeltacht, he was not altogether successful in becoming a fluent Irish speaker. *The Cladagh, Galway, in 1922* is in the Galway County Council offices. At Craigavon Civic Centre, one of the two paintings of the Bann Bridge at Portadown was executed in 1922.

Annual one-person shows in Dublin began in 1923, the year he was appointed ARHA. The exhibition at the St Stephen's Green gallery in 1924 prompted a critique in the *Dublin Magazine* by George Atkinson (q.v.): '... the exhibition consists of a refreshing display of some fifty landscapes, all of them obviously painted out of doors, and neither cooked or incubated in the studio. The subjects range from the Bann to Waterford, and along the marshes of Kent ... Mr Lamb has a fine feeling for the dramatic in nature, and is enabled to intensify his interpretation through a control of design and arrangement that is unusual in painters of landscape *The Salmon Leap, Rostrevor* makes a special appeal for its unity of conception, and complete accord between the intention and the means of expression. Mr Lamb is a sincere and competent artist, and there is a gay abandon in this little sketch that may well become a characteristic of his work.'

In 1924 too he held a show in Belfast at Magee's Gallery. In 1925 he again exhibited in Dublin. He used a caravan as a means of transport, and was credited as being one of the first to paint a kind of heroic, idealised Western peasant or fisherman in monumental pose. But he did not confine his travels to Ireland. In 1926-7 he toured Brittany; *Breton Peasants at Prayer* is in the Waterford Municipal collection. The loan exhibition of Irish Portraits by Ulster Artists at the Belfast Museum and Art Gallery in 1927 included a portrait of a Mrs Flood by Lamb. In 1928, the year he exhibited in Boston, USA, he was on the Aran Islands, and in 1929 and 1930 he showed in New York. *The Quaint Couple*, 1930, was presented by the Thomas Haverty Trust to the Crawford Municipal Art Gallery, Cork.

In 1930 too he was represented in the exhibition of Irish art at Brussels and was appointed one of the first twelve academicians of the Ulster Academy of Arts. By this time his wife Katharine, a great-granddaughter of Ford Madox Brown (1821-93), was learning Irish and becoming fluent. Lamb, a member of the Dublin Painters, showed portraits and landscapes at 7 St Stephen's Green in 1931. He also exhibited at the Brook Street Gallery in London in 1931; *The Studio* reproduced *Galway Peasants* from that exhibition. Represented at the Olympic art exhibition at Los Angeles in 1932, his work was hung in Chicago the following year and he continued to show in London. In 1934 the Haverty Trust commissioned *A Pattern Day in Connemara*, 2m x 3m, now at National University of Ireland, Galway, where there is also a portrait of Professor Alexander Anderson, a past president.

Lamb had a house of local stone built at Carraroe in 1935. A number of Portadown workmen travelled to help him, a practical man himself, with the building. He began a summer school of painting, and his exhibitions in Dublin continued at 7 St Stephen's Green. The school, although small, was attended by a wide range of students, many of them from England or further afield. The instruction he gave was basically practical. The painting classes consisted of working directly from nature. As for his own work, a Connemara woman knitting was the subject of his one and only picture, in 1936, at the Royal Academy. He was elected to full membership of the RHA in 1938, and that year exhibited in Galway. *On Achill Island*, dated 1938, is in the Ulster Museum along with another oil, *Leenane*.

The winter of 1938-9 found Lamb in Germany. As from 1941, he began to spend more time painting on the Bann river and particularly in Rostrevor, Co. Down, holding exhibitions in Belfast and Portadown, although *The Bishop Leaves the Mainland for the Aran Islands* was dated 1942. The Haverty Trust presented in 1945 *Bringing Home the Seaweed* to the Municipal Gallery of Modern Art, Dublin. Commenting on the 1946 exhibition in connection with the Davis and Young Ireland Centenary celebrations, the *Dublin Magazine* considered that his *Ocras* was the best of the Famine pictures. Council for the Encouragement of Music and the Arts arranged an exhibition in Belfast in 1947; he painted in Rostrevor that year, and also held an exhibition in Portadown. Painted in the 1940s, his *Nan Mhicil Liam* is at the National Gallery of Ireland.

The Currach Race was painted in 1947 and exhibited in 1948 at Olympiad Sport in Art exhibition at the Victoria and Albert Museum, London. He was represented in the exhibition of pictures by Irish artists in Technical Schools, 1949. His work was included in the Contemporary Irish Painting exhibition to North America in 1950. On his Western landscapes, notably *The Harbour at Low Tide*, at the 1951 RHA, the *Dublin Magazine* described these as 'formally simple and subtle in colour without losing strength and directness of vision'.

Portadown Borough Council in 1956 commissioned a painting of his native town. The fee was fixed at £250, but later the commission was withdrawn, after lively controversy, on the grounds that it was too much money to spend on one painting. By now Lamb had ceased having one-person shows in Dublin but his support for the RHA remained strong; six works at the 1956 exhibition all had Connemara subjects. He described himself as 'a countryman who paints when he can find time'.

As well as exhibiting at the Oireachtas, Dublin, he also showed at the Munster Fine Art Club and was a member of the United Arts Club, Dublin. In spite of failing health, he continued to paint right to the end, and died at home, on 15 December 1964. He was buried at Barraderry Cemetery. A memorial exhibition took place in the Municipal Gallery of Modern Art, Dublin, in 1969. His widow arranged a number of summer exhibitions of his work in the Carraroe studio. The Stone Art Gallery, Spiddal, Co. Galway, hosted an exhibition in 1981. 'Galway Paintings', an exhibition of forty-two works, was organised at Galway Arts Centre in 1998.

Works signed: C. Lamb or Lamb.
Examples: Armagh: County Museum. Ballinasloe, Co. Galway: St Joseph's College. Belfast: Ulster Museum. Clonmel: South Tipperary County Museum and Art Gallery. Cork: Crawford Municipal Art Gallery; University College. Craigavon, Co. Armagh: Civic Centre. Dublin: Hugh Lane Municipal Gallery of Modern Art; National Gallery of Ireland; United Arts Club; Vocational Education Committee. Galway: Art Gallery Committee; County Council; National University of Ireland. Kilkenny: Art Gallery Society. Limerick: City Gallery of Art; County Library. Navan: Meath County Library. Sligo: Model and Niland Centre. Termonfeckin, Co. Louth: An Grianán. Waterford: City Hall, Municipal Art Collection.
Literature: *The Studio*, September 1924 (also illustration), August 1931 (also illustration), December 1937; *Dublin Magazine*, April 1924, June 1925, October-December 1946, July-September 1951; *Irish Independent*, 14 April 1931; *Ireland To-Day*, April 1937; *Capuchin Annual*, 1940 (illustration); Thomas Bodkin, intro., *Twelve Irish Artists*, Dublin 1940 (also illustration); Máirtain Ó Cadhain, *Cré na Cille*, Dublin 1949 (illustrations); Seán Ó Coisdealbha, *An Tincéara Buí*,Dublin 1962 (illustration); *Belfast Telegraph*, 16 December 1964; *Irish Times*, 17 December 1964, 3 April 1969, 15 February 1986; Municipal Gallery of Modern Art, *Charles Lamb, RHA 1893-1964*, memorial exhibition, catalogue, Dublin 1969 (also illustrations); John Hewitt and Theo Snoddy, *Art in Ulster: 1*, Belfast 1977; *A Dictionary of Contemporary British Artists, 1929*, Woodbridge 1981; Martyn Anglesea, *The Royal Ulster Academy of Arts*, Belfast 1981 (also illustration); Ann M. Stewart, *Royal Hibernian Academy of Arts: Index of Exhibitors 1826-1979*, Dublin 1986; John Turpin, *A School of Art in Dublin since the Eighteenth Century*, Dublin 1995; Galway Arts Centre, *Charles Lamb RHA Galway Paintings*, catalogue, Galway 1998 (also illustrations); National Gallery of Ireland, *Gallery News*, September-November 1999.

LANGFORD, CIARÁN(1964-97), portrait painter. Michael Ciarán Langford was born in Mallow, Co. Cork, on 14 January 1964, the son of a secondary teacher, Michael A. Langford. After attending the Patrician Academy, Mallow, he studied at the Crawford School of Art and Design, Cork, 1983-8, obtaining the Diploma in Fine Art. In 1986 the Thomas Dammann Junior Memorial Travel Award had been won, administered by the Arts Council of Northern Ireland and open to students anywhere in Ireland. He visited Paris.

Langford was involved with the Backwater Artists Group, founded in 1990 by a group of young artists who were in serious need of studio space. That year he spent four months in London as a laboratory technician. In 1992 Backwater moved to a new location in Cork at 12 Pine Street. At the Blackcombe Gallery, Cork, in 1992 and 1993 he held solo exhibitions. He was active in the Backwater Studios administration 1993-6, having participated in 1993 in the inaugural group exhibition at Triskel Arts Centre, Cork. *Mark and Maurice Function* was shown in Dublin in 1993 in a group exhibition in the Irish Life Exhibition Centre. *Man Walking Backwards*, oil, was painted in 1993.

Financial support came from the Crawford Municipal Art Gallery, where he was a store technician, then an exhibitions assistant. In 1993 he shared with Barry McCarthy at the Blackcombe, his works including *Markus and Karol* and *Uncle Remus*. Another one-person show took place in 1994 at The Art Room, Paul's Lane, Cork. According to Vera Ryan, his *City Fathers* of 1994 was painted from a newspaper photograph: 'The cold blue colour range much beloved by the artist is explored in flat, densely worked planes. The volumes are built up with palette knife, as if carved, reminding us that Ciarán did some wood carving...'

In 1994 his work appeared in group exhibitions in Co. Cork at Vanguard Gallery, Macroom, and Schoolyard Theatre, Charleville, and in 1994-5 he was artist in residence at Triskel Arts Centre. In 1995 he organised the catalogue, packing and transport for the 'Nine Irish Artists' exhibition at Churchill Hotel Intercontinental, Portman Square, London. *The Bridge*, oil, 56 cm x 88 cm, was among his exhibits. Back home at Schoolyard Theatre he held an exhibition of oils and woodcarvings in 1996.

Some still life and landscape with the occasional abstract were also painted. The *Sunday Tribune* critic found his portraits 'bravely unfashionable, but soon it becomes clear that Langford was not just painting portraits: his painting was as much about the way we see things as it was about the objects represented...' The *Irish Times* noted that he was influenced by modernists such as Paul Cézanne (1839-1906).

In 1996 too he worked on archaeological digs with scale drawings mainly of wall sections, also labelling and recording all finds. His death was from a heart attack in his sleep at home in Mallow on 6 August 1997. An exhibition took place in Charleville that year. A further tribute was paid in 1998 with a selection of twenty paintings at the Crawford Municipal Art Gallery, and three of his poems were published in the catalogue.
Works signed: Ciarán Langford or M. C. Langford.
Literature: Triskel Arts Centre, *The B.A.G. show*, catalogue, Cork 1993 (also illustration); Ensign Fashions (UK) Ltd., *Nine Irish Artists*, catalogue, Cork 1995 (also illustration); Ciarán Langford, *Curriculum Vitae*, typescript, Cork 1996; *North Cork News,* 23 February 1996; Tate Gallery, *Application for Employment*, London 1996; *Cork Examiner,* 28 January 1998; Crawford Municipal Art Gallery, *Ciarán Langford 'Strange Colours Father...'* catalogue, Cork 1998 (also illustrations); *Irish Times,* 7 March 1998; *Sunday Tribune,* 7 April 1998; Michael A. Langford, *Letters to the author*, 1999.

LANGTRY-LYNAS, J. – see LYNAS, J. LANGTRY

LARKIN, DIARMUID (1918-89), landscape painter. Born in Drumcondra, Dublin, on 1 April 1918, he was the son of a building contractor, Seán Larkin, and became a process engraver, having served his apprenticeship with the Dublin Illustrating Company. Painting, however, commanded his interest and in 1941 he entered the National College of Art. He showed *Winter's Mantle* at the 1942 Royal Hibernian Academy. In his final student year he was awarded a scholarship by the Spanish Government which entailed a year's painting study at San Fernando Academy, Madrid, 1946-7. Life classes were attended in Paris before returning to Dublin, where he set up a photo-litho business. However, having decided to devote himself to art education and pursue his painting, he sold the company.

After some part-time teaching in Dublin, in 1953 he began full-time at Ballinasloe Vocational School, holding an exhibition in the town two years later. He exhibited *Coast at Carraroe* at the 1956 RHA. In 1957 he moved to Mullingar VS, and in 1961 to Dun Laoghaire Technical College, where, in 1962, he began a special art course for students wishing to follow a full-time art education. This developed into a one-year foundation course. Subsequently this course was ratified by the Vocational Education Committee and the

Department of Education, thus establishing the first phase of the Dun Laoghaire School of Art. *Railway Station, Dun Laoghaire*, was one of his three works at the 1966 Academy.

In 1967 he was appointed Professor in Art Education at Carysfort College of Education, Blackrock, Co. Dublin, where he was to remain until his retirement from education. In 1969 he researched art education programmes for elementary schools in Chicago, Washington and New York. What he saw in American painting at that time may have influenced him. Commentators on his exhibitions at the Barrenhill Gallery, Bailey, Howth, in 1970 and the Davis Gallery, Dublin, in 1971, described the works as in abstract style, or abstract expressionism, albeit they bore such titles as *Cherry Blossom Spring* and *In the Park, Washington*. The influence of Franz Kline (1910-62) and Mark Rothko (1903-70) was also suggested.

Links with Mullingar were retained in the 1970s by exhibiting with the local Art Guild. Along with R. Taylor Carson and Owen Walsh, he participated in the 'Three Faces of Erin' exhibition at Aisling Galleries, New York, in 1978. His manual for the primary teacher, *Art Learning and Teaching*, was published in 1981. *The Times Educational Supplement* said in its review: 'This is a guide book which takes us through a course of 24 exercises for each of seven years. Mr Larkin's structured art teaching may do much good, not only to the intellectual development of children but also to better visual discernment in our consumer society.'

Larkin showed about fifty works at the RHA – up until the year of his death – and also exhibited at the Oireachtas and with the Dublin Painters. At the 1980 Academy, he contributed *Ravine, Glencree* and *Oldboleys*, both oils. In 1982 he held one-person shows at the Robinson Gallery, Dublin, and then at the Cork Arts Society. In his work at the Robinson Gallery in 1984, Connemara landscapes predominated. Jill Whyte Gallery, Mullingar, staged an exhibition in 1985. A board member of the National College of Art and Design, he also served on several committees as an art adviser and examiner. Of 34 Hillcourt Road, Glenageary, Co. Dublin, he died in hospital on 25 June 1989. His name was commemorated by the Larkin Prize, a perpetual award which began in 1990 for excellence in the field of art and design and presented by the National Council for Educational Awards.

Works signed: Diarmuid Larkin or D. Larkin.
Examples: Athlone, Co. Westmeath: Public Library. Canberra: Irish Embassy. Dublin:County Dublin Vocational Education Committee. Limerick: University, National Self-Portrait Collection. Mullingar:Westmeath County Library. **Literature**: *Irish Independent*, 28 November 1970; *Evening Herald*, 29 January 1971; *Irish Echo*, New York, 12 July 1978; *Times Educational Supplement*, 6 March 1981; *Irish Times*, 13 May 1982, 25 October 1984, 27 June 1989, 21 December 1996; Jill Whyte Gallery, *Diarmuid Larkin exhibition invitation*, Mullingar 1985; Ann M. Stewart, *Royal Hibernian Academy of Arts: Index of Exhibitors 1826-1979*, Dublin 1986; Mrs Nance Larkin, *Letters to the author*, 1989.

LATIMER, ALICE M. (1874-1964), landscape and portrait painter. Daughter of John James Latimer of 56 Leeson Park, Dublin, she attended the Dublin Metropolitan School of Art and when there won the Taylor Scholarship in 1897 and 1898, but prior to that success she had already exhibited at the Royal Hibernian Academy, on the first occasion when aged about seventeen.

Between 1891 and 1919, she exhibited thirty works at the RHA. Her first address was Leeson Park. Several pictures displayed were either entitled 'Sketch' or included that word in their titles. In 1891, however, she showed *A garden in June*; in 1892, *German home life*; and in 1893, *St Patrick's Cathedral, Dublin*. In 1907 she exhibited three works at the Irish International Exhibition in Dublin: *The Dublin Hills* and two interiors.

By 1905, she was at Larkfield House, Kimmage, Dublin, and five years later at 67 Kenilworth Square, Dublin. *Kimmage Rural Scene* was painted *c.* 1910. In 1911 she showed *The Canal, Dublin*. By 1915 she shared a studio with Frida Perrott (q.v.) above Butler's Medical Hall, Lower Sackville Street. Both artists supplied an etching to the 1918 RHA; Alice's was a portrait of an old woman. Her final contribution in 1919 bore the title, *Portrait of sketch of John Latimer*.

RHA records suggested that she may have given up painting. During her known active period she showed one picture at the Walker Art Gallery, Liverpool. In 1967 the Gorry Gallery, Dublin, held an interior 'with woman in black dress seated knitting opposite a window, younger lady seated in corner asleep.' Of advanced years, and long since forgotten as an exhibiting artist, she died in hospital on 5 January 1964, of 17 Sandymount Avenue, Dublin.

Works signed: A. Latimer.
Literature: *Royal Dublin Society Report of the Council*, 1897, 1898; *Letter from Frida Perrott to Joseph Holloway*, n.d., Joseph Holloway Papers, National Library of Ireland; *Irish Times*, 6 January 1964; Gorry Gallery, *Accession record*, Dublin 1967; Ann M. Stewart, *Royal Hibernian Academy of Arts: Index of Exhibitors 1826-1979*, Dublin 1986; George Gallery, *Irish Paintings*, catalogue, Dublin 1989.

LAVERY, SIR JOHN, RA, RSA, RHA (1856-1941), portrait, landscape and genre painter. Born at 47 North Queen Street, Belfast, on 20 March 1856, he was the son of Henry Lavery who kept a wine and spirit store there. In 1859 Henry embarked on the emigrant ship, *Pomona*. The vessel was wrecked off the Wexford coast and he was drowned, leaving three children. His widow, Mary Donnelly, died heartbroken a few months later. Left an orphan, John was consigned to the farm of his uncle, Edward Lavery, situated between Soldierstown and Moira, Co. Down, known as *The Back of the Wood* but subsequently renamed *Train View Moira*. The local Magheralin National School provided the Belfast boy's education.

Aged ten, John was moved to a 'very rich' bachelor cousin of his aunt's who lived in Saltcoats, Ayrshire, and apparently ran a pawnshop there, as Lavery later recorded acting as an assistant. Unhappy, he ran away to Glasgow and was found impoverished, brought back to Saltcoats and then 'returned' to Ulster and labour on his uncle's farm for two years. Returning to Glasgow with £5 capital, he found an uncongenial job at 7s.6d. per week with the Glasgow and South-Western Railway, but soon parted company. After experiencing a dosshouse in Glasgow, he returned to Saltcoats where he began to draw again, being fascinated by the grocer 'because he drew profiles in pencil that held enormous interest for me'. Not long after, seeing a newspaper advertisement seeking a smart lad with a knowledge of drawing, he became apprenticed to a Glasgow 'photographic artist and portrait painter' at 11 West Nile Street, J. B. McNair, for whom he touched up negatives and coloured prints.

Lavery enrolled in the Haldane Academy of Art in Glasgow in 1874 and became friendly with a fellow student, Alexander Roche (1861-1921). In 1876 he painted his first picture, and in 1879 a work was accepted at the Glasgow Institute of the Fine Arts. After three years' apprenticeship as a miniature painter over photographs, he had departed, being engaged by another photographer at £150 per annum, but he left that job too and opened a studio. His second studio was gutted by fire in 1879, at 101 St Vincent Street, Glasgow. 'I cannot remember ever feeling so happy. I was insured for £300', wrote Lavery in his autobiography, *The Life of a Painter*. Encouraged by a friend, he set off for London and spent about six months at Heatherley's Academy. He had already explained to the staff at the Haldane Academy that he wanted to become a portrait painter.

In 1880 he sold a picture for ten guineas at the Glasgow Institute of the Fine Arts, and for some years he also sent works to the Paisley Art Institute. He exhibited at the Royal Scottish Academy in 1881 from 101 St Vincent Street. In November 1881 he was elected to the Glasgow Art Club, and later the same month he left for Paris and the Académie Julian under W.-A. Bouguereau (1825-1905), staying at the Hôtel de Saxe in Rue Jacob. He also studied at Colarossi's. *Une Jeune Parisienne* was dated 1882. Late in the summer he was back in Glasgow for a few months before returning to Paris. A small student work, *Les Deux Pêcheurs*, was hung at the 1883 Salon.

Lavery's happiest days in France were passed with the artist colony outside Paris at Grès-sur-Loigne. In 1883 three young Scotsmen, William Kennedy (1859-1918), T. M. Dow (1848-1919) and Roche also made the journey to Grès-sur-Loigne. Lavery returned there in 1884 for about nine months, becoming friendly with and supportive of his fellow Irishman, Frank O'Meara (1853-88). *Under The Cherry Tree*, now in the Ulster Museum, was painted at Grès-sur-Loigne in 1884. Returning to Glasgow, he was recognised as one of the 'Glasgow School,' a group of progressive artists resident in Scotland and influenced by contemporary French art. Lavery brought to the group the influence of Jules Bastien-Lepage (1848-84) with his open-air realism. At the RSA in 1884 he gave his address as 160 Bath Street, Glasgow.

In 1883 Lavery had begun work on a theme which was to occupy him, on and off, for four years: *Dawn after the Battle of Langside, 14 May 1568*. In the summer of 1885 he painted *The Tennis Party*, a pioneering work, at the village of Cathcart in the south-west of Glasgow. His watercolour, *Lady on a Safety Tricycle*,

1885, is in the Government Art Collection, London. The tennis painting brought him prominent notice; it was first shown at the Royal Academy in 1886 as *The Tennis Match*. This work won a gold medal at Munich in 1901 and was bought by the Bavarian Government, but after the First World War it was sold and now hangs in Aberdeen Art Gallery. *A Rally*, 1885, watercolour, is at Glasgow Art Gallery and Museum.

Lavery exhibited in London at the New English Art Club show of 1887, and the 1889 catalogue listed him as a member. He had met James Abbott McNeill Whistler (1834-1903) in 1887. He had begun to send work to the Society of British Artists which was then very much under Whistler's influence. When Whistler's autocratic short reign as president ended in 1888, Lavery was one of the artists who left the Society along with the 'Master'. His Glasgow address in 1888 was 248 West George Street.

In 1888 Lavery received the commission that transformed his career into a society painter: recording the visit of Queen Victoria to the Exhibition of 1888. Positioned behind a curtain, he surveyed the Glasgow scene through a hole in the fabric. Fortunate to obtain a sitting from Queen Victoria herself, he then had no difficulty in persuading some 250 individuals present at the Queen's visit to sit for him, establishing him as a leading portraitist and opening the way for him to settle in London. *State Visit of Her Majesty, Queen Victoria, to the International Exhibition, Glasgow, 1888*, 2.6m by 4m, is in the Glasgow Art Gallery. Lavery earned his fee of £600 for the first successful ceremonial composition painted during the Queen's reign. There are several other Exhibition canvases at the same gallery, notably 115 small studies for portraits. At the National Gallery of Scotland is *The Dutch Cocoa House at the Glasgow International Exhibition of 1888*.

In London in 1890, at the Grosvenor Gallery, an exhibition was held for the so-called Glasgow School of painting. The show was visited by two German artists who requested a Glasgow collection for display in Munich. In 1890 he married Kathleen MacDermott who was to die within a year of the birth of their daughter, Eileen.

Morocco attracted him for the first time in 1890, and when he held his first one-person show in London at the Goupil Gallery in 1891 much of the subject matter was Moroccan. *The Snake Charmers* was so dated. *In Morocco* is in the National Gallery of Victoria, Melbourne. Lavery travelled to Spain en route to Morocco the following year. *An Equestrian Lady* (Glasgow Art Gallery and Museum) was dated 1891. In his *Life* he wrote about a visit to Rome 'after Kathleen's death' in 1891. On his winter visits to Tangier he often painted the beach.

Lavery was a close companion of another of the 'Glasgow Boys', James Guthrie (1859-1930). In 1892 Lavery, Roche and Guthrie made a European tour. In that year he was represented at the World's Columbian Exhibition, Chicago. R.B. Cunninghame Graham, who knew several of the 'Glasgow Boys', was painted by Lavery in 1893, a full length work just over two metres in height, at Glasgow Museum and Art Gallery. The Royal Academy tended to ignore him but his name became widely known on the Continent, and he was represented by a portrait in the Berlin Art Exhibition of 1895.

A regular exhibitor at the Glasgow Institute and the Royal Scottish Academy, he became ARSA in 1892 and a Royal Scottish Academician in 1896, the year of his 'Fair Women' show in Lawrie's gallery, Glasgow. Altogether at the RSA, he showed nearly one hundred works. He also painted in Spain: *A Cigarette-Maker at Seville, in 1896*. In that year too the Carnegie Institute at Pittsburgh bought *The Bridge at Grès*, since sold. At the Grafton Gallery in London he was regularly represented in the Society of Portrait Painters' exhibitions, becoming president, and in 1897 showed *Portrait of a German Lady*. In that year *Portrait of a Gentleman* appeared in the Venice exhibition. On his visits to Germany, there was no shortage of commissions, and in 1899 he had the first of three exhibitions at Schulte's Gallery, Berlin.

After his move to London in 1896, he had found a friend in Alfred East (1849-1913) who lent him a studio. By 1898 he had settled at 5 Cromwell Place, Kensington. Lavery's part in assisting Whistler to form the International Society of Sculptors, Painters, and Gravers in 1897-8 was considerable. Whistler, who had been appointed president, returned to Paris after a few council meetings and Lavery, the vice-president, found himself virtually acting as chairman, corresponding constantly with Paris. Nevertheless, he held office as vice-president for ten years. In the year of the first exhibition, 1898, Lavery also exhibited in Vienna and sat on the jury for awards at Pittsburgh.

Musée d'Orsay, Paris, purchased *Père et Fille*, 1898; *A Garden in France* was painted in the same year. *The Night after the Battle of Langside*, 1.3m by 1.8m, on which he had worked intermittently for several years, appeared at the 1899 Ghent Salon and was purchased by the Belgian government. Lavery was one of the four artists appointed in 1899 to decorate the banqueting hall of the Glasgow City Chambers. The theme was an historical account of the city; Lavery's subject was Glasgow's major industry, shipbuilding. Meanwhile, the National Gallery of New South Wales acquired *White Feathers* in 1900, the year he was represented in two Brussels exhibitions.

The Bridge at Grès, 1901 (Ulster Museum) is appropriately reproduced in colour in Kenneth McConkey's 1993 book on the artist. Lavery's work was hung in 1901 at exhibitions in Berlin, Budapest and Vienna, and according to James Stanley Little in *The Studio*: '... presumably his attitude towards the Royal Academy was one of benevolent indifference'. In 1903 he showed in Venice and Munich, and in 1904 he held a one-person exhibition at the Leicester Galleries, London. His 1903 portrait of W. E. H. Lecky is at the National Gallery of Ireland.

Never forgetting his Irish background, he exhibited with the Belfast Art Society and the Royal Hibernian Academy. His portrait of Tosti (Sir Francesco Paolo) was dated 1903 and is at the Royal College of Music, London. In 1904 he was elected an honorary member of the Belfast Art Society. In 1906 he was appointed ARHA with full membership the same year. Auguste Rodin (1840-1917) had succeeded Whistler in 1903 as president of the International Society and he and Lavery were now close friends. His 1904 portrait of the sculptor, who often called at his studio, is in the Tate Gallery, London.

The Studio now found Lavery's *Madame la Baronne de H.*, although marked by fine passages, 'too chic and too empty to be satisfying' in the Royal Scottish Academy exhibition of 1904. In that year his work was exhibited at Dusseldorf, and Paris showed *Spring* which was purchased by the French Government for the Luxembourg Gallery. Generously represented at Hugh Lane's exhibition of Irish art at the Guildhall Galleries, London, 1904, he now purchased for his winter quarters a house on the hill outside Tangier and this he occupied until 1920. The Art Gallery of Ontario has two oils, *Bay of Tangiers*. Soon after his first visit to Tangier, he made a trip through Holland and Belgium, then Italy and Germany, with his Scottish friends, Guthrie and Roche.

The Italian Government in 1906 invited him to paint his own portrait for the Uffizi Gallery, Florence; five years elapsed before they received the final version. International representation continued, for example: Pittsburg, Pennsylvania, 1906; Mannheim, 1907; Paris, 1907, 1909; Franco-British exhibition, 1908; and at Venice in 1909 his *Polyhymnia* was acquired for the National Gallery of Modern Art, Rome. *La Dame aux Perles* was presented by Hugh Lane in 1907 to the Municipal Gallery of Modern Art, Dublin. Moroccan paintings dominated his 1908 show at the Goupil Gallery, London, and in 1910 the Venice Biennale had a retrospective of his most important works, fifty-three in all.

In 1910 at Brompton Oratory, London, he married Mrs Hazel Trudeau, daughter of Edward Jenner Martyn of Chicago. She soon established herself as a popular figure in society, seconding her husband's career as a fashionable portrait painter. Her own work as a painter was mainly exhibited at the Alpine Club Gallery, London. The National Gallery of Ireland holds a portrait by her of John Lavery; the National Portrait Gallery, London, has a portrait of James Maxton. *Mrs Lavery, Sketching* by her husband is in the Hugh Lane Municipal Gallery of Modern Art. Lady Lavery, friend and admirer of Michael Collins, was the original figure painted by Sir John for the new Irish currency note. She died in 1935, the same year as his only child, Eileen, the Hon. Mrs Forbes-Semphill.

Further publicity was forthcoming in 1911 with the publication of Walter Shaw-Sparrow's *John Lavery and his work*, also his appointment as an associate of the Royal Academy, and his appointment as first president of the Royal Society of Portrait Painters. However, his style was not without its critics. A writer in 1912 in *The Studio* said that his early portraits 'made no pretence of digging into character. The sitter was merely part of a scheme of decoration; occasionally a mere clothes-horse for attractive drapery.' In his *Life*, Lavery wrote: 'I have felt ashamed of having spent my life trying to please sitters and make friends instead of telling the truth and making enemies'. He continued to exhibit abroad and in 1912 visited Chicago. Dated

1912, *La Mort du Cygne* is at the Tate Gallery and *A Moorish garden in winter* is at Queen's University, Belfast.

Lavery was one of eight Scottish artists who in 1912 formed themselves into an exhibiting society with a lease of premises in Edinburgh. The winter of 1912-3 was spent on vacation at Wengen. His commission fee for painting the Royal Family in 1913 was £2,000 and this work is in the National Portrait Gallery; a study is at the Ulster Museum. In correspondence with the Belfast Museum and Art Gallery in 1913, Lavery stated that *The Lady in Black* was perhaps the most complete of the 'harmonies' he had done in that colour. 'I would accept 500 guineas for this picture ... my charge for a full length portrait is 1,000 guineas.' Belfast purchased. A portrait of Dr George Sigerson at the 1913 RHA brought criticism from the *Irish Review*: 'The colour is utterly dull; the figure looks as though it had lain for a while in a mud bath' *Loch Katrine*, 1913, found its way to the NGS in Edinburgh. In that year he showed three works at the RSA: *The Amazon*; *Curling*; *Skating*.

Lavery in 1914 presented his portrait of his friend and admirer, Rodin, to the Victoria and Albert Museum; now in the Tate Gallery. A unique exhibition of his work, ranging from 1880 until 1914, was hosted by the Grosvenor Gallery. A critic in *The Studio* found the portraiture 'chic, debonair, facile, dexterous'. Lavery showed at the Royal Academy, 1915, *Wounded: London Hospital*. The Belfast Museum and Art Gallery lent in 1916 *Girls in Sunlight*, painted on the beach at Tangier, to the Royal Hibernian Academy for exhibition and it was destroyed by fire in the rebellion. *High Treason: Court of Criminal Appeal 1916* with Sir Roger Casement is at King's Inns, Dublin. A key to this work distinguishes twenty-one figures.

In August 1917 he was issued with a Special Joint Naval and Military Permit to depict aspects of the war in Britain. In his oeuvre were Admiral Sir Cecil Burney, Commander-in-Chief, Coast of Scotland; a convoy in the North Sea – one of the first artists to work from the air; British mine-laying submarines at Harwich; American troops embarking at Southampton; munitions factories. However, the most extraordinary scene was in the forecabin of *HMS Queen Elizabeth* with Admiral Beatty reading the terms of the surrender of the German Navy, Rosyth, November 1918. Lavery was dressed as a naval officer and executed his studies in the forecabin, while the meeting progressed, concealed behind a bowl of flowers on a sidetable. *The End* and more than fifty other war works painted between 1914 and 1919 are in the Imperial War Museum. Lavery felt that his war pictures were 'totally uninspired and dull as dish-water'.

In 1918 Lavery received a knighthood. Still in touch with the Belfast Art Society, he was elected president in 1919, and served for five years, exhibiting and attending exhibitions. The Medici Society in 1919 published copyright reproductions in colour of a Sea Power series. Lavery's *A Convoy, North Sea* was included. On Easter Day, 1919, the artist presented a triptych or altarpiece to St Patrick's Church, in Belfast, where he was baptised; Lady Lavery modelled for *The Madonna of the Lakes*, which was rescued from a devastating fire in 1995.

In 1921 he painted *The Widow* (Mrs Terence McSwiney, Lady Mayoress of Cork, 1920), now in the Crawford Municipal Art Gallery. Still exhibiting widely, in 1921 for example – as well as an exhibition with Hazel Lavery (1880-1935) at the Alpine Club Gallery – he was represented at exhibitions arranged by the Glasgow Institute, International Society, National Portrait Society, Royal Academy (in this year appointed academician), Royal Scottish Academy, Royal Society of Portrait Painters, and in 1922 at Pittsburgh and Venice. In his introduction to the catalogue for the joint exhibition at the Alpine Club Gallery, Winston Churchill (1874-1965), a painter himself, was generous in his praise of Hazel's talent.

'Portrait Interiors' was the title of a show at the Leicester Galleries, London, in 1925. Portraits, interiors and landscapes were exhibited in 1925 at Duveen Galleries, New York, and the Laverys visited the show, which then toured. *The Countess of Oxford and Asquith, The Wharf, Sutton Courtenay*, a 1925 interior, is in Winnipeg Art Gallery, Canada.

As Oliver St John Gogarty wrote, 5 Cromwell Place was 'a house which was welcomed as an official meeting-place for rebel and ruler'. Lavery was in Kingstown at the time of the death of his friend, Michael Collins, and he painted him in the mortuary chapel in Dublin; the painting is at the Hugh Lane Municipal Gallery of Modern Art. In 1922 he recorded, at the House of Lords, Viscount Morley moving the Address on the Irish Treaty. As he also painted several of the first Ministers of the Irish Free State Government, his

connections with Ireland were, if anything, stronger. In 1924 he was appointed a governor of the National Gallery of Ireland, and was a judge of the paintings in the exhibition of Irish art held in connection with Aonach Tailteann. In London, at the opening of the new galleries at the Tate Gallery in 1926, Lavery was there to record the event. At the 1926 RHA, he showed *The Drawing room at Mount Stewart*; *George Bernard Shaw*; and *Skating at Caux*.

In its Irish Portraits by Ulster Artists exhibition in 1927, Belfast Museum and Art Gallery presented works by Lavery, portraits of Sir Andrew Marshall Porter, Bt; William Cosgrave, President of the Irish Free State; the Rt. Hon. Viscount Craigavon, PM of Northern Ireland. In that year too Lavery gave *Count John McCormack and his Family* to the Municipal Gallery of Modern Art, Dublin.

On the occasion of the opening of the new Belfast Museum and Art Gallery at Stranmillis in 1929, Sir John presented a collection of thirty-three works, including *Michael Cardinal Logue*, 1920 (lent to the Irish exhibition at Brussels, 1930); *The Marquess of Londonderry, KG, Chancellor of Queen's University, Belfast, 1924*; *Hazel in Green and Gold*, 1926; *The Twelfth of July in Portadown*, 1928. When he received the Freedom of Belfast in 1930, he became the first artist to be so honoured. In that year he was one of the first twelve academicians of the Ulster Academy of Arts; appointed president, he retained office until his death.

A girl holding a taut rope as the animal circles her is a most unusual subject for Lavery: *Schooling the Pony*, 1929, at the Rochdale Art Gallery. In 1931 Lavery was among those requisitioned to decorate the chief first-class rooms of the ship, *Empress of Britain*. An exhibition in London of portrait studies and other sketches at P. and D. Colnaghi & Co. in 1932 included *Phil the Fluter* and *The Blacksmiths of Tramore*. In that year his work was also exhibited at the Olympic art exhibition, Los Angeles, and he was elected president of the Royal Society of Portrait Painters. *Shirley Temple and the Painter* was one of the results of his three-week visit to Hollywood in 1936. *Stars in Sunshine*, Maureen O'Sullivan and Loretta Young, is at the Limerick City Gallery of Art. In 1936, Victoria Art Galleries, Albert Institute, Dundee, reported to the Belfast Museum and Art Gallery that more than 25,000 people had visited the Lavery exhibition there. Two years later he was represented in the Empire Exhibition at Glasgow.

Lavery had been made an Honorary Freeman of the City of Dublin in 1935, received an honorary LL D from Queen's University, Belfast in the same year, and from Trinity College, Dublin in 1936. *Self-Portrait (The Silver Casket)* is at Queen's University. In memory of his wife, he had presented thirty-four pictures to Dublin in 1935, including *St Patrick's Purgatory*; a portrait of Winston S. Churchill with whom he had a close friendship, as well as portraits of Arthur Griffith, Eamon de Valera, Archbishop Mannix and George Bernard Shaw. In his *Coronation Procession of George VI 12th May 1937*, now in the Museum of London, he included himself in the crowded balcony. When not travelling, he painted virtually every day. *St Patrick's Purgatory, Lough Derg* (NGI), this one realised in 1939, was dedicated to 'Monsignore Vance'.

Lavery's other honours included: Member of the Academies of Antwerp, Brussels, Milan, Rome and Stockholm; member of the Sécessions of Berlin, Munich and Vienna; Chevalier of the Crown of Italy and of Leopold of Belgium. He was also a member of Sociéte Nationale de Beaux-Arts, Paris, and the Society of Spanish Artists, Madrid. A pencil portrait of him by Hazel Lavery is at NGI, and there is a portrait by Harrington Mann (1864-1937) in the Glasgow Museum and Art Gallery. A bronze bust of Lavery by Ivan Meštrović (1883-1962) is in the Ulster Museum. *Mrs Lavery and Alice (Mother and Child)* is in Dublin at the Municipal Gallery. In his *Homage to Velasquez* at NGI, Hazel is presented with her daughter, Alice, and Lavery's daughter, Eileen.

The National Gallery of Canada has four oil paintings, including *Portrait of Grey Owl* and *HRH Princess Patricia of Connaught*. Lavery wrote an introduction for Anita Leslie's *Rodin: Immortal Peasant*, published in 1937 in New York with his portrait as frontispiece. The autobiographical *The Life of a Painter* appeared in 1940. His 1940 portrait of John Stewart Collis is at NGI. During the War, when his *Venus* in Leipzig was badly damaged, he went to live with his step-daughter, Mrs Alice McEnery at Rossenarra, Kilmoganny, Co. Kilkenny, and died there on 10 January 1941. He was buried at Mount Jerome Cemetery, Dublin.

A memorial exhibition took place at the Leicester Galleries in 1941. Reinterred in 1947, Lavery was placed beside his wife in Putney Vale Cemetery, London. A loan exhibition was held at the Belfast Museum and Art Gallery in 1951. In 1968 the Scottish Arts Council hosted an exhibition of work by the group of artists

who flourished in Glasgow 1880-1900 entitled 'The Glasgow Boys'. A large retrospective exhibition organised by the Ulster Museum and the Fine Art Society, London, was held in Edinburgh, London, Belfast and Dublin in 1984-5. 'Sir John Lavery: The Irish Glasgow Boy' was the title of an exhibition,1997, at the Burrell Collection,Glasgow. In London in 1999, the National Portrait Gallery acquired two portraits: *Edward Knoblock*; *Hugh Cecil Lowther, 5th Earl of Lonsdale*.

Works signed : J. Lavery or John Lavery, rare.
Examples: Aberdeen: Art Gallery. Bedford: Cecil Higgins Art Gallery. Belfast: City Hall; Queen's University; St Patrick's Church, Donegall Street; Ulster Museum. Birmingham: Museum and Art Gallery. Boston, Mass., USA : Museum of Fine Arts. Bournemouth: Russell-Cotes Art Gallery and Museum. Bradford: Cartwright Hall Art Gallery. Brighton: Art Gallery and Museum. Brussels: Musée des Beaux Arts. Cambridge: Fitzwilliam Museum; Girton College. Cardiff: National Museum of Wales. Chicago: Art Institute. Cork: Crawford Municipal Art Gallery. Dublin: Áras an Uachtaráin; Hugh Lane Municipal Gallery of Modern Art; King's Inns; National Gallery of Ireland; Royal Dublin Society; University Hall, Lower Hatch Street. Dundee: City Art Gallery. Edinburgh: City Art Centre; National Gallery of Scotland; Royal Scottish Academy; Scottish National Portrait Gallery. Florence: Uffizi Gallery. Gateshead, Tyne and Wear: Shipley Art Gallery. Glasgow: Art Club; Art Gallery and Museum; Burrell Collection; University. Greenock, Scotland: McLean Museum and Art Gallery. Johannesburg: Art Gallery. Kilkenny: Art Gallery Society. Kingston-upon-Hull: Ferens Art Gallery. Leeds: City Art Gallery. Leipzig: Museum of Fine Arts. Limerick: City Gallery of Art. Liverpool: Walker Art Gallery. London: Government Art Collection; Gray's Inn; Guildhall Art Gallery; Imperial War Museum; Museum of London; National Portrait Gallery; Reform Club; Royal Academy of Arts; Royal College of Music; Tate Gallery. Manchester: City Art Gallery. Melbourne: National Gallery of Victoria. Morley, Yorkshire: Town Hall. Newcastle-upon-Tyne: Laing Art Gallery. Norwich: Castle Museum. Ottawa: National Gallery of Canada. Paisley, Scotland: Museum and Art Galleries. Paris: Musée d'Orsay. Perth, Scotland: Art Gallery and Museum. Pittsburgh, USA: Carnegie Museum of Art. Rochdale, Lancs.: Art Gallery. Rome: Galleria Nazionale d'art Moderna. San Francisco: California Palace of the Legion of Honor. Sheffield: City Art Gallery. Southampton: Art Gallery. Sydney: Art Gallery of New South Wales. Toronto: Art Gallery of Ontario. Wakefield, Yorkshire: Art Gallery. Whalley, Lancs.: Stonyhurst College. Winnipeg, Canada: Art Gallery. Worcester, Mass., USA: Art Museum.
Literature: *Glasgow Post Office Directory*, 1872-3; *The Studio*, July 1897, December 1897, December 1899, June 1900, August 1900, November 1900, August 1901, September 1901, October 1902, August 1903, September 1903, April 1904, May 1904, June 1904, August 1906, August 1907, December 1907, June 1908, December 1909, February 1910, April 1912, January 1913, January 1914, June 1914, January 1915, June 1916, June 1918 (illustrations), January 1920, May 1921, June 1921, August 1921, December 1921, July 1922, August 1922, April 1924, October 1924, June 1930 (illustration), July 1931, November 1932 (illustrations), July 1934 (illustration), February 1937, June 1937 (illustration), October 1939, September 1945 (illustration), April 1950 (illustration); *Burlington Magazine*, October 1907 (illustration); Walter Shaw-Sparrow, *John Lavery and his work*, London 1911 (also illustrations); *Irish Review*, April 1913 (also illustration); John Lavery, *Letter to Belfast Museum and Art Gallery*, 1913; *Belfast Museum and Art Gallery Annual Report*, 1915-6, 1916; *Irish Builder and Engineer*, 3 May 1919; *Imperial War Museum Catalogue of paintings, drawings and sculpture*, London 1924; J. Crampton Walker, *Irish Life and Landscape*, Dublin 1927 (also illustration); *Belfast News-Letter*, 23 April 1930, 11 January 1941;*Capuchin Annual*, 1936 (illustrations), 1940 (illustrations), 1942 (illustration), 1943 (illustration), 1970 (illustrations); Ulster Society for the Prevention of Cruelty to Animals, *The Tree*, Belfast 1936 (illustration); Anne Leslie, *Rodin: Immortal Peasant*, New York 1937; John Lavery, *The Life of a Painter*, London 1940 (also illustrations); Belfast Museum and Art Gallery, *Sir John Lavery Collection of Paintings*, catalogue, 1946 (also illustrations); *Who Was Who 1941-50*, London 1952; Thomas Bodkin, *Hugh Lane and his pictures*, Dublin 1956; Scottish Arts Council, *The Glasgow Boys*, catalogue, Edinburgh 1968 (also illustrations); John Hewitt and Theo Snoddy, *Art in Ulster: 1*, Belfast 1977 (also illustrations); Fred Heatley, *The Story of St Patrick's, Belfast, 1815-1977*, Belfast 1977; Martyn Anglesea, *The Royal Ulster Academy of Arts*, Belfast 1981 (also illustration); Meirion and Susie Haines, *The War Artists*, London 1983; Ulster Museum and the Fine Art Society: Kenneth McConkey, *Sir John Lavery RA 1856-1941*, catalogue, Belfast and London 1984 (also illustrations); National Gallery of Ireland: Julian Campbell, *The Irish Impressionists*, catalogue, Dublin 1984 (also illustrations); Roger Billcliffe, *The Glasgow Boys*, London 1985 (also illustrations); Art Gallery of Ontario, *Letter to the author*, 1988; also, Museum of Fine Arts, Leipzig, 1988; National Gallery of Canada, 1988; National Gallery of Victoria, 1988; Rochdale Art Gallery, 1988; Royal College of Music, 1988; The Fine Arts Museums of San Francisco, 1988; University of Pittsburgh, 1988; Worcester Art Museum, 1988; *The Royal Scottish Academy Exhibitors 1826-1990*, Calne 1991; Kenneth McConkey, *Sir John Lavery*, Edinburgh 1993 (also illustrations); Winnipeg Art Gallery, *Letter to the author*, 1994; Eileen Black, *A Sesquicentennial Celebration: Art from the Queen's University Collection*, Belfast 1995 (also illustrations); Government Art Collection, London, *Letter to the author*, 1995; Sinéad McCoole, *Hazel: A Life of Lady Lavery 1880-1935*, Dublin 1996; Glasgow Museums, *Sir John Lavery: The Irish Glasgow Boy*, catalogue, Glasgow 1997 (also illustrations); National Gallery of Ireland, *Letter to the author*, 1999; also, National Portrait Gallery, 2001.

LAWLOR, MICHAEL (1840-1920), sculptor. A native of Dublin, Michael J. Lawlor was the son of Patrick Lawlor, formerly of Maryborough, Co. Laois, and a nephew of the sculptor, John Lawlor, ARHA (1820-1901), who exhibited at the Royal Hibernian Academy between 1844 and 1885. After studying at the Royal Dublin Society's School, Michael spent some time in Paris and then settled in London, continuing his training at his uncle's studio there. John Lawlor showed at the 1865 RHA a bust, *M. Lawlor, Esq.*

Uncle and nephew had a difference of opinion and the studio association ceased, presumably sometime after Michael had posed for his uncle as the young man standing in the engineering group for the Albert Memorial, which group was completed in 1871. Michael, who also showed at the Paris Salon, first exhibited at the Royal Academy in 1877, a medallion of a lady, from 58 Mayton Street, Holloway. Between 1879 and 1891 he showed six works at Burlington House, mainly portrait busts, *Mrs M. Lawlor* in 1888. In this period of exhibiting at the RA he had half a dozen different addresses. He also showed at the Grosvenor Gallery, London.

In 1878 he contributed five works to the Royal Hibernian Academy, sending from 193 Ladbroke Grove Road, North Kensington, including statuettes, *A Lookout* and *The Great Sea Serpent* at three guineas the pair as companions. Represented at the Exhibition of Irish Arts and Manufactures at the Rotunda, Dublin, in 1882, he also showed at the Cork Industrial Exhibition of 1883. He executed a medallion which was a wedding gift in 1893 for the future George V and his wife. A plaster bust, *Mistletoe*, appeared at the Irish Industrial Exhibition at Herbert Park, Dublin, in 1907, and three years later he returned to the RHA with *J. C. Lawlor, Esq.*

A posthumous bust, commissioned by Queen Alexandra, *H. M. King Edward VII* was exhibited at the 1911 RHA. In 1912 a contributor to *Irish Book Lover* reported being 'at the studio of Mr Michael Lawlor, the well-known Irish sculptor, the occasion being a private view of a very excellent bust of Mr John Redmond, which the sculptor had just completed in the clay'. The writer found him remarkable for his 'tear and the smile' humour. The bust appeared at the 1913 RHA and the sole comment from the *Irish Review* was that it was 'sausage-coloured'. A plaster bas-relief of the MP, donated in 1975, is in the National Gallery of Ireland; there is also a bust in the City Hall, Waterford. Lawlor died at his residence, 17 Brewster Gardens, North Kensington, London, on 24 July 1920. His daughter Gertrude exhibited sculpture, *My Father*, at the 1922 RHA.

Works signed: Michl. Lawlor.
Examples: Dublin: National Gallery of Ireland. Waterford: City Hall.
Literature: *The Royal Academy of Arts Exhibitors 1769-1904*, London 1905; *Irish Book Lover*, June 1912; *Irish Review*, April 1913; W. G. Strickland, *A Dictionary of Irish Artists*, Dublin 1913; *Irish Times*, 27 July 1920; National Gallery of Ireland, *Press release*, 1975; Ann M. Stewart, *Royal Hibernian Academy of Arts: Index of Exhibitors 1826-1979*, Dublin 1986; Mrs Margaret Lawlor, *Letter to the author*, 1988.

LAWRENCE, MERVYN (1868-fl.1931), sculptor and painter. Born in Dublin on 16 September 1868, he was the son of W. M. Lawrence, JP, merchant. Educated at Wesley College, Dublin, he attended the National Art Training School at South Kensington, and also studied in Paris. Most of his life was spent teaching in London, but he had an association early in the century with the Irish Art Companions of 28 Clare Street, Dublin. According to an article in *The Artist* in 1901, he was associated with A. Rottman in the production of garden sculpture. He was elected to membership of the Society of British Sculptors in 1906 but resigned some years later.

At the Irish International Exhibition in 1907 at Herbert Park, Dublin, he showed: *The Lonely Heart*, bronze bust; *Mater Dolorosa*, statuette in wood; and *The Prodigal*, bronze statuette, which he regarded as one of his principal works. He also listed for special mention: *A Donegal Tinker*, oils; *The Embankment, Lambeth*, oils; *Venus Victrix*, bronze statuette; and a portrait in oils of H. J. Dyer.

At the Royal Hibernian Academy he gave a Paris address when he first exhibited in 1897. In the following year he was at 1 St Leonard's Studios, Smith Street, Chelsea. Some of the eight works exhibited at the RHA were paintings. His last contributions were in 1912: *Sunset, Howth, Co. Dublin* and *Extreme Unction*. Just

after the end of the First World War, a student from Ireland, Agnes Frost, attended the Westminster School of Art, then under Randolph Schwabe (1885-1948), and was in Lawrence's 'drawing from life' class. He was then assistant headmaster and she found him an excellent teacher.

Between 1894 and 1931 Lawrence exhibited more than one hundred works in principal exhibitions in England, including a dozen at the Glasgow Institute of the Fine Arts and thirty at the London Salon. He first showed at the Royal Academy in 1905 and between then and 1931 exhibited eleven works. In 1905 he was represented by *Mrs Mervyn Lawrence*, bust; *Mrs G. C. Audsley and daughter*, group bronze; *Hebe*, statue. The only item in 1931 at the RA was *In the Sun* from 44 Markham Square, Chelsea.

The Goupil Gallery also displayed his work, as well as the International Society of Sculptors, Painters, and Gravers. He was vice-president of the South London Group. A marble statue of St Teresa of Avila, unveiled in 1907, is in the Church of St Aloysius at Oxford. In the Leeds City Art Gallery is *The Prodigal Son*, 68.5cm high, but *The Argument*, plaster cast, which the artist presented in 1914, has been lost for many years and is presumed destroyed. *Erina*, a statue in plaster, unsigned, is in the National Museum of Ireland. Despite a search at the General Register Office in London, the date of his death has not been found.

Examples: Dublin: National Museum of Ireland. Leeds: City Art Gallery. Oxford: Church of St Aloysius.
Literature: *The Artist*, February 1901; Fr D. A. Bischoff, SJ, *St Aloysius, the first eighty years*, Oxford 1955; Alan Denson, *John Hughes Sculptor 1865-1941*, Kendal 1969; *Dictionary of British Artists 1880-1940*, Woodbridge 1976; *Royal Academy Exhibitors 1905-1970*, Wakefield 1979; *A Dictionary of Contemporary British Artists, 1929*, Woodbridge 1981; *Irish Times*, 3 September 1982; Ann M. Stewart, *Royal Hibernian Academy of Arts: Index of Exhibitors 1826-1979*, Dublin 1986; Miss Agnes Frost, *Letter to the author*, 1988; also, Leeds City Art Gallery, 1988.

LAWRENSON, CHARLOTTE (1883-*c*.1970), portrait painter, engraver and mural decorator. Born in Dublin on 31 August 1883, she was the daughter of Robert Healy Thompson, writer of poetry, plays and scientific works under the name of Robert Blake. Charlotte Mary Rose was educated at Loreto Convent, Omagh, Co. Tyrone, and University College, Gower Street, London. She began her artistic training under (Sir) William Orpen (q.v.) at the Chelsea Art School in Flood Street. At the Slade School of Fine Art she won the Wilson Steer Prize, and when attending the Byam Shaw School she was awarded first prize for an oil portrait and second prize for a head drawing.

Charlotte Thompson married Edward L. Lawrenson (q.v.) and they lived in Nurney, Hadlow Down, Sussex. She exhibited in several of the main English exhibitions and had sixteen works hung at the Royal Academy between 1921 and 1945, showing *Marigolds* in 1931 and a pencil portrait of Ralph Lawrenson in 1935. The International Society of Sculptors, Painters, and Gravers also displayed her work as well as the London Salon, New English Art Club, the Royal Society of Portrait Painters, and the Walker Art Gallery, Liverpool. At the Royal Scottish Academy, 1921 she showed *Catherine de Medici Bridge, Chinon*, from 3 St Paul's Studios, Baron's Court, London W14.

Some works were also hung at the exhibitions of the Royal Institute of Oil Painters and the Society of Women Artists. She was a faithful exhibitor for several years with the Royal Hibernian Academy and as Charlotte Thompson showed a portrait of Miss Emmie Le Fanu, from 240 Earlswood Road, London, in 1909 and her five pictures the following year included a study of the sea at Portrush and an interior. Street scenes in Quimperle and Montreuil were hung in 1924. A number of lithographs, for example *Breton Wedding* in 1925, were also exhibited, and her last two contributions to the RHA were: 1932, *The Wringer*; 1934, *Molly*, from Hadlow Down.

The Lawrensons also exhibited in London at the Alpine Club Gallery and with the Southern Society of Artists. Charlotte is represented in Brighton Museum and Art Gallery by an oil, *Girl Knitting*. The Art Gallery of New South Wales owns *Portrait of a Lady*, a 1925 drawing in pencil, and *Alice* of the same year, also pencil, is at Cartwright Hall Art Gallery, Bradford. In the 1920s she had turned her attention to lithography, studying under Ernest Jackson (1872-1945), and regarded *Marché de Cochons* and *Study of a Child* as

principal works in the medium. In 1921 she exhibited with her husband at the inaugural exhibition of the Society of Graphic Art.

A member of the Society of Mural Decorators and Painters in Tempera, she was said to be the first artist to exhibit a true fresco in the Royal Academy, 1926. Sarah Purser (q.v.) recommended Charlotte Lawrenson for fresco work at the Franciscan Friary, Athlone, and the Rev. A. Milton of the Priest's House, Uckfield, Surrey, wrote in glowing terms of her work and personality, 'very painstaking and humble about her work.' Jackson of the Byam Shaw School stated that she was 'quite definitely in every way capable of carrying out the work proposed…I know of no more conscientious artist that Mrs Lawrenson.' M. Beddington of Ballader's Plat, Winchester, Sussex, wrote of a fresco Mrs Lawrenson had painted for her on an outside wall and praised it very highly. It is no longer in existence.

In a letter the artist stated that hers was pioneering work and that the commission in Athlone would be the first fresco in Ireland. She also said that a fresco well done would last for 4,000 years! Sadly, hers lasted less that thirty years. By 1965, when the sanctuary at St Anthony's Church was being reordered, it was decided that the fresco was in such a poor state that it would be replaced by a mosaic covering the entire apse wall and dome. Later in life she went to live in Kenya. The year of her death has not been found.

Works signed: Charlotte Lawrenson, C. Lawrenson or C.L., monogram.
Examples: Bradford : Cartwright Hall Art Gallery. Brighton: Museum and Art Gallery. Sydney: Art Gallery of New South Wales.
Literature: *The Studio*, January 1926, January 1928, October 1928 (illustration); J. Crampton Walker, *Irish Life and Landscape*, Dublin 1927 (also illustration); *Who's Who in Art*, 1972; *Dictionary of British Artists 1880-1940*, Woodbridge, 1976; *A Dictionary of Contemporary British Artists, 1929*, Woodbridge 1981; Ann M. Stewart, *Royal Hibernian Academy of Arts: Index of Exhibitors 1826-1979*, Dublin 1986; Brighton Museum and Art Gallery, *Letter to the author*, 1988; also, Art Gallery of New South Wales, 1988; City of Bradford Metropolitan Council, 1988; Society of Graphic Fine Art, 1988; Martin Esslin, 1997; Franciscan Friary, Athlone, 1997.

LAWRENSON, EDWARD L. (1868-1940), landscape painter and etcher. Born on 14 March 1868 in Dublin, Edward Louis Lawrenson's instinct for art developed in childhood, and at thirteen years of age he was allowed to begin studying the subject. In due course he entered Trinity College, and as his family traditions were military he was destined for the army. At the annual meeting of the Dublin Sketching Club in 1897 he was appointed a 'working member'. In 1898 he exhibited with the Water Colour Society of Ireland for the first time, giving the address Belleek Manor, Ballina, and up until 1930 showed a total of twenty-two works.

In the Connaught Rangers, whether stationed at home or in the East, he constantly sketched and made efforts to paint. Regimental routine proved ever irksome, and eventually he gave up soldiering, and went to study art in Paris in 1900, first at Colarossi's atelier and afterwards at a small private class directed by Alphonse Mucha (1860-1939), the poster-painter. Next he went to the village of Egmond in Holland where he studied landscape painting with the American, George Hitchcock (1850-1913).

London with his motor-car offered its scenic allurements to brush and pencil. He also painted on the Continent, in France principally, as well as in the English counties. The ancient castle had a fascination for him. The difficulties of a medium he enjoyed, so long as it was likely to give him the effect he aimed at, and he began to paint in tempera. The Pastel Society showed his work.

Lawrenson, a friend of Harold Speed (1872-1957), had a large studio at 20 Holland Park Road, Kensington, and according to Malcolm C. Salaman in an article in *The Studio* of 1911, a special interest, apart from his paintings, attached to him 'for his experimental efforts in the direction of colour-printing copperplates, for which at the Milan International Exhibition of 1906 he was awarded a gold medal. Having learnt the principles and technique of aquatint and line-etching simply from listening to the lectures of Sir Frank Short, he put these into practice, making endless experiments till he got near to the pictorial effects he desired, always with a view to printing his plates in coloured inks …'.

At the fourth salon of Etchings in Colour in Paris, 1907, Lawrenson was represented by *Fabricant de Bouteilles*. In Dublin three years later he explained and demonstrated the processes of aquatint and colour-etching at a loan exhibition of prints, ancient and modern. In 1912 the Society of Graver-Printers in

Colour held their third exhibition in London at Manzi, Joyant & Co. gallery where his *The Incoming Tide* was particularly noted. *Gateway of the House of Rabelais, Chinon*, aquatint, was shown in 1914 at the fifth annual exhibition, at Goupil & Co. galleries. Some years later he was made an honorary member.

Lawrenson lived with his artist wife, Charlotte Lawrenson (q.v.), at Nurney, Hadlow Down, Sussex. A second article by Salaman appeared in *The Studio*, 1914 ('Laurenson' spelt throughout in the first): 'Mr Lawrenson works little with composite tones, and so far he has found a maximum of three plates sufficient for his simple colour-schemes. This number he used (also) for *Kew Bridge From Brentford ...*' A print at this time was *The Irish Kelp Burners*, a coast of Antrim subject which he had also painted in oils. He manipulated, added Salaman, his colours upon his plates 'with more brilliant effects than most of the makers of colour-prints from aquatint-plates, and doubtless that accounts for their exceptional success in America'. The Art Gallery of Ontario's collection includes two aquatints, *Waterloo Bridge* and *The Harvest Moon*.

The British Museum holds eleven coloured aquatints including *The Dublin Bottlemakers*, 1903. Lawrenson exhibited nearly one hundred works of one kind and another in exhibitions at the Fine Art Society, London. At the Royal Academy, between 1907 and 1934, he showed twenty-three works; *The Serpentine* and *Millbank* in 1907, Kerry subjects in 1927 and Achill scenes in 1929, 1930 and 1934. A fairly regular exhibitor at the Royal Hibernian Academy between 1900, then from 24 Herbert Place, Dublin, and 1934, he showed for example in 1911, *The Plain of Normandy*; 1914, *An Oxfordshire Farm*; and 1925, *The Brickmakers*.

In London, his work was also hung at exhibitions of the International Society of Sculptors, Painters, and Gravers, with which Sir John Lavery (q.v.) was so closely connected. His pictures were also displayed at the New English Art Club and the Alpine Club Gallery. Outside of London, he exhibited at the Glasgow Institute of the Fine Arts and the Walker Art Gallery, Liverpool. He was a member of the Southern Society of Artists, and he exhibited at the inaugural exhibition of the Society of Graphic Art in 1921. He showed *The Sogne Fjord* at the 1925 Royal Scottish Academy.

In what he called the Dublin Autumn Salon, Daniel Egan at his gallery, 38 St Stephen's Green, included works by Lawrenson, for example *Loading Turf on the Grand Canal, Dublin* and *A Breezy Day, Sussex*. The Municipal Gallery of Modern Art in Dublin received in 1926 an oil, *Ploughing on the Sussex Downs*, presented by the artist, and in 1927 the exhibition there of works by living British artists included his *Carrying Turf, Achill Island*.

Artists resident in Great Britain, India and the Dominions were represented in an exhibition in 1928 at the Imperial Gallery of Art, South Kensington, Lawrenson and Paul Henry (q.v.) both being included. At the Fine Art Society in the same year there was an exhibition for four Irish artists : J. H. Craig, Crampton Walker (qq.v.), Lawrenson and Henry. Among his exhibits at the 1929 WCSI event were *The Achill Fiddler* and *The Old Bridge, Limerick*.

In the exhibition of Irish art at Brussels in 1930, Lawrenson provided six aquatints, and in that year his design was before the Irish public when the stamp was issued to commemorate the completion of the Shannon Scheme. Commissioned to supply a series of designs for consideration for the new coinage, he concentrated on famous views of Ireland. In the Brighton Museum and Art Gallery is *Moonrise on the Rape of Hastings*, an oil, and his wife is also represented there. He died on 23 December 1940 at Royal Sussex County Hospital.

Works signed : E. L. Lawrenson.
Examples: Brighton: Museum and Art Gallery. Dublin: Hugh Lane Municipal Gallery of Modern Art. Liverpool: Walker Art Gallery. London: British Museum. Manchester: City Art Gallery. Oxford: Lady Margaret Hall. Toronto: Art Gallery of Ontario.
Literature: *Dublin Sketching Club Minute Book*, 1897; *The Studio*, December 1907, January 1911, August 1911 (also illustration), June 1912, July 1913, June 1914, July 1914 (also illustrations), June 1928 (also illustration); J. Crampton Walker, *Irish Life and Landscape*, Dublin 1927 (also illustration); *Register of Deaths, Brighton*, 1940; Department of Posts and Telegraphs, *Letter to the author*, 1968; *Dictionary of British Artists 1880-1940*, Woodbridge 1976; *A Dictionary of Contemporary British Artists, 1929*, Woodbridge 1981; Ann M. Stewart, *Royal Hibernian Academy of Arts: Index of Exhibitors 1826-1979*, Dublin 1986; Art Gallery of Ontario, *Letter to the author*, 1988; also, Brighton Museum and Art Gallery, 1988; Society of Graphic Fine Art, 1988; *Water Colour Society of Ireland Exhibition List 1872-1994*, Dublin 1995.

LAWRENSON, THEODORA – see HARRISON, THEODORA L.

LE JEUNE, JAMES, RHA (1910-83), portrait and landscape painter. Born in Saskatoon, Canada, on 24 May 1910, James George Le Jeune was the son of Anthony Le Jeune, musician, of English and French descent, and an Irish mother. When he was two his family moved to relations in Brittany, where he attended a Christian Brothers' school. He continued his education at a boarding school in England, Aston-le-Walls House, Northants. Early training in art was in Paris, later in London at Heatherley's Academy and the Byam Shaw School, also at the Students' League, New York.

At the London Polytechnic he studied architecture. He served in the British Army in Africa and Italy during the Second World War. Following the end of hostilities, he worked in London as an architect but had not lost interest in painting, and from 17 Dunstan's Road, London W6 he showed *Santa Maria, Maggiore, Rome* at the Royal Institute of Oil Painters in 1948. In the same year he exhibited *Fisherman's Regatta* at the Society of Marine Artists. From the same address he contributed three works to the Royal Scottish Academy in 1950, including *A Café in Dinan*.

In 1950 he moved to Ireland and continued to practise architecture for a while but gave it up to paint full time. In 1951 he began exhibiting at the Royal Hibernian Academy and, with the exception of a few years, was a regular exhibitor until 1982. He continued to send pictures to London and in 1951, from 'Valmar', Sandycove, Co. Dublin, he showed four works at the United Society of Artists: *Studio Critics*; *A Street in the City of London*; *O'Connell Street, Dublin*; and *A Quarry in the Wicklows*. A portrait of Miss Stephanie Wallace at the Royal Society of Portrait Painters annual exhibition showed, said *The Studio*, 'this Irish painter's attractive and subtle use of mixed colour to fine advantage'. The following year, 1953, the magazine described his *York Minster* at the Royal Water-Colour Society galleries as 'gay as a French travel poster'. At the Royal Institute of Oil Painters in 1954 he exhibited *At the Royal Dublin Society*.

Le Jeune's first one-person show was held at the Victor Waddington Galleries, Dublin, in 1954, and the *Dublin Magazine* said he was 'moderately endowed with the academic virtues ... he shows a certain mastery in the handling of crowd scenes, notably in *A Dublin Street* or *At the Dublin Horse Show*; but his palette is undistinguished. His portraits, or rather in this case a curious portrait-painter's treatment of genre are workmanlike and effective ...'. In the period 1955-59 he showed six works at the Water Colour Society of Ireland exhibitions, including two Annecy subjects.

On his exhibition of oil paintings and watercolours at the Little Theatre, Brown Thomas, in 1956, the *Dublin Magazine* commented: 'This artist's palette in landscape is inclined to be over-sombre; in his portraits, on the other hand, his low tones give depth and background, and his subjects are almost startling in their truth and reality – seen with a touch of humour which stops short of caricature'. In 1958 he gave his address as 76 Upper Leeson Street, Dublin.

In 1961, by which time he had a studio at 38 Baggot Lane, Dublin, he was appointed an associate of the RHA but did not become a full member until 1973. Some of his best work is said to be in the USA, where he painted. Among his portraits in Dublin are: May Craig at the Abbey Theatre; Major-General P. A. Mulcahy at McKee Barracks; Chief Justice Thomas O'Higgins at King's Inns; and Jimmy O'Dea, the comedian, at the National Gallery of Ireland. A self-portrait is at the University of Limerick. After suffering from a heart attack, he died in a nursing home in Blackrock, Co. Dublin, on 29 January 1983; his home was at Delgany, Co. Wicklow. In 1983 a small retrospective exhibition was held at the United Arts Club, Dublin.

Works signed: Le Jeune.
Examples: Bunratty, Co. Clare: Castle. Cork: Crawford Municipal Art Gallery. Dublin: Abbey Theatre; Irish Writers' Centre; King's Inns; McKee Barracks; Masonic Hall, Molesworth Street; National Gallery of Ireland; United Arts Club. Dun Laoghaire, Co. Dublin: Royal St George Yacht Club. Limerick: University, National Self-Portrait Collection. Portmarnock, Co. Dublin: Golf Club.
Literature: *The Studio*, February 1952, November 1953; *Dublin Magazine*, July-September 1954, October-December 1956; *Who's Who in Art*, 1980; *Irish Times*, 31 January 1983, 2 February 1983; Ann M. Stewart, *Royal Hibernian Academy of Arts: Index of Exhibitors 1826-1979*, Dublin 1986; National Institute for Higher Education, Limerick, *The National Self-Portrait Collection*, catalogue two, Limerick n.d.; Mrs P. Le Jeune, *Letter to the author*, 1988; *The Royal*

Scottish Academy Exhibitors 1826-1990, Calne 1991; *WaterColour Society of Ireland Exhibition List 1872-1994*, Dublin 1995.

LEECH, WILLIAM J., RHA (1881-1968), landscape and portrait painter. William John Leech, son of Professor Henry Brougham Leech, former Chief Registrar of Deeds for Ireland and Regius Professor of Law at Trinity College, Dublin, was born on 10 April 1881 at 49 Rutland (now Parnell) Square, Dublin. He was educated partly by private tutors and from 1893-7 at St Columba's College, Rathfarnham, Co. Dublin, where he showed early artistic promise. His education continued under private tutors in Switzerland. In a family of six, he had four brothers.

In 1899 he exhibited his first picture at the Royal Hibernian Academy, *Lake Brienz before a storm*. In 1898 he had returned to the family home at Yew Park, Castle Avenue, Clontarf, and then studied for a year at the Dublin Metropolitan School of Art where he was disappointed with the tuition. Transferring to the Royal Hibernian Academy Schools, he stayed there for two years and came under the influence of Walter F. Osborne (q.v.), who, he said, taught him 'everything I needed to know'. In 1901, however, he moved to Paris, his father having given him a small allowance, and there he met a lifelong friend, Sydney Thompson (1877-1973), a painter from New Zealand. Among the teachers at the Académie Julian was Jean-Paul Laurens (1838-1921). In 1903 Leech exhibited at the RHA from Paris: *Alone* and *A glimpse of Notre Dame*.

In 1902, 1903 and 1904 he won four Taylor prizes, totalling £30, and in 1905 and again in 1906 he secured the £50 Taylor Scholarship for *A Lesson on the Violin* and *The Toilet* respectively, being described as a student at Concarneau, Finistère, France. In 1906 he returned to Dublin from Brittany and was represented in the 'Munster-Connacht' exhibition in Limerick. In 1907 he exhibited with Casimir Dunin Markiewicz, Constance Gore-Booth (qq.v.), another ex-student from Julian's; G. W. Russell and Percy F. Gethin (qq.v.) at the Leinster Lecture Hall, Dublin. The *Irish Times* commented: 'This is the first time that a collected exhibition of Mr Leech's work has been shown in Dublin ... revelation of a very charming personality. With the exception of a few more important works, the majority of Mr Leech's pictures are small sketches done direct from nature *en plein air* ...'.

Leech was appointed an associate of the RHA in 1907, and in 1910 a full member. In 1907 he showed at the Irish International Exhibition in Dublin. At the Leinster Lecture Hall in 1908 he exhibited again in a group exhibition, Dermod O'Brien (q.v.) replacing Gethin. In 1909 his fellow exhibitors were Frances Baker, Markiewicz, Gore-Booth and Russell; and in 1910, Beatrice Elvery (q.v.), Eli Delbert Maybee, Gethin, Baker and Russell.

In Brittany, Leech depicted a number of interiors of kitchens, cafés and the like. *The Green Room – Interior of a Café* was dated 1908, and his address was Hôtel des Voyageurs, Concarneau. *A still afternoon, Concarneau* is at the National Gallery of Ireland. By 1909 he was a member of the Royal Institute of Oil Painters; in that year's exhibition his works included *The Black Scarf* and *La Toilette*. He resigned from the Institute a few years later.

Leech, who was an admirer of the work of Paul Cézanne (1839-1906), exhibited in 1910 at the first exhibition organised by students of the Dublin Metropolitan School of Art, limited to present students and those who had received their training in Kildare Street 'during the past ten years'. *The Studio* reported that Leech exhibited a group of a dozen pictures which were the most conspicuous feature of the exhibition. He had 'divined the secret of transferring the largeness of nature direct to canvas, and his treatment of sea is exceptionally good'. In 1910 he and his parents moved to London, where he missed no opportunity of attending exhibitions.

Although little was seen of him in Ireland after 1910, Leech was a faithful exhibitor at the RHA and in a period of sixty-eight years he missed only ten exhibitions, sending in sometimes as many as eight works to a show. At the Baillie Gallery, London, in 1911 he held a joint exhibition with William A. Wildman (1882-1950). *The Studio* wrote that the Leech paintings 'greatly advance the reputation of this interesting painter'. *Piazza San Marco* was hung in 1911 at the Royal Institute of Oil Painters exhibition, and in the same year at the Goupil Gallery Salon, *The White Bridge, Venice*; also he was represented at the Sketch

Society's second exhibition. In 1911 he had visited Switzerland and Italy. His marriage in 1912 was to Saurin Elizabeth Kerlin, a painter.

In 1912 the Goupil Gallery showed forty-one pictures under the title 'Visions of Switzerland, Venice, etc.' A review in *The Times* referred to Leech as 'an artist who aims at vivid illusion by means of that process of elimination which was practised by Whistler'. In Dublin, the *Irish Review* commented on the RHA for that year : 'There was a time when one expected great things from Mr Leech, but now he seems to have "settled down", mastered by melancholy moods and a desire for brush patterns. It is strange that with a fine capacity for design and a power for harmony there is hardly a suggestion of light or air in any of the eight pictures'. His address was then 55 Castletown Road, West Kensington.

Represented in a special exhibition of Irish art at the Whitechapel Art Gallery, London, in 1913, his portrait of Lieut. C. J. F. Leech was included that year in a loan exhibition of modern paintings at the Belfast Museum and Art Gallery. This is presumably the work which he showed at the 1910 Royal Academy, where he contributed only seven other pictures. Financial success continued to elude him.

Leech won a bronze medal in 1914 at the Paris Salon with *Le Café des Artistes-Concarneau*. On the 1915 RHA exhibition, *The Studio* commented : 'Mr Leech, one of the younger Academicians and the latest member of the National Portrait Society, has sent his beautiful portrait of a lady in rose and grey which was shown at last year's Royal Academy, as well as several landscapes in which his sense of finely modulated tonal harmonies is expressed with a delicate precision.'

In addition to the RA, his work was also hung in London at exhibitions of the International Society of Sculptors, Painters, and Gravers; the New English Art Club, London Salon, and the Royal Society of Portrait Painters. Several English provincial galleries also showed his pictures, notably Derby Museum and Art Gallery. In 1917 he spent the winter with Sydney Thompson at Martiques, near Marseilles.

A visit to North Africa was noted by the titles of at least three works at the 1921 RHA, including *Hammamet, Tunisie*. The 1920s saw his only piece of sculpture, *May*, a head; a bronze and the plaster are at the National Gallery of Ireland, also a bronze at the Ulster Museum. In 1922 he was represented by three works at the exhibition of Irish art at Galeries Barbazanges, Paris. He was represented in the Irish art exhibition at Venice in 1926.

In 1927 he showed paintings and drawings at the Cooling Galleries, London, and was represented in the Dublin Civic Week art exhibition as well as the New Irish Salon. By 1928 his address was 4 Steele's Studios, Haverstock Hill, London NW3, where C. R. W. Nevinson (1889-1946) had a neighbouring studio. When the exhibition of Irish art was held at Brussels in 1930 he was represented. At this point in his career he listed as his principal works: *The Pot of Daisies*; *A Dramatic Critic*; and *La Cimetière St Jeannet*.

Leech exhibited at the RHA 1930-40 inclusive. The Royal Horticultural and Arboricultural Society of Ireland held its first exhibition of flower and garden pictures in Dublin in 1934 and he was represented. His work also appeared in a centennial exhibition of British and European Art in 1939 in the National Art Gallery, Wellington, New Zealand. 'British Painting since Whistler', an exhibition at the Royal Academy in 1940, included Leech. At the RA exhibition that year he showed *The Christmas Tree*. Steele's Studios were damaged by air raids in 1941. He supported the Irish Exhibition of Living Art in 1945 with three works, including *Entrance to the Casino, Grasse*, and in the period 1945-52 he showed sixteen pictures at Oireachtas exhibitions.

Despite various restrictions, the new Dawson Gallery in Dublin managed to arrange a one-person exhibition in 1945. The *Dublin Magazine* said his most pleasant pictures 'are those corners of landscapes in which gates and haystacks are painted with quiet feeling. His sense of colour saves even a conventional theme like *Flowers and a Mirror* from banality. Most delightful of all is a brilliant little canvas, *The Market, Concarneau*, in which sunlight through trees is painted with sheer love of light and in which patches of vivid scarlet almost sing'. Other one-person shows at the same gallery followed in 1947, 1951, when he showed *The Lake, Regent's Park*, and in 1953 he combined with Frances Kelly and Evie Hone (q.v.). An address, 30 Abbey Road, London, was given when he showed at the Contemporary Irish Art exhibition at Aberystwyth in 1953.

For the greater part of his life Leech made the frames for his own pictures. He admitted that for years he had been something of a recluse, suffering under the delusion that the painter's function was merely to paint, and that if the work was good enough, it would sell in the end. Life had since taught him that to be shy and retiring was not necessarily the best way to make a reputation and a living. Alan Denson, a friend who made a close study of the artist's career and published his introductory guide in 1968, found he had a 'quietly observant manner, absorbent, intent ... His social manner unaffectedly charming, sincere, restrained by a fine sense of respect for others' individuality ...'.

Works in the NGI collection during an artist's lifetime was a rare distinction: *Convent Garden, Brittany* and *The Sunshade* both being popular. In that collection there are also three works in charcoal and watercolour. *Un Matin, Waving Things, Concarneau* is in the Hugh Lane Municipal Gallery of Modern Art. Self-portraits are at NGI, the Ulster Museum and the University of Limerick. *The Barber's Shop* is one of three oil paintings at the Crawford Municipal Art Gallery, Cork.

The artist's second marriage was in 1953 to Mrs May Botterell, a lifelong friend, and from 1958 they lived at Candy Cottage, West Clandon, Surrey, where he built a studio. She died in 1965. After a fall from the parapet of a road bridge near his home on to the railway line, W. J. Leech died on 16 July 1968 at the Royal Surrey County Hospital. A girl who witnessed the accident said at the inquest that he fell backwards after sitting on the bridge swinging his legs backwards and forwards. She ran to his assistance, but heard a train coming and ran back to halt it. The remains were cremated at St John's Crematorium, Woking.

In 1981, *Railway Embankment*, an oil painting from the Ulster Museum collection, was reproduced on a Republic of Ireland stamp. A retrospective exhibition took place at NGI in 1996 and then moved to Musée des Beaux-Arts, Quimper, Brittany, 1997, followed by the Ulster Museum. The exhibition was accompanied by the book, *William John Leech: An Irish Painter Abroad*, with illustrations of works in colour, by Denise Ferran, who comprehensively documented the somewhat reclusive life of the artist.

Works signed: Leech or W.J. Leech, rare.
Examples: Belfast: Ulster Museum. Clonmel: South Tipperary County Museum and Art Gallery. Cork: Crawford Municipal Art Gallery. Drogheda, Co. Louth: Library, Municipal Centre. Dublin: Hugh Lane Municipal Gallery of Modern Art; National Gallery of Ireland; Office of Public Works. Kilkenny: Art Gallery Society. Limerick: City Gallery of Art; County Library; University, National Self-Portrait Collection. Manchester: City Art Gallery. Sligo: Model and Niland Centre. Waterford: City Hall, Municipal Art Collection. Wellington, New Zealand: National Art Gallery.
Literature: *Royal Dublin Society Report of the Council*, 1905, 1906; *The Studio*, March 1910, February 1911, March 1911, November 1911, December 1911, May 1915; *Irish Review*, April 1912; *The Times*, 20 April 1912; J. Crampton Walker, *Irish Life and Landscape*, Dublin 1927 (illustration); *Dublin Magazine*, July-September 1945; *Irish Times*, 18 and 28 July 1968, 5 August 1977, 1 September 1977, 19 August 1981; Alan Denson, *An Irish Artist, W. J. Leech, RHA*, Kendal 1968 (also illustrations); *Surrey Advertiser*, 20 July 1968; Alan Denson, *John Hughes Sculptor 1865-1941*, Kendal 1969; Alan Denson, *Capuchin Annual*, 1974; *A Dictionary of Contemporary British Artists, 1929,* Woodbridge 1981; Julian Campbell: National Gallery of Ireland, *The Irish Impressionists: Irish Artists in France and Belgium 1850-1914*, catalogue, Dublin 1984 (also illustrations); Ann M. Stewart, *Royal Hibernian Academy of Arts: Index of Exhibitors 1826-1979*, Dublin 1986; *St Columba's College 150th Anniversary Exhibition*, catalogue, Dublin 1993; Denise Ferran, *William John Leech: An Irish Painter Abroad*, London 1996 (also illustrations); Ann M. Stewart, *Irish Art Societies and Sketching Clubs: Index of Exhibitors 1870-1980*, Dublin 1997.

LEIGH, ROSE J. (1844-1920), landscape painter and etcher. Of Rosegarland, Co. Wexford, where the Leighs had settled in the seventeenth century, she was the daughter of F. A. Leigh, DL, and her mother was from Metz, France. She first exhibited at the Royal Hibernian Academy in 1883, sending from 15 Rue Leopold, Antwerp: *An Autumn Morning* and *Evening in the Moors, Flanders*, and she was still in Belgium in 1884-5, but in 1889 she was back in Co. Wexford, if not before. When the Dublin Art Club issued a portfolio of etchings in 1890, she was one of the artists involved. The British Museum holds a set.

In 1893 she showed the first of half a dozen works at the Royal Academy, *By the lake: autumn*, and by the following year she had presumably moved to London, at 174 Fulham Road, one of several addresses which she was to have in that city. Her work at the RHA in 1892 and 1893 included Cornish scenes.

In 1896 at 175 New Bond Street, London, she had a joint exhibition with a Miss Mabel Young and showed thirty-eight works including: *In the Meadows,Zealand:Summer*; *April Sunset: The Dyke, Zealand*; *November Twilight:Flanders*; *In Epping Forest: November*.

In the late 1890s she shared accommodation in Paris with Constance Gore-Booth (q.v.) and a sculptor, Elizabeth Scott Bell. In 1910 her address was 3 Stanley Studios, Park Walk, Chelsea, and at the RHA exhibition a Co. Cork estuary was among her subjects. Altogether, more than thirty works were exhibited in Dublin, the last in 1917.

Most of Rose Leigh's work was hung in English exhibitions, attracting a USA following. In addition to Burlington House, she also showed at the Walker Art Gallery, Liverpool; the London Salon, Royal Society of Artists, Birmingham; the Manchester City Art Gallery and other exhibitions. Of 39 Heyford Avenue, South Lambeth, London, she died at 126 Brook Street, on 6 January 1920.

Worked signed: R. J. Leigh.
Examples: London: British Museum.
Literature: General Register Office, London, *Register of Deaths*, 1920; *Dictionary of British Artists 1880-1940*, Woodbridge 1976; Ann M. Stewart, *Royal Hibernian Academy of Arts: Index of Exhibitors 1826-1979*, Dublin 1986; Francis Leigh, *Letters to the author*, 1988.

LESLIE, SIR JOHN, HRHA (1822-1916), painter of portraits and figure subjects. Son of Col. Charles P. Leslie, MP, of Glaslough, Co. Monaghan, he was born there on 16 December 1822, lineally descended from John Leslie, Bishop of Clogher, known as the 'Fighting Bishop', who founded in Ireland a branch of the Scottish Leslies, buying Glaslough Castle in 1665. However, Sir John, the first baronet, had a 'gentle, tolerant nature, which never took or gave offence'. After attending a school at Dedham, Essex, he went to Harrow from Glaslough in 1834. Riding on top of a coach, without an overcoat, the journey on occasions took anything from three days to a week in snowy weather.

After studying at Christ Church, Oxford, he served as a captain in the Life Guards. When still in the regiment, an amusing incident occurred owing to his close knowledge of the technique of Sir Edwin Landseer (1803-73). A fellow officer owned and prized a stag drawn by Landseer. For this artistic feeling he was much chaffed by other officers who stole the original and persuaded Leslie to replace it by a copy. Unfortunately, the copy was good enough to deceive the owner, who refused to exchange it even when the joke had been explained to him. In 1847 Leslie went on a grand tour, visiting Seville, Madrid, Frankfurt, Rome, Egypt, Paris, and three years later he left the army to devote himself to art.

Leslie journeyed to Dusseldorf in 1851 and studied intermittently under K. F. Sohn (1805-67), painting his first picture in the Black Forest – a study of children being shown a crucifix – and *Children – they have nailed Him to the Cross* was placed on the line at the Royal Academy of 1853, the year he returned to England. He received a flattering letter about the work from the Prince Consort. This picture, sometimes called *Children, Christ died for you*, hangs in the dining-room at Castle Leslie. The artist exhibited twelve other works at the RA until 1867, mostly portraits of titled sitters, including those of Lady Wharncliffe and Countess Spencer. For some portraits, he did not accept fees. In 1856 he showed *Near Rome. 'Beati i poveri, il Regno dei cieli e loro'*. The Grosvenor Gallery, London, the British Institution and the Paris Salon also showed his work.

A good fencer and cricketer – he became the doyen of the MCC – he hunted at Melton in its palmy days, with his great friend Lord Bradford, then Lord Newport. The walls of Newport Lodge, Melton, bore a fresco with the title, *A Fast Forty Minutes the Vale of Belvoir, 1853*, painted by Sir John, in which appeared hunting celebrities of the day. The lodge has since been demolished. In 1854-5 he was in Dusseldorf and Rome, and finished *A Monk Preaching to Campagna Peasants*.

Prior to his marriage to Lady Constance Damer in 1856, he took his fiancée to visit his friend, G. F. Watts (1817-1904); Thackeray, whom Leslie knew, was also present at the studio. He was also a friend of Charles Dickens and Holman Hunt (1827-1910). The latter has recorded *c.* 1860 that in the lane leading to Holland

Park 'stood the house which had belonged to the Marquis of Bute, and which was now tenanted by the amateur painter, Sir John Leslie ...'.

Regarded as the closest friend of Landseer, Leslie saw him through all the public disputes which followed the appearance of his lions in Trafalgar Square. The pre-Raphaelite, Sir John Everett Millais (1829-96) also knew him. Art was the devotion of Leslie's life and he was acknowledged by Lord Frederic Leighton (1830-96) to be an admirable critic. His grandson, Shane Leslie, had recorded: 'He could paint perfect little oil portraits of lady friends and like Charlotte Brontë he had admired Rachel and there were sketches of her in the family scrap-book ... his pencil saved amusing snaps of such Victorians as Lord Wilton, whose fingers touched the organ as lightly as the reins, Dean Guisford and Lord Blandford (Winston's grandfather)...'.

An accomplished watercolourist, he quarrelled with John Ruskin (1819-1900) over the watercolours of his friend, Lady Waterford (1818-91). The professional Ruskin had tried to improve her drawing – it was a mistake. In 1862 one of Leslie's pictures was shown at the Paris Exhibition, and in 1872 he was appointed an honorary member of the Royal Hibernian Academy. Created a baronet in 1876, he was MP for Co. Monaghan 1871-80.

In 1898 he completed a series of frescoes – *Christ as Healer* – for the chapel of Berkhamsted School in Hertfordshire but these no longer exist. Family caricatures and sketches of neighbours and dependants enlivened his artistic activity, and he worked on a decorative scheme at Castle Leslie, for example the four arches and pillars in the Long Gallery. At Torosay Castle, Isle of Mull, is *Roman Compagna*, 1.4m by 2.4m; it has no easily identifiable signature. However, in the bottom righthand corner is a small brown dog, which by tradition was his personal mark. Also at Torosay is a full length portrait of the artist's wife – and again the little brown dog is included.

In 1904 he was represented by a portrait, *Lady Constance Leslie*, in the exhibition of works by Irish artists held at the Guildhall of the Corporation of London and organised by Hugh P. Lane. In 1906 he donated to the Belfast Museum and Art Gallery *St Peter Denying Christ*, a large oil painting which was believed to have hung at one time in the Oldpark Branch Library, Belfast. As it has now disappeared, it will not be possible to check if St Peter had eleven toes, as claimed by a grandson. However, John Hewitt described it as 'a bit pompous but highly competent'. *The Times* noted that he was 'beautiful in his old age with his white locks and fresh complexion'.

Sir John Leslie died on 23 January 1916 at his London residence, 22 Manchester Square, and was buried at Glaslough. He was succeeded in the baronetcy by Col. Sir John Leslie (1857-1944), who was also artistically inclined. Between 1926 and 1937 the second Sir John contributed six works to the RHA exhibitions, including a self-portrait in 1934, and his watercolour of the Tynan Hunt, 1880, is in the Armagh County Museum.

Works signed: J. L. (if signed at all).
Examples: Glaslough, Co. Monaghan: Castle Leslie. Isle of Mull, Argyll: Torosay Castle.
Literature: Algernon Graves, *A Dictionary of Artists*, London 1901; *Belfast Museum and Art Gallery Quarterly Notes*, December 1908; Robert M. Young, *Belfast and Province of Ulster in the 20th Century*, Brighton 1909; W. Holman-Hunt, *Pre-Raphaelitism and the Pre-Raphaelite Brotherhood*, London 1913; Seymour Leslie, *Of Glaslough in the Kingdom of Oriel and of the noted Men that have dwelt there*, Glaslough 1913; W. G. Strickland, *A Dictionary of Irish Artists*, Dublin 1913; *Belfast News-letter*, 25 January 1916; Shane Leslie, *The End of a Chapter*, London 1916; *The Times*, 25 January 1916; Ronald Chapman, *The Laurel and the Thorn: A Study of G. F. Watts*, London 1945; Shane Leslie, *Long Shadows*, London 1966; John Hewitt, *Letter to the author*, 1967; Seymour Leslie, *Letter to the author*, 1972; Anne Crookshank and the Knight of Glin, *The Painters of Ireland c. 1660-1920*, London 1978 (illustration); Berkhamsted School, *Letter to the author*, 1988; also, Mrs J. Holmes, 1988; Desmond Leslie, 1988; Torosay Castle and Gardens, 1988; Anne Crookshank and the Knight of Glin, *The Watercolours of Ireland*, London 1994 (illustration).

LEX – see MOYNAN, RICHARD T.

LILLEY, H.R. (1886-1970), landscape painter, printmaker and designer. Born in Belfast on 28 October 1886, Herbert Robert Lilley joined in 1901 the Belfast firm of Robert McBride and Co. Ltd., linen manufacturers,

as an apprentice designer. He entered the Belfast School of Art in 1902. He won the Dunville Scholarship and left McBride's to study at the Royal College of Art, London. He won a prize in the National Competition of 1907 for a damask napkin design. At the age of twenty-one he began making holiday trips abroad to sketch and paint.

In 1909 he undertook a series of scientific illustrations for the Belfast Naturalists Field Club on boulder clays. A paper by Joseph Wright, which Lilley illustrated, was seen by members of the Royal Microscopical Society, London, and he was appointed to illustrate a number of their journals, depicting fossils found in Sussex. The Society sent him a microscope to facilitate the highly detailed work.

A member of the Ulster Arts Club in 1909, he was an occasional lecturer and teacher at the Belfast School of Art. In 1912 he began exhibiting at the Ulster Arts Club exhibitions, and in their 1914 show he was represented by two oil paintings, including *Morning in the Pyrenees*; four watercolours, *In the Basque Country* was one; and four etchings, including *Porte de l'Eglise, Fuenterrabia*. The Basque city was also the subject of an etching at the 1914 Royal Hibernian Academy when his address was 65 Weirville Terrace, Bloomfield, Belfast. A watercolour at the Ulster Museum, *Quai St Pierre, Bruges*, was dated 1914. In August 1914, when painting abroad, he left Belgium on his bicycle as German forces invaded the country.

In the period 1915-20 he showed five works at the Royal Scottish Academy, including two Bruges subjects; and in 1918, *The Rock of Cashel* and *St Colman's Cathedral, Queenstown*. In the 1917 Arts and Crafts Society of Ireland exhibition, which was held in Dublin, Belfast and Cork, he showed four lithographs, including *La Porte Marechal, Bruges*; his studio address was 32 Wellington Place, Belfast. Canal and houses was the subject of another Bruges lithograph. He was represented in the loan exhibition of oil paintings and early British watercolours at the Belfast Museum and Art Gallery in 1920. Altogether, he showed some two score works at the RHA, including *Twilight at Michael Mooney's* in his last year, 1922.

In the Ulster Pavilion at the British Empire Exhibition in London in 1924 he was represented in the black and white section. He exhibited at the Ulster Arts Club in 1925, and two years later he presented his copperplate press for use at the club by members. Some of his etchings were displayed for sale in 1926 by the Irish Decorative Art Association Ltd at 35 Wellington Place.

As chief designer for McBride's during the 1920s he travelled to France and Switzerland. The firm went into liquidation in 1931, and he obtained a studio at 33 Howard Street as a freelance designer. After the War he joined Thomas Somerset & Co. as head designer.

In Ireland, in pursuit of subjects for his painting, he journeyed as far as Cork, Donegal and Tipperary. Armagh city, Ballycastle (Co. Antrim), Bangor, Cashel and Cobh Cathedral all figured in his etchings. Outside of Ireland, he also exhibited at the Walker Art Gallery, Liverpool, and Glasgow Institute of the Fine Arts, but in the last forty-five years of his life he virtually gave up exhibiting.

In 1967 he donated to the Ulster Folk and Transport Museum around fifty examples of his work in the design of embroidered linen handkerchiefs. In addition, more than twenty years later, his daughter, Mrs Kathleen Rankin, gave many rough drawings, finished designs, notes on production and so on. He died in Belfast on 20 April 1970. An exhibition on his life and work was held at the Folk and Transport Museum in 1999-2000.

Works signed: H. R. Lilley or Herbert R. Lilley.
Examples: Belfast: Ulster Museum. Cultra, Co. Down: Ulster Folk and Transport Museum.
Literature: The Municipal Technical Institute, *Prospectus 1907-1908*, Belfast 1907 (illustration); *Belfast and Province of Ulster Directory, 1913*; Irish Decorative Art Association, Ltd, *Letter to H. R. Lilley*, 1926; *Dictionary of British Artists 1880-1940*, Woodbridge 1976; Ann M. Stewart, *Royal Hibernian Academy of Arts: Index of Exhibitors 1826-1979*, Dublin 1986; Mrs Kathleen Rankin, *Letter to the author*, 1988; *The Royal Scottish Academy Exhibitors 1826-1990*, Calne 1991; H.J. Bruce, *H.R. Lilley Artist & Designer*, Cultra [1997] (also illustrations); *Artslink*, Belfast, April 1999.

LONG, RICHARD J. (1887-1960), portrait and landscape painter. Richard Joseph Long was born on 13 September 1887 at 15 Friar Street, Cork, son of a cabinetmaker, Thomas Long. The Longs came of a long line of master cabinetmakers and had a furniture making business in Cork city. The family moved to Dublin

where Thomas Long became works manager with the cabinetmakers, Robert Strahan and Co., 24 Henry Street, and son Richard served his time there after attending the Christian Brothers' Schools, Westland Row.

Whilst working at his trade, he studied art in the Dublin Metropolitan School of Art evening classes. As a boy, he so often haunted the National Gallery of Ireland that his frequent presence there attracted the interest of another regular visitor who having questioned him and learned of his wish to become a painter, gave him a sovereign to buy his first box of watercolours. The kind donor was (Sir) Hugh Lane.

During his art apprenticeship he also attended the Royal Hibernian Academy Schools. He won a number of awards, including the Department's prize for the 'highest number of points obtained in one Session in five subjects.' In the 1912 Taylor Art Competition he won first prize value £10 for a picture in watercolours, and another £10 for a work in oils. An early commission was a series of mural panels showing historical Irish celebrities for the hall of the Ancient Order of Hibernians, Rutland Square, Dublin.

Eventually he left the carpentry behind and took out his certificate as an art teacher. Subsequently he worked as an artist with Cogan and Tierney, artists, 14 Westmoreland Street, Dublin. However, in 1912 he took up his first teaching appointment, at City of Galway Technical Institute, where he had complete charge of the art classes. He also conducted at Galway Grammar School special classes for National School teachers; and at St Mary's College he acted as drawing master for two years. In 1914, from 1 High Street, Galway, he showed two works at the Royal Hibernian Academy: *Samuel Anderson, Esq., L.D.S., Galway,* and *Reflections*; the latter, a riverside scene with children, was reproduced in the *Irish Review*, July 1912.

Long was appointed art master at Clonmel Technical School in 1914. At the 1924 Aonach Tailteann in Dublin he won a bronze medal, designed by Oliver Sheppard (q.v.), for his firescreen in wood inlay depicting the death of Cuchulain. Economic recession caused cutbacks in education and the Technical School art department closed down. Fortunately for Long, his dual qualification as a cabinetmaker enabled him to take up an appointment as woodwork instructor at Athy Technical School, Co. Kildare, in 1929. He remained there for two years. In a personal memorandum, he wrote: 'I left due to the fact there was an awful unfriendliness between Protestants and Catholics. One sect occupied one side of room, the other section the other side. If I was giving instructions to a Protestant, a Catholic would call me and *vice versa.* No wonder I cleared out'.

Long resumed as an art master in Co. Tipperary at Clonmel Technical School immediately after he departed from Athy, serving until retirement. He was the key individual in the foundation in the early 1940s of the South Tipperary Fine Arts Club, which, in addition to the shows by local artists, organised exhibitions in which leading Irish artists participated, including his friend, Charles Lamb (q.v.), who lived for a time in Clonmel. As a consequence of the latter exhibitions, Long mooted the idea of establishing a permanent art collection and gallery in Clonmel. He also organised national children's art exhibitions.

South Tipperary County Museum and Art Gallery has two works by Long: *A County Dublin Lane*, lithograph, and a full length portrait in oils of the artist's wife to be, Mary Roche, painted on the occasion of their engagement. He died on 19 September 1960 at his home, 1 O'Rahilly Avenue, Clonmel.

Works signed: R. J. Long or Long.
Examples: Clonmel: South Tipperary County Museum and Art Gallery.
Literature: *Register of Births, Cork*, 1887; *Irish Review*, July 1912 (illustration); *Thom's Official Directory*, 1912; *Application of Richard Joseph Long for position of Art Teacher in Clonmel Technical School, 1914*, mss; Miss Molly Bracken, *Letter to the author*, 1978; Brendan Long, *Letters to the author*, 1998.

LUKE, JOHN, RUA (1906-75), painter of landscape and figure subjects. Born in Belfast on 16 January 1906, the son of James Luke, boilerman, formerly of Ahoghill, Co. Antrim, he had six brothers and one sister. After attending Hillman Street National School, he worked as a riveter's boy at the shipyards, Workman, Clark and Co. Ltd, where he had an accident and fractured his leg. His next employment was with York Street Flax Spinning Co. Ltd, and there he heard by chance of the School of Art.

In boyhood he had painted King William on a gable wall in the approved manner. In 1923 he enrolled at the Belfast School of Art for evening classes and became a full-time student for the 1925-6 session. He was awarded the Sorella scholarship for 1926-7. In 1926 or 1927 he painted a portrait of his sister Sadie, who

was a schoolgirl at the time; it is in the collection of Newtownabbey Borough Council. During his time at the School of Art he did some teaching. In 1927 he entered for the Taylor art competition sponsored by the Royal Dublin Society, winning a £10 prize for a modelled design for a newel post. The local Dunville award of £100 per annum for three sessions took him to London in 1927.

At the Slade School of Fine Art he studied under Professor Henry Tonks (1862-1937), and won the Robert Ross scholarship. The sculptor, F. E. McWilliam (1909-92), was at the Slade with him, and for a time shared his studio with Luke and watched him spend an hour every morning at his ablutions: 'It wasn't just his shaving, he would spend ages stropping his cut-throat razor until it was perfect, and afterwards a similar process. He was meticulous in everything, very tidy, my end of the room was a shambles by comparison'.

Luke, whose self-portrait of 1928 is now in the Ulster Museum, exhibited at the Redfern Galleries, London, in 1930, and in that year and 1931 he was represented in exhibitions of contemporary British art at the Leger Galleries. Another striking self-portrait when at the Slade was *The Tipster*, 1928. His subsidiary subject at the Slade was sculpture under A. H. Gerrard, who declared in his testimonial: 'He was an extremely hard and patient worker and made rapid progress. He has an exceptionally clear idea of construction. He has carried out some excellent works. He has unlimited working ability ...'.

Luke took a major part in the painting of a mural for the travel office of Darnborough Ltd in Piccadilly; the fee may have financed a visit to Paris. In the session 1930-31 he was a part-time evening student at the Westminster School of Art under Walter Bayes (1869-1956), and in January he was represented in a students' exhibition at Heal and Son Ltd. He returned to Belfast at the end of the year.

Technical experiments were made in his search for luminosity, landscape became his principal interest, and a decorative formalism was dominant. His *Carnival* of 1930, with its illusion of spontaneity, bore no relation to later works. In 1933 he exhibited with the short-lived Northern Ireland Guild of Artists. In 1934 he was represented in the Ulster Unit exhibition held at Locksley Hall, Belfast, with *County Down*, tempera, an imaginary composition, also three 1934 oil paintings: *MacArt's Fort*; *Connswater Bridge* (Queen's University); and one of his rare flowerpieces, *The Lustre Jug* (Ulster Museum); also two linocuts, *The Dead Tree* and *Shaw's Bridge*. The catalogue stated the artist's objects: 'to arrange and represent in a personal and orderly manner the spatial relations of forms and masses as perceived in nature or imagination; to select or impose colour relations, resulting to my mind in an aesthetically satisfying work'.

Sculptures were few. His *St Patrick*, plaster, was modelled in 1933, the year he began to exhibit at the Magee Gallery, Belfast. Luke joined his friend Alan Stewart on cycling trips, and in 1935 they were on Achill island where Luke met Paul Henry (q.v.). In his *Geranium and Book* of that year he placed his signature and date on the book cover. A crayon drawing of Charles W. Harvey (q.v.) was dated 1936. *Sunset over Lough Neagh*, also 1936, was in distemper. *The Fox*, 1937, presented by the Thomas Haverty Trust to the Belfast Museum and Art Gallery, was in the decorative and rhythmical style. He showed only a few works at the Royal Hibernian Academy, the first in 1937, the year he visited Paris again, this time with fellow artists Harvey and Nevill Johnson (q.v.). Harvey was annoyed that Luke painted only one picture. When Dr Alexander Irvine visited Belfast in 1938, Luke's portrait, now in the Ulster Museum, was in tempera.

Early in 1938 Luke had been assisting on the panels, each 1.2m by 3m, for the frieze at the Ulster Pavilion, Glasgow Empire Exhibition. Responsible for twelve of the fifteen panels, his theme was Engineering. Representing Northern Ireland, he participated in the Exhibition of the Art of Seventy-Nine Countries at the New York World's Fair, 1939.

Luke stopped painting with the advent of the Second World War although two stone pieces of sculpture, now in the UM, are both credited with a *c.* 1940 date: head of a woman in profile, relief, and *Seraph*, head. After the Easter air raids on Belfast in 1941 he left the city with his mother to stay in the steward's cottage at a farm, Knappagh House, Killylea, Co. Armagh. Johnson – Luke was his original teacher – was also given accommodation by Major Paul Terris at Knappagh. Shortly afterwards, Luke obtained employment as part-time art teacher at Manor House School, Milford, Co. Armagh.

Pax, oil and tempera, a rural scene with house, river and rowing boat, appeared in 1943, the first painting since *Shaw's Bridge* in 1939. At the Belfast Museum and Art Gallery in 1946 his first one-person show was

held. Luke's work was practically unknown outside of Ulster, and when James White from Dublin saw the exhibition, he could hardly have been more impressed.

White wrote in the *Standard*: 'From a landscape composition in 1939 to his delightful *Pax* in 1943, there is a gap. A period presumably of reconsideration and retrenchment – for there follows the seven main works on which the artist would probably desire to be estimated. An undertaking, this, not lightly to be attempted. Here we are faced with craftsmanship on so high a plane that one can do little but gasp ... John Luke has achieved colour tones of a purity, and textural values of a quality unequalled by any painter of the past three centuries whose work I know. The recent pictures are all carried out in the oil and tempera medium ...'. *The Three Dancers*, 1945, UM collection, was particularly noted. On *The Three Dancers*, Luke wrote well over 2,000 words on its technical construction and the approach of the artist to the making of the painting. Commissioned by Armagh County Council in 1945, *The Old Callan Bridge* from the Armagh County Museum collection was also on view; subsequently the museum secured *Judith and Holofernes*. On the back of *Callan Bridge* there are 250 words by Luke on method and materials. In an exhibition of eighty-five items, there were only four pieces of sculpture.

At Ulster House, London, his work was included in 1947 in an exhibition of prominent Ulster painters, arranged by the Northern Ireland Council for the Encouragement of Music and the Arts. In 1948, CEMA held a retrospective exhibition at 55a Donegall Place, Belfast. The organisers felt that the event had gained much from the presence of the artist, 'always willing to elucidate the intricacies of his uncommon technique'. One of his last easel paintings was *Madonna and Child*, 1948, commissioned by a Co. Armagh Catholic priest. Luke's lifelong friend, John Hewitt, was to describe him later as 'a man obsessed and brought to a halt by the convolutions of his thought'. The Roberta and John Hewitt Bequest to the Ulster Museum included the oil, *The Road to the West*.

Belfast Museum and Art Gallery commissioned a large painting, *The Rehearsal*, 1950, which was 'carried out in tempera and oil-glazes, together with the tempera underpainting separately executed. These with the preliminary sketches and the extensive series of preparatory drawings, offer a full exposition of Mr Luke's interesting technique ...'. He was represented in the Contemporary Ulster Art Exhibition, Festival 1951, at the Museum and Art Gallery.

CEMA commemorated the Festival by commissioning a mural for the City Hall on the tympanum of the inner dome, an area of 4.6m at its height by 9.4m wide, at a fee of £500; later increased by £200. The mural represented 'The Life and History of Belfast'. The main figure was a bearded Jacobean reading the town's First Charter in 1613 to a scattered gathering of handloom weavers, rope-makers, and builders of a wooden ship. The mural, begun early in the year, was unfinished when the Queen saw it in May. In August the *Belfast News-Letter* reported: 'From 11 o'clock in the morning until 11 at night the painter is hard at it. He brings his meals with him'. A couple of months later a photograph showed the artist 'still at work'. The mural was presented to the city and accepted by the Lord Mayor in May 1952. The *Northern Whig* reported that the artist had 'laboured for the past 16 months, experimenting with different glazes'.

In 1953 Luke became a part-time lecturer at the Belfast College of Art. In that year he was represented in a CEMA exhibition of sculpture at the Belfast Museum and Art Gallery. The success of the City Hall mural produced in 1956 another commission: the decoration of the tympanum in the new Provincial Masonic Hall lodge room in Rosemary Street, Belfast, the theme being 'King Solomon building the Temple', 9.4m in width by 2.1m at the centre, but on hardboard affixed to the new wall.

In 1959, working in Ancaster stone, his carved relief coat of arms of the Governor of Northern Ireland, Lord Wakehurst, went to Government House, Hillsborough, to join similar plaques. His last exhibition was in 1960 in the staff Common Room at Queen's University, Belfast, and he could not be persuaded to send work again to the Royal Ulster Academy. *The Locks at Edenderry* was purchased in 1996 by Lisburn Museum with a grant of almost £90,000 from the Heritage Lottery Fund.

A mural at the Millfield extension of the Belfast College of Technology, 3.6m by 6m, on the ground floor and representing Building and Engineering, was in hand in the autumn of 1961. In November 1963 the *News Letter* reported him active. In the event, it was never quite finished and the artist offered ill-health – he found great difficulty in standing as his legs were swollen – or the coldness of the site, as the reason for delay. It is

interesting to note that in his personal list of commissions and dates of completion he gives 1971 for Millfield. He was also under pressure for the completion of the stone carving, 71cm by 71cm, of Lord Erskine's coat of arms for Hillsborough. The commission had been given in November 1965 but the carving was not finished until 1969. In reply to one Ministry of Finance letter about the delay, he said that it had been 'a time problem' for his clients but 'a form problem' for himself.

After the death of his mother, Luke, a keen believer in vegan nutrition, led a spartan existence. Not unfriendly, he was slow in making friends. He had to move from Westland Bungalows, where he lived, to a flat at 240 Duncairn Gardens, Belfast, and died at the Mater Infirmorum on 4 February 1975. In 1978 the Arts Councils of Ireland arranged an almost complete collection of his work for display at the Ulster Museum and the Douglas Hyde Gallery, Dublin. To coincide with the show, the Arts Councils published jointly a monograph by John Hewitt. In 1980 the Bell Gallery, Belfast, held a 'Work from the studio' exhibition. In 1998 a plaque was unveiled at 240 Duncairn Gardens.

Works signed: J. Luke; John Luke or Luke, both rare (if signed at all).
Examples: Armagh: County Museum. Belfast: Arts Council of Northern Ireland; City Hall; College of Technology, Millfield; Linen Hall Library; Masonic Hall, Rosemary Street; Queen's University; Ulster Museum. Lisburn, Co. Antrim: Museum. Mossley, Co. Antrim: Newtownabbey Borough Council.
Literature: *Belfast Telegraph*, 9 January 1931, 6 August 1959; *Belfast Museum and Art Gallery Quarterly Notes*, December 1939; Arthur and George Campbell, *Now in Ulster*, Belfast 1944 (illustration); John Luke, *"The Three Dancers"*, 1945, ms at Ulster Museum; Belfast Museum and Art Gallery, *The Work of John Luke*, catalogue, 1946; *The Standard*, 13 September 1946; *The Studio*, January 1947 (illustration), July 1947; *CEMA Annual Report*, 1948-9, Belfast 1949; *Belfast Museum and Art Gallery Annual Report*, 1949-50, 1950; *Belfast News-Letter*, 13 August 1951, 23 October 1951, 19 October 1956, 29 November 1963; *Northern Whig*, 6 May 1952; *Irish Times*, 8 February 1970; John Hewitt and Theo Snoddy, *Art in Ulster*: 1, Belfast 1977 (also illustration); John Hewitt, *John Luke (1906-1975)*, Belfast 1978 (also illustrations); Arts Councils of Ireland, *John Luke (1906-1975)*, catalogue, Belfast and Dublin 1978 (also illustration); Mrs Sadie McKee, *Letter to Newtownabbey Borough Council*, 1980; Nevill Johnson, *The Other Side of Six*, Dublin 1983; Nevill Johnson, *Letter to the author*, 1988; also, F. E. McWilliam, 1988; Henry P. Stinson, 1988; Eileen Black, *A Sesquicentennial Celebration: Art from the Queen's University Collection*, Belfast 1995 (also illustration); Northern Ireland Museums Council, *Insight*, Autumn 1996.

LYNAS, J. LANGTRY, RUA (1879-1956), portrait painter and sculptor. Born of Ulster parents at Greenock, Scotland, on 10 April 1879, the family arrived in Belfast in 1882. John attended Willowfield National School, Woodstock Road, where St John Ervine, the future playwright, was a fellow pupil. At an early age Lynas was admitted to the Government School of Art but explained later: 'I kicked over the traces of the schools of art and took Michelangelo and Alfred Stevens as my teachers'. His first intention had been to take holy orders in the Church of Ireland.

At the age of twenty-five he gave up a business career and with ten shillings in his pocket began a trip through Europe. Returning to England he tried his fortune in Lincoln as a letter-cutter; in London he painted aristocratic crests on stable buckets. In 1905 he became a member of the Belfast Art Society, and in the sculpture section in 1906 he showed *Homer* – '*There, there is something beyond man's conception*'. An oil painting of 1909, *My Mother*, is in the Ulster Museum collection.

Acting as a foreman in a Castlewellan quarry, Co. Down, working in a decorator's business, and supplying posters for a Belfast cinema, were among his occupations. His apprenticeship to art also involved signwriting and stained-glass work. After the First World War he had a business, 'fancy leather goods manufacturer', at 8 College Square East, Belfast, succeeded by work as a contractor in building, painting and general jobbing.

In 1926 his portrait of E. F. Ostinelli, shown in chef's clothes, was reported as having 'gone to Milan', and that in an exhibition at Buenos Ayres, 'open to the world', he had been awarded third prize for sculpture. A sculptured head in marble of Henri De Grand was reported to have gone to 'Bruges Art Gallery', but has not been traced at the Municipal Fine Arts Museum.

In 1927, now at 33 Bridge End, he was represented in the Belfast Museum and Art Gallery's exhibition, Irish Portraits by Ulster Artists, by *The Artist as a Young Man* and portrayals of his son Rodin and Thomas H. Drummond. The hyphened name was used in 1928 with the publication in Belfast of *Psychological Satyr*

or The Hounds of Hell by J. Langtry-Lynas, limited to 200 copies with ample illustrations by the author. A Lynas quotation on the first page read: 'The sneer of the hypocrite shows the blankness of the space in which he lives'. An introduction by J. W. mentioned that the plates were drawn standing at the counter of a little shop in what remained of the Old Castle Market, and that he was 'to his intimates, a soul struggling against the frailties of the flesh, at times almost overcome by the daily burdens of cold and hunger'. Several illustrations were based on quotations from *Paradise Lost*.

A Belfast dealer in fine art, jewellery and stamps, Thos. W. Reid, 29 Wellington Place, provided accommodation for an exhibition in 1931, and later presented *The Dust Cap* to the Walker Art Gallery, Liverpool. The exhibition also contained some flower studies, a portrait of Morris Harding (q.v.) and a self-portrait, *The Bandaged Hand*. The artist was then living at 9 Eastleigh Crescent, Knock, Belfast.

The second Langtry-Lynas book, *Why?*, 1935, contained a collection of reproductions of some of his religio-mystic works. This publication of 1000 copies was dedicated: 'To my unseen friends Christ, Savonarola, Socrates, Paracelsus'. The book also contained his 1934 full-length portrait of Dr Alexander Irvine, 1.8m by 0.9m, and another full-length of the Very Rev. T. M. Johnstone, BA, DD, 1935. Pastels reproduced included *The Creation of the Birds of the Air*. Among the thirty-six illustrations was a bust of Hugh Smylie, JP, FCA, and the coloured frontispiece, *Melody*, was dedicated to the artist's 'unseen friends Beethoven and Schubert'.

In 1937 he completed in his studio at 12 Bloomfield Gardens a clay model of a portrait bust of Harold Spencer, LRAM. An exhibition of sculpture, paintings and drawings was held in 1939 at the Magee Gallery, Belfast; a portrait of Denis Ireland was in both sculpture and oils. In the period 1940-5 he exhibited five works at the Royal Hibernian Academy, and he was included in Council for the Encouragement of Music and the Arts Living Irish Artists exhibition in 1943. In a period of illness the artist temporarily lost the power of his right hand and arm. He presented thirty drawings to the Belfast Museum and Art Gallery; three are self-portraits and there is a pastel portrait of his son, Dante Rossetti Lynas, 1924, also an oil, *My Son Rodin*, 1925.

CEMA arranged an exhibition in 1952 for 55a Donegall Place, and in 1953 he was represented in an exhibition of sculpture at the Belfast Museum and Art Gallery, also organised by CEMA. One of the few 'characters' among the Royal Ulster Academy academicians, he dearly loved a scene, especially at someone else's exhibition. As for his own efforts: 'If I can't rank with the greatest, I do not want to rank at all.' Throughout most of his life, economic necessity meant a search for regular employment to support a wife and four sons, and he was a signwriter for Belfast Corporation at the time of his retirement. He died on 26 August 1956 at Massereene Hospital, Antrim. A picture of his in the Arts Council of Northern Ireland collection was destroyed by fire in 1967.

Works signed: J. Langtry-Lynas or J. L.-L. (if signed at all).
Examples: Armagh: County Museum. Belfast: Ulster Museum. Liverpool: Walker Art Gallery.
Literature: *Belfast and Province of Ulster Directory*, 1920; *Northern Whig*, 16 November 1926; J. Langtry-Lynas, *Psychological Satyr or The Hounds of Hell*, London 1928 (also illustrations); *Belfast News-Letter*, 1 December 1931, 24 May 1939; J. Langtry-Lynas, *Why?*, Belfast 1935 (also illustrations); *Belfast Telegraph*, 7 December 1937, 29 June 1957; *Ulster Post*, 18 March 1949; *Belfast Museum and Art Gallery Annual Report*, 1 April 1948-31 March 1949; John Hewitt and Theo Snoddy, *Art in Ulster: 1*, Belfast 1977; Ulster Museum, *A Concise Catalogue of the Drawings, Paintings & Sculptures in the Ulster Museum*, Belfast 1986.

LYNCH, Sr M. CONCEPTA (1874-1939), Celtic illuminator. Lily Lynch was the daughter of a well-known Dublin illuminator, Thomas Joseph Lynch of Middle Abbey Street. She became as skilled as her father in the illuminated address testimonial. When he died, she left her school at the Dominican Convent, Dun Laoghaire, to assist with the burden of the business, inspiring her father's experienced employees by her own skill. Then she left at the age of twenty-two and entered the Dominican Order, becoming Sister Mary Concepta. She taught art in the school, helped to illustrate the school magazine and was continually involved in musical activities.

In 1919, after the First World War, a small unadorned oratory was built in thanksgiving for the end of hostilities. Sister Concepta, determined to devote her talents to beautifying the little building, requested and received permission from the Mother Prioress to do so. The project was mainly financed by her cousin, Shaun Glenville, and his wife Dorothy, also of the theatre, who performed concerts in Liverpool and elsewhere to raise funds. Sister Concepta began the work in 1920 and carried on until 1936, when she was forced to retire through illness.

Dr George A. Little, writing in the *Irish Rosary*, commented: 'The last moiety of these years were years of pain and tested fortitude for the gracious artist. Arthritis plagued her joints with grievous aches and stiffness. But that dream of the Oratory granted her in 1920 would accept no denial from its bondswoman. Hoisting herself on planks, lying supine (another Michaelangelo), she painted ceiling and high walls – often her right arm, powerless, had to be held aloft for her, often she had to stop work when her fingers could no longer guide her brushes. And the painted glory about her grew as her time shortened ...'.

She had devoted herself to covering the interior, 5.9m by 3.6m, with her own distinctive style of Celtic art, and so the Oratory of the Sacred Heart became a shrine in that manner, some motifs derived from illuminated manuscripts but others showing designs of her own invention. In any case, a profusion of writhing lines of stencilled and painted ornament was created, a remarkable achievement after years of devoted attention. The ceiling was, however, unfinished but has the interest of allowing viewers to study her work methods.

In his book, *A Shrine of Celtic Art*, published by the Irish Dominican Sisters, Professor Etienne Rynne wrote : '... her work is ever *mouvementé*, vibrant with life; her birds squawk, bite and even dance, her serpents wriggle and knot themselves, as do her quadrupeds. Her art has a striking originality throughout, and only in a very few instances can she be accused of even partial plagiarism ...'. The equal-armed wheeled cross, the symbol of the Eucharistic Congress 1932, is used as the centrepiece for the side-walls. Two red-winged birds are back to back on either side of the doorway. There is a fantastic long-necked, bird-headed beast above the statue.

Sister Concepta was also responsible for a few illuminated addresses, now in the National Gallery of Ireland, notably one dedicated to Mother M. Columba and dated 14 April 1907. It had three miniature portraits and was decorated with Celtic interlacing. Annals of the Convent were painted and decorated by her but this work was also unfinished.

A collection of stencils used when decorating the Oratory and a number of rolls of linen with painted Celtic and other motifs and designs which she used in her efforts to teach her pupils at the school are also in the National Gallery of Ireland. One headed 'Saint Columcille' is a prayer requesting the saint to assist contemporary artists working in the Celtic manner. It reads in part:

'O may the spirit of this saint
Watch o'er us, guide us, while we paint
New lines, new tints, tho' we be late
The Book of Kells we'll imitate.'

Sister Concepta Lynch died on 30 April 1939, and was buried in the private cemetery behind the convent. Restoration work on the oratory began in 1996.

Examples: Dublin: National Gallery of Ireland. Dun Laoghaire, Co. Dublin: Oratory, Library Road.
Literature: Dr George A. Little, 'An Oratory and its Eloquent Art', *Irish Rosary*, January-February 1961; Brian de Breffny, ed., *The Irish World*, London, 1977 (also illustration); Etienne Rynne, intro., *A Shrine of Celtic Art*, Dun Laoghaire 1977 (also illustrations); Paul Larmour, *Celtic Ornament*, Dublin 1981 (also illustration); Sligo Art Gallery, *The Illuminated Address 19th-20th Century*, catalogue, 1983; Sr Francis Lally, OP, *Letters to the author*, 1988, 1996; *Irish Times*, 20 January 1996.

LYNN, W. H., RHA (1829-1915), architectural draughtsman and landscape painter. Born on 27 December 1829 at St John's Point, Co. Down, he was the son of Lieut. Henry Lynn, RN, of the coastguard service, and a brother of the sculptor, Samuel Ferres Lynn, ARHA (1836-76), who was born at Fethard, Co. Wexford.

Brought up at Bannow, Co. Wexford, William Henry had the opportunity to develop his native skill at drawing landscape and ancient ruins.

Lynn's claim to fame was as an architect, as the junior partner in Belfast of Sir Charles Lanyon, and as the designer of many mansions, churches and public buildings. His architectural success was assisted in great measure by his skill as a designer and by his ability as a watercolourist – a medium exploited by architects, 'particularly those like Lynn with natural painting ability', the architectural historian, Hugh Dixon, has commented. 'Its fine detail was ideal for the portrayal of proposed buildings, especially in an age when the accurate reproduction of past styles was demanded. Equally important were the glowing sunlit settings or the dramatic skies to which watercolour so readily lends itself. With these the architect could woo clients, competition judges and building committees ...'.

Between 1865 and 1896 he exhibited at the Royal Hibernian Academy, mainly architectural designs although in 1874 he showed two street views of Bayeaux and in 1881 four ruined castles, three in Co. Wexford. In 1867 he won a gold medal at the Paris Universal Exhibition for his architectural drawing of Parliamentary Houses and Government Offices for Sydney, New South Wales, 1861. He became an ARHA in 1865 and a full academician in 1872. The Government School of Art in Belfast was opened in 1870, and Lynn was on the board of managers along with Dr James Moore (1819-83), a noted watercolourist with whom he sometimes sketched.

At the invitation of the Governor-General, Lord Dufferin, who had spent his formative years at Clandeboye, Co. Down, he visited Quebec in 1875 'to advise on public improvements'. He was made an honorary member of the Dublin Sketching Club in 1888 when living at 3 Crumlin Terrace, Belfast. In 1910 a correspondent in the *Irish Builder* wrote: 'In the days of Gothic Revival, Lynn was a keen and brilliant student of medieval work, his ecclesiastical designs having a scholarly and refined flavour and perfect mastery of Gothic detail'. Except to take part in the annual sketching tours of the Architectural Association, he rarely left Ulster except when his profession demanded.

The Ulster Museum's collection of his work is based on 'an important donation of 13 architectural drawings, chiefly in perspective and four watercolours ... presented by his cousin, Miss M. Cooper'. Among these works are: *The Britannia Tubular Bridge, Menai Straits*, pencil and watercolour; *Unitarian Church, St Stephen's Green, Dublin, 1861*, pencil, ink and watercolour; *Design for Carlisle Bridge, Dublin, 1862*, with background views of Sackville Street, groups of figures and traffic, in pencil, ink and watercolour.

Lynn, described by Sir Aston Webb, RA (1849-1930) as 'one of the finest architectural draughtsmen of his day', painted in the Cushendall area of Co. Antrim, and had some engravings and lithographs to his credit. A bachelor and reticent, he died at his residence, 250 Antrim Road, Belfast, on 12 September 1915. An exhibition of drawings and watercolours by W. H. Lynn and sculpture by S. F. Lynn was held at the Belfast Museum and Art Gallery in 1916. The Ulster Museum presented an exhibition of W. H. Lynn's watercolours and building perspectives, arranged by Hugh Dixon, in 1978.

Works signed: W. H. Lynn (if signed at all).
Examples: Belfast: Ulster Museum.
Literature: *Dublin Sketching Club Minute Book*, 1888; *Belfast Municipal Art Gallery and Museum Quarterly Notes*, Spring 1916, and *Annual Report*, 1915-1916; *Building News*, 21 February 1917; C.E.B. Brett, *Buildings of Belfast 1700-1914*, London 1967; John Hewitt and Theo Snoddy, *Art in Ulster: 1*, Belfast 1977; Hugh Dixon: Ulster Museum, *William Henry Lynn (1829-1915)*, catalogue, Belfast 1978 (also illustrations); Ann M. Stewart, *Royal Hibernian Academy of Arts: Index of Exhibitors 1826-1979*, Dublin 1986.

M

"MAC" – see MACNIE, ISA M.

McADOO, VIOLET, RUA (1896-1961), landscape painter. Born in Cookstown, Co. Tyrone, Annie Florence Violet McAdoo was the daughter of Hugh W. McAdoo and was educated at the Ladies' School, Cookstown. After studying at the Belfast School of Art, she went to London, receiving her diploma at the Royal College of Art in 1927. Returning to Northern Ireland to teach, she lived at Holywood, Co. Down. Two watercolours which she painted in 1933, *Haystacks* and *Tiled Roofs, Spain,* are in the Ulster Museum. At the 1938 Ulster Academy of Arts, she showed one watercolour, *Farmyard.*

Between 1941 and 1946 she exhibited six works at the Royal Hibernian Academy. In 1943 she was represented in the Living Irish Artists exhibition, arranged by Council for the Encouragement of Music and the Arts, and also in their second exhibition in Belfast of fourteen resident watercolourists. In 1944 she held a joint exhibition with Olive Henry (q.v.) at the Belfast Museum and Art Gallery. From 39 Rugby Road, Belfast, her watercolours at the 1946 RHA were *Harbour*, *Clogher Head* and *Bogland*. She also painted in oils.

In the period 1946-60 she showed thirty-nine works at the Water Colour Society of Ireland exhibitions, and in 1952 contributed *Bamboos*; *Fishing Boats, Kilkeel*; *Little Farm, Italy*; *Morning Light, Ardglass*. One of four vice-presidents of the Ulster Academy of Arts, she was also an academician. A member of the National Society, London, she contributed to their 1954 exhibition, and in the same year, also in London, *Village Pond, Bernéval* and *Sandhills at Evening, Portstewart* were hung at the United Society of Artists exhibition. She also showed with the Society of Women Artists, London.

Watercolours at the 1957 Royal Ulster Academy were *Sea of grasses* and *Sun through clouds*. In the Academy's collection are: *Waterfall*, 1947; *Fishing Boats, Kilkeel*, 1951. Even after she was forced by illness to retire prematurely from teaching art at Princess Gardens School, Belfast, she continued to take an active interest in this work. Her death took place at Belfast City Hospital, on 22 November 1961.

Works signed: V. McAdoo.
Examples: Belfast: Royal Ulster Academy; Ulster Museum.
Literature: Princess Gardens School, *The Lamp*, 1961; *Who's Who in Art*, 1962; *Dictionary of British Artists Working 1900-50*, Eastbourne 1975; John Hewitt and Theo Snoddy, *Art in Ulster: 1*, Belfast 1977; *A Dictionary of Contemporary British Artists, 1929*, Woodbridge 1981; Martyn Anglesea, *The Royal Ulster Academy of Arts*, Belfast 1981 (also illustration); Ann M. Stewart, *Royal Hibernian Academy of Arts: Index of Exhibitors 1826-1979*, Dublin 1986; General Register Office, Belfast, *Letter to the author*, 1988; also, *Royal Ulster Academy of Arts*, 1988; *Water Colour Society of Ireland Exhibition List 1872-1994*, Dublin 1995.

McALEENAN, FRANK J. (1890-1968), sculptor. Born near Newry, Co. Down, his first job was as a Post Office messenger, a position he lost when he became so engrossed in watching monumental sculptors at work on a new church that he forgot to deliver a telegram to the foreman on the site. After that experience, he decided he had more interest in sculpture than the postal service, and at the age of seventeen he began a career that was to span sixty years, principally as a monumental sculptor, gaining experience in the USA, where a brother lived, and in London.

McAleenan assisted the London sculptor, F. W. Doyle-Jones (q.v.), visiting his studio in Chelsea in connection with the monumental statue of St Patrick for Saul, near Downpatrick, celebrating in 1932 the 1,500th anniversary of the saint's landing. According to a partner of McAleenan, the work was done in sections in Castlewellan, Co. Down. The figure was erected by the Roman Catholic community but is said to bear the face of the Most Rev. C.F. D'Arcy, at that time Primate of the Church of Ireland.

Just before the Second World War, he obtained a site at 502 Falls Road, Belfast, describing himself as 'sculptor' rather than 'monumental sculptor'. Much of his time was taken up with lettering for headstones and the occasional tablet. In 1955 he completed a statue about two metres high in Irish marble for the grave of an IRA commandant at Aughlisnafin Cemetery, Castlewellan, Co. Down. In his work in Portland stone at Muckamore Abbey Hospital, 1959, for the Northern Ireland Hospitals Authority, a coat of arms was supplemented by a six-pointed star representing the six counties, the Red Hand of Ulster, and Asclepius's staff with entwined twin snakes.

McAleenan assisted Morris Harding (q.v.) in the memorial tomb at Mount Stewart, Co. Down, for the Marchioness of Londonderry who commissioned the work in advance of her death in 1959. A bust of John Ngu Foncha, Prime Minister of the West Cameroon Republic, was completed in 1965 in commemoration of independence. The artist died on 10 April 1968 at his home in Rockdale Street, Belfast.

Examples: Belfast: Clonard Monastery, Clonard Gardens. Castlewellan, Co. Down: Auglisnafin Cemetery. Muckamore, Co. Antrim: Abbey Hospital.
Literature: *Belfast and Province of Ulster Directory*, 1939; *Belfast Telegraph*, 8 February 1955, 5 January 1959, 12 April 1968; *Irish News*, 13 April 1968; Maureen Donnelly, *Saint Patrick and his associations with Saul and Downpatrick*, Downpatrick 1972.

McALLISTER, JOHN A. (1896-1925), landscape painter. Born in 1896, John Alphonsus McAllister showed from an early age a taste for drawing which he was eventually able to gratify and improve at the Belfast School of Art, where he made such rapid progress that he was said to have 'outstripped all in the race for honours, carrying off nearly every one of the available scholarships'. A friend at the School of Art was Charles Harvey (q.v.), and with other students they travelled in 1914 by boat, five shillings each way, to Dublin where they attended the Metropolitan School of Art summer term under (Sir) William Orpen (q.v.). Another fellow student was William J. Coombes (1893-1981), whose portrait, oil on panel, by McAllister is in the Ulster Museum.

Early in his short career he worked as a designer for W. J. Jenkins and Co., linen and handkerchief manufacturers, Linen Hall Street West, where his work attracted the attention of the whole trade. Devoting all his spare time – and more than was wise – to his studio work, he hoped to relieve the strain by setting up on his own account as a designer at 7 College Street. A few years before the death of this ill-fated artist, his studio was destroyed by fire and he was left without even a brush.

Through the medium of the Ulster Arts Club's exhibitions, his name became familiar but only to the Belfast public. He was represented in the Club's exhibition in 1925, the year of his death, at the Belfast Museum and Art Gallery. In addition to the portrait at the Ulster Museum, he is represented by nine watercolours, including *The Grand Canal, Dublin*, 1923, and *Waterfoot Harbour, Co. Antrim*, 1924. Lady Antrim was said to have presented two of his landscapes to Queen Alexandra.

The craving for work which had possessed him in his student days continued, and nature exacted the inevitable toll. A couple of months in the summer in Rostrevor, Co. Down, failed to restore his health. *A Mountain View, Omeath* is in the Hugh Lane Municipal Gallery of Modern Art. He was preparing for an exhibition at a London gallery when he died at his home, 18 Amcomri Street, Belfast, on 17 October 1925. An exhibition of watercolours and pastels was held after his death at the Ulster Arts Club.

Works signed: J. A. McAllister, J. McAllister, John McAllister or Sean McAl., rare.
Examples: Belfast: Ulster Museum. Bangor: Town Hall. Dublin: Hugh Lane Municipal Gallery of Modern Art.
Literature: *Irish Statesman*, 16 May 1925; *Irish News*, 19 October 1925; John Hewitt and Theo Snoddy, *Art in Ulster: 1*, Belfast 1977; Ulster Museum, *A Concise Catalogue of the Drawings, Paintings & Sculptures in the Ulster Museum*, Belfast 1986; Hugh Lane Municipal Gallery of Modern Art, *Letter to the author*, 1988.

McAULEY, CHARLES (1910-99), landscape and figure painter. The youngest of eight children, Charles Joseph McAuley, son of Bernard McAuley, was born on 15 March 1910 on a small farm at Lubitavish, Glenaan, near Cushendall, Co. Antrim. A gift for drawing emerged at the local Glenaan school. He attended

Belfast School of Art but only for a few weeks, considering that the lectures concentrated on still life which was not his first interest. In any event, he found difficulty adjusting to city life, so he returned to the Glens and worked on the farm, still continuing to paint.

In 1929 at Feis na nGleann he won the premier award for Celtic Design. The Arts adjudicator was J. Humbert Craig (q.v.), the first professional painter he had ever met. McAuley said that the well-known artist had 'a great influence on me and I suppose was really responsible for my turning into a professional artist. He said to me one time: "People will think you crazy when they see you out painting in the fields but don't you pay any heed."'

Craig suggested that McAuley should send some of his paintings to the Royal Hibernian Academy in Dublin and these were accepted, *Across the Lough* and *Near Cushendun* being hung in 1933, and *The Antrim Hills* in 1934. He showed only two other works at the Academy. The Ulster Academy of Arts also received his work but there was little regular pattern in forwarding pictures to Belfast. He began to paint professionally when he was aged twenty-eight.

In 1940 he married and the couple raised four children in a house overlooking the sea at Dalriada, on the edge of Cushendall village. Having lived to paint, McAuley now had to paint to live — a challenging task when art was undervalued, especially in a rural environment remote from commercial galleries. In addition, he was no salesman.

In 1948 Belfast Museum and Art Gallery purchased his oil on board, *Mid-day on the Moss*. When he exhibited *Salmon Fishing, Antrim Coast* at the 1965 Royal Ulster Academy he was listed in the catalogue among the non-members. A glance at the RUA catalogues for the next five years indicated non-representation.

In his early days he tended to paint landscapes rather than figures 'because that was the type of painting people wanted,' but at his fifth annual exhibition in 1977 at Londonderry Arms Hotel, Carnlough, Co. Antrim, he had 'more paintings of figures at this exhibition than I ever had at any other...' Exhibitions continued there for some years.

McAuley's reputation received a particular boost in 1984 with the publication by the Glens of Antrim Historical Society of *The Day of the Corncrake*, in which twenty-five colour reproductions of his paintings were coupled with thirty poems about the Glens by John Hewitt. Included among the paintings were: *Fair Day*; *Horse and Harness*; *The Old Barn*; *Farmyard*; *Footing Turf*; *The Flat Iron*; *Looking to Tevebulliagh*; *Foddering*; *Sheep-shearing*.

As Hewitt wrote in his foreword to the book in question: 'Charles McAuley, when he began to paint, had some advice from Craig. It was inevitable that the lad should have been attracted to and influenced by the current convention. But it became increasingly evident that as a Glensman born and bred he should take the landscape as his own terrain inhabited by folk he knew and belonged to. His growing awareness was not merely graphic but demographic. This had made him for me the authentic regional artist, the painter who belongs to and finds his themes in a known place. Nowadays with the rapid flow of international styles succeeding each other, this is a distinctive title one can seldom confer.'

In an interview in 1988, McAuley said: 'Most of the modern paintings don't mean that much to me. I've never been one for Cubism, Surrealism or anything like that...The group that appeals to me most is that of the French Impressionists. I have always been very keen on light and that seemed to be their interest too.' He painted until a few weeks before his death on 30 September 1999 and was buried in Cushendall.

Works signed: C. McAuley.

Examples: Belfast: Ulster Museum. Cultra, Co. Down: Ulster Folk and Transport Museum.

Literature: *Belfast Museum and Art Gallery Annual Report*, 1 April 1948 — 31 March 1949; *Irish News*, 17 October 1977; Glens of Antrim Historical Society, *The Day of the Corncrake*, 1984 (also illustrations); Ann M. Stewart, *Royal Hibernian Academy of Arts: Index of Exhibitors 1826-1979*, Dublin 1986; *Belfast Telegraph*, 2 August 1988; *Irish Times*, 1 and 9 October 1999; Henry McAuley, *Letter to the author*, 1999.

McAULIFFE, PATRICK (1846-1921), sculptor and stuccodore. A native of Listowel, Co. Kerry, he was a builder and plasterer in which trade his sons, grandsons and great-grandsons continued the tradition. After a good deal of run-of-the-mill work he began, without any formal training in art, to experiment in casting in

cement and sand from a mould made in local blue clay. He is said to have had old cast-iron ornaments from which he made impressions for casting. When engaged to plaster the front of a house or shop, he demanded a free hand with the design or refused to execute the work.

McAuliffe produced a series of figures – angels, legendary personages, birds and beasts. Musical instruments and especially sunrises were in his repertoire. A merchant or houseowner was given no inkling of the kind of façade in store for the premises until he arrived with his donkey and cart. Of his work in Listowel, the celebrated and most startling specimen is the frontispiece of the Central Hotel at one corner of the square where the amply-bosomed *Maid of Erin* catches the eye. Her left elbow rests on a harp, and there is also a round tower, rising sun, and at her feet is a reclining wolfhound. Beneath this tableaux is the legend 'Erin Go Bráth', while over the words Central Hotel appears 'Fáinne an Lae'.

P.M. Keane's grocery bar in Ashe Street has another central feature, a lion surmounting a harp, and three languages are represented: 'Spes mea in Deo' (My hope in God); 'Maison de Ville' (The Town House); and 'Erin Go Bráth' (Ireland for Ever). Here you can also see a sample of his lettering and his distinctive decorative style in the fascia, urns and the side pilasters with Celtic and classical motifs.

On the front of another house is an American eagle with spread wings, outlined against the sky, and displayed above the legend 'E Pluribus Unum' and the Irish sunburst. Elsewhere is a dragon, reminiscent of China rather than of Ireland. At the dawn of the cycle age he provided a wheel for the façade of a cycle agent's shop. Examples of his work are to be seen on houses in Ashe Street, Market Street, Main Street (Small Square), William Street and Patrick Street, also in Abbeyfeale, Co. Limerick, for example O'Mara's house, pub, and J. D. Daly's shop and house.

In his book *The Shops of Ireland*, Sean Rothery suggested that McAuliffe's work, particularly his lettering which was individual and innovatory, showed strong influences of Art Nouveau. Rothery also wrote: 'He has often been described, or rather dismissed, as a naive artist, but there are features about his work which show him to be a genuine designer working in the new exotic and exciting decorative phase of the late nineteenth century. His figure work is the least successful but it is the work which attracts most notice and most of the many stories about this unusual man. His decorations on buildings were often rather out of scale but there is no denying his genuine desire to turn ordinary dull town buildings into sculptural and textural art objects.'

Bryan MacMahon of Listowel wrote about him in 1962 in the art magazine, *Typographica 6*: 'In retrospect I see him quite clearly, great and black-bearded, his dark eyes alive under a cream-coloured straw hat. He came of an old-established family in the town ... with the passing years the people of Listowel have grown proud of this fine old craftsman, who succeeded in giving them something which is native, noteworthy, and distinctive.'

Examples: Listowel, Co. Kerry: Central Hotel.
Literature: *Typographica 6*, December 1962; J. Anthony Gaughan, *Listowel and its vicinity*, Cork 1973; *Irish Times*, 20 September 1974, 4 August 1979, 2 July 1980; Sean Rothery, *The Shops of Ireland*, Dublin 1978 (also illustrations).

MacBRIDE, MAUD GONNE – see GONNE, MAUD

MacBRIDE, WILLIAM (1880-1962), portrait, landscape painter and stained glass artist. Born in Ballymena, Co. Antrim, he attended the Belfast School of Art and when he exhibited at the Royal Hibernian Academy in 1909, from 32 Wellington Place, Belfast, he showed a portrait of Francis J. Bigger, MRIA. Continuing his art study at the Dublin Metropolitan School of Art, in 1910 Joshua Clarke, ecclesiastical decorator and manufacturer of stained glass, gave him employment as a painter of glass. In 1911 he held an exhibition of paintings at the Branch of the Five Provinces, 7 St Stephen's Green, Dublin. About 1913 he executed some drawings of Dublin alleys, one of which was Johnston's Court, Grafton Street.

Altogether between 1909 and 1941 he showed thirty-six works at the RHA, of which about half were portraits. As from 1915 his address was 36 South Frederick Street, Dublin, where he lived in a flat with his brother, Jack, a tailor, and that year he showed at the RHA: *The Duck Pond* and *The Rain Cloud*.

Shortly after the end of the First World War, MacBride and colleagues opened The Craftworkers Ltd, a co-operative company at 39 Harcourt Street, Dublin, in which all the artists and craftsmen were shareholders. MacBride owned the premises, and at one period Charles B. Land specialised in copper and brasswork and Colm O'Lochlainn in handprinting.

In an advertisement in the 1920 *Irish Catholic Directory and Almanac*, the Craftworkers cordially invited 'the Clergy and all interested in Church Decoration, Stained Glass, Painting, Sculpture, Woodwork, Metalwork, etc. to visit their workshops and see all the stages and processes of manufacture. Those who can visit St Catherine's Church, Meath Street, Dublin, may see the large fresco on the chancel arch, painted by Mr William MacBride ...'. The advertisement then mentioned the stained glass department, singling out work for St Patrick's Cathedral, Dublin, and adding that W. MacBride secured first prize at the Royal Dublin Society Exhibition, Ballsbridge, 1919. MacBride's window in St Patrick's depicts St Patrick, St George and St Michael in memory of three soldiers killed in the First World War.

MacBride, who listed his recreation as yachting, anchored a boat at Howth. In 1922 at the RHA he showed a bronze, *The Spirit of the breeze*. According to the Dublin Corporation's *A Book of Dublin*, 1929, from 'The Craftworkers comes the excellent stained glass of Mr William MacBride. His designs for Sacred Vessels have found much favour also; while his wrought-iron for churches and public buildings has been appreciated not only in Ireland, but in England, Canada and America'. MacBride's *Pro Patria* window is in St John's Church, Malone Road, Belfast.

Dublin Civic Week 1929 Official Handbook was decorated with borders designed by Dublin artists associated with the Dublin Book Studio, 2 Harcourt Terrace, which undertook the designing, illustration and production of books. MacBride had no difficulty holding his own as a black and white artist and of the sixty-six pages decorated with borders, he was responsible for a score with insets in panels. He later provided illustrations for Colm Ó Lochlainn and his Three Candles Press, and exhibited a portrait of the publisher at the 1923 RHA.

On the question of lights for the side altars and shrine for St Anthony's Friary, Athlone, a letter from the architects to the guardian in 1931 notified the decision to give the job to the Craftworkers, mentioning that they had endeavoured to work up Mr MacBride 'to the required pitch of enthusiasm so that he might make a really fine job of it'. He died on 15 February 1962 at a Dublin hospital.

Works signed: William MacBride, W. MacBride, Mac, rare; or W. McB., illustrations.
Examples: Belfast: St John's Church, Malone Road. Dublin: St Patrick's Cathedral.
Literature: *Irish Review*, November 1911; Katherine MacCormack, *The Book of St Ultan*, Dublin 1920 (illustration); *Irish Catholic Directory and Almanac,* 1920; Bulmer Hobson, ed., *A Book of Dublin*, Dublin 1929; E. M. Stephens, ed., *Dublin Civic Week 1929 Official Handbook* (illustrations): Colm O Lochlainn, *Brian's battle as it is told in the Norse saga*, Dublin 1933 (illustrations); *Irish Times*, 17 February 1962; *A Dictionary of Contemporary British Artists, 1929*, Woodbridge 1981; Rev. Patrick Conlan, *Letter to the author*, 1982; Ann M. Stewart, *Royal Hibernian Academy of Arts: Index of Exhibitors 1826-1979*, Dublin 1986; Paul Larmour, *Belfast: An Illustrated Architectural Guide*, Belfast 1987; Nicola Gordon Bowe, David Caron and Michael Wynne, *Gazetteer of Irish Stained Glass*, Blackrock 1988; C. D. Land, *Letters to the author*, 1988; St Patrick's Cathedral, *Letter to the author*, 1988.

McBURNEY, JOHN (1877-1917), landscape, portrait painter and designer. Born on 14 May 1877 in Belfast, he was apprenticed as a damask designer, attending night classes at the Government School of Design and winning prizes valued £10 and £5 in a competition. Referring to the National Competition, 1898, *The Studio* of London commented: 'For semi-naturalistic decoration, the wild rose as treated by John McBurney (Belfast) is first rate'. At the School of Design he met W. R. Gordon (q.v.), who became a lifelong friend.

After winning a scholarship to South Kensington for two years, he returned to Belfast and obtained a position as a designer but ill health necessitated a period in hospital of six months. Advised by his doctor to go abroad, he preferred to remain at home. Heavy smoking did not help his health. Living at 8 Richmond Crescent, Antrim Road, he became associated with the Belfast Art Society in 1902, and was actively involved in the affairs of the Ulster Literary Theatre and the Ulster Arts Club, where he also exhibited, holding presidential office in 1912 and 1913. Also he served as a member of the joint arts committee of Belfast Corporation.

Forrest Reid, the novelist, an active member of the Ulster Arts Club, knew McBurney intimately and dedicated *The Gentle Lover*, published in 1913, to him. In his *Private Road*, Reid wrote: 'McBurney was a man of extraordinary courage and personal charm. Of all those I have ever met I think he had the nimblest wit and the most generous nature ... He was a small man, very dark, with dark bright eyes, a trimmed black beard, and a pale face. His nature was comprised of a curious blend of melancholy and gaiety, with an underlying pride that nothing could shake. His health was wretched and he took no care of himself ...'

As an embroidery designer, his office was at 1 Bankmore Street, Belfast. A self-portrait is in the Ulster Museum, where there are also three other oil paintings: *Waterworks, Antrim Road*; *York Dock, Belfast*; and *Sefton's House, Balmoral Avenue*. In the year of his death, Talbot Press, Dublin, published *Unknown Immortals* by Herbert Moore Pim, illustrated, mainly decorations, by McBurney. Continuing his designing work for the linen industry almost to the end, he died of tuberculosis on 1 December 1917 at his father's residence, 31 Glandore Avenue, Belfast.

Works signed: J. McBurney or J. McB.

Examples: Belfast: Ulster Museum.

Literature: *Belfast Art Society Exhibition*, catalogue, 1903; Herbert Moore Pim, *Unknown Immortals*, Dublin 1917 (illustrations); Forrest Reid, *Private Road*, London 1940; Mrs Isobel McGifford (née McBurney), *Letter to Belfast Museum and Art Gallery*, 1947; *News Letter*, 2, 19 and 23 January 1967; Patrick Shea, *A History of the Ulster Arts Club*, Belfast 1971; John Hewitt and Theo Snoddy, *Art in Ulster: 1*, Belfast 1977.

Mac CANA, SOMHAIRLE (1901-75), painter of landscape and figure subjects. Son of J. P. MacCann, cabinetmaker, Samuel Malachy MacCann was born in Belfast on 23 November 1901, and was educated at the Christian Brothers' School. In 1915 he was appointed as a textile designer to Joseph Mathers Ltd, damask and linen manufacturers, Upper Queen Street, Belfast, and attended Belfast School of Art in his spare time, studying damask and embroidery designing. He might have remained a designer all his life had he not become involved with an IRA company; he was arrested in Co. Cavan in 1921. Sentenced to death, he spent seven months in Crumlin Road prison in Belfast until the general amnesty.

Returning to the Belfast School of Art, he won the Sorella scholarship in 1923; the following year he taught there. In 1925 he was awarded the Dunville scholarship, enabling him to study for three years in London at the Royal College of Art, where he was friendly with Romeo Toogood (q.v.) from Belfast. On arriving home as an ARCA, he taught for a year at the School of Art before becoming art master at Galway Technical School, 1929-35. From 3 Mill Street, Galway, he exhibited in 1935 for the first time at the Royal Hibernian Academy, showing six works, including *Peasants* and *St Martin*, both in egg tempera, the same medium as for *The Fowl Market*, a street in Galway on Fair Day, exhibited at the Munster Fine Art Club exhibition a few years later.

In 1935 he was appointed art inspector in the Department of Education, Dublin, and remained in that post until, in 1937, he became principal of the Crawford Municipal School of Art, Cork. *The Delph Man* was completed in 1941. His *Causa Laetitae* appeared at the 1946 RHA, and Dr Thomas MacGreevy, writing in the 1949 *Capuchin Annual*, commented that this work 'would command respect in any exhibition anywhere'. In that year he was represented in the touring exhibition of pictures by Irish artists in Technical Schools.

Struck by the incongruity, as he thought, of most modern Gaelic lettering, he had by this time evolved a rational Gaelic alphabet. As for portraiture, Presidents Henry St J. Atkins and John J. McHenry are in University College, Cork. A rather shy man, he exhibited infrequently, and had no great desire to sell his work. Responsible for the *Cork Art Galleries Catalogue* which appeared in 1953, he recorded in his biographical note that he had also exhibited with the Belfast Art Society, Ulster Arts Club and the International Society of Sculptors, Painters, and Gravers; also that he was an etcher and engraver. He was also credited with a number of illuminated addresses.

Irish Craftsmanship, his brief survey of arts and crafts in Ireland from the Early Bronze Age to the present century, with his own illustrations, was published in 1956. The contents first appeared in 1947 as a series of advertisements in newspapers for the Irish Hospitals' Trust. 'A labour of love' was how he described the commission. Some years later in an international apprentice competition at the Regional Technical College,

Cork, the booklet was reproduced by the students. The Arts Council, Dublin, appointed him a member in their 1958-9 year.

Representation at the Crawford Municipal Art Gallery includes *The Holy Family*, oil, 99 cm x 107 cm; *Light and Shade, Youghal*, a watercolour, and *Nativity*, woodcut. MacCann, or Mac Cana, designed the three-metre high statue, the *Coronation of Our Lady*, erected on the Lee Road, near St Joseph's Hospital, Mount Desert, Cork, sculptured by Desmond Broe (q.v.), and both men collaborated on representations on a small scale of the fourteen other mysteries of the Rosary. In 1964 his *Stations of the Cross* in memory of the Kent family was unveiled in Coolagown Church, Castlelyons. He retired as principal of the Cork School of Art in 1967, and died in St Stephen's Hospital, Glanmire, Co. Cork, in January 1975.

Works signed: Soirle Mac Cana, S. Mac Cana, Mac Cana or S. McC., monogram.
Examples: Castlelyons, Co. Cork: Coolagown Church. Cork: Crawford Municipal Art Gallery; University College.
Literature: Tomás Ó Crohan, trs. by Robin Flower, *The Islandman*, Dublin 1934 (illustration, dust jacket); *Capuchin Annual*, 1936 (illustrations), 1940 (illustration), 1949; *Father Mathew Record*, February 1939 (illustration); Mairin Allen, *Father Mathew Record*, June 1941 (also illustration); *Cork Art Galleries Catalogue*, Cork 1953 (also illustrations); Soirle M. Mac Cana, *Irish Craftsmanship*, Dublin 1956 (also illustrations); *Cork Holly Bough*, 1962 (illustration), 1963 (illustration); *Irish Press*, 4 May 1964; *Irish News*, 1 April 1967; *Cork Examiner*, 26 January 1975; John Hewitt and Theo Snoddy, *Art in Ulster: 1*, Belfast 1977; Mrs Maisie MacCann, *Letters to the author*, 1983, 1989.

MacCANN, GEORGE, ARUA (1909-67), sculptor, muralist and stage designer. Born in Belfast, on 14 February 1909, George Galway MacCann was the son of a monumental sculptor, David MacCann, and spent six years in the Royal Belfast Academical Institution before entering the Belfast School of Art in 1926 to study sculpture under Seamus Stoupe (q.v.). In 1929 he won a major scholarship to the Royal College of Art, London, and in the following year he was joined there by his wife to be, Mercy Hunter (q.v.) whom he had already met at the School of Art in Belfast.

MacCann graduated from the Royal College of Art in 1932 and was awarded a special prize largely on the commendation of Henry Moore (1898-1986), then a lecturer at the college. When in London, he also knew Eric Gill (1882-1940) and Jacob Epstein (1880-1959). Returning to Northern Ireland, he taught at Royal School, Armagh from 1932 until 1938 and designed a mural there, representing the school and its activities but painted by the pupils; deteriorating, it was destroyed by building operations in 1988. His *Education reclining below the Tree of Knowledge* is above the entrance to Avoniel Primary School, Belfast. In that year he married and set up home at Vinecash, Co. Armagh, where one of his guests was the poet, Louis MacNeice. MacCann has recounted how, in 1939, he travelled to Dublin with MacNeice, who had asked him to design the decor for a long one-act play called *Black Legs*. Despite bringing down a model for the set, they were unable to sell the play to the late F. R. Higgins of the Abbey Theatre. During this Armagh period, George Paterson of Armagh was the subject of a chalk portrait, now in Armagh County Museum, where there is also a portrait head in plaster of the artist's wife, Mercy Hunter; *Reclining Figure*, stone; *Head of Christ*, oil on paper; and an abstract oil on hardboard.

In 1938 he returned to the Belfast College of Art to lecture on sculpture but joined the Royal Inniskilling Fusiliers in 1939, held the rank of captain and served in India and Burma. In 1942 the Mourne Press, Newcastle, published his short stories, *Sparrows Round my Brow* by George Galway, illustrated by Mercy Hunter. Although never prolific in his various activities, he contributed to several magazines and journals, broadcast and excelled in conversation. In MacNeice's *Autumn Sequel*, he was Maguire. On returning to Northern Ireland in 1946, he taught for a short time at Sullivan Upper School, Holywood.

Council for the Encouragement of Music and the Arts, in connection with the Festival of Britain 1951, commissioned two sculptures, *The Four Just Men* and *St Columba* for the Guildhall, Londonderry. These have survived the bombing of the building and are on display in the rear entrance porch. As well as providing sculptures for the British Industry Fair in 1951, he painted murals for the Northern Ireland section of the Festival of Britain in London and also for the exhibition at Castlereagh, Belfast.

Represented at CEMA's exhibition of sculptures at the Belfast Museum and Art Gallery in 1953, he became a freelance designer and painter two years later, working for the Colchester Repertory Company in

Portstewart, Co. Derry, and in Belfast for the Group Theatre and Lyric Theatre as well as painting murals for restaurants and schools but particularly public houses. He was one of six artists represented in 1958 in a Piccolo Gallery, Belfast, show of drawings of people. In his latter years he seldom turned to sculpture.

In collaboration with his wife, he designed costumes for the Patricia Mulholland Irish Ballet, and some of his designs are in the Grand Opera House, Belfast. In 1962 the *News Letter* reported that the Elbow Room in the Windsor Castle, Dublin Road, Belfast, was soon to be adorned with a mural. 'The panel, 18 feet by 5 feet, will represent three well-known Belfast hostelries ...'.

In 1963 MacCann made the death mask of his friend MacNeice; a copy is in the Ulster Museum. In 1965 a one-person show was held at the New Gallery, Belfast; as well as drawings and paintings, a construction in wood and paint, also welded forms, were on view. The following year he was elected an associate of the Royal Ulster Academy. He also exhibited in Dublin at the Irish Exhibition of Living Art. His death in Belfast was on 4 November 1967. A memorial exhibition of paintings, drawings and sculpture was arranged by the Arts Council of Northern Ireland at Queen's University, 1968, in conjunction with the Festival Society.

Works signed: MacCann or G. G. MacCann (if signed at all).
Examples: Armagh: County Museum. Belfast: Arts Council of Northern Ireland; Avoniel Primary School, Avoniel Road; Grand Opera House; Ulster Museum. Londonderry: Guildhall.
Literature: *The Armachian*, December 1935; *News Letter*, 21 November 1962; New Gallery, *George MacCann*, catalogue, Belfast 1965; Kenneth Jamison: Arts Council of Northern Ireland, *George Galway MacCann* (1909-67), catalogue, 1968; John Hewitt and Theo Snoddy, *Art in Ulster: 1*, Belfast 1977; Mercy MacCann, *Letter to the author*, 1988; also, Derry City Council, 1988; Royal School, Armagh, 1989.

MacCANN, JOSEPH – see GERALD, REV. FATHER

MacCARTHY, CLARA – see CHRISTIAN, CLARA

McCARTHY, JOHN F.(1901-59), landscape painter. Born in Cork, he studied at the Crawford School of Art, later exhibited at the Munster Fine Art Club and spent most of his life in business, retiring as a commercial traveller. He first exhibited at the Royal Hibernian Academy in 1935, from 2 Mary Villa, Mardyke, Cork. In 1940, now at 42 Northumberland Road, Dublin, he showed again at the Academy: *West Pier, Dun Laoghaire*. *Low Tide, Malahide* was hung at the 1946 event. Altogether at the RHA, up until 1952, he contributed a total of sixteen works.

In the period 1948-53 inclusive he showed twenty-two pictures, half of these Parisian scenes, at the Water Colour Society of Ireland exhibitions, for example *Early Morning, Paris* in 1949. He began in 1948 with two Inchigeelagh landscapes plus *The Backways, Cork* and *Low Tide, Sandymount*.

An eccentric and subject to malapropism, he patronised the Grafton Gallery in Dublin for his framing. Tom Nisbet, RHA, the proprietor, told the author in 1998 that Jack once returned from a Paris trip and reported that where he was painting the other artists did not allow him to sell his pictures at the site.

On the 1949 RHA, the *Dublin Magazine* critic wrote: 'J. F. McCarthy, in a number of pictures painted in Paris, shows an unusual verve and strength in the handling of watercolour though he still lacks any strong individuality of vision.' The three works presented included *Rue du Jacobin, Paris* and *Montmartre*.

The catalogue for the 1949 exhibition of pictures by Irish artists held in Technical Schools stated that he painted landscapes in oils as well as watercolours. On the WCSI 1950 gathering, the *Dublin Magazine* mentioned his *Apres-Midi Montmartre* and *Au bord de la Seine* and noted that they had 'achieved their delicate atmosphere with sureness of touch'.

Among the four watercolours, three of Paris subjects, at the 1950 RHA was *February morning, Blessington*. His final flourish at the Academy, in 1952, was *Evening sunlight*. He was represented in the Contemporary Irish Art exhibition at Aberystwyth in 1953, giving his address as 13 Anglesea Street, Dublin, where his father, E. J. McCarthy, fabrics agent, had an office.

John F. Kelly, RHA (q.v.), in a letter to the author in 1989, remembered him: 'A pupil of mine in the "Fifties" at the National College of Art. The work I can recollect by him which I thought had competence was his landscapes in watercolour. He exhibited fairly regularly and sold well...He was a small, slight man older than his peers. He worked diligently. He was from Cork I believe.' Of 1 Haddon Road, Clontarf, Dublin, he died on 23 September 1959 at Mater Misericordiae Hospital.

Work signed: J. F. McCarthy.

Literature: *Dublin Magazine*, July-September 1949, July-September 1950; *Exhibition of Pictures by Irish Artists in Technical Schools*, catalogue, Dublin 1949; *Thom's Directory of Ireland*, 1950; *Contemporary Irish Art*, catalogue, Aberystwyth 1953; Registry Office, Dublin, *Register of Deaths*, 1959; Ann M. Stewart, *Royal Hibernian Academy of Arts: Index of Exhibitors 1826-1979*, Dublin 1986; John F. Kelly, *Letter to the author*, 1989; *Water Colour Society of Ireland Exhibition List 1872-1994*, Dublin 1995.

MacCARTHY, JOHN M. (1890-1966), landscape and portrait painter. John Mathias MacCarthy, who was born in Cork city on 24 February 1890, was the son of William MacCarthy, chief clerk in a shipping company. John entered Crawford Municipal School of Art in 1910. In 1911 he was awarded the Cork Exhibition 1883 Scholarship, value £50, tenable at the New Cross School of Art, London, and there he won a bronze medal in the National Competition. Attending day and night sessions, his classes included modelling, book illustration and lithography.

In the period 1911-13 he also participated in the summer courses at the Dublin Metropolitan School of Art, and in 1914 in the Royal Dublin Society's Taylor competition he won a £10 prize for a portrait in oils with landscape background.

In 1914 he was appointed teacher of art at Sligo Technical School, and there he remained until his retirement. Michael Farrell (q.v.) studied under him and was encouraged to enter for scholarships. In 1918 he made a plaque of the head of Padraic Pearse and cast about a dozen copies, one of which is in the Model and Niland Centre, Sligo, where there are two oil paintings, *Martin Savage*, unsigned, and *Connemara*. The main inspiration for his oils and watercolours was County Sligo, for example Lough Gill and Calry. *View of Sligo Cathedral* is an oil painting. In the exhibition of pictures by Irish artists in Technical Schools, 1949, his work was represented.

Apart from painting, he had an exceptional flair for illuminated addresses and parchments; the address to the Most Rev. E. Doorley from 'The Catholic Citizens of Sligo' was by MacCarthy. He also had a gift for craftwork, designing and building hand-weaving looms and teaching weaving and colour design to his pupils and teacher-trainees at St Angela's College of Domestic Science. The designing and making of sailing boats was also within his compass. On 3 June 1966 he died at Sligo County Hospital. At the Sligo Art Gallery in 2000 a retrospective exhibition was held of paintings by MacCarthy, Michael Farrell (q.v.) and Bernard McDonagh.

Works signed: John M. MacCarthy, J. MacCarthy or Seán Mac Cártaig, rare (if signed at all).

Examples: Sligo: Model and Niland Centre.

Literature: *Sligo Urban Technical Instruction Committee Application Form*, 1914; Sligo Art Society, *Sligo and its Painters*, catalogue, 1959; Tomás Mac Evilly, *Letter to the author*, 1969; Miss Nuala MacCarthy, *Letters to the author*, 1969; Sligo Art Gallery, *Sligo Painters of the Past*, catalogue, 1981; Sligo Art Gallery, *The Illuminated Address 19th-20th century*, catalogue, 1983; Sligo County Library, *Letter to the author*, 1988.

MacCATHMHAOIL, SEAGHAN – see CAMPBELL, JOHN P.

Mac CAUSLAND, KATHERINE (1859-1928), portrait and figure painter. The family background and training of Charlotte Katherine Mac Causland remains a mystery, and it was not until she resided in France that there emerged a consensus of her Irishness. The date of her birth, 9 May 1859, has been taken from a French tombstone, and there is little doubt that the correct spelling of her name is Mac Causland and not MacCausland.

She painted at Lowestoft, Suffolk, in 1883, the date from her painting of a fishing boat which she later presented to the Bourron-Marlotte Town Hall Museum, where there is also *Le Père Boyer*. At about the time the English work was executed, Walter F. Osborne (q.v.) painted at Walberswick, a few miles down the coast from Lowestoft.

Katherine Mac Causland settled at the artists' colony of Grez-sur-Loing, near Fontainebleu. John Lavery (q.v.) first went there in 1883 and wrote that his happiest days in France were passed there, 'an inexpensive and delightful place sheltering not only painters but an occasional writer — R. L. Stevenson had just left when I arrived — or musician.' Lavery may have been referring to the composer, Frederick Delius, a resident in the village from 1897.

After staying at Hôtel Chevillon, Katherine Mac Causland bought a house of her own and became friends with the talented Swedish painter, Emma Löwstadt (1855-1932), who was married to the American artist, Francis Brook Chadwick. The Chadwicks had bought a restaurant which became a meeting place for the Swedish artist colony.

In 1891 Katherine painted *La Mère Moreau*, oil on linen, of a well-known old lady in the village, and this work, restored in 1998, was presented to the Town Hall by the English artist, Arthur Heseltine (1855-1930), a neighbour and friend of the Irishwoman. The American artist, John Singer Sargent (1856-1925) had a friendly relationship with Heseltine.

A familiar face in the village, she was popularly known as 'Miss Mac.' Julian Campbell, organiser of the 1984 Irish Impressionists exhibition at the National Gallery of Ireland, recounted an interesting record given by Henri Froment whose mother was painted by Mac Causland about 1902. The Irish artist was attracted by the fine complexion and black curly hair of the nine-year-old girl. The painter, who was lame, was very kind, and she gave the child a fifty centimes piece for each sitting. 'During the sittings, an artist living at St Leger would visit to examine the painting and give his advice.' The visitor was said to have been a Dutch painter.

In a letter to the author, Marie-Claude Lalance of Bourron-Marlotte recounted in 1999 that the artist, who had a studio at the Maison de la Chapelle, was a friend of her grandparents and the family has three portraits painted by her. The first was of her father as a child, dressed as a girl, dating from 1902; the second, the portrait of his mother, dating from 1906; and the third, the writer's father as a schoolboy in Sens in 1909.

The oil painting, 80 cm x 44 cm, which was exhibited at the Irish Impressionist exhibition, was of a smiling albino boy standing by a table, an unusual work. Campbell wrote: 'There is a certain awkwardness in pose in the way the boy stands, and holds the fruit…'The Paris Salon showed one of her portraits.

Incidentally, as well as the money, the village children who posed for her were fortified by buns when the sittings were long. Maurice Mac Causland Blyth, residing at rue du Départ, Paris, and following the artist's death in Paris on 2 December 1928, arranged for her burial in the New Cemetery at Saint-Germain-en-Laye.

Works signed: K. Mac Causland.
Examples: Bourron-Marlotte, near Grez-sur-Loing: Town Hall Museum. Grez-sur Loing: Town Hall.
Literature: (translations from the French by Arthur G. Chapman): John Lavery, *The Life of a Painter*, London 1940; *Svenskt Konstnärslexikon*, Malmö 1961; Julian Campbell: National Gallery of Ireland, *The Irish Impressionists: Irish Artists in France and Belgium, 1850-1914*, catalogue, Dublin 1984 (also illustration); National Gallery of Ireland and Douglas Hyde Gallery, *Irish Women Artists: From the Eighteenth Century to the Present Day*, catalogue, Dublin 1987; *The Oxford Dictionary of Music*, Oxford 1994; Mairie de Grez-sur-Loing, *Letter to the author*, 1998; Marie-Claude Lalance, *Letters to the author*, 1999; Hôtel de Ville, Saint-Germain-en-Laye, *Letters to the author*, 1999.

McCLOY, SAMUEL (1831-1904), genre and landscape painter. Born on 13 March 1831 in Lisburn, Co. Antrim, he was the youngest of five children. Peter McCloy, his father, was a painter and glazier in Bridge Street. Samuel was apprenticed to the firm of engravers, J. and T. Smyth, who had a considerable reputation and an address in the 1850s at 25 Castle Street, Belfast. Whilst serving his time, he studied art at the School of Design, 1850-51, where he gained an exhibition and several prizes. Subsequently he continued his studies at the Central School, Somerset House, London.

In 1854 he was appointed Master of the Waterford School of Art (or School of Practical Art Design), which had opened in 1852. A staunch Presbyterian, he could trace his family back to the Siege of Derry, and he was soon involved in church affairs in Waterford. When living at 34 Queen Street, he showed *The Haunt of*

Meditation at the 1859 Royal Academy. In 1862 he exhibited at the Royal Hibernian Academy for the first time — *The Poacher*; *Evicted*; *Our happiest days*.

In 1865 he married Ellen Lucy Harris (1845-1924), one of his pupils, whose watercolours of heads and children were regarded as much in the style of her husband. In the 1873-91 period, he showed nine works in London at the (Royal) Society of British Artists, being represented in 1873 by *On the Clodah, Curraghmore, Co. Waterford* and *The arrival of 'Phadrig na pib' (Paddy the piper)*, an oil now in the Lisburn Museum. In 1874, from 3 Eldon Terrace, Waterford, *Shrimpers, Tramore Bay, Co. Waterford*, was one of three pictures at the RHA.

When he exhibited at the RHA in 1875, he was then living in Belfast, and judging by the verse which followed the title, *May evening — Irish peasants after labour*, the work depicted a piper and dancers. He and his wife were, indeed, keen members of the Belfast Philharmonic Society. At the Industrial Exhibition in 1876 at Belfast's Ulster Hall, he had eleven pictures on view, including *Flower Girl* and *Gathering Moss*.

As McCloy had steady employment in Waterford, it is difficult to understand why he brought his family to Belfast, where he supported himself by painting figures in illuminated addresses, designing Christmas and greeting cards, and executing illustrations for Marcus Ward & Co., the well-known Belfast publishing firm. He also designed tablecloths for John S. Brown & Sons. According to the *Belfast News-Letter*, he produced many watercolours for an art gallery in London's Pall Mall. One aspect of his work — the anecdotal genre subject matter — classified him as a follower of the Irish artist, William Mulready (1786-1863), who spent most of his life in England.

In 1880 McCloy resided at 11 Magdala Street in the city, and two years later he exhibited at the RHA, *Biddy enjoying the Fragrant Weed*, from 41 Cromwell Road, the address he gave in 1882 with two works at the Royal Scottish Academy: *A jolly good yarn* and *Maiden meditation — 'A thousand thoughts she fashioned in her mind'* — Spencer.

In 1882 McCloy said farewell to the RHA, a total of sixteen works over the years. According to family sources, a decision to settle in London in 1884 had been prompted by his uncle dying and leaving him property in Clapham. At the Royal Institute of Painters in Water Colours in 1887 he showed *A stolen taste*. He was still a member of the Belfast Art Society in 1895.

What was believed to be the first exhibition of his work was hosted at Lisburn Museum in 1982. Eileen Black stated in the catalogue: 'McCloy worked in both oil and watercolour, but seems to have preferred the latter medium. His output was varied, and comprised domestic scenes, child studies, still life subjects and landscapes. He is best known for his child studies and domestic scenes, indeed his name is virtually synonymous with these subjects. In the writer's opinion, however, his true genius lay in landscape painting...' Black's colleague at the Ulster Museum, Martyn Anglesea, had no doubt he was an underrated artist, and: 'Though he had a liking for painting soppy sentimental pictures of little girls, he was an exquisite watercolourist, especially of flowers and landscape, as a large collection of his work in the Ulster Museum shows.'

On his watercolours of fruit, especially grapes, Anne Crookshank and the Knight of Glin wrote in *The Watercolours of Ireland*, 1994, that they had that 'bloom which was felt to give them a living quality, to make them almost edible and succulent, qualities which natural history painters would not have attempted.' The writers regarded *Espalier Apple Blossom* (Ulster Museum) as his masterpiece. In London, a study of black grapes and another of white grapes are in the Victoria and Albert Museum, both watercolours with some gouache, size 25 cm x 35 cm approximately.

Altogether in the Ulster Museum there are forty-two works, of which thirty-eight are watercolours, including *Donkey and Boy with Basket* and *Three Girls Playing Cat's Cradle*. In 1954 William Corran had donated thirty-eight pictures. The three oils in the collection are: *Two Old Friends*; *Caught in the Act*; and *Where the White Foam Kissed my Feet*. At the Lisburn Museum are eight watercolours, including *The Bridal Dress* and *The Love Letter*, and one oil. Four works there are unsigned. At the Haworth Art Gallery in Accrington there is a watercolour, *Returning from Market*, of a young girl holding a basket and standing on a wooden bridge. An oil, *Daydreams*, 41 cm x 51 cm, is at the National Gallery of Ireland. *The Bather*, watercolour, bequeathed to the former Cardiff Museum by James Pyke Thompson, is at the National Museum

of Wales: in the foreground is a nude female figure seated by a rock. The artist died at 117 Fernlea Road, Balham, on 4 October 1904.

Works signed: S. McCloy or S. McC.; Samuel McCloy, Saml. McCloy or McCloy, all three rare (if signed at all).
Examples: Accrington, Lancashire: Haworth Art Gallery. Belfast: Ulster Museum. Cardiff: National Museum of Wales. Dublin: National Gallery of Ireland. Lisburn, Co. Antrim: Museum. London: Victoria and Albert Museum.
Literature: *The Royal Academy of Arts 1769-1904*, London 1905; Walter G. Strickland, *A Dictionary of Irish Artists*, Dublin 1913; John Hewitt and Theo Snoddy, *Art in Ulster: I,* Belfast 1977; Anne Crookshank and The Knight of Glin, *The Painters of Ireland c. 1660-1920*, London 1978; Martyn Anglesea, *The Royal Ulster Academy of Arts*, Belfast 1981; Eileen Black: Lisburn Museum, *Samuel McCloy (1831-1904)*, catalogue, Lisburn 1982 (also illustrations); Brian Kennedy, editor, *A Concise Catalogue of the Drawings, Paintings & Sculptures in the Ulster Museum*, Belfast 1986; Ann M. Stewart, *Royal Hibernian Academy of Arts: Index of Exhibitors 1826-1979*, Dublin 1986; *The Royal Scottish Academy Exhibitors 1826-1990*, Calne 1991; Anne Crookshank and The Knight of Glin, *The Watercolours of Ireland c. 1600-1914*, London 1994 (also illustrations); Lisburn Museum, *Letter to the author*, 1998; also, Haworth Art Gallery, 1999; National Museum of Wales, 1999; Victoria and Albert Museum, 1999.

McCLUGHIN, W. J. (1900-71), landscape and portrait painter. Born on 4 December 1900 at Whitehouse, Co. Antrim, he was the son of a dairy farmer, Samuel McClughin. William served his apprenticeship with a printing firm, as a commercial artist, but became unemployed as the result of being run down by a drunken motorist, a policeman. His interest in art had been stimulated by classes at the Belfast School of Art.

A close friend of John Luke (q.v.) and John Hewitt, the latter has recorded the Belfast scene: 'We three ... maintained a rich and complicated conversation on art, its theories, its techniques, its origins, its directions, its future. Billy had a cautious, plodding, relentless mind, hard to persuade, never by a slick aphorism or a snappy epigram, but tenacious as an octopus when he had hugged an argument to his mind ...'.

Unfortunately, early in his painting career McClughin got bogged down in details on technique, of which he had a 'fantastic knowledge', according to Hewitt. Represented in the Ulster Arts Club exhibition in 1925, he was involved at the same venue, Belfast Museum and Art Gallery, two years later in the Irish portraits by Ulster artists exhibition with paintings of John Heathwood and John McNamee. His pastel of the previous year featuring the Italian Garden at Mount Stewart, Co. Down, is in the Armagh County Museum, where there is also a watercolour, *Ballyduff Brae*, 1932.

McClughin, who worked at a snail's pace reminiscent of Luke, also exhibited at the Ulster Academy of Arts, in 1937 from 23 Alexandra Park Avenue, Belfast. In the Ulster Museum there is an oil painting of Hewitt and a portrait in conté crayon of his father, Robert T. Hewitt. Other works include *Donegore Church*, pencil, and a self-portrait in pastel. He died in Whiteabbey Hospital on 2 December 1971.

Works signed: W. J. McClughin or McClughin, rare.
Examples: Armagh: County Museum. Belfast : Linen Hall Library; Ulster Museum.
Literature: *Irish Statesman*, 16 May 1925; John Hewitt, *Letter to the author*, 1967; John Hewitt, *John Luke (1906-1975)*, Belfast and Dublin 1978; Ulster Museum, *A Concise Catalogue of the Drawings, Paintings & Sculptures in the Ulster Museum*, Belfast 1986: Mrs A. Brooks (née McClughin), *Letter to the author*, 1989.

MacCORMACK, KATHERINE (1892-1975), designer. In 1899 her father, Francis MacCormack, a Tuam, Co. Galway, solicitor died after being thrown from a horse. Her widowed mother was the sister of Evelyn Gleeson (q.v.) who founded the Dun Emer Industries in 1902, subsequently named the Dun Emer Guild. Along with her sister Gracie, Kitty lived at Dun Emer, her aunt's home in Dundrum, Co. Dublin, and attended the Dublin Metropolitan School of Art, no doubt for the purpose of later assisting the Guild.

As a child and young person she did a considerable amount of amateur acting and later designed theatre sets. Author of plays and articles, she had a number of plays performed on Radio Éireann. As a designer for the Guild, she concentrated on Celtic ornament, though of a different character from that of Evelyn Gleeson, with whom, however, she collaborated in the design of the tapestries of the symbols of the Four Evangelists for the Honan Chapel, Cork, in 1917, and in that of the carpet presented to Pius XI by the Irish Government in 1931.

During the First World War she designed six Dun Emer Christmas cards, inscribed in Irish on the front and numbered and stamped with an Irish Trademark on the back. *The Book of St Ultan*, published in Dublin in 1920, was compiled by Katherine MacCormack, and she contributed herself two illustrations and two poems. In the period 1920-6, she produced several plays for the Dublin Drama League, and also acted. When she exhibited at the Royal Hibernian Academy in 1921 she was then living with her aunt at 10 Pembroke Road, Dublin. A watercolour by her shows Dun Emer girls embroidering at the Guild's premises in Hardwicke Street, Dublin.

In 1923 a hand-made set of gold vestments for St Patrick's Church, San Francisco, was displayed at 7 St Stephen's Green, Dublin, consisting of chasuble, dalmatic, tunic and cope and veil. One garment bears the designer's name : 'These vestments have been designed by Katherine MacCormack and embroidered and made by the Dun Emer Guild, Dublin'. Alternative robes for the Free State judiciary were designed by W. B. Yeats and Hugh Kennedy but it was Kitty MacCormack who provided the illustrations; her drawings are in the archives department at University College, Dublin. She designed a historical parchment poster for Dublin Civic Week, 1929.

In 1929 she exhibited at the Water Colour Society of Ireland for the first time, showing four works: *Late Afternoon*; *Snow in Dundrum*; *Illustration for a Fairy Tale: The Persian Carpet*; *The Ski-er*. Altogether she contributed forty-one works to WCSI exhibitions up until 1948, when she included *The Haunted House*.

Dun Emer embroideries and tapestries are in the collection of the National Museum of Ireland but her own contributions have not been singled out. It has been said that Kitty MacCormack was more talented as an artist than her aunt, who died in 1944; twenty years later the Guild at 2 Lincoln Lane, Dublin, closed down. She died on 26 June 1975.

Works signed: C. McC. or K. McC. (if signed at all).
Examples: Dublin: National Museum of Ireland; University College. San Francisco: St Patrick's Church.
Literature: An Pilibín, *The Wisdom of the World*, Dublin 1919 (illustrations); Katherine MacCormack, *The Book of St Ultan*, Dublin 1920 (also illustrations); *Thom's Directory*, 1922, 1962-3, 1965; *Irish Times*, 19 July 1923, 9 June 1990; General Register Office, Dublin, *Register of Deaths*, 1975; Brenna Katz Clarke and Harold Ferrar, *The Dublin Drama League 1918-1941*, Dublin 1979; *Irish Arts Review*, Winter 1984; Nicola Gordon Bowe, *The Dublin Arts and Crafts Movement 1885-1930*, catalogue, Edinburgh 1985; Monsignor C. J. McKenna, *Letter to the author*, 1986; also, Dr Patrick Kelly, 1988; National Museum of Ireland, 1988; *Water Colour Society of Ireland Exhibition List 1872-1994*, Dublin 1995.

McCORMICK, A.D., RBA, RI, ROI (1860-1943), landscape, figure painter and illustrator. Arthur David McCormick, son of Arthur McCormick, was born on 14 October 1860 at Long Commons, Coleraine. After attending school in the Co. Derry town, he studied at the Government School of Design in Belfast. In 1883 he travelled to London with Albert Morrow and Hugh Thomson (qq.v.), applying himself for three years at South Kensington. In the period 1885-8 he contributed to the *English Illustrated Magazine,* and from 1886 until 1897 to the *Illustrated London News*. An etching, 1888, *Waiting at the Ferry*, is in the Russell-Cotes Art Gallery and Museum, Bournemouth.

In 1889 from Trafalgar Studios he exhibited at the Royal Academy for the first time; Burlington House was to see his pictures for another thirty years, about fifty works in all. Early in his career he showed with the Society of British Artists in Suffolk Street. A facility with travel sketching – his first trip outside the British Isles – became evident with the publication in 1894 of Sir Martin Conway's *Climbing and Exploration in the Himalayas*, and in the following year in *An Artist in the Himalayas*, his own account of the year-long expedition with more than a hundred sketches. In 1895 too he accompanied Clinton T. Dent to Central Caucasus, and that year was appointed Fellow of the Royal Geographical Society. His address was now 58 Queen's Road, St John's Wood, where he was to reside for forty years. In one respect he remained something of a mystery – it appears there is not a single photograph of him in existence, although there is a drawing of him by Albert Morrow (q.v.) in *An Artist in the Himalayas*.

In 1897 he was accepted as a member of the Royal Society of British Artists; one of his contributions two years later was *Love's Message*. His 1897 drawing, now in the Victoria and Albert Museum, London, of

packers en route to the Goldfields, Klondyke, appeared in the *Illustrated London News*. Illustrations were also published in *Good Words* and *Strand Magazine*. Yachting as well as mountaineering was a favourite recreation, and many of his historical works had a nautical flavour, Nelson and Drake figuring prominently. *A Tale of the Spanish Main* appeared at the Society of Painters' exhibition in 1903. Seventy full-page illustrations were in colour in Sir Martin Conway's *The Alps*, 1904.

At the Royal Academy he showed *A Pirate's Sunday: mending the 'Jolly Roger'* in 1904, the year he exhibited at the Royal Hibernian Academy for the first time – in 1913 for the last. An exhibition of Alpine views was held at the Alpine Club Gallery, London, in 1904. In 1905 he was appointed a member of the Royal Institute of Oil Painters and, in 1906, of the Royal Institute of Painters in Water Colours. Commenting on *Our Jack's come home from the sea to-day*, appearing at the Royal Institute of Oil Painters' exhibition of 1910, *The Connoisseur* wrote that it 'might have tempted a less robust artist than Mr A. D. McCormick into producing something of the coloured almanac order, of which there were one or two examples to be seen. Mr McCormick, however, sacrificed popularity to art and gave a robust and atmospheric rendering of the scene in which the colour was true and unforced'.

When the critic of *The Connoisseur* saw his *Nelson at the Council of War before Copenhagen, 1801* at the Royal Academy in 1918, he commented : ' ... the picture tells its story well; the grouping of the figures is effective, and the warm-toned lamplight permeating the cabin gives a telling setting for the blue and white uniforms of the naval officers'. At the Imperial War Museum there are two oil paintings associated with WRNS at Portsmouth, one showing boat cleaning at the coastal motor boat base, 1919, and the other valve testing at RN Barracks. In 1922 at the RA, *The Connoisseur* found in his picture of a Drake-and-Saint Domingo episode that he was chiefly interested in seeing 'that the English and Spaniards are gaily attired and effectively grouped, consequently the ensemble is that of a stage tableau'.

McCormick worked in many other parts of the world, illustrations decorating the pages of books on Africa, India, Netherlands, New Zealand, Norway and Switzerland. Including travel books, he was the illustrator of nearly thirty books. These illustrations consisted mainly of watercolour paintings, but for his own *An Artist in the Himalayas* he used his rapid on-the-spot pencil sketches. His book illustrating came to a conclusion during the First World War.

In 1927 the tobacco manufacturers, John Player & Son, commissioned him to paint what was to become the well-known sailor's head and shoulders on their cigarette packets. Since then there have been two changes in the name on the cap band. McCormick used a clean-shaven model for his original painting and painted in the beard to conform as closely as possible to the previously used designs, which had not always featured a bearded sailor. The firm also commissioned a score of paintings from him and one of these, *His Old Ship*, is on permanent loan to the Coleraine Borough Council. Council for the Encouragement of Music and the Arts arranged in 1949 in Coleraine an exhibition of his oil paintings loaned by Player's.

McCormick's large costume-pieces had many admirers. In London, he also exhibited at the Brook Street Art Gallery. Outside the capital, he favoured mainly the Walker Art Gallery, Liverpool. At the National Maritime Museum, London, there are three watercolours with Nelson themes. In the last ten years of his life he lived at 53 Colet Gardens, Barons Court, London, W14. He died on 12 March 1943. In 1973 the Central Library in Belfast arranged a display of paintings and book illustrations by McCormick.

Works signed: A. D. McCormick, A. D. McC. or Mc.

Examples: Bournemouth: Russell-Cotes Art Gallery and Museum. Coleraine, Co. Derry: Borough Council, Cloonavin. London: Imperial War Museum; National Maritime Museum; Victoria and Albert Museum.

Literature: All publications listed until 1900 illustrated by McCormick and published in London: W. M. Conway, *Climbing and Exploration in the Karakoram-Himalayas*, 1894; William H. Hudson, *Lost British Birds*, 1894; W. M. Conway, *The Alps from End to End*, 1895; R. W. Frazer, *Silent Gods and Sun-Steeped Lands*, 1895; A. D. McCormick, *An Artist in the Himalayas*, 1895; Sarah J. Duncan, *His Honor and a Lady*, 1896; E. A. FitzGerald, *Climbs in the New Zealand Alps*, 1896; Charles Montague, *The Virgil*, 1896; Morley Roberts, *The Western Avenue*, 1896; Sir George Scott Robertson, *The Kafirs of the Hindu-Kush*, 1896; P. C. Faly, *Ninety-Eight*, 1897; Arnold Graves, *Prince Patrick*, 1898; William H. Hudson, *Birds in London*, 1898; E. C. Oppenheim, *New Climbs in Norway*, 1898; Edgar Allan Poe, *Arthur Gordon Pym*, 1898; E. Livingston Prescott, *A Small Small Child*, 1898; L. A. Waddell, *Among the Himalayas*, 1899; E. S. Grogan and A. H. Sharp, *From the Cape to Cairo*, 1900; Algernon Graves, *A Dictionary of Artists 1760-1893*, London

1901; Sir Richard F. Burton, *Wanderings in Three Continents*, London 1901 (illustrations); Edmund Downey, ed., *Killarney's lakes and fells*, London 1902 (illustrations); Sir Martin Conway, *The Alps*, London 1904 (illustrations); W. H. Hudson, *A Little Boy Lost*, London 1905 (illustrations); Edgar Allan Poe, *Tales of Mystery and Imagination*, London 1905 (illustrations); Mary Macgregor, *The Netherlands*, London 1907 (illustrations); John Finnemore, *Switzerland*, London 1908 (illustrations); Reginald Horsley, *New Zealand*, London 1908 (illustrations); V. Surridge, *India*, London 1909 (illustrations); *The Connoisseur*, December 1910, June 1918, June 1922; Henry Newbolt, *Drake's Drum*, London 1914 (illustrations); Robert Southey, *The Life of Nelson*, London 1916 (illustrations); *Who Was Who 1941-1950*, London 1952; *Belfast Telegraph*, 9 February 1957, 17 October 1973; *Irish Booklore*, August 1971; *Royal Academy Exhibitors 1905-70*, Wakefield 1979; *Dictionary of British Book Illustrators and Caricaturists 1800-1914*, Woodbridge 1981; *Dictionary of British Book Illustrators: The Twentieth Century*, London 1983; John Player and Son, *Press release*, 1983; Ann M. Stewart, *Royal Hibernian Academy of Arts: Index of Exhibitors 1826-1979*, Dublin 1986; Imperial War Museum, *Letter to the author*, 1997.

McCORMICK, H. C. GORDON (1888-1955), marine painter. Born at Roundstone, Co. Galway, Henry Charles Gordon McCormick was the youngest of a large family, his father, Canon James McCormick, being the Church of Ireland rector there. From an early age, Gordon was attracted to the sea, spending his childhood sailing with the local fishermen and becoming a fluent Gaelic speaker.

After reading Law at Trinity College, Dublin, he joined his brother Howard McCormick in the family firm of solicitors in Sligo. As the Yeats family were friends and relatives, he knew Jack B. Yeats (q.v.). Whilst serving in the First World War, his drawings, mainly of Salonika scenes, were in pen and ink but much of his work was in sepia, particularly for seascapes and boats; a few watercolours were painted in the Mediterranean.

He lived for a number of years after his marriage at The Abbey, Collooney, Co. Sligo, the family then moving to Tanrego, Beltra, still not far from the sea. His brother, Archdeacon George McCormick, was rector of Collooney; in 1935 Gordon's frontispiece appeared in his *In the Glow of the Peat*, a book of verses. Represented in the National Maritime Museum by four works, including *Galway Hookers* and *Connemara Gleitheog*, he died in Dublin in 1955 after his return from a holiday in the West Indies. In the Sligo Painters of the Past exhibition at the Sligo Art Gallery in 1981 some of his works were included.

Works signed: Gordon McCormick, G. McCormick, G. McC., H. C. Gordon McCormick or H. C. G. McCormick.
Examples: Dun Laoghaire, Co. Dublin: National Maritime Museum.
Literature: Seoirse Maccormaic, *In the Glow of the Peat*, London 1935 (illustration); Mrs Pat-Ann Prins, *Letters to the author*, 1982, 1983.

McCORMICK, NETTIE J. (fl. 1906-36), landscape and flower painter. Mrs McCormick attended the Dublin Metropolitan School of Art and first exhibited at the Royal Hibernian Academy in 1907 when she showed *A Road in Capri*, from Wood Lodge, Monkstown, Co. Dublin, giving that address until 1918. Altogether she exhibited forty-six works in Dublin; titles indicated that in addition to Irish, English, and Italian subject matter she also painted in France, Morocco, Spain and possibly British Columbia if one is to judge by *The Seven Sisters* which she contributed to the 1915 RHA. In private possession in Dublin, *Café des Halles, Concarneau* was dated 1908. An oil painting, *The Chateau, Fontainebleau*, was dated 1911 and signed with initials.

At the Walker Art Gallery, Liverpool, she exhibited nine works, and at the Liverpool Academy she held a joint exhibition with her friend, Miss B. A. Pughe. In that show *Bacchus Fountain, Versailles* appeared, possibly the same period – or the same work – as *The Fountain of Bacchus, Versailles*, which raised its head at the 1913 RHA. According to an undated cutting from the *Liverpool Echo*, the Versailles work was 'wonderfully cool ... delicious depth of green water against the varying greens of the forest, an outstanding work'. The critic also said that her watercolour, *La Crèpusculi* had something in it of Cayley Robinson (1862-1927) and 'displayed the same love of bright, clean-cut work'.

In 1919 at the RHA her Dublin address was 137 St Stephen's Green and she showed, with four other works, a portrait of Mrs Wilson Lynch. In 1921 she gave her Dublin address as 31 South Anne Street, where Clare Marsh (q.v.) had her studio. In that year and the following all five works exhibited at the RHA were painted in Northern Italy: Burano, Levanto and Venice subjects. The first note of a London address was 3a Cromwell Crescent, SW5 in 1923 when she showed her one and only picture at the Royal Academy: *The Bacchus*

Fountain, Versailles. In London, she also exhibited two works at the Goupil Gallery; one at the Society of Women Artists.

Mrs K. Affleck-Graves, who never knew Mrs McCormick's husband or her maiden name, wrote to the author in 1989: 'I am now 77 years old and I remember her in my youth as a small, dainty red-haired lady ... My mother went with her to paint in the 1920s to Italy ... My mother and I stayed with her in her charming cottage in Lancing, Sussex in the 1930s, and I know she died there of cancer, I think before the last war; her friend the artist James Sleator came to tell my mother of her fatal illness.' Mrs Affleck-Graves was given an oil painting of Bruges as a wedding present in 1936. Also in family possession is a large oil of a Belgian canal and another of a vase of dahlias. Despite a careful examination at the Registry of Deaths in London and Dublin, the year of her death has not been found.

Works signed: N. McCormick or N. McC.
Literature: *Thom's Directory*, 1922: *Dictionary of British Artists 1880-1940*, Woodbridge 1976; Ann M. Stewart, *Royal Hibernian Academy of Arts: Index of Exhibitors 1826-1979*, Dublin 1986; Mrs K. Affleck-Graves, *Letter to the author*, 1989; also, Mrs Hilary Hamilton, 1989; Gorry Gallery, *An exhibition of 18th,19th and 20th century Irish Paintings*, catalogue, Dublin 1996 (also illustration).

McDADE, WILLIAM (1875-1947), landscape and animal painter. Born near Ballycastle, Co. Antrim, he became engaged at an early age in Belfast in a commercial art career, attending night classes at the Government School of Art under George Trobridge (q.v.). McDade's talent was recognised by the offer of an engagement from Marcus Ward & Co. Ltd. After their liquidation, he worked for other Belfast companies.

An active member of the Belfast Art Society, he showed mainly watercolours, for example *The Old Road, Glenshesk* in 1897 and retained a keen interest in the Glens of Antrim area: *The Dunes, Ballycastle* in 1903. The BAS minute book recorded in 1903 for one of its monthly exhibition meetings at 49 Queen Street: '... also some fine specimens of book and magazine illustrations by Mr McDade. Several of them have been specially drawn for the great publishing firm of Messrs Cassell, war scenes constituting a considerable portion of sketches.' Works at the 1908 annual exhibition of the Art Society indicated a continuing interest in the Ballycastle area.

After the end of the First World War, McDade set up business on his own as a commercial artist at 109 Donegall Street. He was astonishingly versatile, and it was said that as an animal painter he reached his peak, painting pictures of noted horses and dogs. A devoted lover of animals, in 1929 he was specially commissioned by William Barnett, Malone House, to paint Trigo, the celebrated Derby winner of that year, but a painting of the horse which was rescued from fire following a bombing of Malone House in 1976 was by Lynwood Palmer (1867-1941).

The artist had a prodigious memory. On one occasion when a copy of the *Belfast Telegraph* was handed to him he studied two of its pages – advertisement and news – for a quarter hour. Then, returning the issue to those present, he is said to have repeated every word of the pages in proper sequence with but one minor slip.

McDade's knowledge of old Belfast was extensive and half a dozen watercolours at the Ulster Museum are in the local history department. These include a 1923 depiction of a jaunting car on the car stand at St George's Church, High Street. Another is of the corner of North Queen Street and Lancaster Street showing the house where Sir John Lavery (q.v.) was born. Of 123 Cavehill Road, Belfast, the last of several addresses, he died in hospital on 22 November 1947.
Works signed: W. McDade.
Examples: Belfast: Ulster Museum.
Literature: *Belfast Art Society Minute Book*, May 1903; *Belfast and Province of Ulster Directory*, 1920; *Belfast Telegraph*, 24 November 1947; Ulster Museum, *A Concise Catalogue of the Drawings, Paintings & Sculptures in the Ulster Museum*, Belfast 1986.

McDONNELL, IRENE– see BROE, IRENE

MacDONNELL, JAMES (1831-1911), animal and landscape painter. Son of Myles MacDonnell, he first exhibited at the Royal Hibernian Academy in 1850 and from then until 1889 showed a total of twenty-four works, some of which were watercolours. He was employed by the brewers, Sweetman & Co., Francis Street, Dublin, and later by Thomas, William and John Kelly, wine merchants, Westmoreland Street, devoting all his spare time to his art.

In 1872 his address was 19 Belgrave Road, Rathmines, the residence of Miss MacDonnell, presumably his sister. In 1874 he showed *The Scalp, near Dublin* at the RHA. In that year he painted Howth Harbour in the sunset. In 1875 at the Academy, he showed what may have been a horse portrait, *Baronet*, 'The Property of Leonard Morrough, Esq.' In 1877 he contributed to the Academy: *Portrait of Jack*; *Study of a Kerry Cow*; *Farmyard study at Leopardstown*.

In his *A Dictionary of Irish Artist*, Walter G. Strickland described him as 'a clever amateur painter...He painted many portraits of horses,' and one wonders was the subject man or beast for his Academy picture of 1878, *Head of an Arabian*. The three works which he showed in 1882 included *Prize Pony*. His final work in 1889 at the RHA was of an old bridge at Milltown, Co. Dublin, but he may have spent the rest of his painting life on commissions, all of which have proved difficult to trace. A bachelor, he died at home on 3 November 1911.

Works signed: J. MacDonnell.

Literature: *Thom's Directory*, 1890; Registry Office, Dublin, *Register of Deaths*, 1911; Walter G. Strickland, *A Dictionary of Irish Artists*, Dublin 1913; Ann M. Stewart, *Royal Hibernian Academy of Arts: Index of Exhibitors 1826-1979*, Dublin 1986.

McDONNELL, SHANE (1961-94), sculptor. Born in Dublin on 29 August 1961, Shane Desmond McDonnell, the son of Irene Broe (q.v.), spent his first few years in Malaysia, where his father, Jim McDonnell, resided as a research biochemist.

Back in Dublin, he attended Newpark Comprehensive School. During the 1980s he travelled in Europe and Asia. On his return, he had some formal training in sculpture from his mother, who operated at home, so he had already become familiar with her materials and techniques.

McDonnell's first sculptures were portraits, in 1988, *Dmitri* in mixed media at the Royal Hibernian Academy, and *File* at the Oireachtas. His address was 51 York Road, Dun Laoghaire, Co. Dublin. Remaining contributions to the RHA, all bronzes, were: 1990, *Brood*; *Curved Torso* or *Bathing Woman*; 1991, *Old Rose Thorn*; 1992, *Heart of the Forest*. He showed in a number of other group exhibitions including Art '90 and Art '91 at the London Art Fair, also Claremorris Open, 1990.

On his *Arched Female Form*, bronze, presented in 1991 at the Sculptors' Society of Ireland 'Espace' exhibition at the RHA Gallagher Gallery, the artist commented: 'This "curving figure" series, I suspect, will be returned to again and again throughout my career. As with most of my work this series is suitable to large scale, where the outer form, inner tension and enclosed space, will become all the more evident.' At the Boyle Arts Festival in 1992, *Victorian Chestnuts*, bronze, was one of four works.

On his *Living Form* in the Sculpture in Context exhibition at Fernhill Gardens, Sandyford, Co. Dublin, 1993, Patrick Gallagher in the *Sunday Independent* wrote: 'It is a huge, beautifully-cast semi-abstract bronze which could be a gigantic chestnut or the mighty buttocks of a mighty man...A serious and well-considered work, it would look its best in the white space of an urban gallery or in the cool reception area of a wealthy corporation.'

At the Kilcock Art Gallery, Co. Kildare, in 1993 he held a joint display with Margaret Becker, stained glass and prints, and showed fifteen bronzes, including *Roast Chestnut (Emerging Form)*. The Gallery was of the opinion that he had concentrated on developing his own distinctive style, resulting in a series of bronze works on both figurative and natural themes. In 1994, *First Claw* was one of three works which he presented at Aer Rianta's 'Gateway to Art' at Dublin Airport.

Shane McDonnell died almost immediately when hit by a recklessly-driven car on 25 November 1994. The memorial address at Glasnevin Crematorium was given by Colm Brennan of the Sculptors' Society of Ireland, who said in part: 'Shane had a deep sense of personal history and was very conscious of the role of

the Broe family in Irish sculpture over a number of generations. He certainly was not burdened by this genetic bequest but in fact drew quiet strength from it as he walked his own sculptural path.' His ashes were scattered under a great chestnut tree where *Living Form* had been placed during the 1993 Sculpture in Context exhibition. The 1995 exhibition at Malahide Castle Gardens was dedicated to him.

Works signed: Shane McDonnell (if signed at all).

Literature: Sculptors' Society of Ireland, *Espace*, catalogue, Dublin 1991; Kilcock Art Gallery, *Margaret Becker, Stained Glass and prints, S. D. McDonnell, sculpture in bronze*, catalogue, Kilcock 1993; *Sunday Independent*, 6 June 1993; Sculptors' Society of Ireland, *Newsletter*, February-March 1995; Jim McDonnell, *Letters to the author*, 1997, 1998.

McDONNELL, UNA – see WATTERS, UNA

MacEGAN, THE (1856-1939), portrait and landscape painter. Darius Joseph MacEgan was the son of a solicitor of Dublin and Roscrea, Co. Tipperary, Darius John MacEgan, and studied at the School of Art in Dublin and afterwards in London. In his younger days he lived with his parents in London, contributing drawings to newspapers and the *Illustrated London News*, meeting many of the celebrities of the day whom he sketched. The MacEgan title had not been used by the head of the family since the seventeenth century, but was restored and assumed by the artist, and he was the last of the princely line in direct succession. However, he was known in family circles as 'Dari'.

MacEgan began exhibiting at the Royal Hibernian Academy in 1881, from 54 Frankfort Avenue, Rathgar, Dublin, and thereafter showed more than four score works, from several addresses. The Royal Hospital, Kilmainham, appeared not infrequently in titles; in 1883 he showed a portrait of a pensioner there. He also painted on the Shannon at Castleconnell, Co. Limerick; Enniskerry, Co.Wicklow; Killarney and Connemara. At Mount St Joseph Abbey, Roscrea, a three-quarter length portrait of Dom Camillus Beardwood, Abbot, was dated 1892; a head and shoulders, 1893.

In 1898 at the RHA his works included *A November morning on the Thames, near Tower Bridge*, and a 'souvenir' of Naples. By 1910 his address was 12 Sterndale Road, Kensington, London; by 1912 it was c/o D. Egan at 26 Lower Ormond Quay, Dublin. Apart from such subjects as a snow effect at Phoenix Park, sunset on the river at Belfast, and a breezy day at the Bull Wall, Dollymount, he showed a few interiors.

Among his portraits hung at the RHA were: H. C. W. Tisdall (q.v.); Michael Comyn, KC; Rev. Robert Kane, S J, 1923, presumably the work in the Hugh Lane Municipal Gallery of Modern Art; Dr W. F. Starkie; T. M. Healy, KC. A 1924 drawing of Healy as Governor-General of the Irish Free State is in Áras an Uachtaráin, and he was responsible for a series of pencil drawings of the first Executive Government. He was represented at the 1926 exhibition of the Dublin Sketching Club at Mills' Hall, Merrion Row. His 1928 pencil drawings of Judge Fionán Lynch and Desmond FitzGerald were exhibited at the Golden Jubilee of the Easter Rising exhibition at the National Gallery of Ireland in 1966.

In 1933 Combridge's Galleries in Dublin displayed a copy of a portrait of Andrew Wyse commissioned from MacEgan by the Order of St John, London. The artist was described as 'of Redwood Castle and BallyMacEgan, Tipperary'. *The Little Flower*, a large painting in the Carmelite convent at Ranelagh, Dublin, was presented during renovations to the Holy Ghost Fathers, Kimmage Manor, in 1964.

In the Mansion House, Dublin, are portraits of two Lord Mayors, Alderman Alfred Byrne, TD, and Councillor Lorcan G. Sherlock, and at King's Inns is a 1923 pencil drawing of the Rt. Hon. Sir Thomas Lopdell O'Shaughnessy. An oil painting of the Rt. Hon. Lord Ashborne is in the Gaelic League offices. MacEgan's last address was 1 Corrig Castle Terrace, Dun Laoghaire, Co. Dublin, and he died in the town on 10 June 1939. At the Gorry Galleries, Dublin, a memorial exhibition of his drawings and paintings was held in 1940 in aid of his widow.

Works signed: Mac Egan, MacEgan, The Mac Egan or The MacEgan (if signed at all).

Examples: Dublin: Apostolic Nunciature in Ireland; Áras an Uachtaráin; Central Catholic Library; Gaelic League; Holy Ghost Missionary College, Whitehall Road; Hugh Lane Municipal Gallery of Modern Art; King's Inns; Mansion House.

London: Order of St John, Clerkenwell. Roscrea, Co. Tipperary: Mount St. Joseph Abbey. Waterford: City Hall, Municipal Art Collection.
Literature: *Irish Independent*, 23 October 1926, 12 June 1939; *Irish Times*, 30 July 1933, 12 June 1939; *The Irish Genealogist*, October 1939; Gorry Galleries, *Souvenir Exhibition of Drawings and Paintings by The MacEgan*, catalogue, Dublin 1940; Ann M. Stewart, *Royal Hibernian Academy of Arts: Index of Exhibitors 1826-1979*, Dublin 1986; Dean's Grange Joint Burial Board, *Letter to the author*, 1989; also, Mount St Joseph Abbey, 1989; St Joseph's Carmelite Monastery, 1989; Apostolic Nunciature in Ireland, 1993.

McELROY, MAI (1914-93), topographical painter. Born on 14 October 1914 in Co. Wexford, Mary E. McElroy was the daughter of Richard McElroy of Bannow, onetime head gardener in the Duke of Leinster estate, Carton House, Co. Kildare.

Dr George Hadden encouraged Mai's historical and artistic talents and when he founded in 1944 the Old Wexford Society — now the Wexford Historical Society — she was among his first recruits and was later made an honorary member, having served as chairperson and president.

'Mai Mac', as she was affectionately known in Wexford town, loved the fresh air and country life, and as long as she was able she cycled about and worked on her sketches. In 1948 she began a series of pen and ink drawings, with wash, which recorded what were to be the changing scenes of Wexford town and county, presenting in 1984 some hundred drawings in two albums to the Wexford County Library archives. A number of the sites no longer exist, for example Lyngstown Castle, 1950. However, it is in her drawings of Wexford town streetscapes in the 1950s that are of unique historical interest, such as Abbey Street, Cornmarket and Main Street.

Mai McElroy worked backstage at the first Wexford Opera Festival in 1951, helping with the construction and painting of sets. She also assisted drama groups. When Dr Hadden formed in 1960 the corps of guides for the Festival, she enrolled. A McElroy design has been featured on the cover of the *Wexford Historical Society Journal* since 1968.

A founder member in 1973 of the Wexford Arts Centre, she served on its board of directors for several years and on occasion taught children there. She was associated with virtually every cultural endeavour in the town. Works were hung frequently during the Wexford Festival in October, and also in Kilkenny during their Arts Week. She was a member of the Kilkenny Archaeological Society.

At Wexford Technical School and also the Secondary School, she taught art. When Westgate Tower was restored in 1990, she executed a drawing which is in the Wexford Corporation offices. In the County Council building there is an oil painting, *Morning Wexford*. Formerly of 4 Hill Street, she died at her home, Croke Avenue, Wexford, on 18 June 1993.
Works signed: Mai McElroy, M. McElroy or M/McElroy.
Examples: Kilkenny: Rothe House Museum. Wexford: Corporation; County Council; County Library; Perpetual Adoration Convent.
Literature: General Register Office, Dublin, *Register of Births*, 1914; Nicholas Furlong, *Loch Garman and Wexford*, Wexford 1980 (illustrations); *Wexford Historical Society Journal*, 1992-93; *The People*, 24 June 1993; Wexford County Library, *Letter to the author*, 1998; also, Mrs Sadie Hennessy, 1999.

McGOLDRICK, HUBERT (1897-1967), stained glass artist. Born in Rathgar, Dublin, Hubert Vincent McGoldrick, the youngest son of James McGoldrick, was educated by the Christian Brothers at Synge Street. He attended the Dublin Metropolitan School of Art, and in 1913 joined Earley & Co. at 4 Upper Camden Street where he learnt the mechanics of glass painting. In 1918, of 59 Brighton Road, Rathgar, he showed four stained glass designs at the Royal Hibernian Academy, including one for a three-light window, *The Sorrowful Mysteries*.

In 1920 he became a member of An Túr Gloine where he executed his designs in stained glass and *opus sectile*. His career began at a time when there was something of a boom in stained glass caused by a demand for war memorials, and his first window, a three-light of 1920, was a memorial at First Presbyterian Church, Ballymoney, Co. Antrim, made up of a series of heraldic devices with the Burning Bush set in the central light.

Also in 1920, and one of his finest windows, was *Sorrow and Joy*, for St Mary's Church, Gowran, Co. Kilkenny, now closed since the Office of Public Works assumed ownership. Among the dozen or so sketch designs for stained glass windows at the National Gallery of Ireland is a *Punch and Judy Show*, ink and watercolour, dated 1923. Another outstanding window, and a large one, is *The Apparition of the Sacred Heart to St Margaret Mary* in St Brendan's Cathedral, Loughrea, Co. Galway, dated 1925, the year the co-operative was formally registered as a limited company. Outside of his stained glass work, he had other interests, and exhibited cards, block prints, poster designs and decorative painting on plaster at the Arts and Crafts Society of Ireland's exhibition in 1925.

Of his foreign commissions at this period in stained glass, two were outstanding: for the chapel of the Sacred Heart Convent at Newton, near Boston, Massachusetts, 1927, *Sacred Heart*, rose, and *St Margaret Mary*, three lights. Writing in the *Father Mathew Record* in 1942, Máirín Allen referred to 'the great 100 square feet window for the treasure-house of the wealthy Chinese banker, Eu Tong Sen, OBE, at Singapore, and the windows for his home ordered by Eu Tong Sen's son. Those who saw the designs and the work in progress are of the opinion that these Chinese fairy-tales in glass were the artist's masterpiece ...'

In 1929 McGoldrick began work on a set of *opus sectile* Stations of the Cross for St Mary's Church, Westport, Co. Mayo. With those designs he gained an award in the competition held at the 1932 Aonach Tailteann; he had previously won a similar honour in 1928 for his Loughrea windows. His next major commission was the three-light *Rex Regum* for St Anthony's Church, Clontarf, 1933, now a parochial hall. This was followed by the great *opus sectile* Crucifixion group at the Church of Christ the King, Cork.

McGoldrick showed Stations of the Cross in *opus sectile* at the Glasgow Empire Exhibition of 1938, and the same medium was used for his *Christus Salvator Noster* at St Bartholomew's Church, Clyde Road, Dublin. Two small three-light windows, one of the Crucifixion and the other of the Resurrection, at the Church of the Holy Family, Aughrim Street, Dublin, are regarded as fine specimens of the artist's work. He was a member of the Academy of Christian Art.

An influence on the development of his art may have been his visits to the cathedral City of York and especially York Minster, but he was quite at home working on secular themes, judging by his *Dawn* for Singapore. Máirín Allen in her article was of the opinion that the best of his work 'has beauty of colour, sureness and simplicity of design, religious feeling and tenderness, and withal, a quiet, unaggressive strength'.

The An Túr Gloine cooperative was dissolved in 1944; thereafter he produced little stained glass. By the time he made his last window, for Muckross Dominican Convent chapel in Dublin, *c.* 1953, he was in very bad health. Bertie McGoldrick lived in relative obscurity in Dublin until his death in a Dublin hospital on 22 November 1967.

Works signed: H. V. McG. (if signed at all).
Examples: Ballymoney, Co. Antrim: First Presbyterian Church. Blackrock, Co. Dublin: Blackrock College Chapel; Church of Ireland Church, Kill-o-the-Grange. Cahir, Co. Tipperary: Church of Our Lady and St Kieran, Ballylooby. Castletownroche, Co. Cork: Church of Ireland Church. Cork: Church of Christ the King, Turner's Cross; St Ann's Church. Courtown, Co. Wexford: Church of Ireland Church, Kiltennel. Dublin: Church of Ireland College of Education, Upper Rathmines Road; Church of the Holy Family, Aughrim Street; Holy Ghost Missionary College, Whitehall Road; Muckross Dominican Covent; Rathfarnham Parish Church; St Anthony's Church Hall, St Lawrence Road; St Bartholomew's Church, Clyde Road; St George's Church, Temple Street; St Pappin's Church, Ballymun. Ferrymount, Co. Roscommon: Holy Cross Church. Galway: St Mary's Church, The Claddagh. Gateshead, Durham: St Paul's Church. Gowran, Co. Kilkenny: St Mary's Church. Kilfane, Co. Kilkenny: Church of Ireland Church. Killiney, Co. Dublin: Holy Trinity Church. Killorglin, Co. Kerry: St James's Church. Phoenix, Arizona, USA: Brophy College. Swinford, Co. Mayo: Church of Our Lady Help of Christians. Tullamore, Co. Offaly: Church of the Assumption. Wellington, New Zealand: Crematorium Chapel, Karori.
Literature: *Thom's Directory*, 1914; *Academy of Christian Art Journal*, vol. 1, part 2, 1938; Máirín Allen, *Father Mathew Record*, July 1942 (also illustrations); *Capuchin Annual*, 1950-51; James White and Michael Wynne, *Irish Stained Glass*, Dublin 1963; General Register Office, Dublin, *Register of Deaths, 1967*; *Irish Times*, 27 November 1967; Michael Wynne, *Irish Stained Glass*, Dublin 1977; Nicola Gordon Bowe, David Caron and Michael Wynne, *Gazetteer of Irish Stained Glass*, Blackrock 1988.

MacGONIGAL, MAURICE, RHA (1900-79), landscape and portrait painter. Born on 22 January 1900 in Dublin, Maurice Joseph MacGonigal was the only son of a Sligo-born painter and decorator, Francis MacGonigal. Educated at the Christian Brothers' School, Synge Street, his first real contact with the world of art was his apprenticeship to his uncle's firm, Joshua Clarke, ecclesiastical decorator and stained glass artist at 33 North Frederick Street. His cousin, Harry Clarke (q.v.) gave him much encouragement.

In 1917 he joined the first Na Fianna Eireann, subsequently being interned, first in Kilmanham Jail and then at Ballykinlar Camp, Co. Down, for a year until his release in 1921 when he returned to the Clarke studios. A watercolour sketch, *In Ballykinlar 1921*, is in the National Museum of Ireland, where there is also an oil painting of Bulmer Hobson.

Attendance at evening classes in the Dublin Metropolitan School of Art resulted in his winning the three-year scholarship for day classes, 1923-6. A fellow student, now Hilda van Stockum, recalled in 1985 MacGonigal at the School of Art: 'He was short and slender with dark hair, dark eyes, a rather pale complexion, full red lips and the Gaelic beak. He was vivacious, eloquent and knowledgeable, full of wit and intelligence, but also a bit indolent (then, at least), getting rid of his energy in speech ...'

At the School of Art he was awarded in 1924 the Taylor Scholarship in painting. Any possibility of a career in stained glass designing was now remote. In 1924 too he received the silver medal for landscape, Tailteann Games competition, and the silver medal for landscape and bronze medal for drawing, 1928. In 1927 he had made a prolonged study visit to Holland, and returned to Dublin as a visiting teacher to the Royal Hibernian Academy Schools, and as a 'substitute teacher' at the Metropolitan School of Art in 1934.

MacGonigal's association with the RHA was long and distinguished. He first exhibited in 1924 and then every year until 1978, showing an average of five works per year. In 1931 he was appointed ARHA and in 1933 a full member. An initial spell as Keeper of the Academy was from 1936 until 1939; his second, 1950 until 1961. He had a couple of years as treasurer and from 1947 until 1978 he was Professor of Painting. His presidency ran from 1962 until 1977.

In the manner of Sean Keating (q.v.), MacGonigal painted early in life in the West of Ireland, and from the early 1930s paintings executed in Connemara, Aran and Achill islands were hung at the RHA. North County Dublin, counties Donegal, Kerry and Wexford also attracted him. Referring to the 1936 exhibition of the RHA, the critic for *Ireland To-Day* wrote: 'In his work there is none of that self-satisfaction generally visible in the Academy He struggles to get the full value from his materials, and this must mean progression. He is also deeply concerned with design and composition ...' The next year the writer found his interior of Davy Byrne's pub and *The Servant Girl* 'head and shoulders' over anything else in the gallery.

The artist was also interested in stage design and book illustration, designing the sets for the 1935 Abbey Theatre production of Sean O'Casey's *The Silver Tassie*. Associated with the Dublin Book Studio, he made a substantial contribution to the illustrations, for cover design and borders, for the *Dublin Civic Week 1929 Official Handbook*. In 1932 he received a commission to design a setting for the Hospitals' Trust Sweep. Among the artists who assisted him was Harry Kernoff (q.v.). In 1935 and 1937 he contributed illustrations to *A Broadside*, issued by the Cuala Press.

In 1937 MacGonigal was appointed Assistant Professor of Painting, part-time, at the National College of Art, and became Professor there from 1954 until 1969. He was commissioned to paint a mural for the New York World Fair of 1939, a 10.5 metres high panel representing Liberty, America, and thirty of the Irish-born makers of American history. Portrait figures of men such as Commodore John Barry, President Andrew Jackson and General Stephen Moylan were grouped around and beneath a thoughtful young woman symbolising America – subsequently she became his wife – throned under the shadow of the Statue of Liberty. In the preparation of the panel he had the aid of a staff of research workers and in the painting he was assisted by Kernoff and Micheál de Burca (q.v.).

Painted about 1940, *Fishing fleet at Port Oriel, Clogherhead, Co. Louth*, oil, is at the National Gallery of Ireland with a study in pencil. In 1944 – exhibiting also in the Oireachtas exhibition – he held a one-person show at the Victor Waddington Galleries, Dublin, and two years later his *An Ghorta* attracted favourable attention at the Davis and Young Ireland centenary celebrations exhibition. In 1946, then living at 124 Rock

Road, Booterstown, Dublin, he was represented in the Living Irish Art exhibition at the Leicester Galleries, London.

In 1947 he held his first exhibition in Belfast, at 57 Donegall Place. The *Northern Whig* described him as 'a painter of genuine talent, although unspectacular and unpretentious ... Big subjects – famine, the Crucifixion – are also seen by him as clear themes ...'. Represented in 1949 in the exhibition of pictures by Irish artists in Technical Schools, he held an exhibition at the Victor Waddington Galleries, Dublin in 1952, and in the following year he was represented in the Contemporary Irish Art exhibition at Aberystwyth. In 1955 he resided at 16 Booterstown Park, Blackrock, Co. Dublin.

MacGonigal's work continued to attract attention from the critics. Writing about his exhibition at the Ritchie Hendriks Gallery in 1958, Arland Ussher noted in the *Dublin Magazine* that he had shown 'a consistent striving to get at grips with the Irish scene. He has never been lured away by the exotic blandishments of Southern Europe ...'. In 1960 he won the President Hyde Gold Medal at the Oireachtas exhibition with a painting of Kilmainham Jail, and he was similarly honoured in 1975. In 1964 at the RHA he showed a portrait of Aindrias Ó Muimhneacháin (Irish Folklore Commission). When the Golden Jubilee of the Easter Rising exhibition was held in 1966 he was represented by *The Rescue of the Prison Van at Manchester, 1867*, which had been presented by the Thomas Haverty Trust to the Municipal Gallery of Modern Art, Dublin, and by a portrait of Lt.-Gen. Peadar McMahon from McKee Barracks, Dublin. At McKee there is another oil, *Soldier in Battle Green*.

Day of the Big Fair, included in his show at the Dawson Gallery, Dublin, in 1968, had been purchased by the Northern Ireland Fellows and Members' Club of the Royal College of Physicians of London, for presentation to the Royal College on its 450th anniversary. In 1969 he ended his teaching career when he resigned in protest against 'the erosion of the professional authority of the college', caused by the students' revolt. He should have retired in 1965 but the Department of Education had persuaded him to stay on. He had his own studio in which he painted when not teaching. In 1969 too he strongly criticised the Government on its tax-free concession offered to the producers of artistic creative work – he felt it would fill the country with 'the art parasites of Europe'.

The National University of Ireland conferred an honorary LL D at University College, Dublin in 1970. He held another exhibition at the Dawson Gallery in 1970, and in 1971 there he showed paintings of Kerry (Dingle Peninsula), including *The Long Grass of Dún an Óir*; *Waiting Horses, Ballyferriter*. In that year he served on the advisory committee of the Project Arts Centre. In 1972 he was elected a member of the Water Colour Society of Ireland and in the period 1973-78 inclusive he showed seven works. His portrait of Sean F. Lemass was included in The Irish: 1870-1970 exhibition at the National Gallery of Ireland, 1974.

MacGonigal felt that there was 'nothing worse than living surrounded by one's own paintings. They crowd you in. When a picture is finished I like to get rid of it ...'. It was not uncommon for him to destroy works which dissatisfied him. He took pleasure late in life in experimenting – 'I will even try painting with my left hand if I feel like it', he said.

A self-portrait is in Limerick City Gallery of Art. He was a member of the Board of Governors and Guardians of the National Gallery of Ireland. His last one-person show took place at the Taylor Galleries, Dublin, only a few months before his death on 31 January 1979 at Baggot Street Hospital, Dublin; his home was at 2 Templemore Avenue, Rathgar, Dublin. He was buried with palette and brushes at Gorteen Cemetery, Roundstone, Co. Galway, the burial place of Bulmer Hobson. At the RHA exhibition that year, there was a small memorial tribute. In 1981 an exhibition of his work was held at the Taylor Galleries, others in 1985 at the Grafton Gallery, Dublin, and in 1986 at the Taylor Galleries. The Medici Society in 1988 published a birthday card: *A Summer Day*, courtesy of Crawford Municipal Art Gallery, Cork. In Dublin, a further exhibition of his work was held at the Hugh Lane Municipal Gallery of Modern Art in 1991.

Works signed: MacCongail, MacCongal, Muiris MacCongal, MacGonigal, Maurice MacGonigal, Maurice McGonigal, M. McGonigal; M. McG. or M., illustrations.
Examples: Armagh: County Museum. Athlone, Co. Westmeath: Institute of Technology; Public Library; Regional Technical College. Ballinasloe, Co. Galway: St Joseph's College. Bangor, Co. Down: Town Hall. Belfast: Ulster Museum. Cork: Crawford Municipal Art Gallery. Dublin: Bórd na Mona; Hugh Lane Municipal Gallery of Modern Art;

Leinster House; McKee Barracks; National College of Art and Design; National Gallery of Ireland; National Museum of Ireland; Office of Public Works; University College (Belfield), also Irish Folklore Commission. Galway: County Council; National University of Ireland. Limerick: City Gallery of Art; County Library. London: Royal College of Physicians, St Andrews Place. Mullingar: Westmeath County Council. Navan: Meath County Library. Sligo: Model and Niland Centre. Waterford: City Hall, Municipal Art Collection.

Literature: *Thom's Directory*, 1915; Kenneth Sarr, *The White Bolle-Trie*, Dublin 1927 (illustrations); Bulmer Hobson, ed., *A Book of Dublin*, Dublin 1929 (illustrations); E. M. Stephens, ed., *Dublin Civic Week 1929 Official Handbook*, Dublin (illustrations); Bulmer Hobson, ed., *Saorstát Éireann Official Handbook*, Dublin 1932 (illustrations); W. B. Yeats and F. R. Higgins, eds., *A Broadside*, Dublin 1935; *Ireland To-Day*, June 1936, May 1937; *The Studio*, December 1937; W. B. Yeats and Dorothy Wellesley, eds., *A Broadside*, Dublin 1937 (illustrations); Thomas Bodkin, intro., *Twelve Irish Artists*, Dublin 1940 (also illustration); Máirín Allen, *Father Mathew Record*, May 1943; *Dublin Magazine*, January-March 1945, October-December 1946, January-March 1947, April-June 1958; *Northern Whig*, 6 November 1947; *The Bell*, February 1952; *Capuchin Annual*, 1953-4 (illustrations); Dawson Gallery, *Maurice MacGonigal*, catalogue, Dublin 1968; *Irish Times*, 20 February 1969, 18 June 1969, 19 March 1970, 23 April 1970, 26 November 1971, 1 and 2 February 1979, 31 January 1983, 23 March 1985, 31 May 1985, 1 December 1986; *Evening Press*, 1 January 1972; *Water Colour Society of Ireland Minute Book*, 1972; *Arts Council Report*, 1975; National Gallery of Ireland, *Press release*, 11 April 1980; Taylor Galleries, *Maurice MacGonigal, RHA (1900-1979)*, catalogue, Dublin 1981; Ann M. Stewart, *Royal Hibernian Academy of Arts: Index of Exhibitors 1826-1979*, Dublin 1986; Ciarán MacGonigal, *Letter to the author*, 1988; also, Abbey Theatre, 1989; Department of Irish Folklore, University College, Dublin, *Amharc Oidhreacht Éireann*, catalogue, Dublin 1993 (also illustration); John Turpin, *A School of Art in Dublin since the Eighteenth Century*, Dublin 1995 (also illustration); *Water Colour Society of Ireland Exhibition List 1872-1994*, Dublin 1995.

McGOOGAN, ARCHIBALD (1860-1931), landscape and portrait painter. A North Antrim man, he became assistant in the art section of the National Museum of Science and Art and worked in the Kildare Street premises for more than forty years. In 1888 he showed at the Royal Hibernian Academy, from 1 Chester Road, Ranelagh, Dublin, and from then until 1929 he was regularly represented. The Dublin Sketching Club also hung his watercolours: *Baldoyle Strand, Howth* at the 1893 exhibition. In his first twenty years of exhibiting he painted regularly in the Dublin area – rivers Dodder and Tolka; Malahide and North Bull strands; but in 1903 he showed *Autumn – In the Fairy Glen, Rostrevor* at the RHA, and in 1910, *Autumn, North Wales*. Later, Glendalough, Co. Wicklow, became popular.

Photography was also a hobby, and in its Christmas 1912 issue *The Lady of the House* announced: 'The Sun Picture of College Green, secured by means of rotary camera, also of the City Hall, Belfast, the artist, in each case, was Mr A. McGoogan whose fine work has lent distinction to many of our Christmas numbers'. However, it was not just photographs that he contributed to the magazine. In the Christmas issue, 1914, the publishers presented to 'the public of Ireland the first exact copy ever issued' of Francis Wheatley's *Irish Volunteers*, the product of eight months' work at the National Gallery of Ireland. 'Exceptional facilities were granted to enable the work of reproduction to be performed with exactitude.'

At the 1915 RHA, McGoogan showed three portraits: E.C.R. Armstrong, Keeper, Royal Irish Academy Collection, National Museum; J. B. S. MacIlwaine, RHA (q.v.); and George Noble, Count Plunkett, which he later presented to the Royal Society of Antiquaries of Ireland. The National Museum of Ireland has a portrait of W. S. Mossop, RHA (1788-1827), from a painting attributed to Richard Rothwell, RHA (1800-68).

With the advent of the Easter Rising in 1916, McGoogan had something of a scoop. From a series of his own sketches and photographs, he produced *After the Bombardment*, showing Sackville Street and part of Eden Quay in ruins and on fire; two armoured cars on O'Connell Bridge exchanged shots with snipers. *The Lady of the House* published a presentation plate for its Christmas issue. The original work was displayed at the Golden Jubilee of the Easter Rising exhibition at the National Gallery of Ireland in 1966. Reviewing that Christmas number, the *Irish Times* referred to the presentation plate as being 'invested with the interest and artistic excellence associated with the pictures of old Dublin street scenes by Malton and Roberts'. A coloured print was also issued of his *Burning of the Custom House, Dublin, 25th May, 1921 by Irish Republican Army*.

McGoogan was the designer of the Great Seal of Saorstát Éireann. Of this design, Chief Justice Kennedy said: 'Mr McGoogan, who has great experience for many years in preparing plates and studies of the artistic remains of our ancient glory, and himself a practical and able artist, made a number of studies for the seal,

until at last a draft design was reached which seemed to be such a composition as was wholly worthy of the present purpose and the inspiration of the past'.

Travels for landscape painting extended as far as Bantry Bay and Glengarriff in County Cork, and he also worked in Killarney. He was still exhibiting at the Dublin Sketching Club in 1926, and the *Irish Independent* referred to his 'charming little view of a Welsh river with overhanging trees and reflections in the water'. One of his last works was the portrait of J. J. Buckley, his old chief at the Museum. President of Seapoint Boat Club, he died on 10 May 1931 at his residence, 8 Ardenza Terrace, Seapoint, Co. Dublin.

Works signed: A. McGoogan (if signed at all).

Examples: Dublin: National Museum of Ireland; Royal Society of Antiquaries of Ireland.

Literature: *The Lady of the House*, Christmas 1912, 1914 (illustration), 1916 (illustration), 1921 (illustration); W. G. Strickland, *A Dictionary of Irish Artists*, Dublin 1913; *Irish Times*, 13 December 1916, 12 May 1931; *Irish Independent*, 23 October 1926, 12 May 1931; J. Crampton Walker, *Irish Life and Landscape*, Dublin 1927 (illustration); Cynthia O'Connor Gallery, *Topographical Pictures*, catalogue, Dublin 1985; Ann M. Stewart, *Royal Hibernian Academy of Arts: Index of Exhibitors 1826-1979*, Dublin 1986.

McGORAN, KIERAN (1932-90), figure and portrait painter. The son of Francis McGoran, a draper in Ballynahinch, Co. Down, Kieran McGoran was born on 5 March 1932. He attended St Patrick's Primary School and spent a year, 1948-9, at Belfast College of Art. Involved in commercial art, he went to the USA in 1956 for three years and studied graphics. Early in the 1960s, the first of two visits, he travelled to Spain and the fifty-two works, plus some mounted sketches, which he showed in a Belfast furniture store included: *Palma Cathedral*; *Nativity*; *Gathering Storm*; *Leaving the Paddock*; and a number of portraits.

According to a typed family memorandum, he was engaged for 200 hours over a period of three months on his *Baptism of Christ*, painted in 1963 using an egg tempera medium, and that his style followed that of Perugino. This painting is in St Patrick's Church, Ballynahinch.

An exhibition of seventy works took place in 1966 at the Wellington Park Hotel, Belfast, and these included: *Matador*, three versions; *The Market, Clifden*, two versions; *Gipsy Children*; *Evening, Killary*; *Kylemore, Connemara*; *The Gamblers*; *Aran Woman*; *Card Players*, two versions.

In 1977 he painted a mural, *Buncrana Fishing Industry*, 1.5m x 2.2m, for the White Strand Motor Inn, Buncrana, Co. Donegal. Most of his work, however, was in pastel with the occasional oil. Some pastels were sold in auctions organised by Christie's, London. An admirer of William Conor (q.v.), McGoran once told the author that he himself was absorbed in 'figures in casual poses'. Frequently he portrayed beach, horse racing and street scenes. Of 35 High Street, Ballynahinch, he died suddenly in hospital, on 25 December 1990. A studio sale was held at Anderson's Auction Rooms, Belfast, in 1992.

Works signed: Kieran McGoran or K. McGoran.

Examples: Ballynahinch, Co. Down: St. Patrick's Church. Buncrana, Co. Donegal: White Strand Motor Inn.

Literature: Meenan & Co., *Recent Paintings and Sketches by Kieran McGoran*, catalogue, Belfast n.d.; *Baptism of Christ Memorandum*, typescript, 1963; Wellington Park Hotel, *Recent Paintings and Skeches* (sic) *by Kieran McGoran*, catalogue, Belfast 1966; *Irish News*, 27 December 1990; Seamus McGoran, *Letter to the author*, 1992; also, White Strand Motor Inn, 1992.

McGRATH, RAYMOND, RHA (1903-77), landscape painter, architectural draughtsman and designer. Born in Sydney, Australia, on 7 March 1903, Raymond H. McGrath was the son of Herbert Edgar McGrath, originally of New Zealand. During his education at the Fort Street Boys' High School, he showed a prodigious talent in both art and literature. He studied painting at the Julian Ashton School, and executed his first etchings; at a later stage he studied modelling. In 1921 he enrolled in the Faculty of Arts at Sydney University with the idea of pursuing some kind of literary career, but later transferred to the School of Architecture.

In 1923 he produced his first linocut although wood engraving was to become a favourite medium. The following year saw the publication of *The Seven Songs of Meadow Lane*, a book of poetry and woodcuts by Raymond H. McGrath. The edition was limited to thirty numbered copies all of which were printed on Japanese vellum. No. 29 is in the Mitchell Library, Sydney.

In 1926 he graduated as Bachelor of Architecture with first-class honours, and the Wentworth Travelling Scholarship sent him to London and eventually to Westminister School of Art and Clare College, Cambridge. *The Studio* in 1930 drew attention to his furnishing designs in the Palace of Light at the Ideal Home Exhibition. In that year too his wood engraved decorations appeared in *The Labyrinth and Other Poems* by James W. Mill.

Early in the 1930s, he was involved in the decoration of the interior of the new BBC building in Portland Place, and then of the Royal Institute of British Architects where he designed, for example, glass doors opening onto the terrace; the acided and sand-blasted panels represented the six great periods of architecture – Greek, Roman, and so on. The doors were exhibited at the Hayward Gallery in 1979 at the Thirties exhibition.

Until the outbreak of war, he also practised as an architect. *Glass in Architecture and Decoration* by Raymond McGrath and A. C. Frost appeared in 1937. In February 1940 he was appointed an Official War Artist, and on an exhibition of works by war artists that year in the National Gallery, *The Studio* commented: 'Though the human element was all but completely eliminated from his watercolour studies of the assembling of aeroplane parts, they yet attracted attention through their clean technique, perfect economy of line and delicate harmony of colour'. The Imperial War Museum holds five of these watercolours.

As a war artist, his spell was brief, and before the end of 1940 he was in Dublin, working as an architect in the Office of Public Works. He showed only two works with the Water Colour Society of Ireland, in 1941, *Decoration for Easter* and *Farmlands near Delgany*. Appointed principal architect in 1948, he held the post until his retirement in 1968. He took greatly to Ireland – he painted on Achill island – and to Dublin, and in 1940 held an exhibition of watercolours at Combridge's Galleries. In the August issue of *The Bell*, 1941, he wrote and illustrated an architectural review of Dublin.

McGrath first exhibited at the Royal Hibernian Academy in 1941 from Monkstown House, Co. Dublin, and with the exception of a few years was an annual exhibitor until his death. Not all the works were topographical. Occasional flights of fancy produced *Dialogue between shells* in 1946 and *Aoife and the Children of Lir* in 1963, both watercolours. The *Dublin Magazine*, in its appreciation of that medium at the 1943 RHA, referred to 'a striking architectural rendering of Trinity College, Dublin, which is a model in its genre'. However, when he showed his *Pacific* at the Contemporary Picture Galleries in 1943 the critic found it had 'the inconsequent clarity of a dream and smacks of Surrealism without being strained'. In 1945 he held an exhibition of watercolours at the Victor Waddington Galleries.

Appointed an associate of the RHA in 1949, he became a full member in 1967. Appointed Professor of Architecture at the RHA in 1968, he prepared the plans for the new art gallery in Ely Place. His work was included in the Contemporary Irish Painting exhibition which toured North America in 1950, and also in a similar exhibition at Aberystwyth in 1953, the year he executed his interior sketches of the old Abbey Theatre. In an exhibition of flower paintings at the Ritchie Hendriks Gallery in 1957, he was represented. His love of travel found him painting and drawing in Provence in the 1950s, and in the 1960s and 1970s on the Greek islands of Mykonos and Paros, as well as in Athens.

In the early 1950s McGrath embarked on the series of specially-woven carpets, the particular hallmark of his Government work which was to last a quarter of a century. He relied on the traditional skills of hand-knotted carpet manufacture in pure wool, available at the factory of Donegal Carpets Ltd in Killybegs. Nicholas Sheaff, writing in the *Irish Arts Review*, Autumn 1984, was of the opinion that one of the most successful of all McGrath's carpets was that designed for the grand salon of the Paris Embassy in 1954, 'where fluent arabesques surround that most Irish of all symbols, the harp of Brian Boru'. A design for a carpet at Áras an Uachtaráin incorporated one of the riverine heads of the Dublin Custom House. Several of his carpets are in Dublin Castle. In 1966 the Government donated a carpet to the newly-constructed headquarters building of the World Health Organization, Geneva.

Furniture and glassware he also designed, and the Cenotaph on Leinster Lawn, and he was a member of the Stamp Design Advisory Committee. A bookplate for his sister Eileen McGrath is in the British Museum. In the National Gallery of Ireland collection is a design for a certificate for the Board of Architects of New South Wales, also a frontispiece for a book, both ink on card.

A fellow of the Society of Industrial Artists, in 1972 he was founder and president of the Society of Designers in Ireland. In 1977 he was appointed president of the RHA, the first architect to hold the office for many years. At the Irish Architectural Archive there are 500 McGrath drawings. Of Somerton Lodge, Rochestown Avenue, Dun Laoghaire, he died on 23 December 1977. In 1978 his original drawings were used for designs for two Europa stamps, the theme being monuments. At the 1978 RHA, there was a small memorial tribute, and at the Neptune Gallery, Dublin, an exhibition of paintings and drawings in 1979, the year there was also an exhibition of prints and watercolours at the Deutcher Galleries, Armadale, Victoria, Australia.

Works signed: Raymond McGrath, Rayd. McGrath or R. McGt., monogram.
Examples: Dublin: Abbey Theatre; Áras an Uachtaráin (carpet); Dublin Castle (carpet); Irish Architectural Archive; Iveagh House (carpet); National Gallery of Ireland; Office of Public Works. Geneva: World Health Organization (carpet). London: British Museum; Imperial War Museum; Irish Embassy (carpet); Royal Institute of British Architects. Paris: Irish Embassy (carpet).
Literature: Raymond H. McGrath, *The Seven Songs of Meadow Lane*, Sydney 1924 (illustrations); James W. Mills, *The Labyrinth and Other Poems*, London 1930 (illustrations); *The Studio*, March 1930, June 1930, October 1940, November 1940 (also illustration); Elizabeth Montizambert, *London Adventure*, London 1939 (illustrations); *Irish Times*, 7 December 1940, 10 January 1970, 29 July 1972, 6 December 1977, 5 May 1978, 20 November 1978, 28 April 1979; *The Bell*, August 1941 (illustrations); *Dublin Magazine*, July-September 1943, October-December 1943, July-September 1945; *Ireland of the Welcomes*, January-February 1954 (illustrations); *Irish Independent*, 21 July 1970; Deutcher Galleries, *Raymond McGrath Prints*, catalogue, Armadale 1979; Meirion and Susie Harries, *The War Artists*, London 1983 (illustrations); Nicholas Sheaff, *Irish Arts Review*, Autumn 1984; National Gallery of Ireland, *Acquisitions 1982-1983*, catalogue, 1984; Ann M. Stewart, *Royal Hibernian Academy of Arts: Index of Exhibitors 1826-1979*, Dublin 1986; World Health Organization, *Letter to the author*, 1989; also, Imperial War Museum, 1989; State Library of New South Wales, 1989; David J. Griffin and Simon Lincoln, *Drawings from The Irish Architectural Archive*, Dublin 1993 (also illustration); Royal Institute of British Architects, *Letter to the author*, 1995; *Water Colour Society of Ireland Exhibition List 1872-1994*, Dublin 1995.

McGUINNESS, BINGHAM, RHA (1849-1928), landscape painter. In the early part of his life, William Bingham McGuinness was apprenticed to a Dublin architect, John S. Mulvany, RHA, the son of the landscape and figure painter, Thomas J. Mulvany, RHA (1779-1845). When McGuinness became articled, his employer had been showing designs at the Royal Hibernian Academy for several years. During his apprenticeship he attended, in the evening, the special classes held at the Academy, and finding his true vocation he later went to Dusseldorf, Germany, where he studied, specialising in the art of watercolours. Thomas R. Mulvany, a nephew of John S. Mulvany, died in 1907; he was a Consul at Dusseldorf.

Throughout a lengthy period, McGuinness was a staunch supporter of the RHA, first exhibiting in 1866 and with the exception of only two years, showing annually. In these sixty years he sent an average of three works per exhibition. By 1872, apart from his Irish excursions, he had already painted in North Wales, Hereford and Worcester, but in 1875 when he gave an address 3 Turlough Terrace, Clontarf, he exhibited a perspective view of dwelling houses erected at Castrop, Westphalia. In the 1878 show he depicted old houses in Essen, Westphalia, and that year he painted the watercolour, *The Tower of St Romain Church, Rouen, from Rue Horlogue* (National Gallery of Ireland). In the next two years at the RHA, titles indicated painting activity in Belgium and France. When the Dublin Sketching Club was formed in 1874, he joined, later becoming president.

In 1882 he became an ARHA and showed at the annual exhibition *Old Street in Dinan, Brittany* and *Canal scene at Peppendracht, Holland*. In 1884 he became RHA, having been represented at the Cork Industrial Exhibition of 1883 with an address 6 St Stephen's Green, Dublin. In 1884 too Charles Russell (q.v.) showed a portrait of Bingham McGuinness, RHA at the Dublin exhibition. At the Irish Exhibition in London in 1888 McGuinness contributed *Lough Cullen, Co. Mayo*.

McGuinness first exhibited at the Water Colour Society of Ireland in 1892 and was a regular contributor for the rest of his life, averaging more than four works per exhibition and only missing a few. He showed two North Devon coast scenes in 1893.

The catalogue of the Belfast Art Society exhibition of 1895 listed him as an honorary member. A joint exhibition in Dublin with R. T. Moynan and Johnston Inglis (qq.v.) was held in 1900. In that year *The Studio* commented on the Water Colour Society of Ireland exhibition in Dublin, saying that McGuinness deserved 'more than a passing mention. He is one of the most distinguished as well as one of the most facile of our water-colour artists, and showed several landscapes in which the skies were beautifully luminous, the effect being obtained without any apparent effort'.

Continuing his travels abroad, McGuinness painted in Hamburg, Venice and on the Moselle river. Rouen and Troyes also figured in his journeys. Street scenes in Continental towns displayed his knowledge of architectural subjects. In 1902 he showed at the Royal Academy. By 1903 he was resident in London. When Hugh P. Lane organised in 1904 an exhibition of works by Irish artists at the Guildhall he was represented by *Cahir Abbey* and *Moorland Lake, Autumn*. Dated 1905, *Bridge on the Llugwy, Wales* is in the Hugh Lane Municipal Gallery of Modern Art. In 1907 at the New Dudley Gallery in London he exhibited with Mildred Butler, Percy French and Claude Hayes (qq.v.).

In the early summer of 1914 he was in Normandy. His last London address was 104 Wymering Mansions, Elgin Avenue, from about 1915. He also exhibited in London with the Royal Institute of Painters in Watercolours; in Liverpool at the Walker Art Gallery, and in Birmingham with the Royal Society of Artists. As well as being a committee member of the WCSI, he was a member of the Black and White Artists' Society of Ireland – *The Studio* reproduced *An Old Street in Dublin*, pencil drawing, from the third exhibition in Dublin in 1916. In that year at WCSI, his works included *Carting Turf, Connemara*.

Anne Crookshank and the Knight of Glin in their 1994 book on Irish watercolours wrote: 'He is a highly competent, if dull, practitioner in the English tradition, deriving ultimately from Bonington through other Englishmen whom he must have known, such as Samuel Prout and James Holland. He was admired in his lifetime, his rich tones and picturesque subjects finding a ready market and critical acclaim'.

A friend, J. B. Hall, who knew him long and intimately, wrote: ' ... his favourite theme, so to speak, was to be found in the old vistas of Continental cities ...'. He considered him 'a man of endearing qualities. He was of a singularly modest and retiring disposition, a kindly critic of others, and students of the Academy and amateurs ever found him a willing, earnest helper ...'. His death occurred on 26 July 1928 at 78 Grove Park, Rathmines, leaving a widow and son in London.

Works signed: Bingham McGuinness, B. McGuinness or B. McG.
Examples: Dublin: Hugh Lane Municipal Gallery of Modern Art; National Gallery of Ireland. Limerick: City Gallery of Art. Waterford: City Hall, Municipal Art Collection.
Literature: *Irish Times*, 17 December 1881, 1 August 1928; *Cork Industrial Exhibition*, catalogue, 1883; *The Studio*, March 1900, July 1900, June 1916 (also illustration); *Municipal Gallery of Modern Art Catalogue*, Dublin 1908; W. G. Strickland, *A Dictionary of Irish Artists*, Dublin 1913; *Thom's Official Directory*, Dublin 1920; J. Crampton Walker, *Irish Life and Landscape*, Dublin 1927 (also illustration); *Irish Independent*, 2 August 1928; *Dictionary of British Artists 1880-1940*, Woodbridge 1976; Christie's, *Mildred Anne Butler*, catalogue, London 1981; Gorry Gallery, *18th, 19th, 20th century Irish artists*, catalogue, Dublin 1982; Ann M. Stewart, *Royal Hibernian Academy of Arts: Index of Exhibitors 1826-1979*, Dublin 1986; Anne Crookshank and the Knight of Glin, *The Watercolours of Ireland*, London 1994 (also illustration); *Water Colour Society of Ireland Exhibition List 1872-1994*, Dublin 1995.

McGUINNESS, NORAH (1901-80), landscape painter, designer and illustrator. Born in Londonderry, on 7 November 1901, her father, Joseph Allison McGuinness was a coal merchant and shipowner. The family lived at Lawrence Hill and Norah attended Victoria High School. Despite opposition from her family that she should make a career as an artist, she entered the Dublin Metropolitan School of Art in 1921, winning a scholarship tenable for three years. In 1923 she won a Royal Dublin Society medal, and in 1924 she received a medal for her drawings at the Tailteann Competition. The *Dublin Magazine* published some of her illustrations in 1923 and 1924. In 1924, when she first exhibited at the Royal Hibernian Academy, she studied in London for some months at Chelsea Polytechnic.

Early in life she had to support herself, and had no desire to be a teacher. Her first important commission was the illustrating of an edition de luxe of Laurence Sterne's *A Sentimental Journey through France and*

Italy. The drawings were completed in 1925, the year that she married Geoffrey Phibbs (Geoffry Taylor, the poet), a Wicklow librarian. When the book was published in 1926 *The Studio* commented that she was 'emphatically on the right road, in that her drawings are manifestly done with an eye to their place in the typographic scheme as a whole'.

Involved in the theatre, she designed the costumes and decorations for *Deirdre* by W. B. Yeats, performed at the Abbey Theatre in 1926, and in the same year for the Abbey she created a set for the garden scene in Oscar Wilde's *The Importance of Being Earnest*. The Victoria and Albert Museum in London has two watercolours, donated by the artist, designs for the 1926 costumes of Deirdre and the Musician.

The masks of Cúchulainn and the Woman of the Sidhe for *The Only Jealousy of Emer* by Yeats were designed by her for the Abbey, 1926, and she did the masks and costumes for this play when performed at the Abbey by the Dublin Drama League; she played the Woman of the Sidhe. For the opening of the Peacock Theatre, Dublin, in 1927 she designed the sets for Georg Kaiser's *From Morn to Midnight*.

Yeats thought highly of her work, and illustrations were commissioned for his *Stories of Red Hanrahan and the Secret Rose*, 1927; the introductory poem was dedicated to her. Original drawings are in the Model and Niland Centre, Sligo. Reviewing the book, the *Dublin Art Monthly* said it would be difficult to find a better illustrator, 'She has seized, almost inexplicably, upon the spirit of the weird, wild and haunting melodious prose stories, with their permeating vein of Celtic lyricism. Her fluidity of line ignores ordinary standards of illustration...'.

In 1929 her marriage broke up and she decided to study in Paris, partly as the result of advice from Mainie Jellett (q.v.), under André Lhote. In 1931 she visited her sister in India, stayed some months and then returned briefly to France. From 1931 until 1937 she lived in Hammersmith, London, resumed her book illustration work – Maria Edgeworth's *The Most Unfortunate Day of My Life*, 1931 – but returned in summertime to her County Donegal cottage. In 1932 her work was hung at a group exhibition at the Galerie Zac, Paris. In London she exhibited with the Seven and Five Society and the London Group – she showed *Summer Evening, Hammersmith* in 1934. One-person shows were held at the Wertheim Gallery, 1933; Zwemmer Gallery, 1934, provided thirteen oils, including *Trees in Kew Gardens,* and twenty-seven watercolours, for example *Quayside Dieppe*.

Two frontcloths and scene VIII for Denis Johnston's production of his own play *A Bride for the Unicorn* at Westminster Theatre, London, 1936, were McGuinness designed. Her portrait of Denis Johnston is in the National Gallery of Ireland. Throughout her period in London her illustrative work appeared in the *Bystander*, which regularly commissioned her for fashion drawings; also in *Vogue*. The Leicester Galleries, London, ran an exhibition of lithographs in colour in 1938 and her work was included.

Still retaining her Irish links, she exhibited at 7 St Stephen's Green, Dublin, in 1936. Late in 1937 she went to America for the opening in January 1938 of a mixed show by Irish artists in the gallery of Mrs Cornelius J. Sullivan in New York. In 1939 at the Reinhardt Gallery she held her first one-person show in New York. She illustrated for *Harper's Bazaar* and designed Fifth Avenue window displays, particularly for Altman's. Her work was in the 1939 New York World Fair.

After her return to Dublin in 1940 she persuaded Brown Thomas's through its principal, Senator E. A. McGuire (q.v.), to employ her for window display. Such was her success that she continued for more than thirty years with some assistance. Exhibitions in Dublin at the Victor Waddington Galleries, in 1938, and at the Contemporary Pictures Gallery, in 1939, were followed by a resumption in exhibiting at the RHA in 1940, and two one-person shows at 7 St Stephen's Green in 1941 and 1944. She also exhibited there with Dublin Painters.

In 1942 she exhibited for the first time at the Water Colour Society of Ireland and showed more than fifty works up until the year of her death. Contributions in the inaugural year were: *Autumn Bouquet*; *Fitzwilliam Square*; *The First Crocus*; *Autumn Flowers*.

A founder member of the Irish Exhibition of Living Art in 1943, she became president in 1944 when Mainie Jellett's health failed. Dorothy Walker, in her *Modern Art in Ireland,* 1997, described Norah as president: '...vocal, articulate, tough, and charming; she let nothing pass in public life that impinged on the arts, and her letters to the press kept issues of the arts constantly before the public...'. When she returned to

the Victor Waddington Galleries in 1944, and again in 1949, her address was 13 Fitzwilliam Square, Dublin. Her designs were included in Waddington's 1943 Christmas cards. She once again turned her hand to stage sets and for a time was a designer with the Abbey Theatre and also designed some programmes. Sets were provided for Maura Laverty's *Liffey Lane* in 1951 at the Gaiety Theatre.

In 1946 she painted in Italy, and in 1947 held her first solo show at the Leicester Galleries; others followed in 1951, 1957 and 1963. *The Studio* commented on her first exhibition there, of watercolours, that they showed 'courage, coupled with hidden knowledge, a looseness of technique completely free of sloppiness and a richness of colour unusual in its mature balance'. In her 1951 show, works included *St Marine, Brittany* and *Church, Santa Margherita*. The 1963 exhibition at the Leicester of twenty-five paintings included *Drying seaweed* and *Spring planting*.

In 1950 Norah McGuinness was chosen along with Nano Reid (q.v.) to represent Ireland at the Venice Biennale. The Contemporary Irish Painting exhibition which toured North America in 1950 included her work. Among her portraits in 1951 were those of Evie Hone (q.v.), Barbara Warren and Mícheál Mac Liammóir (q.v.). In 1953 she was represented in the Contemporary Irish Art exhibition at Aberystwyth.

On her 1949 exhibition at the Victor Waddington Galleries, the *Dublin Magazine* had commented: 'At its best the work of Norah McGuinness is forthright, spontaneous and dramatic; unfortunately her style is one which, when inspiration is lacking, becomes too easily a parody of itself, producing the effect of over-emphasis with lack of content ...' A series of shows at the Dawson Gallery began in 1958, followed by seven others up to 1977.

In 1957, by which time she had a cottage with studio looking out at the Dublin mountains, she was elected an honorary member of the RHA but resigned in 1969. She loved country life and sometimes stayed with her friend Joan Jameson (q.v.) in Co. Waterford. In 1959 a retrospective exhibition, jointly organised by Council for the Encouragement of Music and the Arts and the Belfast Museum and Art Gallery, was held at the museum, her first in Northern Ireland. Among the loans was *The Yellow Table*, one of the five selected pictures by Irish artists sent to America that year to compete in the International Guggenheim Award.

In the Algrave was painted in 1961. Her works were well known outside Ireland, and she was represented in Irish modern art exhibitions at Monaco in 1962 and New York in 1963. She retained her London connection with an exhibition at the Mercury Gallery in 1967. Something different appeared at the Golden Jubilee of the Easter Rising exhibition held in Dublin in 1966 – *The Howth Gun Running*, watercolour, lent by the National Museum of Ireland. Three works at the Irish Museum of Modern Art include *Blue Pool*, gouache. *Portrait of Frank O'Connor*, oil, is among her pictures at the Crawford Municipal Art Gallery, Cork.

A retrospective exhibition of nearly a hundred works, paintings, drawings, prints, theatrical designs and book illustrations was held at Trinity College, Dublin, in 1968. The exhibition was also hung at the Crawford Municipal Art Gallery, Cork, and in 1969 a selection at the Brooke Park Gallery, Londonderry. She was also an Oireachtas exhibitor. Her work was in the Arts Council's exhibition of modern Irish painting which began its tour of European countries in 1969, and that year she was on the advisory council at the National College of Art.

In 1973 she received an honorary degree, Doctor of Literature from Trinity College, Dublin. In 1974 one of her works was reproduced on a postage stamp. She returned to her native city in 1976 for an exhibition at the Keys Gallery, and among her oils at that gallery in 1979 she included *The Rushy Field, Donegal* and *White Rocks on the Dublin Mountains*. In that year too she had a one-person show at the Taylor Galleries, Dublin. On 22 November 1980 she died at Monkstown Hospital, late of 53 York Road, Dun Laoghaire.

Works signed: N. McGuinness or N. McG.
Examples: Athlone, Co. Westmeath: Public Library. Beijing: Irish Embassy. Belfast:Ulster Museum. Churchill, Letterkenny, Co. Donegal: Glebe Gallery, Derek Hill's Collection. Cork: City Hall; Crawford Municipal Art Gallery; University College. Coventry: Herbert Art Gallery. Dublin: Arts Council; Córas Iompair Éireann, Heuston Station; Dublin Writers' Museum; Hugh Lane Municipal Gallery of Modern Art; Institute of Public Adminstration; Irish Museum of Modern Art; National College of Industrial Relations; National Gallery of Ireland; National Museum of Ireland; Office of Public Works; Trinity College Gallery; University College (Belfield); Voluntary Health Insurance Board. London: Victoria and Albert Museum. Londonderry: Foyle and Londonderry College.Naas: Kildare County Council. Navan:

Meath County Library. New York: Irish Embassy. Sligo: Model and Niland Centre. Waterford: City Hall, Municipal Art Collection. Zurich: Aer Lingus.

Literature: *Dublin Magazine*, August 1923 (illustration), March 1924, June 1924 (illustrations), April-June 1944, January-March 1950; *The Studio*, September 1925 (also illustrations), November 1926, December 1938, June 1939 (also illustration), September 1947; Laurence Sterne, *A Sentimental Journey through France and Italy*, London 1926 (illustrations); W. B. Yeats, *Stories of Red Hanrahan and the Secret Rose*, London 1927 (illustrations); *Dublin Art Monthly*, January 1928; George Sheringham and R. Boyd Morrison, eds., *The Robes of Thespis*, London 1928 (illustrations); Maria Edgeworth, *The Most Unfortunate Day of My Life*, London 1931 (illustrations); *The Bell*, December 1943; Eileen O'Faolain, *Miss Pennyfeather and the Pooka*, Dublin 1944 (illustrations); Michael MacLiammóir, *Theatre in Ireland*, Dublin 1950 (illustrations); Leicester Galleries, *Norah McGuinness*, catalogue, London 1951; Elizabeth Bowen, *The Shelbourne*, London 1951 (illustrations); *Irish Times*, 20 November 1959, 16 November 1967, 25 July 1968, 5 October 1968, 9 June 1969, 22 September 1971, 24 November 1980, 15 October 1981, 11 November 1982, 7 October 1983; Elizabeth Hamilton, *An Irish Childhood*, London 1963 (illustrations); Anne Crookshank: Trinity College, Dublin, *Norah McGuinness*, catalogue, 1968; *Ireland of the Welcomes*, May-June 1968 (also illustration); Irish Exhibition of Living Art, *Letter to the author*, 1968; Liam Miller, *Dolmen XXV*, Dublin 1976 (illustrations); John Hewitt and Theo Snoddy, *Art in Ulster: 1*, Belfast 1977; *A Dictionary of Contemporary British Artists, 1929*, Woodbridge 1981; Taylor Galleries, *Norah McGuinness 1903-1980*, catalogue, Dublin 1982; Marianne Hartigan, *Irish Arts Review*, August 1986; Ann M. Stewart, *Royal Hibernian Academy of Arts: Index of Exhibitors 1826-1979*, Dublin 1986; Aer Lingus, *Letter to the author*, 1989; also, Miss Rhoda McGuinness, 1989; John Turpin, *A School of Art in Dublin since the Eighteenth Century*, Dublin 1995; *Water Colour Society of Ireland Exhibition List 1872-1994*, Dublin 1995; Dorothy Walker, *Modern Art in Ireland*, Dublin 1997 (also illustration).

McGUIRE, EDWARD,jnr.RHA (1932-86), portrait and still life painter. Edward Augustine McGuire was born in Dublin, on 10 April 1932, the son of Edward A. McGuire (q.v.). Senator McGuire's youngest son showed an interest in drawing and painting from an early age. Educated by a private tutor and at Downside School, Bath, he visited Italy in 1951 via Paris and studied in Florence the history of Italian painting, Renaissance period. He began painting there, worked in the studio of Pietro Annigoni (1910-88) and with a group of artists on the Italian island of Ponza. In 1952-3 he attended the Academy of Fine Art in Rome, and when his mother died in 1953 he returned to Ireland. His tenure as a trainee manager in the family business of Brown, Thomas and Co. Ltd was brief.

McGuire attended in 1954-5 the Slade School of Fine Art in London, became friendly with Lucian Freud, who taught there, and was influenced by his work. In London, Francis Bacon (1909-92) was among the other painters whom he met. He returned to Ireland, repaired to Kilronan on Inishmore where he lived in a cottage for a few months, collecting sea shells and the skulls of sheep, which he drew. On his return from the Aran Islands he worked at his father's house, Newtownpark House, Blackrock, with a studio over the stables, and later for brief periods in studios in Parliament Street and Pembroke Lane, Dublin. In 1959 he moved into his studio-flat at 42 Upper Leeson Street, Dublin. Among those who had influenced him to start painting seriously was Patrick Swift (q.v.). Patrick Pollen, the stained glass artist, was a close friend.

McGuire, for a short period, painted under the name Edward Augustine. Involved with the artists and writers of the Dublin scene, he spent much of his spare time reading poetry and general literature. Many of his portraits were of literary figures. Still life studies of birds were also a feature of his work and he did a lenghty series of paintings, twenty-one of them – almost as many as his literary portraits, most of which were uncommissioned. Early in his career he also received much encouragement from the Scot, Robert MacBryde (1913-66), who died in Dublin after a road accident.

Patrick Kavanagh, a watercolour of 1961, was his first portrait of a poet, and in 1962 – he had already shown at the Irish Exhibition of Living Art – he exhibited at the Royal Hibernian Academy for the first time. In 1966 he received, just before he moved to his permanent home in Sandycove, his first commission, a portrait of a little girl, Wanda Ryan. *Rossenara*, a house, 1967, was followed in 1968 by a portrait of Garech Browne. *The Four Snipe*, 1969, was the occasion of an unique event: a full-scale art opening at the Dawson Gallery, Dublin, for this one work.

At Termon, Mahery, Co. Donegal, he worked for several months each year from 1971 until 1980. At the David Hendriks Gallery, Dublin, 1970, he was one of six artists represented as designers of sleeves for Claddagh Records. In 1971 his work was included in The Irish Imagination exhibition in association with

Rosc, at which portraits of Pearse Hutchinson and Michael Hartnett were exhibited at the Municipal Gallery of Modern Art, Dublin.

In the 1970s a number of issues of the *Broadsheet*, published by his friend Hayden Murphy, contained reproductions of his works. Murphy's portrait was completed in 1975, the year after he painted Francis Stuart, now in the Hugh Lane Municipal Gallery of Modern Art. In the period 1973-82 inclusive, McGuire painted twenty-six portraits and nine still lifes. His appointment as ARHA came in 1973; full membership in 1978. Representing Ireland with four works, he won an award in 1974 at the Festival International de la Peinture, Cagnes sur Mer. In that year he showed *Nuala* and *The Window* at the RHA.

Of all his portraits, that of Seamus Heaney, 1974, commissioned by the Ulster Museum, is probably the best known through reproduction. In that year the National Gallery of Ireland purchased a head study for the full-length portrait. In 1976 he won the Dr Douglas Hyde Gold Medal award at the Oireachtas, where he exhibited his portrait of Cearbhall Ó Dalaigh. A portrait of Ó Dalaigh is in the Court of Justice of the European Communities; another is in the National Museum of Ireland.

In 1978 he won the Marten Toonder Award of £2,500. In the previous five years he had been busy with portraits – three for Trinity College, Dublin: Dr W. J. E. Jessop, Dr A. J. McConnell, Professor R.A.Q. O'Meara; one for University College, Cork: Dr M. D. McCarthy; and for the Workers' Union of Ireland: Denis Larkin. In the same period, portraits of writers were still to the fore: Monk Gibbon, Ulick O'Connor, Eilis Dillon, Sean Ó Faolain, Benedict Kiely, Anthony Cronin. One of John Ryan (q.v.) is now in the Dublin Writers' Museum.

After travelling to Cumbria, England, McGuire completed his portrait of William Whitelaw in 1979, and that year he won a mention in the Paul-Louis Weiller International, France. In 1980 he was represented in The Delighted Eye exhibition in London, and also in the Ireland's Literary Renaissance: 20th Century Portraits exhibition at Marshall Field's, Chicago. His 1980 portrait of Dr Thomas Murphy is in University College, Dublin. An equestrian portrait of Charles Haughey, whom he had painted in 1978, followed in 1981.

The 1981 portraits of Paul Durcan and James White are at the National Gallery of Ireland, where there is also a portrait of Liam Miller. The Liam Cosgrave portrait of 1982 is in Leinster House. He rarely had one-person shows, and the 1983 exhibition at Taylor Galleries, Dublin, proved something of an event. The 1983 portrait of fellow artist Patrick Collins (q.v.) is at the Irish Museum of Modern Art; studio contents and archive material are also at Kilmainham, donated by his widow, Sally McGuire.

McGuire often listened to jazz when he painted. In portraiture, he described Patrick Tuohy (q.v.) as his ideal but he also said that another influence on his life was the Belgian surrealist painter, René Magritte (1898-1967). A meticulous craftsman who arranged and graded his colours and tones with scientific accuracy, he often destroyed work that did not satisfy him.

He generally worked on several portraits simultaneously; at the time of his death there were twelve unfinished. He last exhibited at the RHA in 1986: *Barn Owl*, from 26 Sandycove Avenue West, Dun Laoghaire, Co. Dublin. The art critic, Brian Fallon, wrote: 'A conscious pictorial scientist, he gave his heart, nerves and muscle to his work.' A member of Aosdána, he died on 26 November 1986 at St Vincent's Hospital, Dublin. A retrospective exhibition took place at the RHA Gallagher Gallery in 1991.

Works signed: Edward McGuire, Edward McG., E. McGuire, McGuire, E. A., E. M. or E. McG.
Examples: Belfast: Ulster Museum. Churchill, Letterkenny, Co. Donegal: Glebe Gallery, Derek Hill's Collection. Cork: University College. Dublin: City University; Dublin Writers' Museum; Hugh Lane Municipal Gallery of Modern Art; Irish Museum of Modern Art; Irish Transport and General Workers' Union, Liberty Hall; Leinster House; National Gallery of Ireland; National Museum of Ireland; Royal Dublin Society; Trinity College; University College. Limerick: University, National Self-Portrait Collection. Luxembourg: Court of Justice of the European Communities.
Literature: National Gallery of Ireland, *Press release*, 1974; Arts Council, *Press release*, 1978; *Inniu*, 19 January 1979; *Irish Times*, 2 December 1983, 27 November 1986; Ann M. Stewart, *Royal Hibernian Academy of Arts: Index of Exhibitors 1826-1979*, Dublin 1986; Edward A. McGuire, *Letter to the author*, 1987; also, John McGuire, 1987; Mrs Sally McGuire, 1987, 1989; Trinity College, Dublin, 1987; Dorothy Walker, *Irish Arts Review*, Winter 1987; *Martello*, Summer 1988; Royal Hibernian Academy, *Edward McGuire, RHA, 1932-1986*, catalogue, Dublin 1991; Dorothy Walker, *Modern Art in Ireland*, Dublin 1997 (illustrations); Irish Museum of Modern Art, *Catalogue of the Collection*, Dublin 1998.

McGUIRE, EDWARD A., senr.(1901-92), figure painter. Edward Augustine McGuire was born in Waterford on 28 August 1901, the son of John Francis McGuire. He was the father of a painter, Edward McGuire (q.v.). Educated at Clongowes Wood College, Co. Kildare, the Douai School in Berkshire, and University College, Dublin, he confessed to the author: 'I gave my life to commerce and banking with painting as a side interest.' Nevertheless, he was something of a Renaissance man in Dublin, where he took over in the early 1930s the Brown Thomas store in Grafton Street at the request of his father. By then, a regular member of Ireland's Davis Cup team, he also excelled at billiards.

Independent, McGuire studied under his friend, Mainie Jellett (q.v.), and he was a newcomer in 1938 to the Dublin Painters annual exhibition. The critic from *Ireland To-Day* considered that McGuire had begun his rebellion 'without knowing properly what he was rebelling against,' but singled out *Polo Players*. The *Architectural Association Journal* referred to his 'very interesting and modern style.'

The Dublin Painters exhibited at the London Office of the High Commissioner for Ireland in 1938, *The Studio* commenting that a 'dashing effect' was achieved with his painting of boxers. In 1938 too he also showed with the Dublin Sketching Club. His *Punch and July Show*, oil, is in the Waterford municipal collection.

In 1940 he arranged a solo show at the Dublin Painters' Gallery, where works included *O'Connell Bridge*; *Turf Man*; *The Boxers* (Clongowes Wood College). The catalogue reproduced a head of McGuire by Brenda Gogarty; an edition of three. The wonder was that he had time to paint at all, being president of the Federation of Irish Employers, district commander in the Local Defence Forces, on an advisory committee on design in industry, and a lecturer at Contemporary Pictures, 133 Lower Baggot Street, Dublin.

In 1941 *The Bell* was of the opinion that 'from the beginning he stood out by reason of his quick eye for movement and his equally quick discrimination in subject.' Meanwhile, he brought in Norah McGuinness (q.v.) as display director at Brown Thomas's. At that time no one in Dublin had thought of employing an artist to dress their windows.

In 1941 Contemporary Pictures published *The Crucifixion*, a colour print from the Sign of the Three Candles. McGuire had exhibited this painting at his 1940 exhibition. *The Bell*, in giving notice of the reproduction, said: 'In the four years he has been exhibiting he has come far. His work has shown in different degrees the influence of Yeats, Rouault and Vlaminck, and he has finally adopted the technique of expressionism of which this *Crucifixion* finely exemplifies the mode of freely applying heavy pigment and violently splashed colour to accentuate emotion.'

Interested in the White Stag Group in Dublin, he occasionally contributed to their exhibitions and was one of the eighteen artists represented at the first exhibition in 1941. His former tutor, Mainie Jellett, gave lectures to the Group, and she was the first chairman of the Irish Exhibition of Living Art when it was formed in 1943 with McGuire as one of the guarantors; he was a trustee for many years. He also exhibited for several years and was represented in 1944. Appointed a member of Seanad Éireann in 1948, he served until 1965. In 1953 he opened the Little Theatre at Brown Thomas's and various exhibitions were regularly held.

When he exhibited, from Newtown Park House, Blackrock, Co. Dublin, the oil *Nuns* (Limerick City Gallery of Art) at the 1954 IELA, his son also showed but under 'Edward Augustine.' He himself ceased to exhibit but continued to 'dabble in painting, many works being given to friends and family,' said a daughter. He was a member of the Arts Council, Dublin.

McGuire bought a number of Jack B. Yeats' new-style works following visits to his studio in Fitzwilliam Square, frequently meeting Yeats roaming the Dublin streets. Myles na gCopaleen, the *Irish Times* columnist, commented: 'It is well for Ned McGuire he can paint a Jack Yeats in one afternoon.' McGuire has amusingly recounted the day he called at the Waddington Galleries to collect a little picture of his of a cricket match, which he had left to be framed. It was ready, but Waddington had put it in his shop window with some Jack Yeats pictures. As McGuire sat in a dark corner of the shop, Nano Reid (q.v.) walked in and said to Waddington: 'That little picture of a cricket match is one of the best Jack Yeats I have seen.'

In an appreciation in the *Irish Times*, James White wrote: 'To my generation his presence at sporting, social or art occasions was always marked by the restrained elegance of his appearance and the calm, agreeable manners he invariably displayed.' Commander of Order of Civil Merit 1st Class Espagna, Fellow of the Royal

Society of Antiquaries of Ireland, he was on the Board of Governors and Guardians of the National Gallery of Ireland. He died at Altadore Nursing Home, Glenageary, Co. Dublin, on 27 October 1992.

Work signed: E. A. McG.
Examples: Limerick: City Gallery of Art. Naas, Co. Kildare: Clongowes Wood College. Waterford: City Hall, Municipal Art Collection.
Literature: *Ireland To-Day*, March 1938; *The Architectural Association Journal*, April 1938; *The Studio*, September 1938; *The Bell*, September 1941; *Irish Art Handbook*, Dublin 1943; *Who's Who, What's What and Where in Ireland*, London 1973; *Irish Times*, 8 December 1984, 29 October 1992, 1 December 1992; Edward A. McGuire, senr., *Letter to the author*, 1987; S. B. Kennedy, *Irish Art & Modernism 1880-1950*, Belfast 1991; Bruce Arnold, *Jack Yeats*, New Haven 1998; Mrs Barbara Corballis (née McGuire), *Letter to the author*, 1999; also, John F. McGuire, 1999; Seanad Éireann, 1999.

MacILWAINE, J.B.S., RHA (1857-1945), landscape painter. Born in Dublin, on 21 April 1857, the son of John S. MacIlwaine, a banker, John Bedell Stanford MacIlwaine was educated at the High School, Dublin. According to P. L. Dickinson in *The Dublin of Yesterday*, 'he started as an architect but his real talent lay in painting'. Dickinson added that he should be placed high as a landscape painter. He studied architecture under Sir Thomas Drew, PRHA (1838-1910).

MacIlwaine attended the Royal Hibernian Academy Schools, and when there his friend Walter Osborne (q.v.) painted him on Good Friday, 1880. This oil sketch was later presented by MacIlwaine to the Municipal Gallery of Modern Art, Dublin. It was in 1879 that he first exhibited at the RHA, from Stanford House, Foxrock, Co. Dublin, and, with the exception of a few years, he showed regularly until 1944, more than a hundred works in all, many of which he titled as 'Sketch from nature'.

One of Osborne's finest portraits – 'To my friend J. B. S. MacIlwaine, 1892' – depicted the artist sitting in summer sunshine in a garden with his dog beside him. This work is in the National Gallery of Ireland and was reproduced in colour on the front cover of the catalogue for the Aspects of Irish Art exhibition which had a short USA tour in 1974.

In 1893 MacIlwaine became an associate of the RHA. Co. Wicklow was a favourite venue for painting, and in 1894 at the Royal Academy he showed *Cooldross, Co. Wicklow*. As well as working with Osborne, he also painted with Nathaniel Hone (q.v.). *Shining Shannon* was hung at the 1901 RHA, and a few years later he showed Co. Donegal subjects. In 1911 he became a full member of the Academy, and two of the seven pictures which he exhibited at the 1913 exhibition, *Brittas Mill* and *Two's Company*, he regarded as among his principal works. On the 1916 RHA, *The Studio* noted his landscape painting.

An inventor, he was interested in submarine devices and acted as an engineer for the Conan Submarine Fuze from the initial to final stage, and invented the automatic aeroplane range-finder. After the First World War, he moved to Annaghroe House, Caledon, Co. Tyrone, and his painting trips took him to Co. Meath and also to the Glaslough area in Co. Monaghan where the Leslie family found him 'a charming and interesting man'.

The author, Anita Leslie, spent her childhood at the ancestral home, Castle Leslie, Glaslough, and recounted an amusing story, in *The Gilt and the Gingerbread*: ' ... the experiences of an old artist, Mr MacIlwaine, and our dairymaid, Miss MacAdoo, a red-haired lady weighing over eighteen stone. MacIlwaine, whose small oils of the Irish countryside occasionally travelled to exhibitions, often painted in our demesne. One evening he strolled away, leaving a sketch of Kelvey lake on his easel. When he returned the picture had been finished – "by fairy hands", he said. Hurrying to the dairyhouse he related this to Miss MacAdoo, who laughed derisively. Next morning all her milk had turned sour ... the fairy painting of Kelvey lake hangs at Castle Leslie, and is curiously different to MacIlwaine's other work.'

MacIlwaine served on the art committee in connection with the Ulster Pavilion at Wembley, 1924. In 1929 he presented his *Carrickmines Hill* to the Municipal Gallery of Modern Art, Dublin. His painting, *Late Summer*, on board, is at the National Gallery of Ireland. A writer on art, gardening, numismatics, poultry, and spiritism, he died on 14 January 1945.

Works signed: MacIlwaine or monogram (if signed at all).

Examples: Drogheda, Co. Louth: Library, Municipal Centre. Dublin: Hugh Lane Municipal Gallery of Modern Art; National Gallery of Ireland. Glaslough, Co. Monaghan: Castle Leslie.

Literature: *The Studio*, June 1916; *Who's Who in Art*, 1927; P. L. Dickinson, *The Dublin of Yesterday*, London 1929; *Royal Hibernian Academy Minutes*, 1945; *Who Was Who 1941-1950*, London 1952; Jeanne Sheehy, *Walter Osborne*, Ballycotton 1974; Municipal Gallery of Modern Art, *Elements of Landscape*, catalogue, Dublin 1976; Peter Harbison, Homan Potterton, Jeanne Sheehy, *Irish Art and Architecture*, London 1978; Anita Leslie, *The Gilt and the Gingerbread*, London 1981; Ann M. Stewart, *Royal Hibernian Academy of Arts: Index of Exhibitors 1826-1979*, Dublin 1986; Monaghan County Museum, *Letter to the author*, 1989.

McKELVEY, FRANK, jnr.– see MURPHY, FRANK

McKELVEY, FRANK, RHA, RUA (1895-1974), landscape and portrait painter. Born in Belfast on 3 June 1895, the son of William McKelvey, painter and decorator, Francis Baird McKelvey was a poster designer with David Allen and Sons before entering the Belfast School of Art where he won the Sir Charles Brett prize for figure drawing, 1912; in 1912 too he was commended for his drawings from the nude in the National Competition; and he won the Fitzpatrick prize for figure drawing, 1914. He won a bronze medal in the Taylor Art competition, Dublin, 1917, and a prize of ten pounds in 1918 for *The Grandmother*.

In the early stages of his career he was commissioned by Thomas McGowan, a Belfast businessman, to paint pictures of Old Belfast, or to copy old pictures and photographs, and this large collection, which was augmented in the 1930s, is in the Ulster Museum. McKelvey won immediate recognition in Dublin for his landscapes and his work was hung at the Royal Hibernian Academy in 1918, sent from 56 Woodvale Road, Belfast, and from then until 1973 he acquired the remarkable record of never missing a year, showing anything from three to eight works annually. His work was also seen at the Oireachtas, and he was a member of the United Arts Club, Dublin.

In 1919 he showed five works at the Water Colour Society of Ireland exhibition, including *Do you like Butter?* and *Alleyway Children*. In the period 1921-62 he contributed only ten pictures.

By 1920 he had a studio in Rea's Building, Royal Avenue, Belfast, and in that year when the Belfast Museum and Art Gallery held a loan exhibition of oil paintings and early British watercolours, McKelvey's contributions included two oils, *Ballyhornan Bay, Co. Down* and *Feeding Time*. In 1921 he was elected a member of the Belfast Art Society, and also the Ulster Society of Painters, and by 1922 he had already received a portrait commission, that of James McQuitty for the Belfast Printing Trades Employers' Association. *Children in a Park* was painted in 1922, also *Feeding Chickens*, both oils.

In 1923 he had two paintings hung at the Glasgow Institute of the Fine Arts, and continued to exhibit until 1935, twenty-three works in all. He was appointed an associate of the RHA in 1923 and in 1930 he became a full member. In 1923 *The Studio* was of the opinion that in the North the best men were, almost without exception, engrossed in landscape: 'Their landscapes, though by no means emotional, are always most obviously sincere, closely observed, firmly and cleanly handled'. McKelvey, along with J. Humbert Craig and Paul Henry (qq.v.), was among those mentioned in this 'distinct group'.

In 1924 McKelvey married and settled at the Maze, Co. Down. *On the Bann* of that year was included in the exhibition of art at the Tailteann Games, Dublin. At about this time he began painting in Co. Donegal. In 1926 he moved home to 11 Knocklofty Park, Belfast. J. Crampton Walker in his *Irish Life and Landscape* of 1927 referred to McKelvey as a member of the 'Belfast group of young landscape painters that has sprung up and developed with such amazing rapidity in recent years.'

Whatever the commission, McKelvey went to great pains to produce a satisfactory outcome. There are no fewer than ten portraits at Queen's University. In Margaret Holland's book, *My Winter of Content under Indian Skies*, published in 1926 in Belfast, are reproduced six watercolour drawings, all with figures, in colour. The Belfast Museum and Art Gallery held a loan exhibition in 1927 of Irish portraits by Ulster artists and McKelvey was represented by six works, at least five being copies. He was represented by landscapes in the exhibition of Irish art at Brussels in 1930, and was among the Irish painters represented in the Hackett Galleries, New York.

The *Daily Express* reported in 1931 that he led 'a regular, businesslike life; an artist who is on the telephone at his studio and who is punctual at appointments'. In that year, thanks again to the generosity of the Belfast printer and stationer, Thomas McGowan, his thirteen large-scale portrait drawings of Presidents of the United States who had Ulster descent were presented to the Belfast Museum and Art Gallery. Contributions to the 1932 RHA included *Fishing boats – Coast of Donegal* and *Cloud reflections – Lough Neagh*.

When the Ulster Academy of Arts was formed in 1930, McKelvey was one of the first academicians. He travelled to Londonderry on another McGowan commission when he portrayed the Lord Mayor of London, Sir Percy Greenaway, and his coach entering Shipquay Place during his visit for the opening of Craigavon Bridge, 18 July 1933. This work is on longer in the Guildhall and was probably destroyed by bombing in 1972. In 1935 he was elected an honorary member of Ulster Arts Club.

Rare one-person shows were held at Locksley Hall, Fountain Street, Belfast, in 1934 and 1936. In 1936 three Co. Donegal landscapes were purchased as a wedding present for Princess Juliana from the Dutch people residing in Ireland. By this time his studio was at 10 Donegall Square South, Belfast, but he soon moved to 58 Howard Street. His portrait of J.C.M. Martin of the 'Autumn Knot' was for the Friendly Brothers of St Patrick.

In 1937 he held his first exhibition in Dublin, at the Victor Waddington Galleries, another in 1939, and that year the Thomas Haverty Trust purchased *Farmyard, Co. Antrim* from the RHA exhibition. After the end of the Second World War, he painted a portrait of Northern Ireland's first Governor, the Duke of Abercorn. His works at the 1946 RHA included *Carlingford Mountains from Rostrevor* and *Evening at Bunbeg, Co. Donegal*. He was among the prominent Ulster painters represented in 1947 at the exhibition at Ulster House, Regent Street, London. *Roundstone Harbour, Connemara* was painted in 1948, the year of his last exhibition at Combridge's Galleries, Dublin. He was represented at the Contemporary Ulster Art exhibition, Festival 1951, held at Belfast Museum and Art Gallery. By this time he had made his first visit to France. He showed in 1953 in the Contemporary Irish Art exhibition at Aberystwyth. In 1959 he held a one-person show at the Ulster Office, London. He last exhibited at the Royal Ulster Academy in 1969.

S. B. Kennedy in his book, *Frank McKelvey, RHA, RUA*, 1993, wrote: 'In essence he was a Romantic; yet in the inter-war years in particular, with his contemporaries amongst the landscapists, he helped to forge a new and distinct way of representing the Irish scene which is the nearest approximation we have to a distinct Irish school of painting…He had a sharp eye and could, with apparent ease, penetrate the essentials of his subject and set it down with a matching exactitude…'.

Co. Donegal was a favourite painting area, and he was keen on fishing too. The rugged scenery of the West of Ireland also attracted him. The National Maritime Museum in London has a painting of an Aran Island currach. A fair number of his portraits are in board-rooms and offices, but those of John Doherty Barbour, oil, and Nelson Russell, crayon, are at Lisburn Museum. Among his more public commissions were the portraits of Sir Martin Wallace, Belfast City Hall; Sir Kenneth Sinclair, Belfast Harbour Office; Professor William Blair Morton, Queen's University. Of St Clair, My Lady's Mile, Holywood, he died on 30 June 1974 in hospital. An exhibition of his oils and watercolours was held in 1979 at the Oriel Gallery, Dublin. In the exhibition of paintings of the Kelly fleet held at the Linen Hall Library, Belfast, in 2000, eight of the named ships were portrayed by McKelvey.

Works signed: Frank McKelvey; F. McKelvey or McKelvey, both rare.
Examples: Armagh: Church House. Ballinasloe, Co. Galway: St Joseph's College. Bangor, Co. Down: Town Hall. Belfast: City Hall; Harbour Office: Queen's University; Royal Ulster Academy of Arts; Royal Victoria Hospital; Ulster Medical Society; Ulster Museum. Cork: City Library; Crawford Municipal Art Gallery. Dublin: Masonic Hall, Molesworth Street. Kilkenny: Art Gallery Society. Larne, Co. Antrim: Borough Council. Limerick: City Gallery of Art. Lisburn, Co. Antrim: Museum. London: National Maritime Museum. Mullingar: Westmeath County Council. Soestdijk, Netherlands: Royal Palace of Soestdijk. Waterford: City Hall, Municipal Art Collection.
Literature: *Belfast Telegraph*, 2 June 1922, 31 October 1923; *The Studio*, December 1923, July 1947; Margaret Holland, *My Winter of Content under Indian Skies*, Belfast 1926 (illustrations); J. Crampton Walker, *Irish Life and Landscape*, Dublin 1927 (also illustration); *Daily Express*, 10 January 1931; *Irish Daily Telegraph*, 6 April 1931; Ulster Tourist Development Association, *Ulster*, Belfast 1934 (illustration); *Belfast News-Letter*, 2 March 1936; Ulster Society for the Prevention of Cruelty to Animals, *The Tree*, Belfast 1936 (illustration); *Northern Whig*, 10 May 1939; Thomas Bodkin,

intro., *Twelve Irish Artists*, Dublin 1940 (illustration); Cork Rosc, *Irish Art 1900-1950*, catalogue, 1975; *Dictionary of British Artists 1880-1940*, Woodbridge 1976; John Hewitt and Theo Snoddy, *Art in Ulster: 1*, Belfast 1977 (also illustration); *A Dictionary of Contemporary British Artists, 1929*, Woodbridge 1981; Martyn Anglesea, *The Royal Ulster Academy of Arts*, Belfast 1981 (also illustration); Eoin O'Brien and Anne Crookshank, *A Portrait of Irish Medicine*, Swords 1984 (illustrations); Ann M. Stewart, *Royal Hibernian Academy of Arts: Index of Exhibitors 1826-1979*, Dublin 1986; Patricia Boylan, *All Cultivated People: A History of the United Arts Club, Dublin*, Gerrards Cross 1988; City of Glasgow District Council Libraries Department, *Letter to the author*, 1989; also, Derry City Council, 1989; Lisburn Museum, 1993; S.B. Kennedy, *Frank McKelvey,RHA,RUA*, Blackrock 1993 (also illustrations); Eileen Black, *A Sesquicentennial Celebration: Art from the Queen's University Collection*, Belfast 1995 (also illustrations); *Water Colour Society of Ireland Exhibition List 1872-1994*, Dublin 1995;Koninklijk Huisarchief, *Letter to the author*, 1996; also, Friendly Brothers of St Patrick, 1997; Kelly Fuels, *Kelly Fuels Celebrate 160 Years*, catalogue, Belfast 2000.

MacKENZIE, W. G., ARHA (1857-1924), portrait, landscape and genre painter. Born in Belfast, William Gibbes MacKenzie received his early training at the Government School of Design under T. M. Lindsay, and at the expiration of four years obtained a National Scholarship, subsequently studying under Sir Edward Poynter, RA (1836-1919) and at Julian's, Paris. Specimens of his work from the figure were purchased by the authorities at South Kensington, and were used as examples in the Government Schools of Art.

An active member, he showed at the Belfast Ramblers' Sketching Club exhibition in 1889, and in that year was one of four vice-presidents elected. In the 1890 exhibition he showed no fewer than sixteen oils, including *Lost Confidence*; *Old Companions*; and *A Pleasant Recollection*. Turning to Dublin, he showed for the first time at the Royal Hibernian Academy in 1891, four works, including *Fortune Telling*, from 62 Donegall Street, Belfast. Several years elapsed before his work appeared again at the RHA.

MacKenzie moved to London, and used a studio at 452 Fulham Road. In 1894 he showed at the Royal Academy *My New Shoes!*, oil, now in the Ulster Museum collection. In 1895 he exhibited a portrait of Mrs M. Hollams, daughter of Sir Charles Lanyon, and in 1897 another portrait. A portrait of John Robb, painted in 1889, is also in the Ulster Museum together with four landscapes of the River Lagan area.

Early in the century, on his return to Belfast, he acquired studio accommodation in Scottish Provident Buildings, Donegall Square West. *Pond at Belvoir Park, Belfast, seat of L'rd Deramore*, oil, was dated 1905. He resumed exhibiting at the RHA in 1906 and, with the exception of a few years, continued regularly until 1921. In 1919 his presentation portrait of Sir Crawford McCullagh was hung in Dublin, and a portrait of Thomas McGowan in 1920.

Probably the most difficult task of his painting career, which ended in rather a low key, was the completion of a large commemoration picture of the proclamation of King Edward VII, from the front of the Old Town Hall, 1901, with many Ulster public men in the audience. Ernest E. Taylor (q.v.) began this work but it was uncompleted at the time of his unexpected death. This painting is in the Belfast City Hall, where there is also a portrait of Charles C. Connor, MP, the last 'Mayor' of Belfast. A portrait of Alderman James Henderson is at the Belfast Institute of Further and Higher Education, and there are three portraits in the Ulster Reform Club, Belfast, including the Rt. Hon. Thos. Sinclair, DL. In 1912 the Belfast Museum and Art Gallery acquired *William Gray, MRIA*.

In 1915 MacKenzie became an associate of the RHA. He was an active member of the Belfast Art Society with a concern for furthering the interests of art in the city. He exhibited four works in a loan exhibition of oil paintings at the Belfast Museum and Art Gallery in 1920: one portrait, two landscapes and *Not here, but somewhere buried*. His last studio was at 10 Clarence Place. A lonely man, a bachelor, and somewhat of a recluse, he loved his art with intensity but appeared to abhor the business side of his profession. He died on 23 October 1924 at the Royal Victoria Hospital, Belfast.

Works signed: W. G. MacKenzie.
Examples: Bangor, Co. Down: Town Hall. Belfast: City Hall; Department of the Environment for Northern Ireland; Institute of Further and Higher Education; Ulster Museum; Ulster Reform Club.
Literature: *Belfast Telegraph*, 18 October 1920; *Who's Who in Art*, 1920; *Northern Whig*, 29 October 1924; John Hewitt and Theo Snoddy, *Art in Ulster: 1*, Belfast 1977; Martyn Anglesea, *The Royal Ulster Academy of Arts*, Belfast 1981 (also illustration); *A Concise Catalogue of the Drawings, Paintings & Sculptures in the Ulster Museum*, Belfast 1986;

Ann M. Stewart, *Royal Hibernian Academy of Arts: Index of Exhibitors 1826-1979*, Dublin 1986; Gorry Gallery, *An Exhibition of 18th, 19th and 20th century Irish Paintings*, catalogue, Dublin 1999.

MACKIE, KATHLEEN I., ARUA (1899-1996), landscape and figure painter. Born in Belfast on 22 July 1899, Kathleen Isabella Metcalfe was the daughter of Arthur Metcalfe, flaxspinner. Educated at Richmond Lodge School, Belfast, she moved in 1915 to Highcliffe School, near Scarborough, Yorkshire, and in 1916 she transferred to Alexandra College, Dublin. On returning to Belfast in 1918 she entered the School of Art and, in addition, took occasional lessons with Jessie Douglas (q.v.). In 1920 she began exhibiting with the Belfast Art Society.

In 1921 she worked on three paintings: *The Children of Lir*; *The Fortune Teller*; and *Ruin*, which she submitted for the Royal Dublin Society's Taylor Art awards. In the event, she won a premium of ten pounds for *The Fortune Teller*. In October of the same year she enrolled at the Royal Academy Schools, London, winning the £50 Taylor Scholarship in 1922 with *St Brigid and the Fox*. Later, she was awarded a British Institution scholarship of £75 for a period of two years — it was later renewed for a third year — tenable at the Royal Academy Schools. In 1923 she painted *Noah driving the animals into the Ark*, a watercolour.

At the Royal Academy Schools she came under the influence of George Clausen (1852-1944), Gerald Kelly (1879-1972) and William Orpen (q.v.). She took a correspondence course in drawing from the painter, illustrator and poster designer, John Hassall (1868-1948). At Alexandra College she had been involved in a number of posters for fund raising.

Contributions to the BAS exhibition in 1923 included *The Tom-Tom Player, Rabat, Morocco*, and *A Street in Fez, Morocco*. In 1924 she was represented at the Ulster Pavilion, British Empire Exhibition, London. The next year, *The Market*, oil, was exhibited at the Paris Salon, later presented to the Ulster Academy of Arts for its diploma collection. In Dublin, a total of seven works were hung at the Royal Hibernian Academy in 1926 and 1927. *At the 'Point to Point'* and *Chalet Wengen* were contributed in 1926.

At the 1927 RHA, now Kathleen Mackie, wife of the industrialist, Jack Mackie, her address was 'Marietta', Barnett's Road, Knock, Belfast. She was a founder member of the Ulster Gliding Club. An interest in painting the landscape and life of Co. Donegal produced a meeting with Frank Egginton (q.v.) and she often worked with him. An oil, *Dowros Bay, County Donegal*, was dated 1927.

In 1936 she was appointed an associate of the Ulster Academy of Arts. Amy Johnson, the famous aviator who was on a private visit to Belfast in 1938, was taken aloft in Kathleen's glider. Encouraged by her friend of Royal Academy Schools days, Eileen Reid (q.v.), she exhibited with the Water Colour Society of Ireland, eleven works in the period 1938-47 inclusive. In the years 1938, 1939 and 1940 she showed two Donegal landscapes each year. The four pictures accepted in the period 1943-7 were all flowerpieces. She continued, however, exhibiting with the Ulster Academy and with its successor, the Royal Ulster Academy, until 1959.

Not until she was eighty-six was Kathleen Mackie given her first show, in 1985 at the Castle Espie Gallery, Comber, Co. Down. The retrospective exhibition of forty-five works, oils and watercolours, at the Ulster Museum in 1996 covered a period of thirty-five years. She died on 8 May 1996 at her home at Ringdufferin, Toye, Co. Down.

Works signed: K. I. Mackie, K.I.M., K.I. Metcalfe; K.I. Metcalfe Mackie, Kathleen Metcalfe or Metcalfe, all three rare.
Examples: Belfast: Royal Ulster Academy of Arts.
Literature: *A Dictionary of Contemporary British Artists, 1929*, Woodbridge 1981; Martyn Anglesea, *The Royal Ulster Academy of Arts*, Belfast 1981 (also illustration); Lynn Doyle, *An Ulster Childhood*, Belfast 1985 (cover illustration); Ann M. Stewart, *Royal Hibernian Academy of Arts: Index of Exhibitors 1826-1979*, Dublin 1986; National Gallery of Ireland and Douglas Hyde Gallery, *Irish Women Artists: From the Eighteenth Century to the Present Day*, Dublin 1987 (illustration); *Water Colour Society of Ireland Exhibition List 1872-1994*, Dublin 1995; *Irish Times*, 13 May 1996, 10 June 1996; S. B. Kennedy: Ulster Museum, *Kathleen Isabella Mackie*, catalogue, Belfast 1996 (also illustrations); Patrick P. Mackie, *Letter to author*, 1999.

McKINLEY, MURIEL – see BRANDT, MURIEL

MacKINNON, SINE (1901-96), landscape painter. Born at Newcastle, Co. Down, on 11 February 1901, she was the daughter of Ronald MacKinnon, Chief Clerk Royal Courts of Justice. Her mother was a D'Arcy from Galway, and Sine used to go there as a young girl and paint when visiting her grandmother.

After attending Wimbledon High School, she studied at Slade School of Fine Art, 1918-20, 1921-4, winning first prizes in painting and drawing. Taken on a holiday to the Isle of Skye, Muirhead Bone (1876-1953) found her painting. When he heard she was a Slade student, he later asked Henry Tonks (1862-1937) to look after her.

In 1924 she moved to Paris when 'life really started for me and my painting,' rubbing shoulders with such celebrated artists as Raoul Dufy (1877-1953), Henri Matisse (1869-1954) and Maurice Utrillo (1883-1955). Before returning to London she held two exhibitions in Paris. *Waterloo Bridge* (Wakefield City Art Gallery) was painted in 1925. In 1926 her *Winter Evening, Argyllshire* was hung in the Society of Present Day Painters exhibition at the Chenil Galleries, London. *The Studio*, who mistook the artist for a man, found that the work had a 'certain dignified severity of treatment' and a 'decorative simplicity.'

In 1927 the Contemporary Art Society presented an oil, *Springtime*, to the Aberdeen Art Gallery, where, incidentally, Esther Blaikie Mackinnon (1885-1935) is also represented. The Living British Artists exhibition was hosted at the Belfast Museum and Art Gallery in 1927 and she was represented by *Early morning in Argyllshire*. About 1928 she met her future husband, Rupert Granville-Fordham (1898-1974), a painter, in Montparnasse, Paris.

MacKinnon's first London solo show was in the Goupil Gallery in 1928. In 1929 the Fine Art Society in London staged an exhibition of paintings of Connemara by Stephen Bone (1904-58), the son of Muirhead Bone, and Sine MacKinnon, who showed twenty-nine works, including *Red Petticoats and Baby Houses in the Claddagh*; *Evening — The White Houses, Roundstone Harbour*; *The Road to Tully Cross from Letterfrack*.

By 1932 she was back in Paris at 46 Avenue du Parc de Montsoures, XIV, but apparently retained a studio in London at 117 Charlotte Street, W. At the New English Art Club in 1933 she showed *St Rémy de Provence*. In 1934 she painted *Farm Buildings in Provence*, purchased some years later by the Tate Gallery, London. Referring to her exhibition at the Reid and Lefèvre Galleries, London, in 1936, the critic for *The Studio* was 'glad to say' that only a few works were in the Surrealist mood. Most of them were 'straight' pictures of Paris, St Tropez, villages in Brittany and old towns in Provence. 'All of them revealed an accomplished artist with a fine colour sense, and a sensitive understanding of the spirit of the place.'

The Studio noted that human beings seldom appeared in the villages of France, Greece and Portugal as seen by her in the 1940 exhibition at the Tooth Gallery, London. Again, the critic was reminded — as in *Fisherman's House, Audiernes* for instance — of the ghostly quality of the lonely seashores of Christopher Wood (1901-30). But her movement was 'more staccato than Wood's, and her scenes have some suggestion of being made out of boxes of bricks. Which does not prevent them from having a curious charm of their own...' She showed only one work at the Royal Hibernian Academy, in 1940.

In 1944 she contributed her only work to the Royal Academy, *Notre Dame from the Île St Louis*, giving a Reading address. In connection with work at the Lefèvre Galleries in 1945, *The Studio* referred to 'clean, direct painting permeated with an imaginative whimsy.' She was represented in 'Artists of Fame and Promise' at Leicester Galleries in 1949. Unfortunately from about 1950 the sickness of her husband curtailed her painting but after his death she resumed regularly, exhibiting in the Salon des Indépendants.

The Redfern Gallery was another exhibiting venue. In London alone she showed about 250 works in the first twenty years of her exhibiting life. Travels abroad also included Spain. The London dealer, Julian Hartnoll, showed a score of her oils and watercolours at the 20th Century British Art Fair at the Cumberland Hotel in 1988. He discovered her quite by chance when a mutual interest in racing caused them to converse at a café in Paris. She only gave up her car, from which she often painted, at the age of eighty-six. She confessed to the author that she was 'no good as a business woman.' On 6 October 1996 she died at Maison's Laffitte, Paris.

Works signed: Sine MacKinnon or S. MacKinnon, rare.
Examples: Aberdeen: Art Gallery. Belfast: Ulster Museum. London: Tate Gallery. Manchester: City Art Gallery. Wakefield, Yorks. : City Art Gallery.

Literature: *The Studio*, April 1926, January 1937, July 1940, October 1945, January 1950; Fine Art Society, Ltd., *Exhibition of Paintings of Connemara by Stephen Bone and Sine MacKinnon*, catalogue, London 1929; *Tate Gallery Catalogues: The Modern British Paintings, Drawings and Sculpture*, vol. 2, M-Z, London 1964; *Dictionary of British Artists 1880-1940*, Woodbridge 1976; *A Dictionary of Contemporary British Artists, 1929*, Woodbridge 1981; *Royal Academy Exhibitors 1905-1970*, Calne 1987; Sine MacKinnon, *Letters to the author*, 1988, 1989; *Sunday Telegraph*, 25 September 1988; Julian Hartnoll, *Letter to the author*, 1996; Ms Jan Fordham, *Letters to the author*, 1999.

MACKLIN, T. EYRE, RBA (1863-1943), portrait, landscape painter, illustrator and sculptor. Born in Newcastle upon Tyne, Thomas Eyre Macklin was the only son of John Eyre Macklin (1834-1916), a landscape painter who was from a Co. Donegal family and who was buried in Belfast with his wife. The father, when living in Newcastle upon Tyne, was also a toy and fancy goods dealer. His son was educated privately and displayed such a talent for drawing as a child that he was placed as a pupil in the town's School of Art at the age of ten. In his vacations he painted at Cullercoats, Tyne and Wear, where he met, and was befriended by, the American artist, Winslow Homer (1836-1910). Sent from 43 Maple Street, Newcastle, his *Coldingham shore* was exhibited at the 1882 Royal Scottish Academy.

Macklin studied the antique at the British Museum and also attended Calderon's School, London, later gaining admission to the Royal Academy Schools, where he won a silver medal in 1888, and then studying in Paris. He was a special artist to the *Pall Mall Budget* from 1888 to 1892, and he also designed for books, magazines and posters. Between 1899, then at 31 Southampton Street, London, and 1903 he exhibited sixteen works at the Royal Academy, also one picture in 1914, about half being portraits. In 1898 he painted in Italy: an inscribed and dated oil, *On the road to Rapallo*, appeared at a Sotheby auction in London, 1985.

Based in France after his marriage, he lived some years abroad, visiting many Continental cities. In 1902 he became a member of the Royal Society of British Artists, exhibiting *A Bit of the Old Mill*; *Through the Granary Door*; and a portrait of G. E. Macarthy, giving his address as 22 Blaskett Street, Newcastle upon Tyne. His *A Summer Day near Hexham*, which was in a 1981 Sotheby Beresford Adams auction at Chester, was dated '08. In Belfast, he painted the noted group picture of Lord Carson signing the Ulster Covenant at the City Hall in 1912.

Macklin was the designer of the Ward Park War Memorial at Bangor, Co. Down, 1927, having persuaded the committee to abandon the suggested Wilson's Point site. In Portland stone, the height is 12m by 9m square at the base, with bronze embellishments: on the North face a life-size figure of Erin bearing in outstretched arms a palm leaf, and high up on the obelisk is the lion of victory; on the South face, a shield on which are inscribed the names of the fallen. An oil painting, dated May 1920, of his proposal for the memorial is in the Town Hall, Bangor, but contains details which do not appear in the final version. A 1928 portrait of James Milliken, Town Clerk, is also in the Town Hall. In Newcastle upon Tyne, his South African War Memorial is in the Haymarket, unveiled in 1908.

In 1928 a conference of painters, sculptors and architects, held at the Grand Central Hotel, Belfast, passed a resolution to found an Ulster Academy of Arts. Macklin, who took a keen interest in the younger artists, chaired the meeting and said that Ulster people had a character 'peculiar to themselves, and their art was different in expression to that of other people'. He qualified for the select committee to draft a constitution.

In the Belfast Harbour Office is a 1934 oil painting, *Pollock Dock*. A bearded figure in the foreground is Sir Robert Baird, one of the artist's closest friends. In the Ulster Museum are four oil paintings, *City Hall, Belfast by Floodlight*; *The City Hall and Titanic Memorial*; and two portraits. A bust of the artist was modelled by Albert Toft (1862-1949). Macklin died on 1 August 1943 at Budleigh Salterton, Devon.

Works signed: T. Eyre Macklin.

Examples: Bangor: Town Hall; Ward Park. Belfast: Harbour Office; Ulster Museum. Gateshead: Shipley Art Gallery. Newcastle upon Tyne: Haymarket; Laing Art Gallery.

Literature: Algernon Graves, *The Royal Academy of Arts*, London 1905; *Newtownards Spectator*, 2 May 1925; *County Down Spectator*, 28 May 1927; *Belfast Telegraph*, 17 April 1931, 4 August 1943; *Who Was Who 1941-50*, London 1967; Martyn Anglesea, *The Royal Ulster Academy of Arts*, Belfast 1981; *Dictionary of British Book Illustrators and Caricaturists 1800-1914*, Woodbridge 1981; Marshall Hall, *The Artists of Northumbria*, Newcastle upon Tyne 1982; Eileen Black, *Paintings, Sculptures and Bronzes in the Collection of The Belfast Harbour Commissioners*, Belfast 1983; *A Concise Catalogue of the Drawings, Paintings & Sculptures in the Ulster Museum*, Belfast 1986; Laing Art Gallery,

Letter to the author, 1989; also, Newcastle upon Tyne Central Library, 1989; *The Royal Scottish Academy Exhibitors 1826-1990*, Calne 1991.

McLACHLAN, N. FRENCH (1895-1978), portrait and landscape painter. Born in Edinburgh on 19 November 1895, Norman French McLachlan studied at the College of Art night school, 1909-14, where he learnt lithography, and then moved to Glasgow School of Art and studied full time for three years. A conscientious objector, he refused to enlist in Scotland and moved to Belfast, where he had a spell in prison.

After Sir John Lavery (q.v.) visited the 1920 exhibition of the Belfast Art Society, McLachlan was selected on Sir John's advice as one of the first ten 'Members'. At a loan exhibition of oil paintings that year at the Belfast Museum and Art Gallery, he showed two portraits, the High Sheriff of Belfast, Councillor W. G. Turner; and a presentation portrait of Councillor J. A. Doran, now in the Ulster Museum.

In 1920 too he contributed for the first time to the Royal Hibernian Academy, from 1 Terenure Park, Dublin, and from then until 1943 a score of works was accepted, the majority being portraits. In 1921, when he exhibited a portrait of J. Creed Meredith, KC, he gave 11 Harcourt Street, Dublin, as his address; by the next year he was at 31a Westmoreland Street with portraits of Sir Henry McLaughlin, KBE; Professor Eoin McNeill, and Edward Martyn.

Mills' Hall, Dublin, was the venue for an exhibition in 1920. In that year he showed *Portrait of the artist* at the Royal Scottish Academy. In 1921 he exhibited at 51 Dawson Street, Dublin, and *Irish Life* commented: 'His smaller landscape pictures show that freshness and spontaneity of touch which is only obtained by work done at a sitting, and done with the boldness and confidence of a master hand. The subjects for these pictures are taken very largely from Omeath, Co. Longford.' Peasant folk figured in a number of the portraits, which also included one of Cardinal Logue. McLachlan was very much a free spirit and loved the great outdoors, sometimes spending months away at a time.

Warneuke's Gallery, Glasgow, and Petit Salon, Edinburgh, arranged exhibitions in 1921. The foreword to the catalogue for the latter was written by Richard Hayleton. A number of Connemara landscapes and informal portraits from the area appeared in his exhibition at Mills' Hall in 1923. 'Modern Tendencies in Art' was the subject of his address to the Dublin Rotary Club in 1929. There were seven children in his family and when they were young he worked as a commercial lithographer in Dublin. He had a studio at Mount Venus, Ballyboden, Co. Dublin, not far from his friend and contemporary, Sean Keating (q.v.), after which he moved to 1 Lincoln Place, Dublin, his address at the 1933 RHA.

Woman of the House, a sensitive study of a Connemara peasant, attracted attention at his 1936 exhibition at the Daniel Egan Gallery, 38 St Stephen's Green, Dublin, and there were also landscapes of Connemara, Co. Donegal and Co. Dublin. Apparently he considered references as helpful to his prospects. A complimentary letter from Priestley Green, near Halifax, dated 7 November 1933, also mentioned that the two portraits commissioned had cost 150 guineas. Again, a letter dated 19 February 1938 from David Foggie, RSA (1878-1948), secretary of the Royal Scottish Academy, stated: 'To whom it may concern: I have pleasure in stating that about the year 1932 I saw a group of works by N. French MacLauchlan (sic) in Edinburgh and was impressed by their vividness and vitality.'

In 1941 at the RHA he showed *His Excellency the American Minister, Mr David Gray*. His work appeared in the exhibition of pictures by Irish artists in Technical Schools, 1949. His display at the Garnett Gallery, Dublin, in 1955 included seascapes of Roundstone, Killiney and Donegal. His portraits were described as 'strong, deft, positive'. The Royal Irish Academy holds one of R.A.S. Macalister, and that of Edward Martyn was presented by the theatregoer Joseph Holloway to the National Gallery of Ireland. McLachlan's portrait of James Creed Meredith is at King's Inns. The artist's death occurred in a Bray nursing home on 13 July 1978.

Works signed: N. French McLachlan or McLachlan.
Examples: Belfast: Ulster Museum. Dublin: King's Inns; National Gallery of Ireland; Royal Irish Academy.
Literature: *Freeman's Journal*, 11 January 1921; *Irish Life*, 21 January 1921 (also illustrations); *The Bulletin*, 16 April 1921; *Drawing and Design*, July 1921 (illustration); *Irish Times*, 13 and 15 February 1923, 27 April 1929, 14 and 15 July 1978; *Irish Independent*, 10 June 1936; *Dublin Evening Mail*, 16 June 1936; Martyn Anglesea, *The Royal Ulster*

Academy of Arts, Belfast 1981; Ann M. Stewart, *Royal Hibernian Academy of Arts: Index of Exhibitors 1826-1979*, Dublin 1986; Ms Patricia Flynn (née McLachlan), *Letter to the author*, 1989; also, Royal Scottish Academy, 1989.

McLERNON, W. J. W. (1867-1945), portrait, landscape and miniature painter. Born in Coleraine, Co. Derry, William James Watt McLernon was the only child of Robert McLernon who ran a home bakery in Portrush, Co. Antrim. In his youth William showed talent in art and was sent to the school run by Sir Hubert von Herkomer, RA (1849-1914) at Bushey, Herts. At one time a door plate at his Portrush studio recorded his connection with von Herkomer, and also that he had been recommended by him. At first his studio was in Main Street and then he moved to Dhu Varren, where he remained for the rest of his life, some forty years, painting portraits and taking pupils when he was not out painting landscapes.

In 1901, however, he had visited – or emigrated to – Philadelphia, USA, where he held an exhibition, received some portrait commissions and might have made a living there, but yearning for home overcame him and he returned to the North Antrim coast. In the period 1909-15, McLernon received commissions for at least four portraits of notabilities connected with Magee University College, Londonderry. A subscription portrait of the Rev. Professor Francis Petticrew, dated 1909, is now in Union Theological College, Belfast, where there is also a portrait, dated 1913, of the Rev. Professor John Edgar Henry.The Belfast Museum and Art Gallery held in 1927 a loan exhibition of Irish portraits by Ulster artists and McLernon was represented by *Miss Morrow* and *The Late Lord Roberts*.

One of his pupils recalled him painting a portrait of a Portrush Presbyterian minister which was considered 'a speaking likeness' but that he gave considerable offence to some of the congregation by sketching the minister in church, having concealed his sketch-book inside a large Bible. Harry Smyth, Portrush resident, recalled in 1976: 'I remember the artist distinctly from my school-days. He was a regular church attender at morning service, always came halfway through and usually spent the rest of service-time sketching'. Another correspondent considered that he did not sell very much 'and certainly his studio was crammed with work a very quiet and retiring man but kind and pleasant'. He died at Route Hospital, Ballymoney, on 5 April 1945.

Works signed: W. J. W. McLernon.
Examples: Belfast: Union Theological College. Portrush, Co. Antrim: Hopefield Hospital; Presbyterian Church.
Literature: Robert M. Young, *Belfast and the Province of Ulster in the 20th Century*, Brighton 1909; *Northern Constitution*, 7 April 1945; Miss Edith Cromie, *Letter to the author*, 1976; also, Mrs Nancy Kinkead, 1976; Miss Lilian Murdoch, 1976; Harry Smyth, 1976.

Mac LIAMMÓIR, MÍCHEÁL (1899-1978), designer, illustrator and figure painter. Born in Willesden, near London, on 25 October 1899, Michael Willmore was the son of a corn merchant, Alfred Antony Willmore, and there were four daughters. As a child, Michael was 'obsessed by the uncertainty of what I wanted to become. My chief ambition was to become a painter or an actor ...'. In fact he became a famous actor as well as set designer, playwright, autobiographer, storyteller, painter and illustrator. The family moved to London when he was about seven years of age. In 1910, adopting his father's first name for stage purposes, he appeared with Noel Coward in the all-children production of *The Goldfish*.

When his voice broke, he gave up acting. He was in Spain during part of the War but returned to London and studied painting at the Slade School of Fine Art, 1915-16. *Punch* published his cartoon, *The Damosel I Left Behind Me* in 1915. He joined the Gaelic League in London to learn Irish, and said he was obsessed with pagan images: 'fauns, goddesses, centaurs, and figures of the Sidhe'. As a young visual artist, he had been influenced by Aubrey Beardsley (1872-98) and what he called his 'frightening definition of line'.

On coming to Dublin, he signed his watercolours Michael Willmore but in a small part at the Abbey Theatre in 1917 he became Mícheál MacLiammóir. He was, however, principally known then as an artist, and theatregoer Joseph Holloway encouraged him by buying his pictures. In 1917 Holloway recorded in his diary: 'Michael Willmore is a youth with real talent ... He has a fondness for Jack B. Yeats's work and produces some very clever imitations of his style in colour, but with a more refined line that emphasizes the crudeness

of the method he mimics. Some of his black and white designs are really beautiful and clever, and all his work in whatever medium is full of imagination.'

Following the end of the war, he left the stage to devote himself to painting. At the Slade he had met a distant cousin, Máire O'Keeffe, who suffered from tuberculosis. A sketchbook of 1921 has survived from Davos, where he stayed for some years with Máire and her mother, assisting in their support. When the Irish Post Office invited designs for the series of definitive stamps, he sent a design from Switzerland. His developing artistic talents were influenced by the dancers and designers of the Diaghilev Ballet, in particular Léon Bakst (1886-1925). His recreations he described as 'travel, balletomania'.

Written and illustrated by him, *Oícheanta Sí: Faery Nights*, in English and Irish, was published by Talbot Press, Dublin, in 1922, but the first book which he illustrated was in 1917. An exhibition of fifty-eight pictures was held at 7 St Stephen's Green, Dublin, in 1925. According to an advertisement in the *Irish Statesman*: 'Fantasies in Colour and Black and White by Mícheál Mac Liammhóir'. The *Irish Times* wrote that the exhibition revealed 'considerable versatility, both in choice of subjects and treatment'. It found *The Fair*, and several other pictures, with peasant figures, differed so much in colouring and execution from the rest of the exhibits as to suggest the work of quite another type of artist. In *The Lament of Deidre for Naoise*, the light effect was 'weird and striking, but is achieved in quite faint colouring'.

Madonna of the Roads, drawn at Diano Marina, Northern Italy, was dated 1927, the year that Mac Liammóir returned to Dublin from Switzerland to join the Shakespearean touring company run by his brother-in-law, Anew McMaster. The Gate Theatre was established in 1928 with Hilton Edwards. During the McMaster tour, Edwards had arranged, due to an acute shortage of money between the two of them, a successful exhibition of drawings at the art shop run by the son of John Gilbert (q.v.) in Patrick Street, Cork, and the experiment was repeated in Waterford.

Mac Liammóir was also involved in the founding of the Taidhbhearc in Galway in 1928, and that year he held an exhibition of his pictures in the Abbey Theatre's new café. When the Gate opened in Parnell Square, Dublin, in 1930 the black and gold curtain had been painted by him. The title page design was his for the theatre magazine, *Motley*. From the foundation of the Gate, he devoted his life to it. In designs for costumes and stage settings, he was involved in some 200 complete productions and felt that whatever talent he had in visual art was decorative: 'It can take the form of illustration of books, or of décor for the theatre, but it is not painting in the true sense of the word'. As a stage designer, the best of his work was done at the Gate in an extremely rushed period of the 1930s and 40s, 'so that my designs were merely made for the use of carpenters and dressmakers ... Almost all of them have vanished because I was too busy as an actor to carry them out as finished drawings except in a very few cases'.

In his drama commentary, A. J. Leventhal wrote in the *Dublin Magazine* in 1948: '... a romantic relying on fancy and whimsy for the appeal of his early pictures and to make his plays pleasurably plausible.' Two years later in an issue of *Envoy*, he referred to Mac Liammóir's artistic tendencies: 'He is remarkable for three things – his painting, his dreams and his hair. He paints in intense water colour concentric circles that fly off into ornamental flames with a bull's eye to focus attention.'

The Irish Academy of Letters conferred the Lady Gregory Award, and Dublin University conferred on him a Doctorate of Literature. In the year that he designed for his ballet, *Full Moon for the Bride*, 1968, he created a poster for *The Saint and Mary Kate* performed at the Abbey Theatre. Hilton Edwards found in his work 'a romantic beauty, an evocation of things other than the obvious and the commonplace. An almost foot-light glamour is never really absent from them, or at least a light not seen by ordinary eyes. Never is gaiety far from his work, and there is always a sense of other-worldliness, whether that other world be of the Sidhe or of those lands what lie behind the theatre curtain that is about to rise'.

A set design for *The Playboy of the Western World* is at the Dublin Writers' Museum. In 1973, for the Dublin Arts Festival, Richard Pine arranged an exhibition of Mac Liammóir's designs and illustrations 1917-72. On 6 March 1978 he died at his residence, 4 Harcourt Terrace, Dublin. Later in the year the Hugh Lane Municipal Gallery of Modern Art housed a commemorative exhibition celebrating the golden jubilee of the Gate Theatre.

Works signed: Miceal MacLiammoir, Miceal Mac Uallmoir, Michael Mac Liammoir, Micheal Mac Liammoir, Micheal MacLiammoir, M. MacLiammoir, M. OL MacLiammoir, Mac Liammoir, M. MacL., M. Mac U, Michael Willmore or Micheal Willmore.

Examples: Chicago, USA: Northwestern University. Dublin: Dublin Writers' Museum; Irish Writers' Centre.

Literature: Daniel Corkery, *A Munster Twilight*, London 1917 (illustrations, Michael Willmore); T. H. Nally, *Finn Varra Maa*, Dublin 1917 (illustration); Seamus O'Kelly, *Waysiders*, Dublin 1917 (illustration, Micheal Willmore); Seamus O'Kelly, *Hillsiders*, Dublin 1921 (illustrations); Micheál mac Liammóir, *Faery Nights: Oícheanta Sí*, Dublin 1922 (illustrations); *Irish Times*, 10 July 1925, 28 September 1968, 25 October 1969, 7 and 15 March 1978, 5 March 1983, 2 March 1988; *Irish Statesman*, 18 July 1925; Abbey Theatre, *Dublin Shakespearean Festival*, catalogue, 1928; Pádraic Ó Conaire, *Field and Fair*, Dublin 1929 (illustrations); Pádraic Ó Conaire, *The Woman at the Window*, Dublin 1931 (illustrations); Micheál Mac Liammóir, *All for Hecuba*, London 1946 (also illustration, dust cover); *Dublin Magazine*, January-March 1948, July-September 1953; *Envoy*, July 1950; Micheál Mac Liammóir, *Ceo Meala Lá Seaca*, Dublin 1952 (illustration); Micheál Mac Liammóir, *Put Money in Thy Purse*, London 1952 (illustration, dust cover); Tomás Ó Floinn and Proinsias Mac Cana, *Scéalaíocht na Ríthe*, Dublin 1956 (illustrations); Micheál Mac Liammóir, *Aisteorí Faoi Dhá Sholas*, Dublin 1956 (illustration, dust cover); Micheál Mac Liammóir, *Each Actor on His Ass*, London 1961 (illustrations); Micheál Mac Liammóir, *The Importance of Being Oscar*, Dublin 1963 (illustrations); Micheál Mac Liammóir, *Bláth agus Taibhse*, Dublin 1964 (illustration, dust cover); Hilton Edwards, *Elephant in Flight*, Dublin 1967 (illustration); Richard Pine, Orla Murphy: Dublin Arts Festival, *Micheál Mac Liammóir Designs and Illustrations 1917-72*, catalogue, 1973 (also illustrations); Peter Luke, ed., *Enter Certain Players*, Dublin 1978 (also illustrations); National Gallery of Ireland, *The Abbey Theatre 1904-1979*, catalogue, 1980; *Who Was Who 1971-1980*, London 1981; Nicola Gordon Bowe, *The Dublin Arts and Crafts Movement 1885-1930*, catalogue, Edinburgh 1985.

McMANUS, SEÁN (1905-60), illustrator. Seán Brendan McManus was born in Dublin on 17 July 1905. His father, John McManus, a photo-engraver, founded the Dublin Illustrating Company with a 'sleeping partner', and Seán worked there from the outset. On his father's death in 1931, he became the nominated legal successor and built up the family business at 165 Townsend Street, Dublin.

In the period 1926-9 he had attended evening classes at the Dublin Metropolitan School of Art. In due course, his commercial designs included Christmas cards, religious calendars, and he collaborated with Colm O Lochlainn of the Three Candles Press. In the early 1930s he began to illustrate books. In 1932 his work first appeared in the *Father Mathew Record* and the *Capuchin Annual*, continuing with the former until the 1940s. More than one hundred of his drawings appeared in *Saint Francis of Assisi* by Father Aloysius, OFM Cap., published in 1934.

The *Capuchin Annual*, 1936, reproduced in colour his watercolour, *The Twenty-Seven Steps*, which had been exhibited in a Dublin café exhibition of his pictures, including a study of trees in Wicklow and a street in Carcassonne. A drawing of McManus by John O'Gorman also appeared in that issue of the *Capuchin Annual*. In the previous year's annual, watercolours of Kilmainham Jail and an old fort were presented.

For his illustration work he was known as Seán MacManus rather than McManus. He supplied a dozen line drawings, mostly vignettes or small pictures, for R.B.D. French's *The library of Trinity College Dublin*, printed at the Sign of the Three Candles in 1954. He remained as managing director of his own company until his death, on 18 December 1960. Susan MacKay, an exhibitor at the 1988 Royal Hibernian Academy, was one of three daughters who studied art.

Works signed: Seán Mac Mágnusa, Seán Mac Manus, Seán Mac M or Seán Mágnusa.

Literature: Alice Curtayne, *St Anthony of Padua*, Dublin 1931 (illustrations); An Philibín, *The Desire of the World*, Dublin 1932 (illustrations); *Capuchin Annual*, 1932, 1933, 1934, 1935 (all illustrations), 1936 (also illustrations); Colm O Lochlainn, *Brian's battle as it is told in the Norse Saga*, Dublin 1933 (illustrations); Father Aloysius, OFM Cap., *Saint Francis of Assisi*, Dublin 1934 (illustrations); *Father Mathew Record*, March 1934, April 1934; An Philibín, *The Fourth Wise Man*, Dublin 1936 (illustrations); An Philibín, *Wild Honey*, Dundalk 1942 (illustrations); Fr. Aloysius, OFM Cap., *At High Mass*, Dublin 1946 (illustrations); M. L. Ormsby, *Moods and Places*, Dundalk 1946 (illustrations); Fr. Aloysius, OFM Cap., *At Low Mass*, Dublin 1948 (illustrations); R. B. D. French, *The library of Trinity College Dublin*, Dublin 1954 (illustrations), Mrs Margaret J. McManus, *Letter to the author*, 1989; Trinity College Library, *Letters to the author*, 1989.

Mac MURCADA – see MORROW, JACK

MACNIE, ISA M. (1869-1958), caricaturist. Born on 9 August 1869 in Dublin, she was Irish ladies' croquet champion in 1907. She discovered her other skill by accident, happening to mention to the then editor of the *Irish Times*, at a dinner party, that she 'saw' people in geometric shapes. He asked her what she meant, and she gave an illustrated example to produce one of the first 'Mac' caricatures at the age of about fifty. By this time she was firmly established as a member of the United Arts Club, Dublin. In the *Ulster Review* for December 1924 there is a caricature of the Lord Mayor of Belfast, Sir William Turner.

Everything concerning the Arts Club she took very much to heart, and although she indulged in petty bickering and members were a little frightened of her tongue, she was always ready to lend a hand where needed. She generously offered to the Club at a nominal price of one guinea, twenty-five cartoons and caricatures, and among the subjects were Sara Allgood, James Stephens, Lord French, Arthur Shields, Rutherford Mayne and Padraic Colum.

In 1925, three years after the advent of the humorous magazine, *Dublin Opinion*, her book of twenty caricatures appeared with some desultory rhymes. W. B. Yeats, Dr Douglas Hyde, George Russell (q.v.) and William Cosgrave –'The President Bird' – were among those featured in *The Celebrity Zoo*. Yeats was 'The Camel': 'As you survey this Camel, with surprise,/ You'll recognise it as a Nobel Prize,/ When it walks calmly, with uplifted nose,/ I'm sure it's nearer Heaven than to its toes.' Autographed and hand-coloured, the edition de luxe was limited to two hundred copies.

When the Club held a dinner in 1949 to celebrate her eightieth birthday, she presented each of those present with a copy of her famous cartoon, *Chin Angles or How the Poets Passed*, showing Yeats and Russell passing in Merrion Square. A maker, also, of artificial flowers, she had no shop but carried on from her home at 37 Lower Baggot Street. In *Thom's Directory*, she managed two entries in the Dublin and Suburbs Trades Directory: Mac Flower Industry is the sole entry under the 'Artificial Flowers' heading, and in the list under 'Artists': Mac, caricaturist.

In her history of the United Arts Club, published in 1988, Patricia Boylan wrote that Isa Macnie took her position as vice-president seriously, and 'she wore a long black cloak which she used to great theatrical effect and added to her strong, slightly eccentric presence'. She was modest about her main artistic gift. The owner of many signed first editions, she lived in rather untidy conditions in her declining years and died in April 1958.

Works signed: "Mac".
Examples: Dublin: United Arts Club.
Literature: *Ulster Review*, December 1924 (illustration), February 1925 (illustration); 'Mac', *The Celebrity Zoo*, Dublin 1925 (also illustrations); *Thom's Directory*, 1952; *Irish Times*, 29 April 1958; Mrs Kingsmill Moore, *Letter to the author*, 1974; Patricia Boylan, *All Cultivated People: A History of The United Arts Club, Dublin*, Gerrards Cross 1988; Croquet Association of Ireland, *Letter to the author*, 1990.

McPHERSON, DONALD (1874-1935), landscape and portrait painter. Born in Belfast of Inverness parents, he trained as a lithographic artist with McCaw, Stevenson and Orr, printers, Linenhall Street. He was listed among the members of the Belfast Art Society in 1895. His son, Donald McPherson, RUA (1920-86) was also a commercial artist, for John Cleland and Son, printers, and he too was attracted to seascapes in watercolour; he won the Conor Award at the 1980 Royal Ulster Academy, late in life exhibiting at the Royal Hibernian Academy.

McPherson senior's watercolour *Mariners' Church, Belfast, 1897*, is in the Belfast Harbour Office. After serving his apprenticeship, he worked as a commercial artist in Nottingham before returning to Belfast where he was a freelance lithographic artist and designer, later going into partnership with Theo. J. Gracey (q.v.). He was interested in Celtic art and design, and first exhibited at the RHA in 1924, showing five works, including *Where the Channel breezes play* and *Port St Mary*, from his Earlswood Road, Belfast, address. In all, until the year before his death, nineteen pictures were hung at the Dublin exhibition and three at the Fine Art Society, London.

A reproduction of a pencil drawing, *Turf Carriers*, Donegal peasants, appeared in J. Crampton Walker's *Irish Life and Landscape* in 1927, and three years later he was represented in the exhibition of Irish art in

Brussels, entering into the spirit of the occasion by showing two watercolours, *Côte du comté de Down* and *La Plage (Groomsport)*. The Antrim coast was also a favourite painting area. *The Coast Farm*, oil, is in the Queen's University collection. In 1933 he was elected an academician of the Ulster Academy of Arts; McPherson and Gracey, artists, were then at 50 Upper Queen Street, Belfast. A calligraphist, his commissions included illuminated addresses. On 1 July 1935 he died at his residence. The Ulster Arts Club held a memorial exhibition in 1936.

Works signed: Donald McPherson or D. McPherson.

Examples: Belfast: Harbour Office; Queen's University.

Literature: J. Crampton Walker, *Irish Life and Landscape*, Dublin 1927 (illustration); *Belfast News-Letter*, 2 July 1935; *Belfast Telegraph*, 2 July 1935, 12 February 1936; *Belfast and Ulster Directory*, 1935; *Dictionary of British Artists 1880-1940*, Woodbridge 1976; Martyn Anglesea, *The Royal Ulster Academy of Arts*, Belfast 1981 (also illustration, McPherson senior and junior); Ann M. Stewart, *Royal Hibernian Academy of Arts: Index of Exhibitors 1826-1979*, Dublin 1986; Miss Helen McPherson, *Letter to the author*, 1989; Theo Snoddy, *Ulster Television: Catalogue of the Havelock House Works of Art collection*, Belfast 1989; Eileen Black, *A Sesquicentennial Celebration: Art from the Queen's University Collection*, Belfast 1995 (also illustration).

McSWINEY, EUGENE J. (1866-1936), landscape and portrait painter. Son of Morgan McSwiney, leather merchant, Eugene Joseph McSwiney was born in Cork on 11 April 1866. He entered the Cork School of Art in 1882, won prizes and a free studentship, moving on to South Kensington, London. At the age of seventeen, from 22 Dyke Parade, Cork, he exhibited *An Old Weir on the Lee* at the Cork Industrial Exhibition, 1883. He became an assistant master at the Crawford School of Art, Cork, and also taught at other schools in the Co. Cork area.

An illuminator, he was responsible for the address, *c.*1890, to the Rev. John O'Mahony from the Kinsale Temperance Association, now in Kinsale Regional Museum. When he began to exhibit at the Royal Hibernian Academy in 1890, his address was 16 Grattan Street, Cork, as it was in the next two years, but between 1893 and 1900 inclusive he did not show in Dublin; probably he was in London. A writer in the *Journal of the Cork Historical and Archaeological Society*, 1913, may have been referring to this period when the artist 'struggled long and manfully against a strong tide of adversity ... loving persistence enabled him to overcome difficulties which to another man would bring despair'. However, added the writer, he had the satisfaction of seeing his work hung in the Royal Academy 'and other London exhibitions'.

Altogether at the RHA, McSwiney exhibited nearly forty pictures up until 1930, working in oil and watercolour. In 1901 he gave St John's Wood Terrace, London, as his address, and thereafter he made several moves in the city. The four works which were hung at the Royal Academy he regarded as among his principal productions: *Eventide*, 1897; *In sheltered vale*, 1904; *Spring*, 1908; *Ruins of Timoleague Abbey, Co. Cork*, 1912. The last-named is in Crawford Municipal Art Gallery, Cork.

McSwiney also showed occasionally at the Munster Fine Art Club – *Low Tide at Chiswick*, watercolour, at the 1925 exhibition. *Alice in Wonderland* was among his contributions to the 1921 RHA. River Thames scenes often attracted his brush, for example *Evening on the Thames, near Kew* at the 1913 RHA, and *Low tide-Upper Thames* in 1930, the last work exhibited in Dublin. His recreations were sketching from nature, and music. The Gorry Gallery and the Cynthia O'Connor Gallery, Dublin, both included his works in Dublin exhibitions in the 1980s. Of 25 Richmond Avenue, Merton, London, he died in hospital on 17 January 1936.

Works signed: Eugene J. McSwiney (if signed at all).

Examples: Cork: Crawford Municipal Art Gallery. Kinsale, Co. Cork: Regional Museum.

Literature: *Journal of the Cork Historical and Archaeological Society*, 1913; *Who's Who in Art*, 1934; General Register Office, London, *Register of Deaths*, 1936; Crawford Municipal School of Art, *Cork Art Galleries*, catalogue, 1953; Kinsale Regional Museum, *Letter to the author*, 1972; Ann M. Stewart, *Royal Hibernian Academy of Arts: Index of Exhibitors 1826-1979*, Dublin 1986; Crawford Municipal Art Gallery, *Letter to the author*, 1989; Peter Murray, compiler, *Illustrated Summary Catalogue of The Crawford Municipal Art Gallery*, Cork 1991.

McWILLIAM, F.E., RA, HRUA (1909-92), sculptor. Frederick Edward McWilliam was born on 30 April 1909 in Newry Street, Banbridge, Co. Down, the son of Dr William N. McWilliam. Educated at Campbell

College, Belfast, 1922-6, he then entered Belfast College of Art and studied for two years, moving on to the Slade School of Fine Art, London, with the intention of studying painting. In his second year in London he met Henry Moore (1898-1986), who became a lasting friend, and long before he left the Slade he had decided to become a sculptor. He studied there under Henry Tonks (1862-1937) and Randolph Schwabe (1885-1948).

Fellow students at the Slade were Tom Carr and John Luke (qq.v.). McWilliam, who shared a studio with Luke, won the Robert Ross leaving scholarship in 1931, which took him abroad for a year. Before moving to a studio at Port d'Orléans, Paris, he worked as a farm labourer in Var, Provence. In Paris he met the Russian-born sculptor, Ossip Zadkine (1890-1967) and visited his studio. On return, England became his home and he began in earnest to carve in wood, for example *Trio*, cherrywood, 1936.

Newly married, he and his wife Beth, on a trip to Paris, visited the Roumanian sculptor, Constantin Brancusi (1876-1957), long established in the city. In 1936 he attended the International Surrealist Exhibition at the New Burlington Galleries, London. Moore and McWilliam were in the purchasing group which visited Hoptonwood Quarry, Derbyshire, in 1937, hence his *Two Forms*, Hoptonwood stone, 1938. McWilliam exhibited with the British Surrealist Group in 1938. His first one-person show was at the London Gallery in 1939, monoprint drawings included, *The Studio* noting that his Surrealist sculptures were 'rather bare-toothed in conception but very beautiful in execution.'

McWilliam worked for some six months on *Profile* (Tate Gallery), carved from a single piece of lignum vitae, his last work before joining the Royal Air Force in 1940. He served as a intelligence officer in India, 1944-6, first in New Delhi where he taught life drawing on an informal basis at the local Hindu art school.

On his return to civilian life he obtained a teaching appointment at Chelsea School of Art for two days a week, but in 1947 he joined the Slade staff, a post he retained until 1968. His *Kneeling Figure* (Sainsbury Centre for Visual Arts) of 1947 was in plastic wood. *Man and Wife*, one of his twenty-one works at the Hanover Gallery in London in 1949, was donated by the Contemporary Art Society to the Ulster Museum, which described the medium as 'coloured Portland stone aggregate, waste mould.' In his catalogue introduction to the Hanover exhibition, Merlyn Evans stated that McWilliam was convinced 'that one of the essentials for a work of art is the stimulus of breaking new ground...'.

Elected a member of the London Group in 1949, he moved to 8a Holland Villas Road, W. 14, in 1950, a settled address. For the 1951 Festival of Britain he was commissioned to create large figurative work on the subject of 'The Four Seasons' for the Country Pavilion, South Bank. These works represented figures engaged in various agricultural activities. He also contributed to the Festival's International Open Air Sculpture Exhibition in Battersea Park. In 1951 the Irish Exhibition of Living Art Committee invited him as a guest artist to their annual exhibition in Dublin. He showed *Cyclopean Head*.

At another solo show at the Hanover Gallery, in 1952, he exhibited in wood, metal and wire. In the 1953 International Sculpture Competition on the theme of the Unknown Political Prisoner he won a prize of £25. The exhibition was at the New Burlington Galleries, and the Tate Gallery purchased *Cain and Abel*, aluminium. He was represented in 1953 at the CEMA sculpture exhibition at the Belfast Museum and Art Gallery. Nine English sculptors, led by Moore, were involved in 1953 at Antwerp in the second Biennial of International Sculpture held at the Middleheim Open Air Museum. McWilliam was represented by *Parents and Children*.

The idea of bust portraits of William Scott (q.v.) and his wife Mary was suggested at a New Year's Eve party in 1955; that of William was started the next day and completed in a week. The bust of his wife was made in the following week. The first of three casts of William Scott is in the Ulster Museum; the second is in the Tate Gallery. The first of three casts of Mary Scott is at the Tate.

The 1956 exhibition at the Hanover Gallery contained thirty-nine works. The most exciting and controversial sculpture ever to appear in Northern Ireland was *Princess Macha*, 2.4 m high, for Altnagelvin Hospital, Londonderry, 1957. Studies, for the bronze sculpture, in charcoal and coloured chalks are at the Victoria and Albert Museum, London. The Altnagelvin commission had followed one for Harlow, Essex, a lifesize figure in bronze of fellow sculptor, Elizabeth Frink (1930-93). In 1957 he was represented in the Sao Paulo Biennale, also in the exhibition in Holland Park, London.

In 1958 a retrospective exhibition took place at West of England Academy, Bristol, and that year he provided *Man and Bird* for Basildon New Town. Despite never having submitted work to Burlington House, he was appointed ARA in 1959 but resigned in 1963. The Institute of the Sculptors of Ireland arranged an international exhibition at the Municipal Gallery of Modern Art, Dublin, in 1959, and McWilliam was represented by three works, including *Pianist and Pupils*, bronze.

The 1959 *The Witch of Agnesi* has been moved a couple of hundred yards from its Avery Hill College location, where it was damaged on several occasions, to the centre of a small pool in the University of Greenwich's student village. *Father Courage*, 1960, was acquired for University of Kent, Canterbury, and the University has pointed out that the title is a variant of *Mother Courage*, Bertold Brecht's drama. In 1960 he held a one-person show at Queen's University, Belfast.

McWilliam's initial showing at the Royal Academy was *The Communicant* in 1960; other bronzes followed: *Baal* in 1961; *Man at Ease*, 1962. In this decade he exhibited solo in 1961, 1963, 1966 and 1968 at Waddington Galleries, London. *Resistance II* (Leeds City Art Gallery) won second prize of £250 in the open sculpture, John Moores Liverpool exhibition, 1961. From 1962 until 1968 he served as an arts panel member of the Arts Council of Great Britain.

Southampton University has the 1962 bronze, *Puy de Dôme Figure*, 2.4 m in length. The 1962 bronze bust of Chief Hosea Kutato of Namibia is at the United Nations, presented by the African Bureau. *Reclining Figure* was unveiled at Queen's University, Belfast, in 1963.

McWilliam sent twenty-six works in 1963 to his first American exhibition, at Felix Landau Gallery, Los Angeles. In 1963 he visited Greece. An Honorary Doctor of Literature was conferred by Queen's University in 1964. Among other portrait commissions was a bust of Lord Adrian, 1964, for Trinity College, Cambridge; Sir Alan Bullock (St Catherine's College, Oxford); Dr G. B. Jeffery (Institute of Education, University of London). *Hampstead Figure*, 1964, is at Swiss Cottage, London. In his 1964 book on McWilliam, Roland Penrose described him as 'an inventor of styles.'

In 1965-6 emerged his bronze 'Bean' sculptures. The CBE was awarded in 1966. After a visit to Mexico, he experimented with fibreglass and mosaic facing, hence *Head of Picasso*, 1967. His work appeared in many group exhibitions, at home and abroad. Individual shows were hosted by Travers Gallery, London, in 1969, and Waddington Gallery, Montreal, 1970. In Dublin, he won the 1971 Oireachtas gold medal for sculpture, and that year he was appointed a Fellow of University College, London.

A return to Co. Down was provided by his show at the Hillsborough Art Centre opening in 1971. At Waddington Galleries, London, there were solo events in 1971 and 1973. The *Women of Belfast* series, victims of the terrorist bomb blasts, were created in 1972-3, and these works were shown in 1973 at the Dawson Gallery, Dublin, followed by McClelland Galleries International, Belfast. Bronzes in the series are in the Ulster Museum and in Dublin at the Hugh Lane Municipal Gallery of Modern Art, where there are also six pen and ink studies with wash.

In an interview in 1973 with the *Irish Times*, McWilliam confessed: 'I am very much a loner, I work entirely by myself, I've never had assistants and I can't work with anybody else about the place...'. At the Waddington Galleries in 1976 he showed thirty-three pieces. The Bell Gallery, Belfast, held a show in 1977. He exhibited *Picasso* at the 1978 Royal Scottish Academy. He was an honorary member of the Royal Ulster Academy. The Taylor Galleries, Dublin, staged an exhibition in 1980. At this time he was absorbed in the bronze 'Legs' series.

Thirty-seven drawings and 152 sculptures were in the 1981 retrospective exhibition arranged by the Arts Councils, Belfast and Dublin, which opened at the Ulster Museum, followed by the Douglas Hyde Gallery, Dublin, and Crawford Municipal Art Gallery, Cork. Judy Marle and Terence Flanagan were responsible for the catalogue, and they wrote the script for the McWilliam film commissioned by ACNI.

The Warwick Arts Trust, London, displayed sixty works in 1982. Waddington Galleries, London, and Gordon Gallery, Londonderry, were both involved in exhibitions in 1984, and the Shambles Art Gallery, Hillsborough, in 1988. The retrospective at the Tate Gallery in 1989 covered the years 1932-89 with an extensive catalogue by Mel Gooding. A bust of Dame Ninette de Valois is at the National Portrait Gallery,

London, and the Royal Opera House, Covent Garden. In the Arts Council of Great Britain collection is *Reclining Figure,* terracotta.

In December 1989 McWilliam was appointed a Senior Royal Academician. The *Irish Times* said that his work was 'unmistakably his own, craftsmanlike, humorous, imaginative, with a playful, poetic, slightly capricious element which sets it apart.' He died on 13 May 1992, the funeral being held at Putney Vale Crematorium, London.

In 1992 the artist's family bequeathed his working studio and its contents to the Banbridge District Council on the understanding that the Council would re-erect the studio at a suitable site in the district. In 1995 the Solomon Gallery, Dublin, exhibited a selection of sculpture and graphic work.

Works signed: McW. (if signed at all).
Examples: Adelaide: Art Gallery of South Australia. Antwerp: Middleheim Open Air Museum. Banbridge, Co. Down: Council. Basildon, Essex: New Town. Belfast: Arts Council of Northern Ireland; Queen's University; Ulster Museum. Bradford, Yorks. : Cartwright Hall. Cambridge: Trinity College. Canterbury: Kent University. Chicago: Art Institute. Coventry: Herbert Art Gallery and Museum. Dublin: Hugh Lane Municipal Gallery of Modern Art. Harlow, Essex: St John's Arts and Recreation Centre; Town Centre. Ipswich, Suffolk: Christchurch Mansion. Leeds: City Art Gallery; University. Leicester: Leicestershire Museum and Art Gallery. Limerick: University, National Self-Portrait Collection. London: Arts Council of Great Britain; Institute of Education, University of London; University of Greenwich; National Portrait Gallery; Royal Institute of British Architects; Royal Opera House; St Thomas' Hospital; Swiss Cottage, Hampstead; Tate Gallery; Victoria and Albert Museum. New York: Museum of Modern Art; United Nations Headquarters. Norwich: Castle Museum; Sainsbury Centre for Visual Arts, University of East Anglia. Oldham, Lancs: Art Gallery and Museum. Ottawa: National Gallery of Canada. Oxford: St Anne's College; St Catherine's College. Perth: National Gallery of Western Australia. Shrewsbury, Shropshire: College of Arts and Technology. Southampton: University.
Literature: *The Studio,* April 1939, September 1951, January 1953, December 1953; Hanover Gallery, *F. E. McWilliam Recent Sculpture,* catalogue, London 1949; *Who's Who in Art,* Havant 1952; *Tate Gallery Catalogues: The Modern British Paintings, Drawings and Sculpture,* vol. 2, M-Z, London 1964; *Irish Times,* 31 October 1973, 14 May 1992, 22 August 1995; Mike Catto, *Art in Ulster: 2,* Belfast 1977; John Hewitt and Theo Snoddy, *Art in Ulster: I,* Belfast 1977 (also illustration); Witt Library, illustrated records, London [1977]; South London Art Gallery, *A. H. Gerrard,* catalogue, London 1978; Judy Marle and T. P. Flanagan, *F. E. McWilliam,* catalogue, Belfast 1981 (also illustrations); *Royal Academy Exhibitors 1905-1970,* Calne 1987; Tate Gallery: Mel Gooding, *F. E. McWilliam Sculpture 1932-1989,* catalogue, London 1989 (also illustrations); *The Royal Scottish Academy Exhibitors 1826-1990,* Calne 1991; Banbridge District Council, *Letter to the author,* 1999; also, University of Greenwich, 1999; Harlow Council, 1999; Institute of Education, University of London, 1999; University of Kent, 1999; Royal Academy of Arts, 1999; United Nations Headquarters, 1999.

MAGRATH, WILLIAM, NA (1838-1918), landscape, genre and portrait painter. Born in Cork on 20 March 1838, William Magrath in his early years manifested a love for drawing. He was educated at St Stephen's Hospital and the Blue Coat School. He recalled in a letter to a friend: 'One day during school session I amused myself by making a copy in pencil of a castle illustration in one of our readers. A fellow pupil with whom I may have quarrelled, with malice in his heart, snatched my drawing and laid it on the master's desk, saying that was what I was doing in school hours, evidently hoping to see me punished. The old gentleman put his gold-rimmed glasses on, simply folded the little scrap of paper, placed it in his pocket silently, and on the following day called me to him and asked me if I would like to go to the School of Art. Of course I said "Yes", and he then handed me a letter to the Secretary, Mr Dunscombe, and told me to go down and be enrolled as a pupil. He had made all the arrangements necessary, and gave me some hours on several days of the week to attend.'

At the Cork School of Art he made the acquaintance of Thomas Hovenden (1840-95) who was to emigrate to America in 1863, eight years after Magrath had stowed away to New York. Hovenden attended night classes at the National Academy of Design in New York. Magrath established a studio in that city around 1868, having survived early days through sign painting. He married, but his wife died within a year, and their infant son died shortly afterwards.

Elected an associate of the National Academy of Design in 1873, he was appointed an academician in 1876. The National Academy owns three of his works, all oils; a self-portrait and *Portrait of Arthur Parton*

were both unsigned and undated. The third painting, *A Connoisseur*, depicted a monk viewing the *Venus d'Urbino* by Titian.

When *On the Old Sod* was exhibited at the National Academy of Design in 1879, Magrath received praise for his sentiment as well as his technique. A wood engraving of the picture was published the same year in *Harper's New Monthly Magazine*. The original is in the Metropolitan Museum of Art, New York, and shows a single standing figure, presumably an Irish farmer, silhouetted against the landscape and sky. In 1879 too Magrath returned to the home isles for the first time since his departure.

He visited Cork before travelling on to London. He was advised by a well-known Cork citizen and patron of art to send his works to the then forthcoming Royal Academy, giving him at the same time a letter of introduction to an eminent academician. The four paintings submitted were accepted for the 1880 exhibition – including *In the Green Fields of Erin* and *Something towards the rent* – and were eulogised by the art critics. On his return to Cork, he thanked his friend for the advice, returning the letter of introduction with the remark, 'I was afraid if I delivered your kind message, it might have some influence and prejudice the selection'.

When living in London – in 1882 he exhibited *The Binder* and *Paddy's Honeymoon* at the Royal Hibernian Academy – Magrath also showed with the Royal Institute of Painters in Water Colours as well as at the Walker Art Gallery, Liverpool, and the Manchester City Art Gallery. He returned to the United States in 1883, having exhibited three works that year – including *In the Green Fields of Erin* – in the Cork Industrial Exhibition. He must have visited the Continent the following year: *La Grosse Horloge-Rouen*, a watercolour, was dated 1884. Another watercolour, *Ah! Rory, be aisey, don't taze me no more!* was completed in 1886, and is now in the Crawford Municipal Art Gallery, Cork. Samuel Lover's poem, *The Low-backed Car*, illustrated in photogravure, appealed to his American patrons. His figures tended to possess a certain refinement not apparent in the 'stage Irishman' variety.

Magrath was one of the founders of the Society of Painters in Watercolor. In 1891-2, according to the records of the National Academy of Design, he was living in Washington, DC. For a short time in 1893, he was back in his native city, and the *Cork Examiner* urged readers to visit an exhibition of three watercolours at Crawford School of Art as the artist – it was November – 'departs for America in a few days'.

In 1904 his venerable figure was seen again on the Cork streets, and he exhibited his masterpiece, *The Harp that once through Tara's Halls*. Preliminary notes and sketches for this work apparently showed that the artist had visited museums and picture galleries in Europe to obtain and verify details of costumes and accessories. The picture represents a bard reciting before the King, Queen, Chiefs and Court at Tara. A desire of the artist was that this work should find a home in his native city, and it rests safely in the Crawford Municipal Art Gallery. Altogether in the Cork gallery there are five oils, and the four watercolours include *The Fisher Girl* (or *Gathering Kelp*). Six of the nine works in the collection were presented by the artist, including a self-portrait. Elsewhere, among his other portraits, was one of his Scottish-born friend, the painter William Hart (1823-94).

According to the Cork local historian, Michael Holland, Magrath made many sketches during a tour of West Cork and Kerry. He was of 'a retiring and amiable disposition, he was adverse to exploiting his art, so that his reputation was comparatively limited, yet it always appealed to those who appreciate sterling methods and feeling for beauty in painting ...'.

The American artist and critic Samuel G. W. Benjamin (1837-1914) called him 'one of the strongest artists in genre on this side of the Atlantic', and noted that 'he occasionally suggests the inimitable humanity which is the crowning excellence of the paintings of Jean François Millet'. After residing in New Jersey, he made his home in England, where he had relatives, and died on 13 February 1918 at Harlesden near London.

Works signed: W. Magrath or Magrath (if signed at all).
Examples: Cork: Crawford Municipal Art Gallery. New York: Metropolitan Museum of Art; National Academy of Design. Springfield, Mass., USA: George Walker Vincent Smith Museum.
Literature: Algernon Graves, *A Dictionary of Artists 1760-1893*, London 1901; *Journal of the Cork Historical and Archaeological Society*, 1913, January-March 1918, January-June 1943; W. G. Strickland, *A Dictionary of Irish Artists*, Dublin 1913; J. D. Champlin, *Cyclopedia of Painters and Paintings*, London 1938; Mantle Fielding, *Dictionary of American Painters, Sculptors and Engravers*, New York 1945; *The New-York Historical Society's Dictionary of Artists*

in America 1564-1860, New Haven 1957; *Dictionary of British Artists 1880-1940*, Woodbridge 1976; *The Magazine Antiques*, November 1976; National Academy of Design, *From All Walks of Life*, catalogue, New York 1979; Natalie Spassky, *American Paintings in the Metropolitan Museum of Art*, vol. II, catalogue, Princeton 1985; Peter Murray, compiler, *Illustrated Summary Catalogue of The Crawford Municipal Art Gallery*, Cork 1991.

MAGUIRE, RICHARD (1895-1965), portrait, still life and figure painter. The son of Josiah Maguire of Enniskillen, Co. Fermanagh, he was born on 4 November 1895 and entered Portora Royal School at Easter, 1911, leaving in December of the same year. His first painting, of the North Wall, Dublin, was a holiday effort but was accepted for exhibition and bought by Countess Markievicz (q.v., Gore-Booth) for ten shillings. He never forgot her as she encouraged him to continue painting.

Apart from some classes in the Waterford Technical School in the 1940s, he was self-taught. Much of his painting was done and sold in India where he was a Captain in the Bengal Lancers, often changing stations. His *Bombay Boatmen*, oil, in the Waterford collection, was painted in India; he also worked in watercolours. Portraits of his friends were generally given away. He rarely exhibited but had one show at a hill station in the South of India.

Maguire also served in the Second World War; some of his early works were destroyed during the air raids on England. He was in Germany for three years, 1945-7, serving on the Control Commission. Towards the end of his life he experimented by painting bunches of roses on silk. Works in private possession include *A Man in Armour*, a head portrait; *The Pepper Pot*, head of a horse; *The Indian Scribe*.

After living in Lucan, Co. Dublin, for more than ten years, he moved to the Isle of Man and died four years later, on 10 March 1965, holding the rank of Lieut.-Colonel. His niece, Myra Maguire, illustrated Edward MacLysaght's *Irish Families: Their Names, Arms and Origins*, 1972.

Works signed: R. Maguire or R.M.
Examples: Waterford: City Hall, Municipal Art Collection.
Literature: R. L. Doupe, *Letter to the author*, 1978; also, Ms Jane Hämmerle-Maguire, 1989; Mrs Marché Maguire, 1989; Portora Royal School, 1989.

MANN, MILLICENT– see GIRLING, MILLICENT

MANNING, JAMES(1929-83), landscape and figure painter. Born on 7 April 1929 at 8 High Street, Kilkenny, James Anthony Manning was the son of Thomas Manning, publican, tea and wine merchant. Next door was a butcher who drew cowboys and Indians for the boy, on brown paper. 'I would spend hours watching him, I remember. Then one day he was too busy and I started to draw myself,'recounted Manning. He began painting when he was about nine. Later, his mother saw him safely into the Munster and Leinster Bank.

Manning worked in a number of bank branches, including Drogheda, where he received tuition from Bea Orpen (q.v.). In 1954, J. Anthony Manning held a joint exhibition with Florence Cruise at the Drogheda Art Gallery, Public Library. The greater part of his banking career was spent in Dame Street, Dublin, and he was a regular attender at National College of Art evening classes.

In 1956 with fellow banker Bob Ryan contact was made with Tony O'Malley of the New Ross, Co. Wexford, branch, and they organised an exhibition at the Little Theatre, Brown Thomas, Dublin, for 1957. In 1959 they showed again, this time in the Dublin Painters' Gallery, St Stephen's Green, and Manning's contributions included *Painters' Gallery, St Ives*. In 1961 and 1963 he held joint exhibitions with Ryan in the Little Theatre.

In 1963 he exhibited at the Royal Hibernian Academy, contributing nineteen works over a period of almost twenty years. He showed *The Quiet Land* in 1963. In 1965 he was represented in the Irish group show organised by the Jordan Marsh Company in Boston, USA. *Sea Phantom* and *Paris Street* were among his thirty-two paintings in 1966 at the Little Theatre. In 1969, he showed *Blue landscape* and *Sea Cove* at the RHA, sent from 100 Foxrock Park, Foxrock, Co. Dublin.

In the period 1967-83 inclusive, thirty-seven works were hung at the Water Colour Society of Ireland exhibitions, beginning with *Christchurch, Rathgar* and *Quayside, Youghal*. During his summer holidays he made occasional painting journeys to Paris. On his exhibition of forty paintings at the Little Theatre in 1968, the *Irish Times* found 'an array of styles ranging from conventional watercolour to the frankly experimental...' Works included *Sherkin Island* and *Three Ancient Kings*.

When the bank strike arrived in 1970 he took off to St Ives in Cornwall and joined up with fellow Kilkenny man, O'Malley, to catch up on his painting. He stayed with O'Malley at Seal Cottage and also worked at his studio, no. 6 Porthmeor Studios. The upshot of this productive and liberating experience was a 1971 exhibition at the Hellfire Club Studio, Killakee, Rathfarnham, supported by Allied Irish Banks, Ltd.

On the Rathfarnham exhibition, the *Irish Times* critic considered that he had tried to please everyone ... 'What is surprising in Manning's work is that he can display such a wide range of techniques... His series of figures — small, compact and well thought-out, such as *Woman Fixing Hair* and *Hanging Figure* — work well. For myself, however, I preferred his less ambitious attempts in the detailed seascapes which he makes sinister with his doom-laden colours. Here a human is a mere shape against the elements; it is the sky and the land which are active.'

An exhibition in London in 1970 produced a comment in the *Arts Review*: 'His work reveals a characteristically Irish way of directly taking part in the experience of living rather than analysing it. Like most quick, decisive artists, he nearly always achieves a sense of movement within each picture, preferring to suggest rather than state...He captures the most important thing — the atmosphere of the place.'

Variety was underlined by three pictures at the 1971 WCSI exhibition: *The White Bonnet*; *Figure Composition*; *Fitzwilliam Square*. In 1973 he held a show at Graphis Gallery, 113 St Stephen's Green, and the three-dimensional effect of some works was created by his use of wood cuts embodied in the paintings. *Capri Night* was presented at the 1974 RHA, and that year he showed at Kyteler's Inn, Kilkenny, his first exhibition in his native city. *Aphrodite Waiting* was hung at the 1975 WCSI. His exhibition at Rothe House, Kilkenny, in 1977, as part of the Arts Week, centred on island paintings.

At the Lincoln Gallery in Dublin in 1981 he showed forty-three works, the *Irish Times* singling out a night scene, Dooagh in Achill: 'It's very strong and definitely shows what he is capable of when he throws off other influences.' Manning also exhibited in Dublin at the Oireachtas. He was an amusing contributor to *AIB News*, for example a series of sketches on the theme of 'banking is a dog's life.' His friend Ryan found him 'a fascinating companion, with an original mind and vision.' He wished to be remembered as a painter and requested in his will that this be inscribed on his gravestone. He died in Dublin on 24 May 1983.

Works signed: Anthony Manning, James Manning, J. Manning, J. A. Manning, J. A. M., J. M. or Manning.
Literature: General Register Office, Dublin, *Register of Births*, 1929; *Irish Times*, 12 September 1968, 20 and 27 May 1971, 22 September 1981, 3 September 1983; *Exhibition of Paintings by James Manning*, catalogue, Kilkenny 1974; *Southside*, 23 September 1981; *Irish Press*, 26 September 1981; General Registry Office, Dublin, *Register of Deaths*, 1983; Ann M. Stewart, *Royal Hibernian Academy of Arts: Index of Exhibitors 1826-1979*, Dublin 1986; catalogues, 1980-1981; *Water Colour Society of Ireland Exhibition List 1872-1994*, Dublin 1995; Helen Manning, *Letter to the author*, 1999; Jane O'Malley, *Letters to the author*, 1999; Bob Ryan, *Letter to the author*, 1999.

MANNING, MAY (1853-1930), landscape and figure painter. Mary Ruth Manning was born in Dublin, the second daughter of Robert Manning, M Inst CE, chief engineer to the Board of Works. Sarah Purser (q.v.) studied in Paris 1878-9, and May Manning was also there at that time. She became friendly with a student from Switzerland, Louise Breslau (1856-1927), who shared an apartment with Miss Purser.

As she had decided to devote herself to teaching drawing and painting in Dublin, the number of works which she exhibited was very small. In 1880, from her home address, 4 Upper Ely Place, Dublin, she showed at the Royal Hibernian Academy the first two of only four works: *Nellie* and *Found*. In 1885, from 70 Grafton Street, she exhibited *The Graduate*, and in that year the Dublin Sketching Club admitted her to membership.

Looking Thro and Thro, an oil painting, of a young woman, head and shoulders, wearing a tall hat, was signed and dated 1889 with an exhibition label verso giving the address Lower Mount Cottage, Hampstead.

She exhibited only one picture with the Royal Society of Artists, Birmingham, and one with the Walker Art Gallery, Liverpool.

Lily Williams (q.v.), born in 1874, was taught first by May Manning, and Mary Swanzy (q.v.), born eight years later, also received tuition and has recalled that her teacher believed that a student who wished to draw had to learn how to model, and May encouraged her to study modelling at evening classes in the Dublin Metropolitan School of Art under John Hughes (q.v.). She had 'sent students of an earlier generation to Paris, and she encouraged me to go', added Mary Swanzy. Hughes in a letter to Sarah Purser, 19 May 1895, wrote: 'I passed Miss Manning's studio the other night and there was a light in it. I thought the mashed potato supper was on ...'

Miss Bay Jellett told the author in 1976 that May Manning had a studio in Merrion Row and that her sister, Mainie Jellett (q.v.) attended and found her a more agreeable teacher than Sarah Cecilia Harrison (q.v.). Both of May's sisters were also unmarried.

A landscape with a setting sun, an oil, is in the National Gallery of Ireland, but she also painted in watercolours. She is represented by an oil, *Study of a Boy*, in the Hugh Lane Municipal Gallery of Modern Art. As several of her pupils made excellent careers in art, it seems strange that she should be unsung at the time of her death on 27 January 1930 at her residence, 11 Winton Road, Leeson Park. In the subsequent exhibition of Irish art at Brussels, she was represented by *Roses*.

Works signed: M. Manning or M. R. Manning (if signed at all).
Examples: Dublin: Hugh Lane Municipal Gallery of Modern Art; National Gallery of Ireland.
Literature: *Dublin Sketching Club Minute Book*, 1885; *Thom's Directory*, 1890; *Irish Times*, 28 January 1930; Alan Denson, *John Hughes Sculptor 1865-1941*, Kendal 1969; *Dictionary of British Artists 1880-1940*, Woodbridge 1976; Julian Campbell: National Gallery of Ireland, *The Irish Impressionists: Irish Artists in France and Belgium, 1850-1914*, catalogue, 1984; National Gallery of Ireland and Douglas Hyde Gallery, *Irish Woman Artists: From the Eighteenth Century to the Present Day*, catalogue, 1987; Ms Elinor Medlycott, *Letter to the author*, 1989; Frederick Gallery, *Irish Art*, catalogue, Dublin 1999.

MANNIX, ROBERT (c. 1839-1913), portrait and genre painter. Information about this artist has been limited in some respects. The National Gallery of Ireland 1932 catalogue of oil paintings stated that he was 'born at Cork about 1841, the son of a painting contractor. He left Cork at an early age and went to London where he studied and worked for a number of years. He returned to Ireland and settled in Dublin where he carried on a church decorating business in North Frederick Street.'

Mannix's sojourn in London, if the guesses regarding his birth date are in any way accurate, cannot have been long because he exhibited at the RHA in 1858 with a Mount Street, Dublin, address; in 1860, 14 Merrion Row. Altogether he showed more than seventy works at the Academy. A North Wales sketch appeared in 1868. Four years later he was at 17 Bachelor's Walk, and in 1873 the four works hung included *Head of an Apostle* and *The little village maiden*.

Mannix was a regular visitor to the home of the future poet and novelist, Katharine Tynan, Whitehall (between Templeogue and Clondalkin), especially on the family's 'At Home' days, when literary and artistic people were especially welcome. An oil sketch which he executed is inscribed on old label on reverse: 'To Miss Kate Tynan from...Mannix/Dublin Sketching Club 1868.' Born in 1861, Katharine looks older than seven in this work. Perhaps she wore fancy clothes for the occasion. The picture entered NGI more than a century later.

In 1873 he painted C. H. Granby as Sir Peter Teazle in *The School for Scandal*, an oil painting which also found its way into the NGI collection, more than half a century later. No fewer than eight works were accepted for the 1874 RHA, and these included *'Of what is the old man thinking as he leans on his oaken staff?'* and *The Rollicking Ram comes to grief*. Of the six which he showed in 1875, the two highest-priced were: *'In this old chair my father sat'* and *'My love is but a lassie yet.'*

In her *Marching Workers* catalogue, Belfast 1978, Belinda Loftus drew on the *O'Connell Centenary Record*: 'In the 1875 procession the Ironfounders carried a banner painted by the Dublin artist Mr Mannix which showed on one side the English certificate design, full of superb industrial scenes, and on the other

the Maid of Erin with national emblems.' However, there must remain some doubt that the work was by Richard because elsewhere in the catalogue is a reference to 'George Mannix, who painted banners for the Dublin plasterers and painters, was himself a church architectural decorator and housepainter — all with one arm.'

Mannix still showed at the Academy the occasional portrait, generally untitled and not for sale. In 1879 he gave 15 Upper Gloucester Street as an address. *View on the Liffey*, exhibited in 1884, was the dearest of all the pictures which he showed in Dublin. An unusual subject was inmates of the Blind Asylum, Drumcondra Castle, exhibited in 1885 from 33 Chelmsford Road, Leeson Park.

In the 1880s he was still associated with the Dublin Sketching Club. In 1894, among six works at the RHA, he contributed *My Dolly's Birthday* and *The late G. V. Brooks, Esq.* Another named portrait followed in 1896, that of the late Bishop, Most Rev. Dr Michael Comerford, a member of the Royal Irish Academy, the work having been presented by the artist to St Patrick's College, Carlow.

In 1895, from 10 North Frederick Street, he showed *Her Last Moorings* at the Glasgow Institute of the Fine Arts. In 1898 he had moved to 23 Kelvinside Gardens, Glasgow, when he exhibited *Peep o'Day Boy*, and in 1899 from the same address he showed again at the Institute, *Taking it easy*. In 1899, 1901 and 1911 he exhibited in Dublin from his Glasgow address, his final contribution being *In the Vale of Festinog*.

In connection with his business, he described himself as an 'architectural and church painter.' He is represented at the Model and Niland Centre, Sligo, by *The Basket Weavers*, an oil 58 cm x 73 cm of two seated men, both wearing hats, a work that was part of the Bodkin Collection donated to Sligo. The registration of his demise could not be traced in Dublin and death in Scotland is assumed.

Works signed: R. Mannix.
Examples: Carlow: St Patrick's College. Dublin: National Gallery of Ireland. Sligo: Model and Niland Centre.
Literature: *Dublin Sketching Club Minute Book*, 1880s; *Thom's Official Directory*, Dublin 1898; *Dictionary of British Artists 1880-1940*, Woodbridge 1976; Belinda Loftus, *Marching Workers*, Belfast 1978; National Gallery of Ireland, *Acquisitions 1984-86*, catalogue, Dublin 1986 (also illustration); Ann M. Stewart, *Royal Hibernain Academy of Arts: Index of Exhibitors 1826-1979*, Dublin 1986; National Gallery of Ireland, *Letter to the author*, 1998; also, Glasgow City Council, 1999; St Patrick's College, Carlow, 1999; Sligo County Library, 1999.

MARA, TIM (1948-97), printmaker. Born in Dublin on 27 September 1948, Timothy Nicholas Mara was the son of a pharmacist, Timothy Anthony Mara. The family moved to England in 1953 and he was educated at St Joseph's College, Beulah Hill, South London, 1960-7. He chose advertising as a career but left the London Press Exchange after one year to pursue an art education.

From 1968-70 he attended Epsom and Ewell School of Art. His interest in screenprinting developed in his undergraduate course at Wolverhampton Polytechnic, 1970-3. *Mirror Man* won the prestigious Stowells Trophy in 1972. *Portrait of Astrid*, 1973, was another print which established his reputation, and that year he won the British Airways Art Award.

In 1973 he began the printmaking course at the Royal College of Art, and when there he produced another noted screenprint, *Power Cuts Imminent*. His initial one-person exhibition was held in 1974 at Birmingham Arts Lab. Large screenprints sometimes had as many as fifty or sixty separately printed colours, and at RCA it was not unusual for him to spend an entire term making one image. Participation in a series of exhibitions of the British International Print Biennale at Bradford, Yorkshire, began in 1974; he won prizes in 1982 and 1984. In 1976, the year he gained his Master's degree and a major travelling scholarship to the USA, the Institute of Contemporary Art hosted in London his second solo show. He had a visiting lectureship at the National College of Art and Design in Dublin, 1976-7. He was represented in the Recent Acquisitions exhibition at the Tate Gallery, London, in 1976.

In 1977 one-person exhibitions were staged at Project Arts Centre, Dublin; Portland Gallery, Manchester; and Wolverhampton Central Art Gallery. In London, he was represented in the 'Treasures of the Print Room' exhibition, Victoria and Albert Museum. Again in 1977, his work was at the Vienna Graphics Biennale and Miami Graphics Biennale, Florida.

More experimenting, he combined etching with screenprinting, embossing, relief printing and collage. In 1978, as well as the solo exhibition at Southampton University, he renewed his Irish links at the Listowel Graphics Biennale, Co. Kerry, and in a group exhibition at the Douglas Hyde Gallery, Trinity College, Dublin. *Danish Blue*, 1978, etching with photographic print and copper wire, is at the Irish Museum of Modern Art.

Mara was the author of *The Thames and Hudson Manual of Screenprinting*, published in 1979. In 1980 he was appointed principal lecturer in printmaking at Chelsea School of Art and became head of the department in 1981. One-person exhibitions followed at the Thumb Gallery, London, 1980, and David Hendriks Gallery, Dublin, 1981. He began exhibiting in 1981 at the International Biennale of Graphic Art, Ljubljana, Yugoslavia, and in 1982 came the first of several representations at the Norwegian International Print Biennale, Fredrikstad. The Modern Prints exhibition at the Ulster Museum in 1981 also included his work.

Awards followed in 1982 and 1984 at the British International Print Biennale. The Arts Council of Great Britain's touring exhibition, 'Private Views', 1982-4, covered sixteen venues and Mara was represented. In 1985 Dublin Corporation awarded an arts grant for large banners which would be hung outdoors in the Liberties, and he was one of the artists commissioned. In 1986, the year of his show at the Oxford Gallery, he was represented in the National College of Art and Design's Decade Show at Guinness Hop Store, Dublin.

Again in Dublin, he was represented at a mini print exhibition in 1987 at David Hendriks Gallery. Solo exhibitions in 1988 were: Angela Flowers Gallery, London; Drumcroon Education Centre, Wigan. In 1989 he founded the Wildman Corner Studio in Walthamstow with two of his ex-students.

In 1990 he was appointed Professor of Printmaking at the Royal College of Art, and that year saw the first of his shows at Flowers East, London. In 1991 he was represented in the large format printmaking exhibition at the Guinness Hop Store, and that year he held a solo show at the Gardener Centre, Brighton. *Can and Bowl* and *Red Buckets* were two screenprints produced in 1992. His work was seen in Galway at the 'Impressions' exhibition in 1992 at River Run Gallery. A prize was won at the Norwegian International Print Biennale in 1995. Screenprint and oil on canvas produced *Two-bar Electric Fire*, 1996. Glasgow Print Studio hosted an exhibition in 1997.

Mara participated in more than eighty group shows in the United Kingdom and in many international exhibitions. He saw the printed image as being on equal terms with any other medium. His death on 12 August 1997 was in Chelsea and Westminster Hospital. An Honorary Doctor of Arts, University of Wolverhampton, was received posthumously by his widow, Belinda, and two daughters. Also in 1997, an exhibition of his work took place at the University of East London. In association with the RCA, an exhibition was held in 1998 at the University of Alberta, Edmonton, Canada. The exhibition, 'Tim Mara, the complete prints', was presented in 2000 at the University of Ulster, School of Art and Design, Belfast, following a showing at Crawford Municipal Art Gallery, Cork.

Work signed: Tim Mara.
Examples: Belfast: Ulster Museum. Bolton, Gtr. Manchester: Museum and Art Gallery. Boston, USA: Museum of Fine Arts. Bradford, Yorks.: Cartwright Hall Art Gallery. Calgary, Canada: University. Cambridge: Fitzwilliam Museum. Douglas: Isle of Man Arts Council. Dublin: Arts Council; Irish Management Institute; Irish Museum of Modern Art; University College (Belfield); Voluntary Health Insurance Board. Dudley, West Midlands: Museum and Art Gallery. Glasgow: University. Leeds: City Art Gallery. Leicester: County Council. Limerick: University, National Self-Portrait Collection. London: Arts Council of Great Britain; British Council; Department of the Environment; London University; Royal College of Art; Tate Gallery; Victoria and Albert Museum. Manchester: City Art Gallery; Whitworth Art Gallery. Milton Keynes, Bucks. : City Museum. Naas: Kildare County Council. New York: Brooklyn Museum; Public Library. Newport, Gwent: Museum and Art Gallery. Oldham, Greater Manchester: Art Gallery and Museum. Portsmouth: City Museum and Art Gallery. Sheffield: Graves Art Gallery. Southampton: University. Wakefield, Yorks.: Art Gallery. Walsall, West Midlands: Museum and Art Gallery. Wellington, New Zealand: National Art Gallery. Wigan, Greater Manchester: Education Authority. Wolverhampton: Central Art Gallery.
Literature: Tim Mara, *The Thames and Hudson Manual of Screenprinting*, London 1979; *Irish Exhibition of Living Art*, catalogue, Dublin 1985; Flowers East, *Tim Mara*, catalogue, London 1996; Chelsea College of Art and Design, *Letter to the author*, 1997; also, National College of Art and Design, 1997; Royal College of Art, 1997; *The Guardian*, 15 August 1997; Royal College of Art, *Tim Mara The Complete Prints*, catalogue, London 1998 (also illustrations); Mrs

Belinda J. Mara, *Letters to the author*, 1999; *Irish Times*, 2 September 2000; Arts Council of Northern Ireland, *Artslink*, October 2000.

MARESCAUX, KATHLEEN (1868-1944), portrait and flower painter. Born at Raheenduff House near Horetown, Co. Wexford, Kathleen Louisa Rose was the second daughter of Major-General James B. Dennis, Royal Artillery, of Newtown House, Co. Kilkenny. She studied art abroad, first in Bruges, Belgium, in 1888, the following year in Heidelburg and Dusseldorf, and in Florence in 1890.

In 1893, from Rathmore, Naas, she exhibited for the first time at the Royal Hibernian Academy, two portraits, one of the late Meade C. Dennis of Co. Wicklow. Her marriage to Lieut. (afterwards Vice-Admiral, CB, CMG) Gerald Marescaux took place in 1894. The Dublin Sketching Club showed her work from 1911. The following year portraits of her husband and father were hung at the RHA.

In 1912 she first exhibited with the Water Colour Society of Ireland, and was a regular contributor up until the year of her death, contributing more than eighty works. In 1913 she showed *Winter Solitude*, *The Cherwell, Oxford* and *Weymouth Marshes, Dorset*. She also painted in Brittany.

In the last twenty years of her life many of her WCSI exhibits were flowerpieces. *Giant Poppies*, watercolour, is in the Kilkenny Art Gallery Society collection. In 1929 she exhibited a work with the Fine Art Society, London, and also showed one picture with the Royal Academy, in 1936. In the 1930s she showed several times at the Ulster Academy of Arts but only twice at the RHA. At the 1938 Ulster Academy, from Inchiholohan, Kilkenny, she exhibited two flowerpieces and *Dutch Wall Vase*. Exhibitions were held at Waterford in 1940 and, a month before her death, at the Goodwin Galleries, Limerick, 1944.

Works signed: K. Marescaux.
Examples: Kilkenny: Art Gallery Society.
Literature: *Who Was Who 1916-1928*, London 1929; *Dictionary of British Artists 1880-1940*, Woodbridge 1976; Commander the Chevalier Geoffrey Marescaux de Saubruit, *Letter to the author*, 1978; Ann M. Stewart, *Royal Hibernian Academy of Arts: Index of Exhibitors 1826-1979*, Dublin 1986; *Water Colour Society of Ireland Exhibition List 1872-1994*, Dublin 1995.

MARK, BROTHER (1848-1914), religious figure painter. Born on 29 February 1848 at Leeds, Yorkshire, Edward Kangley (alias Brother Mark) was the son of David Kangley, hardware dealer. Whilst at Leeds, Edward received art training. He became in 1883 a member of the Passionists as a lay brother at St Saviour's Retreat, Broadway, Worcestershire, and was known as Brother Mark of St Paul of the Cross. His painting at St Saviour's of St Paul of the Cross may have been executed at a later date as the background is of Mount Argus, Dublin. St Paul is also featured in a work at St Anne's Retreat, Sutton, St Helens.

A first posting was to St Paul's Retreat, Mount Argus, and he arrived there on 31 December 1883. By October 1884 he was at St Joseph's Retreat, Highgate Hill, London, where he may have painted the picture there of the English Martyrs. By January 1885 he was at Holy Cross Retreat, Ardoyne, Belfast, demonstrating his talent in the painting and decorating of the 'old' church.

After a period in Dublin again, he was sent in 1887 to St Joseph's Church, Avenue Hoche, in Paris, the 'English' church, where he was responsible for artistic decorations. This church has since been demolished and replaced. In Dublin, at St Paul of the Cross Church, Mount Argus, eight large paintings of his own were added by June 1889 to four similar works which had come from Rome and required restoration; he undertook this work too. Brother Mark's contributions included *The Flight into Egypt*; *The Resurrection of our Lord*; and *The Ascension into Heaven*.

The Archbishop of Hobart, Tasmania, commissioned a painting, *The Apparition of Our Lady of Knock*, but this work has not been traced. In the 1890s the 'old' Church of the Holy Cross at Ardoyne, Belfast, was partially rebuilt and redecorated. Brother Mark was responsible for the interior decoration and in 1907 his paintings on linoleum were rediscovered, tacked to ground sheeting, nailed with studs. *Finding of the True Cross* and *Exaltation of the Holy Cross* were carefully removed and re-erected as a frieze in the sacristy of the new church. The work was undertaken by George Morrow and Son.

In his *Buildings of Belfast*, 1967, C.E.B. Brett, writing about the Ardoyne church, said: 'The planked and vaulted roof is a charming powder-blue skyscape with angels, painted by one Brother Mark, "assisted by Signor Candine of London"; there are two enormous mural paintings, thirty feet by twelve, on the chancel walls, also by Brother Mark, a little soupy but not too much ...'. The artist's death was on 2 March 1914 at Holy Cross Retreat, Ardoyne.

Examples: Belfast: Church of the Holy Cross, Crumlin Road. Broadway, Worcs.: St Saviour's Retreat. Dublin: St Paul of the Cross Church, Harold's Cross. Sutton, St Helens: St Anne's Retreat.
Literature: C. E. B. Brett, *Buildings of Belfast*, London 1967; Rev. Declan O'Sullivan, CP, *Letter to the author*, 1973, also *St Paul's Retreat, Mount Argus Archives*; James McCarney, *Bro. Mark Kangley, CP, Biography*, 1978; St Saviour's Retreat, *Letter to the author*, 1990; also, Vicar General, Archdiocese of Hobart, 1990.

MARKEY, THOMAS (1885-1967), topographical and figure painter. Born in Drogheda, Co. Louth, and educated at the Christian Brothers' School, he followed the family tradition and was apprenticed to a local builder. Later he joined the Corporation staff, serving as a carpenter for more than forty years. All his ancestors were carpenters and craftsmen in wood; a direct line of carpenters in his family could be traced back to 1722. A lover of classical music and a violinist, his painting activity won him the appellation of 'Drogheda's most unusual carpenter'. A newspaper credited him with publicly exhibiting 'a five pound note made by himself'.

Early in life he studied oil and watercolour painting when he attended classes in Drogheda run by a visiting art teacher, and he was one of the first art students at Drogheda Technical School when it opened in 1902. He also undertook a course of study in copper etching. At the age of about twenty he began sketching noted landmarks and scenes in the district. A painting in the Municipal collection is of Drogheda, dated 1921, and another view was copied from the painting by William Van der Hagen, dated 1745.

During the civil war when the Free State forces were shelling Millmount barracks, he sat behind the 'big gun' in Dominick Street, sketching the scene. Later he transferred the sketch to canvas. *The Shelling of Millmount 1922* is in Millmount Museum, run by the Old Drogheda Society.

Drogheda Corporation acknowledged the skill and value of this spare-time artist. At various points about the town, particularly near where the boundaries used to be when Drogheda was a fortress town, were placed small, glass-enclosed copper etchings of the particular locality as it was when Cromwell sacked the area. The etchings, presented as a gift by the artist to the Corporation, included Laurence Gate, West Gate and the Old Abbey. The copper etchings are now on display at Millmount Museum.

Christ before Pilate was painted for the Church of the Assumption, Tullyallen, Co. Louth. His retirement allowed more time for painting and in 1964 he completed his copy, about 1.8 metres high, of Michaelangelo's *Pietá* for the Augustinian Church in Drogheda. Later he painted *The Resurrection* for the church, and the *Sacred Heart* is also there.

Markey was commissioned in 1966 by the Cistercians of Mellifont Abbey to mark the 800th anniversary of the consecration by basing his work on a painting of old Mellifont at Mount Melleray Abbey, Co. Waterford. His painting when completed was approximately 2m by 1.5m; hundreds of copies were reproduced and sent abroad to help defray the cost of the proposed new abbey. The painting showed several scenes in the life of the monks but the central feature was a reconstruction of the old Abbey as it was at the time of the consecration, with monks labouring in the fields. The abbotical succession at Mellifont was set out; and the *Drogheda Independent* noted: 'Mr Markey's great achievement will not be lost to posterity, for it is reckoned it will be of practical use for about 700 years or more; that is the time it is estimated it will take to fill the vacancies left for the names of Abbots to come.'

Markey had invoked the aid of the monks for the research, and spent about five weeks on the old site on the initial stages of the drawing. Then, with the transition from summertime to winter, the Corporation ex-carpenter sought permission, which was granted, to continue the job in the Mayoralty Rooms. For about half a year, he worked an average of six and a half hours a day in the old ballroom. Vice president of the Old Drogheda Society, his home was at 64 Beamore Road, Drogheda, and he died at the Cottage Hospital.

Works signed: Thomas Markey or T. Markey.
Examples: Collon, Co. Louth: Mellifont Abbey. Drogheda, Co. Louth: Augustinian Church; Church of the Assumption, Tullyallen; Library, Municipal Centre; Millmount Museum.
Literature: *Drogheda Independent*, 5 December 1964, 23 March 1967, and undated newspaper cuttings; C. E. F. Trench, *Letter to the author*, 1967; Mrs Moira Corcoran, *Letter to the author*, 1970; Anne Crookshank and The Knight of Glin, *The Painters of Ireland c.1660-1920*, London 1978; Rev. P. J. O'Reilly, PP, *Letter to the author*, 1989; also, Drogheda Corporation, 1990; Old Drogheda Society, 1990; Corporation of Drogheda, *Drogheda Municipal Art Collection*, catalogue, Drogheda 1995.

MARKIEVICZ, CASIMIR (1874-1932), portrait painter. Casmir Joseph Dunin de Markievicz came from a long line of Polish landowners. The son of Count Peter Dunin Markievicz, he was born on 15 March 1874 on the estate of Denhoffovka, Ukraine. He was sent to the university at Kiev to study law and completed his studies, according to P. L. Dickinson in *The Dublin of Yesterday*, and was then called to the Bar in St Petersburg when a youth, and, by some stroke of fate, added Dickinson, was instructed with the defence of a peculiarly brutal murder charge; he won the case and immediately achieved a reputation. However, he disliked his profession, rebelled against his family and announced his intention of giving up law and following art. He departed to Paris, probably with a family allowance.

The timescale leading up to his meeting with Contance Gore-Booth (q.v.) in Paris throws a shadow of doubt over the account of his connection with the law – he may just have been entertaining his Dublin friends. In Paris he had married a Ukranian girl by whom he had two sons, Richard and Stanislaus. By 1898, the year that Markievicz painted his *Portrait of a Woman* (National Museum, Warsaw), Constance was established in Paris as an art student at Julian's, and when he met her at an art students' ball in 1899, the year his wife died in the Ukraine, he had already been five years in Paris, according to Anne Marreco in *The Rebel Countess*. What is more certain is that in 1899 Casimir celebrated their love by painting a large oil, *Constance in White*, which was exhibited during the Paris international exposition of 1900. In that year too he completed a life-size allegorical oil of two nude lovers, *L'Amour*. This picture had a great success and was exhibited in Paris, St Petersburg and Warsaw.

On 29 September 1900, at Saint Marylebone's Parish Church, London, he married the art student from Sligo. They spent the winter in Kiev with the Count's family. They soon headed for Ireland but not before they had spent part of 1901 in Paris – he had several important portrait commissions – and in July of that year they travelled to the Gore-Booth home at Lissadell where their only child, Maeve Alys, was born.

George Russell (q.v.), writing from Lissadell to Sarah Purser (q.v.) in 1902, reported they were going to settle near Dublin. In that summer, and the next, they painted in the Ukraine and it was there he produced the picture which became the favourite of all for Constance, and which she had until her death, a triptych, *Bread*. Their daughter was virtually brought up by her grandmother, Lady Gore-Booth. The Markieviczes returned to Ireland in October 1903 and settled in Dublin, where they were soon active in society and cultural circles.

A photograph of the 'Young Irish Artists' taken at their exhibition in Dublin in 1903 included the Count, Beatrice Elvery (Lady Glenavy, q.v.) and Estella Solomons (q.v.). Markievicz was credited that year by Evelyn Gleeson (q.v.) in *The Celt* with 'some very sympathetic pictures of Irish peasant life, which are in other ways also most pleasing; but one sees in them the people from the outside; not all his power can approach the truth that is Mr Jack Yeats' birthright'.

In October 1903, he exhibited with his wife and George Russell at the Leinster Lecture Hall, Molesworth Street, Dublin; he had twenty-four pictures on view, nearly all of which were Polish landscapes and townscapes. In 1904 the three artists showed in the same hall. This time he supplied eighty-five pictures, including *L'Amour* at £330; a portrait of Russell, now in the Hugh Lane Municipal Gallery of Modern Art, and a portrait of Judge Seymour Bird. A portrait of his wife was transferred in 1993 from the National Gallery of Ireland to Leinster House.

In 1905, when he exhibited at the Royal Hibernian Academy for the first time, he painted a large picture of the investiture of the Earl of Mayo as Knight of St Patrick. He was then living at St Mary's, Frankfort Avenue, Rathgar, Dublin. In all, he exhibited eleven works at the RHA until 1909, all portraits except one,

The Viceregal Gardens. In 1906 he showed the Mayo portrait and one of the Lord Chief Justice of Ireland, Lord O'Brien of Kilfenora. Commenting on the latter work, which is at King's Inns, *The Studio* described it as a fine painting and the artist's work was 'known in most Continental galleries, from Paris to St Petersburg'; *L'Amour* was reproduced.

In 1905 Markievicz had assisted with his wife and others in the founding of the United Arts Club, and when life classes began there he attended, and in due course exhibited at the Dublin club. His portrait of Mrs Ellie Duncan, the acknowledged founder, is in the club. In 1907 at the Leinster Lecture Hall, Dublin, his fellow exhibitors were: Constance Gore-Booth, George Russell, Percy Gethin (q.v.) and W. J. Leech (q.v.). Another exhibition followed in 1908, Dermod O'Brien (q.v.) replacing Gethin. Frances Baker, the Markieviczs, Leech and Russell were represented in 1909.

During all of this exhibition activity, 'Cassie', as he was known among his Dublin friends, painted at Lissadell House, where there are five mural portraits on five columns in the dining-room: Moredaunt Gore-Booth and a self-portrait, both over life-size; Daniel Campbell, forester; Thomas Kilgannon, butler; and William Woods, gamekeeper, all under life-size. There is a painting of a fox terrier named Jock, and also a second self-portrait. The house also contains some of his Irish landscapes.

Gradually theatricals became an interest, both as producer and playwright, with his wife a leading lady in his own company. He also founded a fencing club – *The Fencing Master* was reproduced in the *Irish Review* of October 1912 – and by now he was well known as a raconteur in Dublin convivial circles. He was described by the poet Padraic Colum as the only stage Irishman he knew, but Arthur Power (q.v.) was of the opinion that what he really wanted was to make Dublin into a continental city and infuse it with continental thought. Sir William Orpen wrote that 'a certain world centred round Cassie – an enormous man, but as gentle in body and mind as a child. He painted, wrote plays, kept his front door open all night in case any stray person might want food, drink, and a sleep ...'.

The Dublin Castle set, noting Constance's political activity, began to distance itself from Markievicz the portrait painter, nor was he in sympathy himself with his wife's militant views. After a dinner in his honour at the Arts Club, he left in December 1913 for the Ukraine and never lived in Dublin again. He fought in the War, and afterwards became legal adviser to the American Consulate-General in Warsaw, and he died in that city at Holy Ghost Hospital, on 2 December 1932. In 1968 his son, Stanislaus Dunin Markievicz, wrote to the *Irish Times* stating that he was anxious to give an exhibition of his father's work at San Diego, California, and listed a number of paintings which he believed were in Irish houses.

Works signed: Dunin Markievicz, C. M. or Kf. Markiewicz, rare (if signed at all).
Examples: Cork: Crawford Municipal Art Gallery. Dublin: Hugh Lane Municipal Gallery of Modern Art; King's Inns; Leinster House; United Arts Club. Lissadell, Co. Sligo: Lissadell House. Sligo: Model and Niland Centre. Warsaw: National Museum.
Literature: *The Celt*, September 1903; *The Studio*, May 1906 (illustration), October 1910; *Irish Review*, June 1912 (illustration), October 1912 (illustration), July-August 1914 (illustration); *Evening Herald*, 12 December 1913; Sir William Orpen, RA, *Stories of Old Ireland and Myself*, London 1924; P. L. Dickinson, *The Dublin of Yesterday*, London 1929; Seán O'Faoláin, *Constance Markievicz*, London 1934; *Burke's Peerage, Baronetage and Knightage*, London 1939; Beatrice Lady Glenavy, *Today we will only Gossip*, London 1964; Anne Marreco, *The Rebel Countess*, London 1967; Alan Denson, *An Irish Artist W. J. Leech RHA*, Kendal 1968; *Ireland*, 24 September 1968; *Irish Times*, 10 December 1968; Miss Aideen Gore-Booth, *Letters to the author*, 1970, 1989; Ann M. Stewart, *Royal Hibernian Academy of Arts: Index of Exhibitors 1826-1979*, Dublin 1986; Patricia Boylan, *All Cultivated People: A History of the United Arts Club*, *Dublin*, Gerrards Cross 1988; National Museum, Warsaw, *Letter to the author*, 1990; also, Department of Arts, Culture and the Gaeltacht, 1995.

MARKIEVICZ, COUNTESS – See GORE-BOOTH, CONSTANCE

MARRINAN, PADRAIG H., RUA (1906-73), figure and portrait painter. Born in Belfast on 10 December 1906, the son of James Marrinan, Royal Irish Constabulary and a native of Co. Louth, Padraig at the age of

five contracted infantile paralysis, and because of this disability he was educated privately; for several years he could not walk.

Virtually a self-taught artist, he recalled that his development was influenced by Bud Fisher (1885-1954), of American comic strip fame. A naval engineer had brought him a set of American comics when he was aged about twelve. 'To me, the characters were all living people. The expressions on their faces intrigued me. The drawings had a sense of movement and gave me the feeling that with a pencil I could express life.'

Although with continuing disability, he spent hours in the Belfast Museum and Art Gallery studying the paintings of noted artists. The inaugural exhibition of the Ulster Academy of Arts in 1930 included his *Ukelele Laddie*; two years later *The Eleventh Night* attracted attention. In 1934 the title of 'picture of the year' was awarded to *The Apache*, dancing in a Paris alley before a crowd of working-men, women and children to the music of a street band.

Marrinan executed in 1934 a charcoal drawing of the Northern Fenian, Robert Johnston, now in the National Gallery of Ireland; a note on the portrait stated that the sitter was ninety-four years old. A 1949 pencil drawing of the West Donegal storyteller, Niall Duffy, is in University College, Dublin (Belfield). As well as Donegal, Marrinan also painted landscapes in Antrim, Connemara and Kerry. *Tinkers* at the 1950 Royal Ulster Academy was voted 'picture of the year'.

In 1951 at 55a Donegall Place, Belfast, he held his first one-person show. John Hewitt wrote in the catalogue introduction: 'When I think of the work of Padraig Marrinan, apart from the texture of the pigment, I think of instants of human experience, usually active, social Not only from the general social comment but also from details of his more minute observation we can say that Marrinan looks with affectionate gaze at his fellow-creatures'. The exhibition demonstrated a new development in his work, an interest in the Legends of Ireland. A bronze bust of John McLaverty also appeared in the show; at one period he devoted much time to sculpture.

A memorial portrait of Commandant Eamonn Ceannt was completed in 1952 for Ceannt Barracks officers' mess, Curragh Camp. Another commission was Vice-Brigadier Peadar Clancy for Clancy Barracks, Dublin. Among his literary portraits were those of Padraic Fiacc, Brian Friel and Joseph Tomelty.

Stations of the Cross for the Church of the Good Shepherd at Churchtown, Dublin, were completed in 1957. He also painted Stations for St Colman's Church, Lambeg, Co. Antrim. A memorial portrait of President John F. Kennedy, bound for the Irish Centre in London, was handed over to the donors, the County Clare Association, in Belfast in 1966. A Kennedy portrait was also painted for the Irish Club, London.

Our Lady of Belfast is in Holy Cross Church, Ardoyne, Belfast. In 1969 his *The Madonna and Child of Loreto* was completed for the new Loreto Convent Grammar School, Omagh. He was an honorary academician of the Royal Ulster Academy. Of James Street, Omagh, he was working on an exhibition for the Irish Club, London, to take place in 1974 but died at Tyrone County Hospital on 25 October 1973.

Works signed: P. H. Marrinan.
Examples: Belfast: Holy Cross Church, Crumlin Road. Curragh, Co. Kildare: Training Camp. Dublin: Church of the Good Shepherd, Nutgrove Avenue; National Gallery of Ireland; University College (Belfield). Lambeg, Co. Antrim: St Colman's Church. London: Irish Centre, 50 Camden Square. Omagh, Co. Tyrone: Loreto Convent Grammar School.
Literature: *Times Pictorial*, 4 November 1950; *Exhibition of Paintings by Padraig H. Marrinan*, catalogue, Belfast 1951; *Irish News*, 13 November 1951; *Irish Independent*, 7 July 1952; *Sunday Press*, 17 March 1957; *Belfast Telegraph*, 22 January 1966, 9 October 1969; *Ulster Herald*, 3 November 1973; John Hewitt and Theo Snoddy, *Art in Ulster: 1*, Belfast 1977; Martyn Anglesea, *The Royal Ulster Academy of Arts*, Belfast 1981.

MARSH, CLARE (1875-1923), portrait, landscape and still life painter. Born on 13 January 1875 at New Court, Bray, Co. Wicklow, the house of her grandfather, Andrew McCullach, a wine merchant, Emily Cecil Clare Marsh was one of five children of Arthur Marsh. Mary Swanzy (q.v.) met Clare Marsh at the studio of May Manning (q.v.) where there was 'excellent and enthusiastic tuition'. Clare also attended night classes for sculpture under John Hughes and Oliver Sheppard (qq.v.) at the Dublin Metropolitan School of Art.

Miss Swanzy recalled Clare as having many devoted friends in various walks of life, and as 'one of a devoted family of brothers and sisters, of great good looks and charm; with a background of impecuniosity

which did not apparently worry them in spite of a more affluent upbringing. Though finances doubtless caused some anxiety from time to time'.

The main influence on Clare Marsh as a student, and indeed for the rest of her life, was the portrait painter, John Butler Yeats (q.v.), who taught at May Manning's studio in the summer of 1898, painted Clare's portrait and formed a lasting friendship, his letters to her from London and New York covering a score of years. She later studied under Norman Garstin (q.v.) in Penzance.

In 1900, from Raheen, Clondalkin, Dublin, she exhibited at the Royal Hibernian Academy for the first time, and from then until 1921 she showed without a break, mainly portraits including some miniatures; she also painted genre and flowerpieces. In 1902 she showed five works at the Water Colour Society of Ireland exhibition, including, *Evening on the Coast, North Berwick* and *Bed Time*.

For three years in succession, giving her address as 9 Trinity Street, Dublin, she showed portraits only at the RHA: 1907 of Leonard Butler, Arthur Marsh; 1908, Mrs James Mowbray, Mrs Robert Marsh; 1909, Mrs James Duncan, Mrs W. D. Marsh. In 1910 she held a show at the United Arts Club, Dublin.

Clare Marsh paid a short visit to France, and in 1911 at the RHA exhibited *Old Doorway in Bayeaux* and *The Washing Place, Bayeaux*. By now, John B. Yeats was urging her to try her luck in America. At the end of November she set out for the USA, staying first at White Plains, New York, with cousins, and then at Yeats's boarding house run by the Petitpas sisters in New York city. She spent only two months abroad. By 1913 she had become interested in women's suffrage.

In the period 1916-19 she lectured in painting at Alexandra College. In 1916 she depicted some of the fire scenes caused by the Rebellion. By 1917 her studio was at 31 South Anne Street, Dublin, where she held classes, which, according to Mary Swanzy, were 'well liked and always full'. Mrs Jack B. Yeats was a pupil. In 1918 she painted the portrait of Jack B. Yeats (q.v.), now in the Drogheda municipal collection, and that year sold some of his father's drawings – 'the money was welcome', he wrote from New York.

In 1920 she shared a studio in Dublin with Mary Swanzy with whom she had an exhibition in the Dublin Painters' Gallery. On 31 March 1921 she signed, along with Jack Yeats and Paul Henry (q.v.), representing the Society of Dublin Painters, a memorandum of agreement for the letting of the artist's studio at 7 St Stephen's Green, Dublin, for the term of three years from 1 June 1920. In 1922 John B. Yeats died in New York. Thomas MacGreevy, writing in the *Capuchin Annual*, said: ' ... not only was her handling of paint notably good but also she approached her subject, as her great master did, in a temper that was unfailingly gracious and often poetic ...'

The *Irish Times* wrote that the artist was 'an avid student of modernism in painting, but adopted its methods only so far as they marched with her own conceptions of the scope and purpose of her art'. Among the 'tentative ventures' in this fashion was *The Backwater*, where black cattle against lilac-hued water 'made for daring, yet restful, composition'.

In England, she exhibited a few works at the Walker Art Gallery, Liverpool, the London Salon and the Society of Women Artists. At the National Gallery of Ireland are seven oil paintings, one a self-portrait, and two watercolours, all unsigned and presented by Mary Tullo, Oxford, through the Friends of the National Collections of Ireland. *Lord Ashbourne* is in the Hugh Lane Municipal Gallery of Modern Art. On 6 May 1923 she died of appendicitis. An exhibition of her studio work was held at the Stephen's Green gallery in October.

Works signed: C. Marsh or C. M., both rare (if signed at all).
Examples: Drogheda, Co. Louth: Library, Municipal Centre. Dublin: Hugh Lane Municipal Gallery of Modern Art; National Gallery of Ireland.
Literature: *The Shanachie*, Autumn 1907 (illustration); *The Studio*, October 1910; *John Butler Yeats letters to Clare Marsh*, 1899-1921, Trinity College, Dublin; *Irish Times*, 8 May 1923, 4 October 1923; *Capuchin Annual*, 1949; *Paul Henry Papers*, Trinity College, Dublin; *Memorandum by Mary Swanzy on Clare Marsh*, 16 September 1958, Trinity College, Dublin; *Dictionary of British Artists 1880-1940*, Woodbridge 1976; William M. Murphy, *Prodigal Father: The Life of John Butler Yeats*, Ithaca 1978; Ann M. Stewart, *Royal Hibernian Academy of Arts: Index of Exhibitors 1826-1979*, Dublin 1986; Julian Campbell: Pyms Gallery, *An Exhibition of Paintings by Mary Swanzy HRHA (1882-1978)*, catalogue, London 1986; National Gallery of Ireland and Douglas Hyde Gallery, *Irish Women Artists: From the Eighteenth Century to the Present Day*, catalogue, Dublin 1987; Hilary Pyle, *GPA Irish Arts Review Yearbook*, 1988; Hilary Pyle, *Letter to*

the author, 1990; also, Alexandra College, 1990; *Water Colour Society of Ireland Exhibition List 1872-1994*, Dublin 1995.

MARSH, HILDA – see ROBERTS, HILDA

MARTIN, LIAM C. (1934-98), topographical illustrator. Born on 25 February 1934 in Kilbeggan, Co. Westmeath, Liam Christopher Martin was the son of Ambrose Victor Martin, who moved with his family to Dublin when Liam was ten months old. His father ran the Irish Iberian Trading Company in Dame Street. When Liam was aged ten his mother, Margaret Martin, set up a boarding house at 9 Stamer Street, and he was given his first art lessons by Harry Kernoff (q.v.), resident at no. 13. The families were close friends. After primary school, he attended Dr E. Teller's private school in Leinster Road, Rathmines.

Martin enrolled at the National College of Art and John Keating (q.v.) was director of the life school. 'He showed a disinclination,' wrote Keating, 'for the prescribed studies as it were, for which I didn't blame him. The system was rigid, cast-iron in fact, and although I administered it in as liberal manner as I could, I couldn't please everybody. So I decided to ask Martin personally what did he want to do, because he didn't seem to know, but he said "buildings, I want to draw buildings."' He was encouraged to do so and Keating became a lifelong friend.

Martin first exhibited at the Royal Hibernian Academy in 1960 and from then until 1992 he showed a total of twenty-three works, the majority watercolours with the occasional gouache. The city's buildings and streets were his main subject manner. His first one-person show was hung at the Coffee Kitchen, Molesworth Street, in 1962.

Liam C. Martin's Dublin Sketch Book, a selection of drawing published individually in the *Irish Times*, appeared in 1962, a special edition being produced for the Irish Georgian Society. The *Dublin Historical Record* considered that the artist had chosen 'well contrasting subjects — the gently sloping houses of old Winetavern Street and the period look of Mount Pleasant Square, decaying splendour in Henrietta Street and the grand southern entrance to the King's Inns…'.

Contributions to the *Evening Herald* 'Know Your Dublin' series began in 1967 and continued for some thirty years. About 2,000 of these drawings — some actually done in the 1950s — were purchased by Dublin Corporation and are now in the Gilbert Library. Over some years the *Herald* series appeared nightly and at another time weekly. The Gilbert also houses a collection of 1,198 drawings from the artist's notebooks covering the 1960s to the 1980s.

In Dublin again with Liam C. Martin, containing additional *Irish Times* drawings, had appeared in 1965. In the 1960s he also contributed to the *Evening Mail* and *Dublin Historical Record*. He also provided an all-round Ireland series for *Irish Tatler and Sketch* magazine.

Martin had a studio at 32 St Alban's Road, South Circular Road, his address when he exhibited *The Dining Hall, Trinity College* at the 1969 RHA. In 1972 he held an exhibition at Ireland House, 3 St Stephen's Green, which included in the thirty-one drawings: *Power and Steam at Watling Street* and *Dublin Bay with Howth Head*. The six watercolours were Aran Islands subjects. Keating opened the exhibition.

The Cobblestone Press, his own private imprint, published *Liam C. Martin's Dublin Print Portfolio* in 1973, a limited edition of 750 copies signed by the artist. In 1974 appeared a soft cover, *Liam C. Martin's Dublin Shopfronts & Street Scenes*, limited edition of 500.

The Peacock Gallery, Abbey Theatre, hosted a show in 1974. In 1975 at the RHA he contributed *Harold's Cross Bridge*, gouache. Described as 'a book of memories,' his *Dublin in Decay*, 1976, had forty-two pen and ink drawings. In 1976 he began a new series, this time for *Irish Independent*, and the Setanta Gallery, Dublin, showed the original drawings from his new book, *A Look at Legal Dublin*. In 1977 he moved to 10 The Rise, Kingswood Heights, Dublin. He exhibited at the United Arts Club in 1978 and 1980. *Irish Wayside Ruin* appeared at the 1979 RHA. He also showed at the Oireachtas.

Pearse Street Library hung local drawings in 1980, and that year he was voted by the Westmeath Association as Man of the Year. In 1987 he began contributing drawings to the magazine, *Ireland's Eye*. An

exhibition, mainly of watercolours and pen and ink drawings, was held at the Kennedy Gallery, Dublin, in 1988. *The Royal Hospital, Kilmainham* and *Old Grandeur in Ranelagh* were watercolours at the 1990 Academy.

Martin spent his whole working life engaged in art and described himself as 'workaholic,' going out every morning and spending his day drawing in the open air, a well-known figure sitting on the stool in front of his easel. He died at Meath Hospital on 27 May 1998.

Works signed: Liam C. Martin.
Examples: Dublin: Gilbert Library; Royal College of Surgeons in Ireland; Voluntary Health Insurance Board.
Literature: all books are illustrated: *Thom's Directory of Ireland,* Dublin 1935, 1952; *Dublin Historical Record,* December 1962; *Liam C. Martin's Dublin Sketch Book,* Dublin 1962; *In Dublin again with Liam C. Martin,* Dublin 1965; Sean McCann, editor, *The World of Brendan Behan,* New York 1965; Beth Bryant, *Ireland on $5 a Day,* New York 1967; J. B. Malone, *Know Your Dublin,* Dublin 1969; Ulick O'Connor, *Brendan Behan,* Dublin 1970 (frontispiece); *Irish Times,* 20 December 1971, 25 February 1980, 28 May 1998; Sean Maher, *The Road to God Knows Where,* Dublin 1972; *Liam C. Martin Paintings and Drawings,* catalogue, Dublin 1972; *Liam C. Martin's Dublin Shopfronts & Street Scenes,* Dublin 1974; Liam C. Martin, *A Look at Legal Dublin,* Dublin 1975; Liam C. Martin, *A Visual Tour of Dublin Hospitals,* Dublin 1975; *Irish Independent,* 9 November 1976, 20 October 1977; Liam C. Martin, *Dublin in Decay,* Dublin 1976; Patrick Logan, *Medical Dublin,* Belfast 1984; Patrick Logan, *Fair Day,* Belfast 1986; Ann M. Stewart, *Royal Hibernian Academy of Arts: Index of Exhibitors 1826-1979,* Dublin 1986; catalogues 1980-1986, 1988-1992; Various priests, *A Walking Tour of Dublin Churches,* Dublin 1988; Liam and Violet Martin, *Cameos of Tallaght and Its Environs,* Dublin 1995; *Evening Herald,* 29 May 1998; Gilbert Library, *Letter to the author,* 1999; also, M. Kennedy & Sons, Ltd., 1999; Mrs Violet Martin, *Letters to the author,* 1999.

MASKEE – see BECKETT, WILLIAM

MATT – see SANDFORD, MATT

MATTHEWS, ROBERT B. (1895-1982), landscape and figure painter. Born in Washington DC on 8 August 1895, Robert Bowman Matthews was the son of Robert Bowman Matthews of the *Washington Post*. The family was originally from North Carolina. He grew up in Washington and attended Georgetown University, where he obtained a science degree. After graduation, he entered the US Naval Academy at Annapolis.

When America entered the First World War in 1917, Matthews was posted to a destroyer squadron stationed at Queenstown (Cobh). An Intelligence Officer, he was on one of the destroyers which arrived in Cork Harbour in May 1917. He married an Irish girl. After the war was over, they returned to the United States where he continued his naval career.

Judging by dates on his paintings, he was active artistically in the 1930s, for example *The Beach at Santa Monica*, 1930, and *Pueblo, New Mexico*, 1938. He had not received any art training. Due to his wife's illness, they returned to Ireland so that she could be with her family. She died in Cork shortly before the outbreak of the Second World War, and her husband, who had taken early retirement, eventually chose to stay on in Ireland.

Biblical and classical history featured in his work, for example *Saint Matthew, Evangelist* and *Life comes to Galatea*. Active in his painting, he chose subjects from his own life as well as the Irish landscape. In the 1950s he painted *The Philosopher meets the Tinkers; Palazzo di Signora, Firenze*; *Lismore Castle and Park*.

Matthews, an early member, regularly submitted works for the Cork Arts Society exhibitions. Paintings of the 1960s included: *Jesus took bread*; *Across the Lee from Lavitt's Quay*; *Clock Tower, Youghal*; and a self-portrait. *The Cliffs of Moher*, 1972, was followed a year later by *The Rock, Cashel*. He held an exhibition at the Cobh Museum in 1975.

In the Crawford Municipal Art Gallery there are eighty-four oils and three gouaches. The Crawford considered that his style of painting defied description: 'It is difficult to say whether his paintings are the result of deliberate adoption of a naive and simplistic style, or whether he was attempting to develop a vaguely Impressionist style. There is no doubt that his use of colour is vibrant and confident...A lack of exposure and

sense of artistic isolation evidently led Matthews to work increasingly in a very personal mode, without reference to current artistic trends or any critical imput. The results are paintings which show a child-like vision of the world and a sense of wonderment with nature...'. His paintings almost served as a record of his life. Of Woodside, West End Terrace, Cobh, he died on 5 April 1982 at Cork University Hospital. An exhibition of his work took place at the Crawford in 1994.

Works signed: R. M. or R. B. M. (if signed at all).
Examples: Cork: Crawford Municipal Art Gallery.
Literature: Crawford Municipal Art Gallery, *Robert B. Matthews (1895-1982)*, information sheet, Cork 1994; Crawford Municipal Art Gallery, *Letters to the author*, 1998, 1999, also inventory list; Cobh Museum, *Letter to the author*, 1999; also, Cork Arts Society, 1999; Robert Matthews, 1999.

MAUGHAN, MAIRTIN – see de BURCA, MICHEÁL

MEGAHEY, WILLIAM H. (1882-1934), designer and illustrator. Born in Belfast on 9 September 1882, William Henry Megahey was the second son of W. H. Megahey, plumber, of 28 Dagmar Street. He served his time in the art department of Marcus Ward's, the publishers, and his record at the Belfast School of Art showed that he began on 14 September 1903 but left on 7 November of the same year, 'resigned to take up studies', and that he had been awarded the Dunville Scholarship. In 1907 from a Belfast address, 'two sketch models' were exhibited in the sculpture division of the arts and crafts section of the International Exhibition at Ballsbridge, Dublin, and an exhibit similarly described appeared in the Irish section of the St Louis, USA, exhibition.

Megahey, who had taught at Magherafelt Technical School, Co. Derry, moved to the Dublin Metropolitan School of Art. In 1911 he married, in Dublin, Ethel Rentoul Hastings of Magherafelt. The designer of the Irish Citizen Army flag – the watercolour is in the National Museum of Ireland – he was also responsible for the *Irish Volunteer* newspaper heading. An advertisement in that publication, 7 February 1914, read: 'Wm. H. Megahey, Heraldic Craftsman, For Flags, Banners, and Enamelled Badges. Address Letters, Box 14, This Office'.

In his *The Story of the Irish Citizen Army*, P. O Cathasaigh wrote: 'The banner, the idea of which was given by a sympathiser, and executed by Mr McGahey (sic), was generally admired, and its symbolic design of the Plough and the Stars was indeed strikingly original'. The playwright, Seán O'Casey, who was secretary of the Citizen Army before the Rising, presented the design in 1954 to the National Museum of Ireland.

When residing at Mount Temple Lodge, Malahide Road, Dublin, Megahey showed *In the Woods* at the 1916 Royal Hibernian Academy, and *A Study in Relief* in 1917. In *Thom's Directory* he was described: 'Assoc. C.I., teacher of drawing and art crafts.' In 1924 he participated in the Aonach Tailteann, giving his address as Taylor's Hill, Galway, and was then an art teacher at Galway Technical School, but left the post in 1927 for Dublin where he resided at 20 Lower Pembroke Street.

In 1928 he designed the new car badge of the Royal Irish Automobile Club. *The Motor News* described it thus: 'The basis of the design is a Celtic cross, having an enamelled centre with a harp argent on a field azure. The name of the Club is inscribed round the circular band, at the bottom of which is the "guiding hand" grasping wings, indicative of speed. The top is surmounted by the royal crown. In the panels forming the arms of the cross are the symbols of the waters, the flame and the hazel tree.'

In 1929 his work as an illustrator appeared in two publications: capital letters, incorporating views of Dublin, for *A Book of Dublin*; and for *Dublin Civil Week 1929 Official Handbook* he contributed a border depicting a number of coats of arms belonging to various bodies prominently connected with the city. All the artists whose work appeared in that publication were associated with the Dublin Book Studio. In this second period in Dublin he also worked as a part-time art teacher, restored pictures at Shelton Abbey, Arklow, for the Earl of Wicklow, and assisted Sir Nevile Wilkinson (q.v.) in his work on Titania's Palace. He died in Dublin on 4 March 1934.

Works signed: Liam Megahey (if signed at all).
Examples: Dublin: National Museum of Ireland.
Literature: Belfast School of Art Register, 1903; *Thom's Directory*, 1918; P. O Cathasaigh, *The Story of the Irish Citizen Army*, Dublin 1919; *The Motor News*, 1 September 1928; Bulmer Hobson, ed., *A Book of Dublin*, Dublin 1929 (illustrations); E. M. Stephens, ed., *Dublin Civic Week 1929 Official Handbook* (also illustrations); Oliver Snoddy, *Letters to the author*, 1967, 1968; G. A. Hayes-McCoy, *A History of Irish Flags from earliest times*, Dublin 1979; Ann M. Stewart, *Royal Hibernian Academy of Arts: Index of Exhibitors 1826-1979*, Dublin 1986; Galway County Libraries, *Letter to the author*, 1989; also, William Rentoul Megahey, 1990; Royal Irish Automobile Club, 1990.

MEIKLE, JEAN – see OSBORNE, JEAN

METCALFE, KATHLEEN I. – see MACKIE, KATHLEEN I.

MIDDLETON, CHARLES C. (1875-1933), designer and seascape painter. Charles Collins Middleton, father of Colin Middleton (q.v.), was born at 117 Hulton Street, Moss Side, Manchester, on 21 February 1875, son of John Middleton, banker's clerk. A fervent soccer player, his exploits on the field were carefully hidden from his parents, who worried about his health. He attended Manchester College of Art and became a damask designer.

After visiting Ireland on his summer holidays – he had an abiding interest in ships – and finding the scenery much to his liking, he decided he would like to live there and obtained employment with a Belfast damask designer, William Moyes of 35 Royal Avenue.

A founder member of the Ulster Arts Club, he was a close friend of a fellow designer from Switzerland, Hans Iten (q.v.). Middleton was an early convert to Impressionism. In 1902 he was elected a member of the Belfast Art Society, and in the following three years he showed seventeen works at society exhibitions, including *Ardglass Harbour*; *Red Bay, Co. Antrim*; and *Plymouth Sound*. In 1907 he included *St Ives Harbour*, and in 1909 there were three Anglesey subjects. Catalogues listed 'C. Collins Middleton'. *Off Dover*, oil, is in the Ulster Museum.

A damask designing partnership was formed with Hugh Page, who had an office at 7 Adelaide Street. In 1931 he visited Belgium with his son Colin and painted in Bruges. As his health had deteriorated, a spacious hut was erected in the garden of his home, 28 Chichester Avenue, where he continued his design work. He died at that address on 4 October 1933.

Works signed: Chas. C. Middleton (if signed at all).
Examples: Belfast: Ulster Museum.
Literature: *Register of Births, Chorlton*, Co. Lancaster, 1875; *Envoy*, April 1950; *Irish Times*, 14 August 1968, 8 October 1970; John Hewitt, *Colin Middleton*, Belfast 1976; John Hewitt and Theo Snoddy, *Art in Ulster: 1*, Belfast 1977; General Register Office, Belfast, *Letter to the author*, 1990.

MIDDLETON, COLIN, RHA (1910-83), landscape and figure painter. The son of Charles C. Middleton (q.v.), he was born at 48 Victoria Gardens, Belfast, on 29 January 1910. He attended Belfast Royal Academy, leaving in 1927. During a holiday visit to London in 1928 he saw an exhibition of paintings by Vincent van Gogh (1853-90) which was, for him, a major revelation. As his father was a damask designer with indifferent health, he had become an apprentice in the firm. In 1931 they visited Belgium. When attending Belfast College of Art for evening and morning classes, principally studying design under Newton Penprase (q.v.), he won the Royal Dublin Society's Taylor Scholarship in 1932.

In 1935 his father died and he accepted responsibility for running the business. He once said that in the 1930s he was the only Surrealist painter working in Ireland. In 1938 his work was hung at the Royal Hibernian Academy for the first time. Middleton contributed to a portfolio of lithographs published by the Ulster Academy of Arts in 1941 for charitable purposes. He contributed *Barges* to the 1941 RHA. His *Landscape*

in May, Carnmoney, 1943, is in the National Gallery of Ireland, which subsequently acquired *Masquerade*, oil.

Belfast Museum and Art Gallery arranged a Middleton exhibition in 1943 which was then the largest one-person show ever held at Stranmillis. His first solo event in Dublin was at the Grafton Gallery in 1944. *Fertility*, oil, was painted in 1944. His work appeared again in Dublin in 1945 at the Irish Exhibition of Living Art, and regular exhibiting spells followed, notably 1949-54 and 1963-7. In Belfast, Council for the Encouragement of Music and the Arts organised a display at Tyrone House in 1945.

Leaving damask designing behind, in 1947 he took his wife Kate and family to John Middleton Murry's community farm at Thelnetham, Suffolk. Because of illness and disillusionment, the venture was not a success; the Middletons returned and made their home at Ardglass, Co. Down. At this time he often used quotations from the Bible in the titles of his works. In 1949 he held his first exhibition at the Victor Waddington Galleries, Dublin, and subsequently his paintings were exhibited outside Ireland. In 1949 too in Dublin he showed initially at the Oireachtas.

On the exhibition of paintings 1942-9 at the Waddington Galleries, the *Dublin Magazine* noted that for some years they had been familiar with his work, which was valued for 'its superb technical finish, its surrealist clarity, its imaginative and semi-abstract invention. Perhaps at times we found him too remote and detached, a Dali without the morbidity, or too obscure in his allegories. Though he still continues to paint in this mode, he has developed besides, another approach and another style, direct, dynamic and vital. From being remote and abstract he has become passionately human ...'. In the 1949 Living Art exhibition he showed *William and Mary* and *Woman with Roses* but his *Isaiah 54* was rejected in 1950. In that year he was again represented at the Oireachtas. When the Royal Ulster Academy came into existence in 1950 he was listed among the academicians but his name does not appear as such in the 1951 catalogue.

In 1950 he was represented in the New Irish Painters exhibition at the Institute of Contemporary Art, Boston, USA, a tour following; the artists were the same as Five Irish Painters at the Tooth Galleries, London, 1951. His first solo show in London was at Tooth's in 1952 when *Give me to Drink*, now in the Ulster Museum, was acquired by the Contemporary Art Society. On that exhibition of twenty-seven paintings, *The Studio* stated that he was 'without doubt one of the few Irish painters who can claim more than local significance ... His pictorial language has a poetic richness of colour, plangent and melodious, composed in strength of tones that give depth and presence...'. In 1952 his *Jacob Wrestling with the Angel* was sent to Gothenburg, Sweden, for the exhibition of contemporary Irish Art. *Nomads* and *Sultry Landscape, Ballymote* appeared at the 1952 RHA.

In a special article in *The Studio* in 1953, Edward Sheehy was of the opinion that in the previous five years Middleton had established himself as one of the foremost of contemporary Irish painters. He continued: 'From being idealist and intellectually remote, his painting became passionately human, concerned directly and unreservedly with the chaotic flux of the real world. Where once his art had attempted to create order by abstraction, by reducing reality to an idealist formula, it now sought emotional, one might more accurately say spiritual, involvement with life in all its mysterious amalgam of meanness and courage, love and hate, nobility and wretchedness...'.

In 1953, the year the family moved to Bangor, where he did some designing for the New Theatre, Middleton was represented in the Contemporary Irish Art exhibition at Aberystwyth. Later in Belfast he designed sets for the Circle Theatre and Lyric Theatre. In 1954, when he had a two-person show in London with Daniel O'Neill (q.v.) at the Tooth Galleries, CEMA organised an exhibition of forty-two works at the Belfast Museum and Art Gallery. In that year there began a sixteen-year period as a teacher of art – first, part-time, at the Belfast College of Art, and then from 1955-61 at Coleraine Technical School. From 1961 to 1970 he was head of the art department at Friends' School, Lisburn. During his teaching career, he continued to exhibit at group shows in Belfast, Dublin and in London at the Royal Academy in 1955.

A retrospective, 1939-54, was staged by the Waddington Galleries in 1955, and the *Dublin Magazine* commented: 'Apart from the brilliance of his paint, he has one rare quality in his inexhaustible capacity for wonder'. In 1958 came the first of his shows at the Ritchie Hendriks Gallery, Dublin, and later he exhibited at the David Hendriks Gallery. In 1961 CEMA paid tribute again with an exhibition at their Belfast gallery,

and in 1962 there was his first exhibition at the Magee Gallery, Belfast. Two years later, through Arts Council of Northern Ireland auspices, he showed at Armagh County Museum.

Middleton, poet and musician, had not confined himself to easel painting – a mural in a health clinic, a mosaic panel in a school, and outside decoration for a Portrush, Co. Antrim, house. ACNI arranged a show in 1965 with an overflow in the Bell Gallery, Belfast, and works included: *Stubble, Tullybrannigan*, 1964, and *Yellow Clouds, Tollymore*, 1965. The New Gallery in Belfast exhibited him in 1966, the year he visited Belgium and painted a Bruges series, hence *Tower with Bunting, Brugge*.

In 1967 there was another ACNI sponsored exhibition. In the year in which he was a prize-winner in their open painting competition, 1968, he was commissioned by them for a poster design. At Coventry that year he exhibited at the Herbert Art Gallery with T. P. Flanagan, nearly all his paintings now being on board.

Paintings by Middleton had not been seen at the Royal Hibernian Academy 1955-67 inclusive, but he resumed exhibiting, and in 1969, the year he was awarded the MBE, he was appointed an associate; full membership came in 1970. The Arts Council's retrospective for the period 1960-70 attracted an attendance at their Belfast gallery of 3,000; it was also seen at the Brooke Park Gallery, Londonderry and at Edinburgh and Glasgow.

In 1970 he was commissioned by the Arts Council for a portrait of J. Kenneth Jamison, and that year the council granted him a major subsistence award covering 1970-2 which enabled him to give up teaching. Among his contributions to the 1972 RHA were: *Dark Figure in Landscape* and *Lagan Valley*, sent from 28 Camden Street, Belfast.

In connection with the Ulster '71 festivities, a Middleton landscape was reproduced on a postage stamp, and he was commissioned for a mural of Co. Down. An honorary MA degree was conferred by Queen's University, Belfast, in 1972, and in that year the Arts Council in Belfast showed a collection of drawings.

In 1972 he and his wife toured extensively, stopping in Perth, Australia, for two months. McClelland International Galleries, Belfast, showed Australian watercolours in 1973. Another trip abroad was made in 1973 to Barcelona. The two visits inspired a group of Surrealist paintings entitled the *Wilderness Series* and an exhibition at the Tom Caldwell Gallery, Belfast, where he had already been exhibiting, in 1974. The previous year he had shown at the Cork Arts Society.

The major Middleton exhibition was the retrospective in 1976 organised by the two Arts Councils, consisting of nearly 300 works, and held at the Ulster Museum and the Hugh Lane Municipal Gallery of Modern Art, Dublin. In association with that exhibition, the Councils published a monograph, *Colin Middleton*, by John Hewitt, a lifelong friend. He showed watercolours in 1978 at his son John's gallery, Pretani, in Bangor, and he continued to send to the Royal Hibernian Academy right up to the year of his death. There is an extensive collection of his work at the Ulster Museum including the oils, *The Skylark* and *If I were a Blackbird*, both from the Roberta and John Hewitt Bequest. Of 6 Victoria Road, Bangor, Co. Down, he died on 23 December 1983 at Belfast City Hospital. Christie's of London held an auction in 1985 of works from his studio.

Works signed: Colin M. and CM, monogram; drawings, M with circle above and dot in centre.
Examples: Athlone, Co. Westmeath: Institute of Technology. Belfast: Arts Council of Northern Ireland; Department of the Environment for Northern Ireland; Education and Library Board; Queen's University, also Students' Union; Ulster Arts Club; Ulster Museum. Cambridge: University. Churchill, Co. Donegal: Glebe Gallery, Derek Hill's Collection. Coleraine, Co. Derry: University of Ulster. Cork: Crawford Municipal Art Gallery; Ursuline Convent, Blackrock. Coventry, England: Herbert Art Gallery and Museum. Downpatrick: Down County Museum. Dublin: Arts Council; Hugh Lane Municipal Gallery of Modern Art; Institute of Public Administration; Irish Museum of Modern Art; Irish Writers' Centre; National Gallery of Ireland; Trinity College Gallery. Kingston upon Hull: Education Committee; Ferens Art Gallery. Melbourne, Australia: National Gallery of Victoria. Navan: Meath County Library. Oxford: University. Waterford: City Hall, Municipal Art Collection.
Literature: *The Studio*, January 1947 (illustration), January 1953 (also illustration), September 1953 (also illustrations); *Dublin Magazine*, April-June 1949, October-December 1949, January-March 1950, October-December 1950, July-September 1955; *Northern Whig*, 29 February 1952, 6 January 1961; *Belfast Telegraph*, 13 September 1954, 4 January 1957; Herbert Art Gallery and Museum, *Two Irish Painters Colin Middleton T. P. Flanagan*, catalogue, Coventry 1968; *The Honest Ulsterman*, March 1969, November 1969 (illustrations); *Irish Times*, 20 October 1969, 23 March 1970;

Arts Council of Northern Ireland Annual Report, 1970-71, Belfast 1971; Arts Council of Northern Ireland and An Chomhairle Ealáion, *Colin Middleton*, catalogue, Belfast 1976 (also illustrations); John Hewitt, *Colin Middleton*, Belfast 1976 (also illustrations); John Hewitt and Theo Snoddy, *Art in Ulster: 1*, Belfast 1977 (also illustrations); Mike Catto, *Art in Ulster: 2*, Belfast 1977(also illustrations); Martyn Anglesea, *The Royal Ulster Academy of Arts*, Belfast 1981 (also illustration); Christie, Manson & Woods, Ltd., *Colin Middleton, RHA*, catalogue, London 1985 (also illustrations); Ann M. Stewart, *Royal Hibernian Academy of Arts: Index of Exhibitors 1826-1979*, Dublin 1986; Ulster Museum, *Letter to the author*, 1990; National Gallery of Ireland, *Gallery News*, March-May 2000.

MIDDLETON, JOHN (1945-81), printmaker and designer. Born in Belfast on 13 November 1945, he was the son of Colin Middleton (q.v.). During his three years' study at the Belfast College of Art, his work appeared in the Young Irish Artists Foundation exhibition of 1965, shown in Belfast, Dublin and Cork. In 1966 he entered the Royal College of Art, London, specialising in printmaking.

In 1968 he held a one-person show at the New Gallery, Belfast, where he exhibited in black and white or in colour, eighteen lithographs, including *Freudian Slip Made to Measure* and *Murder on the Golfcourse*; plus two paintings and two three-dimensional free standing 'things'. The *Belfast Telegraph* commented: 'The prints do not so much illustrate as make wry comment ... arresting, provoking, not always meant to please, these lithographs are imaginative and very much alive ...'. The *Irish Times* review said: 'His work is technically sound, but too self-consciously clever. Lacking the wit of Miro or Klee, he falls back on his titles which are very dated indeed'.

In 1968 too he contributed a centre drawing to two issues of *The Honest Ulsterman*; from 1973 he supplied a cover drawing for several years. The MA course concluded in 1969, and in that year his work appeared in the Royal College of Art Printmakers' exhibition to the USA: Pratt Art Centre, New York, and Florida University. Also in 1969 he was appointed lecturer in printmaking at the Byam Shaw School of Art, London. Concerned about the violence at home, he returned to Northern Ireland in 1971 and became an art teacher at Kelvin Secondary School, Belfast, for two years. He assisted his father with mural decoration.

According to a personal statement by the artist in the catalogue of his show at the Arts Council of Northern Ireland gallery, 1972, the philosophy that determined both the content and the form in his work was that of the yin and the yang, 'the manifestation of the two antagonistic and complementary forces which are at work in the universe, centrifugal force away from the centre and centripetal, towards the centre, or yin and yang respectively as they are known in the east'. The Arts Council in their annual report referred to the exhibition: 'Tantra-inspired compositions with their severe shapes and bright colours'.

Through the auspices of the Arts Council in Belfast, painters and poets collaborated on a series of poster poems; Middleton's partner was Frank Ormsby. Also in 1972 he was commissioned by the Council for a portrait of William John McBride; and in 1975, of Mary Fearon. At the David Hendriks Gallery, Dublin, he was represented in the Irish Artists 1974 exhibition, and in 1975, when he showed at the Irish Exhibition of Living Art, he held a one-person exhibition at the Tom Caldwell Gallery, Dublin. He designed the book on his father by John Hewitt, also the accompanying catalogue for the retrospective exhibition, both 1976 publications.

In 1977 his work was represented in the Eight Northern Irish Artists exhibition, Third Eye Centre, Glasgow, and that year ACNI awarded him £450 for research in Egypt but he was unable to travel. In the Irish Museum of Modern Art in Dublin a silkscreen print, *In Retrospect*, is jointly credited to Colin and John Middleton. John died at Perth, Australia, on 16 September 1981.

Works signed: John Middleton or JAMM
Examples: Belfast: Belfast Education and Library Board. Dublin: Irish Museum of Modern Art.
Literature: *Belfast Telegraph*, 30 August 1968; *Irish Times*, 5 September 1968, 11 May 1972; New Gallery, *John Middleton*, catalogue, Belfast 1968; *The Honest Ulsterman*, September 1968, November 1968, all issues 1973-77 inclusive, March-May 1981 (all illustrations); *Arts Council of Northern Ireland Annual Report*, 1 April 1972-31 March 1973; John Hewitt, *Colin Middleton*, Belfast 1976; Mike Catto, *Art in Ulster: 2*, Belfast 1977 (also illustration).

MILLARD, ELSIE – see O'KEEFE, ELSIE

MILLER, LIAM (1924-87), designer and illustrator. Born at Mountrath, Co. Laois, on 24 April 1924, he was baptised William. Always known as Liam, his father, James Miller, was a farmer. After attending Ballyfin College, Liam studied architecture at University College, Dublin, but did not graduate. At the end of the Second World War, he used his architectural knowledge by working on city reconstruction projects in London.

On his return to Dublin he practised as an architect and at the same time founded the Dolmen Press in 1951, at first working with a second-hand press from the home of his father-in-law at Sion Hill House, Drumcondra. The quality of Dolmen productions gained for him a reputation far outside Ireland as a typographer and book designer.

In addition to his publishing activity, he worked in the theatre as a producer and designer. He designed the Abbey Theatre productions, *The Plough and the Stars*, 1966, and *The Countess Cathleen*, 1969. He was a founding director of the experimental Lantern Theatre, Dublin, and a founder director of the Graphic Studio, Dublin. In 1969 he began a five-year term as president of CLÉ, the Irish Book Publishers' Association, and in 1972 he was appointed a member of the Cultural Advisory Committee of the Department of Foreign Affairs. In 1973 he edited *Retrospect*, a study of the work of Seamus O'Sullivan and Estella Solomons (q.v.). Another Irish artist was featured in *Louis le Broquy*, 1981, by Dorothy Walker, which he also designed.

Miller received awards for his book designing; he was a typographical adviser for a number of liturgical publications. A member of the Philatelic Advisory Committee of the Irish Post Office, he designed the stamp to commemorate in 1977 the golden jubilee of the Folklore Society of Ireland, adapting *The Shanachie* by Jack B. Yeats (q.v.). He was the author of *The Dun Emer Press, later the Cuala Press*, 1973; *Dolmen XXV*, 1976; and *The Dolmen Book of Irish Stamps*, 1986. Of The Lodge, Mountrath, Co. Laois, where he lived and directed the publishing firm, he died in Dublin on 17 May 1987.

Literature: all books published in Dublin: Sigerson Clifford, *Travelling Tinkers*, 1951 (illustration); Thomas Kinsella, *The Starlit Eye*, 1952 (illustrations); Francis J. Barry, *Who, A Stranger*, 1953 (illustration); Sigerson Clifford, *Lascar Rock*, 1953 (illustration); Richard Murphy, *The Archaelogy of Love*, 1955 (illustration); Padraic Colum, *Ten Poems*, 1957 (illustration);Richard Weber, *O'Reilly*, Dolmen Chapbook, 1957 (illustrations); Padraic Colum, *Irish Elegies*, 1958 (illustration); Richard Murphy, *The Woman of the House*, 1959 (illustration); Guillaume Apollinaire, *Zone*, 1972 (illustration); Maurice Harmon, ed., *J. M. Synge Centenary Papers*, 1972 (illustration); *The Easter Proclamation of the Irish Republic*, 1975 (illustrations); Liam Miller, *Dolmen XXV*, 1976 (also illustrations); *Liam Miller*, biographical notes, 1984, per Mrs Josephine Miller; Henry Boylan, *A Dictionary of Irish Biography*, Dublin 1988.

MILLER, P. H., ARHA (1845-1928), portrait and figure painter. Born in Londonderry, Philip Homan Miller was the son of the Rev. J. H. Miller, headmaster of Foyle College 1841-7. After attending Queen's College, Belfast, and the Royal College of Surgeons, Dublin, he expressed a preference for architecture and painting to medicine, entered the Royal Academy Schools and after a short time gained first prize at figure drawing from life. He first exhibited at the Royal Academy in 1879 and showed *A Punjaub water-bottle* and '*Oggi é festa*'. From 1879 until 1903 – his last year exhibiting at the RA – he contributed to the Society of British Artists' exhibitions. His work was also published in leading illustrated papers.

Close on a hundred pictures were displayed at the Royal Hibernian Academy between 1880 and 1928. In 1882 he gave a Bayswater, London, address and showed, with other works, *The Keeper's Pond, Haslemere, Surrey*. His *Workmen and workwomen; interior of a Saltworks* is in Salford Art Gallery and Museum; it was exhibited at the 1885 RA. He married Sophia Holmes, a flower painter, daughter of the Rev. J. P. Holmes of Corbeg, King's County, and possibly they first met at an RHA opening; both showed in the period 1883-91 inclusive. Sophia was then living in Dublin, and continued to exhibit under her married name.

In 1887 at the RHA, from 124 St Stephen's Green, Dublin, *A Belle of the Flowery Land* was among his exhibits, but his address in London continued to change. In 1888 the Dublin Sketching Club elected him a 'working member', of 2 St John's Road, Sandymount, Dublin. When the Dublin Art Club issued a portfolio of etchings in 1890 it included his *Flitters, Tatters, and the Counsellor: a Rehearsal*, and in that year he was appointed an associate of the RHA.

At the 1892 RHA, there were three portraits, and two years later a landscape of Lough Eske, Donegal. A portrait of Alexander G. More, dated 1895, is at the National Botanic Gardens, Dublin. Whilst his wife provided *Fair Maids o' The Spring* for the 1901 RHA, his own contribution included *Her eyes are homes of silent prayer*. In 1904 he was represented in the exhibition of works by Irish painters held at the Guildhall of the Corporation of London and organised by Hugh P. Lane.

Whilst painting in London, he suggested a club for Irish artists, and when it was formed he was elected honorary secretary. He was responsible for forty portraits of noted members in White's Club, London. In addition to the London exhibitions, which included the Salon, he also showed at the Walker Art Gallery, Liverpool; Manchester City Art Gallery; and Royal Society of Artists, Birmingham. A drawing in red chalk, *The Princess* is at the National Gallery of Ireland. His death occurred at Marlow, Buckinghamshire, on 23 December 1928.

Works signed: P. H. Miller.
Examples: Dublin: National Botanic Gardens; National Gallery of Ireland. London: British Museum. Salford: Art Gallery and Museum.
Literature: *Dublin Sketching Club Minute Book*, 1888; Algernon Graves, *The Royal Academy of Arts 1769 to 1904*, London 1905; *Who Was Who 1916-1928*, London 1929; *Dictionary of British Artists 1880-1940*, Woodbridge 1976; *Dictionary of Victorian Painters*, Woodbridge 1978; Ann M. Stewart, *Royal Hibernian Academy of Arts: Index of Exhibitors 1826-1979*, Dublin 1986; Foyle and Londonderry College, *Letter to the author*, 1990; also, Salford Art Gallery and Museum, 1990; Wycombe Registration District, *Death Certificate P. H. Miller*, copy, 1990.

MILLS, CHARLES A., ARHA (1875-1922), illustrator and landscape painter. Born with a talent for art, Charles Alfred Mills had little or no artistic training but devoted the greater part of his life working in Dublin as a newspaper artist, being for many years on the staff of the *Irish Independent* and *Evening Herald*. In his painting, he used both oils and watercolours.

Through his activities with rod and gun, particularly in the Malahide and Portmarnock areas, he gained a deep knowledge of nature which he often depicted in his pen drawings. He is represented in the Hugh Lane Municipal Gallery of Modern Art by two drawings. His busy life allowed him little time for painting but between 1892, when he was listed at 19 Richmond Place, North Circular Road, Dublin, and 1921, he showed thirty-six works at the Royal Hibernian Academy. In 1893 he contributed *Evening on the Liffey* and *A Country Lane*.

In 1906, after an absence of seven years, and from 50 St Patrick's Road, Drumcondra, Dublin, he was represented at the RHA, and another seven-year gap followed. In 1913, the year he was appointed an associate of the RHA, he contributed *The Lovers' Lane*; *Nature's Garden*; and *A Stormy Day*, now at 55 Millmount Avenue, Drumcondra.

In his *Irish Life and Landscape*, 1927, J. Crampton Walker reproduced Mills's portrayal of a wildfowler attired in the garb of the eighteenth century, sitting on the banks of Portmarnock strand, and suggested that the work called to mind the art and times of George Morland (1763-1804). Walker described Mills as a 'jovial character that endeared him to all who knew him, and he was an able artist who, if he had had the opportunities, might have developed more fully what was a great natural talent'. His final contribution to the Academy was *The Leprechaun* in 1921. He died in Dublin on 14 January 1922.

Works signed: Charles A. Mills.
Examples: Dublin: Hugh Lane Municipal Gallery of Modern Art. Limerick: City Gallery of Art.
Literature: Heblon, *Studies in Blue*, Dublin 1903 (illustrations); General Register Office, Dublin, *Register of Deaths*, 1922; J. Crampton Walker, *Irish Life and Landscape*, Dublin 1927 (also illustration); Ann M. Stewart, *Royal Hibernian Academy of Arts: Index of Exhibitors 1826-1979*, Dublin 1986.

MILLS, E. P.(1896-1984), landscape painter. Edgar Parker Mills was born in Bandon, Co. Cork, on 3 December 1896, the son of James Parker Mills, 'Professor of Music', organist at the local church, St Peter's, and whose headstone in the graveyard is engraved with organ pipes.

Ordained in 1919, Edgar Mills devoted his ministry entirely to the united Diocese of Cork, Cloyne and Ross. In 1927 he was appointed to the minor canonry of St Fin Barre's Cathedral, Cork, from St Luke's parish where he had served four years as curate. Later he was Precentor of Cork.

At the age of fifty he began painting when he attended the Crawford School of Art in Cork. A few years later he studied and painted at St Ives, Cornwall, and began travelling around Europe. The reproduction in colour of his *West of Ireland farmer*, an oil of 1956, belied his amateur status. A regular contributor to the Munster Fine Art Club exhibitions, he was a founding member of the Cork Arts Society in 1963. He also painted in watercolour.

The Rt. Rev. G. O. Simms recalled 'a familiar figure on his bicycle which for many years he pushed up the city's hills until the doctor cried halt. His studies of the Cathedral, the Bishop's palace, the city scenes in Cork and elsewhere have a special charm. He loved the lush countryside and was sensitive to the changing colours.'

The fishing village of Ballycotton, Co. Cork, was a favourite painting area. Other subject matter may be noted from titles: *Old Cork Racecourses*; *Winter in Killarney*; *A Canal in Bruges*; *Connemara Inlet*; *Farmhouse Gouganbarra*. A national newspaper photograph showed Canon Mills sitting amid the throbbing traffic of Dublin's O'Connell Bridge with his easel and canvas, capturing the Liffey at sunset. He died in Cork on 12 June 1984. A studio sale of twenty-three lots took place at a Dublin auction in 1988. St Fin Barre's Cathedral hosted a retrospective exhibition in 1997.

Works signed: E. P. Mills or EPM, monogram.
Literature: Rt. Rev. G. O. Simms, *Cork Examiner*, 19 June 1984; *Irish Times*, 4 June 1988; St Fin Barre's Cathedral, *Canon E. P. Mills, M.A., 1896-1984: A Retrospective Exhibition*, catalogue, Cork 1997; Canon Michael Burrows, *Letter to the author*, 1998; also, Rev. Maurice Carey, 1998; Bill Cavanagh, 1998; Church of Ireland Library, 1998; Cork Arts Society, 1998; Very Rev. Michael Jackson, 1998; Frederick Gallery, *Irish Art*, catalogue, Dublin 1998 (also illustration).

MITCHELL, CRAWFORD, ARUA (1908-76), linocut and wood engraver. Born in Belfast on 5 October 1908, he was the son of Joseph Mitchell, confectioner, 222 Grosvenor Road, Belfast. After attending the Belfast Model School, Falls Road, he won the Dunville scholarship at Belfast School of Art, and from there a scholarship to the Royal College of Art, London, where he studied for a further three years as a contemporary of Mercy Hunter and George MacCann (qq.v.), a cousin.

In 1935 he returned to Northern Ireland and taught part-time at Rainey Endowed School, Magherafelt, and also at Lurgan College and Portadown College. In 1950 he became head of the art department of the newly-founded Grosvenor High School, Belfast, then in Roden Street and close to where he had lived as a boy. Remaining at Grosvenor until his retirement in 1970, he subsequently taught part-time at the Rupert Stanley College of Further Education, Belfast, and devoted much of his spare time to printmaking.

Gnarled Oak, a lithograph, was exhibited at the 1965 Royal Ulster Academy. His wood engravings included *Sea Holly*; *Three Little Maids*; and *Gondoliers*. In 1975 he won the RUA silver medal award and in that year became an associate. In 1976 he exhibited in Belfast with a small group, The Masquers, at their second exhibition at the Centre Art Gallery; in addition to five linocuts and one gouache, he showed four oils, including *Strangford Lough* and *Mourne Country*.

At the 1976 RUA he exhibited two prints: *Grey Abbey* and *Yellow Water River*. In the British Council collection is a wood engraving, *Weeds*. His death occurred on 26 November 1976 at his residence, 61 Dunluce Avenue, Belfast. A memorial exhibition was held at the Rupert Stanley College in 1977.
Works signed: C. Mitchell.
Examples: London: British Council; Victoria and Albert Museum.
Literature: *The Artist*, January 1966 (also illustration); *Belfast Telegraph*, 27 November 1976; John Hewitt and Theo Snoddy, *Art in Ulster: 1*, Belfast 1977; Rupert Stanley College of Further Education, *C. Mitchell 1908-1976*, catalogue, Belfast, 1977.

MITCHELL, FLORA H. (1890-1973), topographical painter. Born on 23 December 1890 at Omaha, Nebraska, USA, Flora Hippisley Mitchell was the daughter of Arthur J. C. Mitchell, managing director of

the Anglo-American Cattle Company, and as a consequence of the Sioux Indian Rising the family headed for Ireland. The Jameson family in Dublin had also been associated with the American company, and Flora's father joined the distillery firm. In 1930 she married the great-grandson of the founder, William Jameson, a well-known yachtsman, and moved among the fashionable set who had yachts at Cowes.

Flora Mitchell began drawing at the age of fourteen. She attended Princess Helena College at Ealing, London, 1906-08, where she won all the art prizes available. As a student in 1910 at the Dublin Metropolitan School of Art, she was said to have been particularly attracted by the lesser-known courts, alleyways, bridges, byways and narrow streets of Dublin, and made drawings. Her technique for the works by which she became known was: meticulous pencil sketch from life, subsequently gone over with Indian ink and finally filled in with watercolour.

During the First World War she was involved in voluntary war-work in Dublin, and in 1918 she assisted Voluntary Aid Detachment in England. In 1919 she took up a private teaching post in Canada. When *A Book of Dublin* was published in 1929 she contributed two illustrations, *Dun Laoghaire Harbour* and *The Residence of the Governor-General*. While her husband was alive she lived at St Marnock's, Malahide, Co. Dublin.

In 1935 she exhibited with the Water Colour Society of Ireland for the first time, six works in all, including *Bullock Harbour, Co. Dublin* and *The Old Bridge, Wareham*. Some thirty other exhibits followed.

An exhibition of her drawings of Dublin was held in 1955 at the Dublin Painters' Gallery, 7 St Stephen's Green. The first appearance of her work at the Royal Hibernian Academy came in 1957, and continued each year until 1970, sending from Alloa, Killiney, Co. Dublin, and averaging about three works per exhibition. With one exception, *The Arch of Titus, Rome*, which she showed in 1960, all were Dublin subjects.

The Dublin Painters' Gallery was again the venue for a show in 1957, and in addition to the Dublin townscapes, which the *Irish Independent* described as 'precise in detail, excellent in concept, and wonderfully sensitive in atmosphere', were some oil paintings of the Irish scene. The catalogue for the 1959 exhibition at the same venue listed some seventy items, which were all sold, including *Burgh Quay*; *Mansion House*; and *Parnell Square*. The *Irish Independent* commented that her 'fine touch is less sure when she includes humans in the foreground of her work'.

After an interval of twenty-seven years, she returned to exhibiting at WCSI in 1963 when she showed *Houses which backed on Smock Alley Theatre*; *Parnell Monument*; *West End St Patrick's Cathedral*.

The publication of *Vanishing Dublin* in 1966 with fifty watercolour drawings reproduced in colour prompted *Ireland of the Welcomes* to comment: 'Each is accompanied by a short commentary, often including an amusing anecdote, a snippet of history or of local tradition, or a note of conversations with dustmen and hucksters. The book is a remarkable re-creation of the Dublin of an older day, an eloquent record of the passing scene'. In the preface the artist 'takes a walk in fancy through our well-loved city', beginning in York Street. The illustrations included *The Weavers' Hall*; *St Kevin's Hospital Great Hall*; *Ouzel Galley Court*; and *Henreitta Street*. Plates for the book were destroyed after publication, which has since become a collectors' item. The original drawings were purchased by the National Gallery of Ireland.

She broke her hip and suffered considerable pain, a result of a motor accident in Dublin. In 1969, when she also showed at the Dublin Sketching Club, she had a one-person exhibition in London, at the Upper Grosvenor Galleries – 'London, Yesterday and Today' – but was unable to attend at the age of seventy-eight because she had broken her wrist two days before the opening.

The centenary exhibition, Church Disestablishment 1870-1970, at the National Gallery of Ireland included four of her Dublin works from the gallery's collection. Despite her bad health, she was active to the last and was planning another series of car sorties at the time of her death, 13 April 1973, at Killiney, where she had lived as a widow for some thirty years. After her death NGI received from the Jameson family many additional works, including pencil sketches of London buildings, and sketch books. A memorial service was held at St Patrick's Cathedral, Dublin. 'Flora Mitchell's Views of Dublin' was the title of an exhibition held at NGI in 1999.

Works signed: Flora H. Mitchell.

Examples: Dublin: Civic Museum; National Gallery of Ireland; St. Columba's College. Sandycove, Co. Dublin: James Joyce Museum.

Literature: Bulmur Hobson, ed., *A Book of Dublin*, Dublin 1929 (illustrations); *Irish Times*, 5 March 1955, 4 June 1969, 29 August 1969, 2 September 1969, 16 and 23 April 1973, 23 May 1973; *Irish Independent*, 25 September 1957, 3 September 1959; *Ireland of the Welcomes*, September-October 1966; Flora H. Mitchell, *Vanishing Dublin*, Dublin 1966 (also illustrations); *Irish Press*, 13 August 1969; National Gallery of Ireland, *Press release*, 1969, 1974; Mrs E. F. Jameson, *Letters to the author*, 1973; National Gallery of Ireland, *Fifty views of Ireland*, Dublin 1985 (also illustration); Ann M. Stewart, *Royal Hibernian Academy of Arts: Index of Exhibitors 1826-1979*, Dublin 1986; Shane Jameson, *Letter to the author*, 1990; also, Princess Helena College, 1990; Dublin City and County Regional Tourism Organisation Ltd, 1993; *Water Colour Society of Ireland Exhibition List 1872-1994*, Dublin 1995; National Gallery of Ireland, *Gallery News*, September-November 1999.

MITCHELL, GRACE– see HENRY, GRACE

MOLLOY, AUSTIN (1886-1961), designer and illustrator. Born on 13 April 1886 at Castleknock, Co. Dublin, Austin Molloy was the son of a carpenter, John William Molloy. During his student days at the Dublin Metropolitan School of Art he visited Inisheer, the Aran Islands, in 1909 with Harry Clarke (q.v.), a fellow pupil, the first of three trips for sketching holidays. He was the main follower of Clarke at the School of Art, which he attended intermittently from 1909 until 1916, his fees for the last three years being free.

In 1914, he came second for stained glass with the silver medal from the South Kensington National Competition. The National College of Art and Design has a stained glass panel inscribed: 'Austin Molloy, his window, 25th March 1915, Our Lady of Victorie pray for us, Martha.'

In 1917 he exhibited at the fifth exhibition of the Arts and Crafts Society of Ireland. Oswald Reeves (q.v.), the organiser of the exhibition, reviewed the event in *The Studio* and mentioned the stained glass of Molloy, who showed a cartoon and also the panel, the subject being from the Book of Job. At this time he was a Council member of the Society.

Molloy was one of the early illustrators for the *Dublin Opinion*, founded in March 1922, and in the opinion of editors Tom Collins and Charles E. Kelly (q.v.) his work was 'always beautiful to look at and his humour quaint and whimsical.'

The illustration class at the School of Art incorporated both commercial art and lettering. Formal classes were arranged and were taught by Clarke from 1921 to 1923 during the evenings. On Clarke's resignation, Molloy was appointed to teach evening classes only. The work, according to John Turpin in his history of the School, included original design for illustration, showcards, posters, and lettering. On Friday evening each week students took turns to pose for quick studies.

The seventh exhibition of the Arts and Crafts Society took place in 1925, and Molloy, who was now a member of the Guild of Irish Art-Workers, provided the cover drawing and initial letter for the catalogue foreword; both were exhibited. He was also represented by several drawings for reproduction, for example *Balor of the Evil Eye and Ceithlin of the Crooked Teeth*, and by two books, *Clann Lir* and *In Óige an tSaogail*, both printed by Colm O'Lochlainn. *Clann Lir* contained four full-page illustrations and other embellishments. He illustrated other books, particularly in the 1920s.

On an exhibition of design at the School of Art in 1926, Thomas Bodkin observed in *The Studio*: 'Mr Austin Molloy puts forward a number of excellent designs for posters, show cards and other trade purposes. Irish manufacturers have been too prone in the past to commission such things from abroad. Mr Molloy's efforts should make it possible for them to satisfy in future their most exacting requirements at home.'

French inspectors reported on DMSA in 1927. The teacher who received most praise was Molloy, whom they referred to as a 'publicity artist working for the trade.' The French delegates contrasted the lack of motivation of many of the students in his class with comparable industrial apprentices in Bolton Street. 'It is strange to find in this instance an intelligent active professor possessing a perfect technique, teaching it to pupils who do not want it...The results obtained by Mr Molloy in an indifferently equipped workroom are, in spite of everything, excellent...Here indeed is a genuine professor, full of energy who might be trusted with a great deal but whose activity and ability are badly utilised.'

The relationship to Maura Molloy, who wrote a book on the Tailteann Games and also *The Tale of Cuchulain*, has not been established. Austin Molloy supplied the illustrations for both publications. A set of nine pen and ink drawings for the former is now with the National Irish Visual Arts Library. Of 49 St Laurence's Road, Clontarf, he died at St Laurence's Hospital, Dublin, on 16 April 1961.

Works signed: A. Molloy, A. Ó Maolaoid, A. Ó Maoloid, A. Ó M. or Ó M., rare.
Examples: Dublin: National College of Art and Design; National Irish Visual Arts Library.
Literature: General Register Office, Dublin, *Register of Births*, 1886; *Arts and Crafts Society of Ireland and Guild of Irish Art-Workers*, catalogue, Dublin 1917, 1925; A. Ruby Jackson, *Lepracaun* booklets, Dundalk [1921] (illustrations); Maura Molloy, *The Tale of Cuchulain*, Dublin [1923] (illustrations); *Clann Lir*, Dublin [1924] (illustrations); T. C. Croker, adapted from, *Irish Fairy Tales*, London and Glasgow [1924] (illustrations); M. Ó Colmáin, *In Óige an tSaogail*, Dublin 1924 (illustrations); Maura Molloy, *One Tailteann Week: A Chronicle of The Games in Ancient days*, Dundalk [1930] (illustrations); Tom Collins and Charles E. Kelly, *Forty Years of Dublin Opinion*, Dublin 1961 (also illustrations); General Register Office, Dublin, *Register of Deaths*, 1961; Paul Larmour, *The Arts & Crafts Movement in Ireland*, Belfast 1992 (also illustrations); John Turpin, *A School of Art in Dublin since the Eighteenth Century*, Dublin 1995; *Glass Society of Ireland Newsletter*, April 1998; National Irish Visual Arts Library, *Letter to the author*, 1999.

MONAHAN, ALFRED – see Ó MONACHÁIN, AILBHE

MONAHAN, HUGH (1914-70), wildfowl painter. Born in Dublin on 1 September 1914, Hugh C. C. Monahan began drawing and painting in his early years; hunting with his father, George Monahan, influenced his interest in wildlife. After Stonyhurst College, he studied at Pembroke College, Cambridge, 1933-6, and then joined the British Army. Throughout his career in the army, painting occupied much of his spare time, particularly in India. In the Second World War he won the Military Cross.

Invalided out of the army, he studied at the Slade School of Fine Art, London, in 1946, having attended art classes in Dublin. He joined the staff of University College, London. *Geese on the Solway* was painted in 1948, and during that year, when he was walking home to Cadogan Gardens along Piccadilly he saw one of his paintings in a well-known art gallery, and this led to a long association with the Hon. Aylmer Tryon, with whom he collaborated in the book, *The Wildfowler's Year*, published in 1953 and containing reproductions of his paintings and drawings.

In 1952 he had left the university to concentrate on wildfowling and painting. Still retaining his links with Ireland, he exhibited paintings, including *Back to the Lake, Sligo*, at the Victor Waddington Galleries, Dublin, in 1950, and his contributions to the British Bird Art exhibition at the Belfast Museum and Art Gallery in 1954 included *Barnacles in Mayo* and a wood engraving, *Wide Wing*.

President of the Wildfowlers' Association of Great Britain and Ireland from 1953 until 1956, he settled with his family in British Columbia in 1957. In 1964 the *Vancouver Sun* reported on an exhibition of his works at the Art Emporium: 'The collection of 30 paintings is the result, one might say the fringe result, of a substantial commission for Canada's National Museum, Ottawa, which during the past four years has kept the artist travelling and painting across the country from Quebec to here and to the Arctic.'

The commission was for backgrounds for the bird and mammal halls of the National Museum. The largest wall surfaces measured 11m by 5.8m and 9m by 5.5m, and four others were 8.5m by 5.5m. On these surfaces were the following scenes: the blue and snow goose breeding grounds in the Arctic; a Prairie waterfowl spring Saskatchewan vista; the Bonaventure cliffs of the Gaspé Peninsula where gannets bred; wood buffalo in the Northwest Territories; musk-ox at Wager Bay in the Arctic; polar bears on the iceflows off Ellesmere Island.

Monahan died from a heart attack on 23 November 1970, having left his home in Vancouver and motored to Delta to shoot duck. He was found lying in a field near the foreshore, his dog curled up beside him.

Works signed: H. Monahan.
Examples: Ottawa: National Museum of Canada.

Literature: General Register Office, Dublin, *Register of Births*, 1914; *Vancouver Sun*, 28 February 1964; Mrs Agnes Monahan, *Letter and memorandum to the author*, 1971; Mitchell Press, Ltd, *Fine Art Reproductions*, Vancouver, n.d.

MONSELL, ELINOR M. – see DARWIN, ELINOR M.

MONTGOMERY, NIALL (1915-87), sculptor, figure and landscape painter. Born in Dublin on 24 June 1915, he was the son of James Montgomery, Ireland's first film censor and friend of many of the writers and artists of his generation. It was in 1931, following the period ball of the Royal Dublin Society, that James had his portrait painted by Leo Whelan (q.v.), and he was wearing a tall hat which had belonged to Daniel O'Connell.

Niall Montgomery was educated at the Irish College, Ring, and Belvedere College, Dublin. He graduated in architecture at University College, Dublin, in 1938. After working in the Office of Public Works, he moved into private practice. The transformation of the old Butler stables into the headquarters of the Kilkenny Design Centre was his conception. In the year 1976-7 he was president of the Royal Institute of the Architects of Ireland.

When studying architecture, he had some art training, and after completing his studies he took art classes privately. As well as being a sculptor and painter, he wrote poetry and was an authority on James Joyce. Exhibiting at the Irish Exhibition of Living Art rather than the Royal Hibernian Academy, in 1958, for example, he showed *The Half Moon*; in 1964, *Dublin 4*; and in 1971, *Winter-Disconnecticut*; all three paintings.

In 1973 he was awarded a Carroll's prize at the Living Art exhibition for an audio-visual work, *The High Contracting Parties*, which combined film, sound, slides and voices. In 1980 a one-person show of his work, held at the Peacock Theatre, Dublin, was classified in four sections: 'Inventions-various', 'Drawings-topic'; 'Drawings-somatic'; and Etchings. A total of seventy-five works were presented, including *Paradigm* and *The Winter Man-Mark 3* among the 'inventions'. Landscape drawings were principally of Co. Donegal, and there were drawings of woman, man, girl, lying and sitting. *Gymnosomates* featured among the etchings.

Traffic Symbol, sculpture, is in the Hugh Lane Municipal Gallery of Modern Art. A member of the United Arts Club, Dublin, and also of the Cultural Relations Committee of the Department of Foreign Affairs, Montgomery died at the Adelaide Hospital on 11 March 1987. A memorial that he had designed, in honour of Merchant Seamen who lost their lives at sea in the Second World War, was erected on City Quay, Dublin, in 1990.

Works signed: Niall Montgomery or N. M. (if signed at all).
Examples: Dublin: Hugh Lane Municipal Gallery of Modern Art.
Literature: *Irish Exhibition of Living Art*, catalogue, 1973; *Country Life*, 27 July 1978; Peacock Theatre, *Niall Montgomery*, catalogue, Dublin 1980; *Irish Times*, 13 March 1987; James Montgomery, *Letters to the author*, 1990.

MOONY, R. J. ENRAGHT, RBA (1869-1946), landscape and figure painter. Robert James Enraght Moony was born on 13 December 1869 at The Doon, Athlone, Co. Westmeath, son of G. Enraght Moony, landlord. His mother, Angel Enraght Moony, exhibited at the Royal Hibernian Academy in 1893-4-5, six works in all; her son was credited with only three.

The signatures on some of his pictures indicated a hyphen between Enraght and Moony. The problem as to how to classify his name is exemplified in a book which he illustrated: The outside cover stated that it was illustrated by 'R. J. E. Moony', but according to the title page by 'R. J. Enraght-Moony'. Even the family Bible has two versions!

Educated at Galway Grammar School and Westward Ho!, he was acquainted in Devon with Rudyard Kipling who attended the United Services College nearby. In Paris, among others, he studied painting under Benjamin Constant (1845-1902) and Jean-Paul Laurens (1838-1921). He travelled also to Italy for study in Venice, Padua and Verona. Back home, terracotta sculpture was his subject in Leeds.

In 1900, based in London, he began to exhibit regularly, particularly with the Royal Society of British Artists, with whom he showed more than fifty works. In 1903 he contributed his first picture to the Royal Hibernian Academy, *The Edge of the Bog, an Autumn Sunset Effect*, and when he supplied a study in 1904 his address was 18 Yeoman's Row, Brompton Road. *The Lady and the Poet* was his initial exhibit at the Royal Academy, 1909. Altogether, twenty-six works were hung at the RA up until 1936, classified under 'Moony'.

The final listing at the RHA appeared in 1911: *The Marked Passage*. In 1912 he was appointed an RBA. At the RA in 1913 he showed *The hours of the morning*, and that year at the RBA works hung included *On the Shannon, Limerick* and *In the Hills of Clare*. Pictures presented at Burlington House in 1916 were: *'Tell us a story'* and *Dawn*. Painted in 1916, tempera on board, *The Seasons* was purchased in Dublin in 1998 by the Friends of the National Collections of Ireland and presented to Athlone Public Library. The painting took the form of a triptych.

Kenneth Grahame's *The Golden Age* had been published in 1915 and Moony's name as an illustrator came much to the fore with his nineteen illustrations in colour, opening with *'Once more were damsels rescued, dragons disembowelled.'* By now he was at 29 Coleherne Road, Redcliffe Gardens, SW.

Moony had a close association with Chicago in the 1920s. In the annual exhibitions of the Art Institute of Chicago he was represented each year, 1922-8 inclusive, seventeen works in watercolour, of which three were reproduced in the catalogues. He married in 1927 Isobel Barr, a musician who had gained a scholarship from Chicago College of Music. In the first year of his American showing, he contributed: *A Golden Harvest*; *Dawn*; *Spring's Discovery*, and in 1923, *The Coming of Spring*; *The Watchers*; *The Song of a Bird*. For both those years he gave London as his address but for the remaining five an address was not listed. Among his contributions in 1926 was *Spring in the Shannon Valley, Limerick*.

By 1927 Cornwall subject matter began to appear and he was probably operating by then from Chalcot Studios, Mount Hawke, Truro. On *West Wind*, 1929, tempera on canvas, Nicola Gordon Bowe commented that there was no mistaking the strong influence of the Italian Post-Impressionist painter Giovanni Segantini (1858-99) in the painting's Symbolist subject matter '…with their colourful, evocative "faery" subjects and magical, stylised rendition of the spirit of nature, unique in Irish painting of the early 20th century.'

In London, he showed nearly fifty works at the Beaux Arts Gallery, and a score at the New English Art Club. The Walker Art Gallery, Liverpool, also presented his work as well as the Royal Society of Artists, Birmingham. He died on 5 March 1946 at Newlyn in Cornwall.

Works signed: R. J. Enraght Moony, R. J. Enraght-Moony, R. J. E. Moony, R. J. E. – Moony or quarter moon with letter Y.
Examples: Athlone, Co. Westmeath: Public Library.
Literature: Kenneth Grahame, *The Golden Age*, London 1915 (illustrations); *Classified Directory of Artists Signatures, Symbols & Monograms*, London 1976; *Dictionary of British Artists 1880-1940*, Woodbridge 1976; Ann M. Stewart, *Royal Hibernian Academy of Arts: Index of Exhibitors 1826-1979*, Dublin 1986; *Royal Academy Exhibitors 1905-1970*, Calne 1987; *Annual Exhibition Record of the Art Institute of Chicago 1880-1950*, Madison 1990; Gorry Gallery, *An exhibition of 18th, 19th and 20th century Irish Paintings*, catalogue, Dublin 1996, 1998; Royal Cornwall Museum, *Letter to the author*, 1999; Roy Enraght-Moony, *Letters to the author*, 1999.

MOORE, PHYLIS (1879-1976), botanical illustrator. A daughter of Robert Paul, W. Phylis Paul of Broomhill, Drumcondra, Dublin, exhibited at the 1900 Royal Hibernian Academy a study of fruit and flowers. In 1901 Frederick Moore, her future husband, showed two hybrids of his own raising, 'Kathleen Paul' and 'Phylis Paul' at the Royal Horticultural Society in London. The couple were married that year. Other plants bear her name.

Sir Frederick Moore was for more than forty years Keeper of the Royal (now National) Botanic Gardens at Glasnevin, Dublin, and after his retirement in 1922 he and his wife lived at Willbrook, Rathfarnham, where they formed a garden which was said to be 'unrivalled for the variety of plants grown.' Both served on the council of the Royal Horticultural Society of Ireland, and Lady Moore was president 1950-3.

Ten pen and ink drawings, all unsigned, some with 1930 and 1933 dates, are at the National Botanic Gardens. A cyclamen drawing is known to have been published in *Garden Illustrated* in 1933. She also painted in oils. An honorary director of the American Rock Garden Society when it was instituted in 1934 at the Hotel Commodore in New York, she was described at the meeting, which she attended with her husband, as 'the true godmother' of the Society. She was a senior vice-president.

Phylis Moore's influence on and acquaintance with gardeners was described by an American writer, Francis H. Cabot, as 'prodigious', being remembered as 'a marvellous character — very Irish, a wonderful raconteur with a fabulous knowledge of plants.' She died on 13 February 1976 aged ninety-six and was buried at Whitechurch Parish Church, Rathfarnham.

Examples: Dublin: National Botanic Gardens.
Literature: National Gallery of Ireland and Douglas Hyde Gallery, *Irish Women Artists: From the Eighteenth Century to the Present Day*, catalogue, Dublin 1987; E. Charles Nelson and Eileen McCracken, *The Brightest Jewel*, Kilkenny 1987; Rev. Canon A.H.N. McKinley, *Letter to the Royal Horticultural Society of Ireland*, 1998; National Botanic Gardens, *Letters to the author*, 1998; North American Rock Garden Society, *Letter to the author*, 1998; also, Royal Horticultural Society of Ireland, 1998; Charles S. Guinness, 1999.

MORAN, PAT (1961-92), landscape and figure painter. Born on 7 November 1961 in Portlaoise, Co. Laois, Patrick Gerard Moran was the son of Padraic A. Moran, local Electricity Board officer. In 1979-82 he attended Dun Laoghaire School of Art, followed by a year in Dublin at the National College of Art and Design, again specialising in painting.

During his summer holidays in 1982 he executed a mural for Ballinteer Health Centre. However, in 1999 the Eastern Health Board reported to the author: 'Part of the mural has survived in the Health Centre to this day. Unfortunately a section of it was lost due to an extension of the premises.' In 1983-4 he worked as a community artist with St Audeen's Co-operative in Cook Street, Dublin. His work was hung in the 1983 Claremorris Open Exhibition.

In 1984-5 he painted in Italy whilst working as a gardener-cum-caretaker near Rome. He attended a course in etching as well as in painting. At the Galleria Mafai in Rome in 1984 he was represented in a group show. The Italian sunsets attracted him and he executed a number of studies.

After his return to Dublin he showed in 1985 with four other artists at Ballyfermot Public Library. An advertisement on the NCAD notice board led him to successfully apply for a scholarship, enabling him to travel for several months in Mexico in 1986 studying murals, particularly the work of Diego Rivera (1886-1957).

Back in Dublin he showed in 1987 with Dimitri Broe and Oisin Breathnach at the Peacock Gallery, and then worked as a mural painter in the Inchicore Murals project. There is now no trace of his mural at Dun Laoghaire Shopping Centre.

Before the close of 1988 he held a one-person show of paintings and drawings at the Temple Bar Gallery, Dublin. The *Irish Times* critic found the exhibition 'a slightly schizophrenic one. On one side are the Expressionist-style works, harsh, simplified and generally loud in colour. On the other hand there are a number of quite conventional pictures...The Expressionist ones win...Pat Moran is at his best when he is most uninhibited...'.

Moran had spent holidays and time in Cork when he was a young child and developed a love for the city and its people. In late 1989 he moved there as he considered his work was getting rather stale in Dublin. In 1991 he showed at the Malton Gallery, Dublin, with Stephen Cullen and Stephen Rinn. He was a resident artist at the Triskel Arts Centre, Cork, and in December 1991 he showed fourteen works in an exhibition, including *Kent Station, 7-25 to Dublin*, oil; *Crane, Cork harbour*, pencil; *Full Tide, Sherkin Island*, oil. He was particularly interested in urban landscape. He was one of ten artists involved in the self-portrait exhibition, 'Images of Ourselves,' at Triskel in 1992.

A colleague considered that in Cork Moran had found 'a sense of place and purpose that had eluded him in Dublin. His work gained a new maturity and depth...'He stayed more than two years in Munster, taught

art in the Cork Prison, and then moved back to Dublin as he was involved in the Portlaoise Prison scheme teaching painting one day a week.

In his career he had worked as a volunteer teaching art at Focus Point. An active and popular member of the Association of Artists in Ireland, he died in a drowning accident on 31 May 1992 at Sherkin Island, West Cork, when on a painting and photography trip with friends. Artists in Cork and the AAI raised funds to purchase his oil painting of St Finbarre's Cathedral, donating it to the Crawford Municipal Art Gallery.

Works signed: Pat or Pat Moran.
Examples: Cork: Crawford Municipal Art Gallery.
Literature: *Irish Times*, 31 October and 1 November 1988, 2 July 1992; Pat Moran, *Curriculum Vitae*, typescript, Dublin 1988; Triskel Arts Centre, *What's On*, December 1991-January 1992; also catalogue; Association of Artists in Ireland, *Art Bulletin*, June-July 1992; Temple Bar, *The Bar*, July-August 1992; Anthony Lyttle, *Letter to the author*, 1998; also, Eastern Health Board, 1999; Ms Kay Feely, *Letters to the author*, 2000.

MORRIS, FRANK (1928-70), sculptor. Born in Arklow, Co. Wicklow, Frank Edward Morris was the son of Edward Morris, and the family moved to Dublin in 1939. He attended St Mary's College, Rathmines, 1942-6, and with the intention of becoming an architect he spent three years at the Municipal Technical School. In 1949 he entered the National College of Art, mainly modelling from life until 1953. Ernst Barlach (1870-1938) and Henry Moore (1898-1986) he named as early influences.

At the Victor Waddington Galleries, Dublin, he exhibited at a group show in 1953, and from Mountpleasant Avenue, Rathmines, he sent two pieces to the Institute of the Sculptors of Ireland show. In that year too he moved to Glencree, Co. Wicklow, and worked with the Irish Forestry Department: dating from this period were many carvings in wood, his main material. He once carried a piece of timber on his shoulder from a South of England seaside resort, back by train and boat to Ireland. The timber later became *Bushelitis*. Rarely could he afford to buy good timber.

In 1955 he returned to Dublin and exhibited with the Institute of the Sculptors of Ireland: *Composition* and *Figure*. In the 1956 exhibition, *My Daughter with her Dolls*, lead relief, and *Head*, wood, were contributed; and he was also represented in a group show at the Waddington Galleries. Friendship with Michael Biggs (q.v.) enabled him to share a studio, in Heytesbury Lane, signpainting and lettercutting, but in 1957 he moved to 37 Upper Mount Street and a larger studio. He contributed that year to the Irish Exhibition of Living Art: *Dancer*, wood; *Performers*, lead relief.

Although he did numerous drawings, the notion of making models was alien to his conception of what a sculpture should be. In 1958 he moved to London as assistant to John Skeaping, RA (1901-80), Professor of Sculpture at the Royal College of Art, and he worked with him there on commissions which included *Black Bear* for Eton College War Memorial and a 20m relief for the Imperial College of Science. His first (and only) one-person show was at the New Vision Gallery, London, in 1958. At 28 Cranley Gardens, South Kensington, he shared accommodation with fellow sculptors Irene Broe and Hilary Heron (qq. v.).

The Institute of the Sculptors of Ireland international exhibition in 1959 at the Municipal Gallery of Modern Art, Dublin, saw Morris represented by two lead reliefs, *Birdcatcher* and *Natashagino and Michele*. In 1959 too he produced a 3.6m figure in beaten copper for the Scottish Industrial Fair at Edinburgh. In 1960 he returned to Ireland and worked for a short period with the Department of Posts and Telegraphs. He showed in the Independent Artists' exhibitions of 1960 and 1961; for the latter, he gave his address as Back Lodge, Ballyorney, Enniskerry.

In 1962 with his painter wife, Camille Souter, he settled in Glashamullen House at Calary Bog, Co. Wicklow, and whilst continuing to carve in wood he found the relative peace to rediscover stone, from the granite quarries above Stepaside. In 1963 he made a granite fountain for St Stephen's Green House, Earlsfort Terrace. In 1965 with Francis Barry, the architect, he entered for the Wolfe Tone Memorial Competition and won third prize. His work was in the Irish Exhibition of Living Art in 1965 and 1966; his address was c/o Ritchie Hendriks Gallery, Dublin. His *Plant and Animal Forms* appeared in an exhibition from private collections in Ireland held at the Municipal Gallery of Modern Art in 1965.

In 1966 he took up a post as an art teacher at St Columba's College, Rathfarnham. Wooden platters and bowls were exhibited in a craft exhibition in Munich and New York the following year. The two main doors of the Church of the Redeemer, Dundalk, 1969, are covered with copper sheeting lettered by Morris with translations of Early Christian prayers.

In the sculpture exhibition by contemporary Irish artists at the Cork Sculpture Park in 1969, he was represented by three works in granite; *Mark Stone (2)* was approximately 90cm x 90cm x 60cm. In that year he provided a granite altar, font and ambo for the new church of St Laurence O'Toole at Kilmacud, Stillorgan. By now, his work was included in the David Hendriks Gallery group exhibitions.

Michael Warren, who described himself as a pupil and apprentice of Morris, wrote that he 'suffered cultural isolation, extreme poverty and ill-health for the sake of certain principles of excellence to which he was always faithful. Part of his integrity was that he was not able to produce more work than he did. There are, however, amongst his small output, some six or more woodcarvings of such astonishing originality that they can take their place alongside the finest Irish sculpture of this century'.

Morris, who is represented at the Irish Museum of Modern Art by *Female*, carved wood, died at St Michael's Hospital, Dun Laoghaire, on 11 August 1970. A retrospective exhibition of thirty-eight works was held at the Taylor Galleries, Dublin, in 1982.

Works signed: F. M. or M. (if signed at all).
Examples: Dublin: Irish Museum of Modern Art; St Stephen's Green House, Earlsfort Terrace. Dundalk, Co. Louth: Church of the Redeemer. Kilkenny: Art Gallery Society. Stillorgan, Co. Dublin: Church of St Laurence O'Toole, Kilmacud.
Literature: Sigerson Clifford, *Lascar Rock*, Dublin 1953 (illustration); *Irish Times*, 10 January 1970, 2 August 1980, 20 January 1982; Taylor Galleries: Michael Warren, *Frank Morris*, catalogue, Dublin 1982; Rev. P. Larkin, *Letter to the author*, 1990; also, Camille Souter, 1990; Michael Warren, 1990; Jim McDonnell, 1998.

MORRISON, R. BOYD (1896-1969), portrait, landscape painter and theatrical designer. Born on 15 April 1896 in Belfast, Robert Boyd Morrison left school at fourteen and worked in a lithographic studio under Samuel Leighton, attending classes at the Belfast School of Art. Leighton took a personal interest in his apprentice, and his portrait by Morrison hangs in Arthur Square Masonic Hall, Belfast. The artist was a brother of a prominent Belfast photographer in his day, Louis Morrison.

When the First World War began, he enlisted in the Royal Irish Fusiliers and was wounded at Messines, 1917. After spending more than a year in hospital, he received a rehabilitation grant for the Slade School of Fine Art, London, where he studied for three years under Professor Henry Tonks (1862-1937), taking first prize in life drawing and painting. Tonks was said to have wanted him to become a lecturer at the Slade.

In the early 1920s he designed and painted furniture at Cottar's Market, London, and for his models at the Ulster Pavilion, British Empire Exhibition at Wembley, 1924, he was awarded the British Empire Diploma for Services to the Fine Arts. As well as having a spell as art master and lecturer at Holloway School, he wrote occasional articles, including one for *Apollo* magazine.

Robes of Thespis, costume designs by modern artists, was published in London, 1928, and edited by George Sheringham and R. Boyd Morrison. Samuel Leighton contributed to the section on 'Irish Dramatic Costume'. *The Studio* commented that for its wealth of illustrations and the variety of its contents, the book was 'one of the outstanding volumes on stage design which have appeared in this country. There are 109 plates, a large proportion of which are in colour ...'.

According to Mrs Vera Mooney, who provided accommodation for Morrison in Bangor, Co. Down, late in life, he wrote to the artists of his choice for their designs for the publication, and collected Gordon Craig's in Italy. Sheringham was responsible for the literary content, and *Robes of Thespis* was produced for a wealthy businessman, Rupert Mason. Morrison's four published costume designs were for Gerald Macnamara's *Thompson in Tir-na-n'-Óg*, presented by the Ulster Players, Belfast. *Cuchulain* and *Grania* were both donated by Mason to the Victoria and Albert Museum, London. The third watercolour design at the V. and A. was dated 1918 and presented by the artist.

A contribution by Max Beerbohm (1872-1956) to *Robes of Thespis* suggested that Morrison may have been involved in costume design for the London theatre. The caption to Beerbohm's drawing read: 'Here are five friends of mine – Mr Nicholson, Mr Rutherston, Mr Craig, Mr Morrison, and Mr Ricketts. All are designers of fantastic and lovely costumes ...'. Beerbohm also said: 'Gordon Craig started the revolt, designing costumes, as he designed scenery, rather by his inward fancy than by recourse to facts. The designing of theatrical clothes became a creative art. Ricketts, William Nicholson, Albert Rutherston, Dulac, Glyn Philpot, George Sheringham, Boyd Morrison, and other gifted men, have revelled in it.'

Morrison by the late 1920s was the principal of the Well School of Drawing and Painting in Hampstead, a member of the National Society of Painters, Sculptors, Engravers and Potters, and of the Grub Group. His work was in the National Society's 1931 exhibition. In 1932 he exhibited in Locksley Hall, Belfast, some fifty works, having returned to Belfast about this time. *The Storm, Sussex; Donaghadee Harbour;* and *Inch Island* were included along with the portrait of Leighton and a crayon drawing of the Earl of Jersey. Leighton's portrait was painted in Morrison's studio in Clarence Place Hall, Belfast, where he taught students.

In 1940 he contributed to the Royal Hibernian Academy exhibition, from 36 Grove Park, Bangor, *Trees in the Wind – Surrey.* At the Royal Academy, London, he showed only three works, occasionally exhibiting at the Alpine Club Gallery, Goupil Gallery, Grafton Galleries and the Pastel Society. An oil painting of Florence M. Wilson, 1940, is in the Ulster Museum.

In 1941 *Old man thinking* was exhibited at the Royal Scottish Academy. In 1941 he joined The Rink in Leamington and worked for the Government's Civil Defence Camouflage Unit until 1943, Mrs Mooney also told the author, and then went to Warwick town where he rented a small studio. A portrait of the sculptor, Leon Underwood (1890-1977), whom he had probably met at the Slade, was exhibited at the 1943 RA. He sent a portrait drawing to the 1946 RHA from Warwick, and exhibited with the National Society in 1947: *Flowers and Landscape* and *Co. Down Farm.*

Morrison left Warwick in 1948 and returned to Bangor. He taught from 1948 until 1950 at Royal School, Dungannon, but had to retire because of ill health. He taught also at Bangor Technical School 1954-5. In 1956 he opened a studio in Holywood, Co. Down, in the same building as that used by Rosamond Praeger (q.v.), and accepted pupils. On 29 July 1969 he died in Crawfordsburn Hospital, Co. Down.

Works signed: R. Boyd Morrison or Boyd Morrison.
Examples: Belfast: Arthur Square Masonic Hall; Ulster Museum. Downpatrick: Down County Museum. London: Victoria and Albert Museum.
Literature: George Sheringham and R. Boyd Morrison, *Robes of Thespis*, London 1928 (also illustrations); *Belfast News-Letter*, 6 June 1931, 7 August 1969; *Belfast Telegraph*, 24 June 1932; Brian Kennedy, *Letter to the author*, 1969; *A Dictionary of Contemporary British Artists, 1929*, Woodbridge 1981; *A Concise Catalogue of the Drawings, Paintings & Sculptures in the Ulster Museum*, Belfast 1986; Provincial Grand Lodge of Antrim, *Letter to the author*, 1990; also, Leamington Spa Art Gallery and Museum, 1990; Royal School, Dungannon, 1990; *The Royal Scottish Academy Exhibitors 1826-1990*, Calne 1991.

MORROW, ALBERT (1863-1927), illustrator and poster designer. Albert George Morrow was one of the eight sons of George Morrow, painter and decorator, of Hanover House, Clifton Street, Belfast. A brother of Edwin, George, Jack and Norman Morrow (qq.v.), he was born in Comber, Co. Down, on 26 April 1863, but the family moved to Belfast when he was two. A fervent student of ornithology, his interest, in childhood, was kindled on Belfast's Cave Hill.

After attending the Government School at Art in Belfast, he won a two-year scholarship to South Kensington in 1882 and there met Albert Toft (1862-1949), the beginning of a lifelong friendship. On leaving the National Art Training School, he was engaged by the *English Illustrated Magazine*. By 1890 he was illustrating for *Bits* and *Good Words*, but by then Hugh Thomson (q.v.) was the ascendant star among the *English Illustrated Magazine* contributors.

Between 1890 and 1904, Morrow exhibited nine works at the Royal Academy. From 15 Trafalgar Studios he contributed *The story of the little mermaid* in 1893, and from 1 Albert Studios, Battersea Park, he showed *The Man in the Street* in 1900. Thereafter he exhibited only two pictures at Burlington House. Posters,

particularly for the theatre, were to make his name; he designed hundreds. Landscape sketching was a form of recreation.

Morrow, who also contributed to children's annuals and picture books, illustrated several books for adults, one of the first being Frederick Wicks's *The Stories of the Broadmoor Patient*, 1893. In the Belfast Art Society exhibition catalogue of 1895 he was in the members' list, at 324 King's Road, Chelsea. In 1908, under the auspices of the Ulster Arts Club, an exhibition of poster sketches and other drawings was opened by F. R. Benson in the Municipal Art Gallery, Belfast. The poster designs included *The Bicycle Girl*, several for *Answers*, Martin Harvey in *The Corsican Brothers*, and Mrs Patrick Campbell in *The Second Mrs Tanqueray*. In 1908 too he exhibited with five brothers at 15 D'Olier Street, Dublin.

In the 1917 RA, he gave an Eastbourne address. Only three cartoons appeared in *Punch*, in 1923, 1925 and 1931, according to the magazine's records. An original drawing, for a book illustration, is in the Victoria and Albert Museum and is in pencil and wash, touched with white. He died at his residence, West Hoathly, Sussex, on 26 October 1927. The headstone in the local Highbrook churchyard was designed by his sculptor friend, Albert Toft.

Works signed: Albert Morrow, A. Morrow or A. M.
Examples: London: British Museum; Victoria and Albert Museum.
Literature: Frederick Wicks, *The Stories of the Broadmoor Patient*, London 1893 (illustrations); A. D. McCormick, *An Artist in the Himalayas*, London 1895 (illustration); Algernon Graves, *The Royal Academy of Arts 1769-1904*, London 1905; *Belfast Free Public Library Annual Report*, 1908-09; Frederick Wicks, *My Undiscovered Crimes*, London 1909 (illustrations); Eleanor Luisa Haverfield, *The Happy Comrade*, London 1920 (illustrations); *Northern Whig*, 24 March 1920; Charles Harold Avery, *Between Two Schools*, London 1923 (illustrations); *Who Was Who 1916-1928*, London 1929; Miss Phyllis D. Morrow, *Letters to the author*, 1968; John Hewitt and Theo Snoddy, *Art in Ulster: 1*, Belfast 1977; *Dictionary of British Book Illustrators and Caricaturists 1800-1914*, Woodbridge 1978; Witt Library, London, illustrative records [1979]; *Dictionary of British Book Illustrators: The Twentieth Century*, London 1983.

MORROW, EDWIN A. (1877-1952), portrait, landscape painter and cartoonist. Born on 7 February 1877 in Belfast, Edwin Arthur was one of the eight sons of George Morrow, painter and decorator, of Hanover House, Clifton Street, Belfast, and a brother of Albert, George, Jack and Norman Morrow (qq.v.). He attended the Government School of Art in Belfast, and won mention in *The Studio* for an entry in the National Competition. A scholarship took him to South Kensington where he was one of the few trained in fresco.

Paul Henry (q.v.), who was to meet Eddie Morrow again in London, wrote in his *Further Reminiscences* about Belfast schooldays: 'A shy boy, inclined to be moody and introspective, he had, however, a sense of humour that nothing could suppress for very long, and a way of expressing it in a few lines in drawings made on any old scrap of paper that happened to be near him ...'. A charcoal drawing of Henry by Morrow is in the National Gallery of Ireland.

Along with his brothers George and Norman, Robert Lynd and Henry, he was one of the first members of a literary club in London, which met at the old Napier Tavern in High Holborn. Herbert Hughes was instrumental in founding, in London, Dungannon Club No. 4. Eddie and brother Norman were both members. In 1903 he exhibited at the Royal Academy for the first time, from 1 Albert Studios, Battersea Park. His only other two contributions were in 1905, when he showed *Cuchulain and the witches of the valley*, and 1909.

In Belfast, Morrow contributed to the Ulster Arts Club's first exhibition in 1903, and he was elected a member of the Belfast Art Society in 1904. In 1905 he supplied an illustration to an issue of *Ulad*, a publication associated with the Ulster Literary Theatre, with which he had connections. The first number of an intended series entitled *The Northern Leaders of '98*, edited by Francis Joseph Bigger, was published in 1906 on William Orr; Morrow contributed illustrations, two identified. He illustrated one political postcard, *The Undying Oath*, published by the Dungannon Club.

Along with five brothers, he exhibited at 15 D'Olier Street, Dublin, in 1908. In August 1910 he wrote from Kean's Hotel, Galway, to Seumas O'Sullivan in Dublin, embellishing the letter with sketches. His black and white illustrations for the *Bystander*, *London Opinion* and *Punch* were well known, but as a portrait painter his work did not receive sufficient notice. His cartoon for the *Bystander*, 14 October 1914, bore the caption:

Being unable to take Paris – Kronprinz Wilhelm takes anything else he can lay his hands on. In 1914 he began contributing cartoons to *Punch*, and between then and 1940 had 299 published.

A portrait of Richard Hayward appeared in the loan exhibition of Irish portraits by Ulster artists at the Belfast Museum and Art Gallery in 1927. Morrow painted in 1943 the reredos of Poling Church, near Arundel, Sussex, with local scenery as the background for the central panel. Parishioners had requested that the background for the subject, the nineteenth chapter of Revelation, should include the Downs and the chalkpits of the locality. One parishioner who remembered oxen ploughing on the Downs had asked for these to be included. The Ulster Museum's collection has four oil paintings, including *A Cold Day, Lincoln* and *Youngsters, Aran Island*. A bachelor, he died on 9 December 1952 at 23 Clapham Common, Clapham, Worthing, Sussex.

Works signed: Edwin A. Morrow, Edwin Morrow, En. A. Morrow, rare; E. Morrow, E. A. Morrow, E.A.M. or E.M.
Examples: Belfast: Ulster Museum. Dublin: National Gallery of Ireland. Poling, Sussex: Poling Church, near Arundel.
Literature: *The Studio*, September 1898; *Ulad*, February 1905 (illustration); Francis Joseph Bigger, *The Northern Leaders of '98: William Orr*, Dublin 1906 (illustrations); *Irish Review*, February 1912 (illustration); *Northern Whig*, 24 March 1920; *Dublin Magazine*, February 1924 (illustration), January-March 1950; *The Observer*, 14 November 1943; General Register Office, London, *Register of Deaths*, 1952; *Paul Henry Papers*, Trinity College, Dublin [1958]; Miss Phyllis D. Morrow, *Letter to the author*, 1968; Patrick Shea, *A History of the Ulster Arts Club*, Belfast 1971; Paul Henry, *Further Reminiscences*, Belfast 1973; Brian Rodgers, *Letters to the author*, 1974, 1977; John Hewitt and Theo Snoddy, *Art in Ulster: 1*, Belfast 1977; Witt Library, London, illustrative records [1979]; Martyn Anglesea, *The Royal Ulster Academy of Arts*, Belfast 1981; John Killen, *John Bull's Famous Circus: Ulster History through the Postcard 1905-1985*, Dublin 1985.

MORROW, GEORGE (1869-1955), cartoonist and book illustrator. Born on 5 September 1869 in Belfast, he was the son of George Morrow, painter and decorator, of Hanover House, Clifton Street, Belfast, and brother of Albert, Edwin, Jack and Norman Morrow (qq.v.). After attending in Belfast the Model School and the Government School of Art, he was apprenticed as a signpainter. Among the contributors to the Belfast Ramblers' Sketching Club exhibition in 1888, he later studied in Paris where he must have seen the work of Caran d'Ache (1858-1909). In the Belfast Art Society's exhibition catalogue of 1895, his address was 324 King's Road, Chelsea, London. In 1896 he contributed to *Pick-Me-Up*, and that year his illustrations appeared in Mary Russell Mitford's *Country Stories*. More than seventy other books published in London were to be illustrated by him.

A striking figure of his Chelsea days was Mark Twain, and he designed the menu for a dinner given by the Pilgrim Club in honour of the humorist, who returned to the USA in 1900. Morrow met Paul Henry (q.v.) in London and both were among the first members in 1901 of a literary club which met at the old Napier Tavern in High Holborn.

Morrow contributed in 1905 to the second issue of *Ulad*, a magazine associated with the Ulster Literary Theatre, and to the first number of *The Shanachie* in 1906. The inaugural issue of Bulmer Hobson's *The Republic*, a weekly paper, also appeared in 1906 and for the issue dated 27 December 1906 Morrow's cartoon was *The Stranger in the House*, depicting a complacent John Bull (England) occupying, without invitation, a comfortable seat in the home of a poor widow (Ireland). This cartoon was subsequently reproduced by the Dungannon Club as a postcard.

Morrow's first *Punch* drawing appeared on 19 September 1906, and from 1908 onwards he was a contributor almost every week. He supplied no fewer than 2,704 cartoons of which twenty-two full page were political. A good example in the vein of historical fantasy was the early *A Supper with the Borgias*, and as *The Times* of London described it: '... not only are the guests adopting every possible subterfuge to avoid eating or drinking anything, but even the dogs look suspiciously at the fare surreptitiously passed to them under the table'.

In Dublin, C. P. Curran was secretary of the first Oireachtas Art Exhibition in 1906. Among those on the committee were Sarah Purser, Jack B. Yeats (qq.v.) and George Morrow. In 1908 he exhibited with five brothers at 15 D'Olier Street, Dublin. Regarded as a knowledgeable historian, he could present accurately

the manners and costumes of the past as in Elizabeth O'Neill's *A Nursery History of England*, 1912. *The Studio* commented on this book that he provided 'an unfailing source of entertainment in a series of a hundred pictures in colour and many drawings in black and white'. The first exhibition of the Society of Humorous Art was held in London in 1912: Morrow was represented; so, too, was W. Heath Robinson (1872-1944).

An Alphabet of the War, cartoons reprinted from *Punch Almanack*, appeared in 1915, and that year he illustrated L. M. Oyler's *The Children's Entente Cordiale*. Methuen published *George Morrow: his book*, 1920; *More Morrow*, 1921; and *Some More*, 1928. After contributing to *Punch* for some eighteen years, he had joined the staff in 1924 and thus attended the weekly luncheons round the famous table. In 1925, *Jugged Journalism* by A. B. Cox showed a front cover note: 'thirty-two illustrations by George Morrow'. As the decade closed, he was living at 30 Observatory Road, East Sheen, SW14.

From 1930 until 1937 he was art editor of *Punch*. Sketches of Irish life and character had appeared in Dorothy Large's *Irish Airs*, 1932. In 1945 the Belfast Museum and Art Gallery presented an exhibition of one hundred humorous *Punch* drawings. Among the other periodicals to which he contributed were the *Bystander*; *Pall Mall Magazine*; *Sphere*; *Strand Magazine*; *Tatler*; and *Windsor Magazine*.

Married with no children, he spent some of his holidays painting watercolours in Ireland, particularly in Co. Donegal. In the opinion of E. V. Knox, editor of *Punch* from 1932-49, most things, especially things English, were absurd to George. *The Times* said he was 'the soul of modesty and unpretentiousness ...' and his 'ruminations quite unlike those of anybody else. He was probably the most consistently comic artist of his day'. His work appeared in *Punch* until about a month before his death on 18 January 1955, at his home, Thaxted, Essex.

Works signed: Geo. Morrow, Geo. M.; G. M. or S. MacM., both rare.
Examples: Belfast: Linen Hall Library; Ulster Museum. London: British Museum; Museum of London. Manchester: City Art Gallery.
Literature: Books illustrated, excluding those already mentioned; all London published: A. J. Church, *Heroes of Chivalry and Romance*, 1898; Frank Cowper, *The Island of the English*, 1898; G. Chater, *Helmet and Spear*, 1901; A. J. Church, *Stories of Charlemayne and the Twelve Peers of France*, 1902; Edith Seeley, *Under Cheddar Cliffs a hundred years ago*, 1903; G. Chater, *The Crusaders*, 1904; J. F. M. Carter, *Diana Polwarth, Royalist*, 1905; E. V. Lucas and C. L. Graves, *Change for a Halfpenny*, 1905; A. J. Church, *The Crown of Pine*, 1906; E. V. Lucas and C. L. Graves, *Signs of The Times*, 1906; Taro Miyake and Yukio Tani, *The Game of Ju-Jitsu*, 1906; John Willis Clark, *Cambridge*, 1907; H. W. G. Hyrst, *Adventures – the Great Deserts*, 1907; Richard Stead, *Adventures on the Great Rivers*, 1907; C. L. G. and E. V. L., *If: a nightmare in the conditional mood*, 1908; E. V. L. and C. L. G., *Hustled History*, 1908; Max Rittenberg, *Potted Game*, 1908; C. L. Graves, *Musical Montrosities*, 1909; E. V. Lucas and C. L. Graves, *Farthest from the Truth*, 1909; George Chater, *A Flutter in Feathers*, 1913; Lady Sybil M. C. Grant, *Founded on Fiction*, 1913; J. H. B. Lockhart, *A French Picture Vocabulary*, 1914; E. V. Lucas and C. L. Graves, *All the Papers*, 1914; E. V. Lucas, *Swollen-headed William*, 1914; John K. Kendall, *Odd Creatures*, 1915; W. J. Locke, *Morals for the Young*, 1915; E. V. Lucas, *In Gentlest Germany*, 1915; G. S. Dickson, *A Nursery Geography*, 1916; Noel Ross, *The House-Party Manual*, 1917; G. S. Dickson, *My First Book of Geography*, 1919; E. V. L. and G. M., *Quoth the Raven*, 1919; John Hilton and Joseph Thorp, *Change, The Beginning of a Chapter*, 1919; Elizabeth O'Neill, *My First Book of British History*, 1920; Hilda Finnemore, *Stories of Course*, 1921; A. P. Herbert, *Light Articles Only*, 1921; A. P. Herbert, *The Wherefore and the Why*, 1921; E. V. Knox, *Parodies Regained*, 1921; E. A. Wyke Smith, *Some Pirates and Marmaduke*, 1921; A. P. Herbert, *Tinker Tailor*, 1922; E. V. Lucas, *You Know what People are*, 1922; E. V. Knox, *Fiction as She is Wrote*, 1923; E. V. Knox, *Fancy Now*, 1924; G. C. Faber, *Elnovia*, 1925; A. P. Herbert, *Laughing Ann*, 1925; Cynthia Asquith, *The Flying Carpet*, 1926; George Morrow, *Podgy and I*, 1926; W. M. Dixon, *Cinderella's Garden*, 1927; Margaret L. Gower, *Chuckles*, 1927; E. V. Knox, *I'll Tell the World!*, 1927; Archibald Marshall, *Simple Stories*, 1927; E. A. Wyke Smith, *The Marvellous Land of Snergs*, 1927; Archibald Marshall, *Simple People*, 1928; Susan Charlotte Buchan, Baroness Tweedsmuir, *Jim and the Dragon*, 1929; F. Gwynne Evans, *Puffin, Puma & Co.*, 1929; F. Gwynne Evans, *Here be Dragons*, 1930; A. P. Herbert, *Wisdom for the Wise*, 1930; Archibald Marshall, *Simple Stories from Punch*, 1930; Agnes G. Herbertson, *Hurrah for the O-Pom-Pom*, 1931; Archibald Marshall, *The Birdikin Family*, 1932; Jonathan Swift, *Gulliver's Travels*, 1932; John B. Morton, *The Death of the Dragon*, 1934; G. S. Dickson, *Round the World*, 1937; Cecil W. Wilson, *Had You Lived in London Then*, 1937; Richard Wilson, *A Picture History for Boys and Girls*, 1948.
Literature: General: *Ulad*, February 1905 (illustration); *The Shanachie*, vol. 1, 1906 (illustration); *The Republic*, 27 December 1906 (illustration); *The Studio*, November 1907, December 1912, January 1913; *Belfast News-Letter*, 27 March 1945, 19 January 1955; *The Times*, 20 January 1955; *Punch*, 26 January 1955; *Belfast Telegraph*, 9 February 1957; *Paul Henry Papers*, Trinity College, Dublin [1958]; *Studies*, Spring 1962; Paul Henry, *Further Reminiscences*, Belfast 1973; John Hewitt and Theo Snoddy, *Art in Ulster: 1*, Belfast 1977; *Dictionary of British Book Illustrators and*

Caricaturists 1800-1914, Woodbridge 1978; *A Dictionary of Contemporary British Artists, 1929*, Woodbridge 1981; Martyn Anglesea, *The Royal Ulster Academy of Arts*, Belfast 1981 (illustration); *Dictionary of British Book Illustrators: The Twentieth Century*, London 1983; John Killen, *John Bull's Famous Circus: Ulster History through the Postcard 1905-1985*, Dublin 1985; *Punch, Letter to the author*, 1990.

MORROW, JACK (1872-1926), landscape painter and political cartoonist. One of the eight sons of George Morrow, painter and decorator, of Hanover House, Clifton Street, Belfast, John Cassell Morrow was born in Belfast on 26 February 1872, a brother of Albert, Edwin, George and Norman Morrow (qq.v.).

In 1902 Bulmer Hobson was associated with the first production, *Cathleen Ní Houlihan*, of the Ulster Literary Theatre, as it was later named, and he had also started Na Fianna Éireann, an organisation of hurling clubs for young boys. Hobson asked Francis Joseph Bigger to present a shield for competition. Morrow made a large shield of beaten copper.

In 1902 he was elected a member of the Belfast Art Society. He and his brother Fred, who were later to run a painting and decorating business in Dublin, were both involved in designing stage settings and costumes for the Ulster Literary Theatre. Jack Morrow was listed as a judge for the 'wood-art' competition at the Féis of the Nine Glens in 1904. Hobson's Dungannon Club was inaugurated in Belfast in 1905 but he found 'the utmost difficulty in getting people to come to our meetings'. A magic lantern was introduced and a number of slides prepared, some made from cartoons drawn by Jack Morrow.

In Dublin, Morrow exhibited in 1906 at the Oireachtas, a distinct art exhibition held in the Technical School, Rutland Square. Meanwhile in Belfast, Hobson founded and edited *The Republic*, a separatist weekly. The first issue appeared on 13 December 1906. Cartoons were a notable feature of the paper, and among the contributors was Morrow, whose full-page cartoon, *Catching Recruits*, appeared 20 December 1906, and was advertised for sale in the same issue, as a postcard. The cartoon on 31 January 1907, signed 'Mac', bore the legend: 'The Police, having no useful employment, spend their time in country places sneaking round spying upon the people'.

An exhibition of seventy-three works by six Morrow brothers held at 15 D'Olier Street, Dublin, 1-6 June 1908, may have heralded the opening of the painting and decorating business at that address of George Morrow and Son. Jack's contribution included *Daybreak on the Lagan*. The business only survived about five years. At one period Jack taught design in the Dublin Metropolitan School of Art.

In 1911 his work was included in an exhibition at the Branch of the Five Provinces, 7 St Stephen's Green, where his *Rush, Co. Dublin* was regarded by Thomas Bodkin in the *Irish Review* as a 'scholarly little painting ... which displays a rare sincerity and ability'. At the 1912 Royal Hibernian Academy he exhibited *The Sea Quarry* and *The North Strand*.

Morrow's work was reproduced in some issues of the *Irish Review*. In the issue of March 1914 his portrait appeared, from a painting by his friend, Estella Solomons (q.v.). He showed *The Harvest* at the 1916 RHA, and did some work in book illustration. He was active as a political cartoonist in 1917. In January 1919 he was charged before a general courtmartial 'with having in his possession, without lawful authority, certain papers and writings, being copies of certain confidential documents belonging to Government departments in order that he might publish their contents'.

Estella Solomons gave friendly support as he languished in Mountjoy Jail. In one letter to her dated 4 May 1919, smuggled out by a personal friend of Morrow's, a drawing of a sleeping lion is at the top with the heading 'Mountjoy Hotel & Restaurant'. Then follows: 'Patronised by all the leading men and women of the county'. On the left side of the sheet: 'Strict attention, etc. Black Maria meets all boats and trains'. In another letter he wondered about Estella 'or Duncan' carrying on his classes, one of '400 boys'. In a third letter he acknowledged receipt of an anatomy book.

Associated with The Craftworkers Ltd, 39 Harcourt Street, Dublin, described as the first Irish co-operative company engaged in church decoration, he and all the other artists and craftsmen were shareholders. In an advertisement in the *Catholic Directory*, 1920, the mosaic panels and the renovation of the altars and chancel walls at St Catherine's Church, Meath Street, were credited to him and Albert G. Power (q.v.). Two 1925

pencil portraits of Dr George Sigerson after death are in the National Gallery of Ireland. He died in Dublin on 11 January 1926.

Works signed: Jack Morrow, J. M., Mac, Mac Murcada, Seágan Mac Murcada, Seán Mac or Seán Mac Murcada.
Examples: Dublin: National Gallery of Ireland.
Literature: *Belfast Art Society Minute Book*, 1902; Belfast Central Public Library, F. J. Bigger Collection; *Thom's Directory*, 1907; *Irish Review*, November 1911, August 1913 (also illustration), November 1913 (illustration), March 1914, April 1914 (illustration); Geraldine Plunkett, *Magnificat*, Dublin 1917 (illustration); Michael O'Hanrahan, *When the Norman Came*, Dublin 1918 (illustrations); *Northern Whig*, 29 January 1919; *Catholic Directory*, Dublin 1920; J. Crampton Walker, *Irish Life and Landscape*, Dublin 1927 (also illustration); *Dublin Magazine*, July-September 1936, April-June 1938; *Seumas O'Sullivan Papers*, Trinity College, Dublin [1958]; Bulmer Hobson, *Ireland Yesterday and Tomorrow*, Tralee 1968; Miss P. D. Morrow, *Letter to the author*, 1968; John Hewitt and Theo Snoddy, *Art in Ulster: 1*, Belfast 1977; *Oireachtas Catalogue*, Dublin 1977; John Killen, *John Bull's Famous Circus: Ulster History through the Postcard 1905-1985*, Dublin 1985 (also illustration).

MORROW, MICHAEL (1929-94), figure painter and illustrator. Born in London on 2 October 1929, Norman Michael Macnamara Morrow was the son of H. L. (Larry) Morrow, BBC and Radio Éireann broadcaster, whose father Harry was a brother of George Morrow (q.v., et al). In the Morrow artistic tradition, Michael attended Hammersmith School of Art but the family left London for Dublin and he enrolled at the National College of Art. Only there about a year, he accompanied his mother and sister Brigid to Belfast.

Michael Morrow then attended Belfast College of Art but according to his sister, he 'hated it.' One day he took off on his bicycle, telling only Brigid, and cycled to Dublin, no mean feat for someone apparently with haemophilia (in later life diagnosed as Christmas disease). He returned to the College of Art in Kildare Street. In 1950 he enjoyed touring Galway in a donkey-cart. He showed the oil, *Chloe* (Armagh County Museum) at the Royal Hibernian Academy in 1950.

In 1951 he held an exhibition in Dublin with Beatrice Salkeld (q.v.) and John ffrench at the Grafton Gallery. The *Dublin Magazine* critic commented: 'If Michael Morrow continues in the way that he is going he will be listed among our primitives. I feel, however, that his primitivism is rather self-conscious and that the muddy paint, inexpert drawing and laboured quality are carefully cultivated effects. *Portrait*, a pleasant, if not strikingly original work, shows none of these calculated crudities; while his wood-engravings show talent as an illustrator which should be worth cultivating...'.

Morrow's friend ffrench regarded him as 'one of the most gifted students in the College at that time. His style of painting was very much in the school of the Italian Renaissance which was not at all the style which all the other painting students followed.' His education had often been interrupted by bleeds, resulting in hospitalisation.

In 1951 he won the Henry Higgins travelling scholarship. The *Daily Express* published a photograph: 'The man with a lute showing over his shoulder, a bicycle, a beard, and a haversack is a 21-year-old artist Michael Morrow, of Strand Road, Merrion Gate, Dublin, ready for a journey. It will last a year...The haversack is packed with paint and canvases for the work he plans. He will sleep in a tent...'. He had £5 per week to spend. In the event, he first studied in Paris, where he spent a night in gaol for busking on another fellow's pitch; and he also visited Munich and Florence.

Morrow supplied linocuts for two books published by the Dolmen Press, *Freebooters* by Maurice Kennedy, 1952, and *An Alphabet of Aphorisms* by Arland Ussher, 1953. Musica Da Camera provided a serenade concert in Fellows Gardens, Trinity College, in 1953, with Brigid and Michael Morrow both on the recorder. In the same year he designed and painted the settings for *The Surprise* by G. K. Chesterton at the Pike Theatre Club. In private possession is a large oil painting, *Adam and Eve*.

In 1954, the year he departed Dublin and settled in London, Morrow exhibited a portrait of his friend, Roger Shackleton (q.v.) at the RHA. At this stage he was very involved in early music and had little desire to paint again. However, he supplied some illustrations for *Ireland of the Welcomes*. He founded Musica Reservata in 1960. On music subjects, he worked for *Encyclopaedia Brittanica* and was for a time editor of the *Lute Society Journal*. He died in London on 20 April 1994 at Royal Free Hospital, Hampstead.

Works signed: Michael Morrow, probably verso (if signed at all).
Examples: Armagh: County Museum.
Literature: *Dublin Magazine*, April-June 1951, April-June 1956; *Daily Express*, 27 July 1951; *Royal Dublin Society Report of the Council*, 1951; Maurice Kennedy, *Freebooters*, Dublin 1952 (illustrations); Arland Ussher, *An Alphabet of Aphorisms*, Dublin 1953 (illustrations); Merrill Moore, *Homo Sonetticus Moorensis*, New York 1955 (illustrations); *Ireland of the Welcomes*, July-August 1963 (illustrations); *Musica Reservata*, programme, June 1967; Liam Miller, *Dolmen XXV*, Dublin 1976; *Irish Times*, 23 April 1994; John ffrench, *Letters to the author*, 1997, 2000; Mrs Brigid Ferguson (née Morrow), *Letters to the author*, 2000; Mrs Hedy Morrow, *Letter to the author*, 2000.

MORROW, NORMAN (1879-1917), topical illustrator and cartoonist. One of the eight sons of George Morrow, painter and decorator, of Hanover House, Clifton Street, Belfast, Norman Macnamara Morrow was born in Belfast on 21 August 1879. A brother of Albert, Edwin, George and Jack Morrow (qq.v.), he entered the Royal Belfast Academical Institution in 1895. He also attended the Government School of Art, showing distinctive gifts, and before he left Belfast for London he had contributed a few theatre sketches and several cartoons in 1901 and 1902 to the *Belfast Critic*, a weekly.

Morrow's *Volendamers*, watercolour, dated 1903, is in the Ulster Museum collection. *Venetian Ladies* in coloured chalks was dated '04. Intimately involved in the early days of the Ulster Literary Theatre, he designed sets, acted and managed. He was an active member of the Belfast Art Society.

In London, where he met Paul Henry (q.v.), he was a member of the Dungannon Club; meetings were held in his studio in Chelsea. Herbert Hughes was the main instigator in founding the club, and a portrait of Hughes by Morrow appeared in the Belfast Museum and Art Gallery's loan exhibition of Irish portraits by Ulster artists in 1927. His political cartoon, *Sinn Féin and Prosperity*, appeared in *The Republic*, 24 January 1907, a weekly founded and edited by Bulmer Hobson in Belfast. Subsequently this cartoon was published as a postcard by the Dungannon Club.

In 1908 he exhibited with five brothers at 15 D'Olier Street, Dublin, his own contributions having Italian and Spanish subject matter. In reproducing *South Holland Types* in 1911, the *Irish Review* commented: 'Norman Morrow's mind, as portrayed by that fine and marvellously accurate line of which he is a master, is possessed of a deep and grave humour – a humour that fades the smile it raises and leaves us amused but meditative'.

Morrow contributed drawings to the *Graphic*, but later his cartoons and topical illustrations became a feature in the *Bystander*, particularly his sketches for the weekly dramatic criticism. When war broke out he crossed to Belgium and illustrated certain phases of life under war conditions. In his domestic career, he was responsible for some posters and book illustrations.

Although his health was not good, he undertook eight scene paintings for E. V. Lucas's *His Fatal Beauty; or, The Moore of Chelsea*, at Chelsea Palace on 20 March 1917, satirising Moore's frequent sittings: *A Young Man's Confessional* (The Café Royal), after W. Orpen; *Portrait of a Gentleman*, after W. Nicholson; *The Moore emerging from the Twopenny Cube*, after C.R.W. Nevinson; *The O'Logian* (Portrait of an Irish Virtuoso), after J. S. Sargent; *A Dramatist in Muslin*, after Ambrose McEvoy; *The Moore leaving Tara's Halls*, after James Pryde; *Esther waters the Bananas*, after Roger Fry; *The Mummers*, after Augustus John.

A bachelor, the *Bystander* found him 'a strange, reticent man, with the simplicity of the child in worldly affairs and an enviable wisdom in the things that matter ... His work at the theatre placed him easily at the top of his own particular ladder ...'. *The Belfast Telegraph* discerned humour of 'an ironic cast, with a subtlety that, probably, in conjunction with his independent attitude towards popular taste rather limited his appeal. But, nevertheless, his work was widely and favourably known and appreciated for its dry and pungent humour'. Also at the Ulster Museum are *Man and a Woman*, gouache, and *A Suspicious Looking Couple*, charcoal. He died on 8 September 1917 at his Chelsea residence.

Works signed: Norman Morrow, Mara; N. M., monogram; N. Mac, rare; N. M. or N.
Examples: Belfast: Ulster Museum.
Literature: Fitzroy Gardner, *Pure Folly: The Story of those remarkable people the Follies*, London 1909 (illustrations); *Irish Review*, May 1911 (also illustration); H. G. Pelissier, *Potted Pelissier*, London 1913 (illustrations); *Belfast Telegraph*, 10 September 1917; E. V. Lucas, *His Fatal Beauty; or, the Moore of Chelsea*, London 1917 (illustrations);

The Bystander, 19 September 1917; *Dublin Magazine*, January-March 1950; Paul Henry, *Further Reminiscences*, Belfast 1973; John Hewitt and Theo Snoddy, *Art in Ulster: 1*, Belfast 1977; *Dictionary of British Book Illustrators and Caricaturists 1800-1914*, Woodbridge 1978; *Irish Arts Review*, Winter 1985; John Killen, *John Bull's Famous Circus: Ulster History through the Postcard 1905-1985*, Dublin 1985; Royal Belfast Academical Institution, *Letter to the author*, 1990.

MOSS, HENRY W. (1859-1944), landscape painter. Henry William Moss studied at Dublin Metropolitan School of Art; the Royal Hibernian Academy Schools; under Stanhope Forbes, RA (1857-1947) at Newlyn, Penzance; and at Heatherley's Academy, London. He painted in England, France and Italy but many of the landscapes which he exhibited in Dublin had Irish subject matter.

In 1888 his address was Elmfield, Sandyford, Co. Dublin, and from then until 1936 he showed more than fifty works at the RHA. He contributed three pictures to the Royal Society of Artists, Birmingham. In 1904, when living at Greenmount, Milltown, Co. Dublin, he was on the committee of the Dublin Sketching Club and later became president. In 1908 at the RHA he showed *Evening on the Moors – Holyhead*, and in 1912 a Breton coast scene and *Quiet Fields, Rathfarnham*. The wooded landscape and the fall of sunlight through trees was a feature of his work.

In 1908 he exhibited with the Water Colour Society of Ireland for the first time and altogether showed fifty-one pictures. In 1913 he contributed *A Breton Harbour* and in 1916 two monotypes, *Feltrim Mill* and *The Moor*.

Moss also exhibited with the Munster Fine Art Club. By 1918 he was living at Springmount, Howth, Co. Dublin, and there he recorded Howth Head and its indigenous goats. In 1925 in Dublin he showed five works, including *Older than St Patrick* and *Autumn in the Forest*, at Daniel Egan's Proto-Salon. *The Elms of Warwickshire* was hung in 1925 at WCSI. By 1926 he was still exhibiting with the Dublin Sketching Club, at Mills' Hall, Merrion Row, and at the RHA in 1934 he showed three works: *Guy's Cliff, Warwick*; *Oaks of Brittany*; and *The Waning Year*. He died in Dublin.

Works signed: Henry W. Moss or H. W. M.
Literature: *Dublin Sketching Club Minute Book*, 1904; Daniel Egan, *Proto-Salon, modern oil paintings and water colours*, catalogue, Dublin 1925; *Irish Independent*, 23 October 1926; *Who's Who in Art*, 1934; *Irish Times*, 23 September 1978, 1 December 1979; Ann M. Stewart, *Royal Hibernian Academy of Arts: Index of Exhibitors 1826-1979*, Dublin 1986; *Water Colour Society of Ireland Exhibition List 1872-1994*, Dublin 1995.

MOSS, PHOEBE ANNA – see TRAQUAIR, PHOEBE ANNA

MOYNAN, RICHARD T., RHA (1856-1906), portrait and genre painter. Born on 27 April 1856 at 1 Eldon Terrace, South Circular Road, Dublin, Richard Thomas Moynan was the son of Richard Moynan. Intended for the medical profession, he studied at the Royal College of Surgeons in Ireland and had nearly completed his course when his love for art induced him to abandon a career never congenial to him.

Moynan began exhibiting at the Royal Hibernian Academy in 1880, the year of the record attendance of 35,000, and altogether showed nearly ninety works. The two pictures which he contributed in 1880 were based on quotations from Byron. As a pupil at the Royal Dublin Society's School of Art, he won a prize for painting in 1881 and the Cowper prize for the best drawing from life in 1882, when he showed four works at the Academy.

As a student in the Royal Hibernian Academy Schools he won a silver and a bronze medal, and a prize for a study in the painting class of 1883. In that year he was awarded the Albert Scholarship for the best picture shown at the RHA by a student, with his *The Last Stand of the 24th at Isandula, 1879*, a work which must have surprised the judges, all the more so as it was based on a description in the *Natal Times*.

In October 1883 he entered the Académie Royale des Beaux-Arts in Antwerp with Roderic O'Conor (q.v.) and they lodged at 12 Keizerstraat. He enrolled in the Antique class but soon changed to the Life class under Charles Verlat (1824-90). After six months study he gained the first place for painting from the living model in the annual 'concours', in which a hundred students of all nationalities competed. Moynan, it is assumed,

must have had a short spell at the Dublin Metropolitan School of Art, contemporary with O'Conor, because the headmaster, Edward Lyne, in a later report, singled out his achievement.

In 1885 he moved to Paris and resided at 2 Avenue Victoria, Place du Châtelet. Among those he studied under was W.- A. Bouguereau (1825-1905). Giving the address 61 Grosvenor Road, Dublin, he showed six works at the 1885 RHA. The critic of the *Dublin University Review* observed: 'A certain coldness of tone and a blackness in the shadows...(characteristic of the Antwerp method).' Among his 1885 canvases were *Girls Reading a Newspaper* and *The Laundress*. His four works at the 1886 RHA included *Little Coquet*, and that year he completed his studies in Paris and returned to Dublin.

According to Walter G. Strickland in his *A Dictionary of Irish Artists*, he soon won recognition by the quality of his work. 'He found employment as a portrait painter; but it was a delineator of scenes of domestic life and incidents of the streets that he excelled. He delighted in depicting features in the life of the poor, finding his models in the children of the streets.'

The Artist in his Studio in Dublin, 1887 (National Gallery of Ireland) also depicted four women in the Harold's Cross room. Associate membership of the RHA was awarded in 1889, and in 1890 he became a full member.

Moynan was principal cartoonist of *The Union*, 'a journal devoted to the maintenance of the union of the three Kingdoms,' and published weekly in Dublin. He signed his work 'Lex'. Taking, for example, the first five issues in 1889, illustrations prominent on the front page, he included *'Tanner Challenge Cup'* for the 'worst mannered, most foul-mouthed member of the Irish Parliamentary Party — to be awarded at the end of each Session. Design registered.' In another issue there was *Squirming*: 'Mr William O'Brien, MP, calls upon High Heaven to witness that he meant no insult whatever to the Royal Commission, which he called "blackguard" at Naas. What will his allies in America think of this? The Judges [three in background] let him down easy on promise of good behaviour.'

In 1891 he showed his highest priced work so far at the Academy, *Military Manoeuvres*, now at NGI. The street scene, exhibited in 1893 in the Chicago World's Columbian Exposition, British section, included a member of the 4th (Royal Irish) Dragoon Guards in walking-out dress in Leixlip, Co. Kildare. In the four years 1892-5 he showed no fewer than thirty-one pictures at the Academy including some portraits, but in 1894 there was also *Only a Poor Little Crossing sweeper* and *Only a Waif! Cold and Wearied!*

In his usual amusing style, Michael J. F. McCarthy recorded in his *Five Years in Ireland 1895-1900*: 'The Artists are not what can be styled a pampered class in Ireland. When Lord Iveagh bought a street urchin picture of Mr Moynan's in 1899 for £400, the firesides of Dublin re-echoed the marvellous fact in a hundred thousand echoes that evening. Mr Moynan loves the street urchin, and, it may be safely said, no painter ever had a more unlimited supply of models to work upon than Mr Moynan finds in Dublin.' Incidentally, the price of £400 was listed for *Rescue* at the 1900 RHA. He also showed in Liverpool at the Walker Art Gallery.

In 1901 he exhibited a portrait of Sir James Creed Meredith, Deputy Grand Master, Grand Lodge of Freemasons, Ireland, a work which is in Freemasons' Hall, Molesworth Street, Dublin, where there are also portraits of T. R. G. Jozé and Henry Erasmus Flavelle.

According to Strickland, for several years 'he was a leading and most popular exhibitor at the Academy, and had every prospect of a brilliant career; but unfortunately he gave way to intemperance which gradually affected his powers and his health, and ultimately wrecked his career...'. *The Street Arab's Tribute* of 1902 RHA was regarded as unfinished. *Nestings* and *Two Little Belgians* were hung in 1903, his last year.

At the NGI are also nine sketchbooks, and in one of these are forty used leaves with animal, figure and portrait studies, also a series of political cartoons of which *The Morley Guillotine, a present from Ulster* was one, reference *The Union*. The collection also includes *A Castle on a River, Sunset* and *The Death of the Queen*, both oils. He died at his residence, 15 Garville Avenue, Rathgar, on 10 April 1906 and was buried at Mount Jerome Cemetery.

Works signed: R. T. Moynan, Moynan, rare, or Lex, cartoons.
Examples: Dublin: Freemasons' Hall, Molesworth Street; National Gallery of Ireland.

Literature: Michael J. F. McCarthy, *Five Years in Ireland 1895-1900*, London and Dublin 1901; Walter G. Strickland, *A Dictionary of Irish Artists*, Dublin 1913; *Dictionary of British Artists 1880-1940*, Woodbridge 1976; Anne Crookshank and The Knight of Glin, *The Painters of Ireland c. 1660-1920*, London 1978 (illustration); National Gallery of Ireland, *Exhibition of Acquisitions 1981-82*, catalogue, Dublin 1982 (also illustration); Julian Campbell: National Gallery of Ireland, *The Irish Impressionists: Irish Artists in France and Belgium 1850-1914*, Dublin 1984 (also illustrations); National Gallery of Ireland, *Acquisitions 1982-83*, catalogue, Dublin 1984 (also illustrations); and *Acquisitions 1984-86*, catalogue, Dublin 1986 (also illustration); Ann M. Stewart, *Royal Hibernian Academy of Arts: Index of Exhibitors 1826-1979*, Dublin 1986; John Turpin, *A School of Art in Dublin since the Eighteenth Century*, Dublin 1995; Grand Lodge of A. F. & A. Masons of Ireland, *Letter to the author*, 1999.

MULCAHY, ROBERT (1955-82), sculptor. Born in Castlemahon, Co. Limerick, he studied at the Limerick School of Art and Design from 1974 until 1979, working in stone, wood and metal. In 1977 he held a one-person exhibition at the Newcastle West Festival, and that year, as in 1975, he showed at the Oireachtas exhibition in Dublin.

In 1978, when he won first place in sculpture at the Oireachtas, he was one of ten Irish sculptors who participated in an Arts Council sculpture seminar in Co. Dublin under the directorship of Minoru Niizuma, who travelled from Japan. Following this successful event, he in turn journeyed to Japan in 1979 on an Arts Council bursary to the Iwate stonecarving seminar, invited by Niizuma. In alabaster, *Anu Mumhan*, 46cm by 28cm, was carved in 1979.

Mulcahy, whose main medium was stone, was a member of the ad hoc committee which founded the Sculptors' Society of Ireland in 1980. The next year his work was included in the exhibition at Tulfarris Gallery, Co. Wicklow, of the selected artists who had made submissions for the Guinness Peat Aviation Awards for the Visual Arts.

Logaire Lorc, a figurative work in Kilkenny limestone, is at Dundrum Boys' Vocational School, Co. Dublin. *Carnac* is placed at Upper Leeson Street, Dublin, erected by residents. His *Sjunju Figure* in marble was described by a fellow artist as approximately 20cm high, 20cm wide and 38cm long and as 'a figure turned in half and leaning on its elbows, a carved and incised band around its forehead above an oriental-featured face that looked out in contemplation'.

A lecturer at Dun Laoghaire School of Art, with a studio in Co. Clare, Bob Mulcahy was tragically drowned on 18 July 1982 when his canoe overturned on Lough Derg, Co. Clare.

Works signed: Mulcahy (if signed at all).
Examples: Dublin: Upper Leeson Street. Dundrum, Co. Dublin: Boys' Vocational School.
Literature: *Arts Council Annual Report*, 1979; *The Guinness Peat Aviation Awards for the Visual Arts*, catalogue, Dublin 1981; Roderic Knowles, *Contemporary Irish Art*, Dublin 1982 (also illustration); *Irish Times*, 20, 23 and 29 July 1982, 11 December 1982; *Sculptors' Society of Ireland: photographic index*, Dublin 1982; Cliodna Cussen, *Letter to the author*, 1990.

MULLIGAN, CHARLES J. (1866-1916), sculptor. Born in humble circumstances in Ireland on 28 September 1866, there is some doubt about the exact location. The birthplace is variously described as 'Aughnachy' (Aughnacloy, Co. Tyrone?) and 'Riverdale, Co. Tyrone', also unknown. There is, however, a Riverdale in Co. Westmeath.

Mulligan travelled to America at the age of seventeen and found employment as a stonecutter in Pullman, near Chicago. Here he was discovered by the sculptor of portraits and monumental allegorical works, Lorado Taft (1860-1936), who was trying to encourage artistic craftsmanship by means of a small vocational school in Pullman.

Taft eventually received Mulligan as pupil-assistant in his own studio in Chicago, opened in 1886, and first called on the apprentice to help in the carving of a model bust. The master noted that his new recruit not only had a skilful hand and an active imagination, but also a radiant personality which kindled the enthusiasm of the students in the evening classes of the Art Institute of Chicago, where 'Charley', not content with hard work all day long, spent three evenings a week in modelling.

In addition to his Art Institute training, Mulligan had a brief period of study under Alexandre Falguière (1831-1900) in Paris, where Taft himself had spent three years in training. In 1891 he was chosen by Taft to be the foreman of his Columbian Exposition workshop. Early attempts in creative work revealed his aspiration to become 'the prophet of hopeful, cheerful labour'. At the Buffalo Exposition in 1901 his statue *The Digger* attracted attention by its 'lively sincerity.'

Mulligan was closely associated with the Society of Western Artists. Exhibitions were held at the Art Institute of Chicago. In 1896 he had contributed a portrait to the inaugural exhibition. He also showed with the Society in 1898, from the Athenaeum Building, Chicago; and in 1901 with the Art Institute as his address. In 1903 he rather surprisingly exhibited three photographs, two of *The Miner* and one of *The Digger*.

The Art Institute of Chicago organised exhibitions of 'Works by Chicago Artists'. *The Digger*, which he had shown in plaster at the 1901 event, was 'designed to commemorate the opening of the drainage canal'. In 1902 he again contributed, and in 1903 exhibited a plaster statue of Abraham Lincoln 'for Rosemond, Illinois, copies in bronze for 1,800 dollars'. In 1904 he gave his address as 722 S. Ridgeway Avenue, Chicago; as well as showing a statue of McKinley, he was represented by a figure for the Mining Building, World's Fair. In 1907 he exhibited *Statue of Lincoln* and *Bust of Tanner*.

After Taft's resignation in 1906 as head of the department of sculpture at the Art Institute, where he had introduced marble carving, Mulligan was chosen for the position, and remained there until his death. His *Miner and Child* or *Home*, a pyramidal group in marble, is in Humboldt Park, Chicago. Garfield Park, in the same city, has his statues, *Lincoln as Railsplitter* and *John F. Finerty*; his *President McKinley* is in McKinley Park.

Popular among his artist companions in Chicago, he was instrumental in forming the nucleus of the artist colony, Eagle's Nest, later established in Oregon, Ill. One of the founders of the Palette and Chisel Club, he was, too, a member of the Chicago Society of Artists, Beaux Arts Club, Cliff Dwellers, and the Irish Fellowship Club.

Among his other works were *Justice and Power*, with *Law and Knowledge*, a pair of entrance groups for the State House, Springfield; also in Illinois a statue of General George Rogers Clark at Quincy and *The Three Sisters* at Springfield. He was also responsible for the soldiers' monument at Decatur, Indiana, and the monument depicting Lincoln, the president; Grant, the warrior; and Yates, the governor, at Vicksburg, Mississippi. He died in St Luke's Hospital, Chicago, on 25 March 1916. Taft was one of the seven who spoke at the memorial service.

Examples: All USA: Chicago: Garfield Park; Humboldt Park; McKinley Park. Decatur, Indiana. Quincy, Illinois. Springfield, Ill.: State House. Vicksburg, Mississippi.
Literature: *Bulletin of the Art Institute of Chicago*, May 1916 (also illustration); *Dictionary of American Biography*, New York 1934, 1958; Mantle Fielding, *Dictionary of American Painters, Sculptors and Engravers*, New York 1945; Art Institute of Chicago, *Letter to the author*, 1990.

MULLIGAN, W. A. (1859-1919), landscape and portrait painter. Walter Andrew Mulligan was born in England on 10 June 1859 at Lincoln Hill Cottage, Madeley, Salop, the son of an artist, James A. Mulligan. He was trained at South Kensington, and resided at Malvern, Worcs. in 1888. Two years later he was appointed headmaster of the School of Art in Cork. He showed five works at the Royal Society of Artists, Birmingham, and in 1890, from St Patrick's Hill, Cork, he first exhibited at the Royal Hibernian Academy with three North Yorkshire landscapes, featuring Robin Hood's Bay and Bolton Abbey.

Mulligan must have been a person of some private means. At one point the attention of the School of Art committee was directed 'to the very handsome subscription given each year by Mr Mulligan towards the salaries of the assistant teachers, the amount in 1892 being £80, and in 1893, £98'.

Portrait of John O'Mahony, hung at the RHA in 1891, is at the Crawford Municipal Art Gallery. He continued to exhibit in Dublin and in all showed thirty-seven works, the last in 1916. In 1894 his address was 12 Charlemont Terrace, Cork. Judging by titles, for the next five years or so he spent holidays painting in North Wales, for example at Capel Curig; on the Conwy river; and at Llangollen.

In 1900 Mulligan established crochet classes at the School of Art specifically to help those who wished to earn money by their work. In 1906 he resided at Wellington Villas, Military Road, Cork. A portrait at University College, Cork, of President W. K. Sullivan, who retired from office in 1890, was painted in 1907, and two years later at the RHA he showed portraits of John Gilbert and Mrs W. A. Mulligan. Although *The Times* described him as being 'well known in London art circles' and a portrait painter 'of considerable standing', he did not contribute to the Royal Academy.

In 1910 he became a foundation member of the Guild of Irish Art-Workers, acting as secretary of the Munster committee. In 1912 and 1913 he exhibited in Dublin three street scenes in the market town of Falaise, Normandy, and in 1914 Belgian subjects: *Namur-Old Houses on the Sambre* and *On the Banks of the Meuse*. Thereafer he apparently confined his painting excursions to the West of Ireland.

Mulligan's heart was much in the School of Art, and at one period when it was in 'pecuniary difficulties' he came to its assistance by not accepting his full salary. He also gave financial help in establishing classes which taught the application of art to industry. He retired from his post, on account of failing health, a few months before his death on 12 January 1919.

Works signed: W. A. Mulligan (if signed at all).
Examples: Cork: Crawford Municipal Art Gallery; University College.
Literature: *Register of Births, Madeley*, Co. Salop, 1859; *Cork Examiner*, 14 January 1919; *The Times*, 14 January 1919; Crawford Municipal Art Gallery, *Letters to the author*, 1969, 1990; *Dictionary of British Artists 1880-1940*, Woodbridge 1976; Ann M. Stewart, *Royal Hibernian Academy of Arts: Index of Exhibitors 1826-1979*, Dublin 1986; Cork Corporation, *Letter to the author*, 1990; Peter Murray, compiler, *Illustrated Summary Catalogue of The Crawford Municipal Art Gallery*, Cork 1991 (also illustration); Paul Larmour, *The Arts & Crafts Movement in Ireland*, Belfast 1992.

MURDOCH, ROBERT W. (1880-1956), landscape and seascape painter. Robert Wright Murdoch was born in Magherafelt, the second son of Dr J. Murdoch. He left the Co. Derry town at the age of seventeen for study at the Dublin Metropolitan School of Art, and later he received tuition at Heatherley's Academy, London.

In 1902, giving a Dublin address, he exhibited *A Summer Shower* and *A Fortune Teller* at the Royal Hibernian Academy. He spent some seven years in business as a photographer in Londonderry but gave the profession up to devote his time to painting. He was not, however, a regular exhibitor. When residing at Whitehead, Co. Antrim, he showed three works at the Belfast Art Society exhibition of 1922: *Decorative Landscape*, watercolour; *Port Muck, Islandmagee*, watercolour; *An Old Barn*, oil.

In addition to painting on the Antrim and Derry coasts, he was also responsible for some portraits and flowerpieces. In the 1920s he moved to Portstewart, Co. Derry, and later died there. His daughter Lilian, also an artist, passed away in that town in 1989.

Works signed: R. W. M.
Literature: *Dictionary of British Artists 1880-1940*, Woodbridge 1976; Miss Lilian Murdoch, *Letter to the author*, 1976; also, Miss E. C. Mann, 1990.

MURNAGHAN, ART – see O'MURNAGHAN, ART

MURPHY, DONAL – see Ó MURCHADHA, DOMHNALL

MURPHY, FRANK (1925-79), landscape painter. Born on 24 May 1925 at the Maze, Hillsborough, Co. Down, he was the eldest son of Frank McKelvey (q.v.). Since childhood, he painted as a hobby, and in his younger days he devoted himself to watercolours. Educated at the Royal Belfast Academical Institution and Trinity College, Dublin, where he studied law, he made a career in commerce.

In order to avoid confusion with his father's work, he adopted his mother's maiden name. In 1959, from 17 Inverness Road, Fairview, Dublin, he first exhibited at the Royal Hibernian Academy: a Co. Down and a

Co. Kerry landscape, both watercolours. Taking a great delight in accompanying his father, he painted in Brittany and Normandy. In 1961 at the RHA, from 51 Brighton Road, Rathgar, Dublin, he showed *Near Honfleur, Normandy*.

In the early 1970s he returned to Northern Ireland from Scotland, and held a one-person show in 1976 at the Oriel Gallery, Dublin, the year he retired from business, allowing him to devote more time to painting. In 1977 he exhibited landscapes and seascapes at the Grendor Art Gallery, Holywood, Co. Down. His main love in later years was Irish landscapes in oils, and there was a similarity in style to his father's work. He had, in an incidental way, a special fascination for certain kinds of mechanical and precision drawing.

Before his death, some of his paintings appeared in the Dublin auctions, for example *Near Falcarragh, Co. Donegal* and *Waiting for the Rathlin Boat, Ballycastle*. When living in Co. Antrim, he contributed only three more works to the RHA: in the last three years of his life. Of Cushendall Road, Ballycastle, he died in hospital on 25 August 1979.

Works signed: Frank Murphy or Frank McKelvey.
Literature: Grendor Art Gallery, *Frank Murphy (Frank McKelvey, jun.)*, catalogue, Holywood 1977; *Irish Times*, 13-14 April 1979, 11 September 1979; *News Letter*, 27 August 1979; Ann M. Stewart, *Royal Hibernian Academy of Arts: Index of Exhibitors 1826-1979*, Dublin 1986; Mrs Elizabeth McKelvey, *Letter to the author*, 1990.

MURPHY, MICHAEL T. (1867-1938), sculptor. Born at Bantry, Co. Cork, on 24 November 1867, Michael Thomas Murphy was apprenticed to a marble carver in Cork, and studied at the Crawford School of Art, where he was awarded a £50 grant in 1887, and then moved to South Kensington. A copy in marble of a bas-relief by Donato di Niccolo Donatello (1386-1466), carved in London by Murphy, was purchased by the Director of Art at South Kensington for £25. In 1890 he showed a bust, *T. D. Sullivan, Esq., MP*, at the Royal Academy, from a Chelsea address, and in 1893 another bust, *Mervyn Macartney, Esq.* In 1894 he contributed a medallion, *Frank*.

On his return to Cork he executed several commissions. His marble bust, *Denny Lane,* dated 1897, is in the Crawford Municipal Art Gallery. An unsigned plaster head from life in the same collection may be of Sullivan. There is some uncertainty about two sculptors named Murphy at this time. Thomas Joseph Murphy, sculptor and painter, who also practised in London, was responsible for the bust of G. F. Bodley at the Bodleian Library, Oxford, and is said to have been born in Cork in 1881. If this year is correct, he is certainly not 'the son of Michael Murphy', at least not the one mentioned in this entry.

An obituary in an undated, untitled American newspaper cutting stated that to Murphy 'royalty once sat ... his work of the King's mother was considered his greatest achievement'. It was in 1912 that he emigrated to America. Contrary to American biographical data, he is not represented in the permanent collection of the Art Institute of Chicago, but he exhibited there in five exhibitions between 1913 and 1922 inclusive, mainly portraits. In four, both Christian names were shown in the catalogue; the other entry was M. Thomas Murphy. In 1918 his address was given as 4 E. Ohio Street, Chicago. In 1919 he exhibited *James E. Quigley, DD, Archbishop of Chicago*, plaster; and in 1922: *John A. Carroll, Esq.*, marble; *Most Reverend Archbishop Mundelin*, marble. He was a member of the Chicago Society of Artists.

Among Murphy's principal works were *Aaron Blessing the Israelites*, which he executed for Fourth Presbyterian Church, Chicago (cannot now be traced) and heroic size figures representing an athlete and a student for the University of Michigan's Union building, flanking the bay above the main entrance, having been carved from structural limestone blocks. *Athlete* looks toward the field, and *Student* gazes toward the campus. This building was completed in 1919.

According to the newspaper cutting, his career concluded as a resident in the small Catholic settlement in Perdido Heights, and before the lingering illness which took his life, he had been working on a bust of Bishop Thomas J. Toolen of the Mobile diocese, which included Pensacola, Florida. In 1990, this work could not be found in the diocese of Pensacola-Tallahassee.

Works signed: M. Murphy.

Examples: Cork: Crawford Municipal Art Gallery. Michigan, USA: University.
Literature: *Michigan Alumnus*, April 1920; Mantle Fielding, *Dictionary of American Painters, Sculptors and Engravers*, New York 1945; E. Bénézit, *Dictionnaire des Peintres, Sculpteurs, Dessinateurs et Graveurs*, Paris 1966; *Irish Art in the 19th century*, catalogue, Cork 1971; Art Institute of Chicago, *Letter to the author*, 1990; also, Bodleian Library, 1990; Fourth Presbyterian Church, Chicago, 1990; Peter Murray, compiler, *Illustrated Summary Catalogue of The Crawford Municipal Art Gallery*, Cork 1991; University of Michigan, *Letter to the author*, 2000.

MURPHY, SEAMUS, RHA (1907-75), sculptor. Son of James Murphy, railway engine driver, he was born on 15 July 1907 at Greenhill, Burnfort, near Mallow, Co. Cork. His forebears were stonecutters. His family transferred to Cork city, and from 1912 until 1921 he attended St Patrick's National School, St Luke's Cross, where Daniel Corkery (q.v.) was a teacher. In after-school hours, Corkery taught him drawing, and through his teacher's encouragement and a studentship, he entered Crawford School of Art in 1921 to study modelling.

During his year at the School of Art – his home was at 149 Sun Row, Dillon's Cross – John Aloysius O'Connell of St Patrick's Art Marble Works, Watercourse Road, Blackpool, Cork arrived looking for a promising stonecarver 'and I was it'. He was trained during his seven-year apprenticeship as an architectural and foliage carver, attending night classes at the School of Art. At this period he met the Cork sculptor, Joseph Higgins (q.v.), later marrying his daughter, Maigread, an art teacher.

Day Dream of 1931 in white marble is at the Crawford Municipal Art Gallery. Out of his time, he won the Gibson Bequest Scholarship in 1932 and this took him to Paris for a year, 1932-3, his only travel outside Ireland. Instalments often arrived late in Paris from the School of Art and he had lean periods. He worked under the French sculptor, Marcel Gimond (1894-1961) and studied at Colarossi's with Andrew O'Connor (q.v.).

In 1934 he opened his own stoneyard and studio at 60 Watercourse Road, next door to O'Connell's. His *Ruth Ripley*, marble, 1934, is in the Municipal Art Gallery, and *Dreamline* in Portland stone, a Madonna head, is at the Cork Sculpture Park, Fitzgerald Park. *An Speir Bhean*, a memorial to the four Kerry poets, and an early commission, is at Killarney.

In 1935 University College, Cork, organised an exhibition of sculpture by Seamus Murphy, Marshall Hutson and Michael O'Sullivan, the first exhibition of its kind held in Cork. Transportation of Murphy's large exhibits presented a problem, finally solved by the co-operation of students from the Faculty of Engineering. It was a group of UCC students who intimated to the registrar that unless the Queen Victoria statue high up on the Aula Maxima was removed, they would topple it with dynamite. The replacement was a statue of St Finbarr by Murphy.

Murphy corresponded with Eric Gill (1882-1940), sculptor, wood engraver and typographic designer, on monument letter-forms. He also received commissions from the Imperial War Graves Commission for headstones for Irish soldiers. In lean times, the inscriptional work in stone was welcome. There are many headstones in the Cork area, especially in St Finbarr's cemetery in the city; on that of Wm D. Harrington there is a salmon carved above the inscription, and on H. Hilser's a roof and pine trees on side stones. On that for Lord Longford at Mount Jerome Cemetery, Dublin, the Longford crest is above the inscription and masks of Tragedy and Comedy are on the sides. In the memorial to Michael Patrick Lynch in Dunbullogue Graveyard: medallion profile on front; cow and calf on rear.

In 1935 he provided two panels: a woman cooking, man at bench, for Cork School of Commerce. In that year he began to exhibit at the Royal Hibernian Academy, showing in most years and averaging about two pieces per year. He also sent to the Munster Fine Art Club. In his last twenty-five years most of his RHA pieces were commissioned portraits. In 1936 he showed *After Mass*, a woman in a West Cork cloak, in polished limestone, and this work was placed in the 1938 Glasgow Exhibition.

The year 1936 also produced a head of Daniel Corkery, now at the Municipal Art Gallery in Cork, and that of another friend, *The Tailor* (Tadhg O Buachalla), a cast of which is in the Abbey Theatre, Dublin; the modelling of this head was the subject of a chapter in Eric Cross's *The Tailor and Ansty*. Murphy's *Patrick Pearse*, 1936, at St Enda's, Rathfarnham, Dublin, appeared at the New York World's Fair, 1939. Three 1940 panels in Portland stone, *Spring*, *Summer*, *Autumn*, found their way to the Fitzgerald Park bandstand, Cork.

His 1941 bust of Dr Richard Hayes is at Limerick City Hall. His bust, in bronze, of Dr Douglas Hyde when President, 1941, and that of Archbishop John Charles McQuaid in the same year, was followed in 1942 by his *Thomas Davis*.

At the 1942 Munster Fine Art Club, and at the 1943 RHA exhibition he showed *Virgin of the Twilight*, now in the secular setting of the Cork Enterprise Board. Arthur Power (q.v.) in *The Bell* found that it dominated the entire exhibition, and also wrote: 'This is a fine thing: grave, profound, and beautiful'. His fellow sculptor, Oisín Kelly (q.v.) considered it 'the most important carving made in Ireland this century'. In 1943 he was elected ARHA.

On two occasions he modelled Eamon de Valera, the first as Taoiseach in 1944 and the second as President in 1959. In 1945 at the RHA he showed two works in red sandstone, *Comedy* and *Tragedy*. An unusual commission for any sculptor was the designing of the Church of the Annunciation at Blackpool, Cork, on behalf of William Dwyer, who donated and built it. The church was dedicated in 1945. Murphy also made the statues for the church, designed the tabernacle and various accessories. Two of his statues he delivered to the church in a wheelbarrow.

Bought by public subscription, the *Michael Collins* of 1948 was installed in the Hugh Lane Municipal Gallery of Modern Art; a cast is in the Cork Sculpture Park. Casts of *Sean Ó Faolain* are in Cork City Library and University College Cork. A 1948 commission was received from the USA: *St Brigid and the Twelve Apostles*, each 1.53m, especially designed to fit into thirteen niches across the façade of St Brigid's Church, San Francisco.

Naomh Padraig, 1949, went to St Patrick's College, Maynooth, and his 1950 *Tadhg Ó Donnachadha* to University College, Cork. His book on the lives of the 'stonies', *Stone Mad*, published in 1950, proved a classic. There was no shortage of sculpture commissions but his sculptor friend John Behan felt he was at his best when the subject was of his own choosing. The *Dublin Magazine* considered his *Prayer* at the 1953 RHA as the only really interesting contribution to the sculpture section; it was in fact an old work done in Paris on scholarship.

A limestone statue of St Gobnait, 1951, showed the saint standing on a beehive. He was associated with the Institute of the Sculptors of Ireland and contributed to their exhibitions of 1953, 1954, 1955 and 1959. Elected an RHA in 1954, that year his memorial to the Fenian leader Jeremiah O'Donovan Rossa was unveiled in St Stephen's Green, Dublin. A similar ceremony occurred in 1956 when *Countess Markievicz*, 91cm high, was unveiled.

Cork City Library staged a one-person show in 1956. Public commissioned portraits of Sean T. O'Kelly, when President, 1957; and *James Connolly*, 1960, for Leinster House, followed. A 1961 head of William O'Brien is at Limerick City Hall. His portrait of Monsignor Padraig de Brun is at National University of Ireland, Galway, and that of the composer, Frederick May, is at the National Gallery of Ireland and Radio Telefís Éireann, both casts. A life-size bust of Seán MacEntee is also at NGI. A dogs' drinking trough is in Patrick Street, Cork. The portrait busts continued steadily in the 1960s when there was little demand for carved figures, and he supplied *Tomás MacCurtain* and *Terence MacSwiney* for the Cork City Hall; *Dr A. J. McConnell* for Trinity College, Dublin. In 1964 he was appointed Professor of Sculpture of the RHA.

Cork Arts Society in 1968 arranged a joint exhibition with William Harrington, who showed his drawings for the second edition of *Stone Mad*. In 1969 Murphy received an honorary LL D from the National University of Ireland. Appointed to the Arts Council, Dublin, 1973, in that year he held an exhibition of forty-two portrait heads at Adare, Co. Limerick. Casts of his 1973 life-size head of Jack Lynch are in Cork at Fianna Fail Headquarters and the Airport. In 1975 he completed portraits of Presidents Erskine Childers and Cearbhall Ó Dalaigh. Áras an Uachtaráin now holds portraits of Presidents Childers, de Valera, Hyde and O'Kelly.

Most of his life he suffered from a chronic ulcer condition but always retained a sense of humour. He died on 2 October 1975 at his home 6 Wellesley Terrace, Wellington Road, Cork, and was buried in Rathcooney graveyard. A retrospective exhibition of eighty works, formulated by his daughter Bebhinn Marten, was held in 1982 at the Crawford Municipal Art Gallery and Douglas Hyde Gallery, Trinity College, Dublin.

Works signed: Seamus Murphy, S. Murphy, Seamus O Murcada, Seamus O Murchadha, Seamus O Murchu, S. O Murcada, S. M., monogram; S. M. or Seamus, rare.
Examples: Athlone, Co. Westmeath: Shannon promenade. Ballingeary, Co. Cork: Churchyard. Ballyvourney, Co. Cork: Cork-Killarney road. Bandon, Co. Cork: Newceston Central School. Bantry, Co. Cork: St Finbarr's Church. Benburb, Co. Tyrone: Servite Priory. Blackrock, Co.Dublin: Blackrock College. Carrigaline, Co. Cork: Church of Our Lady and St John. Casla, Co. Galway: Radio na Gaeltachta. Cork: Airport; Bon Secours Hospital; Chamber of Commerce; Christian Brothers' College; Church of the Annunciation, Blackpool; Church of the Descent of the Holy Ghost, Wilton; Church of the Holy Family, Military Hill; City Hall; City Library; Crawford Municipal Art Gallery; Crawford School of Art; Enterprise Board, Albert Quay House; Fianna Fail Headquarters; Fitzgerald Park; Harbour Commissioners; Opera House; Patrick Street; St Finbarr's National Hurling and Football Club; St Vincent's Church, Sunday's Well; School of Commerce; University College. Cul Aodha, Co. Cork. Dublin: Abbey Theatre; American Ambassador's Residence, Phoenix Park; Áras an Uachtaráin; Bakery and Food Workers' Amalgamated Union; Church of Adam and Eve; Hugh Lane Municipal Gallery of Modern Art; Leinster House; National Gallery of Ireland; Pearse Museum; Radio Telefis Eireann; Royal Irish Academy; St Stephen's Green; Trinity College. Finnstown, Co. Donegal: Colaiste Cu Uladh. Galway: National University of Ireland. Glanmire, Co. Cork: Scoil na nOg. Golden, Co. Tipperary. Kildysart, Co. Clare: Town square. Killarney: Fair Hill. Laurel Hill, Co. Limerick: Faithful Companions of Jesus Convent. Limerick: City Hall. Lismore, Co. Waterford: St Carthage's Cathedral. Listowel, Co. Kerry: National School. Mallow, Co. Cork: Town Hall. Maynooth, Co. Kildare: St Patrick's College. Millstreet, Co. Cork: Drishane Sisters' House. Rath Luire, Co. Cork: Shepherd Churchyard. St Paul, Minnesota, USA: Church of St Columba. San Francisco, USA: St Brigid's Church. Stroud, Kent: Church of English Martyrs. Waterford: De La Salle College; Ursuline Convent.
Literature: Eric Cross, *The Tailor and Ansty*, London 1942; *The Bell*, June 1943, December 1943; *Dublin Magazine*, July-September 1953; *Oibre*, 1967; *Irish Times*, 30 January 1968, 18 July 1969, 16 June 1970, 14 October 1982, 20 November 1985; *Cork Holly Bough*, 1975; *Cork Review*, 1980; Bebhinn Marten, *Seamus Murphy 1907-1975*, Cork 1982 (also illustrations); Ann M. Stewart, *Royal Hibernian Academy of Arts: Index of Exhibitors 1826-1979*, Dublin 1986; Mrs Maigread Murphy, *Letters to the author*, 1990, 1994, 2000; Killarney Urban District Council, *Letter to the author*, 1994.

MURRAY, EILEEN (1885-1962), figure and portrait painter. Eileen Frances Jane Bunbury Chester was born at Templemore, Co. Cork, on 21 December 1885, daughter of Col. W. L. Chester, RAMC. Educated privately, she studied with the genre painter, Stanhope Forbes, RA (1857-1947) at Newlyn, Cornwall, and was there with Laura Knight (1877-1970).

After her marriage in 1908 to Major F. S. J. Murray of the Indian Army, she had considerable success with her painting in India, winning the Viceroy's prize for the best picture at the Simla Exhibition, two gold medals at Bombay Art Society exhibitions, and two medals at the Calcutta Art Exhibition. Her work was reproduced in a *Times of India* annual. Subjects for oil paintings at Kashmir included a herdsman with goats and feeding geese.

On her return to Ireland in 1920, she lived at Mosstown House, Kenagh, Co. Longford, inherited by her husband. In Dublin, she showed six works in Daniel Egan's Proto-Salon in 1925, including *After the Day's Work (Achill Island)*, but in 1926 at the same gallery in a one-person show she presented sixty-four pictures, mainly of the West of Ireland and the Himalayas, including *In the Old Town Bordighera*; *Music Hath Charms*. She contributed five works to the 1925 exhibition of the Royal Hiberian Academy, including *Spring in the Kashmir Valley*; two paintings to the 1926 show, and no fewer than eight in 1929, among which were *The Struggle* and *The Silence*.

This – or Emigration, an oil, 91.5cm by 61cm, exhibited at a Belfast Art Society exhibition of 1926, was bought by the Belfast Museum and Art Gallery. In the same year, her studies of juveniles at the Dublin Sketching Club exhibition at Mills' Hall, Merrion Row, drew favourable attention. *A Woodland Piper*, signed and dated 1926, came up for sale at a Sotheby auction, 1985, along with five other oils including a West of Ireland seascape and portraits of Jim and Patrick Corcran. Gorry Gallery, Dublin, showed *Gossip* in a 1985 exhibition and *Donkeys on a Beach, County Mayo* in 1997.

In 1947 she left Mosstown for Killiney, Co. Dublin, and continued with her painting there as well as on Achill Island, Co. Mayo, also in Spain and Canada which she visited. According to the Waterford Municipal Art Gallery 1975 catalogue, Eileen Murray's *The Card Players* was 'probably the most popular work in the whole Waterford collection'. She died at The Balcony, Killiney, on 15 November 1962.

Works signed: E. Murray or EM, monogram.
Examples: Belfast: Ulster Museum. Waterford: City Hall, Municipal Art Collection.
Literature: Daniel Egan, *Proto-Salon, modern oil paintings and water colours*, catalogue, Dublin 1925; *Irish Independent*, 23 October 1926; General Registry Office, Dublin, *Register of Deaths*, 1962; *Waterford Municipal Art Gallery Catalogue*, 1975; *A Dictionary of Contemporary British Artists, 1929*, Woodbridge 1981; *Longford News*, 6 February 1981; Ann M. Stewart, *Royal Hibernian Academy of Arts: Index of Exhibitors 1826-1979*, Dublin 1986; Ulster Museum, *A Concise Catalogue of the Drawings, Paintings & Sculptures in the Ulster Museum*, Belfast 1986; Longford County Library, *Letter to the author*, 1990; also, J. de M. Kellock, 1995; Gorry Gallery, *An exhibition of 18th, 19th and 20th century Irish Paintings*, catalogue, Dublin 1997.

MURRAY-HAYDEN, ADRIAN (1931-75), seascape painter. Marcus Adrian Murray-Hayden was born on 23 July 1931, son of a Dublin doctor, James Murray-Hayden, MD. Educated at Clongowes Wood College, 1943-5, he studied Law for one term only at Trinity College, Dublin, having a horror of examinations. Mainie Jellett (q.v.) gave him private tuition in art, and he also studied at the National College of Art. During the 1950s he exhibited at the Dublin Painters' Gallery, and executed quite a number of anatomical drawings for the Department of Anatomy at University College, Dublin.

An accomplished yachtsman, the sea was the theme of his watercolours. His friend Arthur Power (q.v.) described him as a true Dubliner with a 'gay and witty personality.' Adrian once helped some of his friends reconstruct a Galway hooker in Dun Laoghaire, Co. Dublin, and with them he sailed to Malaga in the South of Spain, where he hoped to renew acquaintance with George Campbell (q.v.).

At the Royal Hibernian Academy he showed only seven works, the first in 1960 from 41 Fitzwilliam Square, Dublin. *Winter's Evening, Ringsend* was contributed in 1961. In 1966 and 1967 he gave the Molesworth Gallery, Dublin, as his address, but he would then have been living with his South African-born wife at The Summerhouse, Towerville, Strand Road, Sandymount. In 1971 he held a joint exhibition with Power at the United Arts Club, Dublin.

In the early 1970s he emigrated to Canada. He taught art at a Catholic missionary school at Prince George in British Columbia. He them moved to Smithers, BC, where he held painting classes, and it was in that town he decorated the walls of an hotel with panels depicting local scenes. In 1974, in Smithers, he held his only exhibition in Canada. As he was having trouble with his eyes, he went to Vancouver to see a specialist and was knocked down by a car. He died on 12 October 1975. A small memorial exhibition was held at the United Arts Club in 1977.

Works signed: Murray Hayden or A. M.-H. (if signed at all).
Literature: *Irish Times*, 11 February 1971, 30 October 1975, 25 January 1977; Mrs Barbara Carron, *Letter to the author*, 1985; Peter Murray-Hayden, *Letters to the author*, 1985; Michael C. Taylor, *Letter to the author*, 1985; also, Mrs Rosemary Tierney, 1985; Ann M. Stewart, *Royal Hibernian Academy of Arts: Index of Exhibitors 1826-1979*, Dublin 1986.

MUSGRAVE, JOAN – see JAMESON, JOAN

N

NAGLE, WILLIAM (1853-1923), draughtsman and stained glass designer. William Flood Nagle was a Dublin man who attended the Royal Hibernian Academy Schools where he won a gold medal for life drawing. He was one of the artists employed by the father of Harry Clarke (q.v.), Joshua Clarke, who established himself in 1887 as an ecclesiastical decorator at 33 North Frederick Street, Dublin.

About 1904, when Harry Clarke joined the firm, Nagle took over the position of draughtsman and stained glass worker. According to a former manager of the firm, William J. Dowling (q.v.): 'Nagle taught the young Harry Clarke many things about drawing and designing for stained glass, and in those early days the young artist came to know the importance of discipline and careful workmanship'. In 1907, at the Irish International Exhibition at Herbert Park, Dublin, Nagle showed a design for church decoration at Blackrock, also a cartoon for a *St Patrick* window.

During the First World War he also taught part-time at the Dublin Technical Schools. He worked closely with Harry Clarke and prepared a preliminary plan for the three-light window for St Barrahane's Church, Castletownshend, Co. Cork. Clarke's cartoon followed and the window was completed in 1918. Nagle painted the lettering for Clarke's *The Angel of Hope and Peace*, 1919, at the Holy Trinity Church, Killiney, Co. Dublin.

In the National Gallery of Ireland are five decorative drawings by Nagle, at least four associated with Joshua Clarke and Sons. One in gold paint, pencil and watercolour on paper is of part of a church wall decoration, including the Nativity, SS Patrick, Peter, Paul and other saints on a frieze. Another is of the altar wall elevation of a chapel dedicated to the Blessed Virgin Mary. A third is the decoration of the chancel arch of the Loreto Convent Chapel, Kilkenny. NGI also has four other decorative drawings, jointly by Clarke and Nagle.

Work at the studios was hampered by the protracted absences from work of Nagle, who had a drinking problem. Joshua Clarke, who was not well himself, was 'worried to death' in 1921 about his employee's irregular behaviour. When Harry Clarke could not find anyone to finish six of the figures in the Stations of the Cross for a Scottish order, he had to finish them himself with Nagle's help. Nagle worked at the studios until his death at Dun Laoghaire, Co. Dublin in April 1923.

Examples: Dublin: National Gallery of Ireland.
Literature: *Irish Independent*, 5 April 1923; *Dublin Historical Record*, March 1962; National Gallery of Ireland, *Illustrated Summary Catalogue of Drawings, Watercolours and Miniatures*, Dublin 1983; Nicola Gordon Bowe, *The Life and Work of Harry Clarke*, Dublin 1989.

NEILL, H. ECHLIN, RUA (1888-1981), landscape and figure painter. Born in Belfast on 14 August 1888, son of H. J. Neill, telegraphist overseer, Harry Neill attended Willowfield National School. He studied at Belfast School of Art and became a lithographic artist, serving his seven-year apprenticeship with McCaw, Stevenson and Orr, Ltd, later joining David Allen and Sons, Ltd. Initially in his career, his first job was to mix the ink for the artists and later empty the spittoons used by those who chewed tobacco.

In 1912 he became a member of the Belfast Art Society and a regular exhibitor. In 1929, from 33 Ardenlee Drive, Belfast, he showed at the Royal Hibernian Academy for the first time: two Co. Down seascapes, but he frequently painted on the Antrim coast and occasionally in Co. Donegal. Between 1930 and 1938 he exhibited fifteen works in Dublin, including *The Lake, Clandeboye*, in 1932; *The Accordion Player*, 1935; and *Blue Stack Mountains, Co. Donegal*, 1937. In 1938 he resided at 408 Woodstock Road, Belfast.

In 1930 he was on the committee of the newly-formed Ulster Academy of Arts, and in 1935 he was appointed an academician. After the bombing in 1941 of the Ulster Hospital for Children and Women, a portfolio of lithographs was published by the Academy to raise funds for the hospital; Neill's work was

included. In 1968 he was elected an honorary academician of the Royal Ulster Academy, and in 1977 at the Grendor Art Gallery, Holywood, Co. Down, he held his first one-person show. At the age of eighty-nine, he conducted an art class in Belfast. His death occurred on 18 September 1981 in hospital.

Works signed: H. Echlin Neill.
Examples: Belfast: Department of the Environment for Northern Ireland; Royal Ulster Academy; Ulster Museum.
Literature: *Belfast Telegraph*, 9 May 1958, 19 September 1981; John Hewitt and Theo Snoddy, *Art in Ulster: 1*, Belfast 1977; *A Dictionary of Contemporary British Artists, 1929*, Woodbridge, 1981; Martyn Anglesea, *The Royal Ulster Academy of Arts*, Belfast 1981 (also illustration); Ann M. Stewart, *Royal Hibernian Academy of Arts: Index of Exhibitors 1826-1979*, Dublin 1987.

NIETSCHE, PAUL (1885-1950), portrait, still life and landscape painter. Born in Kiev, Ukraine, on 17 June 1885, of Lutheran German parents, Paul Felix Franz Nietsche was one of a large family. When he was about six, the family moved to Odessa where his father, who had a personal interest in art, established a lithographic printing business. Paul attended the Imperial Art Academy.

In 1908 he entered the Academy of Fine Arts in Munich. He then moved on to Paris where he became friendly with the sculptor Auguste Rodin (1840-1917) and exhibited at the Salon of 1912. He returned to Odessa in 1914. After the end of the First World War he moved to Berlin and joined his family there. A Nietsche portrait of Feodor Chaliapin, signed and dated 1924, was auctioned by Sotheby's in 1980; the Russian singer was a personal friend.

In Berlin he became friendly with Michael O'Brien from Dublin, then a post-graduate student at the University. In 1924 Dr O'Brien was appointed to a lectureship in English at the University of Leipzig, and in 1926 he transferred to Belfast as a lecturer in Celtic studies at Queen's University. Nietsche arrived in Belfast in 1926 on the invitation of Dr O'Brien and his wife, and before the year was out he had shown five works at the Ulster Art Club's annual exhibition.

Frequently on the move, he retained a studio in his mother's apartment in Berlin and returned there, visiting Yugoslavia in 1928 when he painted on the coast near Dubrovnik. In 1929 he was back in Belfast and held an exhibition in tempera and oils at the O'Briens' home, 411 Lisburn Road. The local press noted his use of a palette knife. In Dublin, he showed only two works – in 1930 – at the Royal Hibernian Academy: *Still Life with Blue Dish* and *Still Life with old English Plate*.

In 1931 he stayed with his fellow-artist H. E. Broderick at the latter's cottage near Castlewellan, Co. Down, but that year he also painted in the South of France, near Avignon, moving on after several months to Switzerland. In 1933, after visiting Berlin again, he was at St Austell in Cornwall where he renewed acquaintance with R. S. Rendle Wood (1894-1971), who had spent some time in Ulster. In a letter from Cornwall to the Belfast Museum and Art Gallery he wrote: 'The next trip will be to London where the dealers are interested in my pictures'.

At the Brook Street Art Galleries in London in 1934 he showed a portrait of Wood, landscapes of Polperro and the South of France, Villeneuve-lès-Avignon. *Near Newtownards* was the title of a work in tempera. He arrived back in Belfast in 1934, when he exhibited at the United Arts Club, Dublin, and two years later he had a show at the Magee Gallery, Belfast.

On the invitation of Major R. G. Heyn, the subject of a portrait, he travelled courtesy of Head Line Shipping to Montreal, where he held an exhibition at the Continental Galleries of Fine Art. He also visited New York, and in 1937 arrived back in Belfast. *Gateway to the Mournes*, oil, was dated 1938. He showed with John Hunter and George MacCann (qq.v.) at the Magee Gallery in 1938, and held another solo exhibition there the following year. During the Second World War he was interned on the Isle of Man for a relatively brief period. His portrait in the Ulster Museum of the Belfast art collector, Zoltan Lewinter-Frankl, was dated 1943.

Nietsche's settling down in Belfast came when he acquired an attic studio at 76 Dublin Road, where he lived and worked until his death. Most of his painting was executed long into the night. His exhibitions were

something of an event in the city, and he had a wide range of friends. Under the auspices of CEMA, he exhibited at Tyrone House, Belfast, in 1945.

At 55a Donegall Place, Belfast, he held exhibitions in 1947, 1948 and 1949. In an appreciation in the 1947 sixpenny catalogue, the novelist F. L. Green wrote: 'Nietsche's talent is mature and philosophical, and is expressed with such clarity and vigour that its impact is startling and frequently provocative of controversy'. The 1949 exhibition included portraits of the actors J. G. Devlin and R. H. McCandless.

In addition to a self-portrait, the Ulster Museum has in its collection portraits of J. H. Craig (q.v.), F. L. Green and F. W. Hull (q.v.); *Green Apples* was dated 1949. The artist spoke fluent Russian, German, French and English, wrote and published some poetry and short stories. Another exhibition in Dublin was planned but he died in the City Hospital, Belfast, on 4 October 1950, and was buried in Belfast City Cemetery. An exhibition organised by friends was held in 1952 at the Ulster Farmers' Union Hall, Belfast. A retrospective exhibition took place at the Arts Council Gallery in Belfast, 1984.

Works signed: Paul Nietsche.
Examples: Belfast: Ulster Museum. Limerick: University, National Self-Portrait Collection.
Literature: Paul Nietsche, *Letter to Belfast Museum and Art Gallery*, 1933; Brook Street Art Galleries, *Exhibition of Paintings by Paul Nietsche*, catalogue, London 1934; *Exhibition of Recent Work by Paul Nietsche*, catalogue, Belfast 1947; *Belfast Telegraph*, 5 October 1950, 29 June 1957; *Sunday Independent*, 5 November 1950; Brian Kennedy: Arts Council of Northern Ireland, *Paul Nietsche 1885-1950*, catalogue, Belfast 1984; St Ives Society of Artists, *Letter to the author*, 1994.

NIXON, MIMA(1861-1939), landscape painter. A cousin of Dorothy Blackham (q.v.), her father was Irish. In 1891 she was a member of the Dublin Sketching Club. From 13 Woodside, Wimbledon, Surrey, she exhibited with the Water Colour Society of Ireland in 1892. She began exhibiting at the Royal Hibernian Academy in 1894, giving the address 1 Marine Terrace, Ballybrack. In 1895 – by then a member of the Belfast Art Society – she contributed to the RHA from Wimbledon. Altogether between 1894 and 1912 she showed a dozen pictures at the Dublin exhibition, including *A Street in Newlyn*, in 1896; *A Cottage Garden, Hampshire*, 1904; and *Market Day – Verona*, 1910.

The first work which she showed at the Royal Academy was *Winter blooms* in 1897. Painting activity was not confined to the London area: *A Bruges canal* was hung at Burlington House in 1903, and *Richmond Castle, Yorkshire*, in 1904. After a gap of four years, she resumed exhibiting, and in 1909 contributed *Market Day, Étaples*. From 1908 until 1913 she exhibited seven works, giving her address in 1913 as the Albermarle Club, Dover Street, London.

Mima Nixon's watercolours were also hung in London at the Fine Art Society, where she held two exhibitions, and a total of more than five score works were exhibited at the Baillie Gallery, Dudley Gallery, London Salon, Royal Institute of Painters in Water Colours, and the Society of Women Artists. In addition, she also showed in Birmingham, Liverpool and Manchester.

The first exhibition at the Fine Art Society, 1907, consisted of eighty-five watercolours, mainly of Algeria and the Low Countries. Seven were painted 'by the kind permission of the Governor-General of Algeria, the General commanding the 19th Army Corps, and the Commandant Godchot.' These works included *The Fort Ard-El-Kadr, Bougie*. In Belgium, she painted in Bruges, Brussels and Ghent; in Holland, she worked in Alkmaar, Dordrecht, Haarlem, Rotterdam, Volendam and Zaandam. Works included *Fish Wives – Bruges* and *Windmills, Zaandam*.

Further attention to her garden pictures was drawn by the publication in 1909 of *Dutch Bulbs and Gardens*, which contained twenty-four full page illustrations in colour. She was the editor of *Royal Palaces and Gardens*, published in 1916 with sixty of her illustrations in colour covering sixteen countries. Most are dated in the period 1914-6. An exhibition of her garden pictures at the Fine Art Society premises in 1914 produced a comment from *The Studio*: '... has considerable art in composing her subject, in suggesting the distances of long garden walks, and the levels of lawns; the flowers she simplifies with much skill'.

The exhibition of sixty-nine watercolours of Royal Palaces and Gardens at the Fine Art Society in March 1914 included *Necessidades' Palace, Lisbon*; *The Crown Prince's Palace Garden, Athens*; *Fredensborg*

Castle ('The autumn residence of the King and Queen of Denmark'); and *The Palace, Versailles*. Presumably some of these exhibition pictures appeared in the book. Dorothy Blackham told the editor in 1969 that she thought her cousin was interned in Europe during the war and this impaired her health. However, two pictures were hung at WCSI in 1916 but there was an interval of fourteen years before she contributed again. Among the four works at her final exhibition in 1932 were *Viceregal Lodge, Dublin* and *The Memorial Gateway, R.D.F. St Stephen's Green*. Altogether in her forty years of exhibiting with this society she showed some eighty works. Jemima Nixon died at Diamond Hill, Rathdrum, Co. Wicklow, on 11 June 1939.

Works signed: Mima Nixon.
Literature: *Dublin Sketching Club Minute Book*, 1891; Fine Art Society, *Catalogue of an Exhibition of Water-Colours of Algeria and the Low Countries by Mima Nixon*, London 1907; Una Lucy Silberrad and Sophie Lyall, *Dutch Bulbs and Gardens*, London 1909 (illustrations); Fine Art Society, *Catalogue of an Exhibition of Water-Colours of Royal Palaces and Gardens by Mima Nixon*, London 1914; *The Studio*, April 1914; Mima Nixon, *Royal Palaces & Gardens*, London 1916 (illustrations); Registry Office, Dublin, *Register of Deaths*, 1939; *Dictionary of British Artists 1880-1940*, Woodbridge 1976; Ann M. Stewart, *Royal Hibernian Academy of Arts: Index of Exhibitors 1826-1979*, Dublin 1987; *Water Colour Society of Ireland Exhibition List 1872-1994*, Dublin 1995.

O

OAKLEY, ARTHUR – see O'KELLY, ALOYSIUS

O'BRIEN, CATHERINE A. (1882-1963), stained glass artist. Catherine Amelia O'Brien was born at Ennis, Co. Clare, on 19 June 1882. She attended Dublin Metropolitan School of Art to study painting but was attracted by the stained glass classes of A. E. Child (q.v.) who became manager of An Túr Gloine in 1903. Sarah Purser (q.v.) invited Kitty O'Brien to join the Tower of Glass, and she remained until it died with her in 1963.

Probably the first of many windows which she designed were *The Annunciation* and *St Conleth and St Brigid*, 1904, both two-light, for Holy Trinity Church, Carbury, Co. Kildare. Among the more immediate commissions which followed were windows for St Enda's Church, Spiddal, Co. Galway: *St Enda*, 1906; *St Michael*, 1907, and she renewed her connection with that church with two more windows in 1919 and 1931.

The display of her stained glass at the first exhibition in 1910 for past and present students of the Metropolitan School of Art elicited favourable comment from *The Studio*. In that year she designed *The Angel of Peace* for Christ Church, Gorey, Co. Wexford, and forty-seven years later the church installed *Our Lord and St Peter walking on the water*.

This artist was responsible for two two-light windows at St Mary's Cathedral, Limerick: *History and Architecture*, 1912; *St Luke drawing the Virgin and Child*, 1914. Catherine O'Brien was taken abroad three times by Sarah Purser so that they could study old French and Italian glass, and also keep abreast of developments. Wilhelmina Geddes (q.v.) travelled with them in 1914 to look at thirteenth-century stained glass in France. At home, on four different occasions in the period 1914-47 inclusive, she designed windows for St Nahi's Church, Dundrum, Co. Dublin.

O'Brien's three 1916 windows for the Honan Chapel, University College, Cork, were: *St Flannan*; *St Munchin*; and *Scenes from the life of St John*. The window for First Presbyterian Church, Ballymena, Co. Antrim, 1920, had five lights, the same as *Crossing the bar* in St Multose's Church, Kinsale, Co. Cork. Her *Te Deum*, three-light, for Rossorry Church, Co. Fermanagh, 1921, was regarded as a principal work from the An Túr Gloine workshop. The first of her five windows for St Bartholomew's Church, Dublin, was dated 1925, the year she became a shareholder in the co-operative, and the last was 1960 in *opus sectile*. Two windows were despatched in 1927 to the Jesuit Fathers at Brophy College, Phoenix, Arizona, USA.

In her *Daughters of Erin*, Elizabeth Coxhead expressed the opinion that the gentle, very 'Irish' talent of Kitty O'Brien was ideally suited to the simplicity of village churches: 'The benign Irish saints, often standing above miniature landscapes ... are the movement's nearest approach to folk-art, and have close affinities with the banners and other embroideries executed for Loughrea by Lily Yeats and her Cuala Industries'. Thomas MacGreevy thought that her work showed a firm grasp of the peculiarities of stained glass technique which made it praiseworthy, 'even though the artist is conservative and chary of personal invention in the matter of religious approach'.

Up until the outbreak of the Second World War, there was no shortage of work, particularly from Church of Ireland churches, and her five-light *Christ and the four Evangelists*, 1931-3, for St Mary's Church, Clonmel, Co. Tipperary, was followed by a four-light for St Laserran's Church, Leighlin, Co. Carlow, 1934. In *opus sectile*, there were three 1936 lunettes for the Franciscan Friary, Athlone. The three-light, *The Good Samaritan*, 1937, went to St Mark's Church, Bradford.

At Drumcliffe Parish Church, Ennis, Co. Clare, twenty-two panels in *opus sectile* were designed between 1938 and 1947 for the reredos. Four of her windows, including a memorial for R. C. Orpen (q.v.), are in St Columba's College, Dublin. After the death of the manager of An Túr Gloine, A. E. Child, in 1939, Sarah Purser paid the debts and handed over the running to O'Brien. The year 1943 brought Miss Purser's death.

The following year the co-operative was dissolved and Miss O'Brien bought out the studio and contents for £235.

During the war some of her windows were publicly displayed at the workshop before being installed. The war caused difficulties but she doggedly continued until business picked up. Her three-light, *Love, Joy, Courage*, 1943-4, was for St Fethlimidh's Church, Kilmore, Co. Cavan. Two war memorials in *opus sectile* were provided in 1947 for Culdaff Parish Church in Co. Donegal.

The Sower, 1953-4, three lights, in Killoughter Parish Church, Redhills, Co. Cavan, was described in Michael Wynne's *Irish Stained Glass* as 'very attractive ... she allows the clear glass of the background to hold a very delicate role, as it changes colour with the weather outside'. He noted her 'strong draughtsmanship' in *The Good Samaritan* at Harold's Cross Parish Church, Dublin.

Part of the stained glass premises was rented to Patrick Pollen, who had arrived in Dublin 'to sit at the feet of Evie Hone, whose work I first saw in England ... She introduced me to Miss O'Brien.' All three showed stained glass at the 1953 Irish Exhibition of Living Art. After the death of Catherine O'Brien, Pollen designed the window in her memory in Christ Church Cathedral, Dublin.

In 1957, sixteen large roundels, which included the Stations of the Cross, were completed for St Helen's Church in Florida, USA. In 1958 a fire destroyed part of the studio and its contents, at Upper Pembroke Street, but Miss O'Brien rebuilt. *Downpatrick Cathedral*, 1960, is in Holy Trinity Church, Ballywalter, Co. Down. The last completed work was a three-light for St Multose's Church, Kinsale, 1962. She was a member of the Guild of Irish Art- Workers. There are about 150 of her Tower of Glass drawings in the National Gallery of Ireland. Her last commission, for the private chapel at Áras an Uachtaráin, was unfinished at the time of her death on 18 June 1963.

Works signed: K. O'Brien (if signed at all), for windows; Catherine A. O'Brien, Miss O'Brien, K. O'B., K O B or O B, for drawings (if signed at all).
Examples: (excluding churches closed or sold): Abbeyleix, Co. Laois: Parish Church. Aghade, Co. Carlow: All Saints' Church. Ashford, Co. Wicklow: Nun's Cross Church. Athlone, Co. Westmeath: Franciscan Friary. Balbriggan, Co. Dublin: St George's Church. Ballintemple, Co. Cavan: Ballintemple Church. Ballybrack, Co. Dublin: St Matthia's Church. Ballymena, Co. Antrim: First Presbyterian Church. Ballywalter, Co. Down: Holy Trinity Church. Belclare, Co. Galway: Church of the Sacred Heart. Belfast: St John's Church, Malone Road; Whitehouse Presbyterian Church, Shore Road. Bradford, Yorks: St Mark's Church, Low Moor. Carbury, Co. Kildare: Holy Trinity Church. Carlow, Co. Carlow: St Mary's Church. Carrickfergus, Co. Antrim: St Nicholas's Church. Castlecomer, Co. Kilkenny: St Mary's Church. Castledermot, Co. Kildare: St James's Church. Castletownbere, Co. Cork: Sacred Heart Church. Clogher, Co. Tyrone: St Macartan's Cathedral. Clonmel, Co. Tipperary: St Mary's Church. Cork: St Luke's Church, Summerhill; University College. Culduff, Co. Donegal: Parish Church. Cullybackey, Co. Antrim: Craigs Parish Church. Culmore, Co. Derry: Holy Trinity Church. Desertserges, Co. Cork: Desertserges Church. Douglas, Co. Cork: St Luke's Church. Dublin: Harold's Cross Parish Church; Rathgar Methodist Church, Brighton Road; Royal College of Surgeons in Ireland; St Bartholomew's Church, Clyde Road; Church of St Catherine and St James; St Columba's College; Church of St John the Baptist, Clontarf Road; St Mary's Home, Pembroke Park; St Michan's Church, Church Street; St Thomas's Church, Cathal Brugha Street; Tullow Church, Brighton Road, Foxrock; Unitarian Church, St Stephen's Green. Dundrum, Co. Dublin: St Nahi's Church. Dunganstown, Co. Wicklow: St Kevin's Church. Dunmore East, Co. Waterford: St Andrew's Church. Easky, Co. Sligo: St Anne's Church. Ennis, Co. Clare: Drumcliffe Parish Church. Enniskillen, Co. Fermanagh: Convent of Mercy; St Michael's Church, Trory. Fahan, Co. Donegal: Christ Church. Ferns, Co. Wexford: St Edan's Church. Finvoy, Co. Antrim: Parish Church. Florida, USA: St Helen's Church, Vero Beach. Gorey, Co. Wexford: Christ Church. Grangegorman, Co. Dublin: All Saints' Church. Groomsport, Co. Down: Groomsport Parish Church. Howth, Co. Dublin; St Mary's Church. Inistioge, Co. Kilkenny: St Mary's Church. Inniscarra, near Coachford, Co. Cork: Inniscarra Church. Izmir (Smyrna), Turkey: St John's Church. Kilberry, Co. Kildare: Kilberry Church. Kill o' the Grange, Co. Dublin: Kill Church. Killan, Co. Wexford: St Anne's Church. Killeshin, Co. Carlow: Killeshin Church. Kilmore, Co. Cavan: St Fethlimidh's Church. Kinnitty, Co. Offaly: Kinnitty Church. Kinsale, Co. Cork: St Multose's Church. Leighlinbridge, Co. Carlow: St Laserian's Cathedral. Letterkenny, Co. Donegal: St Eugene's Cathedral. Limerick: St Mary's Cathedral. Lisburn, Co. Antrim: Christ Church Cathedral. Lissadell, Co. Sligo: Lissadell Church. London: Association of British Chambers of Commerce, 14 Queen Anne's Gate. Lorum, Co. Carlow: Lorum Church. Loughlinstown, Co. Dublin: Rathmichael Church. Lucan, Co. Dublin: St Andrew's Church. Malahide, Co. Dublin: St Andrew's Church. Mallow, Co. Cork: St James's Church. Mayo, Co. Carlow: Mayo Church. Monaghan: Monaghan Presbyterian Church. Newton, nr Boston, Mass., USA: Sacred Heart Covent. Newtownbarry, Co. Wexford: St Mary's Church. Phoenix, Arizona, USA: Brophy College. Rathkeale, Co. Limerick: Holy Trinity Church. Redhills, Co. Cavan:

Killoughter Parish Church. Rossorry, Co. Fermanagh: Rossorry Church. Santry, Co. Dublin: St Pappin's Church. Saul, Co. Down: St Patrick's Memorial Church. Singapore: De La Salle Brothers' School. Spiddal, Co. Galway: St Enda's Church. Stonyford, Co. Kilkenny: St Peter's Church. Straffan, Co. Kildare: Straffan Church. Taughboyne, Co. Donegal: St Baithin's Church. Tibohine, Co. Roscommon: Tibohine Church. Wicklow, Co. Wicklow: Wicklow Church.

Literature: *The Studio*, March 1910; *List of the Principal Stained Glass Windows Executed in Ireland from 1903 to 1928 at An Túr Gloine*, Dublin [1928]; *Irish Times*, 26 February 1944; *Capuchin Annual*, 1949; *Contemporary Irish Art*, catalogue, Aberystwyth 1953; Elizabeth Coxhead, *Daughters of Erin*, London 1965; University College, Cork, *The Honan Chapel, University College, Cork*, Cork 1966; Patrick Pye, *Letter to the author*, 1968; Michael Wynne, *Irish Stained Glass*, Dublin 1977 (also illustrations); Nicola Gordon Bowe, David Caron and Michael Wynne, *Gazetteer of Irish Stained Glass*, Dublin 1988; Christ Church Cathedral, *Letter to the author*, 1990; Church of Ireland Representative Church Body, *Letters to the author*, 1990, 1991.

O'BRIEN, DERMOD, RHA (1865-1945), portrait, landscape and figure painter. William Dermod O'Brien was born on 10 June 1865 at Mount Trenchard, Foynes, Co. Limerick, the son of Edward W. O'Brien, landowner. He was a grandson of the patriot, William Smith O'Brien, MP, and his elder sister was Nelly O'Brien (q.v.). His mother died in 1869. He was sent to a preparatory school, Temple Grove, at East Sheen, Mortlake, and there he met J. O. Hannay, later known as the novelist George A. Birmingham, whose portrait he painted and saw it hung in Burlington House. In 1879 he was sent to Harrow School. Although he entered Trinity College, Cambridge, in 1883, he did not take a degree.

O'Brien did not care for a Government career. In 1886 he first visited the Continent, and studied pictures in the Louvre. Early in 1887 he was in Italy, and had decided to make painting his profession. In that year he entered the Antwerp Academy under Charles Verlat (1824-90), making friends with Walter Osborne (q.v.) from Dublin, and winning a silver medal for drawing. He was keen on animal painting and models were available. An oil painting, *The Fine Art Academy, Antwerp*, in the Ulster Museum, was dated '90. A music lover, he played in string ensembles in Antwerp. In 1891 he moved to the Académie Julian in Paris, and there he made friends with William Rothenstein (1872-1945).

In 1893 O'Brien moved to London and saw a good deal of the painter, Charles Furse (1868-1904), a distant cousin. In 1894 he enrolled as a pupil at the Slade School of Fine Art, and that year he exhibited at the Royal Hibernian Academy for the first time. Whilst living in London, he showed only one work at the Royal Academy, a portrait of Leslie Stephen in 1895. He shared a Chelsea studio in 1899 at 18 Cheyne Row with Henry Tonks (1862-1937) of the Slade. P. Wilson Steer (1860-1942) lived close by; the three artists used to meet frequently. Sir George Clausen (1852-1944) was another artist friend.

In 1901 he rented 42 Mountjoy Square, Dublin. He married in 1902, spent his honeymoon in Italy and did some sketching. When Osborne died in 1903, O'Brien and Sarah Purser (q.v.) were rival successors as portrait painters. In 1904 he was included in the exhibition of works by Irish painters held at the Guildhall of the Corporation of London and organised by Hugh P. Lane, but that year the RHA would not hang his *Infancy of Bacchus*.

In 1905 there began a long and concentrated association with the RHA when he was elected an associate. *The Jewel* of that year, a family portrait group, is in the National Gallery of Ireland. Two years later he was appointed an academician. In 1910 he took office as president, holding the post until his death thirty-five years later, and in his early years of office he did much to clear up debts. He taught at the RHA Schools and showed regularly at the exhibitions for half a century, averaging more than four pictures per year. About one third hung were portraits; in 1912 all seven works shown were in that category.

O'Brien had been a member of the committee which organised the first Oireachtas art exhibition in 1906, and he was among those who promoted the formation – in 1907 – of the United Arts Club, Dublin. Once he became a member his constant presence kept the club going in difficult times; he also exhibited there. A portrait of the poet Aubrey de Vere was subsequently burned in the fire at Curragh Chase. In 1908 he left Dublin and went to live at the family estate, Cahirmoyle, Co. Limerick, where on the farm he observed the habits and attitudes of the animals for his paintings. *Sheep-shearing*, presented by him, is in the Hugh Lane Municipal Gallery of Modern Art.

In 1908 O'Brien took part in a joint exhibition at the Leinster Lecture Hall, Dublin; participants included Constance Gore-Booth, George Russell and W. J. Leech (qq.v.). Thirty-seven years later he opened an exhibition by Leech in Dublin. He became a close friend of Russell and sketched with him in Co. Donegal. In 1909 he exhibited at the New English Art Club, London. In 1910 he was appointed Deputy Lieutenant in Co. Limerick. Also in that year he organised with Capt. Nevile Wilkinson (q.v.) an exhibition in Dublin with a demonstrator on the Art of Engraving. According to Lennox Robinson in his biography, *Palette and Plough*, this event cost O'Brien £290 out of his own money. In 1911 he attended the coronation of King George V in London, doing homage for the RHA in Westminster Abbey.

At this time he was given a commission to paint replicas of a number of portraits of the Lord Mayors of Dublin, which had been damaged by fire. He resumed exhibiting at the Royal Academy in 1912 and between then and 1942 had twenty-six works accepted from Ireland. Portraits included: *The Lord Plunket, GCMG, with the standard of New Zealand, and Hon. Terence Plunket*, in 1912; *The late Richard Bagwell, Esq., DL, LL D Oxon.*, 1920; *The Very Rev. the Dean of Christ Church Cathedral, Dublin*, 1934 – a portrait of Dean Herbert Brownlow Kennedy is in the Chapter Room of the Cathedral.

At an early stage he became deeply interested in the co-operative movement and consequently the Irish Agricultural Wholesale Society, becoming a close associate of Sir Horace Plunkett, whose portrait he exhibited at the loan exhibition of modern paintings at the Belfast Museum and Art Gallery in 1913. His portrait of Shan F. Bullock, in the Dept. of English, Queen's University, Belfast, is inscribed 'To Shan Bullock from Dermod O'Brien 1913'.

Sir Hugh Lane he knew well and strongly supported his efforts to find suitable premises for a gallery of modern art in Dublin. Later, he campaigned for the return from London of the Lane pictures. Lane's gift to the Municipal Gallery included O'Brien's portrait of Alderman W. F. Cotton, MP. A portrait of Mrs Stephen Gwynn is also there. Among his works at the National Gallery of Ireland is *The White Dress (Lady Farrer)*.

In the 1910-14 period *The Studio* noted that the special quality in his work lay 'in its extreme sincerity, and in the feeling for form and balance which it displays. He has painted Irish landscape with an acute perception of its beauty, and yet with a complete absence of sentimentality and that love of rhetorical expression so dear to some Irish painters'. P. L. Dickinson in *The Dublin of Yesterday* saw him as a 'safe and competent artist', but thought that his painting never got a real chance, 'sandwiched as it was, between his other activities'. O'Brien had little patience with idle people.

In May 1915 Russell reported that he was going for a month to Dunfanaghy ant that O'Brien was going with him. O'Brien showed four works at the Royal Scottish Academy; the first was *Heading the stooks* in 1915. When the RHA building went up in flames in 1916, he lost many pictures and possessions. In that year he became High Sheriff for Limerick. Nathaniel Hone (q.v.) died in 1917 and O'Brien was involved in the distribution of the pictures, which numbered about 1,400, and he compiled the complete catalogue. A portrait of Lennox Robinson, who lodged at Cahirmoyle, was dated 1918 and is in the Ulster Museum.

In 1920 – by this time he was president of the United Arts Club – the farm was sold and the family moved to 65 Fitzwilliam Square, Dublin; his studio was in the mews at the back. A portrait of Barry Fitzgerald, presented to the Abbey Theatre by Robinson, was dated 1922, the year he painted a portrait of Gerald FitzGibbon (King's Inns). By this time he was active on the sub-committee appointed to advise on purchases for the Municipal Art Gallery in Cork as stipulated in the Gibson Bequest. He was represented in the exhibition of Irish artists at Galeries Barbazanges, Paris, in 1922. Some of the Hone pictures were sold at his home in 1924.

O'Brien's work was hung at exhibitions of the Royal Society of British Artists in 1924, 1925, and he showed two Cassis scenes in 1929. South-East France was a favourite area for painting holidays and he stayed with W. Crampton Gore (q.v.) at Montreuil-sur-Mer, showing five landscapes associated with the town at the 1926 RHA. In that year he held an exhibition at Mills' Hall, Merrion Row, Dublin, and was appointed a member of the committee to select designs for the new Free State coinage. He designed the memorial in bronze in the National Library of Ireland to T. W. Lyster, librarian, who died in 1929. His portrait of Sir Fredrick W. Moore, 'President of Dublin Knot 1928-31', was for the Friendly Brothers of St Patrick.

In 1930 he served on the committee which organised the Irish exhibition in Brussels. He was a governor of the National Gallery of Ireland, and among other interests was the Royal Irish Academy of Music. His *Michael Hogan, the Bard of Thomond*, dated 1934, is in Limerick Museum. Two years later he was elected a Freeman of that city, and the idea of establishing an art gallery in Limerick was first mooted at the banquet. Needless to say, he took a practical interest in its formation.

In reviewing the 1936 RHA, *Ireland To-Day* noted that he was now painting better than ever, adding: 'His small landscapes are executed more freely, surely and honestly than ever before. He has attained to a high degree of technical perfection, and he has a keen sense of the charm of nature. His work is very pleasing, but it is self-satisfied ...'. Scenes of Cap d'Ail appeared in the 1937, 1938 and 1939 RHA exhibitions. *Trim Castle, Co. Meath*, an 1938 oil, is at NGI. His last portrait, painted in 1943, was of Professor R.A.S. Macalister.

Young artists benefited from his patronage. Professor Thomas Bodkin wrote: 'Tact was not a gift which he possessed abundantly or bothered much to cultivate. Its lack was filled by an extraordinary and unpremeditated impulse of generous kindness and by a forthright honesty that was without flaw.' He died at his residence on 4 October 1945. A small memorial tribute of works was included in the 1946 RHA. An exhibition was held at the Cynthia O'Connor Gallery, Dublin, in 1983.

Works signed: D. O' Brien or Dermod O'Brien, rare (if signed at all).
Examples: Belfast: Queen's University; Ulster Museum. Cork: Crawford Municipal Art Gallery. Dublin: Abbey Theatre; Christ Church Cathedral; Hugh Lane Municipal Gallery of Modern Art; King's Inns; Masonic Hall, Molesworth Street; National Gallery of Ireland; Royal Dublin Society; Royal Irish Academy; Trinity College Gallery; United Arts Club; University Hall, Lower Hatch Street. Kilkenny: Art Gallery Society. Killarney: Town Hall. Limerick: City Gallery of Art; Museum. Longford, Co. Longford: County Library. Portadown, Co. Armagh: Ulster Agricultural Organisation Society. Sligo: Model and Niland Centre. Waterford: City Hall, Municipal Art Collection.
Literature: *The Studio*, October 1910, November 1924, September 1926; *Irish Review*, November 1911 (illustration), September 1913 (illustration), June 1914 (illustration); *Belfast News-Letter*, 13 March 1913; Thomas Bodkin, *Four Irish Landscape Painters*, Dublin 1920; Lady Gregory, *Hugh Lane*, London 1921; *Irish Times*, 28 July 1923, 9 September 1968, 5 April 1983; *Irish Statesman*, 25 September 1926; J. Crampton Walker, *Irish Life and Landscape*, Dublin 1927 (also illustration); P. L. Dickinson, *The Dublin of Yesterday*, London 1929; George A. Birmingham, *Pleasant Places*, London 1934; *Who's Who in Art*, 1934; *Capuchin Annual*, 1936; *Ireland To-Day*, June 1936; Thomas Bodkin, intro., *Twelve Irish Artists*, Dublin 1940 (also illustration); *Irish Independent*, 5 October 1945; *The Times*, 5 October 1945, 12 October 1945; *Dermod O'Brien Papers*, Trinity College, Dublin [1945]; Limerick Art Gallery Committee, *City of Limerick Public Art Gallery*, Limerick 1948; Lennox Robinson, *Palette and Plough*, Dublin 1948 (also illustrations); Thomas Bodkin, *Report on the Arts in Ireland*, Dublin 1949; Thomas Bodkin, *Hugh Lane and His Pictures*, Dublin 1956; *Letters from AE. Selected and edited by Alan Denson*, London 1961; *Studies*, Spring 1962; Alan Denson, *An Irish Artist W. J. Leech, RHA*, Kendal 1968; Dr Brendan O'Brien, *Letter to the author*, 1972; *Oireachtas*, catalogue, 1977; National Gallery of Ireland, *The Abbey Theatre 1904-1979*, catalogue, 1979; Mrs R. Brigid Ganly (née O'Brien), *Letters to the author*, 1981, 1990; Ann M. Stewart, *Royal Hibernian Academy of Arts: Index of Exhibitors 1826-1979*, Dublin 1987; Patricia Boylan, *All Cultivated People: A History of the United Arts Club, Dublin*, Gerrards Cross 1988; Christ Church Cathedral, *Letter to the author*, 1990; also, Hugh Lane Municipal Gallery of Modern Art, 1990; *The Royal Scottish Academy Exhibitors 1826-1990*, Calne 1991; Wanda Ryan-Smolin, *King's Inns Portraits*, Dublin 1992; Eileen Black, *A Sesquicentennial Celebration: Art from the Queen's University Collection*, Belfast 1995 (also illustration); Friendly Brothers of St. Patrick, *Letter to the author*, 1997.

O'BRIEN, KATHARINE F. – see CLAUSEN, KATHARINE F.

O'BRIEN, KITTY WILMER, RHA (1910-82), landscape painter. Pamela Kathleen Helen Wilmer was born on 7 August 1910 in Quetta, then in India, where her father, Captain Harold Wilmer, was on military service. After his death at the Dardanelles in 1915, she was brought home from India. The family moved from London to Dublin, her mother's home city, and she sent Kitty to the Misses Wilsons' High School. Later she went to a school in Folkestone and there displayed her talent for drawing.

By the age of sixteen, all she wanted to do was to go to an art school and so entered the Royal Hibernian Academy Schools where she came under the guidance of Dermod O'Brien (q.v.). In 1931 she won second

prize for drawing and the prize for competition painting. In session 1932-3 she again won prizes and in 1933 was awarded the Taylor Scholarship for painting, by which time she was a member of the United Arts Club, Dublin. Her art education also included some study at the Dublin Metropolitan School of Art. On the strength of her scholarship, she went to London in 1934 for study at the Slade School of Fine Art, where Bea Orpen (q.v.) was a fellow-pupil.

In 1933 and again in 1934 two works were hung at the RHA shows, from 25 Ailesbury Road, Dublin, and the six exhibited in 1935 included a portrait of Charles Boyce, FRCSI, and *Aran Cottage, Co. Galway*. In 1936 she married Dr Brendan O'Brien, son of her former tutor, and they went for their honeymoon to Dresden where she was stimulated by a still life by Vincent van Gogh (1853-90) in the modern art gallery. When her husband suffered a relapse of his tuberculosis, she spent the next eighteen months in Davos, Switzerland, where she painted regularly.

In 1937 she held an exhibition at Combridge's Galleries, Dublin, and the following year she showed mainly Swiss pictures in her show at the United Arts Club. In 1943 there followed a joint exhibition with her sister-in-law, Brigid Ganly, ARHA, at the Contemporary Pictures gallery, Dublin. As Kitty Wilmer O'Brien, 65 Fitzwilliam Square, Dublin, she resumed exhibiting at the RHA in 1943 and from then until 1979 she was a regular exhibitor, showing nearly one hundred works, mostly landscapes with the occasional portrait.

As a housewife she had less time for art, but she painted assiduously when on holiday, particularly in the West of Ireland, recording in oil, gouache, and watercolour. *Near Westport, Co. Mayo* and *Trim Castle, Co. Meath*,both oils, are in the National Gallery of Ireland collection. Occasionally she painted in Counties Clare, Cork, Kerry and Wicklow.

In 1950, from 26 Herbert Park, Dublin, she showed for the first time at the Water Colour Society of Ireland exhibition and became a regular exhibitor, contributing seventy-five works. As an odd exception to her later landscapes, many of Co. Mayo scenes, portraits of Miss Amanda Pringle and Miss Gemmia Pringle were hung at the inaugural exhibition.

In 1951, through a small financial windfall, she studied in Paris under André Lhote (1885-1962). She was represented in 1953 at the Contemporary Irish Art exhibition, Aberystwyth. In 1957 she painted *Low Tide, Clew Bay* and *Eniff Valley*. In 1964 she won the President Hyde Gold Medal award at the Oireachtas exhibition. As president of the WCSI from 1962 until 1981, she played a large part in raising standards by introducing colleagues of some distinction. She was a council member of the Friends of the National Collections of Ireland.

An exhibitor with Dublin Painters, she was elected an associate member of the RHA in 1968. Her gouache, *The Canal, Leeson Street, Dublin* was noted particularly at the 1969 WCSI exhibition. In 1971 she showed watercolours and gouaches at the Dawson Gallery, Dublin; exhibitions were also held there in 1973 and 1975. Appointed a full member of the RHA in 1976, she became an active participant in its affairs. NGI added *Clew Bay from Murrisk, Co. Mayo* to their collection. She died on 16 February 1982 in hospital. Taylor Galleries, Dublin, held a commemorative exhibition in 1983.

Works signed: K. O'Brien, K. O'B. or K. Wilmer.
Examples: Cork: Crawford Municipal Art Gallery. Dublin: National Gallery of Ireland; Voluntary Health Insurance Board. Waterford: City Hall, Municipal Art Collection.
Literature: *Thom's Directory*, 1920; *Ireland To-Day*, December 1937; *Arts Council Report*, 1964-65; *Thomas MacGreevy Papers*, Trinity College, Dublin [1967]; *Irish Times*, 24 June 1968, 4 June 1969, 17 February 1982, 1 March 1982, 14 September 1983, 7 November 1984; Taylor Galleries, *Kitty Wilmer O'Brien, RHA*, catalogue, Dublin 1983; Ann M. Stewart, *Royal Hibernian Academy of Arts: Index of Exhibitors 1826-1979*, Dublin 1987; Patricia Boylan, *All Cultivated People: A History of the United Arts Club, Dublin*, Gerrards Cross 1988; Water Colour Society of Ireland, *Letter to the author*, 1990; also, Dermod W. O'Brien, 1991; *Water Colour Society of Ireland Exhibition List 1872-1994*, Dublin 1995; National Gallery of Ireland, *Gallery News*, September-November 2000.

O'BRIEN, LILAH ASSANTI (1884-1968), landscape painter. Born at Dromoland Castle, Newmarket-on-Fergus, Co. Clare, on 18 October 1884, Lilah O'Brien was the daughter of the 14th Lord Inchiquin. Her first husband died of wounds in the First World War. Early in the 1920s she studied in Rome

under Professor Onorato Carlandi (1848-1939). At that time her sister, Beatrice, was married to Marconi, of radio fame.

In 1924 she exhibited at Walker's Galleries, Bond Street, London, with Riccardo Assanti, sculptor and son of a General. In 1925 they were married and lived for a time in Via Margutta, the artists' quarter, off Piazza di Spagna in Rome. In 1947 she held an exhibition of her watercolours at the Grafton Gallery, Dublin, including *Lichen Covered Roof*; *Appian Way*; and *The Tiber at Prima Porto*. In that year she exhibited with the Water Colour Society of Ireland for the first time; the four works included *Taverna Palace* and *Budding Wisteria*.

In 1948 at the Gorry Gallery, Dublin, she showed jointly with her husband, who displayed small bronze figures. Half of her forty watercolours in that exhibition were associated with Bantry, Co. Cork, and Rome. Information on the two artists, for the catalogue, appeared above the name of James Sleator (q.v.), president of the Royal Hibernian Academy.

In Dublin, an exhibition of her watercolours also took place at the Little Theatre, Brown Thomas's. In 1948, giving the address 42 Via Valadier, Rome, she exhibited at the Royal Hibernian Academy: *Church at Spoleto, Italy*; and one work only in 1949 and 1950. Her last and ninth exhibit at WCSI was *Blue Skies over Donnemark* in 1950. Two of her watercolours, *From the Window, Tivoli* and *Bantry Harbour*, both presented by the artist in 1960, are in the Hugh Lane Municipal Gallery of Modern Art.

By 1948, her work had joined the collections of a number of prominent people, for example the Rt. Hon. Winston S. Churchill and Field Marshal Viscount Alexander, Governor-General of Canada. In 1967 she was seriously ill and, her second husband having died, her son, the Hon. David Fellowes, brought her to Malta where he was living at that time. She died there in the Blue Sisters' Hospital in 1968.

Works signed: Lilah O'Brien or L. A. O'B., monogram.
Examples: Dublin: Hugh Lane Municipal Gallery of Modern Art.
Literature: Gorry Gallery, *Exhibition of small bronze figures by Riccardo Assanti and of watercolours by Lilah Assanti-O'Brien*, catalogue, Dublin 1948; Hon. David Fellowes, *Letters to the author*, 1990; also, Hugh Lane Municipal Gallery of Modern Art, 1990; Lord Killanin, 1990; *Water Colour Society of Ireland Exhibition List 1872-1994*, Dublin 1995.

O'BRIEN, NELLY (1864-1925), miniaturist and landscape painter. Nelly O'Brien was the eldest sister of Dermod O'Brien (q.v.) and the daughter of Edward O'Brien of Cahirmoyle, Ardagh, Co. Limerick, where she was born. Her mother Mary (neé Spring Rice) sculpted and painted. Nelly spent some time at the Slade School of Fine Art, London, studying painting. On her return home she painted miniatures on ivory, with the help of a magnifying glass, and also painted landscapes in watercolour. In private possession is a locket miniature of a little girl with long fair curls, *Maggie*; inscribed on back: 'Nelly O Brien.'

In 1896 she exhibited at the Royal Hibernian Academy for the first time, from 38 Pembroke Road, Dublin, and until 1922 showed about eighty works, many of them miniatures. During this period she had at least nine other addresses in the city. In addition to a 'case of miniatures' in the 1898 exhibition, she contributed *A Garden in Co. Limerick* and *A Hill in Connemara*. In the period 1899 until 1905 she painted a number of watercolours in Co. Donegal but portraits dominated her exhibits – six in 1903 from 48 North Great George's Street, Dublin, including those of Dermot O'Mahony and Mrs Pierce O'Mahony.

In 1904 she exhibited with the Water Colour Society of Ireland for the first time, two sketches of Bere Regis, Dorset. Of the five other works which she contributed, three had Dun Laoghaire, Co. Dublin, subjects.

Nelly O'Brien was very friendly with Walter F. Osborne (q.v.). At least one relative of Nelly's was of the view that she regarded herself as engaged to him. Unfortunately, death intervened. There is a portrait of her by Osborne at the Hugh Lane Municipal Gallery of Modern Art. A friend too of Douglas Hyde, she spoke Irish fluently and was an indefatigable worker in the cause of the revival of the language. In Dublin, she founded the well-known branch of the Gaelic League. Also she was involved in the founding of the Irish College at Carrigaholt, Co. Clare. She was also associated with the *Gaelic Churchman*, a Church of Ireland publication.

A distinct Oireachtas art exhibition was held in 1906 at the Technical Schools, Rutland Square (Parnell Square). Works were exhibited by many of the well-known artists of the day, and she was represented. An art exhibition sub-committee was set up that year and she was appointed honorary secretary. Miss Lilian Duncan reminisced to the editor in 1982: 'When I (with my family) came to live in Dublin in 1907, Nelly O'Brien was living in 7 St Stephen's Green. There was an "elite" grocers' shop there, Smyth's of the Green. Nelly rented rooms for herself and a room for a branch of the Gaelic League which she founded ...'.

After a lapse of five years, she resumed exhibiting at the RHA in 1910, *On the Dodder* and *Burning the Furze*, followed by an interval of six years when, from 10 Nassau Street, Dublin, her works in 1916 included portraits of Douglas Hyde, LL D, William Smith O'Brien and Miss M. C. Knowles. In 1917 she showed *The O'Curry College, Carrigaholt* and *The Shannon at Carrigaholt*. Her heart was weak, and she died suddenly on 2 April 1925 on a visit to London; she was buried in the family vault near Ardagh, Co. Limerick.

Works signed: Nelly O Brien or Neilí ní Briain (if signed at all).
Examples: Carrigaholt, Co. Clare: Colaiste Eoghain Ui Chomhraidhe.
Literature: Michael Hurley, S. J., ed., *Irish Anglicanism 1869-1969*, Dublin 1970; *Capuchin Annual*, 1974; *Oireachtas Catalogue*, 1977; *Feasta*, Mean Fómhair 1979; Mrs Mairin Flegg, *Letter to the author*, 1981; also, Dr Brendan O'Brien, 1981; Carrigaholt College, 1982; Miss Lilian Duncan, 1982; Ann M. Stewart, *Royal Hibernian Academy of Arts: Index of Exhibitors 1826-1979*, Dublin 1987; R. Brigid Ganly, *Letter to the author*, 1990; also, Dr Philip Smyly, 1990; *Water Colour Society of Ireland Exhibition List 1872-1994*, Dublin 1995.

O'CALLAGHAN, JEROME – see Ó CEALLACHÁIN, DIARMUID

O'CALLAGHAN-WESTROPP, ROSEMARY (1896-1982), equestrian portrait painter. Born on 23 April 1896 at Coolreagh, Bodyke, Co. Clare, she was the daughter of Colonel George O'Callaghan-Westropp (The O'Callaghan), ADC to three Kings (Edward VIII the last, 1936). She had always wanted to paint but her parents would not allow her to study for fear of falling into undesirable company. In the First World War, she nursed in the Voluntary Aid Detachment.

Involved in a hunting accident which resulted in a broken neck, the long months of immobility saw her reading and studying books on painting and animal anatomy; having from earliest childhood had an affection for dogs and horses, she specialised in portraits of these, having grown up too in hunting circles. As she could not afford to train in the oils technique, her medium at first was watercolour.

Many commissions were received, including one to paint all the horses of the Irish Army School of Equitation, which in those days were world-famous champions. The seventeen paintings were for a presentation to GHQ Mess in honour of the outright win of the Aga Khan Trophy at Dublin Horse Show. There are eight equestrian portraits of named horses, all painted in 1937, in the Officers' Mess at McKee Barracks, Dublin.

Exhibitions were held at the Horse Show and the Spring Show, and she occasionally exhibited at the Oireachtas, but only contributed one work, in 1937, to the Royal Hibernian Academy. In the period 1937-40 she showed eleven works at Water Colour Society of Ireland exhibitions, mainly equestrian. Included in her 1937 contributions was Capt. Quinn on *Ben Eider* at the International Horse Show in Rome, and a choice in 1939 was Miss Anne Gregory on *Tarlet*, at The Galway Blazers.

Arminell Morshead, the horse and hound painter, whom she had met at the Dublin Horse Show, had been attracted by her watercolours and on hearing that she had not had a chance to work in oils, asked Rosemary to accompany her whilst she painted in Dublin and at the Curragh, and passed on her specialist knowledge. This tuition proved invaluable for the army commissions.

After the Second World War, commissions, beginning with the Irish National Stud, resumed, and for various patrons *Arkle* was painted five times. In 1961, when living at Chapelizod, Co. Dublin, she held an exhibition in Dublin at Brown Thomas's of animal pictures, landscapes and seascapes. In an interview afterwards, she said: 'One must understand the psychology of horses to paint them successfully. Racehorses are difficult to paint as they are so very active and highly strung. I find stallions are the best subjects – they

love to watch what you do and will stand quietly for long periods at a time'. Her death occurred in a private nursing home on 4 January 1982.

Works signed: R. O' Callaghan-Westropp or R. O'C.-W.
Examples: Dublin: McKee Barracks. Kildare: Irish National Stud.
Literature: *Who Was Who 1941-1950*, London 1952; *Irish Times*, 14 May 1961, 5 January 1982; *Model Housekeeping*, May 1961; Miss R. O'Callaghan-Westropp, *Letter to the author*, 1968; *A Dictionary of Contemporary British Artists, 1929*, Woodbridge 1981; Army/ Defence Forces' Headquarters, *Letter to the author*, 1990; *Water Colour Society of Ireland Exhibition List 1872-1994*, Dublin 1995.

Ó CEALLACHÁIN, DIARMUID (1915-93), landscape, genre and portrait painter. Born on 31 October 1915 at Drimoleague, Co. Cork, Jeremiah O'Callaghan was the son of Patrick O'Callaghan, a British Navy stoker who was on the torpedoed cruiser *HMS Warrior* in the Battle of Jutland in 1916. Jerome, as he was known to most people, attended St Patrick's National School in Cork and North Monastery. He then entered a drapery apprenticeship.

A long association with Crawford School of Art began in 1930 with evening classes in life drawing and painting. Eight years later he gave up his job and became a full time day student. On winning the £50 Taylor Scholarship in 1939 for his painting, *The Struggle*, he enrolled at the National College of Art in Dublin. Landscape painting interested him and he had made visits to the West of Ireland from as early as 1937, painting out of doors and visiting Charles Lamb (q.v.) in Carraroe, Co. Galway. In 1940 he was awarded a diploma in painting and he returned to the Crawford School of Art, this time to teach.

In 1938 he had first exhibited at the Royal Hibernian Academy, and from then until 1961 he showed twenty works. In 1940, giving the National College of Art as his address, he contributed three pictures under Jerome O'Callaghan, including *'No place on Earth'*. Among his works at the 1942 South Tipperary Fine Art Club annual exhibition was *Clois-na-Callaig*, oil. About 1943 he began using Diarmuid Ó Ceallacháin as his name.

Cork Art Club hosted in 1943 forty-one oils, for example, *Yellow Shawl; Isaac; 'Contemplation'*. Both titles at the 1944 RHA exhibition were in Irish. In the 1945 Munster Fine Art Club catalogue (price 3d.) he was listed on the committee as Jerome O'Callaghan. He showed at the Oireachtas in 1946, and *The Lee at University College, Cork* appeared at the 1947 RHA.

On the exhibition at the Dublin Painters' Gallery in 1948, the *Dublin Magazine* critic found 'a bewildering variety of styles...he has still a long way to go to achieve the necessary mastery of technique...there are a few pictures which show a refreshing originality both in observation and in the creative use of colour. I refer particularly to *The Morning's Snow, Teach Beag i gCorcaigh* and *A Ship on the Lee*.'

Of Farranlea Park, Model Farm Road, Cork, he painted *I.N.R.I.* in 1950. The work of Father Jack Hanlon (q.v.) was said to have influenced him. *Near Altamara, Spain*, watercolour, was painted in 1951 when he travelled in Spain with Cecil Galbally (q.v.). He did not neglect the Oireachtas exhibitions in the 1950s in Dublin, and home in Cork he was represented in the Contemporary Irish Artists exhibition, Imperial Hotel, 1954. In 1955 his portrait of Christy Ring was in pastel, and in 1956 appeared *Boats on Shannon Bridge*, oil. Another Contemporary Irish Artists exhibition took place in Cork, in 1957, this time at the premises of J. W. Dowden & Co. Ltd. In that year he produced the oil, *The Centre of Athlone Town*.

Ó Ceallacháin's pictures at the 1957 RHA were *Loch Ri* and *Gaeltacht Landscape* (both County Dublin V.E.C.). He was awarded a diploma and bronze medal by the Academie Francaise (prix Thorlet) for drawings exhibited in Paris in 1958. He continued to exhibit in Cork with the Munster Fine Art Society (or Arts Society). In the Irish Artists winter event of 1963, *Road in County Longford* was at the Limerick Art Gallery.

In 1968 at the Everyman Theatre, Cork, an exhibition of oil paintings covered about twenty years work. The *Irish Times* noted that the subjects were varied with one 'penetrating study of the crucified Christ.' The critic also found 'adventurous treatment of boats at the quayside stirs the imagination...'The abstracts were regarded as of 'unequal standard and do not seem to be comfortably in the artist's mind...'.

In 1970 he left the School of Art after thirty years of teaching. Athens and Jerusalem saw him painting there in 1971. Overall, his travels in Europe were widespread, and he also visited the USA. *The Three Wise*

Kings at the Nativity, oil, was painted in 1973. *The Good Shepherd* appeared at the 1982 Munster Fine Arts Society; in 1987, *New Trees*, *New Lake* and *Gentleman in Red Coat.*

The Cork artist had a special relationship with Travellers and regularly entertained and painted them in his home. He was described as wearing a 'funny matador hat and usually draped in a long brown coat.' In 1991 an exhibition of ninety works, nearly all oils but a few pastels and watercolours, took place at the Crawford Municipal Art Gallery, where he is represented by three oil paintings, including *Bith Ghlas*. His death took place on 20 April 1993.

In 1994, an exhibition was held at the Siamsa Trie Gallery, Tralee, Co. Kerry, and Sligo Art Gallery. At the Lavit Gallery in Cork in 1997 he was represented in the 'Four Painter Friends' exhibition with Frank Hourigan, Cormac Mehegan and Walter Verling.

Works signed: Diarmuid Ó Ceallacháin (or Ó Ceallacain), Ó Ceallacháin, Jeremiah Ó Callaghan, Jer (or Jerome) Ó Callaghan or D.O.C. (if signed at all).
Examples: Ballinasloe, Co. Galway: St Joseph's College. Cork: Crawford Municipal Art Gallery. Dublin: County Dublin Vocational Education Committee.
Literature: *Dublin Magazine*, April-June 1948; *Irish Times*, 14 October 1968; *Who's Who in Art*, Havant 1980; Ann M. Stewart, *Royal Hibernian Academy of Arts: Index of Exhibitors 1826-1979*, Dublin 1987; Crawford Municipal Art Gallery, *Diarmuid Ó Ceallacháin : Paintings 1937-1990*, catalogue, Cork 1991 (also illustrations); Ms Noël O' Callaghan, *Letters to the author*, 1993, 1999, 2000; *Sunday Independent*, 26 May 1996.

Ó COLMÁIN, SÉAMUS (1925-90), townscape and landscape painter. James Coleman was born in Dublin on 24 May 1925, the son of William Coleman, baker. He painted from childhood but when he began a career as an artist he became Séamus Ó Colmáin. Formal instruction began at the National College of Art and he continued his studies in Paris. On his return to Dublin he obtained work in a bakery so that he would have time to paint during the day.

An early portrait was that of Hugh P. Corrigan, president of the Pharmaceutical Society of Ireland. In 1959 he held his first exhibition, at the Ritchie Hendriks Gallery, Dublin, and the dominant theme among almost thirty canvases was Dublin. In his foreword to the catalogue, James Plunkett wrote: 'This city of ours has the quality of spiritualising her past and her present, her ease and her poverty, her gaiety and suffering, and of showing them forth at odd moments suddenly, in startling synthesis. It is for such moments that Séamus Ó Colmáin has watched and waited, and these he has recorded, not in the earlier fashion of our literary romantics, but with the balanced and searching eye of a more dispassionate generation.' Other exhibitions followed at the Ritchie Hendriks Gallery, for example in 1961, 1962 and 1963.

In 1966 he accepted a suggestion to teach art at Clogher Road Vocational School, Dublin, and later proved himself valuable in the remedial field. He became a committee member of the Irish branch of the International Committee of Art for the Handicapped. In the 1960s the New York Irish Institute Fund purchased two of his works, *The Spire* and *Connemara Rocks*. Other exhibitions were held in the Hendriks Gallery, and he also showed in Belfast, Cork, Galway and Waterford. On his second visit to the Bell Gallery in Belfast, a number of Belfast views were included.

Most of his pictures found their way into his one-person exhibitions, but from 1966 he contributed in a small way to the Royal Hibernian Academy, and he last exhibited in 1989 with *High Street, Dublin*. The *Irish Times*, writing about his display at the Hendriks Gallery in 1970, said he was very much a 'local', almost topographical artist, 'rather than a practitioner of the various international styles. Which is both his strength and his limitation'. It added that he had painted Dublin's crumbling façades 'with a likeable near-sentimentality and at times a real painterliness'.

In his 1977 exhibition at the Tom Caldwell Gallery in Belfast there were some works, such as *In Pottinger's Entry* and *Kelly's Wine Cellars* which he had painted in that city. Of the forty-six pictures on view, six were collages. He showed at the Oriel Gallery in Dublin in 1983, 1985 and 1988. His oil paintings in 1985 were mainly of Dublin streets and scenes, for example: *St Ann's, Dawson Street*; *Old Houses, Weaver Square*; and *The Balloon Man*. In the St Patrick's College, Dublin, collection is *City by Night*.

Apart from his Irish exhibitions, which included participation in the Irish Exhibition of Living Art, the Oireachtas and the Royal Ulster Academy, some works were seen in New York, Boston, San Francisco and Montreal. He was a long-standing member of the United Arts Club, Dublin, of which he was vice-president. In 1988 he retired from teaching due to ill health. He died at his home, Malahide Road, Dublin, on 3 January 1990.

Works signed: Ó Colmáin or S. Ó Colmáin.
Examples: Dublin: Adam and Eve Church; Irish Museum of Modern Art; Office of Public Works; Pharmaceutical Society of Ireland; St Patrick's College; United Arts Club. Waterford: City Hall, Municipal Art Collection.
Literature: Ritchie Hendriks Gallery, *Séamus Ó Colmáin*, catalogue, Dublin 1959; *Arts Council Report*, 1962-3, 1967-8; *Irish Times*, 4 July 1970, 4, 10 and 30 January 1990; Seán McCrum and Gordon Lambert, eds., *Living with Art: David Hendriks*, Dublin 1985; Oriel Gallery, *Séamus Ó Colmáin*, catalogue, Dublin 1985; Mrs Nora O'Colmáin, *Letters to the author*, 1990; also, Oriel Gallery, 1990; St Patrick's College, 1990.

O'CONNELL,KAY– see CASSON,KAY

O'CONNOR, ANDREW, ANA (1874-1941), sculptor. Born on 7 June 1874 at Worcester, Massachusetts, USA, he was the son of a sculptor, Andrew O'Connor (1846-1924) who was born in Lanarkshire, Scotland, and married a Co. Antrim girl. The son became a pupil of the father at fourteen and worked on monuments for cemeteries. At the age of sixteen he left home, obtaining employment at the Chicago World's Fair in 1891. He also worked in Boston and New York.

Anxious to be a painter, he travelled in 1894 to London where he met the painter, J. S. Sargent (1856-1925), who became a close friend and advised him to study Greek sculpture and the paintings in the National Gallery. Sargent was then working on mural decorations for the Boston Library; O'Connor acted as a model for one of the prophets. Sargent's plan also included bas-reliefs and O'Connor became his sculptor pupil, spending three years in London.

On his return to America he won a bronze medal for a portrait bust at the 1901 Panama Pacific Exposition at Buffalo. He became a pupil of a leading American sculptor, Daniel Chester French (1850-1931), from whom he received his first public commission: the Vanderbilt Memorial bronze doors at St Bartholomew's Church, New York. French, at 125 West 11th Street, was in charge of the sculptural decorations for the church. O'Connor acquitted himself so well that he was later asked to sculpt a tympanum and frieze. The work was completed in 1902 and from then on he was constantly employed. A model of the doors was presented by the artist to the Municipal Gallery of Modern Art, Dublin. Lorado Taft (1860-1936), a member of the American National Sculpture Society, wrote of the doors: '... they show remarkable aptitude for composition in many figures, and an exceptional felicity of handling.'

O'Connor modelled *Inspiration* for the permanent Art Palace of the St Louis Exposition of 1904. In that year he was commissioned for a figure of *Justice* and other statues for Essex County Court House, Newark, New Jersey; also for the escutcheon with supporting winged figures over the central doorway of the New York Custom House. By 1905 he was in Paris with his atelier at 84 boulevard Garibaldi. In the French capital his four sons were born, and his wife Jessie often acted as his model. Born in Albany, New York, her parents were from Co. Down.

At the Paris Salon of 1906 he was the first foreigner to win the second class medal, for his bronze statue, *General Henry Lawton*, now in Garfield Park, Indianapolis. He also showed *Daphné*, a bronze head also called *La Faunesse* which Mrs O'Connor later donated to the Crawford Municipal Art Gallery, Cork, where there is also *Madonna and Child*, plaster. In 1906 too he held a one-person exhibition at the Kunstsalon Walther Zimmermann, Munich.

A competition in 1906 open to sculptors of Irish descent was won by O'Connor for a monument to the Co. Wexford-born Commodore John Barry, 'the Father of the American Navy', for Washington, DC. Apparently because of the Barry family's disapproval, it was never executed. Bronze versions of Commodore John Barry found their way to the Corcoran Art Gallery, Washington, and the Municipal Gallery in Dublin.

O'Connor exhibited only once, in 1907, at the Royal Hibernian Academy: *Nehemiah*, plus two bronze busts and one marble bust. *Nehemiah* is a bronze relief in the Municipal Museum of Art, Bucharest.

O'Connor continued to exhibit regularly at the Paris Salon. In 1908 he gave his address in Clamart, near Paris. Auguste Rodin (1840-1917), who lived nearby at Meudon, frequently visited him at Clamart. At the Salon of 1909 he showed *General Lew Wallace*, a marble statue now in the Hall of Fame at Washington, DC; a facsimile is in Crawfordsville, Indiana. In 1909 he held a one-person show at Galerie A.-A. Hébrard, Paris. *Adam and Eve*, a marble group in the Corcoran Art Gallery, Washington, appeared in the 1910 Paris Salon, and that year he was the representative of Great Britain in the Venice Biennale. His *Governor Johnson* monument was installed in St Paul, Minnesota, in 1912.

By 1913 O'Connor resided at 51 rue Boileau, Paris. The Peace Palace commission for The Hague was completed that year with *Peace by Justice*, marble, a free-standing, female figure of classical dress. However, the extraordinary vitality in most of his other works was attributed by the French critic, Louis Gillet, to his Celtic origins. His commissions from America ensured continued success when he left France in 1914 and set up a studio at Paxton, Massachusetts. His bronze, *Dante*, about 53cm high, was dated 1916; he donated it later to the Municipal Gallery, Dublin.

In 1917 his 1898 Spanish-American war memorial was unveiled in Worcester, Massachusetts; about 50,000, practically the entire population of the city, turned out for the dedication. His standing figure of the youthful Abraham Lincoln was unveiled at Springfield, Illinois, in 1918. A marble of Lincoln, 97cm high, presented by the sculptor, is in the American Ambassador's Residence in Dublin.

An exhibition at the Art Association of Newport, Rhode Island, was held in 1919, and he was represented at the Luxembourg Museum, Paris, in 'Exposition d'Artistes de l'École Americain'. He also exhibited in the first exhibition of the Society of American Painters, Sculptors and Engravers in Buffalo. In 1919 too his *Roosevelt Memorial* to the Boy Scouts of America was unveiled at Glen View Golf Club, Chicago. The four standing boy scouts in the group were modelled after the sculptor's own sons: Hector, Owen, Roderic and Patrick.

In 1919 O'Connor was elected an associate of the National Academy of Design. A memorial, *Orlando Whitney Norcross*, 1920, is in the City Hall, Worcester, Massachusetts. In 1923 he exhibited with the National Sculpture Society, New York, and in 1926 he renewed links with Paris when he contributed to the Salon, *Monument aux Morts de la Grande Guerre*, which later became, in an Irish context, *Triple Cross*. For making it the French Government bestowed the Légion d'Honneur. In 1927 Helen Desmaroux's *L'Oeuvre ou Sculpteur O'Connor* was published in Paris.

In 1928 with a studio address of 17 Rue Campagne Premier, Paris, he showed at the Salon, *Tristan and Iseult*, now in the Brooklyn Museum, New York; this marble won him the Gold Medal, the first foreigner so honoured. It is unusual in that he left exposed in the stone the framework used in building up the clay model. Several years' work was involved in *The Lafayette Monument*, an equestrian statue for the 'Monumental City', Baltimore. At this time too he was working on a project for a huge war memorial for Washington, DC. The 1931 Salon catalogue listed him as a member of the Societé des Artistes Français.

The saga of the *Triple Cross* began on 9 June 1931 with a public meeting in the Town Hall, Dun Laoghaire, Co. Dublin, when it was decided to erect a monument to Christ the King. An appeal booklet appeared the following year announcing Andrew O'Connor as the committee's choice of sculptor. Alexis Rudier of Paris eventually received the commission to cast the *Triple Cross* in bronze but the War intervened, and transport to Ireland was impossible. In order to avoid the three tonnes or so of valuable bronze being melted down, it was hidden.

In 1949 a delegation from the Christ the King Committee inspected the monument at the Rudier works at Malakoff, and Liam S. Gogan on their behalf reported favourably for acceptance and commented: 'It is an artistic achievement of great merit, devotional in tone and having a quality of uniqueness which one asks for in public monuments, as distinct from Church statuary where conventions of necessity rule'.

The despatch of the large monument to Dun Laoghaire was not the end of the journey – or saga. 'Clerical obscurantism' was said to have blocked its erection. The work eventually 'rested' in the back garden of one of the trustees at Rochestown Avenue. In 1969 a firm of Dublin solicitors, in a newspaper advertisement,

asked any persons who had subscribed to the fund for the purchase of the sculpture to contact them ... *Triple Cross*, or *Christ the King*, was unveiled in Haigh Terrace, seafront end, on 16 December 1978, forty-seven years after the public meeting in that town. The work, which is 5.5 metres high and 2.8 metres across the arms, symbolises three distinct aspects of Christ's life: Desolation, Consolation, Triumph.

In her *Irish Public Sculpture: A History*, 1998, Judith Hill wrote on the *Triple Cross*: 'Being a three-sided cross it does not display the two-dimensional outline of a traditional cross. Also, within each right-angled crook there is not only a separate representation of Christ but a number of architectural forms; strips of Gothic decoration, structural elements; brief quotations, applied collage-like. There is no orientating symmetry, only the imperative to circulate. The sculpture conveys intense thought; doubts leading to discoveries — something perhaps of the spirit which impelled O'Connor to embark on the project... O'Connor has attempted with *Triple Cross* to create a new version of the high cross by deconstructing the themes and symbols of Christianity and reworking them into a new form. The themes, the impression of an intense search, and the innovative result were applicable to a memorial to the First World War.'

In 1931 O'Connor worked in a converted stable at Leixlip Castle, Co. Kildare, on his statue, *Daniel O'Connell*, for the National Bank Ltd, College Green, Dublin. A smaller version is in Leinster House. In 1937 his studio was at 50a Glebe Place, London, and he exhibited at the Tate Gallery *Descent from the Cross*, also known as *Deposition* and as *Ghosts*. This work in stone was on loan for the opening of the Duveen Galleries. After the War, the O'Connor family presented the sculpture to the Jesuit Community at Campion House, Osterley, Middlesex. A plaster cast is at Our Lady of the Rosary Church, Limerick. The Tate Gallery owns three bronzes: *The Golden Head*, 1905, a mask noted for its patination in gold over black; *The Wife*, c. 1923; and *Viscount d'Abernon*, 1934. According to the Tate, *The Golden Head* is an idealised portrait of his second wife, Jessie, and a version of this head crowns the funerary figure in the monument to General Thomas in Sleepy Hollow Cemetery, near Tarrytown, New York.

A bust of Lincoln is in the Royal Exchange. Writing in *The Studio* in 1937, Sybil Vincent said that he had probably produced more great monumental pieces of importance than any other living sculptor, 'yet his work is so totally unlike anything else produced to-day that it is never mentioned when the trend of modern sculpture is being discussed. While his style owes nothing to either the academic or modern school of to-day or, indeed, any other period in particular, its originality is not the sort to make a popular sensation ... Outwardly O'Connor is completely Irish. If you met him casually you would never guess his American nationality. The chief inspiration of his work is that strange celtic romanticism with its vivid dramatisation of life that is so typically Irish.'

According to William Henry Fox, commenting after the Brooklyn Museum, New York, acquisition: 'He is an artist of a special temperament. His work shows him to be introspective by nature, distinctly under the spell of a mysticism due to his Celtic descent, and in consequence his work is largely symbolistic.'

The works which O'Connor presented in 1938 to the Municipal Gallery in Dublin included: *The Wife*, bronze; *The Mother of a Hero*, bronze; *Jessie O'Connor*, bronze. His *Self Portrait*, marble bust of 1940, was bequeathed to the gallery after his death. Altogether, twenty-seven pieces are the property of the Hugh Lane Municipal. *The Victim*, 2.7 metres in length, presented by the sculptor's family, is on loan in Merrion Square Park, Dublin.

Deidre, original plaster cast for bronze in the Municipal Gallery, is at Drogheda Library. When he showed two bronzes, *Mr Manson* and *Mrs O'Connor* at the 1939 Royal Scottish Academy, he gave his address at 66 Glebe Place, Chelsea. In the last seven months of his life he resided in Dublin with his wife. He died at 77 Merrion Square on 9 June 1941.

Works signed: A. O'Connor, O'Connor or A. O'C., rare.
Examples: Arlington, Virginia: National Cemetery. Baltimore: Walters Art Gallery; Washington Square. Bucharest: Municipal Museum of Art. Chicago: Glenview Golf Club. Cork: Crawford Municipal Art Gallery. Crawfordsville, Indiana: General Lew Wallace Study grounds. Drogheda, Co. Louth: Library, Municipal Centre. Dublin: American Ambassador's Residence; Arts Council; Bank of Ireland, College Green; Hugh Lane Municipal Gallery of Modern Art; Leinster House; Merrion Square Park; National Gallery of Ireland. The Hague, Netherlands: Peace Palace. Indianapolis: Garfield Park. Limerick: Church of Our Lady of the Rosary. London: Royal Exchange; Tate Gallery. New York: Brooklyn

Museum; Custom House; Metropolitan Museum of Art; St Bartholomew's Church. Osterley, Middlesex: Campion House. Paris: Musée d'Art Moderne. St Paul, Minnesota: State Capitol. Springfield, Illinois: State Capitol. Tarrytown, nr. New York: Sleepy Hollow Cemetery. Washington, DC: Corcoran Art Gallery; Hall of Fame. Wexford: Arts Centre. Worcester, Mass.: City Hall; Holy Cross College; Wheaton Square.

Literature: Lorado Taft, *The History of American Sculpture*, London 1903; *Irish Tatler and Sketch*, Christmas 1931; *The Studio*, August 1937; *Irish Times*, 11 June 1941, 4 November 1974, 15 April 1976, 6 August 1976, 18 December 1978; *The Times*, 17 June 1941; Liam S. Gogan, *Christ the King Monument Committee: Report of delegation's visit to Paris*, 24 February 1949; Hector O'Connor, *National Treasures in Dublin*, Dublin 1953; *American Sculpture, a catalogue of the collection of The Metropolitan Museum of Art*, New York 1965; *Irish Independent*, 1 March 1969; *Country Life*, 3-10 January 1974; Homan Potterton: Trinity College, Dublin, *Andrew O'Connor*, catalogue, Dublin 1974 (also illustrations); Peter Hastings Falk, *Who was Who in American Art*, Connecticut 1985; City of Worcester Parks and Recreation Department, *Artworks in Our Parks*, Worcester 1986; City of Crawfordsville, *Letter to the author*, 1990; also, Dáithí P. Hanly, 1990; Patrick O'Connor, 1990; Brooklyn Museum, 1991; *The Royal Scottish Academy Exhibitors 1826-1990*, Calne 1991; Judith Hill, *Irish Public Sculpture: A History*, Dublin 1998 (also illustration); Campion House, *Letter to the author*, 1999; Tate Gallery, *Letters to the author*, 1999.

O'CONNOR, EDWARD (1898-1955), landscape painter. Born at Carrignavar, Co. Cork, on 5 August 1898, Edward Francis O'Connor was the son of a member of the Royal Irish Constabulary, David O'Connor. He had no artistic training, and was a teacher by profession. Early in his career he lived at Fermoy, Co. Cork, and taught at Lisgoold National School. He became principal teacher at Lisronagh National School outside Clonmel, Co. Tipperary.

A founder member and honorary secretary of the South Tipperary Fine Arts Club, he exhibited at Munster Fine Art Club exhibitions 1940-51 and 1953-4, contributing two or three pictures each year. Among his exhibits were: *Cottages near Maam*, 1942; *Ardmore from the Curragh*, 1944; *Stream in the Comeraghs*, 1946; *Morning on the Suir*, 1948; and *Road to Keel, Achill*, in 1950.

In the period 1943-53 he also showed in Waterford. Of particular local interest there, in the Municipal collection, is his *Ferrybank Church*. In the South Tipperary County Museum and Art Gallery is *West Gate, Clonmel*. In 1946 he held a one-person show of twenty-six watercolours at the Abbey Galleries, Clonmel, opened by Mlle Françoise Henry. The exhibition was supplemented by oil paintings from a few other artists, including Jack B. Yeats (q.v.). In the period 1951-4 O'Connor contributed sixteen works to the Water Colour Society of Ireland exhibitions, four per year, including *Morning on the Suir* in 1951; *Old Road to Cahir*, 1952; *On the River Nore*, 1954. He died at Clonmel on 3 February 1955.

Works signed: E. O'Connor or Ed. O'Connor.
Examples: Clonmel: South Tipperary County Museum and Art Gallery. Waterford: City Hall, Municipal Art Collection.
Literature: Abbey Galleries, *Edward O'Connor*, catalogue, Clonmel 1946; Mrs Catherine O'Connor, *Letters to the author*, 1990; *Water Colour Society of Ireland Exhibition List 1872-1994*, Dublin 1995.

O'CONNOR, PATRICK (1909-97), portrait painter and sculptor. Born in Paris on 7 May 1909, the son of Andrew O'Connor (q.v.), he was a brother of the artist, Roderic O'Connor. The family travelled to America in 1914 on the outbreak of the First World War.

A pupil of his father, Patrick O'Connor advised the author in 1990 that he and his brother Roderic had exhibited every year for many years at the Paris Salon. Patrick, from 31 bis Rue Campagne Première, Paris, showed an oil, *Montparnasse*, at the Glasgow Institute of the Fine Arts in 1930. The brothers held an exhibition of paintings at Daniel Egan's Gallery, 38 St Stephen's Green, Dublin, in 1932, and according to the *Evening Press* they had previously exhibited together in Amsterdam and in Jack Seligmann's Gallery, Paris.

O'Connor's life was a strange and versatile one. He won success as an athlete, a swimming international, later as a professional boxer, then as a wrestler holding the Irish championship. Sadly, this aspect of his life has not been chronicled. His son, the conservator Andrew O'Connor, has recalled that when he was a young man his father challenged Joe Louis for a 'no holds barred contest' and he remembered a poster from Madison Square Garden. Under his father's photograph it said: 'The man who says he can beat Joe Louis.' Patrick

O'Connor's painting, *The Madonna and Child*, posed by his wife and son Andrew, is at St Joseph's Church, Waverley Place, New York.

At the Paris International Exposition of 1937 he showed a bust of Barromés the Monk. He exhibited at the New York World's Fair, 1939. At the Royal Hibernian Academy in Dublin he contributed only four works: *Deer Stalker* and *Andrew O'Connor*, both paintings, in 1940 from 24 Lower Pembroke Street; an unnamed portrait in 1941 from the O'Connor residence, Glencullen House, Glencullen; and another portrait in 1946 from 48 Upper Mount Street, Dublin. A portrait of the poet, Patrick Kavanagh, was painted in 1940. In 1941 he had presented the oil painting of his father to the Municipal Gallery of Modern Art, Dublin, a work which was included in the 1974 exhibition, 'The Irish: 1870-1970,' at the National Gallery of Ireland.

Not a lot was known about his art career either until Seamus Burke's book *Patrick O'Connor* was published in 1941. The writer was of the view that O'Connor's portraits had 'the fire of truth, he excels in getting the likeness, the expression or the grace of an attitude...His realism is strong and direct...'Burke also referred to the compositions 'painted from the Paris music hall revues and individual figures or dancers from the New York Burlesques, are truly amazing.' The book, sub-titled 'Painter of Portraits,' contained seventeen plates, including a self-portrait and portraits of his father and Jack B. Yeats (q.v.). As well as in his native Paris, he had also worked and studied in Madrid, Venice and Berlin, according to the author.

Ulick O'Connor, in a letter to the author, recalled: 'I knew Pat very well and in the fifties I used to drop into his studio a few evenings a week after I had left the Law Library of the Four Courts...Jack Yeats liked the portrait of himself very much. I sat for Pat for two months in the course of which he threatened to kill me on two occasions, but was deterred by his knowledge of the fact that despite his huge strength and weight, I held the Irish boxing record for the quickest knockout and would have been a difficult opponent...'.

In 1955 O'Connor was appointed Curator of the Municipal Gallery of Modern Art, Dublin, but resigned in 1960. During this time he was associated with the Institute of the Sculptors of Ireland, in 1956 showing bronzes of Commodore John Barry (Annapolis Navy Academy) and Robert Emmet. The head of Emmet, height 65.5 cm, was presented to Trinity College Library by the Robert Emmet Society. In 1957 at the Institute he exhibited a bust of Oscar Wilde. A bronze bust of Kavanagh was modelled from drawings, measurements and working diagrams made from life by his father, who never executed the bust.

At the Little Theatre, Brown Thomas, Dublin, he displayed paintings, drawings and sculpture in 1966. The exhibition was opened by Ulick O'Connor. In a list of paintings which the artist sent to the author many years later, he included *Grace O'Malley's Castle*; *Homage to Goya*; *It is a Long Way to Tipperary*. Since the death of his wife in 1963 he had lived variously in London and Dublin before settling in Palm Beach, Florida, near his brother Roderic. Portraits of past presidents were painted for Villanova University in Pennsylvania, and also a large altarpiece for which Peter Kavanagh, brother of Patrick, was a model for one of the figures.

O'Connor survived financially partly through painting and sculpting but also in dealing and restoring. He was credited with a 'brilliant connoisseur's eye for Old Master painting.' He died at Palm Beach on 27 April 1997.

Works signed: Patrick O'Connor, P. O' Connor, P. O'C.; Capulet or Patrice, both rare (if signed at all).
Examples: Annapolis, Maryland, USA: Naval Academy. Dublin: Hugh Lane Municipal Gallery of Modern Art; Trinity College Library. Villanova, Pennsylvania: Villanova University.
Literature: *Evening Press*, 14 June 1932; Seamus Burke, *Patrick O'Connor*, Dublin [1941] (also illustrations); *Irish Times*, 26 January 1966, 6 November 1967, 31 January 1970, 8 May 1997; Ann M. Stewart, *Royal Hibernian Academy of Arts: Index of Exhibitors 1826-1979*, Dublin 1987; Patrick O'Connor, *Letter to the author*, 1990; Andrew O'Connor, *Letters to the author*, 2000; Glasgow City Council, *Letter to the author*, 2000; also, Ulick O'Connor, 2000; Trinity College Library, 2000.

O'CONNOR, SEAN (1909-92), landscape painter. Born on 14 December 1909 at Fossa, Killarney, where the family lived from 1907 until 1990, John Joseph O'Connor was the son of Jeremiah Joseph O'Connor, National School inspector, whose autobiography, *Hostage to Fortune*, by Joseph O'Connor, was published in 1951. V. L. O'Connor (q.v.) was Sean's uncle.

Educated at Fossa National School and St Brendan's Secondary College, Killarney, he spent some time at the Dublin Metropolitan School of Art; his father was a former student. In 1940 he was represented in the Munster Fine Art exhibition in Cork. In 1941 he obtained a studio in the Town Hall, Killarney, and for the next fifty years he painted and exhibited there. At the Royal Hibernian Academy in Dublin in 1945 he exhibited *In the Ruins, Old Victoria, Killarney*, and in 1946, *Beech Trees in National Park, Killarney*.

In 1946 he showed with the Water Colour Society of Ireland for the first time and from then until 1990 presented some fifty pictures. In his inaugural year he contributed *The Last of the Oaks*; *The Castle Arch*; *The Sunlit Square*. He painted almost exclusively in the Co. Kerry area. A work at the 1950 WCSI gathering was *Donovan's Donkey*. In 1957, after an interval of eleven years, he returned to the Academy with *The Pier, Dunquin*, his final showing. *On The Great Blasket* was one of his WCSI contributions that year.

Apart from painting, he had other interests. A founder member of Muckross House, Killarney, project in 1964, he was on the inaugural committee of Kerry Archaeological and Historical Society in 1967. He was associated with both organisations until his death. His illustrations were featured on the covers of the Society's annual journals for many years. There are nine of his watercolours at Muckross House.

O'Connor exhibited in 1968 at WCSI and then there was a gap of eleven years, but 1968 had seen the first work hung by his daughter, Catriona O'Connor, a full-time painter. Among his other contributions to this society's exhibitions were: 1979, *The Boat Pool, Ross Island, Killarney*; 1986, *Low Water, Crinnagh River, Killarney*. He died at his residence, Muckross Grove, Killarney, on 13 July 1992. A memorial panel was included in that year's exhibition.

Works signed: Sean O'Connor or S. O. C., illustrations.
Examples: Dublin: County Dublin Vocational Education Committee. Killarney: Muckross House; Municipal Gallery. Termonfeckin, Co. Louth: An Grianán.
Literature: Ann M. Stewart, *Royal Hibernian Academy of Arts: Index of Exhibitors 1826-1979*, Dublin 1987; *Irish Times*, 16 July 1992; Muckross House, *Letter to the author*, 1993; *Water Colour Society of Ireland Exhibition List 1872-1994*, Dublin 1995; Mrs Eileen O'Connor, *Letters to the author*, 1999, 2000.

O'CONNOR, V. L. (1888-1978), caricaturist, landscape and portrait painter. His father, Daniel O'Connor, served in the British Army and, on deciding to retire, the family moved from Lincoln to Listowel, Co. Kerry, where Vincent Louis O'Connor was born on 8 July 1888. He was a pupil at the Christian Brothers' School in Dingle when the family moved again, this time to London. On returning to Tralee he joined in 1906 the local Christian Brothers' School as a teacher of mathematics and languages. He also taught art as an extra subject and when a schools' inspector saw his work he advised him to go to Dublin and attend the Metropolitan School of Art. He accepted the advice, returning to Co. Kerry with an art teachers' certificate in 1908.

Vincent studied at the Metropolitan School of Art with his brother Joseph. Both were critical of William Orpen (q.v.) as a teacher. Vincent commented: 'He had a habit of staying with select students like Sleator ... Actually he spent mighty little time teaching ...'. In spite of his poor opinion of Orpen as a teacher, he admired him as an artist and *A Book of Caricatures* was dedicated 'without permission' to Orpen and published in Dundalk in 1916 at one shilling. The book carried a preface: 'The artist has fled to America. He is safe. The Publisher having to stay at home, begs, without prejudice, to apologise to the victims of these Caricatures. He hopes they will look upon them as one of the penalties of greatness.'

Caricatures, eighteen in all, included Sara Allgood, George Birmingham, Mrs A. S. Green, Dr Douglas Hyde, the Rev. J. P. Mahaffy, Count Plunkett and G. B. Shaw. Abbreviated biographical information appeared for each person. That for Rev. J. P. Mahaffy, MA, DD, read: 'Occupation: Provost. Characteristics: retiring disposition. Recreation: Visiting Crowned Heads. Favourite pastime: Trumpet solos. Pet aversion: mushroom universities. At Home: with his performing Irish bulls.'

After teaching for nearly ten years with the Christian Brothers in Tralee, O'Connor emigrated to America in 1915. At Terre Haute, Indiana, he practised as a freelance artist and cartoonist. Cartoons appeared in the *Terre Haute Tribune*. By December 1915 he was on the faculty of the University of Notre Dame, Indiana,

and as Professor O'Connor tutored a course in cartooning and caricature in the Journalism department. He also taught freehand drawing at the University, which he left in 1922, and lectured on presentation in advertising. At Notre Dame he and four other professors sponsored an Eamon de Valera visit to America. In turn, he became an educational superintendent in Chicago and taught art at all school levels.

'An Irish Artist and Art in America' was the title in 1940 of an article which he wrote for the *Ireland-America Review*, where he said in part, tongue in cheek: 'It is the rankest, heretical pedagogy to judge one pupil's ability by standards established in the distant past. Accomplishment is not even gauged by achievements of classmates. That which the boy himself does is the only scale by which he can be measured … Be not alarmed that the laws of gravity and perspective are not observed; rather remember that in the new dispensation each artist is the law.'

In the late 1940s he made the first of several trips home to Ireland. After official retirement in 1955, he taught art at Maryknoll Seminary, Chicago. He painted landscapes in the USA and Ireland, France, Mexico and Portugal. On a visit to Ireland in 1960 he rented a studio at 20 Merrion Square, Dublin, and painted there a portrait of Eoin O'Mahony. A vegetarian and non-smoker, drinker of only fruit juice, Vincent O'Connor provided some useful 'copy' in the quiet season by claiming in Dublin in 1963 that he would live to be 114.

In 1964 he painted a portrait of the late President Kennedy for the Federation of Irish Clubs in Chicago. He was then residing at Fairfield Avenue, Elmhurst, Ill., where he had a studio and taught private students. In that year too he gave a lecture entitled 'Irish Art and Irish Artists' to the Federation. Closely associated with the Palette and Chisel Academy of Fine Art in Chicago, he held honorary membership. He died of a massive heart attack at his home on 5 December 1978.

Works signed: V. L. O'Connor or V. Louis O'Connor, rare.
Literature: *Notre Dame Scholastic*, 4 December 1915, 28 February 1920; V. L. O'Connor, *A Book of Caricatures*, Dundalk 1916; *Ireland-American Review*, vol. I, no. 3, 1940; Joseph O'Connor, *Hostage to Fortune*, Dublin 1951; *Irish Press*, 31 October 1959; *Sunday Review*, 7 February 1960; *Terre Haute Tribune-Star*, 1 July 1962; *Irish Independent*, 15 August 1963, 24 May 1974; *Chicago Tribune*, 10 May 1964, 26 July 1964; Bruce Arnold, *Orpen: Mirror to an Age*, London 1981; Sean O'Connor, *Letter to the author*, 1991; also, Sister Margaret Ellen O'Connor, 1991; University of Notre Dame, 1991.

O'CONOR, RODERIC (1860-1940), landscape, portrait and still life painter. Roderic Anthony O'Conor was born on 17 October 1860 at Milton, Castleplunkett, Co. Roscommon, the son of Roderic Joseph O'Conor, a member of the legal profession. Roderic the son was the brother of the maternal grandmother of Sister Mary Theophane, Dominican, who recollected in 1972 to the author that there were seven or eight children originally but only Roderic and three sisters survived. She believed that he was given an allowance by his father to pursue the study of art. In any event, the O'Conors had left Roscommon for Blackrock, Co. Dublin, in 1864, and soon moved to other houses in Dublin city.

O'Conor attended Ampleforth College, York, from 1873 until 1878; an outstanding pupil, he passed the matriculation examination of the London University. His art teacher at Ampleforth was William James Boddy (1832-1911). In January 1879, he enrolled at the Dublin Metropolitan School of Art where he met Nathaniel Hill (q.v.), who lodged for a time with the O'Conors at 88 Pembroke Road. In 1881 O'Conor was awarded the Cowper Prize at the Metropolitan, but he then transferred for a year to the Royal Hibernian Academy Schools where in 1882 he was awarded two bronze medals and two cash prizes for his drawing and painting. He returned to the Metropolitan School of Art for the session 1882-3.

At the Royal Hibernian Academy in 1883, R. T. Moynan (q.v.) won the Albert Scholarship for the best picture shown in the Academy by a student. O'Conor won a special prize as runner-up; he showed *Sylvan Quiet* and *Wild Rabbit* at the exhibition. In the autumn, O'Conor and Moynan followed other Dublin art students – including W. F. Osborne (q.v.) – to Antwerp. O'Conor enrolled at the Académie Royale des Beaux-Arts under Charles Verlat (1824-90), professor of painting. O'Conor and Moynan shared lodgings at 12 Keizerstraat, where Osborne had stayed. O'Conor won a £15 prize in 1884 in the Royal Dublin Society's Taylor Scholarship competition.

O'Conor contributed from 25 Pembroke Road, four works to the RHA in 1885, including *Sunny Day in June* and *Wet Weather*. The earliest known paintings are three small landscapes which he painted about this time at Aberystwyth, Wales; two are in the National Gallery of Ireland collection and all show the Pembroke Road address verso. *On the Shore, Aberystwyth*, presented by the artist's family in 1996, is at Hugh Lane Municipal Gallery of Modern Art. He was allowed 'free study' at the Metropolitan School of Art for the 1885-6 session.

O'Connor arrived in Paris in 1886 for tuition under Charles Carolus-Duran (1838-1917). His *Landscape in Summer*, 1886, and *River Landscape*, 1887, were both painted near the river Loing, and indicated an awareness of Impressionism. When living at 4 Rue Darcet, Paris, he exhibited a portrait of a man at the 1888 Salon. He stayed at the Hôtel Laurent in Grez-sur-Loing near Nemours in 1889, sending a second picture to the Salon and three works to the Salon des Indépendants. In 1890 he was at the Hôtel Beauséjour in Grez and contributed ten canvases to the Salon des Indépendants, the same number as Vincent van Gogh (1853-90). At Grez he met an American painter, Edward Brooks, whose son, Alden Brooks, later recounted how his father and O'Conor had visited van Gogh in his Paris studio. At Grez too he renewed his friendship with a former Antwerp Academy student, Joseph Milner Kite (1862-1945) who settled in France and they remained on good terms all their lives.

O'Conor, unusual as an Irish colourist, exhibited only one work at the New English Art Club, London, in 1891 when he stayed with the painter, Ernest Parton (1845-1933). By 1890 he was in Brittany if one is to judge by *La Jeune Bretonne* (National Gallery of Ireland), dated that year. Like many of his colleagues, he resided at Pont-Aven in Madame Gloanec's pension, where 'the artists allowed their hair and beards to grow', and he befriended Armand Séquin (1869-1903), who became one of O'Conor's closest friends in France. In 1892 he painted *Yellow Landscape, Pont-Aven* (Tate Gallery), *Still Life with Bottles* (Tate Gallery), *The Glade* (Museum of Modern Art, New York) and *Field of Corn, Pont-Aven* (Ulster Museum).

In the period 1892-4 he introduced a new style with his parallel 'stripes' of pure colour. Five Breton landscapes were exhibited at the Indépendants in 1892; he showed again in 1893, followed by a ten-year gap. In the early 1890s too he painted a series of portraits of Breton peasant women. Most of his prints were etched in 1893 when he and his friend Séquin worked together at Le Pouldu. He was responsible for about forty etchings and one lithograph. These included *Maison dans les arbres* and *Sans Titre*, both dated '93, and an undated etching of Paul Gauguin (1848-1903). Gauguin had 'settled' in Brittany in 1886, first at Pont-Aven and then a few miles away at Le Pouldu. O'Conor spent longer in France than any other Irish painter and was the only one who became a friend of Gauguin.

In 1894, the year they first met, Gauguin presented O'Conor with a coloured monotype, *L'Angelus en Bretagne* with the dedication: 'For my friend O'Conor, one man of Samoa, P. Gauguin, 1894'. Gauguin also gave him a proof of his print, *Manoa Tupapau* with the inscription: 'A L'artiste O'Conor, Aita Armoe, Paul Gauguin'. The Irish artist owned pictures and a small wooden sculpture by Gauguin, who urged him to accompany him on his second visit to the South Seas but O'Conor declined. At one period of their friendship Gauguin borrowed O'Conor's studio in Paris.

O'Conor's father had died in Dublin in 1893. Sister Theophane, in one of her letters to the Ulster Museum, wrote: 'He seems to have come back to Ireland only once – to settle up his father's affairs and see to the sale of the family estate in Roscommon ... contacts with his family were few and far between. He wrote at Christmas and sent generous cheques to his sisters and each of his nieces and nephews, some of whom he was never to meet. If ever any of them was in trouble or bereaved, he was prompt to send a cheque as a practical form of sympathy.'

O'Conor exhibited at the Barc de Boutteville's Gallery in Paris in 1894 and 1895, but generally he avoided dealers. Fortunately, he did not have to paint to make a living. In any case, according to his wife, he would never paint for sale – as he said: 'One would lose the whole sense of art, working for money'. By the end of 1894 he was back in Grez; a year later he was in Brittany again but at a new location, Rochefort en Terre, where he remained, apart from some visits to Pont-Aven, until 1899 when he returned to that town. He painted a number of seascapes on the coast of Finistère; *The Wave* in York City Art Gallery was dated 1898.

The International Society of Painters, Sculptors, and Gravers was founded in 1897-8 by J. A. M. Whistler (1834-1903) and John Lavery (q.v.); O'Conor contributed to the exhibitions. In 1903 he participated in the inaugural exhibition of the Salon d'Automne and, with the exception of a few years, he continued until 1935. The earliest known self-portrait of O'Conor is the 1903 one in NGI. Another self-portrait is at the Ulster Museum where there are seven other works. In 1903 too he painted *Une Jeune Bretonne* which was shown at Hugh Lane's exhibition of Irish art at the Guildhall, London, in 1904, and presented by the artist to the Municipal Gallery of Modern Art, Dublin. *Breton Woman* is at the Hunt Museum, Limerick.

In 1904 he moved from Brittany to live at 102 rue du Cherche-Midi, Paris. Interiors, nudes, still lifes and flowerpieces began to figure prominently in his subject matter. O'Conor met in Paris, Clive Bell, aged twenty-three, aspiring as a critic of art and literature. Bell became friendly with O'Conor, found him highly intelligent and well educated but 'gruff' and 'misanthropic'. Later, Bell introduced him to the art critic and painter, Roger Fry (1866-1934). In 1981 NGI bought at Sotheby's, London, thirteen autograph letters from O'Conor to Bell, all written from Paris, dated from 1906 to 1925. They discussed mainly French painting and literature. As well as a collection of paintings and prints, O'Conor had hundreds of volumes in his library.

In 1905 he painted at Montigny-sur-Loing, close to Grez, and in 1907 he served on the selection jury for the Salon d'Automne. In 1908 his work appeared in the Allied Artists' Association exhibition in London. In 1910 he visited Italy; in 1912, Spain. There was considerable animosity between O'Conor and Somerset Maugham, whose novel, *Of Human Bondage*, 1915, contained the fictional character Clutton, partly based on the Irish artist, settled in Montparnasse although he spent several months in 1913 in the South of France at Cassis. At NGI is *La Rose du Ciel, Cassis*.

After the First World War, O'Conor was in touch with Matthew Smith (1879-1959) in Paris. Each of them possessed works by the other and they may have originally met when Smith visited Paris in 1911. O'Conor exhibited at the Salon des Tuileries in 1923 and for some years after. In 1923 he was a member of the London Group, of which Fry was a member. Indeed Fry purchased from him *Still Life with Bowl of Fruit by a Window*, 1924, now in the Courtauld Institute Galleries. In 1925 he exhibited in the Tri-National exhibition in London, Paris and New York. In 1930 he was represented in the exhibition of Irish art at Brussels. In London, the Chenil Gallery, Grosvenor Gallery and the London Salon also displayed his work.

According to Alden Brooks: 'O'Conor was the handsome, gifted young Irish painter, favourite of the ladies, of whom great things were expected.' He was engaged to a Swedish painter but due to a misunderstanding on O'Conor's part, he broke off the engagement. Perhaps this left him embittered. Arthur Power (q.v.) told the author in 1972 that he visited O'Conor's studio in Paris but the door was shut in his face. Sister Theophane's uncle met him twice when passing through Paris in the 1920s but was not invited into the studio or shown anything. O'Conor, who had a bout of illness in 1926, suffered from gout.

Jonathan Benington listed O'Conor's works in his important biography, *Roderic O'Conor*, 1992. He wrote: '...he invariably declined to put figures in his landscapes (except for a few imaginary compositions). He also was solitary, introverted, highly intelligent and lacking in self-belief, so much so that he preferred not to sell his pictures...'.

Anne Crookshank and the Knight of Glin wrote in *The Watercolours of Ireland*, 1994: 'His crayon studies of Breton peasants have strong outline and character conveyed with simple lines. His landscapes, which are mostly of trees, almost assume a life of their own, dancing and walking on the page, like the occasional drawing of peasants clumping along a road. His enormously exciting art ...'.

In 1933 he purchased a house at Nueil-sur-Layon, Maine-et-Loire, in the name of his future wife, Henrietta (Renée) Honta, a painter who had been his model. They were married that year, and together visited Torremolinos, Spain, hence *Torremolinos 1935*, oil on board. In 1937 he agreed to a small one-person show at the Galerie Bonaparte, Paris. On 18 March 1940 he died at his home, and was interred in the local graveyard. His widow died in 1955 and his estate reverted to his family.

A sale of studio contents was held in Paris in 1956, and in that year Roland, Browse and Delbanco organised the first exhibition by this artist in England, shared with his younger friend, Matthew Smith. This London gallery also presented his work in 1957, 1961, 1964 and 1971. Another retrospective was held in 1984 at the Musée de Pont-Aven, organised by Roy Johnston of the University of Ulster and Catherine Puget of the

museum. However, the first large-scale retrospective exhibition was staged at the Barbican Art Gallery, London, in 1985, followed by the Ulster Museum, National Gallery of Ireland and Whitworth Art Gallery, Manchester. This exhibition was selected by Johnston who wrote the extensive catalogue. An exhibition of O'Conor's prints was held at NGI in 2001, guest curated by Johnston, from Eastern Michigan University.

Works signed: Roderic O'Conor, R. O'Conor, O'Conor or R. O'C. (if signed at all).
Examples: Auckland, N.Z. : City Art Gallery. Bedford, Eng. :Cecil Higgins Art Gallery. Belfast: Ulster Museum. Boston, Mass. : Museum of Fine Arts. Bradford, Yorks.: Cartwright Hall Art Gallery. Brisbane: Queensland Art Gallery. Bristol, Gloucs.: Art Gallery. Brunswick, Maine: Bowdoin College. Churchill, Co. Donegal: Glebe Gallery, Derek Hill's Collection. Derby, Eng. : Museum and Art Gallery. Dublin: Hugh Lane Municipal Gallery of Modern Art; National Gallery of Ireland. Edinburgh: Scottish National Gallery of Modern Art. Firle, East Sussex: Charleston Trust. Geneva: Musée du Petit Palais. Gisborne, N.Z.: Art Gallery. Leningrad: Hermitage Museum. Limerick: Hunt Museum. London: Courtauld Institute Galleries; Tate Gallery; Victoria and Albert Museum. New York: Museum of Modern Art. Paris: Bibliothèque d'Art et d'Archéologie; Musée d'Orsay. Pont-Aven, France: Musée. Quimper, France: Musée des Beaux-Arts. Rennes, France: Musée des Beaux-Arts. Stockholm: National Museum. Sydney: Art Gallery of New South Wales. Wellington, N.Z.: National Museum and Art Gallery. York, Eng.: City Art Gallery.
Literature: *Thom's Directory*, 1865; W. G. Strickland, *A Dictionary of Irish Artists*, Dublin 1913; Roland, Browse and Delbanco, *Two Masters in Colour: Matthew Smith and Roderick* (sic) *O'Conor*, catalogue, London 1956; Denys Sutton, 'Roderic O'Conor (1860-1940): Little-known member of the Pont-Aven Circle', *The Studio*, November 1960; Bengt Danielsson, *Gauguin in the South Seas*, London 1965; Harold Osborne, ed., *The Oxford Companion to Art*, Oxford 1970; Roland, Browse and Delbanco, *Roderic O'Conor 1860-1940*, catalogue, London 1971; Sister Mary Theophane, *Letters to the Ulster Museum*, 1972; *Dictionary of British Artists 1880-1940*, Woodbridge 1976; National Gallery of Ireland, *Acquisitions 1981-1982*, Dublin 1982; Julian Campbell: National Gallery of Ireland, *The Irish Impressionists: Irish Artists in France and Belgium 1850-1914*, catalogue, Dublin 1984; *Irish Arts Review*, Autumn 1984; Roy Johnston: Barbican Art Gallery and Ulster Museum, *Roderic O'Conor*, catalogue, London 1985 (also illustrations); Jonathan Benington, 'Thoughts on the Roderic O'Conor Exhibition,' *Irish Arts Review*, Summer 1986; Ann M. Stewart, *Royal Hibernian Academy of Arts: Index of Exhibitors 1826-1979*, Dublin 1987; Musée d'Orsay, *Letter to the author*, 1990; Jonathan Benington, *Roderic O'Conor*, Dublin 1992 (also illustrations); Anne Crookshank and the Knight of Glin, *The Watercolours of Ireland*, London 1994 (also illustrations); National Gallery of Ireland, *Gallery News*, September-November 2000, June-August 2001.

ODELL, ISABEL (1871-1943), landscape, flowerpiece and portrait painter. Isabel Mary Grant Ussher, born in Dublin, the only daughter of Richard J. Ussher of Cappagh, Co. Waterford, lost her mother at an early age. Brought up by a woman who often beat her, at the age of twelve Isabel travelled alone to England to live at Tunbridge Wells with an aunt, who encouraged her to study art. After attending the Slade School of Fine Art, London, she studied at Julian's in Paris when Constance Gore-Booth (q.v.) was also a student. She returned to Cappagh to look after her father and had a studio at home. Generally she used pastel, occasionally oils. Relatives sometimes asked her to copy portraits.

In 1901 she married William Odell; in 1908 the family moved to Ardmore, Co. Waterford, and in 1915 to Bristol. After the death of her husband, the next move was to Southwold, Suffolk, in 1919. According to her daughters: 'She turned to painting with fresh vision and new methods: landscapes and flowerpieces. The flat countryside was an inspiration, continuing later for two years in Norfolk'. In 1925-6 she painted landscapes on the French and Italian Rivieras.

After living in Welwyn Garden City, Hertfordshire, with her daughter Mary, who also painted, they returned to Ardmore in 1934, built a studio-cottage and each summer threw open the studio to visitors. In 1942 they held a joint exhibition at the Country Shop, Dublin, where Isabel showed landscape studies of Co. Waterford and Connemara, also *Tom Murray, Story-Teller of the Decies*, a 1938 portrait of the ploughman, reproduced in the book on him by her nephew, Arland Ussher, and which is in the Waterford municipal collection. She died in Co. Waterford.

Works signed: I. Odell.
Examples: Waterford: City Hall, Municipal Art Collection.
Literature: Arland Ussher, *Cainnt an tsean-shaoghail*, Dublin 1942 (illustration); *Thomas MacGreevy Papers*, Trinity College, Dublin [1967]; Misses Mary and Ruth Odell, *Letter to the author*, 1968.

O'DONNELL, HENRY C.(1900-92), landscape and figure painter. Born in India, Henry C. O'Donnell was the son of Dr Thomas J. O'Donnell, of Cashel, Co. Tipperary, Chief Medical Officer in Kolar, Southern India, a gold fields area. After returning to Ireland, Henry studied at the Catholic University School, Dublin, and later at Clongowes Wood College, Co. Kildare.

O'Donnell's art education lasted about eight years. After Dublin Metropolitan School of Art, he moved to London, where he studied at St John's Wood School and then at Westminster Art School under Walter Bayes (1869-1956), who became principal in 1919.

In the 'Works of Living British Artists' exhibition at Belfast Museum and Art Gallery in 1927 he showed *Sunlight, Alassio*, from Studio 4, Cochrane Mews, St John's Wood. This event, under the auspices of the British Artists' Exhibitions, was seen in Plymouth in 1928. He was represented in London at the Goupil Gallery Salon of 1929, and his work was on view at the Grafton Gallery in 1930. One picture was hung at the Colnaghi & Co. Galleries. He was active at Clifden, Co. Galway, in 1930, and his work was at the Egan Salon, Dublin, in 1931 and 1932.

In 1932 he exhibited with the Royal Society of British Artists. In 1934, still at Cochrane Mews, he presented *The farm gate, Andorra*, at the Royal Academy. A letter which he received from Shell-Mex and B.P. Ltd. in 1934 indicated that the lorry bill, *The Liffey, Dublin*, which he had designed for them in 1932, would be displayed on the rear boards of their lorries for a fortnight.

An exhibition at the Dublin Painters' Gallery in 1936 included *Street Market, Albenga, Italy*, oil. Also painted in the Savona province was *On the Shore, Laigueglia, Italy*. On view too were the oils, *Ruined Cottage, Connemara* and *Romano*. In 1938 when he contributed *Flowers in Sunlight* to the Royal Hibernian Academy, he gave his address at 42 Eglinton Road, Dublin. In 1938 he exhibited at the Paris Salon.

O'Donnell was called up to serve in the Royal Air Force during the Second World War and made technical drawings of Halifax Bombers. He exhibited for a second time at the RA in 1941, from Carshalton, Surrey: *August 1940: Spitfires in action*. Back in Dublin, from 23 Brendan Road, Donnybrook, he contributed *Yearly Colt; Denturius-Santroyal* at the 1947 RHA.

When he staged another show at the Dublin Painters' Gallery in 1950, from 18 Whitethorn Road, Clonskeagh, he presented a number of pictures of equestrian interest, for example *Miss Jill Brady on 'Toby'*; *Miss Faith Howe on 'Candy' — R.D.S. 1948*; *Ward Union Hounds*, all oils. A flowerpiece and *Studio, Iver, Bucks.* were also hung. Edward Sheehy in *Social and Personal* found a 'mixed bag of varying interest and quality...in his portraits Mr O'Donnell shows definite feeling for both character and paint...'.

After an interval of thirty-two years, now at 15 Cherrington Road, Shankill, Co. Dublin, he returned to the RHA in 1979 with *Professor H.D.* and *Studio Sewing Session*. His final contribution came in 1982 with *Allan Warriner*. According to his notes, he also exhibited at the Hackett Galleries, New York. He travelled extensively throughout his life. His death on 18 November 1992 was at St Columcille's Hospital, Co. Dublin. A retrospective exhibition of sixty-three works took place at the Gorry Gallery, Dublin, in 1994.
Works signed: H. C. O'Donnell; H.C. O'D. or O'Donnell, both rare.

Literature: Belfast Museum and Art Gallery, *Catalogue of the Works of Living British Artists under the auspices of the British Artists' Exhibitions*, Belfast 1927; Shell-Mex and B.P. Ltd., *Letter to H.C. O'Donnell*, 1934; Dublin Painters' Gallery, *Exhibition of Paintings by Henry C. O'Donnell*, catalogue, 1950; *Social and Personal*, June 1950; *Dictionary of British Artists 1880-1940*, Woodbridge 1976; *Royal Academy Exhibitors 1905-1970*, Calne 1981; Ann M. Stewart, *Royal Hibernian Academy of Arts: Index of Exhibitors 1826-1979*, Dublin 1987; General Register Office, Dublin, *Register of Deaths*, 1992; Gorry Gallery, *Henry C. O'Donnell 1900-1992*, catalogue, Dublin 1994 (also illustrations); BP Amoco, *Letter to the author*, 2000.

O'DONOHOE, FRANCIS J., ARHA (1878-1911), landscape and figure painter. Francis Joseph O'Donohoe was born on 30 April 1878 at 40 Cuffe Street, Dublin, the son of a jeweller, William O'Donohoe. Educated at the Christian Brothers' School in Great Strand Street, he showed a marked talent for drawing. At the age of eleven he entered the Dublin Metropolitan School of Art.

According to the *Irish Times*: '...at the age of thirteen he became a Queen's prize man at South Kensington; and he also won the Royal Dublin Society's grant three years in succession, and the South Kensington bronze

medal. For the Taylor Art competition he entered every year within the prescribed age limits, and every year he carried off distinctions...'

In 1896 he was sent to London on a special course at the National Art Training School. Studies were concluded in Paris where he spent about a year under Benjamin Constant (1845-1902) at the Académie Julian. Returning to Dublin he was appointed Art Master in the City of Dublin Technical Schools. In 1899 he exhibited at the Royal Hibernian Academy for the first time, from his home address, 15 Essex Quay, Dublin, and from then until 1911 he contributed twenty-four works. In 1901 he showed five, including *At Malahide* and *An Algerian*.

Walter G. Strickland in his *A Dictionary of Irish Artists* was of the opinion that O'Donohoe did not paint any important easel pictures, but found employment in church work. One of his first commissions for ecclesiastical painting was a set of Stations of the Cross for the parish church of Screen, Co. Wexford, executed in 1903.

According to Robert Elliott in his *Art in Ireland*, on the Screen project, 'the colour, its quality and its values, was the chief charm of the whole set. And next to that is their general design and arrangement of well-balanced masses, and well thought-out problems of line and action. As for the artist's selected types and ideas about the treatment of the Sacred Story of the Passion, I have nothing to say, except that the painter has, it appears, looked at everything from the standpoint of the painter. These types may be a weakness among considerable strength. His landscape backgrounds, without being definitely recognisable, are of his native country; their colour, their skies, are of Ireland, not of Italy, nor of Palestine; and the figures moving upon them are directly and solidly painted.' The writer believed that this commission was the first set of Stations painted by an Irishman, living in Ireland.

Subsequently O'Donohoe was entrusted with the execution of a painting of the Sacred Heart for the Cathedral at Loughrea, Co. Galway, and was also responsible for a set of enamels for a ciborium representing the pre-Christian and Christian periods in Ireland.

An 1906 watercolour sketch of O'Donohoe by William Orpen (q.v.) is in Dublin at the Hugh Lane Municipal Gallery of Modern Art. In private possession is a 1907 pencil sketch by O'Donohoe of his sister, Mary Josephine Fenning, with her son Seumas.

At the 1909 RHA he contributed seven pictures, including *The Hayfield*; *In the Dublin Hills*; *The Sally Tree*. Two years later, now an ARHA, he exhibited *The Brook* and *The Fiddler*. He was involved in the renovation of St Andrew's Church, Westland Row, Dublin, where he executed the circular mural paintings of the Twelve Apostles, placed high up in the transepts. He executed a design for a stained glass window for St Saviour's Church, Dominick Street, but its existence has not been established.

Outstanding works in his studio, at least those for sale, would appear to have been: *The Brook*; *The Old Fiddler*; *The Tree*; *The Rehearsal*; *The Stream*; *The Dancer*. Among some of the other places actually named in his landscape titles were: Crumlin, River Liffey, Malahide, Phoenix Park. Michael Healy and Albert Power (qq.v) both owned his works. A grand nephew of O'Donohoe is the artist Brian Mooney of Co. Wicklow.

A career regarded as of some promise was cut short by a tragic end. On 24 December 1911 he left his home to buy a Christmas present for his mother. In Parnell Street he met two friends of his who were in a motorcar, driven by an engineer with a fourth man as 'cleaner'. On invitation, he took a seat in the car. In Morehampton Road the driver tried to pass an outgoing tram. In swerving to the right, the car ran into a stationery breadvan. The force of the collision flung O'Donohoe through the windscreen and his throat was cut by the glass. He was taken to the Royal City of Dublin Hospital but the loss of blood was so great that he soon died. An exhibition of his paintings, watercolours and drawings, 155 in all, took place in February 1912 at the Irish Art Gallery, 28 Clare Street, Dublin.

Works signed: F. O'Donohoe (if signed at all).
Examples: Ballinasloe, Co. Galway: St Brendan's Cathedral. Dublin: St Andrew's Church, Westland Row. Screen, Co. Wexford: St Cyprian's Church.
Literature: Robert Elliott, *Art and Ireland*, Dublin [1906]; *Irish Times*, 26 December 1911; Irish Art Gallery, *Exhibition and Sale of Pictures by the late Francis J. O' Donohoe, ARHA*, catalogue, Dublin 1912; Walter G. Strickland, *A Dictionary of Irish Artists*, Dublin 1913; Julian Campbell: National Gallery of Ireland, *Irish Artists in France and Belgium*

1850-1914, Dublin 1984; Ann M. Stewart, *Royal Hibernian Academy of Arts; Index of Exhibitors 1826-1979*, Dublin 1987; James Fenning, *Letter to the author*, 2000; also, Hugh Lane Municipal Gallery of Modern Art, 2000; Brian Mooney, 2000.

O'FARRELL, MICHAEL – see FARRELL, MICHAEL

O'FLYNN, GERTRUDE (1895-1946), portrait painter. At an early age she entered the Limerick School of Art, and then moved to the Dublin Metropolitan School of Art where she became a teacher-in-training with a special extension granted. She exhibited from 13 Northumberland Road, Dublin, only three works, all portraits, at the Royal Hibernian Academy – in 1916 and 1919 – but was not listed in *Thom's Directory* at that address. The greater part of her art teaching was in various secondary and technical schools in Dublin, Limerick and Dundalk.

The most unusual of her gifts, it was claimed, 'was her power of creating a posthumous likeness – by bringing together in one canvas the slight and scattered records of photographs, sketches and portraits, often inferior, or injured by time or accident, but sufficient, in the hands of Gertrude O'Flynn, to permit of a finished portrait little, if anything, distinguishable from one painted from life'. For the Incorporated Law Society she replaced some pictures of former dignitaries, destroyed in the Four Courts fire. A portrait of Father Michael O'Flanagan, who died in 1942, is in Áras an Uachtaráin but may not be posthumous; it is 'attributable to Miss Gertrude O'Flynn, Limerick'.

Apart from the above information, which was mainly derived from an address by Mrs A. M. Fraser, vice-president of the Old Dublin Society, at the unveiling on 27 January 1947, at the City Assembly Rooms, of a posthumous portrait of Alderman Thomas Kelly, TD, the Society's first president, little is known about this artist who died, said Mrs Fraser, shortly after the portrait was completed. The artist was a member of the Old Dublin Society.

An examination of the records at the Register of Deaths has failed to produce the record of the death of a Gertrude O'Flynn in 1946 or 1947 but there is a record that a Gertrude Flynn of 17 Cabra Road, Dublin, died at Our Lady's Hospice, Harold's Cross, 2 June 1946, aged 51 years, spinster, albeit described 'bookkeeper'. It has been assumed, for this entry, that Gertrude Flynn was the artist and that she used 'O'Flynn' in her painting career. Mrs Fraser described her: 'She was in appearance tall and distinguished, and in manner gentle, cultured and unassuming.'

Works signed: O'Flynn (if signed at all).
Examples: Dublin: Áras an Uachtaráin; Civic Museum.
Literature: *Registrar's Book of Deaths*, 1946; *Dublin Historical Record*, September-November 1947, June 1985; Old Dublin Society, *Letter to the author*, 1973; also, Áras an Uachtaráin, 1976.

O'HAGAN, HARRIET OSBORNE (1830-1921), portrait painter. Born in Dublin, Harriet Osborne first exhibited at the Royal Hibernian Academy in 1849 with a 'drawing in Lithography, after Mr Burton's picture of Mrs Hone'. In 1851 she sent in to the Academy four portraits from 195 Great Brunswick Street, Dublin, including a watercolour of R. D. Williams. The next year she was associated both as artist and lithographer in a testimonial lithograph for Sir John Bourke Howley. George Sharp, RHA (1802-77), portrait and figure painter, of 16 Wentworth Place, was her Dublin teacher; he made the subject of instruction in elementary drawing a special study.

A second lithograph, this time by Harriet O'Hagan, was that of Daniel William Cahill, DD, who had delivered a farewell address in Dublin after receiving an invitation in 1853 to visit the USA; he did not sail until 1859. Sharp, her tutor, had spent some time in London and studied in Paris; he encouraged Harriet to leave Dublin. As Mrs O'Hagan, she contributed to the Royal Academy in 1854, from 193 Stanhope Street, London.

In Paris she studied under Léon Cogniet (1794-1880), J. N. Robert-Fleury (1797-1890) and Thomas Couture (1815-79). Sharp himself had worked under Couture, whose most famous pupil was Édouard Manet

(1832-83). Nathaniel Hone (q.v.) also studied under him. In the period 1866 to 1876 Harriet O'Hagan exhibited in nine of the eleven Salon exhibitions. Six portraits were presented. Her initial acceptance was a still life; in 1867 she showed *Fruit d'automne* and *Marguerite s'amuse*.

Harriet O'Hagan became a teacher herself, and was credited with opening the first academy for women artists in Paris. However, details about her career and family background are sadly lacking. In retrospect, it seems unfortunate that when M. Garbaye and J. de L'Etre of Savigny-sur-Oise, France, presented two O'Hagan oil paintings and four charcoal drawings to the National Gallery of Ireland in 1948 more information was not obtained about the artist. As for the academy, her own name is not mentioned in a 1988 publication on the Paris studios in the late nineteenth century.

Confusion has arisen over Harriet's charcoal studies at NGI of Eugénie O'Hagan and the two of Marguerite Lemercier O'Hagan. Both have been described as the artist's sisters, yet one of the portraits of Marguerite is dated 1869, when she was 'aged ten', so she was hardly the sister of the artist, born 1830. Another source names Marguerite Lemercier O'Hagan as the *daughter* of the artist. Marguerite and the artist's grandson Eugène Emmanuel Lemercier (1886-1915) were also artists and both are represented at NGI. On the undated portrait of Eugénie, Julian Campbell found it 'a charming portrait of a girl, with romantic expression, and large dreamy eyes looking into the middle distance. Although firmly modelled, the technique is loose, with soft shading around the eyes, mouth and chin, and deep shadowing in the wavy lustrous hair.'

The other charcoal drawing at the NGI is *A Farm in Normandy*, 1880. The two oil paintings there are both undated: *Maximilian O'Hagan* and *Interior*, a room with table and furniture, probably of Dublin origin as it is signed 'H. O.'. Apparently the artist, who remained in Paris, had always a 'love of her native country and died regretting she was unable to return to it'.

Works signed: H. Osborne O'Hagan, H. O. O'H., H. Osborne or H. O.
Examples: Dublin: National Gallery of Ireland.
Literature: *Thom's Directory*, 1851; *Dictionary of National Biography*, London 1886; Walter George Strickland, *A Dictionary of Irish Artists*, Dublin 1913; Rosalind M. Elmes, *National Library of Ireland Catalogue of engraved Irish Portraits mainly in the Joly Collection and original drawings*, Dublin [1937]; *Dictionnaire Général Des Artistes De L'Ecole Française*, New York and London 1979; Julian Campbell: National Gallery of Ireland, *The Irish Impressionists: Irish Artists in France and Belgium, 1850-1914*, catalogue, Dublin 1984 (also illustrations); National Gallery of Ireland and Douglas Hyde Gallery, *Irish Women Artists: From the Eighteenth Century to the Present Day*, Dublin 1987 (also illustrations); Ann M. Stewart, *Royal Hibernian Academy of Arts: Index of Exhibitors 1826-1979*, Dublin 1987; John Milner, *The Studios of Paris: The Capital of Art in the late Nineteenth Century*, New Haven 1988; Anne Crookshank and the Knight of Glin, *The Watercolours of Ireland*, London 1994 (illustration).

O'HARA, HELEN (1846-1920), landscape and seascape painter. Helen Sophia O'Hara was the daughter of the Rev. James D. O'Hara of The Castle, Portstewart, Co. Derry, and a sister of the Rt. Rev. H. S. O'Hara, Bishop of Cashel and Emly, Waterford, and Lismore, 1900-19. In 1877 she illustrated the children's book, *Prince Ritto*, written by her friend Fanny Currey (q.v.) of Lismore.

Between 1881 and 1892 inclusive, from The Castle, she exhibited seventeen works at the Royal Hibernian Academy including a number of seascapes and two flowerpieces. In 1884 she showed: *In Autumn*; *Dahlias*; *On the Portstewart Hill*, and contributed only one work in 1892: *A Sparrow's Banquet*. She was represented in the Irish Fine Art Society exhibition in Cork in 1884. The watercolour, *Chicks*, was dated 1886.

In 1892 she first showed with the Water Colour Society of Ireland and from then until 1913 more than one hundred works were hung. She showed ten pictures in 1893 including *Evening, near the Giant's Causeway*.

In 1895 she retired temporarily from active membership of the Belfast Art Society but in 1896 she was elected a vice-president. By 1898 she resided at Mall House, Lismore, Co. Waterford. In 1904 she became an honorary member of the Belfast Art Society, along with Mildred Butler (q.v.), and did not contribute to the exhibitions after 1910. *Evening*, a watercolour seascape now in the Ulster Museum, was exhibited at the Belfast Art Society in 1894.

At the WCSI exhibition of 1904 contributions included *From the Doneraile Walk, Tramore* and *Cliffs at Ardmore*. *Lismore Castle* and *Under the Arches* were among seven works in 1906.

Helen O'Hara must have had a ready market in England, more than five score pictures being hung there, including over sixty at the Society of Women Artists' exhibitions. Also in London she showed at the Dudley Gallery and at the Royal Institute of Painters in Water Colours.

View on the River Blackwater near Lismore, Co. Waterford was described by Anne Crookshank and the Knight of Glin in their 1994 book on Irish watercolours as 'the most detailed, delicate essay, in shades of green and white, showing her masterly talents and that at her best she was as good as Mildred Anne Butler or Rose Barton'.

Subject matter also included bluetits sitting on the branches of a tree; chaffinches; a girl picking wild flowers with Lismore Castle in the background; a woodland path; a country lane. Among her 1913 WCSI contributions were *Calm after Storm* and *Ballycotton*. She died in Co. Waterford on 27 January 1920.

Works signed: H O'H, monogram.
Examples: Belfast: Ulster Museum.
Literature: Fanny W. Currey, *Prince Ritto; or, the Four-leaved shamrock*, London 1877 (illustrations); *Burke's Landed Gentry*, London 1912; General Registry Office, Dublin, *Death Certificate*, 1920; *Who Was Who 1916-1928*, London 1929; *Dictionary of British Artists 1880-1940*, Woodbridge 1976; Martyn Anglesea, *The Royal Ulster Academy of Arts*, Belfast 1981 (also illustration); National Gallery of Ireland and Douglas Hyde Gallery, *Irish Women Artists: From the Eighteenth Century to the Present Day*, Dublin 1987; Ann M. Stewart, *Royal Hibernian Academy of Arts: Index of Exhibitors 1826-1979*, Dublin 1987; Peter Murray, compiler, *Illustrated Summary Catalogue of The Crawford Municipal Art Gallery*, Cork 1991; Anne Crookshank and the Knight of Glin, *The Watercolours of Ireland*, London 1994 (also illustrations); Gorry Gallery, *An exhibition of 18th, 19th and 20th century Irish Paintings*, catalogue, Dublin 1995 (also illustration); *Water Colour Society of Ireland Exhibition List 1872-1994*, Dublin 1995.

O'HEA, JOHN FERGUS (*c.* 1838-1922), political cartoonist and banner painter. One of the O Heas of Kilkerran, Co. Cork, he was the son of James O Hea (or O'Hea) who was a leading member of the Munster Bar and was, presumably, the O'Hea who, with other lawyers, acted as advisers to a controversial Young Ireland conference in 1846.

John Fergus O'Hea attended the Cork School of Design, and as he was there in 1850, that year (as has been published) cannot be his year of birth. In 1857 he was an award-winning student. In the Cork parade of 1864 he was responsible for three trade union banners: Oddfellows, Stonecutters, and Victuallers.

A friend of his youth was Henry Albert Hartland (1840-1893), the landscape painter. They were said to have besieged Cork and its environs. Thomas Crosbie, who wrote an appreciation of Hartland in the *Journal of the Cork Historical and Archaelogical Society*, January 1894, added: 'Those who know Mr. John O'Hea cannot but be aware of what pleasant companionship he is capable, and how the fun of his pictures is reproduced in his talk, while Hartland himself, full of animal spirits, had an inexhaustible fund of native drollery'.

One of the best-known cartoons was that which represented Thomas Davis, Gavan Duffy and John Blake Dillon seated under a tree in the Phoenix Park, Dublin, the occasion when they decided to found *The Nation*, which, on 5 October 1872, published a lengthy notice on John F. O'Hea's picture, *Punchestown in 1868*, text taken from the *Irish Sportsman and Farmer*. The oil painting, exhibited at the Exhibition Palace, was painted to the order of a Mr Chancellor of Sackville Street. 'It commemorates the visit of the heir to the throne and the Princess of Wales to our great national race meeting. It presents faithful portraits of the best-known supporters of the Irish Turf; famous jockeys and racing cracks; and while the magnitude of the work evidences the enterprise and public spirit of Mr Chancellor, the manner in which it has been executed reflects no small credit on the talented artist, who, though still young, is by no means undistinguished ...'. Prints were made of the work.

In the 1870s and 1880s he was commissioned to paint more trade union banners for Cork: Masons, Ropemakers, and Stonecutters again. Involved in political cartooning, he was artist-in-chief with a one-penny weekly, *Zozimus*; launched in May 1870 it lasted until August 1872. In *The European Civiliser* which appeared in the issue of 8 June 1870, he produced a repugnant English stereotype called 'Bill Stiggins of

Uxbridge'. In the next issue a Protestant evangelist was trying to convert some Catholic peasants with the aid of soup in *Connemara Neophytes*. He also contributed a number of sketches of leading Irishmen.

The National Library of Ireland has a caricature, *Good (K)night*, with a note on the mount: 'John S. Carroll, Lord Mayor of Dublin. Drawn by John Fergus O'Hea. Pastel'. But John S. Carroll was never Lord Mayor of Dublin. Sir William Carroll, however, was Lord Mayor, 1868-70, and the title of the work suggests he was the subject.

After the demise of *Zozimus*, O'Hea moved to London and was connected with *Tomahawk*, run by an Irishman, but it ceased publication after a few numbers. He then returned to Dublin. *Ireland's Eye* was started by Christopher Smith of Dame Street, and it contained coloured portraits by Spex (O'Hea). After a promising start, the paper died with the proprietor. In 1876 O'Hea joined the staff of *Zoz*; each issue contained a full or double page cartoon by Spex. Two years later it too disappeared.

O'Hea was also involved with *Pat*, a threepenny comic weekly which first appeared in 1879 and described itself as 'An Irish Weekly Periodical; Artistic, Literary, Humorous, Satirical'. The magazine was owned and printed by the firm of Tomsohn and Wogan at 56 William Street, Dublin, with an office for the magazine at 9 William Street. At this time O'Hea resided at 93 Lower Gardiner Street, a few doors from the Globe Hotel. He supplied sixteen tinted illustrations, all apparently unsigned, for a book, *Irish Pleasantry and Fun*, 1882, but less pleasant was the demise in 1883 of a resuscitated *Pat*.

According to L. Perry Curtis, Jr, author of *Apes and Angels: The Irishman in Victorian Caricature*: 'O'Hea's version of Pat the tenant farmer was a good-looking and good-natured man with only a touch of chin prominence. In some of his cartoons dealing with the Home Rule movement, he neatly reversed the simianizing process of London's comic artists by drawing English ape-men with the object of showing how easily two could play this game ...' In his 1880 sketch for *Pat* of a scene in the House of Commons, an angelic Irish Home Ruler is being set upon and gagged by several ape-like English and Scottish members of parliament, including 'The McAss, MP for Haggis'.

At one period in his career, O'Hea was manager of the pictorial department of the *Evening Telegraph*. In the 1880s he was commissioned for a large cartoon every week for the *Freeman's Journal*, in colour and published on a separate sheet. He also illustrated some books, and poster-size lithographs in colour appeared in the Christmas numbers of such magazines as *Young Ireland*; *The Sunshine*; and *The Irish Fireside*, a supplement of the *Weekly Freeman*.

The National Gallery of Ireland has a portrait in black chalk and pencil of the actor, Barry Sullivan, who died in 1891. Towards the end of his career, in 1914-5, O'Hea drew cartoons for both *The Lepracaun* and *The Quiz*. A great admirer of Parnell, he had returned to London at the time of the split in the party and remained there until his death. A sister, Miss Margaret O'Hea, FRIAM, was a Professor of Pianoforte at the Royal Irish Academy of Music. He made many friends in artistic circles in London, and one was Phil May (1864-1903). He was described as a man 'of charming personality and there was no more popular man of his day in Dublin'. Of 11 Lisgar Terrace, West Kensington, London, he died on 2 September 1922.

Works signed: Spex (if signed at all).
Examples: Dublin: National Gallery of Ireland; National Library of Ireland.
Literature: *The Nation*, 5 October 1872; E. P. Shirley, *The History of the County of Monaghan*, London 1874 (illustration); *Irish Pleasantry and Fun*, Dublin 1882 (illustrations); *Thom's Directory*, 1882; *Journal of the Cork Historical and Archaeological Society*, January 1894, July-December 1946; *Gem Selection Songs of Ireland*, Dublin 1900 (illustrations); *Irish Times*, 5 September 1922; Rosalind M. Elmes, *National Library of Ireland Catalogue of Engraved Irish Portraits mainly in the Joly Collection and original drawings*, Dublin [1937]; L. Perry Curtis, Jr, *Apes and Angels: The Irishman in Victorian Caricature*, Newton Abbot 1971; Belinda Loftus, *Marching Workers*, Belfast 1978; *Waterloo Directory of Irish Newspapers and Periodicals, 1800-1900*, Waterloo 1986; Richard Davis, *The Young Ireland Movement*, Dublin 1987; Peter Murray, compiler, *Illustrated Summary Catalogue of The Crawford Municipal Art Gallery*, Cork 1991; Royal Irish Academy of Music, *Letter to the author*, 1991.

O'KEEFE, ELSIE (1877-fl.1916), miniature painter. Born in England on 17 October 1877 at Wymondham, Norfolk, Elsie Muriel Millard was the daughter of a farmer, George Millard. As Miss Elsie M. Millard,

miniature painter, 13 Southwick Crescent, Hyde Park, she exhibited at the Royal Academy of 1898: *Miss Evelyn Millard as Portia*. A well-known London actress, Evelyn Millard played Portia in Herbert Tree's production of *Julius Caesar*. Evelyn, born in London, was the daughter of John Millard, Professor of Declamation at the Royal College of Music between 1888 and1893. In 1899 at the RA, Elsie showed Evelyn as Lady Ursula.

Elsie Millard first exhibited at the Royal Hibernian Academy in 1897, titles indicating that she had been painting in Ireland, presumably as a miniaturist, which is how she was described in the catalogue with an address, 227 Marylebone Road, London W: *In the Donegal Highlands; Evening, Killarney*. In 1902 she contributed again to the RHA, this time from 25 Edwards Square, Kensington, London W, and works included *Old Alms Houses, Westminster*.

In London she also showed with the Society of Women Artists, two miniatures only, and one each at the New Gallery, Royal Institute of Painters in Water Colours, and Royal Society of British Artists. Three works were accepted at the Walker Art Gallery, Liverpool. In 1904 she showed under her married name in the exhibition by Irish painters held at the Guildhall of the Corporation of London and organised by Hugh P. Lane: three miniatures, *Mother and Child*; *A Kerry Village, Anascaul*; *Eileen*. She resumed exhibiting at the RHA in 1904 from 12 Charleville Road, Rathmines, Dublin, and that year showed two works with the Water Colour Society of Ireland, including *The Quays, Dublin*.

After a lapse of six years, she returned in 1905 to Burlington House with a portrait, *Z. Mennell, Esq.*, member of a well-known London medical family. In 1907 she showed *Miss Soldi*, and in 1908, *J. G. O'Keefe*, almost certainly a portrait of her husband – and the one which was on view at the RHA the previous year. Between 1905 and 1912 from her Rathmines address she exhibited at the RHA ten works, half being portraits. In 1916 her last exhibits at the Dublin exhibition, from 4 Garville Road, Rathgar, were: *Across Dingle Bay; A Kerry Boreen; Sunset*. The date and place of her death have not been found.

Literature: *Register of Births, Wymondham*, Co. Norfolk, 1877; *Thom's Directory*, Dublin 1906; *Who Was Who 1941-1950*, London 1952; *Who Was Who 1951-1960*, London 1961; *Dictionary of British Artists 1880-1940*, Woodbridge 1976; Ann M. Stewart, *Royal Hibernian Academy of Arts: Index of Exhibitors 1826-1979*, Dublin 1986, 1987; Daphne Foskett, *Miniatures Dictionary and Guide*, Woodbridge 1987; Royal College of Music, *Letter to the author*, 1991.

O'KELLY, ALOYSIUS C. (1850-1929), landscape and genre painter. Born in Dublin, he went to Paris aged about twenty-five and at the École des Beaux Arts studied under Léon Bonnat (1833-1922) and the historical and genre painter, Jean-Léon Gérôme (1824-1904). A fellow student was the Cork-born artist Thomas Hovenden (1840-95), who returned to America in 1880. Frank O'Meara (1853-88) from Carlow also studied in Paris at this time.

O'Kelly probably remained in Paris for only a year. He first exhibited at the Royal Academy in 1876 and at the Royal Hibernian Academy in 1878; in both cases his catalogue address was 233 Stanhope Street, Hampstead Road, London. At his initial showing at the Dublin exhibition he contributed *A Game of Bowls* and *Expectation, West of Ireland*. At the RA in 1879 he exhibited *Market morning – Brittany*. Augustus N. Burke, RHA (1839-91), whom O'Kelly may have met, showed at the RHA works with Brittany subjects in the period 1876-8. In 1880 at the RHA, O'Kelly exhibited *Feeding Hens – West of Ireland*.

In Brittany, he painted a number of canvases and small panels: harbour, beach and market scenes, also studies of Breton men and women in traditional costume. Among his works were: *Corpus Christi Procession, Brittany*; *On the Beach Concarneau*; *The Ferry*. The last-named appeared in a Gorry Gallery, Dublin, exhibition in 1988 with the catalogue comment: ' ... a richly-coloured and poetic work ... captures a moment at evening when the light of the setting sun suddenly illuminates the village and the rising cloud behind, while the foreground is already in shadow. Here a party of villagers patiently await the approaching ferry. He observes the group with sympathy.'

In his *Apes and Angels: The Irishman in Victorian Caricature*, L. Perry Curtis, Jr, pointed out that when the editors assigned artists to cover the Irish Land War in the 1880s, the results provided a complete contrast

to the cartoons of the comic weeklies: 'Instead of prognathous and simian brutes, the illustrations contained handsome, even noble faces which belonged to those tenants who dared to defend their cabins from evicting parties. Some of the most saint-like and orthognathous Celtic faces in this series were drawn by Aloysius C. O'Kelly, whose Irish origins may help to account for this effect ...'. Among the drawings which O'Kelly contributed to the *Illustrated London News* in 1881 were: *Disturbed Ireland: Before the Magistrate*, 5 February; *An Eviction in the West of Ireland*, 19 March; *The Irish Land League Agitation: Attack on a Process Server*, 21 May.

The Paris Salon accepted a Connemara landscape in 1884. A Cairo street scene at the RHA in 1885 indicated new terrain. In the Ulster Museum is *Fisherman's Return (Huckleberry Finn)*, dated 1885. In 1886, from Yalding, Kent, he showed at the RA three Cairo subjects and one Brittany scene. In 1888 his address was 40 Shaftesbury Avenue, London. Among the seven pictures which he exhibited in Dublin in 1889 were two in complete contrast: *The Station – Saying Mass in a Connemara Cabin* and *Mosque of Sultan Hassan, Cairo*. His *Game of Draughts*, 1889, suggested contemporary 'Orientalism' in the manner of his former teacher, Gérôme, who had visited Egypt in 1856.

Cairo scenes were now prominent as subject matter for works exhibited in Dublin and London. In addition to the paintings hung at Burlington House, O'Kelly also showed in London with the Royal Society of British Artists, and he sent a few works to the Royal Institute of Oil Painters and the Royal Institute of Painters in Water Colours. He also contributed in a small way to the Manchester City Art Gallery and the Walker Art Gallery, Liverpool, exhibitions.

A remarkable discovery by Julian Campbell would appear to indicate that O'Kelly had a second self, Arthur Oakley. Campbell recounted his detective work in an article in *Irish Arts Review Yearbook*, 2000, where he concluded that the most compelling identification between O'Kelly and Oakley was in the handwriting (samples reproduced). He reckoned that O'Kelly first adopted the name Oakley in the early 1890s. *A Game of Draughts* was exhibited by O'Kelly at the 1893 RHA, and in 1894 he gave his address in the RHA catalogue as 86 Bolsover Street, London, which was the address listed when this work was shown at the Royal Society of British Artists — it too was painted by an artist who lived at that address but he was called Arthur Oakley. Catalogues of Oakley's three Paris Salon entries, 1904-5, and O'Kelly's four entries, 1908-9, were marked with asterisks, indicating that the pictures were not for sale.

His *Peasant Girl in a Poppy Field*, reproduced in colour, is described in *The Painters of Ireland c.1660-1920* by Anne Crookshank and the Knight of Glin as 'an arresting painting with a striking use of colour and a watercolourist technique. It has, too, links with pre-Raphaelite painting'.

O'Kelly's *The Christening Party* was dated 1908, and about this time he had his last fling in Brittany before emigrating to America. His *Religious Procession*, 126cm x 163cm, dated 1909, was of young girls in white Breton costume carrying a statue of the Virgin, villagers looking on. He settled in New York and, as Julian Campbell pointed out in *The Irish Impressionists* catalogue, in December 1909 he wrote to William MacBeth of the MacBeth Gallery: 'Availing myself of your kind permission, I sent you a few of my small paintings of Brittany subjects ...'.

In 1912 he held exhibitions in New York, Chicago and Milwaukee, and that year he spent five months on the Sheepscott River in Maine; one of these landscapes appeared in an exhibition at the Cynthia O'Connor Gallery, Dublin, in 1988. He was a member of the New York Water Color Club with an address at 402 Clermont Avenue, Brooklyn, New York. *A Stroll in the Hospital Grounds* appeared to be dated 1929. He died in 1929.

The first retrospective exhibition of the artist, curated by Niamh O'Sullivan, was held at the Hugh Lane Municipal Gallery of Modern Art, 1999-2000.

Works signed: Aloysius O'Kelly, Aloys. O'Kelly, Al. O'Kelly or A. O'Kelly.
Examples: Belfast: Ulster Museum.
Literature: Walter G. Strickland, *A Dictionary of Irish Artists*, Dublin 1913; L. Perry Curtis, Jr, *Apes and Angels: The Irishman in Victorian Caricature*, Newton Abbot 1971 (also illustrations); *Encyclopaedic Britannica*, Chicago 1974; *Dictionary of British Artists 1880-1940*, Woodbridge 1976; Anne Crookshank and the Knight of Glin, *The Painters of Ireland c. 1660-1920*, London 1978 (also illustration); Witt Library, London, illustrative records [1979]; Julian Campbell:

National Gallery of Ireland, *The Irish Impressionists: Irish Artists in France and Belgium, 1850-1914*, catalogue, Dublin 1984 (also illustrations); Ann M. Stewart, *Royal Hibernian Academy of Arts: Index of Exhibitors 1826-1979*, Dublin 1987; American Watercolor Society, *Letter to the author*, 1991; Julian Campbell, 'Double Identity Aloysius O 'Kelly and Arthur Oakley', *Irish Arts Review Yearbook*, 2000.

O'KELLY, JOHN F. – see KELLY, JOHN F.

O'LEARY, JOHN (1929-99), landscape and abstract painter. John Joseph O'Leary, born on 29 October 1929 at 28 Boyce's Street, Cork, was the eldest of a family of eleven children. His father Francis was a boot and shoe operator with Lee Boot Manufacturing Co. Ltd. John attended the Christian Brothers' School at Blarney Street. He became an apprentice barman. However, his next move in Cork was to the Crawford School of Art, where he studied 1953-7.

In September 1957 he was awarded the Gibson Bequest travel scholarship which enabled him to study abroad for two years. In Paris, he received painting instruction from André Lhote (1885-1962) and at the Académie Julian. He learnt something of the techniques of stained glass at the Bernard Allain Atelier, Montparnesse. When in Paris he befriended Patrick Collins (q.v.). The expatriate Russian painter and designer, Léon Zack (1892-1980), influenced his ideas on painting. The scholarship also allowed him to visit Brittany and he worked with the Breton painter, Jean Martin.

In 1959 O'Leary was commissioned to paint a mural, *The Raising of Lazarus*, for St John the Baptist Church at Ovens, Co. Cork. After the collapse of the balcony in 1986 — and subsequent renovation in the church, the mural was not rehoused. In 1959 he became teacher of drawing and painting for the Cork County Vocational Education Committee.

In 1961 he presented his first one-person exhibition, twenty-five works at the Dublin Painters' Gallery, including *Fishing Boats, Concarneau*; *Breton Fisherman*; *Figure on the Beach, Aran*; *Girl in Black*. In 1962 at the Imperial Hotel, Cork, and in 1964 at the Little Theatre, Cork, other solo shows were held. In 1964 he staged a joint exhibition with John Teahan at the Cork Arts Society Gallery. An early member of the Society, he later served on the committee.

In 1965 he moved to the Crawford School of Art as a teacher of art. He was represented by *Blue Image* at the 1966 Irish Exhibition of Living Art, Dublin. When the Cork Arts Society hosted the Irish Ecclesiastical Art exhibition in 1971 he was represented by a cross executed in silver 'on a pale fine-grained wood,' and a stained glass panel. The cross is at St Michael's Church, Blackrock, Cork.

In 1974 he was appointed head of Sligo Regional Technical College's art department, which he helped to establish. In 1977 he was a founder member of the Sligo Art Gallery, and from 1984 he renewed the Cork link by exhibiting in group exhibitions. In 1986 he held a joint exhibition with Seán McSweeney at Triskel Arts Centre, Cork.

An 1987 exhibition in Sligo was his third 'annual'. Cork Arts Society in 1988, and the Dolan Moore Gallery, Athlone, in 1989, showed recent works, among these *Horseshoe Glen Charcoal Drawing I*. He also participated in group shows with Western Artists and the Claremorris Open. He was president and chairman of Sligo Art Gallery from 1990 until 1997.

'Paintings in this Exhibition are reflections and interpretations of what he has seen and experienced in his wanderings around Sligo — the black rocks and sea of Innismurray, the trees and atmosphere of Lissadell and the environs of his home in Hazelwood' wrote Ronan MacEvilly in Sligo Art Gallery's catalogue of the touring exhibition, 'Sligo — a Landscape of Memories,' presented at the Gallery in 1991, followed by Belltable Arts Centre, Limerick; Galway Arts Centre; and in 1992 at *Kilkenny People* Art Gallery. The exhibition consisted of forty-six works, mainly pastels but some 'Alkyd on canvas,' and included *Innismurray*; *Dark Field*; *Sonnie's Place*; *Hazelwood*; *Into the Woods*; *String of Pearls*.

O'Leary, popular with both students and colleagues as an art educator, held firmly to the view that drawing was the indispensable foundation of visual arts practice. He initiated thematic exhibitions, including Iontas, the National Small Works Competition, which began in 1990. In 1991 he had his first showing at the Rubicon

Gallery, Dublin. In the third Southern Artists exhibition, at the Cork Arts Society in 1992, he contributed two pastels, *Winter, Lough Gill I* and *Grey Morning, Hazelwood I*.

In 1993 he was the recipient of the Ballinglen Arts Foundation Fellowship, Mayo. In the Crawford Municipal Art Gallery is *Night Odyssey*, acrylic, and *Abstract*, pastel and conté. In the Trinity College Gallery collection he is represented by *Harrington*, oil. *Poppy Field Brittany* is one of three works in the Sligo municipal collection. He once commented: 'My paintings evolve from a first idea and as they progress ideas change and in the end one hopefully emerges with something new, exciting or even magical.' He died on 17 November 1999 at Sligo General Hospital. Catriona, Cormac and John O'Leary were represented in a family exhibition at Lavit Gallery, Cork, in 2000.

Works signed: John O'Leary or O'Leary (if signed at all).
Examples: Ballycastle, Co. Mayo: Ballinglen Arts Foundation. Cork: Crawford Municipal Art Gallery; St Michael's Church, Blackrock. Dublin: Office of Public Works; Trinity College Gallery. Sligo: Model and Niland Centre.
Literature: Imperial Hotel, *John O'Leary*, catalogue, Cork 1962; Cork Arts Society Gallery, *John O'Leary*, catalogue, Cork 1988; Sligo Art Gallery, *John O'Leary: Sligo — A Landscape of Memories*, catalogue, Sligo 1991 (also illustrations); Cork Arts Society, *Thirtieth Anniversary Exhibition*, catalogue, Cork 1993; John O'Leary, *Curriculum Vitae*, typescript, Sligo 1997; *Irish Times*, 4 December 1999; Sligo Art Gallery, *Letter to the author*, 1999; also, *Cork Arts Society*, 2000; Mrs Grace O'Leary, *Letters to the author*, 2000; Rev. Patrick Keating, *Letter to the author*, 2000; also, Archdeacon R. E. Bantry White, 2000.

O'MALLEY, HELEN HOOKER–see ROELOFS, HELEN HOOKER O'MALLEY

O'MALLEY, POWER (1870-1946), landscape, figure painter and etcher. A native of Co. Waterford, Michael Augustin Power O'Malley studied art in France and Italy, emigrating to the USA. In October 1912 Maud Gonne (q.v.) returned to Dublin and there she saw an exhibition by Irish-American painter Power O'Malley. She expressed the view that his work was 'as clever and far more sincere than most of the paintings I have seen in France', and gave O'Malley a letter of introduction to the Irish-American Celtic enthusiast, picture collector and lawyer, John Quinn in New York. Also to Quinn she sent a clipping from *The Leader* that compared O'Malley to Édouard Manet (1832-83). In December 1912 the *Irish Review* reproduced *The Fisherman's Daughter (Munster)* by O'Malley, who was not represented in the International Exhibition of Modern Art, known as the Armory Show, held in New York in 1913; Quinn was one of the organisers.

O'Malley was a pupil of the American painter and teacher, Robert Henri (1865-1929), who travelled extensively between 1906 and 1914. Paul Henry (q.v.), when staying on Achill Island, met Henri there. Another of O'Malley's American teachers was the Scottish-born Walter Shirlaw (1838-1909), genre, portrait, mural painter, and engraver. Of Shirlaw, it was said: 'He was a master designer, a serious and weighty painter, an influential teacher, a man of culture and intelligence.'

An undated cutting from the *Irish Times* referred to an exhibition of pictures by Power O'Malley 'at the hall of the Gaelic League, Central Branch, 25 Rutland Square. Mr. O'Malley has gained considerable distinction in black and white work in connection with American magazines. The exhibition numbers almost one hundred paintings in oil, which are solely devoted to Irish subjects ... and include portraits of Irish peasants, village scenes, and landscapes. His atmosphere and cloud effects are particularly fine ...'.

O'Malley, who did not exhibit at the Royal Hibernian Academy, returned at intervals to Ireland. He supplied six illustrations for a book of stories by the Rev. John Condon, OSA, published in Dublin in 1915, and he was awarded first prize for landscape at Aonach Tailteann in 1923. At the Art Institute of Chicago exhibition in 1923, he showed an Irish interior, and in 1924 a Connemara kitchen. In 1926 Daniel Egan in Dublin presented his Exhibition of Modern Art, including 100 works from Paris, at 38 St Stephen's Green, and O'Malley showed two etchings, *Earth* and *Falstaff*.

In the 1920s, when his *Terence*, since in private possession, was purchased from M. Knoedler & Co., New York, for the Phillips Collection, Washington, DC, O'Malley was one of a group of writers, musicians and painters who used the small and inexpensive artists' studios in Ridgefield, New Jersey, within easy

commuting distance of New York City. He was among the painters associated with the Society of Independent Artists. In private possession in New Jersey is a portrait of Elizabeth McCoy Donohue, seated, described by her daughter: 'Art nouveau/Deco influence with bluebird and flower branch background.'

After taking a prize at the San Antonio, Texas, exhibition in 1927, he won a medal in California in 1928. The San Antonio Art League has in its collection a painting, *Evening on X Ranch*. At about this time, 1928, he painted *The Cowboy*, 1.8 metres x .94 metres, which is in the Modern Art Museum of Fort Worth, Texas. According to the Museum, which also holds twenty-eight etchings by him, figurative and landscape, the purchase negotiations for *The Cowboy* conducted by the Art Association 'began in 1929 and the payments were made over a span of time between 1938 and 1941'. He was represented in the American Contemporary Etching exhibition for 1930-31.

When he showed at the exhibition of Irish art at Brussels in 1930 he gave his address: c/o Father Condon, John's Lane, Dublin. In 1935 he was represented in an exhibition of Irish painting and sculpture at the Jersey City Museum, New Jersey. The catalogue listed thirty-eight works by O'Malley; far fewer by Jack B. Yeats, George W. Russell, and John Keating (qq.v.); sculpture by Augustus Saint-Gaudens (q.v.). O'Malley's continued association with his native land was clear from some of the titles: *Aran Fisherman*; *A Donegal Bog*; *Quay at Roundstone*; *Spanish Parade – Galway*.

An exhibition of forty-five paintings at the Beaux Arts Gallery, London, in 1939 drew *The Studio* comment: 'Power O'Malley has not followed modern movements in painting but he can render the quality of the Irish atmosphere whether on bright days or misty days. More than that, he has a sense of dramatic essentials in his subject pictures. Thus he conveys the wonder of an aeroplane by depicting the effect of it on the faces of peasants looking-up – the machine itself not appearing at all. And in a *Supper at Emmaus* only the hands of the Christ (and His shadow on the wall) appeared, attention being quite rightly concentrated on the effect of the revelation on the disciples.'

The exhibition at Beaux Arts also included etchings . Among the other paintings were: *The Connemara Man*; *The Kerry Piper*; *Clearing up, Achill*. The catalogue described him as 'The Irish-American Artist' and quoted Royal Cortissoz in the *New York Herald Tribune*:'Mr O'Malley has found light and air in Ireland and has got them into his pictures...a more winning transcription of the Irish scene has not come out of any man's studio.'

In an exhibition at the Crawford School of Art in 1960, *Gallagher's Farm* and *A Fisherman's House* were both displayed, 'painted in and around County Waterford, during his last visit to Ireland'. Model and Niland Centre in Sligo has two etchings, one of a country village scene and the other, *Old Woman*, both donated by James A. Healy of the USA in 1975. *Aran Woman*, oil, is in the Ulster Museum collection. An etching, *Her place in the sun*, is among the American prints in the Library of Congress collection. Of Scarborough, New York, O'Malley died on 3 July 1946.

Works signed: Power O'Malley.
Examples: Belfast: Ulster Museum. Cork: Crawford Municipal Art Gallery. Fort Worth, Texas: Modern Art Museum. San Antonio, Texas: San Antonio Art League. Sligo: Model and Niland Centre. Washington, DC: Library of Congress.
Literature: *Irish Review*, December 1912 (illustration); John Condon, *The Crackling of Thorns*, Dublin 1915 (illustrations); *Father Mathew Record*, June 1915; Daniel Egan, *Exhibition of Modern Art*, catalogue, Dublin 1926; *Dictionary of American Biography*, London 1932, 1935; Jersey City Museum Association, *Exhibition of Irish Painting and Sculpture*, catalogue, 1935; Beaux Arts Gallery, *Exhibition of Paintings of Ireland and Etchings by Power O'Malley*, catalogue, London 1939; *The Studio*, July 1939; *Who Was Who 1929-1940*, London 1941; Paul Henry, *An Irish Portrait*, London 1951; Crawford School of Art, *Some paintings by modern Irish artists*, catalogue, Cork 1960; William H. Gerdts, Jr, *Painting and Sculpture in New Jersey*, Princeton 1964; *Dictionary of British Artists 1880-1940*, Woodbridge 1976; Samuel Levenson, *Maud Gonne*, London 1977; Peter Hastings Falk, *Who Was Who in American Art*, Madison 1985;*TheAnnual Exhibition Record of the Art Institute of Chicago 1880-1950*, Madison 1990; Modern Art Museum of Fort Worth, *Letter to the author*, 1991; also, Mrs John M. O'Shea, 1991; Phillips Collection, 1991; San Antonio Museum Association, 1991; Brian Meehan, 1992.

Ó MAOLAOID, A.– see MOLLOY, AUSTIN

Ó MONACHÁIN, AILBHE (1889-1967), illustrator. Born in Belfast on 25 January 1889, his Wexford-born father, Robert Joseph Monahan, was a sawyer in Belfast. Ailbhe was christened Alfred Monahan. Apprenticeship as a commercial artist was with David Allen & Sons Ltd, printers, Belfast. He became a fluent Irish speaker and was involved in the Irish National Movement, taking an active part in the 1916 Rising as Liam Mellows' assistant in Co. Galway, after moving from Co. Cavan.

Brian O'Higgins, another 1916 veteran, published cards and calendars in Dublin, employing Ó Monacháin as one of his illustrators and also as the author of some verses for the cards. O'Higgins also published the *Wolfe Tone Annual* and Ó Monacháin's illustrations in the 1946 issue included: *An Outpost in Dublin in 1916*; *At a Barricade in Dublin*; and *A Man of Wexford in 1916*. Additionally, he illustrated some covers for that annual, and for more than a score of years he illustrated covers and stories for *An tUltach*.

Ó Monacháin was equally well known as an author of several books. Among the publishers for whom he illustrated was Colm Ó Lochlainn at the Sign of the Three Candles. Author and illustrator of six books published by An Gúm, the last one, *Ainmhithe Allta Éireann* was on the ancient wild animals of Ireland and appeared about three months before his death. *Patairín agus Patarún*, 1963, was originally published in 1937.

At one period he was an arts and crafts teacher with the Co. Dublin Vocational Education Committee, daytime teaching in Balbriggan and Swords and night classes for adults in various towns and villages of North Co. Dublin. Another activity was articles for the *Irish Press* under the name 'Joe Mac Sweeney' or just 'Joe Mac'. At his home in Swords, Co. Dublin, he died on 30 July 1967.

Works signed: Ailbhe Ó Monacháin, Ailbe Ó Monacáin, A. Ó Monacáin or A. O. M., monogram.
Literature: Ailbhe Ó Monacháin, *Patairín agus Patarún*, Dublin 1937, 1963 (illustrations); Ailbhe Ó Monacháin, *Dóinicíní an Domhain*, Dublin 1939 (illustrations); Ailbhe Ó Monacháin, *Scéilíní Caoine*, Dublin 1940 (illustrations); Ailbhe Ó Monacháin, *An Sionnach Sleamhain Slíochta*, Dublin 1941 (illustrations); Brian O'Higgins, *Oliver of Ireland*, Dublin 1945 (illustrations); *Wolfe Tone Annual*, 1946, 1947, 1949 (all illustrations); C. O'Higgins, *Letter to the author*, 1967; Ailbhe Ó Monacháin, *Ainmhithe Allta Éireann*, Dublin 1967 (illustrations); C. Desmond Greaves, *Liam Mellows and the Irish Revolution*, London 1971; Peter Monahan, *Letter to the author*, 1991; also, Mrs Helmi Saidléar, 1991.

Ó MURCHADHA, DOMHNALL, RHA (1914-91), sculptor. Born at Carrigrohane, Ballincollig, Co. Cork, on 1 April 1914, Daniel Joseph Murphy was the son of Timothy Murphy, who later worked in Bray's of Rosanna. Donal, as he was then known, received gifts of brushes and paints from the Bray family. There was also a living artist in the parish, Robert Gibbings (q.v.), a neighbour.

After schooling at Ballincollig National School and the North Monastery, Cork, he attended Crawford School of Art in Cork and was awarded the City of Cork Vocational Education Committee's Giltinan Memorial Scholarship, and this success took him to Dublin in 1939 and the National College of Art, where he studied under Laurence Campbell (q.v.). At NCA he won the Oliver Sheppard Memorial Prize for figure work. In 1943 he won the Purser-Griffith Scholarship in the History of European Painting which later enabled him to study in Florence. In 1943 the School of Art in Cork announced his name as winner of the Gibson Bequest travel scholarship.

Easter 1943 saw NCA students involved in film-making. By arrangement with Roger Furse, art director of the Laurence Olivier film, *Henry V*, twenty-five students — including Donal — were employed on the Agincourt scenes at Lord Powerscourt's estate at Enniskerry, Co. Wicklow, designing and making costumes, modelling horses' heads and limbs for use in the battlefield scenes, and the making and painting of shields, spears and caparisons for horses made of papier-mâché. The six weeks of the Ireland project cost the film company £80,000, according to one account.

In 1943 he exhibited at the Royal Hibernian Academy, *Girl's Head* and *L.D.F. Trophy*, sixteen sculptors competing for the *Irish Press* trophy award. A study of a head appeared in 1944. In the next four years he contributed only two works to the RHA. In 1945 he initiated an emergency salvage of the studio contents of Jerome Connor (q.v.). He had a spell as art master at Catholic University School, Leeson Street, and he also taught art at Sion Hill College.

In 1945 came the first in a long series of church commissions. In 1948, after teaching part-time since 1945, he was appointed assistant Professor of Sculpture at NCA. In 1949, exhibition of pictures by Irish artists in Technical Schools, he was listed in the catalogue as Donal Murphy, ANCA, 49a Harcourt Street, Dublin, and as a sculptor working in stone, wood, ceramic and metal. He was responsible for the bronze bust and tombstone design for the monument to John McCormack at Deans Grange Cemetery, Dublin, 1951. A similar bust went to the Metropolitan Opera House, New York, but was stolen and had to be replaced.

In 1952 Ó Murchadha began lecturing, both in Irish and English, in the history of art series at the National Gallery of Ireland. In 1952 he married Máirín Allen, later writer and lecturer on art. He was represented in 1952 at the Olympic art exhibition at Helsinki. At Aberystwyth in 1953 he was included in the Contemporary Irish Art exhibition. Irish was often spoken in the sculpture department at NCA. Some students, on the religious atmosphere, recalled the Angelus and a decade of the rosary recited by the tutor.

In 1954 his bronze relief portraits of the Pearse brothers were unveiled at Pearse Bridge, Rathfarnham. A lifesize woodcarving, *Our Lady of Knock*, was completed in oak in 1954 for Boston College, Boston, Mass. The statue, displayed in the Irish Room of the John J. Burns Library, was described: 'She stands erect, a royal crown upon her head, her face turned heavenwards, her hands raised a little above her shoulders in an intercessory posture…From her shoulders hangs a cloak, loosely fastened at the neck…'.

Our Lady of Perpetual Help, limestone, which was in the care of the Redemptorist Fathers, Galway, has been transferred to Marianella, Orwell Road, Dublin. At Loreto Convent, Coleraine, Co. Derry, are the woodcarvings, *St Joseph the Worker* and *Our Lady and the Divine Child*. The Presentation Primary School in Kilkenny, built in 1957, has a *Madonna and Child* on the wall. The Liam Mellowes memorial figure in limestone is at Eyre Square, Galway, and a bronze bust is at Athenry, Co. Galway.

In the 1957 exhibition in Dublin of the Institute of the Sculptors of Ireland he showed a bronze head, *John Bingley Garland*, commissioned by the Newfoundland Government for Parliament House, St John's; he also executed a head of the Hon. Sir Hugh W. Hoyles. On a wall at the Presentation School, Dungarvan, Co. Waterford, is a limestone relief, 1960, of Nano Nagle and a group of children.

From 1961 he visited Dr François Henry at her home near Auxerre, France, producing landscapes over the years. A head in limestone of Dr Henry is at the National College of Art and Design. In 1961 he completed 3.4 m high limestone relief panels, *Saint Patrick and Saint Joseph*, at St Patrick's Training School, Glen Road, Belfast. The figure of Volunteer Edward Lyons, 1962, is at Newport, Co. Mayo. A bronze head of Eamonn Ceannt was the gift of the Government to Leinster House in 1963 with a cast for NGI. *St Brendan*, a woodcarving, is at St Brendan's Home, Loughrea, Co. Galway.

In 1963 he supplied for St Michael's Church tower, Athy, Co. Kildare, the limestone figure, *St Michael The Archangel*, and woodcarvings for the church interior, *St Thérèse of Lisieux*; *St Anthony*; *St Joseph*; *Guardian Angel*. Also executed in 1963 was the limestone figure of John Mitchel for Newry, Co. Down.

In 1964, *Our Lady and St Bernadette* was for Ring, Co. Waterford, and in wood the St Francis altar for Belcamp College, Balgriffin, Dublin. *Our Lady of Wayside*, 1965, was for the 1798 rebellion burial site at Graiguecullen, Carlow town. At Galway Cathedral, 1966, are three tympana in stone over the main entrance doors, relief compositions representing the sacraments of Baptism, Marriage, Ordination. Also a portrait head of Dr Michael Browne at his tomb.

The Arts Council, Dublin, commissioned Ó Murchadha to restore and complete the Lusitania Peace Memorial, Cobh by Jerome Connor (q.v.). The work was delayed, occasioned by extreme fragility and damaged condition of the plaster figure of the Angel of Peace, as also by the floods in the City of Florence where the figure was to be cast in bronze. The project was eventually completed in 1968. After the retirement of Friedrich Herkner (q.v.) as Professor of Sculpture, Ó Murchadha was officially appointed in 1969 to replace him.

The memorial to Peadar Ó Doirnín at Urney, Co. Louth, was followed in 1970 by one for Séamus Dall mac Cuarta for Omeath, Co. Louth. He was also responsible for the Commandant Peter Kearney monument at Glasnevin Cemetery, Dublin. *The Volunteer* in bronze is at Crawford Municipal Art Gallery, Cork.

The 1977 wood relief, *St Brendan*, for St Brendan's Church, Coolock, Dublin, preceded the lifesize granite figure, *Our Lady of Ballyfermot*, at Ballyfermot roundabout. *Our Lady of Knock* is in the basilica at Knock,

Co. Mayo. At Craughwell, Co. Galway, the poet Raftery holds a violin. Adjacent is a bronze head of Augusta, Lady Gregory. At the new Monastery School, Cork, are: *Thomas MacCurtain* and *Terence MacSwiney*, marble reliefs; *Madonna and child*, wood; *Our Lady of Perpetual Help*, plaster; *Blessed Thaddaeus MacCarthy*, wood. *Mater Dei*, wood, is at Mater Dei Institute of Education, Dublin.

In November 1978 he became acting Director of the National College of Art and Design, and remained so until retirement in June 1980. Afterwards he worked as a stone craftsman in the stoneyard of Roe and O'Neill in the Dublin mountains.

In 1982 he was appointed an ARHA, exhibiting that year at the Academy after an absence of thirty-four years. In the period 1982-90 inclusive he contributed twenty-five works. In 1982 he showed *Place de la Cathedrale, Auxerre*, oil. In 1983 he provided an oil study; *The Navigator*, pinewood; *Mother and Child*, Carrara marble. Alliance Francaise, Dublin, hosted a 'Homage to Françoise Henry' exhibition in 1983, and this included paintings by her Irish artist friends — Ó Murchadha included — who had painted at Les Bretons. Among his works at the 1984 RHA was an oil, *Les Bretons*.

In his sculpture exhibits in 1985 at the RHA were *May Leech*, bronze, and *Self Portrait*, limestone. A return to his youth came with *Old Lodge, Carrigrohane*, oil, in 1986. In 1989 he showed two still life. In 1990, the year he was appointed a full academician, he returned to sculpture, *Virgin and Child*, marble; *Caitlin*, bronze.

A relief profile in limestone of Dr Douglas Hyde is in St Patrick's Cathedral, Dublin. The long relief panel in wood, 30.5 cm x 152 cm, *The Vision of St Íte*, 1984, is at the Blackrock Clinic, prayer room. *Mater Misericordiae*, granite, 1985, was for the new parish church, Balally, near Dundrum, Co. Dublin. Bronze busts of Thomas MacCurtain and Terence MacSwiney at the front entrance to Cork City Hall were unveiled in 1987.

Ó Murchadha was an authority on Irish High Crosses. He was a member of National Council for Educational Awards, and he served on the Oireachtas art committee. He illustrated two books. His wide-ranging interests included Gaelic literature, folklore, poetry, politics and traditional music. He died on 8 January 1991 at Beaumont Hospital, Dublin.

Works signed: Domhnall Ó Murchadha, Domnall Ó Murcada, D. Ó Murcada, D.M. or D. Ó M.
Examples: Annascaul, Co. Kerry: Church of the Sacred Heart. Athy, Co. Kildare: St Michael's Church. Belfast: St Patrick's Training School, Glen Road. Blackrock, Co. Dublin: Blackrock Clinic. Boston, Mass.: Boston College. Caherciveen, Co. Kerry: Church of St Joseph, Aghatubbrid. Carlow, Co. Carlow: Graguecullen. Coleraine, Co. Derry: Loreto Convent. Cork: Crawford Municipal Art Gallery; North Monastery. Craughwell, Co. Galway: Dublin-Galway road. Donegal, Co. Donegal: St Agatha's Church, Clar. Dublin: Ballyfermot roundabout; Belcamp College, Balgriffin; Deans Grange Cemetery; Glasnevin Cemetery; Leinster House; Mater Dei Institute of Education, Clonliffe Road; Mount Sackville Secondary School, Chapelizod; National College of Art and Design; Pearse Bridge, Rathfarnham; Redemptorist Fathers, Orwell Road; St Brendan's Church, Coolock; St Patrick's Cathedral; Scoil Chaitríona, Coolock. Dundrum, Co. Dublin: Church of the Ascension of the Lord, Balally. Dungarvan, Co. Waterford: Presentation School. Galway: Cathedral of Our Lady Assumed into Heaven and St Nicholas; Eyre Square. Kilkenny, Co. Kilkenny: Presentation Primary School; Sion House. Knock, Co. Mayo: Our Lady Queen of Ireland Church. Limerick: University, National Self-Portrait Collection. Loughrea, Co. Galway: St Brendan's Home. Mullaghbawn, Co. Armagh: St Mary's Church, opposite. New York: Metropolitan Opera House. Newport, Co. Mayo: Westport approach. Newry, Co. Down: St Colman's Square. Omeath, Co. Louth. Rabat, Malta: Dominican Sisters. Rathmullan, Co. Donegal: Cemetery. Ring, Co. Waterford. St John's, Newfoundland: Parliament House. Urney, Co. Louth: Graveyard.
Literature: *Exhibition of Pictures by Irish Artists in Technical Schools*, catalogue, Dublin 1949; Denis Meehan, *Window on Maynooth*, Dublin 1949 (illustrations); *Contemporary Irish Art*, catalogue, Dublin 1953; Donchadh Ó Ceileachair, *Dialann Oilithrigh*, Dublin 1953 (illustrations); Boston College Library, *Librarium*, April 1954; *Institute of the Sculptors of Ireland*, catalogue, Dublin 1957; *Arts Council report 1966-67*, Dublin; *Capuchin Annual*, 1968; Domhnall Ó Murchadha, *Autobiographical memoir*, typescript, Dublin 1986; Ann M. Stewart, *Royal Hibernian Academy of Arts: Index of Exhibitors 1826-1979*, Dublin 1987; 1980-1990, catalogues; Anthony Holden, *Olivier*, London 1988; Domhnall Ó Murchadha, *Curriculum Vitae*, typescript, Dublin 1990; Dr John Turpin, *Text of eulogy at Mass celebrated in memory of Domhnall Ó Murchadha*, Dublin 1991; John Turpin, *A School of Art in Dublin since the Eighteenth Century*, Dublin 1995; Giollamuire Ó Murchú, *Letters to the author*, 1999, 2000; Mater Dei Institute of Education, *Letter to the author*, 2000, also, Mount Sackville Secondary School; Presentation House, Dungarvan, 2000; The Redemptorists, Esker, 2000.

O'MURNAGHAN, ART (1872-1954), illuminator. Born in Southampton, the son of Arthur William Murnaghan, Ordnance Survey official, whose father was from Loughbrickland, Co. Down, Art won a scholarship to Cambridge University but was unable to accept it. He served a four-year apprenticeship to a chemist but then accepted a post at the Free Public Library, Southampton.

In 1898, an entirely self-taught artist, he left the Hampshire city to become a wallpaper designer with a firm of Dublin decorators. His wife was a niece by marriage of Alexander Williams (q.v.). Soon after their move, he played small parts at the Queen's Theatre, joined the Gaelic League, designing and making the poplin badges for their use. He also designed the weekly headings for Arthur Griffith's *The United Irishman*. According to his grandson, Peter Figgis, in an informative article in *Irish Art Review* in 1985, Art was at one time a pianist at the Volta Cinema, Dublin. This cinema was opened at 45 Mary Street, Dublin, in 1909, after conversion of the premises, arranged by James Joyce.

During the First World War, he was responsible for Sinn Féin Christmas cards; some or all are in the National Museum of Ireland. His studies of ancient manuscripts turned him to penmanship and he became an expert in illumination and calligraphy. In the article, his grandson also named among his erudite interests archaeology, philosophy, chemistry and herbalism. Elsewhere he was credited as an accomplished organist, well-read in English and French literature, with a wide knowledge of the drama.

O'Murnaghan's ornamentation appeared in the *Dublin Magazine* for a series, 'The Adventures of Gubbaun Saor and his Son', retold by Ella Young. The first issue was September 1923 when he was living at 15 Brighton Square, Rathgar. Miss Young had been a leading spirit among a group of Republicans who felt that a special book should record the names of the men who had died in the struggle for independence. The suggestion was accepted by the new Irish Government. O'Murnaghan won the commission in 1922 with his 25.4 cm. x 35.6 cm. page based around the word Éire. Reproductions of the page were sold among the Irish community at home and abroad to obtain funds for financing the book.

Mia Cranwill (q.v.) was treasurer of the Irish Republican Memorial Committee; Ella Young as secretary. In his dedication in the *Book of the Resurrection – Leabhar na hAiséirighe*, O'Murnaghan, who had abandoned his pharmacy, said in part: 'It is Art O'Murnaghan who wrote by inspiration the designed pages, carrying on after more than a thousand years, the Irish tradition of beautiful sacred books. This Book was begun on the Eve of Easter Day 1924 in the City of Dublin in the home of the artist-scribe, continued until the Spring of 1927 when progress was interrupted until December, 1937. Two pages and an unfinished page between this and December, 1938 – again interrupted. In August, 1943 the work was again resumed and continued until February, 1951.'

The Book consisted of twenty-six vellum pages; among these were The Emblem page, The Men of the Harbour page, the Signatories' page, the Treaty page. According to Paul Larmour in his *Celtic Ornament*, 1985, there are 'complex interweavings, symbolistic detail and Irish poems and sayings … It is decorated with tangled interlace incorporating birds, fish, and sacred trees, with words from a very early text … In these freely developed yet tightly controlled designs O'Murnaghan went beyond the straightforward revival of ancient motifs in creating an entirely personal art …'. In some twelve years of work, he used his own paint mixtures. Four drawings for the Book are in Armagh County Museum.

In his autobiography, *All for Hecuba*, Mícheál Mac Liammóir (q.v.) referred to Denis Johnston's *The Old Lady Says No* at the Gate Theatre in 1929, and wrote: 'Art O'Murnaghan wielded the drumsticks with untiring devotion and a rapt expression like a Druid at some sacred rite. He was an elderly saint who worshipped Angus and Lú and the ancient gods of Ireland and who has a miraculous flair for all the known arts, from the loveliest Gaelic illumination in the manner of the fifth-century monks to the making of properties, the writing of music, the research of ancient lore, the management of a stage, and the playing of character parts …' He travelled with the Gate company on its Egyptian tour in 1936.

O'Murnaghan provided a design for a Donegal handtufted carpet for Leinster House, and when he supplied an illustration for the *Dublin Civic Week 1929 Official Handbook*, he was a member of the Dublin Book Studio. He also worked in pastel and watercolour but contributed few pictures to the Royal Hibernian Academy. However, two with a sea rhythm theme and also *The Palace of the Sidhe* were hung in the 1929 exhibition. He donated to the Belfast Museum and Art Gallery two works, *Nature Rhythm – Dawn (Sunrise*

Meditation), ink, gouache, and *Nature Rhythm – Flames in a Bush*, watercolour, ink. His extra-curricular activities also included parts in films, historical digging at Newgrange and a visit to Tibet for study of the monks' way of life.

In 1936 he gave up full-time work in the theatre to take a vellum illustration class at the National College of Art, and three years later he instructed a new class on Oriental Design in Celtic Ornament. In 1944, the *Father Mathew Record* reported that in a room in the National Museum of Ireland he was 'completing his illuminations for the vellum book'.

A friend said he was ' … one of the gentlest and kindest of men, who carried his vast learning and intimate knowledge of much out-of-the-way matter without apparently any idea that he was an exceptional person …'. His portrait by a friend, Estella Solomons (q.v.) is in the National Gallery of Ireland. He died in a Dublin hospital on 8 July 1954.

Works signed: Art O Mornocain, Art O'Murnaghan, Art Ó Murnaghan, A. O'Murnaghan, A. O'M. or A. O M.
Examples: Armagh: County Museum. Belfast: Ulster Museum. Dublin: National Museum of Ireland.
Literature: *Dublin Magazine*, September-December incl., 1923, January 1924, March 1924, June 1924 (all illustrations); E. M. Stephens, ed., *Dublin Civic Week 1929 Official Handbook*, Dublin (illustration); Bulmer Hobson, ed., *Saorstát Éireann Official Handbook*, Dublin 1932 (illustration); *Father Mathew Record*, December 1944; Micheál Mac Liammóir, *All for Hecuba*, London 1946; *Seumas O'Sullivan Papers*, Trinity College, Dublin [1958]; Patrick Murnaghan, *Letter to the author*, 1968; Brian de Breffny, ed., *The Irish World*, London 1977 (illustration); Jeanne Sheehy, *The Rediscovery of Ireland's Past: The Celtic Revival 1830-1930*, London 1980 (illustrations); Paul Larmour, *Celtic Ornament*, Dublin 1981 (also illustrations); Nicola Gordon Bowe, *The Dublin Arts and Crafts Movement 1885-1930*, catalogue, Edinburgh 1983; Peter Figgis, 'Remembering Art O'Murnaghan', *Irish Art Review*, Winter 1985 (also illustrations); Kevin Rockett, Luke Gibbons and John Hill, *Cinema and Ireland*, London 1987; John A. Murnaghan, *Letter to the author*, 1991; also, Professor Etienne Rynne, 1993.

O'NEILL, DANIEL (1920-74), landscape and figure painter. Son of a Belfast electrician, Frank O'Neill, of 4 Dimsdale Street, Belfast, Daniel O'Neill was born on 21 January 1920. Educated at St John's Public Elementary School, he was passionately interested in art. He attended a few life classes at the Belfast College of Art, and worked for a short spell in the Belfast studio of Sidney Smith (q.v.). At this time, he met Gerard Dillon (q.v.). O'Neill was particularly interested in the Italian primitives.

In 1940, one year after he began to paint, he participated in a small group show at the Mol Gallery, Belfast. Not one of his seven paintings was sold. In the 'blitz' of 1941, bombed churches meant piles of workable sandstone; he and his friend Dillon tried their hand at carving. In 1943 they held a joint exhibition of paintings at Contemporary Pictures gallery, 133 Lower Baggot Street, Dublin. O'Neill's seven oil paintings included *Head of Christ*; *Wayside Murder*; *Clowns*; and two pictures were sold.

An electrician in the Belfast Corporation Transport Department, he worked on the night shift and painted at home during the day. Changing his job to the shipyards, the same lifestyle continued. When he exhibited at the Irish Exhibition of Living Art in 1945, the *Dublin Magazine* commented: 'Daniel O'Neill is practically a newcomer; but he promises to figure largely in Irish painting of the future. His sensuous handling of paint, his rich colour and dramatic sense in composition, are used to express an individual vision which is essentially Romantic.'

In 1945 too he received encouragement – and financial help – from the Dublin dealer, Victor Waddington, hence his decision to end the 'double life'. In 1946 he held a one-person show at the Victor Waddington Galleries, selling nearly all the canvases. *Moonlight and Lamplight* and *In an Old Convent Garden* were in that exhibition. The *Irish Times* thought he was romantic 'in a theatrical and mannered way'.

In 1946 he painted a disused railway in Co. Donegal. O'Neill's work began to appear in London and abroad, in New York in 1947 and Beverly Hills, California, in 1948 – in that year George Campbell (q.v.), Nevill Johnson (q.v.), Dillon and O'Neill showed at Heal's Mansard Gallery, London. He first exhibited at the Royal Hibernian Academy in 1947, and between then and 1963 contributed twenty-three works, but he showed regularly in Dublin with the Irish Exhibition of Living Art, and also exhibited at the Oireachtas.

O'Neill held regular exhibitions at the Victor Waddington Galleries until 1955; in 1951, pictures included *Snow, Conlig*; *Old House, Paris*; *First Communion*. His work in London was in a group show of religious paintings at the Ashley Gallery, 1950; and Five Irish Painters at Tooth Galleries, 1951, when his six paintings included *The Gamekeeper* and *Horn Head Donegal*. He also exhibited in a group show in Amsterdam.

In 1949 he had visited Paris for a few months, and *Place du Tertre*, now in the Ulster Museum, was painted at this time. Also in the museum at Stranmillis are *The Blue Skirt*, 1949, and *The First Born* of the same year. Although he had only been painting on a full-time basis for about seven years, Council for the Encouragement of Music and the Arts organised a loan exhibition of paintings 1944-52 at the Belfast Museum and Art Gallery in 1952; more than 4,000 people attended, a record for a CEMA one-person show in Northern Ireland. At this time he was living with his family at 4 Hall Street, Conlig, Co. Down, a village in which Campbell and Dillon also painted.

In spite of such paintings as *Birth* (loaned by ACNI to Ulster Museum), 1952, which depicted childbirth in a working class home, he was not a realist. Brian Fallon, the Dublin art critic, wrote: 'His world is dreamy, rather withdrawn, full of brooding beauties, erotic reverie, figures in half-light, flowers, moody interiors ...'

On his exhibition at the Tooth Galleries in 1952, *The Studio* said it was large enough to show his development 'of an unique vision that springs constant delights... of the man himself, lyrical and just slightly bewitching.' In 1954 he had a joint show at Tooth's with Colin Middleton (q.v.) and his seventeen paintings included *Circus Children* and *Girl Paddling*, both 1953.

By 1953 the *Dublin Magazine* saw him as a 'Kubla Khan of paint, with the talent to indulge an exotic imagination and a sensuous refinement of taste ...'. His work was represented in the Contemporary Irish Art exhibition at Aberystwyth, 1953, and in the 1955 exhibition at the Waddington Galleries the paintings included *Old Lead Works, Conlig*; *Landscape near Fawley*; *Chorus Girls*. He was represented in the travelling exhibition organised by the Boston Institute of Contemporary Art in 1950 and 1954.

In 1958 O'Neill left Ireland for London and lived in Holland Road, W 14. He now began to show in Montreal at the Galerie Waddington. In 1959 he exhibited at Brown Thomas's Little Theatre, Dublin. After a short period in the South of Ireland, a number of landscapes painted there appeared in the exhibition at the Dawson Gallery, 1960: for example, *Desolate Beach, Kerry*; *Landscape, West Cork*; *Sea Road, Brandon*.

In 1963 he returned to the Dawson Gallery, but it was not until 1970 that he showed again in Ireland, this time in Belfast at the McClelland Galleries, where *Solitude, Lough Neagh* and *Reflections, Donegal* were among his thirty-three works, but the artist, T. P. Flanagan, felt that they 'appeared trapped within a technique grown too facile to be convincing'. In 1971, when he returned to live in Belfast, he exhibited again at the Dawson Gallery; among his contributions were: *The Bridesmaid*; *Soutine's Sister*; *All This is Mine*. In the Hugh Lane Municipal Gallery of Modern Art he is represented by *St Joseph's Church, Rathmullan*, and in the Herbert Art Gallery and Museum, Coventry, by *Glendalough in Winter*. The National Gallery of Ireland acquired *Scarecrows, Newtownards, Co. Down*. Of 22 Eglantine Gardens, Belfast, he died at the City Hospital, Belfast, on 9 March 1974.

Works signed: D. O'Neill.
Examples: Belfast: Queen's University; Ulster Museum. Bray: Public Library. Cork: Crawford Municipal Art Gallery. Coventry: Herbert Art Gallery and Museum. Downpatrick: Down County Museum. Dublin: Hugh Lane Municipal Gallery of Modern Art; Irish Writers' Centre; National Gallery of Ireland; Office of Public Works; Trinity College Gallery. Limerick: City Gallery of Art; University, National Self-Portrait Collection. Melbourne, Australia: National Gallery of Victoria. Nelson, New Zealand: Bishop Suter Gallery. Tokyo: Irish Embassy. Waterford: City Hall, Municipal Art Collection.
Literature: *Dublin Magazine*, October-December 1945, July-September 1953; *Irish Times*, 11 October 1946, 19 March 1955; *The Studio*, October 1948, August 1952; *Envoy*, December 1949; *CEMA Annual Report, 1951-1952*, Belfast 1952; *Belfast News-Letter*, 28 February 1959; *Ireland of the Welcomes*, May-June 1968 (illustration); McClelland Galleries, *Recent Paintings by Daniel O'Neill*, catalogue, Belfast 1970 (also illustrations); *Irish News*, 11 March 1974; John Hewitt and Theo Snoddy, *Art in Ulster: 1*, Belfast 1977 (also illustrations); Ann M. Stewart, *Royal Hibernian Academy of Arts: Index of Exhibitors 1826-1979*, Dublin 1987; Mrs Bridget Stalley, *Letter to the author*, 1991; Fortnight Educational Trust, *Daniel O'Neill*, supplement, Belfast 1992; Cynthia O'Connor Gallery, *Paintings for the 30th Irish Antique Dealers' Fair 1995*, catalogue, Dublin 1995; National Gallery of Ireland, *Gallery News*, September-November 2000.

O'NEILL, GEORGE BERNARD (1828-1917), genre painter. Born in Dublin in 1828, George Bernard O'Neill was the ninth child of fifteen, his father being an Ordnance Board clerk. The family moved to England when George Bernard was aged nine and he attended school in Rectory Place, Woolwich. In 1845 he was accepted at the Royal Academy Schools on the recommendation of F. S. Cary who had become headmaster of Sass's Academy. At the RA, he won a gold medal for painting.

O'Neill first exhibited at the Royal Academy in 1847 from 2 Nightingale Terrace, Woolwich, and from then until 1893 contributed seventy-two pictures. A small sketchbook, inscribed at the front 'G. B. O'Neill, Woolwich', is in the Victoria and Albert Museum containing beach scenes and landscapes, including views of the Isle of Wight, figure and portrait studies and sketches of trees, cottages and a church.

By May 1851 the artist had left Woolwich. The first taste of success was with *The Foundling*, RA 1852; acquired by the National Gallery in 1859, it is now in the Tate Gallery. By 1853 he resided in Kensington. John Ruskin (1819-1900) remarked on *Market Day*, exhibited at the 1856 RA, that it was 'of the old school, but very delicately painted. There is far too much to be natural. It is a map of a market day, instead of a picture of one'.

O'Neill was associated with the Cranbrook Colony, a group of artists who congregated during the summer at the old town of Cranbrook in Kent. Thomas Webster (1800-86) was the leader, having in 1856 moved there and remained for the rest of his life. Other followers included F. D. Hardy (1826-1911) and J. C. Horsley (1817-1903). O'Neill had married in 1855 Emma Stuart Callcott, granddaughter of the musician, John Wall Callcott, who was a brother of the painter, Sir A. W. Callcott (1779-1844), Rosamund Horsley's uncle. By 1857 the O'Neills and Horsleys were close friends, both families residing in Kensington.

By 1859 the O'Neills had been introduced to Cranbrook, where the Horsleys spent most of their time, and O'Neill felt confident in asking 450 guineas for *A Statute Fair*. His *Manning the Navy*, 1860 RA, is in the National Maritime Museum. In the Cranbrook area, at Wilslay, O'Neill leased from the early 1860s until 1898 a timber-framed house, an old cloth-hall which had survived from the village's early prosperity in the wool trade. Many of the pictures painted in the years following his move to Cranbrook were set in the house itself; he now had two addresses.

The 1860s also produced *Public Opinion* (Leeds City Art Gallery), a scene in the gallery of the Royal Academy; *Gran's Treasures* (Guildhall Art Gallery); *Mending Dolly* (Walker Art Gallery); *The Doctor's Visit*. His account book for the years 1853 to 1878 has survived. The year 1864-5 realised a gross income of nearly £1,000. The accounts also showed that he painted a number of replicas.

In the early 1870s Arthur Tooth and Sons paid a total of £450 for *The Children's Party*, a smaller replica and the copyright. This work was regarded as one of his best, 'a masterpiece of composition and colouring'. His portrait, labelled 1874, *James Nasmyth (1808-90)*, the inventor and engineer, was purchased from the artist in 1910 by the National Portrait Gallery, London. James Nasmyth was a brother of the artist, Patrick Nasmyth (1787-1831), and lived after his retirement in 1856 at Penshurst, Kent.

In a special article on Irish art in the 1874 Royal Academy, the *Dublin University Magazine* referred to O'Neill's 'two charming representations of child-life', namely *A Little Better* and *The First Sitting*. His *Both Puzzled-Schooldays*, 51cm x 40cm oil on canvas, was of two children. He did not exhibit at the Royal Hibernian Academy but he is represented at the National Gallery of Ireland by an oil, *A Deathbed Scene*.

In addition to the Royal Academy, his work was displayed in London at Tooth's gallery. Differences in sizes may be judged by *New Year's Day*, 1889, 61cm x 76cm, and *Preparing for Christmas*, 1892, 30 cm x 25cm. The British Museum holds three etchings. Seven oil paintings, five from the Mrs Sidney Cartwright Bequest, are in the Wolverhampton Central Art Gallery, where in 1977 The Cranbrook Colony exhibition took place prior to moving on to the Laing Art Gallery, Newcastle-upon-Tyne. O'Neill died on 24 September 1917 at 61 Victoria Road, Kensington, London.

Works signed: G. B. O'Neill or G. B. O'N. (if signed at all).
Examples: Burnley: Towneley Hall Art Gallery and Museum. Bury: Art Gallery and Museum. Dublin: National Gallery of Ireland. Leeds: City Art Gallery. Liverpool: Walker Art Gallery. London: British Museum; Guildhall Art Gallery;

National Maritime Museum; National Portrait Gallery; Tate Gallery; Victoria and Albert Museum. Preston: Harris Museum and Art Gallery. Sheffield: Mappin Art Gallery. Wolverhampton: Central Art Gallery.
Literature: *Dublin University Magazine*, August 1874; Algernon Graves, *The Royal Academy of Arts Exhibitors 1769-1904*, London 1905; General Register Office, London, *Register of Deaths*, 1917; William Gaunt, *The Restless Century: Painting in Britain 1800-1900*, London 1972 (also illustration); *Dictionary of British Artists 1880-1940*, Woodbridge 1976; Wolverhampton Central Art Gallery, *The Cranbrook Colony*, catalogue, Wolverhampton 1977 (also illustrations); *Dictionary of Victorian Painters*, Woodbridge 1978; Witt Library, London, illustrative records [1979]; Graham Reynolds, *Victorian Painting*, London 1987 (also illustration); National Gallery, *Letter to the author*, 1991; Gorry Gallery, *An exhibition of 18th, 19th and 20th century Irish Paintings*, catalogue, Dublin 1996.

O'RIORDAIN, GABRIEL – see HAYES, GABRIEL

ORPEN, BEA, HRHA (1913-80), landscape painter. Daughter of a solicitor, Charles St George Orpen, Beatrice Esther was born on 7 March 1913 at Lisheens, Carrickmines, Co. Dublin, the niece of R. C. Orpen and William Orpen (qq.v.). After attending French School, Bray, Co. Wicklow, and Alexandra College, Dublin, she trained from 1932 until 1935 at the Dublin Metropolitan School of Art and at the Royal Hibernian Academy Schools, where she won first prize in 1933 for drawing from life, and in 1934 for painting from life. At the same time, she studied the organ at the Royal Irish Academy of Music.

From 1935 until 1939 she studied art in London, at the Slade School of Fine Art, where she was awarded first prize in decorative composition in 1936, and the diploma in design in 1939. In London, she also attended the School of Typography in Fleet Street, and courses in textile design and commercial design in the LCC Central School of Arts and Crafts. On her return to Ireland, she became an active member of the Irish Countrywomen's Association.

In 1934, when still at the Metropolitan School of Art, she had exhibited at the Royal Hibernian Academy, and from then until 1980 contributed every year without a break, well over a hundred pictures in all, landscapes being painted in Counties Cork, Donegal, Galway, Kerry, Limerick, Mayo and Meath. At the Water Colour Society of Ireland exhibitions, she was represented every year but one from 1936 until 1980, averaging three works per annum. Her first one-person show was at The Country Shop, Dublin, in 1939. In 1940 at the RHA she showed *Emly House, Co. Limerick* and *Dream*.

In 1942, now married to C.E.F. Trench, she left Dublin residence for The Blue School, Drogheda. In 1944 she began exhibiting at the Oireachtas. From 1943 until 1974 she taught in Drogheda Technical School and from 1949 to 1974 in St Peter's National School, Drogheda, but she was also known as an art teacher in Drogheda Grammar School. In 1946 she was a co-founder with her husband, who became honorary secretary, of the Drogheda Municipal Art Gallery Committee. In 1947 she exhibited solo at the Grafton Gallery, Dublin, and her four landscapes at that year's WCSI exhibition were all of Co. Donegal.

In 1954, the year she showed again at the Grafton Gallery, a visit to France produced, for example, *Normandy Poplars* and *Women washing, Audierne, Brittany*, both in gouache, which she principally used. She executed drawings for An Chomhairle Ealaíon, on behalf of a committee, suggesting an appropriate dress for dancing competitions, based on Irish costume as actually worn. She was closely involved with An Grianán residential adult education college of the ICA, from its establishment in 1954 at Termonfeckin, Co. Louth. That year she contributed to the RHA: *The Sun Hat*; *Near the Mouth of the Boyne*; and *The Butter Gate*.

From 1957 until 1978 she gave art appreciation talks to schools and adult groups throughout the country under the auspices of the Arts Council and the Charlotte Shaw Trust, and each year from 1959 until 1977 she directed an arts course for National teachers at An Grianán. President of the Soroptimist Club, Drogheda, in 1960, she was on the committee that year of the WCSI. In 1961 she moved house to Killrian, Slane, Co. Meath.

Romont, Switzerland was dated 1963. *The Forum, Rome* and *Florence Cathedral* were both 1967. She also showed with the Cork Arts Society and the Dublin Painters. A pen drawing, *Béguinage Doorway, Bruges*, was dated 1970, and in that year she exhibited *Renoir's Garden, Cagnes* at the RHA. Pen drawings of Assisi and Venice are of 1971, and *Farmhouse in Provence*, gouache, 1974. Appointed by the Government as a

member of the governing body, National Institute for Higher Education, Dublin, 1975-8, she was also on the Stamp Design Advisory Committee, 1977-80.

As president of the Irish Countrywomen's Association, she attended the fourteenth Triennial Conference of the Associated Country Women of the World, Perth, Australia, in 1974. Three years later she was a conference speaker at Nairobi, Kenya, taking the opportunity for more painting abroad. In 1977 she held a solo exhibition at the Neptune Gallery, Dublin, and that year at WCSI she showed *Chalet, Lake Huron, Canada* and *Snowdrops at Beauparc*.

In May 1980 she was elected an honorary member of the Royal Hibernian Academy. Bea Orpen died at the Cottage Hospital, Drogheda, on 12 July 1980. A retrospective exhibition followed in 1981 at the Gorry Gallery, Dublin.

Works signed: Bea Orpen (if signed at all).
Examples: Armagh: County Museum. Clonmel: South Tipperary County Museum and Art Gallery. Cork: Crawford Municipal Art Gallery. Drogheda: Library, Municipal Centre; Millmount Museum. Dublin: County Dublin Vocational Education Committee; Office of Public Works. Kilkenny: Art Gallery Society. Monaghan: County Museum. Sligo: Model and Niland Centre. Termonfeckin, Co. Louth: An Grianán. Waterford: City Hall, Municipal Art Collection.
Literature: *An Chomhairle Ealaíon Annual Report*, 1 April 1953-31 March 1954, Dublin 1954; *Water Colour Society of Ireland Minute Book*, 6 December 1960; *Irish Times*, 10 August 1968, 11 May 1970, 14 and 16 July 1980; C. E. F. Trench, *Slane*, Dublin 1976 (illustrations); C. E. F. Trench, *Letters to the author*, 1978, 1981, 1985; *Drogheda Independent*, 18 July 1980; Gorry Gallery, *Bea Orpen, HRHA 1913-1980*, catalogue, Dublin 1981; *Water Colour Society of Ireland Exhibition List 1872-1994*, Dublin 1995.

ORPEN, R. C., RHA (1863-1938), landscape painter and cartoonist. Eldest son of Arthur Herbert Orpen, solicitor, of Oriel, Blackrock, Co. Dublin, Richard Francis Caulfeild Orpen was a brother of Sir William Orpen (q.v.), and was born on 24 December 1863. From 1876 to 1881 he attended St Columba's College, Dublin; his drawings of school life appeared in the school magazine, and from then until his death he was devoted to St Columba's, often in an architectural capacity. In 1881 he took part in a Dublin Sketching Club exhibition.

Orpen graduated at Trinity College, Dublin. According to Page L. Dickinson, who later became his architectural partner, Orpen wanted to be a painter as a young man, 'but for family reasons became an architect instead. It was a great pity,' wrote Dickinson in *The Dublin of Yesterday*. 'Richard Orpen had as much if not more talent than his brother ...'. In the event, he served his apprenticeship as an architect with Sir Thomas Drew (1838-1910), who became Royal Hibernian Academy president in 1900 and held office for ten years.

Orpen's exhibiting association with the RHA began in 1888 and between then and 1936 he showed more than one hundred works. From 1906 until 1936 he did not miss a single year. Some works were architectural drawings but other titles indicated that he painted in Dorsetshire, Yorkshire and Holland, with Co. Donegal a favourite venue. When working with Drew he usually formed one of the contingent of Irish architects who joined in the sketching excursions of the Architectural Association.

For some time he was associated with Percy French (q.v.) in the latter's entertainments; their families were friends. 'Dublin-up-to-date' with sketches, recitations and a comic lecture on the city with magic lantern slides came into being. Orpen did lightning sketching turns during the performance and later his schoolboy brother Billy assisted. He was described as 'a breezy raconteur, an amusing after-dinner speaker, one who viewed life with cheerful philosophy ...'

French was editor of and chief contributor to a humorous weekly, *The Jarvey*, 1d. a copy, which lasted from 3 January 1889 to 27 December 1890 with Orpen as chief cartoonist. Both were involved in *Racquetry Rhymes*, 1888, a satire on the new craze for tennis; also *The First Lord Liftinant*, 1890; and other minor publications. Orpen also illustrated the covers for some French songs. He was the author and illustrator of *The Comic Irish Alphabet For the Present Time*, 'published by Young Ireland & Co., Porkopolis, Ohio'. A copy is in Armagh County Museum.

In 1894 the Arts and Crafts Society of Ireland was formed with the Orpen family actively involved. Richard was honorary secretary to the committee for the first exhibition in 1895, and the designs which he showed

included one for a bedhead in white appliqué on blue linen. William exhibited a design for an embroidered cushion. Both became members of the United Arts Club, Dublin. He was one of the original members of the Architectural Association of Ireland, and its first president in 1896. He applied unsuccessfully for the vacant post of headmaster of the Metropolitan School of Art, filled by James Ward (q.v.) in 1907, but in the 1914-15 period he lectured there on architectural subjects.

A friend of Hugh Lane, Orpen was a member of the original modern art gallery committee. When the Municipal Gallery was founded in 1908 he was one of the honorary secretaries of the committee of management, and Lane presented *Fishing Smacks, St Ives* to the gallery as an example of his watercolour work. There are also in that collection two still lifes and a drawing, *Old Dublin*. In 1907, following the riots over *The Playboy of the Western World*, he had been involved with a pamphlet called 'The Abbey Row,' designing the cover and supplying full-page caricatures of J. M. Synge and W. B. Yeats.

In the period 1908-36 he contributed just over one hundred works to the Water Colour Society of Ireland exhibitions, and for many years he served on the committee.

In 1908, giving his office address as 13 South Frederick Street, Dublin, he showed *The Bridge* and *A Travelling Circus* at the RHA. In 1910 he became a foundation member of the Guild of Irish Art-Workers. In 1911 he was appointed an associate of the Academy; in 1912, a full member. He often studied at the School of Art in the evenings. He was represented in the Black and White Artists' Society of Ireland second exhibition, 1914. In that year five of the six works he showed at the RHA were Richmond, Yorkshire, scenes.

Watercolour interiors – for example, *Pewter and Porcelain* – by Orpen at the 1915 RHA were described in *The Studio* as 'full of charm', and in the following year his watercolour studies of still life had become 'a feature of these exhibitions'. In 1916 at the WCSI event he showed *Interior*; *The Blue Jar*; *La Veille Tante (Belgian Refugee)*.

As the RHA premises had been destroyed in the 1916 Rising, the business of the Academy was carried on in the offices of Orpen and Dickinson. In 1914, residing at Coologe, Carrickmines, Co. Dublin, he was elected president of the Royal Institute of the Architects of Ireland, and served for three years.

Appointed secretary of the RHA in 1925, he held office until 1937. He was also a governor of the National Gallery of Ireland, and he is represented there by three drawings of Dublin alleyways. Included in his works at the 1928 WCSI was *The Monkey Man*.

His work was included in the Irish exhibition at Brussels, 1930, and at the Ulster Academy of Arts exhibition in 1937. Orpen is represented in the group, *Homage to Hugh Lane*, 1924, at the Hugh Lane Municipal Gallery of Modern Art, by Sean Keating (q.v.). A portrait of R. C. Orpen by Sir William Orpen is in St Columba's College, where the former is represented by two watercolours, including *The Gate Lodge, St Columba's*. He died on 27 March 1938. A small memorial exhibition was held at that year's Academy exhibition.

Works signed: R. C. Orpen or R. C. O. (if signed at all).
Examples: Drogheda, Co. Louth: Library, Municipal Centre. Dublin: Hugh Lane Municipal Gallery of Modern Art; National Gallery of Ireland; St Columba's College.
Literature: *Irish Times*, 17 December 1881; Percy French, *Ye Tale of Ye Tournament*, Dublin 1884 (illustrations); W. French, *The Tennis Worshippers*, Dublin 1887 (illustratons); P. French, *Racquetry Rhymes*, Dublin 1888 (illustrations); W. P. French, *The First Lord Liftinant*, Dublin 1890 (illustrations); H. Goldsmith Whitton, *Handbook of the Irish Parliament Houses, College Green, Dublin, now the Bank of Ireland*, Dublin 1891 (illustrations); R. Orpen, *The Comic Irish Alphabet For the Present Time*, n.d. (illustrations); *The Shanachie*, No. 2, 1906 (illustration), Winter 1907 (illustration); *Dublin and Co. Dublin in the Twentieth Century: Contemporary Biographies*, Brighton 1908; *Municipal Gallery of Modern Art, Dublin*, catalogue, 1908; *The Studio*, September 1912, January 1915, May 1915, June 1916; *Thom's Directory*, 1923; J. Crampton Walker, *Irish Life and Landscape*, Dublin 1927 (illustration); *Who's Who in Art*, 1927; P. L. Dickinson, *The Dublin of Yesterday*, London 1929; *Irish Builder and Engineer*, 2 April 1938; Beatrice Lady Glenavy, *Today we will only Gossip*, London 1964; James N. Healy, *Percy French and his Songs*, Cork 1966; L. Perry Curtis, Jr, *Apes and Angels: The Irishman in Victorian Caricature*, Newton Abbot 1971 (also illustration); G. K. White, *Letter to the author*, 1979; Bruce Arnold, *Orpen: Mirror to an Age*, London 1981 (also illustrations); Ann M. Stewart, *Royal Hibernian Academy of Arts: Index of Exhibitors 1826-1979*, Dublin 1987; Patricia Boylan, *All Cultivated People: A History of the United Arts Club, Dublin*, Gerrards Cross 1988; Hugh Lane Municipal Gallery of Modern Art, *Letter to the author*, 1991; Paul Larmour, *The Arts & Crafts Movement in Ireland*, Belfast 1992 (also illustrations); *St Columba's*

College 150th Anniversary Exhibition, catalogue, Dublin 1993; *Water Colour Society of Ireland Exhibition List 1872-1994*, Dublin 1995.

ORPEN, SIR WILLIAM, RA, RI, HRHA (1878-1931), portrait and genre painter. Youngest in a family of six, William Newenham Montague Orpen was born on 27 November 1878. His father, Arthur Herbert Orpen, a solicitor, resided at Oriel, Grove Avenue, Blackrock, Co. Dublin. His grandfather was Sir Richard J. T. Orpen of Ardtully, Kilgarvan, Co. Kerry. In 1891, weeks before his thirteenth birthday, William entered the Dublin Metropolitan School of Art under James Brenan (q.v.), a figure painter. 'I at once,' wrote Orpen later, 'became an old man, one of the world's workers.'

At the end of his second year in the School of Art, 1892-3, he won a £20 scholarship for three years, administered from South Kensington, also first class certificates for drawing. In the next two years he was again an outstanding student, selected to attend the summer course at South Kensington in 1895. The prize list grew longer in 1895-6, with a silver medal for drawing the figure from life. In that year the School of Art gained five Queen's Prizes for art; four were Orpen's, and in two of the subjects, anatomy and drawing from the antique, he was first in the British Isles. In 1896-7, his final year, he won the gold medal in the National Competition with a set of three drawings from life. *A Nude Boy*, 1897, black chalk on paper, is in the National Gallery of Ireland. There are two drawings, 1895 and 1897, both associated with South Kensington, at the National College of Art and Design.

In his report, Brenan said: 'All who knew him here will bear me witness when I say that he was a model student, eminently teachable ...' Orpen said that the chief thing that impressed him in his youth was his own ugliness. When still a schoolboy, he occasionally assisted his brother R. Caulfeild Orpen (q.v.) with sketches in the entertainments organised by Percy French (q.v.). His portrait of R. C. Orpen is in St Columba's College, Dublin.

In 1897 he entered the Slade School of Fine Art, London, headed by Professor Frederick Brown (1851-1941) and aided by Henry Tonks (1862-1937). Already established there as a student was Augustus John (1878-1961) and they became close friends – sometimes enemies. A mutual acquaintance was Albert Rutherston (1881-1953). *The Studio* noted at a later date: 'As regards drawing, he had, indeed, but little to learn when he entered the Slade School ... he drew for practice, not for display, to give sureness to his hand and make it a reliable servant to his eye ...'.

At the end of his first year at the Slade, he took first-class certificates in head painting and figure painting, and the £5 prize for figure drawing. Paris beckoned him for a special trip. In 1899 he won first prize for figure painting with his standing male nude, and also for head painting. Most important of all, in his last year, he won the coveted £40 summer competition prize with *The Play Scene from Hamlet*. In 1899 too he won the Royal Dublin Society's Taylor Scholarship, securing the prize again in 1900.

Orpen first exhibited with the New English Art Club in 1899, from 52 Torrington Square. That year saw him with a group of artists in Normandy, including William Rothenstein (1872-1945), Charles Conder (1868-1909) and John. He now introduced a studio book for his sales. In 1900 he gained membership of NEAC, and with a basement studio at 21 Fitzroy Street, he painted three important works: *The Mirror*; *The English Nude*; and *The Bedroom*; and he returned to Normandy. Before his marriage in 1901 to Grace Knewstub, sister-in-law of William Rothenstein, he lived for a time with Hugh Lane, art collector and dealer. Grace's father, John Knewstub, managed the Chenil Gallery.

Carfax Gallery held a one-person exhibition in 1901, the year of his first important commission, a portrait of James Staats Forbes. In 1901 he exhibited at the Royal Hibernian Academy and from then until 1917 showed a total of forty works. On the 1903 RHA, choosing him from the younger exhibitors, *The Studio* discerned 'plenty of temperament and character, a rare distinction ...'. He became an ARHA in 1904 and a full member in 1907. In 1906 from 13 Royal Hospital Road, Chelsea, he contributed to the Dublin show: *Waiting their Cue*; *William O'Brien, Esq.*; *T. W. Russell, Esq., MP*; *Saint of Poverty*.

Between 1902 and 1914, Orpen travelled to teach part-time at the Dublin Metropolitan School of Art. The work was irregular at first but after a few years he made twice-yearly teaching visits, bringing about a revolution in the life class – and girl models from London. He was allowed to keep a studio in the School of

Art. Up until 1907 he was paid £25 a visit but by 1914 the fee had risen to £200. He was among the teachers who directed courses at the summer schools.

In 1902 he had moved to 13 Queen's Road, Chelsea, where he also had a studio. The Chelsea Art School in Flood Street, a joint venture of John's and Orpen's, opened in 1903 but was taken over within two years. In 1903 George Moore commissioned his portrait from Orpen, who contributed substantially to the exhibition in 1904 of works by Irish painters held at the Guildhall of the Corporation of London and organised by Hugh P. Lane. In 1905 Lane and Orpen made a journey to France and Spain.

Orpen first exhibited at the Royal Academy in 1904 with *Charles Wertheimer, Esq*. From 1908 until 1931 inclusive he showed just over a hundred works, portraits predominating, and in 1908 he gave his address as 8 South Bolton Gardens, SW. In 1904 he had found a model, Lottie of Paradise Walk; his portrait of the washerwoman, *Resting*, is in the Ulster Museum. *Lottie of Paradise Walk* is in Leeds City Art Gallery. The Society of Portrait Painters included his work in the 1905 exhibition, and at the Chenil Gallery he held an exhibition of drawings with John. *The Costermonger*, an old man, was dated 1905 and is in the USA, at Worcester Art Museum, Mass. The National Gallery of Ireland has a pen drawing, *Dinner At Jammet's, 16th October 1906*.

Homage to Manet (Manchester City Art Gallery), begun in 1906, took about two years to paint. P. Wilson Steer (1860-1942), W. R. Sickert (1860-1942), D. S. MacColl (1859-1948), Moore, Lane and Tonks are in the group. A study for the work in pencil, ink and watercolour is at NGI. During the painting of this important conversation piece, Lane took rooms adjoining Orpen's studio in South Bolton Gardens. In 1907 Orpen was appointed an associate of the International Society of Painters, Sculptors, and Gravers; *The Old Cabman* of that year is now in the Art Institute of Chicago.

He was represented in the Irish section of the International Exhibition at Ballsbridge, 1907, and from about this time his family took a summer house on Howth Head. An exhibition of watercolours was held at the Paterson Gallery, London, 1907, and that year he was represented in the seventh International Exhibition of Art at Venice. The Orpens were friendly with William Nicholson (1872-1949): *A Bloomsbury Family* (Scottish National Gallery of Modern Art), an interior, was completed in 1908. Also painted in 1908 was his portrait of Tim Healy, MP, now at Áras an Uachtaráin.

Lane had conceived the idea of commissioning John Butler Yeats (q.v.) to paint a series of portraits of distinguished Irishmen for presentation to the Nation. Orpen was called in to continue the task, adding portraits for example of the Rt. Hon. T. W. Russell, MP; Sir Antony P. MacDonnell; William O'Brien, MP; Michael Davitt, MP; Nathaniel Hone, RHA (q.v.); the Rev. J. P. Mahaffy, DD, CVO; Capt. Shawe-Taylor. All of these oils are in the Hugh Lane Municipal Gallery of Modern Art, where there are more than thirty works, including a pencil drawing of Hugh Lane reading. At this time a full-length portrait by Orpen cost £200.

As well as exhibiting at the RHA, Orpen contributed to some of the Oireachtas exhibitions in Dublin. Among his most promising pupils at the School of Art were: Sean Keating, James Sleator and Leo Whelan (qq.v.). Beatrice Elvery (Lady Glenavy, q.v.) sat for *A Colleen*, hung at the Goupil Gallery in 1908, when he was represented in Lane's exhibition of pictures by Irish artists for the model village of Ballymaclinton at the Franco-British exhibition.

In 1909 Orpen exhibited at the Society of Twelve exhibition; also *The Dead Pharmigan* (NGI), a self-portrait, at the NEAC summer exhibition; and he showed in the Society of Portrait Painters' exhibition. In an article in *The Studio*, T. Martin Flood wrote: 'Perhaps Mr Orpen has expressed himself best in interior painting, because of his pleasure in glasses and picture frames, in papers and trays, in sunny spaces of wall and bright things shining from the shadows, in the curiously pale and rainbow gleams of old porcelain'. However, from about this time and for the next four years, when on holiday with his wife and three daughters, he painted his notable Howth works *en plein* air. *A Breezy Day, Howth* joined the Lane Bequest for the Municipal Gallery of Modern Art.

Appointed an associate of the Royal Academy in 1910, he painted that year *Myself and Venus* and *Myself and Cupid*; the latter was exhibited at the 1912 Royal Scottish Academy. In 1911 *The Studio* commented: '... he is more nearly becoming a great artist than almost any painter of our time, and yet this talent seems

at the mercy of whatever stimulus it accidentally encounters'. He was a founder member in 1911 of the National Portrait Society. Chas Chenil & Co. of Chelsea announced the 'exclusive privilege of reproducing under the artist's personal supervision a set of ten of his pencil and wash studies', but the portfolio does not appear to have been issued until 1914. In Dublin in 1911 he painted a portrait of the Friendly Brothers of St. Patrick president, Rev. T.T.F. Gray.

The Café Royal (Musée d'Orsay) and The Chinese Shawl (National Gallery of Victoria) were exhibited at the NEAC summer exhibition, 1912. When the Black and White Artists' Society of Ireland was founded in 1912 Orpen was appointed president. At the NEAC in 1913 he unburdened his allegory about art in Ireland: Sowing New Seed for the Board of Agriculture and Technical Instruction for Ireland, a decorative composition in tempera, and from this period – and medium – are also The Holy Well (NGI) and The Western Wedding. Between 1912 and 1916 he showed four works at the Royal Scottish Academy.

Described as an 'exquisite study of subtle tones' and 'one of his most fascinating records of acute observation', Afternoon Sleep appeared at the International Society exhibition, 1913, and that year he was represented at the annual exhibition of the Carnegie Institute, Pittsburgh, Pennsylvania. The Roscommon Dragoon, 1913, of Miss Vera Brewster, Cincinnati, inspired a colour collotype, 300 artist's proofs, published at six guineas each. The National Art Gallery in London has ten plates of drawings, issued 1913 but not in book form. Outstanding among his portraits was the full-length of 1914, Mrs St George, with whom he was having an affair.

In 1914 Orpen continued to exhibit with the International Society, the National Portrait Society, and NEAC, contributing also to the Three Arts Club Exhibition Society and, in Dublin, the Black and White Artists' Society of Ireland. In its July issue The Studio reproduced in colour, The Countess of Crawford and Balcarres. After a row with the president, Dermod O'Brien (q.v.), he resigned from the RHA in 1915.

In 1915 Sean Keating (q.v.) arrived in London as an assistant in the studio. Orpen occasionally used him as a model. Keating failed to persuade him in 1916 to return to Ireland with him. Orpen in fact was already committed to serving in the Army Service Corps. The Glasgow Institute of the Fine Arts showed his work that year.

Orpen, appointed an Official War Artist, left for France in April 1917. Stationed at Amiens first, he then went to the Somme battlefields. Almost before he started work, he offered to the nation all the paintings and drawings that would result from his Government employ. By this generous gesture the Imperial War Museum benefited to the extent of 132 works. An unusual feature of the drawings was that they were all unsigned – the media varied, for example: charcoal, chalk and watercolour; pen, pencil and wash; pencil and black chalk. By contrast, virtually all of the oil paintings were signed by the artist.

Among war portraits were those of Field-Marshal Sir Douglas Haig and Major-General H. M. Trenchard, both painted at General Headquarters, 1917; Marshal Foch, 1918, and subsequently reproduced in colour by the Ministry of Information. Among drawings were: A Dead German in a Trench; Graves: Thiepval; Soldiers and Peasants, Cassel; A House at Péronne. By November 1917 he had fallen ill with blood poisoning. His lack of respect for military discipline is evident in his An Onlooker in France 1917-1919, published in 1921 with ninety-six illustrations. As he said in the preface: 'This book must not be considered as a serious work on life in France behind the lines, it is merely an attempt to record some certain little incidents that occurred in my own life there ...'

In the spring of 1918 he held an exhibition of war paintings at Thomas Agnew and Sons' galleries in Old Bond Street, described by The Studio as 'the most important artistic event of the day'. That year he was knighted for his War services. Towards the end of the War, Orpen was commissioned by the Imperial War Museum to paint three pictures to commemorate the coming of peace, hence A Peace Conference at the Quai d'Orsay, showing a number of prominent politicians arranging the peace terms; The Signing of Peace in the Hall of Mirrors, Versailles, 28th June, 1919. The third was to be a representation of statesmen, generals, admirals and other prominent men who had helped to win the War, grouped in the Hall of Peace which led into the Hall of Mirrors.

According to Ernest Blaikley, onetime Keeper of Pictures at the War Museum, about forty figures were completed but Orpen became dissatisfied with his subject. He took all of the figures out and painted the

picture, *To the Unknown British Soldier, 1918*, which caused controversy at the 1923 Royal Academy. 'In the centre of the picture,' wrote Blaikley, 'stood a coffin draped with the Union Jack. On either side of it stood a gaunt and ghostly figure, half draped and wearing a steel helmet. Above, against the dark depths of the Hall of Mirrors, were posed two cherubim who supported festoons of flowers which wreathed the two soldiers and extended from them to the floor. And at the far end of the Hall of Mirrors was an arched opening revealing the Cross.' The picture was refused. In 1928 he eliminated the soldiers and cherubim and gave the work as a memorial to Haig.

Seven portraits which Orpen painted in 1919 at the Peace Conference in Versailles were sold by Christie's, London, in 1977 on behalf of the Royal Masonic Hospital. In 1919 he was appointed an RA and a member of the Royal Institute of Painters in Water Colours. In 1920 at the Carnegie Institute galleries, Pittsburgh, USA, he showed a self-portrait, *A Man from Arran*, presumably Aran, and also his striking portrait of Mrs St George.

Chef de l'Hotel Chatham, Paris attracted the most public attention at the 1921 RA; it was accepted as the artist's diploma work. In 1921 he was appointed president of the International Society of Sculptors, Painters, and Gravers. In both London and Paris he kept studios but early in 1922 it was reported that he had returned from Paris under medical advice 'suffering from tobacco poisoning'. His two nudes, *Early Morning* and *A Disappointing Letter*, exhibited at the NEAC in 1922, are among his most distinguished achievements.

Orpen, who had an exhibition of drawings at the Goupil Gallery in 1923, was involved in two more books, both published in London, as editor of *The Outline of Art*, 1923, and author of *Stories of Old Ireland and Myself*, 1924, of which there were one hundred signed copies of a special edition. He painted a portrait in 1923 of Lord Glenavy for the Honourable Society of Gray's Inn, and his portrait that year of David Lloyd George was a copy of his own 1915 original. There was no shortage of other commissions and he continued to show at the Royal Society of Portrait Painters' exhibitions. Despite a heavy drinking problem, other societies were not neglected.

According to Bruce Arnold in his biography, a major sourcebook on the artist's life, in the mid-1920s Orpen earned £35,000 a year, and charged as much as 2,000 guineas for a portrait. In the last four years of his life his earnings never dropped below £45,000. He was a member of eight clubs.

In addition to five portraits at the 1926 RHA, he showed *Closing Time, Avignon*, a picture of tigers in a cage with a keeper dozing on a box. In that year he was represented in the Venice Biennale, and again in 1928 – with *Marchioness of Cholmondley*. A portrait of Sir Andrew Lewis, LL D, Lord Provost of Aberdeen 1925-30, was presented by subscribers in 1930. At the time of the commission, there was some doubt about the fee. Orpen sent off a telegram: 'Trust Aberdeen to give me as much as possibly [sic]'.

Keating said he painted 'at an incredible speed without alterations or erasures, and then, if it was not exactly what he wanted, he simply wiped it out and began again – but that was seldom'. Keating is the posed figure in *Man of the West* at Limerick City Gallery of Art. R. R. Tatlock of the *Daily Telegraph* wrote that he had two very peculiar habits as a portraitist: 'He never made preliminary sketches, and he commenced his portraits at the first sitting by painting in full detail only one of the sitter's eyes leaving the whole of the rest of the canvas to be filled in later on ...'. Among his oil portraits at the National Gallery of Ireland are: *The Vere Foster Family*; *Augusta Gregory, Dramatist*; *The Artist's Parents*. A score of works are in the National Portrait Gallery, London. A portrait of him by James S. Sleator (q.v.) is in Crawford Municipal Art Gallery, Cork.

Elected an honorary member of the RHA in 1930, that year his portrait of Keating was reproduced on the poster for the exhibition of Irish art at Brussels, and a portrait of Mrs H. M. White, LL D, principal, Alexandra College, Dublin, was hung at the RA; it is still in the school. An illustrated record book of picture commissions 1899-1931 was presented to NGI by Mrs Kit Orpen Casey, daughter of the artist. In May 1931, memory impaired, he became seriously ill. He died on 29 September 1931 and was buried at Putney Vale Cemetery. A memorial service was held at St James's Church, Piccadilly. In 1933 the RA organised a joint memorial exhibition for Orpen, Charles Ricketts (1866-1931) and Ambrose McEvoy (1878-1927). That exhibition was also hung at Manchester City Art Gallery. In 1978 a retrospective exhibition was hosted at the NGI.

Works signed: William Orpen, Orpen; Orps, rare; W. O., monogram, rare; or O., rare (if signed at all).

Examples: Aberdeen: Art Gallery; University of Aberdeen, Marischal Museum. Adelaide: Art Gallery of South Australia. Bedford: Cecil Higgins Art Gallery. Belfast: Ulster Museum. Birkenhead: Williamson Art Gallery and Museum. Birmingham: Museum and Art Gallery. Boston, Mass.: Museum of Fine Arts. Bradford: Cartright Hall Art Gallery. Cambridge: Fitzwilliam Museum. Cambridge, Mass.: Harvard University, Fogg Art Museum. Cardiff: National Museum of Wales. Chicago, Ill.: Art Institute of Chicago. Churchill, Co. Donegal: Glebe Gallery, Derek Hill's Collection. Cork: Crawford Municipal Art Gallery. Coventry: Herbert Art Gallery and Museum. Dublin: Alexandra College; Áras an Uachtaráin; Hugh Lane Municipal Gallery of Modern Art; King's Inns; National College of Art and Design; National Gallery of Ireland; Office of Public Works; Royal College of Surgeons in Ireland; Royal Dublin Society; Royal Hibernian Academy; St Columba's College; University College (Belfield). Dundee: City Art Gallery. Dunedin, New Zealand: Public Art Gallery. Durban: Municipal Art Gallery. Edinburgh: Scottish National Gallery of Modern Art; Scottish National Portrait Gallery. Eton, Berks.: Eton College. Florence: Uffizi Gallery. Glasgow: Art Gallery and Museum. Johannesburg: Art Gallery. Kilkenny: Art Gallery Society. Leeds: City Art Gallery. Leicester: Leicestershire Museum and Art Gallery. Limerick: City Gallery of Art. Liverpool: Walker Art Gallery. London: British Council; British Museum; Cavalry and Guards' Club, 127 Piccadilly; Gray's Inn Library; Guildhall Art Gallery; Imperial War Museum; Lincoln's Inn Library; National Maritime Museum; National Portrait Gallery; Royal Academy of Arts; Royal Institute of British Architects, 66 Portland Place; Royal Society of Medicine, 1 Wimpole Street; Slade School of Fine Art; South London Art Gallery; Tate Gallery; Victoria and Albert Museum. Louisville, Kentucky: J. B. Speed Art Museum. Manchester: City Art Gallery; Whitworth Art Gallery. Melbourne: National Gallery of Victoria. Mildura, Victoria, Aus.: Arts Centre. Naas, Co. Kildare: Clongowes Wood College. New York: Metropolitan Museum of Art; Public Library, Berg Collection. Newcastle-upon-Tyne: Laing Art Gallery. Norwich: Castle Museum. Nottingham: Castle Museum. Ohio, USA: Cleveland Museum of Art. Oldham: Art Gallery and Museum. Ottawa: National Gallery of Canada. Oxford: Ashmolean Museum; University, Brasenose College; Christ Church. Paris: Musée d'Orsay. Pietermaritzburg, S.A.: Tatham Art Gallery. Pittsburgh, Penn.: Carnegie Museum of Art. St Andrews, Fifeshire: Royal and Ancient Golf Club. St Louis, Missouri: City Art Museum. Sheffield: Graves Art Gallery. Sligo: Model and Niland Centre. Stanfield, California: Stanford University Museum of Art. Stockholm: National Museum. Sydney: Art Gallery of New South Wales. Toronto: Art Gallery of Ontario. Wakefield, Yorks.: City Art Gallery. Worcester. Mass.: Art Museum.

Literature: *Royal Dublin Society Report of the Council*, 1899, 1900; *The Studio*, May 1903, August 1909, January 1911, May 1911, June 1918, July 1921, December 1932 (also illustrations), August 1945, plus thirty-one other references of a minor nature in the period January 1902-August 1928; Lady Gregory, *Hugh Lane's Life and Achievement, with some account of the Dublin galleries*, London 1921; Sir William Orpen, KBE, RA, *An Onlooker in France 1917-1919*, London 1921 (also illustrations); *Building News*, 6 January 1922; Sir William Orpen, RA, *Stories of Old Ireland and Myself*, London 1924 (also illustrations); *Daily Telegraph*, 10 October 1931; P. G. Konody and Sidney Dark, *Sir William Orpen, Artist and Man*, London 1932 (also illustrations); Thomas Bodkin, *Hugh Lane and His Pictures*, Dublin 1934; Sean Keating, 'William Orpen: A Tribute', *Ireland To-Day*, August 1937; *Who Was Who 1929-1940*, London 1941; Imperial War Museum, *A concise catalogue of Paintings, Drawings and Sculpture of the First World War 1914-1918*, London 1963; James N. Healy, *Percy French and his Songs*, Cork 1966; *The Connoisseur*, April 1971; National Gallery of Ireland, *William Orpen 1878-1931*, catalogue, Dublin 1978 (also illustrations); John Turpin, 'William Orpen as Student and Teacher', *Studies*, August 1979; Witt Library, London, illustrative records [1979]; Bruce Arnold, *Orpen: Mirror to an Age*, London 1981 (also illustrations); *Irish Times*, 24 January 1981, 25 May 1994; Meirion and Susie Harries, *The War Artists*, London 1983; Dr Robert Becker, 'Artists Look at George Moore', *Irish Arts Review*, Winter 1985; Ann M. Stewart, *Royal Hibernian Academy of Arts: Index of Exhibitors 1826-1979*, Dublin 1987; Alexandra College, *Letter to the author*, 1991; also, Art Institute of Chicago, 1991; Imperial War Museum, 1991; National Gallery of Victoria, 1991; Royal College of Physicians, 1991; Worcester Art Museum, 1991; Mrs Mary Kelleher, 1992; Royal Masonic Hospital, 1992; John Turpin, *A School of Art in Dublin since the Eighteenth Century*, Dublin 1995 (also illustrations); Friendly Brothers of St. Patrick, *Letter to the author*, 1999; also, National Irish Visual Arts Library, 1999.

O'RYAN, FERGUS, RHA (1911-89), landscape and townscape painter. Born in Limerick on 13 March 1911, son of John O'Ryan, painter and decorator, Fergus O'Ryan attended St Mary's School, and then studied under Richard Butcher at the Limerick School of Art. By 1931 he was attending evening classes in the Dublin Metropolitan School of Art; he enrolled for full-time study in 1935. He was passionate about travel, and spent most of his holidays abroad, visiting for example France and Germany before the Second World War.

In 1938 he first exhibited at the Royal Hibernian Academy, giving the National College of Art as his address, and from then until 1984 he showed practically every year, nearly 200 works, including some watercolours. Connemara and Counties Donegal and Wicklow were favourite painting haunts as well as old Dublin areas. When he contributed four works to the RHA in 1941 he gave his address as Railway Hotel,

Westland Row, Dublin. The following year he left the National College of Art, and exhibited *Autumn Sunlight* at the Munster Fine Art Club.

In the early 1940s he worked at McEvoy's Advertising Service Ltd. in Dublin for advertisement lay-outs and fashion drawings in black and white. He became art director for the Rank Organisation at the Theatre Royal, designing the backdrops and scenery as well as looking after cinema posters.

The Walls of Dublin at the 1943 RHA was described in *The Bell* as 'well designed and painted, and with imagination'. In the same year the *Dublin Magazine*, referring to his work in a group exhibition at Contemporary Pictures, Dublin, described it as 'conventionally acceptable and technically accomplished'. At the 1949 RHA, he showed: *The Harbour Cassis*; *The Moore Market, Dublin*; *The Dargle at Kilcroney*.

Represented in the exhibition of pictures by Irish artists in Technical Schools, 1949, he was described in the catalogue as 'a professional designer and commercial artist'. In 1950 he held a one-person show at the Victor Waddington Galleries, Dublin. The *Dublin Magazine* commented: 'As a painter Fergus O'Ryan is extraordinarily fluent; so much so that in an exhibition of thirty-six pictures he tends to appear discursive and at times even sentimentally garrulous. This effect is enhanced by the fact that he paints exclusively with the palette-knife while still remaining in the traditional chromatic range of near-Impressionist landscape. Nevertheless a number of his smaller landscapes have a tender and a lyrical charm...'. He supplied the illustrations for Patricia Lynch's *Tales of Irish Enchantment*, 1952. He designed a stamp to mark An Tóstal in 1953.

O'Ryan also lectured in art at the Masonic School and at evening classes in Rathmines High School. He also taught stage design at the school of theatre production at the Gaiety Theatre, run by Ria Mooney. The visits to the Continent continued. A solo exhibition at the Victor Waddington Galleries in 1954 found the art critic of the *Dublin Magazine* writing that he had achieved 'a consistent technical perfection. His colour is lively and his quality interesting. He has a kind of impressionistic virtuosity which, however, seems to me to overlie a fundamentally academic approach to his subject ...'.

In the period 1955-69 he never missed a year at the Water Colour Society of Ireland exhibitions, showing almost fifty works. His initial showing was *Spring Day, Paris*; *Fishing Boats, Tossa*; *Potato Pickers*.

Whilst still in the employ of the Rank Organisation, he enrolled for lithography classes at Bolton Street Technical School, but when the Theatre Royal was sold off, he joined the staff of the National College of Art and taught lithography there until his retirement. In 1956 he won the President Hyde Gold Medal Award at the Oireachtas exhibition for *The Irish College, Salamanca*. In 1957 at an exhibition in the Dawson Gallery, Dublin, he showed *Spanish Fishermen* as well as *Venice*. In 1959 he was appointed an associate of the RHA; in 1960 a full member. He was RHA treasurer 1962-5. *A small Spanish Pub* figured at the 1965 WCSI event.

O'Ryan was the originator of a journey to Greece via France and Italy in 1969 with two young Irish artists, Brett McEntagart and James Nolan. Although Fergus had brought his painting kit, he never touched a brush during the three-month trip; he justified this by saying there was no market for foreign subject matter in the Dublin galleries. Along with Sean Keating (q.v.) and Thomas Ryan, RHA, he participated in an exhibition commemorating the silver jubilee, 1948-73, of the opening of the Municipal Art Gallery, Limerick. He retired from the College of Art in 1976 as head of Fine Print.

In his last appearance at the RHA, 1984, his six works included *Glendalough River*; *Laragh*; *Riddles Row, Dublin*. *Place de Furstenburg* is one of three oils at Crawford Municipal Art Gallery, Cork. In the Dublin Civic Museum are six woodcuts of old Dublin scenes including one of Thundercut Alley, Queen Street; *Mabbot Arch, off Talbot Street*; *The 37 Steps, Summerhill, Dublin*. His *Cole's Lane*, presented by the Thomas Haverty Trust, is in the Hugh Lane Municipal Gallery of Modern Art. Of Avondale, Bird Avenue, Clonskeagh, Co. Dublin, he died in hospital on 4 March 1989. The Fergus O'Ryan RHA Memorial Award was instituted at the 1993 exhibition. A studio sale was held at the James Gallery, Dalkey, Co. Dublin, in 1997.

Works signed: Fergus O'Ryan, F. O'Ryan or O'Ryan.
Examples: Beijing: Irish Embassy. Bray, Co. Wicklow: Public Library. Canberra: Irish Embassy. Cork: Crawford Municipal Art Gallery. Dublin: Civic Museum; College of Technology, Bolton Street; Hugh Lane Municipal Gallery of

Modern Art; Institute of Public Administration; Office of Public Works; Voluntary Health Insurance Board. Limerick: City Gallery of Art; County Library. Lisbon: Irish Embassy. Luxembourg: Irish Embassy. Riyadh, Saudi Arabia: Irish Embassy. Waterford: City Hall, Municipal Art Collection.

Literature: *The Bell,* June 1943; *Dublin Magazine,* July-September 1943, January-March 1951, April-June 1954, January-March 1958; Patricia Lynch, *Tales of Irish Enchantment,* Dublin 1952 (illustrations); *Who's Who in Art,* 1952; Department of Posts and Telegraphs, *Letter to the author,* 1968; also, Dublin City and Co. Librarian, 1972; Ann M. Stewart, *Royal Hibernian Academy of Arts: Index of Exhibitors 1826-1979,* Dublin 1987; *Irish Times,* 6,7 and 20 March 1989, 19 August 1997; Tom Nisbet, *Letter to the author,* 1991; Brett McEntagart, *Martello,* 1991; John Turpin, *A School of Art in Dublin since the Eighteenth Century,* Dublin 1995; *Water Colour Society of Ireland Exhibition List 1872-1994,* Dublin 1995.

OSBORNE, EDITH – see BLAKE, LADY EDITH

OSBORNE, F.W.– see OSBORNE, WALTER F.

OSBORNE, HARRIET – see O'HAGAN, HARRIET OSBORNE

OSBORNE, JEAN (1926-65), figure and landscape painter. Born in Larne, Co. Antrim, on 21 February 1926, Jean Meikle was the daughter of a shipyard fitter, William Meikle. Interested in art, by 1947 she was a prodigy of Paul Nietsche (q.v.) before going to work in London where she had a short period as a seamstress. In 1948 she began evening classes at Camberwell School of Arts and Crafts on a four-year course. There she met her husband. She finished the last two years of her tuition at the Belfast College of Art where she was first to take a National Diploma in Design.

In 1951 she was represented in the Exhibition of Contemporary Ulster Art at the Belfast Museum and Art Gallery. *Girl in Yellow Blouse* and *Landscape* were shown with the London Group in 1952. The following year she emigrated to Canada, settling in St Catharines, Ontario, and stayed for six years with her English-born painter husband, Dennis H. Osborne. At the 1954 winter exhibition of the Art Gallery of Hamilton she contributed *The Harmonica Player* and *Barbara,* both oils. Two years later she showed *The Fishnets* and *The Coolyard,* also oils, at the annual exhibition of the Colour and Form Society at Hart House, Toronto; and she was again represented there in 1957, when she also exhibited with her husband and Walter Hickling in a three-person show at the Art Gallery of Hamilton.

The year 1957 also saw representation in Toronto at the Ontario Society of Artists' exhibition, and at the Art Gallery of Hamilton annual she showed an oil, *The Welders.* In 1958 she and her husband held a two-person show at the Thielban Gallery, London, Ontario. In that year her work also appeared in the annual exhibitions of the Canadian Society of Painters in Water Colour, the Winnipeg Art Gallery, and again at the Hamilton gallery, this time with *The Pilgrims* and *Kippers.*

In 1959 she returned to Northern Ireland but poor health and a long illness prevented regular exhibiting. However, she was represented in the Flower Paintings exhibition at the RWS Galleries, London, in 1960. She occasionally worked in pastel. In the Armagh County Museum collection is an oil painting, *Grief,* and in that medium was also *Turbulent Forms.* Of Riverside Drive, Lambeg, Co. Antrim, Jeannie Osborne died at Lisburn Hospital on 9 July 1965. A selection of her work was exhibited at the New Gallery, Belfast, in 1967.

Works signed: Jean Osborne or Jeannie Meikle.
Examples: Armagh: County Museum. Belfast: Arts Council of Northern Ireland. Londonderry: Foyle and Londonderry College.
Literature: Paul Nietsche, *Letter to Jean Meikle,* 1947; *Belfast Telegraph,* 10 July 1965; New Gallery, *Jean Osborne 1926-1965,* catalogue, Belfast 1967; Michael Longley, ed., *Causeway: The Arts in Ulster,* Belfast 1971; Dennis H. Osborne, *Letters to the author,* 1991.

OSBORNE, WALTER F.,RHA(1859-1903), portrait, landscape and genre painter. Walter Frederick Osborne was born at 5 Castlewood Avenue, Rathmines, Dublin, on 17 June 1859, the second son of the

animal painter, William Osborne, RHA (1823-1901). In 1870 he entered Rathmines School, 24 Rathmines Road, where the Rev. Charles William Benson was headmaster as well as curate assistant at Sandford Church. In his early years the artist was known as Frederick Osborne, at least as an exhibitor if not among friends.

In 1876 he began study at the Royal Hibernian Academy Schools, taking four out of seven annual prizes in his first year, including the silver medal, first prize, for drawing from the living model. In 1877 he first exhibited at the RHA, continuing annually until the year of his death and averaging just over six pictures per gathering. His contributions in 1878 included *View from Whitepoint, Queenstown* and *Head of Scotch Collie Dog*.

Osborne also attended classes at the Dublin Metropolitan School of Art; an 1879 sketchbook showed the signature 'F.W. Osborne' under the cover. He continued to win prizes — in 1880 the highest one the Academy had to offer, the £20 Albert Prize, for *A Glade in the Phoenix Park*, exhibited that year.

In 1881 he won the RDS £50 prize in the Taylor Scholarship, and repeated the feat in 1882 with *The Tempting Bait*, which he exhibited that year at the Walker Art Gallery, Liverpool. He had set out in the autumn of 1881 with Nathaniel Hill and J. M. Kavanagh (qq.v.), bound for the Académie Royale des Beaux Arts, Antwerp, where he was to study under Charles Verlat (1824-90).

In the period 1881-5 inclusive he showed no fewer than forty-five works at the RHA, listing his Antwerp address in 1882, 12 Rue de l'Empereur. The head of an old woman, *The Flemish Cap*, one of two etchings at the British Museum, was signed F. W. Osborne, 1882. Verlat was a keen etcher. An oil painting of 1882, *A Market Stall*, was signed F. Walter Osborne, and his *View in Antwerp*, an oil of the same period, had two signatures, F.W.O. and F. W. Osborne. Among his contributions at the 1882 RHA were *Portmarnock, from Howth* and *Old Fishing Boats, Baldoyle*.

Osborne spent about a year in Brittany, early 1883 until early 1884. At the 1883 Academy appeared a series of Continental works, including *Beneath St Jacques, Antwerp* and *A Home on the Waters, Bruges*. In 1883 he was elected an associate of the Academy, showing that year at the Cork Exhibition. Works executed in Brittany were exhibited in 1884, for example *In the Sunlight, Pont-Aven*; *La Rue de l'Apport, Dinan*; *Apple Gathering, Quimperlé, Brittany* (National Gallery of Ireland).

From about 1883 he began signing most of his pictures 'Walter Osborne.' After he returned from France and 'settled' in Ireland, he spent long periods on rural painting expeditions in England. In October 1884 he was at North Littleton, near Evesham, Worcestershire, with his friends Hill and the English painter, Edward Stott (1858-1918).

Osborne became a member of the Dublin Sketching Club in 1884, when he first exhibited with the Royal Institute of Oil Painters, showing *The Cloisters, Lincoln Cathedral* and *An Old Waterway, Lincoln*. Stott and Osborne were painting together again in 1885 at Wherwell, near Andover in Hampshire. At Walberswick on the Suffolk coast he met P. Wilson Steer (1860-1942).

In 1885 at the RHA the English landscapes appeared, for example *Walberswick, Early Morning*; *On the Sands, Southwold*. Often he stayed in cottages or farmhouses ready to accept a 'paying guest.' He once boasted that he had reduced his rate of living to twelve shillings a week. In 1886 he became a full member of the RHA. In the same year he was a founding member of the Dublin Art Club (later, Arts Club), and continued to be an active member until the club ceased in 1895.

Osborne first exhibited at the Royal Academy in 1886 and continued every year until 1903, a total of forty-six works; just over half were portraits. In 1887, one of two works, he showed *St Patrick's Close — an Old Dublin Street* (NGI). As he also visited London exhibitions, he was known to some prominent English artists, and in 1887 he became a member of the New English Art Club. *October by the Sea* was his first exhibit at NEAC in 1887; later it was presented by the Artists' Cricket Club to the Guildhall Art Gallery, London, as a memorial to the artist. In the period 1888-1902 he showed thirteen works there. *Fast Falls the Eventide* was included in 1888.

The Dublin artist first exhibited with the Royal Society of Artists, Birmingham, in 1888 and from then until 1897 showed eighteen works. Another of his painting companions was Blandford Fletcher (1858-1937), a classmate at Antwerp. They worked together at Newbury, Berks., in 1887, and at nearby Uffington in 1888. Judging by price, Osborne ranked highly *Idle Shepherds*, 1889 RHA. The *Art Journal* of April 1889 had him

'sojourning' of late in the 'Richard Jeffries district of the Wiltshire Downs.' He had by now introduced pastel to his *oeuvre*.

A serious interest in portrait painting began in 1889, that of Dr Anthony Corley at the RHA. Thomas Bodkin in his *Four Irish Landscape Painters,* 1920, considered that the artist was 'wasting his talent in immortalising the people of reputation, rank, or fashion in Dublin.' Not everyone agreed.

In 1890 and 1891 he painted by the sea again, at Rye and Hastings, hence the oil, *A View of Hastings* (NGI). His pastel drawing, *Life in the Streets, Hard Times*, exhibited at Burlington House in 1892, was purchased for twenty-five guineas under the terms of the Chantrey Bequest and is now in the Tate Gallery.

After being hung at the Walker Art Gallery, Liverpool, in 1891, his *Joe the Swineherd* appeared at the 1892 RHA. He had returned to Ireland the previous year and was to teach at the Academy Schools. William J. Leech (q.v.) said that Osborne taught him 'everything I needed to know.' From 1891 until 1901 he was a member of the Royal Institute of Oil Painters, showing some thirty works. A similar number was exhibited at the Liverpool exhibition.

A regular contributor to the annual exhibitions of the Belfast Art Society, he was made an honorary member in 1892. He painted in 1892 the oil portrait of his friend, J.B.S. MacIlwaine (q.v.) and his dog, now at NGI. In 1892 and 1893 he visited Galway and the surrounding area. In pencil at NGI is the 1893 drawing, *Galway Fishermen, a Donkey and Creels.*

A bronze medal for *The Ferry* was awarded at the World Columbian Exhibition, Chicago, 1893. In the three years 1893-5 he showed a total of thirty works at the Dublin Arts Club's three exhibitions, and his oil, *Milking Time*, was by far the highest priced work in the 1893 show. In 2000, this picture was on loan from Beaumont Hospital, Dublin, to NGI.

During the 1890s Osborne frequented the Patrick Street area of Dublin. *Life in the Streets, Musicians*, at Hugh Lane Municipal Gallery of Modern Art, was painted in 1893. His sister Violet Stockley, married in 1892, died in childbirth in Canada in 1893 and her daughter, also named Violet, was brought home to the Osborne grandparents in Castlewood Avenue. The suggestion that there was now financial concern at home and that this was the reason he concentrated more on portrait painting is difficult to sustain. He died a rich man. Bodkin, incidentally, stated that *The Thornbush*, 71 cm x 91.5 cm, first hung in 1894 at the RA, was regarded by many as his masterpiece.

At the RHA in 1894 he exhibited a portrait of the Rt. Hon. Lord Justice Fitzgibbon. Originally hung in the Masonic Female Orphan School, Ballsbridge — he was a leading figure in the grand centenary bazaar arrangements — it was transferred to Freemasons' Hall when the school closed. It shows him seated. Apparently the Grand Lodge commissioned another portrait of Fitzgibbon and presented it to him. That would have been the work exhibited at the 1895 RHA and now at NGI. *The Masonic Visitor* publication considered it was 'exquisitely painted and a striking likeness, but making the distinguished subject look twenty years older than he is.'

The studio of John Butler Yeats (q.v.) at 7 St Stephen's Green was taken over by Osborne in 1895. His oil, *In a Dublin Park: Light and Shade* (NGI), 71 cm x 91 cm, was shown at the 1895 RA. In that year he was on the executive committee for the first exhibition of the Arts and Crafts Society of Ireland.

In December 1895 he left Dublin with Sir Walter Armstrong, then Director of NGI, and they visited Paris, Bordeaux and Madrid. He found subjects for pencil drawings. He admired the work of Édouard Manet (1832-83) when they visited the Luxembourg. In 1896 they were in Holland, where he painted canal scenes in Amsterdam. His oil portrait of Armstrong is at NGI. He sketched in Roundstone, Co. Galway, in 1896 and 1897. No portrait commissions there either!

One of the earliest of Osborne's groups of mothers and daughters was *Mrs Andrew Jameson and her Daughter Violet*. The picture was apparently caricatured in *Punch* as *The Torture Chamber*. Violet Jameson, playing the violin, was made to keep her poise by having her shoes nailed to the floor.

The most successful of all his commissioned portraits was *Mrs Noel Guinness and her Daughter Margaret*, 1898, exhibited that year at the RA and at the RHA in 1899. The work was awarded a bronze medal at the Exposition Internationale, Paris, 1900, but at the close of the exhibition the artist was invited to forward the cost of the medal he had won; and as he refused to do so, he never received his prize.

Osborne first exhibited with the Water Colour Society of Ireland in 1897 and up until 1901 showed seven works. In 1897 he contributed *The Markets, Bordeaux — A Study*; *An Old Canal, Amsterdam*; *At Zaandam, Holland*. At the RHA in 1898 he showed a portrait of Dr Maurice Fitzgerald Day, Bishop of Cashel, now at The Palace, Kilkenny. He was on the executive committee for the 'Modern Paintings' exhibition held in Dublin in 1899. He was in Hertfordshire in June, and at the WCSI exhibition he showed *Renvyle, Connemara*. At the RA exhibition in 1899 he presented *Lord Ashbourne, Lord Chancellor of Ireland*.

Offered a Knighthood in 1900 in recognition of his services to art and his distinction as a painter, he declined the honour. *Mrs Chadwyck-Healey and her Daughter*, 143 cm x 117.5 cm, was executed in 1900. The watercolour, *At a Child's Bedside*, appeared at the 1901 WCSI exhibition.

Anne Crookshank and The Knight of Glin in *The Painters of Ireland c. 1660-1920* were of the view that the instantaneous quality of his intimate interiors, like *The Lustre Jug*, oil, of 1901 and at NGI, were leading him into a style which, at its best, was close to the domestic pictures of Pierre Bonnard (1867-1947) and Edouard Vuillard (1868-1940). In their book on Irish watercolours, they found *The Dolls' School*, 1900, and *The House Builders*, 1902 (both NGI) as among his finest achievements. The last-named was his final exhibit at NEAC.

Summer Time, 106.5 cm x 122 cm, a sunny day in the garden or park with children, was purchased in 1901 from the RA exhibition by the Preston Corporation. That work and *Tea in the Garden* (HLMGMA) of 1902 both appear related to French Impressionism. In the latter part of his life he rented a cottage in the summer in north Co. Dublin, at Malahide or Portmarnock. At the 1903 RA he showed a portrait of Sir Frederick Falkiner, KC, Recorder of Dublin. One of the last pictures he painted was a watercolour sketch of John Hughes (q.v.).

The NGI collection also includes a large group of drawings, many in sketchbooks. An oil self-portrait is also there together with a portrait in charcoal of Osborne by Hill. There is also an oil by Osborne of his elder brother, Canon Charles E. Osborne. Representation at HLMGMA is also strong as Canon Osborne bequeathed twelve works. Among the portraits is one of Maud Gonne (q.v.) in pencil. Oil portraits of J.P. Mahaffy and R.T. Stack are at Trinity College, Dublin.

Three oil portraits are at King's Inns, Dublin: John Thomas Ball; Edward Gibson, Lord Ashbourne; Hewitt Poole Jellett. Also in Dublin is the portrait of Canon Travers Smith, DD, at St Bartholemew's Church, and that of Lord Plunket, Archbishop of Dublin, at See House. The portrait of William Alexander, Archbishop of Armagh, is in the Synod Hall, Armagh. At the National Library of Ireland are sketches in exhibition catalogues.

In the Limerick City Gallery of Art there is an oil sketch of Mrs Caesar Litton Falkiner for *Portrait of a Lady* at NGI. Among the other works at Limerick is an oil of two Pomeranian dogs. *The Goldfish Bowl*, oil, is at the Crawford Municipal Art Gallery, Cork. *Cherry Ripe* and *Estuary at Walberswick*, both oils, are at the Ulster Museum. The British Museum has two pencil sketches of Irish ports, one of Limerick. A portrait of the Duke of Abercorn was left unfinished at the artist's death and completed by Sarah Purser (q.v.); it is unsigned at Freemasons' Hall, Dublin.

Strickland in his *Dictionary* listed seventy-eight portraits. It is estimated there were a dozen more in a grand total of 600 works, so only about 15% of his output was devoted to portraiture, although at the time of his death he was regarded as Ireland's leading portrait painter, 'a form of art for which he showed a remarkable gift,' noted Walter Armstrong.

Thomas Bodkin wrote: 'As he had always shown a generous temperament, a sense of fun and a spirit of sportsmanship, he left a wide circle of personal friends to whom his charming personality had endeared him. These were by no means all artists or art-lovers, for he had no inveterate taste for such company.' Armstrong was of the opinion that had fate made him a professional cricketer, he would probably have acquired fame as a bowler. He died suddenly of double pneumonia on 24 April 1903 in the house where he was born, and was buried at Mount Jerome Cemetery.

Opening in the year of his death, the RHA held a memorial exhibition of 269 works. At the Guildhall Art Gallery in 1904 Hugh Lane presented his exhibition of works by Irish painters; Osborne was represented by fourteen pictures.

Just over 100 key paintings, watercolours and sketches were exhibited at NGI in 1983, followed by the Ulster Museum in 1984, selected and catalogued by Jeanne Sheehy, author of *Walter Osborne*, 1974, the authority on the artist, without whose industry his life and works would have been sadly neglected.

Works signed: F. W. Osborne, F.W.O., Walter Osborne; F. Walter Osborne, Walter O., W.O. or Osborne, all four rare (if signed at all).

Examples: Armagh: Synod Hall. Belfast: Harbour Office; Ulster Museum. Cork: Crawford Municipal Art Gallery. Dublin: King's Inns; Freemasons' Hall, Molesworth Street; Hugh Lane Municipal Gallery of Modern Art; National Gallery of Ireland; National Library of Ireland; Office of Public Works; St Bartholemew's Church, Clyde Road; See House, Temple Road; Trinity College. Kilkenny: Art Gallery Society; The Palace. Limerick: City Gallery of Art; University, National Self-Portrait Collection. London: British Museum; Guildhall Art Gallery; Tate Gallery. Preston, Lancs. : Harris Museum and Art Gallery.

Literature: *Thom's Irish Almanac and Official Directory*, Dublin 1874; *The Masonic Visitor*, 15 July 1895; *The Royal Academy of Arts 1769-1904*, London 1905; Walter G. Strickland, *A Dictionary of Irish Artists*, Dublin 1913; Thomas Bodkin, *Four Irish Landscape Painters*, Dublin 1920 (also illustrations); *Dictionary of National Biography 1901-1911*, second supplement, London 1920; Jeanne Sheehy, *Walter Osborne*, Ballycotton 1974 (also illustrations); *Dictionary of British Artists 1880-1940*, Woodbridge 1976; Anne Crookshank and The Knight of Glin, *The Painters of Ireland c. 1660-1920*, Dublin 1978 (also illustrations); Martyn Anglesea, *The Royal Ulster Academy of Arts*, Belfast 1981; Jeanne Sheehy: National Gallery of Ireland, *Walter Osborne*, catalogue, Dublin 1983 (also illustrations); National Gallery of Ireland, *Acquisitions 1984-86*, catalogue, Dublin 1986 (also illustrations); Ann M. Stewart, *Royal Hibernian Academy of Arts: Index of Exhibitors 1826-1979*, Dublin 1987; Patricia Butler, *Three Hundred Years of Irish Watercolours and Drawings*, London 1990 (illustrations); Anne Crookshank and David Webb, *Paintings and Sculptures in Trinity College Dublin*, Dublin 1990; S. B. Kennedy, *Irish Art & Modernism 1880-1950*, Belfast 1991; Wanda Ryan-Smolin, *King's Inns Portraits*, Dublin 1992 (also illustrations); Anne Crookshank and The Knight of Glin, *The Watercolours of Ireland*, London 1994 (also illustrations); *Water Colour Society of Ireland Exhibition List 1872-1994*, Dublin 1995; Frederick Gallery, *Drawings, Etchings & Engravings*, catalogue, Dublin 1998; Christie's, *The Irish Sale*, catalogue, London 1999; Bolton Library, Cashel, *Letter to the author*, 2000; also, British Museum, 2000; Church of Ireland Representative Church Body Library, 2000; Grand Lodge of A.F. & A. Masons of Ireland, 2000; Guildhall Art Gallery, 2000; Harris Museum and Art Gallery, 2000; National Gallery of Ireland, *Gallery News*, March-May 2000.

Ó SÉADHACHÁIN, SEÁN(1901-91), genre, history and landscape painter. The son of Dennis Sheahan, a tenant farmer, John Sheahan was born in Cloncoon, Ashford, Co. Limerick, on 21 January 1901. At the age of fourteen Seán left Ashford National School to work as a farm labourer in Ballyferriter, Co. Kerry, for three years, a chosen place because it was an Irish speaking area. In 1922 he returned to school, attending Ring College in summer of 1923 before being apprenticed to pharmacists in Abbeyfeale, Co. Limerick, 1924-6.

In 1927 he emigrated to the USA and became a registered pharmacist in Washington DC. From 1928-34 he attended the George Washington University and completed a Bachelor of Arts course. In 1938 he was awarded a PhD from Catholic University in Washington where he also held the Chair in Gaelic Studies. During evenings he taught Irish at Roosevelt High School, Washington, running a small chemist's shop in a poor neighbourhood during the day. In 1939 he married in Washington Mary T. Whooley of Leap, Co. Cork. So renowned were they for their hospitality that on Mary's death a scholarship was established in their names at Notre Dame High School, Washington.

Untutored, he turned to painting in 1961, apparently having shown no particular interest in either painters or painting. An initial introduction was a colourful creation which he painted in order to brighten up his pharmacy: monkeys in palm trees and flamingos wading in a nearby pool. Customers urged him to delve further in the world of art.

Ó Séadhacháin valued research and paid rigorous attention to detail. In his first picture, *St Patrick Confronting the High King Laoire c. AD 432*, 1962, the types of dye that would have been used in the fifth century were investigated and he reproduced their colours in the painting along with the appropriate style of dress.

In America he worked consistently at his painting, in particular there began a 'cycle' of scenes of Irish rural life remembered from childhood, for example over the years he painted: *Quilting*; *Churning Indoors*; *Tasting the Buttermilk*; *Sieving*; *Basketry*; *Cutting Turf*. A group of slides of his husbandry paintings has now been sent to the National Gallery of Ireland and Muckross House, Killarney, for their archives. Some lively

activities were also recorded in his work, such as *Our Horse Gone Mad*, when a vicious dog bit one of its legs.

The making and decorating of the frames of all the paintings was carried out by the artist. For his *Bishop Aedan and King Oswald Christianizing the Anglo-Saxons AD 635* the frame was patterned on the ornamentations of the Book of Lindisfarne. Among his Irish landscapes were *Glenarm, Co. Antrim* and *Gougane Barra*.

In 1968 he returned to Ireland, living in Glenageary, Co. Dublin, for three years, then in Bishopstown, Cork, from 1971-85 before settling in Leap. Incidentally, a resident of Frankfurt, Germany, with a holiday home in West Cork, purchased nine of his paintings.

In his first one-person show, he supplied 145 works for an exhibition in 1980 at 41 Washington Street, Cork, although the catalogue of thirty printed pages designated neither venue nor date. '*As Each Passing Show Means More,*' the title of the handbook, contained background information to many of the paintings, which included forty-six landscape and forty works on husbandry. The former group included *Sea Coast, State of Maine*; *Bridal Veil Falls, Yosemite, Ca.*; *Glendalough*; *Biarritz, France*.

As a hobby he made furniture well into his seventies, and continued to paint despite poor health. Towards the end of his life he began compiling a Botanical Dictionary of Ireland in Irish. He died in Mercy Hospital, Cork, on 9 April 1991. West Cork Arts Centre, Skibbereen, hosted an exhibition of forty-eight oil paintings in 1994.

Works signed: Seán Ó Séadacáin.
Literature: *Cork Examiner*, 16 June 1980; *Evening Echo*, 18 June 1980; Seán Ó Séadhacháin, '*As Each Passing Show Means More,*' Cork [1980]; West Cork Arts Centre, *Seán O'Seadhachain (1901-1991)*, catalogue, Skibbereen 1994; Mrs Maureen Crowley (née Sheahan), *Letters to the author*, 2000.

O'SHEA, HENRY (1833-1907), portrait painter, illuminator and banner painter. Born in Cork in 1833, he attended the Cork School of Art, winning in 1856 second prize of £2 in a competition for a medal for the School of Design prizewinners. In 1857 he was one of three students awarded silver medals in the Department of Science and Art's National Competition. Other local awards were also won, including the Mayor's Scholarship. At the School of Art in 1857 he exhibited two large sepia drawings depicting *Emperor and Empress of the French*. A portrait that year of a grizzled bearded old Italian man was awarded a medal. In 1858 he was a student teacher at the School of Design.

Accounts differ as to when O'Shea moved from Cork to Limerick, one source stating 'late fifties.' In 1869 he was responsible for the illuminated address of congratulation to William O'Sullivan, junior, of Kilmallock on his release from 'an English dungeon.' Hibernia was chained, seated and with a harp. As well as a sailing ship, a round tower and a high cross, the address included photographs of the Dominican Friary, Kilmallock, and the Treaty Stone.

An illuminated address by O'Shea from 'the people of Limerick' was sent to Isaac Butt, QC, hoping he would be able to address a mass meeting on behalf of political prisoners. Later in the year, 1869, the Prime Minister, William E. Gladstone, wrote to O'Shea at the Committee Room, Brunswick Arms, Limerick, re Fenian prisoners.

In his illuminated address to Mayor Ambrose Hall, from the Building Trades of Limerick, in recognition of his support during an 1875 strike, O'Shea incorporated arms of the various trades, e.g. carpenters, slaters, stonemasons, painters and so on. He had painted a banner for the Limerick bakers in 1874 and illuminated an address for them in 1877. Another source of income was photography.

O'Shea's 1876 portrait of William H. O'Sullivan, MP, is in Limerick City Gallery of Art. At the Limerick Museum, among other O'Shea productions, is the 1878 illuminated address from the Guild of Bakers to their medical attendant, Thomas George O'Sullivan, MD. The Museum also has an 1879 letter from Charles Stewart Parnell to O'Shea.

At Cork Public Museum is the 1882 banner, 3.3 m x 3 m, painted for the Cork Amalgamated Society of Painters and Paperhangers, described by Belinda Loftus in her *Marching Workers* as 'a superb and very interesting banner, with appeal to guild traditions...'

At a cost of £15-£16, Enniscorthy Board of Guardians commissioned in 1882 a portrait of Parnell. At the time of the Parnell split the work was removed by pro-Parnellite members to forestall anti-Parnellites having it removed formally. Brought for safe-keeping to a house in Kilrush, Co. Wexford, it did not reach Wexford County Council chamber until 1972, the Kilrush custodians having agreed to release the painting.

O'Shea's most important commission was the illuminated address to Parnell from the Parnell National Tribute committee. In the opinion of Muriel McCarthy, it is probably the most elaborate illuminated address ever produced in Ireland, and was presented by the Lord Mayor of Dublin at a banquet held in the Round Room of the Rotunda on 11 December 1883.

Now at Trinity College, Dublin, the address is bound in an album of Irish bog oak, deeply carved all over the surface back and front, with celtic scrolling, and silver decoration. O'Shea's contribution consisted, wrote McCarthy, 'of miniature portraits of Parnell, his escutcheon, his distinguished ancestors, members of his family, together with Avondale House and its surroundings. It also contains a prophetic view of the Irish Parliament House with the flags of the Irish nation waving over the portico and a magnificent procession celebrating the opening of the restored Legislature.' The frontispiece of the address presents an allegorical figure of Erin enthroned on a golden chair with her harp by her side, her emblematic greyhound and so on. According to the *Limerick Leader*, the committee was so gratified with O'Shea's work that they paid him a double fee, 200 guineas.

Of 118 George Street, Limerick, O'Shea was described in a directory as a 'photo artist.' An oil portrait of Alderman Stephen O'Mara, a former Mayor, was painted in 1891. An illuminated address, now at Limerick Museum, to Thomas J. O'Sullivan, was presented by the people of Kilmallock on the occasion of his marriage, coloured photographs of the couple appearing above the text. A banner was painted for Knockea and Donoughmore United Irish League. The Limerick Museum holds a 1900 oil painting, *The Exchange, Nicholas Street*, a copy of an 1820 original.

O'Shea, who was credited with some ivory and porcelain miniatures, has three other portraits at Limerick City Gallery of Art: Surgeon Holmes and two Mayors, Patrick Riordan and John J. Cleary. An ardent and sincere Nationalist, he owned a large collection of books on art and general literature; almost a complete set of *Cassell's Academy Pictures*, 1888-1906, seventy-five numbers. He died on 4 June 1907 at his residence, and was buried at Mount St Laurence Cemetery. The grave is unmarked.

Works signed: Henry O'Shea or H. O'Shea.
Examples: Cork: Public Museum. Dublin: Trinity College. Limerick: City Gallery of Art; Museum. Wexford: County Council.
Literature: *Limerick Chronicle*, 4 and 6 June 1907; *Limerick Leader*, 5 June 1907; Ebrill Bros., *Henry O'Shea*, auction catalogue, Limerick 1908; *Irish Times*, 14 February 1972; Wexford County Council, *Letter to the author*, 1972; Belinda Loftus, *Marching Workers*, Belfast 1978 (also illustration); Sligo Art Gallery, *The Illuminated Address 19th-20th Century*, catalogue, 1983; Peter Murray, *Illustrated Summary Catalogue of The Crawford Municipal Art Gallery*, Cork 1991; Limerick Museum, *Letter to the author*, also inventory of objects in Museum re Henry O'Shea, 1999; Limerick Cemeteries Dept., *Letter to the author*, 2000; also, Limerick City Gallery of Art, 2000.

O'SULLIVAN, SEÁN, RHA (1906-64), portrait painter. Seán O'Sullivan (baptised John) was born on 20 June 1906 at 44 St Joseph's Terrace, South Circular Road, Dublin, son of a carpenter, John O'Sullivan. Seán drew from an early age and attended the Christian Brothers' School, Synge Street. At the Dublin Metropolitan School of Art he won a teacher-in-training scholarship, and for three months studied lithography in the Central School of Arts and Crafts, London. One of his two lithographs in the British Museum is of a man with a top hat, seated at a table, dated 1926. He was elected a member of the Senefelder Club.

In his youth he earned some reputation as a boxer and fencer, as well as in other sporting activities. He studied painting in Paris at La Grande Chaumière and Colarossi's. Whilst in Paris he occupied a studio in Montparnasse over that of Antoine Bourdelle (1861-1929), the sculptor. In 1928 his address was 4 rue Joseph

Bara. Among the Irishmen who befriended him in the French capital were James Joyce, Thomas MacGreevy and Sam Beckett. He also met Arthur Power (q.v.) and was friendly with Georges Rouault (1871-1958), who presented him with one of his paintings.

On returning to London, he designed book covers and for Frank Brangwyn (1867-1956) printed lithographs. Portrait commissions in pencil and crayon in Dublin kept him busy there from an early age. In 1927 he had illustrated M. J. MacManus's *So this is Dublin!*. He first exhibited at the Royal Hibernian Academy in 1926, from 35 Lower Baggot Street, Dublin, and lithographs were among his exhibits.

Between 1926 and 1964 he showed an average of six works per year at the Academy, the vast majority portraits, and never missed an exhibition. Some exceptions to portraiture were: *Two Trees*, in 1926; *Rock of Cashel*, 1933; *Dunquin – Interior*, 1942; *Connemara*, 1957; and *Interior, Gaeltacht*, 1963. In 1928 he was appointed an associate of the RHA, the youngest so honoured, and in 1931 a full member. An oil painting of Eugene Tangney is in Muckross House, Killarney; he was employed as a gamekeeper by the Vincent family when they owned Muckross up until 1932.

O'Sullivan's 1929 drawings of T. C. Murray and Maud Gonne MacBride (q.v., Maud Gonne) are in the National Gallery of Ireland. He was represented in the exhibition of Irish art at Brussels, 1930, with 121 Lower Baggot Street, Dublin, as his address. A drawing on cream-coloured paper of Eamon de Valera, at NGI, was dated July 1931. An advertisement in 1932 for the Irish Catholic Art Publishing Co. stated: 'The most beautiful of all our publications is the wonderful interior of Armagh Cathedral showing "First Holy Communion", after the painting by Sean O'Sullivan, RHA.' He executed Stations of the Cross, drawings in black and white chalk, coloured with washes, at the Church of the Little Flower, Ballintogher, Co. Sligo, which was dedicated in 1933. He taught for a spell in 1934 at the Metropolitan School of Art, and it was there during the 1930s that George Atkinson (q.v.) had taught etching in his own private studio to specially interested students, such as O'Sullivan, who had a studio himself at one period.

O'Sullivan was one of the illustrators for a second series of *A Broadside*, published by the Cuala Press in 1935. In that year he drew James Joyce in Paris, and on 18 July in Bournemouth, George Russell (q.v.), who had died the previous day; this work is in the Hugh Lane Municipal Gallery of Modern Art. On the recommendation of the Dublin-born Professor Thomas Bodkin, first director of the Barber Institute of Birmingham, O'Sullivan was commissioned by the Faculty of Law, University of Birmingham, for nine pencil portraits of various presidents of the Holdsworth Club; six were completed in 1935.

Illustrations for two stories and a play appeared in the 1936 issue of the *Capuchin Annual*, which commissioned a posthumous portrait of Matthew Talbot, reproduced in colour in the 1937 issue. Reproductions in colour, signed by the artist, were published, obtainable at two guineas each from the office of the *Father Mathew Record*. St Francis of Assisi was also specially portrayed for the *Capuchin Annual*. By this time his work had been exhibited in New York, at the Hackett Galleries. When M. S. D. Westropp, Keeper of Art and Industrial Division, National Museum of Ireland, retired in 1936 he was presented with his portrait, a drawing.

A drawing of Douglas Hyde was dated 1936, and that year his symbolic phoenix appeared on the first issue cover of *Ireland To-Day*. In 1939 his home was at 18b Sydney House, Sydney Parade Avenue, Sandymount. His studio was at 20 Molesworth Street, Dublin, the address he gave when he showed a portrait of Henry J. Levitt at the 1939 Royal Scottish Academy. He soon moved to 6 St Stephen's Green. Another NGI drawing was of William T. Cosgrave, 1940.

During the Second World War O'Sullivan served in the Naval Service (Eire). Many of his celebrity drawings in the academic linear style were commissioned by a Dublin solicitor, John Burke, who by 1942 held close on thirty. After the latter's death the collection was acquired by NGI.

A 1940 pencil portrait of Timothy Sullivan is at King's Inns. Drawings of personalities continued apace: Ernie O'Malley, 1941; and in 1942, James Larkin, Alice Milligan and F. J. McCormick. In 1942 in the *Father Mathew Record*, Máirín Allen wrote that his oil painting displayed at least two distinct manners: 'The first, his "portrait-manner", when he applies his pigment in a rather "tight" manner and finishes his pictures as carefully as a Sargent. His second "manner" is in contrast to this – it is a sort of loose impressionism. In this

vein he abandons the brush for the palette-knife – a very flexible instrument in his hands – and applies his pigment with joyous abandon, sometimes on wooden panels.'

In 1942 O'Sullivan painted murals in the Murals Bar, Tullamore, Co. Offaly. Eventually this property was sold and demolished, but a small portion of the work was salvaged for the Esker Court Restaurant, Tullamore. The main theme of the full work was a West of Ireland wedding. He designed three commemorative postage stamps: 1943, Gaelic League 50th anniversary, which included a head of Dr Douglas Hyde; Rowan Hamilton, with head; 1944, Brother Rice, with head. The seven portraits used in the Easter Rising 50th anniversary stamps of 1966 were based on O'Sullivan drawings.

The portrait of Eamon de Valera, now at Áras an Uachtaráin, attracted most public interest at the 1943 RHA. The *Dublin Magazine* described it as 'a tour de force of painting, drawing and psychology', finding *Céann Cailín Óg* that year at the Oireachtas 'a brilliant portrait, but in its conventional beauty it is a work of virtuosity rather than art'. On the 1945 RHA, the magazine noted: '… His and Leo Whelan's portraits of Dr Douglas Hyde are on the same plane as so much occasional verse; the weight of the occasion precludes all but the conventional …'. President Hyde commissioned a drawing of Fr Eugene O'Growney; it was based, in 1945, on a photograph. A lithograph of Dr Hyde is also at Áras an Uachtaráin. In the Irish Folklore Commission collection is a 1951 pencil portrait of their Kerry collector, Seán Ó Dubhda.

A 1952 oil painting of Bulmer Hobson was transferred from the National Museum of Ireland to the National Gallery of Ireland. In 1954 An Comhairle Ealaíon commissioned a portrait of Sir Chester Beatty. In August 1955, he left Ireland for Philadelphia and New York, where his fee was one hundred dollars for a portrait drawing. An oil painting of the studio of the sculptor, Paul Landowski (1875-1961) was dated Paris 1957. In 1958 he completed a 'mural' depicting the work of the Medical Missionaries of Mary in the hall of Our Lady of Lourdes Hospital, Drogheda. The mural was erected on a board that was taken down in three sections when the new unit was being built in 1988; two years later it was re-erected in six separate sections.

O'Sullivan, it was said, loved to indulge in the 'pantomime of inebriation', but his heavy drinking caused much concern among his friends. In a letter to Thomas MacGreevy, Sir Alfred Chester Beatty wrote in 1960: 'As regards Sean O'Sullivan, I am afraid it was a wash-out and the attempt to save him has not succeeded. Apparently the drink has got the better of him. It is too bad; he was a man of great talent, but I am afraid he is finished now.'

Some fifty portrait drawings, many in pencil or charcoal, are in the National Gallery of Ireland. Personalities include James Joyce, John McCormack, James Larkin, Thomas MacGreevy, W. B. Yeats, Margaret Burke Sheridan, Ernie O'Malley, Patrick Kavanagh and Seamus O'Sullivan. Among his oil paintings in the Abbey Theatre are portraits of Ernest Blythe, F. R. Higgins, John F. Larchet, F. J. McCormick, W. B. Yeats. Portraits at University College, Dublin, include those of Professor Éoin MacNeill and Dr Michael Tierney. A drawing of W. B. Yeats, 1933, and of his brother, Jack B. Yeats (q.v.), 1942, are in Model and Niland Centre, Sligo. At the National Museum of Ireland are posthumous portrait drawings of sixteen patriots executed in 1916 plus Thomas Ashe, John Daly and Liam Mellows. At the Irish Museum of Modern Art in Dublin is *Lough Gill*, oil. Athlone Public Library holds a 1950 pencil portrait of John Broderick, donated by the novelist. A 1961 charcoal drawing of Brendan Behan is at Crawford Municipal Art Gallery, Cork.

O'Sullivan spoke French and Irish fluently. He was a noted conversationalist and raconteur. In his studio, the 'throne', big table and some of the chairs were made with his own hands. He kept a full-sized carpenter's bench, with all the tools, at his home. He liked having his sitters talking, 'then they forget they are posing and become themselves', he said. In Roscrea, Co. Tipperary, for a portrait of the Lord Abbot of Mount St Joseph, his work had scarcely begun when he suffered a stroke from which he never recovered. He died on 3 May 1964 at Nenagh District Hospital, and was buried at Dean's Grange Cemetery, Dublin.

Works signed: Sean O'Sullivan or Sean O Sullivan; illustrations, S. O Sullivan or S. O. S. (if signed at all).
Examples: Athlone, Co. Westmeath: Public Library. Ballintogher, Co. Sligo: Church of St Therese of the Child Jesus. Belfast: Ulster Museum. Cork: City Library; Crawford Municipal Art Gallery. Drogheda, Co. Louth: Our Lady of Lourdes Hospital. Dublin: Abbey Theatre; Áras an Uachtaráin; Hugh Lane Municipal Gallery of Modern Art; Irish

Museum of Modern Art; King's Inns; Leinster House; McKee Barracks; Mansion House; National Gallery of Ireland; National Museum of Ireland; Office of Public Works; Pharmaceutical Society of Ireland; Royal College of Physicians of Ireland; University College (Belfield; Earlsfort Terrace, also Irish Folklore Commision). Galway: National University of Ireland. Kilkenny: Rothe House Museum. Killarney: Muckross House. Limerick: City Gallery of Art; University, National Self-Portrait Collection. London: British Museum. Maynooth: St Patrick's College. Sligo: Model and Niland Centre. Waterford: City Hall, Municipal Art Collection.

Literature: General Register Office, Dublin, *Birth Certificate John O'Sullivan*, 1906; M. J. MacManus, *So this is Dublin!* Dublin 1927 (illustrations); Bulmer Hobson, ed., *Saorstát Eireann Official Handbook*, Dublin 1932 (illustrations); *Father Mathew Record*, September 1932, January 1934 (illustration), March 1934 (illustration), May 1934 (illustrations), April 1936, February 1937, April 1937, September 1937, November 1937, November 1938, December 1938 (all illustration), March 1942 (also illustrations), February 1945, October 1945 (both illustration); *Capuchin Annual*, 1934 (also illustrations), 1936, 1937 (both illustrations), 1938 (also illustrations), 1940-1944, 1945-46, 1948, 1949, 1952, 1959, 1965, 1966, 1972, 1977 (all illustrations); *Ireland To-Day*, June 1936 (illustration); *Ulster Museum Biographical Notes*, 1936; Rosalind M. Elmes, *National Library of Ireland Catalogue of engraved Irish Portraits mainly in the Joly Collection and original drawings*, Dublin [1937]; Thomas Bodkin, intro., *Twelve Irish Artists*, Dublin 1940 (also illustration); Myles na gCopaleen, *An Béal Bocht*, Dublin 1941 (illustrations); *Irish Times Irish Review and Annual*, 1942; *The Bell*, June 1943; *Dublin Magazine*, July-September 1943, January-March 1944, July-September 1945; *Collections of Historical Pictures etc. established at Áras an Uachtaráin by Dr Douglas Hyde*, Dublin 1944; *Joseph Holloway Papers*, National Library of Ireland [1944]; *Irish Times*, 29 September 1951, 27 August 1955, 4 May 1964, 23 March 1985; Máirtin Ó Cadhain, *Cois Caoláire*, Dublin 1953 (illustrations); *An Comhairle Ealaíon Annual Report*, 1 April 1954-31 March 1955; *Irish Independent*, 4 and 6 May 1964; *Irish Press*, 4 May 1964; National Gallery of Ireland, *Golden Jubilee of the Easter Rising*, catalogue, 1966; *Thomas MacGreevy Papers*, Trinity College, Dublin [1967]; Department of Posts and Telegraphs, *Letter to the author*, 1968; Alan Denson, *John Hughes Sculptor 1865-1941*, Kendal 1969; Liam Miller, *The Dun Emer Press, Later the Cuala Press*, Dublin 1973; John Ryan, *Remembering How We Stood*, Dublin 1975; Medical Missionaries of Mary, Drogheda, *Letter to the author*, 1991; also, National Museum of Ireland, 1991; University of Birmingham, 1991; D. E. Williams Ltd, 1991; *The Royal Scottish Academy Exhibitors 1826-1990*, Calne 1991; Department of Irish Folklore, University College, Dublin, *Amharc Oidhreacht Eiréann*, catalogue, Dublin 1993 (also illustration); Muckross House, *Letter to the author*, 1993; John Turpin, *A School of Art in Dublin since the Eighteenth Century*, Dublin 1995 (also illustrations).

OULTON, EILEEN – see REID, EILEEN

OVENDEN, C. T. (1846-1924), landscape and portrait painter. Born at Carlton House, Enniskillen, Co. Fermanagh, on 11 September 1846, Charles Thomas Ovenden was the son of W. C. Ovenden, MD, of that address. He was educated at Portora Royal School, Enniskillen; Mannheim, Germany; and Trinity College, Dublin, being ordained in 1870.

As Bishop D'Arcy explained in his autobiography, *The Adventures of a Bishop*, Dean Ovenden had many interests: 'With an unusual forcefulness of character he united an extraordinary activity of mind, which sought an outlet in every direction, possible and impossible. He was a preacher and platform speaker of great ability and originality. He was a musician ... His pictures found a place on the walls of the Hibernian Academy. His books were published by the SPCK. He was interested in science ... He would offer an immediate explanation of any problem which he heard discussed. His weakness was an irresistible impulse to take in hand every task, whether intellectual or practical which presented itself ...'. A portrait of Bishop D'Arcy by Ovenden is in Clogher Cathedral, Co. Tyrone.

Ovenden, who also exhibited with the Dublin Sketching Club, first showed with the Royal Hibernian Academy in 1882, and from then until 1902 he exhibited sixteen works, all landscapes, at least five of which were associated with Killarney, for example *Sunny Day in the Deer Forest, Killarney*. In 1883 his contribution included *St Patrick's Cathedral on Saturday Night*. Two years later he showed *Sunset on Bantry Bay* and *Toilers in the Quarry*. From residence in Dublin, he moved ecclesiastically to Portrush and then to Enniskillen, giving Chanter Hill as his address there in 1888.

At St Patrick's Cathedral, Dublin, where he was Dean 1911-24, is a self-portrait. It was said that he was very pleased with a self-portrait, perhaps that one, and remarked that when the dog saw it 'he licked my hand!' A friend said that 'to know him was a liberal education. His spirit was informed by rare simplicity.

Sincere by nature, he was free from any semblance of austerity.' He died suddenly on 9 July 1924 at his summer residence, Baily, Howth, Co. Dublin.

Works signed: C. T. Ovenden or Ovenden.
Examples: Clogher, Co. Tyrone: St Macartan's Cathedral. Dublin: St Patrick's Cathedral. Enniskillen, Co. Fermanagh: St Macartin's Cathedral.
Literature: W. T. Pike, ed., *Ulster Contemporary Biographies*, Brighton 1910; *Irish Times*, 10 July 1924; J. B. Leslie, *Clogher Clergy and Parishes*, Enniskillen 1929; Charles Frederick D'Arcy, *The Adventures of a Bishop*, London 1934; John Kerr, *Letter to the author*, 1971; Ann M. Stewart, *Royal Hibernian Academy of Arts: Index of Exhibitors 1826-1979*, Dublin 1987; St Macartin's Cathedral, *Letter to the author,* 1991; also, St Patrick's Cathedral, 1991.

P

PALMER, KATHLEEN – see COX, KATHLEEN

PARKES, W. THEODORE (1852-1907), medallist, genre painter and illustrator. Isaac Parkes (1792-1870), born in Birmingham, arrived in Dublin in 1807. Three of his sons, Isaac, Samuel and William, were to possess the gift of artistry in metal and settled in Ireland. Samuel, who was an engraver and expert on heraldry, also lived in Dublin and was married there. His son, William Theodore Parkes, was of course a nephew of Isaac junior and not, as recorded by some writers, 'a son of Isaac.'

According to an introduction written by Theodore Parkes in his book on ballads, these were 'the fruit of the seed sown in my heart during those early years when, still a boy, it was my pleasure to listen to the old turf fire legends, tradition and songs that have cheered or saddened the hearthstone gatherings in the peasant homes of Ireland…'.

If the year of his birth is correct, then we have him coming to public notice as a die sinker and medallist in 1865 at about the age of thirteen with his medal commemorating the restoration of St Patrick's Cathedral, depicting the bust of Benjamin Lee Guinness with a view of the building on the reverse. The medal met with praise in the local papers. *Saunder's News-Letter and Daily Advertiser* commented: 'Mr. Theodore Parkes, Jun., of 42 Lr. Clanbrassil Street, has just completed a highly interesting specimen of Irish art in die sinking…The work, which is really entitled to high praise and encouragement as emanating from a clever and enterprising young Irish artist, has met with the approval of his Excellency, the Lord Lieutenant, his Grace the Archbishop of Dublin, the Dean of St Patrick's and many of the gentry of Ireland.'

Rather remarkably, at about the same time as the W. T. Parkes medal, Isaac Parkes senior struck a medal commemorating the same Guiness event. No mention was made in any of the newspapers of the connection between Isaac and Theodore, according to Hilda M. Parkes, whose paper on the family was published by the Numismatic Society of Ireland in 1977. It has been said, she also noted, that the brothers Isaac and Samuel had a disagreement when first they came to Ireland, and that they went their separate ways in business. 'Isaac's family do not appear to have had any contacts with that of Theodore's, so far as is known,' she wrote.

Meanwhile, the versatile Theodore, for everyone's edification, published in 1866 *Tails an' Ballids iv Dublin's Grate Methropolis*, 32 pp, by Barney Bradey! Other similar publications followed, such as *St Patrick's Auction*, again by Barney Bradey!, in 1868. In 1870 he was at 42 Fleet Street, Dublin, where he ran his own printing company, Parkes & Co. A series of heraldic albums and sheets of arms, crests, etc., of Irish families was published in 1872.

A second medal, 1875, marked the centenary of the birth of Daniel O'Connell. The head was bare, and on the reverse an inscription within leaves of shamrock, crowned Irish harp in centre. In 1875 he exhibited at the Royal Hibernian Academy for the first time, and from then until 1883 he showed a total of twenty-eight works, opening with *Drowning the Shamrock*, and verse from an old song appearing in the catalogue.

In 1876 he showed two works at the RHA, a seascape with trawlers and *The Cavalier's Farewell*. In 1877 he contributed *A Flying Star* and *The Babes in the Wood*. *The Trysting Glen* was hung in 1878, and two years later he exhibited five pictures, including *The Tug of War* and *Moonlight over the Bailey, Howth*, from 12 Fleet Street.

In the biographical note in the introduction for one of his books, he wrote: 'Eight years of travel through Ireland, in the days of the Land League, gave me a more intimate and mature knowledge of the characteristics of the Irish peasantry…'. A friend of Charles Stewart Parnell, he became interested in the Land League movement, and executed a drawing of the State Trial in Dublin in 1881. In that year he exhibited eight works at the Academy, including *Blackberry Lane* and *Portrait of a Gentleman*. He also showed in London and Birmingham.

Parkes was also a journalist, contributing to *The Nation, The Weekly Freeman, The Irish Fireside* and *Carlow College Magazine*. As an illustrator, his work was seen to advantage in the supplement for *The Irish Fireside*, 5 November 1883, a full page portraying a crowded gathering down at the shore.

About 1884 he went to London, where he worked as an artist, journalist and also as a public reciter. His third medal appeared in 1885, for the Gaelic Athletic Society. He was also credited with one tavern token.

The Spook Ballads by Wm. Theodore Parkes was published in 1895, illustrated by the author; an estimated 150 illustrations. *The Bookseller* commented: 'A cheery and spirited production, it is hard to say which is more felicitous, the draughtsman or poet.' In 1902 he illustrated *God Save the King* (The National Anthem) for the Mazawattee Tea Co. Two years later appeared his *Comic Snap Shots from Early English history.* He died on 21 April 1907 at 20 Mornington Crescent, St Pancras, London, 'age 55 years.'

Works signed: W. T. Parkes (also medals; Parkes, token), W. T. P. or WTP monogram (if signed at all).
Examples: Medals: Belfast: Ulster Museum. Dublin: National Museum of Ireland. Oxford: Ashmolean Museum.
Literature: *Saunder's News-Letter and Daily Advertiser*, 9 February 1865; *The Irish Fireside*, 5 November 1883 (illustration), 5 May 1884 (illustration), September 1884 (illustration); Wm. Theodore Parkes, *The Spook Ballads*, London 1895 (illustrations); William Theodore Parkes, *Lays of the Moonlight Men*, London n.d.(also illustrations); *God Save the King* (The National Anthem), London [1902] (illustrations); General Registry Office, London, *Register of Deaths*, 1907; L. Farrer, *Biographical Dictionary of Medallists*, London 1909; Walter G. Strickland, *A Dictionary of Irish Artists,* Dublin 1913; Hilda M. Parkes, 'Isaac, John Craig and William Theodore Parkes — Irish Medallists,' *Numismatic Society of Ireland*, Occasional Paper No. 17, 1977 (also illustrations); Laurence Brown, *A Catalogue of British Historical Medals 1837-1901*, London 1987; Ann M. Stewart, *Royal Hibernian Academy of Arts: Index of Exhibitors 1826-1979*, Dublin 1987; Frank Heaney, *Letter to the author,* 2000.

PAT– see MORAN, PAT

PATTERSON, R. M., ARUA (1866-1951), landscape painter. Born at Dundela, Belfast, Robert Michael Patterson was the eldest son of W. H. Patterson, MRIA, the grandson of the naturalist, Robert Patterson, FRS, and a first cousin of Rosamond Praeger (q.v.). Educated at Westward Ho!, Devon, in the school made famous by Kipling in *Stalky & Co.*, he applied his studies to music and art in his early years while meantime carrying on his business training. His father, who was president of the Belfast Art Society 1900-03, is represented in the Ulster Museum collection.

By 1895 R. M. Patterson was a member of the Belfast Art Society residing at Garranard, Strandtown, Belfast. Whatever his standing as a businessman who painted, the time came when he was recognised as having one of the best tenor voices in the city, with a special interest in church music. When he exhibited twenty-seven paintings at Locksley Hall, Belfast, in 1930 all were landscapes with one exception. Cornwall and Devon scenes were included. At the Ulster Academy of Arts exhibition in 1931, *Near Dunfanaghy, County Donegal* and *Trassey Bridge, Mourne District* were singled out, and the *Belfast Telegraph* added: 'One of his hobbies is derived from his love of the rod, as there is no more ardent disciple of Izaak Walton than he, but Mr Patterson never travels on his fishing exploits without his brush and easel'.

The fiftieth anniversary of the first large Ramblers' Sketching Club exhibition of 1885 was celebrated by a jubilee dinner in Belfast. Patterson in proposing a toast, said as a compliment to Sir John Lavery (q.v.), the president, that he was 'glad that their greatest artist had not descended into the cult of Futurism and modern art.' In 1932 he had his portrait painted by David Bond Walker (q.v.), who gave him painting lessons.

In 1936, at the age of seventy and a member of the Ulster Arts Club, he held an exhibition of oils and watercolours, 129 works in all, at Robinson & Cleaver's, Belfast. Subject matter ranged from *The Poison Glen, Donegal* to a harvest field at Craigantlet, Co. Down; and from the unusual kitchen interior, in Mayo, to *Burning the heather above Cushendun.*

At the 1940 Ulster Academy of Arts exhibition he contributed: *A Donegal Landscape*; *A Dreamy Day, Strangford Lough*; *Muckish Mountain.* When the Royal Ulster Academy of Arts emerged in 1950 he was one of the associates. He was the chairman, until his retirement, of the firm of Robert Patterson & Sons, Ltd,

hardware merchants, Ann Street, Belfast. A bachelor, of Jackson Hall, Craigavad, Co. Down, he died in hospital on 29 August 1951.

Works signed: R. M. Patterson.
Examples:Belfast: Department of the Environment for Northern Ireland. Limerick: City Gallery of Art.
Literature: *Belfast Art Society Exhibition*, catalogue, 1895; *Belfast Museum and Art Gallery Quarterly Notes*, June 1907; *Northern Whig*, 5 July 1930; *Belfast Telegraph*, 22 October 1931, 21 April 1936, 30 August 1951; *Irish News*, 10 April 1935; Ulster Society for the Prevention of Cruelty to Animals, *The Tree*, Belfast 1936 (illustration); David Bond Walker, *Letter to Belfast Museum and Art Gallery*, c. 1945; Martyn Anglesea, *The Royal Ulster Academy of Arts*, Belfast 1981.

PEARSALL, W. BOOTH, HRHA (1845-1913), marine painter and illustrator. William Booth Pearsall, born in Dublin in 1845, was the son of a dentist, Thomas Pearsall, a native of Birmingham. Apprenticed to his father, he subsequently entered the Royal College of Surgeons and the Meath Hospital in 1863. His son, Richard M. S. Pearsall, who was born in Dublin in 1891, exhibited in the period 1929-39 when living in England, having studied at the Slade School of Fine Art and Julian's in Paris; he showed eight works at the Royal Academy. Richard was the husband of Phyllis Pearsall (née Cross) who exhibited at the Goupil Gallery, London.

According to the East Belfast Historical Society, W. Booth Pearsall arrived in Belfast from Dublin in 1870 following his father's footsteps as a dentist and surgeon. He was one of those injured in the rail accident at Ballymacarrett in 1871. The morning after he sat in the field and sketched the mayhem. He was awarded £650 damages after the accident, although he sued for £5,000.

W. Booth Pearsall, FRCSI, described as 'a striking and picturesque figure', contributed between 1872 and 1912 inclusive seventy works to the Royal Hibernian Academy exhibitions. In 1872 from 89 Merrion Street, Dublin, he showed two Donegal Highlands subjects, one a cabin interior. Two pictures in 1873, from 13 Upper Merrion Street, were more typical of his work: trawlers on Dublin Bay and sundown at Ringsend.

Pearsall made visits to Holland in the late 1870s and throughout the 1880s, showing *Evening – North Holland* in 1878; *A Stiff Breeze on the Zuyder Zee, N. Holland* in 1879. He exhibited two etchings in 1881. In 1891 he was elected an honorary member of the RHA. *Cape St Vincent, Portugal* in 1901 and *Dublin Bay, Sunset* in 1930 also appeared at the RHA.

A founder member of the Dublin Sketching Club, he was fully involved in 1884 with the Hon. Frederick Lawless and John Butler Yeats (q.v.) in bringing a loan exhibition of paintings by James McNeill Whistler (1834-1903) to Dublin. Lawless, who had returned to Dublin, was a close associate of the controversial artist in London. Pearsall, acting as clerk to the committee, received before the exhibition opened a letter from Whistler stating that the twenty-six paintings despatched to Ireland represented ' ... the largest collection I have sent to any gallery in the United Kingdom, out of London'.

Controversy in the Dublin Sketching Club ensued over the allocation of space for the Whistler pictures with the allegation that members' work had been sacrificed. Publicly, the exhibition had some critics too and Pearsall felt obliged to write to the *Irish Times* over their review: '... no other club or society, except the Dublin Sketching Club, takes any trouble to show their members and the public any of the current art of the day', adding that he had received many letters of thanks and congratulations.

Pearsall wrote to Whistler in London to report on the controversy and his part in the artist's defence. Whistler replied with a word of caution: '... I fear Mr Pearsall that if you once take up the cudgels for Whistler, you will spend the rest of your days in STRIFE! I LIKE FIGHTING – but do not wish to involve all my friends, among whom I trust I may count you – in my battles ...'. A special meeting of the Dublin Sketching Club was held to consider a motion of 'no confidence' in the hanging committee. The motion was defeated. Pearsall then proposed that Whistler should be made an honorary member of the Dublin Sketching Club and this was carried.

Walter F. Osborne (q.v.) became a member of the Dublin Sketching Club in 1884, the year of the Whistler exhibition. Osborne's portrait of the architect, Sir Thomas Drew, hung at the 1892 RHA, became the property of Pearsall. His 1886 Dutch harbour scene he presented to the Royal Irish Yacht Club, which he had joined

in 1877; in 1887 he offered to paint scenes for the recesses in the hall on being repaid the cost of frames and paint. The committee accepted the offer with thanks and the result can be seen in the nine paintings of yachts. He was a founder member of the Dublin Arts Club in 1892 in John B. Yeats's studio, 7 St Stephen's Green, and proposed the motion that 'an art union be formed to raise a capital sum of £500 for the development of Fine Art in Dublin'.

Literary productions included an unconventional, fully illustrated treatise, *Mechanical Practice in Dentistry*, published in 1898; he designed many of the illustrations, and these were drawn by Joseph M. Kavanagh and Charles Russell (qq.v.), but unsigned. In 1904 he moved to 97 Finchley Road, St John's Wood, London, where he resided for the rest of his life. The pursuit of art took this 'complex and many-sided man' to other places abroad. Impressions of the United States and Canada figured in his work, also Morocco and the Canary Islands. His portrait by Sarah Purser (q.v.) is in the Dental Hospital, Dublin. He never claimed more than an amateur's rank as a painter, although the RHA saw fit to honour him. He died at his home on 27 December 1913.

Works signed: W. Booth Pearsall or W. B. Pearsall.
Examples: Dun Laoghaire, Co. Dublin: Royal Irish Yacht Club.
Literature: *Thom's Directory*, 1893; William Booth Pearsall, *Mechanical Practice in Dentistry*, London 1898; Walter G. Strickland, *A Dictionary of Irish Artists*, Dublin 1913; *British Dental Journal*, January to December 1914; *Dictionary of British Artists 1880-1940*, Woodbridge 1976; Ronald Anderson, 'Whistler in Dublin, 1884', *Irish Arts Review*, Autumn 1986; Ann M. Stewart, *Royal Hibernian Academy of Arts: Index of Exhibitors 1826-1979*, Dublin 1987; Patricia Boylan, *All Cultivated People: A History of the United Arts Club, Dublin*, Gerrards Cross 1988; Royal Irish Yacht Club, *Letter to the author*, 1991; also, British Dental Association, 1996; East Belfast Historical Society, *Letters to the author*, 2000.

PEARSE, WILLIAM (1881-1916), sculptor. Born on 15 November 1881 at 27 Great Brunswick Street (now Pearse Street), Dublin, William James Pearse was the son of an Englishman, James Pearse (1839-1900), and the younger brother of Patrick Pearse. James Pearse, born in London, was brought over to Dublin by Yorkshire-born Charles W. Harrison who employed him as a foreman in his firm of monumental sculptors at 178 Brunswick Street. About 1873 James Pearse went into partnership with Patrick J. Neill at 182 Great Brunswick Street – Neill and Pearse – but in 1882 at the Dublin Exhibition it was Pearse and Sharp, architectural and ecclesiastical sculptors of 27 Great Brunswick Street, who won a first-class award for a High Altar for the Rotunda.

The Pearse brothers were born above the firm's workshop, and on one occasion their English grandfather paid them a visit and Patrick remembered 'a little old white-bearded man, quizzical and original, who spent all his time making bird-cages of rare woods, and covering them exquisitely. He left us about twenty when he went back again to England'. On a visit to his brother's home in Birmingham, James Pearse collapsed and died suddenly in 1900.

The burden of carrying on the business was to fall on William's shoulders but the new title for the firm, James Pearse and Sons, would suggest some involvement by his brother, who had graduated in law. William, who had been educated at the Christian Brothers' School, Westland Row, leaving there in 1897, had studied sculpture under Oliver Sheppard (q.v.) at the Dublin Metropolitan School of Art, starting there about the same time as he entered his father's studio. In the year 1898-9 he obtained a '1' for his advanced freehand drawing.

During his studentship, he conducted an Irish class at the School of Art. He later studied art at South Kensington and in Paris. In the Pearse Museum, Dublin, is a charcoal study of a nude girl inscribed 'Paris Lent '03 [or '05] Croquis'. There are several examples of his work at the museum, including an oil portrait of his Uncle Christy from Kerry; a female nude in plaster was moved to Kilmainham Jail.

In 1906 he exhibited at the Royal Hibernian Academy for the first time, showing *Una*, a sketch for a marble, and giving the Irish form of his name. From Cuil Chrannach, Leeson Park, Dublin, he contributed in 1908 a statuette in plaster, *Cailin na Carraige*, and exhibited five other works between 1909 and 1913. *An Old Sinner* was his last contribution.

When the Oireachtas held a distinct art exhibition in 1906, at the Technical Schools, Rutland Square (Parnell Square), works were exhibited by 'all the well-known artists of the day,' and Pearse was included. The Irish Art Companions, of which he was a member, exhibited at the Irish International Exhibition of 1907 and he showed sketch models for statuettes. The model for his sculpture of a kneeling girl, *Memories*, 1907, was probably Mabel Gorman, a young friend who sat for him. One of six casts is in the Pearse Museum.

In 1908 Patrick Pearse opened his bilingual school, St Enda's, at Cullenswood House, Oakley Road, Ranelagh, and his brother William was teacher of art. Two years later the school moved to more extensive premises at The Hermitage, Rathfarnham. William also taught art at the sister school at Cullenswood House – St Ita's. In 1913 he became a regular member of St Enda's staff. Patrick Tuohy (q.v.) was one of the first pupils admitted to St Enda's.

A former pupil of St Enda's, Milo MacGarry, wrote of William Pearse in the *Capuchin Annual*, 1930: 'He was an artist more than anything else. He was a gifted sculptor. He could draw well, but above all he had in him a true love of the drama. It was he who planned and staged our plays and pageants, and he acted a leading role in most of them. He was a gentle, lovable character, deeply attached to his elder brother ...'. He was a founder member of the Leinster Stage Society, a small company of amateur players, and a lifelong student of Shakespeare. Apparently he cultivated an artistic appearance, complete with flowing dark hair and floppy tie and frequently wore a kilt.

Among his work is a *Mater Dolorosa* in St Andrew's Church, Westland Row, Dublin, where he was baptised. A seated girl, plaster, is in the National Museum of Ireland; also a statuette. Two nature study watercolour sketches are in the National Library of Ireland. He was responsible for the reredos behind the main altar of St Mary's Cathedral, Limerick. Also in Co. Limerick at St. Bartholemew's Church, Drumcollogher, is the statue of Our Lady: '...her pregnancy is delicately hinted at... we may regret that the indifferent marble from which it was carved required it to be painted over in deadening white, ' wrote Louis McRedmond. In 1913 he joined the Volunteers. A member of the General Post Office garrison, he was court-martialled after the surrender and executed at Kilmainham Jail on 4 May 1916. An art exhibition to mark the centenary of his birth was held at St Enda's in 1981.

Works signed: W. Pearse or W. P. (if signed at all).
Examples: Drumcollogher, Co. Limerick: St. Bartholemew's Church. Dublin: Kilmainham Jail; National Library of Ireland; National Museum of Ireland; Pearse Museum; St Andrew's Church, Westland Row. Limerick: St Mary's Cathedral.
Literature: *Thom's Directory*, 1882, 1902, 1904; *An Macaomh*, vol. 1, no. 1, 1909 (illustration); Desmond Ryan, *The Man called Pearse*, Dublin 1923; *Capuchin Annual*, 1930, 1942, 1943; National Gallery of Ireland, *Golden Jubilee of the Easter Rising Exhibition*, catalogue, 1966; *Studies*, Spring 1966; Hilary Pyle: Cork Rosc, *Irish Art 1910-1950*, catalogue, 1975; Mrs V. Sparrow (née Harrison), *Letter to the author*, 1976; *Oireachtas*, catalogue, 1977; Henry Boylan, *A Dictionary of Irish Biography*, Dublin 1978; Pearse Museum, *Liam MacPiarais 1881-1916*, catalogue, Dublin 1981; *Irish Times*, 17 January 1984; Ann M. Stewart, *Royal Hibernian Academy of Arts: Index of Exhibitors 1826-1979*, Dublin 1987; St Mary's Cathedral, *Letter to the author*, 1991; Louis McRedmond, 'There's more than one street in Drumcollogher', *Intercom*, July-August 1994; John Turpin, *A School of Art in Dublin since the Eighteenth Century*, Dublin 1995.

PEERS, CHARLES (1875-1944), landscape and marine painter. Charles Ernest Peers was born on 8 August 1875 at Castlereagh, Co. Down, son of William Henry Peers. He grew up in Liverpool, where his family had moved when he was a boy, and it was there, on the Mersey with its busy shipping, that he started sketching. He spent two years at the Admiralty Office, but his ambition to become a naval architect was thwarted by the prohibitive cost of training. He retained a fascination with ships and harbour scenes throughout his life. Meanwhile, he spent a short time studying at the Liverpool School of Art.

A sufferer from asthma, he emigrated to South Africa in 1904 and settled in Cape Town, where his brother was a shipping agent, and established himself as one of the small band of professional artists. In 1905 he was accepted as a member of the South African Society of Artists. Although not a frequent exhibitor, by the 1920s he had established a reputation as one of the country's leading watercolourists. In 1922, however, he began painting

in oils, and in 1923 his first solo exhibition was at Lezard's Gallery, Johannesburg, showing oils, watercolours and pastels. In 1924 he held a joint exhibition with Allerley Glossop at the Taylor Art Gallery, Durban.

Peers became a member of the newly founded South African Institute of Art in 1926, and the following year participated in the inaugural exhibition in Durban. In the Durban Art Gallery he is represented by two watercolours, *Domestic Architecture* and *A Camp in the Berg*. He was the illustrator of two topographical books published in 1930, *The Cape* and *Natal*. In 1931 he was employed in a firm of Cape Town printers as a chromo-lithographer. He became an active president in 1935 of the K Club, Cape Town, an association formed to promote the arts and crafts.

Some of the more progressive artists of the day founded in 1938 the New Group in Cape Town. Peers was not one of the initiators, but he was invited to participate in its first exhibition in the Argus Galleries – and elected the first president, a position he held until his death, giving support for the avant-garde and encouraging young artists. It was the broadness of his own approach, 'his avoidance of prettifying detail and illustrational effects', that also evoked the approval of the New Group.

In 1939 he held a joint exhibition with J. Pope Ellis in Cape Town. At this time he produced a series of a hundred drawings for the United Tobacco Company publication, *Our Land*. Among his watercolours were: *Ships at Cape Town* and *Ruins of Mission Station, Leliefontein*.

In addition to lithographs, he also executed some etchings and linocuts. A lover of music and literature, he was at one time president of the South African Fine Arts Association, forerunner of the South African Association of Arts. Hans Fransen of the South African National Gallery regarded him as a man 'whose modesty, integrity and unflagging devotion to the cause of art had made him without doubt the most widely respected South African artist of his time'. At his cottage in Higgo Vale, Cape Town, he died on 28 December 1944. He was represented in the South African Art Exhibition at the Tate Gallery, London, in 1948. A commemorative exhibition of fifty-five works took place at the South African National Gallery in 1975, the centenary of his birth.

Works signed: Charles E. Peers, Chas. E. Peers or Chas. Peers (if signed at all).
Examples: Cape Town: South African National Gallery; University. Durban: Art Gallery. Grahamstown: Albany Museum. Johannesburg: Africana Museum. Kimberley: William Humphreys Art Gallery. Pietermaritzburg: Tatham Art Gallery. Pretoria: Art Museum.
Literature: Hedley A. Chilvers, *The Seven Wonders of South Africa*, Johannesburg 1929 (illustrations); S. W. Pope, intro., *Natal*, Durban 1930 (illustrations); S. W. Pope, intro., *The Cape*, Durban 1930 (illustrations); Will Costello, *The Coast of Hermanus*, Cape Town c. 1939 (illustrations); United Tobacco Company, *Our Land*, Cape Town 1939 (illustrations); Hans Fransen: South African National Gallery, *Charles E. Peers, 1875-1944: Commemorative Exhibition*, catalogue, Cape Town 1975; Esmé Berman, *Art and Artists of South Africa*, Cape Town 1983; *Retrospective South African National Bibliography for the period 1926-1958*, Pretoria 1985; Grania Ogilvie, *Dictionary of South African Painters and Sculptors, including Namibia*, Johannesburg 1988; Durban Art Gallery, *Letter to the author*, 1991; also, South African National Gallery, 1991; Tate Gallery, 1991.

PENNEFATHER, GEORGE (1905-67), landscape painter. Born at Kilworth, Co. Cork, George Richard Seymour Pennefather was the only child of R. M. S. Pennefather of Glenwood. The Pennefathers were an old Staffordshire family who arrived in Ireland with Cromwell. George, educated in England, once owned a private aeroplane which knocked him down, breaking several bones, when he opened the hangar door.

In 1939, with *January Morning*; *Low Tide*; *Evening Glencree*, he first showed with the Water Colour Society of Ireland and from then until 1954 contributed a total of thirty-five works.

A self-taught artist, his second wife, a cousin, also painted. Helen, who was the daughter of Gerald Pennefather of Australia, frequently exhibited with him and showed some pictures at the Royal Hibernian Academy from 1940. George also exhibited from that year and between then and 1952 contributed a score of works including *The Watchtower, Co. Donegal* in 1940; *St Mary's Church, Carlow*, 1943; *The Pink Cottage, Glengarriff*, 1946.

The Pennefathers toured many parts of Ireland in a caravan, and after a journey in 1940 displayed watercolours at The Country Shop, St Stephen's Green, Dublin; George's works included *The Pool, Bray*

Head and *Rising Mists, Leenane.* The Pennefathers were attracted by the old streets, lanes and fine stone buildings of Kilkenny, and there in wartime they rested their caravan on the Freshford Road.

In 1943 the Kilkenny Art Gallery Society was founded by George Pennefather, who became a member of the WCSI committee in 1944, and that year he held a joint exhibition with his wife at the Victor Waddington Galleries, Dublin. When the Pennefathers left Kilkenny in 1946 the basis of a municipal collection had already been formed. His first solo show in London took place at the Walker's Gallery in Bond Street, 1947, twenty-six works; and in 1948 *Ice on the Serpentine, London* was among his watercolours in an exhibition at the Grafton Gallery, Dublin. He was represented in the exhibition of pictures, by Irish artists, at Technical Schools in 1949 and 1950; his address, c/o Transit, Ltd in Cork.

Elizabeth Bowen opened an exhibition at George's home in Kilworth in 1951, the year he showed *The Long Pool* at the RHA. In February 1955 he flew from Shannon to Melbourne, and stayed in Australia for a year. An exhibition of thirty-five pictures which he held in Melbourne, eighteen painted in Ireland and the rest in Australia, produced favourable reviews, notably from *Age*. On his return from Australia he showed at the Imperial Hotel, Cork, Australian and Irish landscapes. Widely travelled, he also visited Mexico, the United States and Canada. His 1956 watercolour of St Fin Barre's Cathedral, Cork, is in Crawford Municipal Art Gallery.

In 1957 he departed for a three-year visit to South Africa and Australia with exhibitions planned in several cities. He regarded his caravan as something special, 'completely insulated against the heat of the tropics'. Among his other accomplishments was the designing of a turbine to light his house, Glenwood, and he made and decorated wedding cakes. He died at Glenwood on 3 April 1967. A studio sale was held in Dublin in 1998.

Works signed: George Pennefather.
Examples: Clonmel: South Tipperary County Museum and Art Gallery. Cork: Crawford Municipal Art Gallery. Kilkenny: Art Gallery Society. Killarney: Town Hall. Limerick: City Gallery of Art. Waterford: City Hall, Municipal Art Collection.
Literature: *Irish Times*, 5 November 1940, 10 May 1947, 9 September 1955, 16 October 1957, 13 April 1967; Water Colour Society of Ireland, *Minute Book*, November 1944; *Cork Examiner*, 20 September 1951; Rev. Canon James Pennefather, *Letter to the author*, 1969; *Kilkenny People*, 3 December 1976; Ann M. Stewart, *Royal Hibernian Academy of Arts: Index of Exhibitors 1826-1979*, Dublin 1987; *Water Colour Society of Ireland Exhibition List 1872-1994*, Dublin 1995; Kilkenny Art Gallery Society, *Letter to the author*, 1997.

PENPRASE, NEWTON (1888-1978), landscape, figure painter and sculptor. Born on 24 March 1888 at Redruth, Cornwall, Newton Herbert Penprase was the son of Newton Herbert Penprase, an interior decorator whose work involved the maintenance and restoration of church interiors. The father was sometimes accompanied by his son, who, in 1903, entered Redruth School of Mines and Art. When still a student, Newton – he was just seventeen – had nine sheets of drawings and studies purchased by the Victoria and Albert Museum, London; some of these were of woodwork in Cornish churches and antique silverwork in Cornwall.

In 1911 Penprase began teaching at the Belfast School of Art; he retired forty-two years later. In 1915 he was elected a member of the Belfast Art Society. Roy Johnston, a former pupil who organised a Penprase exhibition some months before his teacher's death, wrote that it was significant when you talked to those who were students or teachers during part of the period, that Penprase was the one name which kept recurring most frequently in conversation: 'This, it must be said, is as much due to his personality and what to many were his idiosyncratic ways, as it is due to his influence and impact as a teacher'.

'The students found that his energy and enthusiasm were infectious, they respected his breadth of knowledge, and he became at once both a popular and formidable character in the College,' continued Johnston. 'The skills which he already had were added to at his own initiative. He acquired, for example, the technique of linen damask weaving, of forging, of woodturning and of casting in metal. At one stage an assemblage of wheels, pulleys and drive mechanisms appeared in one of the studios, and for a long time this became the focus of his attention as he attempted to resolve the problem of perpetual motion.'

In 1936 Penprase began the huge task of building in concrete Bendhu House, a holiday home overlooking the harbour and sandy bay at Ballintoy, Co. Antrim, for which he combined the disciplines of architect, engineer, sculptor and painter, occasionally employing some local labour. In 1960 the *Belfast Telegraph* reported that it was six months since he was last at Ballintoy. At their home at Grasmere Gardens, Belfast, his wife ridiculed the idea that her husband might never finish his house.

A group of students stayed at Bendhu in 1962, still unfinished, and Johnston was among them. Later, in the exhibition catalogue, he mentioned finding a group of modelled animal figures above the front door; at the rear of the house the modelled figure of a rising Phoenix; inside, decoration of ceilings with relief features and paintings. In one of the main bedrooms, set into a wooden circular frame, were the signs of the Zodiac painted on each of twelve panels; groups of stars and constellations, in which the individual stars were cut from plywood, were freely distributed across the ceiling. Almost all the windows in the house had stained glass insets.

'In contrast to his practical gifts and the meticulous accuracy of his drawings', wrote John Hewitt in *Art in Ulster: 1*, 'many of his paintings and sculptures went far beyond the confines of observed appearance. One large canvas, for instance, its title, *Progression*, was a rendering of the legendary Hercules and Hydra duel, the many-headed monster belching out, not only smoke and flame, but bats and lizards, the foreground and background rich with symbolical shapes; an unexpected amalgam of G. F. Watts and his Victorian rhetoric with the more recent conventions of Superman.'

Penprase, president in 1953 and 1954, also exhibited at the Ulster Arts Club. In the Ulster Museum collection are eight drawings, six in pencil including *Laughter*; *Rage*; and *Remorse*, also one sculpture, *The Mystic*, and an oil painting, *The Dawn of a New Day – Progress*.

In 1977 the exhibition in Belfast at the Arts Council of Northern Ireland Gallery, in addition to documenting his work on the Ballintoy house, covered other achievements in fine arts. There were watercolour studies of plant, bird, fish and animal. The sculpture included *The Mystic*, described by Hewitt as 'a gaunt, emaciated mask, with shut lids and a single eye staring from the middle of a high bald forehead'. At the time of the exhibition he was ill in a Ballycastle, Co. Antrim, nursing home and died in hospital there on 9 January 1978. (Note – other members of the family at this time spelt the name 'Penpraze'.)

Works signed: Newton H. Penprase, N. H. Penprase or Newton Pen., rare (if signed at all).
Examples: Ballintoy, Co. Antrim: Bendhu House. Belfast: Ulster Museum. London: Victoria and Albert Museum.
Literature: *Belfast Telegraph*, 13 April 1960, 11 January 1978; Patrick Shea, *A History of the Ulster Arts Club*, Belfast 1971; John Hewitt and Theo Snoddy, *Art in Ulster: 1*, Belfast 1977; Roy Johnston: Arts Council of Northern Ireland, *All his own work: Newton Penprase*, catalogue, Belfast 1977 (also illustrations); Martyn Anglesea, *The Royal Ulster Academy of Arts*, Belfast 1981; Ulster Museum, *A Concise Catalogue of the Drawings, Paintings & Sculptures in the Ulster Museum*, Belfast 1986.

PENROSE, J. DOYLE, RHA (1862-1932), portrait, historical and landscape painter. Born on 9 May 1862 at Mitchelstown, Castleknock, Co. Dublin, his father was also James Doyle Penrose, farmer and landowner, of Ballykean, Co. Wicklow, where the family took up residence in the seventeenth century and became Quakers. They were direct descendants of Thomas Penrose, born 1580, who moved from Cornwall to Yorkshire. A George and William Penrose founded the Waterford Glass House in 1783.

J. Doyle Penrose, the artist, educated at Stramongate School, Kendal, studied art at South Kensington, also at the privately-run art school at St. John's Wood and the Royal Academy Schools, where he won a silver medal in 1887 for a copy of an oil painting in the Dulwich Gallery: *Portrait of Molière*. In 1886 he had exhibited, from York Road, Kingstown (Dun Laoghaire), at the Royal Hibernian Academy for the first time, a portrait of the Rev. Samuel Hanson of that town.

In all, he showed fifty works at the RHA exhibition, about one third portraits, including a life-size of Lord Russell of Killowen, Lord Chief Justice of England, which received the place of honour at the 1897 exhibition and is now in the Royal Courts of Justice, London. By 1898 his address was 44 Finchley Road, London N W and he sent over *Iduna's Apples*, 142cm x 183cm, exhibited at the Royal Academy two years later. The

Council of the RHA was of the opinion that the interests of their academy 'were always very close to his heart'.

Penrose's first association with the Royal Academy was in 1889 and between then and 1927 he showed nineteen works, including *A Little Musician* in 1889; *Jacob Wrestling with the Angel*, 1901; *Market Place at Damascus Gate, Jerusalem*, 1905; *Chepstow Castle and the Wye*, 1916. Penrose had been represented in the Irish Exhibition in London in 1888 with a watercolour, *Fishing Boats returning to Castle Townsend Harbour*.

Appointed an associate of the RHA in 1901, he gained full membership in 1904. A painting which he regarded as one of his most important, *The Last Chapter*, 122cm x 152cm, was shown at the exhibition in 1904 of works by Irish painters held at the Guildhall of the Corporation of London and organised by Hugh P. Lane. This painting, hung at the 1904 RHA, showed the Venerable Bede dictating. The Royal Society of Musicians of Great Britain has a three-quarter length portrait, 127cm x 87.5cm, of the American-born contralto, Antoinette Sterling, who died in 1904.

In 1907 his contributions to the Dublin exhibition included *Hagar and Ishmael in the Desert*. By 1909 Penrose resided at Oxhey Grange, Watford, Herts. Active in adult school work and local government, he subsequently worked on behalf of conscientious objectors. The Penrose home was often open to struggling painters in the area. At Bushey, the art school run by Sir Hubert von Herkomer (1849-1914) flourished. Beatrice Wix has recounted how she modelled for many of Berkomer's students and also for Penrose, whose marriage to the Hon. Josephine Peckover produced four sons, one of whom became an artist and a leading authority on modern art, Roland Penrose (1900-84).

In 1918 at the RHA he showed a portrait of another son, Bernard, and in 1920 a self-portrait. He was represented in the exhibition of Irish art at Brussels in 1930. He served on the board of the British Institute Scholarship. Other well-known portraits included those of Lord Jessel and Lord Peckover. *Queen Phillippa Interceding for the Burghers of Calais* and *The First Easter Morning* were also regarded as important works. He also painted pictures of Quaker interest, *The Presence in the Midst* and *None shall make them afraid*, which was stolen from Friends' House, London, in the 1980s. On the former, Penrose wrote in 1916: 'For a long time I hesitated to paint the picture, feeling it was almost too sacred a subject to attempt, but since the War I have felt more and more how utterly misplaced is the confidence which men have put in human power and in material things' He died at Old Manor Cottage, Aldwick, Bognor Regis, on 2 January 1932.

Works signed: J. Doyle Penrose.
Examples: Dublin: Royal Hibernian Academy. London: Friends' House, Euston Road; Royal Courts of Justice; Royal Society of Musicians of Great Britain, 10 Stratford Place. Wanganui, New Zealand: Sargeant Gallery.
Literature: *Royal Academy of Arts Annual Report*, 1887; *The Studio*, May 1897; Algernon Graves, *The Royal Academy of Arts 1769-1904*, London 1905; *Daily Telegraph*, 5 January 1932; *Royal Hibernian Academy Minutes*, 1932; *Thomas MacGreevy Papers*, Trinity College, Dublin [1967]; *Hertfordshire Countryside*, August 1977; Sir Roland Penrose, *Letter to the author*, 1980; *A Dictionary of Contemporary British Artists, 1929*, Woodbridge 1981; Friends' Historical Library, Dublin, *Letters to the author*, 1981, 1991; Phelps Warren, *Irish Glass*, London 1981; Ann M. Stewart, *Royal Hibernian Academy of Arts: Index of Exhibitors 1826-1979*, Dublin 1987; Angela Jarman, *Royal Academy Exhibitors 1905-1970*, Calne 1987; Friends' Library, London, *Letter to the author*, 1991; also, Royal Society of Musicians of Great Britain, 1991; Royal Academy of Arts, 1991; Watford Museum, 1991.

PERROTT, FRIDA (fl. 1899-1946), landscape, portrait and flower painter. A regular exhibitor at the Royal Hibernian Academy from 1899 until 1945, she showed eighty-two works, and for some years lived at Belmont Avenue, Donnybrook, Dublin. In the session 1902-03 she was a student at the Royal Hibernian Academy Schools and with Dorothy Elvery (q.v.) shared £2 for the second-best drawing from life. In 1903 she was accepted as a corresponding member of the Dublin Sketching Club.

In Beatrice Lady Glenavy's *Today we will only Gossip*, 1964, a photograph of a group taken at an exhibition of the work of Young Irish Artists, Dublin, 1903, listed 'Frieda' with the Elvery sisters, Count Markievicz, Cissie Beckett, Lily Williams and Estella Solomons (qq.v.). In the 1908-09 session for students of the RHA,

she won prizes for the best drawing from the life; the second best drawing from the antique; and the best drawing of hands and feet. In 1913 the *Irish Review* reproduced her painting, *On the Canal*.

By 1916 her address was c/o Butler's Medical Hall, Lower Sackville Street, Dublin. She wrote to Joseph Holloway, the theatre enthusiast who had also an interest in art: 'Miss Latimer and I have a studio above and they take our letters for us'. That year at the RHA she showed, in addition to a portrait, six other works including *Breakfast in the Garden* and *O'Connell Bridge and Liffey*. At the 1921 Academy she contributed a portrait of Kathleen Goodfellow, also *The Top Flat* and *The Study*.

In the 1922 RHA catalogue she gave 19 Kildare Street, Dublin, as her address, c/o W. H. Geoghegan, and in 1924 c/o Registry of Business Names in the same building. She held an exhibition in Dublin in 1925. An oil, *A Lock on the Grand Canal*, was reproduced in J. Crampton Walker's *Irish Life and Landscape*, 1927.

In 1940, from 24 Belmont Avenue, Donnybrook, Co. Dublin, she showed with the Water Colour Society of Ireland for the first time: *Trees by a River; Above the Weir; Flowers in a Bowl*. Altogether, she contributed nineteen works.

On the 1943 RHA exhibition, the *Dublin Magazine* commented that 'the light shone as in a Pissarro' in her *Blossom*. About this time she took a basement flat at 5 Royal Marine Terrace, Strand Road, Bray, her last known address.

An exhibition at the Dublin Painters' Gallery in 1945 again attracted the *Dublin Magazine*: it was pleasing 'except where the painter attempted a modern approach for which she obviously had no feeling. *Canal*, painted in a low key and somewhat suggestive of Osborne, has fine composition and a lively mood. Several paintings of pear trees in sunlight have an impressionist liveliness in their broken lights. Between these and most of the other pictures there appears a very wide gap indeed, almost as if they were the work of different hands'.

At the 1946 WCSI exhibition, her last, she showed *Pears; Still Life; Apples*. A watercolour, *Autumn Flowers*, is in the Hugh Lane Municipal Gallery of Modern Art. The Bray flat in her name was apparently occupied until 1970 but the date of her death has not been traced.

Works signed: Frida Perrott (possibly only on reverse).
Examples: Dublin: Hugh Lane Municipal Gallery of Modern Art.
Literature: *Dublin Sketching Club Minute Book*, 7 October 1903; *Irish Review*, October 1913 (illustration); *Dublin Magazine*, June 1925, July-September 1943, October-December 1945; J. Crampton Walker, *Irish Life and Landscape*, Dublin 1927 (illustration); *Joseph Holloway Papers*, National Library of Ireland [1944]; *Dermod O'Brien Papers*, Trinity College, Dublin [1945]; Ann M. Stewart, *Royal Hibernian Academy of Arts: Index of Exhibitors 1826-1979*, Dublin 1987; Bray Urban District Council, *Letter to the author*, 1991; *Water Colour Society of Ireland Exhibition List 1872-1994*, Dublin 1995.

PERRY, LILLA (1888-1974), landscape painter. Born at Marlfield, Clonmel, Co. Tipperary on 10 June 1888, Lilla Minnie Bagwell was the youngest daughter of Richard Bagwell, historian, author of *Ireland under the Tudors* and *Ireland under the Stuarts*. She spent a few months in Italy when young, and is believed to have had some formal art training.

In the period 1908-15 as Lilla Bagwell she contributed seventeen works to the Water Colour Society of Ireland exhibitions.

As early as 1909 she exhibited at the London Salon. In 1911 and 1912 she showed with the Society of Women Artists, London. In 1915 she married Capt. John Perry of Birdhill, a neighbouring estate, and under her married name she showed *Misty day on the Kenmare River* and *A Wild Garden in June* at the 1916 WCSI exhibition. She painted almost entirely in watercolours and in the period 1916-70 inclusive showed close on one hundred works at the Society's exhibitions. She was represented by *Kilmanahan Castle near Clonmel* at the centenary exhibition in 1970.

Only five works were contributed to the Royal Hibernian Academy, in the period 1927-30, including *Holycross Abbey, Co. Tipperary* and *An Old Graveyard at Clonmel*. She also showed with the Munster Fine Art Club – in 1933: *The Gardens, Roche's Hotel*. In 1937 she exhibited in Belfast with the Ulster Academy

of Arts. At the South Tipperary County Museum and Art Gallery she is represented by *Knocklofty Bridge* and *Snow in Clonmel*. At Marlfield, Clonmel, she died on 30 August 1974.

Works signed: L. Perry.
Examples: Clonmel: South Tipperary County Museum and Art Gallery. Kilkenny: Art Gallery Society. Waterford: City Hall, Municipal Art Collection.
Literature: *Irish Times*, 2 September 1974; *Dictionary of British Artists 1880-1940*, Woodbridge 1976; Mary Bagwell, *Letter to the author*, 1977; Ann M. Stewart, *Royal Hibernian Academy of Arts: Index of Exhibitors 1826-1979*, Dublin 1987; *Water Colour Society of Ireland Exhibition List 1872-1994*, Dublin 1995.

PHILLIPS, J. J. (1843-1936), landscape painter and architectural draughtsman. In 1883 James John Phillips resided at 35 High Street, Holywood, Co. Down. The leading Methodist Church architect in the North of Ireland early in the century, in 1894 he was listed among the members of the Belfast Art Society with an address at 20 University Square, Belfast; his office was at 61 Royal Avenue.

Phillips showed only one picture at the Royal Hibernian Academy, in 1879, depicting an hotel in Rouen. Some of his works were contributed to the Old Belfast collection in the Belfast Museum and Art Gallery, for example *Entrance Lodge, Methodist College, Belfast* (c. 1870) in pen, sepia, wash, white on paper. In archaeological circles he was known as a 'clever, painstaking and accomplished writer,' assisted when required by his excellent pen and pencil illustrations.

The Ulster Museum has the original drawings for the illustrations which appeared in his book on the Cistercian monastery at Grey Abbey, Co. Down, 1874, and his bequest also included two watercolours of Belfast Castle together with various other watercolours and pen and ink drawings, for example works on Blarney Castle; Cathedral of St Canice, Ossory; Franciscan Friary, Donegal; Theatre of Dionysius, Athens; L'Hôtel de Colombey, Rue des Cordeliers, Caen, 1891; and Le Turbire, 1905.

A watercolour of Inch Abbey was made, according to the inscription on the back, 'for use at the Excursion of the Royal Historical and Archaeological Association of Ireland, July 1889'. From about 1906 he resided in Portrush, Co. Antrim. An auction sale from his home at Dhu Varren in 1928 produced a predominance of Phillips' works in the fine art section, and these watercolours included: *McLeod's Maidens, Skye*; *Temple of Wingless Victory, Athens*; *Aberdovey, Wales*; *Snow on Mount Hermon*; *Romsdal Horn, Norway*; *Cannes*.

Also in private possession is a large signed watercolour, *Craig Dhu Varren*; the subject is the Black Rocks with a stormy sea and a number of seabirds. The artist died on 7 January 1936 at 9 Marlborough Park Central, Belfast, and his name is recorded on his own creation, the 'late Gothic style' Phillips Memorial Cross (c. 1882) in Belfast City Cemetery. His son's name, James St John Phillips, an architect, is also inscribed on this family memorial.

Works signed: James J. Phillips, Jas. J. Phillips, J. J. Phillips, J. Phillips or J. J. P.
Examples: Belfast: Ulster Museum.
Literature: James J. Phillips, *St Mary's of Grey-Abbey, County Down, Ireland*, Belfast 1874 (illustrations); Jas. J. Phillips, *The Annals and Archaeology of Dundrum Fortress*, Holywood 1883 (illustrations); *Belfast and Province of Ulster Directory*, 1895; *Catalogue of Auction Sale at Dhu Varren, Portrush*, 25 April 1928; *Letter from J. J. Phillips to Belfast Museum and Art Gallery*, 1930; *Belfast News-Letter*, 8 January 1936; Paul Larmour, *Belfast: An Illustrated Architectural Guide*, Belfast 1987; Sir Charles Brett, *Letter to the author*, 1991; also, Dr Alec Lyons, 1991; Jack O'Hare, 1994.

PHILLIPS, SYLVIA – see COOKE-COLLIS, SYLVIA

PIELOU, FLORENCE (1884-1959), landscape, figure and portrait painter. Born on 24 February 1884 at Boyle, Co. Roscommon, Florence Josephine Gillespie was the daughter of Joseph Gillespie, Clerk of Petty Sessions and author of specimen forms of summons and orders in use in Petty Sessions courts. Florence received her first lessons in painting from C. MacIver Grierson (q.v.) of Sligo, who ran a school at Beltra, and it was to him she owed her love of watercolours, although she also painted in oils.

In his book, *Orpen: Mirror to an Age*, Bruce Arnold identified four of the figures in the imaginative painting, *The Fairy Ring*, the missing model being a student, 'an unidentified girl playing a penny whistle'. Florence Gillespie, a devoted pupil, sat for Orpen for this painting, also entitled *On the Irish Shore*, when attending the Dublin Metropolitan School of Art. She also studied under Dermod O'Brien (q.v.). In 1906, from The Crescent, Boyle, she exhibited three landscapes at the Royal Hibernian Academy. She was among the artists, including Jack B. Yeats (q.v.), who exhibited at the Small Concert Room in Dublin in 1911.

A qualified teacher of art, she taught at a girls' school in Reigate, Surrey, and was assistant art mistress at Alexandra College, Dublin. In 1914 she resumed exhibiting at the RHA under her married name, and from then until 1951, from Sandford Road, Dublin, she contributed thirty-eight works. She showed four pictures in 1914, including *Near Bettws-y-Coed, Wales*, but did not contribute again until 1922.

In the period 1928-51 she contributed more than ninety pictures to the Water Colour Society of Ireland exhibitions, and in the first two years a dozen works were hung, including *Bluebell Hill, Abbeyleix* and *Mont Blanc from Lake Geneva*.

In 1928 at the RHA, when she showed six works, these included *Old Houses-Lausanne* and *The Last of the Old Pensioners*. She also painted in the Mediterranean resort of Bandol, France, and in 1929 at the Academy exhibition, when she showed seven pictures, these included *La Côte d'Azure from Bandol*. In 1931 and 1932 she again featured Mediterranean scenes. While on the Riviera, she won a medal for watercolours, awarded by the Cercle Artistique de Bandol, whose patron was Prince Nicholas Galitzin. He purchased a group of her sketches.

In the early 1930s she painted on Achill, Co. Mayo, subjects including a cottage, striving with the hay, and building a turf rick. Her first solo exhibition took place in 1931 at 7 St Stephen's Green, Dublin, where she showed no fewer than seventy-six pictures, including *In Herbert Park*; *A Close Finish, Laytown*; and *Slieve Donard, Newcastle*.

In 1943 at the RHA she contributed a portrait of Olivia Manning Robertson, and that year at the WCSI event her contributions included *The Church on the Hill, Wicklow* and *Fishing on the Liffey*. She died on 19 May 1959 at her Dublin home.

Works signed: F. Pielou; F. P. or P., both rare.
Examples: Kilkenny: Art Gallery Society.
Literature: *Irish Tatler and Sketch*, November 1931; *Model Housekeeping*, December 1931; *Irish Times*, 20 May 1959; Alan Denson, *John Hughes Sculptor 1865-1941*, Kendal 1969; Bruce Arnold, *Orpen: Mirror to an Age*, London 1981; Ann M. Stewart, *Royal Hibernian Academy of Arts: Index of Exhibitors 1826-1979*, Dublin 1987; Mrs Leslie Ashdown (née Pielou), *Letter to the author*, 1991; also, Mrs Sanchia Macey (née Pielou), 1991; Mrs Norma Pielou, 1991; *Water Colour Society of Ireland Exhibition List 1872-1994*, Dublin 1995.

PITT-TAYLOR, DAPHNE (1889-1945), landscape painter. Daphne Helen Stronge was born at Hockley, Co. Armagh, the second daughter of Sir James Stronge, 5th Baronet of Tynan Abbey, Co. Armagh. She attended school in London and spent some time in France, Italy and in Switzerland. She is believed to have received painting tuition at Vevey.

As Daphne Stronge, she showed eleven works in the period 1914-20 inclusive at the Water Colour Society of Ireland exhibitions, and these included the Italian scenes, *Lake Orta*, 1914, and *Old Road to Fiesole*, 1915.

In 1920 she married General Sir Walter W. Pitt-Taylor, and in 1921, 1922 and 1923 she showed six works of Indian subjects at the WCSI exhibitions. She exhibited with the Belfast Art Society in 1927, from Alexandra Road, S. Farnboro', Hants., and her five watercolour landscapes included two of Ilex Woods, Sardinia. In 1928 she showed *The Wild Fig-tree, Algeria*; *A Linen Mill in Ulster*; and *The Roman Bridge, El Kantara*.

A painting of the Matterhorn was dated 1930, and a work depicting houses in Linenhall Street, Armagh, now in Armagh County Museum, was probably painted about 1935. Also in that collection is another watercolour, *Beech Trees, Tynan*, dated 1939; a second Tynan landscape and a rendering of woods in New Zealand.

General Pitt-Taylor was stationed in India for several years. After enjoying en route a visit to the East Indies and New Zealand, he travelled just before the Second World War to Scotland in his retirement. He was a keen angler and his wife often painted as he fished. Lady Pitt-Taylor died in a Belfast nursing home on 22 December 1945. Some of her work was destroyed in the fire at Tynan Abbey in 1981.

Works signed: D. P. -T. (if signed at all).
Examples: Armagh: County Museum.
Literature: *Armagh Guardian*, 28 December 1945; Armagh County Museum, *Lady Pitt-Taylor*, biographical notes [1967]; Mrs Brenda Fletcher, *Letter to the author*, 1992; also, Mrs Daphne Kingan, 1992; ; *Water Colour Society of Ireland Exhibition List 1872-1994*, Dublin 1995.

PLUNKET, KATHARINE (1820-1932), botanical illustrator. The Hon. Katharine Plunket was born on 22 November 1820 at Kilsaran Rectory, Co. Louth, the eldest daughter of the Rt. Rev. Thomas Plunket, Bishop of Tuam, Killala and Achonry, who succeeded his father as the second Baron Plunket in 1854. Her mother was a member of the Foster family, one of whom, John Foster, the last Speaker of the Irish Parliament, was instrumental in founding the Botanic Gardens at Glasnevin, Dublin, in 1795.

In the period 1881-6, from her London residence at 64 Eaton Place, Katharine, who developed a taste for travelling abroad, showed landscapes in watercolour at the Society of Women Artists' exhibitions in London.

In 1903 the Museum of Science and Art, Dublin, now the National Museum of Ireland, received after preliminary correspondence a donation from Katharine Plunket in London of a bound, leather volume, 37.6cm by 50.7cm, with a label on the inside cover: 'Wild Flowers, painted from Nature, by the Honble. Frederica Plunket, and Honble. Katharine Plunket. Presented by them to the Dublin Museum of Science and Art'.

The collection of 1,200 coloured illustrations were painted on tinted card, 12.5cm x 9cm, and mounted eight per page. Each one had its botanical name written beneath, also locality for most and date for some, but unsigned, so it is not always possible to distinguish which sister was the artist. Frederica died in 1886 and judging by those watercolours which have dates, indications are that many were executed by Katharine after her sister's death. The plants were gathered in Ireland, Britain, Austria, France, Germany, Italy and particularly Switzerland.

Maura Scannell of the National Botanic Gardens, where the album now rested, wrote in the *Capuchin Annual*, 1976, that the character of the flowers was well conveyed. She added: 'The quality of the art work varies and this may indicate that the work of more than one person is involved. The illustrations are of value scientifically in that several related plants can be compared at the one time. The Plunket volume is a rare achievement, an object of interest and great beauty, incorporating a record of careful observation of Nature over a period of time.'

Katharine Plunket lived at Ballymascanlon House, Co. Louth, supervised a large garden and her exhibits of flowers, fruit and vegetables took many prizes at the Dundalk Show. Ireland's oldest inhabitant, who at the age of five sat on the knee of Sir Walter Scott and lived in the reign of five British Sovereigns, had been almost entirely confined to her room for ten years, but during her last year she had been carried in her chair around her gardens on several occasions. She died at her home on 14 October 1932.

Works signed: K. P. (if signed at all).
Examples: Dublin: National Botanic Gardens, Glasnevin.
Literature: *Belfast News-Letter*, 15 October 1932; *Irish Times*, 15 October 1932; Maura Scannell, 'Botanic Art and Some Irish Artists', *Capuchin Annual*, 1976; *Dictionary of British Artists 1880-1940*, Woodbridge 1976; Mary J. P. Scannell and Christine I. Houston: National Botanic Gardens, *Wild Flowers from Nature painted by Katharine Plunket (1820-1932) and Frederica Plunket (d. 1886) at the National Botanic Gardens, Glasnevin*, Dublin 1985; Mrs Rosalind Hadden, *Letter to the author*, 1991.

PLUNKETT, GRACE – see GIFFORD, GRACE

POWER, ALBERT G., RHA (1881-1945), sculptor. Albert George Power was born on 16 November 1881 at 8 Barrack Street, Dublin. Within a few years, the family moved to 16 Ellis's Quay, where his father, Henry,

opened a watchmaking and jewellery business. Albert's daughter May advised the author in 1971: 'Albert was often missing. He modelled in the basement with candle wax and Plasticine at about fourteen years, obtaining at this time clay from a brickfield. His father, who had very good taste, was fond of making mechanical models and had an inventive turn of mind.' Albert amused himself by modelling heads which were fixed on sticks for processions of his playmates.

Educated at the Christian Brothers' Schools, North Brunswick Street, a proper apprenticeship began when he was placed in the workshop of George Smyth at 196 Great Brunswick Street, a descendant of Edward Smyth (1749-1812), famous for his riverine heads on the Custom House. At first Power attended evening classes in the Dublin Metropolitan School of Art and then, abandoning his job, joined the day classes in sculpture where he came more under the influence of John Hughes and, in particular, Oliver Sheppard (qq.v.) who became a close friend. He won a series of prizes for modelling, including three silver medals in as many years. In 1906 he was represented when the Oireachtas held a distinct art exhibition.

Married with a family, he was obliged to supplement his income by taking on odd carving jobs as well as some part-time teaching at the School of Art. He assisted Sheppard in carrying through some of his commissions. In 1910 he showed a small group entitled *The Planters* at the first exhibition organised by School of Art students. In the National Competition for schools of art, 1910, *The Studio* commented that one of the most interesting of the models from life was the work of Power: 'a half-length study of a withered old man, executed with uncompromising fidelity.'

Meanwhile, Power had been establishing himself at the Royal Hibernian Academy where he first exhibited in 1906, from 16 Avondale Avenue, Dublin, and from then until 1945 he showed seventy-six works, about one-third portraits. In 1910 he showed with the Arts and Crafts Society of Ireland. Appointed ARHA in 1911, that was the year, at the age of twenty-nine, in which he won the National Competition and the examiner said that the female figure modelled was 'full of charm and faithful observation'. Power expressed an interest in the work of Auguste Rodin (1840-1917).

The first of his architectural commissions dated from 1911: a Portland stone statue of the figure of Science for the pediment of the main portico of the new Royal College of Science, Merrion Street, also the statues of Boyle and Hamilton on the façade. However, the author of those figures was Sheppard who created the clay and the resulting plaster.

In 1912 Power moved to 18 Geraldine Street, off Berkeley Road, and from that address he set up his own business. *Lady Woods*, plaster, in the National Gallery of Ireland, was dated 1912. The *Irish Review* was critical of his *James Stephens*, exhibited at the 1913 RHA: '... good work as modelling, but repellent to anyone who knows the poet'. By this time he was a personal friend of William Orpen (q.v.) and visited the family in their summer house at Howth, Co. Dublin. Two marble statues, 1913, *St Joseph* and *St Patrick*, are in the novitiate chapel of the Christian Brothers' Schools, North Richmond Street, Dublin.

A 1913 bronze bust of James Johnston Shaw is at Queen's University, Belfast. A man of the warmest affections, he was employed to carve a series of seated cherubs for the façade of the Iveagh Play Centre, Bull Abbey Street, Dublin, opened in 1915, but these were later removed. He was also a close friend of Oliver St John Gogarty who instigated the head of W. B. Yeats, executed in 1917, and presumably was the work exhibited at the 1918 RHA, along with a portrait of Lord Dunsany.

Appointed a full member of the Academy in 1919, he executed that year the posthumous head of Thomas Kettle. The memorial was not erected in St Stephen's Green until 25 March 1928, according to report, but a writer in *Studies*, December 1931, commented: 'For reasons which it is not proposed to dwell on, the bust which should rest upon this pedestal is now in the National Art Gallery in Merrion Square.' However, it was eventually restored to St Stephen's Green. The model head, in plaster, is in the National Gallery of Ireland.

The *Irish Builder* in May 1919 reported that amongst other works he had lately been responsible for were: 'the carving of the new Munster and Leinster Bank in Lower Sackville Street, and for carving at the new University College, Earlsford Terrace. His work at the latter includes a fine series of heads depicting philosophers and sages of the ages past, Greek, Roman and Renaissance, as well as early Irish.' He was responsible for the relief over the main entrance to the bank and a series of heads on the upper façade.

All the artists and craftsmen associated with The Craftworkers, Ltd, 39 Harcourt Street, Dublin, were shareholders, and Power on the firm's behalf renovated altars in St Catherine's Church, Meath Street.

Inside a year, Power made two extraordinary excursions to London. The first request came in October 1920 when he was approached by Gogarty on behalf of the family of Terence MacSwiney and asked to visit Brixton Jail and pose as a relative. Within the space of ten minutes in prison he modelled secretly beside the bed of the dying man. According to May Power, the artist's daughter, in conversation with the author: 'He made a sketch of MacSwiney and made a little sketch in wax. He modelled the head when he came back home.' This work is in Cork Public Museum.

A few months before the return to Australia in May 1921 of Archbishop Daniel Mannix, denied access to Ireland by the British Government, Power hurried again to London. Kathleen Fox (q.v.) had obtained permission to paint the Archbishop's portrait. Allowed only four short sittings at Nazareth House, Hammersmith, to complete the preliminary modelling, she decided to share these with her friend, Bertie Power, and wired him to come immediately.

Power arrived in London in his working clothes and had to borrow tools and clay from Lady Kathleen Scott (1878-1947), widow of the explorer, and later Lady Kennet. The bust, carved in marble in Dublin, is in the Diocesan College, Melbourne. A plaster bust of Dr Mannix, 0.35 metres, is in the National Gallery of Ireland.

In 1922 he was represented in the Irish exhibition at Galeries Barbazanges, Paris, with busts of Lord Dunsany, James Stephens and W. B. Yeats. In 1922 the new Free State Government commissioned him to execute posthumous portrait busts in bronze of Arthur Griffith and Michael Collins. Power had been responsible for death masks, that of Collins being taken at St Vincent's Hospital where Gogarty was the doctor on duty.

The death masks were also invaluable for the modelled medallion reliefs for the cenotaph on Leinster Lawn, designed by George Atkinson (q.v.), and which *The Studio* described in 1923 as having won 'universal and deserved praise'. This cenotaph was a temporary structure. These deaths masks, together with those of Cathal Brugha, Terence MacSwiney and P. Ó Cearnaigh are in the National Museum of Ireland. A bust in bronze of Griffith, 0.67 metre high, is in NGI. Another Government commission, in 1923, was a medal for gallantry at sea.

The early 1920s also produced the *Madonna and Child*, his wife Agnes and son Mannix acting as models, carved in Irish limestone, for All Hallows College, Drumcondra, Dublin. The *Queen Tailte* statuette, 46cm high, was designed for the 1924 Aonach Tailteann but problems over casting delayed the award until 1928. The base contained sporting scenes in low relief. In 1925 he exhibited at the RHA a sketch model of a stone seat for St Stephen's Green, a memorial to Thomas and Anna Haslam.

Carvings on the façade of the rebuilt Gresham Hotel, following the Civil War, included two sphinxes modelled on his wife's face. He was also responsible for the monument in Glasnevin Cemetery to Most Rev. Dr Walsh, Archbishop of Dublin, who died in 1921, a recumbent marble figure under an elaborate canopy. In 1928 he was among the artists invited to submit designs for the new Irish Free State coinage.

Power was a close friend of the Rev. J. J. Madden, administrator of Ballinasloe, Co. Galway, 1920-8, and towards the end of his time there Power's high altar in Connemara marble and the figure in white marble of the Dead Christ beneath was completed at St Michael's Church. He also designed the altar furnishings, with the exception of the tabernacle door. Some years later there followed his *St Joseph and Child Jesus* in the same district, at St Joseph's College, Garbally.

In 1930 he acquired larger premises at Berkeley Street and that year was represented in the Brussels exhibition of Irish art. In the early 1930s he completed his statue, *Christ the King*, for Gort, Co. Galway.

Power's eventful life was not without controversy and incident. His memorial to Countess Markievicz unveiled in St Stephen's Green in 1932 and subsequently badly damaged by vandals so that it had to be removed, received fiery criticism from Grace Gifford (q.v.), who said the Countess looked 'like a fireman'.

A bust of Hugh Lane for the 1933 opening of the Municipal Gallery was deliberately placed in an empty room – the room awaiting the disputed pictures. Then at the unveiling of the Pádraic Ó Conaire statue at Eyre Square, Galway, in 1935, there was an ominous cracking and the front of the stage partially collapsed, but

the structure held until those on it made a hurried departure. The previous night a workman, making a final check, raised the canvas sheet that covered the statue only to discover that the figure was wearing a blue shirt, which was duly removed. The monument was unveiled by Eamon de Valera. Alas in 1999, the head was decapitated but gardai recovered it. Some months later Galway Corporation decided to commission a bronze replica of the statue, which will take the place of the original.

Power provided four Irish wolfhounds for the base of a round tower about fifteen metres high in Knockmealdown mountains in memory of Liam Lynch. The edifice was described as a watchtower and was interpreted thus by the *Tipperary Star*, whose 'watchful hounds of Banba' were not, apparently, sufficiently vigilant to stop thieves removing the sculptures.

In 1936 he completed his bust of Michael Collins, 0.67 metres in bronze (National Gallery of Ireland). The bronze oval-shaped plaque with relief showing bust of Emmet was commissioned in 1937 for the renamed Robert Emmet Bridge over the Grand Canal at Harold's Cross, Dublin. A bronze bust dated 1939 of W. B. Yeats is also in the National Gallery; a replica was erected in Sandymount Green, near his birthplace, in 1968.

A portrait bust of Austin Stack, which he was invited to execute for the Dáil, was dated 1939. A plaster bust and death mask of Stack is in Crawford Municipal Art Gallery, Cork. By the end of the 1930s he was regarded as the major Irish sculptor of his generation, yet in 1938 he was turned down for the post of Professor of Sculpture after Sheppard had retired from the National College of Art. This rejection occasioned correspondence in newspapers. He filled Sheppard's place as an RHA representative on the Board of Governors at the National Gallery.

The 1798 pikeman memorial at Tralee, Co. Kerry, was unveiled by Maud Gonne (q.v.) in 1939, and that year Power was also responsible for the St Patrick statue at St Patrick's Church, Skerries, Co. Dublin. The tympanum over the main entrance to the Cathedral of Christ the King, Mullingar, contains a group by Power, executed in Portland stone. It represents the Blessed Virgin handing over the model of the old Cathedral of St Mary's to Christ the King, the central figure. With the Blessed Virgin on the left are St Patrick and St Peter. The group on the right represents Pope Pius XI; the Most Rev. Thomas Mulvany, Bishop of Meath; Cardinal MacRory, Primate of All Ireland.

The memorial statue of Sean MacDiarmada in Kiltyclogher, Co. Leitrim, was unveiled in 1940. According to Judith Hill in her *Irish Public Sculpture: A History*, 1998, Power placed the statue with its back to the Border that runs at the edge of the village in symbolic rejection of partition. She had a close inspection of the 1916 leader: 'A slight, fairly stiff figure, he wears the loose-fitting suit that was worn as Sunday best at the time. Placed against cut stones, which represent the wall of Kilmainham Gaol where he was imprisoned and executed, holding in his left hand the bandage that he tore from his eyes before he was shot, Albert Power has presented him at the mystic moment of execution, and shown him as brave and defiant. This is also expressed in his face and his calm pose...'.

In an article on Power in *Father Mathew Record* in 1942 Máirín Allen wrote: 'He never becomes barbaric, sensational or merely eccentric and he invariably respects the nature of his material, whether limestone, marble or clay'. A writer in the *Irish Art Handbook* of 1943 commented that his work was in no sense derivative. On his exhibiting *Blessed Oliver Plunkett* at the 1943 RHA, the *Dublin Magazine* referred to the head being severed from the body 'in a burst of realism characteristic of the treatment of martyred saints by painters of the Irish Baroque School'. This work is in the Municipal Gallery.

Connemara Trout in Connemara marble was dated 1944. A bust of Thomas Davis was unveiled at Leinster House in 1945. Bronzes of Thomas J. Clarke and Seán Mac Diarmada are also there. He worked at four large granite statues on the dome of the Church of the Sacred Heart at Cardonagh, Co. Donegal: *St Colmcille*; *St Patrick*; *St Brigid*; and the *Sacred Heart*. According to Harry Kernoff (q.v.): 'The best sculptor Ireland has so far produced, his life was cut short by lifting a heavy stone which ruptured his inside' The day the statues were being erected, he died in Dublin on 10 July 1945. A memorial exhibition of ten works took place at the 1946 RHA.

Works signed: Albert G. Power, Albert Power, A. Power, Power; A. de Paor, Paor or A. P., all three rare.

Examples: Ballinasloe, Co. Galway: St Joseph's College, Garbally; St Michael's Church. Belfast: Queen's University. Carndonagh, Co. Donegal: Church of the Sacred Heart. Cork: Crawford Municipal Art Gallery; Public Museum. Dublin: All Hallows College, Grace Park Road; Áras an Uachtaráin; Christian Brothers' Schools, North Richmond Street; Glasnevin Cemetery; Gresham Hotel; Harold's Cross, Robert Emmet Bridge; Hugh Lane Municipal Gallery of Modern Art; Leinster House; National Concert Hall and University College, Earlsfort Terrace; National Gallery of Ireland; National Museum of Ireland; Sandymount Green; St Stephen's Green. Galway: Eyre Square. Gort, Co. Galway: The Square. Melbourne, Australia: Diocesan College. Skerries, Co. Dublin: St Patrick's Church. Sligo: Model and Niland Centre. Tralee, Co. Kerry: Denny Street.

Literature: *Thom's Directory*, 1896; *The Studio*, March 1910, September 1910, October 1923, January 1924, January 1929; *Irish Review*, April 1913; Walter G. Strickland, *A Dictionary of Irish Artists*, Dublin 1913; *Irish Builder*, 3 May 1919; *Catholic Directory*, 1920; *Studies*, December 1931; *Irish Times*, 10 June 1935, 6 February 1968, 2 August 1968, 11 February 1971, 10 April 1999, 20 July 1999; Máirín Allen, 'Albert G. Power, RHA', *Father Mathew Record*, February 1942; *Dublin Magazine*, July-September 1943; *Irish Art Handbook*, Dublin 1943; C. P. Curran, 'Albert Power, RHA', *Father Mathew Record*, August 1945; *Dermod O'Brien Papers*, Trinity College, Dublin [1945]; Noel Brennan, *Dr Mannix*, London 1965; *Capuchin Annual*, 1967; Alan Denson, *John Hughes Sculptor 1865-1941*, Kendal 1969; *Oireachtas*, catalogue, 1977; Rev. Patrick J. Egan, *Letter to the author*, 1979; Nicola Gordon Bowe, *The Dublin Arts and Crafts Movement 1885-1930*, catalogue, Edinburgh 1985; Sighle Bhreathnach-Lynch, 'A Dublin Sculptor: Albert Power, RHA', *Dublin Historical Record*, Spring 1990; Cathedral of Christ the King, *Letter to the author*, 1991; also, Church of the Sacred Heart, 1991; Dublin Public Libraries, Archives Division, 1991; Iveagh Trust, 1991; Gerard Keane, 1991; Tralee Urban District Council, 1991; Professor John Turpin, 1991; Eileen Black, *A Sesquicentennial Celebration: Art from the Queen's University Collection*, Belfast 1995 (also illustration); John Turpin, *A School of Art in Dublin since the Eighteenth Century,* Dublin 1995; Judith Hill, *Irish Public Sculpture: A History*, Dublin 1998 (also illustrations).

POWER, ARTHUR, HRHA (1891-1984), landscape and figure painter. Arthur Richard Power was born in Guernsey, on 22 July 1891, the son of Alfred Power, an officer in the Yorkshire Light Infantry. The family moved from Southsea to Mullingar and thence to Dublin. Arthur attended Oratory School, Birmingham, 1905-07. In later years, after investigating papers at the Power family home, Bellevue, Waterford, he reported that the Power, or Poher, family, were descended from a certain Count Poher of Brittany, 'the original Blue Beard'.

Power served in the British Army during the First World War and was invalided out in 1916 after being badly gassed, and spent some time in a London hospital. In London, he met the American sculptor, Jo Davidson (1883-1952), then a war correspondent, and renewed acquaintance when he went to Paris after the War. Davidson, instrumental in Power being commissioned by the *New York Herald* for a weekly art column on what was going on around the studios, attended the Paris Peace Conference and received important commissions for busts.

Meanwhile, in Dublin, Power witnessed the 1916 Rebellion. Living at 21 Fitzwilliam Place, he attended the theosophical meetings of the Hermetic Society and so knew George Russell (q.v.). After his release from the Army, he travelled to Paris in 1919 via Pisa, Florence and Rome. A steady friendship ensued with James Joyce and his family in Paris and it was Power who suggested Patrick Tuohy (q.v.) for a portrait of Joyce's father. During his stay in Paris, which lasted about ten years, Power painted Joyce in a Cubist manner. A caricature of Joyce in watercolour and pencil is in the James Joyce Museum. Among the other literati whom he met were Ernest Hemingway, Ezra Pound and Padraic Colum.

Among the artists of fame in Paris with whom Power became friendly were the Italian, Amedeo Modigliani (1884-1920); the Bulgarian, Jules Pascin (1885-1930); and the Russian sculptor, Ossip Zadkine (1890-1967), who invited him to his studio to see his work. Power, who had studied figure painting in the city, rented Zadkine's studio when he was away.

Since Modigliani, 'already ravaged-looking, for poverty, drink and drugs had done their work', could not afford to buy stone or marble for his sculptures, Power presented him with some material for carving and, in thanks, Modigliani gave him a stone head. Power owned several of his pictures and found him, when sober, 'intelligent, sensitive and charming'. About a fortnight before his death, the Irishman saw him in his studio.

When on a visit to Dublin in 1921, Power and Paul Henry (q.v.), who had encouraged him to go to Paris, discussed the possibility of holding a Dublin Arts Week, which came to fruition in January 1922 with an exhibition in Mills' Hall and works by Cezanne, Matisse and Picasso on view. Power lent a Modigliani, *A*

Peasant Boy, and a piece of sculpture by Aristide Maillol (1861-1944). The show was opened by the Lord Lieutenant. Lectures were given at the Dublin Metropolitan School of Art, and Power spoke on painting. His association with the United Arts Club, Dublin, began in 1924.

In 1930 he left Paris, returning finally to Ireland where he ran the family estate at Bellevue House, and continued painting. Just before the outbreak of the Second World War, he took up residence in Dublin and for three years was art critic for the *Irish Times*.

In 1940 his first book appeared, *From the Old Waterford House*, a series of newspaper articles of reminiscences, but not confined to Ireland, which had appeared in the *Waterford News*. Paul Henry wrote the foreword. In the formation of the Irish Exhibition of Living Art, in 1943, he took a keen interest. His *Adam and Eve* was exhibited at the 1965 show, and *Snow* in 1966.

In 1969, most of his works now being in pastel rather than oils, he exhibited for the first time at the Royal Hibernian Academy, showing *The Souk, Algiers*, from 40 Park Avenue, Dublin. His contribution for the 1972 hanging included *Long Boat, Nazaré, Portugal*; for 1973, *Spanish Cafe*; and for 1979, *Cafe de la Sirene*. He continued to exhibit until 1983 and that year showed two pastels, *Fishing Boats, Portugal* and *Floods, Co. Wicklow*; he was now an honorary member of the RHA.

In an article in the *Irish Times* in 1970, Brian Fallon referred to his 'small, meticulously-painted, idiosyncratic paintings Talking about or showing his work he is curiously diffident, or perhaps just detached. He will say, in an almost absent way, that he isn't sure whether he is really a painter or a writer' In 1971 he held a joint exhibition with his friend, Adrian Murray-Hayden (q.v.) at the United Arts Club where he was an active exhibitor in mixed shows. In 1971 his work was also displayed at the Project Arts Centre, Dublin.

Conversations with James Joyce, his second book, was published in 1974. The Taylor Galleries, Dublin, held a retrospective exhibition in 1983. By Christmas of that year he was in hospital but still working from his wheelchair by laying a board on the bed. In the Arts Council, Dublin, collection he is represented by a pastel *River Pool*. He died on 7 May 1984 at Leopardstown Park Hospital. A memorial section was included in the Figurative Image exhibition, 1984, at the Bank of Ireland, Baggot Street, Dublin. The United Arts Club held a retrospective in 1986.

Works signed: Arthur Power or A. Power.
Examples: Dublin: Arts Council. Sandycove, Co. Dublin: James Joyce Museum.
Literature: *Thom's Directory*, 1914; Arthur Power, *From the Old Waterford House*, Waterford 1940; *Irish Times*, 10 December 1970, 11 February 1971, 11 November 1971, 25 May 1972, 13 July 1972, 8 and 14 May 1984, 26 October 1984, 25 July 1986; Paul Henry, *Further Reminiscences*, Belfast 1973; Arthur Power, *Conversations with James Joyce*, London 1974; *Dublin Historical Record*, June 1985; United Arts Club, *Arthur Power*, exhibition biography, Dublin 1986; Ann M. Stewart, *Royal Hibernian Academy of Arts: Index of Exhibitors 1826-1979*, Dublin 1987; Patricia Boylan, *All Cultivated People: A History of The United Arts Club, Dublin*, Gerrards Cross 1988; Oratory School, *Letter to the author*, 1991; also, Anita Shelbourne, 1991; United States Information Service, 1992; Dublin City and County Regional Tourism Organisation Ltd, 1993.

POWER, JOHN (1879-1939), landscape, figure painter and sculptor. Born in Midleton, Co. Cork, John Power was the son of Robert Power, shopkeeper and rate collector. He studied in London 1902-12; at South Kensington, 1902-7 and 1911-12, and the Slade School of Fine Art. Board of Education first class certificates in 1912 covered the following: Drawing common objects from memory; Model Drawing; Anatomy; Modelling from the Antique; Painting ornament; Drawing from Life; Drawing the Antique from memory; Modelling from Life.

Power joined the staff of the Crawford School of Art and took life classes principally in painting and drawing, teaching there until his death. He exhibited occasionally with the Munster Fine Art Club – on one occasion his portrait of a child attracted particular attention; he exhibited *The Silvery Path* in 1925.

He showed thirteen works in Dublin at the Royal Hibernian Academy between 1925 and 1937. In 1925 from 2 Roseville, Douglas Road, Cork, he contributed three pictures: *Rich Pastures*, a scene near Cork; a

portrait sketch and a golfing scene. In 1930, then residing at 'Lisnagreine', Old Blackrock Road, Cork, *The Lion and the Mouse* and *The Little Man* were exhibited.

Daniel Corkery (q.v.) presided when Power gave an illustrated lecture entitled 'The Decorative Quality in Painting' at the School of Art, Cork, and he described the Free State postage stamp as 'poor in decoration and lacking in originality'. The advertisement for the lecture stated: 'The Citizens are Cordially Invited'.

Among commissions for portraits was that of the Rt. Rev. Dean Sexton, 1925, for St Finbarr's College, Farrenferris, Cork. A 1925 portrait of Arthur Mannix hangs in the Crawford Municipal Art Gallery. He also painted in watercolour, and received commissions for illuminated addresses – one was presented in 1929 by the local people to the Carmelite Fathers when they arrived at Castlemartyr, Co. Cork, and set up school there. The address included four sketches of local scenes.

Power, who illustrated Rose Lynch's *Call of the Orient*, 1927, and D. L. Kelleher's *The Glamour of the South*, 1934, was versatile. He made a relief map of the harbour on behalf of the Cork Harbour Commissioners at a cost of £200 (exclusive of stand) for exhibition at the Irish Industrial and Agricultural Fair in Cork, 1932. His was the winning poster for the fair. His frieze over the proscenium of the old Opera House, Cork, was destroyed by fire in 1955.

Guy & Co., stationers, Patrick Street, Cork, displayed in their window an oil painting by Power, *Presentation of the Blessed Virgin in the Temple*, now in the Presentation Convent, Midleton, Co. Cork. According to a *Cork Examiner* reader 'with an extensive knowledge of the works of famous artists as displayed in the picture galleries of European capitals', the painting was in itself unique 'inasmuch as it is a subject very rarely treated by artists. Mr Power had then practically no old master from whom to draw inspiration. His treatment of the subject may justly be described as original in the fullest sense. The details and atmosphere of such a subject must have required a great deal of discriminating study ...'.

A 1930 painting of the Crucifixion went to Aghinagh Church, Co. Cork and a life-size statue of St Francis was cut in stone for over the hall door of Holy Trinity Church, Cork, 1932. Oil paintings over side altars in St Finbarr's South Church, Cork, were removed and not replaced in the 1960s when the interior of the church was refurbished. Another commission was a life-sized statue of Christ the King for the exterior of St Colman's Cathedral, Cobh, Co. Cork. Carved from the trunk of an old oak tree, approximately half of the statue was completed when Power was forced to abandon it because of the onset of what proved to be a fatal illness. The work is believed to have been completed by a Cork city stonecutter. Power died on 3 October 1939 in Cork.

Works signed: John Power, J. Power or J. P. (if signed at all).
Examples: Aghinagh, Co. Cork: St John the Baptist Church. Castlemartyr, Co. Cork: Carmelite College. Cork: Crawford Municipal Art Gallery; Holy Trinity Church; St Finbarr's College, Farrenferris. Midleton, Co. Cork: Presentation Convent.
Literature: *Cork Examiner*, undated cuttings, c. 1920-80; Rose Lynch, *Call of the Orient*, Dublin 1927 (illustrations); *Father Mathew Record*, April 1934; D. L. Kelleher, *The Glamour of the South*, Cork 1934 (illustrations); Stephen Coughlan, ed., *Picture That: A Century of Cork Memories*, Cork 1985; Ann M. Stewart, *Royal Hibernian Academy of Arts: Index of Exhibitors 1826-1979*, Dublin 1987; W. H. Power, *Letters to the author*, 1987; Rev. John Slattery, *Letter to the author*, 1991; also, Capuchin Franciscan Friary, Cork, 1992.

POWER, MAY (1904-93), sculptor. Mary Elizabeth Power was born in Dublin on 11 September 1904, the first child in the family of Albert G. Power (q.v.). She received her primary education at St Peter's School, Phibsborough, and she then studied in the Royal Irish Academy of Music. Her father's studio was attached to their home at 18 Geraldine Street and it was there that she received her first training in modelling at a very early age. At the Dublin Metropolitan School of Art her sculpture teacher was Oliver Sheppard (q.v.), instructor of her father many years before. In due course she acted as her father's secretary.

In 1929, George Noble, Count Plunkett, founded the Academy of Christian Art, membership of which was open exclusively to Roman Catholics, promoting what Plunkett termed 'the intellectual commonplaces of Catholic life, while recognising Theology in its relations with the ordinary incidents of civilisation.' May Power became, on a voluntary basis, curator at the Academy, 42 Upper Mount Street, Dublin. Some years

later Miss M. Mac Namara and Miss M. Power were in charge of art classes for children at a fee of 10s.6d per term, Thursdays 4-30-6-00.

In 1932 she exhibited two works at the Oireachtas exhibition, a portrait bust and a statuette. In 1933 she showed for the first time at the Royal Hibernian Academy, both pieces in plaster, *Mrs Sean O'Sullivan* and *Head of a Girl*. In the period 1933-61 she contributed nineteen works to Academy exhibitions.

The Associated Irish Artists' Society — dubbed the 'Rebel Artists' — became the Academy of Irish Art in 1934 and May Power was a founder member. The group disbanded after about five years.

An exhibition of sculpture, watercolours and drawings took place at the Country Shop, Dublin, in 1938, and in 1939 at the RHA she presented *J. J. Holloway, Esq. And Dr Vincent O'Brien*. At the Academy of Christian Art she showed sculpture in December 1941, and again in 1942. Of the series of portraits at the Contemporary Pictures gallery, Dublin, in 1944, most had already been exhibited, for example that of the late Miss Annie Lord, formerly of the RIAM, at the 1940 RHA.

The exhibition, Sport in Art, linked to the 1948 Olympic Games in London, occupied seven galleries in the Victoria and Albert Museum. Each participating nation had set up a national art committee which selected three works of art in each group of arts (architecture, sculpture, painting, etc.) and May Power was one of the three living artists chosen for the sculpture section. She presented *The Athlete*, plaster.

In 1951 she showed at the RHA a bust of the Rt. Rev. Mgr. Edward Kissane, president of St Patrick's College, Maynooth, where the work now rests. The bust of the president of All Hallows' College, Dublin, Rev. William Purcell, was completed in 1952. By this time the Academy of Christian Art had ceased to function. After an interval of twenty-five years she returned to the Oireachtas in 1957 with *An Paidrin*. The 1916 memorial at Sarsfield Bridge, Limerick, was unveiled in 1959, having been designed by Albert Power and completed by his son James. May was the model for the figure of Erin.

At the 1961 RHA, *The Boy Patrick* was listed, but twenty-four years elapsed before her work appeared again; by this time modelling had ceased. Some years previous the Arts Council had assisted the Municipal Gallery in having the Holloway bust cast in bronze. It was shown at the 1991 Academy, when she was an 'honorary guest.'

May Power spent all her working life in her father's studio. In Dublin, as well as the Holloway bust at HLMGMA, there is a drawing of Osborn Joseph Bergin at the Royal Irish Academy. After a long illness, she was admitted to St Mary's Hospital, Phoenix Park, shortly before she died on 11 April 1993.

Works signed: May Power.
Examples: Dublin: All Hallows' College; Hugh Lane Municipal Gallery of Modern Art; Royal Irish Academy. Maynooth, Co. Kildare: St Patrick's College.
Literature: *Capuchin Annual*, 1960 (illustration); *Evening Herald*, 14 May 1965; *Who's Who in Art*, Havant 1966; *The Arts Council, Dublin, 1968-1969 report*; Ann M. Stewart, *Royal Hibernian Academy of Arts: Index of Exhibitors 1826-1979*, Dublin 1987; RHA catalogues, 1980-1986, 1988-1991; S. B. Kennedy, *Irish Art & Modernism 1880-1950*, Belfast 1991; *Irish Times*, 13 April 1993; Dara Ó Conaola, *Saol agus Saothar Albert Power* (also illustration), Dublin 1996; Ms Josephine Power, *Letter to the author*, 2000; also, Victoria and Albert Museum, 2000.

POWERS, MARY FARL (1948-92), graphic artist. Born on 29 November 1948 in St Cloud, Minnesota, USA, she was a daughter of the Irish-American writer, James Farl Powers. The family arrived in Ireland in 1951. She studied at Dun Laoghaire School of Art and in 1969 attended the National College of Art. In 1972 she exhibited at the Peacock Theatre Gallery, Dublin.

In 1973 she joined the Graphic Studio, Dublin, where she specialised in etching at first, gradually moving into other areas of printmaking. In 1973 too she was represented in the International Print Biennale, Ljubljana, Yugoslavia. Jane Powers, the artist's sister, was of the view that she 'dragged Irish printmaking out of the stodgy, one-colour, fuzzy-imaged, early period in the 1970s.'

In the 1974 print biennales at Segovia, Spain, and Frechen, Germany, her work was presented. A gold medal was won at the Listowel Graphics Exhibition of 1975; she continued to exhibit regularly in Co. Kerry. In 1976, the year she won an art materials award from An Chomhairle Ealaíon, she held a retrospective show

at the Graphic Studio and was again represented at Frechen. The Godolphin Gallery, Dublin, hosted an exhibition in 1977.

Powers was awarded a major Arts Council grant in 1978, and that year she was represented in the triennial exhibition of the Lalit Kala Akedemi, New Delhi, India. Exhibitions were held in 1979 in Minnesota at St John's University and St Catherine's College. In 1979 too she was listed at the International Print Biennale, Heidelberg, Germany. The Arts Council of Northern Ireland awarded the fellowship of Printmaker in Residence for 1980-1 at their print workshop. The etching, *Waterfall*, was exhibited at 'The Delighted Eye, A Sense of Ireland' exhibition in London in 1980.

In 1980 she was represented in the Ireland festival at Birmingham, Alabama. In 1981 she became a member of Aosdána, exhibiting that year at the Taylor Galleries, Dublin, and the Tom Caldwell Gallery, Belfast. In the early 1980s she began to use paper in a new and innovative way. According to Sarah Finlay, 'she began to tear, fold, overlap and paint upon embossed sheets of paper, creating relief forms and free-standing sculptural pieces...'.

Powers' work still travelled abroad. In 1982 she was represented in the British Council/ACNI exhibition in West Germany, and also at the print biennale, Fredrikstad, Norway. The art critic, Desmond MacAvock, wrote: 'Her skill is now very considerable and she is now able to obtain effects of gradation of line, tone and colour that betoke complete mastery of the craft.' In 1983 she helped to establish the Graphic Studio Gallery.

One-person shows were held in 1984 at the Taylor Galleries and Gordon Gallery, Londonderry. In the same year her work was presented at the Bradford, England, print biennale, and she also exhibited in Mexico City. Taylor Galleries and Fenderesky Gallery, Belfast, both hosted exhibitions in 1987. At Taiwan, Republic of China, she participated in an international print biennale in 1987. The European Large Format Printmaking Exhibition included her work at the Guinness Hop Store, Dublin, in 1991.

A director of the Graphic Studio for several years, her sister Jane ran the gallery and worked with her for nine years. 'She had an innate aloofness,' wrote Jane, 'apparent even in snapshots of her as a young person. Without a doubt, it was this detached quality which fed the making of her peculiar and idiomatic brand of art...During her years at the Graphic Studio, she was a tireless (and to some, tiresome) teacher, selflessly generous with her time and information, dogged in her determination never to let a problem overcome her...'.

The Office of Public Works, Dublin, has thirty-seven prints in the collection. *Dappled Torso* is one of three works at the Hugh Lane Municipal Gallery of Modern Art. The Ulster Museum owns a woodcut. She died on 4 April 1992 at her home.

The Irish Museum of Modern Art held a major retrospective exhibition in 1995. Works at Taylor Galleries complemented the larger exhibition, which was presented at Ormeau Baths Gallery, Belfast, in 1996. The Arts Council in Dublin agreed in 1996 to administer a Graphic Studio Award for printmakers, established to commemorate the life and work of the artist.

Works signed: Mary Farl Powers or M. F. Powers.
Examples: Belfast: Arts Council of Northern Ireland; Ulster Museum. Cairo: Irish Embassy. Copenhagen: Irish Embassy. Dublin: Arts Council; Hugh Lane Municipal Gallery of Modern Art; Irish Museum of Modern Art; University College. Kilkenny: Art Gallery Society. Lagos: Irish Embassy. Limerick: University, National Self-Portrait Collection. Maseru, Lesotho: Irish Embassy. Naas: Kildare County Council. New Delhi: Lalit Kala Akedemi. New York: Irish Embassy. Ottawa: Irish Embassy. St Paul, Minnesota: St Catherine's College.
Literature: *An Chomhairle Ealaíon 1976 report*, Dublin; Roderic Knowles, *Contemporary Irish Art*, Dublin 1982; National Gallery of Ireland and Douglas Hyde Gallery, *Irish Women Artists: From the Eighteenth Century to the Present Day*, catalogue, Dublin 1987 (also illustration); Sarah Finlay, *The National Self-Portrait Collection of Ireland*, vol. I, 1979-1989, Limerick 1989 (also illustration); *Irish Times*, 6 April 1992, 11 March 1995, 10 May 1995; *Artslink*, October 1995, Belfast; Aileen C. Connor, *Aosdána*, Dublin 1996; Arts Council, *Awards and opportunities for individuals*, Dublin 1997; Dorothy Walker, *Modern Art in Ireland*, Dublin 1997 (illustration).

PRAEGER, ROSAMOND, HRHA, RUA (1867-1954), sculptor and illustrator. Sophia Rosamond Praeger was born in Holywood, Co. Down, on 15 April 1867, the daughter of Willem Emil Praeger, an emigrant to Belfast from The Hague in 1860. Her father ran a linen-exporting business. Rosamond was the granddaughter

of the naturalist, Robert Patterson, FRS, and sister of Robert Lloyd Praeger, MRIA, botanist. The Praeger family is believed to have originated in Bohemia as Von Prague.

Educated at Sullivan Upper School, Holywood, 1879-82, followed by the Government School of Art in Belfast under George Trobridge (q.v.), she entered the Slade School of Fine Art in London at the age of seventeen and studied there for four years under Alphonse Legros (1837-1911). The last year was on a free scholarship. She won the silver medal for drawing from life and a prize for modelling in clay.

In 1888 she was represented at the Belfast Ramblers' Sketching Club exhibition by a portrait in chalk. In the Belfast Art Society exhibition catalogue, 1895, she gave her studio address as 1 Donegall Square West, Belfast. Later she transferred to St Brigid's Studio, Holywood, which she shared at one period with Morris Harding (q.v.)

Rosamond Praeger's name first came to the fore as an illustrator and author of children's books. In 1896 her *A Visit to Babyland* was published in London by the Belfast firm of Marcus Ward & Co., and in the same year her illustrations appeared in Barbara Inson's *A Sunshiny Holiday* and Edith Nesbit's *As Happy as a King*, also from Marcus Ward. She was the author and illustrator of *The Adventures of The Three Bold Babes*, 1897.

Again acting in a dual capacity, *The Child's Picture Grammar* appeared in 1900 and *The Studio* commented: 'Small beginners in the study of the English language will find their way smoothed It deals with the rudiments of grammar in a flippant spirit that is quite attractive, and provides various amusing hints for the assistance of tiny scholars. The illustrations are quaintly conceived, and drawn with much spirit.' Spooky figures represented abstract nouns and exclamation marks were drawn as people. Altogether she illustrated a score of children's books, many written by herself. *The Young Stamp-Collectors* was published in 1985 for the first time.

Line drawings of specimens were supplied for two of her brother Robert's books, *Open-Air Studies in Botany*, 1897, and *Weeds: simple lessons for children*, 1913. She was one of the members of the Belfast Art Society who helped to organise the tableaux in 1898 under the auspices of the Gaelic League in Belfast. *Fáinne an Lae*, commenting on the festival, said that her 'charming illustrations of children's books showed a marked original power, but whose special forte, however, is sculpture'.

In 1899 she exhibited at the Royal Hibernian Academy for the first time, and from then until 1944 showed more than fifty works. In 1901 she made her debut at the Royal Academy and contributed nine works in all to Burlington House up until 1922. *The Fairy Fountain* first appeared in London in 1901, and in Dublin 1902; at the Ulster Museum it is in white marble, and a plaster cast is at Sullivan Upper School, where there is also a frieze, two plaques and other pieces. *A Waif* appeared at the RA in 1905; RHA, 1906. She also showed at the Walker Art Gallery, Liverpool, and the Paris Salon. An early commission was her central figure on spandrels, *Literature*, for the Carnegie library, Falls Road, Belfast.

In 1905 *The Nationalist* commented on her plaster study of a child's head at the Belfast Art Society exhibition: 'the guileless, cherub-like expression on the babe's face has been well caught and rendered.' She was responsible for the portrait medallion in bronze of Samuel Alexander Stewart on the monument in Belfast City Cemetery erected by Belfast Naturalists' Field Club. In 1909 at the RHA she showed portraits of her brother and Sir R. Lloyd Patterson. At Portrush, Co. Antrim in 1913, among the small panels at the Belfast-based Irish Decorative Art Association's annual exhibition was one of a number of girls dancing in a circle to music 'discoursed by a chubby infant who is squatting on the stem of a tree'.

Reputation as a sculptor was probably established in 1913 by *The Philosopher*, and hundreds of copies were sold. Out of the proceeds she bought the Holywood studio. There were two models for the 43.5cm high statuette, which was exhibited in marble at the 1913 RA and bought by an American collector. A work similarly titled, no medium given in catalogue, was exhibited at the 1913 RHA 'without copyright'. The young fellow appeared 'in marble' at the 1920 Belfast Art Society exhibition, in which year she was one of the first ten members elected, having been made an honorary member in 1918. *The Philosopher* is in bronze as well as marble in the Ulster Museum, and in bronze at Hunterhouse College, Belfast.

First World War memorials in Belfast are at Campbell College and at First Presbyterian (Non-Subscribing) Church. Her last exhibit at Burlington House was in 1922 with *These Little Ones*, green marble, which

received 'particular mention' in *The Studio* when it appeared in her joint show with her friend, Wilhelmina Geddes (q.v.) in Belfast in 1924. On that occasion Rosamond showed forty-five works in metal, marble, clay and bronze.

A pencil portrait of Rosamond Praeger by Wilhelmina Geddes is in the Ulster Museum. In the loan exhibition of Irish portraits by Ulster artists at the Belfast Museum and Art Gallery in 1927 she was represented, and that year she was made an honorary member of RHA. She was also represented at the Irish art exhibition in Brussels in 1930. In that year too she held a joint exhibition with Hans Iten (q.v.) in Mills' Hall, Dublin. She was a member of the Guild of Irish Art-Workers, and exhibited with the Arts and Crafts Society of Ireland.

In 1930 she was appointed an academician of the Ulster Academy of Arts. Twin plaques, representing *Mother Love*, were built into the wall of the Royal Maternity Hospital, Belfast, entrance, and a relief of a mother and two children, presented in 1932, was recessed in the entrance hall wall. Carved in 1933 was the slave-boy Patrick, kneeling in prayer at St Patrick's Church, Jordanstown, Co. Antrim. In 1935 she was commissioned for the carved stone font with figured reliefs for Stormont Presbyterian Church, Belfast.

A memorial plaque, 1938, of Lord Carson is in Belfast Cathedral, where there are also children's heads in the baptistry, and she was also responsible for the capital of the pillar, *Justice*, at the Cathedral. Also pre-War is the relief portrait of Florence Holmes in the Ulster Society for Prevention of Cruelty to Animals headquarters, but the location of *The Child and the Sun*, for an English graveyard, has not been traced.

Queen's University conferred an honorary Master of Arts degree in 1938; in 1939 she was awarded the OBE. In 1941 she was appointed president of the Ulster Academy and served for two years. The 1943 RHA saw her last Dublin contribution: *There are Fairies at the Bottom of the Garden*. When she was eighty, she published *Old Fashioned Verses and Sketches*.

An honorary member of the Royal Ulster Academy, she exhibited in Contemporary Ulster Art, Festival 1951, at the Belfast Museum and Art Gallery. R. L. Praeger lived out his final months with his sister and died in 1953, and that year her bronze, *Johnny the Jig*, was unveiled in High Street, Holywood. The plaster cast is in the Heritage Centre, Bangor.

In 1953 she presented Holywood Urban District Council with four works, and among those now at Holywood Library are a head of her brother; *Italian Boy* ;and *The Waif*. She also gave to the Ulster Hospital for Children and Women – now the Ulster Hospital – a plaster cast of a mural statuary group depicting a mother and her family; the original commission was for a Sheffield hospital. Also in the Ulster Hospital is a bronze of the same subject. In 1954, from Rock Cottages, Craigavad, Co. Down, she showed with the Institute of the Sculptors of Ireland in Dublin.

Other works in the Ulster Museum are *The Shawls* and *Old Hannah*. A plaster frieze, *Finola*, is at Queen's University. A bronze bust of R. L. Praeger is in the National Gallery of Ireland and also in the Royal Irish Academy, where there is also a head in terra-cotta. A portrait bust in bronze of Miss E. M. McCormick is in the Ulster Folk and Transport Museum. *Child Angel* is at Downey House School, Belfast, and the Sir Hamilton Harty bird bath memorial is at Hillsborough Parish Church. At Causeway School, Giant's Causeway, is a relief illustrating Fionnula, the daughter of Lir, seated on a rock comforting her swan brothers, and also a bronze of a girl asleep by a pitcher. Rosamond Praeger died on 17 April 1954. In 1976 the Holywood Business and Professional Women's Club arranged a memorial exhibition in the town.

Works signed: S. R. Praeger, S. Rosamond Praeger or S. R. P. (if signed at all).
Examples: Bangor, Co. Down: Heritage Centre. Belfast: Belfast Hospital for Sick Children; Campbell College; City Cemetery; Downey House School, Pirrie Park; Falls Road Public Library; First Presbyterian (Non-Subscribing) Church, Rosemary Street; Jubilee Girls' Club; Queen's University; Royal Maternity Hospital; Stormont Presbyterian Church, Upper Newtownards Road; Ulster Hospital, Dundonald; Ulster Museum. Bushmills, Co. Antrim: Causeway School, Giant's Causeway. Cultra, Co. Down: Ulster Folk and Transport Museum. Dublin: Hugh Lane Municipal Gallery of Modern Art; National Botanic Gardens; National Gallery of Ireland; Royal Irish Academy. Hillsborough, Co. Down: St Malachi's Church. Holywood, Co. Down: High Street; Library; Sullivan Upper School. Jordanstown, Co. Antrim: St Patrick's Church. Lisburn, Co. Antrim: Ulster Society for Prevention of Cruelty to Animals. Sheffield: Jessop Hospital for Women.

Literature: Books illustrated, London published unless otherwise stated: Barbara Inson, *A Sunshiny Holiday*, 1896; Edith Nesbit, *As Happy as a King*, 1896; Rosamond Praeger, *A Visit to Babyland*, 1896; Rosamond Praeger, *The Adventures of the Three Bold Babes*, 1897; R. L. Praeger, *Open-Air Studies in Botany*, 1897 (all illustrations); *Fáinne an Lae*, 14 May 1898; Rosamond Praeger, *Further Doings of The Three Bold Babes*, 1898 (illustrations); *Shan Van Vocht*, 6 June 1898; Rosamond Praeger, *The Child's Picture Grammar*, 1900; Rosamond Praeger, *The Tale of the Little Twin Dragons*, 1900 (both illustrations); *The Studio*, December 1900, December 1924; Brian O'Linn, *The Olde Irish Rimes of Brian O'Linn*, 1901; Rosamond Praeger, *How they Went to School*, 1903 (both illustrations); Louis Chisholm, ed., *Nursery Rhymes*, 1905 (illustrations); Algernon Graves, *The Royal Academy of Arts 1769 to 1904*, London 1905; Maurice C. Hime, *Little Red Riding Hood*, 1905 (illustrations); *The Nationalist*, 2 November 1905; Lena Dalkeith, *Aesop's Fables Told to the Children*, 1906; Rosamond Praeger, *How they Went to the Seaside*, 1909 (both illustrations); W. T. Pike, ed., *Belfast and the Province of Ulster in the 20th century*, Brighton 1909; Rosamond Praeger, *How they Came Back from School*, 1911 (illustrations); *Belfast News-Letter*, 24 June 1913, 5 February 1941, 16 May 1950, 6 November 1953; Rosamond Praeger, *Wee Tony. A Day in his Life*, 1913; R. L. Praeger, *Weeds: simple lessons for children*, Cambridge 1913 (both illustrations); Rosamond Praeger, *Billy's Garden Plot*, 1918 (illustrations); *Belfast Telegraph*, 14 October 1920, 3 February 1935, 11 June 1938, 18 July 1939, 17 April 1954; Rosamond Praeger, *The Fearful Land of Forgets*, 1921 (illustrations); J. Crampton Walker, *Irish Life and Landscape*, Dublin 1927 (illustration); Ulster Society for the Prevention of Cruelty to Animals, *The Tree*, Belfast 1936 (illustration); Rosamond Praeger, *Old Fashioned Verses and Sketches*, Dundalk 1947 (illustrations); *Northern Whig*, 15 May 1953; Cork Rosc, *Irish Art 1910-1950*, catalogue, 1975; *Dictionary of British Artists 1880-1940*, Woodbridge 1976; Holywood Business and Professional Women's Club, *Exhibition of Works by S. R. Praeger*, catalogue, Holywood 1976; John Hewitt and Theo Snoddy, *Art in Ulster: 1*, Belfast 1977; *A Dictionary of Contemporary British Artists, 1929*, Woodbridge 1981; Martyn Anglesea, *The Royal Ulster Academy of Arts*, Belfast 1981 (also illustration); Brigid Peppin and Lucy Micklethwait, *Dictionary of British Book Illustrators: The Twentieth Century*, London 1983; Timothy Collins, *Floreat Hibernia*, Dublin 1985; Rosamond Praeger, *The Young Stamp-Collectors*, Limavady 1985 (also illustrations); Angela Jarman, *Royal Academy Exhibitors 1905-1970*, Calne 1987; Paul Larmour, *Belfast: An Illustrated Architectural Guide*, Belfast 1987 (also illustrations); Ann M. Stewart, *Royal Hibernian Academy of Arts: Index of Exhibitors 1826-1979*, Dublin 1987; North Eastern Education and Library Board, *Letter to the author*, 1991; also, Royal Maternity Hospital, 1991; Sheffield Health Authority, 1991; Eileen Black, *A Sesquicentennial Celebration: Art from the Queen's University Collection*, Belfast 1995 (also illustration).

PROSSER, J. STANLEY, RUA (1887-1959), landscape painter. Born in Manchester, on 1 February 1887, the son of James Prosser, the family arrived in Belfast when James Stanley Prosser was aged eleven. He attended the Belfast School of Art, served an apprenticeship in lithography and design and in his younger days worked as a damask designer for the linen industry. Subsequently he taught music, piano and organ. An accomplished pianist, for a time he was organist of Cairncastle Parish Church, Ballygally, Co. Antrim.

Prior to the First World War, he had stayed and painted outdoors in Cushendun, Co. Antrim, with his future brother-in-law, J. Humbert Craig (q.v.). They married two sisters, the Lilburns. Craig was one of the early members of the Ulster Arts Club, and Prosser later joined. As well as painters, he numbered musicians and writers among his friends, including the novelist, Forrest Reid.

A watercolourist, and by now an associate member, his contributions to the 1922 exhibition of the Belfast Art Society included: *Carrick*; *Town Well, Cushendall*; *Cushendun*; *A Season of Mists*. He lived at 44 Haddington Gardens, Belfast, and in 1924 was represented in the Empire Exhibition, Wembley. A member of the short-lived Ulster Society of Painters, he exhibited at the fourth annual exhibition in 1924, and Richard Hayward in the *Ulster Review* said of *The Little Town*: '... has very perfectly realised his subject. There is an air of brooding quietness, a grey countryside stillness, about the picture which is utterly compelling'

In the years 1923-7 inclusive he exhibited fourteen works at the Royal Hibernian Academy. These were mainly landscapes and included *Muldersley Hill, Islandmagee*, in 1923; *The Summer Moon*, 1924; *The Hill Cottage*, 1925. His sole exhibit in 1927 was a still life. He also showed at the New Irish Salon, Dublin.

A summer cottage was at Islandmagee, Co. Antrim. He became an academician of the Ulster Academy of Arts and in the 1940 exhibition contributed landscapes of Cushendun, Co. Antrim, and Portsalon, Co. Donegal. He wrote a valuable and amusing article on J. Humbert Craig for the last issue of *Lagan* magazine in 1946. In 1946 and 1947 he served as president of the Ulster Arts Club.

John Hewitt described his work as 'in a lyrical, fluent, decorative manner, perhaps influenced by experience of Japanese prints. This against the generally accepted conventions offered a highly individual approach, never much concerned with rendering textures, never using bold colour, but achieving a light rhythmic

pattern. All in all, an artist whose work offers us an individual and lighthearted vision of landscape which to some degree modifies and refreshes the accepted convention.'

An *Irish Times* critic found that what distinguished Prosser particularly was 'the spaciousness of his composition. There is virtually no detail, the significant elements isolated in the wide, mostly unpeopled landscape ...'. His portrait in oils by William J. McClughin (q.v.) is in the Linen Hall Library, Belfast. He died in a Belfast nursing home on 30 July 1959. An exhibition and sale of his watercolours was held at the Linen Hall in 1986.

Works signed: J. Stanley Prosser.
Examples: Belfast: Department of the Environment for Northern Ireland; Linen Hall Library.
Literature: *Ulster Review*, October 1924 (also illustrations); *Who's Who in Art*, 1927; *Lagan*, vol. 2, no. 1, 1946; *Belfast News-Letter*, 31 July 1959; *Belfast Telegraph*, 31 July 1959; Patrick Shea, *A History of the Ulster Arts Club*, Belfast 1971; Martyn Anglesea, *The Royal Ulster Academy of Arts*, Belfast 1981; *Irish Times*, 2 May 1986; *Linen Hall Review*, Spring 1986; Ann M. Stewart, *Royal Hibernian Academy of Arts: Index of Exhibitors 1826-1979*, Dublin 1987; J. M. Nicholson, *Letter to the author*, 1991.

PROUD, LIAM (1920-95), landscape and figure painter. Born on 9 December 1920, Liam Archibald Proud was the son of Ernest W. Proud, solicitor. Educated at Kingstown School, Dun Laoghaire, Co. Dublin, he studied law at Trinity College, Dublin, and was admitted as a student to King's Inns in 1940. He did not, however, qualify as a Barrister-at-Law. He became a member of the Royal St George Yacht Club, Dun Laoghaire, in 1942.

In art, he was self-taught, first exhibiting in 1946 at the Oireachtas, and from then until 1961 he contributed ten works. His *Keem Bay* of 1947 was bought by the Thomas Haverty Trust.

In the period 1948-93 inclusive he showed twenty-six pictures at the Royal Hibernian Academy, opening with *The Annunciation*. At the Irish Exhibition of Living Art in 1949 he was represented by *The Sail Maker's Loft*. He first exhibited with the Dublin Painters in 1950, *Prelude*. He held an exhibition of oil paintings at their gallery in 1950.

Edward Sheehy's critique in *Social and Personal* on the 1950 one-person show considered that he was at his best in *Winter Pattern*, which had 'a cold formalism' somewhat reminiscent of Paul Nash (1889-1946). *The Annunciation* suffered 'from the already mentioned flatness of paint as well as from a uncertainty in the drawing.' He found *The Sail Maker's Loft* 'composed with a fine sense of space.'

In 1952 with Dublin Painters, *More Snow, Kilternan, Co. Dublin* and *Lennox Robinson* were both hung. He was represented in 1953 in the Contemporary Irish Art exhibition at Aberystwyth. He was living in Bray, Co. Wicklow, when he showed *Summer Morning, Bray Head* at the 1957 RHA. His twelfth and final work with Dublin Painters was *Head of a Fool* in 1958. Among his other oil paintings were *Robertstown* and *Roundstone Regatta*.

Proud's concluding contribution to IELA came in 1960 with *'Well Met'*. From his Molesworth Gallery, Dublin, address he exhibited *The Approach to the Wood* in 1965 and *Spanish Reflections* in 1967, both at the RHA. In 1977 he resided at Ballybrack, Co. Dublin; more address changes followed. When he contributed *The New Estate* to the 1982 RHA he lived at Sandyford, Co. Dublin. In the last ten years of his life, however, he resided at Crannog, Seafront, Kilcoole, Co. Wicklow. His final exhibit at the RHA in 1993 was *Some People in My Field*. Black and white work was reproduced in *Hibernia, Junior Digest* and *Social and Personal*. He died in St Columcille's Hospital, Loughlinstown, Co. Dublin, on 16 November 1995.

Works signed: Proud.
Examples: Belfast: Queen's University. Kilkenny: Art Gallery Society.
Literature: *Social and Personal*, March 1950; *Who's Who in Art*, Havant 1954; Ann M. Stewart, *Royal Hibernian Academy of Arts: Index of Exhibitors 1826-1979*, Dublin 1987; RHA catalogues, 1980-1986, 1988-1993; *Irish Times*, 17 November 1995; Ann M. Stewart, *Irish Art Societies and Sketching Clubs: Index of Exhibitors 1870-1980*, Dublin 1997; Royal St George Yacht Club, *Letter to the author*, 2000; also, The Honorable Society of King's Inns, 2000.

PURSER, SARAH, HRHA (1848-1943), portrait painter and stained glass artist. Sarah Henrietta Purser was born in Kingstown (Dun Laoghaire), Co. Dublin, on 22 March 1848, daughter of Benjamin Purser, flour miller and grain merchant at the Quay, Dungarvan, Co. Waterford. The family of nine sons and two daughters lived at The Hermitage. Sarah's mother was Anne Mallet, and so Sarah was related to Sir Frederick W. Burton, RHA (1816-1900), who had married Hannah Mallet. Sarah's brother, Louis Claude Purser, Greek scholar, became Vice-Provost of Trinity College, Dublin, and another brother, John Mallet Purser, was Regius Professor of Medicine.

At the age of thirteen she joined her sister Frances at the Moravian school, Institution Evangélique de Montmirail, near Neûchatel, Switzerland. She stayed for two years, learnt to speak fluent French and began painting. When her father's business failed and he emigrated to America, she and her mother moved to 19 Wellington Road, Dublin. Four of her pictures were hung at the 1872 Royal Hibernian Academy, including *Coming from Mass* and *Taking a Rest*.

Faced with earning her own living, she decided to become a full-time painter. She attended classes at the Dublin Metropolitan School of Art and joined the Dublin Sketching Club, later being appointed an honorary member. In 1874 she distinguished herself in the National Competition. In 1878 she again contributed to the RHA, and for the next fifty years became a regular exhibitor, portraits predominating, and showed an average of about three works per show.

Thanks to financial assistance from her brothers, she studied in Paris 1878-9 at the Académie Julian, six months concentrated work, and shared an apartment with Louise Breslau (1856-1927) from Switzerland. They became close friends. Sarah on later occasions returned to the French capital, and Louise and she corresponded for years. The Irishwoman was also a friend of the French Impressionist painter, Berthe Morisot (1841-95), and was mentioned frequently in the journal of a Russian fellow student, Maria Bashkirtseff (1860-84).

On returning to Dublin, where she found a studio at 2 Leinster Street, she eventually became the city's 'wittiest and most vitriolic hostess,' and began to make a living painting portraits. About 1880 she painted her eldest brother, John Mallet Purser, and a few years later her youngest brother, Louis Claude Purser: both portraits belong to the TCD Association. Another early commission was that of her friend, Jane L'Estrange, from Co. Sligo, exhibited at the 1881 RHA. The sitter introduced her to Lady Gore-Booth of Lissadell, Co. Sligo. Portraits were painted of Sir Henry Gore-Booth, Bt, his wife Georgina, and a double portrait of their daughters, Eva and Constance Gore-Booth (q.v.). On one of her return visits to Paris, she painted *Le Petit Déjeuner* (National Gallery of Ireland).

In 1882 her oil on canvas, *Study in the open air*, appeared in the exhibition of the Irish Fine Art Society. John O'Grady wrote in 1996 on this study of a girl: 'The qualities which gave Purser success with contemporary critics and picture-buyers are evident...The subject is attractive but unpretentious, the head well realised through the fall of outdoors light, face and hair treated directly but sensitively, the flower both real and delicate, and the dress and background boldly and economically painted. Purser's painterly verve makes an eye-catching picture out of everyday normalities.'

In 1883 she was in Paris to view the Salon; exhibited at the Cork Industrial Exhibition; and completed a portrait of the retired Professor of Geology at Trinity College, Samuel Haughton. At IFAS she showed eight pictures; non-portraits tended to be exhibited there. John Butler Yeats (q.v.) wrote to her that year, 1883: 'I have more ease and flow and facility in my work — you have more vitality in your painting as in your character there is more initiative...' He added that she was 'too anxious to arrive.' A pencil portrait of Yeats senior is in the Ulster Museum. In the whole of her career she showed only two works at the Royal Academy: 1885, *Berkeley and Dorothy, children of Sir Robert Sheffield*; 1886, *Viscountess Dalyrmple*.

In 1885 the Dublin Sketching Club admitted women and Sarah had five exhibits; in 1883 she had been a specially invited exhibitor. The Grosvenor Gallery, London, displayed a Purser portrait in 1886. A few of her pictures were hung at the Fine Art Society and the New Gallery; in Liverpool, at the Walker Art Gallery. Back in Dublin, as at Wellington Road, she resided with her brother Louis at 11 Harcourt Terrace, and they were in residence by 1886 with her studio in the annexe. She was among the professional artists who founded

the Dublin Art Club in 1886, and in the exhibition she contributed *The Captivity of Saint Patrick*, one of a cycle of decorations for St. Patrick Dun's Hospital.

A portrait of Sir Samuel Ferguson (Royal Irish Academy) was hung at the 1888 RHA. In 1889 she painted the children of the Lord Lieutenant, and in 1890 the Royal Hibernian Academy elected her an honorary academician. In 1923 the rules allowed the election of a woman as an associate member, and in 1925 she gained full membership.

In 1890 she painted a portrait of the Professor of Mathematics at Queen's University, Belfast, John Purser, and it was presented by former students to the University. Her friend Michael Davitt, editor of *The Labour World*, wrote on 30 August from London asking for a cartoon, which was duly supplied. An 1890 pastel portrait of John Kells Ingram (Ulster Museum), scholar and poet, was utilised after his death in 1907 for an oil painting (Trinity College, Dublin).

A portrait at the 1892 RHA of the Rt. Rev. Lord Bishop of Clogher was followed in 1893 by one of the Lord Bishop of Limerick as well as the Lord Bishop of Down, Connor and Dromore. A cheque for £70 was received from Belfast for the portrait of Bishop Reeves. In 1894 and 1895 she showed ten pictures each year at DAC. The charge in 1897 for a portrait taken from photographs was thirty guineas. She was a member of the Belfast Art Society.

In 1898 at the RHA she showed a portrait of His Excellency the Governor-General, and that year she executed pastel portraits of Maud Gonne and William Butler Yeats. Letters from her friend, Jane Barlow, the writer, indicated that in the period 1898-1900, Sarah provided illustrations for stories by Jane in the *Irish Homestead* and *A Celtic Christmas*, also that she was back in Paris in 1899 and 1900. Her oil portrait of Jane Barlow is in the Hugh Lane Municipal Gallery of Modern Art where there are also oil and pastel portraits of Maud Gonne (q.v.) and a pastel of W. B. Yeats.

In 1899 she was on the organising committee for the art loan exhibition which introduced the Dublin public to French modern painters. Among her other acquaintances in Paris were Edgar Degas (1834-1917) and Jean Louis Forain (1852-1931). At the 1899 exhibition of the Water Colour Society of Ireland she showed portraits, including Maud Gonne and W.B. Yeats. She was prime mover in organising an exhibition of works by Nathaniel Hone and John Butler Yeats (qq.v.) at the latter's studio, 6 St Stephen's Green, in 1901. Hugh Lane visited the exhibition and was greatly impressed by the artists' paintings. Early in 1902, Sarah travelled again and this time inspected the Pyramids.

Edward Martyn succeeded in persuading his friend, T. P. Gill, secretary to the Department of Agriculture and Technical Instruction, to set up classes in stained glass at the Metropolitan School of Art. A. E. Child (q.v.) took up the appointment in 1901. Martyn suggested to Miss Purser the advisability of opening a studio where Child should be the chief artist. 'At first,' recalled Martyn, 'she was inclined to jib; but being a woman of great business capacity as well as an artist, who, of course, would understand the situation, she took the hint'

Sarah Purser financed An Túr Gloine (The Tower of Glass) at 24 Upper Pembroke Street and ran it from its inauguration in 1903 until her retirement in 1940. Michael Healy (q.v.) was the first of a number of distinguished recruits. Purser's oil portrait of Martyn is in the Municipal Gallery.

The number of stained glass windows which she designed hardly exceeded a score. Most of these were painted by other members of the co-operative, presumably under her instruction. In the Examples list appended she has been given full credit. Two early works, 1904, were *St Ita* for St Brendan's Cathedral, Loughrea, and *The Good Shepherd* for St Columba's College, Dublin. At St Brendan's there are also *St Brendan* and two three-light windows, *The Passion*, 1908; *The Nativity*, 1912. Probably her last window was *The Good Shepherd and the Good Samaritan*, 1926, for the Church of Ireland Church at Killucan, Co. Westmeath.

Portrait painting continued; that of the 7th Viscount Powerscourt (Royal Dublin Society) was presented by the sitter shortly before his death in 1904. Hugh P. Lane organised that year an exhibition of works by Irish painters at the Guildhall of the Corporation of London, and there she was represented by *John Kells Ingram, LL D*, this portrait lent by the Royal Irish Academy, and *Douglas Hyde, LL D*, lent by the sitter but later bequeathed to the National Gallery of Ireland.

She was a member in 1906 of the first Oireachtas art exhibition committee. In 1907 she visited Sicily. She was credited with strongly backing Hugh Lane's efforts to secure a permanent gallery of modern art in Dublin. Dermod O'Brien (q.v.) collected subscriptions and on 6 March 1908 she donated 2s. 6d. but the suspicion remains that she was inviting others to show up her 'stinginess'. Miss S. C. Harrison (q.v.) gave £5.00. In 1908 she was included in Lane's exhibition of pictures by Irish artists for the Franco-British Exhibition in London.

In Paris in 1909 she opened an exhibition of Neo-Impressionist painting. In 1909 too she acquired a lease on Mespil House, Mespil Road, Dublin, and her brother John joined her. At this mansion she held her famous monthly Second Tuesdays. Dr Olive Purser, her niece, told the author in 1968 that she remembered seeing Bernard Shaw and G. K. Chesterton there. Dr Purser considered her aunt 'an accomplished landscape artist but there was no money in it'.

On the subject of finance, Lady Glenavy wrote in her autobiography: 'She had the reputation of being very rich and very mean, and carefully fostered this idea of her meanness, speaking of the family as the "pinching parsimonious Pursers". I only remember her generosity' Mary Swanzy (q.v.) advised the author in 1968: 'Among her generous actions was the paying of education for others.' In 1910, active as ever, she was a foundation member of the Guild of Irish Art-Workers.

Her passion for travel continued unabated. In 1913 Jane Barlow wrote to her in Bavaria. Wilhelmina Geddes and Catherine O'Brien (qq.v.) accompanied her to France in 1914 when they viewed thirteenth century stained glass. That year she joined the Board of the National Gallery of Ireland. *The Studio* found her portrait of Miss Maire O'Neill as 'Deidre' at the 1916 RHA as serene and having 'an intimate emotional appeal'. In 1921 she returned to Paris where she would roam around cafés at night talking to her friends, and the following year she was represented in the Irish exhibition at Galeries Barbazanges.

'Extraordinary versatility, one might almost say catholicity of taste' was one comment on her retrospective exhibition, at the age of seventy-five, at the Institution of Civil Engineers' hall, Dawson Street, Dublin, in 1923. Admission, one shilling; catalogue, 2d. Excluding some designs for stained glass, she showed eighty works, about half portraits, with landscapes and flowerpieces. Works included: *The Blue Cloak*; *The Little Regatta: Howth*; *Evening at Baltry*; *In a Cabbage Garden*; *The Balancing Birds*; *Lady with a Monkey: A Portrait*; *Three Fisherwomen, Kinsale*. Anne Crookshank and the Knight of Glin, in their 1994 book on Irish watercolours, considered that her small landscapes showed the influence of Nathaniel Hone (q.v.).

In 1924 she initiated the movement for the launching of the Friends of the National Collections of Ireland. In the beginning it largely occupied itself with the question of the return of the Lane pictures to Dublin. She led the deputation to President Cosgrave about the acquisition of Charlemont House for the Municipal Gallery of Modern Art.

An Túr Gloine became a limited company in 1925; Sarah Purser was the largest shareholder. In J. Crampton Walker's *Irish Life and Landscape*, 1927, the author chose as an illustration for the Purser entry, *An Irish Idyll* (Ulster Museum), 'a pathetic picture showing the sad and careworn features of a poor Irish woman and her little boy from the Dublin slums'.

In 1927 her portrait of Jack B. Yeats (q.v.) was hung at the RHA. She was represented in the exhibition of Irish art at Brussels in 1930. When more than eighty years of age, she visited Italy. Her inspiration about Charlemount House became a reality in 1933. With Sir John Purser Griffith she endowed in 1934 the scholarship which bears their names in the History of Art at Trinity College, Dublin, and University College, Dublin. At the age of eighty-nine, she flew in an aeroplane to inspect the roof of her house. A few days after her ninetieth birthday, FNCI gave a dinner in her honour at the Shelbourne Hotel.

Other portraits by Sarah Purser included those of Sara Allgood (Abbey Theatre); Roger Casement, James MacNeill, Joseph O'Neill (all NGI); Serjeant Richard Armstrong and William Kenny (both King's Inns). Portraits of Sarah Purser included: by Lilian Davidson (NGI); by Mary Swanzy (HLMGMA); by John B. Yeats (Limerick City Gallery of Art). In John O'Grady's biography of Sarah Purser, 1996, the catalogue listed 554 works including eleven sketchbooks.

Lennox Robinson, playwright, wrote in *The Bell* in 1943: 'Sarah Purser was a bright, sparkling east-wind. Very exhilarating, but nippy; at any moment you had to be prepared to turn up your collar and button your coat. She was stingy to herself but, on occasion, extraordinarily generous to her friends'

She refused such tributes as honorary degrees or other public honours and permitted no recognition of generous acts or selfless services. She possessed genuine wit, and made the famous *bon mot* on George Moore to the effect that men usually kissed and didn't tell, but Moore told and didn't kiss. She died, after a short illness, at Mespil House on 7 August 1943, and was buried at Mount Jerome cemetery. A small memorial tribute was paid at the 1944 RHA, and her work was also on view at the 50th anniversary celebration in 1974 of the Friends of the National Collections at the Municipal Gallery. A plaque was unveiled in 1976 at 11 Harcourt Terrace.

Works signed: P.; SHP., SP, monograms; Sarah Purser, S. H. Purser or S. Purser (if signed at all).
Examples: Belfast: Queen's University; Ulster Museum. Castlebar, Co. Mayo: Christ Church. Clogher, Co. Tyrone: St Macartan's Cathedral. Clonmel: South Tipperary County Museum and Art Gallery. Drogheda, Co. Louth: Library, Municipal Centre. Dublin: Abbey Theatre; Dental Hospital; Hugh Lane Municipal Gallery of Modern Art; Kildare Street and Universities Club; King's Inns; Masonic Hall, Molesworth Street; National Gallery of Ireland; National Library of Ireland; Royal College of Physicians of Ireland; Royal College of Surgeons in Ireland; Royal Dublin Society; Royal Hibernian Academy; Royal Irish Academy; Royal Zoological Society of Ireland; St Columba's College; St Patrick's Cathedral; St. Patrick's College, Drumcondra; Trinity College; University College (Belfield). Dun Laoghaire, Co. Dublin: Royal Irish Yacht Club. Emly, Co. Tipperary: St Ailbhe's Church. Enniskillen, Co. Fermanagh: Convent of Mercy. Howth, Co. Dublin: St Mary's Church. Kilcurry, Co. Louth: St Brigid's Church. Killucan, Co. Westmeath: St Etchen's Church. Limerick: City Gallery of Art; University, National Self-Portrait Collection. Lissadell, Co. Sligo: Lissadell House. Londonderry: Foyle and Londonderry College. Loughlinstown, Co. Dublin: Rathmichael Church. Loughrea, Co. Galway: St Brendan's Cathedral. Raphoe, Co. Donegal: St. Eunan's Cathedral. Washington DC, USA: Georgetown University. Waterford: City Hall, Municipal Art Collection.
Literature: *Slater's Directory Ireland*, Dublin 1870; *Notes on the Origin and Early History of the Dublin Sketching Club*, typescript, n.d.; *Letters to Sarah Purser*, 1883-1913, National Library of Ireland; *Thom's Directory*, 1886, 1887; *Dublin Sketching Club Minute Book*, 1888; Walter G. Strickland, *A Dictionary of Irish Artists*, Dublin 1913; *Irish Review*, February 1914 (illustration); *The Studio*, June 1916, September 1923; *Catalogue of pictures old and new by Sarah H. Purser, ARHA*, Dublin [1923]; *Irish Builder and Engineer*, 2 June 1923; J. Crampton Walker, *Irish Life and Landscape*, Dublin 1927 (also illustration); *Irish Times*, 9 and 16 August 1943, 15 February 1974, 21 July 1976; *The Times*, 17 August 1943; *Dermod O'Brien Papers*, Trinity College, Dublin [1945]; *Capuchin Annual*, 1946-47; Thomas Bodkin, *Hugh Lane and his Pictures*, Dublin 1956; *Studies*, Spring 1962; Beatrice Lady Glenavy, *Today we will only Gossip*, London 1964; Elizabeth Coxhead, *Daughters of Erin*, London 1965; Mary Colum, *Life and the Dream*, Dublin 1966; *Thomas MacGreevy Papers*, Trinity College, Dublin [1967]; Miss Aideen Gore-Booth, *Letter to the author*, 1970; Bernard Share, *Irish Lives*, Dublin 1971 (also illustrations); *Dictionary of British Artists 1880-1940*, Woodbridge 1976; John M. O'Grady, 'Sarah Purser 1848-1943', *Capuchin Annual*, 1977 (also illustrations); Ann M. Stewart, *Royal Hibernian Academy of Arts: Index of Exhibitors 1826-1979*, Dublin 1987; Nicola Gordon Bowe, David Caron and Michael Wynne, *Gazetteer of Irish Stained Glass*, Blackrock 1988; Anne Crookshank and the King of Glin, *The Watercolours of Ireland*, London 1994 (also illustration); Eileen Black, *A Sesquicentennial Celebration: Art from the Queen's University Collection*, Belfast 1995; John Turpin, *A School of Art in Dublin since the Eighteenth Century*, Dublin 1995 (also illustrations); *Water Colour Society of Ireland Exhibition List 1872-1994*, Dublin 1995; Gorry Gallery, *An exhibition of 18th, 19th and 20th century Irish Paintings*, catalogue, Dublin 1996; John O' Grady, *The Life and Work of Sarah Purser*, Blackrock 1996 (also illustrations); Royal Dublin Society, *Letter to the author*, 1997.

PYKE, ROBERT (1916-87), caricaturist. Only son of Robert Pyke, onetime butcher, he was enabled to attend the Dublin Metropolitan School of Art through a financial bequest. In later life he was regarded in the family as the most illustrious of the seven generations of Pykes who had lived in Dublin.

In British film studios he sketched the stars for movie magazines, publicity sheets, newspaper columns and social magazines. Back in Dublin, he survived with sketches and backdrops for the shows of comedian Jimmy O'Dea. He supplied the illustrations for the newspaper advertisements for the old sweet firm, Lemon's, and sketched film star Maureen O'Hara for an international magazine.

Many of his most notable caricatures were executed in Dublin during 1940s and 1950s, and he established a reputation as a caricaturist and illustrator which earned him invitations to work in Fleet Street, but these he turned down, preferring to remain in Dublin.

In the early days of the *Sunday Press*, which began in 1949 when Bobby Pyke was most prolific, Douglas Gageby, then assistant editor, has since recalled: ' ... he would often be called to the office of Matt Feehan, the editor, to sketch a visiting personality or a new columnist. I have seen him come in, be introduced to his subject, sit down with his drawing pad, eye the subject as if he were a surgeon examining the bone structure, and then flick in what appeared to be no more than a few faint lines. He would stand up, smile at the sitter and go off He had done the job' His work was a feature of the *Evening Press* in the 1950s.

In 1973 Thomas A. Weldon, former proprietor of the Pearl Bar, Dublin, presented thirty-three caricatures by Pyke to the National Gallery of Ireland. These had been hanging in the Fleet Street premises and some were of journalists connected with the *Irish Times*, notably Robert Smyllie, then editor.

Others in the Weldon collection were: Austin Clarke, Terence de Vere White, A. J. (Con) Leventhal, Donagh McDonagh and Seamus O'Sullivan. Most of the sitters were in profile and facing the viewer's left; medium, often ink and pencil on paper. *Blind Man's Buff* by Pyke in the National Library of Ireland showed Fred Johnson, Eileen Crowe, Michael J. Dolan, F. J. McCormick, Arthur Shields. Also at the Library are caricature pen and ink sketches of May Craig, Maureen Delany and others. Of Monkstown Road, Dublin, he died a bachelor in St Michael's Hospital, Dun Laoghaire, on 12 July 1987.

Works signed: Pyke (if signed at all).
Examples: Dublin: National Gallery of Ireland; National Library of Ireland.
Literature: Adrian Le Harivel: National Gallery of Ireland, *Illustrated Summary Catalogue of Drawings, Watercolours and Miniatures*, Dublin 1983; *Irish Press*, 22 April 1987, 13 July 1987; *Evening Press*, 13 July 1987; *Irish Times*, 22 July 1987; National Library of Ireland, *Letters to the author*, 1992.

PYM, KATHLEEN – see FOX, KATHLEEN

Q

QUIGLY, KATHLEEN (1888-1981), stained glass artist, wood engraver and illuminator. Born on 6 March 1888 in Dublin, the daughter of Richard Quigly, MICE, she travelled abroad with her family in her early years. She attended Central School of Arts and Crafts, London, and the Dublin Metropolitan School of Art, where her sister Ethel won the 1917 Taylor Scholarship for painting.

According to an article in *Die Brandwag*, Johannesburg, written by S. McDermid, Kathleen Quigly was 'pushed into doing stained glass'. In London she was busy studying wood engraving 'when an old lady from Dublin came to the school. She made coloured glass windows and came to ask the head if he could recommend someone with the right temperament to come and learn the work from her'. Kathleen's name was suggested. Up until that time she 'had not for one moment considered such a vocation. Because she was a Dubliner herself, she decided to try out the work for three months. The three months passed,' continued the writer, 'and she never thought of going back to London again. The craft had exerted its magical powers over her.'

Kathleen Quigly exhibited 'a robust copper cup and stand, decorated with figures and trees in enamel', at the 1910 Arts and Crafts Society of Ireland exhibition. She first exhibited at the Royal Hibernian Academy in 1917, from 5 Charleville Road, Dublin, two works: *The Apprentice* and a portrait. In the same year she contributed a woodblock print, *Girl with two lamps*, to the Arts and Crafts exhibition.

Involvement in stained glass was not only with Sarah Purser's An Túr Gloine, but with Harry Clarke (q.v.) and she worked with him on his *Eve of St Agnes* window in the early 1920s. In 1917, however, she was responsible for *The Good Shepherd* for St Andrew's Church at Dunmore East, Co. Waterford. In 1919 she collaborated with Clarke on a lantern, incorporating zodiac stained and painted panels, which they exhibited at the 1921 Arts and Crafts exhibition. That year she showed a design for stained glass at the RHA.

Although her name has been spelt more often than not as 'Quigley', her signature on a woodcut, *Father Time*, 1920, in an autograph book inscribed to Harry Clarke in the Hugh Lane Municipal Gallery of Modern Art, is clearly 'Quigly'.

She was associated with the famous miniature Titania's Palace designed by Nevile Wilkinson (q.v.) and completed in 1922, supplying three windows of *plique-à-jour* enamel for the chapel. The centre window depicted Alpha and Omega, with the symbols of the Evangelists' the angel, the winged lion, the winged bull and the eagle. The palace is now in Denmark.

In 1925 she returned to exhibiting at the RHA, this time from 14 Westmoreland Street, Dublin, three works: a decoration on vellum, an illustration, and a miniature. She may have been associated with Joseph Tierney and his Columbar Studio at 14 Westmoreland Street. In 1925 too she exhibited again at the Arts and Crafts exhibition. The *Annunciation* window, and two small lancet-shaped windows at St Joseph's Church, Bilton, Harrogate, appear to be contemporary with the building of the church in 1926.

In 1926 there began an association with the Guild of Irish Art-Workers, and that year she completed windows, scenes from Greek mythology, for the Treasure House of Eu Tong Sen, a wealthy Chinese merchant in Singapore. A three-light window, 1927, was designed for the chapel at the Sacred Heart Convent, Newton, near Boston, Massachussetts, USA.

Associated with the Dublin Book Studio, she was responsible for three of the decorative borders in the official handbook for Dublin Civic Week, 1929. One border had an inset of the Rotunda Hospital with the design of skulls taken from the frieze of the Rotunda building, the rest of the ornament being from the chapel interior.

At the exhibition of Irish art at Brussels in 1930 she showed enamel work. She was represented in 1932 Aonach Tailteann. Seven items were exhibited between 1930 and 1934 at the RHA, including a colour linocut, two designs for stained glass, and, in 1934, *Mrs T. Kettle*.

In 1934 she emigrated to South Africa and practised as a stained glass artist in Johannesburg for twenty-five years, making more than a hundred windows there, not only for the city but for other parts of the world.

Initially, however, she worked as a painter, exhibiting in 1935, 1936 and 1939 at the South African Academy in Johannesburg. She also showed with the Transvaal Art Society. She worked with A. L. Watson in a stained glass studio situated in a dingy industrial suburb, and in the 1950s she was said to be the only stained glass woman artist in South Africa. Her name was also associated with glass mosaic.

For the chapel at Groote Schuur Hospital, Cape Town, she made a window depicting Holy Elizabeth of Hungary, standing with a bowl of red roses in her hands. She retired to Rhodesia, as it then was, first to Umtali and then to Marandellas, where she died on 15 August 1981.

Works signed: Kathleen Quigly or K. Q. (if signed at all).
Examples: Billund, Denmark: Legoland. Boston, Mass., USA: Sacred Heart Convent, Newton. Cape Town: Groote Schuur Hospital. Dublin: Hugh Lane Municipal Gallery of Modern Art. Dunmore East, Co. Waterford: St Andrew's Church. Harrogate, Yorks.: St Joseph's Church, Bilton.
Literature: *Arts and Crafts*, special number of *The Studio*, 1916; *Royal Dublin Society Report of the Council*, 1917; *Who's Who in Art*, 1927; E. M. Stephens, ed., *Dublin Civic Week 1929 Official Handbook* (also illustrations); *Thom's Directory*, 1930; Major Sir Nevile Wilkinson, KCVO, *Titania's Palace*, Dublin c. 1932; *The Pictorial*, Cape Town, June 1939; *Die Brandwag*, Johannesburg, 22 January 1954; City Hall, Johannesburg, *Women Can Do It*, catalogue, 1955; *Dictionary of British Artists 1880-1940*, Woodbridge 1976; National Gallery of Ireland, *Letter to the author*, 1984; Nicola Gordon Bowe, *The Dublin Arts and Crafts Movement 1885-1930*, catalogue, Edinburgh 1985; National Gallery of Ireland and Douglas Hyde Gallery, *Irish Women Artists: From the Eighteenth Century to the Present Day*, Dublin 1987 (also illustration); Ann M. Stewart, *Royal Hibernian Academy of Arts: Index of Exhibitors 1826-1979*, Dublin 1987; Nicola Gordon Bowe, David Caron and Michael Wynne, *Gazetteer of Irish Stained Glass*, Dublin 1988; Very Rev. Monsignor John T. Dunne, *Letter to the author*, 1992; also, Groote Schuur Hospital, 1992; Johannesburg Art Gallery, 1992; South African Embassy, London, 1992; Royal Danish Embassy, London, 1994.

QUILTY, JOSEPH (1914-95), landscape and figure painter. Born in Limerick on 7 May 1914, Joseph Gerard Quilty was the eldest of nine children. His father, John 'J.J.' Quilty, was a well known figure in the city through his business interests in shipping. Joseph Quilty went to England to set up the London office of Irish Channel Lines in freight.

The strong influence of his father plus business commitment prevented him from pursuing the life of a full-time artist, although he painted and drew in much of his spare time. The Romanian painter, printmaker and teacher, Arthur Segal (1875-1944), a Dadaist in Switzerland in 1916, arrived in London in 1936 and Quilty attended his school of painting in Hampstead. In London, he met Gerard Dillon (q.v.), who became a friend. Dillon used to teach at adult evening classes for the London Borough of Camden and it was there that Quilty met Arthur Armstrong and George Campbell (qq.v).

Summer holidays were often spent in Ireland, where he executed numerous sketches on these trips, some of which would be turned into paintings on his return to London. *Shannon Estuary and Scattery Island from Cappagh*, oil, was dated 1955. However, he painted a number of historical scenes, sometimes involving de Valera or Michael Collins.

In 1961, from 32 Fryent Way, Kingsbury, London, he showed initially at the Irish Exhibition of Living Art with *Children*, and in 1962 with *The Aggressors* and *The Red Grass*. Dillon was a frequent visitor to his home at 159 Station Road, Hendon, and from there he sent in *Evening Cyclists* for the 1963 IELA. In 1964 and 1965 he exhibited three more works at the Dublin event.

The year 1978 marked his permanent return to Ireland, becoming a full-time painter based in Doorus, near Kinvara, Co. Galway. In the early 1980s he painted in Cyprus. Prompted by the artist's wife, Anne, the Galway art gallery proprietor, Tom Kenny, inspected Quilty's work in Doorus. Later, he recorded his impressions: '...a magical world of light, colour, humour, and imagination. A kaleidoscope of Burren hills and winding roads, of ruined castles and small piers, of Kinvara streets and starry nights, and men with scythes and roadside chats. This was the work of an untrained artist with a remarkably fresh vision, an intuitive feel for composition and colour...He painted with great charm and humour in a folksy, pseudo-naive way. There was a spontaneity about these literal translations of Burren people and their surroundings.'

Kenny Gallery hosted his 'Aspects of the Burren' exhibition in 1987, and 'Not far from old Kinvara' in 1989. A visit to South-West France was indicated by *Dordoyne*, oil, 1990. In 1991 he painted *Lough More*,

Clare and *Doorus from the Sea*. He also worked in West Cork. A sole contribution to the Royal Hibernian Academy came in 1992: *Lake Inchiquin*. Other exhibitions were held at the Kenny Gallery in 1992 and 1994.

Aidan Dunne of the *Irish Times* wrote: 'While he has been described as a naive artist he wasn't really naive at all. He aimed for a spontaneous simplicity in his pictures but he was technically very capable indeed and well aware of the subtleties of painterly style...'. Throughout his life he had combined the roles of artist, businessman, family man. He died on 23 January 1995. A retrospective exhibition took place at the Galway gallery in 1999, in association with the Arts Festival.

Works signed: Joseph Quilty, J. Quilty or Seámus O Caolite.
Literature: Jane Turner, editor, *The Dictionary of Art*, London 1996; Ann M. Stewart, *Irish Art Societies and Sketching Clubs: Index of Exhibitors 1870-1980*, Dublin 1997; Kenny Gallery, *Joseph Quilty*, catalogue, Galway 1999 (also illustrations); *Irish Times*, 15 July 1999; Michael J. Quilty, *Letters to the author*, 2000.

QUINN, EDMOND T., ANA (1868-1929), sculptor. Born on 20 December 1868 at Philadelphia, USA, Edmond Thomas Quinn was the eldest son of John and Rosina (McLaughlin) Quinn, of Irish ancestry and in humble circumstances. Studies in art began in 1885 at the Pennsylvania Academy of the Fine Arts, and especially under Thomas Eakins (1844-1916), whose paternal grandfather hailed from the North of Ireland. When a group of students founded the Art Students' League, Eakins, sculptor and painter, agreed to give instruction there too. Quinn was one of the youngest members. In 1891 he exhibited *The Potter*, a painting, at the PAFA exhibition.

At the age of twenty-four he studied some months in Spain, where his main interest was painting, hence *Old Spaniard*, exhibited at the 1894 PAFA, which, in later years, acquired about fifty of his Spanish travel photographs. He next journeyed to Paris and studied modelling under J.-A. Injalbert (1845-1933), and in 1900 he completed a statue of a kneeling Magdalen.

The year 1903 marked the installation of his statue of William Howard seated on a large chair and wearing a robe, for the William Howard Memorial Cathedral at Williamsport, Pennsylvania. During one of his later sojourns in Paris, he painted a portrait of the writer, Anatole France, 1906.

In time he chose sculpture as a means of livelihood, receiving many commissions for portrait busts or heads. In 1906 he moved to New York city where he resided for the rest of his life. In 1907 he became a lifelong member of the National Sculpture Society. In 1908 he completed the reliefs for the battle monument at Kings Mountain, South Carolina. His colossal limestone figure, *Persian Philosophy*, 1909, was for the façade of the Brooklyn Institute of Arts and Sciences.

Nymph, a standing nude woman, bronze statuette, 1912, height 41cm, is in the Metropolitan Museum of Art, New York. He showed at PAFA in 1913, and received a silver medal in 1915 at the Panama-Pacific International Exposition, San Francisco.

In 1917 his statue of General John C. Pemberton was erected in the Vicksburg National Military Park in Mississippi. Regarded as his most significant work is the 'strikingly beautiful' 1918 bronze statue, *Edwin Booth in the Character of Hamlet*, in Gramercy Park, New York. The commission was awarded to him out of a number of competing sculptors of note. The monument was first projected in 1906. A bust of Booth is in New York University.

Quinn had married an Emily Bradley of Newport, Rhode Island, in 1917. Soon afterward, they moved from Brooklyn to Manhattan, where their home became an intellectual centre 'frequented by leaders in all the arts'. He served on the Municipal Art Commission of New York, 1918-19. A few hours after the death of John Butler Yeats (q.v.) in New York in 1922, Quinn made a death mask, which is now with the Yeats Society, Sligo.

A 1927 bronze bust of Victor Herbert is in the Central Park Mall, New York, near the Guggenheim bandstand, where Herbert played with the celebrated 22nd Regiment Band. In 1928 Quinn completed the model for the statue of Henry Clay 'in an attitude of impassioned eloquence'. The work was the gift of the United States Government to Venezuela and was erected at Caracas in 1930.

Among his four busts at New York University is one of James McNeill Whistler (1834-1903). Other subjects included Father Sylvester Malone, Eugene O'Neill and Edgar Allan Poe. A head in bronze of Padraic Colum is in Dublin at the Hugh Lane Municipal Gallery of Modern Art, and one of James Stephens is at the National Gallery of Ireland where there is also a cast of the Yeats death mask, presented by the sculptor in 1926.

Quinn was represented in the Contemporary American Sculpture exhibition held in 1929 by the National Sculpture Society in co-operation with the California Palace of the Legion of Honor. An associate of the National Academy of Design, he was also a member of Architectural League of New York, National Institute of Arts and Letters, Newport Art Society and he was New Society of Artists' treasurer.

According to Adeline Adams in the *Dictionary of American Biography*: 'Quality, not quantity, was his aim, and no work left his studio until after he had devoted to it his best efforts'. Quinn had a keen sense of humour, 'though in his make-up Celtic melancholy predominated over Celtic mirth. The closing months of his life were clouded with melancholy, no trace of which appears in his final work.' On 10 May 1929 he attempted to commit suicide by poisoning. Of 207 East 61st Street, he ended his life by drowning in New York Bay on 9 September 1929, after saying at home that he was going to the bank. A memorial exhibition took place in 1933 at the Century Club, of which he had been a member.

Works signed: E. T. Quinn or Quinn.
Examples: Caracas, Venezuela. Dublin: Hugh Lane Municipal Gallery of Modern Art; National Gallery of Ireland. Kings Mountain, South Carolina: National Military Park. New Rochelle, New York: War Memorial. New York: Brooklyn Institute of Arts and Sciences; Brooklyn Museum; Central Park Mall; Edgar Allan Poe Cottage, Fordham; Gramercy Park; Metropolitan Museum of Art; New York University. Sligo: Yeats Society. Vicksburg, Miss.: National Military Park. Williamsport, Pennsylvania: William Howard Memorial Cathedral.
Literature: Lorado Taft, *The History of American Sculpture*, London 1903; *New York Herald Tribune*, 13 September 1929; *New York Times*, 13 September 1929; *Dictionary of American Biography*, New York 1935; *American Sculpture: A catalogue of the collection of the Metropolitan Museum of Art*, New York 1965; Frederick Fried, *New York Civic Sculpture*, New York 1976 (also illustrations); William M. Murphy, *Prodigal Father: The Life of John Butler Yeats (1839-1922)*, Ithaca 1978; Andrew Weinstein, *Chronology of the Life of Edmond Thomas Quinn*, typescript, 1987; Peter Hastings Falk, *The Annual Exhibition Record of the Pennsylvania Academy of the Fine Arts*, Pennsylvania 1989; Lycoming County Historical Society and Museum, *Letter to the author*, 1992; also, National Sculpture Society, 1992; Pennsylvania Academy of the Fine Arts, 1992.

R

RAFFERTY, PHIL (1919-96), abstract and figure painter. Born in Omagh, Co. Tyrone, on 18 February 1919, she was one of a family of eight children. Eileen Philomena, the daughter of Michael Rafferty, an engineer with Tyrone and Fermanagh County Hospital, attended Loreto Convent School, Omagh, where she was always drawing and sketching. Although she qualified as a teacher, but not in art, she did not take up the profession but sat the entrance examination for the Imperial Civil Service. She moved to London where she filled a clerical position with the Post Office.

During the London 'blitz' she transferred to Harrogate with other Post Office employees. There she was active in art lectures, musical evenings, debates with the Harrogate Discussion Group, formed in 1941, with a painter, Alice M. West, as secretary.

After the war she returned to London and lived at 41 Buckland Crescent, NW5. She met Gerard Dillon (q.v.), who was working in London refurbishing buildings damaged by the bombing, and they formed a lasting friendship. When he was hard up, she fed him. He had a strong influence on her development as a painter. At a later period he taught adult evening classes for the London Borough of Camden and there she studied with, among others, Arthur Armstrong and George Campbell (qq.v.).

The writer, Aidan Higgins, knew her for more than forty years, and she would visit him in Dublin. He first met her via Patrick Collins (q.v.) in the 1940s at the tower in Howth Castle. In a letter to the author, Higgins wrote: 'She was a quiet mystic stunned by rough life…tamed robins and finches in Swiss Cottage, fed toddies to stray neighbouring cats through severe winters in Willesden Green…sent Xmas cards of wading birds, was a steadfast friend…never a cross word; she was a person who saw, had a lovely laugh, was a great reader, made a fable of her friends…London would have been unendurable without her…I think often of her and Gerry Dillon, rare modest beings without any rancour in them, an extinct persona.'

Phil Rafferty travelled extensively, visiting Jamaica, hence *Walled Garden by the Sea, Jamaica*; the Cayman Islands, Paris; and Canada when her sister Agnes lived there. There was no painting in Canada. When the sisters visited New York her first priority was the Museum of Modern Art. She had an abiding interest in art, and her own work favoured mixed media, occasionally producing oil paintings and monotypes.

Dillon had the loan of a cottage on Inishlackan island off Roundstone, Co. Galway. Rafferty and Alice West visited him about 1950, staying on the mainland. Dillon rowed himself over. Correspondence showed that he encouraged and urged her to continue with her study, but she had little interest in selling her work. The only record of her exhibiting is in Dublin at the Irish Exhibition of Living Art in 1960, when she showed *Jamaica*, and in 1961 with *After the Khamsen*.

Several abstract compositions were produced. As already indicated, she had an affinity with nature and its creatures, for example in art, *The Woodpecker*; *Birds by a Pool of Fish*; *Birds Feeding*; *The Two Goats*. Among her other works were: *Crucifixion Group*; *At the Circus*; *Two Figures by a Waterfall*; *Nude in a Hammock*. She executed several sketches of Dillon, but after his death in 1971 she appeared to have lost interest in her own work. In 1985 she returned to Omagh to live with her sister Agnes, and died there on 1 April 1996. A studio sale of 167 works was held in Dublin in 1997.

Works signed: Phil Rafferty.
Literature: de Veres Art Auctions, *Phil Rafferty (1919-1996) Studio Sale*, catalogue, Dublin 1997 (also illustrations); Mrs Agnes Monk (née Rafferty), *Letters to the author*, 1997, 2000; Aidan Higgins, *Letter to the author*, 2000; also, Michael J. Quilty, 2000.

RÁKÓCZI, BASIL (1908-79), landscape, figure and still life painter. Basil Ivan Rákóczi was born on 31 May 1908 in Chelsea, London. His father, Ivan Rákóczi, was Hungarian, a composer, violinist and artist. His mother, Charlotte May Dobbey, hailed from Co. Cork and she was an artist's model. Basil began painting at

the age of three. His childhood was spent between England and France. After receiving a formal art training at Brighton School of Art, he studied at the Académie de la Grande Chaumière, Paris, and years later under the sculptor, Ossip Zadkine (1890-1967). In Brighton, his mother had married the Rev. Harold Beaumont.

In the late 1920s, Rákóczi worked as an interior decorator and commercial artist before turning to painting and psychology. In 1935 he founded the Society for Creative Psychology at 8 Fitzroy Street, London. At one of the meetings he met Kenneth Hall (q.v.) and they became close friends, visiting Spain and other European countries on painting expeditions. The two artists began to make paintings which drew upon the results of their experiments in psychoanalytic techniques. These works, which they called 'Subjective' paintings, were exhibited in Fitzroy Street under the name of the White Stag Group.

Rákóczi painted for a time as Basil Beaumont. His *Iona from Sligmeach*, oil on board, 1935, was signed Beaumont, and an undated watercolour, *Ostend, Harbour Scene*, was signed B. B. However, his common signature was Rákóczi, although *Ship*, oil on card, 1936, was signed R. In the 1930s both Hall and Rákóczi exhibited with the London dealer, Lucy Wertheim. Rákóczi sent a few pictures to the Royal Society of British Artists.

As war approached, the two friends decided to move to Ireland. In July 1939 they arrived in Dublin and after some weeks travelled to the West and rented a cottage at Delphi, Co. Mayo, overlooking Killary Harbour. Rákóczi paid the first of at least two visits to the Aran Islands, thus *Curragh crossing to Aran*, watercolour and ink on paper, exhibited at the White Stag Group show in Dublin, 1940, and *Two Houses, Kilmurvey*, ink, watercolour, gouache on paper, inscribed August 1944.

Missing city life, they returned to Dublin in March 1940, and revived the Society for Creative Psychology, also the White Stag Group for exhibitions. Other artists from England who happened to be living in Dublin lent their support together with some Irish artists such as Evie Hone, Mainie Jellett (qq.v.) and Patrick Scott. Rákóczi showed *Kelp Gatherers* at the 1942 exhibition of the Munster Fine Art Club.

There was no problem over the realistic aspect of Rákóczi's work, but the Subjective pictures with a touch of Surrealism aroused some artistic controversy. In November 1940 he held a one-person show. By 1943 some ten exhibitions of twentieth century art had been held at the White Stag Gallery, mainly at 6 Lower Baggot Street, Dublin.

In 1941, giving the address 60 Fitzwilliam Square, Dublin, he exhibited at the Water Colour Society of Ireland for the first time and from then until 1951 he contributed thirty-four works. In 1942 he showed four works: *Woman carrying a bucket*; *The Curragh*; *Arrangement in a Dream*; *The Newspaper Boy*.

In 1941 he had a work hung in London with the United Society of Artists. He held another solo show in Dublin, and two in 1942. In some of his oil paintings he drew with a pencil into wet paint. He first exhibited in 1942 at the Royal Hibernian Academy, *Digging Potatoes – Carraroe*, from 60 Fitzwilliam Square. *Near Carraroe*, watercolour and ink, is in the collection at the Butler Gallery, Kilkenny.

The introduction to *Three Painters*, by Herbrand Ingouville-Williams, the third original member of the White Stag Group, was written in Connemara in 1944 and featured Hall, Rákóczi and the Dublin artist, Patrick Scott. The theme was Subjective Art, 'drawn from the Unconscious by a process which might be described as meditation with paint'. Rákóczi was quoted: 'I do not start with a subject; it appears. Even if I think I have the conception in my head, ready to transpose on to the canvas, I find I am wrong. My conceptions must necessarily be modified by the medium and the area'. Among the Rákóczi illustrations in the book are: *Construction of an Idol*; *Eye Alone*. Dr Ingouville-Williams, a psychiatrist who assisted the Group financially, died in 1945.

An important art event for wartime Dublin, arranged by the White Stag Group, was the Exhibition of Subjective Art, 1944. However, referring to an exhibition at the White Stag Gallery in 1945, the *Dublin Magazine* commented on Rákóczi: 'The primitive flavour of some of his work is due to his adoption of a number of formal mannerisms in dealing with the human figure, the flat profile, for instance. His pen-drawings with wash are frequently interesting, though nearer to illustration than to painting. He is more successful where the mannerisms are absent, as in *Grave Stones, Kileany*. His oils do not show the same technical concentration and the colour is anaemic without being subtle.'

Although he left Ireland in 1946 and returned to London before eventually settling in Paris, he continued to exhibit occasionally in Dublin. In 1946, from 97 Swan Court, Chelsea, he showed *Percy Place* at the RHA; in all, he exhibited ten works at the Academy. In the last year, 1952, he contributed two monotypes, *The Owl* and *Seated Marionette*, and a watercolour, *The Cock of the Town*. At the Archer Gallery, London, he held an exhibition in 1953, seven cartoons, *The Tarot*. In the period 1944-60 he showed twenty-six works at the Irish Exhibition of Living Art.

On his exhibition at the Dublin Painters' Gallery in 1954 of oils, monotypes, gouaches and watercolours, the *Dublin Magazine* singled out the oils, particularly 'three strongly coloured and decisively patterned, *Father Beast*; *Mother Beast*; and *Beasts of Forest*, with their grotesque yet still suggestively anthropomorphic figures'. His book, *The Painted Caravan*, 'A Penetration into the Secrets of the Tarot Cards', appeared in 1954 and was illustrated by him. Arland Ussher, in his review in the *Dublin Magazine*, referred to the author as 'well known to artistic Dublin'. The 1964 exhibition at the Molton Gallery in London was titled 'Fiestas and Fantasies'.

The National Art Library in London has a copy of *The Caged and The Free*, published in Paris in 1955 'at the expense of the author's friends,' in French and English; 100 copies numbered with seven original lithographs.

Aran Monument and *The News Seller, Dublin*, both drawings, were presented to Queensland Art Gallery in Australia by Mrs Lucy Carrington Wertheim. Rákóczi exhibited in France, Holland, Monaco and elsewhere. He worked in Brittany, 1971-2. He illustrated several books of poems and other texts, many of which were published in Paris under the imprint of the 'White Stag Press'. At the Ulster Museum there are two oil paintings, *Chez les Sinclair* and *Nature Morte au Téléphone*. He died in London on 21 March 1979. In 1990 an exhibition of his work was held at L'Atelier de la Danse, Paris, and an exhibition of his costume designs and sets for the stage at the Galerie Arches et Toiles, Paris. In 1991 there was a retrospective show at a Dublin gallery, European Modern Art. In 1996 the Gorry Gallery, Dublin, held an exhibition of fifty-five works.

Works signed: Rákóczi or R., rare; Beaumont or B. B., rare (if signed at all).
Examples: Auckland, New Zealand: City Art Gallery. Belfast: Ulster Museum. Brighton: Sussex University. Brisbane, Australia: Queensland Art Gallery. Derby: Museum and Art Gallery. Dimona, Israel: Musée. Dublin: Trinity College. Kilkenny: Art Gallery Society. Limerick: University, National Self-Portrait Collection. Manchester: City Art Gallery.
Literature: *Irish Art Handbook*, Dublin 1943; Herbrand Ingouville-Williams, intro., *Three Painters*, Dublin 1945 (also illustrations); *Dublin Magazine*, April-June 1945, October-December 1952, April-June 1954, October-December 1955; *The Studio*, June 1953 (also illustration); Basil Ivan Rákóczi, *The Painted Caravan*, The Hague 1954 (illustrations); Basil Ivan Rákóczi, *The Caged and The Free*, Paris 1955 (illustrations); *Dictionary of British Artists 1880-1940*, Woodbridge 1976; Ann M. Stewart, *Royal Hibernian Academy of Arts: Index of Exhibitors 1826-1979*, Dublin 1987; Brian Kennedy: European Modern Art, *Kenneth Hall 1913-1946*, catalogue, Dublin 1991; S. B. Kennedy: European Modern Art, *Basil Rákóczi 1908-1979*, catalogue, Dublin 1991; S. B. Kennedy, *Irish Art & Modernism*, Belfast 1991 (also illustrations); Patrick Scott, *Letter to the author*, 1991; also, European Modern Art, 1992; Queensland Art Gallery, 1992; *Water Colour Society of Ireland Exhibition List 1872-1994*, Dublin 1995; S.B. Kennedy: Gorry Gallery, *Basil Ivan Rákóczi (1908-1979)*, catalogue, Dublin 1996 (also illustrations).

RATHDONNELL, LADY – see DREW, PAMELA

REDMOND, MARY (1863-1930), sculptor. Born in Nenagh, Co. Tipperary, in 1863, her family moved to Co. Kildare and her father obtained work in the limestone quarries at Ardclough, near Straffan. The yellowish quarry clay had a plastic quality which made it suitable for modelling and she experimented, making dolls for her companions and a model of the old schoolhouse for her teacher. However, she thought her masterpiece was a lady in a tight dress, with a large hat.

A local lady advised her parents to send her to Dublin for tuition but they could not afford it. However, after much persuasion and the help of friends, Mary, now nine years of age, was sent to live with other friends in Dublin, and attended a primary school.

According to Rosa Mulholland in her article in *Irish Monthly*, 1889: 'A gentleman took her to see Mr Farrell' – later Sir Thomas Farrell, PRHA (1827-1900) – at work in his studio and she persuaded him to allow her to do some modelling. He gave her white pipe clay to experiment with, and in a few days she returned with her first serious model, *A Hand on a Cushion*. Farrell righted its imperfections and advised her to study at the School of Art.

'Friends', she said, 'gave me money for sweets from time to time, and I saved this up till I had enough to buy my ticket for the School.' The headmaster of the Dublin Metropolitan School of Art, R. E. Lyne, was reluctant to admit her because of her size and age. In the end, he relented and she was accepted for tuition in drawing and painting and in this phase of study won her first scholarship with *Head of Brutus*.

According to Rosa Mulholland in the *Irish Monthly*, there was a period when she did not like the drawing class and ran away. 'Lyne found her in Farrell's studio. She said she would like to go back to the School if she was allowed to model. She was allowed a corner to mess in.' She soon earned a free scholarship.

In 1880 she exhibited at the Royal Hibernian Academy for the first time. Her contributions, a dozen in all, were mainly – if not entirely – portrait busts and medallions. In 1885 she showed *Bust of Albert B. Leech, Esq.*, giving the address, 16 Nassau Street, of Edmond Johnson's the jeweller, at the back of whose premises she had a tiny studio. At the 1886 RHA she gave another of his addresses, 94 Grafton Street. Her connection with Johnson had originated when he wanted a wolf modelled for the love-cups included in the Lord Wolseley presentation and she had been recommended by Lyne to do the work. Not only did the Dublin jeweller provide a studio free of rent but he also sent her sitters.

In her spare hours she worked at the decoration of pottery for Frederick Vodrey, owner of china, glass and earthenware warehouses in Mary Street and Moore Street, and she gave lessons to ladies in the art.

In either 1886 or 1887 a lady friend who had taken a great interest in her work took her to Rome and placed her in a convent to board, with liberty to extend her art education. Without a word of Italian, she entered a studio. After falling sick, she was ordered away to Florence for a change of air, with new convent accommodation, and she now studied under a Signor Romanelli. 'He introduced me to the School of the Belli Arti, where I remained till I had passed through the School of Perfection, and finished my course'

In 1887 she exhibited at the Walker Art Gallery, Liverpool, and gave Florence as her address. She did not show at the Royal Academy. Back in Ireland, in 1889 she completed the marble bust of Edmund Dwyer Gray in the studio of the portrait painter, Charles Russell (q.v.) at 6 St Stephen's Green, Dublin. Sixty-four years later a replica was presented to the National Gallery of Ireland by her daughter, Signora E. Papascogli. In the list of Sir Thomas Farrell's works, there is a bust of Gray.

In July 1889 Mary Redmond travelled to London to fulfil a commission for a bust of W. E. Gladstone, modelled at his home. This work, not in Hawarden Castle, remains untraced. In open competition, she was selected to do the Martin Memorial, 1889, which remained in the Phoenix Park RIC Depot until after the 'change over' when it was removed to St James's Church in James's Street, Dublin. In 1967 the bust of William Limerick Martin was moved to RUC Headquarters in Belfast; the remainder of the memorial is in St James's Graveyard.

Redmond's crowning work was the Father Mathew statue in O'Connell Street, Dublin, unveiled before a huge crowd on 8 February 1893 with the sculptor a member of the platform party. It was a unique achievement for an Irishwoman in monumental sculpture and executed not without trepidation. Her first model was an ex-footman whom she found in St Joseph's Night Refuge, and the fact that he was an 'out of work' from Naas influenced her selection.

Everything went on satisfactorily and the statue was nearing completion when her model began to give trouble with faulty posing. He arrived one morning in the studio very much under the influence of drink (hardly a fit model for the Apostle of Temperance) and seeing her reprimands were fruitless, she dismissed him. Next morning, returning to her studio, she found her almost completed work in pieces on the floor. The culprit was sentenced to seven years for his wanton act. Nothing daunted, she began all over again with a new model.

Marriage to a Dr Dunn of Florence took place in 1893 in London. Although she settled down to married life and the care of her two children, she subsequently modelled two angels for the Church of the Little

Company of Mary in Florence (since not traced), and in her last illness she was nursed by an Irish nun from that convent. She died on 16 January 1930.

Works signed: Mary Redmond (if signed at all).
Examples: Belfast: Royal Ulster Constabulary Museum, Knock Road. Dublin: O'Connell Street.
Literature: *Thom's Directory*, 1888; Rosa Mulholland, 'Mary Redmond, the Young Irish Sculptor', *Irish Monthly*, August 1889; *Weekly Freeman*, 11 February 1893; Walter G. Strickland, *A Dictionary of Irish Artists*, Dublin 1913; Nora J. Murray, 'Mary Redmond', *Capuchin Annual*, 1932; *Dictionary of British Artists 1880-1940*, Woodbridge 1976; Ann M. Stewart, *Royal Hibernian Academy of Arts: Index of Exhibitors 1826-1979*, Dublin 1987; Church of Ireland, Representative Church Body Library, *Letter to the author*, 1992; also, Clwyd County Council, 1992; Little Company of Mary Generalate, 1992.

REED, LOUIS, RUA (1886-1977), landscape, architectural painter and designer. Born in Liverpool on 20 March 1886, of a long-lived family, he was the son of Jacob Reed, a designer and tailor of ladies' clothes. He attended Liverpool College of Art. In the Department of Architecture at the University of Liverpool he was a prizewinner in the 1905 design class. An architectural prizewinner in the 1906 National Eisteddfod of Wales, he was articled to the Liverpool firm of Thomas, assisting in the design of some unusual undertakings, including the Broad Green Jewish Cemetery, Liverpool.

In 1910 he travelled from Liverpool to London accompanied by his friend, Bernard Meninsky (1891-1950), and saw Roger Fry's first Post-Impressionists' exhibition at the Grafton Galleries. 'We were turned upside down, and it had a lasting effect. In colour, form and design our whole outlook was transformed', he told the author in 1977.

When his father became ill he was obliged to leave Thomas's and assist in the family business. Later he went into wholesale tailoring as a designer but continued to paint, his early work as a portraitist and architectural painter. He showed in 1914 at the Walker Art Gallery, Liverpool, and at the New English Art Club, London, in 1923.

About 1944 he became a member of the Council of Industrial Design. In 1947 he retired from business, settled in Northern Ireland and soon became associated with the local art scene, showing with the Royal Ulster Academy. He also exhibited in Dublin with the Irish Exhibition of Living Art and contributed *Moon over the Wilderness* in 1965; *Mountainside*, 1966; *City of the Mist* and *Red Sky at Morning*, 1968.

In 1966 he had shown forty-two watercolours at the Anderson & McAuley gallery, Belfast. In his preface to the catalogue he wrote: '... these works have generally an underlying linear content and, in fact, in many cases they could be described as stained drawings. I like to develop a subject or idea and consider it more than once, from various aspects, as in the "Moon" series, the "Cathedrale engloutie" series, and here in the "Crawfordsburn" series.'

In 1967, the year he was elected an associate of the Royal Ulster Academy, he spent three weeks in Florence and the results were evident in his exhibition at the Arts Council Gallery, Chichester Street, Belfast, in 1968. The show was dominated by large architectural drawings in watercolour reinforced with crayon and gouache, for example *S. Maria Novella*; and *East Door of the Baptistery* is now in the collection of the Belfast Education and Library Board. He was represented in the Ulster Painting '68 exhibition.

In 1970 he shared again the Arts Council Gallery, this time in Beford Street, with a watercolour, *Loggia, Piazza del Consiglio, Verona* reproduced on his catalogue front cover. In 1970 too he was represented in the Arts Council of Northern Ireland's Open Painting Exhibition. In 1971 he held a one-person show at the Tom Caldwell Gallery, Belfast.

When he exhibited in a group show *Quarry, Co. Mayo* and other works at the Ben Uri Art Gallery, Dean Street, London in 1972 his nephew, the sculptor Marcus Kaye, was also represented. Reed himself, as a hobby, sculpted busts and heads.

A catalogue note for his show at the Octagon Gallery, Belfast, in 1973 stated: '... in spite of his years his work continues to show his particular ability to blend subtlety of perception with vigour in execution. His early training in architecture has influenced his style in which delicacy of line and a feeling for texture combine to give a highly evocative result.'

In 1974 he was elected an academician of the RUA. His association with the Tom Caldwell Gallery continued: 1975 and 1977, exhibitions in Belfast; 1976, Dublin. In 1976 he received an invitation to become president of the RUA but declined on grounds of age. His sister, Esther, was still alive aged 103 when he died on 26 March 1977 at Ards Hospital.

Works signed: Louis Reed; L. Reed or L. R., both rare.
Examples: Belfast: Arts Council of Northern Ireland; Belfast Education and Library Board.
Literature: Anderson & McAuley, Ltd, *Recent Water Colours by Louis Reed*, catalogue, Belfast 1966; Ben Uri Art Gallery, *Annual Exhibition*, catalogue, London 1972; Octagon Gallery, *Louis Reed*, catalogue, Belfast 1973; *Dictionary of British Artists 1880-1940*, Woodbridge 1976; Tom Caldwell Gallery, *Louis Reed*, catalogue, Belfast 1977; *Jewish Chronicle*, 22 April 1977; Mrs Ruth Houston (née Reed), *Letter to the author*, 1992.

REEVES, P. OSWALD (1870-1967), enameller, metalworker and designer. Percy Oswald Reeves was born on 10 August 1870 at 100 Crompton Road, Birmingham, the son of a schoolteacher, John Stanley Reeves. As he disliked the name Percy, he was always called Peter in the family. He studied first at night school in Birmingham and then at South Kensington.

He is believed to have worked with May Morris (1862-1938), daughter of William Morris (1834-96), and with the artist-craftsman, Alexander Fisher (1864-1938), who had his own school of metalwork and enamelling in Kensington, London, from 1896. Second master at the Southport School of Art for three years, he then accepted the headmastership of the Camden School of Art, London. In 1902 he arrived at the Dublin Metropolitan School of Art to teach metalwork and enamelling but during his career there he also gave instruction in design.

In the period 1904-09 he showed three works at the Royal Academy, one at the Walker Art Gallery, Liverpool, and in 1904, from 25 Kenilworth Square, Dublin, two at the Royal Hibernian Academy. The year 1904 also marked his first as a tutor at a Metropolitan School of Art summer course, and at the Arts and Crafts Society of Ireland's third exhibition he showed a Symbolist panel, *A Falling Star* (Cecil Higgins Art Gallery), enamel on copper with silver frame, at the Institution of Civil Engineers of Ireland, 35 Dawson Street.

Reeves was responsible for the 1908 presentation album bound in silver enriched with *repoussé* work and enamels, containing an address written and illuminated, presented by staff of the Department of Agriculture and Technical Instruction to Sir Horace Plunkett on his retirement from office as vice president. This work was destroyed when Plunkett's house was burned down in 1923.

A Double Star, slipcase cover, enclosing green leather book, was created in 1909. The title page of the book, which was shown at the Dublin Arts and Crafts Movement exhibition at Edinburgh in 1985, was inscribed in ink: 'Days to be Remembered'; final page inscribed: 'This book with silver and enamel case designed and executed by P. Oswald Reeves, ARCA, London, Dublin 1909'. The Guild of Irish Art-Workers was founded in 1910 and included Reeves. That year he exhibited in the Arts and Crafts Society exhibition, acting as secretary to the committee. A silver pendant with *repoussé* work was presented to the City of Dresden by the British members of the International Art Congress of 1912.

By 1913 a class in metalwork taught by Reeves was in the summer courses organised by the School of Art, and by 1919 he was instructing on jewellery. On the occasion in 1913 of his marriage to the enamellist, Dora K. Allen (1885-1981), a former pupil, his slipcase, made to contain the marriage certificate record and signatures of the guests, was in silver inlaid with white, green and gold enamel enrichment. He was among the exhibitors at the first exhibition of the Black and White Artists' Society of Ireland in 1913, and he also showed in 1914.

Reeves' contribution to the Honan Chapel, Cork, was described in 1916 by Sir John R. O'Connell in his book on the chapel: ' ... from the plain altar table rises a tabernacle of the same stone made in the form of an early Celtic reliquary. That this tabernacle should be made a note of splendour and of beauty one of the arts of early Ireland has been called to our aid, the art of enamel work ... The splendid conception of Mr Oswald Reeves – without doubt the most capable master of enamelling in this country – the Lamb of God pouring forth His Blood for the life and nourishment of His people ... is a proof, if proof were needed, of what excellent

and suggestive work can be made for the adornment of Irish churches by artists living and working in this country. The work is full of beauty and delicate feeling, and forms a brilliant point of luminous colour at the place where beauty and colour should be concentrated. The upper triangular space in the tabernacle is filled with an enamel representing the three Persons of the Blessed Trinity in the deep blue void of Heaven, attended by angels adoring, bearing in their arms the Sun and the Moon as symbols of the days of Creation.'

Reeves was secretary for the fifth exhibition of the Arts and Crafts Society in 1917. He wrote about it in *The Studio* which reproduced his enamel plaque, *The Response of the Rose*. The war memorial designed by him for Grangegorman Church was displayed at the Arts and Crafts Society exhibition in 1921 at the School of Art. *The Studio* described him as a colourist and the memorial as 'dignified and harmonious. Though this is the only work in the exhibition designed by Mr Reeves, there are, at least, thirty others by his pupils, all of which shows clearly his powerful influence.' The memorial was illustrated and described: 'Triptych of ebony, gold, silver oxidised copper, enamels, etc. Designed by P. Oswald Reeves, ARCA; woodwork by James Hicks; writing by George Atkinson, RHA; enamelling by P. O. Reeves; metalwork by J. F. Hunter and James Wallace.'

Reeves, as well as his wife, was represented in the exhibition of Irish art at Brussels in 1930. The Metropolitan School of Art had an international reputation for its enamelling work. This led to applications from foreign and colonial governments for the loan of examples for exhibitions in their own countries. A copy of the Cross of Cong was made for the centenary in 1934 of St Vincent's Hospital, Dublin, presented by the visiting medical staff.

In an interview in 1958, a jewellery-maker, Elizabeth O'Driscoll, described her former teacher as 'one of the well-known exponents of Art Nouveau. He emphasised the need for everything to have a hand-made look. "The imprint of the hand".'

The president of the Royal Hibernian Academy, Dermod O'Brien (q.v.), made the presentation and an address from students and friends of the School of Art when Reeves 'retired' in 1936; in fact, due to difficulty in finding a replacement, he continued teaching until 1938. The Lord Mayor, Alderman Alfred Byrne, TD, mentioned in his speech that Reeves had made ' ... two memorial tablets for Sir William Hickey; the trophy presented by the Free State to America for horse jumping competitions, and he recently completed the trophy to be presented by the Military Tattoo Committee to the Royal Dublin Society.' He also made badges, chains of office and altar candlesticks. Reeves died at his home, Wentworth Place, Wicklow, on 12 April 1967.

Works signed: OR, monogram, or O. R.
Examples: Bedford: Cecil Higgins Art Gallery. Cork: University College, Honan Chapel. Dublin: All Saints' Church, Grangegorman; St Vincent's Hospital. Sydney, New South Wales: St John's College. Terryglass, Co. Tipperary: Terryglass Church.
Literature: Sir John R. O'Connell, *The Honan Chapel Cork*, Cork 1916; *The Studio*, October 1917 (illustration), December 1921 (also illustration); *Irish Independent*, 31 July 1936; *Irish Times*, 27 May 1958; *Dictionary of British Artists 1880-1940*, Woodbridge 1976; John Turpin, 'The Metropolitan School of Art 1900-1923', *Dublin Historical Record*, March 1984, March 1985, June 1985; Nicola Gordon Bowe, *The Dublin Arts and Crafts Movement 1885-1930*, catalogue, Edinburgh 1985; Nicola Gordon Bowe, 'Symbolism in turn-of-the century Irish art', *GPA Irish Arts Review Yearbook*, 1989-90 (also illustration); Mrs C. Veronica Sexton (née Reeves), *Letters to the author*, 1991, 1992; Cecil Higgins Art Gallery, *Letter to the author*, 1992; also, St Vincent's Hospital, 1992; William Morris Gallery, 1992; John Turpin, *A School of Art in Dublin since the Eighteenth Century*, Dublin 1995 (also illustrations).

REID, EILEEN (1894-1981), landscape and figure painter. Eileen Florence Beatrice Oulton was born on 11 February 1894 at 19 Upper Mount Street, Dublin, the house which was to become her lifelong home. Her father was George Nugent Oulton, a barrister. After attending German High School in Wellington Place, her love of music found her studying at the Royal Irish Academy of Music, where she won a Coulson Exhibition in 1910 and a Coulson Academy Scholarship in 1911.

She must also have had a spell of tuition at the Dublin Metropolitan School of Art because she often spoke of the inspiration there of William Orpen (q.v.). She qualified as a teacher of music, having received her certificate of proficiency with honours in 1914.

A keen interest in painting saw her set off to London after the War and she entered the Royal Academy Schools in 1922. Here her progress was rapid and successful and was noted by Orpen, a friend of the family. On 26 June 1923, at St Stephen's Church, Dublin, where she had been baptised, she married Hugh C. Reid of Sloane Square, London, a member of the Colonial Service in Nigeria. He returned to his post, with his bride booked to follow sometime afterwards. As she was preparing for the long journey, the sad news arrived that he had died on 14 February 1924 of black water fever. He was aged thirty. She must have continued her studies at the RA Schools as she completed her studentship in 1927.

Teaching music eventually became her livelihood but she continued painting, for example in oils; *An Officer*; *Head and Shoulders of a Young Man*, both 1924; *Head of a Woman in a Black Dress*; *Nude Girl posing on a Stool*, both 1926.

Moving more towards watercolours, she was elected secretary to the Water Colour Society of Ireland in 1936 and agreed to act for one year. In the event, it became part of her life and she filled the post until 1973, accepting responsibility for the centenary exhibition in 1970. The annual exhibitions under her guidance were said to be 'triumphs of unobtrusive, benign but firm organisation'. She showed thirty-one works at the Society from 1933 until 1942, from *Berkshire Corn Stacks* in her first year to *Near Carna, Connemara* in 1942.

Eileen Reid did not exhibit at the Royal Hibernian Academy. Among other watercolours were: *Malahide*; *A Dublin Square on a Rainy Day*; *Cornfield near Carrickmines*. Among her undated oils were: *A Nude Girl with Bobbed Hair in front of a Stove*; *A Young Black Boy in Boxer Shorts*.

In an appreciation, Tom Nisbet, RHA, wrote in the *Irish Times* about the last time he left her fireside: '... I felt privileged to have observed a mode of life which transcended tragedy and attained a serenity beyond my understanding'. She died on 8 April 1981 at her home – and the service was in St Stephen's Church. An exhibition of her works took place at the Cynthia O'Connor Gallery, Dublin, in 1984.

Works signed: Oulton, Eileen Reid or E. Reid (if signed at all).
Literature: *Irish Times*, 10 and 23 April 1981; Cynthia O'Connor Gallery, *Eileen Reid (1894-1981)*, catalogue, Dublin 1984 (also illustrations); National Gallery of Ireland and Douglas Hyde Gallery, *Irish Women Artists: From the Eighteenth Century to the Present Day*, Dublin 1987 (illustration); Tom Nisbet, RHA, *Letter to the author*, 1992; also, Royal Academy of Arts, 1992; Royal Irish Academy of Music, 1992; Water Colour Society of Ireland, 1992; *Water Colour Society of Ireland Exhibition List 1872-1994*, Dublin 1995.

REID, NANO (1900-81), landscape, figure and portrait painter. Anne Margaret (Nano) Reid was born on 1 March 1900, the daughter of a Drogheda, Co. Louth, publican, Thomas Reid. Educated at the Sienna Convent, Drogheda, she was encouraged by her mother to paint and subsequently won a scholarship in 1920 to the Dublin Metropolitan School of Art. In later life she said that Harry Clarke (q.v.), who taught in the design room, had wielded a 'forceful influence'. A fellow student, Hilda van Stockum, described Nano Reid as a 'fierce red-head, stared with keen green eyes behind spectacles. She was uncompromising, blunt and desperately looking for truth ...'. At the School of Art, Nano entered on a course of teacher training.

In 1925 she began exhibiting at the Royal Hibernian Academy and continued spasmodically until 1968, forty-two works in all. In 1925 and 1926 she contributed illustrations, eight in all, for example *The Poet's Song*, 1925, and *Days of Loneliness*, 1926, all from 19 Northumberland Road, Dublin.

In 1928 she moved to Paris and attended La Grande Chaumière where a fellow Irish student was Kathleen Fox (q.v.). Nano was impressed by the work of Antonio Berni (1905-72) from Argentina, but of Italian emigrant parents, and in later years of multi-media environment fame. Next she went to London for a year and studied at the Central School of Arts and Crafts under Bernard Meninsky (1891-1950), who won renown as a teacher. She also studied at Chelsea Polytechnic.

In 1930 she returned to Ireland, and in 1931, after a gap of five years and from 20 James Street, Drogheda, exhibited three works at the RHA, including *The Bog Road*. Later in the year she joined Marion King (q.v.) and Olive Cunningham in an exhibition of paintings and craftwork at the Engineers Hall, Dawson Street, Dublin. Associated with the Dublin Painters, her first one-person show in 1934 was at their gallery at 7 St

Stephen's Green, and that year she was impressed with the Irish landscapes of the Belgian, Marie Howet (1897-1984). Reid too painted in the West of Ireland, showing two Achill landscapes at the 1934 RHA.

In her second solo show, in 1936 at the Daniel Egan Gallery, Dublin, she exhibited fifty-three watercolours and twenty-three oils, an exhibition that was rehung in Drogheda at the request of the Mayor. In 1939 she first exhibited with the Water Colour Society of Ireland and from then until 1950 contributed thirteen works. In 1941 Elizabeth Curran in The Bell considered that her watercolours 'conveyed a deep psychological understanding of her landscape subjects with such economy of her medium as to mark her independent merit ...'.

In an effort to make a living, she painted portraits. Reciprocally, she painted Estella Solomons (q.v.). In 1938 she was represented at the Irish drawings and paintings exhibition in New York and in the Dublin Painters' exhibition at the Architectural Association members' rooms, London, by The Bather. Another show took place in Dublin at The Gallery, St Stephen's Green, in 1939.

In 1941 and 1942 she exhibited again at the Dublin Painters' gallery, and among her portraits in 1941 were those of Elizabeth Curran and Art O'Murnaghan (q.v.). She also showed nine pastels, including Digging Potatoes and Road to Maam. Eileen O' Faolain's The King of the Cats, 1941, was the first of four books which she illustrated. When she exhibited at the first Irish Exhibition of Living Art in 1943 the Dublin Magazine described her as 'a bold and original painter but inclined to be rather too energetic in her approach and too afraid of colour'. In another one-person exhibition at 7 St Stephen's Green in 1944, her Bere Countryman was described in the same publication as 'a strong, forthright piece of work, refreshingly unsentimental'. She showed solo again in 1945. Meanwhile, her illustrations had appeared in the book by her good friend, Patricia Hutchins, Ivan and his Wonderful Coat, 1944.

As well as contributing to the IELA exhibitions she also showed at the Oireachtas but in the period 1943-53 inclusive she forsook the RHA. In 1944 at the WCSI, The Fallen Branch and Rhythm in the Corn were both hung. A decorative scheme at the Python Pool in the Dublin Zoological Gardens was completed in 1945 but later destroyed. In 1946 she was represented in the Living Irish Art exhibition at the Leicester Galleries, London.

In 1946 too with Frances Kelly she was commissioned to paint twelve large murals for the ballroom of the Four Provinces in Harcourt Street, Dublin, built by the Irish Bakers', Confectioners' and Allied Workers' Union at its new headquarters. Kelly painted scenes from labour history; Reid concentrated on trade-union movements. The building was demolished in 1988.

In 1947 she held the first of several exhibitions at the Dawson Gallery, Dublin, showing twenty-nine oils and sixteen watercolours, but in 1950 she also had solo exhibitions at the Victor Waddington Galleries, Dublin, and St George's Gallery, London, where she displayed watercolours. At this time she had a flat at 1 Fitzwilliam Square, Dublin.

In 1950 too her portrait of Patrick Swift (q.v.) appeared at the IELA, and the Dublin Magazine critic found it 'rich and low in tone, free and vital in paint and strong in structure, is one of her best pictures. The work has a forthright independence unusual in portraiture.' She was represented by two oils, Portrait of a Young Man and Dark Girl in the Contemporary Irish Painting exhibition which toured North America in 1950.

The most important of her 1950 exhibiting activities was to represent Ireland with Norah McGuinness (q.v.) at the Venice Biennale. Two years later she showed with Vilmo Gibello at the Hanover Gallery, London. Her contribution of twenty-two oil paintings included A Pub at Night and Rough Weather Inishlackan. In his foreword to the catalogue James White stated that at the Biennale at Venice 'critics were amazed to learn that she was a woman artist'. On the Hanover exhibition, The Studio commented that she 'wove a spell of visual Irish charm over patches of her native bog – she too shakes off the niggling demands of appearances and composes little scherzos in strong colour contrasts.' At the 1952 IELA, The Coalman attracted attention, and she was represented in the Contemporary Irish Art exhibition at Aberystwyth in 1953. In order to make ends meet, she gave private tuition.

Represented at the Mostra Internazionale di Bianco e Nero at Lugano in 1956, her work was also on international view at the Guggenheim International Award Exhibition at New York in 1960. Landscapes of her favourite Boyne country were prominent and oils predominated in her exhibition at the Dawson Gallery

in 1956. She was represented in An Chomhairle Ealaíon's exhibition, Twelve Irish Painters, at New York in 1963, by which time she was residing at Errigal, Sunnyside Villas, Drogheda.

The Arts Council of Northern Ireland showed her work at their Belfast gallery in 1964. *Tinkers at Slieve Breagh*, from the Arts Council, Dublin, collection, travelled to the New York World's Fair in 1964. At her 1966 Dawson Gallery show, *Shoal of Fish* and *Horse over Bridge* were two of the seven monotypes which she exhibited, along with oils, watercolours and drawings. By 1969 she had stopped painting in the Boyne Valley.

In the Arts Council's Modern Irish Painting European tour, 1969-70, Nano Reid was represented, also in the Rosc 71, The Irish Imagination, exhibition at the Hugh Lane Municipal Gallery of Modern Art. In 1972 she won the Douglas Hyde Gold Medal at the Oireachtas for the best painting of an Irish historical subject, *Cave of the Firbolg*, and that year she was represented in Florence at the Terzo Biennale Internazionale della Grafica d'Arte.

In 1974 the Arts Councils in Belfast and Dublin organised a major retrospective exhibition of 108 works dating from 1931. In 1980 she was represented in The Delighted Eye exhibition, London. A founder member of the Figurative Image Group, Dublin, she also showed with Independent Artists.

A portrait of Patrick Hennessy (q.v.) is in the National Gallery of Ireland. Some of the other works in public collections are: *Cats in the Kitchen* (HLMGMA); *Galway Peasant* (Ulster Museum); *Tinkers at the Gate* (Model and Niland Centre, Sligo); *Donkeys on Aran Shore* (Irish Museum of Modern Art); *Quayside Strollers* (Arts Council, Dublin).

Dorothy Walker, in her *Modern Art in Ireland*, 1997, wrote that Nano Reid went directly to the pictorial core of her subject-matter, 'assembling the elements of her narrative on a strictly two-dimensional surface and using the paint itself in a spontaneous, even childlike manner. She painted the images of daily life and her immediate surroundings...'.

A close friend of Gerard Dillon (q.v.), they painted in the West of Ireland with George Campbell (q.v.). She worked also in Counties Cork, Donegal and Kilkenny. Ambiguous about her age throughout her life, fiercely critical of church and commerce, on 17 November 1981 she died at Drogheda Cottage Hospital. Taylor Galleries, Dublin, held an exhibition in 1984. A retrospective took place at Droichead Arts Centre, Drogheda, in 1991, and again in 1999 in a joint exhibition with Camille Souter followed by the Linenhall Arts Centre, Castlebar, Co. Mayo.

Works signed: Nano Reid; N. Reid or N. R., rare.
Examples: Ballinasloe, Co. Galway: St Joseph's College. Belfast: Ulster Museum. Churchhill, Co. Donegal: Glebe Gallery, Derek Hill's Collection. Cork: City Library; Crawford Municipal Art Gallery. Drogheda, Co. Louth: Library, Municipal Centre. Dublin: Arts Council; Hugh Lane Municipal Gallery of Modern Art; Irish Museum of Modern Art; National Gallery of Ireland; Office of Public Works; Trinity College Gallery; United Arts Club; University College (Belfield); Vocational Education Committee. Galway: Art Gallery Committee; National University of Ireland. Kilkenny: Art Gallery Society. Limerick: City Gallery of Art; County Library. London: Irish Embassy. Santa Barbara, California: Museum and Art Gallery. Sligo: Model and Niland Centre.
Literature: Ulster Museum, *Nano Reid Biographical Notes*, mss, 1936; *Architectural Association Journal*, April 1938; Elizabeth Curran, 'The Art of Nano Reid', *The Bell*, November 1941; Eileen O'Faolain, *The King of the Cats*, Dublin 1941 (illustrations); *Dublin Magazine*, January-March 1944, April-June 1944, April-June 1950, October-December 1950, October-December 1952, January-March 1957; Patricia Hutchins, *Ivan and his Wonderful Coat, and other stories*, Dublin 1944 (illustrations); Máirtín Ó Diréain, *Rogha Dánta*, Dublin 1949 (illustrations); Patrick Swift, 'Nano Reid', *Envoy*, March 1950; Hanover Gallery, *Vilmo Gibello, paintings, Nano Reid, paintings*, catalogue, London 1952; *The Studio*, December 1952; *An Chomhairle Ealíon Annual Report, 1963-64*, Dublin; *Irish Times*, 16 March 1965, 14 March 1984, 4 April 1988; Elizabeth Hickey, *I Send My Love Along the Boyne*, Dublin 1966 (illustrations); *Who's Who, What's What and Where in Ireland*, Dublin 1973; Jeanne Sheehy, Arts Council: Arts Council of Northern Ireland, *Nano Reid*, catalogue, Dublin 1974 (also illustrations); National Gallery of Ireland and Douglas Hyde Gallery, *Irish Women Artists: From the Eighteenth Century to the Present Day*, Dublin 1987 (illustrations); Harold Osborne, *The Oxford Companion to Twentieth-Century Art*, Oxford 1987; Ann M. Stewart, *Royal Hibernian Academy of Arts: Index of Exhibitors 1826-1979*, Dublin 1987; Declan Mallon: Droichead Arts Centre, *Nano Reid: A Retrospective Exhibition*, catalogue, Drogheda 1991 (also illustrations); Belgian Embassy, London, *Letter to the author*, 1992; Declan Mallon, *Nano Reid*, Drogheda 1994 (also illustrations); *Water Colour Society of Ireland Exhibition List 1872-1994*, Dublin 1995; Dorothy Walker, *Modern Art in Ireland*, Dublin 1997 (also illustration).

REIGH, JOHN D. (1860-1914), cartoonist. Information about his early life has proved elusive. He was responsible for the Regular Carriers' banner carried in Dublin in 1875. In the hope of expanding the circulation of *Zoz*, he and his fellow cartoonists were asked to play down national politics and to play up Dublin society and aldermanic personalities in their work for the publication, which, however, folded in 1877.

By the early 1880s most of Dublin's largest newspapers had started to publish weekly colour cartoons which were printed on separate sheets and folded inside the Saturday edition, Reigh working for *United Ireland*. He showed four works at the 1880 Royal Hibernian Academy, including *A Disputed Point* and *The Arrest*, giving Richmond House, Inchicore, Co. Dublin, as his address.

In his *Apes and Angels: The Irishman in Victorian Caricature*, L. Perry Curtis, Jr, noted that at general election time, cartoonists such as Reigh drew special supplements for the leading newspapers which contained flattering portraits of the nationalist candidates: 'Some of the most angelic features in Irish cartoons were drawn by J. D. Reigh, when he portrayed the members of the Irish parliamentary party in the weekly supplement to *United Ireland* during 1885. In his *The Conventions*, 10 October 1885, Reigh drew dark-haired Erin, standing close to the noble figure of Parnell, reviewing the loyal Irish county conventions on the eve of the general election.' In the issue for 24 December 1885 appeared his double-page illustration, *The Irish Benches – The Irish Parliamentary Party of 1885*.

A portrait of Charles Stewart Parnell, pencil on paper, is in the National Gallery of Ireland. Dated 1891, it is inscribed: 'After finishing the above sketch Mr Parnell remarked to Mr Leamy, MP: "that Reigh is the only one who can do justice to my handsome face".' The work was bought from the artist in 1905.

Despite careful consultation, the registration of his death in Ireland could not be traced. However, turning to England, a John Reigh died at 16 Fairhurst Street, Ardwick South, Manchester, on 25 February 1914. The informant at the registry office was Patrick Reigh, a brother, of Co. Wexford.

Works signed: J. D. Reigh.
Examples: Dublin: National Gallery of Ireland.
Literature: *Register of Deaths, Ardwick,* Manchester 1914; L. Perry Curtis, Jr, *Apes and Angels: The Irishman in Victorian Caricature*, Newton Abbot 1971; Belinda Loftus, *Marching Workers*, Belfast 1978; Adrian Le Harivel, *National Gallery of Ireland Illustrated Summary Catalogue of Drawings, Watercolours and Miniatures*, Dublin 1983; Ann M. Stewart, *Royal Hibernian Academy of Arts: Index of Exhibitors 1826-1979*, Dublin 1987.

RENARD-GOULET, YANN , RHA (1914-99), sculptor. Born on 20 August 1914 in St Nazaire, Brittany, he was baptised Jean Gustave René Goulet, son of Gustave Goulet, hotelier and master chef. Painting and drawing skills went unnoticed until an aunt took an encouraging interest. He won a scholarship to Ecole Nationale Supérieure des Beaux-Arts in Paris, where he studied from 1933 until 1939, winning a first prize in drawing and a second in sculpture. One of his sculpture teachers was Charles Despiau (1874-1946), who had worked in the studio of Auguste Rodin (1840-1917).

Deeply interested in Breton culture, hence Yann instead of Jean, he was one of the Breton artists who decorated the House of Brittany at the Paris international exhibition of 1937, and secured the gold medal in that event. He showed three paintings at La Galerie Susse Frères in Paris in 1941. A member of the Breton Academy of Arts, in 1943 he showed with other members at the Galerie Perdriel, Rennes.

As a passionate Breton nationalist in the separist movement, he found himself in trouble with the French authorities after the Second World War. In 1947, on the pretext of mounting an art exhibition, he travelled to Ireland with a wife and two young children and false identity papers. They settled in Bray, Co. Wicklow, with little money, and he obtained employment making concrete blocks. Later, in the evenings, he gave art classes at his home.

When he won a competition in 1949 to design the Stations of the Cross for the Mother Home of the Redemptorists in Scotland, he borrowed money from the bank to build a studio in which to execute the work. Alas, the benefactor who was funding the project died, without leaving any financial provisions.

Another commission changed his fortunes dramatically. The Custom House Memorial competition in 1950 had been won by John F. Kavanagh (q.v.), who, however, took up a post in 1951 at the University of Auckland.

Dáithi P. Hanly, consultant in architecture and town planning, was initially involved with Kavanagh in designing the site layout. Hanly has recalled that Yann Renard-Goulet's 'inspiring figure was placed next and it will always remain, with his other fine public monuments, as a great tribute to a great sculptor.' The commission was officially awarded in 1952, the year he became an Irish citizen, and completed in 1956, a 5.5 m high bronze group celebrating the Dublin Brigade.

In an 1953 An Tostal exhibition of paintings and sculpture at the International Hotel, Bray, he showed with Paul Henry and Mabel Young (qq.v.) as Jean Renard, the name which he used on leaving France. At Bray Public Library, incidentally, is a head of Parnell. As a consequence of the Custom House achievement, requests for work started to come in and he was able to give up his manual day job. A bronze bust of Sir David Kelly, GCMG, MC, was exhibited in London at the 1956 Royal Academy.

In his 1957 Dublin exhibition at Brown Thomas's Little Theatre he showed twenty-seven paintings, for example: *Chapel, Gougane Barra*; *Roses*; *Florence*. Twenty-three pastels and drawings included *Ponte Vecchio*; *Venetian harmony*; and among the fifteen sculptures, *Guerilla fighter*; *No surrender*; *Dying Christ*. The *Dublin Magazine* critic commented: '...is a strong and accomplished portraitist in sculpture — and would be one in paint also, but for his (I think misguided) penchant for landscape...The sculpture of the *Dying Christ* is in a class by itself; the artist has portrayed pain, and the weariness after suffering, with the moving realism of a Gothic wood-carving...'.

Renard-Goulet was sculptor of the Kerry Memorial bronze group at Ballyseedy, Tralee, 1959. In Dublin, the Institute of the Sculptors of Ireland arranged an international exhibition in 1959 at the Municipal Gallery of Modern Art, where he was represented by five works: *Suffering Christ*; *Morning Dream*; *Victory over Temptation*; *Madonna of the Slums*; *Janet*.

In 1960 he was represented at the Royal Hibernian Academy and from the until 1993 he exhibited more than sixty works, initially under Goulet and then Renard-Goulet, sculpture predominating but occasionally oil paintings. Among his three exhibits in 1960 from Koatkeo, Herbert Road, Bray, was *Refugees*. Among four at the 1967 RHA were *Chain of Misery* and *The Rescue*. In an interview in 1969, he stated he was head of the National Council for the Liberation of Brittany.

In a Contemporary Irish Artists exhibition at the Cork Sculpture Park, 1969, he was represented by *The Gloomy Cock*, ceramic. Unveiled in 1972 was the East Mayo Brigade IRA Memorial at Kilkelly. At this time he was one of the external assessors for the National College of Art and Design. In 1976 at the Academy he exhibited *Fighting Angel*, and in 1979, *No Surrender* and *The Agony of the Artist*. A memorial to the Co. Tipperary athlete, Tom Kiely, was erected outside Ballyneale graveyard in 1978.

Renard-Goulet related how, under conditions of some secrecy, he was commissioned to make a large sculpture of a figure breaking free from its chains. When the piece was cast, the sculptor was taken, at dead of night, to oversee its installation. The destination was Crossmaglen, Co. Armagh, where, very quietly, the symbolic figure was installed in 1979 on a massive granite plinth. According to the Crossmaglen and District Development Co. Ltd. in 2000: 'The statue is a tourist attraction and practically every visitor to the town has a photograph taken in front of it.'

In the early 1980s he was commissioned for a bust of the founder of the Educational Building Society, Alasdair MacCaba. In 1981 a bronze head of Patrick Pearse was unveiled in Pearse Park, Tralee, Co. Kerry. Stations of the Cross were provided for St Fergal's Church in Bray, 1981. A replica of the 1982 bust of John Field for the National Concert Hall, Dublin, went to the Irish Embassy in Moscow. His *Head of Joyce*, 1982 RHA, was in an edition of nine; *Christy Ring*, edition of six. Among the bronzes at the 1983 Academy were *St Michael* and *In the Mood*. He became a foundation member of Aosdána in 1983.

The memorial to Christy Ring in Cloyne, Co. Cork, was unveiled by Jack Lynch in 1983. At the RHA in 1984 he showed six bronzes, including *Liberation Suffering* and *Guerilla Fighter*. In 1986, the year he was elected Professor of Sculpture, he showed seven sculptures. A bust of Parnell for the House of Commons was installed in 1988. In 1989 *Spring* entered the Electricity Supply Board head office, Dublin, where there is also an oil on board, *Turlough Hill*. *The Crucifixion*, 1989 sculpture, is at Most Holy Redeemer Church, Bray.

At the 1990 RHA, *1916* was unique. In 1993 he showed only an oil painting, *The Abyss*, and the same medium for *Cosmos* and *La Tempete* in 1999. He had a studio at 10 Duncairn Mews, Bray. An active part was taken in various organisations in the town, not least St Brigid's Youth Movement. In an appreciation, the RHA considered that his 'expressionist style in bronze marked him out as an innovative voice in Irish sculpture.' He died at Carysfort Nursing Home, Glenageary, on 22 August 1999. The Breton national flag was draped on the coffin and he was buried at Shanganagh Cemetery, Shankill, Co. Dublin.

Works signed: Yann Renard Goulet, Yann R. Goulet, Yann Goulet, Y. Goulet, Jean Renard, J. Renard or Y. Renard.
Examples: Ballyneale, Co. Tipperary: Outside graveyard. Bray, Co. Wicklow: Most Holy Redeemer Church; Public Library; St Fergal's Church. Cloyne, Co. Cork: GAA Park entrance. Crossmaglen, Co. Armagh. Dublin: Custom House; EBS Building Society, Westmoreland Street; Electricity Supply Board, Lower Fitzwilliam Street; Kilmainham Jail Historical Museum; National Concert Hall. Kilkelly, Co. Mayo. Limerick: University, National Self-Portrait Collection. London: House of Commons. Moscow: Irish Embassy. Tralee, Co. Kerry: Ballyseedy; Pearse Park.
Literature: Brown Thomas, Little Theatre, *Jean renard-goulet, u.s.b.,* catalogue, Dublin 1957; *Dublin Magazine*, January-March 1958; *Irish Times*, 9 January 1969, 24 August 1999, 4 and 8 September 1999; *Magill*, May 1979; Yann Renard-Goulet, *Letter to the author*, 1982; *Royal Academy Exhibitors 1905-1970*, Calne 1987; Ann M. Stewart, *Royal Hibernian Academy of Arts: Index of Exhibitors 1826-1979*, Dublin 1987; RHA catalogues, 1980-1986, 1988-2000; John Turpin, *A School of Art in Dublin since the Eighteenth Century*, Dublin 1995; Aileen C. Connor, *Aosdána*, Dublin 1996; *Saoirse*, September 1999; Crossmaglen and District Development Co. Ltd, *Letter to the author*, 2000; also, Electricity Supply Board, 2000; Ms Armelle Goulet-Conway, *Letters to the author*, 2000; Embassy of the Russian Federation in Ireland, *Letter to the author*, 2000; also, Tipperary Libraries, Thurles, 2000.

RHIND, ETHEL (1877-1952), stained glass artist and mosaicist. Ethel Mary Rhind was born on 1 December 1877 at Arrah, Bihar, India. Her father, Robert Hunter Rhind, a native of Edinburgh, was a civil engineer in the Indian Civil Service. Her mother was a Hannah Tate of Whiteabbey, Co. Antrim, related to the Gore-Booths of Lissadell, Co. Sligo. Sent home from abroad for education, Ethel attended the Ladies' Collegiate School, Londonderry.

In Belfast, she entered the Government School of Art and was awarded a scholarship to South Kensington. In 1902, when her father moved to Dublin from Belfast, she was awarded a scholarship for three years to study mosaic at the Dublin Metropolitan School of Art.

In 1907 she joined An Túr Gloine under Sarah Purser (q.v.), who had painted portraits of the Gore-Booth family at Lissadell. Ethel had visited the sisters, Eva and Constance Gore-Booth (q.v.) at their home. In 1907 her window, *Harmony and Fortitude*, was installed in Lissadell Church. Most of her commissions were for the Church of Ireland, and in 1908 she completed another one, again two-light, for Kinnitty Church, Co. Offaly.

Probably the first commission for *opus sectile* was for St Patrick's Church, Lower Glanmire Road, Cork: *Christ and Angels*, 1908. Three two-light windows at York Road Presbyterian Church, Dun Laoghaire, Co. Dublin, were completed in 1909, 1922 and 1925, and all had parables as subject matter. In the first exhibition organised by the Metropolitan School of Art students, in 1910, for past and present, her watercolours were described as 'excellent' by *The Studio*. In 1912 she designed a tapestry, *Smuainteac* (National Museum of Ireland) for the Dun Emer Guild.

In 1913, with a stained glass panel, she made her sole contribution to the Royal Hibernian Academy, from 69 Lower Mount Street, Dublin. In that year she completed the first of her two two-light windows for Townsend Street Presbyterian Church, Belfast: *Pilgrim's Progress*. *St Carthage* was her contribution to the Honan Chapel, Cork, 1916. Stained glass in the 1917 show of the Arts and Crafts Society of Ireland was seen in Dublin, Belfast and Cork.

Ethel Rhind, who lived with her sister, Sophia, a secretarial assistant at the Royal Irish Academy, was not the only employee of 'The Shop' involved in controversy with Sarah Purser over hours worked at An Túr Gloine. On 18 December 1918 she replied from 39 Pembroke Road, Dublin: 'I have myself, from the beginning of this week, been making an effort to get to work earlier in the day and have also on my own account started a book with which I have entered my hours of arrival and departure'

Thomas MacGreevy in 1920 considered that her drawing had gained in significance and one particular piece of stained glass, *Good Samaritan*, 'held its own with gentle insistence beside some of Mr Harry Clarke's most daring small panels'. A three-light window for St Mary's Church, Howth, Co. Dublin, *St Killian, St Michael and St George* was installed in 1920.

In *opus sectile* is the war memorial, *Archangel Michael*, a large panel secured into the exterior surface of the wall of All Saints' Church, Grangegorman, Co. Dublin, 1921. The poet Eva Gore-Booth had moved to Manchester where she was active in trade union organisation for women. She died in 1926 and Ethel Rhind was responsible for the window, *Memorial to Eva Gore-Booth*, 1928, for the Round House, Ancoats. It has been 'lost or destroyed'. A photograph of the window is held by the Pattee Library, Pennsylvania State University.

Following the Stations of the Cross in *opus sectile* for St Enda's Church, Spiddal, Co. Galway, she began in 1929 another set in the same medium for St Brendan's Cathedral, Loughrea, Co. Galway. MacGreevy, writing in the *Capuchin Annual*, highly praised the Loughrea work as 'the finest set of Stations in any church anywhere ... The wanly tragic scenes, with their pathetically dignified central Figure, are made an integral part of their architectural environment by being fitted into the wall. Blue, grey and olive in tone with here and there a little white ... The Connemara marble border or surround to each Station – it is nothing as assertive as a frame – is exactly the right hue and exactly the right width ... The successful calculation of all these technical factors shows Miss Rhind as the possessor of rare artistic cunning ... Miss Rhind is probably best known through the country for her excellent work as a stained glass artist, but I incline to think she will be remembered in ages to come primarily as the creator of the Loughrea Stations.'

A member of the Guild of Irish Art-Workers, her stained glass travelled to the United States. First, the three-light *St Catherine of Alexandria*, 1927, for the Sacred Heart Convent chapel at Newton, near Boston, Mass., and some ten years later a work for the chapel at Brophy College, Arizona.

In 1934 she completed Stations of the Cross in *opus sectile* for the Franciscan Friary at Athlone. She was responsible for *The Good Samaritan* at the Unitarian Church, Dublin, 1937, and in 1938 for the last two of five windows for the Church of Ireland chapel, St Dympna's Hospital, Carlow.

Studies for stained glass – and one for *opus sectile* – generally in ink, pencil and watercolour, are in the National Gallery of Ireland. In 1939 she retired. The last seven years of her life were spent in a Dun Laoghaire, Co. Dublin, nursing home, where she died on 6 March 1952.

Works signed: Ethel Rhind (if signed at all).
Examples: Ardnageehy, Co. Cork: Ardnageehy Church. Ardrahan, Co. Galway: St Teresa of Avila's Church, Labane. Arizona, USA: Brophy College. Armagh: St Mark's Church. Athlone, Co. Westmeath: St Anthony's Church. Aughnacloy, Co. Tyrone: St James's Church. Ballinasloe, Co. Galway: Presbyterian Church Hall. Ballymacormick, Co. Longford: Ballymacormick Church. Belfast: Townsend Street Presbyterian Church. Carlow: St Dympna's Hospital, Church of Ireland chapel. Carrickfergus, Co. Antrim: St Nicholas's Church. Castletownbere, Co. Cork: Sacred Heart Church. Cork: Honan Chapel, University College; St Patrick's Church, Lower Glanmire Road. Dublin: National Gallery of Ireland; National Museum of Ireland; St Columba's College; Unitarian Church, St Stephen's Green. Dun Laoghaire, Co. Dublin: York Road Presbyterian Church. Dundrum, Co. Dublin: St Nahi's Church. Farnaght, Co. Leitrim: Farnaght Church. Gorey, Co. Wexford: Christ Church. Grangegorman, Co. Dublin: All Saints' Church. Howth, Co. Dublin: St Mary's Church. Kilcullen, Co. Kildare: St John the Evangelist Church. Kilkenny: St Canice's Cathedral. Killarney, Co. Kerry: St Brendan's College. Kinnitty, Co. Offaly: Kinnitty Church. Knockaney, Co. Limerick: Knockaney Church. Letterkenny, Co. Donegal: St Eunan's Cathedral. Lissadell, Co. Sligo: Lissadell Church. Loughrea, Co. Galway: St Brendan's Cathedral. Magheralin, Co. Down: Holy Trinity Church. Malahide, Co. Dublin: St Andrew's Church. Newton, nr Boston, Mass., USA: Sacred Heart Convent. Raheny, Co. Dublin: All Saints' Church. Spiddal, Co. Galway: St Enda's Church. Tibohine, Co. Roscommon: Tibohine Church. Wallsend, Northumberland: St Peter's Church.
Literature: *Register of Baptisms at Arrah*, 1877; *Belfast and Province of Ulster Directory*, 1890, 1898; *The Studio*, March 1910, October 1917; Ethel Rhind, *Letter to Sarah Purser*, 1918, National Library of Ireland; An Túr Gloine, *List of Principal Stained Glass Windows Executed in Ireland from 1903 to 1928*, Dublin [1928]; Thomas MacGreevy, 'St Brendan's Cathedral, Loughrea 1897-1947', *Capuchin Annual*, 1946-47; James White and Michael Wynne, *Irish Stained Glass*, Dublin 1963; *Thomas MacGreevy Papers*, Trinity College, Dublin [1967]; Mrs Ruby Gee, *Reminiscences and notes on Ethel Rhind*, mss, 1979; National Gallery of Ireland and Douglas Hyde Gallery, *Irish Women Artists: From the Eighteenth Century to the Present Day*, Dublin 1987 (also illustration); Nicola Gordon Bowe, David Caron and Michael

Wynne, *Gazetteer of Irish Stained Glass*, Blackrock 1988; Church of Ireland, Representative Church Body, *Letter to the author*, 1992; also, Josslyn Gore-Booth, 1992; Royal Irish Academy, 1992; Franciscan Friary, Athlone,1997.

RIBOULET, EUGÈNE, RUA (1883-1972), landscape, figure painter and sculptor. Born on 29 March 1883 at Tarare, near Lyon, he studied at the École Nationale des Beaux-Arts in Lyon, 1902-06, winning a gold medal for anatomy and obtaining a first-class commendation in the 'Concours'. He was art teacher and then principal from 1930 at the École Municipale de Dessin et d'Art Industriel at Tarare. The college closed down in 1952.

During the First World War he was on active service and later he helped with the re-education of war disabled. After further studies in sculpture in Paris, he worked on various war memorials from 1920 to 1928 and one of these, entirely designed and executed by himself, stands in his home village. At an 1937 international exhibition in Paris, he won a gold medal for a vase in ceramic which is now in a public square in Lyon.

After his marriage to a teacher of French, Betty Brown of Belfast, he arrived in Northern Ireland in 1952, and soon became associated with the Royal Ulster Academy, showing one sculpture in 1954 and two paintings, *Mario Guitar Player* and *Standing Corn. Art Condemned* appeared at the 1961 exhibition, by which time he was an academician and was later given honorary status. In 1967, when the exhibition was held at the Ulster Museum and Gwyn's Institution, Londonderry, he contributed *Deserted Street* and *Harlequin*. In 1979 Glendun was the subject of a work.

Although he did not exhibit at the Royal Hibernian Academy, he was active with the Institute of the Sculptors of Ireland and showed at their exhibitions in Dublin in 1954, 1955 and 1956, five works in all. In 1954, from 137 Wandsworth Road, Belfast, where he built a studio at the rear, he contributed *Winter* and *Young Girl*. In Roman stone, he exhibited *Breton Peasant Girl* in 1955, and in the same medium, *Head of Faun*, in 1956.

In 1957 he showed forty-eight works: mainly oils, gouaches and pastels, at 55a Donegall Place, Belfast. Three large compositions dominated the exhibition and in these the artist was described in the *Belfast News-Letter* as having taken 'unlimited artistic licence and has skilfully woven together well-known architectural and natural features of Northern Ireland ...'. Landscapes painted in France and Spain were also on view, and there was a series of Spanish figure compositions, a still life with roses and three pieces of sculpture. North Africa was also a painting venue.

Professor Henri Godin of Queen's University, Belfast, wrote that Riboulet meditated deeply on the contemporary tendencies in art and studied the techniques that went with them. But 'he retained his own individuality and style which at all times reflect his love of life and serenity of spirit. His paintings are a sincere expression of his various moods and the warmth of his colouring conveys his harmonious relationship with the visible world. He had no real urge towards abstraction but, now and again, among intensely realistic productions, he would let loose his fancy and indulge in imaginative compositions just to manifest the sheer joy he took in his art.'

A Riboulet picture which was in the Arts Council of Northern Ireland collection was destroyed by fire in 1967. *June in the Cevennes*, oil, is in the Armagh County Museum collection. *Portrait of an artist* is in the RUA Diploma Collection. In 1971 he received from the French Government the Ordre du Mérite, but died before it could be officially conferred. Of 3 Ormiston Parade, Belfast, his death in hospital occurred on 4 August 1972, and that year the Visual Arts Group, Queen's University, arranged a retrospective exhibition. A studio sale of his works took place in Belfast in 1999.

Works signed: Eug. Riboulet or monogram.
Examples: Armagh: County Museum. Belfast: Royal Ulster Academy.
Literature: *Belfast News-Letter*, 19 March 1957; *Belfast Telegraph*, 7 August 1972; Visual Arts Group, Queen's University of Belfast, *Eugène Riboulet (1883-1972)*, catalogue, 1972; Martyn Anglesea, *The Royal Ulster Academy of Arts*, Belfast 1981 (illustration); Professor Henri Godin, *Letter to the author*, 1992; also, Joëlle Lambert, 1992; *Irish Times*, 24 April 1999.

RIVERS, ELIZABETH (1903-64), wood engraver, figure painter and illustrator. Born in England on 5 August 1903 at Sawbridgeworth, Hertfordshire, Elizabeth Joyce Rivers was the daughter of Thomas A. Rivers, FRHS; a grandmother was Irish. Educated at St Catherine's School, Bramley, Surrey, 1914-21, she studied art at Goldsmith's College, London, under Edmund J. Sullivan (1869-1933) from 1921 until 1924, showing a distinct interest in wood engraving. However, she worked in a commercial art studio for a short while and then succeeded in winning a scholarship in 1926 to the Royal Academy Schools where she 'learnt everything about painting' from Walter Sickert (1860-1942), and won a number of prizes and medals.

During her student days in London she illustrated with woodcuts C. S. Calverley's translation of Theocritus, *The Second and Seventh Idylls*, 1927; Alfred, Lord Tennyson, *The Day-Dream*, 1928; and ffrida Wolfe's rhymes for children, *The Very Thing*, 1928. Maurice Gorham, son of a Co. Galway doctor, became art editor of *Radio Times* in 1928 and further augmented her income by commissioning wood engraving illustrations. Of the seven woodcuts at the British Museum, six are dated, covering the period 1928-32, including *Head of Woman*, 1929, and *Two Dancers Resting*, 1932. In the 1928-31 period she exhibited five works at the Royal Academy.

In 1931 she left the Royal Academy Schools and with a legacy of £300 headed for Paris where she continued her studies for another three years, under André Lhote (1885-1962), the Italian-born Gino Severini (1883-1966), and at the École de Fresque. In 1932, in London, she was represented in the Wertheim Gallery's 'Twenties Group' (ages between 20 and 30) and *The Studio* commented that she showed 'considerable decorative ability in a big figure panel, though no great originality'. The first one-person show was held at the Wertheim Gallery, Manchester, in 1933. The following year she exhibited with the London Group.

In 1935 she journeyed to the Aran Islands. Intending only a stay of three months, the visit lasted a year. She travelled back in 1936 and lived there for seven years until she returned to wartime London for fire service in Westminster. At the Royal Hibernian Academy in 1936 her seven works included *Interval in the Ceilidhe* and *Dawn – Aran Islands*. On Inishmore her life was initially shadowed by a parish priest who was somewhat agitated by women who wore trousers.

In 1939 she showed at the Nicholson Galleries, London, the works including a chalk drawing of Henry Nevinson (National Portrait Gallery) which was done in 1937 for reproduction in the *London Mercury*, for which she did several portraits at that time, but this one was not reproduced.

The Guyon House Press published in 1939 *This Man*, a sequence of her wood engravings. Most copies of the book and all the blocks were destroyed in the fire following a 1940 attack on London. In 1940 she was elected a member of the Society of Women Artists. Contemporary Pictures, Dublin, showed her paintings in 1942. In 1943 she exhibited with the Water Colour Society of Ireland for the first time, with two nudes in the four works, and up until 1964 showed a total of sixteen works. She supplied sketches for Sean Dorman's *Valley of Graneen*, 1944.

In 1944 too she exhibited with the New English Art Club, also the Royal Academy, her address being 26 Princess Road, Regent's Park, London. On her return to Ireland in 1946 she held an exhibition at the Dublin Painters' Gallery; another followed in 1947. A friendship and working association began with Evie Hone (q.v.). During the last nine years of the stained glass artist's life, incapacitated by illness, she was able to pass on inch-scale designs to Elizabeth Rivers who developed them up to the full window scale. The great window for Eton College chapel was included in this work.

One of the results of the visits to the Aran Islands was found in her *Stranger in Aran*, 1946, which she illustrated with her pen and ink drawings, the last book published by the Cuala Press. A friend of Ethel Mannin, she illustrated with wood engravings her *Connemara Journal*, 1947, and contributed drawings for Clara Rogers' *Our Cornwall*, 1948.

Giving her address as Knockrabo Studio, Mount Anville Road, Dundrum, Co. Dublin, she showed a watercolour, *The Building of the Ark*, at the 1948 RHA. In that year she began to exhibit on a regular basis at the Irish Exhibition of Living Art, also she showed at the Oireachtas, and Patricia Lynch's *The Mad O'Haras*, for which she supplied pen and ink drawings, was published.

The Ball Game and *Still Life* at a 1949 exhibition of the Dublin Painters showed, said the *Dublin Magazine*, 'a modified abstract approach which is highly individual and considerable power in building up her

composition'. Later in the year she held a solo show at the Dublin Painters' Gallery. The *Dublin Magazine* critic considered that her oils were 'still in the process of evolution' but her watercolours showed 'an unstudied perfection in their sureness and harmony of colour and in the luminous quality of the wash'. An account of a visit to Israel in 1951 was later published in *Out of Bondage, Israel*, 1957.

In 1952 Victor Waddington Galleries published a portfolio, *Ireland: The Aran Islands*, containing six Rivers' wood engravings of life on the islands. As a tourist souvenir, it was priced at one dollar. She showed twenty-five oil paintings at the Waddington Galleries, 1953, and the *Dublin Magazine* critic was of the opinion that her best work was 'not likely to be easily popular, since it eschews the obvious and the facile'.

Represented at the Contemporary Irish Art exhibition at Aberystwyth in 1953, she exhibited two years' later *Eucalyptus*; *Strange Shore*; and *Still Life with Eggs* at the IELA, from Summerfield, Dalkey, Co. Dublin. She had contributed in 1954 to Waddington's Irish artist series of Christmas cards. In 1956 she was received into the Catholic Church.

For Christopher Smart's *Out of Bedlam*, Dolmen Press, 1956, she supplied twenty-seven wood engravings. She now took a particular interest in wood carving and in 1959 at the international exhibition at the Municipal Gallery of Modern Art of the Institute of the Sculptors of Ireland she was represented by *St Joseph with the child Christ*, elm wood.

The exhibition at the Dawson Gallery, Dublin, in 1960 was her last and among the watercolours were four cartoons for stained glass panels, and two pieces, *Absolution* and *Creation*. Among the oil paintings was the fourteenth Station of the Cross for the new church at Kilconeran, near Loughrea, Co. Galway. The total cost of the Stations was £260.

Noah's Ark, oil, is at the Irish Museum of Modern Art in Dublin. A portrait of Eamon de Valera is in the National University of Ireland, Galway, collection, and *Cat and Egg*, oil, is in the Ulster Museum with two wood engravings. She assisted with the formation of the Independent Artists group in 1960 and exhibited with them, also she was involved in the establishment in 1962 of the Graphic Studio in Dublin where she taught wood engraving.

The Second Fall, a painting of the fifth Station of the Cross, was one of the works selected by a jury at the 1962 exhibition of Irish Sacred Art in Dublin to form the basis of the Irish section, Salzburg Biennale. *The Cat* in 1963, and *Arab Woman and Child* in 1964, were her last contributions to WCSI.

Elizabeth Rivers died at her home in Dalkey, Co. Dublin, on 20 July 1964. A memorial exhibition took place at the Municipal Gallery of Modern Art in 1966. Other shows followed: Barrenhill Gallery, Howth, Co. Dublin, 1974; Gorry Gallery, Dublin, 1989.

Works signed: Elizabeth Rivers, E. J. Rivers, E. Rivers, E. J. R., Rivers or R. (if signed at all).
Examples: Belfast: Ulster Museum. Dublin: Hugh Lane Municipal Gallery of Modern Art; Irish Museum of Modern Art. Galway: National University of Ireland. Kilconeran, Co. Galway: Church of the Immaculate Conception. London: British Museum. Termonfeckin, Co. Louth: An Grianán.
Literature: Books illustrated: Charles Stuart Calverley, trs, Theocritus, *The Second and Seventh Idylls*, London 1927; Alfred, Lord Tennyson, *The Day-Dream*, London 1928; ffrida A. Wolfe, *The Very Thing*, London 1928; Walter de la Mare, *On the Edge*, London 1930; R. MacD. Douglas, *The Irish Book*, Dublin 1936; Elizabeth Rivers, *This Man*, London 1939; Frank O'Connor, *A Picture Book*, Dublin 1943; Sean Dorman, *Valley of Graneen*, London 1944; Elizabeth Rivers, *Stranger in Aran*, Dublin 1946; Ethel Mannin, *Connemara Journal*, London 1947; Patricia Lynch, *The Mad O'Haras*, London 1948; Clara C. Rogers, *Our Cornwall*, London 1948; Sean O'Faolain, *The Man Who Invented Sin and Other Stories*, New York 1949; Daniel Corkery, *The Wager and Other Stories*, New York 1950; Elizabeth Rivers, *Ireland: The Aran Islands,* Dublin 1952; *An Tostal Handbook*, Dublin 1953; *Initium Sancti Evangelii secundum Johannem*, Dublin 1953; Thomas Kinsella, *Poems*, Dublin 1956; Christopher Smart, *Out of Bedlam*, Dublin 1956; Elizabeth Rivers, *Out of Bondage, Israel*, London 1957; Lady Clara Vyvan, *On Timeless Shores*, London 1957; Thomas J. Kiernan, *The White Hound of the Mountain and other Irish Folk Tales*, New York 1962.
Literature: General: *The Studio*, April 1932; British Museum, *Miss E. J. Rivers*, iconography, 1945; Dublin Painters' Gallery, *Elizabeth Rivers Engravings*, catalogue, 1947; *Dublin Magazine*, July-September 1949, January-March 1950, July-September 1953; *Ireland of the Welcomes*, January-February 1953; *The Bell*, November 1954; *Paul Henry Papers*, Trinity College, Dublin [1958]; *Capuchin Annual*, 1961; *Irish Independent*, 19 February 1962; *Independent Artists*, catalogue, Dublin 1964; *Irish Times*, 22 July 1964, 8 May 1974, 28 June 1986; Municipal Gallery of Modern Art, *Elizabeth Rivers Memorial Exhibition*, catalogue, Dublin 1966 (also illustrations); Liam Miller, *The Dun Emer Press,*

Later the Cuala Press, Dublin 1973; Brian Kennedy: Gorry Gallery, *Elizabeth Rivers*, catalogue, Dublin 1989; Monsignor Michael Mooney, *Letter to the author*, 1992; *Water Colour Society of Ireland Exhibition List 1872-1994*, Dublin 1995.

ROBERTS, HILDA, HRHA (1901-82), portrait and figure painter. Born on 12 March 1901 in Dublin into a Quaker family, her father was Samuel Roberts, a builder. Even as a child she showed an interest in portraiture. She attended the German High School, Wellington Place, Dublin ('German' dropped from title in wartime) and said that she received a fine grounding there in drawing. Tradition in her family suggested that the principals, Misses Florence and Edith Wilson, introduced her to D.L.R. and E. O. Lorimer, and Hilda supplied the illustrations for their translation, *Persian Tales*, published by Macmillan, London, in 1919. The illustrations were drawn 'at the early age of 17', according to an article in a 1932 issue of *Model Housekeeping*. There were twenty-four full page illustrations including sixteen in colour.

In 1919 she entered the Dublin Metropolitan School of Art for two years and studied under Patrick Tuohy (q.v.). A colleague, Hilda van Stockum, found her 'a cheerful apparition, always smiling and dimpling with twinkling blue eyes'. In London she studied for two years at the Regent Street Polytechnic, where modelling was part of her course.

On her return to Dublin and the School of Art, she worked at sculpture with Oliver Sheppard (q.v.), winning the Taylor Scholarship for modelling in 1923 and 1924. In 1925 she won the California Medal for *Noon*, a nude sculpture, at the art exhibition, Royal Dublin Society. On the proceeds of the scholarships she studied in Paris for a year, but she also managed a private visit there with friends in 1926, and Tuohy wrote to her from Dublin.

On her return again to Dublin, she forsook sculpture for portrait painting, and when she exhibited at the Royal Hibernian Academy in 1927 from Ardlevan, Milltown, Co. Dublin, her portraits included those of District Justice Reddin and Patrick J. Tuohy. Altogether she showed nearly three score works at the RHA up until 1979, about half of which were portraiture. John Lyle Donaghy was married to her sister, Lilian Roberts; Hilda supplied an illustration for each of his books of poems published in 1927 and 1928. A portrait of Donaghy, 1928, is in the Ulster Museum.

Tuohy, home on a visit from New York, corresponded with her in Paris in October 1928. The much acclaimed portrait of George Russell (q.v.) followed in 1929, painted at his home in Dublin during the course of six Sunday morning sittings and exhibited at the Hackett Galleries, New York, 1930, and is now in the Ulster Museum. In 1929 she had also spent several months in the West of Ireland, painting mostly peasant children.

All the illustrators – and Hilda Roberts was one – of the *Dublin Civic Week 1929 Official Handbook* were associated with the Dublin Book Studio. She was involved in illustrations for other publications, such as designs for the Cuala Press's *Lyrics and Satires from Tom Moore*, 1929.

In 1929 and 1931 she held exhibitions at the Dublin Painters' Gallery, 7 St Stephen's Green. The great majority of her paintings and drawings in the 1931 display were executed in the West of Ireland. Achill children were prominent in the portraits and there were some landscapes in watercolour. By now, her address was Palermo Cottage, Bray, Co. Wicklow, and at the 1931 RHA she showed '*Youth*' and *A Fairy Child*.

Prizewinner at the Aonach Tailteann exhibition of 1932, her child portraits were singled out that year in a group show of the Dublin Painters. In December 1932 she married a headmaster, Arnold Marsh, so that from the New Year she took up residence at Newtown School, Waterford. At the 1933 exhibition of the Munster Fine Art Club she showed a portrait of Mrs T. H. Jacob. Among the portraits at Newtown are those of two headmasters, Marsh and Liam Glynn.

A committee of local artists inspired by Hilda Roberts began the 'Waterford Art Exhibitions' in the gymnasium of the school in 1934. The interest in art which these exhibitions aroused led to the establishment of a permanent collection in Waterford, and she is represented by two portraits rendered in the Newtown area: *Mick Dunne*, pencil; *Mrs Wynne*, oil. A member of the exhibition committee, Robert Burke (q.v.), has recalled that there was no financial assistance for the school exhibitions, and work was sent down from Dublin by the dealer, Victor Waddington, who was 'very helpful'. The 1937 exhibition was opened by Paul Henry (q.v.) and Jack B. Yeats (q.v.) officiated in 1938.

In 1940, when she exhibited at the RHA, her home was at Woodtown, near Rathfarnham, Co. Dublin. At the 1941 Academy she showed *Bobaleen* and *Head of an Old Woman*. On a contribution to the 1943 Irish Exhibition of Living Art, the *Dublin Magazine* expressed astonishment 'with a very fine incursion into a new medium for her, *Resurrection from the Dead*, a design for stained glass in which the contrapuntal composition with the lead was most effective'. (Early in her career she had spent six months in the stained glass studios of J. Clarke & Sons).

The *Dublin Magazine* regarded *The Whitechurch Bus* at the 1945 RHA 'a vivacious picture, humorous in its drawing and gay in colour'. For the 1952 RHA she despatched from Drogheda as her husband had taken over the headmastership of the Grammar School; her portrait of him is in the school. At the 1962 RHA she showed a portrait of the monkey keeper at Phoenix Park Zoo, John Joseph Supple.

Taylor Galleries, Dublin, held a retrospective exhibition in 1979. In that year she recorded that her abiding passion had been the study of the human face, 'its endless variety, character and beauty'. Austin Clarke recalled that she was known in Dublin as 'Cinderella' as she flitted enchantingly from subject to subject. Pencil portraits of Gerda Fromel (q.v.) and Samuel Beckett are in the National Gallery of Ireland, and that of Brinsley MacNamara is at the Abbey Theatre. She received honorary membership of the RHA. At home, she died on 18 June 1982. As part of the school's bicentenary celebration, a retrospective exhibition of her work was held at Newtown School in 1998, followed by RHA Gallagher Gallery; and in 1999 at Hunt Museum, Limerick, and Crawford Municipal Art Gallery, Cork.

Works signed: Hilda Roberts, H. Roberts or HR monogram.
Examples: Belfast: Ulster Museum. Drogheda, Co. Louth: Grammar School; Library, Municipal Centre. Dublin: Abbey Theatre; Arts Council; Hugh Lane Municipal Gallery of Modern Art; National Gallery of Ireland; Royal Zoological Society of Ireland. Limerick: City Gallery of Art. Lisburn, Co. Antrim: Friends' School. Waterford: City Hall, Municipal Art Collection; Newtown School.
Literature: *Thom's Directory*, 1910, 1916; D. L. R. Lorimer and E. O. Lorimer, trs, *Persian Tales*, London 1919 (illustrations); *Royal Dublin Society Report of the Council*, 1923, 1924; Patrick J. Tuohy, *Letters to Hilda Roberts*, 1926, 1928; John Lyle Donaghy, *Primordia Caeca*, Dublin 1927 (illustration); also *Ad Perennis Vita Fontem*, Dublin 1928 (illustration); *Dublin Civic Week 1929 Official Handbook* (also illustrations); Bulmer Hobson, ed., *A Book of Dublin*, Dublin 1929 (illustrations); Seán Ó Faoláin, ed., *Lyrics and Satires from Tom Moore*, Dublin 1929 (illustrations); *New York Times*, 2 March 1930; *Irish Independent*, 9 June 1931; *Daily Express*, 12 June 1931; Isobel Grubb, *Quaker Homespuns*, London 1932 (illustrations); Bulmer Hobson, ed., *Saorstát Éireann Official Handbook*, Dublin 1932 (illustrations); *Model Housekeeping*, n.d. [1932]; *Dublin Magazine*, January-March 1944, July-September 1945; *Ulster Museum Recent Acquisitions*, Belfast 1974; Taylor Galleries, *Hilda Roberts*, catalogue, Dublin 1979; Mrs Eithne Clarke (née Marsh), *Letters to the author*, 1982, 1983, 1992; *Irish Times*, 21 June 1982, 8 June 1983, 16 March 1985; Robert Burke, *Letter to the author*, 1984; Garter Lane Arts Centre, *Waterford Municipal Art Collection*, Waterford 1987; National Gallery of Ireland and Douglas Hyde Gallery, *Irish Women Artists: From the Eighteenth Century to the Present Day*, Dublin 1987 (also illustrations); Royal Zoological Society of Ireland, *Letter to the author*, 1992; Newtown School, *Hilda Roberts, HRHA, 1901-1982*, catalogue, Waterford 1998 (also illustrations).

ROBINSON, A. MARJORIE, ARMS (1858-1924), miniature portrait painter. Born in Windsor Place, Belfast, on 15 August 1858, Annie Marjorie Robinson showed evidence of an interest in art when, at the age of twelve, she spent much time working out ornamental borders for the pages of her homework, consisting of rustic designs of twigs and flowers. The teacher urged her to study drawing and introduced her to Vere Foster, who in turn placed her under the tuition of John Vinycomb (q.v.), head of the art department at Marcus Ward's, where she became skilled in illuminating.

When with the Belfast firm, she also attended classes in the Government School of Design where she won prizes and an exhibition of three years free tuition for proficiency in drawing. For some time she worked at illuminating on her own account and had a considerable connection for illuminated addresses, frequently being called on to insert vignettes, portraits and landscapes in the borders. In the early 1890s she began exhibiting at the Belfast Art Society, mostly portraits and landscapes, and later miniatures. At Garfield Chambers, Belfast, she rented a studio.

In 1907 she decided to take up miniature portraiture and moved to London, where she received tuition from Alyn Williams (1865-1955) of the Royal Society of Miniature Painters. When in London, she also

studied modelling, and in 1911, from the Belfast Art Society exhibition, the Belfast Museum and Art Gallery purchased her plastic bust, *A Study from Life*. Her address was 36 Waterford Road, Fulham, and she showed regularly with the Society of Miniature Painters, being elected associate in 1912. In 1911 she had contributed *Spring*, probably a painting, to the Royal Academy and between 1914 and 1923 showed nine works.

In 1911 too she had exhibited inaugurally at the Royal Hibernian Academy, and in ten years showed thirty-one works. In 1912 with a series of miniatures she gave the address 2 Duncairn Avenue, Belfast, the home of her brother, John B. Robinson, who took a keen interest in her progress. For the 1913 Dublin exhibition, she sent miniatures from 50 Addison Gardens, West Kensington.

On the outbreak of war, she returned to Belfast, at 139 Antrim Road, and in 1917 was appointed an associate of the Society of Women Artists. In 1919, she contributed to the RA: *George Hammond, Esq.* and *Portrait of the artist*. Outside of London, she showed a score of works at the Walker Art Gallery, Liverpool.

Princess Marie Louise wrote to Marjorie Robinson on 10 September 1922 requesting a Colleen for the Queen's Dolls House and acknowledged receipt of same on 25 October 1922. The watercolour, *An Irish Girl*, measured 38 x 24mm. In that year's exhibition of the Belfast Art Society she showed four watercolours, a portrait in oils and a case of six miniatures.

Among other works in the Ulster Museum are three decorative panels on St Brigid; a self-portrait oil on canvas; a watercolour on card, *Cavehill from Belfast Harbour*, and the gift of her brother, twenty-two miniatures, all watercolour on ivory, including *Man in Elizabethan Ruff*, 10cm x 7.5cm; *The Gipsy*, 9cm x 7cm; *The Fortune Teller*, 9.2cm x 7cm.

Reverie, 1914, was exhibited in 1987 in the Irish Women Artists' exhibition in Dublin, and Eileen Black commented in the catalogue: 'The excellence of Marjorie's talent as a miniaturist is clearly obvious in this portrait. Beautifully modelled and delicately handled, it displays an arresting realism, full of introspection and tinged with wistfulness.' A miniature portrait of a young lady is in the National Gallery of Ireland.

'A serene and equable professional career', one writer commented. 'She never came into the full blaze of fame's searchlight, but retained unimpaired to the last the reputation she had gained by excellent artistic work', On 22 October 1924 she died in Belfast. At the Belfast Art Society's exhibition in the Free Library, her pictures were draped in black because she had died since opening day.

Works signed: A. M. Robinson, A. M. R., Marjorie Robinson or M. Robinson.
Examples: Belfast: Ulster Museum. Dublin: National Gallery of Ireland.
Literature: *Belfast Directory*, 1906; *Belfast Museum and Art Gallery Quarterly Notes*, March 1912; *Northern Whig*, 29 October 1924; John B. Robinson, *Letter to Belfast Museum and Art Gallery*, 1925; *Belfast Museum and Art Gallery Annual Report*, 1 April 1925-31 March 1926; *Dictionary of British Artists 1880-1940*, Woodbridge 1976; John Hewitt and Theo Snoddy, *Art in Ulster: 1*, Belfast 1977; *A Concise Catalogue of the Drawings Paintings & Sculptures in the Ulster Museum*, Belfast 1986; National Gallery of Ireland and Douglas Hyde Gallery, *Irish Women Artists: From the Eighteenth Century to the Present Day*, Dublin 1987 (also illustration); Angela Jarman, *Royal Academy Exhibitors 1905-1970*, Calne 1987; Ann M. Stewart, *Royal Hibernian Academy of Arts: Index of Exhibitors 1826-1979*, Dublin 1987; The Royal Library, Windsor Castle, *Letter to the author*, 1992.

ROBINSON, DOLLY (1901-77), theatre designer and landscape painter. Dorothy Travers Smith was born in Dublin, on 26 October 1901, the daughter of Richard Travers Smith, MD, FRCPI, of 20 Lower Fitzwilliam Street. A grandfather was Professor Edward Dowden. In Dublin she studied with Estella Solomons (q.v.) and then at the Chelsea School of Art, London.

In London, she worked for a repertory theatre which put on a different play every week for six months, and designed and painted a change of scenery for each show. A lifelong friend of Norah McGuinness (q.v.), they first met in London where Dolly lived with her mother Hester, a medium and student of psychical phenomena, at Cheyne Gardens.

In Dublin in 1926 Dolly held her first exhibition of oil paintings, and at about the same time *Emperor Jones* by Eugene O'Neill was planned for the Abbey Theatre by the Dublin Drama League. She was asked to do the stage design and it was such a marked success in 1927 that she received commissions in set and

costume design for the Abbey Theatre. Also in 1927 for the Drama League she was responsible for the sets for *Caesar and Cleopatra* by George Bernard Shaw.

In 1928 her futurist designs were used for *King Lear*, the Abbey's first attempt at a Shakespeare play. In the first production of *Fighting the Waves*, 1929, a ballet-play by W. B. Yeats, D. Travers Smith designed the costumes and curtain, and in 1931 the costumes for the Abbey School of Ballet's *Fedelma*.

Yeats wrote to her in November 1929: 'You ask me what I think of the work you have done for us in Dublin. We are greatly indebted to you, you have transformed the whole look of our stage; our setting of *John Bull's Other Island* was meaningless chaos but you gave it order and beauty; the scene where one looks down towards the Round Tower has caught the romance and mystery of Connaught; the whole play seems different. You have done admirable scenes for Lady Gregory's little comedies. I was away when your *King Lear* came upon the stage but I saw the designs and I have no doubt it was as effective as your other work. You certainly contributed your share towards the success of Lennox Robinson's *Ever the Twain* which promised when I left Dublin to be the greatest success we have had for years. You have one very great advantage which is that you combine aesthetic sensitiveness and novelty with a grasp of the necessities of the stage, you have never brought us an impractical design.'

In 1931 she married Lennox Robinson, a former manager of the Abbey, at the Register Office, Chelsea, and accompanied him on an American tour. At their home, Sorrento Cottage, Dalkey, Co. Dublin, she entertained, among others, students from the Abbey School of Acting.

Cordyline Palms, 1935, oil, is in Crawford Municipal Art Gallery, Cork. Her sole contribution to the Royal Hibernian Academy appeared in 1936 when she showed *Bungalows*. In her exhibition at 7 St Stephen's Green, Dublin, in 1938 she showed forty-nine works, including landscapes of Counties Cork, Donegal, Dublin and Sligo. *Donegal Bay*; *The Three Rock*; *Towards the Old Head, Kinsale* were exhibited. In Britain, titles indicated a visit to the Isle of Mull; also included: *A Wiltshire Farm*; *Towards Salisbury*. Further afield, in France for example, she showed *Edith Wharton's Garden, Hyères*; and *A Villa in Cannes*. Majorcan scenes were also on view.

A Dublin critic, on the 1938 exhibition, thought she could make 'something out of the most uninspiring subject ... She is interested in shapes, in the divisions of things ...'. In his autobiography, *Curtain Up*, 1942, Lennox Robinson referred to Edmund Dulac (1882-1953), Dolly Robinson and Norah McGuinness being called on to design for the Plays for Dancers.

Mícheál Mac Liammóir, in his autobiography, *All for Hecuba*, 1946, found her 'easy to know, bubbling with good nature, barbed with wit, her lazy innocent smile would carry her unharmed through the heart of cannibal forests ...'. In visualising Lennox Robinson at home, he thought too of Dolly painting 'the wooden hills beyond the garden'.

A member of the United Arts Club, Dublin, as were her husband and mother, she helped occasionally in organising art exhibitions at the club. In the early 1960s she was curator for a short spell of the Joyce Museum at Sandycove. Lennox was buried at St Patrick's Cathedral, Dublin, and that was his widow's last resting place. A charcoal drawing of her by Margaret Clarke (q.v.) is in the Crawford Municipal Art Gallery. Of 20 Longford Terrace, Monkstown, Co. Dublin, she died in a Dublin nursing home on 4 November 1977.

Works signed: Dolly Robinson.
Examples: Cork: Crawford Municipal Art Gallery.
Literature: General Register Office, Dublin, *Birth Certificate*, 1901; *Thom's Directory*, 1910; Abbey Theatre programmes, 1919-1937; W. B. Yeats, *Letter to Dolly Robinson*, 1929; Constance Powell-Anderson, 'Through Patricia's Eyes', *Model Housekeeping*, n.d.; *Irish Press*, 29 September 1938; *Paintings by Dolly Robinson at The Gallery, 7 St Stephen's Green, Dublin*, catalogue, 1938; Lennox Robinson, *Curtain Up*, London 1942; Mícheál Mac Liammóir, *All for Hecuba*, London 1946; *Who Was Who 1951-1960*, London 1961; Michael J. O'Neill, *Lennox Robinson*, New York 1964; *Irish Times*, 5, 8 and 11 November 1977; Liam Miller, *The Noble Drama of W.B. Yeats*, Dublin 1977 (illustrations); Brenna Katz Clarke and Harold Ferrar, *The Dublin Drama League 1918-1941*, Dublin 1979; Hugh Hunt, *The Abbey: Ireland's National Theatre 1904-1979*, Dublin 1979; Patricia Boylan, *All Cultivated People: A History of the United Arts Club, Dublin*, Gerrards Cross 1988.

ROBINSON, MARKEY (1918-99), landscape, figure painter and sculptor. Born on 7 February 1918 at 4 Arkwright Street, Belfast, David Marcus Robinson was the son of a housepainter of the same name. He attended Perth Street Public Elementary School, borrowing books on art from the public library. At the Belfast College of Art he studied for a short period. He learnt much of his art and colour co-ordination from his grandfather, Thomas Robinson, an established painter and decorator.

A merchant seaman for two years, he travelled to Canada and South Africa. As a lightweight, he boxed in Belfast, under various names, at the Ulster Hall and Ulster Stadium. In 1942, three of his paintings were hung at the Ulster Academy of Arts exhibition: *Autumn Landscape*; *Boulogne*; *Irish Port, 1940*.

A member of the Casualty Service, and now an electric welder, he exhibited at the Northern Ireland Civil Defence Art Exhibition at the Belfast Museum and Art Gallery in 1943: *Bomb Crater in Eglinton Street* (Ulster Museum) and *Fire at the International*. Both paintings were later included in the Civil Defence Exhibition in London. He was represented at the Ulster Academy exhibition in 1944, when *Painting* appeared at the Irish Exhibition of Living Art, Dublin. Another activity was the decoration of water glass sets, which he sold commercially and individually.

Immortalised in F. L. Green's *Odd Man Out*, 1945, he was the basis for the character of Lukey Mulquin: 'The frayed sleeves of his jacket had shrunk, leaving exposed his strong, flowing wrists that terminated in lithe hands that were suggestive of his curious temperament and the peculiar ideas which often massed themselves in a formidable, straining intensity in his mind... It was a curious, wayward existence, led amongst acquaintances who were the same heedless temperament as himself. Yet through it all there was a thread of his fate which gave him individuality. He was like a rare flame amongst these other beings...'.

A 1940s portrait of his wife, May, *Woman in White*, originally owned by Green, is now at UM. In 1947 he held an exhibition at the Country Tea Shop, Dublin. In 1948 he was involved in three exhibitions: At Heal's Mansard Gallery, London, he showed nine works, including *Feast of Corpus Christi*; CEMA gallery, 55a Donegall Place, Belfast; and organised 'Peasant Art' at Mills and Gray's Gallery, Belfast.

On his exhibition at the Cottar's Kitchen, Belfast, in 1950, the *Northern Whig* critic found the individual artist emerging 'in a series of vignettes and fair-sized pictures of France, and in a couple of local country scenes. The French street scenes have a charm all their own and he catches quite admirably the atmosphere of the quieter cafés off the main boulevards...'.

In Contemporary Ulster Paintings at Edinburgh, 1951, he was represented by *The Tobacco Shop*. Thirty-four works at 55a Donegall Place in 1952 included the oils, *Evening at St Michel*; *Summer Shower, Brittany*; *The Shepherdess*. CEMA's exhibition of sculpture, Belfast Museum and Art Gallery, 1953, produced *Man and Wife*. Paintings and sculpture were presented at the Donegall Place gallery, 1953, when *Evening on the Seine, Paris* attracted particular notice. *No Resting Place, Tinkers*, was among the sculptures.

In 1955 he exhibited at the McNeice Gallery, Belfast, and in 1956 at Robinson and Cleaver's, where marine subjects in gouache were accompanied by nets and model boats made by the artist. In 1955 and 1956 he was in correspondence with Société des Artistes Indépendants, Paris. The style of *Flight into Egypt*, oil, painted late 1950s, was compared to the work of Georges Rouault (1871-1958). Piccolo Gallery, Belfast, hosted a one-person show in 1961.

At his home/studio, 14 Lyle Street, Belfast, where the décor was French in style and all windows had shutters, Markey's mail included a letter from Princess Margaret thanking him for his gift, and another from Princess Grace de Monaco for the drawings and four paintings which he had forwarded.

An exhibition of paintings at Furnishing Experts Ltd., Belfast, in 1963 included a small model depicting periods of early Irish history. He showed at Magee Gallery, Belfast, in 1963. Guitar-playing *Singing Clowns*, gouache, appeared in mid-1960s. In 1965 Lord Erskine, at Government House, Hillsborough, added to Markey's correspondence file by thanking him for gift of pictures.

After a working trip to Spain in 1969, he discovered that his Belfast studio had been gutted by fire and demolished. He returned to Spain, worked for about a year before settling in Dublin. Exhibitions followed at the Bell Gallery, Belfast, in 1971; Oriel Gallery, Dublin, 1973. In the period 1976-80 he held four shows at the Oriel; in 1977 he exhibited at Sligo Art Gallery. His work also appeared at the Eleves Gallery, Paris; Redfern Gallery, London; and Attic Gallery, Cardiff.

The *Irish Independent* described his Dublin sojourn: 'For years before he returned to his native Belfast, Markey lived and worked in a room above the Oriel Gallery, and daily wandered around Dublin dressed like a tramp, searching skips and rubbish tips for boards and paper on which he could paint...His pockets would be filled with large amounts of cash.'

Among his woodcarvings were: *Early Troubles*: *Mother and Child*; *The Celtic Warrior*. Mid-1970s was estimated for his *Circus Clowns*, gouache. Only one work, *Market place*, in 1977, was listed at the Royal Hibernian Academy. The Oriel exhibition in 1980, 144 works, took place at two venues. Regular exhibitions at Clare Street continued in the 1980s.

One-person shows continued: 1983, Farins Gallery, Washington DC; 1984, Apollo Galleries, Blackrock Town Hall, Co. Dublin; Peel Gallery, Montreal; 1985, Galerie Weber, Geneva; 1986, Swan Centre, Rathmines, Dublin; Walker Art Gallery, Coleraine, Co. Derry; 1988, George Gallery, Dublin; Lincoln Gallery, Dublin; 1989, Emer Gallery, Belfast. *Marjorcan Dwellings* and *On the Beach, Majorca*, gouaches, were both painted in 1987; he was in Paris the previous year. North Africa also attracted him, and he had visited the USA. The retrospective exhibition at the George Gallery in 1988 contained 100 works.

Exhibitions in the 1990s continued steadily at the Oriel Gallery. Also he showed in this period at the Emer Gallery. At the George Gallery in 1992 all twenty-five works were in gouache, including *Still Life with Oranges*; *Nude with Red Hair*. In 1997 he was back in France.

In the Queen's University collection is a street scene, *Country Town*, oil. At the Ulster Museum are *Unknown* and *Flower Market near the Madeleine*, both oils. Markey preferred payment in cash rather by cheque. Dublin solicitors were later to trace eleven different deposit accounts in banks in both jurisdictions, containing thousands of pounds. Packets of money were found in his home, 33 Tudor Place, Belfast, where he died suddenly on 28 January 1999, and was interred at Ballylesson Graveyard, Co. Down.

Works signed: Markey or M.R., rare.
Examples: Belfast: Arts Council of Northern Ireland; Queen's University; Ulster Museum. Dublin: Voluntary Health Insurance Board.
Literature: *Belfast Telegraph*, 23 February 1943, 10 May 1963; F. L. Green, *Odd Man Out*, London 1945; *Northern Whig*, 11 October 1950; *Belfast News-Letter*, 28 April 1953, 1 May 1956; John Hewitt and Theo Snoddy, *Art in Ulster: I,* Belfast 1977; Susan Stairs: George Gallery, *Markey Robinson : a Life — The Retrospective*, catalogue, Dublin 1988 (also illustrations); Emer Gallery, *Exhibition of Paintings by Markey*, catalogue, Belfast 1989 (also illustrations); Oriel Gallery, *markey*, catalogue, Dublin 1990 (also illustrations); Susan Stairs, *The Irish Figurists and Figurative Painting in Irish Art*, Dublin 1990 (also illustrations); Eileen Black, *A Sesquicentennial Celebration : Art from the Queen's University Collection*, Belfast 1995; Oriel Gallery, *Markey: Celebrating his 80th year*, Dublin 1997 (also illustrations); *Irish Times*, 3 February 1999; *Irish Independent*, 2 April 1999.

ROELOFS, HELEN HOOKER O'MALLEY(1905-93), sculptor. Helen Hooker, born on 1 January 1905 in Greenwich, Connecticut, USA, was the daughter of Elon Huntington Hooker, chemical engineer. At the age of six she modelled her first sculpture — a rabbit. Throughout her school years she persuaded friends and family to pose for her. In 1923 she graduated from Miss Chapin's School in New York.

Helen's mother supported her strong desire to forego family tradition of a formal college education and educate herself as an artist through travel and study with individual teachers. In New York, she studied sculpture with Mahonri Young (1877-1957) and William Zorach (1889-1966), who are both represented in the Metropolitan Museum of Art, and with Edmond Amateis (1897-1981). Later she studied with Émile-Antoine Bourdelle (1861-1929) at La Grande Chaumière in Paris.

Travels in Europe were extensive, studying woodcarving in Oberammergau in Germany, dance and sculpture in Greece, theatre design in Moscow, and painting in Leningrad. An exhibition of her Russian watercolours took place in 1930 at the Darien Art Guild, Darien, Connecticut. An interest in religious sculpture and Oriental art found her in China and Japan.

At the National Art Club, New York, she held an exhibition in 1933. In 1934 she completed her head of Ernie O'Malley; presumably it is a cast in the Kilmainham Jail Museum, Dublin. She married him in London in 1935, established a home in Dublin and shortly thereafter in Co. Mayo. They started to collect works by

contemporary artists. She modelled the people she met in this new Irish world, for example a head of Liam O'Flaherty in 1937. *Island Woman* appeared at the first Irish Exhibition of Living Art in 1943. Sent from Burrishole, Newport, Co. Mayo, a portrait of Mrs Kiernan was exhibited at the 1943 Royal Hibernian Academy. In the 1944-8 period she showed seven more works at IELA.

In 1944 she worked on the Aran Islands, and that year produced heads of Denis Johnston and Liam Redmond. As with most of her other pieces, these were unsigned. In 1945 she was a founder member of the Players' Theatre, Dublin, pursuing her interest in stage and costume design. The sculpture portraits continued, for example in 1945 those of Delia Murphy and Siobhán McKenna, and Maud Gonne MacBride (q.v., Maud Gonne) when she was aged eighty. At the 1947 IELA, *Frank O'Connor* and *Kurt Joos* were exhibited.

In 1950 at the RHA, from 65 Pembroke Lane, Dublin, she showed *Billy Kelly* and *Cormac O'Malley*. At the St Stephen's Green Gallery in 1950 she staged her first solo show in portraits. The *Dublin Magazine* art critic was there: 'Helen Hooker O'Malley is very definitely in the academic tradition as a sculptor. She models well and surely; and in her straight portraiture shows an excellent feeling for character. She is not so successful when she attempts to simplify or formalise which, admittedly, she does rarely. I particularly liked her bold and rugged portrait of Denis Johnston; her very characteristic head of Liam O'Flaherty, and her strongly modelled portrait of Kurt Joos.'

In 1950 she separated from Ernie O'Malley, returned to the United States and settled in Colorado. She obtained a divorce. An exhibition of portraits, the first in USA, took place in 1953 at the Taylor Museum, Colorado Springs. In 1956 she married Richard Roelofs, Jr, and settled in Greenwich, Connecticut. The next year she exhibited at Greenwich Library Gallery; as well as some of her Irish portraits, she included American figures, for example Anne Morrow Lindbergh, Burl Ives and John P. Marquand.

After 1960 she spent six months of the year either in Mayo or Dublin. Following the death of her second husband in 1971, she returned to her artistic work with renewed energy, and that year she completed a head of Mary Lavin. In 1972 Eavan Boland, Austin Clarke and Dana all sat for her. Sponsored by the American-Irish Historical Society, a retrospective exhibition took place in 1973 at Fortfield Court, Greenwich.

Roelofs realised her ambition to sculpt Eamon de Valera after a tea party in Áras an Uachtaráin in 1972. She had already attempted to obtain a proper sitting but was unsuccessful as he received numerous requests. Later came the opportunity to have tea with him which lasted little over twenty minutes, during which time she 'stared and stared.' She had everything set up in a Dublin hotel where she worked, according to report, for thirty-six hours modelling the clay from memory. The model went to America for casting.

The bronze of Jack MacGowran, 1973, a head and outstretched hand, measured 58 cm high. A portrait of Patrick Carey, sent from Burrishole Lodge, appeared at the 1974 Royal Hibernian Academy. The 1970s also produced portraits of Eamon Coghlan, Seamus Heaney and Paddy Moloney.

On the American scene, exhibitions of portraits were held in 1979 during Festival of Ireland at Birmingham Museum of Art, Alabama. At Stamford Museum and Nature Center, Connecticut, 'Faces of Ireland' presented thirty-one works with noted Irish people and also the blind Bard of Clare, Henry Blake; the British actress, Eileen Herlie; and Mrs Luke O'Malley, mother of Ernie O'Malley.

The eighteen pieces, with one exception in bronze, at her exhibition at Birmingham Museum of Art, Alabama, in 1980 were cast in polyester resin from plaster originals, with individual patinas finished under the artist's supervision, presented for the Birmingham Festival of Arts Inc. In the 1980s she completed works on Samuel Beckett, Michael Flatley, James Galway and Seán O'Casey. In 1985 Ferguson Library, Stamford, Connecticut, hosted an exhibition of twenty-one portraits; that for Seamus Heaney was dated 1982.

A donation of 434 photographic prints went to the National Library of Ireland, now housed in the National Photographic Archive, Meeting House Square, Temple Bar, Dublin. This personal collection comprised mainly views, architectural details of ancient monastic sites in Ireland, her home at Burrishoole Lodge, and informal portrait photographs including one of the sculptor, Peter Grant.

With the collaborative sponsorship of the Irish American Cultural Institute, she established the annual O'Malley Art Award and the O'Malley Art Collection of paintings by other artists, part of which is on permanent loan to the Irish Museum of Modern Art; the remainder in the care of Mayo County Council. In

1992 there was the opening at IMMA, held in conjunction with NLI and an exhibition of her photographs. The year also saw the display of thirty bronze heads of her Irish portraits at the University of Limerick.

In addition to being a sculptor and photographer, she was also a painter, stage designer, interior decorator, and a very active poet. Among the many art forms which she explored, sculpture — about 350 heads and figures — ranked the highest. 'Her focus was on the creative rather than the commercial,' her son Cormac K. H. O'Malley commented.

Roelofs died on 2 April 1993 at Greenwich, Connecticut. In September of that year there was the official inauguration of the Helen Hooker O'Malley Roelofs Sculpture Trust at the University of Limerick which included all forty-one heads and figures of her Irish portraits, for permanent display, of which twenty-six were classified: Authors, poets, playwrights.

Works signed: H.H.R. or H.O'M. R. (if signed at all).
Examples: Baltimore, Maryland: John Hopkins University. Dublin: Kilmainham Jail Museum. Huntingdon, Pennsylvania: Juaniata College. Limerick: University. Newbury Port, Massachusetts: Customs House Maritime Museum. Schnecteady, New York: Uniata College. Washington DC: Smithsonian Institution.
Literature: *Dublin Magazine*, October-December 1950; Greenwich Library, Art Gallery, *Helen Hooker Roelofs*, catalogue, Greenwich 1957; Stamford Museum and Nature Center, *The Sculpture of Helen O'Malley Roelofs*, catalogue, Connecticut 1979; Birmingham Museum of Art, *Helen O'Malley Roelofs: Irish insights in sculpture*, catalogue, Alabama 1980; Ann M. Stewart, *Royal Hibernian Academy of Arts: Index of Exhibitors 1826-1979*, Dublin 1987; Cormac K. H. O'Malley, *Letters to the author*, 1990, 1995; Cormac K. H. O'Malley, Etáin O'Malley, editor: University of Limerick, *The Irish Sculptures of Helen Hooker O'Malley Roelofs 1905-1993*, catalogue, Limerick 1993 (also illustrations); Ann M. Stewart, *Irish Art Societies and Sketching Clubs: Index of Exhibitors 1870-1980*, Dublin 1997.

ROGERS, EDWARD J. (1872-1938), portrait, landscape and miniature painter. Born in London on 16 April 1872, Edward James Rogers was the son of James Edward Rogers, ARHA (1838-96), Dublin-born son of James Rogers, QC, and an architect by profession who exhibited regularly at the Royal Hibernian Academy from 1870 until his death. Although an early connection with Cork has not been established, it is interesting to note that an Edward Rogers was at Crawford School of Art in 1893.

Edward J. Rogers, who studied at Heatherley's Academy, showed a miniature at the Royal Academy in 1904, from 8 Denning Road, Hampstead. When he exhibited inaugurally at the RHA in 1908, from 10 Whitton Road, Terenure, Dublin, miniatures were listed. In all, he had forty-five works hung at the Dublin exhibition, portraits being in the majority. In London, he showed two works with the Royal Miniature Society and one with the Royal Institute of Oil Painters.

By 1914 his address was 2 Winton Avenue, Rathgar, Dublin. In 1917 he was at 15 Ashfield Park, Terenure, and pictures hung that year at the RHA included *A Nurse of St John* and, a favourite subject, a portrait of Mrs E. J. Rogers. Indeed at the RA in 1919 he showed a portrait of Mrs Rogers, perhaps the same one. In 1921 he exhibited at the Water Colour Society of Ireland for the first time: *Sunset, Killiney Bay* and a portrait of Dallas Whitehead.

By 1922 he had a room as a studio at 50 Grafton Street, Dublin, the local directory described him as a portrait painter and that year at the RHA he exhibited *Mrs Henry Taylor*. Landscapes included *Howth, from Sandycove*, 1923 RHA, and two years later he contributed *Maureen Knitting* and *The Old Gardener*.

In 1924, with some of the portraits in pastel, he held a joint exhibition with Howard Knee (q.v.) at Mills' Hall, Merrion Row, Dublin. In 1924 and 1925 at WCSI exhibitions he showed a total of fourteen miniatures, none for sale. In 1925 too he exhibited *Betty and her Dog* at the Munster Fine Art Club. Judging by his catalogue addresses, he was at Golders Green, London, in 1926, and at Bellevue, Glenbrook, Co. Cork, by 1929. In the period 1932-6 inclusive he was a regular WCSI exhibitor with a total of seventeen works.

Two 1933 etchings, *The Companile, TCD* and *The Front Square, TCD*, are in the National Library of Ireland. Rogers described his principal works as 'drawings of the Marchioness of Lansdowne and the Hon. Mrs Waller and her four children'. He had moved to County Dublin, and his last address in Dun Laoghaire was 5 Glenageary Terrace with the final picture at the RHA in 1936, *On the Road to Glengarriff*. He died at Royal City of Dublin Hospital on 4 April 1938.

Works signed: E. J. Rogers.
Examples: Dublin: National Library of Ireland.
Literature: Algernon Graves, *The Royal Academy of Arts, 1769-1904*, London 1905; W. G. Strickland, *A Dictionary of Irish Artists*, Dublin 1913; *Irish Statesman*, 20 September 1924, 16 May 1925; *Thom's Directory*, 1925; General Register Office, Dublin, *Register of Deaths*, 1938; *Dictionary of British Artists 1880-1940*, Woodbridge 1976; *A Dictionary of Contemporary British Artists, 1929*, Woodbridge 1981; Angela Jarman, *Royal Academy Exhibitors 1905-1970*, Calne 1987; Ann M. Stewart, *Royal Hibernian Academy of Arts: Index of Exhibitors 1826-1979*, Dublin 1987; Peter Murray, compiler, *Illustrated Summary Catalogue of The Crawford Municipal Art Gallery*, Cork 1991; *Water Colour Society of Ireland Exhibition List 1872-1994*, Dublin 1995.

ROSS, FLORENCE A. (1870-1949), landscape painter. Born on 6 December 1870, daughter of the Rev. William S. Ross, Florence Agnes Ross, as a child, arrived in Dublin from the North with her mother, Mrs Agnes Ross, and two brothers, to live with their grandmother, Mrs Anne Traill, at 3 Orwell Park, Rathgar. In 1872 another daughter of Mrs Traill, Mrs Kathleen Synge, newly widowed, arrived with her family at 4 Orwell Park.

Florence Ross and her cousin, the writer John Millington Synge, were the youngest children in the two families and they had a common interest in natural history, collaborating their observations in a notebook. The first day, 6 November 1882, was written by Florence; the next day by John. On rainy days they would draw animals in their copybooks, and compare their drawings. In good weather they would wander through the woods of Rathfarnham Castle or the fields near their homes. They had a large establishment of pets: rabbits, pigeons, guinea pigs, canaries and dogs which they looked after together. Synge later recorded that he did not remember a single quarrel with Florence.

In 1891, after the death of her mother, Florence Ross went to live with the Synges, now in Kingstown. Mrs Synge disapproved of Florence going to any theatre, but her niece disregarded her aunt's wishes. In 1892 they spent the first of many summers at Castle Kevin, Annamoe, Co. Wicklow, where Florence explored and sketched. In 1895 she travelled to Tonga, Friendly Islands, where she acted as housekeeper to her brother, a doctor. Eleven years were spent abroad, visiting New Zealand, Australia – she was in Sydney in 1897 – and the Argentine.

In 1906 she arrived back in Ireland from South America. In the summer of 1907 she accompanied Mrs Synge to Tomriland House, an old farmhouse near Castle Kevin. Most of her spare time was devoted to watercolour painting, sometimes with her cousin Elizabeth Synge, and she stayed on occasions at her home at Annamoe, Co. Wicklow. They visited the Blasket Islands, and on the Great Blasket sketched, among other things, the 'King's House' in which J. M. Synge had stayed.

In the Water Colour Society of Ireland exhibitions she showed from 1927 until 1948, missing only one year and averaging about four works per exhibition. Painting expeditions took her to Counties Antrim, Donegal, Dublin, Galway, Kerry, Mayo and Waterford. Often she painted in Wicklow.

In 1932 she exhibited at the Aonach Tailteann exhibition of Irish art. Between 1929 and 1938 she showed eight pictures at the Royal Hibernian Academy. In the first year, giving her address 'Balmoral', Greystones, Co. Wicklow, she contributed three Co. Donegal landscapes. Her sole exhibit in 1930 was *Rockport, Cushendun, Co. Antrim*. In 1933 she exhibited *A Summer Day, Kerry* at the Munster Fine Art Club exhibition. Still in Co. Wicklow, she gave an Enniskerry address in 1934. In 1935 from 30 Waterloo Road, Dublin, her subject was Connemara cottages.

At the WCSI in 1938 she contributed six works, including *In the Garden at Silchester house, Glenageary* and *Haycocks*. *White Iris* and *Still Life in Glass* were included in the 1948 exhibition.

Old Mill, Old Trees in the Waterford municipal collection was associated with Bunbeg, Co. Donegal. In the South Tipperary County Museum and Art Gallery she is represented by *A passing gleam of sunshine*. In Wicklow, she ran a sketching club in the Glendasan Valley, near Glendalough. Of Blackrock, Co. Dublin, she died on 10 July 1949 at Royal City of Dublin Hospital.

Works signed: F. A. Ross.
Examples: Clonmel, Co. Tipperary: South Tipperary County Museum and Art Gallery. Dublin: Hugh Lane Municipal Gallery of Modern Art. Waterford: City Hall, Municipal Art Collection.

Literature: *Thom's Directory*, 1876; Rev. Samuel Synge, *Letters to my daughter: memories of John Millington Synge*, Dublin 1931; Register General, Dublin, *Death Certificate*, 1949; David H. Greene and Edward M. Stephens, *J. M. Synge 1871-1909*, New York 1959; Andrew Carpenter, ed., *My Uncle John: Edward Stephens's Life of J. M. Synge*, London 1974; Garter Lane Arts Centre, *Waterford Municipal Art Collection*, Waterford 1987; National Gallery of Ireland and Douglas Hyde Gallery, *Irish Women Artists: From the Eighteenth Century to the Present Day*, catalogue, Dublin 1987 (also illustration); Ann M. Stewart, *Royal Hibernian Academy of Arts: Index of Exhibitors 1826-1979*, Dublin 1987; *Water Colour Society of Ireland Exhibition List 1872-1994*, Dublin 1995.

ROSS, MARGARET M.– see SHERLOCK, MARGARET M.

ROSS, STELLA – see STEYN, STELLA

ROSS, STELLA C.– see SHERLOCK, MARGARET M.

RUSSELL, CHARLES, RHA (1852-1910), landscape, genre and portrait painter. Charles Russell was the second son of John Bucknell Russell (1819-93), painter of fish, fishing scenes and landscape, also woodcarver of Spey salmon; of Fochabers, Scotland. Charles was born at Dumbarton on 4 February 1852. Those who remembered him as a young lad at Fochabers spoke of him as a 'gey wild boy.'

At the age of seventeen, Russell exhibited *The Minnow Fishers, St Margaret's Loch* at the 1869 Royal Hibernian Academy, from 89 George Street, Edinburgh. His father had resided for some years in that city, giving the address 90 George Street when he showed at the Royal Scottish Academy in 1870. John Russell contributed two works to the Dublin exhibition in 1871.

From 1869 until 1910 Charles Russell showed close on 100 works at the RHA, of which some sixty were portraits. In 1874 he had travelled to Dublin, where he was employed by John Chancellor at 55 Lower Sackville Street, in painting portraits from photographs.

Russell's 1875 oil painting, *The O'Connell Centenary Celebrations*, is in the National Gallery of Ireland, where there is also a gouache, *The River Dargle, Co. Wicklow*. In 1879 at the RHA he showed two Dargle Pool subjects. By 1880 his address was 110 Rathgar Road, Dublin. *Old and Rare* and *Old Mike* found their way to the 1882 event.

Apart from his Academy connection, Russell had an active association with the Dublin Sketching Club, where he presented no fewer than sixty pictures in the space of four years, 1882-5. Titles indicated sojourns at Carlingford, Co. Louth, and Katwijk on Zee, Holland. At the Dublin Art Club, 1886-92, he contributed twenty-six works, for example: 1887, *One of the Unemployed*; *Deer Forest, Gordon Castle, Scotland*; 1889, *A Bit of Scandal*; 1892, *Sketch at Donaghadee*.

About 1884 he had ceased working for Chancellor's, devoting more time to his own portrait painting. A portrayal of his fellow artist, Bingham McGuinness (q.v.) appeared at the 1884 Academy, and of another artist, P. Vincent Duffy (q.v.) in 1885. Over in London, in 1889, he showed his only work at the Royal Academy, *A Rival in the Studio*. He exhibited five works, all portraits, including that of the Rt. Hon. Joseph Meade, Lord Mayor, at the 1892 RHA. His election as an academician came in 1893, and no doubt the news reached Scotland. In any event, his sister Dhuie, of Spey Cottage, Fochabers, had work hung at the RHA in 1894 and 1897.

Portraits of Lord Ashbourne and William Findlater have not been traced by the Incorporated Law Society of Ireland, whilst that of the Rt. Hon. Daniel Tallon, Lord Mayor of Dublin, a Mansion House picture, recently rested in the basement of the Hugh Lane Municipal Gallery of Modern Art. His portrait of Most Rev. Dr Croke, Archbishop of Cashel, appeared at the 1896 RHA.

In 1900, now at 4 Hume Street, Dublin, he still painted non-portraits: Kilternan Castle, Fethard, Tipperary, and The Spey near Gordon Castle, Fochabers. At the 1906 RHA, he showed a portrait of another artist, J. M. Kavanagh (q.v.). In 1906 and 1907 he had two pictures each year at the Oireachtas exhibitions, for example in 1906, *Enniskillen Evening; 1907, Baptism of Christ*. Few works were exhibited in England. A watercolour,

said to be in the Aberdeen Art Gallery collection, has not been traced. He died at his residence, 9 Lower Prince Edward Terrace, Blackrock, Co. Dublin, on 12 December 1910.

Works signed: Charles Russell.
Examples: Dublin: National Gallery of Ireland.
Literature: *Thom's Official Directory*, Dublin 1881; Walter G. Strickland, *A Dictionary of Irish Artists*, Dublin 1913; *Dictionary of British Artists 1880-1940*, Woodbridge 1976; *Dictionary of Victorian Painters*, Woodbridge 1978; Ann M. Stewart, *Royal Hibernian Academy of Arts: Index of Exhibitors 1826-1979*, Dublin 1987; Peter McEwan, *Dictionary of Scottish Art and Architecture*, Woodbridge 1994; Hugh Lane Municipal Gallery of Modern Art, *Letter to the author*, 1997; Ann M. Stewart, *Irish Art Societies and Sketching Clubs: Index of Exhibitors 1870-1980*, Dublin 1997; Incorporated Law Society of Ireland, *Letter to the author*, 1999; also, Aberdeen Art Gallery, 2000.

RUSSELL, GEORGE W. ('A. E.') (1867-1935), landscape, portrait and mural painter. George William Russell was born at 10 William Street, Lurgan, Co. Armagh, on 10 April 1867, son of Thomas Elias Russell, a bookkeeper in the local firm of cambric manufacturers, Thomas Bell & Co. He entered the Model School in 1871. The family lived in a cottage on Lord Lurgan's demesne.

When George's father joined the firm of Craig, Gardner & Co., chartered accountants, the family moved in 1878 to 33 Emorville Avenue, Dublin. In his youth he spent holidays with an aunt in Armagh, where he began to paint in watercolour, or with his mother's parents, Armstrongs at Drumgor, near Portadown. His letters to Carrie Rea of College Street, Armagh, provided much information about his early life.

A few weeks before his thirteenth birthday, when attending Edward Power's collegiate school in Harrington Street, Dublin, he showed sufficient talent to enter for evening classes at Dublin Metropolitan School of Art and attended March to May 1880. In 1882 he entered the Rathmines School under the Rev. C. W. Benson, and there he won all the prizes. In 1883 he resumed evening classes at the Metropolitan School of Art.

The Rev. H. C. Browne recalled that they both left Rathmines School about 1884: ' ... I was with him more than once when he was doing some of his earliest painting on the banks of the Dodder.' Four watercolours, all dated 1885, appeared at the Russell memorial exhibition, including *In the Phoenix Park* and *The Dodder*.

His schoolfriend secured two sets of drawings which are now in Armagh County Museum. One set was entitled 'Holyhead Excursion 1884. Sketches by G. W. Russell', and Browne described it: '... sixteen separate, rather clever sketches in Indian ink, of people and episodes in connection with the summer picnic ... Most of the drawings have a touch of humour or even of good-natured satire about them.' A similar but smaller sheet was entitled 'Intermediate Examination. Sketches by G. W. Russell'.

In the summer of 1885, the year the family moved to 67 Grosvenor Square, he left the Metropolitan School of Art and enrolled in the evening classes of the Royal Hibernian Academy. Among his close friends at the School of Art were John Hughes (q.v.), who made a bust of him; George Moore and W. B. Yeats. Yeats recalled that Russell did not draw from the model 'as we tried to, for some other image rose always before his eyes (a St John in the Desert, I remember) and always he spoke to us of his visions ...'. Yeats at this time called him 'a mystic of mediaeval type'. However, in the year 1888-9 he won an RHA prize of £2 for 'the best painting from the living model'.

In 1890 Russell obtained employment in the accounts department of Pim Bros Ltd, general drapers, Great George's Street South, at a salary of £40 per annum. He often amused fellow employees by drawing humorous sketches of them, as well as of himself. But Yeats encouraged him to write, also introduced him to the Theosophical Society, and so he joined the community at 3 Upper Ely Place. Now following the path of mysticism, he regarded the practice of art, at least outside The Lodge, as something of a temptation.

In 1892 he began a series of murals, oil on plaster, at 3 Upper Ely Place. Each of the four works was 122cm by 76cm and in these were figures, both human and divine, the planets, the stars, flowers and serpents. Another mystery was the signature of 'A. E.' to an article in a Dublin newspaper; the compositor had some difficulty reading the word 'Aeon' and it appeared in print as A. E., by which he became familiarly known. His first volume of verse, *Homeward. Songs by the way*, 1894, was by A. E., and he was then living at 5 Seapoint Terrace, Monkstown, Co. Dublin.

In 1897, invited by Sir Horace Plunkett, he joined the staff of the Irish Agricultural Organisation Society as an organiser of co-operative credit banks. The following year he married. In 1899 he painted a poster for Edward Martyn's play, *Maeve*, and in 1900 he took George Moore on a cycling tour and made several pastel sketches; his pastel head and shoulders of the novelist is in the University of Texas.

In 1901, he and his wife had a cottage at Kiltieran, Co. Dublin, and he painted there. In the same year Moore had settled at 4 Upper Ely Place, and A. E. and other friends attended his Saturday night gatherings. According to Henry Summerfield in *That Myriad Minded Man*, in 1902 he was 'still concentrating on portraits of the Irish gods he saw at Rosses Point ... About the same time he decorated with a pastel mural the room where Yeats's sisters had set up their Dun Emer Press, and he drew the symbolic Irish sword with which they adorned *The Nuts of Knowledge*, their second publication'. Also in 1902 he designed the costumes and scenery for his play *Deirdre* at the Abbey Theatre, where he painted, it is said, from the wings during the actual performance, Maire Nic Shiulbhaigh and Maire Quinn.

In 1903 he designed two of the tapestries, *St Patrick* and *St Laurence O'Toole*, for the new Loughrea Cathedral in Co. Galway. *The Celt* commented in its September 1903 issue that 'only the privileged few have seen the delicate interpretations of nature given by "A. E." They are full of the beauty born of murmuring sound.'

In 1903 too he showed forty-four pictures, many being Donegal landscapes, at the Leinster Lecture Hall, Molesworth Street, in a joint exhibition with Count Markievicz and his wife, the former Constance Gore-Booth (qq.v.). A pencil sketch by Russell of the latter is in Dublin Civic Museum. In 1904 the three exhibited again, an exhibition entitled 'Pictures of Two Countries'. A. E.'s tally was sixty-three pictures. Casimir exhibited his portrait of Russell, now in the Hugh Lane Municipal Gallery of Modern Art.

Dana, reviewing the 1904 exhibition at Leinster Lecture Hall, said that his pictures were 'an absolutely unique attempt to interpret in colour the Celtic mood and the divine vision which he had already set forth in verse'. Artefacts rarely appeared in his works, and painting now became an important additional source of income as his salary was meagre.

A 1903 portrait drawing of W. B. Yeats by Russell is in the National Gallery of Ireland, where there is also a portrait of Russell painted in the same year by John Butler Yeats (q.v.). By 1904 he had settled for Breaghy, near Dunfanaghy, Co. Donegal, for regular holidays and painting. *The Winged Horse*, 1904, is in HLMGMA, where there are ten other works, including *The Stone Carriers*.

Russell was on the committee of management of the Municipal Gallery and was on the original Modern Art Gallery Committee. When the James Staats Forbes collection was exhibited in Dublin 1904-05, he was among the lecturers. The only occasion he exhibited at the Royal Hibernian Academy was in 1905 when he showed three works, from 25 Coulson Avenue, Rathgar, Dublin. In that year he became editor of the *Irish Homestead*, organ of the IAOS, and continued until 1923. In London, he showed three works with the Fine Art Society and eight at the London Salon.

In *All Cultivated People: A History of the United Arts Club, Dublin*, Patricia Boylan stated that although A. E. used his influence in support of the founding of the club, he was 'never a member and seldom entered it'. P. L. Dickinson, however, in his *The Dublin of Yesterday*, 1904-14, referred to him as an original member 'but dropped out fairly soon, it was said because he objected to putting on evening-dress at club dinners. During the early life of the club we ran a Life Class two or three nights a week, and Russell used to turn up regularly and work as hard as any of us youngsters ... and never tried to draw the model correctly ...'.

In 1905, before a committee of inquiry, he testified with some candour on the work carried on by the Royal Hibernian Academy and the Metropolitan School of Art. In 1906 the family moved to 17 Rathgar Avenue, famous later for its gatherings on Sunday evenings. A. F. E. Stewart told the author, in 1969, that he was once invited to the studio where he saw 'about a hundred paintings stacked against the walls'. A plaque on this house indicates that he lived there from 1911.

In the period 1907-10 he was involved in four group exhibitions at the Leinster Lecture Hall. The first included the Markieviczs, Percy F. Gethin and William J. Leech (qq.v.). In 1908 the Markieviczes, Dermod O'Brien (q.v.) and Leech also showed.

The headquarters of the IAOS moved in 1908 from Lincoln Place to 84 Merrion Square, which was named Plunkett House, and also bears a plaque. There he began another series of murals, mixed media on wallpaper, nine compositions in all and, with one exception, an animal, all depict women; in height several are 2.8 metres. A female with a parrot and a child is 2.8 metres x 1.3 metres. These murals, presented by IAOS, were moved nearly seventy years later for restoration and mounting on board at NGI.

After Sir Horace Plunkett had returned from the United States in 1911, A. E. undertook to decorate his home at 'Kilteragh', Foxrock, Co. Dublin, with a landscape frieze. Regarded as his finest work, it was destroyed in the Irish Civil War. The monthly *Irish Review*, 1911-13, reproduced four of his paintings: *The Dark Place in the Wood*; *A Donegal Courtship*; *Children at Play* (presumably the work in HLMGMA); and *The Plough and the Earth Spirit*. In 1912 he had neuritis in his painting arm and did not paint for three months.

When War came, he received the first artist's permit issued in the British Isles. In May 1915 he reported that he was going for a month to Dunfanaghy, c/o Janie Stewart, Breaghy, and that Dermod O'Brien (q.v.) was going with him. In 1922, in Paris, he showed three works in the Irish exhibition at Galeries Barbazanges. In 1923 and 1924 he took his holidays at Glengarriff, Co. Cork, hence, for example, *In the Green Shade, Glengarriff*. In 1923 the *Irish Homestead* had merged with the *Irish Statesman*; he was editor until 1930.

River in the Sand he presented in 1924 to the Belfast Museum and Art Gallery 'as an Ulsterman in token of my friendship for Ulster', and in a letter he explained what a 'Whistler frame' was; the way he wanted the picture framed. In the painting by Sean Keating, *Homage to Hugh Lane* (HLMGMA), he is one of the group of seven. In 1926, on the invitation of C. P. Curran and his wife, he visited Paris, where he sketched and patronised the galleries.

The first of several lecture tours to the USA came in 1928, and that year he received an honorary degree at Yale University. Trinity College, Dublin, followed in 1929. In 1930-31 he spent eight months in America. Only twenty-five copies were printed of his *Verses for Friends*, 1932, and each had an original pen and wash drawing by the author. He supplied illustrations for Susan L. Mitchell's manuscript collection of her poems, in book form, now at the Armagh County Museum.

After his wife died in 1933, he left Dublin for London and corresponded with Sarah H. Purser (q.v.) from 41 Sussex Gardens, Hyde Park, London. His friends included Sir William Rothenstein (1872-1945), whom he had met in Ireland; a chalk portrait sketch of Russell by Rothenstein is in NGI. In the summer of 1934 he stayed in a cottage, Parkmore, Ballymore, Co. Donegal. He returned in March 1935 from another USA visit.

More than a score of works are in Armagh County Museum, including *A Warrior of the Sidhe*; *The Potato Gatherers*; *The Prince of Tir-na-oge* and a self-portrait. Among the oil paintings at HLMGMA are *The Waders* and *On the Rooftop, Moonlight*. The NGI collection includes oil paintings of Iseult Gonne, Professor David Houston, and Sadhbh Trinseach (q.v.) together with charcoal drawings of W. B. Yeats (2) and Susan Mitchell. His portraits at the Model and Niland Centre, Sligo, include those of Mary Colum and Yeats. At the Abbey Theatre is a portrait of Lady Gregory. At the Crawford Municipal Art Gallery, Cork, is a portrait of Ruth Lane.

Works at Limerick City Gallery of Art include *The Fairy Ring* and a bust of Russell by Jerome Connor (q.v.). A Connor bust was unveiled in Merrion Square, Dublin, in 1985. Another bronze bust, by Donald Gilbert (1900-61), sits in the Ulster Museum. A marble bust of Russell by Oliver Sheppard (q.v.) is in the NGI, where there is also: model in plasticine and bronze medallion of Russell by T. Spicer-Simson (1871-1959); pencil and oil by John Butler Yeats (q.v.); oil by Sarah H. Purser (q.v.). In the Seumas O'Sullivan Papers at Trinity College, Dublin, are twenty-seven sketchbooks and many crayon drawings. In Canada, at Winnipeg Art Gallery, is a head and shoulders profile portrait in pastel of an unknown man wearing a cap and smoking a pipe.

A brilliant conversationalist with a phenomenal memory, he died in a Bournemouth nursing home on 17 July 1935. Next day Sean O'Sullivan (q.v.) called to make three crayon drawings of A. E.'s face; one is in HLMGMA. Russell was buried in Mount Jerome Cemetery, Dublin. A memorial exhibition took place in 1936 at the Daniel Egan Gallery, Dublin. A centenary exhibition was held at HLMGMA in 1967, and a smaller one at NGI. In Lurgan, Russell Drive was named after him.

Works signed: A. E.; Geo. Russell, G. W. Russell, G. W. R. or G. R., all four rare.

Examples: Armagh: County Museum. Austin, Texas, USA; University of Texas. Belfast: Ulster Museum. Cork: Crawford Municipal Art Gallery. Drogheda, Co. Louth: Library, Municipal Centre. Dublin: Abbey Theatre; Civic Museum; Hugh Lane Municipal Gallery of Modern Art; National Gallery of Ireland; Office of Public Works; Trinity College; 3 Upper Ely Place. Kilkenny: Art Gallery Society. Limerick: City Gallery of Art; University, National Self-Portrait Collection. Lissadell, Co. Sligo: Lissadell House. Sligo: Model and Niland Centre. Termonfeckin, Co. Louth: An Grianán. Waterford: City Hall, Municipal Art Collection. Winnipeg, Canada: Art Gallery.

Literature: *Slater's Directory Ireland*, 1870; *Thom's Directory*, 1882, 1891; Ethna Carbery, *The Passionate Hearts*, London 1903 (illustration); *The Celt*, September 1903; *Dana*, September 1904; *Municipal Gallery of Modern Art, Dublin*, catalogue, 1908; *Irish Review*, September 1911, June 1912, August 1912, March 1913 (illustrations); Katherine MacCormack, ed., *The Book of Saint Ultan*, Dublin 1920 (illustration); *Letter from A. E. to Belfast Museum and Art Gallery*, 1924; J. Crampton Walker, *Irish Life and Landscape*, Dublin 1927 (illustration); P. L. Dickinson, *The Dublin of Yesterday*, London 1929; A. E., *Verses for Friends*, Dublin 1932 (illustration); Friedrich Biens, '*A. E.' George William Russell*, Greifswald 1934 (illustrations); George W. Russell, *Letter to Sarah H. Purser*, 1934; William M.Clyde, '*A. E.'*, Edinburgh 1935; *Dublin Magazine*, October-December 1935, July-September 1955, January-March 1956, April-June 1958; *The Times*, 18 July 1935; *Studies*, September 1935; Daniel Egan Gallery, *George Russell*, memorial exhibition, catalogue, Dublin 1936; Lucy Kingsley Porter, intro., *A. E.'s Letters to Mínanlábáin* (also illustrations), New York 1937; *City of Limerick Public Art Gallery*, catalogue, 1948; Roger McHugh, ed., *Letters of W. B. Yeats to Katharine Tynan*, Dublin 1953; *The Listener*, 10 March 1955; *Belfast Telegraph*, 10 April 1957, 8 April 1967; *Portadown News*, 30 December 1960; *Letters from AE. Selected and edited by Alan Denson*, London 1961; *Irish Times*, 2 December 1967, 3 February 1976, 22 January 1980, 18 July 1985; Alan Denson, *An Irish Artist W. J. Leech, RHA*, Kendal 1968; Alan Denson, *John Hughes Sculptor 1865-1941*, Kendal 1969; Liam Miller, *The Dun Emer Press, Later the Cuala Press*, Dublin 1973; Henry Summerfield, *That Myriad-Minded Man*, Totowa 1975; *Capuchin Annual*, 1976; *Dictionary of British Artists 1880-1940*, Woodbridge 1976; John Hewitt and Theo Snoddy, *Art in Ulster: 1*, Belfast 1977; Ulster Agricultural Organisation Society, *Harold Barbour*, Portadown 1977; National Gallery of Ireland, *The Abbey Theatre 1904-1979*, catalogue, Dublin 1979; Brian Kennedy, *George Russell (A. E.)*, Armagh County Museum, mss, 1984; *Irish Arts Review*, Winter 1985; Patricia Boylan, *All Cultivated People: A History of The United Arts Club, Dublin*, Gerrards Cross 1988; Andrew Cains, *Letter to the author*, 1992; also, Hugh Lane Municipal Gallery of Modern Art, 1992; Winnipeg Art Gallery, 1994.

RYAN, JOHN (1925-92), figure, landscape and marine painter. Born in Dublin on 19 February 1925, John Peter Ryan was the son of Senator Seamus Ryan, who, with his wife Agnes, established the Monument Creamery chain of shops, and a bakery. Educated at Clongowes Wood College, Naas, Co. Kildare, he studied at the National College of Art for one year, 1943-4, but was mainly self-taught and had been drawing since the age of five. However, as the eldest son and heir to the family business, he had a commercial commitment.

In 1949 he first exhibited at the Royal Hibernian Academy, *Scrummage,* from Burton Hall, Stillorgan, Co. Dublin, and from then until 1989 he contributed a total of thirty works. Seán O' Sullivan (q.v.), who had painted several members of his family, he regarded as largely a seminal figure. He should not be confused with the John Ryan of Raheny who showed at the RHA 1945-7.

The literary monthly, *Envoy*, 1949-51, was launched by him, and his occasional drawings of literati appeared in the publication. In 1949 too he showed three works with the Water Colour Society of Ireland: *Existentialists; Internment Camp; Derelict Autobile*. He was a member of the Irish Cultural Relations Committee, 1950-4. In 1950 he first showed at the Irish Exhibition of Living Art with *The Brawl* and *Funeral of an Old Comrade*. In the same year he was represented at the RHA by *Institution* and *The Funeral*, from 5 Hatch Street, Dublin.

When represented in 1953 in the Contemporary Irish Art exhibition at Aberystwyth, his address was listed as 39 Grafton Street, Dublin, that of the Monument Café. On the top floor, where the sculptor, Des MacNamara, had a flat, 1944-8, Ryan had studio accommodation. He savoured Bohemian Dublin, Patrick Kavanagh well to the fore. In quieter mood, he visited Jack B. Yeats (q.v.) in his studio in Fitzwilliam Square, a frequent caller on Thursday afternoons. Ryan wrote in his memoirs: 'He was most truly great and good man I have known.'

Ryan's second one-person show, held at the Grafton Gallery, Dublin, in 1954, attracted the *Dublin Magazine* critic who found that though a great deal of his work was 'still immature and tentative,' a number

of pictures showed that he had 'developed considerably as a painter in the past year or so. Formerly I had looked on him more as an illustrator than as a painter proper…'.

The writer in *Dublin Magazine* found a bewildering variety of both techniques and attitudes. There were at least three or four oils which showed 'definite potentialities as a painter. Two, in particular, in colour, composition, quality of paint, stood so much above the other work at the show that it was difficult to believe that the same painter was responsible. Certainly if he continues to produce more work of the quality of *The Concert Party, Bray* or *Memory of a Clown*, he will be worth watching as a painter.'

Marie, in 1954, was his only other contribution to the WCSI event. In the period 1951-6 he exhibited five pictures at IELA, concluding with *St Francis*. He first contributed to the Oireachtas exhibition in 1954, showing *Cathaoir Shaili* in 1956. At the Dublin Painters' exhibition in 1954 he presented *Lovers' Moon* and *The Brandenburg Gate*. In 1956 he contributed *From Rosapenna* and *The Atlantic Drive*.

In 1955 John Ryan had become the licensee of The Bailey, 2 Duke Street, Dublin, and for some fifteen years he enjoyed the company of writers, poets and painters. He had a studio above the pub. The novelist, J. P. Donlevy, said of him: '…his broad mind and natural kindness united many disparate friends in the dark 1950s.'

At the Ritchie Hendriks Gallery in Dublin his work was included in an exhibition of Flower Paintings in 1957, and he showed a flowerpiece at the 1960 RHA. In the early 1960s he was involved with the James Joyce Museum. In 1964 he became a Radio Éireann broadcaster. In the 'Sunday Miscellany' programme he gave his opinion on a variety of subjects.

At the RHA in 1966 he contributed *Life with a Fish*, and in 1967, *Old Butter Churn with Fruit*. He was secretary of the James Joyce Institute of Ireland 1970-4. He edited the *Dublin Magazine* from 1970 to 1975. He was honorary secretary of the Irish Academy of Letters from 1972 to 1975. His book, *Remembering How We Stood*, 1975, was a valuable source of information on the art and literary scene in Dublin in the period 1945-55.

Ryan's passion for sailing and the sea showed continually in his painting, for example at the RHA in 1979, *The Hook Lighthouse, Wexford*; 1982, *Drying the Nets*; 1983, *A Boisterous Sea*; and his final exhibit, 1989, *The Wreck of the Kowloon Bridge*. The story of his marine love-affair, *A Wave of the Sea,* 1981, included seven of his illustrations. In the Cork Rosc exhibition of 1980 he was represented by *Still Life with Turbot*, oil.

Managing director at one period of Envoy Productions, he was also a theatre designer. He admired the painting of his brother-in-law, Patrick Swift (q.v.). Of Elstow, Knapton Road, Dun Laoghaire, Co. Dublin, he died on 1 May 1992 at the Royal Hospital, Donnybrook, and was buried at Glasnevin Cemetery. A memorial committee was established in 1994 to commemorate his memory.

Works signed: John Ryan, Ryan or R.
Examples: Dublin: Office of Public Works. Galway: National University Ireland
Literature: *Envoy*, April 1951 (illustration); *Dublin Magazine,* April-June 1954, April-June 1957; *Who's Who, What's What and Where in Ireland*, London 1973; John Ryan, *Remembering How We Stood*, Dublin 1975; Cork Rosc, *Irish Art 1943-73*, catalogue, 1980; John Ryan, *A Wave of the Sea*, Swords 1981 (illustrations); Ann M. Stewart, *Royal Hibernian Academy of Arts: Index of Exhibitors 1826-1979*, Dublin 1987; RHA catalogues, 1980-1986, 1988-1989; *Irish Times*, 4 and 6 May 1992, 31 December 1994; *Water Colour Society of Ireland Exhibition List 1872-1994,* Dublin 1995; Ann M. Stewart, *Irish Art Societies and Sketching Clubs: Index of Exhibitors 1870-1980*, Dublin 1997; James Joyce Tower, *Letter to the author,* 2000; Dom Vincent Ryan, *Letters to the author*, 2000.

RYAN, MAUREEN COLLINS (1909-77), illuminator, craftworker and landscape painter. Born on 2 February 1909, Maureen Collins was the daughter of Michael Collins, managing clerk in a Limerick firm of solicitors. After attending Laurel Hill Convent, Limerick, where her artistic talents were early recognised and fostered, she trained at Limerick School of Art, and then taught there for about seven years.

In the late 1920s she produced her first artistic efforts, working in oils, leather and metal and falling into two types, one in Art Nouveau style and the other the so-called Celtic style. About 1930 she concentrated

for a while on high-quality metalwork, designing and making finger-rings and other jewellery, including a rather exotic 'Tara Brooch'.

In the Limerick Museum are two illuminated addresses of the 1930s; one to Rev. J.J. Wallace, PP, Cratloe, County Clare, from his parishioners on his transfer from the parish, and the other to Mr. John Reddan from the members of the Mechanics' Institute.

A hand-wrought silver plate in the Art Nouveau style won first prize in the Department of Education's 1931 craftsmanship competition. On some leatherwork done in 1932 she showed how Art Nouveau and Celtic art-styles could be combined in an individual approach to decorative art.

According to Professor Etienne Rynne, her Art Nouveau tendencies were to change later, 'resulting in a rather oriental, almost ethereal and strongly personal art-style, while her Celtic work continued to develop along more traditional lines, albeit always with her own characteristic touches'.

In 1935 the Mayor of Limerick asked her to provide an illuminated list of all the city's Mayors and Sheriffs. She was in frequent demand for illuminated addresses, which always varied in design. In 1954 she was responsible for the decoration on The Golden Book for the Redemptorist Retreat House in Limerick, now with the Redemptorist Community at Orwell Road, Dublin. In 1963 she executed the illuminated address, 84cm x 69cm, presented by the Arch-Confraternity of the Holy Family, Mount St Alphonsus Church, Limerick, to Pope Paul VI.

The oriental effect was to be seen in her landscapes, which were occasionally hung at various local exhibitions such as the Limerick Art Club. In an appreciation, Professor Rynne wrote: '... much of her best work cannot easily be described in terms of reality, the waves of mists and clouds, the straying clumps of reeds, the branches of shrubs and trees, even the very perspective, being little more than suggestions of doubtful realities.'

A painter in oil and watercolour, some of her oil paintings were on satin and silk. She was an authority on hair-pin crochet. The introductory titles to the film, *The Voice of Ireland*, were her responsibility. Because of ever-increasing arthritis, for the last few years she had to bind her fingers with rubber bands in order to hold a pencil or paint brush.

Late in life too she was an enthusiastic supporter rather than activist of the Thomond Archaeological Society. According to a writer in *North Munster Antiquarian Journal*, she was 'a person of lively and all-round interests in so far as Limerick, art, and Ireland's cultural past were concerned, she perhaps typified the type of member every Society such as ours enjoys having'. Represented at Limerick City Gallery of Art by an oil, *Springtime*, and of 44 Upper William Street, she died on 28 July 1977.

Works signed: Maureen Collins or Maureen Collins Ryan (if signed at all).
Examples: Dublin: Redemptorist Community, 75 Orwell Road. Limerick: City Gallery of Art; City Hall; Museum.
Literature: *Irish Independent*, 3 August 1963; *Limerick Chronicle*, 10 August 1963; *Limerick Leader*, 13 August 1977; *North Munster Antiquarian Journal*, vol. XIX, 1977; Redemptorist Community, Dublin, *Letter to the author*, 1992; also, Miss Mary T. Ryan, 1992; Professor Etienne Rynne, 1992.

SAINT-GAUDENS, AUGUSTUS (1848-1907), sculptor. Born on 1 March 1848 at 35 Charlemont Street, Dublin, Augustus Saint-Gaudens was the son of a Frenchman, Bernard Paul Ernst Saint-Gaudens from the village of Aspet, eight miles from St Gaudens. As a journeyman cobbler Bernard had spent three years in London and seven in Dublin. He met his future wife, Mary McGuinness, from Ballymahon, Co. Longford, at his Dublin workshop where she was employed.

About six months after the birth of Augustus, the family, compelled by the famine, emigrated to Boston, shortly moving on to New York. Bernard was associated with Irish *emigré* circles in New York where he enjoyed entertaining and 'the making of speeches at Irish festivals where he would round off his conclusions with spirited perorations in the Gaelic tongue'.

At the age of thirteen, Augustus was apprenticed to a Frenchman, Louis Avet, a stone cameo-cutter. He left in 1864 and obtained work with a shell cameo-cutter, Jules Le Brethon. As well as working by day, he studied at night at the Cooper Union institute art school, where free tuition was given to the working classes of New York. He moved to the National Academy of Design in 1865.

Aged nineteen, he headed for Paris, where he studied at the École des Beaux-Arts and worked in the atelier of the sculptor François Jouffroy (1806-82). In 1870 the Franco-German War forced him to leave Paris for Rome, where he lived and worked for the next five years, except for a brief visit home. Some commissions from travelling Americans came his way in Rome, and his *Hiawatha*, executed in his Italian studio, attracted attention.

In 1875 he returned to America where he had a brief spell as a mural painter under John La Farge (1835-1910), who was decorating Trinity Church, Boston. The president of the National Academy of Design, John Quincy Adams Ward (1830-1910) proved instrumental in Saint-Gaudens obtaining the award in 1876 for a statue of Admiral David G. Farragut, a watershed in the sculptor's career. He was friendly with the architect, Stanford White, who was to design the pedestal for the *Farragut*. In 1877, Saint-Gaudens, a founder member of the Society of American Artists, travelled again to Paris, having married Augusta F. Homer. He helped choose American artists for the Exposition Universelle in Paris, 1878.

In Paris he worked on the *Farragut*, also on portrait medallions and plaques which were exhibited at the Salon in 1878, 1879 and 1880. The statue was exhibited in plaster at the Salon of 1880. The artist returned to America, bringing with him a portrait of himself by Jules Bastien-Lepage (1848-84), an exchange for a medallion of the French artist. The *Farragut* statue was unveiled at Madison Square, New York, in 1881. 'Here was racy characterization joined to original composition,' one critic wrote, 'a public memorial with the stamp of creativity upon it'.

Saint-Gaudens lived in New York until 1884, when, having obtained the Boston commission for the *Robert Gould Shaw Memorial*, depicting a scene from the Civil War, he looked for a site outside the city and found 'Huggins Folly', an ancient mansion crowning a bare New Hampshire hillside, which he rented in 1885. The barn was turned into a studio and the house remodelled. His move with assistants – including, later, his brother Louis – began the establishment of the Cornish Colony of artists and writers 'working among congenial spirits in an upper-class Bohemia'.

The Puritan was erected in Springfield, Mass., in 1887. A painstaking worker, the bust he made in 1887 of General William T. Sherman took about eighteen periods of two hours each. The *Shaw Memorial* was not finished to his satisfaction until 1897. Despite pressure of work, he taught at the Art Students' League from 1888 to 1897.

Responsible for two *Abraham Lincoln* statues in Chicago, the 3.5 metre standing figure – completed in 1887 – is in Lincoln Park, and a replica is in Parliament Square, London, presented by the US Government. The sculptor spoke of this work as a portrait of Lincoln the man, in contrast with his later delineation of

Lincoln, the head of state, in the seated figure he completed in 1907 for Grant Park but not installed until 1926.

Robert Louis Stevenson posed for the sculptor in New York in 1887. Sittings began while the author, as was his custom, lay in bed propped up with pillows. Replicas of this work include one at the Hugh Lane Municipal Gallery of Modern Art, Dublin. This relief portrait, remodelled with a number of modifications, including a quill pen for a cigarette in the right hand, was used for the memorial plaque erected in St Giles' Cathedral, Edinburgh.

Grief, the 1891 memorial to Mrs Henry Adams, a hooded brooding female figure in bronze, is at Rock Creek Cemetery, Washington. *Diana*, goddess of the hunt, his model being an Irish girl, Nellie Fitzpatrick, was designed in 1892 for Stanford White's Madison Square Garden as a weather vane. The figure, 5.5 metres high, when erected on the tower proved out of scale and was replaced by a smaller copy, 4 metres high, now at Philadelphia Museum of Art. A Columbian Exhibition Medal, 1892 – he was responsible for one side – is in the National Museum of Ireland.

In 1892 he received the *Sherman Monument* commission, and from 1897 in Paris worked on the group, which won the Grand Prix in the Salon of 1900. This equestrian monument, unveiled in New York in 1903 at the entrance to Central Park, was regarded as one of his greatest works.

In Paris he became an officer of the Legion d'Honneur and his *Amor Caritas* was purchased from the 1899 Salon for the Luxembourg Museum, and is now in Musée d'Orsay. One commission overlapped with another and *General John Logan Memorial*, for Grant Park, Chicago, was completed in 1897, oddly enough a joint commission with A. Phimister Proctor (1862-1950); Saint-Gaudens did the figure and Proctor created the horse.

On the *Shaw Memorial* for Boston Common he worked some fourteen years. On his return to New York in 1900 he gave up his residence and studio there, but kept his home in Cornish. During his career he was acquainted with J.A.McN. Whistler (1834-1903) and his son, Homer Saint-Gaudens, has recounted how his father had a trick of singing when he worked,'There was none of that when Whistler appeared'.

Meanwhile in Dublin a movement had begun in 1898 to raise money for a national monument to Parnell. The foundation stone was laid at the top of O'Connell Street, outside the Rotunda, the following year; and the Lord Mayor, John E. Redmond, MP, and his secretary, proceeded to the United States to seek subscriptions. As the result of this tour, and of money donated in Ireland, the sum of £5978.11s 4d. was raised.

After considerable negotiations, a contract was finally entered into whereby Saint-Gaudens agreed to design a monument, of which a heroic statue of Parnell eight feet (2.4m) high was to be the principal figure, and to deliver the statue and plans within three years, for the sum of $25,000, together with $2,500 architect's fees. At the outset of this commission, according to his son, Homer, 'he found trouble in lack of portrait material, because Parnell sat for few photographs... he was lucky enough to think of a series of caricatures in *Punch* and such papers, published during Parnell's trial...'.

In 1904 there was a disastrous fire in the sculptor's studio with the loss of correspondence, sketch books, records of commissions and several works in progress including the *Parnell*, although the head was said to have survived. However, Saint-Gaudens told the New York *Daily News*:'More than all the rest of my losses in the fire I regret, as an Irishman, the loss of the Parnell statue.' *Pilgrim* for Philadelphia was dated 1905.

In 1907 the Parnell statue arrived in Dublin and was shown immediately at the Oireachtas art exhibition where a wreath was placed on the pedestal during the show – the sculptor had died in New Hampshire. The monument, built of Shantalla granite and 17m above the street level, was unveiled on 1 October 1911 by John Redmond after a 'Monster Procession made up of contingents from every part of Ireland'. Assembly was at St Stephen's Green, the procession took eighty minutes to pass the point in Grafton Street, and such was the swell of the crowd that the protective railings around the monument collapsed.

The sculptor, although ill with cancer, was said to have attacked with keen enthusiasm his great work for the Irish. He took endless pains to ensure success and had a model made of the streets and buildings bordering the site in order to determine the scale for the monument, and later he had erected in a field near his studio a full-size timber model of the structure with a plaster cast of the figure placed in front of it. He even obtained from a firm of Dublin tailors replicas of the clothes they had last made for Charles S. Parnell.

The *Irish Builder and Engineer* wrote of the statue: 'It was more peculiar than appealing – though original it undoubtedly is.' The *Irish Architect and Craftsman* was more enthusiastic, saying that the artist had 'laboured with keen zest and an enthusiasm begotten of his Celtic origin. In honouring his mother's nationality he left Ireland a work of art instilled with that feeling of strength and refinement which labels the work as being that of a great artist ...'. Judith Hill in her *Irish Public Sculpture: A History*, 1998, wrote: 'The dominant shaft had the effect of reducing the impact of the figure of Parnell: the unavoidable impression is that Parnell is the subject of something greater, the nation, or the nation state, whereas O'Connell [monument] had soared above all political structures to be their symbol...'.

At the request of President Theodore Roosevelt, a friend and admirer, he had redesigned the ten-dollar and twenty-dollar gold pieces. Altogether in about three decades of work he produced nearly 150 sculptures. More than a score of works are in the Metropolitan Museum of Art, New York.

Harvard, Princeton, and Yale granted him honorary degrees. He was elected an Honorary Foreign Academician of the Royal Academy in London. In the last years of his life, production with assistants never faltered, and even when his family realised he was dying, he insisted on being carried to his studio to superintend. He died on 3 August 1907. His widow and son, Homer Saint-Gaudens, provided for the preservation of the property, where more than a hundred examples of his work are exhibited. A major retrospective exhibition was held in 1969 at the National Portrait Gallery, Washington.

Works signed: Augustus Saint-Gaudens or A St G (monogram).
Examples: Boston, Mass.: Beacon Hill; Public Library; Trinity Church. Chicago: Grant Park; Lincoln Park. Cornish, New Hampshire: Saint- Gaudens National Historic Site. Dublin: Hugh Lane Municipal Gallery of Modern Art; National Museum of Ireland; O'Connell Street. Edinburgh: St Giles' Cathedral. London: Parliament Square. New York: American Academy of Arts and Letters; Cooper Square; Fifth Avenue; Madison Square Park; Metropolitan Museum of Art; St Thomas's Church. Newark, New Jersey: Newark Museum. Paris: Musée d'Orsay. Philadelphia: Fairmount Park; Museum of Art. Springfield, Mass.: Merrick Park. Washington: Rock Creek Cemetery.
Literature: *The Studio*, February 1906; *The Times*, 5 August 1907; Homer Saint-Gaudens, *The Century Magazine*, March 1908; *Irish Builder and Engineer*, 19 August 1911; *Irish Architect and Craftsman*, 30 September 1911; *Souvenir of the Unveiling of the Parnell National Monument, Dublin, 1st October 1911*; Homer Saint-Gaudens, *The American Artist and His Times*, New York 1941; C. P. Curran, *Studies*, Spring 1962; *American Art Directory*, 1964; Albert TenEyck Gardner, *American Sculpture: A Catalogue of the Metropolitan Museum of Art*, New York 1965; US Department of the Interior, National Park Service, *National Historic Site: New Hampshire*, Windsor 1968; Oliver Snoddy, 'Augustus Saint-Gaudens', *Capuchin Annual*, 1971; Frederick Fried, *New York Civic Sculpture*, New York 1976; Whitney Museum of American Art, *200 Years of American Sculpture*, New York 1976; Conway Library, London, illustrative records [1981]; Ira J. Bach and Mary Lackritz Gray, *A Guide to Chicago's Public Sculpture*, Chicago 1983; *Irish Times*, 25 July 1984; *Musée d'Orsay Catalogue sommaire illustré des sculptures*, Paris 1986; Judith Hill, *Irish Public Sculpture: A History*, Dublin 1998 (also illustration).

SALKELD, BEATRICE (1925-93), illustrator and landscape painter. Beatrice Salkeld, the eldest daughter of Cecil ffrench Salkeld (q.v.), was born in Mount Street, Dublin, on 31 December 1925. Her mother, Irma Taesler, born in Silesia of a German father and a Polish mother, encouraged painting from an early age. Educated at Loreto College, St Stephen's Green, Dublin, Beatrice acted as her father's assistant when he painted in 1941-2 the murals in Davy Byrne's public house.

In the 1940s she did some illustrating for her father's Gayfield Press. In the 'Dublin Poets and Artists' series she supplied the illustration for J. Patrick Byrne's *The Green Tree*. She illustrated *Lisheen at the Valley Farm and other stories*, published in 1945.

In her writing, she recorded sitting in the hills in Corsica with her sketchbook. Only three works were exhibited at the Royal Hibernian Academy, the first in 1948: *Spring in Wicklow*; 1949, *Another Spring*; 1950, *The Little Sister*, joining her father at those shows with the address 43 Morehampton Road, Donnybrook, Dublin.

After some months at the National College of Art, she had to find employment, but continued her art classes in the evenings. Meanwhile, in 1949, she had become a botanical assistant in the herbarium when it was in the National Museum of Ireland, near the College of Art. The National Botanic Gardens has no record of any

botanical illustrations left by her although she did collect plants and presented these to the collections. However, her friend John ffrench recollected seeing 'the most wonderful drawings of flowers and other plants.' There are no drawings at the National Museum of Ireland.

In 1950 she studied painting in Florence, Milan and Siena. Paintings in the exhibition at the Grafton Gallery, Dublin, in 1951 were mostly landscapes in oil, with John ffrench and Michael Morrow (q.v.) as co-exhibitors. The show was opened by Seán MacBride, a close friend of the Salkeld family. Edward Sheehy in the *Dublin Magazine* wrote: 'Beatrice Salkeld paints with a smooth and polished sophistication almost indistinguishable from that of her father. While one is astonished at such virtuosity in so young a painter, one is disturbed by the absence of that adventurousness, even with its attendant uncertainties, we expect from youth. Here again there is the impression that the painter is not working out of her own experience or venturing to see with her own eyes. With these reservations I like her portrait *The Little Sister* which had, somehow, a tenderness which overcame its polished manner.'

In the 1950s she showed four works at the Irish Exhibition of Living Art and three at Oireachtas exhibitions. In 1955 at the Oireachtas, she became, at least in the catalogue, Beatrice Salchult, and exhibited: *Cafe na mBión* and *Codladh Sámh*.

After she married in 1955 the playwright and author, Brendan Behan, she had less time for painting, travelling widely with her husband and attending premières of most of his plays. Employment at NMI concluded in 1955. But she brought her sketchbook when she and Brendan visited Connemara. *Bin Day* was her final exhibit at IELA in 1958.

In 1963, forty-six of her drawings, unsigned, appeared in Brendan Behan's *Hold your hour and have another*. Her paintings were credited with exhibition in New York in 1969 and 1970. *My Life with Brendan* by Beatrice Behan appeared in 1973. She died on 9 March 1993 at 5 Anglesea Road, Ballsbridge, Dublin.

Works signed: Beatrice Salkeld or B. S. (if signed at all).
Literature: *Dublin Magazine*, October-December 1942, January-March 1946, April-June 1951; Patricia Lynch, Helen Staunton and Teresa Deevy, *Lisheen at the Valley Farm and other stories*, Dublin 1945 (illustrations); Brendan Behan, *Hold your hour and have another*, London 1963 (illustrations); Beatrice Behan, *My Life with Brendan*, London 1973; *Who's Who, What's What and Where in Ireland*, London, Dublin 1973; Ann M. Stewart, *Royal Hibernian Academy of Arts: Index of Exhibitors 1826-1979*, Dublin 1987; *Irish Times*, 11 and 12 March 1993; John ffrench, *Letter to the author*, 1997; also, National Botanic Gardens, 1997; Ann M. Stewart, *Irish Art Societies and Sketching Clubs: Index of Exhibitors 1870-1980*, Dublin 1997; National Museum of Ireland, *Letter to the author*, 1999.

SALKELD, CECIL FFRENCH, ARHA (1904-69), portrait and figure painter. Born on 9 July 1904 at Karimganj, India, Cecil ffrench Salkeld was the son of Henry L. Salkeld, a member of the Indian Civil Service who had been working in Assam since 1899; in 1909 he died. His widow returned to Ireland with her son the following year. Cecil attended Mount St Benedict's, Gorey, Co. Wicklow, and Dragon School, Oxford. In 1918 he won a scholarship to Oundle which he 'loathed so much that I ran away after ten days'.

As a student at the Dublin Metropolitan School of Art at the age of fifteen, he was something of a prodigy in his mastery of the technique of drawing and painting. In September 1920 as a friend of the family he stayed with Maud Gonne MacBride (q.v., Maud Gonne) and her son Seán on holiday in a lonely cottage in Glenmalure, Co. Wicklow. W.B. Yeats visited them. In 1921 he went to Kassel, Germany, and studied art at Kassel Academy under Ewald Dulberg (1888-1933), who had been artistic adviser for stage settings to the Hamburg Municipal Theatre. Salkeld, who learnt the technique of woodcut, engraving and etching, encountered the New Objectivity movement with which Otto Dix (1891-1969) was associated. After witnessing the horrors of the First World War, Dix had returned to Düsseldorf, where in 1922 Salkeld exhibited at the first Internationale Kunstausstellung along with many notable names in European art.

Salkeld returned to Dublin. In 1924 he held a one-person show at the Dublin Painters' Gallery as well as contributing, at the age of twenty, an article – with illustration – on 'The Principles of Painting' for the short-lived *To-Morrow*. He also exhibited that year in the New Irish Salon exhibition in Mills' Hall, Dublin. In 1925 he had another show at the Dublin Painters' premises, but did not become a member of the Society until

1927. In 1926 he had contributed works to the Radical Painters' Group exhibition at Daniel Egan's Gallery in St Stephen's Green.

At the Dublin Horse Show in 1926 the entries for the Royal Dublin Society's Taylor Scholarship in painting were displayed. The subject set was 'Building', and Salkeld, who had returned to the School of Art, won the scholarship.

Warrior and *Bride* were both executed in 1926 and were reproduced in the 'Fantasy in Costume' chapter in *The Robes of Thespis*, 1928, also three illustrations for the chapter on ballet costume. *Warrior* is in the Victoria and Albert Museum.

Liam O'Flaherty's *Red Barbara and other stories* was published in New York in 1928 with Salkeld illustrations. He was a friend of O'Flaherty and had brought him to one of W.B. Yeats' Monday evenings in Dublin. Salkeld's work was included in a 1929 exhibition at the Library Book Company's Gallery in London of watercolour drawings for stage costumes and settings.

A portrait of the Hon. Mrs Gordon Campbell, sent from Ballyreagh, Enniskerry, Co. Wicklow, was his first exhibit, in 1929, at the Royal Hibernian Academy. According to his curriculum vitae, he was foreign correspondent in Berlin 1932-3. At Daniel Egan's Gallery in 1935 he exhibited with Grace Henry, Doreen Vanston (de Padilla) and C. Edward Gribbon (qq.v.), his works including *Pagan*; *Padraig O Conaire*; *Jesus In Fantulen Pragennis*; and *Moonlight Exiles*. A playwright, poet, book reviewer he was a man of many parts.

After a lapse of ten years, he returned in 1939 to the RHA and from then until 1968 showed fifty-six works. The 1930s also saw his Gayfield Press in action. As owner and often operator of the hand press, he was responsible for all types of commercial art and publicity, and he was the publisher of the Gayfield Dublin Poets and Artists pamphlet series. The Michael Byrne of *At Swim-Two-Birds*, 1939, by Flann O'Brien (Brian O'Nolan), is a portrait of Salkeld.

In 1941 he was engaged in painting panels for Davy Byrne's, the public house with so many literary associations. Each of the three panels, 1.2 metres x 1.5 metres, is a separate composition, entitled respectively: *Morning: Going to the Party with Bacchus*; *Noon: Joys of Enebriation in the Mid-day Sun*; and *Night: Party at the End of Day*. The commission was completed in 1942, and among those represented are Mícheál Mac Liammóir (q.v.), George Bernard Shaw and Myles naGopaleen (Brian O'Nolan). Half a century later his daughter, Beatrice Behan (q.v., Salkeld), widow of Brendan, looked after any touching-up required, on a yearly basis.

The *Dublin Magazine* referred to two unusual Salkeld pictures at the 1943 RHA: '*Arachne, Quaeret Quem Devoret* is a kind of Vogue diablerie, and the second *Room Mates* is much more inspiring. Its colour harmony and intellectual distinction recall Luc-Albert Moreau and indicate that the artist is capable of composition on a much larger scale.'

Ballet scenes often formed the subject matter of his paintings in the 1940s. He showed *Ballerina* at the 1944 Irish Exhibition of Living Art. He exhibited at the Victor Waddington Galleries in 1945, and the *Dublin Magazine* found him using 'a fine classical technique to express a kind of Romantic agony. His pictures are carefully and formally built. His palette is original, sombre, intellectually rather than emotionally conceived'.

In 1946 he was appointed an associate of the RHA, and exhibited again at the Waddington Galleries, where *Birthday Present* was favourably noted. His portraits of Mrs Niall Walsh and Mrs Michael J. Doran at the 1948 exhibition were described in the *Dublin Magazine* as 'polished, sophisticated and highly individual'. At this period he painted *The Vacant Throne: In Memoriam F. J. McCormick* (Abbey Theatre).

The poet, Robert Greacen, has recalled making friends with the Salkelds at 43 Morehampton Road, Dublin: 'Cecil, though flabby and balding and frequently "under the influence" seemed to be right at the centre of the Dublin art world. He knew everybody and everybody knew him ... he spent much of his day sprawled in an attic bed, reading, writing, chatting to his many callers and talking of his future plans. Talking, talking, talking – often wittily, seldom maliciously, always knowledgeably. Times were when he bestirred himself and painted energetically ...'.

In the early 1950s he was closely associated with PEN, Dublin, broadcasted for Radio Éireann, and in 1952 was in charge of cultural events for An Tostal. His wooden handpress for the Gayfield Press editions he gave to the Dolmen Press in 1952 along with a fount of type.

In 1953 his play *Berlin Dusk* was presented at the 37 Theatre Club, Dublin. Also in 1953 he showed a triptych, an altar piece for Benburb Priory, at the RHA but this work has not been traced. Salkeld was also involved with the promotion of ballet and in public relations work. He may have had a nervous breakdown. His friend Arnold Ussher referred to his 'chronic ill health'. Daughter Beatrice has recorded that he became addicted to chloral hydrate.

The novelist Kate O'Brien wrote: 'He was a man of too many gifts – none of them sufficiently strong to control him ...'. Towards the end of his life the New York Irish Institute purchased *Sailors' Mary*. A portrait by Salkeld of Miss Ffrench Mullan is in the National Gallery of Ireland. *Soldiers' Farewell* and *Hunting in Wicklow*, both oils, are in the Irish Museum of Modern Art. Another oil, *Taking their bows*, is in the Office of Public Works collection. A foundation member of the International Union of Progressive Artists, he exhibited in London at the Alpine Gallery and Leicester Galleries. He died at St Laurence's Hospital, Dublin, on 11 May 1969. An exhibition of his work took place at Godolphin Gallery, Dublin, in 1980.

Works signed: Salkeld; Cecil FFr. Salkeld, rare, or C. ff.S.
Examples: Dublin: Abbey Theatre; Irish Museum of Modern Art; National Gallery of Ireland; Office of Public Works; United Arts Club. Limerick: University, National Self-Portrait Collection. London: Victoria and Albert Museum.
Literature: Katherine MacCormack, *The Book of St Ultan*, Dublin 1920 (illustration); *The Studio*, October 1926, September 1929; Liam O'Flaherty, *Red Barbara and other stories*, New York 1928 (illustrations); George Sheringham and R. Boyd Morrison, *The Robes of Thespis*, London 1928 (illustrations); Blanaid Salkeld, *The Engine is Left Running*, Dublin 1938 (illustrations); Ewart Milne, *Forty North Fifty West*, Dublin 1939 (illustrations); *The Bell*, June 1941, December 1941; Joseph Hone, *W.B. Yeats 1865-1939*, London 1942; *Dublin Magazine*, July-September 1943, January-March 1944, July- September 1945, January-March 1947, July-September 1948, April-June 1953; Arnold Ussher, foreword, *Cúrsaí An TSean-Shaoghail*, Dublin 1949 (illustrations); *Who's Who in Art*, Havant 1952; Cecil ffrench Salkeld, *Curriculum Vitae*, typescript, *c.* 1954; *Arts Council 1966-67 Report*, Dublin; *Irish Times*, 12 and 19 May 1969, 27 March 1974; Beatrice Behan, *My Life with Brendan*, London 1973; Lady Grant, *Letter to the author*, 1976; Liam Miller, *Dolmen XXV*, Dublin 1976; S. B. Kennedy, *Irish Art & Modernism*, Dublin 1991 (also illustrations); Davy Byrne's, *Letter to the author*, 1992; also, German Institute, Dublin, 1992.

SANDFORD, MATT (1877-1943), cartoonist and caricaturist. Matthew Austin Sandford, son of John Sandford, was born in Belfast and, according to a former pupil, Padraic Woods (q.v.), attended St Joseph's National School, Slate Street. His knowledge of draughtsmanship was acquired at the Government School of Art, and he began his career as an artist with David Allen & Son, the poster firm.

The Magpie, a Belfast journal of humour and satire, published his first contribution in a 'Familiar Faces' feature in its issue of 22 October 1898, and his work also appeared in its successor, *Nomad's Weekly*. If the definition of a caricature is accepted as 'pictorial ridicule or satire, effected by distortion of personal physical characteristics', then cartoons in these publications, both edited by Alfred S. Moore, would be a more accurate description. Moore presented to the Belfast Museum and Art Gallery during the Second World War a 'Matt' self-portrait as well as drawings of local personages.

Sandford established his reputation while attached to the staff of the *Belfast Telegraph*. He was chief cartoonist for *Ireland's Saturday Night*, and he was the originator of 'Larry O'Hooligan'. In a talk to the Belfast Art Society in 1912 on 'Belfast art past and present', William Laird said that Sandford was 'inordinately happy in portraiture, even when the faces of his figures narrowly escape the border line of buffoonery ... His lines are always crisp and vigorous, and the confidence that pervades his drawings generally proves beyond suspicion an intimate knowledge of the anatomy of the human figure'.

From Belfast he moved to Manchester where he was cartoonist for the *Sunday Chronicle*. Invited to London to work for the *Daily Sketch*, he contributed also to *The Sketch*; *Sporting and Dramatic News*; and other periodicals. *Sixty Daily Sketch Cartoons of Famous People as 'Matt' sees them* was published in 1922 and included the Prime Minister, David Lloyd George; Rt. Hon. Winston Churchill, Michael Collins, Sir James Craig, Eamon de Valera and George Bernard Shaw. The majority of these caricatures – as they were – appeared in the newspaper in 1921 and 1922. Visits to the House of Commons gallery were among his duties when working for the *Evening Standard*.

A writer in *John O'London's Weekly* noted in 1922: 'He may go to a banquet with intent to make a picture of a cotton king, but finding him no more interesting than a cotton bale will make brilliant play with the face of the wine steward – "Matt" has the great faculty of producing caricatures which make the victims laugh, for he is never merely cruel.'

The theatre was also familiar territory for his work, and in 1923 the *Daily Sketch* published a group of forty-seven first-nighters, with plan, including Sir John Lavery (q.v.). By 1924 he had work in *The Graphic*; *Sunday Graphic*; and *T. P.'s Weekly*. The *Ulster Review* first appeared that year and he contributed to an early issue. He collaborated ('in caricature') with the Earl of Birkenhead in *Contemporary Personalities*, 1924, and illustrated Sewell Stokes's *Personal Glimpses* of the same year.

'Matt' was described by Louis J. McQuilland in an *Ulster Review* of 1924 as 'a character. He is not like anyone else. He dresses in a most unconventional way, and whenever he has to endure the misery of new clothes, speedily reduces them to shabbiness – he remains an isolated type from the North of Ireland, an individual, quaint, kindly, cynical, and generous'. He returned to Belfast in 1932 to caricature some of the celebrities of the Province. *1st Viscount Runciman* is in the National Portrait Gallery, London. Of 96 Rodenhurst Road, Clapham Park, he died on 30 December 1943.

Works signed: Matt.
Examples: Belfast: Ulster Museum. London: National Portrait Gallery. Manchester: Press Club.
Literature: *Belfast Museum and Art Gallery Quarterly Notes*, June 1912; *Sixty Daily Sketch Cartoons of Famous People as 'Matt' sees them*, London 1922; *John O'London's Weekly*, 9 and 30 September 1922, 26 November 1948; *Daily Sketch*, 16 February 1923; F. E. Smith, *Contemporary Personalities*, London 1924 (illustrations); Sewell Stokes, *Personal Glimpses*, London 1924 (illustrations); *Ulster Review*, June 1924; *Who's Who in Northern Ireland*, 1939, 1940; *Belfast Telegraph*, 31 December 1943; *Ireland's Saturday Night*, 1 January 1944; *Belfast Museum and Art Gallery Notes*, 1 April 1940-31 March 1945.

SANTRY, DENIS (1879-1960), cartoonist. Born in Cork, he was an apprentice cabinetmaker. He was at Crawford School of Art in 1895, and in 1896 he won a Cork Exhibition scholarship, which presumably was the one which took him to South Kensington. He won the Queen's prize for freehand drawing, being placed joint first in the United Kingdom in this section. Despite these art distinctions, he became articled to James F. McMullen, CE, architect and civil engineer at 30 South Mall, Cork.

Owing to ill health, he was advised to leave the country. In 1902 he arrived at Cape Town, and in 1903 established his own practice as architect and civil engineer. Paintings were shown at the second exhibition of the South African Association of Arts in 1903, and in 1905 he was elected a council member to conduct handcrafts. He established the South African School of Art and Design in Cape Town.

Santry's sketches and cartoons, from 1903, appeared under the pseudonym Adam in Cape newspapers and weekly publications, e.g. in 1904 in the *South African Review*. Shortly after, he gave up his practice as an architect and civil engineer to concentrate on art; he was also a metalworker. He was involved in organising the historic procession in honour of Unification in 1910. A few months later he moved to Johannesburg to become cartoonist on the *Rand Daily Mail* and *Sunday Times*.

In his cartoon *Puzzling!* in the *Rand Daily Mail*, 29 June 1912, General Louis Botha and Sir Thomas Smartt were playing cards – Botha's cards represented ministries: 'Posts', with a portrait of Sir David de Villiers Graaff; 'Mines and Education' showed F. S. Malan; and 'Agriculture' depicted J. W. Sauer. Caption: Sir Thomas (amiably): 'Do you discard from strength or weakness?' Louis (perplexed): 'Blessed if I know! Just as opportunity offers.' (General Botha had made up his mind to have eight ministers instead of nine, and said that one of the Cape ministers would resign 'as opportunity offers'.)

During the First World War his drawings were reproduced in many parts of the world, and were also published in book form in at least three editions. The first, *War Cartoons*, covered those dated 11 August 1914-3 March 1915, from the *Rand Daily Mail* and *Sunday Times*. His last cartoon in the *Rand Daily Mail* appeared 15 December 1917. His knowledge and enthusiasm for Oriental art was influential in Johannesburg cultural life during his residence.

Santry was a pioneer of the animated film strip, and in 1918 had made plans to go to America but was refused entry for medical reasons. He entered a competition for the design of a war memorial and a bank for Singapore. He won both and became a partner in one of the largest architectural concerns in the Far East, where he was also instrumental in the design of many public buildings and churches. In 1945 he returned to South Africa.

As a painter he worked in watercolour and gesso. A brush and black paint were usually used for his cartoons, and he sometimes parodied themes from theatrical productions, for example he linked contemporary political situations with scenes from Gilbert and Sullivan operettas. His wife, Madeline, was also an artist. He died in Durban on 14 April 1960.

Works signed: Adam or Santry.
Examples: Cape Town: South African Cultural History Museum. Johannesburg: Africana Museum.
Literature: *Macdonald's Irish Directory and Gazetteer*, 1902-1903 edition, Edinburgh 1903; *Journal of the Cork Historical and Archaeological Society*, October-December 1913; Pro Patria, *Our Diamonds: plea for a cutting and polishing industry in South Africa*, Johannesburg 1913 (illustrations); Denis Santry, *War Cartoons*, first series, 1915; second series, 1915, Johannesburg 1915; *War and Election Cartoons*, Johannesburg 1915; Anna H. Smith, *Pictorial History of Johannesburg*, Johannesburg 1956 (illustration); *Natal Mercury*, 15 April 1960; Eric Rosenthal, *South African Dictionary of National Biography*, London 1966; R. F. Kennedy, *Catalogue of Pictures in the Africana Museum*, Johannesburg 1968; Esmé Berman, *Art and Artists of South Africa*, Cape Town 1970; Margot Bryant, *Born to act: the story of Freda Godfrey*, Johannesburg 1979 (illustrations); South African Library, *A South African Bibliography to the year 1925*, London 1979; Grania Ogilvie, *Dictionary of South African Painters and Sculptors*, Johannesburg 1988; Murray Schoonraad, *Companion to South African Cartoonists*, Johannesburg 1989 (also illustrations); Peter Murray, compiler, *Illustrated Summary Catalogue of The Crawford Municipal Art Gallery*, Cork 1991; City of Johannesburg Public Library, *Letter to the author*, 1992.

SAUNDERS, MARGARET E. (1851-1918), portrait and figure painter. Apart from her exhibiting record at the Royal Hibernian Academy, little is known about this artist. She did not show in the principal English exhibitions, at least under her married name. The discovery of her maiden name might well produce additional information.

In the RHA collection is a Saunders portrait of their Keeper, P. Vincent Duffy (q.v.), dated 1906; he had been resident in Academy House in Abbey Street since the early 1870s. Between 1904 and 1918 she contributed more than forty works to the Dublin exhibition. Her first address was 14 Leinster Street, Dublin, and she exhibited *An Old Irish Woman*. The following year she gave 18 Dawson Street as her Dublin address, which was that of Mrs Ada Saunders, a nurse. For the 1907 exhibition, 118 St Stephen's Green was listed in the catalogue.

In the period 1908-10 she showed a number of portraits including that of Mrs Richard Maunsell. Among her five contributions in 1912 were: *The Blue Scarf*; *A Daughter of Eve*; and *Wild Flowers*. In 1913 her address was 51 Upper Leeson Street, the same as Mrs Saunders'. In 1915, *Walter G. Strickland, Esq.*; *Miss Strickland*; and *A French Soldier* were among her Academy contributions. Her last exhibiting address was in 1918 in North Kensington, London, and she showed a pastel portrait. Margaret Elizabeth Saunders died on 7 November 1918 at Staines Lodge, Kingston Road, Staines, Middlesex, widow of Dr. F.H. Saunders.

Works signed: Margaret E. Saunders.
Examples: Dublin: Royal Hibernian Academy.
Literature: *Thom's Directory*, 1906, 1916; W. G. Strickland, *A Dictionary of Irish Artists*, Dublin 1913; *Register of Deaths, Staines*, 1918; *Dictionary of British Artists 1880-1940*, Woodbridge 1976; Ann M. Stewart, *Royal Hibernian Academy of Arts: Index of Exhibitors 1826-1979*, Dublin 1987.

SCALLY, CAROLINE (1886-1973), landscape and flower painter. Born on 29 October 1886 at 7 Corrig Avenue, Kingstown, Co. Dublin, Caroline M. Stein was the daughter of Robert F. Stein, an engineer. Educated at the English Institute in Nymphenburg, near Munich, she began her art studies at the Royal Hibernian Academy Schools, and also attended the Dublin Metropolitan School of Art with James Sleator (q.v.), whom

she knew well. His oil portrait of her in fancy dress is in the National Gallery of Ireland. She also studied art in Paris and Italy. In the 1911 Taylor art scholarships and prizes competition, she won £20.

In 1913 and 1914 she contributed to the Royal Hibernian Academy under her maiden name, works including *The Palace, Versailles*; *On the Seine*; and *A Lock, Dieppe*. In all, she showed forty-one pictures at the RHA up until 1958. In 1916, under her married name, giving the address Shielmartin Cottage, Baily, Co. Dublin, *The White Farm, Malahide* and a Biarritz harbour scene were among her exhibits. In 1938, after an interval of eighteen years, she exhibited again at the RHA, this time from Clare Hall, Raheny, Co. Dublin. An oil painting, *Georgian Basement, Dublin*, was exhibited at the 1942 Munster Fine Art Club show.

Winter Flowers and Berries appeared in 1945 at the Academy, and by 1948 she had moved to 81 Upper Leeson Street, Dublin. In 1951 she showed with the Water Colour Society of Ireland for the first time and was a regular contributor for the next twenty years, showing more than fifty works and becoming a member of the committee. In 1951 *The Rose Curtain* and *Cats in the Gardens* were among her exhibits.

In 1952 she exhibited with the Irish Exhibition of Living Art and had a one-person show at the Dublin Painters' Gallery, which produced this comment from the *Dublin Magazine* art critic: 'So far she does not seem to have made up her mind as to either matter or manner; and a variety of styles, not all equally successful, makes it difficult to assess her work definitively. Nevertheless, a number of canvases do show her to be a painter of sensitivity. She uses a warm, rather diffuse palette. In *The Clothes Line* and *Fruit Trees in Spring* the effect is rich, gay and indefinably French.'

In 1953 she was represented in the Contemporary Irish Art exhibition at Aberystwyth. In 1955 another solo show followed at the Dublin Painters' Gallery. At the 1956 IELA, the *Dublin Magazine* found her dropping into 'archaeological lumpiness' with her pictures of Clonmacnoise but this was redeemed by her 'perky sea-gulls of *Old Mills Galway*, a most satisfying picture'. On the Dublin Painters' exhibition in 1957, she was described as a 'subtly adventurous painter in a quiet key'. She continued exhibiting with IELA and the Oireachtas exhibitions.

In 1960 the Thomas Haverty Trust presented to the National Gallery of Ireland *The Canal Lock House*, oil. Weirview, Islandbridge, was now her address. When she showed with the Dublin Painters in 1963, half a century had elapsed since she first exhibited at the RHA. *Three Swans* was one of her works at the 1964 WCSI.

'An elder figure, keeps up a quiet and consistent quality livened with a whimsical humour', commented the *Irish Times* on her pictures in the Independent Artists' exhibition in 1968, and the same publication, reviewing the WCSI exhibition in 1970, the one before her last, stated that she and Sean Keating (q.v.) were the last of the pupils of Sir William Orpen (q.v.) still painting. On 26 September 1973, wife of Gerald Scally, she died at Islandbridge.

Works signed: C. Scally; Scally, C. M. S., C. M. Stein or C. Stein, all four rare.
Examples: Athlone, Co. Westmeath: Public Library. Bray, Co. Wicklow: Public Library. Dublin: National Gallery of Ireland. Sligo: Model and Niland Centre. Waterford: City Hall, Municipal Art Collection.
Literature: *Dublin Magazine*, January-March 1953, October-December 1956, July-September 1957; *Irish Times*, 10 May 1968, 30 May 1970, 27 September 1973; R. S. Scally, *Letters to the author*, 1973, 1992; Ann M. Stewart, *Royal Hibernian Academy of Arts: Index of Exhibitors 1826-1979*, Dublin 1987; *Water Colour Society of Ireland Exhibition List 1872-1994*, Dublin 1995.

SCHOENEMAN, MINA – see CARNEY, MINA

SCHURMANN, GERDA J. – see FRÖMEL, GERDA J.

SCOTT, KATHLEEN A. (1868-1953), woodcarver and designer. Kathleen Agnes Scott was born on 13 April 1868, daughter of the rector of Christ Church, Bray, Co. Wicklow, the Rev. James George Scott. In 1887 a woodcarving class was instituted in Bray by the Misses Faulkner for the choirboys of Christ Church,

and handed on to Kathleen Scott in 1889. Finding that the boys could no longer attend on Saturday mornings when they left school, the class became an evening one for men, open to all denominations.

The 1899 Arts and Crafts Society of Ireland exhibition included a Bishop's Chair, designed by W. L. Whelan and K. A. Scott. The Bray Technical School opened in 1902 at Brighton Terrace, in leased premises known locally as 'The Corrugated Iron University'. At the request of Sir Horace Plunkett, the carving class was affiliated to the Technical School in 1902. Miss Sophia St John Whitty (q.v.) was teacher and designer there.

In 1911 the Bray Art Furniture Industry, active since 1905, decided to sever their connection with the Technical School, and a workshop was built in Florence Road. Kathleen Scott was the committee's honorary secretary and treasurer, and assisted Miss Whitty in designing and teaching in the workshop. A considerable amount of ecclesiastical wood-work was executed for Irish churches. Examples are in Christ Church, Bray. The Bishop's throne, probably designed by her, was partially the work of Kathleen Scott. In 1914 because of the War, the workshop had to close down.

According to a rector of Christ Church, the Rev. E. H. F. Campbell, efficiency, faithfulness and courage were some of Kathleen Scott's qualities, and 'she could not bear to see things done by halves, not did she suffer fools gladly. She was the reverse of a sentimental idealist, and the standard of self-discipline she set for herself she expected of others'. She died on 17 February 1953 at Greystones, Co. Wicklow.

Examples: Bray, Co. Wicklow: Christ Church.
Literature: *Thom's Directory*, 1870; *Bray Parish Quarterly Calendar*, Spring 1902; *Christ Church, Bray, A Guide*, Bray 1948; *Bray Parish Magazine*, June-August 1953; Rev. R. G. Large, *Letter to the author*, 1976, also copy of *Kathleen Scott letter*, undated, on Bray Wood Carving Class; Colbert Martin, *The Woodcarvers of Bray 1887-1914*, Bray [1984]; Paul Larmour, 'The Art-Carving Schools in Ireland', *GPA Irish Arts Review Yearbook*, 1989-90; Seamus Reynolds, Bray Vocational Education Committee, *Letter to the author*, 1992; also, Rev. David S. G. Godfrey, 1992.

SCOTT, WILLIAM, RA (1913-89), still life, landscape, figure and abstract painter. Born on 15 February 1913 at Greenock, Scotland, William George Scott was the son of a housepainter and decorator, William John Scott, who returned in June 1924 to his native town, Enniskillen, Co. Fermanagh. On 1 September William enrolled at the Model School. In later life, he wrote about Enniskillen: 'I was brought up in a grey world, an austere world, the garden I knew was a cemetery and we had no fine furniture. The objects I painted were the symbols of the life I knew best.'

Scott's grandfather, John Scott, was a cabinetmaker from Co. Donegal. William's father noticed his talent for drawing and sought out Kathleen Bridle (q.v.), a young teacher of art who had recently arrived in the town. She accepted him as a special pupil, 1926-8, in her evening classes at the Technical School, and gave him tuition at her home, studio space and loaned him art books. He later acknowledged: 'I was extremely lucky that my first contact with an artist was one so gifted. Her teaching influence on me was profound ...'.

In November 1927 his father was tragically killed in a fire accident in the town, and his Scottish mother was left to bring up a large family; an eleventh child was born after the father's death. A distressed community raised a fund for the family, and with the encouragement of his art teacher, the town assisted William, and in 1928 he entered Belfast College of Art. He then won a scholarship to the Royal Academy Schools, London, where he studied 1931-5, at first sculpture, winning a silver medal in 1933. The next year he joined the painting school and won in 1935 the £75 Leverhulme travelling scholarship. Of this period, Scott said: 'My interest in still life painting grew directly out of looking at Cézanne.'

In 1936 his *Adoration of the Shepherds*, shown in contemporary dress, was exhibited at the Royal Academy. He worked for six months in Cornwall that year and one of his closest friends in Mousehole was the Welsh poet, Dylan Thomas. He met at St Ives the primitive painter, Alfred Wallis (1855-1942). Later he knew in Cornwall Ben Nicholson (1894-1982), Peter Lanyon (1918-64) and other painters. He remained resident in London until 1937, when he married Mary Lucas, painter, sculptor and fellow student at the Royal Academy Schools. An 1938 painting, *Still Life with Flowers*, is now in Fermanagh County Museum.

The Scotts lived in Italy for six months, visiting Florence, Venice and Rome. In the winter of 1938 and 1939 they resided in France at St Tropez and Cagnes-sur-Mer but the summers were spent in Pont-Aven, where with Geoffrey Nelson, a former Slade student, they established the Pont-Aven School of Painting, chiefly for summer visitors. In Brittany Scott painted an old Breton woman who had sat for Paul Gaugin (1848-1903). The Arts Council of Great Britain collection includes *Old Breton Woman*. In 1939 came the first of many honours, elected Sociétaire du Salon d'Automne, Paris. In 1938 he had exhibited two paintings at the Salon.

Girl and Blue Table, oil, at Portsmouth City Museum and Art Gallery, was dated 1938. Five days before war was declared, the Scotts returned to England but before leaving he gave his easel to Emilé Bernard (1868-1941). Another French acquaintance was Maurice Denis (1870-1943). Many paintings were left in France and never recovered.

The Scotts then lived in Dublin for six months, returned to England and in 1941 settled at Elm Tree Cottage, Hallatrow, Somerset; William worked a market garden and taught part-time at Bath Academy of Art. In 1942, at the Leger Gallery, London, he held his first one-person exhibition. Meanwhile, he had joined the Army. His service with the Royal Engineers, learning lithography in the map-making section at Ruabon, North Wales, lasted from 1942 until 1946.

Twelve of his lithographs appeared in *Soldiers' Verse*, 1945, chosen by Patric Dickinson. Leger Gallery showed in 1945 watercolour landscapes by Scott in North Wales, and that year he also exhibited with Mary Scott. In 1945 he contributed for the first time to the Irish Exhibition of Living Art, Dublin, *North Wales*; *Eggs and Leaves* followed in 1947; and *Fish, Jug and Glass* in 1950.

On demobilisation in 1946 he became senior painting master at Bath Academy of Art, now at Corsham Court, Wiltshire, and he returned to Pont-Aven in the summer. That year his work was included in an Arts Council of Great Britain touring exhibition for four young British painters. At this time almost all his still lifes were of pots and pans on a kitchen table.

Endeavouring to enhance their English teashops, J. Lyons & Co. Ltd commissioned sixteen British artists; Scott's 1947 lithograph was *The Bird Cage*. Leicester Galleries, London, hosted an exhibition of paintings in 1948, also 1951. Between 1948 and 1956 five works were hung at the Royal Scottish Academy but all except one, *Girl in Chemise*, exhibited 1951, came from collections. In 1949 he was elected a member of the London Group.

In 1950 he showed a small retrospective exhibition, including one sculpture, at the Whitechapel Art Gallery, London. In response to an Arts Council of Great Britain request, he painted a large still life for a Festival of Britain, 1951, exhibition. *Still Life with Candlestick* was dated 1950.

Cornish Harbour, oil, in the British Council collection, was dated 1951, the year he exhibited a still life at the Royal Hibernian Academy. *Mackerel on a Plate*, 1952, is at the Tate Gallery. He became interested in the contrast and relationship between a few simple shapes and the way he could arrange and place them on the canvas. In 1952 he rented a studio and apartment in Chelsea.

In the summer of 1953 Scott was guest instructor at University of Alberta's Banff School of Fine Arts. On his way home he visited New York and Long Island, being introduced to Jackson Pollock (1912-56), Franz Kline (1910-62), Mark Rothko (1903-70) and others by his future American dealer, Martha Jackson. He was now moving towards abstraction.

According to Dorothy Walker in her *Modern Art in Ireland*, 1997, what most excited Scott about the Abstract Expressionists was the size of their canvases: 'he kept doggedly to his own concerns and the distinctive shapes of his abstract compositions, but he tried the bigger American scale and found himself at ease within it ...'.

Exhibitions abroad now almost matched the number at home. Between 1953 and 1971 he held nine solo shows at the Hanover Gallery, London. On the 1953 exhibition at Hanover, *The Studio* noted that he was now 'almost eschewing representational elements from his pictures which forces them to achieve a fresh identity...'. In 1954 he shared with Francis Bacon (1909-92) and Barbara Hepworth (1903-75) at the Martha Jackson Gallery, New York. In 1953 he was represented at the Bienal, Sao Paulo, Brazil. The Venice Biennale of 1954 included four of his lithographs.

In 1954 too he visited the Lascaux Caves and commented: 'The experience of seeing some of the most remarkable drawings ever made, had I think a profound impression in my future work.' He was represented at Kassel, Germany: Documenta I in 1955, also Documenta II in 1959. In the period 1955-7 he turned back to still life and nudes.

In 1956-79 he held eight shows at the Martha Jackson Gallery. In 1956 he gave up teaching at Bath Academy of Art. By now Pierre Bonnard (1867-1947) held his admiration. In an interview with the *Belfast Telegraph* early in 1958, Scott said: 'I am often called abstract but I do not call myself abstract. I am an individualist. Though modern, I do not fit into any clear movement. My pictures are near to abstract art – and were from the earliest days, even as a boy in Ireland. I would say that my pictures have varied merely in degree towards pure abstraction. I am a modern primitive, if you like. My art belongs to an older world.'

Honeycomb Still Life (Galleria Civica d'Arte Moderna, Turin) was dated 1957. The large central room in the British Pavilion at the 1958 Venice Biennale was devoted to Scott's works; he stayed in Venice during the summer. The British Council then toured this exhibition, showing it at Paris, 1958; Cologne, Brussels, Zurich and Rotterdam, 1959.

An exhibition at the Galleria d'Arte Galatea, Turin, in 1959 was subsequently hung at the Galleria Blu, Milan. Retrospective exhibitions of oils and gouaches were promoted at the Galerie Charles Lienhard, Zurich, 1959; Kestner-Gesellschaft, Hanover, 1960, and subsequently shown with modifications at Freiburg, Dortmund and Munich.

Meanwhile, Scott had been working on a 1958 commission for Altnagelvin Hospital, Londonderry: an abstract mural 13.7 metres long and 2.7 metres high, painted on fifteen plywood panels at Hallatrow, where he worked in a converted stable. The work was shown for a few weeks at the Tate Gallery and installed in 1962, but is now at Belfast City Hospital. Fabric for Altnagelvin Hospital's curtains was designed by Scott.

In 1959 he paid his second visit to New York, and that year he was awarded the £500 first prize in the British painters' section of the John Moores Liverpool Exhibition. *Blue Abstract*, oil, presented by John Moores, is in the Walker Art Gallery, Liverpool. In 1960 he showed *Ochre Still Life* at the IELA exhibition, and his works appeared for the first time at the Gallery Moos, Toronto. A 1960 abstract which was bought by the Gallery of the 20th Century, Berlin, is now, after merger, in the National Gallery, Berlin.

In 1961 he was represented again at the Sao Paulo Bienal, winning the Sanbra prize presented by international critics; subsequently the pictures were displayed in Rio de Janeiro and Buenos Aires. Also in 1961, exhibitions were held at the Esther Robles Gallery, Los Angeles, and Galerie Schmela, Düsseldorf. *White with Red Lines* (Ulster Museum), oil, and *Orange and White* (Royal Albert Memorial Museum, Exeter), oil, were both dated 1962.

The retrospective exhibition at the Kunsthalle, Berne, in 1963, was transferred to the Ulster Museum, with minor modifications, and attracted an attendance of 4,600; the museum's *Brown Still Life* was exhibited. His *Blue and White* oil of 1963 is in Dublin at the Hugh Lane Municipal Gallery of Modern Art.

Invited by the Ford Foundation, Scott was artist in residence in Berlin 1963-4. Exhibitions continued on the Continent in private galleries in Paris, 1963; Berlin, 1964; Zurich, 1966. He moved to a farmhouse at Coleford, near Bath, in 1965, and that year he taught at the Hamburg Academy. *Berlin Blues* was dated 1965. In 1966 he was created CBE. A lithograph won a prize at the 5th International Biennial of Prints, Tokyo, 1966.

In his exhibition of oil paintings at the Dawson Gallery, Dublin, in 1967, *Reverse Back*, 1962, and *Direction*, 1966 (Trinity College, Dublin, Gallery) attracted attention. In 1966, too, lithographs and silkscreen prints were displayed at the Arts Council Gallery, Belfast. A mural on canvas, 1.6m by 3.8m for Radio Telefís Éireann was completed in 1967, by which time he was teaching at the Royal Academy Schools. In 1967 he exhibited gouaches at the Bear Lane Gallery, Oxford, also showed in 1971, and lithographs in 1967 at the Model School, Enniskillen.

In the 1969 Festival he showed gouaches at the Richard Demarco Gallery, Edinburgh. His work was included in the Dublin Arts Council's European tour of 1969 of modern Irish paintings. *Still Life with Orange Note* was dated 1970. That year he showed silkscreen prints at the Waddington Galleries, London.

Scott was represented in Dublin at the Irish Imagination 1959-71 exhibition, in association with Rosc '71. After a show in 1971 of still life and nude drawings at the Scottish National Gallery of Modern Art, Edinburgh, and then the Aberdeen Art Gallery, there followed a large exhibition in 1972 at the Tate Gallery, London, of 1938-71 works, in twelve chronological sections covering the whole range of his painting plus three sections devoted to drawings or gouaches. The artist's elder son, Robert Scott, designed the installation.

On that 1972 exhibition, the Tate Gallery commented: 'Although Scott has tended to develop backwards and forwards from figuration and kitchen still life to complete abstraction, and from puritan austerity to a sensuous richness, his work has always retained a highly individual character. Elegant and subtle, international in outlook yet extremely British, it holds an honoured place in post-war art.'

An exhibition of gouaches was held at the Dawson Gallery, Dublin, in 1972. A visit to Egypt in 1972 was of benefit to the Ulster Museum because he donated *Egypt Series No. 3* in 1974. In 1972 he exhibited at Falchi Arte Moderna, Milan, and the commissioned set of seventeen silkscreen prints *Towards Euclid/The Alexander Suite* at Waddington Galleries, London. Other immediate shows abroad were: 1973, also 1975, 1978, Moos Gallery, Toronto; 1973, Lister Gallery, Perth, Western Australia.

In Belfast, the Arts Council of Northern Ireland presented their 'Teacher and Two Pupils' exhibition at their Belfast gallery in 1973 with the works of Kathleen Bridle (q.v.), William Scott and T. P. Flanagan; later shown at Enniskillen Collegiate School.

In 1973 the Irish Republic issued a stamp, *Berlin Blues II*. In 1973 he contributed four works to the Oireachtas exhibition, Dublin, and a drawing in 1975. In 1973 he showed new screenprints at the Dawson Gallery, Dublin, and visited Australia, Mexico and India as visiting lecturer for the British Council. Between 1974 and 1987 he held six exhibitions at the Gimpel Fils Gallery, London, and showed in 1974 at the Gimpel and Hanover Galerie, Zurich; the Australian Galleries, Collingwood, Victoria; and Arnolfini Gallery, Bristol.

A series of honours came in quick succession: 1975, Honorary Doctor, Royal College of Art, London; 1976, Hon. D Litt, Queen's University, Belfast; 1977, Hon. D Litt, Trinity College, Dublin; Associate of the Royal Academy. His final showing at IELA was in 1976 with two gouaches, *Straight and Curved* and *Two in Blue*.

Other exhibitions were: Wills Lane Gallery, St Ives; Albright-Knox Gallery, Buffalo, both 1975; Santa Barbara Museum, Los Angeles; Galerie Angst + Orny, Munich, both 1976; Gallery Kasahara, Osaka, 1976, 1977 and 1980. In the two-language catalogue for a Japanese exhibition, Chuji Ikegami wrote: 'Scott seems to be setting up a remarkably unique art between realism and abstraction.' Among the oils was *Ochre and Black*, 1973, and in the gouaches, *Pan and Knife*, 1975.

In 1977 he exhibited at the Dawson Gallery, Dublin. An exhibition of still life paintings 1946-78 toured in 1979 to Fermanagh County Museum, Enniskillen; Orchard Gallery, Londonderry; and the Arts Council Gallery, Belfast. Included was *Japanese Tea Ceremony*, 1977. Scott, an honorary member of the Royal Ulster Academy, was represented by four works, including *Permutation, White with Jug*, 1980, at the Rosc '80 show in Dublin.

Scott's war paintings 1942-6 were displayed at the Imperial War Museum, 1981. Gallery Moos, Toronto, showed drawings in 1982. Gimpel and Weitzenhoffer, New York, featured his work in 1983; he visited the exhibition. In 1984 he was elected to the Royal Academy.

With a London address at 13 Edith Terrace, Chelsea, Scott appeared in a feature film, *Every Picture Tells a Story*, Channel 4, 1985, made by his son James. He was a major prizewinner at the RA summer exhibitions 1985 and 1987. The Arts Councils in Belfast and Dublin arranged a retrospective of almost a hundred works in 1986 at the Ulster Museum; the Guinness Hop Store, Dublin; and the Scottish National Gallery of Modern Art, Edinburgh.

On the Wall Gallery, Belfast, and then Taylor Galleries, Dublin, held a 'Works on Paper' exhibition in 1987. In 1988, shows were staged in London at the Berkeley Square Gallery and the Curwen Gallery; and at the Beaux Arts Gallery, Bath.

A bronze bust of Scott by his friend, F. E. McWilliam (q.v.), is in the Ulster Museum. A victim of Alzheimer's disease, Scott continued to paint until his death but there was a gradual decline in his ability. Throughout his career his works had appeared in some 400 group exhibitions. He died at his home, Coleford,

on 28 December 1989. The funeral service was in the sanctuary at Breandrum, Enniskillen; burial in adjoining cemetery where his father lay. In 1990 there was a memorial service at St James's, Piccadilly, and the Royal Academy held a memorial exhibition. Exhibitions followed: Beaux Arts Gallery, Bath; Oireachtas, Dublin; Bernard Jacobsen Gallery, London, all 1990; Kerlin Gallery, Dublin, 1991; André Emmerich Gallery, New York; David Anderson Gallery, Buffalo, New York, both 1992; Bernard Jacobsen Gallery, London, 1997; Irish Museum of Modern Art, Dublin, 1998; Beaux Arts, London, 2000.

Works signed: W. Scott or Scott, rare (if signed at all).

Examples: Great Britain and Ireland: Aberdeen: Art Gallery. Bedford: Cecil Higgins Art Gallery. Belfast: City Hospital, Postgraduate Centre; Education and Library Board; Ulster Museum. Birmingham: Museum and Art Gallery. Brighton: Art Gallery. Bristol: Art Gallery. Cambridge: Fitzwilliam Museum. Cardiff: National Museum of Wales. Chichester: Bishop Otter College. Dublin: Arts Council; Hugh Lane Municipal Gallery of Modern Art; Irish Museum of Modern Art; Office of Public Works; Radio Teleffs Éireann; Trinity College Gallery. Dundee: City Art Gallery. Edinburgh: Scottish National Gallery of Modern Art. Enniskillen: Fermanagh County Museum. Exeter: Royal Albert Memorial Museum. Kingston-upon-Hull: Ferens Art Gallery. Leeds: City Art Gallery. Leicester: Leicestershire Education Authority. Liverpool: Walker Art Gallery. London: Arts Council of Great Britain; British Council; British Museum; Contemporary Art Society; Royal College of Art; Tate Gallery; Victoria and Albert Museum. Manchester: Whitworth Art Gallery. Newcastle-upon-Tyne: University, Hatton Gallery. Nottingham: Castle Museum and Art Gallery. Portsmouth: City Museum and Art Gallery. Sheffield: City Art Galleries. Southampton: Art Gallery. Wakefield, Yorkshire: Art Gallery.

Elsewhere: Adelaide: Art Gallery of South Australia. Auckland: City Art Gallery. Baltimore: Museum of Art. Berlin: National Gallery. Buffalo: Albright-Knox Art Gallery. Genoa: Gallery of Modern Art. Gothenburg: Konstmuseum. Hamburg: Kunsthalle. Houston, Texas: Museum of Fine Arts. Lincoln: University of Nebraska. Lisbon: Calouste Gulbenkian Foundation. Maryland: Baltimore Museum of Art. Melbourne: National Gallery of Victoria. Michigan: University Museum. New York: Brooklyn Museum; Museum of Modern Art; Solomon R. Guggenheim Museum. Ottawa: National Gallery of Canada. Paris: National Museum of Modern Art. Perth: National Gallery of Western Australia; Western Institute of Technology. Phoenix, Arizona: Art Museum. Pittsburgh, Pennsylvania: Carnegie Institute. Providence, Rhode Island: School of Design. Rome: National Gallery of Modern Art. Santa Barbara, California: Museum of Art. Sao Paolo, Brazil: Contemporary Art Museum. Sydney: Art Gallery of New South Wales. Toledo, Ohio: Museum of Art. Toronto: Art Gallery. Turin: Civic Gallery of Modern Art. Vienna: Museum Moderner Kunst.

Literature: *The Studio*, July 1943, April 1946, September 1948, February 1949 (illustration), September 1950 (illustration), September 1953; Patric Dickinson, ed., *Soldiers' Verse*, London 1945 (illustrations); *Belfast Telegraph*, 14 January 1958, 28 November 1961; British Council, *William Scott*, press release, London 1958; Ronald Alley, *William Scott*, London 1963; *Arts Council of Northern Ireland Annual Report, 1963-64*, Belfast 1964; Alan Bowness, intro., *William Scott: Paintings*, London 1964 (also illustrations); *Who's Who in Art*, Havant 1966; *Irish News*, 14 August 1967; *Irish Times*, 21 January 1967, 19 April 1972, 12 January 1990, 18 July 1998; *Model School, Enniskillen, Magazine*, June 1967; *Arts Council, Dublin, Annual Report, 1969-70*; Hanover Gallery: Edward Lucie Smith, poems, *A Girl Surveyed*, London 1971 (illustrations); Alan Bowness, *William Scott: Paintings, Drawings and Gouaches 1938-71*, catalogue, London 1972 (also illustrations); Lou Klepac, ed., *William Scott: drawings*, New York 1975 (also illustrations); Professor J. Braidwood, *William Scott Citation*, mss., 1976; Gallery Kasahara, *William Scott*, catalogue, Osaka 1976; Mike Catto and Theo Snoddy, *Art in Ulster: 2*, Belfast 1977; John Hewitt and Theo Snoddy, *Art in Ulster: 1*, Belfast 1977; Witt Library, London, illustrative records [1979]; William Scott, *Letter to the author*, 1980; Martyn Anglesea, *The Royal Ulster Academy of Arts*, Belfast 1981; Arts Council of Northern Ireland: Ronald Alley and T. P. Flanagan, *William Scott*, catalogue, Belfast 1986 (also illustrations); *Who's Who 1989*, London 1989; *The Guardian*, 5 January 1990; Belfast City Hospital, *Letter to the author*, 1992; also, National Gallery, Berlin, 1992; Royal Scottish Academy, 1992; *Sunday Telegraph*, 18 October 1992; William Scott Foundation, *Letters to the author*, 1992; Northern Ireland Museums Council, *Insight*, Autumn 1996; Ann M. Stewart, *Irish Art Societies and Sketching Clubs:Index of Exhibitors 1870-1980*, Dublin 1997; *Sunday Telegraph*, 4 May 1997; Dorothy Walker, *Modern Art in Ireland*, Dublin 1997 (also illustrations).

SCULLY, HARRY, RHA (*c.* 1863-1935), landscape and portrait painter. Born in Cork, he was a bookkeeper early in his career but rebelled against the commercial life. After attending Cork School of Art, he went to Heatherley's Academy, the London art school. Particularly interested in watercolour, he exhibited six works with the Royal Institute of Painters in Water Colours, giving a London address in 1887.

After a period of study on the Continent, he returned to his native city and established a studio for the teaching and practice of landscape painting and portraiture. *A Farm on the Seine* (Crawford Municipal Art Gallery), watercolour, was dated 1891.

Scully first exhibited at the Royal Hibernian Academy in 1893 when he had a studio at Nelson's Place, Cork. His exhibits included a bird's eye view of a Dartmoor farm. He showed regularly at the Dublin exhibition until 1911, after which there was a gap of twenty years. In all, 101 works were hung at the RHA. Portraits formed a minor part of his *oeuvre* but two were exhibited in 1894; including one of Lucy, daughter of Professor William Ridgeway, MA. A sketch of Penzance, from Newlyn, was also exhibited in 1894 and he probably returned to Cornwall – in 1895 and also 1896 he showed a work with Newlyn subject matter. *Fisher Girl, at Étaples* was hung at the 1897 RHA.

In 1900 he was appointed an associate of the RHA and in 1906 a full member. Over in London, he showed only three pictures at the Royal Academy, the first in 1896: *A Sussex Farmstead*. His *Ringing the Angelus*, RHA 1901, a Normandy church scene, exhibited at the RA in 1900, is probably *The Bellringer at Caudebec* which was 'placed on the favoured "line" at the Royal Academy, where its charm of colour and artistic treatment had the approbation of the leading art critics', according to the *Cork Examiner*. The only other RA exhibit was in 1901: *A Washing Place – Quimperlé*, exhibited in Dublin in 1902 when he also showed *In a Normandy Farm*.

Scully's work on the Continent had also produced a view of Florence. The Netherlands figured in his travels and at the RHA he exhibited: 1904, *A Street in Goes*; 1910, *Grey Evening in Holland*; *On a Dutch Canal*; and *Moonlight – Monnikendam*. *Portrait of a Country Man*, 1909, watercolour, is at the Crawford gallery. In the 1911 Dublin exhibition his works included *Two Breton Children in a Church*.

Other Breton pictures, watercolours, were shown in 1913 at the Belfast Museum and Art Gallery's loan exhibition of modern paintings, and Lady Kate Dobbin (q.v.), one of his pupils, was also represented. Robert Gibbings (q.v.) was another pupil. In conversation with the author, Seamus Murphy (q.v.) was fulsome in his praise of Scully as a watercolourist.

The *Cork Historical and Archaeological Society Journal* in 1913 described Scully thus: 'He is a versatile artist, painting equally well in oils or watercolours, and in landscape, genre, or portrait subjects he is quite at home.' On the occasion of Sir Bertram Windle, president of University College, Cork, 1904-19, going to St Michael's College, Toronto, he was presented with his portrait painted by Scully. This work remained at UCC. He was also credited with many studies of moorland farmsteads, and picturesque scenery not far removed from the environs of the city.

In 1930 he was represented in the Irish art exhibition at Brussels, having departed from Cork to Hill View Road, Orpington, Kent. After the long absence, he resumed exhibiting at the RHA in 1931: *Ballymacoda Bog, Co. Cork* included. Following a street accident and a brief illness, he died at a London hospital on 21 July 1935.

Works signed: H. Scully.
Examples: Cork: Crawford Municipal Art Gallery; University College.
Literature: Algernon Graves, *The Royal Academy of Arts 1769-1904*, London 1905; *Belfast News-Letter*, 13 March 1913; *Cork Historical and Archaeological Society Journal*, 1913; *The Studio*, February 1919; *Studies*, December 1932; *Cork Examiner*, 29 July 1935; *Royal Hibernian Academy Minutes*, 1935; *Dictionary of British Artists 1880-1940*, Woodbridge 1976; Ann M. Stewart, *Royal Hibernian Academy of Arts: Index of Exhibitors 1826-1979*, Dublin 1987; Anne Crookshank and the Knight of Glin, *The Watercolours of Ireland*, London 1994 (illustration).

SHACKLETON, LYDIA (1828-1914), botanical painter. Born at Griesemount, Ballitore, Co. Kildare, on 22 November 1828, the daughter of George Shackleton, miller, she was third in a family of thirteen children, and at an early age assisted in the teaching and care of the younger members. A forebear, Abraham Shackleton of Yorkshire, settled in Ballitore in 1726 and founded the Quaker school where Edmund Burke and others received the rudiments of their education.

Lydia, who wrote poetry, had 'an outlook, both religious and otherwise, a good deal ahead of her period'. In 1850 she studied at the Government School of Design in connection with the Royal Dublin Society. Afterwards she acted as housekeeper to her brother, Joseph, who ran the family flour mill, George Shackleton

& Sons, Anna Liffey Mills, Lucan, Co. Dublin. At the time when she attended the School of Design, she disliked copying other artists' paintings.

In the period 1873-6 she was in the United States visiting relatives and friends and also taking some art classes. At the 1878 Royal Hibernian Academy she showed *Wild Flowers of the Corn Field*. At the Mall, Lucan, where she lived, she had a small school in operation by 1879 for her nephews and niece.

Frederick W. Moore was appointed Curator of the Royal Botanic Gardens, as they were then, in 1879. Five years later Sir Frederick commissioned Lydia to paint faithfully flowers at the Botanic Gardens. How she was commissioned is not known, but on record is a request for ten shillings for one orchid painting.

The earliest of her paintings in the Glasnevin collection is dated September 1884 (some works are undated). Between then, or before, and December 1907, apart from the time spent on a second visit to the United States, she executed fine watercolour portraits of more than 1,000 orchids and several hundred other paintings. Some hybrids depicted are no longer known in cultivation.

In an article in *Glasra*, Brian D. Morley of the National Botanic Gardens wrote: 'Where Miss Shackleton depicts a large floral subject, such as Paeonia, her gouache and watercolour technique enabled her to make the flower glow with colour, and also enabled her to create leaves with good colour and texture. All of her Glasnevin paintings, approximately lifesize, are on tinted paper so that highlights are done with white paint. Where smaller subjects were studied, Miss Shackleton's technique is not so pleasing and botanical details are indistinct.'

Some of her paintings of North American wild plants and of landscapes in Ohio survive in a set of sketchbooks. She also visited Pennsylvania. When she retired from her Dublin work in 1907 her failing eyesight made it impossible for her to continue and she was succeeded by Alice Jacob (q.v.). Of 11 Garville Road, Rathgar, she was blind when she died on 10 December 1914. An exhibition of her works from the National Botanic Gardens, including examples of studies of orchids, peonies and hellebores, was held at the Hugh Lane Municipal Gallery of Modern Art in 1997.

Works signed: L. S. (if signed at all).
Examples: Dublin: National Botanic Gardens, Glasnevin.
Literature: *Slater's Directory Ireland*, 1870; *Lydia Shackleton 1828-1914*, Dundalk 1947 (also illustrations); Brian D. Morley: National Botanic Gardens, 'Lydia Shackleton's paintings in the National Botanic Gardens, Glasnevin', *Glasra*, No. 2, 1979; National Gallery of Ireland and Douglas Hyde Gallery, *Irish Women Artists: From the Eighteenth Century to the Present Day*, Dublin 1987 (also illustration); E. Charles Nelson and Eileen M. McCracken, *The Brightest Jewel: A History of the National Botanic Gardens, Glasnevin, Dublin*, Kilkenny 1987 (also illustrations); Patricia Butler, *Three Hundred Years of Irish Watercolours and Drawings*, London 1990 (also illustrations); Mary Shackleton, *Letter to the author*, 1992; Anne Crookshank and the Knight of Glin, *The Watercolours of Ireland*, London 1994 (illustration); Hugh Lane Municipal Gallery of Modern Art, *Lydia Shackleton 1828-1914*, news release, Dublin 1997.

SHACKLETON, ROGER (1931-87), landscape, still life and portrait painter. Born in Dublin on 14 December 1931, Roger Coryndon Shackleton was the son of George Shackleton of Anna Liffey Mills, Lucan, Co. Dublin. His great-great aunt was Lydia Shackleton (q.v.). Educated at Baymount Castle Preparatory School, Dublin, and from 1946-9 Bootham School, York, his interest in art was encouraged by the Bootham art master, Austin Wright, a sculptor, who subsequently lectured at York School of Art. In 1992 Wright recalled to the author his former pupil: 'It was evident then that he was a natural painter, constantly in the art room and it was in the days when we were getting to know Cézanne ... he did have a certain apprehension about having to return to the Art College in Dublin to be faced with religious subject matter from the past.'

In 1949 Shackleton entered the National College of Art, Dublin, and in the year 1950-1 studied painting at the Bath Academy of Art, Corsham Court, Wilts., the senior painting master being William Scott (q.v.). On his return to Dublin he worked in an office but continued painting and drawing during weekends and evenings. In 1952 he made his debut at the Royal Hibernian Academy, and his *Beatrice Maxwell, Quaker Girl*, impressed the *Dublin Magazine* art critic with the quality of his work; it had 'a bold simplicity of line and fresh clean paint'. His home was at Clonbone, Lucan.

In all, he contributed thirteen works to the RHA. In 1954 he won the Henry Higgins Travelling Scholarship. The adjudicator, W. L. Stevenson, principal of the School of Art, Liverpool, commented: 'Shackleton is by far the best student I have seen in the past seven years.' He studied collections in Paris, Milan, Rome, Naples, Florence, Sienna, Ravenna and Venice. In 1955 he won the Italian Government Winter Scholarship and returned to Italy for further study.

In the period 1953-66, he showed eighteen works at the Irish Exhibition of Living Art. In 1955, from 19a Pembroke Road, Dublin, he contributed *The Fisher*. In 1958 he exhibited four pictures: *Still Life with Crown Imperials*; *Olu Osuba, Esq.*; *Still Life with Anemones*; *Richard*.

Dr James White associated Shackleton with a group of figurative painters with the Living Art milieu of the 1950s, 'whose work was always captivating because although reflecting the reality of the world around us, never failed to exhibit elements of a private personality which captured one's interest'.

At the RHA in 1958 two of his three works were portraits. He returned to Bath Academy of Art for the year 1958-9 but left at the end of Spring term. After working in London, he went to Greece in 1962 and visited various islands, moving on to Crete. Paintings – topographical rather than archaeological – of these visits appeared in 1963 at an exhibition in the Ritchie Hendriks Gallery, Dublin, and included: *Cretan Shepherd*; *Scopelos Main Street*; *Purple Dactura*; *Oranges and Lemon*. About this time the Arts Council in Dublin purchased *Duck Lilies* for the New York Irish Institute.

Shackleton went to live in a coastguard house at Blacksod, Co. Mayo, in 1965 and travelled once a week to Keel on Achill Island, where he gave art lessons in Molloy's Hotel. His students showed their work every summer. He took a keen interest in gardening, and encouraged the local residents at Blacksod. His knowledge of horticulture was admired and imitated.

The final contribution to the RHA was in 1966, a portrait of Edward Richards Orpen. At the 1966 IELA, he showed *Elly*. In 1967 he exhibited paintings of the West of Ireland at the Molesworth Gallery, Dublin. One work was exhibited at the Oireachtas event in 1967 and also in 1969. In 1970 at the RHA small gallery he exhibited paintings and drawings; the former included *The Red Rocks of Aughadoon*; *Bridgie Weir's Garden*; *Blacksod Lighthouse*.

In 1975 he returned to Lucan, gave his services voluntarily as an art teacher to the local Cheshire Home and also worked for a time as an assistant librarian in King's Inns Library. In the last twenty years of his life he exhibited little so that he became a half-forgotten painter, described in the *Irish Times* as having 'a dry, ascetic style with thin paint and very precise, almost finicky drawing. His colour was quiet and tonalist, very much in the English style, but subtle and personal ...'. He occasionally showed a Cubist tendency.

In 1980 he began teaching at the National College of Art and Design, continuing until his sudden death on 18 September 1987 at St James's Hospital, Dublin. An exhibition of his works took place in 1992 at the Taylor Galleries, Dublin.

Works signed: Roger C. Shackleton, Roger Shackleton or R. S.
Examples: Dublin: Royal Hibernian Academy. Limerick: University, National Self-Portrait Collection.
Literature: *Thom's Directory*, 1946; *Dublin Magazine*, July-September 1952; *Royal Dublin Society Report of the Council*, 1954; *Arts Council Report 1963-64*; *Irish Times*, 23 July 1963, 29 April 1969, 10 April 1970, 18 February 1992; *Connaught Telegraph*, 9 March 1972; Ann M. Stewart, *Royal Hibernian Academy of Arts: Index of Exhibitors 1826-1979*, Dublin 1987; Bath College of Higher Education, *Letter to the author*, 1992; Mrs Ann R. Buchanan (née Shackleton), *Letters to the author*, 1992; *Sunday Independent*, 16 February 1992; Taylor Galleries, *Roger Shackleton*, catalogue, Dublin 1992 (also illustrations); Austin Wright, *Letter to the author*, 1992; Ann M. Stewart, *Irish Art Societies and Sketching Clubs: Index of Exhibitors 1870-1980*, Dublin 1997.

SHAW, ELIZABETH (1920-92), graphic artist. Born in the Ulster Bank, York Street, Belfast, on 4 May 1920, Elizabeth Shaw was the daughter of bank manager George W. Shaw of Co. Sligo. Her mother was Mary Magowan of Mount Norris, Co. Armagh. Elizabeth attended Belfast Royal Academy. In 1933 the family left Belfast to live in Bedford, where she entered the High School for Girls, finishing in December 1937. In 1938 she was a Chelsea School of Art student and studied illustration under Graham Sutherland (1903-80). Because of the war, the School of Art closed in 1940, and she was directed into industry.

In 1940 she began to publish drawings, mainly in the radical monthly, *Our Time*, although she only became a full-time freelance artist in 1944, the year she met and married an emigrant sculptor and painter, René Graetz (1908-74), Berlin born but the family was Geneva based. In 1943 she had exhibited in the AIA Gallery, London, with three other young artists. She contributed to the then well-known magazine, *Lilliput*, and other journals. In 1946 she and her husband emigrated to East Berlin to help build a socialist society.

For some twenty years she contributed, with illustrations, monthly articles on places and people for *Das Magazin*. An early innovation was illustrations for Brecht's poems for children. Later she wrote and illustrated a number of children's books which sold widely in East Germany. In 1957 she held a one-person show at Klub der Kulturschaffenden, Berlin. In 1958 the Ulsterman, John Hewitt, director of the Herbert Art Gallery and Museum, Coventry, visited an exhibition in London of sculpture and graphic work from the German Democratic Republic, and there he 'discovered' Elizabeth Shaw.

Hewitt corresponded with the artist and as a consequence an extensive exhibition took place at the Coventry gallery in 1964 with forty-three sets of drawings made on her travels; eighteen lithographs of writers, musicians, artists; eight sets of book illustrations; a dozen or so satirical drawings; a miscellaneous range of designs for theatre programmes and other occasional items. In 1965, incidentally, she executed a pen and ink drawing of William Saroyan. Hewitt considered that in Bertolt Brecht's *Ein Kinderbuch* a first-rate example of her direct but thoughtful good humour could most readily be appreciated.

In 1970 she held a show at Galerie am Turm, Berlin. A visit to Co. Sligo in 1972 produced pen and ink drawings: *Yachts on Rosses Point*; *Benbulben*; *Lissadell Beach*. She painted, some years later, watercolours in Co. Cork at Glengarriff and Youghal. In 1975 she was awarded the Art Prize of GDR. Among her other exhibitions were two in 1977: Kleine Galerie, Madgeburg, and at International Youth Library, Munich.

Judging by her works, she was in New York in 1978 with drypoints, *Battery, N.Y.*; *Manhattan*. In the same medium that year there was also *Elounda, Crete*; *Sofia*; *Renoir's Garden in Cagnes*. Examples of zincography were included in her exhibition of sixty-four works, covering the period 1965-78, at the Arts Council of Northern Ireland gallery in Belfast in 1979. The Käthe Kollwitz Prize was awarded to her in 1981, and the Gutenberg Prize of the City of Leipzig in 1983.

Elizabeth Shaw's memoirs, *Irish Berlin*, published in German, 1990, emphasised her Irish heritage and attachment. The last of her children's books, written and illustrated, *The Little Black Sheep*, was published by the O'Brien Press, Dublin, and translated into several languages, including Japanese, where it was one of the very few foreign books to be accepted on to the schools curriculum (with a first print run of over 250,000 copies).

Hewitt found her art 'goodnatured, whimsical, shrewd in observation, expressed with a deceptive simplicity...Often in the public squares, the streets of her townscapes, you will recognise the trim figure of the artist herself, sketching under a portico, or strolling with her portfolio under her arm. For Elizabeth Shaw takes no Olympian view; she participates in her world, and observes herself doing so.' After a third stroke, she died on 27 June 1992 in Berlin. Her ashes were scattered at Carlingford, Co. Louth.

Works signed: E. S., E. Shaw or Elizabeth Shaw (if signed at all).
Literature: John Hewitt, 'From Belfast to Berlin', *The Owl*, Christmas 1968; Elizabeth Shaw, *Eine Feder am Meerefftrand*, Berlin 1973 (illustrations); John Hewitt and Theo Snoddy, *Art in Ulster: I*, Belfast 1977 (also illustration); Arts Council of Northern Ireland, *Elizabeth Shaw*, catalogue, Belfast 1979; Elizabeth Shaw, *Spiegelbilder*, Berlin 1983 (also illustrations); Elizabeth Shaw, *Lustige Geschichten*, Berlin 1987 (illustrations); Elizabeth Shaw, *Letter to the author*, 1988; *Irish Times*, 2 July 1992; *The Guardian*, 10 and 22 July 1992; Anne Schneider (née Graetz), *Letters to the author*, 1992, 2000; Elizabeth Shaw, *The Little Black Sheep*, Dublin 1995 (illustrations); O'Brien Press, *Letter to the author*, 2000.

SHAW, KATHLEEN,HRHA (1870-1958), sculptor. Kathleen Trousdell Shaw was born in Middlesex in 1870, daughter of Dr Alfred Shaw. In the registered medical practitioners of Ireland in the 1860s is listed a Dr Alfred Shaw, Carlow, but a relationship has not been established.

Kathleen studied sculpture at Dublin Metropolitan School of Art, and the report for 1884-5 mentioned her success in modelling from the full-length antique figure. In the year 1886-7 she received a £10 'exhibition'

from the Royal Dublin Society. About this time she spent a short period in Paris. In 1887 she had first exhibited at the Royal Hibernian Academy, giving 24 Clarinda Park West, Kingstown, as her address, and from then until 1906 she showed some fifty works.

In 1888 she was represented in the Irish Exhibition in London by a plaster bust, *Miss Oonah Conolly*, and that year for the RHA she listed her address as 92 Meath Street, Dublin, where a Mrs Shaw was matron at the Nourishment Dispensary Committee Room. In 1889 she completed a marble bust of John Denham, MD (Royal College of Surgeons in Ireland), which was exhibited at the 1890 RHA, and also displayed at the Royal Academy; Totteridge, Buckinghamshire was now her address.

In 1890 she won a scholarship worth £160 from the RDS to study in Rome. She sent a medal from there to the 1891 RA, and spent some time in Athens where she became friendly with the British Ambassador and received commissions for busts from diplomats and others.

In 1891 at the Dublin exhibition she showed a medallion portrait of a Mrs Bruen as well as a portrait of Prince Edward of Saxe-Weimar; the previous year he had concluded a five-year spell as Commander of Forces in Ireland.

By 1892 she had moved to London, and in 1894 from 8 Balcombe Street, Dorset Square, she showed at the RHA a portrait of Hilda, daughter of the artist, W. Q. Orchardson (1832-1910), also three bronzed decorative panels representing Music, Pottery and Painting for a overmantle. At the Royal Scottish Academy in the period 1894-1910 she contributed sixteen works from London addresses; two medallions in 1902 were of Elizabeth, daughter of the Earl of Albemarle, and Mrs Leigh Brown.

Kathleen Shaw's sculpture was known in France. *Who's Who* mentioned twenty-five works exhibited at the Paris Salon as against eighteen in the Royal Academy. Her ideal figure, *Myron*, was presented at the Paris Salon.

Apparently she began to grow deaf at an early age and was said to be completely deaf at twenty-five. By 1897 she was at 17a Woburn Place, Russell Square, London, and that year *Mowgli*, a statue, appeared at the Royal Academy. Her sole contribution at the 1898 exhibition was a marble bust, *The Earl Egerton of Tatton*. When she showed in Dublin that year, *A Saint of Ancient Ireland*, she gave her studio address as Knutsford, Cheshire, but soon returned to London with various locations.

A bust of Lord Avebury, who had a house in Ballinasloe, Co. Galway, and one of the ophthalmologist, Professor M. M. McHardy, were shown at the 1900 RA. That year at the RHA, *Mowgli* reappeared along with two busts and two medallions, and she was elected an honorary member. Among her Dublin exhibits in 1903 was *Rev. J. P. Mahaffy*, a bust presented to the Trinity College Philosophical Society in memory of the sitter.

In 1904 she completed a memorial bust of Sir William Whitla (Ulster Medical Society) for the Medical Institute in College Square North, Belfast. In February of that year the Society had agreed 'to accept the offer of Miss Kathleen Shaw for £150'. In December she wrote to ask for more money to defray her expenses in going to Belfast to take sittings for the bust. The committee overseeing the project had no more money and did not see their way to raise more. The work was, however, unveiled that month.

The RA in 1905 and the RHA the following year both showed her bust of H. E. Cardinal Logue; location untraced. Another commission was a public memorial for Armagh city to the officers and men of the Royal Irish Fusiliers who fell in the South African War. The statue was unveiled in 1906 and the model for the young capless bugler, who is sounding the Last Post, was a local youth.

At the Irish International Exhibition at Herbert Park, Dublin, 1907, Kathleen Shaw, HRHA, showed a plaster bust, *The Countess Annesley*. In 1914 she completed a half figure in marble, for St Patrick's Cathedral, Armagh, of the late Archbishop William Alexander, exhibited at that year's London Academy. The original plaster model, 91.4cm high, is in the Ulster Museum.

After the First World War she does not appear to have exhibited publicly again. The New Gallery, London, also showed her work, and she contributed sixteen pieces to Royal Scottish Academy exhibitions, fifteen to the Walker Art Gallery, Liverpool, and nine to Glasgow Institute of the Fine Arts. M. H. Grant, in his *A Dictionary of British Sculptors*, wrote: 'Her medallions and medals were numerous and highly admired, displaying portraits of many eminent people.'

In a letter 7 February 1944 from Pitt Cottage, Cadmore, High Wycombe, Buckinghamshire, addressed to the president of the RHA, Dermod O'Brien (q.v.), she explained that she was deaf and had problems with her eyesight. Eventually she became blind and died on 13 June 1958.

Works signed: Kathleen Shaw or K. T. Shaw.
Examples: Armagh: St Patrick's Cathedral; The Mall. Belfast: Ulster Medical Society, 97 Lisburn Road; Ulster Museum. Dublin: Royal College of Surgeons in Ireland; Trinity College.
Literature: *Thom's Directory*, 1861, 1889; Algernon Graves, *The Royal Academy of Arts 1769-1904*, London 1905; *Who Was Who 1897-1916*, London 1920; M. H. Grant, *A Dictionary of British Sculptors*, London 1953; *Who Was Who 1951-1960*, London 1961; Alan Denson, *John Hughes Sculptor 1865-1941*, Kendal 1969; Angela Jarman, *Royal Academy Exhibitors 1905-1970*, Wakefield 1973; *Dictionary of British Artists 1880-1940*, Woodbridge 1976; Royal Hibernian Academy, *Letter to the author*, 1981; Ann M. Stewart, *Royal Hibernian Academy of Arts: Index of Exhibitors 1826-1979*, Dublin 1987; Brian Kennedy: Ulster Museum, *A Catalogue of the Permanent Collection: Twentieth Century Sculpture*, Belfast 1988; *The Royal Scottish Academy Exhibitors 1826-1990*, Calne 1991; Ulster Architectural Heritage Society, *The Buildings of Armagh*, Belfast 1992; Ulster Medical Society, *Letter to the author*, 1992.

SHEAHAN, SEÁN– see Ó SÉADHACHÁIN, SEÁN

SHEEHAN, WILLIAM (1894-1923), portrait painter. Born in Cork city in 1894, he studied at Crawford School of Art and Dublin Metropolitan School of Art. In 1916 he showed two portraits at the Royal Hibernian Academy, giving his address as 86 Great William O'Brien Street, Cork, where M. Sheehan conducted business as a wine and spirit merchant. His portrait sketch of a young lady at the 1917 exhibition was his only other contribution to the RHA, and he does not appear to have exhibited outside Ireland.

The National Library of Ireland has a pen and ink theatre sketch dated 1917, also a portrait drawing in pencil, on card, signed 'W. Sheehan '17'. On the recto of the latter is a note saying that the portrait is of Daniel Corkery (q.v.). Both these works have a Joseph Holloway, theatre-goer, provenance.

Crawford Municipal Art Gallery's oil painting, *The Consultation*, an interior with two figures, was dated 1917. The National Gallery of Ireland's 1920 oil painting is of General Liam Lynch. A self-portrait in oils, presented by Holloway, is in Hugh Lane Municipal Gallery of Modern Art.

George Atkinson (q.v.), headmaster of the Metropolitan School of Art, a member of the Cork scholarship committee, commented that Sheehan was 'the most talented young man in Ireland, with the exception of Keating'. In 1923 he became the first holder of the Gibson Bequest Travelling Scholarship, associated with the Crawford School of Art. It was decided to award Sheehan a scholarship for three months and send him to Paris. However, at the next meeting of the Gibson Committee, it was decided 'for important reasons' that Sheehan should go to Madrid instead.

Sheehan was to be given a subsistence allowance of £20 per month; he was to get third class travelling expense to Madrid – with saloon on steamers – and his tuition and canvases were to be paid for, 'such expenses to be properly vouched'. He was called before the Gibson Committee and given sage advice on how to make the most of this golden opportunity which was being afforded him. Atkinson had undertaken to provide introductions for Sheehan in Madrid, in order that he could visit various painters' studios.

Alas, almost immediately the young scholarship student was in trouble and debt. He reported, incidentally, that he was studying at the Academia de Bellas Artes in Madrid. The Bequest Committee refused to increase his allowance, although they forwarded him £5 to cover his debts. Reports arrived in Cork that Sheehan had been using his letters of introduction to important people in Madrid to cadge for money, whilst under the influence of drink, on the grounds that the Gibson Bequest Committee did not allow him sufficient to live on. The scholarship was terminated.

Sheehan was credited with the Stations of the Cross in Sts Peter and Paul Church, Cork. These Stations were said to have been badly overpainted when the church was redecorated. Seamus Murphy (q.v.) told the author in 1973: 'He was regarded as very promising and had a future but died prematurely of tuberculosis.' His death was at Corbally, Glanmire, Co. Cork, on 24 September 1923. In 1924 an exhibition of paintings which Sheehan had executed in Madrid was mounted in the Art Gallery.

Works signed: W. Sheehan or Sheehan.
Examples: Cork: Crawford Municipal Art Gallery; Sts Peter and Paul's Church. Dublin: Hugh Lane Municipal Gallery of Modern Art; National Gallery of Ireland; National Library of Ireland.
Literature: *Macdonald's Irish Directory and Gazetteer*, Edinburgh 1915; General Registry Office, Dublin, *Death Certificate*, 1923; Cork City Library, *Letter to the Belfast Central Public Library*, 1972; *Dictionary of British Artists 1880-1940*, Woodbridge 1976; Peter Murray, compiler, *Illustrated Summary Catalogue of The Crawford Municipal Art Gallery*, Cork 1991 (also illustration); National Gallery of Ireland, *Letter to the author*, 1992; also, National Library of Ireland, 1992.

SHEERIN, EUGENE (1856-1915), ceramic painter. Of Drumbinnion, Kilskeery, Co. Tyrone, Eugene Sheerin developed rheumatic fever at the age of four, the result of a thorough wetting, leaving him an invalid and confined to a bath-chair. His brother, Joseph Sheerin (1849-1939), became an authority on designing, planning and building staircases and handrails.

Eugene's mother taught him to write and draw, as he could not go to school, Vere Foster's copybooks being of great assistance. He persuaded his family to lay out a garden for him, developed by his mother under his supervision and it won a prize for him, in 1874 from Kilskeery and Trillick Cottage Gardening Society. When he entered two pencil drawings in the Gardening Society's show, his talent was noticed and local people encouraged him to enter works in an annual exhibition of drawings held in Belfast, which produced a prize in 1878 and a certificate of merit.

Encouraged by the benign manager, Robert Williams Armstrong, Sheerin obtained employment in May 1878, much older than the other apprentices, in the decorative department of Belleek Pottery, Co. Fermanagh. Both he and his nephew, Thomas McCallen, a devoted companion, had to stay in lodgings near the works, at 1 Rathmore Terrace, known as the English Row.

The nephew, an apprentice in the parian department, pushed the crippled artist's bath-chair to and from work each day. In December 1878, however, 'when the intense cold rendered it dangerous to my health (if not my life itself) to go daily in my Bath chair to and fro, between my lodgings and the Factory, so with Mr Armstrong's approval I returned home, until the genial breath of Spring should so change the outer world as to enable me to resume my employment,' he recorded. At home, he filled his days writing poetry.

Sheerin's feelings for the firm that had done so much for his self-esteem can be found in his book of poetry, *Shamrock Wreaths* :

'Fair-famed Belleek, long may their products be

Unrivalled here, and far beyond the sea!

For to the world they silently convey

What Celtic brain and hand can do to-day!'

According to Mairead Reynolds in her innovative article in the *Clogher Record*, published by the Clogher Historical Society, Sheerin undertook the usual job-lot work such as painting shamrocks on the characteristic Belleek ware. 'Yet, during 1879-80, he was singled-out to work on wall plaques. The subjects which he painted varied widely. For example, his *Prunus Spray* is an interpretation of the factory's popular transfer-painted design for earthenware.' He interpreted a popular print of Glengarriff Cove, Co. Cork. An example of the plaque, *Innocence*, painted in sepia, is in the Victoria and Albert Museum.

Many of the tourists who visited the Pottery were also taken to Sheerin's 'workshop', and some 'became much interested in his case.' Through the concern thus excited, he went to Dublin, where he stayed with his brother Joseph in Great Brunswick Street. From October 1880 to July 1881 they both attended the Dublin Metropolitan School of Art. Eugene took classes in free-hand, perspective and modelling, winning a drawing prize at South Kensington.

In the Exhibition of Irish Arts and Manufactures held at the Rotunda, Dublin, in 1882, he showed three plaques: *Shades of Evening* and *A Favourite Promenade*, both priced at three guineas, and *A Summer View on the Erne* at £4.5s. After the death through consumption of his nephew in April 1883, he did not return to Belleek. In May 1884 the firm was bought by a limited company. The new management re-organised the factory on 'progressive' business lines.

Sheerin returned to the School of Art 1884-5, and in January 1885, according to the preface in his poetry book, he was under 'special instruction, Designing being the branch of Art to which his attention is chiefly devoted.' However, in 1887-8 he worked on a breakfast service commissioned by Dr O. Ternan, medical practitioner in Enniskillen, Co. Fermanagh, his own monogram and family crest painted in black and gilt on each of the fifty-eight pieces. Prominently depicted on each was an Irish landscape view including well-known beauty spots and some local scenes, all named. This set was later acquired by the National Museum of Ireland. A Mr Breslin, an Irish-American, commissioned another service in 1888, such was his admiration.

By the mid 1890s the number of hands at the factory had been reduced by about a half and salaries also cut. Sheerin's reaction was an article on the potential for ceramic factories in Ireland and criticism of Belleek managers in an article in the *New Ireland Review* in 1896. Here is a passage from the pen of a writer who had never gone to school: 'It is a painful and thankless task to act the censor on one's own people; it is especially irksome when candid comment is liable to be taken as carping criticism; in the present instance this feeling is increased a hundred fold by the fact that, to the writer, Belleek and its pottery and its people are endeared by many cherished recollections. Therefore, a grave sense of duty alone had led to the examination of the causes that underlie its defects, as well as the success of which it is capable.'

Sheerin lived with his brother and nephew at different addresses in Dublin. He acted as his brother Joseph's secretary and left his literary style in Joseph's technical manual, *Handrailing*. In addition to the National Museum of Ireland's breakfast service pieces, they also have a wall plaque and an egg cup. A portrait of a former manager of Belleek Pottery, James Cleary, was portrayed on a plate. He died in Dublin on 24 March 1915 at 50 Seville Place, and was buried in Kilskeery cemetery. In 1981 the Pottery produced a vase for the International Year of the Disabled in commemoration of Eugene Sheerin.

Works signed: E. S. or Sheerin (if signed at all).
Examples: Belleek, Co. Fermanagh: Belleek Pottery Ltd. Dublin: National Museum of Ireland. London: Victoria and Albert Museum.
Literature: *Exhibition of Irish Arts and Manufactures*, catalogue, Dublin 1882; Eugene Sheerin, *Shamrock Wreaths*, Dundalk 1885; *New Ireland Review*, October 1896; General Register Office, Dublin, *Register of Deaths*, 1915; Mairead Reynolds, 'Eugene Sheerin', *Clogher Record*, 1981 (also illustrations); John B. Cunningham, *The Story of Belleek*, Belleck 1992 (also illustration); St Patrick's Church, *The Church upon the hill*, Belleek 1992 (also illustration); Marion Langham, *Belleek Irish Porcelain*, London 1993 (also illustration); National Museum of Ireland, *Letters to the author*, 2000.

SHEPPARD, OLIVER, RHA, RBS (1865-1941), sculptor. Of Cookstown, Co. Tyrone, he was born on 10 April 1865, the eldest son of Simpson Sheppard (1835-1908) and a brother of Reuben Sheppard (q.v.). Soon after his birth, the family moved to Dublin, living for many years at 72 Blessington Street, where his father ran a marble works and was presumably the S. Sheppard of Dublin ('fl. 1866') mentioned by Homan Potterton in *Irish Church Monuments 1570-1880*: he was responsible for the memorial to the Rev. William Colles Moore in Carnew, Co. Wicklow.

Oliver Sheppard entered the Dublin Metropolitan School of Art at an early age, a fellow pupil being John Hughes (q.v.), and he was described in an 1884 entrance form as an 'artisan'. He resided then at 7 St Joseph's Avenue, Drumcondra, and was said to have worked for a time in the monumental sculpture works of Pearse and Sharp. When W. B. Yeats entered the School of Art in 1884, he met Sheppard, who by that time had already visited Paris if one is to judge by the story of Yeats's admiration for Sheppard's loose tie, and so on.

Sheppard also studied at the Royal Hibernian Academy Schools. At the Metropolitan he was awarded in 1888 a scholarship to South Kensington, 1889-91, under Edouard Lanteri (1848-1917), and spent, at some period, two summers as assistant to him. Gaining another scholarship, he studied in Paris at the Colarossi and Julian academies. Returning to London, he enrolled at the Westminister School of Art.

In 1887 he had exhibited at the Royal Hibernian Academy for the first time, from 10 Alphonsus Avenue, Drumcondra. In 1888 he contributed a bust, *Very Rev. Father Ring, OMI*, the plaster for which was exhibited

that year at the Irish exhibition in London. *Head of a Girl, c.* 1890, was carved when Sheppard was staying at Staines in Yorkshire.

From 1891 until 1941, the year of his death, he never missed a single RHA exhibition and in all showed more than a hundred works. In 1891, giving a Fulham address, he exhibited at the Royal Academy for the first time: *Hibbert C. Binney, Esq.,* bust, followed two years later by *W. G. Urquhart, Esq.,* head.

Sheppard's first teaching post was at the School of Art, Leicester, whence he moved to teach modelling at Nottingham School of Art in 1894. In 1895 he showed at the RHA, *An Incident in the Deluge* and *The Bard Oisin and Niam* (awarded the Albert Prize). He gave studio addresses in London, for the RA, in 1896 and in 1897; in the latter year he showed his 'stone of destiny', *Lia-Fail,* statuette.

In 1898 he was appointed an associate of the RHA, and a full member in 1901, the year he exhibited *The Fate of the Children of Lir,* relief, at Burlington House. When living in Nottingham, he showed works at the Castle Museum in 1897, 1900 and 1901.

The Holbrook Bequest trustees commissioned a bust of Henry Kirke White, one of the Nottinghamshire poets being recognised, through the bequest, by memorials. *The Studio* commented: 'Authentic portraits of the poet are rare, and Mr Sheppard has succeeded in producing a bust which is worthy of all praise. The pedestal is enriched with a bronze bas-relief representing the allegorical figure of Genius mourning the early death of the poet, and holding a volume, over which hang laurel wreaths ... Mr Sheppard's work displays creative powers of the highest order, and foretells a brilliant future.' The White bust was presented to the Castle Museum in 1902.

Sheppard's future wife, Rosaline Good, was a student at Nottingham School of Art for the academic year 1899-1900. A ceramic bust of her is in the Hugh Lane Municipal Gallery of Modern Art, and a plaster one is in the National Gallery of Ireland. In 1903 he was appointed instructor in modelling at the Dublin Metropolitan School of Art, 30 Pembroke Road became his permanent residence and in later years he occasionally brought students to his studio there.

In 1904 Sheppard showed at the RHA the 1798 pikeman statue in bronze destined for Wexford town and unveiled in 1905, and also a bronze bust of his friend, the Fenian John O'Leary (HLMGMA). An O'Leary plaster is also at the Municipal Gallery and another at Áras an Uachtaráin, where there is also one of James Clarence Mangan. There are plaster statuettes of the Pikeman, 1798, and the Priest and Pikeman, 1798, on loan to Áras an Uachtaráin from the National Museum of Ireland and presented to the State by the artist's daughter, Miss Cathleen Sheppard.

In 1905 he was a founder member of the (Royal) Society of British Sculptors, and that year he was among the Gaelic Society members photographed at the Metropolitan School of Art. He was on the first Oireachtas Art Exhibition committee formed in 1906. At the RA in 1907 he contributed a bronze medal, *Sir John Banks, MD, KCB,* and a silver medal, *Prof. E. Hallaran Bennett, MD.*

At the Irish International Exhibition at Herbert Park, Dublin, in 1907 he showed nine works, including two bronze statuettes, *Dawn* and *La Jeunesse. Priest and Pikeman, 1798* was unveiled at Enniscorthy, Co. Wexford, in 1908, and showed a peasant rebel being directed by a priestly figure, Father Murphy.

The bust of James Clarence Mangan was erected in 1909 in St Stephen's Green by the National Literary Society of Ireland. A small group of onlookers at the unveiling by Sara Allgood saw her then stand up on a seat and speak Mangan's poem about herself. The bust was based on the pencil drawing by Sir Frederick Burton (1816-1900), made at the Meath Hospital a few hours after the poet's death.

Eoin O'Brien and Anne Crookshank pointed out in their *A Portrait of Irish Medicine,* that the sculptor who was most popular with the medical confraternity was Sheppard: 'He was particularly admired for his bronze low-relief portraits, often with an inscription beneath the profile likeness. These reliefs can be found in several Dublin institutions and must have been admired for their simple realism and for their convenience in being placed flat against the wall.' For example, the Royal Victoria Eye and Ear Hospital has one of Henry Swanzy and another of Arthur Benson. There are three, John Banks, Edward Hallaran Bennett (1907 RHA) and Daniel John Cunningham in St James's Hospital at Trinity College.

Sheppard was also Professor of Sculpture to the RHA and served for more than three decades until a few years before his death. At the Oireachtas in 1909 he exhibited the *Inis Fáil* statue, 1.6 metre high; the plaster,

loaned by NMI, is at the Pearse Museum. A vice-president of the United Arts Club, Dublin, he held a small exhibition there in 1910, the year he showed two medals for Trinity College, Dublin, at the Arts and Crafts Society of Ireland exhibition in Dublin. He also participated in 1910 in the exhibition of work by past and present students of the School of Art.

In 1910 he was commissioned for the figures of Sir William Rowan Hamilton and Robert Boyle for the Royal College of Science, Upper Merrion Street, now Government Buildings. Additionally, he did the seated figure on the pediment of the same building. In this commission he was assisted by C. L. Harrison (q.v.).

Sheppard's most famous sculpture, *The Death of Cuchulain*, which he began in 1911, was exhibited at the RHA in 1914 and chosen years later as a memorial for the 1916 Rising and placed in the General Post Office in 1935. The sculptor knew both Padraic and William Pearse (q.v.). According to Seumas O'Brien in an article in the *Capuchin Annual*, the young man who posed for the body of Cuchulain was a professional Italian model; James Sleator (q.v.) sat for the head; and O'Brien supplied the drapery, 'the hide of a Russian goat that I coaxed from my sister, Nellie, who wanted to make a floor rug of it'. There is no evidence in the guide book that a replica of this work appeared in the New York World's Fair 1939.

The foundation stone of the Honan Chapel, University College, Cork, was laid in 1915 and Sheppard was responsible for the image of St Finbarr, dressed in the garb of a bishop, for above the doorway. In the 1916 RHA exhibition he showed a bust of George Russell (q.v.), which *The Studio* said was 'a fine and dignified work, immensely modern in feeling'. It is now at NGI. Russell was a lifelong friend. In the same year his Sir Henry Swanzy memorial tablet, with portrait, in bronze, was unveiled at the Royal Victoria Eye and Ear Hospital, Dublin. In the 1917 RHA, the marble statuette, *In Mystery the Soul Abides* (NGI) attracted favourable attention.

Soon after the death of Nathaniel Hone (q.v.) in 1917, Dermod O'Brien (q.v.) commissioned a posthumous portrait, in the form of a bronze medallion, 46cm in diameter. This was cast in 1920. Thomas Bodkin considered that technically it was an excellent piece of modelling, 'but, like most posthumous portraits, it was not entirely successful as a likeness'. Another posthumous work, exhibited at the 1918 RHA, was the marble bust of Mrs Anne Jellicoe, foundress of Alexandra College. A marble plaque of the late Frank Brendan O'Carroll, 1920 RHA, destined for Richmond Hospital, is now in Beaumont Hospital.

John Turpin in his book *A School of Art in Dublin since the Eighteenth Century*, wrote that Sheppard was one of Ireland's most respected sculptors, 'excelling at subtle three-dimensional portrayal of poetic figures and portrait busts.'

Sheppard was represented in the exhibition of Irish art held in Paris in 1922, and he was one of seven artists invited to submit designs for the new Free State coinage. On the organising committee, he designed the medals for the 1924 Aonach Tailteann, portraying Queen Tailte on the front and the arms of the four provinces on the back.

Brigid Ganly, who studied sculpture in the 1920s, described Sheppard as a first-rate teacher. He 'went around and talked to students about the construction of things; the feeling was that you were learning all the time... He was a father to us all, more a friend than a master. '

When he showed his bronze relief of Sir Horace Plunkett at the 1927 RA, it was his first exhibit at Burlington House since 1909. In 1927 he sent his marble bust of George Russell to the loan exhibition of Irish Portraits by Ulster Artists at the Belfast Museum and Art Gallery. In 1930 he was represented at the exhibition of Irish Art in Brussels. The bronze bust of Major William Redmond erected on a plinth in Redmond Memorial Park, Wexford, was unveiled in 1931. His work was in the Aonach Tailteann exhibition in 1932 at DMSA. He was among the teachers who directed the summer courses at the School of Art.

Sheppard retired from the College of Art in 1937 and was active until his death. He received a number of State commissions for busts. In this posthumous work were: Kevin O'Higgins, marble, 1932 (NGI); and P.H. Pearse, bronze, 1936, and Cathal Brugha, bronze, 1939, both at Leinster House. A plaster bust of Pearse, loaned by the National Museum of Ireland, is at the Pearse Museum. His bronze group, *Inis Fáil* (HLMGMA) was again exhibited at the RHA, this time in 1938, and bought by public subscription; it is on indefinite loan to the Pearse Museum. Also at NGI is *The Fate of the Children of Lir*, relief, bronze cast; '*In mystery the*

Soul abides'. Altogether, the artist's daughter, Miss Cathleen Sheppard, presented nine plaster statuettes to NGI.

In the Crawford Municipal Art Gallery, Cork, is a plaster bust of Cathal Brugha and the marble, *Aideen*, RHA 1929. In Limerick City Gallery of Art is a bronze nude, *Finnbhéal*. A 1907 pencil drawing of Sheppard by (Sir) William Orpen (q.v.) is in NGI. A bust of his father in his 74th year is in Dublin Civic Museum.

Sean Keating (q.v.) described the sculptor as 'scholarly, kindly, with a distaste for ostentation'. The living room at Pembroke Road had a frieze of several canvases of the King Arthur legend painted by his lifelong friend, Dame Laura Knight, RA (1877-1970), who had attended the School of Art at Nottingham. Her husband, Harold Knight (1874-1961), was a close friend of Sheppard's.

Five paintings by Sheppard are at HLMGMA: *Dublin Bay*, two landscapes, a self-portrait and a portrait of his father. An exhibition of his major works was held in the Municipal Gallery shortly before his death. He died on 14 September 1941 at his summer home, 'Knockranny', Carrickbrack Road, Baily, Howth, Co. Dublin.

Works signed: Oliver Sheppard or OS monogram, rare; paintings probably unsigned.

Examples: Cork: Crawford Municipal Art Gallery; University College, Honan Chapel. Dublin: Alexandra College, Milltown; Áras an Uachtaráin; Civic Museum; General Post Office; Government Buildings; Hugh Lane Municipal Gallery of Modern Art; Leinster House; National Gallery of Ireland; Pearse Museum; Rotunda Hospital; Royal College of Physicians of Ireland; Royal College of Surgeons in Ireland; Royal Dublin Society; Royal Hibernian Academy; Royal Victoria Eye and Ear Hospital; St Patrick's Cathedral; St Stephen's Green; Trinity College. Enniscorthy, Co. Wexford: Market Square. Limerick: City Gallery of Art. Roscommon: County Council, Courthouse. Wexford: Bullring; Redmond Memorial Park.

Literature: *Thom's Directory*, 1870; *The Studio*, August 1903, October 1910, June 1916, July 1917; Algernon Graves, *The Royal Academy of Arts 1769-1904*, London 1905; General Registry Office, Dublin, *Register of Deaths*, 1908; *The Lady of the House*, 15 June 1909; *Irish Times*, 18 October 1916, 3 September 1982; Thomas Bodkin, *Four Irish Landscape Painters*, Dublin 1920; *Irish Independent*, 16 and 17 September 1941; *Irish Press*, 16 September 1941; *Royal Hibernian Academy Minutes*, 1941; Joseph Hone, *W. B. Yeats 1865-1939*, London 1942; *Collection of Historical Pictures, etc. established at Áras an Uachtaráin by Dr Douglas Hyde*, Dublin 1944; *Dermod O'Brien Papers*, Trinity College, Dublin [1945]; *Capuchin Annual*, 1949; *Studies*, Spring 1962; Beatrice Lady Glenavy, *Today we will only Gossip*, London 1964; Laura Knight, *The Magic of a Line*, London 1965; *Ireland of the Welcomes*, March- April 1966, July-August 1966; Michael J. O'Kelly, *The Honan Chapel: University College, Cork*, Cork 1966; Alan Denson, *John Hughes Sculptor 1865-1941*, Kendal 1969; Cyril Barrett, SJ: Cork Rosc, *Irish Art in the 19th century*, catalogue, Cork 1971; Homan Potterton, *Irish Church Monuments 1570-1880*, Belfast 1975; Hilary Pyle: Cork Rosc, *Irish Art 1910-1950*, catalogue, 1975; *Dictionary of British Artists 1880-1940*, Woodbridge 1976; Eoin O'Brien and Anne Crookshank with Sir Gordon Wolstenholme, *A Portrait of Irish Medicine*, Swords 1984; Adrian Le Harivel and Michael Wynne: National Gallery of Ireland, *Acquisitions 1984-86*, Dublin 1986 (also illustrations); Professor John Turpin, *Letters to the author*, 1986; Angela Jarman, *Royal Academy Exhibitors 1905-1970*, Calne 1987; Ann M. Stewart, *Royal Hibernian Academy of Arts: Index of Exhibitors 1826-1979*, Dublin 1987; Patricia Boylan, *All Cultivated People: A History of The United Arts Club, Dublin*, Gerrards Cross 1988; Hugh Lane Municipal Gallery of Modern Art, *Letters to the author*, 1992; Paul Larmour, *The Arts & Crafts Movement in Ireland*, Belfast 1992; Nottingham Castle Museum, *Letter to the author*, 1992; also, Áras an Uachtaráin, 1993; Beaumont Hospital, 1994; John Turpin, *A School of Art in Dublin since the Eighteenth Century*, Dublin 1995; Museum of Modern Art, New York, *Letter to the author*, 1997; Judith Hill, *Irish Public Sculpture: A History*, Dublin 1998 (also illustrations); Office of Public Works, *Letter to the author*, 1998.

SHEPPARD, REUBEN (1874-1946), sculptor. Born in Dublin on 18 October 1874, he was the son of Simpson Sheppard and a brother of Oliver Sheppard (q.v.). He enrolled at the Dublin Metropolitan School of Art in 1889. In 1894 he exhibited a watercolour, *Night*, at the Royal Hibernian Academy. His home was at 10 Alphonsus Avenue, Drumcondra, Dublin.

In the 1895 National Competition associated with South Kensington, and the subsequent exhibition, a drinking fountain by Sheppard gained a silver medal and special mention by the judges. According to *The Studio*, this praise was 'well deserved. It was in general form not unlike a stoup for holy water'. At the first exhibition of the Arts and Crafts Society of Ireland in Dublin in 1895 he showed a model for candelabra.

When studying at the National Art Training School, 1895-7, he won the Royal Dublin Society's 1896 Taylor Scholarship for a statuette and a study of a head in relief. His employment on leaving the school was

with Doulton's, manufacturers of hygienic porcelain fitments. The only other contribution to the RHA was in 1901 from Fulham, London: *How Sweet the Answer Echo Makes*, a panel.

Sheppard was involved in the sculptural work for the Victoria and Albert Museum building, begun in 1899 and opened in 1909. Aston Webb, one of the architects, suggested that certain of the statues should represent ten English painters, occupying 'the central curtains of the Cromwell Road front'. The niches of the entire façade were between the windows on the first floor. Each statue was to be 2.3m high. Seven sculptors were commissioned for the ten statues. Four of the sculptors were students of Professor Edouard Lanteri (1848-1917); Sheppard was one of the remaining three who were 'relatively unknown'.

Each sculptor for the V&A was asked to submit a model of a quarter real size, placed in a model of the niche, which was supplied to him. When the figure had been approved, the artist had to make a full-size version in plaster which was then placed in its correct site on the façade in order that its effect might be judged. Not much time was allowed; the smaller model had to be ready within one month of the acceptance of the commission, and two months after that the large plaster model had to be finished. 'As soon as the full size is approved the carving on the building is to be commenced and to be completed within 3 months of that date ...' By the end of 1905, all the figures were complete. Sheppard was responsible for William Hogarth and Sir Joshua Reynolds at £150 each.

At the Royal Academy he contributed eleven works between 1904 and 1914, *Love in Idleness*, a marble relief, appearing in the first exhibition and presumably the same sculpture exhibited under that title in the 1914 show. In 1906 from 2 The Mall, Park Hill Road, NW, he showed *The Juggler*, a bronze statuette, and *Mrs R. Sheppard*, bust. *The Music of Death*, group, was displayed in 1907.

Sheppard had become a member of the Society of British Sculptors in 1906, and worked in the studio of Sir Thomas Brock (1847-1922), a pupil of the Irishman, John Henry Foley (1818-74), and was said to have been one of Brock's assistants whilst he was working on the Queen Victoria Memorial. A group, *Love and Riches*, in marble was shown at Burlington House in 1912. He exhibited only one work at the Walker Art Gallery, Liverpool, and the Manchester City Art Gallery. He contributed two works to the Royal Institute of Painters in Water Colours.

After the outbreak of the First World War he appeared to have abandoned a career in sculpture, and his name was removed in 1920 from the membership list of the Royal Society of British Sculptors for non-payment of subscriptions. Depression in the trade terminated his employment as a salesman in 1921 with the Beresford Rope and Twine Co., Hornsey. He used the Hampden Club, King's Cross, as his address when he applied successfully for a job with N. M. Rothschild & Sons, the bankers, and worked in the bond coupon posting department until his retirement on pension in 1944 after a bout of illness; he suffered from bronchial trouble. He died on 31 July 1946.

Works signed: Reuben Sheppard.
Examples: London: Victoria and Albert Museum.
Literature: *The Studio*, 1895; *Royal Dublin Society Report of the Council*, 1896; Algernon Graves, *The Royal Academy of Arts 1769-1904*, London 1905; Alan Denson, *John Hughes Sculptor 1865-1941*, Kendal 1969; *Dictionary of British Artists 1880-1940*, Woodbridge 1976; John Physick, *The Victoria and Albert Museum*, London 1982; Angela Jarman, *Royal Academy Exhibitors 1905-1970*, Calne 1987; Ann M. Stewart, *Royal Hibernian Academy of Arts: Index of Exhibitors 1826-1979*, Dublin 1987; Royal Society of British Sculptors, *Letter to the author*, 1993.

SHERIDAN, CLARE (1885-1970), sculptor. Born in London on 9 September 1885, Claire (Clare) Consuelo Frewen was the daughter of Moreton Frewen of Sussex, one-time member for North-East Cork in the Westminster Parliament, and her mother was Clara Jerome, the eldest of three American-born sisters of French origin. One sister married Lord Randolf Churchill and became the mother of Winston Churchill; another married Sir John Leslie, Bart., Glaslough, Co. Monaghan, and became the mother of Shane Leslie. In 1896 Irish estates passed to Clare's father, and most of her childhood was spent at Inishannon, Co. Cork. She was educated at the Convent of the Assumption, Paris.

In 1910 she married, in London, Wilfred Sheridan of Frampton Court, Dorset, the great-great grandson of Richard Brinsley Sheridan. She always considered herself Irish. In 1915 her husband fell in the War and she had to support herself and two young children. A third child had died young, and in her efforts to model a weeping angel for the small grave, she discovered her talent as a sculptress. In London, she moved into 3 St John's Wood Studios, and for shops she made garlands of painted plaster fruit and owl sundials. Each morning she took lessons from the Scottish-born sculptor, John Tweed, RA (1869-1933), and she also studied under Professor Edouard Lanteri (1848-1917) at South Kensington.

Within four years she had established herself as a portrait sculptor. Herbert Asquith, for the Oxford Union, and, in 1919, her own cousin, Winston Churchill, were among her sitters, but there was also Arnold Bennett, Gladys Cooper and H. G. Wells. In 1919, under the auspices of the National Portrait Society, she held her first exhibition, at the Grosvenor Gallery.

In 1920 a trade delegation from Soviet Russia visited London, and there was an unexpected outcome for the sculptor: Krassin and Kamenoff commissioned busts. Afterwards they invited her to return with them for portraits of Lenin and Trotsky. She spent two months in Moscow and also sculpted four other Soviet leaders. In London, consequently, Bolshevik heads were included in her exhibition at the Agnew Gallery, Bond Street. She also exhibited with the International Society of Sculptors, Painters, and Gravers, and at the Paris Salon.

The *New York Times* asked to publish her Russian diary, and in 1921 she embarked on a lecture tour of the United States as a further outcome of having modelled the heads of Lenin and Trotsky: 'It was a great scoop, if an unpopular one,' she said. *Russian Portraits*, a narrative of her Moscow visit, appeared in 1921.

The *New York World* appointed her European correspondent, and in 1922 she visited Dublin, interviewed Rory O'Connor and was the last person to enter the Four Courts before the bombardment. She still sculpted. A head of Lord Birkenhead (Gray's Inn) was dated 1924.

An adventurous life – she also visited Mussolini – was recounted in *Nuda Veritas*, 1927, but she still found time to write novels and visit County Monaghan. At the Royal Academy she showed only three works: 1924, *Lenin*, bronze head; 1936, *Serge Lifar*, bronze head; 1942, *Mrs Oswald Birley*, bronze mask. As the Muslim religion forbade the modelling of human faces, she produced fountains of flying birds when living in Algiers. In 1938 she spent five months with the Indians of the Blood and the Blackfoot tribes. *Redskin Interlude* was published in 1938. In her exhibition at the Storran Gallery, London, in 1938, she showed twelve works, including *Chief Turtle, Blackfoot Tribe, Montana, USA*, bronze, wearing the claws of the grizzly bear which he wrestled with and overcame single-handed.

When the Second World War broke out, she was living at her home in Brede, Sussex, and began to devote her art to religious subjects. No longer possible to reproduce in bronze, metal being unprocurable, or in terracotta, for coal was not obtainable for the furnace, she began to carve trees. The soldiers cut down the dead ones that she designated and carried them to her improvised studio.

In December 1942 she wrote to her cousin Anita Leslie saying that she had been two weeks in London doing the head of their dynamic cousin – 'it's uphill work and very exhausting because he never gives me a chance. Always that blasted cigar in his mouth which twists his face ...'. Churchill asked for a replica of the head, and bronze copies were also bought by the cities of Belfast, Edinburgh; Stafford and by Harrow School.

Returning to her cottage in Brede Park she embarked on two major woodcarvings for Brede parish church. She hewed one great oak into a Resurrecting Christ to hang against the shadow of a cross which she chipped into the wall over the altar. Six soldiers of a Canadian regiment carried the *Statue of the Madonna*, 1941, 3 metres high, in memory of her son Richard Brinsley Sheridan who had died aged twenty-one, to the village church. By the entrance she set up a pregnant Madonna in pine – on the theme of 'Before birth and after death'. She wrote about this period in *My Crowded Sanctuary*, 1945. A bronze bust of Clare Sheridan by Jacob Epstein (1880-1959) formerly stood in the Brede church.

In 1946 she entered the Catholic Church at Assisi. In 1947 she moved to Co. Galway, shipping a quantity of bronzes and a great Sussex oak. She lived in her own reconstructed house at the Spanish Arch, Galway, but much of her time was spent at her cousin Anita's home, Oranmore Castle, five miles along the coast, and the mason there roughed out big blocks. According to Anita Leslie in her biography: 'The West of Ireland

suited Clare and she became a well-known figure floating in her violet-shaded tweed coats of ecclesiastical design.'

Madonna of the Quays was erected on the wall of the Spanish Arch, Galway, stood for forty years and then fell over in bad weather. The base had rotted. After restoration, it was placed in a window over the entrance door of the City Museum there. In Dublin in 1948, at the Dawson Gallery, she showed twenty-five pieces of sculpture, nine on religious themes, notably *Archangel Michael*. Also on view were *Head of Mary*, limestone; *Madonna and Holy Child*, terracotta; *An Apostle*, cement. Winston Churchill, Serge Lifar and Guglielmo Marconi appeared in bronze; *Gandhi Spinning* in terracotta. The heads of American Indians included Shot-on-both-sides, Chief of the Blood tribe of Alberta.

Anita, daughter of Shane Leslie, Bart. appeared at the 1949 Royal Hibernian Academy and she contributed two works in 1951, but as she was living in Galway 'as a Catholic sculptor with the Church for my patron', she was disappointed at the dearth of orders for her carved figures. When she exhibited with the Galway Art Club in 1950 in their exhibition at the Chamber of Commerce, she was the only sculptor represented. She showed in terracotta, *Head of Child*; *Angel of the House*, alabaster head; *Shrine of Our Lady.*

In 1952 she sold the house at Spanish Arch. May O'Flaherty of Sea Road, Galway, had no doubt about Clare's 'itchy feet'. May also told the author in 1974: 'She used to come in for breakfast and had an English secretary who would call in sometimes and say: "Mrs Sheridan wants to see you". We had frequent cocktail parties in the morning.'

English summers were spent near Brede; winters in Algeria. In 1953 at M'Cid, an Arab village outside Biskra, she finished her final memoirs, *To the Four Winds*, 1954. In St Michael's Church, Chenies, near Rickmansworth, Hertfordshire, is a 1956 stone tablet to the memory of the 12th Duke of Bedford, who died in 1953. Two trees are depicted with exotic birds in the branches. In one branch there is a web with spider, and in the roots of a tree a frog – the Duke particularly studied frogs and spiders. A bison and deer are also featured. An inscription states: 'He worked for the peace of the world and was a great naturalist.'

In 1960 she took up residence in the guest house lodge of the Franciscan Convent, Hope Castle, at Castleblayney, Co. Monaghan, staying intermittently until 1965, and there she was described as 'still a tall, erect, graceful lady, physically active and does not look the many years she admits'. At Hope Castle she painted, and in local possession are two works, one of goldfish in a bowl and the other of a flowering bush. She carved on hardwood 'which was hinged together like firescreen', and another activity was an interest in itinerants. *St Francis*, bog oak, is with the Franciscan Sisters of Mill Hill, London, and at their convent at Kilbarrack, Dublin, are two white doves.

Among other works in Ireland is *St Michael the Archangel*, oak, at Blackrock College, Co. Dublin. A sculpture known as *The Black Madonna* in Irish bog oak was transferred in 1992 from Allington Castle to the Order of Carmelites at Aylesford, Kent. 'She was a woman of varied talents which,' said *The Times*, 'throughout a long life, she developed with uninhibited zest and success.' She died on 31 May 1970 and was buried beside Brede church.

Works signed: Clare Sheridan or C. Sheridan, rare.
Examples: Aylesford, Kent: Order of Carmelites. Belfast: Ulster Museum. Blackrock, Co. Dublin: Blackrock College. Brede, Sussex: St George's Church. Chenies, Hertfordshire: St Michael's Church. Dublin: Franciscan Convent, East Kilbarrack. Galway: Church of Christ the King, Salthill; City Museum, Spanish Arch. Hoogstraten, Belgium: Church of St Catherine. London: Honourable Society of Gray's Inn; St Mary's Abbey, Mill Hill.
Literature: *The Studio*, May 1938 (also illustration), January 1944 (illustration); *Father Mathew Record*, July 1948, October 1949; *Capuchin Annual*, 1950-51; *Irish News*, 25 February 1961; *Who's Who in Art*, 1966; *The Times*, 2 June 1970; Seymour Leslie, *Letter to the author*, 1972; *Who Was Who 1961-1970*, London 1972; *Dictionary of British Artists 1880-1940*, Woodbridge 1976; Anita Leslie, *Cousin Clare: The Tempestuous Career of Clare Sheridan*, London 1976; *Royal Academy Exhibitors 1905-1970*, East Ardsley 1982; *A Short Guide to St George's Church, Brede*, Brede 1991; Galway City Museum, *Letter to the author*, 1992; also, Honourable Society of Gray's Inn, 1992; Order of Carmelites, Aylesford, 1992; Mrs Joy D. Atkins, 1993; Convent of Mercy, Castleblayney, 1993; Franciscan Sisters of Mill Hill, 1993; Paul McCarthy, 1993.

SHERLOCK, MARGARET M. (1885-1966), landscape and figure painter. Born on 1 November 1885 at 17 Clarinda Park West, Kingstown, Co. Dublin, Margaret Murray Ross was the daughter of William Ross of Ross and Walpole, iron and brassfounders, engineers, and boilermakers, 65-67 North Wall Quay, Dublin. Partly educated in London, she was admitted to the Dublin Metropolitan School of Art in 1905 and studied under (Sir) William Orpen (q.v.), winning various prizes.

In 1910 she married Captain Charles Sherlock from the Army Medical Corps and they moved to India. Madge Sherlock returned to Ireland on leave with her young daughters. In 1913, from Summerfield, Dalkey, Co. Dublin, she exhibited at the Royal Hibernian Academy, *Balum Bazaar*. Altogether, up until 1926, she contributed eight works.

At the Water Colour Society of Ireland event in 1913 she showed *Chungla Bazaar, Muree Hills*; *Brass Walah*. Contributions, also until 1926, totalled seven. In 1914 she presented : *At Muree, India*; *In the Muree Hills, India*; *Balum Bazaar, India*. She rejoined her husband when war was declared. Sadly, he was killed at Mesopotamia in 1917, and she could not return to Ireland until 1919. Kashmir was a favourite painting ground for her watercolours.

In 1926 she exhibited *Morgins, Switzerland* and *At Lucknow* at the RHA; and in the same year at WCSI she offered *Autumn, Kashmir* and *Snow Sketch, Switzerland*. She returned to India in 1933 and 1936. The Dublin Sketching Club showed three pictures in 1937: *Les Deuts de Midi*; *Morgins, Switzerland*; *Nauchandi Fair*, all not for sale.

Margaret Ross was an elder sister of Stella C. Ross (1900-72), who, as a member of the medical profession, Dr Henry, supplied illustrations signed S.C.R. for three books: Bethel Solomons, *A Handbook of Gynaecology*, London 1934; R. R. Woods, *Painful and Dangerous Diseases of the Ear*, Oxford 1936; Bethel Solomons and Ninian Falkiner, *Tweedy's Practical Obstetrics*, Oxford 1937. Anatomical drawings have been incorrectly credited to her sister Margaret, who, indeed, practically disappeared from the Irish art scene in the last thirty years of her life. Of 2 Temple Crescent, Blackrock, Co. Dublin, she died on 7 January 1966 at Portobello Nursing Home, Dublin. In 1987 a watercolour appeared in the large Irish Women Artists exhibition in Dublin.

Works signed: M.M.R. or M.M. S.
Literature: *Register of Births, Kingstown*, 1885; *Thom's Official Directory*; Dublin 1887; General Register Office, Dublin, *Register of Deaths*, 1966; National Gallery of Ireland and Douglas Hyde Gallery, *Irish Women Artists: From the Eighteenth Century to the Present Day*, catalogue, Dublin 1987 (also illustration); Ann M. Stewart, *Royal Hibernian Academy of Arts: Index of Exhibitors 1826-1979*, Dublin 1987; *Water Colour Society of Ireland Exhibition List 1872-1994*, Dublin 1995; Ann M. Stewart, *Irish Art Societies and Sketching Clubs: Index of Exhibitors 1870-1980*, Dublin 1997; Katherine Affleck-Graves, *Letter to the author*, 2000; Dr George Henry, *Letter to Dr Michael Solomons*, 2000; Dr Michael Solomons, *Letter to the author*, 2000.

SHORE, ROBERT S., RHA (1868-1931), marine painter. Robert Silver Shore was the eldest son of Francis Arundel Shore, bank manager. He was the 'Robert T. Shore' who was registered in 1888 as a student at the Dublin Metropolitan School of Art, and for the 1889-90 session his address was entered as 'St Mildred's', Mellifont Avenue, Kingstown, or 54 Lower Baggot Street, Dublin; the latter address he gave when he first exhibited at the Royal Hibernian Academy in 1890. In the published proceedings of the Royal Dublin Society for 1891-2 was reported the award to Robert S. Shore, 'a student at the Royal Hibernian Academy', of a Taylor Prize of £10, for his work entitled *The Last of the Breeze*.

As for the RHA, from 1890 until 1922 he never missed a single exhibition, showing an average of about five works per year. Although he described himself as a marine and landscape artist, the sea predominated. In his youth he had served in the merchant service. His 1891 contributions to the RHA were: *Colliers*; *At the edge of the Sandbank*; *A Ringsend Man*; *The Port of Dublin*; *In Kingstown Harbour*; *Preparing for Sea*; *The Harbour Mouth*.

In 1891 the Dublin Sketching Club appointed him a 'working member' and such was his industry that from then until 1905 he showed no fewer than 150 works. In his opening year, *On the Seine below Paris* and *In the Coal Harbour, Kingstown* were included.

Shore also painted in the London area. For example, at the 1893 RHA: *The Bishop's Walk, Putney*; 1894, *On the Thames near Greenwich*; 1895, *In the Pool of London*. In private possession, *Morning on the Thames*, a watercolour, was dated 1899. He showed two works at the Royal Academy: 1896, *A Grey Day on the River*; 1897, *From Foreign Parts*.

In 1894 he had been appointed an associate of the RHA, and in 1895 a full member. In 1904 he was represented by *The Irish Mail* in the exhibition of works by Irish painters held at the Guildhall of the Corporation of London and organised by Hugh P. Lane. By 1910 he gave his father's address, 18 Leeson Park, Dublin. At the RHA in 1920 he exhibited *On the Seine*, and that year he was appointed Keeper, 'and his duties in connection with the Academy Life-school were performed with zeal and efficiency ...', it was later recorded at an Academy general assembly. In 1920 he showed *Pastureland* and *The Pierhead* at the Oireachtas exhibition.

In his *Irish Life and Landscape* published in 1927 with an illustration, *Shipping on the Liffey*, J. Crampton Walker wrote: 'The docks, the old boathouses and wharves round about, together with the different classes of steamers and sailing vessels, afford ample material for the marine painter's brush. R. S. Shore had painted many such subjects with marked success'. He also painted at Kilkee, Co. Clare, probably on summer vacation. After being ill for about five months, he died in Baggot Street Hospital on 13 April 1931.

Works signed: R. S. Shore.
Examples: Limerick: City Gallery of Art.
Literature: *Dublin Sketching Club Minute Book*, 1891; J. Crampton Walker, *Irish Life and Landscape*, Dublin 1927 (also illustration); *Who's Who in Art*, 1927; *Irish Independent*, 22 April 1931; *Irish Builder and Engineer*, 25 April 1931; *Royal Hibernian Academy Minutes*, 1931; Alan Denson, *John Hughes Sculptor 1865-1941*, Kendal 1969; Ann M. Stewart, *Royal Hibernian Academy of Arts: Index of Exhibitors 1826- 1979*, Dublin 1987; Ann M. Stewart, *Irish Art Societies and Sketching Clubs: Index of Exhibitors 1870-1980*, Dublin 1997.

SHORTALL, MICHAEL (1868-1951), sculptor. Judging by the age given at the time of his death, he must be the Joseph Michael Shortall registered as born on 31 August 1868, son of Michael Shortall, a cook, and Eliza Shortall (née Clarke) of 11 Lower Clanbrassil Street, Dublin. However, Alan Denson, author of a book on John Hughes (q.v.), stated that Shortall was born in Phibsboro, Dublin, the son of Walter Shortall and his mother was a Margaret Henshaw. He enrolled at the Dublin Metropolitan School of Art in 1883 as a 'mason' of 150 Phibsboro' Road, Dublin; *Thom's Directory* of that period listed the householder as Thomas Henshaw.

The Science and Art Department report for the year 1884-5 at the School of Art described Shortall's modelling as 'excellent'. He was awarded a travelling scholarship and relatives recounted later that he spent several years studying on the Continent, probably in Italy and France. John Hughes became instructor in modelling in 1894 at the School of Art. According to Lady Glenavy (q.v.), Hughes loved the way Shortall used to say 'extraordinarily funny things in a sort of miserable voice, with a very serious face. He admired his stone carving work ...'.

Shortall was back at the School of Art for the year 1895-6 and won a bronze medal in the National Competition for a modelled design with figures, and the Royal Dublin Society awarded him a scholarship. In the following year he received a Queen's Prize for a modelling design, a capital for a pilaster, and the examiners, one of whom was Walter Crane (1845-1915), said that his work was 'a perfectly successful adaptation of natural forms'.

In the year 1897-8 he was awarded two medals, one for a model of a head from life, the other for a modelled design for a tomb. Commenting on that National Competition, *The Studio* said: 'In modelled ornament an ambitious monument by Michael J. Shortall (Dublin) inspires respect rather than admiration.' He gave 15 Berkeley Road as his address for the 1898 Royal Hibernian Academy. He was still at the School of Art for the year 1898-9.

Shortall's name has always been linked with his work for St Brendan's Cathedral, Loughrea, Co. Galway. Hughes, who had received the commission and travelled to Loughrea, wrote in 1901 to Sarah Purser (q.v.) that he had 'started Shortall to make designs for that part of carving which is very high up and which will be

mainly floral and ornamental in character'. In the event, Shortall did the work, carving the upper sixteen corbels with animals, birds and fish entwined with foliate decoration.

An undated letter some years later from Michael Healy (q.v.) to Miss Purser stated: 'I asked Shortall about the Loughrea work and he says he did the following: Designs for chalice, ciborium, candle sticks, crucifix in ebony and silver, vases, crucifix in oak. Designed and carved all the stone work. Altar rail with bronze panels. Brass panels on gates. Designed and carved all decorations on High altar. All carvings on side altars and Holy water font. Baptismal font. Bronze crockets on Bishop's confessional. Statue of St Brendan over side door.' Shortall probably carved the baptismal font, which is in Kilkenny marble, but William A. Scott, the architect, is accepted as the designer. Itself and the ciborium show Art Nouveau influence to which Scott had been exposed in England a short time before. The chalice design is regarded as Shortall's and is in contrast to the ciborium.

Sometime between 1904 and 1906 Shortall and Scott visited Hughes in Paris. The four small bronze crockets for the confessional were modelled in 1906, also the chalice, which is in silver and enamels. The altar rail panels depict eight bronze angels with musical instruments in low relief, illustrating the theme of sacred music.

At the 1906 Oireachtas exhibition, Shortall showed four crockets in bronze for the Loughrea confessional: *The Betrayal*; *Dying Christ*; *Prodigal Son*; *Risen Christ*. At the 1907 Oireachtas, he exhibited a model of four brass panels for the altar rail gates, and four panels in bronze for altar rails.

Shortall made a memorandum on the St Brendan scenes, thirty-two in all, depicted on the capitals of the eight columns in the nave. The variety of subject matter may be judged by a sample from each of the pillars, preceded by the sculptor's title for the group: Birth of the Saint: *Angels in the guise of virgins foster the babe*; Education: *A rich landowner adopts Brendan as godson*; Ordination: *Brendan plays on his harp surrounded by countless birds*; Vogage to America: *Island of Ailbe: they lead a sheep by the horns to celebrate Easter*; Voyage to America (continued): *While Mass is being said innumerable fishes swim round boat. A bird perches on prow of boat and respreads his wings in welcome*; Founds Clonfert: *Brother plays on harp. Brendan takes the two wax balls from his ears and places them on his book*; Various: *Raises a dead youth to life*; Death of Brendan: *His body is piled on a wagon among goods with one Brother in charge*.

In addition to these St Brendan scenes in the nave, there are sculptures on the capitals of the transept columns, representing incidents in the history of the diocese, for example the calculation of the date of Easter and *Miceal O'Cleirigh copying the life of St Ceallach in the friary of Kilnalahan*. The reason two capitals were left uncarved was that the bishop had plans for extending the sanctuary which, however, did not come to fruition. Of the larger corbels, there is a half-length carving of a cloaked and hooded old woman with a rosary and a corresponding figure of a youthful St Patrick bearing a lamb on his shoulders while a serpent slinks away. In the grounds at St Brendan's is his figure, *Ireland*, on the monument over the grave of Father Griffin.

Amongst other works were some carried out under the direction of Scott. Capitals, corbels and datestone depicting animals, foliage and people involved in sporting activities, at Spiddal House, Co. Galway, designed by Scott in 1910. Also the marble baldacchino of 1915 in Laban Church, Co. Galway, the bases of which were carved with four eagles, five birds with reeds at each, two lions, cross and crown of thorns and a lamp. The capitals have the four evangelists, and the arches with Christ, Melchisedech and St John, plus Celtic interlaced ornament.

Celtic motifs were carved on Scott's memorial to Professor Edward Cadic in Glasnevin Cemetery, Dublin, 1916. Shortall was also responsible for the Michael Collins memorial cross at Béal na Bláth, Co. Cork.

According to Vincent O'Connor, in 1979, a well-known stonecutter in the Ballinasloe area, Co. Galway, Shortall was 'a carver who travelled around the country a good deal with various firms and worked for a time with a James Martin of Cookstown, Co. Tyrone', but this claim has not been substantiated. However, Denson credits him with 'ecclesiastical sculptures in various parts of Ireland, including churches in Co. Dublin, Mayo, and in Northern Ireland'. In the mid 1930s he was a member of the Academy of Christian Art. A bachelor, he lived with his sister. In the Hugh Lane Municipal Gallery of Modern Art there is a crayon drawing of him by Christopher Campbell (q.v.). He died in Dublin on 31 October 1951.

Works signed: M. J. Shortall (if signed at all).

Examples: Ardrahan, Co. Galway: St Teresa of Avila's Church, Labane. Béal na Bláth, Co. Cork: Michael Collins memorial cross. Dublin: Glasnevin Cemetery. Loughrea, Co. Galway: St Brendan's Cathedral. Spiddal, Co. Galway: Spiddal House.

Literature: *Thom's Directory*, 1885; *The Studio*, September 1898; Robert Elliott, *Art and Ireland*, Dublin [1906] (illustration); Michael Healy, *Letter to Sarah Purser*, National Library of Ireland, n.d.; Thomas MacGreevy, 'St Brendan's Cathedral, Loughrea, 1897-1947', *Capuchin Annual*, 1946-7; Alan Denson, *John Hughes Sculptor 1865-1941*, Kendal 1969; Rev. P. Jennings, *Letter to the author*, 1978; also, John Cotter, 1979; Rev. P. K. Egan, 1981, 1993; Patrick K. Egan, *St Brendan's Cathedral, Loughrea*, Dublin 1986 (also illustrations); Central Catholic Library Association, Inc., *Letter to the author*, 1992; also, Glasnevin Cemetery, 1992; Very Rev. Joseph Kelly, 1992; Paul Larmour, *The Arts & Crafts Movement in Ireland*, Belfast 1992 (also illustrations); Ann M. Stewart, *Irish Art Societies and Sketching Clubs: Index of Exhibitors 1870-1980*, Dublin 1997.

SINCLAIR, FRANCES – see BECKETT, FRANCES

SINCLAIR, PATRICK – see KERR, ALFRED E.

SLEATOR, JAMES S., RHA (1885-1950), portrait and still life painter. The son of a teacher, William Slator, he was born at Derryvane National School, near Portadown, Co. Armagh, on 27 June 1885. Christened James Samuel Slator, he not only changed the surname spelling but became James Sinton Sleator. Apparently 1885 was his year of birth and not 1889, as originally thought.

When he was about twelve years of age, the family moved to Belfast where his father became principal of Strandtown National School. A close friend, John Coulter, recalled years later that as a youth Sleator worked behind the counter at the Belfast School of Art supplies shop.

Sleator spent five or six years studying at the School of Art in Belfast. Although he joined the Belfast Art Society in 1908, he did not exhibit. On enrolling at the Dublin Metropolitan School of Art in 1909 he gave his occupation as art teacher. He was among the 'promising youth' whom (Sir) William Orpen (q.v.) taught there and became a favoured pupil, winning several prizes, including the gold and silver medals for still life studies under the South Kensington scheme. When still at the Metropolitan, he modelled for the head in *Death of Cuchulain* by Oliver Sheppard (q.v.).

A drawing of an old man appeared at the 1911 Oireachtas exhibition. In 1913 a still life by him was included in the Irish art exhibition at the Whitechapel Art Gallery, London. A statement by his friend Coulter that he had a spell as art master at St Andrew's College, then at St Stephen's Green, has not been substantiated by the school.

In 1914 he left the Metropolitan and became an assistant to Orpen in his London studio. About this time he met (Sir) Winston Churchill(1874-1965) and for a time gave him painting lessons. In 1915, back in Dublin, he exhibited for the first time at the Royal Hibernian Academy, and referring to his four portraits, *The Studio* commented: ' ... one recognises "quality" of a very unique kind. His rapidly executed head of a man in a red coat and his self-portraiture full of distinction and beauty of tone.' The self-portrait is at the National Gallery of Ireland.

A studio which he used at 54 Upper Sackville Street was later destroyed in the Easter Week Rising. In 1915 he had joined the Metropolitan School of Art staff. He also gave instruction at Rathmines Technical School. *Man in Green* at the 1916 RHA was described by *The Studio* as 'a brilliant study of effects of light'.

In 1917, now at 149 Lower Baggot Street, he was appointed an associate of the RHA and in the same year a full member, an unusually rapid advance. A regular exhibitor at the Dublin exhibition up until 1949, he showed in all seventy-six works, of which, among the portraits, *Portrait of Mrs Macnamara* (Armagh County Museum), exhibited in 1918, attracted much attention.

Sleator was an assistant teacher in the life class at the School of Art from February 1919 for one year. In 1920 he became a founder member of the Society of Dublin Painters and in the same year he sent a self-portrait, of which he did several, and a still life to the Belfast Museum and Art Gallery's exhibition of oil paintings and early British watercolours. He visited Spain.

Following the events of the Civil War in Ireland, he left Dublin for Florence, where he painted, it is claimed, portraits and landscapes, but the latter, so far as Ireland is concerned, are 'thin on the ground'. During the early 1920s he still worked intermittently for Orpen, but his home was regarded as in Belfast and he returned there from time to time.

A contributor to the January 1925 issue of the *Ulster Review* stated that Sleator's journeys had included 'several visits to Paris and Italy, for the study of the masters'. The portrait of the Belfast novelist, Forrest Reid (Ulster Museum) was painted in 1924, and in 1926 there was a rare one-person show, at Rodman's Gallery, Belfast, where he exhibited portraits and still lifes.

By 1927 he had settled in London, portrait painting and assisting Orpen. In the loan exhibition of Irish portraits by Ulster artists held by the Belfast Museum and Art Gallery in 1927 he contributed three, including one of Senator Henry Bruce Armstrong (Armagh County Museum); his address was 3 Scarsdale Studios, Stratford Road, London. In 1930 he was represented at the Exposition d'Art Irlandais at Brussels by three works, including *Cyclamens*, and that year he was appointed one of the first academicians of the Ulster Academy of Arts.

After Orpen's death in 1931 he was asked, with his similarity in style, to finish a number of uncompleted commissions in the studio. These included portraits of Prince Arthur of Connaught and the Duchess of Westminster. By 1934 his studio was at 59 Edwardes Square, London.

Sleator kept a diary, at least in the 1930s, in abbreviated form, which showed frequent visits to the Chelsea Arts Club for dinner. On 11 April 1934 he recorded: 'Up town to see Paul Henry's exhibition. Very poor and monotonous.' In that year he noted his election as a member of the Imperial Arts League, also his return to Belfast on three occasions: for example 'arrived home at 9 Edgecumbe Gardens', where his sister Ethel lived. In 1935 he was accorded honorary membership of the Ulster Arts Club, and that year he journeyed to Newcastle for the unveiling of his portrait of William Haughton for the Royal County Down Golf Club.

In 1936 he exhibited an interior at the Royal Academy, and in 1938 a head. Four works were shown at the Royal Society of Portrait Painters. In 1937 the Russell-Cotes Art Gallery and Museum, Bournemouth, purchased *Interior*, a 1931 portrait of Orpen in his studio, at the Coronation Exhibition of Prominent Living Artists.

In 1941 Sleator, homeless because of the air raids, left wartime London and settled in Dublin where he became a member of the United Arts Club. He was appointed RHA secretary, and by 1942 he was installed at the Academy premises, 15 Ely Place.

On the first executive committee, 1943, of the Irish Exhibition of Living Art, he also took an interest in the Irish language and sat on the selection committee of the Oireachtas art committee for some years as well as exhibiting again in 1944, 1947 and 1948. Art movements received his support, and he was interested in the revival of native crafts.

Referring to his portrait of Lennox Robinson (Abbey Theatre) at the 1943 RHA, the *Dublin Magazine* commented that the work 'shows how hands as well as head, pose as well as paint, can give character to the living model'. At the 1944 RHA he showed portraits: of Rutherford Mayne; R. I. Best, Litt D; Dr James Ryan, Minister for Agriculture; the Very Rev. D. F. R. Wilson, Dean of St Patrick's; Raymond Brooke, Deputy Grand Master of the Grand Masonic Lodge of Ireland.

On the death of Dermod O'Brien (q.v.) in 1945, he succeeded as president of the Academy. A portrait of O'Brien is in the RHA collection. The art critic of the *Dublin Magazine* continued to praise. On the 1945 RHA: 'Among the portraitists, James Sleator attracts me most for his sensitivity, honesty and the quiet competence of his painting. He is free from the usual portrait-painter's theatricality and imposes his own discerning evaluation on the sitter ...' A self-portrait painted about this time is in the Ulster Museum. Favourable comment ensued on the 1947 RHA for the work on Miss Kate O'Brien (Limerick City Gallery of Art).

In 1947 he helped to organise the revived Nine Arts Ball. His 1948 presidential portrait of T. Percy Kirkpatrick was for the Friendly Brothers of St. Patrick; another Brothers' portrait was of the architect, Fred Hicks. He was represented in the exhibition of pictures, by Irish artists, in Technical Schools, 1949, and that

year he completed his portrait of the Rt. Rev. Richard Tyner, Bishop of Clogher. Sleator was represented in the Contemporary Irish Painting exhibition sent to the USA in 1950.

Portraits of Professor Thomas Bodkin, Caroline Scally (q.v.) and a second self-portrait are at NGI, also a series of forty-five anatomical drawings for an Orpen treatise. A portrait of Orpen is in the Hugh Lane Municipal Gallery of Modern Art. In the Crawford Municipal Art Gallery, Cork, are portraits of Orpen and, dated '43, Jack B. Yeats (q.v.). At Limerick City Gallery of Art is a portrait of Laurence Campbell (q.v.). Rutherford Mayne is at the Abbey Theatre, where there is also Fred O'Donovan as Robert Emmet in *The Dreamers*. His portrait of Sir Andrew Marshall Porter at King's Inns is a copy of the work by Sir John Lavery (q.v.).

Generous in helping those less fortunate than himself, he was modest and retiring by nature. Related to the Belfast estate agent and picture connoisseur, S. E. Thompson, he often visited him. His widow told the author in 1969: 'They played tennis together. The artist was very sensitive about money and mention of buying a picture would make him disappear for hours.' On 19 January 1950 he died suddenly at Academy House. A small memorial exhibition took place at that year's RHA, followed by a representative show in 1951 at Victor Waddington Galleries, Dublin. Armagh County Museum mounted an exhibition of forty-six works in 1989; the show moved to Fermanagh County Museum, Enniskillen; and RHA Gallagher Gallery, Dublin.

Works signed: James Sleator, J. S. Sleator, J. Sleator, Sleator or J. S. monogram, rare (if signed at all).
Examples: Armagh: County Museum. Belfast: City Hall; Incorporated Law Society of Northern Ireland, Royal Courts of Justice; Ulster Museum. Bournemouth: Russell-Cotes Art Gallery and Museum. Clogher, Co. Tyrone: St Macartin's Cathedral. Cork: City Library; Crawford Municipal Art Gallery; University College. Dublin: Abbey Theatre; Hugh Lane Municipal Gallery of Modern Art; King's Inns; Masonic Hall, Molesworth Street; National Gallery of Ireland; National Maternity Hospital; Office of Public Works; Rotunda Hospital; Royal Hibernian Academy; Royal Irish Academy; St John Ambulance Brigade of Ireland, Upper Leeson Street; St Patrick's Cathedral; University College (Belfield). Limerick: City Gallery of Art; University, National Self-Portrait Collection. Newcastle: Royal County Down Golf Club.
Literature: *Belfast Directory*, 1898; *The Studio*, May 1915, June 1916; *Irish Times*, 7 July 1923, 20 January 1950; William Orpen, *Stories of Old Ireland and Myself*, London 1924; *Ulster Review*, January 1925; *James S. Sleator Diary*, 1934-5; *Bulletin of the Russell-Cotes Art Gallery and Museum*, Bournemouth 1937; *Dublin Magazine*, July-September 1943, July-September 1945, July-September 1947, January-March 1948; *Personality Parade*, May 1947; Seamus O'Brien, 'Sculpture & Sculptors', *Capuchin Annual*, 1949; *Irish Press*, 20 January 1950; *Dictionary of British Artists 1880-1940*, Woodbridge 1976; John Coulter, *In My Day*, Toronto 1980; Martyn Anglesea, *The Royal Ulster Academy of Arts*, Belfast 1981 (also illustration); Adrian Le Harivel and Michael Wynne: National Gallery of Ireland, *Acquisitions 1984-86*, Dublin 1986 (also illustration); Ann M. Stewart, *Royal Hibernian Academy of Arts: Index of Exhibitors 1826-1979*, Dublin 1987; Patricia Boylan, *All Cultivated People: A History of the United Arts Club, Dublin*, Gerrards Cross 1988; Brian Kennedy: Ulster Museum, *James Sinton Sleator*, catalogue, Armagh 1989 (also illustrations); Clogher Historical Society, *Letter to the author*, 1992; Wanda Ryan-Smolin, *King's Inns Portraits*, Dublin 1992; St Andrew's College, *Letter to the author*, 1992; also, St Patrick's Cathedral, 1993; John Turpin, *A School of Art in Dublin since the Eighteenth Century*, Dublin 1995 (also illustration); Friendly Brothers of St. Patrick, *Letter to the author*, 1997; Ann M. Stewart, *Irish Art Societies and Sketching Clubs: Index of Exhibitors 1870-1980*, Dublin 1997.

SMITH, DOROTHY TRAVERS – see ROBINSON, DOLLY

SMITH, EILEEN – see GRAY, EILEEN

SMITH, ROB (1946-90), conceptual artist. Robert John Smith was born on 3 October 1946 at Wordsley, near Birmingham, the son of a head gardener, Horace Smith. An apprentice engraver in a glass factory, he attended Brierley Hill School of Art as a part-time student. At the 1966 exhibition of the Brierley Hill District Society of Artists, he showed a Black Country workman against a background for which Stourbridge junction was used as a basis.

At Wolverhampton College of Art he graduated in 1972 with a BA in Fine Art, and from 1972-4 he attended Manchester College of Art for a postgraduate MA. In 1974 he held a one-person show at Wolverhampton

Polytechnic Gallery; participated with the Northern Young Contemporaries at Whitworth Gallery, Manchester; and also in the Teeside Drawing Biennale at Middlesbrough. In November he became a lecturer in painting at the National College of Art and Design, Dublin.

Smith contributed an untitled work to the Irish Exhibition of Living Art in 1975, and to the 1979 exhibition: *More Fragments*, drawing, and *Circle for Trees*, photo collage. His work also appeared in NCAD staff shows. He was represented in the EVA exhibition in Limerick in 1979. In 1980 he was represented in the Works on Paper exhibition at the Angela Flowers Gallery, London.

At the Project Arts Centre, Dublin, in 1980 he showed with Chris Plowman and Ollie Whelan, the critic Aidan Dunne describing Smith's work as photo-collages: 'The photographs are arranged in a grid which is frequently violated, and the logic of the represented space is juggled and distorted in a variety of ways...' *Beginnings of Streams* was one of five exhibits.

Still associated with IELA, he became a member of the committee. His work appeared again in Limerick in 1981. He also showed in the Sade open drawing exhibition in Cork, 1982. In Dublin, he exhibited with Independent Artists in 1983 and became a member of the Black Church Print Workshop. Prints were exhibited in 1984 in Amsterdam, Cork and Longford.

The Fenderesky Gallery in Belfast hosted in 1986 his only one-person show in Ireland, a recent collection of drawings done primarily as a series of three-day projects. Smith explained: 'The brief was simple, to complete a reasonably large drawing within the given period. The time restriction was imposed simply to force the issue with myself, and hopefully unearth some internal archaeology of ideas. I wanted the drawings free of frames, glass and backing material, to be presented as simply as possible, placed directly on the wall...' Most of the ideas and images grew out of sketchbook material collected over a long period of time.

Generally he did not work for exhibitions. He painted regularly in his studio at the Visual Arts Centre, Strand Street, Dublin. In the final analysis, one critic concluded, the work was made for himself. In his studio and his home some sixty notebooks/sketchbooks were found. About a dozen sketchbooks measured 61 cm x 76 cm closed, and another was larger. Sketchbooks are in the Irish Museum of Modern Art. Luke Clancy wrote in the *Irish Times* that he covered these surfaces 'with sketches — some wiry and flippant, some with dense, heavy colours — featuring images of everyday things, such as tables, spades, forks and birds. Smith used these objects to create his own personalised set of garden-shed hieroglyphics, with which he wrote and rewrote the history of his quest for awareness...'

Annie Dibble, his widow, a lecturer in the Fashion and Textiles department at NCAD, wrote that it was 'difficult to place a label on his work, he actually would not have wished to be categorised. He was interested in the process of transformation, he sought to change our values and perception of everyday objects...' He died at his home, 18 South Terrace, Inchicore, Dublin, on 21 August 1990.

In 1994 IMMA held an exhibition which focused on his artistic practice and his influence as a teacher. The exhibition was linked with an exhibition and residency by Coracle, a small independent British publishing house specialising in creating artists' books, hence *Views from the Windy House: The Notebooks of Rob Smith*, which accompanied the exhibition — transferred in 1995 to the Model Arts Centre, Sligo.

Works Signed: Robert Smith or R. J. Smith (if signed at all).
Examples: Dublin: Arts Council; Irish Museum of Modern Art; Office of Public Works. Kilkenny: Art Gallery Society.
Literature: *In Dublin*, 21 March-3 April 1980; Project Arts Centre, *Rob Smith*, catalogue, Dublin 1980; Fenderesky Gallery, *Rob Smith*, catalogue, Belfast 1986; *Irish Times*, 22 August 1990, 23 March 1994; Irish Museum of Modern Art, 'Rob Smith Exhibition at the Irish Museum of Modern Art,' press release, Dublin 1994; Irish Museum of Modern Art, *Views from the Windy House: The Notebooks of Rob Smith*, 1994 (also illustrations); *Sunday Tribune*, 20 February 1994; Ms Annie Dibble, *Letter to the author*, 2000.

SMITH, S. CATTERSON, RHA (1849-1912), portrait, landscape and genre painter. Stephen Catterson Smith was born on 19 June 1849 at 42 St Stephen's Green, Dublin, the eldest son of the Yorkshire-born Stephen Catterson Smith, RHA (1806-72), portrait painter. The father received numerous commissions in Dublin although it is claimed that due to financial losses at the time, his eldest son had to forgo the intention of adopting a military career.

The son settled down as an artist in the studio of his father. When his father died, the practice was inherited. He completed some of his father's unfinished paintings. Probably under commission, certain of his father's works were copied. The year after his father's death, 1873, he exhibited at the Royal Hibernian Academy and from then until 1909 he showed no fewer than 175 works, with many portraits.

The Scottish connection possibly began in 1873 when he married Henrietta Aitken of Edinburgh. He portrayed a number of members of the Massy Beresford family of Macbie Hill, Peebles. Elected an associate of the RHA in 1876, he became a full member in 1879, when he painted the Rt. Hon. Sir John Barrington, Lord Mayor of Dublin, for the members of the Amicable Club, a work which is now in the Hugh Lane Municipal Gallery of Modern Art. The first of his Scottish landscapes, in this case Argyllshire, were exhibited in 1881, and others followed in 1882, for example, *The Heart of the Trossachs, Perthshire*. Howth, Co. Dublin, featured in at least five works in his 1883 Academy contribution of fourteen pictures.

Among his contributions to the 1884 RHA were: *On the Coast at Kilkee*; *A Limerick Bog*; *'The Child is Father to the Man'*. At the Dublin Sketching Club that year, *A Quiet Pool, Arran, Scotland* and *Twilight on the Moor, Arran* were both hung, and *The Letter* in 1885. At the Dublin Art Club in the period 1886-92 he showed fifteen works, *A Pensioner* and *An Itinerant Merchant* being among the pictures in the opening year.

Judging by titles, he also painted in England in the 1880s, Warwickshire and Worcestershire. *'A Graceful Maiden with a Gentle Brow'* decorated the 1888 RHA, followed in 1889 by a portrait of Her Majesty the Queen, painted for the Royal College of Surgeons in Ireland, in commemoration of her Jubilee. A former headmistress of Alexandra College, Dublin, Miss Isabella Digges La Touche, sat for him in 1889.

The Queen Victoria full-length portrait came to an ignoble end in the RCSI examination hall during Easter Week, 1916, and was destroyed. In after years it was commonly believed that Countess Markievicz (q.v., Constance Gore-Booth) was responsible. But two of the occupying insurgents, Frank Robbins and Liam O'Briain, testified later that the portrait was cut from its frame by a boy, who used it — or part — to make leggings. When James Mallin entered the room he asked what had happened to the portrait, and threatened to shoot the man who had committed the act. Finding the boy, he reprimanded him severely and boxed his ear.

A number of members of the medical profession were portrayed, for example at the 1891 Academy, Aquilla Smith. That of Samuel Gordon, MD, is at the Royal College of Physicians of Ireland. In 1892 he was appointed RHA secretary and served until 1910. Scottish landscapes were still to the fore. In 1894 at the RHA the ten pictures included *The Barbican, Plymouth*, and *St Michael's Mount, Cornwall*. Occasional lectures were given at the Dublin Metropolitan School of Art.

Eoin O'Brien and Anne Crookshank in *A Portrait of Irish Medicine*, 1984, referred to his portraits of Smith and Charles Benson (Royal College of Surgeons in Ireland) as 'excellent examples, competent but dull.' However, from the point of view of their book, his most remarkable portrait was in the Rotunda Hospital of Miss Sara Hampson, who was Lady Superintendent 1892-96: 'Miss Hampson is shown seated, writing, in uniform, with in the background, a statuette of Florence Nightingale by whom she was trained.' The Rotunda also houses the portrait of one of the midwives, Mrs McGrath.

In 1901 at the RHA two works were Co. Cork scenes. In the period 1903-9 inclusive all his eleven contributions were portraits. At the Royal Scottish Academy in 1902 he showed a portrait. According to Strickland, he was deeply interested in the welfare of the Hibernian Academy, and 'it owed much to his knowledge, experience and sound judgment.'

The National Gallery of Ireland has five oil paintings by Smith, including a portrait of the historian and biographer, William John Fitzpatrick, which Strickland described as a replica of the work in Australia, exhibited at the 1892 RHA. There is also a portrait of the journalist and patriot, John Dwyer Gray, also two portraits of 'young ladies', and *Rosa*.

The portrait of Daniel O'Connell by his father was destroyed in the City Hall fire of 1908. The replica portrait was painted in 1910 and is still extant. All three portraits at King's Inns, Dublin, were copies: John Hatchell and Thomas L. Lefroy, from works by his father, and Stephen Woulfe after Martin Cregan, RHA (1788-1870). The three-quarter length portrait of Henry Gray Croly at RCSI has also survived, and at the same location, Richard G. H. Butcher, MD, a copy of his father's work.

At Freemasons' Hall, Dublin, there are portraits of Sir Charles A. Cameron, CB, and, originally in the Masonic Female Orphan School, Dublin, that of Robert D. Speedy, FRCSI. A portrait of Augustus N. Burke, RHA (1839-91), and a posthumous one of George Petrie, RHA (1790-1866), both of which he presented to the RHA, cannot be traced and may have perished in the 1916 fire at the Academy premises.

Smith, described by Strickland as 'a conscientious and painstaking artist,' had some works exhibited at the Walker Art Gallery, Liverpool, and the Glasgow Institute of the Fine Arts. He died on 24 November 1912 at his residence, 42 St Stephen's Green, in the same room in which he had been born, and was buried in Deans Grange cemetery.

Works signed: S. Catterson Smith.
Examples: Dublin: Alexandra College; City Hall; Freemasons' Hall, Molesworth Street; Hugh Lane Municipal Gallery of Modern Art; King's Inns; National Gallery of Ireland; Rotunda Hospital; Royal College of Physicians of Ireland; Royal College of Surgeons in Ireland.
Literature: Walter G. Strickland, *Dictionary of Irish Artists*, Dublin 1913; J. D. H. Widdess, *The Royal College of Surgeons in Ireland and its Medical School 1784-1966*, Edinburgh and London 1967; *Dictionary of British Artists 1880-1940*, Woodbridge 1976; Eoin O'Brien and Anne Crookshank, *A Portrait of Irish Medicine*, Swords 1984 (also illustrations); National Gallery of Ireland, *Acquisitions 1984-86*, catalogue, Dublin 1986 (also illustration); Ann M. Stewart, *Royal Hibernian Academy of Arts: Index of Exhibitors 1826-1979*, Dublin 1987; *Royal Scottish Academy Exhibitors 1826-1990*, Calne 1991; Wanda Ryan-Smolin, *King's Inns Portraits*, Dublin 1992 (also illustrations); John Turpin, *A School of Art in Dublin since the Eighteenth Century*, Dublin 1995; Ann M. Stewart, *Irish Art Societies and Sketching Clubs: Index of Exhibitors 1870-1980*, Dublin 1997; Dublin City Archives, *Letter to the author*, 2000; also, Grand Lodge of A. F. & A. Masons of Ireland, 2000; Royal College of Surgeons in Ireland, 2000; Royal Hibernian Academy. 2000.

SMITH, SIDNEY (1912-82), mural and portrait painter. Born in Belfast on 19 April 1912, son of a draper, Alexander Smith, he received his education at the Royal Belfast Academical Institution. Attending evening classes at the Belfast College of Art, he met Daniel O'Neill (q.v.). Under the private tuition of R. Boyd Morrison (q.v.), during which he spent months drawing, he was eventually allowed to paint his first picture – *Market Day* – and it appeared in the 1938 Royal Hibernian Academy, giving his address, 50 Landscape Terrace, Belfast.

In his attic studio at 20 Howard Street he assisted O'Neill in his painting, and worked himself, principally on local scenes. His friendship with O'Neill continued in London some years later. At the Ulster Academy of Arts in 1938 he included *Spring Crinoline*; *Cornfields near St Lunaire, Brittany*. The last-named along with another St Lunaire work were exhibited in 1939 with the Royal Society of British Artists in London. In 1940 he resumed exhibiting at the RHA and from then until 1944 he showed five works, signing off with *Memory of Les Sylphides* (Queen's Univeristy).

Air raids on Belfast in 1941 provided subject matter; eight drawings were purchased by the Belfast Museum and Art Gallery. Portraits of American Army officers proved lucrative. Donated by the War Artists' Advisory Committee to the Belfast Museum and Art Gallery were two 1941 oil paintings: *Just a Song at Twilight* and *Balloon in Tramway Depot, Evening*. Also in the Stranmillis collection are pencil portraits of Michael McLaverty and W. R. Rodgers; a self-portrait in oils; Sir Orme Rowan Hamilton, 1943, sanguine on paper. A pencil portrait of John Hewitt, 1943, is in Armagh County Museum.

Among his other contributions to the Ulster Academy of Arts were: 1942, *American Negro Soldier*; 1944, *Late Afternoon on the Quays, Dublin*; 1946, *Poteen*.

In 1947 Smith was included in the exhibition of prominent Ulster painters, organised by Council for the Encouragement of Music and the Arts, in Ulster House, Regent Street, London. Another connection with the capital was the appearance of three works at the 1947 exhibition of the National Society: *Back Stage at Ballet Rambert*; and in watercolour, charcoal and pastel: *Clown and Acrobat*; *Dancer Resting*.

In 1947 too he painted his first mural, at the British Restaurant in Victoria Street, Belfast. In 1948 he moved to London where he became fully occupied with the medium. In the members' list for the National Society catalogue for 1950, when he showed *Newcastle Beach* and *Nigerian*, his address was 110 Sutherland Avenue, W9, but he soon moved to 23 Randolph Crescent in the same district.

The Flight of the Huguenots, 2.05 metres by 2.13 metres, was a special commission for the Ulster Farm and Factory Exhibition at Castlereagh, Belfast, 1951, and is now in the Town Hall, Bangor. The work brings out the fatigue of the Huguenot emigrants as they reach the French coast and prepare to sail for Ireland. After this commission, he painted a series of murals and mural decorations for cafes and public houses in London.

Cornwall attracted him in the summer for landscape painting, for example mine workings at Carnkie, Camborne, and scenery near Grampound. By about 1957 he had moved to a studio/flat in Kinnerton Street, SW1. At this time he had been painting murals and *trompe l'œil* decorations for owners of smart flats and houses.

In 1957, however, he received a commission to paint murals in the new Union Castle liner, *Pendennis Castle*, at Queen's Island, Belfast, and having worked everything out to the last detail in his London studio, he returned to his native city in 1958. In the private dining room he painted musical instruments set in over the doorways, and above the fireplace 'a romantic landscape in a frame in the style of *trompe l'œil*'. In the first-class dining saloon there were two different decorative panels representing arches and painted in 'deep perspective'. Each panel was 2 metres by 4.7 metres.

After the work in Belfast, he was reported designing a mural for the grill room of the Ritz Hotel in London. He also painted in the Canadian Pacific liner, *Empress of Britain*, but not as a principal artist, and on five Clan Line ships. A mural 1.5 metres by 9.1 metres was completed in 1960 in a dining saloon of the Union Castle liner, *Windsor Castle*.

The work of a number of distinguished architect/designers, sculptors and painters greeted the first staff moving into the new Shell Centre building at Waterloo, London, in 1961. In the upstream restaurant were four mural paintings – no longer there – by Smith. His subject was the arts and industries of London and the Netherlands. One panel contained a composite design for London, bringing together the National and Tate Galleries for painting, the Athenaeum Club for literature, the Albert Hall for music, and other well-known buildings within a 'Venetian' setting on the River Thames. A second panel brought the symbols of industry and commerce together. At the opposite end of the restaurant the same theme was developed for Amsterdam.

Another important commission was completed in 1964: a complex mural, 3.7 metres by 14.6 metres, with many life-size figures, commissioned by Lady Beaverbrook for the new Playhouse Theatre at Fredericton, New Brunswick. The subject was called *Bal Masque*. After working pretty consistently on murals for about fifteen years, he returned to his first love, easel painting, and travelled in Italy, France and Portugal. But he still continued with his mural work although in the last few years of his life he painted little. A mural in the Culloden Hotel, Craigavad, Co. Down was removed some years ago. He died on 25 May 1982, and was buried in Willesden Cemetery, London.

Works signed: Sidney Smith.
Examples: Armagh: County Museum. Bangor, Co. Down: Town Hall. Belfast: Arts Council of Northern Ireland; Queen's University; Ulster Museum. Fredericton, New Brunswick: Playhouse Theatre. Limerick: University, National Self- Portrait Collection.
Literature: *Belfast and Ulster Directory*, 1938; Maurice J. Craig, *Black Swans*, Dublin 1941 (illustration); Eric Newton, ed., *War Through Artists' Eyes*, London 1945 (illustration); *The Studio*, July 1947; *Belfast News-Letter*, 16 May 1951; *National Society Exhibition*, catalogue, London 1954; *Belfast Telegraph*, 13 August 1958, 25 March 1960, 17 October 1966; John Hewitt and Theo Snoddy, *Art in Ulster: 1*, Belfast 1977; Dr S. M. Smith, *Letter to the author*, 1983; Ann M. Stewart, *Royal Hibernian Academy of Arts: Index of Exhibitors 1826-1979*, Dublin 1987; James Trimble, *Letter to the author*, 1989; also, Canadian Pacific (UK) Ltd, 1992; Culloden Hotel, 1993; David Goldberg, 1993; Shell UK Ltd, 1993; Theatre New Brunswick, 1993; Eileen Black, *A Sesquicentennial Celebration: Art from the Queen's University Collection*, Belfast 1995 (also illustration); Ann M. Stewart, *Irish Art Societies and Sketching Clubs: Index of Exhibitors 1870-1980*, Dublin 1997.

SOLOMONS, ESTELLA, HRHA (1882-1968), landscape, portrait painter and etcher. Estella Frances Solomons was born on 2 April 1882 into a Dublin Jewish family at 32 Waterloo Road; some years later they moved to number 26. Her father, Maurice E. Solomons, born London, had followed his father's calling as

an optician; he was also a maker of mathematical instruments. Estella, as part of her education, went to Hanover and on her return to Dublin attended Alexandra College.

At the Dublin Metropolitan School of Art she studied under (Sir) William Orpen (q.v.), and at the Royal Hibernian Schools under Walter F. Osborne, RHA (q.v.). On the RHA, Caroline Scally (q.v.) has recalled: 'Classes were held in drawing from life and the antique. Each week an academician came to criticise our work but we depended on the senior students more for help and encouragement. It was Estella Solomons I most relied upon for her understanding and good criticisms.'

At the Metropolitan School of Art she received three certificates for drawing, 1899, 1900 and 1901. An exhibition of the work by Young Irish Artists, held in Dublin in 1903 at the Leinster Hall, Molesworth Street, attracted among others Estella Solomons, Frances Beckett, Dorothy and Beatrice Elvery (qq.v.). About this time all four spent a few weeks in Paris, drawing in the mornings at Colarossi's.

By 1904, judging by a letter to her, she had established a studio at 17 Great Brunswick Street, Dublin. In May 1905 she returned to Paris, apparently moving on to Boulogne and then Wimereux; Ambleteuse, a few miles away, was the subject of a crayon drawing dated 18 July 1905.

In 1905, from 26 Waterloo Road, she exhibited at the RHA for the first time and from then until the year of her death, missing only a few exhibitions, she contributed more than 250 works, principally landscapes, interspersed with portraits.

A visit to the Rembrandt tercentenary exhibition in Amsterdam in 1906 must have prompted her interest in etching. In May of that year Orpen, who had founded the school with Augustus John (1878-1961), wrote to her from 13 Royal Hospital Road, Chelsea, re the Chelsea Art School at Rossetti Studios, Flood Street, Chelsea. A receipt dated 22 January 1907 for £7.7.0 acknowledged payment for six days per week for Miss Solomons during the term which ended 30 March.

Although she painted some watercolours, her main interest outside of painting in oils was etching, and in due course she bought an etching press. In 1910 she contributed seven works to the RHA from her studio in Great Brunswick Street, on the top floor, and a close friend in a flat below was James Stephens whose portrait by her is in the Hugh Lane Municipal Gallery of Modern Art.

According to her brother, Dr Bethel Solomons, 'her studio parties were wonderful. She and I used to give mediumistic displays, but the chief entertainment was good conversation'. Her portrait of him as president is in the Royal College of Physicians of Ireland, where there is also a drawing of George Sigerson. By 1910 she had completed companion portraits of her father and mother. Letters addressed to her at Poste Restante, Amsterdam, indicated another visit to Holland in 1911, hence *Harbour Scene, Volendam*, and at the RHA in 1912 she showed *At Dordrecht*, and she also painted at Monnikendam.

Visits to Co. Donegal renewed her friendship with George Russell (q.v.). In November 1915 she received permission from Headquarters, Dublin Garrison, to make sketches in the Zoological Gardens and Botanic Gardens.

Estella Solomons enlisted in Cumann na mBan and through this connection met Kathleen Goodfellow, whom she was to paint several times, and they became lifelong friends. A portrait of Kathleen is in the National Gallery of Ireland. At the time of the Rising the Solomons studio was a 'safe' house for people on the run, and she painted some of the insurgents there.

In 1916 she exhibited an etching, *Near Dublin*, which *The Studio* found 'very delicate in treatment', at the Black and White Artists' Society of Ireland exhibition in Dublin, and that year she painted on Achill Island. A portrait of Monsignor Pádraig de Brún was dated 1917.

A letter dated 18 March 1917 from the Assistant Provost Marshal, Irish Command, Dublin, sought an explanation of her sketching, unauthorised, on Wellington Quay. A second letter dated 19 March advised her of no further permit for sketching in the Dublin area. A portrait of Seamus O'Kelly, playwright and friend of the Rebellion leaders, was dated 1917, and that year she provided a drawing of a Dublin archway for reproduction in *Mud and Purple* by Seumas O'Sullivan, whom she later married. In 1918 she moved studio from 17 to 26 Great Brunswick Street.

Portraits in oils of the writer Alice Milligan, 1918, and the poet, Joseph Campbell, 1919, are both in the Ulster Museum. At the 1919 RHA, she showed eight works, including *Three at Table* and *Pear Trees at*

Harold's Cross. At Mills' Hall, Merrion Row, in October she held a joint exhibition with her friend, Mary Duncan (q.v.). In 1920 she painted a portrait of Frank Gallagher (David Hogan), now at NGI.

A portrait of Father Dineen (HLMGMA) was sent to the Irish exhibition in Paris in 1922. Seumas O'Sullivan was the founder of the *Dublin Magazine* in 1923. The opening number reproduced the Solomons portrait of Jack B. Yeats (q.v.). Within the next few years the magazine also reproduced etchings, *Marsh's Library*; *Hoey's Court, Dublin*; *In the Zoological Gardens, Dublin*, as well as paintings of Joseph Campbell and Padraic Colum.

Ernie O'Malley, republican and writer, wrote from Kilmainham Jail in November 1923 asking Estella if she could do some Christmas cards for him. In that year too she painted the portrait of Frank Aiken, Chief-of-Staff of the IRA. Early 1920s portraits of Yeats and Dr Thomas Bodkin are in the Model and Niland Centre, Sligo.

As a teacher of etching, Estella Solomons was on the staff of the Dublin Municipal Technical Schools. After the Treaty, however, she was asked to take the Oath of Allegiance to the Crown but refused to comply with official regulations. A portrait of a lady at the 1924 RHA attracted *The Studio*: '... admirable ... ample in spacing, charming in colour, thoroughly competent in execution. It owes not a little of its charm to the noble beauty of the subject'.

In 1925 she was appointed an associate of the RHA. An exercise book in the Seumas O'Sullivan Papers at Trinity College, Dublin, which also includes twenty-three sketchbooks, recorded the sale of twenty-two pictures between 15 November 1925 and 27 January 1926. The portrait of Father O'Flanagan realised £12. In 1926 she moved to Grange House, Whitechurch, Rathfarnham, Co. Dublin. In her exhibition at 7 St Stephen's Green in 1928 the works included *On the Coast, Cornwall*; *The Cottage in the Cove, Donegal*; *The Sea near Land's End*. Among the eight etchings were: *The Hell Fire Club (Mount Pelier)*; *The Rotunda Hospital, Dublin*.

Etchings were reproduced in D. L. Kelleher's *The Glamour of Dublin*, 1928. She sketched in Surrey and Sussex in 1929. Landscapes were exhibited in 1930 at the Hackett Galleries, New York. The following year she held another exhibition at 7 St Stephen's Green. Although spending much of her time on landscapes – six of Co. Donegal terrain at the 1932 RHA – she still painted the occasional portrait; her second of Austin Clarke, the poet, in 1934.

When Augustus John wrote to her in March 1935 expressing the hope that he would see her exhibition, he was probably referring to the one at the Arlington Gallery, where she joined Mary Duncan (q.v.) and Louise Jacobs. All were exhibiting in London for the first time. A one-person show at Daniel Egan's Gallery, 38 St Stephen's Green, featured landscapes, many of Donegal.

In 1938 she and her husband moved to 2 Morehampton Road, Dublin, and from then on most of her landscape painting was in Co. Kerry. In response to an appeal from Stephen Bone (1904-58), secretary of the Artists' Refugee Committee, London, she organised in 1939 an exhibition of paintings and sculptures by Irish artists at Mills' Hall, Dublin. *Evening by a Lake, Clohane, West Kerry* was dated 1940.

In the 1940s the *Dublin Magazine* made several references to her work in the RHA, e.g. on the 1943 show the critic found 'a rich Barbizon quality' in *The Grove*, and in 1945 on *Spring Landscape, Dublin* 'a fresh, vivid picture in which rich greens and vivid lights are handled with daring'.

Painting virtually ceased in the mid-1950s. Honorary membership of the RHA was conferred in 1966. Altogether, she worked on more than ninety etchings, aquatints and drypoints; she also produced some linocuts. She was responsible for at least eighty etchings; a score are in Crawford Municipal Art Gallery, Cork. One of her husband's poems *Rain*, inspired an etching in writing.

At NGI are also oil paintings of Father O'Flanagan , Art O'Murnaghan (q.v.) and a self-portrait. Also at the Municipal Gallery is a portrait of Jack Morrow (q.v.), presented by Joseph Holloway, 1944. At Trinity College are also portraits of Austin Clarke (2), W. R. Fearon, F. R. Higgins, Patrick MacDonagh, G. W. Russell (q.v.), J. S. Starkey, all acquired in 1969 as part of the Seumas O'Sullivan and Estella Solomons Collection, which also included the Pádraig de Brún portrait; at Trinity Hall is a portrait of Miss E. M. Cunningham. The Rev. Abraham Gudansky is at the Irish Jewish Museum, where there is also a painting of her parents in their garden at 32 Waterloo Road.

Mainly bedridden for some time, she died at her home on 2 November 1968. A memorial exhibition took place at the David Hendriks Gallery, Dublin, in 1973, and the etchings in a memorial edition printed by Pat Hickey (q.v.) consisted of fifty portfolios each containing twenty prints. This exhibition coincided with the publication of *Retrospect: the work of Seumas O'Sullivan and Estella F. Solomons*, edited by Liam Miller. Her work was represented in 1976 at the Graphic Studio's retrospective exhibition at the Municipal Gallery of Modern Art. The Crawford Municipal Art Gallery in Cork held in 1986 a 'Works from an Artist's Studio' exhibition of 173 pictures. In 1999 the Frederick Gallery in Dublin showed more than seventy works. Another exhibition, of etchings and paintings, took place the next year.

Works signed: Estella F. Solomons, Estella Solomons, E. Solomons, E. F. Solomons, E. F. S. or E. S. (if signed at all).
Examples: Belfast: Ulster Museum. Cork: Crawford Municipal Art Gallery. Dublin: Arts Council; Civic Museum; Hugh Lane Municipal Gallery of Modern Art; Irish Jewish Museum; National Gallery of Ireland; Royal College of Physicians of Ireland; Trinity College. Limerick: City Gallery of Art. Sligo: Model and Niland Centre.
Literature: *The Studio*, June 1916, May 1924, May 1935, December 1937, August 1941; Seumas O'Sullivan, *Mud and Purple*, Dublin 1917 (illustration); Katherine MacCormack, ed., *The Book of Saint Ultan*, Dublin 1920 (illustration); *Dublin Magazine*, August 1923, October 1923, November 1923, February 1924, April 1924, May 1925 (all illustration), July-September 1943, July-September 1945; Padraic Colum, *The Road Round Ireland*, New York 1926 (illustrations); J. Crampton Walker, *Irish Life and landscape*, Dublin 1927 (illustration); D. L. Kelleher, *The Glamour of Dublin*, Dublin 1928 (illustrations); Bulmer Hobson, ed., *A Book of Dublin*, Dublin 1929 (illustrations); Bulmer Hobson, ed., *Saorstát Éireann Official Handbook*, Dublin 1932 (illustration); Daniel Egan's Gallery, *Exhibition of pictures by Estella Solomons, ARHA*, catalogue, Dublin 1936; Bethel Solomons, *One Doctor in his Time*, London 1956; *Seamus O'Sullivan Papers*, Trinity College, Dublin [1958]; Beatrice Lady Glenavy, '*Today we will only Gossip*', London 1964; Hilary Pyle, 'The Portraits of Estella Solomons, ARHA', *The Dubliner*, Autumn 1964; National Gallery of Ireland, *Golden Jubilee of the Easter Rising*, catalogue, Dublin 1966; Hilary Pyle, *Portraits of Patriots*, Dublin 1966 (also illustrations); *Irish Times*, 4 and 12 November 1968, 20 July 1971, 10 July 1976; Louis Hyman, *The Jews of Ireland*, Shannon 1972; David Hendriks Gallery, *Estella F. Solomons, ARHA, 1882-1968*, catalogue, Dublin 1973; Liam Miller, ed., *Retrospect: the work of Seumas O'Sullivan and Estella F. Solomons*, Dublin 1973 (also illustrations); *A Dictionary of Contemporary British Artists, 1929*, Woodbridge 1981; Dr Michael Solomons, *Letters to the author*, 1984, 1993; Crawford Municipal Art Gallery, *Estella Solomons 1882-1968: 'Works from an Artist's Studio'*, catalogue, Cork 1986; Ann M. Stewart, *Royal Hibernian Academy of Arts: Index of Exhibitors 1826-1979*, Dublin 1987; Anne Crookshank and David Webb, *Paintings and Sculptures in Trinity College Dublin*, Dublin 1990; Hugh Lane Municipal Gallery of Modern Art, *Letter to the author*, 1993; Frederick Gallery, *Estella Solomons, ARHA (1882-1968)*, catalogue, Dublin 1999 (also illustrations); National Gallery of Ireland, *Gallery News*, September-November 2000.

SOMERVILLE, EDITH Œ.(1858-1949), landscape painter and illustrator. Edith Anna Œnone Somerville was born on 2 May 1858 at Corfu – hence her third name – the daughter of Lieut.-Col. T. H. Somerville, DL, of Drishane House, Castletownshend, Co. Cork. He was stationed on the Greek island as Colonel of the 3rd Buffs. Her mother was Adelaide, daughter of Sir Josiah Coghill, Bt., and granddaughter of Charles Kendal Bushe. The Somerville family was of Norman origin and had settled in low Scotland with large estates by the twelfth century.

Except for two terms at Alexandra College, Dublin, in 1875, Edith's education was mainly under governesses at home. When not abroad, she was organist at St Barrahane's Church from 1875 to 1945. Automatic writing from her alleged psychic powers was used by her uncle, Kendal Coghill. The decision to make a living – as a painter – was probably tied to her concern of maintaining the family home, Drishane. In 1877 she spent a term at South Kensington but did not respond to drawing from casts. At one period she had a short spell at Westminster School of Art.

An early portrait, that of her brother Aylmer Somerville, was dated 1881. Edith's cousin, Egerton Coghill (q.v.), who later married her sister, Hildegarde, had a studio in Düsseldorf, and on his advice she persuaded her parents to allow her to study abroad for two terms in 1881 and 1882. In Düsseldorf she worked at drawing from life under Gabriel Nicolet (1856-1921), then a student himself, and Carl Sohn (1845-1908); also she copied anatomy studies and took singing lessons. Her work was represented in the exhibition of the Irish Fine Art Society held in Cork in 1883.

In 1884 she painted *Hildegarde in the Masonic Chair*. Meanwhile Coghill had taken a studio in Paris and she joined him there, entering Colarossi's studio for young ladies and studying under P.-A.-J. Dagnan-Bouveret (1852-1929), but she described the atmosphere there as 'distinctly amateur'. In 1884 too she exhibited in the Irish Fine Art Society exhibition in Cork. In 1885 she returned to Paris and found the other Colarossi establishment in the Rue de la Grande Chaumière as 'the real serious, professional studio'.

In 1885 *Cassell's Magazine of Art* published her article on Paris studios, illustrated with sketches made in Colarossi's. Before she left for France again in 1886, she painted the first of a number of portraits in oils of her cousin Violet Martin of Ross House, Co. Galway, and this portrait is in the National Portrait Gallery, London. In February of that year she had returned to Colarossi's, even the ladies' studio, but her most significant work was a series of drawings which she made at Louis Pasteur's clinic.

In 1886 and in 1887 she worked on a series of comic strips for *The Graphic*. The story of the Rev. Paley Dabble was one of the early ones, and all the original pencil drawings, now bound together in one volume, are in Queen's University, Belfast. In 1887 she returned to Paris. On an exhibition that year at the Dudley Gallery, London, the *Daily Telegraph* commented on her painting of an old woman: '... quite one of the most vigorous and masterly pictures in the collection is Miss Edith Somerville's *Retrospect* ...'

The Goose Girl, 1888, which was in Cork City Library, is now on loan to Crawford Municipal Art Gallery. The following year saw the publication of *An Irish Cousin*, a novel, the first work in collaboration with her cousin Violet, who wrote under Ross. Edith took charge of the graphics for the Somerville and Ross books.

In 1889 she showed at the Royal Hibernian Academy, and in 1891, following a holiday in Brittany, she exhibited *La Plage, Saint-Jacut-de-La-Mer*. During this decade she and Violet Martin made several tours for the *Lady's Pictorial* and *Black and White*, writing articles illustrated by Edith. The *Lady's Pictorial* serialised their accounts in 1891 of a visit to the West of Ireland, reissued in the book, *Through Connemara in a Governess Cart*, 1893.

In the autumn of 1891, again for *Lady's Pictorial*, they left for Bordeaux on a vineyard tour. The book, *In the Vine Country*, followed. The same magazine published in 1893 in serial form a visit to Denmark, Edith supplying wash drawings. In April of that year she worked at life drawing in London. Another 1893 publication was for children, *Clear as the Noon Day*, by Ethel Penrose, a *nom de plume* for Ethel Coghill, sister of Egerton; illustrated by Edith Somerville.

Both writers were in Paris in 1894 after the publication of *The Real Charlotte*. This time Edith studied at Délecluse's academy. A pony tour in North Wales, 1894, commissioned by *Black and White*, promoted another book, *Beggars on Horseback*, 1895. In that year they visited the Aran Islands. Edith also studied in Paris in 1895, and returned three years later, working under Dagnan-Bouveret at Délecluse's.

In 1898 too Edith and Violet visited Étaples, the artists' colony near Boulogne, which Edith described in *Irish Memories* as 'the only place that any self-respecting painter could chose for a painting ground', and so was painted *Watering Horses, Étaples*. In 1898 the *Badminton Magazine* began a monthly series of Irish RM stories, culminating in the publication of *Some Experiences of an Irish RM*, 1899, illustrated by Edith.

Back to Délecluse's in 1899, she attended for four months, mainly in the mornings, but in the afternoons assisted the American, Cyrus Cuneo (1879-1916), in setting up an illustration class which was held in the studio where James McNeill Whistler (1834-1903) had taught a class of young ladies. Cuneo was a trusted student of Whistler's. A member of the Paris Club, she was represented in an exhibition at the Grafton Galleries, London, in 1900. In 1901 she exhibited with the Water Colour Society of Ireland for the first time: *In West Galway*; *A Duel*; *Connemara People*. The remainder of her contributions to WCSI were mainly original illustrations for books. At the Belfast Art Society exhibition of 1904 she showed eight illustrations.

In 1903 she became Master of West Carbery Foxhounds, and after an absence of several years contributed again to the RHA: *The Wood of Annagh Ross, Co. Galway*. In 1904 she and Violet visited Amélie-les-Bains, and in 1908 she painted her at Montreuil-sur-Mer. In 1909 she was represented in London by *Ave Maria* at the Women's International Art Club exhibition at Grafton Galleries. A suffragette, she was appointed president of the Munster Women's Franchise League in 1910.

After Violet Martin's death in 1915, Edith Somerville continued to publish novels and essays, generally under the twin signatures of Somerville and Ross, and believed she was communicating and collaborating still with her cousin. A memorial to Violet is her carved reredos at St Barrahane's Church.

In 1919 Dr Ethel Smyth, the musician, was impressed with the Somerville paintings at Drishane House, and was instrumental in arranging an exhibition for the Goupil Gallery, London, in 1920. Ethel wrote a preface for the catalogue, predicting that the public would 'recognise landscapes they have long since known in another medium'. They visited Sicily together and Edith, who painted there, exhibited seven works that year at the RHA, her last showing. She wrote a series of articles on Sicily for *Time and Tide*, 1922.

In 1923 she exhibited at Walker's Galleries, London. Adapted from the Book of Kells, she designed the 1925 floor mosaic for St Barrahane's Church. She visited Spain in 1926, and showed again at Walker's in 1927, altogether about 200 works were hung there. Her landscapes were mainly views of West Cork and Kerry. Along with her sister, Hildegarde Lady Coghill, she visited the United States in 1929, having been invited to lecture. An exhibition at the Ackermann Galleries, New York, made £1,500.

She also showed at Aiken, South California, and always kept a careful account of her income. The book, *The States through Irish Eyes*, appeared in 1930. In New York, a set of four sporting prints, hand coloured by the artist, was published in 1930, limited to fifty sets. In 1930 too she again travelled to Paris to refresh her drawing. In 1932 the degree of D Litt was conferred by Trinity College, Dublin. In 1938, two years after her brother Boyle was murdered in Castletownshend, she exhibited again in New York, this time at the Gallery of Mrs Cornelius J. Sullivan.

The Irish Academy of Letters conferred the Gregory Medal in 1941. The Hugh Lane Municipal Gallery of Modern Art accepted in 1943 *An Old Widow Woman*, and in the same year she took part in the inaugural Irish Exhibition of Living Art. A correspondent with Thomas MacGreevy of Dublin, she reported in 1945: 'I have painted a portrait of the celebrated Countess of Desmond, who lived to be 140! (an ancestor of mine). It is "after" a portrait of her by Holbein (said to be).'

In 1946 she moved to Tally Ho House, Castletownshend. Sir Patrick Coghill, her nephew, said that painting was her first love, and that in her last years she even lamented that writing had taken her away from her beloved easel and paintbox. 'But though a highly competent and successful painter, there is no doubt that with her the Pen was mightier than the Brush,' he added. But in Edith's own words, she practised both with equal enthusiasm.

Anne Crookshank and the Knight of Glin, in *The Watercolours of Ireland*, 1994, wrote that Edith may have seen herself as an oil painter, 'but it is as an illustrator of articles and books written by herself and Violet Martin that one thinks of her today. She developed a somewhat caricatural style of black and white drawing and also a sensitive use of wash in silhouette ... Her feeling for countryfolk is melancholy and her character studies sombre, revealing her compassion for the rigours of the life of the Irish peasant. In contrast, her highly witty illustrations of the hunting field ... and her drawings of studio life in Paris are lighthearted and done with a swift, instant vision.'

At Queen's University, Belfast, are drawings, including a deathbed study of Martin Ross; diaries of both women, notebooks and miscellaneous papers. Ulster Museum representation includes two stage designs for Edith's play, 'A Horse! A Horse!', which was never performed. Crawford Municipal Art Gallery also possesses *A Chieftain's Tomb*, oil on canvas, and a pencil sketch of Violet Martin on the Danish tour. Edith Somerville died at Tally Ho on 8 October 1949. An exhibition of drawings and watercolours took place in 1968 at the Neptune Gallery, Dublin. A symposium, together with a small exhibition of her works, was held at Queen's University, Belfast, in 1968. The first representative selection, eighty-seven pictures, was at Drishane House in 1984, and subsequently at the Crawford Municipal Art Gallery.

Works signed: Edith Œ. Somerville, rare; E. Somerville, E. Œ. Somerville, Œ. Somerville, E. Œ., E. Œ. S. or Œ S monogram, rare (if signed at all).
Examples: Belfast: Queen's University; Ulster Museum. Castletownshend, Co. Cork: St Barrahane's Church. Cork: Crawford Municipal Art Gallery. Dublin: Hugh Lane Municipal Gallery of Modern Art; Trinity College. London: National Portrait Gallery.

Literature: General (see below for illustrated Somerville and Ross books): E. Œ. Somerville, *The Kerry Recruit*, London 1889 (illustrations); Ethel Penrose, *Clear as the Noon Day*, London 1893 (illustrations); E. Œ. Somerville, MFH., *Slipper's ABC of Fox Hunting*, London 1903 (illustrations); *The Lady of the House*, Christmas 1907; *The Studio*, April 1909; J. Crampton Walker, *Irish Life and Landscape*, Dublin 1927 (also illustration); E. Œ. Somerville, *The States through Irish Eyes*, Boston and New York 1930 (illustrations); Elizabeth Hudson, *A Bibliography of the first editions of the works of E. Œ. Somerville and Martin Ross*, New York 1942; *The Times*, 10 October 1949; *Who Was Who 1941-1950*, London 1952; L. G. Pine, *Burke's Landed Gentry of Ireland*, London 1958; Maurice Collis, *Somerville and Ross*, London 1968; Institute of Irish Studies, Queen's University, *Somerville and Ross: A Symposium*, Belfast 1968; *Irish Times*, 14 December 1968, 15 October 1985; Queen's University of Belfast, *Exhibition of Paintings by Edith Œnone Somerville*, catalogue, 1968; John Cronin, *Somerville and Ross*, Cranbury 1972; *Dictionary of British Artists 1880-1940*, Woodbridge 1976; *Thomas MacGreevy Papers*, Trinity College, Dublin [1983]; 'Memories of Somerville and Ross' Committee, *Dr Edith Œnone Somerville 1858-1949: Exhibition of Paintings, Drawings and Illustrations*, catalogue, Drishane 1984 (also illustrations); Gifford Lewis, *Somerville and Ross: The World of the Irish RM*, Harmondworth 1987 (also illustrations); Ann M. Stewart, *Royal Hibernian Academy of Arts: Index of Exhibitors 1826-1979*, Dublin 1987; Brigid Peppin and Lucy Micklethwaite, *Dictionary of British Book Illustrators: The Twentieth Century*, London 1989; Peter Murray, compiler, *Illustrated Summary Catalogue of The Crawford Municipal Art Gallery*, Cork 1991 (also illustrations); P. M. B. Chavasse, *Letter to the author*, 1993; also Queen's University of Belfast, 1993; Anne Crookshank and the Knight of Glin, *The Watercolours of Ireland*, London 1994 (also illustration); *Water Colour Society of Ireland Exhibition List 1872-1994*, Dublin 1995.

Literature: Books by Somerville and Ross illustrated by E. Œ. Somerville (all published London): *Beggars on Horseback*, 1895; *Some Experiences of an Irish RM*, 1899; *A Patrick's Day Hunt*, 1902; *All on the Irish Shore*, 1903; *Some Irish Yesterdays*, 1906; *Further Experiences of an Irish RM*, 1908; *The Story of the Discontented Little Elephant*, 1912; *In Mr Knox's Country*, 1915 (last book by joint authors); *Irish Memories*, 1917; *Stray-aways*, 1920; *Wheel-tracks*, 1923; *The Smile and the Tear*, 1933; *The Sweet Cry of Hounds*, 1936; *Notions in Garrison*, 1941; *Happy Days!*, 1946; *Maria and some other Dogs*, 1949.

SPACKMAN, BASIL (1895-1971), landscape painter. Born on 4 July 1895 at Happisburgh, Norfolk, Charles Basil Slater Spackman was the son of the Rev. George Spackman and was educated at Lancing College, Sussex, which he left in 1912; his address then was Sloley Rectory, Norwich. When he retired from the Royal Air Force he was an Air Vice Marshal with the letters CB, CBE, DFC and bar after his name. He may have taken up painting late in life: an entry in *Who's Who in Art* stated: 'Studied art at Hammersmith School of Art under Frederick Gray (1950)', his year of service retirement.

In 1951 he showed *Hammersmith* and *Churchyard, Battersea* at the Royal Hibernian Academy with a Stamford, Lincolnshire, address, and at the Royal Scottish Academy that year he contributed *The Bridge, Stamford*. He travelled to Ireland and had a close association with the Water Colour Society of Ireland, exhibiting thirty-seven works in the period 1953-70. He lived for some years at Blackwater Bridge, Co. Kerry, painting landscapes and portraits of local residents. He moved to Minane Bridge, Co. Cork, and then to Cork city, where he held several exhibitions. In 1958 he exhibited in London with the Society of Marine Artists.

At the Imperial Hotel, Cork, in 1962 he showed some forty works, for the most part views of Cork city and county, also Co. Kerry. A similar number of works, all watercolours, were exhibited at the same venue in 1964 with Kinsale and locality being represented. In this show were: *Ballea Castle*; *Cobh from Ringaskiddy*; *Ballyfeard Village*; *The Round House, Castle Street*; *Farm at Rocky Bay*. He was represented in the Cork Drama Festival and Art Exhibition, 1965. At the 1970 WCSI show, he contributed *Autumn at Tracton* and *Gorse by Robert's Cove*.

Spackman also painted in oils, and contributed to exhibitions of the Royal Cambrian Academy, Royal Institute of Painters in Water Colours and Royal Society of British Artists. Work was reproduced in the *Connoisseur* and *Illustrated London News*. At Crawford Municipal Art Gallery, Cork, he is represented by a watercolour, *Steps near Lower Glanmire Road*. Of 11 Wood Grove, Cross Douglas Road, Cork, he died on 7 December 1971.

Works signed: B. Spackman.
Examples: Cork: Crawford Municipal Art Gallery.

Literature: *Irish Times*, 4 April 1962; Imperial Hotel, *Water Colours of Cork city, Kinsale and locality by B. Spackman*, catalogue, Cork 1964; *Who Was Who 1971-1980*, London 1981; *Who's Who in Art*, 1982; *The Royal Scottish Academy Exhibitors 1826-1990*, Calne 1991; Mrs Mary Kelleher, *Letters to the author*, 1992; Ms Phillis Skehan, *Letter to the author*, 1992; also, Lancing College, 1993; Royal Society of Marine Artists, 1993; *Water Colour Society of Ireland Exhibition List 1872-1994*, Dublin 1995.

SPEX – see O'HEA, JOHN FERGUS

STACK, A. BLANCHE (1870-fl.1908), sculptor. Born at Siskey, Co. Tyrone, on 8 October 1870, Annie Blanche Stack was the daughter of the Rev. Thomas Lindsay Stack, whose wife, Annie Olivia, had an interest in Shakespearian classes, art – she carved an oak lectern for Kildare Cathedral – and wrote poetry.

Blanche attended the Dublin Metropolitan School of Art in 1898-9. In 1900 she showed two portraits at the Royal Hibernian Academy, giving her address as 7 Appian Way, Dublin. In 1902, from 31 Lower Leeson Street, she exhibited three portraits, including one of the Rev. J. B. Stack.

In 1904 at the RHA, she showed a portrait of the Rt. Rev. Charles M. Stack, which may have been the 'silver plaquette' of Bishop Stack which appeared in London in 1905 at the Royal Academy along with a plaquette of Mlle Genevieve Grainger. These two subjects in plaster were described as 'medallion portraits' at the 1907 Irish International Exhibition, Herbert Park, Dublin. Among her other exhibits there was a design for hall decoration, plaster relief. Bishop Stack retired as Bishop of Clogher in 1902, and there is a portrait head plaquette dated that year in Clogher Cathedral.

A posthumous bust in marble of Bishop James Thomas O'Brien was completed in 1905, and exhibited at the Royal Hibernian Academy in 1906 prior to placing at Trinity College, Dublin. A statuette of a boy blowing bubbles was exhibited at the 1906 RHA, and a statuette of a bathing girl in 1907 along with *Miss H. M. White, LL D*.

In her final year, 1908, at the Dublin exhibition – she is known to have married – the works on view included a bronze group of children; a statuette in terracotta of a mother and children; and a medallion portrait in plaster, *W. King Edwards, Esq., DL*. The date and place of her death have not been found.

Works signed: A. Blanche Stack or AS, monogram.
Examples: Clogher, Co. Tyrone: St Macartin's Cathedral. Dublin: Trinity College.
Literature: Register Office, Dublin, *Register of Births*, 1871; *Irish International Exhibition*, catalogue, Dublin 1907; *Who Was Who 1897-1916*, London 1920; Rev. James B. Leslie, *Derry Clergy and Parishes*, Enniskillen 1937; Angela Jarman, *Royal Academy Exhibitors 1905-1970*, Calne 1982; Ann M. Stewart, *Royal Hibernian Academy of Arts: Index of Exhibitors 1826-1979*, Dublin 1987; Anne Crookshank and David Webb, *Paintings and Sculptures in Trinity College Dublin*, Dublin 1990; Clogher Historical Society, *Letter to the author*, 1993.

STANNUS, ANTHONY CAREY (1830-1919), marine, landscape and genre painter. Born in Carrickfergus, Co. Antrim on 16 April 1830, Anthony Carey Stannus was the son of James Stannus. He entered the Government School of Design in Belfast in 1850 and during his four years there was one of its most versatile students. In London, he attended the Training School for Masters, and later was an art master at Dowlais, Wales. The famous Dowlais Schools opened in 1855; there was a large Irish population in the district.

Stannus also studied under Alfred G. Stevens (1818-75), painter, sculptor, decorator and architectural designer. Stevens' most famous commission was the Wellington Monument in St Paul's Cathedral, on which he began work in 1858 and left unfinished at his death. One of his pupils who helped to complete the monument to his designs was Hugh Hutton Stannus (1840-1908), occasional watercolourist, a first cousin of Anthony Carey Stannus.

Stannus's first recorded commission was for a watercolour, *Belfast High Street, Looking East, c.* 1851. In the local history department at the Ulster Museum is a pencil drawing, *Bawn at Bellahill, near Carrickfergus*. An 1852 watercolour of premises of John G. McGee and Co. in High Street, Belfast, is in the Linen Hall Library, Belfast. *Launch of the Norah Graeme at the Queen's Island, Belfast* (Belfast Harbour Office and Ulster Museum) was dated 1858, and another watercolour at former is *Clarendon Dock and Harbour Office*,

Belfast, 1859. He showed only two works at the Royal Scottish Academy, both in 1858: *Dundrum Bay, Co. Down* and a view of Dunluce Castle in Co. Antrim.

At the final exhibition of the Belfast Fine Art Society in 1859, Stannus showed eleven pictures; he was then living at 13 Donegall Place, Belfast. In the years 1860, 1879, 1880 and 1881 he showed a total of nine works at the Royal Hibernian Academy, including in 1860, *On the Sands, near Portrush*. By 1862 he had returned to London where he exhibited in various exhibitions, for example the British Institution, 1862-4; Royal Academy, irregularly 1863-1909; and Society of British Artists.

Stannus painted in 1863 a series of eleven watercolours connected with South Kensington museum, for example: *Female School* and *Residence of Deputy-General Superintendent*. All are at the Victoria and Albert Museum. In 1865 he painted in Cornwall.

In 1866 he was in Mexico; a series of seven works on Mexican architecture, for example *Dominican Convent, City of Mexico*, are in the V. and A. Another series of Mexican views, twenty-one watercolours nearly all heightened with white, were sold in an auction of topographical works by Sotheby's, London, in 1984. These Mexican works included: *Chapultepec*; *Rancho de Olimar San Angel*; *The Crater of Popocatepetl*. Another set of Mexican views by Stannus was formerly in the collection of Emperor Maximilian. *Mexico City*, watercolour, is in the Ulster Museum collection.

Stannus in Mexico was a correspondent for the *Illustrated London News*, and some if not all of the sketches he made for this magazine were engraved for publication by Mason Jackson (1819-1903), art editor. In the issue of 19 January 1867 there is a reference to 'our own correspondent at Mexico, Mr A. C. Stannus, a clever and enterprising young artist'. *View of the City of Mexico* appeared at the 1868 RA, by which time he again resided in London. He showed *The Pilchard Harvest, Cornwall* at the 1880 RHA.

Dinant, Brittany was shown at the Exhibition of Irish Arts and Manufactures, Dublin, 1882, sent from 11 Chichester Street, Belfast, and he also exhibited at the Cork Industrial Exhibition in 1883, a Breton landscape, watercolour. He was president of the Belfast Ramblers' Sketching Club 1885-90, and in his first year of office used his influence in obtaining clubrooms at 55 Donegall Place. At the 1886 exhibition: *Herman Cortez at the Crater of Popocatepetl*.

After residing at Tudor House, Holywood, Co. Down, he departed for London again and lived at 39 Westbourne Park Road. *Evening on the Dogger Bank*, which he showed at the 1902 RA, is presumably the watercolour which he presented to the Belfast Museum and Art Gallery in 1906.

He illustrated with nineteen drawings his *The King of the Cats*, a Christmas story written for older children and published in 1903. In 1910 he exhibited three works at the London Salon of Photography. He also painted briefly in Belgium. He was represented by *A Rescue* at the loan exhibition, Modern Paintings and Early British Water Colours, Belfast Museum and Art Gallery, 1911. At the 1917 exhibition of the Belfast Art Society he showed *Land's End, Cornwall*.

In his book, *The Royal Ulster Academy of Arts*, Martyn Anglesea wrote: 'He painted seascapes reminiscent of Turner or Stanfield, such as *The Last of the Spanish Armada* or *Land's End*, both in the Ulster Museum. The Museum also has half a dozen watercolours by him, including an attractive scene of haymakers in front of Warksworth Castle, Northumberland, and an ambitious large one of Dinant which again is in the post-Turner tradition and is a typically Victorian gallery watercolour. He seems to have been the ideal person to stimulate art activity in Belfast.' Also in the Ulster Museum are portraits of Canon John Grainger, DD, MRIA, and Alderman W. J. Johnston, JP. He died in London on 3 August 1919.

Works signed: A. C. Stannus, A C S monogram, rare; A. S., rare; or Stannus (if signed at all).
Examples: Bangor, Co. Down: Town Hall. Belfast: Harbour Office; Linen Hall Library; Ulster Museum. London: South London Art Gallery; Victoria and Albert Museum.
Literature: Algernon Graves, *A Dictionary of Artists 1760-1880*, London 1884; A. C. Stannus, *The King of the Cats*, London 1903 (illustrations); *Belfast Museum and Art Gallery Quarterly Notes*, June 1906, June 1912; Algernon Graves, *The Royal Academy of Arts 1769-1904*, London 1906; *Belfast News-Letter*, 22 January 1907; H. S. Stannus, MD, FRCP, *Stannus Family Tree*, Victoria and Albert Museum, 1952; Christopher Wood, *Dictionary of Victorian Painters*, Woodbridge 1971; H. L. Mallalieu, *Dictionary of British Watercolour Artists up to 1920*, Woodbridge 1976; John Hewitt and Theo Snoddy, *Art in Ulster: 1*, Belfast 1977 (also illustration); Martyn Anglesea, *The Royal Ulster Academy of Arts*,

Belfast 1981 (also illustration); Simon Houfe, *The Dictionary of British Book Illustrators and Caricaturists 1800-1914*, Woodbridge 1981; Witt Library, illustrative records, London [1981]; Brian Kennedy: Ulster Museum, *British Art 1900-1937: Robert Lloyd Patterson Collection*, catalogue, Belfast 1982; Eileen Black, *Paintings, Sculptures and Bronzes in the Collection of The Belfast Harbour Commissioners*, Belfast 1983; Sotheby's, *Topographical Works*, catalogue, London 1984; Angela Jarman, *Royal Academy Exhibitors 1905-1970*, Calne 1987; Ann M. Stewart, *Royal Hibernian Academy of Arts: Index of Exhibitors 1826-1979*, Dublin 1987; *The Royal Scottish Academy Exhibitors 1826-1990*, Calne 1991; Merthyr Tydfil Central Library, *Letter to the author*, 1993; Ann M. Stewart, *Irish Art Societies and Sketching Clubs: Index of Exhibitors 1870-1980*, Dublin 1997.

STAPLES, SIR R. PONSONBY, RBA (1853-1943), portrait, genre and landscape painter. The son of Sir Nathaniel Alexander Staples, Bt, Robert Ponsonby Staples was born at Dundee, Scotland, on 30 June 1853, but the family had long been in residence at Lissan House, Cookstown, Co. Tyrone. In 1600 a young barrister from Bristol, Thomas Staples, had settled in Moneymore, Co. Derry, to mine ore at Unagh, Co. Tyrone. The creation of the Irish baronetcy took place in 1628.

Educated by his father, Ponsonby Staples at the age of twelve was sent to Louvain Academy of Fine Arts, 1865-70, to study art and architecture; he also studied at Dresden in 1867. In 1872 he entered the Brussels Academy and spent two years under J. F. Portaels (1818-95).

In 1875 he showed at the Royal Academy for the first time, giving the address 20 Newman Street. In the period 1875-1901 he exhibited thirteen works at Burlington House from seven different addresses, all in London. He also showed with the Society of British Artists. Like the Prince of Wales (later King Edward), he was a member of the Savage Club and sketched the Prince at the Cafe Royal and society events. The Prince addressed him as 'Ponsy'. In 1879-80 he visited Australia, hence *Farmstead, Parramatta, New South Wales*, oil.

In 1875 he had contributed to the Royal Hibernian Academy for the first time and, with interruptions, continued until 1928, a total of thirty-seven works. In 1876 he exhibited *Slievegullion, Ireland*, and in 1881 showed a portrait of Capt. Edgecombe Nicolls. His *'Laurel is green for a season, and love is sweet for a day'* appeared in 1882 at the RHA as well as at the exhibition of Irish Arts and Manufactures at the Rotunda, Dublin.

In conjunction with G. H. Barrable (fl. 1873-90), he completed in 1887 the painting, *Australia v. England*, at Lord's, commemorating the centenary of Marylebone Cricket Club, and for exhibition in Australia and New Zealand. Portrait heads of the twenty-two players appear in the predella but the players never faced each other in that combination. W. G. Grace is the batsman in action in the painting, which was exhibited at the Goupil Gallery, London and now hangs at Lord's.

In 1887 he began *The Last Shot for the Queen's Prize, Wimbledon* (Worthing Museum and Art Gallery), which was to occupy him for almost two years. The picture includes no fewer than fifty-six portraits. Below the picture itself is a collection of medallion portraits of all the Queen's Prize winners from 1860 to 1887 inclusive. Another principal work was *The Dying Emperor Wilhelm I*, 1888.

In 1888 too he was represented in the Irish Exhibition, London, by an angling scene on the River Shannon, Co. Limerick, and he painted that year on holiday with his wife Ada, hence *View of Warminster*. He portrayed Grace at Lord's in 1891, and his first meeting with Sarah Bernhardt, whom he also sketched, was in 1892. A presentation work to Cardinal Vaughan in 1892, *Cardinal Manning's Last Reception*, is in Archbishop's House, Westminster Cathedral.

An 1893 pastel portrait of Lord Randolf Churchill, which he tried to sell to the National Portrait Gallery, was purchased nearly forty years later by the Belfast Museum and Art Gallery. In 1893 he portrayed W. E. Gladstone introducing the Home Rule Bill. A double page presentation plate of Gladstone appeared in 1894 in the *Pall Mall Budget*. In an exhibition at the Continental Gallery, New Bond Street, in 1895 he showed 160 pictures.

In 1897 he served as art master at the People's Palace, Mile End Road. His *Time, Talk, and Oblivion* appeared that year at the RA. In 1898 he was appointed a member of the Royal Society of British Artists. Mark Twain was portrayed at the Savage Club in 1899. Other sketches at the club included those of Sir Edward Elgar, George Bernard Shaw and Sir Arthur Sullivan. A portrait of his cousin, Sir Coutts Lindsay,

founder of the Grosvenor Gallery, was dated 1899. An 1899 pencil and watercolour portrait of Sir Peter O'Brien, executed at the Four Courts, Dublin, is at the King's Inns. At the House of Commons on 26 October 1899 he drew Michael Davitt.

'Whether sketching, riding on the Row, boating at Henley or attending Ascot, or depicting the life of the music hall and theatre, he echoes the glib influence of Helleu and constantly reminds one of other artists such as Boudin and Toulouse-Lautrec,' wrote Anne Crookshank and the Knight of Glin in *The Watercolours of Ireland*, 1994.

A collection of paintings, studies and sketches of a hundred men and women of the time was exhibited at Graves Gallery, Pall Mall, in 1900, and described as 'A Century of Celebrities' and 'Souvenir of the Century'. In the National Portrait Gallery is a 1901 pencil drawing of his friend, James Abbot McNeill Whistler (1834-1903). Another artist subject was Sir Laurence Alma Tadema (1836-1912). He worked on the *Illustrated London News* and contributed articles and cartoons to *Black and White* and *Sporting Life*.

Staples returned to Belfast in 1904, when he was elected a member of the Belfast Art Society, and resided in the Knock district. Thereafter he showed only three works at the RA. In the period 1904-10 he exhibited twenty-six works with the Belfast Art Society, and these included: 1905, *Poet's Corner, Westminster Abbey*; 1906, *Castles in the Air*; 1908, *Golf Links, Newcastle*. In 1904 he began *The Shipbuilding of Belfast*, a triptych for the new City Hall. The cost was to be entirely defrayed by voluntary subscriptions but something went wrong. The work was purchased by the Belfast Museum and Art Gallery in 1913 and even then it cannot have been completed as the Museum gave 1924 as the finish. It consists of the building of *SS America* in Harland and Wolff's yard, 1904; turbine makers at Workman Clark's; view of River Lagan with passengers boarding Bangor Boat.

Something of an eccentric – his dogs were allowed to sit in the family church pew – Staples walked barefoot for at least fifteen minutes each day as he believed that many of the ills of modern living arose from man's foolish practice of complete insulation from the earth's magnetism by encasing his feet in leather, and rubber was worse. His barefoot exercise continued when away from home.

Judging by a drawing, he was in France in 1906, sketched George Moore at the Cafe Royal in 1909 and that year also drew at the Eccentric Club. By 1910, he resided at 'Bonchester', Sandown Road, Belfast, but within the next year or so he returned to the family seat, Lissan House. A portrait of Winston Churchill emerged from Churchill's visit to Belfast in 1912. In 1916 he recorded: *Lord Kitchener* (Armagh County Museum) and *The Green Sphinx, Dublin, Easter Monday, 1916*.

Staples still kept up his London connections, often sketching his fellow travellers. He showed *Lissan Waters*, about 1.8m in width, at the 1923 RA. He drew Jacob Epstein (1880-1959) at the Cafe Royal in August 1924, and in October held an exhibition of some 300 works, 'the greater part of 25 years' labour', at the Alpine Club Gallery in Savile Row, comprising oil paintings, watercolours, pastels, black and white illustrations. Among the principal works were: *The Westminster Boys, attending morning service in Westminster Abbey*, 2.4m high; *Dawn on the Mattoppos – Cecil Rhodes Burying Place*, 2.4m wide, published by Graves & Co. Portraits included His Excellency Tim Healy; John Redmond, MP; Rt. Hon. T. P. O'Connor, MP.

In addition to the Royal Academy and the Royal Society of British Artists, his work appeared in other principal exhibiting venues in London, such as Grosvenor Gallery, Royal Institute of Oil Painters, Royal Society of Portrait Painters and Walker's Galleries.

In writing to the National Portrait Gallery in 1928 offering works for sale and requesting expenses for carriage, presumably 'on approval', he explained: 'The balance of income is small, that I have little margin.' In 1933 he became the 12th baronet. Stringent financial circumstances remained and seeking in 1937 the purchase of drawings, he added in his letter from Craig-Vara House, Portrush, to Belfast Museum and Art Gallery that this would enable Lady Staples and himself 'to have another fortnight in this invigorating air'.

In one of the bathrooms at Lissan House are paintings of birds, fish and a frog swimming through reeds; over the basin are two large swans standing in rushes. He is also represented at the National Portrait Gallery, London, by portraits of Edward Carson, A. C. Swinburne and Phil May (1864-1903). Representation is most extensive at the Ulster Museum which also includes the oil painting, *Flax Pullers*; a watercolour of Percy

French (q.v.); George Moore and a self-portrait. Sir Edward Carson and Joe Devlin, MP, are also represented. At Church House, Armagh, is a portrait of Archbishop R. S. Gregg.

In *Who's Who* he listed his recreations as 'an argument, historical and metaphysical reading, plenty of fresh air, and early barefoot walking'. He was regarded as a man of wit and charm, handsome and gregarious. On 18 October 1943 he died at Lissan House. A selected exhibition of sketches and paintings took place at the Belfast Museum and Art Gallery in 1958. Phillips, London, auctioneers, held a studio sale in 1991.

Works signed: R. Ponsonby Staples or S inside staple shape.
Examples: Armagh: Church House, Abbey Street; County Museum. Belfast: Ulster Museum. Cookstown, Co. Tyrone: Council Chambers. Dublin: King's Inns. London: Marylebone Cricket Club; National Portrait Gallery; Westminster Cathedral, Archbishop's House.
Literature: Algernon Graves, *A Dictionary of Artists*, London 1884; *Pall Mall Gazette*, 29 June 1887, 5 March 1894; *Pall Mall Budget*, 13 June 1889, 8 March 1894 (illustration); *Daily Graphic*, 28 March 1892; Algernon Graves, *The Royal Academy of Arts: 1769-1904*, London 1905; R. Ponsonby Staples, *Memorandum on Alpine Club Gallery exhibition*, Ulster Museum [1924]; R. Ponsonby Staples, *Letters to the National Portrait Gallery*, 1928, 1930, 1931; *Belfast News-Letter*, 12 September 1930; *Who Was Who 1941-1950*, London 1952; *Belfast Telegraph*, 19 April 1958; *Dictionary of British Artists 1880-1940*, Woodbridge 1976; Martyn Anglesea, *The Royal Ulster Academy of Arts*, Belfast 1981 (also illustration); Patricia McComb Kesserick, *Souvenir of the Century: Victorian-Edwardian sketches by Sir Robert Ponsonby Staples*, San Francisco 1981 (also illustrations); Angela Jarman, *Royal Academy Exhibitors 1905-1970*, Calne 1982; Ann M. Stewart, *Royal Hibernian Academy of Arts: Index of Exhibitors 1826-1979*, Dublin 1987; Phillips, London, *Oil Paintings, Drawings and Watercolours from the studio of Sir Robert Ponsonby Staples, Bt.*, catalogue, London 1991 (also illustrations); Mrs Hazel Radclyffe Dolling, *Letters to the author*, 1993, 1996; Marylebone Cricket Club, *Letter to the author*, 1993; Anne Crookshank and the Knight of Glin, *The Watercolours of Ireland*, London 1994 (also illustration); Gorry Gallery, *An exhibition of 18th, 19th and 20th century Irish Paintings*, catalogue, Dublin 1997; Ann M. Stewart, *Irish Art Societies and Sketching Clubs: Index of Exhibitors 1870-1980*, Dublin 1997.

STEIN, CAROLINE – see SCALLY, CAROLINE

STEINER, NINI (1902-74), portrait painter. Born in Vienna in 1902, a sufferer from deafness caused by childhood illness, she studied art in the Austrian capital. Prior to the outbreak of the Second World War, she arrived in Londonderry as a refugee and became one of a small community of Jewish people there, some launching into small factory enterprises.

As a portrait painter, she carried out a number of commissions of personnel and their families at the US Naval Base. Other naval people also had their portraits painted and one of these was Rev. Matthias Bodkin, SJ, Royal Navy, Catholic Chaplain on the battleship *Anson*. His oil portrait in naval uniform is in the National Gallery of Ireland. This 1944 signed work is inscribed on rere: 'Miss Nini Steiner, 18 Glenview Avenue, Londonderry'.

At the Municipal Technical College, Londonderry, in wartime she attended evening art classes under Henry P. Stinson, who gave her a room to work in and lent her the model. Another attender at the classes was a shy little man – most unsure of himself; he was Tom Keating (1917-84) of the Merchant Navy. He later made his name famous as a forger.

Nini Steiner showed only two works at the Royal Hibernian Academy: a portrait – Bodkin probably – in 1946 and a self-portrait in 1947 from 32 Bond's Hill, Londonderry. In 1946 she exhibited *Estelle* at the Ulster Academy of Arts and *Londonderry* and *Hanna* in 1948. She painted an occasional flowerpiece.

After obtaining work with Derrycraft Ltd, she decided to seek her fortune in America and left Northern Ireland in the early 1950s. According to friends in the Derry area, she had a successful career abroad; Ludwig Schenkel advised the author in 1979 that she had died in New York in 1974.

Works signed: N. Steiner.
Examples: Dublin: National Gallery of Ireland.
Literature: National Gallery of Ireland, *Index note* [1976]; Madame Georgette Beck, *Letter to the author*, 1979; also, D. A. Bigger: Londonderry City Council, 1979; B. J. McCormack, 1979; Kurt Sekules, 1980; Henry P. Stinson, 1986, 1993.

STEPHENSON, DESMOND, ARHA (1922-63), landscape, still life and portrait painter. Born in Dublin on 29 August 1922, the son of Patrick J. Stephenson, who became Dublin Chief Librarian, and a brother of the architect, Samuel Stephenson, he was educated at the Christian Brothers' School, North Brunswick Street.

At the National College of Art, 1939-46, he studied painting and was awarded the Henry Higgins Travelling Scholarship in 1946, the year he showed forty-two oils, including *The Crucifixion*, at the Grafton Gallery, Dublin. *The Leader* commented, prior to the artist's visit to Spain: 'One may reasonably hope that the brighter surroundings in which he will soon find himself, will induce him to use a brighter palette than the one he favours at present.'

Stephenson first exhibited at the Royal Hibernian Academy in 1942, from 22 Caragh Road, Dublin, and was a regular exhibitor, showing nearly fifty works. Initially, he contributed landscapes but in 1944 he showed a self-portrait, and in 1946: *The Footballer* and *Head of a Boy*. He occasionally presented Connemara landscapes and Clonmel scenes. His work appeared for the first time at the Oireachtas exhibition in 1944 and from then until 1962 he contributed twenty-four pictures.

In Spain and Italy he continued his studies, and he was awarded an art scholarship by the Spanish Government. In Rome, in 1948, he was elected a member of the Associazone Artistica Internazionale. On the homeward journey, he spent some months in France painting in Brittany, returning in the summer of 1949.

At the RHA in 1952 he showed two still lifes, and in 1953 he was represented in the Contemporary Irish Art exhibition at Aberystwyth and that summer, near Roundstone, Co. Galway, he was painted by his friend, Maurice MacGonigal (q.v.). Steve, as he was known to the family, was described by the artist's son, Ciaran MacGonigal: '... very striking looking, with a broad beard, and at that time almost always wore a black Spanish hat and moleskin trousers'.

At the RHA in 1954 he gave his address as The Studio, 10 Lower Mount Street, Dublin, where the writer Brendan Behan accepted accommodation for a year. In 1954, too, he was appointed, at first part-time, as a teacher of drawing and painting at the National College of Art. The Thomas Haverty Trust bought a still life painting in 1955, the year he showed a watercolour portrait of Behan at the RHA.

In 1955 too he exhibited chalk and charcoal drawings of well-known Dublin characters at Brown Thomas's Little Theatre, Dublin, and in 1956 oil paintings at the Imperial Hotel, Cork, and also oils for his first show in Limerick, at the Goodwin Galleries. In 1956 he exhibited with the Munster Fine Art Club. At the Oireachtas in 1956 he exhibited: *An Bhulog Arain*; *Buachailli Scoile, Baile Atha Cliath*; *Ceann*. His charcoals were reproduced in the *Daily Express* for a series of articles on Northern Ireland.

Another exhibition took place in 1957 at Brown Thomas's, and the *Dublin Magazine* found him a strong composer 'with well-divided areas of colour, though he lacks atmosphere, nuance or quality of paint. These are hard sayings; but Mr Stephenson is just saved by the masculine vigour of his "attack". In *Blue Armchair* he weaves a spiralling design out of the most unpromising of objects.' *Coffee Pot* and *Flotsam and Jetsam* were contributed to the 1958 RHA.

Based on 'The Last Supper', he designed the mosaics over the High Altar at St Magdalen's Church, Drogheda. The Arts Council in Dublin purchased *An Bóthar go San Brieux* in 1959, by which time he resided at 1 Avoca Terrace, Blackrock, Co. Dublin. In 1962, he held three solo shows: Imperial Hotel, Cork; Talbot Hotel, Wexford; Ritchie Hendriks Gallery, Dublin. On the Hendriks exhibition, the *Irish Times* said that looking at the landscapes was 'rather like peering over a hedge at a well-kept farmland ...' The artist was unable to be present because of illness. In 1963 he was appointed an associate of the Royal Hibernian Academy.

At the Crawford Municipal Art Gallery, Cork, are two landscapes both oil on board. A drawing of Dr George Little is in Dublin Civic Museum. *A Scene in Brittany* is at the Vocational School, Crumlin Road, Dublin.

One commentator said that the artist had remained 'firmly in the figurative landscape tradition. His was a very colourful palette and he seemed to turn naturally towards the southern skies following his entanglement with Spanish art'. He died in a Dublin nursing home on 30 April 1963 after a long illness. In 1964 an exhibition

of his paintings was hosted at Brown Thomas's. About three years after his death, the New York Irish Institute Fund purchased three landscapes from the Arts Council, Dublin.

Works signed: D. Stephenson or Stephenson.
Examples: Cork: Crawford Municipal Art Gallery. Drogheda, Co. Louth: St Magdalen's Church. Dublin: City of Dublin Vocational Education Committee, Town Hall, Ballsbridge; Civic Museum; County Dublin Vocational Education Committee; Hugh Lane Municipal Gallery of Modern Art; Vocational School, Crumlin Road; Voluntary Health Insurance Board. Limerick: City Gallery of Art; County Library.
Literature: *The Leader*, 12 October 1946; *Cork Examiner*, 16 June 1955; Goodwin Galleries, *Desmond Stephenson, ANCA, AAI*, catalogue, Limerick 1956; *Dublin Magazine*, July-September 1957; *Daily Express*, 13 June 1963; *Arts Council, Dublin, Report*, 1966-7, Dublin 1967; Ann M. Stewart, *Royal Hibernian Academy of Arts: Index of Exhibitors 1826-1979*, Dublin 1987; Gorry Gallery, *An exhibition of 18th, 19th and 20th Century Irish Paintings*, catalogue, Dublin 1990; *Irish Times*, 19 May 1990; Jim Stephenson, *Letter to the author*, 1993; Ann M. Stewart, *Irish Art Societies and Sketching Clubs: Index of Exhibitors 1870-1980*, Dublin 1997.

STEVENSON, PATRIC, RUA (1909-83), landscape painter. Born on 5 September 1909 at Wadhurst, Sussex, John Patric Leslie Stevenson was the son of the Rev. Leslie C. Stevenson, later Dean of Waterford. Forebears had lived in Co. Derry. In 1920 the family moved from a twenty-room vicarage in Wadhurst to a four-room whitewashed cottage on Rathlin Island, Co. Antrim, 'where the drama of waves, cliffs and wild country made a strong impression' on the rector's son. They lived there for a year.

After attending Methodist College, Belfast, Patric Stevenson studied at Belfast School of Art, 1926-8, and for short spells at the Slade School of Fine Art, London, under Randolf Schwabe (1885-1948). He first exhibited at the Ulster Academy of Arts in 1933 and showed fifteen works up until 1940. In 1936 he exhibited at the Robinson and Cleaver gallery, Belfast, mainly watercolours. The *Northern Whig* commented: '... he shows on occasion his preoccupation with the smaller details which prove the influence of Dutch painters on his work. Roof tiles, bundles of turf, banks of trees are again and again painted with amazing minuteness of detail.' An exhibition of watercolours followed at Magee Gallery, Belfast, 1937. In 1938 he showed in Cork, and in 1937 and 1939 in Waterford.

In 1938, from The Deanery, Waterford, he contributed to the Royal Hibernian Academy for the first time with two Waterford townscapes. He visited The Great Blasket, Co. Kerry, and painted there in 1938; one of two works, a watercolour, in the Irish folklife division of the National Museum of Ireland is *Curraghs on the Great Blasket*. From 1940-5 he served in the Royal Air Force as a radar mechanic 'writing poetry and avoiding promotion'. In 1940, 1941 and 1942 he used the address of Contemporary Pictures, 16 Leinster Street, Dublin, for exhibiting at the RHA.

A book of poems, *Flowing Water*, appeared in 1945 dedicated to his parents 'who encouraged me to fashion the environment needed in order to grow roots of my own devising'. His poetry also appeared in *The Bell*, *Country Life* and other publications.

In the period 1946-50 he was arts assistant at Pendley Centre of Adult Education, Tring, Hertfordshire, lecturing on art and music, and he exhibited with Aylesbury and District Art Society in 1949. In Ireland, his work was included in the exhibition of pictures, by Irish artists, in Technical Schools, 1949. His exhibition at Berkhamsted, Hertfordshire, in 1950 included a painting of Marsworth Churchyard, Hertfordshire, which had been bought by the Duke of Edinburgh the previous year at the Royal Institute of Painters in Water Colours exhibition. He later showed on several occasions with the Institute.

Returning to Northern Ireland in 1950, he devoted his full time to painting at Rostrevor, Co. Down. In 1951, he held his third exhibition in Belfast, at 55a Donegall Place, scenes of the Mourne country being prominent. He pioneered open-air summer exhibitions at Rostrevor, 1951-4; the pictures were hung on the castellated wall of an old house. A 1952 gouache, *Albert Basin, Newry*, is in the Ulster Folk and Transport Museum, and that year he exhibited in Newry, Co. Down.

In the period 1952-82 inclusive he was a regular exhibitor with the Royal Ulster Academy, missing only a few years and showing nearly eighty works.

In 1953 he showed again at the gallery run by Council for the Encouragement of Music and the Arts in Donegall Place, Belfast, where *A County Mayo Turf Cutting* was particularly noted. His appointment as an associate of the RUA came in 1953, and in 1959 as a full member. In 1954 he had shown at the RHA after an interval of twelve years, and he held an exhibition at the Grafton Gallery, Dublin.

On moving to Hillsborough, Co. Down, the open-air exhibitions continued, now at The Shambles, 1955-67. His aim, he said, was to present 'good, pleasing, reasonably-priced pictures to the public suitable for hanging in the average home'. In his own exhibition in Belfast in 1961 at the CEMA gallery, now at 7 Chichester Street, the mediums used were egg tempera, gouache, watercolour and ink. Counties Antrim, Cork, Donegal, Down, Fermanagh, Kerry and Sligo were all represented by works. He also showed *Durham Cathedral*, and an interior of St Anne's Cathedral, Belfast.

In a catalogue note for Stevenson's exhibition at the Magee Gallery, 1963, William Conor (q.v.) wrote that his chief aim was to 'seek a motif, a theme in harmony with his temperament, something that would enable him to give expression to his own individuality. This he is most readily able to achieve as a plein air painter ...'. His *Muckish from Lough Agher, Co. Donegal* was hung at the 1965 Royal Scottish Academy.

In 1963 he became honorary secretary-administrator of the RUA, a post which he held until 1970. At the annual exhibition in 1967, Lord Erskine of Rerrick presented the awards, and Stevenson recited his own parody of Burns in honour of the Governor. Appointed president of the Academy in 1970, he served until 1976. He was director of the Hillsborough Art Centre which opened in 1971 but eventually had to close because of security and the civil unrest. At the 1976 RUA exhibition, he showed an exterior and interior of Durham Cathedral.

In London, he also exhibited with the United Society of Artists and the New English Art Club. Representation in the Ulster Museum consists of: *Cows in a Byre: 1*, pen, ink, gouache; *Breakers, Achill*, gouache. In the Waterford municipal collection are two watercolours: *The Tearaght from Great Blasket* and *Waterford from Mount Misery*. In Armagh County Museum is an oil, *Knockchree and the Mournes from Greencastle, Co. Down*. He died in a Belfast hospital on 25 July 1983. His son Leslie presented in 1993 a 'Father and Son' exhibition at the Byre Theatre, St Andrews, Scotland.

Works signed: Patric Stevenson.
Examples: Armagh: County Museum. Belfast: St Anne's Cathedral; Ulster Museum. Cultra, Co. Down: Ulster Folk and Transport Museum. Dublin: National Museum of Ireland. Waterford: City Hall, Municipal Art Collection.
Literature: *Northern Whig*, 17 November 1936, 12 October 1937, 17 November 1953; Patric Stevenson, *Flowing Water*, London 1945; *Belfast Telegraph*, 13 October 1950, 16 December 1960, 12 March 1962, 9 August 1962, 4 April 1963; *Belfast News-Letter*, 23 October 1951, 4 November 1954; *News Letter*, 26 July 1983; CEMA Art Gallery, *Exhibition of Paintings by Patric Stevenson*, catalogue, Belfast 1961; Patric Stevenson, *Letter to BBC Television Centre*, 1969; John Hewitt and Theo Snoddy, *Art in Ulster: 1*, Belfast 1977; Martyn Anglesea, *The Royal Ulster Academy of Arts*, Belfast 1981; *J. Patric L. Stevenson Curriculum Vitae*, 1983; Ann M. Stewart, *Royal Hibernian Academy of Arts: Index of Exhibitors 1826-1979*, Dublin 1987; Mrs Dorothy B. Stevenson, *Letters to the author*, 1993; National Museum of Ireland, *Letter to Leslie F. Stevenson*, 1997; Ann M. Stewart, *Irish Art Societies and Sketching Clubs: Index of Exhibitors 1870-1980*, Dublin 1997.

STEWART, DOROTHY – see BLACKHAM, DOROTHY

STEYN, STELLA (1907-87), figure painter and lithographer. Born in Dublin on 26 December 1907, she was the daughter of William Steyn, a dentist, and was educated at Alexandra College, Dublin. The Steyn family was of Russian extraction.

Stella enrolled at Dublin Metropolitan School of Art, 1924-6. Hilda van Stockum, writing about the period when she too was a student at the Metropolitan, said: 'Stella Steyn awed me with her elegance; she had long black ringlets framing her face, and wore artistic colour combinations and fashionable get-ups. She was very talented, did beautiful drawings in the Harry Clarke (Aubrey Beardsley) style until she went to Paris to study and came back doing very airy and witty French-style creations ...'.

After the Metropolitan, she had gone to La Grande Chaumière in Paris in 1926 where she met Jules Pascin (1885-1930) and was to some extent influenced by him in her early work. One of her Paris teachers was Charles Despiau (1874-1946), and her studies in Paris included lithography. Meanwhile in Dublin at the Metropolitan in 1928 she was awarded the Tailteann Silver Medal and the Californian Gold Medal for poster design in the Exhibition of Irish Art. At 7 St Stephen's Green, Dublin, in 1928 she held an exhibition of watercolours, etchings and pencil drawings. In 1929 she was represented in the Contemporary Irish Art exhibition held at the Hackett Galleries, New York, and Grace Horne's Galleries, Boston.

At the Royal Hibernian Academy she showed a total of nineteen works in the period 1927-30, giving the Metropolitan School of Art as her address when she contributed four pictures in 1927, including *Rue de Seine* and *The Strand, St Malo*. Another four pictures were exhibited in 1928 with female figures. In 1929, from 16 Lower Fitzwilliam Street, she had no fewer than eight works hung, for example *At Galway Fair*; *Notre Dame, Paris*; *Off to the Fair*. Finally, at the RHA, in 1930 there were two Parisian scenes, also *Sailors-Toulon*. Patrick Tuohy (q.v.), a friend of the family and her teacher at the Metropolitan, had encouraged her to work in Paris. In the 1927-30 period she also showed two works at the New English Art Club, London, and one at Manchester City Art Gallery.

In 1929 she left Ireland for a tour of France and Germany, reportedly 'in search of material for an exhibition in London'. She certainly visited Avignon, Toulon and Marseilles. She illustrated an instalment of James Joyce's *Finnegan's Wake* in *transition* magazine, Paris, 1929, and formed a close friendship with Joyce and his family. At one time in Paris, Samuel Beckett was her boy-friend, whom, in her reminiscences, which her husband persuaded her to write, she described as '... a very silent young man, almost as much so as Joyce himself'.

At the James Joyce Museum, Sandycove, are *The Ondt's Funeral*, lithograph, and *Anna Livia legging a jig*, etching, both dated 1929 and reproduced in the aforementioned *transition* magazine. A drypoint, *In a Galway Pub*, was reproduced in W. Gaunt's *Etchings Today*, 1929. In 1930 came her London exhibition at St George's Gallery and prior to the opening *The Studio* reproduced *The Coupole, Montparnasse*, lithograph; *Coquillage, Marseilles*, drypoint. The magazine later reported: 'Simple countrymen, tough sailors, bars and cafes. Thus Miss Stella Steyn describes the drypoints, lithographs and drawings forming her exhibition at the St George's Gallery this month, and which present a varied human interest depicted in a manner that is both amusing and fresh.'

A second exhibition at the Dublin Painters' Gallery in St Stephen's Green, this time of paintings, was held in 1930. In the exhibition of Irish art at Brussels in 1930, she was represented by two lithographs, including *Fête à Avignon*, and two engravings including *Tramcar, Marseille*. Because she felt that art did not receive sufficient encouragement in Ireland, she returned to Paris and continued her study at the Grande Chaumière, also attending the Académie Scandinave.

An admirer of the work of Paul Cézanne (1839-1906), she copied it at the Louvre. She moved in 1931 to the Bauhaus School of Design at Dessau to work with Wassily Kandinsky (1886-1944), and found herself out of sympathy with his methods, but continued working there for a year, independently, then she moved to the Kunstgewerbeschule, Stuttgart, returning to England in 1933. She was said to be the only Irish person to study and work at the Bauhaus.

After marrying a linguist, David J. A. Ross, she settled in England in 1938. Her *Ladies in a vase* was painted in 1947. In the London Group exhibition of 1951 she was represented, and that year she had a show of paintings at the Leicester Galleries where works included *Nude with clasped hands*, 1949; *Women in the street*, 1950; *Azalea and hyacinth on a yellow ground*, 1951. In the preface to the catalogue for that exhibition, A.D.B. Sylvester wrote:'... the archaic simplicity and grandeur of her forms are not cultivated by way of conforming with preconceived notions of style, designed to charm, but belong to her way of seeing... she sees the world with a gaze as innocent as it is grave...'. A 1951 oil is in the National Self-Portrait Collection of Ireland, and *Woman seated at a table*, oil, 1951, is at the Ulster Museum.

In 1952 she was one of the twelve British exhibitors at the Carnegie Institute Exhibition, Pittsburgh, and in 1953 she exhibited *Models at the Grande Chaumière* in the Contemporary Art Society's 'Figures in their

Setting' exhibition at the Tate Gallery. In her 1954 exhibition at the Leicester Galleries, a score of works included: *The Harbour, Pozzuoli*; *At the Cafe Mabillon*; *The Three Graces*; and seven flowerpieces.

In the period 1952-9 the Royal Academy showed a dozen Steyn works. In 1952, from 30 Percy Street, W1, she exhibited *Reclining Woman*, and in 1955, *Woman in Conversation*. Three years later she contributed two still lifes, and in 1959 *Cain and Abel* and *The Fall of Man*. In Scarborough Art Gallery is *Still Life with Roses and Anemones*, 1953.

Other CAS group exhibitions at the Tate Gallery in which she was represented were: 'The Seasons', 1956, and 'The Religious Theme' in 1958 – her painting was *The Sacrifice of Isaac*. She was also represented in the 'Hampstead in the Thirties' exhibition at the Camden Arts Centre in 1974. In Paris, her work was displayed in 1978 at Bibliotheque Nationale: L'Estampe, aujourd'hui.

Among the six lithographs at the British Museum are abstract compositions based on type, 1931-2. *Reclining Nude*, 1953, rests in Doncaster Museum and Art Gallery. In Dublin, at the Hugh Lane Municipal Gallery of Modern Art, she is represented by *Sunlight*, *Jardins du Luxembourg*, watercolour; *Rue San Antoine, Paris*, pen and ink. Of 33 Tavistock Square, Bloomsbury, London, she painted up to a few days before her death on 21 July 1987. A retrospective exhibition, with an autobiographical memoir in the catalogue, was held at the Gorry Gallery, Dublin, in 1995.

Works signed: Stella Steyn; S. Steyn or Steyn, both rare (if signed at all).
Examples: Belfast: Ulster Museum. Doncaster, Yorkshire: Museum and Art Gallery. Dublin: Hugh Lane Municipal Gallery of Modern Art; Irish Jewish Museum. Limerick: University, National Self-Portrait Collection. London: Arts Council of Great Britain; British Museum; Government Art Collection. Paris: Bibliothèque Nationale, Cabinet des Estampes. Sandycove, Co. Dublin: James Joyce Museum. Scarborough, Yorks.: Art Gallery.
Literature: *Evening Herald*, 4 December 1928; W. Grant, *Etchings of Today*, London 1929 (illustration); *Irish Times*, 8 April 1929, 27 November 1979, 16 March 1985; *The Studio*, February 1930 (illustrations), April 1930; *Dublin Evening Mail*, 31 May 1930; Leicester Galleries, *Stella Steyn, Paintings*, also three others, catalogue, London 1951; Leicester Galleries, *Stella Steyn, New Paintings*, also two others, catalogue, London 1954; *Dictionary of British Artists 1880-1940*, Woodbridge 1976; *Who's Who in Art*, 1984; Angela Jarman, *Royal Academy Exhibitors 1905-1970*, Calne 1987; Ann M. Stewart, *Royal Hibernian Academy of Arts: Index of Exhibitors 1826-1979*, Dublin 1987; Contemporary Art Society, *Letter to the author*, 1993; also, Hugh Lane Municipal Gallery of Modern Art, 1993; Dr Keith F. A. Ross, 1993; Tate Gallery, 1993; Government Art Collection, 1994; Gorry Gallery, 1995; S. B. Kennedy: Gorry Gallery, *Stella Steyn (1907-1987): A retrospective view with an autobiographical memoir*, catalogue, Dublin 1995 (also illustrations); James Joyce Museum, *Letter to the author*, 1995.

STOKES, MARGARET M. (1915-96), wood engraver, landscape and figure painter. Margaret Mary Stokes was born on 19 November 1915, the daughter of Henry Stokes, surgeon. The family lived at 32 Upper Pembroke Street, Dublin. Margaret McNair Stokes (1832-1900), archaeologist and artist, was her great aunt. First influenced in art by Mainie Jellett (q.v.), a first cousin, she received lessons from an early age. At Howel School, Denbighshire, she boarded.

From 1932-5, she attended the Royal Hibernian Academy Schools, moving to London where, until 1938, she studied wood engraving and drawing from life under Iain Macnab (1890-1967) at his Grosvenor School of Modern Art. Winner of the Purser-Griffith scholarship, she went to Paris. When war loomed, she moved to Edinburgh College of Art, where she met a teacher of typography and book production, Joan Hassall (1906-88), wood engraver and illustrator, and worked under William G. Gillies (1898-1973), the noted Scottish painter. Training was interrupted and she became a nurse in Edinburgh.

Meanwhile she first exhibited at the Royal Hibernian Academy in 1938, with a still life, and from then until 1991 showed a total of eighteen works. Closely associated with the Water Colour Society of Ireland, in the period 1940-93 she showed almost 150 works. At the 1942 event *View from a Glasgow Window* and *Spring in Glasgow* were both hung, and in 1943, *Grey Friars, Edinburgh*. At the inaugural exhibition of the Irish Exhibition of Living Art in 1943, she was represented by *The Jockey*. In 1944 at the RHA she contributed *Geraniums* and a wood engraving, *The Swan*.

A return to Dublin enabled her to organise in 1944 a one-person show of forty-seven works for the Grafton Gallery, made up of twenty oils, including *At the Hairdressers* and *Fitzwilliam Square by Night*; seventeen

watercolours, for example *Autumn Crocuses* and *The Old House, Castletownshend*; ten wood engravings, including *The Children of Lir* and *Meath Hospital*. She had a spell of teaching at Alexandra College, Dublin. An occasional pastel was produced.

As a young woman she was blighted by deafness that marred her life. Other solo exhibitions were held at the Grafton Gallery in 1946 and 1949. Her only other contribution to IELA was in 1950, a fantasy. At WCSI in 1950 *The Foreigner* and *Gossips* were among four works. In 1950 too she was represented in the Dublin Painters' exhibition, contributing regularly up until 1960, her work being absent in this period at the Academy.

At the Dublin Painters' Gallery in 1951 she exhibited twenty-eight paintings, including *La Dent Blanche* and *School Children*, with three woodcuts. Another one-person show was held there in 1954. She showed a nude in the Dublin Painters' exhibition of 1957; *Study of Nude* at the 1958 WCSI exhibition.

Holidays were taken in France and Italy, travelling on many sketching forays with Lillias Mitchell (1915-2000). She also painted in Connemara. Among her pictures at the WCSI shows were: 1963, *Good Friday, Orvieto*; 1964, *The Forest near Fontainebleu*. At the 1964 RHA, when living at 11 Temple Villas, Rathmines, she showed *The Forest Marlotte*. A monotype, *Dublin Bay*, appeared at the 1965 WCSI.

A visit to Crete was indicated by a Knossos subject, 1975 WCSI. Exhibitions were hosted by the Robinson Gallery, Dublin, in 1980 and 1983. In a 'Homage to Françoise Henry' exhibition at Alliance Française, Dublin, 1983, works by her Irish art friends who painted at Les Bretons, she showed with Lillias Mitchell and Domhnall Ó Murchadna (q.v.). In an exhibition at the Kennedy Gallery, Dublin, 1990, she showed thirty paintings, including *Boys' Bathing* and *Terenure College grounds*; and forty-four woodcuts, for example *Starlings*; *Lake Naivasha*. She also exhibited at the Kennedy Gallery in 1991. Of 95 Greenlea Road, Terenure, Dublin, she died on 13 August 1996. A memorial exhibition took place at the Kennedy Gallery in 1997.

Works signed: Margaret Stokes, M. Stokes or M. S.
Examples: Dublin : Office of Public Works.
Literature: Edinburgh College of Art, *Prospectus 1941-42*; Grafton Gallery, *Exhibition of Paintings and Wood Engravings by Margaret Stokes*, catalogue, Dublin 1944; Ann M. Stewart, *Royal Hibernian Academy of Arts: Index of Exhibitors 1826-1979*, Dublin 1987; catalogues, 1980-1986, 1988-1991; Kennedy Gallery, *An Exhibition of Works by Margaret Stokes*, Dublin 1990; *Water Colour Society of Ireland Exhibition List 1872-1994*, Dublin 1995; Kennedy Gallery, *Margaret Stokes 1915-1996*, catalogue, Dublin 1997; Ann M. Stewart, *Irish Art Societies and Sketching Clubs: Index of Exhibitors 1870-1980*, Dublin 1997; Mrs Anne White, *Letters to the author*, 2000.

STOUPE, JAMES (SEAMUS) (1872-1949), sculptor and landscape painter. Son of John Stoupe, a carpenter, James Stoupe was born in Belfast on 27 October 1872. Educated at Belfast Model School, it is presumed that he attended the Government School of Art in Belfast. In 1894, when living at 55 Hanover Street, he was elected a member of the Belfast Art Society and exhibited a watercolour, *Ballybrain, near Greyabbey*. In 1904 he joined the staff of the Belfast School of Art as modelling master and remained in the post for thirty-four years.

The interest in Irish culture prompted him to sign his name Seamus Stoupe, and for the 1905 exhibition of the Belfast Art Society he wanted his work labelled in Irish, but was refused permission. On that exhibition, *The Nationalist* found him 'an industrious and painstaking craftsman ... His *Head of an Old Gardener* is good. There is the pain and the optimism of poverty in it ... *The Pagan at Prayer* is ambitious, but it is no more than a study from the nude ... *Reconciliation* is well done in its way, and as an example of decorative low-relief work would take some beating.'

In 1905 he first exhibited at the Royal Hibernian Academy, and from then until 1931 was a regular exhibitor, showing in all seventy works, mainly landscapes with the occasional piece of sculpture. At the Belfast Art Society exhibition in 1906, James Stoupe gave his address as Annieville, Holywood, Co. Down, titled his one sculpture, *Bean an Tighe*, and one of his three oil paintings, *Samhradh*. Watercolour subjects were a village near Hounslow and a Putney Heath scene. In 1906 he showed at the Oireachtas exhibition in Dublin. He last exhibited with BAS in 1911, *Miss M. Gaffikin*, sculpture, but the previous year he had shown three Dutch landscapes.

On his painting, John Hewitt noted that he was 'fondest of sunlight on whitewash and the dapple of blue shadows, for he was an early exponent among us of the Impressionist style'. He visited the Continent and in 1912 at the RHA three titles involved Concarneau: the fishing fleet, the quay and the market place; in 1913, he showed *In Holland*; and in 1914, *Morning on the Ramparts, Montreuil-sur-Mer*. The 1914 Dublin exhibition also included sculpture, *Padric Gregory, Poet*; now in private possession in Belfast.

Stoupe had an interest in practical lithography and attended a course of lectures by one of the founders of the Senefelder Club, F. Ernest Jackson (1872-1945), at the Dublin Metropolitan School of Art in 1915. An etching, *A Wet Day at Concarneau*, dated 1915, was presented to the Municipal Gallery of Modern Art in Dublin by the artist, in remembrance of Sir Hugh Lane. At the 1916 RHA, from his studio at 13 College Street, Belfast, he showed the sculpture, *The Swan Dance*, and his contributions in 1917 included *Motherhood*, glazed pottery, and *The late William Gray, Esq., MRIA*, electro medal.

In 1920 James Stoupe was president of the Ulster Arts Club, and at their 1921 exhibition he showed a portrait bust in plaster of Councillor (later Alderman) James A. Doran, chairman of the Libraries, Museums and Technical Instruction Committee, Belfast Corporation. The Doran bust in bronze was presented by the sitter in 1930 to the Belfast Museum and Art Gallery immediately after he had received it from the committee members.

The only occasion he exhibited with the Water Colour Society of Ireland was in 1926, when three of the five works had Dublin connections: *House on the Grand Canal, Dublin*; *Dundrum, Co. Dublin*; *Killiney Strand*.

A group of members of the Ulster Arts Club commissioned a bust of William Gray, MRIA, which Hewitt considered – in 1957 – 'about the best piece of interpretative modelling that ever came from Ulster hands'. This bronze together with the Doran plaster were exhibited at the Irish portraits by Ulster artists exhibition in the Museum and Art Gallery, 1927.

Stoupe's name does not appear in the 1922 list of members of the Belfast Art Society. In 1924, now living at 82 Willowbank Gardens, Belfast, he showed five works at the RHA, including *Knockmaroon* and *Chapelizod*. Among other landscapes hung in Dublin were: *Phoenix Park*, 1925; *Killiney*, 1928. In the year that he retired from Belfast College of Art, 1938, he exhibited busts of Fred Allen and Miss Virginia Lawson at the Ulster Arts Club annual exhibition. Also in the Ulster Museum are eight oil paintings. Among these are: *French Barque in York Dock*, 1912; *After Milking Time*; *Ballylesson*. A 1941 self-portrait in pastel is also in the collection. He died on 20 May 1949.

Works signed: Seamus Stoupe or Stoupe.
Examples: Belfast: Ulster Arts Club; Ulster Museum. Dublin: Hugh Lane Municipal Gallery of Modern Art.
Literature: *The Nationalist*, 2 November 1905; *The Studio*, October 1915; *Belfast Telegraph*, 30 June 1921, 22 June 1957; Patrick Shea, *A History of the Ulster Arts Club*, Belfast 1971; John Hewitt and Theo Snoddy, *Art in Ulster: 1*, Belfast 1977 (also illustration); *Oireachtas*, catalogue, Dublin 1977; Martyn Anglesea, *The Royal Ulster Academy of Arts*, Belfast 1981; Ann M. Stewart, *Royal Hibernian Academy of Arts: Index of Exhibitors 1826-1979*, Dublin 1987; Brian Kennedy: Ulster Museum, *Twentieth Century Sculpture*, catalogue, Belfast 1988; Hugh Lane Municipal Gallery of Modern Art, *Letter to the author*, 1993; Ann M. Stewart, *Irish Art Societies and Sketching Clubs: Index of Exhibitors 1870-1980*, Dublin 1997.

STRONGE, DAPHNE – see PITT-TAYLOR, DAPHNE

SWANZY, MARY, HRHA (1882-1978), figure, landscape and portrait painter. Second of three daughters of Sir Henry Rosborough Swanzy, opthalmic surgeon, 23 Merrion Square, Dublin, she was born on 15 February 1882. She attended Alexandra College, Dublin, and on Saturdays a Miss Underwood at 5 Herbert Place assisted her with sketching. In those early days Josephine Webb (q.v.) was also an art teacher. Education continued at the Lycée in Versailles and a day school at Freiburg, Germany. She became a speaker of French and German.

When about eighteen years of age, she attended the art classes of May Manning (q.v.) in Dublin. Mary Swanzy told the author in 1968 that Miss Manning 'knew the artists of the day, and was the person who helped me the most'. John B. Yeats (q.v.) was a visiting teacher in the studio and she found him encouraging. Evening classes in the Dublin Metropolitan School of Art were also attended, and she received there lessons in modelling from John Hughes (q.v.). She was also given painting tuition at the Royal Hibernian Academy Schools.

Encouraged by Miss Manning, who had studied in Paris herself, Mary Swanzy departed for Paris and worked at Delacluse's, where there was a studio for women. In 1905 she exhibited at the RHA a portrait of a child, giving her home address. In 1906 she returned to Paris and studied in the studio of the portrait painter, Antonio De La Gandara (1862-1917) and with Lucien Simon (1861-1945), also at La Grande Chaumière and Colarossi's atelier.

When the term at Colarossi's had ended, she attended a short course in a Grasse studio along with avant garde young artists. Making occasional visits to Gertrude Stein's house in Paris, she saw examples of modern French art. On one occasion she travelled on a holiday to Paris with Sarah Purser (q.v.), who became a lifelong friend.

At the 1906 RHA, where she showed a total of fifty-one works up until 1977, a portrait of her father prompted praise from the writer and critic, George Moore: '... a very accomplished portrait for so young a painter'. Nathaniel Hone (q.v.) commented: '... the best picture painted in Dublin for thirty years'. This work is in the Adelaide Hospital.

In the first five years of her inclusion in the Academy, and encouraged by her father, the majority of works were portraits. She tried teaching but only for a short time: 'You can't teach painting, you can only learn by doing it.' She showed at the 1907 Oireachtas art exhibition, held at the RHA premises, and she was represented at the Oireachtas seventy years later. By 1909 she had a studio at 18 Nassau Street, Dublin, and that year she held a small show of eight portraits.

In Dublin, Mary Swanzy was also an illustrator for cartoons and posters. Savoy Chocolates was the subject of a poster. Her first proper one-person show took place in 1913 at Mills' Hall, Dublin. In 1914 she was represented at the Salon des Indépendants, Paris, and *The Times* commented: 'Miss Mary Swanzy of Dublin has highly impressionist studies of Italy and Ireland, expressing originality and temperament.' She was in Italy when war broke out and had to abandon her Florence studio and return to Dublin.

In 1916 she was represented at the exhibition of the International Society of Sculptors, Painters, and Gravers at the Grosvenor Gallery, London. Her address by 1918 in Dublin was 9 Garville Avenue, Rathgar, and she exhibited *Portrait of Mrs R. F. Parker* at the Salon des Indépendants – and showed again in 1919, the year she exhibited *Tulips* at the Salon des Beaux Arts, Paris.

In 1919 she presented fifty-four of her paintings at Mills' Hall, ranging over figures, landscapes, still lifes and interiors, in oils, watercolours and other drawings. Sarah Purser in a review said that the work was 'essentially modern and is quite personal in its point of view, though far removed from the freaks of the futurist. The brush work is sure and swift and the freshness of colour and impression is never lost. The landscapes, mostly from Kerry and Donegal, are invigorating and optimistic ...' *Snow Landscape* (Monaghan County Museum) was dated 1919.

In 1920 she exhibited again at the Salon des Beaux Arts, became a committee member of the Salon des Indépendants and with Clare Marsh (q.v.), another foundation member that year of the Society of Dublin Painters, had a two-person show at the Society's gallery. In 1921 when she participated in a Dublin Painters' exhibition, Stephen Gwynn wrote in the *Irish Times*: 'Miss Swanzy's pictures in this exhibition are the extreme case. I can neither recognise shape or colour of nature in them, nor can I see any beauty in this vision of hers.'

St Clair Swanzy, a sister, was involved in relief work in Yugoslavia and Czechoslovakia after the War and Mary joined her. With colour crayon and oils she depicted everyday life as well as producing landscapes. Czechoslovakian paintings were exhibited at the Dublin Painters' Gallery in 1922. *Pattern of Rooftops, Czechoslovakia* is at the National Gallery of Ireland. She still retained her Paris links, showing with the

Indépendants in 1923, and that year, in Dublin, she was represented in the first exhibition of the New Irish Salon, at Mills' Hall. Also in the NGI collection is *French River Landscape*.

In 1923 she travelled to Honolulu, where she stayed with her aunt, Mrs F. M. Swanzy, and paid a visit to Samoa. An exhibition of Czechoslovakian and Hawaiian paintings took place at her aunt's home in 1924. The *Honolulu Star Bulletin* commented: 'The first impression of all her work is that of decorativeness which is achieved by laying on the colours in a rather flat way suggestive of the poster style ...' In the same year she showed work at an invitation exhibition, and in July she exhibited Samoan canvases at the Cross Road Studios, Honolulu. In September 1924 she moved to California, and in November exhibited at the Santa Barbara Art Club Gallery.

After her return to Ireland in 1925, she held a one-person show at the Galerie Bernheim Jeune, Paris, featuring several Samoan paintings. Gertrude Stein congratulated her on the exhibition, and the art critic for the *New York Herald* praised her work: 'Few painters have ventured thus far, and Mme Swanzy has shown what excellent material for the artist's brush is to be found in the tropical vegetation of the distant archipelago.'

By 1926 she had settled in London with her sister, St Clair Swanzy, at 45 Hervey Road, Blackheath. Wilhelmina Geddes (q.v.), whom she knew at the An Túr Gloine in Dublin, would occasionally stay at Blackheath. Mary exhibited again at the Salon des Indépendants in 1926 (also 1934) and at this time her Cubist/Orphist paintings came to the fore. In 1929 she showed in London with the Women's International Art Club. In 1930 she was represented in the exhibition of Irish art at Brussels. She showed some works at the London Salon.

In 1932 she presented her work to selected guests at Sarah Purser's home, Mespil House, Dublin, and two years later held an exhibition of twenty new paintings, including *Requiem*, at Lefevre Gallery, London, earning a description from *The Times* as 'a Surrealist working in a Cubist convention', with the *Morning Post* commenting: '... the majority of her works look as if each were an illustration of a disordered dream.' Not so her portraits and in 1939 she painted J.F. Tullow of the Friendly Brothers of St. Patrick.

The Sleepwalker and *Crouching Figure with Bowed Head* were both completed in 1941. In 1942 came *A Clown by Candlelight* (NGI), *Hell – The Gnashing of Teeth* and *What Can Happen?* When her London home was damaged by a bomb she returned to Dublin for three years and stayed with her sister, Mrs Tullo, at 'St Brendan's', Coolock, Co. Dublin.

The Power and the Glory and *Between Two Wars* were among five pictures at the inaugural Irish Exhibition of Living Art, 1943, and the *Dublin Magazine* commented: 'She has individuality, somewhat morbid it is true, but consistently expressed in the fusion of form and content. Her tones are rich, subdued and charged with fatality; her drawing is subtly distorted. *Revolution* is a terrible picture, an indictment of human nature as a portrait of the mob. *The Necklace* has a decadence that might be compounded of Beardsley and Gauguin, but isn't. As a painter she has something to say; it may not be reassuring or comfortable, but she says it.'

On her exhibition at the Dublin Painters' Gallery in 1944, the *Dublin Magazine* said: 'Intent at once on polished craftsmanship and on a content which has a certain literary flavour, achieves a curiously morbid and decadent quality.'

In a major group show in 1946 she was represented by three pictures at St George's Gallery, London, with Georges Braque (1882-1963), Marc Chagall (1887-1985), Maurice de Vlaminck (1876-1958) and other notables being included. On her solo presentation at the same gallery in 1947, *The Studio* noted: '... blends her imagination with criticism of Life, yet manages to avoid almost, though not entirely, the dangers of being dubbed literary ...' Eric Newton, in the catalogue, described her work as having 'immense vitality, immense seriousness, a sensitive heart and a tendency to cloak the seriousness with caricature and the sensitiveness with macabre cynicism'.

In 1949 she was elected Honorary RHA, and in 1950, from her London address, she showed *Lady with Dogs* and *The Flat Dweller's Dream*. After exhibiting at the RHA in 1951, her works were not seen in Dublin until 1968 when some friends organised a retrospective exhibition for the Municipal Gallery of Modern Art, bringing together more than sixty works covering 1906-66. *Roundabout* and *The White Horse* were both completed in 1966.

The thirty-four works exhibited at the Dawson Gallery, Dublin, in 1974 all contained figures. She was represented at the Cork Rosc in 1975. Paintings of Samoa were shown at the Dawson Gallery in 1976. In 1977 she presented thirty-nine art books to NGI, continuing painting to her final year.

A Clown by Candlelight is also included in the NGI collection. The Hugh Lane Municipal Gallery of Modern Art holds six oil paintings, including *The Message*; *Honolulu Garden*; and two portraits of Sarah Purser. Among five oil paintings at the Ulster Museum are *Reading the Employment Offers Column* and *Woman in a Green Dress and Cameo*. Frugal in her personal lifestyle, she died on 7 July 1978 at her Blackheath residence, bequeathing twelve paintings to the Friends of the National Collections of Ireland. Other exhibitions ensued: Taylor Galleries, Dublin, 1982; Pyms Gallery, London, 1986, 1989, 1998; Sligo Art Gallery, 1987.

Works signed: Mary Swanzy or Swanzy (if signed at all).
Examples: Beijing: Irish Embassy. Belfast: Ulster Museum. Churchill, Co. Donegal: Glebe Gallery, Derek Hill's Collection. Cork: Crawford Municipal Art Gallery. Drogheda, Co. Louth: Library, Municipal Centre. Dublin: Adelaide Hospital; Alexandra College; Hugh Lane Municipal Gallery of Modern Art; National Gallery of Ireland. Kilkenny: Art Gallery Society. Limerick: City Gallery of Art; University, National Self-Portrait Collection. Monaghan: County Museum. Sligo: Model and Niland Centre. Waterford: City Hall, Municipal Art Collection. Wexford: Arts Centre.
Literature: *Thom's Directory*, 1895; J. Crampton Walker, *Irish Life and Landscape*, Dublin 1927 (illustration); *Dublin Magazine*, January-March 1944, July-September 1944; *The Studio*, July 1947, October 1947 (illustration); Sean Purser: Hugh Lane Municipal Gallery of Modern Art, *Mary Swanzy: Retrospective Exhibition of Paintings*, catalogue, Dublin 1968; Dawson Gallery, *Mary Swanzy, HRHA*, catalogue, Dublin 1974; *Dictionary of British Artists 1880-1940*, Woodbridge 1976; National Gallery of Ireland, *Press release*, 1977; *Oireachtas*, catalogue, 1977; *Irish Times*, 8 July 1978, 12 May 1979, 28 October 1982, 9 May 1998; Pat Murphy: Taylor Galleries, *Mary Swanzy, HRHA*, catalogue, Dublin 1982 (also illustrations); Julian Campbell: Pyms Gallery, *An Exhibition of Paintings by Mary Swanzy, HRHA (1882-1978)*, catalogue, London 1986 (also illustrations); National Gallery of Ireland and Douglas Hyde Gallery, *Irish Women Artists: From the Eighteenth Century to the Present Day*, Dublin 1987 (also illustrations); Sligo Art Gallery, *Mary Swanzy (1882-1978)*, catalogue, 1987; Ann M. Stewart, *Royal Hibernian Academy of Arts: Index of Exhibitors 1826-1979*, Dublin 1987; Fionnuala Brennan: Pyms Gallery, *An Exhibition of Paintings by Mary Swanzy, HRHA (1882-1978)*, catalogue, London 1989 (also illustrations); Patricia Butler, *Three Hundred Years of Irish Watercolours and Drawings*, London 1990 (also illustrations); S. B. Kennedy, *Irish Art & Modernism 1880-1950*, Belfast 1991 (also illustrations); Hugh Lane Municipal Gallery of Modern Art, *Letter to the author*, 1993; also, Friendly Brothers of St. Patrick, 1997; National Gallery of Ireland, *Gallery News*, September-November 1999, September-November 2000.

SWIFT, PATRICK (1927-83), portrait and landscape painter. Born at 19 Carrick Terrace, Dublin on 12 August 1927, Patrick Joseph Swift was the son of Michael E. Swift, a car hire firm employee. His mother was a Mahon of Wicklow origin, hence his *nom de plume*, James Mahon. Among his literary friends was John Jordan, who had also attended the Christian Brothers' School, Synge Street, and he later became very friendly with the poet, Patrick Kavanagh. At Synge Street he was in charge of the art work for the school magazine. He worked in the Dublin Gas Company for a short period.

In 1946-8 he studied at the National College of Art, then freelance in London, and at Grande Chaumière, Paris. By 1949 he had still to exhibit and was virtually unknown. His first painting contact with the public was in 1950 when the Irish Exhibition of Living Art accepted three of his works. Nano Reid (q.v.) in that exhibition showed a portrait of Swift. Earlier in the year he had contributed an article on Reid for *Envoy*.

On the 1951 IELA, the *Dublin Magazine* considered he had 'developed considerably in poise and self-assurance as well as in the control of his medium. His work is characterised by an almost classical coldness and reserve, particularly in its colour; an uncompromising clarity of vision which eschews the accidental or the obvious or the sentimental ...'. *Woodcock on a Chair* was dated 1951.

Envoy in 1951 found his subject matter uncomplicated and might be classified under the headings of portraits and plants; to each, it added, he gave the same intensity of observation. On the 1952 IELA exhibition, the *Dublin Magazine* critic observed that he 'might be classed as a neo-realist and his tendency is more and more to treat his pictures as scientific statements, precise, exact, austere in conception and execution'. Dorothy Walker in her *Modern Art in Ireland*, 1997, described him as 'a thin, intense, bird-like young man...'.

In 1952, at the Victor Waddington Galleries, Dublin, he held his first solo exhibition. In mentioning some of his smaller still lifes, notably *Still Life with Nails* and *Woodcock on a Chair*, the *Dublin Magazine* said that they 'show his power to convey the full impact of the object, as though the spectator were experiencing it for the first time. This curious clarity is a function of a restrained, I might even say, puritanical palette and of a cold light, uniformly diffused.'

At the 1954 IELA exhibition he showed: *Girl Passing Beneath a Tree*; *Winter Landscape*; *A Garden in Pembroke Road*. After being awarded in 1954 an Irish Government grant of £500, he visited Italy in 1955 and spent a year there, returning to live in England. At the IELA of 1956 he contributed a portrait of the poet, Anthony Cronin.

Henry Morris, the educator, had set up on the outskirts of Welwyn Garden City the Digswell Arts Trust in 1957 for promising artists and craftsmen. Swift was invited to become a member. He entered in October 1958 and was there for one year. Among other painters in residence was Michael Andrews (1928-95). Digswell House was officially opened by the Countess Mountbatten in 1959 and Swift supplied an etching of Digswell House for the brochure's cover. Among the landscapes which he painted then were some scenes of Ashwell in Hertfordshire which attracted favourable attention. One of these was presented by Morris to the Melbourn Village College on the occasion of its opening in 1959. Swift's 1959 oil, *Self Portrait in the Studio*, is in Dublin at the Irish Museum of Modern Art.

Swift returned to London and lived at Westbourne Terrace. In 1959 with David Wright he founded the quarterly literary and arts magazine, *X*, in which he wrote under the pseudonym of James Mahon, often very critically, of trends in art, particularly at that time of the current vogue for abstract painting. He brought forward in the magazine's pages a number of young and figurative painters, such as Andrews and Frank Auerbach, as well as renewing interest in the work of David Bomberg (1890-1957). *X* ceased publication in 1962.

In the Soho bohemia, Swift met Francis Bacon (1909-92), John Minton (1917-57), Lucian Freud and others in art and literature; several portraits were painted. Freud, like Bacon, he knew personally, and Dublin regarded Freud as a major influence on his work at that time. The English painter had stayed with Swift at his flat in Hatch Street when visiting Dublin. On the Irish scene, he also knew Ralph Cusack (q.v.) and encouraged Edward McGuire (q.v.) in his painting. He painted portraits of Jordan and Kavanagh. In the summer of 1960 he painted in Co. Donegal; his *Trees at St Columb's* is in the Glebe Gallery.

In 1961 he exhibited in a group show at the Whitechapel Gallery. Studies of trees in London streets were painted on large canvases. In 1962, the year *The Garden* was bought by the Contemporary Art Society, he left London with his wife and family on an extended holiday to Algarve, Portugal. In the event, he remained there and with the Portuguese painter Lima de Freitas, who later became director of the Portuguese National Theatre, founded Porches Pottery near Lagoa in 1968. Traditional shapes and patterns were revived, as well as the making of azulejos. The two artists established a fundamental rule that there would be no slavish copying of design. Instead, emphasis was on free painting within the established style.

In a bar adjoining the pottery, Swift depicted the story of Bacchus on large tiled panels, taking well-known classic masterpieces as his model. Also on tiles was the Stations of the Cross for Porches Church. In 1965 he exhibited in Lisbon at the Galeria Diário de Noticias. In Dublin, he showed the portrait of Kavanagh at the 1968 Royal Hibernian Academy. He was represented in 1969 at the Project Gallery's exhibition in new premises with a large 'torrid landscape' which had an 'expressionist strength and punch one would not have expected from his Lucian Freudian youth', according to the *Irish Times*.

Swift was represented in the 'Irish Imagination' section of the 1971 Rosc exhibition and his brother-in-law, John Ryan (q.v.), wrote in the catalogue: 'Swift's peculiar style reminds us of nobody but the artist – a telling point with a painter who has set no store on this aspect of his job ... a man with an observation that is both curious and affectionate – for his attention to details in his subject is paternal and not academic. He is as clear in his meaning as his painterly technique is pellucid in style.'

A major exhibition of his work took place at the Galeria S Mamede, Lisbon, in 1974. Portraits of his friend, Francisco Sá Carneiro, former Portuguese Prime Minister, were painted shortly before his death in an aeroplane crash in December 1980. He devoted his leisure time to studying all available literature on the

Algarve and was involved in writing – with David Wright – and illustrating three Portuguese travel books. The first, *Algarve*, appeared in 1965. Lima de Freitas's *Pinturas de Patrick Swift* was published in 1974.

Swift, who illustrated other books, including a German edition of Flann O'Brien's *The Hard Life*, tended to shun publicity and was not keen on exhibiting his work. 'In the last years of his health,' his widow recalled, 'he was obsessed with painting his Ancestors from Wicklow. He completed one large masterpiece of the Wicklow mountains, with in the foreground his grandparents, old and weather-beaten, holding in their arms a small baby.' *Positano*, oil, is in the Ulster Museum. He died on 19 July 1983 at his home, Alfanzina, Carvoeiro, Algarve. The Irish Museum of Modern Art hosted an exhibition in 1993. In 1998 a plaque was erected on the site of his studio at 5 Lower Hatch Street.

Works signed: Patrick Swift, rare, or Swift (if signed at all).
Examples: Belfast: Ulster Museum. Churchill, Co. Donegal: Glebe Gallery, Derek Hill's Collection. Dublin: Irish Museum of Modern Art. Lagoa, Algarve, Portugal: Church of Our Lady of the Incarnation. Warrington, Cheshire: Museum and Art Gallery.
Literature: *Envoy*, March 1950, July 1951 (also illustrations); *Dublin Magazine*, October-December 1951, October-December 1952, January- March 1953; *The Bell*, October 1952; *An Tostal Handbook*, Dublin 1953; David Wright, trs., *The Canterbury Tales*, London 1964 (endpapers); David Wright and Patrick Swift, *Algarve*, London 1965 (illustrations); *Digswell, 'a matter done'*, Digswell *c.* 1966; Flann O'Brien, *Das harte Leben*, Hamburg 1966 (illustrations); David Wright and Patrick Swift, *Minho and North Portugal*, London 1968 (illustrations); *Irish Times*, 5 September 1969, 11 June 1992, 22 October 1998; David Wright, *Nerve Ends*, London 1969 (cover design); David Wright and Patrick Swift, *Lisbon*, London 1969 (illustrations); Rosc, *The Irish Imagination 1959-1971*, catalogue, Dublin 1971; Annie Size, *My Love to the Beaks and Tails*, London 1975 (illustrations); Randolph Carey, *Birds of the Algarve*, Lisbon 1976 (illustrations); Anthony Cronin, *Dead as Doornails*, Dublin 1976; Sarah Walmisley, *The Story of Porches Pottery*, Lisbon [1979]; *Anglo-Portuguese News*, 11 August 1983; Derek Hill, *Letter to the author*, 1983; Mrs Oonagh Swift, *Letters to the author*, 1983, 1993; *The Times*, 25 July 1983; Contemporary Art Society, *Letter to the author*, 1993; also, Heinrich-Böll-Stiftung e. V., 1993; Hertfordshire County Council, 1993; Veronica Jane O'Mara, editor, *PS... of course — Patrick Swift 1927-1983*, Oysterhaven 1993 (also illustrations); Dorothy Walker, *Modern Art in Ireland*, Dublin 1997 (also illustration).

SYKES, ANGELA – see ANTRIM, ANGELA

SYNGE, EDWARD M., ARE (1860-1913), etcher and landscape painter. Edward Millington Synge was born at Malvern on 17 April 1860, the son of Rev. Francis Synge, Chief Inspector of Schools, who was the only son of Francis Synge of Glanmore Castle, Ashford, Co. Wicklow, MP for Swords, Co. Dublin. According to family tradition, Edward was named 'Millington' after Canon Millington who, in the sixteenth century was, on account of his musical talents, summoned to sing at the Court. He made such an impression that, by Royal Command, his name was changed from Millington to Synge (pronounced Sing).

Educated first at Norwich School, E. M. Synge passed on to Haileybury, Hertford, and to Trinity College, Cambridge, in 1882, where he took honours in the Classical Tripos. Owing to delicacy of health, he trained for land agency in Shropshire, and later was appointed agent to large estates in Surrey and Sussex, making his home at 'Eastlands', Brooklands Lane, Weybridge, Surrey. In a letter of 2 August 1885 he wrote to his sister Bertha at their family estate in Ireland, inviting her to come and be his housekeeper: 'I guess I shall want your help much in settling in and shall want you to housekeep and so on. I expect I shall have very little spare time at first as there will be a huge lot to do.'

Synge had always employed his spare time with a pencil, but one day he was taken by a notice in a shop window, 'Etching taught here,' which prompted him for lessons in the rudiments of copperplate etching. In 1891 he joined the evening classes under Mouat Loudan (1868-1925) at Westminster School of Art, travelling to town for two hours' work whenever time permitted. Spare hours and holidays were spent in etching, and he had the benefit of help and advice from Sir Frank Short (1857-1945) and Sir Seymour Haden (1818-1910). The latter, in 1897, inspected and advised on his work.

Synge was elected in 1898 an associate of the Royal Society of Painter-Etchers and Engravers, and exhibited two etchings of Weybridge, together with subjects from Amsterdam, Zaandam and Hampstead

Heath. Since 1992 the Society has been known as the Royal Society of Painter-Printmakers, and owns an etching entitled *Zaandam*. In 1899, when he also exhibited at the Paris Salon, he participated at the Royal Academy for the first time, showing *Forge at Samaden*. In the period 1900-4 he contributed each year to the RA, a total of seven works. In 1900 he presented *Tyrolese Cottages* and *Hay-barn, Cortina*.

In 1901 he resigned his land agency in order to devote his whole time to art, exchanging the Salon for the Champ de Mars in 1903. Meanwhile in London at the RA, from 13 St Leonard's Terrace, SW, he showed in 1901 *Low Tide at Pont Aven* and *Concarneau*. Despite poor health, he travelled freely.

In Paris he obtained an introduction to a member of the Durant family, to whom he showed his etchings which so met with approval that he advised Synge to work in his studio, bringing him the result for criticism, rather than that he should attend the French Schools. At the RA in 1902 he showed *St Gervais, Paris*; *St Jacques, Paris* in 1903.

In the autumn of 1902 he was in Rome, working under Fernand Sabatté (1874-1940), who, having won the Prix de Rome, lived at the Villa Medici. During his stay in Paris, Synge devoted much of his time to illustrating *The Story of the World for children of the British Empire*, five volumes by his sister, Margaret Bertha Synge.

At the RA in 1904 he showed *Belfry at Assisi*; he also worked in Venice. Published in London in 1906, *Romantic Cities of Provence*, by Mona Caird, was dedicated to Marguerite Hamilton Synge and illustrated with sketches by Joseph Pennell (1857-1926) and Synge, who supplied forty-six. Pennell, an American, was also an etcher. When Synge contributed *Gateway, Villa Borghese* to the 1906 RA, his address was Byfleet, Weybridge.

In 1907 he visited Spain, where some of his best work was done, according to his daughter, and his Spanish set of ten etchings fetched 100 guineas in his lifetime. He exhibited at the Royal Hibernian Academy for the first time in 1907, contributing thirteen works from then until 1913. In 1908 he married Agnes Freda Helen Molony, herself an artist. In 1909 at the RHA he showed *Study of pines-Villa Borghese, Rome* and *Sawmill at Bad Moos, Tyrol*. He returned to Burlington House in 1910 with *Wheelwright's shop at Étaples*.

The Water Colour Society of Ireland presented his work for the first time in 1911, via *On the Canal*, and at the RHA he contributed: *Gateway, Villa Borghese, Rome* and *The Road of the Pope's Soldiers, Sisteron*. In 1911 he showed for the last time at the RA, *The lock, Wisley*, and at the Oireachtas in Dublin his sole contribution to that exhibition was *Bridge at Cortina*. Final offerings to WCSI were: 1912, *Spring in the Cotswolds*; *Macon*; 1913, *Road near Perth*.

Among his drypoints were: *On the Annamoe River, Co. Wicklow*; *In the Cotswold Country; On the Tay*. He exhibited almost ninety works with the Royal Society of Painter-Etchers and Engravers. He also showed in London with Ridley Art Club, the Goupil Gallery and the London Salon. His work also appeared with Glasgow Institute of the Fine Arts and Walker Art Gallery, Liverpool.

The British Museum has a collection of prints, including the etchings *Gate of the Villa Borghese* and *View of the Villa Borghese*. At the Victoria and Albert Museum he is represented by *At Dannes*. At the Elmbridge Museum in Weybridge, Surrey, are three etchings and two pen and ink drawings. Of later years he did his own printing, assisted by his wife, Freda. He died on 18 June 1913. A memorial exhibition of etchings took place that year at James Connell and Sons, London. According to his daughter, Mrs E. E. Woodhouse, all his plates — about 370 — went for munitions during the First World War.

Works signed: E. M. Synge or EMS monogram (if signed at all).
Examples: London: British Museum; Royal Society of Painter-Printmakers; Victoria and Albert Museum. Weybridge, Surrey: Elmbridge Museum.
Literature: M. B. Synge, *The Story of the World for the children of the British Empire*, Edinburgh and London 1903 (illustrations); *The Royal Academy of Arts 1769-1904*, London 1905; Mona Caird, *Romantic Cities of Provence*, London 1906 (illustrations); Walter G. Strickland, *A Dictionary of Irish Artists*, Dublin 1913; *Burke's Irish Family Records*, London 1976; *Dictionary of British Artists 1880-1940*, Woodbridge 1976; Mrs E. E. Woodhouse (née Synge), *Letter to the Bankside Gallery*, 1986; *Royal Academy Exhibitors 1905-1970*, Calne 1987; Ann M. Stewart, *Royal Hibernian Academy of Arts: Index of Exhibitors 1826-1979*, Dublin 1987; *Water Colour Society of Ireland Exhibition List 1872-1994*, Dublin 1995; Jane Turner, *editor, The Dictionary of Art*, London 1996; Bankside Gallery, *Letter to the author*, 2000; also, British Museum, 2000; Elmbridge Museum, 2000; Victoria and Albert Museum, 2000.

T

TAYLOR, ANNE (1907-76), cartoonist. Born in Belfast on 31 October 1907, Anne Taylor was the daughter of Samuel C. Taylor (q.v.). The name emerged when some of her works, including cartoons, appeared in the studio sale of her father's paintings in 1998.

In *Reverie at St Ives*, a work which was once in the hands of the Belfast art dealers, Rodman's, the figure of a woman in watercolour and gouache would suggest the artist may have received tuition in Cornwall. A very early pencil drawing of a woman's head, dated 19.12.21, also had a St Ives provenance.

A reference in the *Belfast News-Letter* in 1930 referred to Miss A. Taylor's *The Connoisseur* as found worthy of 'honorary mention' at an Ulster Academy of Arts exhibition, adding: 'there is subtlety and wisdom in the expression of the old man examining a treasure, and the colour scheme is carried on in rich and subdued tones...' The subject was her gardener and he was asked to put a ring on his finger and look at it. In 1933, from Pebble Lodge, Holywood, Co. Down, she exhibited a watercolour, *Sunshine in Madeira*, at UAA.

During the 1930s she earned her living partly as a cartoonist, drawing illustrations for various London magazines. These works were often of a political nature and signed 'Tor'. For example, *Jubilee Celebrations in Ireland*, Indian ink, depicted Eamon de Valera seated at a table with Viscount Craigavon conducting 'conversations to settle the Irish question.' Another, in crayon, portrayed Winston Churchill with a cigar, rifle in hand, surrounded by warplanes, guns and battleships. Crayon drawings of public figures such as Marshal Balbo, Neville Chamberlain, Anthony Eden, Aga Khan and Pierre Laval were among those featured. Other personalities included Joan Crawford, Gracie Fields, Beniamino Gigli, Katherine Hepburn and Richard Tauber.

A relative of the artist, Mrs Elizabeth Bell, advised the author that Anne Taylor painted for her own amusement. A coastal landscape at Cushendun, Co. Antrim, was among her oils. *The Builders* was in watercolour and gouache. After the Second World War her great interest in Holywood was bridge and dogs, poodles. She died on 27 March 1976.

Works signed: Anne Taylor, A. T. or Tor.
Literature: *Belfast News-Letter*, 18 October 1930; de Veres Art Auctions, *Sales of paintings, including the studio of Samuel C. Taylor*, catalogue, Dublin 1998 (also illustrations); Frederick Gallery, *Drawings, Etchings & Engravings*, catalogue, Dublin 1998 (also illustrations); Mrs Elizabeth Bell, *Letters to the author*, 2000; Whyte's, *Irish Art*, catalogue, Dublin 2000.

TAYLOR, ERNEST E. (1863-1907), portrait and figure painter. Born at Bournemouth, Hants., he came to Ireland with his father, Thomas H. Taylor, Inland Revenue collector, who may have been stationed initially at Coleraine, Co. Derry; his son exhibited at the Royal Hibernian Academy in 1885, giving the address Dunedin, Coleraine. Opening contributions were *A native of Turkey* and *A Cavalier of the 17th century*. Altogether he showed twenty-three works at the Dublin exhibition.

Associated with the Ramblers' Sketching Club in Belfast, he was elected a vice-president in 1889, a position he retained when the club became the Belfast Art Society in 1890. In that year, from Garfield Chambers, Royal Avenue, Belfast, he showed *Captives* at the RHA; and with the Ramblers, *'On Strike'* and *'La Penserosa'*.

In the period 1891-1902 inclusive he contributed thirty-two works to BAS exhibitions. In 1891 he had eight pictures hung, including *Lost in Slumber*; *Musicians of the Street*; *His Greatest Joy*. In the same year five works were exhibited at the Dublin Sketching Club event, including *'That's Good!'* and *'That's Awfully Good'*. Not only was his art viewed in Belfast and Dublin but also in Edinburgh where in the period 1891-1902 inclusive he contributed six pictures to the Royal Scottish Academy, opening with *'Will you take it now, or wait till you get it?'* In 1892 he was appointed BAS president and served for two years.

In 1893 Taylor exhibited for the second and last time with Dublin Sketching Club when he showed four works, including *Comrades* and *Hope Deferred*. At the BAS show in 1894, his portrait in watercolour was of his father, then operating in Greenock, Scotland, and at the same gathering he showed an Argyllshire landscape, watercolour. In the period 1897-1902 inclusive he did not miss a year at the Belfast exhibition. In 1897 he showed two portraits, Alfred R. Baker (q.v.) and Sir George Williams.

Baker, Rodolfe Christen (1859-1906) and Taylor of Glenburn, Clara Park, Belfast, were all involved in criticism of sketches at BAS summer meetings, 'giving careful and helpful remarks on the merits and defects of the works shown, and suggesting in what way errors in composition, value, proportion, or other points, might be amended.' In the 1898 exhibition he provided eight pictures, including *All in the day's work* and *Begorra*. At the 1900 Paris Salon he was represented by *Taking in a Reef*.

There might well have been a connection between *The pipe of peace*, RHA 1900, and *A soothing pull*, RSA 1900. In any event, *Beating up recruits* appeared at the 1901 RHA and then at the 1902 RSA. A portrait of Michael J. F. McCarthy also received a good showing, first at BAS in 1901 and then at the 1902 RHA. A barrister-at-law, McCarthy was the author of *Five Years in Ireland 1895-1900*, published in 1901, and he recorded: 'A new man, called Ernest Taylor, from Belfast, produced some admirable small studies of old men, in last and this year's Hibernian Academy, upon which I set the highest value, as being full of promise.'

The reason why Taylor, described, incidentally, as having a 'kindly and genial disposition,' did not exhibit after 1903 was mainly due to the fact that he was engaged on a painting, *The Proclamation of King Edward VII in Belfast*, 1901, commissioned by Sir Daniel Dixon, ex-Lord Mayor, for the new City Hall.

John Hewitt has described Taylor's *magnum opus*: 'Set before the Old Town Hall in Victoria Street, Sir Daniel Dixon reads the document...With the Lord Mayor in the middle, he is backed by raised tiers of about 120 notabilities...Below the crowded tiers, a bugle party stands flanked by tophatted, uniformed mace-bearers. The foreground, which looks like MacKenzie's work, is crammed, the common multitude greeting the proclamation with raised arms and huzzas...' W. G. MacKenzie (q.v.) was the artist who completed the work after Taylor's unexpected death. The painting in its unfinished condition was on view at the opening of the City Hall in 1906.

In the Ulster Museum is an oil painting of John Vinycomb (q.v.) by Taylor. His father died suddenly and he travelled to Scotland to make the necessary arrangements for the interment at Bournemouth. Somewhere, he contracted a chill which developed into pneumonia, and he died at his mother's house, 50 Esplanade, Greenock, on 31 January 1907.

Works signed: Ernest E. Taylor.
Examples: Belfast: City Hall; Ulster Museum.
Literature: *Belfast and Province of Ulster Directory*, Belfast 1892, 1901; Michael J. F. McCarthy, *Five Years in Ireland 1895-1900*, London and Dublin 1901; *Belfast News-Letter*, 1 February 1907; Walter G. Strickland, *A Dictionary of Irish Artists*, Dublin 1913; John Hewitt and Theo Snoddy, *Art In Ulster: I*, Belfast 1977; Martyn Anglesea, *The Royal Ulster Academy of Arts*, Belfast 1981; Ann M. Stewart, *Royal Hibernian Academy of Arts: Index of Exhibitors 1826-1979*, Dublin 1987; Ann M. Stewart, *Irish Art Societies and Sketching Clubs: Index of Exhibitors 1870-1980*, Dublin 1997; Greenock Central Library, *Letter to the author*, 2000.

TAYLOR, SAMUEL C. (1870-1944), landscape and figure painter. Born at 21 Albert Street, Belfast, on 21 June 1870, Samuel Connolly Taylor was the son of Henry Taylor, who founded Henry Taylor and Sons, Ltd., manufacturers of parts for textile machinery, 26-28 Brown Square, Belfast. Samuel had four brothers and four sisters.

At the 1891 exhibition of the Belfast Art Society, giving his address as Auburn Villas, The Knock, Belfast, he exhibited two watercolours, *The Tether, Downhill, Co. Derry* and *The Bloody Bridge, Newcastle, Co. Down*. In 1894 he painted *On the Lagan* and *Working in the Fields*, also watercolours. In 1896 he opened his account at the Royal Hibernian Academy with Co. Donegal and Co. Fermanagh landscapes, showing a dozen works until 1936 at the Dublin exhibition.

Taylor had entered in 1889 the Government School of Art in Belfast. In 1896 he won a silver medal first class for flower painting in watercolour in the National Competition. Also in 1897 at South Kensington he

received a prize for sets of works, and in 1898, his last year, he reached advanced level in architecture, painting from still life and drawing from still life. He exhibited a still life at the Royal Academy in 1897, his only appearance.

In 1902 he married in London and became an art master at Belfast School of Art, residing in the city at 6 Stranmillis Park, moving on to Glenalla, Knockbreda Road. In July 1911 he painted at Concarneau, near Pont-Aven, and from France he sent postcards to his wife Rachel and their two children, Harry and Anne (q.v.) in London, probably staying with relatives. The illustration on a 1911 postcard, which he asked to be kept, was of two 'Petits Enfants de Bretâgne' in coy poses dressed in ornate traditional Breton costume. He stayed in the Grand Hôtel des Voyagers, Concarneau, and in a letter to his wife said he was 'going for figures for all I am worth.'

After an interval of sixteen years he showed again at the RHA in 1912: *The Sardine boats, Concarneau, Brittany* and *Morning-Concarneau, Brittany*. In August of that year he wrote from Hôtel Moderne, Guémené-sur-Scorff, Morbihan, to a friend in London describing it 'as a delightful old world place. Very primitive... and the costumes are most wonderful.' The postcard depicted a couple dressed in Guémené costumes.

In August 1913 Taylor found it 'very difficult to secure models this year as five thousand people left Concarneau since last year.' He favoured open air subjects, for example the oil paintings *Breton Market*; *Beach Scene, Brittany*; *Boats in Harbour, Brittany*; *Breton Fisherman.*

In 1915 he moved from Belfast to Ben Edar, Marino, Co. Down, returning to the RHA with the Sardine fleet featured in two works out of three. When he exhibited for the first and only time at the Oireachtas exhibition in Dublin in 1920, all five pictures were of French idiom, for example *La Plage, Concarneau* and *Brittany Gossips — Morbihan*. In 1921 he moved to Pebble Lodge, Holywood, Co. Down, where he remained for the rest of his life. After a gap of eighteen years, he showed for the last time at the RHA, in 1936: *In my garden at early morn.*

Teaching at the Belfast College of Art continued. In his inimitable way, the cartoonist Rowel Friers (q.v.) described his student life there: 'Antique form — drawing from statues — was the lot of one Sam Taylor, a dour and most serious man, well loved by Taylor Carson and the painter Maurice Wilks. Sadly, I was not his most popular student...He always seemed to get more dour and a lot more serious when I entered the antique room. I had a strong suspicion that he had some objection to my throwing my hat onto the head of *The Discus Thrower*, and hanging my coat over the athlete's extended arm. I was never invited to his house, as were the others, but that was possibly good thinking on his part. The antique figure class was about the only one I did not enjoy; I felt it had the atmosphere of a graveyard.'

Taylor, who also painted some portraits and nudes, retired from teaching in 1938, having apparently exhibited only one painting since 1920. Canvases were left unframed, stored in tea chests and cupboards in Pebble Lodge. In a letter to the author, his ex-pupil Taylor Carson considered that he was one of the best teachers at the College of Art. He died in a Belfast nursing home on 26 June 1944. A studio sale of his works took place in Dublin in 1998, when he was 'discovered'. Five of his paintings, including *Girls at the water's edge, Brittany*, appeared in the exhibition 'Irish Painters in Brittany' at the Musée de Pont-Aven in 1999.

Works signed: S. C. Taylor or SCT monogram.
Literature: *Belfast and Province of Ulster Directory*, 1905; *Belfast News-Letter*, 27 June 1944; Ann M. Stewart, *Royal Hibernian Academy of Arts: Index of Exhibitors 1826-1979*, Dublin 1987; Rowel Friers, *Drawn from Life*, Belfast 1994; Ann M. Stewart, *Irish Art Societies and Sketching Clubs: Index of Exhibitors 1870-1980*, Dublin 1997; de Veres Art Auctions, *Sale of paintings, including the studio of Samuel C. Taylor*, catalogue, Dublin 1998 (also illustrations); Mrs Elizabeth Bell, *Letters to the author*, 2000; Taylor Carson, *Letter to the author*, 2000; also, Crawford Municipal Art Gallery, 2000.

TAYLOUR, GWEN (1898-1975), portrait and figure painter. Gwendoline Edith Marion Evans was born in London, 4 February 1898, daughter of William Evans, County Court Judge for Mid-Wales. Under Henry Tonks (1862-1937) she studied at the Slade School of Fine Art. Tonks was closely associated with the New English Art Club and she exhibited a dozen works in its exhibitions. An association with NEAC was suggested

later by one Dublin commentator in 'the reticence of her colour and the restraint with which she approaches her subject...'

W. R. Sickert (1860-1942) and Sylvia Gosse (1881-1968) were also her art mentors, as well as (Dame) Ethel Walker (1861-1951), who became a close friend and Gwen stayed with her at Robin Hood's Bay, North Yorkshire.

In her London exhibition days, from 1917 onwards, most of her pictures were seen at Cooling and Sons Gallery and Goupil Gallery, more than fifty works in all. Still under Gwen Evans, she showed at the Royal Academy in 1922, *Hurdled Sheep*, from 8 Edwardes Square, Kensington, and a pencil drawing in 1931, *In the Library*, from 55 Tregunter Road, SW. *Portrait of Stella Benson*, pencil, is at Whitworth Art Gallery, Manchester.

She also contributed to the London Goupil exhibitions, and had two works hung with the International Society of Sculptors, Painters, and Gravers. An early 1930s drawing of Ethel Walker, executed at Cheyne Walk, was exhibited in Dublin at the 1950 Royal Hibernian Academy under the title, *Contemplation*. According to the artist: 'The sitter said it was a beautiful drawing, but she didn't want it shown under her name, as she disliked the idea of looking sad'.

When Gwen Taylour went abroad, much of her painting was accomplished in Ceylon, Malaya and India. A 1937 portrait head of Jawaharlal Nehru, black chalk and pencil, signed Taylour, and signed by sitter, is in the Ashmolean Museum, as is a portrait bust of Sir Rabindranath Tagore, pencil, similarly signed. Nehru allowed her to draw him – she sat in a corner – as he conducted an interview.

Also in the Oxford collection is a portrait bust of Jack B. Yeats (q.v.), described as in 'pen and black ink over some pencil with gold and faint pink washes'. Her husband, Richard Taylour, who had gone to Singapore from London after qualifying as a barrister, was from an Anglo-Irish family and had inherited property, hence their decision to leave Singapore in 1939 and live in Ireland. In the early 1950s she started painting again.

In a letter to the Ashmolean Museum in 1964, from Clonoughlis Lodge, Straffan, Co. Kildare, she wrote: 'As far as I can remember, I did an elaborate drawing of Jack Yeats in 1953, he said it was a beautiful drawing. Instead of being content with it as it then was, thought it could be improved which unfortunately ended in its being spoilt ... some time later did the one you have from memory aided by a photograph. One thing is certain, in future the drawings must be dated.'

In 1950, from Ardgillan Castle, Balbriggan, Co. Dublin, she had contributed to the RHA for the first time, and between then and 1974 showed thirty-one works, watercolours predominating. In 1960, after a lapse of seven years, she exhibited *The Childless Wife* and *Three Generations*. Among her portraits were those of Terence de Vere White, 1963 exhibition, and Eoin O'Mahony in 1966. In 1967, pictures included *Swans* and *Young Negro*.

Nearly all the works in her exhibition at the Dublin Painters' Gallery, 7 St Stephen's Green, in 1953 were from life abroad, for example: *Rain Clouds near Changli*; *Sunset from the Himalayas*; *A Rickshaw Coolie*.

In her joint exhibition in 1959 with Eleanor Whittall of London, a friend and potter, at the Little Theatre, Brown Thomas, Dublin, a variety of subject matter in oils, watercolours and drawings included the large and 'dramatically interesting' oil, *The Grotto, Lourdes, Feast of the Immaculate Conception*. Also on view were: *The Apple Tree, Swanage*; *Woodland Stream, Cavan Garden*; *The Haycock, Achill Island*.

After an absence of nearly thirty years, she returned to Burlington House in 1960 and showed six works between then and 1969. These included a pencil drawing, *Chinese Grandmother*, in 1962, and *Donkeys on the Beach* in 1969. In 1961 she had begun drawings of 'interesting and well known men in Dublin'.

In the period 1965-74 inclusive she was a regular exhibitor with the Water Colour Society of Ireland, showing twenty-six works. Circus scenes appeared in her *œuvre*. In the Society's exhibition of 1967, she showed *Circus Act*, pen and ink, pastel and gouache. She had taken some lessons in gouache from the Rev. Jack P. Hanlon (q.v.). In 1973 at WCSI she contributed: *Cows in a Meadow* and *The Bird of Paradise Flower*.

Among her Dublin portrait drawings were those of George Dawson, FTCD; Sir Ivone Kirkpatrick, KCB, KCMG; and Leo Smith. Of Bridge House, Straffan, Co. Kildare, she died in a Dublin hospital, on 6 March 1975. In the same year a retrospective exhibition of fifty-eight works, which had been mooted before her death, took place at Neptune Gallery, Dublin.

Works signed: Gwen Evans, G. T. or Taylour (if signed at all).
Examples: Manchester: Whitworth Art Gallery. Oxford: Ashmolean Museum.
Literature: *Dublin Magazine*, April-June 1953; R. R. Figgis: Brown Thomas's Little Theatre, *Paintings and Drawings by Gwen Taylour*, catalogue, Dublin 1959; Gwen Taylour, *Letters to Brinsley Ford*, 1961; Gwen Taylour, *Letter to Ashmolean Museum*, 1964; Bruce Arnold: Neptune Gallery, *Gwen Taylour*, catalogue, Dublin 1975; (also illustration); Powys Evans, *Letter to the author*, 1975; *Irish Times*, 10 March 1975, 11 October 1975; *Dictionary of British Artists 1880-1940*, Woodbridge 1976; *Royal Academy Exhibitors 1905-1970*, East Ardsley 1978; *A Dictionary of Contemporary British Artists, 1929*, Woodbridge 1981; Ann M. Stewart, *Royal Hibernian Academy of Arts: Index of Exhibitors 1826-1979*, Dublin 1987; Terence Taylour, *Letter to the author*, 1994; also, Whitworth Art Gallery, 1994; *Water Colour Society of Ireland Exhibition List 1872-1994*, Dublin 1995.

TEALE, PHYLLIS – see HAYWARD, PHYLLIS

THADDEUS, HENRY J., RHA (1860-1929), portrait painter. Henry Thaddeus Jones, son of an artificer in japanning, Thomas Jones, was born at 32 Nile Street (later Sheares Street), Cork, in 1860. In the Hammond's Marsh neighbourhood, the Jones family was admired and respected for their book-learning, and Harry particularly for his skill in 'drawing pictures'.

At the age of ten he entered Cork School of Art, and about four years later, according to his autobiography, he was appointed assistant master under James Brenan (q.v.). However, published records of the School of Art showed that in 1875 he was awarded a 'Free Studentship'. A copy of his death registration causes further confusion – 'Age 82 years' – and has had to be ignored.

In his spare time, he was credited with fine portraits in crayon of prominent citizens, including Denny Lane. Jones also attracted attention for his design of a book cover showing the picturesque figure of a gallant drawing a curtain aside and revealing the front view of the old George's Street Theatre. Models for his painting, *The Convalescent*, were members of his own family. He left Cork for London. In 1879 he won a Taylor Prize for £15 from the Royal Dublin Society when a student at Heatherley's Academy. He supported himself by drawing in black and white for the illustrated papers.

In 1880, when still at the London art school, Henry T. Jones won the £50 Taylor Scholarship for a work in oils, *Renewal of Lease Refused*, and a purchaser in Dublin also enabled him to pursue his studies in Paris, where he entered Julian's studio.

During his first year at Julian's, he painted *The Wounded Poacher* (National Gallery of Ireland), accepted at the 1881 Paris Salon. This work was signed Thaddeus Jones. The painting was exhibited at the Cork Industrial and Fine Art Exhibition of 1883, visited by more than 10,000 people. In the early summer of 1881 he had left the Paris studio with some other students, stayed at Pont-Aven for a week at two and a half francs per day all-in, and went on to Concarneau. Despite a smallpox epidemic there and many deaths, he remained until the following spring. *On the Sands, Concarneau*, with three children, was signed 'H. Thaddeus Jones '81'.

Harry Jones was uncertain what to call himself as a painter and his Breton study of 1881, *Spilt Milk*, was signed Thad Jones. Another work of the same year, *Jeune Pêcheur Breton*, was signed T. Harry Jones. Suprisingly, and difficult to understand, the Marquess of Zetland from Richmond, North Yorkshire, advised the author in 1993 that the signature on the 1.8 metres by 2.4 metres portrait of Lilian, Countess of Zetland, and her son, the Hon. George Dundas, 'appears to read H. J. Thaddeus – and is certainly marked 1877'. As far as the Marquess was aware, the work had been in the family's possession since 1877 'when it was completed'. But the artist would then have been only seventeen if born in 1860.

Staying at the Grand Hotel, Concarneau, he sent *On the Sands, Carcarneau* to the Royal Society of British Artists exhibition, 1881. In that year's Paris Salon he also showed *Le Retour du Branconnier, Irlande*. His most ambitious work of this period was of market day on the beach, *Jour de Marché, Finistère* (NGI), 2 metres by 1.3 metres, exhibited at the Paris Salon of 1882 and at the Industrial and Fine Art Exhibition, Cork, 1883, as *Market Day in Finistère*. Also shown at the 1882 Salon was *Les Amies du Modèle*.

The artist did not remain long in Paris when he returned from Concarneau in April 1882, but with a few congenial companions travelled to Moret-sur-Loing, Forest of Fontainebleu, where he spent some months

painting outdoor subjects. In September he left Paris for Florence, and there copied and studied in the galleries. He had a studio and accepted pupils. His address in Florence was 13 Via Ghibellina when he sent three works to the Royal Scottish Academy in 1883, including the market day scene.

A commission from HRH the Duke of Teck set him on a career as a society portrait painter. A letter from the Duke dated 15 March 1884 was addressed to H. Thaddeus Jones – 'Some time later I assumed my Christian name of Thaddeus as my surname.' He also painted the Duchess, and the two portraits were exhibited, under H. Thaddeus Jones, at the 1884 Royal Academy. The only other contribution to Burlington House was in 1883: *A Wine Carrier*.

The Duchess of Teck, for Thaddeus's visit to London in 1884, furnished him with letters of introduction to London society. He stayed with Percy French (q.v.). In July he left London to join the Tecks in Switzerland, spent the winter in Florence and, after visiting Cannes, returned to London in May 1885 with his portrait of Princess May of Teck, which the Duchess was anxious he should submit to her royal mother at St James's Palace. He then settled in a house or studio in South Kensington before travelling to Italy in the winter.

In Rome he had the honour of painting a Pontiff, His Holiness Pope Leo XIII. He also portrayed Father Anderledy, General of the Order of the Jesuits, a work dated 1886 and now in Lady Lever Art Gallery, Port Sunlight. The portrait of Leo XIII, on exhibition in 1886 at the Grosvenor Gallery, London, was seen by W. E. Gladstone who congratulated the artist when he visited Florence. Thaddeus painted Gladstone there in 1888, and the portrait was sold to the Reform Club, London, for 500 guineas.

Algeria, Cannes, Monte Carlo and Nice were all visited. In London, Mortimer Menpes (1860-1938), pupil and follower of J. A. M. Whistler (1834-1903), invited Thaddeus to a supper gathering, and he had little difficulty in having a row with 'White Lock'. In 1886 he paid a short visit to Bray, Co. Wicklow, where he met Charles Stewart Parnell. He reported 'many sitters' in London. The Walker Art Gallery, Liverpool, also showed his work.

In 1886 he exhibited at the Royal Hibernian Academy for the first time, from 42 Claudville Grove, London SW, and between then and 1902 he showed thirty-one works. A portrait of William O'Brien, MP (University College, Cork) was painted for a working men's association in Cork. Other sitters were Michael Davitt and Sir Richard Owen. At the Irish Exhibition in London in 1888 he showed five pictures: *The Old Prison, Annecy, France*; *The Sands, Dronheim, Holland*; and three portraits. *An Irish Peasant* (Sheffield City Art Galleries) was dated 1888.

In 1889 he left for Egypt, and studies of Eastern life provided material for *Christ before Caiphas*. The Khedive, among others, sat for him, and he later presented the portrait on His Highness's behalf to the Queen at Windsor Castle. By contrast was *An Eviction Ireland, Co. Galway*, 1.2 metres by 1.5 metres, 1889 (or *An Irish Eviction* at 1890 RHA). Another 1889 work was a portrait of Robert Percy Ffrench of Monivea (Crawford Municipal Art Gallery).

A portrait of W. T. Stead of the *Pall Mall Gazette* was completed in 1890. In 1891 at the Dublin exhibition he gave a Florence address; pictures included *The Origin of the Harp*. At the 1892 RHA, the year he became an associate, there were portraits of the Abbé Liszt and the Rt. Hon. Thomas Sexton, MP, Lord Mayor of Dublin. The Sexton portrait is no longer in existence; a replica was painted by Dermod O'Brien (q.v.).

In 1895 he painted portraits in both Corsica and Hamburg, where he renewed acquaintance with his painter friend, Professor H.-D.-S. Corrodi (1844-1905) of Rome. In 1896 he met with a serious accident, breaking his right leg in three places. He painted his second portrait of Leo XIII, this time sitting in state with cardinals. *The Obbedienza* was exhibited in London and, priced £1,000, at the 1901 RHA.

Full membership of the RHA was granted in 1901, and that year he painted a portrait of the parliamentarian, John Redmond (NGI). In 1901 too he left London for Australia. After a short stay in Melbourne, he visited Sydney where *The Obbedienza* was on exhibition early in 1902, and was acquired for the cathedral.

At this time, Maesmawr Hall was his residence in mid-Wales. In 1903 Pope Pius X became the new Pontiff and Thaddeus painted him, ensuring that a photograph was taken of sitter and artist. A replica was presented by the artist to the Crawford Municipal Art Gallery, where coloured prints could be purchased.

In the 1904 exhibition of works by Irish painters held at the Guildhall of the Corporation of London and organised by Hugh P. Lane, he was represented by a portrait. His autobiography, *Recollections of a Court*

Painter, appeared in 1912. There is no mention in it of his marriage although in 1896 at the RHA he showed a portrait of his wife and son, Frederick Francis. In an article in the *Cork Holly Bough* of 1961, Diarmuid O'Donovan stated that at one period Thaddeus 'lived in California and to-day his grandchildren live in New York and Delaware'. Victor was the other child, then residing at Delaware, and he has recalled that his father was a 'lightning draftsman, and sitting in a room could with a few strokes of his pencil portray someone we know.'

In 1920 he presented to the Crawford Municipal Art Gallery a portrait of his friend, Michael Holland (q.v.), and hoped for 'a closer association in the future not only with the art life of my native city, but with that of a regenerated nation'. He occasionally attended Munster Fine Art Club gatherings, and exhibited. Owing to indifferent health, he relinquished his profession, and it was probably for that reason and the fact that he and his wife devoted themselves to travelling that he resigned his membership of the RHA. About 1923 he moved to the Isle of Wight. A Fellow of the Royal Geographical Society, he died at Appley Court, St Helen's, on 30 April 1929.

Works signed: T. Harry Jones, Thad Jones, Thaddeus Jones, H. Thaddeus, Thaddeus, all rare; or H. J. Thaddeus.
Examples: Cork: Crawford Municipal Art Gallery; University College. Dublin: National Gallery of Ireland. London: Reform Club, Pall Mall. Port Sunlight, Merseyside: Lady Lever Art Gallery. Sheffield: City Art Galleries.
Literature: *Royal Dublin Society Report of the Council*, 1880; Mrs F. Harcourt Williamson, ed., *The Book of Beauty*, London 1896 (illustration); Algernon Graves, *The Royal Academy of Arts Exhibitors 1769-1904*, London 1905; H. Jones Thaddeus, *Recollections of a Court Painter*, London 1912 (also illustrations); *Journal of the Cork Historical and Archaeological Society*, 1913; *Isle of Wight County Press*, 4 May 1929; *Who Was Who 1929-1940*, London 1941; Michael Holland, *Cork Historical and Archaeological Journal*, January-June 1943; Diarmuid O'Donovan, *Cork Holly Bough*, 1961; *Thomas MacGreevy Papers*, Trinity College, Dublin [1967]; *Dictionary of British Artists 1880-1940*, Woodbridge 1976; Julian Campbell: National Gallery of Ireland, *The Irish Impressionists: Irish Artists in France and Belgium 1850-1914*, catalogue, Dublin 1984 (also illustrations); Gorry Gallery, *Irish Paintings*, catalogues, Dublin 1986, 1987 and 1988 (also illustrations); Ann M. Stewart, *Royal Hibernian Academy of Arts: Index of Exhibitors 1826-1979*, Dublin 1987; *The Royal Scottish Academy Exhibitors 1826-1990*, Calne 1991; Peter Murray, *Illustrated Summary Catalogue of The Crawford Municipal Art Gallery*, Cork 1992; Hugh Lane Municipal Gallery of Modern Art, *Letter to the author*, 1993; also, Marquess of Zetland, 1993; Reform Club, London, 1993; Gorry Gallery, *An exhibition of 18th, 19th and 20th century Irish paintings*, catalogue, Dublin 1995 (illustration), also 1998 (illustrations).

THEODORA – see HARRISON, THEODORA L.

THOMPSON, CHARLOTTE – see LAWRENSON, CHARLOTTE

THOMPSON, ELIZABETH (1846-1933), military painter. Elizabeth Southenden Thompson was born at Lausanne when her parents, James Thompson and Christiana Weller were residing in Switzerland. Her sister Alice became Mrs Meynell, the poet and essayist. Elizabeth inherited a love of drawing and painting from her mother. She attended the South Kensington schools, and continued her studies in Florence and Rome.

But as J. Crampton Walker wrote in *Irish Life and Landscape*: 'No doubt many will ask why is she represented at all in a book dealing only with Irish artists? The explanation is that she has spent a great part of her life in Ireland, since she first set foot on its shores to wed a distinguished Irish soldier – General Sir William Butler. One has only to read her memoirs to realise the great love she has always had for the beauty of this country, and her concern for its welfare...' The explanation was supported by the reproduction of a pen and ink drawing of an Irish jaunting car.

In 1874 she was appointed a member of the Royal Institute of Painters in Water Colours, and she became a committee member of the Water Colour Society of Ireland. In an article on Irish art at the Royal Academy, the *Dublin University Magazine* in 1874 included, somewhat unaccountably, a reference to Miss Thompson's *Calling the Roll after an Engagement in the Crimea*. Indeed *The Roll Call*, as it was subsequently called, earned her national fame, and afterwards international renown as a battle painter. *The Studio* said she was

'the exponent of a theme exclusively masculine'. She never reached RA status, and showed only one work at the Royal Scottish Academy.

The Roll Call, however, was the intermediary through which she was introduced to Ireland. One of the viewers in that summer of 1874 was Major William Francis Butler. Afterwards he was introduced to the artist, and in 1877 they were married. Their honeymoon was spent where the Butler family lived, Tipperary.

One result of her Irish honeymoon was, '*Listed for the Connaught Rangers*, a recruiting scene set in Connemara for which studies were made in Glencar, Co. Kerry. In her autobiography she stated that she had two splendid models for the Irish recruits. The painting was shown at the 1879 RA, and is now in Bury Art Gallery and Museum, Lancashire.

Her new role as wife and military hostess took her to various stations at home and abroad, complete with painting equipment. In 1888 the Butlers travelled from Dinan in Brittany to Delgany, Co. Wicklow.

In 1890 she exhibited at the RA, *An Eviction in Ireland*. She had witnessed the aftermath of an eviction. 'I seldom can say I am pleased with my work when done,' she wrote in her autobiography, 'but I am complacent about this picture; it has the true Irish atmosphere, and I was glad to turn out that landscape successfully which I had made all my studies for, on the spot, at Glendalough ... I did not see this picture at all at the Academy, but I am very certain it cannot have been very "popular" in England...'. This work is with the Irish Folklore Commission.

Another painting of Irish Life was *The Emigrant*, but acclaim rested in such military works as *Scotland for Ever!*, 1881. When she returned home to Delgany from Egypt in 1893 she worked on her next big picture, *The Réveil in the Bivouac of the Scots Greys on the Morning of Waterloo – Early Dawn*. She was able to make all her twilight studies at home, all out of doors, pressing many people into her service, including an Irish dragoon home on leave. The Butlers moved on to Aldershot. In 1897 we find her corresponding from The Constable's Tower, Dover. In 1899 she exhibited at the Royal Hibernian Academy: *'To the Front'* and *Halt on a Forced March*.

In 1903 her *Letters from the Holy Land* was published with sixteen full-page illustrations in colour. In 1905 Sir William Butler retired, and from then until his death in 1910 they lived at Bansha, Tipperary. Thereafter Lady Butler lived with her daughter, Viscountess Gormanston, in Co. Meath. During her widowhood she painted unceasingly.

In 1908 she exhibited with WCSI for the first time, *The English General's Syces, Cairo*, but there was a gap of ten years before she participated again, this time with five works, including *Site of the Birthplace of St John the Baptist* and *Bethany*. Thereafter in the period 1926-32 only eight pictures were hung, with *In France, 1915: The Message Home* in 1926.

M. K. O'Byrne has recounted in *Irish Monthly* his personal acquaintance with Lady Butler at Gormanston Castle: 'I found a frail little lady in black ... she was deaf ... More than once, Lady Butler invited me to her studio, where she continued to paint regularly. One of the last things I saw on her easel was a water-colour, fresh and vigorous, of an Iniskilling Dragoon. She painted uniform and accoutrements, of which she had a unique collection, with meticulous regard for detail.'

O'Byrne added that Lady Butler had tremendous capacity for work, and continued: 'A hard and fast rule of hers was to take exercise every morning before going to her studio and again just before luncheon ... She was a woman of high courage, content to lead a secluded life of great simplicity that was such a contrast to the brilliant years of her success as an artist and her role as the wife of an officer of high rank.' Her last picture was painted in 1928 when she was 82, and she exhibited at the RHA in 1929 and 1930. Four sketchbooks are in the British Museum. She died at Gormanston Castle, on 2 October 1933, and was buried at Stamullen, Co. Meath.

Works signed: E. B., E. T., Elizth. Thompson or Mimi Thompson, rare.
Examples: Bournemouth: Russell-Cotes Art Gallery and Museum. Bury: Art Gallery and Museum. Camberley: Staff College. Dublin: University College (Belfield), Irish Folklore Commission. Kingston upon Hull: Ferens Art Gallery. Leeds: City Art Galleries. London: British Museum; National Portrait Gallery; Tate Gallery. Manchester: City Art Gallery. Port Sunlight: Lady Lever Art Gallery.

Literature: Elizabeth Thompson, *Letters from the Holy Land*, London 1903 (illustrations); Elizabeth Butler, *From Sketch-Book and Diary*, London 1909 (also illustrations); Elizabeth Butler, *An Autobiography*, London 1922 (also illustrations); J. Crampton Walker, *Irish Life and Landscape*, Dublin 1927 (also illustration); M. K. O'Byrne, 'Lady Butler', *Irish Monthly*, December 1950; Michael Lee,' A Centenary of Military Painting', *Army Quarterly*, October 1967; *The Classified Directory of Artists Signatures, Symbols & Monograms*, London 1976; *Irish Arts Review*, Winter 1987; *The Royal Scottish Academy Exhibitors 1826-1990*, Calne 1991; *Water Colour Society of Ireland Exhibition List 1872-1994*, Dublin 1995.

THOMPSON, SIDNEY MARY – see CHRISTEN, MADAME

THOMSON, HUGH (1860-1920), illustrator. Born on 1 June 1860 at 9 Church Street, Coleraine, Co. Derry, the son of John Thomson, he attended Coleraine Model School. As a schoolboy he was forever sketching. Before he left school, aged fourteen, his mother died. After remarrying, his father moved to Kilrea, Co. Derry, but Hugh remained in lodgings in Coleraine as his good handwriting had secured employment with the linen manufacturers, E. Gribbon & Sons Ltd.

At the age of sixteeen, he undertook in his spare time an illuminated address. Unsuited to the world of commerce, it was through the firm's proprietor, Henry A. Gribbon, that he secured in 1877 an apprenticeship in Belfast at Marcus Ward's art department. John Vinycomb (q.v.) took him under his care, and later said that he was the most outstanding original draughtsman the firm had ever had. On Vinycomb's advice, he founded his method of drawing on the illustrations of Fred Barnard (1846-96).

Thomson, who attended a few classes at the Government School of Art, was one of the staff of artists of the Royal Ulster Works (Marcus Ward's) who formed the Belfast Ramblers' Sketching Club in 1879 when he was residing at Park View Terrace, Ballynafeigh – a watercolour by Thomson of the Ormeau Road district is in the Ulster Museum. A £10 prize came from Cassell & Co. for the best original drawing in pen and ink. Encouraged, he persevered in his practice of book illustrations and determined, on the completion of his apprenticeship, in 1883, to leave for London.

After a depressing month in London seeking employment, he accepted a position in McClure, Macdonald and MacGregor's lithographic department as a designer, but after a few weeks the editor of the new *English Illustrated Magazine*, J. Comyns Carr, of Macmillan's, appointed him as an illustrator. Carr was another good angel and friend. Thomson's first pen and ink drawing for the magazine appeared in June 1884, and that year saw publication of his first illustrated book, *Charlie Asgarde*, by Alfred St Johnston.

In 1885 he settled in Putney with his wife, who was from Belfast. The publication, again for Macmillan, of *Days with Sir Roger de Coverley*, 1886, with pastoral decorations, saw Thomson almost as the spiritual follower and successor of Randolf Caldecott (1846-86). The book was one of the first British publications with photomechanically reproduced illustrations. He had created, it was said, an idyllic world of stage coaches, sedan chairs, feasts and port wine, although in the *English Illustrated Magazine* he supplied Cockney studies for an article.

In constant demand as a book illustrator, particularly for the classics, he never forgot his homeland, visited it and wrote weekly letters to his father. In London, the Fine Art Society held an exhibition in 1887 of ninety-three of his drawings, including sixty from *Days with Sir Roger de Coverley*. *Coaching Days and Coaching Ways*, 1888, with his 'peppery squires and rubicund coachmen', was a great success. In 1889 he first contributed to *The Graphic*, and in 1890 – when he visited Holland – to *The Art Journal* and *Pall Mall Budget*. Some 180 illustrations, well over a year's work, were produced for *The Vicar of Wakefield*, published in December 1890, and within three weeks the first large edition was sold out.

In the next decade he began illustrating for *Black and White*; *Scribner's Magazine*; *Pears' Annual*; *The Octopus*; *The New Budget*; and *Daily Graphic*. Several bookplates were also executed. Writing years later in *The Studio* on the publication of *Cranford* in 1891, M. Hepworth Dixon in an article on Thomson said that for Mrs Gaskell's book 'the designer reached the high-water mark of his achievement'. These illustrations, said another writer, gave their name to his 'nostalgic, affectionate and slightly whimsical approach to

historical themes: the "Cranford School"'. In 1891 too he visited Holland, and that year the Fine Art Society held an exhibition of the work of Kate Greenaway (1846-1901) and Thomson.

The Ballad of Beau Brocade, 1892, was the first of four books which he illustrated for Austin Dobson, another eighteenth century enthusiast, and the illustrations were shown in an 1893 exhibition at the Fine Art Society gallery and some at the 1894 exhibition of the Belfast Art Society. When living at Seaford, Sussex, he visited Paris in 1895 and was then an honorary member of the BAS. He was represented in the 1896 exhibition of the Fine Art Society: 'A Century and a Half of English Humorous Art'. His contributions to *The Poor in Great Cities*, 1896, showed diversity.

In 1897 he was appointed a member of the Royal Institute of Painters in Water Colours but resigned ten years later because he had failed to exhibit. *Highways and Byways in Devon and Cornwall*, 1897, was the first of twelve books which he illustrated for Macmillan in the series. In these he excelled in the use of lead pencil. At the Fine Art Society in 1897 there was a joint exhibition of the work of Linley Sambourne (1844-1910) and Thomson.

In 1897 he moved back to London. The first and only issue of Hugh Thomson's Illustrated Fairy Books, *Jack the Giant Killer*, appeared in 1898. At the Birmingham and Midland Institute in 1899 there was an exhibition of drawings lent by Macmillan & Co. Ltd, and at the Continental Gallery in Bond Street, sales reached £747; seventy-seven drawings were displayed. The Continental held a second exhibition in the same year. Following an operation in 1900, his output was considerably reduced for a period. He was among the black-and-white artists represented in the British section, Paris International Fine Art Exhibition, 1900. He moved that year to 27 Perham Road, West Kensington. He was a member of the London Sketch Club.

At the exhibition of fairy and folk tale illustrations at Leighton House, 1901, he was represented by work for *Piper of Hamelin*. *Cranford* drawings were shown at the Victoria and Albert Museum in 1901, and that year he made his first contribution to *Little Folks*. At the Continental Gallery, 1902, sixty-seven drawings from *Peg Woffington* were exhibited.

A Swiss holiday in 1903 produced a series of sketches for the *Graphic*. A small exhibition was held at Newcastle-upon-Tyne Academy of Arts. On behalf of the *Graphic*, he visited Monte Carlo in 1905. Tinted drawings for *Evelina* were prominent in his Doré Gallery exhibition. Ulster Arts Club, Belfast, elected him a member, and in 1906 he exhibited there. In 1906 too the *Pall Mall Magazine* published sketches of Foundling Hospital children.

The pencil drawings, *Folkestone from the Harbour* and *Firemen's Quarter, Folkestone* were executed in 1906. There was a rare appearance of his work in Dublin when in 1907 he contributed *The Shipyards, Belfast* and *Dublin, from Clontarf* to the Oireachtas exhibition. Other solo exhibitions were: 1909, Walker's Galleries; 1910, Leicester Galleries. His poor health continued.

In 1911 Thomson was represented at the International Fine Art Exhibition at Rome. *School for Scandal* drawings were exhibited in 1912 at the Leicester Galleries. On *She Stoops to Conquer*, 1912, *The Studio* commented: 'In all his illustrative work Mr Thomson shows a conscientious regard for historical accuracy; hence it is rare to find an anachronism in his portrayal of old-world scenes.' In 1913 he moved from Sidcup to 8 Patten Road, Wandsworth Common, and exhibited again colour-drawings at the Leicester Galleries.

In 1917 he obtained regular employment at India House, Kingsway. In 1918 he was granted a Civil List pension. Three drawings for Sir Isidore Spielmann's pamphlet, *Germany's Impending Doom*, 1918, are in the Imperial War Museum. He designed the diploma for the British Arts and Crafts Exhibition, Paris, 1919. Among the drawings at the Victoria and Albert Museum are designs for cover, title page, and illustrations for *School for Scandal*. A number of book illustrations are in the Ulster Museum, also a caricature of Harry Lauder.

Thomson illustrated about seventy books – see Literature list. Figure work claimed nearly all his time. *The Times*, however, considered that his 'delicate talent was spoilt by humorous exaggeration ... he was above all a landscape artist', but he would be remembered as 'the Charles Lamb of illustration', as Austin Dobson had 'fitly called him'. Sir James Barrie said he was 'a man who drew affection at first sight, so unworldly, so diffident ...'.

After an attack of *angina pectoris*, he died at his Wandsworth Common residence on 7 May 1920. A memorial exhibition followed at the Leicester Galleries in 1923. A comprehensive account of his career appeared in 1931: *Hugh Thomson: His art, his letters, his humour and his charm* by M. H. Spielmann and W. Jerrold. Exhibitions were held in Belfast: 1935, Belfast Museum and Art Gallery; 1960, Central Library; 1970, Linen Hall Library. An auction sale of 136 drawings took place in Belfast in 2001.

Works signed: Hugh Thomson, Hu. Thomson, H. Thomson or H. T.
Examples: Aberdeen: Art Gallery. Belfast: Ulster Museum. Cultra, Co. Down: Ulster Folk and Transport Museum. Eastbourne, Sussex: Towner Art Gallery. Folkestone, Kent: Museum and Art Gallery. London: British Museum; Imperial War Museum; Victoria and Albert Museum.
Literature: Books illustrated, published London unless stated otherwise: Alfred St Johnston, *Charlie Asgarde*, 1884, and *Days with Sir Roger de Coverley*, 1886; Charles Dickens, *Pickwick Papers*, 1886; W. Outram Tristram, *Coaching Days and Coaching Ways*, with Herbert Railton, 1888; Oliver Goldsmith, *The Vicar of Wakefield*, 1890; Mrs Gaskell, *Cranford*, 1891; Sir Walter Scott, *The Antiquary* and *The Bride of Lammermour*, 1891; Austin Dobson, *The Ballad of Beau Brocade*, 1892; Robert Buchanan, *The Piper of Hamelin: A Fantastic Opera in Two Acts*, 1893; Mary Russell Mitford, *Our Village*, 1893; Jane Austen, *Pride and Prejudice*, 1894; Austin Dobson, intro., *Coridon's Song and Other Verses from Various Sources*, 1894; Sir Walter Scott, *St Ronan's Well*, 1894; W. Outram Tristram, *The Dead Gallant* and *The King of Hearts*, second story only, 1894; Austin Dobson, *The Story of Rosina and Other Verses*, 1895; Jane Austen, *Emma* and *Sense and Sensibility*, 1896; William Somerville, *The Chase*, 1896; R. A. Woods, etc., *The Poor in Great Cities*, with others, 1896; Jane Austen, *Mansfield Park*, *Northanger Abbey* and *Persuasion*, 1897; A. H. Norway, *Highways and Byways in Devon and Cornwall*, 1897; A. G. Bradley, *Highways and Byways in North Wales*, 1898; Hugh Thomson, *Jack the Giant Killer*, 1898; W. G. Whyte Melville, *Inside the Bar* (from *Riding Recollections*), 1898; Stephen Gwynn, *Highways and Byways in Donegal and Antrim*, 1899; Mrs Molesworth, *This and That*, 1899; A. H. Norway, *Highways and Byways in Yorkshire*, 1899; Charles Reade, *Peg Woffington*, 1899; James Lane Allen, *A Kentucky Cardinal and Aftermath*, New York 1901; John Moffat and Ernest Druce, *Ray Farley*, 1901; Mrs E. T. Cook, *Highways and Byways in London*, 1902; W. M. Thackeray, *The History of Samuel Titmarsh and the Great Hoggarty Diamond*, 1902; Fanny Burney, *Evelina*, 1903; F. J. Harvey Darton, ed., *Tales from Maria Edgeworth*, 1903; Mrs M. H. Spielmann, *Littledom Castle and Other Tales*, with others, 1903; F. J. Harvey Darton, *Tales of Canterbury Pilgrims*, 1904; W. M. Thackeray, *The History of Henry Esmond*, 1905; George Eliot, *Scenes of Clerical Life*, 1906; Stephen Gwynn, *The Fair Hills of Ireland*, Dublin 1906; George Eliot, *Silas Marner*, 1907; Walter Jerrold, *Highways and Byways in Kent*, 1907; Austin Dobson, *De Libris*, 1908; Eric Parker, *Highways and Byways in Surrey*, 1908; Mrs M. H. Spielmann, *My Son and I*, 1908; Walter Jerrold, *Highways and Byways in Middlesex*, 1909; Charles Morley, *London at Prayer*, 1909; William Shakespeare, *As You Like It*, 1909; Mrs M. H. Spielmann, *The Rainbow Book*, with others, 1909; William Shakespeare, *The Merry Wives of Windsor*, 1910; R. B. Sheridan, *The School for Scandal*, 1911; Oliver Goldsmith, *She Stoops to Conquer*, 1912; J. M. Barrie, *Quality Street*, 1913; Charles Dickens, *The Chimes*, 1913; Andrew and John Lang, *Highways and Byways in the Border*, 1913; J. M. Barrie, *The Admirable Crichton*, 1914; Stephen Gwynn, *The Famous Cities of Ireland*, Dublin 1915; C. W. Dick, *Highways and Byways in Galloway and Carrick*, 1916; Austin Dobson, *A Bookman's Budget*, Oxford 1917; Sir Isidore Spielmann, *The Germans as Others See Them*, 1917; Thomas Hughes, *Tom Brown's School Days*, New York 1918; Walter Jerrold, *Douglas Jerrold, Dramatist and Wit*, one illustration, 1918; Sir Isidore Spielmann, *Germany's Impending Doom*, 1918; P. Anderson Graham, *Highways and Byways in Northumbria*, 1920; Nathaniel Hawthorne, *The Scarlet Letter*, 1920; Edward Hutton, *Highways and Byways in Gloucestershire*, 1931.
Literature: General: *The Shanachie*, Nos 1 and 2, 1906 (illustrations); John Vinycomb: Ulster Arts Club, *Catalogue of an Exhibition of the Works of Hugh Thomson*, Belfast 1906; *The Studio*, December 1912, April 1917, February 1921, May 1932; *The Times*, 10 May 1920; M. H. Spielmann and Walter Jerrold, *Hugh Thomson: His art, his letters, his humour and his charm*, London 1931 (also illustrations); J. W. Carey: Belfast Museum and Art Gallery, *Exhibition of works by Hugh Thomson*, catalogue, Belfast 1935; *Irish Booklore*, Spring 1972; John Hewitt and Theo Snoddy, *Art in Ulster: 1*, Belfast 1977 (also illustration); Martyn Anglesea, *The Royal Ulster Academy of Arts*, Belfast 1981 (also illustration); Simon Houfe, *Dictionary of British Book Illustrators and Caricaturists 1800-1914*, Woodbridge 1981 (also illustrations); Brigid Peppin and Lucy Micklethwait, *Dictionary of British Book Illustrators: The Twentieth Century*, London 1983; Kent County Council, *Letter to the author*, 1993; Ann M. Stewart, *Irish Art Societies and Sketching Clubs: Index of Exhibitors 1870-1980*, Dublin 1997; Ross's, *Hugh Thomson 1860-1920*, catalogue, Belfast 2001 (also illustrations).

TIERNEY, JOSEPH (fl. 1916-40), illuminator and mural painter. Of the Columbar Studio, 14 Westmoreland Street, Dublin, he designed and illuminated a set of altar cards with Celtic designs for the Honan Hostel Chapel, Cork. These were mounted in bejewelled and enamelled silver frames made by Edmond Johnson Ltd, manufacturing jewellers and silversmiths, Grafton Street. The cards were exhibited at the Royal

Hibernian Academy in 1916. An illustration of an altar card in colour appeared in Jeanne Sheehy's *The Rediscovery of Ireland's Past: the Celtic Revival 1830-1930*.

Tierney was represented in the Arts and Crafts Society of Ireland's 1917 exhibition at the Dublin Metropolitan School of Art, and his illumination was mentioned in the review in *The Studio*. He painted in 1921 the murals of St Brendan and St Grellan in the sanctuary of St Michael's Church, Ballinasloe, Co. Galway.

In 1924, Mia Cranwill (q.v.) made frames in silver with gold ornaments for the altar cards which had been illuminated by Tierney for Monsignor John Rogers of St Patrick's Church in San Francisco. Early in the Second World War the Columbar Studio closed down. The registration of his death could not be traced.

Examples: Ballinasloe, Co. Galway: St Michael's Church. Cork: Honan Hostel Chapel, University College. San Francisco: St Patrick's Church.
Literature: *Thom's Directory*, 1917, 1942; Rev. Patrick K. Egan, *The Parish of Ballinasloe*, Ballinasloe 1960; Jeanne Sheehy, *The Rediscovery of Ireland's Past: the Celtic Revival 1830-1930*, London 1980 (illustration); Paul Larmour, *The Arts & Crafts Movement in Ireland*, Belfast 1992 (also illustration).

TISDALL, H. C. W., RHA (1861-1954), landscape, portrait and figure painter. Henry Cusack Wilson Tisdall was born on 14 November 1861, son of the Rev. Charles Edward Tisdall, Chancellor of Christ Church Cathedral, Dublin, who was painted by Stephen Catterson Smith, RHA (1806-72). Henry Tisdall was at the Dublin Metropolitan School of Art in the year 1880-1, and in 1882-3, Académie Royale, Antwerp, where his address was 69 Keizerstraat (rue du Convent). He studied at Antwerp with Nathaniel Hill and Joseph M. Kavanagh (qq.v.).

Tisdall, at the Metropolitan, won the Royal Dublin Society's £50 Taylor Scholarship in 1885 for *Take Care!* This work was exhibited at the Royal Hibernian Academy in 1886. He had been exhibiting at the RHA since 1880, giving his home address, 22 Herbert Place, Dublin. According to the catalogue, he exhibited in 1884: 'A rare etching (Awarded the Albert Scholarship for 1884) £30.' In 1885, still at the School of Art, he was proposed and seconded as a working member of the Dublin Sketching Club and contributed four works that year, including, *A Pensioner* and *Moonlight*. In the period 1886-92 he exhibited thirty-five pictures with the Dublin Art Club.

Altogether he exhibited more than 260 works at the RHA, or an average of four per year until 1945. He showed portraits of Miss O'Brien in 1884; George Posnett, 1886; the Rev. Dr Tisdall, 1888. In 1888 he also exhibited *An Antwerp Model*. Appointed an associate of the RHA in 1892, he became a full member in 1893. Contributions to the exhibiton in 1895 included *La Liseuse* and *Burning Weeds, October*. Titles indicated that he sketched or painted at Dargle, Co. Wicklow, and in the County Dublin districts of Cabinteely, Rathfarnham and Templeogue.

Tisdall's only two contributions to the Water Colour Society of Ireland exhibitions had been in 1892 and 1893. *Haytime* and *Moonrise – a Calm Evening* were among his works at the 1895 DSC event.

One of his highest priced works at the RHA early in the century was *Girl with Chrysanthemums* in 1904, and that year his painting *Josephine* was in the exhibition of works by Irish painters held at the Guildhall of the Corporation of London and organised by Hugh P. Lane. *Twilight* and *Outside the Wood* appeared at the Belfast Art Society exhibition in 1905.

In 1906 at the RHA exhibition he showed a portrait of Darius J. MacEgan (q.v.). In the period 1906-09 inclusive he showed no fewer than thirty-two works at the RHA premises in Lower Abbey Street. An occasional still life appeared. Moonrises and summer and autumn afternoons attracted his brush, but he also painted some interiors. He exhibited at the Oireachtas in 1907 and 1911.

Tisdall was among the Visitors to the RHA's Living Model School. In 1919 he was appointed RHA treasurer and served until 1928. In 1926, following an absence of thirty years, he returned to the DSC exhibition and was a regular exhibitor up until 1946. After his marriage in 1927, he moved to 71 Pembroke Road, Dublin. He was represented at the Exposition d'Art Irlandais at Brussels in 1930 by an interior.

Brigid Ganly, HRHA, knew Tisdall as an RHA teacher in the 1930s and recalled to the author in 1993: 'We students didn't respect his teaching abilities, perhaps because we favoured the Orpen school. I can only recollect one or two of his landscapes, which were quiet in colour, and rather soft in drawing. I never saw an exhibition of his work.'

At the RHA in 1935 works included a street scene in Abbeville, France, and *The Blue Mirror*. At DSC in 1937 he showed *The Model Yacht* and *Late Autumn*. At the Walker Art Gallery, Liverpool, he presented four pictures, and one with the Royal Society of Artists, Birmingham. As a visitor at the RHA Schools, he retired in 1947. The exact date and place of his death have not been traced.

Works signed: Henry C. Tisdall.
Examples: Limerick: City Gallery of Art.
Literature: *Dublin Sketching Club Minute Book*, 1885; *Royal Dublin Society Report of the Council*, 1885; *Thom's Directory*, 1898; W. G. Strickland, *A Dictionary of Irish Artists*, Dublin 1913; *Irish Times*, 25 October 1916; *Burke's Landed Gentry of Ireland*, London 1958; Alan Denson, *John Hughes Sculptor 1865-1941*, Kendal 1969; *Dictionary of British Artists 1880-1940*, Woodbridge 1976; *Oireachtas Catalogue*, Dublin 1977; Julian Campbell: National Gallery of Ireland, *The Irish Impressionists: Irish Artists in France and Belgium*, catalogue, Dublin 1984; Ann M. Stewart, *Royal Hibernian Academy of Arts: Index of Exhibitors 1826-1979*, Dublin 1987; R. Brigid Ganly, *Letter to the author*, 1993; Ann M. Stewart, *Irish Art Societies and Sketching Clubs: Index of Exhibitors 1870-1980*, Dublin 1997.

TOMLIN, CHARLES E. (1882-1957), sculptor. Born in Dublin in 1882, Charles Edward Tomlin was the father of Stanley Tomlin (q.v.). He served his time with Patrick Pearse's father, James Pearse, ecclesiastical and architectural sculptor, 27 Great Brunswick Street. His employer told him he was a 'a good boy', and used to give him a shilling a week as pocket money.

Further training was under his uncle, Patrick Tomlin (q.v.), at 42 Great Brunswick Street, where Edmund Sharp ran a monumental works and described himself as 'sculptor'. Charles Tomlin began as a stonecarver at nine pence per hour, and later became head sculptor at Sharp's.

Tomlin was responsible for the altar at St John's Priory, Thomas Street, Dublin, and the Last Supper group in the Church of Saints Mary and Patrick at Avoca, Co. Wicklow. Statues of St Michael and St George are high up in nooks beside the High Altar in the Church of the Holy Family, Aughrim Street, Dublin.

When on the staff of Farrell and Son, monumental sculptors, Glasnevin, Dublin, he was responsible for the figure in the Sean Russell memorial in Fairview Park, Dublin, opened in 1955. The memorial was executed throughout in Irish limestone from Co. Carlow quarries. Of 37 Warren Street, Dublin, he died in the Adelaide Hospital on 16 July 1957.

Examples: Avoca, Co. Wicklow; Church of Saints Mary and Patrick. Dublin: Church of the Holy Family, Aughrim Street; Fairview Park; St John's Priory, Thomas Street.
Literature: *Thom's Directory*, 1898, 1910; *Evening Press*, 25 January 1957; *Register of Deaths*, Dublin 1957; Stanley Tomlin, *Letter to the author*, 1968; also, Church of the Holy Family, 1993; Farrell and Son, 1993.

TOMLIN, PATRICK E. (fl. 1883-1903), sculptor. The uncle of Charles E. Tomlin (q.v.), Patrick Tomlin was a brother of Arthur Tomlin (1859-1916) of Martin Street, Portobello, who as a sculptor or stonecarver worked at Waterford Cathedral, and was employed by Edmund Sharp of 42 Great Brunswick Street, Dublin.

A marble group by Patrick Tomlin is over the tomb of Fr Thomas Burke, OP, who died in 1883, in St Mary's Church, Tallaght, Co. Dublin. He was head sculptor at Sharp's. According to *The Figaro and Irish Gentlewoman* in 1903, he was credited with a reproduction of Leonardo da Vinci's *Last Supper*. Some of the work was exhibited by 'Mr J. D. Spence, Frame Maker to the Queen, in the window of his establishment in Westmoreland Street ... part of an order for a large altar in Carrara marble, seven groups and two statues, for Waterside, Londonderry. The group is certainly the finest in Ireland ...'. These sculptures are in St Columb's Church but do not appear to bear a signature.

After he left Sharp's, he started his own business, Patrick Tomlin and Sons, which he described as ecclesiastical and architectural sculptors and modellers, Grantham Street and Grantham Place. Of Mountpleasant Avenue, Dublin, the year of his death has not been traced.

Examples: Londonderry: St Columb's Church. Tallaght, Co. Dublin: St Mary's Church.
Literature: *The Figaro and Irish Gentlewoman*, 8 March 1903; *Edmund Sharp, Sculptor, Great Brunswick Street, Dublin*, brochure, n.d.; *Thom's Directory*, 1910; Stanley Tomlin, *Letters to the author*, 1971; also, Miss Ruth Tomlin, 1976; Bishop Edward Daly, 1993; St Mary's Church, 1993.

TOMLIN, STANLEY (1916-76), stained glass artist. The son of Charles E. Tomlin (q.v.), he was born in Dublin, on 2 July 1916. He spent a year at King's Hospital School. In his very early days, he received training from his father, particularly in drawing, and the background of ecclesiastical art work in the family saw him entering in 1933 the firm of Harry Clarke Stained Glass Ltd, Dublin.

Among his windows were those of 1955 for St Patrick's Training School, Belfast; at this time he was working for Myles Kearney & Co. Ltd, Dublin. He decided to open his own studios, and in 1957 Irish Stained Glass Ltd, Herbert Lane, Dublin, came into existence; in 1962 he built new premises at Hanover Quay. His two sons, Alan and Fergus, joined the firm.

A number of his windows went abroad, for example to churches in England, Canada and then California, where a most interesting series of windows were those for St Columba's Church at San Diego, depicting the spread of the Gospel throughout the world.

Among his most notable windows in Ireland were *Annunciation* in St Thomas's Church, Fosters Avenue, Dublin, and the memorial in the chapel at McKee Barracks, Dublin, to the Irish soldiers who lost their lives in the Glen of Imaal tragedy. The windows of the Nativity and *Christ with the Children* in St Mary's Church, Sandyford, Dublin, are not only signed with the artist's name but also have his home address.

William J. Dowling (q.v.), former manager of the Harry Clarke Studios, was of the opinion that during his career Tomlin created 'a personal style of stained glass of rich pattern and glowing colour, which was in harmony with the changing church architecture, but without loss of traditional values in the expression of the subject matter involved'. Of 15 Balally Drive, Dundrum, Co. Dublin, he died in Dublin on 7 July 1976.

Works signed: Stanley Tomlin or S. Tomlin.
Examples: Aughrim, Co. Galway: Holy Trinity Church. Belfast: St Patrick's Training School. Cavan: St Patrick's Church. Dublin: McKee Barracks; St Thomas's Church, Fosters Avenue; St Mary's Church, Sandyford; Synagogue, Rathfarnham Road. Fresno, California: Fresno Cathedral. Johannesburg: Cathedral of Christ the King. Los Alamos, California: St Anthony's Church. Los Angeles: Church of the Holy Name of Jesus. San Diego, California: St Columba's Church. San Francisco: Notre Dame de Victorias. San Jacinto, California: St Anthony's Church. Toronto: St Clement's Church, Marklands Wood.
Literature: Stanley Tomlin, *Letters to the author*, 1968, 1971; *Irish Times*, 8 July 1976; William J. Dowling, 'Stanley Tomlin: An appreciation', *Irish Times*, 4 August 1976; Alan Tomlin, *Letter to the author*, 1994.

TOOGOOD, R. C., RUA (1902-66), landscape and portrait painter. Romeo Charles Toogood was born in Belfast, on 6 May 1902, the son of Charles Toogood, a stonecarver who had travelled from England to work on the City Hall, Belfast, and who also executed carvings of grapes and wheat round the chancel of St Peter's Church, Antrim Road, Belfast. Romeo attended Hillman Street Public Elementary School. In 1916, when living at 74 Hogarth Street, he began a career as a painter and decorator.

In 1922 he entered Belfast School of Art to study painting. In the period 1925-8 he taught there in the evening classes and, encouraged and supported by his mother, managed to save £300 which he reckoned would last him three years at the Royal College of Art. However, towards the end of his second year in London he asked the College authorities if he might sit the exams as his money had run out. After deliberation, they gave him permission, and he returned to Belfast in 1930 as an ARCA.

Larne Technical School was his first teaching post, in 1931. He became art master at Down High School, Downpatrick, in 1933 and taught part-time until 1948; during that period he also did some teaching at

Dungannon Technical School. *Dan Nancy's, Cushendun*, 1933, and *Barge at Edenderry*, 1936, both oils, were donated to the Ulster Museum by the Thomas Haverty Trust, Dublin.

Toogood had joined a small group of artists who combined to form the Ulster Unit. The group's only exhibition was in Locksley Hall in 1934 – the year he showed *The Backyard* at the Ulster Academy of Arts – and in the catalogue he stated his concept of art: 'The painter's aim, I think, is to find in nature some sense of formal order, and to translate the same in terms of form and colour into a pattern which relates to the size and shape of his canvas, the degree of abstraction used depending on the individual painter.'

In 1936, when he was an associate of the Ulster Academy of Arts, his work made its only appearance at the Royal Hibernian Academy: *Edenderry, Co. Antrim* and *Glencoe, Co. Antrim*, from 202 Malone Road, Belfast. *Jeremy's Pool*, 1943, is one of the watercolours which he painted in the Ballintoy, Co. Antrim, area.

In *Northern Harvest*, 1944, John Hewitt wrote: 'His colour is altogether quieter than Luke's, his shapes not so sharply formalised, his vision closer to normal representation. He prefers a high skyline or none at all, and a broad landscape in which the brown ploughed fields, the dark hedges and meadows, the slate roofs and the white-washed gables make a pleasing pattern of unemphatic but subtly related colour, organised mainly by the manipulation of diagonal tensions.' However, in 1948 he showed *The Little White Horse* at the Ulster Academy of Arts.

In 1948-9 he taught art at Friends' School, Lisburn. On 1 August 1949 he became painting and drawing master at Belfast College of Art until his early retirement – he suffered from depression – in 1963. Early in his term of office at the College of Art he designed a mural for the Midland Hotel, Belfast. This was painted by students under his supervision but has since been destroyed. Among his pupils were Basil Blackshaw and Terence Flanagan.

An infrequent exhibitor, he showed the oil, *Clarendon Dock*, painted in the mid-1930s, at the 1957 Royal Ulster Academy. However, he was persuaded by Council for the Encouragement of Music and the Arts to hold a small exhibition at the Piccolo Gallery, Belfast, in 1958. The *Northern Whig* commented: 'It is in pure landscape that Mr Toogood achieves his greatest success ... There are three portraits on view – one of the artist himself, caught in quizzical self-appraisal, and two of young girls. These, also, have a direct unaffected quality, making their statement with the least possible emphasis yet clearly and vividly ...'

The Magee Gallery, Belfast, was the venue for showing thirty-four watercolours and nine oils, all landscapes with the exception of one flowerpiece, in 1964. Many of the works were painted in the Lagan Valley area. In his final appearance — apart from a memorial — at the Royal Ulster Academy, in 1964, he exhibited *Ballylesson* and *On the Road to Ballylesson*. He executed the occasional wood engraving and linocut. In 1965 he was elected an academician of the Royal Ulster Academy.

Kenneth Jamison in *Causeway* wrote that Toogood was 'that *rara avis*, the intuitive teacher. In some ways he was not an obvious "academic", not highly articulate as were some of his colleagues. His teaching was an extraordinary compound of allusion and metaphor patiently contrived for the individual ...'. He died on 11 August 1966 in hospital. A retrospective exhibition was arranged by the Arts Council of Northern Ireland in 1978. The Bell Gallery, Belfast, held an exhibition, mainly of studio works, in 1989.

Works signed: R. C. Toogood; R. C. T. or RCT monogram, both rare (if signed at all).
Examples: Belfast: Arts Council of Northern Ireland; Department of the Environment for Northern Ireland; Ulster Museum. Downpatrick: Down County Museum. Lisburn, Co. Antrim: Friends' School.
Literature: *Belfast and Province of Ulster Directory for 1917*, Belfast 1917; *Northern Whig*, 11 December 1958; Michael Longley, ed., *Causeway: The Arts in Ulster*, Belfast 1971; John Hewitt and Theo Snoddy, *Art in Ulster: 1*, Belfast 1977; Brian Kennedy: Arts Council of Northern Ireland, *R. C. Toogood 1902-1966*, catalogue, Belfast 1978 (also illustrations); Martyn Anglesea, *The Royal Ulster Academy of Arts*, Belfast 1981 (also illustration); Mrs Anne Toogood, *Letter to the author*, 1993; Ann M. Stewart, *Irish Art Societies and Sketching Clubs: Index of Exhibitors 1870-1980*, Dublin 1997.

TOR– see TAYLOR, ANNE

TOWNSHEND, HARRIET HOCKLEY (1877-1941), portrait painter. Born on 1 March 1877 in Co. Kildare, Harriet Hockley Weldon was the daughter, from his second marriage, of Major-General Walter Weldon,

Madras Army, and the granddaughter of Sir Anthony Weldon, Bt. It is not known where she obtained her initial art training but a relative has recalled seeing her studio 'at Merrion, Dublin', and she studied for short periods in Paris and Florence. A record has not been found of her exhibiting outside Ireland but she began showing portraits at the Royal Hibernian Academy in 1903, from her home, Forenaghts, Naas, Co. Kildare.

The initial contribution at the RHA was a portrait of Miss Gertrude Weldon, her younger sister. Altogether at the Academy she showed thirty-seven pictures between 1903 and 1935. In 1904 she exhibited a portrait in pastel of Lady Mary Aldworth. When she exhibited in 1909 her address was Cradockstown, Naas, and that year she began a course at the Dublin Metropolitan School of Art for one year before she married T. Loftus U. Townshend, land agent, of 7 Palmerston Park, Dublin. After that date she painted under her married name.

Castletown House in Co. Kildare owns four pastels. At least two of these, *Summer* and *Portrait of a Young Girl in a White Dress* were executed before her marriage. *Winter* was dated 1911, hung at that year's RHA, the subject being Harriet's stepdaughter, Theodosia Townshend (q.v.), aged eighteen. According to Wanda Ryan-Smolin, the portrait illustrates 'the artist's accomplished and confident style. The pose is formal yet the expression on the young woman's face and her dashing costume with ostrich feather hat lends a lightness and sense of gaiety to the composition ... it is clear from the style of this portrait that she was either directly or indirectly influenced by the work of William Orpen ...'.

In 1914 at the Academy she showed portraits of Miss Margaret Silvertop and Master Joly Dixon. When she contributed eight years later another two portraits these were from 181 Strand Road, Merrion. In 1925, from Waverley, Westminster Road, Foxrock, Co. Dublin, she exhibited with the Water Colour Society of Ireland for the first time, showing twenty-five works up until 1940, many in pastel with some flowerpieces.

In 1935 she concluded her exhibiting at the RHA with a more genre type in four works: a young Irish girl, a young Irish man, *The Carpenter* and *Little Cottage Girl*. In the period 1935-40 at WCSI, as well as the portraits, portrayals of roses were noticeable. She died at her home on 26 August 1941.

Works signed: Harriet Hockley Townshend, H. H. T., H. Weldon or H. W.
Examples: Celbridge, Co. Kildare: Castletown House.
Literature: *Thom's Directory*, 1911; *Irish Times*, 28 August 1941; *Burke's Peerage*, London 1970; *Dictionary of British Artists 1880-1940*, Woodbridge 1976; National Gallery of Ireland and Douglas Hyde Gallery, *Irish Women Artists: From the Eighteenth Century to the Present Day*, catalogue, Dublin 1987 (also illustration); Ann M. Stewart, *Royal Hibernian Academy of Arts: Index of Exhibitors 1826-1979*, Dublin 1987; Castletown House, *Letter to the author*, 1995; also, Madame Anne de Douzon (née Townshend), 1995; Mrs H. B. Justin, 1995; *Water Colour Society of Ireland Exhibition List 1872-1994*, Dublin 1995.

TOWNSHEND, THEODOSIA (1893-1980), collage ornamentalist. The daughter of T. Loftus U. Townshend and Maud Ogilvie, his first wife, Theodosia Madeline Cecilia Townshend was born on 17 July 1893 at Fairyfield, Kilmallock, Co. Limerick, where the family resided until 1895. She was the step-daughter of Harriet Hockley Townshend (q.v.).

In the period 1911-14, after leaving Ireland, she attended the Slade School of Fine Art, studying under Henry Tonks (1862-1937). At the Slade she met Neville Lewis (1895-1972), the South African portrait painter who is represented in the Ulster Museum by *Basuto Boy*, oil on wood. They were married in 1916.

In the 1920s she lived in Hampshire at Well, near Long Sutton, and then at 18 Eton Villas, London, from 1926 to 1930. After her divorce, she reverted to her maiden name and became known as Mrs Townshend. At 2 Queensberry Mews West, South Kensington, and later at No. 18, she resided for fifty years. On the outbreak of the Second World War she joined the Women's Royal Naval Service.

Serious artistic production began in 1952 and continued until her death. Her first experiment was a picture of her two dachshunds, adding coverlet, pillows, sheets and period curtains of real material, and the landscape seen through the window was a tiny early Victorian print.

According to her daughter, Mrs Catherine Jestin of Connecticut, USA, she kept five catalogues of her works numbering a total of 1,739. G. Heywood Hill Ltd, old and new books, of Curzon Street, London, sold

her collages for many years. Another early production was *Graffin Carla Von Wilhelms – Morning Tea at 18 Queensberry Mews West, S. W. 7. April 1952*.

The main body of Theodosia's work was unsigned, and she seldom dated her work, but her style was regarded as unmistakable and unique. Because she avoided publicity, there were no exhibitions, despite overtures. Her work never reached any public institution. The titles of some of her pictures were written in her own hand on a white strip of paper pasted on the back. Sometimes she added her signature.

A great many of her pictures had, in the background, a house and park. She used eighteenth and nineteenth century engravings, in the foreground of which she pasted her own drawings and paintings, for example of the owners' pets, or she decorated gardens with shells (tiny real ones) and her own drawings and paintings of grasses and flowers, for example in *Adare Manor, Co. Limerick, Ireland*.

Although she was asked to sign a collage, she would not do so on the grounds that it was not all her own work. Titles of engravings and publishers' names were often cut out and pasted on the backs of the pictures. However, two 1946 watercolours, still lifes, were both signed.

In one of her pictures, all her own work, she included a posthumous portrait of her cat Tidd, a war casualty. Another original watercolour was a self-portrait of the artist as a small girl, looking across the water to Castle Townshend where her grandfather lived. On the back of the picture she wrote: 'In the background the dinghy "The Cat" tacking across the river to the island to pick me up. Mick the boatman & my cousin Richard on board. – Theo Townshend.'

A favourite subject was the family aspect of Queen Victoria's life, and in one of these pictures a youthful Victoria was posed before the shell grotto at Claremont. Her face was drawn in and painted, but her high comb, her necklace, earrings and bracelet were all hand-made – 'elfin jewellery'.

Another group of Townshend pictures had the sub-marine world for its inspiration; a dim, mysterious world of gliding tropical fish, wreathing weeds and coral reefs. Another group of her pictures concerned itself with snowscapes – 'often of romantic graveyards with Gothic urns and gorgeously plumed and caparisoned horses drawing noble hearses'. Finally, there were floral studies and nosegays, made of shells or coloured papers.

The walls of her sitting-room were lined with a display of early Victorian primitives by itinerant painters. A coloured illustration of her work is in Rumer Godden's *The Butterfly Lions*, 1977, a book on the Pekingese dog. The picture was described there as 'a fanciful collage of Kew Gardens' with pagoda in the background and the author's dog in foreground. Theodosia Townshend died in London, on 4 June 1980.

Works signed: Theo Townshend (if signed at all).
Literature: *Burke's Landed Gentry of Ireland*, London 1912; Bea Howe, 'Mrs Townshend: Ornamental Artist', *The Lady*, 16 April 1959; Rumer Godden, *The Butterfly Lions*, London 1977 (illustration); *Who Was Who 1971-1980*, London 1981; G. Heywood Hill, Ltd, *Letter to the author*, 1995; also, Mrs Catherine Jestin (née Townshend), 1995; Ms Roma Schapiro, 1995.

TRAQUAIR, PHOEBE ANNA, HRSA (1852-1936), mural decorator, craftworker and illustrator. The daughter of a Dublin physician, Dr William Moss of Kilternan, Phoebe Anna Moss was born in Dublin on 24 May 1852. Lady Glenavy (q.v.) was her niece. A brother, Edward Lawton Moss, became a doctor in the Navy and accompanied Capt. G. S. Nares on his Arctic expedition of 1875-6, and narrated and illustrated the voyage of HMS *Alert* in *Shores of the Polar Sea*, 1878. He was lost at sea two years later.

According to *The Studio*, she lived 'a quiet life as a girl and betrayed no special artistic capacity until one day, after a visit to an exhibition in Dublin, she became possessed by a desire to paint. Beauty of form roused her latent powers ...'.

She attended the Government School of Design, Royal Dublin Society, and as a student was assigned the task of providing illustrations of fossil fish for a young Scots palaeontologist, Dr Ramsay Heatley Traquair, then employed in the RDS museum. They were married in Dublin in 1873. On his appointment as Keeper of Natural History collections at the Museum of Science and Art, Edinburgh, they moved in 1874 and settled at 8 Dean Park Crescent.

Early in her married life she did the occasional drawing of natural history specimens that came under her husband's observation, and designed and worked domestic embroideries when her young family permitted, but it was as a mural painter that she was to do her most important work, beginning with the decoration in 1885 of the mortuary chapel, Royal Hospital for Sick Children. Commissioned by the Edinburgh Social Union, the work was completed in 1886. Only the central *The Virgin and Child with Angels* survived to a new location. All studies for the first mortuary chapel are in the National Gallery of Scotland.

Also in the National Gallery of Scotland are fifty-three illuminated pages, *The Psalms of David*, in inks and watercolours on vellum, bound in morocco embossed, tooled and gilded by Traquair. The total work covered roughly the period 1884-91. Personal commissions included a bookplate, an overmantel, decorating seven panels on a cabinet, bookbindings and room decorations.

In 1886 she began her first large scale figural embroidery, *The Angel of Death and Purification*, later to form the central panel of *The Salvation of Mankind* (City Art Centre), completed in 1893. In late 1886 Traquair composed, wrote and illuminated in inks and watercolours on vellum a narrative text, *The Dream* (Victoria and Albert Museum), which was admired by John Ruskin (1819-1900), who lent her medieval manuscripts to study in 1887. She designed the frontispiece and cover of *Women's Voices*, one of several books which she illustrated – see Literature list.

In 1888 the Diocese of Edinburgh commissioned her to decorate the Song School of St Mary's Cathedral, a series of panels completed in 1892. In 1889 she had visited Italy for the first time. According to *The Times*: '... her art was already akin in many ways to that of the earlier Italian fresco-painters, and she returned from Florence with added knowledge of her craft and its possibilities and with her artistic nature enriched by direct contact with the work of the Primitives.'

In 1889 and 1890 she supplied illustrations for *The Children's Guide*, a monthly. In 1889 she met the English designer, illustrator, and painter, Walter Crane (1845-1915) in Edinburgh. In 1890 she illuminated a presentation address to the scientist, Louis Pasteur. She received commissions, including illumination, from her brother, William Richardson Moss, then living in England.

An oil painting, *The Shepherd Boy*, dated 1891, is in the National Gallery of Scotland. Also in that collection are forty-six pages, 1892-7, illuminated in inks, watercolours and gold leaf on vellum of the poems by Elizabeth Barrett Browning, *Sonnets from the Portuguese*. The final page of the publication itself contains the statement: 'This book has been printed and illuminated by me, and finished in January 1897, Phoebe Anna Traquair (born Moss).' In the period 1893-1935 she showed nineteen works at the Royal Scottish Academy.

In 1893 she began in the Catholic Apostolic Church, Edinburgh, what *The Times* considered not only her greatest undertaking 'but one of the most striking and beautiful schemes of mural decoration executed in modern times in this country and, indeed, anywhere. The nave, with its great symbolic figures on each side of the chancel arch, the *Christ in Glory* amid the Heavenly choir, which fills the whole west gable, and the four-and-twenty scenes from the Old and New Testaments along the side walls below the clerestory, is a remarkable achievement; but it is in the side chapel and the northern aisle of the chancel, where the whole scheme has been completed and the effect is extraordinarily beautiful, figure panels and border decorations on walls and ceilings being wrought into one wonderful harmony, that her genius is most fully revealed ...'

The Apostolic Church scheme was completed in 1901 entirely without assistance. The chancel arch is some 20 metres high and at each base 2.7 metres wide. As at the Song School, portraiture formed an integral part of her work.

Although not completed until 1902, she conceived as a suite in 1893 four embroideries, *The Progress of a Soul*, working in her spare moments. The panels were exhibited at the Arts and Crafts Exhibition Society in London in 1903, and the 'St Louis Fair' of 1904. These works, average size 183cm by 74cm, in coloured silks and gold thread on linen, formed part of her bequest to the National Gallery of Scotland, including studies for decorations.

Phoebe Traquair was represented by a binding in Chicago at the World's Columbian Exposition, 1893. In 1895 she again visited Florence, staying with the Pre-Raphaelite, William Holman Hunt (1827-1910) on her return journey, and that year she also visited South Africa.

The Salvation of Mankind embroidered panels appeared at the first exhibition of the Arts and Crafts Society of Ireland in 1895, in Dublin. She showed illuminations in the second exhibition, 1899, and in the third, 1904, exhibited two works in enamel, one an ivory casket decorated with scenes from the life of the Madonna, the other a triptych entitled *The Kiss*.

Decoration in the mortuary chapel of the new Royal Hospital for Sick Children began in 1896: the new scheme included a transfer from the old chapel. In 1898 she exhibited with the Guild of Women-Binders in London, and joined the Scottish Guild of Handicraft, Glasgow. In 1899 she exhibited for the first time at the Arts and Crafts Exhibition Society, London, and in 1900 showed with the Guild of Women-Binders at the Exposition Universalle, Paris.

In the National Library of Scotland is *The House of Life*, 1898-1902, sixty-eight pages, an illumination in inks, watercolours and gold leaf on vellum of the sonnets by Dante Gabriel Rossetti, commissioned by her brother. Kilgobbin and Kilternan, the homes of her grandparents, were illustrated on two of the folios. A representation of brother William and his home in Lancashire was included in another folio.

In the National Gallery of Scotland is a triptych, *Motherhood*, 1901-02, oil on panel. The central panel shows a mother embracing her child in a Borders landscape. Much of her work in enamel was sent to London for the Arts and Crafts Exhibition Society: she showed some thirty enamels in 1903, by which date she was a member. On the enamels, Elizabeth Cumming wrote in her important 1993 catalogue: '... much of her work was uncompromisingly romantic in style and interpretation, vigorous in draughtsmanship and brilliant in colour'. Evelyn Gleeson (q.v.), who had seen the English exhibition, thought that the Traquair enamels displayed a 'supreme sense of colour and poetic thought, which are an Irish birthright'.

In 1904 and 1905 she painted murals in the chancel and sanctuary of the Church of St Peter at Clayworth, Nottinghamshire. The commission was given as a thanksgiving for the safe return of a son from the Boer War. The faces of the cherubs were the faces of local children. As a consequence of damp, only part of the work has survived.

As from 1904 – until 1914 – she worked on her last embroidered triptych, *The Red Cross Knight* (Huntly House Museum) and exhibited it at the World's Fair, St Louis, in 1904. On the retirement of Dr Traquair, they moved to Colinton in 1906.

On 16 June 1906 W. B. Yeats wrote to Lady Gregory from London, saying that in nearly all his time in Edinburgh he was absorbed in Mrs Traquair's work and found it 'more beautiful than I had foreseen – one can only judge of it when one sees it in a great mass, for only then does one get any idea of her extraordinary abundance of imagination. She has but one story, the drama of the soul ...'.

In 1907 she visited South Africa again. In 1910-11 she produced nineteen enamel stallplates, coats of arms, for Thistle Chapel, St Giles' Cathedral. In 1912 a triptych panel altarpiece went to the Cathedral of St James, Chicago. After the death of her husband in 1912, she paid other visits abroad. In 1913 she showed *Psyche meeting Pan* at the RSA. At the Exhibition of British Decorative Arts in Paris in 1914, she was represented.

In 1920 she became the first woman elected an honorary member of the Royal Scottish Academy, and in 1926 she showed a self-portrait there. Her final work in mural decoration was an apse at Manners Chapel, Thorney Hill, New Forest. A Last Judgement triptych was painted as a reredos for All Saints' Church, Jordanhill, Glasgow, and she worked portraiture with ecclesiastical imagery. Another painted altarpiece was for the Cathedral of St Mary, Edinburgh.

A varied selection of her work is in London at the V. & A. Museum. She contributed sixteen works to exhibitions at the Walker Art Gallery, Liverpool. At the Scottish National Portrait Gallery are a self-portrait in oil and a portrait bust of Traquair in marble by James Pittendrigh Macgillivray (1856-1938).

The Times said she was a 'little woman and sparely built but overflowing with nervous energy, her artistic activities were remarkable both in extent and quality ... her conversation, flavoured by just a suspicion of Irish accent, was animated and persuasive and lightened by infective laughter and flashes of illuminative wit'. She died in Edinburgh on 4 August 1936. An important retrospective exhibition, organised by Dr Elizabeth Cumming, took place at the Scottish National Portrait Gallery in 1993.

Works signed: PAT, monogram, or Phoebe A. Traquair, rare.

Examples: Aberdeen: Art Gallery. Alloa, Scotland: St John's Church. Belfast: Ulster Museum. Bembridge, Isle of Wight: Ruskin Galleries. Carlisle, Cumbria: Museum and Art Gallery. Chicago: Cathedral of St James. Clayworth, Nottinghamshire: Church of St Peter. Delaware, USA: Art Museum. Edinburgh: City Art Centre; Huntly House Museum; Mansfield Place Church; Mary Erskine School; National Gallery of Scotland; National Library of Scotland; Royal Hospital for Sick Children; Royal Scottish Academy; St George's West Church; St Giles' Cathedral; St Mary's Cathedral; Scottish National Portrait Gallery; Daniel Stewart's and Melville College; University, Library. Glasgow: All Saints' Church, Jordanhill; Art Gallery and Museum; University, Hunterian Art Gallery. London: Victoria and Albert Museum. Melrose, Scotland: Town Hall. Montreal: McGill University, Library. Paris: Musée Pasteur. Victoria, British Columbia: Art Gallery of Greater Victoria.

Literature: Andrew Lang, *Almae Matres*, Edinburgh 1887 (illustrations); Elizabeth Sharp, ed., *Women's Voices*, London 1887 (illustrations); J. S. Black, *Dante Illustrations and Notes*, Edinburgh 1890 (illustrations); John Bunyan, *The Holy War* and *The Pilgrim's Progress*, both Edinburgh 1894 (illustration); Elizabeth Barrett Browning, *Sonnets from the Portuguese*, Edinburgh 1897 (illustrations); Alexander Whyte, *Saint Teresa, An Appreciation*, and *Father John of the Greek Church*, both Edinburgh 1898 (illustration); *Newman*, Edinburgh 1901 (illustration); Grace Warrack, ed., *Revelations of Divine Love*, London 1901 (illustration); *La Vita Nuova of Dante Alighieri*, Edinburgh 1902 (illustrations); D. G. Rossetti, *The House of Life*, Edinburgh 1904 (illustrations); *The Studio*, May 1905, August 1914; Mary Macgregor, *Stories of Three Saints*, London 1907 (illustrations); Grace Harriet Warrack, *Floregio di Canti Toscani*, London 1914 (illustrations); Mary Warrack, *Song in the Night*, London 1915 (illustrations); Grace Harriet Warrack, *From Isles of the West to Bethlehem*, Oxford 1921 and *Une Guirlande de Poésies Diverse*, Oxford 1923 (both illustrations); *The Times*, 6 August 1936; Beatrice Lady Glenavy, *Today we will only Gossip*, London 1964; *Dictionary of British Artists 1880-1940*, Woodbridge 1976; *The Royal Scottish Academy Exhibitors 1826-1990*, Calne 1991; Paul Larmour, *The Arts & Crafts Movement in Ireland*, Belfast 1992 (also illustration); City Art Centre, *Letter to the author*, 1993; Elizabeth Cumming: Scottish National Portrait Gallery, *Phoebe Anna Traquair*, catalogue, Edinburgh 1993 (also illustrations); Ettrick and Lauderdale Museums Service, *Letter to the author*, 1993; also, St Giles' Cathedral, 1993; St Peter's Church, 1993; Victoria and Albert Museum, 1999.

TRENCH, BEA – see ORPEN, BEA

TRENCH, CESCA – see TRINSEACH, SADHBH

TRENCH, GRACE (1896-fl. 1941), landscape painter. Grace Mary Trench was born on 7 May 1896, only daughter of the 3rd Baron Ashtown of Woodlawn, Co. Galway.

In the period 1915-38 inclusive she contributed twenty-seven works to the Water Colour Society of Ireland exhibitions in Dublin, nearly all landscapes. In 1917 she showed *The Rt. Hon. R. P. Trench – The Queen's Royal West Surrey Regt.* and *Portrait of the Artist.*

Most of her painting took place in the West of Ireland, for example: 1928 WCSI exhibition, *Beech Trees, Woodlawn*; 1929, *Galway Bay: Fishing Boats*; 1932, *Mount Leckavrea, Connemara*; 1933, *Rain on Maumturk Mountains, Connemara.*

Titles of pictures exhibited by the Hon. Grace Trench with the Water Colour Society also indicated South-East France as a painting area, for example in 1932 she showed a street in Aix-Les-Bains. She also painted in Scotland: *Autumn Haze – Lough Etive* was hung at the 1934 Royal Hibernian Academy, one of only two works which she showed there, and in 1938 at the Water Colour Society: *The Sacristy Door, Iona Cathedral.*

In 1937 and 1938 she exhibited with the Dublin Sketching Club, seven works in all, including *Claddagh Cottages, Galway* and *The Ace of Diamonds* in 1938. In 1941 she held an exhibition of watercolours at the Victor Waddington Galleries, Dublin. At the Limerick City Gallery of Art she is represented by *Sugarloaf Mountain*. The date and place of her death have not been traced.

Works signed: Grace Trench.

Examples: Ballinasloe, Co. Galway: St Joseph's College. Limerick: City Gallery of Art.

Literature: *Debrett's Peerage, Baronetage, Knightage*, and *Companionage*, London 1947; Dr Eiric Macfhinn, *Letter to the author*, 1978; Ann M. Stewart, *Irish Art Societies and Sketching Clubs: Index of Exhibitors 1870-1980*, Dublin 1997.

TRENCH, MARIANNE L., ARBA (1888-1940), landscape painter. Born in Guildford, Surrey, on 23 September 1888, Marianne Lucy Le Poer Trench was the youngest of seven children of W. P. B. Trench, bank manager, of Albury Lodge, Austen Road, Guildford. The family belonged to the Clancarty branch of the Trench family, of Garbally, Ballinasloe, Co. Galway.

Educated at Guildford High School for Girls, she then attended the Slade School of Fine Art. She became an art mistress at Penzance, returning to teach at her old school. It was not until 1920 that she began seriously to exhibit, and in 1926 became an associate of the Royal Society of British Artists, with whom she showed forty-six works.

Among the thirteen pictures which she exhibited at the Royal Institute of Oil Painters were: *Waterside – Martiques* and *Sussex Glow* in 1927. Between 1927 and 1938 she showed seventeen works at the Royal Scottish Academy, in 1927 from Albury Lodge.

In 1928 she contributed to the Royal Hibernian Academy for the first time, and from then until 1940 showed eighteen pictures. *From the Ramparts, Montreuil* in 1928, and *Ponte Pieta, Venice* in 1930, were among early acceptances. She also painted at Malcesine, Italy. In 1932 she was represented in London at the United Society of Artists exhibition. Titles of works in the Spring RBA exhibition in 1933 indicated further trips abroad: *Bruges*, and in France, *The Market at Chinon*.

At the 1935 RHA her address was Steep Down, Steyning, Sussex, and she showed *The Drawbridge, Chenonceaux*. She exhibited Italian scenes at the 1935 RSA. During the year of King George VI's coronation, 1937, she painted a number of London scenes, and at an RBA exhibition in 1939 her *St James's Palace* and *Trafalgar Square after Fog* were presented. A visit to the USA was indicated by *The Hills of Moab from Bethany* at the 1939 RHA.

Elsewhere in Britain, she exhibited more than sixty pictures in exhibitions at the Royal Academy; Royal Cambrian Academy; Royal Society of Artists, Birmingham; Walker Art Gallery, Liverpool. An oil painting, *St James's Piccadilly*, is in the Drogheda municipal collection.

Works signed: M. L. Trench.
Examples: Aberdeen: Art Gallery. Drogheda: Library, Municipal Centre. Leeds: City Art Gallery.
Literature: C. E. F. Trench, *Letters to the author*, 1970, 1993; *Dictionary of British Artists 1880-1940*, Woodbridge 1976; *A Dictionary of Contemporary British Artists, 1929*, Woodbridge 1981; Ann M. Stewart, *Royal Hibernian Academy of Arts: Index of Exhibitors 1826-1979*, Dublin 1987; *The Royal Scottish Academy Exhibitors 1826-1990*, Calne 1991.

TREVITHICK, W. E. (1899-1958), botanical and commercial illustrator. Born on 30 April 1899 on the Marquess of Headfort's estate at Kells, Co. Meath, where his father was head gardener, William Edward Trevithick was related to the famous Richard Trevithick of Cornwall, the inventor of a high-pressure steam engine, 1801. He left school in 1913 to work under his father, with whom he remained for three years.

Trevithick then obtained employment in the Duke of Rutland's gardens at Belvoir Castle, Grantham. His testimonial from there noted that he was 'clever at drawing, both freehand and plans and in colour work'. He returned to Ireland and enlisted in 1918 as a 'pupil gardener' at the Botanic Gardens, Glasnevin, Dublin, at a wage of £1.5s 2d. per week.

A keen photographer, his photographs were published in *Irish Gardening* in 1920, and that year he left for London and gained employment at the Royal Botanic Gardens, Kew, where he was promoted to sub-foreman in 1922, and entered the herbarium as temporary technical assistant towards the end of 1923.

Trevithick's skill as an artist was soon recognised at Kew. His contributions to Curtis's *Botanical Magazine* began in 1924. Of the seventy-one plates, he was solely responsible for the drawing of fifty-seven, and the rest were shared. Of the grand total, he lithographed thirty-four.

His friend, John Hutchinson, author of *The Families of Flowering Plants*, 1926, the first volume of which Trevithick largely illustrated, described him as a 'cheerful and jolly companion with a strong sense of humour ... He applied his great talents wholeheartedly and unselfishly to whatever he undertook ...'.

The next publication which he illustrated was prepared at the Kew herbarium, *Flora of West Tropical Africa*, 1927. As the career prospects for this type of work were not promising, he left Kew to study full-time

at the Chelsea School of Art, supporting himself by freelance work. He then partnered his brother, a commercial artist, for three years, later establishing his own business whilst living at Barnes, Surrey.

During the Second World War he carried out some experimental engineering for the Ministry of Supply. In peacetime he resumed his commercial advertising work, and his drawings and inventive mind were in demand by such firms as Rolls-Royce Motor Company and the General Electric Company. His photograph, courtesy of the Royal Botanic Gardens, was reproduced in the 1987 Irish publication on the National Botanic Gardens, *The Brightest Jewel*. Trevithick died suddenly at 88 Evelyn Avenue, Ruislip, Middlesex, on 3 January 1958.

Works signed: Trevithick, W. E. T. or W. E. Trevithick (if signed at all).
Examples: London: Royal Botanical Gardens, Kew.
Literature: John Hutchinson, *The Families of Flowering Plants*, London 1926 (illustrations); John Hutchinson and John McEwan Dalziel, *Flora of West Tropical Africa*, London 1927 (illustrations); General Register Office, London, *Register of Deaths*, 1958; *Journal of the Kew Guild*, vol. 7, no. 63, 1958; *Vitis*, vol. 1, no. 2 [1983]; E. Charles Nelson and Eileen M. McCracken, *The Brightest Jewel*, Kilkenny 1987 (also illustration); Patricia Butler, *Three Hundred Years of Irish Watercolours and Drawings*, London 1990.

TRIMBLE, GARRY, ARHA (1928-79), sculptor. Born in Dublin on 9 May 1928, Conleth Garry Trimble was the son of Padraic Trimble, author of a book of poems, *Irish April*, 1930; drama critic; and later, literary critic to *Irish Book Lover*. Padraic's father was noted for his beaten copperwork in Dublin, and his grandfather, a Co. Kilkenny blacksmith, for his wrought-ironwork.

Garry Trimble – his mother was a McGorry – began modelling in Plasticine at eight years of age. When he attended Belvedere College, 1941-7, the Jesuit Fathers encouraged his gift for sculpture. After leaving Belvedere he studied architecture at University College, Dublin, 1947-52. He was responsible for a likeness of Theobald Wolfe Tone, modelled from the death mask, for the '98 exhibition at the National Museum of Ireland.

A wall plaque for St Luke's Hospital, Dublin, depicting St Luke healing a sick young man, won an award. His first post as an architect was with Dublin Corporation. After joining the architectural section of the Office of Public Works, the chief schools architect, B. R. Boyd Barrett, sponsored him for sculptural works for some new schools.

In its inaugural year, 1953, he was honorary secretary of the Institute of the Sculptors of Ireland and exhibited that year, also in 1954, 1956, 1957 and the international exhibition of 1959 at the Municipal Gallery of Modern Art, Dublin. In 1953 he contributed a portrait of William C. Fogarty, Professor of French, Belvedere College; a rugby subject, *The Forward Breakaway*; and *St Joseph, Patron of Workers*, destined for the Irish Sugar Co. and now with the Brothers of Charity, Thurles, Co. Tipperary. The artist was then living at Howth Road, Clontarf.

After his marriage in 1954, he resided at 50 Ashton Park, Monkstown, Co. Dublin. In that year, at Kingscourt National School, Co. Cavan, over the main entrance, he provided *St Joseph and the Child*, the child feeding birds from a basket. The group, 2 metres high, was described as being 'processed in reconstituted stone-work'. In the main entrance hall of the school is a plaque, *Flight to Egypt*.

At the Institute of the Sculptors of Ireland exhibition in 1957, he showed a crucifix in bronze and wood. At this period he had been working for several years on a memorial to the County Roscommon men who had lost their lives in the War of Independence. An IRA Commemoration Committee had been formed in 1927 to raise funds locally and abroad for a memorial. Preparation of the site began in the late 1950s. Trimble cast two of his three figures, one kneeling, on site, and the monument was erected in 1961 on the hill at Shankill, Elphin. Each figure weighed about twenty tonnes. The figures symbolise mourning for dead comrades, determination, and leadership. The unveiling did not take place until 1963. The monument can be seen from the main Roscommon/Boyle Road.

At our Lady's Bower, Athlone, are three works, all completed in the period 1961-6: A crucified Christ on the exterior of the building; *St Michael the Archangel* on an interior wall; a head of Beethoven. At the Royal

Hibernian Academy he had first exhibited in 1959, and over a period of twenty years he showed thirty-six works, many of which were portrait commissions. His first exhibit was a portrait of Dr Lennox Robinson (Abbey Theatre). When he showed a portrait of President Eamon de Valera in 1963 he gave his address as The Stable Lane, Harcourt Street, Dublin.

By 1965 he was working from 31 Upper Fitzwilliam Street, Dublin, former secret head office of the first Dáil Éireann Bond issue. At the Oireachtas exhibition in 1967 he showed *Buachaill on Chlar*. Dr Mícheál Mac Liammóir (q.v.), in 1969, and James Plunkett Kelly, 1970, were among other RHA portrait subjects.

A set of Stations of the Cross was created by Trimble in 1969 for the new St Canice's Church, Borris-in-Ossory, Co. Laois. By 1969 too he had completed from photographs a head in profile of Francis Sheehy Skeffington; the plaque was placed in 1970 at the main gate of Cathal Brugha Barracks, Portobello, Dublin. An unusual commission that year was the making of a cross in Irish oak for the mounting of a crucifix found in the mud and rubble of a French village in the First World War. He was also responsible for the bronze plaque underneath the crucifix, which is at the Irish School of Ecumenics.

Meanwhile he had been working on what was regarded as one of the largest sculptures ever to be commissioned for export from Ireland. He had visited Bermuda and inspected the site of the new St Patrick's Church, on high ground overlooking the sea, and returned home to make various models for the project. The one chosen was that of St Patrick landing in Ireland, and his conversion of the High King at Slane. The final work was produced in cold-cast bronze by fellow sculptor, Brian King. The completed work was flown to New York in fifteen sections, and thence shipped to Bermuda, where King erected it in 1969 over the front entrance to the church.

Appointed an ARHA in 1970, Trimble's first one-person show was held at the Agnew Somerville Gallery in Molesworth Street, Dublin, 1971. The *Irish Times* commented: 'There is little or no individual idiom, but a general impression of solidity and competence. This is very much RHA art, and at times the artist fails to rise above the rigor mortis of the style; however, he still wrings a degree of sensitivity and honesty out of his slightly anachronistic language. Portrait sculpture is all too rare nowadays, and Garry Trimble is undoubtedly one of the better ones in the country. He can catch a likeness, he can bring an attitude alive, and his modelling is strong if at times unsubtle.'

Among a score of portraits at the Somerville exhibition were those of Charles J. Haughey, TD, and fellow artists James Le Jeune and Harry Kernoff (qq.v.). Kernoff sometimes supplied critical comment on Trimble's work as well as encouragement. Also included in the exhibition were portraits of two men from Roundstone, Co. Galway, where the artist had a holiday home; he and his wife, Mary Joan Trimble, also an architect, designed buildings for the area.

From 1971 until his death he showed each year at the RHA. Among his other subjects were Cyril Cusack, Sean Keating (q.v.), Lord Killanin, Senator Michael Mullen (Liberty Hall), Sean MacBride, and Cearbhall Ó Dálaigh (Áras an Uachtaráin and King's Inns). Also at King's Inns is another head, that of Hon. Justice Brian Walsh.

Among his commercial commissions was the design of the trophies for Carroll's All Stars awards. An eight-minute colour film on the artist and his work for the Carroll pieces, including casting, was shown at the 1971 dinner.

Trimble resigned from the Office of Public Works in 1973 so that he would have more freedom to work as a sculptor and architect. Of his outdoor sculpture, there is his 'Falling Horse' group of St Paul of Tarsus in the playground of St Paul's Junior National School, Athlone. His only other contribution at the Oireachtas was a portrait of Ulick O'Connor in 1975.

One of his most important commissions was a bust of Queen Elizabeth. According to Leo Higgins, then manager of the Dublin Art Foundry, the work was cast in 1976 in bronze and subsequently silver plated. The crown was treated separately and then attached. Higgins believed that the commission was given by the Royal Air Force but confirmation has not been obtained.

Among his other portraits were those of Christy Brown (q.v.); Lester Piggott, believed to be the only one; Tom Ryan, RHA; Richard Harris, actor; Benedict Kiely, writer. An equestrian statue was executed of Emer Haughey on a jumping horse. Trimble was killed in a car accident in Dublin, on 19 August 1979.

Works signed: G. Trimble.
Examples: Athlone: Our Lady's Bower; St Paul's Junior National School. Bermuda, Atlantic: St Patrick's Church. Borris-in-Ossory, Co. Laois: St Canice's Church. Dublin: Abbey Theatre; Áras an Uachtaráin; Belvedere College; Cathal Brugha Barracks; Irish School of Ecumenics, Milltown Park; King's Inns; Liberty Hall; St Luke's Hospital, Highfield Road. Elphin, Co. Roscommon: War of Independence memorial. Kingscourt, Co. Cavan: National School. Thurles, Co. Tipperary: Brothers of Charity.
Literature: *The Belvederian*, 1949, 1980; *Thom's Directory of Ireland*, 1952; *Times Pictorial*, 27 February 1954; *Irish Press*, 14 September 1963; *Roscommon Herald*, 21 September 1963; *Irish Times*, 5 December 1969, 6 February 1970, 2 April 1970, 29 May 1970, 24 June 1971, 1 July 1971, 17 December 1971, 20 August 1979. Agnew Somerville Gallery, *An Exhibition of Sculpture by Garry Trimble, ARHA*, catalogue, Dublin [1971]; Mrs M. J. Trimble, *Letters to the author*, 1979, 1994; Ann M. Stewart, *Royal Hibernian Academy of Arts: Index of Exhibitors 1826-1979*, Dublin 1987; Irish School of Ecumenics, *Letter to the author*, 1993; also, Irish Sugar, plc, 1993; Kingscourt National School, 1993; Leo Mahon, 1993; Our Lady's Bower, 1993; Roscommon County Library, 1993; Belvedere College, 1994; St Canice's Church, 1994; Office of Public Works, 1998.

TRINSEACH, SADHBH (1891-1918), portrait and figure painter. Born in Liverpool on 3 February 1891, Frances Georgina Chenevix Trench was the youngest daughter of the Rev. H. F. C. Trench, vicar of St Peter's Church in Thanet, Kent, and the granddaughter of the noted philologist, the Rt. Rev. R. C. Trench, Archbishop of Dublin 1864-84. She was often referred to as Francesca, known to her family as Cesca, and sometimes called Sive. A cousin was Grace Trench (q.v.). Cesca's sister Margaret, known as Margot, became Mairéad Trinseach.

Another cousin was the writer, Elizabeth Bowen, who recalled the sisters, in about 1907, as 'handsome young girls with black hair, resolutely paraded the Leas at Folkstone in blowing-about Celtic robes of scarlet or green, with Tara brooches clamped to their shoulders. I failed to connect this dress with Ireland, and the Trenches' conspicuousness embarrassed me – especially when they swept down on my school crocodile. Even my mother said, a shade tartly, that no Trenches were ever so Irish as all that. The Trenches continued to inundate us with green booklets with shamrocks on the outside: my resistance to propaganda became extreme, and when my cousins spoke to me of Cuchulain I countered with Perseus and Hercules. But the songbook they gave us had a greater success ...'.

The Trench sisters lived in Folkestone with their widowed mother and, according to C. E. F. Trench, were inspired by Dermot Chenevix Trench, another cousin, 'with a deep and lasting love for Ireland and the Irish language'. Cesca, at least, visited Achill Island, Co. Mayo, in 1911 when she drew in charcoal and crayon Claude Chavasse teaching an Irish class, a work now in the National Gallery of Ireland.

In 1913-14 she studied art in Paris, and attended a course in Celtic studies at the Sorbonne. She returned to Dublin and she and her sister became active members of the Gaelic League and Cumann na mBan. She wrote and illustrated articles for *Irish Homestead* and the official organ of the Gaelic League, *An Claidheamh Soluis*, and she changed her name to the Gaelic.

A Gaelic League Christmas card which she designed, depicted the Virgin and Child, handcoloured, inscribed with Irish messages. A Gaelic League poster designed by her is in the National Museum of Ireland. In the early days of the Irish College at Carrigaholt, Co. Clare, she was associated with Nelly O'Brien (q.v.). Sive Trinseach executed some murals there in 1914 and with Nelly O'Brien made postcards. The murals were restored in the early 1930s but after a passage of half a century the paintings had faded almost beyond recognition. However, in 1982 they were restored again by an artist in the area, Diarmuid O hEadtromain, and, according to the local newspaper, 'the ghosts have come alive and are real people again'.

Miss Saive Coffey, a daughter of Diarmuid Coffey, who inherited the artist's papers, advised the author in 1967 that in November 1914 Cesca or Sive had enrolled at the Dublin Metropolitan School of Art as 'Miss Prionsias French' for five months at a fee of half-a-crown; also , that there was an entry in her passport which indicated that in February 1917 she had travelled to France ('not valid for the Zone of the Armies').

In private possession is an oil painting by her of Margot Trench and, in conté crayon, *Nymphs and Satyrs*, 1917. Among the charcoal portraits at NGI are those of Robert Barton, Una Duncan, Mrs Joseph Hone, Mrs Kissane (Mairead Ni Ghradha) and Blanaid Salkeld. Also the subject of a portrait drawing was Eoin MacNeill.

An oil portrait of Sadhbh Trinseach by George Russell (q.v.) is also at the Merrion Square gallery, and in private possession is another portrait, 1917, by him, given to Sadhbh and her husband as a wedding present.

At the National Library of Ireland are twelve sketchbooks with pencil drawings, mainly portrait studies, many unnamed; also sketches of Irish musicians, West of Ireland peasants, marine and topographic scenes, female anatomic studies, a portrait sketch of the artist's mother and also of the artist's family. After her marriage, she painted *Self-portrait with Diarmuid Coffey*, oil. Her marriage to him lasted only six months, and she died on 30 October 1918 during the flu epidemic in Dublin.

Works signed: Saïve Trinseach, S. T., S. T. monogram or T. (if signed at all).
Examples: Carrigaholt, Co. Clare: Irish College. Dublin: National Gallery of Ireland; National Library of Ireland.
Literature: Elizabeth Bowen, *Bowen's Court*, London 1942; Miss Saive Coffey, *Letters to the author*, 1967, 1993; National Museum of Ireland, *Letter to the author*, 1967; F. X. Martin and F. J. Byrne, *The Scholar Revolutionary*, Shannon 1973 (illustration); C. E. F. Trench, 'Dermot Chenevix Trench and the Haines of Ulysses', *James Joyce Quarterly*, Fall 1975; C. E. F. Trench, *Letters to the author*, 1981, 1982; Carrigaholt College, *Letter to the author*, 1982; *Clare Champion*, 4 June 1982; Nicola Gordon Bowe, *The Dublin Arts and Crafts Movement 1885-1930*, catalogue, Edinburgh 1985; National Gallery of Ireland and Douglas Hyde Gallery, *Irish Women Artists: From the Eighteenth Century to the Present Day*, catalogue, Dublin 1987 (also illustrations); National Library of Ireland, *Letter to the author*, 1994.

TROBRIDGE, GEORGE (1851-1909), landscape painter. Born at Exeter on 25 March 1851, he was the son of George Townsend Trobridge, who removed to Birmingham in 1858, where young George attended Handsworth Bridge Trust School, and later Birmingham School of Art. For a time he filled a situation in the office of a large railway carriage works; but, meanwhile, earnest studies in art enabled him to secure a scholarship to the National Art Training School, South Kensington, where he studied from 1875 to 1880, and among other distinctions won the gold medal for painting.

Trobridge, with a testimonial from Edward J. Poynter (1836-1919), NATS principal and later Royal Academy president, was appointed in 1880 as headmaster of the Government School of Art in Belfast. In 1884, from 2 Mount Pleasant, Belfast, he exhibited with the Royal Hibernian Academy and from then until 1907 sixteen works were hung. *The Principles of Perspective as applied to Model Drawing and Sketching from Nature* by Trobridge was published in London in 1884.

In 1885 he contributed to the RHA: *The Fringe of the Wood; Norwegian peasant; Study of rocks, Co. Down Coast*. He exhibited with the Ramblers' Sketching Club in Belfast in 1886, with ten works, including at least three River Lagan scenes. In 1887 he showed eight pictures at the Dublin Sketching Club event, for example *Orlock Point* and *Summer Haze*; and five works in 1888. Back in Belfast with the Ramblers, he presented nearly thirty pictures in the three years, 1888-90, including *Cornfield, Balloo, Co. Down; Headlands, Ballycastle*.

Trobridge retained his interest in the Ramblers' Sketching Club. At the March 1889 meeting he spoke on 'The relationship of science to art.' In the period 1891-1900 he was an annual exhibitor with the Belfast Art Society, and among his contributions were: *Carrickfergus* in 1891; *Methodist College, Belfast, Twilight*, 1892; *A Peep from my Window*, 1894; *A Flax Field*, 1896; *A Bit of Warwickshire*, 1899.

In the final decade of the century he continued to show with Dublin Sketching Club; however, sometimes works had already been presented at BAS exhibitions, judging by titles. A new interest in Dublin was the Water Colour Society of Ireland and in the period 1892-1909 of extant catalogues he was listed with more than thirty works. On his 1892 appearance, pictures included *A Daughter of Italy*.

Trobridge, in his twenty years as principal of the Government School of Art, had, among other advances, introduced the use of nude models in its life classes, and had seen his students achieve excellent results. In 1900, sixteen awards, including a gold medal, were gained in the National Competition.

In 1901 the School of Art was taken over by Belfast Corporation and the headship fell to R. A. Dawson. As to why Trobridge was succeeded is not clear. However, the staff records showed that he began there as a teacher in September 1901. The previous month in a letter to the *Belfast News-Letter* on the development of Queen's College, Belfast, art being 'entirely out in the cold,' he advocated the establishment of a chair of fine art.

In the period 1901-8 he regularly contributed to BAS exhibition, showing close on sixty works, watercolours again dominating. Possibly he had decided to retire from the headmastership in order to devote more time to painting and writing, *The Foundations of Philosophy* being published in London in 1904. In 1905 he was involved in controversial correspondence in the *Northern Whig* on the Gaelic movement, initially expressing his surprise that no one had taken up the question of the revival of Celtic art, 'which is almost as important as the language question.' His letter contributions in four issues of the broadsheet ran close to three columns in all.

In 1906, after an interval of fourteen years, he returned to the RHA with *Autumn*, but that year six works were hung at the WCSI exhibition. In November he ceased teaching at the School of Art. His name was associated with the Grosvenor Freehand Drawing Cards, London 1907, and that year saw publication of his *Swendenborg, his life, teachings and influence. Golden Autumn* appeared in 1907 at the RHA. His eight contributions to the 1907 BAS exhibition included *A Bit of Old London* and *A Warwickshire Homestead*.

In a letter to the *Northern Whig* in March 1908 on the progress of art in Belfast, he wrote: 'I do not disparage our local Art Society and the Ulster Arts Club, but the former is chiefly composed of amateurs, and the latter is a social club.' He mentioned in the letter that three times within the past three years he had all his pictures 'returned unsold from local exhibitions, whereas in Dublin, during the same period, I have sold my principal picture four times in succession.' *Riverside Meadows, Belvoir Park* is one of two watercolours in the Ulster Museum collection. The author of two novels, he was an honorary member of the Ulster Arts Club.

In 1908 illness forced him to return to his relatives in England, and when he exhibited with BAS in 1909 his address was 10 Edgbaston Road, Smithwick, near Birmingham. At the Royal Society of Artists, Birmingham, he exhibited seven works. A Swedenborgian and therefore a member of the New Jerusalem Church (or New Church), he was regarded as one of their 'most zealous members and best known writers.' He died on 8 April 1909 at Brunswick House, Brunswick Square, Gloucester.

Works signed: G. Trobridge.
Examples: Belfast: Ulster Museum.
Literature: George Trobridge, *The Principles of Perspective as applied to Model Drawing and Sketching from Nature*, London 1884 (illustrations); *Belfast News-Letter*, 6 August 1901; *Northern Whig*, 10, 14, 17 and 21 October 1905, 19 March 1908; Gloucester Registry Office, *Register of Deaths*, 1909; *New-Church Magazine*, May 1909; Walter G. Strickland, *A Dictionary of Irish Artists*, Dublin 1913; *Dictionary of British Artists 1880-1940*, Woodbridge 1976; John Hewitt and Theo Snoddy, *Art in Ulster: I*, Belfast 1977; Martyn Anglesea, *The Royal Ulster Academy of Arts*, Belfast 1981; Ann M. Stewart, *Royal Hibernian Academy of Arts: Index of Exhibitors 1826-1979*, Dublin 1987; *Water Colour Society of Ireland Exhibition List 1872-1994*, Dublin 1995; Ann M. Stewart, *Irish Art Societies and Sketching Clubs: Index of Exhibitors 1870-1980*, Dublin 1997.

TUOHY, PATRICK, RHA (1894-1930), portrait and figure painter. Born on 27 February 1894, Patrick Joseph Tuohy was the son of Dr John Joseph Tuohy of 15 North Frederick Street, Dublin. In conversation with the author in 1971, Patrick's sister, Bride Tuohy recounted that when her mother was pregnant, her father 'told her about a friend getting his hand off. When Patrick was born at 77 Lower Dorset Street, where father practised, he had no fingers on his left hand ...'.

Bride Tuohy remembered the nurse bringing Patrick to Broadstone station to see the engines 'and he came home and drew them in chalk'. At the age of fourteen he entered St Enda's College, run by Patrick Pearse, studying art under William Pearse (q.v.), who particularly encouraged him. He sang in the Palestrina choir at the Pro-Cathedral. 'His mother', according to Bride, 'was anxious that he should keep at the choir but he "mitched" and went to the School of Art at night. The principal was James Ward who dressed up in his grandeur to plead with father that Patrick should go full time to the school, day and night.' Dr Tuohy was St Enda's medical officer. He was also doctor to Albert Power (q.v.), who helped persuade him that Patrick should study art seriously.

At St Enda's, reproductions of his work published in the school magazine, *An Macaomh*, included a sheet of six profile drawings, faces at the school, 1909. His uncle had a farm at Lough Dan; Wicklow scenes were among his earliest paintings. *The Flight of Cuchulainn* and *Entry into Battle*, pen and ink drawings from his

St Enda's period, are in the Hugh Lane Municipal Gallery of Modern Art. He executed some still life oil paintings, and at the age of sixteen he painted *A Portrait of a Young Girl* (National Gallery of Ireland).

Tuohy, on leaving St Enda's entered the Dublin Metropolitan School of Art under (Sir) William Orpen (q.v.) and became one of his favourite pupils during the five years he was there. He exhibited in 1911 at the Small Concert Room in Dublin, where three of his canvases were described in the *Freeman's Journal* as being 'remarkable as coming from the brush of a boy artist'. Jack B. Yeats (q.v.) was among other artists who exhibited there. Tuohy showed *A Sultry Evening* at the 1911 Oireachtas exhibition.

In 1912 Tuohy won the £50 Taylor Scholarship competition for the watercolour, *Supper Time* (NGI). In that year he painted in the West of Ireland, writing from Cappaduff, Tourmakeady, Co. Mayo, to James Sleator (q.v.) in London: 'I have got my fingers, they cost six pounds, six shillings and no pence'. The palette sat on his metal hand.

Near the Bull Wall, or *The Bull*, was painted about 1912. The outstanding *A Mayo Peasant Boy* (HLMGMA), painted at about the age of nineteen according to his sister, showed an accomplished portrait painter. Other works of this period were notably *The Little Seamstress* (HLMGMA), a large watercolour of May Power (q.v.), whom Tuohy sometimes used as a model, and *The Model*, oil, dated 1914.

The Little Seamstress, described by Anne Crookshank and the Knight of Glin as a 'haunting and obsessive watercolour', won him a Royal Dublin Society Taylor award of £30 in 1915. May Power posed in his studio at 15 North Frederick Street, and in conversation with the author in 1977 considered him 'a fine draughtsman, very conscientious and a hard worker'.

Meanwhile, in 1913, Tuohy had received his first commission, ten ceiling panels for the Jesuit Order at Rathfarnham Castle, now under the Office of Public Works, representing scenes from the life of Christ. These paintings were replacements for earlier paintings sold by Battersby's at their auction in the Castle in April 1913, and attributed to Angelica Kauffmann (1740-1807) in the catalogue.

Tuohy had also won a silver medal, for painting from life, from South Kensington. He also won other RDS prizes. Together with his commission money, he had sufficient funds to travel abroad, and in 1916 he journeyed to Spain, leaving behind *An Irish Volunteer, 1916*. In Madrid he stayed for more than a year, and taught in the Loreto Convent there, according to Bride Tuohy, frequenting the Prado in his spare time.

At home, his first contribution to the Royal Hibernian Academy was made in 1918, and from then until 1927 he showed a total of thirty-seven works, mainly portraits in oil or pencil. The West of Ireland peasant boy was exhibited in 1918, and his 1919 pictures included *Tourmakeady, Co. Mayo* and *La Espanola*.

After the War, Tuohy frequently visited Paris. When aged about twenty-five, he painted *The Agony in the Garden* for the church at Loreto Female Boarding and Day Schools, North Great George's Street, Dublin. It was still there in 1924, but is now on an inside wall near the main entrance to the Church of Christ the King at Cabra. Thomas MacGreevy considered it 'the crowning work of his first youth. It has sensibility, pathos and dignity, fine design and beautiful decorative quality'.

By 1920 he was teaching at Dublin Metropolitan School of Art. His *Standing female Nude* and *Self-portrait with two Women* have been described by Dr Rosemarie Mulcahy as 'among the finest paintings produced in Ireland in the first half of this century'. The nude was shown in Paris in 'L'Art Irlandais' at the Galeries Barbazanges, 1922. In his *Self-portrait with two Women*, the artist is seated at his easel and the whole scene is reflected in a mirror. At the 1920 Oireachtas, *Visit to the Artist* and *Landscape* were both hung.

Probably in 1922 Tuohy began a large-scale composition, *The Baptism of Christ* (Ulster Museum), 1.8 metres by 3 metres, a more ambitious undertaking than *The Agony in the Garden*. The work was exhibited at the 1923 RHA – he also showed portraits of Padraic O'Maille, TD, and General Piaras Béaslai, TD – and he included in the composition Sean Keating (q.v.), as John the Baptist; Thomas MacGreevy, Seán O'Sullivan (q.v.) and Phyllis Moss, the student who became his fiancée. He used his studio at the School of Art for private commissions, mainly portraits.

At the exhibition of Irish Art held in connection with Aonach Tailteann in 1924, the judge of the paintings, Sir John Lavery (q.v.), recommended that Tuohy should be awarded a special prize for *The Baptism of Christ*. This work was the only one which he showed at the Royal Academy, and in his review of the 1925 exhibition,

Frank Rutter of the *Sunday Times* wrote: 'The great and delightful suprise of this room is the truly decorative and reverently expressive *Baptism of Christ* (no. 291) by a hitherto unknown Irish artist, P. J. Tuohy'.

Tuohy had spent the summer of 1923 on a study tour in Italy in the company of Phyllis Moss. His *General Richard Mulcahy* (NGI) was painted in 1923. In 1924 he again visited Italy, stopping off on his return at Paris, where Phyllis Moss was then studying art, and there he met his friend MacGreevy. Tuohy approached James Joyce with the request that he sit for his portrait. After much argument, Joyce agreed, but the fifteen sittings promised almost doubled. Relations were strained. The portrait is in the State University of New York at Buffalo. His Dublin portrait of Joyce's father, John Stanislaus Joyce, had appeared at the 1924 RHA along with portraits of Lord Fingall and James Stephens. George Russell (q.v.) in the *Irish Statesman* considered that this exhibition was dominated by Tuohy.

Tuohy then proposed to Joyce that he would go over to Paris and paint the rest of the family. In the event, he executed portraits of Joyce's son, Georgio, and daughter, Lucia, in the apartment at Square Robiac, but after his installation there Arthur Power (q.v.), in his *Conversations with James Joyce*, found that the situation was not 'a happy one, for he and Joyce jarred one another ... Tuohy could be very irritating, for he was nervously unbalanced ...'.

Appointed an associate of the RHA in 1924, he became a full member in 1925. The artist, Hilda van Stockum, who entered the Metropolitan School of Art in 1925, described Tuohy as 'small and dapper, had black hair and a clipped red moustache ... For some reason he was nicknamed "The Flying Dutchman" ... His work was sensitive, painstaking and subtle, and he worked in the traditional style. He had a perfection in his own mind which he never reached, so he was often despondent...' In 1925 he painted Mrs Mabel Noyk (née Steyn), now at NGI. He introduced Hilda to the Radical Club and also to the United Arts Club, which he joined in 1926.

Tuohy did a series of pencil portraits of Irish Theatre personalities, and those of F. R. Higgins and Sean O'Casey are in HLMGMA. A large drawing of the actress, Ria Mooney, was dated 1922, and that of Padraic Colum, 1924. Other portraits included Sara Allgood, F. J. McCormick and Brinsley McNamara.

At this time he executed some religious paintings, for example: *St Brendan*, 1924 RHA; *Saint Bridget* (HLMGMA) and *St Lawrence O'Toole*, both 1925 RHA. The Talbot Press in Dublin published reproductions, 'Four Irish Saints'. He was very friendly with Dr Jack Murnane, the dispensary doctor at Belper, Dunsany, Co. Meath, and painted his portrait, exhibited 1925 RHA. Dr Murnane obtained a commission for Stations of the Cross at St Martin's Church, Culmullen.

Other oil portraits by Tuohy at NGI are those of Frank Fahy and James Stephens wearing a French cloak. His portrait of the NGI director, Robert Langton Douglas, was in private possession. At HLMGMA there is also a view of the Shelbourne Hotel, oil, and an engraving of Dominic Bowe. He is represented in the National Self-Portrait Collection, University of Limerick. At University College, Dublin, is a portrait of Archbishop William Walsh. A watercolour, *In County Wicklow*, is at the Pearse Museum. *Pigeon House*, an oil, is in the Kilkenny Art Gallery Society collection.

Thomas Bodkin considered that his power to produce a true likeness of his sitter was remarkable 'and he displayed, at times, an illuminating insight into character, which never bordered upon caricature'. In 1926 at the RHA he gave his address as 75 Dame Street, Dublin, his sister's residence, now devoting himself almost entirely to portraits in oils. His mother had died and his father had remarried. In November 1926 he ceased teaching at the School of Art.

In 1927 the new *Dublin Art Monthly*, published by Joseph Egan at Egan's Art Saloon, referred to his exhibition of paintings and lithographs ranging through 'many methods, from the most bizarre to the rather conventional. There is undoubted promise and considerable performance in the work shown, and he is likely to do astonishing things.'

In 1927 he left home for America, staying first in South Carolina with the family of an American lady whom he had met at a tea-party given by Arthur Power in Paris. He later settled in New York. In undated letters to Thomas MacGreevy, from 145 W85th Street, NYC, he wrote of 'considerable success' and: 'I have a studio on Riverside Drive here, a penthouse on a roof top, you know quite cheery. I am painting some lovely ladies including Claudette Colbert (cinema star) ... I am also painting Walter Hampden, actor, whose real

name is Doherty and whose people originally came from North of Ireland.' That reference is to Walter Hampden Dougherty.

In October 1928 he wrote from Dublin to Hilda Roberts (q.v.) in Paris saying he was home for a visit. He may have been helping to organise an exhibition of contemporary Irish art planned for the gallery in New York run by Helen Byrne Hackett. On this show, held in 1929, the *New York Sun* critic commented: 'Mr Tuohy paints very well. I fear he paints portraits better than any one we have at present in America ... His people are alive and his affectionate interest in them gives the canvases a sparkle all over.'

On 28 August 1930 he was found dead from the effects of gas-poisoning in his studio. Aware of his fits of depression, many of his friends in Ireland assumed he had committed suicide. In conversation with the author, his sister Bride was adamant that he had not committed suicide, and explained: 'When the Abbey players came over he invited them and they could not get in. They broke in and he was lying on the couch. He had a gas ring. A book was on the floor and the coffee had boiled over. He didn't know the gas was escaping. This was told to me by Padraic Colum. The coroner's verdict was "found dead".' An unfinished portrait of Claudette Colbert was on his easel when he died. The Abbey company as such was not in the USA at this time. He was buried in Dublin at Glasnevin. A memorial exhibition of paintings, drawings and sketches 1911-30 took place at Mills' Hall, Dublin, in 1931.

Works signed: Tuohy; P. Tuohy or P T, monogram, both rare.
Examples: Belfast: Ulster Museum. Buffalo, USA: State University of New York. Cork: Crawford Municipal Art Gallery. Culmullen, Co. Meath: St Martin's Church. Dublin: Church of Christ the King, Cabra; Hugh Lane Municipal Gallery of Modern Art; National Gallery of Ireland; Pearse Museum; Rathfarnham Castle; University College (Earlsfort Terrace). Kilkenny: Art Gallery Society. Limerick: University, National Self-Portrait Collection.
Literature: *An Macaomh*, Summer 1909, Christmas 1909 (illustrations); *Letter from Patrick Tuohy to James Sleator*, 1912; Katherine MacCormack, ed., *The Book of St Ultan*, Dublin 1920 (illustration); *Dublin Magazine*, August 1924, December 1924 (both illustration); *Irish Independent*, 29 August 1924; *The Studio*, October 1924; *Thom's Directory*, 1925; J. Crampton Walker, *Irish Life and Landscape*, Dublin 1927 (illustration); *Letter from Patrick Touhy to Hilda Roberts*, 1928; Thomas Bodkin, *Memorial Exhibition Patrick Tuohy RHA*, catalogue, Dublin 1931 (also illustrations); *Capuchin Annual*, 1940, 1969 (both illustration); Thomas MacGreevy, 'Patrick Tuohy RHA (1894-1930)', *Father Mathew Record*, July 1943; *Studies*, Autumn 1965; *Thomas MacGreevy Papers*, Trinity College, Dublin [1967]; Alan Denson, *John Hughes Sculptor 1865-1941*, Kendal 1969; Arthur Power, *Conversations with James Joyce*, London 1974; *Apollo*, June 1979; *A Dictionary of Contemporary British Artists, 1929*, Woodbridge 1981; Hilda van Stockum, 'Dublin Art School in the 1920s', *Irish Times*, 16 and 23 March 1985, 9 November 1985; Ann M. Stewart, *Royal Hibernian Academy of Arts: Index of Exhibitors 1826-1979*, Dublin 1987; Rosemarie Mulcahy, 'Patrick J. Tuohy 1894-1930', *The GPA Irish Arts Review Yearbook 1989-90*, Dun Laoghaire 1989 (also illustrations); Patricia Butler, *Three Hundred Years of Irish Watercolours and Drawings*, London 1990 (also illustrations); S. B. Kennedy, *Irish Art & Modernism 1880-1950*, Belfast 1991 (illustration); Office of Public Works, *Letter to the author*, 1993; John Walker, ed., *Halliwell's Filmgoer's Companion*, London 1993; Anne Crookshank and the Knight of Glin, *The Watercolours of Ireland*, London 1994 (also illustration); Mrs Irene A. Murnane, *Letter to the author*, 1994; John Turpin, *A School of Art in Dublin since the Eighteenth Century*, Dublin 1995 (also illustrations); Ann M. Stewart, *Irish Art Societies and Sketching Clubs: Index of Exhibitors 1870-1980*, Dublin 1997.

TUTTY, BENEDICT (1924-96), sculptor. Born on 6 July 1924 at Hollywood, Co. Wicklow, John Tutty was the son of Michael Tutty, publican and farmer. He attended the local Primary School and the Christian Brothers' School, Naas, Co. Kildare. He trained as a butcher and later went into the family business.

In 1949 he entered Glenstal Abbey, Murroe, Co. Limerick, and took the religious name Brother Benedict. He was professed on 21 November 1951. After studying metalwork at L'École de Metiers d'art de Maredsous, Maredsous Abbey, in Belgium, 1951-3, he returned to Glenstal Abbey and set up his own studio workshop. He began a lifelong teaching engagement with Limerick School of Art.

According to an article in a Belgian publication by M. P. Hederman, his first work was done along conventionally religious lines: crucifixes, tabernacles, Stations of the Cross. 'Using this framework, he injected his own particular feelings and original spirit into the work by surprising and suggestive patterns, colours and uses of material,' wrote Hederman. 'He was prepared, at this stage, to allow the realism of conventional religious art to provide the limitations within which to express himself.'

At the Institute of the Sculptors of Ireland exhibition in Dublin in 1957 he showed a crucifix in wood and hammered copper. Some of his earliest work was carried out at St Columba's Abbey, Glenstal. At the Irish Exhibition of Living Art he contributed six works: In 1959, *The Prisoner*; 1960, *Dead Christ*; *I Suffered for You*; 1963, *Madonna and Child*; 1966, *Prophesy*; *Hour of Darkness*.

In 1960 he attended the art school of the Abbey of Munsterschwarzach in Germany. Some time was spent in Paris on his studies. He was represented in the Irish Sacred Art exhibition in Dublin in 1962 by a crucifix in bronze. A liturgical conference at Glenstal in 1962, which was devoted to church architecture, brought Benedict into contact with the architect, Richard Hurley. This relationship resulted in him carrying out work for Richard Hurley and Associates in more than a score of institutions in Ireland and England.

In 1964, at St Colmcille's Church, Tully, Co. Galway, he was responsible for the main liturgical and artistic features of the church: Stations of the Cross, the altar and processional crosses, the tabernacle and sanctuary lamp, the baptistry, paschal candlestick and the sacred vessels. This church was regarded as one of the best examples of his art work, and was to set the pattern for his working relationship with architects, according to the Rev. Brian Murphy of Glenstal Abbey. At other times he made individual items.

Stations of the Cross followed at the Convent of Mercy, Cookstown, Co. Tyrone, in 1965. Referring to the renovated chapel in 1969 at St Patrick's, Carlow College, Carlow, the *National and Leinster Times* said that thanks to the skill of Tutty and Ray Carroll (q.v.) 'we have works of art of high quality which enrich without taking from the simplicity of the new layout.' Benedict's Marian image is referred to at the college as Our Lady of Carlow.

Among his contributions in 1971 to the renovated Church of St Saviour's, Dominick Street, Dublin, was the tabernacle. He was represented in the Exhibition of Irish Ecclesiastical Art held at the Cork Arts Society in 1971, and his works were described as 'abstracts' in the *Cork Examiner*, which went on to say that 'in enamelled copper are among the most beautiful exhibits, imaginatively compelling in concept and unobtrusively simple in execution.' Furnishings of 1972, including *Dove*, tabernacle and lamp, were later removed from St Mary's Church, Granard, Co. Longford, to St Dympna's Church, Tydavnet, Co. Monaghan.

The 1974 terracotta Stations of the Cross for St Joseph's Church, Tinryland, Co. Carlow, are now at Glenstal Abbey. Other mediums were used for this type of work. His 1975 *Mother and Child* at the Church of the Nativity, Newtown, Co. Kildare, was in terracotta. In the same year and county he provided *Hanging Dove* for St Brigid's Church, Curragh Camp.

In his article of 1980, Hederman also stated that the latest work of Tutty was best represented by a series of sculptures in fire clay: 'On the one hand there are the "heads", some swathed in bandages, with only the mouth remaining entirely free, others portrayed in the act of singing; on the other hand there are the full figures, some again in the process of singing a song, others like prisoners trying to escape from a cocoon of bandages. The emphasis is on the materiality of the sculpture. Within this material the artist tries to convey a spirit or a presence, mostly by the gesture and the posture of the figure...'.

In 1980 his Stations were in lead at the Church of the Apostles, Wyatville, Ballybrack, Co. Dublin. The tabernacle at Saints Mary and David Church in Naas, Co. Kildare, is noted for its striking colour. Among the works which travelled to England, for example, in 1985 a tabernacle and lamp to St Mary's Church in East Finchley, London, and a few years later tabernacle, cross and candlesticks to St Mary's Church at Becontree, Barking, London.

The year 1987 witnessed a tabernacle in tree sculpture at the Franciscan Church, Wexford, and a sanctuary mural at St Mary's Church, Skull, Co. Cork. In 1995 he exhibited *Singer*, terracotta, at the Royal Hibernian Academy. *Madonna*, copper, is at Limerick City Gallery of Art. In Cork at the Crawford Municipal Art Gallery is *The Christ Child*, enamel on copper panel.

Tutty's contribution to the National Self-Portrait Collection in Limerick has all the appearance of a death mask. The work is in mild steel and painted terracotta for the head, which emerges from a welded tracery of painted steel. His eyes have no sight. His mouth is half open.

Richard Hurley wrote: 'The life of a monk, it is said, is not easy. The life of an artist is also demanding. Being a monk and an artist at the same time requires very special human qualities rarely found in one person. Such a person was Bendict Tutty...He was always seeking to break through, to get out into the open, to take

wings and to sing. The series of doves, the bondage series, the head series with slash marks and, more recently, a return to happier themes, all point to a profound understanding of who we are and the human nature which makes us so.' Brother Benedict Tutty, OSB, died at Glenstal Abbey on 22 March 1996, and was buried in the Abbey Cemetery.

Works signed: Benedict Tutty (if signed at all).
Examples: Aberdorney, Co. Kerry: Church of Our Lady and St Brendan. Aran Islands, Co. Galway: Kilronan Church, Inishmore. Ballybrack, Co. Dublin: Church of the Apostles, Wyatville. Ballycullane, Co. Wexford: Church of the Holy Spirit, St Leonard's. Belfast: Church of the Resurrection. Birmingham, England: Presentation Convent. Carlow, Co. Carlow: Irish Institute for Pastoral Liturgy; St Patrick's, Carlow College. Cookstown, Co. Tyrone: Convent of Mercy. Cork: Crawford Municipal Art Gallery. Curragh Camp, Co. Kildare: St Brigid's Church. Dublin: All Hallows' College; Beaumont Hospital; St Patrick's Training College, Drumcondra; St Saviour's Church, Dominick Street; University Hall, Hatch Street. Dysart, Co. Louth: St Burchill's Church. Glencairn, Co. Waterford : Abbey. Graiguenamanagh, Co. Kilkenny: Duiske Abbey. Limerick: City Gallery of Art; Mary Immaculate College; Our Lady of the Rosary Church; St John's Hospital; University, National Self-Portrait Collection. London: St Joseph's Church, Harrow Weald; St Mary's Church, Becontree, Barking; St Mary's Church, East Finchley. Maynooth, Co. Kildare: St Mary's Oratory; St Patrick's College; Society of African Missions House. Mullagh, Co. Cavan: St Kilian's Church. Murroe, Co. Limerick: St Columba's Abbey, Glenstal. Naas, Co. Kildare: Saints Mary and David Church. Newtown, Co. Kildare: Church of the Nativity. Rathangan, Co. Kildare: Convent of Mercy. Skull, Co. Cork: St Mary's Church. Tralee, Co. Kerry: St Brendan's Church. Tully, Co. Galway: St Colmcille's Church. Tydavnet, Co. Monaghan: St Dympna's Church. Wexford, Co. Wexford: Franciscan Church.
Literature: *National and Leinster Times*, 12 December 1969; *Cork Examiner*, 22 January 1971; *Irish Times*, 25 May 1971, 25 March 1996; M. P. Hederman, 'An approach to the sculpture of Benedict Tutty,' *Art D'Église*, September 1980; Sarah Finlay, ed., *The National Self-Portrait Collection of Ireland*, vol. I, 1979-1989, Limerick 1989; Peter Harbison, *The Shell Guide to Ireland*, Dublin 1989; Richard Hurley, *New Liturgy*, Spring 1996; Ann M. Stewart, *Irish Art Societies and Sketching Clubs: Index of Exhibitors 1870-1980*, Dublin 1997; Sister M. Juliana Tutty, *Letters to the author*, 1999; Richard Hurley and Associates, *Letters to the author*, 2000; Rev. Brian Murphy, OSB, *Letter to the author*, 2000; also, St Patrick's, Carlow College, 2000.

U

UHLEMANN, KARL, senr. (1885-1959), landscape painter. Born near Leipzig, Karl Uhlemann's family owned an hotel. Learning to cook, he became a chef, leaving Germany before the First World War. After working in Manchester and London, his first post in Ireland was at Rosapenna, Co. Donegal. He was interned on the Isle of Man and also at Oldcastle, Co. Meath, according to his grandson, Rai Uhlemann. He was the father of the illustrator, Karl Uhlemann (q.v.).

Uhlemann first exhibited at the Royal Hibernian Academy in 1915, giving the address 36 Longwood Avenue, Dublin. In 1920, from 20 Sandford Avenue, he showed an Austrian Alps scene; also *In the Twilight* and *The Windmill*. Altogether at the RHA, up until 1952, he contributed thirty-four works. At the Oireachtas in 1920, *The Windmill* (2) and *Windswept* were on display.

By 1921 his address was 21 St Thomas Road, Dublin. In 1928 his contributions to the Academy included *An Early Spring View at Oldcastle, Co. Meath*. Some painting was done in the West of Ireland and *Killary Bay, Connemara* and *Claddagh Cabins-Galway* were hung in 1937. At the 1943 event, *Bavarian Alpine Huts* and *Nature at Rest* were presented, the latter attracting the favourable attention of Arthur Power (q.v.) in *The Bell*.

In the period 1943-52 Uhlemann showed twenty-nine works at Dublin Sketching Club exhibitions, opening with *Winter Sun* and *Early Moonrise*. In 1947 his contributions included a Matterhorn scene. In 1949 and 1950 he exhibited two flowerpieces each year, and he broadened his *oeuvre* with *The Octogenarian* in 1949. As for the RHA, his final exhibit in 1952 was *Sunflower*.

A number of his landscapes, in oils, depicted the solitude of winter. His *Head of Old Woman*, oil, is in the Hugh Lane Municipal Gallery of Modern Art collection. During his time in Dublin he was head chef of the Gresham Hotel for twelve years. At Pembroke Hospital, Dublin, he died on 31 March 1959.

Works signed: Karl Uhlemann or KU monogram, rare.
Examples: Dublin: Hugh Lane Municipal Gallery of Modern Art.
Literature: *The Bell*, June 1943; General Register Office, Dublin, *Register of Deaths*, 1959; *Irish Times*, 22 March 1969; Ann M. Stewart, *Royal Hibernian Academy of Arts: Index of Exhibitors 1826-1979*, Dublin 1987; Ann M. Stewart, *Irish Art Societies and Sketching Clubs: Index of Exhibitors 1870-1980*, Dublin 1997.

UHLEMANN, KARL, junr. (1912-92), illustrator and designer. The son of Karl Uhlemann (q.v.), he spent his life as a Dublin commercial artist, working on his own account, but he occasionally produced watercolours, woodcuts and, for example, *Gathering Herbs* was on scraperboard.

In the 1940s he was active in illustrating books for the Three Candles Press, for example Lennox Robinson's *Pictures in a Theatre* and Cathal O Byrne's *Ashes on the Hearth*, from articles published in *The Irish Monthly* and *The Irish Rosary*, with fourteen half page illustrations for the beginnings of chapters.

The first commemorative postage stamp which he designed was issued in 1948, representing the 1798 Insurrection — the 150th anniversary. The design had for its central feature a portrait of Theobald Wolfe Tone. On the right hand side were storm-tossed ships representing the French expedition. On the left was a pikeman standing by a signal fire representing the nation-wide call to resurgence. The second postage stamp, issued in 1960, commemorated World Refugee Year, and he was also responsible for the Freedom from Hunger Campaign stamp of 1963.

The year 1962 saw the publication of Basil Peterson's *Turn of the Tide*, with eighty-seven black and white illustrations by Uhlemann, plus illustrations for the colour supplement, covering flags, funnels, insignia, rank markings of the Naval and Merchant Services.

A watercolour, *The Mummers*, is at University College, Dublin (Belfield). He was working on the design for a postage stamp, Macra na Feirme 1944-1994, when he took ill and the commission was completed by

his son, Rai Uhlemann. He died at St James' Hospital, Dublin, on 27 August 1992 and was interred in Mount Jerome cemetery.

Works signed: KU or Karl Uhlemann, rare.
Examples: Dublin : University College (Belfield).
Literature: Nellie Elliott, *The Sandman's Hour*, Dublin [1945]; Fr. Oliver, O. Cist. R., *In God's Wonderland*, Dublin 1945 (illustrations); Lennox Robinson, *Pictures in a Theatre*, Dublin 1947 (illustrations); Cathal O Byrne, *Ashes on the Hearth*, Dublin 1948 (illustrations); *Capuchin Annual*, 1960 (illustration); *Studies*, Spring 1961 (illustration); Basil Peterson, *Turn of the Tide*, Dublin 1962 (illustrations); Mícheál Ó hOdhráin, *An Tine Bheo*, Dublin 1965 (illustrations); Ballintubber Abbey, '*The Abbey that Refused to Die*', Ballintubber 1967 (illustration); Department of Posts and Telegraphs, *Letter to the author*, 1968; J. J. Feeney, *Tales from Irish History*, Dublin 1968 (illustrations); S. Ó Finneadha, *Stair na hÉireann*, Dublin 1968 (illustrations); Father Thomas Egan, *What to see at Ballintubber Abbey*, Ballintubber 1970 (illustrations); *Irish Times*, 28 May 1970, 29 August 1992; General Register Office, Dublin, *Register of Deaths*, 1992.

USSHER, ISABEL – see ODELL, ISABEL

VANSTON, DOREEN (DÁIRINE) (1903-88), landscape and figure painter. Born in Dublin, she was the daughter of a solicitor, John S. B. Vanston, of 'Willow Bank', Bushy Park Road, Dublin, and her mother, Lilla M. Vanston (q.v.) was a sculptor. After attending Alexandra College, Dublin, she studied art at Goldsmith's College, London, and then under Roger Bissière (1886-1964) at the Académie Ranson, Paris.

In 1926, in Paris, she married a Costa Rican law student and took the name Vanston de Padilla. After a brief stay in Italy, they settled in San José, Costa Rica, where she painted, 'held in thrall by the light, the noise, the colours', and exhibited at the National Opera House in 1928, 1930 and 1932.

After her marriage broke up, she returned to Paris about 1933 and studied with André Lhote (1885-1962), a friend of Bissière. In an interview in 1972 with Harriet Cooke, *Irish Times*, she recounted: 'Lhote made us go to the Louvre and choose one picture, make a rough sketch of the lines of force and then look at it thoroughly, memorise it, then come back and in our own studio repaint that picture. I remember doing that glorious picture *Concert Champêtre*, the Giorgione. It trained your visual memories.'

Cubism influenced her in Paris, and there she was acquainted with the Polish Jew, Jankel Adler (1895-1949), noted for his strongly stylised figure paintings; in 1940 he left France for England. In Dublin, in 1935, she participated at Daniel Egan's Gallery, 38 St Stephen's Green, in an exhibition with Grace Henry, Cecil Salkeld and C. Edward Gribbon (qq.v.), showing seventeen works, including *Landscape in Cartago*; *Park, Port Limón*; *La Ventana*; *Los Caminos*. Living in the South of France when the Second World War broke out, she escaped in 1940 to London, thence to Dublin. Paintings which she had left in Paris were lost.

In Dublin, she was associated with the White Stag Group and exhibited in 1941 in a group show, her *Keel Dance Hall* being on view. An exhibition of theatre design, 'In Theatre Street', took place at Contemporary Pictures in 1942 and she was represented. In 1943 too her work was in a mixed display at the White Stag Gallery, 6 Lower Baggot Street, and also in the most important event arranged by the Group, the 1944 Exhibition of Subjective Art in which *The Wanderers* and *A Dying Animal* (Ulster Museum) made her, according to the *Dublin Magazine*, the 'most effective of the experimental vanguard'.

In 1943 she showed five works, including *Old Woman* and *The Dancer*, at the inaugural exhibition of the Irish Exhibition of Living Art, and from 1948 for the next twenty years continued to contribute, although she did not exhibit at the Royal Hibernian Academy. She also showed at a few Oireachtas exhibitions. In 1945 her work was hung in London at the White Stag Group exhibition, Young Irish Painters, at the Arcade Gallery, Old Bond Street.

In 1947 she returned to Costa Rica where she executed a number of watercolours, including *El Carruno de San Antonio*, 1948, the year of her return to Ireland. In 1953 she was represented in the Contemporary Irish Art exhibition at Aberystwyth, and her contribution to IELA was *Man Making a Net*. Her four pictures at Living Art in 1954 included *Woman in a Mirror*. On the 1956 exhibition, the *Dublin Magazine* critic considered that she had 'the opulence of Matthew Smith together with the abstract use of colour of the Blau Reiter school. Her picture of the flautist has a rare sense of abandon and joy: but in *Study of Flowers* she fails ... by a simple lack of taking trouble.'

At the inaugural exhibition of Independent Artists in 1960 at the Building Centre, Dublin, Doreen Vanston was represented by four works, including *Etruscan Landscape*. In the 1961 catalogue the name of Dairine Vanston appeared in the members' list, and she again showed four pictures. She continued to patronise the IELA and, variable as always, showed, for example, *Race Course, Naas* in 1965, and *Study of a Druid* in 1967. At Independent Artists in 1967, *Joie de Peindre* and *Ardmore* were among four.

In the early 1970s her works in Independent Artists' exhibitions and group shows at the Project Arts Centre attracted attention, and on the Independent show of 1970 the *Irish Times* found her demonstrating a flair for 'vibrant, almost tropical colour, controlled with a distinctly French finesse and intelligence'. In the 1972 interview with Harriet Cooke, she said: 'I think I'm beginning to know a little more about painting. I don't

think painting lets you into her secrets overnight. If the colour is right, all is right; I think it's the most difficult part of painting....'

One of the first painters to be chosen for Aosdána, she lived in Dublin at 3 Mount Street Crescent. Never a portrait painter, her idea 'of bliss' was painting watercolours outdoors. Occasionally she executed woodcuts, and she was a member of the Graphic Studio. *Child* was presented to Bangor Borough Council by the Thomas Haverty Trust. In her last years she exhibited in the Figurative Image exhibitions in Dublin. At a nursing home in Enniskerry, Co. Wicklow, she died on 12 July 1988.

Works signed: D. Vanston.
Examples: Bangor, Co. Down: Town Hall. Belfast: Ulster Museum. Limerick: University, National Self-Portrait Collection.
Literature: *Thom's Directory*, 1905; *Capuchin Annual*, 1935 (illustrations); Daniel Egan's Gallery, *Exhibition Grace Henry, Doreen Vanston de Padilla, Cecil Salkeld, C. Edward Gribbon*, catalogue, Dublin 1935; *Dublin Magazine*, April-June 1944, October-December 1956; William Gaunt, *A Concise History of English Painting*, London 1964; *Irish Times*, 7 August 1970, 19 December 1970, 6 September 1972 (H. Cooke interview), 8 November 1972, 14 and 16 July 1988; National Gallery of Ireland and Douglas Hyde Gallery, *Irish Women Artists: From the Eighteenth Century to the Present Day*, catalogue, Dublin 1987 (also illustration); S. B. Kennedy, *Irish Art & Modernism 1880-1950*, Belfast 1991 (also illustrations); Aileen C. Connor, *Aosdána*, Dublin 1996; Ann M. Stewart, *Irish Art Societies and Sketching Clubs: Index of Exhibitors 1870-1980*, Dublin 1997.

VANSTON, LILLA M. (1870-1959), sculptor. Lydia Mary was born 16 May 1870, daughter of the Rev. John T. Coffey, Rector of Mogorban, Fethard, Co. Tipperary, and who, at one period in his career, taught Irish at St Columba's College, Dublin. She attended Dublin Metropolitan School of Art, and later won the Queen's Prize for sculpture in London. As Lydia Coffey, from 42 Marlborough Road, Dublin, she exhibited a medallion at the 1898 Royal Hibernian Academy. An early member of the Gaelic League, she travelled regularly to Achill, Co. Mayo, keeping in touch with Irish as a community language.

The mother of Doreen Vanston (q.v.), she exhibited under her married name from 'Willow Bank', Bushy Park Road, Dublin, in the 1903 RHA: *Vanity*. Altogether at the Dublin exhibition, until 1921, she showed a dozen works. In 1904 she contributed a portrait of T. O'Neill Russell; the 1905 show included one of John B. Vanston, her solicitor husband, and of Miss Emily Coffey. On the Arts and Crafts Society of Ireland exhibition in Dublin in 1904, *The Studio* commented that Mrs Vanston's work 'showed refinement and skill'.

Described as 'a guild for the improvement of taste and the revivifying of Irish art', the Irish Art Companions was founded in 1904 by setting up a small kiln and mill at 27-28 Clare Street, Dublin, making their own plaster from local gypsum. This they cast into ecclesiastical and secular statuary, which, according to Paul Larmour in his *The Arts & Crafts Movement in Ireland*, 'they then bronzed or tinted according to the taste of their clients'.

Among the sculptors associated with the Companions was Lilla Vanston, who modelled a plaque cast by them; it was featured among the illustrations in *The World's Work*, May 1907. It was titled *Erin Mourns for her Dead Heroes* (National Museum of Ireland) or *The Lament of Banba*. This piece was shown at the Arts and Crafts Society of Ireland 1910 exhibition, and the *Irish Times* critic described it as 'one of the most beautiful decorative designs that have been seen here for some time ... It shows wonderful grace and freedom, without suggesting that the circle confinement is in any way a limitation'.

At the Irish International Exhibition at Herbert Park, Dublin, in 1907, she displayed a silver medallion portrait of Mons. A. Parezewski, Member of the Duma, 1906. Active in the United Arts Club, she suggested that the club should subscribe to the German art magazine, *Jugend*, which supported young artists. At the Oireachtas exhibition in 1907 she showed two works, and three in 1911, including, *Mrs Charles Lane Poole*.

At the 1920 RHA she exhibited a sketch model in plaster of Lord Ashbourne, and in 1921 a statuette of Miss Elizabeth Young. The bronze of Lord Ashbourne was illustrated in J. Crampton Walker's *Irish Life and Landscape*: '... he is represented wearing the Irish national costume, which is his habitual attire'.

In 1925, then a widow, she went to Paris where she exhibited at the Salon d'Automne. In 1932, back in Dublin, she resigned from the United Arts Club because she was going abroad. In Paris, she called to see

John Hughes (q.v.). The outbreak of the Second World War saw her – reportedly now a Buddist – return to Dublin, and in 1946 she was again active in the United Arts Club. Of 13 Herbert Street, she died at the Royal City of Dublin Hospital on 23 March 1959.

Works signed: L. M. Vanston.

Examples: Dublin: National Museum of Ireland.

Literature: *Register of Births*, Dublin, 1870; *The Studio*, January 1905; *Thom's Directory*, 1906; J. Crampton Walker, *Irish Life and Landscape*, Dublin 1927 (also illustration); *Irish Times*, 24 March 1959, 3 September 1982; *Register of Deaths*, Dublin, 1959; Alan Denson, *John Hughes Sculptor 1865-1941*, Kendal 1969; Ann M. Stewart, *Royal Hibernian Academy of Arts: Index of Exhibitors 1826-1979*, Dublin 1987; Patricia Boylan, *All Cultivated People: A History of the United Arts Club, Dublin*, Gerrards Cross 1988; Paul Larmour, *The Arts & Crafts Movement in Ireland*, Belfast 1992 (also illustration); Church of Ireland Library, *Letter to the author*, 1994.

VERSCHOYLE, KATHLEEN (1892-1987), sculptor and portrait painter. Kathleen Laura Verschoyle was born on 7 July 1892, daughter of William Henry Foster Verschoyle, estate and land agent, at Woodley, Dundrum, Co. Dublin. The Verschoyles were of Dutch origin. She attended Dublin Metropolitan School of Art.

In 1918 she exhibited at the Royal Hibernian Academy for the first time, giving her Dundrum address, and from then until 1936 she showed a total of twenty-four works. In 1920 she contributed *The Skipping Rope*, and in 1921, from 19 Fitzwilliam Square, Dublin, a 'portrait' and a 'bust'.

In 1923 at the RHA she showed *Laurence*, and in 1924 a relief, *Persephone*. After the death of her mother, her father married the writer, Winifred M. Letts, in 1926. Three portraits at the 1929 Academy included one of Hugh Law, TD. In 1930 she was represented in the exhibition of Irish art at Brussels by a bronze, *Avril*, from her Fitzwilliam Square address. In that year she had five works at the RHA, including *The Boy Scout*.

In 1932, under Verschoyle, she exhibited four works at the Oireachtas exhibition: a portrait; 'Icarus', statuette; design for *Child's Memorial,* sculpture in relief; *The Blessed Virgin*, sculpture in relief, bronze.

Kathleen Verschoyle married in 1932 the Rev. William K. P. Hogan, vicar of Horsford, Norwich, and that year W. M. Letts's book, *Saint Patrick the Travelling Man*, was dedicated to 'Kathleen Verschoyle who loves Ireland'. It is assumed that the two unsigned full-page illustrations at the front were both by Verschoyle. Between 1933-8 she exhibited under her married name sculpture and drawings with the Norwich Art Circle. In 1933 she supplied four illustrations for her step-mother's *Knockmaroon*: a mountainy woman, a Wexford gardener, *Eileen the Bold* and *A Grandfather*. She also illustrated Letts's *The Gentle Mountain*, 1938.

Under her married name, Kathleen Hogan, she illustrated a 1947 work of children's fiction, *The Norwich Lions* by C. B. Jewson. In 1948, although she was to keep in touch with friends in England, her husband died and she returned to Ireland. In 1952, and for the next twenty years, she exhibited with the Water Colour Society of Ireland, and of some forty works at least three-quarters were portraits. She contributed *Angus, God of Youth* in 1953, and *The Farmer's Wife* in 1964. She died at Kylemore Clinic, Ballybrack, Co. Dublin, on 20 November 1987.

Works signed: Kathleen Verschoyle, K. V.; K. Hogan or K. H., both rare.

Literature: *Register of Births*, Dublin, 1892; *Thom's Directory*, 1895; Winifred M. Letts, *St Patrick the Travelling Man*, London 1932; *Knockmaroon*, London 1933; *The Gentle Mountain*, Dublin 1938 (all illustrations); C. B. Jewson, *The Norwich Lions*, Norwich [1947] (illustrations); *Crockford's Clerical Directory*, 1948; Moira Verschoyle, *So Long to Wait*, London 1960; *Burke's Irish Family Records*, London 1976; *Register of Deaths*, Dublin, 1987; Ann M. Stewart, *Royal Hibernian Academy of Arts: Index of Exhibitors 1826-1979*, Dublin 1987; Peter Hoare, *The Linen Hall Review*, Winter 1993; Kylemore Clinic, *Letter to the author*, 1994; also, Norwich Castle Museum, 1994; Norwich Central Library, 1994; Mrs Irene Wade, 1994; John Turpin, *A School of Art in Dublin since the Eighteenth Century,* Dublin 1995 (illustration); *Water Colour Society of Ireland Exhibition List 1872-1994*, Dublin 1995.

VINYCOMB, JOHN (1833-1928), illuminator and heraldic designer. Born in Newcastle-upon-Tyne on 4 July 1833, John Vinycomb was the son of Andrew Vinycomb of an old Devonshire family. He studied at the Government School of Design, Newcastle, under William Bell Scott (1811-90), painter, illustrator, critic, poet and friend of D. G. Rossetti (1828-82) and the Pre-Raphaelites.

Vinycomb was a direct descendant of John Knox. His son, John Knox Vinycomb (1880-1952), an architect who practised in England but died in Belfast, is represented in the Ulster Museum notably by sepia drawings 1909-11 of Belfast houses, 'Brookvale', 'Hopefield' and 'Maryville'.

In 1855 John Vinycomb entered as an engraver to the art department of Marcus Ward & Co., Belfast, and eventually rose to head the department. Described as 'a man of abounding energy, he was playing before long an important part in the life of the community ...'. His watercolour, *Old Ormeau Bridge from near Stranmillis, 1860*, he donated to the Belfast Museum and Art Gallery. In 1864 he was among half-a-dozen employees of Marcus Ward's who formed the short-lived Belfast Sketching Club. He was on the board of management of the Government School of Art which opened in 1870.

In 1879 the Marcus Ward staff formed the Belfast Ramblers' Sketching Club with Vinycomb as president. He had married a Cork girl who was employed in the firm's illuminating department, and in 1883 he showed at the Cork Industrial Exhibition *An American Liner making for Cork Harbour*, 'sketched on the spot'. The foundation of the Belfast Art Society in 1890 saw John Vinycomb, MRIA, as president; he served for two years.

In 1890 he designed a casket, made by Sharman D. Neill of Belfast, to hold an address from the citizens of Belfast to the Earl of Shaftesbury. The final result was in the form of an ancient Irish shrine lavishly decorated with all types of Celtic ornament.

Among his contributions to the Belfast Art Society exhibitions, concluding in 1903, were: *Entrance to Cork Harbour* in 1894; *Fair Head, Co. Antrim*, 1895; *Bloody Bridge, Co. Down*, 1900; *The Gobbins, Islandmagee*, 1903.

Vinycomb, who was president of Belfast Naturalists' Field Club in 1890-1 (and again 1901-2), had established a widespread reputation for his bookplate designs, and he was appointed a vice-president of the Ex Libris Society. His *On the Processes for the Production of Ex Libris (Book- Plates)* was published in 1894. The information originally appeared in the *Journal of the Ex Libris Society*. Next was a book on the Newcastle engraver, Mark Lambert.

White-metal medals and medallions designed by him were exhibited at the Belfast Art and Industrial Exhibiton, 1895. An authority on heraldry and the Arms of Belfast, he once said: 'I have had to pursue the study of heraldry and some kindred arts without companionship, and in the North, I may say, practically alone'. In 1899 he was elected an honorary member of the Belfast Art Society.

After the liquidation in 1899 of Marcus Ward's, he devoted himself to heraldry design, illumination and writing. On hearing of the likelihood of his soon leaving Belfast for London, some old friends presented him in 1900 with a purse containing one hundred guineas, and to Mrs Vinycomb two silver candelabra. The Vinycombs, however, did not depart Belfast until 1909. The Department of Agriculture and Technical Instruction selected in 1901 a range of Irish art industries and craftwork for display at the Glasgow International Exhibition, and he was represented by bookplates.

Lord Dufferin, in his address at the conferring of degrees – one of Vinycomb's sons was a recipient – at the Royal University in Dublin in 1901, made reference to John Vinycomb: 'The name is one universally honoured in the North of Ireland as borne by an artist of great talent and extraordinary skill in executing illuminations after the best Celtic patterns, as displayed in our most famous Irish manuscripts.'

The Ulster Arts Club was founded in 1902; Vinycomb was president for the first three years. The address presented in 1903 to King Edward VII by the Royal Society of Antiquaries of Ireland at St Patrick's Hall, Dublin Castle, was illuminated by the Belfast specialist, a vice-president of the Society. The address concluded with the hope that the visit would leave pleasant memories 'and conduce towards the establishment of a Royal Residence in Ireland'.

Presentation addresses also included works for Queen Victoria, Queen Alexandra and several Viceroys to Ireland. The addresses presented to several honorary burgesses on receiving the Freedom of Belfast were his workmanship, and he also received commissions from England. Vinycomb was represented by bookplates in the Irish arts and crafts display at the St Louis World's Fair of 1904.

The Ulster Museum has armorial bearings of Sir Robert Lloyd Patterson, 1904, gouache on paper. In *The Art of Heraldry*, 1904, by A. C. Fox Davies, in the chapter on 'Living Heraldic Artists and Book-plate

Designers of Great Britain', the author features seven artists, of whom Vinycomb was one, with examples of their works. He was the author of the chapter therein on the Art of Heraldic Illumination. Davies said that Vinycomb's bookplates, executed in wash and reproduced by the half-tone process, stood 'in a category by themselves' and were of 'considerable artistic merit ...'. His 1905 illuminated address at Belfast Harbour Office was to Captain Andrew Davidson.

Vinycomb supplied 120 illustrations for his *Fictitious & Symbolic Creatures in Art with special reference to their use in British Heraldry*. Also published in 1906, but privately, was a book on fifty of his bookplates. Two years later there followed *J. Vinycomb: his Book of Bookplates*, 'forewords' by Robert Day of Myrtle Hill House, Cork, who stated that the artist in his time had executed some 200 bookplates. At the Laing Art Gallery, Newcastle-upon-Tyne, is a design in watercolour of an architectural scene from the city, for a bookplate for Ernest Appleby.

Vinycomb was an honorary member of the Linen Hall Library, Belfast. He was responsible for original designs for the covers of *The Irish Naturalist* and *The Ulster Journal of Archaeology*. In 1907 at the Oireachtas exhibition in Dublin he showed illuminations and *ex libris* drawings.

In 1909 he moved to London, and at 32 Salford Road, Streatham, according to a change of address card, he hoped 'to continue to receive the orders of his friends and patrons as heretofore'. At the age of ninety-four, he was still active in his work. At the City Hall, Belfast, is a scroll for Mrs W. J. Pirie, first Lady Burgess; and an original painting of the Belfast Arms. His portrait, by Ernest E. Taylor (q.v.), is in the Ulster Museum. He died in London, 27 January 1928.

Works signed: J. V., J V monogram; John Vinycomb, J. Vinycomb or Vinycomb.
Examples: Belfast: City Hall; Harbour Office; Linen Hall Library; Ulster Museum. London: Victoria and Albert Museum.
Literature: *Cork Industrial Exhibition*, catalogue, 1883; John Vinycomb, *An Enquiry into The History and Authenticity of The Belfast Arms*, Belfast 1892 (illustrations); John Vinycomb, *On the Processes for the Production of Ex Libris*, London 1894 (illustrations); John Vinycomb, *Lambert, of Newcastle-upon-Tyne, as an Engraver of Book-Plates*, Newcastle-upon-Tyne 1896; *Belfast Art Society Minute Book*, 1899; *The Journal of the Royal Society of Antiquaries of Ireland*, December 1903; Francis Joseph Bigger, *Sir Arthur Chichester and the Plantation of Ulster*, Belfast 1904 (illustration); A. C. Fox Davies, *The Art of Heraldry*, London 1904 (also illustrations); Francis Joseph Bigger, *The Northern Leaders of '98: William Orr*, Dublin 1906 (illustrations); *Fifty book plates (ex libris) designed by John Vinycomb*, Belfast 1906 (illustrations); John Vinycomb, *Fictitious & Symbolic Creatures in Art with special reference to their use in British Heraldry*, London 1906 (illustrations); *J. Vinycomb: his Book of Bookplates*, Edinburgh 1908 (also illustrations); *Belfast Museum and Art Gallery Quarterly Notes*, June 1909, March 1911, June 1912; *Weekly Telegraph*, 23 October 1909; *Belfast Telegraph*, 27 July 1959; Patrick Shea, *A History of the Ulster Arts Club*, Belfast 1971; John Hewitt and Theo Snoddy, *Art in Ulster: 1*, Belfast 1977; Martyn Anglesea, *The Royal Ulster Academy of Arts*, Belfast 1981; Simon Houfe, *The Dictionary of British Book Illustrators and Caricaturists 1800-1914*, Woodbridge 1981; Paul Larmour, *Celtic Ornament*, Dublin 1981; Brian Kennedy: Ulster Museum, *British Art 1900-1937, Robert Lloyd Patterson Collection*, catalogue, Belfast 1982; Paul Larmour, *The Arts & Crafts Movement in Ireland*, Belfast 1992; Belfast Harbour Commissioners, *Letter to the author*, 1994; also, Laing Art Gallery, 1994; Royal Institute of British Architects, 1994; Ann M. Stewart, *Irish Art Societies and Sketching Clubs: Index of Exhibitors 1870-1980*, Dublin 1997.

W

WADE, JONATHAN (1941-73), urban landscape painter. John Wade was born at Pelletstown, Co. Dublin, on 5 April 1941. After attending the Christian Brothers' School, he began earning his living at the age of thirteen in various jobs. A few years later he began painting, a passion, but for economic reasons he was unable to become a full-time student of art. He enrolled as a part-time night student at the National College of Art and stayed three years. Among the techniques learnt there were serigraphy and etching.

Wade, a convinced Marxist, also had a consuming interest in politics. In 1962 he married, gave up his abattoir job and emigrated to London with his wife. He worked in an oil company depot, and in his spare time continued painting, selling his first work when it hung on Green Park railings. Within half a year the Wades returned to Dublin and settled in Clondalkin with his sister-in-law; he used the shed as a studio.

According to Henry J. Sharpe in his monograph on Wade: 'His rapidly developing painterly skills suggested, for instance, the invention of an alter ego, one "Lucas Kingsley". Lucas Kingsley, as his name may imply, was an academician to the core ...'.

Another job was in the Irish craftwork studios of Fergus O'Farrell Ltd, 24 Duke Street, and he had a hand in producing little wooden figures of ancient Irish monks and warriors. A knowledge of wood-working technique yielded rosewood pendants.

The O'Farrell studios was the venue of his first one-person show in 1966. This early work was painted in a 'German Expressionist idiom, combining brooding colours with a sombre figurative symbolism....' according to the art critic, Dorothy Walker. He never seemed to develop an interest in colour, often painting in pure monochrome, and was more interested in tone and surface texture. In 1966, as Jonathan Wade, he showed three works at the Oireachtas exhibition, including *Abhar Beo*.

In 1967, he exhibited *Painting '67* at the Royal Hibernian Academy; also he showed again at the Oireachtas. As well as contributing to both exhibitions in 1968, he held his second solo show, of sixteen pictures, at the small RHA gallery in Ely Place. The *Irish Times* critic noted that his images 'have a ferocity which, if they can attain splendour as well, would rise to the quality of Goya ...'. The *Evening Press* found Wade's world 'eerie and haunted'. He contributed again to the Oireachtas in 1969 and with *Peinteireacht '70* in 1970.

Associated with the Project Arts Centre in Dublin, it provided him with a venue in 1970 for his largest and most important exhibition, held in the basement of the Metropolitan Hall, Abbey Street. There were thirty-seven paintings on view, including *Flyover*; *Pounding Machine*; *Urban Aspect*; *Wharf Miscellany*.

In 1971 he exhibited again at the RHA, *District 1*, and at the Irish Exhibition of Living Art with *Mainland*. Some work was selected for inclusion in the Rosc '71, Young Irish Artists' Exhibition at Kenny's Art Gallery, Galway, and then at the Richard Demarco Gallery, Edinburgh. His work was included in the Critics' Choice exhibition held in the Project Arts Centre in 1971.

As a part-time art teacher, he joined the Clondalkin Vocational School staff in 1971. The Youth Centre adjacent to the school provided him with space to work on some of his large paintings, one of which measured about 4.6 metres wide. Assemblages made during 1970-1 were constructed mainly of sawn angular sections of hardboard. The flat surfaces were enlivened. *Triptych* in the Córas Iompair Éireann collection is described as in mixed media, 'leather and studs, etc. on acrylic painted board'. They also have *Construction*, acrylic on canvas.

In the 1972 Oireachtas exhibition, Wade won the Waterford Glass Prize for landscape painting with an urban landscape, purchased by the Arts Council, Dublin. *Urban Landscape* is in the Hugh Lane Municipal Gallery of Modern Art, and a triptych is at Deansrath Community College, Clondalkin. The human image had now been almost entirely forsaken for that of the industrial city – and metal, sometimes a polished mass of writhing pipes, recalled the so-called 'Tubist' paintings of Fernand Léger (1881-1955). In 1971 and 1972, he exhibited with Independent Artists; and in 1972 he showed acrylic paintings at the Davis Gallery, Dublin. He was also responsible for some graphic works.

In her *Modern Art in Ireland*, 1997, Dorothy Walker wrote: 'His painting treats of metallic, catastrophic subjects, the earliest work particularly, in which huge piles of metal seem to have been wrecked in some cataclysmic event. Slightly later work involved smoother metal objects like pipes and ducts...'.

Of 14 Michael Collins Park, Clondalkin, he died on 22 January 1973 at Jervis Street Hospital, following an accident on his motor scooter. In March, the Project Arts Centre held a Jonathan Wade Memorial Exhibition to raise money for his widow and two children. More than £5,000 worth of paintings and sculptures were, according to report, donated by artists in Ireland and France. A memorial exhibition of his own paintings was held that month at Green Isle Hotel, Clondalkin. In 1975 a retrospective exhibition of fifty-seven works took place at Trinity College, Dublin.

Works signed: Jonathan Wade or Lucas Kingsley (if signed at all).
Examples: Dublin: Arts Council; Córas Iompair Éireann; Deansrath Community College, Clondalkin; Hugh Lane Municipal Gallery of Modern Art; Mount Temple Comprehensive School; Trinity College Gallery.
Literature: *Register of Births*, Dublin, 1941; *Irish Times*, 25 November 1968, 2 June 1972, 23 and 29 March 1973, 23 May 1975; An Chomhairle Ealaíon: Dorothy Walker, *Jonathan Wade Retrospective Exhibition*, catalogue, Dublin 1975; Henry J. Sharpe, *Jonathan Wade: His life and art – a brief study*, Clondalkin 1977 (also illustrations); Ann M. Stewart, *Royal Hibernian Academy of Arts: Index of Exhibitors 1826-1979*, Dublin 1987; Córas Iompair Éireann, *Letter to the author*, 1994; also, Deansrath Community College, 1994; Dorothy Walker, *Modern Art in Ireland*, Dublin 1997 (also illustration); Ann M. Stewart, *Irish Art Societies and Sketching Clubs: Index of Exhibitors 1870-1980*, Dublin 1997.

WAKEMAN, GERALD (1864-1938), landscape painter. Information on the family of Gerald Hastings Wakeman and his early life is missing. A connection has not been established with William Frederick Wakeman (1822-1900), who was employed in Dublin as a draughtsman in the Ordnance Survey and was an illustrator of the antiquarian works and guide books of the period. A sister of Gerald's, Margaret Anne Wakeman, lived in London at the time of his death there.

Wakeman first exhibited at the Royal Hibernian Academy in 1893 and from then until 1923 contributed some fifty works. At his initial showing he gave the address, 6 Westland Villas, Inchicore, Dublin. In 1895 four works were hung: *Summer Evening on the Liffey; A Cattle Boat; The Freshwater Coach, Yarmouth, Isle of Wight; A Foreigner*. His four pictures at the 1897 RHA included *A Hampshire By-way* and *A Passing Shower, Howth*. In 1902 he exhibited *A Cottage Gardener* and *Portmarnock Mill*.

After residing at two other addresses, at least, he named 8 David Road, Phibsboro, Dublin, in 1904 when he first exhibited with the Water Colour Society of Ireland, and from then until 1911 nineteen works were presented. Early associations with the North of Ireland were evident by the 1904 exhibition with *Portrush Harbour*; and in 1905, *On the Lagan, near Belfast*. Of the 1906 event *The Yellow Steeple, Trim* would appear to be the same work as exhibited in 1907 at the Oireachtas exhibition. In that year he showed at the RHA, *The White Ship, Ringsend* and *The Poor Man's Picture Gallery*.

After exhibiting three works at the Oireachtas in 1907, *Kildare Pastures* was his final contribution in 1911. Other pictures at WCSI exhibitions included *On the beach, Shanganagh*, in 1908; *A Dublin Sunset*, 1909; *Destroyers in Sandown Bay*, 1910; *The Chieftain's Tomb, Killiney*, 1911. Among his remaining pictures at the RHA, *The Goblin Child of Ballyshannon* in 1913 may have aroused most interest.

As from 1913 Wakeman became closely associated with the Dublin Sketching Club and from then until 1937 he missed only a few years, showing just over 100 works, often painting in Co. Dublin and Co. Wicklow, for example Bray, Howth, Killiney, Malahide and Rush. He did not, however, confine his excursions to the area and continued to visit the North, for example in the 1913 exhibition he depicted Ardglass fishing boats; *Portstewart Strand*, 1916; *McArt's Fort, Cave Hill, Belfast*, 1918; *Donaghadee Regatta*, 1919. Although only a minor aspect of his DSC involvement, titles indicated activity outside Ireland, for example in Hampshire at Southampton and the New Forest; also Putney Heath in London.

In 1921 his address was 27 Cherryfield Avenue, Dolphin's Barn, Dublin. In 1928 he exhibited *Excavations* at the Royal Academy, from 209 New King's Road, SW. A retired draughtsman of the Registration of Titles Office, he died on 23 January 1938 at 4 King Edward's Mansions, SW 6.
Works signed: Gerald H. Wakeman.

Literature: Fulman Registry Office, *Register of Deaths*, 1938; Anne Crookshank and The Knight of Glin, *The Painters of Ireland c. 1660-1920*, London 1978; Ann M. Stewart, *Royal Hibernian Academy of Arts: Index of Exhibitors 1826-1979*, Dublin 1987; Ann M. Stewart, *Irish Art Societies and Sketching Clubs: Index of Exhibitors 1870-1980*, Dublin 1997.

WALKER, DAVID BOND (1891-1977), portrait and landscape painter. David Bond Walker was born in Belfast on 6 December 1891, the son of Tom Bond Walker (1861-1933), portrait and landscape painter, who was London-born and arrived in Belfast in the 1880s. Tom Bond Walker's name became associated with that of Paul Henry (q.v.). After the death of Henry's father in 1891, Walker offered art lessons free of charge. In *Further Reminiscences*, Henry wrote: 'a shy, retiring, ineffectual little man with a genuine enthusiasm for teaching: a product of the South Kensington Schools. He had married an Irish girl and was trying to eke out a precarious livelihood by taking pupils for drawing, and supplemented his earnings by painting an occasional portrait ...'. In 1893 Tom Bond Walker was accepted into membership of the Belfast Art Society.

David Bond Walker, educated at St Jude's National School, Belfast, studied art under his father and Hans Iten (q.v.). He had been painting since the age of fourteen. Iten advised him to concentrate on portraiture rather than landscape painting as a career. He showed four portraits at the 1920 exhibition of the Belfast Art Society, including those of Clugston Thompson and John Foster of Stoke-on-Trent.

Selected by Sir John Lavery (q.v.), he was among the first ten 'Members' elected for the Belfast Art Society in 1920. The following year he began exhibiting in Dublin at the Royal Hibernian Academy, and between 1921 and 1926 he showed eight works, half being portraits. In 1921, from Garfield Chambers, Royal Avenue, Belfast, he contributed portraits of F.A.C. Mills (Ulster Museum) and Mrs Robert Forsythe. In 1924 his studio address was 22 Wellington Place, Belfast, and he exhibited *A Passing Grin*.

Included in the four works which he showed in Dublin in 1926 from 5 Donegall Square South, Belfast, were a portrait of Richard Hayward and *'Played Out'*. His 1925 oil painting, *The Pensive Maiden*, is also in the Ulster Museum collection. In the loan exhibition of Irish portraits by Ulster artists held at Belfast Museum and Art Gallery in 1927, he was represented by three works.

In the 1930s with a studio at 29 Howard Street, Belfast, he was awarded several prestigious portrait commissions, notably in 1934 with those of Lord Justice Best in his official robes; Sir Joseph Davison, DL (Clifton Street Orange Hall), presented by the Orangemen of Belfast; and Sir Ernest Herdman (Belfast Harbour Office). Senator T. R. Lavery (*Ards Borough Council*) was commissioned in 1935, and also a posthumous portrait of the author George Borrow for the D. & J. Adams Memorial Bible House, Belfast.

In Armagh County Museum is a portrait of Robert Hugh Henderson, who was born at Kildarton, County Armagh, in 1862, became a member of the South African Cabinet in 1934 and was the author of *An Ulsterman in Africa*, 1944.

When the Ulster Society for the Prevention of Cruelty to Animals published *The Tree* in 1936, his *Cara, an Irish Wolf-Hound*, oil, was reproduced. In 1937 he recorded in pencil and watercolour the Coronation visit to Belfast of King George VI: *The Royal Yacht 'Victoria and Albert' in Belfast Lough* (Belfast Harbour Office). Instead of in his studio, as formerly, he exhibited in 1938 at Robinson and Cleaver Ltd, mainly landscapes.

During the Second World War he left Belfast and settled at 45 Shimna Road, Newcastle, Co. Down, concentrating on landscape painting – he found portraits 'just that wee bit frustrating' – and he opened the Bond Walker Picture Gallery at Pedlar's Bridge, Dinnewater, Annalong. This summer 'gallery' measured about 3.7 metres square. Also in County Down, he taught art at Mourne Grange School, Kilkeel, and at adult evening classes in Rathfriland. He died on 9 January 1977.

Works signed: D. Bond Walker or Bond Walker.
Examples: Armagh: County Museum. Belfast: Clifton Street Orange Hall; Department of the Environment for Northern Ireland; Harbour Office; Ulster Museum. Newtownards, Co. Down: Town Hall.
Literature: General Register Office, Belfast, *Entry of Death, Thomas Bond Walker*, 1933; *Belfast Telegraph*, 27 January 1934, 2 February 1934, 18 June 1935; *Belfast and Ulster Directory*, 1935; *Northern Whig*, 13 February 1935; Ulster Society for the Prevention of Cruelty to Animals, *The Tree*, Belfast 1936 (illustration); *Belfast News-Letter*, 26 October

1938, 31 August 1964; Paul Henry, *Further Reminiscences*, Belfast 1973; *Dictionary of South African Biography*, Pretoria 1977; Martyn Anglesea, *The Royal Ulster Academy of Arts*, Belfast 1981; Eileen Black, *Paintings, Sculptures and Bronzes in the Collection of The Belfast Harbour Commissioners*, Belfast 1983 (also illustrations); Ann M. Stewart, *Royal Hibernian Academy of Arts: Index of Exhibitors 1826-1979*, Dublin 1987; Ards Borough Council, *Letter to the author*, 1994; also, Armagh County Museum, 1994.

WALKER, FRANCIS S., RHA, RE (1848-1916), landscape, genre and portrait painter; illustrator. Francis Sylvester Walker was the eldest son of Thomas Walker, Master of the Workhouse at Dunshaughlin, Co. Meath. He studied at the Catholic University of Ireland, and art at the Royal Dublin Society and Royal Hibernian Academy Schools.

Walker first exhibited at the RHA in 1863, from 14 Irishtown Road, Dublin, and between then and 1916 showed 122 works. *The Good Samaritan*, which was hung in 1865, was awarded the Taylor Prize the previous year. He showed two pictures at the Royal Scottish Academy in 1867: *In the Glen of the Dargle, near Dublin* and *Rathfarnham Park*. He was active as an assistant teacher at the Dublin Metropolitan School of Art in 1867.

On moving in 1868 to London, he worked for the engravers, Dalziel Brothers. His work was seen at the Dudley Gallery, and in 1868 he contributed to *Cassell's Family Magazine*; also to *Good Words* in 1869; *The Sunday Magazine*, 1869; *Good Words For The Young*, 1869-72; and the *Magazine of Art*.

In 1870 he first worked for *The Graphic* and was one of the main illustrators of the Franco-Prussian War, 1870-1. At the Royal Academy he showed for the first time in 1871, from 6 Thurlow Terrace, Maitland Park, NW, and from then until 1915 he contributed fifty-two works. He exhibited *The Farmer's Boy* at the 1871 RSA. He began working for the *Illustrated London News* in 1875. *The Little Shepherdess* and *The Convent Garden* (Leeds City Art Gallery), 1.1 metres by 1.9 metres, signed 'F.S. Walker 1878', were exhibited at the 1878 RA.

Walker, for the 1879 RHA, sent over *The Brigade's Bride* and *The Whisper*. He had been elected an associate the previous year, and in 1879 he became a full member. The Victoria and Albert Museum has a pen and wash drawing, touched with white, on wood block, depicting Sarah Bernhardt as Gilberte in Froufrou, Gaiety, June 1880. He turned to etching and mezzotinting his own pictures. In 1882 at the RHA he showed two original works 'for engraving'. In that year too he was represented in the Exhibition of Irish Arts and Manufactures, Rotunda, Dublin.

When he presented *The Forgotten Sheaf* at the RA in 1883, his address was 1 Wychcombe Villas, England Lane, NW. In the Irish Exhibition at London in 1888 he exhibited, for example, *He's Late*, 'painted and etched'. In 1890 he became an associate of the Royal Society of Painter-Etchers, and in 1897, a full member, showing, in all, some four score works at its exhibitions.

No fewer than seventeen of his pictures were displayed at the Dublin exhibition in 1892, more than half of which were etchings. Involved in book illustration, *The Thames from Oxford to the Tower* had appeared in 1891, of which fifty copies were printed on fine paper; and *Annals of Westminster Abbey* was published in 1895.

By 1897 his address was 58 North Hill, Highgate. Walker painted at Killarney in the summers of 1900 and 1901. As a consequence, he supplied twelve mezzotint engravings for Edmund Downey's *Killarney's lakes and fells*, 1902, including *Storm on the upper Lake*; *The Eagle's Nest*; and *The Meeting of the Waters*. A note in the book stated: 'The twelve original oil paintings and sketches by Mr F. S. Walker ... can be seen at the office of the Publishers. Price for the set, £150; or they will be sold separately at prices varying from £25 to £6 each according to the size.'

In the period 1902-04 Walker produced a number of landscapes for Frank Mathew's *Ireland*, wandering where he chose and painting what he liked, without any thought of depicting notable scenes. In the event, he supplied seventy-nine illustrations which were reproduced in colour. The book was published in 1905, and Walker provided notes for each picture. In 1903 at the RHA he had shown two Killarney landscapes, and in 1904 his contributions included an etching, *The Groves of Blarney*.

At Burlington House in 1905 he exhibited *Columba in exile welcomes the Wild Birds that cross the sea from Ireland*, shown in 1906 at the RHA. (In 1984, Sotheby's of London had up for auction *Scenes from the Life of Saint Columba*, eight oils, average size 32cm x 24cm). A continued interest in Irish subject matter showed in 1906 at the RHA with all four works, and in 1907 his six pictures included *The Salmon Leap, Leixlip* and *Dublin Bay from Killiney*.

A rare appearance at the Oireachtas exhibition came in 1907 when he showed *A Stranger's Welcome* and *Monks of Mount Melleray*. His last address was 2 The Firs, Mill Hill, NW. *Sea Dogs, Achill* and *Donegal Highlanders' Harvest* were both on view at the 1908 RA. Two years later he was represented in the British Fine Art Section of the Japan-British Exhibition.

In the period 1911-14 he showed in Dublin a number of portraits. In England he sent a few works to the exhibitions of the Royal Society of Artists, Birmingham; Glasgow Institute of the Fine Arts; Walker Art Gallery, Liverpool; and Manchester City Art Gallery. He also showed in London with the Society of British Artists, Royal Institute of Painters in Water Colours and the Royal Institute of Oil Painters. He painted many views along the Thames. In the National Gallery of Ireland are two oil paintings, *St Mary Stratford-le-Bow, East London* and a view of Killiney Bay looking towards Bray, 1904, which is plate fifteen of the *Ireland* book. He gave his recreation as walking, and died unmarried on 17 April 1916.

Works signed: Francis S. Walker, F. S. Walker or F. S. W., rare (if signed at all).
Examples: Dublin: National Gallery of Ireland. Leeds: City Art Gallery. London: British Museum; Victoria and Albert Museum.
Literature: William Senior, *The Thames from Oxford to the Tower*, London 1891 (illustrations); E. T. Bradley, *Annals of Westminster Abbey*, London 1895 (illustrations); Edmund Downey, ed., *Killarney's lakes and fells*, London 1902 (illustrations); Algernon Graves, *The Royal Academy of Arts 1769-1904*, London 1905; Frank Mathew, *Ireland*, London 1905 (illustrations); Andrew Lang, ed., *Poets' Country*, London 1907 (illustrations); Katharine Tynan, *Ireland*, 'Peeps at many lands' series, London 1907 (illustrations); *The Studio*, October 1910; *Who Was Who 1916-1928*, London 1929; Christopher Wood, *Dictionary of Victorian Painters*, Woodbridge 1968; *Dictionary of British Artists 1880-1940*, Woodbridge 1976; Simon Houfe, *Dictionary of British Book Illustrators and Caricaturists 1800-1914*, Woodbridge 1978; Witt Library, London, illustrative records [1979]; *National Gallery of Ireland Acquisitions 1984-86*, Dublin 1986; Angela Jarman, *Royal Academy Exhibitors 1905- 1970*, Calne 1987; Ann M. Stewart, *Royal Hibernian Academy of Arts: Index of Exhibitors 1826-1979*, Dublin 1987; *The Royal Scottish Academy Exhibitors 1826-1990*, Calne 1991; Leeds City Art Gallery, *Letter to the author*, 1994; John Turpin, *A School of Art in Dublin since the Eighteeth Century*, Dublin 1995; Ann M. Stewart, *Irish Art Societies and Sketching Clubs: Index of Exhibitors 1870-1980*, Dublin 1997.

WALKER, J. CRAMPTON, ARHA (1890-1942), landscape and flower painter. Born on 22 September 1890 at 9 Gardiner's Place, Dublin, John Crampton Walker was the eldest son of Garrett William Walker, KC. Educated at St Stephen's Green School and at Trinity College, Dublin, 1908-10, he afterwards attended Dublin Metropolitan School of Art. In 1912 he showed with the Dublin Sketching Club and then every year until 1918.

A pastel, *At Sea*, was in (Sir) Hugh Lane's gift to the Dublin Municipal Gallery. In 1913, from 38 Fitzwilliam Square, Dublin, Walker first exhibited at the Water Colour Society of Ireland exhibitions and was a regular participant until 1927, showing fifty-one works. In 1914 he contributed *Evening, Chillon Castle*. In 1914 his work first appeared at the Royal Hibernian Academy, and from then until his death he was a regular exhibitor and showed 132 works.

A born organiser, Walker inaugurated the Black and White Artists' Society of Ireland. Commenting on the second exhibition held in 1914, *The Studio* said that the Society owed much of its success to its energetic honorary secretary, himself an enthusiastic draughtsman. In the same issue, a writer referred to his work in the fortieth exhibition, Dublin Sketching Club, and considered that it bore traces of the influence of Nathaniel Hone (q.v.), and that he was at his best in *The Shower*, 'showing a stretch of land and sea immersed in mist'.

At the RHA in 1915 he showed *Old Bridge, St Ives*. A dozen works exhibited that year with the Dublin Sketching Club included *In the Fen Country* and *The Old Boathouse, Cambridge*. In 1916 at the Sketching Club: *St John's College, Cambridge*.

A 1916 design for a woodcut, *Snow*, appeared in the third Black and White Artists' Society show that year. *The Studio* gave more praise for his organisational ability, and found that the woodcut design showed 'a sense of rhythm and pattern and much vivacity of expression', and his charcoal study, *The Falls of Tummel*, in Perthshire, was 'full of light and atmosphere'. A pen drawing of the construction of the Royal College of Science, Merrion Street, Dublin, is in the National Library of Ireland. Contributions to the 1917 WCSI included *The Rag and Bottle Man*.

After giving 13a Merrion Row, Dublin, as an address in the 1919 RHA catalogue, he listed The Studio, 21 Dawson Street, Dublin, in 1920, showing *Anemones* and *The Marsh*. The New Irish Salon exhibition in 1924, organised for the Dublin public by Walker, contained nearly 200 modern pictures by English, Irish and French artists, together with some jewellery and sculpture. The next year no fewer than 300 pictures by some 130 artists were on display, causing 'no little discussion in Dublin art circles', and a surprising number of sales. In 1926 the Salon was opened by the Governor-General, T. M. Healy, KC. In that year too he showed *La Chateau de Chevreuse* at the WCSI gathering.

Crampton Walker's organisational powers were again to the fore in 1926 when his book *Irish Life and Landscape* appeared, having written and arranged the contents: 'This book is dedicated to the late Nathaniel Hone, RHA, one of Ireland's greatest landscape painters.' The object of the editor was to lay before the public examples of the works of twentieth-century Irish artists with sixty-seven coloured or black and white reproductions of their work, accompanied by notes. His own work reproduced was *Looking towards Glenbeigh, Co. Kerry*. An advertisement for the New Irish Salon annual exhibition gave his name and the address, 38 Fitzwilliam Square, Dublin.

Walker's work was known in London as he showed more than sixty pictures in the Fine Art Society gallery, and in 1928 he organised for that venue paintings by four Irish artists: J. H. Craig, Paul Henry, E. L. Lawrenson (qq.v.) and himself. Malahide, Co. Dublin, and Counties Clare and Kerry figured in his Irish scenes. Among the eight works which he showed at the 1928 RHA were: *The Entrance Gate to Mellifont Abbey*; *Clew Bay* (Waterford Municipal Collection); *Old Dugort Village, Achill*. Also in 1928 he organised the British Contemporary Flowers exhibition at the Fine Art Society.

Operating from 16 Fitzwilliam Place, Dublin, he acted as organising committee secretary for the Exposition d'art Irlandais at Brussels in 1930, and showed eight works, one of which, *Mimulus*, 1928, was bought by the Belgian Government. Appointed an ARHA in 1930, he received an honorary mention in the 1932 Aonach Tailteann exhibition. At the Oireachtas event in 1932 he contributed eight works, including two Achill scenes.

Among his eight pictures at the 1933 RHA was a sketch of the Luxembourg Gardens. From 18 Fitzwilliam Square, Dublin, he showed for a few years at the RHA a flowerpiece or two each session, and in 1934 he organised an exhibition of flower and garden pictures at the Metropolitan School of Art. He was also responsible for displays of Irish landscapes under the auspices of the Royal Dublin Society at the Horse Show and Spring Show.

As the RHA records indicated, Walker painted other works in Britain, for example *Blackboy's Mill, Sussex Downs*, 1937 exhibition; *Showery Weather – near Holyhead*, 1938; *A Welsh Windmill*, 1939. Recreations ranged from crocquet to shooting, and in the last few years of his life he lived at the Grand Hotel, Malahide. *Coal Boat at Malahide* in the 1942 RHA won praise in *The Bell* from Arthur Power (q.v.). He died on 9 June 1942.

Works signed: J. Crampton Walker or J. C. W.
Examples: Belfast: Ulster Museum. Brussels: Museum of Modern Art. Drogheda, Co. Louth: Library, Municipal Centre. Dublin: Hugh Lane Municipal Gallery of Modern Art; National Library of Ireland. Limerick: City Gallery of Art. Sligo: Model and Niland Centre. Waterford: City Hall, Municipal Art Collection.
Literature: *The Studio*, January 1915, June 1916 (also illustration), March 1924, July 1925, May 1926, June 1928; Lady Gregory, *Hugh Lane*, London 1921; J. Crampton Walker, *Irish Life and Landscape*, Dublin 1926 (also illustration); *Dublin Magazine*, January-March 1927; *Who's Who in Art*, 1927, 1934; *Royal Hibernian Academy Minutes*, 1942; *The Bell*, May 1942; *Who Was Who 1941-1950*, London 1952; Tom Ryan, ARHA, *Letter to the author*, 1967; Rosalind M. Elmes and Michael Hewson: National Library of Ireland, *Catalogue of Irish Topographical Prints and Original Drawings*, Dublin 1975; Ms Columba McFadden, *Letter to the author*, 1982; Ann M. Stewart, *Royal Hibernian Academy of Arts: Index of Exhibitors 1826-1979*, Dublin 1987; Museum of Modern Art, Brussels, *Letter to the author*, 1994; also,

Raymond M. Walker, 1994; Water Colour Society of Ireland, 1994; Ann M. Stewart, *Irish Art Societies and Sketching Clubs: Index of Exhibitors 1870-1980*, Dublin 1997.

WALLACE, PAT – see GRIFFITH, PAT

WALSH, GEORGE STEPHEN (1911-88), stained glass artist, painter and sculptor. Born on 3 June 1911 at Garden View, Ranelagh, Dublin, son of William Walsh, a coachpainter specialising in crests and emblems, and in his spare time a builder of model railway engines and ships to his own design. When he died he had only one bequest for his son, George Stephen Walsh, and that was a set of brushes.

George Stephen recalled years later how he began his career with Joshua Clarke, 33 North Frederick Street, in 1927: 'My father told me to answer an ad. in the *Evening Mail* for a stained glass apprentice. I arrived at the studios at 10 o'clock with my sample of drawings. Harry Clarke looked at them and said: "Can you start at half ten?"' During his apprenticeship he studied at the Dublin Metropolitan School of Art.

In 1932 he showed stained glass, *St Paul*, at the 1932 Oireachtas exhibition. In reminiscent mood, he recounted how John Charles McQuaid, the Archbishop of Dublin, had turned down a request to sit for a portrait but became enthusiastic when he heard it was to be done in glass. The sitter liked the result. It was accepted for exhibition by the Royal Hibernian Academy, but when the artist turned up on varnishing day the portrait was not there. He explained: 'I was shocked and then hurt, and later amused when I discovered that it had been removed by a member of the studio management. I was told I could have my job or the exhibit.' He kept his job. The reasoning was that he would receive much work as a result of the exhibit. Later, the Archbishop, who had been appointed in 1940, arranged that the portrait be exhibited for three weeks in the window of the Catholic booksellers, James Duffy and Co. Ltd.

Walsh stayed in Clarke's until about 1941 when, through lack of work in Dublin, he moved to London where he worked for Powell Stained Glass. He first exhibited at the Royal Hibernian Academy in 1941, and from then until 1944 showed seven works. On his return from London to Dublin he was employed by State Glass Co. of Lower Pembroke Street. *'When Day is Done'* — *Dalkey Harbour* was hung at the 1944 Irish Exhibition of Living Art. In 1948 he moved to Belfast with his family and worked on stained glass with W. F. Clokey & Co. Ltd, King Street. A design for a two-light window, *St Bernadette*, is in the Ulster Museum.

In 1957 he emigrated to the USA, settled in Waukesha in the State of Wisconsin, and was employed by the Conrad Pickel Studios, especially in the Dalles de Verre medium, thick glass worked with a glass cutter and hammer. After two visits home, he returned to Ireland permanently in 1963 and opened his own stained glass studio at 68 Upper Drumcondra Road, Dublin, under the title of G. Stephen Walsh Studio, 'stained glass windows, mosaics, murals, bronze work'. He was responsible for the *St Brigid* and *St Columcille* windows at Ballintubber Abbey, Co. Mayo. In his later years he turned to sculpture, producing many figures, one life size.

In 1980 he made his return to the RHA, after an absence of thirty-six years, but the range of his artistic activity was demonstrated in the one- person show at the Kilcock Art Gallery, Kilcock, Co. Kildare, in 1981. Included in the stained glass (fourteen items) were *Orpheus and Eurydice*; *Blue Bird*; and *Samson*. Other examples of his work: ceramics (two): *Temptation*; oils (nine): *Banshee* and *Squall*; watercolours (twelve): *Roundstone* and *Horses on Beach*; scraperboard (four): *The Fall*; bronzes (six): *Young Girl* and *The Kiss*; slate carving (two): *Mother Love*; collage (two): *Window Boxes*. The exhibition also included portraits of George Campbell and Arthur Armstrong (qq.v.), both in charcoal and watercolour.

In 1984 he resumed contributing to the Academy with *The Washer Woman*, bronze. In 1985 and 1986 he showed two bronzes each year, including *Girl Beside the Pool*, and one piece of stained glass, *Andromeda*, which won, in 1986, the Electricity Supply Board's Keating McLoughlin Medal for a work of outstanding merit in any medium, together with the accompanying prize of £1,000.

Meanwhile in 1985 his work had appeared with the Water Colour Society of Ireland for the first time and, altogether, he showed half a dozen pictures under Stephen Walsh, concluding in 1987 with *Restless Sleep* and a design for stained glass.

In Blackrock College, Co. Dublin, is a mosaic in Our Lady's Hall depicting the Annunciation. A large mosaic is in the dome of St Joseph's Church, Wilton, Cork. He designed a number of mosaics for Irish Mosaics Ltd, of Roscommon. For the Church of the Annunciation at Finglas, Co. Dublin, he designed and executed all the windows, Stations, murals and also the mosaics. A memorial window to his parents is in Christ Church, Leeson Park, Dublin.

Walsh was responsible for much variety in church furniture: silver, tabernacles, communion rails, lecterns and vestments. A prolific worker, a sixteen-hour day was not uncommon when in good health. He died in hospital on 25 February 1988.

Works signed: G. Stephen Walsh or G. S. Walsh (if signed at all).
Examples: Windows – USA: Carteret, New Jersey: St Elizabeth's Church. Detroit, Michigan: St Peter's Parish Church. Fall River, Mass.: St Peter and St Paul Church. Falmouth, Mass.: St Elizabeth Seton Church. Fremont, Ohio: Grace Lutheran Church. Manville, New Jersey: Christ the King Church. Milwaukee, Wisconsin: Sherman Park Evangelical Lutheran Church. Mount Vernon, New York: St Mary's Church. Nashua, New Hampshire: Church of the Infant Jesus. New York: St Boniface's Church. Ocean City, New Jersey: St Augustine's Church. Philadelphia, Pennsylvania: Stella Maris Church. Plainfield, New Jersey: Our Lady of Czestochowa Church. Redwood City, California: St Pius Church. Riverton, New Jersey: Sacred Heart Church. Salem, New Jersey: Mary Queen of Peace Church. Stony Point, New York: Church of the Immaculate Conception. Stoughton, Mass.: Church of the Immaculate Conception. Washington, D.C.: National Shrine of the Immaculate Conception. Waterloo, Iowa: St Luke's Lutheran Church. Waukesha, Wisconsin: First United Presbyterian Church. West Allis, Wisconsin: St Paul's Lutheran Church. Westbrook, Maine: St Hyacinth's Church. Westport, Mass.: St John the Baptist Church.
Examples: Windows – Ireland: Ballintubber, Co. Mayo: Abbey. Blackrock, Co. Dublin: Blackrock College. Boherbue, Co. Cork: St Mary's Church. Cork: St Joseph's Church, Wilton. Dublin: Christ Church, Leeson Park. Finglas, Co. Dublin: Church of the Annunciation.
Literature: *Thom's Directory*, 1935, 1938; Kilcock Art Gallery, *G. Stephen Walsh*, catalogue, Kilcock, 1981; *Irish Press*, 8 July 1986; Ann M. Stewart, *Royal Hibernian Academy of Arts: Index of Exhibitors 1826-1979*, Dublin 1987; *Irish Times*, 27 February 1988; Mrs Gloria Robinson (née Walsh), *Letter to the author*, 1989; also, George W. Walsh, 1994; Water Colour Society of Ireland, 1994; Ann M. Stewart, *Irish Art Societies and Sketching Clubs: Index of Exhibitors 1870-1980*, Dublin 1997.

WALSH, SAM, LAA (1934-89), portrait and figure painter. Born at Enniscorthy, Co. Wexford, on 11 January 1934, Samuel Walsh was the son of James Walsh, painting contractor. Sam attended the Christian Brothers' School and had an idyllic childhood, according to a sister.

In 1952 he entered the National College of Art, Dublin. In 1955 he moved to London and spent the next five years in various jobs, and he also played the guitar professionally. He painted some portraits and murals, and his work was included in shows at the Institute of Contemporary Arts and the New Gallery, Chelsea.

In a basement opposite the Gate Theatre, Dublin, two of his paintings were included in the opening group exhibition of the Cavendish Gallery in 1958, and were described by Arland Ussher in the *Dublin Magazine* as 'fantasies which bring us back to the White Stag group of the war years, in their strong glazed symbolic colours'. In 1960 Walsh moved from London to Liverpool, and his first home was a bedsit at 24 Falkner Square, living above the much-talented Adrian Henri, painter, playwright, poet, who later served for nine years as president of the Liverpool Academy of Arts.

As from 1961, Walsh was a regular exhibitor at the Liverpool Academy exhibitions at the Walker Art Gallery. In 1962 he showed with Henri at the Portal Gallery, London, and at Hope Hall, Liverpool. After the opening of the London show, George Melly introduced them to Francis Bacon (1909-92).

In 1962 Walsh began a three-year teacher-training course at C. F. Mott College, Liverpool. In 1963 three works were included in a 'Pop Art' exhibition with Peter Blake and others at the Midland Group Gallery, Nottingham. Henri was of the opinion that 'Pop art liberated him, he gloried in its deliberate ambiguities ...'. *Pin Up 1963 – For Francis Bacon* was selected for John Moores Liverpool Exhibition 4, and bought by the Walker Art Gallery. *Samuel Beckett Himself* (University of Liverpool) was first exhibited at the Bradford Spring Exhibition of 1965, when he was elected an associate member of the Liverpool Academy, and that year he exhibited again at the Portal Gallery.

In 1966 he was elected a full member of the Academy, and his five works in that year's exhibition included *Ambush Party with J. Walsh, Co. Wexford, 1916*, but the year was a mistake? Edward Lucie-Smith wrote in *Studio International* that Walsh was represented in the exhibition 'by a striking series of pictures which seem to combine influences from Schiele and Francis Bacon ...'.

Contributions in 1967 to the Liverpool Academy included *James Joyce, Pin Up for '67*, and that year he held an eighteen-work retrospective at the Everyman Theatre. Paintings at the 1968 Liverpool Academy introduced his new spray-painting style. However, in London he was represented by seven pictures in a group show of contemporary portraiture, 'Friends and Famous People', at the Grosvenor Gallery; his subjects included Beckett, Che Guevara, Kruschchev and Harold Macmillan. His portraiture was generally based on photographs and the media world.

In 1968 he began full-time teaching in Liverpool College of Art, and that year he held a second exhibition at the Everyman Theatre. Of 84 Huskisson Street, Liverpool 8, he was a guest exhibitor at the 1969 exhibition of Independent Artists, held at the Municipal Gallery of Modern Art, Dublin; he showed *Rockefeller Senior*, oil. When he held a solo show at the Neptune Theatre Gallery, Liverpool, in 1970 – others followed in 1971 and 1972 – his address was 39 Ashfield Road, Liverpool 17. A major work of 1970 was *Private View*, one of his sprayed interiors with gleaming steel fittings. He had several techniques and methods.

Walsh showed thirty-one works at the Bluecoat Gallery in a three-person show in 1974. The Liverpool Academy gave him an exhibition in 1975, and in 1977 he contributed for the last time at the annual show. His exhibition, 'Manslaughter: Man's Laughter', forty-eight works, at the Bluecoat Gallery in 1978 included his Baader Meinhof series. By the late 70s he only exhibited occasionally, locally. After the completion of *The Dinner Party* in 1980 he more or less abandoned painting although he continued to draw. In 1983 he was seriously ill in hospital.

In 1986 Walsh retired from teaching at Liverpool College of Art. In 1987 he resided at 21 Greenbank Drive, Liverpool 17. *Three Figures In A Warm Climate* is one of his works at the Walker Art Gallery. The National Portrait Gallery, London, bought at auction in 1993 his large head of Paul McCartney. His friend Henri, with whom he exhibited in 1986 at the Hanover Gallery, Liverpool, found him 'complex, witty, sometimes uneven, gifted, impatient and a highly perceptive person'. He died in Liverpool, on 3 February 1989. The retrospective exhibition of paintings and drawings at the Walker Art Gallery in 1991 charted his career from his arrival in Liverpool; 25,000 people visited the gallery during that time.

Works signed: Sam Walsh, S. Walsh, rare, or Walsh (if signed at all).
Examples: Liverpool: University; Walker Art Gallery. London: National Portrait Gallery.
Literature: *Dublin Magazine*, April-June 1958; Grosvenor Gallery, *Friends and Famous People*, catalogue, London 1968; Adrian Henri, *The Guardian*, 16 February 1989; Walker Art Gallery, *Sam Walsh*, catalogue, Liverpool 1991 (also illustrations); *Who's Who 1994*, London 1994; Walker Art Gallery, *Letters to the author*, 1994, 1996.

WARD, JAMES (1851-1924), designer and mural painter. Born in Belfast on 17 November 1851, James Ward was the eldest son of a housepainter, James Ward of 5 Gavins Buildings, Shankill Road, and was related to the local historian and astronomer, Isaac W. Ward. The family connection went back to Roger Ward from England who settled at Malone, Belfast, in 1688.

James Ward studied at the Government School of Art in Belfast, and gained a scholarship to South Kensington, 1873-6. After leaving the National Art Training School, he was engaged by Sir Edward Poynter (1836-1919), Director for Art, Museum of Ornamental Art, as it was known then. Poynter was working on ornamental decoration for the Museum's lecture theatre. During 1878 this work came to an end, and Ward was introduced by Poynter to Sir Frederic Leighton (1830-96), appointed Royal Academy president that year.

In the summer of 1878 Leighton, assisted by Ward, began work in the 'spirit-fresco' system at the Museum of Ornamental Art on the great fresco, decorating a lunette, *Industrial Arts as Applied to War*. On 5 February 1880, Sir Frederick advised the Director: 'I have this day finished my tasks on your walls. Mr Ward will now take the border in hand after which the work will be ripe for public gaze.' In 1880 Ward became secretary of the new Barnes Institute and master of the art classes, which were held mainly or entirely in the evening.

Ward continued to assist Leighton, this time with *Industrial Arts as Applied to Peace*, also 4.9 metres by 10.7 metres, which was not finished until 1886. He also worked with Leighton on several of his larger decorative pictures in his studio – 'a period to which I shall always look back with gratification and pleasant memories to the many happy days I spent working side by side with one whose princely culture, exhaustive knowledge, and experience of art and artists was so wide and extensive ...'.

Ward, indeed, played a considerable part in the history of both the frescoes. The medium 'spirit-fresco' was experimental, and there was considerable anxiety about state of preservation. He was called in for restoration. In a letter to the Victoria and Albert Museum in 1903 he stated: 'I painted the greater part of these works. Lord Leighton finished off the principal figures, but trusted me with the underpainting, and with the whole of the painting of the Architectural parts, and other accessories ...'.

Sir Philip Cunliffe-Owen regarded Ward as one of the best designers in the country; he had made his acquaintance at the Health Exhibition in London in 1884, 'where Ward had designed the very best objects, including designs for damask table cloths, a decorative work for a great house in Belfast'.

The 1886 catalogue of the Royal Academy described him as a 'decorative artist' with an address at 4 Essex Villas, Barnes, Surrey, and he showed a design, the first of only four contributions, for a frieze in glass mosaic. At the 1888 RA, he exhibited a design for ceiling of boudoir. He also exhibited two works at the Manchester City Art Gallery.

An advertisement for the headship in 1888 of Macclesfield School of Art stated 'knowledge of design indispensable'. There were twenty-two applicants and Ward won the post. By 1890 he had established at the School of Art a large flower painting class, and a class for sketching from nature in the country. The reputation of the School was to be enhanced by Ward's standing as an author. His textbooks achieved a national reputation. *Elementary Principles of Ornament* appeared in 1890, followed by *The Principals of Ornament* two years later. In his preface to the latter he thanked John Vinycomb (q.v.) for his 'valuable suggestions to me in the chapter on symbolic ornament'.

Ward's lectures at Macclesfield, and at the National Art Training School at £5 per session, formed the basis of some of his books. His appointment in 1893 as art master at Battersea Polytechnic Institute whilst holding the Macclesfield post is difficult to understand. The Government commissioned him to report on Continental schools, hence his *Report on the Art and Technical Schools of Crefeld, Zurich, and Lyons*, 1895.

Historic Ornament, in two volumes, a treatise on decorative art and architectural ornament, appeared in 1897. *Floral Studies for Decorative Design*, for the use of students and designers, consisted of a set of twelve plates, containing illustrations of fifteen specimens of plants, 'selected as suitable examples for use in ornamental and decorative compositions'. These were drawn from nature, in black and white chalk on tinted paper, and each loose sheet in the folder measured 64.7cm by 50.9cm. It was hoped that they would find a place on schoolroom walls.

Colour Harmony and Contrast, 1903, for the use of art students, designers, and decorators, was later translated into Japanese and published in 1917. Among his other publications was one on fresco painting, its art and technique, with special reference to the buono and spirit methods. From Springfield, Beech Lane, Macclesfield, he showed seven works with the Belfast Art Society in the years 1904, 1905 and 1906, including *Cottages at Barmouth* and *Bon Nuit Bay, Jersey*, watercolour.

In 1907 he was appointed headmaster of the Dublin Metropolitan School of Art, and mural painting became a feature of the curriculum. In 1908 he returned to his native Belfast and lectured on 'Mural Decoration' at the Municipal Technical Institute. Between 1908 and 1913 he visited the Continent each year, attending a Congress of Art Teachers at Dresden in 1912. Living at 88 Marlborough Road, Donnybrook, Dublin, he exhibited a total of ten works at the Royal Hibernian Academy in 1909, 1910 and 1911, the majority landscapes, for example: *Rathmullan, Co. Donegal*, 1909 exhibition; *Blackhead, Coast of Antrim*, 1910; and an Anne Port, Jersey scene, 1911. Another visit to Germany was indicated by *A Street in Rudesheim*, 1910, and *The Sardine Fishery Fleet, Concarneau*, was included in his 1911 –and last – contribution to the Belfast Art Society. It was in 1910 he became a foundation member of the Guild of Irish Art-Workers, and that year – and 1917 – he exhibited with the Arts and Crafts Society of Ireland.

In 1913, in London, *History and Methods of Ancient and Modern Painting*, the first of four volumes, and *Colour Decoration of Architecture* were published. For the latter he contributed some illustrations, including, in colour, decorations for Park Green Church, Macclesfield (destroyed *c.* 1960 by replastering of damp wall); Town Hall, Macclesfield; morning room ceiling at Queen's Gate, London. A member of the Black and White Artists' Society of Ireland, he was represented at the second exhibition in 1914.

In 1914 Ward and his pupils began work on fresco decoration in the circular entrance hall of the Dublin City Hall. The scheme comprised a series of twelve panels, eight illustrating important events in the early history of Dublin and some old Dublin legends, and four occupied by decorative treatments of the Arms of the Four Provinces of Ireland. *The Studio* commented: 'The interior of the hall is of stone, in the Renaissance style of Architecture, and the panels are divided from the cupola above the stone entablature, and are separated by classic columns. The painting is executed directly on the stone ground in the spirit-fresco medium, and the work, which is carried out in a light scheme of colour, is effective and broad in treatment.'

From a chronological point of view, the first of the frescoes represents: *The Legend of the Origin of the Name of Dublin*; (2) *St Patrick Baptising the King of Dublin, AD 448*; (3) *Irishmen Opposing the Landing of the Danes at Dublin, AD 838*; (4) *Malachy II Receiving the Tribute of Gold from the Danes of Dublin, AD 988*; (5) *Brian Boru Addressing his Troops Before the Battle of Clontarf, AD 1014*; (6) *Tristram and Iseult*; (7) *The Parley Between St Laurence O'Toole and Strongbow Outside the Gates of Dublin, AD 1170*; (8) *Lambert Simnel Carried Through the Streets of Dublin After his Coronation in Christ Church Cathedral, AD 1486*. Assisted by some of the senior pupils of the school, the murals were completed in 1918, and to show its appreciation of Ward's services, the City Council voted him a grant of £350. The frescoes were restored for Dublin Corporation by Matthew Moss in 1968.

Ward first exhibited with the Dublin Sketching Club in 1914, and with the Water Colour Society of Ireland in 1915 when he showed two fresco designs. *Cottages in the Cotswolds* appeared in 1916 at the Sketching Club, and *Colby, Isle of Man* at WCSI. He participated at both exhibitions in 1917 and 1918.

By 1917 Ward was possibly one of the best-known artist-authors alive, with books in use in American, French, German and Japanese universities. In 1918 he retired from the Metropolitan School of Art and returned to England, to Uplands, Newtown Road, Newbury, Berkshire. In 1920 he visited Southern Rhodesia, where he painted landscapes and scenes of rural Black African life. He stayed at the home of a married daughter, wife of Dr W. G. Rose, Lemon Kop, Melsetter, and died there on 18 May 1924, being buried on the farm.

Works signed: J. Ward or J. W. (if signed at all).

Examples: Dublin: City Hall.

Literature: *Putney and Wandsworth News*, 19 May 1888; James Ward, *Elementary Principles of Ornament*, London 1890; Department of Science and Art, *Letter to James Ward*, 1891; James Ward, *The Principles of Ornament*, London 1892 (illustrations); Battersea Polytechnic Institute, *Letter to James Ward*, 1893; *Magazine of Art*, July 1896; James Ward, *Historic Ornament*, London 1897; Ernest Rhys, *Frederic Lord Leighton*, London 1900; James Ward, *Progressive Design for Students*, London 1901 (illustrations); also *Floral Studies for Decorative Design*, London 1902 (illustrations); *Colour Harmony and Contrast*, London 1903; Algernon Graves, *The Royal Academy of Arts 1769-1904*, London 1906; *Belfast News-Letter*, 11 June 1908; James Ward, *Fresco Painting, its art and technique*, London 1909; *Belfast Evening Telegraph*, 6 September 1911; James Ward, *Colour Decoration of Architecture*, London 1913 (also illustrations); also *History and Methods of Ancient and Modern Painting*, London 1913, 1917, 1920, 1921; *The Studio*, January 1915, September 1915 (also illustrations); *Irish Builder and Engineer*, 22 March 1919; Francis Joseph Bigger, MRIA, *Belfast Telegraph*, 10 June 1924 (also illustration); *Who Was Who 1916-1928*, London 1929; William Gaunt, *Victorian Olympus*, London 1952; *Dictionary of British Artists 1880-1940*, Woodbridge 1976; George Longden, *Further Education in Macclesfield 1835-1945*, thesis, University of Manchester, 1980; John Physick, *The Victoria and Albert Museum: The history of its building*, London 1982; Ann M. Stewart, *Royal Hibernian Academy of Arts: Index of Exhibitors 1826-1979*, Dublin 1987; Dublin Public Libraries, Archives Division, *Frescoes in the City Hall, Dublin*, n.d.; Paul Larmour, *The Arts & Crafts Movement in Ireland*, Belfast 1992; A.C.E. Caldicott, *Letters to the author*, 1994, 2001; Park Green Church, *Letter to the author*, 1994; John Turpin, *A School of Art in Dublin since the Eighteenth Century*, Dublin 1995 (also illustration); Ann M. Stewart, *Irish Art Societies and Sketching Clubs: Index of Exhibitors 1870-1980*, Dublin 1997.

WARD, JOHN (1832-1912), landscape painter and illustrator. Born in Belfast on 7 August 1832, he was the son by the second wife of Marcus Ward of Marcus Ward and Co., printers and publishers. After attending

the Royal Belfast Academical Institution, he was one of the first pupils of the Belfast School of Design located in that building. First intended for the architect's profession, his life plans underwent alteration on the death of his father in 1847, and he soon entered the business, became a director and was said to be 'the driving power'.

A watercolour painter, he exhibited in the art gallery connected with the firm, apparently under the name 'Bonnington Smith', and gave every encouragement to the firm's artists to exhibit their work. These exhibitions were held in the Donegall Place premises where the retail fancy business was carried on. Ward also started a drawing class after hours in one of the works rooms with John Vinycomb (q.v.) as superintendent.

Vere Foster arrived in Belfast from London in 1867, and having made a friendly acquaintance with Ward he arranged that Marcus Ward & Co. should undertake the printing of his writing copy-books which were already in circulation, and from then on increased dramatically in popularity. Drawing copy-books followed, and Ward urged Foster to embark on watercolour copy-books for colour printing but these were never a financial success because of the high costs of production.

Meanwhile, a family connection was to be established between the Wards and the American artist, John Sloan (1871-1951), who was born in Philadelphia. William Hardcastle Ward, the second son of Marcus Ward, made a business trip to America in the early 1870s. He was to marry in Philadelphia Emma Ireland, whose father and mother were both originally from Belfast. Emma's sister Henrietta was the mother of John Sloan.

Ward was on the board of management in 1870 of the new Government School of Art. After a quarrel arose among the three Ward brothers over their relative status in the firm, John of Lennoxvale House retired from the partnership in 1876. From 1876 until 1890 he was honorary editor of the *South Kensington Drawing Book* by Sir E. J. Poynter (1836-1919).

Retirement from active business at a comparatively early age gave him opportunities for Eastern travel. He wintered in Egypt and Sicily, indulging in his favourite hobby of sketching. He was described in *Who Was Who in Egyptology* as 'artist and traveller'. He also devoted himself to collecting Greek coins and curios, and Egyptian scarabs. A large collection of ancient Greek coins which he brought together form part of the Pierpont Morgan exhibit in the Metropolitan Museum of Art, New York.

In 1890 he published *A Selection from the Liber Studiorum of J. M. W. Turner as a Drawing-book for students of Landscape Art*. He was the author in his retirement of other books. *Pyramids and Progress: Sketches from Egypt*, 1900, he dedicated to Viscount Cromer, Consul-General in Egypt. Of this publication, the *Irish Times* said: 'We have a perfect picture of the country as it is to-day, drawn in both pen and pencil, and by a master's hand'. His reproduced watercolours do not appear to be signed, although they could have been inscribed on the reverse. Work by him has not been found, either in public collection or in private possession with relatives.

Other publications included *The Sacred Beetle: A popular treatise on Egyptian Scarabs in Art and History*, 1902, and *Our Sudan: Its Pyramids and Progress*, 1905. It is presumed that some of the line illustrations in the latter are by Ward. He also wrote a book on Greek coins. A Fellow of the Society of Antiquaries, he was an active member of the Committee of the Egypt Exploration Fund. He left Belfast to live in England, and died on 17 February 1912 at The Mount, Farningham, Kent.

Literature: John Ward, ed., *A Selection from the Liber Studiorum of J. M. W. Turner as a Drawing-book for students of Landscape Art*, London 1890; John Ward, *Pyramids and Progress: Sketches from Egypt*, London 1900 (illustrations); also, *Greek Coins and their Parent Cities*, London 1902 (illustrations); *The Sacred Beetle: A popular treatise on Egyptian Scarabs in Art and History*, London 1902 (also illustrations); *Our Sudan: Its Pyramids and Progress*, London 1905 (illustrations); *Belfast Telegraph*, 19 February 1912; *The Times*, 23 February 1912; *John S. Crone, A Concise Dictionary of Irish Biography*, Dublin 1937; Mary McNeill, *Vere Foster 1819-1900: An Irish Benefactor*, Newton Abbot 1971; John Hewitt and Theo Snoddy, *Art in Ulster: 1*, Belfast 1977; Martyn Anglesea, *The Royal Ulster Academy of Arts*, Belfast 1981; Betty Elzea: Delaware Art Museum, *The Wards & the Sloans*, Delaware 1990; Metropolitan Museum of Art, Department of Egyptian, *Letter to the author*, 1994.

WARNER – see BROSNAN, MEREDITH

WATERS, GEORGE (1863-1947), landscape painter. Born in Holywood, Co. Down, in 1863, George Waters was the son of Austin Waters, Town Clerk of that town for many years. He studied at the Government School of Art in Belfast and won prizes. Membership in 1885 of the Belfast Ramblers' Sketching Club included 'artist students', Waters being one. He obtained employment with David Allen and Sons, Belfast, as a lithographic artist. In 1886 he showed with the Sketching Club *A Vista, Ballymena* and *White Rocks, Portrush.*

Waters was a founder member of the Belfast Art Society in 1890, and when he exhibited in 1891 his address was Hibernia Place, Holywood. He was not, however, an annual exhibitor. At the 1903 show he presented four watercolours, including *Crab Lane, Cork* and *On the Antrim Coast*, giving 35 Eia Street, Belfast, as his address. At the 1906 exhibition he contributed five watercolours, including *Evening, looking toward Whiteabbey*, and *Cork Harbour from Blackrock.*

In the period 1907-19, from 48 Orphir Gardens, Belfast, he contributed twenty-four works to BAS exhibitions. Included in 1912 were *Cottage at Carnmoney* and *An Impression, Douglas, Isle of Man.* He resigned in 1921.

In 1926 he turned to Dublin, showing at the Royal Hibernian Academy five works, including *Spring's Awakening, Belvoir Park, Belfast* and falls at Ballyshannon, Co. Donegal. He was a member of the short-lived Ulster Society of Painters. His only other RHA contribution was one picture in 1932.

A member of the Ulster Arts Club, he contributed eight works at their 1936 exhibition. About this time the Thomas Haverty Trust, Dublin, purchased three watercolours: *The Last of the Snows*, a Northern landscape; *On the Dargle,* and *On the Dodder* (both Ulster Museum). Also in the Ulster Museum collection are: *April, Colin Glen, Belfast* and *Spring's Advent, Belvoir Park.*

Waters painted mainly in Counties Antrim, Donegal, Dublin and Wicklow, exhibiting occasionally at Magee Gallery, Belfast. According to John Hewitt: 'He developed and maintained a characteristic style, employing the swift resources of true water colour. His subjects, strangely enough, were never far from running water, under bridges or overhanging branches.' He died on 27 March 1947 at his home, 11 Ophir Gardens, Belfast.

Works signed: Geo. Waters, George Waters or G. Waters (if signed at all).
Examples: Belfast: Department of the Environment for Northern Ireland; Linen Hall Library; Ulster Museum. Limerick: City Gallery of Art.
Literature: *Northern Whig*, 8 December 1936, 28 March 1947; *Belfast Telegraph*, 22 June 1957; Mrs Irene R. Carmichael (née Waters), *Letter to the author*, 1976; John Hewitt and Theo Snoddy, *Art in Ulster: 1*, Belfast 1977; Martyn Anglesea, *The Royal Ulster Academy of Arts*, Belfast 1981; Ann M. Stewart, *Irish Art Societies and Sketching Clubs: Index of Exhibitors 1870-1980*, Dublin 1997.

WATSON, HENRY (1822-1911), portrait and coachpainter. Born in Cork in 1822, he was the second son of Henry Watson. He began as a coachpainter in Cork, but after the death of his father in 1836 he moved to Dublin and studied at the Royal Hibernian Academy Schools. His brother, Samuel Watson (1818-66), also travelled to Dublin and became known for his lithographed portraits of leaders of the Young Ireland movement, executed in the late 1840s. Henry Watson was the father of Samuel Rowan Watson (q.v.).

In 1843 at the Cork Art Union Exhibition, Watson's painting, *The Landing of Ith in Ireland*, harkened back to legendary times and depicted Prince Ith, mortally wounded by the Irish, being dragged by his soldiers back onto his ship, 'which has the usual sea-monster look in the prow,' according to the *Cork Constitution*. Watson, depicting a legendary event which was supposed to have taken place 'thousands of years before the advent of Christianity,' had taken the liberty of including a round tower in the composition, which the writer considered was likely to arouse some comment amongst the antiquaries. Indeed, the Cork Art Union had invited members of the British Association for the Advancement of Science, who were then meeting in Cork, to attend the exhibition free of charge. Charles Dickens and Sir William Rowan Hamilton were among the visitors to the city.

Strickland in his *Dictionary* recorded that Watson obtained a good practice in painting portraits, landscapes, animals, and still life. There is no record, however, of him participating in the Dublin exhibitions, at least under his proper name. In 1869 he resided at Elm Lodge, Richmond, Fairview. He apparently executed many pictures for Sir Charles Domville, of Santry Court, among which was a life-size portrait of Queen Victoria, once at Artane Industrial School. A member of the Domville family advised the author in 2,000 that the family appeared to have lost pictures by Watson but the search was continuing.

In his later years he returned to heraldic painting for the coachbuilders, and invented a process for transferring designs, painted in oil on prepared paper, to wood or other material. According to a local newspaper, he was a 'highly esteemed gentleman.' He died at his residence in Sackville Street on 27 July 1911 and was interred in Glasnevin Cemetery.

Literature: *Cork Constitution*, 22 August 1843; General Register Office, Dublin, *Register of Deaths*, 1866; *Thom's Directory*, Dublin 1870; *Freeman's Journal*, 28 July 1911; *Evening Herald*, 29 July 1911; Walter G. Strickland, *A Dictionary of Irish Artists*, Dublin 1913; Peter Murray, compiler, *Illustrated Summary Catalogue of The Crawford Municipal Art Gallery*, Cork 1991; Barry Domville, *Letter to the author*, 2000.

WATSON, SAMUEL ROWAN (1853-1923), portrait, figure and landscape painter. He was the son of Henry Watson (q.v.). A portrait dated 1882 is in private possession, but he did not exhibit at the Royal Hibernian Academy until 1895 when he contributed a portrait of Francis T. Dames-Longworth, DL. Ostensibly a portrait painter, only one portrait appeared at the Academy out of twenty works exhibited. His only address – at least in the catalogues – was 34 Upper Sackville Street (later O'Connell Street), where he had his studio.

After his initial showing at the RHA, there was an interval of fifteen years before his work appeared again: *Autumn on the Dargle, Co. Wicklow* and *The Strip of Corn*. Another six years elapsed before he showed in 1916, five works, four Co. Wicklow landscapes and *The Recitation*. A study in gouache of a nude woman, bequest of Dr R. I. Best through the Friends of the National Collections of Ireland, is at the Hugh Lane Municipal Gallery of Modern Art.

In 1918 he painted *'Wud Yeh!'*, oil on canvas 96.5cm x 68.5cm. This street scene was viewed from the doorway of his studio, showing Miss J. Morris's millinery shop and the Rotunda Hospital. At the RHA in 1918 his contributions included *Taking a 'Sitting'*, and in 1919, *The Inventor*. His last exhibit was a still life in 1923. He was a director of Boland, Ltd., and Duffy and Co., publishers. A bachelor, he was found dead, fully dressed on the floor of his room, on 27 November 1923.

Works signed: S. Rowan Watson; possibly a variation.
Examples: Dublin: Hugh Lane Municipal Gallery of Modern Art.
Literature: *Thom's Directory*, 1896, 1924; *Freeman's Journal*, 25 November 1923; *Register of Deaths*, Dublin, 1923; Gorry Gallery, *18th, 19th and 20th Century Irish Paintings*, catalogue, Dublin 1987; Ann M. Stewart, *Royal Hibernian Academy: Index of Exhibitors 1826-1979*, Dublin 1987; Hugh Lane Municipal Gallery of Modern Art, *Letter to the author*, 1994; also, Mrs Marguerite F. Weld, 1994.

WATTERS, UNA (1918-65), figure and portrait painter. Born on 4 November 1918, Una McDonnell was the daughter of Patrick McDonnell, farmer, Cappagh, Finglas, Co. Dublin. She was a cousin of Seán O'Sullivan (q.v.) who, as a schoolboy, normally spent summer holidays in Cappagh at her grandfather's home.

After attending Holy Faith Convent, Glasnevin, Dublin, in 1937 she entered the Dublin Public Library Service and as she worked staggered hours, was able to attend as a day student at the National College of Art, where she was encouraged to become a painter by Maurice MacGonigal (q.v.). During the Second World War she married Eugene Rutherford Watters, a writer, mainly in the Irish language, a native of Ballinasloe. They normally spent summer holidays in the Co. Galway town, painting, writing and fishing.

Among her early works were *Madonna of the Ash Tree* and *Self-portrait in Green*, both 1943. Cards – Christmas and verse – for a relative, Brian O'Higgins, were designed by her for a number of years. In 1949 she showed *Annunciation* at the Irish Exhibition of Living Art. *Girl in Sand* and *Man Writing* were both

painted in 1950. In the period 1951-61, she showed nine works at the Oireachtas exhibitions. In 1954 she produced *The Game of Chess* and *Man Reading*.

Between 1956 and 1965, from Cappagh, she showed seven works at the Royal Hibernian Academy, opening with *The Red Bridge*. Many of her illustrations appeared in the magazine *Feasta*, which her husband edited.

Silken Thomas in the Tower appeared at the 1957 RHA, and in that year she painted *Blonde in a Blue Chair*. Other works of the late 1950s included *Girl Going by Trinity in the Rain* and *The Four Masters* (Phibsboro Public Library). In the last few years of her life she painted portraits of Brian O'Higgins, her uncle; and of E. R. Watters. A member of the Society of Dublin Painters, she first exhibited in 1962. The oil painting, *The People's Gardens*, was purchased by the Thomas Haverty Trust and presented to the Hugh Lane Municipal Gallery of Modern Art.

One of her last works was a view of a cornfield, mountains in the background, her father on a reaper and binder, two men stooking sheaves and the artist herself as a small girl bringing a three-quart can of tea for their afternoon break.

In manner she was described as 'eclectic, fusing elements from many sources, memories from many times, to render her own developing perception of the divine earthcomedy in its shifting kaleidoscope of light and shape'. In November 1965 she won the Arts Council Award for a Rising symbol with her design, the Sword of Light. She died a week later, on 20 November, and was buried at Ballinasloe. In 1966, thirty-seven of her oil paintings were exhibited in the Dublin Painters' Gallery, 7 St Stephen's Green.

Works signed: Una Watters or U. W.
Examples: Dublin: Hugh Lane Municipal Gallery of Modern Art; Phibsboro Public Library.
Literature: *Capuchin Annual*, 1943 (illustration); *Paintings by Una Watters*, catalogue, Dublin [1966] (also illustration); Criondán O'Higgins, *Letter to the author*, 1967; Ann M. Stewart, *Royal Hibernian Academy of Arts: Index of Exhibitors 1826-1979*, Dublin 1987; Miss Nora McDonnell, *Letters to the author*, 1994; Phibsboro Public Library, *Letter to the author*, 1994; Ann M. Stewart, *Irish Art Societies and Sketching Clubs: Index of Exhibitors 1870-1980*, Dublin 1997.

WEBB, JOSEPHINE (1853-1924), portrait and landscape painter. Born in Dublin on 26 December 1853, a member of a large Quaker family, her father was Thomas Webb of Thomas Webb & Co, 'boot and shoe manufactory; tailoring and gentlemen's general outfitting warehouse', 35 and 36 Upper Sackville Street.

In 1868 she entered Alexandra College, and in 1871 Queen's Institute and College, 25 Molesworth Street, winning two silver medals in 1875 for drawing. This institution was affiliated to the Government Department of Science and Art, South Kensington. Meanwhile the Webb family had moved to 56 Kenilworth Square, Dublin.

In 1878 Josephine Webb travelled to Paris and studied at the Académie Julian under T. Robert-Fleury (1837-1912), a Saturday visitor who pronounced a verdict on the students' work. Josephine's mother, Mary Webb, preserved excerpts from her daughter's letters home. The studio reminded Josephine of the Turkish Baths in Lincoln Place, Dublin. Monsieur Julian was 'a quiet, low sized, tolerable stout little man, comes into the room without any fuss, has a pleasant face and dark cropped beard; his hair is beginning to get a little grey and is cropped very short'.

Robert-Fleury she described as 'a younger man, dark, rather handsome and interesting'. She also mentioned that on a Monday morning 'there came a great string of models for us to choose among – more models by far in the room than artists. They stood in a row and we chose Spagagna ...'.

The Swiss artist, Louise Breslau (1856-1927) at Julian's advised Josephine that her friend, Sarah Purser (q.v.), would be coming back for six months. Josephine Webb considered that Breslau was about the cleverest there, and fancied that painting would be her profession. Another student was the Swede, Anna Nordgren (1847-1916), and for sketches judged for the concours Webb obtained fifth place and Nordgren ninth.

Back in Dublin in 1879, she obtained a studio at 5 Grafton Street, and first exhibited at the Royal Hibernian Academy in 1880, showing a portrait of Sir John Barrington, DL. In all, thirty works were hung at the Dublin

exhibition. Initially, she concentrated on portraits, but in 1884 she contributed *The Dodder, near Templeogue Bridge*, and that year she travelled 'to Scarborough to Miss Wallis, to teach and work in her studio'.

In 1885 she had a new studio at 13 Nassau Street. In 1887, when she spent a month at Julian's, she contributed *An August Evening in Hertfordshire* at the RHA. Holland was visited in 1888. In the next few years she showed some flowerpieces. In 1889 she took up residence at 69 St Stephen's Green.

At the Water Colour Society of Ireland exhibition, she showed nine works in 1892, and ten in 1893, including *Hodge's Home* and *The Main Street of Eckington*. Altogether, up until 1902, she showed more than fifty works at WCSI; French landscapes included scenes at Rambouillet and Seine-et-Oise; and she painted at Walderswick in England.

Practically all her exhibiting was confined to Ireland, but in 1892 she had shown *Boy and Bubble* with the Royal Society of British Artists, London. Among seven works at the 1892 exhibition of the Dublin Art Club were *Snapdragon* and *Sandhills, Malahide*. In 1893 at the RHA she exhibited four works: *A Garden of Poppies*; *To Let for Building*; *Plums*; and *Marigolds*. An 1894 portrait of Isaac Carroll is in the National Botanic Gardens, Dublin.

In 1899 she moved to another studio at 20 Lower Pembroke Street. The following year *The Studio* noted that she had been showing in her studio 'a number of really charming water-colour sketches of French and Irish scenery. They include some clever line and wash drawings, something after the matter of Caldecott's work, and three interesting studies in charcoal, with a wash of colour suggestive of the work of the early water colourists. Miss Webb's method is very rapid and direct, and in her French sketches she has managed to convey the emphatic effect of brilliant sunshine very cleverly.'

In 1901 she took up teaching at Alexandra College. After some indifferent health, she held a one-person exhibition at Leinster Lecture Hall in 1904, and another in 1908 at 122a St Stephen's Green. In 1911 her work was included in an exhibition at the Branch of the Five Provinces, 7 St Stephen's Green, and also at the Oireachtas exhibition.

During the First World War she lived at 12 Brighton Square. In 1919 she presented her pastel portrait of Dora Sigerson to the National Gallery of Ireland, and moved to 29 Lower Leeson Street. In 1920 she moved from there and 'settled in' at 122a St Stephen's Green.

After a long absence, her work reappeared at the RHA in 1920, including *Holyhead Harbour from 'The Mountain'*. In 1923 she held an exhibition at her studio. A landscape study in pastel was presented by her to the Municipal Gallery of Modern Art. She died on 3 November 1924 at Portobello Hospital.

Works signed: J W, monogram (if signed at all).
Examples: Dublin: Hugh Lane Municipal Gallery of Modern Art; National Botanic Gardens; National Gallery of Ireland.
Literature: *Thom's Directory*, 1854, 1876; Josephine Webb, *Record of Events*, 1860-1922; *The Year's Art*, London 1880; *The Studio*, December 1900; *Irish Review*, November 1911; Jack B. Yeats, *Letter to Josephine Webb*, 1923; Miss Stella M. B. Webb, *Letters to the author*, 1969, 1970, 1994; *Dictionary of Victorian Painters*, Woodbridge 1978; National Botanic Gardens, *Letters to the author*, 1981, 1994; National Gallery of Ireland and Douglas Hyde Gallery, *Irish Women Artists: From the Eighteenth Century to the Present Day*, Dublin 1987 (also illustration); Ann M. Stewart, *Royal Hibernian Academy of Arts: Index of Exhibitors 1826-1979*, Dublin 1987; Ann M. Stewart, *Irish Art Societies and Sketching Clubs: Index of Exhibitors 1870-1980*, Dublin 1997.

WEJCHERT, ALEXANDRA, RHA (1921-95), sculptor. Born on 16 October 1921 at Kraków, Poland, Alexandra Wejchert was the daughter of Tadeusz Wejchert, who had a shipping business in Gdańsk (Danzig). An artistic ability was noted from an early age. In 1939 she left Danzig to live and study in Warsaw, where she took a degree in architecture in 1949 at Warsaw University, also a degree from the Academy of Fine Arts in 1956. In the Polish capital she worked as an architect and town planner, also she participated in art exhibitions.

In 1957-9 she studied, worked and exhibited in Italy. The Galeria dell' Obelisco, Rome, hosted in 1959 her first one-person show. She was represented in the 'Fifteen Years of Polish Art' exhibition at the National Museum, Warsaw, in 1961. Opposed to social realism in architecture, she decided in 1963 to concentrate on

art only, including graphics. She wanted to leave Poland because of the Communist regime, but moving out of the country was difficult. A short stay ensued in Paris.

In 1964, Andrzej Wejchert, Polish architect from Warsaw, won the international architectural competition for master plan and administration, arts and aula maxima buildings for the Belfield campus, University College, Dublin. His wife, Danuta Kornaus-Wejchert, an architect too, living and working at that time in Paris, joined him in Dublin in 1965. Alexandra, Andrzej's sister, also moved from Paris, on family invitation, arriving in Dublin in the same year.

'At first,' wrote her son, Jakub Wejchert, 'she worked on paintings/reliefs which quickly moved to highly 3-dimensional reliefs and sculpture, for which she is best known.' A solo exhibition followed in 1966 at the Molesworth Gallery, Dublin. The Irish Exhibition of Living Art first showed her work in 1966: *Partita in White*, painted carving in wood. In 1967, encouraged by the Irish Government's invitation to foreign artists to live and work in Ireland, Wejchert decided to set up a studio. At the IELA exhibition that year she exhibited *Blue Relief*, from 14 McCoy Park, Dalkey, Co. Dublin. Altogether at the IELA she contributed eight works.

In 1968 she held a solo exhibition at the Galerie Lambert, Paris, where she was to become a regular exhibitor. Paule Gauthier, the French critic, said that she worked in the abstract field on the boundaries of constructivism, kinetic art and op art... 'The sculpted paintings of Alexandra Wejchert take on a changing unity which comes from the rhythmic effect obtained by her mixture of structure and colour.' In the same year, at the IELA, she won the Carroll major prize of £300 for *Frequency No. 5*.

On the 1969 exhibition at the David Hendriks Gallery, Dublin, the *Irish Times* critic wrote: 'Broadly speaking, she works in an Op Art idiom; one might call her works reliefs or "constructions" rather than paintings, except they lay such heavy emphasis on colour. They are not easily describable in words — imagine, roughly speaking, innumerable pieces of coloured wood, or some other material, mounted like pieces of coloured chalk projected towards the spectator. It sounds banal, yet some of the effects obtained are strikingly beautiful and elegant...'

Aleatoric Composition (Irish Museum of Modern Art) was created in 1969, wood and paint on canvas. At the 1969 IELA, *Glowing 69* and *Frequency 69* were presented. Of 1970 vintage, *Black Overwhelming Relief*, acrylic on timber 122/cm x 168 cm, is at the Hugh Lane Municipal Gallery of Modern Art. In 1971 she exhibited in Galway at the Kenny Gallery. In a mixed exhibition at the David Hendriks Gallery, *Perforated Form* in Plexiglas was regarded by one observer as 'much more interesting than her slightly saccharine relief.' At the 1971 Royal Hibernian Academy she showed *Black Relief on White Wood*.

At the IELA in 1971 she exhibited *Homage to Stravinsky*. In 1971 the Bank of Ireland Group purchased *Blue Form 1971*, Plexiglas, the first of six pieces which they hold; *Flowing Relief*, timber, .3.7 m x 1.8 m, was acquired in 1972. A second one-person show was held at the David Hendriks Gallery in 1973. Among representation in group exhibitions of the 1970s was 'Irish Directions' which toured museums and universities in the USA, 1974-6. In that period her work was also seen in Amsterdam and The Hague.

In anodised aluminium, *Life*, 4.8 m x 3 m, 1973, was destined for Irish Life Headquarters, Dublin. The three sculptures were for the main entrance hall. The artist said that she wanted 'to express forms, shapes and feelings creating an atmosphere linked to Life in a very abstract way...'. Unfortunately, the work was disassembled during the re-design of the area in the late 1980s and never put back again. However, Irish Life and Permanent plc own *Flame* by Wejchert.

The final IELA exhibit was *Organic Structure* in 1974. In 1975 she won the competition for a stamp marking International Women's Year. The design showed hands reaching towards a dove holding an olive branch. Only two works appeared at the Oireachtas, *Gorm* in 1975 and *Gam Ainm* in 1977. In 1979 she became an Irish citizen. At the Rosc exhibition in Cork in 1980, Irish Art 1943-1973, she was represented by *Gold Relief*, wood with sprayed metallic finish.

A mirror polished stainless steel structure, 3 m x 1.5 m, 1980, untitled, is with Lombard and Ulster Banking, Ltd., Dublin. In 1981 she became a member of Aosdána. Concentrating on commissions for public institutions, *Freedom* in stainless steel, 11.5 m high, was executed in 1985 for Allied Irish Banks at Ballsbridge. Among the group exhibitions was the 'Open Sculpture' event, RHA Gallagher Gallery, 1988.

In 1988 she returned to the RHA, and from then until 1995 she showed a score of works, from Eglinton Cottage, Tivoli Road, Dun Laoghaire, Co. Dublin. In 1988 *Millennium Series No. 6*, bronze, limestone, was followed in 1989 by *Flame*, polished brass, and an untitled work, mirror polished stainless alloy. The 1990 RHA produced two serigraphs. A serigraph is in the National Self-Portrait collection, Limerick.

When the science exhibition, 'Let There be Light,' opened in 1991 at the O'Reilly Institute, Trinity College, Dublin, two permanent works were on display: *Rising Blue*, blue neon and stainless steel; *Arythmicmaze*, yellow neon and metal. In 1991 she was elected an ARHA. The last solo exhibition at the Solomon Gallery, Dublin, was in 1992.

In 1992 she won the competition for an outdoor sculpture at the University of Limerick. *Geometric form*, 7.0 m high, in polished stainless steel, was for the Robert Schumann Building. The artist wrote: 'The proportions of the sculpture permit the visitor to walk beneath it and the area about it provides a convivial gathering place for students without obstructing the pedestrian flow.'

In 1993 Wejchert was represented in the Toyamura International Sculpture Biennale, Japan. In that year she contributed four works to the RHA exhibition including *Suspended Sculpture* in mixed media. In 1995 she was elected to full membership of the Academy.

On the ceramic mosaic, *The Rivers of Time*, at Earlsfort Plaza, Dublin, Judith Hall in her book on Irish public sculpture, noted that it 'benefits from being in a low covered area and, colourful and attractive, from providing a contrast to the pervasive monochrome of the rest of the development.' Also in Dublin, *Floating Beyond* is at University College, Belfield. *Nutations* is at the National University of Ireland, Galway. Architectural training was credited as contributing to her control and mastery of spacial geometry.

'Gifted with a great power of imagination and possessing a formidable strength of character, she has gone her own way. As an explorer, she has been tireless, discovering and presenting in her creations authentically new aesthetic forms. As an innovator, she has turned always afresh in the research of new materials and techniques,' wrote Roderic Knowles in his book, *Contemporary Irish Art*, 1982. 'In all her executions, all is ordered and controlled, but not in any cold or mechanical way...'. On 24 October 1995 she died suddenly at her home.

Works signed: Alexandra Wejchert or A. Wejchert, rare (if signed at all).
Examples: Boyle, Co. Roscommon: Civic Collection. Cork: University College. Dublin: Allied Irish Banks, Ballsbridge; Arts Council; Bank of Ireland Group, Lower Baggot Street; Earlsfort Plaza; Holy Trinity Church, Donaghmede; Hugh Lane Municipal Gallery of Modern Art; Irish Life and Permanent plc; Irish Museum of Modern Art; Lombard and Ulster Banking, Ltd.; Radio Telefís Éireann; Trinity College; University College (Belfield). Galway: National University of Ireland. Limerick: University; National Self-Portrait Collection. Rome: Galleria D'Arte Moderna; Museo Comunale di Roma. Warsaw: University.
Literature: P. J. Carroll & Co., Ltd., *Irish Exhibition of Living Art*, press release, Dundalk 1968; *Irish Times*, 2 December 1969, 22 October 1971, 25 October 1995; *Royal Hibernian Academy of Arts*, catalogues, 1971-1986, 1988-1995; Roderic Knowles, *Contemporary Irish Art*, Dublin 1982 (also illustrations); David Scott, *The Modern Art Collection: Trinity College Dublin*, supplement catalogue, Dublin 1992; Solomon Gallery, *Alexandra Wejchert*, catalogue, Dublin 1992; *Alexandra Wejchert Curriculum Vitae*, typescript, Dun Laoghaire 1995; Arthur Gibney, RHA, *Royal Hibernian Academy of Arts*, catalogue, Dublin 1996; Ann M. Stewart, *Irish Art Societies and Sketching Clubs: Index of Exhibitors 1870-1980*, Dublin 1997; Dorothy Walker, *Modern Art in Ireland*, Dublin 1997 (illustration); Jakub Wejchert, *Letters to the author*, 1997, 2001; Judith Hill, *Irish Public Sculpture: A History*, Dublin 1998; Solomon Gallery, *Important 20th Century Sculpture*, catalogue, Dublin 1998; Allied Irish Banks, *Letter to the author*, 2000; also, Bank of Ireland Group, 2000; Hugh Lane Municipal Gallery of Modern Art, 2000; University of Limerick, 2000; An Post, 2001; Irish Life and Permanent, 2001; A. & D. Wejchert, 2001.

WELDON, HARRIET HOCKLEY – see TOWNSHEND, HARRIET HOCKLEY

WEST, RICHARD W. (1848-1905), landscape painter. Richard Whately West was born in Dublin on 18 January 1848, the second son of the Very Rev. John West, Dean of St Patrick's Cathedral, Dublin, and Elizabeth Margaret, daughter of Charles Dickinson, Bishop of Meath. His father was for many years chaplain and secretary to Archbishop Richard Whately, hence the child received the names of 'Richard Whately'. He

was an older brother of Hercules West who attended Trinity College, Cambridge, 'a classical scholar, an Irishman, full of wit, immensely entertaining and a good actor.'

Educated at St Columba's College, Dublin, which he entered in 1860, he moved to Trinity College in 1866, graduating with honours in 1870. In December 1870 he entered Pembroke College, Cambridge, where he was awarded a number of scholarships, finally heading the list of the Foundation Scholars. He took a BA degree in 1874. On leaving he spent a short time as a schoolmaster. He entered Fettes College, Edinburgh, in 1875 and taught for a year.

According to Walter G. Strickland in his *A Dictionary of Irish Artists*: 'From his earliest years he showed a talent for drawing, but had no special instruction in art. At Cambridge he was noted as a caricaturist, and afterwards went on steadily improving himself in drawing and painting.'

In 1878 he was in London and from 38 Albany Street exhibited at the Royal Academy a local scene, *A coal wharf at Rotherhithe*. In the period 1878-88 he had eight works accepted. On 26 June 1880 he painted the great fire in a timber yard at Lambeth. At the 1881 RA, now at 2 Munster Square, the work was accompanied in the catalogue by a verse: 'Among the waste and lumber of the shore...'.

In 1883 he gave his address as 9 Lidlington Place, London, and that year he went abroad on a commission to make sketches in the Riviera for *The Art Journal*. The articles, entitled 'The Western Riviera', were written by a Scotsman, Rev. Hugh Macmillan, and there were other illustrations besides West's, detailed drawings with figures. An examination of the magazine for 1884 showed that the bulk of his work appeared in the February number, in which there were five illustrations, for example: *View of St Raphael from the Hôtel de la Plage; The Rue Rabaton, Hyères Massillon's Birthplace; Remains of Roman Amphitheatre at Fréjus*. All were signed R.W.W.

At the 1884 RA he exhibited a Menton landscape. Hearing about the climate, in 1885 he spent two months in Alassio, where bathing was popular, and this visit to the Italian Riviera was indicated by the 1886 RA contribution, *A fisherman's home in the Genoese Riviera*. In 1886 he painted in Ireland and Wales.

Outside of the RA, he exhibited little in London. A few works were accepted by the Royal Institute of Oil Painters. However, there are three paintings by him in the Victoria and Albert Museum: *Ponte Garessio, Piedmont; Ponte Longo, Andorra; The Valley of Andorra*. All presented by his widow.

Before he became associated with the Royal Hibernian Academy, he exhibited with the Dublin Art Club in 1886, and showed each year — 1888 no exhibition — until 1891, thirty-two works in all. In 1886 he was still at Lidlington Place and his five pictures included *Calary Moor, Sketch made during the Great Storm of October 16th, 1886*, and by contrast, *Italian Coast Scene-Twilight*. He was in Paris and Dieppe environs in 1887. Among the seven works on view in 1887 were *Coast Scene, Normandy* and *Daybreak at Alassio*. Italian scenes dominated his work.

West showed only seven pictures at the RHA, covering the period 1887-90, and indeed one fewer than the number 'in memorian' at the 1906 exhibition. In 1887 he contributed *Tête du Chien, Monaco, Winter Sunset* (National Gallery of Ireland). In October 1888 he returned to Alassio and settled in an old house, building a studio and dedicating himself to painting, rising at dawn. He never gave up his bathing and would walk for hours searching for new subjects and inspiration. *The Gate of Alassio, Evening* was dated 1888. In 1889, from Alassio, he showed *Buona Pesca* and *A Riviera Washing Place* at the RHA. He was back in Ireland in July 1889 and stayed for a year, his father being ill. At the 1890 DAC exhibition he gave Royal Marine Terrace, Bray, as his address and among the eleven works were: *The Island of Callinaria; A Mule Path, Alassio;* and, rather surprisingly, *An Orange Meeting*.

At the 1891 DAC exhibition he gave a Bayswater, London, address. An 1891 work depicted washing day at the garden of Casa Bianca well, Alassio. He married in 1893 the daughter of an Anglican clergyman, Gertrude Ellen Ragg.

A rainy day at Bellaggio was painted in 1893, and a beach scene at Albenga in 1895. West's reputation as a painter spread to France and there were visits from French artists. Martello Tower in Alassio was painted in 1900. A palette knife impression of rainy effect in Andora Valley was executed in 1904. A work was painted in oil and watercolour. An Italian landscape and an English one are in Dublin at the Hugh Lane Municipal Gallery of Modern Art.

In January 1905 he went to Florence on an artistic visit but was struck down suddenly with bronchial pneumonia and died there on 23 February 1905. He was buried at Florence. A little gallery was erected at Alassio in memory of a 'gentle and jovial artist,' in which about 200 of his works, oils and watercolours, were deposited. In opening in 1907 the gallery, which appears to have been used as a small community hall, Arthur Severn (1842-1931) said that West 'approached nature humbly, trying modestly to show forth its beauties and not his own skill.'

The gallery was closed in 1935 because of political difficulties between Italy and England. The artist's daughter, Kathleen, took the pictures away and put them in a garage where they remained during the War. At the end of hostilities she sold some of the works and gave others to friends. In 1963 a patron of the artist presented some seventy works to Alassio.

Works signed: R. W. West, R. W. or R. W. W.
Examples: Alassio, North Italy: Palazzo Morteo. Dublin: Hugh Lane Municipal Gallery of Modern Art; National Gallery of Ireland. London: Victoria and Albert Museum.
Literature: *The Art Journal*, February 1884 (illustrations); November 1884 (illustration); *The Royal Academy of Arts 1769-1904*, London 1905; Walter G. Strickland, *A Dictionary of Irish Artists*, Dublin 1913; College of St Columba, *1843-1953 Register*, Dublin 1954; J. A. Venn, *Alumni Cantabrigienses*, Cambridge 1954; *Dictionary of British Artists 1880-1940*, Woodbridge 1976; Ann M. Stewart, *Royal Hibernian Academy of Arts: Index of Exhibitors 1826-1979*, Dublin 1987; Palazzo Morteo, *Richard West 1848-1905*, Alassio 1995 (also illustrations); Ann M. Stewart, *Irish Art Societies and Sketching Clubs: Index of Exhibitors 1870-1980*, Dublin 1997; Fettes College, *Letter to the author*, 2001; also, Pembroke College, 2001; Victoria and Albert Museum, 2001.

WESTROPP, THOMAS JOHNSON (1860-1922), archaeological illustrator. Born on 16 August 1860, Thomas Johnson Westropp was the youngest son of John Westropp of Attyflin, Co. Limerick, and also had family connections with Co. Clare. Many of his later illustrated articles dealt with Gothic churches, medieval castles and prehistoric remains in those two counties, where he spent the greater part of his boyhood. He also had an enthusiasm for topography and folklore. Educated at Trinity College, Dublin, he received his MA in 1885.

Westropp, a civil engineer by profession, became a member of the Royal Society of Antiquaries of Ireland in 1886. Early in 1888 he resided at 13 Trafalgar Square, Monkstown, Co. Dublin. His first contribution to the Society's *Journal* was in 1891, and from then onwards he was a regular contributor. The Society holds originals of illustrations which appeared in the *Journal*. In 1893 he became a Fellow. The *Journal of the Cork Historical and Archaeological Society* for 1900 referred to the Dublin *Journal* and Westropp's 'artistically illustrated' description of a summer excursion to Thomond.

In 1909 Westropp presented to Trinity College Library three large volumes and two boxes of archaeological drawings, worked both in watercolour and in pen and ink. In the first volume, in addition to its Irish content, were drawings executed in Prussia, Sweden, Scotland, and Wales. In the second volume the journals in which the views were published were marked in the corner in each case. The contents of the third volume were described as 'Ecclesiastical and residential buildings of the 12th to the 15th century in Munster'. A pen and ink drawing of Lemeneagh Castle, Corrofin, bore the note: 'This gateway was pulled down in 1908 by order of Lord Inchiquin and the facing blocks removed to Dromoland'.

Seven volumes, each made up of bound sketchbooks, were bequeathed by Westropp to the Royal Irish Academy, of which he was a member. These pencil and pen and ink drawings and watercolours ostensibly covered the period from 1880 to 1910, and although each volume was described as 'Sketches in Ireland', with the years – excepting one, 'Sketches in Ireland and Scotland' – there was a volume, 1896-1900, with a Germany section. Beside his drawing, *Ireton's Church, Limerick*, he appended the note: 'Demolished by vandal churchmen in the summer of 1894 to improve grounds of Cathedral.'

All the volumes were indexed, and it is estimated that they contain a total of at least 3,000 drawings, some of which were purely scenic and in watercolour. The general appearance of the sketchbooks gives the impression that the work was by an established artist. Presumably civil engineering had gone by the board. According to his obituary in the RSAI *Journal*: 'As a field-worker, he had no rival ...'

A joint author of *The Antiquities of Limerick and its neighbourhood*, 1916, his illustrations, varied and essential, included, for example: a detailed pen and ink drawing of St Mary's Cathedral, Limerick; Buttingfort and Galway Tomb, Limerick Cathedral; a score of illustrations copied from the carved 'miserere' oak seats, Limerick Cathedral; detail of ornament on Killaloe Cathedral doorway; plans and maps.

In 1916 he was elected RSAI president. Although a prolific author, he had not one book solely to his credit; his articles numbered more than a hundred and fifty. The RSAI felt that his name would remain, 'written high on the Roll of Honour of Ireland, long after many men, who make a much greater noise in these times of ours, have dropped into the oblivion that awaits them'. A bachelor, he died on 9 April 1922 at his residence, 'Luneberg', Strand Road, Sandymount, Dublin.

Works signed: Thos. J. Westropp, T. J. Westropp, T. J. W. or swastika with number 7 (if signed at all).
Examples: Dublin: Royal Irish Academy; Royal Society of Antiquaries of Ireland; Trinity College Library.
Literature: *Thom's Directory*, 1895; *Journal of the Cork Historical and Archaeological Society*, 1900; T. J. Westropp, R. A. S. Macalister and G. U. Macnamara, *The Antiquities of Limerick and its neighbourhood*, Dublin 1916 (illustrations); *Irish Independent*, 11 April 1922; *Journal of The Royal Society of Antiquaries of Ireland*, No. 53, 1923; *Burke's Irish Family Records*, London 1976; Royal Society of Antiquaries of Ireland, *Letter to the author*, 1994.

WHEELER-CUFFE, LADY (1867-1967), botanical illustrator. Charlotte Isobel Williams was born in London, the daughter of William Williams of Park Side, Wimbledon, a president of the Law Society. Charlotte was the granddaughter of the Rev. Sir Hercules Langrishe, Third Baronet of Knocktopher Abbey, Thomastown, Co. Kilkenny. There was a strengthening of her Irish connections when in 1897 she married Sir Otway F. L. Wheeler-Cuffe of Kilkenny. Immediately after their marriage, they went to live for the next twenty-four years in the East.

Sir Otway was a civil engineer in the Public Works Department in Burma, being appointed Superintending Engineer in 1914. In their history, *The Brightest Jewel*, of the National Botanic Gardens, Dublin, E. Charles Nelson and Eileen M. McCracken described his wife as 'a small but formidable lady, an excellent artist, and fond of gardening. During her years in Burma and India she did some superb watercolours of rhododendrons and orchids.'

Charlotte's hobbies of painting and gardening led her to explore the botany of the various regions in which she lived, and she sometimes accompanied her husband on his travels to inspect engineering projects as she collected and painted flowers.

In 1911, invited by Mrs Winifred McNabb, Lady Cuffe ascended Mount Victoria, which rises to over 10,000 feet, and to reach the summit they had to stay at a tiny Military Police outpost at Kampetlet. They brought paints and sketchpads. Charlotte described their discoveries, including a yellow rhododendron and a blue buttercup, in letters to her cousin, Baroness Pauline Prochazka, who lived at Lyrath, the Cuffe family seat near Kilkenny. Many of these discoveries she recorded in her work, and her watercolours also depicted landscapes, mainly of Burma, and animals.

The two explorers decided to return to Mount Victoria in 1912, when she sent seedlings to the Royal Botanic Gardens at Glasnevin. She also corresponded with the Director, Sir Frederick Moore. The white rhododendron bears her name, *Rhododendron cuffeanum*. Officially invited, in 1917 she founded, designed and planted Maymyr Botanic Gardens, reclaimed from virgin marshland by Turkish prisoners of the war.

In 1924 at the Water Colour Society of Ireland exhibition she showed four Burma landscapes, and others followed in 1925 when she also exhibited *A Sussex Cottage*. Among other WCSI contributions were: 1926, *A Connemara Graveyard*; 1927, *The Nore in Flood*; 1931, *A Back Lane in Kilkenny*.

A collection of more than a hundred watercolours, painted between 1897 and 1921, was presented by Lady Cuffe to the Botanic Gardens in Dublin. She is not represented at the Royal Botanic Gardens, Kew, nor the Natural History Museum, London. E. Charles Nelson of Glasnevin wrote in 1987: 'While not pedantic in their botanical details, her flower paintings are most pleasing, oriental in style because of the open and sparse technique that she used.' The Cuffes left Burma in 1921 and took up residence at Lyrath, where she died on 8 March 1967. An exhibition of her work took place at Dublin Castle in 1995.

Works signed: C. I. W. C. (if signed at all).
Examples: Dublin: National Botanic Gardens.
Literature: *Burke's Peerage and Baronetage*, London 1931; *Who Was Who 1929-1940*, London 1941; *Register of Deaths*, Dublin, 1967; *Dictionary of British Artists 1880-1940*, Woodbridge 1976; National Gallery of Ireland and Douglas Hyde Gallery, *Irish Women Artists: From the Eighteenth Century to the Present Day*, Dublin 1987; E. Charles Nelson and Eileen M. McCracken, *The Brightest Jewel: A History of the National Botanic Gardens, Glasnevin, Dublin*, Kilkenny 1987 (also illustration); Caroline Courtauld, *Collins Illustrated Guide to Burma*, London 1988; Patricia Butler, *Three Hundred Years of Irish Watercolours and Drawings*, London 1990 (also illustration); National Botanic Gardens, *Letter to the author*, 1995; also, Natural History Museum, London, 1995; Royal Botanic Gardens, 1995; Captain Anthony Tupper, 1995; *Water Colour Society of Ireland Exhibition List 1872-1994*, Dublin 1995.

WHELAN, LEO, RHA (1892-1956), portrait and genre painter. Born in Dublin on 10 January 1892, Michael Leo Whelan was the son of Maurice Whelan. His parents were natives of Co. Kerry. Educated at Belvedere College, he then attended the Dublin Metropolitan School of Art under (Sir) William Orpen (q.v.), who included him among 'a lot of promising youth'. He was, however, subject to occasional doubts about his ability to achieve his ambitions, and he would leave the School of Art for a few months and work at home. When the depression passed, he returned to his studies.

At an early age he attracted attention as a draughtsman and a painter of genre subjects. Aged nineteen he first exhibited at the Royal Hibernian Academy with a portrait of O'Connell Redmond, FRCSI. His home was at 65 Eccles Street, where Mrs Mary Jane Whelan was described in the local directory as 'hotel proprietress'.

From 1911 until 1956 he never missed contributing to the Academy exhibitions, showing about 250 works, the vast majority portraits. At the Oireachtas exhibition in 1911 he showed *The Sportsman*. In 1912 he painted *The O'Donaghue of the Glens*, now at the Heraldic Museum, Dublin. *The Girl in the Mirror* was exhibited at the 1914 RHA; studio at 64 Dawson Street. He received his first ecclesiastical commission, a portrait, 1.8 metres by 1.4 metres, of Archbishop Patrick Joseph Clunne of Perth, Australia; in 1994 this work could not be traced in the diocese.

As a student at the Royal Hibernian Academy Schools, he won the Taylor Scholarship in 1916 with *The Doctor* (National Gallery of Ireland). The scene showed the artist's cousin ill in bed at Eccles Street. The artist's mother sat by the bed while his sister, in the uniform of a Mater Hospital nurse, opened the door for the doctor who was about to enter. This painting recorded an actual event. *The Blue Dress* and *The Knitter* were both destroyed in the 1916 fire at the Academy premises.

The death of his brother came as a great shock, and he painted in Co. Kerry to be alone with his grief. *Mike, a Kerry Type* (Crawford Municipal Art Gallery) appeared at the 1919 RHA. The next year he was elected ARHA and showed eight works at the exhibition, including *Reverie* and *The Embroideress*. In his interiors of kitchens in old Georgian Dublin houses, often the girl engaged in some household task was his sister. At the 1920 Oireachtas, among seven works, were *The Forge* and *The Cabbage Garden*. Seven works, including *The Waterfall*, were hung in 1921 with Dublin Sketching Club; and another seven, including *The Salmon Leap*, in 1923.

In 1922 Whelan painted a 'conversation piece' of the General Headquarters Staff of the IRA, all realised when alive. General Richard Mulcahy was prominent in arranging the sittings. Between dashes to London, Michael Collins sat for little over an hour. That work is at McKee Barracks, where there is also a portrait of Mulcahy. A portrait of Collins by Whelan was exhibited at the 1922 RHA. In Cork Public Museum is an unsigned portrait registered as being by Whelan; the right hand of Collins was unfinished.

Early in 1924 he was elected a full member of the Academy. He was a visiting teacher of painting and drawing at the RHA Schools. According to *The Studio*, there was 'much admiring comment' for *The Gipsy* at the 1924 RHA; shown later that year at Aonach Tailteann. Commissions from Trinity College, Dublin, included portraits of John Henry Bernard, DD, Provost, 1924 RHA, and Louis Claude Purser, Vice-Provost, 1927 RHA.

On the exhibition organised by J. Crampton Walker (q.v.) in 1926 at Mills' Hall, *The Studio* singled out Whelan's *Interior*: 'It is unaffected as it is accomplished and justifies those many admirers of his work who

place him foremost in the ranks of Irish painters of genre.' Walker's *Irish Life and Landscape*, published in 1927, reproduced *'Jer'*, a man sitting beside the fire. In the text he wrote that Whelan was 'a prominent portrait painter, and has been most successful in portraying the Irish peasantry in their domestic surroundings'.

Whelan was represented in the 1927 exhibition by artists 'resident in Great Britain and the Dominions' held at the Imperial Gallery of Art at South Kensington, London. A portrait of President William T. Cosgrave appeared at the 1928 RHA. His 1928 portrait of James Hicks is at NGI. He was the designer of the first Free State commemorative stamp, issued in 1929 for the Centenary of Catholic Emancipation, being the portrait of Daniel O'Connell. *Lena* found her way to the 1929 exhibition of the Belfast Art Society. A member of the organising committee for the 1930 exhibition of Irish art at Brussels, he was represented by two portraits and two interiors.

The Ulster Academy of Arts came into existence in 1930 and Whelan, who exhibited with the Academy, became an honorary academician. His 1930 RHA portrait of John McCormack was presented by the McCormack family half a century later to the National Concert Hall, Dublin. *The Fiddler* at the 1932 exhibition won praise. His address was now 7 Lower Baggot Street, Dublin.

Whelan was represented in the 1932 Olympic Art Exhibition at Los Angeles. In 1932 the Papal Legate to the Eucharistic Congress, Dublin, Cardinal Lorenzo Lauri, sat for him. In London in 1933 he showed *The Letter* at the Royal Institute of Oil Painters exhibition, and *Ada* at the Royal Society of British Artists. Altogether he exhibited seventeen works with the Royal Society of Portrait Painters, and two at the Royal Academy. His presidential portrait of Ernest J. Phelps, KC, was for the Friendly Brothers of St Patrick. In 1934 he was appointed to the new advisory committee for the Metropolitan School of Art.

At the 1936 RHA he had eight portraits hung, and among the six in 1937 was one of Rt. Hon. Malcolm MacDonald, MP (National Portrait Gallery, London) and the Most Rev. Thomas Keogh, Bishop of Kildare and Leighlin, now at St Patrick's College, Carlow. The latter work was singled out by *Ireland To-Day* but the critic wrote: '... the bulk of the Academy painting is conservative. First here, comes Leo Whelan, with his superb craftsmanship, his perfect finish, his suavity. He is a painter of "Society", guaranteed to make the sitter look as he (the sitter) would like his descendants to think he looked. If it is one of the functions of art to make life seem what it is not, then this is great art.'

Whelan's 1937 portrait, 1.3 metres by 1.1 metres, of Professor J. Kay Jamieson is at University of Leeds. The portrait of the Most Rev. Michael Fogarty, Bishop of Killaloe, exhibited at the 1940 RHA, is at St Patrick's College, Maynooth. A 1941 portrait of Archbishop Joseph Walsh hangs in the Archbishop's House, Tuam, Co. Galway.

At the Academy of Christian Art exhibition in Dublin in 1941, he showed his well-known *St Brigid*, which had a wide circulation in reproductions. *Blessed Virgin Mary, Queen of Ireland*, was also publicised in print form. His Eminence Cardinal MacRory portrait, 1941 RHA, hangs at Ara Coeli, Armagh. He also exhibited with the Munster Fine Art Club. Portraits of Presidents Douglas Hyde and Sean T. O'Kelly are at Áras an Uachtaráin. There are portraits of former principals, the Rev. William Crawford, MA, and the Rev. Thomas J. Irwin, DLitt, at Wesley College, Dublin. At the 1944 Oireachtas he exhibited portraits of John Ingram and James Halpin.

Although the art critic of the *Dublin Magazine* admitted he had never been an admirer of Whelan's later work as a portrait painter, he regarded *Displaced Person* at the 1949 RHA as having been painted with 'the meticulous clarity of a Dutch interior; but it is saved from being a mere *tour de force* by the sympathetic treatment of the young girl seated at the table and the literal rendering of the modest room'.

In an article in *Capuchin Annual*, 1949, Thomas MacGreevy wrote that of the 'prominent painters of the present day' who studied under Orpen and who, on the technical level, showed the benefit of his instruction, 'Mr Whelan is perhaps nearest to his master in sheer skill'. At the 1949 RHA he showed *An Taoiseach, John F. Costello, SC, TD*. In 1950 he was made an honorary academician of the Royal Ulster Academy.

Whelan designed a second commemorative postage stamp: the centenary of the opening of the Catholic University of Ireland, issued in 1954 it featured a pictorial reproduction of a bust of Cardinal Newman. A portrait of Eamon de Valera, painted in 1955, is at Leinster House, where there are also portraits of Michael Collins, Arthur Griffith, Patrick Hogan and Kevin O'Higgins.

Also at the NGI are portraits of Gwladys McCabe and of Rory O'Connor. At the Hugh Lane Municipal Gallery of Modern Art are works on William O'Brien, Dr Mark Ryan and Austin Stack. At the Crawford Municipal Art Gallery, Cork, are three oils: *The Fiddler*; *The Kitchen Window*; and *The Lady in Black*. At the Ulster Museum is *Interior of a Kitchen*.

In Limerick City Gallery of Art is a portrait of Joseph M. Flood, and at the City Hall are two portraits of Mayors of the 1920s. In the Royal Dublin Society premises are several portraits, going back to the early 1930s with that of Dr John Joly, and those at University College, Dublin, include the Rev. Professor Thomas A. Finlay and Professor Arthur W. Conway. At King's Inns, Dublin, are oil paintings of John A. Costello, Hugh Kennedy and Cecil Lavery. A portrait of E. J. Gwynn, Provost of TCD, is at St Columba's College and bears a strong resemblance to the one at Trinity College.

On behalf of the RHA, Whelan was its representative on the board of governors of the National Gallery of Ireland, and he was on the art advisory committee of the Municipal Gallery of Modern Art for many years. He was an active member of the United Arts Club, Dublin. Of 65 Eccles Street, Dublin, he died on 6 November 1956 at the Mater Private Nursing Home.

Works signed: Leo Whelan.
Examples: Armagh: Ara Coeli. Belfast: Ulster Museum. Carlow: St Patrick's College. Cork: Crawford Municipal Art Gallery; Public Museum. Dublin: Alexandra College; College of Technology, Bolton Street; Heraldic Museum; Hugh Lane Municipal Gallery of Modern Art; Incorporated Law Society of Ireland; King's Inns; Leinster House; McKee Barracks; National Concert Hall; National Gallery of Ireland; Royal College of Physicians of Ireland; Royal College of Surgeons in Ireland; Royal Dublin Society; St John Ambulance Brigade of Ireland, Upper Leeson Street; Trinity College; University College (Belfield; Earlsfort Terrace; Newman House); Wesley College. Dun Laoghaire, Co. Dublin: Royal Irish Yacht Club. Killarney: Muckross House. Leeds: University. Limerick: City Gallery of Art; City Hall; County Library; University, National Self-Portrait Collection. London: National Portrait Gallery; Royal Institution of Chartered Surveyors. Maynooth: St Patrick's College. Tuam, Co. Galway: Archbishop's House.
Literature: *Thom's Directory*, 1912; *Royal Dublin Society Report of the Council*, 1916; *The Belvederian*, Summer 1916; Sir William Orpen, *Stories of Old Ireland and Myself*, London 1924; *The Studio*, September 1924 (also illustration), October 1924, May 1926, June 1927; J. Crampton Walker, *Irish Life and Landscape*, Dublin 1927 (also illustration); *Who's Who in Art*, 1927; *Capuchin Annual*, 1933 (illustration), 1940 (illustrations), 1949; *Ireland To-Day*, May 1937; Waddington Publications Ltd, *Twelve Irish Artists*, Dublin 1940 (illustration); *Father Mathew Record*, November 1941; *Dublin Magazine*, January-March 1945, July-September 1949; *Personality Parade*, August 1947 (also illustration); Thomas Bodkin, *Report on the Arts in Ireland*, Dublin 1949; *Irish Independent*, 7 November 1956; *Royal Hibernian Academy Minutes*, 1956; *Who Was Who 1951-1960*, London 1961; National Gallery of Ireland, *Golden Jubilee of the Easter Rising Exhibition*, catalogue, Dublin 1966; Department of Posts and Telegraphs, *Letter to the author*, 1968; *Dictionary of British Artists 1880-1940*, Woodbridge 1976; Martyn Anglesea, *The Royal Ulster Academy of Arts*, Belfast 1981; *Irish Times*, 20 September 1982; *National Gallery of Ireland Acquisitions 1982-83*, catalogue, 1984 (also illustration); Ann M. Stewart, *Royal Hibernian Academy of Arts: Index of Exhibitors 1826-1979*, Dublin 1987; Patricia Boylan, *All Cultivated People: A History of the United Arts Club, Dublin*, Gerrards Cross 1988; Archdiocese of Armagh Office, *Letter to the author*, 1994; also, Catholic Central Library, London, 1994; Cork Public Museum, 1994; Kildare and Leighlin Diocesan Office, 1994; University of Leeds, 1994; Royal Institution of Chartered Surveyors, 1994; St Columba's College, 1994; St John Ambulance Brigade of Ireland, 1994; St Mary's Cathedral, Perth, 1994; Archbishop of Tuam, 1994; John Turpin, *A School of Art in Dublin since the Eighteenth Century*, Dublin 1995; Friendly Brothers of St. Patrick, *Letter to the author*, 1997; Ann M. Stewart, *Irish Art Societies and Sketching Clubs: Index of Exhibitors 1870-1980*, Dublin 1997; National Gallery of Ireland, *Gallery News*, September-November 1999.

WHITTY, SOPHIA ST JOHN (1878-1924), woodcarver and designer. Born in Dublin, Sophia St John Whitty was the daughter of Dr Richard Lawrence Whitty. She studied woodcarving at South Kensington, and also attended the Dublin Metropolitan School of Art. She opened a small studio at 43 Lower Sackville Street, Dublin, where, with her sister Dorothy, she gave lessons in woodcarving, modelling, embroidery and other crafts.

The origin of woodcarving in Bray, Co. Wicklow, went back to 1887 when a class was instituted for the Christ Church choirboys and handed over in 1889 to Kathleen A. Scott (q.v.). The class became an evening one for men, open to all denominations. Meanwhile, early in 1902 St John Whitty had been appointed woodcarving teacher at the new Bray Technical School at seven shillings per two hour session. The original

classes in woodcarving and drawing were now undertaken by the Technical School. Miss Whitty and her mother went to live at 'Old Bawn', Old Connaught, Bray.

During the summer months of 1903 she studied figure carving at Bruges, and also visited some other carving schools on the Continent. Eight exhibits were contributed to the Royal Dublin Society Art Industries exhibiton in 1904, held during the Horse Show week. According to the Bray Parish Calendar: 'The Technical School may be congratulated on the success of the Bray class, and of their teacher, Miss Whitty, who showed an exquisite specimen of figure carving, both in relief and in the round, which far surpassed anything we have seen in previous years at the RDS Exhibition'.

The Bray carvers executed a considerable amount of church commissions, including the carved walnut woodwork at Christ Church. Here, to the design, and under the instruction of St John Whitty, the prayer desk and lectern of 1904 were carved. On the prayer desk are angels of Prayer and Praise, her own work, as well as the little figure of St Patrick mounted on the lectern.

At the Arts and Crafts Society of Ireland's 1904 exhibition at the Institution of Civil Engineers, 35 Dawson Street, Dublin, she exhibited a firescreen in wood and leather, a cupboard with copper panel, and, in the woodwork section, a Gothic triptych with crucifix – in private possession in 1994. Her sister Dorothy also exhibited. Sophia was represented at the St Louis World's Fair of 1904 by leatherwork.

The Bray Art Furniture Industry came into active existence early in 1905 with St John Whitty as manager, designer and instructor. In 1907 a shop was opened at 81 Main Street, Bray. When in 1909 the Arts and Crafts Society of Ireland was reorganised, she became a member of the council. The new constitution provided for the enrolment of professional craftsmen to form the Guild of Irish Art-Workers, and St John Witty was one of them in 1910. A number of exhibits under her name as designer appeared in the 1910 and 1917 Arts and Crafts Society exhibitions, including an inlaid writing cabinet and a long-handled bellows.

The outbreak of War in 1914 caused the closedown of the Bray Art Furniture Industry. Miss Whitty then devoted her energies to working as organising secretary for the United Irishwomen – a society for the development of industries for women throughout Ireland – until the outbreak of Civil War in 1921, when she resigned. She died on 26 February 1924. According to Colbert Martin in his history of the Bray woodcarvers: '... as she lay serene in death in her studio at Old Bawn, Old Connaught, the beautiful carved triptych that she had exhibited in 1904 was at her head. With its magnificent carved crucifix and watching angels it was a poignant reminder of her great talent.'

Examples: Bray, Co. Wicklow: Christ Church.
Literature: *Bray Parish Quarterly Calendar*, Spring 1902, Autumn 1903, Autumn 1904, Spring 1905, Spring 1909; *Christ Church, Bray, A Guide*, Bray 1948; Colbert Martin, *The Woodcarvers of Bray 1887-1914*, Bray [1984]; Paul Larmour, *The Arts & Crafts Movement in Ireland*, Belfast 1992 (also illustration).

WILES, FRANK, RUA (1889-1956), sculptor. Born at 'The Crannie', Larne, Co. Antrim, on 7 January 1889, Francis Wiles was the son of David N. Wiles, Petty Sessions Clerk in Larne. His mother, Margaret, was described as 'a woodcarver of ability'. A sister of Frank's recounted that he became a sculptor when he was ten years of age, modelling a bunch of grapes with clay from the harbour.

Educated at Larne Grammar School, which he entered in 1899, he then moved to Belfast College of Art in 1905 and studied sculpture under Seamus Stoupe (q.v.). In 1909 he won the W. H. Patterson Scholarship which enabled him to continue his studies in Paris. Another scholarship followed in 1911 which took him to the Dublin Metropolitan School of Art where he studied under Oliver Sheppard (q.v.).

In the National Competition in 1912 he won a bronze medal for a model figure, and another bronze in 1913 for a model design for statuary. In the 1914 event he secured a gold medal for *Dawn* or *The Dawn of Womanhood*.

The Studio commented in 1914: 'The general mediocrity of the applied art seen in the National Art Competition was almost equalled in the fine arts section, but here there was at least one work of distinction. This, a modelled figure of a kneeling girl by Francis Wiles ... was one of the best things of its kind that have been shown at South Kensington and well deserved the award of a gold medal and the praise bestowed upon

it by the sculptor-judges, Mr W. R. Colton, ARA, Mr F. W. Pomeroy, ARA, and Mr F. Derwent Wood, ARA.' This work elicited from the critic of the London *Morning Post* that it was 'refined by a perhaps unconscious sense of a classic form and the whole is quickened by spiritual *élan* which alone makes great art possible'.

Shy and reserved, with apparently little use for material things, Wiles turned down advice that he should leave Ireland and practise in London. For a period in Dublin he worked as an assistant to Sheppard in various commissions, and he also taught at the Metropolitan School of Art. He first exhibited at the Royal Hibernian Academy in 1911 and from then until 1951 showed thirty-eight works.

When he exhibited at the 1917 RHA, from 84 Upper Leeson Street, he contributed three pieces: *The Wine Carrier*, plaster; *War Memorial*, bronze; *Sydney Carton*, plaster. He left the School of Art in 1915. In 1917 he won a silver medal in competition, organised by the Royal Dublin Society, for Irish artists.

In 1918 he showed *The Dawn of Womanhood* in marble at both the RHA and the Royal Academy, his only appearance at Burlington House. This marble version had been commissioned by the Dowager Lady Smiley of Larne and London and is now in the Ulster Museum along with a bronze casting. *Reclining Woman (The Butterfly)*, marble, and plaster relief, are also at Stranmillis.

By 1919 his address was 73 Lower Baggot Street, Dublin. In that year he was responsible for the figure of a boy reading a book, with a cricket bat and stumps beside him, for the exterior of a war memorial library at St Columba's College, Dublin. He first exhibited at the Belfast Art Society in 1921 and up until 1929 showed thirteen works.

Awarded a bronze medal at the Aonac Tailteann, Dublin, 1924, he was represented in the following year by the bronze bust of a boy at the British Empire Exhibition at Wembley. In 1925 at the RHA he showed *An Old Lady*, plaster, and a bronze portrait relief of Judge J. Creed Meredith which he sent to the 1927 Irish Portraits by Ulster Artists loan exhibition at the Belfast Museum and Art Gallery. At the 1928 BAS exhibition he showed two works in marble, *The Butterfly* and *Silent, O Moyle*. By now he was working on the seated Lion design for a War Memorial in Mourne granite at Newcastle, Co. Down.

Of his *Silent, O Moyle*, the *Northern Whig* commented that the bland smoothness of the gracious marble figure 'does not at first give any indication of the severe discipline, the austerity of line, the sheer economy with which it is fashioned'.

Most of his exhibits in Dublin were for portraits but public figures were not conspicuous. When he showed *The Butterfly* in marble at the 1929 RHA, the catalogue address was his home one. In 1930 he was elected an associate of the Ulster Academy of Arts, and that year he completed his plaque of John Moore Killen, MD, for Moyle Hospital, Larne.

Among other non-portraits which he displayed at the RHA were: *Psyche*, plaster, 1935 exhibition; *Frog for Fountain*, bronze, 1936; *The Sea Nymph*, bronze, 1939 (also exhibited Ulster Academy of Arts, 1938); *The Sun Lover*, marble, 1950; *An Irish Turkey*, bronze, 1951. In 1950 he had been elected an associate of the Royal Ulster Academy. In 1951 he showed *The Sea Shell* in bronze at the RUA exhibition. His work was included in 1953 in the CEMA exhibition of sculpture at the Belfast Museum and Art Gallery.

A figure in Irish limestone of Saint Fin Barre is at St Fin Barre's Cathedral, Cork. In 1956 he was made an academician of the RUA. At The Cottage Hospital, Larne, he died on 20 September 1956. In 1958 the Royal Ulster Academy arranged a memorial exhibition at the Old Museum building, Belfast.

Works signed: Francis Wiles, Frank Wiles or F. Wiles.
Examples: Belfast: Ulster Museum. Cork: St Fin Barre's Cathedral. Dublin: St Columba's College. Larne, Co. Antrim: Moyle Hospital. Newcastle, Co. Down: Promenade.
Literature: *The Studio*, September 1914; *Who's Who in Art*, 1924, 1927; *Belfast Telegraph*, 21 September 1956, 22 November 1958, 9 March 1962; Larne Grammar School, *The Grammarian*, 1957; *Northern Whig*, 25 November 1958; *Dictionary of British Artists 1880-1940*, Woodbridge 1976; John Hewitt and Theo Snoddy, *Art in Ulster: 1*, Belfast 1977; Martyn Anglesea, *The Royal Ulster Academy of Arts*, Belfast 1981 (also illustration); Larne Grammar School, *Letter to the author*, 1987; Ann M. Stewart, *Royal Hibernian Academy of Arts: Index of Exhibitors 1826-1979*, Dublin 1987; Brian Kennedy: Ulster Museum, *Twentieth Century Sculpture*, Belfast 1988; St Columba's College, *Letter to the author*,

1994; also, Whiteabbey Hospital, 1994; Ann M. Stewart, *Irish Art Societies and Sketching Clubs: Index of Exhibitors 1870-1980*, Dublin 1997.

WILKINSON, NEVILE, ARE, RMS (1869-1940), designer, etcher and miniature craftworker. Nevile Rodwell Wilkinson was born at Southampton Lodge, Highgate village, London, on 26 October 1869, the son of Col. Josiah Wilkinson. Educated at Harrow School, he was gazetted to the Coldstream Guards from the Royal Military College in 1890. The 1st battalion of the Guards was stationed in Dublin in 1891. In his autobiography he reported seeing Maud Gonne (q.v.) 'in her stately classical beauty ... I have seen her stand in the Leinster Hall like a marble goddess ...'.

Back in London, he met many of the artists of the day at the Chelsea Arts Club. He supplied illustrations, mostly drawings of uniformed figures, for a history of the Coldstream Guards, published in 1896. He married, in 1903, Lady Beatrix Herbert, eldest daughter of the 14th Earl of Pembroke, and resided at Mount Merrion, Co. Dublin.

In the period of peace which followed the Boer War he studied heraldry. When he retired from the Army in 1907, he devoted himself to the art of drawing, and at South Kensington he studied engraving. On first exhibiting at the Royal Hibernian Academy in 1907, he showed four etchings, giving his London address, 6 Duchess Street, Portland Place.

During the summer of 1907 when he was working at his easel, drawing the trunk of an old sycamore at Mount Merrion, his daughter, aged three, declared that she saw a fairy disappear among the moss which covered the twisted roots. It occurred to Major Wilkinson that if a special building were made above ground, 'The Fairy Queen and her Court might be persuaded to transfer themselves and their treasures to the visible palace, so that all the children of the world might be invited to admire them'.

Wilkinson planned a miniature building, 'which by the beauty of its decoration should be fit for the residence of Her Iridescence, Queen Titania, her Consort Oberon, and the Royal Family of Fairyland'. The exterior was fashioned in the workshop of James Hicks, Lower Pembroke Street, Dublin; Thomas Lennon was Wilkinson's assistant. The ground plan of the Palace was in the form of a hollow rectangle, 2.7 metres by 2.1 metres; total height, 69cm. The sixteen rooms were built around a central courtyard. Overall scale was one to twelve.

The sensational theft of the Crown Jewels in Dublin in 1908 resulted in Wilkinson's appointment as Ulster King of Arms in succession to Sir Arthur Vicar, their custodian. He was also Registrar of the Order of St Patrick and in 1911 designed the Sword of St. Patrick.

In 1908 at the RHA he showed two bookplates, a pen and ink design for a bookplate, and a coat of arms. In 1909 he was appointed an associate of the Royal Society of Painter-Etchers and Engravers. In conjunction with Dermod O'Brien (q.v.), he organised a loan exhibition in 1910, Art of Engraving, held at the Academy's premises, and also a series of lectures elsewhere. The Lord Lieutenant, the Earl of Aberdeen, formally opened the exhibition.

A portrait of Joseph Ferguson Peacocke, Archbishop of Dublin, was exhibited in 1909 at the Water Colour Society of Ireland exhibition, and he continued to contribute to the Society's exhibitions for the next twenty years, including bookplates and work associated with Titania's Palace. He was a committee member.

Meanwhile, he continued working on Titania's Palace, painting tapestries, mosaics, tiles, frescoes, and, he explained, 'the rest of those interior decorations associated with Italy of the Renaissance'. Up until the outbreak of the First World War, when he rejoined, his contributions at the RHA also included an armorial design, a seal, two designs for a memorial, two for stained glass and one for a magazine cover.

Wilkinson also designed the badge of the president, Royal College of Surgeons in Ireland. In 1917 he was represented in the Graphic Arts Exhibition at the Royal Academy by bookplate, and it was through *ex-libris* that he is represented in the British Museum. Towards the end of his military career he was able to study the technique of etching under Sir Frank Short (1857-1945).

A knighthood came in 1920, and in 1921 he was promoted from CVO to Knight Commander of the Royal Victorian Order, having planned and carried out arrangements for ceremonies at the opening of the Northern Ireland Parliament. He designed the obverse for the first Great Seal for Northern Ireland, exhibited at the

Royal Academy in 1924, and designed, emblazoned and issued from his Office the coat of arms and the supporters for the six counties.

He was represented in 1921 in a show of miniatures, which was supplemented by a selection from the Royal Society of Miniature Painters, at Pennsylvania Academy. In connection with Titania's Palace, he visited Palermo and Ravenna which showed the possibility of a microscopic technique, reproducing 'some of the golden glamour of early Byzantine techniques'.

The year 1921 saw the first completed part of Titania's Palace exhibited at the Royal Society, of which Sir Nevile was vice-president. On 6 July 1922 the Palace, lit and heated by electricity, was opened by Queen Mary, and that summer was displayed to the public at the Women's Exhibition at Olympia.

To meet the difficulty of transport, the Palace had been built in eight sections, each of which occupied its own separate padded packing-case. The total weight of the Palace when packed ready for despatch exceeded three tonnes. In the rooms was a collection of tiny objects of art, many obtained by Wilkinson. In addition to the antique assemblage of specimens of tinycraft, there were some of the most perfect examples of modern craftsmanship, such as reproductions of the Ardagh Chalice and the Cross of Cong.

For the decoration of the Palace, which received gifts from many parts of the world, Wilkinson created a technique which he called 'mosaic painting'. Using an etcher's glass, he laid on minute dabs of watercolour, slightly irregular in shape like mosaic tesserae, the numbers of which were said to have reached 1,000 or more per square inch. The ceilings were all his work.

Among his other contributions were: Hall of the Fairy Kiss: full length figures of Apollo and Diana; portrait of Queen Alexandra, 1908. Chapel: The reredos, 30.5cm by 35.5cm, took four years to complete; ceiling design adapted from Book of Kells. Royal Bedchamber: painting of Doge's Palace. Throne Room: frieze 10cm deep, suggested by visit to Ravenna and the tomb of Galla Placidia; mosaic floor with '250,000 separate dots of watercolour'. He continued adding to the decorations until his death.

In connection with the travels of the Palace, he wrote a number of 'Yvette' books. The doll's house could not be given a monetary value; the throne of Queen Titania, for example, had inlaid into the back a diamond peacock made for the Paris Exhibition of 1856. In the first ten years of the Palace's existence, it had visited more than 160 cities in the British Isles, the United States and South America, Australia, New Zealand and Canada.

Admired by 1,700,000 people, it had raised for associations which worked for the welfare of crippled, neglected or unhappy children the sum of £80,000. Wilkinson took the view that if one cripple walked 'by reason of its making, Ireland's gift to suffering childhood will not have been built in vain'.

In 1925 he was appointed honorary secretary of the Guards' Chapel, Wellington Barracks, and for six years he worked out a design for the renewal of the choir and sanctuary pavements. Between 1927 and 1940 he showed eighteen works at the Royal Academy, including a number of designs for the Guards' Chapel, also a design for mosaics for the Royal Garrison Church, Woolwich. Altogether, he exhibited fifty works at the RHA. In 1928, after an interval of thirteen years, he showed a mosaic pavement, and in 1932 a pearl and peacock ceiling, both for the Palace.

Wilkinson carried out other decorative works besides the Palace itself, and a collective exhibition of these was held at the Fine Art Society, London, in 1937, when he also showed more than thirty bookplates. At this exhibition there was a portrait of Sir Nevile by Sean O'Sullivan (q.v.). His history of the Guards' Chapel was published in 1938. He showed more than fifty works with the Royal Society of Miniature Painters. He was a member of the Art Workers' Guild. On 22 December 1940 he died in Dublin. In 1954 the Palace was on view at the home of Lady Wicklow, Ballynastragh House, near Gorey, County Wexford. Sir Nevile was her first husband. In 1967 the Palace was sold at Christie's, London, and again in 1978, this time for £135,000, to Legoland, Denmark.

Works signed: Nevile R. Wilkinson, Nevile Wilkinson or NRW, monogram, rare (if signed at all).
Examples: Billund, Denmark: Legoland. London: British Museum.
Literature: Lt. Col. Ross-of-Bladensburg, *A History of the Coldstream Guards, From 1815 to 1895*, London 1896 (illustrations); *The Studio*, October 1910, January 1911, March 1917, December 1918 (illustrations), December 1921

(also illustrations), January 1922, December 1926; *Thom's Directory, 1920; Belfast News-Letter*, 23 June 1921; Nevile Wilkinson, *Grey Fairy and Titania's Palace*, London 1922 (illustration); also, *Yvette in Italy and Titania's Palace*, London 1922 (illustrations); *Yvette in Venice and Titania's Palace*, London 1923 (illustration); Major Sir Nevile R. Wilkinson, *To all and singular*, London [1926] (also illustrations); Nevile Wilkinson, *Yvette in Switzerland and Titania's Palace*, London 1926 (illustration); J. Crampton Walker, *Irish Life and Landscape*, Dublin 1927 (illustration); *Who's Who in Art*, 1927; Nevile Wilkinson, *Yvette in the USA and Titania's Palace*, London 1928 (illustration); *Illustrated London News*, 23 January 1932 (illustration); Major Sir Nevile Wilkinson, *Titania's Palace*, Dublin *c.* 1932; The Fine Art Society, *Major Sir Nevile Wilkinson, K.C.V.O., ARE., V.-P. M.S, Ulster King of Arms, Drawings, Etchings, Mosaic Paintings, etc.*, catalogue, London 1937; Nevile Wilkinson, *The Guards' Chapel 1838-1938*, London 1938 (illustrations); *Belfast Telegraph*, 23 December 1940; *The Times*, 23 December 1940; *Dublin Magazine*, November-December 1954; *Dictionary of British Artists 1880-1940*, Woodbridge 1976; *Irish Times*, 3 December 1977, 11 January 1978; Ann M. Stewart, *Royal Hibernian Academy of Arts: Index of Exhibitors 1826-1979*, Dublin 1987; Royal Danish Embassy, London, *Letter to the author*, 1994; *Water Colour Society of Ireland Exhibition List 1872-1994*, Dublin 1995.

WILKS, MAURICE C., RUA, ARHA (1910-84), landscape and portrait painter. Born on 25 November 1910 in Belfast, Maurice Canning Wilks was the son of Randal Wilks, linen designer, and was educated at Malone Public Elementary School, Belfast. He attended night classes at the Belfast School of Art, winning the Dunville scholarship to the day school. An early exhibitor with the Ulster Academy of Arts, he was elected an associate in 1935.

Between 1933 and 1983 he showed thirty-seven pictures at the Royal Hibernian Academy, the majority landscapes with only the occasional portrait, but in 1935 from 36 Sagimor Gardens, Belfast, he contributed: '*Madonna of the West*'; *The Labourer*; and *Miss Daphne Hummel*. His first landscape appeared in 1937. In addition to his local Ulster scenes, he painted in Counties Donegal and Kerry, also in Connemara.

At the 1939 Ulster Academy of Arts, a portrait singled out by one newspaper was *The Green Fan*. His 1939 oil painting, *The Seafarer*, was presented by the Thomas Haverty Trust, Dublin, to the Belfast Museum and Art Gallery in 1941. By 1942, following the air raids on Belfast the previous year, Bangor, Co. Down, was his base.

In 1943 Arthur and George Campbell (q.v.) published a booklet of drawings, *Ulster in Black & White*, and Wilks was a contributor with *Study of a Countryman* and *Seafaring Man*. Prints of all the illustrations were available 'suitable for framing, price 1s. 2½d. each, post free'. At the RHA in 1944, now at Cushendun, Co. Antrim, he showed *Slea Head from Great Blasket Island* and *Glen Head, Co. Donegal*. That year J. Humbert Craig (q.v.), his mentor, died at Cushendun.

The critic for the *Dublin Magazine* found his exhibition in 1944 at the Victor Waddington Gardens, Dublin, 'completely derivative'. The underlying approach was 'popular, sentimental, drawing-room'. However, on his show of twenty-four paintings at the same gallery two years later, Antrim and Donegal landscapes predominating, the *Irish Times* representative discovered 'a fine romantic spirit and considerable feeling' in *A Pool on the Dun River* and *Morning, Belfast Docks*, adding that *Blasket Island Curragh* was a grand splash of colour, and *The Race*, of yachts, 'an invigorating scene'. He showed two pictures at the Oireachtas exhibition in 1945.

As an academician of the Ulster Academy of Arts, the distinction was retained when the Royal Ulster Academy came into existence in 1950. In that year he prepared for exhibitions in Canada and the United States. His work at this time was not unknown in Britain, where reproductions of his paintings – for example of the Donegal highlands – were popular in the art shops. Combridge Galleries, Dublin, advertised his prints.

About 1950 he painted *Gray Morning, Clarendon Dock*, oil, which is in the collection of Belfast Harbour Commissioners. He painted a number of pictures around Belfast docks. Also at the Harbour Office is *The Old Pier*, oil. Among his works at the 1951 RUA was *Above Derwent Water, Cumberland*.

In the 1950s he held several one-person shows at the Anderson & McAuley store in Belfast. Some Dutch paintings were included in 1956, including a Maartensdijk landscape and *Morning Light, Hoorn*. John Hewitt, art critic, considered that some of these works 'seemed to suggest an entirely new terrain, called up an unexpected sensitivity and resource'. The visit to Holland was to complete a portrait of a visiting Dutch naval captain's wife which Wilks had begun in Cushendun.

Watercolours were included in the exhibition at Anderson & McAuley's in 1957, and among his forty works at the 1958 show were two of the pictures which were rejected for the controversial RUA exhibition of the same year. At the same venue in 1959, several of the paintings based on Cushendun recalled for the *Northern Whig* the atmosphere of work by Humbert Craig, but the most ambitious picture was *The Crucifixion*. A crayon portrait of Craig by Wilks is in Bangor Town Hall. In 1960 at the Belfast store, landscapes of the Mourne Mountains were a feature.

The 1960s saw solo shows in Montreal and Boston, Mass. He also exhibited at Magee Gallery, Belfast. Towards the end of his career the Walker Art Gallery, Coleraine, Co. Derry, presented his work. He was represented at the inaugural meeting of the Ulster Watercolour Society in 1977, his last year for exhibiting at the RUA: *Cumbrian Farm Yard*.

In 1978, after an absence of nearly thirty years, he returned to the Dublin exhibition. In his later years he had a summer studio in a small boathouse at Sutton, Co. Dublin. In 1980 he showed thirty-five works at the Oriel Gallery, Dublin; all were landscapes with one exception, *Ballet Rehearsal*. In 1981 a retrospective exhibition was held at the Malone Gallery, Belfast.

Also at the Ulster Museum is *James Quigley*, sanguine chalk. In Armagh County Museum are two oils, *The Mournes from Portaferry* and *Winter, Cushendun*. A modest man, his recipe for success was 'hard work and regular hours', and he took no part in art politics. He died on 1 February 1984 at his home, 73 Priory Park, Belfast. After his death, a retrospective exhibition took place at the Oriel Gallery in 1984. An auction of 285 works from his studio, about 90% drawings in pen and ink or pencil, was held in 1997 in Belfast.

Works signed: Maurice C. Wilks; Maurice Wilks or M. Wilks, both rare.
Examples: Armagh: County Museum. Bangor, Co. Down: Town Hall. Belfast: Department of the Environment for Northern Ireland; Harbour Office; Ulster Museum. Cultra, Co. Down: Ulster Folk and Transport Museum. Downpatrick: Down County Museum. Dublin: Irish Writers' Centre; Office of Public Works. Lagos: Irish Embassy. Limerick: City Gallery of Art. Sligo: Model and Niland Centre.
Literature: *Ulster in Black & White*, Belfast 1943 (also illustrations); *Dublin Magazine*, April-June 1944; *Irish Times*, 2 March 1946, 10 February 1984; *Belfast News-Letter*, 5 August 1950, 2 November 1956, 19 November 1957, 3 November 1960, 2 February 1984; *Capuchin Annual*, 1953-54; *Belfast Telegraph*, 16 February 1956; *Northern Whig*, 5 November 1959; *Dictionary of British Artists 1880-1940*, Woodbridge 1976; John Hewitt and Theo Snoddy, *Art in Ulster: 1*, Belfast 1977 (also illustration); Oriel Gallery, *Exhibition of Paintings by Maurice C. Wilks, RUA, BWS, UWS*, catalogue, Dublin 1980 (illustrations); Martyn Anglesea, *The Royal Ulster Academy of Arts*, Belfast 1981 (also illustration); Eileen Black: Belfast Harbour Commissioners, *Paintings, Sculptures and Bronzes in the Collection of The Belfast Harbour Commissioners*, catalogue, Belfast 1983 (also illustrations); Oriel Gallery, *Maurice Wilks, RUA, ARHA, BWS, UWS (1911-1984)*, catalogue, Dublin 1984 (also illustrations); Ann M. Stewart, *Royal Hibernian Academy of Arts: List of Exhibitors 1826-1979*, Dublin 1987; Patricia Butler, *Three Hundred Years of Irish Watercolours and Drawings*, London 1990 (illustration); John Ross & Co., *Maurice Canning Wilks*, catalogue, Belfast 1997 (also illustrations); Ann M. Stewart, *Irish Art Societies and Sketching Clubs: Index of Exhibitors 1870-1980*, Dublin 1997.

WILLIAMS, ALEXANDER, RHA (1846-1930), landscape and marine painter. Born in Monaghan on 21 April 1846, when his mother was visiting her sister-in-law, Alexander Williams was the son of William Williams, hatter, Laurence Street, Drogheda, Co. Louth. His ancestors originally came from Neath, Wales, settling in Ireland in 1653, at the Groves and Lappan, a County Monaghan estate of 250 acres. At Lappan, his ancestors carried on the trade of 'felt makers', or hatters.

Educated at Drogheda Grammar School, he moved with his family to Dublin in 1860, and he became apprenticed to his father at the hat manufacturing business. He studied drawing at night at the Royal Dublin Society school, but later regretted that he had not 'gone through proper courses of Art Study ...'.

Alexander and his brother Edward founded a natural history studio in Dublin. Some of their works as taxidermists were bought by the Natural History Museum. Another brother, W. J. Williams, was also a keen naturalist. In 1870 Alexander first exhibited at the Royal Hibernian Academy, from 3 Dame Street, Dublin, and from then until 1930 showed no fewer than 450 works, not missing a single exhibition in sixty years.

Initially he exhibited mainly nature studies at the RHA, but among his contributions in 1872 were: *Running from Howth Harbour* and *Penzance Fishing Boat*. When the Dublin Sketching Club was founded in 1874,

he became its first honorary secretary. He exhibited Achill Island scenes that year at the RHA, having painted there the previous year.

At the Dublin Sketching Club hundreds of his works were hung right up until 1930. For example, in the three years, 1876, 1877 and 1878 more than eighty were exhibited, a fair proportion designated 'sketch'.

Retiring from business, he qualified himself for the musical profession, and in 1874 he was in the choir of the Chapel Royal, Dublin Castle. A member of the Dublin Glee and Madrigal Union Quartet, 1875, he was afterwards soloist in the choirs of Christ Church Cathedral and St Patrick's Cathedral, Dublin.

By 1876 he had moved to 102 Lower Mount Street. In the next few years RHA titles of works indicated painting on the Antrim coast, Portballintrae area, and at Rostrevor, Co. Down; and on the Thames and at Yarmouth. In 1882 he showed in the exhibition of Irish Arts and Manufactures at the Rotunda, Dublin.

In 1883 he exhibited at the Cork Industrial Exhibition, and in 1884 at the Irish Fine Art Society exhibition in Cork. In 1884 too he was elected an associate of the RHA, and at Leinster Hall, Dublin, he held his first show. A series of Tramore, Co. Waterford, pencil drawings were dated 1886. In 1887 he was at 58 Harcourt Street; the local directory described him as 'artist and musician'. His work was prominently represented in the Irish Exhibition in London, 1888. In the early 1890s Scotland was on his itinerary. He became an RHA in 1891 and that year exhibited with the Belfast Art Society.

In 1892, as energetic as ever, he was showing with the Water Colour Society of Ireland and the connection continued until 1929.

At the Academy exhibition in 1893 he gave what was to become a permanent address, The Studio, 4 Hatch Street, and he again contributed Scottish scenes, Loch Achray and Loch Vennachar in Perthshire, and Loch Etive in Argyll. But he still paid regular visits to Achill Island, and he also painted in Connemara and Killarney. An oil, *A Summer Day in Groomsport Harbour, Co. Down* was painted in 1895. After being on a sketching tour in Achill in 1896, he directed through the Press attention to the state of Kildownet Castle.

Williams was commissioned by the Corporation of Dublin in 1897 to advise and superintend the cleaning and restoration of the historical collection of portraits in the City Hall and Mansion House, and in the same year he relinquished all his musical appointments. He now began holding exhibitions in England; in 1899 in Manchester, and another later in Liverpool. In 1900 Bristol was selected for a fortnight. A change from his routine work was *Queen Victoria at Kingstown, 1900* with an air of festivity and pageantry. *The Studio* reported that his exhibition of Achill pictures in Dublin in 1900 was 'very well attended'.

Under the title of 'Picturesque Ireland', he held his first London show, oil paintings and watercolours at the Modern Gallery, Bond Street, in 1901 when fifty-three of his pictures were purchased. This exhibition was under the immediate patronage of His Excellency the Lord Lieutenant of Ireland. The Cadogans formed a collection of his pictures. At a later period he showed some works at the Dudley Gallery, London.

Williams stated in later life that he had exhibited in Cape Town, and it is assumed that the 'A. Williams' who showed three pictures at the South African Society of Artists' annual exhibition at Cape Town in 1902 is this painter; *View from Groot Schuur* would indicate he was there.

On three occasions the artist gained the £50 prize in the Art Union of Ireland, which purchased in the RHA exhibitions. *View in the Isle of Achill* was exhibited at the Guildhall of the Corporation of London in 1904, an exhibition of Irish painters organised by Hugh P. Lane. 'Achill Island has for me an ineffaceable charm', he wrote in his memoirs, 'and my friends tell me I paint it as if I thoroughly loved it'.

In the period 1908-10 he contributed four articles to *The Irish Naturalist*, one of which had been read before the Dublin Naturalists' Field Club. In his article, 'Wild Bird Protection in Co. Dublin', he reported 211 nests of the Common and Arctic Terns; number of eggs examined, 338. Writing at length about the Sanderling of Dublin Bay, he stated: '... clad in a sand-coloured Burbury (sic) suit and hat, I have often crawled, even in bright daylight, over the dry sand, face down, and lying as flat as possible, and progressing crocodile fashion, by the assistance of my elbows and knees....'

A series of Youghal Co. Cork, pencil drawings were dated 1910. Williams supplied forty-eight illustrations for Stephen Gwynn's *Beautiful Ireland*, 1911, twelve coloured plates for each Province, for example: *The Meeting of the Waters, Woodenbridge*; *Fair Head, Co. Antrim*; *The Old Clock Tower, Youghal*;

Wrack-gathering on the West Coast. The Provinces were then published separately, Leinster and Ulster in 1911, Munster and Connaught in 1912.

At the 1911 RHA, one of his works was of a lacemaker's home at Youghal. In wartime, Killarney featured in his work. In the USA his first public exhibition was held at O'Leary's Gallery, Detroit, 1916.

When the Dublin Sketching Club celebrated its fiftieth annual exhibition, at Mills' Hall, Dublin, he was among the small band of original members who had survived – and he was still honorary secretary. Bleanaskill Lodge, Achill, was his summer residence and studio, but when he bought the property it was a ruin which he made habitable. His Dublin addresses were The Orchard, Rathgar, and Hatch Street.

In the National Gallery of Ireland he is represented by an oil, *Rocky Cliffs by the Sea*, and a watercolour, *A House by a River.* At the Hugh Lane Municipal Gallery of Modern Art is *A Calm Evening on the Thames at Greenwich*, 48cm by 71cm, watercolour. In the Armagh County Museum is another watercolour, *The White Rocks, Portrush.* He travelled extensively exhibiting his works, particularly in Canada, and he showed, he stated, at Montreal, Prince Albert, Regina, Saskatoon, Toronto and Vancouver. He also exhibited in Australia, at Melbourne and Perth; and at Hamilton, Bermuda.

One of his largest works was *April Showers, Bellingham Harbour, Howth*, 91cm by 165cm. In an article in the *Capuchin Annual*, 1949, 'Fifty years of Irish Painting', Thomas MacGreevy wrote: 'A more popular painter of those days, Alexander Williams, would be almost forgotten now, were it not that his feeling for the pittoresque in nature, overstated in his large canvases, is expressed effortlessly in some of his smaller works, which, as a consequence retain, unexpectedly after all the years of eclipse, a touch of something very like genuine lyrical quality.' He died in Dublin on 15 November 1930.

Works signed: Alec Williams, Alex. Williams, Alexander Williams or A. Williams, rare.
Examples: Armagh: County Museum. Dublin: Hugh Lane Municipal Gallery of Modern Art; National Gallery of Ireland; Royal Hibernian Academy; University College (Belfield; Newman House). Dun Laoghaire, Co. Dublin: National Yacht Club. Kilkenny: Art Gallery Society. Killarney: Muckross House. Limerick: City Gallery of Art. Monaghan: County Museum. Preston, Lancs: Harris Museum and Art Gallery.
Literature: *Slater's Directory of Ireland*, Manchester 1856; *Notes on the Origin and Early History of the Dublin Sketching Club*, n.d.; *Dublin University Review*, June 1886 (illustration); *Dublin Sketching Club Minute Book*, 1887; *Thom's Directory*, 1888; *Belfast Art Society Exhibition*, catalogue, 1895; *The Irish Builder*, 15 November 1896; *The Studio*, March 1900, April 1902, February 1925; Untitled newspaper cutting, 22 March 1901; *The Irish Naturalist*, June 1908, September 1908 (illustration), June 1909, October 1910; Stephen Gwynn, *Beautiful Ireland*, London 1911(illustrations); W. G. Strickland, *A Dictionary of Irish Artists*, Dublin 1913; *Alexander Williams, RHA*, brochure, c. 1920; *Who's Who in Art*, 1927; John S. Crone, *Concise Dictionary of Irish Biography*, Dublin 1937; *Who Was Who 1929-1940*, London 1941; Thomas MacGreevy, 'Fifty Years of Irish Painting', *Capuchin Annual*, 1949; Gordon T. Ledbetter, 'Alexander Williams (1846-1930): Sidelights on a Victorian Painter', *The Irish Ancestor*, vol. VII, no. 2, 1975; *Dictionary of British Artists 1880-1940*, Woodbridge 1976; Gorry Gallery, *18th, 19th and 20th Century Irish Paintings*, catalogue, Dublin 1982; *Irish Times*, 7 December 1985; Ann M. Stewart, *Royal Hibernian Academy of Arts: Index of Exhibitors 1826-1979*, Dublin 1987; Peter Murray, compiler, *Illustrated Summary Catalogue of The Crawford Municipal Art Gallery*, Cork 1991; Terence Dunne, *Letter to Monaghan County Museum*, 1993; Anne Crookshank and the Knight of Glin, *The Watercolours of Ireland*, London 1994; Greene's Antique Galleries, *Letter to the author*, 1994; also, South African National Gallery, 1994; Trinity College Library, 1994; Ann M. Stewart, *Irish Art Societies and Sketching Clubs: Index of Exhibitors 1870-1980*, Dublin 1997; Frederick Gallery, *Drawings, Etchings & Engravings*, catalogue, Dublin 1998.

WILLIAMS, CHARLOTTE – see WHEELER-CUFFE, LADY.

WILLIAMS, LILY, ARHA (1874-1940), portrait and figure painter. Elizabeth Josephine Williams was born in Dublin, on 20 October 1874, the daughter of W. H. Wilkinson Williams. Of Unionist and Protestant stock, she studied under May Manning (q.v.), and also at the Royal Hibernian Academy Schools where, for the session 1902-3, she won £2 for composition in black and white from a given subject. She was a member of the Dublin Sketching Club, and was one of the Young Irish Artists who exhibited in Dublin in 1903; among the other students were Beatrice Elvery (Lady Glenavy, q.v.) and Estella Solomons (q.v.).

Among her contributions to the 1903 and 1904 Dublin Sketching Club exhibitions were a number of Skerries subjects, also portraits, for example in 1904, *Miss Annie Foster, B.A.*

In 1904, from 104 Marlborough Road, Donnybrook, Dublin, or 2 Marlborough Terrace, she contributed to the Royal Hibernian Academy for the first time, and from then until 1939 never missed a year, showing 132 works. Early in her career she presented portraits, including one of Padraic Colum in the 1906 exhibition and Arthur Griffith in 1908, with the occasional landscape. She showed at the Oireachtas exhibition in 1906 and eleven works in 1907.

Griffith found relaxation at the Williams' home at Marlborough Road. The three daughters, Lily, Nora and Flo were to become staunch supporters, and stood by him and his family in times of stress. For Griffith, Lily designed the first Sinn Féin postage stamp or label to help finance his new paper. In 1909, from 1 Leinster Road, Dublin she exhibited *An Irish Peasant* at the RHA.

Influenced by Griffith, and with some other Protestant Sinn Féiners, she sought to learn Irish. In 1911 her pastels were included in an exhibition at the Branch of the Five Provinces, 7 St Stephen's Green. Thomas Bodkin, in the *Irish Review*, found her *Irish Costume* not flattering to the sitter but 'the little study of trees belongs to quite another category and is characterised by very genuine observation and good feeling'. She did not confine her activities to Dublin, painting also in Counties Kerry and Sligo.

After an interval of four years, she returned to the Oireachtas in 1911, and at the Dublin Sketching Club in 1912 her contributions included *Evening at Rush* and *The Hayricks*.

Among the seven works which she showed at the 1916 Academy exhibition were: *An Irish Volunteer*; *The Chinese Umbrella*; and '*Ould Biddy*'. At her studio at 18 Lower Pembroke Street, Dublin, she taught painting for several years, and she was a visiting teacher at the RHA Schools.

Griffith wrote to her from Reading and Gloucester prisons in the period 1916-18. The three portraits which she exhibited at the 1919 Academy were of Miss Lilla Bagwell, Miss Susan Mitchell and Dr Kathleen Lynn. The portrait of Miss Lynn was presented to her by friends and is at Liberty Hall, Dublin. A second portrait of Dr Lynn is at the Royal College of Physicians of Ireland.

The Williams illustration to *The Book of St Ultan*, 1920, was *St Ultan* from a poster. The 1921 oil portrait of Griffith which she presented to the Municipal Gallery of Modern Art in Dublin is now at Áras an Uachtaráin, where there is also a 1916 portrait of The O'Rahilly. *The Late J. B. Yeats, RHA*, a watercolour, appeared at the 1922 RHA.

In 1923 the Irish Free State's Cross of Cong stamp, which she designed, appeared; 3d. blue denomination followed by the 10d. Rembrandt brown. The 11d. cerise was not issued until 1949. In a number of portraits which she exhibited at the Academy the sitters were unnamed in the catalogues, but that of General Mulcahy was listed in 1925 and Ernest Blythe, Minister for Finance, in 1927.

Participation in the Water Colour Society of Ireland exhibitions was confined to two years, 1927 and 1928. In the former, she showed a portrait of Miss Lily O'Brennan; 1928, Dr Dorothy Stopford Price.

In 1929 she was appointed an associate of the RHA. The portrait of Professor Mary Hayden exhibited at the 1937 RHA is in University College, Dublin. By far the highest priced of all her pictures was '*They shall be remembered for ever*' at the 1938 exhibition. A pastel portrait of Padraic Colum is in the Abbey Theatre. In the Dublin Civic Museum is a drawing of a man; an inscription on the back reads: 'Mr Arthur Barron'. In the Hugh Lane Municipal Gallery of Modern Art are two oil paintings, *Moyra* and *Portrait of a Woman*. She died in a Dublin hospital, on 16 January 1940.

Works signed: Lily Williams or L. Williams, rare.
Examples: Dublin: Abbey Theatre; Áras an Uachtaráin; Civic Museum; Hugh Lane Municipal Gallery of Modern Art; Liberty Hall; Royal College of Physicians of Ireland; University College (Earlsfort Terrace). Kilkenny: Art Gallery Society.
Literature: *Thom's Directory*, 1886, 1915; *Dublin Sketching Club Minute Book*, 1901; Newspaper cutting, untitled, undated [1903]; *Irish Review*, November 1911; Katherine MacCormack, ed., *The Book of St Ultan*, Dublin 1920 (illustration); *Capuchin Annual*, 1940 (illustration); *Irish Times*, 18 July 1940; Padraic Colum, *Arthur Griffith*, Dublin 1959; *Studies*, Spring 1962; Beatrice Lady Glenavy, *Today we will only Gossip*, London 1964; Dept. of Posts and Telegraphs, *Letter to the author*, 1968; W. F. Williams, *Letters to the author*, 1969; Dublin Public Libraries, *Letter to*

the author, 1978; Calton Younger, *Arthur Griffith*, Dublin 1981; National Gallery of Ireland and Douglas Hyde Gallery, *Irish Women Artists: From the Eighteenth Century to the Present Day*, Dublin 1987 (illustration); Ann M. Stewart, *Royal Hibernian Academy of Arts: Index of Exhibitors 1826-1979*, Dublin 1987; Hugh Lane Municipal Gallery of Modern Art, *Letter to the author*, 1994; Ann M. Stewart, *Irish Art Societies and Sketching Clubs: Index of Exhibitors 1870-1980*, Dublin 1997.

WILLIS, RICHARD H. A. (1853-1905), sculptor, portrait and landscape painter. Richard Henry Albert Willis was born at Dingle, Co. Kerry, on 5 July 1853, son of Joseph Willis. He produced at the age of fifteen a charcoal drawing, *La Bataliere*, now in the Crawford Municipal Art Gallery, Cork. In the city he was apprenticed to the architect, Arthur Hill, but devoted his spare time to studying at the Cork School of Art. There he was named among the prizewinners in the 1869 examinations, also he won prizes in the three years, 1871-3. On the exhibition of students' work in 1874, the *Cork Examiner* noted Willis's series of illustrations of Shakespeare's *Seven Ages of Man* and Goldsmith's *Deserted Village*. As he had work selected in 1875 for the National Competition, he received another School of Art prize.

Willis gained a scholarship to the National Art Training School, South Kensington. He won a travelling scholarship, besides many medals and prizes. He also studied in Italy, and at the Slade School of Fine Art, London, under Alphonse Legros (1837-1911). In 1880, from 2 Milner Street, Chelsea, he showed at the Royal Hibernian Academy for the first time: *A Mountain Path, Bantry*; and in 1881, also in Co. Cork, *Tending her Flock, Glengarriff, Ireland*. Altogether, he supported the Dublin exhibition with five works. From the Science and Art Club, South Kensington, he first exhibited at the Royal Academy in 1882, *In the South of Ireland*. Up until 1899 he showed a total of nine pictures.

When Sir Edward J. Poynter (1836-1919) undertook the preparation of gigantic cartoons developing part of the sketch-design by Alfred Stevens (1818-75) for the interior of the dome of St Paul's Cathedral, he was assisted by Willis. However, when tested in position they were found to be 'invisible', and the permanent realisation of the scheme was abandoned.

In 1883 he was appointed headmaster of the Manchester School of Art. According to Walter Crane (1845-1915), a founder-member of the Art Workers' Guild in 1884, Willis raised the school to a high position. Thomas Armstrong (1835-1911), under whom Willis had studied at South Kensington, commented: 'He was a born teacher, and with the enthusiasm which provokes enthusiasm in others; he got more out of his pupils than almost anyone I ever knew; to the best of my belief he was the most successful art master produced at the South Kensington Training College.' He had introduced classes in modelling and ornament, established a school library, and promoted a school sketching club.

Under his guidance, Manchester students received many national awards in the 1880s. In 1889 at the RA he gave as his address, School of Art, Cavendish Street, Manchester, and contributed *Study of age*, bust, and *The Slinger*, statuette. In 1891 his bronze panel, 91 cm high, *'O Love, has she done this to Thee?'* (Manchester City Art Gallery) appeared at the RA. Writing in *The Magazine of Art* on the sculpture of the year, Claude Phillips found 'this clever relief' in the French style of the seventeenth century.

In 1892 Willis resigned as headmaster and took a studio in London to continue his own work. However, he was also credited with acting as a drawing master at South Kensington and examiner for the National Competition. For some years he was art adviser to the Corporation of Preston in buying pictures for its gallery.

In 1894, at 4 Scarsdale Studios, Kensington, he showed two works at Burlington House: *Arrival of the Milesians*, watercolour, and *The Fisherman's Dwelling*, sculpture. Both these items were on display the same year at the Autumn exhibition of the Walker Art Gallery, Liverpool. In 1899, from New Street, Killarney, he exhibited *Fate*, described as a medallion, at the RA. He had joined a branch of the Gaelic League in Killarney and designed the cover for its magazine, *Loc Léin*.

In 1904 he was offered the Dublin Metropolitan School of Art headmastership in succession to his old Cork teacher, James Brenan (q.v.). He at first refused, as he desired to devote himself to his artistic work; but he was prevailed upon to accept, and was appointed on 1 July 1904. According to Walter G. Strickland in his *A Dictionary of Irish Artists*: 'He took up his new duties with all his characteristic enthusiasm, and laid

himself out to raise the standard of art and of art teaching in Ireland. He was a strenuous supporter of the work of the Gaelic League, and an enthusiast in the development of "Nationalism" in Irish art education.'

John Turpin in his *A School of Art in Dublin since the Eighteenth Century*, 1995, wrote that Willis was 'one of the most distinguished headmasters ever appointed...He combined breadth of experience of the world of art education with a strong desire to make the school play its part in the Irish cultural revival.' In 1905, after an interval of twenty-four years, he returned to the RHA with three works, including *A Bouquet* and the *O Love* bronze. At the Crawford Municipal Art Gallery, Cork, are oil portraits of the artist's grandfather and grandmother.

The year after his Dublin appointment, he died tragically and suddenly at Ballinskelligs, Co. Kerry, on 15 August 1905. He was interred at Rathcormack, Co. Cork. His wife was from Kerry. His passing occurred through his own kindness of heart, as a consequence of a strain he sustained by assisting an old fisherman to haul his boat up the beach.

At Manchester City Art Gallery in 1907 Sir Walter Armstrong, NGI director, on behalf of subscribers, presented the 'Willis Memorial' to the art gallery committee of the Corporation. According to a local newspaper report, 'subscriptions large and small were received from all over the world, and Ireland in particular contributed liberally.' A surplus of money produced the suggestion at the gathering that a work of art be placed in the Manchester School of Art — 'the scene of his labours.' However, in the same year *Fate*, 60 cm x 60 cm, described as a bronze relief, was presented to NGI by 'a group of friends and former pupils.'

Works signed: R. H. A. Willis or R. H. A. W.
Examples: Cork: Crawford Municipal Art Gallery. Dublin: National Gallery of Ireland. Manchester: City Art Gallery.
Literature: *Cork Examiner*, 31 December 1874; *The Magazine of Art*, 1891; *Loc Léin*, August 1903 (Illustration); *The Royal Academy of Arts 1769-1904*, London 1905; *Courier*, 14 November 1907; Walter G. Strickland, *A Dictionary of Irish Artists*, Dublin 1913; *Dictionary of National Biography 1912-1921*, London 1927; *Dictionary of British Watercolour Artists up to 1920*, Woodbridge 1976; Ann M. Stewart, *Royal Hibernian Academy of Arts: Index of Exhibitors 1826-1979*, Dublin 1987; Adrian Le Harivel, editor, *National Gallery of Ireland: Illustrated Summary Catalogue of Prints and Sculpture*, Dublin 1988; Peter Murray, compiler, *Illustrated Summary Catalogue of The Crawford Municipal Art Gallery*, Cork 1991; John Turpin, *A School of Art in Dublin since the Eighteenth Century*, Dublin 1995 (also illustrations); Manchester City Art Gallery, *Letter to the author*, 2000; also Walker Art Gallery, 2001.

WILLMORE, MICHAEL – see Mac LIAMMÓIR, MÍCHEÁL

WILMER, KITTY – see O'BRIEN, KITTY WILMER

WILSON, DAVID, RBA, RI (1873-1935), caricaturist, cartoonist, landscape and flower painter. Born on 4 July 1873 at Minterburn, County Tyrone, David Ernest Wilson was the son of the Rev. A. J. Wilson, DD, who moved to Belfast in 1883 to minister at Malone Presbyterian Church.

After attending Royal Belfast Academical Institution, David entered the Northern Bank head office in Belfast, but spent evenings at the Government School of Art, where his gift for caricature began to develop. He became a member of the Belfast Art Society with an address at Malone House, Malone Park, Belfast.

On the chance of finding other employment – he was still in Belfast in 1896 – he left the bank for London, 'the one place in the world for me'. He studied for some time in the Sphinx Studio, living in Fitzroy Square. After a very lean period – his daughter Peggy had a theory that a sense of humour was born of adversity – he contributed to various publications, beginning with the *Daily Chronicle*.

In 1898, based in London, he exhibited with the Belfast Art Society, and included in the seven works which he showed in 1899 were the watercolours *A Bit of Hampstead Heath* and *A Middlesex Lane*.

Wilson first made his reputation as a caricaturist and cartoonist. In the years 1899-1900 a number of his caricatures were published in *The Magpie*, a Belfast journal, including those of Sir Thomas Lipton, Rt Hon. Joseph Chamberlain, MP; Field Marshal Lord Roberts, VC; Lord Kitchener and Paul Kruger. *The Magpie*

Annual of 1899 contained a supplement in three colours with Wilson's work. He also drew for the short-lived *The Belfast Critic*, which first appeared in 1900.

According to *Punch* records, Wilson supplied fifty-five cartoons from 1900 until 1933. He illustrated Arthur Waghorne's *Through a Peer Glass: Winnie's Adventures in Wastemonster*, 1908. In 1910 he became chief cartoonist of *The Graphic*, including its Christmas numbers, but he also worked for other publications such as *Fun*; *London Opinion*; *The Sketch*; *The Star*; *Temple Magazine*; and he provided theatrical caricatures for *Passing Show*.

By 1912 his work was a regular feature of the *Daily Chronicle*, and *The Lady of the House* described him as 'a most versatile and quick worker; he is gifted with a delightful sense of humour, an active imagination, much striking originality, and artistic perception'.

A daughter of Wilson, Mrs Peggy Hoppin, claimed that because of her father's work in the *Daily Chronicle* during the First World War he was 'on the Kaiser's black list for all the brilliant caricatures and drawings he did of him and Little Willie, that son of his'. Wilson embellished with decorative designs a book of verse by his brother, Charles M. Wilson, published in 1916.

Another 1916 book which he illustrated was *A Song of the Open Road and other verses* by his friend, Louis J. McQuilland, a Donegal man who also found himself in Fleet Street; *The King's Bride* was one of three decorative drawings. Wilson's brother, Malcolm Wilson, was a theatrical agent in London, and he himself was deeply interested in the theatre. The Belfast newspaper, *Northern Whig*, credited him with Government work in posters, also poster and decorative work for the Apollo Theatre. He also illustrated *Wilhelm the Ruthless*, by A. A. Braun, 1917.

An exhibition of his caricatures was held in 1921 at the Burlington Gallery, London, but in 1924 in the London gallery of Bromhead, Cutts and Co. he exhibited flower paintings and landscapes – *The Studio* found them of 'very sound quality'. It was said of his landscapes that they had an 'intrinsic wistfulness of outlook which makes them poignant in their appeal' and that his flowerpieces were 'never mere nature studies, but are always miniature decorations...'.

In 1924 he was appointed an associate of the Royal Society of British Artists, and in 1926 a full member. A member of the Streatham Art Society, he exhibited at the Royal Academy in 1924 for the first time. His address was 22 Downton Avenue, Streatham, SW, and from 1924 until 1934 he showed seventeen works. At the 1925 exhibition he contributed *Cinerarias* and *Boglands, Co. Tyrone*, and in 1926: *Southwold from Walberswick* and *Primrose and Primula*. Overall at Burlington House, about three-quarters of his exhibits were flowerpieces. In 1931 he was appointed a member of the Royal Institute of Painters in Water Colours. At an Royal Society of British Artists' exhibition in 1933 he showed three watercolours: *Poinsettia*; *Kingston Harbour, Sussex*; and *Wareham, Dorset*. Close on fifty watercolours, landscapes and flower paintings were exhibited in 1932 by Inns and Blake at their showrooms in Queen Victoria Street, London.

The Times noted that in landscape he 'inclined to the methods of the early water-colourists of careful design and simple statement in a limited scale of tones as he showed especially in his pictures of Sussex and Surrey. In his flower pictures his manner was firm and decided, and he made good use of black to support his brighter colours. He was most successful with flowers of a solid habit.' Among his exhibits were *Roses in Italian jug*; *Phlox in French jar*; *Cowslips in ginger jug*.

In the Victoria and Albert Museum, London, are two watercolours, *The Window Sill*, 50.3cm by 33.8cm, and *Poole Harbour from the Dorset Hills*, 34.5cm by 52cm. At the National Portrait Gallery, London, there is a portfolio of nine caricatures of various sitters. In Dublin, he is represented by a pen and ink caricature drawing of Sir John Lavery (q.v.) at the Hugh Lane Municipal Gallery of Modern Art.

In Belfast, there are more than a score of examples of his work at the Ulster Museum, including *Irish Boglands, Donaghmore, Co. Tyrone*; *A Sussex Barn*; *Hyde Park, London*, all watercolours, and *General Booth Looks for New Worlds to Conquer*, ink, pencil and watercolour. His watercolour at Queen's University is titled *On the Ouse, Newhaven*.

Wilson never exhibited at the Royal Hibernian Academy but was credited with Paris Salon representation. In London, he exhibited eighty-one works with the Royal Society of British Artists, seventy-seven at the Fine Art Society, and nineteen with the Royal Institute of Painters in Water Colours. He was a member of the

Savage Club. His death was in London, on 2 January 1935. A memorial exhibition of watercolours — landscapes and flowerpieces — took place at the Fine Art Society that year. Brighton Museum and Art Gallery staged an exhibition of seventy-one watercolours in 1937. Belfast Museum and Art Gallery held an exhibition of his watercolours in 1938, and in 1939 displayed his caricatures. Rodman's Art Gallery, Belfast, showed landscapes and flower studies in 1939.

Works signed: David Wilson; Davy, Davy W. or D. W., all three rare.
Examples: Belfast: Queen's University; Ulster Museum. Dublin; Hugh Lane Municipal Gallery of Modern Art. Eastbourne: Towner Art Gallery. London: National Portrait Gallery; Victoria and Albert Museum.
Literature: *Belfast Art Society Annual Exhibition*, catalogue, 1895; Arthur Waghorne, *Through a Peer Glass: Winnie's Adventures in Wastemonster*, London 1908 (illustrations); *The Lady of the House*, Christmas 1912 (also illustrations); *Irish Book Lover*, February-March 1916; Louis J. McQuilland, *A Song of the Open Road and other verses*, London 1916 (illustrations); Charles M. Wilson, *Consolations*, London 1916 (illustrations); A. A. Braun, *Wilhelm the Ruthless*, London 1917 (illustrations); *Northern Whig*, 24 March 1920; *The Studio*, January 1925; *Belfast Telegraph*, 19 September 1932; *Belfast News-Letter*, 20 September 1932; *Morning Post*, 3 January 1935; *The Times*, 3 and 5 January 1935; Brighton Public Art Galleries, *Memorial Exhibition of Water-Colours by The Late David Wilson, RI, RBA*, catalogue, 1937; *Dictionary of British Artists 1880-1940*, Woodbridge 1976; John Hewitt and Theo Snoddy, *Art in Ulster: 1*, Belfast 1977 (also illustration); *Dictionary of British Book Illustrators and Caricaturists 1800-1914*, Woodbridge 1978; Mrs Peggy Hoppin (née Wilson), *Letter to Mrs Molly Whiteside* (née Wilson), 1978; Angela Jarman, *Royal Academy Exhibitors 1905-1970*, Calne 1987; Patricia Butler, *Three Hundred Years of Irish Watercolours and Drawings*, London 1990 (illustration); National Portrait Gallery, *Letter to the author*, 1994; also, Mrs Isabel Scott, 1994; Eileen Black, *A Sesquicentennial Celebration: Art from the Queen's University Collection*, Belfast 1995; Ann M. Stewart, *Irish Art Societies and Sketching Clubs: Index of Exhibitors 1870-1980*, Dublin 1997.

WILSON, THOMAS G., HRHA (1901-69), illustrator, landscape and marine painter. Thomas George Wilson was born on 1 July 1901 in Belfast, the son of Charles Wilson. Thomas's eldest son, Anthony C. B. Wilson, showed six works at the Royal Hibernian Academy in the period 1954-61. Another son, Thomas D. H. Wilson, assisted in the illustrating of one of his father's books, and was in conversation with the author in 1995 regarding his father's career.

Thomas G. Wilson, of the medical profession, received art instruction at the Dublin Metropolitan School of Art, and in the studio of his friend, James Sleator (q.v.). He exhibited at the RHA in 1930 and from then until 1969 he showed forty-six works. In 1930 from 26 Upper Fitzwilliam Street, Dublin, he contributed *Dr Steevens' Hospital, Dublin*, now in the Royal College of Surgeons in Ireland.

In 1931 at the RHA he exhibited a drypoint, '*Snooker*', and an etching of his brother, C. Herbert Wilson, CB, one of several etchings which he executed. A keen yachtsman, he showed his interest in marine subjects at the 1934 Academy: *The Dredger 'Sisyphus'* and *Old Boat Yard, Ringsend*.

As well as painting at Clifden, Co. Galway, he also worked abroad, for example: *Aggstein, near Vienna*, 1936 exhibition; *The Inner Harbour, Honfleur*, 1941, both sent from 3 Fitzwilliam Square, Dublin. Robert Collis's autobiography, *The Silver Fleece*, 1936, was illustrated by Wilson. At the end of 1938 he was appointed a Commissioner of Irish Lights, hence, presumably, his *Hook Point Lighthouse* some years later.

Wilson contributed sixty-one illustrations – pen and ink, scraperboard – for his *Victorian Doctor*, 1942, the life of Sir William Wilde, a book with a second impression in its year of publication. Titles of his exhibits at the 1951 RHA indicated painting sessions in Andalucia and Madrid.

Wilson was a regular exhibitor with Dublin Painters and at the 1952 exhibition contributed *A Letter from School* and *St James's Square, London*.

An ENT surgeon, he wrote and illustrated a book, 1955, on diseases of the ear, nose and throat in children. In the period 1958-60 he was president of the Royal College of Surgeons in Ireland. A colleague who worked as his houseman in Dr Steevens' Hospital in the early 1960s found him 'a remarkable man of many parts and somewhat of a character'.

In 1961, at the RHA, his interest in the sea was again demonstrated by a Greek work, *Caiques at Tinos*, also by *Shipping at Dun Laoire*. Titles of later works indicated visits to Constantinople; Wurtzburg, Germany; and Venice. In 1961 with Dublin Painters he presented *Morning in the Magic Carpet*.

At the Water Colour Society of Ireland in 1962 he exhibited for the first time, showing *Athens 1962* in 1963, and at the Dublin Painters in 1964, *A Street in Rhodes*. His contributions to the 1966 WCSI event included *From the Hotel Forum, Rome*.

Appointed vice-chairman of the Commissioners of Irish Lights in 1966, two years later his *The Irish Lighthouse Service* was published with sixteen of his illustrations including two colour plates of his oil paintings, one being: *The Relief of Inishtearagh, with ss Isolda in the foreground*, 1968. His son, Thomas, supplied six drawings.

Wilson was the author of various publications on Swift, held a Litt D from Trinity College, Dublin, and was a member of the Royal Irish Academy. He was an honorary member of the Royal Hibernian Academy. His etching press went to the National College of Art. A portrait of Gibbon Fitzgibbon is in the Rotunda Hospital, Dublin. He died on 6 November 1969 in a guest flat at the Royal Hospital when on a visit to London.

Works signed: T. G. Wilson or T. G. W. (if signed at all).
Examples: Dublin: Rotunda Hospital; Royal College of Surgeons in Ireland.
Literature: Robert Collis, *The Silver Fleece*, London 1936 (illustrations); T. G. Wilson, *Victorian Doctor*, London 1942 (illustrations); also, *Diseases of the Ear, Nose and Throat in Children*, London 1955 (illustrations); *The Irish Lighthouse Service*, Dublin 1968 (also illustrations); Eoin O'Brien and Anne Crookshank, *A Portrait of Irish Medicine*, Swords 1984 (also illustration); Ann M. Stewart, *Royal Hibernian Academy of Arts: List of Exhibitors 1826-1979*, Dublin 1987; John E. T. Byrne, FRCS, *Letter to the author*, 1993; John Turpin, *A School of Art in Dublin since the Eighteenth Century*, Dublin 1995; Ann M. Stewart, *Irish Art Societies and Sketching Clubs: Index of Exhibitors 1870-1980*, Dublin 1997.

WINTER, J. EDGAR (1875-1937), stone and wood carver. According to the registration, Joseph Edward Winter, the son of Robert Winter, was born in Belfast on 8 September 1875, but he also became known as James Edgar Winter. He had several locations in Belfast for his stoneyards, and in 1895 he was at 22 College Street, 'carver and modeller', moving on to 27 Waring Street.

Winter had a long association with Holywood, Co. Down, and Seaview Cottage was in his name from early in the century. From this point we are largely in the hands of C.E.B. Brett, author of *Buildings of Belfast*, 1985; Paul Larmour, *Belfast: An Illustrated Architectural Guide*, 1987; and Marcus Patton, *Central Belfast: An Historical Gazetteer*, 1993.

On Ocean Buildings, 1899-1902, at 1-3 Donegall Square East, Belfast, Larmour credited the carvings to James Edgar Winter, and added that the architects Young and Mackenzie used him to carve the Belfast arms on their Fire Brigade Stations at Crumlin Road, 1902, and Albertbridge Road, 1903, both since extinguished.

Brett and Patton referred to the carvings of 'Winter and Thompson', a firm known to be in existence in 1903 (if not before) at 6 Oxford Street, but of Thompson little is known.

On the Ocean project, Patton wrote: 'Richly carved, with mermaids holding lighthouses on shields (the Ocean's trademark) at the corner entrance; an owl, a dragon, a squirrel, various birds, a rabbit and a fox desport themselves above capitals bearing the heads of kings and queens, and ferocious monsters cast envious eyes at the luscious grapes carved below the main oriel windows'. Brett had no problem identifying royalty: '... Edward VII, Queen Victoria, and Queen Alexandra groan under the weight they have to carry'.

On 38 College Square North, Patton noted: 'This was the site of the Whitla Medical Institute, built in 1902 ... the stone carving by James Edgar Winter included lettering set in ivy foliage and portraits of what a contemporary report described as "the four immortals of our Ulster Medical Society – Andrews, Gordon, Henry MacCormac, and Redfern".' The Institute was demolished in 1991.

For the sculpture by Winter and Thompson at 36-38 Donegall Place, completed 1903 for Sharman D. Neill, clockmaker, jeweller and silversmith, Patton found: 'Father Time with scythe and hourglass, in front of a scroll reading "Tempus Fugit" held by two youths ...', but Brett discerned in a shallow pediment 'two elongated horizontal ladies are apparently trying to seduce Father Time'.

Winter was also involved in stone carving around the entrance to Presbyterian Assembly Hall in Belfast, 1902-05, and a portrait of John Knox, placed indoor. On the Presbyterian Buildings, Brett found 'much curious carving, of very uneven quality, partly by Edgar Winter and partly by Purdy and Millard. The themes

include a number of dragons, apparently expiring in agony, and a very sick eagle in deepest moult, as well as a great number of cherubim and seraphim with coyly drooping eyelids.'

The sculpture in the great pediment at the centre of the main façade of Belfast City Hall was designed by Frederick W. Pomeroy, RA (1856-1924), partly executed by him and partly by Winter. Larmour was of the opinion that it was possibly the finest piece of architectural sculpture in Belfast. A monograph on the City Hall, official opening 1 August 1906, gave Pomeroy full credit but in the list of contractors for carving, at the back of the brochure, was the name of 'Mr J. E. Winter'.

Pomeroy was involved with the City Hall architect Brumwell Thomas in the Marquess of Dufferin memorial in the West Garden, and it seems reasonable to assume that Winter played a prominent part in the carving of the other work, which represents, according to the official description:

'Hibernia wearing a mural crown, bearing the torch of knowledge, a symbol of light and advancement, her right hand resting on the harp, the emblem of her nationality. To the right hand stands Minerva, attended by Mercury the Messenger, to whom Industry and Labour are looking for prosperity. On the left stands Liberty, awarding the palm branch to Industry, a female figure offering a roll of finished linen; at her feet sits another figure with the Irish spinning wheel, while the youth and energy of the country are expressed by the boys' figures watching intently the passing events. The other industries are represented by figures typifying Shipbuilding, Design, etc.' Pomeroy, incidentally, married in 1913 Patricia Morrison Coughlan of Douglas, Co. Cork.

The association or partnership with Thompson must have been discontinued. In 1906, for example, J. Edgar Winter, wood and stone carver, operated from 41a May Street and resided at 20 Seymour Street. Other working addresses followed. There is a strong tradition in the Winter family that he supervised and woodcarved in the staterooms of the *Titanic*, launched in 1912, and this may account for an absence of record for work by Winter in the immediately preceding years.

In 1913 the former Prudential Chambers were built at 1-5 Wellington Place. When the Crane & Sons Ltd. piano and organ warehouse occupied the ground floor, Winter carved musical ladies, musical instruments and musical ornaments. Later the building was demolished.

In the 1920s Winter lived at St Leonard's, Kinnegar, Holywood. In 1922 a site at the corner of Dublin Road and Great Victoria Street, Belfast, came into the possession of Glendinning and Gotto, linen manufacturers, and Winter. A 1926 invoice from J. Edgar Winter, sculptor and modeller, stone and wood carver, Shaftesbury Square, Belfast, charged: 'For headstone: including 95 letters in gold: £3.19.2; 8 large letters on base: £1.4.0'.

Winter, whose name appeared in the list of contractors for the new Belfast Museum and Art Gallery opened in 1929, was responsible for the prow of a galley, with head, on the front of the building. Several memorials by him are in the City Cemetery. He carved and erected the pulpit in St Phillip's Church, Belfast, now closed.

The confusion over his Christian names continued until death. The superintendent of the City Cemetery reported in 1994 that he was named 'James Edgar Winter and he was buried ... on 24.7.1937 aged 61 years'. However, the newspaper death notice the previous day referred to 'Joseph E. Winter', of 13 Aigburth Park, Belfast, having died in hospital on 22 July 1937.

Examples: Belfast: City Hall; 36-38 Donegall Place; 1-3 Donegall Square East; Oldpark Library; Presbyterian Church Hall, Fisherwick Place; Ulster Museum.
Literature: *Register of Births*, Dublin, 1875; *Belfast and Province of Ulster Directory*, 1896, 1897, 1902, 1904, 1907, 1928; *Irish Builder*, 20 November 1902, 17 June 1905; *A Monograph of The City Hall of the County Borough of Belfast*, Belfast 1906; *Belfast Municipal Museum and Art Gallery Souvenir of Opening 22 October 1929*; *Who Was Who 1916-1928*, London 1929; *Belfast Telegraph*, 23 July 1937; Ulster Bank, Ltd, *Letter to the author*, 1979; C.E.B. Brett, *Buildings of Belfast*, Belfast 1985; Paul Larmour, *Belfast: An Illustrated Architectural Guide*, Belfast 1987; Marcus Patton, *Central Belfast: An Historical Gazetteer*, Belfast 1993; Robert P. Taylor: Belfast City Cemetery, *Letter to Eileen Winter*, 1994; Eileen Winter, *Letter to the author*, 1994.

WISE, KATE – see DOBBIN, LADY KATE

WOOD, A. VICTOR O. (1904-77), figure painter. Albert Victor Ormsby Wood was born in Dublin on 25 March 1904, the son of Albert E. Wood, KC, and brother of Ernest M. Wood, barrister. He received his formal education at Aravon School, Bray, Co. Wicklow, a school mentioned in the autobiography of Robert Collis, *The Silver Fleece*. Victor attended the Dublin Metropolitan School of Art and felt he had 'escaped from the law'. Further art training took place in London, and he found Augustus John (1878-1961) a 'frightful show-off'. Furthermore, Victor's father was said to be delighted when John advised him that his son 'showed promise as an artist'.

In 1923, from Donerea Lodge, Kilcoole, Co. Wicklow, he showed *The Hair Ribbon* at the Royal Hibernian Academy. He had a spell working with Harry Clarke (q.v.) in Dublin at his stained glass studio. Three watercolours by Clarke which came from Wood's home in England were auctioned after his death. Apparently Clarke used the 'strapping' figure of his young apprentice as a model. For *Fairy Tales by Hans Christian Andersen*, Wood appeared next to Clarke's self-caricature in 'Claus and Little Claus'.

Dr Thomas Bodkin, director of the National Gallery of Ireland 1927-35, encouraged Wood and inspired him 'to delve into technical method, especially egg tempera', claimed Wood, and so he went off to Florence for a year, 'a golden period of my life. I even managed to be of some help to Bodkin at the Barber Institute.'

In one of his letters of the 1970s to Richard Waterhouse, a patron, of Croydon, Surrey, Wood stated that he had been a professional artist 'since I became Ass. Royal College of Art, 1924', adding that his great friends there were Gilbert Spencer (1892-1979) and Stanley Spencer (1891-1959). The Spencers, however, did not attend the Royal College of Art, and indeed were not of his student years. According to Victor's brother, he studied 'at Polytechnic in London'. The Royal College has no record of his attendance.

The painters' group of the Radical Club in Dublin organised in 1926 an exhibition at the Daniel Egan Gallery, 38 St Stephen's Green, and Woods showed two works, *1840* and *M1– E1*. He left for England towards the end of the 1920s. After his marriage he moved to Westbourne Terrace, West London. Another claim was that he knew Duncan Grant (1885-1978) and showed him how to paint in oils on paper 'but he made a mess of it!' Also that he often visited Eric Gill (1882-1940) at Ditchling, Sussex.

He was mostly engaged in restoration of Old Masters but 'managed to paint enough pictures to hold "one man" shows every second or third year in one of the better known London galleries'. He said he restored pictures at the National Gallery in London, but his brother described him as an amateur restorer who worked for a short time in the Victoria and Albert Museum. He apparently attempted to open and operate his own art school but the outbreak of war in 1939 put paid to any chance of the school surviving.

In 1940 he joined the British Army and became a driver for Colonel Buckmaster of the British Secret Service. The correspondence between Wood and Waterhouse also recorded that many of his earlier works were lost when his studio was destroyed by a bomb. He was badly wounded during the Blitz.

His *The Maid makes bed* was painted in 1946, when he was 'finally invalided out of the Army, amongst other things minus one eye'. In 1946, too, he resided at 11 Purley Rise, Purley, Surrey, and he exhibited *Ruth* at the RHA. He reckoned eighty-six hours' work on *Girls playing on the Rocks by the Sea Shore*. In 1949 he moved to Ansty, Sussex.

Since about 1960 he lived at Hunstanton, Norfolk, and he was an exhibitor at the Hunstanton and District Festival of the Arts and for several years supervised the painting section. He donated the Wood Trophy in memory of his wife who died in 1970.

In 1974 he listed in a letter some of his subjects for paintings: An old woman like the ones who used to come and do the laundry on Mondays, and a maid helping her; girl being measured for frock; woman sitting at old-fashioned sewing machine. But he also painted animals and children. In 1975 he reported by letter the impending visit from Michael Clarke of New York, elder son of Harry Clarke who had been 'commissioned to write a biography of his father'.

Wood said that he had a wonderful visual memory, 'total recall', and that his memories of Edwardian life amused him and so he painted them. His correspondent, Richard Waterhouse, in a letter to the author, considered Wood's painting technique as 'meticulous ... choice of subjects from 20th century childhood – maids at their daily chores, girls in calf-length dresses decorously at play ... when for convenience he'd

switched from tempera to acrylic, the maid-servant theme became something of an obsession ... there was an erotic undertone in quite a lot of his work'.

Wood also worked in watercolour and occasionally gouache. His *Green Skirt, Black Bicycle* was in watercolour and gold paint, and *George Moore* in watercolour. He also executed designs for screens.

According to Ronald Anderson, who wrote the foreword to a catalogue for an exhibition at the Michael Parkin Gallery, London, very little was known about the life of this somewhat eccentric and reclusive artist until after his death: 'The facts that have emerged sketch a portrait of a private man, with private means who was burdened, particularly in later life, with a profound sight disability and who, it appeared, worked quietly and methodically creating these somewhat fantastical pictures of women. On the other hand, however, his private sketchbooks and journals, which have recently come to light, reveal a distinctly different creature – a voyeur and eroticist. His journals are full of long erotic stories ...'.

Of Hillside House, 38 Greevegate, Hunstanton, he died on 7 February 1977. The Michael Parkin Gallery, Belgravia, London, staged an exhibition of sixty works in 1992, 'A Voyeur in Art'.

Works signed: A. V. O. Wood, Victor Ormsby Wood or A V (?), monogram.
Literature: Robert Collis, *The Silver Fleece*, London 1936; *Letters from A. Victor Wood to Richard Waterhouse*, 1973-5; Richard Waterhouse, *Letter to the author*, 1980; Graham Barker: Guella Gallery, *Letters to the author*, 1981, 1994; Hunstanton and District Festival of Arts, *Letter to the author*, 1981; also, National Gallery, 1981; Royal College of Art, 1981; Ernest M. Wood, 1981; Ronald Anderson: Michael Parkin Gallery, *A Voyeur in Art: Albert Victor Ormsby Wood*, catalogue, London 1992; *Eastern Daily Press*, 27 April 1992; Michael Parkin Gallery, *Letter to the author*, 1994.

WOODLOCK, DAVID, LAA (1842-1929), figure, landscape and portrait painter. Born at Shanbally Castle, near Cashel, Co. Tipperary, on 10 March 1842, he travelled to Liverpool as a boy of twelve. His ambition even then was to become an artist, an aim his mother encouraged, but his father's wish that the boy should take up a commercial career, prevailed; accordingly, he was apprenticed to a firm of outfitters. During his first year he gathered together five pounds by acting as librarian at the Home of Apprentices. This money he devoted to the study of art by attending classes under John Finnie (1829-1907) at the School of Art, where he succeeded in gaining a £90 scholarship.

Woodlock identified himself with the Liverpool Academy of Arts. He was a founder member in 1872 of Liver Sketching Club; president, 1897. He became a constant contributor to the annual Liverpool Autumn exhibition, from 1871. His career as a professional artist began in 1880. In 1882 he resided in Sheffield. An oil portrait of Cardinal John Henry Newman (National Gallery of Ireland) carried the date 10 November 1883 inscribed on card affixed to front of frame. This work was exhibited at the Franco-British exhibition, 1908.

From 1888 until 1905 he showed a total of seventeen works at the Royal Academy. In 1888 *Spring pastures* and *The good old book* were both hung, sent from 184 Alderson Road, Sheffield. Woodlock was a great admirer of John Ruskin (1819-1900) and studied at Ruskin Museum, Sheffield, in 1889. In 1891 he was at 94 Upper Hanover Street, Sheffield, contributing *The Eagle Tower, Haddon Hall*. His visits to Venice, first in 1894, were said to have had a great influence on his work, and he painted many pictures there. Other countries were also visited.

Woodlock returned to Liverpool. He showed four works at the 1894 RA, including *The bee-master* and *At Conway*. In 1896 he painted the watercolour, *St Mark's Venice* (Walker Art Gallery). In 1901, now at 22 Mill Street, Warwick, he made a triple contribution to the Royal Scottish Academy: *The doorway of the Old Guildhall, Warwick*; *Sunday morning*; *In St Mark's Place, Venice*. He also exhibited at the Royal Academy that year, three works including *The old lace-maker* and *Night and Morning*.

Close to Warwick is Leamington, and he was there at 36 Portland Street when he showed *Will Shakespeare's Courtship* at the 1902 RA. Hugh Lane invited him to contribute to the exhibition of Irish artists at the Guidhall, London, in 1904. In that year, exhibiting again at the RA, he was at 5 The Mall, Ealing. *A Summer day* was his final contribution to Burlington House, in 1905, and by then he was back in Liverpool, at 2 South John Street.

At the 1906 Liverpool Autumn exhibition the hosts, Walker Art Gallery, purchased the watercolour, *Josephine at Malmaison*. In the same medium the gallery also owns *A Coastguardsman* and *Man Ploughing*. Woodlock exhibited more than 100 works at the Walker exhibitions. In that gallery are also two oils: *Old Friends*, a study of Alderman Edward Samuelson and his favourite Amati violin; and *Feeding the Pigeons — St Mark's Square, Venice*. One reviewer called the latter work 'a brave and bold picture, the sumptuous colour well atoning for some merely passing errors of draughtsmanship.'

In the watercolour section of the 1914 Autumn exhibition he was among the artists of 'local talent' who showed up well, according to *The Studio*. Apart from the Royal Institute of Painters in Water Colours, where he presented eight works after 1879, the rest of his exhibiting outside Liverpool was limited. *Springtime*, described as in pencil and watercolour heightened with white, depicted a young seated woman with a feather duster in her left hand.

In the year of his death, 1929, a collective exhibition of 168 works was held at the Walker. Alderman Harford, JP, provided 94 pictures! The exhibition included: *The Belfry, Bruges*; *A Tyrolean Shepherd Boy*: *Arab Boy, Tangier*; *The Carpet Seller, Cairo*; *Flooded Palm Grove, Mesopotamia*. The foreword in the catalogue stated that in technical accomplishment Woodlock's work was original and free, but the outstanding feature throughout was the colour — 'bewildering at times in its brilliance and profuseness...' He died at 2 Voelas, Liverpool, on 4 December 1929.

Works signed: D. Woodlock.
Examples: Dublin: National Gallery of Ireland. Liverpool: Walker Art Gallery.
Literature: *The Royal Academy of Arts 1769-1904*, London 1905; *The Studio*, December 1914; *A Dictionary of Contemporary British Artists, 1929*, London 1929; Walker Art Gallery, *Collective Exhibition of the Art of David Woodlock*, catalogue, Liverpool 1929; Liverpool Registry Office, *Register of Deaths*, 1929; Richard Ormond, *Early Victorian Portraits*, London 1973; *Dictionary of British Artists 1880-1940*, Woodbridge 1976; Walker Art Gallery: Merseyside County Council, *Merseyside Painters, People & Places*, Liverpool 1978; *Royal Academy Exhibitors 1905-1970*, Calne 1987; National Gallery of Ireland, *Acquisitions 1986-88*, catalogue, Dublin 1988 (also illustration); *The Royal Scottish Academy Exhibitors 1826-1990*, Calne 1991; National Portrait Gallery, *Letter to the author*, 2001; also, Walker Art Gallery, 2001.

WOODS, PADRAIC, RUA (1893-1991), landscape and portrait painter. Padraic John Woods was born on 13 July 1893 at Newry, Co. Down, the son of Peter Woods, baker, and one of nine children. The family moved to Castlewellan in 1898, thence to Belfast in 1900. Padraic attended St Joseph's National School, Slate Street, and at the age of fifteen took classes at the Belfast School of Art.

A scholarship took him to St Patrick's Training College, Drumcondra, Dublin, and he studied there 1912-13. On completing the course, he obtained a sub-teaching post at Holy Family School, Newington Avenue, Belfast, but he also renewed his School of Art classes. The teaching post became permanent.

Woods became acquainted with J. Humbert Craig (q.v.) and a friendship lasted thirty years; he valued Craig's aesthetic sense as an artist of the North Antrim coast. He remained a student at the School of Art until 1917. He first exhibited with the Belfast Art Society in 1920, and among his contributions in 1921 were *The Bedouin* and *Lower Mourne*.

In 1926 the family moved to 78 Springfield Road, and here was his Belfast home for the rest of his life. In 1931 he was elected an associate of the Ulster Academy of Arts, and that year he first exhibited at the Royal Hibernian Academy and from then until 1973 he showed twenty-four works. He first exhibited at the Oireachtas in 1932, *Sliabh Mor*.

In the early 1930s he painted on Achill Island, and in 1933 four of his five works at the RHA show were executed there. He painted with Charles Harvey (q.v.) in Brittany in 1935. In 1935 too he included in the Dublin exhibition: *Old Mill, near Newry*; *At Warrenpoint, Co. Down*.

A visit to Switzerland was reflected in his 1936 exhibition of recent paintings at Locksley Hall, Fountain Street, Belfast. County Donegal and Connemara landscapes were also on view. His most ambitious work was *The Return of the Natives*, depicting a lonely bog road, a turf cutter, an old woman and two young girls.

In 1938 at the Dublin Sketching Club he showed two works painted in Concarneau, Brittany, and *Kylemore Lake, Connemara.*

In 1940 he received his most important portrait commission: Professor D. L. Savory, Professor of French, Queen's University. A portrait of Canon John MacLaverty is at St Malachy's Church, Coleraine, Co. Derry. Woods spent some of the War years teaching in Portstewart, Co. Derry. *Ceol* was exhibited at the 1945 Oireachtas.

In 1946 he took early retirement in order to devote himself full time to painting. He exhibited at the Dublin Painters' Gallery in 1948, and the *Dublin Magazine* found him a painter of landscapes 'in a poetised-naturalistic version of a manner which has died since the diffusion of Impressionism. There is even occasionally a hint of Constable and even more frequently the popular sentimentality of his imitators ...'.

A regular exhibitor at Ulster Arts Club exhibitions in Belfast, he was president of the club in 1948 and 1949. As an academician of the Ulster Academy of Arts he retained that status when the Royal Ulster Academy of Arts came into existence in 1950. He was a regular exhibitor. In 1950 he held a one-person show at 55a Donegall Place, Belfast, and canvases ranged from portraiture and landscape in Ireland to Breton fisher folk and Italian scenes, three in Assisi. When he exhibited at the same gallery in 1952, paintings of Northern Spain were on view.

After a break of nine years, he showed in 1952 at the RHA: *Bretons* and *Breton Women*. He also painted in Holland. In his search for subjects, San Sebastian was a favourite city. In 1954 he returned to the Donegall Place gallery in Belfast, and later in the year Siobhan McKenna, the actress, opened another of his exhibitions at 7 St Stephen's Green, Dublin.

On the Dublin exhibition, the *Irish Times* critic found 'tremendous confidence, and the 30-odd paintings in the show range from straightforward landscapes like his delicately coloured *Killyhoey Strand, Donegal* to such subtle and strangely evocative genre studies as *Wedding* and show him to be an artist of wide and diverse talents. His touch is assured, his texture varied, his colour forceful, and his drawing, in the main, sound.'

In 1960 he joined with William Conor and Rowel Friers (qq.v.) in a joint exhibition at the Royal Ulster Academy's rooms, College Square North. Appointed a governor of the Belfast College of Art in 1964, he was back in Spain that year. In 1966 he was one of seven artists, 'Ulster Artists' Group', who exhibited at the Gordon Gallery, Wimbledon.

Of his eighteen paintings on view at the 1968 exhibition at Queen's University, Belfast, organised by the Visual Arts Group, four had Spanish subjects. *Calvario, Spain* with its sense of burning heat attracted the *Irish News* critic, and the *Belfast Telegraph* representative found 'distant suggestions of Vuillard' in *Tea Over*. He exhibited at both the Dublin Sketching Club and the Oireachtas in 1969.

In 1973, after a break of eleven years, he returned to the RHA with *The Field*, his final exhibit. *Old Highway, Newry* in 1980 was his last exhibit at the RUA. A small retrospective exhibition took place in 1987 at the Linen Hall Library, Belfast.

John Hewitt found Woods following ways 'not often trodden, but with a kindly unemphatic art, never dashingly adventurous nor ploddingly pedestrian ...'. Courteous and unpretentious, he kept no diaries or correspondence. At the Hugh Lane Municipal Gallery of Modern Art, he is represented by *Seascape*, and another oil is at the National Museum of Ireland, *Bliadhain na Gorta*. In the Royal Ulster Academy diploma collection is *Path up to a Farmhouse*. He died on 30 June 1991 at St Columbanus Home, Helen's Bay, Co. Down.

Works signed: Padraic Woods.
Examples: Belfast: Queen's University; Royal Ulster Academy. Coleraine, Co. Derry: St Malachy's Church. Dublin: Hugh Lane Municipal Gallery of Modern Art; National Museum of Ireland.
Literature: *Thom's Directory*, 1913; *Belfast News-Letter*, 11 February 1936, 1 July 1991; *Dublin Magazine*, July-September 1948; *Irish News*, 21 November 1950, 10 June 1952, 8 May 1954, 8 August 1964, 17 October 1968; *Irish Times*, 23 November 1954; *Belfast Telegraph*, 18 October 1968; John Hewitt and Theo Snoddy, *Art in Ulster: 1*, Belfast 1977; Martyn Anglesea, *The Royal Ulster Academy of Arts*, Belfast 1981 (also illustration); Linen Hall Library, *Padraic Woods in Retrospect*, catalogue, Belfast 1987; Ann M. Stewart, *Royal Hibernian Academy of Arts: Index of*

Exhibitors 1826-1979, Dublin 1987; Ann M. Stewart, *Irish Art Societies and Sketching Clubs: Index of Exhibitors 1870-1980*, Dublin 1997.

WOODS, R. J. (1871-1955), landscape painter and textile designer. Robert John Woods was born in Belfast on 25 October 1871, son of Hugh Woods of Dublin and Belfast. After attending the Government School of Art in Belfast, he studied at South Kensington and in Paris.

At an early age he learnt print and embroidery handkerchief design, but as this did not provide a wide enough scope he decided to be a damask designer, during all this time studying flower painting from nature. He became principal designer for John S. Brown and Sons, Ltd, Ulster Works, Belfast, 'during which he had the honour to design for Royalty on several occasions ...'.

Woods acted as judge for damask design competitions at the Belfast School of Art. He showed four works at the Belfast Art Society exhibition in 1894, giving an address 3 Duncairn Gardens, Belfast. He took a leading part in the Belfast Operatic Society, and for some years appeared before Belfast and Dublin audiences as a concert singer.

In 1903 he was the first honorary treasurer of the Ulster Arts Club, but resigned after a few months. However, in 1906 and 1907 he was president and occupied the chair for the opening of the Club's first exhibition, held in the art gallery of the Belfast Free Public Library in 1907.

Prior to the First World War, a meeting was held at his home, Princetown Lodge, Bangor, to found St Comgall's Preceptory of the Order of Knights Templar. Later, he had installed two stained glass windows in his lounge commemorating the inception of the Preceptory.

Woods represented the Ulster Arts Club on a deputation in 1922 to Belfast City Council expressing approval and endorsement of the scheme for a new art gallery. He himself had visited many of the principal art galleries and museums in Europe. He was president again of the Club in 1931 and 1932. At this time he opened an office as a designer at 12a Linen Hall Street, Belfast, moving in 1938 to Downshire Place, Belfast.

Speaking on Wood's exhibition of thirty-five paintings at 55a Donegall Place, Belfast in 1951, John Hewitt, who performed the opening ceremony, found 'the sunny hours' and 'richness and mellowness'. The *Northern Whig* said he was an artist who painted 'with fidelity and with very great affection for what he sees ...'. The artist himself felt that it was because of his early training as a designer that his technique was in the traditional manner. Many of the works were painted in Bangor and district.

In 1951 he assisted in organising for Civic Week in Bangor an exhibition of paintings loaned by the residents. Altogether five works by Woods were displayed, including *Port Braddon, Co. Antrim*. Among the six pictures which he lent were a portrait of himself by T. Eyre Macklin (q.v.) and a portrait of his wife by Gerald Brockhurst (1890-1978).

Even at eighty years of age, he still devoted much of his time to his business as a textile designer, but on two days a week he painted. A second exhibition was held in 1952 at the Donegall Place gallery. According to Capt. H. Malcolm McKee in an article that year in the *County Down Spectator*, he designed £20,000 ('now easily £100,000') worth of linen for the Pope, and King Edward VII had cut off from his Court dress solid gold buttons, 'wishing to give him something personal'.

A familiar figure in the seaside town with his Victorian-era bow tie and an eye-glass fixed firmly in his right eye, 'R. J.' presented examples of his work at Bangor Borough Council meetings, almost an annual 'pilgrimage', hoping that the paintings would form the nucleus for an art gallery in the town. There are twelve of his oil paintings in the Town Hall, including *Old Roman Road, Orlock*; *To the Glory of God-Flowers*; and *A View from Killane House, Carnalea*.

A collector and connoisseur of antiques, the *pièce de résistance* in his house was an eighteenth century four-poster bed which belonged to Charles Stewart Parnell. McKee also recorded that Woods purchased the bed from Parnell's sister in County Wicklow. Also in the Bangor house were sixty painted heraldic shields representing Irish towns authorised to have coats of arms, all the work of his son, Cecil Woods. He died at his home, 108 Princetown Road, Bangor, on 9 July 1955.

Works signed: R. J. Woods.

Examples: Bangor, Co. Down: Town Hall.
Literature: *Belfast Free Public Library 1907 Annual Report*; W. T. Pike, ed., *Belfast and the Province of Ulster in the 20th Century*, Brighton 1909; *Belfast Telegraph*, 2 October 1922; *Belfast and Ulster Directory*, 1932, 1939; Bangor Arts Committee, *Bangor Civic Week: Exhibition of Paintings*, catalogue, 1951; *Northern Whig*, 9 and 10 October 1951, 11 November 1952; *County Down Spectator*, 24 and 31 May 1952; *Belfast Telegraph*, 11 July 1955; Patrick Shea, *A History of the Ulster Arts Club*, Belfast 1971.

WORKMAN, EMILY D. – see CORRY, EMILY D.

WORKMAN, JANE SERVICE (1873-1949), landscape and interior painter. Born on 28 October 1873 at the family home, Jane Service Workman was the daughter of Thomas Workman of Craigdarragh, Helen's Bay, Co. Down. Engaged in the linen business, Thomas Workman's interests took him on journeys abroad. He was a director of Workman, Clark & Co. Ltd, shipbuilders, Belfast.

Jane and her sister Ellen ('Nellie') first visited the Low Countries when she was sixteen. They also studied in Paris, and Ellen, who painted Jane's portrait in oil when at home, spent a limited period at the studio of J. A. McN. Whistler (1834-1903).

Jane Workman also took classes with Jessie Douglas (q.v.) in Belfast, and often painted, especially in Co. Donegal, with John Workman, the grandfather of the noted Ulster artist, Tom Carr (q.v.). Her daughter, Margaret A. K. Yeames, studied at Glasgow School of Art.

In 1896 Thomas Workman published in Belfast, as an authority on the subject, *Spiders: Vol. 1 Malaysian Spiders*. Jane and another sister Margaret have been credited with the illustrations, not only for this volume but for the second, which was never published although printed. It would appear, however, that the author, who died in the USA in 1900, was responsible for most of the illustrations.

In his preface to the published volume, Thomas Workman mentioned the 'first twenty-four drawings, in which the Author was assisted by his daughter, who unfortunately had to discontinue her help owing to her eyesight becoming impaired ...'. Jane, according to her son-in-law, had good eyesight. Colours of the illustrations were taken from 'specimens as they appear after immersion in spirits of wine, and not from living spiders'.

Workman's name was given to at least two tropical spiders. The plates for the second volume consisted mainly of black and white photographs, accompanied by small, primarily black and white, line illustrations. There is no information in any part of the volume about the illustrator.

In 1899 at the Belfast Art Society exhibition, Jane – or Janey – Workman showed two watercolours: *Bits of old Oak* and *A Study of a Corner*. At the 1900 event she presented four watercolours, including *A Highland Cottage* and *Cottage Interior, Co. Down*. She exhibited one work at the Society of Women Artists in 1901, in London, and an interior at the 1903 Royal Academy. Similarly, her sister Nellie showed one work with both societies, and contributed two pictures to the Glasgow Institute of the Fine Arts.

Jane had married in 1901 James L. Yeames, a marine engineer, nephew of W. F. Yeames, RA (1835-1918), the artist who painted '*And When Did You Last See Your Father?*'. He is represented at the Ulster Museum. Under Mrs Yeames, she contributed thirteen works to BAS exhibitions in the years 1904-17 inclusive. In the three years 1904-06, she showed five unnamed interiors.

In 1901 she had shown at the Paris Salon a watercolour, *Ombre et Lumière*, also known as *Afternoon Tea*, the tea table set catching the light through the half open door in the hall beyond. In her final showing with BAS, all four works were Co. Donegal scenes. Also an oil painter, she is not represented in any public collections. She died after an accident in the spring of 1949 at Helen's Bay.

Works signed: J. S. Workman.
Literature: Algernon Graves, *The Royal Academy of Arts 1769 to 1904*, London 1905; *The Belfast Natural History and Philosophical Society Centenary Volume 1821-1921*, Belfast 1924; *Dictionary of British Artists 1880-1940*, Woodbridge 1976; National Gallery of Ireland and Douglas Hyde Gallery, *Irish Women Artists: From the Eighteenth Century to the Present Day*, catalogue, Dublin 1987 (also illustration); H. Garner, *Letters to the author*, 1995; also, Mrs M. A. K. Garner

(née Yeames), 1995; Natural History Museum, London, 1995; Ann M. Stewart, *Irish Art Societies and Sketching Clubs: Index of Exhibitors 1870-1980*, Dublin 1997.

WYNNE, GLADYS (1876-1968), landscape painter. Born on 29 June 1876 at Holywood, Co. Down, Edith Gladys Wynne was the youngest daughter of the Rev. George R. Wynne, author of several works, mostly of a religious nature.

Gladys travelled to Florence and Rome for her art education. Apart from two flower studies which she showed at the 1899 Royal Hibernian Academy, when residing at Woodlawn, Killarney, Co. Kerry, she concentrated her exhibiting with the Belfast Art Society, Dublin Sketching Club and, especially, the Water Colour Society of Ireland. She first contributed to the latter exhibitions in 1902, and for the next sixty years was a devoted participant, missing only a few years and showing 145 works.

According to Patricia Butler in her *Three Hundred Years of Irish Watercolours and Drawings*, 1990, her early watercolours displayed a strong sense of feeling for space 'coupled with a confident feeling for colour and light ... Her later work tended to lose its sense of freedom and spontaneity, becoming more tight and concise.' Gladys Wynne visited Germany, and in 1904 at the Water Colour Society she showed two Hildesheim scenes.

In 1904 she first contributed to BAS exhibitions and continued on a regular basis until 1919. In 1909 when she had five pictures at the WCSI exhibition, she gave a Limerick address; her father was then rector at St Michael's Church. Other journeys outside Ireland were indicated by *A Welsh Home, Criccieth* and *Old Water Tower, Lucerne*, both exhibited 1910.

By 1913 her home was at The Lodge, Glendalough. Among her WCSI contributions in 1915 was an evening scene on the Wye, and in 1919, *Garron Point, Co. Antrim*, but most of her subject matter pertained to County Wicklow, and at the Dublin Sketching Club's 1926 exhibition at Mills' Hall she showed *A Glendalough Road*. She became a regular DSC exhibitor until 1963.

In the period 1926-36, in addition to local scenes, titles denoted that she had painted in Cornwall, Somerset, Counties Donegal and Tipperary. In the last thirty years of her life she lived at Lake Cottage, Glendalough. In 1941 at the WCSI exhibition, she showed *Derrynane, Co. Kerry*; *Lake Orta, Italy*; *After Shower, Achill*.

At the DSC exhibition in 1955 she contributed *Aherlow River, Co. Tipperary* and *Galtee Mountains from Vale of Aherlow*. The concluding offering at the 1963 WCSI was *My Old Birch Tree*.

In the *Irish Women Artists* catalogue of 1987, Nicola Gordon Bowe referred to the artist's cousins and said that her watercolours 'sometimes manifest a warm, mottled density, whose colour tones are analogous with the superb tweeds the Wynne sisters used to design from nearby Tigroney House in Avoca'. She last exhibited in 1963, and died suddenly on 24 March 1968 at her home.

Works signed: G. Wynne.
Literature: *Irish Independent*, 23 October 1926; *Irish Times*, 8 July 1937; Rev. James B. Leslie, *Ardfert and Aghadoe Clergy and Parishes*, Dublin 1940; Miss C. I. Houston, *Letters to the author*, 1981, 1982; National Gallery of Ireland and Douglas Hyde Gallery, *Irish Women Artists: From the Eighteenth Century to the Present Day*, Dublin 1987 (also illustration); Patricia Butler, *Three Hundred Years of Irish Watercolours and Drawings*, London 1990 (also illustration); Holywood Parish Church, *Letter to the author*, 1994; Ann M. Stewart, *Irish Art Societies and Sketching Clubs: Index of Exhibitors 1870-1980*, Dublin 1997.

WYSE JACKSON, ROBERT – see JACKSON, ROBERT WYSE

Y

YATES, HELEN (1905-82), sculptor, portrait and figure painter. Helen Frances Yates was born in Dublin, the daughter of Charles Yates, a non-practising barrister who at one period was sports editor of the *Irish Times*. His brother George was a collector of fine art, and they lived in adjoining houses in Blessington Street, Dublin. In the early 1920s Charles Yates's family moved to Glenageary Lodge (now demolished), Glenageary, Co. Dublin. Helen studied the piano in London, receiving her LRAM in 1930. In Dublin, she won gold medals at the Dublin Feis.

At an early age she began teaching at the Read Pianoforte School in Harcourt Street, Dublin. Records show that she was registered at the School of Art for five years from 1927, so her music teaching may have been curtailed. In 1928 she won the £50 Taylor Scholarship for sculpture, the subject being 'Motherhood', and she was also the recipient of the California Gold Medal, awarded to the winner of a first prize 'whose work was considered by the judges to be of outstanding merit'.

R. Brigid Ganly, RHA, a friend at the School of Art, recalled to the author in 1995 watching Helen modelling in clay under Oliver Sheppard (q.v.), adding: 'She had a natural gift in both painting and sculpture, and was a good enough pianist to make her decide to make teaching music her profession.' Her ability in painting and sculpture may be judged by the illustrations in John Turpin's *A School of Art in Dublin since the Eighteenth Century*, 1995.

In the period 1923-35 inclusive she never missed a year exhibiting with the Dublin Sketching Club, showing an average of five works per show. In her 1927 contributions were *The Old Gardener* and *The Girl of Achill*.

In all, she exhibited seventeen works at the Royal Hibernian Academy between 1924 and 1931. The majority were portraits, beginning in 1924 with *Eleanor, daughter of Dr John Morton*. In 1927 she showed a portrait of the Governor of the Apothecaries Hall, Dr John Sheppard, and this painting survives at 95 Merrion Square, but does not appear to be signed. Among other contributions to the RHA were: *The Boxing Instructor*, in 1928; *Painting of a Botanist*, 1929; *The Connemara Woman* and *The Music Makers* in 1930.

In her last four years at DSC event, contributions included: *In Ballynahown, Connemara*, 1932; *The Wedgwood Jug*, 1933; *The Little French Girl*, 1934; *Connemara Fishermen*, 1935.

At the Hugh Lane Municipal Gallery of Modern Art is *The Old Gardener*, watercolour, unsigned. After her marriage to Bernard Ennis of a Co. Wexford family, and brother of her great friend and artist, Kathleen Ennis, whom she had met at the School of Art, she gave up painting and sculpting but continued teaching the piano, at Glenageary Lodge, after the death of Miss Patricia Read. A daughter, Helena, married the potter, Peter Brennan, in 1965, and their porcelain and stoneware were made at the studio, 37 Northumberland Avenue, Dun Laoghaire. Helen Yates died at her home, on 19 January 1982.

Works signed: H. Yates or HY, monogram (if signed at all).
Examples: Dublin: Apothecaries Hall; Hugh Lane Municipal Gallery of Modern Art.
Literature: *Royal Dublin Society Report of the Council*, 1928; *Thom's Directory*, 1938; Ann M. Stewart, *Royal Hibernian Academy of Arts: Index of Exhibitors 1826-1979*, Dublin 1987; Apothecaries Hall of Dublin, *Letter to the author*, 1994; also, Hugh Lane Municipal Gallery of Modern Art, 1994; National College of Art and Design, 1994; Mrs Helena Brennan (née Ennis), *Letters to the author*, 1995; R. Brigid Ganly, RHA, *Letter to the author*, 1995; John Turpin, *A School of Art in Dublin since the Eighteenth Century*, Dublin 1995 (illustrations); Ann M. Stewart, *Irish Art Societies and Sketching Clubs: Index of Exhibitors 1870-1980*, Dublin 1997.

YEAMES, JANE SERVICE – see WORKMAN, JANE SERVICE

YEATES, G. W.(1860-1939), landscape painter. Born in India in 1860, George Wyclief Yeates, the son of Rev. George Yeates, was educated at Dublin University – MB, BCh, 1884. He added LDS in 1885 after

attending the Royal College of Surgeons, and became a dental surgeon at the Dental Hospital of Ireland, Dublin.

In 1884, from 18 Lower Mount Street, Dublin, he showed at the Royal Hibernian Academy *Evening on the Scheldt* and *A Quiet Nook in Antwerp*. In 1886 he was proposed and seconded as a working member of the Dublin Sketching Club with an address at 27 Lower Baggot Street. He married Alma Jane Ussher in 1888. One of the earliest of the formal portraits by Walter F. Osborne (q.v.) was that of Mrs G. W. Yeates, painted in 1891 and now in the National Gallery of Ireland.

In the period 1886-1929 inclusive he exhibited regularly at the DSC event, missing only a few years. In 1892, seven works included *A Cottage in Wales* and *A Surrey Homestead*. Other immediate selections were: *The Liffey, Celbridge*; *Part of Old Town, Whitby*, 1893; *Heather Island, Loch Lomond*, 1895; *Greystones Beach*, 1897.

Altogether at the RHA he exhibited thirty-nine works. In 1916, from 25 Lower Baggot Street, after an absence of thirty-two years, he contributed *The Liffey, Blessington* and *Lough Dan, Co. Wicklow*, and that address was listed in 1937 for George A. Yeates and Annette V. Yeates when they exhibited at the Academy.

In 1918 G. W. Yeates's address was 11 Argyle Road, Dublin. Attracted to river locations, he painted on the Dargle, Liffey and Tolka, and in 1921 his Academy contributions included *The Old Mill by the Stream*; *A Waterway through Meadows Green*; *The Canal, Inchicore*. Most of his work was executed in Counties Dublin and Wicklow, but he painted the harbours at Rostrevor, Co. Down, and Ballycastle, Co. Antrim, exhibited in 1922 and 1924 respectively.

In 1930 Yeates was represented by three pictures at the Irish exhibition at Brussels, including *Temps morne et soleil*. His oil, *Leafy June*, was purchased at that exhibition and is in the Kilkenny Art Gallery Society collection. The parting exhibit at the RHA was in 1931: *Autumn*. A rare street scene, *Dungloe*, was painted in 1934, now located in the Hugh Lane Municipal Gallery of Modern Art. Also in that collection are eight other oil paintings, all nine presented to the gallery by Capt. H. C. Hall in 1942, and these included a Greystones view and *Near Abbotstown*. Yeates died on 5 March 1939 at Merrion Nursing Home, Dublin.

Works signed: G. W. Yeates or G. W. Y.
Examples: Dublin: Hugh Lane Municipal Gallery of Modern Art. Kilkenny: Art Gallery Society.
Literature: *Dublin Sketching Club Minute Book*, 1886; *Thom's Directory*, 1887; E. MacDowel Cosgrave, *Dublin and Co. Dublin in the Twentieth Century*, Brighton 1908; *Register of Deaths*, Dublin 1939; Jeanne Sheehy, *Walter Osborne*, Ballycotton 1974; *Irish Times*, 4 November 1976; *Allied Irish Banks Calendar 1981*, Dublin 1980 (also illustration); *Kilkenny Art Gallery Society Permanent Collection*, catalogue, 1986; Ann M. Stewart, *Royal Hibernian Academy of Arts: Index of Exhibitors 1826-1979*, Dublin 1987; Cynthia O'Connor Gallery, *Spring Exhibition: Irish Pictures*, catalogue, Dublin 1990; Hugh Lane Municipal Gallery of Modern Art, *Letter to the author*, 1994; Ann M. Stewart, *Irish Art Societies and Sketching Clubs: Index of Exhibitors 1870-1980*, Dublin 1997.

YEATS, ELIZABETH C. (1868-1940), designer, flower and landscape painter. Younger of the two sisters of the poet, W. B. Yeats, Elizabeth Corbet Yeats was the daughter of John Butler Yeats (q.v.) and a sister of Jack B. Yeats (q.v.). Born at 23 Fitzroy Road, London, on 11 March 1868, she was nicknamed 'Lolly'.

Susan Mary Yeats (1866-1949), her sister, was born at Enniscrone, County Sligo, and became known as 'Lily'. Family tradition has it that the young children had difficulty in pronouncing 'Elizabeth', hence the nickname. Their mother was Susan Mary Pollexfen of Sligo.

The Yeats family moved from Howth, County Dublin, in 1883 to Terenure, Dublin, and that year Lolly and her sister entered the Dublin Metropolitan School of Art. The family returned to London in 1887 and resided at 58 Eardley Crescent, South Kensington. With some friends, Lolly was involved in an issue of an artistic journal, designed and produced by hand, called *The Pleiades*, for Christmas 1887.

In 1888 the family moved to 3 Blenheim Road, Bedford Park, Chiswick. She had a children's story accepted by the *Vegetarian*; brother Jack supplied the illustrations. Because of her mother's ill health, Lolly was largely responsible for the housekeeping. However, in 1889 she began teaching – without remuneration for a year – as an apprentice at a kindergarten school in Bedford Park, learning the Froebel system and, in due course, passing her examinations. She developed a 'brushwork method' of painting which she taught to neighbourhood children.

Between classes and housework, she wrote and illustrated and had published by George Philip and Son, London, in 1896, *Brush Work*, with an introduction by T. R. Ablett, who wrote in part: 'Miss Yeats, who is the daughter of an artist and a skilful Kindergarten mistress, has proved that she can make good use of the subject. For several years her pupils' Brush work has obtained high awards at the Annual Exhibition of the Royal Drawing Society of Great Britain and Ireland, and it has been specially commended by Her Royal Highness, Princess Louise Marchioness of Lorne, the President of the Society.' In her preface for teachers, E. C. Yeats wrote: 'Success depends on exciting the imitative and artistic instincts, so that the children do their best to observe flowers and leaves, and actively reproduce what they observe.'

In another publication: 'The paintings in this book are not to be used for copies, but are given to show the way different flowers are to be painted, and to give some idea of the sort of result the pupil should obtain when taught by this method', so wrote Elizabeth Corbet Yeats in *Brushwork Studies of Flowers, Fruit, and Animals for Teachers and Advanced Students*, 1898, with twenty-seven plates and explanatory text. *Philips' Brushwork Copy Book* was issued in 1899. Then followed *Elementary Brushwork Studies*, published in two editions. In her introduction for the latter she wrote: 'All the children's work must be done from Nature, but this should not present any great difficulty ...'.

In 1898, from 3 Blenheim Road, she had exhibited for the first time at the Royal Hibernian Academy: *Crohy Head, County Donegal* and *Snail's Castle, Devon*, her brother Jack's home; and in 1899: *Bomore, Sligo* and, classified under 'Miniatures', *Sligo Bay*. One of the two watercolours of Rosses Point at Sligo's Model and Niland Centre was dated 1899. When her mother died early in 1900 she was on vacation in Germany. In April of that year she painted at her brother's home, a watercolour, *Cashlauna Seilmide: the studio* (National Gallery of Ireland). Meanwhile, Lily Yeats had been taking embroidery lessons from May Morris (1862-1938), daughter of William Morris (1834-96), a prime mover in the English arts and crafts movement.

Early in 1902 Evelyn Gleeson (q.v.) called at 3 Blenheim Road with a proposition, expressing the view that Ireland should provide an outlet for its young girls' talents in the making of 'beautiful things'. The typographical designer, Emery Walker (1851-1933), who had advised William Morris when he founded the Kelmscott Press, urged Lolly to take a month's course in printing at the Women's Printing Society in London in preparation for Miss Gleeson's new venture.

In 1902 the Yeats sisters settled with their father at 'Gurteen Dhas', Dundrum, Co. Dublin. Miss Gleeson also took a house in Dundrum, and there she founded the Dun Emer Industries, Lily working at embroidery and Lolly mainly at printing.

In the Spring of 1903 Elizabeth Corbet Yeats founded the Dun Emer Press with her brother W. B. Yeats as editor. The 1903 prospectus for Dun Emer mentioned her as one of the designers for the embroidery, also: 'A Painting Class, flowers from nature, and design, is held by Miss E. C. Yeats on Saturdays from 11 to 12.30. Fee £1.1.0 for ten lessons'. One of her pupils was Mainie Jellett (q.v.).

About 1906 she widened the scope of the Press, and began to specialise in hand-coloured prints, Christmas cards, pamphlets, and she herself executed many of the designs. Some of this work was seen at an exhibition organised by the Gaelic League art committee in Dublin in 1906. Disputes with Miss Gleeson and her brother Willie were not uncommon. In 1906 she showed *Sunset, Dingle Bay* and *A London Garden* at the Oireachtas exhibition, and four works in 1907 included *Brunne, Lake of Lucerne* and *Chrysanthemums*. In 1907 she was in New York selling Dun Emer goods at the Irish Exhibition.

The final publication under the Dun Emer imprint was the first number in June 1908 of a new series, *A Broadside*. After the break with Miss Gleeson, the name of Cuala was adopted and the second number in July was in that name. The monthly series, illustrated by Jack B. Yeats, continued until May 1915, eighty-four in all. Cuala Industries was at Churchtown, Dundrum. Lolly designed *Slainte* Health and Wealth Christmas stamps for the Women's National Health Association of Ireland, 1909. She also designed bookplates.

Suffering from nervous exhaustion, she left Ireland in 1911 for Switzerland and Italy for some three months holiday. In 1917 to coincide with the Arts and Crafts Society of Ireland exhibition, a cardboard cut-out Irish cottage was issued by Cuala, printed from a design by E. C. Yeats and hand-coloured. At the Dublin Sketching Club in 1919 she contributed *Buchalauns* and *A Soft Day*.

On the Arts and Crafts Society's 1921 exhibition at the Dublin Metropolitan School of Art, *The Studio* found that some of the best pieces of embroidery came from the Cuala Industries: 'Special notice should be given of an embroidered fire-screen, *The Garden*, designed by Miss Elizabeth C. Yeats, and executed by her sister, Miss Lily Yeats'. In 1923 the Press moved into W. B. Yeats's house in 82 Merrion Square, Dublin, moving again in 1925 to 133 Lower Baggot Street, with still 100 per cent feminine staff.

In October 1923 she had begun painting classes for children on Saturday mornings at Miss Ellen Sweeny's school, Mount Temple, at 3 Palmerston Park; fee, one guinea per term. Flowers were painted directly in watercolour, without pencil or rubber, a different flower at each weekly lesson. As pupils advanced, she taught them to use their designs to decorate lamp-shades, or for wallpaper.

The artist, Louis le Brocquy, attended Mount Temple and it was Miss Yeats who first noticed his talent for painting and who taught him while he was at that school, according to a former pupil, Lillias Mitchell (1915-2000), whose mother had helped promote the Saturday morning classes. Lolly also taught at Louise Gavan Duffy's Scoil Bhríde, a secondary school for girls, at 70 St Stephen's Green.

The Cuala pressmark of a lone tree in an Irish landscape was reproduced from a line drawing by E. C. Yeats; first used in 1925. Her sister Lily wrote to Sarah Purser (q.v.) in 1926 regarding the embroideries at St Brendan's Cathedral, Loughrea, Co. Galway, saying that Lolly had designed all the women saints with the exception of *St Bridget* by Pamela Colman Smith.

As a means of supplementing her income, she continued giving painting lessons, and in 1931 she was out two afternoons per week. In a letter to her friend, Dorothy Blackham (q.v.), in 1933, Lolly reported: 'It was the pleasanteth sale we have had for years – and better still, the best financially. We even sold £5 Abbey Theatre embroidered picture ...'. A letter in 1934 indicated that financial affairs could be better: 'Things are improving a little – if only Lyle Donaghy would pay his printing bill, then we could pay our artists ... some people do not pay up for months – and some even a year or more before they pay. What we need now is cash down ...'.

The second series of *A Broadside*, edited by W. B. Yeats and F. R. Higgins, consisted of twelve parts and was issued monthly, 1935-6. The third series, edited by her brother and Dorothy Wellesley, was issued monthly in 1937. Jack B. Yeats was among those who contributed drawings for both series.

In her *Life and the Dream*, Mary Colum wrote that the two Yeats sisters 'were like all members of that amazing family, full of personality and artistry; they worked hard ... but this was not as a means to any personal ends: it was a sort of patriotic endeavour'. She is represented in the NGI's Yeats Museum, a permanent tribute to the Yeats family. Elizabeth Corbet Yeats died at a nursing home in Dublin, on 16 January 1940.

Works signed: E. C. Yeats or E.C.Y. (if signed at all).
Examples: Ballinasloe, Co. Galway: St Brendan's Cathedral. Dublin: National Gallery of Ireland. Sligo: Model and Niland Centre.
Literature: E. C. Yeats, *Brush Work*, London 1896 (also illustrations); Elizabeth Corbet Yeats, *Brushwork Studies of Flowers, Fruit, and Animals for Teachers and Advanced Students*, London 1898 (also illustrations); also *Philips' Brushwork Copy Book*, London [1899] (illustrations); *Elementary Brushwork Studies*, London 1900 (also illustrations); *The Studio*, November 1906, December 1921; Lily Yeats, *Letter to Sarah Purser*, 1926, National Library of Ireland; Elizabeth C. Yeats, *Letters to Dorothy Blackham*, 1933, 1934; *Sunday Graphic and Sunday News*, 10 January 1937; *Irish Times*, 18 January 1940, 9 April 1984; Lily Yeats, *Elizabeth Corbet Yeats*, Dublin 1940; Roger McHugh, ed., *W. B. Yeats Letters to Katharine Tynan*, Dublin 1953; Eileen MacCarvill, ed., *Mainie Jellett: The Artist's Vision*, Dundalk 1958; Mary Colum, *Life and the Dream*, Dublin 1966; William M. Murphy, *The Yeats Family and the Pollexfens of Sligo*, Dublin 1971; Liam Miller, *The Dun Emer Press, Later the Cuala Press*, Dublin 1973; William M. Murphy, *Prodigal Father: The Life of John Butler Yeats (1839-1922)*, Ithaca 1978; Nicola Gordon Bowe, *The Dublin Arts and Crafts Movement 1885-1930*, catalogue, Edinburgh 1985; Lillias Mitchell, 'Remember Mother and Miss Yeats', *Irish Arts Review*, Spring 1986; Anne Yeats, *Letter to the author*, 1994; Hilary Pyle, *Yeats: Portrait of an artistic family*, London 1997 (also illustrations); Ann M. Stewart, *Irish Art Societies and Sketching Clubs: Index of Exhibitors 1870-1980*, Dublin 1997.

YEATS, JACK B., RHA (1871-1957), figure painter and illustrator. Christened John Butler Yeats, he was born at 23 Fitzroy Road, Regent's Park, London, on 29 August 1871, youngest of the four surviving children

of John Butler Yeats (q.v.) and Susan Pollexfen of Sligo, and a brother of the poet, W. B. Yeats. Known as Jack from an early age, he showed an intense interest in drawing, and at the age of six drew 'a ghost frightened at the sight of another ghost'.

In the period 1879-87 he lived mainly with his grandparents, William, a shipowner, and Elizabeth Pollexfen of Merville, and then Rathedmond, Sligo. He and his brother sailed on a Pollexfen boat between Liverpool and Sligo. Jack, according to his sister, Lily, was their grandparents' 'white-haired boy', and sometimes Jack and his grandfather would be seen driving in a pony trap through Sligo town, Jack ringing a dinner-bell with which to alert traffic. He attended a private school run by Ellen Blyth at the Mall, and his position at the bottom of the class was explained by his grandmother 'because he is too nice to compete'.

Horses fascinated the young Yeats and he attended races, as well as fairs, sports, circuses and wandered the Sligo quays. Before he was aged fourteen, he composed eight illustrations for *The Beauty and the Beast*, and presented these in 1885, in booklet form, to his other sister, Elizabeth Yeats (q.v.); the coloured drawings are now located at the National Library of Ireland. The Witt Library in London with their illustrative records discovered about sixty works with horse or horses.

In 1887 he joined his family at 58 Eardley Crescent, Earl's Court, London, and had a pass to Buffalo Bill's Wild West show at Earl's Court. At South Kensington School of Art, entering in 1887, he received his first art instruction. He also attended Chiswick Art School, 1888-90; West London Art School, 1890-3, and the Saturday morning classes of Professor Fred Brown (1851-1941) at Westminster School of Art. In 1888 the Yeats family moved to 3 Blenheim Road, Bedford Park. Chiswick Art School was at Bath Road, Bedford Park.

Yeats, still a student, started work as a black-and-white artist for *The Vegetarian* in 1888, a drawing of Fairies. Thus began the first period of his career, lasting about ten years. Meanwhile in Dublin Sarah Purser (q.v.) was selling his 'Menu' and 'Race' cards. Annual summer visits to Sligo, 'my school and the sky above it', ensued. Thomas MacGreevy, an old friend, expressed the view later that Yeats's work showed a whole-hearted sympathy and sense of identity 'with the life of the common people in Ireland which had not been perceptible in the work of any painter before him ...'.

At Easter 1889, he watched and sketched the military manoeuvres at Brighton. *An Irish Race Meeting*, at Drumcliff, Sligo, appeared in the *Daily Graphic*, 29 August 1890. A drawing in Indian ink, *The Lambeth School of Arts*, depicted the first place he watched boxing in London. The music hall also attracted him, and of course the horse-buses. In 1890 he had work accepted by *Puck* and *Ariel*. His biographer, Hilary Pyle, wrote that through his pen he was able 'to communicate not only with the art lover, but with those who would claim to have no interest in aesthetics whatsoever'.

The first book, one of several, which he illustrated was Ernest Rhys's *The Great Cockney Tragedy*, 1891, and that year he began to contribute on various sporting events for *Paddock Life*, an assignment that lasted more than two years. A full page cartoon for *Ariel* was of an East End theatre on Saturday night. He was the illustrator for W. B. Yeats's *Irish Fairy Tales*, 1892.

In 1892-3 he worked as a poster designer for David Allen and Sons in Manchester. Among his other illustrations were those for *Judy*, 1892-7; *Chums*, 1892-6. Another outlet in 1892 was the *Illustrated London News*. From 1893, for some years, he also made cut-out stencils. *Lika Joko*; *Sporting Sketches*; *Cassell's Saturday Journal*; and *Celtic Christmas*, the Christmas supplement of the *Irish Homestead*, also accepted his drawings for several years. Some of his cartoons were in series, for example for eight years from 1893 in *Funny Wonder*, the Saturday edition of *Comic Cuts*.

In 1894 Yeats married a fellow artist, Mary Cottenham White from Devon, and they settled at 'The Chestnuts', Eastworth, Chertsey, Surrey, spending their honeymoon on Norfolk Broads where Jack painted watercolours. When he exhibited for the first time at the Royal Hibernian Academy in 1895 he showed a watercolour, *Strand Races, West of Ireland*. Altogether, he contributed 145 works to the Academy exhibitions. Another source of income early in his career was writing, two stories in 1895 for boys' magazines. Under his own name, a cartoon appeared in *Punch* in 1896.

According to his friend, C. P. Curran, his illustrations appeared in some forty publications in England 'besides six Irish papers and five American papers, including *Life*, the *Dial* and the *New York Herald. Comic*

Cuts deserves special mention if only for the sake of Signor McCoy, a horse with a daisy hanging from the corner of its mouth; adventures in serial form ...'. But in *Big Budget*, not *Comic Cuts*.

In 1897 Yeats and his wife moved to 'Cashlauna Shelmiddy', Strete, near Dartmouth, and that year he painted his first oil painting although for the next ten years he concentrated on watercolours, which he presented with forty-three examples in his first exhibition, at Clifford Gallery, Haymarket, London in November. In 1898 he visited Venice, and was present that year in Sligo and Carricknagat for the centenary celebrations of the 1798 Rising. *A Sunday Morning in Sligo*, 1898, watercolour, is in Sligo's Model and Niland Centre. Within eleven years, until 1899, he had contributed more than 600 drawings to various publications.

Irish subject matter dominated his exhibitions at this time. In 1899 he showed at Walker's Galleries, London, and then at Leinster Hall, Dublin, his first in Ireland. In 1899 too he paid his first visit to Coole, Co. Galway, staying with Lady Gregory, and he also visited Paris that year. As his sketchbook indicated, he also stayed on the Aran Islands. His plan was to visit Ireland each year for a few months with occasional trips to London to visit the haunts of his youth.

Sketches which he made in Dublin in 1899 during rehearsals for *The Countess Cathleen* by W. B. Yeats are now in New York Public Library. In 1899 he showed designs for bookplates at the second exhibition of the Arts and Crafts Society of Ireland in Dublin. York Powell, John Quinn, Lennox Robinson and Lily Yeats were among those who commissioned bookplates during his career.

An important early watercolour, *Memory Harbour*, 1900, was an amalgam of remembrances of Rosses Point, Sligo. He wrote several miniature plays, and the local children attended his toy theatre at his home. On his exhibition 'Sketches of Life in the West of Ireland and Elsewhere' at the Leinster Hall in 1900, *The Studio* hailed him as the first modern Irish artist to sound a clear and definite 'Celtic Note'.

The English magazine also found that Yeats had 'a quite remarkable gift for interpreting the quaintly humorous side of Irish peasant life. His sketches have all an extraordinary vigour and truthfulness, and convey an idea of movement rarely seen in latter-day work. This is especially true of his horses and donkeys. They are all alive, and all unmistakably Irish ...'. In 1900 too he exhibited a similar show at Clarendon Hotel, Oxford.

In 1901 he contributed sketches to *Fun*, and Elkin Mathews published his first miniature play, *James Flaunty or The Terror of the Western Seas*. Copies of the play coloured by the author were obtainable for five shillings. The *Manchester Guardian* said that it was difficult to believe 'that colour can add materially to the excellence of these designs ... We may particularly commend the reticence of effect in the pictures, which aim at no vulgarity or facetiousness ...'.

A second miniature play was *The Treasure of the Garden*, 1903, coloured by the author, 5s. net; uncoloured copies, 2/6 set. In that play the scenes and characters were given a suitable size to be cut out and set up. Stages, with proscenium designed by the author, footlights and slides, 5s. each. 'The play set up ready for acting by the author, with stage and all necessaries, price 3 guineas. Published and sold by Elkin Mathews, Vigo Street, London.' In the same year, 1903, *The Scourge of the Gulf*, appeared, price one shilling; copies coloured by the author, five shillings.

Another West of Ireland exhibition took place at Walker's Galleries in 1901, followed, 'before crowds of visitors', at 9 Merrion Row, Dublin. On the latter exhibition, *The Studio* found 'something elusive, something that suggests a quest after the secret soul of things ... vivid, human dramas on canvas, which seem literally to exhale all the exuberance, all the buoyancy of youth ...'. John Quinn, a successful American lawyer who owned major modern art, bought pictures by Yeats at the 1902 Dublin exhibition at Wells Central Hall, Westmoreland Street; two oils were included in the show.

About 1902, according to Yeats's biographer, Hilary Pyle, he designed comic postcards of horse and jockey for a Vienna firm of printers. His main preoccupation in 1902-03 was the editing of *A Broad Sheet*, at first with the assistance of Pamela Colman Smith, an American; twenty-four numbers in all. Illustrations were by Yeats and others, and Elgin Mathews was the publisher. Subscription: 12s. 6d. a year post free.

More sketches of the West of Ireland appeared at Walker's Galleries in 1903, and Central Hall, Dublin. His friend, John Masefield, the poet, paid a visit to Strete that year. Both had a devotion to the sea and its lore; and they constructed and sailed a fleet of toy boats.

Writing in *The Celt* in 1903, Evelyn Gleeson (q.v.) found that Yeats had 'a weird power of suggesting the Irish atmosphere; his stalwart peasants are men with grim determination and a wild, reckless humour, that tell of the tragic past, poverty and toil, and the mystical enthusiasm of the Celt are there ... I know not with what subtle touches Mr Jack Yeats conveys so much, for his sketches are very slight, but they are full of power ... they are Irish art.' But the year also found him sketching at the Royal Theatre of Varieties, Holborn.

In 1903 Dun Emer Industries, under Gleeson and Yeats's sister, Lily, completed twenty-four banners of Irish saints for Loughrea Cathedral, Co. Galway. Yeats designed all the male saints except two, *St Patrick* and *St Laurence O'Toole*. The design for *St Columcille* is in St Brendan's Cathedral. The 1903 Dun Emer prospectus offered church banners 33 inches by 21 inches, designed by Yeats and others at four guineas each.

In the period 1904-20 he was a regular exhibitor with the Belfast Art Society, showing twenty-seven works. In 1904 he contributed *The Back Strand Races, Co. Sligo*, and in 1905, *'On the Stones', Caledonian Road, London*.

In 1904 Yeats travelled to New York for an exhibition of watercolours organised by John Quinn at the Clausen Galleries, spending a few months in the city with his wife and sketchbooks. In the same year he was represented in the watercolour section of the exhibition of works by Irish painters organised by Hugh P. Lane at the Guildhall of the Corporation of London. Among his seven pictures were *The Stargazer* and *Connemara Innkeeper*. The *Art Journal* claimed that of all the artists represented he was 'the most distinctively Irish painter'. The attendance was 72,268 persons.

The year 1904 also saw the publication of another play for miniature theatre, *The Bosun and the Bog-tailed Comet*, and, according to Hilary Pyle, he was elected an associate of the RHA but allowed it to lapse. *A Little Dublin Theatre*, 1905, watercolour, is in the Abbey Theatre.

Commissioned by the *Manchester Guardian*, Yeats accompanied the dramatist, J. M. Synge, in June and July 1905 as illustrator to a series of articles – twelve in all – on the congested districts of the West of Ireland. A stencil portrait of Synge is in the Royal Library, Windsor Castle. Yeats wrote an occasional article for the *Guardian*, the first in January 1905; 'Racing Donkeys' appeared 26 August 1905. At the end of October he spent a week in Manchester at the *Guardian* editor's request on a series of drawings of life in the city.

In 1905 too he first contributed to *The Shanachie*, and shared exhibition space at Baillie's Gallery, London, with J. H. Donaldson, Elinor Monsell (Elinor Darwin, q.v.) and Mrs Norman. Of his exhibition at Leinster Hall, Dublin, the *All Ireland Review* commented: 'The general effect is sinister. These strange, strong, cunning faces seem somehow to belong, not so much to the wasted or gone astray, as to the damned.'

In his exhibition at Leinster Hall in 1906, thirty-two of the forty-two sketches dealt strictly with the West of Ireland. The *Irish Times* found 'an abundance of originality in his themes. The subjects are seen well and drawn well; and, if the colour treatment is occasionally sportive and liberty-taking, we can forgive it in the light of ideals of the impressionist school, and certain precedents of the "sketch" cult'. *The Studio* noted that he was 'an illustrator rather than a creator, but an illustrator of rare imaginative gift ...'. A landscape in oil, *Spring Tide, Clifden*, was in this show. In 1906 too he contributed short articles to the *Manchester Guardian* with accompanying illustrations, and he served on the first Oireachtas art committee.

The association with the Oireachtas organisers may have prompted him to show nine works in 1906 plus pencil sketches; and eleven in 1907 plus hand-coloured drawings from the Aran Islands and Contemporary Club sketches. In his opening year, nearly all the works were portraits, including those of Norma Borthwick, P. Vincent Duffy (q.v.), George Moore, John O'Leary, Pamela Colman Smith.

Yeats illustrated more than two score books; in 1907 appeared J. M. Synge's *The Aran Islands*, although some copies have the date 1906. A large paper numbered edition of 150 copies (with the twelve Yeats drawings coloured by hand), signed in ink by author and artist, was published simultaneously. Illustrations included *An Island Man* (Model and Niland Centre), *Kelp-Making* and *The Evictions*. He designed a poster for Lady Gregory's *The Rising of the Moon*, Abbey Theatre, 1907, and that year he spent a holiday on the Rhine.

Jack Yeats was regarded as the presiding genius, editing and illustrating, over *A Broadside*. The first issue in June 1908 was published at Dun Emer Press by Elizabeth Yeats, who left Dun Emer to found the *Cuala Press* and it was published by Cuala until May 1915. The contents were not exclusively Irish. Her brother was also involved in the designing and colouring of Cuala prints, also calendars and Christmas cards.

Another exhibition devoted to West of Ireland life took place at Walker's Galleries in 1908. *The Studio* was again represented: 'His art is notable on account of its zest for actualities, but if he escapes the atmosphere of the studios he has something to learn of the craft which is often perfected there'. The joint owners of the little fleet, Yeats and Masefield, told the story of it in *A Little Fleet*, 1909. The text was illustrated with drawings of boats. At the BAS show in 1908, *The Man from Arranmore* and *The Old Quay Watchman*, watercolours, were both hung; in 1909, *The Race Card Seller*.

In 1909 he showed with Allied Artists' Association in London, and continued to exhibit with them for some years. Exhibitions continued at Leinster Hall in 1909 – and in 1910 he provided nine oil paintings; and probably watercolours for the last time. In 1910 he was represented at the Salon des Indépendants, Paris, for the first time, and he also exhibited in 1912 and 1913.

In 1910 he sold the Devon house and went to live at 'Red Ford House', Greystones, Co. Wicklow. He now resumed contributing to *Punch*, but used the pseudonym, W. Bird. According to figures supplied by *Punch* to the author when he enquired in 1984, 'W. Bird' contributed 524 cartoons between 1910 and 1948.

In 1910, and 1917, he exhibited again with the Arts and Crafts Society of Ireland in Dublin. After a lapse of eleven years, he returned to the RHA in 1911. In that year he worked in Roundstone, Co. Galway, during the summer. *In Wicklow, West Kerry and Connemara* by J. M. Synge was published posthumously in 1911, and contained eight illustrations including *A Wicklow Vagrant*; *The Circus*; and *The Strand Race*.

Life in the West of Ireland, drawn and painted by Jack B. Yeats, appeared in 1912 with fifty-six illustrations, classified as: colour prints, eight; line drawings, thirty-two; reproductions from paintings, sixteen. The *Irish Review* described it 'an ample record of Irish adventurousness and extravagance, of Irish sincerity and homeliness'. A special edition 'with an original sketch on fly leaf' was limited to 150 signed copies. West of Ireland pictures were again hung at Walker's Galleries in 1912.

Yeats now joined the United Arts Club, and later served three years on the general committee. P. L. Dickinson in his book *The Dublin of Yesterday* wrote that he played his part in the Arts Club, adding: 'He was a most amusing man in his own very quiet way, and had a simple, childlike sense of fun. He was sensitive to a degree, and if he did not care for his surroundings, never opened his lips.' The artist Brigid Ganly remembered him as 'companionable, witty, always kind, and a brilliant entertainer'.

At the 1911 Oireachtas exhibition he contributed eight pictures, and among these were: *A Circus Bull Fight*; *The Ballad Singers*; *The Trig o' the Loup*. At the 1912 BAS show: *The Sailor Home from Sea*.

The Maggie Man, oil, at the 1912 RHA, was purchased by Hugh Lane and presented to the Municipal Gallery of Modern Art. Oil paintings supplied the twelve coloured illustrations for George A. Birmingham's *Irishmen All*, 1913, and these included *The Police Sergeant*; *The Squireen*; and *The Priest*.

Invited to take part in the Armory Show of modern art in 1913 at New York, he sent five works. He participated in an exhibition of Irish art at Whitechapel Gallery, London, and also in 1913 designed a mountain backcloth for *The King's Threshold* at the Abbey Theatre. The design is in the National Gallery of Ireland. He showed at the Black and White Artists' Society of Ireland exhibition in 1913, 1914 and 1916.

In 1914 he held exhibitions at Mills' Hall, Dublin, and Walker's Galleries. On the London display, *The Studio* commented: 'Drawings of his with the pen betray a lack of flexibility in draughtsmanship, which also makes itself felt throughout the oil paintings. But his art is animated by interest in life, and that power of response to the mood of nature which is typical of a West Irishman ...'.

In 1914 he attended political meetings at which Pearse and other nationalist leaders spoke. An incident in which a detachment of the King's Own Scottish Borderers killed three civilians led to his painting, *Bachelor's Walk, In Memory*. He was now learning Irish. At the Belfast exhibition in 1914 he contributed *Empty Creels* and *The Boat Builder*.

As O'Donovan Rossa lay in state, he drew him at the Dublin City Hall in 1915, the year he was elected ARHA, and executed some pastel drawings at Ballycastle, Co. Mayo. In 1916, now elected RHA, he had a

breakdown in health, and four of his works were destroyed in the burning of the RHA building. He was among the artists who gave their work free for the Irish National Aid Volunteers' Dependants' Fund.

Five pictures at the 1917 Academy exhibition included *A Wind Blown Tree in Roundstone* and *The Road to Croke Park*. At Burlington House in 1917 he was one of the illustrators who contributed to the Graphic Art exhibition in aid of the Red Cross and St John Ambulance Society, showing three works: *Singing 'Down by the Tanyard side'*; *The Fife and Drum*; and *Singing 'I Built a Bower in My Breast'*. He was also represented with the International Society of Sculptors, Painters, and Gravers summer exhibition in London, 1917. In that year he moved to 61 Marlborough Road, Donnybrook, Dublin.

Early in 1918 he executed at least two posters 'To Recover the Lane Pictures for Ireland' for the public meeting at the Mansion House, Dublin. He advised the Belfast Art Society that he had never sold a picture through the Society's exhibition and so there was not much use continuing to be a member. He was asked to reconsider.

In 1918 too he showed again at Mills' Hall 'Drawings and Pictures of Life in the West of Ireland', again in 1919, when a similar show was held in London at the Little Art Rooms, Adelphi, *Here She Comes!* and *Before the start* being each priced at 250 guineas. The Victoria and Albert Museum holds four undated original drawings used as posters to advertise his work at the Art Rooms.

In 1920, as well as exhibiting at Mills' Hall, he became a founder member of the Society of Dublin Painters, signing the lease with Paul Henry and Clare Marsh (qq.v.) for the St Stephen's Green Gallery. In 1920 too he was appointed one of the first ten 'Members' of the Belfast Art Society, chosen by Sir John Lavery (q.v.). In 1921, 1922 and 1923 he held exhibitions at the Stephen's Green Gallery, still on the West of Ireland theme. He exhibited for the first time with the Glasgow Society of Painters and Sculptors in 1921, and also with the Society of Independent Artists in New York.

C. P. Curran was of the opinion that the transition to his later treatment started in the early 1920s, and that it began to show itself in *A Westerly Wind* in 1921: 'From this date the tides run strong and free. The painter sets out on a new course which disconcerted some people who like art fossilised He turned himself from draughtsman into colourist ...'. *Here She Comes!* at the Liverpool city 1921 autumn exhibition was described by *The Studio* as one of the outstanding works; it was purchased by the Walker Art Gallery.

In 1922 he contributed to the Exposition d'Art Irlandais at the Galeries Barbazanges, Paris, and won a medal at the Aonach Tailteann, Dublin. Edward Sheehy, writing in the *Dublin Magazine* at a later date, said that Yeats's finest achievement as a painter was *The Funeral of Harry Boland* (Model and Niland Centre), 1922. Sheehy added that the picture attained 'a tragic dignity and a historical solemnity without the slightest straining after effect, or sacrifice of the painter's native freshness of observation....' Thomas MacGreevy felt that there was nothing 'grandiose or pompous' about his historical pictures and that in the Boland work he 'rose to the full height of the heroic in art'.

In 1923 he went to Paris as a delegate of the Irish nation to the Celtic Congress. In a speech to the assembly, he said that the most exciting sights one could see were a man ploughing and a ship on the sea. Another transitional work was *The Liffey Swim* (NGI), 1923, which won him a silver medal at the 1924 Olympic Games at Paris. *Riverside Long Ago* (Ulster Museum) was also painted in 1923, so was *In Capel Street, Dublin* (Crawford Municipal Art Gallery). In 1924 he exhibited at the Gieves Gallery, London, and thirty-six works at Engineers' Hall, 35 Dawson Street, Dublin. W. R. Sickert (1860-1942) saw the London exhibition and expressed his admiration in a letter to the artist.

In 1925 his London venue was Arthur Tooth and Sons gallery; the Tate Gallery purchased *Back from the Races*. The complementary Dublin exhibition was again at the Engineers' Hall. He showed again at Tooth's in 1926, works including *Man versus Horse* and *The Flapping Meeting*. At the London Salon he showed a total of thirty-two works. MacGreevy was of the opinion that he painted 'the Ireland that matters', and that the landscape was as real as the figures.

In 1925 he disassociated from the *Cuala Press* in the making of prints, devoting himself wholly to painting, the palette knife being frequently substituted for the brush. 'After having established himself as a straightforward narrative artist', wrote Hilary Pyle, 'Jack Yeats suddenly emerged as a poetic introvert, with an idiosyncratic manner, that cannot be defined exactly within any contemporary stylistic framework ...'.

At the RHA in 1926 his contributions included *The Ferry, Kinsale*. In October he stayed at the Eccles Hotel, Glengarriff, Co. Cork. Exhibitions in 1927 were at Engineers' Hall, and with thirty-five paintings of Ireland, including *Lingering Sun*, at Ruskin Galleries, Birmingham. Painted in 1927, *Derrynane* is in the Ulster Museum.

On his exhibition of thirty-two pictures in Dublin, *The Studio* said he had achieved 'a lyric quality of colour, a suavity and elegance of tone that is extraordinarily distinguished'. His sketchbooks for 1927 indicated work in Gort, Co. Galway, and Glenbeigh, Co. Kerry. In that year he exhibited *On the Racecourse* with the Royal Institute of Oil Painters. His exhibition at Tooth's in 1928 found the London critic of *The Studio* saying that the artist 'affects a vagueness of technical statement which is perilously near to incoherence ...'.

In 1929 he moved to 18 Fitzwilliam Square, Dublin, where a plaque was later erected. In his exhibition of thirty paintings at Engineers' Hall in 1929 he included *Going to Wolfe Tone's Grave*; *The Horse Lover*; *A Farewell to Mayo*. He showed at the Alpine Club Gallery, London, in 1929 and 1930. In 1930 appeared his first plotless prose work, *Sligo*.

In 1930 he was represented abroad in two exhibitions of Irish art: at Brussels, showing *Portrait de Miss Horniman*, and in New York at the Hackett Galleries. The Belfast Museum and Art Gallery held an exhibition in 1930 of modern paintings and watercolours, lent by the Contemporary Art Society, London, and Yeats was represented by two oils, *The Jaunting Car* and *The Last Ride*. The artist's friendship with Samuel Beckett began at this time when MacGreevy was living in Paris and asked Beckett to call with Yeats when in Dublin. In a letter to MacGreevy in 1931, Yeats expressed his hatred of reproduction of paintings.

A return to New York in 1931 saw him contributing to the opening exhibition of the Barbizon Museum of Irish Art, followed by a solo show there in 1932, opened by W. B. Yeats, and another at the Ferragail Galleries. Back in Dublin, he had exhibited at the Engineers' Hall in 1931, and that year he represented the RHA in the international exhibition at Carnegie Institute, Pittsburgh; he also sent works there for some future exhibitions. After an interval of twelve years, he returned to exhibiting at the Oireachtas in 1932, works including *A Pipe* and *Music in the Train*.

An exhibition at the Leger Galleries in London, 1932, had distinct Irish subject matter, and he was represented that year in the Olympic Games art exhibition, Los Angeles, and had works on view in New York at the Barbizon. If he painted less during the 1930s, he spent some of his spare time writing. *Sailing, Sailing Swiftly*, 1933, was another puzzling prose work, and in 1933 appeared three plays, *Apparitions*; *The Old Sea Road*; and *Rattle*. On the plays, the *Irish Book Lover* considered that 'no audience could stand them. In fact one wonders whether they are not a dramatic joke ...'.

In 1933 he exhibited at the Chicago Century of Progress Exposition. He sketched at Bantry, Co. Cork, in 1933 and exhibited for the first time at the Munster Fine Art Club, Cork, in 1934. Strongly committed to the development and modernisation of the Dublin Metropolitan School of Art, he was appointed to the advisory committee in 1934 but resigned two years later. *About to Write a Letter* (NGI), regarded as an outstanding work, was exhibited at the 1935 RHA, and that summer he showed two works at the Leger Galleries exhibition.

During 1935 the second series of *A Broadside* was issued monthly, and Yeats contributed drawings with other artists. During the 1930s he painted a series of pictures of roses, blooming and wilting. He wore a single rose in his button-hole at exhibition openings, and tied a paper rose to his easel. He wished to paint sub rosa; he did not want to explain his pictures. As late as the 1930s the Yeats family only discovered Jack's secret of the W. Bird cartoons for *Punch*.

The second novel, *The Amaranthers*, appeared in 1936. The *Irish Book Lover* commented that the publishers apparently had been in some doubt of its nature. The writer suggested that it might have been described as 'a satirical joke of a novel'. On the painting side, he held an exhibition in 1936 at the Rembrandt Gallery, London, and showed two works at the Leger Galleries summer exhibition.

Writing in *Ireland To-Day* in June 1936, John Dowling noted that persons 'apparently intelligent' had hailed Yeats's works as great art 'but an examination of their surfaces makes any further consideration of

them unnecessary'. He then described the technique, and added: 'Any result obtained is and must be accidental, as the materials are quite uncontrolled and his method precludes any possibility of intention.'

Helen, 1937, the product of his fancy, he said, was based on the legend of 'the face that launched a thousand ships'. This oil painting was the gift of a group of Dublin friends in 1958 to Tel Aviv Museum of Art. He was involved in the 'Three Irish Artists' exhibition in 1937 at the Galleries of Mrs Cornelius J. Sullivan, New York, and he was represented in the watercolours exhibition there in 1938. On his pictures at the 1937 RHA, a writer in *Ireland To-Day* had commented: 'Perhaps he is doing emotionally what the surrealists tried to do scientifically, by synthesis where they tried analysis.'

During 1937 the third series of *A Broadside* was issued monthly, and he contributed drawings with other artists. *The Charmed Life*, another novel, saw publication in 1938. Six landscape and genre paintings were exhibited with the National Society at the Royal Institute Galleries, London, in 1938. At the Palace of Arts, Empire Exhibition, Glasgow, 1938, he showed *A Summer Day near a City long ago*. At the National Society exhibition in 1939 he contributed *Helen*; *The Avenger*; and *Evening in Spring*.

In 1939 he was appointed a governor of the National Gallery of Ireland, his *Harlequin's Positions* was produced by the Abbey Experimental Theatre, and he exhibited at 5 Leinster Street, Dublin. He represented Ireland at the Contemporary Art of 79 Countries exhibition at the Golden Gate International Exposition, San Francisco. Yeats was among the local artists who joined with some important contemporary Continental artists in an exhibition at Contemporary Pictures, Dublin, in 1939. About 1939, Hilary Pyle estimated, he finished the seventh and final sketchbook, a series which he called 'Lives', worked in pencil, wax crayon and ink.

In the British and French exhibition at the Leger Gallery in 1939 he showed *The Visit*. In 1940 he painted *Tinkers' Encampment – the Blood of Abel*, which was sold at a Dublin auction in 1994 for £505,000. Thomas MacGreevy had described it in his 1945 book on Yeats as an 'astonishing work'.

An honorary member of the London Group, three of his oils were in the 'British Painting since Whistler' loan exhibition at the National Gallery in 1940: *The Visit*; *The Walk-over*; and *The Winnower*. In 1939, 1940 and 1941 he exhibited at Contemporary Pictures. *The Studio* considered he was the only 'unquestionable master' in the National Society exhibition of 1940.

Writing in *Studies* in 1941, C. P. Curran noted: 'He has no way of rendering any detail, no repetition in his handling. His work is a continuous improvisation ...'. In 1942 the National Gallery held a joint exhibition of the works of Jack B. Yeats and Sir William Nicholson (1872-1949). The attendance figure was 10,518. Maurice Collis, on Yeats's paintings, commented in *Time and Tide*: 'These are alleged to reflect the artistic frenzy which overtook him in his middle age. They purport to convey a strong emotion and seemingly are meant to be a blaze of colour. But they do not convey any more emotion than does a player who keeps his foot on the loud pedal and beats the piano like a madman, as he rolls in his seat ...'.

In his introduction to the 1942 National Gallery catalogue, Sir Kenneth Clark wrote:'... he is still at his best with popular subjects, with those moments when people cease to be economic animals gainfully occupied, when they yield to the magic of an impulse and are willing to take a chance. Bars, bridges, pantomimes, beaches and racecourses, these are his favourite settings, because they all create a feeling of irresponsibility, a feeling that under curious conditions of light and luck anything may happen ...'.

In 1942 another Yeats novel, *Ah Well* was London published, and a play, *La La Noo* was produced at the Abbey Theatre and published in 1943. Controversy continued over his painting, not to mention his writing. In *The Bell* in 1942, Arthur Power (q.v.) wrote: 'Mr Yeats is the most popular artist at present among the intellectuals, and he presents the problem of either being one of the most vital of modern painters, or just being chaotic. I favour the last point of view ...'.

During the 1940s he was producing up to a hundred pictures per year. In 1942, when he contributed to the Gayfield Press's 'Dublin Poets and Artists' series, he was made an honorary member of the United Arts Club. In her article in the *Capuchin Annual*, 1942, Máirin Allen, who called him a romantic realist, noted that he had used colour 'in a way so distinct from the manner of contemporary painters that it is almost possible to say "in this he is unique"'. And it is as a colourist he will make his greatest contribution to the development of painting.'

Yeats was represented in London at the second exhibition, held in Burlington House, of the United Artists in 1942. He contributed nine works to the 'In Theatre Street' show at Contemporary Pictures in 1942. *Two Travellers*, 1943 RHA, was later purchased by the Tate Gallery. Power, in a critique on the 1943 Academy, described him 'a wild romantic'.

Yeats began a close association in 1943 with Victor Waddington Galleries, Dublin, and during the period 1943-55 eight exhibitions were held. Represented at the inaugural showing of the Irish Exhibition of Living Art in 1943, he continued to exhibit at its annual exhibitions; in the opening year he contributed *Farewell*; *The Velvet Strand*; *A Homage to Bret Harte*. The *Dublin Magazine* critic argued in 1943 that his pictures were not, technically, the result of blind chance and this was demonstrated by 'the deplorable results achieved by his imitators'.

In her book, *Modern Art in Ireland*, 1997, Dorothy Walker wrote: 'In 1943 Yeats was entering the sublime phase of his late work; his painting reached that apotheosis which it had been signalling since the late mid-twenties. The elements seemed to have entered the paint: tumultous seas, wild land, colour-streaked skies, and individuals as far removed from the faceless urban masses as it is possible to imagine, anarchic figures captured in archaic paint dragged onto the surface in poetic desperation and loneliness ...'.

On the 1944 IELA exhibition, *Dublin Magazine* commented that Yeats's 'finest achievements as a painter have the appearance of accidents, of pictures seen in the fire, of fortuitous patterns on a wall ...'. The magazine's comment on the RHA that year was: 'At his best in *The Salt Marshes*, a picture painted with Romantic passion of a white horse galloping against a broken landscape of white and pale greens'. *The Grafter*, 1944, found its way to the Aberdeen Art Gallery.

The National Loan Exhibition of Yeats's work, held in 1945 at the National College of Art, Dublin, had an attendance of nearly 20,000 people. The catalogue introduction was written by Earnán O'Malley, who noted: 'As he experiments in technique he reaches a point in mastery where his handling of knife or brush seems to be by instinct'. The show consisted of 168 oil paintings, eleven watercolours. Samuel Beckett loaned a watercolour, *Corner Boys*, and George Bernard Shaw an oil, *Evening Kildare*.

The exhibition was unique in Irish art history, inasmuch as it was the first nation-wide tribute paid in his lifetime to any Irish artist. A rare portrait, that of his wife, appeared in the show. Mrs Yeats told the *Irish Times*: 'I badgered him into it. He doesn't like to paint portraits, because he must be alone when he is painting ...'. Elizabeth Curran, NCA lecturer, wrote in *The Bell*: '... he remains an exceptional "national" figure in painting by reason of his independence of all foreign or decadent tradition ... professes no concern with historical styles and schools ...'. At the 1945 IELA event, he showed *Donnelly's Hollow* and *The Full Tram*.

In 1945 *The Studio* reported the re-opening of the International Art Centre at 3 Orme Square, London. The occasion was celebrated with a show of loaned pictures 'including examples of Cézanne, Picasso, Sickert, John, Jack Yeats and Meninski'. The year 1945 also saw a Yeats exhibition at Goodwin Galleries, Limerick, and the next year he received an invitation to exhibit with the Society of Scottish Artists as special artist. At the Wildenstein Galleries, London, he showed in 1946, and was represented in the Leicester Galleries winter exhibition.

Yeats received an honorary D Litt. from Dublin University in 1946; National University of Ireland followed suit the next year. About this time John Rothenstein, director of the Tate Gallery, visited Dublin and spent some time with the artist. In 1947 his wife died.

Dorothy Blackham (q.v.), who had met Yeats at the home of Sarah Purser, told the author in 1969 that he had actually seen the event which prompted, *The Great Tent Has Collapsed*. The painting was displayed in his exhibition at Victor Waddington Galleries in 1947, publication year of his last novel, *The Careless Flower*.

In the London Group exhibition in 1947 he showed *Now or Never*, and he was represented in the Contemporary Irish Painting exhibition at Associated American Artists' Galleries, New York. There were eighty-four works on view at the 1948 Yeats retrospective at Temple Newsam House, Leeds. The show was then taken over by the Arts Council of Great Britain for presentation at the Tate Gallery, Aberdeen Art Gallery, and the Royal Scottish Academy in Edinburgh. *The Observer* commented: '... the total effect of the exhibition makes one feel momentarily in touch with experience well outside even the common Irish run. And, generally

speaking, it seems to be experience of a heightened and romantic kind, not (as is so often the case in modern painting) a journey across planes at once lunar and Freudian.'

On the exhibition at the Tate Gallery, *Apollo* noted: 'Form almost disappears under the passion for life and movement expressed by thick oil paint slashed on the canvas with brush and palette knife. The result is at first glance disconcertingly chaotic and restless. But Yeats, like Van Gogh, whose passionate temper he shares, somehow has these runaway canvases under an inner control. Out of the rush and speed of form and colour emerges the thing he wants.'

Yeats began retiring to Portobello House nursing home. In 1949 *In Sand* was produced at the Peacock Theatre; and that year he was awarded the Diploma of the Academia Culturale Adriatica, Milan. Jack White in an article in *Art News and Review* in 1949, confirmed a pink paper rose tied to the top of his easel – and seeing the artist wearing a green eyeshade. At the 1949 IELA, he showed *Left-Left* and *We left our Name on the Road, On the Road, On the Famous Road, On the Famous Road of Fame.*

In *Social and Personal*, Edward Sheehy concluded that the 'genius of Yeats lies in the fact that he demands the full collaboration of the spectator. His pictures are worlds to explore, rather than worlds already mapped and conquered.' In 1949 he painted *The Gay Moon* (NGI), presented in 1997 for the Yeats Museum. In 1950 he was invested as Officer of the Legion of Honour at the French Embassy in Dublin. In 1950 too he painted *Queen Maeve walked upon this Strand* (Scottish National Gallery of Modern Art).

On the connection between Yeats and Oskar Kokoschka (1886-1980), the author received in 1973 a letter from Olda Kokoschka at King David Hotel, Jerusalem: 'My husband met Jack B. Yeats through Mr V. Waddington in Dublin round 1950-1. I cannot tell you exactly. We were at his studio and saw many paintings. Yeats was a very correct, charming person. I remember that we went to a regatta together. I think my husband had great sympathy for his work and for the man himself. We read somewhere that Yeats was an influence on Kokoschka. That is not true and would be hardly possible as Kokoschka hardly knew his work before we came to London, just before the war broke out.'

The Institute of Contemporary Art, Boston, organised for 1951-2 a first retrospective American exhibition in collaboration with Phillips Gallery, Washington, DC; M. H. De Young Memorial Museum, San Francisco; Colorado Springs Fine Arts Center, Colorado; Art Gallery of Toronto; District Institute of Arts, Michigan; National Academy of Design, New York. There were thirty-six paintings, of which thirteen were lent by the artist. The introduction to the catalogue noted that Yeats would not allow his paintings to be reproduced, either in colour or black-and-white.

Comments on the American show included: *Christian Science Monitor*: '... he is an expressionist who makes technique an auxiliary of emotion; and who, in holding forth concerning man and his destiny, is really concentrating on one's throbbing responses to human experience – Jack Yeats'.' *Boston Globe*: 'It is a world of imagery, where haunting, lovely color and swirling, often barely suggested form prevail. After a lifetime of painting he has found his own place from which to speak.' *New York Times*: 'His work, let it be said at once, is calculated to bring dismay to the visitor who likes to fit things neatly into categories. Beyond saying that his work is Irish and inevitably romantic, one must conclude that he is a law unto himself.'

Among the largest pictures he ever painted were *Grief* (NGI) and *The Basin in which Pilate Washed His Hands*, both 1 metre by 1.5 metres and in the exhibition at the Victor Waddington Galleries in 1951, defying 'profitable analysis', according to the *Dublin Magazine*.

Represented in the United Nations International Art Exhibition at Edinburgh in 1951, that December, from Portobello House, he sent his personally drawn Christmas card to his friend, C. P. Curran. Another large painting was *Glory*, 1952. Exhibitions in 1953 included Saidenberg Gallery, New York, and Wildenstein's, London, where *The Man on the Wild One waved his hat* was among the twenty-two works. He priced his last exhibit at the RHA, in 1953, *Tales of California Long Ago*, at £2,500; prior to this his dearest work there was £600. *The Explorer Rebuffed*, 1953, is at Huddersfield Art Gallery.

Sponsored by the Irish Department of External Affairs, his first solo show in Paris was in 1954 at Galérie Beaux-Arts. He still exhibited at IELA in Dublin and showed *Grief*, which the *Dublin Magazine* described as 'magnificent and imaginative'. Victor Waddington Galleries held in 1955 the last Yeats exhibition which

the artist attended, and that year he went to live permanently at Portobello House. His last work was probably painted in 1955. CEMA staged his final exhibition in 1956 at the Belfast Museum and Art Gallery.

Altogether in the National Gallery of Ireland there are more than two score works, including the oils, *Flower Girl, Dublin*; *In Memory of Boucicault and Bianconi*; *A Morning in a City*; and *Islandbridge Regatta*, all painted in the 1920s and 1930s. At the Hugh Lane Municipal Gallery of Modern Art there are six oil paintings, including *There is No Night*; six watercolours, including *The Rogue*; and one pen and ink and wash, *An Old Slave*.

Some two score works are in the Model and Niland Centre, Sligo, and of these no fewer than thirteen were presented by James A. Healy, New York, as a memorial to his parents. The Healy gifts included the oil paintings, *Singing 'The Beautiful Picture', 1925*; *The Singing Clown*, 1928; *White Shower*, 1928. Other works in the collection are: *The Island Funeral*, 1923, and *Communicating with Prisoners*, 1924. A drawing of the artist by Sean O' Sullivan (q.v.) and an oil portrait by Estella F. Solomons (q.v.) are also in the Sligo collection.

A portrait of Yeats by James S. Sleator (q.v.) is in the Crawford Municipal Art Gallery, Cork. A portrait by Lilian Davidson (q.v.) is at NGI, where there is also an oil, by his father, of Jack as a boy, and a self-portrait in pencil.

'Nobody could compete with Yeats when he was dealing with Irish life and character,' wrote Anne Crookshank and the Knight of Glin in their 1994 book on Irish watercolours. By the time he had ceased working he had completed some 1,200 oil paintings and 700 drawings. He died in the nursing home on 28 March 1957, and was buried at Mount Jerome Cemetery, Dublin. A memorial panel of his work was displayed at the 1957 RHA. In his will he expressed the wish that no photographs or reproductions of any kind be made or published of any of his paintings or drawings.

In the years after his death there were many exhibitions of his work, several at the Waddington Galleries in London. The following is a short selection: 1961, Sligo Art Society, Town Hall; 1962, Venice Biennale, Irish section, then Municipal Gallery of Modern Art, Dublin; 1962, Willard Gallery, New York; 1963, Sligo County Library and Museum, collections of the late Ernie O' Malley and the Yeats Museum, Sligo; 1964, Arts Council of Northern Ireland: North-West Arts Festival and Belfast May Festival; 1971, National Gallery of Ireland, centenary, attendance exceeded 3,000 in first week; then in part in 1972 to Ulster Museum, followed by New York Cultural Center; 1971, Sligo County Library and Museum, 'Jack B. Yeats and his family', then in 1972 to Municipal Gallery of Modern Art, Dublin, attendance 9,077.

In 1986 NGI organised an exhibition of his works in their collection; 1988, 'Yeats at the Hugh Lane Municipal Gallery of Modern Art'; 1990, Centre de Congrès, Monaco, 'Images in Yeats'; 1991, Arnolfini, Bristol, 'The Late Paintings', then Whitechapel Art Gallery, London, followed by Haags Gemeentemuseum, The Hague; 1996, Manchester City Art Gallery, 'Jack B. Yeats: A Celtic Visionary', then Leeds City Art Gallery; Ormeau Baths Gallery, Belfast.

In 1971 a postage stamp featuring a reproduction of *An Island Man* had been issued in the Contemporary Irish Art series; another stamp commemorating the centenary of Synge's birth was based on stencil portrait by Yeats. *A Little Book of Drawings by Jack B. Yeats,* introduction by Liam Miller, was published by Cuala Press in 1971, and *A Little Book of Bookplates*, introduction by Richard Murdoch, in 1979. Hilary Pyle's catalogue raisonné of the oil paintings appeared in 1992 in three volumes and listed 1194 works, the third volume consisting of illustrations.

In the prologue to his book, *Jack Yeats*, 1998, the most comprehensive biography on the artist, Bruce Arnold wrote: 'Jack Yeats stands as an isolated, giant figure in Irish twentieth-century art. He dominated solely through the talent, magic and inventiveness of his painting. He was a man of calm, self-effacing disposition, witty, elusive, kind, generous, enigmatic. He had an innate originality. His urge was to tell stories. His early drawings were anecdotal. His early paintings were the same. He observed events, read into them the motives and aspirations of the protagonists, and delivered memorable versions of them throughout his life. In later years the "stories" became symbolic; men and their affairs went through an apotheosis into Man and his place in the Universe. His development was towards greater economy, sharper visual shorthand, but never away from the inspiration of some kind of happening which gave each work its life and internal rhythm.

He eschewed all movements, took no pupils, taught only by example. He was modest, restrained, undemonstrative. He conforms to no labelling as a painter.'

NGI's Yeats Museum opened in 1999, offering a permanent display of its Yeats Collection, as well as access to the artist's memorabilia and library, with thirty-four oil paintings. 'Many Horses' was the title of an exhibtion in 2000.

Works signed: Jack B. Yeats, JBY, monogram; Jack, Jack B., Jack B. Y., all rare; or W. Bird, pseudonym.
Examples: Aberdeen: Art Gallery. Baltimore, Maine, USA: The Walters Art Gallery. Bedford: Cecil Higgins Art Gallery. Belfast: Ulster Museum. Birmingham: Museum and Art Gallery. Bloemfontain, South Africa: National Museum. Boston, USA: Boston College, Bapst Library; Museum of Fine Arts. Bristol: Museum and Art Gallery. Cambridge, Mass., USA: Harvard University, Fogg Art Museum. Cleveland, Ohio, USA: Museum of Art. Cork: Crawford Municipal Art Gallery. Dublin: Abbey Theatre; Government Buildings; Hugh Lane Municipal Gallery of Modern Art; Irish Museum of Modern Art; National Gallery of Ireland; National Library of Ireland; Pearse Museum; Trinity College Gallery; United Arts Club. Edinburgh: Scottish National Gallery of Modern Art. Huddersfield: Art Gallery. Kilkenny: Art Gallery Society. Leeds: City Art Gallery. Letterkenny, Co. Donegal: Glebe Gallery, Derek Hill's Collection. Limerick: City Gallery of Art; Hunt Museum. Lisbon: Calouste Gulbenkian Foundation. Liverpool: Walker Art Gallery. London: Tate Gallery; Victoria and Albert Museum. Loughrea, Co. Galway: St Brendan's Cathedral. Madison, USA: University of Wisconsin. Merthyr Tydfil, Glamorgan: Cyfarthfa Castle. Monaco: Princess Grace Irish Library. New York: Public Library, Berg Collection. Ottawa: National Gallery of Canada. Paris: Musée d'Art Moderne. Seattle, Washington: Art Museum. Sligo: Model and Niland Centre. Tel Aviv, Israel: Museum of Art. Toledo, Ohio, USA: Museum of Art. Washington, DC: Phillips Collection; Smithsonian Institution. Waterford: City Hall, Municipal Art Collection. Waterville, Maine, USA: Colby College Museum of Art. Windsor, Berks.: Windsor Castle, Royal Library. York: City Art Gallery.
Literature: General 1880-1950 (see also Books sections): *Slater's Directory*, 1880; *The Studio*, April 1900, December 1901, November 1906, March 1908, August 1914, June 1916 (illustration), March 1917, August 1917, September 1921, May 1927, June 1928, September 1930, October 1932 (illustrations), November 1935, December 1935 (illustration), October 1936, May 1938, December 1939, May 1940, March 1942, February 1945; *A Broad Sheet*, July 1903; *The Celt*, September 1903; *All Ireland Review*, 30 September 1905; *Irish Times*, 2 October 1906, 13 June 1945, 10 August 1948, 3 April 1970, 29 January 1971, 17 August 1971, 6 October 1971, 19 May 1972, 12 October 1994; *Irish Review*, April 1911 (illustrations), September 1912 (illustration), February 1913, April 1913; *The Open Window*, April-September 1911; Stephen Gwynn, *The Famous Cities of Ireland*, Dublin 1915; A. G. Temple, *Guildhall memories*, London 1918; P. L. Dickinson, *The Dublin of Yesterday*, London 1929; *Dublin Magazine*, October-December 1930, January-March 1944, July-September 1944, January-March 1945, July-September 1945, January-March 1952, October-December 1955, July-September 1957; *Irish Book Lover*, November-December 1933, May-June 1936; *Ireland To-Day*, June 1936, May 1937; *Capuchin Annual*, 1940 (illustration), 1942, 1945-46, 1946-47 (illustration), 1968; *Studies*, March 1941, Spring 1962, Summer- Autumn 1977; Gayfield Press, *Padraic Colum*, 1942 (illustration); Joseph Hone, *W. B. Yeats 1865-1939*, London 1942; National Gallery, *Exhibition of Paintings by Sir William Nicholson and Jack B. Yeats*, catalogue, London 1942; *The Bell*, May 1942, June 1943, June 1945; *Time and Tide*, 10 January 1942; *Irish Art Handbook*, Dublin 1943; Runa Press, *Outriders*, Dublin 1943 (illustration); Thomas MacGreevy, *Jack B. Yeats: An Appreciation and an Interpretation*, Dublin 1945 (also illustrations); *Jack B. Yeats National Loan Exhibition*, catalogue, Dublin 1945; *The Observer*, 22 August 1948; *Apollo*, September 1948; *Social and Personal*, August 1949; *Art News and Review*, 22 October 1949;
Literature: General 1951-80 (see also Books sections): *Boston Globe*, 8 April 1951; *Christian Science Monitor*, 9 April 1951; Institute of Contemporary Art, Boston, *Jack B. Yeats: A First Retrospective American Exhibition*, catalogue, 1951; *New York Times*, 6 January 1952; Roger McHugh, ed., *W. B. Yeats Letters to Katharine Tynan*, Dublin 1953; *Will of John Butler Yeats*, 16 November 1955; Department of External Affairs, *Ireland*, 29 April 1957; *Letters from Jack B. Yeats to C. P. Curran*, University College, Dublin, Library [1957]; *Paul Henry Papers*, Trinity College, Dublin, Library [1958]; Waddington Galleries, *Later Works by Jack B. Yeats (1871-1957)*, catalogue, London 1958; Tate Gallery, *Modern British Paintings, Drawings and Sculpture*, London 1964; Alan Price, ed., *J. M. Synge Collected Works*, vol. II, Prose, London 1966 (also illustrations); *Thomas MacGreevy Papers*, Trinity College, Dublin, Library [1967]; *Irish Independent*, 13 December 1971; Roger McHugh, ed., *Jack B. Yeats: A Centenary Gathering*, Dublin 1971; Liam Miller, ed., *A Little Book of Drawings by Jack B. Yeats*, Dublin 1971; William M. Murphy, *The Yeats Family and the Pollexfens of Sligo*, Dublin 1971; National Gallery of Ireland, *Jack B. Yeats 1871-1957: A Centenary Exhibition*, catalogue, Dublin 1971 (also illustrations); Bernard Share, *Irish Lives*, Dublin 1971 (also illustrations); James White, *Jack B. Yeats: Drawings and Paintings*, London 1971 (also illustrations); Anne Yeats, intro., *Broadside Characters*, Dublin 1971 (also illustrations); Robert O'Driscoll and Lorna Edwards, eds., *Yeats Studies*, no. 2, Shannon 1972 (also illustrations); *The Arts Council, Dublin, report April 1, 1972-March 31, 1973*; Lady Gregory, *Sir Hugh Lane: His Life and Legacy*, Gerrards Cross 1973 (also illustration); Liam Miller, *The Dun Emer Press, later the Cuala Press*, Dublin 1973; Cork Rosc, *Irish Art 1900-1950*, catalogue, 1975; *Dictionary of British Artists 1880-1940*, Woodbridge 1976; Richard Murdoch, intro.,

A Little Book of Bookplates, Dalkey 1979; National Gallery of Ireland, *The Abbey Theatre 1904-1979*, catalogue, 1979; Witt Library, London, illustrative records [1979].

Literature: General 1981-2000 (see also Books sections): Martyn Anglesea, *The Royal Ulster Academy of Arts*, Belfast 1981; *Dictionary of British Book Illustrators and Caricaturists 1800-1914*, Woodbridge 1981; Nicola Gordon Bowe, *The Dublin Arts and Crafts Movement 1885-1930*, catalogue, Edinburgh 1985; Hilary Pyle: National Gallery of Ireland, *Jack B. Yeats in The National Gallery of Ireland*, catalogue, Dublin 1986 (also illustrations); Ann M. Stewart, *Royal Hibernian Academy of Arts: Index of Exhibitors 1826-1979*, Dublin 1987; Patricia Boylan, *All Cultivated People: A history of the United Arts Club, Dublin*, Gerrards Cross 1988; Hilary Pyle, *Jack B. Yeats: A biography*, London 1989 (also illustrations); Brian P. Kennedy, *Jack B. Yeats*, Dublin 1991 (also illustrations); S. B. Kennedy, *Irish Art & Modernism 1880-1950*, Belfast 1991 (also illustrations); Sligo County Library, *Catalogue of the Yeats Collection*, Sligo 1991 (also illustrations); Paul Larmour, *The Arts & Crafts Movement in Ireland*, Belfast 1992 (also illustration); Hilary Pyle, *Jack B. Yeats: a Catalogue Raisonné of the oil paintings*, London 1992 (also illustrations); Hilary Pyle, *Jack B. Yeats: His Watercolours, Drawings and Pastels*, Blackrock 1993 (also illustrations); T. G. Rosenthal with Hilary Pyle, *The Art of Jack B. Yeats*, London 1993 (also illustrations); Anne Crookshank and the Knight of Glin, *The Watercolours of Ireland*, London 1994 (also illustrations); Hilary Pyle, *The Different Worlds of Jack B. Yeats: His Cartoons and Illustrations*, Blackrock 1994 (also illustrations); Tel Aviv Museum of Art, *Letter to the author*, 1994; also, Huddersfield Art Gallery, 1995; Royal Academy of Arts, 1995; John Turpin, *A School of Art in Dublin since the Eighteenth Century*, Dublin 1995; National Gallery of Ireland, *Letter to the author*, 1996; also, Westminster Reference Library, 1996; National Gallery of Ireland, *The Yeats Network*, Sept./Nov. 1997, Spring 1999; Hilary Pyle, *Yeats: Portrait of an artistic family*, London 1997 (illustrations); Ann M. Stewart, *Irish Art Societies and Sketching Clubs: Index of Exhibitors 1870-1980*, Dublin 1997; Dorothy Walker, *Modern Art in Ireland*, Dublin 1997 (also illustrations); Bruce Arnold, *Jack Yeats*, New Haven and London 1998 (also illustrations); National Gallery of Ireland, *Gallery News*, September-November 2000.

Literature: Books, written and illustrated by Jack B. Yeats; London published except where stated: *James Flaunty or The Terror of the Western Seas*, 1901; *The Scourge of the Gulph*, 1903; *The Treasure of the Garden*, 1903; *The Bosun and the Bob-tailed Comet*, 1904; *A Little Fleet*, 1909; *Life in the West of Ireland*, Dublin 1912; *Modern Aspects of Irish Art*, Dublin 1922; *Apparitions*, 1933; *Sailing, Sailing Swiftly*, 1933; *Three Plays: Apparitions, The Old Sea Road, Rattle*, 1933; *Ah Well: A Romance in Perpetuity*, 1942; *And to You Also*, 1944; *The Careless Flower*, 1947, jacket; *In Sand*, Dublin 1964.

Literature: Books, by other authors and illustrated by Jack B. Yeats; London published except where stated: Ernest Rhys, *The Great Cockney Tragedy*, 1891; W. B. Yeats, *Irish Fairy Tales*, 1892; Norma Borthwick, *Ceacta beaga Gaedhilge*, Dublin 1902; S. L. McIntosh, *The Last Forward and other stories*, 1902; Gerald Griffin, *The Collegians*, 1904; Grace Rhys, *The Prince of Lisnover*, 1904; G. W. Russell, ed., *New Songs*, Dublin 1904; John Masefield, *A Mainsail Haul*, 1905; J. H. Reynolds, *The Fancy*, 1905; J. M. Synge, *The Aran Islands*, 1907; Séamus O'Beirn, *Páistidheacht*, Dublin [1910]; Norma Borthwick, *Ceachda beoga Gäluingi*, Dublin 1911, II -Dublin 1920; Ernest Marriott, *Jack B. Yeats. Being a true impartial view of his pictorial & dramatic art, etc.*, 1911; John M. Synge, *In Wicklow, West Kerry and Connemara*, Dublin 1911; Robert Lynd, *Rambles in Ireland*, 1912; Susan L. Mitchell, *Frankincense and Myrrh*, Dundrum 1912; George A. Birmingham, *Irishmen All*, 1913; Padraic Colum, *A Boy in Eirinn*, New York 1913; H. Percy Kelly, *Lessoonyn beggey Gailckagh*, Douglas 1914; W. B. Yeats, *Reveries over Childhood & Youth*, 1916; Oliver St John Gogarty, *The Ship and Other Poems*, Dublin 1918; Seumas O'Kelly, *Ranns and Ballads*, Dublin 1918; Katherine MacCormack, ed., *The Book of Saint Ultan*, Dublin 1920; Seumas O'Kelly, *The Weaver's Grave*, Dublin [1922]; Padraic Colum, *The Big Tree of Bunlahy*, New York 1933; Patricia Lynch, *The Turf-Cutter's Donkey*, 1934; G. C. Duggan, *The Stage Irishman*, Dublin 1937; Máirín ní Criagáin, *Sean-Eoin*, Dublin 1938; A. S. Davies, *The Ballads of Montgomeryshire*, Welshpool 1938; W. B. Yeats, *On the Boiler*, Dublin 1939; Frank O'Connor, trs., *A Lament for Art O'Leary*, Dublin 1940; Thomas Bodkin, *My Uncle Frank*, London 1941.

YEATS, JOHN BUTLER, RHA (1839-1922), portrait painter and illustrator. Born on 16 March 1839 at Tullylish, near Laurencetown, Co. Down, he was the son of the Rev. William Butler Yeats, Church of Ireland rector. His grandfather, the Rev. John Yeats, was also a rector, of Drumcliff, Co. Sligo. As a child, according to Thomas Bodkin, 'he showed an instinctive taste and aptitude for graphic art, and was addicted to desultory drawing on old scraps of paper, whitewashed walls, or whatever came readiest to his hands'.

As there were no boys' schools anywhere within reach, he was taught to read by a village schoolmaster, and also received tuition from his father – 'to be with him was to be caught up into a web of delicious visionary hopefulness His charm to me was his voracious intellect.'

In 1849 J. B. Yeats was sent to a 'boarding academy' at the tiny provincial resort of Seaforth, near Liverpool, run by Misses Elizabeth and Emma Davenport. After two years there he was moved to Athol Academy, Douglas, Isle of Man, a private school run by William Forrester, MA, a Scotsman with a solid

faith in flogging. At Athol, he formed a strong friendship with George Pollexfen, the son of a shipowner and miller from Sligo town, and whose sister he afterwards married.

In December 1857 he entered Trinity College, Dublin, where he read classics, metaphysics and logic. He became acquainted with J. S. Mill's works, and more than a century later an Irish second-hand bookseller advertised a copy of *Principals of Political Economy* which belonged to J. B. Yeats at Sandymount, Dublin, 1861. The publication contained approximately one hundred pen and ink or pencil sketches. He graduated from Trinity in 1862, and then won a £10 prize in political economy. Determined to become a barrister, he enrolled at King's Inns. His father died in 1862 and he inherited a small estate in Co. Kildare.

In 1863 he married Susan Pollexfen; they lived at 5 Sandymount Avenue, Dublin, and William Butler Yeats, the future poet, was born there in 1865. Admitted to the Bar in 1866, the father sketched in Court; a drawing of Judge James Whiteside, 1866, is in the National Gallery of Ireland. His friends in Dublin included Edward Dowden, professor of English Literature at TCD, and Isaac Butt, barrister and politician.

In 1867 he abandoned Dublin for London, law for art, finding a house at 23 Fitzroy Road. Some of his sketches were accepted for the magazine *Fun*. He enrolled at Heatherley's Academy where a fellow art student was Samuel Butler (1836-1902), later of *The Way of All Flesh* renown. According to W. M. Murphy in his monumental biography, *Prodigal Father*, J. B. Yeats in his art activity received encouragement in London from Dublin-born sculptor, J. H. Foley, RA, RHA (1818-74), and Richard ('Dicky') Doyle (1824-83) of *Punch*.

Elizabeth Corbet Yeats (q.v.), one of his two daughters, was born in 1868, a year that saw him visit the studio of the Pre-Raphaelite painter, portraitist, and illustrator, Frederick Sandys (1829-1904), who praised his pictures 'very warmly'. Susan took little interest in his painting, but there was not the money coming in to enthuse her, and his Irish property was deteriorating in value.

In 1869 the Heatherley students developed an informal association called 'the Brotherhood'. In that year he managed a visit to the Antwerp galleries with John Dowden, a TCD friend. Also in 1869 he decided to share a studio with Edwin Ellis (1841-95) at 74 Newman Street, near that of another friend, John Nettleship (1841-1902). The studio, an expensive luxury, lasted less than a year. His father-in-law assisted him from time to time with loans.

In 1870 he received a commission for £10 for a drawing: *Pippa Passes* (National Gallery of Ireland) in charcoal, hung at Dudley Gallery, London, early in 1871. Dante Gabriel Rossetti (1828-82) seldom attended picture exhibitions, according to J. B. Y., but by rare chance he went to Dudley and 'saw there a picture of mine which he liked so much that he sent to me by three messengers, one of whom was his brother, an invitation to come and see him. I did not come. I regret it very much.' Robert Browning, author of the 'Pippa' poem, was pleased with the design. After the work was displayed, the artist retrieved it and worked at it again, completing two years after commissioning.

Jack B. Yeats (q.v.), his famous painting son, was born in 1871. Father had moved from Heatherley's to the Slade School of Fine Art. Edward Poynter (1836-1919) accepted him for the Royal Academy Schools. George Wilson (1848-90), Neo-Pre-Raphaelite, lived with him. Susan and family had gone to Sligo. In London his conversational gifts enabled him to enter circles both of writers and painters. Other painting acquaintances were Sydney Hall (1842-1922) and the Hon. John Collier (1850-1934).

Frank Huddlestone Potter (1845-87), according to Thomas Bodkin, was another of Yeats's fellow workers and a 'greatly talented painter who died of neglect and starvation'. Yeats wrote a touching note of 200 words on Potter for the National Gallery catalogue. He began: 'He was the most attractive man I ever met, the most gentle and meekest of men, and yet no art school could have made or marred him; neither in art nor in anything else could the gates of Hell have prevailed against him ...'. *Little Dormouse*, Potter's last and best picture, hung for years in Yeats's house, according to Bodkin, before a purchaser was found. It is now in the Tate Gallery.

By 1872 he had secured just a few commissions in Ireland and London for portraits, one from the Herberts of Muckross, where he began painting, in 1873, a young bride when he was called to Sligo by the death of his son, Robert. As the girl ran away from her husband immediately afterwards, the portrait was not wanted by the family. The artist had not the heart to ask for payment.

In 1874 the Yeats family settled again in London, at 14 Edith Villas, West Kensington. The father painted occasionally at Burnham Beeches, near Slough, with some friends. In 1875 he joined the Dublin Sketching Club. In London, Nettleship thought him 'pigheaded', considering that he would never be any good 'as long as he has the lust of perfection so strongly in him'. At the DSC exhibition in 1876 he showed a portrait of Dr Todhunter and an unfinished portrait of Edward Dowden.

A charcoal portrait of Isaac Butt, MP, which he worked at in 1876, is now in the National Gallery of Ireland. Despite the sale of a house in Dublin, his financial situation remained precarious. He shared a studio for a while with Tristram Ellis (1844-1922), and in 1879, giving the address 7 Holland Park Road, he showed a portrait, *Nieta*, at the Royal Academy. In 1879 too the family moved to 8 Woodstock Road, Bedford Park. He still travelled to Dublin.

J. B. Y. first exhibited at the Royal Hibernian Academy in 1880, c/o Professor Dowden, TCD, and from then until 1908 showed eighty-five works; about one sixth were non-portraits. In 1880 he exhibited four pictures, and in 1881 he gave the address of his Dublin lodgings, 90 Lower Gardiner Street, showing six works, including portraits of George FitzGerald, FTCD, and the Rt. Hon. Lord Justice Fitzgibbon. His studio was at 44 York Street.

Towards the end of 1881 he moved his family to 'Balscadden Cottage' in Howth, Co. Dublin, changing after a few months to 'Island View'. In 1882 he executed a series of drawings of the Phoenix Park murder trials. The family moved from Howth in 1883 to 10 Ashfield Terrace, Terenure, and he found a new studio at 7 St Stephen's Green, expressing the view at about this time that the weakness in his character was a distrust of any kind of personal success.

A member of the Contemporary Club, Lincoln Chambers, Dublin, he spent his time there talking on art, literature and philosophy when he was not busily sketching. His pencil drawings of members and visitors hung in the club as well as a portrait in oils of John O'Leary.

Correspondence from Dublin and London included letters to Sarah Purser (q.v.). Following his 1884 portrait of the Vice-Provost of Trinity College, Sir Andrew Searle Hart, LL D, he earned fifteen guineas from the College in 1885 for a copy portrait of the 1st Earl of Mornington. Among his seven works at the 1884 DSC exhibition were *Apathy* and *Playing Truant*. Ten works were hung in 1885, including *La Parisienne in Dublin*.

A portrait of his fellow artist, J. B. S. MacIlwaine (q.v.) appeared at the 1885 RHA. In writing about *The Bird Market*, 1886 RHA, 'an exquisitely wistful one of street children', Bodkin also noted that it made many regret his devotion to portraiture. J. B. Y. left Dublin for London in 1886, and resided at 58 Eardley Crescent, South Kensington. He supplied in 1886 a portrait of his son for *Mosada*, a dramatic poem by W. B. Yeats, published in book form.

In 1887 he moved his family to London, and they lived at 3 Blenheim Road, in Bedford Park, a haven for artists, poets, and intellectuals. Among those who resided there contemporaneously with the Irish artist were the painters Lucien Pissarro (1863-1944), T. M. Rooke (1842-1942), George C. Harté (1855-1924) and Henry M. Paget (1856-1936), the writers John Todhunter and Edwin Ellis, the scholars F. York Powell and Oliver Elton, also the publisher, Charles Elkin Mathews. Yeats joined the club, the Calumet, a talking society at members' homes in the 'Aesthetic Suburb'.

Among his six portraits at the 1887 RHA was one of the writer, Katharine Tynan (Hugh Lane Municipal Gallery of Modern Art), who was of the opinion that he could have become a kind of 'court painter to the Dublin establishment', but he resisted. Also at the 1887 Academy was a portrait of Ethel Hart, whom he considered his most difficult subject 'because she was an enigma to herself and to me that she tantalised me, being, as she was, just between girlhood and womanhood. I lived in that house many days, perpetually failing and perpetually hopeful.' In 1887 he was appointed ARHA, and that year he showed his second and only other picture at the Royal Academy, *Going to their work*.

Mainly dependent on what his son W. B. Yeats called 'stray drawings', on at least one occasion he had not enough money in the house to buy food. Some unsigned drawings, which were engraved on wood, appeared in *Good Words* and *The Leisure Hour*. In 1891, as in 1887, he showed a John O'Leary portrait at the RHA. *Stolen away by Fairies* was exhibited at the 1892 RHA, the year he was promoted to full

membership; and he illustrated Standish O'Grady's *Finn and His Companions*. In 1892 he showed *King Goll* with the Dublin Art Club. He provided the frontispiece, *The Last Gleeman*, for W. B. Yeats's *The Celtic Twilight*, 1893.

According to J. B. Y., from 1890 to 1897 he never touched a paint brush, but his portrait of Acheson T. Henderson, QC (Ulster Museum) of Dunlamph, Co. Derry, was dated 1891. His most important commission for illustrations was for a sixteen-volume edition of Defoe's work published in 1895 by Dent. In Bodkin's opinion the wash drawings reproduced in photogravure were 'full of insight into the author and his characters. They do, unlike most so-called illustrations, illuminate the text, and give the reader a feeling that they were made with great gusto and sympathetic understanding.' Of five volumes examined in Dublin, there were three illustrations in each. Twenty-five illustrations to Defoe's *Romances and Narratives* are at NGI.

A drawing of Douglas Hyde (NGI), president of the Gaelic League, was dated 1895, and in 1896 he supplied drawings for the Tract Society and the *Pall Mall Magazine* accepted a drawing.

Anne Crookshank and the Knight of Glin in *The Watercolours of Ireland*, 1994, wrote: 'It seems to us that Whistler, who lived in France for many years but later settled in London, was the most important influence. The lithograph of Mallarmé of 1893 by Whistler, for instance, has obvious links with J. B. Yeats's *Self Portrait* of two years later. Yeats's *A Woman Dozing* is also a Whistlerian study.'

In 1897 he provided six illustrations for W. B. Yeats's *The Secret Rose*, and a set of eighteen drawings appeared in *The Leisure Hour* to illustrate a story by Frederick Langbridge, published later in the year under the title *The Dreams of Dania*, with four of the drawings. He had now been working on and off for a year and a half on a portrait of his daughter, Lily.

Returning to Dublin in 1898, he hoped to find work. Disheartened, he wrote to Lady Gregory: 'It is difficult to get portraits to do. In Dublin curiously they have an appetite for posthumous portraits done from photos – a ghoulish and horrible industry, corrupting to him that does it and to him on whose walls the monstrosity is hung. I myself have done many ...'. His lodgings were at 18 Hume Street.

In order to occupy him for a while, Lady Gregory asked him to make some pencil drawings of her 'best countrymen', his own two sons and Douglas Hyde, Edward Martyn, Horace Plunkett, J. M. Synge, George Russell and Standish O'Grady. Then, recounted Lady Gregory in her biography of Hugh Lane, 'he was asked to paint a portrait subscribed for by friends of Standish O'Grady'. This work is in the Municipal Gallery.

J. B. Y. taught, in a school run by May Manning (q.v.), a class of young people, among them Clare Marsh (q.v.), a painter who became almost like a daughter to him. They corresponded, and she visited New York when he lived there.

Some of his spare time was spent drawing his family. On Willie's birthday in 1898 he sketched him at the home of George Russell (q.v.); at Birmingham City Museum and Art Gallery there is a drawing in pencil dated 1899 of 'W. B'. At the end of 1898 he had told his son that he had wasted the autumn doing two large portraits 'for which I got nothing'. In 1899 he worked on a £21 portrait of Mrs Clement Shorter.

In an 1899 letter to W. B. Yeats he advised his son that his portrait of Ashe King (Waterford Municipal Art Collection), a novelist, was done and finished in two mornings and was a 'vivid success!'. That work and a portrait of Nannie Smith, both at the 1900 RHA, were praised by his fellow artist, P. Vincent Duffy (q.v.).

Early in 1900 his ailing wife had died at Blenheim Road. In that year he completed oil paintings of Rosa Butt, daughter of Isaac Butt, and W. B. Yeats; both works are in the National Gallery of Ireland. He also painted the author, Susan Mitchell, who was staying at this time with the Yeats family in London.

Portraits were now a regular occupation with those in pencil usually done at a single sitting and not easy to revise. Through an Irish Land Commission settlement, he was able to visit Paris for a week in 1900. Although there was little evidence of an upturn in his financial affairs, an important portrait gallery was in the making. In the summer of 1900 he stayed in a Devonshire farmhouse beside his son Jack's house and painted in his studio. In the period 1901-08 all his contributions to the RHA were portraits, thirty-six in all, but the portraits which he sent to the Royal Academy in 1901 were rejected.

Sarah Purser organised an exhibition in 1901 of the works of Nathaniel Hone (q.v.) and J. B. Y. at the Royal Society of Antiquaries of Ireland at 6 St Stephen's Green. Yeats showed forty-four items. As there

were twenty-one separate sketches in the two frames lent by the Contemporary Club, sixty-three of his works were actually on display, including *The Village Blacksmith*; *Dressing Dolls*; *Playing Cards*; *Street Children Dancing*; and *In a Gondola*. There were of course portraits and sketches with many familiar names. York Powell, Lily Gordon and George Coffey were also represented. In the Contemporary Club frames, pencil sketches included Mohini Chatterji, Professor Sullivan of Cork College, W. T. Stead of the *Pall Mall Gazette*, Arthur Perceval Graves and William Morris (1834-96).

In his catalogue appreciation for that Dublin exhibition, F. York Powell of Christ Church, Oxford, wrote: 'The inspiration of Mr Yeats's art is sympathy. He cares much about what he is doing, and how he is doing it, but he cares greatly for the thing itself that he is translating into form and colour. A person, a thing, must appeal to his feeling, as well as to his intellect, before he can care enough about it to make it the subject of his brush His work is never trivial, never commonplace; his aim is always high; he seeks to express what is really worth expressing There is in Mr Yeats a mystic element, and in his very portraits he must satisfy his own craving for the spiritual You cannot mistake his work for any other man's ...'.

George Coffey, in his review of the 1901 exhibition in the *Daily Express*, compared Yeats to an Old Master, Rembrandt. He wrote enthusiastically of a portrait of John O'Leary: 'probably the finest portrait painted by an Irish artist in recent years', indeed 'a great portrait'. The critic for the *Irish Times* saw that Yeats had begun as a pre-Raphaelite who found that the school was against 'his natural direction'. *The Studio* said that he had 'stamped his individuality upon his work in such a manner as to give it a certain distinction, a quality of uniqueness ...'. Bodkin described the exhibition 'a success, but did not alter to an appreciable extent the deadly apathy of Dublin to both of these distinguished artists'. J. B. Y. arranged lodgings at 86 Lower Leeson Street.

As he often did not confine himself to one portrait per person, there must be some confusion over provenances. Within a matter of weeks in 1901, for example, there were two drawings of William Kirkpatrick Magee ('John Eglinton'), both now at NGI, and a third was recorded for 1905. In the period 1901-05 he executed at least three pencil drawings of George Moore, one now in the Berg Collection, New York Public Library, and at NGI is an oil painting. In 1903-04 he produced two pencil drawings of W. B. Yeats. He painted several portraits of John O'Leary.

The Hone-Yeats exhibition attracted the notice of a New York lawyer, John Quinn, who wrote to J. B. Y. asking if he might buy certain portraits. The consequence was that Quinn purchased a number of finished works, including a W. B. Yeats portrait, and commissioned others, for twenty pounds each, of John O'Leary, Douglas Hyde and George Russell. In 1902 the Yeats sisters and their father moved from London to 'Gurteen Dhas', Dundrum, Co. Dublin, and that year he had a story published in the *Irish Homestead*. Borrowing money, however, was still necessary.

Hugh Lane, a successful art dealer and an admirer of the work by Hone and Yeats in the Dublin exhibition, conceived the idea of commissioning Yeats to paint a series of portraits of distinguished Irishmen for presentation to the Nation, and in 1903 talked the hesitant painter into accepting the commissions. In the event, he painted portraits of Sir Horace Plunkett, Edward Dowden, J. M. Synge, W. B. Yeats and W.G. Fay, but as he found it almost unbearable to work to a timetable, the series, as projected by Lane, was never completed, much to the latter's annoyance.

Oil paintings of Frank Fay and his brother Willie are in the Abbey Theatre, the actresses Máire Nic Shiubhlaigh and Maire O'Neill are also represented, and there is a 1904 portrait of Miss A. E. F. Horniman. W. G. Fay recorded his recollections of having his portrait painted: 'He was a peculiarly restless worker. He walked back and forward all the time, only halting now and again to use a tiny mirror from his pocket to see by the reflection how the picture was getting on. Also he talked all the time, and it was the most entertaining talk I have ever listened to.' An oil portrait of Máire Nic Shiubhlaigh is also at NGI.

Writing in 1903 in *The Celt*, Evelyn Gleeson (q.v.) referred to his 'worthy portraiture of contemporary Irishmen', and added: 'He has a sympathy and insight to which his brush responds. His work will live and be one of the nation's treasures in years to come.' In 1903 at the RHA he gave his address as 43 Harrington Street, but after the death of Walter Osborne (q.v.) he took over his studio at 7 St Stephen's Green, and still had to appeal to his poet son for financial assistance.

The Studio found his portrait of George Russell (NGI) at the 1903 RHA 'as poetic as the original. It might be described as the portrait of a poet by a poet, so admirably has the artist succeeded in transferring to his canvas the idealism of the sitter.'

Padraic Colum, the writer, recounted later that he had given J. B. Y. at least thirty sittings for his own portrait, and that in those days he received twenty pounds for a portrait. Lady Gregory, who was painted by him in 1903, said he charged £25 for a half length. 'Those sittings', wrote Colum, 'placed me in a world of learning – not learning as the professors retailed it, but learning as men of imagination, reflection and achievement understood it ...'.

In 1904 Hugh Lane arranged an exhibition of works by Irish painters at the Guildhall of the Corporation of London. Yeats attended the exhibition and had ten works on view, including *The Bird Market* (HLMGMA), *In a Gondola* and portraits of Isaac Butt, Lady Gregory, John O'Leary and Mrs H. Melville Smith. Charles Shannon (1863-1937) wrote to Lady Gregory saying that he admired J. B. Y.'s work, the painter having 'great powers of characterization and also great technical gifts in the rendering of faces; a very rare quality indeed ...'. When Lane held an exhibition of paintings at the RHA later in the year, J. B. Y. was one of the lecturers.

Writing about this period in his *The Dublin of Yesterday*, P. L. Dickenson described the artist as a first-rate portrait painter and a charming and striking personality: 'With his erect carriage, flashing dark eyes, and white hair and beard, he caught one's attention at once in a roomful of people, and when he spoke, the musical quality of his voice gripped one. I recollect hearing his lecture on Turner on one occasion, when he spoke for over an hour without notes, and held his audience spellbound throughout the whole of the time he was on the platform. No slight feat ...'.

In the period 1903-06 his pencil studies included those of Padraic Colum, Frank Fay, W. G. Fay, Dr C. E. FitzGerald, Annie Horniman (two), Helen S. Laird, Hugh Lane, George Russell, J. M. Synge and Mary Walker. His oil painting of John O'Leary, 1904, is at NGI. At a price of £10, he copied in 1906 for Trinity College, Dublin, a portrait of John Stearne, DD., belonging to the Diocese of Clogher. He showed a portrait of Synge at the 1906 Oireachtas exhibition, and Contemporary Club drawings in 1907.

At an exhibition in 1907 in honour of George F. Watts (1817-1904) at the Academy premises, he delivered a lecture on Watts in which he said: 'He was the greatest figure-painter England has ever produced ... Years ago, by a happy accident, I met him in my studio. I remember his handsome face and a certain air, as it seemed to me, of imperious detachment; in his voice also there was a touch of austerity....'

When *The Playboy of the Western World* roused bitter controversy in Dublin in 1907, he defended Synge at a public meeting. Quinn in New York commissioned an oil painting of W. B. Yeats for £30, but J. B. Y. still remained in debt to a number of Dublin creditors. Money collected by his friends to give him a holiday in Italy he used for sailing to New York with his daughter Lily in December. Lily was going to the United States for a few weeks to show her embroideries at an exhibition in Madison Square Garden.

Yeats's daughter duly returned to Ireland but only after an extended stay. Her father remained in the USA for the rest of his life, spending his time talking, lecturing, painting, writing letters (particularly to Lily) and articles for magazines, such as *Harper's Weekly*. He was, however, convinced from the time he arrived in New York that fortune awaited him there. It began at Grand Union Hotel where he and Lily were guests of Mrs Julia Ford.

After several shifts, he moved in 1909 to a boarding- house at 317 West Twenty-ninth Street run by three Breton sisters name Petitpas. According to Padraic Colum, intellectuals went to Petitpas' to have dinner at Yeats's table, and to talk to him, or rather have him talk to them. He often brought his sketch book to the table. A warm friendship developed between him and the painter John Sloan (1871-1951), who was related to John Ward (q.v.) of Belfast. Sloan painted in 1910 *Yeats at Petitpas*, showing his friends around the table, now in the Corcoran Gallery of Art, Washington, DC. A pencil drawing of the sisters by Yeats is at Delaware Art Museum.

Another artist among his circle of friends was Robert Henri (1865-1929), painter-teacher, a close friend of Sloan and someone who also had links with Ireland. But it was largely through the efforts of Quinn, who commissioned and obtained other work, that Yeats was able to stay on in New York. His pencil drawing of Sloan is in the Hirshhorn Museum and Sculpture Garden, Smithsonian Institution. Another acquaintance of

J. B. Y.'s was the essayist and literary critic, Van Wyck Brooks, and a pastel portrait of the writer forms the frontispiece of Brooks's *An Autobiography*, 1965.

Largely at the instigation of Henri and Sloan, the Exhibition of Independent Artists took place in 1910. Yeats contributed two oils, the portrait of O'Leary lent by Quinn and a self-portrait, also seven drawings including one of J. M. Synge, who had recently died.

On 3 February 1911, eleven years to the day before J. B. Y.'s death, Quinn commissioned a self-portrait in oils, for which he would pay whatever the artist asked. As William M. Murphy wrote in his biography, *Prodigal Father*: 'The history of the portrait is one of the most fascinating and amusing in the annals of art ...When its creator died in 1922 it stood unfinished on the easel.'

Quinn also gave him a commission for drawings of eight Abbey Theatre players. Linen handkerchiefs sold for one dollar each to raise funds for a building to house Hugh Lane's pictures in Dublin, and the eight Abbey players were reproduced on the handkerchiefs from the pencil sketches: Top row: Arthur Sinclair, Sara Allgood, Eithne Magee, Sydney J. Morgan. Bottom row: J. A. O'Rourke, J. M. Kerrigan, Udolphus Wright, Fred O'Donovan.

By 1913 he was living mostly by writing, still could not make ends meet, and he was in debt to the Petitpas sisters. He still expressed an opinion on art matters and in 1913 wrote to W. B. Yeats: 'Matisse to my mind is an artistic humbug, though probably an honest man ... wisdom has no chance with clever folly.'

In 1914 Mary and Padraic Colum, at their apartment, Beekman Place, New York, introduced Sunday evening gatherings which Yeats attended; he also called on other days. Among the Sunday visitors was Marcel Duchamp (1887-1968), who sprang into notoriety with his *Nude descending a Staircase* at the Armory Show, in New York in 1913 which J. B. Y. had attended. Mary Colum wrote in her autobiography that Yeats had 'a dingy room with an iron bed, a cheap worn rug, and an easel on which was always erected a portrait at which he tinkered day after day....'

Quinn purchased many of W. B. Yeats's manuscripts, beginning in 1914; some of the proceeds were to support his father, who wrote to Willie in 1915 that Quinn had rescued him again. Because of its high standard, he received fifty dollars instead of thirty-five from Knoedler's Gallery for his introduction to an exhibition of Whistler's works. In a later letter to Willie, he said that when Whistler painted his mother, 'an intense filial feeling was part of his subjectivity, and the result is a work of art which is a most vivid portrait of that old lady who, I know, could by a look terrify all the pretty models that came to her son's studio, one of them told me so.'

Although knocked down by a car early in 1915, he recovered. George Bellows (1882-1925) was a student of Henri's who had settled in New York. In 1916 he executed a lithograph, *Artists' Evening*, which showed Yeats, Henri and Bellows himself standing talking in the crowded Petitpas's dining-room. In addition to his lectures, sketches, portrait commissions, magazine articles, writing his memoirs, J. B. Y. gave public readings of his poet-son's writings.

Quinn still tried to persuade him to return to Dublin. Inroads in the debt at Petitpas's were minimal. *Passages from the Letters of John Butler Yeats* was published by *Cuala Press* in 1917, the year he was seriously ill with influenza and pneumonia and was cared for by the writer, Jeanne Robert Foster, of whom he did a portrait sketch. The next book was *Essays Irish and American* published by Talbot Press, Dublin, 1918, followed by another from his daughter's Press, *Further Letters of John Butler Yeats*, 1920.

In his Appreciation in *Essays Irish and American*, George Russell wrote: 'I admire Mr John Yeats as an artist as much as any, but I feel that nature's best gift to him was a humanity which delights in the humanity of others. Few artists I think found it more easy to be interested in the people they met or painted. All his portraits, whether of men or women, seem touched with affection....' In 1919 he made 200 dollars lecturing, and was given his largest single commission since arrival in New York: 400 dollars for the portrait of a long-dead judge. There was now money to settle his long-overdue bill for room and board.

In 1921 he wrote to Quinn: 'What I have most dallied over these several months is my own portrait, not for your benefit but to gratify my own vanity and love of fame (chiefly posthumous). I have been doing my very best. Some days I am on the pinnacles of hope and confidence, and then down in the valley of

despondency. It fills my life....' As for his total completed canvases in his career, one estimate was about seventy; his drawings ran into hundreds.

Among the oil paintings at NGI are portraits of Augusta Gregory, Dr Douglas Hyde, Standish James O'Grady, John O'Leary, George Russell, W. B. Yeats and a self-portrait. Among almost three score drawings, the vast majority in pencil, are portraits of W. G. Fay, Alfred Perceval Graves, Hugh Lane, Maud Gonne MacBride (q.v., Maud Gonne), Edward Martyn, John Millington Synge and Jack B. Yeats.

Another oil portrait of O'Leary is at South Tipperary County Museum and Art Gallery. A self-portrait in oils is at the Model and Niland Centre, Sligo, and among the drawings are those of Antonio Mancini (1852-1930) and Kuno Meyer. There is an unfinished oil portrait of John Redmond at Crawford Municipal Art Gallery, Cork.

According to Lady Gregory in her biography of Hugh Lane, the portraits which Lane presented to the Municipal Gallery of Modern Art were: Edward Dowden, W. G. Fay, Sir Horace Plunkett, J. M. Synge and W. B. Yeats. The collection also includes a portrait of Dr Douglas Hyde. Also in Dublin, at the National Library of Ireland, are twenty-six works, all pencil drawings except one pen and ink of Isaac Butt and a watercolour self-portrait. There are four drawings of his wife, Susan Mary, three of W. B. Yeats, two of Lily Yeats, and one each of Elizabeth and Jack B. Yeats.

At the Dublin Writers' Museum are portraits of Lady Gregory and Edward Martyn. The Dublin Civic Museum has a pencil drawing of George Russell. At King's Inns, in addition to an oil self-portrait, are pencil sketches of Richard Armstrong, Under-Treasurer, and the Chief Baron, Christopher Palles, in a train, 1906. At the Abbey Theatre there are pencil drawings of Padraic Colum, Lady Gregory, Annie Horniman and J. M. Synge.

Among the portraits in oils of Lord Mayors at the Mansion House is one of Councillor T. C. Harrington. A pencil portrait of Sarah Purser is at Limerick City Gallery of Art. At the Naval Base, Haulbowline, Cobh, is an oil painting of W. B. Yeats, presented by Michael Yeats in 1948 to the captain and crew of *Macha*, the vessel which had carried his father's body back to Ireland.

In the National Portrait Gallery, London, works on Isaac Butt and a self-portrait are both described as in chalk. Oil self-portraits are in two USA colleges, Northwestern University and at Hood Museum of Art, Dartmouth College. The work at Dartmouth bears the title *Self-Portrait 'seeing through the Glass Darkly'*, and was the gift of N. R. Petitpas. The Ashmolean Museum, Oxford, has a 1903 oil painting, *Portrait of Miss Margaret Grierson*, presented by Mary Swanzy (q.v.).

After Yeats's death on 3 February 1922, a death mask was taken by Edmond T. Quinn (q.v.). The service at the Church of the Holy Apostle attracted 250 people, and he was buried in the Foster family plot in the Rural Cemetery in Chestertown, New York, in the Adirondacks. Mrs Foster's grave is next to his. The inscription on the stone described him as painter and writer. The unfinished self-portrait was forwarded by Quinn to W. B. Yeats.

In 1923 *Cuala Press* published *Early Memories: Some Chapters of Autobiography*. In an article in the *Dublin Magazine* in 1941, Joseph Hone wrote: 'It has been generally accepted in his own country that J. B. Yeats missed being a great artist, but there are those elsewhere who place him in the highest rank'. He recalled that Henry Lamb, RA (1883-1960) had written to him: 'From the very first I considered him by far the greatest artist Ireland has produced ... But you know A. John shares my opinion, and he has seen many more in America ...'. In 1944 Hone edited *J. B. Yeats: Letters to his son W. B. Yeats and others 1869-1922*.

In 1972, to mark the fiftieth anniversary of the artist's death, the National Gallery of Ireland held an exhibition of paintings and drawings, totalling about 150, from the collection of Senator Michael B. Yeats and the NGI. The Yeats Museum there opened in 1999 and among the twenty-six oil paintings by him was an unfinished self-portrait acquired by NGI in 1997.

Works signed: J. B. Yeats or J. B. Y.
Examples: Belfast: Ulster Museum. Birmingham: City Museum and Art Gallery. Clonmel: South Tipperary County Museum and Art Gallery. Cobh, Co. Cork: Naval Base, Haulbowline. Cork: Crawford Municipal Art Gallery. Delaware, USA: Art Museum. Dublin: Abbey Theatre; Civic Museum; Dublin Writers' Museum; Hugh Lane Municipal Gallery of Modern Art; King's Inns; Mansion House; National Gallery of Ireland; Royal College of Physicians of Ireland; Trinity

College. Evanston, Illinois, USA: Northwestern University. Hanover, New Hampshire, USA: Dartmouth College, Hood Museum of Art. Limerick: City Gallery of Art. London: National Portrait Gallery; Victoria and Albert Museum. Londonderry: University of Ulster, Magee College. New York: Public Library, Berg Collection. Oxford: Ashmolean Museum. Sligo: Model and Niland Centre. Washington, DC: Corcoran Gallery of Art; Smithsonian Institution, Hirshhorn Museum and Sculpture Garden. Waterford: City Hall, Municipal Art Collection.

Literature: *Notes on the Origin and Early History of the Dublin Sketching Club*, typescript, n.d.; *Dublin Sketching Club Minute Book*, 1883; W. B. Yeats, *Mosada*, Dublin 1886 (illustration); Standish O'Grady, *Finn and His Companions*, London 1892 (illustrations); W. B. Yeats, *The Celtic Twilight*, London 1893 (illustration); George A. Aitken, ed., *Romances and Narratives by Daniel Defoe*, London 1895 (illustrations); Frederick Langbridge, *The Dreams of Dania*, London 1897 (illustrations); W. B. Yeats, *The Secret Rose*, London 1897 (illustrations); *A Loan Collection of Pictures by Nathaniel Hone and John Butler Yeats*, catalogue, Dublin 1901; *The Studio*, December 1901, May 1903; *The Celt*, September 1903; Algernon Graves, *The Royal Academy of Arts 1769 to 1904*, London 1905; *The Shanachie*, no. 2, 1906 (illustration), March 1907 (illustrations); *The National Gallery British Art Catalogue*, London 1908; *Irish Review*, June 1911 (illustration); W. B. Yeats, *Poems*, London 1913 (illustration); John Butler Yeats, *Essays Irish and American*, Dublin 1918; Lennox Robinson, ed., *Further Letters of John Butler Yeats*, Dundrum 1920; Lady Gregory, *Hugh Lane's life and achievement, with some account of the Dublin galleries*, London 1921; John Butler Yeats, *Early Memories: Some Chapters of Autobiography*, Dundrum 1923; Thomas Bodkin, 'John Butler Yeats, RHA', *Dublin Magazine*, January 1924; October-December 1941; P. L. Dickinson, *The Dublin of Yesterday*, London 1929; Thomas Bodkin, *Hugh Lane and his Pictures*, Dublin 1932; *Studies*, March 1939; Joseph Hone, *W. B. Yeats 1865-1939*, London 1942; *Capuchin Annual*, 1943 (illustration); *Irish Press*, 29 October 1948; Allan Wade, *A Bibliography of the writings of W. B. Yeats*, London 1951; Roger McHugh, ed., *W. B. Yeats Letters to Katharine Tynan*, Dublin 1953; Padraic Colum, 'My Memories of John Butler Yeats,' *Dublin Magazine*, October-December 1957; National Gallery of Ireland, *W. B. Yeats: A Centenary Exhibition*, catalogue, Dublin 1965; Mary Colum, *Life and the Dream*, Dublin 1966; William M. Murphy, *The Yeats Family and the Pollexfens of Sligo*, Dublin 1971 (also illustrations); William M. Murphy, ed., *Letters from Bedford Park: a selection from the correspondence (1890-1901) of John Butler Yeats*, Dublin 1972; James White, *John Butler Yeats and the Irish Renaissance*, Dublin 1972 (also illustrations); Douglas N. Archibald, *John Butler Yeats*, Lewisburg 1974; *Irish Times*, 6 March 1975; Mrs Caroline H. Fish, *Letter to the author*, 1976; Robert Gordon, *John Butler Yeats and John Sloan: the records of a friendship*, Dublin 1978 (also illustrations); William M. Murphy, *Prodigal Father: The Life of John Butler Yeats (1839-1922)*, Ithaca 1978; *Irish Arts Review*, Winter 1985; Ann M. Stewart, *Royal Hibernian Academy of Arts: Index of Exhibitors 1826-1979*, Dublin 1987; Ashmolean Museum, *Letter to the author*, 1995; also, Crosby Library, 1995; Hood Museum of Art, 1995; King's Inns Library, 1995; John Turpin, *A School of Art in Dublin since the Eighteenth Century*, Dublin 1995 (illustrations); Hilary Pyle, *Yeats: Portrait of an artistic family*, London 1997 (illustrations); Ann M. Stewart, *Irish Art Societies and Sketching Clubs: Index of Exhibitors 1870-1980*, Dublin 1997; National Gallery of Ireland, *Gallery News*, March-May 1999.

YEATS, LOLLY - see YEATS, ELIZABETH C.

YOUNG, MABEL (1889-1974), landscape painter.

Mabel Florence Young was the youngest of seven children, born on 18 August 1889 at 3 Union Street, Ryde, Isle of Wight. Her father, William Henry Young, ran a 'general posting establishment, and dealer in horses, carriages, and harness etc'.

In 1914 she travelled to Dublin to assist a sister who was housekeeping manager at the Shelbourne Hotel. At Easter 1916 another sister travelled from England for a few days holiday. With an hour or two to spare, Mabel decided to show her Phoenix Park but discovered for their return journey that all trams had stopped. Fighting had broken out in the city centre. However, afternoon tea continued in the Shelbourne dining-room until a bullet entered obliquely through the bay window.

In 1922, according to Elizabeth Bowen's history of the Shelbourne, a Civil War shot went through the window of Mabel's sitting-room and buried itself in the wall behind the canary's cage.

In 1924 she met Paul Henry (q.v.) when holidaying in Enniskerry, Co. Wicklow, and on taking up painting became his pupil, managing to retain her own artistic individuality with a quiet style. They went to live at Carrigoona Cottage, Kilmacanogue, Co. Wicklow. She particularly enjoyed painting trees and the landscape of Wicklow county, from cherry blossom to snow scenes.

In 1928 she exhibited for the first time at the Royal Hibernian Academy, and from then until 1961 showed a total of thirty-two works. She contributed *Sugar Loaf Mountain* in 1928, *In the Mourne Mountains* in 1933, and, indicating a visit to the French Riviera, *The Flowers Market – Menton* in 1940. She had also participated in the 1932 Aonach Tailteann exhibition of Irish art and that year had shown *The Horse Pond* at the

Oireachtas. In 1933 she exhibited three works at the Ulster Academy of Arts: *Azalia*; *Affaires de Cuisine*; *The Copper Pot*.

Mabel Young held an exhibition of oils and watercolours at the Shelbourne Hotel in 1940, and in her show there in 1942 *The White Rocks, Killarney* was listed. She also exhibited at Combridge's Galleries, Dublin. So far as exhibition dates are concerned, some of the catalogues are incomplete, for example dates without the year, but one catalogue examined, listing twenty-five oil paintings and twenty-seven watercolours – including *Mountains Above Luggala* – had neither date nor place. In 1944 she contributed *An Abha* to the Oireachtas exhibition. She showed three more works at this event; *Beech Trees* in 1946.

Early business training, but apparently not for art catalogues, made her an invaluable helpmate when Paul Henry's sight failed and he could only dictate the memoirs of his long life. The autobiography, *An Irish Portrait*, appeared in 1951, and in his acknowledgements he singled out Mabel Young 'whose care and patience have made this book possible, and to whom it is dedicated'.

In 1951 at the RHA her contributions included a Co. Mayo landscape, *Croagh Patrick*. Among fine art reproductions of her work were *Evening Sunlight in Wicklow*; *Morning Glory*; and *Sentinels*. On the death of Grace Henry (q.v.), his first wife, in 1953 she married Paul Henry, and that year, now living at 1 Sidmonton Square, Bray, Co. Wicklow, she was represented in the Contemporary Irish Art exhibition at Aberystwyth. She had also held exhibitions in London and New York, according to that catalogue; later biographical information added Cork and Toronto.

In 1953 she showed with Paul Henry and Jean Renard in the An Tóstal exhibition of paintings and sculpture at the International Hotel, Bray. The catalogue note, after referring to her sympathetic painting of trees, added: 'The quiet reaches of the Dargle River where the wild fowl seem to take part in the lyricism of the scene, or the wild approaches to the Wicklow Glens are evidence of her surprising wealth of imaginative but still wholly reasonable monument to the Garden of Ireland.'

The final offering to the Oireachtas exhibition was *Meanma an Earraigh* in 1958. *The Open Road* in 1961 ended the contributions to the RHA, but in 1962 she had a one-person show at the Ritchie Hendriks Gallery in Dublin where *Michaelmas Daisies* was included. A flowerpiece, oil, is in the Hugh Lane Municipal Gallery of Modern Art along with *Autumn Beech Trees*, watercolour.

The *Irish Times* wrote that 'no critical fireworks could ever be expected to explode over her serene and truthful landscapes. But those who know their painting will always be glad to come across any example of what might have to be described as a minor talent, but which, within its own limitations and on its own terms, produced little short of perfection.' She died on 8 February 1974 at a private nursing home.

Works signed: Mabel Young.
Examples: Belfast: Department of the Environment for Northern Ireland. Dublin: Hugh Lane Municipal Gallery of Modern Art; Shelbourne Hotel. Limerick: City Gallery of Art.
Literature: *Kelly's Directory*, 1879; Isle of Wight Registration District, *Registration of Birth: Mabel Florence Young*, 1889; *Irish Times*, 8 November 1940, 9 November 1942, 9 February 1974; Elizabeth Bowen, *The Shelbourne*, London 1951; Paul Henry, *An Irish Portrait*, London 1951; An Tóstal, *Exhibition of Paintings and Sculpture*, catalogue, Bray 1953; *Contemporary Irish Art*, catalogue, Aberystwyth 1953; *Who's Who in Art*, Havant 1972; Seán McCrum and Gordon Lambert, editors, *Living with Art: David Hendriks*, Dublin 1985; National Gallery of Ireland and Douglas Hyde Gallery, *Irish Women Artists: From the Eighteenth Century to the Present Day*, Dublin 1987 (also illustration); Ann M. Stewart, *Royal Hibernian Academy of Arts: Index of Exhibitors 1826-1979*, Dublin 1987; Hugh Lane Municipal Gallery of Modern Art, *Letter to the author*, 1994; also, The Shelbourne, 1995; Ann M. Stewart, *Irish Art Societies and Sketching Clubs: Index of Exhibitors 1870-1980*, Dublin 1997.

SELECTED BIBLIOGRAPHY

General sources used in the preparation of this Dictionary; specific sources are cited with the individual artist entries.

Books

Anglesea, Martyn, *The Royal Ulster Academy of Arts*, Belfast 1981.

Bénézit, E., *Dictionnaire des Peintres, Sculpteurs, Dessinateurs et Graveurs*, Paris 1976.

Bodkin, Thomas, *Four Irish Landscape Painters*, Dublin 1920.

Bowe, Nicola Gordon, Caron, David and Wynne, Michael, *Gazetteer of Irish Stained Glass*, Blackrock 1988.

Boylan, Henry, *A Dictionary of Irish Biography*, Dublin 1978.

Boylan, Patricia, *All Cultivated People: A History of The United Arts Club, Dublin*, Gerrards Cross 1988.

Burke, Sir Bernard and Burke, Ashworth P., *Burke's Peerage and Baronetage*, London 1931.

Butler, Patricia, *Three Hundred Years of Irish Watercolours and Drawings*, London 1990.

Cahill and Co. Ltd., *Irish Art Handbook*, Dublin 1943.

Catto, Mike and Snoddy, Theo, *Art in Ulster:II*, Belfast 1977.

Chilvers, Jan and Osborne, Harold, editors, *The Oxford Dictionary of Art*, Oxford 1997.

Connor, Aileen C., *Aosdána*, Dublin 1996.

Cooper, Barbara and Matheson, Maureen, *The World Museums Guide*, London 1973.

Crookshank, Anne and Glin, The Knight of, *The Painters of Ireland c. 1660-1920*, London 1978.

Crookshank, Anne and Glin, The Knight of, *The Watercolours of Ireland*, London 1994.

Curtis, L. Perry Jr, *Apes and Angels: The Irishman in Victorian Caricature*, Newton Abbot 1971.

de Laperriere, Charles Baile, editor, *The Royal Scottish Academy Exhibitors 1826-1990*, Calne 1991.

Denson, Alan, *John Hughes, Sculptor 1865-1941: a documentary biography,* Kendal 1969.

Dickinson, P. L., *The Dublin of Yesterday*, London 1929.

Dolman, Bernard, editor, *A Dictionary of Contemporary British Artists, 1929*, Woodbridge 1981.

Glenavy, Beatrice Lady, *Today we will only Gossip*, London 1964.

Graves, Algernon, compiler, *A Dictionary of Artists who have exhibited works in the principal London exhibitions of oil paintings from 1760 to 1880*, London 1884.

Graves, Algernon, compiler, *The Royal Academy of Arts: A Complete Dictionary of Contributors and their work from its foundation in 1769 to 1904*, London 1905.

Hewitt, John and Snoddy, Theo, *Art in Ulster: I*, Belfast 1977.

Hill, Judith, *Irish Public Sculpture: A History*, Dublin 1998.

Houfe, Simon, *The Dictionary of British Book Illustrators and Caricaturists 1880-1914*, Woodbridge 1981.

Jarman, Angela, *Royal Academy Exhibitors 1905-1970*, Calne 1985, 1987.

Johnson, J. and Greutzner, A., *The Dictionary of British Artists 1880-1940*, Woodbridge 1976.

Kennedy, S. B., *Irish Art & Modernism 1880-1950*, Belfast 1991.

Larmour, Paul, *Belfast: An Illustrated Architectural Guide*, Belfast 1987.

Larmour, Paul, *The Arts & Crafts Movement in Ireland*, Belfast 1992.

McCrum, Seán and Lambert, Gordon, *Living With Art: David Hendriks*, Dublin 1985.

Mallalieu, H. L., *The Dictionary of British Watercolour Artists up to 1920*, Woodbridge 1976.

Miller, Liam, *Dolmen XXV, Dublin 1976.*

Miller, Liam, *The Dun Emer Press, Later the Cuala Press*, Dublin 1973.

Montgomery-Massingberd, Hugh, editor, *Burke's Irish Family Records*, London 1976.

O'Brien, Eoin and Crookshank, Anne, *A Portrait of Irish Medicine*, Swords 1984.

Osborne, Harold, editor, *The Oxford Companion to Art*, Oxford 1970.

Peppin, Brigid and Micklethwait, Lucy, *Dictionary of British Book Illustrators: The Twentieth Century*, London 1983.

Shea, Patrick, *A History of the Ulster Arts Club*, Belfast 1971.

Sheehy, Jeanne, *The Rediscovery of Ireland's Past: the Celtic Revival 1830-1930*, London 1980.

Stewart, Ann M., compiler, *Irish Art Societies and Sketching Clubs: Index of Exhibitors 1870-1980*, Dublin 1997

Stewart, Ann M., compiler, *Royal Hibernian Academy of Arts: Index of exhibitors and their works, 1826-1979*, Dublin 1986, 1987.

Strickland, Walter G., *A Dictionary of Irish Artists*, Dublin 1913.

Sunderland, John, editor, *A checklist of painters c. 1200-1976 represented in the Witt Library, Courtauld Institute of Art, London*, London 1978.

Turpin, John, *A School of Art in Dublin since the Eighteenth Century*, Dublin 1995.

Walker, Dorothy, *Modern Art in Ireland*, Dublin 1997.

Walker, J. Crampton, *Irish Life and Landscape*, Dublin 1927.

Water Colour Society of Ireland, *Water Colour Society of Ireland Exhibition List 1872-1994*, Dublin 1995.

Waters, Grant M., *Dictionary of British Artists Working 1900-1950*, Eastbourne 1975.

White, James and Wynne, Michael, *Irish Stained Glass*, Dublin 1963.

Wood, Christopher, *The Dictionary of Victorian Painters*, Woodbridge 1978.

Catalogues

Barrett, Cyril, *Irish Art 1943-1973*, Cork 1980.

Campbell, Julian: National Gallery of Ireland, *The Irish Impressionists: Irish Artists in France and Belgium, 1850-1914*, Dublin 1984.

Finlay, Sarah, *The National Self-Portrait Collection of Ireland*, vol. I, 1979-1989, Limerick 1989; supplementary catalogues, 1990-1995.

Hewson, Michael, *National Library of Ireland Catalogue of Irish Topographical Prints and Original Drawings*, Dublin 1975.

Kennedy, Brian, editor, *A Concise Catalogue of the Drawings, Paintings & Sculptures in the Ulster Museum*, Belfast 1986.

Kennedy, Brian, compiler, *A Catalogue of the Permanent Collection: Twentieth Century Sculpture, Ulster Museum*, Belfast 1988.

Lane, Hugh P. and London, Corporation of, *Catalogue of the Exhibition of Works by Irish Painters*, London 1904.

Le Harivel, Adrian, compiler, *National Gallery of Ireland Illustrated Summary Catalogue of Drawings, Watercolours and Miniatures*, Dublin 1983.

Le Harivel, Adrian, editor, *National Gallery of Ireland Illustrated Summary Catalogue of Prints and Sculpture*, Dublin 1988.

Le Harivel, Adrian and Wynne, Michael, *National Gallery of Ireland Acquisitions 1982-83*, Dublin 1984; *Acquisitions 1984-86*, Dublin 1986; *Acquisitions 1986-88*, with other contributors, Dublin 1988.

Loftus, Belinda, compiler, *Marching Workers*, Belfast 1978.

Murray, Peter, compiler, *Illustrated Summary Catalogue of The Crawford Municipal Art Gallery*, Cork 1991.

National Gallery of Ireland and Douglas Hyde Gallery, *Irish Women Artists: From the Eighteenth Century to the Present Day*, Dublin 1987.

O'Connor, Patrick, *Municipal Art Gallery, Dublin*, Dublin 1958.

Potterton, Homan, Le Harivel, Adrian and Wynne, Michael, compilers, *National Gallery of Ireland Illustrated Summary Catalogue of Paintings*, Dublin 1981.

Potterton, Homan and Wynne, Michael, *National Gallery of Ireland Exhibition of Acquisitions 1981-82*, Dublin 1982.

Purser, Sarah H., *List of the Principal Stained Glass Windows Executed in Ireland from 1903 to 1928 at An Túr Gloine*, Dublin [1928].

Pyle, Hilary, *Irish Art 1900-1950*, Cork 1975.

White, James and Cullen, Fintan: National Gallery of Ireland, *The Abbey Theatre 1904/1979*, Dublin 1980.

Periodicals

Bell, The, 1940-54.

Capuchin Annual, The, 1930-77.

Cork Holly Bough, 1935-75.

Dublin Art Monthly, October 1927-March 1928.

Dublin Magazine, The, 1923-58.

Envoy, 1949-51.

Ireland of the Welcomes, May 1952-December 1973.

Ireland To-Day, 1936-38.

Irish Arts Review, 1984-87; *Yearbook*, 1988-90.

Irish Review, The, 1911-14.

Shannonside Annual, The, 1956-60.

Studies, 1912-84.

Studio, The, 1893-1953.

Wolfe Tone Annual, 1932-62.

GENERAL INDEX OF ARTISTS' NAMES

Note: Page references in **bold** indicate principal entries for *Irish Artists*